The New York Times
Film Reviews
1993–1994

The New York Times
Film Reviews
1993–1994

𝕿𝖎𝖒𝖊𝖘 BOOKS / ⒢ℙ

Times Books & Garland Publishing, Inc. / New York 1996

Ref
PN
1995
N4
1993/94

Copyright © 1993, 1994 The New York Times Company

Copyright © 1996 The New York Times Company

Library of Congress Catalog Card Number: 70-112777

ISSN 0362-3688
ISBN 0-8240-7593-5

Manufactured in the United States of America

Contents

Foreword

In 1970, THE NEW YORK TIMES FILM REVIEWS (1913–1968) was published. It was a five-volume set, containing over 18,000 film reviews exactly as they first appeared in The Times.

The collection was accompanied by a sixth volume, an 1,100-page computer-generated index, which afforded ready access to the material by film titles, by producing and distributing companies, and by the names of all actors, directors, and other persons listed in the credits.

Further volumes appeared in 1971, 1973, 1975, 1977, 1979, 1981, 1983, 1988, 1990, 1992, and 1993 reproducing the reviews that were printed in The Times during the years 1969–1970, 1971–1972, 1973–1974, 1975–1976, 1977–1978, 1979–1980, 1981–1982, 1983–1984, 1985–1986, 1987–1988, 1989–1990, and 1991–1992; the present volume carries the collection through 1994. The index as originally conceived was incorporated into the 1969–1970, 1971–1972, 1973–1974, 1975–1976, 1977–1978, 1979–1980, 1981–1982, 1983–1984, 1985–1986, 1987–1988, 1989–1990, 1991–1992 volumes and the present volume.

New compilations will be published periodically to keep the collection constantly updated.

BEST FILMS

Articles listing the best and award-winning films published in The Times appear at the end of each year's reviews. These include the awards of the Academy of Motion Picture Arts and Sciences and the "best films" selections of The New York Times and the New York Film Critics Circle.

The New York Times
Film Reviews
1993

FILM VIEW/Caryn James

Assaying Holiday Movies: After the Pitch, the Reality

LIKE EXQUISITELY WRAPPED presents, movie previews tantalize audiences in the weeks before Christmas with wild expectations — passionate stories, comic surprises, visual candy. But c'mon, were we born yesterday? We've all been in audiences where previews have been greeted with hoots and snickers ("The most frightening words on earth...LAWNMOWER MAN!"). We all try to read between the scenes.

Because this is the season for returning presents, here is a guide to some of the inescapable holiday-movie previews: what they wanted to promise, what they really promised, what they delivered. Sometimes the spin that marketers put on their movies spins right out of control.

'Lorenzo's Oil'

The pitch: Warm, uplifting family story. The pictures tell it all in this trailer, which has no dialogue, only solemn music over scenes from the movie. As Susan Sarandon and Nick Nolte desperately seek a cure for their sick little boy, doctors frown, Mr. Nolte howls in despair, Ms. Sarandon pores over large medical books. "When all hope seems lost," reads the ad line on screen, "some people look for miracles."

The message: Cloying, sentimental family story in which a husband and wife not only cure their child, but do it without speaking a single word to each other. But what does the title mean? Is this a movie or a salad dressing?

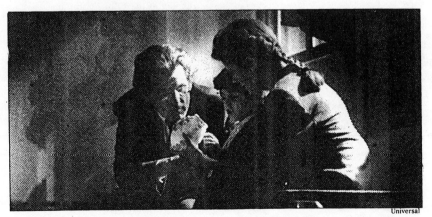

Universal

Salad Days *"Lorenzo's Oil," with Nick Nolte, Zack O'Malley Greenburg and Susan Sarandon—Promise: a warm family tale. Reality: totally different.*

The reality: Totally different, more like "Cries and Whispers" with a child. This tough, well-made movie is grueling to sit through, as little Lorenzo suffers through the effects of a debilitating disease, eventually losing his ability to move and speak. The parents are heroic; the uplift is very little, very late.

The no-dialogue trailer (also a favorite ploy for foreign films) disguises the fact that Mr. Nolte speaks with a thick Italian accent. But the title finally makes sense. The story *is* about salad dressing, which figures in the treatment for Lorenzo's disease.

Now comes judgment day, when movies can be seen for what they are, not what we were told they would be or thought they would be.

'Used People'

The pitch: "A family is like peanut brittle," an off-screen voice says in the trailer. "It takes a lot of sweetness to hold all the nuts together." Shirley MacLaine is unappreciated by her family but courted by Marcello Mastroianni, who kisses her while they stand in a fountain. Kathy Bates plays a sad, overweight woman and Jessica Tandy a tart-tongued older woman.

The message: Warning! Danger! A family is like peanut brittle?! Maybe the actors can save this film from lethal cuteness. Another possibility: maybe this is "Fried Green Tomatoes II" and they forgot to tell us.

The reality: The actors yell their way through trademark routines, saddled with a hopelessly predictable script. Marcello, how did it come to this?

'A Few Good Men'

The pitch: The Jefferson Memorial. Jack Nicholson's voice: "We follow orders, son. We follow orders or people die." Close-up of Jack Nicholson. Close-up of Tom Cruise. Everyone is in military uniform, including Demi Moore. Everyone is in a courtroom. Everything is terse.

The message: Stars chew up the scenery in a claustrophobic new version of "The Caine Mutiny." Jack Nicholson is always fun to watch, but the snooze level for this one could be high.

The reality: A terrific surprise, full of wit (though the trailer has none) and great performances. Mr. Cruise is natural and understated, though the scenes chosen for the preview make his acting seem overwrought. And much of this absorbing courtroom dra-

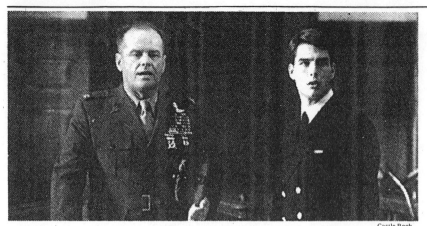

Castle Rock

Naval Combat *"A Few Good Men," with Jack Nicholson and Tom Cruise—Promise: stars in uniform, chewing up scenery. Reality: great performances.*

ma takes place outside the courtroom. A truth-in-advertising note to Nicholson fans: this role belongs in the best *supporting* actor category. A good portion of his performance can be seen in the trailer.

'Toys'

The pitch: A trailer that made fun of trailers featured Robin Williams standing in a wheat field, letting loose with a comic riff on the idea of "Toys," like "Toyz N the Hood" and "The Toyminator." This preview, which was everywhere for months, purposefully said nothing about the movie.

The message: Robin Williams. Trust us.

The reality: The alluring trailer brought expectations way up; the movie lets them crash. Here is a restrained Robin Williams in a curiously unengaging film, art-directed to within an inch of its life. Mr. Williams's comic brilliance is buried under the mushy script that has him playing a toy maker determined to save the family business from the clutches of his warmongering uncle.

The preview's coyness was shrewd, but had its practical purpose, too; the film's special effects weren't in place until the last minute.

'Scent of a Woman'

The pitch: Al Pacino is an irascible, blind, retired Army officer. He berates Charlie, the nervous prep-school student hired to care for him, then unexpectedly whisks the young man off to New York for Thanksgiving weekend. "I don't know whether to shoot you or adopt you," the Pacino character finally admits.

The message: Is Mr. Pacino supposed to be quite this annoying? Is he going to overact for the whole film? And does anyone think he might actually shoot the kid?

20th Century Fox

Legume of Doom *"Used People," with Shirley MacLaine and Marcello Mastroianni—Promise: a family like peanut brittle. Reality: trademark routines.*

The reality: Mr. Pacino's performance is much smarter and the movie more watchable than the preview makes you fear. Chris O'Donnell, as Charlie, is charming. This film proves there is some perverse value in an irritating trailer; when expectations are low, the movie can't disappoint.　　　□

1993 Ja 3, II:9:1

Critic's Notebook

At Wits' End: Algonquinites in Hollywood

By CARYN JAMES

BY 1935, Dorothy Parker had abandoned the life of a New York sophisticate for that of a Hollywood screenwriter, but the sunshine did nothing to mellow her caustic outlook. As she wrote in a letter back east to Alexander Woollcott, her friend from the old days of the Algonquin Round Table, "Aside from the work which I hate like holy water, I love it here." It was the kindest thing she ever said about writing for the movies.

About the same time, George S. Kaufman, the quintessential Broadway playwright, wrote to a friend, "I'm going to Hollywood, God damn it, this Saturday, but only for a few weeks." He was true to his word, which went a long way toward saving his self-respect.

For while Parker, Kaufman, Woollcott and Robert Benchley — the core group of writers who gathered daily for lunch at the Algonquin Hotel in the 1920's — were not big on matters of faith, there were a few things they deeply believed in: wit, fame and the fundamental truth expressed in a telegram from their pal Herman Mankiewicz. Soon after arriving in Hollywood as a screenwriter, Mankiewicz cabled Ben Hecht: "There are millions to be grabbed out here and your only competition is idiots. Don't let this get around."

The Algonquinites *hated* Hollywood, but that doesn't mean they weren't good at it. The proof is in "Tales of the Algonquin Round Table," a deliciously entertaining, extravagant series running at the Film Forum in the South Village from today through Feb. 18. The series includes about 50 features connected (sometimes in a glancing way) to the Algonquinites: great Hollywood valentines like "Dinner at Eight"; arty eccentricities like "The Scoundrel," with Noël Coward as the supercilious title character; the early screwball comedy "Laughter," and several programs of classic Benchley shorts, comic lectures like "How to Sleep" and "The Sex Life of the Polyp." All demonstrate that the Algonquin writers contributed richly to the movies in spite of themselves.

"The Ten-Year Lunch," Aviva Slesin's 1987 documentary (shown at matinees this weekend), offers a vivid introduction to the pre-Hollywood Round Table. They were journalists when they started out: Woollcott, the most influential drama critic of his day; Kaufman, the drama editor of The New York Times; Robert Sherwood, a film critic whose work pre-dated talkies; Benchley and Parker and Donald Ogden Stewart, essayists and critics for various magazines. They ate together, worked to-

Photofest

Robert Benchley in one of his film shorts, "How to Start the Day."

gether and, most important, quoted each other's remarks in print, and so became famous for being famously witty.

In "The Ten-Year Lunch," you can find the Round Table's best and best-known lines. Playing one of the word games the group loved, Parker was asked to use "horticulture" in a sentence and said, "You can lead a whore to culture but you can't make her think."

By 1929, the Round Table had disbanded, partly because so many had become successful on Broadway or, more frequently, in Hollywood.

Some, like Kaufman, took the movie money and ran. Though he worked on some film scripts — notably, "A Night at the Opera," having co-written "The Cocoanuts" and "Animal Crackers" for the Marx Brothers on Broadway — most of Kaufman's contributions to Hollywood came from the constant stream of hit plays he co-wrote, then surrendered to Hollywood studios and writers.

Several films based on his plays — "Dinner at Eight," "The Royal Family of Broadway," "The Man Who Came to Dinner" — are social satires that cozy up to the rich, only to discover that they are as wonderfully foolish as poor folk. (That, basically, is what the Algonquinites did in life, too.) But there is a refreshing current of cynicism in everything Kaufman touched. It was he, after all, who suggested that Irving Berlin change the line "I'll be loving you always" to "I'll be loving you Thursday."

"The Man Who Came to Dinner" (to be shown this weekend) was written by Kaufman and Moss Hart because they had promised Woollcott a play for him to star in. They created Sheriden Whiteside, a Woollcott clone and self-important curmudgeon, who breaks a hip while on a lecture tour

and takes over the house and lives of his nouveau riche host. As it happened, on stage and screen Monty Wooley played Whiteside with a great deal more heart than the insufferable Woollcott might have.

At least that's the conclusion to be drawn from seeing Woollcott on screen in the 1934 short "Mr. W.'s Little Game" (on a later program with "The Man With Two Faces," based on a Kaufman-Woollcott play). It isn't much of a film, but it is a fascinating biographical footnote. Playing himself, Woollcott sits in a restaurant and instigates a word game that he is certain, with his superior intellect, to win. His competitor is a blonde he calls Little Miss Birdbrain. Whatever charms Woollcott had in life — and he was said to be generous as well as insulting and vicious — they fail to come through on screen. His writing seems dated and shallow today, and the petty personality behind "Mr. W.'s Little Game" suggests why.

Woollcott usually stayed far away from the movies, but Hollywood has its revenge on the cautious Kaufman. When the actress Mary Astor was embroiled in an ugly custody suit, her ex-husband leaked parts of her diary to the press. There in print was the evidence of her love affair with Kaufman, including the detail that she considered him a "perfect" lover. Kaufman was in Hollywood when he was summoned to court in the case, but he escaped by hiding out in Moss Hart's house, then on Irving Thalberg's yacht, and then by sneaking onto a train back East, still on the lam.

The Astor diary was a tabloid scandal for weeks, and Kaufman was mortified. So you have to wonder why

the only film Kaufman ever directed, a dozen years later, was a comedy about tabloids competing to get their hands on a scandalous diary. In "The Senator Was Indiscreet" (1947), William Powell plays a genially corrupt Senator. "There's an old saying in my state," the Senator says. "If you can't beat 'em, bribe 'em." When he misplaces the dairy that recorded those bribes, tabloids scramble to find it, much the way they competed to publish the Astor diaries. Kaufman directs this without a wink at the audience.

As a film, "The Senator Was Indiscreet" is stiffly theatrical, with conspicuous painted backdrops. But as a satire (written by Charles MacArthur), it seems fresher than ever. Note the Senator's campaign banner that says: "Against inflation. Against deflation. For flation."

●

Kaufman obviously forgave Hollywood. Other Algonquinites like Parker and Benchley hated themselves for selling out their talent, and basically drank themselves to death.

Parker, who usually worked on scripts with her on-and-off husband, Alan Campbell, contributed little to movies that can be attributed to her with any certainty. Parker and Campbell wrote the screenplay for the 1937 version of "A Star Is Born," still a scathing look at Hollywood's destructive shallowness. But much of her work was additional dialogue and script doctoring. Much of the time, she wasn't sober. There is a story of Parker in Hollywood, weeping into her drink, "I used to be a poet."

Benchley was just as tortured. All his life he intended to write a historical book about Queen Anne, meaning to become a "serious" writer. He never knew that his contribution to the movies would remain enduring and wildly comic.

The dozens of shorts he began making in 1928 are parodies of lectures, with the ever-inept Benchley character explaining some banal experience. His discussion of "How to Start the Day" or "How to Behave" (when you're a houseguest, it doesn't pay to sleep till noon) are examples of deadpan wit at its best. In "Important Business," Benchley plays a businessman who tells his family and colleagues he is going to Washington on top-secret business. He actually goes to Washington, though he never gets beyond the train station. Self-importance was never so genially or sympathetically mocked.

●

The immense range and wealth of the Film Forum series comes with a catch: a broad definition of what the Round Table was, extending the group's reach to include peripheral members like Benchley, Hecht and MacArthur. But Bruce Goldstein, the Film Forum's repertory programmer, has created this series with his usual savvy sense. His generous definition reveals that the wry, sophisticated Algonquin spirit was often best expressed on film by artists who were not charter members of the Round Table.

Hecht and MacArthur and Mankiewicz contributed far more to the movies than any of the true Algonquinites. Not coincidentally (and despite Mankiewicz's telegram), they were not so snobbishly hostile to Hollywood. Their lesser-known films offer some of the best surprises in this series.

Mankiewicz's script for "Ladies' Man" (1931), with William Powell as

an unabashed gigolo involved with Carole Lombard *and* her mother, is a sharp, uncompromising period piece. The audience has no misconceptions about why the wealthy older woman allows Powell to sell her jewels and keep the cash. As in many films of the day, there is too much melodrama here; someone is always threatening suicide or pulling a gun to resolve romantic differences. But Mankiewicz's steely dialogue remains effective.

"If you're not going to marry me, I'll kill myself," Lombard tells Powell. "Are you going to marry me?"

Calmly, urbanely, Powell answers, "I don't think so."

●

Two little-known Hecht-MacArthur films are the most intriguing and cinematic in the series. In the mid-1930's, the team wrote, produced and directed several films, including "Crime Without Passion," in which Claude Rains plays a caddish lawyer who thinks he commits a murder out of jealousy. The film's editor, Slavko Vorkapitch, created a spectacular, surreal opening montage in which women representing the Furies fly up against New York skyscrapers while shattering glass falls around them. Later, as Rains tries to cover up his crime, he walks the streets mentally talking to himself in voice-over. There is an affection for the camera and the possibilities of film here that the true Algonquinites never possessed.

And the 1936 Hecht-MacArthur film, "The Scoundrel," may exemplify the Algonquin spirit best of all. Noël Coward, as a heartless, womanizing book publisher named Anthony Mallare, is the soul of cynical sophistication. Stepping out of the shower next to his office, Mallare tells his colleagues why he will not publish a sure best-seller. "It reeks of morality," he says contemptuously. "It's a vulgar way to swindle the public, selling them the things they least need — virtue and dullness."

Mallare comes to reject — through a laughable return from the dead — his own cold-hearted life. "The Scoundrel" ends bizarrely, as if "It's a Wonderful Life" were grafted onto an Oscar Wilde play. But until then, it offers glimpses of the Algonquin Round Table at its worst and best. The worst is personified by Alexander Woollcott in a cameo role. As an author-friend of Mallare, Woollcott suggests all the chic, empty cynicism of his set.

But you can say this for the multi-talented Algonquinites: They were never virtuous and never dull. They might have taken that as a great compliment.

1993 Ja 8, C1:1

Leprechaun

Written and directed by Mark Jones; director of photography, Levie Isaacks; edited by Christopher Roth; music by Kevin Kiner; production designer, Naomi Slodki; produced by Jeffrey B. Mallian, Michael Prescott, David Price and William Sachs; released by Trimark Pictures. Running time: 92 minutes. This film is rated R.

Leprechaun	Warwick Davis
Tory	Jennifer Aniston
Nathan	Ken Olandt
Ozzie	Mark Holton
Alex	Robert Gorman
J. D.	John Sanderford
Dan O'Grady	Shay Duffin
Pawn shop owner	John Volstad
Leah O'Grady	Pamela Mant
Sheriff Cronin	William Newman
Deputy Tripet	David Permenter
Dispatcher	Raymond Turner

By VINCENT CANBY

The title character in the new horror film titled "Leprechaun" is supposed to be fiendish but, though the movie's body count is respectable, he seems to be no more than dangerously cranky. That may be because the setting is rural North Dakota, which doesn't suit leprechauns, or because the screenplay and direction are amateurish, which doesn't suit films of any kind.

As played by Warwick Davis, the small English actor who appeared in the title role in George Lucas's "Willow," this leprechaun resembles Chucky of "Child's Play" dressed up for St. Patrick's Day, wearing little buckled shoes and little green-and-white ribbed stockings. He could have stepped off, or out of, a bottle of Irish whisky. He's mad and he's come to the States to retrieve his crock of gold, stolen by a tourist. The film, which opened here yesterday, is neither scary nor funny. It looks sort of empty and underpopulated, like North Dakota, though it was shot in southern California. It does feature what is possibly a movie first: a murder committed by a leprechaun riding a pogo stick.

●

"Leprechaun" is rated R (Under 17 requires accompanying parent or adult guardian). It has some vulgar language and simulated gore.

1993 Ja 9, 17:1

FILM VIEW/Caryn James

The Year of the Woman? Not in Movies

WRAPPING UP THE YEAR of the Woman, political observers found it chic to say it was only a slogan after all, a clever phrase somebody else invented. Did the pundits have a choice? To say anything else would be to claim that 1993 and every year after is Not the Year of the Woman.

But in Hollywood, where the belief in cosmetic solutions runs deep, paying lip service to women persists. Even while Oscar voters are scrambling to find five roles meaty enough to fill the best actress category, this year's Academy Awards show is being prepared. Its theme: "Oscar Celebrates Women and the Movies."

To appreciate the ludicrous nerve behind this, imagine a parallel situation. What if Bill Clinton had appointed no women to his cabinet and then declared that the inauguration theme would be "Celebrating Women and Government" (or blacks or Latinos or any other group still struggling for its share of mainstream power)?

■

The Oscars are never a good test of art, but that's another story. They are an excellent test of the opportunities women are getting in commercial movies, and 1992 was the year of the hidden woman.

Men are tripping over one another to fill the best actor category. Al Pacino, Jack Nicholson, Clint Eastwood, Denzel Washington, Tom Cruise, Jack Lemmon, Robert Downey Jr. — some will have to be cut out.

Meanwhile, Emma Thompson is considered a sure thing for best actress by default.

And though she deserves great honors for her deep and subtle performance in "Howards End," it's not as if she has much competition.

The names being tossed around include: Michelle Pfeiffer in "Batman Returns" and Geena Davis in "A League of Their Own," for roles that would not be considered "serious" enough in most years; Judy Davis for "Husbands and Wives," for a portrayal that would be a supporting role in a stronger year.

The interracial romance "Love Field" opened for a week in December to allow Ms. Pfeiffer to be eligible for an Academy Award, and John Sayles's "Passion Fish," which will be released nationally later this month, opened in New York in December so that Alfre Woodard and Mary McDonnell could also be considered. The films' distributors obviously saw a vacuum waiting to be filled.

Only Susan Sarandon is a typical nominee. As the mother determined to find a cure for her dying child in "Lorenzo's Oil," she has the kind of sober, intense role Oscar voters love. Still, no one would call this a good year for women on screen.

Part of the reason is nothing more than coincidence. But the narrow range of recent female characters suggests something more insidious at work, too: the Thelma and Louise backlash. The notoriety of "Thelma and Louise" should have inspired a slew of female-buddy, on-the-road, angry-women movies. Instead, "Thelma and Louise" tapped into such unexpected rage that it seems to have scared Hollywood to death. Rather than reaching for more female characters who are daring — or who are simply confused about their lives — mainstream films made a fast retreat to clichés.

In place of new Thelma and Louises on the rampage, Hollywood came up with the year's dominant female type: a crazed killer updated from the wicked women in 1940's films noirs. Sharon Stone in "Basic Instinct," Rebecca De Mornay in "The Hand That Rocks the Cradle" and Jennifer Jason Leigh in "Single White Female" have nothing to do with Thelma and Louise's unleashed fury and everything to do with easily controlled stereotypes in newfangled genre films.

Even when mainstream film makers try to break down female stereotypes, they do so fearfully. Hollywood's idea of a tough cookie is Melanie Griffith, who won two strong fe-

> ## It's a scramble to come up with five roles meaty enough to fill Oscar's best-actress category.

male roles and turned them to fluff. As the secretary turned spy in "Shining Through" and the New York detective in "A Stranger Among Us," she was bizarrely cast, as if to prove that strong women aren't really tough; they're just acting.

There have been exceptions that offer some hope. Allison Anders's "Gas Food Lodging" took a women's-film formula — a domestic story about a divorced mother and her two daughters — and gave it a sharp contemporary edge. It was a low-budget, independent hit.

Still, there are no simple cures for the scarcity of good female roles. To complicate matters, the killer-women movies were hits, which doesn't give film makers much motivation for heading in new directions.

The glib solution is that Hollywood needs more women in power. True enough, but there's no guarantee they would rethink women's roles. Penny Marshall was successful enough to get "A League of Their Own" made. As it happened, this story of a 1940's women's baseball team was a commercial success, but more predictable than "Big" (her best film) or "Awakenings."

There is another possibility. Everyone in Hollywood could rethink women's roles. Was there some reason why the computer hackers in "Sneakers" were all men, and that Mary McDonnell played the female sidekick, called into action only when the boys needed a Mata Hari?

The Oscar people (who haven't announced details about the show yet) will have no trouble exploiting the wealth of women's contributions to movies of the past. But it's no help to look back wistfully to the days when Katharine Hepburn and Ginger Rogers were given roles to kill for instead of killer roles. There is money to be made in movies about new women as well as familiar ones, and there's only one way for Hollywood to find the next Thelma or Louise. Stop playing it safe. □

1993 Ja 10, II:11:1

Money Man

Directed by Philip Haas; director of photography, Tony Wilson; edited by Belinda Haas; music by Philip Johnston; produced by Philip and Belinda Haas; released by Milestone Films. At the Film Forum 1, 209 West Houston Street, South Village. Running time: 60 minutes. This film is no rating.

The Singing Sculpture

Directed and produced by Philip Haas; director of photography, Mark Trottenberg; edited by Belinda Haas; released by Milestones Films. At the Film Forum 1, 209 West Houston Street, South Village. Running time: 20 minutes. This film has no rating.

BY STEPHEN HOLDEN

J. S. G. Boggs, the subject of Philip Haas's intriguing documentary film "Money Man," is an artistic provocateur whose chosen form of expression is the creation of homemade currency. His hand-drawn bills, while not strictly counterfeit, look enough like the real thing to have alarmed the authorities in several countries. In Australia and England he has been arrested for counterfeiting but later acquitted of the charges. And in 1991, the Secret Service seized 15 of his bills in a hotel room in Cheyenne, Wyo. The agency, while declining to prosecute, refused to return the bills, which the artist prefers to call "notes."

More than a superb draftsman, Mr. Boggs is an ingenious Conceptual artist whose finished works, which he calls "transactions," require the participants to re-think basic notions about money, art and value. He doesn't consider one of his works complete until he has "spent" one of his fake bills and received real currency in exchange. The bills themselves often have whimsical touches, like his signing of his own name as Secretary of the Treasury, or his initialing the back of a one-faced bill with a thumb print.

"Money Man," which opened today at Film Forum 1, follows the artist on a motorcycle trip from his home in Pittsburgh to Washington, where he hopes to retrieve the notes that were confiscated in Cheyenne. Like Michael Moore, who tried futilely to interview the president of General Motors for his film "Roger and Me," Mr. Boggs is portrayed in this film as a pesky seeker of truth and justice going up against a chilly, evasive bureaucracy. He is also, as a reporter who accompanies him to a meeting with a representative of the Secret Service puts it, "a small, annoying gnat" to that bureaucracy.

The film's liveliest scenes show Mr. Boggs trying, with varying degrees of success, to complete "transactions" with potential buyers who range from the manager of an arts supply store to a postal clerk. The artist has refined a clever spiel to explain the purpose of his work. It forces people, he explains, to consider the processes that determine the value of an object. It also subverts the art-world establishment by eliminating the middle man.

On occasion, Mr. Boggs can sound like a grandiose crank. If forced to stop doing what he does, he maintains, he would become a "prisoner."

In a fascinating side trip that is unconnected to his quest for his notes, Mr. Boggs visits the Bureau of Engraving and chats with an artist executing the master engraving for a $20 bill. The engraver says he sees himself as a fine artist doing a "re-interpretation" of another artist's work.

•

Mr. Haas's sympathetic portrait of Mr. Boggs has an aim similar to Mr. Boggs's. With its many close-up shots of currency, both real and homemade, the film subverts the notion of money as a power tool by focusing on its visual beauty.

Mr. Haas's 20-minute film "The Singing Sculpture," which shares the bill with "Money Man," looks at the English conceptual artists Gilbert and George, whose work is in some ways even more subversive of conventional notions of art than Mr. Boggs's. In their work, "The Singing Sculpture," which they first presented at the Sonnabend Gallery in New York in 1971, they exhibited themselves in luminescent body makeup standing on a table and singing along with a 1930's recording by the English music hall team of Flanagan and Allen. "Underneath the Arches," the song they drone over and over while mechanically rotating on a table, is a deceptively cheery-sounding number about being homeless and having to sleep on cobblestones.

Speaking in a deadpan monotone, the pair spout high-minded theories about making art that is "about life." But the life they portray is an unhappy one. Their dreary, robotic performance evokes a treadmill existence of dashed hopes, numbing conformity and hopeless resignation. The subject of "The Singing Sculpture," both men insist, is coming to terms with and accepting being miserable.

1993 Ja 13, C16:3

Body of Evidence

Directed by Uli Edel; written by Brad Mirman; director of photography, Doug Milsome; edited by Thom Noble; music by Graeme Revell; production designer, Victoria Paul; produced by Dino De Laurentiis, Bernd Eichinger and Herman Weigel; released by MGM. Running time: 99 minutes. This film is rated R.

Rebecca Carlson	Madonna
Frank Dulaney	Willem Dafoe
Robert Garrett	Joe Mantegna
Joanne Braslow	Anne Archer
Andrew Marsh	Michael Forest
Dr. McCurdy	Charles Hallahan
Detective Reese	Mark Rolston
Detective Griffin	Richard Riehle
Sharon Dulaney	Julianne Moore
Jeffrey Roston	Frank Langella
Dr. Alan Paley	Jürgen Prochnow

By VINCENT CANBY

What to do about poor Madonna? After gaining screen credibility with sharp, funny performances in smallish roles in "Dick Tracy" and "A League of Their Own," and as the great mocking Queen Bee in her own documentary, "Truth or Dare," she lands back at square one in "Body of Evidence," a sluggish courtroom melodrama relieved only by unintentional laughter. As major corporate decisions go, "Body of Evidence" ranks with the Edsel. It's not going anywhere. As a movie, it looks as if it wanted to be "Basic Instinct," though it winds up more like "Ilsa, She-Wolf of the SS."

It's easy to understand why the actress thought there might be Madonna-like possibilities in Brad Mirman's screenplay. She plays Rebecca Carlson, a woman on trial for a murder in which she allegedly used her body as the lethal weapon. Her victim, who is seen only as a wide-eyed, somewhat surprised-looking corpse in the opening sequence, is a rich old fellow with an unreliable heart and a fondness for sex toys.

Robert Garrett (Joe Mantegna), the district attorney, is sure that Rebecca did willingly, and with full knowledge of the victim's frail ticker, have intercourse with him to the point of his death in a session that involved homemade porn videos, handcuffs and nipple clamps. There's also the matter of the $8 million Rebecca stands to inherit. When questioned about these embarrassing facts by Frank Dulaney (Willem Dafoe), the crackerjack lawyer she hires to defend her, all Rebecca can say is, "They've taken something good between two people in love and made it dirty."

Rebecca has an explanation for everything. When confronted by a witness who claims to have seen her sniffing cocaine, she proves that the white powder was really Chinese peony roots, which, as everyone within the film knows, are a naturally buffered asprin substitute.

•

"Body of Evidence" demonstrates the same teasing, rather parochial obsession with sadomasochistic game-playing that dominates the fantasies of Madonna's 1992 best-selling publishing phenomenon, "Sex," though without the book's redeemingly childlike, go-for-broke smuttiness. "Body of Evidence" is not a star's cannily packaged reveries. It means to be coherent both as a mystery story and as an odyssey of sexual liberation, but works as neither. It's not even blatant as a star vehicle. "Body of Evidence" is a movie that might actually have been better if the star had been more demanding. Perhaps the camera would have been more kind to her. Perhaps not.

"Body of Evidence" is not a movie for which the blame can be assigned

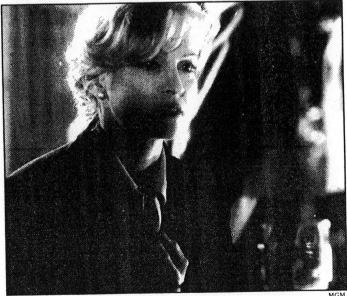

MGM

Madonna in a scene from "Body of Evidence."

by anyone who was not on hand before, during and after production. A lot of good people were involved, including Uli Edel, the German-born director who was responsible for the fine screen adaptation of "Last Exit to Brooklyn." His work here makes Paul Verhoeven, the man who directed "Basic Instinct," seem the equal of Orson Welles.

The movie, set in Portland, Ore., which often looks extremely European, cuts back and forth between the day's sessions in the courtroom, where Frank is defending Rebecca, and Rebecca's after-hours seduction of her strait-laced lawyer. Little by little, the talk of handcuffs, nipple clamps and such gets to Frank.

In their first furious sexual encounter, in the elegant houseboat Rebecca calls home, she slips off his belt and secures his arms behind him so that she can have her way, which involves pouring hot candle wax and Champagne onto his bare chest. Another confrontation takes place in a downtown Portland garage. The submissive Frank lies on the shards of a broken light bulb, atop the roof of an automobile, as the ravenous Rebecca pursues her goal. His shirt in shreds, his back bloodied, Frank appears to be both bewildered and ecstatic. The boys in the locker room never told him it could be like this.

•

In spite of all the thrashing around, very little heat escapes the screen, at least in part because Madonna and Mr. Dafoe, for whatever reason, don't seem made for each other. Mr. Dafoe is a good actor but not a very sensual one. He's an intellectual performer even at the peak of pleasure. For her part, Madonna just seems busy, like someone trying to follow directions on how to microwave a 25-pound turkey in six minutes.

There's also the matter of Madonna's screen persona. She's neither a great actress nor a ravishing beauty. She's a self-made personality of engagingly naked ambition and real if often raw wit. She has a sense of humor, also a particular gift for defining the camp sensibility. Forced to play more or less straight, she's at a loss. "Body of Evidence" is the kind of dopey movie that might work only with someone as stunning to look at as Sharon Stone, whose beautiful face in repose is sullen and sexy and not simply blank.

The terrible truth: Madonna doesn't look great in "Body of Evidence." She's been unflatteringly photographed most of the time. The sometime sex symbol is only evident in one quick scene in which she is lying naked on her stomach, receiving an acupuncture treatment. Spread out in this way, the torso is gorgeous. When she stands up, the torso seems to collapse into itself. The camera makes her appear dwarfish. She isn't helped by frumpy clothes and a hair style that suggests she would be all too at home with Ilsa and the other she-wolves of the SS.

But then, nobody in the movie comes off well. In addition to Mr. Mantegna, the supporting cast includes Anne Archer, Frank Langella, Jürgen Prochnow and Julianne Moore. "Body of Evidence" is so sloppily constructed that it comes as a shock when, late in the running time, it's learned that Ms. Moore is Frank's wife and not his girlfriend. The only believable character in the film is the trial judge who, as played by Lillian Lehman, is impatient, snappish and so reasonably intelligent that she

often seems on the verge of throwing the case out of court.

•

"Body of Evidence," which has been rated R (Under 17 requires an accompanying parent or adult guardian), has a lot of female nudity, simulated sex play and vulgar language.

1993 Ja 15, C3:1

Alive

Directed by Frank Marshall; screenplay by John Patrick Shanley, from the book by Piers Paul Read; director of photography, Peter James; edited by Michael Kahn and William Goldenberg; music by James Newton Howard; production designer, Norman Reynolds; produced by Robert Watts, Kathleen Kennedy and Bruce Cohen; released by Touchstone Pictures. Running time: 125 minutes. This film is rated R.

Nando Parrado	Ethan Hawke
Antonio Balbi	Vincent Spano
Roberto Canessa	Josh Hamilton
The Narrator	John Malkovich

By JANET MASLIN

"Alive," an account of plane-crash survivors who had to resort to cannibalism to last out their ordeal in the Andes, is a study in madness, not on the parts of the Uruguayan rugby players who are the film's principals but on those of the Hollywood film makers who felt this story had the makings of upbeat, big-budget entertainment. Sure enough, despite the air-bag potential of its subject matter, "Alive" is being marketed as yet another "triumph of the human spirit."

Indeed, as directed by Frank Marshall and written by John Patrick Shanley, "Alive" has a bright look and an inspirational tone, not to mention a tendency to sugarcoat its story's more ticklish aspects. Chief among these, of course, is the problem that confronted these stranded survivors once their supply of chocolate-covered peanuts ran out.

In the film, this preppy group (featuring Ethan Hawke, Vincent Spano and Josh Hamilton) is seen calmly weighing the nutritional options. They also wonder whether cannibalism might not be akin to Holy Communion and try to sound brave. ("Could you just promise if you eat me that you'll clean your plates? God bless you all!") They joke gamely ("Hey, I'll pay for the pizza if you go get it!") and wonder how their lost friends would have felt about making the ultimate sacrifice. And they finally decide that since the dead pilots are the cause of so much unpleasantness, they deserve to be served up first. The film makers, for their own sakes, should have worried about the implications of this last line of thought.

•

To be fair, Mr. Marshall and Mr. Shanley have approached this daunting story with what would have to be called good taste. The cannibalism is dealt with briefly and discreetly during the course of a long, low-key account. It is never gruesome and only occasionally risks becoming silly. (Mr. Hawke's Nando, the moodiest of the survivors and the one most resembling Matt Dillon: "You didn't take from my sister, did you? God, she was so beautiful!") Best of all, the frozen plane-crash victims are allowed to remain anonymous and are mercifully left lying face down in the snow.

Doug Curran

Ethan Hawke

The real problems of "Alive" have less to do with queasiness-inducing potential than with pacing. Based on Piers Paul Read's much more detailed book about these survivors' story, the film is slow and methodical to a fault. The ordeal lasted two and a half months, and the film seems to be showing its characters saying good night to each other 70-odd times, even when such scenes do nothing to move the story forward. Meanwhile, important episodes are often given short shrift and mixed in meaninglessly with routine events. Everything has equal weight.

Mr. Shanley's screenplay injects an element of pretension that would have worked better if the basic story had more vigor. His account is framed by glimpses of John Malkovich, who resembles none of the principals but is supposed to be one of them in older, wiser form. His description of the ordeal as a spiritual epiphany is often echoed during the main part of the story, but the film's young actors seem too bland to engage the audience on a philosophical level. Though they ask the big questions — "What's going to become of our innocence if we survive as cannibals?" — they manage to do so without urgency or passion.

"Alive" remains remarkably colorless, despite its difficult subject and the harrowing adventure it describes. Mr. Marshall, a co-producer of some Steven Spielberg films, seems more comfortable with big action sequences (the plane crash is terrifyingly rendered) and stunning mountain scenery than with his characters' personalities or private thoughts. So it is nearly possible, during long, scenic episodes in the snowy mountains (filmed by Peter James, and scored prettily by James Newton Howard), to forget what has really happened to the characters. They could almost be skiing.

•

"Alive" is rated R (Under 17 not admitted without accompanying parent or adult guardian). It has strong language, a disturbing plane crash and discreet scenes of cannibalism.

1993 Ja 15, C6:5

A Captive in the Land

Directed by John Berry; screenplay by Lee Gold, based on the novel by James Aldridge; director of photography, Pierre William

Glenn; edited by George Klotz; music by Bill Conti; production designer, Yurih Konstantinov; produced by Malcolm Stewart and Mr. Berry; released by Gloria Productions. At the Angelika Film Center, 18 West Houston Street, Greenwich Village. Running time: 96 minutes. This film has no rating.

Rupert Royce	Sam Waterston
Averianov	Aleksandr Potapov

By STEPHEN HOLDEN

John Berry's film "A Captive in the Land" is the perfect winter movie for people who can't get enough cold, snow, darkness and gloom. Set in northeast Siberia near the Arctic Circle, where much of it was filmed, it lards a taut, Jack London-like survival story with a sticky dollop of humanistic uplift.

When an American meteorologist (Sam Waterston), bumming a ride in an R.A.F. transport plane over the polar ice cap, spots some aircraft wreckage, he rashly insists on parachuting down with first aid. Upon landing, he finds only one survivor, a Soviet airman (Aleksandr Potapov) who is too badly injured to walk. Once they repair to the shell of the crashed plane, a storm closes in and shifts the position of the ice cap on which they are situated, all but dashing their chances of rescue. Eventually they give up hope of being found, and using the sun to guide them, set out on a desperate journey through the Arctic wilderness toward civilization.

Had it stuck to the stark physical realities of the situation, "A Captive in the Land," which opens today at the Angelika Film Center, could have been a gripping film. But the movie, which was completed before the crumbling of the Soviet Union, insists on lending the relationship between the American and the Russian a turgid metaphoric significance.

•

Because the Russian speaks some English, the two men are able to communicate. Although they find themselves at ideological loggerheads, they share a respect for literature (the Russian fills in the American on the ending of "The Sun Also Rises," the Hemingway novel he was reading before he became stranded). They both admire the Robert Burns poem whose words, "that man to man, the world o'er shall brothers be for a' that," serve as the film's epigraph.

In the screenplay by Lee Gold, the relationship seems contrived and not entirely credible. Mr. Waterston and Mr. Potapov do their best to transcend the stiffness of the dialogue, but many of the words would stick in any actor's throat. It is only without dialogue — laughing hysterically in a stir-crazy panic, or enjoying a rare ecstatic moment of Arctic sunshine — that their performances come alive.

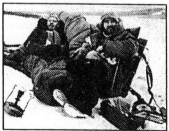

Gloria Productions

Aleksandr Potapov, left, and Sam Waterston in a scene from "A Captive in the Land."

"A Captive in the Land" has moments of real terror, as when the ice cracks in an earthquake-like rumble, nearly destroying their carefully insulated bunker. When another shift seals them from the air and they are threatened with asphyxiation, the film conveys a creepy sense of claustrophobia.

•

Even though the film makers went to the trouble of shooting on location in Siberia, "A Captive in the Land" conveys too little of a sense of the vastness and chill of the Arctic wilderness. And because the telling details of their day-to-day survival — how they eat, clean themselves and mark time — are left mostly unexamined, the physical distress of their situation remains largely overlooked.

The atmosphere is futher undermined by Bill Conti's pushy music, which treats every struggle as a feat of facile Hollywood heroics.

1993 Ja 15, C6:5

Nowhere to Run

Directed by Robert Harmon; screenplay by Joe Eszterhas, Leslie Bohem and Randy Feldman, based on the story by Mr. Eszterhas and Richard Marquand; director of photography, David Gribble; edited by Zach Staenberg and Mark Helfrich; music by Mark Isham; production designer, Dennis Washington; produced by Craig Baumgarten and Gary Adelson; released by Columbia Pictures. Running time: 90 minutes. This film is rated R.

SamJean-Claude Van Damme
ClydieRosanna Arquette
Mookie.......................................Kieran Culkin
Mr. Dunston..Ted Levine
Bree ...Tiffany Taubman
Lonnie...................................Edward Blatchford
Billy ..Anthony Starke
Franklin HaleJoss Ackland
Bus Driver..Allen Graf
Bus Guard................................Leonard Termo

By VINCENT CANBY

Jean-Claude Van Damme's "Nowhere to Run," which opened at theaters here yesterday, means to celebrate the star's crossing over from kickboxing melodramas, for which he is known, to more or less straight action dramas. The difference is not easily detected. The square-jawed, stony-faced Belgian-born actor is still at his best with one foot in the air.

The story is a little bit more benign than those of earlier Van Damme movies. Here he plays a misunderstood escaped convict who helps a pretty young widow (Rosanna Arquette) and her two small children save their farm from a vicious real-estate developer. In addition to the various action and chase sequences, "Nowhere to Run" features first Ms. Arquette and then Mr. Van Damme in a discreet nude scene, and a growing father-son relationship between Mr. Van Damme and Ms. Arquette's son, played by Kieran Culkin, Macauley's younger brother.

The film was directed by Robert Harmon from a screenplay whose contributors include Joe Eszterhas ("Basic Instinct"). Among the members of the supporting cast are Joss Ackland and Ted Levine. Though Mr. Van-Damme's collaborators have become more upscale and mainstream, "Nowhere to Run" remains your basic exercise in kick-him-in-the-groin, stab-him-with-a-pitchfork cinema politics.

This may be why several members of the Astor Plaza audience yesterday afternoon could not contain their merriment when, in the middle of the film, Mr. Van Damme's character identified himself as a lawyer.

•

"Nowhere to Run," which has been rated R (under 17 requires accompanying parent or adult guardian), has a lot of violence, some nudity and vulgar language.

1993 Ja 16, 16:5

FILM VIEW/Caryn James

Madonna's Best Role Remains Madonna

NO ONE DOUBTS THAT MADONna is a marketing genius, so how did she overlook the most obvious tie-in to her new movie? Right next to the popcorn counter at each theater showing "Body of Evidence," she should have put a little stand selling handcuffs, candles, belts and other playthings inspired by the film's on-the-edge (but cautiously R-rated) sex scenes. The Sex 'R Us concession is a wasted opportunity, but then movies are still the weak link in Madonna's otherwise flawlessly planned career.

As a suspense film, in which Madonna is accused of killing a rich older man using sex and drugs as the murder weapons — too much for his weak, diseased heart — it is possibly one of the worst ever made. But as a tongue-in-cheek Madonna movie, it's a hoot.

Who can keep a straight face when Madonna explains to her lawyer why the jury is out to get her? In the flat, matter-of-fact tone she uses throughout the film, she says: "The women hate me. They think I'm a whore. The men will get back at me for every chick who ever blew them off in a bar." Making a movie so bad that it's almost good is tougher than it seems, but "Body of Evidence" is just that entertaining. And it suggests what's wrong with Madonna's film career: she will never let her Madonna image go.

Part of the problem with "Body of Evidence" has nothing to do with Madonna and everything to do with a rock-bottom dreadful script. Madonna plays an art dealer in Portland, Ore., who looks like a bleached-blond floozy and lives on an extravagant houseboat. She swears she loved Andrew, who *wanted* to be handcuffed to the bed he died in and who lied about the seriousness of his heart condition. "I never know why men lie," she says. "They just do. Men lie."

Somehow that loopy plot and laughable dialogue attracted a wealth of wasted talent. Willem Dafoe plays Madonna's lawyer, who quickly tumbles into bed and hot sex with his client. It is literally hot because she drips melting candle wax on his body. The prosecuting attorney is played by Joe Mantegna, and you'd think such first-rate actors would make Madonna look good. Instead, they are dragged down to her level of flatness.

The director, Uli Edel, made the gritty, intelligent, powerful "Last Exit to Brooklyn" (1989). But here he is fond of clichés, like the hokey reaction shot in which Mr. Mantegna sits in the courtroom, frowning and biting a knuckle.

Everyone seems to be playing this bad movie straight. Yet Mr. Edel also shamelessly exploits Madonna's established image. Given such a laughable script, maybe that was the smartest thing he could do.

He must have recognized how many of the film's lines seem to belong to Madonna, not her fictional character. The art dealer she plays, Rebecca Carlson, is vilified as a "bad girl" because of her unconventional sexual attitudes. At times she becomes preachy about the harmlessness of sado-masochism

'Body of Evidence' may be short on suspense, but as a tongue-in-cheek vehicle for its star, it's a hoot.

between consenting adults.

"People here have very conservative views about sex," Mr. Dafoe says.

"No, they don't," Madonna answers. "They just don't talk about it."

At such times, "Body of Evidence" seems like the movie version of "Sex," Madonna's best-selling book of erotic photographs and writings, promoting the kind of sex games the film's heroine thrives on.

"It was different, but it was still making love," the movie-Madonna says of her handcuffed sex life, sounding much like off-screen Madonna defending "Sex" or the "Justify My Love" video.

"Body of Evidence" exists for the erotic scenes, including one on the hood of a car, and for the deadpan Madonna one-liners that owe quite a lot to Mae West. What were the deadly handcuffs doing in the house, Madonna is asked on the witness stand. "Andrew bought them for Valentine's Day," she says.

Andy Schwartz/Orion Pictures

In "Desperately Seeking Susan"—Her first role turned out to be her best.

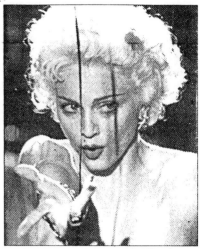

Peter Sorel/Walt Disney Company

In "Dick Tracy"—She was good at playing a cartoonish femme fatale.

Columbia Pictures

In "A League of Their Own"—As All-the-Way Mae, she clung to her image.

Throughout her career, Madonna has made noise about becoming a serious actress, and for a blip of time in 1988, when she appeared on Broadway in David Mamet's "Speed-the-Plow," she seemed headed in that direction. She got away with a shallow performance because she was playing an apparently shallow character, but at least she was not playing Madonna.

As "Body of Evidence" suggests, though, she has never yet lost herself in a screen character. Her best movie role is still her first. In "Desperately Seeking Susan," she erased the distance between her "fictional"

persona and her "nonfictional" one, much as she does in "Body of Evidence." But in 1985 that image was not as familiar as it is today. In fact, the movie helped establish the early lingerie-as-outerwear phase of her career.

Since then her film career has been a largely disastrous pattern of bad scripts and coy jokes. In "Shanghai Surprise" (1986), the joke was that she played against type as a missionary. Madonna did not sink this film alone; she had help from Sean Penn and the irredeemable script.

In the uneven screwball comedy "Who's That Girl?" (1987), she seemed game but too inexperienced to pull off her role as a brassy ex-con involved with Griffin Dunne and a cougar. The heroine's tough, platinum-haired look became the new Madonna look, too, making the distance between the movie Madonna and the nonscreen Madonna harder to believe in.

And though she dyed her hair black for her small part in last summer's "League of Their Own," she was still clinging to her image when she played "All-the-Way Mae," the man-crazy member of an all-women's baseball team.

It makes sense that she was good as Breathless Mahoney in "Dick Tracy" (1990) because the role called for the flatness and exaggeration of a cartoon character. Playing a cartoonish femme fatale, Madonna didn't have to make another whole person believable.

Of course, if Madonna were ready to become a serious actress right now, she wouldn't have made "Body of Evidence." ☐

1993 Ja 17, II:11:1

Critic's Notebook

Can Showy Gestures Fill In the Blanks?

By JANET MASLIN

WHEN Demi Moore paces furiously while talking into a cordless telephone during "A Few Good Men," she takes a big step forward in the name of busy behavior. Aficionados of showy, meaningless gestures have long appreciated both the purposeful walk and the commanding phone call, even before technological progress made it possible for these two maneuvers to be combined into such mega-bluster.

Now the free-range phone caller is sure to become a visual commonplace, just like the important executive who marches down the hall barking instructions to his briefcase-toting secretary. Conventional film-making wisdom insists that a mobile executive or a stalking courtroom lawyer has much more impact than one who is sitting still.

Action is supposed to be character, but examples like these prove otherwise. Busy action — fussy, distracting, indicative of nothing especially personal about the perpetrator — means the absence of character. It's what film makers fall back on when real personality traits aren't there. The more mundane or underwritten a screenplay, the more a director may be forced to rely on such gestures, no matter how empty they turn out to be. Busy behavior and its verbal counterpart, the trading of cute

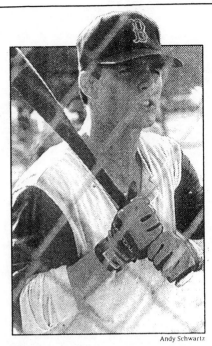

Andy Schwartz

Tom Cruise in "A Few Good Men."

wisecracks, are both popular and useful, since they create the illusion of activity when little is really going on.

Tom Cruise, Ms. Moore's co-star in the tirelessly busy "A Few Good Men," is a master of this sort of thing. Having often been given roles that rely on charm — he grinned and towel-snapped his way through "Top Gun" — he knows well how to fill in the blanks. As Daniel Kaffee, the military lawyer who leads the investigation on which the film is centered, Mr. Cruise has very little of substance to work with. He is of course brash, like a lot of contemporary young movie heroes. And he is brilliant, with the potential to turn into one heck of a good lawyer. But beyond that he's effectively an empty shell.

So Mr. Cruise, as energetically overdirected by Rob Reiner, is often seen with a baseball bat, feigning softball moves when anyone asks him a tough question. At one point he watches television while hugging a bat to his bosom; at another, he claims he can't think straight without his bat.

Freud aside, this is peculiar. So is the character's intrusive tendency to shoot hoops (using miniature indoor basketball apparatus) while preparing his legal briefs. Mr. Cruise even has a scene in which, upon meeting the special counsel played by Ms. Moore and sizing her up as a professional rival, he chomps noisily and defiantly on an apple. Here is the acid test for the busy gesture: Does it occur in nature? When was the last time you saw someone eat defiantly in ordinary life?

"A Few Good Men," which is overloaded with similar tics to disguise the paper-thin nature of its story, is hardly alone in resorting to such camouflage. The current so-so crop of leftover holiday movies offers many other prime examples of this tactic. "Forever Young," which is even fussier than "A Few Good Men," also incorporates a colorful eating scene, this one showing Mel Gibson frantically wolfing pie as he prepares to propose marriage. When working up his courage to propose, Mr. Gibson's daredevil aviator also talks nervously to himself, just as in "A Few Good Men" as she gets ready to ask for a choice assignment. What exactly does such behavior tell the viewer?

Only that the person talking nervously is in fact nervous.

Mr. Gibson's aviator makes his first entrance so furiously that he is greeted, as he steps off his plane, by a doctor, a news photographer, various airfield workers and an old friend. While he talks to the friend, the doctor tries to examine him with a stethoscope and a tongue depressor. This would be fine if "Forever Young" were a screwball comedy, but in fact it means to be a gentle (albeit gimmicky) romance. In that case, an entrance featuring a simple, quiet close-up would do the trick. But Steve Miner, the film's director, so favors cute, obvious touches that he introduces Jamie Lee Curtis's nurse by showing her burn dinner for a date, and ushers in two young boys with the none-too-startling revelation that they like junk food.

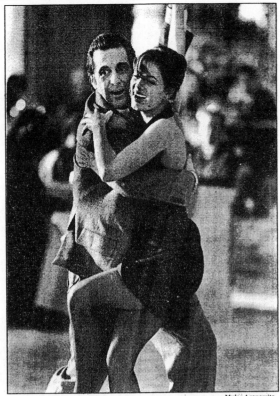

Myles Aronowitz

Al Pacino and Gabrielle Anwar tango in "Scent of a Woman."

Busy behavior like this is so easily achieved that there are whole films — like "Used People," the symphony of chattering, too-colorful relatives in outlandish costumes — that consist of little else. To some degree, it can be seen as an outgrowth of television, with its emphasis on bold, obvious

How on-screen busyness is used to conceal a role's lack of substance.

personality traits and a short attention span. Television commercials abound with thumbnail character portraits and attention-getting props; in that context, a baseball bat as conversational aid is nothing unusual. But these blunt touches have a numbing effect on would-be realistic conversation. And they're even worse when it comes to sex.

•

Busy sex, a relatively new phenomenon, is very visible onscreen at the moment. There are two films ("Used People" and "Body of Evidence") in which a woman amorously tortures a man with hot candle wax, for example. Yes, this is effective in conveying a certain sexual menace, but the relatively prop-free "Basic Instinct" got a lot more mileage out of taunting dialogue and plain, old-fashioned acting. Moving beyond the discreet silk scarf that was the chief sexual aid in "Basic Instinct," the deadly "Body of Evidence" piles on handcuffs, wax, nipple clamps and Madonna, all of which add up to absurd overkill. Willem Dafoe, cast in the ludicrous role of straight man, is never further out

on a limb than when he incurs busy-style injuries — wax burns, glass shards in his back — at the hands of his very busy co-star.

Is painful, acrobatic sex, as in "Body of Evidence" and also "Damage," any more meaningful than sex minus burns or splinters? Whatever the answer, it's clear that strenuous sex currently has greater cachet. But the emotions expressed in these films could have been communicated more simply, and probably more convincingly, without the strident tone or the excess baggage. Surely the intense attraction described in "Damage" could have been conveyed without the long, attention-getting silences and clumsy couplings on which the film relies.

The busiest performer on screen this season is Al Pacino, who spends all of "Scent of a Woman" showing off his blind lieutenant colonel's many mannerisms. Enjoyable as this behavior is — for busy acting is not without its redeeming pleasures — it has begun to seem largely superfluous by the time the film is over. The story's longest and most elaborate busy sequences have the colonel doing a tango and test-driving a Ferrari, for a combined screen time of about half an hour. Yet these two episodes essentially make the same point about the colonel's reawakening joie de vivre. And they also bring home a major liability of busy behavior: it's a form of padding. This becomes especially acute when few of the season's films dip below a two-hour running time.

•

"Lorenzo's Oil" is as busy as the best of them: it shows Nick Nolte and Susan Sarandon making charts and graphs, shuffling papers, collecting vegetables, even fashioning models of molecules by stringing paper clips together. From afar, this may sound showy, but it proves essential in con-

Juliette Binoche and Jeremy Irons in Louis Malle's "Damage."

veying both character and information. As the Odones, a couple determined to find a cure for their son's illness, these actors turn frantic behavior into a means of conveying their desperation. And the film's fussy-sounding touches are often visual aids for communicating big, difficult doses of scientific data.

Even when Mr. Nolte delivers his dialogue while cooking dinner — an endlessly popular pastime among the busy — the film turns the meal into a message. It indicates how worried this husband is about his wife's welfare, and how loving he can be under the most trying circumstances. Still, it's a reminder of the countless movie scenes in which a character opens a refrigerator for no particular reason, brings home groceries or whips up a meal while making small talk. It may appear that someone is busy in the kitchen when, in fact, nobody's home.

1993 Ja 22, C1:1

In Advance of the Landing

Produced and directed by Dan Curtis; based on the book by Douglas Curran; director of photography, Don Hutchison; edited by Kevin Schjerning; music by Fred Mollin; released by Cineplex Odeon Films Canada. At the Joseph Papp Public Theater, 425 Lafayette Street, East Village. Running time: 90 minutes. This film has no rating.

By VINCENT CANBY

Dan Curtis's "In Advance of the Landing," opening today at the Joseph Papp Public Theater, is a feature-length documentary about people in the United States and Canada who have taken rides in unidentified flying objects, have talked to space aliens, are preparing to welcome such aliens to earth or simply daydream about them. Mr. Curtis, the film's producer and director, takes a very benign view of his subjects. Though if he doesn't send them up,

it's probably because he knows he doesn't have to.

Among the people he interviews, some are more plausible than others. There's the bearded young man in northern Michigan who lives in the woods and broadcasts messages to outer space from what appears to be a quite elaborate transmitting station. He admits that he leads a solitary life. "You don't date someone for very long," he says, "without their finding out you're a little different."

Somewhat more flamboyant is the 90-year-old Southern California woman, the founder of a group called Unarius, which apparently is a kind of religion. Swathed in gold robes, holding a rose, she talks slowly about many things, including "our dear brother, Jesus of Nazareth," whom she met in passing in an earlier life. She reports that she has piloted many spaceships in her time, but "we call them star ships."

Several other people also discuss the rides they have taken, including one woman who, with some wit, notes how the aliens seem always to reflect the cultural characteristics of the country in which they are met. As described by the film's witnesses, the spaceships look very much like those in 1950's sci-fi movies, clips from which are shown in "In Advance of the Landing." Or, as one man reports, "the spaceships we see around here look like two soup plates put together."

•

Mr. Curtis gives equal time to the banal, the absurd and the freakish. The audience is shown a battery that is said to store "thought energy" that can be released on demand, and a domed building that when completed will restore missing body parts to humans. "It's already been successfully tested on animals," the guide says.

In these sections, "In Advance of the Landing" is clearly getting into a kind of nutty Southern California culture that long predates the U.F.O. hysteria of the 1950's. Because Mr. Curtis devotes the film entirely to his subjects, who do all the talking, the movie never considers the fact that, with a couple of exceptions, the witnesses are of an age to have had their obsessions shaped entirely in the 50's.

This was when the threat of nuclear holocaust was new, the cold war was becoming increasingly serious, and red-baiting was rampant. To be able to step inside a spaceship was to have the possibility of ascending into heaven, without going through the mess of actually dying. "In Advance of the Landing" is amusing, but it doesn't dig especially deep.

1993 Ja 22, C7:1

Bucharest Mavericks In Love

"The Oak" was shown as part of last year's New York Film Festival. Following are excerpts from Vincent Canby's review, which appeared in The New York Times on Oct. 1, 1992. The film (in Romanian with English

subtitles) opens today at Lincoln Plaza Cinemas, Broadway and 63d Street.

"The Oak" evokes a world that is completely alien to contemporary American experience. Though sometimes baffling, the film is never boring. To feel your way through it is like the exploration of a house of horrors in an amusement park in space. You can't be sure which way is up.

"The Oak" is the work of Lucian Pintilie, a Romanian film maker who has spent most of the last 20 years in exile, earning a formidable reputation as a director of innovative theatrical productions in France, Britain and the United States. This film, a French-Romanian co-production, is Mr. Pintilie's reaction to the 1989 collapse of the Communist regime in his country and his expectations for the future. It begins as a nightmare and ends with a vague expectation of the break of day.

The time is apparently prior to the overthrow of Nicolae Ceausescu in 1989. Among other things, "The Oak" is about the spiritual journey of Nela, a young schoolteacher, after the death of her father, a former big shot in the secret police, though you wouldn't know that he had ever been powerful from the opening scenes.

The two are living in epic squalor in a tiny flat in a Bucharest housing project. The place is a mess of unwashed dishes, soiled sheets and small mountains of cigarette butts. Nela and her father lie in bed, a 16-millimeter movie projector between them, watching home movies of a happier time: a small girl at her birthday party, running around and aiming a toy gun at guests, who dutifully topple over for her amusement.

Nela at first seems completely opaque. She reacts to her father's death as if he had been a lover. She's so possessive that she won't let her sister into the flat.

In the course of "The Oak," Nela accepts a job outside Bucharest, is gang-raped en route to the assignment, learns that her father was something less than a hero and meets a man who is, in his way, just as off the wall as she is. He is Mitica, a cheerfully sardonic doctor whose relations with the regime are not good.

Though Nela's is a spiritual journey, Mr. Pintilie dramatizes it in the bitter ways of social satire. The movie has the tempo of cabaret theater. It is wildly grotesque, shocking and sometimes very funny. The details are vivid. The authorities are alternately fearful, blundering and goodhearted. Late in the film, as Nela and Mitica reach some kind of understanding, Mr. Pintilie seems to suggest that there is still hope for Romania, though it's not just around the corner.

The two central roles are exceptionally well played by Maia Morgenstern (Nela) and Razvan Vasilescu (Mitica). She has the manner and force of a young Anna Magnani. He is an actor who can't help being seriously comic. That the movie doesn't always make sense to the English-speaking audience may be more of a reflection on the subtitles than on the original text of the film itself.

1993 Ja 22, C8:6

Hexed

Written and directed by Alan Spencer; director of photography, James Chressanthis; edited by Debra McDermott; music by Lance

Rubin; production designer, Brenton Swift; produced by Marc S. Fischer and Louis G. Friedman; released by Columbia Pictures. Running time: 90 minutes. Film rating: R.
Matthew Welsh..............................Arye Gross
Hexina..Claudia Christian
Gloria O'Connor.....................Adrienne Shelly
Detective Ferguson...............R. Lee Ermey
Herschel Levine..........................Norman Fell

By JANET MASLIN

For anyone who has ever dreamed of being a hotel desk clerk, "Hexed" describes the comic adventures of Matthew Welsh (Arye Gross), clerk extraordinaire. Matthew's Mittyesque life is filled with far-fetched escapades, since he enjoys borrowing clothes and cars from other parts of the hotel and masquerading as a man about town.

This fantasy life becomes dangerous when Matthew finagles a date with Hexina (Claudia Christian), a homicidal, world-famous model. Hexina, who appears in and out of a variety of skintight, zipper-laden outfits, is in town to murder a blackmailer. He has been threatening her with photos from the days when she was fat.

•

"Hexed," which opened yesterday at the Embassy 2 and other theaters, throws Matthew together with Hexina for a series of lukewarm comic episodes, breaking pace occasionally to incorporate more frantic satire. On one such occasion, Matthew and Hexina grapple furiously in Matthew's kitchen in a scene that recalls "Fatal Attraction," although the pained look on Matthew's face turns out to signify something other than sexual ecstasy. He has a fork stuck in his back.

Alan Spencer, who wrote and directed "Hexed," rarely works to his own best advantage. His screenplay is somewhat funnier than his direction, which often flattens the film's attempts at humor by making them unduly broad and vulgar. There are a couple of stupidly homophobic remarks. A throwaway sight gag about a Japanese banker eating a cake shaped like a map of the United States, for instance, is repeated until the cake is gone. And Hexina's demonic tantrums are allowed to become annoying. Even when the film strays into "Naked Gun" territory, as it occasionally does, the satire is too sloppy to be sharp.

•

Mr. Gross, whose deadpan manner verges on the glum, appears along with Adrienne Shelly, as the pert co-worker who really loves him, and Norman Fell as his bellowing boss. ("You know, you remind me of my own son," he tells Matthew. "That's not a compliment.") Also in the film is R. Lee Ermey, whose wild-eyed intensity is always welcome. As the detective investigating the case once Hexina turns murderous, he cheerfully tells a witness: "You can count on being in this room all night, little lady. I'm divorced, with no charisma. I've got nowhere to go."

•

"Hexed" is rated R (Under 17 requires accompanying parent or adult guardian). It includes nudity, profanity and sexual situations.

1993 Ja 23, 16:1

Knight Moves

Directed by Carl Schenkel; written by Brad Mirman; cinematographer, Dietrich Lohmann; edited by Norbert Herzner; produc-

Republic Pictures

On the Trail Tom Skerritt, right, and Daniel Baldwin play police officers in "Knight Moves," co-starring Christopher Lambert and Diane Lane. The action drama, directed by Carl Schenkel, deals with the hunt for a serial killer.

John Johnson/Hollywood Pictures

On the Slopes Paul Gross and Finola Hughes star in "Aspen Extreme," about two ski instructors and the fast-track life they lead in the Colorado resort. Written and directed by Patrick Hasburgh and based on his own experiences, the adventure film opens on Friday.

tion designer, Graeme Murray; produced t Ziad el-Khoury and Jean Luc Defait; released by Interstar. Running time: 111 minutes. This film is rated R.

Peter Sanderson.............Christopher Lambert
Andy Wagner.............................Daniel Baldwin
Frank Sedman.................................Tom Skerritt
Kathy Sheppard.................................Diane Lane

By STEPHEN HOLDEN

Carl Schenkel's thriller, "Knight Moves," which opened yesterday, is a film that should do nothing but enhance the image of professional chess as a sport for lunatics. Or as Peter Sanderson (Christopher Lambert), the main character, puts it darkly in one of the film's many howlers, "Chess is a reflection of the world, and the world is violent."

Peter, who knits his eyebrows in a continual scowl and speaks in a tense, slightly raised voice, is an international grandmaster who may or may not be a serial killer. In a confusing flashback, the film implies that he became unhinged as a boy after witnessing the gory suicide of his alcoholic mother. The bulk of the story is a cat-and-mouse game that Peter (and perhaps an accomplice) may or may not be playing with the police, who are investigating the murders. The mayhem coincides with an international tournament that takes place during an endless fake thunderstorm. The killings are accompanied by furious explosions of lightning and thunder.

•

Brad Mirman's screenplay is so caught in labyrinthine plot twists — solving the serial killings becomes a combination of chess and anagrams played with a mysterious telephone caller — that all the other elements of the story have been patched together in lumpy clichés. The worst are given to Diane Lane as a psychologist and police consultant who, in the film's most preposterous plot development, has an affair with the prime suspect.

"You have to face the things you feel," Ms. Lane explains to her lover at one point. Then, backing off, she says accusingly, "This is just another game, isn't it?"

"Knight Moves" plays so many games to keep the audience interested that when the solution is finally disclosed, it is a big letdown.

•

The film is rated R (Under 17 requires accompanying parent or adult guardian). It has nudity, violence and strong language.

1993 Ja 23, 16:3

Aspen Extreme

Written and directed by Patrick Hasburgh; edited by Steven Kemper; directors of photography, Steven Fierberg and Robert Primes; music by Michael Convertino; production designer, Roger Cain; produced by Leonard Goldberg; released by Hollywood Pictures; presented in association with Touchwood Pacific Partners 1. Running time: 115 minutes. This film is rated PG-13.

T. J. Burke .. Paul Gross
Dexter Rutecki.................................. Peter Berg
Robin Hand.. Teri Polo
Bryce Kellogg.............................Finola Hughes

By VINCENT CANBY

"Aspen Extreme," which opened at theaters here yesterday, is a cautionary tale with scenery about two young automotive workers from Detroit who become ski instructors in Aspen, Colo., but pay a terrible price for the glamorous lives they achieve.

T. J. Burke (Paul Gross), described as "gorgeous" by women who meet him, slips into the role of gigolo. He's beguiled, at least in part, by his benefactor's offer to advise him on which authors he should read to gain success as a writer. She apparently considers but discards the idea of starting him out on Proust. After one season on the slopes T. J.'s pal, Dexter Rutecki (Peter Berg), who smokes cigarettes anyway, is drinking hard liquor and sniffing cocaine.

Patrick Hasburgh, who makes his feature-film debut as the writer and director of "Aspen Extreme," is a ski enthusiast and former instructor who still knows more about skiing than

about movies. Even though it runs close to two hours, "Aspen Extreme" remains sort of stretched out and dramatically undeveloped.

•

The ski footage is often pretty, but it hasn't much to do with what happens in the movie before or après-ski. Nor do the slopes the audience sees always have much to do with Aspen, where a lot of the movie was photographed. According to the film's production notes, the movie's most spectacular material was shot in the Monashee range of the Canadian Rockies in British Columbia. It seems that Aspen doesn't actually have "the majestic heights and rapid vertical drops" that were considered necessary for the movie.

Teri Polo appears as the pretty Aspen disk jockey who watches sadly as T. J. is swept off his skis by a rich and beautiful older woman, played by Finola Hughes in the Joan Collins manner. "Aspen Extreme" also features one fatal avalanche, put together by special-effects experts in Hollywood.

•

"Aspen Extreme," which has been rated PG-13 (under 13 strongly cautioned), includes some partial nudity and vulgar language.

1993 Ja 23, 16:5

FILM VIEW/Caryn James

'Passion Fish' Nourishes the Grown-Ups

JOHN SAYLES IS ONE OF THOSE UNfortunate film makers who is often damned with great praise. "Matewan," the tale of a 1920 West Virginia miners' strike, and "City of Hope," the story of racial tension and urban blight in a New Jersey town, were acclaimed for being rigorous, uncompromising social visions. That kind of praise can kill a picture, and pretty much did. Audiences saw code words for dreary, depressing, stay away. In fact, both films are exhilarating in a gritty, hard-to-sell way. They carry viewers to unglamorous places where people are as

Bob Marshak/Miramax Films

David Strathairn, Alfre Woodard and Mary McDonnell in "Passion Fish"— Allergic to cheap sentiment and cliché.

worried and messed up as your next-door neighbors, though a lot more interesting about it. But try explaining that to a moviegoer who fears that seeing a Sayles film will be like going to school.

■

His new film, "Passion Fish," which opens nationally on Friday, runs a different risk, that of seeming too slickly upbeat. It is being promoted as a life-affirming movie, with ads promising that it will be a cross between "Driving Miss Daisy" and "Fried Green Tomatoes." That comparison seems more like a threat than a promise, and it's misleading, too, for it suggests a syrupy quality that has always been wonderfully absent from Mr. Sayles's work. Throughout his career, he has accomplished the most difficult thing for a mainstream writer-director: he has created films for and about complicated adults. He refuses to make his characters simple or stupid for the movies.

And "Passion Fish" *could* have been simple or syrupy. Take a glance at the skeleton story and the "Driving Miss Daisy" comparison makes sense. The heroine, a fortyish soap-opera actress named May-Alice (Mary McDonnell), is hit by a taxi and permanently paralyzed from the waist down. She returns alone to the family home she owns in Louisiana. Her hired nurse is a black woman named Chantelle (Alfre Woodard), who is obviously running from something and who just as obviously will become May-Alice's friend.

It is hard to imagine how this story could escape mawkishness. But May-Alice and Chantelle share one of Mr. Sayles's most engaging qualities — an allergy to cheap sentiment and cliché.

"It's important that we have clean walls," May-Alice tells one of her pre-Chantelle nurses, who is busy scrubbing a door frame. "I'll be climbing them soon." She says this in her most sardonic voice. She is tough, angry and self-pitying, but never feisty or hurt in a

predictable way. She drinks wine and watches television all day, with a what-the-hell hopelessness, a buried rage and a residual wit that Ms. McDonnell makes vividly believable. This story is about May-Alice, not about her useless legs or her wheelchair.

Ms. Woodard matches the cliché-free performance. Chantelle is wary and doesn't like being ordered around. When she says, "I need this job," Ms. Woodard reads the line as a statement of fact, not as groveling or an exhibition of swallowed pride. The interracial dynamics are not ignored — May-Alice's soap-opera character *was* named Scarlett — but Chantelle is not asked to represent the entire African-American experience.

In "Passion Fish," as in life, people don't go around babbling about their feelings all day. But the characters' rich, complicated emotions are evident on screen, constructed from a wealth of detailed touches: the lush Louisiana landscape, witty and acerbic dialogue, small facial expressions, unexpected gestures, silences.

One of the film's most original details is the poignant, schoolgirlish crush May-Alice develops on a married handyman named Rennie (David Strathairn). He is beneath her socially, as he was when they were in high school together, but now she can see him for the attractive, sweet-natured man he is. When May-Alice tells Rennie he can drop by to visit sometime, even if he doesn't have a job to do, Ms. McDonnell's face reveals how hard it is to say those words. A complex fabric of influences come together in the scene — sexual need, the difficulty of communication, the fear of rejection, class barriers — yet none of them are expressed directly.

Chantelle's relationship with a blacksmith named Sugar is even less sentimental. When he tells her his name and she thinks he is calling *her* Sugar, she looks as if she's ready to belt him. And Rennie wouldn't ever say that his wife doesn't understand him. Instead, he says in a quiet, deadpan voice, "She got reli-

gion between the second and third babies. She's got the kids in with her now. They pray for me a lot."

"Passion Fish" is not totally free of melodrama. When Chantelle's past catches up with her, she has a double-whammy problem when half the trouble would have been enough. And the choice May-Alice makes at the end feels a bit set up; she isn't forced to choose between two equally attractive possibilities. But these are the slightest whiffs of manipulation in a movie that is entrancing and realistic at once.

Some people will always think of Mr. Sayles as the creator of "The Return of the Secaucus Seven," the 1980 film about a reunion of radical friends that anticipated "The Big Chill" by three years. The difference between those two films reveals something that is still central to Mr. Sayles's work. His movies tackle grown-up problems without that coy, Hollywood "I can't believe I'm a grown-up" tone. Mr. Sayles believes we're all grown-ups.

When May-Alice is left to wheel herself from the lawn to the house, she complains, "It's uphill."

"So's life," Chantelle yells back. John Sayles is betting that we're smart enough to handle it. □

1993 Ja 24, II:11:1

Get Thee Out

Directed and edited by Dimitri Astrakhan; written by Mr. Astrakhan and Oleg Danilov; based on stories by Sholem Aleichem, Isaac Babel and A. Kuprin; cinematography by Yuri Worontsov; music by Aleksandr Pantichin; production design by Aleksandr Kikivkin and Marya Petrova; produced by Mr. Astrakhan and Rafik Zamanov; released by First Run Features. At the Walter Reade Theater, 70 Lincoln Center Plaza. Running time: 90 minutes. This film has no rating.

Motl Otar Mengvinetukutsesy
Golda Yelena Anisimova
Beyelka Tatyana Anisimova
Peter Aleksandr Likov
Trofim Valentin Bukin

By VINCENT CANBY

"Get Thee Out," the new Russian film opening today at the Walter Reade Theater, examines anti-Semitism in czarist Russia, the exact time being unspecified though it seems to be around the turn of the century. It's the first feature to be directed by Dimitri Astrakhan, a St. Petersburg theater director who was born in 1957 and is himself a Jew.

The screenplay, by Oleg Danilov and Mr. Astrakhan, is based on stories by Sholem Aleichem, Isaac Babel and A. Kuprin. Yet the film has a completely contemporary sensibility as it tells the story of Motl, a proud dairy farmer, the patriarch of the only Jewish family in his village, when he is faced by a state-backed pogrom. Mr. Astrakhan is less interested in Jewish culture than in the ways in which racism serves the purposes of nationalism.

•

"Get Thee Out" has the manner of a narrative mural dominated by the imposing figure of Motl, surrounded by the members of his family, his friends, the village drunk, the constable and other easily identifiable types. The movie is composed of generalities that are seen larger than life. As played by Otar Mengvinetukutsesy, Motl is a big, bearded lusty man who looks as if he has stepped out of the Old Testament. He and his neighbors live in such civilized accord that they accept the shock when Motl's daughter converts and marries the son of Motl's best friend.

His friends initially defend Motl when the pogrom comes to their village. With the constable's connivance, the neighbors stage mock attacks on Motl's farm, burning the privy to meet their obligations as good Russians. Then the pogrom turns deadly. Motl, who has always thought of himself as a Russian first, wakes up to realize the extent to which he has fooled himself. When he decides to stay in his village and fight, not all of his old friends desert him.

For all of the horrors of the pogrom, "Get Thee Out" remains surprisingly optimistic. It finally seems to be less about anti-Semitism in czarist Russia than about the crimes being committed all over the world today in the cause of either ethnic or national identity.

1993 Ja 26, C14:3

Guncrazy

Directed by Tamra Davis; written by Matthew Bright; director of photography, Lisa Rinzler; edited by Kevin Tent; music by Ed Tomney; production designer, Abbie Lee Warren; produced by Zane W. Levitt and Diane Firestone; released by Zeta Entertainment in association with First Look Pictures. At Film Forum, 209 West Houston Street, South Village. Running time: 97 minutes. This film is rated R.

Anita Drew Barrymore
Howard James Le Gros
Rooney Joe Dallesandro
Hank Billy Drago
Mr. Sheets Robert Greenberg
Mr. Kincaid Michael Ironside
Tom Rodney Harvey
Bill Jeremy Davies
Chuck Dan Eisenstein
Joy Ione Skye

By VINCENT CANBY

That there's life for film noir in the 1990's is stunningly apparent in "Guncrazy," the very accomplished, cruelly entertaining new movie opening today at the Film Forum. As its murderous young lovers it stars James Le Gros ("My New Gun") and Drew Barrymore, who gives the kind of performance that can transform a sweetly competent actress into a major screen personality.

"Guncrazy," directed by Tamra Davis in her feature debut and written by Matthew Bright, is as vulgar and contemporary as a late-breaking Long Island sex scandal, though its roots reach back into cinema history. In its chilly seriocomic way, "Guncrazy" pays homage to its predecessors while also sending them up.

The characters played by Mr. Le Gros and Ms. Barrymore recall the gun-toting fugitives in both Fritz Lang's "You Only Live Once" (1937) and Nicholas Ray's "They Live by Night" (1949), but they are not star-crossed. The lovers in those earlier films are victims of a careless universe as manifested in the social system. The Lang and Ray films are as romantic as they are politically pointed.

"Guncrazy" was inspired by, but is in no way a remake of, Joseph H. Lewis's 1950 cult favorite, "Gun Crazy," whose lovers go off on a crime spree that's really an extension of their erotic obsession with each other. The new film has even more in common with Terrence Malick's seminal "Badlands" (1973), which opened new territory in film noir. Mr. Malick's fugitives haven't been favored by society, but nothing that has happened to them justifies the mindless murders they commit during their cross-country road trip.

If anything, society is rather benign in "Badlands." The villain isn't society but a culture that encourages the immediate gratification of every impulse and in which actions have no consequences. As in "Badlands," the "Guncrazy" lovers are children of the television age. The setting is a small town in central California, an arid landscape of one- and two-story buildings, trailer homes, service stations and junkyards. When first seen, Anita Minteer (Ms. Barrymore) is walking along a railroad track, taking as much time as possible to get to school. Her face still shows baby fat, but she's astonishingly pretty with her short blond hair and her cherry-red lipstick. She's 16 and has no idea of the power her beauty might one day give her.

Abandoned by her mother, Anita shares a trailer with her mom's former lover, Rooney (Joe Dallesandro), a beer-drinking slob who sleeps with Anita when he has nothing better to do. Anita also has sex with the boys from school out at the town dump. It's one way of keeping them from beating up on her. Anita is the town slut. She's cheerful to a heartbreaking degree, and utterly passive. She's also ready to detonate.

At this opportune time Howard Hickok (Mr. Le Gros) comes on the scene. Along with the other members of her geography class, Anita has been assigned to find a pen pal. Anita finds hers not in Japan, Brazil or Poland but in the California prison at Chino. She answers Howard's ad for a correspondent and soon falls in love with him through his letters. Howard tells her that he is 24 years old and paints. When he writes that he has always dreamed of a girl who likes guns, Anita starts practicing out back with Rooney's revolver and with Rooney as her instructor.

Anita also persuades Hank (Billy Drago), a local mechanic who is the guru of a snake-handling religious cult, to give Howard a job so that he can be paroled. When Howard finally arrives on the bus early one morning, he seems to be the answer to Anita's prayers. He's nice looking, soft spoken and so terrifically polite that Anita thinks he might be a prude. They fool around, but not until they marry, at Hank's insistence, do they get down to serious business.

Howard reveals himself to be impotent. Anita is not even put off by that. It only convinces her how different and special he is. "I don't care if we never do sex," she tells him. "It always makes me want to throw up." Instead of sex, they share their darkest secrets. Among Howard's are his prison term for manslaughter and an earlier conviction for pistol-whipping a man to death. It turns out that Anita's biggest secret can match anything Howard has done.

Their growing intimacy, which eventually leads to sexual fulfillment, both celebrates and makes possible a series of random murders that they more or less stumble into committing. In many ways, Howard is as emotionally damaged as Anita, but he murders with some reluctance. Anita is both more coldhearted and more sentimental. She draws the line at shooting the father of her best girlfriend, who happens to be Howard's parole officer. During a barroom holdup, she can't take money from a victim who cries about the bills he has to pay. Otherwise, she is faster on the draw than Howard.

Anita and Howard have no dreams of a better world. Their horizons are seriously limited. Anita's geography teacher, in making his pen-pal assignment, recalls that at the beginning of the year every student in the class thought Japan was a part of Europe. When Anita and Howard have to flee the police, their goal is Fresno.

"Guncrazy" doesn't have the merciless eye of "Badlands," which is as unrelenting as a bad dream. "Guncrazy" is not sentimental, but it is beguiled by the looks of Ms. Barrymore's Anita, which is an important part of the way the movie works. She's enchanting to watch, both angelic and monstrous. Anita and Howard are woefully ignorant and fatally short on imagination. "Guncrazy" understands that by the time the movie begins, the lovers are lost, lost, lost. It's difficult to believe that two such well-meaning creatures can have fallen so far from grace, so early.

Taking Mr. Bright's excellent screenplay, Ms. Davis, whose background is in music videos, has made a remarkably rich melodrama with a strong narrative line and vivid characters. There's no waste space in this movie. Every second of its 97 minutes counts. The members of the supporting cast are all fine, particularly Ione Skye, who plays Anita's best friend; Mr. Drago as the harmless religious nut, and Mr. Dallesandro, who has survived his early years playing zonked-out hustlers in Paul Morrissey's "Trash," "Flesh" and "Heat," to take on a kind of Rip Torn patina.

Mr. Le Gros has a gravity and reserve that are rare in such a young actor and absolutely essential for his performance here and for the success of "Guncrazy." Yet it's Ms. Barrymore whose presence illuminates the screen. She's come a long way since "E.T. the Extra-Terrestrial" and,

possibly, she has much further to go after she graduates from her Lolita roles. This granddaughter of John Barrymore, daughter of John Jr., great-niece of Lionel and Ethel, and niece of the unhappy Diana ("Too Much, Too Soon") will be 18 next month.

"Guncrazy," which is scheduled to play a two-week engagement at the Film Forum, was presented five times on Showtime, the cable channel, in the fall. It deserves this theatrical showing.

•

"Guncrazy" is rated R (Under 17 requires accompanying parent or adult guardian). It has a lot of vulgar language, sexual situations and violence.

1993 Ja 27, C17:2

Matinee

Directed by Joe Dante; screenplay by Charlie Haas; story by Jerico and Charlie Haas; director of photography, John Hora; edited by Marshall Harvey; music by Jerry Goldsmith; production designer, Steven Legler; produced by Michael Finnell; released by Universal Pictures. Running time: 98 minutes. This film is rated PG.

Lawrence Woolsey	John Goodman
Ruth Corday	Cathy Moriarty
Gene Loomis	Simon Fenton
Stan	Omri Katz
Sandra	Lisa Jakub
Sherry	Kellie Martin
Dennis Loomis	Jesse Lee
Anne Loomis	Lucinda Jenney
Harvey Starkweather	James Villemaire
Howard, the Theater Manager	
	Robert Picardo
Herb	Dick Miller
Bob	John Sayles
Mr. Elroy	Charlie Haas
Mant/Bill	Mark McCracken

By JANET MASLIN

The centerpiece of the movie-mad comedy "Matinee" is "Mant," an expert, side-splitting parody of an early-1960's black-and-white horror film. "Half Man ... Half Ant ... All Terror!!!" proclaim the ads for this low-budget opus, which tells of a mishap involving man, ant and X-rays at a dentist's office. The human patient is accidentally transformed into a large, buggy mutant, leading him to exclaim, "Go, my brothers and sisters!" while smashing an ant farm to smithereens.

His worried wife (Cathy Moriarty) pleads: "Oh, Bill! If you could just listen to the man in you and put the insect aside!" Kevin McCarthy, star of the original "Invasion of the Body Snatchers" and one of this film's many fond reminders of real horror classics, turns up with a megaphone to shout: "Come down off that building! We've got sugar for you!" And the dentist (William Schallert) tries to be consoling when he says: "By the way, I did get your X-rays back, Bill. I don't suppose it makes much difference to you now, but you didn't have a single cavity."

It's clear that "Mant" is a labor of love on the part of the director, Joe Dante, who has his own horror credits ("Piranha," "The Howling," "Gremlins") and an obvious taste for mischief. Collaborating with the screenwriter Charlie Haas, who wrote Mr. Dante's sly, underappreciated "Gremlins 2: The New Batch," he turns "Mant" into a perfect evocation of this era's absurdly solemn, pseudo-scientific horror style. It's a wonderfully nostalgic treat.

Dean Williams
John Goodman

"Matinee" also means to use "Mant" in larger ways, to illustrate the cathartic nature of movie horrors in a world too full of real ones. "Matinee" is set in Key West, Fla., in 1962, at the exact time of the Cuban missile crisis. It incorporates excerpts from President John F. Kennedy's televised speech, the one suggesting the possibility of imminent nuclear war. This is infinitely scarier than anything else in "Matinee." As such, it helps to prime Key West's population for a special sneak preview of "Mant" that is coincidentally being held there.

The self-promoting impresario behind the screening is Lawrence Woolsey (John Goodman). He is modeled affectionately on William Castle, the man who once wired movie seats to provide electric shocks during "The Tingler" (1960) and offered insurance policies that would pay off if viewers of "Macabre" (1958) died of fright. When Woolsey rolls into Key West with his reluctant leading lady (Ms. Moriarty) in tow, he tries every conceivable trick to promote his movie, even commandeering an exterminator's truck to carry "Mant" ads. Woolsey also provides two bogus bluenoses (John Sayles and Dick Miller) to suggest closing down "Mant" on the grounds that it is simply too bold and steamy for decent folk. What about the First Amendment, one citizen asks. "There's no First Amendment to the Ten Commandments, pal," snaps Mr. Sayles.

"Matinee," which devotes a lot of energy to the minor artifacts of American pop culture circa 1962, is funny and ingenious up to a point. Eventually, it becomes much too cluttered, with an oversupply of minor characters and a labored bomb-and-horror-film parallel that necessitates bringing down the movie house (quite literally, with balcony-smashing special effects). The film, like one of the quaint movie monsters it so admires, feels like something small that has been magnified a hundredfold, rather than a legitimately large-scale creation. In the end, the specter of nuclear war is simply too much for this sunny teen-oriented comedy, particularly when it leads to a make-out session in a bomb shelter and a silly supermarket riot over hoarding shredded wheat.

Mr. Goodman, who is great fun as the cigar-chomping Woolsey, is the film's most dependably entertaining

presence, unless you count the Mant himself (played by Mark McCracken). As such, Mr. Goodman makes the most of the producer's gleeful marketing ideas. ("She-gator," he muses, applying his creative talents to a small stuffed alligator he happens to spy. "Alli-gal! "Galligator!") Equally enjoyable is Ms. Moriarty, successfully wisecracking her way through the starlet's off-screen role while also playing it delectably straight in "Mant," as the woman surprised to find herself married to an ant in a business suit.

The other half of the story concerns Gene Loomis (Simon Fenton), a new boy in the peculiarly lily-white, all-heterosexual Key West that is the film's setting. Worried about his father, a Navy man who is away on one of the blockade ships near Cuba, Simon becomes enamored of the more politically aware Sandra (Lisa Jakub), who gets his attention when she denounces an air-raid drill at school and is given detention for this protest. "They put Gandhi away for a year," Sandra says philosophically about

her punishment. "I don't know that many people here," replies Gene, apparently thinking Gandhi is a classmate.

Also in "Matinee" are Kellie Martin as a local teen-age princess; Omri Katz (once the John Ross Ewing of "Dallas") as Gene's school chum; Robert Picardo as the movie theater's fussy, frenetic manager, and James Villemaire in the story's most crazily overcomplicated role, that of a poetry-writing greaser hired to impersonate a Mant and run the theater's special gimmicks, called Atomo-Vision and Rumble-Rama. Mr. Haas, the screenwriter, has an amusing turn as the 1962-style nutrition teacher who stresses the importance of eating red meat three times a day.

•

"Matinee" is rated PG (Parental guidance suggested). It includes harmless horror-movie violence, brief profanity and several adolescent sexual references.

1993 Ja 29, C6:4

China, as a Land of Sorrow That's Also Rich in Hope

"China, My Sorrow" was shown as part of the 1990 New Directors/New Films series. Following are excerpts from Caryn James's review, which appeared in The New York Times on March 19, 1990. The film — in Cantonese, Mandarin, and Shanghai dialect with English subtitles — opens today at the Joseph Papp Public Theater, 425 Lafayette Street, East Village.

In a re-education camp during the Chinese Cultural Revolution, a guard asks a prisoner to identify the melody he's playing on a makeshift wind instrument. The hapless man blurts out "Mozart," then quickly saves himself by adding, "It's a song called 'Mozart Dreams of Mao Zedong.'" Though "China, My Sorrow" is not always so pointed or witty, it is a deft and oddly lighthearted tribute to the traditions and spirit of freedom that survived the Cultural Revolution.

The hero is a 13-year-old with wire-rimmed glasses, fondly nicknamed Four Eyes. After he is accused of playing "obscene records" — they are pop, not Mozart, and not obscene by any standards other than Mao's — he is forced to stand on a public scaffold wearing a large paper dunce cap on which his name and his crime are written. He announces to the crowd: "Reactionary father dead. Mother, enemy of the people, in jail," then is sent to the camp set in extravagantly beautiful green mountains.

•

On the surface, "China, My Sorrow" sounds polemical and strangely detached from time and place. Set more than 25 years ago, it was made before the repression of anti-Government protesters in 1989. (The Chinese-born director, Dai Sijie, shot the film in the Pyrenees.)

But the story is polemical only in the mildest sense. And as it creates a distinctive victim and an unlikely setting, it is informed by hope, not anger. The film assumes enormous and easy sympathy for Four Eyes, the most

innocent of cultural "enemies," a boy with a bit of peach fuzz on his upper lip and an increasingly ragged blue cap and jacket.

As the boy notices, he is in the least oppressive sort of camp, with no Red Guards or barbed wire. The film does not argue against the Cultural Revolution; it offers a quiet testimony to irrepressible traditions and individuality.

•

For though Four Eyes wisely wears a resigned expression on his face, he has the soul of a rebel. He and a friend sneak out to the woods to perform an All Souls' Day ritual for Four Eyes's father, using a cigarette as a substitute for incense. He is befriended by an old Taoist monk, who will show the boy, in dramatic and ambiguous terms, that traditions literally involve life or death. Though the film does not have much intellectual rigor, it succeeds as a symbolic portrayal of a youthful, uncorrupted individual spirit.

1993 Ja 29, C6:5

Sniper

Directed by Luis Llosa; written by Michael Frost Beckner and Crash Leyland; director of photography, Bill Butler; edited by Scott Smith; music by Gary Chang; production designer, Herbert Pinter; produced by Robert L. Rosen; released by Tri-Star Pictures. Running time: 98 minutes. This film is rated R.

Thomas Beckett	Tom Berenger
Richard Miller	Billy Zane
Chester Van Damme	J. T. Walsh
Doug Papich	Aden Young
El Cirujano	Ken Radley

By VINCENT CANBY

Thomas Beckett (Tom Berenger) has reached a crossroads of sorts. As a master gunnery sergeant in the United States Marine Corps, he's a

professional killer, a sniper who assassinates on command. When he was younger, he used to feel an intoxicating rush after taking out a target. Only later did he feel what he calls "the hurt." Now things are worse. Having been on the job too long, he no longer feels the hurt. Whither Thomas Beckett?

In "Sniper," a movie for undiscriminating armchair assassins, he goes off on another assignment in Panama. His targets: a Panamanian politician planning a coup d'état and the Colombian drug lord financing the coup, whom the politician is meeting at a jungle hacienda. Beckett and his partner, Richard Miller (Billy Zane), a young, very green official of the National Security Council, have just one week to complete their mission. Will they? Won't they?

It's not easy to tell even after you have seen all of "Sniper," which is partly a badly choreographed action drama and partly a psychological exploration of Beckett's mind, which comes up empty. As written, directed and played, Miller is as much of a nonentity as Beckett. Their initial enmity and subsequent reconciliation have no more dramatic impact than the battle scenes, which look as if they were planned by amateurs. The two central characters remain as vague as their targets, who are briefly seen at a distance through gun sights.

•

"Sniper," which has been rated R (Under 17 requires accompanying parent or adult guardian), has a lot of obscene language and violence.

1993 Ja 29, C8:6

Children of the Corn II: The Final Sacrifice

Directed by David Price; written by A.L. Katz and Gil Adler; director of photography, Levie Isaacks; edited by Barry Zetlin; production designer, Greg Melton; produced by Scott Stone, David Stanley and Bill Froelich; released by Miramax Films. Running time: 93 minutes. This film is rated R.

Garrett	Terence Knox
Danny	Paul Scherrer
Angela	Rosalind Allen
Lacey	Christie Clark
Red Bear	Ned Romero
Micah	Ryan Bollman
Mordechai	Ted Travelstead

By STEPHEN HOLDEN

One of the more cartoonish subsidiary characters in "Children of the Corn II: The Final Sacrifice" is a fire-and-brimstone-spouting preacher who thunders that "fornication is a pestilence." Moments later in a front pew of his church, a parishioner spontaneously bleeds to death. Another parishioner, Red Bear, a wise American Indian and anthropology professor, speaks darkly of an angry deity who sees "a wrong done to the earth."

Whatever the troubles of the heartland, they manifest themselves in the murderous behavior of the children of Gatlin, Neb., who in the original "Children of the Corn" massacred their parents. In the sequel, the orphaned youths, wearing grim, entranced expressions, are rounded up and sent to a neighboring town where — despite the warnings of a local schoolmarm, who dies like the Wicked Witch of the West — they are soon up to their old tricks.

The movie follows the investigation into the massacre by Garrett (Terence Knox), an intrepid reporter for a tabloid called The World Enquirer. A single parent, he has brought along his rebellious teen-age son Danny (Paul Scherrer). Danny soon strikes up a romance with Lacey (Christie Clark), one of the few local teen-agers who does not belong to the satanic cult.

Unlike the original "Children of the Corn," which was adapted from a Stephen King story, the best-selling author is not credited with having anything to do with the sequel. A muddled pop allegory about moral rot in the Bible Belt, the sequel, which opened locally yesterday, is so poorly conceived that its symbolism has no internal logic. And the special effects are either clichéd (bluish lightning ringing the body of the cult leader) or downright chintzy (gaudy psychedelic plunges into the nether world.) The acting ranges from bad to mediocre.

"Children of the Corn: The Final Sacrifice" is rated R (Under 17 requires accompanying parent or adult guardian). It has strong language and violence.

1993 Ja 30, 16:4

FILM VIEW/Janet Maslin

Audrey Hepburn: Farewell to the Swan

"EVERYBODY'S DEFINITION OF CLASS: Academy Award-winner Audrey Hepburn!" exclaimed a breathless announcer at last year's Academy Awards show. We may have rolled our eyes, but we certainly knew what he meant. Audrey Hepburn, who died on Jan. 20 at the age of 63, was the embodiment of grace, generosity and kindness, a performer who filled the screen with entrancing light. With her passing, the cinema lost more than a well-loved actress: it lost a swan.

There is a deeper than usual sadness associated with the death of this particular star. Audrey Hepburn charmed audiences in unexpected ways, and she set a standard of beauty that touched an entire generation. Like her contemporary, Grace Kelly, she radiated the sort of hothouse loveliness that could not have been manufactured by Hollywood's star-making apparatus. What's more, she softened her regal manner with glacier-melting warmth. "I myself was born with an enormous need for affection and a terrible need to give it," she told Alan Riding of The New York Times in 1991, on the eve of her being honored by the Film Society of Lincoln Center. "That's what I'd like to think maybe has been the appeal."

Sensible and sturdy as she often seemed, especially in her capacity as good-will ambassador for Unicef, Audrey Hepburn had a fragility that made her otherworldly even by screen-goddess standards. Part of the pleasure in watching her was that frisson of sheer amazement: What being could be so fanciful or so free? Indeed, as an

She affected movie audiences in charming, incalculable ways.

actress she faced the constant liability of upstaging herself, since her spritely, elegant manner often overshadowed the characters she played.

Whether she was Sabrina (in Billy Wilder's 1954 film of that name) or Holly Golightly (in the 1961 "Breakfast at Tiffany's") or Eliza Doolittle (in the 1964 "My Fair Lady"), Audrey Hepburn remained the same doe-eyed Cinderella, registering surprise at the admiration of others and always inviting audiences to share her good fortune. Even later, with more seasoned, worldly roles in "Two for the Road" (1967), "Wait Until Dark" (1967) and "Robin and Marian" (1976), she retained an uncommon ability to draw viewers close. It was perfect casting when Steven Spielberg presented her in "Always" (1989) as a radiant yet down-to-earth angel.

Audrey Hepburn made no claims for herself as an actress, often thanking her colleagues and her luck. Yet she managed to acquit herself graciously even when fighting uphill battles. Truman Capote complained that she was all wrong for Holly Golightly (the actress he envisioned was Marilyn Monroe). And Tolstoy probably would have complained about "War and Peace" (she appeared as Natasha in the stiff 1956 version, with a cast that also included Anita Ekberg). Even Shaw might have objected to her in "My Fair Lady," as did admirers of Julie Andrews's stage performance in the role. Yet on film Audrey Hepburn was a marvel anyway. Bosley Crowther, reviewing "My Fair Lady" in The Times, called her "dazzlingly beautiful and comic" and said "she has one perpetually alternating between chuckling laughter and dabbing the moisture from one's eyes."

"Breakfast at Tiffany's" also became a showcase for Ms. Hepburn's magic, presenting her as an idealized waif who could persuade a starchy Tiffany's salesman to engrave a ring found in a Cracker Jack box. That film's title sequence, set in an eerily peaceful New York, with a stunning Audrey Hepburn strolling past Tiffany's at dawn in black evening clothes, presents the most haunting single vision of this actress and her lost, incomparable glamour. No one will ever wave a two-foot-long cigarette holder with the panache of her Holly Golightly. It's lucky Marilyn Monroe never tried.

With her self-imposed retirement from the screen in the late 1960's, Audrey Hepburn effectively ended her career early. She will be remembered as someone who, having reached the ability to rest comfortably on her laurels, chose to do more. The thought of her as a great lady comes from both the sight of her in Cecil Beaton's most fanciful creations (in "My Fair Lady") and the more profoundly beautiful vision of her good-will missions to famine-stricken children around the world.

■

This half-English, half-Dutch actress, who told of eating tulip bulbs during the Nazi occupation of the Netherlands (and who could not bring herself to appear in George Stevens's film of "The Diary of Anne Frank" because the material brought back too many memories), eventually found a way to help others experiencing similar hardships. (She was to receive the Jean Hersholt Humanitarian Award at this year's Academy Awards ceremony, along with Elizabeth Taylor.) And so she will be remembered for what she gave, from and to those in need to less tangible satisfactions.

"I always love it when people write me letters and say, 'I was having a rotten time and I walked into a cinema and saw one of your movies and it made such a difference,' " she once said. She made a difference indeed.□

1993 Ja 31, II:11:1

FILM VIEW/Caryn James

'The Crying Game' Wins at Gimmickry

THE WORLD IS FULL OF PEOPLE WHO don't want to hear another overheated word about "The Crying Game," and I sympathize. So, relax. I have not come to praise a film that has already been overpraised and overhyped. And I have not come to bury it, because it is far too intelligent, stylish and intriguing to deserve that. This is a reality check: "The Crying Game" is not the greatest movie ever made. It is not even the greatest movie Neil Jordan ever made (choose between "The Miracle" and "Mona Lisa"). But it *is* a fascinating example of how a smart, small film can get a huge amount of mileage out of a gimmick.

For anyone who has managed to escape the onslaught of publicity about the cult film of the moment, the critical fact is that "The Crying Game" contains a much talked-about secret, revealed halfway through. In the first part of the film, an Irish Republican Army member named Fergus (Stephen Rea) guards and befriends a kidnapped prisoner named Jody (Forrest Whitaker). In the second part, Fergus goes to London and looks up Jody's lover, Dil (Jaye Davidson).

Inevitably, Fergus and Dil fall for each other. The secret is Dil's, and it changes "The Crying Game" from a story of politics, friendship and love into a study of language, sexual attraction and romantic illusion, not to mention the power of suggestion.

Some viewers guess the secret at the first opportunity; others are still confused as they are walking away from the theater. But most people experience a moment of shock when the truth is revealed — followed quickly by the thought, "How could I be so dumb?" — which is why it is a legitimate secret to keep. Mr. Jordan has written and directed a shrewd and twisty game of mistaken identity laced with an extremely jaded, mordant humor. "Even when you were throwing up, I knew you cared," Dil tells Fergus after he learns the news.

Dil is more than a gimmick to Mr. Jordan. But the film's popularity and its status as the hot topic of the moment depend on its secret, not on the writer-director's wit or his characters' subversive ideas about romance and politics. The film's distributor, Miramax, begged critics and early audiences not to reveal the secret. Later, ads bragged that audiences were talking about the movie but not giving away the plot twist. This created a staggering cycle of publicity, in which the film company got people to echo its thoughts, then quoted the echo.

You can tell the strategy works, because conversations about the film often sound orchestrated. Among people who have seen it, no one expresses real emotion for Fergus or Jody or Dil. No one talks about how well or how little Mr. Jordan's characters know themselves. The discussion is all about the secret.

Among people who haven't seen "The Crying Game," the conversations are positively unnatural. In real life, people usually ask their friends, "Do you want me to tell you the ending?" With "The Crying Game," the publicity campaign has encouraged everyone to act as if revealing the secret were the equivalent of beating dogs or tripping small children.

Yet "The Crying Game" actually becomes better if you know what's coming. The moment of surprise is gone, but the early part of the film reveals hidden messages, and jokes aren't apparent otherwise. You can tell who is in on the secret by where the audience laughter is coming from.

Mr. Whitaker's performance is still strained and overwrought, especially when he tells the fable about a scorpion who can't escape his nature. But Jody and Fergus's discussions about Dil make a lot more sense. "She'd be anybody's type," Fergus says, looking at Dil's picture. Well, he'll find out.

Without its gimmick, though, the movie might have remained as obscure as "The Miracle," Mr. Jordan's 1991 film about a young Irishman's romance with an older woman who also has a secret, though one less titillating than Dil's.

"The Crying Game" is riskier and more daring than "The Miracle" or Mr. Jordan's greatest commercial success, "Mona Lisa" (1986), in which Bob Hoskins falls for a hooker played by Cathy Tyson, who looks quite a bit like Dil. Yet the new film does not touch the same emotional chord as those earlier ones. The tone of "The Crying Game" is closer to that of Mr. Jordan's 1984 adaptation of the Angela Carter story, "The Company of Wolves," which was ambitious but cerebral at the expense of emotion.

Miramax Films

Stephen Rea and Jaye Davidson in "The Crying Game"—A shrewd, twisty game of mistaken identity.

What is brilliant about "The Crying Game" is its gimmick and its publicity campaign, which work to make viewers feel like part of a club. It is a strategy similar to that used for Robert Altman's latest film, "The Player."

With its dozens of stars in cameo roles, "The Player" became a Hollywood version of "Where's Waldo?" Much of the fun came from spotting stars and catching in-jokes. Like "The Crying Game," it is a smart, well-made movie that would not have been nearly as popular without its celebrity trick.

But Mr. Jordan's film has the cleverer gimmick. To those people fed up with hearing about "The Crying Game," brace yourselves. Soon the secret will be everywhere, and another round of publicity is sure to follow. Already, articles have appeared with warning labels, cautioning readers that the secret will be given away. The only thing smarter than a small movie with a gimmick is a movie whose gimmick has an afterlife. □

1993 Ja 31, II:11:3

Volere, Volare

Written and directed by Maurizio Nichetti and Guido Manuli (in Italian with English subtitles); director of photography, Mario Battistoni; edited by Rita Rossi and Anna Missoni; music by Manuel de Sica; executive producer, Ernesto Di Sarro; released by Fine Line Features. Running time: 92 minutes. This film is rated R.

Maurizio	Maurizio Nichetti
Martina	Angela Finocchiaro
Girlfriend	Mariella Valentini
Brother	Patrizio Roversi
The "Child"	Remo Remotti
The Architects	Mario and Luigi Gravier
The Businessmen	Renato Scarpa
The Chef	Massimo Sarchielli
The Necrophiliacs	
Osavaldo Salvi and Lidia Biondi	

By STEPHEN HOLDEN

Maurizio Nichetti's "Volere Volare" is a slapstick love story whose considerable charm begins to evaporate once the movie is taken over by technological gimmickry that is not as captivating as the film makers seem to think. The movie is the follow-up to Mr. Nichetti's "Icicle Thief," a parody of neo-realism and modern television commercials' that was a small tour de force of special effects.

In the new film, Mr. Nichetti, an Italian comedian and director, plays Maurizio, a mousy creator of sound

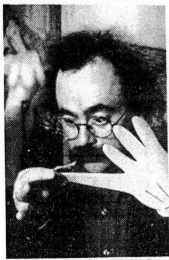

New Line Cinema
Maurizio Nichetti, writer, director and star of "Volere Volare."

effects for cartoons. The most engaging sequences show the timid sound wizard, who suggests a mustachioed Woody Allen, hard at work in the studio he shares with his brother (Patrizio Roversi), a dubber of erotic films. Maurizio deftly slices salami on the reels of his projector and grills a steak on its heated metal body. Maniacally applying sound effects to a Popeye cartoon, he bounces around the dubbing room like a little boy running wild in a dream world of his own creation.

Maurizio is so enamored of silly noises that when asked to supply the sound effects for one of his brother's projects, he naïvely subverts a steamy 18th-century frolic featuring Casanova with a hilarious succession of squeaks, clanks and boings.

●

Martina (Angela Finocchiaro), Maurizio's true love to be, also plies the fantasy trade. The film's opening scenes show her shuttling among several clients, each of whom pays her handsomely for participating in a different quasi-erotic scenario. In the most complicated, she becomes a nurse attending a couple who take turns pretending to die so that each can grieve for the other at a bogus wake. In her most sensual assignment, she allows a chef to cover her with melted chocolate, which he embellishes with intricate cake decorations.

Before they become acquainted, Maurizio and Martina literally bump into each other several times on the street. When they finally go on a date, things seem to be going reasonably well until Maurizio discovers that one of his hands has turned into a glowing, animated cartoon hand. At this juncture, "Volere Volare" abruptly changes from a graceful comic study of two engaging eccentrics into a clever but empty display of live action mixed with animation.

It isn't long before Maurizio's other hand is also transformed, and he is forced to wear gloves to conceal the changes. His new hands, which can detach themselves from his body, exert a cartoonish will of their own. All too predictably, Maurizio's metamorphosis eventually turns his entire body into an animated caricature.

Until it turns into a mundane homage to "Who Framed Roger Rabbit," "Volere Volare" is an amusingly frothy comedy about fantasy and the elusiveness of genuine gratification.

"Volere Volare" is rated R (Under 17 requires accompanying parent or adult guardian). It includes nudity and adult situations.

1993 F 3, C14:1

The Cemetery Club

Directed by Bill Duke; screenplay by Ivan Menchell, based on his play "The Cemetery Club"; director of photography, Steven Poster; edited by John Carter; music by Elmer Bernstein; production designer, Maher Ahmad; produced by David Brown, Sophie Hurst and Bonnie Palef; presented by Touchstone Pictures; released by Buena Vista Pictures. Running time: 100 minutes. This film is rated PG-13.

Esther Moskowitz	Ellen Burstyn
Doris Silverman	Olympia Dukakis
Lucille Rubin	Diane Ladd
Ben Katz	Danny Aiello
Selma	Lainie Kazan
Paul	Jeff Howell
Jessica	Christina Ricci
John	Bernie Casey
Abe Silverman	Alan Manson
Irving Jacobs	Sam Schwartz

By VINCENT CANBY

"The Cemetery Club," adapted by Ivan Menchell from his Broadway play and directed by Bill Duke, is a comedy about three well-heeled widows, pillars of the Jewish community in Pittsburgh, and their attempts to find meaning in their lives after their bereavements. It's meant to be jolly, but it has the manner of a "Moonstruck" made for senior citizens facing the eternal void.

Doris Silverman (Olympia Dukakis) is everybody's scolding conscience. She worships the ground her departed Abe is buried under. Heaven help her pals, Lucille Rubin (Diane Ladd) and Esther Moskowitz (Ellen Burstyn), when they forget their various anniversaries at the cemetery. Though Doris has the tart tongue of a stand-up comedian, she accepts her widowhood as a kind of religious calling.

Lucille is something else. With her dyed hair and clothes that would be more suitable on a 20-year-old, she is trying desperately to say yes to life, but no man listens for long. Lucille is the comic dimwit of the trio, but she also has an unhappy secret, this being the kind of movie in which one is occasionally commanded to weep through the hoped-for laughter.

The newest widow is Esther, who was supremely happy for 39 years with the man she married when she was 18. It is Esther who threatens the club's wise-cracking tranquillity when she becomes involved with Ben Katz (Danny Aiello), a diamond-in-the-rough widower, a retired policeman who now drives a cab.

"The Cemetery Club" depends a lot on one-liners, but "The Golden Girls" it is not. For all of the sarcasm in the dialogue, there is little wit. Unlike that long-running television show, "The Cemetery Club" makes no redeeming efforts to shake up the conventions of the form. The film is so calculating in its methods, so unsurprising in its details, that it will send some people screaming for the exits in the first 20 minutes. Others will watch in contentment. Sentimentality of this naked kind can also soothe.

Ms. Burstyn gives an attractive, absolutely honest performance as a woman who is almost too good to be true, at least in these circumstances,
but then "The Cemetery Club" is always undercutting itself. The movie treats the courtship of Esther and Ben with more solemnity than the situation warrants. Though the characters may be vulnerable, the movie,

A transition from Broadway to the movies via Pittsburgh.

being so slickly contrived, appears to be oblivious to honest feelings. Clichés smother any sense of liberation or humor.

The film makers try very hard to be honest about middle-class Jewish life in Pittsburgh, but then they go for laughs by presenting a couple of weddings of a garishness that might embarrass a nouveau riche mobster. A point is reached in the film where it's impossible to believe the characters would even know each other.

Ms. Dukakis, Ms. Ladd and Mr. Aiello also work well with material not of the highest order. At one point or another, each of them must play a scene talking to a tombstone. The supporting cast is headed by Lainie Kazan as a matron who can say of a hall she has rented, "I always get married here."

●

"The Cemetery Club" is rated PG-13 (Parents strongly cautioned). It has vulgar language and a sexual situation.

1993 F 3, C14:4

Homeward Bound: The Incredible Journey

Directed by Duwayne Dunham; screenplay by Caroline Thompson and Linda Woolverton, based on Sheila Burnford's novel "The Incredible Journey"; director of photography, Reed Smoot; edited by Jonathan P. Shaw; music by Bruce Broughton; production designer, Roger Cain; produced by Franklin R. Levy and Jeffrey Chernov; released by Walt Disney Pictures. Running time: 85 minutes. This film is rated G.

Shadow	Ben
Chance	Rattler
Sassy	Tiki
Shadow's Voice	Don Ameche
Chance's Voice	Michael J. Fox
Sassy's Voice	Sally Field
Jamie	Kevin Chevalia
Laura	Kim Greist
Bob	Robert Hays
Hope	Veronica Lauren
Peter	Benj Thall

By JANET MASLIN

"Homeward Bound: The Incredible Journey" is Walt Disney Pictures' clever, crowd-pleasing remake of the studio's own "Incredible Journey," a nature story first released in 1963 and now obviously dated. Based on the pet-centric novel by Sheila Burnford, it tells how two dogs and a cat are abruptly relocated, after which they set out on a long, perilous trip to find their real home.

"The Incredible Journey," though sweet, was terribly creaky. It left most of the talking to a human narra-

Greg Specht/Buena Vista Pictures Distribution

In Disney's "Homeward Bound: The Incredible Journey," Shadow, Chance and Sassy set out for home.

tor, kept the animals' thoughts a mystery and relied heavily on acting of the give-me-your-paw school. This new version improves on the original in every way by adding heartwarming drama, lots of humor, better scenery (the adventure is set in the Sierras) and, most helpfully, small talk. Thanks to crafty direction and editing, along with the lively voices of Don Ameche, Sally Field and Michael J. Fox, these pets now sound and behave just like people, chatty, wisecracking people any child will understand.

As directed energetically by Duwayne Dunham (who has come several light years from working as an editor for David Lynch) and written in bright, kiddie-friendly style by Caroline Thompson and Linda Woolverton, "Homeward Bound: The Incredible Journey" creates three distinctive animal personalities for its stars. Shadow, the golden retriever (with Mr. Ameche's voice), is the wisest of the three, thanks to much emphasis on his noble profile and dialogue that allots him the role of a kindly group leader. Chance (Mr. Fox's voice), the spotted bulldog, is the pesky one. Sassy (the particularly funny voice of Ms. Field) is the haughty type and has the best dialogue. "Oh, I hate fast food!" she snaps when a bunny scurries by. "I don't have to swim! I have a note!" she shrieks, when the other two jump into a river.

In addition to being cast cuter than its predecessor (the earlier film featured shorter-haired, less adorable breeds), "Homeward Bound" is also savvier about the tastes of its audience. The three original pets were all males, but by making Sassy a female cat the film makers introduce an amusing strain of brother-sister-style teasing. She and Chance engage in an endless series of sibling insults, as when he baits her with: "What's the matter, Sassy, you get up on the wrong side of the litter box?" Sassy easily holds up her share of this sort of conversation, as when Chance noisily trees a baby raccoon. "Oh right, like if you yap at it it's going to come right down and ask you to eat it," she sniffs. "Pitiful!"

The pets' brief stay at a ranch and their subsequent mountain odyssey allow the film plenty of opportunities for interspecies encounters. There are ducks, turkeys, bears ("Go steal

some porridge!" snaps Sassy) and even a mountain lion, whom the others call "Arnold Schwarzenkitty." All of this is expanded beyond a nature-documentary's interest level by the skillful way in which the animal actors are filmed and edited, so that their behavior and dialogue seem truly connected. The fact that such anthropomorphism looks easy when it's done this well should not minimize the achievement.

•

This film is clever even with its human actors, dispensing with the first film's animal-loving hermits and playing up the importance of a cute, newly typical American family. There are a husband and wife (Robert Hays and Kim Greist, just married, along with three children (Benj Thall, Veronica Lauren and Kevin Chevalia) seeking to find their place in this new arrangement. If the children's ties to their pets are made that much more important by their rearranged home life, that just allows the film one more tug at the heartstrings. There's a lot more emotion to the children-pet hugs at the finale of this film than there is in many a more sophisticated movie ending (like the clinch at the end of "The Bodyguard," to name just one).

"Homeward Bound" is manipulative enough to try for similar emotional peaks at regular intervals, but children in the audience should like that just fine; they may also enjoy insults that occasionally border on the mean-spirited or crude. Adults, being more skeptical, can see this as Disney's obvious attempt to capture and revitalize the Lassie-Old Yeller-Rin Tin Tin franchise. If so, they may also wonder why this hasn't been attempted more often. And they will be glad that this time it's been done so well.

1993 F 3, C15:1

The Vanishing

Directed by George Sluizer; screenplay by Todd Graff, based upon the novel "The Golden Egg," by Tim Krabbé; director of photography, Peter Suschitzky; edited by Bruce Green; music by Jerry Goldsmith; production designer, Jeannine C. Oppewall; produced by Larry Brezner and Paul Schiff; released by 20th Century Fox. Running time: 101 minutes. This film is rated R.

Barney	Jeff Bridges
Jeff	Kiefer Sutherland
Rita	Nancy Travis
Diane	Sandra Bullock
Lynn	Park Overall
Denise	Maggie Linderman
Helene	Lisa Eichhorn
Arthur Bernard	George Hearn

By JANET MASLIN

Thanks to the peculiar lily-gilding process that yields the Hollywood remake, "The Vanishing" is one of two haunting European films that open today in newly Americanized form. The other one, "Sommersby," reworks "The Return of Martin Guerre," the story of a man who is reunited with his wife and neighbors after a long, mysterious absence. He looks and sounds recognizable, yet something essential seems to have changed. His fellow citizens regard him with a mixture of warmth, bewilderment and unease, much the same response moviegoers might have to a structurally familiar, spiritually different version of a favorite story.

"The Vanishing" is a fascinating case in point, since it has been made twice by the same director, and since its original version is so dangerously unsuited to mainstream American tastes. As directed by George Sluizer, the Dutch film maker who once worked as an assistant director on "Around the World in 80 Days," "The Vanishing" (released in 1991) told of an ordinary man thrown into limbo by the disappearance of his girlfriend. When these vacationers stopped at a rest area beside a highway, she went off to get them cold drinks and simply did not return.

The circumstances of her disappearance were so banal they became deeply frightening. So did the man responsible for her fate. The kidnapper was a scientist, and his quietly cerebral approach to his crime gave

Ralph Nelson

Jeff Bridges

the film a chilling resonance, as did his desire to ensnare the story's grieving, obsessed hero in his web.

In its Dutch version, "The Vanishing" was presented without violence and still managed to end on a note of devastating cruelty, one that no American studio would dare to match. By piling on a shovel, a two-by-four and a kitchen knife at this point in the story, the remake clearly illustrates why less was so much more.

The new film is twice as busy as its quiet predecessor, and perhaps half as interesting (which still places it several notches above run-of-the-mill studio fare). It adds quintessential American movie elements like jealousy, revenge, ambition and detective work, yet it remains much less enveloping than the earlier film. Part of the reason is easy to explain: a fancy gloss and a lot more action rob the story of its intensity. The setting (once France, and now the Pacific Northwest), the young couple and their mishap no longer seem quite real.

As played by Kiefer Sutherland, the hero, Jeff Harriman, has certainly stopped being ordinary. This time he writes a book about his girlfriend's story, and he is introduced as "the very courageous, very tormented young man Jeff Harriman" when he appears on a television talk show. The girlfriend, played originally with captivating warmth by the Dutch actress Johanna Ter Steege, was once a radiant and compelling figure. But she is now Diane, a giddy fashion-model type played by Sandra Bullock. Trading a sexy, sympathetic heroine for a narcissistic one costs this film a lot. For one thing, she isn't as badly missed.

To pick up the slack, the new film greatly expands the role of Jeff's second girlfriend. (Originally she appeared only briefly, then walked off when she sensed the depth of his obsession with his lost love.) Rita, the waitress played by Nancy Travis, has a heart of gold, an exhausting tenacity and a Nancy Drew-type taste for ferreting out clues. The audience is meant to be distracted by the non-issue of whether Rita and Jeff will sustain their romance.

Rita also becomes a receptacle for the screenplay's crassest sentiments, bellowing lines like "Because I don't know how not to fight!" and at one point showing up in a Diane-style wig. The screenplay, by Todd Graff ("Used People"), is the film's biggest problem, since it is so painfully literal. Mr. Graff never trusts the characters' actions to speak for themselves.

The one performance that rivets interest is Jeff Bridges' as the mysterious Barney, a quiet family man who contemplates his own capacity for evil with scientific detachment. With his benign appearance and his wary, thoughtful manner, Mr. Bridges makes a disturbingly seductive villain. Once again bringing a strong physical dimension to his work, he adopts a stiff, awkward walk and an intense gaze, along with long hair and a vaguely European accent. As the one truly eccentric, fascinating figure in this strange story, he brings the film the credibility it too often lacks. This actor's eerie intensity is a powerful reminder of why the first film worked so well.

Mr. Sluizer, faced with the impossible job of outdoing himself in unfamiliar circumstances, again displays a moody, economical style and an edgy energy. Whatever else this hybrid "Vanishing" is, it isn't dull. The film

has no shortage of momentum, not even in its later sections (which bring to mind Martin Scorsese's version of "Cape Fear"), when it threatens to go over the top. But there is the steady sense that this director, like Martin Guerre, is not entirely at home.

As photographed strikingly by Peter Suschitzky, the film looks good even when it absolutely shouldn't. Even the humble gas station has been transformed into a virtual tourist attraction in its own right. The props have a tendency to be distractingly showy. Jerry Goldsmith's excessive score, by turns too perky and too strenuous, gives this half-familiar film one more foreign touch.

•

"The Vanishing" is rated R (Under 17 requires accompanying parent or adult guardian). It includes profanity and violence.

1993 F 5, C3:4

National Lampoon's Loaded Weapon 1

Directed by Gene Quintano; screenplay by Mr. Quintano and Don Holley, based on a story by Mr. Holley and Tori Tellem; director of photography, Peter Mening; edited by Christopher Greenbury; music by Robert Folk; production designer, Jaymes Hinkle; produced by Suzanne Todd and David Willis; released by New Line Cinema. Running time: 83 minutes. This film is rated PG-13.

Jack Colt	Emilio Estevez
Wes Lugar	Samuel L. Jackson
Becker	Jon Lovitz
Jigsaw	Tim Curry
Destiny Demeanor	Kathy Ireland
General Mortars	William Shatner
Coroner	Dr. Joyce Brothers
Harold Leacher	F. Murray Abraham

By VINCENT CANBY

The gags begin with the title of "National Lampoon's Loaded Weapon 1" and don't stop until the end, though the laughter that greets them is intermittent. Supplementing the good gags are dozens of others, no one of which is too tired, too atrocious or too badly timed or executed to be left out. This is the engagingly brazen method of the film, which, like a fast-food restaurant, emphasizes speed, filler material and functional glitz.

The movie's frame is a sendup of the "Lethal Weapon" movies with Emilio Estevez playing a loose-cannon cop, the role originated by Mel Gibson, and Samuel L. Jackson standing in for Danny Glover. Their mission: to recover a microfilm containing a formula by which cocaine can be turned into cookies.

Along the way, "Loaded Weapon 1" has fun recalling highlights from a number of other movies. Among them: the steamy interrogation scene from "Basic Instinct," and the succession of poetic slow-motion shots of bodies crashing through glass in "48 Hours" and its sequel. At one point Dr. Joyce Brothers, the Dr. Ruth of yesteryear, shows up as a coroner. At another, F. Murray Abraham comes on to do Anthony Hopkins doing Hannibal Lecter. Watching "Loaded Weapon 1" is like playing Trivial Pursuit with experts. It's exhausting.

Whoopi Goldberg makes an unbilled appearance as Mr. Estevez's former partner, her life snuffed out too early, while William Shatner plays an unscrupulous drug king

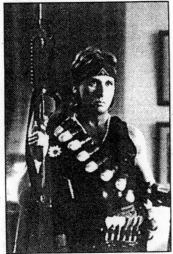

New Line Cinema

Emilio Estevez

named General Mortars. There's also a character named Destiny Demeanor (Kathy Ireland) so people can refer to her as Miss Demeanor.

The screenplay, written by Don Holley and Gene Quintano, was directed by Mr. Quintano. He and his associates are not always as funny as they might be, but in this kind of comedy, tirelessness is an end in itself.

•

"National Lampoon's Loaded Weapon 1," which has been rated PG-13 (Parents strongly cautioned), has rude language, sexual situations and mock violence.

1993 F 5, C6:6

Sommersby

Directed by Jon Amiel; screenplay by Nicholas Meyer and Sarah Kernochan; story by Mr. Meyer and Anthony Shaffer, based on the film "The Return of Martin Guerre," written by Daniel Vigne and Jean-Claude Carrière; director of photography, Philippe Rousselot; edited by Peter Boyle; music by Danny Elfman; production designer, Bruno Rubeo; produced by Arnon Milchan and Steven Reuther; released by Warner Brothers. Running time: 110 minutes. This film is rated PG-13.

Jack Sommersby	Richard Gere
Laurel Sommersby	Jodie Foster
Judge Isaacs	James Earl Jones
Orin Meecham	Bill Pullman
Reverend Powell	William Windom

By VINCENT CANBY

Jodie Foster has already won two Academy Awards, but nothing she has done to date is preparation for the romantic, resolute, elegant performance she gives in "Sommersby," a handsome period film set in the post-Civil War South of the Reconstruction. As Laurel Sommersby, a Tennessee farm woman who welcomes home a long-lost husband who may or may not be hers, Ms. Foster is so strong, passionate and mysterious that she seems almost to be a new actress or, at least, an actress of entirely new dynamism.

"Sommersby" is both about the cyclical nature of the universe, where matter can be neither created nor destroyed, only changed in state, and a demonstration of that law: the film is an updated Americanized adaptation of "The Return of Martin Guerre," Daniel Vigne's fine 1982 French film starring Gérard Depar-

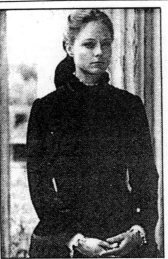

Warner Brothers

Jodie Foster

dieu. Even "The Return of Martin Guerre" is something recycled, being a reworking of a true story that has long fascinated the French public in various novels, plays and even an operetta.

Richard Gere, one of the film's two executive producers, stars as Jack Sommersby, the Confederate equivalent to Martin Guerre, the wandering 16th-century French peasant who was twice tried for passing himself off as someone he wasn't. In this latest incarnation, as in Mr. Vigne's film, the one-time soldier, having been away for six years and presumed dead, shows up at his farm one day to claim his wife, property and money.

Sommersby says that he has been at the Union prisoner-of-war camp at Elmira, N.Y., a place as notorious for its hardships as the Confederate prison near Andersonville, Ga. The experience has taken its toll. He is physically altered. Even his shoe is two sizes smaller. His memory sometimes plays tricks on him. He remembers some things with uncanny accuracy, while others are inexplicably lost.

Possibly out of fear for their livelihoods, his sharecroppers immediately accept him. His son, Rob (Brett Kelley), is too young to remember Sommersby, but his old dog, Jethro, growls at his first approach. Not long after, Jethro is found dead. Sommersby's wife is the key to his reinstatement.

At first Laurel can't believe that he is the husband who gambled, swore and brawled, and who ignored her ever after she became pregnant. The boor has been returned to her miraculously transformed. He is polite, hard-working, considerate and loving. His first night home he asks her to shave his beard. He soon becomes the ardent answer to dreams she might not acknowledge even to herself. By embracing this man, she makes her universe secure.

•

The story of Martin Guerre is true, but it's also the kind of myth that is modernized at a certain risk. Its concerns with love, sex, money and property are timeless. Yet the story only makes sense in a time that is simpler, more dour, more superstitious and more swiftly brutal than that of even the post-Civil War South, especially in a Reconstruction tale that has a late 20th-century sensibility.

Jon Amiel, the director, and Nicholas Meyer and Sarah Kernochan, who wrote the screenplay, have transformed the Martin Guerre character into a 1990's man who behaves as if he had been shaped by the counter-culture of the Vietnam era.

It isn't simply greed that leads Sommersby's old friends, neighbors and family members to denounce him as an impostor. It's racial bigotry. He has a visionary plan to revitalize his farm by setting up a co-op. After the harvest of their first crop of tobacco, Sommersby's sharecroppers, black as well as white, will be allowed to purchase the land they work. The white sharecroppers have no choice but to go along with him. Soon the Ku Klux Klan is burning a cross in front of his house.

The co-op would not be an anachronism in the South of the Reconstruction, but it's not in character for either Sommersby or the ne'er-do-well Confederate Army deserter he's accused of being. The co-op is in character for the man Mr. Gere plays, a fellow who doesn't have much relation to the man described by everyone else in the movie. His Sommersby is an endearing cipher, composed of mannerisms that suggest someone who has recently left his commune and is still tentative about how to behave in the outside world. He's a man full of love, working in his own naïve way to let the sun shine in.

The sun never does shine in to explain the circumstances surrounding the death of Jethro, the dog. Once he's buried, he's never mentioned again. It must be assumed he had a bad heart.

Though the film becomes a courtroom drama near the end, Sommersby is of such nobility that the fundamental question about his identity becomes moot in the course of his two trials. The revelations about Sommersby's past, combined with Laurel's contradictory testimony, may confuse audiences so thoroughly that they will leave the theater thinking that "Sommersby" is about worn-out land, crop rotation and fertilizer.

•

Though there is a near vaccuum at the center of the film, "Sommersby" is never boring, largely because of Ms. Foster's beautifully self-possessed presence. The once-abandoned, now-reclaimed wife becomes the focus. Is it possible to sleep with a man who says he's your husband and not know that he's lying? What degree of longing might lead a comparatively innocent woman to accept a stranger in her house? Has she been fooled? Is she an accomplice? Or, in fact, does she know him to be a scoundrel reborn? These are the operative questions. They give "Sommersby" its drive and cohesion. Everything else is superfluous.

Heading the supporting cast are Bill Pullman, as the angry farmer who had hoped to marry Laurel before her husband's return, and James Earl Jones, who plays the presiding judge at Sommersby's trials. The film, photographed on location in western Virginia by Philippe Rousselot, looks authentic. The production is not helped by the kind of old-fashioned soundtrack score that instructs the emotions. Mr. Amiel is best known as the director of Dennis Potter's great English mini-series, "The Singing Detective," in which music functioned as satiric counterpoint to everything else. He seems to have

picked up a lot of American movie-making habits. But perhaps the music in "Sommersby" wasn't his decision.

•

"Sommersby," which has been rated PG-13 (Parents strongly cautioned), has some violence and sexual situations.

1993 F 5, C8:1

Rain Without Thunder

Written and directed by Gary Bennett; director of photography, Karl Kases; edited by Mallory Gottlieb and Suzanne Pillsbury; music by Randall and Allen Lynch; production designer, Ina Mayhew; produced by Nanette and Gary Sorensen; released by Orion Classics Releasing. Running time: 87 minutes. This film is rated PG-13.

Beverly Goldring Betty Buckley
Jonathan Garson Jeff Daniels
Allison Goldring Ali Thomas
Walker Point Warden Frederic Forrest
Reporter Carolyn McCormick
Atwood Society Director Linda Hunt
Old Lawyer Robert Earl Jones
Author on History Graham Greene
Andrea Murdoch Iona Morris
Roman Catholic Priest Austin Pendleton

By JANET MASLIN

"Rain Without Thunder," a dreary, nondramatic tract envisioning an America in which abortion is outlawed, deserves special notice for its unfortunate timing. Two weeks into the Clinton Administration, here is a film set in a 2042 where pictures of young Dan Quayle still adorn the walls of government offices. And women who have had abortions are imprisoned at Walker Point, a correctional facility presumably imagined in honor of Walker's Point, George Bush's summer home. To be fair, "Rain Without Thunder" would be hopeless even if its foot were not so clearly in its mouth.

As written and directed by Gary Bennett, "Rain Without Thunder" is all talk. Endless subjects are supposedly interviewed by a television reporter (Carolyn McCormick), who is trying to reconstruct the story of Allison Goldring (Ali Thomas). Allison and her mother (Betty Buckley) have been jailed for trying to go to Sweden in the early weeks of Allison's pregnancy, under the provisions of a new Unborn Child Kidnaping Act. The film dwells portentously on this and other imaginary legal developments, like a 28th Amendment giving full Constitutional rights to fertilized eggs.

Constructed listlessly as a drab parade of earnest talking heads, the film seems strangely halfhearted even in its commitment to being futuristic. Not much has changed in 50 years, except that men wear slightly effeminate, multi-cultural costumes while they constrain women with oppressive laws. Also in the film's arsenal are inexpressive slang words ("velvetheads," "hummer," "fruited") and grisly descriptions of abortion-related horrors ("blood dripping down thighs onto filthy tenement floors ..."). Viewers will have had more than enough of this after 15 minutes, though the film lasts an eternal hour and a half.

"Rain Without Thunder," which takes its title from Frederick Douglass (to the effect that progress is impossible without struggle), incorporates several familar actors into an otherwise amateurish-sounding cast. None of them are allowed the chance to do more than recite lines into the camera, punctuating this dialogue with the occasional pregnant pause.

The actors, including Jeff Daniels, Frederic Forrest, Graham Greene, Linda Hunt (by far the most alert cast member) and Austin Pendleton, do the best they can under impossible circumstances. If there is a good way to deliver a line like "Could it be, Father, that society has gone a bit too far in punishing women?," nobody here knows what it would be.

•

"Rain Without Thunder" is rated PG-13 (Parents strongly cautioned). It includes graphic language.

1993 F 5, C8:5

FILM VIEW/Caryn James

Look, Ma, I'm an Auteur!

FOR MOST PEOPLE, INTERACtive movies and television — you talk to the screen and the characters do what you say — still mean clapping to save Tinkerbell. As it happens, I never clapped for Tink, even as a 4-year-old. It was a test. I didn't clap, Tink lived anyway, and I knew the fix was in.

For children growing up in a computer-literate world, talking back to movies is bound to be different. The first inkling of this trend is "I'm Your Man," a low-budget, good-humored, 20-minute "interfilm" (now playing in New York and Lakewood, Calif.) in which the audience directs the plot by pushing green, orange or red buttons connected to the armrest of every seat in the theater.

Will Leslie succeed in turning her corrupt business partner, Richard, over to the F.B.I.? Will Jack, who stumbles across Leslie's path at a party, become a spy or date Leslie, or both?

Who cares? The story means nothing here. Sometimes Jack becomes a spy and gets the girl; sometimes Richard gets away with murder. The still-novel appeal of interactive film is making movie characters do what you want.

This experience is not like watching a real

Interactive films ask viewers to choose the plot twists. Where will it all lead?

movie, of course. It is more like rooting for a basketball team. Before each screening, a cheerleader called Art ("I'm Your Man" knows what it's tweaking) warms up the audience, asking viewers to wave their arms and yell. He encourages them to race from seat to seat, voting on as many empty keypads as possible.

"Don't just sit there!" Art shouts. "You got to make as much noise as you can, and you got to move around as much as you can!" Some people actually do this. They punch buttons along whole empty rows and shout, "Run like a scared rabbit" or "Become a special agent," when Jack offers those options for what to do next. At one screening, someone yelled "Dork" at him, but creative name-calling doesn't count.

It may be that you have to be 13 years old to enjoy this properly. Or it may be that interactive films aren't asking the right questions yet. I can't remember what I told Jack to do, but I would vote early and often for Rhett to return to Scarlett. That wouldn't improve the ending, but it would definitely make me feel better.

Such a thing could happen. Technology will advance, and this dream/nightmare scenario could emerge: in a process that will make colorization look like a gift to the Library of Congress, classic movies will be remade to allow audiences to vote.

Viewers will run through the aisles shouting at Ingrid Bergman, "Don't get on that plane! Ignore him!" They will make Orson Welles say "Tap dance" or "Cream puff" instead of "Rosebud." On a bad day, Tinkerbell could turn into Camille.

Obviously, "I'm Your Man" is just the beginning. Here is a glimpse of what to expect when old movies become interactive and we can reinvent them the way we always thought they should be:

• In "Wuthering Heights," the audience votes to save Cathy's life. How does Heathcliff react?
Green button: Asks her to marry him.
Orange button: Runs like a scared rabbit.
Red button: Reveals that he is the illegitimate son of Queen Victoria and will henceforth be known as Squidgy.

• In "The Wizard of Oz," the audience votes the scarecrow a brain. What will he do next?
Green button: Apply to Harvard Business School.
Orange button: Open a Fred Astaire Dance Studio.
Red button: Stop hanging around with that dopey lion.

• In "Fatal Attraction," Michael Douglas makes one more date with Glenn Close. Where do they go?

Green button: A kitchen appliance store.

Orange button: Disney World.

Red button: A Bugs Bunny cartoon.

• In "The Godfather," Don Corleone is angry at the Tataglia family. What does he do?

Green button: Send them a box of poisoned cannoli.

Orange button: Send Sonny out to kill them.

Red button: Call them dorks.

Tinkerbell, I take it all back. □

1993 F 7, 13:1

Utz

Directed by George Sluizer; screenplay by Hugh Whitemore, based on the novel by Bruce Chatwin; director of photography, Gerard Vandenburg; produced by John Goldschmidt, released by First Run Features/Castle Hill Productions. At Film Forum, 209 West Houston Street, South Village. Running time: 95 minutes. This film has no rating.

Baron von Utz	Armin Mueller-Stahl
Marta	Brenda Fricker
Marius Fischer	Peter Riegert
Dr. Vaclav Orlik	Paul Scofield

By JANET MASLIN

One of the few things than can easily be said about "Utz," Bruce Chatwin's short, eccentric novel about a Czechoslovak baron obsessed with collecting porcelain figurines, is that it does not suggest itself as ready-made movie material. This odd tale is quite serious about its Meissen monkeys and Buddhas and commedia dell'arte caricatures, a thousand of which have been lovingly accumulated by Utz in his tiny Prague apartment.

Utz's collection, no less bizarre and daunting on screen than it was on the page, is seen as the very essence of his nature. It is a nature that transcends ordinary notions of morality or behavior. "He detested violence, yet welcomed the cataclysms that flung fresh works of art onto the market," Mr. Chatwin wrote of a man who had thus benefited from Kristallnacht and the stock market crash of 1929. "Wars, pogroms and revolutions," says Utz (played expertly by Armin Mueller-Stahl), "offer excellent opportunities for the collector."

Despite that note of apparent cynicism, "Utz" describes more singular and uncategorizable passions than might be expected. The quietly whimsical Utz, who adores the large, statuesque figures of opera divas nearly as much as he cherishes tiny Meissen creations, treats his collecting as a link to the glorious past and a sly form of political rebellion against the present. In a story that begins in 1967 and lasts well past the 1968 Soviet takeover of Czechoslovakia, Utz's obsession with Meissen artifacts becomes a means of confounding Government authority. "Marxist-Leninism had never got to grips with the concept of the private collection," the novel observed. "Was the collector a class-enemy? If so, how?"

The film version of "Utz," which opens today at the Film Forum, is far too faithful to its source material to answer such a question head-on. As directed with courtly flair by George Sluizer, it succeeds in being every bit as peculiar and mischievous as the book on which it is based. Mr. Sluizer, who established his substantial talent with the Dutch version of "The Vanishing," and whose new American remake is nothing if not a show of bravado, takes a game approach to an impossible job. In his hands, "Utz" remains appealing but elusive. Its pleasures are akin to those of a Meissen tureen, described by Mr. Chatwin in great detail, "which, but for the bravura of its execution, would have been a monstrosity."

•

Chief among those pleasures are Mr. Mueller-Stahl's fine, gruffly disarming performance, and his way of breathing life into Utz's conversational gambits, on subjects that range from the link between collecting and idolatry to the golem to a discussion of trout. This last disquisition is set in a restaurant where trout are the specialty, but are served only to special patrons with Communist Party connections. In a scene transferred entertainingly to the screen from the novel, Utz is joined in his objections to such favoritism by Professor Orlik, the wild-haired scientist played with droll intelligence by Paul Scofield. Mr. Scofield's presence is immensely welcome, even at times when the character's purpose is less than clear.

Professor Orlik's specialties are the mammoth and the housefly, which is the sort of dichotomy in which "Utz" cheerfully abounds. Roused by the trout shortage, Orlik is moved to offer a ringing defense of the fly as the least communally minded of insects. "He is an anarchist!" cries the professor, loudly enough to be heard by trout-eating party members at a nearby table. "He is an individualist! He is a Don Juan!"

Utz, who also fits that description, is seen chiefly through the eyes of Marius Fischer (Peter Riegert), the vaguely jaded New York art dealer whose interest is piqued by the Utz collection and the mysterious circumstances that surround it. Also important to the story is Marta (Brenda Fricker), the hard-working housekeeper whose role is not limited to tending Utz's treasures. The members of this deliberately international cast are able to meet on common ground, thanks to Mr. Sluizer's ease with actors and his rapt, enveloping approach to the story's obsessive details.

Mr. Chatwin's readers will be interested to note that the film's porcelain figurines correspond to those described in the novel, and that the thousand-piece Meissen collection seen here is real.

1993 F 10, C15:5

Groundhog Day

Directed by Harold Ramis; screenplay by Danny Rubin and Mr. Ramis, based on a story by Mr. Rubin; director of photography, John Bailey; edited by Pembroke J. Herring; music by George Fenton; production designer, David Nichols; produced by Trevor Albert and Mr. Ramis; released by Columbia Pictures. Running time: 103 minutes. This film is rated PG.

Phil	Bill Murray
Rita	Andie MacDowell
Larry	Chris Elliott
Ned	Stephen Tobolowsky
Buster	Brian Doyle-Murray
Nancy	Marita Geraghty
Mrs. Lancaster	Angela Paton

By JANET MASLIN

In "Groundhog Day," playing a formerly smug weatherman who finds himself condemned to relive one Feb. 2 over and over again in Punxsutawney, Pa., Bill Murray explains his feelings to two bleary-eyed, beer-drinking locals. "What would you do if you were stuck in one place and everything was exactly the same and nothing that you did mattered?" he asks despairingly. The two strangers listen very sympathetically. They didn't have to be trapped by a magic spell to know what he means.

That glimmer of recognition is what makes "Groundhog Day" a particularly witty and resonant comedy, even when its jokes are more apt to prompt gentle giggles than rolling in the aisles. The story's premise, conceived as a sitcom-style visit to the Twilight Zone, starts out lightweight but becomes strangely affecting. Phil Connors, Mr. Murray's amusingly rude Pittsburgh television personality, surely deserves to be punished for his arrogance. But who in the audience hasn't ever wished time would stand still and offer a second, third or even a 20th chance?

The jaded Phil, a perfect character for Mr. Murray, begins the story sounding terminally smooth. He refers to himself as "talent," and addresses a fellow newscaster as "Hairdo." He sneers at Punxsutawney and is contemptuous of his own charming

Forward to the past with a television weatherman.

producer (Andie MacDowell) and darkly funny cameraman (Chris Elliott). He even delivers pleasant-sounding insults to the proprietors of the bed-and-breakfast where he is staying, not realizing he may be staying there forever.

As directed breezily by Harold Ramis (who wrote the screenplay with Danny Rubin), "Groundhog Day" employs the sort of time-bending trickery that worked so well for "Back to the Future." Thus, Phil finds himself revisiting the recent past and coming face to face with people not fully aware of his special powers. On the first Feb. 2, he is cheerfully odious to everyone he meets, including an insurance salesman named Ned (Stephen Tobolowsky, hilarious as the quintessential pest). But as time goes by — or doesn't — Phil begins to try out dif-

Columbia Pictures

Seasonal In "Groundhog Day," Bill Murray plays a television weatherman who finds himself endlessly reliving Feb. 2. Harold Ramis's romantic comedy, with Andie MacDowell, Chris Elliott, Stephen Tobolowsky and Brian Doyle Murray.

ferent gambits, testing the limits of his plight. He learns that he can do nothing bad enough to keep himself from waking up under the same flowered quilt, listening to Sonny and Cher sing "I Got You, Babe" on the clock radio at 6 A.M. Not even smashing the radio to bits will make them shut up.

Wildly frustrated at first, Phil gradually begins to treat his plight as a learning experience. He can, for instance, take enough piano lessons to impress Ms. MacDowell's enchanting Rita, once he realizes how wrong he was to treat her badly. One of the film's many repetitive sequences shows Phil on a date with Rita, learning so much about her that he can begin sounding like a mind reader and passing himself off as the perfect mate. "You couldn't *plan* a day like this!" Rita finally sighs happily. "Well, you can," says Phil. "It just takes an awful lot of work."

•

The film makes the most of the sentimental possibilities in Phil's rehabilitation. (Viewers who notice Phil ignoring a panhandler on his first Groundhog Day will surely know where that setup is headed.) But it also has fun with the nihilism. Phil eagerly explores every self-destructive possibility now open to him, from jumping off buildings to smoking cigarettes to overeating and refusing to floss; at one point he even casually robs an armored truck, just to see if he can. "Well, what if there *is* no tomorrow?" he anxiously asks someone. "There wasn't one today!"

Mr. Murray is back in top form with a clever, varied role that draws upon the full range of his talents. As in "Scrooged," he makes a transition from supreme cynic to nice guy, and this time he does so with particularly good grace. Half Capra and half Kafka, the story of "Groundhog Day" presents golden opportunities, particularly in the gently romantic scenes with Ms. MacDowell. Mr. Murray is as believable and appealing at these moments as he is flinging insults. Ms.

MacDowell, a warm comic presence and a thorough delight, plays a modern working woman while also reminding viewers that this is at heart a fairy tale. As Phil tries one desperate tactic after another, fairy tale fans will be way ahead of him, knowing what it takes to break a spell.

•

"Groundhog Day" is rated PG (Parental guidance suggested). It includes mild profanity and tacit sexual situations.

1993 F 12, C3:4

Riffraff

Directed by Ken Loach; written by Bill Jesse; director of photography, Barry Ackroyd; edited by Jonathan Morris; music by Stewart Copeland; production designer, Martin Johnson; produced by Sally Hibbin; released by Fine Line Features. Running time: 96 minutes. This film has no rating.

Stevie	Robert Carlyle
Susan	Emer McCourt
Shem	Jimmy Coleman
Mo	George Moss
Larry	Ricky Tomlinson
Kevin	David Finch

By VINCENT CANBY

"Riffraff," Ken Loach's tough, honest and sometimes achingly funny comedy about a nonunion construction worker in London, is the kind of English movie that could never be made in this country, not because of the subject matter but because of the social structure: Britain still has a working class.

After World War II, the vast majority of America's blue-collar workers became de facto members of the middle class as wages and standards of living rose. Even those who haven't benefited tend to identify with those who have.

Something of the same process must have been going on in Britain, or the Conservative Party could not have remained so long in power. Yet the members of the British working class are as much defined by birth, accent and aspirations as by the jobs they hold. "Riffraff" embraces that hard core of British workers who remain near the bottom of a hierarchy that, at the top, still has a blooded aristocracy.

The film is also an unsentimental update on the lives of the sorts of characters who populated the working-class films of Tony Richardson and Lindsay Anderson in the late 1950's and early 60's. Like his contemporary Mike Leigh ("High Hopes"), Mr. Loach doesn't impose the kind of shapely narrative on his characters that gave the earlier films their sense of clear political mission. "Riffraff" is no less politically aware, but it doesn't preach. It illustrates.

•

Written by Bill Jesse, with English subtitles to translate the argot and the often impenetrable regional accents, "Riffraff" is about a couple of months in the life of Stevie (Robert Carlyle), a skinny, taciturn young man who has come to London from Scotland to find work. Stevie is not his real name but, having a prison record, he is trying to start fresh. "No more thieving," he tells himself.

Stevie goes to a construction site where the old Princess of Wales Hospital building is being renovated as a luxury apartment block. When he says he's looking for a job, the foreman responds in mock surprise, "Oh,

Paul Chedlow
Emer McCourt

I thought you were here to grant me three wishes." The foreman is not being friendly. He's a mean blowhard with the gift of sarcasm. Stevie is hired and quickly accepted by his new mates: white, black, English, Irish, Scottish and Caribbean. Some, like Stevie, are not eager to be identified with earlier lives.

Though "Riffraff" gives the impression of ambling, there's no wasted space in it. The film is small in scope, but so vivid in unhackneyed detail that it has the manner of something improvised. The dialogue is often hilarious, even with the subtitles. Characters emerge as individuals, not types.

With the help of Larry (Ricky Tomlinson), an older construction worker who functions as the film's social conscience, Stevie finds a rat-infested "squat" in an abandoned apartment block. After his friends help clean up the place and reconnect the gas line, Stevie has surprisingly adequate housing. He begins an affair with Susan (Emer McCourt), a pretty, emotionally wan young woman who wants to be a singer.

Unfortunately, Susan has a terrible voice and no great drive, which Stevie refuses to recognize at first. This needy waif who eats diet foods and reads horoscopes seems glamorous to him, possibly even more so when she ridicules his dream of going into "merchandising." To him merchandising means selling boxer shorts and socks, in which, he promises her, there is money to be made. Neither Stevie nor Susan has thought things through. The difference between them is that Stevie learns in the course of this summer, and Susan never does. She has moods. She gets depressed. "Depression is for the middle class," says Stevie. "The rest of us get an early start in the morning."

•

Jobs being as scarce as they are in London today, no great efforts are wasted on safety at Stevie's site. There are accidents. The men beef, but they express their dissatisfactions at the risk of being fired. By the end of "Riffraff," Stevie has been radicalized.

The members of the film's large cast, most of whom will be new to American audiences, are so good that it's impossible to tell the professionals from the amateurs. Ms. McCourt was seen here earlier in Hanif Kureishi's "London Kills Me." Mr. Carlyle also has had extensive theatrical ex-

perience. Mr. Tomlinson, so fine as the loud-mouthed Larry, is an actor who apparently first won notoriety in 1972 when, working as a plasterer, he went to jail following a highly publicized building strike.

Mr. Loach has been turning out socially and politically committed films and documentaries since 1967, when he made his feature-film debut with "Poor Cow," a movie whose sincerity seemed artfully contrived. His biggest popular success remains "Kes" (1969). Of his later films, "The Gamekeeper" (1980) and "Singing the Blues in Red" (1986) have been the most interesting.

Now comes "Riffraff," a movie full of an exuberance that has not been apparent before. It's his best work to date. Credit should also be given to the screenplay by Mr. Jesse, a former construction worker who died at the age of 48 when "Riffraff" was in post-production. It seems to have been his only produced screenplay.

1993 F 12, C10:5

Trusting Beatrice

Written and directed by Cindy Lou Johnson; director of photography, Bernd Heinl; edited by Camilla Toniolo; production designer, Cynthia Kay Charette; produced by Mark Evan Jacobs and Ms. Johnson; released by Castle Hill Productions. At the Quad Cinema, 13th Street between Fifth Avenue and Avenue of the Americas, Manhattan. Running time: 86 minutes. This film is rated PG.

Beatrice de Lucio	Irène Jacob
Claude Dewey	Mark Evan Jacobs
Mrs. Dewey	Charlotte Moore
Daddy V. J.	Leonardo Cimino
Mr. Dewey	Pat McNamara
Danny	Steve Buscemi

By VINCENT CANBY

"Trusting Beatrice," which opens today at the Quad Cinema, is the sort of failed comedy that becomes increasingly difficult to watch as it proceeds. It has no shame. It tries so hard to please that it eventually appears to be groveling, making itself June-bug small and defenseless. The temptation to step on it isn't easily resisted.

The film is the first to be written and directed by Cindy Lou Johnson, a playwright apparently known for her quirky characters and whose latest comedy, "The Years," is now at the Manhattan Theater Club.

Ms. Johnson tells the story of Claude (Mark Evan Jacobs), a young landscape architect who wears long baggy shorts and a bewildered expression, and his attempts to help Beatrice (Irène Jacob), a homeless young Frenchwoman lost in America without a green card. Beatrice does not travel light. She has with her a little girl, a Cambodian refugee, whom she pulls around in a child's red wagon.

When the feckless Claude accidentally burns down the rooming house he shares with Beatrice, he feels obligated to take care of her or, at least, to take her home to his determinedly eccentric mother, father and grandfather so that they will take care of her. The setting is unidentified, though it's actually Providence, R.I., whose picture-postcard prettiness (as photographed by Bernd Heinl) is the only thing about the movie that works at all.

Ms. Johnson may be an adequate director, but it's not easy to tell, considering the awfulness of her screenplay. The oddball characters seem to

be random inspirations unconnected to any larger view of life or the world. What passes for comedy are tiny misunderstandings or Beatrice's coy mangling of the English language. "What's wrong with being on the sheep?" she might say, so that Claude can point out that she means "on the lam."

Ms. Jacob made "Trusting Beatrice" a couple of years ago, just about the time she won the prize at the 1991 Cannes International Film Festival for her performance in Krzystof Zanussi's "Double Life of Véronique." The radiance she showed in the Zanussi film is nowhere in evidence in this movie. She weeps a lot and pretends that she's a free soul, instead of a trapped actress. Mr. Jacobs, the film's co-producer, is equally charmless as Claude. Almost incognizable is Steve Buscemi, so fine in "Reservoir Dogs," who plays Claude's best friend in the style of Don Knotts.

•

"Trusting Beatrice," which has been rated PG (Parental guidance suggested), includes partial nudity and vulgar language.

1993 F 12, C10:5

Correction

A film review in Weekend on Feb. 12 about "Trusting Beatrice" misidentified the director of "The Double Life of Véronique." He is Krzysztof Kieslowski.

1993 F 20, 2:5

'Ballroom': Rivalries And Love

"Strictly Ballroom" was shown as part of last year's New York Film Festival. Here are excerpts from Janet Maslin's review, which appeared in The New York Times on Sept. 26, 1992. The film opens today at the Angelika Film Center, Mercer and Houston Streets, Greenwich Village, and First and 62d Cinemas, 400 East 62d Street, Manhattan.

Inside the bright, brassy confines of an Australian dance palace, a kitschy melodrama unfolds. It is the story of Scott (Paul Mercurio), a contender for the Pan-Pacific dance trophy who may suddenly have sabotaged his chances by daring to do steps of his own, and Fran (Tara Morice), the homely, spunky girl who dreams of becoming Scott's partner. It is a tale of scheming for the trophy, of a corrupt contest official (who hawks his own educational video, titled "Dance to Win"), and of Scott's ambitious parents, who hope their son's triumph can make up for their own broken dreams.

Baz Luhrmann's Australian film "Strictly Ballroom" is, in short, pure corn. But it's corn that has been overlaid with a buoyant veneer of spangles and marabou, and with a tireless sense of fun. (The film's outrageously

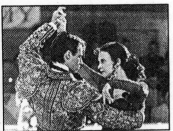

Miramax Films

Paul Mercurio and Tara Morice in a scene from "Strictly Ballroom."

glittery get-ups, according to production notes, "exhausted Australia's supply of Austrian diamantes, which were used on everything from costumes to fingernails," and the film makers no doubt made a dent in supplies of hair mousse and peroxide, too.)

Though none of it can be taken more than half-seriously, the film tells an enjoyably hokey story with flair.

●

"Strictly Ballroom," one of the only films to emerge from this year's Cannes Film Festival as a potential crowd-pleaser, laughs at its own silliness while trying to raise that silliness to a fever pitch. What saves the film from campy overkill is the enjoyable predictability of its central love story, which is played more or less earnestly.

Mr. Mercurio, a talented dancer (he is also a choreographer) and a straightforward actor, makes Scott's growing interest in Fran as plausible as his determination to be his own man. Miss Morice succeeds in blossoming, with suitable miraculousness, from a plain Jane into a dance-hall revelation.

The metaphorical aspects of the story are not easy to miss. Scott is pressured by his elders to conform to the rules and to dance with the partner they have chosen ("It's an answer to our prayers!" exclaims his mother, when told of Scott's potential partnership with the popular blonde named Tina Sparkle). Fran must at first defy her own relatives, who are Spanish and highly suspicious of Scott and all he stands for. They also turn out to be talented flamenco dancers (Fran's father is played by the dancer Antonio Vargas), and eventually they like Scott enough to teach him their secrets. This is the kind of film in which Fran's grandmother can magically produce a flamenco dress at a crucial moment, exclaiming, "I brought this just in case!"

Despite its gleefully flashy dramatic style, "Strictly Ballroom" is less visually appealing than it might be, with its sometimes drab cinematography punctuated by needlessly broad fish-eye shots of various oddball characters. But Mr. Luhrmann knows exactly how he wants this film to look, as he demonstrates in a rooftop rehearsal sequence between Scott and Fran, positioning them before a gleaming red Coca-Cola billboard and beneath rows of socks drying on clotheslines.

1993 F 12, C12:6

Untamed Heart

Directed by Tony Bill; written by Tom Sierchio; director of photography, Jost Vacano; edited by Mia Goldman; music by Cliff Eidelman; production designer, Steven Jordan;

M-G-M

Secretive Christian Slater and Marisa Tomei co-star in "Untamed Heart." Tony Bill's drama revolves around a waitress in a Minneapolis diner who falls in love with a timid busboy who has something to hide.

produced by Tony Bill and Helen Buck Bartlett; released by Metro-Goldwyn-Mayer. Running time: 102 minutes. This film is rated PG-13.

Adam...................................Christian Slater
Caroline.................................Marisa Tomei
Cindy...Rosie Perez
Howard.......................................Kyle Secor
Patsy.......................................Willie Garson

By VINCENT CANBY

"Untamed Heart" is to the mind what freshly discarded chewing gum is to the sole of a shoe: an irritant that slows movement without any real danger of stopping it.

The movie is about the transforming love affair of two innocents, Caroline (Marisa Tomei), a pretty Minneapolis waitress whose boyfriends dump her with alarming regularity, possibly because she talks too much, and Adam (Christian Slater), the busboy at the diner where Caroline works. He's a good-looking, strapping fellow who talks so seldom that people think he's retarded, though he's only shy. "Untamed Heart" would have you believe they are made for each other, like Diane and Chico in an upper Midwestern version of "Seventh Heaven."

Adam at first loves Caroline from afar, discreetly following her home late every night to make sure she arrives safely. When two goons try to rape her, Adam is there to save her. The romantic Caroline suddenly realizes that the man of her dreams is the guy who sweeps up and dumps the garbage. In truth he is a sweet, bookish fellow who loves searching for shooting stars. When he becomes depressed, he tells her, he listens to his records and "the rain stops falling."

Adam looks strong but he has a weak heart, a condition that goes back to his childhood in an orphanage. To help him through the bad days, his favorite nun used to tell him that he has been given a very special, magical heart, that of the baboon king of Kilimanjaro, which leads to some rather peculiar complications in the contemporary story.

Ms. Tomei and Mr. Slater play this nonsense as legitimately as possible. The indomitable Rosie Perez appears as Caroline's wisecracking friend. Tony Bill, best known as the producer of "The Sting," directed the screenplay by Tom Sierchio, his first to reach the screen.

●

"Untamed Heart" is rated PG-13 (Parents strongly cautioned). It has some vulgar language, violence and sexual situations.

1993 F 12, C14:6

Dead Alive

Directed by Peter Jackson; screenplay by Mr. Jackson, Stephen Sinclair and Frances Walsh, from an original story idea by Mr. Sinclair; director of photography, Murray Milne; edited by Jamie Selkirk; music by Peter Dasent; production designer, Kevin Leonard-Jones; produced by Jim Booth; released by Trimark Pictures. Running time 97 minutes. This film has no rating.

Lionel..Timothy Balme
PaquitaDiana Penalver
Mum .. Elizabeth Moody
Uncle Les .. Ian Watkin

By STEPHEN HOLDEN

The ocean of blood in "Dead Alive," a horror-movie spoof from New Zealand, doesn't merely gush. It spurts out of necks, mouths and skulls in angry geysers like exploding packets of cherry Kool-Aid. By the end of the movie, a suburban home has been transformed into one of the slimiest slaughterhouses ever shown in a film.

Severed heads are kicked like footballs over piles of squirming entrails, which resemble lobster legs twitching and wriggling in slippery ankle-deep piles. Two zombies copulate, producing a grotesque cannibalistic baby, and a monster zombie mother with incestuous cravings devours her son, who moments later bursts out of her decomposing body.

Because all of this looks blatantly unreal, and because the timing of the shock effects is so haphazard, "Dead Alive" isn't especially scary or repulsive. Nor is it very funny. Long before it's over, the half-hour-plus bloodbath that is the climax of the film has become an interminable bore.

●

That is not to deny that "Dead Alive" is an amusing concept. The movie, which was directed by Peter Jackson, aspires to be to the horror film what "Airplane" was to the disaster genre. Set in 1957, it also wants to satirize 50's squareness, in the manner of a John Waters movie. Its Day-Glo plastic gore comes out of the "Toxic Avenger" school of comic splatter.

In the story, Lionel (Timothy Balme) and Paquita (Diana Penalver) are star-crossed teen-age sweethearts whose nightmare begins in a local zoo when the boy's nosy, domineering mother (Elizabeth Moody), who is spying on the couple, is bitten by a Sumatran rat-monkey. The demon virus carried by the creature turns her into a predatory ghoul who infects nearly everyone except poor Lionel, who spends half the movie trying to conceal the grisly truth.

"Dead Alive" could have been much funnier had the director given the tone of his parody some rudimentary shading and had the screenplay (by Mr. Jackson, Stephen Sinclair and Frances Walsh) included three or four good jokes. A promising concept run amok, the movie proves that mad comic excess does not always insure laughter.

1993 F 12, C16:6

The Temp

Directed by Tom Holland; screenplay by Kevin Falls, based on a story by Mr. Falls and Tom Engelman; director of photography, Steve Yaconelli; edited by Scott Conrad; music by Frederic Talgorn; production designer, Joel Schiller; produced by David Permut and Mr. Engelman; released by Paramount Pictures. Running time: 96 minutes. This film is rated R.

Peter Derns...............................Timothy Hutton
Kris Bolin..............................Lara Flynn Boyle
Charlene TowneFaye Dunaway
Roger Jasser............................Dwight Schultz
Jack HartsellOliver Platt
Steven WeberBrad Montroe
Sara Meinhold............................Colleen Flynn
Sharon DernsMaura Tierney

By JANET MASLIN

New from hell: Kris Bolin (Lara Flynn Boyle), a temporary secretary who's the latest in a line of too-good-to-be-true female characters in recent horror movies. In "The Temp," Kris has the foresight to get herself hired by Peter Derns (Timothy Hutton), a guileless, newly separated executive who is much too likely to give Kris the benefit of the doubt.

Quickly convincing Peter that she lives to make his corporate life easier, Kris eagerly begins taking over his affairs. She helps him prepare an important report and makes sure it promptly reaches Charlene Towne, the high-strung boss (Faye Dunaway, reprising her "Network" role). She does a nice job of reorganizing Peter's personal finances, even if she manages to antagonize his estranged wife in the process. And she becomes so attached to Peter that she becomes flustered when his permanent secretary, who happens to be a man, comes back from paternity leave. Not long afterward, this man has an unfortunate mishap involving a paper shredder.

As written by Kevin Falls and directed by Tom Holland, "The Temp" starts well and runs into trouble

Matthew Ralston

Lara Flynn Boyle in "The Temp."

about midway through. It never quite decides how evil or powerful Kris ought to be, which means the film's improbably violent moments seem tacked-on. Is Kris truly a witch or merely ambitious? It's hard to tell the difference; actually, that may be the film's point. Kris is never scarier than when assuring her boss that her yen for power is strictly professional. ("This isn't about sex, Peter. It's about work.") She may just mean it.

•

Anyone planning a dissertation on Hollywood's fling with yuppie demonology will want to include "The Temp" in their calculations. The corporate atmosphere of a slick cookie-making operation is amusingly invoked here, from the Granny-minded display in the lobby of the company's Portland, Ore., headquarters (complete with rocking chair) to the furor when a top-secret recipe turns up in the wrong computer directory. Ms. Boyle's Kris, always wickedly per-suasive, manages to create quite a flap by solemnly championing the benefits of molasses during a lab test of cookie samples.

Mr. Hutton gives a confident and appealing performance until the story gets away from him, rising to a frantic denouement from which there is no return. In the film's early stages he presents the quintessential image of a crisp young executive, self-assured on the outside even though he has a psychiatrist who calls him "Mr. Hyde." The dialogue occasionally sounds a suitably ruthless note. "I just want you to know that I take no prisoners," says a friend of Peter's who also happens to be a professional rival. "And I eat the wounded."

•

"The Temp" is rated R (Under 17 requires accompanying parent or adult guardian). It has violence, sexual suggestiveness and mild profanity.

1993 F 13, 17:1

FILM VIEW/Janet Maslin

Old Wine and New Bottle Add Up to Pepsi

THINK OF IT AS A FREE, UNSOlicited Rorschach test of our national character. When a foreign film is remade to suit American audiences, its new version inevitably reflects some perception, fair or otherwise, of American tastes. We are seldom forced to contemplate those tastes as bluntly as we are by "Sommersby," a post-Civil War version of "The Return of Martin Guerre" (1982), and "The Vanishing," a Hollywood remake of the identically titled 1991 Dutch thriller. If we set out to commission a collective self-portrait, we would surely want something a bit more flattering.

The contrasts between these new films and their European predecessors are particularly fascinating because the originals are so quietly contemplative (and so good). On the trip across the Atlantic, reflectiveness has been one of the first things to go. American audiences are presumed to want more action, more explanation and more literal-minded detail to spell out the characters' in-ner thoughts. It seems not to have mattered that both these stories rely on a profound sense of mystery.

Apparently, American audiences are also expected to enjoy more violence, competitiveness and self-interest. And the remakes go out of their way to incorporate scenic settings and not-quite-real props. If the collective effect of these new ingredients is to render the original stories less believable, that seems to have been deemed a small price to pay for livelier, more lavish screen treatment. Or was the price too high?

"Sommersby" is the more ambitious of these remakes, since it seeks to transform a supremely austere story of love, doubt and spiritual identity into a sweeping romance. Along the way, the film makers have made some canny choices, especially in casting Richard Gere and Jodie Foster in roles once played by Gérard Depardieu and Nathalie Baye. Mr. Gere has some equivalent of Mr. Depardieu's imposing physical presence and hard-working charm. Both are essential to a man who returns to his community after a long absence and must labor to win back the good will of his neighbors and wife.

Ms. Foster, an actress whose piercing intelligence becomes more apparent with each new role, is equally right as the demure, wary wife who treads the story's most difficult path. It is her thoughts that hold the answer to the film's central secret. As directed by Jon Amiel, "Sommersby" amplifies the suspensefulness of the wife's position by providing a scene in which she shaves her husband's throat with a straight razor. Three centuries' progress ("Martin Guerre" was based on a 16th-century French story) and a shift of continents also make it possible for the husband and wife to have a more frankly flirtatious union than in the earlier film.

■

A new character (played by Bill Pullman), a romantic rival for the wife's affections, takes some of the edge off this unusual story by adding an element of garden-variety jealousy. And speaking of gardens, "Sommersby" has supplanted the rural, painterly images of a French peasant village in "Martin Guerre" with a large Southern plantation. The fields grow tobacco, and they also grow metaphors. "See what these are?" someone asks with Hollywood-style directness, when worms invade the crop. "They're a sign of the rottenness that's eating this place!"

Obvious as it is at such moments, "Sommersby" becomes strangely confused in its final stages, whereas "Martin Guerre" culminated on a note of wrenching clarity. And "Martin Guerre" employed a basic, unforgettable plot twist that "Sommersby" simply avoids. Why do American remakes of audacious foreign films never have the nerve to leave the endings alone?

Possibly because, as in the case of George Sluizer's Dutch thriller, "The Vanishing," the film ends on so stark and pitiless a note. Mr. Sluizer's American version is much more violent, which makes it that much more familiar. It is also overly cluttered and eventful,

Johanna ter Steeg and Gene Bervoets, left, in the Dutch "Vanishing." Nancy Travis and Kiefer Sutherland, right, in the remake.

Tara Releasing

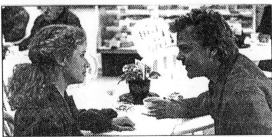

Ralph Nelson/20th Century Fox

even though the earlier film generated its suspense with quiet concentration. The empty spaces that gave this thriller its eerie tone have been filled up, as if Hollywood abhorred such a vacuum.

"The Vanishing" descends so thoroughly from the spiritual to the literal that it dispenses with an opening passage in which the heroine describes her dream. Since that dream is a premonition of her destiny, and the new film has somewhat altered the story's outcome, eliminating the dream makes a certain sense.

But this second film, being fancier than the first, also adds purely American touches like an engraved silver lighter, which the kidnap victim (Sandra Bullock) gives to her boyfriend (Kiefer Sutherland) just before she disappears. And the couple's car keys, an important prop, are now attached to a Bullwinkle chain.

The new "Vanishing" is so American that the kidnapper, once a quiet French scientist with a remote country farmhouse, is now Jeff Bridges (frighteningly persuasive, and the film's biggest asset). In keeping with the remake's more lavish look, he now has a charming cabin in a highly picturesque spot. He fixes up this place as a kind of self-realization project, asking: "What if I'm learning about myself as I go?" When the mystery is replaced by self-help jargon, you know you're watching the made-for-Americans version. □

1993 F 14, II:13:1

Like Water for Chocolate

Produced and directed by Alfonso Arau; screenplay (in Spanish with English subtitles) by Laura Esquivel; based on the novel by Ms. Esquivel; cinematography by Emmanuel Lubezki and Steve Bernstein; edited by Carlos Bolado and Francisco Chiu; music by Leo Brower; released by Miramax Films. Running time: 113 minutes. This film is rated R.

Tita........................... Lumi Cavazos
Pedro...........................Marco Leonardi
Mamá ElenaRegina Torné
John Brown Mario Ivan Martinez
Nacha ... Ada Carrasco
Rosaura........................ Yareli Arizmendi
Gertrudis................................Claudette Maillé
Chencha Pilar Aranda

By JANET MASLIN

Food and passion create a sublime alchemy in "Like Water for Chocolate," a Mexican film whose characters experience life so intensely that they sometimes literally smolder. The kitchen becomes a source of such witchcraft that a fervently prepared meal can fill diners with lust or grief or nausea, depending upon the cook's prevailing mood.

This film, a lively family saga that is centered on forbidden love and spans several generations, relies so enchantingly upon fate, magic and a taste for the supernatural that it suggests Gabriel García Márquez in a cookbook-writing mode. (The bestselling Mexican novel by Laura Esquivel, who also wrote the screenplay, interweaves the fanciful story of "Like Water for Chocolate" with actual recipes.) Whether you approach this swift, eventful tale on the culinary or the cinematic level, prepare for a treat.

"Like Water for Chocolate," which opens today, is the story of Tita (Lumi Cavazos), whose way of connecting cuisine with strong emotion truly begins at birth. Tita is born on a kitchen table to a mother who weeps so profusely, a narrator maintains, that the residue of her tears yields an enormous bag of salt. This formidable mother, known as Mamá Elena (Regina Torné), has endured her share of hardships and is determined to make her youngest child do the same. She decrees that Tita, the last of three daughters, must always serve her and therefore can never marry.

Years later, as a shy and watchful young woman, Tita attracts the attention of Pedro (Marco Leonardi). This is one of many romantic events that the film casts in amusingly food-related terms, as the narrator explains that when Tita felt Pedro's gaze on her shoulders, "she understood exactly how raw dough must feel when it comes into contact with boiling oil."

Pedro asks for Tita's hand in marriage, but his request is denied by Mamá Elena. But she persuades him to marry Rosaura (Yareli Arizmendi), one of Tita's older sisters, instead. Pedro agrees to this empty marriage as a means of staying close to his beloved. But the idea of his marrying Rosaura is roundly criticized, once again by means of a culinary metaphor. "You can't just exchange tacos for enchiladas!" a household servant declares with indignation. Of course, she turns out to be right.

Tita herself is typically acquiescent, resigned to her role as a dutiful spinster. But then, with the help of Nacha (Ada Carrasco), the elderly cook who presides over the story before and after her death as spiritual adviser, Tita works on a wedding meal. Somehow, when saturated with Tita's tears, the food becomes so infused with her longing and frustration that the wedding guests are overcome. All are simultaneously taken sick, mourning for their own lost loves.

"Like Water for Chocolate" takes its title from a Mexican method of making hot chocolate by boiling and re-boiling water with cocoa, until this substance becomes sweetly overagitated, much as Tita herself feels in the presence of her new brother-in-law. In one of the film's most wildly imaginative episodes, Tita pricks her fingers on thorns and thus turns a meal of quails cooked in rose-petal sauce into the pure physical embodiment of her desire for Pedro. At this point in the story, food is described as "voluptuously, ardently fragrant and utterly sensual," and ordinary nourishment is truly beside the point.

The effects of this dish are so potent that Gertrudis (Claudette Maillé), Tita's other sister, feels her temperature rise and rushes to an outdoor shower to cool off. The dinner has so overheated Gertrudis that her body actually gives off smoke. Then the boards surrounding the shower catch fire and Gertrudis is carried off naked by one of Pancho Villa's soldiers, who has also fallen under the quail-and-rose-petal spell. Incidentally, Gertrudis's eventual fate establishes the story's faith in feminine power as a force that extends well beyond the kitchen.

●

Miracles like that of the quail and roses are presented almost matter of factly by the film's producer and director, Alfonso Arau, who acted in "El Topo" and "The Wild Bunch." (Mr. Arau is also the husband of Ms. Esquivel.) His direction can be seen as refreshingly plain, especially in light of the curious events the film often depicts, events that work best without stylistic flourishes. Strong passions produce sparks and lightning; a colossal knitted bedspread that expresses Tita's misery takes on epic proportions; one party scene somehow carries the celebrants 20 years forward in time. All of this is presented with the simplicity of a folk tale, with exaggerated events blending effortlessly into those that seem real.

Miss Cavazos's performance as Tita is reticent and sly, perfectly in keeping with the film's muted manner. Tita never overreacts, preferring to bide her time and marvel silently at outward events that confirm her intuition. Mr. Leonardi, as the person who shares many of Tita's thoughts, enhances the film's romantic mood while also evolving from object of desire to petulant brother-in-law. Miss Torné carries Mamá Elena's sternness to a suitably fierce extreme.

Also appearing in the story, eventually to bedevil Mr. Leonardi's Pedro, is John Brown (Mario Ivan Martinez), the doctor whose American Indian heritage has made him privy to a whole different strain of folklore. It is he who compares the human spirit to a box of matches, suggesting how sad life can be if those matches are allowed to grow soggy. The film itself eagerly embraces the opposite notion, presenting a torrid, slow-burning love affair and never losing its own bright, original flame.

1993 F 17, C13:3

Army of Darkness

Directed by Sam Raimi; written by Mr. Raimi and Ivan Raimi; director of photography, Bill Pope; edited by Bob Murawski and R. O. C. Sandstorm; music by Joseph LoDuca; production designer, Tony Tremblay; produced by Robert Tapert; released by Universal Pictures. Running time: 77 minutes. This film is rated R.

Ash...............................Bruce Campbell
Sheila........................ Embeth Davidtz
LindaBridget Fonda

By JANET MASLIN

Sam Raimi's "Army of Darkness" comes closer to comic book sensibility than many a real comic book does, thanks to Mr. Raimi's broad, jokey visual style and his taste for pre-teenage humor. If your favorite reading matter comes with pictures, you may well appreciate his directorial verve.

Taken on its own terms, "Army of Darkness" displays some ambition and wit, though not nearly enough to lend it broad appeal. It is best watched as a string of wild visual effects that, as in recent films like "Death Becomes Her," take on a life of their own. Among these are tricks showing the film's hero, Ash (Bruce Campbell), growing an extra head and splintering into chattering Lilliputian versions of himself. Moments like these understandably upstage the rest of the action.

Mr. Campbell, the handsome, square-jawed Raimi regular who looks exactly right for this comic book context, finds himself thrust into the Dark Ages amongst knights in tinny armor. (The huge castle used for a backdrop is one of several settings achieved convincingly with Introvision, a visual effects process that eliminates the need for elaborate sets.)

●

In this sword-and-sorcery setting, he delivers constant anachronisms ("Well, hello, Mr. Fancy Pants") and generally strikes an irreverent tone. At one point, as a former housewares salesman, he feels obliged to list the price of his rifle and say it comes from Grand Rapids, Mich. At another, he diverts a potential enemy by telling this medieval warrior that his shoelaces are untied.

Once Ash finds himself locked in combat with an army of skeletons, the film's visual ploys overpower its halfway humorous conversation. The bony hands that reach out from the grave to force Ash's face into silly grimaces or to poke a finger up his nose establish a very limited strain of wit. So "Army of Darkness" would appeal to small children if it were not also too gruesome for them, since Ash does after all wield a chain saw. On the other hand, young adolescents may well feel that Mr. Raimi is speaking their language.

"Army of Darkness," a display of real if misplaced talent, has a crisp, punchy look and an energetic style. Mr. Campbell's manly, mock-heroic posturing is perfectly in keeping with the director's droll outlook.

●

"Army of Darkness" is rated R (Under 17 requires accompanying parent or adult guardian). It includes ample but hardly realistic violence.

1993 F 19, C10:5

Mac

Directed by John Turturro; written by Mr. Turturro and Brandon Cole; director of photography, Ron Fortunato; edited by Michael Berenbaum; music by Richard Termini and Vin Tese; production designer, Robin Standefer; produced by Nancy Tenenbaum and Brenda Goodman; released by the Samuel Goldwyn Company. Running time: 118 minutes. This film is rated R.

Mac .. John Turturro
Vico Michael Badalucco
Bruno Carl Capotorto
Alice Katherine Borowitz
Nat ... John Amos
Polowski Olek Krupa
Oona Ellen Barkin
Papa Joe Paparone

By VINCENT CANBY

The place is Queens, the time the mid-1950's and the occasion the wake for Papa Vitelli (Joe Paparone), an immigrant carpenter from Italy who came to America as a young man to make a new life. Amid the rich confusion of talk, arguments and laughter, the old man's three sons, Niccolo (John Turturro), the eldest, who's called Mac; Vico (Michael Badalucco), and Bruno (Carl Capotorto) stare down at the embalmed remains.

Their silent recollections are shattered when the old man suddenly sits up in a fury to point out the shabby craftsmanship of the coffin. How could they have allowed it? Doesn't anybody care? Doesn't anybody pay attention anymore? Just as abruptly, the tirade is over and the corpse lies back, exhausted. Again properly dead. It's almost as if it didn't happen.

This is the wonderfully vivid introduction to "Mac," Mr. Turturro's loving and contemplative eulogy to his own father, who died in 1988, and to a kind of immigrant experience that is probably forever gone. "Mac," which Mr. Turturro wrote with Brandon Cole, is the actor's very self-assured debut as a director, something that is evident in almost every frame of the film. A more experienced journeyman director, a gun-for-hire type, might have insisted that "Mac" have a stronger, clearer, more conventional story line, one with a more dramatic payoff.

Instead, "Mac" is very much an actor's film. Mr. Turturro conceived

it as a screenplay in 1980 and then, with Mr. Cole, turned it into a play, scenes from which were staged and revised over the years at various theaters around New York, apparent-

John Turturro's eulogy to one kind of immigrant experience.

ly with the collaboration of the actors, including Mr. Badalucco and Mr. Capotorto. The result is a movie that is rich in characters and scenes, that wanders, often creatively, and that expresses as much affection for the craft of the actor as it does for the craft of the blue-collar laborer who takes pride in his work.

●

Mac enthusiastically carries on his father's tradition. Working as a member of a construction gang building private houses, Mac has repeated run-ins with the foreman, who objects to his meticulous attention to detail. Time and money are being wasted. Vico is in the same crew; he works in construction because it's the only thing he knows. He's good-natured, lazy, something of a ladies' man. Bruno, the one brother to attend college, wants to be an artist but goes into construction to make ends meet. The three sons still live at home with a mother who, throughout the film, remains a nagging, unhappy off-screen voice.

In the course of the 8 or 10 years covered by the film, Mac marries and begins his own family while continuing to live at home. The brothers start their own construction business, come close to financial disaster, fall out and then move on. Vico and Bruno enthusiastically embrace the progressing postwar American culture and economy. By the end of the film, only Mac has some idea of the cost of that progress.

Compared to "Riffraff," Ken Loach's new English comedy about nonunion construction workers in London, "Mac" is an intensely romantic work. It reflects the differences not only between American and British labor, but also between the concerns of one very American artist and one who is quintessentially English.

"Riffraff" is politically sophisticated. It's obsessed with particular conditions. Nobody has to tell its characters that the world is old and often unfair. They know that too well. "Mac" seems to be surprised that standards of excellence are slipping. It expresses a longing for the way things were when America was still a dream in the process of being realized. It's not about today, but rather about the past, about things lost that, in time, become idealized.

Mr. Turturro has written a good role for himself and realizes it beautifully, though not at the expense of those around him. Mac is a difficult, exacting man who is out of step with everyone else. Among other things, he likes his work. He's a perfectionist. He has a temper so short that he almost self-destructs. Complementing Mac, and saving him on occasion, is his wife, Alice, nicely played by Katherine Borowitz (who is married to Mr. Turturro), a woman who turns out to have surprising entrepreneurial skills.

"Mac" is the kind of movie in which all of the principal cast members have scenes that define them both as actors and as the characters

they play. Mr. Badalucco's is a night out with the boys in which he tries, unsuccessfully, to teach his younger brother how to pick up women. Mr. Capotorto's is a casual encounter on the bus with a woman with whom he manages to have a heated if brief affair without a word being spoken.

Ellen Barkin is very funny as an artist's model, first seen in Bruno's sketching class, who comes to represent all of the glamour that Vico and Bruno are convinced awaits them outside Queens. Also noteworthy is Olek Krupa, who plays the crooked Polish foreman of a construction gang whose men (white, black, Irish and Italian) passionately hang on to their bigotries as a way of asserting themselves.

There are times when Mr. Turturro appears to shoot scenes too safely. He depends entirely on a succession of close-ups to emphasize the emotions in a crucial encounter among the three brothers toward the end of the film, which is movie making for television. More often, though, he loosens up to let the actors have more than just their heads. "Mac" is a very good movie with a mind.

●

"Mac," which has been rated R (Under 17 requires accompanying parent or adult guardian), has a lot of vulgar language and some sexual situations.

1993 F 19, C17:1

K.C. Bailey

Katherine Borowitz and John Turturro in a scene from "Mac."

FILM VIEW/Caryn James

A Mystery Haunts The Ages

WHEN RICHARD GERE DRUNKENLY asks Jodie Foster, "So who do you think I am?," he seems to be posing the crucial question in "Sommersby." The plot, after all, revolves around whether Mr. Gere is a Civil War veteran named Jack Sommersby or a clever imposter returned from six years of war to claim Sommersby's house, land and wife. But the question he so recklessly flings at his (possible) wife is immediately followed by one that matters more: "Whoever you think I am, do you love me?"

That frisson of uncertainty, that hint of forbidden passion and of a dangerous secret acted out in public is at the heart of "Sommersby" and of the endlessly alluring story that inspired it. Behind "Sommersby" is the 1982 French film "The Return of Martin Guerre," and behind *that* film is the historical Martin Guerre, a 16th-century French peasant who lived a life so enigmatic that three centuries' worth of history and psychology have not cleared up its ambiguities.

The story has been told in histories, novels, in operetta and recently in the poorly received musical "Martin Guerre" at the Hartford Stage. And a similar real-life event from 1984 inspired Agnieszka Holland's psychologically charged "Olivier, Olivier," opening on Friday. The Martin Guerre story would not have such a hold on our imaginations if it were simply a fiction or the legend of a possible fraud.

When the story is told well — and it has never been told better than in the French film — it captures the titillating appeal of loving a stranger, suggests the murky depths of personality, and recreates the mystery at the heart of love.

This mythic appeal is more than a collection of facts, though the history of Martin Guerre is intriguing enough. He was a very young man the day he disappeared from his village of Artigat, abandoning his wife, Bertrande, and their son. Eight years later, he returned. He looked a little different, but no more than anyone who had left as an adolescent and come back as a grown man. His shoe size was suspiciously smaller than before, but so what? This Martin was kinder and more responsible. He and Bertrande lived happily until Martin's uncle — either in pursuit of the truth or in a greedy grab for land — took him to trial as a fraud.

In "The Return of Martin Guerre," viewers never know

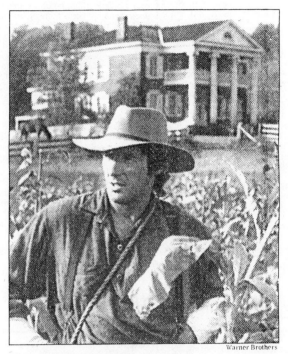

Richard Gere in "Sommersby," the latest version of the Martin Guerre story—Endlessly alluring.

until the last moments whether the smooth-talking Martin (Gérard Depardieu) is an imposter or not. And Bertrande (Nathalie Baye) is wonderfully inscrutable. Perhaps she believes Martin to be her true husband; perhaps she believes he is an imposter but such an improvement she decides to keep him. "Is he or isn't he?" is the most obvious question, but the film is emotionally haunting because it gets at a more profound and tantalizing one: "How much did she know and when did she know it?"

"Sommersby" works best when it stays true to that spirit of willful ambiguity. As Laurel, Sommersby's wife, Ms. Foster suggests layers of possibilities behind her most lucid statements. When she replies to Mr. Gere's "So who do you think I am?" by saying "Jack Sommersby," she may be saying she believes he is her husband. She may be accepting complicity in his lie.

But too little of the film suggests this emotional depth and mystery. With its political awareness of the Reconstruction South, its lush photography and hot-blooded romance, it works better as a poor cousin of "Gone With the Wind." "Sommersby" gets tangled in the wrong questions and is reduced to a series of twists. Jack and Laurel try to out-martyr each other. She will sacrifice herself for him, he will sacrifice himself for her, they will both sacrifice themselves for the children. All this becomes head-spinning, not haunting.

■

Oddly, the current film that best captures the spirit of Martin Guerre is "Olivier, Olivier," inspired by a newspaper account of a French boy who disappeared. When an adolescent returned several years later, there was no proof that he was or was not the child who had vanished.

In Ms. Holland's fictional retelling, Olivier is a 9-year-old who disappears while bringing a basket of goodies to his granny. Here, though nowhere else, Ms. Holland blatantly plays with the story's mythic underpinnings.

Six years later, the detective on the case finds an adolescent he thinks is Olivier. The young man has lived on the streets as a prostitute and, after hearing some leading questions, gives the detective the answers he wants. He looks as if he could be Olivier. He knows things only Olivier would — or, things he might have been told by the real Olivier.

As in "Martin Guerre," self-deception mingles with the ideas of love and identity. Olivier's mother is so desperate for her child's return that she blinds herself to any evidence to the contrary. Perhaps on some subconscious level she accepts him as her son, regardless of his birth. Olivier's sister is skeptical, so when they find themselves attracted to each other, the frisson of forbidden passion goes haywire. Does she see him for a fraud and take him to bed the way she might any other man? Or do they know they are brother and sister, in a willfully incestuous relationship?

There are other themes in "Olivier, Olivier" and elements that go wrong. The sister develops telekinetic powers that seem goofy. The puzzle of Olivier is solved in the most obvious way. But the film takes a smart approach to mysteries they would have recognized in Artigat: How well do you know the people you love? How much does it matter? □

1993 F 21, II:17:5

Passions and Repression In a Family Off Balance

"Olivier, Olivier" was shown as part of the 1992 New York Film Festival. Following are excerpts from Vincent Canby's review, which appeared in The New York Times on Sept. 25, 1992. The film, in French with English subtitles, opens today at the Lincoln Plaza Cinemas, Broadway at 63d Street.

Agnieszka Holland, who wrote and directed the popular "Europa, Europa," is in a far less somber mood with her new "Olivier, Olivier," which is entertaining, initially sunny and very spooky.

"Olivier, Olivier" is a perverse kind of idyll, set not far from Paris in a countryside where quaint old farmhouses are still affordable, wheat fields are golden and children can grow up with a freedom no longer possible amid the congestion and crime of polluted cities.

Serge Duval (François Cluzet), a veterinarian, and Élisabeth (Brigitte Rouän) have two children, Nadine (Faye Gatteau), who is about 11 years old, and Olivier (Emmanuel Morozof), 9. At first the lives of the Duvals appear serene. The children seem especially compatible. The bright, impressionable Olivier looks up to Nadine, whose imagination dominates his. Yet something is

slightly off. There's an edginess to their relationship.

Their beautiful and otherwise sensitive mother spoils the boy outrageously. When she puts the children to bed, she sits beside him and sings, and then goes in to give Nadine a perfunctory kiss. Élisabeth is not cold to Nadine, but it's clear that she is obsessed by the boy in a way that excludes her daughter. Nadine doesn't complain. She can't: she shares the obsession. When Olivier is kicked out of their parents' bed, he crawls in with her.

This is the introduction to "Olivier, Olivier," which is about what happens to the Duvals after their beloved Olivier disappears. Like Red Riding Hood, he is sent off one day to take some food to his grandmother and is never seen again. Search parties are sent out. Days pass. No clues. The boy has been swallowed up. The police are convinced that he has run away.

Six years later, Olivier (Grégoire Colin) turns up, if reluctantly. Inspector Druot (Jean-François Stevinin), who originally handled the case, comes upon a sarcastic, all-too-knowing Paris street hustler who he's convinced is Olivier. Although the boy claims not to remember his childhood, Élisabeth identifies him as her son. Serge and the now-mature Na-

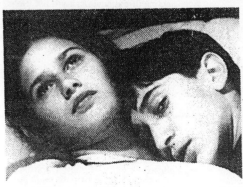

Boy Wonder
Marina Golovine and Grégoire Colin star in "Olivier, Olivier," Agnieszka Holland's mystery about a 9-year-old boy who vanishes suddenly and then reappears six years later.

Sony Pictures Classics

dine (Marina Golovine) are skeptical The adored Olivier remains enigmatic.

•

"Olivier, Olivier" was apparently inspired by a story Ms. Holland read in the French press. Although she does eventually provide answers, she is less interested in them than in the curious relationships within this one French family, whose members are never quite as commonplace as they

A more intimate drama from the director of the epic 'Europa, Europa.'

first seem. As it proceeds, the film exposes a mare's-nest of tangled feelings and repressed passions below the surface of mostly polite behavior.

Yet "Olivier, Olivier" is less a Freudian nightmare than a fairy tale that remains mysterious even after the mysteries are answered. That's what so good about it. The characters are more complex, more interesting, than the singular events that come to shape their lives, which presents something of a problem. The story that inspired "Olivier, Olivier" finally seems inadequate for the movie Ms. Holland made. The ending, which I assume was dictated by the actual events, has the effect of undercutting the film maker's imagination.

Unlike the German-language "Europa, Europa," whose scale was epic, the French-language "Olivier, Olivier" is small, intense, introverted and, it would seem, far more personal.

1993 F 24, C17:5

Falling Down

Directed by Joel Schumacher; written by Ebbe Roe Smith; director of photography, Andrzej Bartkowiak; edited by Paul Hirsch; music by James Newton Howard; production designer, Barbara Ling; produced by Arnold Kopelson, Herschel Weingrod and Timothy Harris; released by Warner Brothers. Running time: 112 minutes. This film is rated R.

D-Fens	Michael Douglas
Prendergast	Robert Duvall
Beth	Barbara Hershey
Sandra	Rachel Ticotin
Mrs. Prendergast	Tuesday Weld
Surplus Store Owner	Frederic Forrest
D-Fens's Mother	Lois Smith
Adele	Joey Hope Singer
Guy on Freeway	Ebbe Roe Smith
Mr. Lee	Michael Paul Chan

By VINCENT CANBY

In the eerie opening sequence of "Falling Down," a man identified by his license plate as D-Fens (Michael Douglas) sits in his car, brought to a halt in a gigantic Los Angeles freeway tie-up. The stalled lanes of glass, chrome and paint jobs sparkle in the midmorning sun, which is very hot. Nothing moves except the tiny beads of sweat on the man's face. They slip down his brow from his military-style brush haircut to his jaw, which is clenched against life. The man grips the steering wheel and stares straight ahead through gold-rimmed glasses.

All is silent at first, as if the man had willed that his mind be blank. Yet little by little, the sounds of the outside world drain into his (and the

Warner Brothers

Michael Douglas

movie's) consciousness: vulgar (to him) rock music, laughter, arguments, children. Someone is yelling into a cellular phone. Without visible emotion, the man takes his briefcase and gets out of his car. The fellow in the car behind angrily asks what he thinks he's doing. D-Fens ignores the other's fury. He walks across the road, up an embankment and away from the miles of stalled automobiles, away from urban order and sanity.

"Falling Down" plays a lot of such tricks. It turns one man's slide toward madness into a wickedly mischievous, entertaining suspense thriller. On one side is D-Fens who, having abandoned his car, moves with purpose across Los Angeles by foot, leaving a trail of casually mangled bodies on street corners, in a clothing store, on a golf course. In pursuit are Detective Prendergast (Robert Duvall) and his colleagues of the Los Angeles Police Department. At first with some boredom, then with apprehension and horror, they follow the trail of the man who keeps saying he just wants to get home.

•

D-Fens, played by Mr. Douglas with astonishing, thin-lipped authority, is a little bit like a paranoid paperback update on Neddy Merrill of John Cheever's story "The Swimmer." Neddy sets out to swim home through the pools of Fairfield County on a bright summer day, encountering a lifetime of failures as he goes. The daylong journey of D-Fens is equally sad and futile, though far less gentle. As he makes his way toward a small house in Venice, and to the ex-wife who has a restraining order against him, he repays a few of the random injustices he has been collecting throughout his adult life. He's a hard-working, tax-paying, politically concerned, white, middle-class American male, and his patience has run out.

What, for example, is a man to do when he walks into a Whammyburger at 11:33 A.M. and is told by the manager, who calls him buddy, that he can't have breakfast because this Whammyburger stops serving breakfast at 11:30? "I don't want to be your buddy," D-Fens says evenly. "I just want breakfast." "Well, hey," says the manager, "I'm really sorry." Replies D-Fens, "Well, hey, I am too." To stress his need, he pulls out a gun and starts shooting at a ceiling fixture.

This is one of the milder, funnier sequences in a succession of increasingly brutal confrontations from which, finally, there is no return.

•

As directed by Joel Schumacher from an original screenplay by Ebbe Roe Smith, "Falling Down" is a movie that couldn't possibly have been made anywhere else in the world today. It exemplifies a quintessentially American kind of pop movie making that, with skill and wit, sends up stereotypical attitudes while also exploiting them with insidious effect. "Falling Down" is glitzy, casually cruel, hip and grim. It's sometimes very funny, and often nasty in the way it manipulates one's darkest feelings.

There is an early encounter between D-Fens and the apprehensive Korean man (Michael Paul Chan) behind the counter of a convenience store. When the Korean refuses to give D-Fens change for the telephone, D-Fens pretends not to understand what the man is saying. He criticizes the Korean for not pronouncing his V's. "Speak slowly and distinctly," he says. One thing leads to another, and the seething customer seizes the Korean's baseball bat and breaks up the store.

Mr. Douglas is terrific in what must be one of the richest, if most thoroughly unpleasant, and difficult roles of his career. It's not a role that reveals much. The character's background is that of thousands of other men who don't go to pieces, at least not in such an irretrievable way. D-Fens has lost his job in the defense industry, but he was a bit odd even before that. He always had a violent side that frightened both his mother (Lois Smith) and his former wife (Barbara Hershey).

D-Fens is not immediately identifiable as a right-wing bigot. In the film's most furiously disorienting sequence, he takes umbrage when a neo-Nazi goon (Frederic Forrest) assumes he's a member of the club. Yet it's an indication of how the movie plays with ambiguities that the reaction of D-Fens can also be interpreted as the ultimate in denial.

"Falling Down" is not meant to be seen as the anatomy of a madman but as a spectacle of civil despair in which some people give in to galvanizing self-pity and others cope as best they can. Among these is Mr. Duvall's Detective Prendergast, a policeman whose career has been hobbled by the demands of a needy wife (Tuesday Weld). By chance, this is the detective's last day on the job before he takes early retirement. Without making a big thing out of it, the movie suggests that D-Fens and Prendergast have some resentments in common.

•

Mr. Smith, an actor who makes his screenwriting debut with "Falling Down," has created a most effective urban panorama with a minimum of exposition. "Falling Down" exists very much in the present tense, a lot like the screenplay Mr. Schumacher wrote for "Car Wash" (1976), directed by Michael Schultz, one of the funnier films to come out of the 1970's. The writing is sharp, alive and quickly to the point, which may be a reason why there are so many fine performances. Actors can realize characters, but they don't often write their own material.

Mr. Duvall and all the members of the huge supporting cast are excellent, including Rachel Ticotin, who

plays Mr. Duvall's police partner. It's a small role, that of a character who is quite normal in the context of the rest of the film, but it's as memorable as anything else in the movie.

Mr. Schumacher would seem to be both nervy and exceptionally able, effortlessly integrating scenes of carnage with others that have the blithely heedless humor of a "Saturday Night Live" sketch. Consider a scene in which a small black boy solemnly instructs the mad-as-a-hatter D-Fens on how to load, aim and fire a bazooka. It's something the boy knows how to do from watching television, and he's proud of himself.

"Falling Down" is going to offend many people, though not, I think, with good reason. Unlike most so-called problem movies, it offers no positive approach to the problems it so coolly observes. Some may call that irresponsible, possibly the same people who find "Terminator 2" so much fun. By not providing phony uplift, "Falling Down" doesn't let the audience off the hook of its own responsibilities.

It's also the most interesting, all-out commercial American film of the year to date, and one that will function much like a Rorschach test to expose the secrets of those who watch it.

•

"Falling Down," which has been rated R (Under 17 requires accompanying parent or adult guardian), has a lot of violence and obscene language.

1993 F 26, C3:1

The Last Days of Chez Nous

Directed by Gillian Armstrong; screenplay by Helen Garner; director of photography, Geoffrey Simpson; edited by Nicholas Beauman; music by Paul Grabowsky; production designer, Janet Patterson; produced by Jan Chapman; released by Fine Line Features. Running time: 96 minutes. This film is rated R.

Beth	Lisa Harrow
J. P.	Bruno Ganz
Vicki	Kerry Fox
Annie	Miranda Otto
Tim	Kiri Paramore
Beth's Father	Bill Hunter

By VINCENT CANBY

"The Last Days of Chez Nous," Gillian Armstrong's new Australian film, is about a crucial summer in the lives of Beth (Lisa Harrow), a successful author of apparently not-great novels, her French husband, J. P. (Bruno Ganz), who increasingly feels he doesn't measure up to Beth, and Beth's younger sister, Vicki (Kerry Fox), newly returned from a long stay in Europe and pregnant. Somewhat more peripherally, it's also about Beth's teen-age daughter, Annie (Miranda Otto), and Beth's old dad (Bill Hunter), who's not exactly a barrel of laughs but more easily tolerated than the others.

Everyone except Dad and Annie seems to be coming apart at the seams. Relationships aren't working. J. P., who resents Beth's self-assurance and success, has been having an affair with a younger woman. Beth knows that she's losing J. P., but can't help being efficient as well as caring. Vicki also resents Beth but depends on her as a surrogate mother. The days and nights at Chez Nous, the family's terrifically picturesque little

house in a Sydney suburb, just across the bay from the city, are filled with occasions of forced gaiety that never quite hide all of the hurt feelings.

•

When Beth goes off for two weeks with her father to the Outback, in hopes of re-establishing their relationship, her sister and her husband are thrown together with results that are surprising only to them. "It's as if, before, I didn't know what love was," says J. P.

"The Last Days of Chez Nous," written by Helen Garner, is the sort of insufferable relationship movie in which characters hector each other with questions not meant to be answered. "What am I going to do without your warm hands?" Or, "Am I always to stand back and not take what I want just because it's yours?" Or, "Will we ever make love again?" This last, directed to J. P. by Beth, does get a reply, if not a satisfactory one: "That's not the right question."

There's something extremely tiresome about people of so little charm and such consuming self-interest. They pretend to be sophisticated but are without humor. Though the actors are attractive enough, the roles they play are not. They're not even believable. The characters behave like the frail figments of the author's imagination, unconnected to a world outside or even to each other except as the plot dictates. Poor J. P., the most shadowy of the major characters, doesn't seem to have a job or, if he does, it's explained away in one line of dialogue. He's treated as badly by the film as he is by Beth.

Ms. Armstrong ("My Brilliant Career," "Mrs. Soffel," among others) works hard to whomp up some sense of passion, often by having the warring characters clutch each other at the end of a confrontation. Sometimes they break into impromptu little dances or paint their faces as if for a masquerade. Yet nothing gives life to this film. When there is the occasional arresting image, it serves only as a reminder of how drab and thin everything else is.

•

"The Last Days of Chez Nous," which has been rated R (Under 17 requires accompanying parent or adult guardian), has some vulgar language and sexual situations.

1993 F 26, C6:5

El Mariachi

Directed and edited by Robert Rodriguez; written and produced by Mr. Rodriguez and Carlos Gallardo, based on a story by Mr. Rodriguez (in Spanish with English subtitles); director of photography, Mr. Rodriguez; released by Columbia Pictures. At Loews Village VII, Third Avenue at 11th Street, Greenwich Village. Running time: 84 minutes. This film is rated R.

El Mariachi	Carlos Gallardo
Domino	Consuelo Gómez
Azul	Reinol Martinez
Moco	Peter Marquardt

By JANET MASLIN

El Mariachi (Carlos Gallardo), the lone, black-clad musician who arrives in a Mexican border town with little more than his guitar case, travels light. So does Robert Rodriguez, the new, 24-year-old director who made "El Mariachi" without benefit of any of the usual Hollywood accouterments, from makeup to money.

Working on a bare-bones budget of $7,000, Mr. Rodriguez has succeeded quite spectacularly in thinking big. His Spanish-language film has all the basic elements of a tough, savvy Hollywood action saga, except possibly for Arnold Schwarzenegger or Steven Seagal in the leading role.

There are two interesting stories attached to "El Mariachi," which opens today at the Loews Village VII. The better is the behind-the-scenes one. Mr. Rodriguez, who has been making films since he was 13 and often used some of his nine siblings as cast members, earned $3,000 as a guinea pig in a research hospital and wrote this screenplay during his stay. He also recruited one of his actors there (Peter Marquardt, who plays an evil drug kingpin and the story's villain).

The film's star, Mr. Gallardo, met the director at a junior seminary boarding school and did double duty as a crew member, sometimes pushing Mr. Rodriguez in a borrowed wheelchair to get the right camera movement for particular scenes. The shots really had to be right, since the budget did not allow for retakes. "El Mariachi" was written, directed, edited and photographed by Mr. Rodriguez, produced by him and Mr. Gallardo, and shot in 14 days in Acuña, Mexico, just across the Texas border from Mr. Gallardo's hometown. The director, who made his film for the Spanish home video market and now has a production deal with Columbia Pictures, is also a Texan.

•

What has all this enterprise yielded? "El Mariachi" is a skillful, familiar-feeling hybrid of film noir and western conventions, with a hint of futuristic nihilism in its final scenes. It is also visually primitive, with a home-movie look that would be distracting if Mr. Rodriguez's storytelling skills were not so keen. While rough around the edges, "El Mariachi" displays a textbook knowledge of Hollywood hallmarks: stock characters (the soigné villain, the decorative moll), well-staged shootouts, showy camera work (fisheye, slow-motion and zoom flourishes), dream sequences and broad humor. If this were music rather than movies, "El Mariachi" would be the demo version of a sure-fire hit record.

The plot is very plain, revolving around a case of mistaken identity. The unnamed Mariachi of the title arrives in a Mexican border town just as Azul (Reinol Martinez), a vicious thug, escapes from the local jail. Both men are dressed in black and carry guitar cases, though only the Mariachi's contains a guitar. Azul totes everything from automatic weapons to brass knuckles, and he is intent on exacting revenge from Moco (Mr. Marquardt), the suave drug-dealer who wears white and has a bikini-clad girlfriend to file his nails.

"Don't worry, Moco," say the gangster's henchmen upon learning that Azul is on the loose. "We'll find him, kill him and feed him to the dogs." But they mistake El Mariachi for their prey, which earns him the sympathy of Domino (Consuelo Gómez), the seductive beauty who runs the local tavern. Suspicious of the Mariachi, Domino at one point entraps him in a bathtub, points a dagger at him underwater, hands him his guitar and orders him to "play something sweet." Mr. Rodriguez, who also shows Azul leaving a big tip for his jailer and Moco lighting matches on the chins of his aides, loves touches

that highlight the mythic pulp aspects of this material.

•

Mythic pulp has its allure, and it also has its limitations. "El Mariachi" displays no real emotion except a profound appreciation for the genre film making that has inspired it, and a delight in manipulating the elements of such stories. Mr. Rodriguez's own characters are so thin that the film's biggest surprise comes in its final moments, when the Mariachi makes the leap to a different dimension and becomes an original creation. Much of the time, this film maker holds his audience's interest with incidental touches, like the one-man mariachi band whose electronic keyboard seems to play only polkas. Mr. Rodriguez observes the cardinal rule of making sure his viewers never have the chance to grow bored.

Some of "El Mariachi" concentrates, with enjoyable self-consciousness, on aggrandizing the Mariachi's image. "What happened to the days when guitarists were gods?" he asks mournfully, even as the film prepares to reinvent him as another kind of deity. "One thing I know is that he'll always dress in black and carry a guitar case," someone says of the Mariachi. "It's his style."

At the film's end, the Mariachi makes his own declaration, armed with the few remaining souvenirs of his bleak adventure. "I'm prepared for the future," says this character, who was conceived as the hero of a trilogy and is indeed all set for subsequent adventures. It goes without saying that Mr. Rodriguez, having made such a clever and inventive debut, is prepared for a big future of his own.

•

"El Mariachi" is rated R (Under 17 requires accompanying parent or adult guardian). It includes considerable violence.

1993 F 26, C6:5

FILM VIEW/Caryn James

Poverty Becomes Oh So Chic

TWO YEARS AGO, MATTY RICH'S "STRAIGHT Out of Brooklyn" sailed out of the Sundance Film Festival and into theaters, propelled by the behind-the-scenes story of the teen-ager who rehearsed actors in his mom's apartment and made a movie for $77,000.

Two days ago, "El Mariachi" opened in theaters. It was made for $7,000 by the 24-year-old Robert Rodriguez, who thought his movie would go straight out to video.

Two months from now, who knows? A major studio could release a movie made for a flat $7 by a 10-year-old. It would sell three tickets and turn a major profit.

While Hollywood studios gripe about escalating budgets yet go on making $40 million movies, films made for a pittance have acquired their own cachet. There is a reverse snobbery, something like working-class chic, attached to any movie made for less than $1 million. Cheapness is publicized as a badge of honor, suggesting that these films are nobler, if not better, than their wealthy relations.

The result is a flood of Little-Movie-That-Could articles (the flip side of budget-run-amok tales): Hal Hartley shot his wry 1990 comedy, "The Unbelievable Truth," in his relatives' Long Island homes; Nick Gomez made his movie about small-time wise guys, "The Laws of Gravity," for $38,000 and got raves at last year's New Directors/New Films Festival; Mr. Rich went on the radio and asked the black community to send money so he could finish "Straight Out of Brooklyn," about a family trying to survive in a Red Hook housing project; and Mr. Rodriguez actually had $2,000 left over after shooting "El Mariachi," his mordant genre film about a mild-mannered musician who becomes a gunslinger.

These directors' off-screen stories are about family and community support, ambition, determination, ingenuity. If Horatio Alger were a film maker, he'd have fit right in.

Low-budget cachet is good publicity, but does it make a bit of difference to viewers? A bit. It can change their expectations. For $7,000, "El Mariachi" is a miracle; for $7 million, it would be just fine; for $40 million, it better have Arnold Schwarzenegger as the mariachi who conquered Mars,

and a planetful of special effects. This is the same principle that makes mediocre movies that you stumble across on cable seem better than they would have in a theater.

Forget megabudgets. Movies made for next to nothing are now something.

Otherwise, a small budget guarantees nothing, and a film has to perform without off-screen excuses. Mr. Rich scores points for youth, ambition and savvy in getting his movie made, but "Straight Out of Brooklyn" is still an amateurish rehash of "A Raisin in the Sun." His originality and artistic promise aren't visible on screen, at least not yet.

In the impressive "Laws of Gravity," Mr. Gomez shrewdly makes a low-budget look — drab, gritty colors and jumpy hand-held camerawork — part of the mean streets atmosphere. The cinéma-vérité look enhances the realism in the story of a petty hood who tries to save his friend, a pettier hood, from self-destruction.

And like "The Laws of Gravity," "El Mariachi" is an example of low-budget chic at its best. This isn't a good film because it's cheap. It's cheap *and* good because Mr. Rodriguez has wit and style, and is accomplished enough to know exactly what he wants on screen. The budget may be a selling point, but behind the hype is talent.

Mr. Rodriguez plays off that granddaddy of cheap-movie cachet, the spaghetti western, as well as the classic mistaken-identity plot. The unnamed hero, a mariachi looking for work, is targeted by hit men searching for an outlaw named Azul. Both men wear black jackets and carry guitar cases, though Azul's is full of automatic weapons. The comic twist is that the burly, scowling Azul looks nothing like the slight, sweet-faced mariachi.

The mariachi is about to become an action hero. He even jumps off a balcony and lands on a dilapidated bus. (Mel Gibson might do this in a "Lethal Weapon" movie, but he would leap from a skyscraper and land on a Range Rover.)

The film's slyness gives it an appeal beyond its discount genre and suggests the director's ambitions. When Azul is surrounded by hit men and about to go for his loaded guitar case, the audience has playfully been allowed to guess what Azul will find inside.

Knowing what small change is behind "El Mariachi" raises a few issues. With its sunny desert landscape, the film looks better than any $7,000 movie has a right to. In fact, Columbia Pictures spent an extra $100,000 transferring the 16-millimeter film to 35 millimeter, editing it and improving the sound and color before releasing it. Now the film looks totally professional, better than any $107,000 movie has a right to.

Mr. Rodriguez has said that his fast editing style was dictated by budget; he didn't have money to shoot lengthy, elaborate scenes. Quick-cutting gives the sense of movement that would have come from more sophisticated camera equipment. Viewers don't need to know this to enjoy the film, though. What matters is that "El Mariachi" has a smart mind and sharp eyes behind it. And if it didn't have cheap chic going for it, too, the film might have languished on video.

Anyone with bravura can make an inexpensive film. Video stores are cluttered with Little Movies That Couldn't. Low-budget cachet works only when film makers put their talent where their money isn't. □

1993 F 28, II:13:5

Il Ladro di Bambini

Directed by Gianni Amelio; written by Mr. Amelio, Sandro Petraglia and Stefano Rulli; photography by Tonino Nardi and Renato Tafuri; edited by Simona Paggi; music by Franco Piersanti; produced by Angelo Rizzoli; released by Samuel Goldwyn Company. Running time: 108 minutes. This film has no rating.

Antonio	Enrico Lo Verso
Rosetta	Valentina Scalici
Luciano	Giuseppe Ieracitano
Martine	Florence Darel
Nathalie	Marina Golovine
Grignani	Fabio Alessandrini

By JANET MASLIN

"Il Ladro di Bambini" is a small, flawless gem of a film, one whose ideas could not be more simply expressed or deeply felt. As directed by Gianni Amelio, whose thoughtful, meticulous "Open Doors" was scant preparation for this film's more intimate style, it recalls the power of Italian neo-realism to address political matters with enormous compassion, and without losing track of people. The people in this case are a shy,

decent carabiniere and two children who have been placed in his care.

Moving subtly and carefully, the film takes such a personal, humane view of its three principals that viewers will only gradually consider the larger problems that affect these characters' lives. Mr. Amelio is able to tell a sad, touching, all too believable story in bracingly clear terms. His tale of lost children is, among other things, amazingly free of mawkishness or sentimentality.

•

"Il Ladro di Bambini" begins with a situation that might have been taken from a newspaper story. In fact it was: the director read of a very young girl who had been steered into prostitution by her mother. And he saw a photograph of the girl being escorted to a children's home by a policeman. In these tabloid-minded times, it's far too easy to register shock at such a situation without wanting to contemplate its aftermath. So Mr. Amelio begins his film where the story might effectively end: with the turning over to Milanese authorities of an 11-year-old prostitute and her 9-year-old brother after their mother is arrested.

The girl, Rosetta (Valentina Scalici), is self-possessed and sullen. Her brother, Luciano (Giuseppe Ieracitano), has been left sickly and almost speechless by his unhappy past. And Antonio (Enrico Lo Verso), the carabiniere assigned to escort these two to a children's home, is far too gawky and inexperienced to know how to proceed. Early in the film, the otherwise gruff, courtly Antonio finds himself kicking a suitcase in frustration. One of the children is sick, Antonio himself is running low on money, and the plans for the children's home have gone terribly awry. Untrained for such contingencies, this would-be authority figure wants to perform properly but simply has no idea of what to do.

Beautifully developed, "Il Ladro di Bambini" watches the evolution of these three characters. As they get to know one another, all three begin to change. Mr. Amelio lets his story unfold in impersonal public settings: railroad stations where the three are forced to wait, fast-food places where the kids demand junk food, a public park where Rosetta sneaks beer from a derelict when Antonio isn't looking. It is against these sad and featureless backdrops that the film's immense humanity begins to emerge.

When they reach the children's home, Rosetta and Luciano explore the place watchfully while Antonio discovers that an 11-year-old ex-prostitute is persona non grata. A nun is seen dictating noble sentiments to orphans ("Life must be lived like a gift," she intones solemnly), but real solace cannot be found here. The trio finds something closer to comfort when they stop, en route to a second children's home in faraway Sicily, at a restaurant run by Antonio's sister. During an especially delicate and well-wrought sequence, they begin to feel like family. And Rosetta behaves like a real child for perhaps the first time.

Mr. Amelio's staging of this sequence is done with typical grace. The restaurant is in a once-scenic coastal setting now dotted with small, half-finished cinderblock buildings. Pointing to a distant spot, Antonio explains that his original village was over in that direction, but that it is now deserted, since the residents prefer these colorless new places. As Antonio warmly embraces his grand-

mother ("I'm honest, just like you taught me," he tells her proudly), traffic whizzes noisily past them, since the family now lives right beside a busy road. The personal ties between Antonio's relatives remain strong, but the social structure of their world is quite visibly a shambles.

•

Mr. Amelio, who wrote the terse, eloquent screenplay with Sandro Petraglia and Stefano Rulli, has chosen his film's settings with great care and his actors even more adroitly. The children, both non-professionals, remain utterly convincing without a hint of coyness or calculation. Valentina Scalici does a particularly fine job of expressing Rosetta's mixture of toughness and yearning.

But the real find here is Mr. Lo Verso, a gentle, gawky figure whose mobile features become endlessly revealing, and whose actions are central to the film's ideas about individuality at odds with authority. Drawing the audience easily into Antonio's thoughts, Mr. Lo Verso captures the character's innocence in very moving terms. By the end of the story, when Antonio's essential decency has taken on tragic overtones, this actor's simple demeanor has assumed a truly heroic dimension.

1993 Mr 3, C13:4

Taiga

Written, directed and photographed by Ulrike Ottinger, in Mongolian and Tuvinian with English subtitles; edited by Bettina Bohler; released by New Yorker Films. At Film Forum 1, 209 West Houston Street, South Village. Running time: 8 hours 21 minutes. This film has no rating.

The film is being shown in three parts. Show times are at 2, 5:20 and 8:40 P.M. Only Part 1 is being shown Wednesday. All three parts are shown in order on Sundays and Mondays and in reverse order on Tuesdays and Fridays. On Thursdays the sequence is Parts 2, 1 and 2; on Saturdays the sequence is Parts 1, 3 and 2. For further information call (212) 727-8110.

By STEPHEN HOLDEN

In the opening moments of "Taiga," a mesmerizing eight-hour journey into the nomadic tribal culture of northern Mongolia, the camera makes a slow 360-degree panning shot across the magnificent desolation of the Darkhad Valley, a remote steppe ringed by snowcapped mountains. The only sounds to be heard are wind, running water, bird calls and the moans of grazing herds of yak, sheep and goats.

After majestically surveying the landscape, the film zeroes in on the region's human inhabitants, a tribe of nomadic herders who live in large tents known as yurts. Slowly and methodically, the film insinuates itself into their culture. An early scene shows a midnight seance in which a wizened old woman, a shaman, dons a sacred robe weighted with pieces of iron to commune with protective spirits who tell her when the tribe should leave its summer encampment.

There follows a procession of scenes, each introduced by a subtitle, that add up to an encyclopedic portrait of tribal life. "The Wedding" closely observes a marriage ceremony. "The White Foods" follows the painstaking preparation of products, from cheeses to yogurt to a tea made from yak's milk. The emphasis gradually shifts from domestic rituals to more rugged outdoor occupations. The film visits a blacksmith and a

boot maker and follows two hunters on a trek to the forest. And one of the liveliest scenes shows the tribe's version of the Olympic Games.

"Taiga," which opened yesterday at Film Forum 1, is the work of Ulrike Ottinger, a noted German avant-garde director whose recent films have looked deeply into Asian cultures. Miss Ottinger's 1985 film, "China: The Arts, the People," focused on Chinese scroll painting and its relation to everyday life. Her 1989 fictional film, "Johanna d'Arc of Mongolia," imagined a group of Western travelers kidnapped by a Mongol princess.

The new film, whose title is the Russian name for the two million square miles of forest covering Siberia and far eastern Russia, is an epic documentary that slowly and relentlessly entices the viewer into becoming an imaginary visitor to northern Mongolia. Although it has its tedious moments, it has the cumulative effect of an extended vacation halfway around the earth in which body and spirit must adjust to a life that has a slower rhythm and a coarser texture.

For the next two weeks, "Taiga" is being shown in three 2½-to-3-hour parts. Theatergoers pay to see any two parts and see the third part free. Critics were shown Part 1, which runs about three hours.

The film follows the journey of two peoples, the Darkhad nomads and the Sojon Urinjanghai, and their animals to rustic towns that used to be Mongolian-Russian trade stations. The journey ends at an amusement park in the Mongolian capital, Ulan Bator, where the ancient tribal ways rub somewhat uncomfortably against modern civilization.

•

At least in the film's opening part, tribal life seems fairly idyllic in its primitive, hard-scrabble way. The nomads appear to be peaceful, diligent workers who share a close-knit sense of community. Daily tasks are carried out with great care, seriousness and a pride in workmanship. And as several scenes illustrate, they reward their labors with exuberant celebrations at which a milk liquor is drunk and snuff is circulated.

Two of the film's jolliest scenes, "Festival of the Mutton Breastbone" and "Wrestlers and Praise Singers" show a festival at which a lamb is slaughtered and ritually dismembered. After it has been cooked between heated stones in an enormous metal container, the portions are passed around and eaten by hand. The festivities culminate in a friendly wrestling match among the younger tribesmen, and the winner gets the lamb's highly prized breastbone.

The most remarkable quality of "Taiga" is its aura of timelessness. Like the way of life it portrays, the film exhibits no sense of urgency. Although it follows a rough chronology, it does not try to tell a conventional story or express a strong historical or sociological point of view. Nor does it seem to want to idealize its subjects, who are aware of the film crew and eager to show off their skills.

In the most effective scenes, conventional cinematic momentum simply halts and the camera dwells on the extended moment. Without making a fetish of showing everything in real time, "Taiga" has enough such moments to give the viewer much more than a tourist's-eye view of an ancient tribal culture. At such times, it conveys a sense of really being there.

1993 Mr 4, C17:1

Mad Dog and Glory

Directed by John McNaughton; written by Richard Price; director of photography, Robby Muller; production designer, David Chapman; edited by Craig McKay and Elena Maganini; music by Elmer Bernstein; produced by Barbara de Fina and Martin Scorsese; released by Universal Pictures. Running time: 97 minutes. This film is rated R.

Wayne	Robert De Niro
Glory	Uma Thurman
Frank	Bill Murray
Mike	David Caruso
Harold	Mike Starr
Andrew	Tom Towles
Lee	Kathy Baker
Shooter	Derek Anunciation

By VINCENT CANBY

"Mad Dog and Glory" is an almost unconscionably enjoyable movie that plays like something conceived by a contemporary, furiously hip Damon Runyon. It's about the spiky relationship of Wayne (Robert De Niro), a mild-mannered Chicago police photographer, derisively nicknamed Mad Dog, and Frank (Bill Murray), a dangerous hoodlum who wants to be a stand-up comedian. At the Comic Cazie, the club he owns, Frank is a smash with his routines on the Cosa Nostra. Like all comics, he's best when dealing with the familiar in front of audiences that share his interests.

The film is also a love story about Wayne and Glory (Uma Thurman), the gorgeous if slightly battered bartender presented to Wayne by Frank after the policeman saves his life. Frank airily describes Glory as "the gift that keeps on giving." In fact, she is supposed to be returned to the sender after one week, something that Wayne doesn't find easy to do.

That little disagreement is enough to end the beautiful friendship, which in reality has been one-sided anyway. Frank is the sort of man who neither cares nor notices that he's crushing the person to whom he's giving a hearty bear hug. Among other things, he's in analysis, trying to get in touch

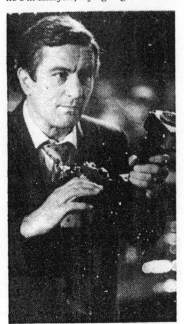

Ron Phillips/Universal City Studios

Puppy Love Robert De Niro stars in John McNaughton's "Mad Dog and Glory" as a timid police photographer who falls in love with a gangster's girlfriend.

with his feelings to improve his performance as a stand-up.

•

"Mad Dog and Glory" can be described many ways, but it is most easily accepted as a first-rate star vehicle for the big, explosive talents of Mr. De Niro, Mr. Murray and Richard Price, who wrote the screenplay. Mr. Price, the author of the best-selling "Clockers," established his film name with his screenplay for Martin Scorsese's "Color of Money." He has a wild and singular gift for the kind of dialogue that synthesizes the commonplace, the crude and the lunatic to create something that sounds both authentic and completely original, as if he were inventing a whole new language.

Mr. Price reportedly initiated the "Mad Dog and Glory" project, then took it to Mr. Scorsese and Barbara de Fina who, having decided to produce the screenplay, showed it to Mr. De Niro. It was only then, it seems, that Mr. Murray and John McNaughton, the director, were signed. Mr. McNaughton is the man who made his directorial debut with the accomplished, morally aloof "Henry: Portrait of a Serial Killer."

This chronology may have something to do with the shape and manner of "Mad Dog and Glory," which, though a comedy, features brutality as stark as anything in Mr. Scorsese's own "Goodfellas." The finished work seems to be the movie that both Mr. Price and Mr. Scorsese envisioned. It doesn't appear to have been interfered with by front-office executives trying to offend as few people as possible. "Mad Dog and Glory" takes risks.

When a movie opens with two back-to-back murders, which are seen in close-up and are as casually carried out as fly-swatting, it requires a little time to realize that it is a comedy. The film's milieu is so dark that its comic rhythm isn't immediately apparent. Indeed, the melodrama is of such force that it occasionally functions less like counterpoint to the comedy than as a warring spirit. The film's ending is not completely satisfactory: it seems too small for all that has gone before. Yet the seedy and bitter realism also effectively disguises the movie's unexpectedly soft heart.

•

The great satisfaction of "Mad Dog and Glory" is watching Mr. De Niro and Mr. Murray play against type with such invigorating ease. Each is the other's straight man, a relationship that is hilariously set up in the initial encounter of the cop and the hoodlum. At the end of a long day and a particularly bloody evening, Wayne walks into a convenience store to find a gun-wielding man standing behind the counter with one foot on Frank, who lies on the floor both humiliated and scared out of his wits.

Though not by nature heroic, Wayne pulls out his police badge and tries to talk the drugged, trigger-happy young man into surrendering his gun, but he refuses. As Frank screams for the policeman to do something, anything, Wayne keeps his cool and prolongs the negotiations. Wayne, to his own surprise, prevails, earning the hoodlum's gratitude and, eventually, the companionship of Glory. As played by Ms. Thurman, Glory is a 1990's update on all Runyon dolls double-crossed by life. Though she really has been through

Charles Hodes

Bill Murray

the mill, she remains unsoiled, infinitely sweet.

•

After playing a long line of larger-than-life characters, Mr. De Niro has a ball as the self-effacing police photographer who would like to be an artist. The movie works so well that it can accommodate a scene in which Wayne hesitantly shows Glory the magical picture he once took when, at 3 A.M., he came upon a lone deer standing in La Salle Street, in the middle of Chicago's financial district.

Mr. De Niro, who put on a dangerous number of pounds to play Jake La Motta in "Raging Bull," gives the impression of having grown shorter for his role here. Mr. Murray's Frank towers over Wayne who, in the manner of men so disadvantaged, is uneasy but ever alert and probably more quick of wit than usual. Not since "The King of Comedy" has Mr. De Niro had such richly comic material to work with.

Mr. Murray is Mr. De Niro's equal in a role that is as funny as it is carelessly sinister. Mr. Murray's timing is superb. His Frank is fastidious in his speech. He has an ear for clichés. He's genuinely amused by the phrase Wayne uses to describe the police's hunt for the convenience-store gunman. "The net's closing?" Frank says, repeating the words Wayne used. He can hardly believe his ears, but it also reinforces his sense of superiority over the cop for whom he feels such avuncular affection.

Briefly warmed by a sense of their friendship, Wayne once allows himself an uncharacteristic moment of reflection. "I wish I were a brave, handsome man," he says. Replies the the hoodlum, "No offense, but that sounds a little immature."

The film's wit extends beyond Mr. Price's dialogue and the two fine central performances. It's there in the work of the members of the supporting cast, especially David Caruso and Mike Starr. It's even in the records Wayne plays at home or on the juke-boxes in the bars that are his social clubs. He has a special fondness angst expressed by Louis Prima singing his exuberant, rickety "Just a Gigolo" and "I Ain't Got Nobody."

"Mad Dog and Glory" is full of such rewards.

•

"Mad Dog and Glory," which has been rated R (Under 17 requires ac-

companying parent or adult guardian), has violence, obscene language and sexual situations.

1993 Mr 5, C3:1

Rich in Love

Directed by Bruce Beresford; screenplay by Alfred Uhry, based on the novel by Josephine Humphreys; director of photography, Peter James; production designer, John Stoddart; edited by Mark Warner; music by Georges Delerue; produced by Richard D. Zanuck and Lili Fini Zanuck; released by MGM. Running time: 105 minutes. This film is rated PG-13.

Warren Odom	Albert Finney
Helen Odom	Jill Clayburgh
Lucille Odom	Kathryn Erbe
Billy McQueen	Kyle MacLachlan
Vera Delmage	Piper Laurie
Wayne Frobiness	Ethan Hawke
Rae Odom	Suzy Amis
Rhody Poole	Alfre Woodard

By JANET MASLIN

"Surely I'm knocked off my perch!" declares Albert Finney as he luxuriates in the role of Warren Odom, a puckish Southerner who has suddenly been left by his wife. Surprised at first by this betrayal, Warren is soon doing a quite a remarkable job of taking things in stride.

From wandering about in his pajamas eating junk food and depending hopelessly on his 17-year-old daughter, Lucille (Kathryn Erbe), he blossoms charmingly into a free spirit, meanwhile delivering ripely colorful dialogue with supreme flair. "I've only recently begun to think of you girls as people," he casually drawls to his two daughters. What did he think they were previously? "Well, pets, to tell you the truth. Your mother's pets."

Mr. Finney's mischievous, jaunty Warren is the best thing about "Rich in Love," a film that is otherwise notable mostly for its pedigree. Reuniting the director (Bruce Beresford), screenwriter (Alfred Uhry) and producers (Richard D. Zanuck and Lili Fini Zanuck) of "Driving Miss Daisy," and drawing upon a novel by Josephine Humphreys with a seductive South Carolina setting, this film has to have the makings of something more substantial than it turns out to be. It winds up as another Southern sojourn with a group of giddy eccentrics, none of whose flamboyant personal problems seems to make much difference to the others. A family can be dysfunctional without being interesting.

•

The film's weightlessness does not seem to originate with the novel, since "Rich in Love" sets a lot of potentially lively conflicts in motion. These events are seen through the eyes of Lucille, presented in the film as such a pert, bright-eyed presence that she seems impervious to the story's painful possibilities. Discovering her mother's curt goodbye note to her father, Lucille quickly rewrites it to include wording like "Dearest" and "absolutely adrift," which strikes Warren as so unfamiliar he thinks maybe his wife has been kidnapped. This would be funnier if the film followed up on anything more about Lucille than her desire to do good.

Lucille and Warren are quickly joined by Rae (Suzy Amis), Lucille's cheerfully dissipated sister, who happens to be pregnant; Billy McQueen (Kyle MacLachlan), Rae's brand-new husband, who is very definitely out of his element; Wayne Frobiness (Ethan Hawke), Lucille's hesitant suitor; Vera Delmage (Piper Laurie), the vixenish hairdresser who has designs on Warren, and Rhody Poole (Alfre Woodard), who owns a local nightclub and knows a lot more about the Odoms than any of them might realize.

As the long-missing Helen Odom, Jill Clayburgh appears so briefly and late in the story that she seems to have straggled back from "An Unmarried Woman." Her character, at first central to the film, is by this point only an afterthought. After a few genuinely bright episodes (most involving Mr. Finney) and a lot of short, atmospheric scenes with no particular drive, the characters' many troubles are cheerfully resolved. The net effect of the film's goings-on is remarkably slight.

Among the actors, it's no surprise to find that Ms. Woodard shines, and that her vitality gives the film a noticeable lift. Ms. Amis finds some pathos and humor in the cavalier Rae, who at one point tells Lucille a major family secret as if it were an afterthought. Ms. Laurie is funny and buoyant as Vera, in one of the story's more broadly drawn roles. Vera likes to bake angel food cake, and the film treats this as if it were a character trait.

•

"Rich in Love" is rated PG-13 (Parents strongly cautioned). It includes mild profanity and sexual situations.

1993 Mr 5, C8:1

Swing Kids

Directed by Thomas Carter; written by Jonathan Marc Feldman; director of photography, Jerzy Zielinski; production designer, Allan Cameron; edited by Michael R. Miller; music by James Horner; produced by Mark Gordon and John Bard Manulis; released by Buena Vista Pictures. Running time: 112 minutes. This film is rated PG-13.

Peter	Robert Sean Leonard
Thomas	Christian Bale
Arvid	Frank Whaley
Frau Muller	Barbara Hershey
Evey	Tushka Bergen

By JANET MASLIN

"Swing heil!" is the battle cry of the Swing Kids, long-haired, big-band-loving teen-age rebels in Nazi Germany. You may want to reread that sentence slowly, just to make sure it does not describe some missing chapter of "Wayne's World" or simply seem too nutty for words.

In fact, there is some historical background to the premise of this surprising musical, which is set in 1939 and revolves around the jubilant American dance music its characters adore. And here's the oddest part of the whole project: the Swing Kids conceit turns out to be the film's best aspect. This is not one of the great wrong-headed movie ideas after all.

Nor is it as unconventional as it sounds, since the principals revert to stock characters whenever they stop their go-for-broke dancing. "Swing Kids" centers upon Peter (Robert Sean Leonard) and Thomas (Christian Bale), handsome friends who find that a shared love for Benny Goodman records may not be enough to keep the Nazis at bay. The setting is Hamburg, and the pressure for boys like these to join the Hitler Youth grows more intense every day. Their wild nightclub dancing with a group of like-minded young resisters becomes the most flamboyant form of rebellion they can imagine.

•

The dance episodes, impressively choreographed by Otis Sallid, are indeed staged with furious energy. And in this context the jitterbug does take on a subversive tone. (Viewers can only imagine whether heavy-metal music, had it been invented earlier, could have changed the course of the war.) But the film, having established the legitimacy of its subject, tends to go embarrassingly overboard at times. On two different occasions characters who have been bloodied in fistfights call out defiantly: "It don't mean a thing if it ain't got that swing!" That can't have been easy to play straight.

Cast with personable, good-looking young actors who have been dashingly costumed by Jenny Beavan, "Swing Kids" eventually begins to suggest that any gathering of sensitive adolescent characters can begin to feel like "Dead Poets Society" after a while. Mr. Leonard, who was one of the stars of that film, brings an appealing gravity to this one. Mr. Bale, who starred in "Empire of the Sun" and sang and danced in "Newsies," an earlier and less successful Disney attempt at a teen-age musical, is well matched with Mr. Leonard.

These two are convincing as good friends, with Frank Whaley memorably cast as the third and most musically knowledgeable member of their circle. It is he who gives his name as "Django Reinhardt" when the Gestapo stops him. But it is also he who has the story's most conspicuous affliction (a limp) and its shrillest lines. "What's the matter with all of you?" he cries. "Can't you see what's happening? Are you afraid to look?" Too much of "Swing Kids," with a screenplay by Jonathan Marc Feldman, has that all-purpose melodramatic ring.

•

As directed by Thomas Carter and shot mostly in Prague, "Swing Kids" looks good and moves quickly at first; later on, mired in familiar-feeling moments, it flounders. The film is noticeably weaker in scenes involving grown-ups than in those centering on the teen-agers themselves. The characters' parents are so thinly drawn that they are best left in the background, though Barbara Hershey has some long, terribly ladylike moments as Peter's mother. An uncredited Kenneth Branagh turns up as a Nazi who admires her and who wishes to play father figure to Peter, since the boy's real parent has met with an unfortunate Nazi-related end. Mr. Branagh delivers this chestnut: "You

Frank Connor
Robert Sean Leonard and Tushka Bergen in "Swing Kids."

know, Peter, you may not believe it, but I was once very much like you."

Some viewers will legitimately feel that "Swing Kids" is a strangely bloodless film in view of its subject matter. The score comprising Benny Goodman, Count Basie, Duke Ellington and others may be a potent refutation of Nazi beliefs, but the real horrors of Nazi rule are allowed to remain implicit. And the film's final title describing the effect of the Swing Kids' rebellion sounds conspicuously weak. ("A new generation of Swing Kids survived to see the defeat of the Nazis.") Audiences may also be startled by occasional anti-gay epithets in the dialogue.

•

"Swing Kids" is rated PG-13 (Parents strongly cautioned). It has mild profanity and limited violence.

1993 Mr 5, C8:5

Amos and Andrew

Written and directed by E. Max Frye; music by Richard Gibbs; edited by Jane Kurson; production designer, Patricia Norris; director of photography, Walt Lloyd; produced by Gary Goetzman; released by Castle Rock Entertainment in association with New Line Cinema. Running time: 92 minutes. This film is rated PG-13.

Amos Odell	Nicolas Cage
Andrew Sterling	Samuel L. Jackson
Phil Gillman	Michael Lerner
Judy Gillman	Margaret Colin
Preacher	Giancarlo Esposito
Chief of Police	Dabney Coleman
Hostage Negotiator	Bob Balaban
Local Woman	Aimee Graham

By VINCENT CANBY

"Amos and Andrew," the first film to be directed as well as written by E. Max Frye, is less breathless than emphysemic, a handicapped satirical farce whose roots are not in life but in other, better movies and sitcoms.

The central situation is this: The white chief of police on a small resort island, not unlike Nantucket, mistakes a celebrated black playwright for a housebreaker, though the man is really the house's new owner in the process of moving in. The chief, believing the man to have taken hostages, sets up an elaborate siege of the house. When he realizes his mistake, the chief initiates a phony hostage situation that makes everything even worse, by which time all of America is watching the debacle through the facilities of national television.

A promising idea, perhaps, but not as executed by Mr. Frye, the man who wrote the funny, sharply observed screenplay for Jonathan Demme's "Something Wild." Mr. Frye's initial conceits are good ones, but the film's humor somehow gets sopped up by the spongy writing and direction. The characters are fuzzily realized. The dialogue is lame and the continuity so shaky that one entire subplot sinks in confusion.

The cast is headed by Nicolas Cage, who plays Amos, a small-time car thief forced by the chief to take Andrew (Samuel L. Jackson) hostage. The chief is played by Dabney Coleman. Michael Lerner and Margaret Colin appear as the nosey neighbors who sound the first alarm, and Bob Balaban comes on as a foolish hostage negotiator. Appearing on screen from time to time, though not visibly connected to the principal action, is a militant black preacher (Giancarlo Esposito) and his large following.

Jim Bridges
Samuel L. Jackson

They are good actors all. Their records are clean. Their appearances here are mostly witless. The one member of the cast who earns a spontaneous smile is Aimee Graham, as the young local woman who delivers a pizza to Mr. Cage in the middle of the ersatz hostage crisis and is dazzled by his celebrity.

The film's antecedents include "The Russians Are Coming, the Russians Are Coming," Norman Jewison's popular 1966 comedy, and Preston Sturges's satirical sendups of small-town American life in the 1940's, particularly "The Miracle of Morgan's Creek" and "Hail the Conquering Hero." Mr. Frye boldly evokes the Sturges memory with the title of Mr. Jackson's Pulitzer Prize-winning play ("Yo, Brother, Where Art Thou?"), a variation on the name of a film within "Sullivan's Travels."

Mr. Frye distributes his second-hand venom as if he were acting according to his own equal-opportunity rules. He attempts to send up his white and black characters without favoritism. Yet because the black stereotypes (the pompous man of letters, the hysterical rabble-rousing preacher) are newer and fresher than the white stereotypes (bigoted law officers, condescending white liberals), the effect is vaguely if unintentionally racist.

•

"Amos and Andrew," which has been rated PG-13 (parents strongly cautioned), has vulgar language.

1993 Mr 5, C14:1

Love Your Mama

Directed, written and produced by Ruby L. Oliver; director of photography, Ronald Courtney; edited by Joy L. Rencher; music by John Van Allen Jr. and Markian Fedorowycz; released by Hemdale Communications. Running time: 93 minutes. This film is rated PG.

Leola	Carol E. Hall
Mama	Audrey Morgan
Wren	André Robinson
Sam	Ernest III Rayford

By VINCENT CANBY

Ruby L. Oliver's "Love Your Mama" is the work of an earnest but unmistakably amateur film maker who wants to create believable role models for all those living in the kind

of black ghetto from which she emerged, her faith intact.

"Love Your Mama" has the bluntly functional manner and look of a training film. It's about a mother whose strong Christian faith helps her to rehabilitate her drunken husband and her teen-age son, a car thief, and to encourage her pregnant teen-age daughter to finish her education in order to open a day-care center. The performances, especially by Carol E. Hall, as the daughter, and Audrey Morgan, as Mama, have a sweet plainness to them that is sometimes as effective as more sophisticated attempts at acting.

Ms. Oliver, who wrote, produced and directed the film, has herself spent more than 23 years setting up and running day-care centers for disadvantaged children.

•

"Love Your Mama," which has been rated PG-13 (parents strongly cautioned), has some vulgar language.

1993 Mr 5, C14:5

Shadow of the Wolf

Directed by Jacques Dorfmann; screenplay by Rudy Wurlitzer and Evan Jones, based on the novel "Agaguk" by Yves Theriault; director of photography, Billy Williams; music by Maurice Jarre; edited by Françoise Bonnot; production designer, Wolf Kroeger; produced by Claude Leger; released by Vision International. Running time: 108 minutes. This film is rated PG-13.

Agaguk	Lou Diamond Phillips
Kroomak	Toshiro Mifune
Igiyook	Jennifer Tilly
Henderson	Donald Sutherland

By VINCENT CANBY

Set in the far Canadian north in the mid-1930's, "Shadow of the Wolf" is a mystical adventure about the beliefs, rituals, lives and loves of Eskimos, who hang onto their old ways by near-frozen fingertips as the white man encroaches. The elaborate but not always coherent Canadian-French production might be of interest to children with exotic tastes, but it's pretty lugubrious stuff for impatient adults.

The very American Lou Diamond Phillips, wearing lots of artificial hair, plays Agaguk, a young hunter and the son of Kroomak, the tribal shaman, played by the very Japanese Toshiro Mifune with some of the same hair. When he sees his father giving in to the white man's booze, Agaguk takes the woman he loves, Igiyook (Jenniger Tilly), and leaves their village, but not before murdering a venal white trader. The movie follows Agaguk's coming of age, first as a husband and a father, then as the reborn spiritual leader of his clan

Takashi Seida
Lou Diamond Phillips in a scene from "Shadow of the Wolf."

after a fight with a mysterious, possibly totemic white wolf.

•

"Shadow of the Wolf" is at its best when it is most specific, showing how Eskimos build igloos, combat polar bears, hunt through the ice for seals and fish and conduct joint assaults on whales. The narrative scenes, in which Donald Sutherland appears as a hard-nosed Canadian policeman, somehow seem more primitive.

A lot of money and time seem to have gone into the production, which was directed by Jacques Dorfmann, a Frenchman better known as a producer than as a director, and adapted by Rudy Wurlitzer and Evan Jones from "Agaguk," a Canadian novel by Yves Theriault. Billy Williams was the cameraman and Maurice Jarre wrote the original musical score.

The physical production, much of which was apparently shot in a huge set constructed in a Montreal suburb, is quite handsome. It's impossible to tell which material was shot on sets and which on actual locations. That's not nothing. The dialogue is not always easily understood, maybe because some of it was post-synchronized. Ms. Tilly makes a very glamorous Eskimo woman, with what sounds like a finishing-school accent. Mr. Mifune looks fine and ferocious and sounds the way he often does in his English-dubbed Japanese movies.

•

"Shadow of the Wolf," which has been rated PG-13 (parents strongly cautioned), has violence, one childbirth scene and partial female nudity.

1993 Mr 5, C19:1

FILM VIEW/Caryn James

Some Holes Don't Come From Bullets

MICHAEL DOUGLAS'S LIFE IN "FALLING Down" is a critical mass of all-American problems. Divorced, unemployed, caught in traffic on a sweltering morning, he walks away from his car to face gang violence, vagrants begging for money, bad service at a fast-food joint.

These things could happen to any of us. But would any of us respond by: beating a Korean grocer, shooting a Latino street gang, stabbing a neo-Nazi, terrorizing a Whammyburger restaurant and using a rocket launcher to blow up a construction site? Even if we were having a really, really bad day?

There are movies that honestly hit a raw nerve and others that cynically push your buttons, and "Falling Down" is a push-your-buttons film. It may also be the last big Bush-era movie, custom-made for the rabidly conservative Rush Limbaugh crowd that sees both social blight as proof that America is lost in a liberal wilderness.

The film catalogues urban disasters and goes out of its way to manufacture "controversy," yet it falls apart on the basic level of common sense. The Douglas character is depicted as both an ordinary Joe and Travis Bickle from "Taxi Driver." That idea is illogical — you either have it in you to be Travis Bickle or you don't — but it sells. Hollywood may

'Falling Down' pretends to be seriously provocative, but it adds up to nonsense.

have voted for Bill Clinton, but "Falling Down" masterfully exploits conservative sentiments.

With his ragged crew cut, short-sleeved white shirt plus pocket protector, and a license plate that reads "D-FENS," Mr. Douglas's character is not part of any cultural elite. The tough-minded performance encourages sympathy yet never asks viewers to like him. Joel Schumacher's vivid direction depicts the harsh reality of urban Los Angeles while letting the film slip into black humor with ease. It's too bad this savvy direction and acting bolster Ebbe Roe Smith's disingenuous script, which evades the fundamental question: Was the main character always crazy, or did society make him snap?

The anonymous D-FENS character starts out as a surrogate for the frustrated working and middle classes. When the Korean grocer mispronounces "five" as "figh," D-FENS shouts, "They don't have v's in China?" He expresses what a segment of the audience might guiltily think but wouldn't dare say. Soon he is threatening the shopkeeper with a baseball bat. The film doesn't ask viewers to condone his behavior, but it assumes they will sympathize with its source.

The character's response to crime and unemployment implies: "Don't blame me. I'm the victim." There is an audience for this opinion, which is the attitude Rush Limbaugh promotes on his radio show and in his best seller, "The Way Things Ought to Be." Just as Mr. Limbaugh's book suggests that the homeless bear some blame for their condition ("I hadn't done anything to cause his homelessness," he complains of a man living in a shelter), so D-FENS rails against a vagrant and snarls at him to get a job.

Like Mr. Limbaugh, the film is smart enough to use satire instead of logic to make political points. A man who asks D-FENS for money says, "I haven't eaten for days," though he happens to be holding a sandwich. When D-FENS shoots up the Whammyburger, he has reason to be annoyed; he wants breakfast and is three minutes too late.

Warner Brothers

Michael Douglas as "D-FENS"—Both an ordinary Joe and Travis Bickle.

If "Falling Down" were content to be an absurdist black comedy, this sleight-of-mind would make sense. But the film also pretends to be seriously provocative. When a neo-Nazi (played by Frederic Forrest) appears, the story takes a turn that leads to utter nonsense.

The deranged neo-Nazi has an arsenal behind his military-surplus store and sees D-FENS as a kindred spirit. "We are not the same," D-FENS says. "I'm an American. You're a sick . . ." Then he puts on a brown shirt and comes a step closer to becoming the neo-Nazi.

It turns out that D-FENS was probably one sick puppy long before any Whammyburger workers got on his nerves. His ex-wife has been so worried about his violent temper that she has gotten a restraining order against him. Home videos show him bullying his wife and daughter years before the pressures of urban life supposedly made him crack.

Yet the film depicts him as if he were some socially relevant missing link between the audience and the neo-Nazi. This is a master stroke of movie manipulation. Conservative viewers can identify with D-FENS as long as it is cathartic to do so; liberals can debate whether he is the cause or the symptom of social problems, and when he turns into a madman, the entire audience can distance itself. To wonder whether we are like D-Fens is simply to fall for a question as contrived as a high-school debate issue.

The film's duplicity is evident in smaller touches as well. The Douglas character is listed in the credits as "D-FENS." But the police learn his name, Bill Foster, and use it when questioning his mother. She is called Mrs. Foster; the credits coyly list her as "D-FENS's mother."

Even Charles Bronson's exploitative "Death Wish" movies are more honest. That series may be vile in its admiration for the vigilante Mr. Bronson plays, but at least it has the courage of its vileness. "Falling Down" wants its madman to be Everymadman, too. "I'm the bad guy?" he asks at

the end, sincerely baffled (though no more than the audience). By then viewers might feel as jerked around by the movie as poor Bill Foster is by urban America. ☐

1993 Mr 7, II:13:5

Ethan Frome

Directed by John Madden; written by Richard Nelson, based on the novella by Edith Wharton; director of photography, Bobby Bukowski; edited by Katherine Wenning; music by Rachel Portman; production designer, Andrew Jackness; produced by Stan Wlodkowski; released by Miramax. Running time: 107 minutes. This film is rated PG.

Ethan Frome	Liam Neeson
Zeena Frome	Joan Allen
Mattie Silver	Patricia Arquette
The Reverend Smith	Tate Donovan

By VINCENT CANBY

Bent almost double and limping awkwardly through a snowy landscape, Ethan Frome (Liam Neeson) cuts a strangely familiar figure when first seen in the film version of the classic Edith Wharton novella. Though humpless, he seems to be as gnarled of frame as Laurence Olivier's Richard III, which is unfortunate. There's also something about him that suggests the skittishness of Charles Laughton's Quasimodo, mysteriously transported from Notre Dame in Paris to the cold granite hills of New England. That's also misleading.

Ethan's spectacularly grotesque initial image is arresting and picturesque, but like the film itself, it's only a distant reflection of the Wharton work, which is about terrible deformity only to the extent that it is a reminder of one great love's awful futility. In the movie, there is no great love to remember; just scenery.

As written by Richard Nelson and directed by John Madden (the English stage and television director making his first theatrical film) "Ethan Frome" is a fairly faithful adaptation of the tragic story published in 1911 and set in the western Massachusetts hills where Wharton maintained one of her several homes. The film carefully re-creates the crucial events in the lives of Ethan, the poor, sensitive farmer who wants to better himself; Zeena (Joan Allen), his mean-spirited, hypochondriacal wife, and Mattie Silver (Patricia Arquette), Zeena's sweet-tempered, orphaned young cousin who comes to help out, only to fall as hopelessly in love with Ethan as he does with her.

●

Like the novella, in which the story is reconstructed by two narrators, neither of whom could possibly be privy to all the facts recalled, the film is told as a succession of flashbacks. It's an awkward device that even the self-assured Wharton felt compelled to justify in a short introduction to the book. She was writing, she said, about inarticulate characters seen through more sophisticated sensibilities. That she was none too comfortable with the device is indicated in the book when one of the narrators suddenly says to the other, "Why am I telling you all this?" It's an involuntary cry of "Help!"

What makes the framing device necessary to both the book and to any adaptation is that the story's climax comes 24 years after the events recalled. There's no easy way that an omniscient author can make such a leap in time without seeming to have

arbitrarily withheld information. Wharton handles the framing device with dispatch and little fuss.

The film makers, with the best of intentions, attempt to make their principal narrator, the Reverend Smith (Tate Donovan), newly arrived in the village of Starkfield, not just an interested observer but a participant. Quite early on, having learned something of what happened to Ethan so many years earlier, the good minister is preaching a sermon in which he instructs his congregation in the need for charity toward the standoffish farmer. In fact, there's no indication that the people of Starkfield are anything but kind to him. His own sense of moral duty and an uncaring universe have doomed him.

It's a small, clumsy adjustment, indicative of the problems facing anyone who would translate "Ethan Frome" into another medium and another language. The delicate, mysterious Wharton precision is gone. In the place of a nearly perfect novella is a sad and solemn little film that never has a life of its own. This "Ethan Frome" is not dead exactly, but rather in a state of suspended animation waiting to be aroused, which never happens.

Though the Wharton novella is composed of observed details, things that a movie can re-create as images, there is not a detail in the novella that isn't illuminated by the author's own long-range perspective. "Ethan Frome" is less about events that can be seen than about a man trapped by his own aching imagination. Take away Wharton and all that's left is a synopsis.

Shot on location in and around Peacham, Vt., "Ethan Frome" presents a New England that looks the way tourists remember it: a place of clean snow, spanking white churches and weathered old farmhouses demanding to be remodeled as summer homes and weekend ski lodges. Though the skies are often dour, they are dour in the beautiful way of something one sees without feeling the cold and the boredom that comes with living day in and day out amid all that sameness. Anyone watching this movie will want to check out the availability of the local bed-and-breakfasts.

As Mr. Neeson demonstrated in the recent stage production of "Anna Christie," he is an actor of remarkable gifts who can find the articulate heart of an inarticulate character. He's a big, strong, vigorous performer, but he plays Ethan as written: a decent though shadowy man whose fall is more physically than emotionally arresting.

●

In attempting to make Ms. Allen's Zeena less monstrous and more comprehensible than the character in the book, the film shortchanges itself and the denouement. As played by Ms. Arquette with a lot of dark hollows around the eyes, Mattie enters the film looking like a New Bedford hooker in the last stages of consumption. She quickly comes back to healthy life, and never appears to be quite as innocent or as lost as she is supposed to be, at least to support the desper-

ate decision she finally forces on Ethan.

Two final quibbles: The soundtrack music seems never to stop. There also are times when the characters' faces are framed in close-ups in such a way that it's not possible to tell what the rest of the body is doing. "Ethan Frome" deserves better than this.

●

"Ethan Frome," which has been rated PG (Parental guidance suggested), includes some mildly suggestive sexual situations.

1993 Mr 12, C8:5

CB4

Directed by Tamra Davis; written by Chris Rock, Nelson George and Robert LoCash; director of photography, Karl Walter Lindenlaub; edited by Earl Watson; music by John Barnes; production designer, Nelson Coates; produced by Mr. George; released by Universal. Running time: 83 minutes. This film is rated R.

Albert	Chris Rock
Euripides	Allen Payne
Otis	Deezer D
A. White	Chris Elliott
Virgil Robinson	Phil Hartman
Gusto	Charlie Murphy
Sissy	Khandi Alexander
Albert Sr.	Arthur Evans

By JANET MASLIN

Made in the shadow of "Wayne's World," "CB4" is another "Saturday Night Live"-related music parody, this time skewering rap instead of heavy metal. Desperately uneven, it works best as a string of sketches about the title band, three guys who were born Albert (Chris Rock), Otis (Deezer D) and Euripides (Allen Payne) until they realized it might be more profitable to rename themselves MC Gusto, Stab Master Arson and Dead Mike.

The names are funny, and so is the act: taking their group's name from the cellblock inhabited by an enemy, the members of CB4 appear in concert wearing denim prison fatigues while the set behind them features uniformed patrol guards and searchlights. Outfitted with gold chains, gold teeth and fake long hair, the group members belt out lyrics that are pure hostility and glare angrily at their fans. The film makers are savvy enough to enlist real rappers (Daddy-O, Hi-C and Kool Moe Dee) to blast out the vocals and give CB4's records a salable sound.

Their popularity eventually makes them the target of a sanctimonious white politician (Phil Hartman, like Mr. Rock a "Saturday Night Live" cast member), who is made even angrier by the fact that his little son is a closet CB4 fan. "Any person who'd defile America's pastime by wearing a baseball cap backwards — well, that's an evil that speaks for itself!" this politician declares.

●

As directed by Tamra Davis ("Guncrazy") and written by Mr. Rock, Nelson George and Robert LoCash, "CB4" promises sharper satire than it actually delivers. Pandering a shade too avidly to the real rap audience, the film sometimes tries to use the same sexist, mean-spirited ethos it makes fun of. In this vein, Khandi Alexander struts enthusiastically through the film as a predatory, gold-digging sexual athlete. She snares a

couple of band members and also tempts the film's glowering villain, Gusto (played by Charlie Murphy, Eddie's brother).

"CB4" is also inconsistent, starting out with a "Spinal Tap" format, which it then forgets. Beginning as "A Rapumentary by A. White," with Chris Elliott playing the star-struck white interviewer, the film incorporates a fast string of cameos from Halle Berry, Ice Cube, Ice-T, Flavor Flav and others. (If you don't know Ice-T from Ice Cube or can't spot the Spike Lee parody, count on missing a lot.) Then the documentary trails off, and the three principals are seen plotting their show-business rise. There are also sentimental scenes between Albert and his father (Arthur Evans), who means to give his son sound advice but has terrible taste in music.

●

The spirit of Eddie Murphy is invoked by his dour brother and also by Mr. Rock, a game, confident performer with an I'll-try-anything approach to comedy. Coasting through the film's more conventional scenes, he springs to life during its satirical snippets (e.g., reading a jailhouse poem entitled "I Didn't Do It") and scowls his way fiercely through the band's videos. Mr. Payne has some highly entertaining moments as the band member who becomes conspicuously radicalized and never lets anyone forget it. When CB4 appears on a call-in radio show and Mr. Payne's character is asked about his favorite foods, he solemnly asks whether the listener knows a black man invented ice cream.

Much of the humor in "CB4" is a lot more sophomoric than that. By the standards of "Wayne's World," sophomoric probably won't hurt.

●

"CB4" is rated R (Under 17 requires accompanying parent or adult guardian). It includes profanity, suggestiveness and sexual situations.

1993 Mr 12, C13:1

A Far-Off Place

Directed by Mikael Salomon; written by Robert Caswell, Jonathan Hensleigh and Sally Robinson, based on the books "A Story Like the Wind" and "A Far-Off Place" by Laurens van der Post; director of photography, Juan Ruiz-Anchia; edited by Ray Lovejoy; music by James Horner; production designer, Gemma Jackson; produced by Eva Monley and Elaine Sperber; released by Buena Vista Pictures. Running time: 104 minutes. This film is rated PG.

Nonnie Parker	Reese Witherspoon
Harry Winslow	Ethan Randall
John Ricketts	Jack Thompson
Xhabbo	Sarel Bok
Col. Mopani Theron	Maximilian Schell

By JANET MASLIN

Children who are eager to see "Trail Mix-Up," the latest Roger Rabbit cartoon, may have second thoughts about "A Far-Off Place," the full-length African adventure that makes up the rest of the bill. Those second thoughts may just manifest themselves in the middle of the night, like thoughts about Bambi's mother.

"A Far-Off Place" begins with peaceful glimpses of animal herds, including a picturesque group of elephants. Within about a minute of the film's opening, most of the elephants have been slaughtered by poachers. A baby elephant hovers near its lifeless mother. The baby looks bewildered. The poachers saw off tusks.

A pious credit explains that these scenes have been achieved without harming real animals, and that the

Animal slaughter and murder amid colorful sunsets.

animals in the film have been treated "with care and concern for their safety and well being." This is of no use to anyone in the audience who can't read. It isn't much more helpful for those who can.

As a matter of fact, the dead elephants in this scene are seven intricately made, life-size models, complete with pinched latex skin and broom bristles for eyelashes. The degree of effort that went into making these replicas is representative of the film's larger miscalculation. "A Far-Off Place" is visually ambitious, but its conception makes little sense, since the story will bore adults and scare children. Those young viewers who make it through the elephant massacre will have even more trouble with the rest of the tale, which involves the problems faced by two brave, newly orphaned white teenagers after the above-mentioned poachers kill their parents.

●

The more appealing of the two is 14-year-old Nonnie (Reese Witherspoon, the radiant young star of "The Man in the Moon"), brought up in Africa and cheerfully unpretentious. At the time of the murders, Nonnie's house guest is Harry Winslow (Ethan Randall), an obnoxious American who is visiting with his father and arrives complaining about the absence of satellite dishes and VCR's. This is meant to be funny, as is Harry's habit of walking through the bush wearing headphones. It quickly wears thin.

Harry and Nonnie are forced to make a trek across the Kalahari desert, which they do in the company of Xhabbo, a wise and kindly teen-age bushman played disarmingly by Sarel Bok. The film clearly doesn't mean to be condescending, but it often contrasts this black character in a loincloth with Harry, a preppy who strides into the Kalahari wearing his blue blazer.

Even allowing for the mutual understanding that grows out of this three-way teen-age adventure, the situation remains resolutely strange. Nonnie and Harry recover instantly from the deaths of their parents and manage a romance. Xhabbo teaches Harry to kill animals for food and helps him make a gift for Nonnie out of instant fur.

As directed by Mikael Salomon and based on books by Laurens van der Post, "A Far-Off Place" relies on orange sunsets and dramatic desert sands to hold the audience's interest much of the time. Even scenery as spectacular as this has its limits. The plot is simple, yet it's still not always easy to follow. Maximilian Schell performs ably but briefly as a poacher-hating big-game hunter.

●

The great outdoors is also vital to "Trail Mix-Up," made in typically lively and irreverent Roger Rabbit

Anthony Bannister

Ethan Randall, left, Reese Witherspoon and Sarel Bok, right.

style. Set in a national park, this bright, colorful cartoon features a string of murderous mishaps, some amusing familiar backdrops ("The Sawmill," where Roger is splintered into little Rogers), and of course Jessica Rabbit, once again with Kathleen Turner's voice and this time available for ogling as a leggy forest ranger. As another character says of Jessica: "Talk about babes in the woods!"

●

"A Far-Off Place" is rated PG (Parental guidance suggested). It includes mild profanity and violence that will be disturbing to young children.

1993 Mr 12, C15:1

Fire in the Sky

Directed by Robert Lieberman; written by Tracy Tormé; director of photography, Bill Pope; edited by Steve Mirkovich; music by Mark Isham; produced by Joe Wizan and Todd Black; released by Paramount. Running time: 98 minutes. This film is rated PG-13.

Travis Walton	D. B. Sweeney
Mike Rogers	Robert Patrick
Allan Dallis	Craig Sheffer
David Whitlock	Peter Berg
Sheriff Frank Watters	James Garner
Greg Hayes	Henry Thomas

By VINCENT CANBY

The ads for "Fire in the Sky," which opened here yesterday, proclaim that it's "based on the true story." That means that it's based on the true story of five Arizona loggers who say that they saw a flying saucer one night in 1975 and that one of them, Travis Walton, was taken aboard for five days. With more hope than conviction, the Paramount publicity material says, "Controversy still surrounds the incident."

"Fire in the Sky" is mostly about the terrible way the loggers are treated by their friends and members of the police and the print and television media during the five days their pal is gone. The loggers are even accused of murdering the man. To prove their truthfulness, they take lie detector tests, the results of which are said to be inconclusive. When the missing man shows up in the middle of the night, dehydrated and chilled, at a remote service station, he says he doesn't remember what happened.

This sort of situation would seem to be material for a great American comedy. "Fire in the Sky" treats the story with cautious, unimaginative, quite boring politeness. James Garner appears as a sheriff who hangs around the fringes of the film making skeptical remarks, though the movie has already shown the audience the saucer the loggers say they saw. At the same time the movie can't quite go on record in support of Mr. Walton's story about his ride.

Instead, the movie features a long-ish sequence in which the Walton character, played by D. B. Sweeney, dreams about his unhappy adventure. It looks as if he's a prisoner inside his own spastic colon. Industrial Light and Magic provided the special effects. Tracy Tormé wrote the screenplay, which was directed by Robert Lieberman.

Henry Thomas, one of the stars of one of the most enchanting science-fiction films ever made, Steven Spielberg's "E.T.: The Extra-Terrestrial," here plays one of the supporting roles in one of the least.

•

"Fire in the Sky," which has been rated PG-13 (Parents strongly cautioned), includes some vulgar language.

1993 Mr 13, 16:5

FILM VIEW/Janet Maslin

Godzilla (Clomp!) Bestrides The Ages

THERE'S A BIG GUY WHO LIVES WITH US, AND when I say big I'm not kidding. Height: 262 feet. Weight: 50,000 tons. Speed: 40 m.p.h. on land, 45 knots in water. Foot size: 50 feet 6 inches. It's the little details, like those six inches, that you've got to love.

His tail length is 354 feet, and his age is "2 million plus." Yes, he is Godzilla. (Were there any other possibilities?) And he is an endless source of interest for the 3-year-old of the household, who sees Godzilla in his dreams. When he asked one day whether Godzilla had made God, we knew this obsession was serious. The only thing we didn't know was why.

We used to have a five-foot-tall inflatable Godzilla that stood guard in the little fan's bedroom. There was a day when this green, human-sized model rode around town in the car's passenger seat and miraculously didn't cause any trouble. Henry J. Saperstein's UPA Productions of America distributes most of the Toho Company's 20 Godzilla movies here (many of which were directed by Ishiro Honda, who died two weeks ago). Mr. Saperstein, whose company also licenses Godzilla, Mr. Magoo and Elvis, says he finds this unremarkable, at least by Godzilla-nut standards. He himself once drove home accompanied by a three-dimensional, life-size Elvis in a gold suit, which is a much easier way to have an accident.

Mr. Saperstein (the source of Godzilla's vital statistics) will be one of those helping to usher Godzilla through a time of change, but more about that in a moment. First, some background: Godzilla started life as Gojira, which has been variously translated from the Japanese as "Gorilla-Whale" or "Devil Monster."

In his first film, released in Japan in 1954 and Americanized in 1956 with the help of new scenes featuring Raymond Burr, he was roused from a million-year sleep by a hydrogen bomb. Godzilla seemed to object vehemently to the bomb's effects on mankind. And he has been something of a strident social critic ever since.

That first film, known here as "Godzilla, King of the Monsters," was one of many directed by Mr. Honda, someone who might be considered the Father of Godzilla. (Godzilla's longtime producer Tomoyuki Tanaka is another candidate for that honor.) Mr. Honda's recent death, at the age of 81, is one reason Godzilla is now in transition. Another is that Tri-Star Pictures has purchased the rights to Godzilla and plans to make a big-budget American monster movie that will make the most of

Godzilla chic. This news is both exciting and alarming to whose who love the fact that Godzilla, in an age of high-tech horrors, is nothing but a man in a lumpy latex suit.

Godzilla's films are sporadically available on video and on television, but it's fair to suppose that his antics are not widely known to American viewers. A whole generation has grown up on monsters like Freddy Krueger, without often being exposed to the more benign and bloodless Godzilla fantasies. Indeed, by American horror standards, the Godzilla

And now the monster from Tokyo is headed for Hollywood.

films are remarkably innocent, even sweet. Roused over and over again from his watery resting place, Godzilla rises up to trample Tokyo and yet seldom seems malevolent. Most of the time, as he shrieks and flails, wearing that beady-eyed, beetle-browed look of puzzlement, he just seems misunderstood. Or at least he does to grown-up viewers; for children, he may be having the quintessential temper tantrum.

When a scientist reduced Godzilla to bare bones with an "oxygen destroyer" in the first film — bringing on the first of many faux Godzilla deaths — he did so sadly and then committed suicide. The same Japanese professors and newspaper reporters who invariably denounce Godzilla as a threat to mankind always seem to respect or like him.

And they should, for Godzilla's favorite targets are frighteningly modern aspects of Japanese life, from skyscrapers to the bullet train to atomic power. Never has he seemed more the guardian of tradition than in the "Mecha-Godzilla" movies, which pit him against a tinny, absurdly modern mechanical replica of himself that has been devised by space aliens. As Mr. Saperstein says succinctly of Godzilla, "He's the guy in the white hat."

Godzilla's less obviously mechanical enemies, like the furry, flying Mothra, the three-headed King Ghidorah and the independently popular Rodan and King Kong, form a rogues' gallery of charmingly low-tech creations. And the dialogue in Godzilla films sounds a similarly naïve note. ("He saw a monster? He's had too much sake!")

One of the chief pleasures of watching Godzilla stride across the Japanese landscape is watching the Godzilla-to-real-world size ratio change freely from scene to scene. Another is watching the extras, whose principal function is to scream and flee. Yet another is the latex suit itself, which flops and puckers as if the audience were watching a monster of a cellulite problem, instead of a real monster.

But the next Godzilla adventure to loom on the horizon will be, according to one Tri-Star executive, "an absolutely first-class event movie." There is talk of expensive, state-of-the-art special-effects wizardry that would seem to run counter to everything Godzilla stands for. Lovable tackiness is essential to the enterprise. As the emblem of the sci-fi film's early, innocent days, is this dinosaur now an endangered species?

What will it be like when he does to Pasadena (or wherever) what he's always done to Tokyo? Will he be scarier? Will he breathe more fire? Will he finally look real? Probably. But when he does, will he still be kind?　☐

1993 Mr 14, II:13:5

FILM VIEW/Caryn James

Bill Murray Takes On De Niro and a Groundhog

ONE DAY BILL MURRAY IS IN A movie with a groundhog; the next, he's in a movie with Robert De Niro. The groundhog is easy to act circles around and doesn't get any good lines. In Mr. De Niro's favor, he offers a richer character to play against and probably doesn't bite when he gets annoyed.

It's a strange and versatile career Bill Murray has, but there is nothing fluky at work. "Groundhog Day" and "Mad Dog and Glory" are the season's most entertaining films because Mr. Murray is the screen's most likable cynic.

Like Steve Martin, he has perfected the ability to be amiable and sardonic about everything from true love to lounge singers. This attitude was honed on "Saturday Night Live" and still appeals to the generation of baby boomers, who are loath to let go of the superciliousness and skepticism that worked so well in the Wall Street 80's. Mr. Murray has refined and deepened that persona over the years, and it is the key to his smashing performances in both new films.

"Groundhog Day" sounds like a dopey kids' comedy. Instead, it's a dopey adult comedy, a major hit with audiences and critics starved for romance and mindless escapism. As a jaded television weatherman sent to cover the groundhog celebration in Punxsutawney, Pa., Mr. Murray (named Phil, like the groundhog) is doomed to relive Feb. 2 in Punxsutawney over and over. Eventually he uses this endless loop of time to win the heart of his producer, Rita (Andie MacDowell).

The romance is sweet, but the movie keeps its funny edge because Mr. Murray remains cynical almost to the end. Realizing there is no tomorrow, he fulfills every selfish desire. He figures out how to steal a bag of money from an armored truck, eats a tableful of calorie-laden food and gets information from a young woman one day that he uses to seduce her the next. And he never mellows to the sound of Sonny and Cher singing "I Got You Babe" every morning at 6.

Even when he maneuvers to win Ms. MacDowell's love, it takes a wonderfully long time before he loses his skepticism. After she drinks a toast to world peace, the next time he buys her a drink, he toasts peace with all the transparent fakery of a cad. But only a cad as engaging and commonsensical as Mr. Murray could keep this film going. Other actors would have made Phil abrasive or sappy as he reveals a good heart.

With its endearing romance and sense of social absurdity, "Groundhog Day" is a twilight-zone beyond typical Murray films like "Caddyshack" (also directed by Harold Ramis) or "Ghostbusters." But it's not Oscar Wilde or Tolstoy, either. Though a wealth of reviews have inflated its romance and time-trap story to something existential, this is still a movie about a groundhog. Mr. Murray plays a character who has no depth, so he makes the surface sparkle with the acerbic wit his generation loves. His attitude gives the happy ending a sardonic twist. What are the odds that Phil and Rita will settle down in Punxsutawney? Would we want them to?

Mr. Murray's role in "Mad Dog and Glory" is smaller and deeper, but just as important to the film's success. Both he and Mr. De Niro play against type. Mr. De Niro is a timid cop, nicknamed Mad Dog, who collects evidence at murder investigations. Mr. Murray is Frank Milo, a mobster who really wants to be a stand-up comic. When Mad Dog saves Frank's life, he receives a thank-you present: a woman named Glory (Uma Thurman) to keep for a week. John McNaughton's direction and Richard Price's script reveal much more wit and character than this harebrained, politically incorrect idea promises.

Mr. Murray disappears for long stretches, and the film belongs to Mr. De Niro. In a wonderfully comic turn, Mad Dog falls in love with Glory and is so transformed he can sing and dance to Louis Prima's "Just a Gigolo" while getting evidence from a corpse. But if Mr. Murray's character hadn't worked, the entire movie would have crumbled.

Frank has to be likable enough for his friendship with Mad Dog to make sense, yet menacing enough for Mad Dog and Glory to fear his power. Mr. Murray handles both the character's wit and darker side with subtlety. This is a mobster who apologizes to Mad Dog because his therapist told him to. He does an unfunny stand-up routine at a comedy club he owns — he begins by spitting out, syllable by syllable, the words "Co-sa Nostra" — that suggests a sinister version of the bad lounge singer Mr. Murray played on "Saturday Night Live."

As Frank, Mr. Murray is less sarcastic than usual but even more deadpan. When he calmly lists the ways in which his men can kill Glory, he doesn't stop at predictable things like car accidents. "Do you know what botulism is?" he says with understated earnestness. "We can get her with soup."

But when he explodes and shouts, "I own her!" there is no doubt that this is a complex, violent, fiercely possessive man. He needs all the therapy he can get.

Obviously, Mr. Murray is ready to do real drama. (He struggled to do so in the 1985 film "The Razor's Edge" but usually relied on a single, impassive expression.) He could even play a nice, uncynical guy, though any actor can play nice. Robert De Niro and the groundhog can both play nice. A likable cynic is something rare. ☐

1993 Mr 14, II:22:1

Garden of Scorpions

Written and directed by Oleg Kovalov (in Russian with English subtitles); director of photography, Anatoly Lapschow; music by Carl Orff, Bela Bartok and Dmitri Shostakovich. Film Forum 1, 209 West Houston Street, South Village. Running time: 96 minutes. No rating.

By VINCENT CANBY

Oleg Kovalov's "Garden of Scorpions," the 1991 Russian film opening today at the Film Forum, is a giddy, surreal documentary portrait of the former Soviet Union made up of bits and pieces of Russian films from the 1930's through the 60's. Since it's possible to edit such bits and pieces to support any number of contradictory points, it's too much to describe the movie as an especially profound indictment of totalitarianism, but it's a very entertaining one.

The material is riveting, particularly the clips from "Corporal Kotschetkov's Case," which are used to give "Garden of Scorpions" some dramatic structure. "Corporal Kotschetkov's Case," made in 1955, is apparently a kind of low-voltage Russian equivalent to "My Son John," Leo McCarey's 1957 inflammatory anti-Communist tear-jerker about an all-American mother (Helen Hayes), whose heart is crushed by the treason of her not-so-all-American son (Robert Walker).

The 1955 Russian feature is more upbeat, being a cautionary tale about a naïve young Russian soldier's narrow escape from the clutches of a pretty young blonde, a spy, who works in a kiosk near his base and whom he almost marries. The other material has been taken from such classics as "Potemkin," "The Man With a Movie Camera," "The End of St. Petersburg" and dozens of other fiction films (including some hilariously lugubrious musicals), as well as documentaries, training and educational films and newsreels.

Nikita S. Khrushchev is recalled as he's welcomed to Hollywood by Frank Sinatra, Marilyn Monroe and Shirley MacLaine in the early 1960's. A youthful Yves Montand is seen performing on a Moscow stage, watched from the wings by an adoring, still beautiful Simone Signoret. There's a brief shot of Sergei Eisenstein dressed up as a London bobby. Some of the material is wonderfully opaque: repeated shots of camels racing across heaven knows what wasteland.

The uninformed American viewer might wish for title cards to identify the various segments. Yet cards might spoil the film's hallucinatory flow. "Garden of Scorpions" evokes a time and place that Mr. Kovalov clearly sees as a gigantic, unreasonable nightmare.

1993 Mr 17, C16:5

Manufacturing Consent and the Media

Directed by Mark Achbar and Peter Wintonick; photography by Mr. Achbar and Norbert Bunge; edited by Mr. Wintonick; produced by Necessary Illusions and the National Film Board of Canada; released by Zeitgeist Films. Film Forum 3, 209 West Houston Street, South Village. Running time: 165 minutes. No rating.

By VINCENT CANBY

For some time Noam Chomsky, the linguist, author, political activist and outspoken critic of what he sees to be the American power elite, has survived attacks by critics of his radically independent thinking. Now he survives, though just barely, attempts by some friends to make his views more widely known in a film, "Manufacturing Consent: Noam Chomsky and the Media."

Put together by Mark Achbar and Peter Wintonick, two admiring Canadian film makers, "Manufacturing Consent" nearly smothers the often revivifying Chomsky skepticism under a woolly blanket of fancy graphics, archival material and redundant images. The film, which runs almost three hours, opens today at the Film Forum.

When presented without frills and allowed to speak for himself, in dozens of interviews filmed and taped around the world, Mr. Chomsky is a most provocative, invigorating commentator on American political and social behavior. Yet Mr. Achbar and Mr. Wintonick never leave well enough alone. They underrate both Mr. Chomsky and the film audience. Nothing Mr. Chomsky says is too clear not to require some fuller explanation by the film makers.

•

When Jeff Greenfield, the producer of ABC's "Nightline," says he thinks Mr. Chomsky's ideas are "from Neptune," the film dutifully shows a clip of Neptune. A hard-hitting Chomsky debate with Fritz Bolkestein, the Minister of Defense of the Netherlands, is crosscut with stock material of a prizefight. Take out the visual similes and "Manufacturing Consent" might be half as long and twice as effective.

Mr. Chomsky is convinced that American public opinion is being manipulated through a de facto conspiracy of big business, big television, newspaper companies (The New York Times in particular), the government and academe. At one point the film makers visit the New York Times building in New York and somehow manage to give the impression that they have cracked the security of the Kremlim.

Whether or not you agree with Mr. Chomsky's conclusions, his reading of the American scene is persuasive: that the government is most responsive to the wishes expressed by the minority of citizens who vote, which is also one of the principal points made by John Kenneth Galbraith in his recent book "The Culture of Contentment." As Mr. Chomsky sees it, his mission is to wake up and activate the electorate.

•

The film is best when Mr. Chomsky talks, which he does with ease, clarity and wit. It's at its worst when it tries to defend him, employing some of the trickier eye-catching techniques associated with advertising campaigns for products the public doesn't yet know it needs. The film offers some interesting biographical material, especially material relating to his antiwar activities during the Vietnam era.

Also convincingly presented is Mr. Chomsky's outrage over press and television inattention to Indonesian atrocities in East Timor, even if these oversights scarcely seem like a conspiracy. Though the case for The New York Times is well argued by Karl E. Meyer, an editorial writer for the paper, "Manufacturing Consent" otherwise presents no Chomsky critics of a caliber to match Mr. Chomsky. Cheap shots creep in, as in the unflattering way the film makers treat William F. Buckley Jr., host of "Firing Line," the syndicated television show.

If you are prepared to sit through a lot of fancified film making, and starry-eyed adoration that softens the sharp edge of the Chomsky personality, "Manufacturing Consent" (also the title of one of his books) is an invigorating introduction to one of the least soporific of American minds.

1993 Mr 17, C17:1

Correction

A film review yesterday about a documentary at Film Forum 3 devoted to the writer and critic Noam Chomsky rendered the title incompletely in the heading of the credits in some copies. The film is "Manufacturing Consent: Noam Chomsky and the Media."

1993 Mr 18, A2:6

Orlando

Written and directed by Sally Potter, based on the novel by Virginia Woolf; director of photography, Aleksei Rodionov; edited by Hervé Schneid; produced by Christopher Sheppard; released by Sony Pictures Classics. At the Roy and Niuta Titus Theater 1 in the Museum of Modern Art, 11 West 53d Street, Manhattan, as part of the New Directors/New Films series of the Film Society of Lincoln Center and the Department of Film of the Museum of Modern Art. Running time: 92 minutes. This film has no rating.

Orlando	Tilda Swinton
Sasha	Charlotte Valandrey
The Khan	Lothaire Bluteau
Elizabeth I	Quentin Crisp
Nick Greene/Publisher	Heathcote Williams
Archduke Harry	John Wood
Shelmerdine	Billy Zane

By VINCENT CANBY

TAKING Virginia Woolf's bountiful and witty 1928 novel, "Orlando," which is as much about words, writing and the dogged pursuit of fine literature as about a number of other things, Sally Potter has made a grand new movie that is as much a richly informed appreciation of the novel as it is a free adaptation.

This ravishing and witty spectacle invades the mind through eyes that are dazzled without ever being anesthetized. Throughout Ms. Potter's "Orlando," as in Woolf's, there are a piercing kind of common sense and a joy that, because they are so rare these days in any medium, create their own kind of cinematic suspense and delightedly surprised laughter. "Orlando" could well become a classic of a very special kind, not mainstream perhaps, but a model for independent film makers who follow their own irrational muses, sometimes to unmourned obscurity, occasionally to glory.

"Orlando" will begin its regular commercial run here in June but, if you're lucky enough to already have tickets, you can see it at the Roy and Niuta Titus Theater 1 in the Museum of Modern Art tonight at 6, or tomorrow at 3 P.M. "Orlando" (on a bill with Philip Haas's "Music of Chance") is the opening attraction of this year's New Directors/New Films series, sponsored by the Film Society of Lincoln Center and the museum's film department. I can't remember any previous series starting off at quite such a high, madcap level. Here is a movie in which Orlando (Tilda Swinton), the hero, a beautiful young nobleman who was earlier adored by the aging Queen Elizabeth I (Quentin Crisp), goes to sleep one night in the 17th century, only to wake up five days later as the heroine. It's no great shock to Orlando. She turns to the camera (as she does from time to time throughout the film) and says tersely: "Same person, no difference at all. Just a different sex."

Orlando, her curiosity undiminished, goes on learning about life through the centuries up into our own, at which point she is somewhere in her late 30's. In one of her last appearances, the woman (about whom Queen Elizabeth once said, according to Woolf, "I know a man when I see one") is shown helmeted and goggled, driving across the English landscape on a motorcycle, her small daughter bouncing happily in the sidecar.

Between the reign of Elizabeth I, when she was a boy, and the 20th century, when motherhood more or less happens to her, Orlando enjoys a serene immortality doing what she chooses. She ponders the differences between men and women and, from her own privileged vantage point, discovers their similarities.

She pursues a poet's career, only to be ridiculed in the 16th century, fawned upon in the 19th and asked to do rewrites in the 20th. While still a man, Orlando falls in love with the gorgeous Sasha (Charlotte Valandrey), a mysterious and wanton Moscovite princess in London at the time of the Great Frost of 1603. As a woman she falls in love with the handsome Shelmerdine (Billy Zane), an idealized American with whom she has a more enduring, if less sexually demanding, relationship. Sometimes it's not always easy to tell exactly where Orlando is in time, but then she has the same problem.

Time keeps flying by even at those moments when it seems to creep for Orlando, as when she finds herself guiltily bored in an 18th-century London drawing room surrounded by Alexander Pope, Joseph Addison and other wits of the day. She darts into a fine old English maze in the 18th century and emerges a few moments later in the 19th century when Queen Victoria is in Buckingham Palace.

•

In such ways does Ms. Potter, who wrote the screenplay and directed the film, make the same kind of breathtaking, utterly rational leaps in time and place that Woolf does in prose. She also rediscovers the timelessness and profoundly comic density of the novel that, when it was published in 1928, critics were inclined to describe as "not one of her more serious works."

This was perhaps because "Orlando" was interpreted as being so much influenced by Woolf's love for the flamboyant Vita Sackville-West.

'Same person, no difference at all. Just a different sex.'

Woolf's male-female Orlando was inspired by the aristocratic Sackville-West who, like Orlando, was a writer who worshipped the idea of great literary reputation while finding only fame. Yet the novel can be seen today to far outclass such gossipy and now almost totally irrelevant associations. It's a major work by a first-class literary mind and technician.

The novel stands on its own. Whether or not the film does, I'm not sure. If you've read the book, it's impossible not to recall it while watching the film, either through the ways Ms. Potter recreates sequences and images from the book, or through the ways she finds equivalents and, occasionally, through the ways in which she goes off on her own recognizance. This is a movie that may well require a preset point of view. I suspect, though, that it's a movie that will prompt a lot of people to read Woolf for the first time, which can't be at all bad.

Ms. Potter's achievement is in translating to film something of the breadth of Woolf's remarkable range of interests, not only in language and literature, but also in history, nature, weather, animals, the relation of the sexes and the very nature of the sexes. The book is feminist, but also much more. The movie, photographed by Aleksei Rodionov, directly and magnificently reflects Woolf's concern for the look of things, which, in prose, must be described in inexact if evocative words, and in similes and metaphors that refer to something other.

•

The movie is a visual trip, from the opening sequences showing Orlando's first encounter with Queen Elizabeth, through his tour of duty as a dreamy British ambassador to a magical Constantinople, and through all of the later sequences in which Orlando must look at the world through the eyes of a woman. Old Queen Bess clutches the youth to her breast with gnarled hands and filthy fingernails, commanding: "Do not fade. Do not wither. Do not grow old."

Equally vivid on the screen is the novel's initial tour de force, the description of the Great Frost of 1603, when the Thames froze and London moved onto the ice for what amounted to an impromptu fair. It's at a grand dinner party in a tent on the ice, the waiters wearing skates, that Orlando first meets Sasha, who loves him treacherously. Orlando moves effortlessly through the ages, through countries, through fashions, from passionate bewilderment to calm enlightenment.

As important to the film's success as anything else are the bewitching face, figure and screen presence of Ms. Swinton who, with her red hair, deeply set eyes and self-assured expression, looks remarkably like portraits of the young Queen Elizabeth I. She has a sweetness, gravity and intelligence about her that make the more bizarre events appear to be completely normal. Before Orlando becomes a woman, Ms. Swinton is an exceptionally pretty youth, but never an effeminate one. This could be the beginning of a major international career for the English actress.

The film's gender-bending scheme is elegantly realized in Mr. Crisp's performance as the virgin queen, a stiff, arthritic old lady who can still appreciate the look of a nicely turned, youthful calf while reaching for the thigh. John Wood is very funny as the Archduke Harry, who lusts after Orlando through time, and Heathcote Williams is hilarious as a scroungy Elizabethan poet, who tells nasty

tales about his better-known colleagues. Ms. Valandrey, a French actress, is missed when Sasha leaves the story. Mr. Zane (Shelmerdine) is almost as beautiful as Ms. Swinton. That sort of thing works for "Orlando."

More than anything else, though, "Orlando" is Ms. Swinton's triumph. With the firmest but lightest of touches, she has spun gossamer.

1993 Mr 19, C1:5

Family Prayers

Directed by Scott Rosenfelt; screenplay by Steven Ginsberg; director of photography, Jeff Jur; edited by Susan R. Crutcher; music by Steve Tyrell; production designer, Chester Kaczenski; produced by Mark Levinson and Bonnie Sugar; released by Arrow Entertainment. At the Quad Cinema, 13th Street between Fifth Avenue and Avenue of the Americas. Running time: 105 minutes. This film is rated PG.

Andrew Jacobs	Tzvi Ratner-Stauber
Martin Jacobs	Joe Mantegna
Rita Jacobs	Anne Archer
Dan	Paul Reiser
Aunt Nan	Patti LuPone
Fay Jacobs	Julianne Michelle

By STEPHEN HOLDEN

Andrew Jacobs (Tzvi Ratner-Stauber), the central character in "Family Prayers," a small, sentimental coming-of-age drama set in Los Angeles in 1969, is a dour adolescent with the rigid posture of a tin soldier. His earnestness and lack of athletic skills make the 13-year-old boy something of an outsider at the Hebrew school he attends. Although he is obviously smart, his psychological problems have made it difficult for him to memorize the Haftarah he must chant at his imminent bar mitzvah.

The source of the boy's anxiety is a family that is coming apart because of his father's compulsive gambling. Martin Jacobs (Joe Mantegna) is a textile worker who spends most of his off hours trying to kick up some easy money in high-stakes poker games and by betting on sports events. When he wins, color television sets and pianos materialize like magic in the Jacobs bungalow. When he loses, thugs pound on the front door demanding money that Martin doesn't have.

Except for his gambling, the film suggests, Martin would be a model father and a model husband to his wife, Rita (Anne Archer). But given their perilous finances, the couple are enmeshed in strife that erupts in hushed, middle-of-the-night quarrels that leave Andrew and his younger sister, Faye (Julianne Michelle), quaking with uncertainty. Augmenting the tension is the periodic appearance of Rita's loudmouthed older sister, Nan (Patti LuPone), who has financially bailed the Jacobses out of more than one jam.

•

"Family Prayers," which was filmed from a semi-autobiographical screenplay by Steven Ginsberg, has the mood and dramatic structure of a Neil Simon memory play, but moved up two decades and without the jokes. Instead of going for hard-edged period realism, the director, Scott Rosenfelt, who is making his feature debut with the movie, has provided a gauzy, golden glow, which gives the film a nostalgic aura that doesn't jibe with the situation.

In its lighter moments, the movie follows Andrew as he learns his bar mitzvah prayers with the help of a semi-hippie tutor (Paul Reiser) who uses rock-and-roll as a teaching tool. The juxtaposition of scenes of 60's countercultural activities with a Jewish family drama adds to the subtle sense of discontinuity between story and mood.

The film, which opens today at the Quad, is almost too successful at seeing the world through Andrew's confused adolescent eyes. That may be why he emerges as the only fully developed character. In a performance that is as believable as it is understated, Mr. Ratner-Stauber, a 14-year-old actor with no previous experience, makes an impressive film debut as an introspective, self-conscious youth who suppresses his own childish urges so that he can play marriage counselor for his own parents.

The film views Martin and Rita through a romantic haze. Mr. Mantegna's Martin is a grave, poker-faced enigma who exudes a pained nobility. Ms. Archer plays the role of the long-suffering wife with just the right mixture of exasperation and resilience.

If the film seems to wander too much from memory to memory, it includes some sharply drawn little set pieces. The best is a perfectly observed scene of eighth graders immersed in a suspenseful game of spin the bottle to the jangling accompaniment of "Incense and Peppermints."

•

"Family Prayers" is rated PG (Parental guidance suggested). It has adult situations and includes some strong language.

1993 Mr 19, C6:5

Last Call at Maud's

Directed by Paris Poirier; director of photography, Cheryl Rosenthal; edited by Elaine Trotter; music by Tim Horrigan; produced by Mr. Poirier and Karen Kiss; released by the Maud's Project. At the Cinema Village, Third Avenue at 13th Streets, East Village. Running time: 75 minutes. This film has no rating.

WITH: Gwenn Craig, Jo Daly, Sally Gearhart, Judy Grahn, JoAnn Loulan, Phyllis Lyon, Del Martin, Pat Norman, Rikki Streicher and Mary Wings.

By STEPHEN HOLDEN

"I can think of no place better to have suspense and a real eerie feeling of decadence than a lesbian bar, because lesbians have always been outlaws," asserts Mary Wings, an author of lesbian mystery novels, in the opening moments of the documentary film "Last Call at Maud's."

Ms. Wings is one of many women interviewed in the film who look back with a mystical nostalgia on the glory days of Maud's, a popular lesbian hangout in the Haight-Ashbury district of San Francisco. More than just a watering hole, Maud's, which flourished between 1966 and 1989, is remembered as a sort of sorority house for a generation of lesbians, most of whom are now over 50.

Besides Ms. Wings, some of the club's former habituées include the writers Judy Grahn, Sally Gearhart and JoAnn Loulan. Phyllis Lyon and Del Martin, who founded the international lesbian organization Daughters of Bilitis, reminisce, as does San Francisco's current police commis-

Looking Back Lesbian life in San Francisco bars from the 1940's to the late 80's is explored in "Last Call at Maud's."

sioner, Gwenn Craig. Their collective stories add up to a small but significant piece of gay history in which social life and political organizing are closely connected.

•

The 75-minute film, which was directed by Paris Poirier, interweaves two parallel narratives. One is an anecdotal history of the bar told largely by its owner, Rikki Streicher. The other, going back to the 1940's, is a wider-ranging story of the struggle for gay civil rights as viewed from a West Coast lesbian perspective.

The vignettes include memories of the days when gay bars were routinely raided by the police, and gay men and women visited them in groups. When a red light flashed to signal a raid, same-sex couples on the dance floor would switch partners and put on a heterosexual charade. One surprising historical tidbit is the fact that until 1973 it was illegal in California for a woman to tend bar.

The late 70's, when the hedonism of San Francisco's gay culture reached a peak, are remembered with some bitterness. Ms. Gearhart recalls the era as "a giant white gay male fraternity party" that excluded women and people of color.

•

If "Last Call at Maud's," which opens today at the Cinema Village, exudes a warmhearted honesty, its focus on the tightly knit social world of one bar over a 23-year period often gives it the feel of an alumni reunion film. For those who weren't there and didn't live the life, the scrapbook photos and newspaper clippings won't mean very much. And because so many of the reminiscences focus on arcane social details, significant historical events like the slayings of Mayor George Moscone and the municipal supervisor Harvey Milk in 1978 are glossed over.

For all its celebration of progress toward a wider acceptance of homosexuality, the film ultimately has its heart in the past. Almost despite itself, it longs for a bygone era of intrigue and subterfuge, when being lesbian really did mean belonging to a secret sisterhood of self-styled "outlaws."

1993 Mr 19, C6:5

Point of No Return

Directed by John Badham; written by Robert Getchell and Alexandra Seros, based on "Nikita," by Luc Besson; director of photography, Michael Watkins; edited by Frank Morriss; music by Hans Zimmer; production designer, Philip Harrison; produced by Art Linson; released by Warner Brothers. Running time: 108 minutes. This film is rated R.

Maggie	Bridget Fonda
Bob	Gabriel Byrne
J. P.	Dermot Mulroney
Kaufman	Miguel Ferrer
Amanda	Anne Bancroft
Angela	Olivia D'Abo
Victor the Cleaner	Harvey Keitel

By JANET MASLIN

Of all the French films that have recently been remade for American audiences, "La Femme Nikita" is the one that has changed least. There's a good reason for that: In spirit, "La Femme Nikita" was half American in the first place. Luc Besson, the original film maker, achieved a stunning synthesis of French contemplativeness and American violence in his slick, manipulative story of a feral punk who is saved from extinction and then trained as an assassin.

His film's secret weapon was the punk herself, a leggy heroine who exuded both glamour and viciousness and performed some of her most savage deeds wearing pearls and a skimpy black dress. In Mr. Besson's calculating tour de force, this woman could behave shockingly while looking like a fashion model. And when Nikita began to soften, discovering

Warner Brothers

Hired Gun Bridget Fonda stars in "Point of No Return" as a condemned killer offered a chance to live if she becomes a government assassin. John Badham's thriller, based on "La Femme Nikita."

her romantic side for the first time and rebelling against the violent, dehumanizing life that had been imposed upon her, the film took on the pomposity of a conversation piece without sacrificing its commercial verve.

For all its pretensions, "La Femme Nikita" worked most cleverly as a showcase for Anne Parillaud. A striking actress (quite literally, in this role), she captured a provocative range of feminine attitudes and combined violence and seductiveness in tantalizing ways. Thanks to that characterization, "La Femme Nikita" still casts a long shadow over other recent femme fatale films, particularly those that concentrate on treachery, manipulativeness and hostility between the sexes.

Remade crassly and effectively as "Point of No Return," this story still packs a wallop, as does its heroine. Bridget Fonda, confirming her status as a captivating new star, fits in effortlessly with the story's other basic ingredients: little black dress, great big gun. With her flirty, incandescent smile and a frame that looks great when truly dressed to kill, Ms. Fonda gives a disarming, believable performance in a role that now seems a shade more peculiar. The change in context makes a big difference. American audiences may be used to savagery from their action heroes, but a woman who can casually stab a man with a pencil is something else again.

●

Most of this heroine's violent, amoral behavior is confined to the story's early sections, which is part of

A fancier American reprise of 'La Femme Nikita.'

the film's ingenuity. Maggie (Ms. Fonda) appears first as a dazed, sullen junkie and participates in an ugly murder, for which she is tried and convicted. Sentenced to die, she gets a reprieve from a mysterious government agency, which decides to recruit her for its top-secret punk-recycling program. Bob (Gabriel Byrne), a supervisor at this agency, has looked on appreciatively while Maggie attacks anyone who comes near her. He decides she has great potential and, as played by Ms. Fonda in Marlene Stewart's seductive costumes, she certainly does.

As directed by John Badham with flashy pulp intelligence, "Point of No Return" is noticeably fancier than its predecessor. The agency's Washington headquarters, which formerly had a dull, bureaucratic look, has been made to resemble a chic downtown health club. Maggie's surly behavior stands out all the more in this setting, as does her gradual transformation from a frightening free spirit into a carefully socialized dinner date. Some viewers will find this latter change the story's scariest aspect.

Anne Bancroft, very well cast in the role first played by Jeanne Moreau, appears as a modified charm school doyenne who teaches Maggie the basics, like how to eat chocolate mousse with something other than

her hands. Ms. Bancroft, combining a maternal smile with her best Mrs. Robinson whip-cracking mode, has been given a lavish, tapestry-lined lair in which to deliver these lessons. Also overseeing Maggie's progress is Miguel Ferrer, lively and snappish as Bob's impatient supervisor. "I want immediate improvement or she gets a bullet in the brain," he says briskly.

●

Eventually, Maggie is renamed Claudia and sent to Venice, Calif., where she awaits assignments that will have her dressing up in a maid's uniform and red satin hot pants to perform various covert tasks. Who says they aren't writing great roles for women anymore?

In Venice, she charms the appealingly raffish J. P. (Dermot Mulroney) by not knowing how to shop in a grocery store. (Even little touches like this come right out of the earlier film, as does much of the dialogue in Robert Getchell and Alexandra Seros's screenplay.) Once the story settles down to wondering whether Maggie/Claudia can find happiness in romantic love, it becomes noticeably less interesting. Ms. Fonda sometimes verges on the mechanical in mouthing her character's nobler sentiments (the film also relies heavily on Nina Simone records to express its heroine's feelings), but that is to be expected. At heart, this woman is little more than a laboratory specimen with great legs, so it's miraculous to find an actress breathing life into her at all.

"Point of No Return" also features Harvey Keitel in a brief, effectively weird appearance as a tight-lipped operative who calls himself "the cleaner." What he cleans up are leftover corpses, and what he uses to do this is sulfuric acid, which may give some idea of the nasty excesses that dampen the film's stylish mood. Another bit of overkill involves Mr. Keitel and a murderous red sports car, which happens to be on top of him with its engine running.

●

"Point of No Return" is rated R (Under 17 requires accompanying parent or adult guardian). It includes sexual situations and considerable violence.

1993 Mr 19, C10:5

Just Another Girl on the IRT

Written and directed by Leslie Harris; director of photography, Richard Connors; edited by Jack Haigis; production designer, Mike Green; produced by Erwin Wilson and Ms. Harris; released by Miramax Films. Running time: 96 minutes. This film is rated R.

Chantel..............................Ariyan Johnson
Tyrone................................Kevin Thigpen
Natete.................................Ebony Jerido
Gerard.............................Jerard Washington
Paula..............................Chequita Jackson
Cedrick.............................William Badget

By VINCENT CANBY

In "Just Another Girl on the IRT," Leslie Harris, a first-time writer and director, has created Chantel, a character who, as played by a terrifically engaging new actress named Ariyan Johnson, is almost as significant of her place and time as Booth Tarkington's Penrod is of his: white middle-class America just before World War I. Both Chantel and Penrod are teenagers, but there the similarities end.

Miramax Films

Ariyan Johnson.

Like Ms. Harris, Chantel is black. She's a pretty, round-faced junior in a Brooklyn high school in the 1990's. She's bright and intelligent, with a gift of gab, and she has a goal. She wants to become a doctor. Unfortunately, she's still more wise-mouthed than wise. It's the mouth that gets her into trouble with her exhausted, battling parents and her teachers, black as well as white.

Chantel gets A's whenever she wants, but her attitude is impossible. It comes with lip that, though frequently funny, makes everything just that much more difficult for her. She wrecks a history class by insisting that they discuss AIDS instead of the assigned lesson. In a showdown, she's as stubborn and as dim-witted as her teachers. When a good-looking young black guy on the subway tells her he is an actor, which may well be true, she laughs in his face. In the fancy gourmet deli where she works on Manhattan's Upper West Side, she gives as good as she gets from testy white matrons living on Central Park West.

●

Chantel has a knack for being uproariously outrageous in everything from her clothes to her slang. As long as "Just Another Girl on the IRT" lets her follow her own natural inclinations, the film is a delight. Bored with her boyfriend, Gerard (Jerard Washington), she allows herself to be picked up by the smooth-talking Tyrone (Kevin Thigpen), who drives a Jeep and has the run of an apartment his parents seldom use. Though learned in the lore of the streets, Chantel is woefully ignorant about birth control, which is where "Just Another Girl on the IRT" starts to become muddled.

Nothing about her pregnancy, or how she deals with it, quite matches the tough but consistently clear tone of the earlier part of the film. Chantel dawdles. In one believably crazy sequence, she takes the $500 Tyrone gives her for an abortion and goes on a shopping spree with her best friend, Natete (Ebony Jerido). After that, it's downhill.

The movie is far from being a failure, but because it misses achieving the complete success promised earlier, the disappointment is greater. Ms. Harris not only knows how to handle a camera and actors, but also how to write a screenplay that says everything by indirection, in commonplace

speech so shaped that it becomes particular and pertinent.

Though slight in size, Ms. Johnson is a big screen performer. She has a future. Chantel might also have a future if she can avoid getting pregnant or, at least, if she follows good advice when she does. "Just Another Girl on the IRT" means to be instructive about teen-age pregnancies, but what it's saying is none too coherent.

●

"Just Another Girl on the IRT," which has been rated R (under 17 requires accompanying parent or adult guardian), has vulgar language and a birth scene.

1993 Mr 19, C12:5

The Music of Chance

Directed by Philip Haas; written by Mr. Haas and Belinda Haas, based on the novel by Paul Auster; director of photography, Bernard Zitzermann; edited by Ms. Haas; music by Phillip Johnston; produced by Frederick Zollo and Dylan Sellers; released by I.R.S./Trans Atlantic Entertainment. At the Roy and Niuta Titus Theater 1 in the Museum of Modern Art, 11 West 53d Street in Manhattan, as part of the New Directors/New Films series of the Film Society of Lincoln Center and the Department of Film of the Museum of Modern Art. Running time: 98 minutes. This film has no rating.

Jack Pozzi...............................James Spader
James Nashe..........................Mandy Patinkin
Calvin Murks.......................M. Emmet Walsh
Bill Flower..........................Charles Durning
Willie Stone................................Joel Grey
Tiffany................................Samantha Mathis
Floyd.............................Christopher Penn
Louise....................................Pearl Jones
Floyd Jr............................Paul Auster

By JANET MASLIN

A miniature city is the haunting centerpiece of "The Music of Chance," Philip Haas's cool, methodical film version of Paul Auster's equally meticulous 1990 novel. Called "City of the World," it is the bizarre plaything of Willie Stone (Joel Grey), a former optometrist who made his fortune by winning the lottery. Together with his friend Bill Flower (Charles Durning), Stone lives in an isolated mansion and contemplates the meaning of fate while playing childlike games. The City of the World is his masterwork. James Nashe (Mandy Patinkin) and Jack Pozzi (James Spader) are his victims.

With the tenor of a Beckett play as filtered through the mathematical mind of Peter Greenaway, Mr. Haas's cryptic, elegantly made "Music of Chance" traces the trajectory of Nashe and Pozzi. Starting out as drifters, they are brought together accidentally and wind up as slaves to Flower and Stone's peculiar vision. Pozzi is a desperate gambler, and Nashe is in the last stages of an existential experiment (of the sort that has made Mr. Auster's work much more widely appreciated in Europe than it is here, where this New Jersey-born novelist remains something of a cult figure). Trapped together on the Flower and Stone estate, they find release in the bleak comforts of a shared destiny.

Mr. Auster's story, which the film follows as faithfully as possible, has the latitude to look deeply into such mysteries. His book first finds Nashe at the end of a yearlong driving spree, and it has the wherewithal to explain how Nashe's life led him to this juncture. Separated from his wife and child, newly flush thanks to an inher-

Film Society of Lincoln Center

From left, Joel Grey, Mandy Patinkin, James Spader and Charles Durning in "The Music of Chance."

By JANET MASLIN

itance from a father he barely knew, this former fireman has severed all ties to his past, bought a new car and simply begun driving.

•

Nashe is nearly out of money when he happens to spot Pozzi, badly beaten, by the side of a road. "It was one of those random, accidental encounters that seem to materialize out of thin air — a twig breaks off in the wind and suddenly lands at your feet," Mr. Auster writes of that meeting. The film, which can show only a car, a road and two drifters making conversation, is already at a disadvantage. Even allowing for the essentially opaque nature of this material, this terse, oddly mesmerizing film often suffers from an inability to provide more than the bare bones of Mr. Auster's story.

Mr. Haas makes up for that by accentuating the material's most pe-

Two drifters find release in the bleak comforts of a shared destiny.

culiar aspects with supreme, piquant clarity. The City of the World, superbly rendered by Rebecca Fuller, is an exact replica of the model described in the novel and discussed glowingly by Stone himself. "It's the way I'd like the world to look," Stone says proudly. "Everything in it happens at once." Sure enough, the replica includes simultaneous depictions of Stone's boyhood, Stone and Flower's momentous purchase of a lottery ticket and Stone's late parents transformed into angels. It also depicts criminals who, Stone explains, are happy to be punished for their transgressions.

"The Music of Chance," which describes how Nashe and Pozzi are themselves meted out punishment

and expected to endure it happily, is filled with curious, resonant parallels. When Nashe and Pozzi (whose name suggests a parallel with the Pozzo of "Waiting for Godot") arrive at the mansion for an all-important poker game, they come with $10,000, the last of Nashe's money. They lose it all, and are instead given 10,000 stones: they are forced to agree to build a monument made from these identical blocks, imported from Ireland by Flowers and left over from a castle destroyed by Oliver Cromwell. To emphasize the infantilizing aspect of this task, they are given a child's little red wagon for carrying blocks. And as they work on the project to Stone's exacting specifications, their progress is incorporated into his model city.

Mr. Auster's writing is filled by such gamesmanship, and is saved from preciousness by the leanness and simplicity of the author's style. Mr. Haas, a well-respected documentary film maker making his feature debut, has these same virtues. His film has a sustaining air of mystery and a quiet, rarefied beauty that saves it from seeming too myopic or coy. Superbly photographed by Bernard Zitzermann and greatly aided by Phillip Johnston's score (which is augmented by Beethoven and Berlioz), "The Music of Chance" is as inviting as it is puzzling. Only in its final scene (which features Mr. Auster in a tiny role) does the film lose its nerve.

•

Mr. Patinkin, looking lean and tough (the credits mention his "strength and conditioning consultant"), gives an effectively terse performance. Mr. Spader is more of a wild card, and a greater source of leavening humor. With his hair dyed black and greasy, a small spot of beard beneath his lower lip, he exudes Pozzi's sleaziness and also captures the character's outlandish charm. When a prostitute (Samantha Mathis, trying gamely with a poorly developed role) is brought to the work site for a festive dinner, Pozzi informs her that the two men are architects specializing in "historical

reverberations." They are living in a trailer, he says, because "atmosphere means everything to us."

Also in the cast, and especially good, is M. Emmet Walsh as the estate's countrified, faintly dangerous overseer. Mr. Walsh's sly performance perfectly captures the novel's description of Calvin Murks, the character he plays: "There was something so deeply imperturbable about the man, so fundamentally oblique and humorless, that Nashe could never decide if he was inwardly laughing at them or just plain dumb."

"The Music of Chance," one of the opening-night selections of this year's New Directors/New Films series at the Museum of Modern Art, has been paired with "Rules of the Road," a short film by Su Friedrich that at 30 minutes' length is badly overgrown. Centering on the 1983 station wagon the unseen narrator shared with her former girlfriend, the film takes a literary tone, offering roundabout descriptions of the car as a way of crystallizing the lost romance. The narrator's flirtations with banal detail (e.g., a promise to her ex that she'd always check the car's oil and water) come much too close to the real thing.

"The Music of Chance" and "Rules of the Road" will be shown tonight at 9 and tomorrow at noon.

1993 Mr 19, C25:1

Savage Nights

Written and directed by Cyril Collard; in French, with English subtitles; director of photography, Manuel Teran; edited by Lise Beaulieu; produced by Nella Banfi. At the Roy and Niuta Titus Theater 1 in the Museum of Modern Art, 11 West 53d Street, as part of the New Directors/New Films series, presented by the Film Society of Lincoln Center and the Department of Film of the Museum of Modern Art. Running time: 129 minutes. This film has no rating.

Jean Cyril Collard
Laura Romane Bohringer
Samy Carlos López
Noria Maria Schneider

Cyril Collard can be seen in his own film "Savage Nights" as a warm, attractive actor with a rueful grin that never quite fades away. Mr. Collard's vivid presence in the film makes it especially sad to note that he died of AIDS on March 5, less than a week before "Savage Nights" received four French César awards, including the one for best picture. Under happier circumstances, the appearance of "Savage Nights" in the New Directors/New Films series (at 9 P.M. today and tomorrow) would be an occasion to hail an impressive new talent.

Mr. Collard appears in this autobiographical story as Jean, a charmingly flirtatious 30-year-old with an especially complicated sex life. Ever receptive to both men and women, he becomes involved simultaneously with Laura (Romane Bohringer), a feisty and voluptuous teen-ager, and Samy (Carlos López), a handsome rugby player who is living with a woman when Jean first meets him. The frustrations brought on by these two affairs are sometimes more than Jean can manage. When that happens he goes cruising, finding release and comfort in wordless group sex with strangers.

•

Early in the film, Jean also discovers that he is HIV positive. "Lose your grip," exhorts Maria Schneider in a solemn, unspecified role. "Drop your illusions. Learn from your disease." In Mr. Collard's turbulent account of Jean's progress, such peaceful acceptance does not come easily. Jean spends much of the film ricocheting urgently from one blind coupling to another, trying to make sense of his situation. The film's biggest success is in moving beyond the potential myopia of such material to create a broader portrait of troubled, aimless youth.

Late in the film, a car crash occurs suddenly, with neither warning nor aftermath. Mr. Collard put together "Savage Nights" in an abrupt, tumultuous spirit that truly reduces the car crash to nothing special. All of the events seen here, even those presented casually, become as furious and arbitrary as that accident once they are glimpsed in the light of Jean's growing desperation. The film begins with apparent nonchalance but eventually reaches an effectively frantic pitch.

Mr. Collard's direction emphasizes the rawness of his story by discarding the connective tissue that might ordinarily hold it together. He never bothers to explain how Jean has gotten to Laura, then to Samy, then to Laura again or to someone else entirely. He simply juxtaposes these meetings without fanfare, thus offering some idea of how they may overlap in Jean's life. There are times when this stylistic affectation raises more questions than it answers, but most often the film maker's kaleidoscopic approach is as involving as it's meant to be.

Throughout "Savage Nights" there are distress signals, not all of them from Jean. Samy seems to be developing a taste for sadomasochism and some sympathy for the neo-Nazi types who appear briefly in the story. Samy's girlfriend angrily berates Jean. Laura is made uncontrollably furious by Jean's admission that he had unsafe sex with her after knowing he was HIV positive. Laura's mother is equally livid, and Jean is happy to bait her. Such moments are interspersed with more sentimental

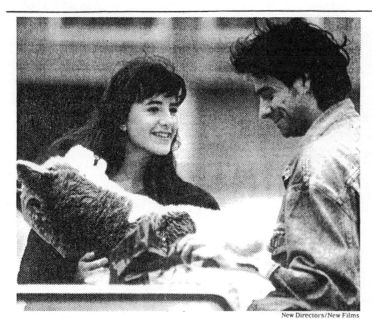

New Directors/New Films

Cyril Collard in his film "Savage Nights" with Romane Bohringer.

episodes, as when Jean buys Laura a puppy.

At one point Laura erupts at the owner of the dress shop where she works, stealing a jacket and spitting at her boss. "I think I'll go to film school," Laura muses, right after this incident. Mr. Collard's wry sense of humor extends to the stereotypically rebellious posturing that his own film often employs.

The screenplay provides its own definition of a rebel: "Someone marked by fate and with real dignity inside." Mr. Collard, by communicating his anxiety in such honest, troubling terms, surely met that definition. He leaves behind a brave, wrenching self-portrait and a great deal of unfulfilled promise.

1993 Mr 20, 11:4

Teen-Age Mutant Ninja Turtles III

Written and directed by Stuart Gillard; director of photography, David Gurfinkel; edited by William D. Gordean and James R. Symons; music by John du Prez; production designer, Roy Forge Smith; produced by Thomas K. Gray, Kim Dawson and David Chan; released by New Line Cinema. Running time: 95 minutes. This film is rated PG.

Casey Jones/Whit	Elias Koteas
April O'Neil	Paige Turco
Walker	Stuart Wilson
Lord Norinaga	Sab Shimono
Mitsu	Vivian Wu
Leonardo	Mark Caso
Raphael	Matt Hill
Donatello	Jim Raposa
Michaelangelo	David Fraser

By JANET MASLIN

Seldom has a movie production company been more aptly named than Golden Harvest, whose "Teen-Age Mutant Ninja Turtles III" began raking in lucre at neighborhood theaters yesterday. That's not entirely bad news. This Ninja Turtles tale is less violent and more scenic than its predecessors, since it gets the title characters out of the sewer and transports them back to feudal Japan. There, they go native while exclaiming "Whoa!" and "Check it out!" and so on, thus staying in touch with their roots.

This film, written and directed by Stuart Gillard, has a conventional action plot involving a feudal lord, his rebellious son, the son's beautiful sweetheart and a wicked English trader. It will hold no surprises for adult viewers but should sustain the interest of children. The story is so unremarkable, by time-traveling adventure standards, that one must struggle to remember that the heroes actually have hard shells and green, spotty heads. The nonchalant humor, supplied by the jokey Turtles and by Elias Koteas as their unofficial camp counselor, is always something of a relief.

The story starts when April (Paige Turco), the Turtles' loyal friend, is accidentally made to change places with a samurai, and the four Turtles visit the Japan of 1603 in order to rescue her. It's worth mentioning that Paige gets to fight alongside her friends and deliver scorching wisecracks, or at least lines that 5-year-olds in the audience will find funny. By Hollywood's current standards, that almost gives her one of the better women's roles around.

The Turtles themselves are better-natured than ever, and even nicely mellowed. They stick to kidding around until the film's final fight sequence, which involves the usual kicking and weapon-waving. (Young viewers should be kept away from kitchen knives when they get home.) Along the way, the Turtles make reference to Clint Eastwood, Wayne's World, Geraldo Rivera, pizza, frisbees and other cultural reference points. Even in 17th-century Japan, they've never left home.

•

"Teen-Age Mutant Ninja Turtles III" is rated PG (Parental guidance suggested). It includes mild violence that is unlikely to disturb children.

1993 Mr 20, 15:1

You, Me and Marley

Directed by Richard Spence; written by Graham Reid; director of photography, Graham Veevers; edited by Greg Miller; music by Stephen Warbeck; produced by Chris Parr. At the Roy and Niuta Titus Theater 1 in the Museum of Modern Art, 11 West 53d Street, as part of the New Directors/New Films series of the Film Society of Lincoln Center and the Department of Film of the Museum of Modern Art. Running time: 86 minutes. This film has no rating.

Sean	Marc O'Shea
Francis	Bronagh Gallagher
Marley	Michael Liebmann
Father Tom	Lorcan Cranitch
Mr. Hagan	Frank Grimes
Reggie Devine	Ian McElhinney

By VINCENT CANBY

"You, Me and Marley," written by Graham Reid and directed by Richard Spence, dramatizes the extent to which goals have been lost and loyalties have blurred over the years during the undeclared, unending civil war in Northern Ireland.

No longer is it just the Irish Republican Army against the British Army, or the Roman Catholics against the Protestants. Now it's also the I.R.A. establishment against gangs of aimless Catholic teen-agers who are seen to be giving the sacred I.R.A. cause a bad name. The teen-agers' idea of fun is to steal cars, go joyriding around Belfast for a while, then abandon the

cars, set them afire or sell them for spare parts.

The kids have no political aims. In the course of their nightly rampages they accidently destroy Catholic lives and property as casually as those of the I.R.A.'s enemies. The bored and angry teen-agers, who were originally encouraged to steal cars for the I.R.A. cause, have become as much of an embarrassment for the I.R.A. as for the British Army and the local police. They take pride in having established their own position independent of their elders.

"You, Me and Marley" will be shown in the New Directors/New Films series at the Museum of Modern Art today at 6 P.M. and tomorrow at 3 P.M.

The film was written by an Irishman and directed by an Englishman. It is an efficient, very bleak melodrama about three joyriding young men, their staunch girlfriends, their families and the I.R.A. officers with whom their families have long ties. Sean (Marc O'Shea), a joyriding star, has had two older brothers killed fighting for the I.R.A. At one point his pal Marley (Michael Liebmann) is picked up by an I.R.A. squad and taken to headquarters where his hands, knees and ankles are brutally smashed to set an example for the others.

Though the movie is visually graphic and well acted, it doesn't pack the emotional weight one might expect, at least in part because the heavy Irish accents make approximately half the dialogue unintelligible. There are also times when the movie seems to contradict the gravity of the conditions it has so carefully laid out.

Almost immediately after the harrowing scene of Marley's punishment, the film cuts to a rather jolly party around his hospital bed as his pals celebrate his heroism. From what the audience has seen, Marley, now chipper, should be dead or permanently crippled.

"You, Me and Marley" is mainly a movie of political import: sympathetic to a new generation of uncommitted, possibly lost teen-agers and soberly reportorial in its details.

1993 Mr 20, 16:1

Jit

Written and directed by Michael Raeburn; director of photography, João Costa; edited by Justin Krish; produced by Rory Kilalea; released by Northern Arts Entertainment. At the Roy and Niuta Titus Theater 1 in the Museum of Modern Art, 11 West 53d Street, as part of the New Directors/New Films Series presented by the Film Society of Lincoln Center and the Department of Film of the Museum of Modern Art. Running time: 98 minutes. This film has no rating.

U. K.	Dominic Makuvachuma
Sofi	Sibongile Nene
Johnson	Farai Sevenzo
Jukwa	Winnie Ndemera
Oliver	Oliver Mtukudzi
Chamba	Lawrence Simbarashe
Nomsa	Kathy Kuleya
Gift	Jackie Eeson

By STEPHEN HOLDEN

The airy African pop sound known as jit-jive washes like sunshine through "Jit," a playful romantic comedy from Zimbabwe that the New Directors/New Films series is showing this evening and tomorrow afternoon at the Museum of Modern Art. With its sparkling guitar-and-keyboard textures spun into bouncy

New Line Cinema

Travis A. Moon as Yoshi, a rebellious boy, with one of the title characters in Stuart Gillard's film "Teen-Age Mutant Ninja Turtles III."

Northern Arts Entertainment

Sibongile Nene, left, and Farai Sevenzo in "Jit," a comedy from Zimbabwe in the New Directors/New Films series.

three-against-two rhythmic patterns, the sound defines the irrepressible spirit of the film's central character, a mischievous youth nicknamed U. K. (Dominic Makuvachuma).

The fearless young man with an impish grin has left his parents' village to seek his fortune in the city, where he lives with his uncle, a Zimbabwean pop singer (Oliver Mtukudzi). While riding in a crowded taxi one afternoon, he defends a beautiful woman being verbally harassed and is promptly thrown out onto the street and knocked unconscious. When he comes to, he has a vision of paradise. Leaning over him, her face filled with concern, is Sofi (Sibongile Nene), the passenger he tried to help. He falls instantly and totally in love.

U. K. vows then and there to marry this woman of his dreams, even though the obstacles are seemingly insurmountable. He is unemployed, and Sofi already has a boyfriend, a flashy-dressing tough guy (Farai Sevenzo) who favors bright red suits and travels with an entourage of bullies. When U. K. asks Sofi's father for her hand, he is told he has to pay a bride-price that includes a fancy sound system.

His biggest challenge is winning over a pesky ancestral spirit (Winnie Ndemera) who has followed him to the city from his village to be a kind of spiritual chaperone. Until he agrees to take a certain sum of money home, she warns, she will not let him earn a cent. True to her word, she causes him to lose his first few jobs through various slapstick mishaps.

The spirit, who suggests a black African version of a stereotypical Jewish mother, is the film's funniest and most original character. The scolding old crone also happens to have a weakness for beer, a taste that the shrewd U. K. soon learns to use to his advantage.

"Jit," which was directed by Michael Raeburn, who also wrote the script, has the antic, anything-goes spirit of the Beatles' first movies, although its pace is not quite as hectic. Among several speeded-up sequences depicting U. K.'s early ill-fated flings at employment, the funniest finds him working as a delivery boy for a bakery. Furiously peddling his bike without even stopping at customer's houses, he heedlessly flings

the loaves into swimming pools and onto lawns where they are devoured by pets.

The spirit of the film is so giddily upbeat that U. K. proves as unstoppable as Superman. In the movie's teenage fantasy world, a boozy bribe to a tippling ancestral spirit can engineer feats of magic.

Whenever "Jit" doesn't know where to go next, much like a 1950's rock-'n'-roll movie, it repairs to a nightclub where the music bubbles joyously and bodies gyrate. The terrific score features music by an array of African performers including the Bhundu Boys and Thomas Mapfumo, Ilanga and Lovemore Majaivana. Mr. Mtukudzi, a wonderful soul singer, lip-synchs to three of his recordings.

"Jit" begins a commercial run at the Joseph Papp Public Theater on Tuesday.

1993 Mr 20, 16:1

The Blue Eyes of Yonta

Directed by Flora Gomes; written (in Portuguese-Creole, with English subtitles) by Ms. Flores, Ina Césaire, David Lang and Manuel Rambout Barcelos; director of photography, Dominique Gentil; edited by Dominique Paris; music by Adriano G. Ferreira-Atchutchi. At the Roy and Niuta Titus Theater 1 in the Museum of Modern Art, 11 West 53d Street, as part of the New Directors/New Films series of the Film Society of Lincoln Center and the Department of Film of the Museum of Modern Art. Running time: 100 minutes. This film has no rating.

Yonta	Maysa Marta
Vincente	António Simão Mendes
Zé	Pedro Días
Mana	Dina Váz
Amílcar	Mohamed Seidi
Belante	Bia Gomes

By STEPHEN HOLDEN

Flora Gomes's moody film, "The Blue Eyes of Yonta," offers a richly shaded vision of a post-colonial African society on the verge of losing hope. Set in Bissau, the capital of the small West African republic of Guinea-Bissau, it shows a bustling city that wants to be a modern metropolis but barely functions.

A layer of red dirt covers boulevards dotted with mud puddles in which farm animals mingle with the traffic. The city's electrical power sputters off and on at irregular intervals, plunging nightclubs into sudden darkness and causing warehouses of fresh fish to rot. The collapse of the real-estate market has brought a wave of evictions that is causing innocent people to be thrown out on the street with their possessions.

Some of the film's most anxious scenes are set in Bissau's smoggy harbor where unskilled workers, desperate for employment, gather each day in hopes of loading and unloading boxes of cargo on the occasional ship that docks.

When not observing the sun-drenched chaos of Bissau, "The Blue Eyes of Yonta," which the New Directors/New Films series is showing on Sunday and Monday at the Museum of Modern Art, follows the daily lives of two people who would seem to be an ideal couple but who fail to connect. Vincente (António Simaô), a local hero, is a former freedom fighter turned businessman who is trying to establish a fish-exporting business. Yonta (Maysa Marta) is a beautiful and spirited young store clerk whose family is friendly with Vincente.

When Yonta begins receiving anonymous love letters that exalt her blue eyes (they are actually brown) in flowery diction, she imagines that they are being written by Vincente. But he is far too wrapped up in business and political concerns to notice her. In fact, her secret admirer (Pedro Dias) is a shy would-be poet with European pretensions and a head so far up in the clouds that he is incapable of holding even a menial job.

Yonta belongs to a fun-loving circle of friends for whom the victory of the freedom movement over the Portuguese colonial government 20 years earlier has little reality. She is far more interested in pretty clothes and nightclubs. Like others her age, she is also tantalized by visions of a European affluence. Luxuries in Bissau are so scarce that when she is given an oversized, silly-looking belt-watch she is thrilled and wears it proudly.

The film's considerable power comes not from the story, which is really a gently insinuated metaphor for a society's failure to grasp reality, but from its many pungent images of people muddling along from day to day.

Yonta, for all her charm, is something of a cipher. More compelling, although not terribly likable, is Vincente. A natural leader, he is as bold and forceful an entrepreneur as he was a freedom fighter. But he is also frustrated and impatient. Gazing out of his window, and clutching an ancestral statue, all he sees are vultures circling above the palms.

Besides its screenings tomorrow and Monday, "The Blue Eyes of Yonta" will be shown on April 24 and 25 in the African film-making series, "Modern Days/Ancient Nights," at the Brooklyn Museum.

At the New Directors series screenings, it is preceded by Jane Weinstock's drily amusing short "The Cleanup." In the 14-minute film, a detached narrator talks obliquely about an architect's plans to murder her lover as visual images evoke a compulsively tidy personality. With its extreme close-ups of teeth being flossed, vegetables being sliced and a telephone mouthpiece being cleaned with a Q-Tip, the film has the feel of an eerie preface to a murder mystery yet to be made.

1993 Mr 20, 16:5

Tito and Me

Written and directed by Goran Markovic, (in Serbo-Croatian with English subtitles); director of photography, Racoslav Vladic; edited by Snezana Ivanovic; music by Zoran Simjanovic; production designer, Veljko Despotovic; produced by Mr. Markovic, Zoran Masirevic, Michel Mavros and Zoran Tasic; released by Kino International. At the Roy and Niuta Titus Theater 1 in the Museum of Modern Art, 11 West 53d Street, as part of the New Directors/New Films series presented by the Film Society of Lincoln Center and the Department of Film of the Museum of Modern Art. Running time: 110 minutes. This film has no rating.

Zoran	Dimitrie Vojnov
Raja	Lazar Ristovski
Zoran's Mother	Anica Dobra
Zoran's Father	Predrag Manojlovic
Zoran's Aunt	Ljiljana Dragutinovic
Zoran's Uncle	Bogdan Diklic
The Grandmother	Olivera Markovic
The Grandfather	Rade Markovic
The Instructor	Vesna Trivalic
Marshall Tito	Voja Brajovic

By VINCENT CANBY

As he remembers himself years later, the narrator of Goran Markovic's full-bodied, initially charming farcical memoir, "Tito and Me," is a rather impossible little boy named Zoran (Dimitrie Vojnov), who is 10 and fat. He's not just "rounded" as his grandmother says, but overweight in the big-bellied, multi-chinned way of children who consume too many sweets and, in Zoran's case, plaster.

The boy has a compulsion to eat plaster. The walls of the family apartment in Belgrade in 1954 look pitted, as if damaged by small-arms fire during an insurrection. Zoran sneaks around the rooms and, when unobserved, peels back the wallpaper to stuff himself with a building material he finds as satisfying as meringues. It could be a sign of some kind of emotional as well as nutritional need. His ill-tempered uncle says it's a symptom of Zoran's degeneracy, pure and simple.

Yet nothing in "Tito and Me" is all that pure and simple. The movie is a carefully layered comedy that leaves a disturbing and ambiguous afterglow.

"Tito and Me" will be shown in the New Directors/New Films series at the Museum of Modern Art today at 6 P.M. and tomorrow at 9 P.M.

Unlike most of the Yugoslav comedies that have come this way in recent years, this film has a political point of view and is refreshingly free of things folkloric and picturesque. It's the work of a sophisticated, comic mind.

Zoran lives with his father, a musician, and mother, a ballet dancer, in a big old-fashioned flat that might once have been comfortable. Yet now it is shared with his aunt and uncle, their tiny daughter (Zoran's "hideous" cousin) and his grandmother, who sleeps in the entry hall.

There's also Zoran's philandering grandfather, a handsome old fellow with the manners of a dandy, whom his grandmother threw out some years earlier. Though the grandfather doesn't live there anymore, he still comes by every day at noon to share the big family meal, read the newspaper and observe the rows that erupt with regularity. It's to see a family Balkanized when brothers, sisters and in-laws scream at one another over territorial rights to the bathroom.

They are an overwhelming crew. They're also proudly bourgeois. Zoran is the black sheep. Possibly as

much to assert his own identity as out of need for order, Zoran has come to admire Marshal Tito, Yugoslavia's strong-man president, with the kind of passion young boys usually reserve for sports heroes. Zoran keeps scrapbooks on Tito's every move. He imitates his gestures. He stays up all night on a street corner just to see the president drive by in the morning.

The family is embarrassed. His father attempts to be understanding, as if he had a son with a severe learning disorder. When Zoran's fulsome composition, "Why I Like the President," is judged the best of those submitted by all the schoolchildren in Belgrade, the family is caught between pride and humiliation. There is nothing they can do to prevent him from enjoying his prize, a "March Around Tito's Homeland": a week's camping trip with other privileged children, with the highlight a reception at Tito's palace.

This excursion, led by Raja (Lazar Ristovski), a vain, dimwitted young teacher, is the film's principal point as Zoran learns firsthand about totalitarianism. Raja is Tito drawn small so that a 10-year-old boy can recognize the idiocies and dangers of one-man rule. It's also at this point that "Tito and Me" loses a lot of its cockeyed exuberance. As the role is written and acted, Raja is neither funny nor especially believable. He's a bare-boned plot function.

"Tito and Me" was made before the Yugoslav war broke out, which doesn't help one's passive enjoyment of the film today. Tito's excesses, his rule by repression, his cult of personality, all of these things could be more easily satirized while the federation he helped forge still held together. The satire now looks short-sighted, over-simplified, almost ghoulish. Compared with the horrors of the present situation, the Tito era takes on a golden aura.

Time has played a dirty trick on Mr. Markovic and his film. In other, less apocalyptic circumstances, "Tito and Me" might not prompt one to remember that Tito was, in addition to everything else, a complex, remarkably gifted politician and the first Communist head of state to follow a course independent of Moscow. Contemporary events give the comedy an unexpected, unforeseeable edge.

"Tito and Me" survives as a funny, pungent, beautifully acted family memoir, recollected in tranquillity just before the ceiling collapsed.

•

Sharing the bill with "Tito and Me" is "When I Was a Boy," a five-minute, black-and-white short by Matthew Modine, the actor. In it, a paunchy grown man remembers himself going through his childhood, reliving the events in the physical person of the man he became. He recalls childhood defeats (being ridiculed and beaten up by his friends) and some of the pleasures: pushing a shopping cart through the supermarket while listening to the soothing background music.

"When I Was a Boy" is rueful and self-mocking. It's a gentle divertissement in which Mr. Modine, in his role as a film maker, seems to be finding his character, much like the film's protagonist but with happier results.

1993 Mr 23, C13:4

Correction

A film review on Tuesday about "Tito and Me," in the series New Directors/New Films at the Museum of Modern Art, omitted the name of a co-director in a brief appraisal of the short "When I Was a Boy." He is William Todd Field.

1993 Mr 26, A2:6

Passages

Written and directed by Yilmaz Arslan, (in German with English subtitles); director of photography, Izzet Akay; edited by Bettina Böhler; music by Ralph Graf. At the Roy and Niuta Titus Theater 1 in the Museum of Modern Art, 11 West 53d Street, Manhattan, as part of the New Directors/New Films series presented by the Film Society of Lincoln Center and the Department of Film of the Museum of Modern Art. Running time: 80 minutes. This film has no rating.

With: Nina Kunzendorf, Dieter Resch, Martin Seeger, Marco Neumeier, Tarik Senouci, Alexandra Krieger, Juana Volkers, Agnes Steinacker, Hermine Mischon, Andreas Frank and Christian Verhoeven.

By STEPHEN HOLDEN

Yilmaz Arslan's semi-documentary film "Passages" sets out with a vengeance to undermine Hollywood's reassuring portrayals of physically disabled people as heroic conquerers of despair and immobility. Set in a German rehabilitation center that despite its spiffy, ultra-modern appearance is filmed to resemble an eerie, cavernous shadowland, the film portrays the volatile interactions of a group of teen-agers who have serious disabilities.

Because much of the film looks as if it was shot from a motorized wheelchair, the center has the scary oppressive feel of a large, well-kept prison as experienced by a child. As the camera swoops down the halls and lurches around corners, the film often evokes a feeling of life about to career out of control.

"Passages" is a film of few words, but much of what is said is either unhappy or taunting. The patients in this hothouse atmosphere are highstrung, quarrelsome and sexually obsessed. One of the most disturbing scenes shows a boy with limited coordination forcing himself on a girl who is similiarly afflicted.

Although the film wanders from character to character, it gives special attention to a clique of rebel dreamers. Huddling in a corner, drinking whisky and smoking pot, they exchange sick jokes about Thalidomide babies and fantasize about moving to Venezuela to cultivate marijuana.

The most vivid character, Dieter (Dieter Resch), is a talented artist with no arms who paints with a brush between his toes and uses the tapering appendages from his shoulders to mix the colors. The other patients include a young woman who becomes pregnant and jumps out of a window rather than face her parents' wrath, and a would-be blues singer who is about to be taken to New York by her parents.

•

"Passages," which the New Directors/New Films series is showing this evening at 9 o'clock and tomorrow at 6 P.M. at the Museum of Modern Art, is the first film by Mr. Arslan, a 24-year-old Turkish-born film maker who moved to Germany in 1975 to be treated for polio. At Neckargmünd, a rehabilitation center near Heidelberg, he founded the Summer-Winter theater group, which has toured internationally.

He and his actors have made a film in which the desperate pangs of adolescence and the physical challenges faced by the actors fuse into a vision of human struggle that offers no comfortingly sentimental palliatives.

1993 Mr 23, C14:3

Our Twisted Hero

Directed by Park Chong Won; screenplay by Park Chong Won and Chang Hyun Soo, based on the novel by Yi Mun Yol, (in Korean with English subtitles); director of photography, Chung Kwang Seok; edited by Lee Kyung Ja;

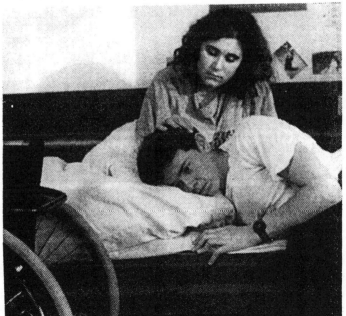

Film Society of Lincoln Center

A scene from Yilmaz Arslan's semi-documentary film "Passages," which is part of the New Directors/New Films series.

music by Song Byang Jun; production designer, Do Wong Woo; produced by Do Dong Hwan. At the Roy and Niuta Titus Theater 1 in the Museum of Modern Art, 11 West 53d Street, Manhattan, as part of the New Directors/New Films Series of the Film Society of Lincoln Center and the department of film of the Museum of Modern Art. Running time: 119 minutes. This film has no rating.

Um Suk Dae	Hong Kyung In
Han Byung Yae	Ko Jung Il
Mr. Kim	Choe Min Sik

By STEPHEN HOLDEN

If Park Chong Won, the South Korean director and co-writer of "Our Twisted Hero," is to be taken literally, the social structures formed by children in elementary school precisely mirror the hierarchy of adult society.

That is the message of the film, a blunt political fable of repression and corruption in modern South Korea that the New Directors/New Films series is showing this evening at 6 and on Saturday at noon at the Museum of Modern Art. The film, based on a popular Korean novel by Yi Mun Yol, portrays an English teacher's boyhood recollections that are prompted by the news of a grade-school teacher's death.

As a 12-year-old in 1959, Han Byung Yae (Ko Jung Il) moves with his family from Seoul to the provinces. At the provincial school he attends, he discovers that the teacher has delegated many disciplinary responsibilities to the class's student monitor Um Suk Dae (Hong Kyung In).

Um, whom the students have unanimously elected to the post year after year, is slightly older and bigger than the other boys. And as Han quickly learns to his chagrin, he has established a grade-school version of a police-state dictatorship. His fellow students bring him daily tributes of fresh fruit and trinkets. They do his homework and help him cheat on his exams. Those who resist his authority are punished with grueling work details and the most incorrigible are beaten up by Um and his henchmen.

A bright, self-confident boy who was a star pupil in Seoul, Han repeatedly stands up to Um but is systematically abased in a series of humiliating assignments, dirty tricks and beatings. Eventually Han gives in and begins doing favors for Um, who makes him his right-hand man. It is only when the class gets a new teacher the following year that Um's reign of terror ends.

As a political allegory of modern South Korea, "Our Twisted Hero" is a bit too literal minded for its own good. Um's rule and downfall coincide with those of the anti-Communist dictatorship of President Syngman Rhee that was toppled by a student-led revolt in April 1960. The story's attempts to parallel an elementary-school strongman's techniques with those of the Government feel somewhat strained and not entirely convincing.

The film nevertheless offers an indelible portrait of South Korea's public education system in the 1950's, which was far harsher and more regimented than the American system. Corporal punishment — usually the sharp slapping of hands with a stick and in extreme cases, severe spanking with a cane — was routine. A remarkable cast of several dozen child actors creates an elementary-school ambiance that is so palpable you an almost catch the bitter aroma of schoolbooks and fresh paint.

The key performances are outstanding. Mr. Hong's Um is anything

Ko Jung Il, left, and Hong Kyung In, in "Our Twisted Hero."

New Directors/New Films

Shinobu Ohtake

but a typical schoolyard bully. A model student on the surface, he surveys his kingdom with a poised, watchful sense of authority and only a hint of menace. Mr. Ko's Han is even more impressive. Far from being a persecuted little darling, the character is an arrogant young rebel with flashing eyes, a will of iron and a devious turn of mind. Mr. Ko plays his volatility for all it is worth.

The film's bluntly stated final message is that the country's political climate has not really changed that much in 30 years. The Um Suk Daes of contemporary South Korea may not show their faces anymore. But they continue to prosper through the same old dirty deeds.

1993 Mr 25, C20:1

The Peach Blossom Land

Written and directed by Stan Lai (in Mandarin Chinese with English subtitles); director of photography, Christopher Doyle; edited by Chen Po-Wen; produced by Ding Nai-Chu. At the Roy and Niuta Titus Theater 1 in the Museum of Modern Art, 11 West 53d Street, Manhattan, as part of the New Directors/ New Films series presented by the Film Society of Lincoln Center and the department of film of the Museum of Modern Art. Running time: 105 minutes. This film has no rating.

Yuan Zhifen	Brigitte Lin (Lin Ching-Hsia)
Jiang Bingliu	Chin Shih-Chieh
Mrs. Jiang	Lin Li-Ching
Old Tao	Li Li-Chun
Spring Flower	Ismene Ting
Master Yuan	Ku Pao-Ming
Directir	Ding Chung
Assistant	Lin Ju-Ping
Lost Woman	Wei-Hui
Theater Manager	Wang Hui-ling

By JANET MASLIN

"The Peach Blossom Land," a gentle Taiwanese film with a theatrical spirit, revolves around a single contrivance: that two different theater troupes might find themselves trapped in the same rehearsal space, and that their seemingly different plays might overlap thematically. Once known as "Secret Love for the Peach Blossom Spring" and developed by Performance Workshop, a well-regarded Taiwanese theater company, it finds its basis in a fifth-century allegory by the Chinese poet Tao Yuanming.

This utopian text tells of a paradise called the Peach Blossom Land, and of a fisherman who accidentally finds his way there. The residents are peaceful and happy, knowing nothing of the outside world and its troubles. Having lived serenely in this place for a while, the fisherman departs and is never able to find his way back.

The film's writer and director, Stan Lai, treats the story of the Peach Blossom Land as an allegory for the separation of Taiwan and mainland China after the Communist takeover of China in 1949. The more modern of his two plays, "Secret Love," is about a man who has been cruelly separated from his past and yearns for his lost sweetheart.

•

As seen in a string of excerpts, "Secret Love" has clear political overtones and the feeling of a lofty soap opera. Meanwhile, on the same stage, a broadly farcical performance of "The Peach Blossom Land" is also under way. That play, a traditional period piece involving an impotent fisherman, his faithless wife and her sly lover, is being directed as such low comedy that the director of "Secret Love" is offended. Meanwhile, the "Peach Blossom" troupe is equally mocking about "Secret Love" and its pretensions (the leading lady has been directed to behave like a white camellia).

Mr. Lai does an able job of shifting gears between the two overlapping plays, and of finding elements of humor in their juxtaposition. (When the Peach Blossom scenery is somehow missing a peach tree, one stagehand observes that white space is said to be very philosophical, and that the blank space in the scenery may represent "the relation between the canvas and the peach tree that has escaped it.") The actors' stage training, too, is impressively evident. But at certain points, each of the two separate plays becomes engaging in its own right, more so than the film's cumulative concept. The two-play idea is a mild one to begin with. It runs out of energy long before lines of dialogue like "Sorry, I didn't mean that" have begun to overlap.

"The Peach Blossom Land" can be seen tonight at 9 P.M. and Saturday at 3 P.M. as part of the New Directors/ New Films series.

1993 Mr 25, C20:5

Original Sin

Written and directed by Takashi Ishii, based on the novel by Bo Nishimura (in Japanese with English subtitles); director of photography, Yasushi Sasakihara; edited by Yoshio Sugano; music by Gorou Yasukawa; produced by Kei Ijichi. At the Roy and Niuta Titus Theater 1 in the Museum of Modern Art, 11 West 53d Street, Manhattan, as part of the New Directors/New Films series presented by the Film Society of Lincoln Center and the museum's department of film. Running time: 117 minutes. This film has no rating.

Nami Tsuchiya	Shinobu Ohtake
Makoto Hirano	Masatoshi Nagase
Hideki Tsuchiya	Hideo Murota
Murakami	Kouen Murakami

By JANET MASLIN

The events that shape Takashi Ishii's "Original Sin" won't startle anyone who has seen or read "The Postman Always Rings Twice," but they cast contemporary Japanese mores in a surprising light. Even viewers familiar with recent Japanese film at its most iconoclastic may be startled by some of the rebelliousness seen here. The film's central character is an anomaly by definition: a surly young drifter in a society that seemingly places much value on discipline and purpose. "Original Sin" takes a slightly awed view of this drifter's utter amorality and self-interest.

The film begins startlingly as this drifter, Makoto (Masatoshi Nagase), glimpses the demurely beautiful Nami (Shinobu Ohtake) at a train station. Almost literally thunderstruck, he watches her through torrential rain that is filmed so slowly and grandiosely it looks like snow. After this, he feels destined to follow her to the real estate office where she works, and where the boss turns out to be her husband. Undeterred by this, Makoto gets a low-level job in the same office. "If I can work with a woman like you, I won't be greedy about money," he tells Nami, who looks stunned by his brash assurance.

The attraction between Makoto and Nami develops along familiar film noir lines. But Mr. Ishii's direction is less stylized than his story (which is based on a novel by Bo Nishimura). His spare, watchful direction links Makoto's audacity with a strikingly non-traditional view of Japanese behavior. It seems fitting that some of the story's most illicit activity takes place in what Hideki (Hideo Murota), Nami's trendy-looking, much older husband, calls "the American custom-made bed."

The bed is in a model house that generally reflects changing Japanese attitudes, not only in its modern décor but in some of the events for which it becomes a backdrop. Hideki is seen showing the place to a flamboyantly gay couple, who make no secret of their plans for the bedroom.

Hideki also smirks convivially when discovering Makoto on the premises unexpectedly, not realizing that Makoto's assignation has been with Nami. The lovers' violent first coupling also takes place here, with Makoto assaulting Nami savagely, then weeping after the act has been consummated. While the two are struggling, rain pours in an open doorway. Mr. Ishii has an occasional taste for broad strokes, as with his much-used water imagery.

Before it stumbles badly with a dragged-out, waterlogged final struggle, "Original Sin" offers glimpses of drunken Japanese conventioneers, of a man watching a sporting event on television, of female employees engaging in bawdy after-hours conversation with their boss. It even moves on to a view of Tokyo from an unusual dockside perspective, with a view of what looks like a Y.M.C.A. in the background. In all these details Mr. Ishii offers provocative views of a culture in transition, which makes it especially apt for this story to center on a nervy 22-year-old.

But Makoto often seems too surly and loutish to account for his effect on others, particularly on the daintier Nami. Although rude posturing has its own artistry, in the Japan Mr. Ishii presents here that artistry may simply be too new.

"Original Sin" can be seen tonight at 9 and Sunday at 6 P.M. at the Museum of Modern Art as part of the New Directors/New Films series.

1993 Mr 26, C6:1

Vermont Is for Lovers

Produced, directed, photographed and edited by John O'Brien; screenplay improvised, based on a story by Mr. O'Brien; music by Tony Silber; released by Zeitgeist Films. At the Roy and Niuta Titus Theater 1 in the Museum of Modern Art, 11 West 53d Street, Manhattan, as part of the New Directors/ New Films series presented by the Film Society of Lincoln Center and the museum's department of film. Running time: 88 minutes. This film has no rating.

With: George Thrush, Marya Cohn, Ann O'Brien, Euclid Farnham, Jeramiah and Dan Mullen, Edgar Dodge, George and Alan Lyford, Robert Button, Joe and Fred Tuttle, Gladys Noyes and others.

By VINCENT CANBY

"Vermont Is for Lovers" is vaguely amiable in the way of a home movie made by people you don't know. It was directed, photographed and edited by John O'Brien, a 29-year-old Harvard graduate and film maker who runs his family's sheep farm near Tunbridge, Vt. Though Mr. O'Brien is also responsible for the story, the screenplay was reportedly improvised by the nonprofessional actors, mainly by George Thrush, an architect, and Marya Cohn, who is studying to become a film maker herself.

The film will be shown in the New Directors/New Films series at the Museum of Modern Art today at 6 P.M. and Sunday at 3 P.M.

Mr. Thrush and Ms. Cohn appear as a couple from the big city who come to Vermont to be married on the farm of her aunt. When they get cold feet, each sets out to ask people in the neighborhood what they think about marriage, and whatever else that pops into the conversation. Most of the movie is made of the responses, none of which is memorably funny, wise, silly or provocative.

Mr. O'Brien's search for "found" material goes unrewarded. Mr. Thrush and Ms. Cohn may be good company in real life, but when improvising on film, they aren't. At best she seems game and a good sport. He is slightly overbearing without redeem-

ing humor. Both are self-conscious. The Vermonters they talk to are decent, unspectacular folk who resolutely refuse to become colorful.

Even at 88 minutes the movie seems very long. The scenery is pretty, full of rolling farm land, covered bridges and two-lane roads. When the interviews run down, Mr. O'Brien cuts to shots of animals, often sheep. Vermont may be for lovers, but it seems to have wall-to-wall sheep.

•

Two good shorts share the bill with the feature. Mike Mitchell's "Frannie's Christmas" is a four-minute animated film about a little girl who becomes outraged when she learns there is no Santa Claus. With her even smaller brother, she pieces together her own Santa, following the methods of good old Dr. Frankenstein with more or less the same bizarre results.

K. D. Davis's "Over the Hedge" is a very funny, brisk (10 minute) documentary about topiary enthusiasts, people who express themselves through the shapes in which they prune their bushes. The unbilled star of the film is an elderly fellow, something of a recluse, who devotes himself to his front lawn, its topiary and the plaster statues with which it's furnished. The lawn is much friendlier than he is, which is the way he planned it.

1993 Mr 26, C6:5

Married to It

Directed by Arthur Hiller; written by Janet Kovalcik; director of photography, Victor Kemper; edited by Robert C. Jones; music by Henry Mancini; production designer, Robert Gundlach; produced by Thomas Baer; released by Orion Pictures. Running time: 112 minutes. This film is rated R.

John Morden	Beau Bridges
Iris Morden	Stockard Channing
Chuck Bishop	Robert Sean Leonard
Nina Bishop	Mary Stuart Masterson
Claire Laurent	Cybill Shepherd
Leo Rothenberg	Ron Silver

By JANET MASLIN

"Married to It" presents a small Noah's Ark of wedded stereotypes, as three cute couples are conveniently thrown together. For reasons that would be most apparent to the makers of a television sitcom, they all become fast friends. Two are blushing newlyweds (Mary Stuart Masterson and Robert Sean Leonard). Two are sexual athletes (Cybill Shepherd and Ron Silver). Two are wearily middle-aged (Beau Bridges and Stockard Channing). All would be better off anywhere else.

As directed by Arthur Hiller and written glibly by Janet Kovalcik, "Married to It" at least starts off on a lively note. Everyone bustles about ferociously, trying to establish character and some sort of socio-economic milieu. The newlyweds exemplify yuppie ambition, though much is made of their honest Iowa background. The middle-aged parents groan about their rent-controlled apartment and their low-paying government jobs, lamenting the loss of their hippie past.

The rich second wife of a toy manufacturer hones her skills as a wicked stepmother, and boasts so much about her husband's sexual prowess that she makes everyone nervous, especially her spouse. "I do my best in the boardroom *and* the bedroom,"

Ben Mark Holzberg
Cybill Shepherd

she proclaims, demonstrating the screenplay's light touch.

There's a certain grim satisfaction in watching the story's wheels turn, as contrivance after contrivance brings the three couples together. If you believe that they could all meet through a Manhattan private school (where the older couples have children and the young bride is a staff psychologist), then perhaps you'll also believe that no one in the story has any other friends.

Somehow, these six characters are trapped at dinner party after dinner party for the supposed purpose of their planning the school pageant, which will have an excruciating 1960's motif. To break up these dinner scenes the film throws in assorted other romps, like a trip the three wives make rummaging through urban Dumpsters to furnish the newlyweds' apartment. Ms. Shepherd's caustic, eye-rolling character is supposed to be charming as she slums her way through this episode and has junk tied onto her Jaguar.

This is the fun part of the film, relatively speaking. Its second half, in which each of the couples has the predictable spat, can best be described by the word ouch. Sample dialogue: "Marriage isn't just fun!" "I'm just starting to ask questions about things I thought I had answers to." "Power, glamour, wealth aren't what they're cracked up to be." "How about a little recognition that someone who loves you very, very much is trying the best he can?"

•

Trying very hard indeed, the actors sometimes manage to be pleasant if not persuasive. Ms. Masterson is always solemnly appealing, even when playing the sort of giddy ingénue she embodies here. Mr. Bridges and Ms. Channing seem to fare best, perhaps because by playing the story's crankiest characters they succeed in reflecting the audience's mood.

Mr. Bridges does contend with two of the film's most awful scenes, one in which he visits his son's class to offer some historical perspective on Woodstock and another in which he and Mr. Silver's character first find some common ground. They do this by reminiscing about bad Woodstock-era rock songs while worrying whether cheese puffs contain too much cholesterol. Listening to this outburst, the newlyweds inject some added misery by pointing out that they weren't born until 1966.

Those who enjoy feeling their skin crawl will want to stay for the film's closing sequence, a school pageant in which little children impersonate hippies, waving placards that say "Peace" and "Love" and singing every last verse of "The Circle Game." Joni Mitchell, whose song and album cover are also used elsewhere in the film, just might be in a position to sue.

"Married to It" is rated R (Under 17 requires accompanying parent or adult guardian). It includes profanity, sexual situations and much sexual innuendo.

1993 Mr 26, C8:6

Masala

Written, produced and directed by Srinivas Krishna; director of photography, Paul Sarossy; edited by Michael Munn; music by the West End Music Company and Leslie Winston; released by Strand Releasing. Running time: 105 minutes. At the Quad Cinema, 34 West 13th Street, Greenwich Village. This film has no rating.

Krishna	Srinivas Krishna
Rita	Sakina Jaffrey
Grandma	Zohra Segal
Lord Krishna/Lallu Bhai/Mr. Tikkoo	Saeed Jaffrey
Lieut. Hilary Macintyre	Janet Joy Wilson

By STEPHEN HOLDEN

Srinivas Krishna's audacious comedy "Masala" is a film distinguished by extreme cultural double vision. Its 25-year-old director, writer, co-producer and star is a film maker who was born in India and moved to Canada in 1970. Rather than aspire to a traditional Western style of film making for his first feature, the director has larded some of the quirkier aspects of Indian commercial movies into a film that is already an experiment in scrambled genres.

Indian phantasmagoria and Bombay-style movie kitsch keep bubbling up unexpectedly in this frantic comedy about a bunch of middle-class Indians who live in Toronto. In one subplot, an Indian grandmother (Zohra Segal) carries on a running argument with Lord Krishna (Saeed Jaffrey), a deity who appears on her television set whenever she summons him. Periodically, the film breaks completely away from conventional storytelling for a glitzy musical-comedy number or an erotic fantasy sequence. Such sudden changes of pace are commonplace conventions in commercial Bombay cinema.

The characters who collide through the film are as nutty an assortment as might be found in a Marx Brothers farce. Mr. Jaffrey, in addition to playing Lord Krishna, portrays the young man's wealthy uncle Lallu Bhai, a sari merchant, and his less-affluent cousin, Mr. Tikkoo, an obsessive philatelist. In the course of the film, both men get into deep trouble.

The avaricious Lallu, in return for a worldwide monopoly on the sari trade, allows a group of terrorists to stockpile weapons in his dress shop. Through divine intervention, Mr. Tikkoo comes into the possession of a priceless stamp that he refuses to hand over to the Canadian Government, which claims ownership. Donning an assortment of wigs, Mr. Jaffrey, who recalls Claude Rains in his more avuncular roles, smoothly negotiates the character transitions.

•

The director plays Krishna (not to be confused with the deity), a hotheaded young drug dealer whose family was killed five years earlier when their India-bound plane exploded in midair. Scowling in his black leather jacket, he suggests a smoldering Indian answer to James Dean.

The most ingenious aspect of "Masala," which opens today at the Quad

Cinema, is its use of clashing cinematic genres to illustrate the theme of cultural collision and dislocation. If the character of Krishna has a tragic aura, most of the other characters are farcical figures who carry the director's vision of cultural relativism to absurdist lengths.

The film's most ludicrous figure is Lord Krishna, a peevish old androgyne in lipstick, jewels and whiteface makeup. A symbol of Canadian tradition who seems equally silly and anachronistic is a grim-faced young policewoman (Janet Joy Wilson) who gallops about the street on horseback wearing full Canadian Mountie gear.

"Masala" is a comedy only 80 percent of the time. When the story focuses on the angry young man who becomes a thorn in his uncle's side, the mood edges toward darker-toned melodrama.

For all the energy and invention that went into "Masala," its pieces don't quite mesh. The film's juxtaposition of genres often feels jarring, with no point other than to surprise. Nevertheless, it shows Mr. Krishna to be a film maker of considerable promise and with a flair for the flamboyant.

1993 Mr 26, C10:1

Watch It

Written and directed by Tom Flynn; director of photography, Stephen Katz; edited by Dorian Harris; music by Stanley Clarke; production designer, Jeff Stevens Ginn; produced by Thomas J. Mangan 4th, J. Christopher Burch and John C. McGinley; released by Skouras Pictures. Running time 102 minutes. This film is rated R.

John	Peter Gallagher
Anne	Suzy Amis
Rick	John C. McGinley
Michael	Jon Tenney
Ellen	Cynthia Stevenson
Brenda	Lili Taylor
Danny	Tom Sizemore
Denise	Terri Hawkins

By VINCENT CANBY

"Watch It," the first film to be written and directed by Tom Flynn, is a surprisingly enjoyable romantic comedy about four young men, three of whom are recent graduates of Northwestern University, and the women they become involved with during one Chicago summer. The most unusual thing about the movie is the way it appreciates its characters' mini-problems without for a minute overplaying them. Though small in scale, "Watch It" isn't trivial.

The title is taken from an undergraduate game, an obsessive, trivial pursuit, really, in which extremely elaborate practical jokes are played on unsuspecting victims, who then must answer in kind. As the film begins, the jokes are becoming increasingly complicated. On his first night in Chicago, staying in the house shared by his cousin and three

James Zenk
Lili Taylor

friends, John (Peter Gallagher) is set up for a "watch it" gag.

Standing around at a party where he knows nobody, John is taken into a back bedroom by a pretty young woman who, to his astonishment, starts taking her clothes off, saying she must have him immediately. At just the point when he might respond, if only to be polite, the door bursts open, to the delight of everyone else. This is not John's idea of fun.

Nor, indeed, is much of the summer. He falls in love with Anne (Suzy Amis), a beautiful young veterinarian who's on the rebound from his cousin Michael (Jon Tenney). Michael, the kind of a handsome rat a lot of women find irresistible, then decides he wants Anne back and so returns, an impasse resolved only in a "watch it" gag of real viciousness.

•

The film is exceptionally well acted by the members of the young cast, most notably by Mr. Gallagher (seen on Broadway in the revival of "Guys and Dolls"), Ms. Amis, Mr. Tenney, John C. McGinley (who plays the group's most fearful womanizer and is one of the film's producers), Cynthia Stevenson and Lili Taylor.

"Watch It" should not be oversold. It's not a "Big Chill" for the yet-to-be-married set. Its characters are decent though lightweight. It's possibly significant that only Anne is seen at work at her job, which seems to mean as much to her as what she does at nights and on weekends. The others take life as it comes, without apparent aim except pleasure. These young men and women are very much the products of the affluent 1980's. They're self-absorbed children, waiting to grow up.

The difference between them and characters in dozens of other similar but utterly forgettable comedies is that Mr. Flynn, who created them, is aware of the world outside, which they only vaguely comprehend and scarcely ever talk about. He doesn't make a big moral deal of it, but he knows what they are missing.

•

"Watch It," which has been rated R (Under 17 requires accompanying parent or adult guardian), has some sexual activity, partial nudity and vulgar language.

1993 Mr 26, C12:1

Born Yesterday

Directed by Luis Mandoki; screenplay by Douglas McGrath, based on the play by Garson Kanin; director of photography, Lajos Koltai; edited by Lesley Walker; music by George Fenton; production designer, Lawrence G. Paull; produced by D. Constantine Conte and Stephen Traxler; released by Hollywood Pictures. Running time: 102 minutes. This film is rated PG.

Billie Dawn.....................Melanie Griffith
Harry Brock......................John Goodman
Paul Verrall.......................Don Johnson
Ed Devery.....................Edward Herrmann
J.J..................................Max Perlich
Senator Hedges.........Fred Dalton Thompson
Cynthia Schreiber....................Nora Dunn
Secretary Duffee........Benjamin C. Bradlee
Beatrice Duffee.....................Sally Quinn
Phillipe..........................Michael Ensign
Senator Kelley.............William Frankfather
Mrs. Hedges....................Celeste Yarnall
Mrs. Kelley........................Meg Wittner

By VINCENT CANBY

They don't make "dumb broads" like Billie Dawn anymore or, if they do, they don't call them that in our sensitized society. This may be one of the reasons why "Born Yesterday," based on Garson Kanin's classic 1946 Broadway farce, plays so amely in its glitzy new film version updated to the 1990's. You can take Billie Dawn out of the chorus, but you can't take her out of her own post-World War II time.

It's difficult to believe that this Billie Dawn, played by Melanie Griffith, even shares the same planet with Oprah Winfrey and Phil Donahue. If she did, she couldn't be quite as stupid as she must be to make the glorious transformation to wisdom that is the drop-dead heart of the Kanin comedy.

Though the principal performances by Ms. Griffith, John Goodman and Don Johnson are no more than thoroughly adequate, summer-stock style, the new film has some good things going for it, including the excellent supporting cast headed by Edward Herrmann, Max Perlich, Fred Dalton Thompson and Nora Dunn. The adaptation is intelligent. If all of Mr. Kanin's original lines aren't there, most of the new ones supplied by Douglas McGrath, who wrote the adaptation, are still pretty funny and in the Kanin spirit.

Yet this "Born Yesterday" is a shadow's shadow. It's like those unlamented television remakes of Alfred Hitchcock's "Notorious" and Otto Preminger's "Laura." It's not only haunted by its spectacularly fine predecessor, the 1950 George Cukor version for which Judy Holliday won an Oscar, but also by time. There is a fatal disconnection between place and characters who, conceived in one era, are crazily transported into another in which they don't quite fit.

•

The story remains essentially the same: Harry Brock (Mr. Goodman), self-made millionaire and lout, comes to Washington with his mistress, Billie, to bribe a few Senators to get legislation passed that will benefit his empire, most of which is held in Billie's name for tax purposes. When Billie, whom Harry adores, becomes a social embarrassment, he hires Paul Verrall (Mr. Johnson), a liberal reporter, to give her a crash course in government, language, esthetics and general deportment.

In the Kanin original, and as played by the great Miss Holliday on the stage and in the Cukor film, Billie succeeds in a fashion that matches Eliza Doolittle's triumph when she makes her announcement about the rain in Spain. Yet Mr. Kanin's "Born Yesterday" is not only an enchanted fairy tale, it is also a plea for a new kind of enlightened American populism.

Today the message seems just a bit naïve, but in its own day, when the anti-Communist witch hunters were roving Washington, "Born Yesterday" was seen by some as flaming pinko propaganda. At the time Cukor directed the first film, it was thought wise to change the play's crooked Senator to a crooked Congressman, apparently to protect the reputation of the Senate.

Because the new film can't tell audiences anything about the ethics of senators they don't already know, this "Born Yesterday" is principally about Billie's enlightenment and her

humiliation of the boorish Harry. Yet even Billie's achievement now seems smaller and unnecessarily cruel. Harry, as Mr. Goodman plays him, is far less menacing than comic.

Luis Mandoki, the director, has created something new: a "Born Yesterday" in which the audience's sympathy eventually goes to Harry rather than to Billie and Paul. That's overstating the case, but confusions in loyalties arise when the play's sharply observed characterizations are blunted.

•

Ms. Griffith's Billie never tries to evoke the Holliday performance, and she somehow manages to seem stylish even when she's not supposed to. Instead of being brassy, her Billie is sincerely dim. When she puts on glasses and starts to read "Democracy in America," she suddenly looks like the Sarah Lawrence student her earlier disguise has never quite hidden.

Mr. Goodman has a few temper tantrums, but his Harry is not much different from the teddy bear he plays on weekly television. Possibly he isn't helped by the character as reconceived for the 90's. The original Harry Brock was a junkman with international aspirations. Mr. Goodman's Harry is a comparatively commonplace real-estate hustler. Perhaps he should have been a corporate raider. In any case, he's benign.

As the mild-mannered reporter, Mr. Johnson is gentlemanly and polite in a role that must have been thankless.

Most of "Born Yesterday" is simply inoffensive, almost leisurely in pace, but there is one really ghastly sequence: a dinner party at which Billie stuns and delights the worldly guests by demonstrating how she remembers the Constitutional amendments. She sings them to the tune of "The 12 Days of Christmas."

There's no way to tell how the general public will respond to this "Born Yesterday," but it should be a smash in Georgetown for a week or two. Benjamin C. Bradlee, the former executive editor of The Washington Post, appears in several scenes as the Secretary of the Navy, and Sally Quinn, the writer and journalist who is married to Mr. Bradlee, appears as the Secretary's wife. They look fit and say their lines without visible panic.

•

"Born Yesterday," which has been rated PG (Parental guidance suggested), has some mildly vulgar language.

1993 Mr 26, C17:2

Combination Platter

Directed by Tony Chan; screenplay by Edwin Baker and Mr. Chan; director of photography, Yoshifumi Hosoya; edited by Mr. Chan and James Y. Kwei; music by Brian Tibbs; produced by Judy Moy, Mr. Chan, Ulla Zwicker and Bluehorse Films Inc. at the Roy and Niuta Titus Theater 1 in the Museum of Modern Art, 11 West 53d Street, as part of the New Directors/New Films series presented by the Film Society of Lincoln Center and the Department of Film of the Museum of Modern Art. Running time: 84 minutes. This film has no rating.

Robert.................................Jeff Lau
Claire..........................Colleen O'Brien
Sam....................Lester (Chit Man) Chan
Benny...........................Colin Mitchell
Andy.............................Kenneth Lu
Mr. Lee.....................Thomas K. Hsiung
WITH: Jia Fu Liu, Ellen Synn, Nathanael Geng, Peter Kwong, Eleonora Kihlberg, James DuMont.

By JANET MASLIN

Setting his refreshingly candid "Combination Platter" in a Chinese restaurant, Tony Chan serves up many things that are not on the usual menu. This film's events are seen through the eyes of Robert (Jeff Lau), an illegal immigrant from Hong Kong who works as a waiter in Queens. Robert's desire for a green card gives the film its nominal impetus, but the real subject is the behind-the-scenes aspect of the restaurant's operation. In the culture gap between occasionally rude American customers and deceptively dutiful Chinese workers, "Combination Platter" finds a rich and offbeat subject.

Whether it is following the fate of leftovers or glancing at the huge vat of MSG in the restaurant's basement, Mr. Chan's film provides honest, often humorous glimpses of restaurant life. Among the kitchen workers, who bicker playfully among themselves, a match between a Mandarin and a Cantonese is considered a mixed marriage. Meanwhile, Robert and the other waiters are exposed to more radical differences as they deal with American customers, who miss an awful lot by not understanding Chinese.

Robert's friend Sam (Lester "Chit Man" Chan) is a big favorite with obnoxious baseball players (the restaurant is near Shea Stadium) and has perfected the art of saying "That's a great story" as these bores drone on and on. Robert, who is more timid, looks alarmed whenever Sam pleasantly curses the very patrons he appears to be admiring. He is even more troubled by the sight of a white man and his Asian date, who are regulars at the restaurant and often argue while they're having dinner. Robert is still sheltered enough to find the idea of such a couple shocking.

At the same time, Robert himself may be forced to find an American bride. He is now Americanized enough to joke that a green card is better than a gold card, and he very much wants to stay. But if the restaurant's owner tries to help him it may take five years, whereas marriage offers an instant solution. So Robert's more worldly friend Andy (Kenneth Lu) introduces him to the shy, spinsterish Claire (Colleen O'Brien), who is at first flattered by Robert's attention. The film displays tact and deli-

New Directors/New Films

Jeff Lau in a scene from the movie "Combination Platter."

cacy as it observes the awkward relationship between these two.

•

. Mr. Chan, who was born in Hong Kong and later moved to New York, captures Robert's apprehensiveness beautifully. So does Mr. Lau, who plays the role in a simple and utterly believable fashion. "Combination Platter" provides a funny, involving glimpse of a painful predicament, and manages to do this with charm and verisimilitude. As the owner instructs his employees that "if the table will be ready in 20 minutes, say 10 to 20 minutes" because it "sound better with the 10," it's clear that Mr. Chan's warm, rueful film has the ring of truth.

On the same bill is "Through an Open Window," Eric Mendelsohn's visually accomplished, conceptually obvious story of a suburban housewife (Anne Meara) who comes apart at the seams. Adopting a "Twilight Zone"-style vision of suburban menace, this handsome black-and-white short is helped greatly by Ms. Meara's palpable terror in the role.

"Combination Platter" and "Through an Open Window" can be seen tonight at 6 and tomorrow at 9 P.M. as part of the New Directors/New Films series.

1993 Mr 27, 11:2

Virgina

Written and directed by Srdjan Karanovic, (in Serbo-Croatian with English subtitles); director of photography, Slobodan Trninic; edited by Branka Ceperac; music by Zoran Simjanovic; produced by Rajko Grlic, Mladen Koceic, Djordje Milojevic, Claudie Ossard and Cedomir Kolar. At the Roy and Niuta Titus Theater 1, the Museum of Modern Art, 11 West 53d Street, Manhattan, as part of the New Directors/New Films series of the Film Society of Lincoln Center and the Museum of Modern Art film department. Running time: 100 minutes. This film has no rating.

Timotije..............................Miodrag Krivokapic
Stephen..............................Marta Keler
Dostana..............................Ina Gogalova
Mijat..................................Igor Bjelan
Paun....................................Slobodan Milovanovic

By VINCENT CANBY

Srdjan Karanovic's "Virgina," said to be the last film to come out of a united Yugoslavia, is a grim tale of Serbian peasant life at the end of the 19th century, with particular reference to the status and nature of women. The film will be shown in the New Directors/New Films series at the Museum of Modern Art tonight at 9 and tomorrow at noon.

"Better to be a rooster for one day than a hen all your life," Dostana, the exhausted farm wife, tells her child, who's called Stephen though actually a girl. Stephen has her doubts, now that she's on the verge of womanhood. The fourth daughter in a family without sons, she has been raised as a boy to save the family's reputation.

Over the centuries, the male-dominated peasant society has gone from regarding a daughter as an economic liability to the conviction that too many are a sign of God's punishment. On the night Stephen is born, her father, Timotije, takes the infant into the field. He is about to put a bullet through her brain when his hand is stayed by a mighty wind; the film uses the syntax of superstition to make its points. Instead of murdering her, Timotije vows to bring her up as

New Directors/New Films

Marta Keler in Srdjan Karanovic's film "Virgina."

a virgina (virgin), which is apparently the Serbian term for a child raised in such a deception.

The next morning, a young man runs through the countryside telling the neighbors that "the cursed one has had a boy." Dostana tries to comfort Stephen as the girl grows up, but the mother herself is a somewhat suspect figure. "You don't bear sons," an angry Timothije shouts at her at one point. "You bear misfortunes."

"Virgina" is much like its landscape, chilly, barren and arid, but also quite beautiful in the way of something exotic seen from a great distance. Mr. Karanovic, who wrote and directed the film, tells of Stephen's increasing desperation as she tries, at her father's obsessive bidding, to be something she isn't.

She becomes as adept at arm-wrestling as any boy. She can work the land like a man. Yet she yearns for feminine things, including dolls. She

To save face, a farm family turns its youngest hen into a rooster.

is tongue-tied and shy around the girl to whom she is betrothed, and more and more fond and bold with the boy who has always been her best friend. After she suddenly and visibly becomes a woman on Christmas Eve, she is driven to asserting her true nature. The ending is both tragic and liberating.

The performances are straightforward and honest, without frills and fanciness. Mr. Karanovic doesn't soften "Virgina" with sentimental touches. Toward the end, there is one story twist that becomes the most haunting thing in the film. Like the disciplined film maker he seems to be, Mr. Karanovic doesn't overplay this moment. He presents it and moves on.

1993 Mr 27, 15:1

The Opposite Sex

Directed by Matthew Meshekoff; written by Noah Stern; director of photography, Jacek Laskus; edited by Adam Weiss; music by Ira Newborn; production designer, Alex Tavoularis; produced by Stanley M. Brooks and Robert Newmyer; released by Miramax Films. Running time: 86 minutes. This film is rated R.

David Crown........................Arye Gross
Carrie Davenport.................Courteney Cox
Eli.......................................Kevin Pollak
Zoe.....................................Julie Brown
Kenneth Davenport.............Mitch Ryan
Irv Crown...........................Phil Bruns
Freida Crown......................Mitzi McCall
Gisella Davenport...............B. J. Ward

By JANET MASLIN

When a battle-of-the-sexes comedy has one combatant complaining that the other never caps the toothpaste tube, there's bound to be a shortage of new thinking. That's the trouble with "The Opposite Sex," which means to present a series of droll dating tips but mostly falls flat. That the movie's full title ("The Opposite Sex and How to Live With Them") is ungrammatical doesn't help at all.

As written by Noah Stern and directed by Matthew Meshekoff, the film tries to take a breezy look at the courtship of David (Arye Gross) and Carrie (Courteney Cox). Egged on by their acerbic best friends (Kevin Pollak and Julie Brown), these two go through the usual motions, like meeting cute and breaking up, in somewhat dated fashion. To keep itself afloat at all, the film relies on a series of gimmicks and interruptions that occasionally bring it close to Woody Allen territory. "The Opposite Sex" is in deep trouble whenever it steps into the shadow of "Annie Hall."

•

Aside from kidding about the religious differences between these lovers ("I don't care for semantics." "Too bad, I'm Jewish"), the film also uses humorous titles and mock football diagrams to describe their progress. The best gags are the wild cards, like one that has Mr. Pollak telling Mr. Gross that Ms. Cox is "not sitting around like Olivia Newton-John in 'Grease,' pal." Cut to Ms. Cox with a crowd of girlfriends, singing one of the musical numbers from that show.

"The Opposite Sex," which opened yesterday, may not settle any argu-

ments about romance. But it does give a clear advantage to its male characters, at least as far as funny dialogue is concerned. Mr. Pollak in particular displays a droll, deadpan manner that makes the most of this uneven material. Shooting fish in a barrel, he makes the rounds at a preppy party while making studiously empty small talk ("That ice looks cold. Is it?") and guessing charades answers ("Fatal Attraction," "The Bonfire of the Vanities") before the game is even played.

1993 Mr 27, 15:2

Okoge

Written and directed by Takehiro Nakajima, (in Japanese with English subtitles); director of photography, Yoshimasa Hakata; edited by Kenji Goto; music by Edison and Hiroshi Ariyoshi; produced by Masashi Moromizato, Mr. Nakajima and Yoshinori Takazawa; released by Cinevista. At the Roy and Niuta Titus Theater 1 in the Museum of Modern Art, 11 West 53d Street, Manhattan, as part of the New Directors/New Films series of the Film Society of Lincoln Center and the department of film of the Museum of Modern Art. Running time: 120 minutes. This film has no rating.

Sayoko..............................Misa Shimizu
Goh....................................Takehiro Murata
Tochi..................................Takeo Nakahara
Kurihara.............................Masayuki Shionoya
Kineo, Goh's Mother...........Noriko Songoku
Touichi, Goh's Brother........Kyozo Nagatsuka
Yayoi, Tochi's Wife.............Toshie Nogishi
Tamio, the Transvestite Singer
 Atsushi Fukazawa
Tsuyuki, the Bartender........Takatoshi Takeda

By VINCENT CANBY

Sayoko, who is bright and pretty, would seem to be not very different from many other young women in the affluent Japan of today. She isn't a career-driven, but she has a career of sorts as an actress, dubbing the voices for animated films. She lives alone in a small, cluttered duplex flat in what could be either Osaka or Tokyo, without a boyfriend, without commitments. If she's a bit aimless and lonely, she's not especially aware of it.

All this changes in the opening sequence of "Okoge," Takehiro Nakajima's very fine new Japanese film, which is as melancholy as it is wise and funny. One afternoon at the beach with a girlfriend, Sayoko suddenly realizes that they are sitting in the middle of a sort of gay enclave. Men of all ages, sizes, builds and temperaments line the sea wall behind them. Sayoko is curious. Her girlfriend is appalled.

When a young man named Noh offers them rice cakes, Sayoko accepts with delight. Her friend warns her not to eat them. "You might get AIDS," she says. Later Sayoko watches as Noh and his older lover, Tochi, stand in the water, their backs to the beach, and kiss in a way that appears to be utterly without self-consciousness. For reasons she cannot explain, Sayoko is both charmed and excited.

Not long afterward, she meets the two men in a bar. They don't immediately remember her but she has not forgotten them. She reminds them of the day at the beach. "You looked so beautiful when you kissed," she says. When she learns they have no place to go that night, she offers them the use of a room in her flat. The sequence that follows crosscuts between Noh and Tochi having abandoned sex upstairs, while Sayoko sits below, sort of prim but content, thumbing through a

coffee-table book of paintings by Frida Kahlo.

Okoge is the Japanese word for the rice that sticks to the bottom of the cooking pot, or okama, which is also pejorative slang for homosexual. Through this route, okoge has become the Japanese term for a woman who prefers the company of gay men. Yet Sayoko's okoge is quite different from the sort of older, tougher American women who, out of social need as much as for pleasure, favor gay men as companions and escorts.

The movie never spells it out, but Sayoko is a particular Japanese type. She's the kind of young woman who, as a teen-ager beset by the perils of puberty, was an avid reader of literature (including comic books) glorifying bishonen. In Japan, bishonen are beautiful, idealized, androgynous youths who often prefer one another to girls. More important, they are brave and rebellious, and never make dread sexual demands on budding young women.

•

Though "Okoge" comes from a country that remains puritanical in all matters relating to sex (or, possibly, because of that), the film is a remarkably unsentimental, civilized, clear-eyed look at the gay world that a lot of Japanese would probably like to ignore. "Okoge" is the second feature to be directed by the 57-year-old Mr. Nakajima, who has long been a successful film and television writer. After 18 years of marriage and two children, he was divorced five years ago and now lives an openly gay life.

It's indicative of Mr. Nakajima's thinking that Tochi, Noh's married lover who says he was 40 before he ever went into a gay bar, is the film's least sympathetic character. As the film opens, Tochi is a spineless family man who works at a white-collar job in the kind of company that exalts conformity. At the same time he's carrying on his passionate affair with Noh, a stocky, good-looking leatherworker.

In one of the film's more riotous sequences, Noh admits his homosexuality to his frequently hysterical mother, his brother and horrendous sister-in-law after a genteel meeting with a young woman they want him to marry. Their immediate response is to talk about something else. This is quickly followed by fury and embarrassment, but Noh is, at last, his own man. Tochi does not come out of his closet until much later, after Noh has abandoned him and his wife has blackmailed him into returning to her by threatening to expose him to his bosses.

•

The stories of Noh, Tochi and their friends are seen mostly through the eyes of the troubled but ever-gallant Sayoko. It's she who has the toughest time. Among other things, she winds up raped and pregnant after she tries to help Noh get together with a man he has admired in a bar. But Mr. Nakajima gives a comic, cutting edge to even this situation. Having brought the man home to her place, Sayoko tries to call Noh to come over, but the line is busy. Noh's mother is on the telephone, pouring out her troubles on a psychiatric hot line.

"Okoge" is rich with satiric detail. There's the gay bartender who tells Sayoko that he really doesn't mind being ostracized. Being ostracized, he says, makes him feel different; otherwise he might think he was just as ordinary as everyone else. Noh's mother, trying to come to terms with what she sees as her son's tragedy, says that when she was pregnant she

cut her finger: "Some homosexual bacteria got into the wound." A drag queen emerges from a street brawl announcing, "I've lost my eyelashes."

There is a halcyon (and heartbreaking) picnic shared by Sayoko, Noh and Tochi, when Sayoko tells her two friends, who are casually necking, "I love you both."

Misa Shimizu (Sayoko), Takehiro Murata (Noh) and Takeo Nakahara (Tochi) are terrifically good in the well-written central roles. "Okoge" looks like the sort of work that could not have been made at any earlier time in Mr. Nakajima's career. It has not only humane vision, but also the authority of a writer and director who has discarded all the excess mannerisms of his craft to find the essential, as well as something amounting to the pure.

"Okoge" will be shown at the Museum of Modern Art today at 6 P.M. and tomorrow at 9 P.M. in the series New Directors/New Films.

1993 Mr 29, C13:1

Hear No Evil

Directed by Robert Greenwald; screenplay by R. M. Badat and Kathleen Rowell; story by R. M. Badat and Danny Rubin; director of photography, Steven Shaw; edited by Eva Gardos; music by Graeme Revell; production designer, Bernt Capra; produced by David Matalon; released by 20th Century-Fox. Running time: 97 minutes. This film is rated R.

Jillian Shananhan	Marlee Matlin
Ben Kendall	D. B. Sweeney
Lieut. Philip Brock	Martin Sheen
Mickey O'Malley	John C. McGinley
Grace	Christina Carlisi
Cooper	Greg Elam
Wiley	Charley Lang

By STEPHEN HOLDEN

In Robert Greenwald's suspense film "Hear No Evil," Marlee Matlin plays Jillian Shananhan, a fiercely self-reliant deaf woman who unwittingly comes into possession of a priceless stolen coin. Through much of the film, she is menaced by Lieutenant Brock (Martin Sheen), the sadistic police officer who engineered the heist and wants his treasure back. Brock happens to be an opera nut who when interrogating witnesses turns up the volume on "Cavalleria Rusticana" to drown out their screams. Jillian's ally and soon-to-be-lover Ben

Merrick Morton/20th Century-Fox

Marlee Matlin in a scene from "Hear No Evil."

(D. B. Sweeney) is that epitome of sensitive male perfection, a rock-climbing chef.

"Hear No Evil," which opened locally on Friday, aspires to be a kind of yuppie "Wait Until Dark" for the deaf. Its strongest asset is its star, who exudes some of the same defiant sensuality that animated her Oscar-winning performance in "Children of a Lesser God." Periodically, the film suspends its conventional soundtrack to try to imagine what it's like to be deaf and in mortal peril. But its gestures in that direction are only token.

•

Although the film has serviceable performances, they cannot cover up the story's gaping holes or redeem the thudding predictability of R. M. Badat's screenplay. No sooner have Ben and Jillian got into bed than he asks her to teach him erotic sign language. The mechanical dialogue is interrupted by chase sequences that have some visceral energy despite being too drawn out.

"Hear No Evil" is set in Portland, Ore., and its environs. With its gobs of pretty scenery, it is, if nothing else, an effective travel brochure for the Pacific Northwest.

•

"Hear No Evil" is rated R (Under 17 requires accompanying parent or adult guardian). It includes brief glimpses of nudity and racy dialogue.

1993 Mr 29, C16:1

Cows

Directed by Julio Medem; screenplay by Mr. Medem and Michel Gaztambide, (in Spanish with English subtitles); director of photography, Carles Gusi; edited by Maria Elena Sainz de Rozas; music by Alberto Iglesias. At the Roy and Niuta Titus Theater 1, Museum of Modern Art, 11 West 53d Street, Manhattan, as part of the New Directors/New Films series of the Film Society of Lincoln Center and the department of film of the Museum of Modern Art. Running time 96 minutes. This film has no rating.

Cristina	Emma Suárez
Perú	Carmelo Gómez
Catalina	Ana Torrent
Manuel	Manuel Blasco
Clara	Clara Badiola
Juan/Carmelo	Cándido Uranga

By STEPHEN HOLDEN

Every so often in "Cows" ("Vacas"), Julio Medem's epic portrayal of two feuding families in the Basque region of northern Spain, the camera

draws away from the tumultuous passions of its characters to focus on the eyes of the cattle who are essential to these people's livelihoods. After contemplating their expressionless faces, the camera returns to the drama, but detached, as though the director has decided to observe the world and its butchery through uncomprehending bovine eyes.

Wielded by a lesser film maker, this conceit, which alludes to the eye-slashing opening sequence in "Un Chien Andalou," the seminal 1929 Surreal collaboration between Luis Buñuel and Salvador Dali, might seem pretentious. But "Cows" is a film so overflowing with what can only be called life-force energy that these digressions lend it an extra depth and poignancy. At these turning points, the viewer is momentarily prodded to see the film's larger-than-life characters as tragic, mortal creatures in a landscape that will outlast them and their joys and torments no matter how intensely they live.

"Cows," which the New Directors/New Films series is showing at the Museum of Modern Art this evening and tomorrow night, tells four related short stories that cover 60 years. It begins in 1875 in a trench during the Second Carlist War. Manuel Irigibel, a panic-stricken soldier, escapes a massacre by playing dead. He covers his face with the blood of his dead neighbor Camilo and rolls out of the cart that is carrying away the bodies of the slain soldiers. Only a lone cow witnesses his tumble to survival.

•

The film then jumps ahead 30 years. Manuel, who has never fully recovered from his war experience, is now a gentle, eccentric painter (obsessed with drawing cows) who shares a farmhouse with his son Ignacio and his family at one end of a beautiful, remote valley. At the other end, separated by a lush forest teeming with mystery and enchantment, live Camilo's children, Juan and Paulina. In one of the film's most viscerally exciting scenes, the rival clans meet at a log-chopping contest between Ignacio and Juan; it has the ferocity of a duel.

The intensity of that contest is matched by the secret passion shared by Ignacio and Paulina, which is later consummated violently in the forest. Their union produces an illegitimate son, Perú, who lives for a time with Manuel's family and becomes deeply attached to his half sister, Cristina.

In the final story, set in 1936, Perú, who has been living in America with his parents, returns to the valley to cover the Spanish Civil War as a photojournalist. This final section includes some remarkable in-the-thick-of-battle sequences set in the forest and shot with a hand-held camera.

More successfully than any film in recent memory, "Cows" brings to the screen the epic sweep and magical realist sensibility found in the work of writers like Gabriel García Márquez. Much more than a witty Surrealist joke, the recurrent cow imagery builds into a resonant symbol of the natural world and of the profound ties that the characters have to the land and to their past.

•

The movie offers many other powerful allegorical symbols. One is a scarecrow-like figure of the scythe-bearing reaper, built by Manuel, that turns in the wind and is a potentially deadly booby trap. Another, situated in the heart of the forest, is a bottom-

less pit in which dead animals are buried and out of which eerie cries emanate.

In a stroke of conceptual audacity, the director has cast Carmelo Gómez, an actor with hawklike features and slightly hooded eyes, as the young Manuel, his son Ignacio, and the adult Perú. Mr. Gómez succeeds wonderfully in creating very different personalities while at the same time suggesting a mystical continuity that transcends genetics and has to do with the soul and its relation to the land.

Ultimately, of course, the bovines that wander through the film lack any way of retrieving the past and forming an idea of history that the human characters create with their paintings, photographs and memories. In Mr. Medem's eyes, the related wars that form the bookends of the story are only manifestations of the mysterious, nearly ungovernable drives of people reared in a landscape that is as savage as it is ravishingly beautiful.

If "Cows" is so intense that its emotions border on the excessive, this stunning feature debut is clearly the work of a born film maker with a talent for translating memory into images so sharp and sensuous you can almost touch and smell them.

1993 Mr 30, C19:1

Oedipus Rex

Directed by Julie Taymor; based on Igor Stravinsky's opéra-oratorio (in Latin); performed by the Saito Kinen Orchestra and Shinyukai Chorus, conducted by Seiji Ozawa; produced by Peter Gelb and Pat Jaffe. At the Walter Reade Theater, 70 Lincoln Center Plaza. Running time: 60 minutes. No rating.

Oedipus Rex............................Philip Langridge
Jocasta.....................................Jessye Norman
Narrator................................Kayoko Shiraishi

By EDWARD ROTHSTEIN

There are two Oedipuses in the newly released film of Igor Stravinsky's opera "Oedipus Rex." One plays the traditional role, singing words adapted from Sophocles, words chronicling the downfall of the man who has given psychiatry its most potent myth. The other is a Butoh dancer, Min Tanaka. He is seemingly clad in layers of clay, wearing a stiff earthen mask, miming the doomed ruler's every gesture or enacting his history in formalized gestures. He is a lifesize puppet, a mirror of Oedipus, the Theban king who is himself a sort of puppet, forced into a tragic snare set by the gods.

But as the horrifying truth of Oedipus's past comes to light, the clay

From Stravinsky's opera, an eccentric vision of a disturbing work.

shell around Mr. Tanaka is shed, leaving a vulnerable, nearly naked man: the only human figure free of elaborate costume and cosmetic trappings in the entire film. He who has been so blind to himself blinds himself. We see shredded strips of blood-red ribbon hanging on his face. Groping, with a blank stare, he stumbles under the scaffolding and ramps that compose the somber stage set, until he is walking knee-deep in a pool of dark water, surrounded by ghostly figures. The chanting of the chorus has come to an end. We watch the water dripping from above, then hear the sound of cleansing, pouring rain. The king's almost primitive self-sac-

rifice has made him human; Thebes's plague is brought to an end.

•

This production, directed by Julie Taymor, adds a significant dimension to Stravinsky's work, bringing resonance without distortion. It was designed, from the start, for live performances at the first Saito Kinen Festival in Japan last September as well as for this hourlong film produced by Peter Gelb and Pat Jaffe. The film, which was a selection of the 1993 Sundance Film Festival, will be shown by the Film Society of Lincoln Center through Friday at the Walter Reade Theater. It will also be shown as part of the "Great Performances" series on PBS in May and will be released by Philips in compact-disk and video formats next fall.

Given its strong musical reading, with Seiji Ozawa conducting the festival's orchestra and a cast that includes Jessye Norman as Jocasta and Philip Langridge as Oedipus, the film offers an eccentric but powerful vision of this odd and disturbing work. Stravinsky wanted his transformation of the Sophocles drama to have an almost ecclesiastical power. The libretto, by Jean Cocteau, includes a declamatory narration meant to be delivered in the audience's own language, but the text of the ancient Greek drama is in Ciceronian Latin. The language, meant to be incomprehensible, distances the work, giving it a mythic stature.

The drama's major events are also told about, not shown or acted out, adding to the work's cool formality. Moreover, the score is astonishing, managing to have the ceremonial weight of a Russian Orthodox Church service while including parodies of Handel, Verdi, Mozart, Bizet and even, at a moment of supposedly high tragedy, a song Stravinsky borrowed from the Folies Bergère.

•

Ms. Taymor, who has won a MacArthur Foundation Fellowship for her dramatic work with puppetry and masks, has added several other lay-

ers to those in which Stravinsky encased Sophocles. The narration is delivered with knowing fury in Japanese by Kayoko Shiraishi, in traditional garb, who adds a Japanese ceremoniousness to what the narration calls the "monumental aspect" of the drama. Ms. Shiraishi begins the work begin by slashing through a curtain with a knife, revealing the stark set created by George Tsypin, who has also designed sets for recent Peter Sellars productions of "St. Francis of Assisi" and "The Death of Klinghoffer."

The banked platform elevated above a pool of dark liquid makes Thebes seem like the surface of another planet, on which troubled creatures roam; everything is dark, earth-toned; reflections from the pool shimmer on the singers. The 80-member chorus and 20 dancers look like plague victims, clad in frayed, ragged garments with their faces covered with gray, deathlike makeup. Ms. Taymor created enormous puppets, masks and sculpture, including a model of the Sphinx that disintegrates into fragments as Oedipus sings of his solving its riddle.

Characters wear sculptured heads perched on top of heavily made-up faces, with large sculptured hands frozen in expressive gestures. In one of the most haunting images, as Oedipus begins to discover that the man he killed at the famous crossroads was indeed his father, a web of red ribbons is stretched between Oedipus, his mother/wife Jocasta and a model of the chariot that carried Laius, the previous king, Oedipus's father.

•

Musically, the performance is acute, missing some of the humor in the score but preserving its grandeur. Mr. Ozawa's conducting is pungent. Mr. Landgridge's tenor sometimes has a domineering vibrato, but it is compensated for by a humane sympathy, particularly in Oedipus's delusional aria about how envied he must be for his good fortune. Ms. Norman gives an edgy anxiety to Jocasta, her first Carmenesque aria having the right element of bizarre playfulness. Bryn Terfel is an authoritative Creon, Harry Peeters a bit strained as Tiresius; the Shepherd and Messenger are well sung by Robert Swensen and Michio Tatara.

Caveats? One might have wished for more detailed subtitles; the text has more nuance than the screen allowed. The costumes of rotted cloth made the chorus seem like mummies come alive from a different film genre. There was also occasional awkwardness in the attempts to capture multiple stage events on camera. And some elements of intimacy that Stravinsky wrote into the score did not emerge from the ceremonial quality of this production, which sometimes flirted with excess.

But the masks and puppets, Oedipus's dancing double, the echoes of classical Japanese drama in most of the costumes by Emi Wada and make-up by Reiko Kruk, along with the Japanese narration, give this opera, usually staged as little more than an oratorio with costumes, extraordinary power. This production brought together a product of Parisian 20th-century modernism with the ancient classical cultures of Russia, Japan and Greece. Ms. Taymor also added elements of a contemporary avant-garde culture that, following Stravinsky's example, is attempting to recapture the primitive energy once possessed by art. On the television and movie screen, that venture is a success.

1993 Mr 31, C15:1

Krishi Miura

Jessye Norman, center, as Jocasta in the newly released film of Stravinsky's opera "Oedipus Rex."

Night Dance

Written and directed by Aleko Tsabadze (in Georgian with English subtitles); director of photography, Leri Matschaidze; edited by Lali Kolchidaschvili; music by Awto Nazaraschwili. At the Roy and Niuta Titus Theater 1, the Museum of Modern Art, 11 West 53d Street, Manhattan, as part of the New Directors/New Films series of the Film Society of Lincoln Center and the department of film of the Museum of Modern Art. Running time: 128 minutes. This film has no rating.

Moshe.....................Surab Begalischvili
Shiba.............................Amiran Amiranaschvili

By VINCENT CANBY

The setting is the former Soviet Socialist Republic of Georgia, a place where, according to Aleko Tsabadze's "Night Dance," the sun never shines. One can tell the difference between day and night because night is somewhat darker. The only warmth in the landscape is the kind that burns: the blast furnace of a steel mill not working at full capacity. Vacant lots are garbage dumps. Houses are dank. People wear long overcoats and walk with their heads down. Men need shaves. Every woman's face is pinched. A little girl sits on a small pot, constipated.

This is the devastated world of "Night Dance," which expresses its outrage about life in one corner of the old Soviet Union through poetic evocation. "Night Dance" is so strong and unremitting that it becomes an extension of that world, which is probably just what the film maker intended.

"Night Dance" will be shown at the Museum of Modern Art today at 6 P.M. and on Saturday at noon in the series New Directors/New Films.

•

Mr. Tsabadze, who now lives in Germany, is quoted in the film's publicity material as saying that he had to leave his native Georgia because he "couldn't sit down and write a script while people were being shot in the streets." One is thus led to assume that people are still being shot in the streets while he sits in Germany writing his scripts. That bears reporting only because everything about the Georgia in "Night Dance" appears to be hopeless. It's so hopeless that even the film's writer and director has turned his back on it.

"Night Dance" has a slight narrative about two friends, Moshe and Shiba, one of whom is more lively than the other, though which is Moshe and which is Shiba isn't always clear. They both drink too much. One has a quarrel with his mother-in-law and is taken to the police. Someone else is mistaken for an escaped convict. The police are no less authoritarian than they were in the old days, but there's no order left.

"Night Dance" is mostly effective as a collection of sometimes startling, almost surreal images of civilization's decline into boredom, drink and general dislocation.

1993 Mr 31, C20:1

Two Mikes Don't Make A Wright

THE APPOINTMENT OF DENNIS JENNINGS, directed by Dean Parisot; written by Steven Wright and Mike Armstrong, cinematography by Frank Prinzi. With: Steven Wright, Rowan Atkinson and Laurie Metcalf. PETS OR MEAT: THE RETURN TO FLINT, written and directed by Michael Moore; cinematography by Ed Lachman.

Film Forum

Steven Wright, seated, and Rowan Atkinson in a scene from "The Appointments of Dennis Jennings," one of the three satiric shorts that make up "Two Mikes Don't Make a Wright."

A SENSE OF HISTORY, directed by Mike Leigh; written by Jim Broadbent; cinematography by Dick Pope; released by October Films. These films are at Film Forum 1, 209 West Houston Street, South Village. Total running time of 79 minutes. These films have no rating.

By VINCENT CANBY

"Two Mikes Don't Make a Wright" is the title of the program of three short films opening today at the Film Forum, two of which, Michael Moore's "Pets or Meat: Return to Flint" and Mike Leigh's "Sense of History," were reviewed when they were shown at the New York Film Festival in September.

The third film is the 29-minute "The Appointments of Dennis Jennings," starring Steven Wright and written by him and Mike Armstrong, which won a 1989 Oscar as best live-action short. It's very much like one of Mr. Wright's stand-up monologues in which, with expressionless face and toneless voice, the comic looks at life's betrayals through the eyes of someone suffering from serious paranoia.

Mr. Wright plays Dennis Jennings who, when first met at his psychiatrist's office, is asking for help in finding his real stepfather, because his natural parents refuse to cooperate. He goes on to say that he remembers when he was in the womb: "I was on the right side." When Dennis looks at television, the people on the screen call others on to look at him.

"The Appointments of Dennis Jennings," which was directed by Dean Parisot, is about Dennis's unhappy relations with his girlfriend (Laurie Metcalf) and his eventually fatal run-in with his doctor (Rowan Atkinson). The gags are constructed entirely out of Mr. Wright's gift for describing singular neuroses. Among other things, he hates the idea of having cars behind him when he's driving, and he isn't sure whether his girlfriend really is pretty or just looks that way.

If you find Mr. Wright hysterically funny, you won't want to miss "The Appointments of Dennis Jennings." It is otherwise a very large dose of a comedian whose deadpan stories are funnier when they don't go on so monotonously long.

The two other films on the program are must-sees.

Mr. Moore's 25-minute "Pets or Meat: The Return to Flint" is an engagingly tatterdemalion sequel to his 1989 hit documentary, in which he examined the sad state of Flint, Mich., after mass layoffs by General Motors. Since he last visited Flint with a camera crew, things have continued to change, meaning that they've become worse for everyone, including Roger Smith, the G.M. chairman the film maker tried to interview earlier.

The program's high point is Mr. Leigh's "Sense of History," a one-character film that is not, strictly speaking, a Mike Leigh film at all. Mr. Leigh didn't write the script, as he usually does. Instead he sort of presides over it as the director. The

true auteur is Jim Broadbent, the 40-ish English actor who plays the bartender in "The Crying Game." Mr. Broadbent wrote the screenplay for "A Sense of History" and plays the portly, 70-ish 23d Earl of Leete.

In the course of a 25-minute monologue, the earl takes his unseen interviewer on a tour of the 900-year-old Leete estate, chatting all the while about his family, politics, his marriages and the skeletons in his closet. The film is a merciless, sometimes hilarious portrait of the aristocracy, though the earl is far from being a twit. He's a bigoted, arrogant lethal weapon of privilege.

"A Sense of History" is an exemplary work.

1993 Mr 31, C20:1

A Night in Versailles

Directed by Bruno Podalydès; screenplay by Bruno and Denis Podalydès, (in French with English subtitles); director of photography, Pierre Stoeber; edited by Marie-France Cuenot; music by Dominique Paulin. At the Roy and Niuta Titus Theater 1 in the Museum of Modern Art, 11 West 53d Street, Manhattan, as part of the New Directors/New Films' series presented by the Film Society of Lincoln Center and the department of film of the Museum of Modern Art. Running time: 47 minutes. This film has no rating.

Claire............................Isabelle Candelier
Arnaud.....................Denis Podalydès
André..............................Philippe Uchan
Jean-Claude...................Michel Vuillermoz
Chantal..............................Arian Pirie

Another Girl, Another Planet

Written and directed by Michael Almereyda; director of photography, Jim Denault; edited by David Leonard; produced by Mr. Almereyda, Robin O'Hara and Bob Gosse. At the Roy and Niuta Titus Theater 1 in the Museum of Modern Art, 11 West 53d Street, Manhattan, as part of the New Directors/New Films series presented by the Film Society of Lincoln Center and the department of film of the Museum of Modern Art. Running time: 56 minutes. This film has no rating.

Nic.............................Nic Ratner
Bill...........................Barry Sherman
Ramona............................Mary ward
Prudence.......................Lisa Perisot
Trish...............................Maggie Rush
Finley...............................Isabel Gilles
Mia..........................Elina Lowensohn
Bartender.....................Paula Malcomson
Men in Bar...........Thomas Roma; Bob Gosse

By VINCENT CANBY

"A Night in Versailles" and "Another Girl, Another Planet" are both shortish comedies about the anxious relations between the sexes. But in every other way they're as dissimilar as two films can be and still share the same host medium. They form the engagingly offbeat program that will be shown at the Museum of Modern Art today at 6 P.M. and on Saturday at 9 P.M. as part of the New Directors/New Films series.

The French-made, 47-minute "Night in Versailles" was directed by Bruno Podalydès and written by him and his brother Denis, who also plays the hilariously hapless central character. The film is a boisterous farce in the spirit of Feydeau, updated to the 1990's and scaled down to the dimensions of an especially small two-room flat.

Michael Almereyda's 56-minute "Another Girl, Another Planet" is something else entirely. It's as American as the East Village walk-up in which it was made, and as comically

angst-ridden and gray as its images. "Another Girl, Another Planet" was initially shot on a Fisher-Price Pixel toy video camera, then transferred to 16-millimeter film.

In this blow-up of the original tape, backgrounds appear to shimmer, as if molten, when the camera pans too fast. Dimly seen characters aren't always recognizable, and spoken words dissolve like cigarette smoke before they reach the ears. Yet what would be disadvantages in any other film become part of the texture of this comedy about the search for life's meaning and someone to go to bed with. The film's solemn ideas, like the characters who express them, are earnestly fuzzy.

•

A confession is in order here: it took me a second viewing to catch the rhythm as well as a good deal of the dialogue of "Another Girl, Another Planet." It follows the French film on the museum program to its disadvantage. Because "A Night in Versailles" is all bright color and bold, carefully choreographed movement, it takes a while to adjust to the miasmic conceits of "Another Girl, Another Planet."

The adjustment is worth the effort. Here is a singularly comic, deadpan appreciation of the feckless lives of a casual womanizer named Bill (Barry Sherman), his married pal Nic (Nic Ratner), who lives just downstairs, Nic's wife, Prudence (Lisa Perisot), and the other women who pass through their apartments. Everyone in the film appears to be at a different plateau in the upward quest for enlightenment. Some — like Nic, who drinks too much, and Bill, whose laidback manner disguises his desperate need for women — may still be at the bottom of enlightenment's ladder.

Among the women who walk in and out of Bill's life are Ramona (Mary Ward), a member of a rock group for which she sings back-up and shakes a tambourine, and Finley (Isabel Gilles), the most intense and affecting of the young women. Finley, a receptionist at the Museum of Modern Art, is recovering from her husband's death from cancer, an event she describes in detail that is far funnier than you might expect. There's also Mia (Elina Lowensohn), an exotic-looking Romanian whose truisms ("Eventually you learn you're no good unless you love yourself") seem to make her even more attractive to Bill.

Though they are living on the cheap, Bill and Nic seem to be no more than a subway ride from the Upper East or West Side comfort of indulgent families. Mr. Almereyda, who wrote and directed "Another Girl, Another Planet," was earlier responsible for the more conventional yet still pretty bizarre feature "Twister," about a supremely dysfunctional family in the Middle West.

•

"A Night in Versailles" demonstrates with great gusto and style the extent to which disasters can accumulate after one small lie has been told. Arnaud (Denis Podalydès), a fussy young man, has invited Claire (Isabelle Candelier) out from Paris to have supper with him at his tiny apartment in Versailles. The frozen moussaka is ready to be defrosted when she arrives. Then, because of a plumbing problem that need not be explained, Arnaud invites his brother to come by, too.

In the course of the evening, in which the lights go out, an intimate little dinner for two becomes a noisy circus that involves two of Arnaud's brothers, the building's opinionated janitor, the members of an orchestra and a very drunk young woman to whom someone gives a radish to settle her stomach. Like every decision Arnaud makes in the course of the night, the radish has unfortunate results.

"A Night in Versailles" is a delight.

1993 Ap 1, C22:1

Ingalo

Written and directed by Asdis Thoroddsen (in Icelandic with English subtitles); director of photography, Tahvo Hirovnen; edited by Valdis Oskarsdottir; music by Christoph Oertel; produced by Martin Schluter, Albert Kitzler and Heikki Takkinen. At the Roy and Niuta Titus Theater 1 in the Museum of Modern Art, 11 West 53d Street, Manhattan, as part of the New Directors/New Films series of the Film Society of Lincoln Center and the department of film of the Museum of Modern Art. Running time: 98 minutes. This film has no rating.

Ingalo Solveig Arnarsdottir
Sveinn........................ Haraldur Hallgrimsson
Skuli.............................Ingvar Sigurdsson
Vihjalmur.....................Thorlakur Kristinsson
The Crew.............. Eggert Thorleifsson, Bjorn Karlsson, Magnus Olafsson, Bessi Bjarnason, Jon Hjartarson, Bjorn Br. Bjornsson and Stefan Jonsson.

By JANET MASLIN

The bleak, scrappy Icelandic film "Ingalo" centers on the sullen title character, a tough adolescent with an unhappy past. First seen deflecting the catcalls of leering fisherman and fighting bitterly with her parents, Ingalo (Solveig Arnarsdottir) soon finds herself in difficulty. After starting a brawl in a local dance hall, she is sent from her rural home to a clinic in Reykjavik for observation. A doctor there, having considered the effects of Ingalo's childhood head injury and her penchant for physical attacks, pronounces the patient "a selfish bastard."

At the clinic, Ingalo meets a fellow patient (Thorlakur Kristinsson) and has a quick affair that is no less brutalizing than her other experiences. Dismissed by the man who seduced her, she returns to her small town, only to run away from home. Ingalo, along with her brother Sveinn (Haraldur Hallgrimsson), joins the crew of the very same fishing boat whose workers eyed her in the film's opening scene. The presence of this comely strawberry-blond cook makes the boat's raucous atmosphere even rowdier, but the tough-as-nails Ingalo remains unfazed.

•

At this point in Asdis Thoroddsen's film, it is revealed that Ingalo's lover from the hospital happens to be the owner of the fishing boat. This makes for the sort of stunning coincidence from which no film could easily recover, let alone a film as sprawling and uncertain as this one. Having seemed to focus on Ingalo's personal history, the film moves on to a larger, more general view of working conditions among Icelandic fishermen, who are lodged in fish processing plants between voyages and complain bitterly about living conditions in the dormitories there. Although it appears as if Ingalo's coincidental romances with both the company owner and a budding union leader will crystallize the drama, that never happens.

Described rather euphemistically as "a mosaic of stories" by its director, "Ingalo" is best watched for its grimly convincing view of the fishermen's lives. Ingalo herself remains too downcast and withdrawn to command much interest. but Miss Arnarsdottir does have a striking visual presence and strong self-assurance. She can also hold her own in a fistfight. She is eventually seen starting a riot to protest being lodged near a supply of dried fish, which attracts worms that then find their way into the fishermen's mattresses. The film is duly attentive to such details.

"Ingalo" can be seen tonight at 9 and Sunday at 3 P.M. as part of the New Directors/New Films series at the Museum of Modern Art.

1993 Ap 1, C24:1

Critic's Notebook

'Nosferatu' Is Still the Father of all Horror Movies

By CARYN JAMES

THE contemporary vampire has a certain charm, a je ne sais quoi that comes only from being undead. Think of the irresistible passion of Gary Oldman in Francis Ford Coppola's recent "Bram Stoker's 'Dracula,' " or the smooth-talking manner of Frank Langella in the stage and screen versions of "Dracula" from the late 1970's. Even Bela Lugosi's classic count looked like nothing more than a 1930's Latin lover shipped to Transylvania. They are suave seducers, able to steal a woman's soul and body with a neat prick to the neck. (Female vampires have not been so successful on screen; "Innocent Blood," with Anne Parillaud as the vampire who seduced Pittsburgh, and "Buffy the Vampire Slayer" were among last year's conspicuous flops.)

Vampires have not always been so appealing. The first major movie Dracula, and still the one most capable of producing nightmares, appears in F. W. Murnau's 1922 silent film, "Nosferatu: A Symphony of Horror." As Nosferatu (or the Undead), Max Schreck looks positively ratlike. He has a bald head, pointy ears, elongated hands with clawlike nails and two conspicuous fangs where his front teeth should be. His pasty-white coffin pallor hints at too many days out of the sun, and he walks stiff-armed and hunched over, like an animal not quite used to standing on his hind legs. This guy is no cutie face.

He is, however, the last of the great Victorian vampires and the father of all horror films. "Nosferatu" will be shown, with piano accompaniment and newly translated intertitles, today through Thursday at the Joseph Papp Public Theater in one of the rarest prints available. Every scene of this version is tinted either sepia or blue, following Murnau's instructions and the fashion of the day. This early form of coloring does not improve the atmosphere (a blue vampire is not as macabre as a black-and-white one), but it has the advantage of helping us see a classic with

Kino International Release

Victorian vampire: Max Schreck in "Nosferatu: A Symphony of Horror."

fresh eyes. The enduring power of "Nosferatu" is more than a testament to Murnau. It also suggests the depth and complexity of the vampire myth, which adapts to every era and genre. The disease-carrying hero can refer to the bubonic plague or to AIDS; his state of eternal unrest holds meaning for the religious and the godless; he is often alluring and repulsive at once. Vampires are shape shifters, in the symbolic as well as the physical sense.

The myth we know so well comes from Bram Stoker, whose 1897 novel, "Dracula," was about those inexhaustible subjects, sex and death. His late-Victorian vampire paid for the sin of uncontrollable passion by being doomed to a state in which no peaceful afterlife was possible. Barely under the surface of Stoker's novel is all the repressed Victorian sexuality about to break free at the turn of the century and the power of science (embodied by Professor van Helsing) ready to push aside religious faith.

When these undercurrents are brought to the surface, they shape the sexual, faithless vampires of contemporary culture: everything from the soap opera "Dark Shadows" to Anne Rice's best-selling series of vampire novels, to Werner Herzog's 1979 "Nosferatu the Vampyre," a brilliantly updated version of the Murnau film.

•

Murnau's "Nosferatu" followed Bram Stoker so closely that Stoker's widow sued for copyright infringement. Murnau's screenwriter, Henrik Galeen, had the sense to change the names. Count Dracula becomes Count Orlok; Jonathan Harker, the clerk who is sent to Transylvania to rent the count a house, is called Thomas Hutter; his wife, Mina, becomes Ellen, who gives herself to the vampire one night so that he will be with her when the sun rises and so will be destroyed.

None of this fooled the German courts, which ruled in favor of Mrs. Stoker, stopped screenings of the film and ordered that all prints and negatives be destroyed. Of course they weren't, but what remained were pirated and re-edited prints. There are probably as many bastardized versions of "Nosferatu" as there are of James Joyce's "Ulysses."

The "Nosferatu" at the Public is 84 minutes long (a blip by today's movie standards), but even so it takes quite

A revival from 1922, before vampires became glamourpusses.

a while for Hutter to make his way from his blissful honeymoon cottage to the count's castle. As soon as Hutter gets in sight of the Carpathian mountains, Murnau's visual genius takes charge.

When the count's carriage takes Hutter to the castle, the ride through the woods is shown as a negative image. The trees are white during this eerie ride carrying Hutter to a place where the ordinary rules of nature don't apply. Murnau's ghastly vampire walks toward the camera at a threatening angle and casts creepy shadows on the castle walls.

Klaus Kinski and Isabelle Adjani in Werner Herzog's "Nosferatu."

After all these years, no old vampire movie is completely free of camp. Murnau's campiest moment comes when Nosferatu looks at a photograph of Ellen and tells Hutter, "Your wife has a beautiful neck." When he arrives in Visborg from Transylvania, he prances in front of the Hutter house, carrying his trusty coffin under his arm. But for most of the film, he is seriously ghoulish.

One of the most chilling scenes ever filmed is the one in which Nosferatu climbs the stairs to Ellen's bedroom. He appears only as a silhouette on the wall, his hunched figure and lethally long claws slowly heading toward the bride who is shuddering in her bed. Such moments of intense horror leap out from a sometimes flabby narrative and make this "Nosferatu" worthwhile.

The vampire's sexual nature is obvious in Stoker, but attitudes have shifted since then. Sympathy for the vampire becomes pronounced in the late 20th century. Today's vampire (even in the age of AIDS) is often admired for his passion. And there is genuine pity for a creature trapped in an unnatural state between life and death.

Mr. Herzog's "Nosferatu" is an homage to Murnau's, sometimes right down to his camera angles. It is a remarkably haunting film that remains faithful to the myth passed on from Stoker yet adds a contemporary sensibility. Klaus Kinski is made up to resemble Max Schreck's rodentlike count, but where the original was simply ghoulish, Mr. Kinski's vampire is a tortured soul who retains traces of humanity. (Without those pesky copyright problems, his character can again be called Count Dracula.)

"Centuries come and go," Dracula tells Harker (Bruno Ganz) in a low and mournful voice. "To be unable to grow old is terrible. Death is not the worst."

When he serves a late supper to Harker, who accidentally cuts his thumb on a bread knife, we can see the vampire turn away and resist the impulse to suck the blood from his guest's thumb. Then he pounces, grabbing Harker's thumb into his own mouth. This has become a stock scene in vampire movies, going back to Murnau, but it had never been played with so much tension before.

And this Nosferatu goes to Harker's wife (Isabelle Adjani) and asks her to give herself to him not only to save her husband, but also because, "The absence of love is the most abject pain." When she finally lies in her bed waiting for the vampire, it is with a great deal more peace and resignation than the wife had in the Murnau version. There is even a hint of sexual enjoyment. When he plunges his fangs into her neck in an obvious sexual gesture, she arches her neck back and gasps in a manner that makes it impossible to separate pleasure from pain. Photographed in romantic, jewellike colors, the Herzog "Nosferatu" is less a horror film than an exploration of the horrors of modern love and loneliness.

If the Kinski Dracula is tortured, Mr. Oldman's vampire in the Coppola film is both tortured and heroic. He loves and desires Mina (Winona Ryder), but wonders if he should have sex with her and doom her to eternal unrest. Mina says yes, a response that is only partly about sexual abandon. For while vampires loathe their undead condition, that state also possesses a forbidden allure, the next best thing to eternal life. In the modern age, Dracula can seem like a messenger from the other world, suggesting a kind of afterlife for an era not unanimously inclined to believe in one. Being undead doesn't seem like a bad alternative to no existence at all. "Bram Stoker's 'Dracula' " is very much Francis Ford Coppola's Dracula, a product of its age.

Of course, the Nosferatu myth is also goofy. The long list of vampire movies includes the stylish, underrated 1983 film "The Hunger," with Catherine Deneuve and David Bowie as aging vampires in contemporary Manhattan. But that list is dominated by campier titles like "Billy the Kid vs. Dracula," "Dracula's Widow," and "Dracula's Dog" (also known as "Zoltan, Hound of Dracula"). The typical movie Dracula is a bloodsucking creature who turns to dust in sunlight, is allergic to crucifixes, garlic and mirrors and can fly like a bat out of Transylvania. He is just waiting for a stake through the heart.

But the great vampire movies, like "Nosferatu," never die.

1993 Ap 2, C1:4

Visions of Light
The Art of Cinematography

Directed by Arnold Glassman, Todd McCarthy and Stuart Samuels; screenplay by Mr. McCarthy; director of photography, Nancy Schreiber; edited by Mr. Glassman; produced by Mr. Glassman and Mr. Samuels; released by Kino International. At the Film Forum, 209 West Houston Street, South Village. Running time: 90 minutes. This film has no rating.

WITH: Conrad Hall, Ernest Dickerson, Vilmos Zsigmond, Gordon Willis and others.

By VINCENT CANBY

Don't be put off by the title, which, though perfectly correct, would seem to promise a long snooze in an arid hall of academe. "Visions of Light: The Art of Cinematography" is the vibrant, gloriously documented tale of the evolution of motion-picture photography, told in the words of the cinematographers themselves and in scenes from 125 films.

This 90-minute documentary is so energizing that when you leave the Film Forum, where "Visions of Light" opens today, you'll want to rush out to see, or see again, virtually every film that has just been recalled. "Visions of Light" may not change your life, but it will certainly enrich your appreciation for the whole complex, collaborative process by which random ideas are somehow transformed into films that occasionally exalt.

The clips in "Visions of Light" recall virtually the entire history of cinematography, from D. W. Griffith's "Birth of a Nation" (1915) through such 1990 releases as "Goodfellas" and "Do the Right Thing." Though it has the manner of a conventional anthology film, this documentary is no mere exercise in nostalgia. It's a vastly entertaining introduction to an art that's not always easy to see.

•

The first time one watches any film, whether it's "Coconuts" (1928) with the Marx Brothers, Orson Welles's "Magnificent Ambersons" (1942) or Jules Dassin's "Naked City" (1948), the immediate response is to the entire experience, not to the particular elements that make up that experience. One remembers general feelings: pleasure, pain, laughter, boredom, anger, joy. Films, even bad ones, have a way of being so totally involving that only great and terrible moments are remembered. The craft by which effects are achieved goes unnoticed. This is the way it should be, according to the 27 cinematographers who are interviewed here.

There are exceptions. There's absolutely no way that anyone can look at "The Magnificent Ambersons" for the first time and not emerge from the theater bewitched by Stanley Cortez's remarkable deep-focus camera work. It's almost as if the movie were in 3-D. Deep-focus, the method by which characters and objects far from the camera are seen as clearly as those that are close, had been used many times before, most memorably in "The Long Voyage Home" (1940) and in Welles's "Citizen Kane" (1941). Yet in "Ambersons," deep-focus becomes the film's resonant "voice": as important to the story as the information supplied by the soundtrack narrator.

It was also impossible to ignore the effect of color in the first great Technicolor films of the 1930's. Indeed, the Technicolor movies were shot in a way to constantly remind audiences

they were seeing color, as when in "Becky Sharp" (1935), photographed by Ray Rennahan, the heroine's cheeks turn a decided red when she's suddenly embarrassed.

Mostly, though, the cinematographer's art is supposed to go unremarked upon by everyone except other film makers. "Visions of Light" recognizes the possibility that today's more sophisticated, more cinema-literate audiences stand to have their enjoyment enhanced by these insiders' comments on their art.

•

Arnold Glassman, Todd McCarthy and Stuart Samuels share credit as the directors of "Visions of Light." In such circumstances, it is usually difficult to tell who contributed what, though Mr. McCarthy, a critic for Variety as well as a writer of other film documentaries, is also credited with having written "Visions of Light" and conducted the interviews. Some extra credit must therefore go to him for somehow managing to obtain remarkably informative testimony from the sort of artists who are not usually all that articulate.

Or, as Conrad Hall, the man who shot "In Cold Blood" (1967), says at one point, "I think visually." He and his associates may think visually, but before the camera in "Visions of Light" they also talk extremely well about what they do best.

Ernest Dickerson, Spike Lee's long-time collaborator, remembers when he was a boy and first saw David Lean's "Oliver Twist" (1948), photographed by Guy Greene. The huge emotional impact, he says, was at first mysterious to him; then he realized that "it was the light." His story, like those of the others interviewed here, is a story of light and the absence of light. In cinematography, it's a magical, constantly shifting equation.

•

"Visions of Light" follows the history of cinematography from the remarkably productive collaboration of Griffith and his cameraman, the great Billy Bitzer, into the Golden Age of the silents when, the interviewees agree, the camera was free, being small and portable. "Sound," says Vilmos Zsigmond ("McCabe and Mrs. Miller," "Close Encounters of the Third Kind," among others), "was a great catastrophe for movie making." Because the early sound cameras were so big and cumbersome, movies almost stopped moving.

"Visions of Light" recollects, among other things, how movies (and cinematographers) recovered their freedom, how cinematographers invented what they needed to develop along the way, how individual studios established their own visual identity through the kinds of films they specialized in, and how the "look" of movies changed in the 1960's when directors moved out of the studios to actual locations.

It's a documentary loaded with its own memorable first-hand moments, as when Gordon Willis talks about his contributions to the "Godfather" films, which earned him the nickname "Prince of Darkness." "Sometimes I went too far," Mr. Willis says of the deep shadows he favored when lighting Marlon Brando. He pauses, then adds with no false modesty, "I think Rembrandt went too far, too, sometimes."

"Visions of Light" is a sumptuous achievement of its kind. The responses to Mr. McCarthy's questions are so

good and so rich that its text might well make a book. In any case, that text exists in "Visions of Light," accompanied by a dazzling array of clips to show what the interviewees are talking about. This is not a movie to be seen on anything except a screen that is at least three times taller than the person sitting in front of it.

For a big movie, a big screen.

1993 Ap 2, C10:5

Jack the Bear

Directed by Marshall Herskovitz; screenplay by Steven Zaillian, based on the novel by Dan McCall; director of photography, Fred Murphy; edited by Steven Rosenblum; music by James Horner, Ian Underwood, Ralph Grierson, clayton Haslop, Jim Walker and Tommy Morgan; production designer, Lilly Kilvert; produced by Bruce Gilbert; released by 20th Century Fox. Running time: 98 minutes. This film is rated PG-13.

John Leary	Danny DeVito
Jack Leary	Robert J. Steinmiller Jr.
Dylan Leary	Miko Hughes
Norman Strick	Gary Sinise
Mr. Festinger	Art LaFleur
Elizabeth Leary	Andrea Marcovicci
Peggy Etinger	Julia Louis-Dreyfus
Karen Morris	Reese Witherspoon

By JANET MASLIN

"Jack the Bear" is the dark, peril-ridden story of a widowed father (Danny DeVito) trying to bring up his two young sons. The place is Oakland, Calif., the year 1972, and the neighborhood so frightening that every house holds some new terror. "I didn't know yet what I was going to learn that year: that monsters are real," says the title character, Jack Leary (Robert J. Steinmiller Jr.), an otherwise likable boy with the onerous job of delivering frequent doses of foreshadowing.

Presented as a grim coming-of-age drama, "Jack the Bear" was directed by Marshall Herskovitz, co-creator of television's "Thirtysomething." It's an instant reminder of that show's taste for navel-gazing, since it takes a potentially small, delicate story and overloads every bit of the tale. Based on Dan McCall's novel and written with strained sensitivity by Steven Zaillian, "Jack the Bear" has a basic and insurmountable problem. Though its characters are played appealingly, nothing that happens to them can be believed.

Without the help of some remarkably trumped-up coincidences, this would simply be the tale of a family trying to heal itself after the death of one parent. And that would be enough. But "Jack the Bear" is filled with red-hued flashbacks of the dead mother (Andrea Marcovicci), weird events in the neighborhood and a scary criminal episode that seems wholly contrived. Not even Gary Sinise's frighteningly intense performance as a blind neighbor can make that neighbor credible, not after he talks an unsuspecting child into dressing up as a Nazi for Halloween. That episode, like many in the film, would have worked a lot better without the overkill. •

Mr. DeVito has his own odd habits as John Leary, a man who plays monsters on late-night television and can march off to work cheerily hoisting a cleaver. The neighborhood children are meant to love him, and he is meant to discover the meaning of true monstrousness before the film is over. He is also meant to discover his nurturing, family-loving side, which is where the navel-gazing comes in

Danny DeVito

Melinda Sue Gordon

and where the film goes particularly soggy.

Mr. DeVito tackles this role with obvious conviction, but he fares best with its sardonic side. "I didn't poison your dog, Norman," he tells Mr. Sinise's character after an unfortunate prank has occurred. "If you knew me better, you'd know it's not my style. I'd-a shot him."

Also part of the film's sturdy cast are Miko Hughes as the younger brother who becomes central to the story's least-believable episode, and Reese Witherspoon as a pretty classmate with whom Jack has a pre-adolescent date. Ms. Witherspoon's current appearance in "A Far-Off Place" has her looking a couple of years older than she does in "Jack the Bear," which may indicate how much time this somber, problematic film has spent on the shelf.

•

"Jack the Bear" is rated PG-13 (Parents strongly cautioned). It includes mild profanity and several menacing scenes that might frighten young children.

1993 Ap 2, C12:6

The Adventures of Huck Finn

Directed and written by Stephen Sommers; director of photography, Janusz Kaminski; edited by Bob Ducsay; music by Bill Conti; production designer, Richard Sherman; produced by Laurence Mark and John Baldecchi; released by Walt Disney Pictures. Running time: 106 minutes. This film is rated PG.

Huck	Elijah Wood
Jim	Courtney B. Vance
The Duke	Robbie Coltrane
The King	Jason Robards
Pap Finn	Ron Perlman
Widow Douglas	Dana Ivey

By JANET MASLIN

Viewed as a cinematic property even if it never was intended as one, "The Adventures of Huckleberry Finn" is an either-or proposition. Either the sweeping breadth and satirical tone of Mark Twain's classic novel are somehow approximated, in which case the material will elude most young viewers, or the story must be scaled down.

Choosing the latter route, Walt Disney Pictures has succeeded in turning "The Adventures of Huck Finn" into a simple, spirited escapade

meant for older children, who will certainly grasp the essence of Twain's story if not the nuances. For viewers of any age, this film is good fun and demonstrates a certain daring. Disney's "Adventures of Huck Finn" serves as a sprightly, good-humored introduction to a book that would otherwise be seriously out of fashion.

Despite the film's opening exhortation ("Get ready for a spit-lickin' good time!"), it works hard to avoid turning cute. As directed and adapted by Stephen Sommers, it also does well at retaining the flavor of Twain's language while shifting the dialogue toward present-day vernacular. And it is reasonably true to Twain's conception of his central characters, successfully presenting the union of a rascally white boy and a runaway slave (the film eschews Twain's use of the word "nigger" in describing Jim) as a flesh-and-blood friendship. The film does not compromise Huck's first benighted opinions about slavery to soft-pedal its hero.

A flesh-and-blood friendship with moral overtones.

As played by the precociously self-assured Elijah Wood, this Huck is a smart, winsome kid with a mischievous streak. For all practical purposes, that's close enough, as is Courtney B. Vance's sympathetic but independent-minded Jim. These two work well together in voicing the debate about slavery that is at the heart of the story and can also be seen as a larger moral argument. Jim articulates the latter when he tells Huck, "Just because you're taught something's right and everybody believes it's right, that don't make it right."

That Huck is slow to embrace such ideas ("I never heard such talk in my life!" he says at the thought that all men should be free) provides part of the drama. Otherwise, this "Huck Finn" is an episodic set of adventures, some of them cannily heightened to suit the tastes of contemporary viewers. Huck's masquerading as a girl in one scene now has him stuffing kitchen supplies into his dress, for example. The novel's version of this event is less antic and more wry.

Since the story drifts as languidly as a raft on the Mississippi, it might have benefited from a bit more cinematic glamour than Mr. Sommers provides. The cast is admirable (Jason Robards and an Americanized Robbie Coltrane turn up as the story's flimflamming King and Duke), but the film at times looks drab and lacks an essential flamboyance. A more daring, outlandish approach along these same lines would certainly have been welcome. There are times when this "Huck Finn" grows colorless, although it always holds the attention.

Mr. Wood does have the requisite verve for the story's central role. His Huck is a breezy, entertaining embodiment of Twain's little pragmatist, the boy who asked himself: "What's the use you learning to do right when it's troublesome to do right and ain't no trouble to do wrong, and the wages is just the same?" The movie's Huck demonstrates the kind of spark that would lead him to ask a similar question. He also shows the sense to find the right answer.

John Bramley

Elijah Wood, left, and Courtney B. Vance.

"The Adventures of Huck Finn" is rated PG (Parental guidance suggested). It includes mild violence and slightly rude language.

1993 Ap 2, C15:1

Cop and a Half

Directed by Henry Winkler; written by Arne Olsen; director of photography, Bill Butler; edited by Daniel Hanley and Roger Tweten; music by Alan Silvestri; production designer, Maria Caso; produced by Paul Maslansky; released by Universal Pictures. Running time: 87 minutes. This film is rated PG.

Nick McKenna Burt Reynolds
Devon Butler Norman D. Golden 2d

By STEPHEN HOLDEN

The gimmick may be cute, but it is also somewhat unsettling to watch Norman D. Golden 2d, a child actor who suggests a pint-size Eddie Murphy, imitate a police officer in the action-comedy "Cop and a Half."

In the film, Norman plays Devon Butler, a sassy third grader who has his own handcuffs and wields his red-and-gold plastic water pistol as though it were a lethal weapon. Stalking through the schoolyard with his toys, he earnestly re-enacts the clichés of police action films, grimly ordering people to "Freeze!" and warning, "You're dead meat now."

Soon enough, Devon gets his chance to play the role for real. After witnessing a murder in a warehouse, he refuses to divulge any information unless he is made a policeman. In a compromise, he becomes partner for a day with Nick McKenna (Burt Reynolds), a cranky middle-aged officer who claims to hate children.

Before long, the pair are being pursued with intent to kill by the drug-dealing gang that carried out the warehouse murder. Eventually, of course, Nick warms to Devon (who is being brought up by a stern but loving grandmother, Ruby Dee) and the two form a father-son bond. Among the macho trials they survive on the way to becoming a family of sorts are a brawl in a biker bar and a boat chase in which they prepare themselves for a particularly daring stunt by singing "The Star-Spangled Banner."

In the film's most amusing scene, Devon also gets to stop one of his grade-school teachers for speeding and grills him in his best mean-cop manner. "I'm your worst nightmare," he growls, from behind oversize sunglasses. "An 8-year-old with a badge." "Cop and a Half," which was directed by Henry Winkler, has quite a few such comic moments. The outlaw leader (Ray Sharkey) fancies himself a latter-day Dion DiMucci, and meetings with his henchmen are prefaced with an enforced group rendition of "The Wanderer."

For all its amusing touches, "Cop and a Half" is as slick and predictable, and as glib about exalting juve-

nile violence, as last year's family-comedy hit "3 Ninjas." When Devon is asked how, at the age of 8, he has learned to swagger like a police officer, he breaks into a grin and boasts, "From prime-time TV."

"Cop and a Half" is rated PG (Parental guidance suggested). It has several violent scenes staged in a comic way with almost no blood.

1993 Ap 2, C17:1

A Boy Who Prefers Fantasy to Reality

"Léolo" was shown as part of last year's New York Film Festival. Following are excerpts from Janet Maslin's review, which appeared in The New York Times on Sept. 29, 1992. The film, in French with English subtitles, opens today at the Lincoln Plaza Cinema, 63d Street and Broadway, and the Angelika Film Center, Mercer and Houston Streets, SoHo.

To watch Jean-Claude Lauzon's daring, bracingly original "Léolo" is to descend into a carnal nightmare, the dream of a clever and desperate French Canadian boy. His name is Leo Lauzon, but he has determined through sheer force of will to become someone else. Renaming himself Léolo Lozone, he imagines a new life as an exultant young Sicilian in an effort to escape the misery he faces at home in Montreal. Léolo's theory of his own genesis — involving his corpulent mother (Ginette Reno), a Sicilian peasant and a sperm-laden tomato — is typical of the bizarre lengths to which this boy will go to escape his fate.

As the film hauntingly demonstrates, through eccentric humor that gradually gives way to devastating seriousness, Léolo (Maxime Collin) is the only healthy member of a demented family. He hangs onto hope and sanity by the most fragile thread. Only by inventing various escape routes can Léolo endure the series of everyday humiliations that come his way, humiliations depicted by Mr. Lauzon (whose film is described as semi-autobiographical) in sometimes startlingly crude detail. This film maker's taste for the scatological may send some viewers heading for the exits. But that aspect is linked to a remarkable delicacy, and to a pure, fearless sense of purpose that raises "Léolo" far out of the ordinary.

"My family had become characters in a fiction, and I spoke of them as if they were strangers," Léolo says in the deep, pensive voice of the film's mature narrator. The boyish Léolo writes a memoir about his family, looking to art and self-expression as his only available means of escape, and revering the power of the written word.

•

The rest of his relatives numbly indulge various strange tastes and move in and out of a nearby mental hospital with frightening ease. The mixture of terror, bemusement and grudging loyalty with which Léolo observes all this is the basis for the film's fluid, unusual style.

Mr. Lauzon moves in a circular way past all the freakish landmarks of Léolo's home life: the fanatical attention to toilet training, the brutish father, the oblivious mother, the doomed sisters and the grandfather (Julien Guiomar) on whose genes Léolo blames all these troubles. It is,

he writes, "as if my grandfather's legacy had exploded in our family, and that little extra cell had lodged itself in everybody's brain." So during the film Léolo and his grandfather try to kill each other, with the kinds of fanciful results that make "Léolo" so thoroughly unpredictable. When his grandfather tries to drown Léolo in a tiny wading pool (because the boy has splashed him), Léolo suddenly finds himself deep underwater, gazing at a golden treasure chest on the ocean floor.

The film's seemingly whimsical anecdotes begin to take on a terrible gravity as Mr. Lauzon moves his story past some point of no return. Initially amusing episodes begin to turn grim. Among the brutish physical experiences the film describes, only a few stand out as gratuitous, most notably a "Portnoy's Complaint"-style encounter between the sexually overeager Léolo and whatever his family will have for dinner. Mr. Lauzon also lets the film spend excessive time in the bathroom, in episodes that are part Philip Roth and part Addams Family. But in the end, these sequences work as part of the film's cumulative success in making Léolo's revulsion and horror viscerally real.

1993 Ap 2, C17:1

Rock Hudson's Home Movies

Written, edited, directed and produced by Mark Rappaport; released by Couch Potato Productions. The Joseph Papp Public Theater, 425 Lafayette Street, East Village. Running time: 63 minutes. This film has no rating.

Rock Hudson Eric Farr

By JANET MASLIN

Rock Hudson's cinematic pillow talk went unexamined during the 1950's, but it now comes under the caustic gaze of Mark Rappaport, whose hourlong documentary "Rock Hudson's Home Movies" locates the latent content of many a Hudson mannerism. It is Mr. Rappaport's not very debatable assertion that the star's hidden homosexuality was in fact an open secret and that his performances as a romantic leading man had their sly side. Maintaining that the actor displayed a split personality on screen ("Dr. Macho Jekyll and Mr. Homo Hyde"), Mr. Rappaport avidly assembles evidence to support his claims.

Certainly this engrossing documentary finds a lot to work with, particularly when it comes to Hudson's movie romances. "I haven't any wife," he is heard explaining to Elizabeth Taylor. "I live with my sister." When

Doris Day asks why he can't marry, he replies that "it's the kind of thing a man doesn't discuss with a nice woman." And Dorothy Malone eyes him knowingly as she says, "There's only so much a woman can do, and no more."

The film devotes special attention to scenes in which Hudson feigns stereotypically gay behavior in order to fool Ms. Day into thinking he is no lady-killer. Eric Farr, who is seen posing beside cutouts of Hudson and supplies what is supposed to be Hudson's inner voice, describes this as "doing my shy homo routine to get Doris to seduce me." The film indeed finds something startling in the sight of a shocked Hudson exclaiming: "In your apartment? *Alone* with you? All night?" It also watches him sit by innocently as his films dish out innuendoes about male characters who like recipes or are devoted to their mothers.

•

Mr. Rappaport is even more enterprising in ferreting out provocative behavior between Hudson and other men, devoting especially close scrutiny to comic scenes in which Tony Randall played Hudson's sidekick. "Tony reads his lines, which are obviously engraved on my chest," the film's "Rock" says sarcastically, while the camera offers a salient freeze-frame of the encounter. In this case, the film is careful to offer a disclaimer of sorts. "In all fairness, I had nothing to do with writing these scripts any more than Tony did," "Rock" says. "We just did what we were paid to do."

At times like this, despite the ostensible tact, Mr. Rappaport's approach becomes much too smirky. That's too bad, because so many of his observations are actually so shrewd. Only in emphasizing cruising does the film begin to seem tenuous, as when it suggests that every time Hudson said, "Do you live around here?" or "Don't I know you from somewhere?" he was speaking a language that is solely gay. And Mr. Rappaport's search for covert meanings need not have led him to a selection of death scenes and AIDS innuendoes, which seem more ghoulish than prescient in this context.

For all its occasional flippancy, "Rock Hudson's Home Movies," which opens today at the Joseph Papp Public Theater, is a savvy and entertaining compilation. Its net effect is best conveyed by Mr. Farr, whose "Rock" asks, "Who can look at my movies the same way ever again?"

1993 Ap 2, C20:6

The Genius

Directed by Joe Gibbons, with Emily Breer; screenplay by Mr. Gibbons; edited by Ms. Breer. At the Roy and Niuta Titus Theater 1 in the Museum of Modern Art, 11 West 53d Street, Manhattan, as part of the New Directors/New Films series of the Film Society of Lincoln Center and the museum's department of film. Running time: 100 minutes. This film has no rating.

Desmond Denton Joe Gibbons
Kitty Church Karen Finley
Les Alabaster Tony Oursler
Dirk Dirkson Tony Conrad
Kiki Dirkson Corinne Mallet

By STEPHEN HOLDEN

Few subjects are riper for satire than the New York art world, with its hyperinflated egos and exalted prices

for gimmicky trash. And in their goofy 16-millimeter feature, "The Genius," the directing team of Joe Gibbons and Emily Breer has created a ramshackle art-world farce whose charm lies in its not taking itself too seriously.

"The Genius," which the New Directors/New Films series is showing at the Museum of Modern Art tonight at 9 and tomorrow at 3 P.M., is part science-fiction spoof, part SoHo-style home movie. Set in the near future, it imagines a time when Manhattan's downtown galleries have been taken over by the ultra-conservative American Family League. They now bear the names of Wall Street brokerage houses and promote what is called "the new formalism."

The film's most nefarious character is a greedy dealer (Tony Conrad) who hooks his artists on a creativity-enhancing drug. Turned into compulsive painting machines, they grind out canvases of corporate logos.

Into this milieu stumbles Desmond Denton (Mr. Gibbons), a scientist who has discovered a technique for extracting the personality attributes of one individual and transferring them to the brain of another. When Desmond falls in love with Kitty Church (Karen Finley), an artist who was dropped by her gallery for being too controversial, he conceives the notion of transplanting the personality of her boyfriend, Les (Tony Oursler), into his own brain.

Although Desmond achieves the romantic results he had hoped for, he remains unsatisfied. Ultimately, he decides that instead of trying to appeal to Kitty, he will simply assume her personality. Unbeknownst to him, she is the terrorist who has made national headlines bombing Manhattan galleries, and soon he is stalking around SoHo, planting explosives.

Mr. Gibbons, who produced and wrote "The Genius," in addition to being a co-director and one of its stars, has achieved cult popularity with a series of Super-8 comic fantasies with an autobiographical bent, in which he addresses the camera directly. "The Genius" is a technically more sophisticated extension of those experiments. Desmond is not only the central character, but also a combination of host, narrator, lab specimen and loopy alter ego for Mr. Gibbons.

As diverting as it is, "The Genius" is too long. Its dullest moments are sequences in which Desmond tries on euphoric, depressed and psychopathic personalities. And in spoofing the censorship battles of the George Bush Administration, the film also feels slightly behind the times. Among the home-movie-style comic performances, Ms. Finley nearly walks away with the film. As Kitty, Ms. Finley is volatile, funny and scary in many of the same ways she is in her outspoken solo performance-art pieces.

1993 Ap 2, C34:1

Manhattan by Numbers

Written, directed and edited by Amir Naderi; director of photography, James Callanan; music by Gato Barbieri; produced by Ramin Niami. At the Roy and Niuta Titus Theater 1 in the Museum of Modern Art, 11 West 53d Street, Manhattan, as part of the New Directors/New Films series presented by the Film Society of Lincoln Center and the museum's department of film. Running time: 88 minutes. This film has no rating.

George Murphy.................John Wojda
Chuck Lehman.............Branislav Tomich
Ruby.....................Mary Chang Faulk
Fabric Store Owner..........Lee Crogham
Mouse Man..................William Rafab

By VINCENT CANBY

Amir Naderi's "Manhattan by Numbers" is a quite beautiful if uninvolving exercise in urban alienation, prettily shot against a variety of photogenic New York locations. The film will be shown at the Museum of Modern Art today and Sunday at 6 P.M. as part of the New Directors/New Films series.

In the course of a single day, George Murphy (John Wojda), a youngish out-of-work newspaper reporter, desperately crisscrosses Manhattan in a futile hunt for the $1,200 needed to pay the back rent on his apartment. George is about to be evicted, and his life is collapsing. His wife has left him, taking their child. He's out of touch with former colleagues.

In his need to find the money, he searches for Tom, a long-lost friend who becomes as elusive as the grail. Many mutual friends have seen Tom recently, but either they have forgotten where, or Tom has departed when George arrives at the place. The search for Tom doesn't narrow, it widens. It turns into a search for Tom's apartment superintendent, for his other friends, for his wife.

•

It's quickly obvious that Mr. Naderi, who wrote, directed and edited the film, regards the search as an end in itself, though the unfortunate George continues to push on. That much is clear almost from the start of the film. "Manhattan by Numbers" is less concerned with conventional narrative than with evoking a state of mind and a sense of place.

Yet Mr. Naderi's manner of evoking a sense of place overwhelms George's state of mind. The film's images are so pristine, and so perfectly chosen to create a cross-section of the city, that poor George, who looks handsome and untouched by care, becomes a tiny cipher at the center of the screen. He's a mobile model surrounded by scenery. The film's poetic concerns seem to have little to do with the elegance of its techniques.

"Manhattan by Numbers" is the first English-language feature by the Iranian-born film maker, whose "Water, Wind, Sand" was presented at the New Directors/New Films series in 1990.

•

Sharing the program is "The Thrill," Angelika Mönning's 28-minute film based on the Anton Chekhov story "The Joke." Shot in New Jersey, the film is a deadpan tale of how a young woman, who works in a suburban beauty shop, eventually frees herself from her obsessive love for a young man not of her caliber. In "The Thrill," the almost idyllic setting works as ironic counterpoint to the seething emotions of the principal character. In its own uninflected way, "The Thrill" is funny.

1993 Ap 2, C34:4

A Bergman Memoir By Son and Father

By VINCENT CANBY

Having begun in celebratory fashion with Sally Potter's extravagant and witty adaptation of Virginia Woolf's "Orlando," the 1993 New Directors/New Films series ends this weekend with a new Swedish film of equally high and exciting caliber: "Sunday's Children," another gorgeous, richly poignant memoir written by Ingmar Bergman but directed by his son Daniel as his first feature. The film will be shown at the Museum of Modern Art today at 6 P.M. and tomorrow at 9 P.M.

"Sunday's Children" is smaller in scale than both "Fanny and Alexander" (1982), Mr. Bergman's fantastical epic about his maternal grandparents' family, and "The Best Intentions" (1992), which examines the troubled relationship of his parents just before his own birth in 1918. Bille August directed that film from Mr. Bergman's screenplay.

•

Though the master keeps saying that he has retired from film making, you would hardly know it from the extraordinary films that continue to appear. "Sunday's Children" is of such a piece with "Fanny and Alexander" and "The Best Intentions" that comparisons are beside the point. It is a continuation of those films, not necessarily of their narratives but of their concerns.

"Sunday's Children" is a novella alongside the two novelistic earlier films. It's really little more than a single anecdote, but an anecdote so full of mirrors, so magically placed, that the film manages to reflect the future while also revealing new interpretations of the past. Not since "Wild Strawberries" has Mr. Bergman dealt with time in a way that is simultaneously quite so limpid and so mysterious.

The new film is set in the late 1920's in a serene Swedish countryside where the Bergman surrogate figure, Pu (Henrik Linnros), who appears to be about 9 or 10 years old, is spending the summer with his family: Henrik, his father; Karin, his mother; his older brother, younger sister, aunts, uncles, cousins and family retainers. It's a big, gregarious household. People drop in unannounced. The servants sit at the family table to share the meals they prepare.

When first seen, the independent little boy is taking a short cut through a birch forest to a village railroad station. The rest of the family travels by carriage. They are meeting his father, returning home after tending to his duties as pastor to the royal family. Arriving at the station before the others, Pu calls on the stationmaster. His father, he announces, has been visiting the king and queen. He pauses, then adds, "The queen is in love with him."

Pu seems to idolize his father, who loves him in return. Yet as the summer progresses, there is increasing tension between them. Henrik (Thommy Berggren) isn't a naturally demonstrative man. He is in all ways correct, though a little chilly. All of this vacation intimacy makes him feel cornered. Through the walls of the summer house at night, Pu hears muffled arguments between his parents. At one point his mother (Lena Endre) says that she's going to take the children and go back to her parents in Uppsala.

The nights are troubled. The days continue as if nothing were wrong. There are the usual sibling wars and humiliations. One afternoon his brother offers Pu the equivalent of 75 cents to swallow a worm. Pu is willing to eat half the worm. No deal, says his brother. Greed winning, Pu swallows the worm. At which point his brother states flatly, "If you're stupid enough to eat a worm, you're too dumb to earn the money."

•

It is midsummer and hot. Flies and mosquitoes come in such swarms that windows must be closed against breezes as well as insects. A pretty serving girl tells Pu about the Feast of the Transfiguration, Aug. 6, when it's possible to know the future. On this day, which celebrates Jesus' manifestation to His disciples in all His heavenly glory, Pu accompanies his father on one of his journeys to a distant parish. It's a long trip, first on the handle bars of his father's bicycle, then by train, by ferry boat and again on the bicycle. This outing becomes the substance of the film.

The day is full of bewildering emotions. His father flies into a fury when Pu sits on the prow of the ferry, dangling his legs in the water. The boy comes upon an old woman laid out in her coffin. In the course of the day, the future is seen in brief, bold flashes. It is suddenly 1968, and the aging Pu is visiting his ancient, widowed father, who has lost his faith and become afraid of death. Henrik asks Pu's forgiveness.

Is the film jumping forward, or is the story of Pu's childhood summer the flashback from 1968? It makes no difference in the long, rigorous view of things that Mr. Bergman takes. These shifts in time force an abrupt reconsideration of everything that's gone before. They're also a spectacular coup de cinéma of a kind that only Mr. Bergman could bring off.

On their way home, Pu and Henrik are caught in a great summer thunder storm. The boy thinks the day of judgment is at hand. Father and son are drenched but liberated by the elements. They're almost giddy. Yet 1968 continues to impinge on Pu in ways to suggest that the son has been forever bent by his father's fraud. The exact nature of that fraud remains unclear, but its effect has been to make the adult Pu as merciless as any god his father ever believed in. The aging Pu offers friendship to the dying man. Forgiveness? Never.

The relations of Henrik and Pu are so profoundly dark that "Sunday's Children" inevitably prompts speculation about the relations between Ingmar Bergman and Daniel, who was born in 1962 to Kabi Laretei, an Estonian pianist. From the evidence of this film, the son would seem to be a gifted film maker, though having an Ingmar Bergman screenplay must be an enormous advantage. The screenplay dictates the manner of the film

to such a degree that, for anyone who wasn't on the set during the production, it's impossible to be sure who did what or how.

Mr. Berggren, who played the young officer in Bo Widerberg's "Elvira Madigan," and Mr. Linnros work exceptionally well together as father and son. Tony Forsberg is the cinematographer responsible for the luminous look of the film that, underneath, is as severe and painful as a hair shirt.

1993 Ap 3, 13:1

The Crush

Written and directed by Alan Shapiro; director of photography, Bruce Surtees; edited by Ian Crafford; music by Graeme Revell; production designer, Michael Bolton; produced by James G. Robinson; released by Warner Brothers. Running time: 110 minutes. This film is rated R.

Nick... Cary Elwes
Darian.................................... Alicia Silverstone
Amy.. Jennifer Rubin
Cheyenne..................................... Amber Benson
Cliff Forrester...................... Kurtwood Smith
Liv Forrester.......................... Gwynyth Walsh

By JANET MASLIN

"The Crush," a movie that looks like a make-work project for wayward models, tells what happens when a 28-year-old journalist attracts the amorous attentions of a 14-year-old Lolita wannabe. Darian Forrester, supposedly a brilliant coquette equally at home on Rollerblades or at the grand piano, is played by Alicia Silverstone as if she had learned everything she knows — not that much — from Drew Barrymore.

Cary Elwes plays Nick, the journalist, with the help of horn-rims, hair mousse and an accent that wavers unpredictably between British and Brooklynese. Mr. Elwes behaves completely impassively except in those scenes that cause his character to sweat. There are few such moments to be found since the film, written and directed by Alan Shapiro, never succeeds in becoming either torrid or scary. It does generate a few chuckles in its depiction of what are supposedly the workings of a chic and hard-hitting magazine.

"The Crush," which opened yesterday at neighborhood theaters, is for the most part grindingly predictable and mechanically played. Among its rare forays into unexpected territory are a scene in which Darian tries to kill a rival for Nick's affections by locking the woman in a darkroom and feeding wasps into the air-conditioning system. The film's grip on reality is such that Darian is able to transport an entire wasps' nest in a plastic bag. Its attention to vanity allows the pretty victim (Jennifer Rubin) to show up a few scenes later looking entirely unscathed.

In the interests of originality, "The Crush" does present Darian as someone who has a fully working carnival merry-go-round in her attic. Building it was supposedly a project of her father's. Not surprisingly, this merry-go-round is used briefly and quite ineffectively as an instrument of terror before the story is over.

Overheard among teen-age boys leaving the theater:

"What'd you learn from that movie?" "Don't spend $7 on a lousy movie." "Don't ever have crushes on girls that know about bees."

"The Crush" is rated R (Under 17 requires accompanying parent or adult guardian). It includes mild violence, brief nudity and some profanity.

1993 Ap 3, 17:1

Children" — a handful of films that are both audacious and accessible. Together they have created the sense of discovery that is any festival's secret weapon.

New Directors, held at the Modern, ends tonight with "Sunday's Children," an eloquent, witty and moving memoir of Ingmar Bergman's childhood, written by Mr. Bergman and directed by his son Daniel. Young Ingmar is a golden-haired, death-obsessed boy who will, without doubt, grow into the uncompromising director we know so well. But the Bergman brand name and the film's elegance are not typical of anything else in the festival.

In fact, during this festival it was possible to experience one of the most eerie, provocative and poignant moments any filmgoer is likely to have: watching Cyril Collard in "Savage Nights," the brash semi-autobiographical movie he wrote, directed and stars in. He plays a bisexual who is H.I.V.-positive, who sleeps with a young woman without telling her about the risk; then juggles relationships with her and a man.

Lincoln Center/Museum of Modern Art

"Savage Nights" is a landmark film that portrays an H.I.V.-positive character as complex, morally flawed and ultimately sympathetic — a portrait Hollywood hasn't yet dared. It is especially haunting because Mr. Collard, a dynamic presence on screen, died of AIDS just

Thommy Bergen, left, and Henrik Limos in "Sunday's Children"—An eloquent, witty and moving memoir.

Lincoln Center/Museum of Modern Art

Cyril Collard, left, Romane Bohringer and Carlos Lopez in "Savage Nights"—A poignant moment.

two weeks before the film was shown at the museum.

As different as they are, "Sunday's Children" and "Savage Nights" represent what is best about New Directors. Neither film has an American distributor yet, though there is interest in them. They will both be commercial risks. When "Savage Nights" opened in France last fall, it was called everything from brilliant to unethical (an opinion that confuses its shrewd creator with his fictional alter ego). And the last film that Ingmar Bergman wrote but didn't direct, Bille August's "Best Intentions," was a commercial failure.

Films like "Sunday's Children" and "Savage Nights" are not easy to throw money at, but attention from New Directors can help them make their way to a wider audience.

"Orlando," Sally Potter's stylized romp through four centuries of sexual politics, and "The Music of Chance," Philip Haas's hyper-real tale of two men who gamble away their freedom, will both arrive in theaters in June. But they are quirky enough to need help, too. ("Orlando" was the undisputed hit of the Sundance Film Festival, even though it played out of competition; ordinarily, competition films generate the most excitement.)

Of course, a festival can only be as good as the films that are available, and some practical factors benefited New Directors this year. Richard Peña, program director of the Film Society of Lincoln Center, said the selection committee had been tracking "Orlando" and wanted to consider it for last year's New York Film Festival, but it wasn't ready in

FILM VIEW/Caryn James

A Plain Jane Becomes A Swan

NO ONE COULD HAVE PREDICTED THE WAY this fall and winter's film festivals have turned out: the New York Film Festival seemed old and stale, Sundance was young and vapid, and the New Directors/New Films Festival, of all things, has become the hot series of the moment. If this season were made into a movie, New Directors would play the part of the plain and studious librarian who suddenly tosses away her (or his) glasses, gets made over in stylish clothes and emerges as a glamorous sex symbol.

New Directors, co-sponsored by the Film Society of Lincoln Center and the Museum of Modern Art, has had successes over the years (most famously, Steven Spielberg's "Sugarland Express" in 1974). But it has been better known for obscure art films from countries you've barely heard of and directors never heard from again. This year its selection committee had the luck and judgment to find "Orlando," "The Music of Chance," "Savage Nights" and "Sunday's

time. "Savage Nights" arrived days after the New York Film Festival's program was set. Either movie might have enlivened that program.

And, especially this year, being a "new director" doesn't mean being a beginner. Ms. Potter has made shorts and television films; Mr. Haas has created many sophisticated documentaries about artists; Daniel Bergman has made children's films.

But perhaps the most telling aspect of this year's program is that there were few films that the six-person committee unanimously loved ("Orlando" being one). "There were many films that one or two of us had a lot of passion for and that the others had questions about," said Laurence Kardish, a film curator at the Modern. "So passion won."

A film like "Savage Nights" will never please an entire committee anywhere in the world. But choosing films that audiences will love or hate has helped give this festival its sense of energy.

Going with risky choices also means there are bound to be clunkers; Michael Almereyda's "Another Girl, Another Planet" is determinedly low-rent and too clever for its own good. While looking for highlights, I did not catch the films from South Korea or Iceland or the two from Yugoslavia. But this much is clear: while the New York Film Festival was searching for something daring and settling for the mundane "Night and the City," and while Sundance was trying to coax something substantial out of twentysomething film makers, the New Directors festival left its ugly duckling image behind.

1993 Ap 4, II:17:5

Indecent Proposal

Directed by Adrian Lyne; screenplay by Amy Holden Jones, based on the novel by Jack Engelhard; director of photography, Howard Atherton; editor, Joe Hutshing; production designer, Mel Bourne; producer, Sherry Lansing; released by Paramount Pictures. Running time: 118 minutes. This film is rated R.

John Gage..................Robert Redford
Diana Murphy..................Demi Moore
David Murphy..................Woody Harrelson
Mr. Shackleford..................Seymour Cassel
Jeremy..................Oliver Platt
Day Tripper..................Billy Bob Thornton
Mr. Langford..................Rip Taylor
Auction Emcee..................Billy Connolly
Realtor..................Joel Brooks
Van Buren..................Pierre Epstein

By JANET MASLIN

Maybe you'd do it and maybe you wouldn't. Maybe you'd just like to think about it for a while. The tease behind "Indecent Proposal," the surreally slick new daydream from Adrian Lyne, is that a lonely billionaire would offer a happily married young couple $1 million in exchange for one night's worth of companionship from the sultry wife. Would the event mean anything? Would it change the course of true love? Have you ever bought a greeting card? Then you probably know the answer.

The first and less useful way of looking at "Indecent Proposal" is as a story so crass and farfetched that it makes no real sense. Of course it makes business sense — which is something quite different — within the context of other post-"Pretty Woman" romances about well-heeled lonely guys and sweet, innocent women who happen to be for sale.

The second and more practical view calls for grudging admiration. Working from a ridiculous premise and Amy Holden Jones's badly underwritten script (based on Jack Engelhard's novel), the director of "Flashdance" and "Fatal Attraction" has still come up with the sort of sexy pop parable that is his specialty. Mr. Lyne's films may not cast any new light on the human condition, but they do keep you glued to the screen.

Mr. Lyne's understanding of cinematic allure goes well beyond the basics, like realizing that an audience would rather watch a billionaire who looks like Robert Redford than one resembling Ross Perot. This film maker has a particular flair for warm, inviting imagery heightened by cleverly commercial touches (like the family dog looking on attentively while its owners have a heated discussion). The style itself is powerfully seductive, and part of the gamesmanship of "Indecent Proposal" is built into its glossy directorial tricks. After all, this is a film whose credits list three costume designers but only one writer. Appearances count for everything.

So the film establishes David (Woody Harrelson) and Diana Murphy (Demi Moore) as healthy, attractive characters sharing a robustly physical love affair. That's really all it has to say about either of them. David is an idealistic architect, and Diana favors outfits that hold their own degree of architectural interest. Diana also narrates the film in fluent romance-ese: "I told myself it was over, like a dream that vanishes in the morning light. And in time — enough time — I would forget."

What Diana wants to forget is what audiences will be expecting to remember: the paid encounter she is lured into by John Gage, a debonair gambler. Conceived as a latter-day Gatsby and played by Mr. Redford with great courtly charm, Gage turns out to be a better-than-perfect gentleman. The film carefully maneuvers the Murphys and Gage into the same Las Vegas gambling hall, lingers lovingly on Gage's $1 million in cash and lets him recruit Diana "for luck" to help him bet. The screenplay's paper-thin explanations for such an encounter are really part of the fun.

After this, the film allows Mr. Redford to demonstrate his talents as one of the screen's great flirts while setting forth the title offer to the Murphys, who are conveniently in debt, for conveniently high-minded reasons. And after that — well, "Indecent Proposal" has only half of a

workable premise, and nowhere to go once its cards have been put on the table.

•

Mr. Lyne may have the tact to leave the Diana-Gage evening to his viewers' imaginations. But he cannot skip the sights of a tormented David, a standoffish Diana and a Gage who must now speak Diana's dreadful language. ("I know he didn't stop you. And if you were mine, I wouldn't share you with anyone.") And he cannot keep the film from spiraling down to an ending that truly defies belief.

For all its ostensible daring, "Indecent Proposal" is much too cautious. None of the three principals really change as a consequence of the story. None of the frankness that might make matters interesting is allowed to sully the romantic mood. None of the characters have lives outside the confines of the story, although the lonely Gage, when celebrating a big gambling win, suddenly gives a party for 200 anonymous, soigné-looking friends. Nowhere in this crowd is there a woman who might make this mogul's life a little easier, with or without an astronomical fee.

"Indecent Proposal" is riddled with such lapses, and is best watched with a stronger-than-usual suspension of disbelief. So let yourself believe that Ms. Moore's Diana might barge into a restaurant wearing hot pants and a baseball jacket, then corner her billionaire and overturn his table as a way of getting his attention. Imagine her gardening in a straw hat and flowered frock, or slipping halfway out of her T-shirt to try on an architecturally fascinating evening gown. (It begins to be clear why three costume designers were necessary.) Ms. Moore pours all of her effort into going through such motions smolderingly, and none into whatever sense may lie behind them. That's fine for the role; she falters only when the screenplay turns mute or turns up howlers ("I took a second job teaching citizenship just to keep myself busy").

Mr. Harrelson brings a similarly physical approach to the least credible role, radiating hunky well-being in the early scenes and indulging in door-banging, bottle-smashing, punch-throwing fits of rage later on. (This is the kind of film in which a white terry-cloth bathrobe means contentment and tousled hair indicates inner trouble.) Mr. Harrelson's character is also made to deliver a lecture on architecture that creates grave doubts as to his professional future. Mr. Redford's performance has a different stature, seasoned with the rueful suggestion that nothing would surprise his character, not even a movie like this one.

Mr. Lyne gets exactly the color and comic relief he wants from his supporting actors, most notably Oliver Platt as the Murphys' astounded lawyer and Seymour Cassel as Gage's chief henchman. (Beyond Mr. Cassel's implacable smile, the film explains nothing about how Gage arrived at money-squandering billionaire status.) The film is also helped by Mel Bourne's lively production design, Howard Atherton's glamorous cinematography and especially by Joe Hutshing's savvy, vigorous editing. Even when "Indecent Proposal" starts missing the boat in dramatic terms, it never misses a beat.

One of Mr. Lyne's quick comic flourishes is the sight of a blond receptionist filing her nails while reading Susan Faludi's "Backlash." In case the director is indirectly addressing feminist critics of this film's premise, he's right to worry.

"Indecent Proposal" is rated R. It includes mild profanity, brief nudity and sexual suggestiveness.

1993 Ap 7, C13:1

The Sandlot

Directed by David Mickey Evans; written by Mr. Evans and Robert Gunter; director of photography, Anthony B. Richmond; edited by Michael A. Stevenson; music by David Newman; production designer, Chester Kaczenski; produced by Dale de la Torre and William S. Gilmore; released by 20th Century Fox. Running time: 101. This film is rated PG.

Scotty Smalls..................Tom Guiry
Benjamin Franklin Rodriguez.......Mike Vitar
Ham Porter..................Patrick Renna
Squints Palledorous.........Chauncey Leopardi
Yeah-Yeah McClennan..................Marty York
Kenny DeNunez..................Brandon Adams
Mom..................Karen Allen
Mr. Mertle..................James Earl Jones
The Babe..................Art La Fleur

By JANET MASLIN

"The Sandlot," a movie that is exceptionally fond of hyperbole, deserves a little hyperbole of its own. This is the biggest, fanciest film about kiddie baseball that you will ever see, although why it happens to be so big is a serious question. David Mickey Evans, whose screenplay for the disastrous "Radio Flyer" had a similarly inflated tone, has directed and co-written "The Sandlot" as if it were stunningly momentous, even though nothing about his modest coming-of-age comedy demands anything like this awestruck approach.

Mr. Evans's technical talents appear to be wildly out of proportion to the subjects that interest him. Summoning up a Salt Lake City boyhood, circa 1962, his screenplay (co-written by Robert Gunter) introduces a nostalgic adult narrator remembering a shadowy, sinister new stepfather, just as "Radio Flyer" did. But this time the tone is lighter as Scotty Smalls (Tom Guiry) moves into a new neighborhood and tries to make new friends. He immediately finds eight of them, kids who do everything together, from delivering wisecracks to worshipping baseball. Scotty initially has trouble fitting in with these sandlot players, since he has only dimly heard of Babe Ruth and thinks the name must belong to a girl.

•

The story of how Scotty makes friends and conquers his fears is set amid stylized nostalgia, with the camera lingering proudly over every vintage cereal box and every Edsel. It is also punctuated by crazy overstatements, as the adult Scotty bills the film's minor developments as "the most desperate thing any of us had ever seen" or "the stupidest thing any of us had ever done." The latter refers to the day the players tried chewing tobacco and went on a dizzying carnival ride that made them all throw up. The film's quick succession of individual throw-up scenes constitutes one of its stabs at boyish humor.

The greatest exaggeration in "The Sandlot" is reserved for one end of the title baseball diamond, where a flimsy fence separates the boys from a near-supernatural being they call "The Beast." Fierce growls, puffs of smoke and shots of huge, hairy paws portend something terrible, which of course turns out to be something not so bad after all. James Earl Jones turns up late in the film as the boys confront this particular demon, and he figures in a denouement that is especially absurd. Not content to drop

Babe Ruth's name in this late episode, Mr. Evans has also thrown Ruth's ghost into an earlier scene. Scaling new heights of hubris, the film has Ruth appearing to tell Scotty, "Follow your heart, kid, and you'll never go wrong."

•

With its slow-motion flying baseballs and its close-ups of amazed-looking little players, some of "The Sandlot" (as handsomely shot by Anthony B. Richmond) has a weirdly exalted tone. The rest is terribly cute, with a cast exclusively made up of actors who would do very well in commercials. Mr. Evans's idea of treating the boys in the film as ensemble players is to have them chatter either in rapid succession or in unison.

Karen Allen appears briefly in the shadowy role of Mom, but the film's attention is on its child actors. Of these, Patrick Renna and Chauncey Leopardi stand out most sharply as a funny, domineering fat boy with freckles and a bespectacled little Romeo. The latter's ploy of feigning drowning in order to get mouth-to-mouth resuscitation from a pretty lifeguard is filmed as if it were riotously funny and treated as a major event.

•

"The Sandlot" is rated PG (Parental guidance suggested). It includes mild profanity and mock-scary episodes that will not scare many children.

1993 Ap 7, C17:1

American Friends

Directed by Tristram Powell; screenplay by Michael Palin and Mr. Powell; director of photography, Philip Bonham-Carter; edited by George Akers; production designer, Andrew McAlpine; produced by Patrick Cassavetti and Steve Abbott; released by Castle Hill Productions. Running time: 95 minutes. This film has no rating.

The Rev. Francis Ashby	Michael Palin
Caroline Hartley	Connie Booth
Elinor	Trini Alvarado
Oliver Syme	Alfred Molina

By VINCENT CANBY

Anyone who has ever underrated the wit, intelligence and sheer classiness of "Howards End," "A Room With a View" and other Ismail Merchant, James Ivory and Ruth Prawer Jhabvala collaborations should be sentenced to sit through "American Friends" at least twice. This new English film, made by people who have otherwise always seemed sane and talented, is a ghastly if unintentional parody of the sort of thing the Merchant-Ivory-Jhabvala team does successfully with such seemingly supreme ease.

"American Friends" stars Michael Palin, who also wrote the screenplay with Tristram Powell, the director. E. M. Forster, unfortunately, had nothing to do with their original story. Instead, the screenplay is said to have been inspired by an incident in the life of Mr. Palin's great-grandfather, who as a middle-aged Oxford tutor on a hiking trip in Switzerland in 1861, met a young woman whom he later married.

Forster sometimes found more in less, but not Mr. Palin and Mr. Powell, the son of the writer Anthony Powell and heretofore a television director. "American Friends" is a tedious exercise in gentility masquerading as high comedy.

Castle Hill Productions
Connie Booth, left, and Trini Alvarado in "American Friends."

The Rev. Francis Ashby (Mr. Palin) is a fussy senior tutor at St. John's College, Oxford, who hopes to become head of the college when the aging, near-senile president finally passes on. Before going off on his Swiss holiday, Ashby, a classics scholar, is the picture of the smug, self-satisfied don, content in the celibacy that is required of a man in his position.

In the course of his holiday he meets the Misses Caroline Hartley (Connie Booth), a handsome, middle-aged American woman, and her beautiful, Irish-born adopted daughter, Elinor (Trini Alvarado). For reasons that are none too clear in the writing or the performance, both women find Ashby immensely attractive. They follow him back to Oxford, where he's engaged in a terribly discreet battle of succession with a younger, more hip don named Oliver Syme (Alfred Molina).

The screenplay is especially dim. It has a way of setting up dread situations and then side-stepping them in a way that's frowned upon in Screenwriting 101. When Ashby takes a terrible fall off an Alp, he winds up with nothing more than a mildly sprained ankle. Back at Oxford, the headstrong Elinor boldly visits his rooms late at night, an infraction that could cost him the college presidency if they're caught. How do they escape? They walk out the front door.

The dialogue is so tiresome that all one remembers is everyone calling everyone else by a last name, preceded by the appropriate Mr. or Miss. The only moral dilemma seems to be Ashby's, because he has fallen in love in spite of his vow of celibacy. The only question to be answered: Which woman will he marry, the mother or the daughter? It is very difficult to care.

Not one of the performances is worth noting. Everybody has done far better work in other endeavors: Mr. Palin in particular, in his various Monty Python films and in the Alan Bennett classic "A Private Function." Ms. Booth will be remembered for her role as the saucy maid in "Fawlty Towers," which she also wrote with John Cleese. The correct if unexceptional cinematography is by Philip Bonham-Carter, a BBC cameraman who has photographed all of Queen Elizabeth's annual Christmas broadcasts since 1973.

1993 Ap 9, C8:5

Tales of the Brothers Quay

A collection of six animated short films by Stephen and Timothy Quay. Film Forum 2, 209 West Houston Street, South Village. Running time: 78 minutes. This film has no rating.

By STEPHEN HOLDEN

The surreal visions of the film-making team known as the Brothers Quay have an angst-ridden intensity that can make watching a three-minute short feel like gobbling an exceedingly rich and exotic candy and wondering afterward what exactly has been consumed. For those who have a taste for such things, Film Forum 2 is offering a program of six animated short films by the Quays, which opens today and plays through Thursday. They range from a recent music video for the singer and songwriter Michael Penn, to "Anamorphosis," a formal examination of perspective in 16th- and 17th-century paintings.

Timothy and Stephen Quay, identical twins who were born in Philadelphia and now live in England, are masters of an eclectic Eastern European mode of Surrealism. Their most experimental films re-imagine the world as a waking nightmare experienced in mysterious, frequently decrepit settings. The puppet figures in a film like "Street of Crocodiles" (1986) bob and lurch through spaces so dingy and encrusted with age that they conjure up images of an anguished collective memory, buried but still stirring under a mountain of detritus.

There is a deeply childlike quality to much of the brothers' work. Time seems to slow down, and inanimate objects often have as much life and personality as human beings. In the most vivid recurrent image from "Street of Crocodiles," a bunch of screws comes to life like a pack of metallic rodents, furtively scuttling across a floor to fasten and unfasten themselves on weather-beaten wooden planks. Underscoring the eeriness is chamber music, composed by Leszek Jankowski, whose creaks and scratches sound ancient, even though the style is modernist.

Three of the six films — "Street of Crocodiles," "Rehearsals for Extinct Anatomies" and "The Comb" — have been shown in New York before. Of those that haven't, "Anamorphosis," a documentary made in 1991, is the most significant.

As a lecturer delivers a solemn history of anamorphosis — the secreting of visual messages in paintings — the film demonstrates that when certain art works are viewed from the side, new images appear that are much too stretched out to be discerned when the canvases are faced directly. These hidden images are often subversive. One example shown is Hans Holbein's painting "The Ambassadors," an apparent celebration of worldly success and material well-being that conceals a death's head.

The other two new films, "Look What the Cat Drug In" (1993) and "Are We Still Married?" (1992) are among the most sophisticated and hauntingly enigmatic music videos ever created for MTV. For Mr. Penn's "Look What the Cat Drug In," which echoes the dreamy psychedelic sound of the Beatles' "Strawberry Fields Forever," the Quays use cut-out images of cats and a fork whose prongs turn into feline whiskers to create an abstract but sensuous scenario of sexual warfare.

"Are We Still Married?" a similarly eerie ballad by the band His

Name Is Alive, which uses images of a toy white rabbit playing with a Ping-Pong ball and a doll to evoke an ominously charged emotional atmosphere.

1993 Ap 9, C8:5

This Boy's Life

Directed by Michael Caton-Jones; screenplay by Robert Getchell, based on the book by Tobias Wolff; director of photography, David Watkin; edited by Jim Clark; music by Carter Burwell; production designer, Stephen J. Lineweaver; produced by Art Linson and Fitch Cady; released by Warner Brothers. Running time: 115 minutes. This film is rated R.

Dwight	Robert De Niro
Caroline	Ellen Barkin
Toby	Leonardo DiCaprio
Arthur Gayle	Jonah Blechman
Pearl	Eliza Dushku
Roy	Chris Cooper

By VINCENT CANBY

The opening sequence of "This Boy's Life" defines the style of almost everything that comes after in the film adaptation of Tobias Wolff's fine, spare boyhood memoir about growing up at loose ends in the 1950's. As with the rest of the movie, the introduction is both a little too much and nowhere near enough:

The voice of Frank Sinatra ("Let's take a boat to Bermuda/Let's take a train to St. Paul") fills the soundtrack with a rich stereo fidelity that reminds you how great the Chairman of the Board once was. The camera swoops in graceful arcs over, around and between huge, naturally formed stone sculptures in what looks to be Monument Valley. The camera performs a kind of dance on its own before discovering 15-year-old Toby Wolff (Leonardo DiCaprio) and his mother, Caroline (Ellen Barkin), as they drive their Nash Rambler through this idealized Western landscape.

With the highest of hopes, very little money and a car whose engine regularly overheats, Toby and Caroline are getting away from it all with a vengeance. They have pulled up stakes on the East Coast, left Caroline's latest slob of a boyfriend and are now heading West to make their fortunes as uranium prospectors. The landscapes, the camera movements and even the shared, slightly forced good humor of Toby and Caroline are terrifically promising. Yet they also get in the way of Toby's personal story, which is simultaneously a lot more melancholy and a lot funnier than the movie is able to acknowledge.

It's as if Michael Caton-Jones, the director ("Scandal," "Memphis Belle," among others), had wanted to make a comedy on the nostalgic order of "American Graffiti." "This Boy's Life" is so steeped in period detail (music, cars, television shows, hair styles) that Toby and Caroline's sad, bumbling search for freedom seems secondary, almost impolite to the décor.

•

As recollected by Mr. Wolff, Toby and his mother are not prototypical characters of their time; at least, not prototypical of their time as recollected in movies that look to the past with detailed fondness. Instead, they are closely related to the lost people Sam Shepard writes about. They are disconnected from their middle-class roots, free-floating through an all-

Warner Brothers

Ellen Barkin, Leonardo DiCaprio, and Robert De Niro in a scene from "This Boy's Life."

American void without family, community or serious goals to give them direction. Life is a series of stop-gap measures and last-minute decisions. Essential emotions are denied.

The film recreates Toby and Caroline's aimlessness, but without appearing to understand it enough to make it as moving and important as it ought to be. Robert Getchell, who wrote the screenplay, did not have an easy job to do. Mr. Wolff tells his story in a series of beautifully laconic anecdotes, many of which Mr. Getchell preserves with fidelity. Somehow overlooked, though, is the book's subtext, which is Toby's desperate yearning to reconnect with the ordered world he lost when his father and mother divorced. The movie follows the surface of the original, but loses its spirit.

That may be why "This Boy's Life" is dominated by the big, sometimes gloriously off-the-wall performance of Robert De Niro, who enters the film late but gives it a coherence it otherwise lacks. With a curious accent that sounds as if it had lot of unexplained Irish in it, Mr. De Niro plays Dwight, a garage mechanic from Concrete, Wash., who woos Caroline and marries her, thus to become Toby's stepfather and nemesis.

Dwight is a caution. At first he's a comic figure with his nervous, obsequious manners, his slightly skewed vocabulary, his prissiness and his carefully matched haberdashery. Even the elaborate gestures he uses to light his Zippo become a grotesque spectacle. Dwight is a terrifying joke. By the time he takes charge of Toby, he is clearly seen as a dangerously unstable man.

Dwight is a liar, a cheat and a drunk without being aware of it. Hanging onto his own sanity by a thread, he pretends to be the voice of reason to Caroline, Toby and his own three children, to whom Caroline becomes an understanding but helpless stepmother. Dwight and Caroline's wedding night is one of Mr. Getchell's most brutally effective inventions. Dwight insists on making love to Caroline as she faces away from him. She wants to see his face. "I don't," Dwight tells her. "This is my house and I get to say."

Dwight humilates Toby by refusing to buy him gym shoes. Toby plays basketball in his street shoes, nearly breaking his neck on the waxed floor, then in his bare feet. Possibly with the best intentions, Dwight forces Toby to join the Boy Scouts. Dwight accepts the Boy Scout Handbook as gospel. As if they were holy commandments, Toby must repeat the handbook's guides to good conduct: "Assist a foreign boy with some English grammar; help put out a burning field; give water to a crippled dog."

Toby plots to escape this lunatic world by returning to the East Coast where his father is married to a rich

woman and his older brother is a student at Princeton. By entirely devious means, he wins entrance to an exclusive Eastern prep school, with a scholarship, though the story doesn't end there.

•

Mr. Wolff's book is utterly specific, but it is full of ellipses that give it haunting power. There appear to be no ellipses in the film. Instead, it simply seems to be fuzzy and unexplained, like Ms. Barkin's Caroline. In writing about his mother, Mr. Wolff somehow makes clear that he is idealizing her, though he doesn't deny the possibility that she is, in her own way, nearly fatally careless when it comes to men and to Toby. In the movie, she seems to be singularly passive and a bit unreal.

As played by Mr. DiCaprio, Toby comes alive only in his scenes with Mr. De Niro's Dwight, who is so well defined and complex that he gives point to everybody and everything around him. Toby is otherwise a rather vapid if eccentric kid who is never quite at home in the small town of Concrete. The director's conventional use of, among other things, period artifacts, including clips from "The Lawrence Welk Show," are more vivid than anything else in the movie except the ferocious character of Dwight. Mr. De Niro appears to be acting in a movie that is far tougher than the one that Mr. Caton-Jones has made.

•

"This Boy's Life," which has been rated R (Under 17 requires accompanying parent or adult guardian), has obscene language, an intentionally vulgar sex scene and a brutal fight between a teen-age boy and his stepfather.

1993 Ap 9, C10:1

Nitrate Kisses

Produced, directed and edited by Barbara Hammer; released by Strand Releasing. At Cinema Village, 22 East 12th Street, East Village. Running time: 65 minutes. This film has no rating.

By VINCENT CANBY

Barbara Hammer's "Nitrate Kisses," opening today at the Cinema Village, is a passionate, very subjective meditation on what the film maker describes as the "repressed and marginalized history" of gay women and men in contemporary Western culture since World War I. Ms. Hammer describes her work as "a postmodern constructivist collage," though it's difficult to hold her to that: the terms are vague at best.

"Nitrate Kisses" is a 63-minute black-and-white documentary in which material from earlier experimental features are intercut with new material in which gay women and men — old and young, in this country and abroad — talk about their lives today and yesterday.

Two quite gallant aging women, their naked bodies discreetly latticed by the shadows of a venetian blind, make gentle, graphic love for Ms. Hammer's camera. Two somewhat younger men do the same. There are a number of clips from the photographically accomplished "Lot in Sodom," a 1933 experimental film that treats homoerotic love with unabashed lyricism. The women and men who testify — some of whom are

only voices on the soundtrack — talk with feeling and wit about their own particular histories and the high price all have paid to assert their identities in a world that would prefer to ignore them.

•

This theme is clearly sounded in the film's opening sequence, which recalls how history overlooks the lesbianism of Willa Cather, and how Cather did her best to destroy all records of it before she died. The novelist said she wanted to be remembered for her work, not for how she lived her life. The point is that in a different society there would have been no need for such games.

The quality of the print of "Nitrate Kisses" is not always great. This is especially unfortunate when Ms. Hammer inserts long title cards, the words on which are frequently unreadable.

1993 Ap 9, C10:6

Bodies, Rest and Motion

Directed by Michael Steinberg; screenplay by Roger Hedden; director of photography, Bernd Heinl; edited by Jay Cassidy; music by Michael Convertino; production designer, Stephen McCabe; produced by Allan Mindel, Denise Shaw, Eric Stoltz, Mr. Hedden and Jeffrey Sudzin; released by Fine Line Pictures. Running time: 94 minutes. This film is rated R.

Carol..Phoebe Cates
Beth..Bridget Fonda
Nick...Tim Roth
Sid..Eric Stoltz

By JANET MASLIN

"Bodies, Rest and Motion" takes its title from Newton's first law of motion, the one that says a body at rest or in motion will remain that way unless acted upon by an outside force. Inertia is the more common name for this phenomenon, but it sounds much less like "Sex, Lies and Videotape," a film to which this one owes a noticeable debt.

And inertia does not do justice to this film's quirky, magnetic characters, even though the material consigns them to passivity much of the time. If anything, the film's four central actors seem much too vibrant and alert to play people who have fallen so deeply into the doldrums. Marooned in Enfield, Ariz., and caught up in the aftermath of fading love affairs, they spend much of the story contemplating change and fearing the unknown. "When we got to Enfield, I dumped you and we just stayed," one of them says casually to another.

Despite this apparent languor, Michael Steinberg's film (with a screenplay by Roger Hedden, adapted from his play) has a crisp, alert manner and a strong sense that something momentous may be on its way. The principals are introduced just as their quiet frustrations are reaching critical mass. In a deliberately misleading opening scene, Mr. Steinberg presents Carol (Phoebe Cates) and Nick (Tim Roth) at the end of a long, boozy evening. They are reclining lazily, which is the film's favorite physical attitude, and thinking the sorts of thoughts that most often occur late at night. Their friendship is vaguely sexual, but they both look too tired to care.

Nor does it matter when their evening is interrupted by another

woman: Beth (Bridget Fonda), who greets Nick in quasi-wifely fashion and then takes him home. It develops that Nick and Carol are former lovers, Nick and Beth are living together, and Beth and Carol are best friends. In another film this might be a volatile triangle, but these characters are beyond jealous love. Stuck in some cosmic Enfield of the soul, reaching their late 20's while still working at dead-end jobs in local stores and restaurants, they are all ready to put this awkward stage behind them.

In "The Waterdance," the very fine film he co-directed with Neal Jimenez, Mr. Steinberg dealt with a larger subject in a less portentous way. This time, contrasting Enfield's mall architecture with the magnificent desert that surrounds it, he does his best to let this small story expand. The film's implicit backdrop is a bland, artificial culture winning its war with nature. The principals are only vaguely aware of this, but it's enough to leave them enervated and reluctant to fight. This film is much too studiedly hip to indulge in a happy ending, but in its wry, offbeat way it does inch forward. In this jaded context, a small step in the right direction is indeed a large step for mankind.

So Beth meets Sid (Eric Stoltz), a flaky housepainter who manages to fall deeply in love with her during the course of 24 hours. Carol watches Sid suspiciously while much of this goes on, trying to sand-bag him with tough questions. "This is what you do?" she asks dubiously while Sid paints. "I also mow lawns," he says cheerfully. "Which is your career?" Carol inquires. Meanwhile, Nick, whose career is selling televisions at a chain store, has hit the road.

In contrast to the other three actors' flirty, laid-back style, Mr. Roth's diabolical manner makes him the film's resident wild man. Behaving erratically, laughing manically at the wrong moments, doing his best to be unreliable at all times, Mr. Roth makes Nick a barely lovable wreck. The performance is startling, and it is not mitigated by easy charm, which makes the others' devotion to Nick a little hard to understand. But Nick is volatile, which may be why his friends need him, and he can also be devilishly funny. "You got something like that, but fake?" he asks, spotting an authentic Indian artifact at a roadside souvenir stand.

The other actors share an easy, appealing rapport and a flair for dry understatement, which is the film's prevailing tone. Bernd Heinl's clean, sharp cinematography further emphasizes the absurd contrasts that shape these characters' lives. And Michael Convertino's music provides some lovely choral accents, brief hints that beyond this story's veil of anomie there lies a world of promise.

Appearing in supporting roles are Alicia Witt as the shy, radiant young woman who turns up disconcertingly where Nick's parents ought to be, and Peter Fonda, Ms. Fonda's own parent, in a very brief cameo. Mr. Fonda, long hair covered by a bandanna, passes through the film on his motorcycle as if to offer the younger characters a warning: this is what happens if you drift too long.

•

"Bodies, Rest and Motion" is rated R (Under 17 requires accompanying parent or adult guardian). It includes sexual situations, brief nudity and profanity.

1993 Ap 9, C11:1

FILM VIEW/Caryn James

Women: Swap 'Em Or Sell 'Em

David James/Paramount Pictures

Woody Harrelson, Robert Redford and Demi Moore in Adrian Lyne's "Indecent Proposal"—A million dollars for one night with her.

MOM ALWAYS SAID THAT IT'S JUST AS EASY to fall in love with a rich man as a poor man. "Indecent Proposal" proves that it's easier. To reveal the film's premise gives away nothing important. Demi Moore and Woody Harrelson are Diana and David Murphy, a married couple passionately in love and seriously in debt, who go to Las Vegas to try to beat the odds. There, a billionaire named John Gage offers them a million dollars for one night with the wife.

It says everything about the film, though, that Gage is played by Robert Redford. Here is Diana torn between one of America's genuine sex symbols, looking better than he has in years, and the bar guy from "Cheers," whose movie character behaves like a dweeb. What would *you* do?

The first thing the Murphys do, proving they are true children of the 80's, is call in their lawyer (the superbly unctuous Oliver Platt) to draw up a contract. He provides the story's one touch of humor and goes to the heart of the film's complexity when he says, "For a million bucks *I'd* sleep with him. It's not like it's hard duty or anything. He's a great-looking guy."

Lines like this make "Indecent Proposal" the most adult and intriguing of the recent films in which women are objects to be bought, sold and used to pay off gambling debts. "Honeymoon in Vegas" and "Mad Dog and Glory" engage in verbal acrobatics and labyrinthine plot twists to justify this antediluvian attitude and get on with their comic stories.

The grown-up "Indecent Proposal" is front and center about the nexis of money, power and sex (which no one, let's face it, has ever figured out). When Diana says, "You can't to buy people," the megabucks businessman Gage replies with suave certainty: "That's a bit naïve, Diana. I buy people all the time." You can argue with him, but you'll have a hard case to make.

The casting, as much as the script, determines how effectively the film toys with viewers' reactions and defies simple responses. No offense to Mr. Harrelson, but his David is likely to have viewers resisting the obvious sympathies the triangular affair is designed to evoke. When the Murphys' Faustian bargain breaks the marriage apart, Diana pines over her unemployed architect, a man who puts his sneakers on the kitchen table (meant to be an endearingly annoying habit). While the film is coaxing viewers to remember that David is Diana's one true love, he comes off like a self-pitying nerd.

Meanwhile, the handsome billionaire, though manipulative to a fault, is turning on the charm for her and revealing his sensitive side in a mansion on his estate. He hasn't simply bought her; he loves her, too. This is the point at which Mom gets to say, "I told you so."

Imagine how different the film would have been if an actor with typical leading-man looks and a more dynamic screen presence — someone like Peter Gallagher — had played David. The attractiveness factor would have been neutralized. The only issue left would have been money, and the film would have been infinitely less provocative. It is impossible to say whether the director, Adrian Lyne (Mr. "Fatal Attraction" himself), intended to make David quite so unappealing. Intentional or not, the trick works.

AT FIRST GAGE SEEMS MERELY CONDESCENDing; he makes his million-dollar offer to David when Diana is standing right there. But this approach turns out to be one of Gage's more masterly power plays, allowing him to drive a wedge between the couple, who must share responsibility for the decision. It allows Gage to tell Diana later, "If you were mine, I wouldn't share you with anyone." There is still the rankling

sense that she is treated as her husband's property, but the choice and its consequences are evenly shared.

"Indecent Proposal" doesn't want viewers to be comfortable or complacent about this choice, though an easy conscience is precisely what the other women-as-object films aim for.

The recent "Honeymoon in Vegas" is a comic version of a similar story, with Sarah Jessica Parker agreeing to spend a platonic weekend with James Caan to pay off her fiancé's $65,000 gambling debt. (The question of whether Demi Moore is worth *that* much more than Sarah Jessica Parker is a whole other story.) The film is so smart and funny that you would have to be humorless to take the deal seriously in this Vegas filled with Elvis impersonators.

"Mad Dog and Glory" has to work harder to justify itself and glides too easily past its disturbing premise. Uma Thurman labors to convince the audience that it was her idea to work off her brother's gambling debt by giving herself to Bill Murray. She's selfless but not too bright. In both these films, the woman's nominal choice is contrived to allow viewers to sigh with relief, sit back and enjoy the movie.

There is even a man gambled away in a poker game in "Benny and Joon," opening on Friday. It is significant that he is a weak man, barely able to care for himself but with a genius for impersonating silent screen comedians. This mime savant has none of the power society confers on men.

While other films dance around the issue of buying and bartering people, "Indecent Proposal" embraces it. It isn't aways a good film; it employs lazy voice-overs to express sappy sentiments about the Murphys' eternal love. But it turns an inflammatory plot into a surprisingly honest and entertaining movie. ☐

1993 Ap 11, II:11:5

Joan Mitchell
Portrait of an Abstract Painter

Directed by Marion Cajori; co-produced by Christian Blackwood and Ms. Cajori; cinematography by Ken Kobland; released by Christian Blackwood Films. Film Forum 1, 209 Houston Street, South Village. Running time: 58 minutes. This film has no rating.

Guerrillas in Our Midst

Produced and directed by Amy Harrison; principal cinematography by Ellen Kuras; released by Women Make Movies. Film Forum 1, 209 Houston Street, South Village. Running time: 35 minutes. This film has no rating.

By STEPHEN HOLDEN

The best thing about Marion Cajori's study of Joan Mitchell, the Abstract Expressionist painter who died in October at the age of 66, is the way it makes a complete emotional portrait of the toweringly acerbic artist by interweaving her conversation with shots of works that reveal her vulnerable inner life.

Ms. Mitchell had the demeanor of a formidable grande dame, 1950's bohemian-style, who was as imposing in her way as Jackson Pollock was in his. Reminiscing in an imperious baritone, in sentences that are clipped but loaded with emotional baggage, she recalls growing up in a

Film Forum

A Guerrilla Girl in the documentary "Guerrillas in Our Midst."

well-to-do Chicago family. From early childhood, she says in the film, "Joan Mitchell: Portrait of an Abstract Painter," she was an achiever who won athletic medals to the delight of a father who drove her hard.

She became an abstract painter because she thought it was something he couldn't judge her on, she recalls. But the macho world of the Abstract Expressionists was in its way as competitive an environment as what she was trying to escape. She became something of a token female star. And her remarks about the none-too-subtle discrimination she endured are tinged with a deep bitterness and frustration.

In 1955, she moved to France to be with the French Canadian painter Jean-Paul Riopelle, with whom she lived until 1979. "I was his mistress," she says bluntly about the man whose name she is loath to bring up. She says she never wanted to move abroad and shrugs, "But you do what the man wants."

In France, she bought an estate near Vétheuil, a town where Claude Monet lived. And although she vehemently denies the influence, her French canvases seem to have taken on some of Monet's color and light. Comparisons to Cézanne and Matisse, however, are not rejected. The closest she comes to evoking a personal esthetic is in an anecdote about finding a viper on her foot and her awareness at that moment of "being in nature."

The gorgeous shots of Mitchell's canvases, intercut with scenes of Paris and of Vétheuil and its environs, offer eloquent visual testimony to Mitchell's appetite for being in the moment. The canvases have grand chaotic romanticism. While celebrating the physical universe with an ecstatic love of color, they don't shy away from expressing a harsh, feral apprehension of nature and its violence.

Sharing the bill with "Joan Mitchell: Portrait of an Abstract Painter," which opened today at Film Forum 1, is Amy Harrison's witty, politically pointed art-world documentary, "Guerrillas in Our Midst." The film examines the Guerrilla Girls, a group of self-proclaimed art terrorists who formed in 1985 to protest sexism and racism in the art world. Members of the all-female group, which calls itself "the conscience of the art world,"

will not reveal their identities and appear in public wearing gorilla masks. Their tactics include dashing around in the middle of the night slapping up posters protesting sexual discrimination in the arts.

Some posters are bitterly funny, like the one listing "the advantages of being a woman artist." These include "working without the pressures of success," "not having to be in shows with men" and "knowing your career might pick up after you're 80." Others offer specific and damning statistics on the percentages of women and blacks shown by leading galleries.

And judging by the film's interviews with a selection of seemingly callous male gallery owners and art-world figures, the Guerrilla Girls are sorely needed. Although some of the men express a grudging respect for the group, the tone of most of the commentary is hostile. It ranges from defensive (the art world is market-driven and the public infatuated with the myth of the male artist as creator-hero) to dismissive (the Guerrilla Girls are talentless showoffs seeking attention the only way they can).

The film is firmly on the side of the group, whose members are portrayed as justifiably outraged advocates of equality in a cynical, unregulated milieu of insider trading, entrenched sexism and unlimited greed.

1993 Ap 14, C14:5

Critic's Choice

Revival of a Revival House

Regulars at the old Regency, once a pre-eminent revival house on the Upper West Side, will be happy to hear that the Gramercy Theater at 127 East 23d Street, Manhattan, begins its new life as a revival house tomorrow. It will be programmed by Frank Rowley, who was once the Regency's dedicated programmer and then moved to the Biograph, which closed in 1991. The Gramercy will now be run by Mr. Rowley as a nonprofit theater, with help from the Samuel Goldwyn Company and EVAC Inc., a New York nonprofit community improvement organization. The theater will charge $6.50 for each double feature.

The Gramercy's first series, beginning tomorrow, will be "Hollywood Musicals Starring New York," with an opening bill of "On the Town" and "42d Street." Later, the theater will show other New York-minded musicals, from "Easter Parade" to "West Side Story." Next month brings a tribute to Audrey Hepburn. And starting June 13 there will be a New Prints for a New Theater series offering scratch-free versions of old favorites, from "Kiss Me Deadly" to "Annie Hall." Information: (212) 475-1660.

It's worthwhile to remember that the Regency's demise brought speculation that the lov-

ingly programmed revival house might be a thing of the past. How nice to be wrong.

JANET MASLIN

1993 Ap 16, C3:5

Wide Sargasso Sea

Directed by John Duigan; screenplay by Jan Sharp, Carole Angier and Mr. Duigan, based on the novel by Jean Rhys; director of photography, Geoff Burton; edited by Anne Goursaud and Jimmy Sandoval; music by Stewart Copeland; production designer, Franckie D; produced by Ms. Sharp; released by Fine Line Features. At Cinema 1, Third Avenue at 60th Street, Manhattan. Running time: 100 minutes. This film is rated NC-17.

Antoinette Cosway	Karina Lombard
Rochester	Nathaniel Parker
Annette Cosway	Rachel Ward
Paul Mason	Michael York
Aunt Cora	Martine Beswicke
Christophène	Claudia Robinson
Amélie	Rowena King

By VINCENT CANBY

John Duigan's "Wide Sargasso Sea," adapted from the Jean Rhys novel, is something you don't often see in movies these days: a seriously exotic Gothic romance that is as lean and pared down as, say, the 1944 film adaptation of Charlotte Brontë's "Jane Eyre" is big and thunderously emotional.

The comparison is not accidental. The Rhys novel, published in 1966, is a remarkable literary conceit, what's called a prequel today, being the story of the mad first Mrs. Rochester, the mysterious Creole heiress whose existence almost wrecks the life of sweet, steadfast Jane Eyre. Taking the scant information supplied by Brontë, Rhys imagined a tale of love and loss that stands triumphantly on its own, and whose style is very much outside its mid-19th-century period, without doing a disservice to its Brontë origins.

Although the film makes its associations to "Jane Eyre" somewhat more explicit than they are in the novel, "Wide Sargasso Sea" is in all other ways an unusually faithful adaptation, even of the novel's sometimes awkward ellipses. The setting is Jamaica in the 1840's, shortly after Britain freed the slaves in its Caribbean colonies and threw the island economies into temporary chaos.

The film's Jamaica is no paradise remembered by tourists who drop in for 10 days of all-expenses-paid sun and fun and then depart. This Jamaica is stunningly beautiful without being pretty. It is a dangerous, untamed place where the heat is unrelieved, the vegetation primeval, and obeah, the local sorcery, is still practiced, although no one will admit that it exists. Since their recent manumission, the blacks are openly contemptuous of the former slaveholders, sometimes called white cockroaches.

Antoinette Cosway (Karina Lombard) is an alien in her own country. Though still in her teens, she has the desperation of someone at the end of a life. The daughter of a slave-holding Englishman, who has died of drink, and a French mother, who has become a recluse on one of the family's unworked, gone-to-seed plantations, Antoinette grows up with only one constant in her life, Christophène (Claudia Robinson), her formidable black nurse.

After her mother's remarriage and descent into terminal madness, Antoinette is forced into an arranged

Kimberly Wright

Karina Lombard

marriage to Edward Rochester (Nathaniel Parker), an upper-class English family's penniless younger son, who has been sent to the colonies to find a rich wife. Though cash-poor, Antoinette is a singular catch. The lands held in her name remain terrifically valuable.

At first the convent-bred Antoinette and the conventionally English Edward are ecstatically happy. She sees him as her romantic deliverer, her refuge in a world in which she has never belonged. He initially pays no attention to her emotional neediness and strange ways. Her lush beauty and sexual abandon are as intoxicating as the landscape; the film's eroticism is real.

When Antoinette and Edward are making love one night, she says that if he were to tell her to die at that moment, she could cease to live through the power of her happiness. This is clearly not Brontë country. It is Jean Rhys country, where women are easily crushed, drink too much, and love too well and too carelessly, but still manage to have wills of steel that outlast even their sanity.

Mr. Duigan, the Australian director ("The Year My Voice Broke," "Flirting"), collaborated on the screenplay with Jan Sharp, the film's producer, and Carole Angier, a Rhys biographer. Their work is comprehensive and sometimes blunt. The film opens with a cascade of information of "the story so far" variety. In a matter of minutes the audience is force-fed information covering the young Antoinette's tumultuous childhood: a plantation house is burned down around her; her younger brother dies; her mother withdraws from all society, only to come back briefly to make a disastrous second marriage.

Yet this approach becomes integral to the film's effect. Though infinitely romantic, "Wide Sargasso Sea" is anything but sentimental. It's without soft edges. It is as cool, precise and hard as the Rhys prose. The disintegration of Antoinette's marriage (and sanity) is vividly dramatized as Edward becomes increasingly aware that he is being overwhelmed by the intensity of a love he doesn't understand or want.

After responding to Antoinette's passion, he begins to find it unseemly, then threatening. There are rumors about her half-brother, the son of a slave woman; about earlier lovers, about her mother's insanity. More than anything else, he is appalled by Christophène, Antoinette's nurse,

who is reputed to be a sorceress. Christophène is an aloof, unforgiving woman. She holds her head high as she accuses him of being a fortune-hunter.

As quickly as Edward falls in love with Antoinette, he is turned off by her. The desperate Antoinette resorts to obeah to bring Edward back to her bed, only to make him violently sick and to throw him into the arms of someone else.

Miss Lombard, a new actress who is half Lakota Indian, is dark-complexioned and voluptuous in a way that adds an effective if unstated racial dimension to the love story, something not in the Rhys novel. In the film, race is not only a fundamental concern of Jamaican society, but also a metaphor for the power struggle between Antoinette and Edward.

Don't worry whether Mr. Parker's Rochester could go on to become the Orson Welles figure in Robert Stevenson's 1944 adaptation of "Jane Eyre." Mr. Parker, who played Laertes to Mel Gibson's Hamlet in the Franco Zeffirelli film, is exceptionally good in a difficult, shadowy role. He also must bare more of himself than is required of most actors these days, which has something to do with the film's NC-17 rating.

Miss Robinson is majestically fine as Christophène. Rachel Ward and Michael York appear in comparatively small but important supporting roles as Antoinette's mother and stepfather. A stunning-looking actress named Rowena King plays the black maidservant, Amélie, just as she is described by Rhys: that is, with a fascinating mixture of contempt and detached compassion.

Although "Wide Sargasso Sea" is a most poetic film, Mr. Duigan uses his poetic effects sparingly, nowhere more effectively than in the film's final shot: atop what looks to be an English castle parapet, the distant silhouette of a lone woman sways to a merengue beat that only she can hear.

●

"Wide Sargasso Sea" has been rated NC-17 (No one under 17 admitted). The film has complete nudity and sex scenes that are frank without being graphic.

1993 Ap 16, C6:5

Wife Seeks To Right Wrong Done To Husband

"The Story of Qiu Ju" was shown as part of the 1992 New York Film Festival. Following are excerpts from Janet Maslin's review, which appeared in The New York Times on Oct. 2, 1992. The film, in Mandarin with English subtitles, opens today at the Lincoln Plaza Cinema, Broadway at 63d Street, with a rating of PG (Parental guidance suggested).

Zhang Yimou is the superb Chinese film maker whose life sounds like the stuff of legend (he is said to have "sold his blood to buy his first camera") and whose rural historical dra-

Sony Pictures Classics Release
Gong Li

mas (among them "Raise the Red Lantern" and "Ju Dou") would be accessible in any part of the globe. Now, in "The Story of Qiu Ju," Mr. Zhang has attempted something more modern and no less fascinating. With the simplicity of a folk tale or a fable, he tells of a farmer's wife and her search for justice, and in the process he provides a remarkably detailed view of contemporary Chinese life.

The principal performers in "The Story of Qiu Ju" are professional actors, most notably his familiar star, the beautiful Gong Li, who again emerges as a figure of astonishing fortitude. But this film's background figures are real people, caught unawares by Mr. Zhang's cameras as they travel and congregate in public settings. Without diminishing the film's dramatic interest, this realistic backdrop gives the film a documentary aspect, which is presented no less elegantly than the spare, historical details of the director's earlier films. Once again, it is Mr. Zhang's keen and universal view of human nature that raises his work far above its own visual beauty and into the realm of timeless storytelling.

●

"The Story of Qiu Ju" is, for Mr. Zhang, exceptionally down to earth. It tells of a very simple problem. The pregnant Qiu Ju (played by Gong Li) is incensed because her husband, Qinglai, has been kicked in the groin by a man named Wang, the head of the small village in which they all live. Qiu Ju wants to know exactly what happened; she wants justice, and she is not shy about saying so. "If we can't fix your plumbing, we're stuck with the single-child policy for good," she grouses to Qinglai as she pulls him in a cart so he can visit a local doctor. The doctor, when first seen, is splitting logs with a hatchet instead of treating patients.

Slowly but surely, the film carries the stubborn Qiu Ju up the ladder of Chinese justice as she enlists ever-higher authorities to help her right this wrong. A local official, the smiling and compromise-minded Officer Li, initially suggests a monetary settlement to cover Qinglai's medical bills. He also advises the principals of the case: "I want both of you to do some self-criticism. Is that clear?" But Wang, who is gallingly amused by Qiu Ju's outrage, merely throws the financial settlement at her in cash, expecting her to retrieve it.

Needless to say, Qiu Ju will have none of this. So she embarks on arduous journeys to see different officials, journeys the film records with impressive attention to detail. In rural contemporary China, the viewer learns, a pregnant woman may travel sidesaddle on someone else's bicycle over icy roads if she badly wants to get to town. She may also haul a wagon filled with chili peppers if she thinks that can influence her case.

Mr. Zhang, incidentally, still has a fine eye for the fastidious beauty of Chinese peasant customs. The simple farm dwellings of Qiu Ju's village are festooned with spectacular garlands of drying peppers and corn.

●

As Qiu Ju travels to ever more modern settings, the film overflows with interesting information. In town, the viewer can see how certain Western images, like pinups of Arnold Schwarzenegger, have infiltrated the indigenous culture. The film also observes Qiu Ju's reactions to such things as dishonest taxi drivers (the taxi is actually a bicycle-driven wagon) and loud, printed leggings.

Along the way, it also notes the behavior of public officials toward a woman of Qiu Ju's beauty and persistence, and it underscores some of the more basic inequities of Chinese life.

"The Story of Qiu Ju" manages to weave its dramatic spell while providing a clear, detailed picture of the way China works. From the petty graft at a cheap urban hotel (the rate is higher for those who want a receipt) to the way enemies, enmeshed in a bitter legal dispute, still sit down amicably to a meal of noodle soup, the film offers close and witty observations about Chinese daily life. The story's last moments, giving it an ending O. Henry would have appreciated, provide as much wisdom about Chinese hospitality and Chinese justice as what has come before.

1993 Ap 16, C8:6

Claire of the Moon

Directed and written by Nicole Conn; director of photography, Randolph Sellars; edited by Michael Solinger; music by Michael Allen Harrison; produced by Pamela S. Kuri; released by Demi-Monde Productions. Running time: 105 minutes. This film has no rating.

Claire Jabrowski	Trisha Todd
Dr. Noel Benedict	Karen Trumbo
Maggie	Faith McDevitt

By JANET MASLIN

"Claire of the Moon" follows its heroine, an author so famous she has appeared on "Oprah," to a seaside writers' retreat. A renowned satirist (though she has no apparent sense of humor), Claire (Trisha Todd) is assigned to room with Dr. Noel Benedict (Karen Trumbo), a solemn therapist who has written a book called "The Naked Truth." When Claire first arrives at her cabin, she hears the sounds of a noisy sexual encounter in the bedroom. "Research," Noel says with a shrug.

Claire and Noel are to be participants in a long, cozy retreat for female writers, who are presented in what are meant to be broadly humorous terms. Tara O'Hara, for instance,

Karen Trumbo, left, and Trisha Todd in "Claire of the Moon."

is the name of a romance writer from the South. Another participant is a housewife, the mother of twins, who is writing a book imagining a planet where men must go through childbirth. The session is led by the jovial, beer-swigging Maggie (Faith McDevitt), who looks and sounds a bit like Martin Sheen. Maggie describes the program as "just a bunch of loony chicks writing our guts out, trying to find the meaning of life."

It soon develops that Claire and Noel may be ready to discover the meaning of life in more personal terms. Noel, who is serious and articulate, spends a lot of time explaining her lesbian orientation to Claire after the two of them have got past a period of cute domestic spats. Claire is increasingly interested, but she also has the sort of rogue impulses that lead her to a local bar while all the other women are having one of their nightly literary sessions, involving "discussions of everything from syntax to Playtex," in Maggie's words.

●

The film, written, directed and co-produced by Nicole Conn, treats Claire's escapade with a man — the kind of man who resorts to astrology for his pickup lines — as a form of extreme bad taste. "Claire of the Moon," which opens today at the Village East Cinemas, has its own form of talkiness. Although it is structured as an earnest, slow-burning romance, Ms. Conn's film incorporates many long interludes during which the lesbian characters engage in philosophical debate and define their points of view. The dialogue is ponderous at such times, undercutting what might seem a more daring drama. For instance: "Most of us are so vulnerable and riddled with neuroses that we're not really equipped to truly communicate."

The film culminates in a soft-core sexual encounter between the lanky, dignified Noel and the tawny, athletic-looking Claire, a scene that says much more about gentle, romantic love between women than any of the dialogue has. Ms. Conn, whose low-budget film has a smoothly professional look except when it indulges in slow motion, fills some of the story's other silences with swelling piano music (both principals love Chopin) and predictable images of characters gazing thoughtfully out to sea.

1993 Ap 16, C11:1

Benny and Joon

Directed by Jeremiah Chechik; screenplay by Barry Berman; story by Mr. Berman and Leslie Schwartzman; director of photography, John Schwartzman; edited by Carol Littleton; music by Rachel Portman; production designer, Neil Spisak; produced by Susan Arnold and Donna Roth; released by Metro-Goldwyn-Mayer. Running time: 98 minutes. This film is rated PG.

Sam	Johnny Depp
Joon	Mary Stuart Masterson
Benny	Aidan Quinn
Ruthie	Julianne Moore
Eric	Oliver Platt
Dr. Garvey	C. C. H. Pounder
Thomas	Dan Hedaya
Mike	Joe Grifasi
Randy Burch	William H. Macy

By JANET MASLIN

"Benny and Joon" is a dangerously fanciful story of cute eccentrics, characters whose quirks are the very essence of their appeal. Some of us experience a form of red alert at the

Bruce Birmelin

Johnny Depp

very notion of adorable oddballs on screen, but "Benny and Joon" turns out to be remarkably benign in that regard.

Cheerfully conceived and presented with admirable restraint, it tells of a kindly, long-suffering mechanic named Benny (Aidan Quinn) who struggles to take care of his erratic sister, Joon (Mary Stuart Masterson). Their home life is further complicated midway through the film by the arrival of Sam (Johnny Depp), whose fine-tuned Buster Keaton and Charlie Chaplin routines keep him as far from contemporary reality as Joon happens to be.

Joon winds up with Sam because of a losing bet in a poker game, which makes no less sense than anything else in this breezy, whimsical story. The screenwriter Barry Berman (who wrote the story with Leslie McNeil) has formal training as a circus clown, which explains a lot about Joon's use of props like a snorkel mask and a Ping-Pong paddle, as well as the notion of Sam as some kind of clown savant.

Sam is seen happily making grilled-cheese sandwiches on an ironing board and mashing potatoes with a tennis racket, gambits that deeply appeal to Benny and Joon's collective sense of the absurd. "Did you have to go to school for that?" one of them asks him. "No, I got thrown out of school for that," Sam replies.

•

Joon, who loves to paint but also likes to set fires, has initially seemed smart, unpredictable and scarily intense. She's capable of placing an emergency call to her brother's repair shop to report a food shortage, and the messages are often as alarming as she means them to be. ("Joon called. She said that you've run out of tapioca. Oh, and the police will corroborate.") She's also capable of breaking a lamp or dropping a burning tissue on the floor for no particular reason, which makes Benny's life with her a constant trial. The story finds them at the point of realizing that each must somehow separate from the other and go it alone.

Benny's garage attracts a remarkably high percentage of attractive female customers, whom he tries hard to ignore. But eventually he finds one (Julianne Moore) to help him overcome his shyness. Meanwhile, Joon and Sam discover to their gradual delight that they see the world in much the same way. They become close enough to engage in passionate discussions of common interests, like the suspicious fate of raisins. ("Oh, they taste sweet, but they're really just humiliated grapes," Joon says.) But since Sam is functionally illiterate, not even able to fill out a job application in a video store that rents his beloved Chaplin and Keaton films, the possibility of either his or Joon's being able to survive independently remains dim.

In a more realistic film (and to some degree this film recalls "Dominick and Eugene," which also dealt with a hard-working brother taking care of a mentally impaired sibling), troubling issues might well shade the story. But "Benny and Joon" succeeds in remaining blithe and sunny, directed by Jeremiah Chechik ("National Lampoon's Christmas Vacation") with a commercial liveliness and a suitable sense of the absurd.

The film's greatest asset is the obvious conviction of its actors, who never condescend to their roles. Mr. Depp may look nothing like Buster Keaton, but there are times when he genuinely seems to become the Great Stone Face, bringing Keaton's mannerisms sweetly and magically to life. As Mr. Depp and the rest of the film makers surely must have known, an impersonation like that is an all-or-nothing proposition.

Ms. Masterson, a remarkably incisive and determined actress, never sentimentalizes Joon despite many ripe opportunities to do exactly that. She remains fierce, funny and persuasive even when the film conveniently soft-pedals the reality of Joon's situation. Mr. Quinn, often in the position of playing straight man to the other two leads, still makes Benny a touchingly sincere and sympathetic figure. Also in the cast are Oliver Platt as Benny's wistful, patient partner and Dan Hedaya and Joe Grifasi as longtime participants in the poker game where Sam's services as a roommate are bet. That night, the other ante includes a salad shooter and 150 feet of coaxial cable.

•

"Benny and Joon" is rated PG (Parental guidance suggested). It includes mild profanity and discreet sexual situations.

1993 Ap 16, C13:1

The War Against the Indians

Written, narrated, produced and directed by Harry Rasky; cinematography by Milan Klepl, with Kenneth Gregg; edited by Ken Mullally; music consultants, Gary Gilfillan and John Nailer; released by CBC Film. At the Joseph Papp Public Theater, 425 Lafayette Street, Greenwich Village. Running time: 145 minutes. This film has no rating.

By VINCENT CANBY

"The War Against the Indians," produced, directed, written and narrated by Harry Rasky, is the cinema equivalent of one of those coffee-table books that is actually worth its price. It's an impressive, beautifully photographed, oversized (nearly three-hour) consideration of the melancholy history of North American Indians from the arrival of Christopher Columbus to the present day. The Canadian film, originally made for television, opens today at the Joseph Papp Public Theater.

Mr. Rasky uses paintings, photographs, songs and dances, artifacts (including masks) and dozens of interviews as he meditates on the high cost of the European invasion to the indigenous peoples: near-genocide. The film's method is more impressionistic than anthropological, more subjective than scientific, although there's no disputing the injustices that American Indians have been collecting for the last 500 years.

Early on, Mr. Rasky and his subjects recall various myths relating to the origins of American Indians. Gloria Cranmer Webster, an anthropologist, remembers her father's laughter when she came home from school one day to announce that they had all originally made their way to America across the Bering Strait from Asia. "Nonsense," he said in effect. "Our family came from the river, from a sea monster and a thunderbird."

•

Later, one of her students was similarly dumbfounded by the Bering Straits theory. "Now they're trying to make second-class Chinamen out of us," he said.

In the course of his journeys back and forth across the continent, Mr. Rasky talks to Eskimos in the far north and descendents of the cliff-dwellers in the Southwest. He talks to tribal leaders, artists, advocates and teachers. Customs, beliefs and rituals are described and explained, as well as the Battle of the Little Big Horn, the Massacre at Wounded Knee, reservation life and various official attempts to deny Indian cultures. The voices he listens to are strong and firm.

As much as "The War Against the Indians" is about history, it's also a celebration of a newly articulate, dedicated American Indian consciousness.

1993 Ap 16, C15:1

Boiling Point

Directed and written by James B. Harris; based on the novel "Money Men" by Gerald Petievich; director of photography, King Baggot; edited by Jerry Brady; music by Cory Lerios and John d'Andrea; production designer, Ron Foreman; produced by Marc Frydman and Leonardo de la Fuente; released by Warner Brothers. Running time: 98 minutes. This film is rated R.

Jimmy	Wesley Snipes
Red	Dennis Hopper
Vikki	Lolita Davidovich
Ronnie	Viggo Mortensen
Brady	Dan Hedaya
Mona	Valerie Perrine
Leach	Seymour Cassel

By JANET MASLIN

"Boiling Point" is a barely tepid police story co-starring Wesley Snipes and Dennis Hopper, cast respectively as a hard-boiled detective and a wily con man. Since the material (written and directed by James B. Harris, from a novel by Gerald Petievich) offers not one shred of surprise, it's understandable that neither actor seems to believe anything he has to say.

The perfunctory story sends Jimmy Mercer (Mr. Snipes) out to avenge the death of a fellow officer and provides familiar accouterments like a beloved son, an estranged wife, a trusty partner (Dan Hedaya) and a hooker (Lolita Davidovich) with a heart of gold. One of the guilty parties turns out to be Red Diamond (Mr. Hopper, swaggering grandly and sporting a headful of strawberry-blond hair).

Red is newly out of prison and has his own standard-issue relationships with a forgiving ex-wife (Valerie Perrine), a hot-headed young partner (Viggo Mortensen) and the same hooker who adores Jimmy. In one of the film's few stabs at originality, Red surprises the hooker by taking her dancing to the tune of big-band music. Otherwise, the film is a parade of stakeouts, standoffs and shootings, with dialogue that falls back on one-word epithets on those frequent occasions when no one has anything interesting to say.

"Boiling Point," which opened yesterday at neighborhood theaters, isn't much of a showcase for either of its stars. Mr. Snipes, for whom this might have been a plausible action vehicle if it had had more action, conducts himself with stony composure. Mr. Hopper seems to be in a different movie as he waves his hands expansively, performing for the bleacher seats. Somewhere in between is Seymour Cassel, who appears briefly as a merry counterfeiter and rivals Mr. Hopper when it comes to weirdly scene-stealing supporting turns.

•

"Boiling Point" is rated R (Under 17 requires accompanying parent and adult guardian). It includes obscenities, violence and sexual situations.

1993 Ap 17, 16:1

FILM VIEW/Caryn James

Life Lacks Warmth in 20-Something Movies

BRIDGET FONDA AS A WAITress in "Singles": "I'm 23. I think time is running out to do something bizarre."
Bridget Fonda as a waitress in "Bodies, Rest and Motion," when her lover says, "I'm the one": "I'm 28 years old. I've had lots of ones."

Bridget Fonda as a murderer in "Point of No Return": "Mommy!"
Ms. Fonda shouldn't have to carry the weight of her generation personally, but on-screen she is the definitive 20-something. And though "Point of No Return" is not a 20-something movie, "Mommy!" might be the

Arlene Pachesa/Fine Line Features

Bridget Fonda and Eric Stoltz in "Bodies, Rest and Motion"—
A good example of where the genre succeeds and fails.

unspoken rallying cry behind the slew of films about people in their 20's and early 30's. Living in a twilight zone between Peter Pan-hood and adulthood, they don't want to grow up but don't want to be misfits, either. That's a dismal choice in life, but it has shaped a deft and entertaining genre of films, from last year's "Singles" to the current "Bodies,

Between Peter Pan and maturity, young adults in these films shy away from growing up but fear becoming misfits.

Rest and Motion" and "Watch It" to the forthcoming "The Night We Never Met."

A formula has already emerged.

First, give the characters low-level jobs and a large dose of professional lethargy. In "Bodies, Rest and Motion," the main characters are a waitress, a television salesman, a house painter and a boutique manager at a mall — a perfect record of career avoidance.

Next, let them swap romantic partners, as if the whole generation were one small town. In "Bodies," Nick (Tim Roth) used to live with Carol (Phoebe Cates) and now lives with Beth (Bridget Fonda), who is Carol's best friend. In "Watch It," a veterinarian has affairs with two men who happen to be cousins, adding an extra familial twist to the small-town rule.

Include at least one hopelessly juvenile male, like the Wall Street broker in "The Night We Never Met" who keeps his bachelor apartment so he and his friends can swill beer and belch loudly once a week.

And, finally, admit that you don't have a clue how to wrap things up. Add one contrived leap into maturity and romantic commitment, a supposedly happy ending.

This recipe doesn't guarantee a good 20-something movie, of course. There is a more fundamental principle behind that: the more a film strives to define its generation, the more it is doomed to fail. The fearful, tenta-tive quality of these characters' lives is best captured in everyday details, not in philosophical dialogue.

The uneven "Bodies, Rest and Motion" is an almost perfect example of where the genre succeeds and fails. The film is a mix of wonderful acting, revealing gestures and bits of dialogue that suddenly become top-heavy and portentous, throwing the whole movie out of whack.

When Carol and Beth pass Nick back and forth, knowing perfectly well that he's no prize, their affairs reveal something serious about the characters' low expectations in life. But using Newton's first law of motion to describe this pattern is unbearably pretentious; the film's title comes from the principle that a body at rest or in motion will remain that way, and it's the first clue that the film is straining to define a generation.

As Sid, the house painter who instantly falls in love with Beth, Eric Stoltz has to grapple with the worst lines. "Hey, Beth, leave it behind," he tells her.

"Leave what behind?" she says.

"Unhappiness."

Is he for real?

The deepest scenes are smaller and sneakier. Ms. Fonda wakes up after spending the night with this strange house painter, sits on the edge of her bed and gives a tiny shudder. Her face and body suggest everything going on in her mind. She can't believe what she did; her life is out of control; she simply wants to run. At such moments she reflects the confusion of a generation adrift.

"Watch It" is an unpretentious comedy that takes a different approach to the generational issue; its plot depends on arrested development. Three men who were college friends now share a house and still play a game of elaborate practical jokes in which the joker reveals himself by yelling, "Watch it!" The men are way too old for this (and though ages are never mentioned, the 30-something actors probably look even older than they're meant to).

■

But the game of watch it is a clever narrative trick, making viewers doubt whether anything that happens is serious or real. When John (Peter Gallagher) learns that the woman he loves is engaged to his cousin, the audience is poised for someone to yell, "Watch it!" and admit it is just a bad joke. All of life might be one big joke in this film — a premise that matches the goofing attitudes of the 20-something characters.

As in "Bodies, Rest and Motion," "Watch It" has its deeply revealing lines and gestures. John says to the veterinarian, Anne (Suzy Amis), "I don't know that I don't love you." Talk about backing into things. But it's the best his Peter Pan generation can do.

The leaps to maturity are never so convincing. Toward the end, when one character says to the most adolescent guy, "I'm a woman. If you ever become a man, why don't you look me up?," it's as if she hit him upside the head and suddenly knocked some adulthood into him.

The credibility of a 20-something movie has nothing to do with the ages of the writers or directors — some are in their 20's, some aren't, and who's which seems beside the point. What matters is that directors and viewers enjoy the texture of these half-grown lives without condescension.

And above all, when watching a 20-something movie, forget that you ever saw "The Big Chill." This generation hasn't ever warmed up; they're not nearly ready to chill out. □

1993 Ap 18, II:11:1

The Dark Half

Written and directed by George A. Romero, based on the book by Stephen King; director of photography, Tony Pierce-Roberts; edited by Pasquale Buba; music by Christopher Young; production designer, Cletus Anderson; produced by Declan Baldwin; released by Orion Pictures. Running time: 121 minutes. This film is rated R.

Thad Beaumont/George Stark
 Timothy Hutton
Liz Beaumont................................ Amy Madigan
Young Thad Beaumont........ Patrick Brannan
Beaumont Twins Sarah and Elizabeth Parker
Fred Clawson.................................... Robert Joy
Reggie Delessepts........................ Julie Harris
Hilary.. Molly Renfroe

By VINCENT CANBY

The scene is an operating room, the patient a teen-age boy who has been suffering terrible headaches. It's a tense moment as the surgeon removes a portion of the skull to reveal the cause of the problem: embedded in the boy's brain are an eye and two fully developed teeth, one of which has a slight cavity. The attending nurse screams. "Hilary," someone shouts, "remember where you are!"

Hilary doesn't know it, but she's up to her armpits in Stephen King territory. It seems that the eye and the teeth are all that remain of the patient's undeveloped twin, absorbed by the stronger fetus when the two were in their mother's womb.

More specifically, Hilary is a supporting character in George A. Romero's funny and horrific screen adaptation of Mr. King's 1989 novel "The Dark Half." Like "Misery," though wittier, "The Dark Half" is another nightmare vision by the best-selling

When an author goes public, a trail of bodies results.

author, who is fond of meditating, in his own singular way, on the cost and dimensions of his success.

After the introductory scenes, "The Dark Half" jumps ahead 23 years to find that Thad Beaumont, the boy on the operating table, has grown up to be a much-admired professor of creative writing and a respected novelist. On the side, writing under the pseudonym of George Stark, Thad (Timothy Hutton) is also the author of a series of wildly popular, disgustingly bloody novels about a psychopathic killer.

When first met, Thad seems to have the ideal life in a serenely rural academe in Maine. His only problems are theoretical. He is happily married to Liz (Amy Madigan) and the father of twins not old enough to talk. Thanks to George Stark, his income is substantial. When a blackmailer (Robert Joy) from New York threatens to expose him as the author of the George Stark novels, Thad decides to go public. He doesn't want to write any more of the George Stark trash anyway. Liz, his agents and his publishers all agree that the publicity can't hurt.

How little they know.

What they don't take into consideration is George Stark himself, who, outraged at being junked in such peremptory fashion, is called into being. Thad's dark half, also played by Mr. Hutton in makeup that subtly rearranges his looks, starts leaving a trail of dead bodies from Maine to

Orion Pictures
Timothy Hutton

New York. His goal: the destruction of Liz and the twins.

Is George Stark really Thad in his Mr. Hyde mode? Is he someone who knows Thad extremely well? Or possibly (and Thad and everybody else in the movie realize that such an idea is incredible), is he some kind of supernatural manifestation, the spirit of the twin who never accepted his fatal fetal absorption?

Mr. Romero, who both wrote and directed "The Dark Half," answers these questions somewhat earlier and more explicitly than is absolutely necessary. Yet "The Dark Half" is an exceptionally entertaining film of its kind. Only Stanley Kubrick has ever adapted a King novel ("The Shining") in such a way that the ending remains as satisfyingly spooky as the beginning. (If you haven't seen "The Shining" recently, rent the video sometime soon. In some eerie fashion, it gets better every year.)

"The Dark Half" is not in the same league with "The Shining," but it outdistances every other King adaptation I've seen. Unlike Mr. Kubrick, Mr. Romero observes the conventions of the horror-film genre, but he observes them with inventive humor, and he holds off on the fancier special effects until virtually the last minute.

For all the ghastly things that happen to Thad, "The Dark Half" makes a number of comic comments about writers and the creative process. The dark half of Mr. King clearly resents the kind of success the other half works so hard to achieve. The dark half wants more success and less condescension from the critics. Mr. King's dreams are nightmares, but he seems to be an unusually good-humored man.

Mr. Romero's intelligent screenplay and production serve the author well, especially with Mr. Hutton's performance as both Thad, who appears to be aware of his own darker impulses but in control of them, and George Stark, who exists only as an ego running amok. The members of the supporting cast don't have Mr. Hutton's possibilities, but they are all first-rate. Not to be overlooked are Sarah and Elizabeth Parker. They play the Beaumont twins, not quite talking, just on the verge of walking, as if they'd been born not too many months ago at the Actors Studio.

The Pittsburgh-based Mr. Romero has come a long way since he made his debut in 1968 with the low-budget cult favorite "The Night of the Living

Dead." "The Dark Half" was apparently shot in Pennsylvania (by Tony Pierce-Roberts) and looks very rich and real. Don't worry that Mr. Romero recalls the method and sound of "The Birds," the Hitchcock classic, in several scenes. The scenes are so beautifully done that Hitchcock might have admired them, or at least their technical facility.

●

"The Dark Half" has been rated R (Under 17 requires accompanying parent or adult guardian). It has some vulgar language and several intentionally gory special effects.

1993 Ap 23, C10:1

Indian Summer

Written and directed by Mike Binder; director of photography, Tom Sigel; edited by Adam Weiss; music by Miles Goodman; production designer, Craig Stearns; produced by Jeffrey Silver, Robert Newmyer, Caroline Baron and Jack Binder; released by Touchstone Pictures. Running time: 98 minutes. This film is rated PG-13.

Unca Lou..Alan Arkin
Jamie Ross.................................... Matt Craven
Beth WardenDiane Lane
Jack Belston.................................... Bill Paxton
Jennifer Morton Elizabeth Perkins
Brad Berman..............................Kevin Pollak
Stick Coder ...Sam Raimi
Matthew Berman Vincent Spano
Kelly Berman............................Julie Warner
Gwen Daugherty.............. Kimberly Williams
Sam Grover...................... Richard Chevolleau

By VINCENT CANBY

"Indian Summer," written and directed by Mike Binder, is a decently acted, extremely mild romantic comedy that you may think you've seen before, although you haven't. It's about a group of men and women in their mid-30's who return to Camp Tamakwa, the summer camp where, 20 years before, they learned about life, love and sex.

Jennifer (Elizabeth Perkins) is the pretty, wise-cracking one who lost her first great love to someone else. Beth (Diane Lane) is a new widow. Matthew (Vincent Spano) and Kelly (Julie Warner) are married but having problems. Jack (Bill Paxton), once the group's most glamorous member, is unmarried and at loose ends. Jamie (Matt Craven) is a tireless womanizer, traveling with his "new fiancée," Gwen (Kimberly Williams), a beauty almost young

Buena Vista Pictures
Vincent Spano

enough to be his daughter. Brad (Kevin Pollak) is the boring one.

The reunion has been called by Unca Lou (Alan Arkin), the camp's owner and a major influence in the life of each of the characters. He is retiring now and planning to sell Camp Tamakwa. Crafty, lovable old fellow that he is, he knows that someone will make a bid during this week of carefully programmed nostalgia. So does the audience.

●

The members of the audience are ahead of "Indian Summer" all the way, not because they know exactly how things will happen but, given the setup, they know what must happen before the movie can end. That kind of insight makes "Indian Summer" seem longer than a rainy night in the woods in a tent that leaks.

The movie is so sincere that it can't be politely knocked. It was actually shot at the Canadian summer camp once attended by Mr. Binder and his friend Sam Raimi, the film director ("Evil Dead" and "Darkman," among others), who here plays a small role as the camp's clumsy handyman. It's full of lethargic situations that may well have their origins in life. There are a lot of jokes that make the characters laugh louder than the people watching the movie. The jokes aren't great, but they're better than the sometimes embarrassing dramatic moments devised to reveal character.

Ms. Perkins, Mr. Paxton and Ms. Lane come off best, if only because their roles are a shade less dim than the others. The film has been photographed with that slightly golden tinge currently favored for movies about good times past. If you like to go to weddings of humdrum people you don't know, you won't want to miss "Indian Summer."

●

"Indian Summer," which has been rated PG-13 (Parents strongly cautioned), has some vulgar language and sexual situations.

1993 Ap 23, C10:5

Good Evening, Mr. Wallenberg

Written and directed by Kjell Grede (in Swedish, German and Hungarian with English subtitles); director of photography, Esa Vuorinen; edited by Darek Hodor; produced by Katinka Farago. At the Joseph Papp Public Theater, 425 Lafayette Street, East Village. Running time: 115 minutes. This film has no rating.

Raoul Wallenberg.............. Stellan Skarsgard
Rabbi in Stockholm............ Erland Josephson
Marja................................. Katharina Thalbach

By STEPHEN HOLDEN

Raoul Wallenberg, the subject of Kjell Grede's deeply unsettling film "Good Evening, Mr. Wallenberg," is considered one of the great heroes of World War II. A mild-mannered, apolitical upper-class Swede who was an importer of luxury foods from Hungary, he was directly responsible for saving thousands of Hungarian Jews from massacre by the Nazis.

In the film's opening scene, Wallenberg is traveling in the luxury dining car of a train speeding through central Europe when it suddenly halts, and policemen run through the cars drawing the shades. Peeking out his window, Wallenberg watches the bodies of Jewish prisoners being dumped from the cattle car of a freight train

across the tracks. One is a little boy whose father leaps out to be with him and is shot to death clutching the dead child in his arms.

The horrifying scene is only a prelude of what is to come in the film, which opens today at the Joseph Papp Public Theater. The Swedish director doesn't shy away from graphic portrayals of Nazi brutality. Again and again, people are shot almost at random, like stray dogs who have suddenly become a nuisance. A young woman is savagely beaten with a rifle butt. And in the most harrowing sequence, dozens of dazed, shivering young men are stripped to the waist, lined up against a wall and mowed down by a firing squad in front of their families.

•

What gives these scenes an especially chilling resonance is the utter casualness of it all. More sharply than any film in recent memory, "Good Evening, Mr. Wallenberg" depicts the Nazi campaign against the Jews as coldly executed by people who viewed their victims as contaminated and therefore disposable. Appeals to humanity meant little to murderers who refused to recognize the humanness of those they slaughtered.

The film is set mostly in Budapest in late 1944, where Wallenberg is using phony documents of Swedish citizenship to install Hungarian Jews in safe houses from which they can be evacuated in small groups. Wallenberg operates with impunity largely because he is a master of authoritarian bluff. He can outshout any officer who might be suspicious of his rescue missions, and he is expert at tweaking bureaucratic paranoia to his advantage.

"Good Evening, Mr. Wallenberg" tells parallel stories. In the more compelling of the two, Wallenberg, using trumped-up papers, arranges the rescue of a group of about 20 Jews, only to have the truck that is supposed to transport them to safety stall in front of the building where they were hiding. As they huddle in the vehicle for two days and nights on a back street in the heart of Budapest, Wallenberg attempts to prevent their massacre by the jumpy Hungarian collaborationist officer who guards them.

At the same time, Wallenberg learns that an order has been given to kill the 65,000 Jews in the Budapest ghetto. Although informed that his usefulness is over and that his death has been ordered, Wallenberg refuses to leave the city, and in one brilliant final bluff, he tries to save the ghetto by confronting the general who will be responsible. It is a race against time. The Soviet Army has surrounded Budapest. And Adolph Eichmann, the region's top Nazi, and his adjutant have left the city.

A film of epic ambitions, "Good Evening, Mr. Wallenberg" is particularly good at evoking a feeling of absolute chaos at a moment when the world is in a state of collapse. The eerily silent back street in which a rapidly diminishing group of survivors and their captor wait for their fate to descend is like an apocalyptic eye of the storm.

"Good Evening, Mr. Wallenberg" is also an unabashed hagiography in which, perhaps inevitably, the characters are dwarfed by events. As portrayed by Stellan Skarsgard, Wallenberg is a heroic man of action who is entirely sympathetic, but also unknowable. In those moments when the film tries to humanize him, the tone turns preachy and portentous.

Wallenberg forms an attachment to Marja, a half-mad survivor who witnessed the slaughter of her two children and who imagines that if she appeared naked in front of the Nazis they would realize she is made of the same flesh and blood. Although the character is well acted by Katharina Thalbach, she becomes too much of a symbolic mouthpiece. And Wallenberg's romantic interest in her seems thuddingly unbelievable.

Less than a month after the events portrayed in the film, Wallenberg was taken prisoner by the Russians. He was never released. An epigraph to the film reflects: "Raoul Wallenberg saved directly and indirectly a hundred thousand lives. We didn't save his."

1993 Ap 23, C12:6

Who's the Man?

Directed by Ted Demme; written by Seth Greenland; director of photography, Adam Kimmel; edited by Jeffrey Wolf and John Gilroy; music by Andre Harrell; production designer, Ruth Ammon; produced by Charles Stettler and Maynell Thomas; released by New Line Cinema. Running time: 124 minutes. This film is rated R.

Doctor Dre	Himself
Ed Lover	Himself
Teesha Braxton	Cheryl (Salt) James
Nick Crawford	Jim Moody
Sergeant Cooper	Denis Leary

By JANET MASLIN

"Who's the Man?" is a genial but slow-moving vehicle for Ed Lover and Doctor Dre, hosts of the daily version of "Yo! MTV Raps." Using their familiar names, they appear as two hapless Harlem barbers who are talked into a career change and become rookies on the police force. Thanks to a collective brainstorm, they pass the entrance exam by answering A-B-R-A-C-A-D-A-B-R-A to a series of multiple-choice questions. Once in uniform, they amaze their old friends, whose disbelieving cries of "You the man?" help to set up the film's title.

These new recruits don't take their work very seriously. The stars have a strong, relaxed presence and remain a sullenly funny couple of losers, with each actor the butt of a running joke (about Ed Lover's failures with women and Doctor Dre's prodigious weight). Unfortunately, the film insists on a coherent story, losing its rambling, jokey tone to a predictable detective plot that centers on the murder of a beloved neighborhood barber (Jim Moody), whose fate is linked to the attendant issue of gentrification.

The facts surrounding the killing would be obvious to anyone, but the film itself is an inside job. "Who's the Man?" is loaded with rap-related cameos that work only if you recognize the players (Fab 5 Freddy, Kid Capri, Naughty by Nature and the Bob Hope of rap cinema, Ice-T), and have little intrinsic humor of their own. Much of the time, the film simply produces these and other performers in walk-on roles and trades heavily on their relative familiarity. Only occasionally will the jokes work for a wider audience, as when the juvenile duo Kriss Kross turn up as aspiring stars. "You can't even dress yourselves!" someone says to the little rappers who popularized clothing worn backward.

"Who's the Man?" also features Denis Leary as an unfunny white cop who taunts the film's heroes; Cheryl

(Salt) James as the occasion for an otherwise pointless fashion show sequence, and other performers with names like Beast, B-Real, Humpty Hump, No Face and Apache. It is energetically directed by Ted Demme, the creator and producer of "Yo! MTV Raps," as if the screenplay, by Seth Greenland, were much better than it is. Despite their obvious comic potential, Doctor Dre and Mr. Lover have a lot more droopy, colorful stocking caps than funny lines.

•

"Who's the Man?" has been rated R (Under 17 requires accompanying parent or adult guardian). It includes considerable profanity and slight violence.

1993 Ap 23, C19:1

Map of the Human Heart

Directed by Vincent Ward; written by Mr. Ward and Louis Nowra; director of photography, Eduardo Serra; edited by John Scott; production designer, John Beard; produced by Tim Bevan, Mr. Ward, Tim White, Linda Beath and Sylviane Sainderichin; released by Miramax Films. Running time: 109 minutes. This fim is rated R.

Avik	Jason Scott Lee
Young Avik	Robert Joamie
Albertine	Anne Parillaud
Young Albertine	Annie Galipeau
Walter Russell	Patrick Bergin
Clark	John Cusack
Sister Banville	Jeanne Moreau

By JANET MASLIN

Vincent Ward of New Zealand is an extraordinarily inventive film maker, having sent his characters tunneling from medieval times to the present in "The Navigator" (1988) and having spent two years studying a Maori mother and son for an earlier short film, "In Spring One Plants Alone." He now ventures to Alaska for "Map of the Human Heart," the strange and single-minded story of a young Eskimo, his half-breed sweetheart and the events that carry him from the Arctic to Dresden, Germany, where he participates in a World War II bombing mission. Even by Mr. Ward's own high standards in the area of idiosyncrasy, this is a daringly peculiar tale.

With its many recurring motifs and symbolic elements — maps, flames, flying machines — "Map of the Human Heart" surely sounds fascinating, at least on paper. It tells of Avik (Jason Scott Lee), who is first seen in 1965 as a dissipated wreck living on the fringes of an Alaskan oil settlement and telling his story to a stranger named Clark (John Cusack). The narrative moves backward to 1931, when Avik is a boy (Robert Joamie) bouncing on an Eskimo-style trampoline. As he hurls himself skyward, a biplane appears. "Every time Avik is thrown up in the sky, he brings down an airplane," someone later says.

Aboard this first plane is the map maker Walter Russell (Patrick Bergin), who singles out Avik as a bright and promising young protégé. There in the snow, against a landscape of fierce, forbidding beauty, a curious friendship between Walter and Avik is forged. Walter calls his young friend "Holy Boy" after Avik's way of confusing two English exclamations ("Oh, boy!" and "Holy cow!"). The film finds this a particularly apt nickname, one that lasts throughout the story.

The film lingers a while in the Eskimos' world, observing such sights as a wizened old woman with dotted lines tattooed into the folds of her face, who plays a primitive accordion to celebrate the killing of a seal. (One of the film's undeniable strengths is the eerie authenticity of its Eskimo episodes.) It then abruptly carries Avik to Montreal once Walter has decided the boy is desperately ill. In a hospital, treated by white doctors and subjected to new forms of medicine, Avik improves but also changes. At the same time, he becomes smitten with Albertine (Annie Galipeau), a beautiful young girl with whom he feels an immediate kinship.

Half French Canadian and half Indian, Albertine shares Avik's sense of being an outsider in white society. She also arouses enough early romantic longings to enrage Sister Banville (Jeanne Moreau, in the unlikely role of a nun who punishes her charges by hitting them with a ruler). Mr. Ward, with his typical taste for oddly salient moments, encapsulates the budding romance between these two wild young characters by showing them alone at night, singing songs, playing with a piece of raw meat. When they are forcibly separated, the film dwells on an equally strange detail: Albertine's chest X-ray, the only thing Avik has to remember her by.

Years later, having felt and resisted the tug of his native society, Avik is in England flying fighter missions and still trusting in fate. Sure enough, fate provides a meeting with the grown-up Albertine, who has metamorphosed beautifully into the elegant Anne Parillaud. She and Avik resume their closeness in what is by now a predictably quirky manner; it even involves using aerial photographs of bombing patterns (Albertine is a WAAF photo analyst) to transmit romantic data. So Albertine is coyly sent to meet Avik at Royal Albert Hall. And the two make love atop a small dirigible, which is surely a cinematic first.

•

Despite that last image and many other strikingly eccentric ones, Mr. Ward (who wrote the screenplay with Louis Nowra) gives the film a conventional core. Its obsession with maps, heritage, love and loss can boil down to surprisingly conventional small talk. (Walter: "Women *are* a map, Avik. You've got to understand their longitude and how much latitude you can take.") Its tracking of Avik and Albertine's star-crossed romance culminates in a closing sequence that makes a full leap into soap opera, though it has begun to sound banal long before then.

Ms. Parillaud, the smashing star of "La Femme Nikita," has another feral, glamorous character to play. But she speaks in a wispy voice that barely sounds like her own, and her scenes with Mr. Lee lack an all-important sense of the inevitable. Mr. Bergin is more suitably distant as the cryptic Walter, but his character is also bogged down by the material's soap-opera strain. "Sometimes I don't know what to make of you," he says to Albertine, with whom he has become romantically involved. (The revelation that Walter has lied about his map making seems to signal this betrayal.) "Sometimes I don't know what to make of myself," Albertine replies.

"Map of the Human Heart," which is far more memorable for the spectacular wildness of its Arctic and Dresden scenes (as photographed by

Eduardo Serra) than for its uneven efforts to bind such images together, is helped by the two young actors who play Avik and Albertine as hospitalized children. Both Mr. Joamie and Miss Galipeau are fresh, natural performers, in keeping with the untamed spirit that this sprawling, ambitious film seems to be after.

"Map of the Human Heart" is rated R (Under 17 requires accompanying parent or adult guardian). It includes brief nudity, sexual situations and some profanity.

1993 Ap 23, C21:3

FILM VIEW/Caryn James

Lots of Pain And Not Much Gain

BY THE END OF "THIS BOY'S LIFE," ROBERT De Niro has become the perfect demon stepfather. As Dwight, he shouts relentlessly at his adolescent stepson, Toby, and calls the boy a pig for eating candy. He knocks over chairs and smashes dishes, forces an empty mustard jar over Toby's eye because he doesn't think it's empty enough to be tossed out, and eventually comes to a brutal, all-out punching match with him. By then the audience is likely to feel as thrashed as Toby. So why isn't that a compliment? Because sitting through "This Boy's Life" means experiencing two hours of emotional abuse, and life is too short to put yourself through such a lot of pain for so little in return.

Such graphic films are often highly praised, and too wrenching to sit through. "Il Ladro di Bambini" ("Stolen Children"), the tale of an abused and unloved brother and sister being taken to an orphanage, and "Lorenzo's Oil," a medical mystery about parents who try to find a cure for their son's degenerative disease, are other recent works that fit the pattern. Like "This Boy's Life," these films are so admirable, with serious themes and unsentimental styles, that they are hard to fault (which may account for some of the glowing reviews). But they are also grueling to watch and impossible to send a friend to see.

This is not a plea for more fluff and fake-happy Hollywood

If it hurts to watch movies like 'This Boy's Life,' what should audiences expect in return?

endings, for nothing is more insulting to audiences than contrived detours from reality. And the issue is not about using movies as escapism; that's simply a matter of a viewer's mood at the moment. It is about the crucial questions these serious films raise: How much emotional pain can a viewer be asked to bear? When is the agony worth it?

Immersing a viewer in some brutally realistic scene is never enough. When the characters are in visible pain and the audience in visceral pain, the story has to be emotionally engaging or psychologically illuminating or simply new enough to match those feelings. That is precisely where these three films fail.

"This Boy's Life" should have been better than it is, and would have been if the adult characters had been written with more complexity. Dwight's lovely but muddled wife, Caroline (Ellen Barkin), is especially frustrating. It is easy to understand why a woman in the 1950's, unable to cope with an adolescent son, would feel the need to marry. But why would Caroline settle for Dwight, who at best seems oafish and at worst conspicuously false, with hearty bad jokes and an overpolite manner that must be masking something? Viewers can posit all sorts of explanations for Caroline's bad

judgment, but not one of them comes from the film. Yet the audience is asked to suffer Dwight's abuse along with her.

The movie offers no better understanding of Dwight. He is obviously threatened by his smart, ambitious, unruly stepson, but most threatened stepfathers don't go for the nearest mustard jar. Recreating the family's hellish situation becomes the movie's point.

"Il Ladro di Bambini" places its physical abuse in the story's past. An 11-year-old girl, whose mother has made her a prostitute, and her little brother are being brought to the orphanage by a young carabiniere. The film effectively and langorously recreates the journey of these unloved children and the young man, who wants to save them but cannot.

This is neo-neo-realism, descended from the Italian postwar films that took a nearly documentary look at a shattered world. At the time, just showing devastation may have been enough. Today, with headlines blaring about abused children and neo-realism a style of the past, this film seems dated and hollow no matter how eloquently it depicts its characters' pained lives.

"Lorenzo's Oil" takes a different approach but has a similar problem. It puts a suffering child on dramatic, though not lurid, display. Through two and a quarter hours, viewers watch a 6-year-old boy gradually and irreversibly lose his ability to walk, talk and function in any way. The film is unflinching about the boy's suffering.

It flinches, instead, at the parents': Susan Sarandon and Nick Nolte are so determined to find a cure, and the film so determined to be a medical detective story, that their most emotional scenes feel empty. When Mr. Nolte falls apart in a deserted hospital stairwell, howling because he believes his son will die, the scene seems to be about acting rather than a father's anguish. When the couple's marriage is about to shatter under the strain, their supposedly explosive argument feels like an obligatory scene. It's as if the film had done enough by portraying a failing child.

These films may be especially difficult to endure because they are about children, whose suffering is always harder to watch. But that is only part of the problem. It is just as brutal to hear an adult's death rattle in Ingmar Bergman's "Cries and Whispers" or to sit through the relentless catalogue of evidence from concentration camps in Alain Renais's "Night and Fog." Both films evoke emotions and knowledge that make the viewer's discomfort necessary.

And a film doesn't have to be a classic to justify a painful experience. It is upsetting to witness the debased life that Harvey Keitel depicts in "The Bad Lieutenant" or the way a bloody Tim Roth screams that he is dying in "Reservoir Dogs." But these movies are not afraid of their own characters and emotions, so the audience leaves the theater knowing and feeling more than it did walking in. When a film rubs a viewer's nose in misery, the moviegoer should come away with more than a dirty nose and deep depression. ☐

1993 Ap 25, II:17:5

The Execution Protocol

Directed by Stephen Trombley; cinematographer, Paul Gibson; music by Robert Lockhart; produced by Mitch Wood and Mr. Trombley; released by First Run Features. Film Forum 1, 209 West Houston Street, South Village. Running time: 90 minutes. This film has no rating.

WITH: Bill Armontrout, Dr. Pedro Cayabyab, Paul Delo, Don Roper, Gary Sutterfield and Gary Tune, all prison officials, and Joe Amrine, A. J. Bannister and Dolye Williams, inmates.

By VINCENT CANBY

The Potosi Correctional Center near Mineral Point, Mo., is a clean, well-lighted place. From the outside, it looks like a compound of big, functional, not ungraceful cement-block bunkers that sits in the middle of a broad grassy plain from which each tree, bush and weed has been removed. The view is Spartan, almost abstract, but then the people at Potosi don't often look out. Attention is focused inward.

Potosi, the subject of Stephen Trombley's haunting new documentary, "The Execution Protocol," was built to house some 300 inmates convicted of capital crimes. It prides itself on being as up to date as any prison in the United States as well as one of the most humane. In a Shavian twist, it's the humaneness of the place that Mr. Trombley, an American-born, English-based film maker, finds to be so merciless.

Yet he makes his argument against capital punishment with such seeming detachment that the Missouri Department of Corrections has asked to use videos of his film for "educational training purposes." "The Execution Protocol," which starts today at the Film Forum, is so coolly and carefully constructed that it can apparently be interpreted as an audio-visual aid if you happen to be in the business of legalized killing.

•

When Mr. Trombley made the film in March 1992, each Potosi inmate faced a sentence of 50 years without parole, life without parole or death. (Shortly after filming was completed,

the prison was integrated to include other types of prisoners.) Mr. Trombley's focus is on the death row prisoners and on the introduction of lethal injection as the favored form of inducing death. He talks at length to the prison superintendent, his staff and, in particular, to three prisoners, each of whom is facing execution.

Of the staff members and the prisoners, Mr. Trombley says, "They have this in common: Each of them has taken a life."

As a kind of dividend, Mr. Trombley also interviews Fred A. Leuchter, the Massachusetts man who designed the prison's lethal-injection machine. With the enthusiasm of Dr. J. I. Guillotin 200 years ago, Mr. Leuchter and other specialists see their work as a breakthrough in the technology of capital punishment.

Its promoters say lethal injection is painless, though no one has ever come back to report firsthand. Certainly it does not arouse the kind of horror and outrage that are prompted by vivid descriptions of hanging, electrocution and death by gas.

It's this very ordinariness that disturbs the prisoners Mr. Trombley talks to. Like A. J. Bannister, a big, articulate man who chooses his words with care, the prisoners see lethal injection as a way the state can defuse public objections to capital punishment. Lethal injection seems also to have lightened some of the emotional load carried by the people responsible for the executions.

For the most part, the members of the Potosi staff seem a decent group of people who take their responsibilities seriously. Mr. Trombley sits in on meetings at which they discuss possible glitches in the technology and try to smooth out what the filmmaker calls the execution protocol, those procedures that are followed before, during and after any execution.

Mr. Trombley listens to the prisoners who, with some understatement, talk about their reactions to these new humane methods. Doyle Williams recalls how he got a reprieve three hours before his execution was to take place, after having already received the first of the series of tranquilizers that are administered over a four-hour period before the inmate is wheeled into the execution chamber. (As more than one person notes, the execution chamber is attached to the prison hospital.)

The prisoners' testimony is tough, delivered with awful calm. Asked what he thinks about the prison chaplain, whom he sees as part of the capital-punishment system, a prisoner named Joe Amrine answers, "It's a little hard to relate to him." Mr. Williams remembers the last visit he had with members of his family and friends on the night he was to die. "Even though you aren't alone, you are alone," he says.

Though the film resolutely avoids inflammatory material, its effect is as powerful as that of "The Titicut Follies," Frederick Wiseman's seminal work about conditions at the state prison for the criminally insane at Bridgewater, Mass. "The Execution Protocol" is not easy to sit through, but it touches nerves that force a rethinking of essential values. It is exceptionally well done.

1993 Ap 28, C13:1

Bound by Honor

Directed by Taylor Hackford; screenplay by Jimmy Santiago Baca, Jeremy Iacone and Floyd Mutrux, based on a story by Ross Thomas; director of photography, Gabriel Beristain; edited by Fredric Steinkamp and Karl F. Steinkamp; music by Bill Conti; production designer, Bruno Rubeo; produced by Mr. Hackford and Jerry Gershwin; released by Hollywood Pictures. Running time: 180 minutes. This film is rated R.

Miklo................Damian Chapa
Cruz................Jesse Borrego
Paco................Benjamin Bratt
Montana................Enrique Castillo
Big Al................Lanny Flaherty

By VINCENT CANBY

"Bound by Honor," Taylor Hackford's ambitious melodrama about the Chicano experience in and around East Los Angeles, is like one of those huge wall murals that give bold, defiant color to an urban landscape that otherwise looks passive and drab. The film is big and long (nearly three hours), passionate and flat. It's full of heroic and tragic incident, but skimpy about the details of quotidian lives. Though it's not the epic it means to be, it is not a failure.

"Bound by Honor" is the story of 12 crucial years in the formation of three young men: Paco (Benjamin Bratt), who seems to have been born angry; his half-brother, Cruz (Jesse Borrego), who has the talent and temperament of an artist, and Paco's cousin Miklo (Damian Chapa), whose father is Anglo and mother is Mexican-American, a fact that determines the direction of his life.

With his light skin, sandy hair and blue eyes, Miklo grows up always having to certify his claim to be a member of the macho Chicano brotherhood. Of the three young men, he becomes the most furious and fanatical, the one with the most obsessed

The crucial years in the lives of three young men.

vision. Paco, a seeming loose cannon with a hair-trigger temper, goes through an off-screen conversion of character while serving a hitch in the United States Marines. By the middle of the film, he is a police detective and, it seems, a good one, patiently negotiating his way between his own minority culture and that of the dominant white society. Cruz's early success as a painter is nearly wrecked by his addiction to drugs.

•

This is the barest outline of the screenplay, which was written by Jimmy Santiago Baca, the New Mexico-born poet, after earlier versions had been written by Floyd Mutrux and then by Jeremy Iacone, from a story by Ross Thomas. The film's title was not idly chosen. "Bound by Honor" is almost exclusively concerned with each of the three friends' sense of his own identity in a perilous environment in which the hostile forces are whites, blacks and other Chicanos.

The initial impulse is to compare "Bound by Honor" to Luchino Visconti's epic "Rocco and His Brothers." Yet "Bound by Honor" is no great family saga set in a time of over-

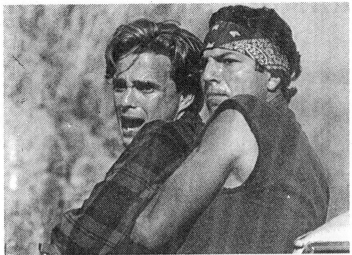

Merrick Morton/Hollywood Pictures

Blood Ties Damian Chapa and Benjamin Bratt portray Chicano cousins in "Bound by Honor," which co-stars Jesse Borrego.

whelming social, political and economic change. "Bound by Honor" is an action melodrama with a social conscience.

Miklo, Paco and Cruz are characters whose rich potential is severely limited by the circumstances in which their stories are played out: gang fights and beatings, car chases and shootouts, sit-downs and reconciliations, in East Los Angeles and in San Quentin prison, where Miklo effectively grows up. Much of the film is riveting, especially the San Quentin sequences actually shot inside the prison. "Bound by Honor" takes on real heft as it follows Miklo's cool, brutal rise through the prison's Chicano power structure to become a figure of dark political importance.

•

Yet a lot is missing. Miklo, Paco and Cruz are defined almost entirely in the terms in which they choose to present themselves to their peers. They are all swagger, intimidation and attitude. It's as if they had no private moments, to say nothing of private lives.

With the exception of a sequence involving the accidental death of Paco's and Cruz's younger brother, the film pays little attention to their families. The movie sees virtually nothing of how these Chicanos earn their livings, eat, sleep and make love. Only Cruz is seen to have a girlfriend, and then only briefly. Paco and Miklo would appear to be celibate. "Bound by Honor" presents their lives as an unending succession of moments of high melodrama.

If there were a greater urgency to the melodrama, the mind might not have time to wander, and to wonder about everything that is not seen. The movie's narrative is full of twists and turns, some of which remain undramatized (like Paco's reformation), without gathering momentum until near the end. Even the film's time frame seems arbitrary.

The story begins in 1972. Succeeding sequences are identified as taking place in 1973, 1980, 1983 and 1984. The significance of these dates remains unexplained, either by the film or by anything the moviegoer can bring to it. A lot was going on outside East Los Angeles and San Quentin in that period. Yet nothing the audience sees in the film has any particular relation to the end of the Vietnam War, or the collapse of the Nixon era or the beginning of the Reagan years. If this is the

film's point, it's an unilluminating one.

•

Mr. Hackford has cast the film well. Though they must play at a fever pitch most of the time, Mr. Chapa, Mr. Bratt and Mr. Borrego are excellent, as are the members of the large supporting cast, notably Enrique Castillo, who appears as the leader of San Quentin's Chicanos, and Lanny Flaherty, as the San Quentin con who makes an unfortunate bargain with Miklo.

"Bound by Honor" looks and sounds authentic but, like many community wall paintings, it has the manner less of one artist's vision than of a community endeavor. This may explain its singular shortcomings and its redeeming sincerity.

•

"Bound by Honor" has been rated R (Under 17 requires accompanying parent or adult guardian). It has a lot of vulgar language and scenes of physical and psychological violence.

1993 Ap 30, C8:1

Dead Flowers

Written and directed by Peter Ily Huemer, (in German with English subtitles); director of photography, Walter Kindler; edited by Eliska Stibrova; music by Peter Scherer; produced by Veit Heiduschka; released by Upfront Films. Le Cinématographe/Bleecker at Anthology Film Archives, 32 Second Avenue, East Village. Running time: 90 minutes. This film has no rating.

Alex................Thierry van Werveke
Alice................Kate Valk
Oma................Tana Schanzara
Willy d'Ville................Dominique Horwitz

By STEPHEN HOLDEN

Alex (Thierry van Werveke), the protagonist of "Dead Flowers," a supernatural mystery film from Austria, is a dour-faced exterminator who lives with his widowed grandmother (Tana Schanzara) in a Vienna suburb.

One day while driving around in his van, he picks up an attractive hitchhiker named Alice (Kate Valk), who has an intense, slightly mischievous stare and a tendency to shed her clothes at a moment's notice. Alex takes her home with him, and it isn't

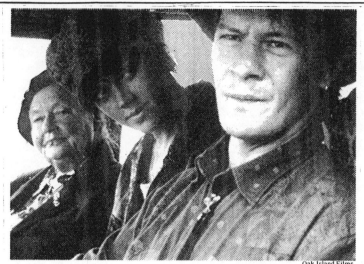

Oak Island Films

Affair of the Heart Tana Schanzara, Kate Valk and Thierry van Werueke appear in "Dead Flowers." Set in suburban Vienna, Peter Ily Huemer's mystery concerns an exterminator who falls in love with a diplomat's daughter.

long before they are a couple. As it happens, Alice is being pursued by a sinister stranger. At first she explains she is in danger because her father is a United Nations diplomat in the pay of the Central Intelligence Agency. But as she later reveals, she is really a ghost who has escaped from the underworld. The Mephistophelean hoodlum who pursues her, Willy d'Ville (Dominique Horwitz), is an agent of forces who want to capture her and bring her back.

"Dead Flowers," which opens today at the Anthology Film Archives in the East Village, is the kind of film that would probably be much more exciting if it were a $20 million Hollywood thriller instead of a low-budget semi-avant-garde movie done with tongue-in-cheek humor. The film, written and directed by Peter Ily Huemer, takes far too long to set up its ingenious plot. But once the story begins to click, it suggests a clever episode of "Star Trek" or "Twilight Zone."

•

What begins as a flat, uninvolving mystery with no visual energy assumes a creepier edge once Alice has disappeared and Alex confronts Willy in a funeral parlor, forcing him to grant Alex temporary passage to the underworld. What he discovers after a misty rowboat ride is a drab modern warehouse environment where the residents hang around with little to do and the mood is one of all-encompassing boredom. Overseeing things in a giant, dusty library, crowded with files and pieces of broken sculptures, is an androgynous young woman who is unfailingly reasonable and polite.

"Dead Flowers," though generally well-acted, is not helped by a charmless central performance by Mr. Van Werveke, who projects an unrelieved crankiness. But Miss Valk, of the Wooster Group, the well-regarded New York City theater collective, is an impishly enigmatic Alice, and Mr. Horwitz, wearing sunglasses and a ruffled purple shirt, exudes the sleazy menace of a lounge lizard with poisoned fangs.

1993 Ap 30, C8:5

The Night We Never Met

Written and directed by Warren Leight; cinematographer, John A. Thomas; edited by Camilla Toniolo; production designer, Lester Cohen; produced by Michael Peyser; released by Miramax Films. Running time: 99 minutes. This film has no rating.

Sam Lester Matthew Broderick
Ellen Holder Annabella Sciorra
Brian McVeigh Kevin Anderson
Secretary Louise Lasser
Pastel Jeanne Tripplehorn
Janet Beehan Justine Bateman
Aaron Holder Michael Mantell
Lucy Christine Baranski
Nosy Neighbors
 Doris Roberts and Dominic Chianese
Dental Patient Garry Shandling
Cabbie Ranjit Chowdhry

By JANET MASLIN

"The Night We Never Met" describes a downtown pied-à-terre that is used on alternating days by three total strangers, who wind up washing one another's dirty dishes and trying to impose their conflicting housekeeping styles on the chaotic décor. The film is intended as a light romantic comedy, even though it sounds more like a prescription for murder.

Working in what is at best a hip sitcom style (and more often a labored, unconvincing version of same), the writer and director Warren Leight explains this premise as best he can. It seems that Brian McVeigh (Kevin Anderson), an obnoxious yuppie stockbroker, holds the lease to this rent-controlled hideaway and wants to use the place with his frat buddies after he marries Janet Beehan (Justine Bateman), a yuppie princess. Brian and his pals have filled the recessed, lighted bookshelves with their collection of beer bottles, mugs, baseball caps and book ("Trump"). The sets and costumes are often funnier than the characters.

Since Brian is so often otherwise engaged, he uses his secretary (Louise Lasser, looking acutely uncomfortable) to sublet time-share use of the apartment to Sam Lester (Matthew Broderick), who is getting tired of his crowded East Village crash pad. The third tenant is Ellen Holder (Annabella Sciorra), a Queens dental hygienist who wants to paint. In case this setup isn't cute enough, Mr. Leight also works in a pair of nosy

neighbors (Doris Roberts and Dominic Chianese) who are repeatedly seen peering into the apartment and looking scandalized by the not-very-scandalous things they see.

•

Since the tenants never knowingly cross paths, they are able to develop misleading impressions of one another, which is where the potential for comedy lies. But the film condescends to its characters so consistently that it takes on a sour edge. Ellen's husband (Michael Mantell) runs a dry-cleaning business, wears a gold necklace, boasts about having Neil Diamond tickets and watches sports on a pocket television set when Ellen drags him to a subtitled Scandinavian film. Sam's ex (Jeanne Tripplehorn) is an inexplicably loud and abrasive French performance artist. Brian himself, though deftly played by Mr. Anderson, is a walking catalogue of boorish behavior.

"The Night We Never Met" is never lifelike enough to evoke the madly romantic New York atmosphere it seems to be after. The actors try hard, but they are hamstrung by too many broad strokes and silly inconsistencies. Both Mr. Broderick and Ms. Sciorra manage to seem warmly appealing in the face of overwhelming obstacles, but the story doesn't fling them together until its closing scene. This is reason enough to wish Mr. Leight had moved directly to the sequel and skipped the preliminaries.

Also in the cast are Christine Baranski as the sister who shops too much and helps Ellen cover up her indiscretions; Ranjit Chowdhry as the cabbie who tries to calm Ellen down at a critical moment, and Garry Shandling as a dental patient who repeatedly makes passes at her. Observing that Ellen touches him only while wearing rubber gloves, he wonders whether to take this personally.

1993 Ap 30, C10:6

Three of Hearts

Directed by Yurek Bogayevicz; screenplay by Adam Greenman and Mitch Glazer, based on a story by Mr. Greenman; director of photography, Andrzej Sekula; edited by Dennis M. Hill; music by Joe Jackson; production designer, Nelson Coates; produced by Joel B. Michaels, Matthew Irmas and Hannah Hempstead; released by New Line Cinema. Running time: 97 minutes. This film is rated R.

Joe William Baldwin
Connie Kelly Lynch
Ellen Sherilyn Fenn
Mickey Joe Pantoliano
Yvonne Gail Strickland

By JANET MASLIN

He's a dreamboat. She's a lovelorn nurse. They may sound like ordinary characters in terms of movie romance, but the story of how they move in together and share a purpose in life does have a few new wrinkles. For one thing, Joe Casella (William Baldwin) is being paid for his trouble by Connie Czapski (Kelly Lynch), who has just been ditched by the person she loves. For another, that person is Ellen Armstrong (Sherilyn Fenn), a beautiful English teacher who might just like Joe better than she ever liked Connie.

"Three of Hearts" finds a fresh, engaging story within the dynamics of this romantic triangle, taking a droll and believable view of these characters and their uncommon problems. Connie, first seen in biker garb being abandoned by the much primmer-looking Ellen, makes no attempt to hide her heartbreak. She was planning to shock her relatives by declaring her love for Ellen at a large Polish wedding, and now finds herself without either a mate or a suitably bold dramatic gesture. Then a patient suggests Connie try an escort service. And a phone call produces Joe, who's a lot more than Connie ever bargained for.

"Any woman. Any time. Any place. Guaranteed." That is Joe's unofficial motto, and Mr. Baldwin plays him with a smooth, lady-killing charm that makes the motto seem no idle boast. As the film's principal love object, Joe is watched appreciatively as he works his wiles on everyone, including Connie, who has no great romantic interest in men. "That's how I do it!" Joe gloats after he successfully sweet-talks Connie, just to show her that he can.

Delighted by Joe after he puts in a dashing appearance at her relative's wedding, Connie has an even better idea. "Are you good with women?" she asks. "Are you good at your job?" Naturally, Joe answers in the affirmative. "So you can break her heart and send her running back to me!" Connie decides, offering to pay Joe for what she hopes will be his brief, cavalier pursuit of Ellen. But from

Kimberly Wright/New Line Cinema

A Few Friends and Lovers Sherilyn Fenn and William Baldwin star in "Three of Hearts," a romantic comedy by Yurek Bogayevicz about a bachelor and two women.

the way Ellen discreetly slips off her glasses when Joe strides into her classroom, the viewer can be sure that Connie's plan is headed for trouble.

By far the breezier and more plausible of the two New York triangular romantic comedies opening today (the other is "The Night We Never Met"), "Three of Hearts" skates onto thin ice when it lets the demure, beautiful Ellen choose between Connie and Joe. Will the film take the route of a conventional heterosexual love story? Or will it ultimately treat its lesbian lovers as comfortably and naturally as it did during that opening sequence? As written by Adam Greenman and Mitch Glazer and directed with verve by Yurek Bogayevicz ("Anna"), "Three of Hearts" manages to find some middle ground by letting each of its characters discover his or her independence. The last part of the film falls back on heavy contrivances, but the resolution rings true.

Ms. Fenn, as the sought-after Ellen, has the lush good looks of an old-fashioned film star without the forceful personality of her co-stars. But Ms. Lynch gives a tough, funny performance that captures all of Connie's torment, and she displays a wonderful rapport with Mr. Baldwin, who radiates serious star quality of his own. Teasing and charming his way through the story like the gigolo he's supposed to be, Mr. Baldwin loses ground only during a talky, sincere section that comes late in the film. He appears much more comfortable delivering wisecracks and playing the perfect foil to Ms. Lynch's confused, suspicious heroine.

Also in the film are Joe Pantoliano, amusingly nonchalant as the sleazy escort entrepreneur who is Joe's boss, and Gail Strickland, whose scenes as a predatory Park Avenue matron wind up giving the film an unwelcome mean streak. Mr. Baldwin, as the consummate pretty boy, is able to remain involving and sympathetic even when the film underscores his character's cynicism. Not every actor can deliver a line like "You're so beautiful you make my heart stop" (as he does later, in a more earnest spirit) and make it stick.

"Three of Hearts" is rated R (Under 17 requires accompanying parent or adult guardian). It includes profanity and sexual situations.

1993 Ap 30, C16:4

The Pickle

Written and directed by Paul Mazursky; director of photography, Fred Murphy; edited by Sturat Pappé; music by Michael Legrand; production designer, James Bissell; produced by Mr Mazursky and Mr. Pappé; released by Columbia Pictures. Running time: 103 minutes. This film is rated R.

Harry Stone	Danny Aiello
Ellen Stone	Dyan Cannon
Françoise	Clotilde Courau
Yetta	Shelley Winters
Ronnie Liebowitz	Barry Miller
Mike Krakower	Stephen Tobolowsky
Phil Hirsch	Jerry Stiller
President	Little Richard
Molly-Girl	Ally Sheedy
Doctor	Spalding Gray
Butch Levine	Paul Mazursky

By JANET MASLIN

"The Pickle" is Paul Mazursky's comedy about a movie director who, though he is so famous that strangers often recognize him and talk about

his work, has still been persuaded to sell out. At the behest of a smug, overconfident young studio executive, Harry Stone (Danny Aiello) has been talked into making a movie about a giant pickle that flies through space. "I didn't direct a movie," Harry says. "I committed a crime."

Accordingly, "The Pickle" has fun with the kinds of studio high-rollers who keep too many cactuses in their offices, watch their weight fanatically and never make an independent decision when they can fall back on audience opinion polls instead. The unceremonious way in which Mr. Mazursky's film arrived here yesterday, opening at the Beekman and other theaters without benefit of advance press screenings, may more or less prove this veteran director's point.

"The Pickle" uses Harry's arrival in New York, where he will have to live through a sneak preview of his latest opus, as an occasion to look back on his past. Like Mr. Mazursky's much earlier "Alex in Wonderland," it presents a film maker in turmoil, one who looks at his own career with something of a jaundiced eye. During the couple of days that Harry spends holed up at the Plaza Hotel (naturally, the film includes a Donald Trump cameo), Harry touches bases with two ex-wives (Dyan Cannon is particularly warm and glamorous as the one who wants money). He also sees his mother (Shelley Winters), who tells him he ought to dress his age. Harry is accompanied on these visits by a very young French girlfriend (Clotilde Courau) who looks all too comfortable with the huge stuffed panda he means to give to his grandchild.

Occasionally Mr. Mazursky cuts to "The Pickle," the film-within-a-film that stars Ally Sheedy as a pickle-growing farm girl. She winds up on the Planet Cleveland, which is ruled by Little Richard and looks like a mixture of New York and Washington. It is stipulated that everyone on Cleveland must wear black spandex, eat meat exclusively and die at the age of 49. And on Cleveland, the Bible is available in video form. Mr. Mazursky may be attempting the impossible in trying to out-silly a huge Hollywood science-fiction epic, but at the writing level, at least, he sustains his satirical edge.

"The Pickle" also incorporates black-and-white flashbacks to Harry's childhood, like the scene in which his mother tells him that listening to the right music will give him goose bumps. "And never forget it, Harold," she says. "That's what a human being can make you feel." Mr. Mazursky, ever the humanist even when working in a gently satirical mode, does his best to underscore that point.

This film is enjoyably caustic in its movie-business scenes, which amount to shooting fish in a barrel (Barry Miller and Stephen Tobolowsky are especially funny as pure Hollywood stereotypes) but nonetheless leave the fish dead. It becomes more maudlin and introspective as Harry visits with his long parade of friends and relatives. For all of them, he retains a warm spot as big as the Ritz.

Eventually, "The Pickle" goes overboard in allowing Harry to make a sentimental tape recording meant for all of them. But Mr. Mazursky, a seasoned observer with a wry and generous outlook, does sustain his truly gentle touch. (He also appears briefly as an old school friend of Harry's.) And Mr. Aiello succeeds in

turning Harry's unraveling into a kind of extended love-in.

The film is best when it curbs its sentiment and manages to stay droll. In one scene, the panicky Harry tries to buy a blood-pressure monitor and encounters a salesman who's also a movie fan. The salesman explains that he sold the same monitor to Woody Allen (who co-starred in Mr. Mazursky's "Scenes From a Mall," the failure of which may have helped inspire this film). "What was *his* pressure?" Harry wants to know.

•

"The Pickle" is rated R (Under 17 requires accompanying parent or adult guardian). It includes profanity, brief nudity and sexual situations.

1993 My 1, 11:1

Splitting Heirs

Directed by Robert Young; written by Eric Idle; director of photography, Tony Pierce-Roberts; edited by John Jympson; music by Michael Kaman; production designer, John Beard; produced by Simon Bosanquet and Redmond Morris; released by Universal Pictures. Running time: 87 minutes. This film is rated PG-13.

Henry	Rick Moranis
Tommy	Eric Idle
Duchess Lucinda	Barbara Hershey
Kitty	Catherine Zeta Jones
Shadgrind	John Cleese
Angela	Sadie Frost
Butler	Stratford Johns
Mrs. Bullock	Brenda Bruce
Andrews	William Franklyn
Mrs. Patel	Charubala Chokshi
14th Duke	Jeremy Clyde
Brittle	Richard Huw

By VINCENT CANBY

The 15th Duke of Bournemouth has never had an easy time of it. When he was a baby in the 1960's, his father, the hippie 14th duke, and his American mother mislaid him in a restaurant. As an adult named Tommy (Eric Idle), the adopted son of a Pakistani family living in London, he continues to get the short end of the stick. He's a passive fellow until the day he finds out that he's the rightful heir to the Bournemouth title.

It's then that Tommy takes action. He schemes to kill off the bogus 15th duke, a nervy American nitwit named Henry (Rick Moranis), who also happens to be his best friend. Though it's never really clear how Henry fell into his good fortune, don't look cockeyed gift horses in the mouth.

It makes no difference that "Splitting Heirs," a brisk new English farce, has a plot more hysterically convoluted than that of "The Big Sleep." The film is a genial entertainment in the Monty Python tradition, a series of madly illogical sequences that even include something a screen card identifies as "Hindu Dream Sequence."

As written by Mr. Idle and directed by Robert Young (an English film maker not to be confused with the American director of the same name), "Splitting Heirs" rambles with spirit and speed. The jokes and comedy routines are often intentionally awful ("I'm bisexual; whenever I want sex, I buy it"), and sometimes hilarious even though not entirely new.

Tommy's astonishment on learning that he is not the natural son of his Pakistani parents recalls a similar scene in "The Jerk" with Steve Martin. Though Tommy's attempts to murder Henry evoke memories of "Kind Hearts and Coronets," there's still laughter when he tries to do the dirty deed by filling Henry's scuba tank with helium.

•

Mr. Moranis works very well with the otherwise very British cast, as does another American performer, Barbara Hershey, who plays the sex-starved Duchess of Bournemouth, Tommy's mother. Very funny, too, is Catherine Zeta Jones, a new, sultrily beautiful young Welsh actress, who appears as a woman willing do anything to become a duchess. As if to keep tabs on everyone else, the incomparable John Cleese butts in from time to time as a shabby lawyer named Raoul Shadgrind.

"Splitting Heirs" opened here yesterday at a number of theaters, including the Worldwide Cinemas 2 where, at the noon show, there were approximately 10 people in the house when the lights went down. It deserves far better. It's a movie, not a state secret.

•

"Splitting Heirs" has been rated PG-13 (parents strongly cautioned). It has some vulgar language and partial nudity.

1993 My 1, 17:1

Clive Coote/Universal City Studios

Rick Moranis, left, and Eric Idle in a scene from "Splitting Heirs."

Sidekicks

Directed by Aaron Norris; screenplay by Donald G. Thompson and Lou Illar, from a story by Mr. Illar; director of photography, João Fernandes; edited by David Rawlins and Bernard Weiser; music by Alan Silvestri; production designer, Rueben Freed; produced by Don Carmody; released by Vision International and Triumph Releasing. Running time: 100 minutes. This film is rated PG-13

Chuck Norris	Himself
Jerry Gabrewski	Beau Bridges
Barry Gabrewski	Jonathan Brandis
Mr. Lee	Mako
Noreen Chen	Julia Nickson-Soul
Stone	Joe Piscopo
Lauren	Danica McKellar
Randy Cellini	John Buchanan
Horn	Richard Moll

By STEPHEN HOLDEN

"Sidekicks" is one of the more far-fetched examples of what might be called the 97-pound-weakling school of film making. The weakling in this case is Barry Gabrewski (Jonathan Brandis), an asthmatic high school student who turns himself into a karate champion capable of smashing nine bricks with the side of a skinny forearm. Never mind that he looks almost as frail at the end of the film as at the beginning or that the transformation from mouse to Hercules seems to take place in only a few weeks.

Bullied by his fellow students and jeered at by his gym teacher, Barry, at the beginning of the film, spends much of his time lost in elaborate fantasies in which he and his hero, the action star Chuck Norris, execute pyrotechnical feats of cinematic bravery. These daydreams, which usually feature the people in Barry's life, are extravagantly costumed parodies of assorted genres, from westerns to war movies. As directed by Aaron Norris, Chuck Norris's brother, they are meant to be funny. But they are so broadly acted, unfocused and pointlessly ornate that they sink under their own weight.

The key to Barry's triumph is Mr. Lee (Mako), the wise old uncle of Noreen Chen (Julia Nickson-Soul), a sympathetic high school teacher whom the partners rescue in several of the fantasies.

●

"Sidekicks," which opened yesterday, gives Barry a number of adversaries to overcome. The peskiest is Randy (John Buchanan), a high school bully who also happens to be a karate student. The weirdest is Stone (Joe Piscopo), a karate teacher who is so hypercompetitive his eyes bulge out of his head and his neck seems about to pop. On hand is a would-be sweetheart (Danica McKellar), whose interest in Barry increases in direct proportion to his martial-arts skills.

In Mr. Brandis's very straighforward performance, Barry's progress can be gauged by the gleam in his eye and the set of his jaw, not by any significant physical changes.

The movie is burdened by a fill-in-the-blanks screenplay in which the actors have to spout such nuggets as "dreams do come true if you want them bad enough" and remain kindly and straight-faced.

●

"Sidekicks" is rated PG-13 (Parents strongly cautioned). It has lots of violent action but almost no blood.

1993 My 1, 17:4

FILM VIEW/Caryn James

Today's Ways Color an Old-Fashioned Movie

YOU HAVE TO LOVE A MOVIE that casts Jeanne Moreau so convincingly as a nun. That kind of skewed but astute thinking is typical of the New Zealand director Vincent Ward, and it makes "Map of the Human Heart" a lively new version of a laughable genre.

In its soul, the movie is a big, old-fashioned World War II melodrama: Will the war-torn lovers get together? Will the hero, ace bomber pilot that he is, survive his most dangerous raid? Will the heroine be waiting for him? They don't make movies like that anymore, for a good reason. Today, who would take such a cockeyed story seriously?

But this romantic adventure is seen through a scrim of contemporary social awareness. The hero is half Eskimo, the heroine half Indian, and the war is much less to blame for their problems than the ethnic prejudice of white society. Mr. Ward, who also created the story, takes the soapy sensibility of favorite war-era romances like "Casablanca" and "Waterloo Bridge" and, without changing the historical setting, updates the attitude. The result is melodrama without guilt or camp. The ploy is blatantly commercial, but it was good enough for "Dances With Wolves"; and it certainly works here.

Addie Passen/Miramax Films

Jeanne Moreau, Robert Joamie and the director Vincent Ward on the set of "Map of the Human Heart."

Though "Map of the Human Heart" borrows many old-movie conventions, its reach through 30 years and several countries is more ambitious than the films on which it is modeled. Don't panic if you've seen the preview, a jumble of scenes suggesting only that

'Map of the Human Heart' is a traditional romantic adventure seen through a scrim of contemporary social awareness.

the story has something to do with John Cusack making maps somewhere snowy and another man flying planes somewhere fiery.

The film, like all successful melodramas, has an engaging narrative that carries viewers over the plot's complications and outrageous coincidences. In 1931 an English map maker named Walter Russell arrives in the Arctic and meets Avik, the half-Eskimo boy. Walter learns that the child has tuberculosis and takes him to a hospital in Montreal, where he meets Albertine, the part-Indian girl. "Eskimos hate Indians!" Avik yells when he learns of her background, and he punches his new friend. The children (played with natural charm by Robert Joamie and Annie Galipeau) are obviously fated for each other. So, of course, they must be separated.

They are reunited in England in 1944. Avik (now played by Jason Scott Lee) has joined the R.A.F., and Albertine (who has become Anne Parillaud) is working for British intelligence, both thanks to a suddenly treacherous Walter (Patrick Bergin). All this is told in flashback by the middle-aged Avik, sitting in the Arctic in 1965, talking to another map maker (aha! John Cusack).

The map that matters most, however, belongs to Miss Moreau, in a small but crucial role that defines the film's clever strategy. As the nun who takes charge of the young Avik and Albertine at the hospital, she points to a chart that shows "hell, where the Protestants go." It is she who tells Albertine not to

act like "a half-breed" if the girl doesn't want
to be treated like one. Primly self-assured
(and almost unrecognizable as Miss Moreau
until the actress's voice is heard), the char-
acter embodies all the wrongheadedness and
intolerance of her society. The 1990's spin
concerns the way Albertine accepts those
views, while Avik comes to despise them.

Ingrid Bergman or Vivien Leigh would
never have confronted Albertine's problems.
She tells Avik plainly that she wants to mar-
ry a white man and be regarded as proper.
Avik's future is determined when he is sent to
bomb Dresden. In 1965, looking back, he tells
the map maker, "After Dresden I thought all
white people were cannibals, and I couldn't
live among them." Such ethnic awareness of-
fers 1990's viewers a fresh view of the past
and a foothold in this distant world by provid-
ing an attitude that makes sense today.

The social theme never overwhelms the ro-
mance and adventure of the story. Mr. Ward
seems to savor the time-honored appeal of
near-misses in love and war. The young Al-
bertine says she will one day sing on the ra-
dio, and years later Avik hears a familiar
voice carried over the airwaves in the Arctic.
When they are adults, bombs fall during their
first rendezvous, on the roof of Albert Hall.
Such scenes suggest the dash and daring
viewers savored in old movies that many
people grew up watching.

But Mr. Ward's quirky touches and con-
temporary sensibility turn the nostalgic ma-
terial into a sweetly entertaining modern
romp. The young Albertine gives Avik a me-
mento of their days together in the hospital:
an X-ray, which he cherishes.

"Map of the Human Heart" extends the 37-
year-old director's playful use of genres and
interest in fluid social attitudes. In his 1988
film, "The Navigator," medieval men are led
by a visionary child through a tunnel in the
earth, emerging in the 20th century. An ad-
venture story with a brain, "The Navigator"
recreates a medieval sensibility and sees the
20th century through anachronistic eyes.
That film was more innovative and image-
laden than "Map of the Human Heart," but
they share an approach that layers past and
present, using adventure as a vehicle.

At the end, "Map of the Human Heart"
shows signs of too much tinkering. There is a
sad conclusion, then a fantasy of a happy end-
ing, as if someone had insisted that the audi-
ence needed to see everything work out per-
fectly. Until that coy moment, Mr. Ward's
contemporary savvy invigorates a tired
genre and allows viewers to believe in a past
where an X-ray is a romantic object and
Jeanne Moreau is a nun. ☐

1993 My 2, II:24:1

François Duhamel
Kevin Kline and Sigourney
Weaver in "Dave."

them over to handlers immediately
after the cameras stop flashing —
then a Dave might just be invaluable.
That is, once he stops looking around
the White House in astonishment and
trying to take home souvenirs.

Although "Dave" carefully harks
back to the uplifting little-guy movies
of Frank Capra's day, it is very much
a creation of its own more media-
mad time. In the age of the photo op,
this film maintains, looking Presiden-
tial may be the most crucial of all
political talents. And even a Presi-
dent may have moments when he
feels just a little like Dave, whose
first impulse, when he is left alone in
the Commander in Chief's bedroom,
is to test the mattress furtively and
wonder whether anyone is watching
him.

"Dave" does a delightful job of
setting up this strange situation. It
presents President Mitchell as a
slick, aloof politician who is hated by
the First Lady (Sigourney Weaver)
but very popular with at least one
woman on his staff. Meanwhile, Dave
makes his entrance riding on a sow,
impersonating President Mitchell in
behalf of a Chevrolet dealership. Mr.
Kline is equally comfortable in each
of these roles, but it is as Dave that he
shows off the dashing, physically con-
fident manner that is one of the film's
great comic assets. Riding home
from work on his bicycle, belting out
an amazingly expressive rendition of
"Oklahoma!," he makes a wonderful-
ly ingenuous fall guy for the political
handlers who plan to use him.

•

The plot elements, as set forth in
Gary Ross's screenplay, have a nice-
ly familiar ring. President Mitchell is
the creation of his chief of staff, Bob
Alexander (played with perfect
scheming malevolence by Frank
Langella), whose confidant is the
White House press secretary, Alan
Reed (Kevin Dunn). A stand-in is
needed after the President suffers
what Mr. Reed diplomatically de-
scribes as "a minor circulatory prob-
lem of the head" at a press confer-
ence, which, he admits upon question-
ing, is "technically" a stroke. The
President has taken ill, like so many
figures in recent political satires,
while involved in an extramarital liai-
son. "Why can't you die from a stroke
like everybody else?" the First Lady
asks a startled Dave, who has been
pressed into round-the-clock service
because of the medical emergency.

The best part of "Dave" is this get-
acquainted period, which is fast-
paced and mischievous in its view of
White House intrigue. (J. Michael Ri-
va's production design makes the cor-
ridors of power look perfectly con-
vincing, unless, like Dave, you have
personally tried out the White House
furniture and palmed a few ballpoint
pens.) The opening hour is so enter-
taining, in fact, that it's possible to
pinpoint the exact moment at which
the film takes a wrong turn.

This happens during a fireside chat
between Dave and the First Lady, as
Ms. Weaver abandons her charac-
ter's formerly lofty manner to reveal
a romantic side (and to invoke "The
Return of Martin Guerre," one of
countless other films, from "The
Great Dictator" to "The Distin-
guished Gentleman," that the dog-
gedly synthetic "Dave" brings to
mind). As she and President Dave
strike up a new friendship, the film
moves from lively satire to sentimen-
tality, and even to voyeurism, of the
Charles-and-Diana kind. Behind the
facades of power, the film reveals,
there are lonely, pent-up people who
yearn desperately to live normally
and fall in love.

In spite of this sogginess, and de-
spite a self-congratulatory, do-gooder
streak that the film discovers within
Dave, this comedy remains bright
and buoyant much of the way
through. Mr. Kline, who brings wit
and presence to his dual role, is the
film's main attraction, but he is sur-
rounded by an impressive lineup of
supporting players. Ms. Weaver is
funniest when being supremely
frosty, as is Mr. Langella when con-
centrating on the wickedest intrigue.
Ben Kingsley also appears, as the
story's Boy Scout of a Vice President,
and Ving Rhames makes a sturdy
Secret Service man. Charles Grodin
flashes his crafty, suspicious glare as
an old friend of Dave's, an account-
ant, who drops by the White House to
help with budget-cutting and warns
Dave, "Get out of here as fast as you
can!"

"Dave," a big, confident film with a
strong sense of its own commercial
destiny, includes a long list of cameo
players, only a few of whom (several
television commentators, including
the members of the McLaughlin
Group, and a memorably funny Oli-
ver Stone) are cleverly used. Also in
the cast, and unaccountably given
near-cameo status, is Faith Prince,
the enchanting new Miss Adelaide of
Broadway's "Guys and Dolls," who
appears as a worker at the tempo-
rary-employment agency headed by
Dave. (As far as the film is con-
cerned, this business experience
makes him eminently qualified to run
the country.) Just as the viewer is
settling in to enjoy this actress's irre-
sistible presence, she's gone.

•

*"Dave" is rated PG-13 (Parents
strongly cautioned). It includes pro-
fanity, partial nudity and one sexual
episode.*

1993 My 7, C12:1

Dave

Directed by Ivan Reitman; written by Gary
Ross; director of photography, Adan Green-
berg; edited by Sheldon Kahn; music by
James Newton Howard; production designer,
J. Michael Riva; produced by Lauren Shuler-
Donner and Mr. Reitman; released by War-
ner Brothers. Running time: 112 minutes.
This film is rated PG-13.

Dave Kovic/Bill Mitchell	Kevin Kline
Ellen Mitchell	Sigourney Weaver
Bob Alexander	Frank Langella
Alan Reed	Kevin Dunn
Duane Stevensen	Ving Rhames
Vice President Nance	Ben Kingsley
Murray Blum	Charles Grodin
Alice	Faith Prince
Mrs. Travis	Anna Deavere Smith

By JANET MASLIN

When Dave Kovic (Kevin Kline)
finds Secret Service agents in his
living room, he thinks their presence
must have something to do with his
tax returns. He is much too naïve to
realize that because he looks exactly
like Bill Mitchell, the President of the
United States (also Mr. Kline), he can
be used to impersonate the President
while greeting foreign dignitaries,
throwing out ceremonial baseballs,
reading from a hidden Teleprompter
as he talks to the press, and of course
kissing babies.

Dave is also too innocent to think
that duties like these constitute the
most influential part of the Presi-
dent's job. But audiences may feel
otherwise, which is the joke at the
heart of "Dave," Ivan Reitman's
glossy, energetic new Washington
comedy. If President Mitchell is cyni-
cal enough to have his pets on call for
photo opportunities — and to turn

Amazonia
Voices From the Rain Forest

Written, directed and produced by Monti
Aguirre and Glenn Switkes; released by Tara
Releasing. At the Cinema Village, 22 East
12th Street, East Village. Running time: 70
minutes. This film has no rating.

Anima Mundi

Directed by Godfrey Reggio; director of pho-
tography, Graham Berry; edited by Miroslav
Janek; music by Philip Glass; produced by
Lawrence Taub; released by Tara Releasing.
At the Cinema Village, 22 East 12th Street,
East Village. Running time: 28 minutes. This
film has no rating.

BY STEPHEN HOLDEN

"Amazonia: Voices From the Rain
Forest," a documentary about life in

the Amazon River basin, is a handsome, well-meaning film that is overwhelmed by the scope and complexity of its subject.

The 70-minute film, which opens today at the Cinema Village on a double-bill with "Anima Mundi," a nature documentary, explores the devastating impact of Western civilization on one of the world's richest natural habitats. Although "Amazonia" offers passionate arguments about the necessity of preserving the region from development, its evocation of the political and social forces affecting the area is far too sketchy and confusing for the pieces to form a coherent historical portrait.

"Amazonia" is really two movies rolled into one. Initially it appears to be a mystical celebration of the beauty and healing power of the rain forest along with an idealistic portrait of the tribal peoples who have lived for centuries in harmony with the environment. As the film goes on, it becomes a political documentary exploring the lives of those who inhabit the area. They range from businessmen who support large-scale exploitation of its natural resources, to laborers who have moved there to develop the land, to native leaders who foresee the eventual eradication of their own people if the development continues.

According to the film, which was made by Monti Aguirre, a Colombian anthropologist, and Glenn Switkes, a journalist and film maker, the destruction began 500 years ago with the arrival of the first European explorers. Among the 900 indigenous tribes who existed in Brazil when they arrived, the film states, only 180 remain. The rest died out after their land was taken from them.

The profound physical and spiritual relationship between the surviving native peoples and the environment is pointedly illustrated in several scenes. The most vivid is an Indian ceremony of prayer for God's protection at the foot of a rubber tree.

Among those interviewed is Francisco (Chico) Mendes, a rubber tapper who organized his fellow workers to demand better living conditions and who was killed some time after he was filmed. Another powerful voice belongs to Ailton Krenak, a young Indian leader who is at the forefront of the local movement to preserve the rain forest.

The film devotes considerable time to showing the plight of landless farmers who were brought into the region hoping for a better life but who instead found themselves the victims of disease, malnutrition and environmental poisoning. It is not the farmers but the developers and landowners who employ them, the film argues, who are to blame for the destruction of the rain forest.

The movie's overview of these political forces and their interaction is too brief to provide a full picture of what is really going on in the area. And because many of the subjects talk in simple broken English, the subtleties of the situation are lost.

●

"Anima Mundi," which shares the bill, is a spectacular sequence of cinematic portraits of wildlife, underscored with propulsive music by Philip Glass. The 28-minute film focuses on the faces of dozens of creatures, from a mountain lion to assorted microorganisms to evoke the stunning beauty and diversity of nature. Quiveringly alive and shown magnified in close-up, the proud procession of life forms has an incandescence and mystery that neither still photographs nor museum exhibitions can begin to capture. Even such everyday creatures as ants, grasshoppers and bees look infinitely more exotic and complex than the wildest inventions of Hollywood special-effects designers.

1993 My 7, C12:4

For a Lost Soldier

Directed by Roeland Kerbosch; screenplay by Mr. Kerbosch, adapted by Don Bloch (in Dutch with English subtitles); director of photography, Nils Post; edited by August Verschueren; music by Joop Stokkermans; produced by Matthijs van Heijningen; released by Strand Releasing. At the Quad Cinema, 13th Street, west of Fifth Avenue, Greenwich Village. Running time: 92 minutes. This film has no rating.

Young Jeroen Boman	Maarten Smit
Walt Cook	Andrew Kelley
Old Jeroen Boman	Jeroen Krabbe
Hait	Feark Smink
Mem	Elsje de Wijn
Jan	Derk-Jan Kroon

By STEPHEN HOLDEN

Roeland Kerbosch's film "For a Lost Soldier" takes up the most delicate of subjects, a romantic relationship between a grown-up and a child, and invests it with an aching tenderness that stays just this side of nostalgic mush.

Set in the Netherlands near the end of the World War II, the film is an extended flashback in which Jeroen Boman (Jeroen Krabbe), a middle-aged choreographer at work on a piece about the Allied liberation, recalls his adolescent relationship with a Canadian soldier more than 40 years ago.

More than a love story, the film, which opens today at the Quad Cinema, offers a rose-colored portrait of a more austere and innocent era when the love that dare not speak its name remained mute. Most of the story is remembered through the eyes of the young Jeroen (Maarten Smit), an introspective blond youth of 13 who, because of food shortages, is sent by his mother from Amsterdam to live in the country. Jeroen's foster parents are a stern but kindly fisherman and his wife, who have three children of their own and lead a spare, hardy existence that seems scarcely touched by the war.

Life in the country for Jeroen is exhilarating but lonely. Sitting at the seaside, he and his best friend and fellow exile, Jan (Derk-Jan Kroon), fantasize about rowing their way home to Amsterdam. Because Jeroen's foster parents are deeply religious, the boy spends more time than he would like in church and in Sunday school.

At the same time, Jeroen also begins to feel the first twinges of puberty. But his feelings, unlike those of his playmates, are homoerotic. Attracted to Jan, who is rapidly becoming girl crazy, Jeroen longs for a deeper, more soulful friendship. And when liberating Allied soldiers arrive, he catches the eye of Walt Cook (Andrew Kelley), a handsome Canadian soldier who recognizes a kindred spirit and becomes a mentor and older brother figure. Although the language barrier precludes much verbal communication between them, Jeroen and Walt form a brief but intense attachment that ends abruptly with the troops' departure.

Except for an inexplicable streak of bitterness, Walt seems almost as innocent as Jeroen. He lavishes him with candy, teaches him to jitterbug and to drive a jeep and tells him he's special. In the film's one love scene, an affectionate game of roughhouse turns stumblingly amorous, with Walt calling the boy his little prince.

●

One of the strengths of the film is its refusal to load the story with contemporary psychological and social baggage. There is no mention of homosexuality. Nor is there any implied accusation of child abuse. Although Jeroen is shattered by Walt's departure, the film assigns no blame and assesses no damages.

As the central couple, Mr. Smit and Mr. Kelley give appealing, low-key performances that remain in smooth emotional sync. The affection that flows between them is all the more touching for its being almost entirely unspoken.

Where "For a Lost Soldier" fails is in finding a coherent dramatic frame for the story. The scenes of the grown-up Jeroen struggling to create a dance piece based on his wartime experiences are rushed and confusing. Nothing is shown that would connect the young Jeroen to the cranky middle-aged choreographer trying to resurrect his adolescence.

The film also includes at least one glaring anachronism. The song "Sh-Boom," a version of which is sung by a group of Canadian soldiers, was a hit nearly a decade after the events being portrayed.

1993 My 7, C14:1

Much Ado About Nothing

Directed by Kenneth Branagh; adapted by Mr. Branagh from Shakespeare's play; director of photography, Roger Lanser; edited by Andrew Marcus; music by Patrick Doyle; production designer, Tim Harvey; produced by Mr. Branagh, David Parfitt and Stephen Evans; released by Samuel Goldwyn Company. Running time: 111 minutes. This film is rated PG-13.

Don Pedro	Denzel Washington
Benedick	Kenneth Branagh
Beatrice	Emma Thompson
Dogberry	Michael Keaton
Claudio	Robert Sean Leonard
Don John	Keanu Reeves
Leonato	Richard Briers
Antonio	Brian Blessed
Hero	Kate Beckinsale
Margaret	Imelda Staunton
Ursula	Phyllida Law

By VINCENT CANBY

Kenneth Branagh, the nervy young Belfast-born actor and director, has done it again. In 1989 he challenged Laurence Olivier's lordly reputation by making his own very fine, dark and dour, pocket-sized "Henry V" to stand alongside the classic Olivier film. Now he has accomplished something equally difficult. He has taken a Shakespearean romantic comedy, the sort of thing that usually turns to mush on the screen, and made a movie that is triumphantly romantic, comic and, most surprising of all, emotionally alive.

The Branagh "Much Ado About Nothing" is a dreamlike house party set in and around a magnificent Tuscan villa in the erotic heat of an Italian summer. The period is not specified, although it seems to be a distant, vaguely Renaissance past. As can happen during a month of well-

Clive Coote

Emma Thompson and Kenneth Branagh in a scene from "Much Ado About Nothing."

fed indolence in the country, connections to the outside world are forgotten. Time stops. Life becomes a pursuit of pleasure: eating, drinking, dancing, making love.

●

Mr. Branagh, Emma Thompson, Denzel Washington, Keanu Reeves and Michael Keaton head the strong British-American cast. In most instances, the actors find just the right manner in which to play out a comedy of passionate love affairs, misunderstandings, renunciations and reconciliations. Mr. Branagh has cut and rearranged the text. Yet the omissions will not be evident to anyone whose only earlier contact with the play in performance was a second-rate theatrical performance to snooze through. The film uncovers a radiant heart.

The movie celebrates the artifice of the play and finds the humanity within it, which is not easy to do in these days of meta-realism. It's not by chance that there have been far fewer attempts to film Shakespeare's comedies than his tragedies and histories. The camera is merciless to such conventions of Elizabethan comedy as disguises, gender reversals, garrulous country bumpkins and the notion that someone is not hiding in the hedge where his feet are clearly visible.

By shifting the locale of "Much Ado" from Messina to a sunlit country estate, which is as removed from the ordinary world in spirit as it is in place, Mr. Branagh sidesteps the whole notion of reality. The reality of the film is its language, its characters and its characters' perceptions. Disbelief melts with the pre-credit sequence.

The voice of Beatrice (Ms. Thompson) is heard against a black screen as she reads the mocking words: "Sigh no more, ladies, sigh no more/ Men were deceivers ever/One foot in sea and one on shore/To one thing constant never." The lights come up on a picnic. Beatrice and her friends are thus passing a lazy afternoon when news comes of the imminent arrival of the victorious Don Pedro, Prince of Aragon, (Denzel Washington) and his men on their way home from the wars. The prince has asked to spend some time at the villa of her uncle, Leonato (Richard Briers), the governor of Messina.

Everything that happens later is promised in the sequence that follows. Behind the credits, through what appears to be a zoom lens, Don Pedro and his soldiers are seen as they approach on horseback, jouncing rhythmically up and down in their saddles in slow motion, as if anticipating sexual unions still to be negotiated. It's a wonderfully funny poetic conceit, setting the tone for the film and everything it's about. It also alerts the ear to a text far more

sensual than movie audiences are accustomed to hearing when paying their high-culture dues to Shakespeare.

•

"Much Ado About Nothing" casts the battle of the sexes in the form of an elegant dance, but it's a dance that goes uproariously to pieces after the proper introductory measures. At the center are Beatrice, an acid-tongued, beauty and skeptic, and Benedick (Mr. Branagh), a young lord whose self-esteem denies the possibility of his ever finding a woman worthy of him. When the story begins, the mutually antagonistic, perfectly matched Beatrice and Benedick have already battled to a stalemate that only a rude trick by their friends can end.

Hero (Kate Beckinsale) and Claudio (Robert Sean Leonard) are more conventional lovers. She is Leonato's virginal, dutiful daughter who, in the manner of midsummer masques like "Much Ado," falls in love with Claudio as immediately and completely as he with her. Love at first sight, though, is full of dangers. The stalwart Claudio is brave on the battlefield, but he so loses his reason in love that he can be easily gulled into believing that Hero is a strumpet. As quickly as he falls in love, his love seems to turn to loathing, but he waits until the wedding ceremony to denounce her.

More or less presiding over these perilous revels is Don Pedro, who, in the majestic presence of Mr. Washington, is a benign, wise but lonely prince. Don Pedro is much taken with Beatrice, but though tempted to become a participant in the dance, he remains aloof. Benedick is his friend, and his subjects come first. Mr. Washington is amazingly good as an idealized Shakespearean monarch, the sort of character that sleeps on a page but comes to life when played by a charismatic actor.

In a review of a London production of "Much Ado" just 95 years ago, George Bernard Shaw took exception to what he described as Beatrice's "conscientious gambolling," which he found exhausting. The same sort of objection might be made to the pumped-up pacing of Mr. Branagh's production. There are times when one longs for him to pull back the camera, not only from the alternating close-ups that turn some of the Beatrice-and-Benedick exchanges into tennis matches, but also from the generalized dither of the big scenes.

Everyone seems to smile too much and to laugh too quickly. Yet I also suspect that if it weren't for this helium-high manner, Mr. Branagh would not be able to discover the moments of pathos that, by contrast, unexpectedly illuminate the comedy and give it value. Benedick's suddenly abject, intensely felt admission of his love for Beatrice, in a chapel during one of their otherwise barbed arguments, takes the breath away. Because it is such a surprise amid the tumult, it has an emotional impact I've never before experienced in Shakespeare, on stage or screen.

Ms. Thompson is enchanting. Looking gloriously tanned and windblown, wearing the kinds of gauzy slip-ons that today would be for après-swim in Majorca, she moves through the film like an especially desirable, unstoppable life force. Her submission to Benedick is as moving as his submission to her. Mr. Branagh is not your average Benedick. He's no supercilious aristocrat. For all of his intellectual affectations, he has his feet planted on earth.

Ms. Thompson and Mr. Branagh are a such a terrifically engaging couple that even the differences in their accents work. Hers is traditional English upper-class; his is more contemporary, representative of a newly classless, English-hip generation. It would seem to indicate that this Beatrice and Benedick still have things to learn from each other.

•

One of Mr. Branagh's boldest maneuvers was to save Mr. Keaton from the limbo of Batman and to cast him as Dogberry, the bumbling constable who discovers the plot to slander Hero. Mr. Keaton's scenes aren't really funny, but they fascinate. Dogberry's malapropisms ("Comparisons are odorous") are like jokes in grand opera: tedious. As Mr. Keaton plays him, he is a fat, slobbish, menacing oaf. When he enters and exits, he mimes the galloping of a child who rides a broomstick pretending to be riding a horse.

It's as if Mr. Branagh, knowing that conventional low-comedy routines would not prompt anything but empty laughter, had opted to create a kind of surreal diversion.

Black-bearded, heavy-lidded, Keanu Reeves is elegantly handsome and speaks his lines with authority as Don John, Don Pedro's evil half-brother. As Hero and Claudio, Ms. Beckinsale and Mr. Leonard look right and behave with a certain naïve sincerity, although they often seem numb with surprise at hearing the complex locutions they speak. Giving excellent performances in supporting roles are Brian Blessed and Phyllida Law, who, off screen, is the mother of Ms. Thompson and the mother-in-law of the director.

Mr. Branagh has done well by everyone, particularly Shakespeare. This "Much Ado About Nothing" is a ravishing entertainment.

•

"Much Ado About Nothing" has been rated PG-13 (Parents strongly cautioned). There is one scene of partial nudity.

1993 My 7, C16:1

Dragon
The Bruce Lee Story

Directed by Rob Cohen; screenplay by Edward Khmara, John Raffo and Mr. Cohen, based on the book "Bruce Lee: The Man Only I Knew," by Linda Lee Cadwell; director of photography, David Eggby; edited by Peter Amundson; music by Randy Edelman; production designer, Robert Ziembicki; produced by Raffaella De Laurentiis; released by Universal Pictures. Running time: 119 minutes. This film is rated PG-13.

Bruce Lee	Jason Scott Lee
Linda Lee	Lauren Holly
Bill Krieger	Robert Wagner
Vivian Emery	Michael Learned

By VINCENT CANBY

"Dragon: The Bruce Lee Story" is an enjoyably hokey, big-budget theatrical film with a lot of kicks and the soul of a television movie. It's exactly what it announces itself to be and won't offend (or surprise) anyone, except those fans who would rather see a real Bruce Lee film, one with a more hysterical plot, more gangsters, more kung fu choreography and fewer demands on the heart.

For those who came in late, Bruce Lee was the Chinese-American martial-arts expert who, after a short

career in American television playing Kato in "The Green Hornet," went to Hong Kong, where he made of succession of hugely successful action films. At the time of his death of cerebral edema in 1973, the 33-year-old actor was on the verge of cashing in on his cult fame in the United States and Europe to become a major motion-picture star with international clout.

The new movie was directed by Rob Cohen and adapted from the book, "Bruce Lee: The Man Only I Knew," by Lee's widow, Linda Lee Cadwell. Ms. Cadwell was also the mother of Brandon Lee, her son by Bruce, the young actor who was recently killed in an accident on a movie set in North Carolina. In "Dragon" Brandon is portrayed only as a small boy. Even so, "Dragon" is heavy with the sort of mystical associations that, in these circumstances, can be interpreted as having some bearing on the younger Lee's unfortunate fate.

"Dragon" is studded with spectacularly staged, Bruce Lee-type kung fu confrontations, which either recreate sequences from his films or are variations on what he did with such oddball grace, skill, speed and humor. Yet the movie owes less to Lee's own films ("The Big Boss" and "Enter the Dragon," among others) than it does to "The Other Side of the Mountain." It's less about daring deeds than about Lee's triumph over adversity. Like Jill Kinmont, the skier in "The Other Side of the Mountain," Lee was once paralyzed, although he recovered. In his case, adversity was, more traumatically, being a virile young Chinese man in an America that recognized only comic Asian stereotypes.

Although "Dragon" has few surprises, it is an entertainingly predictable enterprise. Hawaiian-born Jason Scott Lee (no relation to Bruce) plays the title role and Lauren Holly the young woman he marries, to the initial consternation of her white family. Linda's devotion to her husband sees him through the writing of a book in which he explains his refinement of kung fu (he calls it jeet kune do), his success as an instructor, his brief and disappointing career in American television and, at last, his success in Hong Kong.

There are no hints that Bruce is anything less than a devoted husband and father, even though he spends too much time on the movie set. At one point toward the end, Linda must say to her work-obsessed husband: "This place is eating you up. Can't you see that, Bruce?" In the course of the movie, Bruce is haunted by a spectral figure identified as his inner demon, meaning his inner fears. Says his Hong Kong guru, "You must fight and defeat him, if you are not to pass the demon on to your son."

The screenplay is also full of wisdom about the metaphysical meaning of the martial arts: "Kung fu is not about winning; it's about perfection." And "It's not the strength that matters; it's the focus." For all of this fortune-cookie stuff, the script is efficiently written and directed, and acted with ease and humor by Jason Scott Lee, Ms. Holly and a supporting cast that includes Robert Wagner as Bruce's first Hollywood producer and Michael Learned as Linda's mother.

•

"Dragon: The Bruce Lee Story" has been rated PG-13 (Parents strongly cautioned). It has simulated violence, some vulgar language and mildly suggestive sexual situations.

1993 My 7, C19:1

Serbian Epics

Directed and produced by Pawel Pawlikowski, (in Serbian with English subtitles); cinematographers, Bogdan Dziworski and Jacek Petryck; edited by Stefan Ronowicz. At the Human Rights Watch Film Festival, at Loews Village Theater VII, Third Avenue and 11th Street, East Village. Running time: 50 minutes. This film has no rating.

By STEPHEN HOLDEN

"Who is the liar who dares say Serbia is small?" asks the chorus of a militant folk song from World War I that is sung today by Serbian nationalists waging what they see as a holy war for sovereignty. "She is not small! She is not small!" the lyrics insist. "She has been to war three times!"

As the documentary film "Serbian Epics" shows, the song is one of many threads in a bizarre tapestry of myth and folklore used by Serbian nationalists to justify their terrorism in Bosnia in pursuit of what they call "ethnic cleansing."

Christian fanaticism plays a major role in the scenes the film depicts. In an early one, an intensely emotional mass baptism is portrayed. A bishop in medieval garb exalts an eternal Serbia that will "shine like a flock of stars in God's grace." While church bells peal, the camera glides down the side of a rifle barrel aimed at the smoking city of Sarajevo.

"Serbian Epics," which opens today at the Loews Village VII Theater, shares the bill with "A Day in the Death of Sarajevo," another recent documentary about the fighting in the Balkans. Both are being shown as part of the Human Rights Watch Film Festival. From now through May 20, on two screens at the Loews Village VII, the festival will present 60 films from around the world that the sponsors say document injustice and oppression.

•

At the center of "Serbian Epics" stands Radovan Karadzic, who appears as a pompous Serbian warlord and self-described epic poet who oversees the shelling of Sarajevo. He is one of several people interviewed for the film who piece together the mythological patchwork that underlies the Serbian cause.

The story begins in 1389 with the Battle of Kosovo, in which the Turks defeated the Serbian king and his army, who sacrificed themselves for the Christian faith. From this sacrifice King Lazar evolved as a Christ-like figure, and the myth grew that the Serbs were a persecuted chosen people with a divinely appointed national destiny.

Five centuries later, Serbian autonomy was re-affirmed by the Karadjordjes, a family of highway robbers who established "a national monarchy."

Although "Serbian Epics" includes scattered combat scenes, it deals primarily with the power of mythology to drive people to the most vicious, inhumane warfare. As portrayed by the film's Polish director, Pawel Pawlikowski, the Serbian aggressors, who claim to be only "defending our territory," are simple mountain folk who are easily roused by nationalistic appeals. Epic songs, performed to the accompaniment of the gusle, a bowed instrument with a single horsehair string, are an important way of stoking the militant fires.

In the film's creepiest scene, Mr. Karadzic and his lieutenants pore over a map of Bosnia and smugly

divide the country into jigsaw puzzle pieces, most of which, they declare, belong to them. The scene has an eerie similarity to old newsreel shots of a confident Hitler, surrounded by his henchmen, smilingly studying a map of Europe.

1993 My 7, C21:1

The Beekeeper

Directed by Theo Angelopoulos; screenplay by Mr. Angelopoulos, in collaboration with Dimitris Nollas and Tonino Guerra (in Greek with English subtitles); director of photography, Giorgos Arvanitis; edited by Takis Yannopoulos; music by Helen Karaindrou; released by MK2. At the Joseph Papp Public Theater, 425 Lafayette Street, East Village. Running time 120 minutes. This film has no rating.

Spyros	Marcello Mastroianni
The Girl	Nadia Mourouzi
Sick Man	Serge Reggiani
Spyros's Wife	Jenny Roussea
Spyros's Friend	Dinos Iliopoulos

By JANET MASLIN

"The Beekeeper," a bleak and turgid 1986 film by the estimable Greek director Theo Angelopoulos, wastes Marcello Mastroianni in its title role. Mr. Mastroianni appears as a solemn, uncommunicative schoolteacher who retires from his job, leaves his wife and newly married daughter, and embarks on a lonely bee-tending journey of seemingly epic proportions.

Following in the footsteps of his father and grandfather, he travels through Greece in the early springtime, setting up hives and keeping a sporadic journal. Entries like "I am constantly losing my colonies" are meant to provide the film's few verbal indications of what Spyros (Mr. Mastroianni) is going through. Late in the film, in a moment of uncharacteristic talkativeness, he evokes the film's morose spirit in telling himself: "Someone will ask me, a woman, perhaps: 'Who are you? What do you want?' Nothing. Nothing. I was just passing by."

The light in Spyros's new life is meant to be the Girl (Nadia Mourouzi), a vixenish hitchhiker who becomes attached to him along the road. Presented as an innocent of sorts (though played by an actress who looks a lot older and worldlier than her character should), this Girl begs Spyros to let her share his humble hotel room. Once installed there, she preens tirelessly but fails to get his attention, which leads her to go out, pick up a young man and have sex with him in the twin bed right beside Spyros's.

Spyros says nothing, but he later leaves town and does not see the Girl until several other quiet, dolorous episodes have gone by. When they meet again, she looks coquettishly baffled. "Was it something I did?" she wants to know.

Mr. Mastroianni, giving what can best be described as a performance of great patience, can do nothing to improve an exchange like that one. He maintains much the same lost, unhappy expression even when finally pounced upon by the Girl in an empty movie theater (a scene all too fraught with symbolic import) or attacked by his own bees.

"The Beekeeper," which opens today at the Joseph Papp Public Theater, is of interest chiefly within the context of Mr. Angelopoulos's other work ("Landscape in the Mist," "Voyage to Cythera"). Not even those inclined to dwell on the film's occasional honeycomb imagery or its heavy sense of foreboding will find much to command the attention.

1993 My 7, C21:4

Serial Killer and Audience

"Man Bites Dog" was shown as part of the 1992 New York Film Festival. Following are excerpts from Stephen Holden's review, which appeared in The New York Times on Oct. 9, 1992. The film, in French with English subtitles, opens today at the Quad Cinema, 13th Street, west of Fifth Avenue, Greenwich Village.

Two things can safely be said about "Man Bites Dog," a pseudodocumentary of a serial killer, which was directed and written by its three young producers, who also appear in it (Rémy Belvaux, André Bonzel and Benoit Poelvoorde). The film is jampacked with graphic violence. And its gun-toting, speed-rapping subject, Ben (Mr. Poelvoorde), has the edgy charisma of James Woods in one of his more maniacal star turns.

The character is casually, viciously racist and xenophobic and murders both for sport and money. As the killing spree intensifies, it becomes clear that the two-man camera crew attending Ben at all times is not about to step in and stop the violence. In fact, the two are active collaborators who help prepare the action. More than that, it is their mere presence that incites him to new levels of virtuosic savagery.

"Man Bites Dog," which was filmed in grainy black and white and has the jerky momentum of cinema vérité, is a grisly sick joke of a film that some will find funny, others simply appalling. It satirizes real-life television shows that purport to take viewers into the thick of the action. It suggests how profoundly the presence of the camera affects events, and thumbs its nose at the very notion of documentary objectivity.

1993 My 7, C21:5

FILM VIEW/Caryn James

What's Hot In Summer Movies?

THE BUSIEST PEOPLE IN HOLLYWOOD RIGHT now are probably the shrinks. Even from a distance, you can feel the industry's mass hysteria rising as the studios gear up for a summer of bruising competition among 60 or so films. There is such a glut that the traditional opening date for the season's first films, Memorial Day, has been jumped by nearly a month. Summer started for Hollywood two days ago, with the release of a big comedy, "Dave," a big action film, "Dragon: The Bruce Lee Story," and a piece of upscale counterprogramming, 'Much Ado About Nothing."

While executives are hyperventiliating about whether "Jurassic Park" will give Universal Studios a desperately needed hit, whether "Cliffhanger" can save Sylvester Stallone's career, whether "The Last Action Hero" will be ready for its June 18 release, the rest of us can say, "Relax. It's just a movie."

The question for the average moviegoer is how to sort through the hype. Basically, you need to see two movies to keep up your end of the conversation at barbecues: "Jurassic Park" and "The Last Action Hero." (If you are the kind of filmgoer who watches only PBS at home, you still need to see two movies, but they are "Much Ado About Nothing," Kenneth Branagh's latest Shakespeare adaptation, and "Orlando," Sally Potter's version of Virginia Woolf's novel.)

If you're game after that, here is a guide to the top-10 must-see movies of summer, in order of importance. Most have not yet been screened for critics. What follows is an educated guess based on advance word (test-audience responses have an uncanny way of leaking out) and on the principle that when hype really works, you end up watching some rotten films just to see what the fuss is about (the "Basic Instinct" principle). These may not be the best summer movies, but they're likely to be the biggest.

D. Stevens/Touchstone Pictures

Angela Bassett belting out a song as Tina Turner in "What's Love Got to Do With It?"—Bound to take off.

"Jurassic Park" *(Opening June 11)*

There's no avoiding Steven Spielberg's giant special-effects adventure about theme-park dinosaurs run amok — partly because it cost at least $60 million (some guess closer to $80 million), so no one is going to skimp on marketing. On the plus side, this is the kind of movie Mr. Spielberg does best. It promises to be less fussy than "Hook" and less violent than the Michael Crichton novel on which it is based.

"The Last Action Hero" *(June 18)*

He *said* he'd be back. Another megabucks movie starring the man who has never had a flop. Arnold Schwarzenegger tweaks his own image in a comedy-adventure about a boy who walks onto a movie screen and meets his hero. Directed by John McTiernan ("Die Hard"), this could be the ultimate combination of comic-Arnold and action-Arnold.

"In the Line of Fire" *(July 9)*

Here is Clint Eastwood (acting, not directing) in what sounds like last year's Kevin Costner movie. He's a guilt-ridden Secret Service agent who failed to save President Kennedy and is now playing cat-and-mouse with another potential assassin. Mr. Eastwood won't win any Oscars for this one, but he can ride his popularity all the way to the bank.

"Sleepless in Seattle" *(June 25)*

Preview audiences reportedly loved this romantic comedy, in which Tom Hanks and Meg Ryan are made for each other, though they live a continent apart. A warning sign: They meet cutesy-cute when his son calls a radio talk show. A good sign: The trailer has more comedy than treacle. The film was directed by Nora Ephron, who wrote "When Harry Met Sally . . ."; before the summer ends, you will get very tired of hearing those two movies compared.

"What's Love Got to Do With It?" *(June 25)*

The Tina Turner story, with Angela Bassett (Betty Shabazz in "Malcolm X") as Tina, rocking and rolling with the punches she gets from Ike (Laurence Fishburne). The real Tina rerecorded her old hits and four new songs for the soundtrack. This film is bound to take off, following the "Bodyguard" principle that a movie with a hit soundtrack is unstoppable.

"Dave" *(Now playing at a theater near you)*

Kevin Kline is a very smart actor; Ivan Reitman ("Ghostbusters") is not a subtle director. Somehow this combination makes for a wonderfully funny and goofy satire about a guy who looks so much like the President he takes over his job.

"The Firm" *(July 2)*

There isn't much of a buzz about "The Firm"; maybe things are *too* quiet. But you can't count out Tom Cruise, directed by Sydney Pollack, in an adaptation of John Grisham's best-selling legal thriller.

"Rising Sun" *(July 30)*

Sean Connery, as a retired Los Angeles detective who knows the mysterious ways of the Japanese, instructs his partner, Wesley Snipes, while they go through a murder investigation. There has been some mucking around with Michael Crichton's novel, probably for better *and* for worse. The interracial casting adds another layer of tension, but the director and co-writer, Philip Kaufman, has changed the identity of the murderer in a move that has political correctness written all over it.

"Free Willy" *(July 16)*

The tender story of a boy and his pet whale. Willy is a captive orca, and Jesse the neglected 12-year-old who tries to free him. In a season filled with family-film hopefuls, this is the one being talked about as a sleeper.

"Cliffhanger" *(May 28)*

Sylvester Stallone climbs a mountain in one of the season's most expensive movies (around $70 million). There are great action sequences from the director Renny Harlin ("Die Hard 2"), but the trailer makes you wonder about the rest of the movie. Against majestic choral music, John Lithgow looks mad, Janine Turner from "Northern Exposure" looks sad, Mr. Stallone looks confused, and no dialogue is heard. What can they be saying? ("Yo, mountain!")

One final warning. As the wise Sean Connery says in "Rising Sun," "When something looks too good to be true, then it's not true." □

1993 My 9, II:15:3

Time Indefinite

Produced, directed and edited by Ross McElwee; released by First Run Features. Film Forum 1, 209 West Houston Street, South Village. Running time: 117 minutes. This film has no rating.

By STEPHEN HOLDEN

Intriguing contradictions run to the heart of Ross McElwee's enthralling autobiographical film journal, "Time Indefinite." Even though the creator and central figure in this cinéma vérité documentary matter-of-factly bares his anxieties about death, marriage and parenthood, he emerges as a shadowy enigma, a man in hiding. And since "Time Indefinite" comes about as close as a movie can to capturing the texture of everyday life, what does this absence of personality imply about film reality versus actual experience?

"Time Indefinite," which opens today at Film Forum 1, is the sequel to Mr. McElwee's 1986 documentary "Sherman's March," which won him acclaim for his dry comic sensibility. That nearly three-hour movie followed the film maker around the South on a whimsical erotic odyssey whose path loosely paralleled the swath cut by Gen. William Tecumseh Sherman at the end of the Civil War.

In "Time Indefinite," Mr. McElwee again serves as the low-key, sardonic narrator, chronicler and observer of his own life. Characters from earlier McElwee films, most notably his old friend Charleen Swansea, a salt-of-the-earth Southern woman with a twangy storyteller's voice, reappear.

•

"Time Indefinite" begins with a leisurely family reunion on the North Carolina shoreline at which Mr. McElwee announces his engagement to Marilyn Levine, a fellow film maker, with whom he co-directed a 1992 documentary about the Berlin Wall. Particular attention is focused on Mr. McElwee's father, a surgeon who, the film maker asserts half-jokingly, creates "a Freudian force field that plays havoc with my equipment."

Mr. McElwee's camera goes on to record the process of becoming married, from obtaining a license and taking a blood test to the wedding ceremony, which is shot by a friend. No sooner have they wed than Marilyn becomes pregnant, and they find themselves shopping for baby things. Then out of the blue, the film maker's jovial mood is shattered by three deaths. His wife miscarries, his only surviving grandmother dies and his seemingly robust father keels over behind the wheel of a car.

At this point, "Time Indefinite" takes a sharp left turn. A film that began as a leisurely celebration of family ties and Mr. McElwee's happy surrender to a traditional bourgeois way of life becomes a pained, stumbling search for rational explanations in a world gone haywire.

•

Hit especially hard by the loss of a father who seemed the epitome of well-being, Mr. McElwee becomes preoccupied with death. The image that haunts him and becomes the movie's closest thing to a poetic symbol is of a fish out of water gasping on a North Carolina dock. Early in the film, Mr. McElwee tells how when he was very young his father taught him how to catch, kill and clean a fish. It was a process that made him uneasy and that prompted him to ask his father heavy metaphysical questions about whether fish have souls and ultimately why anybody or anything has to die.

When Mr. McElwee reaches the nadir of metaphysical angst, he interviews himself and offers reflections that sound like the musings of a WASP Woody Allen, minus the ego and epigrammatic wit of an Allen character.

What makes "Time Indefinite" a rich and compelling cinematic experience isn't the story, which is really everyone's story at a certain time of life, nor is it Mr. McElwee's drily witty commentary. It is the movie's visual appetite for life. "Time Indefinite" conveys a sensuous appreciation of the physical world that is so acute that the environment is almost as important as the people. The season, the weather, the time of day and the light and spatial dimensions of a room are so palpable that the movie often gives the feeling of being there. Again and again, the film pauses to study the faces of people who, for all their problems, radiate a deep, poignant enjoyment of life.

It is all done with a minimum of self-consciousness. Even in those scenes where people acknowledge the camera and sometimes play to it, the film communicates a sense of the elusive moment in all its complexity and richness being captured.

The most ingenious thing about "Time Indefinite" is the way it breezes along in its early scenes without dropping any hints as to what is ahead. Late in the movie, after its themes have become clear, events continue to unfold and characters pop up with a randomness that seems to reflect the unpredictability of life.

Of course, it is all a calculated effect. In retrospect, "Time Indefinite" reveals itself as a work that has been as rigorously structured and meticulously edited as any fiction film. It reaches a triumphal and very formal conclusion by bringing back characters who were inconspicuously brought in at the beginning and who provide a crucial spiritual weight at the end.

The film's biggest mystery is Mr. McElwee himself. A droll, easygoing observer of his own life, who remains quietly self-effacing even during his own spiritual crisis, he virtually disappears into his own creation. All his stifled passion comes through in what he shows, not in what he says.

1993 My 12, C13:1

Herman

Directed by Erik Gustavson; written by Lars Saabye Christensen; director of photography, Kjell Vassdal; music by Randall Meyers; produced by Petter J. Borgli; released by Herman Films through RKO Pictures Distribution. At the 68th Street Playhouse, Third Avenue at 68th Street, Manhattan. Running time: 100 minutes. This film has no rating.

Herman	Anders Danielson Lie
Herman's Grandfather	Frank Robert
Herman's Mother	Elisabeth Sand
Jacobson	Kar Remlow
Mrs. Jacobson	Sassen Krohg
Fatso the Barber	Harold Hude Steen Jr.
Herman's Father	Bjorn Floberg
Panten	Jarl Kulle

By JANET MASLIN

Films about illness almost always take stronger attitudes toward their subjects than "Herman" does. This Norwegian film, which opened yesterday at the 68th Street Playhouse, adopts a strangely whimsical, erratic tone as it tells of the title character, a handsome 11-year-old boy (Anders Danielson Lie) who reveals his medical condition in his first moments on screen.

Herman has alopecia areata, a disease that has caused him to lose his hair. It has also transformed his inner life. With opening titles that evoke the robust, ski-sweater Scandinavia of the 1950's, "Herman" can treat its young hero's sickness as a form of unwanted social rebellion, something that sets him in direct opposition to the conformity of the world in which he is growing up.

•

In that sense, his medical ordeal becomes a process of liberation, punctuated by peculiar flights of fancy. For instance, for reasons that the film never needs to explain, this Norwegian boy has made Zorro his imaginary playmate. His daydreams occasionally interrupt the telling of this coming-of-age story, though they rarely reveal more about the sunny, independent-minded Herman than the audience already knows.

Had it confined itself to the isolating effects of Herman's medical ordeal, Erik Gustavson's film would have lived up to the somber foreshadowing with which it begins. As it is, "Herman" fluctuates unpredictably between uplifting moments and upsetting ones, which may well have been what the director had in mind.

But the effect leaves the film ultimately at cross-purposes with itself, and not easily able to generate much emotion. Although young Mr. Lie, a feisty and earnest young actor, plays the title role with great sincerity, Herman remains a mild, loosely drawn character without strong impact.

"Herman," which has a jolly, genial manner during many of its domestic scenes (and an unduly playful one when it jokes too heartily over Herman's giving a urine specimen during a medical exam), has been made with competence and care. Its look evokes a strenuously cheerful culture very like that seen on American television shows, particularly those with an inspirational edge. As Herman's parents, Elisabeth Sand and Bjorn Floberg generate a mixture of love and concern that would be appropriate for any character of Herman's tender age, with or without his health problems. Also briefly in the film is a little girl on whom Herman has a schoolboy crush — and whose full, gorgeous head of red hair is a cruel reminder of his own situation. Their final scene together gives the film one of its stronger grace notes.

"Herman," a gently charming film of only moderate weight, was one of last year's Academy Award nominees in the best foreign film category, where the choice of nominees has been quite controversial in recent years. "Herman" only adds fuel to that fire.

1993 My 13, C20:3

American Heart

Directed by Martin Bell; screenplay by Peter Silverman, based on a story by Mr. Silverman; director of photography, James R. Bagdonas; edited by Nancy Baker; music by James Newton Howard; production designer, Joel Schiller; produced by Rosilyn Heller, Jeff Bridges and Neil Koenigsberg; released by Triton Pictures. Running time: 113 minutes. This film is rated R.

Jack	Jeff Bridges
Nick	Edward Furlong
Charlotte	Lucinda Jenny
Molly	Tracey Kapisky

By JANET MASLIN

When Martin Bell made "Streetwise," his highly praised documentary about teen-age vagrants living by their wits on the streets of Seattle, he conjured up a world of clever scams and survival strategies that seemed almost too good to be true. "American Heart," Mr. Bell's fictional film that unfolds in a similarly colorful setting, has remarkable verisimilitude and much of the same gritty, honest spirit.

It would be hard to believe some of the events described here if they did not correspond so closely to the earlier film's observations, and if they did not also seem so utterly right. This tough, audacious film maker eloquently captures both the bitterness and the promise of his characters' lives.

"American Heart," a wrenching, beautifully acted tale of love and redemption, stars Jeff Bridges as a newly released ex-convict who is cornered by the teen-age son he virtually abandoned. Their reunion is given added poignancy by an opening montage of family snapshots in chronological order. Jack Kelson (Mr. Bridges) started out as a handsome, healthy young father, and his son, Nick (Edward Furlong), was once his

pride and joy. But a lot went wrong. And now, in the film's first scene, a surly, dissolute Jack stands washing himself in the restroom at a bus station while Nick quietly implores Jack to become his father again.

It's time to recognize Mr. Bridges as the most underappreciated great actor of his generation. Although he approaches this potentially showy role without fanfare or ostentation, he has managed to transform himself to an astonishing degree. Looking muscular and mean, sporting chest-length, unkempt hair and a prominent tattoo, he sheds all of the guileless optimism that once colored so many of his performances, instead becoming a sour, suspicious failure who seems lost beyond hope. "Any special skills?" he is asked by a parole officer after he is released from prison, where he has been serving time for robbery. "Naw, I can't do nothin'," he replies.

The film's early scenes between Jack and Nick are so harsh they border on black comedy. Nick, a lonely boy who has eagerly tracked down his long-lost father, is rebuffed in no uncertain terms. It takes a lot of persuasion for him to talk Jack into letting him share Jack's room at a cheap residential hotel, since Jack grumbles that the boy will cost him an extra $10 a week. Even then, there are problems. Jack grudgingly lets his son have the better of the room's two mattresses, then moves the boy to the less comfortable spot after Nick falls asleep.

Gradually, Jack tries to put down roots. He gets a job washing windows and sends Nick off to school. ("What school?" the boy asks. "I don't know; find one," his father grumbles.) And he pursues Charlotte (Lucinda Jenny), a feisty cabby with whom he feels a particular bond. When he talks Charlotte into visiting his room and finds Nick at home reading a book, he hands the boy some money and shoos him off to an all-night restaurant nearby. A little while later, after Charlotte has rejected him and Nick has straggled back home, Jack angrily demands that money back.

•

As "American Heart" moves toward a thawing of relations between father and son, it also depicts the bleak, scrappy atmosphere in which these two live. One of the film's more remarkable episodes shows Molly (Tracey Kapisky), a rebellious little teen-age hooker who lives in the same hotel with her mother, visiting a downtown peep show with some friends and her kid brother in tow. Sneaking past a cashier, they find their way to a booth and begin banging on the glass, badly startling one of the topless dancers. It turns out that this is where Molly's mother works. And she's willing to park the kids in her dressing room with a couple of sodas and call it day care.

The actors in many of these scenes (including Ms. Kapisky) are movie newcomers, and they add a lot to the film's air of authenticity. (This material, from a terse, vivid screenplay by Peter Silverman, can be traced back to a Life magazine photo essay by Mary Ellen Mark, whose work provided the original inspiration for "Streetwise" and who is married to Mr. Bell.) The film's supporting performances are uniformly savvy and hardboiled, helping to make "American Heart" as powerful an urban tableau as it is a father-son drama.

But the real core of the story rests with its two superb principals. Mr. Furlong, the boy who held his own

with Arnold Schwarzenegger in "Terminator 2: Judgment Day," brings great dignity and a powerful sense of yearning to Nick's efforts to win over his father. He is equally good at capturing the frustration that sets in once Nick realizes what an uphill battle this will be. And Mr. Bridges, who can make even a fierce, stony expression reveal everything about his character's inner demons, is at his very best.

The songs heard in "American Heart" are by Tom Waits, whose gravelly, desolate voice is the perfect aural equivalent of what is seen on screen.

•

"American Heart" is rated R (Under 17 requires accompanying parent or adult guardian). It includes profanity, violence, partial nudity and sexual situations.

1993 My 14, C10:1

Lost In Yonkers

Directed by Martha Coolidge; screenplay by Neil Simon, based on his play; director of photography, Johnny E. Jensen; edited by Steven Cohen; music by Elmer Bernstein; production designer, David Chapman; produced by Ray Stark and Emanuel Azenberg; released by Columbia Pictures. Running time: 110 minutes. This film is rated PG.

Louie	Richard Dreyfuss
Bella	Mercedes Ruehl
Grandma	Irene Worth
Jay	Brad Stoll
Arty	Mike Damus
Johnny	David Strathairn
Eddie	Jack Laufer

By JANET MASLIN

Within the canon of its author's work, the Pulitzer Prize-winning "Lost in Yonkers" is an oxymoron. This is the serious Neil Simon play, the heartbreaking family comedy, the nostalgia piece with the strangely contemporary air. Whichever way you look at it, Mr. Simon's best-received play is one of his most idiosyncratic, being the story of an emotionally arrested child-woman, her Prussian general of a mother, two temporarily abandoned teen-age boys and their gangster uncle, who is either "a henchman" or "a hunchback," depending upon who in the family is asked to describe him.

Only because it comes from Mr. Simon does this material take on universal appeal. "Lost in Yonkers" somehow isolates a central vision of domestic love and conflict, one that emerges more and more clearly as the play focuses tightly on Bella, the young woman yearning for independence, and Grandma, the mother who refuses to let her go. Before it is over, the story has traded in its more whimsical touches for moments of real anguish, and for a riveting climactic argument between these two formidable women.

It's not necessary to feel much about the play's time (1942), its place (Yonkers) or its precise setting (a family-run candy store and adjoining apartment) to be moved by this fierce final battle. But Mr. Simon has supplied ample comic interludes and distractions to surround this central struggle, and all of those lighter aspects have been preserved and expanded on screen.

As adapted by Mr. Simon himself and directed smoothly and adroitly by Martha Coolidge, Neil Simon's "Lost in Yonkers" is sometimes more picturesque than powerful. But it conveys all the warmth and color of

Columbia Pictures

Mercedes Ruehl and Richard Dreyfuss in "Lost in Yonkers."

the original material. Mr. Simon may have written droll dialogue about the candy store (it's said that Grandma is so watchful she even knows when salt is missing from a pretzel), but the movie can bring that dialogue to life. It can linger lovingly on the décor, the soda fountain, the candy, and it does.

Indeed, the film itself seems candy-coated at times, particularly when it dwells on the adorable ingenuousness of Bella (played by Mercedes Ruehl, in a reprise of her Tony-winning role). Prancing in anklets and a startling array of tight, girlish frocks, Ms. Ruehl leaves no doubt that Bella's childlike spirit is trapped in an extremely womanly form. The film expands the pathos of Bella's predicament by bringing on Johnny (David Strathairn, in an especially touching, offbeat performance), the shy movie usher with whom Bella embarks on a tentative courtship. Late in the story, a surprisingly emotional scene between these two gives the film a welcome element of raw emotion.

It takes a while for "Lost in Yonkers" to reveal its serious side. First Mr. Simon must introduce his array of antic characters, from the wise-cracking brothers Jay and Arty (Brad Stoll and Mike Damus, two deft and funny young actors) to the relatives with whom they are unceremoniously parked by their father (Jack Laufer). Much is made of the boys' tremulousness around Grandma, who is played so commandingly by Irene Worth (also in a reprise of a Tony-winning role) that the whole film seems ready to stand at attention when she appears. Ms. Worth's wonderfully formidable performance brings the film strength and menace, as well as a gravity it might otherwise lack.

Providing a lot of comic relief is Richard Dreyfuss in the expanded role of Uncle Louie, the ineffectual gangster who hides out with his family at a critical moment and wins over Arty and Jay with his well-developed sense of fun. (At one point, teaching one of his nephews how to play cards, he tries to insist that four aces make a bad hand.) "It's like having a James Cagney movie in your own house," one of the boys says proudly of Uncle Louie, although it's a bit like having Ralph Kramden around, too. Mr. Dreyfuss postures up a storm and makes the most of the role's grandstanding possibilities.

Although there are moments when the film's Yonkers starts to resemble Paris ("Lost in Yonkers" was actually shot in Kentucky), the production design by David Chapman is nicely evocative of many things (among them Woody Allen's Brooklyn). The film's tone remains tirelessly pert right up to the point where its battle royal is allowed to take center stage.

"Lost in Yonkers" is rated PG (Parental guidance suggested). It includes mildly off-color language.

1993 My 14, C10:5

My Neighbor Totoro

Written, directed and original story by Hayao Miyazaki; production designer, Yoshiharu Sato; edited by Takeshi Seyama; music by Jo Hisaishi; produced by Toru Hara; released by Troma Films. Running time: 76 minutes. This film is rated G.

By STEPHEN HOLDEN

What will American children make of "My Neighbor Totoro," a Japanese animated film whose tone is so relentlessly goody-goody that it crosses the line from sweet into saccharine?

The film creates an idealized vision of family life that is even more unreal than the perkiest 1950's television sitcom. In this storybook world, parents possess infinite reserves of encouragement and patience, and their children are unfailingly polite and responsible little angels. In the English-language version of the film, the actors speak in such uniformly cheery and soothing tones that they could turn even an incorrigible optimist like Mr. Rogers into a grouch.

"My Neighbor Totoro" follows the adventures of two little girls, Satsuki and her younger sister, Lucy, who move with their father to a house in the country while their mother recovers in the hospital from an unnamed illness.

Their new home is haunted by all sorts of benign magical presences. Among the more exciting moments in the serenely paced film is when swarms of dust bunnies living in the attic flee en masse in a late-evening windstorm. Of the many magical beings who inhabit the property, the most impressive is a mythical creature named Totoro, a cuddly beast that resembles a bear crossed with an owl crossed with a seal, has whiskers and roars gently. Totoro lives in an enchanted hollow at the bottom of a tree trunk.

A familiar figure in Japanese children's literature and animated films, Totoro appears only when he feels like it. But those appearances usually coincide with emergencies that require magic, as when a lost child needs to be found or an urgent message delivered.

Among other feats, the creature can fly and make giant trees sprout in the middle of the night and then disappear by morning. For transportation, he uses a magic bus that soars and loops over the landscape. And he can be seen only by children.

When "My Neighbor Totoro," which was written and directed by Hayao Miyazaki, is dispensing enchantment, it can be very charming. The scenes in which the girls have midnight adventures and witness miracles have the yearning dreamlike exhilaration of Mary Poppins's nocturnal adventures with her charges. Too much of the film, however, is taken up with stiff, mechanical chitchat.

"My Neighbor Totoro" is visually very handsome. All the action is set in lush Japanese landscapes whose bright blue skies and gorgeous sunsets evoke a paradisiacal garden of earthly delights.

1993 My 14, C14:1

Posse

Directed by Mario Van Peebles; written by Sy Richardson and Dario Scardapane; director of photography, Peter Menzies; production designer, Catherine Hardwicke; produced by Preston Holmes, Jim Steele and Jim Fishman; released by Gramercy Pictures. Running time: 110 minutes. This film is rated R.

Jesse Lee	Mario Van Peebles
Little J	Stephen Baldwin
Weezie	Charles Lane
Obobo	Tiny Lister Jr.
Father Time	Big Daddy Kane
Colonel Graham	Billy Zane
Carver	Blair Underwood
Papa Joe	Melvin Van Peebles
Angel	Tone Loc
Phoebe	Pam Grier
Cable	Isaac Hayes
King David	Robert Hooks
Sheriff Bates	Richard Jordan
Snopes	Nipsey Russell

By JANET MASLIN

"Posse," a big, brawny western starring and directed by Mario Van Peebles, displays a stormy love-hate relationship with westerns gone by. On the one hand, this obviously talented film maker celebrates all the aggrandizing features of the genre: the laconic tough talk, the manly camaraderie, the proud posturing, the power of walking tall past the awestruck citizenry of a prairie town. On the other hand, "Posse" does its best to reject and avenge what it regards as the flagrant distortions of the past.

So the turbulent, high-voltage "Posse" is part entertainment and part history lesson. In the course of describing the adventures of a band of black heroes (with one token white boy in their midst), it also seeks redress for the racial attitudes of Hollywood's most thoughtless cowboys-and-Indians pictures. Mr. Van Peebles and his screenwriters, Sy Richardson and Dario Scardapane, care most about making their points emphatically, even if that sometimes leaves "Posse" riding heavy in the saddle. Luckily, most of their film is fast-paced and star-studded enough to avoid an overly preachy tone.

The story, presented as a flashback drawn from the memories of an unnamed Old Man (Woody Strode), starts with a brisk Cuban prologue. The Spanish-American War brings together the film's five principals, who will join forces against a common enemy. Huge, cheerful Obobo (Tiny Lister Jr.), jocular Weezie (Charles Lane), earnest Angel (Tone Loc), the commanding Jesse Lee (Mr. Van Peebles) and one grinning white cohort, Little J (Stephen Baldwin), are all mistreated by Colonel Graham (Billy Zane), who behaves like a preening yuppie. "Posse" employs many such sharp, deliberate anachronisms, from the Colonel's pretty-boy swaggering to Jesse Lee's declaration, "We be outlaws."

The film's considerable taste for graphic, noisy violence becomes clear during this tumultuous opening. So does its mean streak, as the Colonel delivers outrageous insults to one and all. "Did you know that this man is the last surviving member of the Mo-tee-suh tribe?" he inquires, waving a teacup in Weezie's direction. "More tea, sir?" Weezie asks reflexively, providing the punch line for the Colonel's nasty joke.

•

Since nothing happens slowly in the frenetic "Posse," it is only a matter of moments before rebellion kicks in. The members of the newly formed

Gramercy Pictures

Armed and Ready Mario Van Peebles directed and stars in "Posse," about black heroes of the Spanish-American War who become outlaws hounded by their former commander.

posse attack the Colonel, make off with a stash of gold, and set off on the series of adventures that will carry them to the frontier of the American ville, the story's heroes seem motivated mostly by necessity: to sustain its momentum, the film needs to work in as many showy settings and cameo appearances as possible. It's possible to blink and miss the well-known performers in some scenes. It's easy to be overwhelmed by the sea of familiar faces in others.

Mr. Van Peebles's direction is assertively fancy, sometimes imposing speed or visual gimmicks on scenes that would have worked better if staged more simply. He even refuses to dwell on what are potentially the film's most effective moments. There are dizzying times when the head nearly spins. And the camera quite literally does, whirling around and around the posse members as they lay their plans. Knives hurtle toward the camera; actors move on trolleys; hand-held shots abound. Nothing is allowed to linger or stand still.

Despite such excesses, Mr. Van Peebles also reveals a firm command of his material and a clear idea of his own star power. He's the guy who says the least and whose few words have the most impact. He's the outlaw least likely to wear a shirt. He's the one who, when the other outlaws briefly frolic naked in a wading pool, manages to keep wearing his big-brimmed black hat and his cool, bemused expression.

Mr. Van Peebles finds a similar panache in the rapper Big Daddy Kane, who plays a riverboat gambler named Father Time and joins the posse (after a typically over-the-top New Orleans sequence involving firecrackers, fire-eaters, prostitutes and other attention-getting extras). He and Mr. Van Peebles stand out most successfully from the film's core group of actors, though Mr. Baldwin's wisecracking manner is also appealing. (Mr. Lane, who directed and starred in "Sidewalk Stories," can overdo the jokey, motor-mouthed aspects of his role.) In addition to its excess of comic relief, "Posse" also has an overabundance of sadistic white villains. Richard Jordan double

times Mr. Zane's Colonel as an evil sheriff who means to take over Freemanville, the black settlement that is Jesse Lee's hometown.

In the film, Jesse Lee's father is a preacher named King David (Robert Hooks) who met a terrible fate at the hands of Ku Klux Klan marauders. (Mr. Richardson, one of the screenwriters, had a grandfather named the Rev. King David Lee who founded a similar black township.) In fact, Mr. Van Peebles shares several scenes with his real father, the director Melvin Van Peebles, whose own work has clearly been a strong influence on his son's. The senior Mr. Van Peebles plays Papa Joe, the father of Jesse Lee's sweetheart and a person instrumental in encouraging Freemanville's citizens to fight for their rights. "I was your age," he tells Jesse Lee as he asserts his authority over the younger man. "You ain't never been mine."

Also appearing in "Posse," sometimes quite confusingly, are black performers as diverse as Blair Underwood, Isaac Hayes, Nipsey Russell, Pam Grier, Aaron Neville and the Hudlin brothers. It is Mr. Russell who fleetingly echoes Rodney King's cry of "Can't we all get along?" late in the story. The film treats that remark as a joke.

•

"Posse" is rated R (Under 17 requires accompanying parent or adult guardian). It includes many noisy, violent incidents and strong language and several sexual situations.

1993 My 14, C15:1

Joey Breaker

Written and directed by Steven Starr; director of photography, Joe Desalvo; edited by Michael Schweitzer; music by Paul Aston; production designer, Jocelyne Beaudoin; produced by Amos Poe and Mr. Starr; released by Skouras Pictures. Running time: 92 minutes. This film is rated R.

Joey Breaker	Richard Edson
Cyan Worthington	Cedella Marley
Alfred Moore	Fred Fondren
Hip Hop Hank	Erik King

By STEPHEN HOLDEN

"Joey Breaker," a small, heartfelt movie set dead-center in the show-business jungle of Manhattan, offers an unusually candid picture of a high-powered talent agent gleefully wheeling and dealing. Written, directed and co-produced by Steven Starr, who used to run the William Morris Agency's motion picture department, the film is filled with colorful nuggets of agent talk. In its most frenetic behind-the-scenes sequence, the title character conducts a bullying telephone auction of a screenplay with several movie studios, in which the bidding is jacked up to more than $1 million.

The film belongs squarely to the time-honored genre of fiction, movies and television in which a fair-haired boy on the fast track to the top of some lucrative profession suddenly has a vision of a gentler, more authentic way of life and abruptly shifts gear. In the case of Joey Breaker (Richard Edson), a hotshot dealmaker at the Morgan Creative Agency, the light begins to dawn with his reluctant delivery of a hot meal to an AIDS patient.

While trying to entice a rising young comedian named Hip Hop Hank (Erik King) to sign with the

agency, Joey also meets Cyan (Cedella Marley), a soulful Jamaican waitress who is working her way through nursing school. Both Hip Hop Hank and Cyan provide object lessons in integrity. The comedian is not about to camouflage a gay relationship, even though it could be a career impediment. Cyan, after her graduation, plans to move back to Jamaica to minister to the poor.

Mr. Starr's screenplay paints these likable characters as just a little too wonderful to be true. And Joey's infatuation with Cyan and his simultaneous moral awakening seem too much like contrivances devised to dramatize a pat vision of good and evil.

As portrayed by Mr. Edson, an actor who suggests a de-fanged James Woods, Joey is not a diabolical slimeball so much as a secret softie with a protective shell that keeps him unconscious of the world around him. That shell proves ridiculously easy to crack. Although the talent agency world, like the rest of show business, must certainly have its share of skeletons in closets, the film doesn't purport to be an exposé. The nastiest bit of business shown is one agency stealing an especially greedy client away from another agency.

For all the money and glamour that supposedly come with the license to buy and sell big-name talent, the world of agenting as depicted by the movie is grubby, mean-spirited and brutally competitive. The best argument for the profession, voiced by the head of the agency, is the motto, "Stars come and go, we last forever." The movie's gloomier point of view echoes a joke told early in the film: "What's the difference between a catfish and an agent?" The reply is, "One is a bottom-feeding mudsucker. The other is just a fish."

"Joey Breaker" is rated R (Under 17 requires accompanying parent or adult guardian). It includes some strong language and glimpses of nudity.

1993 My 14, C19:1

John Ford's 'Searchers'

It would be difficult, not to say impossible, to name a film that begins more beautifully than "The Searchers," the John Ford western that heads many a list of all-time cinematic favorites. (Opening image, both ravishing and symbolic: a cabin door swinging open to reveal the splendid sight of Monument Valley in full color.) And it would be difficult to find a cleaner copy of this profoundly moving, formidably influential classic than the gorgeous new print at the Papp Public Theater (425 Lafayette Street in the East Village), where "The Searchers" is having a three-week run.

Yes, you can see it on videotape or on television; yes, you probably have. But here is a stunning reminder of why movie audiences once felt it necessary to leave their living rooms for the sake of peak cinematic experiences. A superb 35-millimeter print has been struck from this 1956 film's original negative, which amounts to the closest modern equivalent of mint condition.

"The Searchers" is being shown to celebrate the Film at the Public program's 15th anniversary, and there are more wonders to come. Later this season: pristine prints of Terrence Malick's "Days of Heaven" and Max Ophuls's "Lola Montes."
JANET MASLIN

1993 My 14, C28:5

Why Branagh's Bard Glows on the Screen

EARLY IN "MUCH ADO ABOUT Nothing," Kenneth Branagh takes a simple line of exposition from the play — "Don Pedro is approached" — and turns it into an exuberant movie spectacle. The noble Don Pedro and his soldiers gallop toward the house of their host, Leonato. As the opening credits appear, Mr. Branagh cuts furiously between the fast-approaching soldiers (long shots of horsemen coming over the hill, close-ups of each man riding in dust and wind) and the household's preparations (women in a flurry of bathing bodies and flying clothes). Finally the two groups march toward each other in Leonato's courtyard, with the camera rising in the air to gaze down on the beautifully resolved scene. The episode captures visually all the spirit and excitement behind that single line, and sets the joyful tone of the film.

This "Much Ado" is a glorious version of Shakespeare, and it works not because it is Shakespearean but because it is cinematic. Mr. Branagh, who adapted the play for the screen and directed it, is faithful to Shakespeare's language and true to the raucous spirit of romance in the courtship of the determinedly unmarried Benedick (Mr. Branagh) and Beatrice (Emma Thompson). As Shakespeare movies go, that's the easy part.

Mr. Branagh's stroke of brilliance is to turn the camera into an active storyteller. It leads viewers visually through the intricate plot, emphasizes characters' reactions, situ-

The director's stroke of brilliance is to turn the camera into an active storyteller.

ates Shakespeare's language in a sunlit world too elaborate to be created onstage.

The director drops an important clue to his method in a book published as a companion to the film, when he describes that first sight of Don Pedro's horsemen riding in a row straight into the camera. Mr. Branagh calls the vision "a nod to 'The Magnificent Seven.'" Several times in the script (printed in the "Much Ado" book), his stage directions refer to movies. The lovelorn Benedick tries to be impressive but looks as ridiculous as "Tony Curtis as Cary Grant in 'Some Like It Hot.'" Dogberry, the slapstick and self-important constable, leads his inept men as if they were in "The Three Stooges Meet 'Terminator 2.'" Such comparisons are not as cavalier as they sound. By taking movies to heart, Mr. Branagh pays Shakespeare the honor of remembering that his works were meant to be played for a popular audience and not enshrined on a page.

And though Mr. Branagh has much experience acting in and directing Shakespeare onstage, his 1989 film of "Henry V" owes more to Orson Welles's cinematic story of Falstaff, "Chimes at Midnight," than to Laurence Olivier's 1945 theatrical film of "Henry V." When Mr. Branagh takes liberties with Shakespeare, they often take the form of flashbacks and voice-overs, made for the movies. (Falstaff, already dead in Shakespeare's "Henry V," lives in Mr. Branagh's, thanks to a flashback from "Henry IV.")

In "Much Ado," Mr. Branagh's boldest invention could exist only on film. The movie begins simply, with words on the screen and the voice of Beatrice reading: "Sigh no more ladies, sigh no more, men were deceivers ever." The lyrics belong to a song that appears later in the play. Placed at the start, they set up the themes of deception and of the battle between the sexes. As Beatrice continues to read, the screen is filled with the painted image of a house. When the camera pulls back, that image turns out to be on Leonato's easel; his entire household is picnicking in the real landscape of Tuscany. Mr. Branagh has deftly moved from words, to art, to the world of the story — an invented scene that eases the audience into Shakespeare's realm.

Within that world, Mr. Branagh trusts the language to speak for itself. Who could miss the point when Beatrice snaps at Benedick, "I would rather hear my dog bark at a crow than a man swear he loves me"? Mr. Branagh pares the speeches with the deftness of a surgeon, to keep the most crucial and accessible lines, and to keep the story moving.

The camera keeps moving, too, making viewers aware of how full Shakespeare's world is: full of people who scheme and eavesdrop and mutter. "I know you of old," Beatrice says warily after a long and loud battle of words with Benedick. On film, she says this quietly and in close-up, as if the camera were letting us in on a secret. The line becomes a comment on her unhealed scars from other Benedick skirmishes.

And the camera enhances the characters' reactions when Benedick and Beatrice fall in love. Don Pedro (Denzel Washington) concocts a plan. The men let Benedick overhear them say that Beatrice is dying for love of him, and the women stage a similar conversation for Beatrice, so she will believe that Benedick is pining away. As Mr. Branagh films these scenes, Benedick and Beatrice's desperation to hear about themselves, and their change of heart after, become visible.

Benedick hides behind the garden's shrubs and flails (too much) with a collapsing lawn chair as the news of Beatrice's affection hits him. When the women walk in the garden, Beatrice has to race along behind another row of trees, trying to keep up and hide at the same time. And after Beatrice and Benedick decide, separately, to love each other, Mr. Branagh presents overlapping images on the screen. Benedick is splashing in a fountain; Beatrice is riding on a swing. They are visually, though not yet emotionally, together.

"Much Ado" ends with Mr. Branagh's most enchanting set piece. As dozens of dancers swirl through the courtyard and into the garden, the camera follows them in a dance of its own, rising to offer a final aerial view. Like a storyteller with the last word, the camera leads us gracefully out of the movie. There is nothing here to make Shakespeare spin in his grave, but there is much that might make him dance.

1993 My 16, II:17:1

Critic's Notebook

Early Cannes Favorite: A Post-Freudian Romance

By VINCENT CANBY

Special to The New York Times

CANNES, France, May 17 — An inflatable, rather pudgy-looking Arnold Schwarzenegger, 75 feet tall and 20 feet wide, lately seen in Times Square, rides a barge 1,000 yards offshore here, looking like some sort of soft sentinel who is seriously disoriented. He faces not the sea but the hotels along the Croisette. Depending on how much air has been pumped into him, his rubber gun is less often pointed straight up than it is drooping, thus aimed at the heart of Cannes, which has been his host for the last five days.

This is just one of the ways in which things become turned around at this 46th Cannes International Film Festival. Mr. Schwarzenegger doesn't have a film at the festival, though he has been its biggest attraction to date. He's here promoting his new film, "Last Action Hero," which he describes as "an action-film for the 90's," meaning, he says, that he plays "vulnerable" and the body count is modest.

Long before anyone (including the jury) had a chance to see it, "The Piano," written and directed by Jane Campion, the New Zealand-born Australian film maker, was being called a shoo-in to win the Palm D'Or, the festival's top prize. Nobody seems to know where the rumors started. Abel Ferrara, the American director whose "Body Snatchers" is also in competition, was so miffed that he told a news conference that the festival had handed the prize to Ms. Campion when she stepped off the plane.

Feeding the general skepticism was the fact that the English-language Campion film, though shot in New Zealand, was largely financed by Ciby 2000, a French production company with friends in high places.

Whether artificially induced or not, the rumors resulted in a first press screening this morning so crowded with what looked to be Cannes pen-

In 'The Piano,' a mute widow and an illiterate settler fall in love.

sioners and other nonprofessionals that many members of the press couldn't find seats at the huge festival palace.

The remarkable news: "The Piano" is even better than everybody was saying it was. It is a triumph. It confirms the judgment of those of us who found Ms. Campion's first feature, "Sweetie," the most exciting film at the 1989 Cannes festival, where it was talked about a lot but won no major prizes.

In fact "The Piano" is so good, so tough, so moving and, especially, so original that one might reasonably worry whether any festival jury would honor its splendid idiosyncrasies. Festival juries often compromise their way to middle-brow consensus. If that happens here, "The Piano" will get lost.

The film is a post-Freudian period romance about a mute (but not deaf) young Scots widow (Holly Hunter) who travels to New South Wales in the 1850's to marry a pinched, unimaginative landowner (Sam Neill) she has never met. Only two things matter to the widow, her precocious young daughter (Anna Paquin) and her piano, through both of which she communicates to the outside world.

When her husband refuses to allow her to transport the piano to their farm, she makes a bizarre bargain with a another settler (Harvey Keitel), a crude, illiterate fellow with a nose tattooed Maori-style. He says he'll bring the piano in from the coast if she will give him lessons on it, one lesson for each of the keys on the piano. She haggles: one lesson for each black key. He agrees. In this fashion begins one of the most enchanting and erotic love stories to be seen on the screen in years.

There are no obvious precedents for Ms. Campion's cinema. Though the world she photographs is real, it looks unlike the one the rest of us inhabit. Everything is more finely detailed, more brightly lit, more fog shrouded, more highly colored. Even the grays, the beiges and the blacks have striking resonance. Characters don't analyze their feelings. They seldom even express them. They simply behave. It's up to the audience to find out why they do what they do. Yet such audience involvement comes naturally. By some manner I don't understand, Ms. Campion manages to get inside the heads of her characters in ways that other writers can only do with dialogue. The result is exhilarating.

The cast is superb. Ms. Hunter wears little makeup but she's almost unrecognizable as the woman who starred in "Broadcast News." Her face is a magical mask, sometimes utterly opaque, sometimes transparent. There's not a sentimental moment in the movie, but she is heartbreaking. Mr. Neill is fine in a less complex role, while Mr. Keitel gives the performance of his career as a

most unlikely romantic hero. If he doesn't win an award here, there is always the possibility of an Oscar. Miramax will be releasing "The Piano" in the United States later this year.

●

There are still 15 films to be shown in competition before the festival ends and the awards are given out on Monday evening. Among those still be to screened are Kenneth Branagh's "Much Ado About Nothing," in which Emma Thompson gives a performance that ought to make her a contender for the best-actress award; Joel Schumacher's "Falling Down"; Steven Soderbergh's "King of the Hill"; Ken Loach's "Raining Stones," and a sizable number of entries by directors heretofore unknown to international audiences.

Next to "The Piano," the most popular festival entries to date have been Mike Leigh's "Naked" (Britain), Paolo and Vittorio Taviani's "Fiorile" (Italy) and Mr. Ferrara's "Body Snatchers," which is a post-modern remake of the sci-fi horror film first made by Don Siegel in 1956 and then by Philip Kaufman in 1978. The Ferrara film is as much about the genre as it is about scaring the wits out of audiences.

"Body Snatchers" has a lot of special effects and simulated gore, but it's far less brutal than the low-budget gangster melodramas that have won the director large cult followings both in the United States and in Europe. The new film is post-modern to the extent that Mr. Ferrara makes no attempt to provide a pseudo-scientific basis for the goings-on. He knows that audiences get quickly bored with explanations and so cuts constantly to some newly delicious horror-film outrage.

The film is a bluntly tongue-in-cheek rehash of the tale about alien creatures who go around the country stashing away what look like giant peapods (in the Siegel film) or giant clams (in this film), whose contents, at maturity, then occupy the bodies of weak and paranoid earthlings. It may be time to put this metaphor to pasture. Its social-political significance is not inexhaustible.

The Taviani brothers are beloved at Cannes, where they became international film figures when their "Padre Padrone" won the Palm D'Or in 1977. They are in top form with "Fiorile," a gentle, sweetly funny cautionary tale about a chest full of gold, stolen from Napoleon's soldiers, and how it affects one Tuscan peasant family's fortunes up to the present day. In Italy, where prominent politicians are being exposed (it seems) weekly, greed is a hot topic right now.

Anyone familiar with Mr. Leigh's earlier work, "Life Is Sweet," "High Hopes" and the much earlier films (among them, "Abigail's Party" and "Nuts in May"), will recognize the way they connect to "Naked," though the new film is otherwise something of a departure for the director. It's a dour if beautifully acted (particularly by David Thewlis) exercise in disconnection from a society that's not worth being connected to in the first place. Two men and several young women engage in a series of power struggles in and around a seedy London flat over a period of two days.

The film has the manner of one of Mr. Leigh's theatrical productions, which he puts together in the course of a long period of improvisations during which the actors shape their characters and find the dramatic events that best define those charac-

ters. This time, however, the process seems unfinished. The film is full of arresting, very melancholy scenes and long swatches of vivid dialogue that call attention to actors acting. There are few if any of the connections to family, society and politics that give the other Leigh films such viciously comic heft.

People who don't know the earlier films are high on "Naked." Those of us who regard "High Hopes" and "Nuts in May" as two of the finest film satires ever made are inclined to be disappointed. Expectations can be treacherous. Long-time admirers want a favored director to repeat himself, and become surly when he doesn't. "Naked" is something I'll want to see again in less gaudy surroundings.

•

The circumstances in which Mr. Schwarzenegger greeted the press the other afternoon were not as gaudy as they were out of this world: the Hôtel du Cap, a sunlit terrace overlooking a cobalt-blue Mediterranean. The invitations promised that the star would meet "personally" with groups of 20 reporters at round tables, where each of us would be the only representative of his particular country.

It didn't quite work out that way. There were several other Americans at my table, where much of the 20 minutes was spent congratulating Mr. Schwarzenegger on the humanitarianism of his new film, which none of us had seen. It was as if the world had become a Golden Globes awards show, where everybody gets an award and has something nice to say about everybody else. Mr. Schwarzenegger actually looks in great shape, less beefy than on screen, and, being a serious businessman among actors, he seems genuinely to enjoy swapping platitudes for newspaper space.

My first and second not-quite exclusives: Mr. Schwarzenegger hopes President Clinton will not allow America to lose the respect won for it by President George Bush after President Jimmy Carter allowed it to fritter away, and his wife, Maria Shriver, is having an easy pregnancy. Stories like these don't grow on trees except at Cannes.

1993 My 18, C13:3

Critic's Notebook

Ever-Shifting Odds At Cannes Festival

By VINCENT CANBY

CANNES, France

"JUDGMENT," Jack Valenti said here the other night, "is the elf who acts like a computer when you get to that fork in the road."

If that's true, and there's no reason to disbelieve the president of the Motion Picture Association of America, then it's apparent that a lot of elves are at the point of nervous breakdown as the 46th Cannes International Film Festival enters its final days.

Mr. Valenti, speaking in his own memorable syntax at a black-tie dinner, was toasting a colleague for the consistency of his wisdom and vision in matters relating to the American movie business in Europe. The judgment of Mr. Valenti's colleague may still be firm, but elsewhere in Cannes, judgments are as unreliable as they are unpredictable. Neither elves nor computers work well here.

Two days ago, it seemed as if "The Piano," Jane Campion's period romantic comedy with a modern sensibility, would be a cinch to win the Palme d'Or, the festival's top prize, when the awards are announced on Monday night. Today, all that has changed. If the local reviews are any indication of how the jury may vote, then "The Piano" has a formidable rival in Chen Kaige's "Farewell to My Concubine," the only Chinese entry in the main competition.

"Farewell to My Concubine," screened on Wednesday night, is a nearly three-hour epic covering 50 years of recent Chinese history in sexual, social and political terms that would have been unthinkable in a Chinese film just a few years ago. It's a handsome, exotic, beautifully acted film, full of the kind of humanism that festival juries like to commend. It's also one of the few films seen at the festival so far that are worth serious discussion.

Shown in competition on Thursday night was "Splitting Heirs," the genially slapdash, neo-Monty Python English farce that opened in New York City a few weeks ago. The main attraction on Thursday night was the out-of-competition screening of Sylvester Stallone's latest action film, "Cliffhanger," the proceeds from which are to go to AIDS research.

Almost as big a surprise as the popularity of "Farewell to My Concubine" has been the hostility with which the European press has greeted "Far Away So Close," a decidedly serious, elegantly made new film by Wim Wenders, who can usually do no wrong at Cannes. Among other things, he won the Palme d'Or for "Paris, Texas" in 1984. "Far Away So Close" is the German film maker's follow-up to his immensely successful "Wings of Desire," for which he was given the best director's prize at the 1987 festival.

Although he resolutely denies that "Far Away So Close" is a sequel to "Wings of Desire," it shares with the earlier film the same concerns and many of the same actors (Bruno Ganz, Otto Sander, Peter Falk and Solveig Dommartin) playing the same roles. It is also based on a strikingly similar situation: an angel's seduction by earthly love and the concept of mortality. In "Wings of Desire," it is the angel played by Mr. Ganz who falls to Earth to stay in West Berlin; in the new film, it is the angel played by Mr. Sander. The setting is today's reunified Berlin. The new film also features Willem Dafoe and, as a new angel, Nastassja Kinski.

The news conference after the screening got off to a confrontational start when a German critic asked the director, "How does it feel to run out of ideas?" His reply: "It's a terrible feeling, especially for a journalist." It was all sort of spiteful and unrewarding, although it was a change. At most such news conferences, grown-up men and women, in their capacity as critics, spend less time asking questions than congratulating the person on the dais.

•

Clearly a disappointment to admirers of Steven Soderbergh, though not a film to be ashamed of, is his new "King of the Hill." The Cannes festival has an almost parental regard for the young American director. He came to international attention here in 1989 when his first feature, "Sex, Lies and Videotape," won the Palme d'Or.

The source material for the new film is A. E. Hotchner's memoir of growing up poor and often untended in a seedy St. Louis hotel in the Depression. There's nothing drastically wrong with the movie, but also nothing that's especially arresting or distinctive. Jesse Bradford, who plays Aaron, the teen-age Hotchner surrogate, has the kind of idealized good looks that suggest a generic rather than an idiosyncratic character. Even more troublesome is the manner in which the movie seems not to recognize the truly dark circumstances in which Aaron finds himself.

Because the family is so hard up, Aaron's beloved younger brother is sent away to live with relatives. After his tubercular mother is put into a sanitarium, Aaron's father, who is not supposed to be unfeeling or stupid, blithely goes off to sell wristwatches in Nebraska. He leaves the boy to fend for himself without money or anyone to call on for help. Somehow, Mr. Soderbergh misses both the serious comedy and the drama of the situation. The movie is sweet and unsentimental, but it frequently appears heedless.

The economic and political chaos in the rest of the world has taken its toll on Cannes this year. Movie makers seem to be either ignoring the world, incapable of coming to grips with it or

Darlings of years past find fewer rose petals strewn in their paths.

unable to find the money and facilities with which to work. Aleksandr Khvan's "Douba-Douba," the only Russian film in competition, is both melancholy and morally muddled. It's about a conscience-stricken young screenwriter who turns to robbery and murder to bail his former girlfriend out of prison, where she's serving time for a crime she didn't commit. The film is not about spiritual and emotional confusion. It's a demonstration of it.

In the unreal circumstances of such a festival, which is like spending 12 days on a determinedly carefree cruise to nowhere, a small, solid, unspectacular film like Raoul Peck's "Homme sur les Quais" ("Man on the Quays") comes close to being a momentous event. Without tears or much dramatic artifice, the Haitian-born Mr. Peck recalls a terrifying childhood in the Haiti of François (Papa Doc) Duvalier's dictatorship. The film, shot in the Dominican Republic, looks and sounds authentic.

"Farewell to My Concubine" has the scope, breadth and something of the detachment of a big, carefully researched historical novel. The story it tells is a good one about the intense, long-term relationship of two men, apprenticed to the Beijing Opera as boys in the 1920's. The film records the evolution of that relationship through the Japanese occupation of China in the 1930's, the fall of the Nationalist Government, the consolidation of power by the Communists and, finally, the chaos of the Cultural Revolution. A lot of ground is covered with efficiency.

At the center of the film is the unrequited love of one of the men for the other, and how, during the Cultural Revolution, each is driven to denounce the other, for different reasons. The movie is full of event, period detail and arcane information about the life and traditions of the Peking Opera. It doesn't dawdle. Like James A. Michener, Chen Kaige can be called a good read; the film's subtitles are voluminous. The images also are lovely.

•

One of the most enjoyable films here is not even in the main competition, but in the Directors' Fortnight, a side event. It's "The Snapper," a rowdy Irish comedy directed by Stephen Frears and adapted by Roddy Doyle from his own novel. "The Snapper" is from the same trilogy of Doyle novels that provided the basis for Alan Parker's film "The Commitments."

In "The Snapper," the amazingly resilient and good-natured members of the lower-middle-class Curley family must come to terms with the accidental pregnancy of the unmarried eldest daughter. Mr. Frears appears to have had a picnic with the material, which is exceptionally funny in the ways sitcoms are supposed to be but seldom are. "The Snapper," which has no need of a laugh track, will be coming to the United States soon.

Sally Potter has been cheering up Cannes for several days. Ms. Potter, who adapted and directed the remarkable film version of "Orlando," was last here six years ago trying to raise money for the Virginia Woolf project. Now she's just having fun going to movies. Her particular mustsees: Jane Campion's "Piano" and Mr. Wenders's "Far Away So Close." She's still brooding about her next project. That is, she's not talking about it. She is talking, with infectious pleasure, about the unexpected success of "Orlando." For three weeks, it was No. 1 at the London box office, beating out "Scent of a Woman." Or was it "Indecent Proposal"? Who cares? "Orlando" was on top.

1993 My 21, C1:1

Hot Shots! Part Deux

Directed by Jim Abrahams; written by Pat Proft and Mr. Abrahams; director of photography, John R. Leonetti; edited by Malcolm Campbell; music by Basil Poledouris; production designer, William A. Elliott; produced by Bill Badalato; released by 20th Century Fox. Running time: 87 minutes. This film is rated PG-13.

President Tug Benson..............Lloyd Bridges
Topper HarleyCharlie Sheen
Ramada Rodham Hayman......Valeria Golino
Michelle Rodham Huddleston.Brenda Bakke
Harbinger.......................................Miguel Ferrer
Col. Denton Walters................Richard Crenna
Rabinowitz...Ryan Stiles
WilliamsMichael Colyar

By JANET MASLIN

Is nothing sacred to the makers of "Hot Shots! Part Deux"? Nope. Not a thing. In their latest sendup of Hollywood-style heroics, the team behind this deliciously silly satire takes aim at every imaginable target from "Sea Hunt" to Saddam Hussein (who is revealed, at least by this account, to have a fondness for chintz). And the comic carnage doesn't stop there: "Hot Shots!" also trifles with hit films from "The Wizard of Oz" to "Basic Instinct," along the way revealing the secret of "The Crying Game." Don't even consider seeing it unless you can find humor in a line like this: "These men have taken a vow of celibacy, like their fathers and their fathers before them."

As directed shamelessly by Jim Abrahams (one-third of the original "Airplane!" team) and written by Mr. Abrahams and Pat Proft, this second "Hot Shots!" parody relies on a dependable method, if not an especially classy one. The film makers are happy to lob jokes at their audience with head-spinning speed, content in the knowledge that at least some of these missiles will hit the broad side of the barn. So "Hot Shots! Part Deux" had better be watched closely for its quick takeoffs, sneaky background action and various female characters who (as the closing credits indicate) happen to have "Rodham" as their middle names.

Less closely tethered to any one comic source than the first "Hot Shots!" was to "Top Gun," this sequel nonetheless finds a lot to work with in "Rambo." Hidden away in a remote Asian monastery, the heroic Topper Harley (Charlie Sheen) is tracked down by Col. Denton Walters (Richard Crenna, poking fun at his own "Rambo" role). "Topper, let me tell you a little story," begins the colonel, trying to recruit his man for a secret hostage-rescuing mission. He then regales him with the tale of Goldilocks and the three bears.

"So what you're saying is that little blond girl is ... me!" muses Topper, ever the straight man. Mr. Sheen doesn't have to be overly funny at such moments. All he has to do is squint suspiciously and look a wee bit confused by what goes on around him, which grows ever more confusing by the minute. Among the satirical episodes found here are a "No Way Out" limousine scene, a tearful railroad station scene involving a train that's bound for Hawaii, a "Terminator 2: Judgment Day" morphing effect that turns Saddam Hussein into mercury droplets but has trouble putting him back together and a version of the "Basic Instinct" interrogation scene that provides Mr. Sheen with the perfect rejoinder for Brenda Bakke's Sharon Stone type. It's too good to spoil by repeating it here.

The film's single biggest laugh comes from a moment that finds Mr. Sheen and his real-life father, Martin Sheen, on separate riverboats as they mutter to themselves while venturing into "Apocalypse Now" country. And its best sustained gags feature Lloyd Bridges in the role of Tug Benson, the hearty, mixed-up sportsman who has somehow become the President of the United States (he was only an admiral in the first film). "He'll try to prove that you're incompetent," Benson is warned about a rival, prompting him to declare, "I can prove that as well as he can!" Of course, "Hot Shots! Part Deux" cannot resist engaging President Benson in a messy confrontation with Japan's Prime Minister, complete with still-wriggling sushi that accounts for his indigestion.

Notwithstanding that episode, this film is refreshingly low on scatological gags and other gross-out humor, preferring all-purpose bad jokes to bathroom ones. ("It's not all I hoped for," Topper says of "Great Expectations.") The only scenes in which it bogs down noticeably are the violent episodes, since the real thing is hard to make fun of. This film does offer a running tally to indicate when its body count beats those of a couple of acknowledged blood-and-guts classics.

Within this film's cast of extremely good sports, Miguel Ferrer is well used as a nail-spitting tough guy who becomes worried when he briefly loses the desire to kill. Valeria Golino returns charmingly as Ramada, the woman Topper really loves, although he would probably be just as happy with Ms. Bakke's Michelle, a sleek Central Intelligence Agency operative. "Why me, ma'am?" Topper asks manfully when she first tries to recruit him for a dangerous mission. "Because you're the best of what's left," she sweetly replies.

•

"Hot Shots! Part Deux" is rated PG-13 (Parents strongly cautioned). It includes mild profanity, brief nudity and several sexual situations, one of which involves the use of a diving board.

1993 My 21, C6:5

Sofie

Directed by Liv Ullmann; screenplay by Ms. Ullmann and Peter Poulsen (in Danish, with English subtitles); director of photography, Jorgen Persson; edited by Grethe Moldrup; produced by Lars Kolvig; released by Arrow Entertainment. Running time: 145 minutes. At the Angelika Film Center 1 and 2, Mercer and Houston Streets, Greenwich Village. This film has no rating.

Sofie...............................Karen-Lise Mynster
Frederikke.................................Ghita Norby
Semmy............................Erland Josephson
Hojby.................................Jesper Christensen
Jonas....................................Torben Zeller
Frederik............................Henning Moritzen
Gottlieb.................................Stig Hoffmeyer
Jonas' Mother.........................Kirsten Rolffes
Tante Pulle................................Lotte Herman

By STEPHEN HOLDEN

In the diary fragment that opens and closes Liv Ullmann's dour, stately film, "Sofie," the title character compares the flow of human life to currents in a river. People pop up and sail for awhile until the current closes around their lives again, she reflects. The two-and-a-half-hour film, which follows the life of an intelligent, attractive, middle-class woman in late 19th-century Copenhagen over two decades, is a ruminative poetic diary that at heart is really an extended elaboration of that image.

"Sofie," which opens today at the Angelika Film Center, is the directorial debut of Ms. Ullmann, the Swedish actress and author who has starred in nine Ingmar Bergman films. Inevitably, "Sofie," which was adapted by Ms. Ullmann and Peter Poulsen from Henri Nathansen's 1932 novel, "Mendel Philipsen & Son," has a strong Bergmanesque ambiance. In scene after scene, the camera draws back from the characters to study the distances between people and to suggest the mortal apprehensions that lurk below the surface of the most convivial family gatherings.

•

Like Mr. Bergman, Ms. Ullmann has a particular fascination with people's eyes. The camera searches their faces to discover wells of unexpressed fear and longing, and a profound sense of isolation and awareness of time. Erotic passion, in the rare moments it erupts, is tormented and grasping.

As the film opens, the year is 1886, and Sofie Philipsen, a sheltered middle-class woman in her late 20's, is on the verge of spinsterhood. But at a party in her wealthy uncle's palace, she meets Hojby (Jesper Christensen), a successful painter who discerns in her an extraordinary inner beauty and integrity of spirit. Fascinated by Jewish culture, he persuades Sofie's parents to sit for a portrait that becomes one of the film's most important thematic elements. But because Hojby is not Jewish, he is deemed an unsuitable husband and Sofie is thwarted.

Desperate to marry, she settles for a cousin, Jonas (Torben Zeller), a shy, homely mama's boy who runs a drapery shop and composes Hugo Wolf-like songs on the piano. Although the marriage is largely passionless, it produces a son, Aron, who is a great joy to Sofie. But after Jonas's mother dies, his shyness and melancholia grow into a catatonic depression. Sofie gradually takes over the business and has an affair with her unhappily married brother-in-law, Gottlieb (Stig Hoffmeyer). As the film progresses, it accelerates and makes several leaps ahead, ending when Aron is 18 and about to leave home.

Where other directors would try to turn the events of Sofie's life into an epic drama, Ms. Ullmann's film deliberately steers away from much of the high drama. In a film that is deeply concerned with age, death and the handing down of family traditions from one generation to another, there is only one brief death-bed scene. Other characters simply appear in one scene and are absent in the next. That absence may be noted in a diary entry or an epistolary fragment that introduces a scene, or it may not.

Where Ms. Ullmann departs from a heavy Bergmanesque solemnity is in her view of family psychology. Where Mr. Bergman's movies have often expressed a harsh cause-and-effect view of parent-child relations, "Sofie" looks with mistier eyes at the Philipsens' family history. Even in old age, Sofie's parents, Semmy (Erland Josephson) and Frederikke (Ghita Norby), are cuddly, giggly lovebirds who seem to share a perfect understanding. The three maiden aunts who appear at family gatherings are drawn with an affectionate comic edge that softens what could have been grotesque and sad.

When, late in the film, Frederikke apologizes to Sofie for having been too controlling a parent and warns her not to try to control Aron, the confession does not assume any earthshaking significance.

The film's preference for dwelling on family gatherings, rituals and scenes of everyday life while avoiding high drama ultimately robs it of narrative continuity. Especially in its last third, the use of visual leitmotifs and flashbacks becomes so insistent that it seems a substitute for dramatic development.

Karen-Lise Mynster's portrayal of Sofie is remarkable for its understatement and utter lack of vanity. It sets the self-effacing tone of a film that portrays Scandinavia at the turn of the century as an austere but orderly world with ample time for contemplating the mysterious currents of life.

1993 My 21, C8:1

Correction

A movie review in Weekend yesterday about "Sophie" misstated the nationality of its director, Liv Ullmann. She is Norwegian, not Swedish.

1993 My 22, 2:6

Mein Krieg

Directed by Harriet Eder and Thomas Kufus (in German, with English subtitles); director of photography, Johann Feindt; production director, Hans-George Ullrich; produced by Känguruh-Film Berlin and WDR (Cologne); released by Leisure Time Features. At the Joseph Papp Public Theater, 425 Lafayette Street, East Village. Running time: 90 minutes. This film has no rating.

By JANET MASLIN

The documentary "Mein Krieg" ("My Private War") offers stunningly un-self-conscious World War II memories from six German veterans, each of whom took a home movie camera with him into the fray. As directed with chilling simplicity by Harriet Eder and Thomas Kufus, it presents both a compilation of eerie wartime scenes and a catalogue of the photographers' present-day attitudes toward their experience. "I wouldn't be talking about these things if my conscience weren't clear as crystal," one of them calmly declares.

The film makers have their own ideas about their interviewees' complicity, as demonstrated by the emphasis they place on that particular remark. But their approach is restrained as they allow each of these six veterans to reminisce about everything from the condition of their movie cameras (which are well maintained and have yielded high-quality home movies) to the indelible sights they have seen. "Here we're going into Warsaw, and this is a tour of the buildings destroyed in '39," one man says, casually describing his images of wholesale destruction.

Much of the material seen here has a peculiar gentleness, as German soldiers cook and exercise and smile for the cameras. (There do not appear to have been restrictions on what the soldiers could photograph, since the later part of the film also includes glimpses of mass graves and civilian

casualties.) And some of it recalls the more calculated wartime images we are more used to seeing in connection with Allied troops. So pretty nurses beam at Nazi soldiers; the soldiers' faces betray both fear and determination; the troops are seen celebrating after they shoot down an enemy plane. They were, a photographer recalls about the plane's dead Russian pilot, "full of joy over having been able to destroy this hornet."

•

"Mein Krieg," which opens today at the Joseph Papp Public Theater, also allows its interviewees to discuss their own fears and uncertainties. Tanks are seen rolling off to battle as the veterans describe not having any idea what their destination would be. Eventually, they found themselves at the Russian front, and one veteran recalls his amazement at realizing that the Russians he met, who had been described to him as "subhuman," were actually "absolutely normal people."

None of the interviewees care to talk much about how many of those absolutely normal people were subsequently slaughtered. "Do I have to answer that?" asks the most sympathetic of the photographers, when questioned about his own role in executing prisoners. "Spare me this answer." And as another veteran narrates scenes in which Russian women dig mass graves for their men, explaining that this was not fit work for German soldiers, he says: "They were glad they could do that. Maybe they weren't, but I don't know."

That kind of candor is, for better or worse, this documentary's greatest strength. The film makers make no noticeable attempt to shape their material, simply allowing these six veterans to reveal themselves as frankly as their cameras depict wartime. Today, one man is seen arranging toy soldiers before his own model of an intact, imposing Brandenburg gate, which he much prefers to the demolished version. "I don't want those ruins," he says. "That's not me. Painting a tin figure, I want to have fun."

And another interviewee says his chief regret is that his unit traveled only to places like Russia and Hungary without ever visiting the West. Can he really pay such heed to touristy considerations when thinking of military life? "Seeing is seeing," he says flatly about his wartime memories. "You just disregard what's unimportant."

1993 My 21, C8:6

Sliver

Directed by Phillip Noyce; screenplay by Joe Eszterhas, based on the novel by Ira Levin; director of photography, Vilmos Zsigmond; edited by Richard Francis-Bruce; music by Howard Shore; production designer, Paul Sylbert; produced by Robert Evans; released by Paramount Pictures. Running time: 111 minutes. This film is rated R.

Carly Norris....................Sharon Stone
Zeke Hawkins....................William Baldwin
Jack Landsford....................Tom Berenger
Alex Parsons....................Martin Landau
Vida Jordan....................Polly Walker
Judy....................Colleen Camp
Mrs. McEvoy....................Nina Foch
Lieut. Victoria Hendrix....................CCH Pounder
Gus Hale....................Keene Curtis

By JANET MASLIN

Sharon Stone is seen practicing her golf putts in "Sliver," which is one of many good reasons this film was kept under wraps until it opened yesterday. Faced with the challenge of fol-

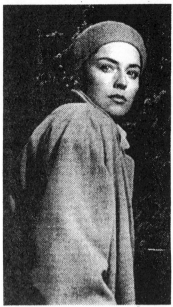
Paramount
Sharon Stone in "Sliver."

lowing up Ms. Stone's sensational appearance in "Basic Instinct," the makers of "Sliver" have wound up violating what should have been sacrosanct rules. Among them: Sharon Stone should not appear in roles that require her to do laundry. Or go to the supermarket. Or talk about Pavarotti. Or trade pleasantries with her neighbors. Or toss little cocktail parties. Or generally be nice.

But in "Sliver," playing a book editor named Carly Norris, Ms. Stone comes across as the kind of person who wears underwear, even if Joe Eszterhas's exceptionally crass screenplay does include a scene in which she takes it off in a restaurant. (If Ms. Stone isn't careful, this could become a trademark gesture, the kind of thing that winds up in a Las Vegas act 30 years down the line.) It is as if Mr. Eszterhas, who also wrote "Basic Instinct," has lost track of why this actress could so stunningly embody sexual power and menace in his earlier tale.

This time around, playing a scared, passive figure at the center of a senseless story, Ms. Stone has little of interest to do. The performance is so wan, as is all the acting in "Sliver," that it calls attention to the kind of artifice that was everywhere in a well-crafted pulp classic like "Basic Instinct." In fact, each of the principals in "Sliver" has been shown off to such better advantage in other films (particularly William Baldwin, who is as tepid here as he is magnetic in the current "Three of Hearts") that the problem clearly does not lie with the actors. Nobody could shine in the listless atmosphere created by Phillip Noyce's perfunctory direction. And nobody could do much with a line like "Zeke, I want to have a real relationship." Or "Listen, do you work out?"

Throwing out most of Ira Levin's novel, from which "Sliver" takes not much more than its title and a central situation, the film places Carly in a high-rise Manhattan apartment house that has a bad reputation. The tenants' mortality rate is exceptionally high, although this is not the sort of coherent mystery that makes such fatal mishaps add up in the end.

Another feature of the building is that it is completely monitored by hidden video cameras, so that someone in a sleek control room can spy on

all his neighbors. The film manages to find remarkably cute, phony or uninteresting things going on in each apartment. One couple is actually seen doing the tango.

A handsome and ubiquitous young bachelor in the building is Zeke Hawkins (Mr. Baldwin). Trying to create suspense where not much exists, the film makes a major character out of Jack Landsford (Tom Berenger), a hearty he-man of a novelist who specializes in police procedurals and at one point refers to detective work as his "craft." There is remarkably little reason to have included Jack in this story, except as an excuse for this screenplay to keep its options open the way "Basic Instinct" did. This film's ending is even less believable than that one's was, although audiences are much less likely to care.

The film, of course, leads Ms. Stone into as many sexual situations as possible, most of them involving Mr. Baldwin and one finding her alone, emoting furiously in her bathtub. None of this generates much heat, since the characters are so paper-thin that there's no real drama to anything they do. Along with its stilted sex scenes, the film also incorporates a lot of implausible, wearyingly vulgar dialogue, especially from Carly's female friends. Lines like "You've been spending too much time with your vibrator" — from a colleague at the office? — help set the generally crude tone.

"Sliver" is heavily invested in the notion that its voyeurism will stir the audience. But in fact this aspect of the plot mostly manages to turn the principals into high-tech couch potatoes. Arriving at last in the video control room, Ms. Stone stares at the many monitors with that mixture of awe, astonishment and wisdom generally associated with talk-show hosts. She spends some time looking at the video images but otherwise doesn't change at all. And the impresario who has set up this video operation must explain himself in amazingly trite terms. "It's real life," he explains. "It's a tragedy. It's funny; it's sad; it's unpredictable." Not really; it's just a room full of television screens.

"Sliver" is not helped by a thoroughly unconvincing New York atmosphere (in which the residents of the high-rise behave like members of one big happy family) and by a noticeable absence of glamour. Ms. Stone is costumed and photographed much less cleverly than she was last time, to the point where her very real magic only occasionally shines through. Shown off to poor advantage in a small role is Polly Walker, who played the beautiful, self-assured socialite in "Enchanted April" and appeared as a terrorist in Mr. Noyce's earlier and better "Patriot Games." This time, she turns up as Ms. Stone's annoying neighbor, spouting obscenities and snorting cocaine.

•

"Sliver" is rated R (Under 17 requires accompanying parent or adult guardian). It includes nudity, profanity, sexual situations and brief violence.

1993 My 22, 11:5

Menace II Society

Directed by the Hughes Brothers; screenplay by Tyger Williams, based on a story by Allen Hughes, Albert Hughes and Mr. Williams; director of photography, Lisa Rinzler; edited by Christopher Koefoed; music by QD III; production designer, Penny Barrett; pro-

duced by Darin Scott, the Hughes Brothers and Mr. Williams; released by New Line Cinema. Running time: 90 minutes. This film is rated R.

Caine....................Tyrin Turner
O-Dog....................Larenz Tate
Tat Lawson....................Samuel L. Jackson
Pernell....................Glenn Plummer
Anthony....................Jullian Roy Doster
Ronnie....................Jada Pinkett
Grandmama....................Marilyn Coleman
Grandpapa....................Arnold Johnson
Doc....................Pooh Man
A-Wax....................M. C. Eiht
Sharif....................Vonte Sweet
Chauncy....................Clifton Powell
Detective....................Bill Duke
Mr. Butler....................Charles S. Dutton

By STEPHEN HOLDEN

In the riveting opening scene of "Menace II Society," a tense transaction between a Korean grocer and two young black men in South-Central Los Angeles explodes into lethal violence.

Caine (Tyrin Turner), a high school senior who lives with his grandparents, has gone out to buy some beers with his volatile sidekick O-Dog (Larenz Tate). When the grocer mutters an insult, O-Dog goes ballistic, pulls a gun and shoots him in the head. Running to the back of the store, he kills the grocer's wife and seizes the store's surveillance tape. Later in the film he boastfully plays and replays it for his friends, freeze-framing the video at the moment the grocer's brains are blown out.

Filmed in a jerky cinéma vérité style, the opening scene has the jarring immediacy of a television news flash enhanced with expressionistic camera angles and color. This aura of front-line reportage informed by an action-comics visual flair defines the tone of the movie, which disturbingly blurs the line between brutal slice-of-life realism and sensationalistic gore.

•

What is clear, however, is that "Menace II Society," which was directed by the Hughes Brothers, 21-year-old twins who were born in Detroit and whose previous credits include music videos for Digital Underground and KRS-One, is a very flashy debut. Where earlier films with similar settings, like John Singleton's "Boyz N the Hood" and Matty Rich's "Straight Out of Brooklyn," have offered a somber, almost elegiac view of inner-city life, "Menace II Society" has a manic energy and at times a lyricism that recall movies like "Mean Streets" and "Bonnie and Clyde." More acutely than any movie before, it gives cinematic expression to the hot-tempered, defiantly nihilistic ethos that ignites gangster rap.

The film, which is narrated in fits and starts by Caine, is both an autobiography and a jumpy, impromptu guided tour of teen-age life in the Watts district of Los Angeles. In its blunt, awkward way, it also tries to hammer home some political points. The opening scene of slaughter is followed by grainy flashbacks to the 1965 Watts riots. In the most inflammatory scene — one that seems gratuitously inserted into the film — Caine and his friend Sharif (Vonte Sweet) are pulled off the street and into the back of a police car, beaten up by white policemen and dumped on the sidewalk in a Latino neighborhood where they presumably could be executed by rival gang leaders.

Among the film's most powerful scenes are lurid, dreamlike flashbacks to Caine's childhood, when his father was a drug dealer and his mother a heroin addict. In an apartment drenched in red light, the boy witnesses his father casually shoot-

Tyrin Turner, left, and Jullian Roy Doster in a scene from the film "Menace II Society."

D. Stevens/New Line Cinema

ing a crony during a card game in an argument over money. By the time Caine is a teen-ager, both parents are dead, and he lives with upright Christian grandparents whose biblical sermonizing has no impact on him.

•

"Menace II Society," which opened locally today, follows Caine's irreversible plunge into deeper levels of violence the summer after his high school graduation. After rival gang members ambush him and a cousin while they are sitting in a car, killing the cousin and wounding Caine, he and his posse wreak lethal revenge at a burger stand. Caine's only hope of salvation lies in Ronnie (Jada Pinkett), the girlfriend of Pernell (Glenn Plummer), Caine's imprisoned mentor. With Pernell's blessing, she invites him to start a new life with her in Atlanta, where she has the promise of a decent job. The rest of the movie becomes a race against time: Whether Caine, who is now a killer and who has impregnated another woman, can survive the streets of Los Angeles before the lovers can make their escape.

The screenplay, which was written by Tyger Williams from a story he wrote with the Hughes Brothers, is little more than a jerry-built mechanical contrivance on which to hang a series of searing pictures of inner-city life. But the film's crackling ensemble acting, which involves a good deal of improvisation, gives a number of those scenes an intense, painful believability. Sequences in which Caine and his posse hang out and toy with guns, drinking beer and spouting an endless litany of sullen profanities, offer a convincing close-up picture of a generation of black teen-agers lost in inner-city hell.

The movie is especially good at showing how the ubiquity of firearms, the violence of television and video games and an insanely inflated macho ethic combine with boredom and hopelessness to create a combustible atmosphere that can explode at any second. Some of the movie's most chilling moments show Ronnie's nat-

urally curious 6-year-old son, Anthony (Jullian Roy Doster), being taught how to hold a gun. The violence, when it erupts, is some of the bloodiest and most unsettling ever shown in a commercial film.

If "Menace II Society" is terrific on ambiance, it is considerably less successful in revealing character. While Mr. Tate gives a scary, red-hot performance as O-Dog, the screenplay offers no clue as to who he really is. Ms. Pinkett's Ronnie is wonderfully strong, sassy and beautiful: in short, too smart to want someone like Caine to be her life companion in a strange city. Of all the characters, Caine is the most problematic. Mr. Turner, to his credit, gives him flashes of likability. But in the end, after all the personal history he supplies, the character remains opaque, more an unsettling symbol of a social malaise than a tragic figure.

•

"Menace II Society" is rated R. It has almost nonstop profanity and several scenes of extreme, graphic violence.

1993 My 26, C13:4

Children of Fate

Directed by Andrew Young and Susan Todd; (in English and Italian with English subtitles); produced by Adam Friedson; released by First Run Features. Film Forum 1, 209 West Houston Street, South Village. Running time: 85 minutes. This film has no rating.

By JANET MASLIN

The documentary "Children of Fate" follows in the footsteps of "Cortile Cascino," which was made for NBC-TV in 1961 but never shown. The earlier film, which has been incorporated into this new work, was co-directed by Robert M. Young and Michael Roemer, who assembled a vivid, devastatingly sad portrait of a Sicilian slum.

Now Mr. Young's son, Andrew, and his wife, Susan Todd, have created a follow-up film by revisiting Angela, seen as a long-suffering young mother in the first film and now the grandmother of nine. Thus the sad, unflinching "Children of Fate" can be seen as a family affair in every way.

It's easy to see why Angela became central to this undertaking. A vigorous, articulate woman with a madonna's face, she lived a life of exceptional hardship when the first film was made. She had three young, malnourished children, one of whom died during the course of the earlier account. And she was regularly beaten by Luigi, the husband she hated. Black and white scenes from the early film show Angela serving a humble dinner to her family under this spouse's watchful eye. "My husband Luigi always made sure he ate first," she now recalls.

•

Angela's life typified conditions in Cortile Cascino at the time the film was made, as Mr. Roemer and the senior Mr. Young clearly indicated. In this crowded, impoverished part of Palermo, where 300 people shared the water from a single faucet, hopes rarely rose beyond mere survival. Angela's mother was seen brushing the beautiful hair of another daughter, Beatrice, in hopes that this child would some day escape by marrying a wealthy man, but the people of Cortile Cascino appeared largely trapped by their circumstances. Now, tragically, "Children of Fate" corroborates that impression. Although Cortile Cascino was razed decades ago and Angela now lives in a clean, modern apartment, the legacy of poverty lives on.

Ms. Todd and Mr. Young observe Angela as she works, visits relatives and talks about the past. They also follow the lives of her six children, all of whom have experienced great unhappiness. One daughter, newly out of prison and mourning a husband who recently died of a heroin overdose, has already begun to vent anger and frustration on her own child. A son who has ties to the Mafia and has

spent half his life in jail feels washed up at 31. Another daughter, gravely ill with cancer, is seen weakening as the film goes on. By the time it is over, Angela has had to attend yet another funeral.

Not surprisingly, this family history has bred a terrible fatalism. "If a person is destined to lead an awful life, I don't think there's anything you can do about it," one family member says. Another says, "I can't hope for anything better because I know better can never happen." The only traces of sentimentality come from Luigi, who was left by Angela seven years earlier and still hasn't come to terms with that loss. Seen scavenging listlessly for scrap metal, Luigi talks with some bewilderment about how surprised he is not to have Angela taking care of him anymore.

•

"Children of Fate," which opened yesterday at the Film Forum, immediately brings to mind Michael Apted's "35 Up," another cumulative, longitudinal study of people whose lives have been largely determined by economic factors. This film doesn't quite match the acuity of Mr. Apted's, in part because it lacks a narrative voice or a sharply inquisitive viewpoint. Angela and her family members talk freely to the camera, but their observations sometimes sound well-honed and self-conscious. That's certainly understandable: Angela has had 30 years to think about the world she allowed to be filmed the first time, and to assess her progress.

Still, this earnest, painstaking documentary would have been more revealing if it were less repetitively bleak, and if its format allowed for more of an overview. The black-and-white excerpts from "Cortile Cascino" seen here have a stark, disturbing power that the talkier present-day scenes often lack.

Of course, Ms. Todd and Mr. Young have shot their new material in a very different world. The social fabric that held together a place like Cortile Cascino, even at its most wretched, created some kind of cohesion and community. Resettled now in featureless public housing, Angela celebrates her freedom, but also seems to live a lonelier life. "I think the city has gotten better, but the people have gotten worse," she says. "Children of Fate" does its best to explain and lament that observation.

1993 My 27, C13:1

Cliffhanger

Directed by Renny Harlin; screenplay by Michael France and Sylvester Stallone, based on a premise by John Long; director of photography, Alex Thomson; edited by Frank J. Urioste; music by Trevor Jones; production designer, John Vallone; produced by Alan Marshall, Mr. Harlin, Gene Patrick Hines, James R. Zatolokin and David Rotman; released by Tristar Pictures. Running time: 118 minutes. This film is rated R.

Gabe Walker Sylvester Stallone
Eric Qualen John Lithgow
Hal Tucker................................. Michael Rooker
Jessie Deighan Janine Turner
Delmar...................................... Craig Fairbrass
Walter Wright.............................. Paul Winfield

By JANET MASLIN

"CLIFFHANGER," the new high-altitude thriller starring Sylvester Stallone, wastes no time in establishing its first priority, that of sending its audience into a cold sweat. This effect is achieved spectacularly well with a long, death-defying credit sequence set somewhere near the ozone layer. Mr. Stallone, playing a pumped-up Rocky Mountain rescue worker with an incongruously Presidential haircut, does his best to save a young woman who hangs precariously from a rope across a terrifyingly deep abyss. You will be in no hurry to mountain-climb after watching this scene.

At such moments, and "Cliffhanger" has many of them, thoughts about life insurance come to mind. Was Sylvester Stallone really filmed atop the dizzyingly high, needle-shaped peak that figures prominently in the film's opening? Did he really scale the kinds of cliffs and mountainsides that are seen here? Did he hang in midair from a fraying rope, cross great chasms via rickety bridges or battle over a helicopter about to plunge into oblivion? Obviously, a great deal of credit goes to stunt doubles and optical tricks, but the illusion is still astonishingly effective. "Cliffhanger" really seems to be set somewhere up in the sky.

Featuring beautiful Alpine vistas (much of "Cliffhanger" was shot in Italy, in the Dolomites), this film treats Mr. Stallone as a smaller, more mobile and no less impressive piece of scenery. His muscles bulging, the veins of his neck etched in sharp relief, his jaw set determinedly, Mr. Stallone is every bit as physically impressive as the material requires him to be. As with Steven Seagal, who finally had a big, entertaining film built around him by the makers of "Under Siege," Mr. Stallone has been surrounded by better actors but is unrivaled as his film's main attraction.

Main animate attraction, that is. All of the performers are upstaged by the film's breathtaking backdrop, and by the fast and furious way Renny Harlin, the director, approaches action sequences. Just as he did in "Die Hard 2," Mr. Harlin concentrates on generating nonstop excitement at the expense of small talk. In fact, his pacing can be so fast that the occasional transition is missing, though the film's staging remains perfectly clear. Quickly and efficiently, Mr. Harlin leads the film from one perilous escapade to another, following a visceral plot that somehow manages to avoid repetition. Even though "Cliffhanger" leads off with a couple of its biggest scenes, a can-you-top-this momentum sustains it all the way through.

Dialogue is the only real drawback, since the screenplay by Michael France and Mr. Stallone tends to be as drab as the mountains are beautiful. Mr. Stallone plays Gabe Walker, whose morale is badly injured during that opening rescue attempt and who spends the rest of the film getting it back. In the process, he also loses and re-wins Jessie Deighan (Janine Turner), the plucky mountaineer who is part of his rescue team, and proves his grit to Hal Tucker (Michael Rooker), who still bears a grudge against Gabe for the debacle that haunts them both. "If you don't do this now," Jessie tells Gabe, prodding him into action by recalling the trauma, "you're going to be stuck on that ledge for the rest of your life."

Gabe is forced back into action by a harrowing air crash, which Mr. Harlin stages in typical high-octane style. A plane carrying Treasury Department officials and $100 million in new bills is hijacked in midair, and later goes down in the mountains. When Gabe goes to the rescue, he becomes the captive of a gang led by Eric Qualen (John Lithgow), an urbane Englishman who oozes sarcasm from every pore. Mr. Lithgow's suave delivery is rarely matched by the lame repartee that has been written for him (when someone is called a "piece of work" in this screenplay, it's pretty obvious what the rejoinder will be). Still, Mr. Lithgow's debonair performance is as refreshing as the snowy panoramas that surround him.

•

Until it takes a turn toward nasty sadism in its later stages — one character is impaled on an icicle, for instance — "Cliffhanger" remains relatively bloodless and crisp, preferring to concentrate on sheer gamesmanship and clever effects. The sophistication of the latter is one of the film's most enjoyable aspects. Whenever the actors seem to be doing the impossible, it's time to draw back and wonder what was used to help them, but the film works very credibly on its own terms. The special effects seen here are as perfect and hardwon as Mr. Stallone's musculature, and that's saying a lot.

Ms. Turner and Mr. Rooker contribute as much spark and variety as is humanly possible, which turns out to be a great deal. The film is also helped by John Vallone's rustic production design on those few occasions when it moves indoors. The rest of the time, Alex Thomson's bright, hard-edged cinematography contributes to the film's rugged atmosphere. Even Trevor Jones's music has muscle.

•

"Cliffhanger" is rated R (Under 17 requires accompanying parent or adult guardian). It includes violence and profanity.

1993 My 28, C1:4

Made In America

Directed by Richard Benjamin; screenplay by Holly Goldberg Sloan, based on a story by Marcia Brandwynne, Nadine Schiff and Ms. Sloan; director of photography, Ralf Bode; edited by Jacqueline Cambas; music by Mark Isham; production designer, Evelyn Sakash; produced by Arnon Milchan, Michael Douglas, Rick Bieber and Patrick Palmer; released by Warner Bros. Running time: 70 minutes. This film is rated PG-13.

Sarah Mathews	Whoopi Goldberg
Hal Jackson	Ted Danson
Tea Cake Walters	Will Smith
Zora Mathews	Nia Long
Jose	Paul Rodriguez
Stacy	Jennifer Tilly
White woman No. 1	Phyllis Avery
White woman No. 2	Frances Bergen

By JANET MASLIN

"So you bought sperm!" the horrified Zora Matthews (Nia Long) says accusingly to her mother. Sarah Matthews (Whoopi Goldberg) has just explained that she conceived Zora by means of artificial insemination, paving the way for "Made in America" to launch a succession of sperm bank jokes. Ordinarily, a comedy aiming for gags of that order could scarcely lay claim to any delicacy. But this one, broad as it is in other regards, features charming, well-matched and

Warner Brothers
Whoopi Goldberg

even subtle performances from its two principal stars.

Tabloid headlines may not mean much to a finished film, but chemistry certainly does. And "Made in America" pairs Ms. Goldberg and Ted Danson in a funny, disarming and believable screen romance, the first such movie role Ms. Goldberg has had. Seeming warmer and more comfortable in this antic comedy than she has before, Ms. Goldberg is helped not only by the right co-star but also by the right role. As the feisty proprietor of a bookstore specializing in African-American topics, she radiates intelligence and humor. As the mother of Ms. Long's earnest science student, she manages to seem a lot more youthful than her child.

And as a smart woman improbably thrown together with a slick used-car salesman (Mr. Danson), she gives off just the right degree of furious indignation. Mr. Danson's Hal Jackson ("Hal's your Pal," say his television ads, which often feature animal acts) is every bit as smooth and witless as Sarah is tough. "I read black authors, you know," he says pleasantly when he visits Sarah's bookstore. "Wilt Chamberlain changed my life." Mr. Danson may be playing a simple variation on his "Cheers" character, but it's something he does with supreme courtliness and style.

•

As directed by Richard Benjamin and written by Holly Goldberg Sloan, "Made in America" needn't have been so convincingly sweet. Bad driving, animal antics and your-fly-is-open gags are eagerly exploited, and the screenplay need not ever be believed. It tells what happens when Zora is given a blood test by a classmate and discovers that her mother's late husband could not have been her father. As soon as the students are seen heedlessly drawing one another's blood in the age of AIDS, the film takes on a farfetched air.

It becomes even more so when Zora and her friend Tea Cake Walters (Will Smith) visit the sperm bank, still easy to find nearly 20 years after Zora was conceived, and easily break a computer code to find the name of Zora's real father. The name is Hal's, and Hal is white, which is most upsetting to Zora and her mother. The film thus raises racial issues but it also manages to be commendably colorblind where its characters' real feelings for each other are concerned.

Tri-Star Pictures
Sylvester Stallone as a Rocky Mountain rescue worker in "Cliffhanger."

However, "Made in America" embroils Sarah and Hal in a meaningless feud, since she has no real reason to think Hal deliberately deceived her. The film tries to load too much plotting onto the slender thread of one laboratory mix-up. Really, all it needs are pretexts for Sarah and Hal to cross paths and trade insults, which they do with great enthusiasm. It wasn't necessary to place Mr. Danson atop a runaway elephant to add flavor to one such sequence, but the extreme silliness of that episode makes it work.

•

Eventually, en route to a regrettably trumped-up final conflict, the story brings Sarah and Hal together for a romantic dinner date. The actors' friendliness seems so genuine and appealing that Mr. Benjamin had little need to throw his stars into paroxysms of jokey, furniture-wrecking passion in the next scene. "Made in America" is funniest when it seems least forced.

Among the film's more blatant elements are Jennifer Tilly's brief appearance as Hal's very young girlfriend, who's enough to give aerobic exercise a bad name. Also too obvious are conspicuous product plugs for soda, crackers, cigarettes and so on. Much less strenuous is Mr. Smith, who hovers on the outskirts of the action and provides a lot of humorous asides. Frances Bergen and Phyllis Avery appear briefly as two white matrons who serve Sarah as comic foils. Also deserving mention are Mark Isham's jaunty score and Elizabeth McBride's costumes, which give each character a lively and distinctive visual identity. Ms. Goldberg turns up in an especially vibrant array of African-inspired clothes.

•

"Made in America" is rated PG-13 (Parents strongly cautioned). It includes mild profanity and sexual situations.

1993 My 28, C5:1

The Long Day Closes

Written and directed by Terence Davies; director of photography, Michael Coulter; edited by William Diver; production designer, Christopher Hobbs; produced by Olivia Stewart; released by Sony Pictures Classics. Film Forum, 209 West Houston Street, South Village. Running time: 82 minutes. This film is rated PG.

Bud	Leigh McCormack
Mother	Marjorie Yates
Kevin	Anthony Watson
Helen	Ayse Owens

By STEPHEN HOLDEN

In a heavy soaking rain, the camera inches along a dingy, soot-blackened stairwell in Liverpool, England. As it creeps up the steps like an exhausted, shivering creature seeking shelter from the deluge, the soundtrack soars with Nat (King) Cole's radiant 1957 recording of "Star Dust." Cole's voice, awash in heavenly violins, conjures up a mood of romantic nostalgia that seems almost grotesquely inappropriate given the grimness of the setting.

Terence Davies's film "The Long Day Closes" revels in such juxtapositions of sound and image. Much later in the film, its central character, Bud

Tom Hilton/Sony Pictures

Leigh McCormack and Ayse Owens in "The Long Day Closes."

(Leigh McCormack), a dreamy-eyed 11-year-old boy, aimlessly swings from a rusted metal bar to the wistful strains of Debbie Reynolds singing "Tammy."

•

In addition to a slew of vintage popular songs, the film includes sound clips from such movies as "Great Expectations," "The Magnificent Ambersons" and "Meet Me in St. Louis." Together these fragments evoke a postwar England starved for beauty, fantasy and a place to escape.

"The Long Day Closes," which opens today at the Film Forum, is the sequel to Mr. Davies's film "Distant Voices, Still Lives," which opened in New York in 1989. Like its forerunner, "The Long Day Closes" is an autobiographical scrapbook of working-class family life in northern England in the mid-1950's. But where "Distant Voices" offered a fairly naturalistic look at the past, "The Long Day Closes" is filled with surreal, expres-

A boy's wish to make things wonderful.

sionistic touches that lend it the aura of a phantasmagoric cinematic poem.

The sequel also offers a much sunnier vision of family life. Where "Distant Voices," which was set a few years earlier, focused on a violently abusive father who dies of stomach cancer, the new film exalts idyllic family gatherings in shabby surroundings. Knitting the family together is a tirelessly cheerful and hardworking mother whom Marjorie Yates imbues with an angelic warmth.

The film, which is beautifully photographed and edited, wants above all to reimagine the world as experienced through the eyes and ears of a sensitive boy on the verge of puberty. It celebrates the way a child's imagination can conjure up glorious possibilities amid dankness and squalor. Mr. McCormack, the young actor who plays Bud, has few words, but conveys the intense soulfulness of a sensitive dreamer who doesn't quite fit in.

In one scene, the camera lingers to study the play of light and shadow on the well-worn family carpet. In another, a recording of Kathleen Ferrier singing a traditional folk song evokes a vision of a schooner in the mist.

Among the most vivid nuggets are scenes of life in an austere parochial school run by authoritarian black-robed nuns and sharp-tongued teachers who dispense corporal punishment even when no offenses have been committed. One of the film's most striking visual comparisons presents successive overhead shots of an audience in a movie theater, a crowded classroom and a church congregation.

"The Long Day Closes" doesn't develop characters in any literary sense. Nor does it tell a coherent story. A deeply personal film, and at times a touching one, it is a collection of fragments and memories artfully pieced into a quirky, captivating book of dreams.

•

"The Long Day Closes" is rated PG (Parental guidance suggested). It includes images that might frighten and confuse children.

1993 My 28, C12:3

Sprucing Up Hoboken, Ready or Not

"Delivered Vacant" was shown as part of the 1992 New York Film Festival. Following are excerpts from Vincent Canby's review, which appeared in The New York Times on Oct. 10, 1992. The film opens today at the Cinema Village, 22 East 12th Street, Greenwich Village.

Nora Jacobson's "Delivered Vacant" is a big, long, ungainly documentary about the gentrification of Hoboken. Though not neat, it is a fine, rich film, a large lode of raw material accumulated by Ms. Jacobson over an eight-year period beginning in 1984.

That's when young, upwardly mobile New Yorkers, having discovered Hoboken's charms and comparatively cheap rents, began moving across the river in droves, and when property owners and land developers jumped in to reap the profits. The result was an upscale feeding frenzy. The first victims: Hoboken's longtime blue-collar residents, the newer immigrant families from Latin America and the Indian subcontinent, and the elderly pensioners, mostly retired merchant seamen and railroad men, who filled the city's rooming houses.

Ms. Jacobson documents the changing Hoboken character with a concern that is always very polite, in part because she is supposed to be an impartial observer and in part because, being herself a new arrival, she is a player in the story she is telling. "Delivered Vacant" is a story of greed, hope, political action, bewilderment, free enterprise, idealism and rampant opportunism. A lot of colorful characters pass in front of Ms. Jacobson's camera.

There's Tom Vezetti, who walked Hoboken's streets glad-handing the citizens to be elected Mayor in 1985, largely on promises to find housing for the city's increasingly squeezed underclasses. There are speculators who buy out tenants, refurbish the buildings and then sell the units as condominiums.

The tactics of some are sleazy. Others are just unmindful, like the well-dressed young man who speaks with disgust of the smells and the deplorable conditions of the old rooming houses he acquires.

Looking on, at first with amusement and then with fear, are the pre-boom residents. Says one woman: "I don't understand what people want with condominiums. Maybe an elevator?" She's even more puzzled when told that the condos don't necessarily have elevators. Nobody has told her about tax writeoffs or the easy commute to Manhattan.

The yuppies are a varied lot. "We sort of like ethnic communities," says one, "but not when they're falling apart or noisy." Others make conscious attempts to fit into the community.

The rising value of the real estate prompts a lot of ugly scenes. Buildings are torched, some say by owners desperate to evict low-rent tenants, others say by disgruntled pre-boom residents.

"Delivered Vacant" is shaped by the events it records, which is why one gets the feeling near the end that the original victims of gentrification have been forgotten. Ms. Jacobson revisits a few, but time has moved on. Most of these people have moved or died.

In the way of drama that satisfies, time wounds all heels. By the 1990's many of the developers, earlier seen wheeling and dealing with such enthusiasm, have gone bust, their properties sold at auction. "Delivered Vacant" is something of an urban epic.

1993 My 28, C15:1

Something Within Me

Directed by Emma Joan Morris; edited by Jean Tsien; created and produced by Jerret Engle; released by Panorama Entertainment Corporation. Cinema Village, 22 East 12th Street, Greenwich Village. Running time: 55 minutes. This film has no rating.

By JANET MASLIN

"Something Within Me," opening today at the Cinema Village, is an uncomplicatedly sunny testimonial to St. Augustine's, a parochial school in the South Bronx that has stirred its students with a lively, creative curriculum. As filmed by Jerret Engle and Emma Joan Morris, the students and teachers of St. Augustine's warmly testify to the beneficial effects of learning to play music, especially jazz.

The students have been encouraged to improvise, in part as a way of building their self-confidence. One after another, these smiling schoolchildren describe their enjoyment of learning, and the ways in which St. Augustine's has heightened that experience in the face of adversity. Problems in the surrounding community, like drugs and random violence, are also mentioned. But this film's clear purpose is to accentuate the positive, and that's what it does.

"Something Within Me" takes a laudable, unobjectionable view of its subject matter without offering any element of discovery or surprise. That makes it the kind of documenta-

ry that often wins awards, and indeed it is the winner of this year's Audience Award from the Sundance Film Festival. This 55-minute feature opens on the same bill with the 30-minute "Educating Peter," which won this year's Oscar as the best documentary short subject.

1993 My 28, C15:1

Super Mario Brothers

Directed by Rocky Morton and Annabel Jankel; written by Parker Bennett, Terry Runté and Ed Solomon; director of photography, Dean Semler; edited by Mark Goldblatt; music by Alan Silvestri; production designer, David L. Snyder; produced by Jake Eberts and Roland Joffé; co-producer, Fred Caruso; released by Hollywood Pictures. Running time: 104 minutes. This film is rated PG.

Mario Mario	Bob Hoskins
Luigi Mario	John Leguizamo
King Koopa	Dennis Hopper
Daisy	Samantha Mathis
Iggy	Fisher Stevens
Spike	Richard Edson
Lena	Fiona Shaw
Daniella	Dana Kaminski
Toad	Mojo Nixon
Scapelli	Gianni Russo
Bertha	Francesca Roberts
The King	Lance Henriksen
Old Lady	Sylvia Harman
Angelica	Desiree Marie Velez

By JANET MASLIN

The tiny truants and curiosity seekers who turned up at the first showing of "Super Mario Brothers," which opened yesterday at neighborhood theaters without benefit of advance screenings, must have been awfully surprised. This bizarre, special effects-filled movie doesn't have the jaunty hop-and-zap spirit of the Nintendo video game from which it takes — ahem — its inspiration. What it has instead are a weird, jokey science-fiction story, "Batman"-caliber violence and enough computer-generated dinosaurs to get the jump on "Jurassic Park."

Eleven-year-old boys, the ideal viewers for this vigorous live-action comic strip, will no doubt be impressed with the expense and energy that have gone into bringing "Super Mario Brothers" to the screen. Other viewers may wonder how they came to be watching a film about parallel universes, punitive devolution, creatures who eat grilled salamanders on hot-dog rolls, and one memorably disgusting character who has been transformed into a ball of slime.

The answer doubtless has more to do with marketing tie-ins than with creative thinking. Allowing for that, and for the total superfluity of this whole enterprise, "Super Mario Brothers" is not without its selling points. This film's two directors and three screenwriters have clearly tried hard to breathe life into their nonstory, to the point where the film's intensity seems more crazy than cynical. And its special effects are well executed even when their purpose is less than clear.

The plot? Sit down. There were dinosaurs in Brooklyn. They wound up in quasi-human form living somewhere far beneath the East River. Their leader is King Koopa (Dennis Hopper), whose ridged, reptilian coiffure contributes to the film's bad-hair-day motif. Princess Daisy (Samantha Mathis), who hatched out of her egg in a Brooklyn convent, has been kidnapped by Koopa so that he can get her magic meteorite fragment, which can be used to bring the two universes together. Only the

Mario brothers, Luigi (John Leguizamo) and Mario (Bob Hoskins), can prevent this terrible thing from happening. Perhaps only the Mario brothers can figure it out.

●

Aside from Mr. Hoskins's furry mustache and the fact that the Marios are still plumbers, the film doesn't pay a lot of attention to its video-game roots. Instead, it has fun with minor characters (Fisher Stevens and Richard Edson as two cartoonish creeps) and sly little touches, like the campaign posters that show Koopa cuddling a baby and stating his political ideas. ("Don't worry — we'll get more" is Koopa's position on the environment.)

Broader strokes include a lot of lizard references, a cuddly and believable dinosaur as a household pet, and the special effects that transform Koopa's subjects into pin-headed, grinning dinos in storm-trooper garb. The last conceit is rendered less grotesque by the fact that the troops get silly when they hear the love theme from "Dr. Zhivago."

Under these scene-stealing circumstances and the constraints of a plot that turns barely comprehensible in its last half-hour, it's remarkable that the human actors fare as decently as they do. Apparently Mr. Hoskins can handle any role with grace and good humor. Ms. Mathis and Mr. Leguizamo make likable ingenues. Mr. Stevens and Mr. Edson, who are mercifully given a brain-power transplant midway through the movie, come closest to the wired, antic spirit of the Nintendo original.

Mr. Hopper is alarmingly natural in the role of a highly evolved tyrannosaurus rex who happens to have a wonderful way with platitudes. He seems entirely comfortable with everything he has to do here, from wallowing in a mud bath to describing himself as linked to "that little part of all of us that can't stand to see someone else in need or pain." Look for some fun clips from this one when the Film Society of Lincoln Center honors Mr. Hopper in the year 2005.

●

"Super Mario Brothers" is rated PG. It includes some minor sexual suggestiveness and the kind of strange, spooky violence that could upset young children.

1993 My 29, 11:1

Happily Ever After

Directed by John Howley; screenplay by Martha Moran and Robby London; animation by Filmation; produced by Lou Scheimer; released by the First National Film Corporation. Running time: 80 minutes. This film is rated G.

VOICES:

Snow White	Irene Cara
Scowl	Edward Asner
Muddy	Carol Channing
Looking Glass	Dom DeLuise
Mother Nature	Phyllis Diller
Blossom	Zsa Zsa Gabor
Sunburn	Sally Kellerman
Lord Maliss	Malcolm McDowell
Thunderella	Tracey Ullman

By STEPHEN HOLDEN

If movie blockbusters from "The Godfather" to "Batman" can beget successful sequels, why not "Snow White and the Seven Dwarfs" 56 years after the original? That must have been the reasoning behind "Happily Ever After," a clever but hardly memorable follow-up to the Disney animated film classic.

"Happily Ever After," which opened yesterday, is by no means an official Disney-approved sequel. Presented by the First National Film Corporation with animation by Filmation, its Snow White bears a strong family resemblance to the Disney character without actually looking like her. Its prince has red hair, and the Seven Dwarfs are nowhere to be found.

The film, which strikes a steady balance between the dreamy romantic tone of the original and a Saturday morning cartoon, imagines that the Evil Queen had an equally evil brother, Lord Maliss. On returning to the castle he shared with his sister, he intimidates her magic mirror into revealing she is dead. Vowing revenge on Snow White and her prince, he turns himself into a flying red dragon and plucks Snow White from the side of the prince, whom he imprisons in his castle.

Snow White succeeds in escaping his clutches long enough to flee into a forest, where she finds herself at the cottage of the Seven Dwarfs. To her surprise, the premises have been taken over by their female cousins the Dwarfelles — Sunburn, Muddy, Thunderella, Blossom, Moonbeam, Critterina and Marina — each of whom controls a different aspect of life on earth.

●

They take Snow White to visit Mother Nature, their pointy-headed, sharp-tongued boss, who warns that if they don't do a better job they'll all be fired. Following her directions, they leave her garden and make their way through the cavernous Realm of Doom toward Lord Maliss's territory, which is patrolled by a pack of wolves.

The most original thing about "Happily Ever After," which was directed by John Howley from a screenplay by Martha Moran and Robby London, are the Dwarfelles, several of whom are played by stars. The most insecure of the group is Thunderella, (Tracey Ullman), a perky red-headed little girl who is supposed to control the weather but can't always deliver what she promises. The giddiest is Blossom (Zsa Zsa Gabor), who can create flowers with the wave of her hand and is a big flirt. Sally Kellerman is a gruff, husky-voiced Sunburn, Carol Channing a loquacious Muddy and Phyllis Diller a warmhearted but moody Mother Nature.

Lord Maliss (Malcolm McDowell), with his thin handle-bar mustache and sinister glare, suggests Captain Hook in the age of "Star Trek." His bumbling assistant Scowl (Ed Asner), is a cigar-smoking owl who delivers one of the film's several mediocre songs, a feeble rap number called "The Baddest." Irene Cara plays Snow White and sings the movie's trite, clangy theme song, "Love Is the Reason Why."

Visually, "Happily Ever After" is mundane. The animation is jumpy, the settings flat, the colors pretty but less than enchanting. The movie's strongest element is its storytelling, which is not only imaginative but also clear and smoothly paced. The trip from Mother Nature's garden to Lord Maliss's castle of stone and chains is a journey that most young children should find diverting and not very scary.

1993 My 29, 13:1

FILM VIEW/Caryn James

Movies Used to Be Really Good by Being Bad

FROM THE VERY START OF "Red-Headed Woman," Jean Harlow is looking for trouble. Trying on a dress in a shop, she asks the saleswoman, "Can you see through this?"

"I'm afraid you can, ma'am," the clerk answers. Harlow snaps back, "I'll wear it."

As a good-natured, small-town secretary named Lil Andrews, Harlow sleeps with her boss, breaks up his marriage, then moves on to his older, wealthier business associate. By the time she says, "I'm the happiest girl in the world! I'm in love, and I'm gonna be married!," only a fool would imagine she's talking about just one man. Her fiancé is the businessman; her lover is his French chauffeur (played by the young Charles Boyer). She ends up with yet a third rich man but brings the chauffeur along. Through it all, Harlow is immensely likable, and this 1932 film suggests everyone should be so lucky.

"Red-Headed Woman" is one of the most outrageously funny movies ever to come out of Hollywood, and just two years later it would have been impossible to make. In 1934,

a stringent version of the industry's self-po-licing Production Code went into effect. The code decreed that no unmarried sex would be sanctioned, no evil deed would go unpun-ished, no raunchy remark would pass the heroine's lips. Much of the liveliness, sexi-ness and realism went out of movies, re-placed by a coyness and romantic haze that persisted until the 1960's.

Many of those pre-code movies deserve to be better known, and many are available on video from MGM/UA in a series called "For-bidden Hollywood." They are entertaining, eye-opening in their frank depiction of con-ventional morals under attack, and often a generation ahead of their time. Bette Davis is a commercial artist who lives with her boy-friend but refuses to marry him in "Ex-Lady." Loretta Young is starving and so des-perate for a job that she sleeps with a depart-ment-store manager to get one in "Employ-ees Entrance." In "Female" (like "Ex-Lady" and "Employees Entrance," made in 1933) Ruth Chatterton runs a huge car-manu-facturing company, which makes it conven-ient for her to sleep with the handsome young men who work for her, then have her male secretary pay them off.

Barbara Stanwyck is a genre all her own. In "Ladies They Talk About" (1933) she is an unrepentant bank robber sent to prison ("New fish, new fish!" the other lady in-mates yell when she arrives; they wear high heels and look like sorority sisters). In "Baby Face" (1933) she is even more ruthless, as a woman who works for a bank and sleeps her way to the top. With her every move to an-other man's office, the camera shows a win-dow on a higher floor of the bank building un-til she reaches the penthouse.

As in most pre-code movies, the precise de-tails of Baby Face's conquests are left to the imagination. When people are about to have sex, the scene fades out. Loretta Young is seen lying on a bed; her employer enters the room; suddenly, it is the next morning, and she feels rotten. Harlow goes to visit her wealthy businessman, and the next thing we know she's snapping a garter back into place.

But if these early-30's films are not visual-ly explicit about sex, they are more realistic and open-minded than the circumspect mov-ies that followed. Pre-code films not only ac-knowledged that sex existed outside mar-riage (however scandalous that was). They also showed that in those Depression years, poor people found themselves in compromis-ing situations. The employer's sexual de-mands are reprehensible in "Employees En-trance," but the audience is encouraged to feel sorry for Miss Young. A few years later such human foibles would seem too danger-ous for Hollywood to handle.

■

"Life should not be misrepresented," an early version of the code stated, but ironical-ly the standards it set led to massive misrep-resentation. Only in the movies do the ruth-less always get their comeuppance or have a change of heart. Maybe in real life a woman shouldn't get away with shooting an ex-hus-band, as Harlow does in "Red-Headed Wom-an," but it's fun to see how far she can go. She didn't actually kill him, after all.

Some films have soppy, dated endings. In "Female," the executive marries and turns the company over to her husband. In "Ex-Lady" Bette Davis caves in and gets mar-ried, too. Such cowardly endings are under-standable, though, because studios had been tussling with versions of the code since the late 1920's, trying to balance the success of scandalous movies with a genuine threat of government censorship. What made 1934 the benchmark year was that studios agreed that a film would not be released without the Pro-duction Code Seal of Approval.

This situation sounds chillingly similar to the way today's Motion Picture Association of America — the ratings people — operates, with studios and directors snipping a few sec-onds of sex here and a few shots of blood there to avoid the dreaded NC-17. The "For-bidden Hollywood" videos suggest that such self-censorship makes films dull. "There we were, like an uncensored movie," Harlow says about a night with the boss in "Red-Headed Woman." Lucky for us, she got all the uncensored trouble she was asking for. ☐

1993 My 30, II:20:1

Un Coeur en Hiver

Directed by Claude Sautet; written by Yves Ulmann, Jacques Fieschi and Jérôme Ton-nerre (in French with English subtitles); director of photography, Ves Angelo; edited by Jacqueline Thiedot; musical director, Phi-lippe Sard; production designer, Christian Marti; produced by Jean-Louis Livi and Phi-lippe Carcassonne; released by October Films. Lincoln Plaza Cinemas, Broadway at 63d Street. Running time: 105 minutes. This film is not rated.

Stéphane	Daniel Auteuil
Camille	Emmanuelle Béart
Maxime	André Dussollier
Hélène	Elisabeth Bourgine
Régine	Brigitte Catillon
Lachaume	Maurice Garrel
Madame Amet	Myriam Boyer
Brice	Stanislas Carre de Malberg
Ostende	Jean-Luc Bideau

By JANET MASLIN

"Un Coeur en Hiver" ("A Heart in Winter"), a coolly elegant romance directed by Claude Sautet, is centered on Stéphane (Daniel Auteuil), who is solemn and expert when it comes to his craft (repairing fine violins) but has no skill in matters of emotion.

There is a certain irony to this film's title. Stéphane is hardly more wintry-hearted than the story's other two principals, with whom he be-comes involved in a subtle and diffi-cult romantic triangle. Each of these refined, self-involved characters has his or her own form of chilly isolation, but it is Stéphane who pays most noticeably for his shortcomings.

The reason has as much to do with Stéphane's demeanor as with his heartlessness. The prim, serious Sté-phane is first seen gluing a violin together, taking his solitary satisfac-tion in the meticulousness of such work. He and Maxime (André Dussol-lier) run an atelier frequented by renowned musicians, and they can comment knowingly on "brightness on the E string" and other fine points. Their expertise is clearly well re-spected. Maxime, in particular, radi-ates the confidence of knowing that he performs an essential service within the musicians' rarefied world.

Maxime's suave assurance has re-cently brought him an added benefit, as he quietly confides to Stéphane over lunch one day. He has fallen in love with Camille (Emmanuelle Béart), a heart-stoppingly beautiful young woman who is also a violinist of discipline and talent. He plans to move in with her as soon as he can find the proper quarters and extri-cate himself from his marriage, which is referred to only briefly and in passing. "You don't spend a life-time with a good friend," Maxime says pragmatically about his wife. About Camille, he later says: "It's a new experience, admiring someone I love. It makes me more rigorous."

October Films

Trio Emmanuelle Béart stars in "Un Coeur en Hiver" as a concert violinist torn between a Parisian violin repair shop owner and his friend and partner.

Camille is, in her own exquisite way, no less self-interested or severe. She lives with her manager, Régine (Brigitte Catillon), a woman who is obviously in the thrall of her protégée and has done her utmost to further Camille's career. The younger wom-an's single-minded concentration ap-parently goes back to her childhood. "I remember her as a smooth, hard little girl who keeps one at a dis-tance," a former teacher says of her. "But behind it you could feel a real temperament." "Un Coeur en Hiver," which opens today at the Lin-coln Plaza Cinemas, is about what happens when Camille's tempera-ment leads her to set her sights on Stéphane.

Any story focused on a lonely, love-less character risks allowing its view-er or reader to draw back, convinced that he or she will never share the protagonist's pitiable state. Hence Mr. Sautet's willfully aloof direction of "Un Coeur en Hiver" comes as an interesting surprise. This director, best known here for films he made 20 years ago ("César and Rosalie" in 1972, "Vincent, Paul, François and the Others" in 1973) makes no effort to wring pathos out of Stéphane's plight. Nor does he encourage Mr. Auteuil to reduce the character to two dimensions. "Un Coeur en Hiver" ac-cepts Stéphane's remoteness as something clinical, and adopts a Roh-meresque detachment in observing and analyzing its consequences.

"Un Coeur en Hiver," which is as much about its characters' ideals of beauty as it is about anything else, uses Camille's esthetic perfectionism as a romantic spark. It begins to dawn on her, as the ambitious Maxime is called away for various long-distance phone calls, leaving her alone with Stéphane, that Stéphane may subscribe to especially high standards. A career spent honing exquisite instruments has given him an astute ear. Camille's growing attraction to Stéphane comes in part from the thought of winning his professional admiration. "I thought you were eager to follow my work!" she exclaims in disbelief, when Stéphane seems to reject her overtures. And when Stéphane does heed and admire her music, he leads her to a new height of achievement.

There is both fascination and frustration in watching this odd story unfold, since the director avoids commenting overtly on his characters' inner lives. Working from a screenplay by Yves Ulmann, Jacques Fieschi and Jérôme Tonnerre, Mr. Sautet makes this story powerfully vivid without often penetrating its smooth veneer. The film's settings, invitingly evoked, are used as landmarks in the lives of the principals: the atelier, several bistros, recording studios and concert halls and a large, handsome house in the country. Yet Stéphane can travel this landscape quietly and inexpressively, except in the remarkable moment when he describes his isolation. "You're talking about feelings which don't exist for me," he tells the ashamed and astonished Camille. "I can't feel them. I don't love you."

•

"Un Coeur en Hiver," the winner of César awards last year for Mr. Sautet's direction and Mr. Dussollier's polished performance as Maxime, offers satisfactions that go beyond the scope of its strange story. Within its atmosphere of intelligence and precision, the film makes deft use of the Ravel sonatas and trio that are actually performed by Jean-Jacques Kantorow, but feigned captivatingly by Ms. Béart.

This actress is an esthetic delight in her own right, and she gives a carefully measured performance that suits her role. Mr. Auteuil, prim and watchful, conveys the delicately calibrated changes in Stéphane's nature as fully as the material allows him to. And he manages the remarkable feat of commanding attention even when Ms. Béart is at center stage.

1993 Je 4, C3:1

Life With Mikey

Directed by James Lapine; written by Marc Lawrence; director of photography, Rob Hahn; edited by Robert Leighton; music by Alan Menken; production designer, Adrianne Lobel; produced by Teri Schwartz and Scott Rudin; released by Touchstone Pictures. Running time: 94 minutes. This film is rated PG.

Michael Chapman......................Michael J. Fox
Angie VegaChristina Vidal
Ed ChapmanNathan Lane
Geena Briganti...........................Cyndi Lauper
Barry Corman......................David Krumholtz
Judy...Barbara Hollerman
Mr. Corcoran.......................David Huddleston
Brian SpiroVictor Garber

By JANET MASLIN

The lullaby of Broadway wafts helpfully through "Life With Mikey," elevating this film's pat premise to a more sophisticated realm. Though "Life With Mikey" has the setup of a sitcom, it also has the director James Lapine, who brings with him a theatrical sparkle this material would otherwise lack. So the film is enlivened by Broadway cameos and humorous audition scenes, touches that come more naturally to Mr. Lapine than the story's hackneyed elements do. The breezy, lightweight "Life with Mikey" would have benefited from much more of the same.

This film's not-so-secret weapon is Michael J. Fox, who works tirelessly to keep the comedy afloat even when its sentimental side begins to show. Mr. Fox plays Michael Chapman, a former child star whose glory days live mostly in his own memory, though he is occasionally invited to help open a fast-food restaurant in honor of his television past (on the "Leave It to Beaver"-type sitcom for which the film is named). "I just started to hate the superficiality of the whole scene," he says unconvincingly, to explain why his performing career skidded to a halt. "I'm an agent now."

Michael and his brother, Ed (the irresistible Nathan Lane), handle a roster of would-be child stars who provide frequent doses of comic relief and who guarantee Mr. Lane some of the film's best lines. "Judy, switch to decaf," Mr. Lane advises a funny little girl (Barbara Hollerman) who means to be the next Ethel Merman. And when a solemn boy with Woody Allen's demeanor sighs and says that "in a hundred years we'll all be dead," Mr. Lane groans, "I'm not sure I can wait that long." The third wheel at the talent agency is Geena Briganti, played by Cyndi Lauper as the kind of gum-chewing gal Friday who brings back countless show-biz sagas gone by.

•

Into this nicely nostalgic universe bounds little Angie Vega (the buoyant Christina Vidal), a big-eyed, smart-mouthed prodigy whom Michael discovers when she tries to steal his wallet. Angie is supposed to be a tough street kid, and she's nobody's fool; when Michael gets her an acting job and tries to negotiate his fee, Angie is a lot better at figuring out percentages than he is. But Angie is also lonely, and she needs to find her lost childhood, and Michael needs to grow up by learning to take care of her. Everything about this side of Marc Lawrence's screenplay is all too apparent from Angie's very first scene.

It's best to avoid the life lessons in "Life With Mikey" and concentrate on the color. Broadway luminaries like Christine Baranski, Mandy Patinkin, William Finn (Mr. Lapine's collaborator on "Falsettos"), Wendy Wasserstein and Christopher Durang turn up in small roles, and most of them will seem piquantly odd even to those who don't find them instantly recognizable. (It is not necessary to know Mr. Durang as a playwright to realize he makes a strange Santa Claus.) And Alan Menken contributes a sunny score. When it comes to music, the film also has fun with its young auditioners and their tone-deaf versions of "You're a Grand Old Flag," "Kumbaya" and "A Spoonful of Sugar," to name but a merciful few.

"Life With Mikey" makes its ultimate nod to show-business silliness with David Krumholtz's Barry Corman, a junior Mr. Big. Barry is very big in cereal commercials, but what he really wants is to work with Michelle Pfeiffer. He's the kind of kid who, when he sends his mother out for Big Macs, makes a point of offering her a tip.

•

"Life With Mikey" is rated PG. (Parental guidance suggested.) It includes mild profanity.

1993 Je 4, C8:5

Correction

A review of the film "Life With Mikey" in Weekend yesterday referred incorrectly to the actress who plays the little girl Judy. She is Barbara Hollander.

1993 Je 5, 2:6

Guilty as Sin

Directed by Sidney Lumet; written by Larry Cohen; director of photography, Andrzej Bartkowiak; edited by Evan Lottman; music by Howard Shore; production designer, Philip Rosenberg; produced by Martin Ransohoff; released by Hollywood Pictures. Running time: 107 minutes. This film is rated R.

Jennifer Haines.............. Rebecca De Mornay
David Greenhill.............................. Don Johnson
Phil GarsonStephen Lang
Moe ...Jack Warden
Judge Tompkins................................Dana Ivey

By JANET MASLIN

In "Guilty as Sin," a strange thing happens to Don Johnson when he's called upon to play a slick, handsome operator who is irresistible to women. In theory, this role shouldn't really have been much of a stretch. But Mr. Johnson somehow feels obliged to act most broadly when trying to be charming, which puts this courtroom drama at a needless disadvantage. It takes a while to figure out who Mr. Johnson's David Greenhill is supposed to be and where Sidney Lumet's latest film is headed.

David is first seen sizing up Jennifer Haines (Rebecca De Mornay), a famous Chicago trial lawyer with a real flair for sashaying past the jury. The film tries to make a case for Jennifer's legal brilliance. But it discredits itself with a post-verdict scene in which she marches to her boyfriend's office, rips off her dress and crows, "Is there anything better than winning?"

At first the high-powered Jennifer mistakes David for a mere fan, but it turns out that he has an ulterior motive. Accused of having thrown his wife out a window, David is in the market for expert legal advice. So he piques Jennifer's interest with various sorts of innuendoes. Some of these suggest that he may regard her as a new conquest. ("You interest me, and I really delve into anything that interests me.") Others suggest that he may be a one-man crime wave, which somehow strikes Jennifer as a professional challenge.

•

Only midway through the film, as Mr. Johnson looks paunchy in his monogrammed bathrobe and scares Jennifer by waving a kitchen knife too vigorously while he makes a sandwich, does it become clear that his David Greenhill is meant to be all villain. After this point, the awkward "Guilty as Sin" actually begins to improve. Unlike the sort of high-concept film that starts strongly and

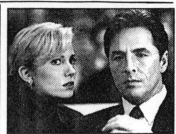

Kerry Hayes

Rebecca DeMornay and Don Johnson in "Guilty as Sin."

subsequently fizzles, this one picks up steam as David feels freer to express his diabolical side. His real plan involves taking unfair advantage of the lawyer-client relationship and treating this as a malevolent game.

So "Guilty as Sin" winds up in Hitchcock territory, but it never achieves much of a foothold. Even as the story grows progressively stranger, it seldom generates suspense. Much of the problem lies with Larry Cohen's leaden dialogue. (David: "You don't know how crazy some women can behave." Jennifer: "I've got to get him before he gets me. It's that simple.") Even when Ms. De Mornay and Mr. Johnson finally do lock horns, the film doesn't give them enough to say.

Mr. Lumet, as a New York institution transferred to unfamiliar territory (this Chicago-based film was shot in Toronto), supplies surprisingly little of the lively background detail that is ordinarily his trademark. This film's settings are blandly modern, and its set decoration often looks like exactly that. Not even the minor actors provide the kind of texture that is usually a Lumet staple, although Jack Warden is invaluable as Jennifer's crusty old friend and mentor. (By contrast, the film does surprisingly little with the role of Jennifer's boyfriend, played by Stephen Lang.) But "Guilty as Sin" does have its occasional deft touches. When Mr. Lumet begins abruptly with the bang of a gavel and the shout of "Sustained!" you may wonder why every courtroom drama doesn't start in precisely this way.

"Guilty as Sin" lets Ms. De Mornay be sleek and commanding while Mr. Johnson plumbs the wicked, sometimes humorous depths of David Greenhill's gigolo chic. Asked by a woman at a bar whether she can buy him a drink, he answers sourly: "I already have one, but you can pay for it. Bartender? This one's on him." About his lawyer, he says nastily, "See, I just sit here and look pretty, and she does all the work."

•

"Guilty as Sin" is rated R (Under 17 requires accompanying parent or adult guardian). It includes brief sexual suggestiveness, occasional strong language and one gratuitously violent episode involving buckets of blood.

1993 Je 4, C8:5

Games Meticulous And Mean

"The Music of Chance" was shown as part of the recent New Directors/ New Films series at the Museum of Modern Art. Following are excerpts from Janet Maslin's review, which appeared in The New York Times on March 19, 1993. The film opens today at the Fine Arts, 4 West 58th Street, Manhattan.

A miniature city is the haunting centerpiece of "The Music of Chance," Philip Haas's cool, methodical film version of Paul Auster's equally meticulous 1990 novel. Called City of the World, it is the bizarre plaything of Willie Stone (Joel Grey), a former optometrist who made his fortune by winning the lottery. Together with his friend Bill Flower (Charles Durning), Stone lives in an isolated mansion and contemplates the meaning of fate while playing childlike games. The City of the World is his masterwork. James Nashe (Mandy Patinkin) and Jack Pozzi (James Spader) are his victims.

With the tenor of a Beckett play as filtered through the mathematical mind of Peter Greenaway, Mr. Haas's cryptic, elegantly made "Music of Chance" traces the trajectory of Nashe and Pozzi. Starting out as drifters, they are brought together accidentally and wind up as slaves to Flower and Stone's peculiar vision. Pozzi is a desperate gambler, and Nashe is in the last stages of an existential experiment (of the sort that has made Mr. Auster's work much more widely appreciated in Europe than it is here, where this New Jersey-born novelist remains something of a cult figure). Trapped together in the Flower and Stone estate, they find release in the bleak comforts of a shared destiny.

Mr. Auster's story, which the film follows as faithfully as possible, has the latitude to look deeply into such mysteries. His book first finds Nashe

Becoming slaves to a peculiar vision.

at the end of a yearlong driving spree, and it has the wherewithal to explain how Nashe's life led him to this juncture. Separated from his wife and child, newly flush thanks to an inheritance from a father he barely knew, this former fireman has severed all ties to his past, bought a new car and simply begun driving.

Nashe is nearly out of money when he happens to spot Pozzi, badly beaten, by the side of a road. "It was one of those random, accidental encounters that seem to materialize out of thin air; a twig breaks off in the wind and suddenly lands at your feet," Mr. Auster writes of that meeting. The film, which can show only a car, a road and two drifters making conversation, is already at a disadvantage. Even allowing for the essentially opaque nature of this material, this

terse, oddly mesmerizing film often suffers from an inability to provide more than the bare bones of Mr. Auster's story.

Mr. Haas makes up for that by accentuating the material's most peculiar aspects with supreme, piquant clarity. "The Music of Chance" is filled with curious, resonant parallels. When Nashe and Pozzi (whose name suggests a parallel with the Pozzo of "Waiting for Godot") arrive at the mansion for an all-important poker game, they come with $10,000, the last of Nashe's money. They lose it all, and are instead given 10,000 stones: they are forced to agree to build a monument made from these identical blocks, imported from Ireland by Flowers and left over from a castle destroyed by Oliver Cromwell. To emphasize the infantilizing aspect of this task, they are given a child's little red wagon for carrying blocks. And as they work on the project to Stone's exacting specifications, their progress is incorporated into his model city.

Mr. Auster's writing is filled by such gamesmanship, and is saved from preciousness by the leanness and simplicity of the author's style. Mr. Haas, a well-respected documentary film maker making his feature debut, has these same virtues. His film has a sustaining air of mystery and a quiet, rarefied beauty that saves it from seeming too myopic or coy. Superbly photographed by Bernard Zitzermann and greatly aided by Phillip Johnston's score (which is augmented by Beethoven and Berlioz), "The Music of Chance" is as inviting as it is puzzling. Only in its final scene (which features Mr. Auster in a tiny role) does the film lose its nerve.

•

Mr. Patinkin, looking lean and tough (the credits mention his "strength and conditioning consultant"), gives an effectively terse performance. Mr. Spader is more of a wild card, and a greater source of leavening humor. With his hair dyed black and greasy, a small spot of beard beneath his lower lip, he exudes Pozzi's sleaziness and also captures the character's outlandish charm. Also in the cast, and especially good, is M. Emmet Walsh as the estate's countrified, faintly dangerous overseer. Mr. Walsh's sly performance perfectly captures the novel's description of Calvin Murks, the character he plays: "There was something so deeply imperturbable about the man, so fundamentally oblique and humorless, that Nashe could never decide if he was inwardly laughing at them or just plain dumb."

1993 Je 4, C13:1

What's Love Got to Do With It

Directed by Brian Gibson; screenplay by Kate Lanier, based upon the book "I, Tina," by Tina Turner and Kurt Loder; director of photography, Jamie Anderson; edited by Stuart Pappé; music by Stanley Clarke; production designer, Stephen Altman; produced by Doug Chapin and Barry Krost; released by Touchstone Pictures. Running time 120 minutes. This film is rated R.

Tina Turner	Angela Bassett
Ike Turner	Laurence Fishburne
Jackie	Vanessa Bell Calloway
Anna Mae Bullock	Rae'ven Kelly
Zelma Bullock	Jenifer Lewis
Fross	Chi
Alline Bullock	Phyllis Yvonne Stickney
Darlene	Khandi Alexander
Club Owner	Robert Guy Miranda
Lorraine	Penny Johnson

By JANET MASLIN

"What's Love Got to Do With It" begins perfectly. It presents Anna Mae Bullock (Rae'ven Kelly) as a shy little country girl singing with a church choir. The song is "This Little Light of Mine," and Anna Mae is letting her own light shine a lot more brightly than the choirmistress wants it to. This girl can't help herself. She has a natural talent. It's a gift that will save her from poverty and obscurity, turn her into the world-famous musical dynamo known as Tina Turner, and place her in the clutches of a sexy, smooth-talking Svengali named Ike.

In less confessional times, the tale of Ike Turner's stormy, violent relationship with his long-abused wife and star attraction might not have had the makings of a Hollywood biography. Even in the abridged, somewhat sanitized account given here (adapted by Kate Lanier from "I, Tina," the autobiography Ms. Turner wrote with Kurt Loder), this Touchstone Pictures release is hardly the Disney version. Forced into show business servitude no matter how sick or exhausted she might be, Tina Turner suffered years of vicious beatings, marital infidelities and other indignities. It took vast reserves of courage for her to break free and tell her husband, "Go straight to hell, Ike."

Depicted by this broad, savvy, entertaining film as a survivor and a victim in equal parts, Ms. Turner becomes an emblem of contemporary tell-all dramaturgy. She also remains something of a cipher, since "What's Love Got to Do With It" has the ring of an authorized version. As played by Angela Bassett, who transforms herself memorably into the kind of hard-working powerhouse Ms. Turner is onstage, this film's heroine is largely uncomplicated, motivated by decency and fear. The deeper, more painful side of her experience remains unexpressed, except through the film's depiction of its riveting villain.

The brilliant, mercurial portrayal of Ike Turner by Laurence Fishburne, formerly known as Larry, is what elevates "What's Love Got to Do With It" beyond the realm of run-of-the-mill biography. First seen as a sinuous charmer with a pompadour and pencil-thin mustache, Mr. Fishburne's Ike leaves no doubt as to how he was able to hold the young, sheltered Anna Mae (whom he renamed Tina) in such thrall. Early in the story, when Anna Mae has newly moved to St. Louis to be with the mother who had abandoned her in childhood, Ike is seen as a veritable human magnet.

Locally famous as both a bandleader and a ladies' man, Ike gives Tina her first chance to perform onstage, then marvels in true "Star Is Born" fashion at her show-stopping talent. This scene, a nicely staged version of the standard crowd-pleaser, constitutes almost the only point in the story at which Ike displays an unselfish appreciation of what Tina can do.

•

Smiling, cajoling and sweet-talking his way through the first part of the story, Mr. Fishburne's Ike reshapes his protégée. Ike's considerable acumen makes him understand just how Tina should dress, sing and move to best effect, and Tina obligingly becomes his creature. The film, punctuated by frequent, lively reminders of Ike and Tina's stage act and its best-

known numbers, takes obvious satisfaction in charting Tina's rise to stardom. Anyone familiar with her career will appreciate the degree to which "What's Love Got to Do With It" gets the wigs, the clothes and the choreography just right.

•

When a film's subject is as familiar visually as Ms. Turner is, verisimilitude can become limiting and unrewarding, movie-of-the-week style. This film is wise to avoid the aspects of Ms. Turner's life that would have been impossible to recreate for a video-literate audience (like her early days on tour with the Rolling Stones) and keep the celebrity tie-ins to a minimum. Instead of dropping famous names, the film evokes the 1960's and 70's through gleefully garish props, outfits and coiffures, most notably on the perpetually hip and fashion-minded Ike. Even at his most embittered and dangerous, Ike never forgets to try and look his best.

Mr. Fishburne finds something unexpectedly moving in Ike's decline, despite the terrible effect his problems had on his wife. Under the influence of drugs, Ike becomes a desperate, jive-talking mess, venting his jealousy of Tina's success in excruciating ways. The film retains its fundamentally glossy tone despite the fact that Ike is seen beating Tina with his boot in a limousine, raping her during a domestic quarrel, blackening her eye before a performance and forcing her to leave her hospital bed when she says she's too weak to work. It understands that the dream of success that intoxicated Ike somehow damaged him as badly as it hurt those around him.

•

"What's Love Got to Do With It" has been directed by Brian Gibson with the sweep of an old-fashioned biopic and the energy of a more contemporary kind of musical. Mr. Gibson also directed "Breaking Glass," with a punk ethos very different from this film's rhythm-and-blues atmosphere but with similar commercial verve.

This biography steadily teases its audience with hints of the real Ms. Turner, who is heard on the soundtrack singing old and rerecorded versions of her hit songs. Ms. Turner also appears, at least figuratively, in those uncanny moments when Ms. Bassett pulls her lips taut, bares her teeth, flaunts her hair and legs and captures the star's muscular, kinetic stage style to a T. In the film's closing moments, when the real Ms. Turner takes a kind of curtain call, she arrives with the power of a pop prophecy fulfilled.

•

"What's Love Got to Do With It" is rated R (Under 17 requires accompanying parent or adult guardian). It includes violence, profanity and sexual situations.

1993 Je 9, C15:1

Romper Stomper

Written and directed by Geoffrey Wright; director of photography, Ron Hagen; edited by Bill Murphy; music by John Clifford White; production designer, Steven Jones-Evans; produced by Daniel Scharf and Ian Pringle; released by Academy Entertainment. Film Forum 1, 209 West Houston Street, lower East Side. Running time 92 minutes. This film is rated NC-17.

Hando	Russell Crowe
Davey	Daniel Pollack
Gabe	Jacqueline McKenzie
Martin	Alex Scott
Sonny Jim	Leigh Russell
Cackles	Daniel Wyllie

By STEPHEN HOLDEN

"Romper Stomper," Geoffrey Wright's viscerally supercharged film about neo-Nazi skinheads in Melbourne, Australia, is a film that runs on the adrenaline of hate. From its harrowing opening scene, in which a gang of skinheads terrorizes a group of Vietnamese immigrants, through a prolonged sequence in which the Vietnamese strike back at their tormentors, the film exults at being in the thick of action that is often savagely and sadistically violent.

This being Australia, not the United States, the violence is done with fist, boot, baseball bat and tire chain; not with firearms. But the absence of high-efficiency technological splatter doesn't make it any less bloody or intense.

The gang in question is a bunch of swaggering misfits and their cackling camp followers (women made up to resemble a cross between Kiss and Boy George) who occupy a used-tire depot. Although they could lash out at almost anybody, they have a particular hatred for the Asian immigrants who are flooding the city.

•

"Romper Stomper" pretends to be a close-up critique of a malignant social phenomenon, but its perspective is disturbingly ambivalent. At one moment it is staring up in abject terror at gaunt skinhead faces contorted with a murderous fury. The next, it is hurtling down the street with the same skinheads, as they kick and smash things in a gleeful spree of random destruction.

During a scene in which the gang trashes the home of a wealthy film producer, the movie parodies a similar scene in Stanley Kubrick's film "A Clockwork Orange," using an operatic soundtrack to turn the victim's outrage into a comic tantrum.

"Romper Stomper," which opened a two-week engagement yesterday at Film Forum 1, has already generated heated arguments in Australia, and for good reason. Its portrayal of a

bunch of racist sociopaths wreaking havoc has a delirious energy that stirs the emotions. While enticing you to hate the gang and take delight in everything bad that happens to its members, the film also gives you the vicarious thrill of being one of the gang.

And in Russell Crowe, who plays the skinheads' sinister leader, Hando, it has a leading man whose mixture of menace and animal magnetism suggests a post-punk answer to Marlon Brando in "The Wild One."

•

Hando has swastikas tattooed on his body, sleeps under a Nazi flag, and reads passages from "Mein Kampf" aloud with biblical solemnity. As ludicrous as Hando may be, in Mr. Crowe's portrayal he exudes an antiheroic charisma that could persuade more forgiving audience members to take him as a role model, a sexy rebel with the wrong cause.

When not plunged in battle, "Romper Stomper" becomes a twisted triangular love story involving Hando, his right-hand man, Davey (Daniel Pollack), and Gabe (Jacqueline McKenzie), an emotionally disturbed rich girl whom Hando picks up in a bar. Gabe, who has a headful of blond Shirley Temple girls and a deep streak of cruelty, is the daughter of the movie producer (Alex Scott) with whom she has carried on an incestuous relationship for years. In their confrontations, he is a slavering wreck and she an angry hysteric. Portraying a 90's version of a Carroll Baker character, Ms. McKenzie finds a mixture of little-girl-lost and lethal vamp that is as unsettling as it is believable.

If "Romper Stomper" has a message, it is a nastier contemporary version of the same misunderstood-kids message that permeated 1950's movies like "Rebel Without a Cause." For these alienated, frightened losers from unhappy family backgrounds, the skinhead way of life is just a hook on which to hang their rage.

1993 Je 9, C17:1

as a huge hunk of friendly, prehistoric exotica will not want to see a T. rex bite a lawyer in half.

Who will? Well, anyone of an age and disposition to appreciate one of Mr. Spielberg's canniest roller-coaster rides and to have read Michael Crichton's novel. "Jurassic Park" is a gripping, seductively scientific account of a top-secret theme park, named for the era during which dinosaurs reigned. Jurassic Park's main attractions are real live dinosaurs, which have been created through the reconstruction of dinosaur DNA. The DNA has been obtained through blood found in prehistoric mosquitoes preserved in amber. (The film, being much more mainstream, explains this process with the help of an animated "Mr. D.N.A.")

Mr. Crichton, who wrote the film with David Koepp, delights in such details and presents his story as a fascinating, obsessively detailed treatise on both the possibilities and the evils of modern science. "Jurassic Park" is that rare high-tech best seller punctuated by occasional computer grids to advance its story.

The savviest character in Mr. Crichton's book, a glamorous mathematician (yes) named Ian Malcolm, is among several scientists taken to Jurassic Park to inspect the place before it opens. Confronted with the apparent glitch-free nature of this computerized Eden, Malcolm is skeptical. He frequently cites chaos theory as a way of suggesting that theoretically perfect models have a way of going haywire once they run up against reality. This idea has some bearing on the film version of "Jurassic Park," too.

On paper, this story is tailor-made for Mr. Spielberg's talents, combining the scares of "Jaws" with the high-tech, otherworldly romance of "E.T. the Extra-Terrestrial" and "Close Encounters of the Third Kind," and of course adding the challenge of creating the dinosaurs themselves. Yet once it meets reality, "Jurassic Park" changes. It becomes less crisp on screen than it was on the page, with much of the enjoyable jargon either mumbled confusingly or otherwise thrown away. Sweetening the human characters, eradicating most of their evil motives and dispensing with a dinosaur-bombing ending (so the material is now sequel-friendly), Mr. Spielberg has taken the bite out of this story. Luckily, this film's most interesting characters have teeth to spare.

Jeff Goldblum plays Dr. Ian Malcolm in Steven Spielberg's new film.

Jurassic Park

Directed by Steven Spielberg; screenplay by Michael Crichton and David Koepp, based on the novel by Mr. Crichton; director of photography, Dean Cundey; edited by Michael Kahn; music by John Williams; production designer, Rick Carter; produced by Kathleen Kennedy and Gerald R. Molen; released by Universal Pictures. Running time: 123 minutes. This film is rated PG-13.

Grant	Sam Neill
Ellie	Laura Dern
Malcolm	Jeff Goldblum
Hammond	Richard Attenborough
Wu	B. D. Wong
Arnold	Samuel L. Jackson
Nedry	Wayne Knight
Tim	Joseph Mazzello
Lex	Ariana Richards

By JANET MASLIN

STEVEN SPIELBERG'S "Jurassic Park" is a true movie milestone, presenting awe- and fear-inspiring sights never before seen on the screen. The more spectacular of these involve the fierce, lifelike dinosaurs that stalk through the film with astounding ease. Much scarier, however, are those aspects of "Jurassic Park" that establish it as the overnight flagship of a brand-new entertainment empire. Even while capturing the imagination of its audience, this film lays the groundwork for the theme-park rides, sequels and souvenirs that insure the "Jurassic Park" experience will live on. And on. And on.

The timing of this cinematic marketing coup could not be better, since an entire generation of children has fallen in love with dinosaurs, transforming the fossils of yesteryear into the totems of today. On the other hand, "Jurassic Park" has its planning problems, since this PG-13-rated film is clearly too frightening for the young viewers who could have best appreciated its magic, and who will most easily be drawn in by its marketing arm. Parents and guardians, take note: children who think of Tyrannosaurus rex

Murray Close

The lifelike dinosaurs in "Jurassic Park," including this Tyrannosaurus rex, set a new standard for computer-generated special effects.

Sometimes matching the scare value of "Jaws" (though they also occasionally suggest an educational trip to the World's Fair), this film's dinosaurs trample its humans both literally and figuratively. They appear only for brief interludes, but the dinosaurs dominate "Jurassic Park" in every way. Amazingly graceful and convincing, they set a sky-high new standard for computer-generated special effects. But thoughts about how those effects were achieved aren't likely to surface while the film is under way. The most important thing about the dinosaurs of "Jurassic Park" is that they create a triumphant illusion. You will believe you have spent time in a dino-filled world.

That world, on an island near Costa Rica, is the brainchild of John Hammond (Richard Attenborough), a mostly venal developer in Mr. Crichton's account but now a tediously merry old codger. Hammond recruits Dr. Alan Grant (Sam Neill) and Dr. Ellie Sattler (Laura Dern) as part of a team that is expected to give Jurassic Park its seal of approval. But a funny thing happens on the way to the T. rex pen. Because of an industrial saboteur (Wayne Knight) who tries to steal dinosaur embryos, electricity within this automated theme park is turned off. Huge, mean, hungry things start to escape.

●

Plotting the dinosaurs' escapades is Mr. Spielberg's strongest suit, and the director's glee is clear. Mr. Spielberg has great fun with every last growl and rumble signaling the approach of danger, as when Ian Malcolm (Jeff Goldblum) looks down to see a mud puddle shake. He also leaps to the challenge of choreographing ingenious duels, as in a terrific sequence that shows vicious velociraptors stalking Hammond's two grandchildren (Ariana Richards and Joseph Mazzello) through the large kitchen of the Jurassic Park visitor's center.

Anybody can stage a fight, but it takes Mr. Spielberg to show just how the pots and pans might go flying at the stroke of a velociraptor's tail, or how the children might trick their wily attackers. In assessing such an episode, it also helps to look at the big picture. Who but Mr. Spielberg could convince an audience that there are dinosaurs loose in a kitchen at all?

"Jurassic Park" keeps its viewers on edge while leaving much of its real violence to the imagination. When it's dinosaur feeding time, Mr. Spielberg avoids obvious gore; he gets a greater frisson out of showing farm animals that are left near the hungry beasts and suddenly disappear. To give the velociraptors a suitable introduction, he opens the film with a character whose upper body remains visible while the rest of him is being attacked off camera, à la "Jaws."

"Jurassic Park" mixes such horrific touches with sentimental strokes, suspenseful action scenes and occasional droll notes. The camera effectively winks at a "Jurassic Park" souvenir book shown at a concession stand (though this may be most clever to those who plan on selling programs). Mr. Spielberg also gets a last laugh by letting a T. rex muscle aside a museum exhibit of a dinosaur skeleton, rising up against a banner that reads "When Dinosaurs Ruled the Earth." Obviously, they rule again.

●

"Jurassic Park" is rated PG-13 (Parents strongly cautioned). That rating appropriately reflects the lim-ited, mostly off-camera violence included here. This film's nerve-racking suspense is less quantifiable. It is likely to scare young and even pre-teen-age children.

1993 Je 11, C1:1

Waking Up To a Change: He Is a She

"Orlando" was shown as part of the New Directors/New Film Series. Following are excerpts from Vincent Canby's review, which appeared in The New York Times on March 19, 1993. The film opens today at the Angelika Film Center, 18 West Houston Street, NoHo, and the Lincoln Plaza Cinemas, Broadway between 62d and 63d Streets, Manhattan.

Taking Virginia Woolf's bountiful and witty 1928 novel, "Orlando," which is as much about words, writing and the dogged pursuit of fine literature as about a number of other things, Sally Potter has made a grand new movie that is as much a richly informed appreciation of the novel as it is a free adaptation.

This ravishing and witty spectacle invades the mind through eyes that are dazzled without ever being anesthetized.

Throughout Ms. Potter's "Orlando," as in Woolf's, there are a piercing kind of common sense and a joy that, because they are so rare these days in any medium, create their own kind of cinematic suspense and delightedly surprised laughter. "Orlando" could well become a classic of a very special kind, not mainstream, perhaps, but a model for independent film makers who follow their own irrational muses, sometimes to unmourned obscurity, occasionally to glory.

Here is a movie in which Orlando (Tilda Swinton), the hero, a beautiful young nobleman who was earlier adored by the aging Queen Elizabeth I (Quentin Crisp), goes to sleep one night in the 17th century, only to wake up five days later as the heroine. It's no great shock to Orlando. She turns to the camera (as she does from time to time throughout the film) and says tersely: "Same person, no difference at all. Just a different sex."

Orlando, her curiosity undiminished, goes on learning about life through the centuries up into our own, at which point she is somewhere in her late 30's. Between the reign of Elizabeth I, when she was a boy, and the 20th century, when motherhood more or less happens to her, Orlando enjoys a serene immortality doing what she chooses. She ponders the differences between men and women and, from her own privileged vantage point, discovers their similarities.

She pursues a poet's career, only to be ridiculed in the 16th century, fawned upon in the 19th and asked to do rewrites in the 20th. Time keeps flying by even at those moments when it seems to creep for Orlando, as when she finds herself guiltily bored in an 18th-century London drawing room surrounded by Alexander Pope, Joseph Addison and other wits of the day. She darts into a fine old English maze in the 18th century and emerges a few moments later in the 19th century when Queen Victoria is in Buckingham Palace.

In such ways does Ms. Potter, who wrote the screenplay and directed the film, make the same kind of breathtaking, utterly rational leaps in time and place that Woolf does in prose.

Sony Pictures
Tilda Swinton

She also rediscovers the timelessness and profoundly comic density of the novel.

●

As important to the film's success as anything else are the bewitching face, figure and screen presence of Ms. Swinton, who, with her red hair, deeply set eyes and self-assured expression, looks remarkably like portraits of the young Queen Elizabeth I. She has a sweetness, gravity and intelligence about her that make the more bizarre events appear to be completely normal. Before Orlando becomes a woman, Ms. Swinton is an exceptionally pretty youth, but never an effeminate one. This could be the beginning of a major international career for the English actress.

The film's gender-bending scheme is elegantly realized in Mr. Crisp's performance as the virgin queen, a stiff, arthritic old lady who can still appreciate the look of a nicely turned, youthful calf while reaching for the thigh. John Wood is very funny as the Archduke Harry, who lusts after Orlando through time, and Heathcote Williams is hilarious as a scroungy Elizabethan poet, who tells nasty tales about his better-known colleagues.

More than anything else, though, "Orlando" is Ms. Potter's triumph. With the firmest but lightest of touches, she has spun gossamer.

1993 Je 11, C12:6

FILM VIEW/Vincent Canby

French Cinema Offers A Ticket to Controversy

PARIS

NOWHERE IN THE WORLD ARE films still taken as seriously as they are in Paris. Old films, new films, dreadful films and sublime films. In any week, nearly 300 different movies are available in theaters that vary in size and décor from the big and the grand to the minuscule and the barely functional. On one recent Saturday afternoon I watched the first-run "Pétain" in a 28-seat theater at the complex called the 7 Parnassiens. There were five other people in the house. (Showing at adjoining theaters in the same complex: "Indecent Proposal," "The Crying Game," "Singles," "Toys" and "Enchanted April.") Moviegoing of such intimacy becomes something akin to group therapy.

Only in Paris, too, could there be the kind of controversy that now surrounds "François Truffaut: Portraits Volés" ("François Truffaut: Stolen Portraits"), a fascinating, very good (if incomplete) new feature-length documentary about the life and work of the artist who, when he was alive, was often dismissed as being too bourgeois. The man whom his detractors thought to be too nice, too gentle, too eager to please, is now revealed to have been a rat.

Or so those detractors say.

The principal evidence offered by the film: testimony by Bertrand Tavernier, a success-

ful post-New Wave director of some clout ("The Watchmaker," " 'Round Midnight"). He reports that the very young Truffaut once wrote a letter apologizing for bending the facts in an article to gain publicity for himself and the New Wave's manifesto against the French "cinema of quality."

The letter was addressed to Pierre Bost, a veteran French screenwriter who had earlier been interviewed by Truffaut and had even given the then-critic access to a script he was still working on. Bost, who was later to write the screenplay for "The Watchmaker," and Jean Aurenche, the director ("La Symphonie Pastorale," "Devil in the Flesh"), were among the principal targets for the ridicule of Truffaut and his cohorts on the magazine Cahiers du Cinema.

Mr. Tavernier says that Bost refused to publish the incriminating letter and, indeed, never even told Aurenche about it. According to Tavernier, Bost said he felt Truffaut had been "discourteous," and he didn't wish to be discourteous in return. The fact that the letter has never been shown publicly leads some Truffaut supporters to suggest that it probably was not quite as incriminating as it has been made to sound.

Among these advocates is Madeleine Morgenstern, who was married to Truffaut from 1957 to 1965 and who today runs the company that controls Truffaut's films. "François was shrewd and ambitious," she says, "but he wasn't stupid. He would never have written something that could have been used against him like that."

Ms. Morgenstern and her two daughters by Truffaut, Laura and Ewa, also appear in "Stolen Portraits" along with a large cast of Truffaut associates, including Gérard Depardieu, Fanny Ardant, Eric Rohmer, Claude Chabrol, Janine Bazin (the widow of André Bazin, one of Truffaut's earliest mentors) and Robert Lachenay (Truffaut's boyhood friend, with whom he started his first film society).

Creating a deep hole in the movie is the absence of a number of people who played crucial roles in both Truffaut's private and professional life: Jean-Pierre Léaud, who grew up on screen playing Truffaut's surrogate figure in the Antoine Doinel films; Jeanne Moreau, Catherine Deneuve, Suzanne Schiffman, who collaborated with Truffaut on the screenplays for many of his best films, and Jean-Luc Godard. Claude Berri, the director and producer who was a longtime Truffaut friend, was interviewed for the film but wound up on the cutting room floor.

"Stolen Portraits" is the work of Michel Pascal and Serge Toubiana, both of whom have backgrounds in film criticism. Their aim, they say, was to find "the Rosebud" in Truffaut's life, which, as they reveal it, is the film maker's search for his real father, who was not his mother's husband. This gives their film a certain psychoanalytical shape, but its power is in its other revelations.

The man who emerges from this testimony (more than 30 people were interviewed) is profoundly romantic, forever concerned with the meaning, effect and even the duration of romantic love. Beneath his neatly buttoned-up exterior he hides a wild, not always predictable nature. He's also severely self-critical but not above purloining other people's lives, either to assume as his own or for use in his films.

Mr. Lachenay points out that Truffaut was, as a boy, not the natural leader that Antoine Doinel is shown to be in the films. Truffaut was a loner who learned. Among other things, "Stolen Portraits" should help moviegoers discover the dark recesses of two of his best, least-"nice" films, both murderously passionate love stories, "La Peau Douce" and "Two English Girls."

There's also some terrifically revealing testimony about his relationship to Mr. Léaud. Truffaut, says one witness, "felt responsible for Léaud, for hijacking his destiny." Later Truffaut realized that "Léaud was preying on his films," forcing them into areas that didn't jibe with Trauffaut's visions. It was about then that Truffaut began appearing in his own films, playing roles that might conceivably have gone to Mr. Léaud.

Very complicated.

The most moving moment in the film is provided by Mr. Depardieu's reading of a letter written by Truffaut when he was 17 and under state supervision as a juvenile delinquent. It goes in part:

"I like the arts, especially film. I see work as a necessity, like defecating. I avoid adventures. Three films a day, three books a week and some good music will keep me happy until my death, which will come one day and which, selfishly, I dread. I don't believe in friendship or peace. I try to live quietly, away from noise. I don't look at the sky because afterward the earth looks awful."

"François Truffaut: Stolen Portraits" is not the whole story, but it is a rare film consideration of a most particular artist and some of the people and events that shaped his character and career.

Baverel-Kipa

Jacques Dufilho as Marshal Henri Philippe Pétain, Ludwig Hass as Hitler and Jean Yanne, second from right, as Pierre Laval in Jean Marboeuf's "Pétain"—Two new films deal with occupied France.

FRENCH FILMS HAVE produced no new masters recently, but crowds are still flocking to see "Les Visiteurs," by Jean-Marie Poire, and the latest Catherine Deneuve vehicle, "Ma Saison Préférée" ("My Favorite Season"), the André Téchiné drama about a sister and a brother coping with a dying mother and their own, very close attachment to each other. "Les Visiteurs" is a knockabout farce about a medieval knight and his aide suddenly set down in modern-day France — bathroom jokes abound. Disney has already purchased the English-language remake rights. Miramax Films, recently acquired by Disney, will release the original version in the United States first.

There is no exact American equivalent to French films like "Ma Saison Préférée," though the so-called women's pictures turned out by Ross Hunter in the 1950's and 1960's ("Magnificent Obsession," "Imitation of Life," "Madame X") come close. "Ma Saison Préférée" aims higher. Yet even with the occasionally arresting scene or performance, it all boils down to the spectacle of an immaculately turned-out Deneuve suffering prettily in upscale surroundings.

Ms. Deneuve was once a vibrant actress. Today, as a result of films like "Indochine" and "Ma Saison Préférée," she seems to be congealing into an icon. One has the feeling that she could run five miles in her sable coat on the hottest day of summer and still be, in the words of an old ad, "lovely to know."

■

One of my more arresting moviegoing experiences was seeing Jean Marboeuf's "Pétain" in the afternoon and Claude Chabrol's "Oeil de Vichy" ("Eye of Vichy") the same evening. Both deal with France during the German occupation but in entirely different ways. "Pétain" is historical fiction of the sort that demands the eye and the ear of a George Bernard Shaw, neither of which Mr. Marboeuf has. Yet the subject rivets. One is inclined to sit through it, mind alert. Jacques Dufilho gives a waxy portrayal of Pétain, the hero of Verdun who, for whatever misguided reasons, agreed to head the French Government during the occupation. As Pierre Laval, the man responsible for France's most infamous dealings with the Nazis, Jean Yanne is sweaty and evil from the start.

The Chabrol film is something else: a documentary composed almost entirely of cheery newsreels and propaganda films turned out in France during the occupation. The film has been criticized for not showing what was really going on at the time the newsreels and propaganda films were made, though Mr. Chabrol's own voice-over narration bridges most of those gaps.

■

The existence of the European Community has stiffened the resolve of member nations, including France, to protect local film makers and their films. Americans clearly are disturbed by French threats to enforce quotas that demand that 40 percent of films shown on television here be French. This is one of the reasons Jack Valenti, the president of the Motion Picture Association of America, was in attendance at the Cannes film festival. France remains a vital market for American movies, on television as well as in theaters.

The French seem to regard Mr. Valenti's charm as a lethal weapon because of his success as a negotiator on behalf of the American companies. At Cannes, I was told, the word went out never to leave him alone with Jacques Toubon, the new Minister of Culture and successor to Jack Lang. As they say here, nous verrons. □

1993 Je 13, II:15:1

Critic's Notebook

A 25½-Hour German Epic of Discovery and Art

By STEPHEN HOLDEN

The statistics are daunting. The German director Edgar Reitz's 25½-hour epic film, "Heimat II: Chronicle of a Generation," has 2,143 pages of script and consumed more than a million feet of exposed film. It took six years to write, 557 days to shoot and 117 days to edit. The cast includes 71 leading roles, 310 smaller ones and 2,300 extras.

The product of this prodigious teamwork is an alternately gripping and lyrical 13-episode serial about German life in the 1960's that is being shown in roughly four-hour installments at the Joseph Papp Public Theater through July 29. Handsomely photographed and superbly acted, with English subtitles and a remarkably evocative soundtrack, it might be the ultimate highbrow soap opera for couch potatoes except that there are no plans to show "Heimat II" on television in the United States.

The director has emphasized that the 1992 film is not a sequel to his 15-hour film "Heimat," which told the history of a fictitious German village over 63 years. That film made it to television (on the Bravo cable service and then on Channel 13) and ran at the Public Theater in 1986.

"Heimat II," which is set mostly in Munich, follows 10 years in the lives of a circle of musicians and film makers who come of age at the height of Germany's "economic miracle." Although it begins in 1960, just 15 years after World War II, the war might as well have been over for 50 years for all the attention it is paid, at least at the start of the series. All that matters is the future. The musicians are intoxicated with modernism, the film makers inspired by the take-to-the-streets esthetic of the French New Wave.

If these young Turks of the arts are openly derisive of those whom they believe to have been Nazis, their contempt is expressed more as social snobbery than as a deep moral revulsion. Most have left their families to make their way in a largely reconstructed city in a fresh new decade. They shrug off such uncomfortable reminders of the past as the occasional unexploded bomb that is discovered and quickly defused.

Although the 13 episodes of "Heimat II" move from character to character, the most prominent recurrent figure is Hermann Simon (Henry Arnold), a fiercely ambitious young composer, pianist and guitarist who leaves his provincial village to study at the Munich Conservatory. A hot-headed romantic who suggests a Germanic hybrid of Tom Cruise and Mandy Patinkin, he leaves home in a fury, determined never to return to the town that drove away his socially unacceptable childhood sweetheart.

Hermann emerges as the representative young German of a generation that today is in its early 50's. Arrogant, self-centered and passionate, he is much more intellectual than any corresponding figure from an American film set in the same period. One of the most intriguing qualities of "Heimat II" is the intellectual tenor of the conversation. Even in casual discourse, names like Leibniz and Schopenhauer are thrown around without a second thought.

●

Unlike most films about artists, "Heimat II" shows its characters struggling to create. It follows Hermann through an oral exam for the Munich Conservatory and features several of his compositions. These fiery atonal pieces, which perfectly reflect his personality, were composed by Nikos Mamangakis, who wrote the series' voluminous and gorgeous music in a rainbow of styles. The film devotes similar attention to the musical life of Hermann's sometime girlfriend, Clarissa (Salome Kammer), a gifted cellist, and to the studio labors of Reinhard (Laszlo I. Kish), a documentary film maker, as well as to Reinhard's lover, Esther (Susanne Lothar), a tempestuous Venetian photographer.

An elegiac thread of the story concerns Foxholes, a lushly appointed estate run by Elisabeth Cerphal (Hannelore Hoger), the niece of a German publishing magnate. Elisabeth, infatuated with youth, allows her home to become a free-floating bohemian salon in the early 1960's. Ultimately Foxholes is demolished. And the house and memories of its carefree romantic nights loom as a nostalgic touchstone for a more innocent and golden time.

The house also becomes a darker symbol of an unspoken agreement by almost everybody to regard the Nazi era as an embarrassing historical aberration that is best left behind. But as Elisabeth's family secrets come to light, willful ignorance of the past proves impossible. One of the most shattering scenes is a confrontation at the Dachau concentration camp.

●

At least two dozen memorable characters wind in and out of the series' 13 episodes. If Hermann is the most vivid, the most touching is Juan (Daniel Smith), a Peruvian expatriate musician and man of multiple talents who is refused entrance to the Munich Conservatory because his music is too folkloric. Juan, who eventually attempts suicide, hovers on the periphery of the action like a moth drawn to the flame of a society in which he can never feel as though he belongs. In Mr. Smith's portrayal he is an infinitely sad clown and truth-teller, a Robin Williams waif with the soul of Goethe's Werther.

Running through "Heimat II" is a strain of romantic fervor that echoes the lofty swirl of Wagner's operas. Most of the characters take love very seriously. In this still quite Puritanical atmosphere, kisses are not exchanged lightly, and passions run deep and long. Many of the young characters' stories take sharp melodramatic turns, and some individuals die unexpectedly.

These sudden reversals, along with the film's moody tone and expressionistic touches (black-and-white sequences are strikingly alternated with scenes in color) make it not quite realistic. Rather like the culturally literate never-never land of Woody Allen's New York, Mr. Reitz's 1960's Munich is the exotic city of a young man's dream.

"Heimat II" opened at the Joseph Papp Public Theater, 425 Lafayette Street, at Astor Place, in the East Village, on June 4. Episodes 2 and 3 are being shown through Sunday afternoon with two new episodes being shown each week thereafter, except for an early July recapitulation. The recap will show episode 1 on July 1, episodes 2 and 3 on July 3, episodes 4 and 5 on July 6, and episodes 6 and 7 on July 7. The series resumes on July 9 with episodes 8 and 9.

1993 Je 17, C11:3

Anti-Nazism as snobbery rather than revulsion.

Correction

An article on June 13 about French films referred incorrectly to the director Jean Aurenche. With the movie's director, Jean Delannoy, Mr. Aurenche was co-adapter of the André Gide novel on which "La Symphonie Pastorale" was based, and he wrote the screenplay with Pierre Bost. He collaborated again with Bost on the screenplay for "Devil in the Flesh," directed by Claude Autant-Lara.

1993 Je 27, II:4:6

Last Action Hero

Directed by John McTiernan; screenplay by Shane Black and David Arnott, based on a story by Zak Penn and Adam Leff; director of photography, Dean Semler; edited by Richard A. Harris; music by Michael Kamin; production designer, Eugenio Zanetti; produced by Steve Roth, Mr. McTiernan, Robert

Relyea and Neal Nordlinger; released by Columbia Pictures. Running time: 122 minutes. This film is rated PG-13.

Jack Slater................Arnold Schwarzenegger
Danny..Austin O'Brien
Benedict..Charles Dance
Practice...............................F. Murray Abraham

Frank...Art Carney
Deckker......................................Frank McRae
Teacher....................................Joan Plowright
The Ripper.................................Tom Noonan
Nick..Robert Prosky
Tony Vivaldi.............................Anthony Quinn
Mrs. Madigan........................Mercedes Ruehl

By VINCENT CANBY

YOU'VE read the T-shirt, now you can see the movie.

That's if you're dying to find out what a two-hour "Saturday Night Live" sketch might look like given, reportedly, a $60 million budget, some of Hollywood's best special-effects people and an Arnold Schwarzenegger who wants desperately to please. "Last Action Hero" was written by four writers and directed by John McTiernan, but the auteur of it all is Mr. Schwarzenegger. It's his aggressively self-assured personality that shapes it. He may not have thought it up, designed the sets or photographed it, but he certainly approved of everything that went into it.

That would include its basic premise, suggested by, if not actually stolen from, "The Purple Rose of Cairo": a generic 11-year-old boy named Danny (Austin O'Brien) sits entranced in a New York theater watching for the 37th time a movie with his favorite screen character, the Los Angeles police detective Jack Slater, played by Mr. Schwarzenegger as Arnold Schwarzenegger. For reasons that need not be explained (though they are, and at too great a length), Danny suddenly finds himself inside the movie as Jack's pint-sized partner.

For a while, Danny enjoys the make-believe as he tries to warn Jack about forthcoming plot twists and shares the detective's manic car chases, shootouts and last-minute evasions of death. "I'm a comedy sidekick," Danny tells himself. "I can't get hurt." That abruptly changes when both Danny and Slater are tossed out of the film into the real world of Manhattan, which is scarcely less violent than the movie-within's fictional Los Angeles. It's also a place where fictional characters like Slater can wind up as dead as real people like Danny.

"Last Action Hero" is something of a mess, but a frequently enjoyable one. It tries to be too many things to too many different kinds of audiences, the result being that it will probably confuse, and perhaps even alienate, the hard-core action fans who transformed "Terminator 2" into a box-office phenomenon. More sophisticated audiences are likely never to see the film's occasionally funny gags at the expense of movies the action fans have never heard of.

It's to Mr. Schwarzenegger's credit that "Last Action Hero" is the riskiest film he has ever made. If it succeeds at the box office, he may well run for public office. Icons of his stature get easily restless.

In such films as "Twins" and "Kindergarten Cop," Mr. Schwarzenegger demonstrated that unlike Sylvester Stallone, he could play it for laughs and not send audiences screaming from the theaters. Yet there is a terrible esthetic muddle at the heart of "Last Action Hero," which Mr. Schwarzenegger has described as an action film for the 1990's.

The movie has a kind of gross charm in the way it portrays Jack Slater's fictional world in the movie-within. The Los Angeles police headquarters are as glitzy and as filled with exotic plants as the atrium of some just-opened Las Vegas casino hotel. There is even an animated cat on the premises. The set is funny, even though no legitimate Schwarzenegger movie was ever so far off the mark. What is being parodied?

I would also suspect that Mr. Schwarzenegger's most faithful fans won't find the film-within's car chases, shootouts and exploding houses especially gripping, since nothing is at stake. What they look so much like the effects in conventional "Die Hard" and "Robo Cop" movies that other audiences may be put off by even the simulated violence.

•

"Last Action Hero" is alternately too clunky and too clever. It takes far

A mix of gags and shootouts, with echoes of Allen and Pirandello.

too long to set up the original gimmick of the little boy's entrance into the film-within. When the situation is reversed and Slater enters the supposed real world, you may cringe at lines that rework Woody Allen's better ones in "The Purple Rose of Cairo." Says someone to Slater at this point, "I've never met a fictional character before."

At the same time, there is the occasional movie gag that delights: Danny sits in his classroom listening to his teacher drone on about "Hamlet." The teacher, played by Joan Plowright, the widow of Laurence Olivier, then shows the class Olivier's version in which, in Danny's eyes, Slater takes over for Olivier in the title role. This clip, shot in silvery black-and-white with only a fireball seen in bright orange, is possibly the film's best special effect.

"Last Action Hero" otherwise looks as if it had been made in too great a hurry. It's full of scenes and characters that lead nowhere. It's also the kind of movie in which a number of stars show up playing roles that, though identified as "featured," are no bigger really than those of the stars who play cameos. The cast includes F. Murray Abraham, Art Carney, Charles Dance, Mercedes Ruehl, Anthony Quinn, Sharon Stone, Little Richard, Jean-Claude Van Damme, Tina Turner and Ian McKellan (who appears as Death from Ingmar Bergman's "Seventh Seal," lost in present-day Manhattan).

Toward the end of the film, Mr. Schwarzenegger appears as himself, attending the New York opening of his latest Jack Slater film, accompanied by his wife, Maria Shriver, and blithely unaware that Jack Slater is fighting for his life in another part of the theater. Instead, Mr. Schwarzenegger is seen hustling the Jack Slater merchandise that, like the "Last Action Hero" T-shirts, caps and poster, are being sold to promote the movie. Pirandello was never both this complicated and commonplace.

With his lantern jaw and square-cut, comic-book looks, Mr. Schwarzenegger handles his various roles with good humor: it's fun being the boss. Young Mr. O'Brien is also a very slick performer. Note should be made of the contributions of Dean Semler, the director of photography; Eugenio Zanetti, the production designer, and Richard Greenberg, the visual effects consultant.

•

"Last Action Hero" has been rated PG-13 (Parents strongly cautioned). It has a lot of violence, not all of it clearly simulated, and scenes in which children are shown to be in real jeopardy.

1993 Je 18, C1:3

Playing to the balcony: Arnold Schwarzenegger swings into action in the movie theater.

Once Upon a Forest

Directed by Charles Grosvenor; written by Mark Young and Kelly Ward, based on the Welsh story by Rae Lambert; director of animation, Dave Michener; edited by Pat A. Foley; music by James Horner; production designers, Carol Holman Grosvenor and Bill Proctor; produced by David Kirschner and Jerry Mills; released by 20th Century-Fox Film Corporation. Running time: 105 minutes. This film is rated G.

Voices:
Cornelius.................................Michael Crawford
Phineas...Ben Vereen
Abigail...Ellen Blain
Edgar..Ben Gregory
Russell...Paige Gosney
Michelle.....................................Elizabeth Moss

By STEPHEN HOLDEN

Environmentalists should applaud "Once Upon a Forest," an animated film for children that preaches a respect for nature and portrays human beings as rampaging destroyers of the precarious ecological order. In this likable fable about growing up, learning teamwork and developing courage, three small creatures who dwell in Dapplewood, an idyllic forest, go on a far-flung quest for healing

20th Century Fox

A scene from the film "Once Upon a Forest."

herbs to save the life of a dying friend.

Dapplewood is a paradise, until a truck carrying poisoned gas crashes and leaks a deadly cloud that withers the foliage and drives away the wildlife. The disaster strikes while Abigail (a wood mouse), Edgar (a mole) and Russell (a hedgehog) are on a walk with their mentor, Cornelius, a wise old badger, and his niece, Michelle.

Upon their return, they find a strange stillness has crept over their home. Venturing into her parents' lair, Michelle discovers their dead bodies, and she herself collapses from the lingering fumes and hovers

Small, though brave, furry creatures try to save their world.

near death. Realizing that his niece's only chance for survival lies in curative herbs that can be found in a distant meadow, Cornelius instructs Abigail, Edgar and Russell to search for them. All they have to guide them is a crude map showing the way out of the forest.

•

The film follows the three friends' perilous journey into unknown territory. Their first challenge is a predatory owl who plucks Abigail into his tree hole and nearly devours her. On a happier note, they also befriend a clan of gospel-singing birds led by a crested grebe named Phineas. By improvising a catapult, they help save the life of a member of the flock who is stuck in the mud. But before they reach the meadow, they must cross a barren wasteland occupied by "the yellow dragons," bulldozers and other heavy earth-moving equipment that looks almost as ominous as the dinosaurs in "Jurassic Park."

"Once Upon a Forest" knows how to tell a story. Adapted by Mark Young and Kelly Ward from a tale by Rae Lambert, it also knows how to evoke an adventurous storybook ambiance, especially in scenes involving a "wing-a-ma-thing," a crude Leonard da Vinci-style flying machine that Cornelius invents and that his pupils sail home on.

If its overly cute cartoon images of the creatures bear only distant resemblances to the animals' actual appearances, the screenplay does a good job of distinguishing the travelers' personalities. And in Michael Crawford, who is the voice of Cornel-

ius, it has the vocal embodiment of kindly wisdom tinged with a world-weary anxiety. Early in the film, Mr. Crawford sings a ballad, "Please Wake Up," to the comatose Michelle that quivers with a plaintive tenderness. It is one of three solid songs in the movie, whose score (by James Horner) transcends the normally atrocious clang of animated film music.

1993 Je 18, C10:1

Hard-Boiled

Directed by John Woo; screenplay by Barry Wong, based on an original story by Mr. Woo (in Chinese with English subtitles); director of photography, Wang Wing Heng; edited by Mr. Woo, David Wu, Kai Kit Wai and Jack; music by Michael Gibbs and James Wong; produced by Linda Kuk and Terence Chang; released by Rim Film Distributors with East Coast distribution by Peter Chow. Cinema Village, 22 East 12th Street, Greenwich Village. Running time: 127 minutes. This film has no rating.

Tequila Yuen	Chow Yun Fat
Tony (Long)	Tony Chiu Wai Leung
Teresa	Teresa Mo
Pang	Philip Chan
Johnny Wong	Anthony Wong
A-Lung	Bowie Lam
Hoi	Kwan Hoi Shan
Little Ko	Tung Wai

By VINCENT CANBY

English subtitles do not go well with a foreign-language action film. If you spend time reading the titles, then you can't really appreciate the action. But if you stare raptly at the action, then you often don't know the reasons behind what's going on.

This was one of my problems watching "Hard-Boiled," the 1992 Hong Kong melodrama opening today at the Cinema Village with a Mandarin Chinese soundtrack. "Hard-Boiled" is the work of John Woo, who, in his mid-40's, is being celebrated by a number of critics here and abroad as the new master of the action-film genre. His first Hollywood movie, Jean-Claude Van Damme's "Hard Target," is due for release later this year.

"Hard-Boiled" is being presented here in what's described as the "full-length director's cut," which means that it runs 127 minutes. The movie was apparently abbreviated by the Hong Kong censors, who objected to the violence. Just why, I'm not sure. Films as packed with violence as this, but with little in the way of a coherent story to give the violence meaning, are no less serene than "Swan Lake," if somewhat more instructive.

Also adding to the film's running time is Mr. Woo's tendency to slip into slow motion every time his characters aim guns at each other, are blown up, catch fire or deal with other mortal tests. Virtually every action scene in "Hard-Boiled" becomes a mini-homage to the slow-motion blood ballets Sam Peckinpah introduced in "The Wild Bunch."

•

Mr. Woo does, in fact, seem to be a very brisk, talented director with a gift for the flashy effect and the bizarre confrontation. The movie opens with a shoot-out in a Hong Kong teahouse in which more people are left dead than in any month of Hollywood movies. The final sequence involves the destruction of a hospital, which the police allow to burn to the ground in their eagerness to destroy a gang's arms warehouse.

The quaint story involves Tequila, a tough-guy Hong Kong cop, his chaste affection for Teresa, a woman who works in his office, and his unspoken affection for Tony, an undercover cop who goes through pure hell doing his duty. "Hard-Boiled" often has a smokily atmospheric, Ridley Scott

sort of look to it, but until I learn Mandarin, or until someone adds an English language soundtrack to "Hard-Boiled," I'll reserve judgment about Mr. Woo's place in the hierarchy of action-film directors.

1993 Je 18, C12:6

FILM VIEW/Caryn James

No Arnold. No T. Rex. Just Art.

THIS TIME OF YEAR, YOU MIGHT FEEL AS IF you need a private detective to track down a serious movie — one without superstars, life-threatening stunts or fast-food tie-ins. In fact, the situation isn't nearly so desperate. There are plenty of new films aimed at viewers who don't care to see Arnold climb a mountain carrying a dinosaur under his arm. Though "Much Ado About Nothing" and "Orlando" are the most visible signs of counterprogramming, they are just the beginning.

Here is a critical guide to this summer's art films. (Most have opened in New York and Los Angeles and will gradually make their way across the country during the next two months.) Some are better than others at avoiding dopey situations, but all are guaranteed dinosaur-free.

"Jacquot" One of the season's most charming films, "Jacquot" is Agnès Varda's loving and eloquent re-creation of the childhood of her husband, the film maker Jacques Demy. Though Demy was ill while the film was being made and died halfway through production, this is a thoroughly joyful look at the young Jacquot, as he was known. The local mechanic's son, he fell in love with puppet shows as a boy, traded his Erector Set for a movie camera as a youth and grew up to be one of France's most popular directors ("The Umbrellas of Cherbourg" is his most famous film). Interspersed with vibrant scenes of family life are glimpses of Demy on screen recalling his past, snippets from his movies and a feast of music from Bach to "La Cucaracha." This tale of a boy who loves movies is reminiscent of "Cinema Paradiso," but the reality behind "Jacquot" lends it unusual depth.

"Sofie" The first film directed by Liv Ullmann is a rich, luxurious look at three generations of a Jewish family in 19th-century Denmark and Sweden. Sofie (played with subtlety and strength by Karen-Lise Mynster) is a 28-year-old near-spinster who bypasses an affair with a gentile poet and settles for a passionless marriage to her dour cousin Jonas. Her consolations are her son and her parents (made irresistibly sweet by Erland Josephson and Ghita Norby). The plot matters less than the detailed texture of Sofie's life, depicted by Ms. Ullmann with such careful attention to detail that even the pet birds kept by Sofie's aunt become touchstones of a vanished era. Comparisons to Ingmar Bergman are inevitable, but some of us have a weakness for just this sort of Bergmanesque film, which creates its own resonant emotional landscape. At almost two and a half hours, "Sofie" is longer than it needs to be, but it is always captivating.

"The Music of Chance" This movie gives delicious new meaning to the word quirky. The first feature by the documentary-maker Philip Haas (from Paul Auster's novel) revels in its own implausibility. On the road, Mandy Patinkin picks up a drifting gambler, played by James Spader with supreme sleaze and greasy black hair. They lose everything in a card game with a couple of wealthy eccentrics (Charles Durning and Joel Grey), whose peculiarities are so insidious they defy description; building a scale-model town doesn't

Sony Pictures Classics

Philippe Maron and Brigitte de Villepoix in Agnès Varda's "Jacquot"—Counterprogramming.

sound nearly as weird as it plays on screen. The losers are held captive and forced to build a wall to repay their debt, and this Beckettian comedy becomes an absorbing tale of odd personalities. Who, after all, can ever be called normal?

"Romper Stomper" An Australian film, "Romper Stomper" is more brutal than anything Hollywood ever dreamed of, and more realistic. Written and directed by Geoffrey Wright, the fictional story about violent skinheads may be set in Melbourne but it is a chilling reflection of neo-Nazis around the world. Playing Hando, the cold-blooded and mindlessly bigoted leader of the group, Russell Crowe gives the character a frightening veneer of attractiveness. Mr. Wright never explores the source of neo-Nazi rage; instead, his volatile and graphic film mirrors Hando's lethal, unquestioning sense of supremacy. "Romper Stomper" is not a feel-good movie, but it is a stunning one.

■

Even art films have flaws, of course, and some high-minded movies may send you scurrying to "Jurassic Park." Though the English director Terence Davies ("Distant Voices, Still Lives") has his fans, they are a select group. "The Long Day Closes" is billed as a memoir of his happy childhood in Liverpool in the 1950's, but the autobiographical character in this slow-moving work seems strangely sad. Maybe it's because his Mum has a tendency to burst into song and then burst into tears.

"Un Coeur en Hiver" could give French films about love triangles a bad name. The beautiful Emmanuelle Béart is having an affair with the owner of a violin repair shop. His partner, Daniel Auteil, also longs for her, but he is so passive and fearful of life that his heart is in winter (or, his coeur is in hiver). Chilly guy, chilly film.

But don't despair. More promising movies are coming later in the summer. "La Vie de Bohème" is the latest mordant and witty gem from the Finnish director Aki Kaurismaki, who updates the classic tale of Rodolfo, Mimi and their Bohemian life to contemporary Paris. "Amongst Friends," acclaimed at the Sundance Film Festival, is a gritty tale of rich and bored suburban kids lured into a life of crime. Rob Weiss's first film might be "Mean Streets" meets "Bright Lights, Big City."

And remember, if you decide to park your mind and sneak into "Last Action Hero," you won't be alone. ☐

1993 Je 20, II:19:5

Films Inspired by a Master of Literary Delicacy

By CARYN JAMES

WHEN Henry James's play "Guy Domville" was produced in 1895, he appeared on stage for an opening-night bow and was hit with jeers, boos and catcalls that drowned out his friends' polite applause. It was not the last time an audience decided James wasn't much of a showman, and he soon returned to what he did best: writing novels and tales of exquisite subtlety. But he always longed for large public acclaim, and finally, curiously, belatedly, James found his mass audience on film.

There is nothing Hollywood would call high-concept in his fiction. His characters' most dramatic moments often exist in what they see or think or sense, or think they possibly might have seen or sensed. Isabel Archer's wedding in "The Portrait of a Lady" is an absolute nonevent that takes place between chapters, nothing compared to the quiet moment when she realizes her husband has deceived her. And James's career is filled with heroes whose most energetic action is running from their own emotions. Yet film makers as different as William Wyler, François Truffaut, Jacques Rivette and James Ivory have been gloriously inspired by James, in unpredictable ways.

"The Spell of the Picture: Envisioning Henry James" is a small gem of a series beginning today and running through July 5 at the Museum of Modern Art. The program, honoring James's 150th birthday year, includes the few films that pop into mind at the mention of that unlikely hybrid, a Henry James movie: Wyler's 1949 classic, "The Heiress," based on the novel "Washington Square"; the enticing Merchant-Ivory productions of "The Europeans" and "The Bostonians"; the 1961 film "The Innocents," a chillingly effective and faithful version of "The Turn of the Screw."

But the series' intelligence and wit comes through in those lesser-known films whose connections to James are real though half-buried. "The Green Room," Truffaut's least famous masterpiece, and "Céline and Julie Go Boating," by his New Wave colleague Jacques Rivette, bring to James's fiction the vast imagination it deserves. "The Nightcomers," a prequel to "The Turn of the Screw," has the audacity to invent what Peter Quint and Miss Jessell really did to corrupt those innocent children. The film is sometimes a hoot, but features the irresistible casting of Marlon Brando as the debauched, over-the-top Quint. These films provide a revealing glimpse at the elaborate garden path leading from story to screen, a look at the illogical process of inspiration itself.

"The Green Room" shows how the most nuanced, least promising James material can become an extraordinary film. In this deeply beautiful story of love and mourning, Truffaut himself plays Julien Davenne, a man whose young wife died soon after their marriage. Dedicating the rest of his life to her memory, he turns a green-wallpapered room into a shrine and later builds a chapel to honor all his cherished dead.

Truffaut and James come together most visibly in a scene in which Julien leads his soulmate and fellow mourner — Nathalie Baye as the woman he doesn't dare love for fear of offending the past — on a tour of the photographs that line the walls of his candlelit chapel. Pausing before the picture of a portly, balding, distinguished gentleman, Truffaut/Davenne says: "This man is an American. He was so attached to Europe that he opted to become an English citizen. I hardly knew him, but it was he who taught me the importance of respecting the dead." The unnamed American, of course, is Henry James, whose stories "The Altar of the Dead," "The Friend of the Friends" and "The Beast in the Jungle" — all tales of men who choose memory over life — inspired "The Green Room."

●

Truffaut knew that a faithful translation would never do justice to these elliptical stories, as he made plain in a letter to Jean Gruault, with whom he wrote the script: "The real problem with James is that nothing is ever stated and film doesn't allow that kind of vagueness; we're going to have to explain everything, make everything clear, and we're also going to have to find a thousand ways of emphasizing what I call the privileged moments."

"In this instance," he went on, "the privileged moments are the religious ceremonies, the lighting of the candles, the rituals, all that sort of Japanese religiosity, which is our real reason for wanting to make the film."

The elegant visual drama Truffaut describes is abundant on screen: in

Stephanie Beacham and Marlon Brando in the "The Nightcomers."

the serene and shadowy chapel; in the fire that attacks the green room, and especially in the way Davenne is often seen behind windows and glass doors, hiding from life.

Truffaut also makes some brilliant changes that come from a profound understanding of James. The film moves the story from James's late 19th century ahead to World War I, and makes Davenne a soldier who survives the slaughter only to face death afterward. These changes not only give Davenne another motive for his mourning; they also reflect James's life. The author became an English citizen in 1915, a year before he died, because he was so distressed at being an alien in wartime Europe. And years after publishing the stories behind "The Green Room," the aging author wrote that the war "almost killed me." He added, "I loathed so having lived on and on into anything so hideous and horrible."

Other small, sly connections enrich the film invisibly. In the country house where James spent the last 19 years of his life, there was a portrait-filled study known as the Green Room. Pictures of people James cherished, many of them dead, lined the walls.

If ghosts of memory dominate "The Green Room," the possibility of real ghosts haunts "The Turn of the Screw," that endlessly debated tale about the high-strung governess who discovers or imagines that the dead gardener and governess are visiting little Miles and Flora. "The Innocents," like James's story, depends on ambiguity. Leaving every inter-

pretation open, the film becomes both a study of hysteria and a frightening ghost story, and suggests how perfectly James's attention to point of view translates to the screen.

This elegantly photographed black-and-white film, directed by Jack Clayton, jumps into the governess's version of the story: the heart of James's Chinese-box narrative. Deborah Kerr's shaky voice says, "All I want to do is save the children, not destroy them," and we see her hands clasped in prayer.

When this governess sees Peter Quint's face appear out of the darkness at the window, so do we. When she sees Miss Jessell weeping in the schoolroom, we not only see the dead woman dressed in black but also the teardrop she has left on her slate.

Because we share the governess's perspective, it makes sense that we would see the ghosts on screen, though perhaps we are seeing what she imagines. In this script (by William Archibald and Truman Capote, with additional dialogue by John Mortimer) she jumps to conclusions; she kisses Miles goodnight ardently, on the lips. With a style full of rich shadows and softly haunting sounds, this could be a genteel Victorian ghost story, or a reverie shaped by the repressed Victorian imagination of the governess.

•

There is no repression anywhere in "The Nightcomers." Despite its near-total detachment from anything James actually wrote, this weird 1972 film is nonetheless too literal-minded.

The sexual relation between Quint and Jessell that James referred to so delicately becomes explicit when Quint ties the naked Jessell to the bedpost. She quite likes that, but wishes he were not so déclassé the rest of the time.

Quint's unpolished accent is some peculiar blend of British countryside and incipient Brando mumble. The housekeeper, Mrs. Grose — played beautifully by Megs Jenkins as a kind, befuddled woman in "The Innocents" — becomes a harridan who pulls a shotgun on Quint and yells, "Why don't you go back to the stables where scum-belongs?" "The Nightcomers" can be irreverent fun (more than it intended), and it demonstrates how *not* to raise those subterranean James themes to the surface.

James was not always vague, of course, especially in his earlier novels. Some of those works seem more contemporary than ever. In "The Heiress," Olivia de Havilland is the plain and sensitive Catherine Sloper, who gets cruel revenge on Montgomery Clift as the man who jilted her and Ralph Richardson as the father who thought too little of her. A century later, Catherine could be diagnosed as a woman with low self-esteem.

In reverse, the unchanging human dramas James described can be dropped into any age. There is much

How Jamesian nuances proved cinematic.

of his sensibility in "Céline and Julie Go Boating," set in the 1970's. Two friends return over and over to a house haunted by a memory they can barely grasp. Throughout this charming 3-hour-and-13-minute film, they reconstruct what happened in that house, events based on James's tale "The Romance of Certain Old Clothes" and his novella "The Other House," works about female rivals, the man they fight over and his small daughter.

"The Maltese Falcon" is included in the series playfully, and largely on James Thurber's word. He recalled in a serious literary essay that Dashiell Hammett, soon after publishing "The Maltese Falcon," shocked a whole saloon by saying he had been influenced by "The Wings of the Dove." Thurber discerned in Hammett's plot distant echoes of James's great novel about a greedy woman and a love triangle, but warned that he had failed to find "many feathers of 'The Dove' in the claws of 'The Falcon.'" It is a fact, though, that both Thurber and Hammett were great readers and admirers of James, whose influence on them — and countless others — may never emerge in any crass, discernible way.

•

Even now the movies haven't finished with Henry James. Jane Campion, the New Zealand director who shared this year's grand prize at the Cannes Film Festival for "The Piano," is about to make her version of "The Portrait of a Lady," with Nicole Kidman as Isabel. That will pre-empt the version Merchant and Ivory had been considering, although the producer Ismail Merchant says they will definitely make another James film

one day. Henry James might even join his old friend Edith Wharton (who has at least three films in the works) as a suddenly-hot movie property. That might make up for the hoots and jeers James faced in that other theater long ago.

"The Spell of the Picture" was originated by Stephen Harvey, an associate curator of the museum who died in January; the program was organized by Joshua Siegel, research assistant. Henry James's creative legacy is kept happily alive here, and so is Mr. Harvey's.

1993 Je 25, C1:1

Sleepless In Seattle

Directed by Nora Ephron; screenplay by Ms. Ephron, David S. Ward and Jeff Arch, based on a story by Mr. Arch; director of photography, Sven Nykvist; edited by Robert Reitano; music by Marc Shaiman; production designer, Jeffrey Townsend; produced by Gary Foster; released by Tri-Star Pictures. Running time: 100 minutes. This film is rated PG.

Sam Baldwin	Tom Hanks
Jonah Baldwin	Ross Malinger
Annie Reed	Meg Ryan
Suzy	Rita Wilson
Greg	Victor Garber
Rob	Tom Riis Farrell
Maggie Baldwin	Carey Lowell
Walter	Bill Pullman
Barbara Reed	Le Clanché du Rand
Cliff Reed	Kevin O'Morrison
Dennis Reed	David Hyde Pierce
Betsy Reed	Valerie Wright
Becky	Rosie O'Donnell
Jay	Rob Reiner

By VINCENT CANBY

Nora Ephron's "Sleepless in Seattle" is a feather-light romantic comedy about two lovers who meet for the first time in the last reel. It's a stunt, but it's a stunt that works far more effectively than anybody in his right mind has reason to expect. Not since "Love Story" has there been a movie that so shrewdly and predictably manipulated the emotions for such entertaining effect. Be warned, though: "Sleepless in Seattle" is a movie you may hate yourself in the morning for having loved the night before.

The situation is this: the recently widowed Sam Baldwin (Tom Hanks), a successful architect, has moved to Seattle from Chicago to try to assuage his sorrow. One night, his 8-year-old son, Jonah (Ross Malinger), calls a late-night radio talk-show psychiatrist. It is Christmas, and the boy is worried about his dad. The furious, embarrassed Sam then gets on the phone. Before he realizes it, he's talking about his perfect marriage before a large portion of the United States population.

Three thousand miles away, Annie Reed (Meg Ryan), a successful feature writer for The Baltimore Sun, is driving to Washington to spend the holidays with her wimpish fiancé's family. Annie hears Sam's confession and is so moved that she nearly drives off the road. She's bewitched by something about his voice, the ill-concealed lump in his throat, his choice of clichés. She doesn't immediately know it, but she's in love and will one day wind up with Sam to live in the 1990's version of the kind of bliss that old-fashioned movies used to celebrate.

•

Evoked by "Sleepless in Seattle," through clips and numerous references in dialogue and soundtrack music, is Leo McCarey's sentimental 1957 classic "An Affair to Remember," a movie that instantly reduces

every woman in the new film to tears. "An Affair to Remember" serves as an interesting yardstick for "Sleepless in Seattle." It a reminder of just how much smaller and more self-conscious romantic movies are today than they were when they were played by such icons as Cary Grant and Deborah Kerr, when love could be a matter of life and death, and when fate, not an interfering television-bred child, shaped the outcome.

It's clear that Ms. Ephron understands this. "Sleepless in Seattle" is so cannily concocted that it somehow manages to stand above the sitcom world in which it is set. You won't for a minute misidentify that world. It's there in the unquestioned material perks enjoyed both by Sam and Annie, in the picturesque houseboat on which Sam and Jonah live in Seattle, in the tone of the wisecracks delivered by Annie's pal Becky (Rosie O'Donnell) and even in the nature of Sam's grief.

Sam's beautiful first wife, Maggie (Carey Lowell), materializes from time to time in fantasy sequences, but the movie makes sure that his grief is not contagious. The audience knows, from Ms. Lowell's billing if nothing else, that Maggie is history, that Sam has a woman with co-star status waiting for him around the corner. The movie uses grief, but makes it safely meaningless. This is, after all, the world of sitcoms.

Mr. Hanks and Ms. Ryan are terrifically attractive, each somehow persuading the audience of the validity of all of the things that keep them apart and then miraculously bring them together. Annie's fiancé, Walter (Bill Pullman), is a comic nerd for our time. He's not ridiculous in the manner of the other men once played by Ralph Bellamy, but he does have a large problem with allergies. Walter is allergic to almost everything.

No great effort is made to explain how Annie could have fallen in love with him in the first place. He's a plot function, as is Victoria (Barbara Garrick), the woman Sam courts halfheartedly in Seattle. She is pretty and has a manic giggle that would curdle hollandaise sauce. The film was made by the book.

•

Yet Ms. Ephron and her associates create a make-believe world so engaging that "Sleepless in Seattle" is finally impossible to resist. Both Mr. Hanks and Ms. Ryan bring substance to their roles. The film will probably call up memories of "When Harry Met Sally," although "Sleepless in Seattle," compared with that denatured version of a Woody Allen comedy, looks like a stunning original.

It's not easy keeping apart two lovers who the film tells you are made for each other at the beginning, but the digressions are often extremely funny. The manner by which they are united is outrageous and painfully cute, but finally satisfying. Ms. Ephron makes Machiavellian use of soundtrack music.

There's no doubt how you're supposed to respond when you hear "Over the Rainbow," "Star Dust," "Bye-Bye, Blackbird" and "Jingle Bells." Every now and then, however, there is a comic invention that lifts the movie up, up and away, as with the choices of "As Times Goes By," which more or less opens the film, and "Make Someone Happy," which both ends the movie, both sung by the incomparable, gravel-voiced Jimmy Durante in a way that puts the lyrics in movingly bold relief.

In a way, "Sleepless in Seattle" is vamping for time from start to finish. It knows that it couldn't possibly show us (at least, for any length of time) a Sam and Annie together as fully in love as they are apart, before they've met. That would have to be an anticlimax. The movie, in which pacing is all, stops on a dime.

•

"Sleepless in Seattle" has been rated PG (Parental guidance suggested). It includes some vulgar language.

1993 Je 25, C10:5

Dennis the Menace

Directed by Nick Castle; written by John Hughes, based on the characters created by Hank Ketcham; director of photography, Thomas Ackerman; edited by Alan Heim; music by Jerry Goldsmith; production designer, James Bissell; produced by Mr. Hughes and Richard Vane; released by Warner Brothers. Running time: 110 minutes. This film is rated PG.

Mr. Wilson	Walter Matthau
Dennis Mitchell	Mason Gamble
Martha Wilson	Joan Plowright
Switchblade Sam	Christopher Lloyd
Alice Mitchell	Lea Thompson
Henry Mitchell	Robert Stanton
Chief of Police	Paul Winfield

By VINCENT CANBY

It's not easy turning comic strips into movies, especially comic strips that are short on narrative and include no more than a gag or two per strip. If you are desperate for confirmation of that woolly thought, you can see "Dennis the Menace," the new screen incarnation of the Hank Ketcham comic strip, written and produced by John Hughes and directed by Nick Castle.

This "Dennis the Menace" isn't a comic strip, but then it's not really a movie, certainly not one in the same giddy league with the two "Home Alone" movies, written and produced by Mr. Hughes and directed by Chris Columbus. "Dennis the Menace" invites comparisons if only because, like "Home Alone," it's about a mischievous little boy with a gift for the potentially lethal prank.

Mason Gamble, the 7-year-old who plays the title role, won't be any competition for Macaulay Culkin of "Home Alone." He's a handsome boy, but he displays none of the spontaneity that initially made Mr. Culkin so refreshing. He seems to follow direction well, if in a somewhat robotic way.

There's nothing perfunctory about the actors around him, but their material is limiting. Walter Matthau plays Mr. Wilson, the retired postman who lives next door and whose life is made a nonstop series of slow burns by Dennis. Joan Plowright appears as Mr. Wilson's loving wife. Christopher Lloyd is a dirty-toothed tramp who arrives in town on a freight train and stays around to steal Mr. Wilson's collection of gold coins.

Mr. Hughes and Mr. Castle try hard to re-create a kind of timeless, idealized comic-strip atmosphere, but except for the performances of Lea Thompson and Robert Stanton, who play Dennis's parents, nobody in the movie seems in touch with the nature of the comedy. "Dennis the Menace" simply looks bland, unrooted in any reality.

Mr. Hughes's screenplay is not great. Two of the gags end with Mr. Matthau's getting rather soundly hit in the genitals. Dennis himself is so

Marsha Blackburn

Walter Matthau

without personality that it would seem possible he's a lobotomized demon from hell. There is thus a certain surprise at the end when he's revealed to be just a sweet-natured scamp, or so we are supposed to believe.

The film has one genuinely funny moment at its start. It involves two cats.

•

"Dennis the Menace" has been rated PG (Parental guidance suggested). It has some gags that might frighten children who haven't yet achieved the halfway point in their first decade.

1993 Je 25, C12:6

A Question Of Color

Directed and produced by Kathe Sandler; written by Ms. Sandler and Luke Charles Harris; released by California Newsreel. Film Forum 1, 209 West Houston Street, South Village. Running time: 58 minutes. This film has no rating.

No Regret

Directed and produced by Marlon Riggs; music by Blackberri, Linda Tillery; released by Frameline. Film Forum 1, 209 West Houston Street, South Village. Running time: 38 minutes. This film has no rating.

By STEPHEN HOLDEN

Kathe Sandler's documentary film "A Question of Color" begins with a sequence in which a group of black men and women of varying complexions recite many of the terms, from "high yellow" to "chocolate" to "blue-black," that are used to describe differences in skin tone. From this formal opening, the film plunges bravely into the ticklish subject of color consciousness among blacks.

What it finds is the prevalence of a subtle caste system in which those whose looks come closest to approximating white European standards of attractiveness tend to fare better in American society than those who look more African. It also finds that the tensions generated by this system, which is really an internalized expression of white racism, leave almost everybody feeling insecure. While those who are darker skinned are made to feel less desirable as mates and tend not to do as well economically, light-skinned blacks

can find themselves accused of being pretenders to their African heritage.

For a film dealing with such a loaded subject, "A Question of Color," which opened on Wednesday at Film Forum 1 on a double bill with Marlon Riggs's "No Regret," is remarkably evenhanded and free of rhetoric. The film, which includes interviews with everyone from urban teen-agers to a 96-year-old woman in rural Alabama, also puts the issue into historical perspective. Dr. Benjamin Payton, the president of Tuskegee Institute, talks about the days of slavery, when a slave owner could have any woman he wanted and how the interracial sex resulted in a rainbow of skin tones.

The only moment in American history when that white-oriented color consciousness among blacks seemed to be crumbling, the film says, was in the 1960's when the black-consciousness movement, with its slogan "black is beautiful," prompted mil-

Two very personal documentary affirmations.

lions to adopt the Afro hairstyle. For Ms. Sandler, the white reaction against that movement is symbolized by the pressure brought against a television anchor, Melba Tolliver, who risked losing her job for wearing an Afro.

The movement's sense of exhilaration was short-lived. As the political pendulum swung toward the right, the old values were re-entrenched.

The film has an intriguing personal footnote. In 1977, after Ms. Sandler, who is light-skinned, was photographed with her mother on the cover of a mother-daughter issue of Essence magazine, she says, the publication was deluged with letters complaining that it had put a white woman on the cover. She goes on to reflect sadly on why she, and not her darker-skinned sister, was chosen for the cover.

In "No Regret," whose subtitle, "Non, Je ne Regrette Rien," is the name of one of Edith Piaf's signature songs, Mr. Riggs interviews five black gay men who are H.I.V.-positive. His subjects — Michael Lee, Joseph Long, Assoto Saint, Reggie Williams and Donald Woods — are all courageous, articulate advocates for personal disclosure about both their homosexuality and their H.I.V. status.

Among the issues touched on are how to break the news to a parent, whether to continue to have sex and how to maintain morale in a society that attaches a moral stigma to AIDS.

Of the five, Mr. Long may have had the most difficult journey toward disclosure. A devout churchgoer and recovering alcoholic who led a sexually closeted existence for 40 years, he has become an AIDS educator in the church, an institution that he says is in deep denial about the extent of H.I.V. infection among its flock.

Like Riggs's 1989 video documentary "Tongues Untied," which was attacked by Senator Jesse Helms and excerpted by Pat Buchanan in an ad for his campaign for the Presidency, "No Regret" is part documentary, part cinematic collage. Interwoven with the personal testaments are fragments of a poem by Mr. Woods, "Prescription," and stirring a-cappella gospel singing by Linda Tillery.

Both "A Question of Color" and "No Regret" were clearly made on shoestring budgets. If their scratchy soundtracks, crude visuals and rather haphazard structures make them occasionally hard to follow, their sensible, positive messages about self-acceptance in the face of racism and homophobia resonate strongly.

1993 Je 25, C15:1

House of Cards

Written and directed by Michael Lessac, based on a story by Mr. Lessac and Robert Jay Litz; director of photography, Victor Hammer; edited by Walter Murch; music by James Horner; production designer, Peter Larkin; produced by Dale Pollock, Lianne Halfon and Wolfgang Glattes; released by Miramax Films. Running time: 108 minutes. This film is rated PG-13.

Ruth Matthews......................Kathleen Turner
Dr. Jake Beerlander..........Tommy Lee Jones
Sally Matthews...............................Asha Menina
Michael Matthews......................Shiloh Strong
Adelle..Esther Rolle
Lillian Huber.................................Park Overall

By VINCENT CANBY

"You spent seven and a half months shoring up that old pyramid, and I bet you haven't had a good cry yet," a friend says to Ruth Matthews (Kathleen Turner) near the beginning of "House of Cards," a decidedly serious but utterly opaque movie about an autistic child.

The friend is trying to raise Ruth's spirits after her return to the United States from Mexico, where her husband was killed in an accident at an archeological site. Ruth, an architect, is not the sort to cry easily. She doesn't even acknowledge that there may be something more than culture shock behind the fact that her 6-year-old daughter, Sally (Asha Menina), has stopped talking.

"House of Cards," the first film written and directed by Michael Lessac, is the story of Ruth's attempts to reach the child, who has withdrawn into her own fantasy world. The audience has some clues that Ruth doesn't. In the opening sequence, the audience hears a Mexican shaman telling Sally that dead people go to the moon, and that the best way to see things is to be quiet.

That seems to be why Sally has stopped talking and often stares at the sky. Ruth seeks medical help from Dr. Jake Beerlander (Tommy Lee Jones) only after she finds Sally walking on the roof of their house, three stories above the ground. Even then, she pays no attention to the doctor's suggestions.

●

The movie goes on to become increasingly baffling. The child builds a marvelous house of cards, so complex in structure that it appears to defy gravity. With this clue, Ruth builds a huge plywood and metal spiral in her backyard, more or less reproducing the child's house of cards. The doctor stands around shaking his head. Ruth perseveres, and after some more non sequiturs, the movie ends.

"House of Cards" looks like a movie that may have been fiddled with after the initial production was completed. I don't know. Nothing quite makes sense. Mr. Jones has no role. He wears a lot of white shirts and a concerned expression. Ms. Turner also behaves in a concerned fashion.

Jim Bridges

Kathleen Turner

She is assertive and sometimes on the edge of hysteria, but why she does what she does is frequently beyond knowing.

It's all murk.

●

"House of Cards" has been rated PG-13 (Parents strongly cautioned). Young children may be troubled by sequences in which a small girl is seen to be in jeopardy.

1993 Je 25, C18:5

Chain Of Desire

Written and directed by Temistocles Lopez; director of photography, Nancy Schreiber; edited by Suzanne Fenn; music by Nathan Birnbaum; production designer, Scott Chambliss; produced by Brian Cox; released by Mad Dog Pictures. Running time: 107 minutes. This film has no rating.

Hubert Bailey.................. Malcolm McDowell
Alma D'Angeli......................Linda Fiorentino
Joe..Kevin Conroy
Mel..Seymour Cassell
Cleo...Assumpta Serna
Jusus...Elias Koteas
Isa..Angel Aviles
Jerald Buckley......................Patrick Bauchau
Linda Bailey..........................Grace Zabriskie
Keith...Jamie Harrold
Ken... Tim Guinee
David Bango..............................Dewey Weber
Diana.............................. Holly Marie Combs
Angie.....................................Suzzanne Douglas

By STEPHEN HOLDEN

In "Chain of Desire," Temistocles Lopez's contemporary version of "La Ronde," characters from various strata of Manhattan society rub elbows at an imaginary nightclub tucked inside the spire of the Chrysler Building.

The opening scene, in which the club's resident diva (Linda Fiorentino) moans a dreary imitation of a Kurt Weill song, sets the heavy-handed tone for Mr. Lopez's contemporary update of the much admired 1950 Max Ophuls film. That film, adapted from a classic play by Arthur Schnitzler, evoked the spiritual emptiness of an urban society through a daisy chain of exploitative sexual encounters. In Mr. Lopez's up-to-the-minute version, the players include gay and bisexual men, and the couplings take place in the shadow of AIDS.

"Chain of Desire" is a botched execution of a nifty idea. The symmetry of the couplings in the movie and play has been destroyed, and many connections between the partners are far-fetched. Mr. Lopez's screenplay lurches toward comedy, but except for a few clunky one-liners, the humor falls so flat that the conversations assume the stiff, perfunctory tone of the verbal filler found in soft-core porn movies.

In the silliest encounter, a stuffy bibliophile (Patrick Bauchau) persuades a friend's wife (Grace Zabriskie) to play dominatrix in a game that stalls when she loses interest. The most excruciatingly self-conscious is an assignation between a married-but-gay correspondent for a tabloid television show (Malcolm McDowell) and a young male prostitute (Jamie Harrold). The most ludicrous erotic sequence, one that would seem to belong to another film, is a potpourri of telephone sex, exhibitionism and voyeurism involving three Manhattanites gazing out their apartment windows.

Although the film's wildly uneven acting suggests that the actors were largely left to their own devices, there is one comic nugget of a performance. In the role of a cynical, 60-something painter with a mild Lolita complex, a simpering Seymour Cassel delivers a satirical portrait of a jaded bon vivant that is as funny as it is scathingly observant.

1993 Je 25, C19:3

Loving Portrait of a Director's Roots

"Jacquot" was shown as part of the 1991 New York Film Festival under its original title, "Jacquot de Nantes." Here are excerpts from Vincent Canby's review, which appeared in The New York Times on Sept. 25, 1991. The film, in French with English subtitles, opens today at Lincoln Plaza Cinemas.

Agnès Varda, who made her first feature, "Cleo From 5 to 7," in 1961, remains one of the most long-lived, productive and difficult-to-categorize directors associated with France's New Wave.

Though many of her colleagues have lost their momentum or died, she continues; in part, it seems, because she has never become locked into a particular form or dominant ideology. As the years go by, her focus shifts. She lives in a present that is ever enriched by the accumulating past.

Yet in all of her films there is a consistent personal commitment that illuminates the material. That commitment has never been more compellingly evident than in "Jacquot de Nantes."

"Jacquot de Nantes" is the sort of film that no one but Miss Varda would have made or, for that matter, could have made. It's neither documentary nor, in the usual sense, fiction. It's a one-of-a-kind celebration of a very gentle man, Jacques Demy, the French film maker ("The Umbrellas of Cherbourg," among oth-

Agnès Varda gives life to her husband's memories.

ers), who died in October 1990 and who was Miss Varda's husband. The film's origins were singular.

●

Miss Varda said that her husband, during his illness, talked increasingly about his childhood in Nantes, about the members of his family, about growing up during the German Occupation and the struggle he had to convince his father that he should be allowed to study film making in Paris.

As Demy talked, and the anecdotes came forth, his wife suggested that he should record these stories and that, eventually, the two of them should use them as the basis for a film. He asked her to make it, refusing even to write the screenplay or any of the dialogue so the finished work would be hers.

"Jacquot de Nantes" is as gentle as Demy is remembered to have been by those who knew him. In its scrubbed-clean look of a nearly trouble-free past, the film is also respectful of the physical and emotional artifice that Demy's films exalted. Neither sarcasm nor irony has any place in this world, where every particular detail is a kind of generalized ideal.

●

Jacquot's father, who runs a small garage, is stern but kind, even when he insists that Jacquot learn a trade instead of filling his head with movie nonsense. His mother supplements the family income as a hairdresser and is equally supportive. Jacquot never fights with his little brother. His friendships are warm. Even the war remains a benign experience.

Though Miss Varda uses clips from various Demy films to illustrate the ways in which the director's life directly influenced him, she has no interest in making a film scholar's associations. There is something far less parochial going on: the film mourns not only the loss of one man, but also a way of small-town French life.

"Jacquot de Nantes" doesn't mean to be a critical evaluation, a psychological profile or a biography. It's a memoir of Demy's love affair with Nantes and with movies, by the woman who shared his life for 32 years.

1993 Je 25, C21:1

FILM VIEW/Caryn James

Arnold as Icon: From Hulk to Hero

WHEN THE FICTIONAL Jack Slater leaps off the screen into New York City in "Last Action Hero," he masquerades as the actor who plays him. "I'm Ah-nold Braunschweiger," he introduces himself pleasantly. The last action hero is the last man on earth who can't say the word Schwarzenegger.

Not long ago, he wasn't alone. Now there is "Last Action Hero," a self-mocking film built around the idea that everyone knows Arnold. The cleverest moments in this comic adventure do not come while the star plays the explosive Slater, but during a brief episode in which he plays himself. As Arnold walks into the premiere of his new Jack Slater movie with his wife, Maria Shriver, she mutters to him: "And remember, *don't* plug the restaurants. I just hate it when you plug the restaurants and the gyms. It's so tacky."

The screen Arnold tells an interviewer, "In this movie we only kill 48 people," compared to a body count of more than a hundred last time. Sound familiar? Then Chris Connelly of MTV offers a gushy comment that parodies every Schwarzenegger interview that has appeared since he stopped being a Hollywood joke and became a Hollywood power. "Is this guy an American success story or what?"

The changing iconography of Arnold, from bodybuilding hulk to mainstream hero, is very much an American success story. And like most, it is largely a product of public relations. The first rule of movie stardom is that fans never know the "real" star. The second rule is that they think they do. Arnold Schwarzenegger is a master of this sort of image making. We know about his wife, his businesses, his in-laws and his newer, less-violent pose. He is every bit as shrewd as Madonna but remains likable because he makes the process seem less manipulative than it is. The trick is that he doesn't shed his skin with each new incarnation; he simply takes the old Arnolds along with him into the future, turning them into jokes if he must.

Like most icons, he also has an impeccable sense of timing. The narcissistic bodybuilder became famous during the early me-me-me 1980's. The real-estate mogul and Republican spokesman thrived during the late-80's Reagan-Bush years. Now the caring father who appeals to baby boomers and their impressionable offspring is moving ahead in the Clinton 90's.

The newest Arnold, who in "Last Action Hero" gets to have his violence and make fun of it, too, is certainly not his final incarnation. As the film's weak reception suggests, it becomes harder and harder to mock an image that is fast receding into the past. It has been too many years since anyone called him Braunschweiger for that joke to work as well as it should, too long since he played a villain for his tough-guy image to be prolonged. But as the evolution of the Schwarzenegger image continues, a look at his transformation provides a case study in how to project an image and build an American icon. Here is how the media-savvy Mr. Schwarzenegger created the beloved Ah-nold.

Phase 1: Arnold Is Not Human

1976 "Pumping Iron" Arnold the hulk plays himself in this documentary about a fiercely ambitious bodybuilder with a killer Austrian accent. In the most notorious scene, he compares bodybuilding to having an orgasm. This early Arnold is arrogant but likable, and there is a crucial hint at his cleverness. Beneath the astonishing pumped-up body is a man who savors psyching out his opponents.

1984 "The Terminator" Instead he is hired to play the ultimate non-human, a cyborg, in what may be his greatest role. As the leather-clad terminator sent to kill a child who would one day save the world, his monotone delivery comes across as wry and deadpan. "i'll be back" becomes his trademark, and "The Terminator" sets him up with a franchise of violent action movies like "Commando" and "Predator." He still can't act, but he is surrounded by enough dead bodies and tongue-in-cheek lines so that no one seems to care.

1982 "Conan the Barbarian" Arnold is still hulking, still not quite human as the cartoonish prehistoric hero. He says: "When I was 10 and 12 and 15, I only went to R-rated movies. I would refuse to go to PG movies." (Who knew they had American ratings in Austria?) "Who wants to see people talk and have a good time? I wanted to see violence and hanky-panky." Though "Conan" is a hit, no one hires him to play a real man.

Phase 2: The Metamorphosis

1986 Marriage A major turning point in the Schwarzenegger career takes place off the screen but in a blaze of publicity. He marries Maria Shriver, the television journalist and Kennedy niece. Kissed by an American princess, he not only becomes human, he suddenly turns into a prince of the establishment. The message is clear: If the Kennedys have to take this guy seriously, then so do we. Over the years, as his pumped-up body returns to something resembling normal, that toothy smile, square jaw and chestnut hair come to seem eerily Kennedyesque.

Phase 3: Arnold Becomes Humane

1988 "Twins" Turning from violence to comedy, he plays Danny DeVito's non-identical twin as a sweet-natured giant. He says, "I feel much more comfortable with gentle scenes than violent ones," creating the appropriate image for a man who is now known as an astute real-estate investor and whose campaign appearances for George Bush tag him as "Conan the Republican." His political independence from the Kennedys enhances his image as a powerful man in his own right.

1991 "Terminator 2: Judgment Day"
He's back, but this time as a good, fatherly cyborg. Instead of trying to destroy the boy-savior, he becomes his protector and promises not to kill.

1993 "Last Action Hero" Mr. Schwarzenegger appears on a half-dozen magazine covers, including TV Guide Parents' Guide to Children's Entertainment next to the line "Arnold, my hero! Why your kids love him." He says proudly of his latest film, "My daughters will be able to watch this new movie." He sounds suspiciously like a man growing to maturity, but Hollywood image making is never that simple.

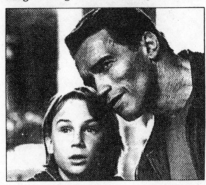

1993 Je 27, II:15:4

Correction

A picture caption about Arnold Schwarzenegger with the Film View column today, on page 15 of the Arts and Leisure section, misstates the release date for the film "Pumping Iron." It was 1977.

1993 Je 27, 2:6

The Firm

Directed by Sydney Pollack; written by David Rabe, Robert Towne and David Rayfiel, based on the novel by John Grisham; director of photography, John Seale; edited by William Steinkamp and Fredric Steinkamp; music by Dave Grusin; production designer, Richard MacDonald; produced by Scott Rudin and John Davis; released by Paramount. Running time: 154 minutes. This film is rated R.

Mitch McDeere	Tom Cruise
Abby McDeere	Jeanne Tripplehorn
Avery Tolar	Gene Hackman
Oliver Lambert	Hal Holbrook
Lamar Quinn	Terry Kinney
William Devasher	Wilford Brimley
Wayne Tarrance	Ed Harris
Tammy Hemphill	Holly Hunter

By VINCENT CANBY

At the time it was published in 1991, "The Firm," John Grisham's best-selling suspense novel, was described by one critic as "mean and lean." Mean, possibly, but lean? The book is 501 pages.

Now Sydney Pollack's film version far more accurately characterizes the source material. The movie is extremely long (two hours and 34 minutes) and so slow that by the end you feel as if you've been standing up even if you've been sitting down. It moves around the map a lot, from Boston to Memphis to the Caribbean to Washington, without getting anywhere. It is also physically elaborate, the cinematic equivalent of the book's relentlessly descriptive prose. One of its sets is reported to have required seven and a half miles of 2-by-4 lumber and 225 gallons of glue to hold it together.

But, you may well ask, what about the story? After all, underneath Mr. Grisham's verbiage but not quite suffocated by it, there is an entertaining moral tale about the 1980's:

Mitch McDeere, a bright young man, born poor and deprived, lusts for the good things in life. He graduates from Harvard Law School near the top of his class and joins a small, conservative, very rich firm of tax and corporate law specialists in Memphis. Almost immediately, he discovers that he has sold his soul to the devil. Or, as a Federal agent tells Mitch in the movie, "Your life, as you've known it, is now over."

Bendini, Lambert & Locke is a front for a conspiracy of delicious malevolence and, early on, anyway, quite persuasive complexity. Only its senior partners know its full scope. The firm has a policy of bringing aboard crackerjack young lawyers of Mitch's hungry background, and then overpaying and materially spoiling them to the point that when they find out the firm's true nature, they can't afford to quit.

There are only two ways for lawyers to exit Bendini, Lambert & Locke. They can stick around until they retire as thoroughly compromised, multi-millionaire senior partners, or they die before their time in mysterious circumstances.

Not long after he joins the firm, Mitch is approached by the F.B.I. The bureau wants him to act as a mole. They point out that his house and his office are bugged by the firm, and that at least three of his restless predecessors have been murdered. On the other hand, Mitch realizes that the firm's business associates have

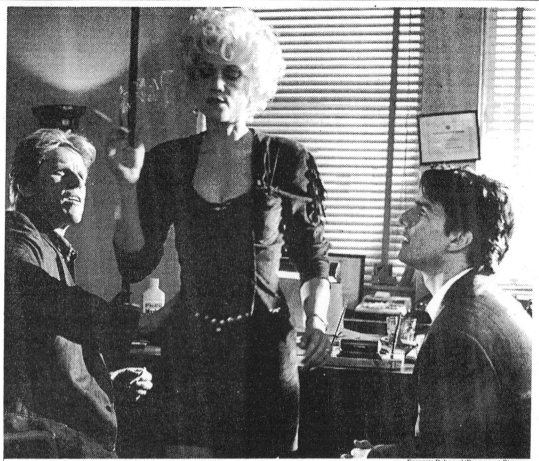

François Duhamel/Paramount Pictures

In a scene from "The Firm," Tom Cruise, right, meets with a private detective (Gary Busey) and his secretary (Holly Hunter). The film, based on the John Grisham's best seller, was directed by Sydney Pollack.

Luke Wynne

Pauly Shore

long memories and that no witness protection program is 100 percent reliable. What is a guy to do?

As in the novel, what the guy does is the heart of the film directed by Mr. Pollack and written by David Rabe, Robert Towne and David Rayfiel. Mitch (Tom Cruise) plays each side against the other in a manner that becomes increasing mysterious until, near the end, even someone who has read the book is likely to be lost. Whether the problem is in the writing, the direction or maybe the editing is anybody's guess. Whatever the reason, the film's end is a long time coming and, when it finally does arrive, is unable to do justice to the buildup.

"The Firm" has been so extravagantly cast that its two liveliest performances are by stars in comparatively small roles. Holly Hunter, who was named the best actress at this year's Cannes festival for Jane Campion's "Piano," has a ball as a cheeky Memphis secretary, who's married to an Elvis Presley impersonator and who turns into an unlikely heroine when the chips are down. Equally good is Gary Busey as a cheerful, down-and-dirty private eye who figures in Mitch's initial investigations into the firm's darker associations.

•

The ever-reliable Gene Hackman appears as Avery Tolar, the firm's partner who becomes, in effect, Mitch's control, the man assigned to break in the new recruit and to guide him on the downward path. Mr. Hackman has reached that plateau in his career where he can play almost any kind of part in a way that gives it both credibility and humanity.

For that matter, there's nothing wrong with any of the performances in "The Firm." Mr. Cruise and Jeanne Tripplehorn, who plays Mitch's wife, Abby, are attractive as a young, rather vacuous couple in distress, defined more by their actions than by anything they are given to say, which is as it should be. David Straithairn appears as Mitch's somewhat enigmatic brother, Ray, a jailbird, and Ed Harris gives a strong performance as an F.B.I. agent whose shiny, eye-catching bald head would not make it easy for him to go unnoticed in a stakeout.

As if to change his television image as a lovable old geezer who can't eat enough Quaker Oats, Wilford Brimley turns up as the firm's most vicious hit man. Aw, shucks.

In spite of all this talent, "The Firm" is something less than a nonstop pleasure. The adjustments made in the story are intelligent ones even if, by the end, Mitch has come to seem almost as devious and opportunistic as the people he's fighting. That could be the film's own comment on the time, place and characters.

A more difficult problem is the film's pace, which may have something to do with the editing. "The Firm" maintains its sluggish gait even through its concluding sequence, which frantically cross-cuts between simultaneous actions in the Cayman Islands and Memphis. One will accept almost anything in a suspense movie as long as the payoff satisfies. That's what they're all about.

"The Firm" ultimately provides no liberation from the sweet tyranny of its own plotting.

"The Firm" has been rated R (Under 17 requires accompanying parent or adult guardian). It has a lot of vulgar language and some violence.

1993 Je 30, C15:3

Son-in-Law

Directed by Steve Rash; written by Fax Bahr, Adam Small and Shawn Schepps, based on a story by Patrick J. Clifton, Susan McMartin and Peter M. Lenkov; director of photography, Peter Deming; edited by Dennis M. Hill; music by Richard Gibbs; production designer, Joseph T. Garrity; produced by Michael Rotenberg and Mr. Lenkov; released by Hollywood Pictures. Running time: 95 minutes. This film is rated PG-13.

Crawl	Pauly Shore
Rebecca	Carla Gugino
Walter	Lane Smith
Connie	Cindy Pickett
Zack	Patrick Renna
Walter, Sr	Mason Adams

By VINCENT CANBY

The new Disney comedy titled "Son-in-Law" is of a ghastliness so consistent that it becomes remarkable. Even failed comedies sometimes stumble upon a laugh. Not "Son-in-Law," which is so befuddled that it doesn't even introduce its star, Pauly Shore — for whom the film is supposed to be a vehicle — until it seems to be halfway over.

Mr. Shore is the MTV stand-up comic who appeared in "Encino Man." He has frizzy hair and a public persona that suggests he failed his correspondence course in "The Improvisational Comedy of Robin Williams." There is far less of Mr. Wil-

liams in this performance than of Richard Simmons, the television fitness guru.

•

Much of "Son-in-Law" takes place on a farm, where the androgynous, supposedly urban-hip Mr. Shore, playing a character named Crawl, must learn how to shovel manure, feed the hogs and milk a cow, which (are you ready?) urinates on him in one of the film's less effective special effects.

Crawl has been invited to spend the Thankgiving holidays on the farm by the pretty Rebecca (Carla Gugino), his naïve classmate at a Southern California college. Earlier in the film, he forever endeared himself to her by teaching her how to put on makeup, dye her hair and buy eccentric clothes. It is just one of the curious points of "Son-in-Law" that a person becomes acceptable in the scholastic community by being eccentric exactly like everybody else.

Crawl is supposed to be a free spirit, but he is charmless and conventional. The screenplay has it that he wins Rebecca's love and the respect of her family, in part because he's as brilliant doing her mom's hair as Rebecca's. The movie plays around with male-female gender expectations, but without conviction or wit.

•

"Son-in-Law" has been rated PG-13 (parents strongly cautioned). It has vulgar and sexually suggestive language.

1993 Jl 2, C14:6

Barjo

Directed by Jerome Boivin; written by Jacques Audiard and Mr. Boivin, based on "Confessions of a Crap Artist," by Philip K. Dick, in French with English subtitles; director of photography, Jean-Claude Larrieu; edited by Anne Lefarge; music by Hughes LeBars; production designer, Dominique Maleret; produced by Patrick Godeau; released by Myriad Pictures. Film Forum 1, 209 West Houston Street. Running time: 85 minutes. This film has no rating.

Fanfan	Anne Brochet
Barjo	Hippolyte Girardot
Charles	Richard Bohringer
Mme. Hermelin	Consuelo de Haviland

By VINCENT CANBY

For satire to be effective there must be some idea of what is being

Film Forum

Anne Brochet

satirized. Disconnected from any particular reality, satire becomes merely a demonstration of eccentric behavior, which is a fairly accurate description of "Barjo," the new French comedy opening today at the Film Forum.

The film's provenance is impressive. It was directed by Jerome Boivin and written by him with Jacques Audiard. They had collaborated on the ghoulishly funny "Baxter," a first-person (first-dog?) account of the rise and fall of a dirty-white bull terrier in search of the perfect master. Like the exemplary "Baxter," which was inspired by a novel by the American writer Ken Greenhall, the new film has as its source material an involving, seriously lunatic American novel, "Confessions of a Crap Artist" (1975) by Philip K. Dick, who died in 1982.

"Confessions of a Crap Artist," however, cannot be as easily transposed to a French setting as "Baxter"; at least it isn't in this film. Mr. Dick's novel is very much about California in the years after World War II. The French film takes place today in what appears to be an idyllically beautiful section of eastern France not far from the Alps.

It's a kind of no man's land, so isolated that what goes on in the film seems as removed as the activities on a fictitious planet, where the bizarre is the norm. Yet because the real norm is unknown, the bizarre loses its impact. The characters in "Barjo" wind up being unbelievable on any level.

They include Barjo (Hippolyte Girardot), a young man who you know is supposed to be funny because he wears thick glasses. He is obsessed by facts and lists. He has unpleasant habits, like sniffing a plastic bag full of old milk-bottle caps. He savors the sour aroma. Barjo was born 10 minutes after his sister Fanfan (Anne Brochet) and has trailed her ever since.

Fanfan, a willful woman with her own moral standards, is married to Charles (Richard Bohringer), at one point described as "the king of aluminum," a successful businessman with a bad heart, who is somewhat older than Fanfan. In the course of the movie, Fanfan drives Charles crazy with an extramarital affair, while Barjo watches and says things that suggest he is not only eccentric but also simple-minded.

•

Like the novel on which it's based, "Barjo" sometimes sees things from the young man's point of view and sometimes from that of an omnis-

cient third-person narrator. The novel is held together by the author's consistent voice, which is colloquial, deadpan and witty. There is always the awareness that the author is describing people and events that seem just a tiny shade different from everyone and everything else, but that the difference is scarily immense.

Mr. Dick, it should be noted, was also the author of "Do Androids Dream of Electric Sheep?" which became Ridley Scott's "Blade Runner," and "We Can Remember It for You Wholesale," which became Paul Verhoeven's "Total Recall." There is a lot of wickedly disorienting humor in his work.

"Barjo" gives the impression of being so ill thought-out that it doesn't seem finished. The black humor with which the novel is laced is never more than medium gray.

1993 Jl 7, C14:3

Rookie of the Year

Directed by Daniel Stern; written by Sam Harper; director of photography, Jack Green; edited by Donn Cambern and Raja Gosnell; music by Bill Conti; production designer, Steven Jordan; produced by Robert Harper; released by 20th Century Fox. Running time: 103 minutes. This film is rated PG.

Henry Rowengartner....Thomas Ian Nicholas
Chet Steadman..................Gary Busey
Martinella........................Albert Hall
Mary Rowengartner..............Amy Morton
Larry (Fish) Fisher.............Dan Hedaya
Jack Bradfield....................Bruce Altman

By STEPHEN HOLDEN

In "Rookie of the Year," a lighter-than-air movie fantasy of major-league stardom, Thomas Ian Nicholas plays 12-year-old Henry Rowengartner, an avid baseball fan who can't catch a fly ball to save himself. One day while chasing a ball, Henry falls and breaks his right arm. Four months later, when his cast is removed, he discovers that through a freak of orthopedics, he has developed a 100-mile-an-hour fastball. In no time, he finds himself the star pitcher for the Chicago Cubs and the team's only hope of winning its first pennant in nearly 50 years.

•

"Rookie of the Year," which opens today, is a slick featherweight comedy whose paint-by-the-numbers plot has young Henry trying to pair his single mother (Amy Morton) with the Cubs' nearly-over-the-hill pitching idol, Chet Steadman (Gary Busey). Chet is Henry's only hope in saving his mom from the clutches of her smarmy, unscrupulous boyfriend (Bruce Altman), who appoints himself Henry's agent and schemes to make a fortune by having him endorse soft drinks and sneakers.

The movie's most diverting scenes are those that send the reassuring message that Henry remains an unspoiled all-American boy in the face of all the hoopla. Mobbed by television camera crews, and besieged with multimillion-dollar offers, Henry remains completely untouched by his celebrity. In what could have been the movie's funniest scene, until it abruptly cuts away, Henry is shown filming a soft-drink commercial wearing formal garb and surrounded by beautiful women while a director urges him to "be sexier."

•

Even at the peak of his fame, Henry's idea of a good time is puttering

around in an old motorboat with his grade-school pals. On the pitcher's mound, he frequently resorts to making funny faces and hurling innocuous schoolyard taunts to shake up his opponents. They prove surprisingly effective weapons against athletes who, beneath their toughened professional surfaces, the movie suggests, are at heart little boys like him.

"Rookie of the Year," which was directed by Daniel Stern from a script by Sam Harper, has an appealing central performance by Mr. Nicholas, who manages to be cocky without seeming obnoxious. As a summer diversion, the film has about as much substance as cotton candy.

1993 Jl 7, C14:6

In the Line of Fire

Directed by Wolfgang Petersen; written by Jeff Maguire; director of photography, John Bailey; edited by Anne V. Coates; music by Ennio Morricone; production designer, Lilly Kilvert; produced by Jeff Apple; released by Columbia Pictures. Running time: 126 minutes. This film is rated R.

Frank Horrigan....................Clint Eastwood
Mitch Leary......................John Malkovich
Lilly Raines......................Rene Russo
Al D'Andrea.....................Dylan McDermott

By VINCENT CANBY

CLINT EASTWOOD'S timing is uncanny. After all the noise and hot air attending the releases of the somewhat less than perfect "Jurassic Park," "Last Action Hero" and "The Firm," he slips into town, almost modestly, giving the "True Grit" performance of his career in the most uproariously entertaining movie of the summer so far.

"In the Line of Fire" is not exactly "Potemkin." It's movie making of the high, smooth, commercial order that Hollywood prides itself on but achieves with singular infrequency.

Mr. Eastwood's charcoal-mellowed persona lends "In the Line of Fire" its tone and class. He is the movie's spine. At the same time, note should also be made of those who gave the film its shape: Jeff Maguire, who wrote the original screenplay based on an idea by Jeff Apple, the producer, and Wolfgang Petersen, the German-born director of "Das Boot," who has finally found an American property to equal his earlier international success.

"In the Line of Fire" is the kind of movie that gives teamwork a good name. Taking the remnants of a dozen other movies, this team has concocted a suspense melodrama so satisfying that its clichés, which keep it zipping forward, become epiphanies: by the time you reach the end and look back, everything makes sense. There are very few movies this summer about which that can be said with a straight face.

Mr. Eastwood's role would appear to have been made to order, although he has a way of inhabiting his roles so completely that it's never easy to tell where the writing leaves off and he begins. He plays Frank Horrigan, self-described as "a white, piano-playing male over the age of 50," while he may be over 60 in fact. His age makes no difference to the audience (he looks agelessly great), but it's a major factor in the film.

Frank is a Secret Service agent who probably should have retired some time ago but can't. His job has become his life since it caused his

split from his wife and family. He's the sort of guy who winds up each day in a favorite cocktail bar, noodling on the piano, drinking too much Jack Daniels. (Jack Daniels isn't mentioned in the film, but Frank would be a brand-name drinker.) He also has a secret.

•

On one of his first assignments 30 years ago, Frank was a member of the Secret Service detail that did not prevent the assassination of President John F. Kennedy in Dallas. Frank is haunted by the memory of that failure and by the question he keeps asking himself: would he have had the courage or instinct to throw himself between the President and the bullet if he had had that split-second opportunity?

When first met, Frank and his young partner, Al D'Andrea (Dylan McDermott), are working on routine if dangerous assignments relating to counterfeiters and such. During an investigation of a man who seems obsessed by Presidential assassinations, Frank suspects that the fellow is not a crackpot but someone with a seriously deranged mind.

This suspicion is confirmed when the man begins to telephone Frank at all hours to chat about his plans to kill the President, and to make sarcastic comments about Frank's behavior as part of the Dallas motorcade. He either knows Frank, has studied him or has access to his agency files. Frank alerts his superiors and asks that he and Al be assigned to the Presidential security team.

•

"In the Line of Fire" is the story of Frank's efforts to identify and stop the would-be killer, who stalks him with malicious joy as he stalks the President in earnest. It's also the story of Frank's need to prove himself. Finally, though not least, it's the story of his hilarious September-May affair with Lilly Raines (Rene Russo), a beautiful, much younger agent also assigned to the President's security.

Lilly is as odd as Frank. She knows she must be nuts to fall for this dinosaur. When she tells him, "Let's face it, Frank, you're too old," it's as much to convince herself as it is to persuade him that he ought to retire gracefully and not mess up other people's lives, including hers.

"In the Line of Fire" also has a first-rate villain in Mitch Leary, played by John Malkovich with the same insinuating mixture of wit and malevolence that the actor brought to his New York stage performance in Sam Shepard's "True West." Mr. Malkovich eases into the film in a kind of slither. First he's a voice on the telephone, then an eye, a nose, a face seen in a pore-tight close-up. When finally seen in full figure, he appears to be both maniacal and utterly ordinary.

•

The screenplay does well by both Mr. Eastwood and Mr. Malkovich, especially in their telephone exchanges in which Mitch delights in sending up the Secret Service man while the rest of the agency is frantically trying to trace the call. Mitch constantly questions Frank's sincerity about being willing to give his life to protect the President's. Mitch acknowledges that his will be a suicide mission.

"I have a rendezvous with death," he tells Frank, dramatizing himself with the self-consciousness of a first-year English major. When Frank in-

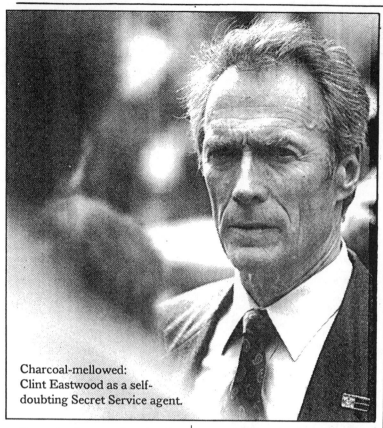

Charcoal-mellowed: Clint Eastwood as a self-doubting Secret Service agent.

The campaign in "In the Line of Fire" isn't about issues and ideas, but about the naked wish to win. Sound familiar?

Ms. Russo, who played Mel Gibson's battle-scarred lover in "Lethal Weapon 3," works terrifically well with Mr. Eastwood. Their scenes have some of the caustic spirit of the material Ruth Gordon and Garson Kanin used to write for Spencer Tracy and Katharine Hepburn. They are genuinely funny lovers. Mr. McDermott is also very good as Al, Frank's partner, a guy who remains unconvinced that he's cut out for the only kind of work that makes his friend feel alive.

Commanding the film but never getting in the way of it is Mr. Eastwood. His Frank is as obsessed as Mr. Malkovich's assassin, but also easy and self-aware, cool and amused. This is the richest performance yet by an actor who, among other things, keeps getting better and better.

●

"In the Line of Fire" is rated R (Under 17 requires accompanying parent or adult guardian). It includes vulgar language and a lot of violence.

1993 Jl 9, C1:3

dicates that he recognizes the Alan Seeger lines, Mitch can't resist setting Frank straight about literature: "It's really not a good poem, Frank."

There is equal intelligence in Mr. Petersen's direction of the action sequences, beginning with the film's scarily funny opening in which the arrest of some counterfeiters goes dangerously wrong. "In the Line of Fire" is so neatly constructed that even though Frank and Mitch confront each other quite early, the tension of the virtually movie-long chase does not let up until the end. One pursuit across the rooftops of Washington is as elegantly staged as it is brutal and revealing of character.

Although the film moves at a dizzy pace from Washington to Los Angeles to Chicago and back again, there are no false moves. Nor does the audience ever get lost.

●

"In the Line of Fire" is one of the few Hollywood suspense melodramas that don't seem to ignore the realities of the world outside. It uses them. It's not really vital to the narrative, but it helps, that the film takes place during the final weeks of a President's campaign for re-election. Because he is trailing in the polls, his handlers put him in jeopardy that at any other time would be unthinkable.

Critic's Choice

A Rich Array of Italian Concerns

Starting today at the Joseph Papp Public Theater is a month-long feast of films covering those subjects most precious to Italian cinema: politics, love, religion and food (probably not in that order).

"The Italian Summer Festival: 30 Days of Italian Cinema at the Public" begins with Pupi Avati's charming 1984 film, "We Three," best described as an antidote to "Amadeus." Based on the 14-year-old Mozart's brief stay in Bologna while on an Italian tour, the film portrays the composer as an earnest and normal adolescent. His father reminds him to practice his music; he makes a friend of a young man his age, and they both have crushes on a girl from a neighboring estate. Except for an occasional reference to his fame, and the way he is addressed as "Signore Amade," you'd never know he was *the* Mozart. Like Mr. Avati's 1991 film, "The Story of Boys and Girls," this one is richly photographed in the Bolognese countryside, and populated with enticing, eccentric minor characters.

"We Three" will play through Sunday, paired with one of the most eloquent of all Italian films, Vittorio De Sica's great "Bicycle Thief" (1949), shown in a new print. The series usually pairs an enduring older film like "The Innocent" (1976), by Luchino Visconti, with one released in the last five years. Because foreign films often have trouble finding American distributors today, most of the newer films have not been released here. (Tickets are $7 for each double feature; call (212) 598-7171 to hear a recorded schedule. The Public is at 425 Lafayette Street, at Astor Place, Greenwich Village.)

In the food category, there is Fiorella Infascelli's 1992 family saga, "Fish Soup" (the title loses its comic rhythm in translation from "Zuppa di Pesce"), starring Philippe Noiret. On the political side is Carlo Lizzani's "Dear Gorbachev" (1988), with Harvey Keitel as the Soviet revolutionary Bukharin on the long night before

Stalin has him arrested. As the presence of Mr. Noiret, Mr. Keitel and Signore Amade suggest, you don't have to be Italian to show up.
CARYN JAMES

1993 Jl 9, C10:1

Weekend at Bernie's II

Written and directed by Robert Klane; director of photography, Edward Morey 3d; edited by Peck Prior; music by Peter Wolf; produced by Michael Bolton; released by Tri-Star. Running time: 89 minutes. This film is rated PG.

Larry	Andrew McCarthy
Richard	Jonathan Silverman
Bernie	Terry Kiser
The Mobu	Novella Nelson
Investigator	Barry Bostwick

BY STEPHEN HOLDEN

Easily the funniest performance in the frantic sequel to the 1989 hit comedy "Weekend at Bernie's" is Terry Kiser's droll impersonation of a dead bon vivant who becomes a lurching, limbo-dancing zombie whenever calypso music is in the vicinity.

Mr. Kiser isn't the only actor who appeared in the original film who has returned for the sequel. Jonathan Silverman and Andrew McCarthy are back as gung-ho Abbott and Costello-like sidekicks who will do anything to find $2 million that the dead man embezzled from the insurance company in which they worked.

Just as eager to get their hands on the cash, which is somewhere in the Virgin Islands, are the agents for the Mobu (Novella Nelson), a voodoo priestess in the pay of mobsters, and the insurance company's bumbling internal investigator (Barry Bostwick). The film, which opened yesterday, begins in New York, but the scene quickly shifts to a picturesque island resort teeming with buxom young women and writhing natives with painted faces.

"Weekend at Bernie's II," which was written and directed by Robert Klane, is a much more high-pitched movie than its forerunner. Its best scene comes early in the film, when the Mobu's agents have kidnapped Bernie's corpse from the morgue and

Columbia Pictures

John Malkovich as Mitch Leary, the villain of "In the Line of Fire."

taken it to the lavatory of a sleazy movie house. As they are about to resurrect him in a ceremony that involves 117 candles, goat urine and a live chicken, the chicken escapes into the theater. After a desperate but futile chase to capture the bird, they settle on a pigeon.

But as it turns out, a pigeon won't do as good a job as a chicken. Although the corpse stirs, it only gets up when music, preferably calypso, is playing. They discover this quirk through trial and error on the boom box supplying the soundtrack for their ritual. When the music stops, the body keels over.

This running joke, which is repeated incessantly throughout the movie, is kept fresh by adding new and increasingly bizarre twists. One evening at the resort, Bernie, looking terminally dissipated, with one eye-

brow rakishly raised above his sunglasses, leads a conga line. To keep him alive so he can lead them to his stolen treasure, the sidekicks rig Bernie up with headphones and send him into the ocean where he is observed as a rare form of marine life by visitors aboard a submarine touring the coral reef.

Through it all, Mr. Kiser, who says not a word, exudes the foolish amiability of a partygoer who is beyond plotzed and is living in a private world of his own.

•

"Weekend at Bernie's II" is rated PG (Parental guidance suggested). It has off-color humor, and more squeamish viewers may be offended by its premise.

1993 Jl 10, 15:4

FILM VIEW/Caryn James

Clint Eastwood Cozies Up To the 1990's

MANY YEARS AGO, IN AN EPIsode of the television western "Rawhide," Rowdy Yates got sick. He got so sick that he had to take off his shirt. The writers were probably searching for ways to get Rowdy's shirt off, because he was played by the very young, very handsome Clint Eastwood. There he was, lying on his bedroll among the cattle, looking all sweaty and shirtless, insisting he was well enough to get up. At that moment Rowdy was tough but vulnerable, and irresistibly attractive.

About 30 years later, Mr. Eastwood may not be so fast to yank off his shirt, but he has carried a trace of Rowdy — tougher and more vulnerable than ever — to his new film, "In the Line of Fire." Directed by Wolfgang Petersen, the film promised to be a blip in Mr. Eastwood's career. It would be nothing next to last year's hit, "Unforgiven," which gained him an Academy Award as best director and the serious critical attention he had merely flirted with throughout his career.

"In the Line of Fire" is certainly commercial fluff, but it may also be another benchmark for Mr. Eastwood — not because it is brilliant art but because it shows the actor aging brilliantly on screen. The tired story concerns a hero battling a psycho-killer. Mr. Eastwood plays Frank Horrigan, a Secret Service agent who couldn't save John F. Kennedy; now he has a last chance to redeem himself by saving the current President from the madman played by John Malkovich.

But Mr. Eastwood, now 63 years old, makes Frank much more than a cliché. He is a shrewd combination of the familiar, invincible Clint and a new, vulnerable man for the 90's. This appealing persona helps make "In the Line of Fire" the best commercial movie of the summer so far. Unlike "Jurassic

Park," it has a story and characters; unlike "Cliffhanger," it has action that makes sense; unlike "Sleepless in Seattle," it is genuinely romantic and doesn't have to stand on its head to make you think so.

The script has fun with the idea that Frank is a dinosaur. That is partly a matter of physical age and partly a generational attitude. When Frank runs next to the President's car, he becomes short of breath. While chasing the madman, he has trouble jumping across rooftops. He has requested this assignment, but no one is sure he can still handle it.

The younger agents sneer at him, which only makes the audience root for him more. He is still Clint Eastwood, and we suspect he'll turn out to be stronger and more competent than anyone around him. But we're never entirely sure, either. The film's smartest move is to convince us that Frank might collapse any minute. He does create havoc during a Presidential speech because his senses are dulled by a bad cold. That cold might have been too much; Mr. Eastwood makes it touchingly human rather than comic.

Frank admits that he misses the old days, when the country was different and Kennedy was a President worth taking a bullet for. And he has other dated attitudes where that one came from. When Frank meets a colleague named Lily (Rene Russo), he tries to be gallant by telling her "the secretaries are getting prettier." A younger man might have guessed that she is a hotshot agent herself. When she looks at Frank and snaps that agents are getting older, the exchange begins an entirely convincing love story. Frank and Lily's verbal snap and underlying warmth suggest an updated Tracy-Hepburn movie. It helps that Lily is in her 30's, smart as well as pretty, and played by Ms. Russo as someone whose self-assurance never becomes smug or rigid. Frank has to learn fast to keep up with this professional woman from another generation, and he does.

In a scene that turns Frank convincingly into a sensitive guy, he suspects that Lily's last love affair ended because she wouldn't quit her job. "You swore you'd never again let a man come between you and your career," he guesses, then suggests he could quit his job for her. "Why would you want to do that?" she says. He answers: "Maybe I swore I'd never again let my career come between me and a woman." Forget the practical details; this is a radical offer that would never have crossed Dirty Harry's mind.

Frank is not a thoroughly new Eastwood character, though. Retiring from the gunslinging life is exactly what Mr. Eastwood does as Bill Munny in "Unforgiven." As different as that film is from "In the Line of Fire," both Bill and Frank are men who make late, life-shaping changes because the world is shifting around them. Having retired from his violent life, Bill is called back. Like Frank, he has one last villain to take care of and hopes he is still up to it. These gentle men, pulled into the films' bloody action by necessity, are the Eastwood heroes for today.

Mr. Petersen's sharp direction shouldn't be overlooked. He not only keeps the film moving but also creates a convincing sense of danger. When the President steps out of his car to shake hands with people lining the street, the camera moves into the crowd with him. The audience knows that the killer is hiding nearby. The scene plays into the public's worst, most reasonable fears.

But it is Mr. Eastwood who gives the film its alluring balance of sly wit and straightforward action. There must have been a moment, carefully calculated yet daring, when Cary Grant decided to let his hair go white. No movie star ever aged better than he did, but Clint Eastwood is now in the running. □

1993 Jl 11,II:10:4

Free Willy

Directed by Simon Wincer; written by Keith A. Walker and Corey Blechman, based on a story by Mr. Walker; director of photography, Robbie Greenberg; edited by O. Nicholas Brown; music by Basil Poledouris; production designer, Charles Rosen; produced by Jennie Lew Tugend and Lauren Shuler-Donner; released by Warner Brothers. Running time: 112 minutes. This film is rated PG.

Jesse........................Jason James Richter
Rae.....................................Lori Petty
Annie..........................Jayne Atkinson
Randolph..............August Schellenberg
Glen............................Michael Madsen
Willy....................................Keiko

By VINCENT CANBY

"Free Willy" is a sweet-natured boy-and-his-orca tale for the very young and possibly for their parents or, at least, for those graying fans of "Flipper" who are ready to graduate from dolphins to cuddly 7,000-pound killer whales.

The setting is a city in the Pacific Northwest where chance brings together two of society's outcasts: 12-year-old Jesse (Jason James Richter), an abandoned street kid, and Willy, a handsome young black-and-white orca, the morose star attraction at something called the Northwest Adventure Park.

When Jesse is nabbed by the police for spraying grafitti on the adventure park's walls, he is put into the care of foster parents and told that he must clean up the graffiti at the park. It's there that he meets the unhappy Willy, recently captured at sea and separated from his parents. Both Jesse and Willy are mad at the world. Each needs love and reassurance. How each frees the other is the stuff of "Free Willy," which is as engaging as such films can be without offering rude surprises.

Willy is played with startling docility by the star attraction at a marine park in Mexico City, where all his scenes were shot. He initially responds to Jesse's playing a harmonica, which seems to remind him of home. When Jesse accidentally falls into the tank, Willy saves him. And when the boy discovers a nasty scheme by which the park's venal owners hope to cash in on Willy's life insurance, Jesse is there for the orca.

•

The film is nicely acted by young Mr. Richter and by his older associates, including Lori Petty, who plays a warm-hearted marine biologist,

Ron Batzdorff
Jason James Richter

and Jayne Atkinson and Michael Madsen, as the childless couple who come to love Jesse and, through him, Willy. The orca also has a quite impressive double, a full-size, free-swimming animatronic killer whale built for the film by Walt Conti.

"Free Willy" was directed by Simon Wincer, the Australian director best known here for "Lonesome Dove," and written by Keith A. Walker and Corey Blechman. They do their work with efficient simplicity. No child will mistake the good guys for the bad guys when the park's owner says to his smarmy assistant about Willy, "It will take at least $100,000 to expand that psychotic malcontent's playpen." It's not what they say, but how they say it. They are mean in the slightly bogus way children appreciate.

•

"Free Willy" has been rated PG (Parental guidance suggested). It has some mildly vulgar language and scenes of abandoned children that might upset extremely young audiences.

1993 Jl 16, C12:6

Road Scholar

Produced and directed by Roger Weisberg; written by Andrei Codrescu; director of photography, Jean de Segonzac; edited by Alan Miller; music by North Forty Music/Wave Band Sound; released by Samuel Goldwyn. At the Carnegie Hall Cinemas, Seventh Avenue at 57th Street, Manhattan. Running time: 90 minutes. This film is not rated.

WITH: Andrei Codrescu and Allen Ginsberg.

By STEPHEN HOLDEN

Roger Weisberg's documentary film "Road Scholar" is the antithesis of the typical American road movie. Instead of a mystical journey into the unknown undertaken by restless youths pursuing an elusive personal transcendence, it is a cross-country tour by an Eastern European immigrant who has a smart apercu for every phenomenon he encounters.

Andrei Codrescu, the film's tour guide and screenwriter, is a poet, humorist and commentator on the National Public Radio program "All Things Considered." The film, which opens today at the Carnegie Hall Cinemas, follows him as as he drives across America in a bright red 1968 Cadillac convertible. His journey begins in New Orleans and ends in San Francisco with numerous stops, including New York, Detroit, Chicago, Denver, Santa Fe, Tucson and Las Vegas.

On one level, "Road Scholar" is a quirky personal re-enactment of Jack Kerouac's novel "On the Road." Mr. Codrescu's journey, which is blessed by Allen Ginsberg near the beginning of the film, takes him to Walt Whitman's Camden, N.J., home, which he finds situated across the street from a prison. In San Francisco, he makes an obligatory pilgrimage to City Lights Bookstore, the legendary Beat poet hangout in the North Beach district.

On a deeper level, the film is a humorous, and sometimes smart-aleck investigation of the idea of freedom in America. A Romanian expatriate who immigrated to the United States in 1966, Mr. Condrescu grew up under a totalitarian government and has an acute appreciation for the

David Graham
Andrei Codrescu

personal freedoms that Americans tend to take for granted. He shows a particular fascination with marginal communities with utopian leanings.

•

In upstate New York, he visits the Hutterian Bruderhof, a straitlaced Christian communal sect that does not believe in personal property. Here, all marriages are arranged by the elders, and television and radio are forbidden. In the Southwest, he mingles with the Taos Pueblo Indians, who are maintaining the traditions of their centuries-old culture, and he observes the religious ceremonies of a group of Sikhs.

For a film that wants to evoke the ties that bind the extremities of American society, "Road Scholar" too often settles for the flippant, slightly mocking tone of the "Mondo Cane" school of cinematic voyeurism. At a New Age bookstore in Santa Fe, Mr. Codrescu listens patiently as a woman babbles on about extraterrestrial visitors to the planet. He puts himself in the hands of a silly-looking crystal healer who communicates with a spirit called the Archangel Ariel. Latter-day hippies in a psychedelic bus are filmed singing "Aquarius."

Mr. Codrescu is as intrigued by garish cultural kitsch as he is by eccentricity. One of the film's longer sequences is a close-up look at couples being married in Las Vegas at a drive-by wedding chapel. Some of the phenomena, like a Western town where episodes of "Rawhide" are re-enacted for tourists, are glimpsed too fleetingly for the local color to rub off. And in general, the film is so busy chronicling the offbeat that it forgets to contemplate the landscape.

•

At the beginning of the journey, Mr. Ginsberg admiringly quotes Kerouac's observation that "the earth is an Indian thing." At the end of the film, Mr. Codrescu repeats that quote, as if to suggest that the film has somehow proved the point. But except for the visit to American Indians in Taos, the film hasn't thought about it at all.

What does emerge out of this entertaining if scattershot survey of American cultural diversity is Mr. Codrescu's profound sense of good fortune in living here.

1993 Jl 16, C14:6

Hocus Pocus

Directed by Kenny Ortega; written by Mick Garris and Neil Cuthbert, based on a story by David Kirschner and Mr. Garris; director of photography, Hiro Narita; edited by Peter E. Berger; music by John Debney; production designer, William Sandell; produced by Mr. Kirschner and Steven Haft; released by Walt Disney. Running time: 93 minutes. This film is rated PG.

Winifred..........................Bette Midler
Sarah.....................Sarah Jessica Parker
Mary.................................Kathy Najimy
Max..................................Omri Katz
Dani................................Thora Birch
Allison..........................Vinessa Shaw
Billy..................................Doug Jones
Headless Billy................Karyn Malchus

By JANET MASLIN

Apparently too much eye of newt got into the formula for "Hocus Pocus," transforming a potentially wicked Bette Midler vehicle into an unholy mess. That's too bad, since Ms. Midler's appearance in a role like the one she has here could have been pure witchcraft. As the foremost of three sisters from 17th-century Salem who are magically transported forward three centuries to bedevil modern trick or treaters, Ms. Midler flounces in high comic style. Not for her the cackling and hobbling of ordinary screen witches; Ms. Midler grandly plays this harpy as if she were Norma Desmond tackling the opening of "Macbeth."

Ms. Midler's performance is such a crazy amalgam of great-lady mannerisms and withering sneers that it deserves to have been shown off more clearly. Instead, the star is buried beneath a mountain of makeup, while the combined effects of prosthetic buck teeth and affected Britishisms make her hard to hear. More problematic, the movie that has been built

A star vehicle that propels its star on a broomstick.

around Ms. Midler's feisty Winifred is badly cluttered, as the witches mix with zombies, parents and teen-agers on Halloween. Entirely too diverting is the spectacle of an entire cast elaborately overdressed for a costume party.

Andrew Cooper
Bette Midler

"Hocus Pocus" is aimed squarely at the Nowheresville between juvenile and adult audiences, making its most blatant pitch for the young teenage crowd. So despite the presence of sly Winifred, buffoonish Mary (Kathy Najimy) and cleavage-flashing Sarah (Sarah Jessica Parker), who have been programmed to walk and fly together in comical team maneuvers, the film gives equal time to its nice-kid characters.

The witches' young nemeses are Max (Omri Katz), a new high school boy in town, and his cute, wisecracking sister, Dani (played by the effervescent Thora Birch as if she were an honorary member of the Culkin family). Also in the cast is Vinessa Shaw as Max's pretty new classmate. She inadvertently brings down the house by trying to explain the witches vs. teen-agers battle with a straight face.

As directed by Kenny Ortega, "Hocus Pocus" has flashes of visual stylishness but virtually no grip on its story (from a screenplay by Mick Garris and Neil Cuthbert). It changes tone as casually as the actors don their masquerade costumes, and has no scruples about breaking its own mood altogether (as when the three witches suddenly perform "I Put a Spell on You" at a Halloween party). Perhaps the film's most trenchant remark comes from Penny Marshall, who has a brief cameo with her brother, Garry, as (it seems) Mr. and Mrs. Devil, and asks the witches, "Aren't you broads a little old to be out trick or treating?"

Of special note in "Hocus Pocus" are a computer-generated talking cat, whose laboriously achieved presence falls under the heading of stupid pet tricks, and a finale that drags out almost all the film's characters for a series of needless, sentimental goodbyes. When brave Max and a weepy Dani bid an emotional farewell to Billy, a zombie who has helped them out for the evening but now must return to the grave, it truly is time to say goodbye.

•

"Hocus Pocus" is rated PG (Parental guidance suggested). It includes very mild scares, occasional rude language and a few jokes about one young character's virginity.

1993 Jl 16, C16:1

Benefit of the Doubt

Directed by Jonathan Heap; written by Jeffrey Polman and Christopher Keyser, based on a story by Michael Lieber; director of photography, Johnny Jensen; edited by Sharyn L. Ross; music by Hummie Mann; production designer, Marina Keiser; produced by Michael Spielberg and Brad M. Gilbert; released by Miramax. Running time: 91 minutes. This film is rated R.

Frank..................................Donald Sutherland
Karen..Amy Irving
Calhoun...Graham Greene
Attorney......................................Theodore Bikel
Pete...Rider Strong
Dan...............................Christopher McDonald

By VINCENT CANBY

"Benefit of the Doubt" is an over-produced, under-achieving suspense melodrama about a father who, after serving 22 years in prison for the murder of his wife, returns home to bond with the daughter whose testimony as a little girl helped send him away.

Donald Sutherland plays the dad, who loudly proclaims his innocence

Michael Paris/Miramax Pictures

Out and Around Amy Irving and Rider Strong appear in "Benefit of the Doubt," about a woman whose psychopathic father is released from prison 22 years after her testimony helped convict him of murder.

and keeps talking about the importance of the family unit. Amy Irving is the daughter, grown up to be a waitress in a topless bar and a single mother of an 11-year-old boy. Her father is so persuasive that she begins to suspect that the prosecuting attorney brainwashed her as a little girl. The audience is in doubt for perhaps three minutes.

Meanwhile Dad tries to establish ties with his daughter and grandson in various ways, some less offensive than others, until the film goes into a very long, exceptionally unexciting chase sequence.

"Benefit of the Doubt" was written by Jeffrey Polman and Christopher Keyser and directed by Jonathan Heap, none of whom display any aptitude for movies except as location scouts. The film was photographed in Arizona, where every stone mountain and craggy tower looks like something spun off from Monument Valley. The dialogue is arch and wooden, the plot twists too little and too late.

It's sort of fun seeing Ms. Irving playing a tough-talking cocktail waitress, but it's the actress who seems vulnerable, not the character. Mr. Sutherland's performance is over the top from beginning to end, which may be the only way to treat the material. Theodore Bikel turns up briefly as the prosecuting attorney and Graham Greene plays a sheriff.

How do movies of this ineptitude get made?

•

"Benefit of the Doubt" has been rated R (under 17 requires accompanying parent or adult guardian). There is a lot of vulgar language, partial female nudity and one scene of attempted incest.

1993 Jl 16, C17:1

FILM VIEW/Caryn James

The Buzz Says: Enough With the Hype

WELL BEFORE THEY ARrived in theaters, "Last Action Hero" was pronounced Arnold Schwarzenegger's first flop, "Jurassic Park" a record-breaking hit, and "Sleepless in Seattle" the sleeper of the summer. That shouldn't be surprising at a time when the Presidential elections are accurately predicted by exit polls hours before the voting ends. Tom, Dan and Peter know who won; they just don't tell you and me, and everyone pretends we don't know they know. Politics and movies are both areas where the spin doctor is king, and both have been slow to wake up to the fact that the public is now savvy about the spin itself.

Movie hype, always at its peak when dealing with summer's potential blockbusters, has become more complex as audiences have grown increasingly knowledgeable. Box-office grosses, once confined to the pages of Variety, now appear everywhere from The New York Times to Entertainment Weekly; Vanity Fair profiles Hollywood agents alongside celebs. In this environment, advance word goes beyond advertising. It includes the good buzz that a studio wants the public to hear ("Arnold's biggest movie yet!"), the bad buzz that a studio's competitors want the public to hear ("Arnold's in trouble! The movie will never be finished in time."), and all sorts of analysis from serious reporters as well as gossip columnists. Even the most sophisticated viewer can find this process so confusing that politics seems straightforward by comparison.

The buzz syndrome matters to viewers because it creates the expectations everyone carries into theaters. But the spin about this summer's movies has spun wildly out of control.

"The Fugitive" is already being called a hit, even though Harrison Ford's version of the old television series won't open until Aug. 6. "Last Action Hero," the much-maligned Schwarzenegger movie, is only half-bad, but the unfailingly successful Mr. Schwarzenegger was so ripe for a fall that the advance word made the film seem unwatchable instead of just unprofitable. And the newest, most nonsensical phenomenon is the "sleeper" announced months in advance.

A true sleeper is a film that arrives with such a low profile that it raises no expectations at all. "Home Alone" snuck into town one Thanksgiving as just another children's movie; its wild success was a surprise. "Wayne's World" was last summer's truest sleeper, a cheap, throwaway movie that stunned everyone by becoming a hit.

Calling a yet-to-open film a sleeper makes no sense. "Sleepless in Seattle" was actually promoted with television commercials as early as January. Soon after, the word went out that test audiences adored the story about Meg Ryan falling in love with Tom Hanks's voice on the radio. (Leaking audience test scores is the buzz technique du jour.) Before the movie opened, audiences were conditioned to think of it as the romantic-comedy hit of the season. The film is a true success but a false sleeper.

"Free Willy," which opened on Friday, is another case in which the "sleeper" tag was used as a self-fulfilling prophecy. Naturally,

Bruce McBroom/Tri-Star Pictures

When is a sleeper not a sleeper? When the designation is awarded five months before the movie opens, as with "Sleepless in Seattle," starring Meg Ryan, above.

the word went out that test audiences adored the sentimental family story of a neglected 12-year-old boy and a captive whale. Entertainment Weekly highlighted it as the summer's potential sleeper. And a month before the opening, "Willy" stuffed animals, soundtracks and other memorabilia were sold on the cable home-shopping channel QVC. "Willy" was disqualified as a sleeper long ago.

The strategy here is clever but transparent. A film is made to sound appealing by suggesting, "No one ever thought of this as big, but real people love it." The underlying message, of course, is, "You have to see this movie."

Lowering expectations is not a stupid idea, if it is managed shrewdly enough. Two of this summer's biggest movies have come with relatively little hype, an approach that now seems the height of marketing brilliance. No Tom Cruise or Clint Eastwood movie will ever be a secret. But "The Firm" and "In the Line of Fire" were not preceded by the deafening buzz that surrounded other summer movies. Remember when "Cliffhanger" was supposed to be a laughable flop? Remember "Sliver," the big sexy movie that wasn't?

No one had heard much about "The Firm," which seemed like a bad sign for a movie with such high-profile credentials: starring Tom Cruise, directed by Sydney Pollack, based on the John Grisham best seller. But Mr. Cruise has had major flops (most recently "Far and Away"), Mr. Pollack's last movie was "Havana," and no best-selling book can guarantee success on screen. Would it have been smart to ask "The Firm" to live up to Schwarzenegger-level hype? The film's underplayed strategy has made its box-office success seem almost a surprise. And it seems totally in keeping with Clint Eastwood's laid-back manner that his Secret Service thriller, "In the Line of Fire," arrived in a confidently modest style. It turned out to be one of the summer's best films.

Movies, unlike politicians, sometimes meet the expectations raised by their campaigns. "Jurassic Park" promised amazing dinosaurs and delivered amazing dinosaurs — nothing more or less. But in this hype-crazy season, "The Firm" and "In the Line of Fire" suggest that sometimes it's wiser to promise nothing at all. □

1993 Jl 18, II:10:1

From Hollywood to Hanoi

Written, directed and produced by Tiana (Thi Thanh Nga), in English, French and Vietnamese with English subtitles; cinematography by Michael Dodds, Bruce Dorfman and Jamie Maxtone-Graham; edited by Roger Schulte; released by Friendship Bridge Productions. Film Forum 1, 209 West Houston Street, South Village. Running time: 78 minutes. This film has no rating.

By VINCENT CANBY

"From Hollywood to Hanoi," opening today at Film Forum, is an intense, personal, supremely self-confident feature-length documentary that owes a lot to the cinema journalism of Michael Moore, the man who confronted General Motors in "Roger and Me." Like the Moore film, "From Hollywood to Hanoi" is as much about the film maker behind it as it is about the subject it appears to be exploring.

On the surface that subject is life in Vietnam today, so many years after the end of hostilities. In fact, "From Hollywood to Hanoi" is the record of one remarkable young woman's efforts to construct a coherent identity out of bits and pieces of lives lived as a series of compromises.

Tiana, who wrote, directed and produced "From Hollywood to Hanoi," was named Thi Thanh Nga when she was born in Saigon, where her father was in charge of press and information for the South Vietnamese Government. In 1966, when she was still a little girl, she and her family moved to the United States after her father became convinced that the Government cause was lost. They settled first in Washington, where her father worked for the Voice of America, and later moved to San Jose, Calif.

•

"We tried to become perfect Americans," Tiana says on the soundtrack. Her brothers grew up to become policemen. At the age of 16, she ran away to Hollywood to be an actress, appearing in Sam Peckinpah's "Killer Elite" in 1975, among other films. She was also in "Pearl," the television mini-series, some kung-fu movies playing a sort of female version of Bruce Lee, a music video made in France and a karate video. The roles available to Asian actresses being limited, she became increasingly obsessed by her real-life role as an Americanized Vietnamese. Who was she?

To find out, she made the first of a series of trips back to Vietnam in 1988 over the objections of her father. She has continued to return several times a year, always with a camera and with an insatiable desire somehow to reconcile the two sides of her life. The initial result of these explorations is "From Hollywood to Hanoi," the packed and layered journal of a very special innocent abroad.

Tiana would seem to be a woman with the gift of gab, a lot of push and except for her need to learn, a redeemingly skeptical point of view. In Vietnam there are emotional reunions with long-lost relatives, including an uncle, a former South Vietnamese Defense Minister recently released after 13 years in a Government re-education camp.

•

There also are interviews with Gen. Vo Nguyen Giap, the former commander of the North Vietnamese forces, and Le Duc Tho, who led the North Vietnamese delegation to the Paris peace talks. It's clear that the two men were enchanted by Tiana,

whom they seem to regard as a sort of prodigal daughter returned. There are interviews with Amerasian children whose American fathers abandoned their Vietnamese mothers, and visits to a hospital where, in what is said to be an Agent Orange ward, war victims still languish.

Poverty is everywhere. Though relations between Vietnam and the United States have not returned to normal, Tiana notes that the dollar has returned to Saigon, which is what everyone still calls Ho Chi Minh City. She attends a performance of Tennessee Williams's "Glass Menagerie," which is played, as she describes it, with a ferocity better suited to Edward Albee's "Who's Afraid of Virginia Woolf?" In Hanoi she meets and dances with Oliver Stone, the American film director.

•

Back in the United States, at a benefit performance of "Miss Saigon," she runs into Gen. William C. Westmoreland, the former American commander in Vietnam. She doesn't hesitate to push a microphone into his face and ask him why, in the film "Hearts and Minds," he said that Asians do not value human life as dearly as people in Western civilizations do. The surprised general thought he was just going out to see a Broadway show.

Though Tiana has included the "Hearts and Minds" clip in "From Hollywood to Hanoi," the general at first insists that he never said any such thing, but he goes on to explain what he really meant, none too successfully.

The film makes superb, sometimes sarcastic use of material from old newsreels and propaganda films. Equally important, though, is the way the director portrays her affection for her father and the other members of her family in this country. In many ways hers is a divided family, but it also appears to be an unusually strong and loving one. There's a lot of rich, sometimes still raw material here.

1993 Jl 21, C13:1

Boys' Shorts
The New Queer Cinema

Six short films exploring gay themes.

RESONANCE, directed by Stephen Cummins; written by Mr. Cummins and Simon Hunt. WITH: Mathew Bergan, Chad Courtney and Annette Evans.

R.S.V.P., written and directed by Laurie Lynd.

ANTHEM, directed by Marlon Riggs.

RELAX, written and directed by Christopher Newby.

BILLY TURNER'S SECRET, written and directed by Michael Mayson.

THE DEAD BOYS' CLUB, written and directed by Mark Christopher.

Released by Frameline. Village East Cinemas, Second Avenue at 12th Street, East Village. Running time: 119 minutes. These films are not rated.

By STEPHEN HOLDEN

Sadness, sensuality and a defiant militance infuse "Boys' Shorts: The New Queer Cinema," a program of six short films that opens today at the Village East Cinema. Of the film makers, two (Marlon Riggs and Michael Mayson) are black Americans, and one (Mark Christopher) is a white American. The remaining three are Australian (Stephen Cummins), Canadian (Laurie Lynd) and English

(Christopher Newby). Despite their diversity of backgrounds and style, their overlapping concerns with AIDS, homophobia and sexual liberation suggest an underlying commonality of spirit.

Mr. Cummins's film, "Resonance," deals with a gay-bashing and its psychological aftermath. A handsomely photographed essay in body language featuring three dancers (Mathew Bergan, Chad Courtney and Annette Evans), it follows the man who was beaten when he goes to a martial arts class. As it proceeds, its choreography systematically blurs the line between macho posturing and erotic expression. The most striking scene, a male pas de deux in a boxing ring, thoroughly confuses the rites of combat with those of love.

•

"R.S.V.P.," by Mr. Lynd, is an austere exploration of grief. In the movie, which has almost no dialogue, Jessye Norman's recording of "Le Spectre de la Rose" from Berlioz's "Nuits d'Été," is heard on the radio in various locations across Canada. The broadcast becomes the emotional link uniting the surviving friends, parents and lover of a man who died of AIDS. Well acted, "R.S.V.P." has an elegiac resonance that transcends the painful, private feelings that must have inspired it.

Mr. Riggs's dense nine-minute film "Anthem" is almost opposite in tone to Mr. Lynd's meditation. Cramming erotic images, political symbols, poetry and music into a collage that has a feverish hip-hop energy, it is an impassioned hymn to black gay male sexuality tinged with revolutionary rhetoric.

In Mr. Newby's visually elegant film, "Relax," a young man (Philip Rosch) who has been tested for H.I.V. has a succession of surreal, scary fantasies while waiting for his test results. The hallucinations range from suffocation in clear plastic to an ambivalent sexual encounter with a cyclist wielding an oil can. The recurrent image in a film that chillingly evokes gay anxiety in the age of AIDS is a flow chart of blood circulating through the body.

•

Of the six films, Mr. Mayson's comedy, "Billy Turner's Secret," is the closest in style to a mainstream Hollywood movie. It tells the story of two roommates, one secretly gay, the other homophobic, who are accidentally forced to confront their sexual difference. The comic slice of urban life has a verve and streetwise charm that recall Spike Lee's debut film, "She's Gotta Have It."

"The Dead Boys' Club," which was written and directed by Mr. Christopher, also puts a light spin on a dark subject. In this humorous variation on the city mouse-country mouse fable, an innocent young gay man visits his older, more sophisticated New York cousin, whose lover has recently died of AIDS. When the visitor steps into a pair of the dead man's shoes, he finds he is magically transported into the 1970's pre-AIDS world of unbridled hedonism. Thelma Houston's 1977 disco hit, "Don't Leave Me This Way," is the running theme for a film that behind its "Wizard of Oz" plot conceit is a cry of loss for thousands who have died.

Whether comic or sad, surreal or straightforward, all six films have one thing in common. While gazing into the eye of the extinguishing storm of AIDS, they proclaim the primacy of sexual expression in the lives of gay men.

1993 Jl 21, C17:1

Poetic Justice

Written and directed by John Singleton; director of photography, Peter Lyons Collister; edited by Bruce Cannon; music by Stanley Clarke; production designer, Keith Brian Burns; produced by Steve Nicolaides and Mr. Singleton; released by Columbia. Running time: 110 minutes. This film is rated R.

Justice	Janet Jackson
Lucky	Tupac Shakur
Iesha	Regina King
Chicago	Joe Torry
Aunt June	Maya Angelou
Jesse	Tyra Ferrell
Heywood	Roger Guenveur Smith
Markell	Q-Tip

By VINCENT CANBY

FROM time to time throughout "Poetic Justice," John Singleton's new romantic melodrama, a pretty, buttonnosed South-Central Los Angeles beautician named Justice, played by the pop superstar Janet Jackson, muses about life and loneliness on the soundtrack. It might be better if she sang the words accompanied by a loud backup group, so we couldn't hear them.

Instead, Justice speaks the words clearly, with the fearful reverence of a child ordered to commit Portia's "quality of mercy" speech to memory overnight. Not only the individual words are comprehensible, but also enough of their meanings so that we are aware of the singular disparity between the speaker and her musings. Although these are supposed to be poems dashed off by Justice to ease her pain, they are, in fact, the work of the celebrated Maya Angelou, poet and earth mother.

Ms. Angelou's poems, longviews of the human condition with rolling cadences and melancholy codas, seem no less foreign to Justice than Shakespeare's language. The Angelou poems buzz around Justice's head like a swarm of benign bees on a hot summer day. They neither sting nor provoke. They just happen to be in the neighborhood.

"Poetic Justice" is a mess, but it's an adventurous one. It's a movie whose unrealized ambitions are in many ways more interesting than the goals achieved by the success of Mr. Singleton's first film, which endeared him to the Hollywood establishment.

He hit the box-office jackpot in 1991 with "Boyz N the Hood," which also won him Oscar nominations as best director and best writer. As a follow-up to that comparatively conventional melodrama about growing up black and disadvantaged in South-Central, Mr. Singleton is now making a serious effort to do something different. "Poetic Justice" is nothing less than an attempt to celebrate the creative impulse as a means of

Columbia Pictures Release

Maya Angelou

salvation, not only for the individual but also for society.

At least, that seems to be the point of the fuzzy new movie, which, in common with so many other second films, has neither the coherence nor the spontaneity of the film that preceded it. It has the air of something awkwardly fabricated to reach an inspirational goal.

Nothing in the character of Justice, as written by Mr. Singleton or as passively played by Ms. Jackson, remotely suggests that she's the repository of the ideas and emotions attributed to her by Ms. Angelou's poetry. True, in the pre-credit sequence that opens the film, she is the horrified witness when her boyfriend's head is blown away by a rival gang at a drive-in theater. Yet Justice seems more dim than despairing. At best, her sadness appears to be entirely self-addressed.

She lives alone in South-Central in a big, roomy, well-furnished middle-class house, left to her by her grandmother. When someone asks about her name, she says her mother (who apparently died a junkie) named her Justice because she became pregnant with Justice in law school. No further mention is made of either her mother or law school.

Justice is popular with her colleagues at the beauty shop, but after her sorrow at the drive-in, she doesn't date. She dresses immaculately and with her own chic. She looks terrific in corn rows and wearing a sort of poor-boy cap. Yet she's a large empty space at the center of the movie.

Far more believable and involving are the people around her: Lucky (Tupac Shakur), the spirited young postman who falls in love with Justice; Iesha (Regina King), her good-hearted best friend, who drinks too much and loves too easily, and Chicago (Joe Torry), Iesha's short-tempered boyfriend, who works with Lucky at the post office.

Most of "Poetic Justice" is a road movie. Iesha persuades Justice to go on a blind date. The two women accompany Chicago and Lucky as they drive a load of mail from Los Angeles to Oakland, Calif. As Iesha and Chicago drink and make love in the back of the truck, Justice shares the cab with Lucky. It turns out that Justice has met Lucky before and doesn't like him. Instead of talking, she sits in her corner writing poems.

He: "What do you write about." She: "Whatever's in my heart." He: "What's that?" She: "I don't know." In that way they begin to connect.

En route they make unscheduled stops at a beach and a fair. In the film's most engaging sequence, they crash a huge barbecue billed as "The Johnson Family Reunion." There Justice has a brief encounter with a most patrician-looking Ms. Angelou, playing Aunt June. As with most of their other stops, this one ends in some bitterness: Iesha flirts with the wrong man, and a fight breaks out.

Columbia Pictures Release

Looking for inspiration: Janet Jackson and Tupac Shakur.

"Poetic Justice" is not strong on narrative and not very clear about what narrative there is. Although its aspirations are high, the film works only fitfully when Mr. Singleton exercises his gift for vernacular speech, for finding the comic undertow in otherwise tragic situations, and even for parody.

The last is apparent in a brief glimpse of the film Justice and her boyfriend are watching at the beginning of "Poetic Justice." It's something called "Deadly Diva," in which two super-smooth black stars act out a fantasy that's as far removed from life in South-Central Los Angeles as Iceland.

•

"Poetic Justice" has been rated R (Under 17 requires accompanying parent or adult guardian). It has a lot of vulgar language and several scenes of violence and sexual action.

1993 Jl 23, C1:1

Coneheads

Directed by Steve Barron; written by Dan Aykroyd, Tom Davis, Bonnie Turner and Terry Turner; director of photography, Francis Kenny; edited by Paul Trejo; music by David Newman; production designer, Gregg Fonseca; produced by Lorne Michaels; released by Paramount. Running time: 87 minutes. This film is rated PG.

Beldar Conehead	Dan Aykroyd
Prymaat Conehead	Jane Curtin
Connie Conehead	Michelle Burke
Laarta	Laraine Newman
Seedling	Michael McKean
Ronnie	Chris Farley
Turnbull	David Spade
Carmine	Adam Sandler
Captain Orecruiser	Garrett Morris

By JANET MASLIN

You'd have to visit the planet Remulak to find anyone who really thinks the Coneheads needed to be brought to the big screen. Based on the string of gleefully absurd "Saturday Night Live" sketches about a family of queasy extraterrestrials going native in America, "Coneheads" is not conspicuous for its wide-ranging wit. Nonetheless, the idea has been stretched out to feature length and propped up with sight gags, "Saturday Night Live" cameos and special effects. These visual tricks allow the Coneheads to broaden their horizons in expensive and not-terribly-necessary ways. They are actually seen visiting the planet Remulak, for example.

As Hollywood's latest effort to build the Empire State Building out of toothpicks, and as a film squarely aimed at those who found "Wayne's World" too demanding, "Coneheads" still has its dopey charms. It brings back Dan Aykroyd and Jane Curtin in the welcome roles of Beldar and Prymaat, a Conehead couple bound by weirdly touching notions of Earthly propriety. Prymaat forms her ideas of wifely behavior by reading women's magazines and looks particularly poignant in head cone, pearls and cardigan sweater. Beldar, who like his wife speaks fluent techno-jargon ("starch disk" is what they call a pizza), has the darting-eyed, paranoid manner of someone who almost thinks his ruse is a success.

These venerable Coneheads (along with Michelle Burke, who now plays their vixenish daughter, Connie) are embroiled in a plot about their esca-

Murray Close/Paramount

Head Cases
Jane Curtin and Dan Aykroyd star in "The Coneheads" as Prymaat and Beldar Conehead, pilgrims from another planet who become stranded in Paramus, N.J. Steve Barron's comedy, based on a "Saturday Night Live" skit, also stars Michael McKean, Michelle Burke and Larraine Newman.

pades in Paramus, N.J. The chief point of the film's meandering screenplay seems to be incorporating as many other "Saturday Night Live" players as possible. Many of the current cast members are here, with Chris Farley genuinely funny as the love-struck slob who becomes wildly devoted to Connie after watching her devour a hero sandwich. Adam Sandler appears briefly as a mobster who helps Beldar to assume a new identity and teaches him to say he attended Hobart College.

•

The film's limited intrigue concerns the efforts of an overzealous Immigration and Naturalization Service agent, whom Michael McKean has the good sense to play straight, to apprehend these illegal aliens. "The United States of America can no longer solve the employment problems of the universe!" he proclaims grandly, ever the Government bureaucrat, even though he happens to be on Remulak at the time. David Spade has some droll moments as his unctuous aide. Jon Lovitz plays an Earth dentist who is unfazed by Beldar's three rows of teeth. Blink and you will miss the original "Saturday Night Live" cast members Garrett Morris and Laraine Newman, neither of whom was given a real role.

As directed by Steve Barron ("Teen-Age Mutant Ninja Turtles"), "Coneheads" falls flat about as often as it turns funny, and displays more amiability than style. Visually, Mr. Barron has trouble making huge, awkward close-ups of these Coneheads look as enjoyably silly as they did on the smaller screen. The film's best visual conceit comes late, in the form of an old-fashioned movie mon-

ster named Garthok who has the jerky movements and constant blinking of a Japanese Cyclops, circa 1958. The idea that simpler and cheaper-looking effects can be more fun does not otherwise seem to have sunk in.

•

"Coneheads" is rated PG (Parental guidance suggested). It includes profanity from the planet Remulak and brief sexual references.

1993 Jl 23, C3:2

Another Stakeout

Directed by John Badham; written by Jim Kouf; director of photography, Roy H. Wagner; edited by Frank Morris; music by Arthur B. Rubinstein; production designer, Lawrence G. Paull; produced by Mr. Kouf, Cathleen Summers and Lynn Bigelow; released by Touchstone. Running time: 109 minutes. This film is rated PG-13.

Chris Lecce	Richard Dreyfuss
Bill Reimers	Emilio Estevez
Gina Garrett	Rosie O'Donnell
Brian O'Hara	Dennis Farina
Pam O'Hara	Marica Strassman

By VINCENT CANBY

"Another Stakeout" is made for the kind of person whom television drives out of the house to the movies but who doesn't want surprises when he arrives at the theater. It's big-screen television fare. Directed by John Badham, written by Jim Kouf and starring Richard Dreyfuss and Emilio Estevez, the film is not only a sequel to the same team's "Stakeout" (1987), but also to approximately 9 out of every 10 comic-cop movies made.

This time the policemen played by Mr. Dreyfuss and Mr. Estevez are joined by Rosie O'Donnell, who appears as an assistant district attorney. The three are assigned to stake out a house in an upscale island community near Seattle. Their goal is to find a key witness in the trial of some Las Vegas mobsters. Their cover: Mr. Dreyfuss and Ms. O'Donnell will pretend to be the happily married parents of Mr. Estevez.

Once installed in their house next door, the three become so happily embroiled as they trade television-style insults that they hardly notice what's going on across the way. The screenplay makes references to Madonna's sex book, to Johnny Carson and other similarly controversial topics. There are gags about dogs, about getting locked into the wrong house at the wrong time, and about a disastrous dinner cooked by Ms. O'Donnell for the people they're spying on.

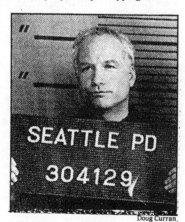

SEATTLE PD
304129

Doug Curran

Richard Dreyfuss

It's thin material, but what appears to have been a fortune was spent to make it look heftier than it is. The movie opens with a series of spectacular explosions that level a Las Vegas bungalow. The scene is photographed in such a way that people set on fire from the first blast share the frame with the house as it continues to explode. That's not easy. It's not even integral to the movie, but it catches the attention. So does a scene that Mr. Badham chooses to shoot from the point of view of a cat's rear end.

A good time seems to have been had by all who made the film.

In every other respect, "Another Stakeout" defies criticism. Everyone who goes to see it will probably know what to expect. There's no need to say more.

•

"Another Stakeout" has been rated PG-13 (Parents strongly cautioned). It has some violence and vulgar language.

1993 Jl 23, C8:5

Amongst Friends

Written and directed by Rob Weiss; director of photography, Michael Bonvillain; edited by Leo Trombetta; music by Mick Jones; production designer, Terrence Foster; produced by Matt Blumberg; released by Fine Line Features. Running time: 88 minutes. This film is rated R.

Billy	Joseph Lindsey
Trevor	Patrick McGaw
Andy	Steve Parlavecchio
Laura	Mira Sorvino
Jack Trattner	David Stepkin
Michael	Michael Artura

By JANET MASLIN

The single modern film most likely to put film schools out of business is Martin Scorsese's "Mean Streets," since it serves as a blueprint for so many new film makers eager to emulate Mr. Scorsese's fierce, boisterous brilliance. The mark of "Mean Streets" is all over "Amongst Friends," Rob Weiss's showy, energetic debut feature about (of course) boyhood buddies intoxicated by a life of crime.

Mr. Weiss, whose film was well received at this year's Sundance Film Festival, certainly has the right idea. And he also has geography on his side. "Amongst Friends" is helpfully situated "on the killer streets of Hewlett Harbor" and in other prosperous Long Island locations, places where the mob kingpins wear loud sweaters and the visual ironies are inescapable. The freshest thing about his film is its depiction of how bored, well-heeled boys from the Five Towns (the film maker's own home turf) have turned themselves into drug-dealing petty crooks. Thus transformed, they spar and jive with raucous authority and taunt one another in fluent, staccato Scorsese-ese.

•

The suburban setting, which naturally brings to mind Mr. Scorsese's "Goodfellas" as well, gives "Amongst Friends" a streak of lively incongruity even when its narrative is unsurprising. The central characters are far too familiar. Billy (Joseph Lindsey) is the blowhard, goading his friends into taking big risks and never forgetting to look out for No. 1. Trevor (Patrick McGaw) is sensitive and principled, which in this context makes him a saintly victim. Andy (Steve Parlavecchio) is the one who watches cautiously, hoping not to be too deeply embroiled in Billy's

Fine Line Features

Steve Parlavecchio

schemes. On the fringes of the story there is also Laura (Mira Sorvino), the nice girl who holds forth some promise of redemption and sounds like the voice of reason.

The film's dialogue is so motor-mouthed and so relentlessly profane that these characters don't always emerge sharply. Parts of "Amongst Friends" are overpowered by the principals' noisy posturing, which too often becomes their only real purpose. Mr. Weiss is more successful in introducing these people and setting them in motion than he is in allowing sharp, revealing details to emerge from the turmoil that surrounds them. When the film maker does underscore flamboyant touches, like two talkative, chubby hoods (Frank Medrano and Louis Lombardi) who favor gold chains and nylon warm-up suits, he can have a heavy hand.

"Amongst Friends" has particular affection for the grandfatherly gangster Jack Trattner (David Stepkin), who voices the story's ideas about how crime has changed over the last few generations. "When I was a kid, we stole because we had no money," says Jack, who is now a big-time bookie and the owner of a nightclub with zebra-patterned banquettes. But his tough-talking young protégés from places like Cedarhurst, Jack speculates, have probably never missed a meal.

The occasional dry wit of "Amongst Friends" is best demonstrated by Michael Artura, who plays Michael, Jack's main henchman. When Jack's club is robbed while Michael is overseeing the place, he makes a point of calmly warning the thieves that they're in trouble. While witnessing a violent argument, he complains: "Will you finish this? I gotta go home." Diffidence like that carries "Amongst Friends" away from its roots in Little Italy, and gives it a Long Island home.

•

"Amongst Friends" is rated R (under 17 requires accompanying parent or adult guardian). It includes incessant profanity and some violence.

1993 Jl 23, C10:6

Silent Möbius

Directed by Michitaka Kikuchi; written by Ms. Kikuchi and Kei Shigema, based on a story by Kia Asamiya; released by Streamline. This animated film is dubbed in English. Cinema Village, 22 East 12th Street, Greenwich Village. Running time: 50 minutes. This film is not rated.

Neo-Tokyo

Three short animated films.

LABYRINTH, written and directed by Rin Taro.

RUNNING MAN, written and directed by Yoshiaki Kawajiri.

THE ORDER TO STOP CONSTRUCTION, written and directed by Katsuhiro Otomo.

These films are dubbed in English. Running time: 50 minutes. Cinema Village, 22 East 12th Street, Greenwich Village. These films are not rated.

By STEPHEN HOLDEN

For those whose ideal movie is a sophisticated extension of Nintendo, the Japanese animated films "Silent Möbius" and "Neo-Tokyo" are the next best thing to diving into a video game and becoming part of the electronic landscape.

Michitaka Kikuchi's "Silent Möbius," the longer film in the program, which opens today at the Cinema Village, visualizes Tokyo in the year 2024 as an endless city of identical skyscrapers and permanent gridlock. An all-female police force patrols the streets, its main task the destruction of a nether world led by an "Alien"-esque devil called Lucifer Hawke. Lucifer, in the language of the film, can shift at will "from corporal to intangible states of being."

The film, which is based on popular comic books by Kia Asamiya, tells the complex and ultimately confusing story of a young woman with ties to Lucifer who is reluctantly awakened to supernatural powers she did not know she possessed. As in so many animated science-fiction films, the more mystical "Silent Möbius" becomes, the more it loses coherence and relies increasingly on visual effects to sustain interest.

•

With the exception of Katsuhiro Otomo's political satire "The Order to Stop Construction," the three shorter animated films collected under the title "Neo-Tokyo," are also more fun to look at than to analyze.

In "Construction," a nerdy corporate executive is delegated to shut down a vast development project in the Amazon jungle after a revolution has overthrown the country's Government. Arriving, he finds a city that suggests the Los Angeles of "Blade Runner" after a nuclear accident and an oblivious work force of robots that is breaking down from the strain of meeting impossible deadlines. Although marred by an abrupt ending, the film makes some nasty points about big business, corrupt government, overseas development, slave labor and corporate jargon, which the robots parrot.

Although not as quick-witted as "Construction," Yoshiaki Kawajiri's "Running Man" and Rin Taro's "Labyrinth" each has some striking images. "Running Man" portrays with a flashy panache the fiery demise of a 21st-century race-car driver who goes crazy behind the wheel of a vehicle to which he is cybernetically connected. "Labyrinth" is a futuristic "Through the Looking Glass," in which a little boy and his cat jump through a dresser mirror into a nightmarish world and end up in a surreal carnival called Le Nouveau Cirque.

1993 Jl 23, C12:6

Robin Hood
Men In Tights

Directed and produced by Mel Brooks; written by Mr. Brooks, Evan Chandler and J. David Shapiro, based on a story by Mr. Shapiro and Mr. Chandler; director of photography, Michael D. O'Shea; edited by Stephen E. Rivkin; music by Hummie Mann; production designer, Roy Forge Smith; released by 20th Century Fox. Running time: 104 minutes. This film is rated PG-13.

Robin Hood	Cary Elwes
Prince John	Richard Lewis
Sheriff of Rottingham	Roger Rees
Marian	Amy Yasbeck
Blinkin	Mark Blankfield
Ahchoo	Dave Chappelle
Asneeze	Isaac Hayes
Latrine	Tracey Ullman
King Richard	Patrick Stewart
Don Giovanni	Dom DeLuise
Rabbi Tuckman	Mel Brooks

By VINCENT CANBY

"Robin Hood: Men in Tights" is Mel Brooks's breezy sendup of every Robin Hood movie ever made, with subsidiary references to other movies, most of them made by Mr. Brooks. The new film's favorite target is Kevin Costner's politically correct "Robin Hood, Prince of Thieves," which championed not only the civil rights of serfs but also feminism, racial understanding and maybe even whales, though my memory is now hazy about that. The Costner film remains memorable mostly for the scenes in which the camera sometimes adopted the point of view of an arrow whizzing unerringly toward its mark.

The trajectory of "Men in Tights" is a good deal less certain. The movie takes a long time to get off the ground, and then it wobbles. It hits a couple of ecstatically funny high points, only to plummet into a bog of second-rate gags, emerging a long time later to engage the audience by the sheer, unstoppable force of the Brooks chutzpah.

Any review of "Men in Tights" must waffle in somewhat the same manner. Even in circumstances that are far from ideal, it's good to have Mr. Brooks back on screen as a director, a writer (in collaboration with Evan Chandler and J. David Shapiro) and an actor (if only in a small role). He shows up here as the itinerant Rabbi Tuckman, newly arrived in Sherwood Forest to purvey wine and to perform circumcisions (which never do catch on with Robin and his merry men).

The best thing about "Men in Tights" is its cast. Appearing as Robin is Cary Elwes, a young English actor who looks something like the athletic, unlined Errol Flynn but who behaves as if there were a seven-second time-lapse between the world and his brain. His Robin is earnest, stalwart, dashing and always a little bit slow.

Mr. Elwes swashbuckles with conviction. He's also good exclaiming the mad Brooks dialogue ("Stop that castle!") when Robin arrives home from the crusades to find Loxley Hall, his ancestral home, being carted away because of nonpayment of taxes. Amy Yasbeck, who plays Marian, is a perfect mate for this Robin. She's beautiful and sincere, though there's not much going on upstairs. On one giddy occasion in her bubble bath, she sings with the purity of Julie Andrews (with a voice supplied by Debbie James). If Marian sometimes appears distracted, it's probably because of the bulky chastity belt she wears with otherwise maidenly resignation.

Peter Sorel/20th Century Fox

Cary Elwes in Mel Brooks's "Robin Hood: Men in Tights."

Roger Rees, still best known here for his Tony Award-winning performance in the title role of Broadway's "Nicholas Nickleby," is extremely funny as the evil Sheriff of Rottingham, a character that seems to be based less on legend than on Alan Rickman's overripe performance as the Sheriff of Nottingham in the Costner production. Mr. Rees also has a fine foil in Richard Lewis, the television comic who appears as a

Friar Tuck has become Rabbi Tuckman. Get the picture?

seriously neurotic Prince John, a fellow who is afraid of absolutely everything.

The supporting cast includes Tracey Ullman as Latrine, Prince John's chief cook and soothsayer; Dave Chappelle as Ahchoo (son of Asneeze, played by Isaac Hayes), a Moorish exchange student studying in England, and Mark Blankfield as Blinken, Robin's blind servant, a role that could have been played to the lunatic hilt by Marty Feldman.

What's missing is the kind of densely packed comic screenplay that helped to make "Young Frankenstein" and "High Anxiety" two of the most delectable movie parodies of the last 20 years. "Men in Tights" has the manner of something that wasn't argued over long enough. A few good gags are supplemented by dozens of others that still need to be worked on or tossed out entirely. Occasional lines are delightfully dizzy, but they are random shots. There's no comic momentum.

•

Unlike the Costner film it is kidding, "Men in Tights" is enthusiastically revisionist in its social conscience. Bad-taste jokes about the disadvataged and minorities abound. Yet it's so frontally rude that only the terminally humorless might object. Toward the end of the movie, Robin's merry men sing the title song in which they assert their manliness, swearing that though they do wear tights, they're not sissies, at which point they go into a brief can-can. This is the humor of Princeton Triangle shows, Harvard Hasty Puddings and "Charley's Aunt."

The most damaging thing to be said about "Men in Tights" is that in spite of the references to "Prince of Thieves" and other comparatively recent films, it seems embedded in a movie world that's far more ancient. It's a shock when Mr. Brooks brings on Dom DeLuise to do his parody of Marlon Brando in his "Godfather" performance.

The director also has an unfortunate way of reminding us of his own earlier, better, much more riotous comedies. He even has a reprise of a beloved gag from "Young Frankenstein." It's perfectly acceptable in a comedy of this sort to be offensive, but it's something else to scrape the bottom of your own barrel in front of everybody. Adults may be watching.

•

"Robin Hood: Men in Tights" has been rated PG (parents strongly cautioned). It includes some vulgar language and sexual situations.

1993 Jl 28, C13:1

Guelwaar

Written and directed by Ousmane Sembène, (in Wolof and French, with English subtitles); director of photography, Dominique Gentil; edited by Marie-Aimée Debril; music by Baaba Maal; produced by Mr. Sembène and Jacques Perrin; released by New Yorker Films. At Lincoln Plaza Cinemas, Broadway at 63d Street. Running time: 115 minutes. This film has no rating.

Gora	Omar Seck
Nogoy Marie Thioune	Mame Ndoumbé Diop
Pierre Henri Thioune (Guelwaar)	
	Thierno Ndiaye
Barthélémy	Ndiawar Diop
Aloys	Moustapha Diop
Sophie	Marie-Augustine Diatta
Gor Mag	Samba Wane
Father Léon	Joseph Sane
Alfred	Coly Mbaye
Véronique	Isseu Niang

By JANET MASLIN

Ousmane Sembène, the esteemed and daring Senegalese film maker, occupies a remarkable position in the realm of African cinema. At 70, Mr. Sembène manages to be both founding father and young Turk, as he demonstrates in "Guelwaar," the seventh feature he has made during a pioneering 30-year career. This director has divided his energies between making films and writing fiction, and the scope of his work is especially clear in this beautifully observed human comedy. "Guelwaar," a visually spare film that mixes political assertiveness with rueful wisdom and generosity, presents Mr. Sembène at his considerable best.

The scale of "Guelwaar," which opens today at the Lincoln Plaza Cinemas, is deliberately microscopic, limited to the events surrounding a funeral in a tiny Senegalese village. The dead man is Pierre Thioune (Thierno Ndiaye), nicknamed "Guelwaar," or "Noble One," for his accomplishments as an outspoken community leader. As Pierre's Roman Catholic family gathers to bury him, it is discovered that his body has disappeared from the local morgue. At first this raises the possibility that the corpse has been stolen by fetishists, but the truth is even more troubling to the Thioune family: Pierre has been buried in a Muslim cemetery by mistake.

•

Using a narrative technique very like that of Spike Lee's "Do the Right Thing" (a film that is otherwise worlds away), Mr. Sembène magnifies this central episode through much community debate and discord.

Soon the burial mishap has come to crystallize deep-seated resentments between Christians and Muslims within the film's tiny frame of reference, and by extension within Senegal's larger population. "Guelwaar" also takes on the problems of colonialism and its legacy through Barthélémy (Ndiawar Diop), Pierre's son, who has been living abroad and likes to think of himself as a Frenchman. The film's linguistic switches between French and Wolof further underscore its sense of warring factions trapped on common ground.

The film maker lets these conflicts reveal themselves in leisurely fashion; "Guelwaar" begins simply, with a plot that truly thickens as the film moves along. Delving into the disappearance of Pierre's body, the story begins to find mischief or confusion at every turn, as when an undertaker defends himself a shade too heatedly against corpse-peddling charges. Even the tension between Muslim and Christian communities takes on an added element of intrigue when it is revealed that Pierre was once caught in a liaison with a married Muslim woman, an event that did nothing to endear him to his neighbors.

"Guelwaar" also incorporates flashbacks that present Pierre as a rousing public figure, making the kinds of audacious speeches that may have got him killed. He passionately renounces charity in general and foreign aid in particular, warning: "If you want to kill a man of great dignity, give him every day what he needs to live." Pierre so strongly opposes the idea of accepting charity that he has allowed his daughter Sophie (Marie-Augustine Diatta) to support the family by working as a prostitute, which is deeply troubling to his wife, Nogoy Marie (Mame Ndoumbé Diop). When the newly widowed Nogoy Marie addresses a soliloquy to her departed husband, she speaks with a wrenching mixture of resentment and love.

Using a mostly nonprofessional cast, shooting straightforwardly in the humblest of surroundings, Mr. Sembène nonetheless constructs a work of wry sophistication. The camera patiently observes all aspects of village life, from the way a young widow can petulantly read a fashion magazine while she is supposed to be in mourning to the ways in which ceremonious rural manners have been changed by modern life. (Village elders appear in traditional African garb and Western felt hats.) An extraordinary amount of time is spent sitting, visiting and waiting, yet the film manages to escalate even at such quiet moments. Using remarkably little violence or invective, Mr. Sembène still powerfully conveys the importance of what is at stake.

Aside from its quasi-humorous visits to the family of Meyssa Ciss, the dead Muslim man with whom Pierre has been confused, the film also incorporates a local policeman trying vainly to keep the peace, a corrupt Mayor who arrives insisting that his Mercedes be parked in the shade, a prostitute with no sense of how to dress for a funeral, and many other minor characters who contribute memorably to this story's surprising scope. In the end, "Guelwaar" offers a rich, vivid and universal portrait of a community that is revealed fully as it reacts to a crisis: a community that will be buried by the past if it cannot look to the future. There's a lesson here, and Mr. Sembène presents it with grace and ease.

1993 Jl 28, C18:1

'La Vie de Bohème' With a Finnish Lilt

"La Vie de Bohème" was shown as part of the 1992 New York Film Festival. Following are excerpts from Vincent Canby's review, which appeared in The New York Times on Oct. 9, 1992. The French-language film opens today at Film Forum 3, 209 West Houston Street, South Village.

From the look and manner of his films, Aki Kaurismaki would seem to be like the character in "Li'l Abner" who walks the earth shadowed by a small dark cloud. The cloud follows him with the fidelity of a severely depressed hound dog. It's almost affectionate. Yet the cloud isn't big enough to block out the sun completely, and life lived in the penumbra can sometimes be astonishingly rich.

Well, if not rich, then not so poor, though melancholy.

Such is the world of Mr. Kaurismaki's singular comedies, the latest being "La Vie de Bohème," the Finnish film maker's coolly funny, laid back, very free update of the same Henri Murger novel that inspired Puccini's opera "La Bohème." As Mr. Kaurismaki puts it in the production notes, the film is his way of rescuing Murger's work from the bourgeois fancies of the composer. In other words: à bas Puccini!

Mr. Kaurismaki carries with him a sense of foreboding that is forever at war with his natural exuberance. Though filmed in Paris, his "Vie de Bohème" takes place in a city that somehow looks like the forgotten fringes of Helsinki. No matter what the season is said to be in the movie, it always seems to be that time of year when winter is on the edge of spring but won't give way to it.

•

As he rediscovers the milieu of the Murger original, Mr. Kaurismaki reinvents the identities of the Murger characters, all of whom now appear to be approaching middle age. Rodolfo (Matti Pellonpaa), a dour, unsmiling man, is an obsessed Albanian artist living in Paris without the proper papers. Marcel (André Wilms) looks like a truck driver whose license has been revoked, possibly for D.W.I.

When first met, Marcel is having his 21-act play rejected because he refuses to cut even a semicolon. Also intensely committed to his art is the always scowling Schaunard (Kari Vaananen), a composer in the midst of creating something he calls "The Influence of Blue on Art." The women in their lives, the tubercular Mimi (Evelyne Didi) and the commonsensical Musette (Christine Murillo), exist solely in the dimly reflected light of the men they love.

•

In his "Leningrad Cowboys Go America," about the world's worst polka band and its disastrous road tour through the United States and Mexico, Mr. Kaurismaki couldn't help but tip his hand about the film's comic intentions: there's no way that a bunch of deadpan polka-band players will seem anything but funny.

The film maker is working with much more ambiguously comic material in "La Vie de Bohème," in which Rodolfo, Marcel and Schaunard often seem no less mad than the polka players, though their concerns are completely serious.

Mr. Kaurismaki has shot some of his films in color, but black and white suits the blunt temperament of "La Vie de Bohème." "Here is a fine, deceptively querulous comedy that mocks the conventions of art and romantic love while, at the same time, exalting them as the only means of salvation.

1993 Jl 29, C15:4

Rising Sun

Directed by Philip Kaufman; screenplay by Mr. Kaufman, Michael Crichton and Michael Backes, based on the novel by Mr. Crichton; director of photography, Michael Chapman; edited by Stephen A. Rotter and William S. Scharf; music by Toru Takemitsu; production designer, Dean Tavoularis; produced by Peter Kaufman; released by 20th Century Fox. Running time: 126 minutes. This film is rated R.

John Connor	Sean Connery
Web Smith	Wesley Snipes
Tom Graham	Harvey Keitel
Eddie Sakamura	Cary-Hiroyuki Tagawa
Bob Richmond	Kevin Anderson
Yoshida-san	Mako
Senator John Morton	Ray Wise
Jingo Asakuma	Tia Carrere
Cheryl Lynn Austin	Tatjana Patitz

By VINCENT CANBY

THE opening sequence of "Rising Sun," Philip Kaufman's glitzy adaptation of Michael Crichton's best-selling mystery novel, establishes the movie's tone, method and manner.

There is first a series of grainy, definitely not high-definition television images from a sing-along music video: shots of wide-open Western spaces and, at the bottom of the screen, looking like subtitles, the lyrics of "Don't Fence Me In." Someone sings along offscreen. Among other things, the singer wants land, lots of land, and a starry sky above.

The camera pulls back to reveal a youngish Japanese man standing in the middle of the floor in a third-rate nightclub. It's the end of a long night. With eyes closed and tie loosened, the man pours his drunken voice and heart into a hand mike. The place is almost deserted. A few other Japanese men sit around in various stages of stupor. At one table sits a very beautiful young American woman who is not enchanted by her date's performance. She wants to go home.

When the two do leave the club, arguing so furiously that the man threatens to beat up the woman, it is dawn but not in Osaka or Tokyo. It's somewhere on the edge of Los Angeles. It's not the Los Angeles that Americans know, but a Los Angeles that Mr. Crichton describes in his novel as "a shadow world," "a second world," a world occupied by faceless Japanese businessmen and their yakuza gangster associates. Much like the aliens in Mr. Kaufman's "Invasion of the Body Snatchers," these Japanese are trafficking in American souls, sometimes with their victims' complicity.

It's a good sequence that effectively introduces the somewhat remodeled, though no less xenophobic remains of Mr. Crichton's wake-up call to America. The novel proclaims its concerns proudly with a simple mind. The film, which Mr. Kaufman adapted with Mr. Crichton and Michael Backes, tries to sound the same alarm, but without giving offense.

It changes the identity of the killer. One of its two principal American characters (both of whom are now morally flawed) has become a black man rather than white, and one of its principal female characters is the product of the union of a black American soldier and a Japanese mother. The movie aims to be demographically balanced.

Yet the onscreen "Rising Sun" remains insufferably smug. It still offends. It directs attention not to the internal reasons for America's economic problems, but to inscrutable, generalized, unknown others from abroad, whose yellow skins and strange manners announce their evil purposes as much as their unfair trade practices.

In most other, superficial ways, "Rising Sun" is a rather slick piece of movie making. It stars Sean Connery at his most avuncular as a Los Angeles police detective, John Connor, an old Japan hand and a font of arcane wisdom. At the film's beginning, Connor is assigned to investigate the death of a high-priced American call girl, found on a boardroom table while a gala reception is in progress at the shiny, new, 53-story Nakamoto Building in Los Angeles.

The head of Nakamoto has himself asked that Connor be put on the case. The Japanese businessman doesn't want his reception terminated by a mere murder. The publicity could also be embarrassing because Nakamoto is in the midst of controversial negotiations to acquire yet another American company involved in space-age computer technology. Connor is regarded as some kind of sage.

In fact, as written and played, he is a pompous old windbag, though his new partner, Web Smith (Wesley Snipes), a police lieutenant, remains surprisingly polite as they drive to the murder scene. Connor is said to be a master of Japanese, but he speaks it much in the way that Miss Piggy ("Who? Moi?") speaks French. He's not quite as overstuffed with questionable observations as the character in the book, but those he comes up with are dillies.

●

Connor advises Smith to be modest in his body language. "The Japanese find big arm movements threatening," he says, not adding, as he might, that they have this in common with the mountain gorillas of Ruwanda. Connor has the makings of a rich character, that of a man fascinated by a culture he understands less and less the more he gets to know it. Yet that character remains unrealized, first in the book and now the movie, which lays more on Mr. Connery than he can make coherent.

The film's form is also unclear, though much of it is an extended flashback. It seems to be an after-the-fact police inquiry into the manner in which the murder investigation was conducted. Yet the film includes material that Smith, the officer who is giving testimony, would not know about. Though the point of the story is who killed the call girl Cheryl Austin (Tatjana Patitz), that's only the ex-

cuse for Mr. Crichton's and the film's larger concerns: American-Japanese trade relations and the unscrupulous practices that give the Japanese such an edge.

Americans invented robber barons in the 19th century but, from "Rising Sun," you might think that this country's economic successes were based entirely on hard work, pluck and willful stupidity. That's the way it looks in a scene in the film in which the Japanese are shown to be monitoring the private conversation of their American counterparts during high-level business negotiations.

As if to defuse all accusations of Japan-bashing and racism on its own part, the movie, like the book, has a character, Tom Graham (a police officer comically well played by Harvey Keitel), who gets to present the bigoted nut-case's view of things. When it's finally revealed that the call girl was killed by someone who liked to play sado-masochistic games, Graham says of the Japanese, "These guys are known world-class perversion freaks."

●

Yet the movie, which sends up Graham's excesses, also invites the audience into a kind of private brothel where beautiful American women are kept for the sole purpose of satisfying the unspeakable demands of their Japanese employers. The Japanese are not only stealing our trade secrets, they're also despoiling our women! Even Fu Manchu, Sax Rohmer's Chinese arch-fiend, was never quite so bold.

With all this peripheral nonsense going on, it's not always easy to follow the unraveling of the mystery, which centers on the careful decoding of the images on a videotape, shot by a hidden camera in the Japanese company's board room. In the interests of the plot, the film's audiences are put into the position of being world-class perversion freaks as, over and over again, they study the images of the woman as she entertains a succession of men.

Ms. Patitz doesn't get the opportunity to say much, but she's a very attractive victim. Mr. Snipes's performance is suitably cool and sometimes seriously funny. Prominent in the supporting cast are Kevin Anderson, as an American flunky for the Japanese; Cary-Hiroyuki Tagawa, as one of the few Japanese characters who, though hot-headed, generates sympathy; Ray Wise, as a soft-headed United States Senator, and Tia Carrere, who plays the woman of mixed Japanese-American blood.

The film's mysteriousness is not profound. Anybody who hasn't guessed the killer's identity after 30 minutes should be forced to watch

"Rising Sun" three times a day until Christmas. Or, as Connor says in a Zen-like mood at the end of the film, "The Japanese have a saying: if you sit by a river long enough, you'll see the body of your enemy float by."

O.K., so it doesn't make sense here, but then it doesn't make sense in the movie either. End of Zen.

●

"Rising Sun" has been rated R (Under 17 requires accompanying parent or adult guardian). The film has vulgar language and scenes of violence and various kinds of sexual relations.

1993 Jl 30, C1:4

So I Married an Axe Murderer

Directed by Thomas Schlamme; written by Robbie Fox; director of photography, Julio Macat; edited by Richard Halsey and Colleen Halsey; music by Bruce Broughton; production designer, John Graysmark; produced by Robert N. Fried, Cary Woods and Jana Sue Memel; released by Tri-Star Pictures. Running time: 110 minutes. This film is rated PG-13.

Charlie Mackenzie and Stuart Mackenzie	Mike Myers
Harriet Michaels	Nancy Travis
Tony Giardino	Anthony LaPaglia
Rose Michaels	Amanda Plummer
May Mackenzie	Brenda Fricker
Heed	Matt Doherty
Commandeered Car Driver	Charles Grodin
Park Ranger	Phil Hartman
Pilot	Steven Wright

By JANET MASLIN

The mountain climber's school of film making tells us that Mike Myers is now a movie star because he's there. Where he is, precisely, is at the spot where "Saturday Night Live" meets "Wayne's World," a locus that guarantees him the attention of younger audiences regardless of what he does or how funny it happens to be. It comes as a welcome surprise that "So I Married an Axe Murderer," which might have been nothing more than a by-the-numbers star vehicle, surrounds Mr. Myers with amusing cameos and gives him a chance to do more than just coast.

Peering out warily from beneath a boyish hair mass, Mr. Myers plays Charlie Mackenzie, whose two salient traits are wariness about women and strong ties with his Scottish heritage. The latter provides "So I Married an Axe Murderer" with its biggest comic bonanza, since Mr. Myers also appears as his own father, speaking in an unintelligible accent and sometimes wearing kilts. In his paternal role, Mr. Myers has a way of unexpectedly bursting into Rod Stewart songs as he presides over an equally weird family. The wonderful Brenda Fricker adds great spark to these scenes as Charlie's flirty, trivia-mad mother, even though this Oscar-winning Irish actress deserves better American film roles than she seems to be getting.

"So I Married an Axe Murderer," written by Robbie Fox and directed jauntily by Thomas Schlamme, also has fun with the San Francisco coffeehouse setting in which Charlie is first seen, as a neo-Beat poet bewailing his miserable love life. His romantic fortunes seem to improve when he meets Harriet Michaels (Nancy Travis), the beautiful butcher who sells him his haggis. (Mr. Schlamme treats this as the occasion

Tri-Star Pictures

Mike Myers

to concoct the kind of "meat cute" montage that could make anyone a vegetarian.)

But Harriet's past history dovetails a little too neatly with that of an infamous ax murderer whose exploits have been lovingly described in The Weekly World News, a publication Charlie's mum refers to devotedly as "the Paper." Naturally, Charlie begins to worry. The idea that Harriet might hack him to bits is a natural extension of his own misgivings. The film's slight but worthwhile bit of realism grows out of Charlie's fears.

In addition to Ms. Travis, who brings a warmly seductive presence to the film's one difficult role, "So I Married an Axe Murderer" also features Anthony LaPaglia as a loyal, very patient pal of Charlie's, and Amanda Plummer as Harriet's sister, in a role the film makers seem barely to have been given five minutes' thought. The film also includes a funny assortment of cameo performers, among them Steven Wright as an alarming pilot, Charles Grodin as an amusingly bad Samaritan and Phil Hartman as an Alcatraz tour guide ("My name is John Johnson, but everyone here calls me Vicki"). Alan Arkin has a delightful turn as a police captain who's a shy sort but doing his best to sound like something off a television show. Unlike the other cameos, Mr. Arkin's really is truly unbilled, which makes it a kind of cameo and a half.

The look of "So I Married an Axe Murderer" is crisply professional, and John Graysmark's production design provides an element of visual surprise. There are surprises on the soundtrack, too, with touches like a Bay City Rollers song to keep the audience wondering what might happen next.

●

"So I Married an Axe Murderer" is rated PG-13 (Parents strongly cautioned). It includes profanity, brief nudity and sexual situations.

1993 Jl 30, C3:1

Tom and Jerry
The Movie

Produced and directed by Phil Roman; screenplay by Dennis Marks; music by Henry Mancini; released by Miramax Films. Running time 80 minutes. This film is rated G.

Tom and Jerry

Miramax Films Release

Voices: Richard Kind, Dana Hill, Charlotte Rae, Tony Jay, Henry Gibson, Rip Taylor, Howard Morris, Michael Bell, Edmund Gilbert, David L. Lander and Anndi McAfee.

By VINCENT CANBY

Fifty-three years after they made their debut in the M-G-M short "Puss Gets the Boot," Hanna-Barbera's great cartoon characters, Tom, the raffish cat with the demonic grin, and Jerry, a mild-mannered, fast-thinking mouse, co-star in a feature-length musical, "Tom and Jerry: The Movie."

Unfortunately, Tom and Jerry here spend less time tormenting each other with golf clubs, mousetraps, mallets and other weapons than they do acting in concert to right the world's wrongs. The principal beneficiary of their good work: Robyn, a sweet but drab, yellow-haired girl mistreated by her wicked guardian, Aunt Figg, after her father, an explorer, is presumed dead in a Himalayan avalanche.

Though mayhem is their natural métier, Tom and Jerry are adaptable creatures. They not only talk (something they avoid doing in their short films, in which they communicate almost exclusively via lethal combat), but they also sing and dance. The score (music by Henry Mancini, lyrics by Leslie Bricusse) has a pleasantly old-fashioned feel to it, as does the attractive artwork in which a house is a house and a tree is a tree.

Among the supporting characters are Puggsy, a mutt, and Frank da Flea, the street characters who befriend Tom and Jerry after their house is knocked into kindling by a wrecker's ball. There are also a brazenly aggressive bunch of alley cats, who sing about the joys of being mean and dirty; a not so kindly fellow who kidnaps animals for ransom, and Captain Kiddie, a down-on-his-luck carnival man, and his parrot, a hand-puppet named Squawk.

The most entertaining villain is Aunt Figg. With a voice supplied by Charlotte Rae, she has the face and ample form of Florence Bates, the great M-G-M character actress who made her debut in "Rebecca," playing Joan Fontaine's employer. Also entertaining is Lickboot, Aunt Figg's lawyer, who recalls Vincent Price at his hammy rottenest.

Nearly everyone in the film has his or her own song. The best: "Friends to the End," sung by Tom and Jerry and their street pals, and "What Do We Care?," in which the alley cats celebrate anarchic slovenliness.

The film was written by Dennis Marks and produced and directed by Phil Roman. Joe Barbera, now 82, served as creative consultant. The movie might have used a lot more manic splats, kerplunks and booms, but, even on their good behavior, Tom and Jerry have charm.

1993 Jl 30, C10:6

Hold Me, Thrill Me, Kiss Me

Written and directed by Joel Hershman; director of photography, Kent Wakeford; edited by Kathryn Himoff; music by Gerald Gouriet; production designer, Dominic Wymark; produced by Travis Swords; released by Mad Dog Pictures. At the Village East, Second Avenue at 12th Street, East Village. Running time: 92 minutes. This film has no rating.

Dannie	Adrienne Shelly
Eli, Bud, Fritz	Max Parrish
Twinkle	Sean Young
Lucille	Diane Ladd
Sabra	Andrea Naschak
Laszlo	Bela Lehoczky
Olga	Ania Suli
Mr. Jones	Timothy Leary

By JANET MASLIN

Timothy Leary plays a small role in "Hold Me, Thrill Me, Kiss Me," contributing to the sneaking suspicion that the whole film is vaguely his fault. Without the kind of creative license that Mr. Leary's psychedelic studies helped foster, there might not have been either Paul Morrissey's or John Waters's outrageous brands of humor. Both those styles are strongly reflected in Joel Hershman's freewheeling, trash-filled debut feature.

According to production notes, Mr. Hershman came up with the idea for this film (which opens today at the Village East) "when the investors' wish to make sexually charged action films for the Korean video market proved too expensive." The solution: a campy, garish quickie shot in a trailer park with a cast of camera-loving grotesques. The possibilities for unpleasantness in such material are sizable, but Mr. Hershman does succeed in keeping them under control. It's a relief to note that Sean Young, dressed in spangles as a homicidal nut-case named Twinkle, is a lot more frantic than the rest of the tongue-in-cheek cast.

The plot of "Hold Me, Thrill Me, Kiss Me" involves bondage, theft and murder, none of which is taken any too seriously by the characters themselves. Events are set in motion when Eli (Max Parrish, a good-humored "surfer/model" with no previous film experience) commits a semi-accidental crime and takes refuge in the hot-pink trailer of Sabra, a foul-tempered stripper (Andrea Naschak, who appears in porn films under the name April Rayne). Sabra is one of the film's more colorful creations, since she lives on chocolate milk, spouts endless obscenities, hoards Barbie dolls and sex aids with equal enthusiasm, and wears skintight clothes with huge holes in them (because she cuts out the anti-theft tags before she shoplifts). "How come I never meet any *nice* girls?" asks Eli (who's also called Bud or Fritz), once he gets a look at Sabra's handcuff collection.

•

Conveniently on hand is Sabra's saintly sister, Dannie, played by Adrienne Shelly with a lot more verve and soulfulness than the material deserves. Ms. Shelly, who here suggests the baby-doll version of Rosanna Arquette, has emerged in films by Hal Hartley ("Trust," "The Unbelievable Truth") as a spirited and captivating actress capable of perfect deadpan delivery, and she has many occasions here to show off her timing. One of the more memorable episodes in "Hold Me, Thrill Me, Kiss Me" sends her and Mr. Parrish to a nice restaurant, where she does her best to have an elegant evening despite the fact that her hands are cuffed behind her back.

Also in "Hold Me, Thrill Me, Kiss Me" are Bela Lehoczky as a nonstop screamer who invokes the Rev. Dr. Martin Luther King Jr.'s "I have a dream" speech as he curses his mother (Ania Suli); Allan Warnick and Joseph Anthony Richards as amusing straight men to the film's over-the-top principals, and Diane Ladd in curlers as an element of local color. A major and, in this context, better-than-human role is played by Gus the dog, a handsome specimen with the spots of a Dalmatian and the shape of a Great Dane.

1993 Jl 30, C12:1

Tokyo Decadence

Written and directed by Ryu Murakami (in Japanese with English subtitles); director of photography, Tadashi Aoki; edited by Kazuki Katashima; music by Ryuichi Sakamoto; produced by Yoshitaka Suzuki, Tadanobu Hirao and Yosuke Nagata; released by Northern Arts Entertainment. At Cinema Village, 22 East 12th Street, Greenwich Village. Running time: 112 minutes. This film has no rating.

Ai	Miho Nikaido
Ishioka	Tenmei Kano
Fortuneteller	Yayoi Kusama
Saki	Sayoko Amano

By STEPHEN HOLDEN

It is sadly appropriate that the message of Ryu Murakami's film "Tokyo Decadence" should be voiced by a professional dominatrix. High on cocaine in her luxurious Tokyo apartment, Saki (Sayoko Amano), an experienced prostitute, explains to Ai (Miho Nikaido), a relative novice to the profession, the reason so many Japanese businessmen are masochists. They may have wealth, she asserts, but it is "wealth without pride."

The equation of sexual humiliation with a lack of self-respect is the grotesquely overstated premise that drives the movie, which Mr. Murakami adapted from his novel "Topaz." The film, which opens today at the Cinema Village, follows in graphic detail the professional assignations of Ai, a Tokyo call girl who works for an agency that specializes in sado-masochism.

As portrayed by Miss Nikaido, Ai is an attractive 22-year-old cipher who drifts into a life of prostitution for no apparent reason. Before entering the life, she consults a fortuneteller who informs her that she will come to no harm if she wears a topaz ring on her middle finger and puts two telephone books under her television set. Ai accepts this advice as gospel.

•

If "Tokyo Decadence" weren't such a grim film, it might be confused with soft-core pornography. Unrated by the Motion Picture Association of America, the movie has several extended sex scenes that are depicted in harrowing close-up. Ai's first professional date is with a bullying coke-snorting businessman who pays her to stand in front of the window of his hotel room and expose herself. Later, his wife joins them for some further humiliation.

Accompanied by another prostitute, she participates in an erotic strangling ritual with a babbling maniac who imitates Kermit the Frog while having a belt tightened around his neck. Another man wants to re-enact a rape in front of a slide of Mount Fuji. The film makes it clear that the clients are all wealthy businessmen whose erotic fantasies are related to the cruelty and cutthroat

Miho Nikaido

competitiveness of the workplace. Interspersed with the sexual sequences are shots of Tokyo skyscrapers bathed in an eerie blue light that makes the city seem divested of human warmth.

"Tokyo Decadence" is much better at evoking a creepy urban sophistication than at revealing character or telling a story. Two-thirds of the way through the film, it unaccountably switches gears and follows Ai as she tries to track down a married client with whom she fancies herself in love. Since the man hasn't appeared in the film, her quest has no dramatic weight.

Fortified by a drug that gives her hallucinations, Ai rushes around her neighborhood like a madwoman and eventually tries to enter his house by climbing a ladder to a second-story window. By this point, "Tokyo Decadence" has lost its bearings and become as blank and unfocused as its hapless leading character.

1993 Jl 30, C12:6

Where Are We?
Our Trip Through America

Produced and directed by Jeffrey Friedman and Robert Epstein; director of photography, Jean de Segonzac; edited by Ned Bastille. At the Joseph Papp Public Theater, 425 Lafayette Street, East Village. Running time: 75 minutes. This film has no rating.

By STEPHEN HOLDEN

One of the more colorful characters interviewed in "Where Are We? Our Trip Through America," Jeffrey Friedman and Robert Epstein's engrossing documentary tour of the nation's byways, is a Southern woman who tends a miniature replica of Elvis Presley's Graceland mansion on her front lawn. Standing next to her husband, who built the elaborate dollhouse, she carefully differentiates her feelings for Elvis ("I love Elvis") from those for her husband ("I'm in love with my husband"). At the thought that her husband, who has multiple sclerosis, will probably never get to see the real Graceland, she grows teary-eyed.

In the hands of other documentary film makers, the woman could easily have been patronized and made to seem slightly ridiculous. What distinguishes "Where Are We?" is the uniform sympathy extended to a broad range of Americans talking about their hopes, dreams and fears. Even the most eccentric and narrow-minded are given their say without editorial comment.

"Where Are We?," which opens today at the Joseph Papp Public Theater, chronicles an 18-day cross-country trip through the Southern and Southwestern United States that the film makers made two years ago. Along the way, they conducted dozens

of random interviews, most with rural middle- and working-class Americans. Without being pretentious about it, the 75-minute film, which was shot in video and transferred to 16 millimeter, takes the spiritual pulse of the country outside of its big cities.

Lending the project a slight edge of tension is the fact that the film makers, who appear only long enough to introduce themselves, are both gay men living in San Francisco. Neither Mr. Epstein, who directed the Academy Award-winning documentaries "The Times of Harvey Milk" and "Common Threads," nor Mr. Friedman (who co-directed "Common Threads") makes much of a fuss about it. But at the same time, their documentary doesn't shy away from homosexuality.

In the film's most fascinating segment, they interview a trio of marines, recently returned from the Persian Gulf war, who patronize a gay bar near Camp Lejeune in North Carolina. The place, which is officially off-limits to the military, is run by a part-time drag queen named Brandy, who leads her "boys" in a group sing-along of "United We Stand." In a spontaneous coming out, two of the marines, who have been photographed in shadow inside the bar, eventually allow themselves to be filmed in daylight.

"Where Are We?" has many moments in which, prompted by questions like "What is your biggest fear?," people come up with surprising, sometimes pithy responses. One of the most loquacious subjects is the cocky owner of a Las Vegas casino who dispenses his gambling philosophy ("Bet more when you're winning and less when you're losing"). Asked about their image of San Francisco, two teen-age boys in North Carolina unhesitatingly reply that it has "a sort of a faggish image." When asked his thoughts about California, an old man in a Mississippi barbershop ventures, "We appreciate people from different countries." In one of the film's more exuberant moments, the film makers attend a gospel celebration of Mother's Day at a black church.

If "Where Are We?" draws no sharp conclusions about Americans, it does imply that they divide roughly into two types. There are those, like the film makers themselves and several restless travelers they interview during a westward train ride, who gravitate toward the coastal cities. Then there are those who stay put. In general, the film suggests, those who have stayed put are reasonably happy with their lot.

1993 Jl 30, C14:1

FILM VIEW/Caryn James

Mel Brooks Vs. the Boyz N the Wood

"**S**PELLBOUND" IS ONE OF HITCHCOCK'S most deliciously melodramatic movies — the one in which Gregory Peck is the amnesiac director of a psychiatric rest home and Ingrid Bergman the doctor who cures him. But the last time I saw it, the sober film had acquired surprising moments of hilarity. When the heroine settled down to dinner with her fellow doctors, instead of Ingrid Bergman, Leo G. Carroll and Gregory Peck, all I could see was Cloris Leachman, Harvey Korman and Mel Brooks as the staff of the Psycho-Neurotic Institute for the Very Very Nervous. This was the effect of having watched Mr. Brooks's loving Hitchcock parody, "High Anxiety," a few weeks before. When a movie satire works, the original may never look the same again.

Over the years, no one has spoofed movies better than Mr. Brooks. "Blazing Saddles," "Young Frankenstein" and "High Anxiety," his 1970's classics, have spawned a mini-industry of imitators: the goofy "Airplane!" and "Naked Gun" series; the howlingly comic "Hot Shots!" and its current, lesser sequel, "Hot Shots! Part Deux"; the lame, optimistically titled "National Lampoon's Loaded Weapon 1," which came and went quickly last winter. The best Brooks movies have become so familiar, the clones so plentiful and the audience so jaded that his new film, "Robin Hood: Men in Tights," puts him in the odd position of competing with his own unmatched reputation.

"Men in Tights" is not as relentlessly clever and comic as his 70's films, but its funniest moments prove that Mr. Brooks has not lost his shrewd, nutty irreverence. (That will be a great relief to anyone who saw his last film, "Life

Stinks," a peculiar valentine to the homeless that appeared in 1991.) And, as some lesser movie parodies suggest, making this kind of humor work as well as it does in "Men in Tights" is tougher than it looks.

Like Mr. Brooks's earlier films, this one follows a simple but crucial rule: It plays off the conventions of a genre, not one specific film. "Blazing Saddles" takes on westerns; "High Anxiety" is a mishmash of Hitchcock moments; "Young Frankenstein" breaks the rule, but brilliantly.

The preview for "Robin Hood: Men in Tights," with a whizzing arrow that takes sharp corners as if it were negoti-

'Men in Tights' shows it's good to be the king of spoofs.

ating heavy traffic, was an early strike at "Robin Hood: Prince of Thieves" and *its* famous zooming-arrow trailer. But Mr. Brooks's Robin, played by Cary Elwes as a dashing hero with a pencil-thin mustache, owes less to Kevin Costner than to Errol Flynn, whose 1938 portrayal created the standard for all future Robin Hoods.

It's true that one of the new film's sharpest lines comes after Robin is asked why the English people should listen to him. "Because, unlike some other Robin Hoods, *I* can speak with an English accent," Mr. Elwes answers, without a trace of California in his voice. The line efficiently demolishes Mr. Costner, and the movie pretty much leaves him alone after that. "Prince of Thieves" isn't the target; the Robin Hood image and all those movies of swashbuckling romance are.

In fact, "Men in Tights" takes such a broad view of movie mockery that its most successful episode is not a Robin Hood parody at all but a savagely funny spoof of "The Godfather." When the evil Sheriff of Rottingham (Roger Rees) wants to take out a contract on Robin, he goes to Don Giovanni (Dom DeLuise). That "The Godfather" has nothing to do with the Robin Hood myth is part of the scene's lunatic charm. But as the darkly lit Don, Mr. DeLuise's character is perfectly in tune with the film's satiric approach. He imitates the generic Brando, dragging in references to "On the Waterfront" and "The Freshman" and offering an astute explanation for the famous Godfather mumble.

Of course, aiming at an easy, familiar target doesn't mean you'll hit it. The short-lived "Loaded Weapon 1" took on a series ripe for satire. But its flat script bludgeoned the "Lethal Weapon" movies and became a tiresome string of jokes about Emilio Estevez (as the Mel Gibson character) and his dog. In the first "Hot Shots!," Charlie Sheen's wonderfully deadpan approach as Topper Harley, the Tom Cruise-like pilot, obliterates "Top Gun" as a movie anyone can watch without laughing. But the liveliest humor in the spoof came from absurd touches that evoke common movie moments: Topper erotically feeding bits of food to his girlfriend (Valeria Golino) and escalating the seduction until he is frying bacon on her stomach.

"Hot Shots! Part Deux" is weaker because it relies on a plot borrowed from "Rambo," about rescuing American prisoners. The last thing a spoof needs is a plot to limit its throwaway moments. The out-of-nowhere "Lady and the Tramp" scene, in which Mr. Sheen nudges a meatball across his plate with his nose and offers it to Ms. Golino, is funnier than all the film's stale Saddam Hussein gibes.

In "Men in Tights," Mr. Brooks chooses his targets well and has the flair to carry off the genial attack. There are dumb-but-funny jokes: the giant Little John flailing in a inch of water and yelling, "Help! I'm drowning!" There are shrewd movie satires: The perfectly chosen "Malcolm X" moment spoofs the clip everyone has seen ("We didn't land on Plymouth Rock. Plymouth rock landed on us."), so even if you missed the movie you'll get the joke. And there is Mr. Brooks himself in the role that used to belong to Friar Tuck. After "Men in Tights," it will take a long time for that friar to be anyone except Rabbi Tuckman. ☐

1993 Ag 1, II:11:4

The Wedding Banquet

Directed by Ang Lee; screenplay (in English and Chinese, with English subtitles) by Mr. Lee, Neil Peng and James Schamus; director of photography, Jong Lin; edited by Tim Squyres; production designer, Steve Rosenzweig; music by Mader produced by Mr. Lee, Ted Hope and Mr. Schamus; released by Samuel Goldwyn Company. At Angelika Film Center, 18 West Houston Street, Greenwich Village, and Lincoln Plaza Cinemas, 63d and Broadway. Running time: 111 minutes. This film is rated R.

Wai Tung	Winston Chao
Wei Wei	May Chin
Simon	Mitchell Lichtenstein
Mr. Gao	Sihung Lung
Mrs. Gao	Ah-Leh Gua
Old Chen	Tien Pien

By STEPHEN HOLDEN

If the lavish bar mitzvah has become a familiar comic set piece in movies over the last two decades, Ang Lee's film "The Wedding Banquet" introduces its Asian-American counterpart in festive excess. The Chinese wedding banquet that gives his funny and poignant comedy of manners both its title and its most riotous moments is an opulent nuptial celebration that refuses to end.

In the movie's virtuosic banquet sequence, 300 wedding guests gorge themselves on a sumptuous feast that leaves many of them literally retching from overindulgence. The newlyweds are coerced into kissing ostentatiously and into drinking so many obligatory toasts that they are left reeling.

No sooner have they retired to their hotel room than their suite is overrun with boisterous wedding guests. Enforcing a prankish Chinese custom, the revelers refuse to leave until the exhausted couple, huddled under their bedclothes, have shed every last stitch of clothing.

The kicker to the celebration is that unbeknownst to almost everyone, the marriage is a sham. The bridegroom, Wai Tung (Winston Chao), is a gay real estate entrepreneur who lives with his lover, Simon (Mitchell Lichtenstein), in Greenwich Village. A naturalized American born in Taiwan, Wai Tung is marrying only to please his parents, a Taiwanese army general (Sihung Lung)

A marriage blurs distinctions of sex, race and customs.

and his proper wife (Ah-Leh Gua). To his chagrin, General and Mrs. Gao, who live for the day they will have a grandchild, insist on flying all the way from Taipei to New York City to meet the bride.

Wai Tung's fiancée, Wei Wei (May Chin), happens to be one of her husband's tenants. A painter and part-time waitress from the Chinese mainland, she is marrying him to obtain her green card. She also finds Wai Tung very attractive. And the wedding-night pranks played on the couple facilitate a pregnancy that adds layers of unwanted complication to a ruse dreamed up by Simon.

On one level, "The Wedding Banquet," which opens today at Angelika Film Center and the Lincoln Plaza Cinemas, is a contemporary bedroom farce in which lovers go to extravagant comic lengths to conceal the nature of their relationship. Simon is presented to the Gaos rather preposterously as their son's landlord and roommate. The lovers' apartment, divested of tell-tale gay accouterments and redecorated with Chinese artifacts, is transformed into an austere guest house for the parents' two-week stay.

The fakery even extends to meals. Night after night, Wei Wei, who can't even fry an egg, serves her future in-laws homemade dinners that are actually prepared by Simon. Adding to the confusion is an apparent language barrier. Since the Gaos speak only rudimentary English, the lovers and

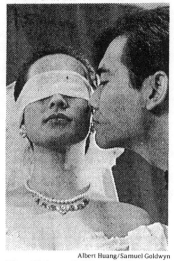

Albert Huang/Samuel Goldwyn

May Chin and Winston Chao star in a contemporary bedroom farce, "The Wedding Banquet."

Wei Wei feel free to squabble in front of them in English.

"The Wedding Banquet," which starts out as a sophisticated light comedy, gradually darkens as it goes along. What begins as a lark becomes an ordeal once the general runs into Old Chen (Tien Pien), a former army compatriot who now owns a successful New York restaurant. When Chen insists on giving the young couple an elaborate banquet, the wheels of social convention begin to bear down on them. Relations between the lovers become strained, and Wei Wei feels increasingly guilty about the weight of family tradition she is expected to bear.

After Wei Wei becomes pregnant, the screenplay, which Mr. Lee co-wrote with Neil Peng and James Schamus, could take any number of directions. Its resolution ultimately revolves around a mechanical plot contrivance. Although not very credible, it is emotionally generous in the way it leaves the five main characters wiser and more compassionate than they started out.

Considering that it cost only $750,000, "The Wedding Banquet," is a remarkably polished looking film. But its biggest strengths have little to do with production values. It is the unusual film comedy in which the humor springs as much from character as from situation. Wai Tung, whom Mr. Chao plays with a intense nervous drive, is a culturally divided soul. His American half is a dapper workaholic yuppie who spends hours a week working out at a gym. The other half — the one he tries to deny — is a puritanical Asian traditionalist with a strong sense of family loyalty. When these two selves are forced to coincide, Wai Tung is nearly torn apart by their conflicting demands.

Wei Wei, who is equally intriguing, embodies a different variation of the same conflict. The American side of her is freewheeling bohemian with a tough urban shell. But once she is caught up in the elaborate wedding preparations, she seems at once crushed and strangely fulfilled. Mr. Lichtenstein gives the role of Simon a quirky depth, allowing an edgy volatility to erupt unpleasantly through a veneer of strained bonhomie. The film's most touching character is the Gao family's indefatigably proper matriarch. As played by Miss Gua, she is finally a vulnerable soul whose

whole existence seems sadly if proudly tied to pursuit of social convention.

On a more metaphoric level, "The Wedding Banquet" has an ironic sense of history built into its plot. The marriage of Wai Tung and Wei Wei can also be taken as a symbolic reunion of mainland China and Taiwan. The fact that the future of the Gao family line depends upon this shaky marriage of convenience gives the film an extra dash of comic resonance.

1993 Ag 4, C18:1

Forbidden Love
The Unashamed Stories of Lesbian Lives

Written and directed by Aerlyn Weissman and Lynne Fernie; director of photography, Zoe Dirse; a National Film Board of Canada Studio D Production; distributed by Women Make Movies. At Film Forum 1, 209 West Houston Street, South Village. Running time: 85 minutes. This film has no rating.

Laura............................Stephanie Morgenstern
Mitch ..Lynne Adams

By JANET MASLIN

Whether they look like truckers or cowboys or sweet-faced grannies, the women seen in "Forbidden Love" have a shared sense of humor. How could they not? They grew up under the influence of pulp novels of the 1950's, books with titles like "Lesbians in Black Lace," "The Third Sex" and "Strange Are the Ways of Love." The covers of these potboilers are lingered over lovingly by the Canadian film makers Aerlyn Weissman and Lynne Fernie while their interviewees, a lively and well-chosen group, reminisce about first love.

All of them came to recognize their lesbianism in an atmosphere they recall as both oppressive and puzzling, since they garnered much of their information from reading hate-filled newspaper stories and amusingly cheap fiction. ("Society has an ugly word for these women: different!" screams a typical sentiment of the 1950's.) Some say that one of the hardest aspects of awakening to their sexual orientation was trying to guess what other lesbians looked like, or where they could be found.

So one interviewee in this colorful, anecdotal film describes a weekend field trip to Greenwich Village in search of the exaggerated butch and femme types she had read about so avidly, and not being able to spot a single one. Another talks of having no luck in finding other lesbians until a straight man jeered at her, naming a particular part of town and saying "You ought to go down there, 'cause that's where you belong." She remembers answering "Oh, thank you very much."

All the women interviewed in "Forbidden Love," which opens today at the Film Forum, have fond memories of the sly, flirty and bohemian aspects of their earlier days. Some also speak affectingly about their experiences with prejudice and violence. (In old newsreels of a police raid on a lesbian gathering, one officer is heard to mutter "I know what *you* need" to a woman he is arresting.) Even in discussing the more turbulent aspects of their history, though, most of these women retain their wry outlook.

One says that when straight couples appeared as sightseers at a lesbian bar, the regular patrons would making a point of following the

straight women to the bathroom in order to upset their male escorts. Another, describing the sometimes truculent encounters between masculine-looking lesbians fighting over demure, feminine types, recalls that "we always stood with our coats on and our backs to the door so we could get out in a hurry, if necessary." And a dainty, ladylike interviewee speaks of her angry husband, who is not about to accept his wife's new lifestyle. "He uses those kinds of words, like 'Satan's house' or 'pits of hell,'" she says matter-of-factly about her ex and his epithets.

In addition to putting together their chatty, nostalgic group portrait, the film makers also indulge themselves in a string of stylized seduction scenes between demure, blond Laura (Stephanie Morgenstern) and Mitch (Lynne Adams), an equally pretty brunette who sends Laura a crème de menthe as a come-on. Set up as a tiny serial, with each installment segueing into a pulp paperback cover illustration featuring Laura and Mitch, this fictionalized erotica isn't nearly as engaging as the real women who tell their real stories.

1993 Ag 4, C18:4

The Fugitive

Directed by Andrew Davis; screenplay by Jeb Stuart and David Twohy, based on characters created by Roy Huggins; director of photography, Michael Chapman; edited by Dennis Virkler and David Finfer; music by James Newton Howard; production designer, Dennis Washington; produced by Arnold Kopelson; released by Warner Brothers. Running time: 128 minutes. This film is rated PG-13.

Dr. Richard Kimble.................Harrison Ford
Sam Gerard.........................Tommy Lee Jones
Dr. Charles Nichols..................Jeroen Krabbe
Dr. Anne Eastman................Julianne Moore
Renfro.......................................Joe Pantoliano
Poole...............................L. Scott Caldwell
Helen Kimble..................................Sela Ward
Sykes...............................Andreas Katsulas
Biggs.....................................Daniel Roebuck
Newman.......................................Tom Wood

By JANET MASLIN

A LOT of us watched Dr. Richard Kimble catch his one-armed man in the final episode of "The Fugitive," the hit television series that lasted four years in the mid-1960's. And not many of us have given Dr. Kimble a moment's thought since then. So there was no reason to expect much from a feature-length "Fugitive," since it had the makings of one more present-day project with a desperately nostalgic ring. If Hollywood has taught us anything lately, it's that old television shows never die; they just get rehashed on a bigger, costlier scale.

Not this time, however. The film version of "The Fugitive" turns out to be a smashing success, a juggernaut of an action-adventure saga that owes nothing to the past. As directed sensationally by Andrew Davis and acted to steely perfection by Harrison Ford, Tommy Lee Jones and a flawless supporting cast, it is a film where every element conspires to sustain crisp intelligence and a relentless pace. Tight editing, a powerhouse score, adroit sound effects and a clever, inventive screenplay all contribute mightily to the fever pitch. To put it simply, this is a home run.

In appreciating "The Fugitive," it's worthwhile to mention what the film is missing. It has no gratuitous

bloodshed, no noxious posturing and no sadism. There are no schoolyard insults or four-letter witticisms, of the sort so often used when nothing better comes to the screenwriters' minds. There are no pop songs, bikini-clad extras or other cheap tricks to keep the audience occupied. The audience has enough to do simply keeping up with a cliché-free story told at breakneck pace. Creating both suspense and surprise, Mr. Davis makes sure his viewers almost never guess what will happen next.

Having previously made "The Package" and action films starring Chuck Norris ("Code of Silence") and Steven Seagal ("Above the Law"), Mr. Davis piqued increasing interest last year with "Under Siege," a film that craftily surrounded Mr. Seagal with humor, intrigue and a fine supporting cast. Mr. Jones, a sardonic delight as that film's villain, is this time much more interestingly matched as Deputy United States Marshal Gerard to Mr. Ford's Richard Kimble.

Both stars have toughness and restraint that make their characters' battle of wits truly hypnotic, and in many ways more credible than it was on television. One amazing aspect of this "Fugitive" is the ease with which it escalates to full intensity. Kimble's most extreme exploits, like his terrified leap into a dam's waterfall from a dizzying height, are made to seem perfectly reasonable, as is Gerard's insistence on pursuing him to the bitter end.

As it turns out, compressing four years of "The Fugitive" into two tight hours was a fine idea, giving the film a simple and effective plot. It begins with the murder of Kimble's wife (Sela Ward), who is seen briefly as a beautiful, sexy and ever-smiling mate. (Making the beloved dead woman look like a radiant fashion model, as in "Sleepless in Seattle," is one of this film's rare lapses into Hollywood stereotype.) Not being someone who wastes time, Mr. Davis swiftly intercuts Dr. Kimble's memories of that fateful night with his subsequent murder trial, including his brief glimpses identifying the killer as that one-armed man. Everything Kimble remembers will turn out to have some bearing later on.

The film essentially has two sections, the first of which is about Kimble's escape. Convicted of murder and en route to prison, he is caught up in an accident that will set a new

standard for stunt sequences, as Mr. Davis brings together a bus, a group of rebellious prisoners and an oncoming train. Mr. Jones, who makes a witty and riveting entrance as he arrives to investigate the aftermath of this crash, instantly assumes the role of Kimble's nemesis, and the chase is on.

In blocking out the various stages of this cat-and-mouse game, Mr. Davis and the screenwriters (Jeb Stuart and David Twohy) make a point of playing fair with the audience. When Kimble is trapped, say, in a tunnel that has been blocked off by cars and a helicopter, the film makes sure he finds a plausible, exciting way out.

Later on, "The Fugitive" sends Kimble back to his home turf in Chicago to try to find his wife's killer, and still the film has some tricks in store. Playing on Kimble's training as a doctor, the film stages some of its critical sequences in hospitals and even lets its hero surreptitiously save the life of one young patient.

•

If audiences didn't like Kimble already, they would surely love him for that, but Mr. Ford succeeds in making his character deeply sympathetic from the film's opening frames. This actor's wary intelligence is no surprise, but he projects it with particular grace in this spare, visceral story. Mr. Ford works furiously to turn his character's terror into something starkly physical. And he looks like a doctor, not like a movie star with a personal trainer.

Although Gerard (whom the word hard-boiled does not begin to describe) and Kimble are rarely in the same frame, the film links them forcefully by means of sharp editing and a determinedly narrow focus. Nobody dawdles, certainly not the supporting players who echo the principals' dry, terse delivery. Particularly memorable are Joe Pantoliano and L. Scott Caldwell as members of Gerard's investigative team ("Don't ever argue with the big dog," he warns these underlings); Jeroen Krabbe and Julianne Moore as fellow doctors, and Andreas Katsulas as the one-armed killer. It certainly is nice not to have to wait out four years' worth of red herrings to find out what he was up to.

"The Fugitive" is especially well served by James Newton Howard's hugely effective music and by its bold yet realistic special effects. Its technical elements are reliably first-rate, even when they momentarily appear otherwise. For instance, Michael

Chapman's shot of a green-looking river does not mean the fine camera work required any color adjustment. It means Kimble is headed for shenanigans in a St. Patrick's Day parade.

•

"The Fugitive" is rated PG-13 (Parents strongly cautioned). It includes minimal violence, mild gore (mostly in surgery sequences) and occasional profanity.

1993 Ag 6, C1:1

That Night

Written and directed by Craig Bolotin; screenplay based on the novel by Alice McDermott; director of photography, Bruce Surtees; edited by Priscilla Nedd-Friendly; music by David Newman; production designer, Maher Ahmad; produced by Arnon Milchan and Steven Reuther; released by Warner Brothers. Running time: 90 minutes. This film is rated PG-13.

Rick	C. Thomas Howell
Sheryl O'Conner	Juliette Lewis
Ann O'Conner	Helen Shaver
Alice Bloom	Eliza Dushku
Carol Bloom	J. Smith-Cameron
Larry Bloom	John Dossett

By JANET MASLIN

"That Night," Alice McDermott's haunting and elusive portrait of a Long Island suburb in the early 1960's, is a novel filtered through the viewpoint of a pre-adolescent girl. With hindsight, writing many years later, she narrates the story and reconstructs her first true glimpses of the adult world. As a child, she was fascinated by a daring, rebellious teen-ager named Sheryl, and by the way Sheryl's exploits brought their tiny community to the boiling point. Sheryl is seen and imagined from a great distance. The book contrasts its characters' private yearnings with their middle-class propriety, and it is full of secrets.

The film version of "That Night" has no secrets at all. With Juliette Lewis as Sheryl and Eliza Dushku as a precocious 10-year-old called Alice Bloom (the novel's narrator was nameless), it works awkwardly to dramatize all the feelings that Ms. McDermott carefully left unspoken. As written and directed by Craig Bolotin, the film invents an unconvincing friendship between Sheryl and Alice, makes Alice the third wheel in Sheryl's furtive love affair with Rick (C. Thomas Howell), and fleshes out any extra ambiguity with a blunt selection of pop songs on the soundtrack. When Alice says about Sheryl and Rick, for instance, "I wanted them to stay around forever," the song heard in the background is "Stay."

•

The film's change of focus is so complete that even that night, the one of the title, is different. In the book, it was the evening on which Rick and his friends invaded the neighborhood in search of Sheryl, who was pregnant and had been spirited out of town by her widowed mother. The neighborhood erupted in violence, and the lives of all its residents were subtly changed by the episode.

This fight is still seen in the film, but when Alice says "that night" she seems to mean the time she and Sheryl sneaked out to meet Rick under the boardwalk at a nearby beach resort. The spot was crowded with young lovers (even though at other points in the film, when Rick and

Warner Brothers

Juliette Lewis and C. Thomas Howell in "That Night."

Sheryl have their sexual trysts, it is conveniently deserted). That night Alice watched the teen-agers share a romantic evening, which was remarkably not dampened by her presence. And she herself danced tenderly with Rick (to the tune of "Try a Little Tenderness").

Like many of the events that have been added to the narrative by Mr. Bolotin, this one leaves little to the imagination. The film also concocts parallels between Sheryl's and Alice's sexual experiences (spin-the-bottle for Alice), recording-booth scenes in which they voice their innermost thoughts, and a moment when they simultaneously greet their fathers at a railroad station. The death of Sheryl's father is presented by Ms. McDermott as part of what sends her into a romance with Rick. But the film is so eager to dramatize this that it juxtaposes the events too closely, so that Sheryl unfortunately flirts with her boyfriend right after her father's funeral.

Ms. Lewis sounds at first like an inspired choice for this story's willful, daring heroine. But her slinky, demonstrative performance is way out of proportion to the tepid film built around it. This odd and captivating actress, with her unpredictable mannerisms and her lazy, flirtatious drawl, seems so much more assured than anyone else in the story that it becomes impossible to believe she could be thwarted by her mother (played by Helen Shaver). None of the parents seen in the film are remotely believable, even though Ms. McDermott's child's-eye description of these adults was one of the novel's most evocative aspects.

Mr. Howell does what he can with the role of Rick, playing him as a handsome, sensitive greaser. But Rick's troubled history has been virtually dropped from the film, which leaves him only one dimension. As for Alice, Ms. Dushku is appropriately wide-eyed and feisty, but she has an impossibly thin and sentimental role. No young actress should be asked to say, "But I learned things that summer I'd never forget."

•

"That Night" is rated PG-13 (Parents strongly cautioned). It includes mild profanity and sexual situations.

1993 Ag 6, C8:1

Being at Home With Claude

Directed by Jean Boudin; written by Johanne Boisvert, based on the play by René-Daniel DuBois (in French with English subtitles); director of photography, Thomas Vamos; edited by André Corriveau; music by Richard Grégoire; produced by Louise Gendron; released by Strand Releasing. At the Village

Arnold Kopleson

Tommy Lee Jones as Sam Gerard in "The Fugitive."

East Cinemas, Second Avenue and 12th Street, East Village. Running time: 84 minutes. This film has no rating.

Yves	Roy Dupuis
Inspector	Jacques Godin
Claude	Jean-François Pichette

BY STEPHEN HOLDEN

"Being at Home With Claude" is a film that goes to great lengths to pump cinematic frenzy into a story that originated as a long-winded stage drama of sexual obsession. Adapted from a play by René-Daniel DuBois, it follows the interrogation of Yves (Roy Dupuis), a 22-year-old male prostitute in Montreal, several days after he has murdered his lover on a steamy July night.

The inspector (Jacques Godin) who does the grilling specializes in dealing with hustlers. His interrogation, in the library of a judge who is one of the prostitute's clients, is a strident, often confusing cat-and-mouse game. Because Yves has already admitted to the homicide, the goal isn't to extract a confession but to reconstruct the events surrounding the crime and to determine the motive.

The film, which opens today at the Village East Cinemas, is an extended tease, padded with sinister flashbacks, in which Yves at first resists his interrogator and then gradually opens up his heart in agonized bursts.

•

Beginning with its snazzy opening sequence — a black-and-white montage in which snippets of the crime underscored with bloodcurdling cries are intercut with Montreal night scenes involving a jazz festival — the film strives for an atmosphere of high-toned menace. From here on, it veers back and forth between color (the interrogation scenes) and black-and-white (the flashbacks).

Yves emerges as a descendant of a Tennessee Williams character. A sexual outlaw who conducts his busy erotic life with a semi-religious fervor, Yves is painted as a beautiful and tragic angel of death. Claude (Jean-François Pichette), whom he kills during a transcendent sexual union, is a more ambiguous and shadowy figure. In flashbacks, the two are shown meeting in a public park and going to Claude's apartment. Because they come from opposite sides of the tracks, Yves suggests, a long-term relationship would have been impossible.

When Yves finally recalls the killing, what he describes is a spontaneous love-death in which the victim wordlessly and ecstatically acquiesced.

The film's few gripping moments all belong to Mr. Dupuis. Exuding a troubled rough-cut sweetness, his Yves comes close to embodying the fantasy of a hustler as an erotic holy man. There is little he can do, however, to redeem the screenplay's flood of pretentious, often unfathomable dialogue.

1993 Ag 6, C8:5

Colin Nutley's House of Angels

Directed by Colin Nutley; written by Susanne Falck (in Swedish with English subtitles); director of photography, Jens Fischer; edited by Perry Shaffer; music by Bjorn Isfalt; production designer, Ulla Herdin; produced by Lars Jonson; released by Sony Pictures Classics. At Cinema 2, Third Avenue and 60th Street, Manhattan. Running time: 119 minutes. This film has no rating.

Fanny	Helena Bergstrom
Zac	Rikard Wolff
Axel Flogfalt	Sven Wollter
Morten	Jakob Eklund
Erik Zander	Per Oscarsson
Rut Flogfalt	Viveka Seldahl

By JANET MASLIN

In a tiny Swedish village, a funeral is taking place. The dead man, Erik Zander (Per Oscarsson), was a bohemian sort who traveled on a bicycle and wore a beret, and he was knocked off his bicycle by the local minister, who was driving his car and listening to Abba at the time. "Erik is lucky with the weather, anyway," one of the pallbearers gamely says.

Erik was eccentric, and he was also a wealthy landowner, one whose estate is now much in demand. It is virtually within the grasp of Axel Flogfalt (Sven Wollter), a crafty but dense local farmer, when a strange young woman arrives at the funeral. Fashionable in black, she zips into town on a motorcycle, accompanied by a raffish male friend with an earring and an evil grin. Her identity remains a mystery until she reaches the cemetery, at which point she cries out, "It's a shame I never met you, Grandpa!" At this, several of Axel's relatives very nearly tumble into the grave.

"Colin Nutley's House of Angels," a whimsical and amusing Swedish comedy (apparently this is *not* an oxymoron), follows the further adventures of Fanny (Helena Bergstrom) once she takes over Erik's estate. One of last year's Oscar nominees for best foreign film and a big hit in Sweden, it features a light touch and a nice array of small-town eccentrics. The remote setting, which in spirit is somewhere between Mike Leigh's England and Aki Kaurismaki's Finland, yields all manner of furtive, suspicious local residents, who are systematically invited for tea by Fanny, the newcomer, and her companion, Zac (Rikard Wolff). The film, which opens today at Cinema 2, uses these encounters as a means of measuring the community's conventional values and Fanny's power to wreck the status quo.

•

As directed by an Englishman, Colin Nutley, this gentle, offbeat comedy (which takes its title from the name of Erik's farm) has an anecdotal style. It moves from encounter to encounter among the villagers, all of whom are affected by Fanny's arrival. All the men in town find her an exceptionally interesting new neighbor. She is also the talk of the ladies' sewing circle, where the minister provides piano entertainment in vain hopes of creating a cabaret atmosphere.

Even Fanny's orders at the grocery store are closely monitored, especially when she and Zac engage Axel's good-looking son, Morten (Jakob Eklund), to work on their house. Fanny serenely tells Morten that she has plenty of work for him. "There's surely things to fix in *my* room, too," adds Zac, with a merry little leer.

Eventually, Fanny scandalizes the local burghers and is denounced as a "foreigner" by a woman who says Fanny will introduce striptease, drugs and corsets into the community. ("I've seen it all on TV!" the accuser shrieks.) But Fanny's obvious good-heartedness has also won her many friends, especially among elderly gentlemen who have fond memories of her mother. Fanny's very real charm apparently runs in the family.

Ms. Bergstrom is as appealing as she's meant to be. And the film includes a number of sly, understated performances in small roles. Its scene-stealer is Mr. Wolff, who makes Zac both the story's most mischievous figure and also, somehow, its most touching. The viewer will never believe that either he or Fanny is a bad influence, not even when they strike a blow against small-town prejudice by bringing in a band of foreign cronies, stripping naked and singing "Auld Lang Syne."

1993 Ag 6, C10:6

My Boyfriend's Back

Directed by Bob Balaban; written by Dean Lorey; director of photography, Mac Ahlberg; edited by Michael Jablow; music by Harry Manfredini; production designer, Michael Hanan; produced by Sean S. Cunningham; released by Buena Vista Pictures. Running time: 80 minutes. This film is rated PG-13.

Johnny Dingle	Andrew Lowery
Missy McCloud	Traci Lind
Eddie	Danny Zorn
Mr. Dingle	Edward Herrmann
Mrs. Dingle	Mary Beth Hurt
Buck Van Patten	Matthew Fox
Chuck Bronski	Philip Hoffman
Dr. Bronson	Austin Pendleton
Maggie the Zombie Expert	
	Cloris Leachman

BY STEPHEN HOLDEN

If you crossed an Archie comic book with a teen-age zombie film and added a dash of "Carrie," plus smidgens of "Ghost" and "Defending Your Life," you might end up with a movie like "My Boyfriend's Back." The one-joke comedy is the whimsical autobiography of Johnny Dingle (Andrew Lowery), a teen-ager killed in a robbery who returns from the grave for the sole purpose of escorting his sweetheart, Missy McCloud (Traci Lind), to the prom.

It is only hours after his interment that Johnny pops up from the earth, arm first, clutching the single red rose Missy tossed onto his lowered coffin. Minutes later, he cheerfully shakes off the dirt and heads for home, where his parents (Edward Herrmann and Mary Beth Hurt) greet him as casually as if he had just stepped around the corner to pick up a quart of milk.

At school the next day, Johnny's classmates are repulsed by the bluish tinge of his complexion and start calling him names. Johnny's best friend, Eddie (Danny Zorn), freaks out when Johnny absent-mindedly tries to munch on one of his arms. Missy, however, is fiercely protective, and it isn't long before they are exchanging steamy kisses. Even when one of Johnny's ears falls off, it is no big deal. It is just glued back on.

Johnny's biggest problem is staying alive long enough to keep his prom date. From an eccentric local woman (Cloris Leachman) who is rumored to have lived with a zombie, he learns that consumption of human flesh is the key to survival. Johnny's ever-accommodating mom begins stocking the family refrigerator with

Garry Farr

Andrew Lowery

corpses and protecting him with a shotgun.

Finding nourishment is not the only obstacle Johnny faces. The class bully (Philip Hoffman) attacks him with a baseball bat, and the handsome class jock (Matthew Fox) is determined to be Missy's prom date. A mad doctor (Austin Pendleton) also wants to use Johnny's body parts to develop an eternal youth serum.

If "My Boyfriend's Back" is an irredeemably silly movie, it has an engaging lightness of tone and uniformly impeccable performances by a cast that maintains just the right attitude of deadpan parody. What are actors of the caliber of Mr. Herrmann, Ms. Hurt and Mr. Pendleton doing in a vehicle like this, you might ask? But watching them go through their paces under the expert direction of Bob Balaban, a superb actor in his own right, you have to admire their professionalism.

The movie has several ingenious touches. The story, narrated by Johnny in a gee-whiz "Leave It to Beaver" voice, prefaces many of its scenes with comic-book panels that turn into a live-action sequences. The blend serves as a continual and amusing reminder that the movie is essentially a comic book come to life. Dean Lorey's economical screenplay is all balloon dialogue laced with sexual double-entendres.

Without straining to make the point, the movie also comments on teen-age cruelty and prejudice. The epithets that Johnny's peers hurl at him have exactly same tone of stinging hatred as those spat at any youth who becomes an object of scorn simply for being different.

•

"My Boyfriend's Back" is rated PG-13 (Parents strongly cautioned). It has some strong language.

1993 Ag 6, C16:6

So her date is dead. At least he doesn't stand her up.

The Meteor Man

Written and directed by Robert Townsend; director of photography, John A. Alonzo; edited by Adam Bernardi; music by Cliff Eidelman; production designer, Toby Corbett; produced by Loretha C. Jones; released by Metro-Goldwyn-Mayer. Running time: 100 minutes. This film is rated PG.

Jefferson Reed	Robert Townsend
Mrs. Reed	Marla Gibbs
Michael	Eddie Griffin
Mr. Reed	Robert Guillaume
Mr. Moses	James Earl Jones
Simon	Roy Fegan

Robert Townsend, the star of "The Meteor Man," also wrote and directed the comedy, which offers an inner-city answer to Superman.

Mrs. Harris.............................Cynthia Belgrave
Mrs. WalkerMarilyn Coleman
Goldilocks..Don Cheadle
Marvin...Bill Cosby

By STEPHEN HOLDEN

Robert Townsend's film "The Meteor Man" doesn't lack nerve. The low-budget adventure comedy, which Mr. Townsend wrote and directed and in which he plays the title role, wants to establish an inner-city answer to Superman.

In Mr. Townsend's variation, which is aimed specifically at inner-city children, the Clark Kent character is a mild-mannered Washington schoolteacher named Jefferson Reed, who advises his students to run from a fight. His alter ego is somewhat feistier. Wearing an outfit sewn by his mother — a green cape and silver armor stenciled with the initials M M — he disarms the Crips and the Bloods, destroys crack houses, and with a wave of his hand transforms a vacant lot into a flourishing vegetable garden.

•

With all his magical powers, Meteor Man has his limitations. He is so terrified of heights that when he starts flying around Washington, he hugs the ground. Although blessed with the ability to retain every detail of any piece of literature he touches, that ability lasts only 30 seconds after contact.

Even more worrisome is that to keep his powers, Meteor Man needs periodic recharging from the glowing green hunk of meteor that strikes him at the beginning of the story. Those powers include X-ray vision, telekinesis and invulnerability to bullets.

The bad guys in the film are the Golden Lords, a preposterous band of drug-dealing thugs with bleached blond hair who are so powerful that they have developed junior and baby divisions.

•

Mr. Townsend's 1987 film "Hollywood Shuffle" displayed a well-developed talent for satire, flashes of which also illuminated his more serious 1991 movie, called "The Five Heartbeats," about a Motown-style vocal group. "The Meteor Man," which opened yesterday, puts that promise on hold. The movie collapses on its own confusing and contradictory impulses. On the one hand, it would like to create a valid superhero for black children. On the other, it is much more concerned with sending up the superhero genre. And the heroics and spoofing thoroughly undercut each other.

With virtually no plot to speak of, the film is a series of disconnected comic-book adventures with little visceral charge, played mostly for laughs but lacking wit. The acting, by an all-star multigenerational cast that ranges from Bill Cosby and James Earl Jones to the pop and rap groups Another Bad Creation, Naughty by Nature and Cypress Hill, has no consistency of tone.

Mr. Jones is reduced to desperate mugging in a series of grotesque wigs, while the pop singer Luther Vandross in a cameo role as a hit man is a complete blank. In the title role, Mr. Townsend seems vaguely bemused. Neither charismatic nor funny and lacking distinguishing characteristics, he floats through the film, a benign cipher.

Although the efficiency with which Meteor Man disarms opposing forces seems to put the movie firmly against the possession of firearms, its memory is so short that by the end that position has been compromised. It is not reassuring that in the final scene the Crips and Bloods, who have supposedly surrendered their guns and joined forces, appear on the rooftops armed to the teeth to drive the Golden Lords out of the neighborhood.

•

"Meteor Man" is rated PG (Parental guidance suggested). It has scenes of violence.

1993 Ag 7, 9:3

Searching for Bobby Fischer

Directed and screenplay by Steven Zaillian; director of photography, Conrad L. Hall; edited by Wayne Wahrman; music by James Horner; production designer, David Gropman; produced by Scott Rudin and William Horberg; released by Paramount Pictures. Running time: 110 minutes. This film is rated PG.

Josh Waitzkin...........................Max Pomeranc
Fred Waitzkin.............................Joe Mantegna
Bonnie Waitzkin.............................Joan Allen
Bruce Pandolfini.........................Ben Kingsley
VinnieLaurence Fishburne
Jonathan PoeMichael Nirenberg
Poe's Teacher........................Robert Stephens
Kalev ...David Paymer
Morgan...Hal Scardino
Russian Park Player...................Vasek Simek
Tunafish Father...................William H. Macy

By JANET MASLIN

"Searching for Bobby Fischer" isn't about Mr. Fischer, but it's well named. The film tells the story of Josh Waitzkin, a gifted young chess player growing up in the shadow of the legendary boy wonder, the one whose name is still mentioned in awestruck tones. Yet Mr. Fischer, who is seen here in old news clips as a boy playing against rows of different grown-up opponents and otherwise dazzling the chess establishment, is as well remembered for arrogance and eccentricity as he is for brilliance. Hovering over this absorbing story, the image of Mr. Fischer embodies genius as a double-edged sword.

The price of being a prodigy is very much at the heart of "Searching for Bobby Fischer," which is adapted from the book by Fred Waitzkin about his son's experience. As written and directed thoughtfully by Steven Zaillian (whose other, much broader screenplays include "Awakenings" and "Jack the Bear"), the film seems to worry about the very talents it also celebrates. This separates it valuably from the standard-issue success story it occasionally approaches.

The well-invoked world of chess has a similarly bracing effect. Mr. Zaillian's single smartest move has been to cast Max Pomeranc, an 8-year-old who is himself among the 100 top-ranked American chess players in his age group, as the story's young hero. This young actor has no trouble conveying the intense concentration that goes with playing the game, along with the slightly distracted air that accompanies anything else. Aside from giving a performance that is touching and credible in its own right, Mr. Pomeranc beautifully communicates the quiet enthusiasm of a true chess devotee.

•

As the makers of "Searching for Bobby Fischer" surely know, a movie aimed at the mass audience had better have more than clever chess moves working in its favor. So even though this film may do for chess what "The Red Shoes" did for ballet, it works movingly and most effectively as a family drama. The story's principal tension arises from relations between Josh and his devoted, somewhat overbearing father, Fred (Joe Mantegna), as Fred begins to understand the extent of his son's abilities. The film establishes Josh's gifts in a lovely sequence that shows him casually making chess moves from all over the apartment — even calling out instructions from the bathtub — while his father sits, dumbstruck, at the chess board.

Josh's sturdy mother (played with affecting gravity by Joan Allen) understands better than her husband does that Josh's brilliance may also be a burden. She makes Fred see that when Josh initially loses a game to his father, it's only because the boy is afraid to win. And she understands Josh's attraction to the "blitz chess" games played in Washington Square Park, by a lively mix of street hustlers and chess eccentrics, where the action is dominated by fast-talking Vinnie (Laurence Fishburne). Both of Josh's parents are caught between two schools of chess-playing when Josh also becomes a student of Bruce Pandolfini (Ben Kingsley), a teacher who claims to remember every game Bobby Fischer ever played. The real Mr. Pandolfini was one of the film's technical advisers.

As it follows Josh from brilliant dabbling into the cutthroat world of competitive chess, "Searching for Bobby Fischer" hints tantalizingly at the contrasts this boy discovers. There is the difference between the avid young players and their much pushier parents; in one scene, the children cheer after their parents are forcibly kept away from them during a tournament. And there is the schism between Vinnie, who trades on speed and instinct, and Bruce, who seems to take an elitist and somewhat mystical view of the game. Bruce even counsels Josh about the importance of having disdain for his opponents, though the boy does come by such thinking naturally. "Bobby Fischer held the world in contempt!" Bruce declares. "I'm not him," Josh insists. "You're telling me!" the teacher says scathingly to his young pupil

•

"Searching for Bobby Fischer" never delves deeper than that, and perhaps it doesn't have to. Nor does it focus strongly on what chess is like for competitive players without Josh Waitzkin's skill and good fortune (at 16, he is now the highest-ranked American player under 18). The strains inherent in Josh's story come through tacitly as Mr. Zaillian concentrates more openly on the triumph. Though Josh falters, worries and even faces disappointing his father in the course of the story, he also reaches a pinnacle of Zen chess warfare during the film's excitingly staged tournament scenes. "You've lost," he tells one young rival calmly during a match. "You just don't know it."

"Searching for Bobby Fischer" will be as lively and accessible to the chess-impaired viewers as it will to those who, like Bruce Pandolfini or for that matter Bobby Fischer, can look at a chess board and see events that are many moves away. In addition to its love for its subject, the film also displays believable New York City ambiance and interesting glimpses of various chess-related settings. (Conrad L. Hall's cinematography has warmth and clarity, and the detailed, excellent production design is by David Gropman, who did "Mr. and Mrs. Bridge.")

The Fischer name is specifically invoked at various points in the story, in a manner that is both exuberant and somehow chilling. "I want back what Bobby Fischer took with him when he disappeared!" Bruce Pandolfini says passionately in one scene. What Bobby Fischer took away, dashing the hopes and the innocence of his acolytes when he spurned chess, may never truly be recaptured. But some of it has found its way to the screen.

•

"Searching for Bobby Fischer" is rated PG (Parental guidance sug-

gested.) It includes mild profanity, but is otherwise well suited to young viewers.

1993 Ag 11, C13:3

The Secret Garden

Directed by Agnieszka Holland; screenplay by Caroline Thompson, based on the book by Frances Hodgson Burnett; director of photography, Roger Deakins; edited by Isabelle Lorente; music by Zbigniew Preisner; production designer, Stuart Craig; produced by Fred Fuchs, Fred Roos and Tom Luddy; released by Warner Brothers. Running time: 103 minutes. This film is rated G.

Mary Lennox	Kate Maberly
Colin Craven	Heydon Prowse
Dickon	Andrew Knott
Mrs. Medlock	Maggie Smith
Lord Craven	John Lynch
Martha	Laura Crossley
Mary's Mother and Aunt	Irène Jacob

By JANET MASLIN

A fawn, a bunny, a lamb: these are among the last things anyone might expect to see in a film directed by Agnieszka Holland, whose other work (including "Europa, Europa" and "Olivier, Olivier") had not a trace of sugarplums in its makeup. Yet Ms. Holland's film of "The Secret Garden" is elegantly expressive, a discreet and lovely rendering of the children's classic by Frances Hodgson Burnett. That book is a paean to the restorative powers of the natural world, and Ms. Holland succeeds in conveying much of its delicate beauty.

For all its raining rose petals and time-lapse shots of springtime, this "Secret Garden" remains in some ways relatively austere. It has been made without the preciousness that is this story's greatest liability, and with a lush visual prettiness that could not have been captured onstage (where "The Secret Garden" was the basis for a successful 1991 musical). Aside from simply telling this story, Ms. Holland (and the screenwriter Caroline Thompson, who wrote "Edward Scissorhands") also strengthen some of its underpinnings. The director's touch is most noticeable in scenes setting forth the trauma and the unhappiness from which Mary Lennox, the 10-year-old heroine of "The Secret Garden," must gradually recover.

In a striking and mysterious opening sequence, Mary is seen as a child in India, standing by solemnly while her servants dress her. As played by Kate Maberly, she is at first spoiled and unpleasant, though by no means the sallow and homely creature Burnett described. Mary's life of privilege and her parents' neglect leave her wholly unprepared for her destiny, which takes her to England after her parents die suddenly (of cholera in the novel, and in a far more photogenic earthquake in the film). To Mary's surprise, the servants in her uncle's manor house expect her to dress herself, and to entertain herself as well.

Ms. Holland's "Secret Garden," being the kind of film in which a kitchen maid sings "Greensleeves" while rolling dough, is not blunt in presenting many of life's little difficulties. So it offers a charming depiction of Martha (Laura Crossley), the smiling Yorkshire servant girl who manages to become Mary's friend, without dwelling too long on those contrasts between the two girls' lives that Burnett described. (Mary lives in a 100-room house, while 14 members of Martha's family share a cottage and live on 16 shillings a week.) Signs of Mary's unhappiness, like a quick, wrenching nightmare that shows a child being abandoned in a garden by her mother, are easily outweighed by the grandeur of her new surroundings.

Even as it displays a fine appreciation of the decorative arts, the film manages to remain carefully ambiguous. It can be seen reveling in a subtly rarefied atmosphere, but it can be seen as celebrating nature as a force for freedom. This much is certain: once Mary falls in love with the outdoors and discovers the garden of the title, the place develops the kind of tangled, profusely exploding greenery that cannot be achieved without the help of a good-sized staff. Magically, Mary tends the place alone all day and never returns home caked in telltale mud.

The sun comes out midway through "The Secret Garden," once Mary begins spending time with ruddy-cheeked Dickon (Andrew Knott), the lad who is Martha's brother and a great friend to flora and fauna. Under the influence of Dickon, and of mysterious powers that Ms. Holland renders as rushing clouds and swirling leaves, Mary begins to blossom just as surely as the bulbs send up shoots. Photographed luxuriantly by Roger Deakins, the film's abundant floral imagery eventually eradicates the stately gloom of its early scenes.

●

The flowers and creatures don't precisely speak for themselves, but they seem more alive than some of the adults in the story. Mary's uncle, Lord Craven (John Lynch), has the stylish look of a gentleman buccaneer; he does have a hunchback, as the character in the novel did, but it's nothing that would keep him out of a Ralph Lauren ad. Irène Jacob, appearing fleetingly as both Mary's mother and her aunt, serves an equally ornamental function. Fortunately, Maggie Smith is on hand as the story's prim, supercilious housekeeper, Mrs. Medlock, and her superbly measured performance gives the film a welcome tartness at times. When Mary's presence begins to have a medicinal effect on Colin Craven (Heydon Prowse), the girl's sickly 10-year-old cousin, Mrs. Medlock is more disturbed by the disruption than pleased by its results.

"The Secret Garden" benefits greatly from Zbigniew Preisner's subtle and imaginative music, from Stuart Craig's extravagant production design, and from costumes by Marit Allen that make the characters look exactly as Burnett's readers may have imagined them. A closing disclaimer stating that these characters are fictitious is about as needless as a disclaimer can be.

1993 Ag 13, C3:1

Especially on Sunday

Directed by Giuseppe Tornatore, Giuseppe Bertolucci and Marco Tullio Giordana; written by Tonino Guerra (in Italian with English subtitles); music by Ennio Morricone; produced by Amedeo Pagani, Giovanna Romagnoli and Mario Orfini; released by Miramax Films. Running time: 86 minutes. This film is rated R.

Amleto	Phillipe Noiret
Vittorio	Bruno Ganz
Anna	Ornella Muti
Marco	Andrea Prodan
Booth Girl	Nicoletta Braschi
Caterina	Maria Maddalena Fellini
Bride	Chiara Caselli
Husband	Bruno Berdoni
Don Vincenzo	Ivano Marescotti

By STEPHEN HOLDEN

Canines have always been notorious scene-stealers in movies. And in "Especially on Sunday," a trilogy of vignettes conceived by the revered Italian screenwriter Tonino Guerra, a slightly corny fable about a stray dog that attaches himself to a reluctant widower nearly walks off with the film.

Each of the stories, which are all set in the vicinity of the Marecchia River Valley in north-central Italy, is assigned to a different young director. But because they share the same screenwriter and the same ruggedly beautiful landscape, they flow into one another almost as though they were the work of a single hand.

The opening episode, "The Blue Dog," was directed by Giuseppe Tornatore, whose film "Cinema Paradiso" established his reputation as a jovial storyteller with a crowd-pleasing streak of sentimentality. Here, Phillipe Noiret, who played the kindly old projectionist in that film, portrays Amleto, a gnarly barber and shoemaker to whom a dog with a phosphorescent blue spot on its head attaches itself with a stubborn devotion.

By day, the creature stands outside Amleto's shop and regards him with the beseeching gaze of a wide-eyed orphan pleading to be adopted. By night, it parks itself under his window and barks piteously, waking up the neighbors, who urge Amleto, a self-proclaimed dog-hater, to take it in. Eventually an irate neighbor shoots the animal in the leg, and it hobbles off, whining in agony.

No sooner has it disappeared, however, than Amleto begins missing its nighttime visits. His longing becomes so acute that he begins hallucinating its presence in the streets. A frantic search leads him to a mountain pasture, where the story reaches a supernatural ending with a comic twist.

●

The two remaining chapters of "Especially on Sunday" are more sophisticated evocations of love, longing and loss. In the title episode, directed by Giuseppe Bertolucci, Vittorio (Bruno Ganz), a middle-aged roué traveling through the countryside, happens upon a strange young couple, Marco (Andrew Prodan) and Anna (Ornella Muti), tossing a Frisbee by a riverbank.

Instantly smitten with Anna, and discovering that she has never slept with Marco, Vittorio takes the couple to his home, where his every attempt at seduction is interrupted at the very last second by the younger man.

Mr. Guerra's story incorporates the same kinds of symbolism that ran through his classic screenplays for Michelangelo Antonioni's early 1960's films. Marco, who may or may not be sexually impotent, reveals himself as an iron sculptor unable to pursue his art for lack of a partner familiar with

Warner Brothers

Celebrating nature as a force for freedom: Kate Maberly, Heydon Prowse, seated, and Andrew Knott.

the old tradition. Vittorio treats the couple to an impromptu slide show of women surreptitiously photographed in the bathroom. In his final attempt to connect with Anna, he leaves his house to telephone her and is accosted in the rain by a mysterious woman who shares his mixture of frustration and feverish desire.

As in the Antonioni films, the symbolism suggests a world in which modern technology has short-circuited erotic connections by overheating the sexual climate. The moody vignette, in which Ms. Muti smolders as Anna, is accompanied by one of Ennio Morricone's most romantic scores.

•

The trilogy achieves an elegiac symmetry with the final tale, "Snow on Fire," a brooding meditation on aging and desire, directed by Marco Tullio Giordana. Whispered to the same priest who is a minor character in "The Blue Dog," it is the shamed confession of a widow whose son and his new bride have come to live with her after their wedding. Hearing the sounds of their lovemaking night after night from the floor below rekindles old desires that compel her to remove a brick from the floor of her room and observe their passion. After her daughter-in-law catches her spying, the nightly observation becomes a secret ritual and an unspoken gift of love exchanged by the two women.

As the bride, Chiara Caselli, who played Keanu Reeves's Italian wife in "My Own Private Idaho," radiates the same paradoxical mixture of porcelain and steel. Maria Maddalena Fellini, the sister of Federico Fellini, makes an impressive acting debut as the older woman.

Like small but lovely poetic variations on a theme, the pieces of "Especially on Sunday," in bumping against one another, give off a gentle, satisfying resonance.

•

"Especially on Sunday" is rated R (Under 17 requires accompanying parent or adult guardian.) It includes scenes of nudity and sexual situations.

1993 Ag 13, C14:5

Heart and Souls

Directed by Ron Underwood; screenplay by Brent Maddock, S. S. Wilson, Gregory Hansen and Erik Hansen; director of photography, Michael Watkins; edited by O. Nicholas Brown; music by Marc Shaiman; production designer, John Muto; produced by Nancy Roberts and Sean Daniel; released by Universal Pictures. Running time: 104 minutes. This film is rated PG-13.

Thomas Reilly	Robert Downey Jr.
Harrison Winslow	Charles Grodin
Penny Washington	Alfre Woodard
Julia	Kyra Sedgwick
Milo Peck	Tom Sizemore
Hal the Bus Driver	David Paymer
Anne	Elisabeth Shue
Frank Reilly	Bill Calvert
B. B. King	Himself

By JANET MASLIN

"Heart and Souls," a whimsical film that could raise the dead for the wrong reasons, has the cute idea of bringing together four bus passengers and a pregnant woman for a fatal crash. The souls of the dead enter into the body of the woman's newborn baby, paving the way for all manner of supernatural high jinks. Whoever thought this premise was a good idea also thought it would be

fun to have each dead person use the baby, once he grows up to be a yuppie named Thomas Reilly (Robert Downey Jr.), as a vehicle for settling one unresolved problem apiece. When the film announces, halfway through, that it will be devoting the rest of its running time to tying up these loose ends, the audience may as well give up the ghost.

•

"Heart and Souls" was directed by Ron Underwood (whose luck was infinitely better with "City Slickers") and written by four writers, though one would have been more than enough. It is presented in a bouncy sitcom style that veers into heavy sentiment every 15 minutes or so. Only one or two of the film's events register at all on the weep-o-meter, though a slushy score by Marc Shaiman seems to mistake this for the warmest, most wonderful movie ever made.

The dead cutups are Charles Grodin as a shy loner who yearns to sing, Kyra Sedgwick as a waitress who has just turned down her sweetheart's marriage proposal, Alfre Woodard as a loving mother who has just bid goodbye to her three children, and Tom Sizemore as a jovial greaser who has foolishly got himself involved in a crime. Anyone reading this description will be able to imagine the film's endless string of miniplot resolutions, right down to the last hanky. However, Mr. Underwood does throw in the occasional wild card, like B. B. King to accompany Mr. Grodin's character when he's coaxed into singing "The Star-Spangled Banner."

At least the latter part of the film improves on its earlier scenes, the ones involving the baby as he grows up. The four ghosts are forced to accompany the boy everywhere, sometimes singing a doo-wop version of "Walk Like a Man" (which seems to have been thrown in mostly to enliven the film's ads and trailer). As they sit trapped together, pestering little Tommy, the ghosts deliver witticisms like: "You're killing me! Oh yeah, I'm already dead. I forgot."

•

"Heart and Souls," which also features Elisabeth Shue as Tommy's strident girlfriend and David Paymer as the bus driver who caused the fatal accident (by ogling a babe in a red dress), has a cast that does try hard to please. Mr. Grodin's nutty solemnity is always engaging, in this case making him seem more substantial than the others.

Ms. Woodard manages to be charming in what could have been an insufferable role. (Not surprisingly, her character's motherly love gives the film its only workable sentimental streak.) And Mr. Downey, as he demonstrated in "Chaplin," is an amazing mimic. The best thing about the film is the chance to watch his uncanny impersonations of his co-stars.

•

"Heart and Souls" is rated PG-13 (Parents strongly cautioned). It includes mild profanity and one brief sexual situation.

1993 Ag 13, C14:5

Twist

Produced and directed by Ron Mann; director of photography, Bob Fresco; edited by Robert Kennedy; released by Triton Pictures in association with Alliance Communications. At Village East Cinemas, Second Avenue and 12th Street, East Village. Running time: 90 minutes. This film has no rating.

WITH: Hank Ballard, Chubby Checker and Cholly Atkins.

By STEPHEN HOLDEN

American pop culture since World War II has been one long, aggressive assault on Puritan codes of behavior. One of the earliest and headiest moments in the rebellion was the ascendancy of the twist in 1960. Five years after Elvis Presley scandalized the guardians of public decency with his televised gyrations, the biggest dance craze since the Charleston liberated social dancing from genteel ballroom conventions and made everybody an Elvis imitator.

As Ron Mann's entertaining documentary "Twist," which opens today at the Village East Cinemas, reconstructs the craze, it came in several phases. Early in 1960, Hank Ballard and the Midnighters scored a sizable hit with "The Twist," a record that had been the B-side of a minor hit he had released the previous year. Chubby Checker, a vocal impressionist from Philadelphia, quickly recorded an imitation of Mr. Ballard's record that was so close to the original in sound that even Mr. Ballard thought it was his own version the first time he heard it on the radio. Promoted on Dick Clark's dance show, "American Bandstand," the record went to No. 1 that September.

•

The dance style it spawned, however, didn't become a full-scale craze until a year later, when New York cafe society was discovered patronizing the Peppermint Lounge, a seedy club on West 45th Street that featured the twist. As the craze snowballed, Mr. Checker's record re-entered the charts and became No. 1 a second time. It remains the only record besides Bing Crosby's "White Christmas" to top the charts more than once.

The aftershocks that followed included innumerable offshoots like the pony, the swim, the monkey, the jerk, the limbo, the locomotion, the mashed potato, the fly, and the Watusi. These all quickly merged into contemporary free-style dancing.

Triton Pictures
Chubby Checker in 1960.

Mr. Mann's film smartly interweaves video and film from the period with the present-day recollections by Mr. Ballard, Mr. Checker and a number of dancers who appeared regularly on "American Bandstand" in the early 60's. The legendary tap-dancer Cholly Atkins, who choreographed shows for rhythm-and-blues groups and the stars of Motown, also reminisces.

•

The film offers some amusing visual tidbits that suggest the astonishing naïveté of late 50's and early 60's teen-age culture. Frankie Avalon's lip-synched performance of his insipid 1959 hit "Bobby Sox to Stockings" on "American Bandstand" elicits semi-hysterical adulation from an audience of drab, regimented youths. A tepid demonstration of the mambo on "The Arthur Murray Dance Party" suggests how adult pop culture of the era promoted oppressively formal modes of social discourse.

Divided into dance "lessons," the story is told in a breezy pop magazine style in which pictures do most of the work. Historical analysis is cursory. The people interviewed are clearly thrilled to find themselves footnotes in pop history, although no one is especially thoughtful or articulate. One white couple, who took credit for introducing a twist offshoot on "American Bandstand," expresses regrets for having actually stolen the dance from some black friends.

But for the most part "Twist" shies away from any probing analysis of the styles and politics of mass culture. As a slickly conceived and edited slice of pop nostalgia, however, it is as yummy as pizza with all the toppings.

1993 Ag 13, C17:1

Jason Goes to Hell: The Final Friday

Directed by Adam Marcus; screenplay by Dean Lorey and Jay Huguely, based on a story by Mr. Huguely and Mr. Marcus; director of photography, William Dill; edited by David Handman; music by Harry Manfredini; production designer, W. Brooke Wheeler; produced by Sean S. Cunningham; released by New Line Cinema. Running time: 88 minutes. This film is rated R.

Steven Freeman	John D. LeMay
Jessica Kimble	Kari Keegan
Jason Vorhees	Kane Hodder
Creighton Duke	Steven Williams
Robert Campbell	Steven Culp
Diana Kimble	Erin Gray
Joey B	Rusty Schwimmer
Coroner	Richard Gant
Shelby	Leslie Jordan

By STEPHEN HOLDEN

Although the movie's final image of a pitchforked hand thrust up through the ground hints otherwise, "Jason Goes to Hell: The Final Friday," which opened yesterday, claims to be absolutely the last in the "Friday the 13th" horror series. It's about time.

The ninth episode in the phenomenally successful series, which began in 1980, "The Final Friday" is a largely incoherent movie that generates little suspense and relies for the majority of its thrills on close-up gore. Most of the grosser images in the film, which was directed by Adam Marcus, come near the beginning, not long after Jason Voorhees, the series' hockey-masked fiend, is dismembered by a squad of machine gun-toting police.

Cut up and splayed like a giant charred pork roast in the autopsy room of the Federal Morgue, Jason seems well beyond repair. Then suddenly his extracted heart begins to beat. The coroner, who was analyzing the organ, becomes transfixed and grabs the heart, cramming it into his mouth. With many flashes of lightning, Jason is reborn in the coroner's body.

Once back in action, the unstoppable serial killer heads straight for — where else? — his hometown of Crystal Lake, where the local restaurant is foolhardy enough to be advertising a "Jason Is Dead 2 for 1 Burger Sale." Over the the next few days, Jason inhabits one body after another, transferring from person to person in a messy ritual that might be described as a forced mouth-to-mouth heart transplant.

The only person possessing the secret to Jason's undoing is Creighton Duke (Steven Williams), a glowering professional bounty hunter, who has been studying Jason for years. Creighton becomes involved after a tabloid television show offers a $500,000 reward for Jason's demise. In order to learn Creighton's secrets, Steven Freeman (John D. LeMay), who leads the anti-Jason forces, must allow Creighton to break several of his fingers.

Such gratuitous sadism gives "The Final Friday" an edge of sourness that is unusual for a horror movie. It doesn't help that Jason's intended victims (and the actors who play them) are pallid sitting ducks.

•

"Jason Goes to Hell" is rated R (Under 17 requires accompanying parent or adult guardian). It includes nudity and violence.

1993 Ag 14, 12:4

Brian Hamill/Tri-Star Pictures
Diane Keaton and Woody Allen in "Manhattan Murder Mystery."

Manhattan Murder Mystery

Directed by Woody Allen; written by Mr. Allen and Marshall Brickman; director of photography, Carlo Di Palma; edited by Susan E. Morse; production designer, Santo Loquasto; produced by Robert Greenhut, Helen Robin and Joseph Hartwick; released by Tri-Star Pictures. Running time: 108 minutes. This film is rated PG.

Larry Lipton	Woody Allen
Carol Lipton	Diane Keaton
Paul House	Jerry Adler
Lillian House	Lynn Cohen
Sy	Ron Rifkin
Marilyn	Joy Behar
Jack, the Super	William Addy
Ted	Alan Alda
Marcia Fox	Anjelica Huston
Helen Moss	Melanie Norris

By JANET MASLIN

No one could cling to the notion that Woody Allen's art simply imitates his life after watching "Manhattan Murder Mystery," the mild, middle-aged, atypically blithe comedy Mr. Allen was busy directing when his private difficulties became front-page news. Nor could anyone watch this latest film of Mr. Allen's in a vacuum. Reuniting Mr. Allen with Diane Keaton, this time to play a nagging, hopelessly neurotic Nick and Nora Charles investigating the disappearance of their neighbor, "Manhattan Murder Mystery" cannot help conjuring up the rapport these two shared so memorably, several lifetimes ago.

At its amiable best, the new film offers glimmers of its stars' charming, quarrelsome old teamwork, although their exchanges are now dampened by the down-to-earth realities of long acquaintance. But in its less successful moments, hamstrung by the demands of a dated detective story, "Manhattan Murder Mystery" ignores its own obvious possibilities. It would be far more interesting to watch these two work out the aftermath of "Annie Hall" than to hear them theorize endlessly about an empty, genre-bound crime.

Of course, neither Mr. Allen nor Ms. Keaton approaches any aspect of "Manhattan Murder Mystery" without a trademark idiosyncrasy or two. When Ms. Keaton's Carol Lipton snoops sufficiently to open a suspicious-looking urn in her neighbor's kitchen, her husband, Larry, expresses a purely Allenesque horror. "Ashes? *Funeral* ashes? Did you wash you hands?" he demands to know. When Carol goes sleuthing, she complains that she can't do the job without her reading glasses. When Larry tries to play detective, he snaps, "We'll take very good care of you if you play ball with us," offering $1 to a bored-looking woman who's mopping a floor. And when the intrigue becomes too exciting for Larry, he shrieks: "Move! Move! Adrenaline is leaking out of my ears."

•

Mr. Allen's audience will not have much trouble keeping its own adrenaline level in check, since "Manhattan Murder Mystery" is likelier to prompt appreciative chuckles than flat-out laughter. But this film's mood is gratifyingly gentle and uncomplicated, as the director (and co-writer, with his longtime collaborator Marshall Brickman) work in a matter-of-fact vein. The long-married Larry and Carol are badly in need of common interests when a mystery springs up in the apartment next door. Having just met their dull neighbors, Paul (Jerry Adler) and Lillian House (Lynn Cohen), the Liptons are surprised to learn of Lillian's death and Paul's subsequent sprightliness. Carol decides that she must follow her intuition and find out what Paul is up to, a process that eventually makes her declare, "I'm just dizzy with freedom!"

"Manhattan Murder Mystery" is visually dizzy as well, since Mr. Allen has directed his cinematographer, Carlo Di Palma, to rely on hand-held camera work. In "Husbands and Wives," the jerkiness of the camera's movement was less frequent and more apt, and it grew more naturally out of the turbulence of that film's story. Here, with the camera swiveling restlessly from one room to another, or zooming in abruptly for a close look at a clue, the style seems a more meaningless affectation.

Coupled with the new film's deliberately drab décor and its taste for glaring overhead light, the camera work provides "Manhattan Murder Mystery" with a kind of anti-glam-

our. It's an unhelpful flourish. These characters, appealing as they are, are presented as wearily embroiled in their habits and relatively humdrum lives. They already have anti-glamour to spare.

Set on the Upper East Side, "Manhattan Murder Mystery" draws its minor figures from the upscale, self-regarding set that is already enjoyably familiar from other Allen films. Constructing a romantic rectangle of sorts, the story introduces Ted (Alan Alda), an old friend who's not shy about his attraction to Carol, and Marcia (Anjelica Huston), an author whom Larry meets through his work as a book editor. (When Marcia insists that she doesn't want her latest book to be "too transparent," Larry assures her that it "makes 'Finnegans Wake' look like 'Airplane.'" Neither Mr. Allen nor Mr. Brickman has lost his flair for the throwaway bon mot.)

At times, the film flirts as openly as its characters do, toying with the idea that either detective work or sexual intrigue will put the spark back into the Lipton marriage. In the end, though, plot mechanics about the missing Mrs. House take up a disproportionate amount of energy, even when Larry, Carol, Marcia and Ted all join forces to settle the case. The tiny nuances among these four — Larry's way of avoiding Marcia's overtures, Carol's unreasonable possessiveness about Ted — are well enough observed to become the film's most interesting aspect. But they're never allowed to take center stage.

Although "Manhattan Murder Mystery" struggles with its own contrivances, it achieves a gentle, nostalgic grace and a hint of un-self-conscious wisdom. Those who appreciate the long, daring continuum of Mr. Allen's work will be glad to find him simply carrying on.

•

"Manhattan Murder Mystery" is rated PG (Parental guidance suggested). It includes mild violence.

1993 Ag 18, C13:5

112th and Central
Through the Eyes of the Children

Directed by Jim Chambers; cinematography by John Simmons; edited by Michael Schultz; music by Delfeayo Marsalis; produced by Mr. Chambers, Vondie Curtis-Hall and Hal Hisey; released by Flatfields. Village East Cinemas, Second Avenue and 12th Street, East Village. Running time: 108 minutes. This film has no rating.

By STEPHEN HOLDEN

"112th and Central: Through the Eyes of the Children," a documentary about the effects of the 1992 Los Angeles riots on the lives of the young people who lived through them, has one strikingly unusual feature. When the film-making team of Jim Chambers, Hal Hisey and Vondie Curtis-Hall undertook the project, they invited their subjects to be their creative collaborators.

They equipped 25 mostly black and Hispanic students from the Los Angeles Achievement Center, a youth guidance program in South-Central Los Angeles, with super-8 video cameras and had them interview one another and their friends and families. The result is a documentary film that

Kartoon recites his poetry in the film "112th and Central: Through the Eyes of the Children."

is crude, and occasionally rambling and inarticulate, but one that captures a more intimate sense of community than could probably have been conveyed through more conventionally polished methods.

Those who tell their stories run from shy young schoolchildren to hardened former gang members. Although the points of view range from bitterly defiant to hopeful, the common denominator of attitude is saddened resignation of the war-weary.

Several officials — including Willie Williams, who succeeded Daryl F. Gates as the chief of the Los Angeles Police Department, City Councilman Michael Woo and Representative Maxine Waters — also comment on the riots. But their remarks lack the poignancy and candor that the area's everyday residents provide.

"112th and Central," which opens today at the Village East, begins with a Los Angeles Achievement Center meeting at which many of the partici-

pants introduce themselves and give their impressions of the riots; the impressions are interwoven with excerpts from television coverage. After this formal beginning, the film — whose material is roughly organized into five subjects: family and friends, relations with the police, the truce between gangs, art, and the future — progressively loosens up.

•

At least half a dozen vivid personalities stand out. The most endearing is Cleophas Jackson, a smart, chubby grade-schooler whose announced ambition is to be an Attorney General.

Kartoon, the most flamboyant, is a cocky 35-year-old former gang member who serves as the movie's one-person Greek chorus and whose street poetry recalls the stretched-out 1970's narratives of Curtis Mayfield. The most disturbing is Yolanda Woods, a tough, fiercely intelligent 16-year-old former gang member whose boyfriend was shot and killed while she was pregnant and who subsequently had an abortion. The goal of this cynical, heartbroken teen-ager is to be a mortician.

Teresa Allison, a woman whose says her young nephew was killed by the police in front of his home during a blackout, is the most anguished. Her son, Dewayne Holmes, interviewed in prison, where he is serving an eight-year sentence for stealing $10, is credited by several in the film for initiating a truce between the Crips and the Bloods that has drastically reduced gang violence in the neighborhood. The film portrays him as a soft-spoken local hero who is being persecuted.

That gang truce is treated as a major turning point in the recent history of South-Central, and the film goes out of its way to show young men who were once each other's deadly enemies embracing and emotionally pledging their mutual support.

But how much optimism can there be in an environment as desolate as South-Central? Except for glances at some public artworks commemorating recent events, the film's ground-level view of the riot-scarred landscape, with housing developments that look like army barracks, is a portrait of bleakness.

1993 Ag 18, C18:1

tiny daughter and his grandmother, who sleeps in the entry hall.

There's also Zoran's philandering grandfather, a handsome fellow with the manners of a dandy, whom his grandmother threw out some years earlier. Though the grandfather doesn't live there anymore, he comes by every day at noon to share the big family meal, read the newspaper and observe the rows that erupt with regularity. It's time to see a family Balkanized when brothers, sisters and in-laws scream at one another over territorial rights to the bathroom.

They are an overwhelming crew. They're also proudly bourgeois. Possibly as much to assert his own identity as out of need for order, Zoran has come to admire Marshal Tito, Yugoslavia's strong-man president, with the kind of passion young boys usually reserve for sports heroes. He keeps scrapbooks on Tito's every move, imitates his gestures and stays up all night on a street corner just to see him drive by in the morning.

When Zoran's fulsome composition, "Why I Like the President," is judged the best of those submitted by all the schoolchildren in Belgrade, the family is caught between pride and

humiliation. Nothing they do can prevent him from enjoying his prize: a week's camping trip with other privileged children, with the highlight a reception at Tito's palace.

This excursion is the film's principal point, as Zoran learns firsthand about totalitarianism.

•

"Tito and Me" was made before the Yugoslav war broke out, which doesn't help one's passive enjoyment of the film today. Tito's excesses, his rule by repression, his cult of personality, could be more easily satirized while the federation he helped forge still held together. The satire now looks shortsighted, over-simplified, almost ghoulish. Compared with the horrors of the present situation, the Tito era takes on a golden aura.

Time has played a dirty trick on Mr. Markovic and his film. In other, less apocalyptic circumstances, "Tito and Me" might not prompt one to remember that Tito was, in addition to everything else, a complex, remarkably gifted politician and the first Communist head of state to follow a course independent of Moscow. Contemporary events give the comedy an unexpected edge.

1993 Ag 18, C18:5

Satiric Look at the Tito Era

"Tito and Me" was shown as part of the 1993 New Directors/New Films Series. Following are excerpts from Vincent Canby's review, which appeared in The New York Times on March 23, 1993. The film opens today at the Lincoln Plaza Cinemas, Broadway at 63d Street.

As he remembers himself years later, the narrator of Goran Markovic's full-bodied, initially charming, farcical memoir, "Tito and Me," is a rather impossible little boy named Zoran (Dimitrie Vojnov), who is 10 and fat. He's not just "rounded" as his grandmother says, but overweight in the big-bellied, multi-chinned way of children who consume too many sweets and, in Zoran's case, plaster.

The boy has a compulsion to eat plaster. The walls of the family apartment in Belgrade in 1954 look pitted, as if damaged by small-arms fire. Zoran sneaks around the rooms peel-

ing back the wallpaper to stuff himself with material he finds as satisfying as meringues. It could be a sign of emotional as well as nutritional need. His ill-tempered uncle says it's a symptom of Zoran's degeneracy, pure and simple.

Yet nothing in "Tito and Me" is pure and simple. The movie is a carefully layered comedy that leaves a disturbing and ambiguous afterglow.

•

Unlike most of the Yugoslav comedies that have come this way in recent years, this film has a political point of view and is refreshingly free of things folkloric and picturesque. It's the work of a sophisticated comic mind.

Zoran lives with his father, a musician, and mother, a ballet dancer, in a big old-fashioned flat that might once have been comfortable. Yet now it is shared with his aunt and uncle, their

King of the Hill

Directed and written by Steven Soderbergh, based on the memoir by A. E. Hotchner; director of photography, Elliot Davis; music by Cliff Martinez; production designer, Gary Frutkoff; produced by Albert Berger, Barbara Maltby and Ron Yerxa; released by Gramercy Pictures. Running time : 109 minutes. This film is rated PG-13.

Aaron	Jesse Bradford
Miss Mathey	Karen Allen
Mr. Kurlander	Jeroen Krabbe
Mrs. Kurlander	Lisa Eichhorn
Sullivan	Cameron Boyd
Mr. Mungo	Spalding Gray
Lydia	Elizabeth McGovern
Lester	Adrien Brody
Ben	Joseph Chrest
Billy Thompson	Chris Samples
Christina Sebastian	Katherine Heigl
Ella McShane	Amber Benson
Patrolman Burns	John McConnell
Mr. Sandoz	John Durbin
Elevator Operator	Lauryn Hill
Principal Stellwater	Remak Ramsey

By JANET MASLIN

WHEN present-day movies try to recreate the Depression, they tend to concentrate on period details: old cars, quaint costumes, dusty rugs on boarding-house floors. "King of the Hill," the new film by Steven Soderbergh, which has been adapted from A. E. Hotchner's boyhood memoir, captures something more basic: the way it felt to have that rug pulled out from underneath one without warning, and the recognition that most of one's acquaintances were trapped in similar situations. With warmth, wit and none of the usual overlay of nostalgia, "King of the Hill" presents the scary yet liberating precariousness of life on the edge.

There is a point in the film at which Aaron Kurlander (Jesse Bradford), the story's 12-year-old hero, is so hungry he cuts out magazine pictures of food, arranges them on a plate and digs in. In another film such a moment might be milked for either humor or pathos. But Mr. Soderbergh, as a film maker who keenly appreciates the idiosyncrasies of any situation, has a way of defying the usual expectations, and he turns that image into something surprisingly buoyant. "King of the Hill" bears no substantial resemblance to either Mr. Soderbergh's "Sex, Lies and Videotape" or his impenetrable "Kafka," but it does reaffirm the iconoclasm of both those earlier works.

Proceeding gently, and refining Mr. Hotchner's ripely anecdotal account to its bare essentials, "King of the Hill" is mostly set at the Empire Hotel in St. Louis, a seedy outpost at which the Kurlanders and other like-minded individuals find themselves marooned. "There was one bellhop, no ice water and no restaurant," Mr. Hotchner wrote of the place. And the bellhop had a selection of

padlocks for securing the property of those who happened to be late with the rent.

The Kurlanders — Aaron's father (Jeroen Krabbe), a traveling salesman, his kindly, consumptive mother (Lisa Eichhorn) and his little brother, Sullivan (Cameron Boyd) — can't escape. But they can make certain accommodations. One day Aaron is told that the family is shipping Sullivan off to relatives. "That way we can save at least a dollar a week," his father explains, with an excitement that Aaron finds hard to share. Though Aaron's character is neither written nor played as a figure of undue precocity, it's clear that circumstances have forced him to be responsible at a tender age.

Losing Sullivan, the only character in the film with whom Aaron can behave boyishly, is not an isolated event. During the course of the film, Aaron is peremptorily abandoned by each of his parents, not because they don't care for him but because other contin-

gencies (a new job for his father, a hospital stay for his mother) loom larger than he does. The boy is left to fend for himself, and to study the survival tactics of his neighbors. Among the hotel's lively residents are Lester (Adrien Brody), an older boy with very well-developed survival skills, and Mr. Mungo (Spalding Gray), the threadbare gentleman who lives across the hall.

Mr. Mungo makes references to the time "years ago, when people like me were using currency to light their cigars," but he does not seem despondent over his reduced circumstances. He spends much of his time with a bored prostitute (Elizabeth McGovern), lecturing her about the classics. ("And then to be fooled by a horse! A wooden horse!") Like most of the film's characters, he clings touchingly to the outer edges of respectability, knowing that the appearance of gentility may evaporate at any moment. Aaron sees this frailty in his neighbors, and learns to take a more aggressive approach on his own.

So Aaron tells whoppers, particularly when he's left in the company of wealthy classmates who know nothing about the Kurlanders, and who are willing to believe that Aaron's

on finds himself in a position to celebrate having a phone, a mattress, running water and a whole family, the audience will be moved by his private odyssey and understand exactly where he's been.

•

"King of the Hill" is rated PG-13 (Parents strongly cautioned). It includes mild profanity and one implied sexual situation.

1993 Ag 20, C1:

Hard Target

Directed by John Woo; screenplay by Chuck Pfarrer; director of photography, Russell Carpenter; edited by Bob Murawski; music by Graeme Revell; production designer, Phil Dagort; produced by James Jacks, Sean Daniel, Mr. Pfarrer and Terence Chang; released by Universal Pictures. Running time: 92 minutes. This film is rated R.

Chance Boudreaux	Jean-Claude Van Damme
Emil Fouchon	Lance Henriksen
Natasha Binder	Yancy Butler
Uncle Douvee	Wilford Brimley
Carmine Mitchell	Kasi Lemmons
Pik Van Cleaf	Arnold Vosloo
Elijah Roper	Willie Carpenter
Binder	Chuck Pfarrer

By JANET MASLIN

Swishing, whooshing, lovingly photographed weaponry. Nasty gurgles from the wounded. The clonking sound of a head hitting wrought iron. A bullet in the eye. These are the cornerstones of "Hard Target," one of this summer's few super-bloodthirsty action films, and the one that actually stood a chance of rising above its genre.

"Hard Target" was an opportunity for both John Woo, the Hong Kong–born action-film director with an ardent cult following, and Jean-Claude Van Damme, the self-appointed Muscles From Brussels, to reach a mainstream audience. "Hard Target" had a hard time getting past the Motion Picture Association of America's rating board without an NC-17 rating. But even in this somewhat adulterated form, Mr. Woo's film remains overwhelmingly violent and not always stylish enough to give its excesses the appearance of wit. Not even when its star bites the tail off a rattlesnake and then slugs the snake for good measure.

Mr. Woo's obvious gusto and his taste for myth making are readily apparent. But so is his fondness for the slow, lingering death scene coupled with sickening sound effects. Presenting Mr. Van Damme as reverentially as Sergio Leone did the

Randee St. Nicholas/Universal Pictures
Jean-Claude Van Damme

young Clint Eastwood, Mr. Woo displays a real aptitude for malignant mischief, which is this story's stock in trade.

Derived from the 1932 film "The Most Dangerous Game," from a story by Richard Connell, "Hard Target" tells of wealthy thrill-seekers who pay large sums of money to stalk human prey. Right after it opens vividly with one such hunt-to-the-death, the film presents a perfect B-movie conversation. "It's like a drug, isn't it — to bring a man down?" observes the entrepreneur who arranges this blood sport. "Was it worth it?" he asks his client. "Every nickel," the client solemnly replies.

The screenplay by Chuck Pfarrer (who appears in this sequence as the ill-fated victim) concentrates most of its creativity on the characters' names, which include Pik Van Cleaf (Arnold Vosloo), Emil Fouchon (Lance Henriksen) and Chance Boudreaux (Mr. Van Damme). The film does have one first-rate rejoinder, when Mr. Henriksen's rich, jaded entrepreneur asks Chance why he insists on spoiling all the fun. "Poor people get bored, too," Chance replies.

Speaking of bored, Mr. Van Damme has still not broken the habit of his own blank-faced posturing, although Mr. Woo films him in the most aggrandizing style imaginable. From the first tight close-up of the star's brooding eyes to the loving images of his feet kicking various faces, "Hard Target" does what it can to present Mr. Van Damme in a bold new light. Curiously, the film's neo-Peckinpah taste for slow motion gives Mr. Van Damme's stunts a balletic quality that diminishes their spontaneity. It's necessary for Mr. Woo to place his star standing on the seat of a moving motorcycle, for instance, and send him catapulting over the hood of an oncoming van to create the requisite high excitement.

Mr. Van Damme's Chance (who is said to have been "raised in the bayous," in this latest on-screen effort to explain his accent) is supposed to be a derelict, which allows Mr. Woo the opportunity for occasional flashes of social commentary. The film's glimpses of the homeless are sharp and unexpectedly substantial, which makes its frivolous ugliness that much more unfortunate. The plot involves Chance's being recruited by long-haired, wide-eyed Natasha Binder (Yancy Butler) to find her father, who is of course well past finding.

"Hard Target," which is set in New Orleans, also includes a warehouse full of Mardi Gras floats and Wilford Brimley, who rides a horse and tries out a conspicuous Louisiana accent. Clearly, Mr. Woo's sense of humor is as perverse as his other talents.

•

"Hard Target" is rated R (Under 17 requires accompanying parent or adult guardian). It is extremely violent.

1993 Ag 20, C8:5

God Is My Witness

Directed by Mukul S. Anand; written by Santosh Saroj (in Hindi with English subtitles); cinematographer, W. B. Rao; edited by R. Rajendran; music by Laxmikant Pyarelal; produced by Manoj Desai and Nazir Ahmed; released by Headliner Productions Releasing. Quad Cinema, 13th Street, west of Fifth Avenue, Greenwich Village. Running time: 180 minutes. This film has no rating.

Badshah Khan	Amitabh Bachchan
Benazir, Menhdi	Sridevi
Raja	Nagarjuna
Henna	Shilpa Shirodkar

By STEPHEN HOLDEN

Movies rarely offer more rip-roaring action per minute than does "God Is My Witness," a three-hour epic adventure from India that is as crude as it is energetic. The movie, which opens today at the Quad Cinema, wants to be an Indian answer to "Ben Hur," "Duel in the Sun," "The Desert Song," "Giant" and "The Seven Samurai," all rolled into one churning, palpitating package.

It opens with a game of buzkashi, a dangerous equestrian sport involving a dead goat, and closes with a version of the same game played with a live human. In between, enough plot is jammed in to fill several seasons of "Dallas," along with a musical's worth of songs.

Anchoring this multigenerational saga, directed by Mukul S. Anand, is the actor Amitabh Bachchan, an Indian superstar who outthunders Charlton Heston and outglares Rudolph Valentino. In "God Is My Witness," his 85th film, Mr. Bachchan plays Badshah Khan, a heroic patriarch who gets into all kinds of trouble because he is such a stickler about keeping his word. The moral of the story seems to be that one's honor is something that must be upheld at all costs. Or must it, various characters wonder late in the story.

When Mr. Bachchan speaks, he proclaims his lines in a deep impassioned roar. As he locks eyes with Sridevi, the actress who plays his wife, Benazir, the screen is in danger of melting.

•

Over the course of the film, Badshah is beaten, tortured, imprisoned, shot at and bombed, but he always rises up, as indestructible as Superman. Benazir is so madly in love with him that she instantly goes crazy when told he has been killed. (He hasn't been, of course.) For the next 18 years, she mumbles only three words over and over: "He will return." Sridevi also plays the couple's daughter, who eventually travels to India to find the father she never knew.

With scenes of high adventure that are abruptly broken by elaborate musical production numbers, "God Is My Witness" is stylistically typical of mainstream Indian movies. What distinguishes it from assembly-line fare is its relative grandeur. The arid mountain landscapes in which much of the action takes place are as impressively spacious as the Wild West of Hollywood. The musical numbers have an opulence that recalls the most jewel-encrusted M-G-M fantasies.

For all its borrowing of Hollywood formulas, "God Is My Witness" suggests that the busy Indian film industry is happy to remain 40 to 60 years behind Hollywood both stylistically and technologically. The musical numbers, with their dubbed voices, recall Howard Keel and Kathryn

Growing up with nearly nothing and the fear of losing it.

parents are either scientists or spies. (In the film's opening scene, Aaron reads a nervy essay expressing his admiration for Charles Lindbergh, whereas the next student's hero is John D. Rockefeller.) The film does a lovely job of juxtaposing the sharp contrasts in Aaron's life, and in marveling at the fact that he survives as buoyantly as he does.

•

Mr. Soderbergh, who edited his film as well as having written and directed it, sometimes places the camera at a slight angle to present a literally skewed point of view. More often, and just as effectively, he depicts events as delicately off-balance in a manner that gives his film its fundamental honesty and subtle, eccentric charm.

The sudden reversals Aaron witnesses — evictions, firings, illness, a boy being nabbed by a policeman for stealing apples — are touched on only lightly, but their cumulative effect is surprisingly intense. By the time Aar-

Grayson. The lumbering fight sequences suggest that the martial-arts revolution begun by Bruce Lee has yet to affect the Indian cinema. What fun lies ahead!

1993 Ag 20, C8:5

The Ballad of Little Jo

Written and directed by Maggie Greenwald; director of photography, Declan Quinn; edited by Keith Reamer; music by David Mansfield; production designer, Mark Friedberg; produced by Fred Berner and Brenda Goodman; released by Fine Line Features. Running time: 120 minutes. This film is rated R.

Little Jo	Suzy Amis
Tinman Wong	David Chung
Streight Hollander	Rene Auberjonois
Frank Badger	Bo Hopkins
Percy Corcoran	Ian McKellen
Ruth Badger	Carrie Snodgress
Henry Grey	Anthony Heald
Jasper Hill	Sam Robards

By STEPHEN HOLDEN

It isn't every day that a movie reimagines the Old West in a vision as acute and provocative as Maggie Greenwald's astonishing film "The Ballad of Little Jo." In this feminist interpretation of the West, the frontiersmen have been stripped of any vestiges of a traditionally heroic machismo. Instead of rough-hewn conquerors braving the unknown, they are pictured as dangerously unsocialized beasts stomping rapaciously through a rustic paradise. And pity the woman who asks for their help.

Into this treacherous environment slips Josephine Monaghan (Suzy Amis), a young woman from a genteel Eastern family whose father has turned her out of his house for having an illegitimate baby. Josephine heads West, and on the road she discovers that a woman alone is fair game. In defense, she dons men's clothing and carves a vicious scar on her cheek. Eventually arriving in Ruby City, a shabby mining village, she carries off a precarious male impersonation that becomes a lifelong charade.

●

As a feminine man, Josephine, who is nicknamed Little Jo, has to struggle hard to win respect. With her soft features and adolescent-sounding voice, she is initially suspected of being a dude, an effeminate Easterner with striped stockings. Gradually, she proves her mettle. She survives a harsh mountain winter as a shepherd and teaches herself to shoot. Eventually she builds her own homestead. By this time, she is a fully accepted member of the frontier community, although her disinterest in sex, her taciturnity and hermetic tendencies mark her as an oddball.

"The Ballad of Little Jo" has the structure of a spun-out ballad, complete with a final verse in which the amazing truth is revealed. Like verses of a ballad, each sequence describes a different challenge Little Jo faces and successfully meets.

Little Jo performs two noble acts, both of which involve helping outsiders like herself. When a family of Russian immigrants arrives in Ruby City, she leads them to their property and befriends them. But the most heroic act she performs is rescuing from imminent lynching a Chinese railroad worker, Tinman Wong (David Chung), who has drifted into town looking for work.

When Little Jo discovers Tinman, he is tied up and being tormented by

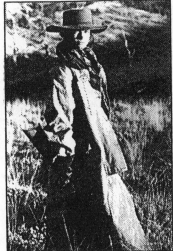
Bill Foley/Fine Line Features
Suzy Amis

the townsmen. Little Jo demands that they let him go, but in return for his release, she must agree to take him on as a cook and housekeeper. It isn't long before Tinman discovers Jo's secret. The couple become lovers and recreational opium smokers.

The idyllic union of Little Jo and Tinman is the movie's most explicit lesson in tolerance and sexual and racial politics. The relationship is also touched with sadness, since Little Jo and Tinman realize that there is nowhere else they can live together undisturbed. If the citizens of Ruby City discovered their secret, they would almost certainly kill them.

In starkly contrasting Jo and Tinman's tender passion with the marauding appetites of everyone around them, the film becomes dreamily didactic. These two sensitive souls, clinging to each other in the wilderness, are clearly superior in most ways to their boorish neighbors, whose propensity for violence necessitates the lie that Jo and Tinman are living. At the same time, the lovers, unconstrained by traditional sexual roles, forge a transcendent bond. Except for the Little Jo-Tinman relationship, "The Ballad of Little Jo" steers clear of sentimentality.

The film is illuminated by Ms. Amis's haunting performance. Radiating a profound watchfulness, wide-eyed and tight-lipped, her Little Jo is a riveting study of self-discipline, courage and emotional suppression.

With the exception of Tinman, all the significant male characters are louts or worse. Rene Auberjonois is a traveling salesman who befriends Jo when she is still dressing as a woman, then makes a deal to sell her to two soldiers. Ian McKellen plays Percy Corcoran, a seemingly sympathetic miner who takes Little Jo under his wing but who has a streak of sadistic misogyny that comes out when he drinks. On discovering Jo's secret, he trys to rape her. Bo Hopkins plays Frank Badger, the homesteading neighbor who becomes Jo's friend. The least dangerous of the three, he is a racist, not very bright and he requires careful manipulation.

The view of these characters in Ms. Greenwald's screenplay is as wary and ultimately as merciless as Little Jo's attitude toward them. One slip, and these predators could do her in. And the performances by Mr. Auberjonois, Mr. McKellen and Mr. Hopkins are accordingly sharp edged.

"The Ballad of Little Jo" offers a stinging rebuke to the traditional Hollywood myth of the Old West. In Ms. Greenwald's countermyth, the outsiders — a cross-dressed woman and an Asian man — are the enlightened ones, and the frontiersmen rapacious pillagers and barbarians. When big business arrives, in the form of an ambitious cattle rancher whose hired gunmen shoot homesteaders who refuse to sell their land, Little Jo, who has been peaceable, is compelled to take up arms. For her, it is a sad moment that brings tears.

It's not hard to view "The Ballad of Little Jo" as an allegorical critique of sex and power and men's-club values in America. In its disdain for those values, the film is as focused and cool-headed as the remarkable character whose story it tells.

●

"The Ballad of Little Jo" is rated R (Under 17 requires accompanying parent or adult guardian). It includes brief nudity and sexual situations.

1993 Ag 20, C10:1

Betty

Directed and written by Claude Chabrol, based on the novel "Betty" by Georges Simenon (in French with English subtitles); director of photography, Bernard Zitzermann; edited by Monique Fardoulis; music by Matthieu Chabrol; production designer, Françoise Benoit-Fresco; produced by Marin Karmitz; released by MK2 Productions USA. At Cinema Third Avenue, at 60th Street, Manhattan. Running time: 103 minutes. This film has no rating.

Betty	Marie Trintignant
Laure	Stéphane Audran
Mario	Jean-François Garreau
Guy Étamble	Yves Lambrecht
Madame Étamble	Christiane Minazolli

By JANET MASLIN

Claude Chabrol's slow, deliberate, exceedingly strange "Betty," which opens today at Cinema Third Avenue, has the feeling of a short story building up to one all-important twist. As based on a novel by Georges Simenon, "Betty" does culminate in a discovery, but still its closing moments do not entirely illuminate what has come before. Mr. Chabrol's talky, contemplative study of two women, strangers whose lives become unexpectedly intertwined, is finally incomplete and not entirely satisfying. But to a large extent its eerie intelligence compensates for that. Mr. Chabrol finds a quiet fascination in these two women and their slowly revealed secrets.

Betty (Marie Trintignant), first seen in a state of extreme dissipation, was once the prim and ladylike Elizabeth. But the facts of her previous life seep out very slowly, as she throws herself into the process of hitting bottom. Drinking and smoking furiously, bedraggled in her once-matronly clothes, Betty winds up in a bar called the Hole being picked up by a

A road to hell paved with firm intentions.

man who, quite matter of factly, tells her she has worms under her skin. The whole film has the quality of a dream that may be interrupted any moment by a different reality.

Betty's apparent plight arouses the concern of Laure (Stéphane Audran),

MK2 Productions
Marie Trintignant and Stéphane Audran in a scene from "Betty."

a kindly, well-heeled widow who has fallen into the Hole for her own reasons. Laure takes Betty home to her hotel room, cleans her up, lets her rest and listens to her story. Warming to her newly sympathetic surroundings, Betty tells of experiencing a childhood trauma, of having married into a proper, socially prominent family, and of having done her very best to become a pariah to her in-laws. The flat, uninflected tone of these confessions leaves some ambiguity as to whether Betty's behavior grows out of simple rebelliousness or something darker.

The structure of "Betty" is particularly hypnotic, as the film circles in and out of Betty's memories. Sometimes Betty's and Laure's conversation even seems to run together, though Betty's memories are the more overpowering ones. She remembers how her in-laws separated her from her children; she summons thoughts of her various lovers. ("It's not his fault," she says to one of them, about her colorless husband. "It's his upbringing.") Betty's memories of the incident that left her ostracized, and of the total debasement she sank into afterward, provide some of the film's more startling moments.

But much of "Betty" is static, anchored in Laure's hotel room, as Ms. Trintignant tells stories in a manner that is variously coquettish and sly. Meanwhile, Ms. Audran, so often Mr. Chabrol's greatest resource on screen, is limited to listening to her co-star much of the time, something this elegant actress manages with immense grace. Still, Ms. Audran's role is a slim one, and Ms. Trintignant's performance is less revealing than it might have been, even under these opaque circumstances. Only in Ms. Trintignant's rare flashes of feral cunning does the real essence of "Betty" begin to emerge.

1993 Ag 20, C12:1

Dark at Noon

Directed and written by Raúl Ruiz, (in French with English subtitles); cinematographer, Ramón Suárez; edited by Helene Weiss-Muller; music by Jorge Arriagada; production designer, Luis Monteiro; produced by Leonardo De La Fuente. Walter Reade Theater, 165 West 65th Street, at Lincoln Center. Running time: 100 minutes. This film has no rating.

Anthony	John Hurt
Félicien	Didier Bourdon
Inés	Lorraine Evanoff
Ellic	David Warner
The Priest	Daniel Prévost
The Virgin of Imitations	Myriem Roussel
The Child	Filipe Dias
Francisca	Rosa Castro Andre
Ana	Maria João Reis
Paula	Adriana Novais

Film Society of Lincoln Center

A scene from Raúl Ruiz's film "Dark at Noon."

By STEPHEN HOLDEN

"Dinner time approaches and the paintings are getting hungrier and hungrier," warns Ellic (David Warner), one of many eccentrics who wander through Raúl Ruiz's film, "Dark at Noon." The character is the superintendent of a very unusual factory in Portugal that manufactures one-size-fits-all prosthetic limbs. Ellic is also a realist painter whose creations require regular doses of a potion brewed in his Frankensteines-que laboratory.

Such strange goings-on constitute the very texture of daily life as it is imagined in the newest surreal comedy by Mr. Ruiz, the exiled Chilean film maker who has lived and worked in Paris since the late 1970's. "Dark at Noon," which opens a one-week engagement at the Walter Reade Theater today, is one of the more complex and provocative of Mr. Ruiz's absurdist fantasies. Although it has many amusing moments, there is so much happening in the film that even viewers familiar with Mr. Ruiz's inventive cinematic imagination may find it mystifying.

It is November 1918, and Félicien (Didier Bourdon), a Parisian doctor who specializes in miraculous cures, has traveled to Portugal to visit the factory in which his late father had invested the family fortune. What he stumbles into is a surreal dream world in which visions and miracles are everyday realities. Paintings that require feeding are the least of it. Life exists in a time warp where the dead can continue living a sort of half-life in the bodies of their descendents.

The village is inhabited by sleepwalkers. Dogs are sacred animals, and the Virgin Mary pays frequent visits in several different guises. As Our Lady of Imitations, she appears in a glowing white vision outside Félicien's window. When he wiggles his finger at her and makes faces, she wiggles her finger back and mimics his expressions.

•

Presiding over this madhouse is an aristocratic kook named Anthony (John Hurt). Anthony is inhabited by the souls of his uncle (Mr. Hurt) and his uncle's lover, Inés (Lorraine Evanoff), who use his body to make love. During a medical examination in which he masturbates, Anthony changes gender and is revealed as having five nipples.

Hovering on the premises is a priest (Daniel Prévost) whose job it is to hunt miracles and who is continually excommunicating people for wondrous happenings that have not been authorized by the Church. A little boy with special powers also shows up at crucial moments to help Félicien. When the visitor can't find a bathroom to relieve himself, the child ends his discomfort with a wave of his hand. When Félicien is levitated against his will, the boy brings him back to the ground.

Given the film's religious imagery and its casual talk about the relation of the soul to a work of art, some might be tempted to look for an upside-down cosmology or political ideology in all the goings on. That would be foolhardy.

The movie, acted with a deadpan comic elegance, is at heart an elaborate Dadaist joke that invites any number of readings of its mischievous games.

1993 Ag 20, C12:5

Wilder Napalm

Directed by Glenn Gordon Caron; written by Vince Gilligan; director of photography, Jerry Hartleben; edited by Artie Mandelberg; music by Michael Kamen; production designer, John Muto; produced by Mark Johnson and Stuart Cornfeld; released by Tri-Star Pictures. At the Village Theater VII, Third Avenue at 11th Street, East Village. Running time: 110 minutes. This film is rated PG-13.

Vida	Debra Winger
Wallace	Dennis Quaid
Wilder	Arliss Howard
Fire Chief	M. Emmet Walsh
Rex	Jim Varney

By JANET MASLIN

Somewhere on the cusp between the inspired and the flat-out unreleasable there is "Wilder Napalm," a bizarre romantic comic strip about two brothers and the woman they love. Both Wilder and Wallace Foudroyant (Arliss Howard and Dennis Quaid) have the power to start fires telekinetically, which is why Wilder happens to be hairless beneath his proper-looking wig. As for Vida (played buoyantly by Debra Winger), she wears only green and is stuck in her trailer under house arrest, so she has troubles of her own.

Wilder works timidly in a photo-processing booth in the middle of a parking lot. Wallace makes his first appearance in a brightly colored clown suit, cursing his brother and playing to the rafters. Wilder and Vida clearly live in their own little world of super-cute affectations, as when Vida says "Last night I dreamed we were Elvis and Ann-Margret in 'Viva Las Vegas.'" "Again?" Wilder asks wearily. It takes a while to get past the realization that the whole film will be trying to sustain this level of whimsy.

Though "Wilder Napalm," which opens today at the Village Theater VII, takes some getting used to, it finally does have its charms. The characters may be wildly nonsensical, but there is some core of earnestness to them, particular to Ms. Winger's madly exuberant Vida. There's also a surprising tenderness to the film's little romantic interludes, even the one that brings Vida and Wallace to a loony-looking miniature golf course that catches fire when they kiss. (Compared with this film's incendiary excesses, the similar moments in "Like Water for Chocolate" look positively realistic.) Mr. Howard gives the meek, downcast Wilder a pleasing gravity, and thus provides the film with some much-needed ballast.

•

The film's least effective aspect is its effort to contrast Wilder's guileless view of his fire-starting abilities with Wallace's determination to get onto the David Letterman show. Long before the action culminates in a flaming fraternal blowout (with Wallace egged on by his sidekick, played by Jim Varney), the brothers' noisy warfare has begun to wear thin. There is also a scene in which one Foudroyant tries to kill the other with a lawnmower, but in fact the film's overriding spirit is gentle and playful. What it's about, and what finally gives it some appeal, is one brother's willingness to walk through fire for the woman he loves.

"Wilder Napalm" was directed by Glenn Gordon Caron, the creator of television's "Moonlighting," with the apparent intention of getting as far away as possible from his earlier, better and more levelheaded "Clean and Sober." Mr. Caron, directing Vince Gilligan's screenplay, gives "Wilder Napalm" a flamboyant, crayon-colored visual style that winds up looking a lot better than might be expected. (John Muto's production design sometimes suggests the film may actually be taking place in an enormous toy store.) One very nice touch is the inclusion of four singing firemen, the Mighty Echoes, who burst into a cappella versions of songs with fire-related lyrics ("Ring of Fire," for instance) whenever such interludes are least expected.

•

"Wilder Napalm" is rated PG-13 (Parents strongly cautioned). It includes profanity, mild violence and sexual situations.

1993 Ag 20, C14:1

Stepping Razor-Red X

Written and directed by Nicholas Campbell; cinematographer and producer, Edgar Egger; edited by Trevor Ambrose; released by Northern Arts Entertainment. Film Forum 1, 209 West Houston, South Village. Running time: 103 minutes. This film has no rating.

By STEPHEN HOLDEN

When the Jamaican reggae star Peter Tosh was slain by three gunmen at his home in September 1987, there were rumors of a conspiracy to silence the singer and songwriter, whose music cried out against colonialism and racial injustice. Tosh, who was 42, had been hoping to buy a Kingston radio station in order to broadcast Rastafarian reggae music full time. Some speculated that his enemies, alarmed at the prospect, had him assassinated.

The murder, which was officially ruled to be robbery related, is re-enacted near the end of "Stepping Razor-Red X," Nicholas Campbell's flashy but confusing biography of the singer. In pseudo-cinéma vérité style, the camera lurches wildly up the stairs of his house to the room where Tosh and his common-law wife, Marlene Brown, were having dinner with friends. Screams and gunfire erupt.

Although "Stepping Razor-Red" gives conspiracy theorists their say, the movie, which opened this week at Film Forum 1, offers no hard evidence in support of a political plot. It is an adulatory portrait constructed around excerpts from Tosh's tape-recorded diaries, discovered in 1990, which he called the Red X Tapes. The name refers to the ominous red X that Tosh often found next to the signature line on documents he was required to sign.

Reminiscing on tape about his life and times, Tosh reflected gravely on everything from his strict Christian upbringing to the spiritually enlightening powers of marijuana, or ganja,

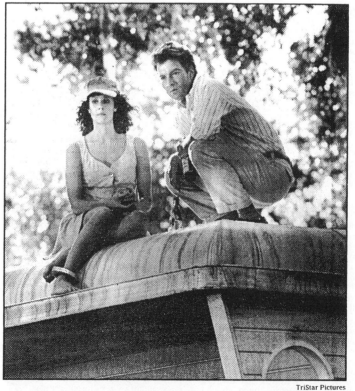

TriStar Pictures

Debra Winger and Dennis Quaid in the comedy "Wilder Napalm."

The reggae musician Peter Tosh in "Stepping Razor-Red X," a film that combines interviews, concert scenes and archival material.

as he called it. Along with his mystical idealism, Tosh also harbored a streak of paranoia. There is talk of the Devil and of vampires.

The film that Mr. Campbell has spun around these tape-recorded thoughts is a loosely knit montage of interviews, fragments of recordings, excerpts from concert and television performances, and re-enactments of scenes from Tosh's life. In evoking his childhood, the film maker unfortunately resorts too often to slick, advertising images like that of a child running on the beach, silhouetted against the sun.

•

More impressionistic than historical, the film follows a rough chronology, from Tosh's days as a choirboy to his career as a professional musician, first as a member of Bob Marley's group, the Wailers, and later as a solo star. The film's most painful scenes are shots of Trenchtown, the squalid Kingston slum in which Tosh was born and whose residents live in jammed-together shacks made from cardboard and scrap metal. Against these scenes, Tosh speaks movingly of Jamaica's poor blacks, who suffer their plight, he says, with "the dignity of a millionaire."

The movie's funniest scene is an excerpt from a "Saturday Night Live" appearance, in which Tosh is joined by Mick Jagger, who ungraciously hogs the spotlight with a ludicrous flapping and prancing routine.

As he matured, Tosh became increasingly militant, and his religious beliefs more African-oriented. He inveighed against the romantic bromides of pop-soul music and the shallowness of the "shake your booty" school of dance music. Visiting Africa, he was impressed by a medicine man whom he claimed to have seen imbibe a potion made of roots and transform into a tiger and then a serpent.

The story that "Stepping Razor-Red X" tells may be an absorbing

one, but the film's narrative method is frustratingly vague. No dates are given, and no one interviewed is identified. There are many moments in which the Jamaican patois is so thickly accented that the words are unintelligible. Only those familiar with Jamaican politics and the history of reggae music will be able to grasp many of the film's references.

1993 Ag 20, C21:1

The Last Butterfly

Directed by Karel Kachyna; screenplay by Ota Hofman and Mr. Kachyna, based on the novel by Michael Jacot; director of photography, Jiri Krejcik; edited by Jiri Brozek; music by Alex North; production designer, Zbynek Hloch; produced by Steven North; released by Arrow. Running time: 110 minutes. This film has no rating.

Antoine Moreau	Tom Courtenay
Vera	Brigitte Fossey
Michèle	Ingrid Held
Rheinberg	Freddie Jones
Stella	Linda Jablonska

By STEPHEN HOLDEN

"The Last Butterfly" is one of the quietest movies about the Holocaust ever made. Although many of its characters are Jews caged in the Czechoslovak ghetto city of Theresienstadt and face imminent deportation to death camps, you wouldn't know it from the way they talk. Musing on their fate, they adopt the sorrowful-to-sardonic tone of Chekhov aristocrats lamenting the boorishness of modern life. Everybody in the movie, including the Nazis, speaks in an impeccable "Masterpiece Theater"-style English that rarely rises above the volume of drawing-room conversation.

The mood of calm despair that hangs over the film lends it a disquietingly surreal aura. But it also plays into the story, which describes an

attempt to deliver a horrifying message without stating it in words.

The central character in "The Last Butterfly," which was directed by the Czech film maker Karel Kachyna, is a noted mime living in occupied Paris. Antoine Moreau (Tom Courtenay) lives an unharried existence until the Gestapo arrives at his door one evening to arrest his girlfriend, Michèle (Ingrid Held). She has been secretly working for the French Resistance, and in fleeing the Gestapo, she falls to her death.

Under suspicion himself, Antoine is interrogated by the Nazis and instructed to travel to Theresienstadt, where thousands of Jews have been interned. His assignment, he is told, is to give a special performance for the children of the city, after which he will be whisked safely back home. But once he arrives, it is unclear whether Antoine is an honored guest or an unwitting prisoner.

•

The film's vision of Theresienstadt, which the Nazis used as a showplace to demonstrate to the outside world their supposedly humane treatment of Jewish prisoners, is eerily low-key. Freight trains arrive regularly to carry away the sick and the aged, yet the terror, grief and despair are barely visible. The streets are crowded with docile, mostly silent pedestrians, and the children are incredibly well behaved. Although there is talk of lice, filth and starvation, the complaints often have a cheerfully sardonic edge.

Eventually Antoine learns that his real assignment is to organize and star in a mime pageant that will demonstrate to a team of Red Cross observers the well-being of the children. Antoine decides to subvert the propaganda campaign and alert the Red Cross to the reality of life in Theresienstadt with a version of "Hansel and Gretel," in which the witch feeds the children into the oven.

The performances are as muted as the screenplay, which was adapted from a novel by Michael Jacot by the director and Ota Hofman and translated into English by Mark Princi. As Antoine, Mr. Courtenay, a gifted English actor who is too seldom seen in movies nowadays, gives a performance so understated that it borders on the blank. His most expressive moments are his skillful re-enactments of classic mime routines in which a man chases butterflies and teaches a dog how to jump. In a nifty double-entendre of body language, Antoine turns the dog-jumping routine into a Chaplinesque parody of a Nazi salute, performed under the noses of enemy officers who don't get the joke.

1993 Ag 20, C23:1

Surf Ninjas

Directed by Neal Israel; written by Dan Gordon; directors of photography, Arthur Albert and Victor Hammer; edited by Tom Walls; music by David Kitay; production designer, Michael Novotny; produced by Evzen Kolar; released by New Line Cinema. Running time: 87 minutes. This film is rated PG.

Zatch	Ernie Reyes Sr.
Johnny	Ernie Reyes Jr.
Adam	Nicolas Cowan
Mac	John Karlen
Iggy	Rob Schneider
Moto Surfer	Olivier Mills
Mr. Dunbar	Neal Israel
Captain Ming	Phillip Tan
Baba Ram	Keone Young
Miss Robertson	Romy Walthall
Rachel	Rachel Kolar
Wendell	Yoni Gordon
Colonel Chi	Leslie Nielsen

New Line Cinema

Ernie Reyes Jr. in "Surf Ninjas."

By JANET MASLIN

"Surf Ninjas," the movies' latest Kiddie Flavor of the Week, is another of Hollywood's efforts to prove that the American mall mentality is at home in any corner of the globe. This mock-Turtle adventure brings fast-talking, wisecracking Santa Monica surfer boys to a remote Asian kingdom, where they are happy to behave as if they were still at home. A plot development that has the boys, who turn out to be crown princes, leveling a local rain forest to make surfboards is the film's one nontrendy move.

"Surf Ninjas" opened yesterday to a bustling audience that was essentially pre-sold, because its title is one any child-friendly computer might have devised. Doing its best to appeal to young children in every other way, the story throws in gimmicks like a video game that shows 11-year-old Adam (Nicolas Cowan), who has been brought to Asia with his teenage brother Johnny (Ernie Reyes Jr.), what the bad guys will be doing next. The bad guys dress in military gear and practice the usual jokey-violent martial-arts moves. In the course of fighting them, and in the interest of offering children one more bit of excitement, little Adam gets to drive a car.

•

As directed by Neal Israel and written by Dan Gordon, most of "Surf Ninjas" is only mindlessly watchable, although it perks up when the occasional satirical note creeps in. Both Adam and Johnny manage to tell their adoptive dad that they love him in the film's opening moments, as if to prove that they've been watching too many television shows. Leslie Nielsen, turning up briefly as the incompetent warlord who is the story's villain, barks out orders to kill his enemies on a telephone that has call-waiting. Telling his minions to hold on a minute takes the sting out of such death threats.

Among the none-too-exotic moments in "Surf Ninjas" is the scene that has Johnny being introduced to his prospective bride in what looks like a big Chinese restaurant. Then there's Adam's eagerness to get a T-shirt when he comes across a sacred place in Asia, and the tireless clowning of Iggy (Rob Schneider), the brothers' red-haired American friend, who doesn't see why he can't be an Asian crown prince, too. Also memorably Californian is the moment when Johnny and friends introduce a spiritual leader named Baba Ram by singing his name to the tune of "Barbara Ann." Incidentally, aside

from this song and a few isolated watery sequences, the surf touches are in short supply.

● "Surf Ninjas" is rated PG (Parental guidance suggested). It includes mild violence and a couple of indirect sexual references.

1993 Ag 21, 9:1

The Man Without a Face

Directed by Mel Gibson; written by Malcolm MacRury, based on a novel by Isabelle Holland; director of photography, Donald M. McAlpine; edited by Tony Gibbs; music by James Horner; production designer, Barbara Dunphy; produced by Bruce Davey; released by Warner Brothers. Running time: 114 minutes. This film is rated PG-13.

McLeod	Mel Gibson
Chuck	Nick Stahl
Catherine	Margaret Whitton
Gloria	Fay Masterson
Megan	Gaby Hoffmann
Chief Stark	Geoffrey Lewis
Carl	Richard Masur

By JANET MASLIN

When a man has a face like Mel Gibson's, a movie studio is apt to want to keep that face happy. That's one explanation for "The Man Without a Face," with which Mr. Gibson makes his directorial debut. Following the time-honored tradition whereby handsome performers prove their seriousness by camouflaging their looks, Mr. Gibson appears in the title role as a hermit half-disfigured by scar tissue. (The other half, the one more often on camera, looks just fine.) A former teacher, he enjoys speaking Latin and listening to opera in a book-lined, wood-paneled lair.

This is the "Hamlet" Mel Gibson, not the "Lethal Weapon" guy.

The best that can be said about Mr. Gibson as a director — and this is no mean achievement — is that it's often possible to forget he was the man behind the camera. Most of this film has a crisp, picturesque look and a believable manner. Set in 1968 in a charming Maine coastal village, the film tells why 12-year-old Chuck Norstadt feels like such an outsider in his own family. Chuck's much-married mother (Margaret Whitton) and his bickering half-sisters (Gaby Hoffman and Fay Masterson) make him ill at ease, and his father is long gone.

Chuck's solution is to try to go to military school, even though his mother describes such institutions as "fascist and unnatural." But he fails the entrance exam, and no one in the family is inclined to help him. Then Chuck crosses paths with Justin McLeod, the village outcast, who tries to hide his disfigurement by avoiding his neighbors. Feared and pitied, Justin is such a loner that he has persuaded the local grocers to sell to him after business hours, so that no one else will see him.

The fatherless Chuck begins paying long, educational visits to Justin's seaside hideaway, a place that has been turned into a dark, manly shrine to scholarly erudition. Together, Chuck and Justin read aloud by candlelight, with Justin's impassioned recital of scenes from "The Merchant of Venice" underscoring the pathos of his disfigurement. It develops that he was burned in a car crash that involved another young pupil, and that Chuck's past conceals a painful secret as well. So these two come to understand each other and help to heal old wounds. Meanwhile, the townsfolk raise nasty questions about

the teacher's close attachment to his young friend.

The few occasions when "The Man Without a Face" calls attention to Mr. Gibson's capable direction are when he himself strikes a lofty tone. Much of his performance is solemn and sturdy, and his encounters with Nick Stahl's Chuck are affectingly staged. But when Justin speaks out about his hardship and his neighbors' small-mindedness, the film veers toward obviousness and sentimentality. Luckily, Mr. Gibson mostly sustains the deep, authoritative tones of a former headmaster. And Mr. Stahl gives an especially tough, credible performance as the lonely young boy.

"The Man Without a Face," with its characters who read Balzac and talk about Marcuse, occasionally goes overboard in wearing its erudition on its sleeve. Yet Mr. Gibson, even when explaining a geometry problem by writing in magic marker on his oceanfront window, sustains a gravity that manages to escape seeming absurd. Ms. Whitton is also serious and persuasive as Nick's mother, an attractive, intelligent woman always on the lookout for Mr. Right. The film, as written by Malcolm MacRury from a novel by Isabelle Holland, deserves special thanks for not turning her, Justin and Nick into one big, happy family.

● "The Man Without a Face" is rated PG-13 (Parents strongly cautioned). It includes mild profanity and one brief sexual situation.

1993 Ag 25, C13:1

Only the Strong

Directed by Sheldon Lettich; written by Mr. Lettich and Luis Esteban; director of photography, Edward Pei; edited by Stephen Semel; music by Harvey W. Mason; production designer, J. Mark Harrington; produced by Samuel Hadida, Stuart S. Shapiro and Steven G. Menkin; released by 20th Century Fox. Running time: 96 minutes. This film is rated PG-13.

Louis Stevens	Mark Dacascos
Dianna	Stacey Travis
Kerrigan	Geoffrey Lewis
Silverio	Paco Christian Prieto
Cochran	Todd Susman
Philippe	Jeffrey Anderson Gunter
Orlando	Richard Coca

By STEPHEN HOLDEN

Martial-arts styles in the movies come and go like dance crazes. One year, karate is the fashion, the next it's tae kwon do. "Only the Strong" is

the first Hollywood film to feature capoeira (pronounced cop-WAY-ruh), the fusion of dance and combat that was developed by Brazilian slaves in the 16th century as a defense, masked as entertainment, against white colonials.

Introduced by Mark Dacascos, a gymnastic wonder without a trace of acting ability, capoeira looks suspiciously like the lambada of martial-arts styles. Although it outdoes competing forms in show-business flash, capoeira is a wildly impractical form of self-defense. Capoeira can deliver lethal blows, but only after an elaborate windup involving quadruple handsprings or multiple cartwheels. A percussive musical accompaniment featuring the berimbao, a bow-and-arrow-like traditional instrument of Brazil, is often called for.

In "Only the Strong," Mr. Dacascos plays Louis Stevens, a former Green Beret who returns to his Miami high school to find the place so infested with drugs and gangs that it barely functions. In an experimental program, he trains the 12 least corrigible students in capoeira, transforming them almost overnight into self-respecting, gymnastic fighting machines.

Before the program can succeed, Louis must face down a neighborhood gang led by Silverio (Paco Christian Prieto), the fearsome, capoeira-trained cousin of one of his students. The film also includes a very half-hearted love story.

"Only the Strong," which was directed by Sheldon Lettich and features choreography by Frank Dux and Joselito (Amen) Santo, is a movie that exists solely for its fight sequences and to show off its star's muscles and gymnastic grace. Mr. Dacascos, who enunciates his dialogue in a tense, pinched monotone, is a complete blank when not in action. But when galvanized into a leaping, gyrating, human lightning bolt, casually flicking off his enemies with the tips of his toes, he is something to watch.

Martial arts in movies have become increasingly balletic over the last decade, and "Only the Strong," whose fight sequences are staged like theatrical production numbers, continues the trend. Can "Swan Lake" in the slums be far behind?

● "Only the Strong" is rated PG-13 (Parents strongly cautioned). It has scenes of violence but without significant bloodshed.

1993 Ag 27, C8:4

Garthorpe Inc.

Mel Gibson and Nick Stahl in a scene from "The Man Without a Face." Mr. Gibson makes his directing debut in addition to starring in the film.

Incestuous Dreams And Real-Life Results

"Careful" was shown as part of the 1992 New York Film Festival. Following are excerpts from Stephen Holden's review, which appeared in The New York Times on Oct. 7, 1992. The film opens today at the Cinema Village, 22 East 12th Street, East Village.

"Careful" is the third full-length movie by Guy Maddin, an eccentric Canadian film maker who achieved

cult status with his two earlier films, "Archangel" and "Tales From the Gimli Hospital." Both were spoofs of early talkies that caught the look and sound of a bygone era while telling virtually impenetrable stories. Although "Careful" shares some of those films' obsessions, it is by far Mr. Maddin's most polished and coherent work.

The film is one long and amusing pun on German Expressionistic film

imagery, Freudian psychology and quasi-Wagnerian storytelling, all carried to absurdist lengths. The plot concentrates on a star-crossed family of four. Zenaida (Gosia Dobrowolska), the beautiful widow of an oafish swan feeder, tends a home she shares with her three sons, Johann (Brent Neale), Grigorss (Kyle McCulloch) and Franz (Vince Rimmer).

●

The family's orderly little world begins to crumble when Johann, who has just become engaged to Klara (Sarah Neville), has an incestuous dream about his mother. Suddenly mad with forbidden passion, he drugs his mother, slits open her bodice and places his lips on her breast. Then in a paroxysm of guilt, he sears his mouth with hot coals, cuts off several fingers and leaps off a precipice.

That's just the beginning of the sexual Sturm und Drang that rises in the characters like an avalanche from within.

The movie's biggest strength is its knowing burlesques of antiquated cinematic techniques. Its biggest weakness is its acting. Most of the players, including Mr. McCulloch, the director's regular leading man, go about their chores with an amateurish enthusiasm that gives the movie a homemade quality.

1993 Ag 27, C8:5

The Last Party

Directed by Mark Benjamin and Marc Levin; director of photography, Mr. Benjamin; edited by Wendey Stanzler; produced by Eric Cahan, Donovan Leitch and Josh Richman; released by Triton Pictures. At the Village East, Second Avenue and 12th Street, East Village. Running time: 96 minutes. This film is not rated.

WITH: Robert Downey Jr., Robert Downey Sr. and others.

By STEPHEN HOLDEN

In "The Last Party," a documentary filmed during last year's Presidential election, Robert Downey Jr. plays interviewer, commentator and soul-searching everyman trekking across America to meet the people. The goal of a trip that takes him to the Democratic and Republican National Conventions and from Washington to Wall Street is nothing less than the diagnosis of the malaise at the heart of American society. Everybody from the Rev. Jerry Falwell to the Rev. Al Sharpton, from Oliver Stone to Oliver L. North is given a sound bite on the subject.

More than an interviewer, Mr. Downey has the impossible task of being the emotional and spiritual grounding wire for the film, which Mark Benjamin and Marc Levin have directed in the style of an jeans commercial on MTV. The film is so jumpy that no one, including Mr. Downey, gets to say much of anything. Adopting a cheery, guy-next-door attitude, he offers autobiographical tidbits about his parents' divorce, his sexual problems with women and his enrollment in a 12-step program, which are supposed to be emblematic of the "Less Than Zero" generation.

●

Crisscrossing the country with Mr. Downey is the furthest thing from being on the road with Charles Kuralt or Tom Brokaw, since Mr. Downey

prefers the role of clown to pundit. Early in the film, he announces he has two sides to his personality, "the good boy" and "the goat boy." The goat boy is shown, stripped to his underwear splashing around in a public fountain. The goat boy prefaces a group interview with some young Wall Street traders who chant "greed is good" with a string of glib obscenities about how he loathes them.

The Wall Street colloquy is one of the more pungent fragments in "The Last Party," which opens today at the Village East. Far too much of the time, the film dashes around trying to cover as many political bases as possible. Mr. Downey attends marches and demonstrations involving feminists and gay-rights advocates, but the visits are so brief that the issues are barely addressed. Whether the people facing the camera are poor, angry blacks or rich Young Republicans, everybody tries to cram as much rhetoric as possible into their 15 seconds of celluloid. The collective voices add up to a cocktail party din in which no one is heard distinctly.

The closest thing to a conclusion that "The Last Party" draws is the model, offered by Ronald Reagan's daughter Patti Davis, of America as a dysfunctional family. That theory plays neatly into Mr. Downey's own personal drama. When his parents were divorced at 12, he recalls, he went to live with his mother, and it was painful.

His father, the film maker Robert Downey Sr., theorizes, in retrospect, that it was a mistake for him to smoke marijuana with his children back in the 1970's. He gets misty-eyed over Bill Clinton, whose potential he compares to John F. Kennedy's. As the father and the son exchange warm, meaningful hugs, the film intimates that the era of the dysfunctional family is about to end. If we would all follow their example, the healing process could begin.

1993 Ag 27, C14:1

Needful Things

Directed by Fraser C. Heston; written by W. D. Richter, based on the novel by Stephen King; director of photography, Tony Westman; edited by Rob Kobrin; music by Patrick Doyle; production designer, Douglas Higgins; produced by Jack Cummins; released by Columbia Pictures. Running time: 118 minutes. This film is rated R.

Leland Gaunt	Max von Sydow
Sheriff Alan Pangborn	Ed Harris
Polly Chalmers	Bonnie Bedelia
Nettie Cobb	Amanda Plummer
Danforth Keeton 3d	J. T. Walsh
Deputy Norris Ridgewick	Ray McKinnon
Wilma Jerzyk	Valri Bromfield

By JANET MASLIN

In the wide spectrum of films made from Stephen King's novels — the spectrum with "The Shining" at its high end, "Misery" a few slight notches down, and all manner of misfires in the middle — "Needful Things" occupies an unfortunate position. Though this is by no means the grisliest or most witless film made from one of Mr. King's horrific fantasies, it can lay claim to being the most unpleasant. Why? Because when you strip away the suspenseful buildup to a King story, you're often left with mechanical moralizing and crude, sophomoric small talk. "Needful Things" has more of both than any film could ever need.

The alarm bell goes off immediately, with an opening sequence that presents Amanda Plummer acting wide-eyed and loco, forcing her odd, wispy speaking voice into an even stranger Maine accent. When a film like this starts out at full throttle, subtlety is sure to be in short supply. So when Leland Gaunt (Max von Sydow) arrives in Castle Rock, Me., to open the antiques shop of the title, it is instantly clear that Gaunt is one debonair devil. Regrettably, the local sheriff (Ed Harris) takes an hour and a half to figure out what the audience knows from the start.

●

What Gaunt wants, and what the film manages to express rather muddily despite the simplicity of the concept, is to tempt each townsperson with some special treasure. Thus seduced, Gaunt's prey will then turn against his neighbors, and all of Cas-

A transient wreaks havoc from a small-town antiques shop.

tle Rock will erupt in predictable discord. Late in the story, a cache of old newspapers is discovered among Gaunt's belongings, with headlines about Hitler, plagues, assassinations and the atomic bomb. In light of his grandiose past, Gaunt's exploits in Castle Rock seem like awfully small potatoes.

Incidentally, neither Gaunt's past nor anything else about this story is left to the imagination. "The young carpenter from Nazareth?" Gaunt

asks. "I knew him well. Promising young man. He died badly." Even the tale's less painfully obvious points are expressed with a flippancy badly suited to Mr. von Sydow's solemn demeanor. "Hey, don't blame me," he must explain wryly, once Castle Rock has begun going to pot. "Blame it on the bossa nova."

Once its premise has been established, "Needful Things" devotes itself to wholly predictable skirmishes, some of them staged with a strained irony that only makes matters worse. As two local women go at each other with kitchen knives, for instance, the strains of "Ave Maria" are heard on the soundtrack. The director, Fraser C. Heston, displays a workable visual style with no sense of timing or modulation. All of "Needful Things" unfolds at full throttle, which means the film never surprises its audience in any way.

●

"Needful Things" is punctuated by the occasional gruesome crime against nature (like the skinning of a beloved pet dog) and by the expected array of explosions, assaults and colorful murders. In spite of that, it manages to seem remarkably uneventful, perhaps because Mr. Heston and the screenwriter, W. D. Richter, allow the evil goings-on to proceed like clockwork. Just when the film has begun to seem as tedious as it can be, it blossoms into last-minute speechiness, as the few remaining townsfolk renounce the devil and reaffirm humanity's fundamental goodness. Unfortunately for them, in this film the devil has all the good lines.

Bonnie Bedelia (as a waitress), J. T. Walsh (as the worst guy in town) and Valri Bromfield are among those who try none too successfully to impersonate the countrified residents of Castle Rock. The film is overlong, and none of these performances do anything to make the time pass more quickly. ●

"Needful Things" is rated R (Under 17 requires accompanying parent or adult guardian). It includes profanity and occasional ugly violence.

1993 Ag 27, C17:1

Son of the Pink Panther

Directed by Blake Edwards; written by Mr. Edwards, Madeline Sunshine and Steve Sunshine; director of photography, Dick Bush; edited by Robert Pergament; music by Henry Mancini; production designer, Peter Mullins; produced by Tony Adams; released by Metro-Goldwyn-Mayer. Running time: 93 minutes. This film is rated PG.

Bob Akester/Castle Rock Entertainment

The devil as antiques shop owner: Max von Sydow stars in Stephen King's "Needful Things."

Jacques	Roberto Benigni
Dreyfus	Herbert Lom
Maria	Claudia Cardinale
Queen	Shabana Azmi
Princess Yasmin	Debrah Farentino
Yussa	Jennifer Edwards
Cato	Burt Kwouk
Dr. Balls	Graham Stark

By STEPHEN HOLDEN

The future of Blake Edwards's "Pink Panther" series, which has resumed after a 10-year absence with "Son of the Pink Panther," will depend largely on whether audiences find Roberto Benigni, the talented comic actor who has appeared in two Jim Jarmusch films, as funny as Peter Sellers.

It almost goes without saying that Mr. Benigni's character, Jacques Clouseau Jr., the French detective who follows in his famous father's bumbling footsteps, has inherited many of the elder Clouseau's qualities. He is indefatigably self-confident but hopelessly clumsy. Although given to literary airs, he slaughters the language (once again a parody of French-accented English), turning flowery oratory into farcical mush.

•

Notwithstanding the many traits that have been passed from father to son, Mr. Benigni has a sharply different comic style from Mr. Sellers, who died in 1980. Where Mr. Sellers's Clouseau père was a hopeless snob who exuded a preposterous pomposity when not groping his way out of scrapes, Mr. Benigni's Clouseau fils has no visible social ambitions. He is a dimwitted clown with a goofy gleam in his eye. Where Mr. Sellers was always brushing himself off and hastily trying to reassemble a shattered dignity, Mr. Benigni has no dignity to salvage. The character is just an overgrown kid whose every movement is an exercise in colossal ineptitude. When he first appears on a bicycle, he loses the handlebars and drives straight into a bed of wet cement. In the final scene, as he is decorated with honors, he nearly wounds his royal hosts with a ceremonial sword that refuses to go back into its sheath.

"Son of the Pink Panther," which opened yesterday, seems intent enough on wanting to continue the series to have brought back characters from earlier episodes. Once

again, Herbert Lom plays Dreyfus, the police commissioner whom Clouseau unwittingly outwits. Burt Kwouk and Graham Stark put in token appearances as Clouseau's manservant, Cato, and his disguise maker, Dr. Balls.

What "Son of the Pink Panther" doesn't have, in addition to Mr. Sellers, is a screenplay that is even semicoherent. The tale begins with the kidnapping of a Middle Eastern princess (Debrah Farentino) from the royal yacht by a gang demanding a $100 million ransom and the king's abdication. No sooner has the plot been set up than it is all but discarded, and the movie turns into one long, messy chase interspersed with farcical set pieces.

The funniest bit, set in a hospital room, involves a television remote control that also raises and lowers the bed with the speed of a rocket launcher. As the gadget turns a bedside conference into bedlam, a scene from a Marx Brothers movie on the television parallels the chaos. Almost as amusing is a sequence in which Clouseau, in doctor's disguise, is ordered at gunpoint to stitch up a kidnapper's wounds. After fainting, the squeamish detective fortifies himself with rubbing alcohol, accidentally injects himself and winds up passed out on the chest of his patient.

Such moments give the film some levity. But as the movie accelerates out of control into a series of frantically intercut scenes that lack basic continuity, the fun turns into a collection of abrupt non sequiturs.

"Son of the Pink Panther" has the flashiest title sequence in the history of a series that is famous for its openings. As an animated pink panther illustrates fancy animated technology, Bobby McFerrin, singing several different parts, weaves virtuosic a cappella variations around Henry Mancini's familiar theme music.

•

"Son of the Pink Panther" is rated PG (Parental guidance suggested). It has some sexually suggestive moments.

1993 Ag 28, 9:5

FILM VIEW/Janet Maslin

Summer's Message: No Baloney

THE TWO BEST-RECEIVED THRILLERS OF the summer certainly look as if they have a lot in common. Their stories are different, being about an assassination attempt and a doctor fleeing unjust imprisonment; yet on a scene-by-scene basis their similarities are remarkable. The main characters of both "In the Line of Fire" and "The Fugitive," for example, rent

rooms from heavily accented landladies. In both films, authorities kid around when the phone rings at headquarters, then frantically try to trace conversations once they realize their quarries are on the line.

Both films feature middle-of-the-night raids on the wrong suspects, scenes used to catch an audience off guard. And then there are the endings: both build up to showdowns staged in hotel ballrooms. Incidentally, the ballroom confrontation is such a staple of this genre that Andrew Davis, the director of "The Fugitive," included another ballroom showdown in "The Package," one of his earlier thrillers. Like Wolfgang Petersen's "In the Line of Fire," "The Package" is about an attempted political assassination.

Despite their surface similarities, "The Fugitive" and "In the Line of Fire" have a fundamental difference: one keeps its audience constantly off balance, while the other is seldom really surprising.

The smooth, workmanlike "In the Line of Fire" embroils its sly assassin (John Malkovich) and its immensely charming Secret Service agent (Clint Eastwood) in a running debate about the meaning of their respective roles. That debate is couched in painfully portentous language ("What do you see when you're in the dark and the demons come?") meant to elevate the film's intrigue above the ordinary good-versus-evil plane. Yet that intrigue is often thoroughly predictable. By contrast, "The Fugitive" has no such lofty pretensions, but it sustains a level of surprise that "In the Line of Fire" rarely reaches.

Audiences seem to have noticed this distinction, which is one of the heartening aspects of this summer's moviegoing patterns. If viewers have expressed one attitude this season, it can be summed up this way: no baloney. For once, the hype actually backfired ("The Last Action Hero"). The efforts to cash in on sure-fire selling points (Sharon Stone in "Sliver"; a John Hughes production and a cute, bad kid in "Dennis the Menace") went awry. No-brainer comedies with a "Saturday Night Live" pedigree ("So I Married an Axe Murderer," "Coneheads") lacked the cleverness to bring in big crowds.

Instead, viewers showed a meat-and-potatoes preference for the well-told stories with interesting characters ("The Firm"), predictably orchestrated laughs ("Sleepless in Seattle"), and novelties that were actually new ("Jurassic Park"). The runaway success of "The Fugitive" looks like part of this same back-to-basics spirit.

With its terse dialogue, jigsaw-puzzle plotting and genuinely smart antagonists (one of them a classic ordinary man in extraordinary circumstances), "The Fugitive" clearly harks back to Hitchcock. It also recalls quick-witted, economical thrillers of the more recent past, from the days when a car chase represented the height of special effects wizardry and high-tech, super-violent action had yet to overwhelm the genre. This film's basic simplicity and its ability to avoid plot clichés are especially satisfying in light of the popularity such clichés now enjoy.

In fact, "In the Line of Fire" would tell a much fresher story if it had dispensed with the nice-guy partner who is about to retire, the female co-worker who taunts the hero but then falls for him, and the killer who thinks too grandiosely and talks too much. There's a damaging obviousness about, say, the way Mr. Malkovich's assassin has drawn a bull's-eye on the President's forehead on a Time magazine cover to indicate what his plans are.

WHEN MR. EASTWOOD PLAYED AN earlier version of this cat-and-mouse game with a serial killer in "Dirty Harry," the killer's bizarre manner was truly frightening; this time, as Mr. Malkovich frequently changes his makeup and identity, his main function is to keep the audience entertained. Many of his character's actions are foregone conclusions. When two dopey duck hunters interrupt him while he is trying out his new pistol, for instance, every viewer can predict just how the encounter will end.

Meanwhile, "The Fugitive" creates the impression that Harrison Ford's Dr. Richard Kimble is thinking fast and has no idea what will happen to him next. In that film's bravura jailhouse chase, for instance, the story leads Kimble and his pursuer (the wonderfully acerbic Tommy Lee Jones) to the same prison at slightly different times, then lets them spot each other and sends Kimble racing through the building. The twist that ends this encounter comes out of nowhere, settles the matter excitingly and makes perfect sense. What more does a thriller's audience really ask for?

"In the Line of Fire" still stands out as one of the more entertaining, memorably acted films of an unexpectedly strong summer. But there are good reasons why "The Fugi-

tive" is shaping up as a much bigger hit. It includes no villains killed with icicles ("Cliffhanger"), no sleazeballs pouring sake on naked women ("Rising Sun"), no Uzis or chainsaws or laser guns. No baloney. If Hollywood pays attention to its box-office receipts this season, those could be words to live by. ☐

1993 Ag 29, II:11:5

Once Upon a Time in China, Part 2

Directed and produced by Tsui Hark; written by Mr. Hark, Chan Tin Suen and Cheung Tan (in Cantonese with Chinese and English subtitles); director of photography, Wong Ngor Tai; released by Raw Film. At Film Forum 1, 209 West Houston Street, South Village. Running time: 118 minutes. This film is not rated.

Wong Fey Hong	Jet Li
Aunt Yee	Rosemund Kwan
Fu	Mok Siu Chung
Kung	Xiong Xin Xin
Luke	John Chiang
Sun Yat-sen	Zhang Tie Lin
Commander Lan	Yen Chi Tan

By STEPHEN HOLDEN

In depicting kung fu fighting as a kind of big top aerial ballet, the films of the Hong Kong director Tsui Hark are far more abstract than the choreographed clashes of American martial arts films. Where in American movies, such combat is grounded in a muscle-flexing machismo, the adversaries in Mr. Tsui's spectacles zip around like Peter Pans attached to invisible wires.

During the protracted fight sequence that is the climax of "Once

A kung fu farce and fantastic adventure with touches of comedy.

Upon a Time in China, Part 2," the combatants exhibit the grace and timing of trapeze artists as they fly through the air with what seems like the greatest of ease, often landing in the oddest places. A typical perch is a stack of wooden chairs arranged into a precarious tower. From here the fighter dives back into the fray, then swoops up to alight like Superman on another shaky foothold.

Such lighter-than-air antics define the giddy tone of "Once Upon a Time in China, Part 2," which opened today at Film Forum 1. Set in Imperial China in 1895, the movie treats history as an exuberant cartoon that veers between farce and fantastic adventure.

The movie brings back several of the characters in the original, which had a successful engagement last year at Film Forum 1. Once again the nero is Wong Fey Hong (Jet Li), a Chinese acupuncturist and martial arts whiz who goes to Canton with his beautiful but peril-prone Aunt Yee (Rosemund Kwan). Yee, his sweetheart (and not a blood relative) has recently returned to China after living in the West, and much to the dismay of some of her more conservative countrymen wears European clothes.

While in the city, they encounter tne White Lotus Sect, a gang that is fanatically opposed to all things Western and whose leader, Kung (Xiong Xin Xin), has magical powers that render him invulnerable to firearms. Kung and his followers attack a foreign-language school, forcing the students to hide out in the British Consulate. Wong becomes involved and along the way befriends Sun Yatsen (Zhang Tie Lin) and his partner, Luke (John Chiang). Since the Emperor views them as an enemy, Wong ends up facing down not only Kung but also Lan (Yen Chi Tan), the imperial commander.

From its opening scene of a White Lotus rite in which Kung walks on hot coals and repels cannonballs, the movie is a splendid if frankly fake-looking spectacle. In those rare moments when the action slows, it turns into a comedy. The funniest scene comes early in the film when Wong and Aunt Yee are going to Canton with Wong's imbecilic sidekick Fu (Mok Siu Chung). As the train plunges into a tunnel, Fu becomes convinced that a solar eclipse is in progress. As they try to eat European food with knives and forks while being jounced around their dining-car, dinner turns into the Hong Kong version of a Hollywood food fight.

Underneath the fun, the film considers the age-old Chinese debate over Westernization versus traditionalism. The White Lotus Sect, the movie implies, provided the late 19th century's equivalent of the Cultural Revolution under Mao Zedong.

1993 S 1, C13:1

Boxing Helena

Directed by Jennifer Chambers Lynch; written by Ms. Lynch, based on a story by Philippe Caland; director of photography, Frank Byers; edited by David Finfer; music by Graeme Revell; produced by Carl Mazzocone and Mr. Caland; released by Orion Classics. Running time: 105 minutes. This film is rated R.

Dr. Nick Cavanaugh	Julian Sands
Helena	Sherilyn Fenn
Ray O'Mally	Bill Paxton
Dr. Alan Harrison	Kurtwood Smith
Dr. Lawrence Augustine	Art Garfunkel

By JANET MASLIN

SURELY you've heard about Jennifer Chambers Lynch's "Boxing Helena" by now. It's the film that made legal history when its prospective star, Kim Basinger, was held liable for having got cold feet. Speaking of feet, "Boxing Helena" is the one that sounds as if its story, about a surgeon who amputates the arms and legs of the woman he loves, could make Ms. Lynch's father, David ("Blue Velvet") Lynch, look like Norman Rockwell.

It's also the film that threatens to give the concept of metaphor a bad name. In the hailstorm of publicity that surrounds the film's opening, Ms. Lynch has been trying hard to leap past the lurid to the metaphorical as she explains what her film is about. Ignore the severed limbs, and this is a story about love and obsession. Or about darkest fantasy. Or about the impossibility of truly possessing anyone. Whatever.

As it turns out, Ms. Lynch has both talent and a point. Her film is by no means the gory, exploitative quasi-pornography that it sounds like from afar. Presented instead as a macabre modern fairy tale, and staged in unexpectedly discreet style (under the circumstances), her "Boxing Helena" is at least as hypnotically peculiar as it is per-

Film Forum

Jet Li, as Wong Fey Hong, the kung fu master and medicine man, in a scene from "Once Upon a Time In China, Part 2," at the Film Forum 1.

verse. Kinky? Very definitely, since the film's emphasis is on erotic fascination and not on disfigurement. Contemptuous of women? Well, no. Even without her arms, the cruel, beautiful Helena (Sherilyn Fenn) manages to hold all the cards.

"Boxing Helena," which is sardonic enough to open to the strains of "You're Nobody Till Somebody Loves You," introduces its protagonist, Dr. Nick Cavanaugh (Julian Sands), as a rich and unloved little boy. (Ms. Lynch does lose some ground by casting the role of Nick's mother, whose neglectfulness is meant to explain some of her son's subsequent strangeness, with an actress who looks like a Playboy bunny.) Nick grows up, under the shadow of a Venus de Milo in the family mansion, to become an odd bird. A talented surgeon with an ardent girlfriend (Betsy Clark), he nonetheless trembles a lot and spends much of his time spying on the gorgeous Helena, with whom he once had a dismal date. Helena hates him, which is nothing special, since Helena seems to hate everyone.

Ms. Fenn, supremely voluptuous and commanding in this role, plays Helena as someone who makes the most of her sexual power. Casually insulting to her current lover (Bill Paxton), and much more directly nasty to poor, hopeless Nick, she's the sort to make a drop-dead party entrance in a clingy black dress, then jump into a fountain just to make a splash. Nick, who has lured her to the party in question at his vast, empty house, pursues her pathetically. "What is it going to take," she finally asks him, sneeringly, "for you to realize I don't want anything to do with you?"

It takes a car accident to set in motion the events that make Helena Nick's prisoner, as the plot (Ms. Lynch's screenplay is written from a story by Philippe Caland) does what it can to make John Fowles's novel "The Collector" look like a book about butterflies. Still, Ms. Lynch keeps her film's bizarre elements under control, and sustains its darkly dreamlike manner. No visible bloodshed is involved in transforming Helena from a cursing, prop-throwing hellion to the enshrined beauty Nick thought he wanted her to be.

•

Worshiped by her jailor, and somehow not looking nearly as victimized as the characters in run-of-the-mill horror films, Helena becomes a guiding force in the transformation of shy, bloodless Nick into a more sexual being. That is not to say that the relationship between Nick and Helena has directly romantic overtones; it involves more voyeurism and ver-

bal sparring than direct contact of any sort. Ultimately, Ms. Lynch has nowhere to take her erotic parable except to a dead end, but she makes the unfolding of the story a spooky, engrossing process. There's a lot more emotion to Ms. Lynch's work than there is to her father's.

"Boxing Helena," while not the work of a Girl Scout, could also not be mistaken for a film made by a man. Ms. Lynch's sense of her heroine's intrinsic power comes through very clearly, and Helena's ordeal is not presented as an attack on that power; indeed, Helena's experience plays more like an eerie fantasy than as anything involving real pain. Though this film is sure to make enemies, it is also guaranteed a cult following on the strength of Ms. Lynch's odd but coherent imagination.

The set design of "Boxing Helena" gives it an added strangeness, particularly in its seductively Gothic-looking interiors. The film's hermetic quality is most clearly present in the performance of Mr. Sands, an ordinarily wan, remote actor whose otherworldliness is exactly right for this curious role.

•

"Boxing Helena" is rated R (Under 17 requires accompanying parent or adult guardian). It includes the suggestion of violence, but virtually no gore. It also includes profanity, considerable nudity and graphic sexual episodes.

1993 S 3, C1:3

Critics' Choices

Sample the bone-dry wit of Aki Kaurismaki in "La Vie de Bohème" (at the Quad Cinema in Greenwich Village), Mr. Kaurismaki's perfectly deadpan black-and-white film about struggling artists living in Paris. For reasons that are not easily described, Mr. Kaurismaki's favorite sad-sack actors can be irresistibly droll as they make their courtly way through a story based on Henri Murger's "Scenes de la Vie de Bohème." Mr. Kaurismaki's strange, idiosyncratic humor is very much in evidence, despite the characters' perfect solemnity about their many travails.

Ousmane Sembene's "Guelwaar" (at Lincoln Plaza Cinemas in Manhattan) offers a deceptively plain, wonderfully well-observed portrait of Senegalese society, as it is mirrored by an elaborately described tribal dispute. Starting small, with a mixup that mushrooms into a communal battle, Mr. Sembene's film shares some re-

markable (and clearly coincidental) similarities with Spike Lee's "Do the Right Thing." But this septuagenarian African film maker supplies much quieter insights, and a subtler view of human nature.

"Searching for Bobby Fischer" isn't perfect, but it's an intelligent, thoughtful film for and about older children, and a worthwhile alternative to ordinary children's fare. Young viewers will share the characters' excitement and their intellectual curiosity while also wondering why so much competitive pressure is supplied by the film's parental figures.

Haven't seen "The Fugitive" yet? It's the summer's most sure-fire entertainment. Do yourself a favor and go.
JANET MASLIN

1993 S 3, C3:1

Bad Behavior

Written and directed by Les Blair; director of photography, Witold Stok; edited by Martin Walsh; music by John Altman; production designer, Jim Grant; produced by Sarah Curtis; released by October Films. Running time: 103 minutes. This film is rated R.

Gerry McAllister	Stephen Rea
Ellie McAllister	Sinead Cusack
Howard Spink	Philip Jackson
Jessica Kennedy	Clare Higgins
The Nunn Brothers	Phil Daniels
Sophie Bevan	Saira Todd

By JANET MASLIN

Shambling, modest and really very likable in its sly, slow-moving fashion, Les Blair's "Bad Behavior" neither looks nor sounds like what it actually is. This conversational domestic comedy began as a kind of actors' exercise, with its improvised characterizations woven together to form a loose-knit story. Like Mike Leigh's "Life Is Sweet," a film it gently resembles, Mr. Blair's comedy of manners has a keen sense of the absurd and takes a compassionate view of its fretful characters.

Though "Life Is Sweet" was much more sharply focused, Mr. Leigh's work often comes to mind as "Bad Behavior" unfolds. This story is centered on the marriage of Gerry McAllister (Stephen Rea), a wry and perpetually disheveled urban planner, and Ellie (Sinead Cusack), his exasperated wife of many years. The McAllisters, who are Irish, live in North London, which is only one of the many reasons they feel ill at ease. Another is that early in the film, Ellie is told by the annoying Howard Spink (Philip Jackson) that her house is badly in need of repairs. Never all

Stephen Rea

October Films

that peaceful to begin with, the place is soon taken over by contractors.

Actually, there are two contractors, the Nunn brothers. And they are both played by the same person (Phil Daniels), which only heightens the film's sense of comic confusion. Expanding this web of relationships are a couple of Ellie's women friends, a young colleague of Gerry's (Saira Todd) who flirts with him at the office, and various others who drop nonchalantly into the story at times. The film includes quite a few impromptu late-night drinking sessions and midday teas, yet it doesn't really seem to dawdle. It creates a believable portrait of its characters' middle-class, middle-aged existence, and it also has the coherence of a scripted work.

Mr. Rea is particularly enjoyable to watch, since he finds so much withering humor in Gerry's frustration. As a man whose annoyance with his humdrum circumstances is outweighed only by his enjoyment of the familiar, he rails furtively and often against his fate. (Drawing cartoons at his planner's office, he invents an alter ego in the form of "Paddy Plan-it, trapped in a world not of his making.") Ms. Cusack brings a lively edge to Ellie's half-fond, half-caustic exchanges with her husband. Mr. Blair has described Ellie's restlessness as "pre-menopausal," and Ms. Cusack certainly captures the mood swings that implies.

Also quite good are Mr. Daniels, playing gleefully on the mix-ups that arise from his dual role, and Mr. Jackson, who makes the most of his unctuous, lascivious businessman. Since pettiness is a big feature in this film's view of its characters, this businessman is inevitably embroiled in a fight about one of his bills.

"Bad Behavior" is better appreciated as a funny and believable slice of life than as a story with strong forward momentum. Its actors slowly work up to a level of insight, verisimilitude and rueful humor. In this case, that's enough.

•

"Bad Behavior" is rated R (Under 17 requires accompanying parent or adult guardian). It includes profanity and sexual references.

1993 S 3, C6:1

Split

Directed by Andrew Weeks and Ellen Fisher Turk; written by Don Chayefsky; edited by Peter Ringer and Keith Brown; music by Jimmy Camicia; produced by Ms. Turk. Running time: 60 minutes. At the Quad Cinema, 13th Street between Fifth Avenue and Avenue

Ken Duncan/Ellen Fisher Turk Production

International Chrysis

of the Americas, Greenwich Village. This film is not rated.

WITH: International Chrysis, Justin Davis, Gerald Duval, Jeremiah Newton and Teri Paris.

By STEPHEN HOLDEN

International Chrysis, the Bronx-born drag queen who is the subject of the documentary film "Split," had long red hair, a ferociously engaging smile and oversized breasts that she liked to show off in New York City nightspots like La Vie en Rose and Club 82. Although friends compared her to Rita Hayworth, as shown in "Split" she more closely resembled a plump Raquel Welch.

Chrysis's breasts, which she jokingly christened Johnson and Johnson, helped bring about her death three years ago at the age of 39. They were injected with wax that hardened into painful lumps and that eventually seeped into her bloodstream. Along with her unregulated use of female hormones, that seepage contributed to a fatal case of liver cancer.

These are among the many stories about Chrysis that are loosely strung together in the one-hour film, which opens today at the Quad Cinema. The movie, directed by Andrew Weeks and Ellen Fisher Turk, is an affectionate homage to the would-be star who became a woman above the waist while remaining a man below. Chrysis, according to friends, did not have the woman-trapped-in-a-man's-body fixation of a transsexual. In the bedroom, she was an aggressive homosexual who fancied blond New Jersey college boys.

"Split" interweaves grainy film of Chrysis socializing and performing with the matter-of-fact reminiscences of friends who sometimes find it hard to separate fact from fiction. Little is known of her background, except that she was born in the Bronx and was alienated from her parents at an early age. As an adolescent, she spent time in the mental ward of Bellevue Hospital.

During her period of underground fame, which began in the late 1970's, Salvador Dali became a friend and frequent escort. She was a bigger celebrity in Europe (especially in Berlin) than in the United States. Chrysis lived a life of extremes. She worked as a prostitute and was addicted to heroin and alcohol. Eventually she cleaned up her act.

"Split" is frustrating to watch. The interviews are haphazardly edited. There is barely enough film of Chrysis to justify a documentary, and what is shown is of fair-to-poor quality. Perhaps that's why the glamour and vivacity that her friends claim she personified register only as a desperate desire to be noticed.

1993 S 3, C6:5

Space Is the Place

Directed by John Coney; written by Joshua Smith with additional dialogue by Sun Ra, Christopher Brooks and Jim Newman; edited by Mark Gorney; produced by Mr. Newman; released by Rhapsody Films. Running time: 63 minutes. At the Walter Reade Theater, 165 West 65th Street, Manhattan, today, tomorrow, Sunday and Thursday. This film is not rated.

WITH: Sun Ra.

By JON PARELES

Sun Ra, the late composer, band leader and keyboardist, created music that combined the singsong simplicity of nursery rhymes with open-ended squeals and twitters and rumbles. He claimed Saturn as his birthplace and filled his lyrics with interstellar imagery. Unlike most jazz films, "Space Is the Place," which opens today at the Walter Reade Theater, doesn't bother with the composer's biography, although it does offer glimpses of Ra's Intergalactic Myth-Science Solar Arkestra. Most of the time, however, it proffers fantasies to match the hallucinatory music. Made in 1974, it's already an artifact of a time when the hangover of the late 1960's met the disillusioned 1970's; black power and free jazz collided with the fashion sense of Superfly. "Space Is the Place" is the "Putney Swope" of jazz films.

In the movie's episodic plot, Sun Ra — dressed in full glitter-Egyptian regalia — lives on a bluish planet populated entirely by black people. He comes to Earth, in a spaceship that looks like a pair of bloodshot eyeballs painted on a rubber raft, to recruit more black colonists and to philosophize. "Are you ready to alter your destiny?" he asks.

On Earth, Ra has run-ins with two black opponents, an obeisant newscaster and the diabolical Mr. Overseer, and two white Federal Bureau of Investigation agents. There's a vignette in a mid-1940's jazz club in Chicago (where Ra's piano-playing is too avant-garde for the management), a cosmic card game and some proselytizing at an inner-city youth center, where one teen-ager dismisses Ra as "some old hippie." "How do we know you're for real?" another asks.

"I'm not real," he replies calmly. "I'm just like you. You don't exist in this society." Later, after Ra has won the right to play a concert from Mr. Overseer, he's picked up in a clumsy kidnap attempt by F.B.I. agents. "There's an African space program, isn't there?" one asks suspiciously. Along the way, the Arkestra, a 12-member big band, is heard and sometimes seen, in music that uses kinetic percussion, squalling saxophones and zapping synthesizer, or that drifts into quietly atmospheric passages. June Tyson, the group's singer, makes slogans like "If you find Earth boring, sign up with Outer Spaceways Incorporated" sound almost sultry.

"Space Is the Place" has more than a few hokey moments, but it also illuminates Ra's work. For him, outer space wasn't just a gimmick or a convenient source of song titles. It was a zone where racism was inoperative, where blacks could make their own destinies. Given the limitations of medium-budget special effects and directorial imagination, Sun Ra's music explored that zone better than "Space Is the Place" does. Yet for its time-capsule quality and its genial silliness, the film is enjoyable as well as goofy.

1993 S 3, C9:1

Calendar Girl

Directed by John Whitesell; written by Paul W. Shapiro; director of photography, Tom Priestley; edited by Wendy Greene Bricmont; music by Hans Zimmer; production designer, Bill Groom; produced by Debbie Robins and Gary Marsh; released by Columbia. Running time: 91 minutes. This film is rated PG-13.

Roy Darpinian	Jason Priestley
Ned Bleuer	Gabriel Olds
Scott Foreman	Jerry O'Connell
Harvey Darpinian	Joe Pantoliano
Antonio Gallo	Stephen Tobolowsky

By JANET MASLIN

"Calendar Girl," a film involving one of yesterday's pin-ups (Marilyn Monroe) and a vehicle for one of today's (Jason Priestley, of the television show "Beverly Hills 90210"), certainly demonstrates that calendar art isn't what it used to be. Mr. Priestley stars as one of three teen-age boys who fall in love with Monroe's famous nude calendar shot. In what is surely one of the least interesting fantasies ever engendered by that photograph, the three head for California in hopes of meeting their dream girl. Other films, like Robert Zemeckis's "I Wanna Hold Your Hand," have had infinitely more fun with similar ideas.

Roy (Mr. Priestley), Ned (Gabriel Olds) and Scott (Jerry O'Connell) actually do catch glimpses of something resembling Monroe. She is made to seem pert, giggly and accessible, despite the fact that the film is set in 1962, shortly before her death and certainly not when she was in the best of spirits. Eventually she even invites one of the boys for an innocent late-night assignation (during which the Monroe look-alike goes to unwittingly hilarious lengths to turn away from the camera or block her face with her arm). "I'd rather be your friend than your hero," she says wispily to her young companion. "Friends last longer."

No, the dead can't sue.

•

Mr. Priestley is not shown off to good advantage in the role of a smug, wisecracking blowhard, a guy who continually goads his buddies and spends a lot of time adjusting his dark glasses. (In fairness, Mr. Priestley also has one weepy, sensitive scene.) Despite the charmless nature of this star turn, the movie has no other possible audience beyond the "90210" set, which may be why it includes a fleeting montage of real Monroe film clips. It's possible that many of Mr. Priestley's fans have never seen her before. It's also depressing to contemplate an audience more familiar with "90210" than with "Some Like It Hot."

Occasionally "Calendar Girl" does perk up, thanks to a couple of seasoned actors who are also on hand. Stephen Tobolowsky is dependably comical as one of two gangsters who are wasting their time chasing Roy (who can add petty thievery to the list of his good deeds). And Joe Pantoliano helps a lot as Roy's relative, who hopes to break into show business and thinks a nose job may hold the key to his fortune.

•

"Calendar Girl" is rated PG-13 (Parents strongly cautioned). It includes occasional nudity, most notably several shots of Mr. Priestley's tattooed rear end.

1993 S 3, C9:1

Kalifornia

Directed by Dominic Sena; written by Tim Metcalfe; director of photography, Bojan Bazelli; edited by Martin Hunter; production designer, Michael White; produced by Steve Golin, Aris McGarry and Joni Sighvatsson; released by Gramercy Pictures. Running time: 117 minutes. This film is rated R.

Early Grayce	Brad Pitt
Adele Corners	Juliette Lewis
Brian Kessler	David Duchovny
Carrie Laughlin	Michelle Forbes

By JANET MASLIN

"Kalifornia" gets rolling as Brian Kessler (David Duchovny) and Carrie Laughlin (Michelle Forbes), a couple of artily bored yuppies with a lot of black in their wardrobes, decide to collaborate on a book. Carrie, a photographer who favors erotic self-portraits, and Brian, a magazine writer with a self-important streak, think it might be stimulating to join forces on a coffee-table volume about famous American murder sites. Great idea, right? Jaded, thrill-seeking potential buyers of such a book constitute the likeliest audience for Dominic Sena's desperately stylish film about Carrie and Brian's fact-finding trip.

Embarking on "a weeklong, cross-country, blue highways tour of historic murder sites," Carrie and Brian feel the need to take along two passengers to share expenses. (Already the film is in dreamland, since Carrie and Brian have more than enough money for black leather.) They engage in some colorful slumming when they pick up Adele Corners (Juliette Lewis), a trashy, anorexic-looking baby doll with barrettes in her hair, and Early Grayce (Brad Pitt), a tough-talking, tobacco-spitting sadist with a certain innate charm. Early, understandably anxious to hit the road after having killed his landlord and torched his trailer, turns out to be a big bonanza for Brian and Carrie. They were interested in homicidal Americana to begin with, and now they have a real live specimen in their back seat. Early exerts a strong grip on everyone, whether he is nonchalantly killing strangers at gas stations or showing off his hole-ridden, disgusting socks at mealtimes. He exerts an especially strong grip on Adele, who confides that Early only beats her when she deserves it and who giggles crazily at all the wrong moments. (Ms. Lewis, who has many similar mannerisms, may be fast becoming the Sandy Dennis of her generation.)

"Kalifornia," which was written by Tim Metcalfe, lets its stars overact to the rafters as it vacillates between wild pretentiousness and occasional high style. Unfolding in a mode that might be called baby noir, the film allows Brian some regrettably serious-sounding voice-overs, asking questions like, "What's the difference between a killer and any one of us?"

This film's main answer seems to be that killers dress worse, although not without a certain trailer-park flair. But for anyone who lingers on the fact that Mr. Pitt's Early also stabs, hacks or clubs anyone who rubs him the wrong way, "Kalifornia" will appear to be badly lacking a moral compass. The film's prevailing attitude — morally bankrupt, and proud of it — is all attitude, and not much more.

•

"Kalifornia," which has been described as being "like a musical

135

quartet" by Mr. Pitt, is mostly an exercise in contrasting personalities, with Ms. Lewis's Adele by far the most arresting. Her way with loopy, scene-stealing touches ("Boys will be boys!" she tells Carrie, after Early has forced Brian into some target shooting) is truly special, even if it usually has no bearing on what goes on around her. Meanwhile, as Ms. Lewis slyly vamps her way through the film, Mr. Pitt lends nasty credence to Early's viciousness. "Kalifornia" confirms that Mr. Pitt is an interesting, persuasive actor, but it won't do much for anyone's résumé.

Ms. Forbes makes a striking visual impression, in no small part because she has been given a full wardrobe of black underwear. Mr. Duchovny is less well served by his role as the high-minded narrator, and he brings the film to a pinnacle of silliness when he squares off against Early for a final confrontation. In the real world, the one in which magazine writers perhaps feel less empowered by their own brooding, there's not much doubt about who would win.

Mr. Sena's earlier experience as a director of videos and commercials is very much in evidence in "Kalifornia." Time and again, the film prefers an unusual angle (e.g., a blender's-eye view of a drink being made) or a nutty gesture to anything more substantive. In keeping with those choices, "Kalifornia" is indeed good-looking, with its striking desert landscapes nicely photographed by Bojan Bazelli, and with costumes by Kelle Kutsugaras that say everything — and more — about the people who wear them. If looks were everything, maybe they'd be on the right track.

•

"Kalifornia" is rated R (Under 17 requires accompanying parent or adult guardian). It includes nudity, profanity and violence.

1993 S 3, C11:1

Fortress

Directed by Stuart Gordon; written by Steve Feinberg, Troy Neighbors and Terry Curtis Fox; director of photography, David Eggby; edited by Timothy Wellburn; production designer, David Copping; produced by John Davis and John Flock; released by Dimension. Running time: 91 minutes. This film is rated R.

John Brennick	Christopher Lambert
Poe	Kurtwood Smith
Karen Brennick	Loryn Locklin
Abraham	Lincoln Kilpatrick

By STEPHEN HOLDEN

In the hellish futureworld of Stuart Gordon's film "Fortress," overpopulation has led to the passage of laws decreeing that a woman can be pregnant only once in her lifetime. The film's creepy opening scenes show what happens to those caught breaking the rules. Apprehended at the border while trying to flee the country, John Brennick (Christopher Lambert), a former Black Beret captain, and his wife, Karen (Loryn Locklin), pregnant with her second child, are shipped to the Fortress, an impermeable 33-story underground prison in the middle of the desert.

The structure is one of the more ingenious fantasies of high-tech fiendishness to be seen in films recently. A privately operated facility run by the Men-Tel Corporation, it has a surveillance system that not only monitors the prisoners' activities 24 hours a day but also looks in on their dreams and even enters them.

Discipline is enforced with a device called an intestinator, which is orally implanted in the stomach of each prisoner upon arrival. Infractions of discipline are punished with excruciating laser-activated pains in the gut. Cells are guarded by red laser borders, which if crossed, result in instant death.

The facility is run by an unholy twosome, a computer named Zed-10 and Poe (Kurtwood Smith), an icy, thin-lipped bureaucrat who is both a voyeur and a sadist. As it develops, Poe, whose name seems an apt and witty allusion to the author of "The Pit and the Pendulum," is really subservient to the mercilessly efficient Zed-10, whose voice recalls Laurie Anderson delivering one of her more ominous monologues.

The screenplay, written by Steve Feinberg, Troy Neighbors and Terry Curtis Fox, savors the chilly, formal jargon spoken by the machine in a tone of unwavering calm. Infractions of the rules are invariably countered with the reminder "Crime does not pay," reiterated through the film like a cheery mantra.

•

Like so many other futuristic movies, "Fortress," which opened yesterday, is a lot better at setting up its premise than in developing a story around it. And after its chilling opening scenes, it turns into a conventional prison escape drama with a right-to-life subtext.

Poe, who is revealed to be a technologically "enhanced" human who neither eats nor sleeps but subsists on elaborate mechanical infusions of an amino-acid compound, becomes enamored of Karen. In return for saving her rebellious husband's life, he persuades her to be his companion. The deal is made after Poe shows Karen her husband in the clutches of one of the movie's nastiest torture tools, a mind-wipe chamber, which spins him around and around and slowly turns him into a vegetable. Or, as one of John's cellmates puts it when he is returned: "The man is dead, but his body doesn't know it yet."

As the movie changes from visionary science-fiction horror into an escape yarn driven by clunking mechanical plot contrivances, it loses much of its creepiness. The film is also bogged down by mediocre acting. In the role of John, Mr. Lambert, whose drily nasty voice is far from heroic, gives a brittle, unsympathetic performance. Ms. Locklin's Karen is an emotional blank. The wittiest performance is Mr. Smith's peevish pow-

The tools of torture become excruciatingly sophisticated.

er-monger Poe, whose voyeurism gets the better of him.

For all its faults, "Fortress" has an unusually energetic imagination. At its best, it blends "Robocop," "The Handmaid's Tale" and "Brave New World" into something scary, original and grimly amusing.

•

"Fortress" is rated R. It has scenes of torture and unusually bloody violence.

1993 S 4, 11:1

The Joy Luck Club

Directed by Wayne Wang; written by Amy Tan and Ronald Bass, based on the novel by Ms. Tan; director of photography, Amir Mokri; edited by Maysie Hoy; music by Rachel Portman; production designer, Donald Graham Burt; produced by Mr. Wang, Ms. Tan, Mr. Bass and Patrick Markey; released by Hollywood Pictures. Running time: 135 minutes. This film is rated R.

Suyuan	Kieu Chinh
Lindo	Tsai Chin
Ying Ying	France Nuyen
An Mei	Lisa Lu
June	Ming-Na Wen
Waverly	Tamlyn Tomita
Lena	Lauren Tom
Rose	Rosalind Chao

By JANET MASLIN

Amy Tan's readers luxuriated in the wealth of stories she coaxed forth from the Joy Luck Club, a group of dedicated Chinese-American mah-jongg players whose present-day serenity belied their tumultuous early years. Each of these women had searing, highly dramatic memories of her Chinese girlhood; each encountered a different sort of trouble in trying to bring up her own offspring on American soil. Each recalled the events of her life in lavish and exotic detail, and those events had a way of teaching lessons. The parallels that linked the novel's parents and children provided it with a source of foolproof wisdom.

Ms. Tan found such a heady blend of melodrama and psychodrama in her novel's many mother-daughter conflicts that her "Joy Luck Club," with all its tearful showdowns and gratifying symmetries, had a stereotypically feminine outlook. But now, handsomely brought to the screen with a cast of dozens of actresses and no men of any consequence, "The Joy Luck Club" is anything but a traditional women's picture.

As directed simply and forcefully by Wayne Wang, with a screenplay skillfully written by Ms. Tan and Ronald Bass, "The Joy Luck Club" is both sweeping and intimate, a lovely evocation of changing cultures and enduring family ties. Admirers of the best-selling novel will be delighted by the graceful way it has been transferred to the screen. Those unfamiliar with the book will simply appreciate a stirring, many-sided fable, one that is exceptionally well told.

•

Feeling streamlined despite its more-than-two-hour running time, Mr. Wang's film glides through the essentials of Ms. Tan's novel while solving difficult narrative problems with deceptive ease. On film, the story's point of view makes sudden, acrobatic shifts from one character to another, in a manner that artfully underscores the story's many parallels. Since Mr. Wang must span three generations, describing the early life of each Joy Luck mah-jongg player and sometimes even creating links between her mother and her daughter, the agility with which he weaves together these elements is at times quite amazing. Buried beneath the particulars of each reminiscence, there is the quiet certainty that the film's characters are, in some fundamental way, the same.

If this idea produces a certain patness by the time "The Joy Luck Club" is over, it also helps to impose order on an otherwise sprawling narrative. And some of the film's segments are so beautifully realized that their predictable aspects never detract from their emotional power.

Despite its huge cast, the film is virtually stolen by Tsai Chin as the sly, acerbic Auntie Lindo and Tamlyn Tomita as her beautiful, headstrong daughter, Waverly, whose stories intersect in a particularly adroit way. Auntie Lindo, the unofficial leader of the Joy Luck Club by sheer force of her personality, is presented as a 15-year-old girl (Irene Ng) whose marriage is arranged by a matchmaker because her mother cannot afford to support her. When the marriage proves disastrous, Lindo schemes her way out of it in a fashion that reveals much about the tough, calculating woman she will grow up to be.

Lindo is later seen in America, hovering over little Waverly (Vu Mai) in what is surely an overreaction to her own childhood abandonment. Yet Waverly grows up to be just as cunning and rebellious as Lindo was, and their story reaches a breaking point as Waverly prepares to marry a man of whom her mother disapproves. In a tearful yet remarkably soap-free confrontation, which Mr. Wang stages in a beauty parlor, this mother and daughter voice the timeless sentiments on which "The Joy Luck Club" turns: "You don't know the power you have over me!" and "Nothing I can do can ever, ever please you!" This film's emotional impact will be felt by anyone who has ever experienced such feelings over a parent or a child.

•

It would be easy for Mr. Wang to lose the men in the audience at such moments, particularly because the film's husbands and boyfriends are all such cads or fools, and because its daughters barely seem to have fathers at all. But "The Joy Luck Club" creates such a powerful sense of its older women's suffering, and presents such brutalizing events in several of their lives, that its impact achieves a welcome degree of universality. These are sad, gripping stories, eloquently told, and only occasionally are they softened by greeting-card saccharinity. Only late in the film, when some of the weaker anecdotes surface and when the structure of these tales becomes too familiar, does "The Joy Luck Club" lose steam.

The four mah-jongg players, looking surprisingly modern and Americanized on screen, are ably played by Ms. Chin, Lisa Lu, Kieu Chinh and France Nuyen, the latter a beautiful and familiar face long absent from stage and screen. ("The World of Suzie Wong," in which Ms. Nuyen once starred, is fleetingly criticized as the sort of mock-Asian entertainment that "The Joy Luck Club" very clearly is not. Mr. Wang has assembled an enormous and terrifically effective group of Asian-American actors for his cast.)

Among the younger players, Ming-Na Wen has the pivotal role of June, who is off to find her long-lost siblings and whose going-away party becomes the pretext for bringing all these characters together. June is still mourning the recent death of her mother, which makes it odd that the party is so lavish and jolly that it includes barely a trace of grief. But then "The Joy Luck Club," for all the harshness of the events it describes, has more than a little of Hollywood at its heart. And Hollywood has been unusually well served by this richly sentimental tale.

•

This film is rated R (Under 17 requires accompanying parent or adult guardian). It has sexual situations and implied violence.

1993 S 8, C15:3

Correction

A movie review on Wednesday about "The Joy Luck Club" referred incompletely to the previous credits of one star, France Nuyen. She starred in "The World of Suzie Wong" on Broadway, not in the movie. In the film, Suzie Wong was played by Nancy Kwan.

1993 S 11, 2:6

Equinox

Written and directed by Alan Rudolph; director of photography, Elliot Davis; edited by Michael Ruscio; production designer, Steven Legler; produced by David Blocker; released by I.R.S. Releasing. At Village East, Second Avenue and 12th Street, East Village. Running time: 108 minutes. This film is not rated.

Henry Petosa, Freddy Ace..Matthew Modine
Beverly Franks...............Lara Flynn Boyle
Paris...Fred Ward
Sonya Kirk.............................Tyra Ferrell
Sharon Ace...........................Lori Singer
Rosie Copa.........................Marisa Tomei

By STEPHEN HOLDEN

In the moody, stylized films of Alan Rudolph, the world is an urban lonely-hearts club whose members drift through the city numb with longing. Even when fate delivers them to their ideal lovers, the odds are strong that the connection will be missed and that happily ever after will end up lonely ever after.

So it goes in Mr. Rudolph's new film, "Equinox," which opens today at the Village East and has many of his directorial hallmarks. Set in Empire, a decaying city that suggests a surreal version of New York (it was actually shot in Minneapolis and St. Paul), the film is strewn with lonely men and women wandering through an environment aglow with portents. Lotto signs loom mysteriously through the smog on streets churning with the homeless. And even though the film is set in the present, the camera gives its major characters the shimmer of old-time Hollywood icons.

In this particular Rudolph yarn — and yarn is the only word for its Dickensian plot — Matthew Modine plays identical twins, separated at birth, who both live in Empire. For most of the movie, Henry Petosa, a shy, goody-goody garage worker and his slick-haired twin brother, Freddy Ace, a gangster's chauffeur, drift through the city unaware of each other's existence. Eventually fate brings them together in a galvanizing moment of violence.

•

Henry, who lives in a tenement teeming with misery, is in love with his best friend's sister, Beverly Franks (Lara Flynn Boyle). Even though Beverly loves him back, he is too shy to pursue the relationship. Both live in self-created fantasy worlds. Henry's dingy apartment is plastered with travel posters. Beverly's is decorated to suggest an elegant old-fashioned rusticity. She reads Emily Dickinson and dances alone to period recordings of "I'm in the Mood for Love" and "Temptation."

Freddy's romantic life is much less clearly drawn. He is married to Sharon (Lori Singer), an attractive but materialistic woman who is wildly in love with him.

Segueing back and forth between the twins, "Equinox" pieces its story together like a jigsaw puzzle. The amateur detective who puts some complicated pieces of family history together is Sonya (Tyra Ferrell), a morgue janitor who accidentally comes across a letter revealing the twins' parentage and telling of the unclaimed fortune that has been left to them.

As much as the director tries to pack his story with meaning, it would be a mistake to read too much into it. It is a likable if mush-hearted fable about people who feel incomplete and don't know why. The twins are portrayed as two halves of a whole each struggling unconsciously to complete itself. In the same way that Henry lives out Freddy's repressed goodness, Freddy does the same for his twin's repressed sensuality and appetite for adventure.

Mr. Modine does a fine job of differentiating between the two without resorting to caricature. He is especially good at showing how the repressed qualities of each twin peek through their surfaces. As Henry's sweetheart, Ms. Boyle exudes the right mixture of warm-blooded ardor and strait-laced defensiveness.

Marisa Tomei, who was so memorable in "My Cousin Vinnie," is striking in the small but meaty role of Henry's prostitute neighbor, who parks her baby in his apartment while she plies her trade. Whenever she visits Henry, he is watching a television show in which an oversized wrestler demonstrates brutal techniques in self-defense. Like almost everything else in "Equinox," his seemingly out-of-character absorption in television violence makes a none-to-subtle comment about repression and personality.

1993 S 8, C20:3

Sex Is . . .

Directed by Marc Huestis; director of photography, Fawn Yacker; edited by Lara Mac and Hrafnhildur Gunnarsdottir; music by Donna Viscuso and Pussy Tourette; produced by Mr. Huestis and Lawrence Helman. At Cinema Village, 22 East 12th Street, Greenwich Village. Running time: 80 minutes. This film is not rated.

WITH: Larry Brinkin, Danny Castellow, Alex Chee, Wayne Corbitt, Jim Glyer, Miguel Gutierrez, Bob Hawk, Marc Huestis, Gerard Koskovich, Bambi Lake, Lulu, R. Wood Massi, David Perry, Brad Phillips and Madame X.

By STEPHEN HOLDEN

Candid discussions of sex in the movies and on television often seem to be so fraught with anxiety and prurience that any useful information comes enveloped in an atmosphere of hysteria. And if the sex is homosexual, that hysteria can become panic. That's one reason "Sex Is ...," Marc Huestis's documentary film about gay sex, is so welcome. Although this very explicit film is not for everybody, it addresses male homosexual intimacy with a refreshing directness. At a moment when gay sexuality is often glibly equated with AIDS, it is firmly but responsibly pro-sex.

Interweaving the erotic autobiographies of 15 gay male talking heads with snippets of pornography, the film offers a survey of gay men's attitudes toward coming out, relationships, promiscuity and gay life before and after the AIDS epidemic struck.

The subjects of the 80-minute film, which opened today at the Cinema Village, range in age from 19 to 73. Most live in the San Francisco area. The carefully chosen ethnic and cultural mosaic includes one Asian, one Hispanic and three black men. They include a minister, artists, AIDS workers, a porn star and a transvestite prostitute. Several men disclose that they are H.I.V. positive.

The material has been skillfully organized into broad overlapping topics. In the coming-out section, several of the men recall first homosexual experiences that were brief encounters with older strangers. Later there is much reminiscing about gay life in San Francisco in the 1970's, when sexual liberation reached a frenzied (and often drug- and alcohol-fogged) peak of promiscuous experimentation. These recollections segue into discussion of the problems of adjusting to the need for caution in the age of AIDS. The responses range from celibacy to a defiant nonchalance.

Among those interviewed the most vivid personality is Wayne Corbitt, a black performance poet and playwright who is forthright about his sadomasochistic tastes. In describing being whipped by a white South African, he shrugs off any political significance to the encounter.

Middle-class monogamy is represented by R. Wood Massi, a college administrator, and Larry Brinkin, a sexual discrimination investigator, who are both in their 40's and who have lived together for a decade. Bob Hawk, a film exhibitor in his 50's, offers a richly detailed description of gay bars three decades ago, when the atmosphere had an illicit speak-easy sense of danger and well-dressed couples who were strangers slow-danced.

For all the candor of the interviews, most of the verbal evocations of sex stop short of graphic description. The gaps are filled with very brief clips from porno films and offer fleeting glimpses of oral and anal sex and ritual S&M, among other activities.

Amusingly interspersed among the interviews are fragments of vintage educational films about sex.

1993 S 9, C17:5

Samba Traoré

Directed and produced by Idrissa Ouédraogo; written by Mr. Ouédraogo, Jacques Arhex and Santiago Amigoréna; cinematography by Pierre Laurent Chenieux and Mathieu Vadepied; edited by Joëlle Dufour; music by Fanton Cahen and Lamine Konté; released by New Yorker Films. In Mooré, with English subtitles. Lincoln Plaza Cinema, Broadway at 63d Street. Running time: 85 minutes. This film is not rated.

Samba Traoré......................... Bakary Sangaré
Saratou...............................Mariam Kaba
Salif.........................Abdoulaye Komboudri
Binta...................................Irène Tassembedo

By JANET MASLIN

Idrissa Ouédraogo, the film maker from Burkina Faso whose spare, beautiful films command worldwide attention, uses little more than people and places to tell his stories. The places are quiet, just barren landscapes or tiny groupings of thatched-roof mud huts. And the people are often nonprofessional actors, so unself-conscious before Mr. Ouédraogo's camera that they seem to be doing little more than expressing the broad outlines of their characters' attitudes.

Yet this director's films — among them "Yaaba" (1989), "Tilai" (1990) and now "Samba Traoré," the story

New Yorker Films Release

Bakary Sangaré

of a thief who returns to his native village — achieve the kind of deep resonance that such simplicity rarely allows. Mr. Ouédraogo permits nothing to come between his audience and the basic, universal matters his films consider. A true and brilliant Minimalist, he tells his stories with extraordinary humanity and without embellishment. Mr. Ouédraogo sustains his gentle, enveloping films with little more than the clarifying honesty of his vision.

That vision has seemed particularly acute in the rural settings where "Yaaba" and "Tilai" took place, but "Samba Traoré," which opens today at the Lincoln Plaza Cinema, starts out in a city. Without explanation, the title character is seen participating in a gas-station robbery that ends in bloodshed, leaving Samba a wanted man. He is next seen aboard the bus that takes him back to his friends and family, who welcome him with great and unquestioning affection. ("I don't know whether Samba didn't commit a robbery just to get back home," the director has said.)

Back in his village, Samba (Bakary Sangaré) resumes his friendship with the clowning, good-hearted Salif (Abdoulaye/Komboudri), now married to Binta (Irène Tassembedo), a woman so big and strong she can carry little Salif on her shoulders. Meanwhile, Samba also takes notice of the beautiful, serene Saratou (Mariam Kaba), and begins to court her. One day, dressed in clothes for courtship and riding a bicycle when his neighbors mostly walk barefoot, Samba visits Saratou at a watering hole while she washes clothes. "You know that you are beautiful," he says. "I love you. That's what I wanted to tell you. Now you must decide."

In a film whose characters express themselves as bluntly and simply as that, big events can take place with surprisingly little fanfare. Soon Samba has realized his dream of marrying Saratou, and he has also brought some form of wealth and progress to the village. He gives the community a gift of cattle, and he embarks on plans to build a house and open a bar, even though this is a place where residents have ordinarily drunk out of water bottles or crockery, sitting in the dust. The bar itself is nothing more than a straw roof over a tiny open space, but it is a resounding symbol of change, the kind of change that may have made Samba a thief in the first place.

Should the elements of this story sound primitive, consider these almost unimaginable details: Samba's largesse apparently all springs from the proceeds of one gas station robbery. That robbery is front-page news in the urban community where it takes place. It is still in the news many months later, and the police have resolved to catch their thief because, as one of them puts it, "We must!"

Crime is not forgiven or forgotten within this film's moral universe, but Samba's life is understood within the wider world of his friends and family, his shame and his regret, his unexpected hopes for redemption. The wisdom that emerges from this film's primitive-looking setting deserves to be heard in many a more sophisticated-looking place.

"Samba Traoré," winner of the Silver Bear at this year's Berlin Film Festival, is so straightforwardly acted that it's difficult to tell which of the film's performers are professionally trained. All of them strike the same note of perfect, unaffected candor. Mr. Ouédraogo, whose eye for visual composition gives his films a serene, stately beauty, also makes "Samba Traoré" a quiet study of the culture in which it unfolds.

Venturing outside that culture for the film's urban opening scene is a form of risk-taking for the director, since thoughts of the wider world make it harder to leave so many questions unasked and unanswered. Where did Samba get his money? Who was the father of Saratou's young son? The truth about these and other matters emerges only slowly, sometimes in a way that threatens to disrupt the story's self-contained, contemplative mood. But in the end, Mr. Ouédraogo uses carefully calibrated ambiguity as artfully as he has in the past: that is to say, very artfully indeed.

1993 S 10, C3:1

True Romance

Directed by Tony Scott; written by Quentin Tarantino; director of photography, Jeffrey L. Kimball; edited by Michael Tronick and Christian Wagner; music by Hans Zimmer; production designer, Benjamin Fernandez; produced by Samuel Hadida, Steve Perry and Bill Unger; released by Warner Brothers. Running time: 118 minutes. This film is rated R.

Clarence Worley	Christian Slater
Alabama Whitman	Patricia Arquette
Clifford Worley	Dennis Hopper
Mentor	Val Kilmer
Drexl Spivey	Gary Oldman
Floyd	Brad Pitt
Vincenzo Coccotti	Christopher Walken
Lee Donowitz	Saul Rubinek
Elliot Blitzer	Bronson Pinchot
Dick Ritchie	Michael Rapaport
Nicky Dimes	Chris Penn

By JANET MASLIN

"True Romance," a vibrant, grisly, gleefully amoral road movie directed by Tony Scott and dominated by the machismo of Quentin Tarantino (who wrote this screenplay before he directed "Reservoir Dogs"), is sure to offend a good-sized segment of the moviegoing population. But those viewers are the ones who would never go to see a film starring Christian Slater in the first place, and who have no taste for the malevolently funny bad-boy posturing that is the very essence of "True Romance."

Its title notwithstanding, this film is about tough guys. And it has been

cast to present a super-hip white villains' Hall of Fame. Despite the unexplained absence of Harvey Keitel, practically every other dyed-in-the-wool contemporary heavy is on hand, each of them thoroughly enjoying Mr. Tarantino's arch, colorful dialogue and the ripe opportunities it provides. The story also has a heroine, a jiggly, bird-brained call girl named Alabama Whitman. Though played with surprising sweetness by Patricia Arquette, Alabama will do nothing to melt the hearts of those who object to films like this one on principle.

Compared with other recent works of sadism-laced marginalia ("Kalifornia" and "Hard Target" come to mind), "True Romance" has a lot more consistency and a much surer sense of dark humor. (This film is closer in spirit to something like "Winter Kills," another cameo-filled bit of craziness.) From its opening scene, in which a disconsolate comic-

Take a suitcase full of cocaine. Add 2 outlaws. Mix well.

book salesman named Clarence Worley (Mr. Slater) and a woman sit in a bar discussing which of them would be more willing to sleep with Elvis Presley, this film sticks to its own stylistic guns, which often call for guns of the real kind. "True Romance" has occasional moments of very ugly violence, which it savors just as much as it enjoys wickedly tongue-in-cheek wisecracks and reveries.

●

As befits the B-movie traditions from which they come, Clarence and Alabama fall instantly in love and hit the road. "Don't wait for the dust to settle," says a billboard outside Clarence's window, and in this film no one ever does. Thanks to a mix-up involving a suitcase full of cocaine, the two lovers are also outlaws, having fatally antagonized Drexl Spivey, who was once Alabama's pimp. As played by Gary Oldman, Drexl has dreadlocks, scars, silk underwear, an incongruous accent, a leopard-skin robe and one milky eye. Each of the minor performers here is treated as a guest star, and allowed to make the most of his character's little idiosyncrasies.

Also in "True Romance," and squaring off for a monumental cool-dude showdown midway through the story, are Dennis Hopper as Clarence's father and Christopher Walken as a debonair mafioso. Mr. Hopper at first seems wasted in the role of a security guard, but he becomes his familiar self after he is tortured

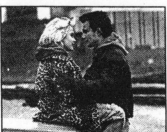

Ron Phillips/Warner Bros.

Patricia Arquette and Christian Slater in "True Romance."

briefly and subjected to Mr. Walken's long, sly, deadpan monologue. Rising calmly to the occasion, Mr. Hopper offers a calculated racial remark that is offensive without being entirely gratuitous; his comments do have an obvious dramatic purpose. This film's various outrages are committed unapologetically, and are very much in the service of its bizarre story.

●

"True Romance" eventually goes Hollywood, quite hilariously, in a plot turn that has Clarence trying to sell his cocaine to a smug movie producer (played perfectly by Saul Rubinek) through an actor who serves as the producer's errand boy. As played by the very droll Bronson Pinchot, who knows everything about how to steal a movie, this actor offers an uproarious, obscene illustration of just how far a Hollywood yes man may be willing to go.

Also in "True Romance," and well worth mentioning, are Michael Rapaport (who starred in "Zebrahead") as a nice-guy friend of Clarence's who is up for a ridiculous television role; Chris Penn as one of several police detectives marveling at the sheer stupidity of their suspects; Val Kilmer as a fleetingly visible Elvis Presley who gives Clarence advice, and Brad Pitt as a guy so stoned that he's woozily hospitable to armed thugs. Mr. Scott handles all these characters with a lot more flair and personality than he brought to "Top Gun." And he keeps this film moving too fast for its audience to grow restless or ask questions.

"True Romance" is loaded with flamboyant artifacts, from the fuchsia Cadillac in which the principals travel to the flurry of feathers that accompanies their final showdown. The score varies from Burl Ives to Aerosmith, with theme music by Hans Zimmer that has the jingling sound of a Christmas carol, yet all the music feels exactly right. The soundtrack underscores the sense that this film is a fable, albeit a movie-mad fairy tale with a body count for modern times. By the time Clarence lists among his favorite films "Mad Max" and "The Good, the Bad and the Ugly," the audience will be well aware of where his tastes lie.

●

"True Romance" is rated R (Under 17 requires accompanying parent or adult guardian). It includes extremely gory episodes involving slicing, stabbing, torching, beating and other violent acts. It also includes profanity and sexual situations.

1993 S 10, C5:1

The Seventh Coin

Directed by Dror Soref; written by Mr. Soref and Michael Lewis; director of photography, Avi Karpik; edited by Carole Kravetz; music by Misha Segal; produced by Lee Nelson and Omri Maron; released by Hemdale. At the Sutton, Third Avenue and 57th Street, Manhattan. Running time: 92 minutes. This film is rated PG-13.

Ronnie Segal	Alexandra Powers
Salim Zouabi	Navin Chowdhry
Emil Saber	Peter O'Toole
Captain Galil	John Rhys-Davies
Lisa	Ally Walker

By STEPHEN HOLDEN

In "The Seventh Coin," Peter O'Toole shamelessly hams it up as a retired British army officer named

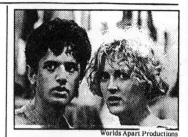

Worlds Apart Productions

Navin Chowdhry and Alexandra Powers in "The Seventh Coin."

Emil Saber who will stop at nothing to get his hands on a priceless ancient coin. Mr. O'Toole has specialized in characters gripped by obsession. And in Saber, a homicidal madman who believes himself to be the reincarnation of King Herod, he has one of the weirdest roles of his career.

For the movie, which opens today at the Sutton, the 61-year-old actor is made up to look like something out of a wax museum. As he stalks the streets of Jerusalem, his glazed eyes bore out of a face that is as cadaverous as a death mask.

The story, concocted by Dror Soref (who directed) and Michael Lewis, imagines that two millenniums ago King Herod minted seven coins bearing his image that collectors have been hunting with a murderous zeal ever since. Saber has succeeded in gaining possession of six of them. For reasons that are too silly to go into, the seventh has wound up in a camera case that Salim (Navin Chowdhry), an Arab pickpocket, has snatched from Ronnie (Alexandra Powers), an American teen-ager visiting Jerusalem.

The story is little more than an extended cat-and-mouse game in which Ronnie and Salim, who become allies and eventually sweethearts, try to elude Saber and his henchmen. Their flight takes them from the rooftops of Jerusalem to an underground tunnel to a Turkish bathhouse. In an extraneous and poorly integrated subplot, Ally Walker plays a young policewoman hot on the trail of Saber.

"The Seventh Coin," which was filmed on location in Jerusalem, has plenty of snazzy local color but no idea what kind of film it wants to be. When Mr. O'Toole is doing his campy caricature of British hauteur, it seems to be a spoof of a caper film. In Ms. Walker's scenes, it descends into a half-baked Nancy Drew adventure. Once Ronnie and Salim begin making eyes at each other, it turns into a maudlin star-crossed romance.

Even though it is all thoroughly unbelievable, Ms. Powers, as the tomboyish teen-ager, and Mr. Chowdhry, as the waifish pickpocket who speaks impossibly good English, make an appealing if far-fetched couple.

●

"The Seventh Coin" is rated PG-13 (Parents strongly cautioned). It has a mildly suggestive love scene and some violence.

1993 S 10, C5:1

Leon the Pig Farmer

Directed and produced by Vadim Jean and Gary Sinyor; written by Mr. Sinyor and Michael Normand; director of photography, Gordon Hickie; edited by Ewa J. Lind; production designer, Simon Hicks; released by Cinevista. At the 68th Street Playhouse, at Third Avenue, Manhattan. Running time: 98 minutes. This film is not rated.

Cinevista

Mark Frankel

Leon Geller.....................Mark Frankel
Judith Geller...............................Janet Suzman
Brian Chadwick........................Brian Glover
Yvonne Chadwick........................Connie Booth
Sidney Geller..........................David De Keyser
Madeleine..................................Maryam D'Abo
Lisa...Gina Bellman

By STEPHEN HOLDEN

If you mated a sheep with a pig, would the offspring be kosher or non-kosher? That is one of the amusing questions raised in "Leon the Pig Farmer," a dry satirical comedy from England, which opens today at the 68th Street Playhouse.

When the product of an accidental crossbreeding of the two species is actually born on a Yorkshire farm, two rabbis hurry down from London to inspect the creature, which is heard but not seen in the movie. The sound it emits comes in two parts: an ovine bleat immediately followed by a porcine snort.

The hybrid animal is an audacious comic metaphor for the identity crisis suffered by the movie's central character, Leon Geller (Mark Frankel). The son of a successful net curtain salesman, Leon has never quite fitted into his parents' comfortable Jewish society in north London. In the film's opening scene, he shocks his family at a lavish birthday party by announcing he has quit his job for a sharp-shooting real-estate agency over a matter of principle. The agency has decided to develop a block of land where Charles Dickens's house stands into something called a leisure complex. Leon quits in protest against the razing of a landmark.

While deciding what to do next, Leon goes to work for his mother's catering business. Delivering sandwiches to a medical facility one day, he accidentally discovers that he is the product of artificial insemination. Worried that he might have inherited his father's low sperm count, Leon has himself tested for the same condition. On returning for the results, he is informed that through a test-tube mixup 30 years earlier, Sidney Geller is not his biological father. The sperm that fertilized him really belonged to Brian Chadwick of Lower Dinthorpe, Yorkshire.

•

Rejected by Sidney (David De Keyser), who is horrified that his son might not be 100 percent Jewish, Leon visits Lower Dinthorpe, where he is welcomed by his biological father (Brian Glover) like a long-lost son. A pig farmer who is decidedly gentile, Brian and his wife, Yvonne (Connie Booth), bend over backward to make Leon feel at home. Yvonne goes to great lengths to prepare the perfect chicken soup. Aided by books like "Portnoy's Complaint" and "The Joy of Yiddish," the Chadwicks begin spicing their conversation with Yiddish expressions.

Eventually, the two families come together in a London restaurant at which each clan scrupulously affects what it imagines to be the other's social style.

"Leon the Pig Farmer," which was directed by Vadim Jean and Gary Sinyor from a screenplay by Mr. Sinyor and Michael Normand, is really one attenuated Jewish joke. Although it has its witty moments, that joke is far from uproarious because of the deadpan absurdist style in which it is told. The climactic scene in which the Gellers and the Chadwicks converge and reverse social roles should have been a grandly funny set piece. But because the screenplay is too timid and the tone too tongue in cheek, it never bursts into comic life.

The movie scores its sharpest satirical points in scenes portraying Leon's torrid affair with Madeleine (Maryam D'Abo), a woman he accidentally knocks off a bicycle while driving home in a daze from the sperm bank. Madeleine is an artist who works in stained glass and who specializes in depicting the Crucifixion. When Leon informs her of his Jewish background, she announces, "Dad hates Jews" and in a frenzy of desire drags him into bed and after that onto a cross to pose as Jesus. Later, when Leon innocently tells her of his true paternity, he is thrown out of the house.

1993 S 10, C8:1

Crush

Directed by Alison Maclean; written by Ms. Maclean and Anne Kennedy; director of photography, Dion Beebe; edited by John Gilbert; production designer, Meryl Cronin; produced by Bridget Ikin; released by Strand. At the Village East Cinema, Second Avenue and 12th Street, East Village. Running time: 97 minutes. This film is not rated.

Lane....................Marcia Gay Harden
Christina.....................Donogh Rees
Angela.........................Caitlin Bossley
Colin...........................William Zappa

By VINCENT CANBY

"Crush," the New Zealand film opening today at the Village East, begins with a certain amount of evil promise.

Two youngish women are motoring through a picturesque New Zealand geothermal landscape. Christina (Donogh Rees), a blond Meryl Streep lookalike, is a local literary critic who's on her way to interview a reclusive novelist. Lane (Marcia Gay Harden), whose jet black hair looks like a wig, is American and apparently without any occupation except as a seductress. It's clear the two women know each other extremely well.

With Lane at the wheel at one point, the car goes off the road and is badly smashed. Lane emerges from the wreck with a small bump on the head and every hair in place. Ignoring her companion, who may be dead, she rummages around for her things (and some of Christina's), and leaves the scene of the accident. She next turns up at the modest bungalow of the reclusive novelist, which is when the evil promise of the movie starts to fade into utter confusion.

•

For a couple of minutes she allows herself to be accepted as Christina, but acknowledges her true identity. She first flirts with the novelist's teen-age daughter Angela (Caitlin Bossley), and then sets about the serious business of seducing Angela's dad, Colin (William Zappa), which is easy: he's none too bright. The movie subsequently becomes a series of power games played by the wanton Lane, the jealous Angela, the dopey Colin and the bed-ridden Christina. Though unable to walk and nearly brain-dead, Christina is able to hold her end up when push comes to shove.

"Crush" is the first feature to be directed by Alison Maclean, who also wrote the screenplay with Anne Kennedy. I haven't a clue whether it's really about anything more substantial than Lane's wardrobe, which looks like the entire fall collection of a would-be kicky new SoHo designer.

Among the film's other problems is Lane herself, who is supposed to drive both men and women mad with desire. As written, directed and acted, however, Lane is as desirable as a noisily abusive subway panhandler whose eyes you avoid at all costs. She's rude, she's a sloppy drunk and she talks too much during sex. The character is no unstoppable life force. It's the figment of a fuzzy imagination.

•

The original screenplay is not good. It has the manner of a novella that was turned into a movie before it had been thought through. Ms. Maclean obtains good performances from the New Zealand members of the cast, but she lets Ms. Harden do a lot of unconscionably silly, unbelievable bits of business.

Much of the movie is shot around or in various New Zealand geothermal wonders: geysers, lakes of bubbling mud and natural hot springs. These settings are attractively bizarre. Yet instead of evoking great, hidden forces that are about to explode, they suggest that the film's characters have the souls of day trippers.

1993 S 10, C8:5

The Real McCoy

Directed by Russell Mulcahy; written by William Davies and William Osborne; director of photography, Denis Crossan; edited by Peter Honess; music by Brad Fiedel; production designer, Kim Colefax; produced by Martin Bregman, Willi Baer and Michael S. Bregman; released by Universal. Running time: 105 minutes. This film is rated PG-13.

Karen McCoy.................Kim Basinger
J. T. Barker.......................Val Kilmer
Jack Schmidt.................Terence Stamp
Gary Buckner.................Gailard Sartain

By VINCENT CANBY

"The Real McCoy" looks like a television movie that won a raffle and became a theatrical film instead.

The high concept: a beautiful cat burglar (Kim Basinger) wants nothing more than to go straight and raise her young son after serving six years in prison. Mother love is thwarted when her former associates kidnap the child to force her to carry out one last bank job. The movie has a certain store-bought surface polish, but, inside, it's just as rickety as it sounds.

The cast includes Val Kilmer, as a nonprofessional criminal who comes to Ms. Basinger's aid; Terence Stamp, as the vile "Mr. Big" who blackmails the woman, and Gailard Sartain, as Ms. Basinger's lecherous and crooked parole officer. The movie was shot entirely in Atlanta. It features a lot of high-tech equipment for breaking, entering and cutting through bank-vault doors, and not one moment that surprises.

"The Real McCoy" isn't ghastly in the way of something pretentious. It's wan: a movie that totally fails its small purpose to make the time between commercials pass quickly.

•

."The Real McCoy" has been rated PG-13 (parents strongly cautioned). The film has vulgar language and one scene in which a mother is badly beaten as her small son watches in horror.

1993 S 10, C10:6

Undercover Blues

Directed by Herbert Ross; written by Ian Abrams; director of photography, Donald E. Thorin; edited by Priscilla Nedd-Friendly; music by David Newman; production designer, Ken Adam; produced by Mike Lobell; released by MGM. Running time: 95 minutes. This film is rated PG-13.

Jane Blue.................Kathleen Turner
Jeff Blue.....................Dennis Quaid
Jane Louise Blue.................Michelle Schuelke
Novacek.........................Fiona Shaw
Muerte.........................Stanley Tucci
Halsey..........................Larry Miller

By VINCENT CANBY

Because it relies so heavily on manners identified with either the James Bond or "Thin Man" movies, you might suspect that "Undercover Blues" would be a sort of hybrid rip-off. The new film also uses New Orleans locations with the tenacity of a sightseer who won't rest until his feet bleed. The movie was made a year ago, but opened in New York theaters only yesterday.

Bad signs, all.

Possibly because of those signs, or at least in part, "Undercover Blues" turns out to seem a most genial surprise, a comic update of cold war espionage movies that, because of the New Orleans location, has the enhanced charm of a stolen holiday. It stars Kathleen Turner and Dennis Quaid, playing extremely well together, as Jane and Jeff Blue, who recall Nora and Nick Charles without making you wince. Jane and Jeff are wise-cracking, loving, incredibly adept American spies on maternity leave in New Orleans with their baby daughter in constant tow.

Exactly what agency might be employing Jane and Jeff is never clear, though they have apparently worked for both the C.I.A. and the F.B.I. When first met, they have just arrived in New Orleans to get away from it all. Jeff immediately makes a lifetime enemy of Muerte (Stanley Tucci), a vicious but hilariously incompetent mugger he calls Morty.

The next day they are enlisted to track down an international super-criminal named Novacek (Fiona Shaw), who was once the head of the secret police in Communist Czechoslovakia. The woman has apparently stolen a half-dozen containers of a

new plastic explosive so dangerous that even the United States Army won't use it. It's beyond analyzing how Jane, Jeff, Muerte and Novacek all happen to come together for the frenetic climax in a Louisiana salt mine. Somehow they do.

•

Reason is beside the point of "Undercover Blues," as written by Ian Abrams and directed by Herbert Ross. The movie has enough style to make you overlook reason and the occasionally erratic continuity. It also has moments of explosive comedy, not so arbitrarily set in the New Orleans zoo, a picturesque restaurant in the French Quarter and the old French Market.

From time to time the jolly banter between Jane and Jeff comes close to being twee, but often it is as laugh-out-loud funny as it means to be. Mr. Ross also manages to direct the scenes involving the baby in such a way that they are both very funny and crazily accurate. The baby, played by 11-month-old Michelle Schuelke, is a scene-stealer in the tradition of W. C. Fields's arch-foe, Baby LeRoy, and Robert Altman's grandson, Welsey Ivan Hurt, who played Swee' Pea in Mr. Altman's "Popeye" (1980).

Ms. Turner, a seriously funny comedienne, has her best role since "The War of the Roses," though "Undercover Blues" itself is not in the same category. The laughs she gets are genuine. They don't come from a sit-com reading of the lines. Mr. Quaid seems to work harder to get the same results, maybe because he's required to smile too often. Ms. Shaw is not on the screen that much, but she's also a delight. Good support is given by Obba Babatunde and Larry Miller as two hopelessly outwitted New Orleans detectives.

This movie is a breeze.

•

"Undercover Blues" has been rated PG-13 (Parents strongly cautioned). It includes some mildly vulgar language and scenes that are sexually suggestive.

1993 S 11, 13:1

Household Saints

Directed by Nancy Savoca; screenplay by Ms. Savoca and Richard Guay, based on the novel by Francine Prose; director of photography, Bobby Bukowski; edited by Beth Kling; production designer, Kalina Ivanov; produced by Mr. Guay and Peter Newman; released by Fine Line Features. Running time: 124 minutes. This film is rated R.

Catherine Falconetti..................Tracey Ullman
Joseph Santangelo..............Vincent D'Onofrio
Teresa...Lili Taylor
Carmela Santangelo.................Judith Malina
Nicky Falconetti......................Michael Rispoli
Lino Falconetti................................Victor Argo
Leonard Villanova..............Michael Imperioli

By JANET MASLIN

After Nancy Savoca made "True Love," her wonderfully funny and candid-looking film about a Bronx wedding, she surely could have taken the traditional route to Hollywood. "True Love" was so promising that it could have allowed Ms. Savoca to make films much bigger and blander, but instead she has retained her idiosyncratic tastes. Her third film, after the 1990 "Dogfight," is "Household Saints," a warm, rueful, thoroughly peculiar tale set in Little Italy. The story is filled with strange, homespun

Abigayle Tarsches/Fineline Features
Vincent D'Onofrio and Tracey Ullman in "Household Saints."

miracles, and this single-minded little film could be counted as one of them.

Adapted with exceptional skill from the novel by Francine Prose (Ms. Savoca wrote the screenplay with her husband, Richard Guay), "Household Saints" spans three generations in two small Italian families. Those families are brought together with the help of a card game and a butcher shop. "Man deals, and God stacks the deck," says one character, who happens to be a ghost. He aptly describes the film's view of spiritual matters.

Ms. Savoca, who has a way of magnifying small, unglamorous events until they become unaccountably magical, sees a supreme inevitability in the occurrence that begins this story. It is a hot summer night, and Joseph Santangelo (Vincent D'Onofrio), a sly young butcher, wins Catherine Falconetti (Tracey Ullman) in a pinochle game. He bets her father a blast of cold air from the Santangelo meat locker, and in the process he casts a kind of spell. The film actually suggests that everything about this couple's destiny, and the odd life of their fiercely devout daughter, Teresa (Lili Taylor), was determined the moment Joseph opened that freezer.

Ms. Prose's novel makes a clear connection between the Falconetti family, renowned for its bad luck, and Maria Falconetti, the haunting star of Carl Dreyer's 1928 film "The Passion of Joan of Arc." (Catherine, an avid reader of Silver Screen magazine as the story begins in the late 1940's, recalls vaguely that one of her relatives was once an actress.) Since Teresa will later strive for sainthood in her own way, the link is interesting and inexplicable, as are many of the film's background motifs. Ms. Savoca underscores certain quirky details — the sudden resuscitation of house plants, the amazing importance of sausage in the lives of the Santangelos — without overexplaining them. The film, like its fundamental subject, works in mysterious ways.

The fourth major figure in "Household Saints," a film whose minor

roles are also very well cast, is Carmela, Joseph's witch of a mother. Played with gleeful nastiness by Judith Malina, she uses the full force of her many superstitions to make Catherine miserable, once she realizes that her son is hellbent on having this lank-haired, sullen girl. Joseph has suddenly become determined to marry Catherine, not only because he has won her but also because her virginity and drabness intrigue him somehow.

The film includes a long, entertainingly wretched dinner sequence during which the two families meet and Carmela offers some unmistakably hostile opinions about Catherine's cooking. The old woman also boasts of having been so poor she "picked shells out of the garbage at Umberto's Clam House — and believe me, I made a delicious soup!" "When?" her son wants to know.

An unexpectedly tender wedding-night scene between Joseph and his sulky bride gives "Household Saints" one of its occasional opportunities to burst into pure fantasy. Others come from "Madama Butterfly," which is an intense preoccupation for Catherine's half-crazy brother (Michael Rispoli). Carmela has her own fanciful side, conversing with her dead husband and becoming certain that Catherine, once she becomes pregnant, will give birth to a chicken. Carmela forces Catherine to pray that this will not happen. Somehow the old woman's religious devotion becomes a curse in its own right. After Carmela dies, an event quickly followed by the first flourishes of color in the dim apartment she has shared with the newlyweds, her spirit somehow reasserts itself through their baby, Teresa.

Ms. Taylor gives an eerie, radiant performance as the teen-age Teresa, who yearns to join a convent and is thwarted by her parents. Although Ms. Taylor doesn't appear until an hour and a quarter into the film, she dominates it the rest of the way. And by the time Teresa experiences a miraculous vision of Jesus as she obsessively irons her boyfriend's

shirt, it's clear that "Household Saints" is too single-minded to concern itself with credibility in the usual sense. The director is able both to handle the fancifulness of her material and to evoke the pop-cultural background of the early 1970's with a few well-chosen strokes. The latter touches underscore Teresa's utter isolation from the ordinary world.

"Household Saints," an offbeat, involving story told with perfect confidence, is credibly acted despite the difficulty of its central roles. Ms. Ullman, who remains deliberately subdued, and especially Mr. D'Onofrio, who makes a warm and subtle butcher, manage to evolve convincingly over time. Ms. Malina turns her character's meanness into a comic virtue. Ms. Taylor strikes a note of fascinating ambiguity, which is just what the film requires. Equally effective in a smaller role is Michael Imperioli as the young man who cares for Teresa but is dumbfounded when he sees beyond her beatific smile.

•

"Household Saints" is rated R (Under 17 requires accompanying parent or adult guardian). It includes profanity, brief nudity and sexual situations.

1993 S 15, C15:2

Praying With Anger

Written and directed by M. Night Shyamalan; director of photography, Madhu Ambat; edited by Frank Reynolds; music by Edmund K. Choi; produced by Mr. Shyamalan. Released by Cinevista. At the Village East Cinema, Second Avenue and 12th Street, East Village. Running time: 101 minutes. This film is not rated.

Dev Raman......................M. Night Shyamalan
Sunjay Mohan................................Mike Muthu
Raj Kahn..............................Arun Balachandran
Rupal Mohan..................................Richa Ahuja

By STEPHEN HOLDEN

"Praying With Anger" is a standard male rites-of-passage film with one fascinating difference: Dev Raman (M. Night Shyamalan), a hotheaded exchange student who endures assorted trials on his way to responsible manhood, is an American-born Indian who goes all the way to Madras to grow up.

The film, which opens today at the Village East, is the cinematic debut of Mr. Shyamalan, a 22-year-old director, who wrote and produced the movie in which he also plays the leading role. Sumptuously photographed on location in Madras, it offers a vision of contemporary life strikingly different from that shown in most films set in modern India, which tend to dwell on the mystical and the exotic.

•

"Praying With Anger" explores a middle-class Indian existence that is so restrictive in comparison with its American counterpart that Dev appears as the exotic, slightly dangerous interloper in a very staid milieu. Untutored in the country's middle-class ways, he is continually infringing customs and traditions that seem to him unfair, unreasonable and benighted.

The Mohans, the family with whom he stays, are an austere, tradition-bound clan whose son, Sunjay (Mike Muthu), becomes Dev's guide and best friend. The Mohans also have a daughter, Rupal (Richa Ahuja), whose determination to marry a boy

Unapix/Cinevista

M. Night Shyamalan in "Praying With Anger," which he directed. The film opens today at the Village East.

from another region incurs her parents' fierce resistance. Of all the customs Dev encounters, it is the limited freedom allowed to Indian women that most disconcerts him.

•

Dev's stay in India turns into one long frustrating series of conflicts with the established order. During a class on Shakespeare, he discovers that in Indian colleges it is considered a gross insult for a student to question a teacher. Unaware of a hazing system known as ragging, he fights back against Raj Kahn (Arun Balachandran), a bullying upperclassman, and pays heavily for it. He conceives a hopeless crush on a beautiful classmate, Sabitha (Christabal Howie), whose family has arranged her marriage to a man she has not met.

•

Other experiences gradually bring Dev under the country's spell. He consults a swami who improvises a valuable parable. Visiting the childhood home of his father, a financier who has recently died and from whom he was estranged, he feels an unexpected closeness. The ultimate test of Dev's maturity comes when a riot outside the Mohans' home threatens to escalate into major bloodshed and he rashly enters the fray.

If "Praying With Anger" is an astonishingly accomplished movie for such a young director, it is also emotionally immature. Dev, whom one might reasonably assume to be a directorial alter ego, churns with inchoate longings and hostilities that the story resolves far too neatly. At moments of revelation, the screenplay lapses into vague, sentimental hyperbole about learning "respect" and the sense of being "home."

The film has one cute running joke. The question that pops out of everyone's mouth as soon as Dev arrives is whether he knows Michael Jackson. That's the only American phenomenon about which the film's traditionminded Indians seem even mildly curious.

1993 S 15, C26:1

Djembefola

In French, English and African dialects, with English subtitles. Produced, directed and photographed by Laurent Chevalier, based on an idea by Pierre Marcault. Released by Interama. At Film Forum 1, 209 West Houston Street, South Village. Running time: 65 minutes. This film is not rated.

Mizike Mama

In French, English and African dialects, with English subtitles. Directed by Violaine de Villers, with the collaboration of Denise Vindevogel. Released by Interama. At Film Forum 1, 209 West Houston Street, South Village. Running time: 51 minutes. This film is not rated

By STEPHEN HOLDEN

A story that is heard more than once in Laurent Chevalier's "Djembefola," a documentary portrait of the African master drummer Mamady Keita, tells of how as a baby he cried so much that his father took him to a witch doctor. After predicting a great future in which the baby would grow up to overshadow everybody else in the village, the doctor washed the infant's hands in a rare herbal potion.

Mr. Keita became a prodigy who at 14 was one of five percussionists selected for membership in the National Djoliba Ballet. His instrument, the djembe, is a large drum that is made of goat's hide tautly stretched over yoroko wood and is beaten with the hands. Depending on which part of the instrument is touched, it yields three distinctive tones. Even now, the 43-year-old drummer marvels at how, after hours of playing, his hands never become stiff or blistered.

In the portrait that emerges from the film, which opens today at Film Forum 1, Mr. Keita is a radiant being of almost superhuman stamina who exudes an aura of hearty spiritual beneficence. The straightforward, smoothly edited film follows him from Brussels, where he now lives and teaches, on a pilgrimage to his native village of Balandugu, Guinea. After flying from Brussels to Conakry, Guinea's capital, Mr. Keita and

the film crew make the rest of the trip by jeep to the remote village. There, he has a tear-filled reunion with friends and relatives who had assumed he was dead.

"Djembefola" accomplishes a lot in its 65 minutes. In addition to sketching a vivid portrait of its subject, it clearly describes the basic qualities of the djembe. The film's

several extended musical sequences suggest how the instrument's beats and tones become a complex emotional language that serves as a kind of communal heartbeat for the people of Balandugu.

"Mizike Mama," which shares the bill with "Djembefola," is an ideal companion piece. Directed by Violaine de Villers with the collaboration of Denise Vindevogel, the film is a group portrait of Zap Mama, a dazzling a cappella quintet of mixed Zairian and Belgian descent that recently recorded its first album on David Byrne's Luaka Bop label.

Although all five members discuss the implications of membership in a racially mixed group that consciously fuses African rhythms and vocal tones with European polyphony, the film focuses on their charismatic founder and leader, Marie Daulne. The daughter of a Zairian mother and a Belgian father, Miss Daulne was born in the forest, among the pygmies who provided a safe refuge from the revolution in which her father was killed. The family later moved to Belgium and lived with relatives of her father.

Miss Daulne and her family recall a reverse cultural tug-of-war for her allegiance. Her mother, fearing she would grow up too African, did not teach her the tribal songs she only discovered as an adult. The Belgian side of her family encouraged her explorations of her African heritage. Eventually she visited the pygmies, whose eerily beautiful chants became the most important influence on the group's sound, which is multilingual, rhythmically free-floating and truly "world music" in its swirl of tones, accents and traditions.

1993 S 15, C26:2

The Age of Innocence

Directed by Martin Scorsese; written by Jay Cocks and Mr. Scorsese, based on the novel by Edith Wharton; director of photography, Michael Ballhaus; edited by Thelma Schoonmaker; music by Elmer Bernstein; production designer, Dante Ferretti; produced by Barbara De Fina; released by Columbia. Running time: 133 minutes. This film is rated PG.

Newland Archer	Daniel Day-Lewis
Ellen Olenska	Michelle Pfeiffer
May Welland	Winona Ryder
Larry Lefferts	Richard E. Grant
Sillerton Jackson	Alec McCowen
Mrs. Welland	Geraldine Chaplin
Regina Beaufort	Mary Beth Hurt
Julius Beaufort	Stuart Wilson
Mrs. Mingott	Miriam Margolyes
Henry van der Luyden	Michael Gough
Louisa van der Luyden	Alexis Smith
Rivière	Jonathan Pryce
Ted Archer	Robert Sean Leonard

By VINCENT CANBY

TAKING "The Age of Innocence," Edith Wharton's sad and elegantly funny novel about New York's highest society in the 1870's, Martin Scorsese has made a gorgeously uncharacteristic Scorsese film. It would be difficult to imagine anything further removed from the director's canon than Wharton's Pulitzer Prize-winning page-turner, not even "The Last Temptation of Christ."

Yet with a fine cast headed by Daniel Day-Lewis, Michelle Pfeiffer and Winona Ryder, Mr. Scorsese has made a big, intelligent movie that functions as if it were a window on a world he had just discovered, and about which he can't wait to spread the news.

The Wharton novel is far more than a romantic tale of a love that can never be. It's a deliciously hard-edged satire of the manners and customs of a small, inbred, very privileged circle of people in an era already long past when the book was published in 1920. Mr. Scorsese's outsider's fascination with the rules of this world matches that of Wharton, whose novel is a bittersweet recollection of the world she was born into, and eventually broke away from.

Working from her text in an adaptation written with Jay Cocks, Mr. Scorsese takes an anthropologist's view of the desperate plight of the three central characters. They are Newland Archer (Mr. Day-Lewis), a rich, well-born young lawyer; his most proper fiancée, May Welland (Ms. Ryder), and the worldly Ellen Olenska (Ms. Pfeiffer), May's first cousin, who has recently returned to New York as a countess after leaving her dissolute Polish husband.

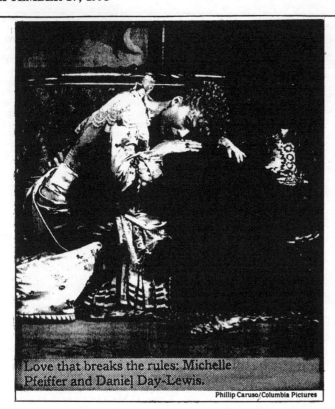

Love that breaks the rules: Michelle Pfeiffer and Daniel Day-Lewis.

Phillip Caruso/Columbia Pictures

Dissolute? The count is described at one point as having a lot of lashes and two interests: women and china. The money he doesn't spend on one, he spends on the other.

Having lived so long abroad, and having abandoned her husband, Ellen is under a cloud, initially regarded as little better than a fallen woman, a pariah, by the old-guard, upper bourgeoisie with whom she grew up. She's welcomed back, reluctantly, only after Newland and May's families pull various power plays, mostly having to do with dinner invitations to the right houses. Yet Ellen really doesn't understand the society that appears to offer her comfort.

She's astonished when the members of her family rise up as one to denounce her intention to divorce the count. Nobody denies that he has treated her rottenly but, as Newland explains, "Our legislation favors divorce, but our customs don't." She is a woman. The publicity could be nasty. Appearance is all. People can behave abominably as long they don't allow it to become public knowledge.

Newland, chosen by the family to persuade Ellen to abandon her divorce, succeeds, but only to fall profoundly in love with her. In the affair that follows (a few short, clandestine meetings in which hands are held and discreet kisses stolen), it is Ellen who remains strong. "I can't love you," she tells him, "unless I give you up." What she is really telling him is that she couldn't love him if he dishonored the code he still believes in.

Poor Newland is split up the middle: he finds peace in the predictable, often hypocritical rituals of society, but he is drawn to a kind of life that accepts spontaneity and acts on feelings without regard to form. It's a life of risk, chance and self-awareness.

Though Newland is utterly sincere what he refers to as "the rest of the world" is represented not by the lower classes or even by the artists and writers he admires, but by the beautiful, sad, wise, emotionally battered Ellen. His own world is embodied by the pretty, well-trained, steadfast May. Newland adores her even as he realizes that she's a woman completely without curiosity. On their honeymoon, he sees the futility of his dream of creating a soul mate in her: "There's no point in liberating someone who doesn't realize she is not free."

Newland's struggle to liberate himself is carried out in a series of sometimes hilariously genteel confrontations at the opera, at perfectly served dinner parties (where the food is sometimes inedible), at weekends in the country and during summer vacations in Newport. In the course of these, he stumbles on one amazing fact: though the proper May is an empty vessel, she knows, as if by instinct, how to play the desperate game she never seems to be aware is taking place.

Ms. Ryder is wonderful as this sweet young thing who's hard as nails, as much out of ignorance as of self-interest. Ms. Pfeiffer is lovely,

She can love him only if he adheres to a code that forbids their love.

the visual focal point of the film, but also much more. With her soft voice, her reserve and her quickness of mind, her Ellen has emotional weight. She's the film's heart and conscience.

Mr. Day-Lewis has a good, upper-class American accent, but at first seems more of an English dandy than a well-bred American with an inquiring mind. The performance seems to improve as the film goes along. He's a terrifically accomplished actor, but the screenplay does him a disservice. The soundtrack narrator (Joanne Woodward), who is presumably Edith Wharton, spells out so many of his thoughts, amid her own observations, that he often appears to be acting out instead of doing for himself.

The good thing about the screenplay is that it manages to preserve so much of the original text, largely through the use of the narrator, not always a graceful device. The Wharton observations are sometimes so truncated that I'm not sure they'll be understood by someone who hasn't read the novel.

Mr. Scorsese and Mr. Cocks have got almost everything of any importance in the novel onto the screen, but at a cost. Though it comes as something of a surprise to realize it today, Wharton was not only ferociously witty and morally committed, she was also a great storyteller. The novel's breathless pace is gone, sometimes because the narrator seems to be butting in as often as she is clarifying things. Mr. Scorsese could have used Ruth Prawer Jhabvala, who, in her screenplays for Ismail Merchant and James Ivory, has demonstrated an uncanny ability to find the tone as well as the voice of each novel she has adapted.

The film is also slowed down, but less awkwardly, by its fascination with the same sort of period details Wharton describes so lovingly in the novel: the place-settings at dinner parties, the second-rate paintings so proudly displayed by New York's social elite, their furniture, their architecture and such. This is rich stuff, but to some it will seem just set decoration.

As if to offset this somewhat static preoccupation with inventories, Mr. Scorsese and Michael Ballhaus, the cinematographer, employ a camera style of sometimes dizzy, sweeping, lyrical romanticism. It works beautifully. Less successful is the way dialogue from a new scene is introduced before the old scene is quite through. It seems a pushy ploy to keep things moving right along. In these form-conscious circumstances, it's not in the best of taste.

•

The excellent supporting cast, largely English, includes Michael Gough, Richard E. Grant, Alec McCowen, Jonathan Pryce, Stuart Wilson and, as May's formidably au-

Phillip Caruso/Columbia Pictures

Winona Ryder

tocratic and overweight grandmother, Miriam Margolyes, an actress who recalls Laura Hope Crews (Aunt Pittypat in "Gone With the Wind"), but with a spine of steel. Among the Americans are Alexis Smith and Robert Sean Leonard.

Don't be put off by the film's rocky reception at the recent Venice Film Festival, where, it seems, only the Communist daily, Il Manifesto, hailed it, as a "triumph," but as an exposé of capitalist decadence (not a quote to sell many tickets on either side of the Atlantic). "The Age of Innocence" isn't perfect, but it's a robust gamble that pays off.

The film is the work of one of America's handful of master craftsmen, a director whose decisions command attention and haunt the imagination, even when they don't entirely succeed.

•

"The Age of Innocence" has been rated PG (Parental guidance suggested). It includes nothing of an overtly sexual, violent or vulgar nature, but the subject matter will be over the heads of young children.

1993 S 17, C1:3

Morning Glory

Directed by Steven Hilliard Stern; written by Charles Jarrott and Deborah Raffin; director of photography, Laszlo George; edited by Richard Benwick; music by Jonathan Elias; produced by Michael Viner; released by Academy Entertainment. Running time: 90 minutes. This film is rated PG-13.

Will Parker.........................Christopher Reeve
Elly Dinsmore..............................Deborah Raffin
Bob Collins..............................Lloyd Bochner
Miss Beasley...........................Nina Foch
Lula Peaks..........................Helen Shaver
Sheriff..................................J. T. Walsh

By JANET MASLIN

No audience in the world will believe that Will Parker, the starving, desperate ex-con who is at the center of "Morning Glory," could have the robust physical well-being of Christopher Reeve. Nor could any audience seriously believe Deborah Raffin (who wrote the film with Charles Jarrott) as Elly Dinsmore, a pregnant widow leading a threadbare existence on a dusty, neglected farm.

Ms. Raffin, her cheeks rosy and her blond hair gleaming, is meant to be suffering such dire adversity that she has placed a "husband wanted" ad in the local newspaper, an ad that Mr. Reeve's Will duly answers. Nowhere this side of Madison County could a lonely woman in a farmhouse (albeit one wearing fashionably waiflike frocks and ankle-high work boots) expect to find so eligible a stranger. "All I'm lookin' for is a dry bed and a full plate," Will says.

Will is shy at first (there are a lot of "Ma'ams" and "reckons" in the screenplay), but it is not surprising to watch him warm to Elly and her two young children. But there is a complication. It turns out that Will has done time for killing a prostitute in a whorehouse. (The competition is stiff, but this, by far, is the film's most unbelievable detail.) And now that he has become attached to Elly, the local tramp, Lula Peaks (Helen Shaver), has set her cap for him, thereby touching off memories of Will's unfortunate past. The characters' names offer some indication of what the material is like.

So do the résumés of all concerned. Mr. Jarrott, the co-screenwriter, has credits including "Anne of a Thou-

Academy Entertainment

Deborah Raffin and Christopher Reeve in "Morning Glory."

sand Days." The director, Steven Hilliard Stern, also directed "The Devil and Max Devlin" with Bill Cosby in 1981. Lavyrle Spencer, from whose 1989 novel the film was adapted, has written many best-selling romances, and her work has been condensed in Reader's Digest and Good Housekeeping. Anyone interested in gritty authenticity had better look elsewhere.

"Morning Glory," which is set during the Depression and has a glowy visual style ill suited to the period, plays less like theatrical fare than like the kind of television movie that inspires channel-surfing. Its storytelling is calm, genteel and thoroughly unsurprising. The behavior of the performers could never be confused with that of real people. Among the actors, including Nina Foch as a nice small-town librarian and Lloyd Bochner as the lawyer defending Will during the expected courtroom scenes, only J..T. Walsh strikes some sparks as the local sheriff. No one else seems to be fully awake.

"Morning Glory" is rated PG-13 (Parents strongly cautioned). It includes brief nudity and sexual situations.

1993 S 17, C12:6

Dr. Bethune

Directed by Phillip Borsos; written by Ted Allan; photographed by Raoul Coutard and Mike Molloy; edited by Yves Langlois and Angelo Corrao; music by Alan Reeves; produced by Nicolas Clermont and Pieter Kroonenberg; released by Tara. At the Sutton, Third Avenue at 57th Street, Manhattan. Running time: 115 minutes. This film is not rated.

Dr. Norman Bethune	Donald Sutherland
Frances Penny Bethune	Helen Mirren
Mrs. Dowd	Helen Shaver
Chester Rice	Colm Feore
Marie-France Coudaire	Anouk Aimée

By STEPHEN HOLDEN

If modern medicine had a figure comparable to Ernest Hemingway, it may have been the swashbuckling Canadian surgeon Dr. Norman Bethune, who died in 1939. One of the fathers of socialized medicine and an instrumental figure in the development of mobile medical units for treating soldiers wounded on the front lines of battle, he was a larger-than-life hero with many glaring warts.

Imperious, hot-tempered, a womanizer and a drunk, he carried a portable gramophone with him to the farthest reaches of China to stoke himself with Beethoven while working with Mao Zedong's revolutionary army. Before that he worked for the Loyalist forces in the Spanish Civil War, until asked to leave because of his personal improprieties.

In a puritanical era, Dr. Bethune delighted in offending people by de-

Tara Releasing

Donald Sutherland

claiming heated sexual passages from D. H. Lawrence with a lyrical gusto.

In his lectures and in his writings, he railed eloquently against Fascism, which he compared to a contagious virus. He was equally outspoken in his denunciations of the Canadian medical establishment, which he accused of inhumanity and greed. A doctor who lived by his principles, he offered medical care to the poor of Montreal without hope of payment.

All this and much more is included in Phillip Borsos's epic movie biography, "Dr. Bethune," which opens today at the Sutton Theater. The film, which was shot on location in Montreal, Madrid and in several areas of China, cost $18 million to make and is one of the most expensive films to have come out of Canada. It is also a movie whose reach exceeds its grasp, since there is more story than fits comfortably into the film's 115-minute mosaic structure.

•

Chief among the movie's strengths is Donald Sutherland's portrayal of the title character. His eyes blazing with a visionary intensity, the actor practically stomps through the film, conveying the doctor's blend of intelligence, moral fervor and voracity with a gripping authority.

Mr. Sutherland's performance goes a long way toward unifying a movie that has been strangely pieced together in a way that robs the story of much of its narrative drive. Instead of a straightforward biography, the film jumps abruptly back and forth in time and place, with little regard to consistency of tone. One minute it feels like a sprawling picturesque epic, the next like a persnickety documentary.

After an opening scene that is narrated by Dr. Bethune's biographer, Chester Rice (Colm Feore), the doctor is shown arriving in China in 1938. From here, the movie frequently cuts back from the action to Rice's office for snippets of interviews with Dr. Bethune's wife, Frances (Helen Mirren), and others, while awkwardly inserting short scenes that sketch in Dr. Bethune's tumultuous domestic life. One character, Marie-France Coudaire (Anouk Aimée), a woman he picks up on a park bench and who becomes his mistress, pops up in several scenes without adequate explanation.

In the most confusing structural decision, the doctor's Spanish Civil War experiences, which actually pre-

ceded his trip to China, are introduced so late in the film that they derail its already shaky continuity.

Amid all the fussiness and confusion, "Dr. Bethune" still has quite a few memorable moments. The Chinese and Spanish sequences have an impressive picturesque sweep. And the truncated domestic scenes, in which Ms. Mirren's acting matches Mr. Sutherland's in intelligent refinement, convey the interactions of smart, complicated adults with an unusual subtlety.

1993 S 17, C13:1

Wittgenstein

Directed by Derek Jarman; written by Mr. Jarman, Terry Eagleton and Ken Butler; edited by Budge Tremlett; produced by Tariq Ali; released by Zeitgeist. Running time: 75 minutes. This film is not rated.

Ludwig Wittgenstein	Karl Johnson
Bertrand Russell	Michael Gough
Lady Ottoline Morrell	Tilda Swinton
Martian	Nabil Shaban
John Maynard Keynes	John Quentin

By JANET MASLIN

"Wittgenstein" is Derek Jarman's terribly arch, occasionally clever portrait of the Viennese-born philosopher Ludwig Wittgenstein, whose analyses of language and its meaning help to define the audience that will find this film of interest. Mr. Jarman's outlook should appeal chiefly to those who share a playful, contextual approach to the meaning of language, and to those who once watched Ken Russell's biographical films wishing that Mr. Russell would calm down.

Mr. Jarman's approach to serious biography is no less overheated than Mr. Russell's ever was. But it is more stridently experimental, and it does look more spare. Set against black backgrounds, using brightly colored costumes and props, and constructed as a string of puckish blackout sketches, "Wittgenstein" abounds with giddy theatrical tricks meant to illustrate biographical details and ideas of real substance.

So Bertrand Russell (Michael Gough) and Lady Ottoline Morrell (Tilda Swinton) lounge languidly in absurd costumes as they discuss the correspondence of Wittgenstein (Karl Johnson), their mutual friend. A fey Martian dwarf (Nabil Shaban), painted green and decked out with antennae and a xylophone, engages Wittgenstein in debates that illustrate some of the philosopher's thinking. And when the young Wittgenstein conducts experiments in aeronautics, he is seen wielding two lawn sprinklers and angelic white wings. Wittgenstein's love for movies in general and Carmen Miranda's movies in particular is encapsulated in the image of a young boy wearing 3-D glasses, sucking on ices and staring at a blue projector's beam in an empty theater.

•

Although the film explains itself now and then (as with a road sign reading "To Cambridge — Again" to chart the course of Wittgenstein's progress), Mr. Jarman assumes his audience's familiarity with the subject's life and times. The film maker devotes far more relish to, say, the sight of three of the principals tiptoeing around each other carrying colored balls, thus illustrating the paths

Howard Sooley/Zeitgeist Films

Karl Johnson

of the sun, moon and earth, than he does to delivering information more directly.

Wittgenstein himself is conceived in dynamic terms, engaging in stunts and conversations that define his thinking rather than serving as the subject of a passive portrait. Every so often the film's dark wit works, as when the dying Wittgenstein tells John Maynard Keynes (John Quentin), "I'd quite like to have composed a philosophical work that consisted only of jokes."

"Why didn't you do it?" Keynes inquires.

"Sadly, I had no sense of humor," Wittgenstein says.

Mr. Jarman's film develops an emotional component only when it describes Wittgenstein's tender relationships with his male lovers, and it reverberates with eerie echoes of the present. "Philosophy is a sickness of the mind," says the worried Wittgenstein, who at one point finds himself confined to a birdcage, accompanied by a caged parrot. "I shouldn't infect too many young men."

At its conclusion, the film's playful and more heartfelt aspects are fused in mournfully beautiful imagery representing the philosopher's death. But the Martian dwarf has his place in the final moments of "Wittgenstein" too.

1993 S 17, C15:1

Divertimento

Directed by Jacques Rivette; written by Pascal Bonitzer, Christine Laurent and Mr. Rivette; director of photography, William Lubtchansky; edited by Nicole Lubtchansky; production designer, Manu De Chauvigny; produced by Pierre Grise; released by MK2. Running time: 126 minutes. At the Lincoln Plaza Cinemas, Broadway and 63d Street. This film is not rated.

Frenhofer	Michel Piccoli
Liz	Jane Birkin
Marianne	Emmanuelle Béart
Julienne	Marianne Denicourt
Nicolas	David Bursztein
Porbus	Gilles Arbona

By VINCENT CANBY

"Divertimento," opening today at Lincoln Plaza Cinemas, is a straight-faced bit of tomfoolery sent out under the name of Jacques Rivette. He is the French director of "La Belle Noiseuse," the hypnotically beautiful,

Jane Birkin and Michel Piccoli

numbing four-hour film, released here in 1991, about the angst of a great, if severely blocked, painter.

In fact, "Divertimento" is "La Belle Noiseuse," but with its running time cut in half. According to press material handed to critics at the "Divertimento" screening, Mr. Rivette, obligated to deliver a two-hour television version of the film, "turned this chore into a challenge." That is, he recut the film, eliminating much of the original material and putting in other material not used in the first version. The idea was to see the original story from an entirely new perspective.

In view of the huge amount of cutting he had to do, it would seem as if the new material had been added with a salt shaker. It can't have been a lot. It is certainly not significant.

The original film featured long, quite wonderful sequences in which the audience watched the artist's hand at work. The effect was to implicate the audience in the act of creation. Now, by eliminating most of those sequences, Mr. Rivette, we are told, has created an entirely new film

A director adds to and subtracts from a lengthy original.

that "is much more concerned with the emotional toll created by the artist's immersion in his work and the toll it takes on himself, his wife and his model."

Unfortunately, the artist's personal problems are the creakiest part of "La Belle Noiseuse." "Divertimento" is now a sort of classy soap opera, with more soap than opera. Michel Piccoli is still very fine as the aging painter and Emmanuelle Béart a vision as his model.

The re-editing has not helped Jane Birkin's performance as the artist's aging waif of a wife. The eliminated material gave the audience some sense of what she was up against: living with a self-centered artist who put his art ahead of everything. In this new cut, she appears to be the kind of drudge who asks to be stepped on so she can be noble by not complaining. She would drive Lassie to drink.

The academically romantic nonsense preached by "La Belle Noiseuse" (something to the effect that the creation of art requires pain and sacrifice) is balanced by the onscreen evidence of another requirement: hard work over long hours, plus a certain amount of thought. All that is now gone in "Divertimento."

The original review of "La Belle Noiseuse" ran in this paper on Oct. 7, 1991.

1993 S 17, C16:6

Into the West

Directed by Mike Newell; written by Jim Sheridan, based on a story by Michael Pearce; director of photography, Tom Sigel; edited by Peter Boyle; music by Patrick Doyle; production designer, Jamie Leonard; produced by Jonathan Cavendish and Tim Palmer; released by Miramax. Running time: 92 minutes. This film is rated PG.

Papa Riley	Gabriel Byrne
Kathleen	Ellen Barkin
Ossie	Ciaran Fitzgerald
Tito	Rory Conroy

By JANET MASLIN

The combination of Jim Sheridan, the writer and director of "My Left Foot," and Mike Newell, the director of "Enchanted April," looks good on paper. It looks even better on screen. These two film makers, each of whom has demonstrated his ability to charm viewers in unexpected ways, have joined forces to tell the tale of two motherless boys, their grieving father and a magical white horse, with much of the tale set against the rugged terrain of western Ireland. "Into the West," which Mr. Sheridan wrote and Mr. Newell directed, has both storytelling and scenery to recommend it.

"Into the West" also has an element of built-in exotica, some stemming from the travelers, Irish gypsies who are the film's principal characters and some arising from the underlying mysticism of the plot. This film, which has a distinctly family-minded spirit, shows how the boys escape their own sad memories and the oppressiveness of life among those city-dwellers they refer to, quite contemptuously, as "settled people." The boys themselves, are part of a different, more adventurous tradition.

Their father, Papa Riley (Gabriel Byrne), has mourned the death of his wife for so long that he has lost touch with his feisty young sons, Tito (Rory Conroy) and Ossie (Ciaran Fitzgerald). Papa Riley has also given up his standing as King of the Travelers; he now lives in Dublin, in a dreary housing project, and speaks dismissively of "the old ways" of the countryside. He drinks, he grieves and he remains preoccupied with the past. "When you throw a stone into a lake, it's not happy until it hits bottom," one of the travelers says about Papa Riley.

•

The film begins with the image of a white horse racing along a beach at moonlight, and watches curiously as this horse finds its way to Tito and Ossie in Dublin. The horse's mission, which will not be nearly as mysterious to parents as it may be to children, involves helping the boys to make their getaway from drab urban lives. Adopting the horse as a pet and naming it Tir na nOg, the boys keep it in their apartment for a while, which gives the film a whimsical tone that suits its Irish setting. "Into the West" is only occasionally farfetched, which is an odd thing to say about a film that depicts a horse riding in an elevator and sleeping in a movie theater.

The boys become notorious after Papa Riley unwittingly loses title to Tir na nOg, and an unscrupulous policeman sells the horse to a rich businessman. The horse turns out to be a champion jumper (here comes the farfetched part), is renamed National Security, and is poised to win prizes when Tito and Ossie steal Tir na nOg away and are caught in the act by television cameras. Undaunted by their new status as hunted criminals, the boys are delighted by the chance to play outlaws, since they love watching westerns. They escape the city and begin a series of quixotic adventures on and off the road. Meanwhile, Papa Riley rises to the occasion of reclaiming his children.

•

Picturesque and warm-hearted, "Into the West" moves enjoyably toward the inevitable family reconciliation, and an ending with a supernatural spin. Along the way, it manages to

sustain a high level of interest, thanks to fine acting and plenty of local color. Mr. Byrne seems fully engaged by his role, and he brings Papa Riley vigorously to life; this father's flashing eyes and black moods give "Into the West" something other than the usual family-film aura.

The two young boys, who carry much of the film's dramatic weight, are utterly disarming, whether they are raising money through Ossie's sickly rendition of "Danny Boy" on the streets of Dublin or imitating all the cowboy attitudes they've seen on the screen. ("Into the West" works in a film clip from "Butch Cassidy and the Sundance Kid," and it aspires to some of the same irreverent humor.) Ellen Barkin appears in the smaller role of Kathleen, one of the travelers who help Papa Riley track his sons, and with a long mane of reddish hair Ms. Barkin very much inhabits the part. Her tough, sturdy stance and her crooked grin perfectly suit the role of a woman fiercely proud of being an outsider.

One of the film's major strengths is its lively depiction of the travelers and their world, from the small trailers that have mostly replaced painted gypsy caravans to the bleak urban settings in which these wanderers now congregate. "Into the West" will capture the imaginations of older children who like horses, ghost stories and the unbridled freedom that the travelers embody on screen.

•

"Into the West" is rated PG (Parental guidance suggested). It includes mild profanity.

1993 S 17, C17:1

Striking Distance

Directed by Rowdy Herrington; written by Mr. Herrington and Martin Kaplan; director of photography, Mac Ahlberg; edited by Pasquale Buba and Mark Helfrich; music by Brad Fiedel; production designer, Gregg Fonseca; produced by Arnon Milchan, Tony Thomopoulos and Hunt Lowry; released by Columbia. Running time: 101 minutes. This film is rated R.

Tom Hardy	Bruce Willis
Jo Christman	Sarah Jessica Parker
Nick Detillo	Dennis Farina
Danny Detillo	Tom Sizemore
Vince Hardy	John Mahoney

By VINCENT CANBY

"Striking Distance," the new Bruce Willis action-melodrama, isn't long on coherence, which makes very little difference. It's an enjoyably brisk movie spectacle, much of which takes place in and around Pittsburgh, on the Allegheny, Ohio and Monongahela Rivers. Pittsburgh is not a special effect. As used by Rowdy Herrington, the director, and as photographed by Mac Ahlberg, Pittsburgh looks so beautiful and clean that it seems slightly unreal, the perfect setting for this kind of make-believe.

The story (quite tall and not exceptionally original) is about Tom Hardy (Mr. Willis), a homicide detective who's hated by his colleagues for testifying against his partner (also his first cousin) in a police brutality case. Later, Hardy is demoted to the river rescue squad. His crime: He publicly challenges the department's prosecution of a man he thinks innocent of some highly publicized serial killings. Hardy could well know the truth, but he doesn't know at the time he objects.

The serial killings, to no one's surprise, involve Hardy much more intimately than he originally guesses. Though the film's initial chase is dimly motivated, most of the action sequences are very well staged, particularly those on Pittsburgh's rivers. They are the film's true subject.

Despite the fact that Hardy is talked about as a terminal drunk, Mr. Willis looks very fit in an extremely energetic performance. Sarah Jessica Parker plays his diving partner in the river-rescue squad. Dennis Farina is Hardy's uncle, who becomes chief of homicide after Hardy's father (John Mahoney) is murdered. More you need not know.

If "Striking Distance" were a book, it could be called a good read. Instead, it's a painless watch.

•

"Striking Distance" has been rated R. It has some brutality and a lot of vulgar language and violence.

1993 S 17, C17:1

Airborne

Directed by Rob Bowman; written by Bill Apablasa, based on a story by Stephen McEveety and Mr. Apablasa; director of photography, Daryn Okada; edited by Harry B. Miller 3d; music by Stewart Copeland; production designer, John Myhre; produced by Bruce Davey and Mr. McEveety; released by Warner Brothers. Running time: 90 minutes. This film is rated PG.

Mitchell	Shane McDermott
Wiley	Seth Green
Nikki	Brittney Powell
Aunt Irene	Edie McClurg
Uncle Louie	Patrick O'Brien

By STEPHEN HOLDEN

"Airborne" is a modest attempt to take a familiar genre, the surf movie, and spin it into a new subgenre, the Rollerblades film. The movie's teenage hero, Mitchell (Shane McDermott), is a baby-faced Southern California surfer who also skates. When his parents break the news that he will have to live with relatives in Cincinnati for six months while they complete a research project in Australia, his lotus-land idyll is rudely interrupted.

Mitchell proves to be an unflappably good sport about his forced stay with an aunt and uncle (Edie McClurg and Patrick O'Brien) who suggest caricatures of the icky Lubner family from "Saturday Night Live" skits. And he is a loyal pal to their teen-age son, Wiley, a dweeb with rebel pretensions. But at the medium-tough high school they attend, Mitchell is resented for his golden-boy aura and his refusal to fight back when challenged. After he makes a crucial error in an ice-hockey game, he becomes the butt of countless pranks.

Eventually, Mitchell has to prove his mettle while sticking by his nonviolent principles. He succeeds, first by shaming his girlfriend's bullying brother and then by participating in a skating race down a treacherously hilly area known as the Devil's Backbone.

Slackly directed and thinly written, "Airborne," which opened yesterday, exists mainly for its scenes of the big race, in which two teams rocket down a series of winding hills, jumping over cars, scooting under trucks and bouncing down stairs. The camera work in this extended sequence has a nice gliding energy, but the partici-

pants are so thickly encased in helmets, goggles and padding that it is impossible to see how the two sides are doing as they elbow each other around the course's hairpin turns.

The movie, which was filmed in Cincinnati, is no Chamber of Commerce ad for Ohio's third-largest city. As shown in "Airborne," it looks like one of the drabbest places in America.

•

"Airborne" is rated PG (Parental guidance suggested). The dialogue includes a few remarks that are off color in a veiled way.

1993 S 18, 14:3

FILM VIEW/Caryn James

As a B Movie, 'True Romance' Is Grade A

THE BODY COUNT IS SPRINKLED like confetti through "True Romance," as cops shoot it out with mobsters, someone's head is bashed in, and a pimp pays for his crimes by being shot in the crotch. Yet it would be wrongheaded to get worked up over the apparent amorality or violence in the hot genre picture of the moment. This is a tale of young lovers — played with piquant emotion by Christian Slater and Patricia Arquette — who accidentally fall into murderous doings and still manage to remain sweet kids.

Look at the witty grace notes surrounding their suddenly violent honeymoon: a cop, realizing he is aiming his gun at a thug who speaks only Italian, growls, "Come outta from behinda the couch"; the man whose head is smashed is attacked in self-defense with the heavy lid of a toilet tank; one amateur killer actually drops a photo-ID at the scene of the crime. These goofy elements suggest the skewed way in which the writer

In the anything-goes 1990's, can't young lovers commit a few murders and still manage to remain just a couple of sweet kids?

Quentin Tarantino redefines the B movie, sprucing it up for an age that worships pop culture and takes violence for granted.

Though the film was directed by Tony Scott, best known for "Top Gun," the film's voice belongs to Mr. Tarantino. It shares a defining element with the first movie he wrote and directed, "Reservoir Dogs," the slick, ultraviolent, superbly acted 1992 crime caper that brought new life and blood to the genre.

When the call girl named Alabama (Ms. Arquette) and the shy comic-book store clerk named Clarence (Mr. Slater) wind up with a suitcase full of someone else's cocaine, Mr. Tarantino goes on to exploit the B movie's classic gift. Its formulaic unreality — of course the lovers hit the road, of course they get a gun, of course they make love in a phone booth — serves as a safety valve that distances viewers from violence and makes murder palatable, a lark.

Yet, unlike most genre heroes (Bonnie and Clyde are conspicuous exceptions), Clarence and Alabama seem real and humanly moving, even while they drive their purple Cadillac through the unreal landscape of the film noir. Like "Reservoir Dogs," "True Romance" concocts scenes that are bloodily hard to sit through without losing the film's noirish air of fantasy.

And "True Romance" adds much humor and a 90's spin of pop-culture self-consciousness. Clarence behaves the way he imagines Elvis would have wanted him to. A fantasy Elvis (Val Kilmer in a gold lamé suit) even appears in the bathroom to say, "Clarence, I like you — always have, always will." Clarence and Alabama meet at a kung fu movie; they watch gangster flicks and soaps on television.

This is not hipness for its own sake but for the purpose of making the formula relevant to a new generation. Mr. Tarantino, 30 years old and famous in interviews as a former video-store clerk, is a product of the movies by chronology and inclination. Here he is redefining violence and morality in terms of pulp fiction, but also in pop-cultural terms his audience will instantly be in sync with.

When Clarence follows Elvis's advice and turns violent, he is listening to a voice that is like a god's to him. Hearing Elvis is his version of a religious experience.

So what if Alabama was a prostitute? She is beguiling and honest about it. When she tells Clarence she loves him, she begins by saying how foolish she feels, because they've known each other for less than 24 hours and, as she puts it, "me being a call girl" But in this unpoetic age, you take romance where you find it.

And when Clarence's father (Dennis Hopper) tells the kids, "I think you make a real cute couple," he means it; and the audience believes it. This is a world where clichés become real, though in a twisted, often macabre way.

The very title "True Romance" comes to suggest a new reality as well as the old, trashy magazines that inspired such stories. It makes sense that Mr. Tarantino's next film, which he has written and will direct, is called "Pulp Fiction." That title makes a neat match with the current film and would fit it easily. "True Romance" itself is 90's pulp fiction and proud of it.

It would be impossible to sort out precisely what is Mr. Scott's and what is Mr. Tarantino's here, though the writer has said that his original bleak ending was changed. Certainly Mr. Scott must get credit for directing these deeply credible performances. Ordinary people stand up to torture by professional thugs — one of the genre's unbelievable conventions that seems thoroughly convincing on screen here. There are comic lines and surprising gestures too clever to give away, though it doesn't ruin a scene to quote Christopher Walken's deadpan, "I never killed anybody. Since 1984."

And the candy-colored look of the film, with touches like Alabama's blue plastic heart-shaped earrings, perfectly suits its pop-culture ambiance. Whether from the writer or director or production designer, the movie is filled with signals that this is at once a revision of B-movie conventions and something more. It is also true to the experiences of a 90's woman compelled to protest that she's not white trash and an Elvis fanatic happy to find true love with a whore.

There may be something darkly disturbing about the appeal of crime films themselves, for they speak to some deep need to release violence. But that's a different story, which these film makers seem to take as a given. By exploiting the genre so cleverly, Mr. Tarantino reveals the virtues of being a video kid. □

1993 S 19, II:15:1

The Red Circle

Written and directed by Jean-Pierre Melville; dubbed into English; director of photography, Henri Decae; music by Eric de Marsan; produced by Robert Dorfman; released by UGC D.A. International. At Film Forum 1, 209 West Houston Street, South Village. Running time: 99 minutes. This film is not rated.

Corey	Alain Delon
Jansen	Yves Montand
Vogel	Gian-Maria Volonté
Mattei	André Bourvil

By VINCENT CANBY

Of the major French film makers, Jean-Pierre Melville (1917-1973) remains one of the least known in this country. Those Americans who do know him are probably more familiar with his reputation as the father of the New Wave than with his films, especially the film noir melodramas so adored by the young French critics of the 1950's and 60's. Two of his best, most characteristic films are "Bob le Flambeur," which was made in 1955

but was not seen in this country until 1981, and "Le Samourai" (1967), released here as "The Godson" in 1972.

"The Red Circle" (1970), opening today at the Film Forum, will be of interest primarily to those who already know Melville's work. It may baffle anyone coming upon him for the first time. Having been cut from 140 minutes to 99, "The Red Circle" would seem to be good deal more laconic and austere than even Melville would have wished.

Somewhat more tolerable is the film's soundtrack, in which the original French dialogue has been dubbed into slightly accented English. It's not great, but, in a crazy way, it is not all that inappropriate: the flatness of the absolutely functional speech reflects something essential in Melville's work. His characters don't talk a lot, and when they do, it's to exchange information. They never express their feelings. Passions are controlled. Behavior is everything.

Yet the film's characters are now cut so close to the bone that they seem almost to parody the seedy bank robbers, tight-lipped hit men and sad informers who play out the dark Melville fables according to their own moral codes. A staunch admirer of American films, Melville made movies that turn B-picture plots into cool meditations on the upside-down gallantry of those he saw to be the only true warriors of our age. His thieves steal not because they are acquisitive, but because it has become their profession.

Though severely cut, "The Red Circle" doesn't exactly sweep along. It has a deliberate pace as Melville sets up the story of three chance acquaintances who plan and carry out the sacking of an elegant, supposedly impregnable jewelry store on the Place Vendôme in Paris. They are Corey (Alain Delon), newly released from a prison near Marseilles; Vogel (Gian-Maria Volonté), a convict who escapes from the train taking him to Paris, and Jansen (Yves Montand), an alcoholic former police detective who has become a marksman for hire by the underworld.

It's possible that in the original version of the film these characters would have been presented with more in the way of personal histories than they have now. Yet it's not untypical of Melville that they appear to exist entirely within the demands of the film's present situations. Only Montand's Jansen comes onto the screen with a clearly defined past. The Delon character could have been born the minute before he's first seen.

The only information that identifies Volonté's Vogel is that he is not a professional criminal. He may be a political prisoner. Whatever he is, he doesn't hesitate to shoot to kill when the situation demands. Women have no place in these men's lives. Melville's concern is the manner in which the three jewel thieves behave toward one another, and they are honorable to a fault.

Understatement is the method of the film, from Melville's pared-down screenplay to the performances by the three trenchcoated principals, even to the muted photography by Henri Decae, which is in color but has the chilly effect of black and white.

1993 S 22, C13:1

The Good Son

Directed by Joseph Ruben; written by Ian McEwan; director of photography, John Lindley; edited by George Bowers; music by Elmer Bernstein; production designer, Bill Groom; produced by Mary Anne Page and Mr. Ruben; released by 20th Century Fox. Running time: 87 minutes. This film is rated R.

Henry	Macaulay Culkin
Mark	Elijah Wood
Susan	Wendy Crewson
Jack	David Morse
Wallace	Daniel Hugh Kelly
Connie	Quinn Culkin

By JANET MASLIN

Macaulay Culkin is not too young to need career advice. It's a triple mistake for him to have appeared in "The Good Son" as Henry Evans, a disturbed and malicious little boy. First of all, this character's brattiness is deeply unappealing. Second, a role as solemn as this one makes it clear that wisecrack-filled comedy is what Mr. Culkin does best. And third, his co-star is Elijah Wood, the second hottest child star of the moment (whose credits include "The Adventures of Huckleberry Finn"), and a fine little actor who is much more comfortable with dramatic material. Although Mr. Culkin has top billing, Mr. Wood serves as the hero of this story.

As directed by Joseph Ruben ("Sleeping With the Enemy," "The Stepfather") and written by the novelist Ian McEwan, "The Good Son" has more interesting ambiguity in its title than it does anywhere else. Mark Evans (Mr. Wood) is grief-stricken by the death of his mother and feels somehow responsible for her illness. And then, just after his mother dies, Mark is left behind while his father goes on a two-week business trip to Tokyo.

Mark, who lives in the Southwest, is sent to a snowy New England village to visit his aunt (Wendy Crewson), his uncle (David Morse) and most particularly his cousin Henry. Henry first appears playfully wearing a horror mask, which doesn't leave much doubt about where the story is headed.

Henry operates out of a little shed that has a doll hanging by a noose from its ceiling. But his parents don't seem to have noticed anything peculiar about their boy. And so, during Mark's two-week visit, Henry tries out various menacing and dangerous pranks, like dropping a dummy from a highway overpass just to see how big a traffic accident he can cause. Mark looks understandably horrified. "I feel sorry for you, Mark," Mr. Culkin says solemnly. "You just don't know how to have fun."

When Mark decides that Henry's mother must now replace his own lost mother, Henry's jealousy spins out of control. He does so much damage in a relatively short time that viewers will wonder what he did to keep busy before Mark came along. They will also wonder if Mr. Culkin is doing himself any favors snarling at a vicious dog, trying to drown his little sister (played by his real sister, Quinn Culkin) or delivering the occasional grown-up taunting line of dialogue.

Mr. Ruben is an accomplished visual stylist who often makes actors seem less lifelike than the sets they inhabit. Mr. Wood, wide-eyed and terrified much of the time, gives the only performance that has any urgency. Henry's parents are presented as saccharine and oblivious, which is only partly explained by the fact that they are still mourning the death of another child. Henry's mother, who has not yet put two and two together where that death is concerned, has an unfortunate habit of standing atop a steep cliff to think about the son she lost.

"The Good Son" has a handsome, scenic look that sustains interest, and a suspenseful ending that is quite literally gripping. The film's final scene is one of its few suspenseful and original moments.

"The Good Son" is rated R (Under 17 requires accompanying parent or adult guardian). It includes profanity and violence.

1993 S 24, C12:5

Dazed and Confused

Written and directed by Richard Linklater; director of photography, Lee Daniel; edited by Sandra Adair; production design, John Frick; produced by James Jacks, Sean Daniel and Mr. Linklater; released by Gramercy Pictures. Running time: 97 minutes. This film is rated R.

Pink	Jason London
Slater	Rory Cochrane
Don	Sasha Jenson
Mitch	Wiley Wiggins
Jodi	Michelle Burke
Mike	Adam Goldberg
Tony	Anthony Rapp
Cynthia	Marissa Ribisi

By JANET MASLIN

Richard Linklater, the 31-year-old director of "Slacker" and now "Dazed and Confused," is a contemporary of the high school-age characters who appear in his new film. And Mr. Linklater remembers exactly how things looked and felt and sounded on May 28, 1976, the date on which his story unfolds. It is the last day of school in the nameless Middle American community where the film takes place, and a couple of dozen characters are dealing with their hopes and fears. The film has a large cast and a microscopic scale, since many of the matters it addresses are deliberately small.

The school's seniors-to-be, for instance, have embarked on a hazing campaign aimed at next year's freshmen. And the hazing is nasty; there are pretty teen-age girls in this film who sound like drill sergeants in the Marines. Mr. Linklater understands how silly this would look to anyone except an incoming freshman, who might live in terror of being hit with a paddle or coated with ketchup and mustard. He is charmingly aware that his characters see their troubles as silly and earth-shaking at the same time.

"Dazed and Confused" unfolds in a loose, natural style that suits its teen-age characters, whose collective mental state is reflected by the title. To the blaring, less-than-nostalgic music of bands like Foghat and Deep Purple and Black Oak Arkansas, these high school students drive around and contemplate the future in "American Graffiti" fashion. Their drifting is treated as a form of forward momentum, even though it sometimes becomes aimless and the film's improvised quality becomes overpowering. The actors bounce off one another with crazy riffs and cosmic observations, some of them unexpectedly funny. Mr. Linklater wrote "Dazed and Confused" as well as

directing it, but not much of the film sounds tightly scripted.

•

Beginning at school and culminating with a big, sprawling end-of-school party in the woods, "Dazed and Confused" coasts easily from actor to actor. Randy (Pink) Floyd, played by Jason London, is a football star from the days when football stars wore shell necklaces and shoulder-length hair. He's troubled by his coach's insistence that he sign a pledge swearing off drugs and alcohol, seeing this as an invasion of his privacy and a threat to his independence.

Meanwhile, his interest is piqued by one of his classmates, Jodi Kramer (Michelle Burke), who's worried about the hazing of her kid brother, Mitch (Wiley Wiggins). Cruising knowingly through the film are Mike (Adam Goldberg), Tony (Anthony Rapp) and Cynthia (Marissa Ribisi), offering running commentary on their classmates' sophomoric pranks. These three are smarter than the rest, and they have a sneaking suspicion that it will do them absolutely no good. Then there is Slater (Rory Cochrane), who holds the distinction of being the film's most stoned character, a more languid version of Sean Penn's character in "Fast Times at Ridgemont High." It is he who gives history a new spin by suggesting that George Washington was a marijuana grower and Martha Washington "was a hip, hip lady, man."

No film whose plot involves the quest for Aerosmith tickets can take itself too seriously. So "Dazed and Confused" has an enjoyably playful spirit, one that amply compensates for its lack of structure. And at the heart of many of its tiny encounters are matters of real tenderness, as when Mitch Kramer succeeds in deflecting his attackers and making friends with some of the older characters in the story. Mr. Linklater convincingly evokes a spirit in which Mitch's progress, all in the course of a single busy night, can be considered a real triumph.

•

"Dazed and Confused" is rated R (Under 17 requires accompanying parent or adult guardian). It includes profanity.

1993 S 24, C12:5

Baraka

Directed and photographed by Ron Fricke; written by Mr. Fricke, Mark Magidson and Bob Green; edited by Mr. Fricke, Mr. Magidson and David E. Aubrey; music by Michael Stearns; produced by Mr. Magidson; released by Samuel Goldwyn Company. At the Plaza, 42 East 58th Street, Manhattan. Running time: 96 minutes. This film is not rated.

By STEPHEN HOLDEN

Film technology and global consciousness have both come a long way since the quaint old days when "This Is Cinerama" was the leading edge of wide-screen film spectacle and the Seven Wonders of the World were touted as the hit parade of international tourist attractions.

Just how far things have progressed is demonstrated by "Baraka," an awesome cinematic world tour directed and photographed by Ron Fricke, which opens today at the Plaza. Shot on 6 continents and in 24 countries, the 70-millimeter film, which has a portentous world-music

Magidson Films

A view of Mesa Arch, Utah, from the film "Baraka."

score by Michael Stearns and no dialogue, is an aggressively spectacular exercise in planetary consciousness-raising.

The film, which begins with an image of a solar eclipse, is structured like an epic poem: it begins in heavenly climes, descends into hell, recapitulates its opening themes and ends with a celestial starburst. A succession of pictures of religious shrines and holy places intermingled with scenes of natural wonders gradually gives way to the portrayal of squalor, urban freneticism and ecological horror before the film regains the high ground.

Although the film has no lecturers thundering out warnings about the destruction of the rain forest or lamenting man's inhumanity to man, its pictures do the job as efficiently as any verbal sermon. In scenes where the camera studies the faces of impoverished children, who look as though they had been lined up and instructed to brood enigmatically, the film tugs shamelessly on the heartstrings and makes blunt appeals to the conscience.

•

The essential message that the film conveys is really a question: How is it that in the face of a collective spiritual aspiration that inspired so much exalted art can humanity still be embarked on a path that seems perilously self-destructive? A partial answer offered by the film is that there is a terrible beauty in evil and destruction as well as in creation. The film's aerial shots of the fiery oil fields of Kuwait after the Persian Gulf war and the burning, rubble-strewn landfill of Calcutta are as impressive in their way as its views of Angkor Wat or the Pyramids at Giza.

Stylistically, "Baraka" is a direct descendant of the 1983 film "Koyaanisqatsi," for which Mr. Fricke served as director of photography, co-editor and co-writer. Like "Koyaanisqatsi," "Baraka" makes dazzling use of time-lapse photography in which hours of surveying a vista are compressed into minutes. Six hours of weather over Canyonlands National Park in Utah are telescoped into a 30-second panorama of racing clouds and shifting light. Synchronized with music that suggests deep wheezing breaths, the traffic zipping up Park Avenue in Manhattan assumes an inevitable organic rhythm.

Ultimately, the camera is turned toward the stars, which are shown in dizzying deep-blue fields of sky behind the silhouettes of monuments. Throughout the film, Mr. Fricke's camera movements have a stately fluency that often suggests a three-dimensional depth.

•

The decision to make "Baraka" a visual poem without words entails a frustrating price. Again and again, the film records religious and tribal ceremonies whose grace and pageantry make you long for some identification. But "Baraka" doesn't even have captions. If it did, they would mar its visual splendor and interfere with the dreamlike state of wonder that the film wants to evoke.

Mr. Stearns's score is in its way as technologically sophisticated as Mr. Fricke's cinematography. He has stitched together and embellished a compendium of ethnic and original music that weaves sounds ranging from the David Hykes Harmonic Choir to the chanting monks of the Dip Tse Chok Ling Monastery in Dharamsala, India. Although the music occasionally surges into bombast, most of the time it makes for an austere, elevated musical tapestry that underscores the imagery with an astonishing precision, fluency and genuine grandeur.

1993 S 24, C14:6

The Program

Directed by David S. Ward; written by Mr. Ward and Aaron Latham; director of photography, Victor Hammer; edited by Paul Seydor and Kimberly Ray; music by Michel Colombier; production designer, Albert Brenner; produced by Samuel Goldwyn Jr.; released by Buena Vista Pictures. Running time: 112 minutes. This film is rated R.

Coach Winters	James Caan
Autumn	Halle Berry
Darnell Jefferson	Omar Epps
Joe Kane	Craig Sheffer
Camille	Kristy Swanson
Alvin Mack	Duane Davis
Steve Lattimer	Andrew Bryniarski

By JANET MASLIN

"The Program" is a routine Joe College movie, with the added twist that Joe College is Joe Kane (Craig Sheffer), a prime contender for the Heisman Trophy. So his school buddies are other members of the football team at Eastern State University, where Coach Winters (James Caan) is on hand to guide them to glory. The film's title is used to refer to football whenever possible, as in: "I'm concerned about our program. It's always been a source of pride to our students and our alumni."

Joe has a drinking problem that makes him a daredevil, as when he lies down on a busy highway as the cars and trucks whiz by. (The film's optical effects aren't persuasive enough to make it look as if Joe is in real danger.) He is also oppressed by all "the adulation," as he sometimes calls it, of having been on the cover of Sports Illustrated. Joe grouses so much about this that the audience isn't likely to be holding its breath about whether he comes up a winner.

Luckily, the film's other football players are more appealing, especially Omar Epps as a shy new recruit, Duane Davis as the guy who shouts the best insults at the opposition, and Andrew Bryniarski as a player who has mysteriously gained 35 pounds of muscle over the summer. When high on steroids, he turns into a competition-crazed monster, but the film manages to make him likable anyhow.

•

"The Program," which was directed by David S. Ward and written by Mr. Ward and Aaron Latham, also finds time for symmetrical romances for Joe and for Mr. Epps's character, Darnell Jefferson. Naturally, each love story has a gimmick. Joe and Camille (Kristy Swanson, the star of "Buffy the Vampire Slayer") are competitive types, so they trade tough-looking attitudes while playing tennis or squash. Darnell becomes smitten with the gorgeous Autumn (Halle Berry), who tutors him in math and English. The film achieves a lively and comfortable racial mix most of the time. But it makes these two black characters so much more clean-cut than their classmates that they do little more than go to the library and share a cute ice-skating date.

Mr. Caan has a relatively small role, since the coaching is kept to a minimum until "The Program" culminates in an obligatory Big Game. When he is seen, he seems to have been made harried and irritable by the demands of the job. (At one point, he knocks over several dozen cups of Gatorade for emphasis.) Mr. Caan's character is also given a few poignant moments, like this one:

Injured player (lying in hospital bed): "I'm never gonna play again, am I?"

Coach (looking away): "Doctors aren't always right. Either way, I want you to know that you're the best damn defensive player I ever coached."

Music: Sad.

•

"The Program" is rated R (Under 17 requires accompanying parent or adult guardian). It includes assorted profanities.

1993 S 24, C16:6

Bopha!

Directed by Morgan Freeman; written by Brian Bird and John Wierick, based on the play by Percy Mtwa; director of photography, David Watkin; edited by Neil Travis; music by James Horner; production designer, Michael Philips; produced by Lawrence Taubman; released by Paramount. Tower East, Third Avenue at 71st Street, Manhattan. Running time: 120 minutes. This film is rated PG-13.

Micah Mangena	Danny Glover
Zweli Mangena	Maynard Eziashi
De Villiers	Malcolm McDowell
Rosie Mangena	Alfre Woodard
Van Tonder	Marius Weyers

By VINCENT CANBY

Morgan Freeman, twice nominated for an Oscar as an actor ("Street Smart" and "Driving Miss Daisy"), now makes a strong directorial debut with "Bopha!," a big, angry, extremely well-acted movie about the powder keg labeled South Africa. Bopha is a Zulu word meaning either arrest or detention.

Adapted from Percy Mtwa's play, "Bopha!" looks at apartheid from an unusual point of view, that of a black master sergeant in the South African Police, a man who has the pride of corps in his blood. Micah Mangena (Danny Glover) is the kind of man the military loves. He's a natural leader, strong, loyal and bright, but not so bright that he questions authority, either his own or others'.

The time is 1980 and the place a fictitious South African township called Moroka. Micah's life is placid. He has a good wife, Rosie (Alfre Woodard), and a son, Zweli (Maynard Eziashi), whom Micah expects to follow in his footsteps when the young man graduates from university. Micah is so self-satisfied that possibly God would have ordered his fall if history hadn't already stacked the cards against him.

Bob Greene/Paramount

Clash In "Bopha!," Danny Glover plays a South African police officer who finds himself in conflict with a son who opposes apartheid.

"Bopha!" is a classic tragedy about one man, played out in heat and dust against a background of South Africa's own struggle to come to terms with itself. Micah is almost ludicrously blind to what's going on around him. He doesn't question apartheid or seem to see the appalling economic and social conditions built into the system. When other blacks ostracize him and his family, he's inclined to see that as a testament to a job well done.

Early in "Bopha!" there is an extraordinary scene in which Micah gives a pep talk to new black recruits. Sounding like a United States Marine Corps sergeant, he tells the men to be honored when they hear themselves called pigs. He writes "PIG" on the blackboard and explains: "P" is for pride, "I" for intelligence and "G" for guts or glory.

Micah has been such a good father to Zweli that he has brought up a son who isn't afraid to think for himself. This is Micah's flaw. Zweli becomes a member of a student political group, which has its origins in the students' refusal to speak the Afrikaans language in school. Inevitably there are raids on the students' headquarters. Soon Micah, sworn to uphold the law and keep the peace, is forced into decisions he should have made years ago.

This sort of film has a built-in problem, which Mr. Freeman, as the director, and Brian Bird and John Wierick, who wrote the screenplay, never solve in a completely satisfactory way: the audience, given the circumstances, is always way ahead of what must happen on the screen. Yet "Bopha!" is so firmly grounded in physical reality (it was shot in Zimbabwe), in the looks and passions of its characters, even in its music, that its deliberate progress from one obligatory scene to the next still carries surprising emotional weight.

•

Mr. Glover is only the first of the equals in the outstanding cast. His Micah is big, rugged and well meaning. He's also a tragic fool. Ms. Woodard plays Rosie without tipping her hand. It is a fine, restrained perform-

ance that's never allowed to seek easy sympathy. Mr. Eziashi, last seen here in Bruce Beresford's "Mister Johnson," is splendid as the son who must break the bonds with his father.

Malcolm McDowell has a colorful if thankless role, that of the white member of the police's Special Branch who comes to Moroka to insure that peace will be maintained but becomes the cause for the apocalyptic finale. Almost equally thankless, though, is the film's other major white role, that of a good guy, Van Tonder (Marius Weyers), who is Micah's sympathetic but helpless superior officer.

"Bopha!" is a logistically big movie, but Mr. Freeman handles all its elements with seeming ease. Special mention should also be made of David Watkin's camera work, which is fine. Much has happened in South Africa since 1980. It's to the credit of these film makers that "Bopha!" has not been overwhelmed by time. But then, Master Sergeant Mangena, as written and played, is a figure of timeless folly.

•

"Bopha!" is rated PG-13 (Parents strongly cautioned). It has scenes of bloodshed and torture.

1993 S 24, C18:1

Jamón Jamón

Directed by Bigas Luna; written by Cuca Canals and Mr. Luna, in Spanish with English subtitles; director of photography, José Luis Alcaine; edited by Teresa Font; music by Nicola Piovani; production design by Chu Uroz and Noemi Campano; released by Academy Entertainment. At the Paris, 4 West 58th Street, Manhattan. Running time: 90 minutes. This film is not rated.

Silvia	Penélope Cruz
Carmen	Anna Galiena
Raúl	Javier Bardem
Conchita	Stefania Sandrelli
Manuel	Juan Diego
José Luis	Jordi Molla

By VINCENT CANBY

"Jamón Jamón" ("Ham Ham"), Bigas Luna's melodramatic Spanish comedy, means to satirize a number of things about the Spanish character, including the confusions that sometimes arise when food and sex somehow become so closely related that one becomes an extension of the other. This isn't exactly unique to his countrymen; think of the eating scenes in Tony Richardson's "Tom Jones," which is as English as the raglan sleeve, and in Juzo Itami's "Tampopo," which is quintessentially Japanese.

Sex as an act of ingestion is a gloriously universal concept, which is only one of the reasons "Jamón Jamón" seems so much less funny and outrageous than it intends to be. The film, which won the Silver Lion award at the 1992 Venice Film Festival, opens today at the Paris Theater.

A brief synopsis suggests that Mr. Luna is exploring much of the same territory opened up by another Spanish director, Pedro Almodóvar, in a series of comedies that are as explosively comic as they are pertinent.

•

The setting of "Jamón Jamón" is a small, arid town in southern Spain, an almost mythically depleted place dominated by two establishments: the Samson underwear factory, which specializes in men's briefs (its

motto: "You've a Samson Inside"), and a bordello that seems as important to the town's economic and emotional health as the factory. A strong woman dominates each establishment.

Carmen (Anna Galiena) has apparently been the bordello's star attraction for many years, although she looks beautiful and no more than 35 years old. She's an earthy, soothing mother figure as well as a mother in fact. She has a large brood of loving, noisy children, the oldest being the nubile (and unfortunately pregnant) Silvia (Penélope Cruz).

The lubricious, greedy and socially ambitious Conchita (Stefania Sandrelli) is the wife of José Luis (Jordi Molla), the factory's owner, but she's the one who runs the business. José Luis prefers to watch football on television. When Conchita learns that her son, Manuel (Juan Diego), is the father of Silvia's unborn child and wants to marry her, she is determined to break up the match.

She hires Raúl (Javier Bardem), a local stud, to romance Silvia, in this way to discredit her in Manuel's eyes. As it must, everything goes wrong. Both Conchita and Silvia fall for Raúl, who obliges each, Silvia because he loves her and Conchita because she gives him a Japanese motorcycle. Meanwhile, Manuel seeks solace with Carmen, his favorite at the bordello, as she was his father's years before. The crossed connections multiply.

This might have been the material for a splendid farce, but Mr. Luna and Cuca Canals, who collaborated with him on the screenplay, seem to have more important goals in mind than pure laughter. To read what Mr. Luna has to say about his film, you might think "Jamón Jamón" was conceived as a kind of surreal anthropological study. Whatever it is, it's too crude to be satisfying as farce, and too blunt to invite the kind of automatic interpretation that comes when watching a satire by Luis Buñuel, a film maker much admired by Mr. Bigas.

The director freights his jokey movie with more symbolic importance than it can carry. This is as lethal to laughter as explaining a joke.

Mr. Luna's hand is heavy, which, I suspect, is part of his conscious method. Raúl is introduced more or less crotch first, the camera lingering on the bulge in the trousers, as it does later when Conchita is interviewing young men for jobs as models of Samson underwear. Both Raúl and Manuel have what are possibly meant to be typically macho Spanish male breast fetishes. Each treats Silvia as if she were a long-remembered wet nurse. Raúl says that he can taste the onion omelets she makes in the local diner.

Raúl is convinced that his sexual prowess is the result of eating a lot of ham and whole garlic gloves. Jokes about garlic breath follow. Nothing leading up to the film's final confrontation can support the intentionally melodramatic visual gag that ends the movie. Yet the performances are good, particularly those of Ms. Cruz, who has a mind of her own but doesn't turn up her nose at being a sex object, and Ms. Galiena, who plays the whore as an idealized mother.

"Jamón Jamón" is not quite pop art, and it's not surprising or witty enough to work as satire. It's on a wavelength not easy to tune in.

1993 S 24, C18:4

Me and Veronica

Directed by Don Scardino; written by Leslie Lyles; director of photography, Michael Barrow; edited by Jeffrey Wolf; production designer, John Arnone; produced by Mark Linn-Baker, Max Mayer, Nellie Nugiel and Leslie Urdang; released by Arrow. Running time: 97 minutes. This film is rated R.

Fanny	Elizabeth McGovern
Veronica	Patricia Wettig
Michael	Michael O'Keefe
Frankie	John Heard

By STEPHEN HOLDEN

In "Me and Veronica," a tempestuous little drama set in a dingy area of the New Jersey shoreline, Elizabeth McGovern and Patricia Wettig play sisters whose lives are approaching dead ends. Fanny (Ms. McGovern), the "good" sister, is a divorced part-time waitress with artistic leanings who lives in a bungalow in one of those desolate seaside towns of packed-together houses that look like they could be washed away at any moment.

One day her "bad" sister, Veronica (Ms. Wettig), from whom she has been estranged for five years, comes to visit. Veronica informs Fanny that she is about to go to jail for welfare fraud. An unmarried mother of two, she was caught collecting checks from two states at once and has to serve time on Rikers Island.

Fanny and Veronica share a desperately buoyant night on the town, getting drunk in fishermen's bars and playing a dangerous game called Jersey Chicken, in which they grab the girders of a lifting drawbridge and jump into the inky water. Although they share an edgy affection, there has been bad blood between them ever since Fanny caught Veronica in bed with her husband.

Arrow Release

Reunited In "Me and Veronica," Elizabeth McGovern plays a reclusive woman whose troubled older sister reappears after a five-year absence.

After Veronica goes to jail, Fanny, posing as a state investigator, rescues her sister's children from the northern New Jersey trailer park where Veronica left them with Michael (Michael O'Keefe), the latest in a string of lovers. While visiting Veronica in jail, Fanny also begins to realize that her sister is not just down and out but mentally ill and possibly suicidal. From here the story takes an inevitably grim turn in which Fanny is left to pick up the pieces.

"Me and Veronica" was written by Leslie Lyles, a playwright whose work has been performed at Ensemble Studio Theater, and directed by Don Scardino, the artistic director of Playwrights Horizons. With its ambling, talky dialogue, the movie has the feel of a filmed play. And the contrast between the film's authentic setting and its stagy working-class dialogue lends it a slightly artificial flavor, although the movie has a real integrity.

The film's strengths lie in its superior acting and its moody ambiance, in which the same light that grays the actors' weatherbeaten faces seems to tint the New Jersey sky with oil-slick grittiness. Alternately nostalgic and combative, Ms. McGovern and Ms. Wettig convey the sisters' complicated and ambivalent bond with a piercing depth.

While Ms. McGovern's innate gentility occasionally cuts against her role as an eccentric working-class woman who devotes her spare time to designing multicolored bed linens, Ms. Wettig's Veronica is devastatingly on target.

From the moment Veronica shows up on Fanny's doorstep provocatively attired in a skin-tight mini-dress, spike heels, a jean jacket and big hoop earrings, it is clear there is something slightly off about her. She is a feisty woman on the verge of middle age who wields a great deal of personal power but who suffers from a lack of self-esteem so acute that she is incapable of taking responsibility for herself or anybody else. Ms. Wettig's performance burns with such a scary intensity that once her character takes a suicidal swan dive from the railing of a ferry, the film is left feeling slightly empty.

•

"Me and Veronica" is rated R (Under 17 requires accompanying parent or adult guardian). It has strong language and sexual situations.

1993 S 24, C25:1

Why Has Bodhi-Dharma Left for the East?

Written, directed, photographed, edited and produced by Bae Yong Kyun; in Korean, with English subtitles; music by Chin Kyu Yong; released by Milestone. At the Walter Reade Theater, 165 West 65th Street, Manhattan. Running time: 135 minutes. This film is not rated.

Hye Gok	Yi Pan Yong
Ki Bong	Sin Won Sop
Hae Jin	Huang Hae Jin
Superior	Ko Su Yong
Fellow Disciple	Kim Hae Yong

By STEPHEN HOLDEN

"I am insubstantial in the universe, but in the universe there is nothing that is not me," reflects Hye Gok (Yi Pan Yong), an elderly and ailing Zen Buddhist monk in Bae Yong Kyun's ravishingly beautiful film "Why Has Bodhi-Dharma Left for the East?"

Not long after Hye Gok speaks these words to his young student Ki Bong (Sin Won Sop), his riddle finds a haunting visual corollary. As Ki Bong scatters the ashes of his teacher in a mountain pool strewn with autumn leaves, the colored foliage floating on the pool's surface intermingles with the reflections of leaves still clinging to the trees above.

At the same moment, the monk's reflection and his shadow overlap. The sounds of water, wind, birds and faraway animals blend with the imagery to evoke as intense an experience of being in nature as one could hope to glean from a film. Life and death, shadow and substance, image and reflection, all seem united and indistinguishable.

The scene, which the camera holds for several seconds, is one of many stunning visionary moments in the film, which opened yesterday at the Walter Reade Theater. Produced, directed, written, photographed and edited by Mr. Bae, a South Korean film maker, the movie, whose title is a Zen Buddhist koan, is a glacially slow but often spellbinding attempt to find a cinematic language for the Zen mode of perception.

The film tells the stories of the aging monk, his student and an orphaned child, Hae Jin (Huang Hae Jin), who live together in a remote Zen monastery on Mount Chonan, in South Korea. Several of the film's most striking early scenes portray the child's spiritual rites of passage.

One day, he throws a stone at a bird and seriously wounds it. Taking the creature home, he tries to nurse it back to life, but it dies. The boy hides its carcass under a rock, which he later turns over to discover the remains being devoured by maggots. Then he instinctively gives it a proper burial.

•

In a scene that suggests a Rousseau painting sprung to life, the child, while running through the woods at night, encounters a cow that has broken free from its shed. The two stand inches apart, gazing into each other's eyes. When Hae Jin has a toothache, Hye Gok ties a string around the tooth and yanks it out. Hae Jin's saving of his extracted tooth prompts a lesson in renunciation of the physical body.

Ki Bong also has difficult rites of passage. Both Hye Gok and Ki Bong pursue enlightenment through such intense physical challenges as meditating for hours on a rock while being lashed by icy river rapids that chill them to the bone. The young monk, who renounced the world to live in the monastery, returns briefly to the urban slum where he left behind his elderly blind mother. Sensing his presence, she greets him, but he doesn't acknowledge her call and steals silently and guiltily out of the house.

His most solemn task is the ritualistic cremation of his teacher in a mountain clearing. As his body becomes covered with ashes and soot from the blaze, he begins to grasp Hye Gok's teaching that birth and death are one.

Again and again, the film finds visual analogues for the oneness of the universe and the enlightenment to be found through the renunciation of earthly desires. In gazing into the physical world with a fixity, clarity and depth rarely found in the cinema, "Why Has Bodhi-Dharma Left for the East?" goes about as far as a film can go in conjuring a meditative state.

1993 S 25, 13:1

Warning: Warlock at Work

By JANET MASLIN

"Warlock," which opened yesterday at neighborhood theaters, dishes up stylish satanism for the druids-and-rune-stones set. It was directed by Anthony Hickox ("Waxwork," "Waxwork II," "Hellraiser III"), who has extremely limited interests but a definite flair for hellish visual tricks.

For instance, there is the way that Julian Sands, who plays the title role, makes his entrance. The film has barely begun when an eclipse occurs, the world turns ominous and a woman busy dressing for a date becomes the devil's bride. It takes Mr. Hickox no time at all to move from her conception of the devil's child to the birth, seconds later, of a pulsating mound of protoplasm. The protoplasm quickly evolves into Mr. Sands, who kills the woman, then locates important information that has been etched on her skin. The protoplasm also finds time to eat the woman's dog.

True, this is grisly. And some of it is arcane. (The dialogue is full of references to things like mandrake juice. A thorough reading of liner notes of heavy metal albums may be helpful in deciphering the plot.) But Mr. Hickox does have a certain wry wit, as when he sends his Warlock off in search of six rune-stones and locates them at a fashion show, a circus and other colorful backdrops. Mr. Hickox can find something sinister anywhere, as when he turns the sound of fashion photographers' popping flashbulbs into something resembling gunfire.

Mr. Sands, as someone who has only six days to make the world safe for Satan and therefore must wreak great havoc in a hurry, is suitably ghoulish. Also in the film are Chris Young and Paula Marshall as Kenny and Samantha, two nice teen-agers who turn out to be druid warriors.

Unbeknown to them, their elders are in charge of keeping warlocks at bay, which prompts one of the film's better lines. Kenny's father has to shoot and kill his son to bring out the boy's druid warrior potential. And this makes Kenny understandably upset. "Look, Kenny," says his dad, "just give me a chance to explain." Explanation is indeed in order.

•

"Warlock" is rated R. (Under 17 requires accompanying parent or adult guardian). It includes violence.

1993 S 25, 19:5

Malina

Directed by Werner Schroeter; written by Elfriede Jelinek, based on the book by Ingeborg Bachman, in French with English subtitles; director of photography, Elfi Mikesch; edited by Juliane Lorenz; music by Giacomo Manzoni; produced by Thomas and Steffen Kuchenreuther. At the Joseph Papp Public Theater, 425 Lafayette Street, East Village. Through Oct. 7. Running time: 125 minutes. This film is not rated.

The WomanIsabelle Huppert
Malina Mathieu Carrière
Ivan...Can Togay

By STEPHEN HOLDEN

In "Malina," the German film maker Werner Schroeter's adaptation of a novel by Ingeborg Bachman, Isabelle Huppert portrays a writer

New York Shakespeare Festival

Isabelle Huppert and Can Togay in Werner Schroeter's film adaptation of the novel "Malina," at the Joseph Papp Public Theater.

who suffers from an interminable case of existential angst.

Ms. Huppert's unnamed character is a chain-smoking novelist who lives in Vienna with a calm and devoted male companion, Malina (Mathieu Carrière). Although attractive and successful, she is emotionally disturbed. In the film's opening scene, she has a vision of herself as a little girl being thrown to her death by her father from the roof of a building. The father, a demonic figure, reappears in several expressionistic set pieces, sometimes to the accompaniment of operatic music.

One day in front of a flower shop, she spies a handsome stranger, Ivan (Can Togay), whom she chases into a bank and inveigles into embarking on a steamy affair. Although Ivan enjoys the relationship, he takes it more lightly than does the woman, who grows obsessed.

Shuttling between Malina, who is calm and accepting, and Ivan, who is sexy but nonchalant, Ms. Huppert asks out loud such burning questions as "Do I exist?" Her fantasies and recollections are evoked in several surreal sequences, including one in which she and Ivan become characters in an animated adventure film they are watching with his two children. In another, she and Ivan are observed making love by her parents, who are perched on the corner of an iceberg.

Increasingly unstrung, Miss Huppert's character violently beats her head against a wall, then flaunts the bloodstained bandage as a badge of her suffering. She ultimately immolates herself in her apartment.

"Malina," which opens today at the Joseph Papp Public Theater, is a handsomely photographed and well-acted film. But it is also terribly tedious. More than two hours long, it lacks a conventional narrative structure, and its symbolism, much of it heavily Freudian, is often pretentious and needlessly redundant. In one motif that is replayed several times, Ms. Huppert distractedly pulls stacks of unfinished letters out of her desk and tosses them onto the floor. For the last half-hour of the film, she thrashes desperately around an apartment in which many little fires have been set, but none seem to be spreading.

It may be that Mr. Schroeter, one of Germany's most revered younger film makers, is a director whose work doesn't travel well. It may also be that you have to be intimately familiar with the Bachman novel and with the author's legend for the film to resonate.

"Malina" was the only novel completed by the notoriously self-destructive author, whose death in 1973 turned her into a feminist martyr comparable to Sylvia Plath. "Malina," published two years before her death, was the first part of a projected autobiographical trilogy, "Ways of Dying," which is also the title of the work Miss Huppert's character is planning to write but is too distracted to get down to work on.

1993 S 27, C15:1

A Bronx Tale

Directed by Robert De Niro; written by Chazz Palminteri; director of photography, Reynaldo Villalobos; production designer, Wynn Thomas; produced by Jane Rosenthal, Jon Kilik and Mr. De Niro; released by Savoy Pictures. Running time: 120 minutes. This film is rated R.

Lorenzo	Robert De Niro
Sonny	Chazz Palminteri
Calogero (Age 17)	Lillo Brancato
Calogero (Age 9)	Francis Capra
Jane	Taral Hicks

By JANET MASLIN

Robert De Niro starts off "A Bronx Tale" with the perfect sound, as if he were striking a tuning fork: the sweet harmonies of an a cappella doo-wop group, to accompany an image of the Bronx sky at twilight. This film, the first to be directed by one of the screen's most intuitive stars, instantly establishes a rueful, romantic view of its time and place. Beginning in 1960, and never venturing very far from East 187th Street, "A Bronx Tale" offers a warm, vibrant and sometimes troubling portrait of the community it describes. Almost everyone within that community sounds a little bit like Robert De Niro except Mr. De Niro himself.

That the film's large and varied group of actors should echo its director is hardly surprising: "A Bronx Tale" is about small-time mobsters, and Mr. De Niro has time and again set the standard for such characters. He would dominate this film even if he did not happen to be in it, let alone be behind the camera. Yet his work here, as both actor and director, is impressively unobtrusive. The first test of any film in which a star directs himself is whether the viewer can ever forget who is at the helm, and Mr. De Niro's direction is generous and thoughtful enough to let that happen.

"A Bronx Tale" is really more of a showcase for Chazz Palminteri, who wrote the screenplay, first performed this material as a one-man show and now has the film's dominant role. Mr. Palminteri plays Sonny, the neighborhood mobster who is as much admired for his sleek personal style as for his absolute power. Some suave crooner — Frank Sinatra, Tony Bennett or Dean Martin — is often heard on the soundtrack as Sonny holds court at Chez Bippy, the corner bar and social club to which 9-year-old Calogero (Francis Capra) has been forbidden to go. Calogero's parents have the worried feeling that they are fighting a losing battle.

•

Mr. De Niro plays Lorenzo, Calogero's father, a bus driver who tries his best to counteract Sonny's wiseguy allure. "The working man is the tough guy," Lorenzo repeatedly tells his son. "Your father's the tough guy." But Sonny looks tougher, because he is surrounded by hoods with colorful nicknames (Frankie Coffeecake, Tony Toupee) and is central to an incident that Calogero will never forget. One day, as part of the neighborhood rituals that the film evokes so vividly, Calogero is watching the grown-ups when he witnesses a traffic problem that ends in murder. "It wasn't over a parking space," his father tries to tell him. "They just met at the wrong time in their lives."

Once Calogero has been interrogated by the police and has fearfully refused to identify Sonny as the killer, he becomes Sonny's apprentice. Eight years later, when the world has changed a lot but not much has happened to East 187th Street, an adolescent Calogero (Lillo Brancato) is known as C to Sonny and is very much a part of Sonny's world. His father is still sounding the same note, declaring: "You want to be somebody? Be somebody that works for a living and takes care of his family!"

Without Mr. De Niro's sturdy, affecting performance in this role, Lorenzo could easily have seemed weak and caricatured.

"A Bronx Tale" is seldom blunt enough to contrast Sonny and Lorenzo too directly. Indeed, their principles are not always polar opposites, and the film touchingly captures Calogero's efforts to reconcile the values of these two men he loves. The film's black-and-white distinctions are reserved for racial matters, which give the story an ugly turn once prejudice threatens Calogero's attraction to Jane (Taral Hicks), a serenely beautiful young woman.

"She was tall," he says in voiceover. "She was beautiful. She was classy. But she was black, and that was a no-no in my neighborhood." Those sentiments, which so strongly echo something Harvey Keitel's character tells himself early in "Mean Streets," set up the violent hostility between blacks and Italian-Americans that erupts late in the story. The film's musical soundtrack, which is loaded with evocative pop music, makes its own commentary by giving virtual Ku Klux Klan overtones to "Nights in White Satin," the Moody Blues song.

"A Bronx Tale" encounters some awkwardness in the courtship between Calogero and Jane; Mr. De Niro has a much easier time directing men than he does women, to the point where Calogero's mother is a virtual phantom in the story. But most of the film brings its characters very comfortably to life. Mr. De Niro gets a particularly savvy performance out of young Mr. Capra, as a boy who is understandably fascinated by his elders. When little Calogero goes to his priest to confess his role in murder, and there is some question about whether "the Fifth" means the amendment or the commandment, it's easy to see how confusing this boy's life can be.

Mr. Palminteri gives the kind of coolly magnetic performance that makes it easy to see why Mr. De Niro gravitated toward this material in the first place. And Mr. De Niro is able to lend toughness to an ending that risks becoming overpoweringly sentimental, and instead succeeds in conveying a strong sense of father-son love. The film is dedicated to Sammy Cahn and to Mr. De Niro's late father.

Joe Pesci appears briefly at the end of "A Bronx Tale," establishing a kind of continuity that is already clear. This film can be seen as a natural offshoot of the work Mr. De Niro has done with Mr. Pesci, and more particularly with Martin Scorsese, whose influence is everywhere.

"A Bronx Tale" is rated R (Under 17 requires accompanying parent or adult guardian). It includes violence and profanity.

1993 S 29, C13:4

Short Cuts

Directed by Robert Altman; written by Mr. Altman and Frank Barhydt; director of photography, Walt Lloyd; editor, Geraldine Peroni; music by Mark Isham; production designer, Stephen Altman; produced by Cary Brokaw; released by Fine Line Features. At Alice Tully Hall at 7:30; Avery Fisher Hall at 8 P.M., as part of the 31st New York Film Festival. Running time: 189 minutes. This film is rated R.

Ann Finnigan	Andie MacDowell
Howard Finnigan	Bruce Davison
Paul Finnigan	Jack Lemmon
Casey Finnigan	Zane Cassidy
Marian Wyman	Julianne Moore

Dr. Ralph Wyman	Matthew Modine
Stuart Kane	Fred Ward
Claire Kane	Anne Archer
Lois Kaiser	Jennifer Jason Leigh
Jerry Kaiser	Chris Penn
Honey Bush	Lili Taylor
Bill Bush	Robert Downey Jr.
Sherri Shepard	Madeleine Stowe
Gene Shepard	Tim Robbins
Doreen Piggot	Lily Tomlin
Earl Piggot	Tom Waits
Betty Weathers	Frances McDormand
Stormy Weathers	Peter Gallagher
Chad Weathers	Jarrett Lennon
Tess Trainer	Annie Ross
Zoe Trainer	Lori Singer
Andy Bitkower	Lyle Lovett
Gordon Johnson	Buck Henry
Vern Miller	Huey Lewis

By VINCENT CANBY

THE night skies over Los Angeles, which is in a medfly siege of bibical proportions, are filled with helicopters flying in formation as they indiscriminately spray everything below: people, swimming pools, royal palms, trailer parks, stretch limos, possibly also medflies and their larvae. The helicopters menace as they pretend to protect. Their rotors chop the air and puncture the eardrums. With bright red and green wing lights ablink, the machines have the cold precision of android policemen, waggishly festooned.

These images and sounds usher the audience into the world of Robert Altman's big, tumultuous, very fine new film, "Short Cuts," which opens the 31st New York Film Festival tonight at Lincoln Center. The film will be shown at 7:30 at Alice Tully Hall and at 8 P.M. at Avery Fisher Hall, and begins its commercial run on Sunday in Manhattan.

"Short Cuts" is a wonderfully apt selection to open this year's festival. It calls attention not only to the entire career of one of America's most brilliant, most engagingly original film makers, but also to the manner by which this bristly master has managed to endure. Certainly not by giving audiences what some pollster thinks they want, or by revamping last year's megahit.

Mr. Altman goes his own way, though not exactly alone. Like all memorable Altman works, "Short Cuts" openly celebrates movie making as a communal endeavor. In this case, it's an endeavor in which the actors, whom he appears to adore, have been encouraged to realize characters to an extent that might not have been originally imagined by either Mr. Altman or Frank Barhydt, with whom he collaborated on the screenplay.

The paradoxical result of all this collaboration: a film in which the director's personality is evident in every frame. Like Mr. Altman's 1975 classic, "Nashville," the new movie is a vast panorama of interweaving narratives. Like "Nashville," too, it's a movie that beguiles on two levels at once.

One responds to its quite doomy vision of America-the-banal as it approaches the millennium, and to the apparent enthusiasm with which the film came into being. "Short Cuts" is a bifocal experience. It's sometimes alarmingly dispassionate. It raises the spirits not by phony sentimentality but by the amplitude of its art. From time to time, it is also roaringly funny.

Photographs by Joyce Rudolph/Fine Line Features, incorporated in an illustration by Matthew Martin

Group portrait: Appearing in Robert Altman's "Short Cuts" are, from left, Matthew Modine, Lori Singer, Annie Ross, Peter Gallagher, Frances McDormand, Jarrett Lennon, Jack Lemmon and Bruce Davison.

"Short Cuts" was inspired by the voice and some of the characters in the short stories of Raymond Carver, who died five years ago at age 50. Yet it is in no way a conventional adaptation. It is Carver as re-imagined by the film maker, the locations transplanted from the Pacific Northwest to Los Angeles, which Mr. Altman knows so well that he and Mr. Barhydt create Carver characters the writer never wrote.

The movie crosscuts among approximately 10 stories with two dozen principal characters. The paths of some characters meet. Other characters remain unconnected and disconnected, sharing only a messy urban landscape. Among the most memorable:

Gene Shepard (Tim Robbins), a Los Angeles motorcycle cop who spends as little time as possible at home with his wife, Sherri (Madeleine Stowe), their noisy children and yapping dog. With his carefully practiced cowboy stride, he pursues women so relentlessly, on and off duty, that he can't even be faithful to Betty Weathers (Frances McDormand), the woman with whom he's being unfaithful to Sherri.

Doreen and Earl Piggot (Lily Tomlin and Tom Waits). She slings hash in a diner and he takes what work he can find, which, when he's first seen, is chauffeur of a stretch limo. He drinks too much and treats her badly. When he's not in a foul mood, she drinks with him and is glad of the companionship.

Howard and Ann Finnigan (Bruce Davison and Andie MacDowell), whose small son is left seemingly unharmed after he's hit in the street by Doreen Piggott, who drives a car with a For Sale sign in the rear window.

Dr. Ralph Wyman (Matthew Modine), the doctor who attends the Finnigan boy. Andy Bitkower (Lyle Lovett), a baker who specializes in name-on birthday cakes and makes malevolent phone calls to a no-show customer.

Lois and Jerry Kaiser (Jennifer Jason Leigh and Chris Penn). Jerry cleans swimming pools. Lois helps support the family by talking obscenely on the telephone to clients who pay her by the minute, often while she's cooking dinner or changing the baby's diapers.

Stuart Kane (Fred Ward), Gordon Johnson (Buck Henry) and Vern Miller (Huey Lewis), three pals who go off on a fishing trip together and don't let the corpse they find in the river interrupt the outing. After all, they reason, she's already dead; waiting 24 hours to report the death won't bring her back to life. It wouldn't, but not reporting the death changes Stuart's marriage forever.

Stormy Weathers (Peter Gallagher), a helicopter pilot who takes sweet revenge on his estranged wife, Betty, with the help of a man who chances by to demonstrate a rug-cleaning machine. Tess Trainer (Annie Ross), a singer in a jazz club, and her daughter, Zoe (Lori Singer), who plays the cello and mourns the demonstrative mother love she never had.

Strange characters, who are also utterly commonplace. Their passions are sometimes proudly announced, even flaunted. Sometimes the passions are nursed, self-pityingly, only to explode with fatal consequences. Mr. Penn's Jerry Kaiser hangs around the house, listening to his wife talk dirty on the phone, then furiously berates her for not exciting him in the same way.

Most of the performances are astonishingly fine, but there is one that doesn't quite belong. Jack Lemmon, so fine in "Glengarry Glen Ross," nearly stops "Short Cuts" for the wrong reasons. Mr. Altman allows him to go on at embarrassing length in a soppy monologue that has a perfunctory sound to it, something extremely rare in this director's work. The film isn't helped by the fact that several of the principal actresses look just enough alike to create confusion about who is doing what to whom. End of reservations.

"Short Cuts" is more mature, less hysterical than "Nashville." Though the characters are seen in close-up, the film itself has the manner of something seen in a continuing long shot. It doesn't comment. It is amused by the eccentric, acknowledges the melancholy, and moves on.

It gives the impression of being something one might like to read, not because it is self-consciously literary, which it isn't. No script could reproduce the experience of watching the film. Yet because the images are so packed with detail, it's almost impossible to take everything in at one sitting.

●

"Short Cuts" doesn't have the unifying event that brings "Nashville" to such a rousing conclusion. Instead it depends on an act of God, but it's a satisfying act that calls attention to the randomness of the lives that Mr. Altman has been looking in on. The lives are often desperate and the characters inarticulate, but the group portrait is as grandly, sometimes as hilariously, realized as anything the director has ever done.

When future social historians want to know what the temper of life was like in one corner of America in 1993, "Short Cuts" will be a mother lode of information. It's also a terrific movie.

●

"Short Cuts" has been rated R (under 17 requires accompanying parent or adult guardian). It has vulgar language, nudity, sexual situations and violence.

1993 O 1, C1:1

Takashi Seida/Warner Brothers

John Lone

M. Butterfly

Directed by David Cronenberg; written by David Henry Hwang, based on his play; director of photography, Peter Suschitzky; edited by Ronald Sanders; music by Howard Shore; production designer, Carol Spier; produced by Gabriella Martinelli; released by Geffen Pictures. At First and 62d Cinemas, 62d Street between First and York Avenues, Manhattan. Running time: 100 minutes. This film is rated R.

René Gallimard.............................Jeremy Irons
Song Liling...John Lone
Jeanne Gallimard..................Barbara Sukowa
Ambassador Toulon...............Ian Richardson

By JANET MASLIN

The film version of "M. Butterfly" introduces a critically important new element into David Henry Hwang's play: the camera. The artifice that was possible on stage, in Mr. Hwang's daring, multi-faceted meditation on the love affair between a French diplomat and the Chinese transvestite he mistakenly believed was a woman, is simply out of the question on screen.

For some film makers that might constitute an insurmountable problem, but this "M. Butterfly" is the work of David Cronenberg ("Dead Ringers," "Scanners," "Naked Lunch"). Mr. Cronenberg's idea of a dramatically viable situation is a man's metamorphosing into a giant fly ("The Fly").

The anomalies of "M. Butterfly" — which opens today at the First and 62d Cinemas — are well suited to the icy daring of Mr. Cronenberg's style, in a film that seems to be challenging its audience's credulity right from the start. Of course, it is possible to view this "M. Butterfly" as a kind of failed offshoot of "The Crying Game," with John Lone so much less convincing a female figure than Jaye Davidson was. But it's a lot more interesting to give Mr. Cronenberg credit for understanding exactly what his audience sees.

Anyone who can read this film's credits will find it unsurprising that Song Liling, the Beijing Opera diva played by Mr. Lone, has a faint mustache visible beneath a thick layer of pancake makeup. But René Gallimard, the urbane Frenchman played by Jeremy Irons, is not just anyone. From the outset of the story, which begins in Beijing in 1964, Gallimard personifies so much innate arrogance, of both a masculine and an imperialist nature, that his complacency can be seen as having its shaky side. When he sits at the opera thunderstruck, watching Liling perform a strangely wan rendition of an aria from "Madama Butterfly," the full measure of Gallimard's capacity for self-delusion starts to show.

●

In a courtship that pivots as much on gamesmanship and political dominance as it does on sexual seduction, Gallimard begins to nurture an almost ludicrous obsession with the demure, big-boned "woman" of his dreams. But the film's Liling is anything but an ordinary seductress. Mr. Lone's masculine good looks translate so poorly to this feminine incarnation, and his voice is so disembodiedly flat, that his teasing rejoinders to Gallimard sound eerie. Meanwhile, Mr. Cronenberg explores his own affinity for the macabre by presenting Gallimard's furtive pursuit of his diva as nocturnal and strange. Gallimard might as well be William Burroughs exploring the Interzone of "Naked Lunch" when he pauses, late one evening, to watch a Chinese man collect dragonflies in a cage.

Mr. Irons, in a risky, mesmerizing performance, once again demonstrates how fully in tune he is with Mr. Cronenberg's brand of monstrously chilly sophistication. Playing yet another fool for love, Mr. Irons courts the ridiculous with lines like: "I came tonight for an answer. Are you my Butterfly?" Yet his desperate, impassioned Gallimard is able to rise above realism, drawing the audience deep into the many layers of Gallimard's obsession. Mr. Irons performs with such complete conviction that it becomes impossible not to understand his character's bizarre point of view.

On film, with its emphasis somewhat shifted away from the play's rhetorical elements, "M. Butterfly" works best as a fascinatingly cold-blooded assessment of love. Intense as Gallimard's longing is, it emerges

Joyce Rudolph/Fine Line Features

Lily Tomlin and Tom Waits in a scene from "Short Cuts."

more and more clearly as a product of his imagination as the story moves on. This Frenchman views Asians with such condescension ("You don't think those little men could have beaten us without our unconscious consent, do you?" he asks about the Vietnamese) that he is deeply gratified by the fantasy of a passive Asian lover. But when the love affair turns to bitterness and betrayal, Gallimard at last tells the unmasked Liling, "You're nothing like my Butterfly."

"Are you sure?" Liling asks. The film can be seen as a dark, unnerving exploration of that answer.

•

Mr. Cronenberg, whose malicious wit is often quietly apparent, contrasts Liling with Gallimard's pedestrian wife (Barbara Sukowa) and with a German woman with whom he has a brief affair. The latter proves herself the polar opposite of the coy, seductive Liling by abruptly appearing naked and saying: "So? Come and get it." The film also lends wryness to Liling's perfidy by showing the diva, who is gradually revealed to be a Chinese spy cultivating Gallimard for espionage purposes, studying a movie-magazine portrait of Anna May Wong. A Communist official denounces this Hollywood image as decadent. But to Liling it represents a world of artifice and possibility.

"M. Butterfly," as idiosyncratic as Mr. Cronenberg's work always is, is sometimes too flat and ambiguous for its own good. Mr. Lone's portrayal of Liling is most effective when its unnaturalness is clear. Those scenes that try to cloak the character in shadow or heavy costumes threaten to dull the film's unsettling spirit. But Mr. Cronenberg, with his sharp, deliberate images of human nature at its most extreme, has not lost his power to disturb.

•

"M. Butterfly" is rated R (Under 17 requires accompanying parent or adult guardian). It includes nudity, sexual situations and bloodshed.

1993 O 1, C3:4

Malice

Directed by Harold Becker; screenplay by Aaron Sorkin and Scott Frank; director of photography, Gordon Willis; edited by David Bretherton; music by Jerry Goldsmith; production designed by Philip Harrison; produced by Rachel Pfeffer, Charles Mulvehill and Mr. Becker; released by Columbia Pictures. Running time: 107 minutes. This film is rated R.

Jed	Alec Baldwin
Tracy	Nicole Kidman
Andy	Bill Pullman
Dennis Riley	Peter Gallagher
Dana	Bebe Neuwirth
Dr. Kessler	George C. Scott
Ms. Kennsinger	Anne Bancroft

By VINCENT CANBY

"Malice" could turn out to be the new season's pop mystery-suspense melodrama you won't want to miss. The film is deviously entertaining from its start through its finish, when most such movies go as irretrievably to pieces as Margo's face at the end of "Lost Horizon." "Malice" stays the course. If it were a car, it could be called a mean machine. Though light of weight, it hugs the road around every hairpin curve in its cruel and twisty narrative.

Cruel?

Stephen Vaughan/Castle Rock Entertainment
Alec Baldwin, left, and Bill Pullman in a scene from "Malice."

As written by Aaron Sorkin ("A Few Good Men") and Scott Frank, and directed by Harold Becker ("Sea of Love"), the movie opens on a gorgeous autumn afternoon with a montage of shots of an idyllic New England town that is the seat of a women's college rather like Smith. A pretty student bicycles home after classes, looking so pure and clean that it's axiomatic that something unspeakably dirty is about to happen to her. Two minutes later, as her cat watches nonjudgmentally from under a chair, she is brutally attacked by an unseen intruder and left for dead.

Cut to the operating room in the local hospital sometime later: Jed Hill (Alec Baldwin), a hotshot brain surgeon, is working to save the young woman's life. While doing incredibly adept things with scalpels, clamps and suction pumps, he's also insulting his O.R. associates with his sarcastic, supremely arrogant put-downs and

A surgeon, a beauty and a medical crisis.

asides. Jed is more than self-assured; he's high on the fun of the bloody business at hand. The thought arises that he might be the person who is raping and killing pretty young college students with alarming regularity.

In this way begins a convoluted tale of murder, lust, greed and mendacity. In addition to the charmingly vain and therefore suspicious brain sur-

Stephen Vaughn/Castle Rock Entertainment
Triangle George C. Scott plays a Harvard Medical School professor in "Malice."

geon, the principal characters are Andy Safian (Bill Pullman), the mild-mannered but seemingly staunch dean of the women's college, and his adoring wife, Tracy (Nicole Kidman), who works in a day-care center and wants nothing more than to have her own children.

Tracy takes an instant dislike to Jed, which, as anyone familiar with such fiction knows, indicates that there must be a turnaround of those feelings at some point. Yet when it comes, it's not something easily predicted.

Andy is fascinated by Jed. Starstruck, really. It turns out that years before they were classmates in high school, where Jed was a glamorous football player and Andy the nice, quiet, unassuming school drudge. To help pay their bills, Andy invites Jed to rent the top floor of the old Victorian mansion that he and Tracy are still in the process of paying for and doing over.

Jed becomes every landlord's nightmare tenant: he plays rock music at top volume at all hours. The ceiling fixtures shake as he entertains a string of giggly women, who are inclined to moan loudly when making love and who always run, never walk, to the bathroom afterward.

Tracy wants to kick him out. Andy defends his campus idol. It is Jed, though, who operates on Tracy when emergency surgery is necessary. He saves the patient but leaves her incapable of having children. That trauma transforms Tracy into an unforgiving termagant.

More about the story cannot be told without giving away some of the nifty surprises in Mr. Sorkin's confident, spooky, sometimes very funny screenplay. Mr. Baldwin is capable of playing all kinds of roles well, but maybe no one else in films today has his menacing physicality and vicious humor when playing conceited bullies with slicked-back hair. He's cold as dry ice ("Glengarry Glen Ross") and sometimes deadly ("Miami Blues"). His performance in "Malice" is simultaneously comic and scary, never more so than in a sequence in which he rationalizes his freely admitted God complex.

Ms. Kidman, always considered a serious actress in Australia where she began her career, has mostly been set decoration in her American films to date. For a change, "Malice" gives her something comparatively substantial to do.

Though Tracy Safian has little in common with Isabel Archer, the heroine of Henry James's "Portrait of a Lady" — a role Ms. Kidman is scheduled to play in Jane Campion's forthcoming film adaptation — her work in "Malice" suggests for the first time that she has the range and quality to become quite special. Bill Pullman also does very well in a role that allows the audience to suspect the worst about Mr. Nice Guy.

The excellent supporting cast is headed by Peter Gallagher and Bebe Neuwirth, while George C. Scott and Anne Bancroft are super in very small but vivid one-scene set-pieces, Mr. Scott as a famous old doctor who looks like God, and Ms. Bancroft as one of life's boozy drop-outs with a taste for single-malt whisky.

Mr. Becker's direction and Gordon Willis's cinematography serve the exuberant cleverness of Mr. Sorkin and Mr. Frank's screenplay. No matter how wild the plot reversals, there's always a slightly madder one to come.

"Malice" has been rated R (Under 17 requires accompanying parent or adult guardian). It has vulgar language, sexual situations and moments of brutal violence.

1993 O 1, C5:1

Between Heaven and Earth

Directed and produced by Marion Hänsel; screenplay (in French, with English subtitles) by Ms. Hänsel and Paul Le; director of photography, Josep M. Civit; editor, Susanna Rossberg; music by Takashi Kako; released by Arrow Entertainment. At the 57th Street Playhouse, 110 West 57th Street, Manhattan. Running time: 80 minutes. This film is not rated.

Maria	Carmen Maura
Editor in Chief	Jean-Pierre Cassel
Tom	Didier Bezace
Jeremy	Samuel Mussen
Professor	André Delvaux

By STEPHEN HOLDEN

Could the world be so terrible that in the near future unborn babies refuse en masse to leave their mothers' wombs? That is the bizarre supposition of Marion Hänsel's deadly earnest film, "Between Heaven and Earth," which opens today at the 57th Street Playhouse.

An uneasy hybrid of science fiction and medical information, the movie follows the mood swings of Maria (Carmen Maura), a television journalist in her 40's who becomes pregnant after a one-night encounter with a man in a stalled elevator.

Initially thrilled at her impending motherhood, Maria begins having nightmares after meeting, outside her obstetrician's office, a woman who says her unborn child has been screaming warnings about the end of the world. Maria's growing anxiety prompts her to do research, which shows that an alarming number of births are having to be induced.

In Maria's dreams, her unborn child (a fetus shown floating in amber liquid) whispers that it doesn't want to enter the world. During a television discussion of induced birth, Maria creates a small panic by announcing her certainty that more and more babies are choosing not to be born.

Eventually Maria agrees to have her labor induced to save the child. But moments before the procedure, she overhears two nurses commenting worriedly on the number of stillborn babies they have seen. She flees to the seashore, where she sweet-talks her unborn child into changing its attitude.

"Between Heaven and Earth" is a philosophical cry from the heart, in which all the characters are programmatic stick figures. Jean-Pierre Cassel plays Maria's sexist boss; Didier Bezace, her would-be lover; Samuel Mussen, the metaphysically precocious little boy next door, and André Delvaux, a disenchanted genetic engineer. Miss Maura, an actress who has illuminated many of Pedro Almodóvar's films, has little to do in the film but run around and look distraught.

1993 O 1, C5:1

Cool Runnings

Directed by Jon Turteltaub; screenplay by Lynn Siefert and Tommy Swerdlow and Michael Goldberg; editor, Bruce Green; director of photography, Phedon Papamichael; score by Hans Zimmer; production designer, Stephen Marsh; produced by Dawn Steel; released by Buena Vista Pictures Distribution Inc. Running time: 98 minutes. This film is rated PG.

Derice Bannock	Leon
Sanka Coffie	Doug E. Doug
Junior Bevil	Rawle D. Lewis
Yul Brenner	Malik Yoba
Irv Blitzer	John Candy

By JANET MASLIN

The usual high-concept film is one that can be described in a sentence or two. But "Cool Runnings" boils down to just three words: Jamaican bobsled team. Since nothing about that phrase says "stroke of genius," there's reason to wonder what kind of film can have been spun out of it. The answer: a cute, buoyant sports fantasy, jolted along by a reggae soundtrack and playfully acted by an appealing cast. This new Disney comedy is slick, funny and warmhearted, very much in the old-fashioned Disney mode.

Though this film's vision of Jamaica is about as authentically Caribbean as Sebastian the crab, it is picturesque and bright. In sunny Jamaica, a champion sprinter named Derice Bannock (Leon) joins forces with the comical Sanka Coffie (Doug E. Doug) and two other friends to form an unlikely Olympic team. Derice, the bald-headed Yul Brenner (Malik Yoba) and Junior Bevil (Rawle D. Lewis) have all crossed paths, quite literally, in the Olympic trials for Jamaican runners. And they have lost their chance to qualify as runners.

But then, with the help of a down-at-the-heels coach named Irv Blitzer (John Candy), Derice realizes it may be possible to go to the Olympics in some other category. Bobsledding enters the picture. These three runners have no idea what a bobsled is, but they recruit Sanka, a star among Jamaican pushcart racers, and begin training in the sand. The film makes the most of this scenic backdrop and of the comic possibilities of cramming four rambunctious athletes onto a tiny sled.

•

As directed by Jon Turteltaub ("3 Ninjas"), "Cool Runnings" works in so many four-man sight gags that it recalls "The Monkees," which aimed for audiences in a similar age bracket. This film's jokey potential is greatly heightened by cold weather. Once the Jamaicans and Irv, now their devoted trainer, make it to Calgary for the 1988 Winter Olympics, there is ample time for the film to kid around about frosty breath and freezing bobsledders. The contrast between these zany underdogs and more sternly behaved Olympic teams, like the Swiss, is also fully exploited.

Since "Cool Runnings" is distinctly family-minded, it includes no bobsled groupies and makes room for the occasional uplifting sentiment. ("We're different. People are always afraid of what's different.") But Mr. Turteltaub has a relatively light touch with potentially preachy dialogue, and so does Mr. Candy: his obligatory Big Speech defending the Jamaicans' right to compete is handled with a minimum of self-righteousness or corn. This film isn't long on surprises, but it unfolds with hu-

Rob McEwen/Walt Disney Pictures
John Candy

mor and ease. Colorful costumes and reggae rhythms give it another big boost.

"Cool Runnings" also happens to contain some very visible plugs for brand names like Coca-Cola and Adidas. The young viewers toward whom the film is geared may be especially receptive to such details.

•

"Cool Runnings" is rated PG (parental guidance suggested). It includes very mild profanity.

1993 O 1, C8:5

For Love or Money

Directed by Barry Sonnenfeld; produced by Brian Grazer; written by Mark Rosenthal and Lawrence Konner; director of photography, Oliver Wood; film editor, Jim Miller; production designer, Peter Larkin; released by Universal Studios. Running time: 95 minutes. This film is rated PG.

Doug Ireland	Michael J. Fox
Andy Hart	Gabrielle Anwar
Christian Hanover	Anthony Higgins
Mr. Wegman	Michael Tucker
Mr. Drinkwater	Bob Balaban
Julian Russell	Isaac Mizrahi
Gene Salvatore	Dan Hedaya
Milton	Fyvush Finkel
Bobby Short	Himself

By JANET MASLIN

"For Love or Money" begins by having some fun with the notion of Michael J. Fox as Mr. Big, riding around Manhattan in a long white limousine and indulging in a big-ticket shopping spree. This is Mr. Fox as no one particularly wants to see him: cold, aloof and corrupted by power. He is much more at home when he is revealed to be Doug Ireland, the sneaky, quick-witted concierge at a grand New York hotel, working hard to parlay each guest's needs into a golden opportunity of his own.

"Don't confuse yourself with all these small denominations," he tells an out-of-towner (Michael Tucker) who tries to give him a $5 tip in gratitude for a big favor. "You wait until I feel like the best friend you ever had. Then you give me a tip so big it feels like passing a kidney stone." Doug Ireland, a dyed-in-the-wool cynic who describes himself as "a genie in a suit," should probably do something to change his life, but the viewer will wind up hoping that he doesn't. Doug's Machiavellian hotel-management tricks are much more

Andy Schwartz/Universal Studios
Michael J. Fox

gratifying than his inevitable decision to clean up his act.

"For Love or Money" was directed by Barry Sonnenfeld, who proves that he does not need the Addams family to develop a wry, cartoonish atmosphere filled with funny, well-etched minor characters. Set in the lavish Bradbury Hotel (an amalgam of the Pierre's exterior and Peter Larkin's sweeping set design), the film evokes a sleek, romantic New York filled with lively eccentrics, like the aging, tyrannical bellhop (Fyvush Finkel) who is a perfectionist about things like properly sculptured sand in hotel ashtrays. In the midst of this setting, Mr. Fox holds court in high style, fielding each new request ("Mr. Mohammed needs a translator to go with him to Jackie Mason") with tireless energy.

•

As written snappily by Mark Rosenthal and Lawrence Konner, the film introduces Doug to Andy (Gabrielle Anwar), a beautiful young woman whose brand of self-prostitution is even more abject than Doug's. Andy, a perfume saleswoman and would-be singer, looks great in spandex and is sleeping with a suave, married tycoon (Anthony Higgins). Knowledgeable about the affair, which is taking place in the Bradbury, Doug is prompted to say: "I'll tell you what. I'm going to come back when I'm older, richer and married. That way you won't be able to resist me." Andy does resist him throughout most of the story, but the film takes the inevitable turn toward high ground before it is over. Still, Mr. Sonnenfeld's direction is sprightly enough to produce a viable fairy-tale ending.

New York is so admiringly shown off by "For Love or Money" that Doug's secret ambition, a plan to build an elegant hotel on Roosevelt Island, is actually made to look like a decent idea. The film's other characters, briefly but entertainingly drawn, include Dan Hedaya as an unbelievably hairy gangster and Bob Balaban as a pesty I.R.S. agent. ("I got Leona and I'll get you," he tells Doug.) Isaac Mizrahi is well used as a petulant fashion designer. Bobby Short belongs in this movie, and he's here too.

•

"For Love or Money" is rated PG (Parental guidance suggested). It includes profanity and implied sexual situations.

1993 O 1, C8:5

Raining Stones

Directed by Ken Loach; screenplay by Jim Allen; photography by Barry Ackroyd; editor, Jonathan Morris; music by Stewart Copeland; production designer, Martin Johnson; produced by Sally Hibbin. Presented by Film Four International. A Parallax Pictures production. At Alice Tully Hall, Lincoln Center, as part of the 31st New York Film Festival. Running time: 90 minutes. This film is not rated.

Anne	Julie Brown
Tommy	Ricky Tomlinson
Bob	Bruce Jones
Father Barry	Tom Hickey
Coleen	Gemma Phoenix
Tansey	Jonathan James

By VINCENT CANBY

Ken Loach, the English film maker, first came on the international scene in the early 1970's with such films as "Poor Cow" and "Kes." With "Riff-Raff" (1991) and now "Raining Stones," which will be shown at the New York Film Festival at 9 tonight, it's abundantly evident that he's on a new roll.

Like "Riff-Raff," a bitterly comic response to the policies of Britain's Tory governments, "Raining Stones" focuses on working-class folk who have somehow failed to benefit from trickle-down economic theories. The setting is a medium-sized city in the north of England where Bob (Bruce Jones), a youngish, balding man who's no better than he should be, is trying to make ends meet in a depressed job market.

When first seen, Bob and his pal Tommy (Ricky Tomlinson) are in a foggy meadow at dawn trying to steal a large, uncooperative sheep. After they have finally caught and trussed the animal, but failed to screw their courage to the point where they might either stick or bash it to death, they deliver it to a friendly butcher. "You said lamb," scoffs the butcher. "This is mutton. You can't give mutton away."

So it goes for Bob through a series of alternately hilarious and melodramatic misadventures in the world of self-help. When he tries to make a little money by going door-to-door cleaning drains, the only person who accepts his services is his pastor, Father Barry (Tom Hickey), a Roman Catholic priest who assumes it's Bob's contribution to the church. Stealing sod from a golf course for a landscape gardener is not much more profitable. A job as a bouncer at a disco lasts one night.

Behind Bob's increasing desperation is the forthcoming first Communion of his daughter, Coleen (Gemma Phoenix). Though both Anne (Julie Brown), his wife, and Father Barry point out that clothes do not make the Communion, Bob remains obsessed with the idea that Coleen must have a new wardrobe costing in the neighborhood of 150 pounds ($224). His is a pride made terrible by poverty.

With a fine screenplay by Jim Allen and the wizardly camera work of Barry Ackroyd, Mr. Loach again shows himself to be in top form. "Raining Stones" is brisk, richly characterized fiction that cuts as deeply and truly as any documentary. The movie slides effortlessly from farce to melodrama (as Bob becomes involved with loan sharks) and on into affecting domestic drama.

The regional accents are sometimes difficult to understand, but enough comes through to suggest that Mr. Allen has a remarkable ear for working-class speech. Listen to the story someone tells in a pub about what happened to a boy in a wheelchair at Lourdes, and to Bob's de-

scription of his own situation. "I'm just ducking and weaving," he says, "trying to keep my head above water."

Mr. Jones, an actor new to me, is splendid in the central role. Though intense and funny, the performance is free of mannerisms. Bob behaves like someone being trailed by a hidden camera. Almost as fine is Mr. Tomlinson's Tommy, a big talker who always fails at a crucial moment. The entire supporting cast is good, but special mention must be made of Ms. Phoenix, who recalls Peggy Ann Garner in "A Tree Grows in Brooklyn," and Jonathan James, the vicious loan-shark collector whose appearance on the scene prompts the film's very rough climactic sequence.

Mr. Loach is not a fashionable director at the minute. He's an anachronism in a time when even politically committed directors are expected to stand at a distance from their material, in this way to protect their cool. Mr. Loach doesn't worry about that. Yet because he has such command of craft, his films leap beyond politics, beyond genre, to a life in what might be called pure cinema.

•

Sharing the festival bill with "Raining Stones" is a wonderful animated short from Australia by Dennis Tupicoff. The film, titled "The Darra Dogs," is a recollection of boyhood told entirely in terms of the mortality of dogs. The drawings have the blunt simplicity and grace of woodblock prints. These perfectly suit the narrator's tale of a succession of stray dogs found, adopted, named Laddie, faithfully loved and then lost, mostly through death by one sort of accident or another. "The Darra Dogs" is tough and haunting in ways not easily described.

1993 O 2, 11:3

Freaked

Directed by Tom Stern and Alex Winter; written by Tim Burns, Mr. Stern and Mr. Winter; director of photography, Jamie Thompson; edited by Malcolm Campbell; music by Kevin Kiner; production designer, Catherine Hardwicke; produced by Harry J. Ufland and Mary Jane Ufland; a Tommy Production; presented by 20th Century Fox. Running time: 80 minutes. This film is rated PG-13.

Ricky Coogin	Alex Winter
Elijah C. Skuggs	Randy Quaid
Skye Daley	Brooke Shields
Dick Brian	William Sadler
Julie	Megan Ward
Worm	Derek McGrath
Sockhead	Karyn Malchus
Voice of Sockhead	Bobcat Goldthwait
Bearded Lady	Mr. T

By STEPHEN HOLDEN

In "Freaked," a rambunctiously slobbering entrant in the "Toxic Avenger" school of gross-out movie comedy, Alex Winter plays Ricky Coogin, a greedy television star who is chemically transformed into a freak-show attraction for a South American carnival. Ricky's altered appearance is his comeuppance for agreeing to be the $5 million spokesman for the nefarious E.E.S. (Everything Except Shoes) Corporation, which markets a toxic fertilizer called Zygrot-24 in the third world.

When Alex and two companions stumble upon a mysterious sideshow on a South American hillside, its mad-scientist proprieter (Randy Quaid) imprisons them and hooks them to a computerized monster-making ma-

chine. After swabbing them with Zygrot-24, a noxious green slime that spews throughout the movie, he presses "enter" on the junk-heap contraption and turns them into custom-made freaks.

Alex's companions, a feminist and a male chauvinist, are melded into feuding Siamese twins. Alex becomes a pustulant half-man-half-beast who makes his carnival stage debut soliloquizing from "Richard III."

The new recruits join a menagerie of a dozen machine-made mutants that include a giant talking worm (Derek McGrath), Sockhead (Karyn Malchus and the voice of Bobcat Goldthwait), a creature whose head is a limp, dirty sock, and a bearded lady (Mr. T). Patrolling the premises to make sure no one escapes are two giant, machine-gun wielding eyeballs who speak in a Rasta dialect.

"Freaked," which was directed by Mr. Winter and Tom Stern from a screenplay they wrote with Tim Burns, has the candy-colored glow of a goofy psychedelic comic book and the irreverent sensibility of Mad Magazine.

The film, which opened yesterday, is also a movie in which any and every relic of 80's pop culture is liable to show up. In addition to Mr. T, whose bearded lady is the least imaginative creature in sight, Brooke Shields and Morgan Fairchild show up as a talk-show host and a flight attendant.

Anything can happen at any moment. During the "Richard III" soliloquy, an English professor in the carnival audience turns to the camera and announces that there will be subtitles for the culturally illiterate. Late in the movie, the film pauses to deliver an amusingly bogus commercial for Macheesmo, a loathsome-looking paste in an aluminum beer can, billed as "real cheese for real men."

•

"Freaked" is rated PG-13 (Parents strongly cautioned). It includes strong language.

1993 O 2, 14:3

Shades of Doubt

Directed and written by Aline Issermann; in French, with English subtitles; director of photography, Darius Khondji; editor, Hervé Schneid; music by Reno Isaac; produced by Ciby 2000 and TF1. At Alice Tully Hall, as part of the 31st New York Film Festival. Running time: 105 minutes. This film is not rated.

Alexandrine	Sandrine Blancke
Jean	Alain Bashung
Marie	Mireille Perrier

By JANET MASLIN

Aline Issermann's "Shades of Doubt" ("L'Ombre du Doute"), a French film about a wrenching family crisis, is set forth with remarkable restraint. The subject is incest, but the story's potential for tawdriness is never exploited. Instead, Ms. Issermann presents a discreet, methodical account of how 12-year-old Alexandrine (Sandrine Blancke) comes to bring and then recant charges against her father, Jean (Alain Bashung).

If the director's approach is at all representative, then the cultural differences between French and American approaches to this subject are fascinating. The American impulse toward tabloid sensationalism is nowhere evident; nor is the urge to air

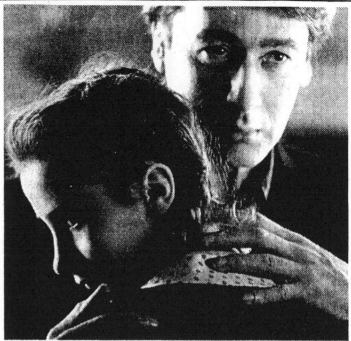

The Film Society of Lincoln Center

Sandrine Blancke and Alain Bashung in Aline Issermann's "Shades of Doubt," showing at the 31st New York Film Festival at Lincoln Center.

all the family's dirty laundry in the interests of catharsis. If anything, the LeBlancs feel profoundly embarrassed by their problem and wish it would simply go away. In a climate of sexual sophistication and naturalness, the charge of incest is perhaps even more devastating than it would be in dysfunction-conscious America.

Alexandrine, a tall, somber girl in pigtails, is first seen running warily away from her father as he tries to take home movies of a family outing in the woods. The film's implication of sexual abuse is seldom more direct than that, because Ms. Issermann attempts to sustain some degree of ambiguity about what actually may have happened. Although Alexandrine levels her charges very early in the story, the film avoids the kind of thorough questioning that would accompany a full police investigation of the matter. Similarly, it keeps Jean's private conversations with his daughter on a deliberately evasive note: "You're my child that I love. I am helpless before you. I never wanted to hurt you."

The film goes on to observe the various individuals who try to investigate the case: a teacher, a lawyer, a social worker (played warmly and earnestly by Josiane Balasko). And it ascribes to most of them a surprisingly uncomplicated faith in Alexandrine's story. Ms. Issermann's outlook is somewhat limited by pat psychological profiles of LeBlanc family members, and by a uniformly romantic conception of childhood innocence. "Believing children changes a lot," one of the characters says fervently. "It changes the world."

"Shades of Doubt," which will be shown tonight at 6 and tomorrow at 3:45 P.M. as part of the New York Film Festival, is most effective in its solemn, detailed evocation of Alexandrine and her dilemma. As played hauntingly by Ms. Blancke, a girl with the serene, distant gaze of a Botticelli vision, Alexandrine is extremely watchful and frightened much of the time. As she drifts into fantasies and talks to herself alone at night, her working mother (Mireille Perrier) practices a different form of denial,

expressing great irritation at anyone who comes to investigate the family. But the pressure eventually mounts, and Jean is tarred by his daughter's accusations. "The way I see it," Jean's lawyer insists, "this is mythomania on an epic scale."

Ms. Issermann, whose power to dramatize this case study is eventually constrained by the preconceptions she brings to it, finds no easy way to end "Shades of Doubt." A statistic about sexual-abuse cases is no substitute for the thoughtful resolution this sad story needs.

•

On a much lighter note, this program begins with "Grown Up," Joanne Priestly's whimsical animated short film about the travails of middle age. Deftly and wittily drawn, this brief self-portrait is a lot more likable than its subject makes it sound.

1993 O 2, 16:1

Blue

Directed by Derek Jarman; produced by James Mackay and Takashi Asai; Simon Fisher Turner, composer; Marvin Black, sound designer. At Alice Tully Hall as part of the 31st New York Film Festival. Running time: 75 minutes. This film is not rated.

Voices...John Quentin, Nigel Terry and Tilda Swinton

By STEPHEN HOLDEN

The sole visual content of Derek Jarman's film "Blue" is the color blue projected uninterruptedly and without variation for the movie's entire 76 minutes. Against this field of color so evocative of sky, ocean, blindness, heaven and eternity unfolds a soundtrack of music, poetry and scalding excerpts from a diary by the English film maker who has been living with AIDS for several years.

"Blue," which the New York Film Festival is presenting at Alice Tully Hall tomorrow evening at 9:30, is by turns heartbreaking, enraged, boring, pretentious and riveting. The narration, delivered with a stately equanimity by John Quentin, Nigel Terry

and Tilda Swinton, is interwoven with music and sound effects to suggest a stream of consciousness that is continually changing levels. There are moments when the film maker's spirit seems on the verge of taking leave of his body and drifting into the ether. At other times the writing is so incendiary that he seems ready to jump out of his sickbed and burn down the hospital.

After a gentle beginning in which bells toll elegiacally and a voice contemplates the color blue and its associations, the screenplay narrows in on the film maker's physical problems, of which the most acute is failing eyesight. From here, it veers between lulling metaphysical speculation and brutal physical reality.

•

When the language turns vague and dreamy, "Blue" can seem like an indulgent exercise in languid poeticizing. But when the narrator expresses fear, rage and contempt, the film assumes a ferocious intensity in which the gap between the blankness on the screen and the emotions being expressed becomes the distance between one brilliant, cranky individual and nothingness.

In the most pointed passages, the film maker, who is being treated in a public hospice, rails against the very idea of charity and the way it salves the conscience, allowing people to avoid contact with what disturbs them. The recitation of the possible side effects of an experimental drug is horrifying; many sound far worse than the blindness the drug is intended to thwart. In other searing moments the film maker asserts his homosexuality with the vengeful pride of someone for whom it is a badge of integrity in a corrupt, mediocre, inhuman society whose imminent destruction is to be devoutly wished for.

•

Preceding "Blue" is "Sleepy Haven," a 15-minute movie by Matthias Müller, a German version of Kenneth Anger. It is almost a romantic variation on Mr. Jarman's film. The central image in this turbulent collage with homoerotic flashes is an ocean liner plowing through the sea. The cinematography is drenched in an inky blue.

1993 O 2, 16:2

The Blue Kite

Directed by Tian Zhuangzhuang; screenplay (in Mandarin, with English subtitles) by Xiao Mao; cinematography by Hou Yong; edited by Qian Lengleng; music by Yoshihide Otomo; produced by Longwick Films in Hong Kong and the Beijing Film Studio. At Alice Tully Hall, Lincoln Center, as part of the 31st New York Film Festival. Running time: 138 minutes. This film is not rated.

Tietou Yi Tian, Zhang Wenyao and Chen Xiao-man
Mum ... Lu Liping
Dad... Pu Quanxin
Uncle Li....................................... Li Xuejian

By VINCENT CANBY

In China it can't be easy being a film maker, someone who wants to explore onscreen the contradictory events that have shaped not only the Communist revolution but also his own life. It's a delicate, complicated task. The film maker is dependent on Government departments created by the same system whose legacies he's examining. The production and release of any film of this kind thus become something of a triumph.

Such a film is "The Blue Kite," which will be shown at the New York Film Festival this afternoon at 2:30. Co-produced by the Chinese Government and private Hong Kong movie interests, it's the work of Tian Zhuangzhuang, whose "Horse Thief" was seen at the Film Forum in 1988.

"The Blue Kite" is the story of the Chen family of Beijing, as the son, Tietou, recalls his infancy, childhood and adolescence. It follows the fortunes of the Chens, their relatives and friends from 1953, when Tietou's parents marry and Chairman Mao's revolution is still young and vigorous, into the dark, vengeful days of the Cultural Revolution in the late 1960's.

•

This mix of politics and domestic drama isn't always easy to follow, but Mr. Tian demonstrates a rigorous, unsentimental control of the material that becomes very moving, at least in part because of the director's understatement.

The Chens initially appear to be members of an enlightened, comparatively prosperous lower middle class. I say "appear to be" because it's never clear where they belonged in the social structure of pre-revolutionary China. Some of the Chens enthusiastically support the new Government's radical reforms. Others seem apolitical. Whatever their commitments, all suffer equally.

That "The Blue Kite" had problems with the Chinese censors is not surprising: it makes no attempt to show any of the revolution's accomplishments. In its own mild way, the film is unrelenting in its indictment of the Communist regime, saying, in effect, that whatever the benefits, the toll taken on individual freedom was too high.

•

"The Blue Kite" is also about the many downs and infrequent ups of Tietou's childhood. His father is killed in a logging accident while working as a Government labor recruit. His mother remarries twice. A beloved family friend, an ardent supporter of the Government, is an early victim of the Cultural Revolution, as are, eventually, Tietou and his mother.

The movie comes to dramatic life only in its final sections, relating to the excesses of the Red Guards. These sequences are harrowing.

"The Blue Kite" looks gorgeous. It's well acted by a large cast, but, to appreciate it fully, one needs more footnotes to history than most ordinary moviegoers are going to have in mind or pocket.

1993 O 2, 16:6

Night

Directed by Mohammed Malas; screenplay (in Arabic, with English subtitles) by Mr. Malas and Oussma Mohammed; photography by Youssef Ben Youssef; edited by Kais al-Zoubaidi; produced by Omar Amiralay. At Alice Tully Hall as part of the 31st New York Film Festival. Running time: 115 minutes. This film is not rated.

Wissall... Sabah Jazairi
Allalah.. Fares al-Helou
The BoyOmar Malas
Wissal's Father....................... Riad Chahrour
Wissal's MotherRaja Qotrach
Awad... Maher Sleibi
Awad's WifeNada Homsi

By STEPHEN HOLDEN

Mohammed Malas's difficult autobiographical film "The Night" has the distinction of being the first Syri-

an movie to appear in the New York Film Festival. Set in the late 1930's and 40's, it portrays a rustic tribal society struggling to become a nation without any compelling nationalistic agenda other than the expulsion of enemies who range from European colonials to Zionist settlers in Palestine.

Until Syria achieved independence in 1946, the country was a mandated territory administered by France under a League of Nations agreement. After the fall of the Vichy Government at the end of World War II, the British arrived and installed a civilian regime that was quickly overthrown by the first in a succession of unstable military governments. Unless you have some knowledge of this period of Middle Eastern history, the film, whose time sense is abrupt and difficult to follow, is almost impenetrable.

"The Night," which is playing tonight at Alice Tully Hall, views these events through the eyes of a young boy (Omar Malas) who is the film maker's alter ego. Narrated by his grown-up self, with additional comments by his mother, Wissal (Sabah Jazairi), the movie is a remembrance of things past in which the film maker tries to make sense of his childhood and come to terms with his wildly unstable father, Allalah (Fares al-Helou).

The portrait of Allalah that emerges is of a devoted family man who is also a hothead and a zealot who is considered insane by many inhabitants of the city of Quneitra. In one scene he becomes so overwrought that he sets himself on fire with gasoline. In another fit of pique, he destroys a store owned by his tyrannical father-in-law. Ultimately, he runs afoul of the military government, portrayed in the film as a bunch of pompous fools. In his son's eyes, however, he is the only pure soul in a community of petty chiselers.

If the film's portrayal of Syrian history is confusing, its picture of Quneitra offers an intimate glimpse of daily life in the Islamic world. It is a harsh society where men rule, women obey, and unruly children are disciplined with sharp slaps across the face.

The film makes effective use of recurrent images. Before each conflict, the boy is handed a camera and told to take a group snapshot of the soldiers. In the most striking image, the bewildered youngster runs into the dusty street to observe the chaos. The shadows of the nearby windmill rotating across his face are like the pages of a family history he will spend the rest of his life trying to unravel.

1993 O 4, C15:3

Valley Of Abraham

Directed and written by Manoel de Oliveira (in Portuguese with English subtitles), from the novel "Vale Abraão" by Agustina Bessa-Luís; cinematographer, Mário Barroso; edited by Mr. de Oliveira and Valerie Loiseleux; produced by Paulo Branco. At Alice Tully Hall, as part of the 31st New York Film Festival. Running time: 187 minutes. This film has no rating.

Ema... Leonor Silveira
Ema (young)Cecile Sanz De Alba
Carlos de Paiva Luís Miguel Cintra
Paulino Cardeano................. Rui De Carvalho
Pedro Lumiares................. Luís Lima Barreto
SimonaMicheline Larpin

By VINCENT CANBY

At the age of 85, the Portuguese director Manoel de Oliveira, who has

been making movies since 1931 and is still little known in this country, has brought forth what a number of European critics describe as his chef-d'oeuvre: "Valley of Abraham" ("Vale Abraão"), a contemporary variation on Gustave Flaubert's "Madame Bovary," inspired by Agustina Bessa-Luís's Portuguese novel also titled "Valley of Abraham."

The film is a grand, singularly idiosyncratic work, as austere as Robert Bresson's "Diary of a Country Priest" and as thick with narrative details and chatty asides as "Little Dorrit." It mesmerizes, sometimes maddens and tests the emotional and physical reflexes.

"Valley of Abraham," which is 3 hours 7 minutes long, will be shown at 8:30 tonight at the New York Film Festival.

•

In this case, citing the film maker's age is not impertinent. In "Valley of Abraham" Mr. de Oliveira exhibits an Olympian confidence that comes only after having lived, worked, thought and considered for a very long time. He has achieved a freedom denied others. He can break conventions and make his own rules. What's the worst that can happen to him? Be denied a long-term contract with Disney?

More important, Mr. de Oliveira represents a kind of sensibility that today has all but disappeared. Like Luis Buñuel, he is a man shaped by the 19th century, working in a 20th-century art form to which he brings a richly hybrid point of view. Even as he exploits the possibilities of the camera to record the mysterious surfaces of things, he evokes the power of words both to clarify and contradict. His films invite a kind of speculation rare in cinema as this century's end approaches.

Mr. de Oliveira's heroine is almost the antithesis of Emma Bovary, the foolish, vain, deluded French provincial who reads silly magazines and books and lives her life accordingly, with fatal results. Flaubert appreciated Emma's situation, but he wasted no sympathy on her. He dismembered her with care.

Mr. de Oliveira adores his Ema Cardeano. For all her failings, few of which we actually see, she is an idealized woman, her nature too finely tuned and poetic for this world, where she is surrounded by men who are moral and spiritual midgets. To the disgust of her devout, unmarried aunt, who spends hours each day on her knees praying to Jesus, Ema reads novels, but good ones, including "Madame Bovary."

When first seen by Carlos de Paina, a much older, married, well-to-do doctor and gentleman farmer, Ema is a 14-year-old beauty, dining on eels in a restaurant in the provinces with her father. Carlos is dazzled by the girl who, at that first meeting, notes "his nice neat salesman teeth" but is otherwise unimpressed. He's not an exciting man. A few years later, after being widowed, Carlos meets Ema again when her father calls him in for a consultation. In terms of screen time, marriage follows quickly. The marriage's inevitable disaster takes much, much longer.

•

Infusing the film with its particular tone is the soundtrack narration spoken by the omniscient tale-teller. Not since "Diary of a Country Priest," and maybe François Truffaut's "Jules and Jim," has narration been

used for such curious and exhilarating effect. In the film's opening sequence, before Ema has been introduced, the narrator is already leaping ahead of himself to tell us how Carlos sometimes introduced his second wife as his sister, "which made things easier when men fancied her."

The narrator is given to contemplative thoughts and lyrical interpretations, but he also has the manner of a brilliant busybody. He tells us everything and, from time to time, nothing: one can't always be sure whether his observations are sometimes intentionally allusive or just vague because the English subtitles are inadequate.

Most of the time the narration works extremely well, even as the narrator tells us things we do not see. He reads the thoughts of two frostily aristocratic old ladies when they meet young Ema for the first time. One of them describes her beauty as "sinister." The other says it has "a kind of genius to it." These aren't observations one often encounters in movies. They wouldn't easily fit into dialogue but, as voice-over narration, they give emotional presence to Mr. de Oliveira's obsession with his subject.

Ema is played by Cecile Sanz De Alba as a girl and Leonor Silveira as a woman, both of whom are pretty but not immediately hypnotizing. The fully written narration supplements images of startling clarity and simplicity. The director shares Buñuel's preference for the functional camera movement and the uncluttered film frame, which, if there had been feature films 100 years ago, one might call a 19th-century film style.

"Valley of Abraham" proceeds leisurely at the pace of the narrator. Mr. de Oliveira's Ema, unlike Flaubert's, has a limp that the narrator describes as "slight," though it looks pronounced to us. He remarks that Satan is also supposed to have a limp, which some people think is a warning to would-be victims. As a young woman Ema has a fondness for showing herself on her father's veranda, just above a sharp turn in the highway leading into town. Car and after car goes smash into a stone wall as their drivers become bewitched. The mayor officially labels her a road hazard.

•

The manner in which the young Ema fingers the blossom of a blood-red rose suggests that nothing good is going to come of her. Yet Ema seems a very passive femme fatale. She takes lovers, but the narrator tells us her lust was "imaginary." She simply wanted men to desire her. It is Mr. de Oliveira's method that by the end of the film she has become as beautiful as she is supposed to be, and even more of a mystery than she is at the beginning.

The film has wit. Mr. de Oliveira's version of Flaubert's grand ball, which excites Emma Bovary's romantic ambitions, is a party that looks upper-middle-class exurban, at-

In Portugal, a woman too poetic for this world.

tended by men who golf and women who garden. Society is scaled down in "Valley of Abraham," but not Ema's confused aspirations.

The director's fondness for women in general, and not just Ema, is apparent in the fact that all of the women's roles are more interesting, and more vividly played, than the men's. His actors look and behave like hand-me-downs from a not-great repertory company.

The film also has its version of Ema's limp: Mr. de Oliveira's decision to score Ema's romanticism with relentless repetitions of Beethoven's "Moonlight" Sonata and Debussy's "Clair de Lune" on the soundtrack. There can be no greater praise for this spectacular and eccentric film than to report that "Valley of Abraham" never gets buried under the overload of marshmallow din.

1993 O 5, C13:5

Avant-Garde Visions

At Alice Tully Hall as part of the 31st New York Film Festival.

PASSAGE À L'ACTE, directed by Martin Arnold. Running time: 12 minutes. This film has no rating.

POVERTIES, directed by Laurie Dunphy; written and performed by Mark Freeman; cinematographers, Ms. Dunphy and Beth Barnett. Running time: 30 minutes. This film has no rating.

DOTTIE GETS SPANKED, written and directed by Todd Haynes; director of photography, Maryse Alberti; edited by James Lyons; music by James Bennett; production designer, Therese Deprez; produced by Christine Vachon and Lauren Zalaznick. WITH: Evan Bonifant, Ashley Chapman, Barbara Garrick, Julie Halston, Irving Metzman, Robert Pall and Harriet Harris. Running time: 30 minutes. This film has no rating.

By STEPHEN HOLDEN

Anyone who has nursed a childhood obsession with a television program — and who hasn't devoutly wished at one time to escape childhood growing pains by diving through the tube into a magical realm? — should find a haunting resonance in Todd Haynes's half-hour film, "Dottie Gets Spanked."

The longest and most original of the three short films in the "Avant-Garde Visions" program of the New York Film Festival at 6 o'clock this evening, "Dottie Gets Spanked" observes the world through the eyes of a shy 6-year-old boy named Steven Gale (Evan Bonifant). It is 1966 in suburban New York, and Steven has a fixation on a Lucy-like television star named Dottie Frank (Julie Halston). His fervor is so all-consuming that his parents are beginning to worry.

Sitting inches from the television set, Steven scrawls scenarios starring his idol in a drawing book. At night, Dottie's zany misadventures become entangled with his own dreams. Even after Steven wins a contest to visit the New York studio where the program is shot and dis-

Short works make up 'Avant-Garde Visions.'

covers that the actress playing Dottie is a tough professional cookie who is not like her character, he persists in his obsession.

•

During the episode under way in the studio, Dottie is given a comic spanking. And the image becomes confused in his own mind with his stern father's tacit threats of corporal punishment. It all comes together in a dream sequence in which spanking assumes a mythical import, and shame and desire become intermingled.

A similar sense of an oppressive, regimented society cruelly bearing down on a sensitive individual infused Mr. Haynes's films "Superstar: The Karen Carpenter Story" and "Poison." But in "Dottie Gets Spanked," that feeling is more acute and the directorial hand more secure. The most daring sections of the film are its dream sequences, in which the director tries to go beyond surrealistic symbolism and evoke actual dreams. Although Mr. Haynes doesn't succeed in what may be an impossible quest, there are moments when he comes eerily close.

•

Laurie Dunphy's "Poverties," and Martin Arnold's "Passage à l'Acte," are at once more abstract and more conventional exercises in experimental film making. Ms. Dunphy's jaggedly edited film juxtaposes a documentary of a squatter community in Chicago (one section was actually shot by the street people using hand-held cameras) with images and songs that evoke societal indifference to the squalor being documented. The most telling contrasts are overhead shots of a garbage dump being plundered by dozens of the homeless with glimpses of a television aerobics instructor counting out a flab-reducing routine.

"Passage à l'Acte," an Austrian film, is a 12-minute exercise in what might be described as hip-hop film editing. A tiny scene from "To Kill a Mockingbird," in which four people sit down to breakfast, is deconstructed second by second so that every gesture is replayed and fragments of sound become a sharp, usually unintelligible digital clatter. Although intended as an ominous, microscopic examination of body language and psychological tensions, the film is so funny that it is better seen as a comic stunt.

1993 O 5, C18:3

Ruby in Paradise

Written, directed and edited by Victor Nuñez; director of photography, Alex Vlacos; music by Charles Engstrom; production designer, John Iacovelli; produced by Keith Crofford; released by October Films. At Alice Tully Hall, Lincoln Center, as part of the 31st New York Film Festival. Running time: 114 minutes. This film has no rating.

Ruby Lee Gissing	Ashley Judd
Mike McCaslin	Todd Field
Ricky Chambers	Bentley Mitchum
Rochelle Bridges	Allison Dean
Mildred Chambers	Dorothy Lyman
Debrah Ann	Betsy Douds
Persefina	Felicia Hernandez
Indian Singer	Divya Satia
Wanda	Bobby Barnes

By JANET MASLIN

The best news about tonight's program at the New York Film Festival comes first: "Excursions to the Bridge of Friendship," an irresistible 12-minute Australian short presented without dialogue. The film's dreadfully pertinent soundtrack consists of wailing, clanging music heard steadily in the background.

The caterwauling highlights the efforts of a Bulgarian folk singer to bring her artistry to Australia, with the help of a reluctant would-be entrepreneur who imagines glowing head-

lines ("Cultural Visionary Brings Unique Sound to Sydney") should the plan succeed. Presented in crisp, funny black-and-white images, it is replete with droll subtitles ("Meanwhile, back in the Balkans") and widespread expressions of dismay on all sides. Christina Andreef, whose cast includes Genevieve Lemon of "Sweetie," shows firm control of her off-the-wall subject and a witty, wonderfully inventive visual style. Like Jane Campion, who is thanked in this short film's credits, she displays a memorably skewed world view.

The evening's other good news is Ashley Judd, who plays the title role in "Ruby in Paradise," appearing as a strong-willed young woman who strikes out on her own in a Florida beach town. Running away from a dead-end existence in Tennessee, Ruby settles in Panama City Beach to begin a new life, and quickly lands a job selling meaningless souvenirs to the tourist trade. Along with the job, Ruby also wins the unwanted attentions of her boss's son, Ricky Chambers (Bentley Mitchum), who threatens to spoil Ruby's newfound freedom almost as soon as it has begun.

"Ruby in Paradise," written and directed by Victor Nuñez ("Gal Young 'Un," "A Flash of Green"), moves lullingly from the gift shop to Ruby's little kitchen to the various seaside vistas she stops to contemplate from time to time. Its real focus is on Ruby's inner thoughts, which are expressed in voice-over as Ruby writes frequently in her journal. Her writings, which are earnest and serious without being particularly surprising, help to set the film's highly sensitive tone. "Like where does caring come from?" Ruby asks herself at one point. "Can we ever know our true desires? And why are we all of us so often lonely and afraid?"

"Ruby in Paradise" is more often pensive than genuinely thoughtful, but it is helped immensely by Ms. Judd's gravity and strength. With a girlish face that contrasts hauntingly with her steady, mature speaking voice, Ms. Judd projects a seductive radiance that becomes the film's inner core. She gives substance to the film's slow, reflective manner and to its suggestion that Ruby's journey of self-exploration may truly lead to some greater serenity. Ms. Judd, the daughter and younger sister, respectively, of the country singers Naomi and Wynonna Judd, has enough presence to carry "Ruby in Paradise" through its many long pauses.

•

Ruby's experiences are meant to be gentle but telling as she forms friendships, advances at the gift shop and makes some serious mistakes. "Ricky is 100 percent of something I would like to forget," she tells herself, after the film has chronicled her brief, empty affair with him. The film is uneven enough to present both Ricky and his mother (Dorothy Lyman) quite unconvincingly, and to send Ruby to bed with Ricky without benefit of much dialogue. The plot, which also takes Ruby to an illuminating job at an industrial laundry, manages to seem contrived despite the film's peaceful, languid pace.

Ruby also becomes close to a former colleague (Allison Dean) and begins a romance with the gentle, well-read Mike (Todd Field), whose affections are real but whose downbeat attitude sometimes troubles her. Much of the time, though, Ruby sits thoughtfully with a cup of tea at her kitchen table, or gazes dreamily off into the distance. Mr. Nuñez's emphasis is less on high drama than on quotidian honesty, which he achieves

in sporadic but sometimes gentle, pleasing ways. "Ruby in Paradise" was a Grand Prize Winner at the Sundance Film Festival this year.

"Ruby in Paradise" and "Excursions to the Bridge of Friendship" will be shown tonight at 9:15 and tomorrow at 6 P.M.

1993 O 6, C15:1

The Puppetmaster

Directed by Hou Hsiao-hsien; screenplay (in Taiwnese, Mandarin and Japanese) by Wu Nien-Jen and Chu Tien-Wen; director of photography, Lee Pin-Bing; edited by Liao Ching-Sung; music by Chen Ming-Chang; produced by Chiu Fu Sheng. At Alice Tully Hall as part of the 31st New York Film Festival. Running time: 142 minutes. This film has no rating.

Li Tien Lu (child)	Cho Ju-wei
Li Tien Lu (teen-ager)	Cheng Kuei-chung
Li Tien Lu (adult)	Lin Chung
Li Hei	Hung Liu
Ong Hsiu	Bai Ming-hwa
Ko Meng Dang	Tsai Chen-nan
Li Nee	Kao Tung-hsiu
Lai Hwat	Yang Li-yin
Tan Dei	Hwang Ching-ru
Tan Shing	Wu La-yun

By VINCENT CANBY

The work of Hou Hsiao-hsien, Taiwan's premier film maker, has been turning up regularly at American festivals since "A Summer at Grandpa's" was shown in the 1986 New Directors/New Films series at the Museum of Modern Art. With his very fine new film, "The Puppetmaster," Mr. Hou has come into full control of his talents. He's an artist who has absorbed all the outside influences he needs and is now speaking with his own voice. It's a clear, assertive voice, though not exactly loud, which wouldn't be in character either for the director or for his subject.

"The Puppetmaster" will be shown at the New York Film Festival at 6:15 P.M. today and at 9 P.M. tomorrow.

Everything seems to come together in "The Puppetmaster." Working with an excellent screenplay by Wu Nien-Jen and Chu Tien-Wen, who also wrote his "City of Sadness," Mr. Hou examines the life and times of 84-year-old Li Tien Lu, a master of hand-puppet theater. As represented by the film maker, Mr. Li's life and times are those of Taiwan, from the early years of this century through World War II, which ended 50 years of Japanese occupation.

The puppetmaster's is a turbulent life full of hard times, mysterious turnings, mystical coincidences, births, deaths and political upheaval, all of which lead to an unforeseen celebrity, conferred in part by this film.

"The Puppetmaster" might be classified as documentary-fiction. It's a bold, free blend of Mr. Li's recollections, dramatized by actors, and the puppetmaster's own commentary, either spoken on the soundtrack or delivered on camera. Though he's not on the screen that long, his is the film's dominant image. With his skinny frame and sharp features, he looks a bit like Chishu Ryu, the patrician Japanese actor so frequently used by Yasujiro Ozu.

Yet there's also something indomitably raffish about Mr. Li, whether he's telling a bizarre story about his grandmother in her role as an angel of death, or simply being seen seated in front of the camera, sometimes wearing a jaunty straw hat, sometimes a beret and dark glasses. As the film goes on, his hair seems to grow

Film Society of Lincoln Center

Lin Chung as Li Tien Lu in "The Puppetmaster," by Hou Hsiao-hsien, at the New York Film Festival today and tomorrow night.

as unaccountably black as Burt Reynolds's, though not quite so thick. In addition to being Taiwan, Mr. Li is also show biz, Taiwan style.

●

His story is revealed in a succession of short, often oblique but vivid vignettes. These begin with a dramatization of a family row about whether the baby is to bear the name of his mother's or father's family, a tale cut short by the real Mr. Li's terse soundtrack interjection: "That's how I was born."

There are harrowing tales about his mother's death, his unloved stepmother, his disinterested father and his rebellion as an adolescent, when he was apprenticed to a traveling puppet-theater troupe. From time to time, the audience is given long, wonderful chunks of Mr. Li, as a boy and as a young man, working his delicately fashioned hand puppets during performance.

A synopsis can't convey the particular quality of "The Puppetmaster"; that is, the seductive way Mr. Hou takes the audience into a world of arcane rituals and rites. The director's fondness for the meditative, stationary camera, which was favored by the Japanese film master Ozu, no longer looks borrowed but reimagined. The lack of camera movement and the long takes, in which an entire scene is shot without a cut, reflect the searching manner of an old man as he tries to make sense of the past.

The camera occasionally simply stares at a room or into a series of rooms that open one out of another before a character has entered or after a character has departed. It's as if the mind of this singularly alert survivor were dealing with Proustian associations, memories uncovered by a kind of afternoon sunlight, or a cooking smell or the touch of someone long gone.

"The Puppetmaster" is not a movie to see when pressed for time. It has to be received at its own speed, without impatience and with trust. Only in that way can one properly appreciate its method. Uproarious events are recalled in a dramatic monotone, as

when we see Mr. Li's comic courtship of a beautiful prostitute with whom he's far happier than with his wife. The deliberate pace builds to the spellbinding last quarter of the film about the war years in Taiwan, when Mr. Li, among other things, remembers his friendship with a melancholy Japanese officer who doesn't want to go home.

●

There's an especially dark and funny sequence in which the audience watches Mr. Li, played by an actor, as he performs a puppet play for Japanese soldiers. The play's hero: a Taiwanese recruit who became a radio operator and heroically gave his life for the Emperor.

The real Mr. Li and his actor-surrogates alternate places seamlessly, as do his in-person recollections and their dramatizations, which is a testament to the director's secure sense of what he's doing. Mr. Hou is as marvelous (and sometimes as laconic) a storyteller as his admired subject is.

With "The Puppetmaster," Mr. Hou has now completed two films in his planned trilogy about Taiwan. The events in "City of Sadness," made earlier, deal with the years immediately after "The Puppetmaster." Still to come: "A Man Named Putao Tailang," which will bring the Taiwan story up to date.

1993 O 6, C19:

Half Japanese

Directed and produced by Jeff Feuerzeig; cinematography by Fortunato Procopio; edited by Peter Sorcher; sound by Bill Drucklieb. At Film Forum 1, 209 West Houston Street, South Village. Running time: 90 minutes. This film has no rating.

WITH: Byron Coley, Gerard Cosloy, Jad and David Fair, Don Fleming, David Greenberger, Penn Jillette, Phil Milstein and Maureen Tucker.

By STEPHEN HOLDEN

Even by the forgiving standards that rock critics tend to apply to

dedicated underground bands with little commercial potential, the music of Half Japanese, a group from Uniontown, Md., is difficult to admire. Formed in 1975 by the brothers Jad and David Fair, the band has always prided itself on not being able to play its instruments. And Jad Fair, its indomitably cheery lead singer and chief songwriter, has a voice that comes about as close as rock singing can to sounding like chalk on a blackboard.

Physically and vocally, Mr. Fair is the caricature of a nerd. Wiry, graceless and wearing a tense little smile, he declaims his lyrics in a shrill, neighing monotone that is oblivious to pitch. His ineptitude seems almost calculated when he interprets blues songs in jerky mechanical phrases that make every beat feel laboriously counted out.

"Half Japanese: The Band That Would Be King," Jeff Feuerzeig's documentary portrait of the band's life and times, includes many excruciating minutes of Mr. Fair singing his crude, unpolished material. Most of his songs are one- or two-chord ditties that range from innocuous party anthems ("Roman Candles") to scenarios from horror comics ("Thing With a Hook").

In the early scenes of Mr. Feuerzeig's documentary tribute, which opened today at Film Forum 1, "Half Japanese" has the feel of a complete put-on. As it goes along, and champions of the band like Penn Jillette (of the comedy duo Penn and Teller) and Moe Tucker (the original drummer of the Velvet Underground) exalt its integrity, you begin to wonder. Is "Half Japanese" the "This Is Spinal Tap" of underground rock or does it truly love its subject?

Mr. Jillette put his money where his mouth is. In the film's funniest anecdote, he tells of the myriad problems he had in forming his own label, 50 Skadillion Watts, to put out an album by the group. Ms. Tucker, who is shown drumming with the band, inveighs against MTV and mainstream pop culture with puritanical grimness.

Two music journalists, Byron Coley and Gerard Cosloy, both affiliated with independent record labels, offer witty tongue-in-cheek assessments of the band's place in rock history, which is of course, far beyond that of the Beatles, the Rolling Stones or Elvis. More facetious than sincere, their elaborate analyses of the band's importance, along with their reflections on the independent rock movement, nevertheless provide valuable insights into the philosophy of that movement.

It is a philosophy that coats everything with an adolescent cynicism and a self-protected irony. But underneath the pose burns a fiercely antiestablishment passion and an anarchic teen-age spirit that insists on the ultimate value of noise for noise's sake.

1993 O 7, C20:5

On the Bridge

Directed and produced by Frank Perry; director of photography, Kevin Keating; edited by Emily Paine; music by Toni Childs; released by Panorama Entertainment in association with Direct Cinema, Ltd. At Angelika 57, 225 West 57th Street, Manhattan. Running time: 95 minutes. This film has no rating.

By JANET MASLIN

Frank Perry's prostate cancer is famous. He describes exactly how it

became well known in "On the Bridge," the autobiographical film he began directing after being diagnosed as terminally ill. When Mr. Perry and his small film crew went to a party in East Hampton, L.I., they were spotted by a gossip columnist and became headline news on Page Six of The New York Post ("Director Lensing Own Cancer Fight?"). For this, Mr. Perry was duly congratulated by his doorman. "So, how's the cancer?" he was later asked by a reporter from "Entertainment Tonight."

Mr. Perry, the director of "David and Lisa," "Mommie Dearest" and many other films, could be accused of fomenting this kind of publicity if his film were not so obviously heartfelt. He seems to have made "On the Bridge" as a means of both fighting his illness and communicating the things he has learned in the process. As "On the Bridge" follows the frustrating ups and downs of Mr. Perry's cancer treatment, he pauses at one point after learning some good news. "I know I'm not out of the woods," he tells his oncologist, "but being in the woods has been wonderful for me." This film, a brave and helpful chronicle of Mr. Perry's experience, succeeds in making that statement ring true.

Mr. Perry begins "On the Bridge" by riveting his audience's attention with the prospect of surgical castration, one of the suggested treatments for his condition. "That was a bit severe for me, and I just frankly said 'no,'" he explains, with an urbane little laugh. The film maker's wry tone and his determinedly good spirits amount to more than mere superficialities, since he has come to believe that an affirmative attitude is a vital part of remaining well.

◆

The camera follows him to a weekendlong seminar led by Dr. Bernie Siegel, the author of "Love, Medicine and Miracles." (Mr. Perry jokes that his film is full of best-seller-writing physicians, and it does include a few. The Dalai Lama is also seen briefly, as he addresses a medical convention.) At the meeting, where people coping with illness tell one another their stories, one speaker proclaims: "I'm going to tell you something right now. The organs of the body weep the tears that are not shed by the eyes." Throughout his film, Mr. Perry affirms his belief that changing one's perspective and rearranging priorities must be part of the healing process.

"On the Bridge" is by turns objective and confessional; it says nothing about Mr. Perry's friends or family, but it does follow him through the most intimate sessions with doctors and medical technicians. He is seen undergoing a radiation treatment, the 38th of 39, as he discusses the state of his cancer and the ways in which it may or may not have spread. (The film derives much suspense from a suspicious-looking spot on the director's rib.) At one point, discussing a sudden setback in his progress, he is seen near the Central Park statue of Lewis Carroll's Alice, a reference the film makes instantly understandable. Falling into the network of doctors, healers, CAT scans, sonograms and other medical treatments is made to seem like a trip down the rabbit hole.

The director is filmed during periodic, thoughtful consultations with Dr. Howard I. Scher, his young oncologist, who talks of losing his own father to cancer at about the time Mr. Perry's condition was diagnosed. The

film maker's insistence on understanding and assessing his own chances is also captured on camera. As his fate seems to seesaw during the period covered by "On the Bridge," Mr. Perry talks about having read "Final Exit" and muses about whether an on-camera suicide would look like a Warhol film. "Call it self-dramatizing," he tells his cameraman, Kevin Keating, "but I was smiling when I thought of it."

"On the Bridge" cannot be called self-dramatizing, not even when Mr. Perry films a television crew watching him being interviewed by Barbara Walters about his illness. The film's prevailing spirit is one of affirmation and curiosity, sustaining the director's claim that he has learned a lot about living through the experience of facing death. "He is doing his best to use what he learned while making this movie, to live from his heart and sing his own song," says a purplish closing title, as the film ends on an encouraging note. Mr. Perry can take solace from his stable health (as of June 15 of this year), his remarkable determination, and his success in communicating hope and light.

1993 O 8, C10:5

Mr. Jones

Directed by Mike Figgis; screenplay by Eric Roth and Michael Cristofer, story by Mr. Roth; director of photography, Juan Ruiz Anchia; edited by Tom Rolf; music by Maurice Jarre; production design by Waldemar Kalinowski; produced by Alan Greisman and Debra Greenfield; released by Tri-Star Pictures. Running time: 110 minutes. This film is rated R.

Mr. Jones	Richard Gere
Dr. Libbie Bowen	Lena Olin
Susan	Lisa Malkiewicz
Dr. Catherine Holland	Anne Bancroft
Howard	Delroy Lindo
Patient	Thomas Kopache

By JANET MASLIN

"Mr. Jones" finds Richard Gere working at full throttle to play the manic-depressive of the title, a man who has so few ties to ordinary life that he doesn't even admit to knowing his real name. Soaring on a high that appears endless, Mr. Jones is someone who can pick up a pretty bank teller (Lisa Malkiewicz), whisk her away on a spree involving a hotel room, a limousine and concert tickets, and only get into trouble when he tries to conduct a symphony orchestra as it plays Beethoven's "Ode to Joy." It turns out the symphony already has a conductor.

Behavior like this, and his habit of trying to fly off a rooftop when he becomes excited by airplanes overhead, lands Mr. Jones in the care of Dr. Libbie Bowen (Lena Olin), a psychiatrist who can best be described as dedicated. Libbie is also lonely, having recently been separated from her husband, and she is not immune to Mr. Jones's charms. Regardless of whether it is easy to flirt while remaining strapped to a hospital bed, Mr. Jones finds a way to do so. He and Libbie share a couple of warm, friendly outings that would hold great romantic promise if Mr. Jones were not constantly ricocheting in and out of hospital wards.

"Mr. Jones" was directed by Mike Figgis ("Stormy Monday," "Internal Affairs"), who usually finds ways to make his films voluptuous and alluring. This one is unexpectedly spark-free, in part because it manages to avoid the more lively, insinuating

questions that its story raises. How will Libbie ward off feeling ethically compromised if she takes up with one of her patients? And does a romance with a manic-depressive crystallize the uncertainty of never really knowing a loved one? In this case, it crystallizes very little, since the affair comes very late in the story and seems stiffly perfunctory. This time, Mr. Figgis's taste for moody musical accents and atmospheric touches is too muted to be of much help.

Mr. Gere's showy but intense performance is the film's real focus, and it commands attention. "Mr. Jones" tries hard to convey the dizzying extremes of a manic-depressive's experience, from the sight of Mr. Gere in jubilant James Brown mode to the image of him shambling, dirty and dejected, down a nighttime street, or muttering to himself as he walks by a roadside in the rain. Indeed, Mr. Gere makes his character so immediate that the film ought to find more pathos in his problem. But the screenplay, by Eric Roth and Michael Cristofer, can sound pat enough to diminish the characters. "You're an interesting man, Mr. Jones," Libbie tells her patient. "Would you want to make me ordinary?" he asks in reply.

"Mr. Jones" has a crisp, lively look and a few supporting performances that add credence to its story. Delroy Lindo is especially affecting as a construction worker who first meets Mr. Jones during the film's deceptively upbeat opening, as Mr. Jones sweet-talks his way into a construction job and then scares everyone working on the same rooftop. Anne Bancroft is predictably crisp as Libbie's superior at the hospital, and Thomas Kopache is memorable as a real-sounding mental patient, the kind without Mr. Gere's good looks and seductive manner. This man's furious rantings about pollution and other, less decipherable problems lend some much-needed gravity to the story.

●

"Mr. Jones" is rated R (Under 17 requires accompanying parent or adult guardian). It includes some profanity.

1993 O 8, C10:5

Gettysburg

Directed and written by Ronald F. Maxwell, based on the novel by Michael Shaara; director of photography, Kees Van Oostrum; edited by Corky Ehlers; music by Randy Edelman; production designer, Cary White; produced by Robert Katz and Moctesuma Esparza; released by New Line Cinema. Running time: 244 minutes. This film is rated PG.

Lieut. Gen. James Longstreet	Tom Berenger
Gen. Robert E. Lee	Martin Sheen
Col. Joshua Chamberlain	Jeff Daniels
Brig. Gen. Lewis Armistead	Richard Jordan
Brig. Gen. John Buford	Sam Elliott
Maj. Gen. George E. Pickett	Stephen Lang
Brig. Gen. Richard B. Garnett	Andrew Prine

By STEPHEN HOLDEN

Ronald F. Maxwell's four-hour cinematic re-creation of the battle that was the turning point of the Civil War has a stately tone and meticulous attention to historical detail that make it feel more like an epic documentary than a dramatic film. "Gettysburg," adapted by Mr. Maxwell from Michael Shaara's novel "The Killer Angels," limits itself to the first three days of July 1863, when 150,000 soldiers threw themselves into a battle in which more than a quarter of them became casualties.

Probably no American movie has devoted more time to discussions of battlefield strategy than "Gettysburg," which is a film to warm the cockles of a military tactician's heart. Its battle scenes, which used more than 5,000 Civil War re-enactors surging over the actual site of the original conflict, are impressively choreographed. In their sweep and grandeur, these scenes convey a strong visceral sense of what fighting a war used to be like. With the pageantry of marching bands and flag-waving, entwined with powerfully held notions of honor and glory, a battle resembled a lethal football game in which the stadium was emptied onto the playing field and the fans organized and handed rifles and bayonets.

●

The film offers a rich and detailed picture of how the Civil War was fought, what weapons were used, what uniforms were worn and what political passions stirred the conflict. By shifting its perspective back and forth from the thick of battle to behind the lines, where the military brass observe the carnage through field glasses, the film does a wonderful job of conveying the physical dimensions of the conflict. It is also scrupulous about giving the Union and Confederate sides equal time, although the Confederates are painted as a bit loonier than the Federals. The film's most flamboyant patriot is the Confederate Brig. Gen. Lewis A. Armistead (Richard Jordan), who truly believes that he and his Virginia brigade are God's chosen victors.

But if "Gettysburg" is a spectacular exercise in logistics, does it succeed as human drama? It does, but only intermittently and in a chilly way. The same meticulousness that went into its battle scenes has produced a bloated screenplay (by Mr. Maxwell) in which the characters soliloquize and debate in a flowery language that aspires toward a Shakespearean elevation. While these windy exercises in period rhetoric are probably true to the flavor of the American language as spoken in the mid-19th century, they usually run on far too long. And for all the linguistic flourishes and high-minded sentiments being bandied about, the ideas rarely warrant such expansion.

"Gettysburg" is divided into two halves that don't fit together snugly. Much of the first part is devoted to the steep, woodsy battleground known as Little Roundtop, on which Col. Joshua Chamberlain (Jeff Daniels) commanded a Union brigade that against all odds successfully resisted wave after wave of Confederates. Had those troops broken through, they would have given the Confederate Army a clear path to Washington. Mr. Daniels's luminous performance as the heroic colonel dominates this half of the film. And when the actor all but disappears in Part 2, he is sorely missed.

The film's second half focuses on Pickett's Charge, the disastrous Confederate attempt to break a hole through the center of the Union line. In the charge, ordered by Gen. Robert E. Lee (Martin Sheen) against the strenuous objections of his right-hand man, Lieut. Gen. James Longstreet (Tom Berenger), a line of 15,000 soldiers poured across an open field toward the Union Army and was systematically mowed down by an overwhelming barrage of Union fire.

There is a tragicomic majesty to the scenes in which hundreds of soldiers are raked with gunfire as they

stumble over a wooden fence, tripping over their comrades' dead and wounded bodies in an almost suicidal lunge toward an invincible enemy.

●

That the second part of the film ultimately fails to touch the heart is the fault of both the screenplay and the casting of Mr. Sheen in the crucial role of Lee. The film makes much of the fact that the Confederate general was worshipped almost as a god by his soldiers. And in actual photographs of Lee, there is something in the eyes that suggests a rare mixture of empathy and nobility.

Mr. Sheen projects the requisite nobility, along with a sense of the general's profound quiet suffering and self-blame for the catastrophe. He even apologizes out loud for his mistake. What's missing from the performance is a flash of holiness that would make the character a spiritual lightning rod.

Mr. Daniels radiates the very qualities that Mr. Sheen reserves. The most moving scenes in "Gettysburg" come early in the film, when Colonel Chamberlain confronts an exhausted, battleworn brigade of Union soldiers who refuse to fight any more and who have been thrust under his supervision at the worst possible moment.

Addressing them with a simplicity and directness that convey a complete understanding of their plight, he wins a loyalty that transcends all the conflicting issues and philosophies that the film brings up. He is a leader whose sad blue eyes contain the "divine spark" that the character professes with a trembling passion to believe is innate in every human being.

●

"Gettysburg" is rated PG (parental guidance suggested). There is much violence, but no gratuitous bloodshed.

1993 O 8, C16:1

The Snapper

Directed by Stephen Frears; screenplay by Roddy Doyle, adapted from his novel; edited by Mick Audsley; photography by Oliver Stapleton; production design by Mark Geraghty; produced by Lynda Myles; released by Miramax Films. At Alice Tully Hall, Lincoln Center, as part of the 31st New York Film Festival. Running time: 90 minutes. This film is not rated.

Sharon................................Tina Kellegher
Dessie...............................Colm Meaney
Kay....................................Ruth McCabe
Darren..............................Colm O'Byrne
George..............................Pat Laffan

By VINCENT CANBY

With "The Snapper," a small, joyful lark of a film, Stephen Frears rediscovers the essence of the comedy of mundane situation, a perfectly respectable genre before television took it over and turned it into the mass-produced, wafer-thin, low-calorie entertainment called the sitcom. As demonstrated by Mr. Frears and Roddy Doyle, who adapted his own novel for the screen, there are still wonderful comedies to be made when care is taken and attention is paid.

The situation in "The Snapper" is this: Sharon Curley (Tina Kellegher), a supermarket checkout clerk in Barrytown, a north Dublin working-class suburb, becomes pregnant. Or, as it's put more colloquially throughout the film, "Sharon Curley's up the pole." The trouble is that the unmarried Sharon refuses to identify the father.

Dessie and Kay (Colm Meaney and Ruth McCabe), Sharon's parents, accept the news of the pregnancy with surprising equanimity. That's possibly because Sharon is 20 years old and not getting any younger. After the announcement, Dessie even asks Sharon to join him in a pint at the pub.

Kay later suggests to Dessie that they should point out to the younger Curley children that Sharon has done wrong by allowing herself to get pregnant without being married. If for no other reason than it's bad planning. Dessie says no, that it would stigmatize the baby in the children's eyes.

Sharon's girlfriends, the neighbors and Dessie's drinking buddies are similarly understanding. All that changes with the rumors that the father is none other than George Burgess (Pat Laffan), a wimpish middle-aged family man who lives across the street and whose daughter is one of Sharon's pals. Sharon is suddenly a tart and a home-wrecker.

As a defensive tactic, Sharon says that a dark, handsome Spanish sailor, in port for two days, was the man responsible. "What do you think?" she asks her mother with some apprehension. Kay's reply: "I think I'd like to believe it was a Spanish sailor."

●

Mr. Frears treats this lighter-than-air material with an easy gravity that never mocks the situation or trivializes the comedy. As written, directed and performed, the Curleys and their friends are a most engaging lot.

Mr. Meaney's Dessie is a man with unexpected reserves of common sense and sweetness, though his temper is sometimes short. It's the same character the actor played in Alan Parker's screen adaptation of "The Commitments," the first of the three Doyle novels known as the Barrytown trilogy. Because the producer of "The Commitments" holds the copyright on the original names of the characters, their surnames were changed for the film version of "The Snapper," the second novel in the trilogy, which ends with "The Van."

Ms. Kellegher's Sharon is not a great beauty. Her eyebrows don't seem to match, her nose is too prominent and she never gives much thought to her hair. Yet she has grit, determination and humor. Nobody pushes her around unless she drinks too much. That's what happened the night of her seduction, in circumstances she still finds mortifying. By the end of the film, the actress glows. Each member of the all-Irish cast shares that breezy authenticity.

In the neighborhood pub, the film's favorite location after the Curley row house, which is always full of noise and domestic tumult, Mr. Frears's camera seems to unbend and become as high and disheveled as the patrons. Brows sweat, mascara runs. As the night wears on, the camera mercilessly records exhausted faces in a series of pre-hangover friezes.

The situation in "The Snapper" is comic, but the film never denies the reality that makes its characters gallant.

"The Snapper" will be shown at the New York Film Festival today at 6 P.M. and tomorrow at 3 P.M. It will be commercially released here later in the year.

1993 O 8, C21:1

Farewell My Concubine

Directed by Chen Kaige; screenplay (in Mandarin, with English subtitles) by Lilian Lee and Lu Wei, based on the novel by Miss Lee; photography by Gu Changwei; edited by Pei Xiaonan; music by Zhao Jiping; production designer, Chen Huaikai; produced by Hsu Feng; released by Miramax Films. At Alice Tully Hall, as part of the 31st New York Film Festival. Running time: 154 minutes. This film is rated R.

Dieyi.................................Leslie Cheung
Xiaolou...........................Zhang Fengyi
Juxian......................................Gong Li

By VINCENT CANBY

Chen Kaige's "Farewell My Concubine," the Chinese epic that has proved so troublesome to the Communist authorities at home, is one of those very rare film spectacles that deliver just about everything the ads are likely to promise: action, history, exotic color, multitudes in confrontation, broad overviews of social and political landscapes, all intimately rooted in a love story of vicious intensity, the kind that plays best when it goes badly, which is most of the time.

"Farewell My Concubine," which shared the top prize at this year's Cannes International Film Festival with "The Piano," by Jane Campion, is a vastly entertaining movie. It's also one of such recognizably serious concerns that you can sink into it with pleasure and count it a cultural achievement.

The film will be shown at the New York Film Festival today at 9 P.M. and tomorrow at 11 A.M. It will open commercially next Friday.

The time covered is 1925 through 1977. The setting is Beijing, earlier called Peking and, when not the national capital, Peiping. The film's title is taken from a favorite work in Chinese opera repertory, a tragic tale out of an ancient past that has become myth. It's about a concubine who's so loyal and true that rather than abandon her king as he faces military defeat, she chooses to dance for him one last time and then to cut her throat with his sword.

●

The opera is important to the film for several reasons. It is the work that makes stars of the two actors who are its principal characters, Dieyi and Xiaolou. It comes to dominate the professional lives of both men, and even to shape the emotional and sexual development of Dieyi, who is loved by the public for the women's roles he plays in the all-male opera company. The opera is also a reminder that in life, as in the story of the concubine and the king, each of us must take responsibility for his own fate.

Dieyi and Xiaolou meet as boys when both are apprenticed to an opera school. It is the mid-1920's, near the end of the period when warlords were the effective rulers of China. Dieyi, a pretty, gentle boy, is the son of a prostitute who dumps him at the school to get him out of the brothel. When the school's master initially refuses to accept Dieyi because he has six fingers on one hand, his mother takes an ax and chops off the extra digit.

During those first days at the school, which makes a Dickensian orphanage look like Disney World, the robust Xiaolou befriends Dieyi, initiating a relationship that becomes the obsessive center of Dieyi's life. As often happens in such fiction, crucial events in the friends' lives coincide with great public events that, in turn, shape their destinies.

Miramax

Leslie Cheung

In this way "Farewell My Concubine" interweaves the story of Dieyi and Xiaolou with the Japanese invasion of China in the 1930's, the surrender of the Japanese at the end of World War II, the rule of the Nationalist Government, the Chinese civil war, the victory of the Communists in 1949 and, finally, the Cultural Revolution (1966-1976) and its exhausted aftermath.

●

That's a lot of ground for any film to cover, but Mr. Chen and his screenwriters (Lilian Lee and Lu Wei) succeed with astonishing intelligence and clarity. For all of the complexities of its leading characters, "Farewell My Concubine" is not a subtle film. It's a long declarative statement, reporting complexities without in any way reflecting them, which ultimately distinguishes a film as thoroughly accomplished as this from a truly great one.

Instead of subtleties, "Farewell My Concubine" offers a physical production of grand scale and sometimes ravishing good looks, though those looks overwork the director's fondness for shooting through filtered lenses, glass, smoke, mist, gauze, fish tanks and flames. All of the sequences relating to Chinese opera are riveting, from the brutal discipline and training of the boys to their exquisite performances on the stage when they have grown up. Mr. Chen is a director who has as much command of the intimate moments as of the big scenes of crowds, chaos and confusion.

The film's central love story is actually a triangle: Dieyi, Xiaolou and Juxian, the beautiful, strong-minded prostitute whom Xiaolou, an aggressive heterosexual as an adult, marries to the furious resentment of his co-star and boyhood friend. Dieyi drifts into a liaison with a rich, older opera patron. The co-stars break up their act on the night the Japanese enter Peiping. Yet when Xiaolou is arrested by the Japanese, it is Dieyi who sings a command performance for the occupation officers to win Xiaolou's release.

●

The movie is full of memorable scenes, including Xiaolou's courtship of Juxian while she's still working at the notorious House of Blossoms, and a harrowing sequence toward the end when the Red Guards successfully reduce their initially decent victims to desperate, panicked wrecks, each furiously denouncing old friends and lovers as counter-revolutionaries. It's a narrative of suicides, miscarriages, betrayals, drug addiction and sorrowful paradoxes: good intentions inevitably go wrong, which could be an observation about the Communist revolution.

Leslie Cheung is exceptionally good as the adult Dieyi, a waif transformed into a glamorous star, a boy trained from adolescence to think of himself as a woman, and then scorned when he succeeds. He's bitchy, forever vulnerable, vain and, in his own way, loyal to the end to his first and only love.

Zhang Fengyi's Xiaolou is equally effective, a man full of bravado but one whose sense of honor is seriously flawed. The film's most luminous presence is Gong Li (the gorgeous actress in "Raise the Red Lanterns"), who is splendid as Juxian. Hers is the movie's most sophisticated performance.

You don't have to be a China hand to understand why "Farewell My Concubine" has had the Beijing authorities climbing the walls. Though the evils it describes would not be denied by the present Communist regime, the film doesn't preach truisms. It celebrates the rights of the individual and the importance of idiosyncrasy. Its treatment of the homosexual Dieyi is sympathetic to the point of being deeply romantic. "Farewell My Concubine" examines the activities of the Red Guards with such implacable fury that the criticism extends to the entire system itself, before and after the Cultural Revolution.

Probably the film's most maddening fault in the eyes of official Beijing, where no news is good news: It will bewitch audiences everywhere, people who have never before spent two consecutive moments thinking about the nature of the world's least-known major power.

•

"Farewell My Concubine" has been rated R (Under 17 requires accompanying parent or adult guardian). It has scenes of explicit brutality to children and vulgar language in the English subtitles.

1993 O 8, C22:5

Demolition Man

Directed by Marco Brambilla; screenplay by Daniel Waters and Robert Reneau and Peter M. Lenkov; story by Mr. Lenkov and Mr. Reneau; director of photography, Alex Thomson; film editor, Stuart Baird; music by Elliot Goldenthal; production designer, David L. Snyder; produced by Joel Silver, Michael Levy and Howard Kazanjian; released by Warner Brothers. Running time: 120 minutes. This film has rated R.

John Spartan	Sylvester Stallone
Simon Phoenix	Wesley Snipes
Lenina Huxley	Sandra Bullock
Dr. Raymond Cocteau	Nigel Hawthorne

By VINCENT CANBY

The ads for "Demolition Man" feature head shots of Sylvester Stallone and Wesley Snipes as they face each other across a short expanse of space, much like the recent ads for "Rising Sun" in which Mr. Snipes faced Sean Connery. Don't be put off, though. "Demolition Man," though sleazy, is better than "Rising Sun."

For one thing, its antecedents are more impressive. "Demolition Man" is a futuristic action-melodrama that looks as if it had been conceived by film students who adore Woody Allen's "Sleeper." That classic, you may remember, is about the part-owner of the Happy Carrot Health Food Restaurant who goes into the hospital for minor surgery in 1973,

only to awaken 200 years later after being accidently frozen.

"Demolition Man" takes Mr. Allen's idea (including a gag about electronic sex) and slowly runs with it in all directions. The new film is a jokey action-melodrama in which John Spartan (Mr. Stallone), the toughest Los Angeles cop of the 1990's, and Simon Phoenix (Mr. Snipes), the most vicious Los Angeles criminal of the 1990's, are both frozen in their own day, only to be defrosted to carry on their war in 2032.

Los Angeles is now a megalopolis called San Angeles, ruled by a fascist guru who has created an Eden that, we are supposed to believe, is what might happen if today's health fanatics and antipollution lobbies get their way. There are laws against smoking, drinking, sexual contact and even firearms in this society. Mr. Stallone, looking both more muscular and younger than he did in his "Rambo" era, and Mr. Snipes, who sports a peroxide coiffure, go after each other amid lots of explosions, shootouts and fire effects.

There's an Arnold Schwarzenegger joke and a running gag about the ways in which Mr. Stallone's 2032 girlfriend (Sandra Bullock) never gets 1993 vulgarisms quite right. Nigel Hawthorne, the celebrated English actor, plays the nasty guru much in the lordly manner that Ralph Richardson once used in similar endeavors. The movie is the first feature by Marco Brambilla, an Italian-born, Canadian-bred director who made his name in commercials, which shows.

As in all of Mr. Stallone's films, there is a political message in "Demolition Man." Behind its sendup of today's do-gooders, there's a plaintive longing to return to the good old days of the Reagan era, when government regulators kept quiet and red-blooded American men could exchange body fluids with the women of their choice without being hectored by public health nuts.

"Demolition Man" is a significant artifact of our time or, at least, of this week.

•

"Demolition Man" has been rated R (Under 17 requires accompanying parent or adult guardian). It has a lot of simulated violence, vulgar language and partial nudity (all shots of Mr. Stallone).

1993 O 8, C23:1

Tim Burton's the Nightmare Before Christmas

Directed by Henry Selick; photography by Pete Kozachik; edited by Stan Webb; music by Danny Elfman; produced by Tim Burton and Denise De Novi; released by Touchstone Pictures. At Alice Tully Hall, as part of the 31st New York Film Festival. Running time: 75 minutes.

Voices:

Jack Skellington	Chris Sarandon and Danny Elfman
Sally	Catherine O'Hara
The Mayor	Glenn Shadix
Oogie Boogie	Ken Page
Lock	Paul Reubens
Shock	Catherine O'Hara

By JANET MASLIN

Tim Burton is already well known as a master of macabre ingenuity, but "Tim Burton's the Nightmare Before Christmas" presents him in a new light. This delectably ghoulish fairy tale, conceived by Mr. Burton as

Joel Fletcher/Touchstone Pictures

A scene from the stop-motion animated film "Tim Burton's the Nightmare Before Christmas."

a full-length film made in stop-motion animation (think of the California Raisins on a dark and stormy night), has a clever visual format that keeps it streamlined and sharp. As directed painstakingly by Henry Selick, a stop-motion veteran who worked from Mr. Burton's blueprint, this buoyant film blends the most likable aspects of "Edward Scissorhands," "Beetlejuice" and "Batman," and sends them off to Toyland. It also stamps the unmistakable Burton sensibility onto every frame.

"Tim Burton's the Nightmare Before Christmas" is fun for the whole Addams family, as well as for anyone else inclined to appreciate the spectacle of Santa Claus being kidnapped and harassed. It is Mr. Burton's peculiar gift to find benign mischief in that kind of spectacle, just as Danny Elfman, who wrote the many serviceable songs that turn this into a full-fledged movie musical, is capable of writing gleefully in a minor key.

This is a film in which "Jingle Bells" is made to sound like a dirge and the main character, Jack Skellington, is accused of "mocking and mangling this joyous holiday" when he tries to steal Christmas. And yet "Nightmare Before Christmas" is in no way mean-spirited, despite its tarantula- and bat-shaped neckties and its skeletal reindeer leaping through the sky. Mr. Burton can take a character like Jack, this story's Grinch, and give his skull of a face blinking eyes and a button nose. The film maker's taste for jokey malevolence is much less troubling here than it was in the live-action world of "Batman."

•

"Nightmare Before Christmas" begins in gray, spooky Halloweentown, where every evil-looking creature has been designed with the utmost delight. Straight lines are anathema to Mr. Burton, who dreams up a swirling, out-of-kilter universe filled with wonderfully eerie playthings. The film's plot isn't much, having to

do with Jack's discovery of a sugary Christmas world and his plot to subvert it to his own Halloweenish tastes. But at least it affords the film a lot of visual variety. Still, "Nightmare Before Christmas" is better watched for its countless bits of inspired wickedness — snakes as wall sconces, ghosts jumping out of a pumpkin patch — than for its story line.

Among the film makers' more indelible touches are Lock, Shock and Barrel, three bad little ghouls given the job of bagging Santa, and Oogie Boogie, this film's answer to the "Aladdin" genie, who shows off his tuneful side during a spirited Santa-baiting song. Because this film, for all the fun it has with fright gags, is about as menacing as a gumdrop, children in the audience can rest assured that Santa will make it through his ordeal.

Very young children may be alarmed by this film's mock-scariness, but slightly older viewers should be thoroughly in sync with Mr. Burton's comic tastes. "The Nightmare Before Christmas" will be shown tonight at 9 and tomorrow at 1:30 P.M. as part of the New York Film Festival, along with Mr. Burton's 1982 "Vincent." This prize-winning 11-minute short, a black-and-white tale that anticipates some of the visual ideas used in the new film, finds Mr. Burton effectively inventing the wheel. Eleven years later, that wheel is off and running.

"The Nightmare Before Christmas" is a major step forward for both stop-motion animation, which is stunningly well used, and for Mr. Burton himself. He now moves from the level of extremely talented eccentric to that of Disney-style household word.

•

"Tim Burton's the Nightmare Before Christmas" is rated PG (Parental guidance suggested). Spme of its creepier imagery is apt to disturb small children.

1993 O 9, 13:1

Aileen Wuornos
The Selling of a Serial Killer

Directed by Nick Broomfield; photography by Barry Ackroyd; music by David Bergeaud; produced by Mr. Bloomfield and Rieta Oord; released by . At Alice Tully Hall, Lincoln Center, as part of the 31st New York Film Festival. Running time: 87 minutes. This film has no rating.

By VINCENT CANBY

In January 1991, Aileen Wuornos, a prostitute in her late 20's, admitted to the murders of seven men, each picked up on a Florida highway, which was her usual venue. Some months later, after pleading no contest to the murders, Ms. Wuornos was sentenced to six life sentences, though she had been tried for only one of the murders.

The press and especially the television tabloid shows had a field day with the story about what they called "the man-hating murderer," apparently because Ms. Wuornos was an admitted lesbian. It was Tyria Moore, her lover, who tricked Ms. Wuornos into a confession during a telephone call monitored by the police. One immediate result of all this public interest: "Overkill," the television feature in which Jean Smart played Ms. Wuornos.

Now Nick Broomfield, an English film maker, has made a fine docu-

Film Society of Lincoln Center
Aileen Wuornos, who admitted to the murders of seven men in Florida, in Nick Broomfield's "Aileen Wuornos: The Selling of a Serial Killer."

mentary feature that examines not only the Wuornos story but also the entire phenomenon surrounding it.

A serial killer's lawyer and friends cash in on her confessions.

"Aileen Wuornos: The Selling of a Serial Killer" doesn't have the personal swagger of Michael Moore's "Roger and Me," but it is that film's equal in all other ways.

It is sometimes funny, but far more often very sad and appalling. It's a slice of Americana to make you cringe with embarrassment as you recognize the society it reveals. In its way of suggesting that justice has not been adequately done, it also recalls Errol Morris's "Thin Blue Line."

"The Selling of a Serial Killer" will be shown at the New York Film Festival tomorrow at 9:30 P.M.

The film's two most breathtaking real-life characters: Steve Glazer, the bearded, fast-talking, guitar-playing lawyer who took over the Wuornos defense from a public defender, and Arlene Pralle, a born-again Christian who read about the case in the newspapers and felt a call to help Ms. Wuornos. After a busy correspondence and many prison visits, Ms. Pralle, who is married and raises Tennessee walking horses, legally adopted Ms. Wuornos.

Mr. Glazer is not only a lawyer but also a card. When asked what he would say to his client facing the electric chair, he recalls the lawyer's advice to Virgil Starkwell in Woody Allen's "Take the Money and Run": "Don't sit down." In the course of all the hoopla surrounding the case, he also became the agent for Ms. Moore in her dealings with the press, television and film people. Together they demand $25,000 to cooperate with Mr. Broomfield, but settle for $10,000.

Revealed in the course of the film is the fact that Mr. Glazer and Ms. Pralle advised the prisoner to enter her no-contest plea, which made

death sentences almost certain. Says Ms. Moore: "The state has a death sentence so, golly, in a few years she could be with Jesus. Why not go for it?"

There are also charges that members of a county sheriff's office and Ms. Moore were dealing with film producers about rights to their stories even before Ms. Wuornos confessed. In addition, it appears to be Mr. Broomfield's point that relevant evidence was not presented in her behalf during the trial.

The agonized center of the movie are television clips of the prisoner's trial testimony and, toward the end, an interview with Ms. Wuornos in which she questions the motives of her lawyer and adoptive mother. Though there's no thought that she is innocent, her testimony suggests persuasive mitigating circumstances. Mr. Broomfield and others he interviewed also wonder why there was no investigation of Ms. Moore's possible complicity in the crimes.

"The Selling of a Serial Killer" examines a very large can of worms. Not a pretty sight, but a significant one. We live in an age when to be associated with a crime, an accident or an act of God, as long as it's sufficiently bizarre, may be as profitable as winning a lottery.

1993 O 9, 16:3

Totally F***ed Up

Written, directed and photographed by Gregg Araki; produced by Andrea Sperling and Mr. Araki. At Alice Tully Hall, as part of the 31st New York Film Festival. Running time: 85 minutes. This film is not rated.

Andy	James Duval
Tommy	Roko Belic
Michele	Susan Behshid

By JANET MASLIN

"Everything that homos are supposed to like — disco music, drag shows, Joan Crawford — I hate," says one of the characters in "Totally F***ed Up," Gregg Araki's fractured, corrosive portrait of a group of gay comrades. Mr. Araki, who has described his film as a "ragtag story of the fag-and-dyke teen under-

ground," brings an angry intelligence to bear upon disaffected characters, so that his work plays vigorously as part movie, part manifesto.

"Formally, the picture's use of an exploded, free-associative narrative and direct-to-camera address is as radical as the 60's French New Wave (or its rip-off, 90's MTV)," Mr. Araki has also written, none too bashfully, about his film. In its closing credits, where friends and sponsors are usually thanked, he also includes a colorful "no thanks" to "you all know who you are." And the asterisks in the title amount to more of the same.

Clearly, Mr. Araki means to underscore the subversive aspects of his work. That attitude was especially effective in "The Living End," his bold, bleakly funny road movie about two young nihilists who were H.I.V.-positive. This time, paying more strenuous homage to Jean-Luc Godard, Mr. Araki avoids a story line as linear as that. Instead, he presents 15 numbered segments, interspersed with titles like "Lifestyles of the Bored and Disenfranchised" and "To Live and Fry in L.A.," as a means of describing six intimate, highly opinionated gay friends. Questions of identity are all-important to these four teen-age boys and two girls, who get together to discuss everything from masturbation to whether love exists. "Can this world really be as sad as it seems?" one of the film maker's titles asks.

Because the film begins and ends with the thought of teen-age suicide, it offers a potentially despairing answer to that question. But Mr. Araki also captures the vitality of his characters and the urgency of their yearnings, even if he does so in scattershot style. Making one of them an aspiring film maker gives Mr. Araki occasion to overuse the home video interview format, but the actors' speeches to the camera are sometimes memorably raw. This feisty, disjointed film finds something compelling in its characters even when they're so druggy they can barely stand.

Standing up is pretty well beside the point anyway, because Mr. Araki's characters spend much of their time on the floor, either sitting and talking or communing on mattresses. The film's settings are as studiously cool as its characters, one of whom is seen speaking between two television sets, each with the sound turned down, and flanked by a foot-high replica of Michelangelo's "David."

In this atmosphere, the friends' various romantic troubles make as much sense as anything else does, even if one character's loneliness and uncertainty eventually lead to a fatal cocktail of house-cleaning chemicals. Another of the film's idiosyncratic milestones, an artificial-insemination party for one of its lesbian characters, is equally plausible under these circumstances.

The film is at times overly scrambled and affectless in presenting its narrative (even if Mr. Araki helpfully includes a title reading "Start Narrative Here"). But its sting comes from attitude-defining asides, like the above-mentioned remark about discos, Joan Crawford and the purported gay establishment. Even when Mr. Araki's directorial affectations overshadow his film's lucidity, his daring, outrage and inventiveness are always clear.

On the same program is Jim Jarmusch's 12-minute "Coffee and Cigarettes," a kind of Morning on Earth encounter between the musicians Iggy Pop and Tom Waits, who play

loose versions of themselves. Meeting in a deserted coffee shop (where, unaccountably, Hawaiian music and the light cast from a mirrored ball heighten the ambience), they trade edgy, improvised-sounding pleasantries aimed at one another's little insecurities. Mr. Pop isn't an actor, but his attitude is bemused and game, and his sunken cheekbones speak volumes. Mr. Waits, supremely insouciant and perfectly in his element, describes his interests in life as "music and medicine, really ... living in that place where they overlap."

The program will be presented tonight at midnight and tomorrow at 7 P.M. as part of the New York Film Festival.

1993 O 9, 16:3

Wendemi

Directed by S. Pierre Yameogo; screenplay (in French and Morré, with English subtitles) by Mr. Yameogo, with Rene Sintzel; photography by Jürg Hassler and Moussa Diakite; edited by Michele Darmon; music by Mahmoud Tabrizizadeh; produced by Mr. Sintzel. At Alice Tully Hall, Lincoln Center, as part of the 31st New York Film Festival. Running time: 93 minutes. This film is not rated.

Wendemi	Sylvain Minoungou
The Son of the Man	Abdoulaye Komboudri
Cécile	Sylvie Yameogo
Madeleine	Moussognouma Kouyate
Michel	Alassane Dakissage

By STEPHEN HOLDEN

In his deceptively easygoing film, "Wendemi," S. Pierre Yameogo, a film maker from Burkina Faso, uses the story of an abandoned child as a metaphor for a society that is drifting in a kind spiritual and political limbo.

When Cécile (Sylvie Yameogo), an unwed mother-to-be, refuses to identify the father of her child, she is thrown out of her parents' home and eventually leaves her baby in a field, where another family finds him and takes him home. Michel (Alassane Dakissaga), the head of the household, reluctantly assumes responsibility for the baby after going to the police, the local priest and the traditional village chief, each of whom advises him to seek the counsel of another authority.

The film, which the New York Film Festival is showing today at 6 P.M. and tomorrow at 4 P.M., abruptly lunges forward in time. Suddenly, the child, Wendemi (Sylvain Minoungou), is a sullen adolescent who fights incessantly with his brother. After a violent incident between them, Wendemi is taken away from Michel's home by the authorities and brought up by the tribal chief.

When Wendemi falls in love and wants to marry, he is told that he cannot move ahead with his plans until his paternity is determined. He leaves the village for the capital city, Ouagadaogou, hoping somehow to find his mother. His only sign of identification is a bracelet that was on his wrist when he was found.

In the early scenes of "Wendemi," the plight of the baby's mother is treated almost as an abrasive situation comedy, in which the father rants and raves and the local authorities try to pass the buck in taking responsibility. Once Wendemi arrives in Ouagadaogou, the film becomes more somber. The nearly penniless youth falls in with an old friend, a shepherd who was run out of the village and who now calls himself the Son of the Man (Abdoulaye Komboudri). The

Son of the Man is now doing well as a pimp selling under-age girls to wealthy clients, and he enlists Wendemi as a partner entrusted with cultivating new talent at a public swimming pool.

The sequences in which the Son of the Man tries to teach Wendemi the flesh-peddling business are the film's saddest and most sharply focused. The Son of the Man's recruits, sullen teen-agers who are willing to sell their bodies for the price of a bikini, are emblems of an urban society corroding from poverty, corruption and a soulless modernity.

"Wendemi" would be a much more gripping film if it had a strong title performance. But Mr. Minoungou radiates little energy or expression. In the one scene, in which he required to weep, the two or three tears that drip down his cheeks seem to have been applied. The best performance is Mr. Komboudri's Son of the Man, a smug, cocky manipulator whose jocularity can turn instantly to hysteria and sadistic violence.

"Untrue Stories," the short Venezuelan film that opens the program, is a comically surreal evocation of modern-day colonialism in which a group of Spanish conquistadors, in full regalia, arrive by boat on a Caribbean beach. Instead of an unspoiled natural paradise, they find a shanty-town awash with garbage where the inhabitants paint their faces to charm the tourists with their exotic culture. The film, directed by Cezary Jaworski and John Petrizelli, uses bravura camera angles and flashy editing to underline its vision of culture shock exacerbated by a time warp. The nasty message the film communicates with a frothy comic bravado is that the conquest of the New World is a continuing process. In a sense, we are still living in 1492.

1993 O 9, 16:5

FILM VIEW/Caryn James

You Are What You Wear

"IT'S AGAINST THE LAW TO DRESS IMPROPER TO your sex," says a surly, suspicious shopkeeper as she watches a young woman look over the men's clothes. The setting happens to be the American frontier in the 19th century, but the shopkeeper in "The Ballad of Little Jo" is expressing an idea that a half-dozen film makers have decided to challenge in places as far-flung as Beijing and Middle America.

Even before "The Crying Game" made transvestites the trendiest of heroes, three current films with cross-dressing characters were in the works. Maggie Greenwald's richly textured and eloquent "Little Jo" and David Cronenberg's shrewd "M. Butterfly" are now playing. Chen Kaige's "Farewell My Concubine," an extraordinary tale that sweeps through 50 years of Chinese theater and politics, opens on Friday after having played at the New York Film Festival.

And a wild variety of men in drag are coming up faster than you can say RuPaul. Robin Williams disguises himself as a woman and signs on as his own children's nanny in the family film "Mrs. Doubtfire," opening in December. In preparation is the campier story of Edward Wood Jr., trash-film director and famous transvestite.

Overall, these films are as different as "Some Like It Hot" is from "Orlando." But the three current films, while tapping into the recent fascination with cross-dressing and androgyny, have something deeper in mind. In these stories, cross-dressing resonates with social and political implications. Whether or not they are set in a time and place where it is illegal to "dress improper to your sex," the films examine and challenge the unwritten fashion code defining what men and women may do.

In "Little Jo," Josephine (Suzy Amis) has urgent reasons for turning her back on her female identity and masquerading as a young man named Jo. Thrown out of her father's house after giving birth to an illegitimate child, hunted down by renegade soldiers who have bought her from a salesman who befriended her on the road, Jo first assumes a male identity as a means of physical survival. Eventually she discovers how much her skirts had hobbled her. Like the other current films, "Little Jo" is not about cross-dressing;

Miramax

Leslie Cheung as Cheng Dieyi in "Farewell My Concubine"—What is he by nature?

it is concerned with the way clothes help to shape male and female roles.

It is a mark of the sophistication of all three films that while other characters are often asked to accept the illusion of gender that clothes suggest, the movie audience never is. These are not movies about "Crying Game" surprises and secrecy but about social conditioning.

A crucial scene in "Farewell My Concubine," which follows two Beijing Opera singers from boyhood in the 1920's through the 1970's, takes place during their training. Cheng Dieyi, being prepared to play female parts, must sing, "I am by nature a girl, not a boy." The child sings "I am by nature a boy" until he is beaten enough to say what his teachers want.

The question of what he is by nature resonates throughout the film. As an adult, in the opera that gives the film its title, he plays a female concubine in elaborate makeup, jeweled headdress and robes. "Has he not blurred the distinction between theater and life, male and female?" one of his proud teachers asks.

He may have blurred them too much. Offstage, Dieyi desires his heterosexual partner, Duan Xiaolou, the man who plays the king to his concubine. The most stunning aspect of the film is the deft way that Dieyi's confusion — of sexual identity, of art and life — becomes a metaphor for the identity crisis of China itself, as the film goes from the days of the warlords to the end of Mao's Cultural Revolution.

During the Cultural Revolution, people are asked to deny who and what they are. According to the revolution, Dieyi should not have been a traditional opera star; he should not be a homosexual. But what is he by nature? The question is as unanswerable as any "what if?" posed about history. The film shows that any denial of one's identity — by Dieyi or Xiaolou or China — creates chaos and tragedy.

"M. Butterfly" is also set in the world of Chinese opera, but it assumes a vastly different perspective on sexual identity and artifice. It is, of course, based on the true story of a

French diplomat who, beginning in the 1960's, had a long affair with an opera star and later claimed that he had no idea she was a man. The story is now so well known, largely from David Henry Hwang's Broadway play of a few years back, that no viewer of the film could possibly be surprised at the gender of the singer, Song Liling (John Lone).

No one could be confused except the diplomat, René Gallimard (Jeremy Irons). Mr. Lone is certainly not lighted as softly as he might have been. The planes of his face and the strength of his jaw are conspicuous, prodding the audience to wonder through most of the film what Gallimard knew and when he knew it. The film is not about Song's artifice but about perception: Gallimard's of the woman he calls his Butterfly, and a Westerner's of China.

At the start of the film, Chinese objects float across the screen: fans, vases, landscape paintings. Gallimard cannot see through these typical signs of China any more than he can view Song Liling as anyone except Madame Butterfly (another European view of China). He believes in

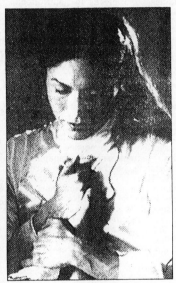

Takashi Seida/Geffen Pictures

John Lone in "M. Butterfly"—Conveying an illusion.

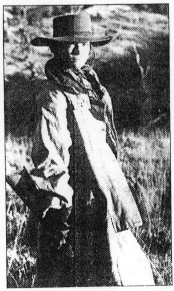

Bill Foley/Fine Line Features

Suzy Amis in "The Ballad of Little Jo"—Convincing a town.

the superficial signs of womanhood, in Song's flowing hair and heavy makeup, more than any genuine physical evidence of her gender. Explaining the tradition of men playing women in the Beijing Opera, Song says quite devilishly, "Only a man knows how a woman should behave." What he knows is how to convey the social illusion of being female. He does not need to convince the camera that he is a woman, only that he can pass for one well enough to have fooled the love-struck Gallimard, at least for a while.

Similarly "Little Jo" can gloss over any nagging questions about how Josephine could pass for Jo so thoroughly for so many years. In fact, after Ms. Amis hacks off her hair she looks rather convincingly like Eric Stoltz. More to the point, dressing like a man and working like a man means that the town believes she *is* a man. Her dress and her behavior define her role in society, and so define her sex.

"The Ballad of Little Jo" is much finer than the plot makes it sound because Ms. Greenwald's compassionate yet tough-minded film is not a political tract. Jo realizes she has sacrificed a great deal to live as a man; her greatest sorrow is not seeing her son. Ms. Greenwald's script and direction and Ms. Amis's subtly passionate performance make Jo more than a cardboard symbol of sexual unfairness — something any cross-dressing character might easily become.

None of these films is finally about whether a man should wear a dress or a woman should cut off her hair. The point they make is not about trading sexual identities but about breaking down simplistic, superficial notions of them. The most daring and effective scene in "M. Butterfly" comes late and shows Mr. Irons in full opera makeup, trading his identity for that of Madame Butterfly herself. His wig and makeup become, in that context, a sign of his tragedy. At that moment, "M. Butterfly" becomes a serious game to cry over. □

1993 O 10, II:13:5

The Scent of the Green Papaya

Directed by Tran Anh Hung; screenplay (Vietnamese, with English subtitles) by Mr. Hung and Patricia Petit; photographed by Benoît Delhomme; edited by Nicole Dedieu and Jean-Pierre Roques; music by Ton-That Tiet; production designer, Alain Negre; produced by Christophe Rossignon; released by First Look Pictures. At Alice Tully Hall, Lincoln Center, as part of the 31st New York Film Festival. Running time: 100 minutes. This film has no rating.

Mui, 20 years old	Tran Nu Yen-Khe
Mui, 10 years old	Lu Man San
The Mother	Truong Thi Loc
Khuyen	Vuong Hoa Hoi

By JANET MASLIN

"The Scent of the Green Papaya" is Tran Anh Hung's tranquilly beautiful film about a lost Vietnam, a peaceful, orderly place not yet touched by wartime. The film begins in Saigon in 1951, in a household safely insulated from the first rumblings of trouble. The family in question has more personal problems, since these people are still mourning the death of a young daughter several years earlier, and since the husband (Tran Ngoc Trung) has a history of disappearing for long periods with his family's money. The wife (Truong Thi Loc) endures these desertions with the stoicism the film generally ascribes to Vietnamese women.

Into this family comes Mui (Lu Man San), a lovely 10-year-old servant girl and a contemporary of the daughter who died. The camera watches Mui contemplatively as she learns her new duties and does her hard-working best to keep her masters happy. Mui is someone who smiles knowingly at the sight of ants lifting heavy burdens, and who communes effortlessly with the natural forces all around her. The film works hypnotically as it gazes upon the leaves, birds, frogs and insects that are welcome parts of Mui's world.

Despite Mui's status as a servant, she manages to enjoy a life of more constancy and quiet joy than do those around her. The film chronicles the series of small changes that rearrange the life of the family, all the while sustaining the rhythm of womanly work that shapes Mui's existence. Mr. Hung's view of placid, spiritually elevated Vietnamese womanhood poses its problems, since Mui is so often seen scrubbing floors or shining shoes. Fortunately, this misplaced romanticism is well outweighed by the film's haunting visual loveliness.

"The Scent of the Green Papaya" takes its title from a childhood memory of the director's. Mr. Hung, who was born in Vietnam and grew up mostly in France, has said that "the smell of green papaya is for me a childhood memory of maternal gestures." The papaya also provides a useful metaphor, since in its green state it is apparently considered a vegetable, and it is thought to blossom into a fruit later on. Mui herself follows a similar evolution as the film unfolds.

During the latter part of the film, Mui is seen as a quiet, graceful 20-year-old (Tran Nu Yen-Khe) who needs a new position once her original employers' lives have changed. She winds up as a devoted servant to the handsome musician she has gazed at admiringly since her girlhood. This musician, seen at his Steinway playing Gershwin-like melodies and engaged to a thoroughly liberated Vietnamese glamour girl, is part of a world Mui has barely seen before. But she does her wordless, gracious best to accommodate him. The film's idea of what might ultimately liberate Mui is every bit as nostalgic as its other memories.

"The Scent of the Green Papaya" marks a luxuriant, visually seductive debut for Mr. Hung, whose film is often so wordlessly evocative that it barely needs dialogue. Reaching into the past for its precisely drawn memories, it casts a rich, delicate spell.

"The Scent of the Green Papaya" will be shown tonight at 6:15 and tomorrow at 9:15 P.M. as part of the New York Film Festival.

1993 O 11, C15:2

Blue

Directed by Krzysztof Kieslowski; screenplay by Mr. Kieslowski and Kryzsztof Piesiewicz, with Agnieszka Holland, Edward Zebrowski and Slawomir Idziak; photography by Mr. Idziak; edited by Jacques Witte; music by Zbigniew Preisner; produced by Marin Karmitz; released by Miramax Films. Running time: 97 minutes. This film has no rating.

Julie	Juliette Binoche
Olivier	Benoît Régent
Sandrine	Florence Pernel
Lucille	Charlotte Véry
Julie's mother	Emmanuelle Riva

By VINCENT CANBY

Krzysztof Kieslowski's "Blue," the Polish director's latest French film, is about Julie (Juliette Binoche), a grieving widow and mother whose husband, "one of the most important composers of our time," and young daughter are killed in the car accident she survives.

The film, which will be shown at the New York Film Festival tonight at 6:15, is the first in Mr. Kieslowski's trilogy "Three Colors: Blue, White, Red," in which he examines the meaning of liberty ("Blue"), equality ("White") and fraternity ("Red"), not as political or social concepts, which, he says, have already been achieved in France, but in terms of the individual. This is a deep-dish endeavor.

Julie is no ordinary individual. She was devoted to her husband and, it turns out, she wrote much of his music, which must mean that Julie is also one of the most important composers of our time. Possibly even more important than her husband in any list of the most important, though the movie never explores this. Neither does it explore, except in obliquely genteel terms, how her husband must have felt about being so dependent on his sweet, loving, understanding, gloriously gifted wife.

Instead "Blue" is a lyrically studied, solemn, sometimes almost abstract consideration of Julie's attempt to liberate herself from her sorrowful love and to establish a new life. But love, which is a contradiction of liberty, cannot be easily fooled. That's a concept that wouldn't have appeared out of place in slick-magazine fiction of the 1950's.

Julie closes up her picturesque country house and moves to Paris, where she seeks anonimity, taking the first apartment she sees. It happens to be as picturesque, in its way, as her house in the country. It is large and airy, with lots of windows and views over Paris's picturesque rooftops. It probably costs a fortune, but money is no object. When you have to grieve, this is how to do it.

At the time of Julie's husband's death, he was working on a huge musical composition to be the centerpiece of a concert celebrating the unification of Europe. One of her first acts in Paris is to burn what she thinks is the only copy of the work. She then goes about her new life. She swims. She befriends a prostitute. She has a curious confrontation with a rat that gives birth in the closet of her otherwise ideal flat.

Suddenly she learns that her husband's devotion may have been somewhat less than all-consuming. How does Julie take it? She takes it like the brick she is: that is, with even more love and understanding than before. Does the huge musical work celebrating Europe's oneness ever get performed? Foolish question.

Miramax
Juliette Binoche

All of Mr. Kieslowski's considerable film-making talents can't bring this impossibly highfalutin composition to recognizable life. It's a 40-finger exercise for the director and his three screenwriting associates. It's full of the mystical bravado that distinguished the French portion of his "Double Life of Véronique," and it's dead. "Blue" doesn't seduce the viewer into its very complex, musically formal arrangements. The narrative is too precious and absurd. The interpretation it demands seems dilettantish.

The movie is relentlessly upscale in looks, manners and Ms. Binoche's chicly casual wardrobe. The sets are gorgeous. The cinematography is bold but also a little silly; it favors curious close-ups and point-of-view shots from positions no one could ever get into except a movie director.

"Blue" also represents an aridly intellectual kind of film making thought highly of in Europe. At this year's Venice International Film Festival, "Blue" shared the top prize with Robert Altman's "Short Cuts," and Ms. Binoche won the best-actress award. The film will be commercially released here later this year or early next.

1993 O 12, C15:1

The War Room

Directed by D. A. Pennebaker and Chris Hegedus; director of photography, Nick Doob, Mr. Pennebaker and Kevin Rafferty; edited by Mr. Hegedus, Erez Laufer and Mr. Pennebaker; produced by R. J. Cutler, Wendy Ettinger and Frazer Pennebaker; released by October Films. At Alice Tully Hall, Lincoln Center, as part of the 31st New York Film Festival. Running-time: 92 minutes. This film has no rating.

With: James Carville, George Stephanopoulos, Heather Beckel, Paul Begala, Bob Boorstin, Michael C. Donilon, Jeff Eller, Stan Greenberg, Mandy Grundwald, Harold Ickes, Mickey Kantor, Mary Matalin, Mitchell Schwartz and others.

By JANET MASLIN

Is there any stone left unturned in a modern Presidential campaign? When every last whistle-stop and handshake is thoroughly documented in print and on television, can there be anything more for a film maker to find? When D. A. Pennebaker and Chris Hegedus set out to chronicle the Clinton campaign, they were treading on familiar territory, taking on a seemingly redundant task. And yet "The War Room," their glimpse of behind-the-scenes maneuvers among Clinton strategists, finds new facets of the story and manages to coax cliffhanging suspense out of a fait accompli.

However much "The War Room" reveals about how Mr. Clinton won the election, its real subject is why he won. The true focus of this watchful, frankly admiring film is the Clinton campaign staff, with James Carville and George Stephanopoulos receiving star billing. The film presents these two as tireless new-breed strategists whose fast, aggressive tactics helped to reshape their party's political thinking, and who themselves played a high-profile role in the election. Theirs was an attitude that promised something different in Presidential politics, and this film examines that attitude in riveting detail.

"The War Room" crystallizes both the idealism and the cunning that cast Mr. Clinton as a departure from candidate stereotypes like the one in "The Candidate," and swept him to victory. In the process, it looks right through the public masks both Mr. Carville and Mr. Stephanopoulos adopted to defend, champion and otherwise spin their man for the media's benefit. The film makers capture these political operatives in their natural element, working the phones, conducting planning sessions and trading casual assessments of their man and his opponents. The film also captures both the exhilarating and daunting aspects of the campaign for relative newcomers thrust suddenly into the major leagues.

An immediate question raised by "The War Room" is whether individuals as image-conscious as these two, or the other Clinton strategists who wander through the film, can ever have behaved naturally in the presence of a camera. The answer is self-evident as the film moves along, starting in storefront campaign headquarters in wintry Manchester, N.H., (where the Clinton corps is feuding with other factions about tearing down each other's campaign signs) and ending with election-night euphoria in Little Rock, Ark. Given that its subjects are all extraordinarily skillful politicians, this film does achieve moments of remarkable candor. The principals can be seen eyeing the camera warily at first and sometimes speaking grandiosely for its benefit. But they can also be watched as they grow acclimated to the film makers' presence, to the point where Mr. Carville can relax his attack-dog public aspect and Mr. Stephanopoulos can make some surprisingly un-self-conscious phone calls. One of the film's more memorable glimpses finds Mr. Stephanopoulos talking down an 11th-hour blackmailer threatening to go public with gossip about the candidate's sexual peccadilloes. Mr. Stephanopoulos calmly moves from dismissal ("You would be laughed at") to flat-out threat ("I guarantee you that if you do this, you'll never work in Democratic politics again") to Godfatherese ("You'll know that you did the right thing, and you didn't dishonor yourself") without missing a beat.

Mr. Carville's distinctive brand of Southern charm emerges equally clearly. "The country's goin' el busto," he says flatly. "Fix it. If you can't, get out of the way." Since both he and Mr. Stephanopoulos appear to believe in that sentiment fervently, their strategy sessions are seen to go beyond the cynicism and dirty tricks associated with too many political campaigns. Confronted with the specter of Gennifer Flowers, Mr. Carville speaks fiercely to a small group of campaign workers in New England, telling them that if they let Mr. Clinton sink under the weight of such a story, they will be giving up their own hopes of changing the political process. That same motif is heard throughout the film, most movingly as a tearful Mr. Carville thanks his staff on election eve.

•

Since Mr. Carville is also capable of grinning broadly and spouting imaginary press reports of a rousing Bush victory, "The War Room" also includes its share of wry moments. The Tracy-Hepburn aspect of Mr. Carville's public persona is captured through his occasional run-ins with Mary Matalin, now his fiancée and then a bulwark of the Bush campaign. "Everybody's got an opinion," he says, in answer to a question about how the two of them get along without seeing eye to eye about the election. "This is just the most American thing you can do."

"The War Room" watches as Mr. Carville and his fellow strategists leap gleefully at every opportunity (even at a potential Bush-related scandal that turns out to be a non-story) and sweat out the terrible suspense. By the morning of Election Day, Mr. Carville and Mr. Stephanopoulos are un-self-conscious enough to allow the camera to watch them in their otherwise empty War Room headquarters, wondering whether their hopes and their labor will be worth anything at all. But, as Mr. Carville puts it playfully at one point, "The harder you work, the luckier you are." "The War Room," a revealing film and an invaluable document, illustrates exactly what that means.

"The War Room" will be shown tonight at 6:15 as part of the New York Film Festival.

1993 O 13, C15:4

Rudy

Directed by David Anspaugh; written by Angelo Pizzo; director of photography, Oliver Wood; edited by David Rosenbloom, A.C.E.; music by Jerry Goldsmith; production designer, Robb Wilson King; produced by Robert N. Fried and Cary Woods; released by Tri-Star Pictures. Running time: 112 minutes. This film is rated PG.

Rudy	Sean Astin
D-Bob	Jon Favreau
Daniel	Ned Beatty
Mary	Greta Lind
Frank	Scott Benjaminson
Betty	Mary Ann Thebus
Fortune	Charles S. Dutton
Sherry	Lili Taylor
Pete	Christopher Reed

By STEPHEN HOLDEN

Some people dream of being rock stars, others Nobel Prize-winning authors, The dream of Daniel E. (Rudy) Ruettiger (Sean Astin), the central character of David Anspaugh's film "Rudy," is only a little more down-to-earth, given the odds against him. Physically small and a mediocre student, he lives to play football for Notre Dame.

Set in the 1960's and based on a true story, "Rudy" is a reasonably convincing study of a young man's obsessive quest for the nearly impossible. Directed by Mr. Anspaugh with the same rah-rah fervor he brought to "Hoosiers," the film also offers a

Tri-Star Pictures
Sean Astin

knowing glimpse of working-class life in Joliet, Ill., the steel-mill town where Rudy grows up.

Mr. Astin's character is a day-dreaming football fanatic who is about to settle into a predetermined blue-collar existence when his best friend's death in a mill accident snaps him out of his doldrums. He is jolted into realizing that time has nearly run out for pursuing his dream. Against the strenuous advice of his father (Ned Beatty), a steelworker, he quits his job, dumps his fiancée and moves to South Bend, Ind., with only a thousand dollars in his pocket.

Encouraged by the chaplain at Notre Dame, Rudy enrolls at a nearby junior college with the hope that if he studies hard enough, he can make the leap to his first choice. And through sheer, grinding determination, he succeeds. He goes out for football, and although physically too small to be a varsity player, he becomes a valuable and much-loved member of the college's practice team.

"Rudy," which opened locally today, shamelessly manipulates the heartstrings and pumps the adrenaline. There are many moments in which it seems like nothing more than a promotional film for Notre Dame. It also has its share of clichéd minor characters: the flinty coach (Jason Miller), the wise, kindly groundskeeper (Charles S. Dutton) and the helpful priest (Robert Prosky).

For all its patness, the movie also has a gritty realism that is not found in many higher-priced versions of the same thing, and its happy ending is not the typical Hollywood leap into fantasy. Its portrait of a blue-collar family (Rudy has two resentful brothers who lack his pluck) carries an edge. It conveys a palpable sense of life in America's industrial heartland during the 60's and evokes the deep emotional connection between football fanaticism and the brawling teamwork of steel-mill life.

Most important, it has a tough, persuasive performance by Mr. Astin that keeps the role firmly in perspective. Although his portrayal is basically sympathetic, the actor doesn't soft-pedal his character's annoying obstinacy. He is not afraid of making Rudy a royal pain.

•

"Rudy" is rated PG (parental guidance suggested). It includes some strong language.

1993 O 13, C21:1

Fiorile

Directed by Paolo and Vittorio Taviani; written (in Italian, with English subtitles) by Sandro Petraglia and the Tavianis; director of photography, Giuseppe Lanci; edited by Roberto Perpignani; music by Nicola Pio-

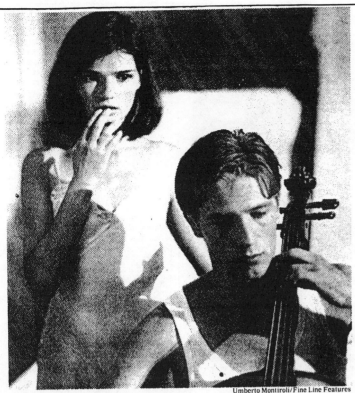

Umberto Montiroli/Fine Line Features

Chiara Caselli and Michael Vartan in a scene from "Fiorile."

vani; produced by Grazia Volpi; released by Fine Line Features. At Alice Tully Hall, Lincoln Center, as part of the 31st New York Film Festival. Running time: 118 minutes. This film has no rating.

Corrado/Alessandro................ Claudio Bigagli
Elisabetta/Elisa........................ Galatea Ranzi
Jean/Massimo.......................... Michael Vartan
Luigi.. Lino Capolicchio
Juliette........................ Constanze Engelbrecht
Gina ... Athina Cenci
Elio.. Giovanni Guidelli
Chiara... Chiara Caselli

By STEPHEN HOLDEN

In "Fiorile," Paolo and Vittorio Taviani's sweeping and sensuous fable of how several generations of a Tuscan clan have lived out a family curse, the ghosts of the past are always threatening to jump out at its characters from the shadows of their troubled family history.

The movie, which the New York Film Festival is showing tonight at 9:30 and Saturday at noon, doesn't exactly believe in ghosts. It is an engaging yarn that suggests how a potent legend handed down from generation to generation can become a kind of determining karmic force field. It also affords the Taviani brothers, whose films are steeped in a love of Italian history and an identification with peasant folklore, rich visual opportunities to evoke a mythical Italian spirit that the sterile trappings of modernity only partially conceal.

In the film's opening scenes, Luigi Benedetti (Lino Capolicchio) and his French wife (Constanza Engelbrecht) are driving with their two children through the Tuscan countryside to visit the eccentric grandfather the children have never met. To amuse them, Luigi regales them with the details of a family curse that dates back to Napoleon's invasion of Italy. As the children listen with rapt fascination, they envisage soldiers in 18th-century costume riding through the countryside. And the movie slips effortlessly back two centuries.

In these early flashbacks, which are among the movie's most beautiful, Jean (Michael Vartan), a handsome, idealistic French lieutenant, falls in love at first sight with Elisabetta Benedetti (Galatea Ranzi), a Tuscan peasant girl whom he nicknames Fiorile. While they are making love in the woods, the girl's brother Corrado (Claudio Bigagli) steals a regimental chest of gold coins that Jean was guarding. When no one returns them, Jean is executed, according to martial law. And Elisabetta, who is pregnant, vows revenge, never knowing that her family's greed brought about his death.

With their ill-gotten gains, the Benedettis build an empire to rival the Medicis in scope and opulence, but the stolen wealth carries a curse that ruins the lives of those who live off it. Their bad luck becomes so conspicuous that the Benedettis are nicknamed the Maledettis by the Tuscan locals, and their legend is passed down in whispers.

A century after the original theft, history repeats itself when Fiorile's wealthy descendant Elisa (Miss Ranzi) is prevented by her politically ambitious brother Alessandro (Mr. Bigagli) from marrying Elio (Giovanni Guidelli), the handsome peasant youth who has impregnated her. Recalling Elisabetta's vow, Elisa takes revenge by feeding her two brothers poisoned mushrooms while they are traveling to Rome.

●

The story jumps ahead four decades to World War II. Elisa's grandson, Massimo (Mr. Vartan), who works with the Italian Resistance, is so intimidated by the family curse that he keeps a mannequin of his French ancestor Jean in his home. When he and his peasant comrades are rounded up by the Fascists, he is the only one spared from execution, because of his wealth and breeding. And in his old age, he becomes a half-mad recluse who is bitterly haunted by the past and whose ancestral home has a funereal atmosphere. The

appearance there of the grandchildren who have been transfixed by the family legend stirs old fantasies and terrors. A mushroom dinner takes on sinister overtones, and the children's game of dress-up becomes confused with a ghostly visitation.

"Fiorile" isn't an especially deep film, but it offers many pleasures, Shifting deftly between centuries, it combines a confident narrative drive with visual style that drinks in the beauty of the rolling Tuscan landscape. And the smooth, low-key performances by an attractive cast lend each vignette a delicious romantic flavor. By having Miss Ranzi and Mr. Vartan play their characters' ancestors as well, the continuity is enhanced with a dash of magical realism.

The most memorable of the film's many striking tableaux is an elaborate banquet given by the scheming Alessandro in which he insists that the guests eat their food the way the Medicis would have centuries earlier, without utensils. Although intitially shocked by the suggestion, the elegantly dressed guests one by one enter into the spirit of the feast, throwing their knives and forks over their shoulders, picking up their meat and gnawing voraciously.

1993 O 13, C21:1

The Wonderful, Horrible Life of Leni Riefenstahl

Directed by Ray Müller (in German, with English subtitles); photography by Walter A. Franke, Michel Baudour, Jürgen Martin, Ulrich Jaenchen and Horst Kettner; edited by Beate Köster, Stefan Mothes and Vera Dubsikova; music by Ulrich Bassenge and Wolfgang Neumann; production designer, Michael Graser; produced by Hans-Jürgen Panitz, Jacques de Clercq and Dimitri de Clercq. At Alice Tully Hall, as part of the 31st New York Film Festival. Running time: 180 minutes. This film has no rating.

By VINCENT CANBY

Ray Müller's "Wonderful, Horrible Life of Leni Riefenstahl" is a big, long (over three hours), sometimes clunky but consistently fascinating documentary portrait of the woman most easily identified as Hitler's favorite film maker, with good reason. Ms. Riefenstahl's two outstanding films, "Triumph of the Will" (1935) and "Olympia" (1938), for all of their esthetic glories, served the propaganda machine of National Socialism in ways that probably neither Hitler nor Ms. Riefenstahl could have foreseen.

The films gave Hitler a credibility at home and around the world that nothing else produced by a German artist in the 1930's ever achieved. It was Ms. Riefenstahl's fate not only to survive the war, but also to live on and on and on.

Today, at 91, she is still answering the same questions about her relationship to Hitler and to the Nazi Party (she was never a member), and about her sense of responsibility for the crimes committed by the man in whom she continued to believe right through the end of the war. Her eyes were not opened, she says, until she learned of the death camps.

For nearly 50 years, she has been setting her record straight, often splitting hairs, a task sometimes made easier when she has been able to prove the accusations against her to be wrong, which serves to make those not so clearly off the mark

seem fuzzier than they are. Thus for most of her adult life she has been on the defensive, not easy for a strong woman whose early years were so full of success and acclaim. The defensive position is exhausting, but Ms. Riefenstahl still hasn't knuckled under to accumulated fatigue. This film is the astonishing record of how she has survived.

"The Wonderful, Horrible Life of Leni Riefenstahl" will be shown at the New York Film Festival today at 8:30 P.M.

●

Just about everything in the film is covered more fully in Ms. Riefenstahl's recently published autobiography. Sometimes in her on-screen interviews with Mr. Müller, she even uses the same words she uses in the book.

Yet "The Wonderful, Horrible Life of Leni Riefenstahl" can demonstrate where the book can only describe. Included in the film are clips from the silent and early sound films she made as an actress, and extensive, quite wonderful clips from her two classics, as well as from her first film as a director, "The Blue Light" (1932). This very significant film is the fable-like story of a woman whose search for the ideal, not unlike Ms. Riefenstahl's search in a very different world, leads to disaster.

Ms. Riefenstahl doesn't come across as an especially likable character, which is to her credit and Mr. Müller's. She's beyond likability. She's too complex, too particular and too arrogant to be seen as either sympathetic or unsympathetic. There's the suspicion that she has always had arrogance and that it, backed up by her singular talent, is what helped to shape her wonderful and horrible life.

Today she takes the breath away: a strange-looking woman in her 90's, sure-footed, her backbone straight, her hair fluffy and blond, her tanned face appearing to have been lifted at some point in the distant past. She wears a pink raincoat when, accompanied by Mr. Müller and a camera crew, she visits sites associated with her short, brilliant career as cinema master.

When the director asks her to walk toward the camera and answer his questions, she balks. "I've never walked and talked at the same time," she says. "I'm not a ghost." But she does it. She also tells him how to shoot an interview to be able to suggest the gigantic scale of the mountains behind her. When she has a reunion with two of the cameramen who worked with her on "Olympia," she remembers that one of them used a Bell & Howell and a Sinclair. To the other, she says, "You had two Bell & Howells."

She has told the same, still riveting stories about Hitler and Goebbels so many times that there's the sense they have become memories of memories. Yet the passion is genuine when she talks about light, lenses, filters, film stock and editing. She even remembers the aperture stop (lens opening) she used to obtain a particular effect more than 50 years ago. Her recollections of how she shot "Triumph of the Will," her record of the giant 1934 Nazi rally at Nuremburg, and "Olympia," the epic about the 1936 Olympic Games in Berlin, says as much about her character as anything else in the film.

On a couple of occasions, Mr. Müller engages her in something like a cross-examination about what she calls her apolitical behavior in the Nazi years. He says one thing; she gives a denial, which is followed by material that appears to support his charges. Hindsight is on his side. She does seem to go too far when she suggests that she thought "Triumph of the Will" was all about peace. It's also a stretch when she says that émigré friends urged her to remain in Nazi Germany to act as a "bulwark" against anti-Semitism.

Mr. Müller brings her life up to date:

She has had success as a still photographer, though her photographs of muscular African tribesmen have been interpreted as a variation on the fascist physical ideal she was celebrating in "Olympia." At an age when other women are reaching for their lap robes, she's putting on her scuba gear to dive into the Indian Ocean. She is regularly honored at film festivals. People continue to attack her, but she sees herself as having been betrayed too many times to be surprised. The skin grows thick with time.

The film's English-language voice-over is stuffed with clichés. Yet that's unimportant when Ms. Riefenstahl is also on hand to speak for herself. She's authentic as both artist and relic. What seem to be perfectly adequate English subtitles translate the German dialogue.

1993 O 14, C15:1

Birthplace

Directed by Pavel Lozinski (in Polish, with English subtitles); director of photography, Arthur Reinhart; edited by Katarzyna Maciejko-Kowalczyk; produced by Kronika Film Studio, Polish Television Channel 1, the Film School of Lodz and the Batory Foundation. At Alice Tully Hall, as part of the 31st New York Film Festival. Running time: 50 minutes. This film has no rating.

By JANET MASLIN

Although "Birthplace," Pavel Lozinski's documentary about an American Jew's return to his native village in Poland, unfolds in a quiet, unremarkable manner, this film is shocking simply on the basis of what is being said. Henry Greenberg has gone back to inquire about the fates of his father and brother, and a surprising number of elderly villagers remember exactly what happened to them.

The villagers' attitudes are astonishingly unchanged and unguarded, as if the forces behind the Holocaust remained preserved in amber. "You know, we were Poles and they were Jews, but I didn't mind going to their shop," says one of the town's atypically open-minded citizens.

Mr. Greenberg is seen maintaining a calm, polite demeanor as he investigates the unspeakable. He is told that while most of the village's Jews were hidden at the edge of a nearby woods, some living in the kind of underground dugout used to store potatoes, his 18-month-old brother was placed in the custody of a man who had been paid to keep him. Life quickly became difficult for this man, and when he was suspected of harboring a Jewish child, he abandoned his young charge.

"I knew you all," says the man who is telling Mr. Greenberg much of this story. He stares coldly at Mr. Greenberg while describing how he went out of his way to watch the police shoot this particular toddler. "Nice little boy," he says indifferently. And then, ignoring the camera, he goes back to work.

•

The story involving Mr. Greenberg's father proves to be equally grim. And it is set forth by various villagers in similarly cool, noncommittal fashion. A few of these people welcome Mr. Greenberg warmly, but the majority of those seen here harbor obvious bitterness about the position in which they found themselves in wartime. "Do you know how dangerous it was to hide a Jew?" one man asks angrily. "We couldn't keep you! People were complaining about us."

Mr. Greenberg, offering one of his few stark memories of what it was like to live in hiding in the woods, dependent on his neighbors' uncertain generosity, says, "I remember needles of the pine trees dropping into my soup." Much of the time, he simply asks his questions and absorbs the cruelty of the answers with resignation. He is even able to stand by stoically as the site at which his father supposedly died is excavated by several helpful villagers. His father's remains are there, along with the milk bottle the man was carrying at the time he was murdered. Witnesses still marvel at the pettiness of the dispute that led to the killing.

"Birthplace," which will be shown tonight at 6:15 as part of the New York Film Festival, is well served by the plainness of Mr. Lozinski's direction. This film's testimony speaks clearly for itself.

1993 O 14, C20:5

Naked

Written and directed by Mike Leigh; director of photography, Dick Pope; edited by Jon Gregory; music by Andrew Dickson; production designer, Alison Chitty; produced by Simon Channing-Williams; released by Fine Line Features. At Alice Tully Hall, Lincoln Center, as part of the 31st New York Film Festival. Running time: 126 minutes. This film has no rating.

Johnny	David Thewlis
Louise	Lesley Sharp
Sophie	Katrin Cartlidge
Jeremy/Sebastian	Greg Cruttwell
Sandra	Claire Skinner
Brian	Peter Wight
Archie	Ewen Bremner
Maggie	Susan Vidler
Woman in Window	Deborah MacLaren

By VINCENT CANBY

Meet Johnny (David Thewlis), the 27-year-old Manchester lad who is the central figure in Mike Leigh's "Naked," a brilliant somersault of a movie that lands this fine English director in dark new cinematic territory.

As nothing that Mr. Leigh has done in the past (especially his recent "High Hopes" and "Life Is Sweet") is adequate preparation for "Naked," no movie character you may have met quite measures up (or down) to the caustic and abusive Johnny. He's "not waving, but drowning." Though the cool order of the poet Stevie Smith's line succinctly describes Johnny's situation, it has little to do with his often revivifying, sardonic fury.

Johnny recalls Jimmy Porter of "Look Back in Anger," but homeless in the London streets of the 1990's. He raises his fist not at the Empire, the class system and the Tory mentality, but at God: Johnny goes to the

FineLine Features/New Line Cinema
Deborah MacLaren and David Thewlis in Mike Leigh's "Naked."

source. A product of the English working class, a man with possibly a year or two at a Midlands university behind him, he has the gift of gab of one of James Joyce's Dubliners who has lost his faith but not his voice.

•

Johnny invites compassion, especially from women. His scroungy good looks inspire trust: the sad expression, the skinny frame, the great reddish-brown mustache that indicates some reassuring sense of self-worth. But they're all a disguise. Beneath his cheap raincoat, which provides no protection against the winter chill, Johnny is a kind of satanic angel. He's as capable of expressing love as Jack the Ripper.

He doesn't murder; he doesn't have to. During his several days of wanderings about London, which are the focus of Mr. Leigh's screenplay, he leaves a trail of living corpses, the victims, possibly, of a social system but beyond that, of a disinterested universe. He's fed up with himself and his lot, but directs his anger at everyone around him. When a young woman he's about to make love to says she is bored, Johnny, who has nothing but unused time on his hands, becomes lyrical in behalf of small and large mysteries to be pondered.

"Naked" will be shown at the New York Film Festival today at 9:15 P.M. and tomorrow at 3 P.M. It will open here commercially later this year.

•

When I first saw "Naked," at this year's Cannes International Film Festival, where Mr. Leigh received the best-director award and Mr. Thewlis won as the best actor, the film didn't fit easily into the dozen or so Leigh works I already know. It seemed as disconnected from the other Leigh films as its characters are from one another and from the world in which they live. The picture cleared after a second viewing, one without jet lag.

The revelation: "Naked" not only fits, but is also a logical if unexpected extension of such earlier Leigh films as "Bleak Moments," "Grown-Ups," "Meantime" and "Home Sweet Home," each a harrowing tale of the domestic problems of the English working and lower-middle classes. Yet those films are all rooted in recognizable homes, such as they may be, and deal with approximations of the nuclear family. "Naked" is something else.

The characters in "Naked" have abandoned whatever homes they had. Their families are somewhere else; they're scarcely mentioned. The flats and rooms we see in "Naked" are temporary refuges. These characters aren't mired in domestic relationships; they're as free-floating in limbo as Johnny, though they don't know it.

•

When first seen, before the film's title credits, Johnny is standing in a Manchester alley late at night having sex with a woman he has just picked up. That's a delicate way of describing what he's doing. He's brutalizing the woman, who tries to fight him off. When finished, he walks away, steals a car and drives to London. His purpose: to find his former girlfriend Louise (Lesley Sharp). She shares a flat with a spaced-out druggie named Sophie (Katrin Cartlidge) and Sandra (Claire Skinner), whose name is on the lease, a prissy nurse who returns from a vacation in Zimbabwe in the course of Johnny's visit.

During the next several days, Johnny descends into hell, though at one point, when he's asked where he has been, he says "down the via dolorosa." Johnny's being sarcastic, but the movie isn't. "Naked" is as corrosive and sometimes as funny as anything Mr. Leigh has done to date. It's loaded with wild flights of absurd rhetoric and encounters with characters so eccentric that they seem to have come directly from life. Nobody would dare imagine them.

There's the lonely, philosophical night watchman Brian (Peter Wight), who finds Johnny huddled in the doorway and invites him in, not necessarily to be kind but to have someone to talk to. Brian gets more than he bargained for. Says Johnny on entering the lobby of the office building, "So what goes on in this post-modern gas chamber?"

There are also two young Scots, Archie (Ewen Bremner) and Maggie (Susan Vidler), whose accents are so thick that most of the vitriolic things they fling at each other remain unintelligible to Johnny. He knocks on the door of a woman he has seen undressing in a window. She invites him in, offers him vodka and is ready to have sex with him. At the last minute Johnny declines; he says she looks like his mother.

•

Intercut with Johnny's journey through nighttown, with his seduction by Sophie and his half-hearted attempts to reconcile with Louise, is the story of a sadistic fellow alternately known as Jeremy and Sebastian, played by Greg Cruttwell, who looks like a young, pre-"Servant" Dirk Bogarde. Eventually Johnny, Jeremy/Sebastian, Louise, Sophie and Sandra all wind up in Sandra's flat in an extended sequence that slips effortlessly from melodrama to comedy to farce and something like psychic exhaustion.

Perhaps "Naked" should not be analyzed too closely in any conventional way. It's as much about actors acting, finding their remarkable characters in their collaborations with Mr. Leigh, who is both the writer and director, as it is about the characters thus created and the landscape they inhabit.

Mr. Thewlis is staggeringly fine, but everyone else in the cast is also special. The dialogue dazzles, wheth-

166

er it sounds like something overheard during a beery undergraduate discussion on the meaning of life, or takes off into its own mad stratosphere, as when Johnny considers the mystery of the silence of the human body: "The most complex mechanism in the universe, but it still doesn't make any noise. What's going on in there?"

1993 O 15, C3:3

Judgment Night

Directed by Stephen Hopkins; written by Lewis Colick, based on a story by Mr. Colick and Jere Cunningham; director of photography, Peter Levy; edited by Timothy Wellburn; production designer, Joseph Nemec 3d; produced by Gene Levy; released by Largo Entertainment. Running time: 109 minutes. This film is rated R.

Frank Wyatt	Emilio Estevez
Mike Peterson	Cuba Gooding Jr.
Fallon	Denis Leary
John Wyatt	Stephen Dorff
Ray Cochran	Jeremy Piven
Sykes	Peter Greene

By JANET MASLIN

"Judgment Night," a tight, energetic sleeper in the action-adventure genre, manages to pack a few antimachismo sentiments into an otherwise brawny tale. The story concerns four suburban buddies who take a wrong turn en route to a boxing match and wind up lost in Chicago's inner city. As such, it sounds like a fairly standard occasion for mean-spirited mayhem.

But the film manages to avoid excessive gore, lurid violence and the potentially racist aspects of its story. Indeed, it even includes a moment when one hero hugs his brother and says: "Hey John, everybody gets scared, whether they admit it or not. I'm scared too." Emilio Estevez, in the role of this sensitive guy, strikes another blow for gentleness by actually stating that he would like to survive the evening's death race and get home to see his wife and baby. Thoughts like that are generally anathema in a manhunt story.

As directed with vigor by Stephen Hopkins, "Judgment Night" also attempts its share of social commentary by thrusting comfortable middle-class types into a desolate urban landscape. The film has grim fun with the complete unavailability of police assistance or phone service in the part of town where the action unfolds.

Beyond that, it doesn't have a lot to say, not even when its tireless villain (Denis Leary, doing a suitably nasty turn) subjects the four tourist types to endless taunts. When they happen to witness a murder, they somehow engage the undying attention of this heavy and his loyal henchmen (among them, Peter Greene).

The story's other nice-guy roles are filled by Stephen Dorff as Mr. Estevez's fearful brother, Cuba Gooding Jr. (of "Boyz N the Hood") as a more headstrong type, and Jeremy Piven as the genial fool who thinks he can buy his way out of trouble. This kind of material isn't exactly a field day for the actors, but the principal roles are better than skin deep.

The film's biggest problem is apparent in its title. Most of the action in "Judgment Night" takes place after dark, in bleak and visually limited settings. The orangey lighting is often effective, but parts of the film will be hard to make out when it gets to home video. Mr. Hopkins tries his best to overcome this liability. But when

you're staging a big scene in a sewer, there's a limit to what you can do.

•

"Judgment Night" is rated R (Under 17 requires accompanying parent or adult guardian). It includes profanity and violence.

1993 O 15, C8:5

It's All True
Based on an Unfinished Film by Orson Welles

Original director and producer, Orson Welles; directed by Richard Wilson, Myron Meisel and Bill Krohn; written by Mr. Krohn, Mr. Wilson and Mr. Meisel; photography for "Four Men on a Raft," George Fanto; director of photography, Gary Graver; edited by Ed Marx; music by Jorge Arriagada; produced by Regine Konckier, Mr. Wilson, Mr. Krohn, Mr. Meisel and Jean-Luc Ormieres; released by Paramount Pictures. At Alice Tully Hall, Lincoln Center, as part of the 31st New York Film Festival. Running time: 89 minutes. This film is rated G.

Narrator: Miguel Ferrer

By VINCENT CANBY

In terms of cinema history and scholarship, the highlight of this year's New York Film Festival is the presentation of "It's All True: Based on an Unfinished Film by Orson Welles." This is the story of the aborted production of the master's 1942 Latin American, three-part "It's All True."

The documentary will be shown at the festival today at 6:15 P.M. and tomorrow at 9 P.M. Both screenings are sold out, but the film begins a regular run in Manhattan on Sunday. It's a must-see.

The events surrounding the making of "It's All True" aren't mysterious but, like so many chapters in Welles's professional life, they are full of production complications, financial problems and the interference of money men who never see themselves as made of money. Conspiring in the disaster was Welles's own tendency to be high of hand, loving of fun and casual about schedules set by others.

The initial conception of "It's All True": Welles was already planning an anthology film in 1941 when he was approached by Nelson Rockefeller, who was a large stockholder in RKO Pictures (Welles's studio) and the coordinator of the Office of Inter-American Affairs. Rockefeller's idea was for Welles to make an entertainment film to help promote President Franklin D. Roosevelt's Good Neighbor Policy.

•

It was a busy time for Welles. He was finishing work on "The Magnificent Ambersons" and acting in "Journey Into Fear," which he had supervised though it was being directed by Norman Foster. By chance he had earlier envisioned a short film about a Mexican boy and his bull, "My Friend Bonito," which was to be one of the three segments in the RKO-produced, Government-promoted movie celebrating Latin America. He decided that the second segment would center on the annual carnival in Rio de Janeiro, and that the third would be determined when he arrived in Rio.

In those youthful days, Welles was full of energy and magnificent self-assurance. Yet "It's All True" seems never to have been thought through with any realistic sense of time, place and money. He oversaw the shooting

of several sequences of "My Friend Bonito" in Mexico and then, in February 1942, took off for Rio with both Technicolor and black-and-white cameras to photograph the carnival.

That did not go easily, but he did get the idea to use the story of the history of the samba as one of the principal themes of what became the two Brazilian segments. The second segment was to be a re-enactment of the story of four Brazilian fishermen from the northeast who, the year before, had caused a sensation when they sailed their tiny fishing raft across 1,600 miles of open ocean to Rio to seek redress for social ills.

•

RKO officials quickly panicked about the money Welles was spending in Rio without having a finished script. The carnival material they saw was formless. But they truly hit the ceiling when Welles's interest turned to Rio's favelas (mountainside slums) and blacks in his search for the samba's roots. Poor people, particularly poor black people, did not fit into any good neighbor policy that RKO or the United States State Department wanted to publicize.

The production was halted in midstream by RKO, but Welles persisted in his efforts to finish the film's third segment, "Four Men on a Raft," with a modest budget and primitive equipment. This material, which he shot but never edited, changed hands several times and then was lost. Some of it was destroyed. In 1985, the year Welles died, the surviving material was found in a Paramount vault.

Because there was no screenplay, Richard Wilson, Welles's assistant in Brazil, used letters and memorandums to put together a 22-minute version of "Four Men on a Raft," which was shown at the 1986 Venice Film Festival. That material remains the heart of the new documentary.

The new film also makes use of the remaining Technicolor carnival material and several sequences from "My Friend Bonito," all supplemented by filmed interviews with Welles, both as a young man and in later years; with Wilson, who died of cancer in 1991; with other associates, and with some of the Brazilian members of the project who are still alive.

•

It's the black-and-white material from "Four Men on a Raft" and "My Friend Bonito" that gives the documentary its importance. There is the initial surprise at the way it recalls the look and style of the great Russian film maker Sergei Eisenstein in his monumental "Que Viva Mexico!" (1930-31), a project almost as cursed as "It's All True." Planned as four distinct stories, with a prologue and an epilogue, "Que Viva Mexico!" was taken away from Eisenstein by his American partners before he could put it together. It was later edited into four separate films that could only hazily suggest what Eisenstein would have done.

Yet the Eisenstein material was preserved and, if not honored, it was at least used. Welles's material was casually trashed.

Both "Four Men on a Raft" and "My Friend Bonito" have the gloriously liquid look of the heavily filtered, black-and-white photography favored in the 1930's to ennoble peasants and other common folk. It's corny and possibly condescending, but it still works. Glauber Rocha, a leading talent in Brazil's own Cinema Novo movement, used the same style in his "Barravento" (1961), which is set in the fishing villages of Bahia.

Of special interest is the funeral procession sequence in "Four Men on a Raft," a stunning preview of the even more remarkable sequence that would later open Welles's "Othello."

•

"It's All True: Based on an Unfinished Film by Orson Welles" might have been even more fascinating if Welles's raw material hadn't been so smoothly edited that it's impossible to tell how sequences were put together, what was saved and what was discarded. Such a film would be unwieldy, if of more scholarly interest.

Though Welles's own "It's All True" remained unfinished, its place in history is firm: if Welles had not undertaken the project, the chances are that his greatest film, "The Magnificent Ambersons," would not have been butchered by the studio while he was flying down in Rio.

This documentary is a long, seductive footnote to a cinema legend.

1993 O 15, C8:5

Fearless

Directed by Peter Weir; written by Rafael Yglesias, based on his novel; director of photography, Allen Daviau; edited by William Anderson; music by Maurice Jarre; production designer, John Stoddart; produced by Paula Weinstein and Mark Rosenberg; released by Warner Brothers. Running time: 125 minutes. At Loews Tower East, Third Avenue at 71st Street. This film is rated R.

Max Klein	Jeff Bridges
Laura Klein	Isabella Rossellini
Jonah Klein	Spencer Vrooman
Carla Rodrigo	Rosie Perez
Brillstein	Tom Hulce
Dr. Bill Perlman	John Turturro

By VINCENT CANBY

Peter Weir's "Fearless," adapted by Rafael Yglesias from his own novel, is a serious, confidently made film that's as singular and remote as Max Klein (Jeff Bridges), the successful San Francisco architect whose story it is.

En route to Houston on a commercial airliner, Max survives a horrendous crash without a scratch, though he is profoundly changed. Moments before the plane hit the ground, while other passengers were screaming in panic, he experienced an epiphany. "This is it," he told himself. "This is the moment of your death, and I am not afraid." He later sees himself as liberated. Having passed through death, he feels not immortal but forever freed from the fear of death.

"Fearless" is about many things: Max's increasingly strained relations with his loving wife, Laura (Isabella Rossellini), and young son, Jonah (Spencer Vrooman), who remain unenlightened in the mundane world; the hustling lawyers who show up to make big bucks after any such disaster; the specialists in post-traumatic stress disorders, who mean well but haven't a clue to what their patients have gone through.

It is most effective in exploring the tentative relationship that grows up between Max and Carla Rodrigo (Rosie Perez), a young Puerto Rican mother who also survived the crash, though she lost the baby son she held in her arms. Carla has become catatonic, blaming herself for the child's death. Their therapist (John Turturro) brings Carla and Max together.

While Carla's husband is seizing the chance to sue the airline for as

much as the insurance company will bear ("A dead baby ought to be worth $2 million"), Carla is finding her way back to life with Max's guidance. He's able to demonstrate to her that she need not feel guilty, but he cannot help himself.

At points in the movie one might think that Max ought to be left in his blessed, not quite out-of-body state. But he's dangerous. He feels so self-assured that he comes close to trying to fly off the top of a San Francisco office building unassisted. Though "Fearless" touches on many things, it's difficult to tell where its center is.

Max isn't an immediately appealing character. He's smug without reason. His philosophical observations are dim. "If life and death make no sense," he tells Carla, "there's no reason to do anything," but he does do things: he helps her. For someone so out of sympathy with the world the rest of us live in, he's remarkably benign about its idiocies (except video games).

Yet it's difficult to forgive him for inspiring the film's most saccharine sequence. He persuades Carla that they should go to the mall to buy Christmas presents for their dead loved ones: her baby and his dad, who died long ago, before Max could tell him that he loved him. Since there is little electricity between Max and his wife, there's not much interest in how that marriage turns out.

•

"Fearless" is well acted by the principals, especially by Ms. Perez, and by Tom Hulce, a lawyer who says such things as "I know I'm awful, but ..." as he exults over winning even more money than he expected.

Mr. Bridges does well with a difficult role. Max isn't ambiguously complex. He's ill-defined, or maybe required to exhibit more contradictory impulses simultaneously than is possible for any single actor. At times Max suggests a Christ figure, at other times a would-be dropout from life. It's difficult to fix him in the mind of the emotions.

The film's physical production is quite fine. Here's a movie with a truly first-rate airplane crash, to which Max keeps returning in chronological flashbacks. The noise, the flames, the chaos and the suspension of time are beautifully caught in these scenes. They're both frightening and, reflecting Max's state of mind, eerily peaceful.

The ending of "Fearless" makes sense without being satisfying.

•

"Fearless" is rated R (Under 17 requires accompanying parent or adult guardian). It has scenes of panic and carnage that could badly frighten small children, and some vulgar language.

1993 O 15, C12:5

Inside Monkey Zetterland

Directed by Jefery Levy; written by Steven Antin; director of photography, Christopher Taylor; edited by Lauren Zuckerman; music by Rick Cox and Jeff Elmassian; production designer, Jane Stewart; produced by Tani Cohen and Chuck Grieve; released by I.R.S. Releasing. Running time: 92 minutes. At Village East Cinemas, Second Avenue at 12th Street, East Village. This film is rated R.

Monkey Zetterland	Steve Antin
Grace Zetterland	Patricia Arquette
Imogene	Sandra Bernhard
Cindy	Sofia Coppola
Brent Zetterland	Tate Donovan
Honor Zetterland	Katherine Helmond
Mike Zetterland	Bo Hopkins
Daphne	Debi Mazar
Sofie	Martha Plimpton
Sasha	Rupert Everett
Bella	Ricki Lake

By STEPHEN HOLDEN

"Inside Monkey Zetterland," a dark comedy set in contemporary Los Angeles, strains so hard to be hip, zany and offbeat that you can almost feel the movie gasping for breath. Written by Steven Antin, who also plays the title character, and directed by Jefery Levy, the movie offers a view of Los Angeles that echoes Robert Altman's "Short Cuts" in its grimness, although the tone of Mr. Antin's movie is more farcically cheeky than grandly pessimistic.

The movie flaunts a number of audacious cinematic tricks. In one early scene the camera faces a blank wall while overlapping arguments by off-screen characters converge. In other scenes, the halting dialogue sounds as though it were improvised on the spot. The soundtrack keeps shifting between excerpts from Tchaikovsky's Piano Concerto No. 1, played straight, and the same music heard on a calliope.

"Inside Monkey Zetterland," which opens today at the Village East, explores the emotionally chaotic world of Monkey Zetterland, a young screenwriter and former actor, and his eccentric extended family. Monkey's actress mother, Honor (Katherine Helmond), is an insecure grande dame of soap opera who nags Monkey mercilessly. His father, Mike (Bo Hopkins), is a superannuated hippie who shows up only on Thanksgiving. Monkey's intense, soft-spoken sister, Grace (Patricia Arquette), comes to live with him after she ends a lesbian relationship with Cindy (Sofia Coppola), who has become pregnant. His brother, Brent (Tate Donovan), is a self-absorbed hairdresser.

Swirling in and out of the Zetterlands' lives are assorted lunatics who keep things topsy-turvy. Imogene (Sandra Bernhard), Monkey's hysterical next-door neighbor, is a compulsive talker and show-off who throws herself at him recklessly. Daphne (Debi Mazar), his vicious girlfriend, steals his favorite curtains as a prelude to breaking up with him because he is "just too boring." Sasha (Rupert Everett) and Sofie (Martha Plimpton), who live in the same apartment house, are urban terrorists. Sofie, who speaks only in infuriated political accusations, is a truly nasty piece of work, and Ms. Plimpton imbues her with a frightening hysteria.

Peopled with so many fine young actors, "Inside Monkey Zetterland" is an ensemble piece in search of a strong director. Instead of seeking a finely meshed psychological group portrait, Mr. Levy has gone after a mood of manic chaos. Many of the performances go over the top in their ranting and raving. The accusatory edge with which Ms. Bernhard, Ms. Helmond, Ms. Mazar and Ms. Plimpton hurl their lines makes their characters unsympathetic and leaves the movie with an unintentionally misogynistic aftertaste.

Although Mr. Antin is pleasant enough as the beleaguered young screenwriter, his character is too passive to be compelling. And when the film pauses to show excerpts from his screenplay-in-progress, a documentary history of mass transit in Los Angeles, "Inside Monkey Zetterland" stops dead in its tracks.

"Inside Monkey Zetterland" is rated R (Under 17 requires accompanying parent or adult guardian). It has strong language and sexual situations.

1993 O 15, C12:5

Mr. Wonderful

Directed by Anthony Minghella; written by Amy Schor and Vicki Polon; director of photography, Geoffrey Simpson; edited by John Tintori; music by Michael Gore; production designer, Doug Kraner; produced by Marianne Moloney; released by Warner Brothers. Running time: 98 minutes. This film is rated PG-13.

Gus	Matt Dillon
Dominic	Vincent D'Onofrio
Lee	Annabella Sciorra
Rita	Mary-Louise Parker
Tom	William Hurt

By JANET MASLIN

"Mr. Wonderful" finds Matt Dillon playing Gus, a Con Edison electrical worker, and Annabella Sciorra playing Lee, Gus's ex-wife, who left him none too amicably and is now a college student. "Somebody please explain to me how I get into a situation where my ex-husband is finding me dates!" Lee cries exasperatedly at one point. Indeed, it would have been nice if the screenplay had explained that, since the dating gimmick becomes all too central to the plot. "Mr. Wonderful" is well cast and convincingly played, but its actors are hamstrung by the cute excesses of the story.

Gus is supposedly eager to marry off Lee so that he can stop paying alimony and sink his money into an abandoned bowling alley he plans to refurbish, with the help of four equally handy friends. Even viewers who buy that idea will have a hard time understanding why Gus and Lee, who supposedly hate each other, can spend so much time conspiring over Lee's social life. Lee has been seeing her English professor (William Hurt) and Gus has an adoring girlfriend, a nurse named Rita (Mary-Louise Parker). So in theory these ex-spouses are otherwise engaged.

But it's clear from the start that the film itself will mimic Gus's matchmaking tricks, and that the secondary players will be manipulated more and more arbitrarily as Amy Schor and Vicki Polon's screenplay moves along. By its last reel, "Mr. Wonderful" has become so crazily abrupt that it injures Gus badly enough to land him in the hospital, just so that he and Rita can be thrown together.

•

As directed by Anthony Minghella ("Truly, Madly, Deeply"), "Mr. Wonderful" does offer a captivatingly romantic view of New York. The city is made to seem amazingly bucolic, and it also becomes a place filled with colorful Con Edison work sites. (One of the film's typically cute flourishes has two minor characters having sex inside a Con Ed manhole.) But the story goes over the top when Gus grills every eligible-looking electrical worker on the 59th Street Bridge about his marital status, the better to find takers for Lee. As played by the always warmly down-to-earth Ms. Sciorra, Lee looks like she can manage just fine on her own.

Several of the performances run much deeper than the material, particularly Mr. Hurt's odd, uneasy turn as a married professor who affects a deliberately superficial air in seducing his student. Ms. Parker is especially good as a sweet, wishful young woman whose skittishness seems to indicate some fundamental pessimism behind her smile. Also in the film, and unfortunately wasted, is Vincent D'Onofrio as the pharmacist who falls hard for Lee, proclaiming himself "completely gaga" about her. No actor could make that phrase sound right.

Among the film's artificially snappy little extras is a couple who meet through a matchmaking ad (the title comes from this), an elevator full of strangers who give Gus advice, and a moment when the wives of Gus's buddies advise Rita to cry on gnocchi in order to win his love. The actors are at their most impressive when they make themselves lifelike at moments like these.

•

"Mr. Wonderful" is rated PG-13 (Parents strongly cautioned). It includes mild profanity and discreet sexual situations.

1993 O 15, C16:5

The Beverly Hillbillies

Directed by Penelope Spheeris; written by Lawrence Konner and Mark Rosenthal, and Jim Fisher and Jim Staahl, based on the television series created by Paul Henning; director of photography, Robert Brinkmann; edited by Ross Albert; music by Lalo Schifrin; production designer, Peter Jamison; produced by Ian Bryce and Ms. Spheeris; released by 20th Century Fox. Running time: 90 minutes. This film is rated PG.

Jed	Jim Varney
Elly May	Erika Eleniak
Granny	Cloris Leachman
Jethro	Diedrich Bader
Miss Hathaway	Lily Tomlin
Mr. Drysdale	Dabney Coleman
Barnaby Jones	Buddy Ebsen
Herself	Zsa Zsa Gabor
Herself	Dolly Parton
Tyler	Rob Schneider
Laura	Lea Thompson

By JANET MASLIN

Consider it a sign of the times that when "The Beverly Hillbillies" first appeared on television, the show was excoriated for lowering the level of popular taste. Now "The Beverly Hillbillies" has been lovingly expanded into a full-length movie, and it is by no means the dopiest thing on the big screen.

The director, Penelope Spheeris, doing her best to turn the cheerful no-brainer into an art form, has moved effortlessly from the purple haze of "Wayne's World" to the pink stucco mansion that becomes home to Hollywood's favorite hicks. In this setting, the film enshrines every last staple of the television series and also adds some modern references, like a distinct hint that the Clampetts of Arkansas are related to the Clintons. You'll hate yourself for enjoying this, but enjoy it you will.

•

Actually, there's a good bit of cunning behind the stylized idiocy of "The Beverly Hillbillies," starting with the idea of resurrecting this material at all. The Clampetts, you will recall, are backwoods rustics who become billionaires when Jed, the patriarch, accidentally strikes oil. (The film incorporates the television show's theme song explaining this, which will come as a relief to trivia nuts everywhere.) And they are quainter than ever in the modern world, as characters who have never

Deana Newcomb/20th Century Fox

Cloris Leachman

seen a satellite dish or been to a mall, and who keep body and soul together with specialties like road-kill stew. Elly May Clampett, the foxy blond tomboy who is seen outwrestling a bear in the film's opening moments, can even be viewed as a prehistoric feminist by those who are so inclined.

The idea of breaching Beverly Hills etiquette is also funnier than it used to be, particularly when Ms. Spheeris supplies the local high school girls with cellular phones and car fax machines. When the Clampetts arrive, filthy rich but crude enough to eat dinner off their billiards table, they set the place all the more emphatically on its ear. Free to go beyond the constraints of network television, Ms. Spheeris can also show them mistakenly assuming that a familiar angry gesture is "a Beverly Hills howdy," and howdying gaily at strangers on the freeway. If you can't identify the gesture, don't even think about becoming a highly paid, sophisticated Hollywood screenwriter in today's creative atmosphere.

"The Beverly Hillbillies" goes to great pains to mimic the television characters exactly, and the results can be weirdly gratifying. As the sniveling, officious Miss Hathaway, the schoolmarm type once played by Nancy Culp, Lily Tomlin appears to be having such a deliriously good time that she steals the movie. Cloris Leachman turns herself ferociously into Granny Clampett, the scrappy old bird first played by Irene Ryan. Erika Eleniak makes a delectably dim Elly May, and Jim Varney is impressively upright as Jed Clampett, in Buddy Ebsen's old role.

It's another sign of the times that Mr. Varney, best known for playing the moronic hero of the "Ernest" movies, is the most sober-sided actor in "The Beverly Hillbillies." And that Dolly Parton, who puts in a brief appearance, comes off as a virtual city slicker. Also in familiar roles are Dabney Coleman as the irascible banker Mr. Drysdale (now the proud owner of a photograph of himself with Richard Nixon), and Diedrich Bader as a grinning, slack-jawed Jethro Clampett. Mr. Bader, who seems unbearably imbecilic at first, becomes quite likable by the time the film has finished working its mindless magic.

"The Beverly Hillbillies" has enough low humor to delight teenagers and offend any semblance of a serious audience. But it also has a steady stream of gags and an enjoyably nonsensical plot, having to do with whether a sneaky gold digger (Lea Thompson), coached by her banker boyfriend (Rob Schneider), can pass herself off as a French governess and land Jed, a marriageable lonely guy. The film, which also incorporates cameos by Mr. Ebsen and (as a kind of Beverly Hills Poster Girl) Zsa Zsa Gabor, leaves itself wide open. Neither a sequel nor a "Real McCoys" revival can be far behind.

"The Beverly Hillbillies" is rated PG (parental guidance suggested). It includes profanity and gleeful vulgarity.

1993 O 15, C20:3

The Piano

Directed and written by Jane Campion; director of photography, Stuart Dryburgh; edited by Veronika Jenet; music by Michael Nyman; production designer, Andrew McAlpine; produced by Jan Chapman; released by Miramax. Running time: 120 minutes.

Ada	Holly Hunter
Baines	Harvey Keitel
Stewart	Sam Neill
Flora	Anna Paquin
Aunt Morag	Kerry Walker
Nessie	Geneviève Lemon

By VINCENT CANBY

Don't let the mountains of superlatives that have already been heaped on "The Piano" put you off: Jane Campion's 19th-century love story lives up to its advance notices. Prepare for something very special.

"The Piano" is much like its remarkable heroine, Ada (Holly Hunter), a mute (but not deaf) young Scots widow who, with her 9-year-old daughter, travels to the New Zealand bush to marry a man she has never met. Ada's husband-to-be calls her "stunted." The film looks deceptively small, but in character it's big and strong and complex. Here's a severely beautiful, mysterious movie that, as if by magic, liberates the romantic imagination.

"The Piano" will be shown at Avery Fisher Hall tomorrow night at 8:30, an especially celebratory choice to close this year's New York Film Festival, and will open its commercial run here on Nov. 19. It could be the movie sensation of the year.

●

You know you're in uncharted cinema territory early on. Ada and Flora (Anna Paquin), her pretty but gnomelike child, are dumped onto a wild New Zealand beach and then abandoned by the ship that's brought them halfway around the world. With their crated belongings (including Ada's beloved piano) spread around them on the sand, the mother and daughter spend the night alone, huddled inside a sort of tent made out of one of Ada's hoop skirts.

This is how they're found the next morning by Stewart (Sam Neill), the well-meaning but dangerously unimaginative man who has ordered Ada by mail; Baines (Harvey Keitel), an illiterate settler with a nose tattooed Maori-style, and the Maori tribesmen hired as bearers.

The confusion of emotions of the moment is echoed in the confusion of languages being spoken: English, Maori (translated by English subtitles) and the sign language by which Ada instructs Flora what to say to the others. When Ada and Flora want privacy, they both sign, which is also translated by subtitles. "The Piano" is full of secrets.

When a pushy woman later pumps Flora for information about her mother's inability to speak, the girl spins a wondrous tale. Her parents, according to Flora, were German opera singers, renowned and celebrated. One day they were caught in a terrible storm in the forest. Suddenly a bolt of lightning struck her father, who went up in flames, a veritable torch. From that day to this, Flora concludes with gravity, her mother has never said a word.

Miramax

Holly Hunter, rear, and Anna Paquin in Jane Campion's film "The Piano," which will close this year's New York Film Festival.

In fact, it's as good an explanation as any for Ada's singular incapacity.

More important, "The Piano" is the story of the heedless and surprising sexual passion that eventually erupts to unite the grossly crude Baines and the seemingly remote and reserved Ada, whose marriage to Stewart hasn't been a happy one. Things had begun badly when Stewart refused to transport her piano inland to their house.

Sometime later, Baines acquires the piano (still sitting on the beach) from Stewart for 80 acres of land. Baines retrieves the piano, then offers to return it to Ada if she will teach him how to play. He asks for one lesson for each key. They haggle, finally agreeing on one lesson for each black key.

In this way begins one of the funniest, most strangely erotic love stories in the recent history of film. Ada seems not at all surprised when, at the beginning of the first lesson in Baines's shack, he admits that he really doesn't want to learn how to play. Rather, he says, "there are things I'd like to do while you play." It begins by his having her lift her skirts a few inches as she sits at the piano. He stretches out on the floor, looking up.

One lesson leads to another. Soon he's proposing that she lie with him on his bed, fully clothed, the act to be the equivalent of five keys, or five lessons. Ada says 10 keys. Baines agrees. Meanwhile, Flora, who is told to stay outside during the lessons, becomes curious when the piano falls silent. She peeks, but holds her tongue for the time being.

There are things, though, that even this worldly child finds too much. One day when Stewart asks her where her mother has gone, Flora, with the wrath of an Old Testament prophet, shouts, "To hell!"

Like "Sweetie," Ms. Campion's marvelous first feature, "The Piano" is never predictable, though it is seamless. It's the work of a major writer and director. The film has the enchanted manner of a fairy tale. Even the setting suggests a fairy tale: the New Zealand bush, with its lush and rain-soaked vegetation, is as strange as the forest in which Flora says her mother was struck dumb.

Trips through this primeval forest are full of peril. When Ada goes off to her first assignation with Baines, she appears to be as innocent as Red Riding Hood. Yet this Red Riding Hood falls head over heels in love with the wolf, who turns out to be not a sheep in wolf's clothing, but a recklessly romantic prince with dirty fingernails.

Not the least of Ms. Campion's achievements is her ability to communicate the heady importance of sexual and romantic feelings to both Ada and Baines. Their love is a simultaneous liberation. The director's style is spare. No swooping camera movements over naked, writhing bodies. The camera observes the lovers from a distance, from the points of view of the spying child and then of the spying, fascinated and furious Stewart. It's as if the camera respected the lovers' privacy but felt compelled to show us what the others see.

●

Along with everything else, there is great wit in "The Piano."

The film's effect is such that it's almost impossible to consider the contributors separately. The four principal performances are extraordinary: Ms. Hunter, with her plain, steely beauty and intelligence; Mr. Keitel, so robust and intense in what could be an Oscar performance; Mr.

Neill, earnest and forever baffled, and the tiny Ms. Paquin, who is so sure of herself that she doesn't seem to be a child of this world.

The physical production, smashingly photographed by Stuart Dryburgh, is elegant without fanciness, which is the mark of Ms. Campion's work. She takes the breath away not by conventionally spectacular effects, but by the simple audacity of her choices about where to put the camera and what to show.

At one point we are staring at a vast, virgin beach, as it might have looked at the beginning of time. The next minute the camera is staring down into the contents of a teacup, seen in close-up. In such ways Ms. Campion somehow suggests states of mind you've never before recognized on the screen.

●

"The Piano" has been rated R (Under 17 requires accompanying parent or adult guardian). It has one scene of brutal, bloody violence and another of nudity and sexual play.

1993 O 16, 13:1

Calendar

Directed and written by Atom Egoyan; director of photography, Norayr Kasper; produced by Doris Hepp; released by Zeitgeist Films. At Alice Tully Hall, Lincoln Center, as part of the 31st New York Film Festival. Running time: 75 minutes. This film has no rating.

Translator..............................Arsinée Khanjian
Driver...Ashot Adamian
Photographer..............................Atom Egoyan

Moving In

Directed and written by Chantal Akerman; director of photography, Raymond Fromont; edited by Rudi Maerten; produced by Sophie Goupil. Running time: 37 minutes. This film has no rating.

With: Sami Frey.

By STEPHEN HOLDEN

The emotional twists and turns of Atom Egoyan's film "Calendar" are so thoroughly intertwined with communications gadgetry that the movie might almost as well have been called "Sex, Lies, Videotape, Film, Telephone and Answering Machine."

In the movie, which has been pieced together like an elaborate jigsaw puzzle, Mr. Egoyan portrays a Canadian photographer hired to take pictures of ancient Armenian churches for a glossy calendar. Accompanying him on the journey, shown in flashbacks, are his wife (Arsinée Khanjian), who serves as his translator, and a driver (Ashot Adamian), who turns out to be a walking encyclopedia of the architecture being photographed. Only gradually does it emerge that somewhere during the trip a romantic triangle has formed that will eventually lead the photographer's wife to remain in Armenia after her husband returns to Canada.

"Calendar," which the New York Film Festival is showing tonight at 6 on a bill with Chantal Akerman's short film, "Moving In," is a typically labyrinthine exercise in psychological scrutiny by Mr. Egoyan. For the Canadian director and screenwriter, who was born in Cairo and brought up in Armenia, it also feels like an exploration of his own ancestral ties and the ways they tug at him. Very deli-

Film Society of Lincoln Center

Arsinée Khanjian, left, and Ashot Adamian in the film "Calendar," which will be shown tonight at the New York Film Festival.

cately, it implies that the technology that allows us to preserve beautiful, monumental images of the past also threatens to alienate us from the spiritual essence of that past.

●

The photographer is so caught up in the technical demands of his assignment that he is indifferent to the actual history of the structures, which the guide explains were selected and built according to specific religious dictates. His detachment also allows his wife, for whom the trip is a spiritual revelation, to drift away from him. On returning home alone, he uses that technology to try to decode the truth of a situation he was too preoccupied to realize would separate them. And he obsessively replays a video record of his trip to try to determine the moment his wife's relationship with the driver became romantic.

In the film's wittiest scenes, the photographer has a series of identical dinners with attractive women of Middle Eastern descent whom he has met through a personal ad. Toward the end of each rendezvous, his date excuses herself to make a telephone call, during which she is shown transformed from a polite English-speaking dinner companion into a passionately engaged woman speaking to an unidentified party in an unsubtitled Middle Eastern language. Interspersed with the dates, which the photographer treats as interviews for replacements for his wife, are her own long, exasperated phone messages from overseas, left on his answering machine.

If "Calendar," like such earlier Egoyan films as "The Adjuster" and "Speaking Parts," has to be pieced together backward, it is so finely constructed and beautifully acted a movie that its game of detective is quite enticing. Seamlessly edited, the film sustains a visual rhythm that is as confident as it is edgy. And the juxtaposition of ancient Middle Eastern

music with modern blues neatly underscores the story's psychological tug of war. Recurrent images — videotape of the travelers driving through a sheep herd, the finished calendar perched next to the photographer's telephone — acquire a subtly potent resonance. The performances, especially Miss Khanjian's as the passionate, free-spirited wife, have the fluency and naturalness of real-life moments stolen for the camera.

Chantal Akerman's film, which makes an ideal prelude to "Calendar," shares Mr. Egoyan's interest in the elusive souls of things, in this case a room and its associations. The film is an extended monologue by the French actor Sami Frey, as a man who just moved into a sterile new apartment. As he recalls his old home, his memory settles on a particular summer years ago, when he lived next door to three attractive young women. Methodically, with an academic precision, he recalls the details of how they looked and talked. It gradually becomes clear that he was rapturously in love with all three.

As he reminisces, the camera inches imperceptibly closer, so that by the end of the 37-minute film, his drawn face nearly fills up the screen, and he is shown fighting back tears. A film that starts out seeming like a dry exercise in recall slowly assumes a rich emotional hue. Mr. Frey's prominence as an actor in the French New Wave cinema lends the monologue the feel of an elegy for a finer and braver film-making era that has slipped into legend.

1993 O 16, 18:1

Strictly Propaganda

Written and directed by Wolfgang Kissel; executive producer, C. Cay Wesnigk; released by First Run Features. Film Forum 1, 209 West Houston Street, South Village. Running time: 94 minutes. This film is not rated.

Narrated by Manfred Krug.

By JANET MASLIN

"Strictly Propaganda" offers a virtual-reality-style voyage into a brave new world, a place where housewives tirelessly salvage bricks from bombed-out rubble and children sing sweetly about wanting to join the army some day. If the effect of such scenes is disorienting, it ought to be, since this documentary consists entirely of excerpts from East German newsreels and educational material. Promoting everything from sex education for teen-agers to steamer cruises on the Volga, each of these snippets has its own blunt agenda. "Show us where children are not so well off," a teacher asks a student, spinning a globe. "Yes! Where capitalism dominates! A good answer."

Using no narration, interruptions or other means of breaking the spell, Wolfgang Kissel has strung together a riveting series of vignettes, each of them intended to sway the audience in what now seem laughably clumsy ways. Despite the dated, unbecoming light in which they now appear, though, these scenes are ultimately too sad and serious to play like anything out of "Reefer Madness." Spanning 40 years' worth of East German history, "Strictly Propaganda" documents endless deceptions, variously large or insignificant, that add up to a national tragedy. Mr. Kissel makes his film all the more disturbing by never stopping to contrast real events with their absurdly sunny, inspirational counterparts on screen.

●

"Strictly Propaganda" begins just after World War II, as East Germans are seen dividing their time between cheerful rebuilding efforts and extravagant homages to Stalin. Blond children in Lederhosen (a visual staple of this sort of film making) are seen celebrating peace, shunning toy cannons and gathering at the feet of public officials to learn valuable lessons. "It's the biggest honor I've ever received," the minister of culture tells his captive young audience, about a prize that has come his way. "It's coupled with the name of Stalin, the best friend of my people." On a related note, the film witnesses the joyous ceremonial naming of an ironworks collective combine in Stalin's honor.

Who can have been fooled by newsreels celebrating the triumph of a miner who dug four times his quota's worth of coal? Or by the promotional material praising a state-run department store, ridiculing the thought of inferior merchandise or shortages? The specifics may be far-fetched, but the scenes included here take on a cumulative power. Compressing four decades' worth of manipulation into an hour and a half, this film successfully conveys just how maddening and debilitating such information can be over time.

●

The more frequently one sees well-scrubbed schoolchildren proudly parroting official state sentiments, the less easy such images are to resist. Only the absurd particulars that are included here, like the claim that East Germany's Wartburg automobile will inevitably outsell the Volkswagen, or the explanation of why East German military uniforms are more honest than American-style ones, help to bring the film firmly back to earth.

One of the dicier periods covered by "Strictly Propaganda," which opens today at the Film Forum, is the late 1960's, when neat, obedient children were unusually hard to find. Mr.

Kissel includes a remarkable training film in which high school teachers are taught how to answer unpleasant questions from budding counterrevolutionaries in the classroom. In contrast to the kindergarten students seen delighting in a visit from soldiers (and being told that their drawings of little golden suns are just like the stars on the soldiers' epaulettes), these older students show signs of having passed right out of the realm of propaganda and into the real world.

1993 O 20, C22:3

Flight of the Innocent

Directed by Carlo Carlei; screenplay (in Italian, with English subtitles) by Mr. Carlei and Gualtiero Rosella, based on a story by Mr. Carlei; director of photography, Raffaele Mertes; edited by Carlo Fontana and Claudio Di Mauro; music by Carlo Siliotto; production designer, Franco Ceraolo; produced by Franco Cristaldi and Domenico Procacci; released by MGM and Rocket Pictures. Running time: 105 minutes.

Vito	Manuel Colao
Marta Rienzi	Francesca Neri
Davide Rienzi	Brendan Fraser
Scarface	Federico Pacifici
Vito's Father	Sal Borgese

By VINCENT CANBY

"Flight of the Innocent," an Italian film by Carlo Carlei, is about the desperate attempt of a wide-eyed, remarkably self-sufficient 10-year-old Calabrian boy named Vito (Manuel Colao) to escape his southern Italian heritage.

In an opening sequence, Vito is the terrified witness to the massacre of his entire family by the members of another Calabrian family that wants to cut itself in on the profits of a kidnapping. It seems that Vito's father and older brothers, made destitute by a social system that ignores them, have turned to crime. They have kidnapped the son of a rich Roman couple and have been holding the child for ransom.

Thus begins Vito's somberly picaresque journey, as he is pursued by a murderous peasant with a weather-beaten face scarred like a pirate's. In Rome, there's an encounter with Vito's cousin, which ends badly; with double-crossing family friends; with the police, and, finally, with the parents of the kidnapped boy.

"Flight of the Innocent" is the first theatrical feature to be directed by Mr. Carlei, who is 31 and was apparently something of an ace student in film school. This precociousness is evident in "Flight of the Innocent." It is full of handsome if borrowed cinematic effects, which are presented with such enthusiasm and giddy pride that they get in the way of the solemn nature of the movie itself.

Mr. Carlei likes point-of-view shots. These often have less to do with how Vito sees the world than with films the director admires, including, it would seem, Sam Peckinpah's early blood ballets ("The Wild Bunch," among others), in which bullet-ridden bodies spurt slow-motion blood. This emphasis on visual fanciness also obscures and softens the true horror of the child's situation.

The film's short, Fellini-esque fantasy sequences work better. They define Vito's vague longings for a world in which irreconcilable enemies, living and dead, can sit down together to feast in a peasant child's idea of paradise.

"Flight of the Innocent" suggests that Mr. Carlei will do better things in the future. One thing is sure already: he obtains a very effective, believably reserved performance from his young leading actor, Mr. Colao, a Calabrian schoolboy who had never acted before.

•

"Flight of the Innocent" has been rated R (Under 17 requires accompanying parent or adult guardian). The film has a lot of graphic, bloody violence.

1993 O 22, C8:5

Twenty Bucks

Directed by Keva Rosenfeld; screenplay by Leslie and Endre Bohem; director of photography, Emmanuel Lubezki; edited by Michael Ruscio; music by David Robbins; production designer, Joseph T. Garrity; produced by Karen Murphy; released by Triton Pictures. Running time: 91 minutes. This film is rated R.

Angeline	Linda Hunt
Baker	David Rasche
Jack	George Morfogen
Anna	Sam Jenkins
Sam	Brendan Fraser
Mrs. McCormac	Gladys Knight
Emily Adams	Elisabeth Shue
Frank	Steve Buscemi
Jimmy	Christopher Lloyd
Stripper	Melora Walters
Bobby McCormac	Kamal Holloway
Policeman	William H. Macy
Ruth Adams	Diane Baker
The Priest	Spalding Gray

By JANET MASLIN

Endre Bohem wrote his draft of the screenplay for "Twenty Bucks" in 1935, but it wound up on the shelf. It sat there for nearly 50 years, at which point Mr. Bohem turned the idea over to Leslie Bohem, his son. In the early 80's the younger Mr. Bohem was a bass player for the rock band Sparks, but he was in the market for a career change. So he picked up the abandoned script and made it the basis for Keva Rosenfeld's first dramatic feature, a charming, offbeat tale shaped whimsically by the hand of fate.

In the process of writing their screenplay, the Bohems provided a prime example of the kind of gentle coincidence that governs their story. "Twenty Bucks" follows a single $20 bill from birth (at a cash machine) to death (torn, tattered and returned to a bank for shredding). And it stands by bemusedly as the currency passes from owner to owner. This conceit has great potential for ponderousness, but Mr. Rosenfeld (whose previous films have been documentaries) succeeds in reading almost nothing into the money's movements. It simply drifts through the lives of different people, sometimes pausing long enough to alter their luck.

"Twenty Bucks" can be enjoyed as a brief, modest variation on "Short Cuts," another film that weaves together interlocking stories with tireless sleight-of-hand. Mr. Rosenfeld skillfully links 50-odd speaking parts to the destiny of his $20 bill, and brings back certain characters (like Melora Walters, as a stripper who later turns up working in a funeral parlor) in nicely unexpected ways. This film sustains its playful touch without ever bothering to announce that money is the root of all evil, or that its characters have somehow become compromised by allowing the tainted 20 into their lives. It also achieves a much droller, more lighthearted tone than most films developed under the Sundance Institute's earnest auspices.

•

The money moves fast in the film's opening scenes: it blows from the bank to a derelict with dreams of winning the lottery (Linda Hunt), and is then whisked out of her hands by a boy on a skateboard, who spends it at a bakery. Through that connection, the money falls into the hands of the Holiday family, Arab-Americans in the process of buying an uncommonly elaborate, ambitious wedding cake.

The groom marrying into this wealthy family is Sam (Brendan Fraser), and he is astonished to learn that his future father-in-law (George Morfogen) plans to make the $20 a symbolic wedding gift to the newlyweds. Sam, who had in mind something a bit less symbolic, winds up bestowing the money upon the practical-minded stripper (Ms. Walters) who has been hired to show up at his bachelor party. By the time Sam's fiancée (Sam Jenkins) also appears and asks for the $20, the stripper is being ordered out the window to hide. "Fire escape's gonna cost you an extra $50," she explains.

The money reaches a critical juncture when it winds up at the coffee shop where Emily (Elisabeth Shue), the film's most substantial character, works as a waitress. This coffee shop also helps bring together two petty crooks (Christopher Lloyd and Steve Buscemi), one much smarter than the other, and a grandmother (the singer Gladys Knight) who means to send $20 to her grandson for his birthday. The grandson, Bobby (Kamal Holloway), is one of the film's typically eccentric surprises, since he is a teen-age boy pretending he has his own cooking show, and needing white wine to put in his cassoulet. A film that can use this as a plot pretext can also naturally cast Spalding Gray as a talkative priest.

Ms. Hunt, waxing poetic about the lottery and what it can do for hopes and dreams, plays one of the few overripe characters in "Twenty Bucks." This film, which also works in William H. Macy as a policeman and Diane Baker as someone whose secret for great apple pie is not using any apples, is otherwise most impressive for its restraint. Mr. Rosenfeld manages to take a premise that is all contrivance and make it seem natural, as if every bit of legal tender had such a colorful life, or such an attentive camera to follow it around. The city of Minneapolis provides "Twenty Bucks" with bland, normal-looking backdrops that are somehow ideally suited to a money-minded modern tale.

•

"Twenty Bucks" is rated R (Under 17 requires accompanying parent or adult guardian). It includes nudity, profanity and brief violence.

1993 O 22, C8:5

Chasing Butterflies

Written, directed and edited by Otar Iosseliani; in French, with English subtitles; director of photography, William Lubtchansky; music by Nicolas Zurabichvili; produced by Martine Marignac; released by New Yorker Films. At Lincoln Plaza Cinemas, Broadway at 63d Street. Running time: 115 minutes. This film is not rated.

Solange	Narda Blanchet
Valérie	Pierrette Pompom Bailhache
Henri de Lampadère	Alexandre Tcherkassoff
Marie-Agnès de Bayonette	Thamar Tarassachvili

New Yorker Films Release

Pierrette Pompom Bailhache

Hélène von Zastro	Alexandra Liebermann
Olga	Lilia Ollivier
Father André	Emmanuel de Chauvigny
The Maharajah	Sacha Piatigorsky

By VINCENT CANBY

"Chasing Butterflies" ("La Chasse aux Papillons") is the new French film by Otar Iosseliani, a director from Russian Georgia who's proud of it. He resents being identified as Russian and describes most of the directors who flourished in the former Soviet Union as whores and hypocrites. This may be why Mr. Iosseliani, who was born in Tbilisi in 1934, has been making films in Western Europe since 1984.

"Chasing Butterflies," which opens at the Lincoln Plaza Cinemas today, is my second encounter with Mr. Iosseliani's work, the first being his lugubriously surreal "Favoris de la Lune," released here as "Favorites of the Moon" in 1985. He's a taste I've yet to acquire.

The new film is best approached through information supplied by its American distributor, whose publicity notes describe it as "a whimsical comedy of social decline by one of Europe's most skilled satirists." You could have fooled me. It isn't that. "Chasing Butterflies" is difficult to understand, only that it works so hard and randomly for such small effect.

•

"Chasing Butterflies" takes a very long, very leisurely look at life in a small, picturesque French village. The film initially makes so much of the quaintly alcoholic country priest that he seems to be the central character. Not at all. The movie then moves on to the inhabitants of a formerly grand, now rundown local chateau. It's presided over by Solange (Narda Blanchet), a vigorous old lady who's the cousin of the chateau's owner, Marie-Agnès de Bayonette (Thamar Tarassachvili), a somewhat younger woman confined to a wheelchair.

For a while the film watches Solange, who plays the organ at church, is a member of the local brass band and, when fish is required for dinner, goes out to shoot them with a bow and arrow in the chateau's pond. Meanwhile, Marie-Agnès is having a little target practice with her pistol on the lawn while being serenaded by her Hari Krishna guests. The people in the neighboring chateau are equally eccentric. The dogs there are required to wear white socks so as not to scratch the parquet floors.

When Marie-Agnès suddenly dies, Mr. Iosseliani takes the opportunity to lampoon, in his singularly heavy fashion, the greediness of the potential heirs and antiques dealers and the foolishness of Marie-Agnès's sister and niece from Moscow. He also seems to have just heard that Japanese businessmen have a lot of money with which to acquire real estate abroad.

The film maker cites Luis Buñuel and Jacques Tati as two of his idols. The Buñuel influence does not show up in his style, but Mr. Iosseliani does crib from the plot of "That Obscure Object of Desire." From Tati he has learned to keep his camera in the middle distance as much as possible.

Tati did this so that the audience could see not only the gag in the middle of the screen, but also its effects on the people and objects on the periphery. Mr. Iosseliani's problem is that the action at the center of the screen is usually predictable or just witless. In a Tati comedy, every frame is packed with hilarious information. Mr. Iosseliani's frames look empty.

"Chasing Butterflies" seems endless and excruciating, like a phonograph record played at half speed.

1993 O 22, C10:6

New York in Short

At Cinema Village, 22 East 12th Street, Greenwich Village.

THE SHVITZ. Directed and produced by Jonathan Berman; cameramen and camerawoman, Evan Estern, Laurence Salzmann and Ellen Kuras; film editor, Amanda Zinoman; composer, the Klezmatics/Frank London. Running time: 50 minutes. This film has no rating.

LET'S FALL IN LOVE: A SINGLES' WEEKEND AT THE CONCORD HOTEL. Directed and produced by Constance Marks; director of photography, Michael Mayers; edited by Deborah Dickson. Running time: 30 minutes. This film has no rating.

By STEPHEN HOLDEN

"The Shvitz," Jonathan Berman's rambling documentary history of New York steam baths, is only 50 minutes long. But so much of the film is devoted to showing pot-bellied, hairy-chested men over 50 waddle around in towels and drip sweat that watching it is not unlike sitting in a steam room too long. You are likely to leave the film feeling wrung out rather than energized.

The film, the longest part of "New York In Short," a double bill at the Cinema Village exploring Jewish life in New York City, wants to be a jolly celebration of a healthful tradition that Eastern European Jews brought with them to America. At one time, New York City had more than 200 steam baths, many of them in Brighton Beach in Brooklyn. "The Shvitz" tours Brighton Beach and the Lower East Side of Manhattan, weaving vintage film and photographs with interviews, with longtime patrons of the baths.

But in a film that relies almost totally for coherence and wit on the anecdotes and observations of bathhouse aficionados, not one memorable storyteller appears. And the film's token effort to relate the history of gay bathhouses to the Eastern European tradition is so sketchy that it is more confusing than enlightening.

Constance Marks's 30-minute film, "Let's Fall in Love: A Singles' Weekend at the Concord Hotel," is better organized and more fun. But its study of an adult mixer at the famous Catskill resort hotel feels like a sketch for a longer movie.

Limiting itself entirely to the events of a single weekend, the movie tracks the romantic fates of more than half a dozen visitors who have arrived hoping to meet their future spouses. They range from spry singles in their 60's and 70's to sleekly tended young women who say they will settle for nothing less than "athletic multimillionaires." The star entertainer is a gaunt-looking B. J. Thomas, who is shown singing his hit, "Raindrops Keep Fallin' on My Head," a song that captures the spirit of the weekend as much as any conversation.

Although the meat-rack atmosphere has its grotesque aspects, those whom the movie follows around appear to be a remarkably practical and resilient bunch of go-getters with no illusions about what they're doing. They seem almost to relish the jungle-like rules of the game. The smartest operator on the premises is a young man who meets girls by cradling a shaggy white dog in his arms. It is the ultimate bait and icebreaker for a horde of cooing dog-lovers.

1993 O 22, C13:1

By the Sword

Directed by Jeremy Kagan; written by John McDonald and James Donadio; director of photography, Arthur Albert; edited by David Holden; music by Bill Conti; production designer, Gary Frutkoff; produced by Peter E. Strauss and Marlon Staggs; released by Hansen Entertainment. At the 34th Street Showplace on Second Avenue, Manhattan. Running time: 90 minutes. This film is rated R.

Maximilian Suba	F. Murray Abraham
Alexander Villard	Eric Roberts
Clavelli	Mia Sara
Trebor	Chris Rydell

By VINCENT CANBY

"By the Sword" is a half-baked little movie about modern fencing as a sport and a way of life. F. Murray Abraham and Eric Roberts star in the film, which was directed by Jeremy Kagan and written by John McDonald and James Donadio. It opens today at the Loews 34th Street Showplace.

Mr. Abraham plays Maximilian Suba, a once-ambitious fencing wizard who has spent the last 25 years in prison, atoning for the murder of his mentor during a fencing match. Mr. Roberts is Alexander Villard, the murdered man's son.

The principal setting is Villard's fencing academy in New York City. On his release from prison and using a false name, Suba goes to the academy to seek work and to find out how the boy he left fatherless has fared in the world. Suba is astonished and dismayed. Villard, having retired as an undefeated champion, is teaching his students to be just as ruthless and ambitious as Suba once was.

The older man accepts a job as a janitor to keep an eye on things, gradually insinuating himself to the extent that he becomes an instructor. Suba wants to straighten out Villard and to save the honor of fencing. Or so it seems.

All of this is laid out with fewer surprises and less dramatic punch

than you might expect in a Julia Child television show on how to make a basic roux. The fencing terms are arcane, but the movie itself could as well have been about croquet. The drama is fraught with anticlimax. The actors, their roles being incoherent, spend their time behaving with an intensity that emphasizes their panic instead of disguising it.

The screenplay is terrible, full of unfinished subplots and lines that appear to announce its essential aimlessness. You know a movie is in trouble when one character asks another, "Why are you telling me this?" It's as if some gremlin deep inside the screenwriters' computer could not process this nonsense without registering a token complaint.

"By the Sword" is rated R (Under 17 requires accompanying parent or adult guardian). It has vulgar language and some violence.

1993 O 22, C15:1

No More Mr. Nice Guy

Directed by Detlev Buck; screenplay by Ernst Kahl and Mr. Buck; director of photography, Roger Heereman; edited by Peter R. Adam; music by Detlef Petersen; produced by Claus Boje; released by Cinepool. Joseph Papp Public Theater, 425 Lafayette Street, East Village. Running time: 92 minutes. This film is not rated.

Rudi Kipp	Joachim Krol
Most Kipp	Horst Krause
Viktor	Konstantin Kotljarov
Nadine	Sophie Rois
Kommissar	Heinrich Giskes

By STEPHEN HOLDEN

German cinema has never been known for the richness and variety of its comic tradition. That may be why "No More Mr. Nice Guy," an absurdist road film by the German director Detlev Buck, huffs and puffs so hard to produce only a few mild chuckles.

The film, which opened on Wednesday at the Joseph Papp Public Theater, follows the misadventures of Rudi Kipp (Joachim Krol) and his brother, Most (Horst Krause), as they travel across the country in a rickety pickup truck. The destination of the brothers, who are illiterate and insane (Rudi is picked up by Most in front of a mental hospital from which he has just escaped), is a property in eastern Germany that they have inherited from their grandmother. When they eventually reach their goal, it is not exactly the lavish estate they had fantasized.

Early in their trip, a machine-gun-toting deserter from the Russian army named Viktor (Konstantin Kotljarov), jumps into their vehicle and demands to be driven to the Russian frontier. More trouble arrives when a gang of highwaymen block the road and hold them up for money. Waving his machine gun, Viktor frightens them off and forces them to drive their car backward into a lake.

Farther along on their journey, they are talked into spending all their money on a rowboat, which the dimwitted Rudi imagines will transport them to Scandinavia. Before long, the idiotic threesome become the focus of a countrywide manhunt presided over by a pompous police commissioner (Heinrich Giskes), who mobilizes a small army of officers and helicopters to track them down.

"No More Mr. Nice Guy" would suggest a Germanic answer to Bertrand Blier's "Going Places" if that film's two brothers had been played by members of Monty Python instead of Gérard Depardieu and Patrick Dewaere. As the movie clumps along, it also presents a picture of contemporary Germany that is sharply divergent from the common image of a supersleek modern industrial power.

The terrain takes the trio through backwoods areas inhabited by crude, beer-guzzling peasants and surly working people. Except for the modern technology, they could be medieval travelers on a chaotic road for which there are no maps.

1993 O 23, 16:1

FILM VIEW/Caryn James

'Demolition Man' Makes Recycling an Art

WHAT DO THE NEW YORK City Department of Sanitation and the action-movie industry have in common? A passionate belief in the motto: "Recycling! It's the law!"

New York uses the slogan to threaten miscreants who fail to tie up old newspapers. But the city lags far behind Hollywood, where the unwritten law is that no successful movie concept can ever be tossed out. After "Die Hard," who would dare make an action film without shattering an abundant amount of glass?

Oddly, this fear of innovation has a bright side. "Demolition Man," the new Sylvester Stallone-Wesley Snipes hit, knowingly takes recycling to a head-spinning, enjoyable extreme. Rarely has a film tossed in so many jokey references to old movie plots, commer-

Rarely has a film tossed in so many jokey references to old movie plots, commercial jingles and television characters.

cial jingles, television characters. The dunderhead story concerns a policeman (Mr. Stallone) and a criminal (Mr. Snipes) who are frozen in 1996 and thawed out to stalk each other again in 2032. That idea becomes a futuristic-action-comedy-cop movie, though that doesn't begin to exhaust all the elements salvaged from the pop-culture junk heap.

Recycling is the precise word for what this glib entertainment is up to. There is no reinvention, no arch post-modernist sensibility involved. Instead, the scattershot allusions — some clever, some goofy — become a nontaxing game, like spotting celebrities in "The Player."

Along the way, "Demolition Man" provides a case study in how to build an action film out of spare parts. Here is a glimpse at some of its proudly recycled elements.

Parts Lifted From Other Movies

If you steal boldly from other movies, theft becomes homage. Could the blown-up building at the start of "Demolition Man" be a homage to the exploding high-rise that kicks off "Lethal Weapon 3"? For a hint that it is, notice the conspicuous "Lethal Weapon 3" poster in the office of Lenina Huxley (Sandra Bullock), the policewoman fascinated with the ancient history of the 20th century.

The fires burning amid the rubble of Los Angeles in 1996 bring to mind the apocalyptic vision of "The Terminator." So does the way a car plows into the front of a police station, just like the original-flavor Terminator did.

Of course, the apocalyptic debris also resembles that in the Mad Max trilogy. And Mr. Snipes's costume (it's supposed to be armor but looks like rubber) could have been borrowed from "Beyond Thunderdome."

Don't forget "Blade Runner" and "Sleeper" for futuristic inspiration. And the invented language of "Demolition Man" ("Mellow greetings") suggests a defanged version of "A Clockwork Orange."

Old Familiar Tunes

In the future world of "Demolition Man," oldies are commercial jingles. A nutty idea? Not when you consider how familiar these tunes are right now.

Lenina and her partner belt out that old standard, "Hot dogs! Armour hot dogs!"

A nervous cop calms himself by singing the ever-soothing Ken-L Ration jingle, "My dog's better than your dog."

At Taco Bell a lounge singer croons about "The valley of the jolly, ho ho ho" — you know the rest.

Easy-Listening Pop References

They're simple to grasp and oh-so-reassuring in a weird future world.

Mr. Snipes takes a gun from a mannequin and says, "Rambo, I need to borrow this." (Double points for the Stallone reference.) He calls a manipulative mayor with a soothing manner "an evil Mr. Rogers."

And in the future, it seems there will be a Schwarzenegger Presidential Library.

High-Art References

These are used sparingly. Wayne and Garth have to understand this film, too.

The story's starving underclass is literally under, living below ground in an area called the Wasteland.

The exotic French playwright and film maker Jean Cocteau might have enjoyed seeing the evil governor named after him, as well as the Cocteau CryoPenitentiary.

Lenina Huxley is as literary as this movie gets. Her family name, of course, comes from Aldous Huxley, author of "Brave New World," in which the character Lenina Crowne travels to the Savage Reservation in New Mexico to see samples of primitive humans on display. To the Lenina of "Demolition Man," the unfrozen cop and villain seem primitive, but can you trust the judgment of a woman who likes the "Love Boat" theme? Some things ought never to be recycled. □

1993 O 24, II:11:1

The Architects

Directed by Peter Kahane; written (German, with English subtitles) by Thomas Knauf and Mr. Kahane; director of photography, Andreas Kofer; edited by Ilse Peters; produced by DEFA-Studio Babelsberg, Potsdam. At the Joseph Papp Public Theater, 425 Lafayette Street, East Village. Running time: 95 minutes. This film has no rating.

Daniel Brenner	Kurt Naumann
Wanda Brenner	Rita Feidmeier
Renate Reese	Uta Eisold
Martin Bulla	Jürgen Watzke
Franziska Scarf	Ute Lubosch
Elke Krug	Catherine Stoyan

By STEPHEN HOLDEN

Some of the most telling moments in Peter Kahane's film "The Architects," a somber, finely drawn portrait of life in East Berlin in the final days of the Communist regime, are long panning shots of the city's ugly, factorylike public housing. Shot from moving cars, these views of block after block of anonymous rectangular buildings evoke a joyless environment in which the imagination is systematically stifled and where people live in a state of chronic, low-grade depression.

The film depicts this society's grinding down of Daniel Brenner (Kurt Naumann), an idealistic architect in his late 30's. Daniel, like many others of his generation, is deeply frustrated by life under the Communists but somehow tolerates it. Hired to design a miniature city on the fringe of Berlin, he fools himself into thinking that he can counteract the prevailing gloom with a cheerier, more innovative approach. Working with a hand-picked team of friends who were classmates in architecture school, he comes up with a design that incorporates rooftop gardens and modern sculptures and that has architectural variety and generous breathing space.

Daniel's absorption in the project costs him his marriage; his wife, Wanda (Rita Feidmeier), is fed up with a life of scarcity and low expectations. And when he submits his

plans to the powers that be, they denounce his innovations as frivolous and costly and insist on compromises. A typical demand is that a sculpture titled "Family in Stress" be renamed "Family in Socialism." The scenes in which Daniel confronts the scornful, intransigent bureaucrats, who address him as though he were a disobedient child, have a chilling psychological conviction.

"The Architects," which opens today at the Joseph Papp Public Theater as part of its Germany in Autumn series, is drenched in a mood of edgy despair. And more than any film in recent memory, it portrays the destructive impact that a spiritually cold environment can have on the human spirit. When the attractive, high-strung Wanda leaves Daniel, it is clear that it is the drabness of their lives more than any lack of love that drives her away. Their breakup scenes are acute, superbly acted depictions of a marriage coming apart.

The decay of a society isn't always signified by a flashy Roman orgy. As "The Architects" suggests, it can be synonymous with a pervasive, souldeadening dreariness.

1993 O 27, C14:3

Fatal Instinct

Directed by Carl Reiner; written by David O'Malley; director of photography, Gabriel Beristain; edited by Bud Molin and Stephen Myers; music by Richard Gibbs; production designer, Sandy Veneziano; produced by Katie Jacobs and Pierce Gardner; released by MGM. Running time: 89 minutes. This film is rated PG-13.

Ned Ravine	Armand Assante
Laura	Sherilyn Fenn
Lana Ravine	Kate Nelligan
Lola Cain	Sean Young
Frank Kelbo	Christopher McDonald
Max Shady	James Remar
Judge Skanky	Tony Randall

By JANET MASLIN

"Fatal Instinct" is Carl Reiner's hit-or-miss film noir parody, a collec-

Steve Schapiro/Metro Goldwyn Mayer
Armand Assante

tion of gags that vary much too wildly in terms of timing and wit. All that hold this comedy together are a playful outlook and a conviction that detective stories are intrinsically funny, especially if the detective is as much of a blockhead as Ned Ravine. As played by Armand Assante, Ned is a bit too convincingly dense, but he does make a useful fall guy.

Even if Mr. Assante doesn't approach the level of Leslie Nielsen's inspired obliviousness in the "Naked Gun" comedies, he can sound suitably solemn when delivering lines like: "Women are an open book. You know how to read 'em, you can always tell the apples from the peaches." The absurdity is heightened by the fact that Ned happens to be both a policeman and a lawyer (a situation that eventually yields the newspaper headline "Cop Arrests Wife in Murder — Will Defend Her in Court"). He also happens to need cue cards to read suspects their Miranda rights when he arrests them.

"Fatal Instinct," with a screenplay by David O'Malley, uses Ned as an excuse to string together random memories of other movies. Ned is pursued by the beautiful, troublesome Lola Cain (Sean Young), who has developed a romantic obsession with him even though he can't tell "Madama Butterfly" from Iron Butterfly ("Fatal Attraction"). Lola doesn't wear underwear, which is about as clever as Mr. Reiner's film can be about "Basic Instinct," though that film is certainly ripe for parody. Meanwhile, Ned's wife, Lana (Kate Nelligan, doing a sly Barbara Stanwyck turn), behaves like a seductress out of James M. Cain as she enlists her lover (Christopher McDonald) in a plot to get rid of Ned. Another of the story's relatively quaint ingredients is the devoted secretary (Sherilyn Fenn) who would be a pure 1940's nice-girl type if she weren't also terrified of her abusive husband, à la Julia Roberts in "Sleeping With the Enemy."

●

The job of cobbling together all these elements is often cumbersome. "Fatal Instinct" is funnier when it stops trying to make sense. One of the film's gambits involves throwing together Max Shady (James Remar, very amusing in this small role), a tattooed stalker out of Martin Scorsese's "Cape Fear," with Ms. Young's Lola as they both pursue Ned. By the end of the story, Mr. Reiner can stage several different violent showdowns simultaneouly, even throwing in a "my sister" slapping scene from "Chinatown."

Some of these comic collisions, particularly a hat-modeling montage mixing up "Cape Fear" with "Sleeping With the Enemy," have a silliness

that really is inspired. But parts of the film are also creaky and strained. Mr. Reiner repeats certain gags much too steadily (like the many shots of Ms. Young's high-heeled foot trailing litter). And he slows down for sequences that have no particular point, especially the laboriously flirty conversations involving Ms. Young. Cast rather mischievously as a stalker, Ms. Young flounces through the film playing her femme fatale role to the hilt and beyond. Subtlety is hardly the mainstay of this type of send-up, but sometimes it does help.

●

"Fatal Instinct" is rated PG-13 (Parents strongly cautioned). It includes sexual references and mild profanity.

1993 O 29, C8:1

Return of the Living Dead 3

Directed by Brian Yuzna; written by John Penney; director of photography, Gerry Lively; edited by Christopher Roth; music by Barry Goldberg; production designer, Anthony Tremblay; produced by Gary Schmoeller and Mr. Yuzna; released by Trimark Pictures. Running time: 97 minutes. This film is rated R.

Julie	Mindy Clarke
Curt Reynolds	J. Trevor Edmond
Colonel Reynolds	Kent McCord
Riverman	Basil Wallace
Mogo	Fabio Urena

By JANET MASLIN

Q. When your girlfriend develops long metal claws, glass spikes sticking out of her shoulders and a craving for human flesh, what time is it?

A. Time to get a new girlfriend. Or at least it ought to be for Curt Reynolds (J. Trevor Edmond) once his beloved Julie (Mindy Clarke) begins exhibiting these and other telltale signs of trouble. But "Return of the Living Dead 3" is an "I'm O.K., You're Undead" love story in which Curt and Julie just can't quit. Not even after Julie is killed in a motorcycle crash, which would seem like a natural time to say goodbye.

●

A very upset Curt sneaks Julie's body into the secret lab where Curt's father (Kent McCord) is supervising a top secret military program for reviving corpses. Hours earlier, Curt and Julie have been to the lab and watched a colorfully horrific experiment that goes awry. "Strap that damn thing down before it wakes up again!" cry the scientists, when one of the milky-eyed undead begins behaving in mischievous ways. "Return of the Living Dead 3" is for horror aficionados who can admire the stylish way blood spatters the laboratory's walls and windows during such a sequence.

Brian Yuzna, who directed this film and produced "Re-Animator," concentrates on a lurid teen-dream style that can treat this zombie's rampage as a sexual turn-on for Curt and Julie, who finds herself wondering what it was like for the dead man to wake up. When she herself is similarly revived, she turns eagerly to Curt and says: "That was incredible! Let's do it again."

Julie whines her way through too much of the zombie experience ("I get these *cramps;* I feel so *stiff").*

But she does undergo the visual transformation that provides the film's main fashion experience, finally emerging in cut-offs and torn fishnet stockings, with her body pierced and punctured in startlingly elaborate ways. In order to kill time between Julie's death and this little apotheosis, the film strains noticeably to invent minor characters and keep Curt and Julie on the run. A subplot involving a group of Hispanic hoodlums is as nasty and violent as the film's main event.

"Return of the Living Dead 3" has more visual than dramatic flair, with the actors most memorable for their sharply-lit cheekbones and upstaged regularly by the macabre special effects. The film's scientist types look suitably helpless in the face of trouble, and Mr. Edmond sounds the right rebellious note. Ms. Clarke, whose sole purpose here is to give new meaning to the "Live fast, die young, leave a beautiful corpse" credo, doesn't fully come to life until she is spectacularly undead.

●

"Return of the Living Dead 3" is rated R (Under 17 requires accompanying parent or adult guardian). It is extremely violent.

1993 O 29, C8:4

Black Cat

Directed and produced by Stephen Shin; written by Lam Wai-lun, Chan Bo-Shun and Lam Tan-Ping; in Chinese, with English subtitles; director of photography, Lee Kin-Keung; edited by Wong Wing-Ming, Kwok Ting-Hung and Wong Chau-On; music by Danny Chung; released by Headliners. At the Quad Cinema, 34 West 13th Street, Greenwich Village. Running time: 91 minutes. This film has no rating.

Catherine	Jade Leung
Brian	Simon Yam
Allen Yeung	Thomas Lam

By STEPHEN HOLDEN

Like so many other films from Hong Kong, Stephen Shin's action thriller "Black Cat" has the gaudy color, carefree rhythm and detachment of a high-powered comic strip. In its wildly expressionistic opening sequence, Catherine (Jade Leung), a waitress in an eerie, blue-lighted truck stop, goes berserk when a customer makes a pass at her, killing him and a police officer who has been called to the scene. At her arraignment, Catherine shoots her way out of a Los Angeles courtroom in a blitz of gunfire. Moments later, she is kidnapped by the C.I.A., which implants a microchip in her brain and trains her to become a political assassin with the code name Black Cat.

The film, which opens today at the Quad Cinema, makes no pretenses toward realism: the film is a Hong Kong answer to "La Femme Nikita" and its American remake, "Point of No Return." "Black Cat" is a stylish pop fantasy spun around an invincible female action hero. Miss Leung, a Hong Kong-based model turned actress, survives more assaults than the Terminator and Rambo put together while executing various impossible missions.

Especially in the film's early scenes, Miss Leung, who in repose is an elegant gamine, lashes out with the fury of an endangered wildcat. Once tamed by the C.I.A., she is an unstoppable lethal weapon who discharges her task with a machinelike efficiency. Her most spectacular feat

involves shinnying down a building crane hundreds of feet tall to arrange for some steel bars to fall onto a speeding car.

The movie's weakest element is the love story between Catherine, who poses as a photojournalist named Erica, and Allen (Thomas Lam), a fellow photographer, during one of her assignments. The character is simply too bland and passive to make a scintillating partner for a dynamo like Catherine.

1993 O 29, C10:6

Sex and Zen

Directed by Michael Mak; based on the novel "The Carnal Prayer Mat" by Li Yu; in Cantonese dialect, with English subtitles; director of photography, Peter Ngor; edited by Poon Hung; music by Chan Wing Leung; produced by Stephen Siu; released by Rim Film Distributors. At Cinema Village, 22 East 12th Street, East Village. Running time: 99 minutes. This film has no rating.

Mei Yeung Sheng	Lawrence Ng
Yuk Heung	Amy Yip
Doctor	Kent Cheng
Kuen	Xu Jin-Jiang
Kuen's wife	Isabella Chow
Choi Run Lun	Lo Lieh

By STEPHEN HOLDEN

Many of the simulated sexual couplings that make up a good portion of Michael Mak's erotic comedy "Sex and Zen" are so outlandishly acrobatic that they are no more believable than scenes from martial arts movies in which the combatants fly like Superman. But because what's being depicted is passionate, voracious sex rather than stylized combat, the spirit of "Sex and Zen" is quite different from Hong Kong martial arts films that are just as far-fetched. For those who accept the absurd simulations as realistic, "Sex and Zen" will have soft-core pornographic appeal. For others, its appeal should be as a cheeky if predictable sendup of erotic obsession and its unhappy consequences.

"Sex and Zen," which opened today at the Cinema Village, is based on Li Yu's novel "The Carnal Prayer Mat," an erotic work that was banned for centuries in China. It follows the sexual swath cut by Mei Yeung Sheng (Lawrence Ng), a knight-errant in fanatical pursuit of ultimate pleasure.

In the film's funniest scene, Mei Yeung is operated upon with a miniature guillotine so that he can be given the organ of a horse. But before the transplant can proceed, the animal must be thoroughly inebriated. After a number of farcical mishaps, the operation is successfully completed and Mei Yeung redoubles the intensity of his quest, in bedtime activities that become increasingly populous.

Even though it is a cautionary tale, "Sex and Zen" could offend many viewers with its erotic explicitness and its 17th-century view of women as sexual objects. For those who step back from such issues, this candy-colored Kamasutra of a comedy should provide at least a couple of laughs.

1993 O 29, C10:6

FILM VIEW/Caryn James

Terrorize A Child, Pull a Crowd

AT THE END OF "THE GOOD SON," TWO OF THE world's most valuable child actors are dangled off the edge of a cliff — for real. This stunt may be the latest cultural symptom of how quickly children are growing up. Macaulay Culkin, as a murderous little boy, and Elijah Wood, as the good-seed cousin who spots his crimes, were suspended high above the ocean, just like macho adults who insist on doing their own tricks.

How can you hang a kid off the side of a cliff?

"Carefully," said the director, Joseph Ruben, explaining that the scene was both scary and fun for the boys. They were willing to do the stunt, were protected by foolproof double harnesses and were never in any danger.

That danger-free zone doesn't exist for their on-screen characters and for other fictional children, who have lately been terrorized by dinosaurs, stalked by the Mafia and an evil Terminator and left in the hands of deranged baby sitters. Children in peril are the new toys for makers of thrillers.

Films have always treated serious themes about childhood, of course. But rarely have children been used for so many cheap thrills in movies that are disposable entertainments: "Jurassic Park," the new Italian film "Flight of the Innocent," "Terminator 2" and the quintessential baby-in-peril movie, "The Hand That Rocks the Cradle."

To look beneath the surface of these pop confections is to glimpse a complex, sometimes contradictory, social attitude toward children. To make them fair game is to elevate them to an adult's level; when a killer stalks the screen, there are no special concessions for youth. But presenting children as targets also taps into parents' deepest fears. The frisson of seeing a youngster in peril may be cheap, but it draws on an adult's frightening inability to protect children all the time.

The plots have little to do with this powerful emotion. "The Good Son" works as a slick suspense movie that requires viewers to toss logic aside, to believe that a stolen rubber duck is evidence of murder rather than sibling rivalry. And despite heavy references to evil and many scenes with the family therapist, the drama is not about innocence or psychology. It is about whether the Culkin character, Henry, will bump off his little sister and his mom.

In this context, it is plausible that a child character might die. Henry's mother leans over that cliff and struggles to hang onto the boys, one hand gripping each of them. Before long, something — or someone — will have to go. This is not exactly "Sophie's Choice." There is no serious issue here, no true moral dilemma for the mother, because the entire story is contrived. The film pushes the right buttons without leaving any nagging residue of thought.

Such feather weight sets the child-in-jeopardy thriller apart from serious coming-of-age movies. In Robert De Niro's "Bronx Tale," a boy witnesses a Mafia murder and wisely keeps his mouth shut about it. The point is not his close call, though. Mr. De Niro, playing the child's father, puts it succinctly; he is upset because his son has been forced "to grow up so fast." Similarly, Steven Soderbergh's "King of the Hill" concerns a boy who struggles through the Depression largely on his own, assuming adult worries long before any 12-year-old should have to face them.

BUT A THRILLER LIKE "FLIGHT OF THE INnocent" merely uses a child as a device to crank up emotion. The 10-year-old Vito (Manuel Colao) sees his family destroyed by members of a rival mob and spends the rest of the film evading them. Though the film begins with a statement that it is based on the epidemic of kidnapping in Italy, the story has more in common with the slick "Good Son" than the thoughtful "Bronx Tale."

Kerry Hayes/20th Century Fox

Elijah Wood, left, and Macaulay Culkin in "The Good Son"—Children in peril are the new toys.

As in "The Good Son," there are some pointed, artificial nods to the theme of innocence. Vito looks at his father's bloody boots and recognizes that he is the son of a killer. But the film is finally about shootouts, chases and tracking shots. It's not surprising that the director, Carlo Carlei, is Hollywood's latest hot property. "Flight of the Innocent" works best as a successful audition for the role of mainstream action director, with Vito as "The Fugitive Jr."

Commercially, putting young people in danger seems to work. The presence of children accounts for at least as much terror in "Jurassic Park" as the dinosaurs do. And the film speaks most directly to children's fears. Young viewers can see themselves in the little boy and pre-teen-age girl in peril on screen. When the brother and sister are abandoned in a car by a cowardly lawyer, the girl's hysterical cry is not "A dinosaur is coming" but "He left us alone." It is easy to hear in her wail an echo of the fears many children face in the era of divorce. And when her brother is electrocuted, thrown from a high-voltage fence, for a long moment he doesn't breathe. This is a world in which children can die.

The success of the 1992 thriller "The Hand That Rocks the Cradle" may account for part of film makers' eagerness to put infants and children in jeopardy. It spoke to a primary fear of baby-boomer parents: your child comes to harm, and it is your fault for not checking the nanny's references. But the current willingness to use children for cheap thrills also suggests a hardening in viewers, who may have built up a tolerance for most on-screen danger. Dangling little boys off a cliff may be the last resort of a jaded culture. □

1993 O 31, II:15:5

The Tango Player

Directed and written by Roland Graf, based on a novel by Christoph Hein; director of photography, Peter Ziesche; music by Günther Fischer and Julio C. Sanders; produced by Herbert Ehler; released by DEFA Studio Babelsberg, Potsdam, Germany. Running time: 112 minutes. This film has no rating.

Hans Peter Dallow	Michael Gwisdek
Elke	Corinna Harfouch
Dr. Berger	Hermann Beyer
Roessler	Peter Prager
Schulze	Peter Sodann
Harry	Jaecki Schwarz

By STEPHEN HOLDEN

Movies and spy novels have so relentlessly portrayed life under Communism as a paranoid adventure fan-

tasy that a drab little film like Roland Graf's "Tango Player," which is set in East Germany in 1968, stands as revealing corrective to the action-adventure cliché. Set mostly in Leipzig, the movie follows the desultory post-prison odyssey of Dallow (Michael Gwisdek), an assistant professor and part-time pianist who has spent time in jail for being in the wrong place at the wrong time.

One night in a Leipzig cabaret, Dallow was the substitute pianist in a revue whose songs ridiculed Marxism. Even though he had been unaware of the lyrical content of the show's material, he was convicted of crimes against the state. The film begins on the day of his release after 21 months of incarceration. The political climate has relaxed enough so

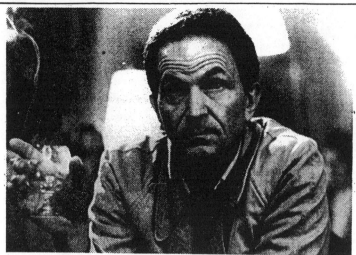
New York Shakespeare Festival
Michael Gwisdek in a scene from "The Tango Player."

that if Dallow were to repeat what he did, he would not get into trouble.

"The Tango Player," which opens today at the Joseph Papp Public Theater, is a leisurely close-up study of a man being devoured by his own impotent rage. Bitterly resentful, Dallow finds it almost impossible to find employment. His furious sense of injustice proves so uncontainable that it poisons a relationship he establishes with a woman named Elke (Corinna Harfouch). He even risks his freedom by following the judge who sentenced him and nearly strangling the man.

Mr. Gwisdek, an actor with sunken cheeks and hungry deep-set eyes, imbues Dallow with a grim, coiled intensity that ultimately makes the character more forbidding than sympa-

thetic. Before his arrest, Dallow was an assistant professor of history specializing in the European working-class movement. The film contrasts his personal turmoil with scenes of the aborted Czechoslovak uprising of 1968 as shown on East German television. While everyone around Dallow is emotionally fired up by the events unfolding in Czechoslovakia, Dallow, who before his arrest would have rooted passionately for the anti-Soviet cause, remains indifferent, lost in an angry sulk.

"The Tango Player" offers a moody portrait of East German life in the late 1960's, but it never catches dramatic fire. Rambling and a bit too long for its own good, it succumbs to the depression that engulfs its main character.

1993 N 3, C23:1

'The War Room': Behind the Scenes of Clinton's Campaign

"The War Room" was shown during the recent New York Film Festival. Following are excerpts from Janet Maslin's review, which appeared in The New York Times on Oct. 13. The film opens today at Film Forum 1, 209 West Houston Street, South Village, and is to run until Nov. 16.

Is any stone left unturned in a modern Presidential campaign? When every last whistle-stop and handshake is thoroughly documented, can there be anything more for a film maker to find? When D. A. Pennebaker and Chris Hegedus set out to chronicle the Clinton campaign, they were taking on a seemingly redundant task. And yet "The War Room," their glimpse of maneuvers by Clinton strategists, finds new facets of the story and manages to coax cliffhanging suspense out of a fait accompli.

Whatever "The War Room" reveals about how Mr. Clinton won the election, its real subject is why he won. The true focus of this watchful, frankly admiring film is the Clinton campaign staff, with James Carville and George Stephanopoulos receiving

star billing. These tireless new-breed strategists, whose fast, aggressive tactics helped reshape their party's thinking, played a high-profile role in the election.

•

"The War Room" crystallizes both the idealism and the cunning that swept Mr. Clinton to victory. In the process, it looks right through the public masks and captures Mr. Carville and Mr. Stephanopoulos in their natural element, working the phones, conducting planning sessions and trading assessments of their man and his opponents.

An immediate question raised by "The War Room" is whether these two image-conscious individuals could ever have behaved naturally in the presence of a camera. The answer is self-evident as the film moves along, achieving moments of remarkable candor.

One of the film's more memorable glimpses finds Mr. Stephanopoulos talking down an 11th-hour blackmailer threatening to go public with gos-

sip about the candidate's sexual peccadilloes. Mr. Stephanopoulos calmly moves from dismissal ("You would be laughed at") to flat-out threat ("I guarantee you that if you do this, you'll never work in Democratic politics again") to Godfatherese ("You'll know that you did the right thing, and you didn't dishonor yourself") without missing a beat.

"The War Room" watches as Mr. Carville and his fellow strategists leap gleefully at every opportunity and sweat out the terrible suspense.

By Election Day, Mr. Carville and Mr. Stephanopoulos are un-self-conscious enough to allow the camera to watch them in their deserted War Room headquarters, wondering whether their hopes and labor will be worth anything at all. But as Mr. Carville puts it playfully at one point, "The harder you work, the luckier you are." "The War Room," a revealing film and an invaluable document, illustrates exactly what that means.

1993 N 3, C23:1

Behind the Scenes At a Chinese Restaurant

"Combination Platter" was shown as part of the 1993 New Directors/ New Films Series. Following are excerpts from Janet Maslin's review, which appeared in The New York Times on March 27. The film opened this week.

Setting his refreshingly candid "Combination Platter" in a Chinese restaurant, Tony Chan serves up many things that are not on the usual menu. This film's events are seen through the eyes of Robert (Jeff Lau), an illegal immigrant from Hong Kong who works as a waiter in Queens. Robert's desire for a green card gives the film its nominal impetus, but the real subject is the behind-the-scenes aspect of the restaurant's operation. In the culture gap between occasionally rude American customers and deceptively dutiful Chinese workers, "Combination Platter" finds a rich and offbeat subject.

Whether it is following the fate of leftovers or glancing at the huge vat of MSG in the restaurant's basement, Mr. Chan's film provides honest, often humorous glimpses of restaurant life. Among the kitchen workers, who bicker playfully among themselves, a match between a Mandarin and a Cantonese is considered a mixed marriage. Meanwhile, Robert and the other waiters are exposed to more radical differences as they deal with American customers, who miss an awful lot by not understanding Chinese.

Robert's friend Sam, played by Lester (Chit Man) Chan, is a big

favorite with obnoxious baseball players (the restaurant is near Shea Stadium) and has perfected the art of saying "That's a great story" as these bores drone on and on. Robert, who is more timid, looks alarmed whenever Sam pleasantly curses the very patrons he appears to be admiring. He is even more troubled by the sight of a white man and his Asian date, who are regulars at the restaurant and often argue while they're having dinner. Robert is sheltered enough to find the idea of such a couple shocking.

At the same time, Robert himself may be forced to find an American bride. He is now Americanized enough to joke that a green card is better than a gold card, and he very much wants to stay. But if the restaurant's owner tries to help him it may take five years, whereas marriage offers an instant solution. So Robert's more worldly friend Andy (Kenneth Lu) introduces him to the shy, spinsterish Claire (Colleen O'Brien), who is at first flattered by Robert's attention. The film displays tact and delicacy as it observes the awkward relationship between these two.

Mr. Chan, who was born in Hong Kong and later moved to New York, captures Robert's apprehensiveness beautifully. So does Mr. Lau, who plays the role in a simple and utterly believable fashion. "Combination Platter" provides a funny, involving glimpse of a painful predicament, and manages to do this with charm and verisimilitude.

1993 N 4, C22:1

The Remains of the Day

Directed by James Ivory; written by Ruth Prawer Jhabvala, based on the novel by Kazuo Ishiguro; director of photography, Tony Pierce-Roberts; edited by Andrew Marcus; music by Richard Robbins; production designer, Luciana Arrighi; produced by Mike Nichols, John Calley and Ismail Merchant;

released by Columbia Pictures. Running time: 134 minutes. This film is rated PG.

Stevens	Anthony Hopkins
Miss Kenton	Emma Thompson
Lewis	Christopher Reeve
Lord Darlington	James Fox
Father	Peter Vaughan
Cardinal	Hugh Grant
Benn	Tim Pigott-Smith
Spencer	Patrick Godfrey

By VINCENT CANBY

IN the late 1930's, in a stately home of England called Darlington Hall, Stevens (Anthony Hopkins) is the butler. He's the supreme commander of a vast staff that includes the housekeeper, the underbutlers, the cooks, the maids, the footmen, the scullery helpers, even those people who work outside the great house. As the members of his staff are expected to serve him, so Stevens serves his master, Lord Darlington (James Fox). He

serves without question. Or, as he says at one point, "It's not my place to have an opinion."

Stevens is not just any butler. Through a combination of hard work, long hours, denial of his own needs and carefully blinkered intelligence, Stevens has become what his peers would acknowledge to be a great butler. In his world he's the equivalent to Lord Darlington, someone who, when the chips are down, is to be trusted. Stevens is a man of honor and dignity, which become for him, as for the intensely dim-witted Lord Darlington, fatal flaws.

Taking this rather arcane story, adapted from Kazuo Ishiguro's award-winning novel, Ismail Merchant, the producer; James Ivory, the director, and Ruth Prawer Jhabvala, the writer, have made "The Remains of the Day," a spellbinding new tragi-comedy of high and most entertaining order. Here is an exquisite work that could become a quite unlikely smash.

Nothing that Mr. Merchant, Mr. Ivory and Ms. Jhabvala have done before — not even "The Bostonians," "A Room With a View" or "Howards End" — has the psychological and political scope and the spare authority of this enchantingly realized film.

"The Remains of the Day," like the novel, is nothing if not metaphoric. Stevens is the proudly subservient, pre-World War II English working class. Darlington Hall is England. Stevens's fierce determination to serve, and the satisfaction it gives him, are the last, worn-out gasps of a feudal system that was supposed to have vanished centuries before.

The film also has its roots in history. The people who gather around Lord Darlington recall the members of the so-called "Cliveden set." These were the high-minded, sometimes fascist-leaning, thoroughly wrongheaded English Tories who, in the years before Munich and the partition of Czechoslovakia in 1938, worked so hard to accommodate Hitler and to preserve England's rigid social hierarchies.

In one of the film's nastiest, most vicious scenes, Lord Darlington allows two of his guests to ask Stevens about his views on German war reparations and other international matters of the day. Says the mannerly Stevens

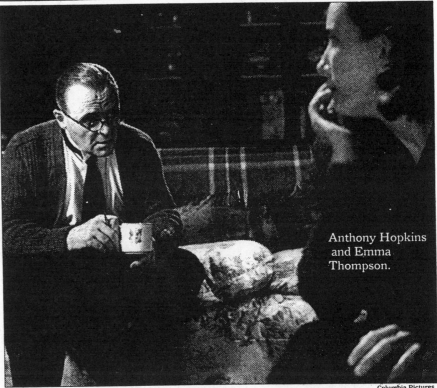

Anthony Hopkins and Emma Thompson.

Columbia Pictures

in response to each question, "I'm sorry, sir, but I'm unable to be of assistance in this matter." Lord Darlington's friends have proved their point: universal suffrage is an appalling waste of time.

Yet history and metaphors never get in the way of the film's piercing social and psychological comedy. "The Remains of the Day" is so lucid and so minutely detailed that it has its own triumphant life, which is enriched by other associations without being dependent on them. Among other things, the film offers riveting, almost documentarylike sequences showing how such great houses once functioned, how dozens of guests were accommodated, how elaborate meals were prepared, how the servants preserved order among themselves through their own hierarchies.

•

Stevens, as wondrously played by Mr. Hopkins, is a very strange romantic hero. He's fussy, uptight, humorless and seemingly asexual. As improbable as it might seem, "The Remains of the Day" is a love story, possibly two love stories. It is most immediately about the edgy relationship of Stevens and Miss Kenton (Emma Thompson), the beautiful, lively and very efficient housekeeper whom he hires after the previous housekeeper runs off with the under-butler.

In spite of her beauty, Miss Kenton wins the sober-sided Stevens's support. She's obviously motivated by a strong need for work and would appear to be commonsensical. "I know from my own experience," she tells him early on, "how the staff is at

sixes and sevens when they start marrying each other." In the months that follow, it's clear that Miss Kenton is drawn to the commanding, cool Stevens.

Yet Stevens allows nothing to come between him and his duties, which is just another way of saying between him and Lord Darlington. There isn't anything either overtly or covertly sexual about their relationship. They are servant and master, but it's a relationship so satisfactory to both, each in a different way, that it subsumes the sexual and even the romantic.

Stevens worships Lord Darlington, a well-meaning twit of dangerously serious ambitions to serve England and save it from war as Hitler consolidates his hold on Germany. Darlington Hall becomes the center of all sorts of unofficial diplomatic conferences that, Stevens understands, will decide the fate of Europe. It is through Lord Darlington that Stevens, whether he's planning a banquet for 40 or passing port in the library, sees himself as serving history. When his master is accused of being a Nazi sympathizer of possibly treasonous proportions, Stevens's world also collapses.

This is not giving away the plot. Lord Darlington's awesome naïveté is made known early in the film, which unfolds in a series of flashbacks from 1958, shortly after Lord Darlington's death and the sale of Darlington Hall. The hall's purchaser is Lewis (Christopher Reeve), a rich American who, as a United States Congressman, participated in one of Lord Darlington's peace-now conferences just before Munich.

The film begins when Stevens, having been given a week's holiday by Lewis, as well as the use of the old Daimler, sets off on a journey to the west of England. His goal: to see Miss Kenton, now Mrs. Benn, whom he believes is ready to come back to Darlington Hall since the failure of her 20-year marriage. As Stevens rolls majestically through the rolling countryside, his adventures prompt a shattering re-evaluation of his life.

Harold Pinter wrote an earlier screen adaptation of the novel, but it's difficult to imagine how anyone could improve on Ms. Jhabvala's screenplay and Mr. Ivory's direction of it. Though the collaborators are sometimes less indirect than Mr. Ishiguro, the film retains the sense of the novel and is as rich in texture and incident.

In Ms. Thompson's performance, which suggests Miss Kenton's desperate, aching sexuality, the film makes coherent a passion not really believable in the novel. Ms. Thompson is splendid, even to the way Miss Kenton's carefully acquired upper-class accent, which she uses while in service at Darlington Hall, slips a few notches when she's met 20 years later.

Mr. Fox and Mr. Reeve head the fine supporting cast, which also includes notable work by Peter Vaughan, as Stevens's fearful old father; Hugh Grant as Lord Darlington's godson, an aristocrat who becomes a caustic critic of the politics of appeasement, and Tim Pigott-Smith, who plays Miss Kenton's husband, a very good role that isn't even in the book.

In the way that "The Remains of the Day" looks grand without being overdressed, it is full of feeling without being sentimental. Here's a film for adults. It's also about time to recognize that Mr. Ivory is one of our finest directors, something that critics tend to overlook because most of his films have been literary adaptations. It's the film, not the source material, that counts. "The Remains of the Day" has its own, securely original cinematic life.

"The Remains of the Day" has been rated PG (Parental guidance suggested). It would bore most children, though without corrupting them.

1993 N 5, C1:1

The Silent Touch

Directed by Krzysztof Zanussi; written by Peter Morgan and Mark Wadlow; director of photography, Jaroslaw Zamojda; edited by Marek Denys; music by Wojciech Kilar; production designer, Ewa Braun; produced by Mark Forstater; released by Castle Hill Productions Inc. At the Quad, 13th Street, west of Fifth Avenue, Greenwich Village. Running time: 92 minutes. This film is rated PG-13.

Henry Kesdi.............................Max Von Sydow
Stefan Bugajski.....................Lothaire Bluteau
Helena Kesdi.................................Sarah Miles
Annette Berg.................................Sofie Grabol
Professor Jerzy Kern......Aleksander Bardini
Joseph Kesdi.............. Peter Hesse Overgaard

By VINCENT CANBY

Since his vintage years with Ingmar Bergman, Max Von Sydow has seemingly worked without stop around the world playing roles that don't come up to his instep, wrestling with Satan in "The Exorcist" and suffering serenely as God's son in "The Greatest Story Ever Told." With the exception of "Hannah and Her Sisters" and "Pelle the Conqueror," he hasn't had much to do recently except collect his paychecks. He's one of the cinema's great underused resources.

This is the principal reason to see "The Silent Touch," the new British-Polish-Danish co-production starring Mr. Von Sydow, who is Swedish; Sarah Miles, who is English, and Lothaire Bluteau, who is French Canadian. The film, which was directed by Krzysztof Zanussi, who is Polish, is set mostly in Denmark, though everyone speaks English, maybe because it's the lingua franca of the people who put the movie deal together.

Though you have every right to expect that such a film would be a mess, "The Silent Touch" is a sooth-

Castle Hill Productions

Max Von Sydow

ingly mystical tale that gives Mr. Von Sydow a rare opportunity to play a character of certain, quite crazy substance. He is Henry Kesdi, described as "a world-famous composer," but he's a composer who hasn't written a note in 40 years. He lives with his long-suffering wife, Helena (Ms. Miles), in Denmark, where he spends most of his time being rude to people and complaining of physical ailments.

A young man named Stefan (Mr. Bluteau), who's studying for his degree in musicology at the University of Cracow, wakes up one morning still hearing a few bars of music that he has dreamed. When he puts them down on paper, he becomes convinced they represent something composed years before by Kesdi, though the work is still unfinished.

In a fashion common both to trashy fiction and to the mystical sort of movies Mr. Zanussi makes, Stefan sets off for Denmark to save Kesdi from inactive old age. What follows is more mysterious than surprising. Stefan suddenly finds he has healing powers. He cures the composer not only of his asthma and his sore back but also of his composer's block. The result is a glorious symphony the entire world is waiting for; but, as Kesdi's doctor tells Stefan, the old man is not cured. Instead, "it's the last burst of light before the candle goes out."

So be it.

"The Silent Touch" should not be analyzed too closely. It offers a robustly funny performance by Mr. Von Sydow, who's most interesting before he has cured by someone who may be God's unwitting messenger. It takes effort to be as unpleasant as Kesdi. He means to offend by refusing to bathe. Helena explains it more genteely: "He happens to like the natural smell of his body."

Without Mr. Von Sydow, "The Silent Touch" would be lugubrious fluff, but he's very much in it and he's fun to watch. Mr. Bluteau, who may be remembered here for his performance in "Jesus of Montreal," and Ms. Miles are perfectly professional. Sofie Grabol, a pretty young Danish actress, appears as a music student who inspires the old man in less refined ways.

"The Silent Touch" opens today at the Quad Cinema.

•

"The Silent Touch" has been rated PG-13 (Parents strongly cautioned).

It has some vulgar language and sexual situations.

1993 N 5, C3:1

Wild West

Directed by David Attwood; written by Harwant Bains; director of photography, Nic Knowland; edited by Martin Walsh; production designer, Caroline Hanania; produced by Eric Fellner; released by the Samuel Goldwyn Company. Running time: 85 minutes. This film has no rating.

Zaf	Naveen Andrews
Rifat	Sarita Choudhury

By STEPHEN HOLDEN

The appeal of American cowboy mythology is so potent that almost anybody can succumb to it. That is one of the themes of "Wild West," an antic romp about three Pakistani brothers in London who form a country-and-western band called the Honky Tonk Cowboys.

Stoked on the hard country music of Steve Earle and Dwight Yoakam and decked out in fringe and a cowboy hat, the band's leader, Zaf Ayub (Naveen Andrews), dreams of making it big in Nashville. Zaf's fantasies are hyped by the band's loony manager, who drives a garish limousine and totes a pistol.

"Wild West," which is the directorial debut of David Attwood, is a messy little movie with a lot of energy expended in too many directions for it to add up to much. On one level, it is a conventional rock-and-roll movie about a young band on the make. On another, it is a satirical celebration of the Southall district of London as a lawless frontier town.

In the movie's gleefully anarchic eyes, Southall is a place where clashing gangs casually blow up each other's cars and houses. The Ayub brothers, who operate a shady used-car business, carry on a running feud with a local gang.

"Wild West" is also a love story, in which Zaf falls in love at first sight for Rifat (Sarita Choudhury), a beautiful Asian woman who is unaccountably married to an abusive English lout. Rifat turns out to be a country-music fanatic, and Zaf turns her into the Cowboys' lead singer.

Beneath the movie's manic energy, Harwant Bains's screenplay wants to raise serious points about images, stereotypes and popular culture. After a tape the Honky Tonk Cowboys made catches the ear of a London record company executive, the band visits his office, where he is dismayed to discover that the players' looks don't match their music.

The film's plea for an open-minded acceptance that allows everyone to be anything he wants is somewhat undermined by the depiction of the record company executive, an anti-Semitic caricature. As much as "Wild West" wants to put its heart in the right place, its thinking isn't focused enough for its message to hit home.

1993 N 5, C6:6

Flesh and Bone

Written and directed by Steve Kloves; director of photography, Philippe Rousselot; edited by Mia Goldman; music by Thomas Newman; production designer, Jon Hutman; produced by Mark Rosenberg and Paula Weinstein; released by Paramount Pictures. Running time: 127 minutes. This film is rated R.

Lorey Sebastian/Paramount Pictures
Meg Ryan and Dennis Quaid.

Arlis Sweeney	Dennis Quaid
Kay Davies	Meg Ryan
Roy Sweeney	James Caan
Ginnie	Gwyneth Paltrow
Young Arlis	Jerry Swindall
Elliot	Scott Wilson
Reese Davies	Christopher Rydell

By JANET MASLIN

"Bone" isn't a word that often turns up in movie titles. As used by the writer and director Steve Kloves in "Flesh and Bone," it suggests something tough, ominous and strikingly deliberate, qualities that perfectly capture the mood of Mr. Kloves's transfixing second feature. Although this film's story and setting locate it light-years away from "The Fabulous Baker Boys," his earlier romance steeped in world-weary diffidence and late-night glamour, these two films have a lot in common. They share the sharp stylistic imprint of a young film maker who is no longer merely going places. He has arrived.

Mr. Kloves happens to make films — he also wrote "Racing With the Moon" (1984) — but he thinks like a novelist. He creates original stories out of whole cloth, with a novelist's ability to interweave narrative threads, sustain haunting symmetries and look deep into his characters' hearts. That aspect of his talent is especially clear in "Flesh and Bone," which doesn't match the sultriness of "The Fabulous Baker Boys" but tells a much more ambitious story. It begins with a heart-stopping prologue set in an isolated Texas farmhouse. This house, seen twice during the story, provides the film with a set of dramatic bookends, and with a near-biblical sense of right and wrong.

As Philippe Rousselot's camera singles out critical details — a worn cradle, a suspicious dog, a china closet full of valuables, a shotgun — this near-silent prologue unfolds. A strange boy appears at the farm-

Two of life's lost meet on a road to nowhere and try to find a way home.

house late at night, and is taken in by the Willets family: stern father, pretty young mother, infant daughter and school-age son. The lost boy reveals nothing about himself, but the mother notices a star-shaped tattoo at his hairline. "Who'd do such a thing to a boy?" she asks in astonishment. Mr. Kloves has a precise way of guiding his viewers' attention with questions like that one. His spare, lively screenplay is free of stray remarks.

It is soon apparent who would do that and even worse things to the boy, once his father, Roy Sweeney (James Caan), steals onto the scene. The farmhouse episode ends devastatingly, with no image more troubling than the stony face of young Arlis Sweeney (Jerry Swindall) as he witnesses the full extent of his father's cruelty. The adult Arlis (Dennis Quaid) has broken away from Roy, but he still wears the same guarded look, as if he has spent his whole life trying to insulate himself from the memory of his childhood. "Flesh and Bone" is about what happens when that memory reasserts itself once and for all.

Once again, Mr. Kloves comes up with an offbeat line of work for his hard-bitten hero: Arlis supplies vending machines, riding across Texas with a truckful of novelties and a schedule like clockwork. He doesn't like surprises, and he doesn't have or want a home. He's more comfortable with pastel-dyed chickens that play tick-tack-toe (a vending-machine specialty) than he is with people. But the story flings him together with Kay Davies (Meg Ryan), another footloose type, and sends the two of them on the road together. Their meeting would have the look and feel of a coincidence in any other film, but this one ascribes rare powers to the long arm of Fate.

Kay Davies, a feistier variation on Michelle Pfeiffer's Susie Diamond in the earlier film, very nearly throws "Flesh and Bone" off balance. Ms. Ryan is an actress who can flounce petulantly in a fringed satin bikini, and her perkiness threatens to turn this into a tale of lovable eccentrics, Texas style. But her performance proves to be more muted than it seems at first, when Mr. Kloves provides her with a memorable entrance jumping out of a cake (falling out, actually). Even here, when Arlis gets his first partial glimpse of Kay, the details are sharp and evocative: a jug of whiskey, a cigarette and an outstretched hand gloved in white lace.

•

The arrival of Kay is not as irrelevant to Arlis's story as it may seem. "Flesh and Bone" hinges on the experience shared by these two, an experience that remains clearer to the audience for a while than it is to the characters. Part of the story's interest lies in Arlis's process of discovery, and in his trying to understand just how fully his future must be shaped by his past. These revelations are given more urgency when the free-floating ominousness that pervades the story re-emerges in the form of Roy Sweeney, whose presence Arlis has somehow sensed from a distance. It's in keeping with the film's title that the blood tie between father and son is visually reaffirmed, quite literally, as soon as they meet.

There are stars and old wounds and other motifs to hold the story together, as well as the stunning, open landscapes against which this deliberately claustrophobic tale unfolds. (Mr. Rousselot can make the inside of a seedy motel room look as spectacular as a waving wheatfield, and he has the chance to photograph both. The film's forboding mood is also greatly enhanced by Thomas Newman's score.)

But most of what keeps "Flesh and Bone" so gripping is the ways in which the characters themselves evolve. Mr. Quaid has the difficult role of a man defined more by what he can't do than by what he can. But he performs with affecting restraint, and with a deep, believable sense of how badly Arlis has been damaged.

Together, he and Ms. Ryan eventually convey the full weight of the story, even if Mr. Kloves cannot allow them to rise above it. Like "The Fabulous Baker Boys," this film ends honestly but stops short of the transcendent leap it needs.

●

Mr. Caan is effectively unnerving, thanks to some of the screenplay's most menacing dialogue and to his truly otherworldy calm. The fourth and strangest of this story's principals is Ginnie, a young scavenger whose larceny sets the story in motion and who eventually hooks up with the other three. Ginnie is played with startling aplomb by the scene-stealing Gwyneth Paltrow, who is Blythe Danner's daughter and has her mother's way of making a camera fall in love with her.

Ginnie can look as girlish as Kay while surpassing Roy when it comes to ruthlessness; one of her favorite gambits is pretending to be a mourner and stealing jewelry from the dead. "I'll have to watch my back with this one," Roy tells Arlis about Ginnie. "Heart beats about twice a minute."

"Least it beats," Arlis answers his father.

●

"Flesh and Bone" is rated R (Under 17 not admitted without accompanying parent or adult guardian). It includes profanity, fleeting violence, brief nudity and sexual situations.

1993 N 5, C10:1

Look Who's Talking Now

Directed by Tom Ropelewski; written by Mr. Ropelewski and Leslie Dixon; director of photography, Oliver Stapleton; production designer, Michael Bolton; edited by Michael A. Stevenson and Harry Hitner; music by William Ross; produced by Jonathan D. Krane; released by Tri-Star Pictures. Running time: 92 minutes. This film is rated PG-13.

James Ubriacco	John Travolta
Mollie Ubriacco	Kirstie Alley
Mikey Ubriacco	David Gallagher
Julie Ubriacco	Tabitha Lupien
Samantha	Lysette Anthony
Rosie	Olympia Dukakis
Voice of Rocks	Danny DeVito
Voice of Daphne	Diane Keaton
Albert	George Segal

By STEPHEN HOLDEN

Like an over-dressed Christmas tree, "Look Who's Talking Now" is a movie so eager to shine that it arrives draped in several layers of sentimental tinsel and cutesy-pie decorations. The third film in the series that began four years ago with the surprise blockbuster "Look Who's Talking" continues the gimmick of observing an all-American family through the eyes of creatures who don't speak. But in Part 3, the perspective has shifted from the human to the canine. And the sound of stars mouthing the inner thoughts of dogs is somehow funnier than that of grownup actors doing wisecracking voice-overs for gurgling infants.

Once again John Travolta and Kirstie Alley play James and Mollie Ubriacco, an indefatigably cheery middle-class couple whose two frisky children, Mikey (David Gallagher) and Julie (Tabitha Lupien), have reached the ages of 6 and 4, respectively. The fun begins when James is hired to be the highly paid private pilot for Samantha D'Bonne (Lysette Anthony), the beautiful, snooty chief executive of an international cosmet-

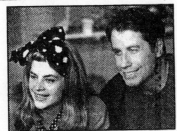

Joseph Lederer/Tri-Star Pictures
Kirstie Alley and John Travolta.

ics company. When Samantha donates her elegantly coiffed poodle to the Ubriaccos at the same moment that they acquire a stray mongrel, their home becomes the site of a comic class struggle.

●

For much of the film, Samantha's pampered poodle, Daphne (Diane Keaton's voice) looks down her nose at the untrained, streetwise Rocks (Danny DeVito), who likes to root through garbage, drink from the toilet and munch on Mollie's shoes. Things get off to a bad start when Rocks offends Daphne by calling her Daffy. "I don't associate with mutts," she replies haughtily. "I've got papers."

These canine capers, which are the movie's funniest moments, reach a height of silliness on the evening Rocks persuades Daphne to drop her highfalutin airs and go out on the town with him. During a romp in which she squeals with liberated delight, Rocks introduces her to the déclassé pleasures of eating discarded Chinese takeout food and running through mud.

"Look Who's Talking Now," which was directed by Tom Ropelewski, is shrewdly aimed at the same Middle American family audience that watches "Roseanne" and "Cheers." The class struggle between the dogs, which is resolved when Daphne learns to get down with the working class and savor life's simple, dirty pleasures, is paralleled by the struggle between Mollie and Samantha for James.

Samantha, who sets her sights on James, commits the cardinal sin of spiriting him away to her secluded country house on Christmas Eve under false pretenses. And in the moral universe of the movie, keeping a father from his children on Christmas is as heinous as committing mass murder. The plucky Mollie, who smells a rat, packs the children, dogs and Christmas presents into a yellow cab and sets out in a blizzard to bring Christmas to her husband.

The movie is shameless in the way it pits James's rich, haughty employer, who is English and upper class, against his loyal, down-home wife. In a movie in which Christmas symbolizes everything that is good and warm and real in a world full of phonies, it is an ultimate sign of Mollie's integrity that after being laid off from her regular job, she finds temporary employment as one of Santa's helpers in a department store.

Among the movie's gaudy trimmings are a dancing dream sequence that plays off Mr. Travolta's "Saturday Night Fever" image, another sequence in which James and Mollie lip-sync "The Chipmunk Song," and most improbably, a scene in which Daphne and Rocks confront a vicious wolf pack.

"Look Who's Talking Now" is a movie that takes to heart the idea of putting on the dog.

"Look Who's Talking Now" is rated PG-13 (Parents strongly cautioned). It includes some mildly vulgar language.

1993 N 5, C12:6

Robocop 3

Directed by Fred Dekker; screenplay by Frank Miller and Mr. Dekker; director of photography, Gary B. Kibbe; edited by Bert Lovitt; music by Basil Poledouris; production designer, Hilda Stark; produced by Patrick Crowley; released by Orion Pictures. Running time: 105 minutes. This film is rated PG-13.

Robocop	Robert John Burke
Anne Lewis	Nancy Allen
The C.E.O.	Rip Torn
McDaggett	John Castle
Dr. Marie Lazarus	Jill Hennessy
Bertha	C. C. H. Pounder
Nikko	Remy Ryan
Otomo	Bruce Locke

By STEPHEN HOLDEN

It is not a good sign that Peter Weller, who originated the title role of the cyborg police officer in the hit movie "Robocop" and its sequel is not around for Part 3. In the latest episode of the series, which seems to have nearly run out of steam, he is portrayed by Robert John Burke, an actor who bears some resemblance to Mr. Weller while lacking his forerunner's tongue-in-cheek glint of authoritarian machismo.

Once again, the setting is a crumbling, futuristic Detroit that is riddled with crime. When the police are not battling gangs of "Splatterpunks" — rotten-toothed, spiky-haired youths who look like a surreal hangover from 1977 — they are in cahoots with Omni Consumer Products, a Japanese-owned conglomerate.

Before the company can begin building a sprawling upscale development known as Delta City, it must oust hundreds of homeless squatters from the city's faded but still-vital Cadillac City district. A guerrilla movement has begun to fight the corporation. And in the film's opening scenes, Nikko (Remy Ryan), a homeless 10-year-old computer whiz, helps the guerrillas raid a police arsenal for weapons by reprogramming its robot guard.

In "Robocop 3," which was directed by Fred Dekker, there are only scant glimpses of the satirical imagination that lent the original "Robocop" a facetious hipness. Where the director Paul Verhoeven infused the original "Robocop" with an attitude of mock solemnity, "Robocop 3," which opens today, has the energy and style of a cartoon free-for-all. Robocop's archenemy, McDaggett (John Castle), is the sadistic leader of the conglomerate's private army of "Urban Rehabilitation Officers," who drag people out of their homes and into buses for forcible relocation.

Midway through the film McDaggett acquires a formidable ally in Otomo (Bruce Locke), an android Ninja warrior imported from Japan to do battle with Robocop. As agile as Robocop is clunky, Otomo does triple somersaults over his metallic adversary and can slice through metal with one deft flick of his sword. But the confrontations between the two are disappointingly brief and unsuspenseful. They are typical of the film's abruptly edited action sequences, in which a lot of frantic activity generates very little excitement.

In place of satire and gripping action, "Robocop 3" tries to be heart-tugging, but its efforts are about as clumsy as the title character's attempts to stand after he has been knocked over. In one underdeveloped subplot, Nikko, the brave little computer expert, becomes attached to Bertha (C. C. H. Pounder), the rebels' underground leader, who is slain. In another, Robocop's sidekick Anne Lewis (Nancy Allen, making her third Robocop appearance) is killed. The film tries futilely to evoke pathos by having the cyborg relate images of his partner with those of his mother and a rebellious technician, Dr. Marie Lazarus (Jill Hennessy), who saves his memory from being erased.

In the film's ultimate gimmick, Robocop suddenly turns into Superman by donning a special flight jacket Dr. Lazarus has designed for him. The crudely edited scenes of Robocop whizzing around Detroit seem like a desperate and ill-advised attempt to give the character an identity than can be stretched for more episodes.

●

"Robocop3" is rated PG-13 (Parents strongly cautioned). It includes some mildly off-color language.

1993 N 5, C29:3

A Home of Our Own

Directed by Tony Bill; written by Patrick Duncan; director of photography, Jean Lépine; edited by Axel Hubert; production designer, James Schoppe; produced by Bill Borden; released by Gramercy Pictures. Running time: 104 minutes. This film is rated PG.

Frances Lacey	Kathy Bates
Shayne Lacey	Edward Furlong
Mr. Munimura	Soon-Teck Oh
Norman	Tony Campisi
Annie Lacey	Amy Sakasitz

By VINCENT CANBY

"A Home of Our Own" is a shamelessly heart-warming family memoir that, with a good, crafty performance by Kathy Bates and with soundtrack music that tells you when to sob, often succeeds.

Tony Bill directed Patrick Duncan's screenplay, which is set in 1962 and is about the self-styled "Lacey tribe," six indomitable children, 5 years old to 15, and their plucky, widowed mom, Frances (Ms. Bates). When first seen in Los Angeles, Mom is at the end of her rope.

The foreman at the potato chip factory makes a pass at her, but she's the one to be fired. Things get worse when she returns to her ugly, noisy, overcrowded apartment. The cops bring home Shayne (Edward Furlong), her oldest child, saying they found him stealing nickels from a pay phone.

"Well," says Mom, "are you going to keep him or throw him back?" That's the way she talks. This being thirtysome years ago, the cops are nice. They let Shayne off with a warning but, as Frances says, "I don't have the chance of an ice cube in a frying pan of making things better if we stay in this town." Mom's speeches are not only colorful, but they are also mouthfuls.

The next morning she piles the kids and their baggage into the '48 Plymouth and heads east to look for a home of their own. They find it in Idaho, just about the time the Plymouth gives up the ghost. It's not a house exactly. It's the shell of an abandoned, half-built house standing on three acres of land. The owner is Mr. Munimura (Soon-Teck Oh), soon

to be nick-named Mr. Moon, a kindly, lonely old Japanese-American who runs a nursery. With her gift of relentless gab, Mom trades manual labor for the right to revitalize the property.

•

Thereafter "A Home of Our Own" follows the somewhat predictable fortunes of the Lacey tribe as they battle poverty (Mom refuses to take charity), bad luck and other kinds of heart break when Mom falls briefly for a cad. Some disappointments are smaller than others. There's one near-disaster as well as a finale of spiritual triumph.

The movie is cleverly manufactured, but also smug about the so-called American values it celebrates. There's one awful scene in which the kindly, lonely Mr. Moon reveals why he is lonely, if not kindly.

The movie is full of slushy moments that verge on the bogus. Yet one's eyes moisten with regularity. Don't be embarrassed. With that soundtrack music pumping away, "A Home of Our Own" could bring tears to the eyes of a brass monkey.

•

"A Home of Their Own" has been rated PG (Parental guidance suggested). It has some vulgar language and sequences in which children are seen to be in jeopardy.

1993 N 5, C29:3

The Harvest

Written and directed by David Marconi; director of photography, Emmanuel Lubezki; edited by Carlos Puentes; production designer, Rae Fox; produced by Morgan Mason and Jason Clark; released by Arrow Releasing. Running time: 97 minutes. This film is rated R.

Charlie Pope.....................Miguel Ferrer
Natalie...........................Leilani Sarelle
Bob Lakin......................Harvey Fierstein
Noel Guzman.............Anthony John Denison
Detective TopoHenry Silva
Steve..................Joseph Timothy Thomerson

By JANET MASLIN

Maybe there are many screenwriters who daydream about stepping into their own stories to find a deeper meaning and fundamental truth. Luckily, most of them have the sense to let the whim pass. Not Charlie Pope (Miguel Ferrer), the tough-guy hero of "The Harvest," who ventures to Mexico to do some research after certain studio types are less than charitable about his latest oeuvre. "They'd treated me like a hack," he mutters, in a voice-over meant to heighten the film noir atmosphere. "But frankly, at that point I wasn't so sure they were wrong."

David Marconi, the writer and director of this self-congratulatory fantasy, sends Charlie into the midst of a murder mystery, complete with Mexican workers who mysteriously swab blood off the walls of Charlie's room. The story also supplies the beautiful, mysterious Natalie (Leilani Sarelle) and a few pretentiously dissolute locals, all of whom seem to be conspiring to hide something from Charlie. These circumstances lead, not exactly inevitably, to Charlie's abduction by organ thieves who covet his kidney. The film is at its most wildly optimistic in referring to Charlie's adventure as " 'Chinatown' all over again."

"The Harvest" has a drab, unpolished look that does nothing to encourage such comparisons. And it unfolds in remarkably clumsy ways. It is made memorable only by late-night dormitory dialogue ("I once read that a man always dies before he's fully born") and by a sex scene in which Charlie and Natalie make love very acrobatically while Charlie drives a car. The good news is that Mr. Ferrer and Ms. Sarelle met while making this film, have since married, and can both be much better in other roles. Mr. Ferrer remains a grittily effective character actor, and Ms. Sarelle finds a few occasions to look sultry and intimidating, as she did playing Sharon Stone's consort in "Basic Instinct."

Also in "The Harvest" are Henry Silva, whose speaking voice is overused (since he usually plays silent, evil-faced villains), and Harvey Fierstein. Gilding the lily, Mr. Fierstein makes himself comically crass in the role of a vulgar Hollywood producer.

•

"The Harvest" has been rated R (Under 17 requires accompanying parent or adult guardian). It includes some violence and nudity.

1993 N 5, C30:4

The Northerners

Directed and written by Alex van Warmerdam (in Dutch, with English subtitles); director of photography, Marc Felperlaan; edited by René Wiegmans; music by Vincent van Warmerdam; produced by Laurens Geels and Dick Maas. At the Walter Reade Theater, 165 West 65th Street. Running time: 100 minutes. This film has no rating.

Thomas...........................Leonard Lucieer
Jacob Jack Wouterse
Simon............................Mr. van Warmerdam
MarthaAnnet Malherbe
Agnes...........................Veerle Dobbelaere
AntonRudolf Lucieer
ElisabethLoes Wouterson
The Negro.......................Dary Somé

By STEPHEN HOLDEN

It's no wonder the residents of the grotesque, unfinished housing development where Alex van Warmerdam has set his surreal comedy, "The Northerners," are an unbalanced lot. The place is little more than a row of modern houses and a few shops on the edge of a forest somewhere in the Netherlands. Just to get to church, which is miles away, the residents must line up every Sunday morning to take a bus.

•

The film, set in 1960, follows the interactions of a group of the townspeople who become progressively more unstrung as the movie goes along. The local butcher, Jacob (Jack Wouterse), desperately desires his wife, Martha (Annet Malherbe), who finds him repulsive. Following the instructions of a religious statue, which comes to life when Jacob is not around, she refuses to eat. And as she wastes away, their home becomes a shrine in front of whose picture window the neighbors gather in a silent prayer vigil.

The couple are so caught up in their own troubles that they ignore those of their 12-year-old son, Thomas (Leonard Lucieer). Inspired by news coverage of the struggle for Congolese independence, the boy likes to paint his face black, call himself Lumumba, after the Congolese prime minister, and spend hours alone in the forest. It is there that he meets Agnes (Veerle Dobbelaere), a half-naked woman who lives at the bottom of a pond and shows him how to breathe under water by sucking on the blade of a certain plant.

The butcher's next-door neighbors, Anton (Rudolf Lucieer) and Elisabeth (Loes Wouterson), also have marital problems. The persnickety, gun-crazed Anton, upon learning that he is infertile, has no interest in making love to his beautiful and adoring wife. Armed with a rifle, he regularly visits the forest looking for signs of an illegal bonfire. During one of his prowls, he accidentally shoots Agnes.

Keeping an eye on everyone is the local mailman, Simon (Mr. van Warmerdam), who likes to go into the forest, build a forbidden fire and open everyone's mail with the steam from a tea kettle. Adding further complications are two Belgian priests who visit the community, bringing with them an exhibition of Africana. One of the exhibits is a "real Negro" (Dary Somé), who hides in the forest after Thomas helps him escape from his cage.

"The Northerners," which opened yesterday at the Walter Reade Theater as part of a series on contemporary Dutch film, is a darkly amusing satire of bourgeois life and its repressions, executed with visual and dramatic flair. If its imagery, right down to its Freudian forest of libidinous fantasies, seems terribly obvious, its plot machinations are still fun to follow.

The director and the actors, who play their roles broadly, obviously relish spoofing small-town life and its simmering pressures. There are moments when the film suggests Sherwood Anderson's "Winesburg, Ohio," reinvented in the Netherlands of 1960 as a surreal sideshow of voyeurs, fetishists and eccentrics.

The show the Belgian priests bring to the town is really an exhibition within an exhibition. For the overriding premise of the film is the notion of human nature and its quirks as something to be observed as though under glass. The attitude with which the director pulls the strings is as amused and prankish as Shakespeare's Puck perched in a tree crowing, "Lord, what fools these mortals be."

1993 N 6, 13:1

FILM VIEW/Caryn James

Fellini's World Was So Real It Was Bizarre

IN A SECTION OF NEW YORK where an old Italian neighborhood intersected art galleries and chi-chi restaurants, I once turned a corner and walked into the middle of a religious procession. Altar boys in red-and-white costumes were heading toward me carrying large candles; behind them men carried a large statue of the Blessed Virgin on their shoulders; on this gentrified street people were singing in Latin. The one word that came to mind was Felliniesque.

Very few film makers have created a landscape so distinct that the director's name has become a generic term. But even people who have never sat through an entire film by Federico Fellini, who died last week at the age of 73, know the meaning of Felliniesque. It describes that moment when you walk headlong into a scene so strange you think you're hallucinating; then it turns out to be real.

Fellini did not trade in the physically impossible; he was no magical realist. And he was not a surrealist, encouraging his imagination to romp among the absurd. He was, instead, a sly poet. In a Felliniesque scene, some colorful, extravagant, inappropriate element invades the flatness of ordinary life.

Such moments can be as symbolic and enigmatic as the giant statue of Christ that hovers over the opening scene of "La Dolce Vita," his 1960 film about jet-set decadence in Rome.

They can be as darkly funny as the town rally before a giant face of Mussolini, made of pink flowers, in "Amarcord," his warm 1973 memoir of life in a village much like the one where Fellini grew up. He loved processions and costumes and circus parades because the bizarre could literally walk into town and take over.

A perfect Felliniesque moment in "Amarcord" takes place when a battered old bus lets out a Far Eastern potentate and his harem at a luxurious hotel. They are a mere sidelight to the film's episodes of village life. And like so much in Fellini's world, their unlikely appearance makes no sense at all. But with their whiff of exoticism, of the faraway and the sexual, they suggest everything the confined villagers most desire.

To load the scene with even that much meaning might be overexplaining. At his best, as in "Amarcord" and "8 ½" (1963), his grand autobiographical film about a blocked director, Fellini's works gained their power from the mysterious and inexplicable. The giant Christ figure is loaded with cultural significance, but who can parse what that image truly means?

Felliniesque scenes work like dreams, in which some random comment made during the day can set off a resonant and haunting episode while one sleeps. Fellini saw that dreams cut to our very souls, so he never dismissed them as mere fantasies.

In his late autobiographical film, "Intervista" (1987), Fellini layers art within art, fantasy within fantasy. Within the frame of a documentary about Fellini making a movie, he spins out memories of past movies and reveals himself in the process of making the very film we are watching. But the lucid and evocative heart of the work is the purest Felliniesque sequence.

While the director is sitting in an office at the Cinecittà studios, his back to a window, Marcello Mastroianni rises into the air behind him. The actor is dressed as Mandrake the Magician, complete with cape and tacky pencil-thin moustache. Because this is a Fellini film, there is a perfectly good, movie-making explanation for all this. Mr. Mastroianni, playing himself, is costumed to appear in a commercial, and a crane has lifted him into the air.

Fellini whisks Mr. Mastroianni into a car, along with an actor playing the young Fellini in the movie within the movie. They talk about drinking, smoking and masturbation, and stop while a priest on a motorbike gives them directions to the Villa Pandora. There, they visit the actress Anita Ekberg, Mr. Mastroianni's co-star in "La Dolce Vita."

AND AT THAT POINT IN "Intervista" the real magic begins. Mandrake conjures a movie screen, and before their eyes appear the Mastroianni and Ekberg of almost 30 years before. They are younger, slimmer, gloriously and artificially black and white, dancing in the Trevi Fountain in Rome. It is a moment both heartbreaking and wonderful, this youthful and sexy scene preserved forever, shown to an aging actor and an actress who has gained 50 pounds.

However dreamlike Fellini became, he never lost sight of life's cruelties, from Fascism to aging and death. To say he captured the dreamlike and unusual is not to say he was frivolous but the opposite. Even his most fantastic scenes gain their resonance from the director's earthy appreciation of love and sex and the passing of time.

"When I am not making movies, I feel I am not alive," Fellini once said. However exaggerated that remark, it helps explain why some of his best films were about film making and why his unlikely and meandering narratives so resembled reality. Every life, Fellini knew, is a story whose grand design can never be seen while one is in it. The plotless pattern of his movies mirrored the way life itself is composed of a string of episodes.

Some film makers create memorable scenes, but Fellini did more. He created a sense of life so wonderfully askew that we can all recognize those Felliniesque moments, even when he didn't invent them. □

1993 N 7, II:26:4

Carlito's Way

Directed by Brian De Palma; written by David Koepp; director of photography, Stephen H. Burum; edited by Bill Pankow and Kristina Boden; music by Patrick Doyle; music supervisor, Jellybean Benitez; produc-tion designer, Richard Sylbert; produced by Martin Bregman, Willi Baer and Michael S. Bregman; released by Universal Pictures. At the Ziegfeld, 141 West 54th Street, Manhattan. Running time: 141 minutes. This film is rated R.

Carlito	Al Pacino
Kleinfeld	Sean Penn
Gail	Penelope Ann Miller
Benny Blanco	John Leguizamo
Steffie	Ingrid Rogers
Pachanga	Luis Guzman
Norwalk	James Rebhorn
Lalin	Viggo Mortensen
Judge Feinstein	Paul Mazursky

By JANET MASLIN

When Carlito Brigante gets out of prison in 1975, he returns to Spanish Harlem as a street-smart Mr. Big. This has less to do with Carlito (a vaguely written, not-so-clever character) than it does with casting, since "Carlito's Way" brings Al Pacino back to familiar dramatic territory. Playing one more tough, savvy gangster, Mr. Pacino brings vast entertainment value to a film that otherwise would not make great sense. And Brian De Palma finally succeeds in a "Bonfire of the Vanities" vein, delivering a droll portrait of the disco years as seen through a bemused, jaundiced eye.

"Carlito's Way" is supposedly fueled by Carlito's dreams, which are to open a car rental business in the Bahamas (really) and resume his romance with Gail (Penelope Ann Miller), the kind of woman who calls him Charlie. But the film's real heart is in the very places Carlito speaks of escaping: the seedy social clubs and slick dance palaces where the story's main action unfolds.

In these settings, letting his camera swoop and soar in countless unexpected ways, Mr. De Palma captures the grandiose romanticism of his story without concentrating too heavily on the hard facts. "Carlito's Way" is best watched as lively, colorful posturing and as a fine demonstration of this director's bravura visual style.

•

Based on two novels by Justice Edwin Torres of New York State Supreme Court (one of them so steeped in street argot that it includes a glossary), "Carlito's Way" also has its gritty side. At times the film's sharply urban look and its vivid minor characters suggest Mr. Pacino's work with Sidney Lumet ("Dog Day Afternoon," "Serpico"), but "Carlito's Way" turns out to be more overheated than those films were.

This one unfolds against a backdrop of such churning decadence that Carlito becomes the one cool head in the story, not its crusading maverick. Indeed, Carlito's main job is to stay out of trouble, trying to defend himself against the new breed of hoodlum, the type that sneeringly brands him "a used-to-be bad guy."

One of the plot's more dubious contrivances is the idea of Carlito's huge debt to David Kleinfeld, a lawyer who epitomizes the film's wry view of get-rich-quick chic. Look closely at David Kleinfeld: behind the glasses, sideburns, flashy clothes and thinning, frizzy hairdo, Sean Penn remains truly unrecognizable for a while.

But Mr. Penn's presence becomes more obvious as Dave gets crazier, thanks to a cocaine habit that the film documents in ominous detail. (Among the film's indelible images is that of Dave in ascot and blazer, awash in bad vibes and new money as he throws a huge, druggy party in his waterfront backyard.) Mr. Penn's strange, jarringly intense perform-ances are infrequent these days, but this one was worth waiting for.

Intent on breaking with his criminal past, Carlito has become something of a businessman. A voluptuously grisly shootout early in the film leaves him holding a nest egg, and he pursues his dream of paradise at a nightclub by that name. The club has the look of a garish cruise ship, which somehow fits in with the scheme that will drag Carlito into trouble. The fast-sinking Dave enlists his favorite client in a plot involving an Italian gangster, with a central episode that is meant to take place on water. "You killed us," Carlito tells Dave simply, when the plan goes wrong.

Actions eventually have consequences in "Carlito's Way," but the film includes many vivid digressions along the way. Foremost among these is Carlito's romance with Gail, a would-be ballerina and Broadway actress who actually dances in a strip club. Gail is perhaps meant, in David Koepp's screenplay, to be more substantial than the film makes her, but Ms. Miller keeps the character both sexy and shrill. The role is essentially thankless, since no woman (notwithstanding Michelle Pfeiffer's appearance in Mr. De Palma's "Scarface") can really compete with the fiery machismo on which "Carlito's Way" thrives.

Also in "Carlito's Way" are a couple of short, searing performances from John Leguizamo as the young tough guy who is Carlito's worst nightmare, and Viggo Mortensen as the desperate, wheelchair-bound hoodlum who also plays into Carlito's self-image. Luis Guzman, cast as another thug, provides sinister proof that Carlito isn't as shrewd as he should be, and James Rebhorn is dryly effective as the District Attorney who won't believe that Carlito has escaped his life of crime. Paul Mazursky appears briefly as the exasperated judge who lets Carlito out of jail.

Among the film's sweeping atmospheric touches are a weird, witty soundtrack of disco hits assembled by Jellybean Benitez, and another appearance by a major train station, like the one that figured so prominently in Mr. De Palma's film of "The Untouchables." This time, Grand Central Terminal is used as the backdrop for a sustained, thrilling chase that starts out on the subway and ends, for Carlito, in a place that is not simple to describe. Aided by the staccato editing of Bill Pankow and Kristina Boden, and by Stephen H. Burum's dazzlingly supple camerawork, Mr. De Palma ends his film with a sequence Hitchcock might have envied.

•

"Carlito's Way" is rated R (Under 17 requires accompanying parent or adult guardian). It includes nudity, profanity and occasional, very vivid violence.

1993 N 10, C19:4

Ernest Rides Again

Directed by John R. Cherry 3d; written by Mr. Cherry and William M. Akers; director of photography, David Geddes; edited by Craig Bassett; music by Bruce Arntson and Kirby Shelstad; production designer, Chris August; produced by Stacy Williams; released by Emshell Producers Group. Running time: 93 minutes. This film is rated PG.

Ernest P. Worrell	Jim Varney
Abner Melon	Ron K. James
Nan Melon	Linda Kash
Dr. Glencliff	Tom Butler
The Mighty Workboy Salesmen	
	Duke Ernsberger and Jeffrey Pillars

Louis Goldman/Universal City Studios
Sean Penn, left, and Al Pacino in "Carlito's Way," a film based on two novels by Justice Edwin Torres and directed by Brian De Palma.

By STEPHEN HOLDEN

He is Jerry Lewis with rubber lips, Don Knotts as a plucky yokel, Lou Costello with a knack for mimicry. As long as zany situations can be dreamed up to entangle Jim Varney's character, Ernest P. Worrell, with inanimate objects that have a will of their own, there can be no end to the popular "Ernest" series.

In "Ernest Rides Again," Mr. Varney is pursued by a power tool, gets his head stuck in the barrel of a cannon and dons the crown of Britain only to have it fit on his head so tightly that even a cranial saw can't remove it. In the movie's most extended gag, Ernest, his head unstuck, rides the cannon over the fields and roads of Virginia as it coasts out of control, squashing everything in its path.

In hot pursuit are a murderous history professor and a bunch of dour British spies eager to get their hands on those crown jewels. Don't ask how they found their way to a rusty old cannon in contemporary Virginia. The screenplay scarcely bothers to explain.

•

"Ernest Rides Again," which is the fifth movie in the "Ernest" series, finds the character bumping up against a cast of slapstick fools who are as unpredictable as the objects that seem to take on a life of their own whenever Ernest is around. Abner (Ron K. James), Ernest's partner in foolishness, is a milquetoast academic with a cockamamie theory about American history that puts him in mortal danger when it proves correct.

Abner's wife, Nan (Linda Kash), is a bossy, acquisitive type with awful taste in clothes. She first appears in a red jumpsuit of a hue that is loud even for Las Vegas. Nan spends much of the movie fending off a pair of pesky vacuum-cleaner salesmen who give new meaning to the word "persistent." Eventually, however, their demonstration appliance, the Workboy Home Cleaning System, comes in handy. Just as Ernest is about to be dispatched by a rapacious collector of historical artifacts, the device sucks his nemesis out of the room.

The movie, which was directed by John R. Cherry 3d, knows its audience, which is roughly between the ages of 5 and 13 and enjoys inane, goofy slapstick that seldom lets up.

•

"Ernest Rides Again" is rated PG (Parental guidance suggested). Some young children might be frightened by such things as a rampaging power tool.

1993 N 12, C10:5

The Three Musketeers

Directed by Stephen Herek; written by David Loughery, based on the novel by Alexandre Dumas; director of photography, Dean Semler; edited by John F. Link; music by Michael Kamen; production designer, Wolf Kroeger; produced by Joe Roth and Roger Birnbaum; released by Walt Disney Pictures. Running time: 102 minutes. This film is rated PG.

Aramis	Charlie Sheen
Athos	Kiefer Sutherland
D'Artagnan	Chris O'Donnell
Porthos	Oliver Platt
Cardinal Richelieu	Tim Curry
Milady	Rebecca de Mornay
Queen Anne	Gabrielle Anwar
Lady-in-Waiting	Julie Delpy

By JANET MASLIN

It's a little-known fact that the Teen-Age Mutant Ninja Turtles once romped through 17th-century France, and that when they took off those green masks they looked like long-haired, teen-throb movie stars. That seems to be the point of "The Three Musketeers," a big, swashbuckling Disney version that manages to incorporate explosions, martial arts and wise-guy dialogue into what's left — not too terribly much — of the classic Dumas story.

This "Three Musketeers" was directed by Stephen Herek, whose credits include "Bill and Ted's Excellent Adventure" and "The Mighty Ducks." It was written by David Loughery ("The Good Son"), whose idea of a witty line is "I hope your sword is as good as your mouth!" Together, their efforts do little more than summon fond memories of other, more amusing Musketeer films (like Richard Lester's from the mid-1970's), but this latest retread doesn't really care about such comparisons. It has been tailor-made for young viewers who think of Aramis as the name of an aftershave lotion for Dad.

Conceived frankly as a product, complete with hit-to-be theme song over the closing credits, this adventure film cares less about storytelling than about keeping the Musketeers' feathered hats on straight whenever they go galloping. The thunder of hoofbeats has been rendered in blaring Dolby sound, just to make the experience that much more intense, and the sounds of swords being unsheathed are similarly loud. The film includes as much idle, aimless jousting as any Turtles story. It finds no particular urgency in the prospect of saving France.

•

This time Athos (Kiefer Sutherland), Porthos (Oliver Platt) and Aramis (Charlie Sheen) are much more charming than their material, as is the boyish D'Artagnan (played by a tousle-haired, wide-eyed Chris O'Donnell, the film's most conspicuous pin-up boy). Each of these actors seems more seasoned here than he has playing nice young men (or buffoonish ones, in Mr. Platt's case) in grown-up movies. And each appears much funnier and more substantial than the lame dialogue the screenplay supplies.

The dialogue problem is even more acute with Tim Curry's Cardinal Richelieu. It's a crime to outfit Mr. Curry as such a delectable villain and then leave him little to say beyond "All for one . . . and more for me!" Incidentally, the Musketeers actually manage to tack their "All for One" motto to trees in the forest, perhaps as a means of evoking the Classics Illustrated comic-book version of the tale.

Also in "The Three Musketeers" are Gabrielle Anwar as Queen Anne of Austria, Rebecca de Mornay as Madame de Winter (known here only as Milady) and Julie Delpy as the Queen's lady-in-waiting. The film's boys-will-be-boys spirit is strong enough to mean that its women are treated dismissively, as when D'Artagnan is told: "To be a proper Musketeer, you must be schooled in the manly art of wenching." In the same scene, D'Artagnan is also told: "You fight like a man. See if you can drink like one."

Shot in Austria, and picturesquely photographed by Dean Semler, "The Three Musketeers" is loaded with real castles and local color. No race through a marketplace is staged without the obligatory peddlers, vegetables and flapping chickens underfoot. These Musketeers themselves are part of the scenery, and the scenery really does look grand.

•

"The Three Musketeers" is rated PG (Parental guidance suggested). It includes frequent but mostly innocuous violence, and mild sexual innuendoes.

1993 N 12, C10:5

─────────

'The Piano': Love Story With a Twist

"The Piano" was shown as part of the recent New York Film Festival. Following are excerpts from Vincent Canby's review, which appeared in The New York Times on Oct. 16. The film opens today in Manhattan.

Don't let the mountains of superlatives that have already been heaped on "The Piano" put you off: Jane Campion's 19th-century love story lives up to its advance notices. Prepare for something very special.

"The Piano" is much like its remarkable heroine, Ada (Holly Hunter), a mute (but not deaf), young unmarried Scots woman who, with her 9-year-old daughter, travels to the New Zealand bush to marry a man she has never met. Ada's husband-to-be calls her "stunted." The film looks deceptively small, but in character it's big and strong and complex. Here's a severely beautiful, mysterious movie that, as if by magic, liberates the romantic imagination.

"The Piano" could be the movie sensation of the year.

You know you're in uncharted cinema territory early on. Ada and Flora (Anna Paquin), her pretty but gnomelike child, are dumped onto a wild New Zealand beach and then abandoned by the ship that brought them halfway around the world. With their crated belongings (including Ada's beloved piano) spread around them on the sand, the mother and daughter spend the night alone, huddled inside a sort of tent made out of one of Ada's hoop skirts.

This is how they're found the next morning by Stewart (Sam Neill), the well-meaning but dangerously unimaginative man who has ordered Ada by mail; Baines (Harvey Keitel), an illiterate settler with a nose tattooed Maori-style, and the Maori tribesmen hired as bearers.

The confusion of emotions of the moment is echoed in the confusion of languages being spoken: English, Maori (translated by English subtitles) and the sign language by which Ada instructs Flora what to say to the others. When Ada and Flora want privacy, they both sign, which is also translated by subtitles. "The Piano" is full of secrets.

"The Piano" is the story of the heedless and surprising sexual passion that eventually erupts to unite the grossly crude Baines and the seemingly remote and reserved Ada, whose marriage to Stewart hasn't been a happy one. Things had begun badly when Stewart refused to transport her piano inland to their house.

Sometime later, Baines acquires the piano (still sitting on the beach) from Stewart for 80 acres of land. Baines retrieves the piano, then offers to return it to Ada if she will teach him how to play. He asks for one lesson for each key. They haggle, finally agreeing on one lesson for each black key.

In this way begins one of the funniest, most strangely erotic love stories in the recent history of film. Like "Sweetie," Ms. Campion's marvelous first feature, "The Piano" is never predictable, though it is seamless. It's the work of a major writer and director. The film has the enchanted manner of a fairy tale. Even the setting suggests a fairy tale: the New Zealand bush, with its lush, rain-soaked vegetation, is as strange as the forest in which Flora says her mother was struck dumb.

Trips through this primeval forest are full of peril. When Ada goes off to her first assignation with Baines, she appears to be as innocent as Red Riding Hood. Yet this Red Riding Hood falls head over heels in love with the wolf, who turns out to be not a sheep in wolf's clothing, but a recklessly romantic prince with dirty fingernails.

Not the least of Ms. Campion's achievements is her ability to communicate the heady importance of sexual and romantic feelings to both Ada and Baines. Their love is a simultaneous liberation. The director's style is spare. No swooping camera movements over naked, writhing bodies. The camera observes the lovers from a distance, from the points of view of the spying child and then of the spying, fascinated and furious Stewart. It's as if the camera respected the lovers' privacy but felt compelled to show us what the others see.

The film's effect is such that it's almost impossible to consider the contributors separately. The four principal performances are extraordinary: Ms. Hunter, with her plain, steely beauty and intelligence; Mr. Keitel, so robust and intense in what could be an Oscar performance, Mr. Neill, earnest and forever baffled, and the tiny Ms. Paquin, who is so sure of herself that she doesn't seem to be a child of this world.

The physical production, smashingly photographed by Stuart Dryburgh, is elegant without fanciness, which is the mark of Ms. Campion's work. She takes the breath away not by conventionally spectacular effects, but by the simple audacity of her choices about where to put the camera and what to show.

"The Piano" has been rated R (Under 17 requires accompanying parent or adult guardian). It has one scene of brutal, bloody violence and another of nudity and sexual play.

1993 N 12, C12:6

─────────

My Life

Directed and written by Bruce Joel Rubin; director of photography, Peter James; edited by Richard Chew; music by John Barry; production designer, Neil Spisak; produced by Jerry Zucker, Mr. Rubin and Hunt Lowry; released by Columbia Pictures. Running time: 118 minutes. This film is rated PG-13.

Bob Jones	Michael Keaton
Gail Jones	Nicole Kidman
Paul	Bradley Whitford
Theresa	Queen Latifah
Bill	Michael Constantine
Rose	Rebecca Schull
Mr. Ho	Haing S. Ngor

By JANET MASLIN

That faint, terrified cry you hear in the distance is the sound of the baby-boom generation experiencing its mid-life crisis on screen. Bit by bit, the current crop of middle-aged film makers has begun to explore the thought of mortality, though the idea is not necessarily couched in the greatest candor. Films about stopping to smell the roses often have their sobering side, as do uplifting tales of learning to enjoy life after a terrible scare. Not surprisingly, the D-word has yet to turn up in the advertising campaign for any such story.

But Bruce Joel Rubin, the screenwriter who makes his directorial debut with "My Life," has made death his dramatic specialty. "Ghost" was Mr. Rubin's romance about a love that transcended mortality, in so many audience-pleasing ways. And "Jacob's Ladder" presented the writer's strange, hallucinatory vision of one man's demise. Now Mr. Rubin has imagined a loving young family coping with terminal cancer, in a film well poised to kick the yuppie audience squarely in the solar plexus. The imminent death of Bob Jones (Michael Keaton) is linked heartbreakingly with the birth of a child he may never know.

The very outline of Mr. Rubin's screenplay provides four-hankie material. Deeply in love with his pregnant wife, Gail (Nicole Kidman), but much too focused on his shallow career, Bob is caught up short by his doctor's diagnosis. "I don't have time for this," he complains angrily, about being ill. Nor does he have time for his humble Ukrainian-American parents, having so distanced himself from his relatives that he has even abandoned the family name. (It wasn't Jones.) "You always hated Dad for being a junkman," Bob's brother finally tells him, in one of the film's moralistic moments. "I always loved him for being a hard worker."

A public relations man, Bob has led "not exactly what you'd call an examined life," in the words of one of his colleagues. "He's really a product of his own P.R.," another says, in a remark that fills Bob with sudden regret. Faced with the prospect of not being able to watch his son grow up, Bob decides to leave behind a video legacy and make a home movie about his life. In the process he comes to understand himself at last. As he confides to his video camera, "Dying's a really hard way to learn about life."

With this kind of automatic grip on his viewers' heartstrings, Mr. Rubin really needn't do more than tug. But "My Life" has trouble modulating its moods, maintaining a lightly sentimental spirit much of the way through and then abruptly taking a turn for the tragic in its final reel. Indeed, the film's early sections are so peculiarly sunny, in light of the circumstances, that they limit the credibility of Mr. Keaton's performance, which is otherwise thoughtful, wry and finely honed.

Again proving himself a lifelike and appealing everyman for problem stories (with "Clean and Sober" also to his credit), Mr. Keaton easily makes droll, charming asides for Bob's home movie. His demonstrations of how to shave, for instance, or how to walk manfully into a room are as amusing as they're meant to be.

But Bob isn't allowed equal time for the genuinely black moods he must be experiencing. Nor is Gail (played warmly by Ms. Kidman, who bears an odd resemblance to Ann-Margret here) able to voice much beside stalwart wifely support. These two spend an awful lot of time simply being sweet to each other. But it's a mistake to let characters remain so uncomplicated when they are dealing with matters of life and death.

Clearly, realism is only part of what Mr. Rubin is after. His story leans heavily toward the upbeat and inspirational, as in a boyhood disappointment of Bob's that becomes a maudlin consolation in his final days. A lengthy middle section of the film, devoted to the joyous arrival of the Jones's baby, delivers so much warmth that Bob's problem seems to disappear for a while.

•

And Bob's visits to an Asian healer (Haing S. Ngor, the Oscar-winning actor from "The Killing Fields"), provide the film with a soothing spiritual dimension, in contrast with the brusque treatment Bob receives from conventional doctors. "You hold too much anger inside," the healer says early in the story. "It poisons you." By the end, this soothing figure can offer Bob some degree of serenity by telling him: "Put your house in order. Find peace."

There won't be a dry eye in the house by the time Mr. Rubin reaches this juncture. Nor will the film's target audience be able to resist a still life of medicine bottles, warm sunlight, a petal falling off a rose and a copy of Dr. Seuss's "Green Eggs and Ham." This film's intensity is unmistakable, but so is the idea that it could have been better. A less sentimental portrait of Bob need not have stinted on the raw emotions that accompany his experience, and might have done a stronger job of driving that experience home. But even in its present uneven, manipulative form, "My Life" is finally wrenching in ways that will leave viewers thinking hard about their own lives.

In addition to the stars' sincere, affecting performances, "My Life" includes sturdy supporting appearances by Michael Constantine as Bob's loving father and Queen Latifah as the hospice nurse who provides great comfort in the film's later scenes. Peter James's cinematography is interestingly ambitious, especially in its apparent efforts to convey Elisabeth Kubler-Ross's five stages of dying through varied lighting effects. The camera work comes even closer to mortality in following Mr. Keaton on a hair-raising roller coaster ride. He must have badly wanted to play this role.

•

"My Life" is rated PG-13 (Parents strongly cautioned). It includes brief sexual situations and mild profanity.

1993 N 12, C17:1

Radio Stories

Directed and written by José Luis Sáenz de Heredia (in Spanish with English subtitles); director of photography, Antonio L. Balesteros; edited by Julio Pena; music by Ernesto Halfter. At the Joseph Papp Public Theater, 425 Lafayette Street, East Village. Running time: 92 minutes. This film has no rating.

Gabriel Francisco Raba
Carmen Margarita Andrey
Inventor José Isbert
Thief Angel de Andrés
Don Senen José María Lamet
Don Anselmo Alberto Romer

By STEPHEN HOLDEN

There is a touching innocence to José Luis Sáenz de Heredia's 1955 film, "Radio Stories," three small comic vignettes linked by a radio show that keeps the Spanish populace enthralled. Made in the quaint old days before television had entirely usurped radio's place as the center of home entertainment, it is an agreeable reminder that not too long ago a mellifluous voice from an electronic box could cast a spell as potent as any telegenic image.

The movie, which opens today at the Joseph Papp Public Theater, is the first in a series, "Spanish Eyes: Classics of the Spanish Cinema (1935-60)," which the theater is presenting through the end of this month. Its 11 films offer a revealing look at Spanish movies made during the repressive years of the Franco regime.

In the most dramatic of the three, a schoolteacher from a small Spanish village reluctantly agrees to be a contestant on a double-or-nothing quiz show to raise money to save the life of an ailing child. On the day of the program, the entire village gathers around the only radio available to cheer him on as if for a sporting event. So nervous that he barely makes it through the contest without collapsing, the schoolteacher fares well enough to become a threat whom the program's hosts try to oust by shifting from academic questions to sports trivia.

In the funniest vignette, a radio announcer offers a cash prize to the first person to arrive at the studio dressed as an Eskimo, complete with sleigh and husky. An aged inventor, who needs the money to buy a patent for his latest device dresses himself up in a ludicrous polar outfit, borrows a friend's hostile police dog and huffs and puffs his way to the studio only to find two other phony Eskimos competing for the cash.

The weakest story, which involves a landlord, his indigent tenant, a priest and some radio prize money, never amounts to much.

"Radio Days" is surprisingly similar in tone and format to American television sitcoms from the same period. Oblivious to social issues, it offers wholesome family fun in an environment where people pull together, generosity triumphs over selfishness, and happy endings are a matter of course. It is a very minor film.

1993 N 12, C20:5

Philadelphia Experiment 2

Directed by Stephen Cornwell; written by Kevin Rock and Nick Paine; director of photography, Ronn Schmidt; production designer, Armin Ganz; produced by Mark Levinson; released by Trimark Pictures. Running time: 97 minutes. This film is rated PG-13.

David Herdeg Brad Johnson
Col. William Mailer Gerrit Graham
Jess Marjean Holden
Professor Longstreet James Greene
Logan Geoffrey Blake
Benjamin John Christian Graas

By STEPHEN HOLDEN

What would America be like today if Germany had won World War II by dropping a bomb on Washington? Much of "Philadelphia Experiment 2" is devoted to imagining that alternative, but with a paucity of wit that is mind-numbing, given the possibilities.

Instead of a sun-drenched suburban landscape, Southern California is a sprawling, heavily policed labor camp called Freedom City, which looks like an endless oil refinery. Loudspeakers posted everywhere incessantly play a children's chorus intoning slogans like "propagate, educate, suplicate," which are also flashed on movie screens. (The repeated misspelling of supplicate seems unintentional.) There is not a swastika in sight.

In a plot that suggests a particularly desperate episode of "Star Trek," David Herdeg (Brad Johnson), a scientific guinea pig, finds himself propelled into this nightmare world. His adversary, Col. William Mailer (Gerrit Graham), is the mad scientist who invented the machine that lands him there. To right history's course, David has to zoom back to 1943 to prevent the Germans from deploying the deadly bomber. In the penny-pinching world of "Philadelphia Experiment 2," this is accomplished by igniting some fuel oil.

"Philadelphia Experiment 2," which was directed by Stephen Cornwell from a script by Kevin Rock and Nick Paine, is not helped by a mumbling, stone-faced performance from Mr. Johnson. In the best tradition of grade-C science fiction, the movie, which is strongly anti-science, is regularly peppered with pronouncements like, "Man was not meant to play with time."

•

"Philadelphia Experiment 2" has been rated PG-13 (Parents strongly cautioned). It has scenes of violence, including several shootings.

1993 N 13, 18:3

183

FILM VIEW/Caryn James

Just Don't Call It 'Unfilmable'

AS THE REPRESSED BUTLER IN "THE REMAINS of the Day," Anthony Hopkins carries the weight of the film literally in his shoulders. When he plays the aging Stevens of the 1950's, Mr. Hopkins's shoulders are slightly hunched up and rounded, so full of tension they look painful. In flashbacks to Stevens in his prime during the 1930's, the shoulders are less tense. In those days of Stevens's blind and self-satisfied devotion to his master, Lord Darlington, the butler has a rigid bearing and placid face, though his worried eyes hint at the merciless denial of his emotional life.

The actor's posture is one visual equivalent of the self-deluded and defensive monologue by Stevens that makes up the English writer Kazuo Ishiguro's 1989 novel, on which the film is based. What is "a great butler," Stevens fussily wonders in the novel. Who "set the standards amongst our generation"? That sense of a generation whose time and standards have passed is a major theme on the page. Stevens's musing about it is absent from the film, but Mr. Hopkins's punctilious diction and changing posture provide perfect cinematic equals.

"The Remains of the Day" is the deepest, most heart-breakingly real of the many extraordinary films directed by James Ivory, produced by Ismail Merchant and written by Ruth Prawer Jhabvala. And in a season rich with dazzling literary adaptations, including "The Age of Innocence" and "Short Cuts," it is the most sublime and difficult accomplishment.

It is based on an apparently unfilmable novel, whose action is largely that of a mind sifting through the past. The previous Merchant-Ivory work, "Howards End," was based on a similarly subtle and challenging book, but E. M. Forster's novel reads like a ready-made script next to Mr. Ishiguro's. The way the film makers have adapted the book while preserving its spirit suggests what is superb about the movie and speaks to some fundamental differences betweeen fiction and film.

The very qualities that enrich the novel make it a dare for a screenwriter. On the page, Stevens is an unreliable narrator and stingy with details. The frame of the story is his journey from Darlington Hall, where he now works for a rich American, to the countryside where he will meet the former housekeeper, Miss Kenton, after 20 years. On the way, Stevens flashes back and forth in time to fill in the past, though not in a simple way. He backtracks and then backtracks from there, dropping hints like land mines — about Lord Darlington's political activities, about his relationship with Miss Kenton — whose significance will explode into view much later. What could be less dramatic than the memories of a man determined not to question the rigid social order that has ruled his life?

THE FIRST WRITER TO TACKLE THE PROBlem was Harold Pinter, who bought the rights to the Ishiguro novel before it was published. Though "The Remains of the Day" is unmistakably a Merchant-Ivory-Jhabvala film, it took quite a while to get that way. Mike Nichols originally intended to direct the Pinter script. When he chose to pass, he stayed on as a producer. Mr. Merchant and Mr. Ivory were brought in, and they in turn brought along Mrs. Jhabvala as writer.

As Mr. Nichols explained, "Pinter's approach was more austere and had more mystery. Jhabvala filled us in completely." Her version was "clearer and more accessible." Mr. Pinter was sent the Jhabvala script and was offered a co-screenwriting credit, which he declined.

It is hard to separate the Pinteresque whiffs in the film from those in the novel (especially the layering of time), but the deftness of the translation is clearly Mrs. Jhabvala's. As with "Howards End," she found what was under the surface of the story and made it concrete without destroying its mystery. Her dialogue is sometimes straight from the book ("History could well be made under this roof," Stevens tells the staff before one of Lord Darlington's political conferences) and sometimes only sounds as if it is.

The film's point of view is almost exclusively Stevens's; as in the novel, that device allows us to see and hear only what he does but usually to understand much more.

Some changes involved minor but crucial bits of compression. Mr. Lewis (Christopher Reeve) is a United States Congressman who attends one of Lord Darlington's conferences in the 1930's and buys Darlington Hall in the 1950's; he was two characters in the novel. On screen, Lord Darlington's role in Nazi appeasement is hinted at much earlier in the story.

But the most important change is the expanded role of Miss Kenton. In the novel, the housekeeper is a shadowy figure, whom Stevens can scarcely admit he might have been attracted to once. On screen, played by Emma Thompson in a performance as exquisitely poignant as Mr. Hopkins's, she is a woman whose affection for Stevens slowly becomes apparent.

■

When she finally flirts with him, after years of working together, the scene is even more effective than on the page. She must physically back him into a corner in his own sitting room. It is, of course, a doomed overture, but the moment resonates with the audience's sympathy for Miss Kenton and the hope that Stevens might respond. She understands that the orderlinesss of his profession provides the substance of his life; in fact, she possesses a comfortable aloofness of her own. Their relationship unearths the dramatic and passionate possibilities in the story of a determinedly unpassionate man.

The film's emotionally devastating ending is evoked by the sense that both Stevens and Miss Kenton have missed great love and happiness. "There are times when I think, 'What a terrible mistake I've made with my life,' " Miss Kenton says at her final meeting with Stevens in the 1950's. In the novel, that line is almost a revelation, adding to the reader's meager proof of her affection for Stevens decades before. (Provided Stevens's memory of the dialogue can be trusted, which it can't.) On screen, that

Phillip Caruso/Columbia Pictures

Michelle Pfeiffer, left, Geraldine Chaplin and Winona Ryder in "The Age of Innocence."

affection has been evident, and the same line becomes an elegy for the possibilities we have seen evaporate before our eyes.

Though "The Remains of the Day" might seem a model translation from one art to another, the season's other literary films suggest there is no single best way to adapt a novel.

Martin Scorsese's "Age of Innocence" is the most faithful of the three, but its fidelity to Edith Wharton's novel would be meaningless without a sophisticated understanding of what the author was up to. The film's voiceover, read by Joanne Woodward, comes straight from Wharton. It defines Old New York society and mirrors the novel's ironic distance from events. Yet Mr. Scorsese (who co-wrote the script with Jay Cocks) lets us know only as much as Newland Archer (Daniel Day-Lewis) does, as the hero struggles between his proper marriage to May Welland (Winona Ryder) and his love for her exotic cousin, Ellen Olenska (Michelle Pfeiffer). The lavishly beautiful film recreates all the seductive elegance of Archer's world; it is not pretty merely for the sake of being pretty but for the sake of luring us in as easily and inescapably as Archer.

When he discovers that his wife is capable of the subtlest manipulation, he is stunned, just as he is in the novel. That, Mr. Scorsese has said, was for him the most powerful moment in the novel. And his understanding of that moment shapes the entire film, just as surely as the tone of the film is set by the bit of dated dialogue lifted from Wharton that he has chosen to begin the film. Stunned at the way Ellen Olenska's family has brazenly taken her to the opera, a social insider says, "I didn't think the Mingotts would have tried it on."

Robert Altman's "Short Cuts" is often unfaithful to the Raymond Carver stories that inspired it, and that infidelity is one of the film's great achievements. A simple equation has emerged about the movie: the more you like Carver, the less you like the "Short Cuts" and vice versa.

Mr. Altman and his co-writer, Frank Barhydt, have done more than link and overlap nine Carver tales plus a poem. Essentially, Carver wrote the same story over and over, so turning them into a whole was the easy part. The generous improvement on the fiction comes in the way "Short Cuts" expands the depth and reach of the modest, minimalist tales about working-class characters who bump into a crisis.

Mr. Altman's suburban characters are sometimes richly connected. Two sisters, one an artist married to a doctor and the other a housewife married to a cop, suggest a range of social and family distinctions that Carver never bothered with. In this season of literary adaptations, the only easy call is that you can never judge a movie by its book. □

1993 N 14, II:13:5

The Saint of Fort Washington

Directed by Tim Hunter; written by Lyle Kessler; director of photography, Frederick Elmes; edited by Howard Smith; music by John Barnes; production designer, Stuart Wurtzel; produced by David V. Picker and Nessa Hyams; released by Warner Brothers. Running time: 102 minutes. This film is rated R.

Jerry..................................Danny Glover
Matthew.................................Matt Dillon
Rosario....................................Rick Aviles
Tamsen............................Nina Siemaszko
Little LeroyVing Rhames
Spits.......................................Joe Seneca

By JANET MASLIN

Matthew (Matt Dillon), a gentle soul, has lived quietly until circumstances force him out on the street. A wrecking crane appears at the start of "The Saint of Fort Washington" to smash a condemned building, and inadvertently shatter Matthew's life. Fragile and bewildered, Matthew is ill-equipped to fend for himself, so he has no hope of finding a new place to stay. With no address for receiving his public assistance checks, he is left homeless, indigent and alone.

Matthew is not literally alone when he is sent to the Fort Washington Armory, an enormous city-operated shelter where he must sleep on a cot alongside hundreds of other homeless men. And "The Saint of Fort Washington," Tim Hunter's heartfelt new film about homeless characters, is most disturbing in presenting straightforward images of this hellish, impersonal place. With a documentarian's eye for detail, Mr. Hunter (the director of "Tex" and "River's Edge") shows how to keep shoes and valuables from being stolen overnight, and why it's best never to visit the bathroom without an escort. This film has no trouble communicating how devastating it can be to spend time in such a place.

But "The Saint of Fort Washington" is no documentary; it's a drama in which saintliness plays an oversized role. As written by Lyle Kessler, it shows how a friendship develops between Matthew and Jerry (Danny Glover), a kindly Vietnam veteran who is well versed in the ways of street survival. Once a middle-class husband and father, Jerry has been homeless for so long that he can help teach Matthew certain basic tricks, like how to linger for hours in a fast-food restaurant over a salvaged newspaper and a single cup of coffee. If Matthew, as Jerry suggests, is the de facto saint of the homeless community, then Jerry is surely its mayor.

•

The film watches attentively as Jerry takes Matthew under his wing. Ever cheerful (either despite or because of painkillers prescribed to him by V.A. doctors), Jerry tries to teach Matthew how to clean automobile windshields with only an occasional burst of sarcasm. ("Hey, thanks a lot," Jerry says to one driver. "This is your world; we just live in it.") Then he finds that even this job is too much for the childlike, distracted Matthew to handle. Once Jerry grasps the extent of Matthew's helplessness, he does his best to become the younger man's protector. But the characters in "The Saint of Fort Washington" need a lot more than one another's kindness. In his tacit, thoughtful way, Mr. Hunter makes that inescapably clear.

"The Saint of Fort Washington" is a movingly acted and often bleakly believable film, but it does not

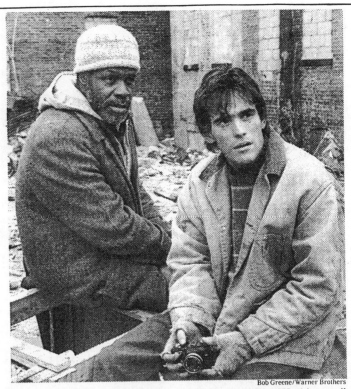

Bob Greene/Warner Brothers

Danny Glover, left, and Matt Dillon in "The Saint of Fort Washington."

strengthen its story by draping a cloak of nobility over its characters. Jerry and Matthew would be sympathetic under any circumstances, thanks to Mr. Glover's warm, sturdy presence and Mr. Dillon's way of suggesting that Matthew truly does enjoy a state of grace. But the film's spirit of compassion can be dangerously pat, as with the homeless lovers (Rick Aviles and Nina Siemaszko) whose eager anticipation of a new baby sets up the screenplay's most mawkish, predictable development. It does not help that the story allows for exactly one bully (Ving Rhames) plus his henchman, within its not always three-dimensional world.

The film's visual backdrop often supplies what its dialogue lacks, as Mr. Hunter — and the cinematographer Frederick Elmes, creating vivid urban landcapes — convey a strong sense of the characters' restrictive domain. The locations are especially well chosen, from the real shelters seen here to the drab government office where Matthew runs afoul of red tape. Potter's field, on Hart Island, is a seldom-seen location that lends real sorrow to the film's closing moments, especially when Mr. Hunter quietly depicts the procedures by which the homeless are buried there. Whatever its shortcomings, "The Saint of Fort Washington" takes its subject very seriously, in ways that no audience can fail to find wrenchingly sad.

•

Mr. Dillon, who goes back a long way with this director (having made his screen debut in the 1979 "Over the Edge," which Mr. Hunter co-wrote), again finds surprising ways to play a troubled, affecting loner. With a disheveled look and an expression that is both dazed and somehow watchful, he makes Matthew's extreme sensitivity a riveting quality, even if the screenplay takes it a step too far. Matthew is often seen snapping pictures with a camera, which is revealed to have no film. "The Saint of Fort Washington" works best when it avoids even a hint of the metaphorical and sticks to the plain, hard facts.

"The Saint of Fort Washington" is rated R (Under 17 requires accompanying parent or adult guardian). It includes profanity and violence.

1993 N 17, C19:3

Highway Patrolman

Directed by Alex Cox; written and produced by Lorenzo O'Brien; in Spanish, with English subtitles; director of photography, Miguel Garzón; released by Together Brothers/Ultra Film. Film Forum 1, 209 West Houston Street, South Village. Running time: 104 minutes. This film has no rating.

Pedro.................................Roberto Sosa
Aníbal..................................Bruno Bichir
Maribel..............................Vanessa Bauche
Griselda.........................Zaide Silvia Gutiérrez

By STEPHEN HOLDEN

Alex Cox's "Highway Patrolman" comes as a brash rebuke to the hundreds of movies that have glamorized law enforcement as an occupational springboard into a real-life action-adventure film. Filled with heat, dust and corruption, Mr. Cox's film traces the erosion of body and spirit of Pedro Rojas (Roberto Sosa), an idealistic young graduate from the National Highway Patrol Academy in Mexico City.

In their first assignment, Pedro and his best friend, Aníbal Guerrero (Bruno Bichir), are sent to patrol a desolate highway in Durango. Pedro quickly discovers that his job is not at all the equivalent of being a modern-day road warrior. Most of the people he stops for petty violations are too poor to afford the licenses required to transport their goods legally. One woman he stops, Griselda (Zaide Silvia Gutiérrez), invites him home for breakfast and makes a heated play for him. Weeks later they are married.

Pedro's life becomes a series of rude awakenings. When he doesn't meet his arrest quotas, he is sharply reprimanded and reassigned to "the pig route," a highway traveled by hog

farmers. Here he discovers that bribery is a matter of course. The bossy, demanding Griselda has no interest in the ethics of his profession; all she wants is money. Pedro begins salving his psychic wounds with tequila and visits to Maribel (Vanessa Bauche), a local prostitute addicted to heroin.

One day, as he is rescuing two men from a fiery car crash, a drunken driver nearly runs him down. While apprehending the driver, Pedro is shot in the leg by the car's other passenger. For the rest of the movie, he drags his leg behind him like a wounded dog. His mounting rage leads him to wreck his own police car accidentally. And after he foolishly arrests the Governor's arrogant teenage son, he nearly loses his job and is ordered to take a psychiatric examination.

Pedro's new police car, a dilapidated heap, fails him when Aníbal, shot by drug smugglers, radios for help. In the film's most grueling scene, he jumps out of his smoking vehicle and desperately limps up the highway to help his friend. Tracking Aníbal's bloodstains into the desert, he reaches him in time for Aníbal to die in his arms. The murder galvanizes Pedro to launch a fanatical one-man crusade against the drug trade.

In dispassionately examining a mundane life, "Highway Patrolman," which opened today at Film Forum 1, is very much in keeping with the mood of earlier films by Mr. Cox, like "Repo Man" and "Sid and Nancy." Without entering into Pedro's innermost thoughts and feelings, the movie looks at the world through his essentially innocent eyes. More than anything, it is a character study of a contemporary naif with decent human impulses and vague aspirations toward noble service who is driven to the edge by the grubby realities he is forced to accept.

Although the movie has a confident, almost stately flow, there are occasional glitches in Lorenzo O'Brien's Spanish-language screenplay. The film concentrates so fixedly on Pedro's job that the portrayals of his marriage and of his relationship with Maribel seem rushed and incomplete.

The beautiful but arid landscape of north central Mexico is as almost as much a character in the film as Pedro, whom Mr. Sosa portrays in a performance that is at once strong and unassuming. Whether speeding on the highway or scurrying through the mountain chaparral with rifle, Pedro emerges finally as a small, vulnerable speck of life in an harsh environment that has many punishing lessons to teach those creatures who don't adapt.

1993 N 17, C26:5

Addams Family Values

Directed by Barry Sonnenfeld; written by Paul Rudnick, based on characters created by Charles Addams; director of photography, Donald Peterman; edited by Arthur Schmidt and Jim Miller; music by Marc Shaiman; production designer, Ken Adam; produced by Scott Rudin; released by Paramount Pictures. Running time: 93 minutes. This film is rated PG-13.

Morticia Addams	Anjelica Huston
Gomez Addams	Raul Julia
Fester Addams	Christopher Lloyd
Wednesday Addams	Christina Ricci
Pugsley Addams	Jimmy Workman
Debbie Jellinsky	Joan Cusack
Granny	Carol Kane
Pubert Addams	Kaitlyn and Kristin Hooper
Joel Glicker	David Krumholtz
Becky Granger	Christine Baranski
Gary Granger	Peter MacNicol

Melinda Sue Gordon/Paramount Pictures

Christopher Lloyd

By JANET MASLIN

"These Addams men; where do you *find* them?" coos the family's voluptuous new nanny (Joan Cusack), trying to make a good impression. "It has to be damp," explains Morticia (Anjelica Huston), the Addamses' reigning mistress of witchy delivery and sly, sugar-coated malice.

"He has my father's eyes," coos Gomez (Raul Julia), admiring little mustachioed Pubert, the baby who arrives at the start of "Addams Family Values." "Gomez," Morticia says evenly, "take those out of his mouth."

Now it could be that the making of this sequel was sheer drudgery for all concerned. But it doesn't seem likely. There's simply too much glee on the screen, thanks to a cast and visual conception that were perfect in the first place, and a screenplay by Paul Rudnick that specializes in delightfully arch, subversive humor. That the ghoulish Addamses somehow remain much sweeter than the rest of us is no small part of the joke.

Even if Mr. Rudnick's script isn't as wall-to-wall funny as "Jeffrey," his current hit Off Broadway, it is buoyant in absurd, wonderful ways that the Addamses would themselves enjoy. "Have you really never had sex?" asks this same nanny, once she has begun to entrap the bald, bashful Fester (Christopher Lloyd) in her gold-digging scheme. "Well then how do you know we're not having it right now?"

•

Armed with its irresistible title, "Addams Family Values" does have a potential problem. Once Gomez and Morticia become parents again, must they abandon the Addams taste for the macabre and begin acting like normal people? Could a baby curb the family penchant for deadly practical jokes and other mayhem? The answer, thanks to Mr. Rudnick and the director, Barry Sonnenfeld, is a clever and tactful one. Baby-baiting is left strictly to Pubert's siblings, Pugsley ("We don't hate him, we just want to play with him") and Wednesday ("Especially his head!").

The senior Addamses are allowed to wax parental, but only up to a point. One of the film's better sight gags is the nursery design featuring sharks and vultures painted on the walls, black swaddling, and an over-the-crib mobile made of knives. Later on — these touches are nicely spread out

over the course of the movie — a tiny Hannibal Lecter mask completes the effect.

With less novelty than its predecessor but more of a plot, "Addams Family Values" contrives some changes of scene. It sends Pugsley (Jimmy Workman) and the enchantingly glum Wednesday (Christina Ricci) off to Camp Chippewa, "America's foremost facility for privileged young adults" and a place where just about everyone else is a blue-eyed blond. Presided over with insane pep by the counselors Becky and Gary Granger (played hilariously by Christine Baranski and Peter MacNicol), this place provides an ideal new context for appreciating the Addams point of view.

It also gives the Addamses a chance to sabotage the camp's Thanksgiving pageant in memorably creative ways. "Your people will wear cardigans and drink highballs!" Wednesday warns the Pilgrims, as she horrifies their pastel-clad parents while playing a Pocahontas hell-bent on revenge. The pageant's holiday song is among the film's musical highlights, along with a "Whoomp!" Addams rap number

Welcome to the nursery. Just ignore the sharks.

heard over the closing credits.

Meanwhile, in an equally amusing subplot, Fester is spirited off by the nanny and transformed into a nouveau riche version of his former self. Mr. Rudnick, also the author of a novel about a shopping spree called "I'll Take It," brings obvious enthusiasm to this section of the story, perhaps in part because the lonely Fester is such an innocent. Planting Fester in the midst of a group of foreign sailors who sing "Macho Man" is the sort of thing the film does best.

Mr. Sonnenfeld repeats some of the first film's favorite visual stunts without wearing out their welcome, and he sustains much more exuberance than a sequel might be expected to have. The cast, which now includes Carol Kane playing Granny Addams, remains foolproof and great fun. New to this second story is Joel Glicker (David Krumholtz), Wednesday's first boyfriend, the kind of boy who enjoys reading "A Brief History of Time" at summer camp. Joel generates a Michael Jackson gag, one of several highly topical references in a film that also includes a dig at Amy Fisher, whose name is misspelled. That may be the point.

•

"Addams Family Values" is rated PG-13 (Parents strongly cautioned). It includes sexual references and mild violence, neither of which should deter older children.

1993 N 19, C3:4

Dangerous Game

Directed by Abel Ferrara; written by Nicholas St. John; director of photography, Ken Kelsch; edited by Anthony Redman; music by Joe Delia; production designer, Alex Tavoularis; produced by Mary Kane; released by Metro-Goldwyn-Mayer. At the Art Greenwich Twin, 12th Street and Seventh Avenue, Greenwich Village. Running time: 105 minutes. This film is rated R.

Lorey Sebastian/MGM

Madonna

Eddie Israel	Harvey Keitel
Sarah Jennings	Madonna
Francis	James Russo
Madlyn	Nancy Ferrara
Tommy	Reilly Murphy

By JANET MASLIN

It takes a certain moxie to use Madonna in a film, cast her as a famous actress who casually sleeps with both her director and her leading man, devise a plot in which she is violently slapped around and manage to make her the most demure character in the story. (It takes even more moxie to do this for Maverick, Madonna's own production company, but that's another matter.) But by now Abel Ferrara is well known for having nerve to spare, and for stopping at nothing when it comes to putting his raw, corrosive visions on screen.

"Dangerous Game," his latest, is a "Bad Director" to Mr. Ferrara's previous "Bad Lieutenant," with Harvey Keitel again personifying the film maker's darkest, most mischievous thoughts about the human condition. Those who admired Mr. Keitel's warmly romantic performance in "The Piano" had better see "The Piano" again for more of the same, since the Mr. Keitel on display here is a far more sodden and primal being. This time he plays Eddie Israel, a passionate film director and not-so-dedicated family man. "You been a good boy?" he asks his young son idly. "Why?"

Eddie is first seen in a domesticated state, complimenting his wife on her pasta and listening to classical music. This, by Mr. Ferrara's standards, amounts to a colossal joke. The real Eddie is obsessed with his lurid film about domestic violence, in which a husband hooked on drugs, booze and infidelity (James Russo) attacks his pious wife (Madonna), whom he considers a fraud. Eddie is seen directing from the sidelines, encouraging his actor to do things like urinate on the wall-to-wall carpet in order to show his wife what he thinks of her middle-class hypocrisies.

•

"So it becomes an argument between heaven and hell, if you will, to find what the right path is," Eddie comments solemnly about the film being made. That was more true of "Bad Lieutenant," in which Mr. Keitel's corrupt police officer wrestled so agonizingly with his many demons, than it is of "Dangerous Game," a ragged, scorching psychodrama played out in a smaller arena. Be-

sides, Mr. Ferrara, working from a screenplay by Nicholas St. John, his longtime collaborator, appears to see the absurdity in Eddie's grandiose side. So he lets Eddie croon Harry Chapin's "Taxi" at a supposedly romantic moment. And he kills off Eddie's unseen father-in-law just so Eddie can be especially awful to his wife on the day of the funeral.

Much of "Dangerous Game" concentrates on filming the aptly named "Mother of Mirrors," which indeed has a hall-of-mirrors quality. Mr. Ferrara's own presence is strongly felt in scenes showing Eddie charming and browbeating the actors who work for him. Madonna's public image is invoked pointedly as she plays Sarah Jennings, a jaded star with a lot of sway over her fans. Eddie's wife is played forcefully and well by Nancy Ferrara, the film maker's own wife, who can't help adding an extra dimension to the tale. It is she who must chatter away obliviously at a family barbecue while her husband reaches new heights of alienation, stretched out in a lawn chair with all of Los Angeles beckoning in the distance.

Mr. Keitel's ability to immerse himself in Mr. Ferrara's stories of self-abasement is once again stunningly complete. It is also given a playful twist by this film's Hollywood context. When a boozy, debauched Eddie gazes at the film being shown aboard an airplane ("The Cutting Edge," an uplifting ice-skating fantasy), the sheer disbelief on his face says everything about how Mr. Ferrara perceives mainstream movie making. Yet it's not entirely clear whether he intends "Mother of Mirrors" as a viable alternative, given the pulpiness of its action and the sheer viciousness of its escalating violence.

Mr. Ferrara retains enough detachment to see that a man as wasted as Eddie may not be working at the peak of his talents, and that when he encourages his actors to improvise, the results may not always be golden. "I want you to hit the points about the American way of life," he instructs his actor, who then simply inserts the word "consumerism" into one of his wife-abusing harangues.

•

Whatever else actors do in Mr. Ferrara's films, there's no question that they're given real opportunities to act. And Madonna submits impressively to the emotions raging furiously around her. She cries, whines, pleads and lets herself look dreadful for Eddie's camera. But she becomes a much more nonchalant presence in private moments, like the scene that finds her in bed with her co-star. (Mr. Ferrara saves a particularly mocking surprise for the end of this episode.) The role, which isn't glamorous, is free of artifice in a way that Madonna's screen roles seldom are. Viewers may actually have to remind themselves that they've seen this actress somewhere before.

"Dangerous Game," which opens today at the Art Greenwich Twin, is not Mr. Ferrara's most daring film ("Bad Lieutenant" still holds that distinction), but it may be the one that cuts closest to the bone. Shot in a grainy, urgent style with occasional lapses into video, it has a fury that goes well beyond the story at hand, and an energy level that transcends the story's self-indulgence. This tough, abrasive film maker is seldom without his deadly serious side. "Dangerous Game" is angry and painful, and the pain feels real.

"Dangerous Game" is rated R (Under 17 requires accompanying parent or adult guardian). It includes violence, profanity, nudity and sexual situations.

1993 N 19, C14:5

Welcome Mr. Marshall

Directed by Luis García Berlanga; written by Juan Antonio Bardem, Mr. García Berlanga and Miguel Mihura. In Spanish, with English subtitles. Director of photography, Manuel Berenguer; edited by Pepita Orduña; music by Jesús García Leoz. At the Joseph Papp Public Theater, 425 Lafayette Street, East Village. Running time: 78 minutes. This film has no rating.

Carmen Vargas	Lolita Sevilla
Manolo	Manolo Morán
The Mayor	José Isbert
Don Luis	Alberto Romea
Eloísa	Elvira Quintilla
Don Cosme	Luis Pérez de León
Don Simón	Felix Fernández
Narrator	Fernando Rey

By STEPHEN HOLDEN

"Welcome Mr. Marshall," a satirical Spanish comedy made in 1952, is a remarkably cheeky film considering that it was made during the repressive Franco era. Set in Villar del Río, a tiny Andalusian farming village where life has hardly changed over many decades, it remembers an event that turned life upside down.

Shortly after the end of World War II, a Government official arrives in the village to announce that an American committee for the Marshall Plan to rebuild Europe will be visiting Villar del Río. Although it isn't clear exactly when the Americans will show up, every town in the region has been asked to prepare a grand welcome.

To the mostly uneducated farming population of Villar del Río, the United States is about as remote as Mars, and the notion that one country would actually give something away without expecting something in return seems fishy. At a town meeting, the local schoolmistress reads off some facts and figures about America that make this supposedly beneficent nation sound like a crime-ridden country of warring ethnic groups.

•

The mayor is hard put to come up with a plan for an appropriately festive greeting until the manager of a popular singer from the village suggests they turn the community into a theatrical fantasy of an Andalusian town complete with cardboard facades and props. To pay for it all, the villagers agree to sell their valuables. Their investment, they reason, will soon repay itself many times over, once the Americans arrive with their gifts.

They imagine that the Marshall Plan committee, having arrived, will sit behind a table in the town square and, like kings distributing boons, grant each person his heart's desire. The village goes so far as to stage an elaborate dress rehearsal in which everyone solemnly lines up to put in his gift order. It goes without saying that when the Americans finally appear in Villar del Río, things don't go as expected.

"Welcome Mr. Marshall," which opens today at the Joseph Papp Public Theater as part of its Spanish Eyes series, veers into the surreal with a succession of comic dream sequences about the soon-to-arrive Americans. In the funniest, the may-

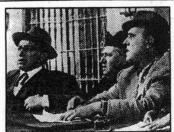
Papp Public Theater
From left: Felix Fernández, Luis Pérez de León and Manolo Morán

or (José Isbert), who suggests a chubby, hearing-impaired Jimmy Durante, slouches as a farcical caricature of an American cowboy star, facing down an outlaw in a bar that is a weird hybrid of an Old West saloon and a Spanish dance hall. The sequence mercilessly burlesques the rituals of American horse operas.

•

"Welcome Mr. Marshall," which was directed by Luis García Berlanga, tells its story very economically. A narrator (Fernando Rey) offers a brief history of Villar del Río and introduces the various key players. He returns at the end of the film to tie up the loose ends. The perfectly controlled tone of the performances is one of subdued farce with the faintest undercurrent of bittersweetness.

Although more than 40 years old, this funny, compassionate little fable has an ebullience and freshness that transcend its historical context.

1993 N 19, C18:6

Man's Best Friend

Directed and written by John Lafia; director of photography, Mark Irwin; edited by Michael N. Knue; music by Joel Goldsmith; production designer, Jaymes Hinkle; produced by Bob Engelman; released by New Line Productions. Running time: 87 minutes.

Lori Tanner	Ally Sheedy
Dr. Jarret	Lance Henriksen
Detective Kovacs	Robert Costanzo
Perry	Fredric Lehne
Detective Bendetti	John Cassini
Rudy	J. D. Daniels

WITH: Max, a Tibetan mastiff, and Heidi, a collie.

By STEPHEN HOLDEN

Don't blame poor Max for all the mayhem he wreaks. Without his tranquilizers, the canine horror who growls and chomps his way through John Lafia's film "Man's Best Friend" can't help losing his temper. A guard dog who becomes increasingly crazed and vicious as the movie goes along, he is the object of a genetic experiment that has infused him with the aggressive qualities of other creatures, including a cobra and a leopard. If Max, an enormous Tibetan mastiff, doesn't get his regular shots, he will go ballistic. And when he escapes from the laboratory in which he is being bred by the fiendish Dr. Jarret (Lance Henriksen), there is no one to pacify him.

Max can scurry up trees, outrun any police car and comprehend 350 spoken words, in English and Spanish. If he doesn't like his food, he'll personally dump it into the toilet. He is even capable of mechanically sabotaging an automobile. And heaven help the mailman.

Max is also fanatically loyal. After being rescued by Lori Tanner (Ally Sheedy), a television journalist preparing an exposé on the laboratory

where Max is being tested, the dog takes a homicidal dislike to her boyfriend, Perry (Fredric Lehne). Once Max peeps through her bedroom keyhole and observes Perry making love to his savior, the boy had better watch his step. Max is himself a phenomenal lover. His union with Heidi, a collie from next door, produces a piercing canine squeal that echoes through the neighborhood.

That love match is one of several smirking little jokes that give this efficiently made horror film some moments of levity. When some neighborhood boys sic Max on a mean-tempered cat, he consumes the creature in one ferocious gulp, which is followed by a big, echoing belch from hell. (It must be the snake in Max that enables him to swallow animals whole.)

"Man's Best Friend," which opened locally yesterday, isn't as scary as it could be. With each canine attack, the camera nimbly cuts from the carnage, leaving the full extent of the gore to the imagination. The movie's final scene, which reveals the fruits of Max's afternoon tryst, suggests that there is a lot more growling and chomping to come.

•

"Man's Best Friend" is rated R (Under 17 requires accompanying parent or adult guardian). It includes profanity and sexual situations.

1993 N 20, 17:1

A Perfect World

Directed by Clint Eastwood; written by John Lee Hancock; director of photography, Jack N. Green; edited by Joel Cox; music by Lennie Niehaus; production designer, Henry Bumstead; produced by Mark Johnson and David Valdes; released by Warner Brothers. Running time: 130 minutes. This film is rated PG-13.

Red Garnett	Clint Eastwood
Butch Haynes	Kevin Costner
Sally Gerber	Laura Dern
Phillip Perry	T. J. Lowther
Terry Push	Keith Szarabajka
Mack	Wayne Dehart

By JANET MASLIN

In a perfect world, says one rueful character in Clint Eastwood's quietly devastating new film, the events that shape the story of Butch Haynes and Philip Perry wouldn't have to happen. But the world in which "A Perfect World" unfolds is a place of sad, ineradicable scars that shape their characters' destinies. Many of those scars have to do with the burdens and misapprehensions of manhood, as illustrated beautifully during the course of this eloquent road film and understood by Mr. Eastwood in subtle, profoundly moving ways. The time and place — Texas, just before the Kennedy assassination — tacitly heighten the film's sense of needless tragedy.

"A Perfect World," a deeply felt, deceptively simple film that marks the high point of Mr. Eastwood's directing career thus far, could never be mistaken for a young man's movie. Nor could it pass for a reckless, action-packed tale of characters on the run. A lifetime's worth of experience colors the shifting relationship between Butch, superbly played by Kevin Costner with an unexpected toughness and passion, and Phillip (T. J. Lowther), the little boy who starts out as Butch's prisoner and winds up as his surrogate son.

A plot like this has many opportunities to turn maudlin, but "A Perfect

World" remains remarkably free of sentimentality. Instead, it is sustained by small, revealing surprises that carry Butch and Phillip ever closer to the film's stunning climax. This story builds up to an event that crystallizes all of its regrets about the mistakes that are passed from father to son, and about the kind of machismo that operates on cue.

•

"I don't know nothin'," mutters a stricken Mr. Eastwood, who appears in the smaller role of Red Garnett, the Texas Ranger assigned to recover Butch and Phillip, and who finally meets them in this anguished closing scene. "Not one damn thing." With sober intelligence and a welcome dearth of empty heroics, the film allows the wisdom of this moment to hit home.

The story begins when Butch escapes from prison along with Terry Pugh (Keith Szarabjka), a much more vicious convict. In short order, they break into the Perry house and wind up taking Phillip hostage. For Phillip, a fatherless boy cowed by his stern, religious mother, this makes for a terrifying yet thrilling brush with masculinity. Being a smart boy, Phillip quickly understands the difference between trigger-happy Terry, who isn't long for this story, and a more laconic and laid-back man like Butch. And Butch, despite his diffidence, finds himself wanting to give this boy the fatherly presence he himself never had.

The film recognizes Butch as a killer. And it is discriminating enough to admire his latter-day cowboy magnetism without treating him as a hero. But it does see him as a complex and fascinating figure, a person of principle who has been damaged in ways the story only gradually reveals. The closeness between Butch and Phillip, written and acted with such understated grace, develops in ways that make sense because of Butch's own history. Meanwhile, Phillip is seen rising to the point of making moral choices, and learning to understand right and wrong on his own.

"A Perfect World," a rare high-powered Hollywood film that is actually about something, evokes the cinematic past in effortless, interesting ways. If its story (from a terse, colorful screenplay by John Lee Hancock) is pure western and its backdrop one of wide-open spaces, its doomed, claustrophobic sense of the modern world makes for a compelling contrast. So does the air of inevitability about its principals' destinies, as do the doubts that plague Red Garnett as he tries to do what was once a Texas Ranger's traditional job. It's not so simple any more.

•

Mr. Eastwood's direction of this handsome film (with its Texas tableaux shot by Jack N. Green, also the cinematographer on "Unforgiven") manages to be both majestic and self-effacing. The same can be said of his own performance, as he jokes about age and infirmity (Red drinks Geritol) while inevitably projecting substance and grit. Also on the Texas Rangers' team is Laura Dern, in the small but enjoyable role of a criminologist trying to bring a modern approach to the job. "Penal escape situation" is what she calls this manhunt.

Mr. Costner's performance is absolutely riveting, a marvel of guarded, watchful, a character revealed through sly understatement and precise details. Despite its slow Southern tempo, this is Mr. Costner's most vigorous screen performance since "No

Way Out," and an overdue reminder of why he is a film star of such magnitude. Mr. Eastwood also elicits uncommonly fine acting from little T. J. Lowther, who makes Phillip's yearning palpable and real. Also memorable in small roles are Mr. Szarabajka, as scary and erratic as his escaped convict is meant to be, and Wayne Dehart as the sharecropper who helps out Butch and in the process sends him over the edge.

It's worth pointing out that the thought of men's legacies to their children, and of their failures or frustrations in bringing up those children, has figured prominently in a number of recent films (among them "My Life," "Carlito's Way" and the new "Mrs. Doubtfire"). "A Perfect World" gives that subject real meaning.

•

"A Perfect World" is rated PG-13 (Parents strongly cautioned). It includes violence, strong language and one brief sexual situation.

1993 N 24, C11:1

George Balanchine's 'The Nutcracker'

Directed by Emile Ardolino; choreographed by George Balanchine; adapted from the stage production by Peter Martins; music by Tchaikovsky; narration by Kevin Kline; costumes by Karinska; scenery by Rouben Ter-Arutunian; director of photography, Ralf Bode; edited by Girish Bhargava; produced by Robert A. Krasnow and Robert Hurwitz; released by Warner Brothers. Running time: 93 minutes. This film is rated G.

Marie	Jessica Lynn Cohen
The Nutcracker	Macaulay Culkin
Herr Drosselmeier	Bart Robinson Cook
The Sugarplum Fairy	Darci Kistler
Her Cavalier	Damian Woetzel
Dewdrop	Kyra Nichols
Coffee	Wendy Whelan
Tea	Gen Horiuchi

By STEPHEN HOLDEN

You don't have to believe in Santa Claus to be swept up in the magic of Christmas. By the same token, some of the fairy-tale magic of "George Balanchine's 'The Nutcracker'" has been lost in its translation from a staged ballet into a film, but it doesn't hurt; it is only a fraction. If Rouben Ter-Arutunian's depiction of the Sugarplum Fairy's Palace of Pleasures is obviously a painted stage set, its elegant swirl of domes and pedestals is still gorgeous.

And what is sacrificed in realism is gained in intimacy. In close-up, Karinska's original costumes are even more awesome in their beauty and richness of detail than when seen from afar. And children who watch Emile Ardolino's handsome film version of the New York City Ballet's classic production can be vicarious participants in its Christmas Eve games, folk dances and roughhouse. The film places you directly under the production's spectacular Christmas tree, which magically grows to be 40 feet tall. And once the tree has reached its full height, the camera mischievously peers down from the top. The intimate perspective also provides a throne's-eye view of the ballet's waltzing snowflakes and whirling candy canes and of its comic giantess, Mother Ginger. And when at the end, the Nutcracker Prince (Macaulay Culkin) and his sweetheart Marie (Jessica Lynn Cohen) soar off in a sleigh, you're there to bid them goodbye.

Eric Liebowitz/Warner Brothers
Macaulay Culkin and Jessica Lynn Cohen in a scene from "George Balanchine's 'The Nutcracker.'" The movie opens today.

The movie, which opened today, doesn't spend too much time gazing into people's faces. It is very scrupulous in the way it establishes a mood of participatory excitement, then draws back far enough so that the classic ballet sequences choreographed by Balanchine and staged by Peter Martins can be seen in their full glory. In these sequences, the camera enhances the fluency of the dancing and of the sweeping Tchaikovsky score by slowly, almost imperceptibly floating forward and upward.

Much of the dancing is breathtaking. Darci Kistler's Sugarplum Fairy whirls and leaps with an otherworldly lightness and speed. And Damian Woetzel as her Cavalier moves with a slashing grace. Wendy Whelan's Coffee projects an enigmatic sensuality. And Gen Horiuchi's Tea is a spectacularly acrobatic jack-in-the-box.

The film's inclusion of a narration by Kevin Kline pays off. Key changes of scene are unobtrusively introduced by the actor in two or three sentences that clear up any confusion and keep the story moving. Mr. Ardolino (who died on Saturday) has also added several short transitional sequences that were not choreographed by Balanchine. But they are close enough in style to the original ballet so as not to seem intrusive.

One reason the film is so captivating is that this 1816 fairy tale by E. T. A. Hoffmann is almost as well acted as it is danced. As Herr Drosselmeier, the white-haired old magician who dispenses the magic, Bart Robinson Cook inserts enough of a hint of the sinister into a benignly twinkling portrait to give the character a mystical stature. Miss Cohen's Marie is at once dignified and heartfelt. And the ensemble's depictions of parents, guests and children sharing a 19th-century Christmas have all the right storybook inflections.

The film's only serious flaw is Mr. Culkin's Nutcracker Prince. The entrance of the 11-year-old child star into this traditional setting is a little like having a baby Mick Jagger leap onto the stage as Jumping Jack Flash.

Heavy-lidded and pouting and wearing too much lipstick, Mr. Culkin radiates a narcissistic star buzz. And his uncomfortably heavy presence in the nonspeaking role suggests that much of this young actor's appeal comes from his cutely spunky line readings. Mr. Culkin also walks through the Nutcracker Prince's big number, in which the character recapitulates the story in pantomime; he

simply goes through the motions looking superior and detached.

If Mr. Culkin's presence throws the film slightly off balance at moments, the role is finally too small for the performance to undermine the film significantly. The Nutcracker Prince is merely an observer of magic that is conjured in one glorious scene after another by dancers who are virtuosos in the art of bringing dreams to life.

1993 N 24, C11:1

Mrs. Doubtfire

Directed by Chris Columbus; screenplay by Randi Mayem Singer and Leslie Dixon, based on "Alias Madame Doubtfire," by Anne Fine; director of photography, Donald McAlpine; edited by Raja Gosnell; music by Howard Shore; production designer, Angelo Graham; produced by Marsha Garces Williams, Robin Williams and Mark Radcliffe; released by 20th Century Fox. Running time: 120 minutes. This film is rated PG-13.

Daniel Hillard/Mrs. Doubtfire	Robin Williams
Miranda Hillard	Sally Field
Stu	Pierce Brosnan
Frank	Harvey Fierstein
Gloria	Polly Holliday

By JANET MASLIN

"Mrs. Doubtfire" is about a man who dresses as a dowager to invade the household of his estranged wife, who has thrown him out. The movie's biggest challenge, one that it does not exactly meet, is to persuade the audience that this husband and father's escapade is somehow an act of love.

Fortunately, Robin Williams lurks behind that latex face mask, ready to scatter wicked jokes and brilliant non sequiturs about whatever crosses his mind. Mr. Williams's genius is in these details, and it is given free rein during much of "Mrs. Doubtfire," as in the sequence that has him improvising with toy dinosaurs at a television studio and coming up with a Raptor Rap. ("Yo, yo, see me/I'm livin' below the soil/I'll be back/But I'm comin' as oil.") But if this film creates as good a showcase for the Williams zaniness as anything short of "Aladdin," it also spends too much time making nice. And not enough time making sense.

•

A lot of trouble has gone into giving a sitcom shininess to "Mrs. Doubtfire," which was directed by Chris Columbus (who also did both "Home Alone" films). Attention has been paid to everything from the sunny, well-heeled look of the family house-

20th Century Fox

Robin Williams starring in the new movie "Mrs. Doubtfire."

hold to the pert costumes on Sally Field, who plays Mr. Williams's careerist wife. The story is so simpleminded that the wife's job alone is enough to villainize her: Miranda Hillard (Ms. Field) is seen doing something terribly important involving fabric swatches, while her sweet, helpless husband, Daniel (Mr. Williams), can barely stay employed dubbing voices onto animated films. When Miranda complains about his childishness, kicks him out of the house and keeps him from seeing enough of their three children, Daniel remains much too good-hearted to sue for support.

Conveniently, Daniel has a brother (Harvey Fierstein, tart and funny here) who specializes in makeup effects. And naturally Daniel is an actor, just as Dustin Hoffman's character was in the funnier, more substantial "Tootsie," which unavoidably comes to mind. That film made the most of its hero's hostility, allowing it to become part of the joke. This one insists on a veneer of good intentions, which wears thin long before the story culminates in a speech about families and love.

Once the screenplay, by Randi Mayem Singer and Leslie Dixon, has accomplished the gargantuan job of getting Daniel into a dress (so that he can play nanny to his own children), it stops adding up. There's a sequence about how Daniel, now done up as the broad-backed, hairy-legged matron of the title, can't cook dinner for the children, even though he has been feeding and caring for them for years. There are also two separate episodes, one elaborately staged in a restaurant, when Daniel must become a quick-change artist and jump into and out of his Doubtfire drag. No audience will believe he can do this in a few seconds' time.

The film keeps busy by finding Miranda a handsome chump of a boyfriend (Pierce Brosnan), who becomes a fine target for Daniel's insults and the subject of Mrs. Doubtfire's motherly advice to Miranda. ("Once the father of your children is

out of the picture, the only solution is lifelong celibacy," the nanny says sweetly.) It also lets Daniel's son (Matthew Lawrence) catch his father in the bathroom and discover his disguise, asking nervously: "You don't really like wearing that stuff, do you, Dad?" Even then, the comic possibilities posed by letting the children in on the joke are never explored.

Mr. Williams remains this film's main and only real attraction (although Ms. Field tries gamely to generate sitcom-caliber sparks). He is well worth seeing whatever he's wearing, but he's most fun in an anarchic mode, threatening to blow the film's illusions wide open. The dress, the mask and Mrs. Doubtfire's gentility are inherently limiting, but nothing holds Mr. Williams back when he's on a roll. You may not believe he could pass for a woman, but you'll want to see what he can do with a vacuum cleaner all the same.

•

"Mrs. Doubtfire" is rated PG-13 (Parents strongly cautioned!) It includes plenty of off-color asides that should go over the heads of small children.

1993 N 24, C11:1

Josh and S.A.M.

Directed by Billy Weber; screenplay by Frank Deese; director of photography, Don Burgess; edited by Chris Lebenzon; production designer, Marcia Hinds-Johnson; produced by Martin Brest; released by Castle Rock Entertainment. Running time: 97 minutes. This film is rated PG-13.

Josh Whitney	Jacob Tierney
Sam Whitney	Noah Fleiss
Alison	Martha Plimpton
Caroline Whitney	Joan Allen
Thom Whitney	Stephen Tobolowsky
Jean Pierre	Ronald Guttman
Derek	Chris Penn

By STEPHEN HOLDEN

Twelve-year-old Josh Whitney (Jacob Tierney) is a computer whiz and a fast-talking liar who can worm his way out of any scrape by inventing an ingenious story. He is also acutely sensitive to his divorced father's disappointment in him because he can't catch a football.

Josh's feisty 8-year-old brother, Sam (Noah Fleiss), also has problems. His schoolmates call him Alien and Spaceman, he gets into fights, and he may not be promoted into the third grade.

As Billy Weber's movie "Josh and S.A.M." makes clear within minutes, their parents' divorce is the major cause of the boys' troubles. They are routinely shuttled between Los Angeles, where their mother, Caroline (Joan Allen), is engaged to Jean Pierre (Ronald Guttman), a supercilious French businessman, and Florida, where their father, Thom (Stephen Tobolowksy), lives with a new wife and her two bullying sons.

After a particularly nasty fraternal spat, Josh rigs up a document on his father's computer that purports to show that Sam's name is really an acronym for Strategically Altered Mutant. He convinces his younger brother that their parents have sold him to the United States as a child soldier to be deployed in secret wars around the world. Sam buys the tale because it helps explain his fits of aggression.

The movie, which opens today, cooks up a clever plot in which the

Castle Rock Entertainment

Jacob Tierney and Noah Fleiss in Billy Weber's "Josh and S.A.M."

two brothers find themselves on the lam. On their way back to Los Angeles from Florida, the boys' flight is grounded in Dallas by bad weather. At their hotel, Josh crashes a high school reunion and, for a lark, convinces a loutish drunken Texan named Derek (Chris Penn) that he is his son by a former sweetheart. When the truth comes out, Derek becomes enraged, and Sam knocks him unconscious with a pool cue. Believing he has murdered the Texan, he flees with Sam in the man's rented car.

From this point on, "Josh and S.A.M." becomes a picturesque road movie in which the two lost boys have a series of whimsical adventures as they make their way their from Dallas to the Canadian border. The most significant person to enter their lives, Alison (Martha Plimpton), is a hitchhiking runaway who becomes their driver and older sister. To Josh's consternation, Alison bolsters the lie

that he is now trying to talk Sam out of believing. She plays along with Sam's certainty that she is the Liberty Maid, a freedom fighter in the underground movement to rescue child soldiers from the clutches of the Pentagon.

•

"Josh and S.A.M" has a nifty premise, terrific scenery and a procession of oddball minor characters who are wonderfully well observed. Frank Deese's screenplay is particularly adept at suggesting the nuances of fraternal strife and affection.

But the movie wears a much too heavy layer of Hollywood gloss. Mr. Tierney and Mr. Fleiss are appealing child actors who interact convincingly, but they are far too articulate and self-assured to be credible, given their plight.

The movie wants to be two things at once: a cute little road movie about the comic misadventures of two adorable children, and a searching family drama about lost boys, divorce, and the danger and uncertainty of life on the road. By the time the movie reaches its pat, sentimental conclusion, manipulative Hollywood slickness has triumphed over psychological sense.

•

"Josh and S.A.M." is rated PG-13 (Parents strongly cautioned). Younger children may be frightened by the depiction of a child separated from his parents.

1993 N 24, C12:1

Irish, Unwed, Pregnant: Why Is She Glowing?

"The Snapper" was shown as part of the recent New York Film Festival. Following are excerpts from Vincent Canby's review, which appeared in The New York Times on Oct. 8. The film opens today at the Lincoln Plaza Cinemas, 63d Street and Broadway.

With "The Snapper," a small, joyful lark of a film, Stephen Frears rediscovers the essence of the comedy of mundane situation, a perfectly respectable genre before television took it over and turned it into the mass-produced, wafer-thin, low-calorie entertainment called the sitcom. As demonstrated by Mr. Frears and Roddy Doyle, who adapted his own novel for the screen, there are still wonderful comedies to be made when care is taken and attention is paid.

The situation in "The Snapper" is this: Sharon Curley (Tina Kellegher), a supermarket checkout clerk in Barrytown, a north Dublin working-class suburb, becomes pregnant. Or, as it's put more colloquially throughout the film, "Sharon Curley's up the pole." The trouble is that the unmarried Sharon refuses to identify the father.

Dessie and Kay (Colm Meaney and Ruth McCabe), Sharon's parents, accept the news of the pregnancy with surprising equanimity. That's possibly because Sharon is 20 years old and not getting any younger. After the announcement, Dessie even asks Sharon to join him in a pint at the pub.

Kay later suggests to Dessie that they should point out to the younger Curley children that Sharon has done wrong by allowing herself to get pregnant without being married. If for no

other reason than it's bad planning. Dessie says no, that it would stigmatize the baby in the children's eyes.

Sharon's girlfriends, the neighbors and Dessie's drinking buddies, are similarly understanding. All that changes with the rumors that the father is none other than George Burgess (Pat Laffan), a wimpish middle-aged family man who lives across the street and whose daughter is one of Sharon's pals. Sharon is suddenly a tart and a home-wrecker.

As a defensive tactic, Sharon says that a dark, handsome Spanish sailor, in port for two days, was the man responsible. "What do you think?" she asks her mother with some apprehension. Kay's reply: "I think I'd like to believe it was a Spanish sailor." Mr. Frears treats this lighter-than-air material with an easy gravity that never mocks the situation or trivializes the comedy. As written, directed and performed, the Curleys and their friends are a most engaging lot.

Mr. Meaney's Dessie is a man with unexpected reserves of common sense and sweetness, though his temper is sometimes short. It's the same character the actor played in Alan Parker's screen adaptation of "The Commitments," the first of the three Doyle novels known as the Barrytown trilogy. Because the producer of "The Commitments" holds the copyright on the original names of the characters, their surnames were changed for the film version of "The Snap-

per,'' the second novel in the trilogy, which ends with "The Van." Ms. Kellegher's Sharon is not a great beauty. Her eyebrows don't seem to match, her nose is too prominent and she never gives much thought to her hair. Yet she has grit, determination and humor. Nobody pushes her around unless she drinks too much. That's what happened the night of her seduction, in circumstances she still finds mortifying. By the end of the film, the actress glows. Each member of the all-Irish cast shares that breezy authenticity.

In the neighborhood pub, the film's favorite location after the Curley row house, which is always full of noise and domestic tumult, Mr. Frears's camera seems to unbend and become as high and disheveled as the patrons. Brows sweat, mascara runs. As the night wears on, the camera mercilessly records exhausted faces in a series of pre-hangover friezes.

The situation in "The Snapper" is comic, but the film never denies the reality that makes its characters gallant.

"The Snapper" opens at Lincoln Plaza Cinemas today.

1993 N 24, C14:1

The Trial

Directed by David Jones; written by Harold Pinter, based on the novel by Franz Kafka; director of photography, Phil Meheux; edited by John Stothart; music by Carl Davis; produced by Louis Marks; released by Angelika Films. At Angelika 57, 225 West 57th Street, Manhattan. Running time: 120 minutes. This film has no rating.

Josef K	Kyle MacLachlan
The Priest	Anthony Hopkins
Huld	Jason Robards
Leni	Polly Walker
Fraulein Burstner	Juliet Stevenson
Titorelli	Alfred Molina

By JANET MASLIN

Harold Pinter can be Kafkaesque even when presenting a love story, as he did in letting the finely calibrated events of "Betrayal" unfold in reverse chronological order. So the combination of Mr. Pinter and Franz Kafka would appear to be made in heaven, or at least in the kind of hell that both parties might understand. In fact, Mr. Pinter's spare, faithful adaptation of "The Trial," which opens today at Angelika 57, sounds as much like his own work as it does like Kafka's, thanks to the mocking tone and the mysteries built into the material. The distinctions between the two voices are as specific and fascinating as they are minuscule.

Kafka (speaking for Josef K, his story's protagonist, on the morning he is arrested on unnamed charges): "I mean that I am very much surprised, of course, but when one has lived for 30 years in this world and had to fight one's way through it, as I have had to do, one becomes hardened to surprises and doesn't take them too seriously."

Mr. Pinter: "I mean, of course I'm surprised. But after all, the world is the world. One gets used to surprises. One doesn't take them too seriously."

•

Clearly, Mr. Pinter's urbanity is one of the salient features of this adaptation, which has a calm, rich, mostly daytime look very different from the austere black-and-white imagery of Orson Welles's 1963 version. As filmed in Prague and directed with suitable sang-froid by David

Jones, this "Trial" has a sedate period look and an implacable manner, accentuating the dreamlike irrationality of the events it describes.

Welles concentrated on the guilt and paranoia in Kafka, casting a jittery Anthony Perkins as his guilt-stricken leading man, and even invoking a then-newfangled computer (or "electronic brain") as an instrument of futuristic terror. But for Mr. Pinter and Mr. Jones, the events of "The Trial" offer danger of a more mundane kind. Told straightforwardly, as if it made sense, the story of Josef K's ordeal at the hands of an impenetrable and unforgiving legal system retains its ripe metaphorical possibilities and at least a modicum of its chilling power. This time, "The Trial" can be read as political, religious or psychological allegory. It can also be seen as a string of misadventures in the life of an incongruously modern man.

But it cannot be watched lightly, without the dense connective tissue that holds Kafka's novel together. Reduced to its bare bones, the story of "The Trial" is a string of abrupt, disjointed episodes linked by not much more than an overriding sense of menace. The piquantly odd juxtapositions of the text — like the washerwoman's bedroom that opens onto a packed, fetid courtroom, which only Josef K is allowed to enter — lend limited drama to material that must remain deliberately opaque. The gift Kafka described as "my talent for portraying my dreamlike inner life" remains more palpable on the page than it is on the screen.

•

Casting Kyle MacLachlan as a suave, gentlemanly and somewhat bland Josef K, this film surrounds him with what amounts to an array of colorful cameo appearances by his co-stars. Anthony Hopkins, who plays the prison chaplain delivering Kafka's parable about the doorkeeper who guards the Law, is on screen for about 10 minutes. (Ten minutes that are well worth waiting for, however.) Jason Robards appears solemnly as Josef K's ailing lawyer, with Polly Walker as his nurse, whose webbed fingers and seductive manner make her so memorable. The novel's insinuating sexuality is heightened several notches by Mr. Pinter, who makes it his own.

Also in "The Trial" are Alfred Molina as Titorelli, the mysteriously well-connected portrait painter, and Juliet Stevenson as Josef K's unaccountably seductive neighbor. The ominous clarity of the film's visual style is sometimes overwhelmed by its heavy, pedestrian musical score.

1993 N 24, C16:1

We're Back! A Dinosaur's Story

Directed by Dick Zondag, Ralph Zondag, Phil Nibbelink and Simon Wells; written by John Patrick Shanley, based on the book by Hudson Talbott; music by James Horner; produced by Stephen Hickner; released by Universal. Running time: 78 minutes. This film is rated G.

Voices:

Louie	Joey Shea
Rex	John Goodman
Elsa	Felicity Kendal
Captain NewEyes	Walter Cronkite
Vorb	Jay Leno
Dr. Bleeb	Julia Child
Professor ScrewEyes	Kenneth Mars
Stubbs the Clown	Martin Short
Mama Bird	Rhea Perlman

By JANET MASLIN

"We're Back! A Dinosaur's Story" is a brief, witty children's book about dinosaurs who pay a visit to New York City, a place that is described amusingly from the dinosaurs' point of view. But tiny admirers of Hudson Talbott's illustrated volume will be surprised to find the dinosaurs in the animated screen version, "We're Back! A Dinosaur's Story," play second fiddle to a cast of people. The people are brash, rude and occasionally scary. This was somebody's idea of how to enhance the authentic New York City atmosphere.

That somebody is apparently John Patrick Shanley, whose screenplay creates a wise-talking little boy named Louie as the story's human hero. Louie is the kind of confident lad who addresses dinosaurs as "you morons" when he first sees them, although of course he comes to love them deeply only moments later. (The film is also shamelessly sentimental.) Accompanying Louie is a lonely rich girl named Cecilia, whom he addresses as "Babe" at one point and kisses amorously in the film's finale.

Louie also battles the story's menacing, newly invented villain, Professor ScrewEyes (with the voice of Kenneth Mars), who wants to capture the dinosaurs and put them in his circus. Parents seeking innocent kiddie entertainment should know that the dinosaurs are drugged, the children are briefly transformed into monkeys and the Professor is eventually devoured by crows.

•

"We're Back!" does feature swooping 3-D animation that makes the most of New York's skyscrapers, and a good cast of voices on its soundtrack. John Goodman, sounding like Bing Crosby, provides the voice of Rex, the dinos' suave leader. And Felicity Kendal plays the pterodactyl who is his soigné sidekick. Martin Short is heard briefly as a manic clown, and Jay Leno and Rhea Perlman are also on hand, though they're less noticeable. The bushy-haired, kindly scientist who helps the dinosaurs in their time-traveling has the voice of Walter Cronkite. He delivers an "and that's the way it is," too.

Also heard, over the closing credits, is Little Richard in fine form delivering a sprightly dinosaur anthem. The rest of the film's 79-minute running time moves at a slower pace.

1993 N 24, C20:6

El Pisito

Directed by Marco Ferreri; written by Rafael Azcona and Mr. Ferreri; director of photography, Francisco Sempere; edited by José Antonio Rojo; music by Federico Contreras; sets by José Aldudo. At the Joseph Papp Public Theater, 425 Lafayette Street, East Village. Running time: 95 minutes. This film is not rated.

Petrita	Mary Carrillo
Rodolfo	José Luis López Vázquez
Dimas	José Cordero
Doña Martina	Concha López Silva

By STEPHEN HOLDEN

To judge from "El Pisito" ("The Little Apartment"), an excessively noisy, dark comedy directed by the Spanish film maker Marco Ferreri, New York City's real estate squeeze in the 1980's was nothing compared with Madrid's in the 1950's. In the

Public Theater
José Luis López Vázquez

movie's vision of real estate hell, middle-class people who can't afford modern housing — and that seems to be almost everyone — often live eight to an apartment in a space that is more appropriate for two. Because of overcrowding, thin ceilings and frequently raised voices, apartment living often borders on bedlam.

Rodolfo (José Luis López Vázquez), a novelty-store clerk, is a typical victim of the squeeze. Along with several others, he leases a room in the four-room apartment of Doña Martina (Concha López Silva), a crotchety woman in her 80's who is dying.

Until he can afford his own place, Rodolfo cannot marry Petrita (Mary Carrillo), his increasingly embittered fiancée of 12 years. So desperate has the situation grown that Petrita per-

In Madrid, people would do anything, *anything*, for an apartment.

suades her meek boyfriend to propose to Doña Martina. If he marries her, he can inherit the apartment at its current affordable rent. When Rodolfo balks, Petrita takes matters into her own hands and forces the arrangement.

But marriage agrees with Doña Martina, who dotes on her new husband in the same way she dotes on her cat. To everyone's dismay, she lingers on for more than two years.

•

Although its style borders on farce, the underlying tone of "El Pisito," which opens today at the Joseph Papp Public Theater as part of its Spanish Eyes series, is unsparingly harsh and often jarringly loud. In the screenplay by Mr. Ferreri and Rafael Azcona, Doña Martina is routinely referred to as "the old hag." Rodolfo is a weakling who drinks too much wine and is easily bullied by Petrita, whom he tells his friends he doesn't care for her anymore.

Petrita, who sees her life and her dreams slipping away, is alternately pitiful and monstrous. After initially

being dismissed by Doña Martina as a hussy, she cannily wins over the old woman and drives a hard financial bargain. In one of the movie's nastiest scenes, she inspects the apartment as though it were already hers and spits out her contempt at how ugly and dirty it is. Miss Carrillo's performance — the best in the movie — is as bluntly hard-edged as her formidable character.

As the movie makes abundantly clear, the years of waiting and frustration have so curdled the relationship between Rodolfo and Petrita that any chances of their finding happiness have vanished long ago. Their home sweet home promises to be a miserable battleground.

1993 N 26, C14:1

Australia's Films Display a Distinctive Gothic Darkness

By CARYN JAMES

ADA McGRATH, THE IMPASsioned 19th-century heroine of Jane Campion's eerily beautiful film "The Piano," has chosen not to talk since she was 6. In the voice-over that begins the film, the rare and lilting voice of Ada's inner mind is heard offering a plausible explanation for her silence: "My father says it's a dark talent, and the day I take it into my head to stop breathing, it will be my last."

"The Piano" is about those dark talents — the eccentric bordering on the crazed — that spring from the depths of one's soul and imagination to meet an exquisite and threatening landscape. Ada evokes generations of Gothic heroines, from Catherine in "Wuthering Heights" to the schoolgirls who vanish in the woods in Peter Weir's classic 1975 film, "Picnic at Hanging Rock." And though "The Piano" is distinctly and unmistakably the work of Jane Campion, it is also a rich example of the Gothic impulse that has shaped much Australian film.

■

The Australian Gothic is not concerned with the way lightning hits the castle walls, as in Europe. And it is different from the American Gothic fear of the killer in the farmhouse, a strain that runs from folk tales through "In Cold Blood." The Australian Gothic begins with a sunnier disposition, with characters who at first seem to be garden-variety neurotics. Then at some point they turn a corner and explode in acts of horrific violence.

In "The Piano," Ms. Campion reinvents Emily Brontë's sensibility, transplanting it to New Zealand along with the film's European settlers. As Ms. Campion wrote in production notes for "The Piano": "I feel a kinship between the kind of romance Emily Brontë portrayed in 'Wuthering Heights' and this film. Hers is not the notion of romance that we've come to use; it's very harsh and extreme, a Gothic exploration of the romantic impulse."

Like Catherine in "Wuthering Heights," the refined Ada (Holly Hunter) is torn between her cold and respectable husband, Stewart (Sam Neill) and the passionate but socially improper Baines (Harvey Keitel), whose affinity with nature is suggested by the Maori tattoos on his face. The deep blue color that shades much of the film hints at the Gothic undertow that will erupt in this lush but ominous landscape of overgrown trees, ankle-deep mud, a sweeping sea beneath a cliff.

The peculiar lessons that Ada gives Baines on her treasured piano — earning it back in a bargain exchanging one sexual favor for each black key — are eccentric, not crazy. But the sexual jealousy that explodes as a result of Ada and Baines's liaison carries the film around the bend into Gothic violence.

Ms. Campion's first feature, "Sweetie" (1989), is a black-comic version of the eccentric turned deadly. The title character is a young woman whose emotional disturbance is minor but always about to erupt. Her sister, Kay, calls Sweetie a "dark spirit." But it is Kay, the normal one, who begins the film by saying, "Trees scare me. It's like they have hidden powers." And by the film's end, her worst fears about the power of trees have become brutally real.

In the past few years, other film makers from Australia and New Zealand have specialized in similarly skewed characters. The New Zealand director Jocelyn Moorhouse's "Proof" (1992) is about a blind photographer with a corrosive spirit. Vincent Ward, also from New Zealand, created a bizarre and visually lovely time-traveling fantasy, "The Navigator" (1988), in which a young boy from the Middle Ages leads his family to the

The Australian Gothic strain in 'The Piano' springs from a disposition sunnier than that of killer-in-the-farmhouse American Gothic.

21st century to escape a plague. In the new Australian director Rolf de Heer's "Bad Boy Bubby" (which has not been shown in the United States), the mother of a 38-year-old man has held him prisoner in his room since birth.

That the Gothic pattern has shaped much recent fiction as well suggests a broad cultural impetus behind it. The trajectory from eccentric to Gothic is most emphatic in "The Tax Inspector," the 1992 novel by Peter Carey. A contemporary family of car dealers called the Catchprices at first seems dysfunctional in ordinary, feuding ways. As the story progresses, it turns out that the granny carries a bomb in her purse; that there is sexual abuse behind the black comedy; that a grandson, Benny, may be seriously disturbed. By the end, Benny has trapped a pregnant tax inspector in a dank basement, where she gives birth in inches of filthy water.

In Elizabeth Jolley's short and typical 1986 novel, "The Well," the relationship of two women who live together on an isolated farm is disturbed when a strange man comes along. Suddenly, one of them tosses the man to the bottom of a well.

All these works travel beautifully across cultures, but there is a definite Australian lunacy pervading them. The Australian writer Thomas Keneally, whose novels include "The Chant of Jimmie Blacksmith" and "Schindler's List," traces his country's Gothic to European settlers, whose spirits and sense of God were distorted by their abrupt contact with the harsh Australian landscape. He describes a part of Australian culture perfectly captured by Ms. Campion's image of the piano stranded on a lonely beach.

"There are many stories of settlers arriving in Western Australia with their pianos and being unable to move them," Mr. Keneally said. "It was a more sunburnt climate than Jane Campion's New Zealand, but the idea of the abandoned grand piano is very strong in the Antipodes. In the old world, the piano is where it belongs, in the living room. Then the SS will come and hack it up, but that's another story. In the New World, the piano is on the beach. The feeling was very powerful for a long time that there were not the proper civilizing elements here, that the environment was a deranging environment. There is a residue of feeling that the country is so harsh on the European soul, it can easily tip the European soul into brutality."

He added: "The God you talked about in Europe, the God you found in the landscape, isn't here. Some other bugger's here."

It is that devilish Other that manifests itself in the tendency to toss a man into a well; it is Stewart's European soul, unbalanced in lush New Zealand, that makes Ada pay dearly for her sexual passion. And it was that same voracious landscape that swallowed up two litle girls in Mr. Weir's "Picnic at Hanging Rock," the quintessential Australian Gothic movie.

Mr. Weir's films dominated the Australian New Wave of the late 1970's, a period when directors like Bruce Beresford and Fred Schepisi brought that country's film makers their first taste of worldwide acclaim. "Picnic at Hanging Rock," with its ominous woods, sexual undercurrent and unresolved ending, still haunts the memories of viewers who saw it 15 years ago. Mr. Weir's 1977 film, "The Last Wave," presents an apocalyptic vision of Australia in the near future; the country's disruption is foreseen by aborigines with special knowledge of the land and its history.

Though Mr. Weir lives part of the year in Australia, he has become an honorary American film maker with movies like "Witness" and "Dead Poets Society." But look at his current film, "Fearless," in which Jeff Bridges survives near death in a plane crash, and the shaping force of the director's earlier films is clear. In a haunting, hallucinatory scene near the film's end, Mr. Bridges's character leads the other passengers out of the plane and walks into a blue-tinged light that heralds death. In that sequence, it is clear that "Fearless" would have been a very different film without "Picnic at Hanging Rock" or "The Last Wave."

Many other Australian New Wave directors have made their way to Hollywood: George Miller went from the apocalpytic Australian "Mad Max" series of the late 70's and 80's to the mushy "Witches of Eastwick" and the starkly realistic "Lorenzo's Oil"; Mr. Beresford, from Australian history in the 1980 film "Breaker Morant" to "Tender Mercies" and "Driving Miss Daisy"; Phillip Noyce from the ragtag world of Australian journalism in "Newsfront" (1978) to "Patriot Games" and "Sliver"; Mr. Schepisi from the aboriginal heroes in "The Chant of Jimmie Blacksmith" (1978) to the distinctly American characters of "Roxanne" and the forthcoming "Six Degrees of Separation." Mostly, they have left the Gothic to be picked up by the next generation.

Gillian Armstrong, whose 1979 film 'My Brilliant Career" is one of the New Wave classics, has continued to make quirky Australian movies like "High Tide," in which Judy Davis is a backup singer for an Elvis impersonator, and most recently "The Last Days of Chez Nous." And the Australian influence in strong in her 1985 Hollywood film, "Mrs. Soffel," in which Diane Keaton is a turn-of-the-century warden's wife who helps convicted murderers, played by Mel Gibson and Matthew Modine, escape from her husband's prison in Pittsburgh.

The blue tones of "Mrs. Soffel" and the dark Gothic look of the 19th-century prison give the love affair between Ms. Keaton and Mr. Gibson's characters a distinctly Gothic twist. (It's no coincidence that the film was photographed by Russell Boyd, who also shot "Hanging Rock.")

To discern this Gothic strain is not to lump all of Australia and New Zealand together into one narrow, crooked mold. There is obviously room for hit movies like " 'Crocodile' Dundee," with its stereotypically macho Aussie hero, or Baz Luhrmann's recent "Strictly Ballroom," a Hollywood wannabe. (Mr. Luhrmann has, in fact, signed a two-film deal with Fox.) But these are the most homogenized, least interesting Australian films.

The most inventive and powerful new works from Australia and New Zealand pick up the thread of Gothic romance. Jane Campion might be the perfect artistic daughter of the New Wave. From Mr. Weir she has inherited a sense of the haunted landscape and the passionate power of the aborigines and Maoris. At a school pageant in "The Piano," children stage the story of Bluebeard, which the Maoris disrupt because they think it is real. Like Kay's fear of trees in "Sweetie," what at first seems a native mysticism is, in a deeper sense, an astute recognition of the imagination's dark power. And from Ms. Armstrong, Ms. Campion has inherited a lucid, tough-minded feminism tinged with Gothic romance. Ada and Mrs. Soffel are kindred souls, least of all because they walk through Gothic blue light.

Ada has one kind of dark talent. Jane Campion has another. She has transformed all her influences into films that are among the most impressive being made by her generation, anywhere in the world, and she may well herald the next Australian wave. □

1993 N 28, II:13:1

1993 N 28, II:13:1

Critic's Notebook

A Balanchine 'Nutcracker'

By ANNA KISSELGOFF

Fans of the seven-headed Mouse King will be thrilled to see their favorite villain in yucky detail as he sallies forth in the film "George Balanchine's 'The Nutcracker.'" Like Tchaikovsky's two other ballets, "The Sleeping Beauty" and "Swan Lake," "The Nutcracker" incorporates a fable about the forces of light and darkness. But in "The Nutcracker," this struggle is seen, delightfully, from a child's point of view and is symbolized in the Nutcracker's battle with the mouse monarch.

Details and close-ups would seem inimical to the sweep and grandeur of Balanchine's choreography, with its sophisticated use of pattern and structure. Yet the newly released film, which is based on his 1954 production of "The Nutcracker," embodies a marriage of art forms that Balanchine once envisaged.

"Picnic at Hanging Rock"—In Peter Weir's quintessentially Australian Gothic classic, made in 1975, schoolgirls vanish in the woods.

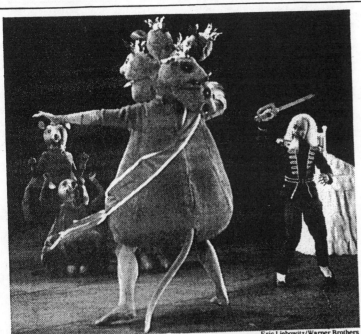

Eric Liebowitz/Warner Brothers

Robert Lyon as the Mouse King battling the Nutcracker (Macaulay Culkin) in the film "George Balanchine's 'The Nutcracker.'"

In January 1934, shortly after emigrating from Europe to New York, the choreographer told the British critic Arnold Haskell that he hoped to wed film to ballet. Film, he said, could explore "pattern and new angles" and provide close-ups of "the face, the arm, a wrist, the pointes, all arranged so that the full significance of the work could be revealed."

In this penetrating interview, which foretold the course his career would take ("I do not believe in anything in ballet but classicism"), Balanchine spoke of film as a tool for popularizing ballet: "I am thinking of ballet in a much wider sense of bringing it back to the masses as the ideal form of entertainment."

•

"George Balanchine's 'The Nutcracker'" is that form of entertainment, lovingly directed by Emile Ardolino and with Balanchine's choreography faithfully staged for the New York City Ballet's dancers by Peter Martins, the artistic director of that company, which Balanchine co-founded with Lincoln Kirstein.

The film, with its well-rehearsed perfection, is no substitute for a live performance of Balanchine's "Nutcracker," which makes its 19th-century stagecraft visible and exerts its charms through the immediacy of a three-dimensional performance. But this film is not merely the next-best thing. It is an alternative version that keeps Balanchine's dance values intact. You would be hard put to find a more gloriously danced pas de deux on film than the grand image of idealized happiness by Darci Kistler's Sugar Plum Fairy and Damian Woetzel's Cavalier.

Luckily, what you won't find in this movie, as opposed to other film or video versions of "The Nutcracker," is the pop psychology that insists on a subliminal erotic element in the scenario. In those versions, it is not enough for Marie, a pre-adolescent girl at a Christmas party, to project her fantasies from a male nutcracker doll onto the prince of her dreams; her godfather, Drosselmeier, even has designs on the little heroine. Drosselmeier was up this sort of mischief in the 1986 commercial film of the Pacific Northwest Ballet's version, directed by Carroll Ballard.

•

Balanchine would have none of this. His ballet, while original in its choreography, refers to what "The Nutcracker" was at its creation in 1892 in Russia: a tale of domestic warmth in the first act and a danced entertainment in the second. The choreographer did not live to make his own film of "Nutcracker," but in the 1970's he did collaborate with the PBS "Dance in America" team that translated his other choreography so effectively for television. That team included Mr. Ardolino and Merrill Brockway, who collaborated on this film.

Mr. Ardolino, who died on Nov. 20, remained faithful to Balanchine's principles. He never cut away from the dancing's most important features, and he knew how to zero in on the details that Balanchine, in 1934, said would reveal the "significance of the work."

There is one weakness in the camera work. The fabled speed of the City Ballet dancers makes the ensembles (the "Snowflakes Dance" and the "Waltz of the Flowers") look blurred. The City Ballet states that the film is not speeded up. Perhaps it needs to be slowed down. Nonetheless, there is some first-class dancing on view from the soloists, notably Kyra Nichols as Dewdrop and Wendy Whelan as Coffee in Act II.

•

Yes, Macaulay Culkin is in the film, and he doesn't do badly. It was Balanchine who added the character of Drosselmeier's nephew to the ballet, identifying him with the Nutcracker, who is transformed by Marie's love into a little prince. There is an unexpected glint of evil in Mr. Culkin's eye when he helps his uncle unwrap the toys. But then Drosselmeier is scary, too. Once transformed into a prince, Mr. Culkin should have exchanged the smirk for a smile. His mime scene, if devoid of classical style, is fresh in its naturalness.

The movie's genuine child stars are Jessica Lynn Cohen, an enchanting Marie, and Peter Reznick, all frisky charm as her brother, Fritz.

For a ballet company short on acting experience, the City Ballet offers some scene-stealing moments. Bart Robinson Cook's Drosselmeier is a smart old codger, brilliantly timed to the music. An inside joke comes with two alumni, Edward Bigelow and Karin von Aroldingen, being cast as hilarious grandparents.

On stage, "The Nutcracker" divides into the reality of Act I and the fantasy of Act II. Was the film's voice-over, by Kevin Kline, added because it was feared that viewers would not realize they were watching a splendidly filmed ballet, that they would confuse ballet reality with film realism? The narrative is not intrusive, but in Balanchine's case, pictures do speak louder than words.

1993 D 1, C17:3

Deception

Directed by Graeme Clifford; screenplay by Robert Dillon and Michael Thomas; story by Mr. Dillon; director of photography, Laszlo Kovacs; edited by Caroline Biggerstaff; music by John Barry; production designer, Richard Sylbert; costumes by Rudy Dillon; produced by Lloyd Phillips; released by Miramax Films. Running time: 90 minutes. This film is rated PG-13.

Bessie Faro	Andie MacDowell
Fergus Lamb	Liam Neeson
Johnny Faro	Viggo Mortensen
Ed	Jack Thompson

By JANET MASLIN

"Deception" is a fabulously far-fetched story about the string of surprises that leads Bessie Faro (Andie MacDowell) all over the world. The first of these surprises is her husband's bridgework, which arrives in the mail, along with the news that he has been in a plane crash. He has supposedly been burned beyond recognition. Anyone familiar with detective fiction will know what that means, but Bessie has to do a lot of globe-trotting to figure it out.

Bessie, a harried but sweet-tempered Los Angeles wife and mother, has had no experience as a private eye. But she is caught up in intrigue involving baseball cards marked with a secret code. (The film has a strong but meaningless baseball motif.) These clues lead to an international assortment of safe-deposit boxes held under assumed names. And *those* lead to surreptitious trafficking in either grain, ballpoint-pen ink or poison gas, depending on how closely you care to follow the plot.

One more problem with this scheme, aside from those that are already obvious, is that no one in "Deception" seems clever enough to have thought it up. Also in the film are Viggo Mortensen as Bessie's snake-charmer of a husband and Liam Neeson as a noble doctor supervising a food-aid distribution project. Mr. Neeson, who deserves better roles than this one, figures in a final scene that is a true howler, for viewers who can last that long.

As directed by Graeme Clifford ("Frances"), "Deception" would seem to have the makings of a touristy, high-gloss caper film; after all, it manages to take Bessie to the Sphinx and the Acropolis on a single trip. But Mr. Clifford, a former film editor, does not make nearly enough of the opportunities to cut stylishly from country to country. Nor does Laszlo Kovacs's clear but harsh cinematography look particularly inviting. Richard Sylbert, the production

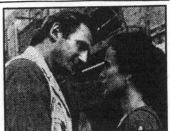

Miramax Films

Liam Neeson and Andie MacDowell in "Deception."

designer, and Rudy Dillon, the costumer who puts Ms. MacDowell into everything from Mexican to Arabian mufti, have considerably more fun.

Ms. MacDowell is the only participant who is actually shown off to good advantage. In the midst of this nutty story, she manages to seem eminently gentle and sensible, offering some kind of reassurance that the film will not get too far off its tracks. Even when it does, moving beyond the point where she or anyone else could make it palatable, Ms. MacDowell manages to remain a soothing presence. She looks great when going native for her sojourn in Cairo, and she has the good sense never to ask how or why she got there.

•

"Deception" is rated PG-13 (Parents strongly cautioned). It includes slight violence and discreet sexual situations.

1993 D 3, C10:1

Mazeppa

Directed by Bartabas; screenplay (in French, with English subtitles) by Claude-Henri Buffard, Bartabas and Homeric, based on an original idea by Bartabas and a story by him and Mr. Buffard; cinematography, Bernard Zitzermann; edited by Joseph Licide; music by Jean-Pierre Drouet; produced by Marin Karmitz; an MK2 Productions USA Release. At Village East, Second Avenue and 12th Street, East Village. Running time: 111 minutes. This film has no rating.

Géricault	Miguel Bosé
Franconi	Bartabas
Mousté	Brigitte Marty
Alexandrine	Eva Schakmundes
Cascabelle	Fatima Aibout
Joseph	Bakary Sangare

By STEPHEN HOLDEN

"Mazeppa," which calls itself a speculative meditation on the life and art of the French Romantic painter Théodore Géricault, is a film that will literally make you dizzy. Conceived and directed by Bartabas, a renowned horse trainer and impresario of the Théâtre Équestre Zingaro, it is an equestrian fever dream that suggests Peter Shaffer's play "Equus," but with the mystical fervor multiplied severalfold.

Filmed largely in Bartabas's theater in Aubervilliers, France, "Mazeppa" has many breathtaking scenes of the troupe performing gymnastic feats on the backs of horses. As the camera tracks the animals trotting around and around the circus ring, you can lose your balance in the gliding merry-go-round swirl.

The movie studies equestrian form and anatomy with a painter's and a horse breeder's eye. Horses are graphically photographed excreting, mating and giving birth, as well as cantering, galloping and executing tricks. In one of the movie's most

sensual moments, the camera compares human and equine limbs as naked humans make love in a stable.

•

If the film, which opens today at the Village East, is one of the most visually poetic celebrations of horses ever filmed, it is not as successful at telling a story. Using a narrator and sparse dialogue, it tries to force together two separate tales into a coherent romantic fable.

One element of that fable is a sketchy biography of Géricault, the painter who died insane in 1824 at the age of 33 and who was renowned for his paintings of horses. The other half is a famous 17th-century myth that inspired Romantic artists from Lord Byron to Victor Hugo to Tchaikovsky. That legend tells of Ivan Mazeppa, a Polish nobleman's page who is punished for sleeping with his patron's wife by being tied naked to a wild horse that is sent into the wilderness.

Drawing on the historical fact that Géricault admired Franconi, a famous horseman of the early 19th century who also ran his own equestrian troupe, the film imagines that the painter went to live with the circus in order to study the animals. A love-hate relationship develops between Géricault (Miguel Bosé) and the forbidding Franconi (Bartabas), who wears a bronze mask to cover a face disfigured in battle. They engage in a fierce philosophical dialogue about horses that pits Géricault's estheticism against Franconi's belief in the physical truth of the moment.

As Géricault loses his sanity, he has hallucinations in which he begins to confuse humans with wild horses. In his dying vision, he imagines that he is Mazeppa lashed to the back of a wild horse performing for eternity in Franconi's circus.

•

With its circus imagery and its gallery of leering grotesques, "Mazeppa" resembles one of Federico Fellini's more extravagant fantasies but without Fellini's warmth. In its ambitious mixture of myth, biography and art history, it is more like a Peter Greenaway film, while its menacing erotic imagery and its mystical equation of horsemanship with sexual transcendence suggest Ken Russell.

With all its pretensions, the film is still best appreciated as a series of gorgeous cinematic tableaux that are as romantically extravagant as Géricault's canvases. Exquisitely photographed and underscored with Jean-Pierre Drouet's evocative blend of world music and medieval chants, the film conjures a world of cavaliers, chanteurs and circus people that is so exotic it seems almost to exist outside of time.

1993 D 3, C10:4

Aclà

Story, screenplay and direction by Aurelio Grimaldi; in Italian, with English subtitles; photography by Maurizio Calvesi; edited by Raimondo Crociani; music by Dario Lucantoni; a production by Cineuropa '92 and Nova Films, in collaboration with Pentafilm. At the Joseph Papp Public Theater, 425 Lafayette Street, East Village. Running time: 86 minutes. This film has no rating.

WITH: Francesco Cusimano, Tony Sperandeo, Luigi Maria Burruano, Lucia Sardo, Giovanni Alamia, Benedetto Ranelli, Giuseppe Cusimano, Rita Barbancra, Salvatore Scianna, Ignazio Donato and Luciano Venturino.

By STEPHEN HOLDEN

The description "living hell" almost doesn't do justice to the portrait of life in a Sicilian sulphur mine during the 1930's that Aurelio Grimaldi's film "Aclà'" paints. Six days a week, the miners descend into a hole in the earth with pickaxes and baskets to chip away sulphur. Because of the intense heat they work nearly naked, in yellowish-brown lantern light that turns them into gleaming penitents out of Dante's Inferno.

Sustenance is meager, and an olive or an almond is considered a treat. At night the workers sleep in a cave, sprawled over one another like sweating animals. Sodomy is rampant.

The Italian film, which is having its American premiere today at the Joseph Papp Public Theater, tells the story of Aclà (Francesco Cusimano), an 11-year-old boy whose father sells him to a fellow digger for 500 lira. Working in the mine is a family tradition; Aclà's father and brother have spent their lives in the pits.

By the terms of the agreement, Aclà is owned by the digger, Caramazza (Tony Sperandeo), for eight years, until he turns 19. His job is to load the sulphur mined by his mean-tempered boss into 50-pound baskets and carry it away. Sometimes he has to keep watch at night to make sure that the extracted sulphur isn't stolen.

Rather than trying to be a brutal exposé, the movie looks at life through the innocent eyes of its title character, whose only concept of the outside world is gleaned from letters written by an aunt in Australia. Her letters, which have to be read aloud to his illiterate family, instill in Aclà an inchoate vision of the sea as a place of redemption and escape, although he hasn't even seen pictures of it. And when he runs away from the mine and comes upon a lake, he asks a fisherman if he has reached the ocean.

In observing the rituals of peasant life, the film is especially good at presenting its brutish aspects in a matter-of-fact way. Childish disobedience is met unquestioningly with harsh corporeal punishment that today would be considered severe child abuse. Despite the grim admonishments of a local priest who calls the miners beasts, the homosexuality in the mining camp is laughingly taken for granted. So is illiteracy. In the film's most poignant scene, several children in the village are rounded up, frightened and sobbing, and carted away to a boarding school. The notion of compulsory education seems almost as terrifying to the mothers as to their children.

Much of the last third of the film follows Aclà's attempt to escape his fate by fleeing into the semi-arid countryside, where he subsists on wild berries and befriends a stray dog. It is the closest that any of the characters comes to an idyllic moment.

The movie is flawed by Dario Lucantoni's music, which in the mining scenes imposes a pretentiously heavy-handed religiosity to the miners' suffering.

1993 D 3, C12:6

A Dangerous Woman

Directed by Stephen Gyllenhaal; written and produced by Naomi Foner; director of photography, Robert Elswit; edited by Harvey Rosenstock; music by Carter Burwell; pro-

duction designer, David Brisbin; released by Gramercy Pictures. Running time: 101 minutes. This film is rated R.

Martha	Debra Winger
Frances	Barbara Hershey
Mackey	Gabriel Byrne
Getso	David Strathairn
Birdy	Chloe Webb
Steve	John Terry
Makeup Girl	Jan Hooks
Anita	Laurie Metcalf

By JANET MASLIN

In "A Dangerous Woman," Debra Winger sinks deeply into the drab role of Martha Horgan, a sheltered innocent living in a small California town. Characters like Martha have a way of attracting the storyteller's interest at a very precise point in their lives. It is the moment just before the character's peaceful existence is ruptured by some seismic force, a force like sex or death or a symbolic coming of age. "A Dangerous Woman" is soap opera enough to churn up all three.

With Ms. Winger's eerily convincing performance as its centerpiece, the film creates a world of sexual chicanery that would do any television series proud. Martha is taken care of by her Aunt Frances (Barbara Hershey), a rich, beautiful widow involved in an extramarital affair with a state assemblyman (John Terry). That liaison starts off the film with a suitable bang, as the assemblyman's wife (Laurie Metcalf) drunkenly drives her car into the widow's front porch as a means of registering her irritation.

•

Martha, a fragile creature in a girlish nightgown and thick glasses, watches this outburst in bewildered horror. But the film intends it as a harbinger of Martha's own act of violence, which is already in the works and will serve as the story's dramatic climax. "A Dangerous Woman" builds, vividly if not entirely believably, to an enduringly strange crime that almost resembles an act of tenderness, and to a crazy coda that reaches the last word in dysfunctional family life.

Martha is kept occupied by a menial job at the local dry cleaner's, where some additional hanky-panky is under way. A co-worker there is Birdy (Chloe Webb), a kind soul who tolerates Martha's notion that the two women are best friends. Birdy has a no-good boyfriend named Getso (David Strathairn), who steals from the till and romances other women behind Birdy's back. Martha, who has a kind of moral clairvoyance, sees and abhors Getso's dishonesty when no one else can.

Also on hand, in the story's sudsiest role, is Gabriel Byrne as Mackey, the handsome, hard-drinking carpenter who shows up to fix Frances's porch and manages to romance Martha along the way. Although played with a robust physicality by Mr. Byrne, Mackey is also the most literary conceit in this story, which has been adapted by Naomi Foner from the novel by Mary McGarry Morris. The scene that has him making a simulated confession, with Martha enlisted to play priest, makes it clear that "A Dangerous Woman" has its origins on the page rather than on screen.

The film has been given an appealingly languid and intimate mood by the director, Stephen Gyllenhaal ("Waterland"). And its cast is attractive, holding the interest even when the story's contrivances are left needlessly exposed. (Martha's purchase of Tupperware is allowed to take on symbolic meaning.) Among the more

entertaining small performances is Jan Hooks's brief turn as a cosmetics saleswoman trying awfully hard to adapt her sales pitch to a customer as challenging as Martha.

But the only real focus of "A Dangerous Woman" is Ms. Winger's furiously self-effacing performance. She stares out perplexedly from behind Martha's glasses and tries to make the audience understand what Martha sees. Affecting a quizzical, bird-like posture (and a look so dowdy she resembles Gilda Radner in her satirical nerd role on "Saturday Night Live"), Ms. Winger breathes life into Martha's thwarted gentleness even when the film leaves her at a disadvantage. "A Dangerous Woman" never quite explains Martha's past or the forces that shaped her. It only catches her at a fateful moment, when the makings of a small-town melodrama are already in place.

•

"A Dangerous Woman" is rated R (Under 17 requires accompanying parent or adult guardian). It includes violence, nudity and sexual situations.

1993 D 3, C19:1

Critics' Choice

2 Well-Cut Gems

As Hollywood's Christmas behemoths begin arriving on movie screens, bear in mind some smaller pleasures. Two lively, quick-witted films to remember:

"The Snapper," Stephen Frears's sly, boisterous comedy about an unwanted pregnancy in a crowded Irish household. The mood is raw, the look realistic and the comic timing exactly right. Based on Roddy Doyle's novel, with a title that refers to the blessed event expected by the unwed 20-year-old Sharon (Tina Kellegher), this film has great fun watching Sharon's father cope with the unthinkable. Colm Meaney gives a devilishly funny performance as a man forced by nature to broaden his once-narrow horizons.

"The War Room," directed by D. A. Pennebaker and Chris Hegedus, displays the Pennebaker knack for isolating documentary images that withstand the test of time. A remarkably unfettered look behind the scenes of the Clinton Presidential campaign, with James Carville and George Stephanopoulos letting the camera watch what makes them tick. The film makers understand, just as these political strategists do, that the 1992 campaign broke old rules and made a lot of new ones. The unobtrusive Pennebaker style manages to be wry, humorous and even suspenseful while capturing the very essence of political change. *JANET MASLIN*

1993 D 3, C31:1

Spike and Mike's Festival of Animation 1993

The 1993 Festival of Animation features 16 short films. At Cinema Village, 22 East 12th Street. Running time: 106 minutes. These films have no rating.

By STEPHEN HOLDEN

In his animated characters Wallace and Gromit — an eccentric inventor and his faithful dog — Nick Park, the English film maker who won an Academy Award in 1991 for his animated short "Creature Comforts," has created a pair who could easily become a classic cartoon duo. "The Wrong Trousers," the second Wallace and Gromit adventure, is a comedy thriller of such charm that it walks away with the 16-film program, "Spike and Mike's Festival of Animation 1993," which opened yesterday at the Cinema Village.

In this edition, Wallace gives Gromit a birthday present of a pair of pants called techno-trousers that look like the bottom half of a space suit. When put on, their adhesive shoes enable the wearer to climb the sides of buildings and walk upside down on ceilings. The trousers are also guided by remote control. And their very first assignment is to give Gromit his morning walk. Gromit isn't so sure he likes his gift as it mechanically jerks him along the street.

Those trousers turn into a sinister tool after Wallace, who needs money, rents a spare room to an ominously solemn penguin with a briefcase and taste for playing the radio very loud late at night. The wily penguin so thoroughly supplants Gromit in Wallace's affections that the dog leaves the house to find temporary shelter. While away from home, Gromit discovers that the penguin is plotting a diamond robbery from a London museum, using the techno-trousers.

"The Wrong Trousers" has everything one wants from a half-hour cartoon: sharply defined characters, a story that is clearly told, many light joking touches and endless technical

ingenuity. Wallace's amusing inventions are the cartoon equivalents of Rube Goldberg contraptions that go to the most elaborate lengths to accomplish simple tasks. The film reaches a peak of giddy excitement during a hurtling three-character chase on an electric train set.

With its clay characters frisking through richly detailed sets, "The Wrong Trousers" has a storybook realism that is not often found in family cartoons. And in the part of the story where Gromit plays sleuth, it even achieves a mood of Hitchcockian menace.

Another outstanding short is Joan Gratz and Joanna Priestley's "Pro and Con." Using animated line drawings of its two subjects, the film consists of interviews with a corrections officer and an inmate at the Oregon State Penitentiary that raise deep questions about crime, punishment and incarceration. Barry Purves's "Screenplay" is a stylized Japanese soap opera that uses animated Bunraku puppets, fans, Shoji screens, a turntable and props to create an exquisite miniature world.

Almost as striking is "The Prince and the Princess" by the French animator Michel Ocelot. In this cautionary fairy tale, a stolen premarital kiss by lovers of royal blood abruptly turns them into a toad and a slug. As they try to kiss their way back to normalcy they adopt a succession of forms from elephant to flea, from giraffe to praying mantis. Visually the tale is told with witty cut-out silhouettes of the various animals.

The festival, an earlier edition of which gave us Beavis and Butt-head, has its moments of pure silliness that keep the tone appropriately light, and the changes of pace are well-orchestrated. For those who care about quality animated shorts with mainstream appeal, it projects a future in which conventional cartoon animation is being ever more seriously challenged by sculptured figures.

1993 D 4, 11:1

A scene from "The Wrong Trousers," a feature of "Spike and Mike's Festival of Animation 1993," which opened at the Cinema Village.

'Blue,' the First Installment of a Tricolor Trilogy

"Blue" was shown as part of the recent New York Film Festival. Following are excerpts from Vincent Canby's review, which appeared in The New York Times on Oct. 12. The film opens tomorrow at the Lincoln Plaza Cinemas, Broadway and 63d Street.

Krzysztof Kieslowski's "Blue," the Polish director's latest French film, is about Julie (Juliette Binoche), a grieving widow and mother whose husband, "one of the most important composers of our time," and young daughter are killed in the car accident she survives.

The film is the first in Mr. Kieslowski's trilogy "Three Colors: Blue, White, Red," in which he examines the meaning of liberty ("Blue"), equality ("White") and fraternity ("Red"), not as political or social concepts, which, he says, have already been achieved in France, but in terms of the individual. This is a deep-dish endeavor.

Julie is no ordinary individual. She was devoted to her husband and, it turns out, she wrote much of his music, which must mean that Julie is also one of the most important composers of our time. Possibly even more important than her husband in any list of the most important, though the movie never explores this. Neither does it explore, except in obliquely genteel terms, how her husband must have felt about being so dependent on his sweet, loving, understanding, gloriously gifted wife.

Instead, "Blue" is a lyrically studied, solemn, sometimes almost abstract consideration of Julie's attempt to liberate herself from her sorrowful love and to establish a new life. But love, which is a contradiction of liberty, cannot be easily fooled. That's a concept that wouldn't have appeared out of place in slick-magazine fiction of the 1950's.

Julie closes up her picturesque country house and moves to Paris, where she seeks anonimity, taking the first apartment she sees. It is large and airy, with lots of windows and views over Paris's picturesque rooftops. It probably costs a fortune, but money is no object. When you have to grieve, this is how to do it.

●

At the time of Julie's husband's death, he was working on a huge musical composition to be the centerpiece of a concert celebrating the unification of Europe. One of her first acts in Paris is to burn what she thinks is the only copy of the work. She then goes about her new life. She swims. She befriends a prostitute. She has a curious confrontation with a rat that gives birth in the closet of her otherwise ideal flat.

Suddenly she learns that her husband's devotion may have been somewhat less than all-consuming. How does Julie take it? She takes it like the brick she is: that is, with even more love and understanding than before. Does the huge musical work celebrating Europe's oneness ever get performed? Foolish question.

All of Mr. Kieslowski's considerable film-making talents can't bring this impossibly highfalutin composition to recognizable life. It's full of the mystical bravado that distinguished the French portion of his "Double Life of Véronique," and it's dead. "Blue" doesn't seduce the viewer into its very complex, musically formal arrangements. The narrative is too precious and absurd. The interpretation it demands seems dilettantish.

1993 D 4, 16:3

Six Degrees of Separation

Directed by Fred Schepisi; written by John Guare, based on his play; director of photography, Ian Baker; edited by Peter Honess; music by Jerry Goldsmith; production designer, Patrizia von Brandenstein; produced by Mr. Schepisi and Arnon Milchan; released by MGM. Baronet, Third Avenue at 59th Street. Running time: 102 minutes. This film is rated R.

Ouisa	Stockard Channing
Paul	Will Smith
Flan	Donald Sutherland
Geoffrey	Ian McKellen
Kitty	Mary Beth Hurt

By JANET MASLIN

The Fifth Avenue apartment where much of "Six Degrees of Separation" unfolds is filled with expensive artifacts, most notably Flan and Ouisa Kittredge themselves. Flan (Donald Sutherland) and Ouisa (Stockard Channing), a self-important art dealer and the wife he describes as "a Dada manifesto," live all too comfortably within this sanctuary. The Kittredges are serenely unaware that their lives can be rearranged by a single uninvited guest, one who manages to tap into their fears, desires and hilariously fatuous daydreams. Neither Flan nor Ouisa might have suspected, before this story begins, that they could yearn so desperately for the respect of their own children, or hope to be extras in a movie version of "Cats."

The visitor is Paul Poitier (Will Smith), the cunning, too-good-to-be-true imposter whose exploits are derived from a real news story. Paul has done enough homework to know how perfectly a fake connection to Sidney Poitier will sway uneasy white socialites, people who may be self-styled liberals but can still address a friend as "You darling old poop." It is Paul's visit that prompts Ouisa to muse about the title phrase, which in John Guare's play (and now his screenplay) presents destiny as a kind of mathematical puzzle. Chance meetings with exactly the right people can permanently alter unexamined lives.

●

A seventh degree of separation, and the one that matters most here, is the gap between stage and screen. It has been bridged very aggressively by the director Fred Schepisi, whose frenetic and literal-minded approach

Myles Aronowitz/Metro-Goldwyn-Mayer

Donald Sutherland, left, Ian McKellen, Stockard Channing and Will Smith, right, in the movie "Six Degrees of Separation."

to this material takes getting used to. Onstage, directed by Jerry Zaks with a backdrop of only two sofas and a fake Kandinsky, "Six Degrees of Separation" had a quick, precise comic style that left a great deal to the imagination. Much of the play's hilarity came from its lightning-fast juxtapositions, and the dizzying ways in which they allowed the story to escalate. The film moves just as speedily, but it's much more cluttered. In the presence of so much extra baggage, the screwball timing takes on a frantic edge.

However, Mr. Schepisi's directorial vigor wins out over his film's skittishness. This version may horrify purists, but it winds up working entertainingly on its own broader, flashier terms. Seldom has a play been opened up this spiritedly, with a crowd of onlookers to hear Flan and Ouisa's titillating story (a role once played by the theater audience), a number of well-chosen New York locations and an array of people and paintings to flesh out Mr. Guare's social satire. The film uses its extras as skillfully as it uses a mock Kandinsky, which is prominently featured. It seems appropriate that the film's real and phony artworks are casually intermingled.

Despite its busier style, the film is very faithful to Mr. Guare's story, with Stockard Channing in a reprise of her fine performance as its hilariously brittle heroine. Equally deft is Donald Sutherland, who turns Flan's fatuousness into a great comic asset. (When Paul delivers a speech that he claims is part of a thesis that has been stolen from him, Flan says solemnly, "I hope your muggers read every word!") Also amusing are Mary Beth Hurt and Bruce Davison as two more Upper East Side types who have been seduced by Paul and bitten by the "Cats" bug. "My son has no involvement with any black frauds!" Ms. Hurt declares indignantly, upon learning that Paul's trickery spans two generations.

•

The story's college-age characters are also funny, especially Jeffrey Abrams (the screenwriter of "Regarding Henry") as the wildly outraged son of a divorced doctor (Richard Masur). And there is an amusingly sardonic turn by Ian McKellen as a visiting South African who happens to

witness Paul's night at the Kittredges'. ("Your father means a great deal in South Africa," he informs Paul.) The film's only casting misstep comes with Mr. Smith, who plays Paul as a smooth, pleasant interloper without the hints of mockery or desperation that should accompany his deception. Mr. Smith recites his lines plausibly without bringing great passion to the role.

As "Six Degrees of Separation" ricochets about town (and to Cambridge, Mass., where these mink-draped matrons travel indignantly to question their surly children), it has great fun defining the habitat of its privileged characters. "Are these all rich people?" Paul asks Trent (Anthony Michael Hall), the gay man who helps to coach him about the Kittredges and their circle. "No," Trent answers definitively. "Hand to mouth on a higher plateau."

Patrizia von Brandenstein's production design is witty and ambitious in establishing the proper ambiance. And Ian Baker's cinematography gives the film a mischievously sophisticated look. Also helpful are the authentic extras who fill out the party scenes (Kitty Carlisle Hart plays one hostess) and look properly aghast over the Kittredges' ordeal. Less imaginative are the side trips to every minor setting (the Strand Bookstore, the Rainbow Room, a skating rink) that figures even faintly in this story.

"Six Degrees of Separation" is rated R (under 17 not admitted without parent or adult guardian). It features brief frontal nudity and fleeting violence.

1993 D 8, C17:1

Bank Robber

Written and directed by Nick Mead; director of photography, Andrej Sekula; edited by Richard E. Westover and Maysie Hoy; music by Stewart Copeland; production designer, Scott Chambliss; produced by Lila Cazes; released by I.R.S. Media and Initial Groupe. At the Village East, Second Avenue and 12th Street, East Village. Running time: 94 minutes. This film is rated NC-17.

Billy .. Patrick Dempsey
Priscilla Lisa Bonet

Selina Olivia D'Abo
Chris .. James Garde
Officer Battle Forest Whitaker
Officer Gross Judge Reinhold

By STEPHEN HOLDEN

The title character of Nick Mead's terminally whimsical satire, "Bank Robber," is a handsome thief named Billy (Patrick Dempsey), who, whenever he needs money, simply dresses up in a fancy business suit and holds up a bank. As the movie begins, Billy has decided that it's time to retire. All he needs is enough money to buy the sloop of his dreams and sail off into a tropical sunset with his girlfriend, Selina (Olivia D'Abo).

Billy pulls off his final heist but makes one fatal mistake. He fails to destroy a surveillance camera. No sooner has he hid out in the Heartbreak Hotel than he finds his own image flashed on the television news.

"Bank Robber," which was filmed in Los Angeles, wants to evoke a similar mixture of urban nightmare and surreal zaniness as Martin Scorsese's New York fantasy "After Hours," but it lacks the focus of Mr. Scorsese's comedy. Most of the movie, which is the directorial debut of Mr. Mead, an English film maker, is set in Billy's hotel hideaway where he discovers that he is anything but anonymous. A greedy desk clerk, who recognizes his picture, extorts hundreds of dollars for changing a light bulb. A pizza delivery man, a drug dealer and a messenger from a home shopping program hold him up for more cash. A television news crew, informed of his whereabouts, also arrives to interview him.

In between visitors, he drifts off into surreal reveries about his true love, who is actually sleeping with his best friend, Chris (James Garde). The only warm encounter Billy enjoys is with Priscilla (Lisa Bonet), a call girl he summons and who promptly falls in love with him.

•

Billy is also the object of an extremely lackadaisical manhunt led by two pot-smoking policemen (Judge Reinhold and Forest Whitaker). The scenes in which they exchange absurd 1940's-style clichés about how Billy grew up in a bad neighborhood are the movie's lamest.

Among the topics spoofed by the movie, which opens today at the Village East, are Billy the Kid, outlaw celebrity and the "Lethal Weapon" series. But the humor is both too oblique and too mild-mannered for the movie to cohere as a modern comic fable. It amounts to little more than a series of loosely connected tangents that come to an abrupt and unsatisfying conclusion.

For all its flightiness, "Bank Robber" is not without charm. Mr. Dempsey's Billy is an endearing, romantic jerk who hardly has a mean bone in his body. The film also has some of the juicier sex scenes to be found in a recent movie. The chemistry between Mr. Dempsey and Ms. Bonet, who both exude a carefree animal magnetism, gives "Bank Robber" a heady erotic glow.

•

"Bank Robber" has been rated NC-17 (No one under 17 admitted). It includes explicit sex scenes that stop short of pornography.

1993 D 10, C10:1

Sister Act 2
Back in the Habit

Directed by Bill Duke; written by James Orr, Jim Cruickshank and Judi Ann Mason; director of photography, Oliver Wood; edited by John Carter, Pem Herring and Stuart Pappé; music by Miles Goodman; production designer, John DeCuir Jr.; produced by Dawn Steel and Scott Rudin; released by Buena Vista. Running time: 100 minutes. This film is rated PG.

Deloris Whoopi Goldberg
Sister Mary Patrick Kathy Najimy
Sister Mary Lazarus Mary Wickes
Sister Mary Robert Wendy Makkena
Father Maurice Barnard Hughes
Mother Superior Maggie Smith
Mr. Crisp James Coburn
Father Ignatius Michael Jeter
Father Thomas Brad Sullivan

By CARYN JAMES

Whoopi Goldberg must have an evil twin. The bad twin is the one who can't stay out of the tabloids, one day being happily roasted with racial jokes at the Friars Club and the next offering a cookbook recipe for "Jewish American Princess Fried Chicken." She may be tasteless but at least she's interesting. It's the good twin who surfaces in "Sister Act 2: Back in the Habit," and she's pretty much a snooze.

Ms. Goldberg's brash persona brought a whiff of mischief to the original "Sister Act," in which she played a mediocre lounge singer, Deloris Van Cartier, forced to masquerade as Sister Mary Clarence. There was plenty of sentimental uplift at the end, but throughout Ms. Goldberg made it clear that a convent was the last place Deloris's married, mobster boyfriend would find her.

The sequel suffers from a lame, saccharine premise and a fatally earnest manner. This time, Deloris is called back by her old convent cohorts when they can't get through to their streetwise high-school students. "Help us by becoming a teacher," implores Maggie Smith as Mother Superior. Before long Mary Clarence is entering her music class in a statewide choral competition and along the way saving the troubled school from becoming a parking lot.

Now Ms. Goldberg looks comfortable wearing a habit; no more penguin jokes for her. There is no irreverence here, and no sense of what street kids are like. Sister Mary Clarence's supposedly belligerent students act out by putting glue on her chair. (In real life wouldn't they just pull their guns on her?)

And if the movie seems muddled about high school, it is hopeless about music. The original "Sister Act" counted on hokey but catchy adaptations of girl-group songs. The sequel whizzes through a bit of everything from gospel to Motown to the tamest versions of rap ever recorded (they're like rap lite). The movie may not intend to be creaky and condescending, but it flirts with the idea that rap is the devil's music.

Bill Duke, who has directed much smarter films ("A Rage in Harlem") as well as the syrupy Disney movie "The Cemetery Club," is less at fault than the Up With People script. The returning nuns have little to do except walk through smaller versions of their old roles: Kathy Najimy is still the bubbly Sister Mary Patrick, Mary Wickes the tough Sister Mary Lazarus, and Wendy Makenna the meek Sister Mary Robert. Three fine character actors — Barnard Hughes, Michael Jeter and Brad Sullivan — are wasted as priests. And though Ms.

Goldberg was reportedly paid $7 million to make this movie, she seems curiously low on energy, even when doing a James Brown impression.

The best part of "Sister Act 2" is the closing credits. The nuns bop around singing "Ain't No Mountain High Enough" and the priests are photographed from above while they lie on the floor doing a Busby Berkeley dance routine. Only then does this sequel hint at the gentle, entertaining satire of the original.

There is one conspicuous missed opportunity. Early on, the school's misinformed headmaster tells Sister Mary Clarence what he has heard: "Your last posting was at a women's prison in the Louisiana bayou." Now *that* is a premise with possibilities.

●

"Sister Act 2" is rated PG (Parental guidance suggested). It includes a mild expletive.

1993 D 10, C10:4

Wayne's World 2

Directed by Stephen Surjik; written by Mike Myers, Bonnie Turner and Terry Turner; director of photography, Francis Kenny; edited by Malcolm Campbell; music by Carter Burwell; production designer, Gregg Fonseca; produced by Lorne Michaels; released by Paramount. Running time: 96 minutes. This film is rated PG-13.

Wayne Campbell	Mike Myers
Garth Algar	Dana Carvey
Cassandra	Tia Carrere
Bobby Cahn	Christopher Walken
Mr. Wong	James Hong
Del Preston	Ralph Brown
Honey Hornee	Kim Basinger

By JANET MASLIN

Time has caught up with Wayne (Mike Myers) and Garth (Dana Carvey), even if it hasn't actually made them any smarter. In "Wayne's World 2," they begin to feel a strange aging sensation, "like I'm in a John Hughes rite du passage movie," as Wayne grandly describes it. Spurred on by this, Wayne begins searching for the meaning of his life. He finds it through the help of Jim Morrison, who appears to him in a dream. According to the film, Jim Morrison spends his time with Sammy Davis Jr. when he isn't busy giving Wayne advice.

"Wayne's World 2," a very good-humored sequel for anyone in tune with its subject, sends Wayne and Garth back through the mists of rock-and-roll history at Morrison's suggestion. He has advised them to stage Waynestock, a retro-style outdoor rock concert. This is terribly confusing for Garth, who always thought the peace sign and the Mercedes-Benz logo were identical. Even more bewilderingly, Wayne and Garth stumble across ancient rock artifacts as they try to plan the show. Showing a worn old "Frampton Comes Alive" LP to his girlfriend, Cassandra (Tia Carrere), Wayne explains: "If you lived in the suburbs, you were issued it. It came in the mail with samples of Tide."

Studying a Gerry and the Pacemakers record, Wayne muses: "You know, I bet those guys actually *have* pacemakers by now." The audience that finds this funny will also know why Wayne and Garth make their road crew practice straightening out a toppled microphone while being pelted by a tennis-ball-serving machine. This is a perfect way of simulating the refined atmosphere to which Waynestock aspires.

Elliot Marks/Paramount Pictures
Mike Myers

It should be noted that neither this film nor the original "Wayne's World" aims much higher than that, and that both have been carefully calibrated as home video-style comedies. It barely matters whether the gags here have any bearing on each other, as long as they fly by quickly; these films' disjointed, grab-bag humor works best at its most absurd. So a ridiculous martial arts interlude between Wayne and Cassandra's father (James Hong) becomes droll because its audio is dubbed into English, and because the same loud noises that indicate mighty blows also accompany a phone call. A brief sequence bringing the story to London is funny because Wayne and Garth make it clear Paramount wouldn't pay to send them there.

"Wayne's World 2," which also includes a few movie parodies of uneven cleverness, spends a lot of time winking at its audience in similar ways. Calling attention to its own artifice whenever possible, the film finds its craftiest silliness in Wayne and Garth themselves. Mr. Myers, and particularly the sly Mr. Carvey, still breathe life into these lovable burnouts, who manage to be innocents abroad even in the privacy of their own homes. This film is sometimes too familiar, especially in early scenes that deliberately repeat the first film's gags. But the formula isn't tired yet.

Particularly entertaining this time is Ralph Brown as a venerable English roadie who delivers several shades of "Spinal Tap"; sorting the M & M's by color was once an important part of his job, and he never tires of telling the same name-dropping stories to unsuspecting listeners. Also on hand is Aerosmith, the Dorian Gray of rock bands, to serve the same purpose Alice Cooper did in the first film. If you were Wayne or Garth, you could spend time wondering what Aerosmith's importance here has to do with "Dazed and Confused," in which Aerosmith is also conspicuously mentioned.

●

Also appearing, in brief cameos, are Charlton Heston, Drew Barrymore and Rip Taylor, who delivers the definitive assessment of Jim Morrison's vocal style. ("He's a *god* in my country," the Hong Kong-born Cassandra says breathlessly of Mr. Taylor.) Kim Basinger is a lot foxier than funny as the woman who does her utmost to seduce Garth. ("Can I

have some cocoa later?" he wants to know.) Christopher Walken, sleek and sinister as ever, has the role of the record producer who promises to further Cassandra's tiresome career. It comes as a relief that Cassandra, an aspiring rock vocalist and successful trash-flash fashion plate, does not have a chance to sing this time.

As directed by Stephen Surjik and written by Mr. Myers with Bonnie Turner and Terry Turner, "Wayne's World 2" keeps the franchise alive in ways that may eventually prove quite scary. After all, as the mixed-up English roadie points out, it's not as if the Grateful Dead were still together any more, is it? Wayne and Garth just might outlast them all.

●

"Wayne's World 2" is rated PG-13 (Parents strongly cautioned). It includes profanity and sexual situations.

1993 D 10, C20:6

Geronimo
An American Legend

Directed by Walter Hill; written by John Milius and Larry Gross; director of photography, Lloyd Ahern; edited by Freeman Davies, Carmel Davies and Donn Aron; music by Ry Cooder; production designer, Joe Alves; produced by Mr. Hill and Neil Canton; released by Columbia. Running time: 115 minutes. This film is rated PG-13.

Lieut. Charles Gatewood	Jason Patric
Brig. Gen. George Crook	Gene Hackman
Al Sieber	Robert Duvall
Geronimo	Wes Studi
Lieut. Britton Davis	Matt Damon

By JANET MASLIN

"A powerful stocky warrior with a perpetual scowl on his face, Geronimo personified all that was savage and cruel in the Apache," states Robert M. Utley's introduction to a recent edition of "The Truth About Geronimo," written by Britton Davis in 1929. "Few whites who knew him had much praise for him, and most of his own people feared and disliked him. Davis characterized him as 'a thoroughly vicious, intractable and treacherous man. His only redeeming traits were courage and determination. His word, no matter how earnestly pledged, was worthless.' History has supported this judgment."

Obviously, times have changed. The revisionist view of Geronimo is apparent in "Geronimo: An American Legend," an earnest, leaden epic directed by Walter Hill from a reverential screenplay by John Milius and Larry Gross. No matter that this film's narrator is actually Britton Davis, played as a bland young West Point graduate by Matt Damon and urging the story forward with colorless observations. The real flavor of Davis's account, and of the ferocity that earned Geronimo his place in history, is nowhere evident on screen.

If the baby, so to speak, is Geronimo's dauntless fighting spirit, it has been thrown out with the bath water of outmoded film stereotypes regarding American Indians. Shooting evocatively amid Utah landscapes that summon John Ford's westerns, Mr. Hill finds ample opportunities to settle old scores. The contempt and condescension with which Indian warriors were so often treated has given way to a warm bath of noble sentiments, none of which advances this film's dramatic purposes at all. "With all this land, why is there no room for the Apache?" asks Geroni-

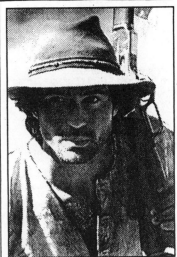
Merrick Morton/Columbia Pictures
Jason Patric

mo, on one of the many occasions when the film's characters seem to speak their lines in capital letters. "Why does the White-Eye want *all* land?"

●

As played by Wes Studi, who was so formidable and effective as Magua in "The Last of the Mohicans," Geronimo is more often made to seem gently perplexed than fierce. This is more a dramatic problem than a political one, since all the film's actors share a placid, reasonable demeanor that becomes unexpectedly dull. As the film recounts the last battles, in the 1880's, between the Chiricahua Apache and the American and Mexican soldiers who overwhelmingly outnumbered them, it adopts an attitude of undifferentiated regret. Almost no one dares play the villain in the fight that destroyed the Indians' independence and altered their destiny.

The film views the events it depicts as part of a colossal misunderstanding, rarely doing justice to the Apaches' anger or going so far as to assign blame. The story's American soldiers are an unusually open-minded group, led at first by Brig. Gen. George Crook (Gene Hackman). General Crook, such an easygoing officer that he at one point invites Geronimo in for coffee, offers Mr. Hackman a role not even he can breathe much life into. Potentially more interesting is another nice-guy officer, Lieut. Charles Gatewood, played by Jason Patric with a soft, purring drawl and a pensive manner. The formidable Mr. Hill ("The Warriors," "The Long Riders") has more often presented tough, vinegary characters who don't waste time questioning their sense of purpose. This subject brings out his kinder, gentler side, which effectively reins him in.

Also in the film, and showing some of its few signs of life, is Robert Duvall as one of the story's maverick characters, a veteran Indian scout named Al Sieber. Sieber sometimes voices a healthy skepticism that would have been welcome elsewhere in the story.

The dialogue ("It is good to see the great warrior") does not seem any weightier by virtue of its having been translated into the Apache language in some places. The scenery is automatically vivid, especially when it takes advantage of the landscape's stark contrasts, but Lloyd Ahern's cinematography is sometimes suffused with dusty reddish tones. Even the musical score by the resourceful

Ry Cooder has a droning, authentic quality, suggesting that earnestness has taken precedence over energy. It has, every time.

•

"Geronimo: An American Legend" is rated PG-13 (Parents strongly cautioned). It includes violence.

1993 D 10, C21:1

The Hawk

Directed by David Hayman; written by Peter Ransley, based on his novel; director of photography, Andrew Dunn; edited by Justin Krish; music by Nick Bicat; production designer, David Myerscough-Jones; produced by Ann Wingate and Eileen Quinn; released by Castle Hill. At the Quad Cinema, 13th Street, west of Fifth Avenue, Greenwich Village. Running time: 86 minutes. This film is rated R.

Annie Marsh.................................Helen Mirren
Stephen Marsh......................George Costigan
Ken Marsh.................................Owen Teale
Norma...Melanie Till
Mrs. Marsh............................Rosemary Leach

By CARYN JAMES

"The Hawk" is a small, efficient English thriller that plays off the question: How well do you know the people closest to you? Helen Mirren plays a suburban housewife named Annie, who begins to suspect that her husband, Stephen, is a serial killer called the Hawk. Stephen always happens to be traveling on business when the Hawk strikes; the murder weapon is a hammer, possibly like the one Annie can't find around the house; worst of all, the Hawk preys on women with two children, just like Annie.

Ms. Mirren is the centerpiece of the film, in a role that might be the reverse image of her best-known part, Inspector Jane Tennison on the television series "Prime Suspect." Instead of playing a fiercely confident detective, here she is a befuddled woman trying to be strong: tortured by doubts, short on self-esteem, stuck in a bad marriage. In one smartly detailed and affecting scene, when Annie goes out to dinner she dresses garishly wrong and is humiliated by her drunken husband.

•

"The Hawk," which opens today at the Quad Cinema, is best when it stays close to Annie's self-doubts and growing fears. Ms. Mirren creates a character so sympathetic that her worst nightmares seem plausible. She keeps the audience weighing evidence and wondering along with her: Is Stephen a killer or just a louse? And why does his brother give everyone the creeps?

The film turns weaker and too tricked up when it drags in Annie's history of depression, which allows Stephen (George Costigan) and his interfering mother (Rosemary Leach) to discredit her suspicions. By

Castle Hill Productions
Helen Mirren

then the audience knows that while Annie might be wrong, she's not stupid or delusional.

Though the film redeems itself with a couple of surprise twists, it is not as taut or inventive as it needs to be. The director, David Hayman, has a penchant for ominous music, but he creates a clear, steady vision that reflects his level-headed heroine. "The Hawk" is not as gripping as "Prime Suspect," but it passes easily as a weaker cousin.

•

"The Hawk" is rated R (Under 17 requires accompanying parent or adult guardian). It includes violence and some graphic views of corpses.

1993 D 10, C21:1

Schindler's List

Directed by Steven Spielberg; written by Steven Zaillian, based on the novel by Thomas Keneally; director of photography, Janusz Kaminski; edited by Michael Kahn; music by John Williams; production designer, Allan Starski; produced by Mr. Spielberg, Gerald R. Molen and Branko Lustig; released by Universal Pictures. Running time: 185 minutes. This film is rated R.

Oskar Schindler............................Liam Neeson
Itzhak Stern..................................Ben Kingsley
Amon Goeth................................Ralph Fiennes
Emilie Schindler.....................Caroline Goodall
Poldek Pfefferberg..............Jonathan Sagalle
Helen Hirsch..............................Embeth Davidtz

By JANET MASLIN

There is a real photographic record of some of the people and places depicted in "Schindler's List," and it has a haunting history. Raimund Titsch, an Austrian Catholic who managed a uniform factory within the Plaszow labor camp in Poland, surreptitiously took pictures of what he saw. Fearful of having the pictures developed, he hid his film in a steel box, which he buried in a park outside Vienna and then did not disturb for nearly 20 years. Although it was sold secretly by Titsch when he was terminally ill, the film remained undeveloped until after his death.

The pictures that emerged, like so many visual representations of the Holocaust, are tragic, ghostly and remote. The horrors of the Holocaust are often viewed from a similar distance, filtered through memory or insulated by grief and recrimination. Documented exhaustively and dramatized in terms by now dangerously familiar, the Holocaust threatens to become unimaginable precisely because it has been imagined so fully. But the film "Schindler's List," directed with fury and immediacy by a profoundly surprising Steven Spielberg, presents the subject as if discovering it anew.

"Schindler's List" brings a preeminent pop mastermind together with a story that demands the deepest reserves of courage and passion. Rising brilliantly to the challenge of this material and displaying an electrifying creative intelligence, Mr. Spielberg has made sure that neither he nor the Holocaust will ever be thought of in the same way again. With every frame, he demonstrates the power of the film maker to distill complex events into fiercely indelible images. "Schindler's List" begins with the sight of Jewish prayer candles burning down to leave only wisps of smoke, and there can be no purer evocation of the Holocaust than that.

A deserted street littered with the suitcases of those who have just been

rounded up and taken away. The look on the face of a captive Jewish jeweler as he is tossed a handful of human teeth to mine for fillings. A snowy sky that proves to be raining ashes. The panic of a prisoner unable to find his identity papers while he is screamed at by an armed soldier, a man with an obviously dangerous temper. These visceral scenes, and countless others like them, invite empathy as surely as Mr. Spielberg once made viewers wish E.T. would get well again.

But this time his emphasis is on the coolly Kafkaesque aspects of an authoritarian nightmare. Drawing upon the best of his storytelling talents, Mr. Spielberg has made "Schindler's List" an experience that is no less enveloping than his earlier works of pure entertainment. Dark, sobering and also invigoratingly dramatic, "Schindler's List" will make terrifying sense to anyone, anywhere.

The big man at the center of this film is Oskar Schindler, a Catholic businessman from the Sudetenland who came to occupied Poland to reap the spoils of war. (You can be sure this is not the last time the words "Oscar" and "Schindler" will be heard together.) Schindler is also something of a cipher, just as he was for Thomas Keneally, whose 1982 book, "Schindler's List," marked a daring synthesis of fiction and fact. Reconstructing the facts of Schindler's life to fit the format of a novel, Mr. Keneally could only draw upon the memories of those who owed their lives to the man's unexpected heroism. Compiling these accounts (in a book that included some of the Titsch photographs), Mr. Keneally told "the story of the pragmatic triumph of good over evil, a triumph in eminently measurable, statistical, unsubtle terms."

The great strength of Mr. Keneally's book, and now of Mr. Spielberg's film, lies precisely in this pragmatism. Knowing only the particulars of Schindler's behavior, the audience is drawn into wondering about his higher motives, about the experiences that transformed a casual profiteer into a selfless hero.

•

Schindler's story becomes much more involving than a tale of more conventional courage might be, just as Mr. Spielberg's use of unfamiliar actors to play Jewish prisoners makes it hard to view them as stock movie characters (even when the real events that befall these people threaten to do just that). The prisoners' stories come straight from Mr. Keneally's factual account, which is beautifully recapitulated by Steven Zaillian's screenplay.

Oskar Schindler, played with mesmerizing authority by Liam Neeson, is unmistakably larger than life, with the panache of an old-time movie star. (The real Schindler was said to resemble George Sanders and Curt Jurgens.) From its first glimpse of Oskar as he dresses for a typically flamboyant evening socializing with German officers — and even from the way his hand appears, nonchalantly holding a cigarette and a bribe — the film studies him with rapt attention.

Mr. Neeson, captured so glamorously by Janusz Kaminski's richly versatile black-and-white cinematography, presents Oskar as an amalgam of canny opportunism and supreme, well-warranted confidence. Mr. Spielberg does not have to underscore the contrast between Oskar's life of privilege and the hardships of his Jewish employees.

Taking over a kitchenware factory in Cracow and benefiting from Jew-

ish slave labor, Oskar at first is no hero. During a deft, seamless section of the film that depicts the setting up of this business operation, Oskar is seen happily occupying an apartment from which a wealthy Jewish couple has just been evicted. Meanwhile, the film's Jews are relegated to the Cracow ghetto. After the ghetto is evacuated and shut down, they are sent to Plaszow, which is overseen by a coolly brutal SS commandant named Amon Goeth.

Goeth, played fascinatingly by the English stage actor Ralph Fiennes, is the film's most sobering creation. The third of its spectacularly fine performances comes from Ben Kingsley as the reserved, wary Jewish accountant who becomes Oskar's trusted business manager, and who at one point has been rounded up by Nazi officers before Oskar saves him. "What if I got here five minutes later?" Oskar asks angrily, with the self-interest that keeps this story so startling. "Then where would I be?"

As the glossy, voluptuous look of Oskar's sequences gives way to a stark documentary-style account of the Jews' experience, "Schindler's List" witnesses a pivotal transformation. Oskar and a girlfriend, on horseback, watch from a hilltop as the ghetto is evacuated, and the image of a little girl in red seems to crystallize Oskar's horror.

But there is a more telling sequence later on, when Oskar is briefly arrested for having kissed a young Jewish woman during a party at his factory. Kissing women is, for Oskar, the most natural act in the world. And he is stunned to find it forbidden on racial grounds. All at once, he understands how murderous and irrational the world has become, and why no prisoners can be safe without the intervention of an Oskar Schindler.

The real Schindler saved more than a thousand Jewish workers by sheltering them in his factory, and even accomplished the unimaginable feat of rescuing some of them from Auschwitz. This film's moving coda, a full-color sequence, offers an unforgettable testimonial to Schindler's achievement.

•

The tension in "Schindler's List" comes, of course, from the omnipresent threat of violence. But here again, Mr. Spielberg departs from the familiar. The film's violent acts are relatively few, considering its subject matter, and are staged without the blatant sadism that might be expected. Goeth's hobby of playing sniper, casually targeting his prisoners with a high-powered rifle, is presented so matter-of-factly that it becomes much more terrible than it would be if given more lingering attention.

Mr. Spielberg knows well how to make such events truly shocking, and how to catch his audience off guard. Most of these shootings are seen from a great distance, and occur unexpectedly. When it appears that the film is leading up to the point-blank execution of a rabbi, the director has something else in store.

Goeth's lordly balcony, which overlooks the film's vast labor-camp set, presents an extraordinary set of visual possibilities, and Mr. Spielberg marshals them most compellingly. But the presence of huge crowds and an immense setting also plays to this director's weakness for staging effects en masse. "Schindler's List" falters only when the crowd of prisoners is reduced to a uniform entity, so that events no longer have the tumultuous variety of real life.

This effect is most noticeable in Schindler's last scene, the film's only

major misstep, as a throng listens silently to Oskar's overwrought farewell. In a film that moves swiftly and urgently through its three-hour running time, this stagey ending — plus a few touches of fundamentally false uplift, most notably in a sequence at Auschwitz — amounts to a very small failing.

Among the many outstanding elements that contribute to "Schindler's List," Michael Kahn's nimble editing deserves special mention. So does the production design by Allan Starski, which finds just the right balance between realism and drama. John Williams's music has a somber, understated loveliness. The soundtrack becomes piercingly beautiful as Itzhak Perlman's violin solos occasionally augment the score.

It should be noted, if only in passing, that Mr. Spielberg has this year delivered the most astounding one-two punch in the history of American cinema. "Jurassic Park," now closing in on billion-dollar grosses, is the biggest movie moneymaker of all time. "Schindler's List," destined to have a permanent place in memory, will earn something better.

•

"Schindler's List" is rated R (Under 17 requires accompanying parent or adult guardian). It includes violence and graphic nudity.

1993 D 15, C19:3

Famine-33

Directed by Oles Yanchuk; written (in Ukrainian, with English subtitles) by Serhij Diachenko and Les Taniuk, based on the novel "The Yellow Prince," by Vasyl Barka; directors of photography, Vasyl Borodin and Mykhajlo Kretov; edited by Natalia Akajomova; music by Mykola Kalandjonak and Victor Pacukevych. At Film Forum 1, 209 Houston Street, South Village. Running time: 95 minutes. This film is not rated.

Odarka .. Halyna Sulyma
Myron Georgi Moroziuk

By STEPHEN HOLDEN

The indelible images of human suffering that permeate Oles Yanchuk's film "Famine-33" are memorable precisely because they are so far removed in tone from the raucous, shoot-'em-up violence and hysteria of Hollywood movies. In this drama of a

Film Forum

Halyna Sulyma in a scene from Oles Yanchuk's film "Famine-33."

Ukrainian family's struggle to survive a Government-created famine that killed more than seven million (a quarter of the population) in 1933, the suffering is etched in the stony faces of people too weary and weak to raise their voices.

In an early scene, the members of an impoverished farming family solemnly take turns dipping their ladles into the single bowl of watery soup that is their only meal of the day. Later in the film, scores of villagers numb with despair and hunger huddle silently in the pouring rain outside a Government office until a truckload of armed soldiers arrives to disperse them. In the most poignant scene, a little boy who has lost his parents calls for his mother as he wanders panic-stricken through a snowy woodland where the trees are outnumbered by crosses marking the dead.

In the film's grimmest moment, a train stops on the side of a hill, and Russian soldiers unload hundreds of dead bodies from a flatcar, tossing them down a slope and into a burning pit. For every few bodies deposited, a log is rolled to fuel the fire.

Although the Katrannyks, the family portrayed in "Famine-33" are fictional, the historical events covered by the film are real. In 1932 and '33, Stalin instituted a program in which Soviet troops seized all the livestock, crops and seed stocks grown in Ukraine, the Soviet Union's richest agricultural region, deliberately bringing about mass starvation. One goal of the program was to raise capital for Soviet industrialization by selling the grain abroad. A more insidious goal was to force the independent farmers to work in collectives, where they were patrolled by soldiers and treated no better than serfs. Integral to the program was the crushing of any notions of Ukrainian independence through the destruction of churches and other cultural institutions.

"Famine-33," which opens today at Film Forum 1, relies more on images than on words as it follows the inexorable disintegration of the Katrannyks, a family of six, after Soviet troops invade their house and remove their food supply. Shot mostly in grimy black-and-white, the film occasionally explodes into misty pastel colors for scenes in which the characters hallucinate a time of peace and plenty. The film has a dioramic quality. Instead of following the day-to-day decline of the Katrannyks, it is a series of tableaux of crucial moments in the lives of the family and their neighbors.

•

Technically, the movie is quite crude. The screenplay, written by Serhij Diachenko and Les Taniuk from Vasyl Barka's novel "The Yellow Prince," is hardly more than a series of spoken captions. There is no conventional character development. Everyone in the fiercely polemical film is an archetype. In those few scenes that require acting, the performances are uneven.

The Soviet forces who carry out the savagery are portrayed as uniformly monstrous. They take sadistic pleasure in flaunting their grain, vodka and sausages in the faces of the hungry and think nothing of slaughtering hundreds of unarmed protesting farmers with machine guns. When Myron Katrannyk (Georgi Moroziuk), the head of the household, is suspected of hiding a sacred chalice, he is summoned to Communist party headquarters, suspended on a rack and beaten. After he and his wife, Odarka (Halyna Sulyma), refuse to talk, they are held prisoner and their children are left to fend for themselves. One of the perils they face is being kidnapped and eaten.

"Famine-33" is a difficult movie to watch, but it has a stark monumentality. As the camera lingers on the wasted faces and desolate terrain of a land without hope, the film builds up a portrait of suffering and oppression that has universal echoes.

1993 D 15, C23:1

Floating in Limbo in London's Streets

"Naked" was shown as part of the 1993 New York Film Festival. Following are excerpts from Vincent Canby's review, which appeared in The New York Times on Oct. 15. The film opened yesterday.

Meet Johnny (David Thewlis), the 27-year-old Manchester lad who is the central figure in Mike Leigh's "Naked," a brilliant somersault of a movie that lands this fine English director in dark new cinematic territory.

As nothing that Mr. Leigh has done in the past (especially his recent "High Hopes" and "Life Is Sweet") is adequate preparation for "Naked," no movie character you may have met quite measures up (or down) to the caustic and abusive Johnny. He's "not waving, but drowning." Although the cool order of the poet Stevie Smith's line succinctly describes Johnny's situation, it has little to do with his often revivifying, sardonic fury.

Johnny recalls Jimmy Porter of "Look Back in Anger," but homeless in the London streets of the 1990's. He raises his fist not at the Empire, the class system and the Tory mentality, but at God: Johnny goes to the source. A product of the English working class, a man with possibly a year or two at a Midlands university behind him, he has the gift of gab of one of James Joyce's Dubliners who has lost his faith but not his voice.

•

Johnny invites compassion, especially from women. His scroungy good looks inspire trust: the sad expression, the skinny frame, the great reddish-brown mustache that indicates some reassuring sense of self-worth. But they're all a disguise. Beneath his cheap raincoat, which provides no protection against the winter chill, Johnny is a kind of satanic angel. He's as capable of expressing love as Jack the Ripper.

He doesn't murder; he doesn't have to. During his several days of wanderings about London, which are the focus of Mr. Leigh's screenplay, he leaves a trail of living corpses, the victims, possibly, of a social system but, beyond that, of an indifferent universe. He's fed up with himself and his lot, but he directs his anger at everyone around him.

"Naked" is a logical if unexpected extension of such earlier Leigh films as "Bleak Moments," "Grown-Ups," "Meantime" and "Home Sweet Home," each a harrowing tale of the domestic problems of the English working and lower middle classes. Yet those films are all rooted in recognizable homes, such as they may be, and deal with approximations of the nuclear family. "Naked" is something else.

The characters in "Naked" have abandoned whatever homes they had. Their families are somewhere else; they're scarcely mentioned. The flats and rooms seen in "Naked" are temporary refuges. These characters aren't mired in domestic relationships; they're as free-floating in limbo as Johnny, although they don't know it.

When first seen, before the title credits, Johnny is standing in a Manchester alley late at night having sex with a woman he has just picked up. That's a delicate way of describing what he's doing. He's brutalizing the woman, who tries to fight him off. When finished, he walks away, steals a car and drives to London. His purpose: to find his former girlfriend Louise (Lesley Sharp). She shares a flat with a spaced-out druggie named Sophie (Katrin Cartlidge) and Sandra (Claire Skinner), whose name is on the lease, a prissy nurse who returns from a vacation in Zimbabwe in the course of Johnny's visit.

During the next several days, Johnny descends into hell, though at one point, when he's asked where he has been, he says, "Down the Via Dolorosa." Johnny's being sarcastic, but the movie isn't. "Naked" is as corrosive and sometimes as funny as anything Mr. Leigh has done to date. It's loaded with wild flights of absurd rhetoric and encounters with characters so eccentric they seem to have come directly from life. Nobody would dare imagine them.

Perhaps "Naked" should not be analyzed too closely in any conventional way. It's as much about actors acting, finding their remarkable characters in their collaborations with Mr. Leigh, who is both the writer and director, as it is about the characters thus created and the landscape they inhabit.

Mr. Thewlis is staggeringly fine, but everyone else in the cast is also special. The dialogue dazzles, whether it sounds like something overheard during a beery undergraduate discussion on the meaning of life or takes off into its own mad stratosphere, as when Johnny considers the mystery of the silence of the human body: "The most complex mechanism in the universe, but it still doesn't make any noise. What's going on in there?"

1993 D 16, C20:3

The Pelican Brief

Directed by Alan J. Pakula; written by Mr. Pakula, based on the novel by John Grisham; director of photography, Stephen Goldblatt; edited by Tom Rolf and Trudy Ship; music by James Horner; production designer, Philip Rosenberg; produced by Mr. Pakula and Pieter Jan Brugge; released by Warner Brothers. Running time: 125 minutes. This film is rated PG-13.

Darby Shaw	Julia Roberts
Gray Grantham	Denzel Washington
Thomas Callahan	Sam Shepard
Gavin Verheek	John Heard
Fletcher Coal	Tony Goldwyn
Bob Gminski	William Atherton
The President	Robert Culp
Justice Abraham Rosenberg	Hume Cronyn
Smith Keen	John Lithgow

By JANET MASLIN

MILLIONS of people have already seen "The Pelican Brief," though it is only now opening at neighborhood theaters. That's because John Grisham's novel is written as instant movie material. It has a big secret; it has a big explosion; it has a conspiracy plot that leads all the way to the top. It has a heroine who sounds exactly like Julia Roberts, if Julia Roberts were going to law school. Mr. Grisham has even incorporated lots of New Orleans and Washington scenery, thus giving his intrigue plot some extra tourist appeal.

Mr. Grisham, a fixture at the top of the best-seller list and the most cinematic popular author this side of Michael Crichton, habitually writes half-books. The opening setups are what sell his stories, even if they disintegrate into empty skullduggery and endings that are conspicuously weak. It helps that his prose is crisp and streamlined enough to persuade the reader that something substantial is afoot, even when there are strong indications to the contrary. At best, a Grisham book offers a veneer of seriousness and a strong jolt of clever escapism. Food for thought it's not.

As written and directed by Alan J. Pakula with all the glossy professionalism he can muster, the film version of "The Pelican Brief" has much the same tenor. It is, in fact, the closest thing to an exact transcription of Mr. Grisham's novel as might have been imagined, to the point where the author's devoted readers will experience strong déjà vu.

The story, neatly compressed, unfolds in dependable and photogenic ways. And it is coaxed along by Mr. Pakula's considerable skills as a brisk, methodical film maker. It could be shorter, and it could be more imaginative. (Sydney Pollack's superior Grisham film, "The Firm," really did breathe life into the author's paper-thin characters.) But as a fast-moving, good-looking visual replica of an intrigue potboiler, it also could have been a lot worse.

"The Pelican Brief" is best watched as a celebration of liquid brown eyes and serious star quality, thanks to the casting of Ms. Roberts and Denzel Washington in its leading roles. Neither of these first-rate actors is shown to great dramatic advantage, but they both do a lot to make the movie shine.

Ms. Roberts is cast as Darby Shaw, a brilliant law student who becomes the Nancy Drew of the 90's. And Mr. Washington plays Gray Grantham, the brilliant black newspaper reporter who was white in Mr. Grisham's novel. Mr. Grisham didn't actually write an ending, but he did close his book with a clinch and a promise of romance between Darby and Gray. The film, which thrives on the comfortable chemistry between its two stars, isn't quite gutsy or colorblind enough to do the same.

The premise, in short: two Supreme Court Justices are assassinated, and a feisty Tulane University Law School student wants to know why. Encouraged by her professor, Thomas Callahan (Sam Shepard, who is also her lover), Darby does some research. Amazingly, she digs up something very, very pertinent to the assassinations, and she nicknames her written report the Pelican Brief. Callahan casually turns this brief over to an F.B.I. friend (John Heard), to whom he boasts about Darby.

"Here, take a look at it," Callahan says. "You'd get a kick out of how her mind works."

Kick, eh? Callahan soon receives a kick of his own, and then Darby is off and running. Viewers and/or readers are asked to believe that this lone, gorgeous law student has stumbled onto the power to bring down people in high places, and that skilled assassins are stalking her every move. To the rescue: Gray Grantham, journalist, whom Darby first gets in touch with by telephone, calling herself Alice. Gray scribbles on his notepad while they talk. "Name not Alice?" Gray writes. Gray is supposed to be a star reporter.

As the film piles on shovelfuls of further exposition, Mr. Washington and Ms. Roberts are left to look terrific and recite perfunctory lines. She (for instance): "How can you be so sure?" Or he (authoritatively): "Darby, if this thing reaches as deep and goes as high as we think it does, these men will do anything not to be exposed." It's a shame that Ms. Roberts is relegated to looking worried most of the time, but even in a by-the-numbers role she manages to glow. During a hiatus from screen acting, she has spent time becoming even more drop-dead beautiful and a shade more self-possessed.

•

Also seen to good advantage in Mr. Pakula's cleverly cast film are Tony Goldwyn as the nice young man who effectively runs the country, and Robert Culp as the President who very clearly doesn't. Mr. Culp, seen avidly training his dog in the Oval Office, gives the film one of its rare flashes of wit. The supporting cast also includes William Atherton as the instantly fishy director of the C.I.A., and John Lithgow as the blustery, suspender-wearing newspaper editor who refers to the author of the Pelican Brief as "Bird Girl."

As photographed by Stephen Goldblatt, "The Pelican Brief" looks picturesque whether it is dawdling in New Orleans's French Quarter or at Mount Vernon. Mr. Pakula's screenplay does a heroic job of cramming in information and keeping the characters in motion. But it never answers the story's most nagging question: Why don't the assassins simply ambush Darby on a shopping trip? She goes into hiding with only the dress she is wearing, then manages a number of nice costume changes throughout the rest of the film.

•

"The Pelican Brief" is rated PG-13 (Parents strongly cautioned). It includes violence, most of it discreetly staged.

1993 D 17, C1:5

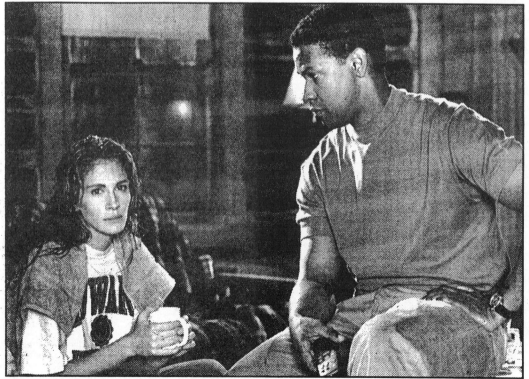

Ken Regan/Camera 5/Warner Brothers

Julia Roberts and **Denzel Washington** in a scene from "The Pelican Brief," based on John Grisham's novel.

What's Eating Gilbert Grape

Directed by Lasse Hallstrom; written by Peter Hedges, based on his novel; director of photography, Sven Nykvist; edited by Andrew Mondshein; music by Alan Parker and Bjorn Isfalt; production designer, Bernt Capra; produced by Meir Teper, Bertil Ohlsson and David Matalon; released by Paramount Pictures. Running time: 117 minutes. This film is rated PG-13.

Gilbert Grape	Johnny Depp
Arnie Grape	Leonardo DiCaprio
Becky	Juliette Lewis
Momma	Darlene Cates
Betty Carver	Mary Steenburgen
Mortician	Crispin Glover

By JANET MASLIN

It's hard to describe the many eccentricities of "What's Eating Gilbert Grape" without making the film sound as if it had a case of terminal whimsy. Better to say that this is the work of Lasse Hallstrom, the Swedish director of "My Life as a Dog," whose gentle, rueful style can accommodate vast amounts of quirkiness in enchanting ways. Mr. Hallstrom is also adept at viewing the world from the perspective of troubled young characters. And Gilbert Grape, the hero and narrator of this story, has troubles to spare.

Gilbert lives in Endora, Iowa, a town so flat and featureless that all of its energy seems to have turned inward, particularly where the Grape family is concerned. The Grape household is dominated by 500-pound Momma (Darlene Cates), who hasn't ventured outside in so long that local children sneak up to the Grape windows to stare at her. Gilbert helps them.

The household, which also includes two quarrelsome sisters, is kept in a constant state of emergency by Arnie (Leonardo DiCaprio), Gilbert's retarded younger brother. Arnie enjoys heights, and he has a way of climbing to the top of the local water tower whenever Gilbert forgets to watch him.

Gilbert himself has a career as a delivery boy, working in the small, outmoded grocery store where few Endorans shop now that a big, modern supermarket has come to town. (The fact that the supermarket has a tank containing live lobsters has created a considerable stir.) Gilbert has been making very special deliveries to Mrs. Betty Carver (Mary Steenburgen) for a long time. "Uh, get out," Betty says to her two small children when Gilbert comes over. "Go outside and play right now."

Betty may see some urgency in these meetings, but Gilbert has begun to grow bored. Everything in Endora bores him a little, until flirty, diffident Becky (Juliette Lewis) comes to town. To the extent that this offbeat, slyly deadpan film has any forward momentum, it has to do with how Becky's arrival raises Endora's energy level a little. It's also about how Arnie and Momma's various problems finally bring Gilbert to the brink of change.

•

"What's Eating Gilbert Grape" is based on a somewhat darker, more acerbic first novel by Peter Hedges, who also wrote the screenplay. Like a lot of first novels, this one is much stronger on texture and character than on plot, and the film has inherited the same problem. But the screen version of "What's Eating Gilbert Grape" also has a lot to recommend it. Particularly impressive are the sweet, weirdly idyllic tone of Mr. Hallstrom's direction and Johnny

Depp's tender, disarming performance as the long-suffering Gilbert Grape.

In films like "Edward Scissorhands" and "Benny and Joon," Mr. Depp has made a specialty of playing gentle outsiders, and doing so with enormous charm. He brings much the same soulfulness and strength to this role, even though for once he is cast as a pillar of the community. This particular community needs every pillar it can find, as does the Grape house itself, which sags badly under the spot where Momma holds court in the living room. Momma so seldom leaves the sofa that her children bring the kitchen table over to her at mealtimes.

Mr. Hallstrom, working much more comfortably in an American setting than he did in the 1990 "Once Around" (which took place in the Boston area), has done a particularly canny job of casting this film. The impossible role of Momma is ideally played by Ms. Cates, who was spotted on a "Sally Jessy Raphaël" episode about overweight women who never leave home. Ms. Cates, believable and emphatic, has done herself and the film a big favor by getting out of the house for this. Some of the film's minor characters are also very well etched, particularly the avid young mortician (Crispin Glover) who takes his work a little too seriously and likes to talk about it over lunch.

Ms. Lewis is seductively good as someone obviously bemused by what goes on in Endora, and by Gilbert himself. But the film's real show-stopping turn comes from Mr. DiCaprio, who makes Arnie's many tics so startling and vivid that at first he is difficult to watch. Mr. DiCaprio, who also had a prominent role in "This Boy's Life" earlier this year, winds up capturing the enormous range of Arnie's raw emotions, and making it clear why the Grape brothers share such an unbreakable bond. The performance has a sharp, desperate intensity from beginning to end.

"What's Eating Gilbert Grape" has been given an invitingly bucolic glow by Sven Nykvist's cinematography, which makes the antics of the Grapes that much more colorfully incongruous. The film's hairdresser, apparently thinking like a Grape herself, gives Ms. Lewis a spiky-looking brush cut while letting Mr. Depp fit one of Gilbert's lines from the novel: "My hair is so long that it's beginning to eat my head."

•

"What's Eating Gilbert Grape" is rated PG-13 (Parents strongly cautioned). It includes mild profanity and sexual situations.

1993 D 17, C3:4

Beethoven's 2d

Directed by Rod Daniel; written by Len Blum; director of photography, Bill Butler; edited by Sheldon Kahn and William D. Gordean; music by Randy Edelman; production designer, Lawrence Miller; produced by Michael C. Gross and Joe Medjuck; released by Universal Pictures. Running time: 87 minutes. This film is rated PG.

George Newton	Charles Grodin
Alice Newton	Bonnie Hunt
Ryce	Nicholle Tom
Ted	Christopher Castile
Emily	Sarah Rose Karr
Regina	Debi Mazar
Floyd	Chris Penn

BY CARYN JAMES

Anyone making a dog movie could do much worse than to borrow the

plot of "101 Dalmatians." "Beethoven's 2d" may be the sequel to last year's hit about a lovable, sloppy St. Bernard adopted by a suburban family, but it is also a lively and sweetly told story of puppy-napping.

Now a beloved member of the Newton family, Beethoven sows a few wild oats with another St. Bernard named Missy. She's the one with the pink bow between her ears. Missy is also a pawn in an ugly divorce. The wife, Regina, takes her away from her kindly owner, and threatens to hold her until she gets money. And when she discovers the four puppies born to Missy and Beethoven, she threatens to take them as well. Fortunately, the younger Newton children, 13-year-old Ted and 9-year-old Emily, escape with the pups and hide them in the basement. They remember how long it took their father, Charles Grodin, to learn to love Beethoven in the original movie.

The comic villains are never much of a threat to Beethoven's family. With her swooping eyebrows, Regina (Debi Mazar) is a fair match for Cruella De Vil. She does everything short of threaten to turn the puppies into a coat. "Drown 'em," she whines. Her partner, Floyd (Chris Penn), a man too stupid to eat with his mouth shut.

•

As in the first "Beethoven," Mr. Grodin holds the film together. He is the most soothing and protective dad since Pongo, the original Dalmatian. He is one of the few comic actors who can hold his own with a dog, without mugging it up, and is especially game when he and Beethoven are entered in a burger-eating contest.

"Beethoven's 2d" will be irresistible to children, but it doesn't have the crossover appeal that allowed the original to be entertaining for adults as well. And it has three long musical montages that may drag for everybody. In two of them, James Ingram and Dolly Parton sing "The Day I Fall in Love." At least it's not called "The Love Theme From Beethoven," though Beethoven and Missy do look soulfully into each other's eyes.

The relative tameness of "Bethoven's 2d" may come from the change in directors. The original was directed by Ivan Reitman, of "Ghostbusters," "Twins" and "Dave" fame. The sequel is directed by Rod Daniel, who directed the James Belushi flop "K-9." But he does have a way with dogs. He makes the Beethoven family seem adorable, even to those of us capable of imagining a St. Bernard coat.

•

"Beethoven's 2d" is rated PG (Parental guidance suggested). It includes some drunken teen-agers, who learn that drinking doesn't pay.

1993 D 17, C10:5

Correction

A film review in Weekend on Friday about "Beethoven's 2d" misidentified the director of the earlier movie "Beethoven." He was Brian Levant; Ivan Reitman was the executive producer.

1993 D 21, A2:6

Wrestling Ernest Hemingway

Directed by Randa Haines; written by Steve Conrad; director of photography, Lajos Koltai; edited by Paul Hirsch; music by Michael Convertino; production designer, Waldemar Kalinowski; produced by Todd Black and Joe Wizan; released by Warner Brothers. At the First and 62d Cinemas, 62d Street between First and York Avenues, Manhattan. Running time: 123 minutes. This film is rated PG-13.

Walt	Robert Duvall
Frank	Richard Harris
Helen	Shirley MacLaine
Elaine	Sandra Bullock
Georgia	Piper Laurie

By CARYN JAMES

"Wrestling Ernest Hemingway" begins with the camera looking down at Richard Harris, as a man in his 70's, naked on the floor doing push-ups. This is not the most flattering angle from which the actor has ever been shot, which is very much the point. The film, which follows the growing friendship of two aging men who have nothing in common but loneliness, means to do something radical, at least by Hollywood standards: it tells the demographically unpopular tale of old people.

But the self-conscious bravado of the opening scene also suggests the film's overwhelming weakness. Instead of simply assuming that the old have interesting lives, the film never stops congratulating itself for being daring enough to focus on them. It shows the terrible strain of trying too hard.

The story belongs to Mr. Harris, as Frank, once a daring sea captain and now a loud, hard-drinking retiree who has been divorced four times. He has lived so wildly that he actually wrestled Hemingway in Puerto Rico in 1938, or so he claims. He flirts with Piper Laurie, as a proud and proper woman he meets at the movies. He argues with Shirley MacLaine, as the weary owner of the rundown apartment house to which he has just moved.

Mr. Harris's over-the-top performance suits his character, whose Hemingway story suggests the escapist myths by which he has lived. The character is helped by the film's exact use of detail. Frank takes a bottle and a Hemingway book to the park. He wears bright orange shorts, is grizzled and unshaven. It is not upsetting to see Mr. Harris looking old here, but it is extremely disconcerting to realize how much he has come to resemble George Carlin.

Robert Duvall plays Walter, a fussy Cuban bachelor and one-time barber who also lives in the fictional Florida town of Sweetwater. The cautious Walter goes to the same restaurant every day and always gets two bacon sandwiches (one for breakfast, one to keep for lunch), mainly so he can continue a sweet friendship with a young waitress (Sandra Bullock, from "Demolition Man"). Mr. Duvall's restraint suits his character as well, but he is saddled with a Cuban accent that calls attention to the film's many contrivances. Here are two intelligent but distant performances, which make it impossible to forget that we are watching Richard Harris and Robert Duvall acting old.

•

The three actresses are appealing, but their roles are understandably tiny. This is a story about male bonding, geriatric style. When Frank forces his friendship on Walter, the pattern is instantly predictable: Walter's resistance, the inevitable close-

ness, the explosive argument in the street. Frank and Walter are like "The Odd Couple" without the jokes.

But the film, which opens today at the First and 62d Cinemas, also offers scenes that are generous and genuine. Among this season's many overlong movies, this is the one, running 2 hours and 3 minutes, that would have benefitted most from losing a half-hour. There is a finer movie hidden inside the scenery chewing and predictability.

Among the most eloquent touches is the wordless image of Walter, viewed from outside his apartment window, dressed in a suit and tie and dancing quite debonairly by himself, an imaginary woman in his arms.

And an episode between Mr. Harris and Ms. MacLaine is exceptionally poignant. Frank drunkenly goes to his landlady's apartment late at night. He desperately wants to sleep with her; she is guarded and self-protective, but may be as lonely as he is. It is heartbreaking to hear Frank admit, "I can't do this anymore." He is talking not only about this physical moment, but also about his desperately isolated life.

The director, Randa Haines, is best known for her feature films "Children of a Lesser God" and "The Doctor." But her strongest work was the tough, made-for-television movie about incest, "Something About Amelia." As in her other features, "Wrestling Ernest" too often gives in to an easy, sentimental impulse, creating the kind of scene in which Frank and Walter urinate in the ocean while fireworks explode in the background. Mr. Macho Hemingway would have felt right at home using the ocean as a toilet, but what would he have made of those fancy fireworks?

•

"Wrestling Ernest Hemingway" is rated PG-13 (Parents strongly cautioned). It includes strong language and a glimpse of nudity.

1993 D 17, C12:6

The Summer House

Directed by Waris Hussein; written by Martin Sherman, based on the novel "The Clothes in the Wardrobe," by Alice Thomas Ellis; director of photography, Rex Maidment; edited by Ken Pearce; music by Stanley Myers; production designer, Stuart Walker; produced by Norma Heyman; released by the Samuel Goldwyn Company. Running time: 85 minutes. This film has no rating.

Margaret	Lena Headey
Syl	David Threlfall
Monica	Julie Walters
Nour	Padraig Casey
Mrs. Monro	Joan Plowright
Lili	Jeanne Moreau

By CARYN JAMES

"The Summer House" might as well be called "The Jeanne Moreau Show." Like a television series tailored to the image of its star, this small-scale English movie presents the actress as a flamboyant, exotic and cynical woman with a rich sexual past. Her supposed function in the story is to save an unhappy young woman named Margaret from a disastrous marriage to her next-door neighbor, a 40-year-old twit who still lives with his mother. But her real purpose is to swoop through the film being Jeanne Moreau, in a performance that is over the top and tremendous fun to watch. She doesn't ever wink at the camera, but she and the audience know exactly what she is up to.

Photographs by Simon Mein/Samuel Goldwyn

Joan Plowright, top, and Jeanne Moreau star in the film "The Summer House," which is directed by Waris Hussein.

Margaret (Lena Headey, who plays the rosy-cheeked housemaid in "The Remains of the Day") begins the film with an ominous dream about her recent trip to Egypt. The dream includes a young man and a bloody dagger, and hints at some disturbing reason why she has agreed to marry the dunderheaded neighbor, Syl (David Threlfall).

Of course, the setting is 1959, when a girl wouldn't want to be "left on the shelf," as Margaret's drab mother, Monica, puts it. (Julie Walters is unrecognizably prim and gray as Monica.) But that is a trifling excuse here; the film is so contemporary in its freewheeling attitude toward sex and marriage that Monica's attitudes seem as frumpy as her clothes.

Even Syl's widowed mother, played with incomparable wit by Joan Plowright, can see that Margaret loathes her fiancé. And from the moment Monica's girlhood friend Lili (Ms. Moreau) arrives for the wedding, the question is how she will save Margaret from a fate worse than spinsterhood.

The answer is not hard to guess. The issue is a delaying tactic that allows Lili to possess the screen. She is half-Egyptian and half-English, with bright orange-red hair. She trails multicolored scarves and is loaded down with enormous Egyptian rings and necklaces. She delivers her droll lines with a world-weary wisdom that has been nearly patented by Ms. Moreau. "I wonder if he wears lace panties," Lili casually wonders about Syl while she and Margaret walk to the butcher's. "Egyptian men don't as a rule, but the English are a breed apart."

•

Joan Plowright is one of the few actresses confident and smart enough to realize that the only way to steal a scene from Jeanne Moreau is

to claim the opposite camp. Looking totally unglamorous and underplaying in the extreme, she is every bit her co-star's match.

When Ms. Plowright first appears as Mrs. Monro she is sitting in bed wearing a white nightcap, resembling Little Red Riding Hood's granny. Eventually she and Lili develop a friendship, and in one scene they go to a pub where they become falling-down drunk and honest. It has been easy for Mrs. Monro to forgive Lili for a long-ago affair with her husband; as she admits, she is quite a bit happier as a widow. "I look forward to it," Lili says, efficiently dismissing her artist-husband (John Wood).

Mrs. Monro also has the perfect response to her friend's portentous remarks. "Oh, Lili, that makes no sense," she says, "but I believe you."

The director, Waris Hussein, was wise to let these two actresses run away with the movie. The screenplay is at times too whimsical and at times too slight. When Lili pulls off her ultimate trick, in the garden house of the title, it hints at a darkness in her character that has been suggested but not developed. And it was hardly necessary to make *all* the men unfaithful idiots.

But it would be too bad if this charming film were lost among the season's big commercial movies. Acting together in top form, Ms. Moreau and Ms. Plowright are something to see.

1993 D 21, C19:1

Faraway, So Close

Directed by Wim Wenders; written by Mr. Wenders, Ulrich Zieger and Richard Reitinger in German, with English subtitles; director of photography, Jurgen Jurges; edited by Peter Przygodda; music by Laurent Petitgand; production designer, Albrecht Konrad; produced by Mr. Wenders; released by Sony Pictures Classics. Running time: 140 minutes. This film is not rated.

Cassiel	Otto Sander
Damiel	Bruno Ganz
Marion	Solveig Dommartin
Raphaela	Nastassja Kinski
Peter Falk	Himself
Lou Reed	Himself
Emit Flesti	Willem Dafoe
Mikhail Gorbachev	Himself
Tony Baker	Horst Buchholz

By CARYN JAMES

In all the publicity material for all the season's films, this is surely the most peculiar and deadpan star's bio: " 'Faraway, So Close' marks Mikhail Gorbachev's feature film debut." The former Soviet president has a tiny cameo in Wim Wenders's latest film. And he has a guardian angel looking over his shoulder while he sits at his desk meditating that "a secure world can't be built on blood; only on harmony."

The angel, Cassiel (Otto Sander), is the true star of "Faraway, So Close," a lyrical and profoundly goofy continuation of Mr. Wenders's 1987 cult hit "Wings of Desire." But in spirit Mr. Gorbachev presides over the film like the guardian angel of glasnost, for Mr. Wenders has taken the major characters from "Wings of Desire" and set them down in a unified, and strangely multi-lingual, Germany.

Damiel (Bruno Ganz), the angel who became human near the end of the earlier film, is now a pizza maker who sings "Funiculi, Funicula" while riding his delivery bike. He is married to Marion (Solveig Dommartin), the French trapeze artist who inspired him to become a man in the first place. Damiel can sense the presence of his old colleague, Cassiel, though angels are visible only to one another and to the movie camera.

As in the earlier film, angels hover around reading humans' minds. Sometimes they wear wings. Always, they wear greatcoats and ponytails, which make the male angels resemble 1980's art dealers. When Cassiel catches a little girl who has fallen off a balcony, he violates the angels' rule of nonintervention and becomes human. You can tell, because his ponytail floats to the ground and he suddenly appears in color rather than black and white. (Most of the film is in deliciously rich black and white, with color reserved for those scenes in which no angels are eavesdropping.)

Mr. Wenders, the king of road movies, is at his best when he sets his angels free as if they were in a road movie of the air. Cassiel and a beautiful angel called Raphaela (Nastassja Kinski, underused here) discover that Berlin is rife with Americans. Among them are Peter Falk and Lou Reed,

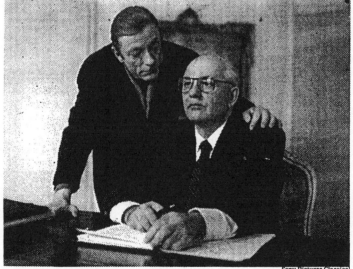

Sony Pictures Classics

Otto Sander, left, plays the angel Cassiel and Mikhail S. Gorbachev plays himself in the film "Faraway, So Close."

whose cameos provide some bright, tongue-in-cheek moments, though the scenes also suggest that Mr. Wenders's idea of German unification has more to do with geography and slogans than with politics.

Mr. Falk, who also played himself in "Wings of Desire," wants to see East Berlin now that the wall is down, but has trouble getting a cab driver who knows his way around. Mr. Reed noodles with his guitar and sings, "In Berlin after the wall/It's very nice, it's paradise." Mr. Wenders's politics never sound more profound than those lyrics. But the soundtrack, with songs by Mr. Reed, U2 and Nick Cave, is one of the film's savvy strong points. "Why can't I be good, why can't I act like a man," the human Cassiel sings to himself, echoing a Lou Reed concert he has sneaked into.

•

Mr. Sander is a valuable, steadying presence. He carries his ponderous lines lightly, and his somber face offers ballast to the most fanciful scenes. But the human Cassiel gets into trouble when he tries some angelic good deeds, and Mr. Wenders gets into trouble at about the same time. He constructs an unintelligible suspense plot that involves a German-American gangster, gunrunners and circus acrobats.

Another major misstep is the prominent character played by Willem Dafoe. He seems like a fallen angel, able to move between the human and the spirit world, and buys Cassiel a drink that instantly turns him into a drunk begging on the street. He is intended to represent mortal time: his pocket watch ticks like a time bomb and his name, Emit Flesti, is simply "Time Itself" spelled backwards. But the character is as meaningful as gibberish. When he says things like, "Time is the absence of money," the only proper audience response is "Huh?" At such moments it is wise to remember that while "Faraway, So Close" sounds like a poetic title, it is just a fancy way of saying "so near and yet so far." There are nasty clichés lurking at the heart of Mr. Wenders's lyricism.

But there is also great daring, wit and style. Like Mr. Wenders's previous film, last year's "Until the End of the World," this one begins as a swirl of dazzling ambition and at midpoint turns into a mess. Even so, and even at 2 hours and 20 minutes, it is one of the more intriguing messes on screen.

•

"Faraway, So Close" is rated PG-13 (Parents Strongly Cautioned.) It includes some violence.

1993 D 22, C15:1

Philadelphia

Directed by Jonathan Demme; written by Ron Nyswaner; director of photography, Tak Fujimoto; edited by Craig McKay; music by Howard Shore; production designer, Kristi Zea; produced by Edward Saxon and Mr. Demme; released by Tri-Star Pictures. At the Gemini, Second Avenue and 64th Street, Manhattan. Running time: 119 minutes. This film is rated PG-13.

Andrew Beckett	Tom Hanks
Joe Miller	Denzel Washington
Sarah Beckett	Joanne Woodward
Charles Wheeler	Jason Robards
Belinda Conine	Mary Steenburgen
Miguel Alvarez	Antonio Banderas
Bud Beckett	Robert Castle
Bob Seidman	Ron Vawter
Anthea Buton	Anna Deavere Smith

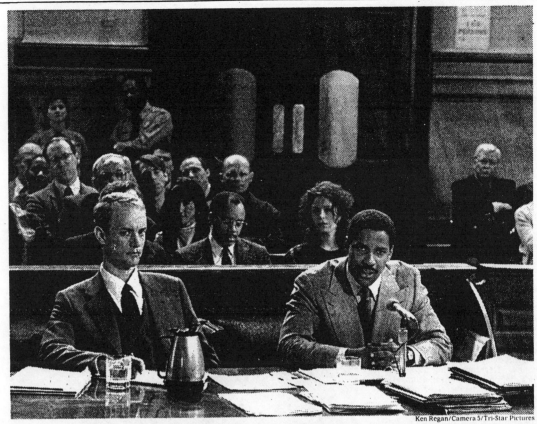

Ken Regan/Camera 5/Tri-Star Pictures

Tom Hanks, left, and Denzel Washington in a scene from Jonathan Demme's film "Philadelphia."

By JANET MASLIN

For a film maker who thrives on taking chances, "Philadelphia" sounds like the biggest gamble of all. As the first high-profile Hollywood film to take the AIDS plague seriously, Jonathan Demme's latest work has stubborn preconceptions to overcome as well as enormous potential to make waves. What it does not have, despite the fine acting and immense decency that give it substance, is much evidence of Mr. Demme's usual daring. Maybe that's not surprising: it isn't easy to leave fingerprints when you're wearing kid gloves.

Hollywood's past reluctance to take on AIDS isn't strictly a matter of cowardice. This subject, with all its anguished inevitability, does not easily lend itself to run-of-the-mill movie methods. If the theater has led the way, with works as different as "Jeffrey" and "Angels in America," it also has more freedom to experiment with format. Conventional wisdom has it that a big-budget film needs reassuring familiarity if it means to play at the multiplex, even if Mr. Demme proved otherwise with his bracingly tough "Silence of the Lambs."

If the dread-disease drama has often been relegated to television, there, too, AIDS has proved daunting: HBO's attention-getting "And the Band Played On" was a much more tepid undertaking than "Philadelphia" turns out to be. Unlike that obviously hamstrung dramatization, "Philadelphia" mostly succeeds in being forceful, impassioned and moving, sometimes even rising to the full range of emotion that its subject warrants. But too often, even at its most assertive, it works in safely predictable ways.

•

"Philadelphia," which has the year's most elegant and apt movie title, begins with great promise and with a reminder of what the unfettered Mr. Demme can do. A stirring montage of Philadelphia street life, accompanied by a mournfully beautiful new Bruce Springsteen song, offers a resounding sense of vitality and communal obligation. (The film is suffused with haunting music, with operatic arias used much too pointedly in several places and Neil Young's title song floating gently through its final scene.) Mr. Demme knows how to breathe both hope and frustration into the promise of brotherly love.

Soon afterward, Mr. Demme shows an equally impressive tact as he introduces Andrew Beckett, the lawyer played by Tom Hanks. First seen defending a construction company accused of spreading pestilent dust, Andrew is next shown visiting a clinic for AIDS treatment. The film attaches no fanfare to this information, and it spares the audience a melodramatic scene in which Andrew's AIDS is first diagnosed. Likewise, it presents his mother (Joanne Woodward) as determinedly brave and well aware of her son's situation. With these touches, the film promises not to exploit its subject in maudlin ways, and that is a promise it keeps.

Mr. Demme and his screenwriter, Ron Nyswaner, elect to dramatize their material by presenting AIDS as a cause as well as a personal calamity. So "Philadelphia" gives Andrew a tangible grievance. First, he is established as an ambitious, gung-ho young corporate lawyer. "Outstanding!" exclaims Andrew, upon hearing that the firm has landed an important account. Next, he is seen arousing suspicion among the firm's equally hearty senior partners. "What's that on your forehead, pal?" one of them asks, staring at a Kaposi's sarcoma lesion.

"Oh, that!" says Andrew, with the forced heartiness that hides his real nature, and as such is the habit of a lifetime. "I got whacked in the head with a racquetball." Nobody believes him.

When Andrew is summarily fired on a trumped-up charge of incompetence, the film gives him a mission: to sue his former firm for wrongful termination and to fight the bigotry faced by people with AIDS. Admirable as this is in the abstract, it steers the movie in exactly the wrong direction. "Philadelphia" winds up centered on the courtroom, devoting an inordinate amount of time to what should only have been this story's MacGuffin, a minor but galvanizing plot device. The courtroom scenes, which lack suspense and too often have a soapbox tenor, will not tell the audience anything it doesn't already know.

A much more interesting side of "Philadelphia" depicts the relationship between Andrew and Joe Miller (Denzel Washington), his anti-gay, ambulance-chasing lawyer. ("We take no cash unless we get cash justice for you," Joe informs one potential client.) Reluctant to take Andrew's case at first, and flaunting his fears and prejudices with his doctor and his wife, Joe changes gratifyingly during the course of the story. Mr. Hanks gives a brave, stirring, tremendously dignified performance as a man slowly wasting away. But Mr. Washington, who is also very fine as the small-minded shyster who becomes a crusading hero, has the better role.

It shouldn't have been that way. But Mr. Nyswaner's screenplay allows Andrew almost nothing in the way of individual characteristics. It makes him a gay Everyman whose love of opera — awkwardly underscored in a scene that shows the audience how little it really knows about Andrew — hardly qualifies as a distinctive trait. Andrew's domestic relationship with Miguel (Antonio Banderas) is presented so sketchily that it barely seems real.

The screenplay's tendency to evade and overgeneralize is not helped by the depiction of gay men as gentle souls, straight men as bigots, and Andrew's large family as a monolithic, enlightened entity. Andrew's father: "We're incredibly proud of you." Andrew's mother: "You get in there and you fight for your rights." Andrew: "Gee, I love you guys."

•

Most of "Philadelphia" is a lot better than that. Neither Mr. Demme's attention to detail nor his talent for tight, urgent storytelling has let him down. He has assembled a large, expertly cast group of actors to fill out the film's background, among them Ron Vawter as the law firm's one conscience-stricken partner, Jason Robards as its overbearing patriarch, Anna Deavere Smith as an astute paralegal and Robert Castle (the priest who is Mr. Demme's cousin, and the subject of his "Cousin Bobby") as Andrew's father.

Ms. Woodward is especially memorable in a brief but luminous appearance. And Mary Steenburgen has the potentially interesting role of a ruthless, sarcastic defense attorney determined to wear down a now-frail Andrew when he gets to the courtroom. But even here, the film pulls its punches. After conducting a particularly grueling cross-examination, Ms. Steenburgen is allowed to acquit herself by muttering "I hate this case!"

"Philadelphia" may be equivocal in its attitudes, but Mr. Demme will never make a film that lacks visual color. Tak Fujimoto, Craig McKay and Kristi Zea, who have collaborated with the director before as cinematographer, editor and production designer, respectively, give the film a warm, believable look and a vigorous pace. Mention should also be made of Carl Fullerton's makeup, which makes sure that Mr. Hanks's transformation from robust lawyer to visibly suffering AIDS patient will not soon be forgotten.

In the end, thanks to such effects and to the simple grace of Mr. Hanks's performance, this film does accomplish what it means to. "Philadelphia" rises above its flaws to convey the full urgency of its difficult subject, and to bring that subject home.

•

"Philadelphia" is rated PG-13 (Parents Strongly Cautioned). It includes mild profanity and brief nudity.

1993 D 22, C15:3

The Accompanist

Directed by Claude Miller; written by Mr. Miller and Luc Beraud, based on the novel by Nina Berberova, in French with English subtitles; director of photography, Yves Angelo; edited by Albert Jurgenson; music by Alain Jomy; released by Sony Pictures Classics. At Lincoln Plaza Cinemas, Broadway at 63d Street. Running time: 110 minutes. This film is rated PG.

Charles Brice...................... Richard Bohringer
Irène Brice Elena Safonova
Sophie Vasseur.................. Romane Bohringer

By JANET MASLIN

Romane Bohringer is about to create a stir. This plain, baleful-looking young French actress will soon be seen in two very different films, including Cyril Collard's "Savage Nights," which was shown at this

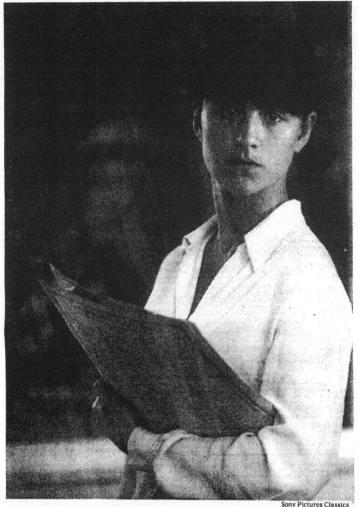

Sony Pictures Classics
Romane Bohringer in a scene from the film "The Accompanist."

year's New Directors/New Films festival and is to begin its commercial run early next year. Her César-winning performance in that film, as the wild, rebellious teen-age girlfriend of a man with AIDS, could not be less like her demure title role in "The Accompanist," the urbane new film by Claude Miller opening today at Lincoln Plaza Cinemas.

Both performances reveal Miss Bohringer as a demanding, furiously intense screen presence, someone who can behave quite passively and still take up all the oxygen in a room. She has a raw, desperate quality that seems doubly startling against the sophisticated context of "The Accompanist," in which a veneer of elegance shields the principals from most forms of rude reality.

Beginning late in 1942 in occupied France, "The Accompanist" devotes center stage to Irène Brice (Elena Safonova), a ravishing singer who is a great favorite with the Vichy set. But the glum, silent young woman by Irène's side commands a different kind of attention. Originally hired as a pianist for Irène's rehearsal sessions, Sophie Vasseur (Miss Bohringer) soon becomes a fixture in Irène's household. Cautious and watchful, well attuned to all the nuances of Irène's professional and romantic lives, Sophie glories in her employer's triumphs while wondering when her own moment in the spotlight will come.

"The Accompanist," adapted by Mr. Miller and Luc Beraud from a novel by Nina Berberova, would be more like "All About Eve" if it were

made with anything bolder than Mr. Miller's smoothly contemplative sensibility. As it is, Sophie's Eve Harrington thoughts remain unspoken, delivered to the audience in voice-over while Ms. Bohringer gazes dutifully at Ms. Safonova's lovely Irène. For all her silent frustration, Sophie cannot settle the question of just how actively she ought to assert herself. Her inaction can be seen in wider terms, given the wartime setting and France's larger paralysis during the German occupation.

The third principal in "The Accompanist" is Charles Brice, Irène's husband, a businessman (played by Richard Bohringer, Romane's father). Rich and successful, determined to stay that way, the feisty Charles is sustained by Irène's glamorous career just as surely Sophie is. Charles is the film's most volatile character, the one who goes from idly

dropping Marshal Petain's name to realizing it is time to pack the Vuitton luggage and personally carry it over the Pyrenees.

Charles is also the story's main victim, being no match for either Sophie's silences or Irène's treacherous wiles. "Is being a woman so difficult?" he finally asks Sophie, who has become everybody's confidante. "Yes, I think so," she answers, very much in earnest. Having studied Irène's travails and betrayals so intimately, Sophie knows whereof she speaks.

Although Mr. Miller (whose earlier films include the 1981 "Garde à Vue") divides "The Accompanist" informally into three sections, one devoted to each of the main characters, it is Sophie who quietly burns a hole in the screen. Catapulted from the deprivation of wartime life to the sumptuousness of Irène's sheltered existence, Sophie quite literally swoons; soon afterward, her first experience of a grand late-night dinner with Irène's admirers makes her physically ill. The film is most striking in watching Ms. Bohringer subtly absorb the lessons of Irène's world and try, not always successfully, to make them her own.

"The Accompanist" is fashionably open-ended in describing this process. Life is said to be passing Sophie by as the film begins, and it is still passing her by when the story is over. A contrived shipboard romance, as Sophie and the Brices flee to England, is never as affecting or credible as it's meant to be, but "The Accompanist" is not the sort of film that is watched for plot. Its chief pleasures are atmospheric, thanks to the keenly observed details of Irène's cosseted existence and the cascade of beautiful music that makes up the score.

The soundtrack incorporates selections by Mozart, Strauss, Berlioz, Schumann and numerous others, making this one more recent French film (along with "Un Coeur en Hiver" and "Tous les Matins du Monde") in which music supplies an extra dimension of sensual delight. The audience will be as overwhelmed by Irène's recitals (with voice supplied by Laurence Monteyrol) as Sophie is herself, as the music combines with the imagery of this radiant, alluring singer draped in white satin and flanked by flowers.

The film, which has its denouement in an English pub called the Angel, takes Sophie well beyond the surface of Irène's glamour. But the memory of Irène's music stays with her protégée long after the bloom is off the rose. It will stay with the audience, too.

•

"The Accompanist" is rated PG (Parental guidance suggested). It includes brief nudity and implicitly sexual situations.

1993 D 23, C7:1

A Deconstructed Bovary

"Valley of Abraham" was shown as part of this year's New York Film Festival. Following are excerpts from Vincent Canby's review, which appeared in The New York Times on Oct. 5. The film opened yesterday at the Joseph Papp Public Theater, 425 Lafayette Street, East Village.

At the age of 85, the Portuguese director Manoel de Oliveira, who has

been making movies since 1931 and is still little known in this country, has brought forth what some European critics describe as his chef-d'oeuvre: "Valley of Abraham," a variation on Gustave Flaubert's "Madame Bovary," inspired by Agustina Bessa-Luís's Portuguese novel also titled "Valley of Abraham."

The film is a grand, singularly idiosyncratic work, as austere as Robert

Bresson's "Diary of a Country Priest" and as thick with narrative details and chatty asides as "Little Dorrit." It mesmerizes, sometimes maddens, and tests the emotional and physical reflexes.

In this case, citing the film maker's age is not impertinent. In "Valley of Abraham," Mr. de Oliveira exhibits an Olympian confidence that comes only after having lived, worked, thought and considered for a very long time. He has achieved a freedom denied others. He can break conventions and make his own rules. What's the worst that can happen to him?—Be denied a long-term contract with Disney?

Mr. de Oliveira's heroine is almost the antithesis of Emma Bovary, the foolish, vain, deluded French provincial who reads silly magazines and books and lives her life accordingly, with fatal results. Flaubert appreciated Emma's situation, but he wasted no sympathy on her. He dismembered her with care.

Mr. de Oliveira adores his Ema Cardeano. For all her failings, few of which we actually see, she is an idealized woman, her nature too finely tuned and poetic for this world, where she is surrounded by men who are moral and spiritual midgets. To the disgust of her devout, unmarried aunt, who spends hours each day on her knees praying to Jesus, Ema reads novels, but good ones, including "Madame Bovary."

Infusing the film with its particular tone is the narration. Not since "Diary of a Country Priest" and maybe Truffaut's "Jules and Jim" has narration been used for such curious and exhilarating effect. The narrator is given to contemplative thoughts and lyrical interpretations, but he also has the manner of a brilliant busybody. He tells us everything and, from time to time, nothing; one can't always be sure whether his observations are sometimes intentionally allusive or just vague because the English subtitles are inadequate.

Ema is played by Cecile Sanz De Alba as a girl and Leonor Silveira as a woman, both of whom are pretty but not immediately hypnotizing. The fully written narration supplements images of startling clarity and simplicity. The director shares Bunuel's preference for the functional camera movement and the uncluttered film frame, which, if there had been feature films 100 years ago, one might call a 19th-century film style.

Mr. de Oliveira's Ema, unlike Flaubert's, has a limp that the narrator describes as "slight," although it looks pronounced to us. As a young woman, Ema has a fondness for showing herself on her father's veranda, just above a sharp turn in the highway. Car after car smashes into a stone wall as drivers become bewitched. The mayor officially labels her a road hazard.

The film has wit. The director's fondness for women in general, not just for Ema, is apparent in the fact that all the women's roles are more interesting, and more vividly played, than the men's. His actors look and behave like hand-me-downs from a not-great repertory company.

1993 D 23, C9:1

Heaven and Earth

Directed by Oliver Stone; written by Mr. Stone, based on the books "When Heaven and Earth Changed Places," by Le Ly Hayslip with Jay Wurts, and "Child of War, Woman of Peace," by Le Ly Hayslip and James Hays-

Roland Neveu/Warner Brothers

Hiep Thi Le, right, as the character Le Ly, and Haing S. Ngor, who plays her father, in Oliver Stone's film "Heaven and Earth."

lip; director of photography, Robert Richardson; edited by David Brenner and Sally Menke; music by Kitaro; production designer, Victor Kempster; produced by Mr. Stone, Arnon Milchan, Robert Kline and A. Kitman Ho; released by Warner Brothers. Running time: 135 minutes. This film is rated R.

Le Ly.................................Hiep Thi Le
Steve Butler.....................Tommy Lee Jones
Mama.................................Joan Chen
Papa.................................Haing S. Ngor

By JANET MASLIN

MAKING his third film about the Vietnam War and its consequences, Oliver Stone suddenly finds himself on foreign terrain. The reason: "Heaven and Earth," his latest and least controversial film on the subject, tells its story from the standpoint of a Vietnamese woman. This is a tale of extraordinarily melodramatic hardship, involving rape, torture, disgrace, prostitution and a disastrous marriage to an American G.I., all heightened by the despoliation of the heroine's homeland. Her name is Le Ly Hayslip. But considering all these perils, it could have been Pauline.

A computer could have suggested that after describing the American soldier's combat experience ("Platoon") and its aftermath ("Born on the Fourth of July"), Mr. Stone might round out his work with a shift of gender and nationality. But a computer would not have factored in the essentials of Mr. Stone's style. His best direction is volatile, angry and muscular in ways that Ms. Hayslip's story, that of a resilient, long-suffering victim, simply cannot accommodate. Mr. Stone tells this tale vigorously, but he has the wrong cinematic vocabulary for his heroine's essentially passive experience.

"Heaven and Earth," which opens tomorrow, runs nearly two and a half hours and still manages to seem abrupt in places, thanks to the tumultuous, chameleonlike quality of Ms. Hayslip's life. (Her own account, on which the film is based, fills two books.) It encompasses wild extremes of lyrical beauty — most notably in the opening glimpses of Le Ly's Vietnamese village — and of lurid excess, too. The same is true of most of Mr. Stone's films, but this one lacks an emotional center, despite Ms. Hayslip's presence in nearly every scene. Sympathetic as she seems, she is never allowed a wide range of attitudes or reactions. She

emerges as a strong person rather than a strong dramatic character.

As played with impressive confidence by Hiep Thi Le, a Vietnamese-born California college student making her film debut, Le Ly certainly does not lack energy. She moves through the film with a scrappy vigor that suits her story.

First seen as a young girl living with her parents (the beautiful Joan Chen, disguised here as a toothless peasant, and Haing S. Ngor), Le Ly watches apprehensively as the French and then the Viet Cong take over her village. The film often returns evocatively to her memories of a lost, peaceful home.

The early sections have the feeling of an illustrated history lesson, despite Mr. Stone's ravishing images of the unspoiled natural scenery. (The film, photographed vibrantly by Mr. Stone's usual cinematographer, Robert Richardson, was shot mostly in Thailand.) Only when Le Ly begins to be abused does the story come perversely alive.

After bringing a shade too much zeal to scenes depicting Le Ly's suffering at the hands of the Viet Cong, Mr. Stone next takes her to Da Nang, where she becomes a servant in the household of a wealthy man and soon becomes attracted to, and pregnant by, her employer. The film, trying to present this episode as both romantic and cruel, winds up making it muddy and unconvincing, which is what often happens in sequences describing Le Ly's feelings about men. When Mr. Stone treats his Vietnamese heroine as both sexual martyr and national metaphor, he so overburdens her story that Le Ly disappears as a real person.

•

The film's extremes of masculine guilt are often overpowering, as in the sequence that has Le Ly lured into having lucrative sex with American soldiers. When one G.I. tries to talk her into this ("Fifteen minutes and it ain't even work"), the director sympathetically depicts Le Ly as having no choice and shamefacedly accepting her fate. But as she walks helplessly toward the Americans, she leaves her half-naked baby crying in the dust, in the midst of bustling soldiers, as a truck rolls by. The audience will sense something oversimplified and incredible in such images of Le Ly's total abjection.

Certainly "Heaven and Earth" sets off sparks with the arrival of Tommy Lee Jones, as the one American soldier who isn't out to exploit this woman. But Mr. Jones, whose Sgt. Steve Butler is a composite of several men

the real Ms. Hayslip knew, has a tough row to hoe. Steve changes from unbelievably nice guy into violent, abusive husband in record time, even if these are among the film's most colorful and involving episodes. When Mr. Stone brings Le Ly to the United States as an astonished war bride, he is suddenly comfortable again. He may not know what life in a Vietnamese hamlet is like, but he certainly knows how middle-class America looks, as seen through a worldly and jaundiced eye.

"Heaven and Earth" incorporates an element of Buddhist acceptance and serenity, particularly in the thoughts that end the film on a philosophical note. It seems unimaginable that Mr. Stone would conclude a film about any man's wartime experiences quite this beatifically, no matter how true the film is to Ms. Hayslip's attitudes or her ordeal. On screen, her story is vivid but incomplete, diminished by its nobility and by the director's obvious respect for his subject. Mr. Stone's reverence is understandable. But he remains a fiery, impassioned film maker, and reverence is not what he does best.

•

"Heaven and Earth" is rated R (Under 17 requires accompanying parent or adult guardian). It includes violence, profanity and sexual situations.

1993 D 24, C1;4

Tombstone

Directed by George P. Cosmatos; written by Kevin Jarre; director of photography, William A. Fraker; edited by Frank J. Urioste, Roberto Silvi and Harvey Rosenstock; music by Bruce Broughton; production designer, Catherine Hardwicke; produced by James Jacks, Sean Daniel and Bob Misiorowski; released by Buena Vista Pictures. Running time: 132 minutes. This film is rated R.

Wyatt Earp.........................Kurt Russell
Doc Holliday......................Val Kilmer
Johnny Ringo.....................Michael Biehn
Josephine..........................Dana Delany
Billy Breckenridge............Jason Priestley
Morgan Earp......................Bill Paxton
Virgil Earp........................Sam Elliott
Mattie Earp............ Dana Wheeler-Nicholson
Henry Hooker.....................Charlton Heston
Narrator.............................Robert Mitchum

By STEPHEN HOLDEN

The Old West has rarely looked as opulent as it does in "Tombstone," the director George P. Cosmatos's retelling of the Wyatt Earp story. In this capacious western with many modern touches, the Arizona boom town and site of the legendary O.K. Corral has a seedy, vaudevillian grandeur that makes it a direct forerunner of Las Vegas.

The streets may be dusty, but they are very wide. The gambling halls and theaters have a gilt-edged Victorian glamour that contrasts sharply with the shoot-'em-up exuberance of patrons who when roused to enthusiasm are liable to fire their guns into the air. And in time-honored nouveau-riche style, the affluent citizens of a city made rich from silver enjoy dressing to the nines.

"Tombstone," which opens tomorrow, is as up-to-date in its political consciousness as it is visually spiffy. When Wyatt Earp (Kurt Russell) arrives in Tombstone from Dodge City, hoping to start a business and live peacefully, he bears the weight heavily of having once killed people in his line of duty as a peace officer. It takes

John Bramley/Cinergi Productions

Val Kilmer, left, and Kurt Russell in a scene from "Tombstone."

a lot of prodding before he reluctantly pins on a marshal's badge and pursues the cowboy gang that is terrorizing the town.

That gang of more than 30 is explicitly compared to a modern-day crime syndicate in Kevin Jarre's self-consciously up-to-date screenplay. Led by the evil Johnny Ringo (Michael Biehn), an outlaw who is described as wanting "revenge for being born," it even includes one Old West homosexual, a character nicknamed "Sister Boy" (Jason Priestley). The screenplay also takes pains to establish the existence of an Asian population in Tombstone that is discriminated against.

•

The film has a very contemporary attitude toward alcohol and drug abuse. Although Wyatt's best friend, Doc Holliday (Val Kilmer), executes a number of heroic deeds, throughout the film he is a jaundiced, perspiring wreck who is clearly drinking himself to death. Twice during the film, he collapses from what appears to be liver failure and coughs up blood. Wyatt's wife, Mattie (Dana Wheeler-Nicholson), who suffers from recurrent headaches, is addicted to laudanum. A wild-eyed wraith, subject to intense mood swings, she is by turns scary and pitiful.

The movie's most modern psychological touch is its depiction of Josephine (Dana Delany), the itinerant actress with whom Wyatt falls in love at first sight, as the most casually and comfortably liberated woman ever to set foot in 1880's Arizona. In their first conversation, Josephine intimidates Wyatt with philosophical questions like "Are you happy?" and "What do you want out of life?" The only times she is not happy, she says, are those times when she is sexually bored. Wyatt regards her with a respect bordering on awe. Unfortunately, Ms. Delany's bland screen presence doesn't match the flash of her verbal bravado.

Freighted with all this sociological and psychological baggage, "Tombstone" is really two movies loosely sewn together. One is a conventional western in which Wyatt and his broth-

ers Morgan (Bill Paxton) and Virgil (Sam Elliott) set out to save Tombstone from the clutches of an outlaw gang. The other is a self-consciously digressive meditation on the iconography of the Hollywood western.

•

As in Clint Eastwood's "Unforgiven," a film that clearly exerted a powerful influence on "Tombstone," the traditional archetypes triumph over modernist conventions. Efficiently directed, with a minimum of audience-teasing suspense, the shoot-out at the O.K. Corral has a crackling energy and believability. The scene, although short, is very intense and the film's high point. And the confrontations between Wyatt and his team and the forces of malevolent anarchy have a gut-twisting tension.

Grafted onto this traditional framework, the film's meditative aspects are generally too self-conscious to fit comfortably. Especially when the movie tries to imagine a more enlightened role for women in the Old West, the screenplay begins to strain.

"Tombstone" goes to great lengths to portray Doc as a prefiguration of a dissolute modern poet, a frontier-era Jim Morrison. In one scene, the character flourishes Latin phrases. In another, he bangs out part of a Chopin nocturne on an out-of-tune piano. Mr. Kilmer, who gave an uncanny impersonation of Morrison in "The Doors," can be terrific at this sort of thing. But in "Tombstone," a performance that aims to chew all the scenery in sight seems slightly mannered.

Mr. Russell's clear, steady portrayal of Wyatt Earp gives the film a core of emotional integrity. While he doesn't project the mythic heroic stature of a Wayne or an Eastwood, he conveys the dignified rectitude of someone who has seen more than he wishes of the world's evil and still believes that civility can prevail over chaos. As he faces two moral crises — one involving violence and the other love — you can almost feel the wheels in his mind turning as he decides what to do.

If Wyatt Earp's decision to meet violence with violence accords with

classic Western tradition, his cautiously allowing himself to love Josephine, while still married, belongs to a different moral universe. It's a measure of Mr. Russell's thoughtful, understated performance that this decision carries real weight.

"Tombstone" is, finally, a movie that wants to have it both ways. It wants to be at once traditional and morally ambiguous. The two visions don't quite harmonize.

•

"Tombstone" is rated R (Under 17 requires accompanying parent or adult guardian). It has strong language, violence and a fair amount of gore.

1993 D 24, C6:1

Grumpy Old Men

Directed by Donald Petrie; written by Mark Steven Johnson; director of photography, John E. Jensen; edited by Bonnie Koehler; music by Alan Silvestri; production designer, David Chapman; produced by John Davis and Richard C. Berman; released by Warner Brothers. Running time: 105 minutes. This film is rated PG-13.

John	Jack Lemmon
Max	Walter Matthau
Ariel	Ann-Margret
Grandpa	Burgess Meredith
Melanie	Daryl Hannah
Snyder	Buck Henry
Jacob	Kevin Pollak
Chuck	Ossie Davis

By CARYN JAMES

"Grumpy Old Men" is the kind of holiday movie a lot of people are searching for. It's cheerful, it's well under two hours and it doesn't concern any major social blights, unless you think Jack Lemmon tossing a dead fish into Walter Matthau's car is cause for alarm.

Those rare qualities might make the film, which opens tomorrow, one of the season's more entertaining simply by default. What gives it a jolt in its own right is that Mr. Lemmon and Mr. Matthau have only got wilier in the years since "The Odd Couple." They can do wonders even with this middling material about two neighbors in their late 60's, lifelong friends who express their affection by pretending to hate each other.

The title may be generic and the setting an icy Minnesota town, but these grumps are positively related to Oscar and Felix. Mr. Matthau plays Max Goodman, the more slovenly of the two. A divorced former television repairman, Max seems to have an endless wardrobe of plaid hunting caps with earflaps. Mr. Lemmon plays John Gustafson, a widowed former history teacher who now spends a fair amount of time climbing out his second-story window and down a ladder to escape an I.R.S. investigator (Buck Henry).

The supposed feud between the men has been going on for so long — more than 50 years — that only they can remember why it started. What's clear is that playing practical jokes and tolerating each other's presence has become their shared retirement hobby, along with fiercely competitive ice fishing.

Just don't expect their bickering to be on the level of Neil Simon, and you won't be disappointed. The lines here include "Morning, moron," a greeting Mr. Lemmon conveys with acid conviction. Mr. Matthau drawls out "Eat my shorts" as if Max thinks he has invented a clever new insult.

These men are not warmed-up caricatures of Felix and Oscar, but blood brothers who have got older without figuring out what to do with their empty retirements. One solution suddenly zooms into the neighborhood on a snowmobile. Ann-Margret plays Max and John's new neighbor, a middle-aged widow who gives them someone new to fight over. She is an artist and teacher transplanted from California, which gives her a mild, refreshing hint of spaciness. Max and John's cautious and rusty attempts at flirting and dating are funny without being condescending.

Audiences have come to expect that every time Mr. Matthau raises an eyebrow it will be a perfect comic gesture, and his record is intact. But it is Mr. Lemmon who is especially engaging. After a string of high-pitched dramatic roles that seemed calculated to reach Oscar voters ("Glengarry Glen Ross" and "Short Cuts"), he is at ease and restrained here. He can pile up dramatic awards, but the light comic flair that shines through in "Some Like It Hot" and "Mr. Roberts" is still the best side of him.

Donald Petrie, the director of "Mystic Pizza," shows the same sureness and affection for small-town life and characters here. Kevin Pollak as Max's son and Daryl Hannah as John's daughter both seem bemused by their parents and simply by being in this film. Ossie Davis has a small, crafty role as Max and John's friend. Only Burgess Meredith is forced into a foolish part as John's ninetysomething father, who smokes, drinks, fantasizes about women and calls his son a kid. He is a geezer, the sort of cliché that "Grumpy Old Men" otherwise avoids.

Mr. Matthau and Mr. Lemmon may be familiar in these roles, but their characters are not really old or stale. And they're just grumpy enough.

•

"Grumpy Old Men" is rated PG-13 (Parents strongly cautioned). It includes some strong language.

1993 D 24, C16:1

Batman
Mask of the Phantasm

Directed by Eric Radomski and Bruce W. Timm; written by Alan Burnett, Paul Dini, Martin Pasko and Michael Reeves, based on characters created by Bob Kane; edited by Al Breitenbach; music by Shirley Walker; produced by Benjamin Melniker and Michael Uslan; released by Warner Brothers. Running time: 90 minutes. This film is rated PG.

Batman	Kevin Conroy
Andrea Beaumont	Dana Delany
Arthur Reeves	Hart Bochner
Phantasm/Carl Beaumont	Stacy Keach Jr.
Salvatore Valestra	Abe Vigoda
The Joker	Mark Hamill

By STEPHEN HOLDEN

"You're harder to kill than a cockroach on steroids," complains the Joker to Batman after a brutal clash from which the Caped Crusader emerges miraculously unscathed.

"Is my shirt too big or is my flesh crawling?" quips another character in "Batman: Mask of the Phantasm," the movie spinoff of the animated television series.

"Batman: Mask of the Phantasm," is heavily larded with sarcastic remarks whose tone of 90's cynicism clashes jarringly with the film's sleek 1940's ambiance. That discontinuity

FILM REVIEWS

Warner Bros.

"Batman: Mask of the Phantasm" is a spinoff of the television series.

is the least of the many problems afflicting the movie, which opened locally on Christmas Day.

Set in the 1940's, "Mask of the Phantasm" is a cartoon film noir evocation of events that purport to explain the origins of Batman. In convoluted flashbacks, it portrays a star-crossed love affair between Bruce Wayne, the reclusive millionaire who is Batman's alter ego and Andrea Beaumont, a beautiful banker's daughter who suggests a svelte hybrid of Lauren Bacall and Veronica Lake.

•

After the violent deaths of Bruce's parents, Andrea's love enables him to give up his vow to avenge the killings. But when she abruptly breaks off their engagement and disappears with her father, the Caped Crusader is born out of the emptiness and disillusionment. In solving a series of murders of aging mobsters, Batman discovers that Andrea and her father are caught up in a web of international loansharking. The killer, with whom Batman does battle, is a sinister caped figure who looks so much like him that he finds himself a prime suspect.

With its pointed, cavernous backgrounds and a Gotham City setting that evokes a 1940's-style futurism, "Mask of the Phantasm" looks splendid. But its story is too complicated and the editing too jerky for the movie to achieve narrative coherence. And the resemblance between the movie's hero and its enigmatic arch-villain is so close that audiences are likely to be confused.

The actor's voices may suit animated television characters, but on a large screen Kevin Conroy's Batman, Mark Hamill's Joker, and Dana Delany's Andrea sound flat and one-dimensional. Shirley Walker's overblown score floods the movie with choral bombast that only points up an absence of anything remotely gripping.

•

The movie is rated PG (Parental guidance suggested). It has violent scenes.

1993 D 28, C21:1

Shadowlands

Directed by Richard Attenborough; screenplay by William Nicholson; director of photography, Roger Pratt; edited by Lesley Walker; production designer, Stuart Craig; produced by Mr. Attenborough and Brian Eastman; released by Savoy Pictures. Running time: 170 minutes. This film is rated PG.

Jack Lewis	Anthony Hopkins
Joy Gresham	Debra Winger
Douglas Gresham	Joseph Mazzello
Warnie Lewis	Edward Hardwicke
Harry Harrington	Michael Denison
Christopher Riley	John Wood

By JANET MASLIN

"Shadowlands" is the most soothing film of the Christmas season, even though it happens to be about tragic loss. That's because it has been directed, in ripely sentimental fashion, by Richard Attenborough, an uncommonly reliable film maker on subjects both large and small. Most of Mr. Attenborough's subjects ("Gandhi," "Chaplin," "Young Winston") are more grandiose than this one, yet all of his films can be counted on for the same homey predictability. When a painting of an English valley is revealed in "Shadowlands" to be a relic left over from a lonely boyhood, rest easy: of course the real valley will be visited before the film is over.

As the autumnal romance that coaxes Anthony Hopkins out of his genteel shell, inviting the audience to join him in a spectacularly good cry, "Shadowlands" actually has lots of old-fashioned virtues to recommend it. Here is Mr. Hopkins giving an amazingly versatile and moving performance, shifting the light in those knowing blue eyes to reveal endless shadings between delight and sorrow. Here is Debra Winger, dying bravely in one more movie yet managing gracefully to avoid maudlin histrionics. Here is Oxford, filmed on a sizable budget, most of which has been spent on tweeds. Here is a screenplay in which Mr. Hopkins gets to say both "beastly" and "balderdash," though not in the same scene.

"Shadowlands" is the unlikely love story of C. S. Lewis, the Irish-born writer and lecturer (whose theological works and Chronicles of Narnia books are invoked here), and the American poet Joy Gresham, who married Lewis late in both their lives. It was adapted by William Nicholson from his own play, which is loosely fashioned around biographical facts about Gresham and Lewis.

The film's production notes quote Mr. Nicholson as saying, "I have used parts of their story, not used other parts and imagined the rest," adding "no one knows exactly how and why they fell in love." But it goes without saying that much of the film's punchy, point-making dialogue is not quite verbatim. (These same production notes, which are pricelessly earnest, also point out that Bill Clinton, Margaret Thatcher and Crown Prince Naruhito of Japan share C. S. Lewis's link with Oxford.)

Pedigree aside, "Shadowlands" offers a gratifyingly soapy love story, handsomely told. It is set in motion once the donnish Lewis, who is known as Jack and lives staidly with his brother Warnie (Edward Hardwicke), is visited by the adventurous Joy Gresham. Prim and reserved (who does this better than Mr. Hopkins?), Jack has known Joy only as someone who writes him fan letters. "Her letters are rather unusual," he muses. "She writes as if she knows me somehow."

The film makes a point of treating Joy like a bull in a china shop when she visits her first English tearoom. "Anybody here called Lewis?" she bellows, to the astonishment of Jack and Warnie. But Joy's crudeness, which is exacerbated by Ms. Winger's awkward Brooklyn accent, is soon peeled away to reveal the obligatory heart of gold and life-affirming sense of humor. "I don't really go in for seeing the sights," Jack says haughtily as he escorts Joy around Oxford. "So what do you do, walk around with your eyes shut?" she inquires.

•

It doesn't take long before Jack, who seems to have a natural abhorrence of women and children, develops a great gentlemanly fondness for both Joy and her young son, Douglas (Joseph Mazzello). But he is teased about this by his starchy professorial colleagues (most notably John Wood, as a prig named Riley), and so he keeps it secret when he marries Joy

as "a technicality" in order to allow her to remain in England. Only after their wedding do Jack and Joy truly fall in love.

But Fate is about to deal them a terrible blow, which prompts Mr. Hopkins's Jack to reach his full heights of eloquence and emotion. Mr. Hopkins's performance, a model of clipped diction and veiled affection during most of the film, becomes desperately intense in those portions of the film that deal with grief.

The screenplay's most moving dialogue and most quotable quotes deal with pain as a component of love. On this subject, there is ample room for Jack's later observations to humanize his earlier thoughts. In his professorial mode, he has delivered a lecture, telling his listeners: "I'm not sure that God particularly *wants* us to be happy." Later on, in the film's anguished last stages, he says: "Experience is a brutal teacher. But you learn — my God, you learn."

"Shadowlands" is acted with great tenderness by both Ms. Winger, who seems vigorous and sprightly despite obvious impediments (not least of them a matronly mid-1950's wardrobe), and Mr. Hopkins, who is simply wonderful. Among its secondary characters are the smug Oxford professors who learn about love through Jack and the book-loving student who tells Jack, "We read to know we're not alone." That's why we watch warm, weepy movies, too.

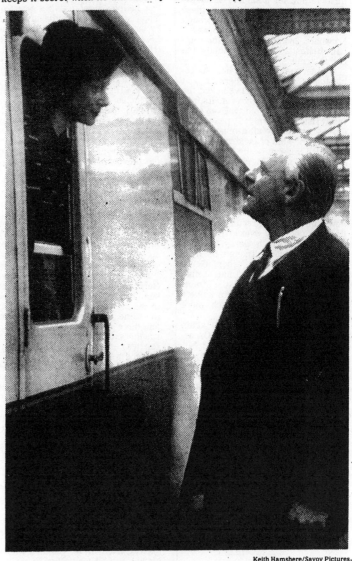

Keith Hamshere/Savoy Pictures

Debra Winger and Anthony Hopkins in a scene from "Shadowlands."

"Shadowlands" is rated PG (Parental guidance suggested). It includes mild profanity.

1993 D 29, C11:1

In The Name of the Father

Produced and directed by Jim Sheridan; screenplay by Terry George and Mr. Sheridan, based on the book "Proved Innocent" by Gerry Conlon; director of photography, Peter Biziou; edited by Gerry Hambling; music by Trevor Jones; production designer, Caroline Amies; co-producer, Arthur Lappin; released by Universal Pictures. Running time: 127 minutes. This film is rated R.

Gerry Conlon	Daniel Day-Lewis
Giuseppe Conlon	Pete Postlethwaite
Gareth Pierce	Emma Thompson
Robert Dixon	Corin Redgrave
Paul Hill	John Lynch
Benbay	Paterson Joseph
Annie Maguire	Britta Smith
Joe McAndrew	Don Baker

By JANET MASLIN

Anatomy of a riot: early in "In the Name of the Father," the feckless antics of Gerry Conlon (Daniel Day-Lewis), a young Belfast ne'er-do-well in the early 1970's, are seen triggering a serious military confrontation. As Gerry horses around on a rooftop, stealing scrap metal and wielding a stick guitar-style, English soldiers mistake him for a sniper. Gerry begins a mad dash away from these authorities, and as he runs through streets and houses, panic erupts everywhere. Instantly roused for combat, Belfast's citizenry sounds the call to arms.

Women bang trash-can lids on cobblestones; English soldiers in riot gear roll up in armored vehicles; the Irish Republican Army vents its fury at Gerry's sheer stupidity. Even after the crisis is resolved peacefully, nerves are jittery all around. In the wake of the kind of incident that has preceded this riot — the film's quick depiction of an I.R.A. pub bombing in Guildford, England — such skittishness is painfully easy to understand.

By the end of this extended opening sequence to his scathingly brilliant new film, the Irish director Jim Sheridan has perfectly evoked the backdrop against which Gerry Conlon's story takes place. Though he lives within a political tinderbox, Gerry has no foresight and no native cunning. The film's edgy, volatile atmosphere and Gerry's pathetic naïveté make his ordeal that much more monstrous as it unfolds.

Collaborating triumphantly again with Mr. Day-Lewis (after the Oscar-winning "My Left Foot" in 1990), Mr. Sheridan shows the same ability to tell a story both matter-of-factly and metaphorically. His direction is plain and amazingly resonant, pinpointing all the larger misapprehensions that shaped Mr. Conlon's Kafkaesque fate.

Ostensibly the tale of one big glaring injustice, "In the Name of the Father" actually delves much deeper, emerging as a fervent indictment

The director and star of 'My Left Foot' reunite.

of the bitterness between English and I.R.A. partisans. In making his point

through the tale of a hapless victim, Mr. Sheridan could not have invented anyone more weirdly compelling than Mr. Conlon, whose story is true.

•

Already admired as a startlingly inventive actor, Mr. Day-Lewis gives another dazzling performance in what is so far the role of his career. As played so grippingly and unpredictably, the film's Gerry Conlon is anything but a one-dimensional fall guy. "Proved Innocent" is the title of Mr. Conlon's memoir (adapted by Mr. Sheridan with Terry George), which suggests a certain lack of suspense in this story. But Mr. Day-Lewis draws endless interest out of the ways in which Gerry's character is forged right before the audience's eyes.

Gerry is particularly surprising playing the fool in the film's early sequences, since he lacks the self-possessed cleverness Mr. Day-Lewis so often brings to a role. Adrift in classic post-adolescent rebellion, he is by his own account more interested in "free love and dope" than in politics. When the story's opening riot makes him persona non grata in Belfast, he flees to London for a while. "Remember, honest money goes farther," advises his father, Giuseppe Conlon (Pete Postlethwaite). At this stage in the younger man's life, his father's little pieties merely make Gerry sneer.

The film vividly sets forth the strange facts of Gerry's case: in London, he lives briefly with a group of hippie squatters before being named by one of them as a suspect in the I.R.A.'s two Guildford bombings. Contributing to the case against Gerry is the fact that he breaks into a prostitute's apartment and steals enough money to go home to Belfast in showy finery. (The film has great fun with the image of Mr. Day-Lewis in his Carnaby Street splendor.) This will eventually make him a very poor witness on his own behalf.

Without warning, under the sweeping provisions of the Prevention of Terrorism Act, Gerry is arrested and held for seven days' of questioning, during which a confession is forced out of him. The specter of Mr. Day-Lewis's terrified hippie, sobbing in bewilderment when faced with unrelenting cruelty, is one of the film's most harrowing and sharply etched sights.

But the worst is yet to come. After Gerry is hosed down, de-loused and humiliated, he peers out of his jail cell to see *his father* being subjected to the same treatment. Giuseppe Conlon, three of Gerry's fellow London squatters and a group of the Conlons' relatives are eventually rounded up, charged with terrorist activities and sent to prison. The film, which shows no interest in being evenhanded, presents a forceful, disturbing case for the innocence of all of them.

"In the Name of the Father" is faithful to the larger facts while taking minor liberties with the Conlons' case, most notably confining both Gerry and Giuseppe in the same prison cell. This shift provides an extraordinary dramatic opportunity for the film to explore the complexities of love between father and son. Their mutual tenderness is thoroughly unsentimental, as when the film lets Gerry reveal that he is still seething over childhood insults. By the same token, Giuseppe (an Irishman whose mother named him after an Italian ice-cream maker) harbors his own anger. When the father falls mortally

ill and the son tries to show a responsible side, Giuseppe snaps: "You haven't the maturity to take care of yourself, let alone your mother."

•

As the film's settings move from city streets to courtroom and then to prison, "In the Name of the Father" sustains a devastating simplicity and a cool, watchful tone. Among the actors who contribute to its steely naturalness are Mr. Postlethwaite, both fond and caustic as a father in an unimaginable predicament, and Emma Thompson as the Conlons' crusading legal counsel.

Corin Redgrave is grimly effective as the English police official who drives the case forward. And Don Baker is equally formidable as the story's emblematic I.R.A. figure. Paterson Joseph (as a Rastafarian prisoner who befriends Gerry), John Lynch (as Paul Hill, his co-defendant) and Britta Smith (as Gerry's gentle-looking aunt, who cooks him a meal and winds up in police custody) further heighten the film's gritty mood. Peter Biziou's cinematography is properly crisp and plain.

"In the Name of the Father" has a title that evokes both familial devotion and prayer. A personal tragedy and a plea for reason, Mr. Sheridan's tough, riveting film succeeds on both scores.

1993 D 29, C11:3

Atlantis

Directed by Luc Besson; director of photography, Christian Pétron; music composed by Eric Serra; music performed by the London Royal Philharmonic Orchestra and the Ambrosian Singers; released by Milestone. At Film Forum 1, 209 West Houston Street, South Village. Running time: 75 minutes. This film has no rating.

By CARYN JAMES

The French director Luc Besson is best known in the United States for "La Femme Nikita," the fast, stylish 1990 film about a punk murderer turned glamorous government assassin. But it's time to remember that he also made "The Big Blue," a hit in France and nowhere else, which told the muddled story of a diver whose love for a dolphin surpassed his attraction to Rosanna Arquette. "Atlantis," which opens today at Film Forum, comes from the man who thought that diver made the right choice. The nearly wordless film is 75 minutes of underwater photography: no dialogue, no drama, no humans, only fish after fish after fish.

Some of them, filmed over two and a half years and two world tours from the Galápagos to the North Pole, are spectacular and rare. There is a large, elegant sea snake with black-and-white stripes from New Caledonia. A giant manta ray glides through the Pacific and across the screen looking like a flat spaceship with wings. Sea lions from the Galápagos do loop the loops. "Atlantis" suggests a peaceable kingdom beneath the sea, until the end. Then some ominous scenes hint otherwise as the camera stares into sharks' open mouths and along rows of killer teeth.

•

Intriguing though this is for a while, "Atlantis" is packaged in a way that forces viewers to enter an alternate experience that is often more mystifying than mysterious. After an initial invocation to leave the ordinary world behind, there is no narration,

no whiff of a Jacques Cousteau-style explanation; the fish are not identified until the final credits. The music, by Eric Serra, is sometimes syncopated and jaunty, sometimes lulling; much of it sounds tinny and synthesized. And although Mr. Besson often gives in to a bad case of the cutes, without a little mermaid in sight the film will have trouble holding small children's attention for long.

Pretentious phrases flash on screen before some segments. "First Day. Light" is one example, but there is no human allegory here. Mr. Besson's point is that fish are different from you and me. He has said about the creatures in his film, "The idea was to show that even when they feel emotions similar to ours, they don't experience them in the same way." No doubt he has made exactly the film he wanted to make, but it may take a very particular audience to discern the emotion in "Atlantis," fishy or otherwise.

1993 D 29, C19:5

Ghost in the Machine

Directed by Rachel Talalay; written by William Davies and William Osborne; director of photography, Phil Meheux; edited by Janice Hampton and Erica Huggins; music by Graeme Revell; production designer, James Spencer; produced by Paul Schiff, Mr. Osborne, Mr. Davies and Barry Sabath; released by 20th Century Fox. Running time: 104 minutes. This film is rated R.

Terry Munroe	Karen Allen
Josh Munroe	Wil Horneff
Bram	Chris Mulkey
Karl	Ted Marcoux
Elaine	Jessica Walter
Frazer	Brandon Quintin Adams
Phil	Rick Ducommun
Karl's Landlord	Nancy Fish

By CARYN JAMES

"Ghost in the Machine" is the kind of movie in which a curling iron, a garbage disposal and a dishwasher become potential murder weapons. The explanation will thrill technophobes: a serial killer dies during a lightning storm and his soul seeps from the hospital's X-ray scanner into a mainframe computer. From there he roams through Ohio's electrical system, ejecting videos from VCR's at will and terrorizing Terry Munroe (Karen Allen) and her 13-year-old son, Josh (Wil Horneff).

Considering that premise, the film should have been a lot wackier. Although "Ghost in the Machine" opened yesterday without advance screenings (the surest sign of trouble), the movie is not a disaster. It is a competent, occasionally witty genre piece that never tries to be anything more.

It's no mistake that the story begins with a house that looks suspiciously as if it belongs on Elm Street, and ominous music that suggests Freddy Krueger has come to town. The director is Rachel Talalay, who produced two of the "Nightmare on Elm Street" movies and directed the last one, "Freddy's Dead: The Final Nightmare."

"Ghost in the Machine" echoes Freddy's weird ability to creep into supposedly safe places. Here it's the telephone instead of your dreams, but the premise is the same. So is the film's rhythm. Viewers know the computer killer will stike and sometimes even who is up for grabs. (When a sexy teen-age baby sitter appears in "Ghost in the Machine," she's obviously a goner.) The question is when and how, and the best

moments in "Ghost in the Machine" have fun playing with that question. Choosing his victims from Terry's address book, the killer first attacks her boss with a lethal microwave that invades the entire kitchen. First the popcorn on the counter pops; then a banana explodes; then the boss's face begins to pop, too.

The film isn't sharp enough to make its premise seem new, though. It has trouble juggling all the things it tries to be: a special-effects movie filled with computer graphics; a high-tech slasher film; a joke. But its real shortcoming is that it doesn't have the haunting resonance of the "Elm Street" series. A killer who enters dreams is one thing; a killer who plays with the electric swimming-pool cover doesn't have quite the same claim on the unconscious.

"Ghost in the Machine" is rated R (Under 17 requires accompanying parent or adult guardian). It includes violence, some of it not computer generated.

1993 D 30, C11:5

CRITIC'S CHOICES

Video

"Dave," an airy Capraesque comedy about a Presidential impersonator who secretly fills in at the White House after the Chief Executive suffers a stroke, is a 1930's-style political fairy tale in 90's dress. Dave Kovic, the modern-day Mr. Smith who finds himself running the country, may be a virtual body double for Bill Mitchell, the stricken President, but in his personality he is everything the Chief Executive is not: uncorrupted, happy-go-lucky and concerned for the less fortunate.

More than the story, which turns a bit sticky toward the end, what infuses Ivan Reitman's movie with charm are the performances of Kevin Kline, in dual roles as Dave and the President, and Sigourney Weaver, as an unhappy First Lady who warms to her suddenly transformed husband. Mr. Kline's Dave is a sunny-hearted Everyman who combines the sincerity of the young James Stewart with the suavity of Cary Grant, but he brings to the mix his own brand of springy, deceptively blank-faced niceness.

Underneath its cheery surface, the movie has darker echoes. Being the President, it proposes, is ultimately a matter of keeping up appearances. The actual mechanics of running the country are handled by unscrupulous wheeler-dealers like Bob Alexander (Frank Langella), the skulduggerous chief of staff who installs Dave in the Oval Office and lives to regret it.

(1993. Warner. $95.45. Laser disk: $34.98. 110 minutes. Closed-captioned. PG-13.)
STEPHEN HOLDEN

1993 D 31, C26:4

Film

It was a very good year for Gong Li, the sturdy and beautiful Chinese actress who played the title role in "The Story of Qiu Ju" and also appears so strikingly in "Farewell My Concubine." Tonight she can also be seen at the Walter Reade Theater at Lincoln Center starring in "Ju Dou," a memorably lurid 1990 film by Zhang Yimou, who has directed her often to such fine effect. ("Raise the Red Lantern" provides another example of their teamwork.)

Mr. Zhang is in James M. Cain country with this tale of forbidden romance, in which Gong Li plays a woman who becomes treacherously involved with her husband's adopted son. But Mr. Zhang is also in the rural China of the 1920's, which gives this tale its peculiar wickedness. The director's eye for color and composition is startlingly lovely, as ever. And Gong Li shines.

Christmas crunch: this has been the best year-end movie season in recent memory, and that kind of good news has its sorry side. Too many worthwhile films are forced to compete for movie screens and audience attention, which means there are bound to be casualties. "A Perfect World," one of the best-acted and most deeply felt films of the year, hasn't found the audience it deserves. Is it hard to believe that Kevin Costner could give a truly wrenching, subtle performance? That Clint Eastwood has become one of Hollywood's most thoughtful film makers? It's not too late: take a chance on this one. You'll be surprised on every score.
JANET MASLIN

Whatever horrid things you've heard about the recent, short-lived Broadway musical "The Red Shoes," don't hold them against the lush, beloved Technicolor movie that inspired it. The 1948 extravaganza about a ballerina doomed to choose between love and her career is a holiday sugarplum of a movie. It has returned to Film Forum in the South Village, where it will play through Jan. 13.

The film has the same overripe appeal of many smaller 1940's movies in which a tragic love affair sends some woman flying in front of a train or dropping on the pavement (the "Waterloo Bridge" genre). Victoria Page (Moira Shearer) is torn mercilessly between two men: the heartless impresario Boris Lermontov (Anton Walbrook), who only wants her to dance, and the young conductor Julian Craster (Marius Goring), who wants her to give up her art for love of him. The acting is florid, but the melodrama and snippets of ballet are as alluring as ever.

Although "The Red Shoes" is best known as a dance film and a fairy tale, based on a Hans Christian Andersen story, it is also filled with the ecstatic love of movies that informs so many other films by Michael Powell and Emeric Pressburger. The 17-minute "Red Shoes Ballet" created for the film is as much about movie magic as about dance. Victoria's imagination becomes visible in ways that could never take place onstage. Through quick cuts and dissolves, she sees herself in the shoemaker's window; she watches the shoemaker become Lermontov and Craster before her eyes; the red shoes stand upright onstage, sparkling with some inner light. Taking "The Red Shoes" away from the movies was never an inspired idea.

("The Red Shoes" is at Film Forum, 209 West Houston Street, South Village, through Jan. 13. Screenings are daily at 2, 4:30, 7 and 9:30 P.M. Tickets: $7.50. Information: 212-727-8110.)
CARYN JAMES

1993 D 31, C26:5

Film/1993

Miramax Films

Anna Paquin, left, and Holly Hunter played daughter and mother in "The Piano," a love story set in New Zealand during the 19th century. Jane Campion's drama won a Palme d'Or at the Cannes festival.

VINCENT CANBY

Much Ado About Clint, Sly, Woody and Emma

Self-Inflicted Wounds Madonna's performance in "Body of Evidence," playing a sex toy who is supposed to arouse, not tranquilize. Arnold Schwarzenegger's all-out assault on the public to promote his "Last Action Hero," turning some people off from the film itself, which is actually pretty funny.

It's All in the Teamwork Woody Allen and Diane Keaton together again in "Manhattan Murder Mystery," the most satisfactory comedy team since Tracy and Hepburn. James Le Gros and Drew Barrymore in Tamra Davis's "Guncrazy," the most satisfactory outlaw team since Henry Fonda and Sylvia Sidney.

Comeback of the Year After such duds as "Stop! or My Mom Will Shoot," Sylvester Stallone became a box-office draw again as one of the screen's preeminent action heroes in "Cliffhanger" and "Demolition Man." On second thought, bring back "Stop! or My Mom Will Shoot."

Institutions Clint Eastwood as the star of "In the Line of Fire," giving the "True Grit" performance of his long and increasingly remarkable career. Robert Altman as the director of "Short Cuts," a funny, dark, panoramic film that's predictable only by being unpredictable.

Shakespeare as Invigorating as a Month in the Country Kenneth Branagh's "Much Ado About Nothing," with Emma Thompson and Denzel Washington as the hosts of this house party.

You've Heard These Songs Before "As Time Goes By" and "Make Someone Happy," but not the way the late great Jimmy Durante sings them, with such surprising feeling, on the soundtrack of "Sleepless in Seattle," Nora Ephron's crowd-pleasing comedy.

Promises Made By Sally Potter, the director and adapter of the gorgeous screen version of Virginia Woolf's "Orlando," and by Tilda Swinton, who plays the androgynous title role with such wit, skill and beauty. What can they do for an encore?

Promises Kept By Jane Campion with her erotic romance "The Piano," which fulfills the expectations created by her splendidly off-the-wall first film, "Sweetie." Also, by Holly Hunter and Harvey Keitel, whose performances richly realize the potential each has shown in earlier, pre-"Piano" films.

The Party's Over For Federico Fellini, 73, Lillian Gish, 99, and Myrna Loy 88; and the world is a lesser place.

JANET MASLIN

Good Men, Good Women And a Presence of 'Malice'

The Screenplay It Took a Man — No, Two Men — to Write "Malice," in which a woman conspires to have her ovary mangled and then removed by her surgeon, who is also her lover, for the sake of an insurance scam. Ouch.

Is Happily-Ever-After Passé? Films like "Sommersby," "The Age of Innocence," "The Piano," "Like Water for Chocolate" and "The Remains of the Day" take exceptional pains to avoid the cliché of a final clinch.

New Talent Ashley Judd, radiantly natural actress ("Ruby in Paradise"); Clint Eastwood, subtle and serious film maker ("A Perfect World"); Andrew Davis, the next action hero ("The Fugitive"); the Hughes brothers, ambitious neophytes ("Menace II Society"); Elijah Wood, impressive child actor ("The Adventures of Huck Finn," "The Good Son"); Steven Spielberg, impressive grown-up ("Schindler's List").

A Few Good Men Tommy Lee Jones ("The Fugitive"), Laurence Fishburne ("What's Love Got to Do With It"), Kevin Costner ("A Perfect World"), Daniel Day-Lewis ("The Age of Innocence," "In the Name of the Father"), Jeff Bridges ("American Heart," "Fearless"), Tom Hanks and Denzel Washington ("Philadelphia"), Liam Neeson, Ben Kingsley and Ralph Fiennes ("Schindler's List").

A Few Good Women Holly Hunter ("The Piano," "The Firm"), Gong Li ("The Story of Qiu Ju"), Stockard Channing ("Six Degrees of Separation"), Tsai Chin ("The Joy Luck Club"), Robin Williams ("Mrs. Doubtfire"), Edith Wharton.

Overlooked "American Heart," "Guelwaar," "Il Lladro di Bambini," "The Firm," "Flesh and Bone," "Mad Dog and Glory," "Household Saints," "La Vie de Bohème."

Overrated "Dazed and Confused," "Short Cuts."

Fun Dysfunction Manic-depression ("Mr. Jones"), pyromania ("Wilder Napalm"), facial disfigurement ("The Man Without a Face"), fatal illness ("My Life"), lethal eccentricity ("A Dangerous Woman"), you name it ("Boxing Helena," "M. Butterfly"). Hall of Fame: "Short Cuts," "What's Eating Gilbert Grape."

Déjà Vu Anthony Hopkins and Emma Thompson are still as superb as they were last year. Robert De Niro (promising director), Harvey Keitel (nice guy) and Martin Scorsese (social doyen) remain in fine form. "Groundhog Day" is a film to see over and over again.

CARYN JAMES

Dumb Lawyers and Sublimated Sex Were a Potent Mix

Best New Role Model Christina Ricci as the somber daughter, Wednesday, in "Addams Family Values." She's the perfect antidote to Barbie and comes with a chic all-black wardrobe.

Hottest New Sex Symbol Harvey Keitel with Maori tattoos in "The Piano."

Most Overrated Movie "A Perfect World," with Kevin Costner as a nice guy who, oh, yeah, happens to be a killer. The story is as suspenseful as milk.

Best Movie Hardly Anybody Saw Nancy Savoca's "Household Saints," in which Judith Malina, Tracey Ullman and Lili Taylor portray three generations of women in a story that mixes harsh realism with magic.

Kerry Hayes/20th Century Fox
Elijah Wood was in "The Good Son" and "The Adventures of Huck Finn."

Derrick Santini/Columbia Pictures
Emma Thompson and Anthony Hopkins played an English housekeeper and butler in James Ivory's "Remains of the Day."

Lawyers Who Should Have Been Smarter Tom Cruise, hoodwinked by the mob in "The Firm"; Jason Robards, who fires Tom Hanks in "Philadelphia"; Sam Shepard, passing around legal briefs and getting people killed in "The Pelican Brief."

Missing in Action Major movies promised for this season that are yet to appear: Gus Van Sant's "Even Cowgirls Get the Blues"; James Brooks's singing, dancing "I'll Do Anything"; Geena Davis in "Angie, I Says"; Jeremy Irons in "The House of the Spirits."

Period Pieces "The Age of Innocence," "The Piano" and "The Remains of the Day" brought back times when sex was sublimated into set decoration. Call it a coincidence, but they were the three best films of the year.

A Man With a Future Robert De Niro, director. His strong and confident "Bronx Tale" proved to be more than a vanity production.

Best New Artiste Steven Spielberg, who confounded the cynics with the powerful "Schindler's List."

Big-Budget Battle That Fizzled In the much-hyped showdown of the summer blockbusters, "Jurassic Park" wiped up the beach with Arnold Schwarzenegger in "Last Action Hero."

Worst Title "Wrestling Ernest Hemingway." What's next? "Bowling With Scott Fitzgerald"?

1993 D 26, II:9:1

Sundance Winners and Notable Losers

By BERNARD WEINRAUB

Special to The New York Times

PARK CITY, Utah, Jan. 31 — Mainstream was once a derisive word at the Sundance Film Festival.

Only a few years ago, audiences and judges at the nation's major showcase for independent films embraced arty, esoteric movies and snubbed those dreaded Hollywood-style products. But the increasing influx of the Hollywood crowd — coupled with changing styles of film makers — was evident on Saturday night when audience awards were presented to films that are — let's face it — mainstream.

The Talk of Sundance

"El Mariachi," a comedy-drama by Richard Rodriguez, a 24-year-old Texas film maker, won the Audience Award for a feature film, which is given on a vote by the festival's 5,000 filmgoers and is a good gauge of a film's commercial prospects. The film, about a mariachi musician who enters a Mexican border town at the same time as a hit man, was made by Mr. Rodriguez and his friends for only $7,000. Initially made as a quickie for the Spanish-language video market, it is about as arty as "Lethal Weapon." But much funnier.

(Not as funny, and overlooked in the awards, but still the most talked about film, was "Boxing Helena," about obsessive love gone haywire. Audiences reacted in two ways: they loved it or they hated it.)

Mr. Rodriguez, an engaging, coolly confident film maker whose movie is to be released by Columbia Pictures in January, said on Saturday night, "I just hope this inspires people to make their own movies, no matter who they are, no matter how rich or poor."

A Winning Documentary

The Audience Award for a documentary was given to "Something Within Me," an affectionate portrait of St. Augustine's School of the Arts in the South Bronx. This unusual elementary school uses music and other forms of artistic expression to nurture a sense of responsibility and pride among its poor, minority students. The movie won two other awards: the Film Makers Trophy and a Special Jury Award for Merit.

The documentary's producer, Jerret Engle, a former editor at the Dutton publishing house, initially heard about the school on the evening news in New York City about five years ago. Since then, she has worked at part-time jobs and spent years raising $250,000 to make the film.

"I'm just floored," she said on Saturday night. "I love these kids and their teachers, but I didn't know anyone else would be interested." The film, set for a modest commercial release, has already drawn the interest of the Public Broadcasting Service and Home Box Office.

Four Grand Prizes

In presenting the awards, the audience was somewhat out of sync with the more traditional Sundance jury.

The panel split the Grand Jury prizes among two dramas and two documentaries.

The dramas are "Ruby in Paradise," Victor Nunez's rambling film about a young woman who flees her Tennessee town to find her sense of self on the Florida coast, and Bryan J. Singer's "Public Access." The latter is about a slick, slightly eerie newcomer to a fictional Midwestern town, Brewster, who takes over the public-access cable network and asks the question: "What's wrong with Brewster?" The result is nothing less than paranoia.

The jury's documentary awards were given to two powerful works: "Children of Fate: Life and Death in a Sicilian Family," a heart-wrenching portrait of three generations of a Sicilian family, and "Silverlake Life: The View From Here," a harrowing film about AIDS.

(Other prize-winners included Steve Gomer's "Fly By Night," a drama about New York rappers; Tony Chan's "Combination Platter," about illegal Chinese immigrants; Everett Lewis's "Ambush of Ghosts," about a dysfunctional family; Leslie Harris's "Just Another Girl on the IRT," about a black Brooklyn teen-ager, and "Lillian," about the struggles of a black woman. A documentary prize also went to "Earth and the American Dream," about the destruction of the nation's environment).

"Silverlake Life" traces the final journey of a film teacher, Tom Joslin, and his companion of 22 years, Mark Maasi, both of whom had AIDS. The two men lived in the Silverlake area of Los Angeles, and both videotaped the film themselves. The graphic film, which includes a hard-to-watch death scene, was completed by a friend, Peter Friedman, a documentary director.

Mr. Friedman, 34, a former student of Mr. Joslin's at Hampshire College in Amherst, Mass., said he culled 40 hours of videotapes to produce the 99-minute film. "It is a direct and a difficult film which shows the realities of day-to-day life with AIDS," Mr. Friedman said after the awards. "The whole spirit of the film is to confront the pain and the love shared by these two men." In recent days, he said, television and theatrical distributors have expressed interest in the documentary.

A Few Words From the Founder

Sundance is plainly going a bit Hollywood; at least six agents from United Talent Agency, one of the festival's numerous sponsors and more aggressive agencies, were seeking new clients. Still, the awards ceremony hardly resembled the Oscars.

Robert Redford, the founder of the festival, was welcomed onstage with applause and whistles. He wore boots, jeans, a leather jacket and a striped sweat shirt.

Mr. Redford, one of the few millionaire movie stars who have actually paid back the industry by nurturing new film makers, told the packed crowd in a converted basketball gym in this ski resort town: "Nobody can understand the blood, the sweat, the dedication it takes to make these films. Nobody can understand that except the film maker."

He said the festival stands for "innovation, for the avant-garde." But other film makers and executives say it was virtually unavoidable for Sundance to turn, unwittingly, into a hunting ground for Hollywood. In many ways, Hollywood is less interested in the films shown here — which often flounder at the box office — than in new film makers with commercial potential.

"It really is a festival of agents," said Jonathan Dana, the president of Triton Pictures, an independent film company, who has been visiting the festival for several years. "It's a barter economy. Everyone's trading information. But it's a tricky conversion from the narrow world of independent films to the market place."

Mr. Dana speaks from personal experience. Last year, Triton bought two of the big prize-winners at Sundance: the comedy, "In the Soup," whose star, Seymour Cassel, was master of ceremonies at this year's awards, and the documentary "A Brief History of Time."

Mr. Dana, standing outside a movie theater in Park City, said simply, "One worked; one didn't."

Like another big favorite last year, "The Waterdance," "In the Soup" failed at the box office. But "A Brief History" succeeded. Mr. Dana shrugged and voiced the oft-heard Hollywood complaint: "Who knows what works?"

'Orlando' and 'Helena'

Curiously, the two pictures that were most widely discussed at Sundance went unmentioned last night.

One of them, "Orlando," an adaptation of the Virginia Woolf novel by an English film maker, Sally Potter, had its United States premiere at the festival but was not in competition for prizes. (The festival divides films into two major categories, those in competition and those having premieres.) By virtual consensus, "Orlando" was the most dazzling film at the festival.

And then there was "Boxing Helena."

No film at the festival provoked as much rage, hisses, applause and debate as this one. The film was directed and written by Jennifer Chambers Lynch, the daughter of David Lynch. Even before it was shown here, the movie created an unusual amount of talk because of the last-minute withdrawals of Madonna and then Kim Basinger from the lead role. Helena is now played by Sherilyn Fenn. The film deals with a lunatic surgeon (Julian Sands) obsessed by an elusive, beautiful woman named Hel-

Chris Lamb

Joseph Lindsey in "Amongst Friends," which turned out to be one of the strongest films at the Sundance festival.

ena. To keep her, he transforms her into his own Venus de Milo by cutting off her arms and legs and placing her on a pedestal. Hard to believe, but the film is a comedy, albeit very dark.

Ms. Lynch, like many of the twenty-something directors here, is a very confident, assured film maker, without a hint of self-doubt.

Sipping coffee and chain-smoking the other morning in a hotel dining room, Ms. Lynch said she was startled by the almost violent reaction to her film. The film has been called anti-feminist, anti-male and exploitative.

"People want the film abolished," she said. "They scream at us. I wish they would talk to me. I want to hear them. They don't want to have a discussion. They just get up and leave."

Ms. Lynch, who never went to college, grew up in Los Angeles and attended Interlochen Arts Academy in Interlochen, Mich. Upon graduation, she said, she went on a "fairly extensive hike with my boyfriend," lived in Baltimore for several months, and then moved to Los Angeles at 19 to work for her father and write the movie. She's now 24. The movie is awaiting a distributor in the United States

"My whole intent was to parody and to show seriously what we do to each other in relationships," she said. "It's about how we try to change each other. We are equally vulnerable to self-hatred, to obsession, and we try and change each other. It's about how we try to break each other down and control each other — the thievery that goes on in obsessive relationships."

Although other film makers here find it hard to believe, Ms. Lynch said being her father's daughter was not a blessing.

"Believe me, people wanted nothing to do with me," she said. "I was 19; it was a risky script; I was some big director's daughter and female. There's something about being a daughter. You would think it gives you some credibility. It doesn't."

At least, Ms. Lynch had no trouble getting through the doors of agents and executives.

A Long Island Story

At the other end of the spectrum is Rob Weiss, 26, whose father, Carl, runs a touring business for gamblers in Cedarhurst, L.I. To raise money for his son's film, "Amongst Friends," which turned out to be one of the strongest at the festival, Mr. Weiss sent out letters to his customers.

Rob Weiss, who wears his cap backwards and speaks with an unmistakable New York accent, said: "My dad's friends are pretty much high rollers. The letter wasn't done in a schlock manner. It was classy. It said, like: 'Hey, if you're going to bet on ball games your entire life, if you're going to bet on horses, do something good with the money for a change. Bet it on the kid."

The bet on the kid seems to be paying off.

The movie is a gritty exploration of a group of wealthy high-school graduates, most of them Jewish or Italian, from the Five Towns of Long Island who drift into boredom, drugs, petty crime and tragedy. The director, who grew up on Long Island and attended the Parsons School of Design for about a year, said this was the world in which he grew up. Mr. Weiss said he owed a great deal to the works of Martin Scorsese, Francis Ford Coppola and Oliver Stone. He said he had seen Phillip Kaufman's "Wander-

ers," about 40 times. (Mr. Kaufman was honored at this year's Sundance Film Festival.)

Mr. Weiss now has an agent, a lawyer, a manager and a publicity agent. Studios are beckoning. But he's not going Hollywood, he insisted. "You've got to know where you came from," he said. "I live in South-Central L.A., by U.S.C., with my girlfriend. The neighborhood is predominantly African-American and Mexican. It's reality. That's what I want. That's what I need. Nothing's going to change."

1993 F 1, C15:3

Top Prize at Cannes Is Shared

By VINCENT CANBY

Special to The New York Times

CANNES, France, May 24 — As if unable to make up its mind, the jury at the 46th Cannes International Film Festival tonight split the Palme d'Or, the festival's top prize, between two films: "The Piano," Jane Campion's romantic comedy set in New Zealand in the 1850's, and "Farewell to My Concubine," Chen Kaige's epic covering approximately 50 years of recent Chinese political and cultural history.

The awards were presented in the Festival Palace at closing ceremonies with Jeanne Moreau as the host.

Although the Palme d'Or has been shared in the past, this year's jury set two precedents. This is the first time the Palme d'Or has gone to either a woman or a Chinese film maker. Holly Hunter, the American star of "The Piano," received the award as best

Films from China and from Down Under split the Palme d'Or.

actress for her performance as a young Scots widow who goes to New Zealand to marry a man she doesn't know.

The best-director prize went to Mike Leigh, the English film maker, for "Naked," a bitter, brutal film about emotional disconnection in today's England. David Thewlis, the star of "Naked," was named best actor for his performance as the film's sardonic central character.

The Jury's Grand Prize, which is, in effect, the festival's second prize, was presented to Wim Wenders for his German entry, "Far Away, So Close," which brings back the characters introduced in his "Wings of Desire." He received the 1986 Cannes award as best director for the earlier film.

The Kinds of Surprise

In this fashion this year's international jury, headed by Louis Malle, the French director, managed to cite each of the four films that had been rumored to be the leading competitors for major prizes. The surprise tonight was not in the names of the

Associated Press

The Cannes International Film Festival awarded its top prize yesterday to two films. Holly Hunter, left, was named best actress for "The Piano"; Sam Neill, center, accepted the Palme d'Or for Jane Campion, the director. Chen Kaige, right, who directed "Farewell to My Concubine," accepted his own award.

winners but in the specific awards they received. The jury also managed to give recognition to two films that were not shown until the weekend and about which there were no rumors at all.

The Jury Prize, which is the festival's third prize and is given only at the jury's discretion, was shared by two popular entries: Ken Loach's English "Raining Stones," a forlorn yet sometimes very funny tale of an out-of-work Manchester husband and father who becomes involved with loan sharks, and Hou Hsiao-hsien's "Puppet Master," a beautiful, austere Taiwanese film that crosscuts between interviews with Tien Lu Li, an 85-year-old actor and puppeteer, and scenes from his life recreated by actors.

The Camera d'Or, presented each year to the best first feature, went to Tran Anh Hung's "Scent of Green Papaya," a leisurely memoir about growing up in Vietnam in the 1950's. Though the film has sometimes been identified as Vietnamese, it is French, having been shot entirely in a big, very authentic-looking set inside a movie studio in Paris. Mr. Tran, who is Vietnamese, lives in France.

From South Africa

The Camera d'Or jury, headed by Micheline Presle, the actress, also voted a special mention to Elaine Proctor's "Friends" from South Africa. It is a melodrama about the close relationship of three young women, one English, one an Afrikaner and one a black South African.

The Palme d'Or for best short subject was won by Jim Jarmusch, the American film maker better known for his features ("Stranger Than Paradise," "Night on Earth," among others). His "Coffee and Cigarettes (Somewhere in California)" is a kind of 12-minute black-and-white takeoff on "My Dinner With André." Tom Waites and Iggy Pop sit drinking and smoking in a bar and talk about road-

side surgery, Abbott and Costello and other arcane matters.

The prize for best technical achievement in images and sound was shared by Jean Gargonne and Vincent Arnardi for their work on the French "Mazeppa," directed by a new film maker named Bartabas. The same award for a short subject went to Grant Lahood of New Zealand for "The Singing Trophy."

In addition to winning the Palme d'Or, "Farewell to My Concubine" received the International Critics' Prize for "its incisive analysis of the political and cultural history of China and for its brilliant combination of the spectacular and the intimate."

Though there were some boos when Mr. Wenders's award was announced early in the ceremonies, the audience at the Festival Palace was well behaved. Sam Neill, one of the stars of "The Piano," accepted the Palme d'Or on behalf of Ms. Campion, who is seven and a half months' pregnant and returned to Australia on Friday. The evening ended with the out-of-competition screening of "Toxic Affair," a new French film starring Isabelle Adjani.

1993 My 25, C13:2

Awards at Hamptons Film Festival

EAST HAMPTON, L.I., Oct. 24 — The first Hamptons International Film Festival came to an end yesterday with the presentation here of Golden Arrow Audience Awards for best film, best short and best director, and 10 Student Film Showcase Awards.

Carlo Carlei won the Golden Arrow for his direction of "Flight of the

Innocent," an Italian-French release about a young boy abandoned after his family is assassinated in Calabria. "Flight of the Innocent" also won the prize for most popular film. The winner of the award for most popular short film was "The Big Gig," directed by Jeffrey Nachmanoff.

Winners of the Student Showcase Awards, which include scholarships of $2,500 each, were: Ethan Spigland, Maria Magenti, Rick Velleu, Yoav Grunstein and Bartholomew Freundlich (New York University); Alexandra Sichel and Stephen James (Columbia University); Jonah Meyers (Ithaca College); and Nuria Olivé-Bellés and Arie Ohayon (School of Visual Arts in Manhattan).

Irene Papas was given the Golden Arrow Award for lifetime achievement in a ceremony on Saturday. The awards are sponsored by the Arrow Shirt Company, a major corporate donor to the festival with Time Warner and American Airlines.

The American Independent Production Award was given to Jonathan Kahn, director of "The Chili Con Carni Club." Sponsored by Silvercup Studios and the New York Production Partnership, the award consists of $60,000 in production goods and services given to an American independent film maker whose film demonstrates excellence despite budget limitations.

1993 O 25, C18:1

plays a Nazi labor-camp commandant in "Schindler's List" as best supporting actor, and Janusz Kaminski for his cinematography on the film.

Ms. Campion won best-screenwriter award for "The Piano," and the film's star, Holly Hunter, was named best actress. The best-actor award went to David Thewlis, the acerbic star of Mike Leigh's "Naked."

The best foreign-language award went to "The Story of Qiu Ju," a film about a farmer's wife and her search for justice by the Chinese director

Zhang Yimou. "Visions of Light," a history of great cinematographers by Arnold Glassman, Todd McCarthy and Stuart Samuels, was chosen as best documentary. Winning for supporting actress was Madeleine Stowe, as the wife of a Los Angeles motorcycle police officer in Robert Altman's "Short Cuts."

Thirty-two members of the society voted yesterday at the Algonquin Hotel in Manhattan.

1994 Ja 4, C18:6

New York Critics Honor 'Schindler's List'

By JANET MASLIN

"Schindler's List," the three-hour black-and-white story of Holocaust heroism directed by Steven Spielberg, was voted the best film of 1993 by the New York Film Critics' Circle. Voting yesterday at the offices of the Newspaper Guild of New York, the 27-member group also cited "Schindler's List" for Ralph Fiennes's supporting performance as a Nazi labor camp commandant and for Janusz Kaminski's cinematography.

"The Piano" received a best-director award for Jane Campion and a best-actress award for Holly Hunter, who plays the film's mute heroine. The group named Mr. Spielberg a close runner-up as best director, just as "The Piano" was a close runner-up in the best-picture category.

Like the Los Angeles film critics, who voted last week, the New York group cited "Schindler's List" as best film while passing over Mr. Spielberg.

The group's choice for best actor was David Thewlis, the acerbic star of Mike Leigh's "Naked," who was also named best actor at this year's Cannes International Film Festival. Anthony Hopkins, whose films this year include "The Remains of the Day" and the forthcoming "Shadowlands," was named runner-up. In the best actress category, Ms. Hunter was followed by Ashley Judd, the star of "Ruby in Paradise."

2 Chinese Films Honored

"Farewell My Concubine," by the Chinese director Chen Kaige, was voted the year's best foreign film and was also cited for Gong Li's supporting performance as a beautiful prostitute. "The Story of Qiu Ju," in which Gong Li plays the title role, was runner-up. In the supporting actress category, the runner-up was Rosie Perez, who appeared in both "Fearless" and "Untamed Heart." The runner-up among supporting actors, Leonardo Di Caprio, had also appeared in two films, "This Boy's Life" and "What's Eating Gilbert Grape."

Ms. Campion's screenplay for "The Piano" was voted the year's best, followed by an unlikely tie between screenplays for "Schindler's List" and "Groundhog Day." The group's

award for best documentary went to "Visions of Light," a survey of many cinematographers and their work. The runner-up was "The War Room," a look at strategists behind the Clinton Presidential campaign.

The group's chairman is Larry Cohen of Premiere magazine, and its vice chairman is Armand White of The City Sun. The awards are to be presented on Jan. 16 in a ceremony at the Pegasus Room at Rockefeller Center.

1993 D 16, C18:4

Critics Name Spielberg Best Director

By GLENN COLLINS

The National Society of Film Critics yesterday voted Steven Spielberg's "Schindler's List" as the best film of 1993, and also named Mr. Spielberg as the best director. Previously, both the Los Angeles Film Critics Association and the New York Film Critics Circle had chosen Mr. Spielberg's three-hour film of the Holocaust for the top award, but presented the best-director citation to Jane Campion for "The Piano" rather than Mr. Spielberg.

The critics' votes are often considered bellwethers of the annual presentation of the Academy Awards, which will be made this year on March 21. Although Mr. Spielberg, 46, is commercially the most successful director in movie history, he has never won an Oscar. In 1987, the Academy of Motion Picture Arts and Sciences presented him with the Irving G. Thalberg Memorial award, in recognition of his collective body of work.

The national society, a 35-member group of critics from New York, Los Angeles, Boston, Chicago and other cities, also cited Ralph Fiennes, who

Spielberg Gets Golden Globes in Two Categories

By BERNARD WEINRAUB

Special to The New York Times

HOLLYWOOD, Jan. 23 — Five days after a devastating earthquake struck Los Angeles, the folks in Hollywood did exactly what was expected of them: they put on their best clothes and went to an awards party.

The 51st annual Golden Globes presentations on Saturday night, an annual rite that is often predictive of the Academy Awards, was gripped this year by the impact of last Monday morning's earthquake. Some expected guests, like Kirstie Alley and Arsenio Hall, canceled because their homes were severely damaged. Others, like Debra Winger and Tim Robbins, chose not to fly in from New York. Many people seemed nervous.

"No, no, no, I'm not nervous about living in L.A.," insisted Tom Hanks, who won the best-actor award for his performance in "Philadelphia" as a lawyer stricken with AIDS. Standing near the swarming red-carpeted entry of the Beverly Hilton Hotel, Mr. Hanks summed up the eerie show-must-go-on quality not only of the evening but, perhaps, of life here.

"I don't think there'll be another earthquake, but if there is we'll be O.K.," he said quickly. "I don't think there'll be another fire, but if there is, we'll be O.K. I don't think there'll be another riot, but if there is we'll be O.K."

Nearby, Steven Spielberg, who won as best director for "Schindler's List," which was named best picture, took a little flashlight from the pocket of his jacket. "Just in case," he said. Liam Neeson, the star of the film, lit a cigarette. "I'm told the chandeliers are all strapped up," he said, half-smiling. Natasha Richardson, who accompanied him, said, "I thought of wearing a hard hat but it wouldn't go with the clothes."

'No Earthquakes in Brooklyn'

As they spoke, the actress Rosie Perez, who still keeps her apartment in Brooklyn, rushed past. "The morning after the earthquake I went straight to the airport, but there were no flights to New York," she said. "I wanted to go back immediately. I'd rather freeze than have the earth move. Believe me, no earthquakes in Brooklyn. Hoodlums, yeah. I know most of them, so I'm fine."

It was that kind of evening at a yearly Hollywood ritual that is the oddest, biggest and most charming party in town. The Golden Globes are

given by the 84 members of the Hollywood Foreign Press Association, which is composed of some journalists and some hangers-on.

Over the years, the Golden Globes ceremony — which was broadcast this time on the TBS cable network — has endeared itself to the movie industry with its informal cocktail party, dinner, large amounts of wine, table-hopping and numerous awards for movies and television shows. (Years ago, before the show was televised, it was not uncommon for movie stars and executives to get a little drunk; but those days are long gone.) The Globes are not only a marked contrast to the formality, tensions and enormously high stakes of the Academy Awards (which are to be presented on March 21), but are also sometimes a bellwether for the Oscars.

This year, the only surprise was the selection of Winona Ryder as best supporting actress for "The Age of Innocence." She was selected over Ms. Perez, who was nominated for the drama "Fearless"; Anna Paquin, the child in "The Piano"; Penelope Ann Miller in "Carlito's Way," and Emma Thompson for "In the Name of the Father."

The other winners were expected. There was Mr. Spielberg, whose drama about the Holocaust is favored to win numerous Academy Awards. It appeared in the same year that his dinosaur fantasy, "Jurassic Park," emerged as one of the top-grossing films of all time.

"All the letters I'm getting on 'Schindler's List,' the reaction to it," he said, shaking his head after winning the award. "I mean I wouldn't trade three (Jurassic) Parks for 'Schindler's List.'" He was asked about a story, widely published here, that high school students laughed during a screening of the movie in Oakland.

"It's fascinating that in certain cultures within America, certain socio-economic circles, a lot of our kids are so desensitized to violence," he said. "So many high school kids don't know what the word 'Holocaust' means."

One of the more emotional comments was given by Branko Lustig, a producer of "Schindler's List," who was born in Yugoslavia and spent three years in German labor camps in World War II. "I remember," he told reporters haltingly, "anytime somebody died, anytime somebody was hanged, the last words these peo-

Tom Hanks and Holly Hunter on Saturday after they won the Golden Globe Awards for best actor and best actress in a drama.

Reuters

where to go, just in case something happens." Ms. Ryan turned to Mr. Quaid and said: "We should have brought a cellular phone here. That would have been cool."

1994 Ja 24, C11:3

The 1994 Golden Globe Winners

BEVERLY HILLS, Calif., Jan. 23 (AP) — *These are the winners of the 51st Golden Globe Awards, which were presented on Saturday:*

FILM

Drama
"Schindler's List"

Musical or Comedy
"Mrs. Doubtfire"

Actress, drama
Holly Hunter, "The Piano"

Actor, drama
Tom Hanks, "Philadelphia"

Actress, musical or comedy
Angela Bassett, "What's Love Got To Do With It"

Actor, musical or comedy
Robin Williams, "Mrs. Doubtfire"

Supporting Actress
Winona Ryder, "The Age of Innocence"

Supporting Actor
Tommy Lee Jones, "The Fugitive"

Director
Steven Spielberg, "Schindler's List"

Screenplay
Steven Zaillian, "Schindler's List"

Foreign-Language Film
"Farewell My Concubine"

Original Score
Kitaro, "Heaven and Earth"

Original Song
"Streets of Philadelphia" from "Philadelphia," Bruce Springsteen

Cecil B. De Mille Award for Lifetime Achievement
Robert Redford

Special Achievement Award
"Short Cuts"

TELEVISION

Series, drama
"N.Y.P.D. Blue"

Actress, drama
Kathy Baker, "Picket Fences"

Actor, drama
David Caruso, "N.Y.P.D. Blue"

Series, musical or comedy
"Seinfeld"

Actress, musical or comedy
Helen Hunt, "Mad About You"

Actor, musical or comedy
Jerry Seinfeld, "Seinfeld"

Mini-series or movie made for television
"Barbarians at the Gate"

Actress, mini-series or movie made for television
Bette Midler, "Gypsy"

Actor, mini-series or movie made for television
James Garner, "Barbarians at the Gate"

Supporting actress, mini-series or movie made for television
Julia Louis-Dreyfus, "Seinfeld"

Supporting actor, mini-series or movie made for television
Beau Bridges, "The Positively True Adventures of the Alleged Texas Cheerleader-Murdering Mom"

1994 Ja 24, C12:1

ple had was, 'Do not forget us.' Those were the words." The movie, he said, helps fulfill the wishes of those who perished.

Wide Range of Responses

Mr. Hanks delivered one of the more elegant speeches of the evening in accepting the best-actor award, paying tribute to AIDS victims and then citing the role that his wife, the actress Rita Wilson, plays in his life. "I'm a lucky man," he said.

The best performance by an actress in a drama was attributed to Holly Hunter for her role in "The Piano" as a mute who has an illicit affair in colonial New Zealand. Tommy Lee Jones was named best supporting actor for "The Fugitive."

The award for best actress in a musical or comedy was given to Angela Bassett for her portrayal as the singer Tina Turner in "What's Love Got to Do With It." Robin Williams, who masquerades as a British nanny in "Mrs. Doubtfire," won as best actor in a musical or comedy.

Of course Mr. Williams had a field day with the earthquake. "I'm not nervous about the awards, I'm nervous about the buildings," he said, entering the hotel. "What'll I do if another one hits? Look for exits. Hide under solid tables. Stand near a lady who's had a face lift because it won't fall." Mr. Williams's wife, Marcia, standing beside him, rolled her eyes.

Top winners among television shows included "Seinfeld," which won as best comedy series, "N.Y.P.D. Blue," best drama, and "Barbarians at the Gate," about Wall Street in the 1980's, which was honored as best mini-series or movie made for television. David Caruso was named best actor in a dramatic show for playing a policeman on "N.Y.P.D. Blue," and Kathy Baker best actress in a dramatic series, for "Picket Fences."

Perhaps the strangest comment of the strange evening was given by Mr. Seinfeld, who spoke glibly about the earthquake and said it was probably "sensationalized" by the press.

In some ways the most unsparingly honest comment was offered by Chen Kaige, the director of "Farewell My Concubine," the Chinese-made epic that won as best foreign film.

"First of all, I must say I deserve it," he said. "I can't tell you how difficult it is to make a film."

As usual, the sometimes curious dependency between movie stars and the press was evident. Stars lined up like customers at a supermarket to be interviewed by Juliette Hohnen, the cheerful MTV news reporter.

"What was the earthquake like?" Ms. Hohnen asked Juliette Lewis, the actress, who was in a glittery headdress.

"I was at my house with my sister and we had to calm her boyfriend down," said Ms. Lewis. "Here, I have fantasies of everyone all dressed up crawling under a table. That's when people's true colors come out."

As she spoke, Dennis Quaid and his wife, Meg Ryan, moved past.

"I'm sort of surprised they didn't cancel this or put it off for a week," Mr. Quaid said.

Ms. Ryan said, "Our son's at home and knows exactly what to do and

Critic's Notebook

Minus Suspense Factor, Oscars Cut to the Chase

By JANET MASLIN

This year's Academy Awards telecast promised so little suspense that as the big night approached, the statuette's Sphinx-like features began to look even stonier than usual. Would Oscar be watching? Would he be sleeping? Would he even have a pulse?

After all, most of the evening's winners were pre-ordained. There was no prospect of Billy Crystal to enliven the proceedings with inspired wisecracks. And the dominant film, "Schindler's List," was no laughing matter. Clearly, the show faced an uphill battle. The rumors of its demise, noted in a Variety story citing flagging audience interest and competition from other awards shows, did not sound exaggerated.

●

Well, surprise: if Oscar had eyes, he would have kept them wide open this year. And the producer, Gilbert Cates, who has presided over the show during Mr. Crystal's tenure and now with Whoopi Goldberg in the role of host, emerged as the evening's unsung hero. Under Mr. Cates's aegis, there was less silliness and less small talk, with more emphasis on cleverly chosen film clips and the bona fide Hollywood magic being celebrated. Wrapping up this lively show in only a little more than three hours, Mr. Cates even made the trains run on time.

There was one disastrous production number, choreographed by Debbie Allen in a nuttily chaotic style that managed to echo the Oscar-night parody in "Naked Gun 33⅓." (Who ever said the score from "The Fugitive" had a good beat? Who said you could dance to it?) There was also a joke about Elizabeth Taylor's many husbands, but this was otherwise quite a forward-looking affair.

Young talent was much in evidence, particularly when "veteran actor Elijah Wood" stepped into the mismanaged footsteps of Macaulay Culkin and confidently delivered the visual-effects Oscar with the help of a T. rex. Eleven-year-old Anna Paquin's look of delight and astonishment at receiving her award for best supporting actress was a touching reminder of just how jubilant every Oscar winner must feel.

●

Naturally, the winners gave voice to their happiness in different ways. One of the sound-effects winners from "Jurassic Park" thanked "my family, for knowing that I'm not usually this wooden." Tommy Lee Jones, daring to show up with a half-shaved

head for his best-supporting-actor award, reminded viewers that he wasn't really bald. Bruce Springsteen, whose musical performance was one of the night's galvanizing highlights, accepted his award with humility and grace. A frail, gallant Deborah Kerr, accepting her honorary Oscar for career achievement, provided one of the show's most moving moments when she simply said: "You have all made my life truly a happy one. Thank you from the bottom of my heart."

Fernando Trueba, whose "Belle Époque" provided one of the evening's few upsets when it won as best foreign film over "Farewell My Concubine," succeeded in making the night's most offbeat speech. "I would like to believe in God in order to thank Him," Mr. Trueba said, "but I just believe in Billy Wilder. So thank you, Mr. Wilder." A tearful Tom Hanks accepted his best-actor award with extraordinary grace, not only speaking eloquently of AIDS victims but also thanking his "Philadelphia" costar, Denzel Washington, for doing valiant work in an image-tarnishing role.

Speaking of images, they were much in evidence thanks to the witty montages that punctuated the program, and thanks also to the evening's built-in fashion show. Usually it's the actresses who make the fashion news, but this time the men took a strong stand. Actor after actor (Al Pacino, Tom Cruise, Jeff Bridges) turned up with long hair and a conspicuously patchy beard; the collarless shirt (Liam Neeson), especially in black (also Mr. Neeson), was another must. However seriously Hollywood's newer guard secretly takes the Oscars, these actors place a premium on looking as if they'd rather be surfing.

Compared with this, the women looked positively conservative (especially Glenn Close, whose beaded gown was the great-lady outfit of the evening), even if some of them (Goldie Hawn, Marisa Tomei) opted for

the I-lost-my-dress-so-I'll-just-wear-my-slip look. Geena Davis and Sharon Stone managed to slink and sparkle, but Ms. Hawn, in clinging white satin, pushed her luck. "God gave us bodies, and they know what to do with them, I'll tell you!" she gushed as the dancers finished laying to rest the "Fugitive" score.

Ms. Goldberg, who showed up in a stately brown gown before switching to an Armani tuxedo at halftime, made a poised and funny host much of the time, although she relied heavily on the kinds of man-ogling jokes that no male host could get away with making about women. Certainly she sustained a tone of levity, which became particularly important as the sweep by "Schindler's List" threatened to bring out great ponderousness in some quarters. Describing the film as "a contemplation of the mystery of goodness" and acting the daylights out of his introduction, Richard Dreyfuss declaimed: "It is my profound personal honor to nominate 'Schindler's List.'" The sight of Steven Spielberg's beaming mother provided a welcome contrast later in the show.

In accepting his Oscar for best director (with which he nervously stroked his beard as his best-picture award was later announced), Mr. Spielberg spoke of "the six million who can't be watching this tonight." Another fitting tribute to the departed came with the show's montage recalling film luminaries who died in the last year. In addition to actors and actresses (John Candy, Don Ameche, River Phoenix, Audrey Hepburn), the clips took care to honor movie luminaries from different realms: the writer and director Joseph L. Mankiewicz, the costume designer Irene Sharaff, the songwriter Sammy Cahn. When Hollywood pays generous homage to its glittering past, the future looks that much more bright.

1994 Mr 23, C13:3

Supporting Actor: Tommy Lee Jones, "The Fugitive"

Supporting Actress: Anna Paquin, "The Piano"

Foreign Film: "Belle Époque," Spain

Original Screenplay: Jane Campion, "The Piano"

Adapted Screenplay: Steven Zaillian, "Schindler's List"

Cinematography: "Schindler's List"

Editing: "Schindler's List"

Original Score: John Williams, "Schindler's List"

Original Song: "Streets of Philadelphia," from "Philadelphia"

Art Direction: "Schindler's List"

Costume Design: "The Age of Innocence"

Makeup: "Mrs. Doubtfire"

Visual Effects: "Jurassic Park"

Sound: "Jurassic Park"

Sound Editing: "Jurassic Park"

Documentary Feature: "I Am a Promise: The Children of Stanton Elementary School"

Documentary Short Subject: "Defending Our Lives"

Short Film, Live: "Black Rider"

Short Film, Animated: "The Wrong Trousers"

Jean Hersholt Award: Paul Newman for humanitarian efforts

Honorary Award: Deborah Kerr for career achievement

Gordon E. Sawyer Technical Award: Petro Vlahos, for technical contributions to the motion picture industry

Technical Award of Merit: Panavision Inc. for lens development

Technical Award of Merit: Manfred G. Michelson of Technical Film Systems Inc. for film processor development

1994 Mr 23, C16:5

A Dark Comedy Wins at Cannes

By JANET MASLIN

Special to The New York Times

CANNES, France, May 23 — "Pulp Fiction," Quentin Tarantino's electrifying and original dark comedy about an assortment of underworld characters, received the Palme d'Or tonight as the best film at this year's Cannes International Film Festival. This film, an American entry, stars Bruce Willis, John Travolta, Harvey Keitel and Uma Thurman.

A grand jury prize, honoring runners-up in the best-film category, was split between the festival's two most politically charged favorites: Zhang Yimou's "To Live," the story of a long-married couple whose lives reflect changing phases of recent Chinese history, and "Burnt by the Sun," Nikita Mikhalkov's tragic yet lyrical tale of a Stalinist hero in the Soviet Union.

Ge You, who plays the husband in Mr. Zhang's film, was voted best actor. He had been considered a leading candidate for the acting prize, but the best-actress winner, Virna Lisi, was a surprise. Miss Lisi, who is made up to look pale and sinister for her performance as Catherine di Medici in Patrice Chereau's "La Reine Margot," arrived at the Palais du Festival looking blond and radiant by contrast. She cried profusely upon ac-

cepting her award, and was greeted with especially warm applause.

Rare Prize for a Script

Nanni Moretti, the Italian film maker whose "Caro Diario" takes the form of a cinematic diary, was voted best director. A screenwriting prize that had not been given in a decade was awarded to Michel Blanc, who is also the star of his own "Grosse Fatigue." Mr. Blanc's film, which often shows him conversing with his own double, also won an award for special effects.

An additional jury prize, ranking below the others, was also given to Mr. Chereau for "La Reine Margot." A separate international critics' prize was awarded earlier to Atom Egoyan, the Canadian film maker of Armenian extraction, for "Exotica."

No Prize for a Favorite

Among those presenting awards were Mr. Willis, John Travolta, Carmen Maura, Geraldine Chaplin and Kathleen Turner, the star of "Serial Mom," which was the festival's out-of-competition closing-night film.

Among the most unexpected developments was the complete overlooking of "Rouge," the well-received third film in Krzysztof Kieslowski's "Trois Couleurs" trilogy. Even more remarkable was that the rest of the awards, by and large, made terrific good sense. In Cannes, that is always the biggest surprise of all.

1994 My 24, C15:6

The 1994 Oscar Winners

Here are the winners of Oscars at the 66th annual Academy Awards ceremony, held on Monday night at the Dorothy Chandler Pavilion of the Los Angeles Music Center:

Film: "Schindler's List"

Director: Steven Spielberg, "Schindler's List"

Actor: Tom Hanks, "Philadelphia"

Actress: Holly Hunter, "The Piano"

The New York Times
Film Reviews
1994

Forbidden Quest

Written and directed by Peter Delpeut; studio photography by Stef Tijdink; edited by Menno Boerema; music by Loek Dikker; produced by Suzanne Van Voorst; released by Zeitgeist Films. At Film Forum 1, 209 West Houston Street, South Village. Running time: 75 minutes. This film is not rated.

J. C. Sullivan	Joseph O'Conor
Interviewer	Roy Ward

By JANET MASLIN

Nowadays, when no behavior is too trivial to be captured by a video camera, it takes some effort to remember that the moving image once seemed a miracle. "The Forbidden Quest," a new film punctuated by archival scenes of early polar expeditions, offers some striking, ghostly reminders of cinema's intrinsic magic.

Antarctica has been photographed more startlingly than it is here, and scenes of polar exploration have been staged with greater visual ingenuity. But these authentic glimpses, shot between 1905 and the 1930's and found by Peter Delpeut in the Netherlands Film Museum, where he is a programmer, capture the daring of film making as an adventure in its own right. Scenes of sailors as they battle the polar elements are doubly audacious, not only because of the sailors' courage but also because a camera was there at all. The icy cliffs of the Antarctic are presented with straightforward awe, in scenes that really convey what the explorers' astonishment must have been like.

Mr. Delpeut, who also directed "Lyrical Nitrate," has assembled a haunting array of images, from the sight of a ship's shadow plowing through frozen waters to the icy breath of the sled dogs on deck. But he has not left well enough alone. "The Forbidden Quest," which opens today at the Film Forum, is a reckless hybrid of fact and fiction, with the archival material packaged as part of an exasperating ghost story.

The film trumps up a tale of Ahab-caliber determination, hungry sailors and very, very unfortunate dogs. It also contrives a lone, long-winded survivor named J. C. Sullivan (Joseph O'Conor), who is supposedly discovered in an Irish cottage in 1941. Sullivan, submitting to a bogus interview about his experience, delivers a molasses-paced account of a ship called the Hollandia and its disastrous 1905 voyage. The portentousness of this narrative detracts needlessly from the honest power of the film's archival scenes, which have been arranged and manipulated to suit the fictitious story.

The dialogue, written by Mr. Delpeut, also happens to be just awful. "Even worse than heaven's rage is her silence — her raging silence," Sullivan says. And: "The ice laughs and smiles, but under her skin she's secretly closing herself, turning to stone." (Sullivan attributes feminine qualities to much of what he describes here, with the blessed exception of a dead polar bear.) Not to mention: "There are creatures smart in silence. Sea lions are tures with a loud pain."

Loud pain aside, "The Forb Quest" is vivid evidence of how stranger than fiction truth can be Delpeut should have let that evid stand on its own.

1994 Ja 5, C15:5

Cabin Boy

Written and directed by Adam Resnick, based on a story by Mr. Resnick and Chris Elliott; director of photography, Steve Yaconelli; edited by Jon Poll; music by Steve Bartek; production designer, Steven Legler; produced by Tim Burton and Denise Di Novi; released by Buena Vista Pictures. Running time: 81 minutes. This film is rated PG-13.

Nathanial Mayweather	Chris Elliott
Calli	Ann Magnuson
Captain Greybar	Ritch Brinkley
Paps	James Gammon
Skunk	Brian-Doyle Murray
Chocki	Russ Tamblyn
Figurehead	Ricki Lake
Earl Hofert	David Letterman

By CARYN JAMES

"Come on over here, honey," coos Ann Magnuson as a six-armed vamp with sapphire-blue skin. "You've managed to charm me with your moronic innocence." Well, we've all got our weaknesses. Hers is Chris Elliott as a pampered rich kid who accidentally wanders onto a ramshackle ship and becomes a cabin boy. During his adventures, he has climbed the side of a mountain to find the seductive Calli. He is bound to return, as he puts it, "a cabin man."

Mr. Elliott knows how to play moronic innocence. He did it as a 30-year-old paperboy on his former television series, "Get a Life," and most successfully in a series of running characters on "Late Night With David Letterman." But there is a limit to how much charm, and how many laughs, he can wring out of deadpan idiocy. What's comic in a skit becomes labored over 81 minutes. The hero's tongue-in-cheek encounter with Calli is one of the few effective

A wily lad takes to the high seas. Will the high seas take to him?

scenes in "Cabin Boy," a film as messy as the ship that Nathanial Mayweather stumbles onto.

Mr. Elliott and the director, Adam Resnick (the co-creator of "Get a Life" and a former Letterman writer), took Mr. Elliott's persona — the guy who's arrogant for no reason at all — and tossed him into a sea of mock adventure-movie clichés, complete with intentionally tacky painted backgrounds. Nathanial has four drunken, smelly shipmates. But recognizing stereotypes isn't the same as giving them good lines.

They are surrounded by self-consciously whimsical and painfully flat touches. A flying cupcake spits tobacco juice at Nathanial in a hallucination. Chocki (played by Russ Tamblyn) is half-man and half-shark, and saves Nathanial's life twice. All this is bizarre without being funny.

The film needed something else: a little manic energy, the profound weirdness of Tim Burton (who is, improbably, a producer of "Cabin Boy") or the quick, absurd wit of Mr. Elliott's appearances on the Letterman show. Mr. Letterman, billed as Earl Hofert, appears briefly as an old salt. His delivery is exactly the same as on television, as he tells Nathanial: "You remind me of my niece Sally. Lovely girl. She's a dietitian." It's a nonsensical moment, and it works better than all the fake adventure that follows.

●

"Cabin Boy" is rated PG-13 (Parents strongly cautioned). It includes strong language.

1994 Ja 7, C12:6

The Air Up There

Directed by Paul M. Glaser; written by Max Apple; director of photography, Dick Pope; edited by Michael E. Polakow; music by David Newman; production designer, Roger Hall; produced by Ted Field, Rosalie Swedlin and Robert W. Cort; released by Buena Vista Pictures. Running time: 88 minutes. This film is rated PG.

Jimmy Dolan	Kevin Bacon
Coach Ray Fox	Sean McCann
Saleh	Charles Gitonga Maina

By JANET MASLIN

Film making is not an exact science, but you might think otherwise watching "The Air Up There," Disney's latest sports clone. Parts of it recall at least three other recent Disney efforts, and those weren't exactly original in the first place. From "The Program": a college coach, doing his best to beat the system. From "The Mighty Ducks": a chance for that coach to train unlikely athletes, redeem himself spiritually and restore his own reputation. From "Cool Runnings": a shift to a third-world setting, nominally exotic but thoroughly Americanized, showing particularly strong signs of American sitcoms. It's a small world after all.

In this film, as in "Cool Runnings," black athletes are trained by a white coach who would look like a terrible know-it-all if he weren't so darn raffish and cute. And from "The Program" again: a party game that definitely should not be copied by the fans. Instead of lying down intraffic, two of this film's characters submit to an African tribal ritual that involves a knife incision in the lower abdomen, just above the groin. Anyone who thinks this will make him a better basketball player should sit down and watch "The Mighty Ducks" until the urge passes.

"The Air Up There" provides Jimmy Dolan (Kevin Bacon), a young coach disgusted with the bribes used to recruit promising college athletes, with a golden and touristy opportunity. One night, having had too much to drink at a testimonial dinner, Jimmy gazes blearily at film of a Roman Catholic missionary school in Kenya, and spies a very tall tribesman bouncing a ball in the background. In a flash, Jimmy is aboard the kind of local African bus that has a live chicken as part of its cargo and a zebra running alongside. He is searching for Saleh (Charles Gitonga Maina), the good-natured, towering athlete he saw on the screen.

Once he reaches his destination, Jimmy devotes himself to persuading Saleh, who is a tribal prince, that he will make a better ruler of his people if he takes a few years off to play team sports at an American college. In the process, Jimmy himself is much improved. He makes new friends, sheds his cynicism and rediscovers the joys of pure basketball. He reaches such a spiritual high that he symbolically tosses his beloved 1981 championship ring off an African mountain.

This white visitor also conveniently solves most of the tribe's problems, which are settled during the obligatory Big Game that ends the movie. The game is livelier and more exciting than most of what precedes it. "The Air Up There," which jokes about the fact that its rural African characters know about ESPN, MTV, the Home Shopping Network and the Sports Illustrated swimsuit issue, manages to make its real African actors and scenery seem not fully authentic. Too many of the film's plot developments could take place on any Main Street, U.S.A.

As directed by Paul M. Glaser and written by Max Apple, "The Air Up There" only occasionally rises above its own perfunctory manner. "Sometimes you've got to put it all on the line and go for it," someone says, summing up the film's prefab philosophy.

Mr. Maina, a 6-foot, 10-inch Kenyan, is warmly appealing even when the film gives him little to do. Mr. Bacon, typically brash at first, eventually succeeds in making himself quite likable, even though the screenplay hangs one comic sequence on his character's diarrhea. Children may find this funny, but the film isn't geared to very young audiences. It includes much more violence and profanity than its PG rating indicates.

"The Air Up There" is rated PG (Parental guidance suggested). It includes strong language and vivid glimpses of the knife ritual described above.

1994 Ja 7, C16:6

DANCE VIEW/Anna Kisselgoff

Why 'The Red Shoes' Is Still a Hit — on Film

WHAT ACCOUNTS FOR THE enduring appeal of the 1948 film "The Red Shoes," a spell that can even compel some to attempt an ill-fated Broadway musical of the same name?

The secret of the film's success was its atmosphere. Vividly, magically, the creative team of Michael Powell and Emeric Pressburger recast the exotic myth of Diaghilev's Ballets Russes (1909-29) in their own era. Yet at the same time, the movie's surface glamour reflected the postwar disillusionment of a specifically European sensibility.

This uneasy but colorful atmosphere, enhanced by surreal images in the ballet that is danced within the movie and based on Hans Christian Andersen's tale of "The Red Shoes," extends the melodramatic plot into an allegorical theme. Amid warring artistic obsessions, the heroine chooses death, literally consumed by her drive to dance.

By contrast, the Broadway adaptation, which closed three days after its opening on Dec. 16, reduced the same plot to a mere love

The ill-fated musical reduced the allegorical theme of the 1948 movie to a mere love triangle.

triangle. In this "Red Shoes," the aspiring ballerina, Victoria (Vicky) Page, is loved not only by the young composer, Julian Craster, but, surprisingly, also by her Pygmalion: the despotic Diaghilev-like impresario, Boris Lermontov. Immediately, the allegorical divide that Vicky faces in the film — Life or Art — is cut down to lower case.

The distinction is crucial. In the film, Lermontov's possessiveness toward Vicky has nothing to do with romantic love but with a domination over the star he wishes to create and mold. When Craster yells, "You're jealous of her," Lermontov's retort is on the mark: "Yes, but in a way you will never understand."

However misunderstood, the film's mystique inevitably led many to consider a stage adaptation. The movie seized the public imagination from the start. Powell himself envisaged a theatrical version shortly after the film's release. The project was never realized. The recent musical, which had excellent choreography by Lar Lubovitch and was the brainchild of the composer Jule Styne and the producer Martin Starger, was short lived, but the film is enjoying yet another local rerun (Film Forum, through Thursday).

The question still remains as to whether it was possible to translate this particular 1948 film into another medium and era. The point is not that in this day and age, it is absurd — as some said about the musical — for a heroine to be torn between a career and a private life. (It isn't.) It is, rather, that the movie had a special tinge of 1940's disillusionment, which, incidentally, informed many European ballets of the time. Roland Petit's street-dress heroes often die after prosaic encounters with symbolic Death figures. Powell and Pressburger strike the same hopeless note. They shoot down the dazzling glamour of the film's ballet milieu and the beauty of its Monte Carlo locale (Diaghilev's base) with Vicky's suicide.

Everything is not beautiful at the ballet but downright bloody. Vicky, maddened by conflicting demands from her husband (Craster) and Lermontov, jumps in front of a train, still wearing the tutu and scarlet toe shoes she put on to dance in the "Red Shoes" ballet.

In a single sophisticated stroke, Powell and Pressburger raise their story of backstage bitchery and onstage glitter to a more allegorical resonance. Vicky, obsessed with dancing, "becomes" the Andersen heroine

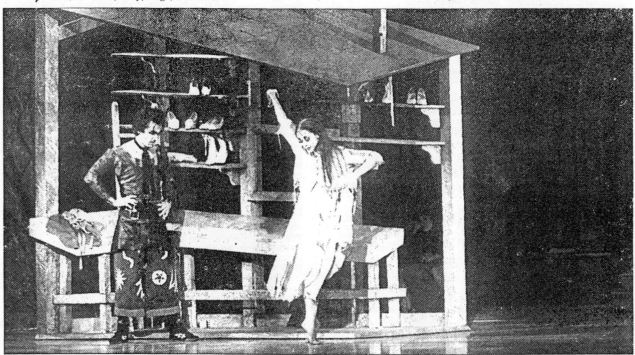

Jim Estrin/The New York Times

George de la Peña and Margaret Illmann on Broadway—Lar Lubovitch's choreography preserved the idea of salvation.

she has depicted in the ballet, a girl who dances to death in a pair of magical red shoes.

The ballet in both the film and the musical is worth comparing to its source. Andersen's "Red Shoes" is strongly moralistic. Karen, a little girl, forsakes her Christian duty and also succumbs to vanity. When she cannot resist the magic red shoes, an avenging angel condemns her to dance to death. In desperation, the girl has an executioner chop off her feet, and the angel forgives the repentant heroine.

In their film, Powell and Pressburger preach no moral: They do not view Vicky's drive to dance as a sin, and they know that Lermontov will find another protégé. Robert Helpmann's ballet, in 1940's street-clothes style, thus has no angel, only a sympathetic priest.

MR. LUBOVITCH'S CHOREOGraphy for the musical's ballet was much better in its mix of classical and contemporary idioms and preserved both the angel and the theme of salvation. He placed the action in Russia, but his medley of images ranged from folk out of "Petrouchka" to a chain of wilis in red shoes from "Giselle"; their ghostly fate was a sardonic warning to the heroine. As the protagonist, Margaret Illmann showed a streamlined energy and impressively strong line, while George de la Peña brilliantly captured Mr. Lubovitch's nod to Leonide Massine's character dancing.

Mr. Lubovitch did even better in his pastiche of styles for the musical's other dance numbers. There was a wonderful rehearsal segment for six men. They performed with amazing resiliency, but they were also self-mocking. This is where the musical, set in the 1920's, shifted into occasional camp and diverged sharply in tone from the movie.

In fact, a major reason for the film's success was its authenticity. The actors in the dancers' roles were virtually playing themselves. Ludmilla Tcherina really was a French-Russian ballerina in the 1940's, Moira Shearer really was a British dancer on the rise and Mr. Helpmann really was a male ballet star. Massine, as the ballet master, had once been Diaghilev's main choreographer, and Marie Rambert, who makes a cameo appearance, left Diaghilev to become a founder of British ballet. Unlike their counterparts in the musical, these characters had emotions that rang true. □

1994 Ja 9, II:6:1

Sure Fire

Written, directed, filmed and edited by Jon Jost; music by Erling Wold; produced by Henry S. Rosenthal; released by Strand Releasing. Joseph Papp Public Theater, 425 Lafayette Street, East Village. Through Jan. 20. Running time: 86 minutes. This film is not rated.

Wes.....................................Tom Blair
BobbiKristi Hager
Larry..................................Robert Ernst
Ellen..................................Kate Dezina

By STEPHEN HOLDEN

"Sure Fire," Jon Jost's scathing character study of an ambitious land developer in the rural part of Utah that has been called the Mormon Dixie, might as well have been called "The Last American Patriarch." The film's central character, Wes, who is portrayed by Tom Blair with the intensity of a coiled cobra about to

strike, isn't just any old modern-day frontiersman. He is presented as the grimly self-righteous and puritanical embodiment of primitive code of values in which the meaning of life is defined by the ritual of the deer hunt.

As the film makes almost too clear in its climactic hunting sequence, preparing to kill an animal is much more than a sport for people like Wes. It is a rite of purification and a sexual substitute. The hunters talk of their first kills in the same mystical tones that others might adopt in describing their loss of virginity.

The film, which opens today at the Joseph Papp Public Theater, begins with a scene in which the camera eavesdrops on a conversation Wes is having in a cafe with his friend Larry (Robert Ernst) about a local woman named Sandra-Jean, who has disappeared. Inklings of Wes's loathing for

Strand Releasing

Tom Blair, center, with, from left, Robert Ernst, Dennis R. Brown and Phillip R. Brown in a scene from Jon Jost's "Sure Fire."

women leak out when he mutters darkly that her place never smelled clean.

Developed more like an essay than a conventional narrative film, and augmented with surreal touches, "Sure Fire" meticulously takes the measure of Wes's life. Indefatigably self-confident, he has embarked on a grand scheme to buy up local real estate and sell it to Californians looking for a clean environment with good hunting, fishing and skiing. As the camera leisurely surveys the ruggedly beautiful landscape of south-central Utah, with its fiery autumn leaves under deep blue skies, Wes's scheme seems almost sure-fire. All it will take is the kind of ruthless perseverance that he has in abundance.

At home with his wife, Bobbi (Kristi Hager); son, Phillip (Phillip R. Brown), and daughter, Haley (Haley Westwood), Wes behaves like the king in his castle. Bobbi is expected to double as a secretary. His children must address him as sir.

Wes's friendship with Larry is also anything but relaxed. In one of the film's most dramatic scenes, he tries to browbeat Larry into working for him, ostensibly to save the friend from losing the ranch his family has held for several generations. It is instantly clear that Wes would be hell to work for.

Even more chilling is a scene in which Wes ceremoniously presents the 16-year-old Phillip with his first hunting rifle and gives elaborate instructions on how to care for the weapon.

Many of the scenes in "Sure Fire," which was filmed on location using local residents in several of the smaller roles, have an almost documentary authenticity. But Mr. Jost, an experimental film maker known for putting an idiosyncratic personal stamp on his work, ostentatiously subverts these quasi-documentary leanings. Three times during the film, sacred texts of the Church of Jesus Christ of Latter-day Saints are scrolled across the screen in red letters. These interpolations lend the film an ominously portentous atmosphere. That sense of foreboding is borne out in the film's climax, an abruptly melodramatic sequence that is its weakest and most awkward moment.

"Sure Fire" makes only a token effort to explore the lives of its female characters, in a scene between Bobbi and Larry's wife, Ellen (Kate Dezina). Their dialogue focuses on the description of a dream about a bird caught in a barbed-wire fence, a metaphoric conceit that is a poor substitute for more down-to-earth characterization.

But for all its quirks and lapses, "Sure Fire" has an indelible resonance. If its portrait of an archetypal patriarch is unsparing, it is also convincing. Wes, stalking through the forest, his rifle slung over one shoulder, is a figure sprung right out of the landscape through which he moves with deadly authority.

1994 Ja 12, C13:1

House Party 3

Directed by Eric Meza; written by Takashi Bufford, based on a story by David Toney and Mr. Bufford, and characters created by Reginald Hudlin; director of photography, Anghel Decca; edited by Tom Walls; music by David Allen Jones; production designer, Simon Dobbin; produced by Carl Craig; released by New Line Cinema. Running time: 94 minutes. This film is rated R.

Kid.............................Christopher Reid
Play............................Christopher Martin
Stinky.........................David Edwards
Veda...........................Angela Means
Sydney........................Tisha Campbell

By CARYN JAMES

There is a major cosmetic change in the latest edition of the "House Party" series, starring the hip-hop team of Kid 'N Play. Kid has traded in his improbably high fade haircut — the one that made people call him "eraserhead" in the original movie — for a topknot of dreadlocks. But it would take more than that to keep this series fresh. "House Party 3" has lost the loose-limbed, high-spirited spark of the original "House Party" (the director Reginald Hudlin's knock-'em-dead debut) and the fun-loving spirit of "House Party 2" (directed by Doug McHenry and George Jackson).

●

"House Party 3," which had its low-profile opening yesterday, begins

Nicola Goode/New Line Cinema
Christopher Reid

with the smart-sounding premise that Kid 'N Play can't pretend to be partying teen-agers forever. Kid (Christopher Reid) is engaged to be married, and Play (Christopher Martin) arranges what's meant to be a blowout bachelor party.

Kid's fiancée, Veda (Angela Means), is set to have a premarital party of her own. This time Kid's three prepubescent cousins — the hip-hop group Immature, playing themselves — are the ones who plot a forbidden house party.

If you haven't seen the first "House Party" films, there's no point in trying to catch up now. And if you have, there's still no point in witnessing this dull by-the-numbers sequel. You can see every party mix-up coming from here.

"House Party 3" shows other signs of late-serial desperation. This edition is rougher, less Cosby, than the earlier movies. Each of the three parties has its own stripper, providing equal-gender exploitation for male and female dancers. There is a string of fat-lady jokes. Still, this is a far cry from gangster rap.

The comedian Bernie Mac has some high-energy moments as Kid's brash Uncle. Kid 'N Play themselves

A bachelor party revives the 'House Party' series. The news is the hair.

haven't lost their appeal. They're just trapped in a cookie-cutter script that even makes the music blend into the background (an odd situation, since this is the first film by Eric Meza, a music-video director). Immature seems to get the most musical screen time. They're cute, but they're not movie stars.

•

"House Party 3" is rated R (Under 17 requires accompanying parent or guardian). It includes strong language and sexual suggestiveness, but no nudity.

Critic's Notebook

Sex and Terror: The Male View Of the She-Boss

By JANET MASLIN

LORENA BOBBITT aside, there are some very scary women out there. And the scariest of all, whether in the news or in the forefront of popular culture, are suddenly high-powered career types with a yen to humiliate men. The motivating force in "Mrs. Doubtfire," the season's most popular film, is a woman who kicks her husband out for no good reason, and whose crisp professionalism is presented as her worst character flaw. Meanwhile, back at the bookstore, Michael Crichton's latest movie-on-paper is "Disclosure" (Alfred A. Knopf), about a female executive who connives her way to the top and then tries to force an ex-boyfriend to have sex with her.

"Remember the night we broke the bed?" Mr. Crichton's Meredith Johnson asks playfully, at the start of a closed-door session that is supposed to be a business meeting. But Tom Sanders is suspicious, as well he should be: Meredith forces a drink on him, then arranges for her assistant (also a woman) to deliver a package of condoms and lock the door to Meredith's office. If Senator Bob Packwood were accused of this particular behavior it might sound embarrassingly clumsy, but Mr. Crichton presents Meredith as a serious threat to Tom's well-being. "She moved toward him in a steady, confident way, almost stalking," he writes in another scene.

America's fear of the she-boss goes right to the top, with David Brock's risible descriptions in The American Spectator of Hillary Rodham Clinton as a foul-mouthed, trooper-bashing harpy intent on abusing her position. Even scarier are Vanity Fair's current photographs of a lingerie-clad Roseanne Arnold, one of the most daunting women in show business, done up as every man's sexual nightmare as she discusses her extremely powerful position in television. What's going on here? Whatever it is, it certainly looks toxic, at least where the link between sex and power is concerned.

An interesting corollary to the mass-market popularity of "Mrs. Doubtfire" is the critical and arthouse success of "Naked," Mike Leigh's portrait of a staggeringly caustic English drifter whose anger often takes the form of verbal and sexual brutality toward women. The fact that the film's lonely, alienated women are so receptive to abuse from Johnny (David Thewlis), who is himself so tormented, gives "Naked" its complexity, and even a semblance of social commentary. (What has made the lives of Johnny's conquests so uniformly desolate?) But much of what fuels "Naked" is one man's

sexual rage against those who underscore his feelings of helplessness, and women bear the brunt of his fury.

"Naked" makes no bones about its vituperativeness, or about the desperation that lies behind that feeling. But when working within mainstream popular culture, it's necessary to be more careful. So the sugar-coated "Mrs. Doubtfire" tries to sound reasonable as it explains the breakup of Miranda (Sally Field) and Daniel Hillard (Robin Williams) over irreconcilable differences, mostly having to do with professional disparities. Miranda, who works in decorating, is supposed to be hard-hitting and ambitious. Daniel, an actor, is supposed to be the saner and nicer of the two, which just goes to show what can happen when an actor (Mr. Williams) and his wife (Marsha Garces Williams) become co-producers of their own movie.

As a comedy about a man in a dress "Mrs. Doubtfire" inevitably recalls "Tootsie," but there's an important difference. At the end of his masquerade, Dustin Hoffman's character in "Tootsie" realized that pretending to be a woman had made him a better man. "Mrs. Doubtfire" takes that idea a notch higher by suggesting that Daniel, a.k.a. Mrs. Doubtfire, is now a better mother than his wife ever was, since Miranda spends so much time studying fabric swatches at the office.

•

Among the many interesting questions "Mrs. Doubtfire" never answers is why Daniel needed to be evicted by his wife in order to discover what a terrific parent he could be. Incidentally, any man in Daniel's position would probably consider suing his wife for support payments, but this film isn't willing to face the angry side of its own premise.

Mr. Crichton doesn't have that problem: "Disclosure" is eager to vent its anger against a woman like Meredith Johnson, who has been given an unwarranted promotion at the expense of men who consider themselves more qualified. "Pale males eat it again," observes one of Tom's resentful colleagues. "I keep coming back to the idea that we have to make allowances for women," Tom's boss explains. "We have to cut them a little slack."

Ever the skilled technician, Mr. Crichton takes pains to state that the men at Digital Communications Technology, the large company in whose Seattle office Meredith and Tom work, resent Meredith only because of her dubious track record. She is in no way typical of all female executives, which is why it's all right for Tom to keep remembering that she used to favor white stockings and a white garter belt decorated with little white flowers.

Similarly, the fact that Meredith is a former Miss Teen Connecticut and

Phil Bray/Twentieth Century Fox
The scary career woman: Sally Field in "Mrs. Doubtfire."

has taken great advantage of her good looks is not meant to have sexist connotations. Neither is the fact that Meredith, whose sexual overtures are rejected by Tom, later claims that Tom tried to rape her. Not all women behave this way. Maybe it's only the ones who tap into today's angry zeitgeist, and whose stories (like "Disclosure" are headed for the big screen.

•

Poor Tom: it's bad enough that he works in a place where the small talk is pure technospeak ("if the laser read-write heads are out of sync with the m-ubset instructions off the controller chip, what is that going to mean for us, in terms of down time?"). To add insult to injury, does he also have to have a boss who chases him around the office, and a busy, hardboiled wife (a lawyer) who browbeats him for not spending enough time taking care of the children? It's not hard to fathom the depth of anger in either Tom or Daniel Hillard. What's more mysterious is the way that anger manifests itself in works of popular entertainment that try to maintain an evenhanded tone.

So in "Mrs. Doubtfire," Daniel doesn't voice any overt hostility toward Miranda; he just snipes at her new boyfriend, in a series of antics that are thinly disguised as mere sexual jealousy. And he mutters about his mother-in-law. This film's real cattiness lies in its casting, since the perky, brittle Ms. Field can't match Mr. Williams's child-pleasing abilities. Naturally, Miranda comes in second in the parenting department.

And there's so little chemistry between Ms. Field and Mr. Williams that the film doesn't even bother to drum up a flashback about their happy courtship. No one would believe that these two were once lovestruck newlyweds. It would be easier to convince audiences that Daniel, as a male Supermom, found his children in a cabbage patch or experienced some form of immaculate conception.

Last year brought us a number of films about sick ("My Life"), repressed ("The Remains of the Day"), traumatized ("Fearless"), griefstricken ("Sleepless in Seattle") or otherwise dysfunctional men. So if what we're seeing now is male characters who have found a target for their anger, perhaps it represents some form of progress. In any case, the men behind these latest tales of helpless men and overbearing women have moved beyond the point of getting mad. Now they're getting even.

Iron Will

Directed by Charles Haid; written by John Michael Hayes, Djordje Milicevic and Jeff Arch; director of photography, William Wages; edited by Andrew Doerfer; music by Joel McNeely; production designer, Stephen Storer; produced by Patrick Palmer and Robert Schwartz; released by Buena Vista Pictures. Running time: 104 minutes. This film is rated PG.

Will Stoneman	Mackenzie Astin
Harry Kingsley	Kevin Spacey
J. P. Harper	David Ogden Stiers
Ned Dodd	August Schellenberg
Borg Guillarson	George Gerdes
Jack Stoneman	John Terry

By JANET MASLIN

"Iron Will," a dandy film for dog-sledding enthusiasts the world over, is a dicier bet for audiences less tempted by the call of the wild. Based on the real story of a 1917 dog-sled race from Winnipeg, Manitoba, to St. Paul, it tells of how young Will Stoneman (Mackenzie Astin) enters the competition as, pardon the expression, an underdog. "Don't let fear stand in the way of your dream, son," counsels Will's father (John Terry) shortly before becoming a casualty of the dog sled himself. "Why didn't you pull him out, Gus?" Will asks the film's leading canine actor after his father drowns in icy waters.

Fueled by grief, determination, a lot of homespun boosterism and his mother's special fruitcake, Will overcomes mountainous odds as he struggles to the head of the pack. The movie means to be quaint about Will's adventure, providing flag-waving fans to cheer his progress and actually referring to him as a "plucky lad." "Pembina Welcomes Dog Derby Mushers," reads a banner in one town. As war looms on the horizon, a newspaper headline declares: "America Finds New Hero in Iron Will."

But "Iron Will" has a thoroughly 90's outlook, despite the vintage railroad cars that carry the avid press contingent following the dog-race's progress. So Will's celebrity becomes a prominent part of the story, even if the film means to make a bitter commentary on the media and its feeding frenzies. Socking a reporter, Will says: "That's for using me and my family to sell your damn newspapers, and printing pictures that'll make my mother worry." Who couldn't say that today?

In tune with its modern outlook, "Iron Will" also supplies a mystical American Indian character (August Schellenberg) to help coach Will to a higher plane, and enough mean-spirited fellow sledders (including George Gerdes) to give the story a competitive edge. There is also a mantra of sorts, a special tune that was once whistled by Will's father and becomes the younger man's rallying cry. Its four notes, played twice, sound exactly like the "But you'd look sweet upon the seat" part of "Daisy, Daisy."

The dog race that is central to the story is exactly that, a dog race. The film's four-legged, blue-eyed actors have a limited repertory, and the sledding itself soon begins to seem familiar, no matter how challenging it actually was to film. As directed by Charles Haid, "Iron Will" sounds wholesome and looks lively without having any special flair. The screenplay, credited to three writers, originated in 1971 with an idea first com-

John Bramley/Walt Disney Company
Mackenzie Astin

missioned by Bing Crosby's production company and was more recently worked on by Jeff Arch ("Sleepless in Seattle"). Despite this lively history, the material seldom rises above the level of upbeat platitudes.

Mr. Astin is earnest, as are the actors who play his relatives and friends. The story's most colorful actors have relatively minor roles, like that of Harry Kingsley (Kevin Spacey), a once-cynical journalist who is of course inspired to new heights by Will's story. "You know," he finally says, "last night for the first time since I've been in the newspaper business, I actually felt excited by what I do for a living." In the same vein, David Ogden Stiers plays the tycoon who sponsors the race and, upon watching Will, says, "When I look in that boy's eyes I see myself 35 years ago." Mush.

•

"Iron Will" is rated PG (Parental guidance suggested). It includes very mild profanity.

1994 Ja 14, C6:3

Critic's Choice/Film

A Young and Promising Kubrick

"Fear and Desire," a 1953 film "directed, photographed and edited by Stanley Kubrick," is a skeleton in Mr. Kubrick's closet. Or at least that's the way he sees it: Mr. Kubrick recently asked Warner Brothers to issue a letter to call this fledgling effort a "bumbling, amateur film exercise" and "a completely inept oddity, boring and pretentious." Nevertheless, "Fear and Desire" opens today for a weeklong run at the Film Forum, together with "Killer's Kiss," Mr. Kubrick's second feature.

Hindsight can be very convenient in a case like this. It would be nice to think that the film maker's first feature, made when in his early 20's on a budget of $40,000 and then described as "a drama of 'man' lost in a hostile world," is a harbinger of things to come. And as a matter of fact, "Fear and Desire" is better than the director now says it is, although his own description is largely fair. Definitely pretentious, and indeed sometimes boring, the 68-minute "Fear and Desire" is still a revealing and in some ways impressive effort. The few viewers who saw it in 1953 — among them the critic James Agee, who offered backhanded praise — must have realized it was a work of great promise.

"Fear and Desire" features a thin, morose, baby-faced Paul Mazursky as one of four soldiers enduring an exercise in high school existentialism. Trapped behind enemy lines in an unspecified war (but actually outdoors in the San Gabriel mountains, thus saving Mr. Kubrick any expenses for sce-

Two works by a talent in the embryonic stage.

nery), they ponder their fate. The screenplay, by the director's Bronx high school friend Howard Sackler (who later won the Pulitzer Prize for "The Great White Hope"), would not have passed muster with any film maker a day over 25, which may be why Mr. Kubrick chooses to renounce the film now. But its editing is superb, its compositional sense quite striking, and its cinematography uncommonly handsome for a low-budget film by a neophyte. For Kubrick aficionados, this rare and quirky artifact is a must.

"Killer's Kiss" brought the director onto more conventional territory, with a film noir plot about a boxer, a gangster and a dance hall girl. Using Times Square and even the subway as his backdrop, Mr. Kubrick worked in an uncharacteristically naturalistic style despite the genre material, with mixed but still fascinating results. The actress playing the dance hall girl, billed as Irene Kane, is the writer Chris Chase, whose work has frequently appeared in The New York Times. Frank Silvera plays the boxer, whose career is described as "one long promise without fulfillment." In the case of Mr. Kubrick's own career, the fulfillment came later. But here is the promise.

"Fear and Desire" and "Killer's Kiss" run through Thursday at the Film Forum, at 209 West Houston Street in the East Village. Admission is $7.50. Screening times and other information: 212-727-8110.

JANET MASLIN

1994 Ja 14, C6:3

Death Wish V
The Face of Death

Directed and written by Allen Goldstein; produced by Damian Lee; released by Trimark Pictures. Running time: 95 minutes. This film is rated R.

Paul Kersey	Charles Bronson
Olivia Regent	Lesley Anne Down
Chelsea Regent	Erica Lancaster
Tommy O'Shay	Michael Parks
Lieut. King	Kenneth Welsh

By STEPHEN HOLDEN

Among the devices used to maim, torture and kill in "Death Wish V: The Face of Death" are an industrial sewing machine, a steam press, an acidic chemical bath and a shrink-wrap machine that trusses up a victim who is then suspended on a hook like an item of laundry. These tools of the trade are in a clothing factory that is the setting for the film's creepier action sequences. There is also a soccer ball, operated by remote control that explodes in someone's face.

But the most grisly scene in a movie that has one of the highest levels of gratuitous sadism to be found in a modern film, is one in which a mobster in drag follows a beautiful woman into the ladies room of a restaurant, gags her and repeatedly smashes her face into a wall mirror.

"Death Wish V," which opened locally on Friday, is the latest, and one hopes the last, in the 20-year-old series starring Charles Bronson as Paul Kersey, a middle-class civilian who takes the law into his own hands. Even though its characters tote cellular phones and live in ultramodern high-rise apartments, the film still has a sleazy 1970's ambiance. And while Mr. Bronson goes through the motions of revenge with his characteristic deliberation, he looks puffy and sounds terminally bored.

In this episode, Kersey, who is teaching in a suburban New York college, reluctantly returns to vigilantism when his fiancée, Olivia (Lesley Anne Down), a fashion model turned clothing manufacturer, is menaced by organized crime. Adding a nasty twist to a preposterous plot is the fact that Tommy O'Shea (Michael Parks), the head racketeer, is Olivia's ex-husband. In the screenplay by Allen Goldstein, who directed, Tommy emerges as a sadistic, racist, child-hating archfiend.

What is especially repugnant about the "Death Wish" movies is the cruelty with which the supposedly mild-mannered Kersey dispenses vigilante justice. It isn't enough that the bad guys eventually get theirs. They must look their avenger in the face before being executed with maximum agony and humiliation. When Tommy is finally pushed into a swirling acidic bath, the camera makes sure he surfaces at least twice, missing several layers of skin and still screaming.

•

"Death Wish V" is rated R. In addition to scenes of extreme violence and cruelty, it includes nudity and strong language.

1994 Ja 17, C18:1

Secuestro: A Story of a Kidnapping

A documentary, directed and produced by Camila Motta (in Spanish with English subtitles); director of photography, Barry Ellsworth; edited by Holly Fisher; music by German Arreta and Nicolas Uribe. At Film Forum, 209 West Houston Street. Running time: 92 minutes. This film has no rating.

By STEPHEN HOLDEN

"Secuestro: A Story of a Kidnapping," Camila Motta's documentary

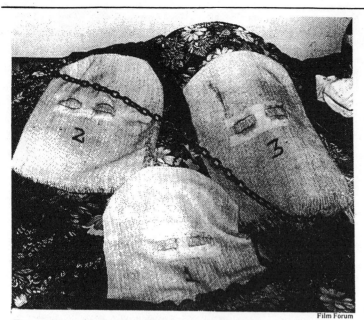

The masks and chains used by the kidnappers in Camila Motta's documentary "Secuestro: A Story of a Kidnapping."

Film Forum

film about an abduction in Colombia, is really the story of an excruciatingly delicate, drawn-out business negotiation. There is no overt violence or melodrama in this laborious day-by-day account of the kidnapping of the film maker's 20-year-old sister, Sylvia, in 1985 by 10 armed men while she was on her way to school.

It took three months of telephone negotiations between Sylvia's father, a banker in Bogotá, and the kidnappers to secure Sylvia's release. Among other things, the film, which opened today at Film Forum 1, is a sort of cinematic primer on keeping your head while under extraordinary emotional stress. Had her father become hysterical, the film suggests, Sylvia would probably not have survived her ordeal.

The film also places the abduction in a wider social context. While audiotapes of the telephone exchanges are played, the camera roams around Bogotá casually surveying the urban blight. The crude home-movie cinematography takes pains to chronicle the economic inequity between families like the Mottas, who live in well-manicured upper-middle-class neighborhoods, and the underprivileged majority.

Largely because of that inequity, the film suggests, kidnapping has become a steady and lucrative business in Colombia, with one occurring every seven hours.

•

Although the subject is grim and the negotiating tense, "Secuestro" has such a dry, methodical tone that it often becomes tedious. The film weaves interviews with family members, the police, kidnapping experts and the recollections of the victim and one of her captors into a dispassionate dossier that keeps the emotions at arm's length.

"Secuestro" devotes much of its energy to detailing the war of nerves between Sylvia's father and one of her abductors, who calls himself Frank. Frank, who claims to have made a detailed study of the family's finances, initially demands 60 million pesos (around $450,000) for her release, but after weeks of haggling he finally agrees to accept less than a

fourth of that amount. The bargaining is done in conversations that never last more than 30 seconds lest the caller's location be discovered. It isn't long into the movie before these little colloquies all begin to blur into the same monotonous staccato ritual.

•

The film's most absorbing moments are the reflections on her captivity by Sylvia, who spent the entire three months with one leg chained to a bed. Initially hopeful but later despairing and angry, Sylvia, even in her worst moments, seems to endure the experience with a remarkable equanimity. In keeping with the film's attitude of chilly objectivity, only her tape-recorded voice is heard through much of the film. She doesn't appear on the screen until the end.

For the rigor with which she has turned wrenching family drama into a social casebook study, the film maker deserves a certain admiration. But the price of that assumed objectivity, in the loss of dramatic, emotionally gripping material, is very steep.

1994 Ja 19, C20:1

Luna Park

Directed and written by Pavel Lounguine (in Russian with English subtitles); director of photography, Denis Yevstigneyev; music by Isaac Schwartz; produced by Georges Benayoun; released by Northern Entertainment. At the Papp Public Theater, 425 Lafayette Street, East Village. Running time: 107 minutes. This film has no rating.

Naoum	Oleg Borisov
Andrei	Andrei Goutine
Alyona	Natalya Yegorova
The Aunt	Nonna Mordiyoukova
The Mute	Mikhail Goloubovich

By JANET MASLIN

Made in 1991, Pavel Lounguine's "Luna Park" now seems eerily prophetic in its depiction of brawny Russian neo-facists, a gang of thugs who may look buffoonish but are capable of causing real danger. The goons who set this story in motion hold court in an amusement park, where they randomly engage in drunken, violent outbursts. It's some measure

of this film's tumultuousness that Andrei (Andrei Goutine), the brutish central character, takes solitary rides on a roller coaster in order to collect his thoughts and calm down.

The roller coaster is used to suggest the wild, breakneck trajectory of a society gone out of control, which gives "Luna Park" some common ground with Mr. Lounguine's earlier "Taxi Blues." Once again, the film maker offers a startlingly vivid cross-section of a crumbling Russia, and strikes sparks off the relationship between an angry, musclebound anti-Semite and a dissipated Jewish musician.

In "Taxi Blues," they were accidental acquaintances; this time they are blood relatives. Early in the story, Andrei is told by his drunken, mocking friend Alyona (Natalya Yegorova) that he is actually half-Jewish, and that his father was not an Aryan military hero after all. Andrei is enraged to learn he is the son of Naoum (Oleg Borisov), a dapper old reprobate who does everything he can to escape the harsh realities of Russian life. Naoum is the sort of cagey, tattered survivor whose very existence is seen by Mr. Lounguine as a victory of art over misery.

•

Naoum worries noisily about his prostate, drinks enthusiastically at breakfast and has made his large, rambling apartment home to any band of oddballs who care to use it. (The film at one point glimpses a meeting of the Ecological Association of the Great North, a band of Eskimos with a tent and a computer.) Naoum can maintain his equanimity in the face of any hardship, save perhaps for the news that he has Andrei for a son.

This revelation nearly gives the older man a heart attack, but even in distress Naoum is wily. He climbs out of the ambulance that has come to get him, insisting that sickness is a lot better than Russian medical care. Mr. Lounguine is able to both find humor in the older man's scrappiness and demonstrate that the problems being satirized are very real.

"Luna Park," which opens today at the Papp Public Theater, is a messier and more turbulent work than "Taxi Blues," which itself was deliberately rough around the edges. This time, Mr. Lounguine writes and directs in a deliberately elliptical fashion, never bothering to explain what the Eskimos are doing in the apartment or indeed why anything else is happening as it does. The film's angry assertiveness is allowed to speak for itself, just as Andrei's way of pushing and shoving others as he talks to them has its own obvious urgency. This narrative style is deliberately explosive, but it is distractingly incomplete. "Luna Park" is a visceral, passionate film that would have been much improved if its storytelling were less oblique.

•

But Mr. Lounguine is a tough, idiosyncratic film maker who makes very deliberate choices. In the role of Andrei, he has cast a muscular, blandly handsome bodybuilder with no acting experience ("a socialist realist fresco become flesh and blood," the director has said of his character) and a bellicose air.

The film cares less about Andrei's private thoughts, which often seem anguished and impenetrable, than about the forces that have produced him. Part dramatist and part explorer, Mr. Lounguine simply observes this angry, inarticulate young tough,

treats him as an emblematic Russian specimen, and wonders what his future will bring.

"Luna Park" is often murky and jumbled, but it becomes genuinely wrenching as it captures Andrei's frustration with his boozy, vicious comrades. "I believe that violence is mostly a collective phenomenon, and that escape is an individual experience," Mr. Lounguine once told an interviewer, thus offering an apt description of his film's overriding vision.

Sometimes the parts of "Luna Park," in all their exhausting squalor, overwhelm the whole. Audiences will be as apt to remember the furtive gatherings in Naoum's apartment, the mute horticulturalist who peddles grenades, the savage brawls and the futile merrymaking glimpsed in Mr. Lounguine's ragged tapestry, as they will the central story of a father, a son and a gulf almost too wide to cross.

1994 Ja 21, C6:5

The 24th International Tournée of Animation

A series of 14 animated short films, produced by Terry Thoren; released by the Samuel Goldwyn Company. At the Angelika Film Center, 18 West Houston Street, Greenwich Village. Running time: 90 minutes. This film has no rating.

By STEPHEN HOLDEN

That an animated film can convey the feeling of being pummeled in a boxing ring with a visceral intensity that matches the prizefighting sequences in Martin Scorsese's "Raging Bull" says much about the advanced state of the art of movie animation. The film that accomplishes this, Daniel Suter's "Square of Light," comes from Switzerland and lasts less than five minutes. But with splaying crayon flashes, splats and swirls, synchronized with a soundtrack of thuds and crowd noises that vibrates with the dizzying sense of someone going in and out of consciousness, the film evokes brutal physical contact with a startling intimacy.

"The Square of Light" is one of several dazzling short films that make "The 24th International Tournée of Animation," a 14-part survey of artists and styles, well worth a look. Like previous anthologies in the series, this one, which opens today at the Angelika Film Center in Greenwich Village, casts a wide stylistic net. You will find everything from latter-day descendants of "The Flintstones" and prehistoric cousins of the dinosaurs in "Jurassic Park" to a thoughtful Eastern European surrealism. The selections are arranged in an entertaining variety format so that the darker works are often sandwiched between lighter, jauntier cartoons.

Paul Berry's 10-minute film "The Sandman" does for child psychology what "The Square of Light" does for the body under attack. The British animator has spun an eerie fairy tale of nighttime terrors in which a little boy who is afraid of the dark is visited in his bed by a sinister creature that is a hybrid of a human and a haughty, beady-eyed bird of prey.

Mr. Berry, who was the lead animator on "Tim Burton's Nightmare Before Christmas," has an uncanny knack for evoking a distorted reality in which the familiar world is re-

imagined as a warped, angular environment suffused with threat, as it might look and feel in a child's fever dream. The setting is a decrepit, haunted-looking house streaked with ominous shadows. And the boy has a remote, forbidding mother who seems more frightening than comforting when he cries out for her in the middle of the night. "The Sandman" goes all the way in imagining a young mind consumed with terrifying phantasms.

"The Sandman" is considerably more successful than "The Stain," another British film about childhood and, at 11 minutes, the program's longest movie. Created by Marjut Rimminen and Christine Roche, "The Stain" tells a troubled family history from the dual perspective of identical twins. Its characters and images, although inventive, lack the psychological resonance to bring to life a fable that has an abrupt and shocking ending.

On the artier side, the Czech film maker Michaela Pavlatova's "Words, Words, Words" depicts cartoon balloon conversations in which colors and body language communicate a range of emotions, all without verbalization. The Swiss animator Georges Schwizgebel's film, "The Ride to the Abyss," is an elaborate exercise in sophisticated cartoon pageantry set to a fragment of Berlioz's "Damnation of Faust."

The program's centerpiece is a 21-minute salute to Will Vinton, the American animator who pioneered Claymation, the computer-driven style featuring three-dimensional clay puppets, the most famous of whom are the California Raisins. In a program abounding with technical virtuosity, the Vinton studio's work stands out for its almost photographic cartoon realism. The images are sharp and exquisitely rounded and detailed, and anything can magically metamorphose into anything else.

The salute interweaves a number of the studio's best television ads with more abstract noncommercial shorts, like "Cool Tools," a hip-hop ballet for hammers and nails, and "Mr. Resistor," the amazing adventures of an aggressive little light fixture. The Vinton studio's work may not have much psychological heft. But as an enraptured celebration of technological wizardry, it is in a class by itself.

1994 Ja 21, C6:5

Intersection

Directed by Mark Rydell; written by David Rayfiel and Marshall Brickman; director of photography, Vilmos Zsigmond; edited by Mark Warner; music by James Newton Howard; production designer, Harold Michelson; produced by Bud Yorkin and Mr. Rydell; released by Paramount Pictures. Running time: 98 minutes. This film is rated R.

Vincent Eastman.........................Richard Gere
Sally Eastman...............................Sharon Stone
Olivia Marshak....................Lolita Davidovich
Neal...Martin Landau
Richard Quarry.............................David Selby
Meaghan Eastman..................Jenny Morrison

By JANET MASLIN

"Intersection," a film about a man, two women and a traffic accident, could not have been more crazily miscast if those responsible had worn blindfolds and pulled names out of a hat. Its biggest gaffe — and, naturally, its biggest drawing card — is Sharon Stone's appearance in the role

of Sally Eastman, a woman so sexually standoffish that she complains when her lover wrinkles her dress.

"What's a girl have to do to get a little action around here?" Ms. Stone also asks, even though all of her star power is predicated on knowing the answer to that question. Two smaller but equally unconvincing details are the fact that Sally lives in Vancouver, British Columbia, and that her estranged husband has taken up with a feminist-magazine columnist. The film's nuttiest scene finds the husband (Richard Gere) and his girlfriend (Lolita Davidovich) using her breasts as clues in a giggly bedroom game. Yes, that's right: he traded in Sharon Stone for a woman who likes to play topless charades.

The husband, Vincent Eastman, is a successful architect whose whole life flashes before his eyes during the course of the film. As played by Mr. Gere, Vincent is a big kidder. Levity may not be Mr. Gere's strong suit, but this time he beams and jokes even more compulsively than he did in "Mr. Jones," a film that cast him as a clinical manic-depressive.

Despite Vincent's playful exterior, the audience is meant to regard him as a man with a lot of excess baggage in his life, like the yacht on which he first makes love to his girlfriend. "I'm sorry," he says during this seduction scene. "I'm not very good at this." Mr. Gere's delivery of this line ranks right up there with Ms. Stone's complaints about not wanting to have her clothes mussed.

Ms. Davidovich, as the third of the story's frisky Canadians, has the sort of role Valerie Perrine has often played, that of the tarty but tender-

A cold wife and a warm girlfriend can be hazardous.

hearted mistress of a difficult man. Anyone who believes that this bombshell's magazine column is the talk of Vancouver may also be convinced that Mark Rydell, the film's director, employs arty shots of an elaborate brass clock because time is significant in this story. Actually, "Intersection" has time on its hands.

•

As a soap opera elevated by its stellar cast and given the illusion of contemplativeness by repeated slow-motion shots of a car crash, "Intersection" really ought to be more fun. But despite the glossiness, it winds up seeming profoundly uneventful, perhaps because the car crash is the story's only real dramatic turn. The film's uncredited fourth star, the scenery of Vancouver, adds visual appeal without raising the energy level, although Harold Michelson's lavish production design will hold an audience's interest.

Beginning after the fact of the Eastmans' marital breakup, the film flits moodily from scenes of their courtship (Ms. Stone wears a Barbie-doll hairdo) and brittle later life (Ms. Stone does Grace Kelly, right down to the pocketbook), with occasional giddy glimpses of Vincent's second chance with Olivia (Ms. Davidovich). But beyond the drama of one man's intense and myopic self-scrutiny, "Intersection" has no real forward motion. It's unclear which of the two

accomplished writers credited with "Intersection," David Rayfiel (several Sydney Pollack films) and Marshall Brickman ("Annie Hall"), has a taste for charades.

One of this film's few revelations, beyond the fact that it is painful to be a successful architect with two beautiful women in your life, is that Ms. Stone may really make the transition from sex goddess to movie queen if she ever finds the right role. Wearing sleekly attractive costumes and a graceful, determined air, Ms. Stone shows the kind of photogenic fortitude that was everything in the 1940's and is only a memory today. If there's any contemporary actress who is equipped to re-invent that kind of stardom, it's Sharon Stone.

•

"Intersection" is rated R (Under 17 requires accompanying parent or adult guardian). It includes nudity and profanity.

1994 Ja 21, C8:6

Critic's Choice/Film

Altman: Then and Now

Robert Altman has always been ahead of his time. Long before "Unforgiven" made revisionist westerns trendy, Mr. Altman directed "McCabe and Mrs. Miller," a lyrical and hardheaded masterpiece with Warren Beatty as a two-bit gambler and Julie Christie as a madam in a ramshackle mining town. The 1971 film only looks better with age. It will be playing through Feb. 3 (except Mondays) at Film Forum, 209 West Houston Street in the South Village.

The affecting McCabe wears a gold tooth and bowler hat to set him apart from the local riffraff. When he tells his mirror, "I got poetry in my soul," he's almost believable. Mrs. Miller teaches him how to run a profitable house, and smokes opium to make her life bearable. In two of the best performances of their careers, Mr. Beatty and Ms. Christie play business partners and sexual partners who never quite admit they might also be lovers.

Though the story is radically unsentimental, the film's images are ravishingly beautiful. The great cinematographer Vilmos Zsigmond creates the foggy atmosphere of a damp, oppressive Northwestern winter. (Film Forum's new wide-screen print is a must; cropped for some video versions, McCabe, Mrs. Miller and everyone else in town take on long, narrow, funhouse-mirror shapes.) Leonard Cohen's songs haunt the film, reflecting both its beauty and its pessimism.

"McCabe and Mrs. Miller" is the rare period piece in the Altman career, but it shares the mark of all his work: a feel for the rich texture of everyday life and a rambling narrative to match. His most recent film, "Short Cuts," is an up-to-the-minute view of dozens of characters in a Los Angeles suburb. Andie MacDowell and

Bruce Davison are the emotional center of the film, as the parents of a little boy hit by a car. One way or another, their lives overlap with those of several tragicomic couples, including Lily Tomlin and Tom Waits, Julianne Moore and Matthew Modine, Madeleine Stowe and Tim Robbins.

When the film opened in October, much was made of its connection to, or disconnection from, the Raymond Carver working-class stories that inspired it. But "Short Cuts" works just as well — maybe better — apart from its source. And the cataclysmic earthquake that ends the film seems far less contrived now than it did a few months ago.

Like its director, "Short Cuts" is a survivor. It stayed alive against heavyweight holiday competition and is still around to prove that the director's got poetry in his soul.

CARYN JAMES

1994 Ja 21, C16:5

Blink

Directed by Michael Apted; written by Dana Stevens; director of photography, Dante Spinotti; edited by Rick Shaine; music by Brad Fiedel; production designer, Dan Bishop; produced by David Blocker; released by New Line. Running time: 106 minutes. This film is rated R.

Emma Brody.........................Madeleine Stowe
Detective John Hallstrom............Aidan Quinn
Thomas Ridgely.........................James Remar
Dr. Ryan Pierce....................Peter Friedman
Lieutenant Mitchell................Bruce A. Young
Candice.....................................Laurie Metcalf
Neal Book.......................................Paul Dillon

By JANET MASLIN

Whenever Hollywood trots out its favorite premise about the beautiful blind woman and the deadly stalker, the audience discovers something new. So "Blink," the latest variation on this discreetly sadistic formula, brings its share of little revelations. That even a mystery story can be overpowered by high-tech special effects. That if a stalker wants to be scary he'd better show a little style. And that beautiful blind women are a lot tougher than they used to be.

"Blink" finds something enticingly spooky in Emma Brody, who is first seen as the milky-eyed, bewitchingly lovely fiddler with an Irish rock band. It helps that Emma is played by Madeleine Stowe, the actress who gave the most interestingly subtle performance in "Short Cuts" and who is always a study in contrasts. With a deep, brassy voice that offsets her fragile beauty, Ms. Stowe can be as sharp and unpredictable as "Blink" needs her to be. But this film isn't content to explore Emma's colorful character. It insists on having a gimmick, too.

As directed by the versatile Michael Apted, whose films ("7 Up," "Coal Miner's Daughter," "Thunderheart," "Agatha") have examined vastly different subjects with the same watchful intelligence, "Blink" focuses on Emma's uncertain vision. When Emma, early in the story, receives corneal transplants after 20 years of blindness, her eyesight comes back in a peculiar way. She can see someone without registering the image until hours later, a phenomenon that is central to Dana Stevens's uneven screenplay. So "Blink" has Emma being stalked by phantom villains who may or may not be any-

Madeleine Stowe being stalked by Paul Dillon in a scene from Michael Apted's film "Blink."

Joyce Rudolph/New Line Cinema

where near her. That device, used thoughtfully and coupled with startlingly abrupt sound effects, provides a good way of scaring viewers out of their seats.

"Blink" also makes elaborate use of fun house morphing, so that the images Emma does register are unsteady and distorted and the story's main suspect cannot be clearly seen. But the film gets so sidetracked by its computer tricks that it neglects to fill in some very basic elements of its, suspense plot. "Blink" resembles last year's "Malice" as a mystery with a compelling setup, good actors, a lot of well-evoked atmosphere and a solution so nutty it takes the breath away. The denouement of "Blink" is such a doozy that it winds up deflating the whole film, which otherwise might have sustained its sharp characterizations and gritty atmosphere.

•

When the film isn't giving Emma menacing hallucinations, it is throwing her together with Detective John Hallstrom (Aidan Quinn), a textbook version of the brash and irreverent movie cop. A drunken, fun-loving Hallstrom so embarrasses himself over Emma in the film's first scene that he is relieved to learn she couldn't see him at the time. But even in more sober moments, Hallstrom is the predictable wise guy. "Not talking?" he wisecracks to a naked corpse at a crime scene. "All right, it's your funeral."

After Emma, who was a neighbor of this particular corpse, goes to the Chicago police seeking protection from a killer, she and Hallstrom embark on exactly the kind of combative romance you might expect. Still, this love story is lively enough to be compelling, and it would be a lot more so without all the red herrings that complicate Hallstrom's detective work.

It's as if the film makers had decided that ocular distractions could take the place of lucid plotting. Instead of creating a web of intrigue, they wind up undermining even those aspects of the story that actually work.

In addition to Ms. Stowe, who makes a savvy and headstrong heroine, and Mr. Quinn, who successfully charms his way through a stereotypical role, the cast also includes Laurie Metcalf and James Remar. To no one's surprise, these two play sidekicks, but each does it with dependable flair. Bruce A. Young makes a

sturdy police lieutenant, and Peter Friedman is suitably creepy as an eye surgeon who's much too interested in his attractive patient. There are more undeveloped minor characters than there should be. In the days when plain old plotting took center stage, a film like this would have kept the list of suspects short and sweet.

•

"Blink" is rated R (Under 17 requires accompanying parent or adult guardian). It includes violence, nudity and sexual situations.

1994 Ja 26, C15:1

Critic's Notebook

Sundance: Some Surprises Amid the Frivolity

By CARYN JAMES

Special to The New York Times

PARK CITY, Utah, Jan. 27 — Just when you think the show-biz mania at the Sundance Film Festival can't get more intense, when it seems that every other person on Main Street is carrying a cellular phone, the atmosphere turns loopier. Now people are making their cellular power calls from their seats in the movie theaters. "I will *talk* to them," a young

woman promised her office minutes before a 9:30 screening the other morning. "I'll *deal* with it." The problem had to do with underlings who were letting too many rotten scripts move up the chain.

It's easy to roll your eyes at this behavior, and there has been more of it since the Hollywood contingent arrived in a swarm on Wednesday, midway through this 10-day festival. But it's also easy to sympathize with the poor readers who can't tell a good script from a bad. One of the most

revealing, eloquent and well-received films at the festival, a documentary about two elderly women called "Martha and Ethel," still sounds awful on paper.

The film, by Jyll Johnstone and Barbara Ettinger, is about the two nannies who raised them. Martha, a German refugee, worked for the Johnstones for 30 years, then retired to an apartment in Queens. Ethel, a black woman who brought up the Ettinger children, still lives with Mrs. Ettinger. This idea sounded so bad on paper that the film makers applied for more than 50 grants to help with the budget and were turned down every time.

But what sounds like a narrow view of a privileged world is ambitious and emotionally deep. An affectionate portrait of two completely different women — the stern, well-meaning Martha and the loving, self-assured Ethel — it deftly becomes a history of social change over 40 years, and a meditation on motherhood and family. Martha and Ethel themselves, interviewed in their late 80's, are such rich screen presences that one viewer asked, in a question-and-answer session with the film makers here: "Does Ethel have an agent yet?"

Ms. Johnstone, a former actress, and Ms. Ettinger, a former photographer, may be first-time film makers, but they are not naifs. They were smart enough to get good advice. "Everyone said if we were going to Sundance we should get a publicist because we don't know anything about the business," Ms. Johnstone said. There is no better Sundance tone: new but learning fast, and adjusting to a dream ending. Just before the film arrived at the festival, Sony Pictures Classics bought it, and will open it in theaters later this year. The only problem with the film is its title, which brings to mind Lucy and Ethel. Martha and Ethel have their comic moments, but they are far less familiar.

Among the best films at this festival, many come from unexpected sources. "The Last Supper," the short that precedes "Martha and Ethel," is the mordant story of a little girl who pilfers a forbidden object from her neighbor's refrigerator and shrewdly uses it to scare off her mother's boyfriend. It is directed with flair and authority by Daryl Hannah, of "Splash" and tabloid fame.

•

The dramatic competition was once the most talked-about part of the Sundance festival. No more. A glance at some of the titles suggests why. How can you tell "Fun" from "Fresh" from "Floundering"? What's the difference between "Risk" and "Grief"? Try to remember that "Blessing" is about a dysfunctional farm family, "Spanking the Monkey" about incest, and "Clean, Shaven" about a schizophrenic wanted for murder. Not that they aren't sincere. It's just that so many seem familiar; so many are part art, part Oprah.

"Fun," the story of two abused teen-age girls who meet, find that they are soulmates, and murder an old woman as a lark, plays like a high-school version of "Henry: Portrait of a Serial Killer." The direction, by Rafal Zielinski, grabs viewers. The performances by the young women (Renee Humphrey and Alicia Witt) are viscerally strong. But the shallow psychology of "Fun" is finally as disturbing as its technique is powerful.

Stephanie Berger/Sony Classics Pictures
Martha Kniefel, left, and Ethel Edwards in a scene from Barbara Ettinger and Jyll Johnstone's film "Martha and Ethel."

The extremely violent "Clean, Shaven," deserves its reputation as the hardest film at the festival to sit through (though you could argue for hours about whether it is more gruesome than "Reservoir Dogs," which was shown here two years ago). When the writer and director, Lodge H. Kerrigan, assumes the persepective of his schizophrenic character — with buzzing noises replacing most of the dialogue — the film is impressive. When he leaves that character and follows the detective on the case, the film's awkwardness is painful. This is the kind of portentous film in which the camera shows a close-up of milk being poured into a cup of coffee, followed by a close-up of sugar being poured into the cup of coffee.

•

"Clerks" is one of the few films in the competition that won't send viewers out of the theater in tears or with their stomachs churning, which is only part of the reason for its popularity here. It is also extremely funny and unpretentious. This film comes with such a pre-packaged Sundance story that the background almost works against it. The writer and director, Kevin Smith, is a 23-year-old clerk in a New Jersey convenience store, who insists he is going back to work there on Monday. Really.

He shot this black-and-white film for just over $27,000. It is the meandering, irreverent story of a convenience-store clerk named Dante and his friend Randel, who works in the video store next door. They are having a bad day; creating a disaster at a funeral home is not even the worst of it. •

The film maker already seems in control of his camera and his material. The acting (some by amateurs) is much more natural and convincing than in most no-budget films. "Clerks" has been invited to the New Directors/New Films festival at the Museum of Modern Art this spring, which is a good indication that if you want to buy milk from Kevin Smith you better move fast.

•

Because many of the dramatic-competition films are fledgling and uneven, the talked-about films here are often in the documentary competition or out-of-competition programs.

"Cronos," a Mexican film by a first-time director, Guillermo del Toro, is the stylishly told story of an accidental vampire and the search for eternal life. It has strong cult-film possibilities and will be released in April by October Films.

"Naked in New York" is a first film with unusual panache. Eric Stoltz gives an engaging performance as a 25-year-old playwright as muddled as any early Woody Allen character. The director, Dan Algrant, was a student of Martin Scorsese at Columbia University. Mr. Scorsese, the film's executive producer, and Frederick Zollo, its producer, helped fill the movie with cameos that make it seem like a junior New York version of "The Player" (released by the same company, Fine Line). The cameos by Richard Price, Ariel Dorfman, William Styron, Eric Bogosian and others are fun but overdone. No first director should seem *that* well connected; it could distract attention from his own comic flair.

The film also includes a small acting role by the great director Arthur Penn, who is coincidentally the subject of a tribute at the festival this year. For all its show-business slickness, sometimes there is an air of purity at Sundance. Mr. Penn, whose films include "Bonnie and Clyde" and "Little Big Man," is regarded here with great warmth and a touch of awe. Ordinary fans and many film makers turned up to hear a casual "Conversation With Arthur Penn." There was not a cellular phone evident in the room.

1994 Ja 28, C5:1

Bad Girls

Written and directed by Amos Kollek; director of photography, Ed Talavera; edited by Dana Congdon; art director, A. Lars Bjornlund; produced by Julian Schlossberg; released by Castle Hill. Quad Cinema, 13th Street, west of Fifth Avenue, Greenwich Village. Running time: 85 minutes. This film is not rated.

Jack...Amos Kollek
Lori..Marla Sucharetza
Mary Lou..Mari Nelson

By STEPHEN HOLDEN

The line between reality and make-believe is painfully apparent in Amos Kollek's pseudo-documentary film, "Bad Girls." In the movie, which opens today at the Quad Cinema, Mr.

Osnat Shalev/Castle Hill Productions
Amos Kollek

Kollek portrays a middle-aged writer named Jack who is researching a book about the lives of prostitutes in mid-Manhattan.

Jack sets up shop in a seedy hotel near Times Square and goes about interviewing his subjects. Approximately half the women in the film are actresses playing streetwalkers whose reminiscences Mr. Kollek captured on tape but who could not appear in the movie. The rest are actual prostitutes who tell their stories directly to the camera.

•

The contrast in appearance and style between the actresses dramatizing Mr. Kollek's interview material and the real-life streetwalkers is roughly the difference between a Playboy centerfold and a prison mug shot. The actual prostitutes, none of whom figure in the movie's jerry-built plot, have the hollow-eyed, beaten-up quality of war casualties. The saddest is Kathy, a heroin addict whose happiest memory, she says, was when she was 9 and "got a kitty cat." After describing a life of neglect, abuse, addiction and pregnancy (she has a 5-year-old son living in Arizona with an aunt), she shrugs off any hope of a better life by observing, "This is all I know."

•

"Bad Girls" loosely strings together Jack's interviews and observations around a story in which he becomes involved with two of the women he interviews. The more interesting is Lori (Marla Sucharetza), a stereotypical tough-but-vulnerable streetwalker and sex club performer whose contemptuous defiance toward her customers puts her at special risk for violence.

Mary Lou (Mari Nelson), with whom Jack has an affair, is a childlike 32-year-old woman who pathetically puts up a "Home Sweet Home" sign on the wall of his hotel room. Jack, Lori and Mary Lou form an uneasy triangle in which Lori (whose charms Jack resists) becomes jealous and resentful. Jack is especially patronizing toward Lori, whom he tries to save from her wayward ways by paying for her bus fare to her hometown in Pennsylvania.

"Bad Girls," which was shot on location in the Times Square vicinity, has a grittier, more realistic ambiance than Hollywood movies dealing

Rafal Zielinski
Renee Humphrey, left, and Alicia Witt in Rafal Zielinski's film "Fun."

with prostitution. Ms. Sucharetza brings a hard-edged sexiness and anger to the role of Lori. Undermining the film is the director's ponderous portrayal of Jack. Mr. Kollek, who has appeared in other films of his own, is a smotheringly dull screen presence who speaks in a droning monotone. Although the generalizations Jack draws about the prostitutes he meets may be correct, they have a tritely sentimental ring. Underneath their hard shells, he declares, they are really lost little girls.

It seems odd that amid all the flesh-peddling, only one pimp is shown. The threat of AIDS is only cursorily mentioned. And although the film has one scene of violence, it grossly understates the enormous physical dangers that the women face each day and that they acknowledge with a chilling equanimity.

1994 Ja 28, C8:5

Living Proof
H.I.V. and the Pursuit of Happiness

Directed by Kermit Cole; written by Jameson Currier; cinematography by Richard Dallett; edited by Michael Gersh; music by James Legg and Mark Suozzo; produced by Mr. Cole, Beth Tyler and Anthony Bennett; released by First Run Features. At Cinema Village, 22 East 12th Street, Greenwich Village. Running time: 72 minutes. This film is not rated.

By JANET MASLIN

The smiling, laughing people seen in "Living Proof" have sad news in common. These men, women and children are all H.I.V.-positive, which should make "Living Proof" a somber documentary instead of the relentlessly upbeat group portrait that it is. But the individuals who are interviewed in Kermit Cole's film, which opens today at the Cinema Village, share a determination to make the best of their troubles. "For the first time I'm really living," says one interviewee, who speaks for all of them. "And maybe for the first time I'm really happy."

That idea is echoed throughout this film, even when Mr. Cole has to strain to emphasize it. Much of "Living Proof" was shot in a photographer's studio, where Carolyn Jones and George DeSipio are seen working on a series of portraits. The subjects, posed for their sittings as if this were a fashion spread, would radiate serenity and optimism even if the film did not indulge in cheerful gimmicks, like jokey high-speed cinematography in a couple of scenes. It comes as a relief when the speakers are allowed to stop sounding so sunny and reflect candidly on their situation.

•

"Living Proof" is more reassuring than imaginative. It's less a work of art than a labor of love. (Food, services and film-making equipment were all donated for this project.) While Mr. Cole finds no surprises in the way his subjects have faced their shared diagnosis, he does present a group of brave people who have learned to cope with being H.I.V.-positive in resourceful ways. "It's like you're sick, but you don't look sick," says a smiling triathlete. Another interviewee says, "You know, pain and suffering is life, but misery is a choice." Another says: "I don't have a lot of time to waste. None of us do, really, but I'm just reminded of it every day."

The film's talking heads range from a matron to a panhandler, from a drag queen to an Eagle Scout. Their backgrounds are obviously quite different, but many of them voice similar thoughts about having been forced to reassess their lives. Some have made career changes to pursue work that really interests them. Others have made peace with their families and friends. All have found ways to use their time more thoughtfully. The film underscores the thought that you don't have to be H.I.V.-positive to learn these lessons.

One of the most eloquent and ingratiating people interviewed here died while the film was being made. So "Living Proof" includes some quiet, moving glimpses of a memorial service. Production notes for the film include Mr. Cole's request that reviewers not reveal the identity of this person in advance, for fear of undermining the effectiveness of the material. But "Living Proof" isn't a drama. Nor is it really a tragedy. It's a simple study of hope in the face of adversity. And viewers will find it a comfort, if not a revelation.

1994 Ja 28, C8:5

Golden Gate

Directed by John Madden; written by David Henry Hwang; director of photography, Bobby Bukowski; edited by Sean Barton; music by Elliot Goldenthal; production designer, Andrew Jackness; produced by Michael Brandman; released by Samuel Goldwyn. Running time: 95 minutes. This film is rated R.

Kevin Walker	Matt Dillon
Ron Pirelli	Bruno Kirby
Marilyn Song	Joan Chen
Chen Jung Song	Tzi Ma
The Teacher	Stan Egi

By JANET MASLIN

"Golden Gate" is not a quiet failure. It's a big, bright and flamboyant one, boldly made despite the fact that everything about it is so desperately wrong. Films misconceived from the ground up could once be counted on to achieve a certain negative stature, but the video age is not kind to grandiose misfires. When "Golden Gate" turns up on home video — in the very near future — it is sure to be glimpsed briefly in many a household. But it won't often be watched all the way through.

"Golden Gate" was written by David Henry Hwang, the prize-winning playwright ("M. Butterfly"). And his writing here has obvious merits. Spanning two decades and two generations, Mr. Hwang tells a story of love and intrigue in San Francisco's Chinatown. Woven into the romance between an F.B.I. agent (Matt Dillon) and the young Chinese woman (Joan Chen) who has been unwittingly victimized by the agent's actions are the author's ideas about law, justice and bigotry, which should have given the material considerable heft.

But Mr. Hwang has written a play, not a screenplay. And "Golden Gate" winds up offering a stark illustration of why the two forms are different. These scenes, as written, call for plain, abrupt staging that would give the dialogue an abstract power. The words need to be heard in sharp relief from the characters themselves, who are symbolic constructs as much as they are people anyway. The author's dramatic devices, as when one person seems to speak directly to another's thoughts, call for streamlined direction. So do certain staccato scenes so intense that they need to be set off by

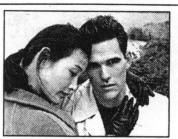
Bob Greene/Samuel Goldwyn Company
Joan Chen and Matt Dillon

theatrical blackouts, not by ordinary screen editing.

But "Golden Gate" has been strenuously overdirected by John Madden ("Ethan Frome"), pushed so hard that it practically perspires. Mr. Madden, who has often directed for the stage (his credits include "Beyond Therapy"), eagerly clutters this film with every imaginable movie cliché. A nightclub scene in the 1950's? Mr. Madden supplies a mirrored ceiling ball and jitterbugging extras in sailor suits. San Francisco hippies in the 60's? Shot of a psychedelic painted van, plus acid rock. Sinister goings-on? Rain-slicked alleys and skewed camera angles. Tough-guy G-men? Felt hats and fancy neckties in every possible scene. When the ties draw attention away from the actors as steadily as they do here, it's time to ditch that fashion sense.

When not being eclipsed by props and wardrobe, the actors are reduced to playing broad caricatures. Mr. Dillon, looking square-jawed and acutely uncomfortable, must adapt his usually naturalistic style to heavily mannered material. Ms. Chen's role is ambitious, as when she calls herself "the Woman Warrior," but often emptily glamorous, as when she is seen doing laundry wearing a tight red sweater and sling-back shoes.

Bruno Kirby is saddled with the film's worst role, that of the loudly bigoted F.B.I. man who evolves from the hero's friend to his nemesis. As the main mouthpiece for the film's political ideas, Mr. Kirby carries the burden of the author's overworked sarcasm. Stan Egi, appearing late in the story as the leader of an Asian consciousness-raising seminar, has an equally strident role.

Describing the film's early action as occurring "when life was a party and the lights blazed high," Mr. Hwang certainly has stylized exaggeration in mind. ("Yeah, I work in the laundry," says a Chinese character who becomes a victim of politics and prejudice. "It's a nice clean living.") But like at least one of its principals, "Golden Gate" winds up taking a leap into the void.

•

"Golden Gate" is rated R (Under 17 requires accompanying parent or adult guardian). It includes profanity and mild violence.

1994 Ja 28, C10:6

Incremental Changes in a Peaceful World, Saigon 1951

"The Scent of Green Papaya" was shown as part of the 1993 New York Film Festival. Following are excerpts from Janet Maslin's review, which appeared in The New York Times on Oct. 11. The film, in Vietnamese with English subtitles, opens today at the Lincoln Plaza Cinema, Broadway at 63d Street.

"The Scent of Green Papaya" is Tran Anh Hung's tranquilly beautiful film about a lost Vietnam, a peaceful, orderly place not yet touched by wartime. The film begins in Saigon in 1951, in a household safely insulated from the first rumblings of trouble. The family in question has more personal problems, since these people are still mourning the death of a young daughter several years earlier, and since the husband (Tran Ngoc Trung) has a history of disappearing for long periods with his family's

First Look Pictures
Tran Nu Yen-Khe

money. The wife (Truong Thi Loc) endures these desertions with the stoicism the film generally ascribes to Vietnamese women.

Into this family comes Mui (Lu Man San), a lovely 10-year-old servant girl and a contemporary of the daughter who died. The camera watches Mui contemplatively as she learns her new duties and does her hard-working best to keep her masters happy. Mui is someone who smiles knowingly at the sight of ants lifting heavy burdens, and who communes effortlessly with the natural forces all around her. The film works hypnotically as it gazes upon the leaves, birds, frogs and insects that are welcome parts of Mui's world.

•

Despite Mui's status as a servant, she manages to enjoy a life of more constancy and quiet joy than do those around her. The film chronicles the series of small changes that rearrange the life of the family, all the while sustaining the rhythm of womanly work that shapes Mui's existence. Mr. Hung's view of placid, spiritually elevated Vietnamese womanhood poses its problems, since Mui is so often seen scrubbing floors or shining shoes. Fortunately, this misplaced romanticism is well outweighed by the film's haunting visual loveliness.

"The Scent of Green Papaya" takes its title from a childhood mem-

ory of the director's. Mr. Hung, who was born in Vietnam and grew up mostly in France, has said that "the smell of green papaya is for me a childhood memory of maternal gestures." The papaya also provides a useful metaphor, since in its green state it is apparently considered a vegetable, and it is thought to blossom into a fruit later on. Mui herself follows a similar evolution as the film unfolds.

During the latter part of the film, Mui is seen as a quiet, graceful 20-year-old (Tran Nu Yen-Khe) who needs a new position once her original employers' lives have changed. She winds up as a devoted servant to the handsome musician she has gazed at admiringly since her girlhood. This musician, seen at his Steinway playing Gershwin-like melodies and engaged to a thoroughly liberated Vietnamese glamour girl, is part of a world Mui has barely seen before. But she does her wordless, gracious best to accommodate him. The film's idea of what might ultimately liberate Mui is every bit as nostalgic as its other memories.

"The Scent of Green Papaya" marks a luxuriant, visually seductive debut for Mr. Hung, whose film is often so wordlessly evocative that it barely needs dialogue. Reaching into the past for its precisely drawn memories, it casts a rich, delicate spell.

1994 Ja 28, C15:1

Critic's Notebook

Innovation And Incest, Glitches And Tinsel

By CARYN JAMES

Special to The New York Times

PARK CITY, Utah, Jan. 30 —

The deadly ceremony was far different from the scene on Thursday and Friday at the premieres of two studio films: "The Hudsucker Proxy," by Joel and Ethan Coen, and Mr. Stiller's "Reality Bites." They were the hottest tickets at this wide-ranging festival, which included many strong, out-of-competition premieres. Each was a hit with a different segment of the audience.

"Reality Bites" is for the MTV generation. Its stars, Ethan Hawke and Winona Ryder, were at the screening of the film, a slick, engaging comedy about recent college graduates fumbling to give some shape to their lives. Universal is to release it on Feb. 18.

"The Hudsucker Proxy," which Warner Brothers has scheduled to open on March 11, brought the Coen brothers back to Sundance a decade after their success with "Blood Simple." A smart comedy for movie lovers, "Hudsucker" is a stylized piece that toys with the conventions of 1940's films by Frank Capra and Howard Hawks. Tim Robbins and

Jennifer Jason Leigh, who were at the Thursday night premiere, play an idiot-savant businessman and a fast-talking newspaperwoman.

The Coen brothers were not the only Sundance alums to return with new films this year. Ms. Anders, whose career took off when "Gas,

Dysfunction and malfunction at the Sundance festival.

Food, Lodging" was shown at Sundance two years ago, brought her new film, "Mi Vida Loca." It is a sympathetic look at the lives of women the movies have ignored so far: female gang members. A party on Friday for the film, featuring music by the group Los Lobos, was so overcrowded that fire marshals threatened to close down the building, and a long line of people were left outdoors, shivering in the cold. The event says more about how overcrowded Park City has become during this festival than it says about Los Lobos' popularity.

There's no guarantee that Sundance alumni will keep the spark of innovation that is this festival's hallmark, of course. Matty Rich, the 22-year-old director who made a precocious Sundance debut a few years ago with "Straight Out of Brooklyn," returned with his new film, "The Inkwell," which Disney's Touchstone division plans to release. Though Sundance says it is about independent films — independent in spirit as well as financing — "The Inkwell" is as co-opted and Disneyfied as a film can be. A view of the black middle class in the 1970's, "The Inkwell" is so predictable it plays like a rerun of a bad sitcom, mixed with the coming-of-age clichés of "Summer of '42."

It was Mr. Russell, the 35-year-old creator of "Spanking the Monkey," who showed the best side of the independent spirit. Asked why he included so much humor in an unsettling film about incest, he said, "I don't think there's any point in making a morose movie of the week." His film smoothly leads from the hero's sexual frustration and boredom at spending a summer with his mother to a situation where the Oedipus complex runs amok. Along the way, Mr. Russell makes fun of psychobabble and demonstrates a quality all too rare at Sundance: irreverence.

1994 Ja 31, C17:1

Car 54, Where Are You?

Directed by Bill Fishman; written by Eric Tarloff, Ebbe Roe Smith, Peter McCarthy and Peter Crabbe, based on the television series created by Nat Hiken; director of photography, Rodney Charters; edited by Alan Balsam and Earl Watson; music by Bernie Worrell and Pray For Rain; production designer, Catherine Hardwicke; produced by Robert H. Solo; released by Orion Pictures. Running time: 89 minutes. This film is rated PG-13.

Gunther Toody......................David Johansen
Francis Muldoon...............John C. McGinley
Velma Velour...........................Fran Drescher
Capt. Dave Anderson..............Nipsey Russell
Lucille ToodyRosie O'Donnell
Leo SchnauzerAl Lewis
Don MottiDaniel Baldwin
Herbert HortzJeremy Piven

By JANET MASLIN

We already know that nothing is sacred, not when it comes to trawling the depths of popular culture in search of movie ideas. But "Car 54, Where Are You?" The original series, created by Nat Hiken (also the inspired creator of "Sergeant Bilko"), delivered the most innocently stupid brand of television comedy. And innocence is not what any present-day movie remake is after. So is it stupidity? That's a tricky business. When it comes to dopiness, "Car 54, Where Are You?" is too convincing for its own good.

Though it has a potentially funny cast, this sprawling comedy has been made in a near-total wit vacuum. Its humor can perhaps be gauged by the fact that the director, Bill Fishman, manages to insert an obscenity into the title phrase, and that Officer Gunther Toody's familiar cry of "Ooh! Ooh!" is now used in a sexual context. As the irrepressible Toody, David Johansen mugs endlessly and mimics the grunt of his sitcom predecessor, Joe E. Ross, all the while winking broadly at the audience. Mr. Johansen sometimes steps entirely out of his role, jumping into a musical number in one scene and sporting a purple satin suit in another.

As Gunther's wife, Lucille, the funnier Rosie O'Donnell is used mostly for one-note hollering, in crass domestic scenes that play like John Waters without the taste. John C. McGinley is more effectively restrained in the Fred Gwynne role, as Toody's prim partner, Francis Muldoon, who sternly uses a pointer to indicate "illegally obtained kebab stains" on Toody's shirt.

The plot, a four-writer mishmash, involves a Godfather (Daniel Baldwin) who wants to kill an amusingly fatuous yuppie (Jeremy Piven) whom Toody and Muldoon are supposed to protect. Fran Drescher is also on hand as the glamorous Velma Velour, a vamp who takes up with Muldoon after working her way through the rest of the police department. Penn and Teller turn up briefly parodying the gun salesman scene from "Taxi Driver," to no great comic effect. Also around is Al Lewis, watching reruns of himself as Grandpa Munster and becoming the butt of a sight gag involving a catheter bag.

"Car 54, Where Are You?" has an amateurish visual style, sometimes flat and garish-looking, at other times unexpectedly hazy. The sound is occasionally muffled. There are four noticeable product plugs — for juice, pizza, hot dogs and corn chips — before the opening credits are over.

•

"Car 54, Where Are You?" is rated PG-13 (Parents strongly cautioned). It includes sexual suggestiveness and profanity.

1994 Ja 31, C16:5

Between The Teeth

Directed by David Byrne and David Wild; director of photography, Roger Tonry; edited by Mr. Wild and Lou Angelo; music by 10 Car Pile-Up; produced by Joel D. Hinman; released by Todo Mundo Ltd. Film Forum 1, 209 West Houston Street, South Village. Running time: 71 minutes. This film is not rated.

By JON PARELES

In 1983, Jonathan Demme filmed Talking Heads in concert for "Stop

Making Sense," presenting the performance seen from the outside: a stage show, nothing more. Now, with the Heads dissolved, the band's songwriter and leader, David Byrne, has created what might be its sequel. Its title is "Between the Teeth," but it could be called "Start Making Syncopation."

The movie, which opens today at Film Forum 1, shows a concert on Halloween 1992 at the Count Basie Theater in Red Bank, N.J. Mr. Byrne leads 10 Car Pile-Up, a band that zigzags from rock to funk to Latin rhythms in songs that are sometimes whimsical, sometimes dire. The cameras focus on the prosaic details of music making like Mr. Byrne's toes tapping in his cowboy boots and the red light of an amplifier glowing in the darkness between songs, yet they capture the sweaty, heady pleasures of rhythm becoming motion.

When "Stop Making Sense" was made, Talking Heads were at rock's leading edge, where rock-funk-African fusions and arty SoHo impulses merged on the dance floor. A decade later, Mr. Byrne's musical fusions are more accomplished but much less trendy. Although he emerged in the era of punk-rock, he's closer to Paul Simon, another world-music fan, than he is to a younger generation that prefers the bluntness of grunge, hip-hop and techno.

•

Like Mr. Simon, Mr. Byrne remains a slightly awkward visitor to the supple rhythms of his own songs; it's embarrassing when he wiggles his hips in "Mr. Jones." But the sense of strain brings dramatic tension to his music, and it keeps him from simply imitating sources in the Caribbean or Brazil; instead, he merges them with rock guitar.

The concert includes material from the 1980's Talking Heads and from Mr. Byrne's solo albums. Mr. Byrne, who says barely a word between songs, is an impassioned enigma on stage. He begins the show alone with an acoustic guitar and a drum machine; then the full band appears and the music takes off, groove after groove.

•

In Mr. Byrne's songs, he's often a bewildered bystander or an information-barraged everyman, musing, "You don't even know what you're knowing." But even when he's setting forth fragmentary imagery, he sings as if every word matters, without distance or irony. While he becomes increasingly disheveled and wild-eyed during the show, the band stays unruffled, punching out its horn riffs and holding down the funk bass lines.

For most of the concert, the audience is barely acknowledged; the action is onstage. At first the camerawork is unobtrusive, avoiding the acute angles and jumpy editing of typical MTV fare. Gradually, it emerges that Mr. Byrne and the co-director, David Wild, have a strategy for each song. One is all mouth-level close-ups; another shows musicians from head to toe, moving to the rhythm; a third is one unswerving shot for the length of the song. "Life During Wartime," the oldest tune in the film, is all hand-held swoops, blurs of faces and flashing lights. Arty and schematic as they might seem, the choices bring added variety to the music.

"Between the Teeth," like "Stop Making Sense," ends a chapter in Mr. Byrne's career. He has said that his

next album will drop the big band and return to more basic rock instrumentation. But the film preserves performances that are at once more playful and more serious than Mr. Byrne's studio productions. Trendy or not, the songs have staying power.

1994 F 2, C15:1

A Curse That Bridges Centuries

"Fiorile" was shown as part of the 1993 New York Film Festival. Following are excerpts from Stephen Holden's review, which appeared in The New York Times on Oct. 13. The film opens today at the Lincoln Plaza Cinema, Broadway at 63d Street.

In "Fiorile," Paolo and Vittorio Taviani's sweeping and sensuous fable of how several generations of a Tuscan clan have lived out a family curse, the ghosts of the past are always threatening to jump out at its characters from the shadows of their troubled family history.

The movie doesn't exactly believe in ghosts. It is an engaging yarn that suggests how a potent legend handed down from generation to generation can become a kind of determining karmic force field. It also affords the Taviani brothers, whose films are steeped in a love of Italian history and an identification with peasant folklore, rich visual opportunities to evoke a mythical Italian spirit that the sterile trappings of modernity only partly conceal.

In the film's opening scenes, Luigi Benedetti (Lino Capolicchio) and his French wife (Constanza Engelbrecht) are driving with their two children through the Tuscan countryside to visit the eccentric grandfather the children have never met. To amuse them, Luigi regales them with the details of a family curse that dates to Napoleon's invasion of Italy.

In these early flashbacks, which are among the movie's most beautiful, Jean (Michael Vartan), a handsome, idealistic French lieutenant, falls in love at first sight with Elisabetta Benedetti (Galatea Ranzi), a Tuscan peasant girl whom he nicknames Fiorile. While they are making love in the woods, the girl's brother, Corrado (Claudio Bigagli), steals a regimental chest of gold coins that Jean was guarding. When the money is not returned, Jean is executed, according to martial law. Elisabetta, who is pregnant, vows revenge, not knowing that her family's greed brought about Jean's death.

With their ill-gotten gains, the Benedettis build an empire to rival the Medicis in scope and opulence, but the stolen wealth carries a curse that ruins the lives of those who live off it.

The curse repeats itself a century later. Then the story jumps ahead four decades to World War II, and finally back to the present.

"Fiorile" isn't an especially deep film, but it offers many pleasures. Shifting deftly between centuries, it combines a confident narrative drive with visual style that drinks in the beauty of the rolling Tuscan landscape. And the smooth, low-key performances by an attractive cast lend each vignette a delicious romantic flavor.

1994 F 2, C20:1

Recollections of the Yellow House

Written, directed by and starring João César Monteiro, in Portuguese with English subtitles; director of photography, José António Loureiro. Joseph Papp Public Theater, 425 Lafayette Street, East Village. Running time: 120 minutes. This film is not rated.

João de Deus...................João César Monteiro

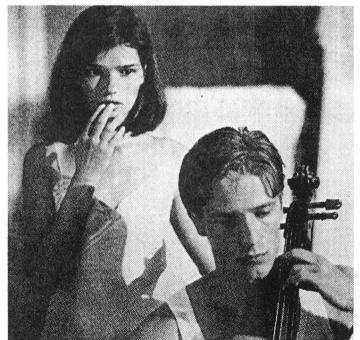

Umberto Montiroli/FineLine Features
Chiara Caselli and Michael Vartan in a scene from "Fiorile."

By STEPHEN HOLDEN

A gaunt middle-aged hypochondriac with a taste for voyeurism is not the sort of person one expects to be the central character in a movie, even a European art film. But in João César Monteiro's deadpan comedy "Recollections of the Yellow House," the director himself plays just such a character. João de Deus, the Portuguese film maker's cinematic alter ego, is a bumbling, sad-eyed everyman and sometime hack writer of meager resources who exudes disorder.

João is one of several eccentric tenants who inhabit a seedy Lisbon rooming house run by the fanatically proper and puritanical Dona Violeta (Manuela de Freiras). In a mordantly funny early scene, João complains to his landlady about bedbugs, which may or may not be imaginary. He even chases down one bug and traps it in a container; but it is invisible to the viewer, and when he displays it for Violeta it is also indiscernible. A bedbug rash is not João's only ailment. He also has sores in his mouth and an inflamed groin that requires the wearing of an athletic supporter packed with ice cubes.

Even more than his precarious health, João is obsessed with Violeta's daughter, a haughty clarinetist whom he likes to observe through a keyhole while she is bathing. So smitten is he that no sooner has she finished than he rushes to the tub and sips her soapy bath water as though it were sacramental wine.

In his attempts to win her favor, João offers tawdry bouquets accompanied by absurdly pretentious oratory praising her musical talents. In the film's most farcical scene, he loses control and pounces on her. It is the beginning of his downfall.

Just like its main character, "Recollections of the Yellow House," which opened yesterday at the Joseph Papp Public Theater, rambles around aimlessly observing the neighborhood and the people and focusing on their petty hopes and dreams. Believing that the clarinet will be her daughter's ticket to a better life, Violeta lives for the day her daughter is discovered by a wealthy Prince Charming, although that prospect is unlikely because she works in a military band.

João also befriends a prostitute who lives in the rooming house and who dies from an abortion, leaving her life savings stuffed in a rag doll. Eventually João himself begins to self-destruct. He is arrested and sent to jail for impersonating a cavalry officer.

Although the film has undercurrent of humor, it is too long and slow, and the connections between some scenes are often tenuous. Characters appear and vanish with little sense of follow-through. Now and then the camera breaks away from the characters to take the measure of the dingy architecture that surrounds them.

"Recollections of the Yellow House" doesn't mock its characters. Nor does it moralize. "Isn't life shabby!" it proclaims in a comic voice that is compassionate but too dry to provoke laughter.

1994 F 3, C18:1

Critic's Notebook

When Hollywood Could Be Naughty

By JANET MASLIN

THE "moral importance of entertainment" was once very much on Hollywood's mind. "It enters intimately into the lives of men and women; it affects them closely; it occupies their minds and affections during leisure hours; and ultimately touches the whole of their lives. A man may be judged by his standard of entertainment as easily as by the standard of his work." The real power of those words lies not in their truth, which is self-evident, but in the way they kept Hollywood in line.

As part of the paper cudgel known as the Motion Picture Production Code, first formulated in 1930, later revised and then seriously enforced beginning in 1934, those statements accompanied a set of rules that will strike present-day readers as curiously familiar. The same strictures still apply, but in inverse fashion. Practically everything the Production Code cited as anathema has become commonplace, not to say even preferable, in films today.

"The courts of the land should not be presented as unjust," the code cautioned. Films must not "make crimi-

nals seemed heroic and justified." "Impure love must never be presented as attractive and beautiful." "The use of firearms should be restricted to essentials." "Revenge in modern times shall not be justified." Drinking, childbirth and surgery were also specified, not to mention white slavery. As for sex: "In general passion should so be treated that these scenes do not stimulate the lower and baser element."

Naturally, there was another side to this story. Beginning today, it will be celebrated uproariously at Film Forum 2 in the South Village, with an ambitious and vastly entertaining two-month series devoted to all those outrages that brought the code into being. "Naughty! Bawdy! Gaudy! Warner Brothers Before the Code" is this theater's affectionate tribute to unfettered Hollywood, not because it brought forth such licentiousness but for the sake of some larger liberties. Perhaps the biggest surprise in this collection of overlooked titles, many of them B-movies by directors who could crank out five films a year, is their pure, exhilarating joie de vivre.

The terrors of the code, as overseen by Joseph Breen (who was nicknamed "the Hitler of Hollywood" in

Warner Brothers

Barbara Stanwyck and John Wayne in "Baby Face," at Film Forum 2.

some quarters), went beyond the letter of the document and brought about a more generalized moral purge. Gone with all the loose ladies and bootleg gin were ethnic traits, honest sexual behavior of all persuasions, lively wisecracks and even normal-sounding conversation. If Joe Breen had had his way, the line might have been, "Frankly, my dear, I don't give a darn," and it would have had a very different place in film history.

Compare that with "Blessed Event," a witheringly funny 1932 film about an unscrupulous newspaper columnist (Lee Tracy) whose specialty is announcing illegitimate pregnancies and events that unfold "in the BVD hours of the night." "A family's a great thing, especially for a *married man*," one character remarks. "Well, I'll be damned," says the columnist's sweet-faced old mother-in another scene.

•

This impressively scholarly series, enthusiastically programmed by Bruce Goldstein of the Film Forum, also happens to be great fun. The narrow focus on Warners is most effective, even though other studios (notably Paramount, whose Mae West movies were just as galling to the censors) found themselves in similar straits. If racy films with corrupt, ambitious characters threatened to bring on a more restrictive climate, they also attracted big audiences during the Depression years. Warners was particularly adept at exploiting this potential in the name of social realism, and the consistency of Warners' style gives this series an extra depth.

Just as they range from swanky boudoirs and Orry-Kelly costume fantasies to back-alley degradation (the glittery-eyed young Barbara Stanwyck had a particular flair for the latter), these films run a wide gamut where quality is concerned. At the high end of the scale, along with familiar titles like Mervyn LeRoy's 1932 "I Am a Fugitive From a Chain Gang," are Roy Del Ruth's "Blessed Event," along with Robert Florey's "Ex-Lady" (featuring an amazingly

forthright, unmannered Bette Davis in her first leading role) and William Dieterle's debonair "Jewel Robbery."

But Michael Curtiz's "Female" (with Ruth Chatterton as a sexually predatory executive who throws silk pillows meaningfully on the floor as she seduces her male employees) is more notable for its camp value. "I can't go on! I don't belong here! This is no place for a woman!" she finally declares, having worked herself through most of the staff before meeting George Brent, who resists her. "You're just a woman, after all," he says reassuringly. Despite that perfunctory ending and the clumsy moralizing with which some of Warners' less adroit screenwriters tied up their racy stories, all of these films are more notable for their daring than for pulling any punches.

Chatterton's character illustrates an interesting aspect of pre-code storytelling: the clampdown on movie morals proved much more restrictive for women than for men. A gangster-turned-actor like the one James Cagney played in Del Ruth's "Lady Killer" ("Take a gander at her." "Did you say gander? I wonder how she'd go for a goose?") could have survived the code without too much trouble. And the Hollywood satire that makes "Lady Killer" so lively could similarly have been saved. But the whole idea behind "Female" was objectionable, as were most films about strong women who stopped at nothing to get

Before the code, films were filled with loose ladies and bootleg gin.

what they wanted. It became much harder to depict willful, believable women once the code was actively enforced.

Needless to say, quite a few daunting pre-code heroines can be seen here. Staggeringly amoral until late in the last reel, Stanwyck claws (and sleeps) her way from a speakeasy to a lavish "love nest" in Alfred E. Green's 1933 "Baby Face," which opens the series today (along with Del Ruth's lesser but still highly enjoyable "Employees' Entrance," made the same year). One of the men Stanwyck climbs past is John Wayne; this must be the only film in which he held a desk job at a bank and said, "Gee." Even more astonishing is the thoroughly modern Bette Davis, enjoying a lavishly idealized life of freedom in "Ex-Lady."

A successful illustrator with a penchant for white satin, Davis disdains the idea of marrying Gene Raymond's advertising executive, although he is on hand to bring her breakfast in bed. Their love affair is presented glamorously and straightforwardly, as are Davis's assertions of independence. ("When I'm 40 I'll think of babies," she says, shrugging off the idea of children.) After she is persuaded to conform anyway, the film sustains its candor with a torrid vacation sequence, a depiction of how difficult it is to be business partners with one's spouse, and some lively extramarital flirting. "If I weren't a wife, I wouldn't be jealous," Davis says.

•

A different kind of unabashed behavior came from Warren William, a now-forgotten star who specialized in crass, amoral climbing in the business sphere. William's pencil-thin mustache is the perfect flourish for the heartless department-store manager he plays in "Employees' Entrance," which finds him taking cruel, casual advantage . of Loretta Young. William, who kept almost as busy at Warner Brothers as Roy Del Ruth did, is even more ideally cast in "The Mouthpiece" (1932, Elliott Nugent and James Flood), in which he plays a breathtakingly unscrupulous lawyer. This film's pièce de résistance is the courtroom scene in which William drinks poison to prove that it isn't really deadly (his client is an accused poisoner), and then rushes back to his office to have his stomach pumped.

William's screen characters often took advantage of naïve young women, but seduction was relatively small potatoes in pre-code days. One of this series' wicked highlights will be a dramatic reading of the screenplay for "Convention City," a now-lost 1933 film that was thought to have been instrumental in bringing on strictly enforced censorship. "Several of the jokes need a subterranean mind to be correctly understood," a reviewer for The New York Times wrote diplomatically, when "Convention City" opened on Christmas Day in 1933. Subterranean thinking was clearly all the rage until it was driven underground.

Some further pre-code highlights: the way these Prohibition-era films make flamboyant use of alcohol, either as the height of sophistication or as the mark of depravity. (In Mervyn LeRoy's "Two Seconds," which begins and ends with Edward G. Robinson in the electric chair, his fall from innocence is engineered by a moll who gets him drunk on bootleg whisky, served in a teacup.) And speaking of flamboyant, there is "Wonder Bar," directed by Lloyd Bacon, with musical numbers by Busby Berkeley. Made in 1934, "Wonder Bar" got in just under the censorship wire with an objectionable blackface dance

number from Al Jolson and the extravagantly raunchy "Pettin' in the Park" musical sequence. "Pettin' in the Park" is not about visiting the zoo.

Ethnic references like Jolson's may have given offense, but at least the world wasn't all white bread. In these films, blacks, homosexuals, Jews and other minorities are actually acknowledged to exist, which was not often the case in post-code days. The series includes a show of early Looney Tunes cartoons in which a large-nosed Jewish baby has his diaper stamped as kosher, and references to blacks and jazz are daringly intertwined. Offensive but also oddly innocent, these cartoons radiate a playfulness that was less easily achieved under the code.

•

Once the code took hold, audiences had to see movie characters a little differently. (Did anyone really believe that Nick and Nora Charles slept in twin beds?) And necessity created many a metaphor. (Would we have seen half as many trains entering tunnels in a code-free world?) How, then, can it not be both quaint and refreshing to watch something like "Ladies They Talk About" (1932, Howard Bretherton), in which Barbara Stanwyck goes to San Quentin for bank robbery (and finds a hairdresser on the premises!). The female inmates are of different races, varied economic backgrounds and obvious sexual orientations. And some of them have distinctly pre-code stories to tell.

"This little cream puff met a guy at dinner one night and wanted to know what his name was," somebody says of one demure-looking prisoner. "So she shot him and read it in the morning paper."

1994 F 4, C1:1

I'll Do Anything

Written and directed by James L. Brooks; director of photography, Michael Ballhaus; edited by Richard Marks; music by Hans Zimmer; production designer, Stephen J. Lineweaver; produced by Mr. Brooks and Polly Platt; released by Columbia Pictures. Running time: 116 minutes. This film is rated PG-13.

Matt Hobbs	Nick Nolte
Jeannie Hobbs	Whittni Wright
Burke Adler	Albert Brooks
Nan Mulhanney	Julie Kavner
Cathy Breslow	Joely Richardson
Beth Hobbs	Tracey Ullman

By JANET MASLIN

There were two ways of looking at the ending of "Broadcast News," the witty, rueful, amazingly perceptive 1987 romantic comedy by James L. Brooks that has made Mr. Brooks's next film so well worth waiting for. In "Broadcast News," you may recall, a high-strung television producer named Jane found herself falling in love with an unreasonably successful newscaster named Tom, who represented everything Jane found troubling about her profession. Tom was bad news — quite literally. But he was also terrifically charming, which made Jane's tortured response all too easy to understand.

So should Jane take Tom up on his 11th-hour proposition? Should she stop hiding behind her scruples and try to live happily ever after? There must have been viewers who wished that "Broadcast News" had managed a sunnier ending, but they missed the point. The intelligence and generosity

Ralph Nelson/Columbia Pictures

Albert Brooks, left, with Nick Nolte in "I'll Do Anything," the James L. Brooks film that opens today.

with which Mr. Brooks described Jane's moral dilemma were precisely what made the film so fine. A deep, lingering seriousness colored even its lightest moments.

Good news: That same acuity is at the heart of "I'll Do Anything," Mr. Brooks's droll, improbably buoyant near-musical about an out-of-work actor and his scary little daughter. This time, the film maker turns his attention to Hollywood, which he presents as a place ruled by insane paradox. The movie executives seen here are infantile, self-involved and arrogant. Not surprisingly, these are qualities that Mr. Brooks has no trouble rendering in high comic style. (Imagine an executive who, learning that his driver is late because there was a shooting on the freeway, bellows: "You should leave *time* for that kind of thing!").

But self-important as they are, these high rollers live and die by the opinions of ordinary moviegoers, provided that those opinions have been quantified in quasi-scientific fashion. It's true that common folk inspire nothing but contempt in Burke Adler (Albert Brooks), a producer who proudly announces that his lamps say more about his taste than his movies do. But it's also true that Burke quails over the results of audience preview cards. During the course of the story, those cards lead to the drastic cutting of Burke's latest action picture, in which the star is seen slugging somebody with a side of beef, and identify Burke's most satisfied customers as 11-year-old boys.

•

It's almost fitting that "I'll Do Anything" has come to illustrate the writer and director's satirical premise, since this film lost its musical numbers (written by Prince, Sinead O'Connor and others, and choreographed by Twyla Tharp) after a preview audience delivered a thumbs-down verdict. It's also a shame. Even in its present song-free form, miraculously reconstituted

without many glaring gaps, "I'll Do Anything" remains defiantly quirky. Audiences that appreciate Mr. Brooks's sensibility would have followed this film anywhere, even into musical interludes that were probably more redolent of "The Singing Detective" than "Singin' in the Rain."

The film's main character is Matt Hobbs (Nick Nolte), who reveals himself in a prologue. In 1980, as a nominee for the best-actor Emmy, Matt didn't really mind when somebody else won. Within the film's moral scheme, this means that Matt is hopelessly out of synch with any of the cutthroat people who might hire him. When he does land a job, it's that of playing chauffeur to Burke Adler, who can drive his own BMW but doesn't like to park. "I'm all alone," Burke says to himself, while Matt is at the wheel. "At least there's that."

As the film gets going, Matt takes on an added responsibility: care of his 6-year-old daughter, Jeannie (Whittni Wright), whose mother (Tracey Ullman, doing an uncanny Holly Hunter impersonation) is, in her own words, "going to help others who need her for a few years." (Translation: jail.) Jeannie is nominally Matt's child, but she may just be the demonic offspring of the movie community. Tough, scheming and manipulatively adorable, Jeannie makes a terrifyingly perfect show-biz kid. Starting out as one more reason for her father's helplessness, Jeannie ultimately prompts Matt to take back control of his life.

•

The father-daughter sections of "I'll Do Anything" are slower and less assured than the film's satirical scenes; it may be that the music was meant to play a larger role here. The film's real center is at the offices of Popcorn Pictures, Burke's production company, where the Terminator 2 video game in the waiting room may just say everything about the employees and their ambitions.

Among Burke's professional coterie are Nan Mulhanney (Julie Kavner), the movie pollster whose antidepressants and nutritional supplements have combined to form a mysterious truth serum. "I'm here," she tells Burke after they become romantically involved, "for the same reason that 86 percent of older women loved 'Beauty and the Beast.'"

Also at the production company is Cathy Breslow (played slyly and subtly by Joely Richardson), who would be terrific at evaluating screenplays if she had any idea what her own opinions were. It is Cathy who establishes this film's moral coordinates, and she does it with as much quiet shock value as William Hurt's character did when he faked tears on-camera in "Broadcast News." Once again, a film by Mr. Brooks seems to meander all over the map until its closing scenes crystallize the director's vision. Cathy's small, perfect betrayal of Matt, with whom she has become involved, brings the whole film sharply into focus.

Bubbling unobtrusively through "I'll Do Anything" are some wonderfully satirical ingredients, touches that are no less scathingly hilarious than anything in "The Player," despite the comparative gentleness of Mr. Brooks's style. There's no small irony in the fact that Cathy, a decidedly non-Capraesque person, dreams of remaking "Mr. Deeds Goes to Town." (You can bet that half the staff of Popcorn Pictures would name Capra's "It's a Wonderful Life" as a sentimental favorite.) There is the progressive dumbing-down of a bad new television show. There are occasional references to Oliver Stone's plans to direct a comedy. There is whispered advice, to an actor preparing to audition: "Just be yourself, but remember to smile."

There are Burke's surroundings: a bathroom full of hair conditioners, a bed like a giant playpen, an office wall carefully displaying a rack of baseball jackets. (Along with Michael Ballhaus's warmly seductive cinema-

tography, Stephen J. Lineweaver's production design deserves special mention.) And there is Burke himself, the irresistibly funny embodiment of modern Hollywood at its most monstrous. Where Mr. Nolte's performance is sturdy and reactive, Mr. Brooks is simply outrageous, barking out all the terrible thoughts in which his character so honestly believes. Albert Brooks, who steals this movie, isn't linked to the director by blood, but in spirit they are certainly related.

•

"I'll Do Anything" is rated PG-13 (Parents strongly cautioned). It includes mild profanity, satirical violence, sexual situations and brief nudity.

1994 F 4, C3:1

Paris, France

Directed by Gerard Ciccoritti; written by Tom Walmsley, based on his novel; director of photography, Barry Stone; edited by Roushell Goldstein; music by John McCarthy; production designer, Marian Wihack; produced by Eric Norlen and Allen Levine; released by Alliance Releasing. At the Quad Cinema, 13th Street, west of Fifth Avenue, Greenwich Village. Running time: 111 minutes. This film is not rated.

Lucy	Leslie Hope
Sloan	Peter Outerbridge
Michael	Victor Ertmanis
William	Dan Lett
Minter	Raoul Trujillo

By STEPHEN HOLDEN

Can sexual passion unleash a creative deluge? It is a possibility that Lucy (Leslie Hope), a frustrated writer living in Toronto, pursues with a ravenous intensity in Gerard Ciccoritti's "Paris, France."

The Canadian film, which opens today at the Quad Cinema, goes gleefully over the top in several ways at once. It has more explicit sex of more different varieties than can be found in any recent nonporn film. And its feverish eroticism is matched only by its literary pretentiousnsss.

The city of Paris, to which its characters refer continually, is the mythical mecca of erotic transcendence and literary genius whose spirit has infused everyone from Ernest Hemingway to the Jean Seberg of "Breathless." Most portentously, the film is set during an Easter weekend in which Lucy's publisher and husband, Michael (Victor Ertmanis), decides he has only three days to live. He learns this from an enigmatic answering-machine message left by a voice he swears is the ghost of John Lennon.

Lucy's main sexual partner, Sloan (Peter Outerbridge), is a handsome young writer whose poetry her husband is championing. Their simulated but steamy erotic bouts, some of which involve leather and bondage, are frequently interrupted by flashbacks to Lucy's torrid affair in Paris years earlier with another writer. Minter (Raoul Trujillo), her Parisian fling and gangster fantasy, has since died of liver cancer. Lucy furiously tries to turn Sloan into a latter-day reincarnation of Minter, who wrote awful poetry and claimed to be friends with John Lennon.

During these flashbacks, which are photographed to suggest a baroque soft-core burlesque of the Jean Seberg-Jean Paul Belmondo relationship in "Breathless," excerpts from Lucy's dreadful early writings are intoned by her fictional alter ego. These diaristic musings are a purple

234

Alliance

Leslie Hope, left, Dan Lett, center, and Peter Outerbridge.

mush, a schoolgirl's "Story of O." And they make these portions of the movie feel like a savagely knowing spoof of talentless writers and their self-delusions.

On the fringes of the action lurks Michael's friend William (Dan Lett), who is gay and whom Sloan selfishly uses to explore his own possible homosexuality. Of the film's four major characters, William is the only one who doesn't have sex with more than one person.

•

If the movie's earnest grapplings weren't directed and acted with so much zest and humor, "Paris, France" would be a hopelessly silly erotic stew. But its actors perform with a gusto and radiate an intelligence that makes their characters seem like credible, if hysterical, literary types. The best thing about Tom Walmsley's overwrought screenplay, which he adapted from his novel, is the genuine passion with which they talk about literature and music.

Ms. Hope gives Lucy a fine, high-strung edge, and Mr. Outerbridge's Sloan exudes exactly the right mixture of confused narcissism and hostility. When Mr. Ertmanis's Michael goes to pieces, he suggests an oversized Dudley Moore flailing in a booze-filled bathtub. Mr. Lett deftly intimates the loneliness lurking beneath William's cynical bravado. Glowering and slit-eyed, Mr. Trujillo suggests a fantasy lover out of Jean Genet.

As for the question of whether hot, kinky sex can trigger creativity, the movie's answer is a resounding no.

1994 F 4, C6:5

Body Snatchers

Directed by Abel Ferrara; written by Stuart Gordon, Dennis Paoli and Nicholas St. John, based on a story by Raymond Cistheri and Larry Cohen; director of photography, Bojan Bazelli; edited by Anthony Redman; music by Joe Delia; production designer, Peter Jamison; produced by Robert H. Solo; released by Warner Brothers. Running time: 87 minutes. This film is rated R.

Marti Malone	Gabrielle Anwar
Carol Malone	Meg Tilly
Steve Malone	Terry Kinney
Dr. Collins	Forest Whitaker

By CARYN JAMES

It's impossible to prove this, but I think a pod person stole Abel Ferrara's soul while he was making "Body Snatchers."

The world wasn't begging for another remake of "Invasion of the Body Snatchers," Don Siegel's creepy 1956 classic about aliens who hatch out of pods and replace thinking individuals with conformist doubles. Philip Kaufman's wittily paranoid 1978 version holds up beautifully today.

Dale Robinette/Warner Brothers

Gabrielle Anwar

But if there were going to be a remake, who better to tackle it than Mr. Ferrara, the over-the-top director of "Bad Lieutenant," "Dangerous Game" (the recent Madonna-Harvey Keitel movie) and a slew of other overwrought films? Taste and moderation are the last things a new "Body Snatchers" needs.

But somehow, moderation is the tone of this smooth but pedestrian version. It could have been made by any innocuous director who knows how to aim a camera and keep from offending or startling anyone.

•

There are some clever new touches in the old story. The narrator and heroine is a teen-ager named Marti, played with a nice mix of rebellion and innocence by Gabrielle Anwar (Al Pacino's tango partner in "Scent of a Woman"). Along with her father, stepmother and 5-year-old half-brother, she has just moved to a military base where Dad, a scientist with the Environmental Protection Agency, is helping to clean up toxic waste.

The 90's step-family and the environmental theme bring the tale up to date, but the best joke comes from plopping this group down in a military community. The soldiers are already so poker-faced, how can anyone tell the humans from the soulless, emotionless pod people? Dad himself (Terry Kinney) has a laid-back attitude, which is also good for disguising podness.

The original "Invasion" all but stated that McCarthyism was the symbolic meaning behind the conformist body snatchers, but even then it never made much sense to turn this chiller into sociology. Mr. Ferrara knows that, and he also knows that the story is familiar to viewers who have never seen the original. So he gets right to the point. Early on, an hysterical soldier ambushes Marti in a gas station rest room, leaping out of the dark to offer the crazed warning: "They're out there. They get you when you sleep."

Nothing that follows comes close to that initial jolt. A few twisted camera angles and some fuzzy-yellow lighting are the only hints of Mr. Ferrara's deliciously skewed perspective.

"Body Snatchers" pilfers its eeriest touches from the 1978 version: the tentacles that creep out of the pods; the way the pod people point at humans and let loose with a mechanical-sounding shriek. No wonder; "Body Snatchers" shares the 1978 film's producer and one of its special-effects make-up artists. It doesn't share that film's sense of fun.

And there is only a muddled acknowledgment of many other, better horror stories that "Body Snatchers" evokes. The opening credits bring to mind television's "Twilight Zone." One glassy-eyed mother belongs in "The Stepford Wives." The fear of sleep, which was in the original film, has since been claimed by the "Night-

mare on Elm Street" movies. The makers of "Body Snatchers" must have realized this, but there is no tongue-in-cheek wit about these borrowings.

With its homogenized flavor, this "Body Snatchers" seems like a movie made BY pod people, FOR pod people.

•

"Body Snatchers" is rated R (Under 17 requires accompanying parent or adult guardian). It includes nudity and violence.

1994 F 4, C6:5

Gunmen

Directed by Deran Sarafian; written by Stephen Sommers; director of photography, Hiro Narita; edited by Bonnie Koehler; music by John Debney; production designer, Michael Seymour; produced by Laurence Mark, John Davis and John Flock; released by Dimension Films. Running time: 90 minutes. This film is rated R.

Dani Servigo	Christopher Lambert
Cole	Mario Van Peebles
Loomis	Patrick Stewart
Bennett	Sally Kirkland

By CARYN JAMES

Who would have thought that Christopher Lambert, the stony-faced hero of "Greystoke: The Legend of Tarzan," had a sense of humor? His career has included some unintentional comedy, but the planned goofiness of his performance in "Gunmen" is the best surprise in this otherwise witless action movie.

Mr. Lambert's character, a smuggler named Dani, reluctantly becomes part of a buddy team with a drug-enforcement agent named Cole, played by Mario Van Peebles. Mr. Van Peebles is less surprising here because everyone assumes that the star and director of "New Jack City" and "Posse" is smarter and more stylish than this mess.

The plot involves a boatload of stolen drug money. Loomis, the drug lord from whom the money was taken, sends his henchmen after Dani, who might be able to locate the boat. Cole wants to find the money because Loomis killed his father. That is easier to say than it is to figure out as you're going along.

Loomis (Patrick Stewart, of "Star Trek: The Next Generation") sits in a wheelchair and watches while his screaming bride is tossed into a coffin and buried. It seems she has been disloyal. Most of "Gunmen" is just this blunt.

The buddy scenes seem to be in a different movie. Mr. Lambert's character is ingenuous and not too bright. Mr. Van Peebles's is cagey, though not as cagey as he thinks. They might have been an engaging team, but they are stranded without a script. Mr. Lambert's humor comes from comic grimaces rather than anything he is given to say. This movie's idea of a joke is to have him eat bugs, in close-up.

When "Gunmen" does stumble across a decent gimmick, it goes wrong. Dani and Cole shoot each other in the leg, as a guarantee that neither will run off on his own. But this is the kind of sloppy film in which their slapstick limps come and go from scene to scene.

Mr. Lambert and Mr. Van Peebles are planning to team up again in "Highlander III." Get them a script, fast.

"Gunmen" is R (Under 17 requires accompanying parent or adult guardian). It includes sex, violence and impolite language.

1994 F 4, C8:6

Ace Ventura
Pet Detective

Directed by Tom Shadyac; written by Jack Bernstein, Mr. Shadyac and Jim Carrey; director of photography, Julio Macat; edited by Don Zimmerman; music by Ira Newborn; production designer, William Elliott; produced by James G. Robinson; released by Warner Brothers. Running time: 85 minutes. This film is rated PG-13.

Ace Ventura	Jim Carrey
Melissa	Courteney Cox
Einhorn	Sean Young

By STEPHEN HOLDEN

As "Ace Ventura: Pet Detective," the comic actor Jim Carrey gives one the most hyperactive performances ever brought to the screen. With his hair swept into a precarious leaning tower, his eyes wide as saucers, moving in spasms, he suggests Desi Arnaz as Don Knotts on speed.

Only a child could love Mr. Carrey's character, but that may be the point. The movie has the metabolism, logic and attention span of a peevish 6-year-old. It's not the story that matters, but the silly asides, like the way Ace starts doing impersonations of "Star Trek" characters at odd moments or singing the theme from "Mission Impossible."

Ace shares a small apartment with a vast menagerie of pets that he conceals from his landlady by stowing them in closets, garbage cans, even the toilet. (The film is loaded with children's potty humor.) The few scenes of Ace communicating with his animals hint at an endearing wackiness that is abruptly undercut by the movie's ridiculous plot.

That story concerns the kidnapping of the Miami Dolphins' mascot, a 500-pound dolphin named Snowflake. Ace, taking time off from his quest to find a true albino pigeon, is not quite as dumb as he seems. He succeeds in returning Snowflake to the Dolphins just in time for it to appear at halftime in the Super Bowl.

•

"Ace Ventura: Pet Detective" is rated PG-13 (Parents strongly cautioned). It has slimy bathroom humor and sexual situations.

1994 F 4, C8:6

My Father, the Hero

Directed by Steve Miner; written by Francis Veber and Charlie Peters, based on the film "Mon Père, Ce Héros," by Gérard Lauzier; director of photography, Daryn Okada; edited by Marshall Harvey; music by David Newman; production designer, Christopher Nowak; produced by Jacques Bar and Jean-Louis Livi; released by Buena Vista Pictures. Running time: 90 minutes. This film is rated PG.

André	Gérard Depardieu
Nicole	Katherine Heigl
Ben	Dalton James
Megan	Lauren Hutton
Diana	Faith Prince

By JANET MASLIN

Providing a graphic illustration of what troubled the French during the GATT talks, France's greatest living

film actor makes a fool of himself on water skis in "My Father, the Hero." In this latest example of that all-American art form known as "le re-make," Gérard Depardieu also wears loud shirts, cavorts on a Jet Ski, lets American teen-agers get the better of him and imitates Maurice Chevalier singing "Thank Heaven for Little Girls." Many words could describe what he does here, but "hero" is not one of them.

•

Actually, Mr. Depardieu acquits himself with remarkably good cheer. Since "Green Card," he has reached the point of being able to banter amusingly in English, which puts him way ahead of almost everybody else involved with this film. Steve Miner, the director whose "Forever Young," looks like a work of great sophistication by comparison, stages "My Father, the Hero" in a startlingly perfunctory manner. Katherine Heigl, playing the teen-age daughter who is mistaken for Mr. Depardieu's girlfriend, parades about in skimpy bathing suits, displaying almost everything but a sense of humor.

Francis Veber, the French writer and director whose comedies ("La Cage aux Folles," "The Tall Blond Man With One Black Shoe," "The Toy") have crossed the Atlantic so regularly, this time contributes to a screenplay that expects viewers to laugh at a dog urinating on Mr. Depardieu's leg. Charlie Peters ("Three Men and a Little Lady") is his co-writer, though it's not clear which of them would claim credit for a subplot, involving boorish American tourists. Based on a French film called "Mon Père, Ce Héros," this remake sends André (Mr. Depardieu) and his half-American daughter on a tropical vacation, which helps them to settle their longstanding differences. Nothing else about the film is moving, but its Bahamian beachfront scenery just might make you cry.

•

Mr. Depardieu, who in fact does quite a funny Chevalier imitation, shambles beefily through the story and manages to suggest that a spa might have been a better setting. Also in the film is Lauren Hutton, who appears only momentarily to play the star's one-dimensional ex-wife. A last-minute cameo appearance by Emma Thompson is even more glaringly wasted. Nor is there much of a role for Faith Prince, the witty and captivating star of Broadway's "Guys and Dolls," who has yet to find her niche in movies. Ms. Prince can't do much with the part of a lovelorn, middle-aged American. However, she can pronounce "André" as if it had three syllables and spanned two octaves.

•

"My Father, the Hero" is rated PG (Parental guidance suggested). It includes mild sexual suggestiveness.

1994 F 4, C10:6

Romeo Is Bleeding

Directed by Peter Medak; written by Hilary Henkin; director of photography, Dariusz Wolski; edited by Walter Murch; music by Mark Isham; production designer, Stuart Wurtzel; produced by Paul Webster, Michael Flynn and Ms. Henkin; released by Gramercy Pictures. Running time: 106 minutes. This film is rated R.

Jack	Gary Oldman
Mona	Lena Olin

Gary Oldman
Gramercy Pictures

Natalie	Annabella Sciorra
Sheri	Juliette Lewis
Don Falcone	Roy Scheider

By JANET MASLIN

In the most recent phase of an unusual career, the director Peter Medak turned to film noir with surprising success. Best remembered for "The Ruling Class," his wildly eccentric 1972 comedy starring Peter O'Toole, Mr. Medak had languished for a while in Hollywood ("Zorro the Gay Blade," "The Men's Club") before resurfacing with two dark, quintessentially English crime stories.

Both "The Krays" (1990) and "Let Him Have It" (1991) told bitter, deadly, sardonic tales set off by Mr. Medak's newly hardboiled direction. And both displayed a real noir nihilism, perhaps because the film maker was obliged to reinvent his form. Bound by true stories and confined to English row houses and seedy nightclubs, both these films became as visually distinctive as they were temperamentally tough. They were made without condescension. That is not the case with "Romeo Is Bleeding," Mr. Medak's latest foray into noir terrain.

With a Hungarian-born director and an English star (Gary Oldman), "Romeo Is Bleeding" works over-time to establish the kind of extreme seriousness that carries a satirical edge. Every ceiling fan and jaded voice-over announces that this film is steeped in Hollywood memorabilia, to the point where its own personality seems needlessly secondhand. "Romeo Is Bleeding" has a good cast, abundant flash and a lot of shallow jokeyness, but its surface attractions pale long before the story is over. And by that time, the film's dissipated hero has gone bonkers and its super-sadistic heroine has removed her own arm.

Part of what makes "Romeo Is Bleeding" such a novelty item is its women, both off and on the screen. The screenplay is by Hilary Henkin, whose goal seems to have been out-Hammetting Hammett, and whose better moments are well worth remembering. ("There was always a little daylight between his dreams and his wallet.") In a comparably lurid vein, the film immortalizes Mona Demarkov (Lena Olin), the "Queen of Queens rackets" and a woman who never met a garter belt she didn't like. Mona's lingerie flaunting appears to be one of the film's main raisons d'être.

The effort to show off Ms. Olin in a Sharon Stone role is a big success, up to a point. (The point comes when she loses the arm.) Ms. Olin looks great, and she's a lot more fiery in this hit-woman's role than she has been when trying, in tamer films, to be nice. But otherwise, "Romeo Is Bleeding" adds up to much less than the sum of its parts. Mr. Medak fared better in the service of true, wrenching stories than he does under the spell of this

material's desperate fancifulness. The joke isn't much of a joke to begin with, and it wears thin.

•

Among the valuable elements of "Romeo Is Bleeding" are Mr. Oldman's uncanny performance as a slang-spouting American. An English actor who can sound like more of a New Yorker than Annabella Sciorra is indeed a master craftsman. Mr. Oldman plays a cop named Jack Grimaldi, a hopeless romantic who is not quite satisfied living with Natalie (Ms. Sciorra), his wife. (Mr. Medak, whose visual style is best at its most icy and unsparing, indicates this with shots showing how the Grimaldis' tiny backyard overlooks a cemetery.)

So Jack has a secret life, one that incorporates sweet, dim Sheri (Juliette Lewis). Like Mona, Sheri establishes her character traits with the help of the right underclothes.

For all its promise, and for all the brittle beauty of Dariusz Wolski's cinematography, "Romeo Is Bleeding" eventually collapses under the weight of its violent affectations. But along the way, Mark Isham's brooding, jazzy score adds a lot to the film's superficial allure.

•

"Romeo Is Bleeding" is rated R (Under 17 requires accompanying parent or guardian). It includes nudity, sexual episodes and disturbing violence.

1994 F 4, C15:1

Lawyers, Guns And Murder

"Aileen Wuornos: The Selling of a Serial Killer" was shown as part of the 1993 New York Film Festival. Following are excerpts from Vincent Canby's review, which appeared in The New York Times on Oct. 9. The film opens today in Manhattan.

In January 1991, Aileen Wuornos, a prostitute in her late 20's, admitted to the murders of seven men, each picked up on a Florida highway, which was her usual venue. Some months later, after pleading no contest to the murders, Ms. Wuornos was sentenced to six life sentences, though she had been tried for only one of the murders.

The press and especially the television tabloid shows had a field day with the story about what they called "the man-hating murderer," apparently because Ms. Wuornos was an admitted lesbian. It was Tyria Moore, her lover, who tricked Ms. Wuornos into a confession during a telephone call monitored by the police. One immediate result of all this public interest: "Overkill," the television feature in which Jean Smart played Ms. Wuornos.

•

Now Nick Broomfield, an English film maker, has made a fine documentary feature that examines not only the Wuornos story, but also the

Aileen Wuornos
Strand Releasing

entire phenomenon surrounding it. "Aileen Wuornos: The Selling of a Serial Killer" doesn't have the personal swagger of Michael Moore's "Roger and Me," but it is that film's equal in all other ways.

It is sometimes funny, but far more often very sad and appalling. It's a slice of Americana to make you cringe with embarrassment as you recognize the society it reveals. In its way of suggesting that justice has not been adequately done, it also recalls Errol Morris's "Thin Blue Line." The film's two most breathtaking real-life characters: Steve Glazer, the bearded, fast-talking, guitar-playing lawyer who took over the Wuornos defense from a public defender, and Arlene Pralle, a born-again Christian who read about the case in the newspapers and felt a call to help Ms. Wuornos. After a busy correspondence and many prison visits, Ms. Pralle, who is married and raises Tennessee walking horses, legally adopted Ms. Wuornos.

Mr. Glazer is not only a lawyer, but also a card. When asked what he would say to his client facing the electric chair, he recalls the lawyer's advice to Virgil Starkwell in Woody Allen's "Take the Money and Run": "Don't sit down." In the course of all the hoopla surrounding the case, he also became the agent for Ms. Moore in her dealings with the press, television and film people. Together they demand $25,000 to cooperate with Mr. Broomfield, but settle for $10,000.

•

Revealed in the course of the film is the fact that Mr. Glazer and Ms. Pralle advised the prisoner to enter her no-contest plea, which made death sentences almost certain. Says Ms. Moore: "The state has a death sentence so, golly, in a few years she could be with Jesus. Why not go for it?"

The agonized center of the movie are television clips of the prisoner's trial testimony and, toward the end, an interview with Ms. Wuornos in which she questions the motives of her lawyer and adoptive mother. Though there's no thought that she is innocent, her testimony suggests persuasive mitigating circumstances. Mr. Broomfield and others he interviewed also wonder why there was no investigation of Ms. Moore's possible complicity in the crimes.

1994 F 4, C15:1

The Getaway

Directed by Roger Donaldson; written by Walter Hill and Amy Jones, based on the novel by Jim Thompson; director of photography, Peter Menzies Jr.; edited by Conrad Buff; music by Mark Isham; production designer, Joseph Nemec 3d; produced by David Foster, Lawrence Turman and John Alan Simon; released by Universal. Running time: 110 minutes. This film is rated R.

Doc McCoy	Alec Baldwin
Carol McCoy	Kim Basinger

Rudy Travis	Michael Madsen
Jack Benyon	James Woods
Jim Deer Jackson	David Morse
Fran Carvey	Jennifer Tilly

By CARYN JAMES

Not everyone can tumble out of a garbage truck and still look glamorously tousled. After "The Getaway," you'd have to put Kim Basinger and Alec Baldwin at the top of that list. Their appeal as a couple of gorgeous outlaws is the main reason to see this sleek, entertaining remake of Sam Peckinpah's 1972 action film, the one that brought Steve McQueen and Ali MacGraw together in real life. Ms. Basinger and Mr. Baldwin, who have been an old married couple for five months now, have the wit and unabashed vanity to give this update a cynical 90's flavor, and to make this movie their own.

Directed by Roger Donaldson ("No Way Out"), it is a tale of trust, double crosses and car chases, not necessarily in that order. Mr. Baldwin plays Doc McCoy, an expert safecracker who is let down by his colleagues and ends up in a dank Mexican jail. (Is there any other kind in the movies?)

Ms. Basinger is his wife and accomplice, Carol. She wears a long, skinny skirt to visit him in the dank jail, and agrees to take a message to a well-connected crook named Benyon (James Woods). The message is that Doc is for sale: if Benyon springs him from prison, Doc will pull off a major robbery in return. But Benyon assumes Carol is for sale, too. What's a devoted wife to do? She sleeps with Benyon to close the deal and free her husband (and never even whines about sexual harassment on the job). Eventually, Carol's secret and a botched robbery make them a sparring couple on the run.

•

Doc and Carol are no more virtuous than they have to be, but it's not necessary to admire them. You just have to enjoy watching Mr. Baldwin and Ms. Basinger look at each other, sometimes lustfully, sometimes warily, always with a healthy sense that this movie is a lark. And they are much more likable than the heavy-duty and equally entertaining villains who surround them.

Michael Madsen (who delighted in slicing off a detective's ear in "Reservoir Dogs") wears a long reddish wig. This adds a comic touch to yet another role as a psycho killer, who tries to betray Doc. This time, Mr. Madsen's character, Rudy, shoots a partner while driving a car, then opens the passenger door to let the body fall out, all without slowing down. Jennifer Tilly is a veterinarian's meek wife who becomes Rudy's hostage, to her immense pleasure. This subplot could easily have been spun off on its own.

Fun though it is, "The Getaway" could have been a lot better. Its too-slick action scenes are no match for its two slick stars. A heist at a dog track, the payback to Benyon for Doc's release, is suspenseful and taut, and it includes some dramatic explosions. But in general "The Getaway" starts off slowly and never achieves the snap of Mr. Donaldson's "No Way Out." Here he relies on action clichés to an embarrassing degree. When a villain walks onto a skylight, its obvious he'll be shot right there, the better to create a scene in which he falls through crashing glass.

Too many scenes seem clipped and perfunctory, especially the love scenes between Mr. Baldwin and Ms. Basinger. (She is never seen having sex with Benyon.) Those scenes tend to end just when they promise to become truly erotic, as if the stars had a sudden attack of shyness and decided to go home instead.

•

But anyone with nostalgic memories of the original should try sitting through it on video. That's all it takes to see what an improvement this "Getaway" is, even though it follows the earlier film faithfully, right down to Doc and Carol's escape by hiding in the garbage truck. The original crept along at first, too. Its characters were less vibrant, and it included what may be the rock-bottom performance of Ms. MacGraw's career.

Ms. Basinger's Carol is not only more lifelike; she is also a perfect match for her husband. They are equal in everything: in toughness; in their great and greatly revealed bodies; in the fantastic way their hair responds to gel. Who knows if they aspire to be the next Lunt and Fontanne? For now they've found a niche that fits them just right.

•

"The Getaway" is rated R (Under 17 requires accompanying parent or adult guardian). It includes some nudity and graphic violence.

1994 F 11, C12:5

Blank Check

Directed by Rupert Wainwright; written by Blake Snyder and Colby Carr; director of photography, Bill Pope; edited by Hubert de la Bouillerie and Jill Savitt; music by Nicholas Pike; production designer, Nelson Coates; produced by Craig Baumgarten and Gary Adelson; released by Buena Vista Pictures. Running time: 90 minutes. This film is rated PG.

Preston Waters	Brian Bonsall
Shay Stanley	Karen Duffy
Quigley	Miguel Ferrer
Biderman	Michael Lerner
Juice	Tone Loc
Chauffeur	Rick Ducommun

BY STEPHEN HOLDEN

Poor Preston Waters, the 11-year-old protagonist of "Blank Check," finds himself in a tight financial squeeze. His father has no idea how much it costs nowadays for a boy to have fun. When Preston visits an amusement park with his friends, his father gives him only $2 to spend, while his pals have 10 times that. In the film's most wistful scene, Preston rides alone on a boring old merry-go-round while his friends take more exciting and expensive spins on a nearby roller coaster.

Preston's fortunes magically change through a sequence of events that could only happen in a children's fantasy movie. A fleeing crook who accidentally runs over Preston's bicycle hastily writes him a check on which he forgets to fill in the amount. Preston has his computer type in a million dollars. When he goes to cash the check, the corrupt bank president, who is in cahoots with the crook, assumes Preston is a courier and stuffs his backpack with a million dollars in cash.

•

The bulk of "Blank Check" follows Preston on one of the giddiest spending sprees ever filmed. Using the pseudonym of Macintosh (after his computer), he buys a nearby stone castle for $300,000 and stuffs it with junk. Among the more elaborate toys are a wall-size screen for video games, a miniature car and a swimming pool with a toy yacht. At one point, there is a traffic jam in the driveway from trucks delivering several lifetime supplies of cola and cookies. Eventually, Preston gives himself a 12th-birthday party that costs $100,000, but that turns into a colossal fizzle because of a cash shortage.

"Blank Check," which was directed by Rupert Wainwright from a screenplay by Blake Snyder and Colby Carr, is a film that tries aggressively to rework the basic concept of "Home Alone." Overnight, a boy who has felt slightly misunderstood by his nice, well-meaning parents has an opportunity to wield enormous, unsupervised power. As in the "Home Alone" movies, "Blank Check" has its hero make fools of the criminals who pursue him, by improvising booby traps. The chase scene in which Preston eludes them by strategically deploying his toys carries the unintended warning that children's playthings might be even more hazardous than annual pre-holiday alarms about toy safety suggest.

The movie sags noticeably when its attention is diverted from its main character and in some scenes when it turns coy and self-conscious. Compared to the slapstick villains in the "Home Alone" movies, these bad guys — Miguel Ferrer, Michael Lerner and the rapper Tone Loc — are ineffectual buffoons. The movie could do without a limp subplot in which Preston pursues his crush on a pretty bank teller (Karen Duffy). The screenplay doesn't even bother trying to explain how Preston convinces his family that he has a high-powered job working for the mysterious Macintosh.

Brian Bonsall, who plays Preston, is an appealing youngster, but he is not the next Macaulay Culkin. That is to say that he does not project the soul of a heavy-metal star trapped in the body of a choirboy.

Like a typical Hollywood fable for children, "Blank Check" wants to have its moral cake and eat it, too. It expends the bulk of its energy proclaiming that greed is good, then takes it all back with a sweetness and light that are not entirely convincing.

•

The movie is rated PG (Parental guidance suggested). Very young children might be frightened by the movie's chase scenes.

1994 F 11, C12:5

My Girl 2

Directed by Howard Zieff; written by Janet Kovalcik; director of photography, Paul Elliott; edited by Wendy Greene Bricmont; music by Cliff Eidelman; production designer, Charles Rosen; produced by Brian Grazer; released by Columbia Pictures. Running time: 94 minutes. This film is rated PG.

Harry Sultenfuss	Dan Aykroyd
Shelly Sultenfuss	Jamie Lee Curtis
Vada Sultenfuss	Anna Chlumsky
Uncle Phil	Richard Masur
Rose	Christine Ebersole
Nick	Austin O'Brien

By STEPHEN HOLDEN

From Elton John singing "Bennie and the Jets," to mood rings, to Richard Nixon declaring, "The President has nothing to hide," Howard Zieff's film "My Girl 2" is awash in 1970's nostalgia. It is a measure of this family comedy's reflective good mood that even the embattled President's televised grimace seems more forlorn than forbidding.

"My Girl 2" is the appealingly sentimental sequel to one of the bigger hits of the 1991 holiday season. That movie followed the growing pains of Vada Sultenfuss (Anna Chlumsky), a smart, attractive Pennsylvania schoolgirl whose best friend (Macaulay Culkin) dies from bee stings in a freak accident.

All the significant principals, with the obvious exception of Mr. Culkin, are back for the sequel. Dan Aykroyd and Jamie Lee Curtis give reprises of their roles of Harry and Shelly Sultenfuss, a tuba-playing undertaker and his adoring second wife, who is now pregnant. Two years have passed and Vada, 13, is going through the first stirrings of adolescence.

The new movie picks up a strand of Vada's history that the first one barely touched on. When the students in her English class are asked to research and file reports on people they admire but don't know, Vada decides to trace the background of her mother, Maggie, who died giving birth to her. Because her father and Maggie married after a whirlwind courtship, even Harry is at a loss to provide much information on his first wife's background. Among a small box of mementos she left behind, the most mysterious item is a brown paper bag with a date scrawled on it.

At Shelly's urging, Vada flies to Los Angeles, her mother's hometown, for a five-day field trip. She stays with her Uncle Phil (Richard Masur), who runs an auto-repair shop and who lives with his longtime girlfriend, Rose (Christine Ebersole), and her adolescent son, Nick (Austin O'Brien). Accompanied by Nick, who metamorphoses from pest to boyfriend, Vada sets about filling in the blanks of her mother's past with the help of an old high school yearbook.

•

"My Girl 2," like its predecessor, is a family movie that wants to seem very grown-up while maintaining the perspective of a still-innocent 13-year-old girl. Where the first movie forced Vada to face some jarring realities (a best friend's death, a grandmother's senility) and was heavily salted with mortuary humor, the atmosphere of the sequel is softer and more golden. Among other things, the film is a nostalgic valentine to Los Angeles in palmier days when the city still wore the mystique of a laid-back, post-hippie lotus land.

This movie doesn't juxtapose the macabre and the sentimental nearly as aggressively as the original did. Janet Kovalcik's screenplay tells a coming-of-age story in straightforward dialogue, which, while deficient in laugh lines, largely manages to avoid stickier clichés.

The movie's female characters are strikingly richer than most of its men. Ms. Curtis's Shelly is the ideal stepmother: beautiful, patient and wise. Ms. Ebersole, as Shelly's spunkier West Coast counterpart, is correspondingly radiant. But nice as they are, their male partners are dull, domesticated schlumps. Why these perfect women would want to settle down with them is anybody's guess.

If the story takes some turns that seem far-fetched and contrived, the movie at least has the consistency of tone of an intelligent sitcom. It knows how to play the heartstrings without strumming too hard. One key to that tone is Ms. Chlumsky's appealingly understated performance. A strong-

er, more focused personality here than in the original, Ms. Chlumsky's Vada is so good-natured and reasonable that she comes dangerously close to being a dreamy-eyed little princess. It will be interesting to discover whether children and adolescents in the age of hip-hop and "Roseanne" can relate to her at all.

•

"My Girl 2" is rated PG (Parental guidance suggested). The story, although pitched for children and teenagers, portrays adult situations.

1994 F 11, C22:1

The Cement Garden

Written and directed by Andrew Birkin, based on the novel by Ian McEwan; director of photography, Stephen Blackman; edited by Toby Tremlett; music by Edward Shearmer; production designer, Bernd Lepel; produced by Bee Gilbert and Ene Vanaveski; released by October Films. At the Angelika Film Center, 18 West Houston Street, Greenwich Village. Running time: 101 minutes. This film is not rated.

Jack Andrew Robertson
Julie Charlotte Gainsbourg
Sue Alice Coultard
Tom .. Ned Birkin
Mother Sinead Cusack

By CARYN JAMES

It's hard to imagine that a film about burying your mum in the basement and sleeping with your sister could turn out to be as flat as "The Cement Garden." Andrew Birkin's version of Ian McEwan's dark coming-of-age novel treats its subject with such earnest matter-of-factness that the most unsettling elements turn dull. Even a handful of exquisitely delicate and difficult performances can't save the movie, which opens today at the Angelika Film Center.

The screen version is a less explicit version of Mr. McEwan's story about a 15-year-old named Jack (Andrew Robertson) and his claustrophobic family. Jack's father dies at the start of the tale, leaving him with his sickly mother (Sinead Cusack) and three siblings.

Jack is a gangly, pimply faced adolescent, obsessed with his own body and with that of his older sister, Julie (Charlotte Gainsbourg). Masturbation is one of his primary activities, shown discreetly but unmistakably.

When their mother dies, Jack and Julie decide to hide the body in the basement, in an old trunk filled with fresh cement. Along with their younger sister, Sue, and little brother, Tom, the children are then on their own. Jack stops bathing; Tom dresses in girls' clothes; something smells funny in the cellar; Jack and Julie head toward forbidden ground.

Mr. Birkin has a grip on the superficial elements of the story. The family lives in a boxy cement house

October Films
Charlotte Gainsbourg, left, and Andrew Robertson.

somewhere in England, eerily isolated among rubble-filled fields. All the performances are first rate, especially those by Alice Coultard as Sue and Ned Birkin (the director's son), as Tom. Ms. Cusack is fine as the weary mother who doesn't have a clue, and Mr. Robertson suggests the confusion behind Jack's rebellious, detached pose. Ms. Gainsbourg is, intentionally, just as inscrutable to viewers as she is to Jack.

The emotional heart of the story is what eludes Mr. Birkin. Following the novel, the film means to present Jack as Everyboy set free from the constraints of society or a superego. In both its forms, "The Cement Garden" owes less to incest fantasies than to "The Lord of the Flies." But in trying so hard to make Jack's obsessions seem natural rather than lurid, Mr. Birkin makes his hero and everyone around him uninteresting.

1994 F 11, C24:1

Women From the Lake of Scented Souls

Written and directed by Xie Fei, in Mandarin, with English subtitles; director of photography, Bao Xianran; music by Wang Liping; production designer, Ma Huiwu and Wang Jie; released by Yellow Line International. At Film Forum 1, 209 Houston Street, South Village. Running time: 105 minutes. This film is not rated.

Xiang Siqin Gaowa
Huanhuan Wu Yujuan
Que Lei Luosheng
Ren Chen Baoguo

By JANET MASLIN

In a rural Chinese village, the men make furtive plans to watch the occasional sex or action videotape from Hong Kong (though the sex films never seem to arrive). How misguided: if they're looking for lurid stories, these men needn't look far from home. As "Women From the Lake of Scented Souls" unfolds, it becomes clear that the village's own secret life is a lot more torrid and scandal-ridden than anything Hong Kong could come up with and that beneath this film's tranquil surface there lurks an intense and tragic soap opera. If the men don't notice, maybe that's because the story's strongest figure is a demure-looking woman.

"Women From the Lake of Scented Souls," which opens today at Film Forum, was a co-winner of the Golden Bear Award at last year's Berlin Film Festival. The film is a much slier and harder-edged drama than its delicately lovely title suggests. (This title may be oblique, but it's a big improvement upon "Woman Sesame Oil Maker," as the film was previously known.) The story revolves around a mom-and-pop sesame oil making business in which the mom, a no-nonsense matriarch named Xiang, does all the work.

Her husband, a lazy and abusive drunk, pays attention to the business only when it attracts the interest of Japanese investors, who find the quality of the oil to be extraordinary. Is there something special about the local water, they inquire? Xiang explains that the vast lotus-covered lake beside the village has a mysterious history and is thought to have been the place where two teen-age girls once drowned themselves over lost love. Throughout the film, the writer and director, Xie Fei, returns ruefully to the lake, a stirring visual

expression of the story's romance and grief.

The film maker devotes time to the homespun process of oil making (in the manner of Zhang Yimou, the director of "Ju Dou" and "The Story of Qiu Ju," who more or less wrote the book on this kind of down-to-earth Chinese drama). He also follows the changes and revelations brought about by Xiang's new success. This hard-working heroine is shown to be desperately devoted to her simpleminded son; though he is a grown man, his mother is seen washing him tenderly as he sleeps and tucking him into bed with a stuffed doll. When it develops that the son wants a real woman, Xiang uses her new prosperity to force the beautiful and deeply reluctant Huanhuan (Wu Yujuan) into an arranged marriage.

Xiang is herself no stranger to sexual duplicity. It is revealed that she has had a long affair with a married neighbor, partly because she loves him and partly just to make up for her own misery. Despite this intrigue, Xiang remains naïve enough to be shocked by the fashionable Japanese businesswoman who invites her to a meeting in the city as part of the newly formed sesame oil alliance. The Japanese woman is abruptly summoned to sleep with her boss. "This is very popular in foreign land," an interpreter explains sweetly to Xiang. "Good night."

The story of "Women From the Lake of Scented Souls" is presented gently, but its tension is unmistak-

able. If strong rural heroines are especially popular with today's Chinese film makers, that is because their lives remain so tragically constrained. Willful and hard-working as she is, Xiang is forced to face her life's limited possibilities and to recognize her own destiny being re-enacted by her helpless new daughter-in-law. As a 13-year-old bride sold into an unhappy marriage, Xiang once looked to the lake for release. Now, in her 30's, perhaps on the verge of grandmotherhood and having "passed middle age" (as her lover puts it), she is left to contemplate the culture that has left her life so sadly limited.

"Women From the Lake of Scented Souls" cannot match the supreme visual mastery of Zhang Yimou's films, but its own style is gratifyingly rich in detail. From the lotus blossoms on the lake to the ceremonial grandeur of a Chinese wedding, the film is gentle, moving and precise. It is also a study in compelling extremes, paying no less attention to the bruises on Huanhuan's neck than to the flower her husband tries to gives her as a gift of love. The viewer is forcefully drawn into the thoughts of Xiang, played with formidable strength and grace by Siqin Gaowa, as she tries to make sense of such a world.

1994 F 16, C20:1

From France, Depardieu as God And Other Joys

By CARYN JAMES

MANY in the French film industry think Gérard Depardieu is God, but only Jean-Luc Godard has dared to take the idea literally. In "Hélas Pour Moi" ("Woe Is Me"), the actor plays an ordinary man named Simon whose body is briefly inhabited by God, or so it seems when God's gravelly voice comes out of Simon's mouth, speaking "thine" and "thou," to the astonishment of his wife.

No road company of "The Odd Couple" could have come up with a less likely pair than these two men. The cerebral and often inaccessible Mr. Godard, a master of the French New Wave of the 1960's, has been under a critical and commercial cloud for two decades. Mr. Depardieu is so popular and lucrative a property that a recent story in Variety practically suggested that the French film business might collapse without him. But in "Hélas Pour Moi," they inspire each other's best tendencies. Beautifully photographed beside a Swiss lake, the film has a poetry and emotion rarely associated with Mr. Godard. Mr. De-

pardieu's performance is surprisingly restrained and resonant.

The tirades about French film that erupted during the recent GATT talks have mercifully faded away. (To refresh your memory, both sides sounded like little boys squaring off in the playground: "No fair! You're trying to kill us!" the French screamed at Hollywood. "Are not! And your movies stink anyway!" Hollywood yelled back.) "Hélas Pour Moi" hints that reports of French film's demise were wildly exaggerated. And there is plenty more evidence in a provocative, exciting series hiding behind a drab, uninviting title: "Cahiers du Cinéma Selects Recent French Films."

The series of a dozen films, most made within the last year and being shown in this country for the first time, begins today at the Walter Reade Theater at Lincoln Center and runs through March 1. It is the third annual installment of the program, chosen by the Film Society of Lincoln Center along with editors of the French journal Cahiers du Cinéma. Even in France, Cahiers has far less influence than it did 30 years ago, when its best critics turned to film making and created the personal, fluent style of the New Wave. But the journal still champions films that re-

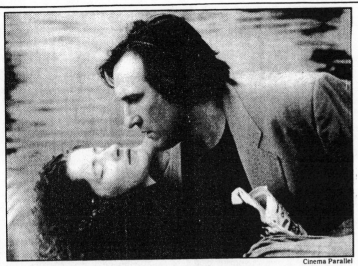

Cinema Parallel

Gérard Depardieu in the Jean-Luc Godard film "Hélas Pour Moi."

veal a director's distinctive vision and signature.

Though this year's series includes several names from the Cahiers pantheon, the program is not bathed in nostalgia. Eric Rohmer's "Tale of Winter," Claude Chabrol's documentary "The Eye of Vichy" and the Godard film present those directors in top form. And a documentary by Serge Toubiana and Michel Pascal, "François Truffaut: Stolen Portraits," is a surprising view of the much-loved director as his family and colleagues saw him.

Teen-Age Werther

One of the most charming films will be shown on Sunday and Monday. Jacques Doillon's "Young Werther" is more lighthearted and engaging than its title and plot make it sound. Ismael, the film's endearing 15-year-old hero, is not the suicidal Werther character based on Goethe's novel; his friend, Guillaume, is. Early on, Ismael and his friends learn of Guillaume's suicide and spend the rest of the film talking about life, love and death, and trying to track down the young woman who might have broken their friend's heart and left him in despair. "Young Werther" is most affecting in the way it gives adult weight to its unmistakably teen-age characters.

"Hélas Pour Moi," showing today, tomorrow and Monday, is not as easy to slip into, but its rewards are profound. Mr. Godard's sometimes fragmented narrative is broken by chapter titles and words on the screen. Townspeople tell what they know of Simon's possibly miraculous transformation, as if they were a Greek chorus. It helps to know that the story was inspired in part by the Greek legend of Amphitryon, whose body Zeus borrowed to seduce the man's wife. Mr. Godard's rigorous film mirrors the complexity of his themes: the process of storytelling; rediscovering traditions; the possibility of believing in God. All these ideas are eloquently embodied in Mr. Depardieu's sorrowful Simon. "Hélas Pour Moi" will also be shown at the Joseph Papp Public Theater from March 18 to 31.

Mr. Chabrol's "Eye of Vichy" is an engrossing look at French propaganda films and newsreels made for the collaborationist government of Marshall Pétain during World War II. As the narrator notes at the start, the film depicts France "not as it was,

but as Pétain and the collaborators wanted it to be seen." The film could have used more context. How many French people saw these films? What Allied or Resistance works might have counterbalanced them? But this firsthand evidence of what was put forth as happy news — unemployed French find jobs in Germany and Pétain is beloved by children all over France — is still chilling.

"François Truffaut: Stolen Portraits" plays off the title of Truffaut's own "Stolen Kisses." As a film it is merely competent, but as a glimpse at the director it is fascinating. More a professional view than a personal one, it nonetheless has moments of wrenching personal tenderness. Here is Mr. Depardieu again (maybe he *is* a one-man industry) reading a despairing letter Truffaut wrote while he was in a juvenile detention home.

A Rohmer Substitution

A new Rohmer film, "The Tree, the Mayor and the Médiathèque," was originally scheduled for the series, but at the last minute legal tangles kept it away. No one should complain about its substitute, though. Mr. Rohmer's charming and wise "Tale of Winter" is the story of a young woman who is misplaced by her lover. She gives him a wrong address, goes home to have his child and blithely assumes that one day he will turn up again. Meanwhile, she gets on with her life. Romantic and wry at once, "A Tale of Winter" suggests that while the French film industry is far from dead, it does not have an easy time in the United States. This film was shown at the 1992 New York Film Festival and is only now about to be released commercially, sometime in the spring.

Fifteen years ago, when it cost far less to distribute a film and there were more art houses around the country, many of the films in this series would automatically have had theatrical releases here. That they have struggled to be seen raises a crucial question: have action movies and juvenile comedies forced them out of the marketplace, or are they simply not very good? The answer, of course, is a little of both.

Not every French film is a gem. The series includes all three features by Léos Carax, a favorite of the New York Film Festival. "Les Amants du Pont Neuf," about two straggly lovers (Juliette Binoche and Denis Lavant) who live under a bridge and

find themselves soul mates during the French bicentennial celebration, is nearly unwatchable. But the overwhelming majority of films on the program deserve an audience. This

enticing series should help them find it. Whether anyone finds God in Gérard Depardieu is quite another story.

1994 F 18, C1:1

Reality Bites

Directed by Ben Stiller; written by Helen Childress; director of photography, Emmanuel Lubezki; edited by Lisa Churgin; music by Karl Wallinger; production designer, Sharon Seymour; produced by Danny DeVito and Michael Shamberg; released by Universal. Running time: 99 minutes. This film is rated PG-13.

Lelaina Pierce	Winona Ryder
Troy Dyer	Ethan Hawke
Vickie Miner	Janeane Garofalo
Sammy Gray	Steve Zahn
Michael Grates	Ben Stiller
Charlane McGregor	Swoosie Kurtz
Tom Pierce	Joe Don Baker
Grant Gubler	John Mahoney

By CARYN JAMES

There are many ways to peg the twenty-something generation, but none funnier, more accurate or less pretentious than by using the details that stick to characters like a second skin in "Reality Bites." On their college graduation day, the film's heroes — Lelaina, Vickie, Troy and Sammy — gather on a rooftop in Houston to smoke cigarettes, drink beer and sing "Conjunction Junction," a Saturday-morning cartoon snippet that helped educate them. Higher education is fine, but as a life-shaping experience it's just no match for television.

Lelaina (Winona Ryder) is the center of the film and of its romantic triangle. An aspiring film maker and her class valedictorian, she is taping a documentary about her friends. The audience sees snippets of this throughout "Reality Bites," a technique that offers a visual tie to the MTV generation without becoming intrusive. "I kind of made a promise to myself that I wouldn't think about where it was going to end up," Lelaina says of her film. "I didn't want to unintentionally commercialize it." That's not a problem "Reality Bites" has, and that mainstream sleekness accounts for a great deal of its charm. This film is "Slacker" without the slackness, intentionally commercial and breezily entertaining.

"Reality Bites" is directed by the comedian Ben Stiller with a sure comic touch and a feel for the texture of lives that are pretty much all texture and no forward drive. This generation has the overwhelming sense that ambition is wasted on the old. Helen Childress, the 23-year-old screenwriter, perfectly captures the slightly defensive wit of people like Lelaina, who can hold up a giant soft-drink cup and announce, "The most profound, important invention of my life: the Big Gulp."

It takes a spectacular cast to pull off this kind of meandering romantic comedy, and "Reality Bites" couldn't have done better. After "The Age of Innocence," it comes as a surprise to find Ms. Ryder acting and looking like the kid she is.

Lelaina has a brief stint as an intern at a local television show called "Good Morning, Grant." John Mahoney does a wicked satiric turn as the empty-headed, ever-smiling talk-show host, the most vapid television star since Ted Baxter.

When Lelaina is fired, it's time for platitudes from her parents. Her father (Joe Don Baker) says she's got to use a little ingenuity. Her mother (Swoosie Kurtz) says: "You're just going to have to swallow your pride. Why don't you get a job at Burger-rama?" Sound familiar? Generations come and go but some things never change.

Vickie (Janeane Garofalo) carries around a "Charlie's Angels" lunch box and keeps a

diary of all the men she has slept with. She's up to No. 66, though she isn't sure of his name. Vickie becomes a manager at the Gap and demonstrates for Lelaina's documentary how to use a little plastic board to fold a sweater. "People don't know," she says with delicious mock-seriousness as she folds away. "They don't know what it takes."

●

When Lelaina begins hanging around the house, smoking and running up a big bill by calling a 900-number psychic hotline, Vickie has to pull her out of it. "Man, you are *in* the Bell Jar," she says.

Troy (Ethan Hawke) is Lelaina's best friend, a glassy-eyed, ruddy-faced guitarist who always looks stoned. Mr. Hawke's subtle and strong performance makes it clear that Troy feels things too deeply to risk failure and admit he's feeling anything at all. "He will turn this place into a den of slack," Lelaina says when Troy loses his job and Vickie invites him to move into their shared apartment. As in any classic Hollywood romance, Troy and Lelaina are obviously in love. But they can't admit it until another suitor comes along and almost steals her away.

Mr. Stiller plays the rival, a good-hearted yuppie named Michael who works for a slick and shallow MTV-style network called In Your Face TV. The real MTV took no offense. In fact, they ran a "Reality Bites" contest, sending winners to the film's premiere last month at the Sundance Film Festival. Mr. Stiller, who briefly had a comedy show on MTV and later on the Fox network (both called "The Ben Stiller Show"), knows that the line between satire and reality is shadow-thin. "Reality Bites" walks that line with perfect balance. If it featured unknown actors and had less-funny lines, it might be MTV's "Real Life" series. And like MTV, its music is a mix of up-to-the-minute and trendy retro-70's.

Sammy (Steve Zahn), the friend who is gay but afraid of a relationship, is the only underwritten character. His function is to be supportive and let his friends take all the best lines.

When Lelaina wonders why life can't flow along as neatly as "The Brady Bunch," Troy says, "Because Mr. Brady died of AIDS." It's a rare moment of seriousness for the character and the film, and Mr. Hawke stops short of making it portentous. That's smart, because the best joke here is that "Reality Bites" doesn't have much bite and doesn't intend to. Like the generation it presents so appealingly, it doesn't see any point in getting all bent out of shape and overambitious. But it knows how to hang out and have a great time.

●

"Reality Bites" is rated PG-13 (Parents strongly cautioned). It includes strong language and hints at drug use.

1994 F 18, C3:2

The Life and Times of Allen Ginsberg

Directed by Jerry Aronson; photography by Jean de Segonzoc, Roger Carter and Richard Lerner; edited by Nathaniel Dorsky; music by Tom Capek; released by First Run Features. Cinema Village, 22 East 12th Street, Greenwich Village. Running time: 83 minutes. This film is not rated.

WITH: Allen Ginsberg, Edith Ginsberg, Joan Baez, Amiri Baraka, Ken Kesey, Norman Mailer and others

By JANET MASLIN

Having led the most public of private lives, Allen Ginsberg makes a difficult subject for a biographer. So Jerry Aronson's "Life and Times of Allen Ginsberg" is more dutiful than surprising, with more emphasis on the poet's times than on his life. Mr. Ginsberg has written so intimately and eloquently about his own experience that the film is most revealing when it lets him speak (or read his poetry) for himself. When Mr. Ginsberg sits at a kitchen table and simply reads "Kaddish," the mournful poem about his mother, Naomi, the words barely require further amplification.

Unlike his more furtive old friend William S. Burroughs, who was the subject of Howard Brookner's inventive 1983 documentary, Mr. Ginsberg can explain himself freely and is inclined to lay himself bare. Mr. Aronson has assembled a helpful array of home movies, brief interviews and wonderful photographs, but beyond that he cannot outdo his subject when it comes to candor or revelation. As a result, his film displays its seriousness while offering only the occasional surprise.

The best of these is an old television clip from "Firing Line" that shows Mr. Ginsberg singing "Hare Krishna" at William F. Buckley, who is struggling theatrically to keep a straight face. Mr. Buckley's look of last-ditch civility is outdone only by the beatitude of Mr. Ginsberg, who seems to know exactly what effect he has on others.

This documentary, which opens today at Cinema Village, begins with sunny-looking snapshots that contradict the poet's own memories of his difficult childhood. The mental illness of Mr. Ginsberg's mother, he says, left him a legacy of "poetic paranoia" and also strengthened him somehow. "He really bore the brunt, because he saw a lot that he should never have seen," says Edith Ginsberg, his stepmother. Later in the film, in speaking somberly of friends and lovers whose lives have been more troubled, Mr. Ginsberg explains: "My world had broken up long ago."

The film draws on Mr. Ginsberg's own mesmerizing photographs of the friends who would become so protean and famous: Jack Kerouac, Mr. Burroughs, Neal Cassady, Gregory Corso, Peter Orlovsky and others. While "The Life and Times of Allen Ginsberg" would seem best suited to devotees of this charmed circle, Mr. Aronson sometimes makes one wonder: Did this film really need a title identifying John Lennon and Yoko Ono?

Among the many others who are heard from is Joan Baez, who calls Mr. Ginsberg "very colorful and very crazy — and we need that." Ken Kesey describes Mr. Ginsberg et al. as "the old gunfighters: the real heavies in our mythology." Norman Mailer and Amiri Baraka speak of Mr. Ginsberg's strength and of his anger. The lineup is stellar, but the comments unsurprising. If Mr. Ginsberg were the sort to be self-promoting, he might say most of these things himself.

Mr. Ginsberg has emerged as such a magnetic and influential figure in biographies of his friends, both on the page and on film, that this portrait of him feels incomplete. Only when his own words and images (from a collection of remarkable photographs) dominate the film does it have real force.

1994 F 18, C10:1

Blue Chips

Directed by William Friedkin; written by Ron Shelton; director of photography, Tom Priestley Jr.; edited by David Rosenbloom and Robert K. Lambert; music by Nile Rodgers, Jeff Beck and Jed Leiber; production designer, James Bissell; produced by Michele Rappaport; released by Paramount. Running time: 108 minutes. This film is rated PG-13.

Pete	Nick Nolte
Jenny	Mary McDonnell
Happy	J. T. Walsh
Lavada McRae	Alfre Woodard
Neon	Shaquille O'Neal
Butch	Anfernee (Penny) Hardaway
Ed	Ed O'Neill

By JANET MASLIN

The writer and director Ron Shelton ("Bull Durham," "White Men Can't Jump") can slam-dunk a sports story with the best of them. And William Friedkin, who directed "Blue Chips" from Mr. Shelton's screenplay, obviously loves basketball. Together, they give "Blue Chips" a vigor that works well even for the sports-impaired, and that keeps the film scrappy and exciting almost all the way through. Only late in the game do they make an unforgivable mistake. "Blue Chips" falls apart when the film makers, figuratively speaking, haul their soapbox right onto the court.

Most of the time, "Blue Chips" is too energetic to sound self-righteous. And indeed, it begins at fever pitch. Pete Bell (Nick Nolte), one of those fanatically dedicated coaches most often found in the movies, starts off by browbeating his players so savagely that Pete looks ready to burst an artery. What this is supposed to mean is that Pete really cares about his college athletes. What it also means is that no matter how much he cares (i.e., screams), he can't make them good enough to win.

The film establishes this with fast, furious sports sequences during which Mr. Friedkin sends the camera racing along with the basketball, and Pete screams his very loudest at the referee. (Real games were played for the film, using current and former college stars, and their energy level comes through.) Hard as he tries, Pete can't avoid the conclusion that he had better start criss-crossing America in search of new talent. The trouble, and also the point, is that new talent costs money.

"Blue Chips" addresses the corrupt recruiting practices that were touched on in this year's earlier, much feebler basketball film ("The Air Up There") as it stretches Pete's principles to the limit. Yes, he will happily lie to each new prospect — among them, Anfernee (Penny) Hardaway — about his own religion if

Neil Leifer/Paramount Pictures

Courting Nick Nolte stars in "Blue Chips" as a basketball coach with recruiting problems.

that makes matters any easier. But will he buy that player's father a new tractor, or another one's mother (Alfre Woodard) a new house? Will he do the bidding of rich, dishonest Happy, who represents the alumni and is played by J. T. Walsh in true mad-dog style? Too many of the athletes play by Happy's rules. The film even finds one athlete who demands $30,000 in cash as an incentive to sign up.

It's no small matter that one of the players Pete finds is Neon Bodeaux, who is played by Shaquille O'Neal. The film seems quite reasonable in treating Mr. O'Neal's arrival on screen as a religious experience. When Mr. O'Neal is first seen playing amateur basketball with a few pals in New Orleans, the sound on the court turns thunderous and Mr. Nolte quite literally drops his jaw. Fair enough: later on, Mr. O'Neal winds up making the most spectacular play in the film. He also gives a genuinely appealing performance as the most honest and good-hearted of the new recruits. Matter of fact, if Mr. Friedkin didn't have to work so strenuously framing two-shots of Mr. Nolte with this seven-foot athlete, it might be hard to remember that Mr. O'Neal has a day job.

Also in "Blue Chips" is Mary McDonnell, playing the ex-wife who really speaks Pete's language. ("No rebounding. You got beat on the boards.") Ms. McDonnell is also made to deliver the story's preachiest sentiments, but she manages to do this with wry, sardonic charm. As a schoolteacher, she seems to be here only so that she can tutor Mr. O'Neal for his S.A.T.'s, a plot twist that is included mostly to fill time between games. Mr. O'Neal, who can be wry himself, is heard grousing mightily over having to sit through a college lecture on "Sir Gawain and the Green Knight."

In addition to Mr. Nolte's authentically bilious pep talks, the film's realistic elements include a lot of bona fide college players, who make the action scenes suitably intense. Other real sports figures like Bob Cousy and Larry Bird heighten the mood, as does Tom Priestley Jr.'s agile camera work during basketball scenes. Mr. Friedkin's direction is so brisk and taut that it's bound to appeal to the Boston Celtics, with whom (according to the production notes) he has worked out for each of the last 17 years. They're sure to ask him back for another season.

●

"Blue Chips" is rated PG-13 (Parents strongly cautioned). It includes profanity.

1994 F 18, C17:3

On Deadly Ground

Directed by Steven Seagal; written by Ed Horowitz and Robin U. Russin; director of photography, Ric Waite; edited by Robert A. Ferretti; music by Basil Poledouris; production designer, William Skinner; produced by Mr. Seagall, Julius R. Nasso and A. Kitman Ho; released by Warner Brothers. Running time: 90 minutes. This film is rated R.

Forrest Taft Steven Seagal
Michael Jennings Michael Caine
Masu ... Joan Chen
MacGruder John C. McGinley

By JANET MASLIN

"I'm a mouse hiding from the hawks in the house of a raven," says Steven Seagal in "On Deadly Ground," the film that marks his directorial debut. Actually, if you're

Joel Warren/Warner Brothers

Fighting Steven Seagal stars in and directs "On Deadly Ground."

looking for animal imagery to describe Mr. Seagal, try 800-pound gorilla. Clout counted for a lot more than talent in the decision to let this box-office phenomenon take the reins of his own wasteful, explosion-filled movie. But clout goes only so far. It took an alchemist like Andrew Davis — who directed two Seagal films, "Above the Law" and the huge hit "Under Siege," before making "The Fugitive" — to make Mr. Seagal look like gold.

Mr. Seagal's own film is awesomely incoherent, a mixture of poorly executed violence and "Dances With Wolves"-style astral musings. Nothing about it is first-rate except some of the scenery. And on the debit side, the editing, writing and occasional slow-motion flourishes are clumsy in the extreme. The confusion extends all the way to Mr. Seagal's character, Forrest Taft, who starts out as an Alaskan oil company trouble-shooter before revealing himself fully as a more benign and thoughtful fellow. Forrest, a blurrier version of Mr. Seagal's usual image, is a kind of philosopher-thug.

Sometimes Forrest is a guy who says, "Don't sneak up on me, I might shoot you in the eye." At other times, he is a spiritual bald eagle (honestly) who is personally asked by Mother Earth to save the planet. Much of what holds the character together is Forrest's taste for leisure clothes with an American Indian motif, though these make him look less like a trouble-shooter than a movie star at play in Montana. Mr. Seagal makes an impressive number of unexplained jacket changes during the course of the story.

●

The story pits Forrest against Michael Jennings, an evil oil tycoon played with uncharacteristic coarseness by Michael Caine. Mr. Caine, looking jarringly dark-haired, is not in the habit of giving bad performances, but Mr. Seagal has not exactly brought out the best in his actors. For the most part, they dutifully praise Forrest's manliness ("Forrest Taft is the patron saint of the impossible!") and deliver obscenity-dotted

dialogue in expressionless, tough-guy fashion. Joan Chen, as the daughter of an Eskimo chieftain, is one of the few non-tough-guy types here. But she is mostly window dressing. And even she winds up toting a gun.

The scene that best captures this film's conflicting moods is one in which a good-hearted old employee of the oil company is tortured enthusiastically by Jennings's henchmen. (The company is conniving to open "the biggest rig and refinery on the face of this planet" unless Forrest can blow up these big plans. Think he can?) The camera watches attentively while the old gent's fingers are broken by his assailants, then looks aside tactfully when the bad guys begin wielding a pipe-fitting tool. Mr. Seagal ends the sequence with a kind of grace note, as the camera drifts upward from the bloody victim and

gazes out a picture window at Alaskan mountain scenery.

Speaking of grace notes, "On Deadly Ground" concludes with a lecture delivered to an appreciative Eskimo audience in Alaska's State Capitol. Mr. Seagal, decked out in embroidered buckskin, shows pictures of oil-covered shore birds and speaks solemnly about our vanishing plankton. Truly, this is hubris and a half. You can't preach about preserving the environment and make movies full of sludge.

●

"On Deadly Ground" is rated R (Under 17 requires accompanying parent or adult guardian). It includes considerably ugly violence, much profanity and brief nudity.

1994 F 19, 11:1

FILM VIEW/Janet Maslin

The Sad Tale Of a Hustler Is Reissued

THE FILM "MIDNIGHT COWBOY" CAME TO mind recently, with the death two months ago of Harry Nilsson, the singer whose rendition of "Everybody's Talkin' " reverberates throughout the movie. Rarely has a pop song been better used as a musical accent on film, as Nilsson's sweet, soaring vocal conveys the fragile optimism of Joe Buck, the story's self-styled stud. The music buoyantly follows Joe to New York City as he dreams of his bright future as a gigolo. But as the film spirals downward, from high hopes to seedy realities and from Park Avenue to 42d Street, it delivers a stark cross section of Joe's brutalizing new world.

Slapped with an X rating when it opened in 1969, "Midnight Cowboy" was controversial in its day. That X was later scaled down to an R after the film won three Academy Awards, including the Oscar for best picture. ("Midnight Cowboy" is now being reissued for a 25th-anniversary engagement in New York and Los Angeles. With its vibrant New York scenes, its color and sound now restored to match present-day standards, and such stunningly good performances from Dustin Hoffman and Jon Voight, it's well worth watching on a big screen.)

The ratings contretemps grew out of the film's legitimate shock value — for its time. It told the graphic story of a would-be ladies' man who became a homosexual street hustler, and it romanticized his odd friendship with Ratso Rizzo, an unforgettable small-time crook. Today "Midnight Cowboy" is startling for a different reason: for its innocence. To watch this film now is to be reminded of how drastically the world has changed. Always wrenchingly sad, "Midnight Cowboy" has taken on an additional layer of pathos with the passage of time.

The late 60's were famous for licentiousness, but this film attained its X rating without any significant violence, profanity or frontal nudity. Partial nudity, simulated sex and painful metaphors (Mr. Schlesinger uses a shot of creamed corn to suggest orgasm) were enough to do the trick. But despite its supposed raunchiness, the film's tone now seems surprisingly repressed. Once he reaches New York, Joe never experiences sex as anything other than an act of anger or humiliation.

For all its supposed toughness, the story is more tender than bleak. As a 28-year-old hustler roaming a New York

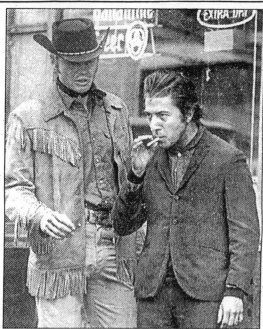

Jon Voight, left, and Dustin Hoffman in "Midnight Cowboy"—The X-rated film won three Oscars.

Movie Still Archives

free of guns, hard drugs, significant homelessness or violent crime, Joe leads a life that looks charmed by today's standards. The film's world may be harsh, but it is also safe. The main dangers Joe and Ratso face are social (a heavy dose of weirdness, supplied by the Warhol crowd during an orgiastic party scene) and environmental. Freezing and starving are the chief risks in this age before AIDS.

The film is at its most oblique in depicting the loving friendship between Joe and Ratso, whose scornful use of the word "faggot" turns their conversation into a litany of denial. Today you'd have to be as naïve as Joe Buck to miss the impact of a scene in which Joe is impotent with his one female paying customer (Brenda Vaccaro). Only after she taunts him with the word "gay" is he able to perform.

James Leo Herlihy's 1965 novel, which Waldo Salt adapted for the screen, was more blunt. Mr. Herlihy (who also died recently) made it clear that Ratso occasionally pimped for Joe with homosexual customers, and his book underscored Joe's humiliation. "The sadness of what he was doing had gotten through to him," Mr. Herlihy wrote about Joe's first gay pickup, "a sense of what this night was the first phase of, a leaden, paralyzing knowledge that in this pursuit success was in a way even worse than failure."

MR. HERLIHY WAS ALSO MORE GRAPHIC about the homosexual rape in Joe's past, which the film presents in a series of slick, confusing flashbacks. The film suggests that Joe's rape was brought on by his lust for Crazy Annie, the town tramp, and that he was somehow being punished for heterosexual passion. Mr. Herlihy, who set the rape in a brothel and left Annie out of it, had something more bizarre in mind.

"Midnight Cowboy" betrays a different innocence in terms of cinematic technique, with Mr. Schlesinger indulging in flights of fantasy built upon glib, sometimes empty juxtapositions. Still, those images have staying power, even if the film looks much less like trenchant social criticism than it did at the time. The glimpses of a snarling poodle fitted with false eyelashes and of Ratso's hellish daydreams about the high life in Florida work because they are intuitively linked to the film's grotesque characters. And Mr. Schlesinger, with his uncommonly fine eye for acting talent, got exactly what he wanted from every performer on the screen.

From Sylvia Miles's brassy turn as the "gorgeous chick" who out-hustles Joe Buck to the stars themselves, the actors in "Midnight Cowboy" make themselves desperately believable. As Joe sadly watches that snarling poodle, the audience knows he's met people who are no less horrifying. "His eyes clearly said, 'Help me,' but he had no idea any

message at all was being transmitted," Mr. Herlihy wrote about this lost soul of a hero.

Twenty-five years after it was filmed, "Midnight Cowboy" still looks pityingly into Joe Buck's eyes. ☐

1994 F 20, II:11:5

Silent Tongue

Directed and written by Sam Shepard; director of photography, Jack Conroy; edited by Bill Yahraus; music by Patrick O'Hearn; production designer, Cary White; produced by Carolyn Pfeiffer and Ludi Boeken; released by Trimark Pictures. Running time: 98 minutes. This film is rated PG-13.

Prescott Roe	Richard Harris
Awbonnie/Ghost	Sheila Tousey
Eamon McCree	Alan Bates
Talbot Roe	River Phoenix
Reeves McCree	Dermot Mulroney
Silent Tongue	Tantoo Cardinal
Comic	Bill Irwin
Straight Man	David Shiner

By CARYN JAMES

"I want to purchase your second daughter," Richard Harris tells Alan Bates. Prescott Roe (Mr. Harris) has already made one dirty deal with Eamon McCree (Mr. Bates). He bought the older of McCree's two half-Indian daughters as a bride for his son, Talbot (River Phoenix). But she has died in childbirth, his son is deranged with grief and the hapless father has hunted down McCree's traveling medicine show to make another bargain.

"I am not a bottomless pit of daughters, Mr. Roe," says the drunken McCree, who in top hat and fancy vest looks and sounds a bit like the Mad Hatter. And this is the *realistic* part of "Silent Tongue," Sam Shepard's eerie, inventive, poetic new film.

Even while the men speak, the body of the dead bride, Awbonnie (Sheila Tousey), is lying on the limbs of a tree, among talismans that hang from its branches. Talbot refuses to burn the body and set her soul free, so Awbonnie appears as a tortured, vengeful ghost. She roams through the film and becomes its strongest character. One side of her face is already shriveling, with a milky-blue eye; the other half is still human, one brown eye lucid.

Early in the tale, it is impossible to tell whether Awbonnie is ghost or hallucination, but it is instantly clear that Mr. Shepard's vision of the 19th-century plains is unlike any other film maker's. It would be misguided to lump "Silent Tongue" among the wave of recent revisionist westerns like "Dances With Wolves" and "Unforgiven," for Mr. Shepard's imagistic style is daringly different from anything Hollywood might offer.

This is the second film Mr. Shepard has written and directed, and it signals a gigantic leap beyond the first. "Far North" (1989) was a facile comedy-drama about a contemporary farm family falling apart. "Silent Tongue" comes from a deeper part of Mr. Shepard's imagination. It deals with mysticism, history and the kind of profound family tangle that echoes his best plays ("Buried Child," "True West," "A Lie of the Mind"). But while "Silent Tongue" is powerfully connected to Mr. Shepard's dramas, here he truly becomes a film maker. He composes eloquent pictures within the vast space of the plains, and uses his images to tell a story layered with meaning.

McCree's daughters are the children of a Kiowa woman called Silent Tongue (Tantoo Cardinal), who has a chilling history of her own. His son, Reeves (Dermot Mulroney), is irate at the treatment of his half-sisters. When Roe kidnaps the second daughter, the McCrees go after her, Reeves to save his sister and Eamon to recapture stolen property.

were forced by their mother to help her mainline heroin. One day, the mother injected an overdose and died before her sons' eyes.

Roemello also witnessed the drug-related shooting of his father (Clarence Williams 3d), whose drug dealing got him into trouble with Italian gangsters. Somehow, the film insists, these early traumas made both Roemello and Raynathan determined to go into the drug business themselves. Now Roemello is a major kingpin, with a taste for suave clothes, Art Deco furniture (heavy on the urns) and endless angst. "I'm sorry I let you down," he says in voice-over, while visiting his mother's grave. "I'm consumed by chaos, consumed by guilt, consumed by grief."

"Sugar Hill," which is about Roemello's last-ditch efforts to change his life after he finds the love of a good woman (Theresa Randle), has a story that cries out for either Spike Lee's dynamic moralizing or Abel Ferrara's fiery street style. Instead, it is presented with aching solemnity by Leon Ichaso ("El Super," "Crossover Dreams"), whose talents and shortcomings are both readily apparent here.

Mr. Ichaso can be a striking visual stylist, and his film has a studied, handsome veneer. (The elegant cinematography is by Bojan Bazelli, who has also done grittier work for Mr. Ferrara. Terence Blanchard's brooding trumpet score and Eduardo Castro's expressive set design are also notable contributions.) But Mr. Ichaso's slow, deliberate direction of Barry Michael Cooper's windy screenplay is painfully slack. If this film doesn't resort to much vicious gunplay until its later sections, that may be because the characters are always in danger of talking one another to death.

•

It's a shame that "Sugar Hill" is so becalmed, because the cast is impressive and the material carries a lot of raw conviction. "Sugar Hill," which may mean to evoke Romulus and Remus in this story of two powerful brothers whose paths diverge, uses Roemello and Raynathan as cautionary role models. The film seems serious in its eagerness to emphasize the waste and destruction caused by drugs, but it has a heavy hand. Mr. Williams, as the father who survived that shooting only to become a pathetic junkie, has far too many opportunities to embody drug-induced devastation at close camera range.

As this story's Italian Godfather, Abe Vigoda delivers one of the film's strained history lessons. "After King was killed, the people went crazy," he says about Harlem. "Destroyed the place. Decent colored people couldn't even walk down the street. Life changed!" It's unimaginable that in a film of Mr. Lee's, for instance, either a white or black character could say that without prompting some kind of back talk. Here, the response is barely a shrug.

Mr. Snipes is an actor who always commands attention, but he has a peculiarly passive role. Roemello's sophistication is established by touches like chess-playing and patience with women. ("Look, don't answer me now, all right? Just go upstairs and think about it.") Like most of the film's flagrantly dramatic scenes, the ones depicting arguments between the two brothers drag on well past the breaking point, which doesn't help. Neither does an awkward coda that marks the biggest change in Roemello's character. This ending might as well bear a title reading: "Scene in-

serted at preview audience's suggestion."

Among the casting surprises in "Sugar Hill" are appearances by Ernie Hudson as a rival drug dealer, Joe D'Allesandro as a petty gangster with great hair, and Leslie Uggams as the upstanding mother of Ms. Randle's nice-girl character. Ms. Randle is attractive and sincere, but she's stuck with three of the film's most absurd touches. There's the scene in which she's shocked to learn that the rich, debonair Roemello, who has no known job, is a drug dealer. There's the scene in which she's shocked, after going out on a date wearing a gold-spangled mini-slip and then visiting a man's apartment, to find the man becoming sexually aggressive. And there's this line, delivered worriedly to Roemello: "Do you know that every time I go out with you, somebody dies?"

•

"Sugar Hill" is rated R (Under 17 requires parent or adult guardian). It includes considerable profanity and several isolated instances of extreme violence.

1994 F 25, C10:6

8 Seconds

Directed by John G. Avildsen; written by Monte Merrick; director of photography, Victor Hammer; edited by J. Douglas Seelig; music by Bill Conti; production designer, William J. Cassidy; produced by Michael Shamberg; released by New Line Productions. Running time: 104 minutes. This film is rated PG-13.

Lane Frost	Luke Perry
Tuff Hedeman	Stephen Baldwin
Kellie Frost	Cynthia Geary
Cody Lambert	Red Mitchell
Clyde Frost	James Rebhorn
Elsie Frost	Carrie Snodgress
Young Lane	Cameron Finley

By STEPHEN HOLDEN

John G. Avildsen's film "8 Seconds" could spawn a boom in rodeo bull riding the way the movie "Urban Cowboy" did in mechanical bull riding 14 years ago, except for one crucial fact. The sport it depicts is just too dangerous. As the film makes graphically clear, trying to stay atop a snorting, bucking 2,000-pound bull for eight seconds while holding a mount with only one hand is no idle party game.

The movie's viscerally gripping scenes of competitive bull riding take the camera into the thundering heart of the action, where maintaining a precarious perch is only one challenge. Once a rider is thrown, he faces the immediate threat of being trampled or gored. And the film has scenes of both.

The true story of Lane Frost, the world champion bull rider who died in the ring in 1989 at the peak of his career, "8 Seconds" was directed by Mr. Avildsen with the same narrative exuberance he brought to "Rocky" and "The Karate Kid." The movie has the streamlined energy and emotional directness of a modern country-rock ballad. Bill Conti's aggressively brassy soundtrack is augmented by an album's worth of tough and tender country songs performed by John Anderson, Brooks and Dunn, Reba McEntire and others that enhance the rural atmosphere.

•

Not the least of the movie's strengths is a screenplay by Monte Merrick, which captures the clipped

New Line Cinema

Luke Perry

vernacular of country people who live close to the land and are not given to deep psychological self-scrutiny. The movie's happiest surprise is the strong, persuasive portrayal of Lane by the television heartthrob Luke Perry. The wiry young actor, who adopted a convincing Southwestern twang for the part, gives what might be called a defensive performance in its shunning of sentimentality and pretty-boy poses.

In Mr. Perry's hands, Lane emerges as an obsessively competitive, insecure and emotionally underdeveloped farm boy driven by a desperate need to please his undemonstrative father (James Rebhorn). Lane is so sensitive to his father's lack of praise that he goes out of his way to encourage younger boys with rodeo dreams. And this generosity of spirit, the film suggests, is his nicest quality.

A very straightforward biography, "8 Seconds" occasionally assumes the tone of a cinematic ballad like "Sweet Dreams," the movie biography of Patsy Cline. The story begins in 1968 with scenes of young Lane (Cameron Finley) competing in children's rodeos, then quickly jumps to the 1980's. With his pals, the supermacho Tuff Hedeman (Stephen Baldwin) and Cody Lambert (Red Mitchell), who writes cowboy poetry in his spare time, Lane is part of a threesome traveling the rodeo circuit, sharing cheap motel rooms and living on burgers.

The rowdy, hard-drinking Tuff is both a mentor and a rival to the puritanical Lane. After Lane suffers an excruciating groin injury, it is Tuff who urges him to "cowboy up" and goads him to get back on a bull before he has fully recovered. The film's portrayal of their friendship, which deepens and changes over several years, strikes its deepest emotional chord, as Tuff metamorphoses from a friendly bully into an unabashed admirer. And Mr. Baldwin's depiction of Tuff's emotional meltdown nearly steals the film.

Lane's life becomes complicated when he falls in love with Kellie Kyle (Cynthia Geary), a champion horse rider who gives up her career to marry him. Ms. Geary imbues the role with just the right mixture of true grit and naïveté. And the screenplay conveys the inevitable problems that afflict the marriage with a minimum of words. Self-centered and career-driven, Lane is on the road much of the time, and the couple's attempts at long-distance communication turn into awkward games of telephone answering-machine tag.

As Lane becomes a star, his success goes to his head and magnifies his obsessiveness. The couple's awkward, if heartfelt dialogues never let us forget the youth and innocence of two people who have only an elementary idea of how to verbalize their feelings. In the most pathetic scene, Lane, responding to Kellie's desire for a home, presents her with a garishly painted mobile home that is his idea of the perfect love nest and her worst nightmare of a domestic haven. After a few stumbling protests, she accepts it.

In such scenes it would be easy for "8 Seconds" to patronize its characters. But one pleasure of the movie is the way it takes the rodeo world on its own terms. Since "8 Seconds" is both a Hollywood movie and an elegy for a real-life hero, it, of course, ennobles that world and softens its harsher edges. And in its final minutes, it comes perilously close to turning to mush. But when it's over, it leaves you feeling more invigorated than played upon.

•

The film "8 Seconds" is rated PG-13 (Parents strongly cautioned). It includes strong language, and its bull-riding scenes might frighten young children.

1994 F 25, C14:1

French Director Says Adieu With 'Savage Nights'

"Savage Nights" was shown as part of the 1993 New Directors/New Films series. Here are excerpts from Janet Maslin's review, which appeared in The New York Times on March 20. The film — in French with English subtitles — opens today at the Angelika Film Center, Mercer and Houston Streets, Greenwich Village.

Gramercy Pictures
Cyril Collard

Cyril Collard can be seen in his own film "Savage Nights" as a warm, attractive actor with a rueful grin that never quite fades away. Mr. Collard's vivid presence in the film makes it especially sad to note that he died of AIDS on March 5, 1993, less than a week before "Savage Nights" received four French César awards, including the one for best picture.

Mr. Collard appears in this autobiographical story as Jean, a charmingly flirtatious 30-year-old with an especially complicated sex life. Ever receptive to both men and women, he becomes involved simultaneously with Laura (Romane Bohringer), a feisty and voluptuous teen-ager, and Samy (Carlos Lopez), a handsome rugby player who is living with a woman when Jean first meets him. The frustrations brought on by these two affairs are sometimes more than Jean can manage. When that happens he goes cruising, finding release and comfort in wordless group sex with strangers.

Jean also discovers that he is HIV positive. "Lose your grip," exhorts Maria Schneider in a solemn, unspecified role. "Drop your illusions. Learn from your disease." In Mr. Collard's turbulent account of Jean's progress, such peaceful acceptance does not come easily.

Late in the film, a car crash occurs suddenly, with neither warning nor aftermath. Mr. Collard put together "Savage Nights" in an abrupt, tumultuous spirit that truly reduces the car crash to nothing special. All of the events seen here, even those presented casually, become as furious and arbitrary as that accident once they are glimpsed in the light of Jean's growing desperation.

Mr. Collard's direction emphasizes the rawness of his story by discarding the connective tissue that might ordinarily hold it together. He never bothers to explain how Jean has got to Laura, then to Samy, then to Laura again or to someone else entirely. He simply juxtaposes these meetings without fanfare, thus offering some idea of how they may overlap in Jean's life. There are times when this stylistic affectation raises more questions than it answers, but most often the film maker's kaleidoscopic approach is as involving as it's meant to be.

Throughout "Savage Nights" there are distress signals, not all of them from Jean. Samy seems to be developing a taste for sadomasochism and some sympathy for the neo-Nazi types who appear briefly in the story. Samy's girlfriend angrily berates Laura. Laura is made uncontrollably furious by Jean's admission that he had unsafe sex with her after knowing he was HIV positive.

At one point Laura erupts at the owner of the dress shop where she works, stealing a jacket and spitting at her boss. "I think I'll go to film school," Laura muses, right after this incident. Mr. Collard's wry sense of humor extends to the rebellious posturing that his own film often employs.

The screenplay provides its own definition of a rebel: "Someone marked by fate and with real dignity inside." Mr. Collard, by communicating his anxiety in such honest, troubling terms, surely met that definition. He leaves behind a brave, wrenching self-portrait and a great deal of unfulfilled promise.

1994 F 25, C16:1

tive bisexual named Jean, played by Collard, the film turned him into both hero and villain.

"Savage Nights" opened in New York on Friday (after having been shown at last year's New Directors/New Films Festival). Perhaps it will benefit from the commercial success of "Philadelphia," which has been surprisingly popular with audiences across the country, but the French film could not be further from any mainstream AIDS story.

In France, Collard was admired for the openness with which he admitted that he had the AIDS virus and for the sexual bravado of his film. The character Jean has no qualms about quick sex with strange men under a bridge on the bank of the Seine; he sleeps with Laura, his 18-year-old girlfriend (Romane Bohringer), without telling her he is H.I.V.-positive. This apparently amoral hero led some to praise Collard as the heir to Jean Genet, whom the director admired. Collard was vilified by others, who thought he was irresponsible because he did not portray Jean as the devil.

These polarized views make "Savage Nights" seem more moralistic and political than it is. The film is astonishing precisely because it refuses to preach. Collard does not ask viewers to approve of Jean, and clearly doesn't care whether they do. But he cares passionately about making

The French film 'Savage Nights' is far from a mainstream AIDS story.

them understand Jean's behavior. Unlike a Genet character, Jean is not defiantly antisocial. He is trying to live while facing the knowledge that he is dying, which leads to confused and reckless behavior.

The bright colors and flashy look of the film — Jean zooming along the highway in his red convertible is one of its essential images — capture the character's fast life. But as writer, director and actor, Collard is more sophisticated than that. He knows that Jean is charming; the camera plays to his good looks and seductive smile. He knows that Jean is irresponsible (something the film's detractors choose to ignore). He knows what it is like to live with AIDS.

The provocative power of "Savage Nights" does not come from its sexual content. (The love scenes between Jean and Laura are more intense and explicit than any of Jean's casual homosexual episodes.) The film's force comes from Collard's ability to analyze Jean, to embody him on screen and ultimately to turn him inside out.

Collard was aware that this attitude might seem like sympathy for the devil. In an interview printed shortly after the film's release, he emphasized that he set the story in 1986, when AIDS testing was new. "If the same story were to take place in 1992," he said, "Jean would almost be consid-

Gramercy Pictures
Cyril Collard tells Romane Bohringer a bit late.

ered a criminal." Yet he also said, with wild understatement, "My film is not an ad for the health department." Collard refuses to make the situation any easier for the audience than it is for his confused hero.

When Jean first sleeps with Laura, he begins to have a conversation with her that he doesn't complete. He can't — or won't — tell her he has the AIDS virus. "It was like a

FILM VIEW/Caryn James

Bisexual Bravado Unto Death

WHEN THE FRENCH WRITER AND DIRECtor Cyril Collard died of AIDS last year, 1,000 people showed up for his funeral at Père Lachaise Cemetery — the final home of pop icons like Edith Piaf, whose melancholy romanticism Collard echoed, and Jim Morrison, whose live-fast, die-young allure the film maker's own appeal vaguely resembled. In the few years during which he was a celebrity in France, Collard was an ambiguous hero. His first and only feature film, "Savage Nights," won a César (the French version of the Oscar) for best film just three days after his death at the age of 35. The autobiographical story of an H.I.V.-posi-

dream, like I'd forgotten the virus was a part of me," he tells a friend later, without justifying his behavior.

When he finally does tell Laura, she screams, "You're a monster!" Collard's absolute conviction as an actor makes Jean's response far less preachy than it sounds on paper. "Don't make judgments," he says of his situation. "You don't know what it does."

What his behavior does to Laura is devastating. Her response is crazed denial. She refuses to use a condom when she sleeps with him. When she seems to be losing him to Samy, a working-class man, she phones Jean relentlessly, creates screaming scenes and seems about to lose her sanity. Laura's enraged behavior is only partly obsessive passion. It is more strongly a displaced response to AIDS, which has made sex literally a matter of life and death for her.

While Jean is never seen as the culprit, Collard avoids any easy or mawkish sympathy for him. When he sees a young man being beaten, he cuts his own finger and threatens to infect the thug with tainted blood.

Jean says, "Sometimes I'll do anything just to forget I'm wasting away." But unlike Tom Hanks in "Philadelphia," Jean never looks ill. Part of the jolt of watching "Savage Nights" comes from seeing the charismatic and healthy-looking actor on screen and realizing that in a short time he will be dead.

"Savage Nights" does not entirely avoid melodrama, especially at the end, when Jean learns to love humanity and to embrace life, complete with overblown dialogue and images of a sunrise. But despite its weaknesses, the film is more realistic and tougher than any AIDS story that preaches humanity. Jean, knowing he is doomed, asks a friend, "Can you imagine living with that every second of the day?" Unlike any soothing mainstream work, Collard's rigorous film offers a glimpse of the answer to that lethal question. □

1994 F 27, II:17:5

Angie

Directed by Martha Coolidge; written by Todd Graff, based on the novel "Angie, I Says," by Avra Wing; director of photography, Johnny E. Jensen; production designer, Mel Bourne; produced by Larry Brezner and Patrick McCormick; released by Buena Vista Pictures. Running time: 108 minutes. This film is rated R.

Angie	Geena Davis
Tina	Aïda Turturro
Noel	Stephen Rea
Vinnie	James Gandolfini
Frank	Philip Bosco
Kathy	Jenny O'Hara

By JANET MASLIN

The title character in "Angie" is supposed to be a tough, wisecracking, not-too-worldly office worker from Bensonhurst, Brooklyn. She may be spirited and feisty, but her basic attributes hardly bring Geena Davis to mind. In light of that, Ms. Davis's presence doesn't guarantee "Angie" much verisimilitude, but rarely has authenticity counted for less. Ms. Davis, whose performance is exhilaratingly funny and touching, compensates for her lack of grit by sending this film's goddess quotient over the moon.

Ms. Davis's star turn anchors a film that, as directed ebulliently but unevenly by Martha Coolidge, might otherwise be dangerously adrift. As the story of an unmarried woman whose pregnancy forces her to reassess her life, "Angie" is oddly torn between contemporary feminism and the comforting tenets of an old-fashioned women's picture. Angie's search for meaning and independence finally leads her to a surprisingly traditional destination, but she has her share of eye-opening experiences along the way. Luckily "Angie," for all its "Moonstruck"-type and nagging inconsistencies, succeeds in making those experiences matter.

The father-to-be is a bighearted plumber named Vinnie, and he is truly baffled. His girlfriend, who ought to be making wedding plans, is bailing out instead. "Most girls get pregnant 'cause they want the guy to marry 'em," Vinnie marvels in "Angie, I Says," the novel by Avra Wing on which Todd Graff's screenplay is based. "You get pregnant so's you can break up with the guy. It don't make no sense."

•

The book's pregnant heroine is called Tina, and she has a friend at the office — Angie — whose violently unhappy marriage helps to crystallize Tina's fears. On screen, with Angie's and Tina's names transposed, the atmosphere becomes more effervescent and less harsh. Tina (played memorably as a hearty comic sidekick by Aïda Turturro) has a husband who ridicules her weight and wears awful-looking warm-up suits. But his big offense is vulgarity, not serious abuse. In this film, with its heavy accents and scrappy Brooklyn stereotypes, obnoxiousness may be offense enough.

As for Vinnie, who is saved from condescension by James Gandolfini's affable performance, he has no real strikes against him either. Exemplifying the film's taste for ersatz earthiness, he comes across as decent but crude. He doesn't deserve to lose Angie any more than he deserved to land her in the first place. And he doesn't mean to scare her, but he can't spell plumber. He says things like: "A house, a crib, a nice, normal life. I mean, I can't wait — can you?"

Ms. Davis has no trouble suggesting that Angie, for all her salt-of-the-earth humility, knows she is meant for bigger things. She sees the promise of a different life when she is picked up by raffish Noel (Stephen Rea) at the Metropolitan Museum of Art. (One of the details this film gets

right is that Mr. Rea, with his sheepish grin, and Ms. Davis, with her long hair and leotard, look like a couple who might really meet that way.) Noel is a charmer, but his character is supposed to have a weak side. The novel didn't make sense of him and the film doesn't either, despite the great appeal Mr. Rea brings to the role. •

•

"Angie" would have the feel of a standard love-triangle story if it weren't for the film's more brazen details, not the least of them being Angie's pregnancy. There are times when the film seems to confuse obstetrical candor with some sort of larger daring. There are also times when the principals' outspoken brassiness, thick accents and loud costumes threaten to turn them into caricatures. Nevertheless, Ms. Coolidge keeps track of her heroine's essential seriousness, and of Angie's yearning for some kind of substance in her life. Late in the story, Angie faces real trouble in ways that stir unexpectedly deep emotions.

Ms. Davis, whose physical stature matches her supreme confidence, is particularly good in roles that find her battling the limitations of ordinary life. Even if such stories literally go off a cliff (as "Thelma and Louise" did), this actress seems to win her fight. Looking great in wild costumes and flashing that snow-melting grin, she makes "Angie" seem much nervier than it really is. She also carries the plot's shakier side. When Angie embarks on an improbable last-minute voyage of discovery, her actions might seem seriously off-putting if the audience weren't in her thrall.

"Angie," which also features Philip Bosco and Jenny O'Hara as the heroine's beleaguered father and stepmother, will have great curiosity value for anyone pondering the difference between anti-feminist backlash and backhanded progress. There's something to debate in whether "Angie," in embracing single motherhood, is ahead of or behind its times.

•

"Angie" is rated R (Under 17 requires accompanying parent or adult guardian). It includes profanity, brief nudity and sexual situations.

1994 Mr 4, C6:5

China Moon

Directed by John Bailey; written by Roy Carlson; director of photography, Willy Kurant; edited by Carol Littleton and Jill Savitt; music by George Fenton; production designer, Conrad E. Angone; produced by Barrie M. Osborne; released by Orion Pictures. Running time: 99 minutes. This film is rated R.

Kyle Bodine	Ed Harris
Rachel Munro	Madeleine Stowe
Rupert Munro	Charles Dance
Lamar Dickey	Benicio Del Toro

By CARYN JAMES

"China Moon" is such a shameless rip-off it should have been called something more honest, like "Body Heat: The Return," or "The New Adventures of Body Heat," or "Body Heat With a Couple of Different People." This film is a lot less effective than the genuine "Body Heat," the steamy 1981 thriller in which Kathleen Turner found in William Hurt just what she was looking for: a guy dumb enough to help her kill her rich husband. But even second-generation

copies have their modest charms, and "China Moon" is absorbing and twisty enough to keep an audience watching.

This time Madeleine Stowe plays the most beautiful bored wife in Florida, Rachel Munro, and Charles Dance is her handsome but abusive husband, Rupert. Mr. Dance's Southern accent comes and goes, but he always seems elegantly at home in their large, white-columned house.

Ed Harris is Kyle Bodine, the sensitive, working-class detective (a minor twist on Mr. Hurt's corrupt lawyer) who falls for Rachel. He eventually helps her dispose of her husband, literally; the film is not a bad primer on how to dump a body without leaving clues. Kyle doesn't actually pull the trigger, but he leaps into his role as accessory to murder as only a love-struck cop can.

From the start, of course, Rachel looks suspicious to us, if not to Kyle. He seems to think he's the first man she ever picked up in a bar. After "Body Heat," it's hard not to assume the worst about her, and "China Moon" isn't crafty enough to deflect those suspicions as much as it should. Its suspense comes from half-heard phone conversations and missing links in the story rather than clever plotting and ambiguous scenes.

But the actors are appealing, especially Mr. Harris as the man who loves not wisely but too gullibly. Benicio Del Toro does a smart turn as his young partner, who learns a little too fast for Kyle's good.

The director, John Bailey, keeps the story moving quickly. He is better known as a cinematographer, of films like "Groundhog Day" and "In the Line of Fire," which helps explain why the actors have never looked better in their careers. And if they look a little younger than they do now, it's not all a matter of lighting. "China Moon" was one of those films put in cold storage after Orion Pictures declared bankruptcy in late 1991.

The film is not moldy, or an embarrassment to anyone, except during some moments of laughable dialogue. When Kyle takes Rachel out on the lake in the moonlight, he recalls what his grandmother used to say: when the moon is full, "like a big old plate of china," it makes people act weird. Grandma should have told him that if you want to see people act weird, nothing beats passion and larceny.

•

"China Moon" is rated R (Under 17 requires accompanying parent or adult guardian). It includes nudity, violence and strong language.

1994 Mr 4, C6:5

The Chase

Written and directed by Adam Rifkin; director of photography, Alan Jones; edited by Peter Schink; music by Richard Gibbs; production designer, Sherman Williams; produced by Brad Wyman and Cassian Elwes; released by 20th Century Fox. Running time: 87 minutes. This film is rated PG-13.

Jack Hammond	Charlie Sheen
Natalie Voss	Kristy Swanson
Officer Dobbs	Henry Rollins
Dalton Voss	Ray Wise
Dale	Flea
Will	Anthony Kiedis

By STEPHEN HOLDEN

Adam Rifkin's satirical comedy, "The Chase," takes one of Hollywood's most sure-fire adrenaline-

pumping devices, a high-speed car chase, and turns it on its ear with a malicious, flailing glee. Virtually the entire movie takes place on the freeway between the outskirts of Los Angeles and the Mexican border as a routine police action rapidly escalates into a grotesque media circus. Anyone who has ever loathed the way television news anchors camouflage the medium's insatiable appetite for live-action excitement under a guise of pious concern will get some nasty chuckles out of the film.

The journey begins at a convenience store in Newport Beach, Calif., where 28-year-old Jack Hammond (Charlie Sheen) is being questioned by the police about a car theft. Pretending it's a gun, Jack shoves a candy bar into the neck of a young woman near the checkout counter, takes her hostage and flees in her red BMW. Unbeknownst to Jack until it's too late, his hostage, Natalie Voss (Kristy Swanson), happens to be the only daughter of a publicity-hungry billionaire (Ray Wise) known as "the Donald Trump of California." An impulsive act of self-protection is assumed by the outside world to be a premeditated kidnapping.

"The Chase" is a very crude but often amusing sendup of car chases, real-life television and the way television bends stories to fit its pre-packaged formulas. Coming right on the heels of the Tonya Harding-Nancy Kerrigan follies, its spoofing of rampant news lust seems almost eerily on target.

But this wild and woolly action farce doesn't even make a token attempt at believability or continuity. It is one long series of gags, some of them gross, others satirically pointed, at the expense of all its characters except for the fugitive and his traveling companion. Every few minutes, just as its energy begins to flag, it throws in a gratuitous explosion and car crash.

Some of the most heavy-handed satire is aimed at the macho fantasies of Southern California policemen. Officer Dobbs (Henry Rollins), Jack's most persistent — and persistently inept — pursuer is a grimly self-important policeman who when called into the chase is being videotaped in his car for a program called "Fuzz: The Real Cop Show." Clenching his jaw like Superman, he compares himself to Bruce Springsteen and Sylvester Stallone and describes his occupation as "standard-issue street soldier." The first of many embarrassments occurs when Natalie becomes car sick and her vomit splatters onto Dobbs's windshield.

The movie is very coy in its presentation of its antihero. A character who initially appears to be a dangerous criminal is gradually revealed to be a nice guy who is only trying to stay out of prison for a robbery he didn't commit. By the end of the film, this scuzzy car thief has metamorphosed preposterously into a heroic victim whose captive has fallen completely in love with him. She too has undergone an astounding change from spoiled, whining rich girl to the brave protector of the incorruptible Jack. In the movie's most ludicrous scene, they make passionate love in the driver's seat of her BMW while going 100 miles an hour.

•

The movie's characters are mostly one-dimensional cartoons drawn with an awfully heavy hand. At one point, the film abruptly throws in a "Wayne's World" parody in the per-

son of two hideously grungy teenagers (Anthony Kiedis and Flea of the Red Hot Chili Peppers) who try to intercept the red BMW. The movie is particularly nasty toward Natalie's father, a miser, a bully and a power-mad maniac whose chief mode of communication is the screaming threat.

But if "The Chase," is a big loud mess of a movie, it still detonates laughs. And after watching it, a high-speed car chase will probably never quite seem the same again.

•

"The Chase" is rated PG-13 (Parents strongly cautioned). It has strong language and one moderately steamy sex scene.

1994 Mr 4, C14:1

Where the Rivers Flow North

Directed by Jay Craven; written by Mr. Craven and Don Bredes, based on the novella by Howard Frank Mosher; director of photography, Paul Ryan; edited by Barbara Tulliver; music by the Horse Flies with Ben Wittman; production designer, David Wasco; produced by Bess O'Brien and Mr. Craven; released by Caledonia Pictures. Running time: 104 minutes. This film is not rated.

Noel Lord	Rip Torn
Bangor	Tantoo Cardinal
Wayne Quinn	Bill Raymond
Clayton Farnsworth	Michael J. Fox
Champ's Manager	Treat Williams

By CARYN JAMES

The real-life story behind "Where the Rivers Flow North" is the stuff of independent film makers' fantasies. A Vermonter named Jay Craven put together the money for his film from a variety of sources, ranging from foreign sales rights to local small investors, and made the kind of period piece that would be produced in Hollywood only as a fluke.

Based on Howard Frank Mosher's regional novella, the film is set in 1927 and centers on two unlikely characters. Noel Lord (Rip Torn), an old man with white hair flowing below his shoulders and a metal hook for a hand, has lived on his land all his life and is resisting a power company's attempt to take it over. An Indian woman named Bangor (Tantoo Cardinal) has been with him as housekeeper and lover for decades. She wears a man's crushed hat, is missing a front tooth and holds no illusions about the need to take the power company's money and go. Mr. Craven, who directed and co-wrote the script, also persuaded Michael J. Fox and Treat Williams to appear in small roles.

•

There is so much good will behind the scenes that it seems heartless to say "Where the Rivers Flow North" is as pretty and as flat as a Vermont postcard. But in truth, there isn't much to recommend it beyond Ms. Cardinal's performance and some rich potential that never comes to life.

Ms. Cardinal gives Bangor a freshness rarely seen on screen. She refers to Lord as "mister" and herself as "her," but her dialect is the flavor of her uniqueness. She is so tough and blunt that when she begins to cry about the children she never had, it becomes clear that emotion has been a luxury in her hardscrabble life.

But her character only suggests the depths that the film fails to reach.

Mr. Craven directs as if the story could tell itself, without any hand to guide its dramatic structure. Mr. Torn grumbles his way through the role, and Mr. Fox appears briefly in a few short scenes as a merciless power-company executive. For sheer drama, "Where the Rivers Flow North" is no match for the story of its conception.

1994 Mr 4, C15:1

Greedy

Directed by Jonathan Lynn; written by Lowell Ganz and Babaloo Mandel; director of photography, Gabriel Beristain; edited by Tony Lombardo; music by Randy Edelman; production designer, Victoria Paul; produced by Brian Grazer; released by Universal. Running time: 109 minutes. This film is rated PG-13.

Daniel	Michael J. Fox
Uncle Joe	Kirk Douglas
Robin	Nancy Travis
Molly	Olivia d'Abo
Frank	Phil Hartman
Carl	Ed Begley Jr.
Ed	Bob Balaban
Patty	Colleen Camp
Glen	Jere Burns
Detective	Khandi Alexander
Butler	Jonathan Lynn

By JANET MASLIN

"Greedy," which has the makings of a gleefully malevolent family comedy, begins on a note of inspired wickedness. Members of the McTeague clan are making their slavish pilgrimage to the home of Uncle Joe (Kirk Douglas), the foxy old millionaire whose health is very much on their minds. Nobody likes Uncle Joe, but the McTeagues can agree on this much: they want his money. Bearing stuffed birds of prey (which the old man apparently loves) and shepherding children with names like Joette and Jolene, they will do anything to win their uncle's favor.

"Try and bring up my cousin Tina's drinking," Carl McTeague (Ed Begley Jr.) advises his family as they all head for the mansion. Once they arrive, "Greedy" spins out a hilarious scene in which the cousins do their best to embarrass each other for Uncle Joe's benefit. Fending off one such attack, Frank (Phil Hartman) typically declares: "I guess you have a lot of time to notice these things, Ed, *now that you're out of work.*" Uncle Joe originated the McTeague mean streak, and he thrives on this sort of thing.

"Greedy" gives all the McTeagues something to worry about, in the eye-catching form of Molly (Olivia d'Abo), the young British blond who is Uncle Joe's new companion. Formerly a bikini model and pizza deliverer, Molly has lately moved in and turned the old man's head. "Her tongue is practically in his wallet!" exclaims Frank, who, as played by Mr. Hartman, is the funniest member of this miserable clan. Taking it upon himself to browbeat Molly, Frank delivers the nastiest slur he can think of. "I didn't like the Beatles," he sneers, "and I don't like you."

Far from the bosom of his family is Daniel McTeague (Michael J. Fox), a professional bowler whom nobody much misses. His cousins have not forgiven Daniel for once being nicknamed "Uncle Joe's special boy." But when the cousins decide to produce Daniel as a birthday surprise and send a detective (Khandi Alexander) to find him, Daniel becomes reimmersed in his family's craziness. He also discovers, to his

horror, that he, too, is becoming interested in Uncle Joe for the wrong reasons. It turns out that there is a bowling alley Daniel would invest in if he had the chance.

•

"Greedy" works fine whenever it allows all this venality to run free, preventing its principals from becoming any more charitable than the characters in a Preston Sturges comedy. At times, the director, Jonathan Lynn ("My Cousin Vinny"), displays a refreshing misanthropy that Mr. Sturges himself might have appreciated. Mr. Lynn also happens to give one of the film's funniest performances, playing Douglas, the butler, whom Uncle Joe likes to splash with when he's in the swimming pool. Upon hearing that Molly, whose interest was formerly platonic, is about to sleep with the frail old millionaire, Douglas says: "Sir? May I ask for a reference *before* you go upstairs?"

There hangs over "Greedy" a terrible possibility that these characters may get over their avarice and develop some form of fellowship. The screenplay, by Lowell Ganz and Babaloo Mandel, flirts too often with this kind of danger. Once Daniel and Uncle Joe are reunited, the film finds time for much more soul-searching and value-questioning than any audience really wants to see, and its momentum suffers accordingly. It's a great relief when the film shakes off its doldrums to end on a sneaky note.

Mr. Fox, who has been the unsung hero of many a movie comedy, once again displays deft timing and all the sprightly energy his role demands. (This film may incorporate a few beefcake shots of Mr. Fox and show him to be a good bowler, but it keeps him on familiar territory; his screen persona here is still determinedly boyish.) Mr. Douglas has great fun with the role of the old reprobate, and he and Mr. Fox work well together even when the material shows its maudlin side.

Also in the cast are Bob Balaban, Colleen Camp and Jere Burns as various nattering McTeagues. And Nancy Travis plays Daniel's level-headed girlfriend. Those looking for cinematic allusions will be made mindful of both Erich von Stroheim (whose "Greed" had its own McTeague, from Frank Norris's novel) and Nora Ephron. Like "Sleepless in Seattle," "Greedy" treats Jimmy Durante as an old friend.

•

"Greedy" is rated PG-13 (Parents strongly cautioned). It includes profanity, sexual suggestiveness and very brief nudity.

1994 Mr 4, C15:1

Sirens

Written and directed by John Duigan; director of photography, Geoff Burton Acs; edited by Humphrey Dixon; music by Rachel Portman; production designer, Roger Ford; produced by Sue Milliken; released by Miramax. Running time: 96 minutes. This film is rated R.

Norman Lindsay	Sam Neill
Anthony Campion	Hugh Grant
Estella Campion	Tara Fitzgerald
Sheela	Elle MacPherson
Prue	Kate Fischer
Giddy	Portia de Rossi

By JANET MASLIN

In a bosky Australian hideaway, the artist Norman Lindsay (Sam

Neill) follows his muse. Actually there are quite a few muses, scampering through the gardens in various states of undress and posing thoughtfully for what look like Playboy pictorials on "The Girls of Pre-Raphaelite Kitsch." The painter, whose wife and sweet little daughters are also on the premises, makes a point of never being distracted by such goings-on. After all, he is an artist with a serious mission. He lives to glorify the human body and appall the bourgeoisie.

Into this hotbed of high culture is sent Anthony Campion (Hugh Grant), a dapper young Anglican priest who fancies himself a worldly fellow. ("I gather you were something of a progressive at Oxford," an older priest says suspiciously, while Campion positively beams.) Campion has been sent to ask Lindsay if he will kindly withdraw an etching of a nude woman on a crucifix from an exhibition. "Standards of public decency" are mentioned.

Campion (whose name provides what will doubtless be the Australian film homage of choice for a long time to come) is accompanied on this mission by his wife, Estella (Tara Fitzgerald). Estella, a ripe young woman ready to burst free of the constraints of ordinary existence, appears to have sprung full-grown from D. H. Lawrence's imagination.

So do most of the story's other characters, although Lindsay was a real Australian artist whose statuary can be seen throughout "Sirens," and whose real house in the Blue Mountains of Australia was used as its setting. Lindsay, whose bohemian ideals generated their share of controversy during the 1930's and who really did draw the "Crucified Venus" seen in the film, is better known for a children's book called "The Magic Pudding."

●

Once "Sirens" shows the Campions arriving at the Lindsay outpost, it becomes clear that they've come to the right place. Husband and wife call each other Pooh and Piglet, which is the film's way of announcing that their sex life has room for improvement. Meanwhile, Lindsay's nymphs skip daringly past the handsome priest at every opportunity, and Estella begins to notice the blind, barechested, smolderingly handsome fellow who grooms the horses. He's mysterious. And he's available. But even by D. H. Lawrence's standards, he's a bit much.

"Sirens" is best watched as a softcore, high-minded daydream about the liberating sensuality of art. Its bubble tends to burst whenever the nymphs are asked to make clever dinner-table conversation, but the mood is nicely lulling anyhow. Like Lindsay himself, the film seems to imagine itself awfully bold, which becomes one of its most amusing aspects. Another is the nymphs themselves, led by the model Elle MacPherson, who doesn't say much but sucks her fingers insinuatingly as a means of getting the priest's attention. Guess what? It works.

Sometimes the sirens (Kate Fischer and Portia de Rossi are the others) tickle one another merrily, and sometimes they talk about whether sea slugs make a good aphrodisiac. So "Sirens" has a well-developed airhead side, but it also has an archly intelligent performance from Mr. Grant, who turns the priest's embarrassment into a real comic virtue. Ms. Fitzgerald, who made a strong first impression in "Hear My Song," is again a forceful presence, even

when acting out the story's giddy erotic fantasies, like the one in which she finds herself naked in church. Estella's subconscious gets a strenuous workout during the course of the film.

As written and directed by John Duigan ("Flirting," "The Year My Voice Broke"), "Sirens" often verges on silliness and desperately overworks the symbolic importance of snakes. Still, it's hard not to enjoy a film whose most intellectually daring character — Mr. Neill's stern Lindsay — claims to have spent a previous life in Atlantis. After that, perhaps the bourgeoisie-baiting wilds of Australia look tame.

●

"Sirens" has been rated R (Under 17 requires accompanying parent or adult guardian). It has considerable explicit nudity and sexual situations.

1994 Mr 4, C16:1

Oscar Shorts 1993

Five Academy Award-nominated short films: "Blood Ties: The Life and Works of Sally Mann," directed by Steven Cantor; "Black Rider," directed by Pepe Danquart; "Chicks in White Satin," directed by Elaine Holliman; "Defending Our Lives," produced by Margaret Lazarus and Renner Wunderlich; "Down on the Waterfront," directed by Stacy Title. Cinema Village, 22 East 12th Street, Greenwich Village.

By STEPHEN HOLDEN

All three of the films nominated this year for Academy Awards in the category of "best documentary short subject" deal with women's issues. Elaine Holliman and Jason Schneider's cozy 22-minute film, "Chicks in White Satin," follows the preparations for a lesbian Jewish wedding. "Defending Our Lives," a half-hour film produced by Margaret Lazarus and Renner Wunderlich, is a grueling polemical study of battered women that focuses on the testimony of women who killed the men who attacked them.

The third, "Blood Ties: The Life and Work of Sally Mann," explores the world of the controversial photographer whose studies of her own three children have been criticized for using nudity and being otherwise exploitative. This half-hour film, in which Ms. Mann, backed by her husband and children, vigorously defends herself, raises questions about the rights and responsibilities of motherhood.

These three films share the "Oscar Shorts 1993" program that opened yesterday at Cinema Village with two of the five nominees in the "best live-action short subject" category: Stacy Title's whimsical "Down on the Waterfront," and the German director Pepe Danquart's "Black Rider." An added attraction (not screened for critics) is last year's winner in the same category, Sam Karmann's "Omnibus."

For all their seriousness of purpose, the films do not add up to a very well-rounded program. In exploring ambivalent family feelings about a lesbian wedding in which both partners wear white gowns and veils, "Chicks in White Satin" only scratches the psychological and social surfaces of its subject. It is essentially a valentine to lovers who emerge as very nice but quite dull people.

"Defending Our Lives" builds its polemic around a central irony: the

women who offer graphic, sometimes tearful testimony on the violent treatment they suffered at the hands of abusive men escaped their psychological imprisonment only to land in actual prison for defending their lives. All the women in the film, which is a collaboration between Cambridge Documentary Films and Battered Women Fighting Back, a prison support group for women who killed their abusers, come from the Boston area. The tone of the film throughout is stridently outraged.

"Blood Ties," directed by Steven Cantor, is the most compelling of all the films because Ms. Mann's work is such pleasure to look at. At the same time, it raises the same questions about the value of esthetic truth versus the discomfort it can cause that have dogged photographers from Diane Arbus to Robert Mapplethorpe. In Ms. Mann's beautiful family photographs, her children embody an innocent sensuality that is so palpable that some might read into the pictures a prurient intent. One public figure offended by Ms. Mann's work is the evangelist Pat Robertson. The photographer emerges in the film as a defiant and persuasive defender of both her artistic freedom and her children's dignity.

"The Black Rider" and "Down on the Waterfront" both mask their serious concerns with a joking sense of humor. In Mr. Danquart's film, a young black man sitting next to an elderly white woman on a trolley car endures her racist, xenophobic babble for only so long before he improvises a wonderfully satisfying and funny revenge.

In "Down on the Waterfront," which is set in 1955, a pair of aspiring film makers have a weird park-bench meeting with a corrupt official of the longshoremen's union (Edward Asner), who arrives with a goonlike bodyguard. The official is stewing about the success of the movie "On the Waterfront," especially Budd Schulberg's screenplay. The meeting turns into a comic story conference for a pro-union propaganda movie that would star Sal Mineo.

"Down on the Waterfront," although witty and filled with the right period references, has no credible 1950's ambiance. At heart it is an Albert Brooks-style comic parable about the obsession to make movies and the lengths people will go to get the financing.

1994 Mr 5, 19:1

FILM VIEW/Janet Maslin

At the Polls, Ace Tops Schindler

UP ON THE high ground, there are would-be moviegoers wondering whether they'll get around to seeing "Schindler's List" or "The Piano" or "Philadelphia" before Oscar night. Down in the trenches, it's another story. The films that aim low and arrive without fanfare don't even register with serious audiences most of the time. But that doesn't mean they don't warrant serious attention.

These bottom-feeding films often have real impact, no matter how imbecilic they seem from afar. After all, when films are geared to appeal to impulse viewing — does anyone make advance plans to see "Blank Check?" — they say something about what our impulses really mean. Who can be sure that "Ace Ventura, Pet Detective," the low-ball hit that has been thoroughly enjoyed by at

Jon Farmer/Warner Brothers
Jim Carrey in "Ace Ventura, Pet Detective"— Dopey.

least one United States Senator, doesn't tell us something about the state of the nation? What did we find out when Christmas audiences, confronted with the biggest array of high-minded Hollywood films in recent memory, stole away in droves to see the no-brainer comedies "Mrs. Doubtfire" and "Grumpy Old Men?"

Sure, some audiences secretly enjoy the prospect of a good laugh more than the promise of an elevating experience. But what are they laughing at in "Blank Check," one of the least-heralded comedies of the moment? "Blank Check" is noteworthy for two reasons: It looks like the best bet for family audiences in a season short on kiddie-oriented entertainment. And it's a movie that no parents in their right minds should let children see.

"Blank Check," shamelessly modeled on "Home Alone" and marketed as one more cute Disney comedy, is about an 11-year-old with a one-track mind. "So, you gonna have fun today?" his father asks him. "How can I, Dad?" asks Preston Waters (Brian Bonsall). "I don't have any money." The movie is about what happens to Preston after he finds a fun way to steal $1 million and spend as much of it on playthings as he possibly can.

In addition to celebrating this spree with festive shopping scenes and slow-motion flying cash, the film gives Preston new respect once he strikes it rich. Even his parents are impressed when the child comes home in a business suit and pretends to have an important new boss. Preston's dad, him-

Queue up at Le Cinema for an enobling film? Or catch the flick at the Bijou about that money-grubbing brat?

self no stranger to cupidity, forgets about disciplining his son when he offers to put in a good word with this imaginary Mr. Big.

"Blank Check" even throws in a pretty young woman whose flirtatious interest in Preston is indirectly linked to his new loot. Coup de grâce: blatant product plugs for all of Preston's new-found merchandise. Despite a make-nice ending, impressionable little viewers are bound to come away convinced that money makes the world go round. In some corners of the globe, this film may also be enough to foment revolution.

The curious thing about this avaricious fantasy is that it plays like an adult's daydream, not a child's. The kiddie mentality is much better represented by "Ace Ventura, Pet Detective," which is silly in a cruder, funnier and much more original way. This film's several-week reign at the top of the box-office charts isn't surprising, nor is it entirely cause for celebration. (Ace's antics include rear-end ventriloquism. And the story finds room for Sean Young in a supposedly comic role.) Still, it's easy to see why this cheerfully dopey film has struck pay dirt.

Jim Carrey, until now always described as "the white guy on 'In Living Color,'" has no trouble carrying this movie. Mr. Carrey's grinning, tightly wound Ace has distinct talents, like being able to mime a football pass in slow-motion instant replay while wearing a pink tutu. Despite a sex-change ending that leaves the film too weird for small children, "Ace Ventura" is sly but good-natured, a lot more than "Blank Check" happens to be. "You really like animals, don't you?" someone asks Ace, whose apartment is amusingly well-stocked with wildlife. "If it gets cold enough," he answers pleasantly. Drawing room comedy it's not, but "Ace Ventura" knows what its audience wants.

STEVEN SEAGAL USED TO KNOW THAT, TOO, which is how he became such an improbable movie star. Among the many things Mr. Seagal hit in his first films was a raw nerve, at least as far as his audience was concerned. Here was an action star for supposedly nonviolent times, a zen avenger whose moral superiority gave him a nominally upscale appeal. With "Under Siege," the top-notch Seagal hit that Andrew Davis directed just before making "The Fugitive," this star confirmed his hold on the action audience's imagination.

Just how smart is that audience? Will word-of-mouth begin to affect "On Deadly Ground," the awful new film that Mr. Seagal has seen fit to direct himself? Creeping into town

without advance screenings, this preachy, inept mess became an instant hit, drawing viewers solely on the basis of Mr. Seagal's scowling face. Two guys behind me did go home happy, chuckling over a witticism about how Seagal's character is tough enough to drink gasoline and then urinate on a fire. Figuratively speaking, of course.

Is this all it takes to please the non-"Piano" audience? We're sure to find out. Not all of America's significant voting occurs at the polling place. Some of it happens at the box office, too. □

1994 Mr 6, II:17:1

Four Weddings and a Funeral

Directed by Mike Newell; written by Richard Curtis; director of photography, Michael Coulter; edited by Jon Gregory; music by Richard Rodney Bennett; production designer, Maggie Gray; produced by Duncan Kenworthy; released by Gramercy Pictures. Running time: 118 minutes. This film is rated R.

Carrie	Andie MacDowell
Charles	Hugh Grant
Fiona	Kristin Scott Thomas
Gareth	Simon Callow
Tom	James Fleet
Matthew	John Hannah

By JANET MASLIN

Gramercy Pictures
Hugh Grant in a scene from "Four Weddings and a Funeral."

If ever a film resembled a wedding cake it is "Four Weddings and a Funeral," a multi-tiered confection with a romantic spirit and an enchantingly pretty veneer. Elegant, festive and very, very funny, this deft English comedy also constitutes a remarkable tightrope act on the part of Mike Newell ("Enchanted April"), who directed, and Richard Curtis ("The Tall Guy"), the screenwriter.

In a feat of daring gamesmanship, they confine their film's central love story to the events described by the title, veering off only occasionally to nearby hotels or shops for wedding-related gambits. That conceit would seem strained if it didn't prove so unexpectedly graceful and inspired.

Although "Four Weddings and a Funeral" brings to mind other films as diverse as "A Wedding" (for its mishap-plagued party atmosphere) and "Peter's Friends" (for the collegiality of its English ensemble players), it has a light, engaging style that is very much its own. Much of the mood is set by Hugh Grant's Charles, whose dapper good looks and bashful manner make him understandably popular as a best man. Charles is both suave and hapless. Everything about him suggests that years of breeding and education have produced not a single advantage beyond the ability to look delightful in a morning coat.

•

Shy, nervous and nicely acerbic, Charles makes the perfect fall guy at his friends' nuptials. (One of the film's more hilarious episodes finds him seated at a table with a full complement of ex-girlfriends, each of whom remembers exactly what he said about the others.) And Mr. Grant, who is a hard actor to miss at the moment (he also plays a minister in "Sirens" and will soon be seen in Roman Polanski's "Bitter Moon"), turns this into a career-making role.

By the way, none of the film's droll English characters would ever dream of phrasing anything as vulgarly as that. Vulgarity here is the province of Americans, as represented by Carrie (Andie MacDowell), the blunt-talking beauty who bewilders Charles from their very first meet-

ing. Catching Charles's eye during the film's initial wedding sequence, Carrie seduces him mischievously at the end of the evening. Then, just as abruptly, she disappears until the next wedding (which happens to be a witty offshoot of the first).

To some extent, Carrie finds herself taking the initiative because Charles is a lot less bold. "Do you think there really are people who can go up and say, 'Hi babe, name's Charles, this is your lucky night?'" he asks a friend, as he wonders whether to attempt a conquest. "Well, if there are, they're not English," the friend replies.

Carrie is the film's one misstep, since she is meant to seem both ruthless and sympathetic in ways that don't really add up. And Ms. MacDowell, ordinarily so gently alluring, sounds oddly mechanical here; she isn't right for this character's hard-boiled outlook and occasionally brittle humor. Luckily, "Four Weddings and a Funeral" is truly an ensemble piece, and its convivial supporting characters are all beautifully played. Running counter to the film's ostensibly romantic manner, there is the suggestion that these friends are bound together in ways no mere marriage could match.

One of the film makers' small but memorable accomplishments is their utterly comfortable way of working a gay couple and a deaf man into the revelry. (The latter, Charles's sly brother, takes advantage of his disability by smiling pleasantly while making rude remarks only Charles can understand.) As Gareth, the boisterous character who unofficially presides over the merrymaking, Simon Callow is a particularly vibrant presence. Charlotte Coleman also has some funny moments as Charles's spiky little roommate, Scarlett. As she hopefully explains to one handsome wedding guest, she is "named

after Scarlett O'Hara but much less trouble."

•

There is also a broadly comic performance from Rowan Atkinson, as a newly minted clergyman who can't quite master the words of the wedding ceremony. (The phrases "Holy Goat" and "Holy Spigot" enliven his reading of the service.) Also slinking through the film is Kristin Scott Thomas as one of the more jaded members of Charles's circle. Corin Redgrave plays a kilted Scotsman referred to as "the stiff in the skirt" by the woman who marries him. The cast's minor characters are identified in the credits with names like Frightful Folk Duo, John With the Unfaithful Wife and Tea-Tasting Alistair, which should provide some idea of the merry tone.

Much of the fun in watching "Four Weddings and a Funeral" comes from a story that spirals ingeniously without spinning out of control. Despite the many elements he must keep in check here, Mr. Newell more than matches the easy seductiveness that made "Enchanted April" such a crowd-pleaser. Mr. Curtis, a veteran of the BBC's "Not the Nine O'Clock News," lives up to the comic high points of his "Tall Guy" while constructing a more coherent story this time. Mr. Curtis goes beyond the demands of ordinary dialogue and delivers a screenplay full of bona-fide repartee.

The funeral mentioned in the title provides a sobering contrast, jarring the principals to see past their idle wedding-going and get serious about falling in love. But this is a film that can find something drily witty to say even when bidding a last farewell. "The recipe for duck à la banana," someone says of the departed, "fortunately goes with him to his grave."

•

"Four Weddings and a Funeral" is rated R (Under 17 requires accompanying parent or adult guardian). It includes profanity, brief nudity and sexual situations.

1994 Mr 9, C15:5

The Ref

Directed by Ted Demme; written by Richard LaGravenese and Marie Weiss; director of photography, Adam Kimmel; edited by Jeffrey Wolf; music by David A. Stewart; production designer, Dan Davis; produced by Ron Bozman, Mr. LaGravenese and Jeff Weiss; released by Buena Vista. Running time: 92 minutes. This film is rated R.

Gus......................................Denis Leary
CarolineJudy Davis
Lloyd....................................Kevin Spacey
Jesse.....................Robert J. Steinmiller Jr.
Rose.....................................Glynis Johns
Connie...............................Christine Baranski

By CARYN JAMES

Set on Christmas Eve, "The Ref" evokes a familiar kind of holiday feeling: the high anxiety and claustrophobia of spending a long dinner with feuding relatives. The plot sounds hopeless, but the film is handled with gleeful irreverence, dark wit and cynicism. Denis Leary plays a burglar who holds a bitter married couple hostage in their luxurious Connecticut house. They were on their way back from a useless session with a marriage counselor when they were abducted, obnoxious in-laws are arriving at the house any minute and even a crook on the run wouldn't want to be trapped with this group. Staying clear of any mean-spirited attitudes,

Jack Rowand/Buena Vista Pictures
Judy Davis in "The Ref."

"The Ref" is a film to warm the hearts and touch the nerves of dysfunctional families everywhere.

The smart cast is a major reason for the film's wonderfully pitched tone. Judy Davis plays the wife, Caroline, who has been unfaithful largely out of boredom. She is the kind of edgy, comically self-absorbed character Ms. Davis has perfected. (Caroline could be the sister of the woman Ms. Davis played in Woody Allen's "Husbands and Wives.") Kevin Spacey is her husband, Lloyd, who is a truly boring guy and doesn't see that as a problem. Mr. Spacey slowly reveals the frustration beneath Lloyd's blandness until he explodes in a semiserious tirade.

They don't even pretend to be a well-adjusted family. Their son, Jesse, (Robert J. Steinmiller Jr.) is about to arrive home from military school, where he has been efficiently blackmailing a teacher. Lloyd's mother (Glynis Johns) and his brother's family are driving down from Boston, but they stop for a bite first because Caroline's cooking is famously inedible.

Mr. Leary, as Gus the burglar, has to hold the film together, and he is unexpectedly terrific in the lead. Best known for his one-man show, "No Cure for Cancer," and his biting spots on MTV, here he has subtly wiped the abrasiveness away from his style without making Gus seem mushy. For the first time he displays his appeal and potential as an actor instead of a comic with a sneering persona.

Don't be misled by commercials that make "The Ref" look like slapstick silliness. This is a grown-up film that delights in undermining Christmas clichés. Some of us are bound to love a movie in which watching "It's a Wonderful Life" leads to a minor calamity. When Lloyd's sister-in-law gets another mingy gift from her rich mother-in-law, Christine Baranski puts a withering spin on her delivery of the word "Slippersocks!" And as the night goes on, one of the funniest lines turns out to be Lloyd's instruction to his niece to help out the burglar: "Mary, gag your grandma."

The centerpiece of the story is a droll and hilarious Christmas dinner with a Scandinavian theme (as if Caroline has seen too many Bergman films). The actors wear deadpan expressions on their faces and wreaths

topped with candles on their heads, while Mr. Leary masquerades as Lloyd and Caroline's marriage counselor, Dr. Woo.

The director, Ted Demme, is 30 years old and "The Ref" benefits from his youthful irreverence as well as his self-assurance and background. He is a veteran of MTV and the rap-comedy feature "Who's the Man?"

•

The screenplay, by Marie Weiss and Richard LaGravenese, includes a minor happy ending but avoids sentimentality. Mr. LaGravenese was the writer of the Robin Williams-Jeff Bridges film "The Fisher King," about a wise homeless man. Like "The Ref," its script was also shrewder and fresher than its icky-sounding premise.

Though "The Ref" is technically a Disney film, it is absolutely not for children. The language approximates what Beavis and Butt-head might say in their private moments, and will make some adults red-faced.

In fact, Disney has made some curious marketing decisions about this sardonic film. One is the title. "The Ref" sounds like one more in the stream of indistinguishable sports movies that have come along lately. Another is the decision to release it now instead of at Christmas, when legions of happy-looking families would have been primed to appreciate the dark comic undercurrents of a holiday at home.

•

"The Ref" is rated R. It includes a great deal of strong language and some crude sexual references.

1994 Mr 9, C15:5

Germinal

Directed by Claude Berri; written by Mr. Berri and Arlette Langmann, in French with English subtitles, based on the novel by Émile Zola. Director of photography, Yves Angelo; edited by Hervé de Luze; music by Jean-Louis Roques; produced by Mr. Berri; released by Sony Pictures Classics. At the Paris Theater, 4 West 58th Street, Manhattan. Running time: 158 minutes. This film is rated R.

Maheu......................Gérard Depardieu
Maheude............................Miou-Miou
Étienne Lantier........................Renaud
Deneulin.....................Bernard Fresson
Bonnemort..........................Jean Carmet
SouvarineLaurent Terzieff
M. Hennebeau...............Jacques Dacqmine
Mme. Hennebeau..............Anny Duperey

By JANET MASLIN

"**G**ERMINAL,**"** Claude Berri's epic, reverential screen version of the classic Émile Zola novel about striking coal miners, is as brutally honest as a $30 million movie can be. The poverty seen here is not pretty, but neither is it without a certain bleak appeal. Muted gray-brown tableaux are eloquent in their composition. A comely female miner wears off-the-shoulder rags and mines topless when the temperature gets high. Circumstances force this same miner to bathe in a kitchen washtub as her father and brothers devour their meager dinner. Naturally, being concerned with oppression and survival, the men are too busy to notice.

Who says romance is a matter of love songs and long strolls in the moonlight? Surely "Germinal," which opens today at the Paris Theater, is one of the most desperately romantic films ever made. It harks back fervently to the simpler world that was roused to outrage by the

vividness of Zola's social realism. In that world, the rich are parasites, the poor are ennobled by their suffering and the solution is distant but within view. The film yearns passionately for such clarity, to the point where the black and white polarities of its politics are not compromised by subtler shadings.

Though he spent little more than a week observing striking miners in northeastern France, Zola was able to transform his thousand pages of notes into an 1884 novel (the 13th of 20 in his Rougon-Macquart series) that came as a revelation to his readers. At that time, the truth about the exploitation of miners was not widely known. Shaped into the wrenching story of one family's struggle for survival and set against the broad canvas of the miners' uprising, that truth became as shocking as the idea that workers of the world might unite.

The journalistic impact of "Germinal" is theoretically unchanged, since Mr. Berri's film will be seen by plenty of viewers who have never been down a mine shaft. ("Germinal" is among France's all-time top 10 box-office hits.) But the hardships that Mr. Berri has rendered so faithfully now seem as artificial, in their way, as the Broadway musical version of "Les Misérables." It's difficult for a film to pretend that real characters speak in the language of placards ("We're hungry and tired of being poor!" "Why is the price of justice so high?"). It's no easier to believe that Gérard Depardieu, despite another astonishingly honest and unaffected performance, could be a miner fighting off the threat of starvation.

•

Unlike Mr. Berri's "Jean de Florette" or "Manon of the Springs" (or even Bernardo Bertolucci's "1900," another handsome epic with a sternly polemical bent), "Germinal" does not allow its actors much room for nuance. The characters in this Gallic "Grapes of Wrath" are powerful but paper-thin. Mr. Depardieu appears as Maheu, the salt-of-the-earth father of a large brood and a foreman at Le Voreux mine, which itself is so important it is almost a living character. Miou-Miou gives a fiery performance as his valiant wife, Maheude, who has much reason to grieve during the latter part of the story.

The third principal in the miners' village (which is controlled by the mining company, like everything else about the workers' lives) is Étienne Lantier, the character linking "Germinal" to Zola's other novels in this series. As played by Renaud, a French singer and activist with the intensity of a firebrand graduate student, Lantier crystallizes the story's quiet fury. Arriving at Le Voreux in need of a job, he first observes the horrifying particulars of the miners' existence. (The film re-creates these details with impressive fidelity, from the miners' fear of firedamp to the cart horse that is lowered down the mine shaft.) Later, Lantier is central to the rebellion alongside Maheu, who becomes its unlikely leader.

•

When Maheu and Lantier address one large gathering of their fellow workers, they are seen flanking a large crucifix. And the workers' ranks happen to incorporate 800 extras who are descended from the original miners who inspired Zola's story. Here and elsewhere, Mr. Berri misses no opportunity to go overboard in self-righteous fashion. His scenes contrasting the story's well-fed, morally bankrupt capitalists

Sony Pictures Classics

Gérard Depardieu as a coal miner, in a scene from "Germinal."

(played by Jacques Dacqmine, Anny Duperey and others) with its impoverished workers are even blunter than Zola's versions, in which the fresh-baked brioche of the wealthy underscores the workers' lack of bread.

If "Germinal" embraces the attitudes of a diatribe, its manner is much more moderate. Mr. Berri is a skillful storyteller even when working with material that has no psychological dimension. That is one of the challenges posed by "Germinal," the other being the fact that very little of Zola's tale unfolds in broad daylight. Despite the story's many nocturnal and underground episodes, "Germinal" achieves an impressively varied visual style. Yves Angelo, the superb cinematographer whose credits include "Un Coeur en Hiver," "The Accompanist" and "Tous Les Matins du Monde," gives this film a delicately varied palette and a spare, haunting beauty.

"Germinal" (adapted by Mr. Berri and Arlette Langmann) may be hobbled by obviousness, but it remains a formidable accomplishment. Mr. Berri does succeed in capturing the novel's sweep, and he never minimizes its sense of purpose. Even when set forth in the multi-million-dollar language of present-day film making, the hard facts of this story have enduring force. Mr. Berri keeps the story's violence abrupt and shocking just as Zola did, which has the effect of magnifying its pent-up rage.

Difficult as it is to think of a coal-mining drama as sheer escapism, "Germinal" is most tempting for its vision of moral purity. The world in which this film was made is much more daunting than the one it brings to life.

•

"Germinal" is rated R (Under 17 requires accompanying parent or adult guardian). It includes nudity, sexual situations and graphic violence.

1994 Mr 11, C1:1

Lightning Jack

Directed by Simon Wincer; written by Paul Hogan; director of photography, David Eggby; edited by O. Nicholas Brown; music by Bruce Rowland; production designer, Bernard Hides; produced by Mr. Hogan, Greg Coote and Mr. Wincer; released by Savoy Pictures. Running time: 101 minutes. This film is rated PG-13.

Lightning Jack Kane.....................Paul Hogan
Ben Doyle..............................Cuba Gooding Jr.
Lana...Beverly D'Angelo.

By STEPHEN HOLDEN

"Lightning Jack," a comic western produced and written by its star, Paul Hogan, sinks under the weight of a disastrous, if innocent, miscalculation. This takeoff on an Old West buddy movie mismatches the sardonic Australian star of the "Crocodile Dundee" films with Cuba Gooding Jr., who made such an impressive debut in John Singleton's "Boyz N the Hood."

Mr. Gooding plays Ben Doyle, a literate but mute store clerk who runs away from his abusive boss to be the sidekick of a notorious bank robber. Ben, who communicates by scribbling notes on a pad he carries around, comes uncomfortably close to the old-fashioned movie stereotype of a bowing and smiling Negro servant. Even though race is never mentioned in the movie, audiences are likely to wince in scenes where Ben, patronized as "boy," reacts by rolling his eyes in discomfort.

Lightning Jack Kane (Mr. Hogan), Ben's partner and teacher, fancies himself the fastest gun in the West but is insulted by the paltry rewards being offered for his capture. One of the film's limp running jokes is that Jack, who is getting on in years, couldn't locate the broad side of a barn without first putting on his glasses. The movie follows the team's misadventures, including a bungled bank robbery in which Ben shoots himself in the foot.

Simon Wincer, the Australian director whose credits include "Free Willy" and the mini-series "Lonesome Dove," doesn't know what to do with material this whimsical. The film has no internal comic rhythm to match its faltering sense of humor. Much of the time, it plods along like a mediocre conventional western.

On the rare occasions when "Lightning Jack" pulls out a comic trick, its humor is puerile. Typical is a scene in which Jack and Ben find themselves pursued by some angry Comanches. Suddenly the camera pulls away from the duo to focus on an Indian horseman shouting furiously to his companion. Subtitles translate, "But he called me coyote drippings!"

"Lightning Jack" is rated PG-13 (Parents strongly cautioned). It includes some off-color humor.

1994 Mr 11, C8:5

The Hudsucker Proxy

Directed by Joel Coen; written by Joel Coen, Ethan Coen and Sam Raimi; director of photography, Roger Deakins; edited by Thom Noble; music by Carter Burwell; production designer, Dennis Gassner; produced by Ethan Coen; released by Warner Brothers. At Tower East, Third Avenue at 71st Street, Manhattan. Running time: 115 minutes. This film is rated PG.

Norville Barnes............................Tim Robbins
Amy Archer Jennifer Jason Leigh
Sidney J. Mussburger............... Paul Newman
Waring HudsuckerCharles Durning
Vic TenettaPeter Gallagher

By CARYN JAMES

"The Hudsucker Proxy" begins with a lush, romantic image of a New York City that never was. Heavy snow falls as the camera moves in among a crush of skyscrapers that stand as symbols of progress and glamour. On a ledge, ready to jump, is Norville Barnes (Tim Robbins). Like the cityscape around him, like everything else in the visually stunning and funny new film by Joel and Ethan Coen, Norville is a pop-culture myth straight out of old movies. Although the story is set in 1958, the look and the dialogue and the plot evoke films of the 30's and 40's. Historical accuracy means nothing when you're fondly retelling legends built by Frank Capra, Preston Sturges and Howard Hawks.

As the film flashes back, it is instantly clear that Norville is the Capraesque little guy. An innocent from Muncie, Ind., he arrives in New York and gets a job in the mail room of giant, heartless Hudsucker Industries. The next day, he is its president.

Jennifer Jason Leigh plays a smart-talking girl reporter named Amy Archer, who poses as Norville's secretary to get the story. A career woman not nearly as tough or brittle as she pretends, she is part Rosalind Russell, but her extra-rapid dialogue is delivered in a delightfully perfect Katharine Hepburn accent. "He's the bunk!" she snaps at her editor about Norville. "I'll stake my Pulitzer on it." Norville and Amy will, of course, verbally spar their way to romance.

•

"The Hudsucker Proxy," which opens today at Tower East, is likely to evoke the standard complaint about the Coens. (Joel directs, Ethan produces and they write their scripts together, this time with Sam Raimi). They are accused of being cold, and so they are. They don't mean to create realistic, fuzzy-warm people. What they love is genres, and they reserve their warmth for the styles of old movies. Their "Blood Simple" is revived film noir, "Miller's Crossing" a poetic gangster tale and "Barton Fink" 1940's naturalism. To appreciate the Coens, it is necessary to delight in their films' stylized, surface charms. Those charms are abundant in "Hudsucker," which is a shrewd comic valentine to the kind of movies they don't make anymore. It is also the Coens' funniest, most accessible film since the dark comedy "Raising Arizona."

As Norville, Mr. Robbins projects a goofy appeal. Norville is not dumb, but he sure looks that way when he glances at a quickly changing board

Jim Bridges/Warner Brothers

Tim Robbins and Paul Newman.

that advertises job openings. ("Soda Jerk. Need Experience.") And he looks especially small against the dramatically huge sets of "Hudsucker." Norville labors in the crowded basement mail room, a dark mechanical monster of pneumatic tubes. The executive offices have high ceilings, immense windows, oversize furniture. Big business is the sinister force that overpowers everyone.

While Norville labors below, the company president, Waring Hudsucker (Charles Durning), is about to make a daring leap out the window, enacting another American myth: how big businessmen behave when life turns sour. The jump is one of the film's most impressive visual set-pieces. Hudsucker seems to dive out the window and sail through a long canyon. On the way down, he has the time and wit to gesture helpfully to people on the ground so they can scatter before he hits.

The ruthless executive Sidney J. Mussburger (Paul Newman) decides the executives must depress the Hudsucker stock so they can buy it cheaply and gain control of the company. They need a foolproof idiot to become their proxy president. Getting a movie icon to play the representative of big business was inspired, and Mr. Newman has great fun rasping his way through the part.

When Norville takes over, he brings along an invention. A much-folded piece of paper with a design on it: a simple circle. The film makers haven't been very discreet about keeping the secret behind this design, which is revealed halfway through the movie and is worth discovering. It's enough to say that the invention is another pop legend of sorts. As Norville keeps insisting, the circle is, "You know, for kids." Ms. Leigh is wonderfully funny as Amy, who regrets writing a story about Norville that runs under the headline "Imbecile Heads Hudsucker."

•

Stylish and witty though it is, "The Hudsucker Proxy" has its problems, even for Coen fans. The film begins to falter after Norville's invention makes him a success. When he loses his innocent appeal, it is easy to lose interest in him.

But throughout, there are wonderfully rich touches. Peter Gallagher has the tiniest of cameo roles as Vic Tenetta, a singer in the Frank Sinatra-Dean Martin mold. His scene can't last more than a minute, but it may be the film's most howlingly funny satire.

Carter Burwell's music is excessive in just the right way, echoing the overwrought, clue-giving scores of 50 years ago. And Dennis Gassner's design is a flawless addition to the film's muted, fairy-tale mood.

Movies are, after all, about fakery; so is the story of Norville's rise and fall and redemption.

"The Hudsucker Proxy" is rated PG (Parental guidance suggested). It includes one scene of drunkenness and some stylish suicide attempts.

1994 Mr 11, C8:5

Guarding Tess

Directed by Hugh Wilson; written by Mr. Wilson and Peter Torokvei; director of photography, Brian J. Reynolds; edited by Sidney Levin; music by Michael Convertino; production designer, Peter Larkin; produced by Ned Tanen and Nancy Graham Tanen; released by Tri-Star. Running time: 98 minutes. This film is rated PG-13.

Tess CarlisleShirley MacLaine
Doug ChesnicNicolas Cage
Earl..Austin Pendleton
Barry Carlisle.............................Edward Albert
FrederickRichard Griffiths

By JANET MASLIN

Doug Chesnic (Nicolas Cage) would love to quit his job, but there's a little problem: every time he tries to leave he gets a threatening phone call from the President of the United States. Doug is a Secret Service man assigned to guard Tess Carlisle (Shirley MacLaine), a widowed former First Lady whose favorite pursuits are wearing pillbox hats that match her umbrellas and torturing members of her staff. Tess is one tough customer. She scares Doug and she scares the President, too.

This promising setup introduces "Guarding Tess" as a tug of war between a grande dame and her resentful young aide, and as such it has lively potential. Ms. MacLaine does wonderfully with flinty-old-broad roles, and here she has a chance to peer balefully out over her eyeglasses while making sneaky, impossible demands. She can be royally condescending whether forcing the Secret Service to watch her play golf in blustery weather or merely ordering up Secret Service-delivered snacks.

Mr. Cage, once again sounding mock-suave and Elvisy, makes the most of his character's fragile cool. Doug's big mistake is thinking he can make Tess play by the rules. One of the film's funnier scenes pits these intractable enemies in an argument about whether Tess should sit on the right or the left side of her limousine, and whether she really has to wear her seat belt. This film works best when it doesn't tackle anything more important than that.

•

But "Guarding Tess," with Hugh Wilson ("Police Academy" and television comedies including "WKRP in Cincinnati" and "The Famous Teddy Z") as director and co-writer, has a premise rather than a full-fledged plot. Having introduced the two principals and had some fun with their antagonism, the film has nowhere to go. So midway through the running time, terrible things start to happen: the music turns syrupy, the enemies turn sentimental, and Edward Albert turns up to play Tess's no-good son. Mr. Wilson ultimately drums up an absurd intrigue plot and even throws in a bit of maudlin medical news.

Until it switches gears so clumsily, "Guarding Tess" makes the most of two able stars (plus Richard Griffiths as another of Tess's long-suffering helpers) and some sporadically clever situations. One of the film's better episodes finds Tess forcing her Secret Service team to take her to the opera.

Another has her visiting the supermarket while Secret Service personnel use walkie-talkies to help her check the price of canned peas. This comedy could have stayed funny had it kept that up. Viewers will have no trouble believing that such abuses of power really happen.

•

"Guarding Tess" is rated PG-13 (Parents strongly cautioned). It includes slight violence and some profanity.

1994 Mr 11, C12:1

A Bumbler Not Quite Making Ends Meet

"Raining Stones" was shown as part of the 1993 New York Film Festival. Here are excerpts from Vincent Canby's review, which appeared in The New York Times on Oct. 2. The film opens today at Cinema Village, 22 East 12th Street, Greenwich Village.

Ken Loach, the English film maker, is on a new roll.

Like "Riff-Raff," a bitterly comic response to the policies of Britain's Tory Governments, "Raining Stones," his new film, focuses on working-class folk who have somehow failed to benefit from trickle-down economic theories. The setting is a medium-sized city in the north of England where Bob (Bruce Jones), a youngish, balding man who's no better than he should be, is trying to make ends meet in a depressed job market.

When first seen, Bob and his pal Tommy (Ricky Tomlinson) are in a foggy meadow at dawn trying to steal a large, uncooperative sheep. After they have finally caught and trussed the animal, but failed to screw their courage to the point where they might either stick or bash it to death, they deliver it to a friendly butcher. "You said lamb," scoffs the butcher. "This is mutton. You can't give mutton away."

So it goes for Bob through a series of alternately hilarious and melodramatic misadventures in the world of self-help. When he tries to make a little money by going door-to-door cleaning drains, the only person who accepts his services is his pastor, Father Barry (Tom Hickey), a Roman Catholic priest who assumes it's Bob's contribution to the church. Stealing sod from a golf course for a landscape gardener is not much more profitable. A job as a bouncer at a disco lasts one night.

Behind Bob's increasing desperation is the forthcoming first Communion of his daughter, Coleen (Gemma Phoenix). Although both Anne (Julie Brown), his wife, and Father Barry point out that clothes do not make the Communion, Bob remains obsessed with the idea that Coleen must have a new wardrobe costing in the neighborhood of £150 ($224). His is a pride made terrible by poverty.

With a fine screenplay by Jim Allen and the wizardly camera work of

Barry Ackroyd, Mr. Loach again shows himself to be in top form. "Raining Stones" is brisk, richly characterized fiction that cuts as deeply and truly as any documentary. The movie slides effortlessly from farce to melodrama.

Mr. Jones, an actor new to me, is splendid in the central role. Though intense and funny, the performance is free of mannerisms. Bob behaves like someone being trailed by a hidden camera.

Mr. Loach is not a fashionable director at the minute. He's an anachronism in a time when even politically committed directors are expected to stand at a distance from their material, in this way to protect their cool. Mr. Loach doesn't worry about that. Yet because he has such command of craft, his films leap beyond politics, beyond genre, to a life in what might be called pure cinema.

1994 Mr 11, C13:1

Unnoticed, a Triangle Forms

"Calendar" was shown as part of the 1993 New York Film Festival. Here are excerpts from Stephen Holden's review, which appeared in The New York Times on Oct. 16. The film opens today at the Quad Cinema, on 13th Street, west of Fifth Avenue, Greenwich Village.

The emotional twists and turns of Atom Egoyan's "Calendar" are so thoroughly intertwined with communications gadgetry that the movie might almost as well have been called "Sex, Lies, Videotape, Film, Telephone and Answering Machine."

In the movie, which has been pieced together like an elaborate jig-saw puzzle, Mr. Egoyan portrays a Canadian photographer hired to take pictures of ancient Armenian churches for a glossy calendar. Accompanying him on the journey, shown in flashbacks, are his wife (Arsinee Khanjian), who serves as his translator, and a driver (Ashot Adamian), who turns out to be a walking encyclopedia of the architecture being photographed. Only gradually does it emerge that somewhere during the trip a romantic triangle has formed that will eventually lead the photographer's wife to remain in Armenia after her husband returns to Canada.

"Calendar" is a typically labyrinthine exercise in psychological scrutiny by Mr. Egoyan. For the Canadian director and screenwriter, who is of Armenian extraction, it also feels like an exploration of his own ancestral ties and the ways they tug at him. The photographer is so caught up in the technical demands of his assignment that he is indifferent to the actual history of the structures, which, the guide explains, were selected and built according to specific religious dictates. His detachment also allows his wife, for whom the trip is a spiritual revelation, to drift away from him. On returning home alone, he uses that technology to try to decode the truth of a situation he was too preoccupied to realize would separate them. And he obsessively replays a video record of his trip to try to determine the moment his wife's relationship with the driver became romantic.

If "Calendar," like such earlier Egoyan films as "The Adjuster" and "Speaking Parts," has to be pieced together backward, its game of detective is quite enticing. Seamlessly edited, the film sustains a visual rhythm as confident as it is edgy. The performances, especially Miss Khanjian's as the passionate, free-spirited wife, have the fluency and naturalness of real-life moments stolen for the camera.

1994 Mr 11, C14:5

After 50 Years on the Defensive, Still a Cinema Master

"The Wonderful, Horrible Life of Leni Riefenstahl" was shown as part of the 1993 New York Film Festival. Following are excerpts from Vincent Canby's review, which appeared in The New York Times on Oct. 14. The film opens today at Film Forum 2, 209 West Houston Street, South Village.

Ray Muller's "Wonderful, Horrible Life of Leni Riefenstahl" is a big, long (over three hours), sometimes clunky but consistently fascinating documentary portrait of the woman most easily identified as Hitler's favorite film maker, with good reason. Ms. Riefenstahl's two outstanding films, "Triumph of the Will" (1935) and "Olympia" (1938), for all of their esthetic glories, served the propaganda machine of National Socialism in ways that probably neither Hitler nor Ms. Riefenstahl could have foreseen.

The films gave Hitler a credibility at home and around the world that nothing else produced by a German

artist in the 1930's ever achieved. It was Ms. Riefenstahl's fate not only to survive the war, but also to live on and on and on.

Today, at 91, she is still answering the same questions about her relationship to Hitler and to the Nazi Party (she was never a member), and about her sense of responsibility for the crimes committed by the man in whom she continued to believe right through the end of the war. Her eyes were not opened, she says, until she learned of the death camps.

•

For nearly 50 years, she has been setting her record straight, often splitting hairs, a task sometimes made easier when she has been able to prove the accusations against her to be wrong, which serves to make those not so clearly off the mark seem fuzzier than they are. Thus for most of her adult life she has been on the defensive, not easy for a strong woman whose early years were so

full of success and acclaim. The defensive position is exhausting, but Ms. Riefenstahl still hasn't knuckled under to accumulated fatigue. This film is the astonishing record of how she has survived.

Today she takes the breath away: a strange-looking woman in her 90's, sure-footed, her backbone straight, her hair fluffy and blond, her tanned face appearing to have been lifted at some point in the distant past. She wears a pink raincoat when, accompanied by Mr. Muller and a camera crew, she visits sites associated with her short, brilliant career as cinema master.

She has told the same, still riveting stories about Hitler and Goebbels so many times that there's the sense they have become memories of memories. On a couple of occasions, Mr. Muller engages her in something like a cross-examination about what she calls her apolitical behavior in the Nazi years. He says one thing; she gives a denial, which is followed by material that appears to support his charges. Hindsight is on his side. She does seem to go too far when she suggests that she thought "Triumph of the Will" was all about peace. It's also a stretch when she says that émigré friends urged her to remain in Nazi Germany to act as a "bulwark" against anti-Semitism.

•

The film's English-language voice-over is stuffed with clichés. Yet that's unimportant when Ms. Riefenstahl is also on hand to speak for herself. She's authentic as both artist and relic. What seem to be perfectly adequate English subtitles translate the German dialogue.

1994 Mr 16, C20:1

Normal People Are Nothing Special

Directed by Laurence Ferreira Barbosa; written (in French, with English subtitles) by Ms. Barbosa, Santiago Amigorena, Berroyer and Cédric Kahn; director of photography, Antoine Héberlé; edited by Emmanuelle Castro; music by Cesaria Evora, Cuco Valoy and Melvil Poupaud; production designer, Brigitte Perreau; produced by Paulo Branco. At the Roy and Niuta Titus Theaters in the Museum of Modern Art, 11 West 53d Street, Manhattan, part of the New Directors/New Films series of the Film Society of Lincoln Center and the museum's department of film and video. Running time: 102 minutes. This film is not rated.

Martine Valeria Bruni-Tedeschi
GermainMelvil Poupaud
Pierre.......................................Marc Citti
Anne..Claire Laroche

By JANET MASLIN

EACH year at this time, the New Directors/New Films series invites New York's dedicated film audience to test its foresight. And it's best to bring hindsight to the task. Look backward, and you'll see how solidly this series is supported by its own track record. Recent selections have included "Proof," "Slacker," "Orlando," "The Living End," "The Music of Chance" and "Metropolitan," to name only

The Museum of Modern Art

Mood swings: Melvil Poupaud and Valeria Bruni-Tedeschi.

a few of the festival's most auspicious finds.

Part of the challenge is guessing which new films will take their place in this distinguished lineup and which will be more like "A Wopbopaloobop a Lopbamboom." (That was a grim 1990 selection from Luxembourg, a film with no relation to whatever Little Richard had in mind when he coined the phrase.) Whether each New Directors film is headed for glory or oblivion, it's likely to arrive here with little advance word and even less other baggage. The viewer is encouraged to take chances, and why not? This is pot luck of a high order.

(Speaking of pot luck, New Directors will have a run for its money this year from the upstart New York Underground Film and Video Festival, which promises to show what happens "when the East Village collides with Lincoln Center in a battle for independent cinema." That festival's selections include a live-action feature by the animator Bill Plympton and a short that attacks Spike Lee for commercializing the X symbol. Geared to a younger, more irreverent audience, the Underground Festival cites as a point of pride the fact that half its selections were rejected by New Directors. Is this town big enough for the both of them? We'll see.)

Most years, New Directors is memorable for witnessing the start of several promising careers. Sadly, in 1993 it captured both the beginning and end of one. Cyril Collard, the audacious star and director of "Savage Nights," died of AIDS just before his film won four Césars; and this year his name has been given to a French award for promising new

talent. The festival opens with Laurence Ferreira Barbosa's "Normal People Are Nothing Special," winner of the Cyril Collard Prize and in fact a film that recalls "Savage Nights" for its raw, unruly emotions. "Normal People Are Nothing Special" is the story of Martine, a young woman whose troubles are obvious from the first frame. This film's startling prologue finds Martine (Valeria Bruni-Tedeschi) in a state of frantic distress. She stands smoking and fidgeting, eyes brimming with tears. She goes to work, where she is supposed to be soliciting business over the telephone, and picks a fight with the person she calls. On a coffee date with a young co-worker, Martine can't help making the first move. It's a clumsy and desperate one, saying much more about Martine's misery than about her need for love.

•

In quick, frightening succession, Martine is seen rupturing every tie that binds her to workaday routine. After she accosts the ex-boyfriend who has triggered her unhappiness, and then bangs her head violently against a store window, she is picked up by the police and sent to a mental hospital. Once there, she seems to have little memory of her self-destructive outburst. Removed from the pressures of appearing sane, she becomes relieved and even philosophical. "I have this existence problem," she says sweetly, whenever anyone asks why she has come to the hospital for refuge.

Most of "Normal People Are Nothing Special" takes place after Martine makes herself part of the hospital community. Finding herself surrounded by people whose pain is even more noticeable than her own, Martine becomes intensely interested in others. She becomes friend, confessor and interpreter; she even plays Cupid. She finds ways to feel useful without feeling constrained by pressure to conform.

Martine fluctuates wildly from grief to euphoria with a volatility that suggests she will always remain something of a mystery, even to her-

self. Meanwhile, the film experiences its own mood swings. Starting out with great promise on a tough, disturbing note, Ms. Barbosa softens the mood considerably once the hospital becomes her principal setting. Like many a story set in such surroundings, this one flirts with the rosy idea that madness is a state of grace. Together with the other patients, a group of gentle souls, Martine finds the kind of peace and playfulness that begs the story's hard questions.

•

The film is never more wrenching than when a doctor tells Martine she isn't disturbed enough to belong in the hospital. "I wonder if there's a place for me in this world," she answers wistfully. Ms. Barbosa wonders, too: she is most effective in outlining the frustrations faced by someone who will never quite cope with the demands of everyday life. When Martine, who can leave the hospital at will, makes periodic visits to the film's supposedly normal characters, she might as well be landing on the moon.

"Normal People Are Nothing Special" is greatly helped by the bristling intensity of Ms. Bruni-Tedeschi, a blunt, strong-jawed actress with a muscular and insistent presence. Even when the film goes soft, threatening to turn into a French "Awakenings" (one cute character builds an Eiffel Tower out of Popsicle sticks), Ms. Bruni-Tedeschi sustains her nervous energy. The viewer never quite knows what Martine will do next, which is just the point. Martine doesn't know, either.

"Normal People Are Nothing Special" begins the New Directors/New Films series tonight at 6 at the Museum of Modern Art (with other screenings at 6:30 tonight and at 3 P.M. tomorrow). On the same program is "Last Week of Summer '92," a 12-minute short directed by Ching-Ching Ip with cool precision. The film presents the diary of a Japanese girl who becomes pregnant while living in America. "My worries are not their worries," she thinks to herself, while watching American women at a pro-choice march. "Family honor, personal disgrace; it's not just a matter of choice." In thoughtfully weighing the alternatives, this graceful young woman succeeds in finding her strength.

1994 Mr 18, C1:1

Bitter Moon

Produced and directed by Roman Polanski; written by Mr. Polanski, Gérard Brach and John Brownjohn, based on the novel "Lunes de Fiel," by Pascal Bruckner; director of photography, Tonino Delli Colli; music by Vangelis; production designer, Willy Holt; released by Fine Line Features. Running time: 135 minutes. This film is rated R.

Oscar.......................................Peter Coyote
Mimi Emmanuelle Seigner
Nigel ...Hugh Grant
FionaKristin Scott-Thomas
WITH: Victor Banerjee and Stockard Channing

By JANET MASLIN

On an awfully long ocean voyage, two buttoned-down English travelers named Nigel (Hugh Grant) and Fiona (Kristin Scott-Thomas) meet Oscar (Peter Coyote), a determined raconteur. Getting away from Oscar is impossible, even if it's well worth a

walk off the gangplank. Oscar is determined to pry Nigel away from his spouse and regale him with red-hot memories of Oscar's own rocky romance. Oscar and Mimi (Emmanuelle Seigner), who is also very conspicuously on board, have had a sufficiently tumultuous time of it to land Oscar in a wheelchair.

One of Oscar's memories is of how Mimi first told him he would be paralyzed. She had good news and bad news, she said. The part about the wheelchair? "That WAS the good news," Mimi told him. "The bad news is that from now on, I'm taking care of you."

In much the same spirit, there is both good news and bad news about "Bitter Moon," the gleefully sadomasochistic love story directed by Roman Polanski, who is nothing if not the man for the job. The bad news: "Bitter Moon" is, by any reasonable standard, just awful. It's smutty, far-fetched and bizarrely acted, especially by Ms. Seigner, who gives the kind of performance that can only be explained by the fact that she is the director's wife.

The good news: Mr. Polanski seems to know all this, and even to encourage it. This material obviously appeals to his sense of mischief, which remains alive and well. Whatever else Mr. Polanski may be — nasty, mocking, darkly subversive in his view of the world — he definitely isn't dull. "Bitter Moon" is the kind of world-class, defiantly bad film that has a life of its own.

●

One of the ripe little quasi-jokes here is that Oscar is a writer, and apparently not a very good one. As he regales the poor, sandbagged Nigel with the story of his love affair, he dishes out the purplest of prose. (The screenplay, by Mr. Polanski, Gérard Brach and John Brownjohn, almost certainly has its tongue somewhere near its cheek.) "Eternity for me began one fall day in Paris," begins Oscar to his captive audience. He later describes himself as "a man demolished by a love that was too strong."

In flashback, Ms. Seigner is seen as the youthful Mimi ("my sorceress in white sneakers"), the kind of carefree nymph who can giddily indulge in a game of hopscotch but still has a suggestive way of carrying a baguette. Ms. Seigner looks big-boned and blowzy during the rest of the film (heavy makeup and black rubber dresses will do that), and she is not exactly nymph material. She only comes alive when mimicking her husband's taunting inflections ("O.K., Nigel — amuse me!")

Credibility is apparently not a real concern. When Mr. Polanski sends the lovebirds out to buy their first set of handcuffs, after Oscar and Mimi have developed the kind of passion that lends even the act of making morning toast a sexual connotation, he is presumably having fun with his material. Subsequent fun moves into the realm of bondage-style porn. "We were inseparable by day and insatiable by night," Oscar rhapsodizes in his inimitable fashion. "We just lived on love and stale croissants." Eventually, love turns sour and Mr. Polanski is even more the prankster. He gives Mimi a terrible haircut, puts her in a "Kiss the Cook" apron and lets Oscar turn cartoonishly mean in a flurry of creative ways.

Nigel is meant to be at first horrified at "being used as a rubbish dump for your unsavory reminiscences," as he tells Oscar. Later, he is supposed to be titillated, although the suave Mr.

Grant is much more convincingly aghast. Mr. Coyote plays his sicko Scheherezade with over-the-top gusto, but this wasn't a role that cried out for restraint. Stockard Channing supplies a sporting cameo. The cool, poised Ms. Scott-Thomas has the film's hardest job, that of maintaining a calm veneer while everyone else goes off the deep end.

●

"Bitter Moon" is rated R (Under 17 requires accompanying parent or adult guardian). It includes nudity, strong language and a great many sexual situations.

1994 Mr 18, C8:1

Monkey Trouble

Directed by Franco Amurri; written by Mr. Amurri and Stu Krieger; director of photography, Luciano Tovoli; edited by Ray Lovejoy and Chris Peppe; music by Mark Mancina; production designer, Les Dilley; produced by Mimi Polk and Heide Rufus Isaacs; released by New Line Cinema. Running time: 95 minutes. This film is rated PG.

Dodger .. Finster
Eva ... Thora Birch
Azro .. Harvey Keitel
Amy ... Mimi Rogers
Tom ... Christopher McDonald

By JANET MASLIN

On screen, Harvey Keitel has done things that would shock you so hard (as the phrase goes) they'd kill your whole family. So what is Mr. Keitel doing in a family movie? In the PG-rated "Monkey Trouble," he lurches through the role of a snaggle-toothed, greasy-haired Gypsy organ grinder whose monkey has special pickpocketing skills. Wonders never cease: Mr. Keitel turns out to be innocently funny this time. And "Monkey Trouble" is one of those rare children's films to which you can actually take small children.

Falling loosely into the Swell New Pet genre (think "Beethoven"), "Monkey Trouble" tells what happens when the Gypsy's monkey runs away. He is found and nicknamed Dodger by Eva Gregory (Thora Birch), a girl who could use a secret friend. Eva's mother (Mimi Rogers) and stepfather (Christopher McDonald) have a new baby, and they're the kind of couple who sit around singing "The Itsy-Bitsy Spider" to their new progeny. Understandably, Eva is upset. Dodger turns out to be the perfect remedy.

●

The film follows Eva through the getting-acquainted stage with Dodger, which is mostly devoted to figuring out how to get him into diapers. And it moves on to a decent assortment of other antics. Eva takes the monkey with her almost everywhere, not realizing that he sometimes reaches out of her backpack to steal the wallet of whoever is standing nearby. The film makes this funny without suggesting it's a cool thing to do.

Meanwhile, Mr. Keitel's character turns out to be a con man heavily dependent on the monkey, since a couple of dangerous-looking gangsters want to use Dodger in a burglary. The gangsters are doing this at the behest of their boss. This is the kind of film in which the boss is actually referred to as "Mr. Big."

The monkey (Finster) acquits himself nicely and knows quite a few monkey tricks. Miss Birch makes a natural and sprightly preadolescent heroine. The director, Franco Amurri ("Flashback"), holds the interest and avoids the saccharine. He is helped in the latter area by Mr. Keitel, who comes across as refreshingly surly, never more so than when he turns up in a Harvard T-shirt while irritably following the monkey's trail.

●

"Monkey Trouble" is rated PG (Parental guidance suggested). It includes mild profanity and monkey bathroom jokes.

1994 Mr 18, C8:4

Naked Gun 33⅓
The Final Insult

Directed by Peter Segal; written by Pat Proft, David Zucker and Robert LoCash; director of photography, Robert Stevens; edited by James R. Symons; music by Ira Newborn; production designer, Lawrence G. Paull; produced by Robert K. Weiss and Mr. Zucker; released by Paramount Pictures. Running time: 75 minutes. This film is rated PG-13.

Lieut. Frank Drebin Leslie Nielsen
Jane Spencer Priscilla Presley
Ed Hocken George Kennedy
Nordberg O. J. Simpson
Rocco Fred Ward
Muriel Kathleen Freeman
Tanya Anna Nicole Smith
Pia Zadora Herself

By CARYN JAMES

There are always priceless moments during the Academy Awards ceremony, those special moments that are impossible to watch with a straight face. After you've seen the big Oscar parody that is the centerpiece of "Naked Gun 33⅓: The Final Insult," when the real thing turns up on Monday night it may be hard to tell the difference. Movies have always been the prime target of the "Naked Gun" series, and this time Lieut. Frank Drebin (Leslie Nielsen) goes right to the source when he is assigned to thwart a terrorist at the Oscars. The result is a series of wickedly funny scenes, none better than the production number in which Pia Zadora, playing herself, sings and dances to a brassy Las Vegas arrangement of "This Could Be the Start of Something."

This third installment of the silly and often hilarious send-up of cop clichés is slower to start than the earlier "Naked Gun" movies. As always, it is a scattershot mix of throw-away lines, topical references and sight gags (a newspaper headline that reads: "Dyslexia for Cure Found"). Drebin is now married to Jane (Priscilla Presley). She is a hot-shot lawyer and he is retired, so he cooks and hangs around the house. Mr. Nielsen sets the tone with his authoritative deadpan approach. The key to this series' success is the way he maintains his dignified demeanor without winking at the audience, even when he is wearing fuzzy pink slippers.

●

The plot is a flimsy excuse for new jokes. Drebin's colleagues, played by George Kennedy and O. J. Simpson, lure him back on the job to thwart a gangster named Rocco (Fred Ward), who has a mother (Kathleen Freeman) tougher than he is. Rocco's sexy girlfriend (Anna Nicole Smith) hasn't aged a day since the police

Ron Phillips/Paramount Pictures

Leslie Nielsen

squad first set eyes on her in the 1970's; this is evident in a goofy disco flashback.

Even before Drebin discovers that a bomb is hidden in one of the Oscar envelopes, "Naked Gun 33⅓" tosses him and his friends into some irresistible scenes that echo "The Untouchables," "Thelma and Louise" and "The Crying Game." But it is the long Academy Awards ceremony near the end that makes the film worthwhile. The familiar-sounding list of nominees includes movies like "Fatal Affair," "Fatal Proposal," "Basic Analysis" and "Geriatric Park." Best of all is a short clip from Sir Richard Attenborough's latest epic, a musical biography of Mother Teresa.

The film's first-time director, Peter Segal, has adopted the series' style seamlessly. And this "Naked Gun," written by Pat Proft, David Zucker (who directed and co-wrote the earlier installments) and Robert LoCash, keeps some favorite touches. Be sure to stay around until the very end, to find out how Joey Buttafuoco and Marlon Brando slipped into the closing credits.

●

"Naked Gun 33⅓: The Final Insult" is rated PG-13 (Parents strongly cautioned). It includes mock violence and mock sex.

1994 Mr 18, C14:6

Suture

Written, produced and directed by Scott McGehee and David Siegel; director of photography, Greg Gardiner; edited by Lauren Zuckerman; music by Cary Berger; production designer, Kelly McGehee; released by Samuel Goldwyn. At Angelika Film Center, Mercer and Houston Streets, Greenwich Village. Running time: 96 minutes. This film has no rating.

Clay Arlington Dennis Haysbert
Dr. Renee Descartes Mel Harris
Dr. Max Shinoda Sab Shimono
Alice Jameson Dina Merrill
Vincent Towers Michael Harris

By CARYN JAMES

The best way to approach "Suture" is to consider it a witty, stylish goof on psychiatry, identity and murder mysteries. Elegantly photographed in black-and-white, it may seem to be about blacks, whites and racial bias. But creating a clever and visually

The Samuel Goldwyn Company

Dennis Haysbert

striking surface is the most important issue in the film, the first feature written and directed by Scott McGehee and David Siegel, collaborators with backgrounds in art and design.

The story begins with the eerily calm, authoritative voice of a psychiatrist making pronouncements about identity. Looking down from above, the camera captures a startling image. A black man dressed in white stands on one side of a white shower curtain; a white man dressed in black stands on the other. They are pointing guns at each other. The flashback story of "Suture" leads full circle, back to this point and beyond.

The black man is Clay (Dennis Haysbert), who has arrived in Phoenix to visit the white man, Vincent (Michael Harris). They are long-lost half-brothers who met at their father's recent funeral. Clay says with wonder to Vincent, "To see how much we look alike!"

Clay is tall and well built; his brother is ghostly pale and slight. Vincent agrees, "Our physical similarity is disarming, isn't it?" The main joke that runs through "Suture" is that everyone acts as if Clay and Vincent could be identical twins. It is a purely visual joke and never carries any weight.

•

Vincent uses the family resemblance against his brother. He plants his own identification on Clay, then tries to murder him. When Clay awakens with amnesia and a badly burned face, he is told that he is Vincent, the prime suspect in their rich father's murder. Clay sets out to find clues to his own memory and identity, but he is looking in someone else's life.

This is an intriguing idea, and it serves the film well as long as it is handled lightly. Mel Harris plays a plastic surgeon named Renee Descartes (a joke that is mercifully never pressed), who falls for Clay-as-Vincent. Sab Shimono is Max Shinoda, the psychiatrist. He displays giant Rorschach blobs on his office walls as if they were decorative art and helps Clay sort out disturbing dreams, some about hypodermic needles and one about turning into a car. At times the film threatens to take itself seriously, especially while Clay is constructing his new identity as Vincent. But no audience has to go along.

Although the film has dramatic cinematography by Greg Gardiner, also making his first feature, it does not have anything like the suspense or psychological depth of a Hitchcock movie. "Suture" has very little to say but says it with great panache.

1994 Mr 18, C15:1

Hélas Pour Moi

Written and directed by Jean-Luc Godard, in French, with English subtitles; director of photography, Caroline Champtier; released by Cinema Parallel. Joseph Papp Public Theater, 425 Lafayette Street, East Village. Running time: 84 minutes. This film is not rated.

Simon Donnadieu..............Gérard Depardieu
Rachel Donnadieu.............Laurence Masliah
Abraham Klimt.....................Bernard Verley
Max Mercure.........................Jean-Louis Loca

By CARYN JAMES

"Hélas Pour Moi" is about the search for faith, memory, truth and love: the deep human emotions ordinarily masked by the rigorous intellectual form of Jean-Luc Godard's films. But here is Mr. Godard in a strangely lyrical and contemplative mood. The film opens today at the Joseph Papp Public Theater, with its title awkwardly translated on screen as "Woe Is Me." A better alternative would be "Alas for Me," which captures Mr. Godard's meditative tone.

Like his 1985 film, "Hail Mary," this new work depicts the possible appearance of the divine in ordinary contemporary lives. But where "Hail Mary" outraged some Christians by reinventing one of their most sacred myths, here Mr. Godard plays it safe by reaching back to Greek mythology for his god figure. The story, he has said, is based partly on the legend in which Zeus impersonated Amphitryon in order to seduce Amphitryon's wife. In Mr. Godard's version, Amphitryon is named Simon Donnadieu (Gérard Depardieu). His wife is Rachel (Laurence Masliah) and the God who borrows Simon's body is a man in a trench coat and slouched hat, with a gravelly voice that holds the rumble of thunder behind it.

Simon and Rachel are compelling, the actors powerfully understated as they reveal the characters' confusion. Mr. Depardieu is not given his usual opportunity to be bombastic, and his intense but restrained performance provides much of the film's human heart.

But the tale is not easy to approach. The film begins when a publisher arrives in the picturesque Swiss town where the Donnadieus live, having heard their strange story. (Their name, which might loosely mean "given to God," isn't a bad clue.) The publisher begins with a voice-over that sets the tone of the film, recalling how his ancestors used to go to the woods to light a fire and pray. Gradually, through the generations, the elements of that ritual were lost: the ability to pray, to light a fire, even to know where the sacred place was. "But we do know how to tell the story," he says.

Mr. Godard sometimes makes his storytelling more difficult than it needs to be. The townspeople act like a Greek chorus as they comment on the Donnadieus; they have flippant

Cinema Parallel

Laurence Masliah and Gérard Depardieu in "Hélas Pour Moi."

conversations at the video store; words and chapter headings flash on screen. All these are conscientous elements of Mr. Godard's strategy, forcing the viewer to search out the truth. But the devices ultimately detract from the power of Simon and Rachel's struggle with the divine.

Did God really enter Simon and through him touch Rachel? The audience sees and hears the man with the gravelly voice. He is not a product of anyone's imagination. But who he is and what he means are questions that remain as ineffable as faith itself.

Filmed at a Swiss lake, "Hélas Pour Moi" looks beautiful. With music by Bach, Beethoven and Tchaikovsky, it sounds exquisite. It will be a surprise to anyone who thinks of Jean-Luc Godard as a cold and cerebral film maker. Here he is warm and cerebral, and more quietly provocative than he has been in years.

1994 Mr 18, C15:1

The Paper

Directed by Ron Howard; written by David Koepp and Stephen Koepp; director of photography, John Seale; edited by Daniel Hanley and Michael Hill; music by Randy Newman; production designer, Todd Hallowell; produced by Brian Grazer and Frederick Zollo; released by Universal Pictures. At the Coronet, Third Avenue at 59th Street, Manhattan. Running time: 112 minutes. This film is rated R.

Henry Hackett..........................Michael Keaton
Bernie White.............................Robert Duvall
Alicia Clark.................................Glenn Close
Martha Hackett........................Marisa Tomei
McDougal..Randy Quaid
Graham Keighley.....................Jason Robards
Marion Sandusky....................Jason Alexander
Paul Bladden.............................Spalding Gray
Susan...Catherine O'Hara
Janet..Lynne Thigpen

By JANET MASLIN

It's a busy day for the staff of The New York Sun, the raffish newspaper that is the subject of "The Paper," Ron Howard's strenuously eventful new comedy-drama. In the 24 hours spanned by the film, the audience witnesses, among other things, one birth, one affair, one shooting and one cancer diagnosis. To make sure all bases are covered, newspaperwise, there is even one full-throated cry of "Stop the presses!"

Naturally, there's a story behind each of these little epiphanies. But it is never a story colorful or fresh enough to suit The Sun's supposedly bold, savvy style. Mr. Howard trumpets the bighearted boisterousness of this tale without really straying from the calm, predictable waters of his earlier "Backdraft" and "Parenthood," films most memorable for their eagerness to please and near-total lack of individual personality. Mr. Howard has a talent for keeping his storytelling on an even keel, but it's not possible to be a yuppie Damon Runyon.

The absence of grit is especially noticeable in "The Paper," which opens today at the Coronet, since this time Mr. Howard has ventured onto terrain a lot of us know well. I'm not referring to the newspaper business (although "The Paper" makes vigorous fun of his paper, which it says runs headlines like "Nepal Premier Won't Resgn"), but rather to the irresistible world of newspaper movies. In half the newspaper films this side of "His Girl Friday" — the gold standard for the form — reporters are ruthless but heroic, and editors are impressively wise. The banter is smart and spirited. And fact-finding

missions always uncover the truth, which exonerates the blameless. This formula is outsize and magical. It is not easily adapted to fit nice, family-minded professionals.

•

But beyond letting its characters talk fast, use jargon and interrupt each other, "The Paper" misses most of the genre's real flavor. Its progress is methodical and sane. The Sun's offices, which are the setting for an ethical crisis about the next day's big news story, are used mostly as an excuse for gathering together a broad array of characters under one roof. (And even on that roof: some of "The Paper" was shot at the offices of The New York Post. The film includes an

Today, the ethical crisis. Tomorrow, the big story.

outdoor scene featuring a sensational view of the Brooklyn Bridge.)

Each principal has a problem that is conveniently addressed during this one-day interlude, thanks to a screenplay (by David Koepp and Stephen Koepp) that feels like the work of a committee. The film's general drift is to start these people off at fever pitch and then let them gradually unveil life's inner meaning as the tale trudges toward resolution. By dawn the next day, most of them have decided to slow down and smell the roses. It's not clear how The Sun will keep up its breakneck tempo with such a newly laid-back staff, but never mind.

The film's main character is Henry Hackett (Michael Keaton), the metropolitan editor, whose wife, Marty (Marisa Tomei), is expecting a baby any minute and still yearns for her old reporting job. Henry is suffering through his own career crisis and must decide whether to sell out and "count pencils uptown" (i.e., take a job at New York's much stuffier newspaper, presided over by a suspender-wearing Spalding Gray). Meanwhile, The Sun's top editor, Bernie White (Robert Duvall), is worried about his health. The film's way of underscoring this is to have Bernie cough so hard at an editorial meeting that the other staffers exchange worried glances.

Also on hand, and spicing up the film considerably, is a wickedly funny Glenn Close as Alicia Clark, The Sun's devious managing editor. Alicia's antics include trying to wheedle free benefit tickets out of "Bobby" De Niro, whose name she drops, and proudly coming up with "Gotcha!" as a front-page headline for what she knows to be a dishonest story.

Played devilishly by Ms. Close and cut from a flashier cloth than her co-workers, Alicia is one of the few characters here who warrant more screen time than they get. One of the film's livelier scenes has her bulldozing her way into the men's room at Radio City Music Hall, capping off a sequence that features fleeting appearances by many New York media figures. These cameos, like the Washington ones in last year's "Dave," bolster the film's inside-joke quotient without doing much for the non-insider.

With a strong cast that also includes Randy Quaid (as a dissolute but talented columnist), Jason Alexander (as someone the columnist has maligned), Jason Robards (as the paper's salty publisher), Lynne Thigpen (as Henry's right-hand assistant) and Catherine O'Hara (as Marty's worst nightmare of her own future), "The Paper" makes up in warmth some of what it lacks in cleverness. Mr. Duvall and Ms. Tomei are particularly appealing, suggesting there may be real people lurking somewhere behind the superficiality of the screenplay. As Henry, Mr. Keaton overdoes his wise-guy diffidence in the interest of screwball patter, but even he shows off a sensitive side before the story ends.

Incidentally, Henry's love of Coca-Cola is presented so flagrantly that it looks like one of his main personality traits. There's a large Coke machine in The Sun's newsroom, and Henry usually has at least one Coke on his desk. In one scene, he shares a Coke break with Bernie; in another, he anxiously cadges change until he has collected enough money to buy a soda. Coke is one of the most conspicuously plugged products in movies, but the advertising barrage here is outrageous. You're apt to leave the theater feeling annoyed and thirsty. And remembering that soft drinks had nothing to do with newsroom ambiance in the days of "The Front Page."

"The Paper" is rated R (Under 17 requires accompanying parent or adult guardian). It includes profanity and mild violence.

1994 Mr 18, C19:1

The Girl in the Watermelon

Directed and written by Sergio M. Castilla; director of photography, Irek Hartowicz; edited by Elizabeth Schwartz; production designer, Mr. Castilla; produced by Sergio Moskowicz and Andrew Louca; a Mommy and Daddy Production. At the Roy and Niuta Titus Theaters at 9 and 9:30 tonight and 12:30 P.M. tomorrow, in the Museum of Modern Art, 11 West 53d Street, Manhattan; part of the New Directors/New Films series of the Film Society of Lincoln Center and the museum's department of film and video. Running time: 92 minutes. This film has no rating.

Samantha Mayerofsky..Meredith Scott Lynn
Diane Maycrofsky................. Michele Pawk
Eddie Alvarez..............................Lazaro Perez
Robert Willbarth.........................Steven Stahl

By CARYN JAMES

Shot in Brooklyn and Manhatttan, "The Girl in the Watermelon" is loaded with local flavor and with the wry comic sense of its heroine, a smart 17-year-old named Samantha Mayerofsky. Sam carries a battered copy of Freud in her backpack, is inspired by typical adolescent anger at her mother and is engaged in a search for her missing father. Part Freud and part sitcom, "The Girl in the Watermelon" is also deft enough to turn its hackneyed subjects into a charming, up-to-the-minute urban fairy tale. The film will be shown tonight and tomorrow as part of the New Directors/New Films series at the Museum of Modern Art.

Sam's mother, Diane, is still young and about to marry a man her daughter calls the Toad. When an outraged Sam peeks into Diane's diary from 1976, she learns that her father might not be Samuel Mayerofsky, whose photograph she worships and who died in a motorcycle accident before Sam was born. It seems there are two other paternal candidates she has never heard of. She writes to both men. In true fantasy fashion, the post office and good fortune both work to her advantage, and she finds them.

"The Girl in the Watermelon" was sharply written and directed by Sergio M. Castilla, who has made several features in Latin America and now teaches film directing at Columbia University. His mordant short film, "One Thousand Dollars," was shown at the 1992 New York Film Festival.

His new film includes rich, natural performances by Meredith Scott Lynn as Sam, Michele Pawk as Diane and the actors who play the improbably opposite men who might be Sam's father.

Eddie Alvarez (Lazaro Perez) is a Latino trumpet player who turns up to serenade Sam under her window. He wears a white ruffled shirt and rides in a large convertible decorated with balloons and Christmas lights. He may be gauche but he's warmhearted, and thrilled to find a daughter after having fathered nine sons. He has a mole on his cheek that is the mirror image of Sam's.

Robert Willbarth (Steven Stahl) is a wealthy SoHo art dealer who shares a large loft with his gay lover and has a butler who drives his Rolls-Royce. Robert may be a snob, but he is every bit as warm-hearted as Eddie, and just as thrilled to find the ready-made family he thought he'd never have. Of course, he also has a cheek mole like Sam's. At first, she savors the attention. Finally, she becomes so confused that she says morosely, "I've got 2 fathers, 9 brothers, 85 dogs and a butler."

Sam's increasingly cluttered life is depicted in vibrant detail, from Eddie's salsa music to the large abstract canvases on Robert's walls. And Mr. Castilla seems shrewdly aware that Sam's two affectionate father figures move the film into fantasy land.

But there are more serious, unintentional missteps here. Sam talks out loud to her goldfish, whom she calls Dr. Goldstein and uses as a therapist. She has several portentous dreams, played out on screen. In one, a man grows a watermelon in his stomach, then gives birth to a baby living in the melon; that child is the fully grown Sam. Like the film's too-cute title, such touches are heavy-handed rather than whimsical. Putting the film in one of the opening-night slots of the New Directors series may raise expectations beyond anything this small picture can bear.

Still, "The Girl in the Watermelon" is a bright reflection of the multiethnic New York City of the 90's. It raises questions about generational differences between the 70's and the 90's, and does so without becoming pompous or saccharine. You can't ask a contemporary fairy tale to do much more.

1994 Mr 18, C29:1

Bhaji on the Beach

Directed by Gurinder Chadha; written by Meera Syal, based on a story by Ms. Chadha and Ms. Syal; director of photography, John Kenway; edited by Oral Norrie Ottey; music by John Altman and Craig Pruess; production designer, Derek Brown; produced by Nadine Marsh-Edwards. Released by First Look Pictures. At the Roy and Niuta Titus Theaters in the Museum of Modern Art, 11 West 53d Street, Manhattan, as part of the New Directors/New Films series of the Film Society of Lincoln Center and the museum's department of film and video. Running time: 100 minutes. This film has no rating.

Ginder ...Kim Vithana
RanjitJimmi Harkishin
Hashida..................................... Sarita Khajuria

By JANET MASLIN

"This is your day!" exclaims the organizer of the bus outing seen in Gurinder Chadha's "Bhaji on the Beach," a thoughtful, warmly inviting film about Asian women adapting to life in England. "Have a female fun time!" That feeble nod to feminist solidarity avoids the fact that these women actually seem to have little in common. They range from boy-crazy teen-agers to old ladies in saris, with a stylish visitor from Bombay who waves a cigarette holder and wears a fuchsia suit. Their problems and prejudices are as different as their clothes.

On an organized trip from Birmingham to Blackpool, for a day and night of sampling tacky seaside ambience and avoiding the men in their lives, these women provide this film's enterprising director with a colorful cross section of attitudes. Ms. Chadha, who has said that she thinks of this as a very English film and that the director she most admires is Ken Loach, weaves her characters' personal crises into a broader social portrait of their adopted homeland. She does this with impressive deftness and humor, even when addressing the ever-present matter of racism. "They Curried My Budgie!" reads a shrill tabloid headline on the morning when the film begins.

Ms. Chadha very successfully confines "Bhaji on the Beach" to the events of a single day. ("Bhaji" refers to a snack food that is itself an English-Indian hybrid.) It is the day when Hashida (Sarita Khajuria), the first person in her family to plan to go to medical school, discovers she is pregnant by Oliver (Mo Sesay), her boyfriend, who is black. It is also the day when Ranjit (Jimmi Harkishin), whose wife, Ginder (Kim Vithana), has run away from him, is goaded into trying to get her back. Ms. Chadha lets these and other developments emerge during the course of a

Samantha Dean & Associates
Meredith Scott Lynn in Sergio M. Castilla's "Girl in the Watermelon," part of the New Directors film series.

First Look Pictures Releasing

Zohra Segal in a scene from Gurinder Chadha's "Bhaji on the Beach."

busy morning, while she also depicts vibrant life in various other Asian households around Birmingham.

•

A man who runs a newsstand washes racist graffiti off his door. When one young woman, who shares a crowded kitchen with members of her husband's family, is asked to name an American movie, she very pointedly mentions "Married to the Mob." The teen-agers Ladhu (Nisha Nayar) and Madhu (Renu Kochar) tote a boom box, which is one of many reasons they have their mother worried. Simi (Shaheen Khan), one of the story's cooler heads, has daydreams in the giddy, overblown style of Indian commercial movies, and fantasizes about ways in which traditional Indian culture is being demolished by everyday English realities. "This country has cost us our children," one of the story's older characters eventually says.

"Bhaji on the Beach," which is to be shown tonight at 9 and tomorrow at 12:30 at the Museum of Modern Art as part of the New Directors/New Films series (and will open May 18 at the Film Forum), generates enough small culture clashes to remain bustling and energetic most of the way through. The touristy Blackpool setting is used well and provides its own set of distractions, from the foppish "actor, historian and ancient Blackpudlian" who tries to woo Simi (she has a hilarious Indian musical fantasy in which she tries to imagine him as a traditional suitor) to a restaurant where the women are gratuitously insulted. "The Khyber Pass is just around the corner," the proprietor sneers.

By the later stages of the story, the screenplay was written by Meera Syal), Ms. Chadha is forced into a certain amount of manipulation. She lets several of the film's male characters also turn up at the beach, most notably Oliver, who is played tenderly by Mr. Sesay and faces his own set of

problems dealing with the bigotry of Hashida's elders. (Zohra Segal is memorably stubborn and testy as the most small-minded of the group.) Yet even when the film develops a case of third-act-itis, leaving Ms. Chadha too busy tying up loose ends, it sustains its intelligence and charm.

Among the actresses seen here, Ms. Khajuria does a fine job of registering Hashida's complex emotions, and Ms. Vithana brings Ginder both seriousness and glamour. Incidentally, Ginder's situation happens to reach the crisis stage at a male strip club where the dancers dress like American sailors and call themselves the Sons of Liberty. Blackpool makes the perfect melting pot for Ms. Chadha's entertaining story.

1994 Mr 19, 13:1

Betrayal

Directed by Radu Mihaileanu; written by Mr. Mihaileanu and Laurent Moussard (in French, with English subtitles); director of photography, Laurent Dailland; edited by Catherine Quesemand; music by Temistocle Popa; production designer, Christian Niculescu; produced by Eliane Stutterheim and Sylvain Bursztejn. At the Roy and Niuta Titus Theaters in the Museum of Modern Art, 11 West 53d Street, Manhattan, as part of the New Directors/New Films series of the Film Society of Lincoln Center and the museum's department of film and video. Running time: 103 minutes. This film is not rated.

George Vlaicu.............................Johan Leysen
Laura Cocea...............................Mireille Perrier
The Inspector.........................Alexandru Repan
Cristea..Razvan Vasilescu

By CARYN JAMES

It's easy to say that the personal and political cannot be separated, especially when describing Eastern Europe during the cold war years. "Betrayal" gives that glib idea a sympathetic human shape. This is the story of a poet who insists he will never sell

his soul to Government agents, then desperately tries to survive by selling off a tiny portion of it. "Betrayal," directed by Radu Mihaileanu, a Romanian writer and film maker now living in Paris, is to be shown today at 6 P.M. and tomorrow at 3:15 P.M. at the Museum of Modern Art as part of the New Directors/New Films series. The film is an absorbing, intellectually forceful and emotionally wrenching account of a poet's bargain with the Devil.

Though the film is set in Romania, it has less to do with the particulars of that country's politics than with the way individuals deal with repressive states. A brief prologue, set in the late 1940's, shows the poet, George Vlaicu, writing an anti-Stalin editorial that lands him in prison. Eleven years later he is still in an isolated cell, hardly able to shape his fingers around a pencil.

•

An unnamed Government inspector (Alexandru Repan) praises George's poetry and cruelly tempts him into a deal. When George is given a taste of the opportunity to write, to hear music, to have sex, these ordinary actions are almost a form of torture. The inspector then offers an irresistible pact. In exchange for his freedom, George will inform on his friends, but will never be asked to provide information the Government does not already have. This doesn't make much sense, even to George, but he buys the idea that he will be a corroborating witness, doing no real harm. Because the story is told almost entirely from George's point of view, his actions are understandable and even sympathetic. As George, Johan Leysen makes the character a fundamentally good man in a harrowing situation.

Much of "Betrayal" is taken up with George's attempt to live with his uneasy compromise. He finds his former secretary, who had also been imprisoned, for having typed his offensive article. They marry, but George neither tells her about his deal nor asks if she has made one, too. All his friends are regarded with suspicion, for they might be informers. Every phone call might be bugged. For the next decade, the inspector is the only person with whom George can be completely honest.

Mr. Mihaileanu's straightforward directing style is extremely powerful. In a few scenes the directing gets fancy and symbolic, especially when George visits a gypsy theatrical troupe. But usually Mr. Milaileanu recognizes there is no need for melodrama when the most ordinary conversations are fraught with danger.

At the end, both George and the audience are brutally reminded that it isn't possible to sell a fraction of your soul. "Betrayal" allows the viewer to learn this with immediacy and intensity, and without political lectures.

1994 Mr 19, 18:1

Looking for Fun

Directed by Ning Ying; written by Ning Dai and Ms. Ning (in Chinese, with English subtitles), based on a novella by Chen Jiangong; director of photography, Xiao Feng; edited by Zhou Meiping; music by Meng Weidong; production designer, Yang Xiaowen; produced by Cheng Zhigu and Cai Cheng; released by Cinevista. At the Roy and Niuta Titus Theaters in the Museum of Modern Art, 11 West 53d Street, Manhattan, as part of the New Directors/New Films series of the Film Society of Lincoln Center and the museum's department of film and video. Running time: 95 minutes. This film has no rating.

Old Man Han................................Huang Zongluo
Qiao Wanyou..............................Huang Wenjie
Old Man Dong.............................Han Shanxu
Retarded boy......................................He Ming

By STEPHEN HOLDEN

Retirement can be a wrenching experience for someone who is suddenly plunged into a life of uninterrupted leisure. That is the prospect facing Old Han (Huang Zongluo), the main character in Ning Ying's serious comedy "Looking for Fun." Finding himself at loose ends at 65, the former janitor and doorman for the Beijing Opera Academy disconsolately wanders the streets of a city that seems poised on the brink of becoming a modern international hub.

Han, who lives an ascetic, solitary life in a dingy room whose walls are lined with newspaper, is a walking encyclopedia of Beijing Opera lore. While ambling through a park one day, he happens across a group of retirees who are also Beijing Opera fanatics; they meet regularly to trade stories and perform favorite arias for one another. After he impresses them with his knowledge, Han persuades them to form an amateur opera troupe and helps arrange for an indoor rehearsal space.

What begins as a hobby for the pensioners becomes intensely serious. Under Han's imperious leadership, the informal music making turns into a grueling series of rehearsals during which Han is unstinting in his criticism. Their once-friendly debates about musical style and vocal nuance are now angry arguments. The group's biggest troublemaker is Qiao Wanyou (Huang Wenjie), a proudly effeminate opera buff with a cracked voice and hysterical temperament who specializes in women's roles.

•

In the film's thorniest scene, the group enters a talent show at a street fair. During the performance, Han becomes nearly apoplectic as he screams directions at cast members who have become increasingly resentful of his dictatorial ways. Mr. Huang's wonderfully subtle portrayal of Han brings just enough of the sour-faced clown to the role to give it a dash of humor.

"Looking for Fun," which will be shown at the Museum of Modern Art tomorrow at 6 P.M. and on Tuesday at 9 P.M. as part of the New Directors/New Films series can be read as a wistfully humorous parable about the changing social and political climate in China. The crusty Han, whose face seems frozen in an expression of scowling disapproval, has the fussy critical manner and humorlessness of an old-line Communist bureaucrat. The opera troupe is a kind of last hurrah, not only for Han but also for an entire puritanical breed that seems to be dying out in China.

As the sounds of Western pop music bubble on the streets of Beijing, Han can sense the arrival of a consumer culture that will soon relegate institutions like the Beijing Opera into a marginal museum tradition. As clearly as he can imagine the future, he resents it.

1994 Mr 19, 18:4

Portrait of a Boy With Dog

A documentary directed by Robin Hessman and James Longley. At the Roy and Niuta Titus Theaters in the Museum of Modern Art, 11 West 53d Street, Manhattan, as part of the New Directors/New Films series of the Film

Society of Lincoln Center and the museum's department of film and video. Running time: 27 minutes. This film has no rating.

With: Gosha Prokoshenkov

Gosha Prokoshenkov, the 13-year-old boy who is the subject of "Portrait of a Boy With Dog," a documentary film by Robin Hessman and James Longley, is a Russian version of what in America might be called a throwaway child.

While Gosha tells his story in voice-overs, the movie shows him frisking in the park with his dog as well as playing with other young people, who, like him, live in a children's home in Moscow. The 27-minute film, which will be shown tomorrow night at 9 and on Monday at 6 P.M. at the Museum of Modern Art, doesn't try to separate the facts of the boy's life from the fictions he might be inventing. Gosha says his mother sent him to the home after an act of vandalism that his brother committed and blamed him for.

The boy's fantasies, like finding American adoptive parents and growing up to be a hired killer, suggest that a lot more is wrong than one act of vandalism. Gosha briefly goes to live with a farmer, who is interviewed and says he was drawn by the boy's devotion to the dog. Although the farmer seems genuinely kind, the boy leaves him after what he claims were sexual advances.

Whatever the truth, the picture of contemporary Russia that emerges is unremittingly bleak. It is clear that the boy's future is far from rosy. And in a country that is coming apart at the seams it is probably worse than that. "Portrait of a Boy With Dog" is the short film on the bill with "The Chekist," a Russian film that is a last-minute replacement for "Drumroll" in the New Directors/New Films series. STEPHEN HOLDEN

1994 Mr 19, 18:5

Mother's Boys

Directed by Yves Simoneau; written by Barry Schneider and Richard Hawley, based on the novel by Bernard Taylor; director of photography, Elliot Davis; edited by Michael Ornstein; music by George S. Clinton; production designer, David Bomba; produced by Jack E. Freedman, Wayne S. Williams and Patricia Herskovic; released by Dimension Films. Running time: 95 minutes. This film is rated R.

Jude Jamie Lee Curtis
Robert Peter Gallagher
Callie............... Joanne Whalley-Kilmer
Lydia Vanessa Redgrave
Kes................................. Luke Edwards

By STEPHEN HOLDEN

Yves Simoneau's inept psychological thriller, "Mother's Boys," uses every cinematic trick in the book to make Jamie Lee Curtis look like the most ominous spiderwoman ever to spin a web of doom around an all-American family. When the actress isn't photographed in deep shadow, she is shown dressed in black, furiously puffing on a cigarette. With her sharp features and deep-set eyes, Ms. Curtis certainly has the physical equipment to appear threatening. But when she begins to speak in her usual no-nonsense, girl-next-door voice, the illusion of evil evaporates instantly.

In "Mother's Boys," Ms. Curtis is painfully miscast as Jude, a disturbed woman who will stop at nothing to win back the family she abandoned three years earlier. Unable to seduce her husband, Robert (Peter Gallagher), who has filed for divorce

and plans to marry Callie (Joanne Whalley-Kilmer), an assistant school principal, she focuses all her energy on poisoning the minds of her three sons.

•

The key to her campaign is her emotionally disturbed eldest son, 12-year-old Kes (Luke Edwards). In the movie's opening scene, this unsmiling boy goes berserk in his biology class and repeatedly stabs the dead frog he is supposed to be dissecting. Jude eventually wins Kes's loyalty in the movie's only genuinely creepy scene. While taking a bubble bath in her fancy apartment, she entices him into the bathroom and shows him her scar from the Caesarean operation that brought him into the world. She was in labor with him for two days, she explains, because he didn't want to leave her.

From this low point, "Mother's Boys" descends into a confusing, fifth-rate imitation of "Fatal Attraction" in which Jude pulls several sick stunts that are so poorly filmed they have little or no shock value. As if overcompensating for the disjointedness of the screenplay, the director throws in far too many gratuitous shock effects and extreme close-ups. Among the actors, only Mr. Gallagher emerges unscathed.

The saddest element of "Mother's Boys" is the movie's misuse of Vanessa Redgrave, who plays the small role of Jude's mother, Lydia. If Miss Redgrave's face in repose evokes several lifetimes of experience and wisdom, not even she can give emotional credibility to the clunking psychological explanations that are brought in to explain Jude's psychotic behavior.

"Mother's Boys" is rated R. It has partial nudity, some strong language and sexual situations.

1994 Mr 19, 18:6

Clean, Shaven

Directed, written and produced by Lodge H. Kerrigan; photography, Teodoro Maniaci; edited by Jay Rabinowitz; music by Hahn Rowe; production design, Tania Ferrier; production Company, DSM III Films. At the Roy and Niuta Titus Theater 1 in the Museum of Modern Art, 11 West 53d Street, Manhattan, as part of the New Directors/New Films series of the Film Society of Lincoln Center and the museum's department of film and video. Running time: 80 minutes. This film has no rating.

Peter Winter Peter Greene
Jack McNally........................... Robert Albert
Nicole Frayne................ Jennifer MacDonald
Mrs. Winter Megan Owen
Melinda Frayne....................... Molly Castelloe

By JANET MASLIN

Lodge H. Kerrigan's "Clean, Shaven" quickly demonstrates that Mr. Kerrigan is capable of scaring the daylights out of his audience, given the right material. Mr. Kerrigan, who wrote, produced and directed this unsettling psychological portrait, begins by powerfully conveying the disturbed mental state of his film's main character. Peter Winter (Peter Greene) appears to be a child-killer, but not much about him is objectively clear. The film heightens the tension by confining its narrow focus to Peter's bizarre, angry view of the world.

As the soundtrack reverberates with conversational snippets and uncategorizable sounds, the camera shows how Peter's field of vision de-

liberately excludes other people. He is seen traveling alone, in a car whose windows he protectively pastes over with tabloid newspapers. Even so, memories intrude, and they crop up in ways that are as frightening to the viewer as they are to Peter. It's impossible to guess what sort of minor event might send him over the edge.

Peter's thought processes, captured by jarringly unpredictable editing, deliver the constant prospect of terrible violence. And Peter winds up visiting the film's most gruesome violence upon himself. In graphic and disturbing sequences, Mr. Kerrigan shows Peter gouging his own body to remove what he imagines are a receiver in his scalp and a transmitter under his fingernail. Watching these scenes at a preview screening of "Clean, Shaven" (which will be shown tonight at 6 and tomorrow at 9 P.M. as part of the New Directors/New Films series), many viewers went right up the wall.

The violence in "Clean, Shaven" is severe enough to warrant what might be called the Quentin Tarantino test. It's a way of asking whether a film that deliberately shocks its audience, as Mr. Tarantino did when he staged a scene in which an ear is sliced off in "Reservoir Dogs," could stand on its own without blatant sensationalism. Mr. Tarantino's film might actually have been better that way, but Mr. Kerrigan's is more dependent on scare tactics. Once Peter moves past the film's wordless early scenes and begins talking to other characters, "Clean, Shaven" loses much of its eerie mystery.

As "Clean, Shaven" begins to tell a story, it becomes increasingly ordinary. In addition to being a possibly murderous schizophrenic, Peter is a lonely father figure who wants his little girl back. He has an investigator on his trail. He has a strained, unhappy relationship with his mother, who seems to bring out the Norman Bates in her son. As a catchall explanation for many of her son's problems, this type of maternal character says more about uninventive writing than bad child rearing. It doesn't help that Mr. Kerrigan has a taste for nonprofessional-sounding actors who speak in flat, undramatic tones.

By the time it is over, "Clean, Shaven" has lost much of its power to surprise. But it still speaks well for Mr. Kerrigan, even if his directorial skills are more impressive than his subject matter. "Clean, Shaven" has been shot and edited with obvious ingenuity, and it makes good use of Mr. Greene's unnervingly chilly presence. Mr. Greene turns Peter into a compellingly anguished, volatile character, someone who didn't even have to slice himself up to get an audience's attention.

1994 Mr 22, C19:1

Ivan and Abraham

Written and directed by Yolande Zauberman, in Yiddish, Polish, Russian and Romany, with English subtitles; director of photography, Jean-Marc Fabre; edited by Yann Dedet; music by Ghedalia Tazartes; production designer, Alexandre Sagoskin; produced by René Cleitman and Jean-Luc Ormières; released by New Yorker Films. At the Roy and Niuta Titus Theater 1 in the Museum of Modern Art, 11 West 53d Street, Manhattan, as part of the New Directors/New Films series of the Film Society of Lincoln Center and the museum's department of film and video. Running time: 105 minutes. This film is not rated.

AbrahamRoma Aleksandrovitch
Ivan............................... Sacha Iakovlev
Aaron.........................Vladimir Machkov
Nachman........................Rolan Bykov
The Prince...................Oleg Iankovski
Rachel.........................Maria Lipkina

By JANET MASLIN

"Ivan and Abraham," Yolande Zauberman's lushly beautiful black-and-white film about the friendship between two boys in pre-World War II Poland, is full of visual surprises. The setting is a shtetl near the eastern border of Poland (the film was shot in a real shtetl in Ukraine), but the imagery has a peculiar and incongruous glamour. Life is languid and slow. Characters are voluptuous, even when the realities of their existence are ominous and harsh. In this atmosphere, a wife responds amorously when her husband embraces her, even though she happens to be busy scrubbing the floor.

Ms. Zauberman uses this intoxicating manner to tell the story of Abraham (Roma Aleksandrovitch), his family and his neighbors, who reflect varying political changes that are in the offing. Nachman (Rolan Bykov), Abraham's grandfather, is the estate manager for a brooding, world-weary Prince (Oleg Iankovski) who presides over the region until his money runs out. Rachel (Maria Lipkina), Abraham's sister, is in love with Aaron (Vladimir Machkov), who is a member of the illegal Communist party.

Ivan (Sacha Iakovlev) is a Polish Christian who lives with Abraham's family as an apprentice. The film shows what happens when these and other bonds between the characters are stretched to the breaking point, after the Prince's defection triggers intimations of anti-Semitism. These changes occur just as some of the principals are reaching the age of independence. So Rachel and Aaron wind up embarking on a voyage of discovery, as do Ivan and Abraham in their own way. The shtetl they all wish to leave, the film observes ruefully, is a place that will never be the same again.

•

Ms. Zauberman, who wrote and directed "Ivan and Abraham," deliberately avoids the melodramatic flourishes that might be used to shape such a story. Her film is artfully unpredictable, suffused with physical warmth and a dreamlike, inviting glow. But this visual style, while alluring, is also deeply distracting, forcing the film's handsome characters into coy, model-like poses and allowing long silences (particularly from the solemn young boys in the leading roles) to take the place of illuminating talk. "Ivan and Abraham" unfolds in four languages — Yiddish, Polish, Russian and Romany — but it still has too many moody, wordless moments for its own good.

Ms. Zauberman's story is detailed and exotic, leading the runaway boys to Gypsies, anti-Semites and a farmer with a near-mystical love of horses. The film also pays keen attention to Jewish life within the shtetl, depicting events within a communal house of religious study as well as other specific glimpses of the time and place. But this is no historical narrative, even if it has the makings of one. The film relies too heavily on arch, elliptical methods, which are often as anachronistic as its posturing good looks.

"Ivan and Abraham" is notable for Ms. Zauberman's striking compositions, for her obviously fierce interest in her subject matter and even for the

very strangeness of its internal contradictions. It will be shown tonight at 6 and tomorrow at 9 P.M. as part of the New Directors/New Films series at the Museum of Modern Art. After that, it opens on Friday at the Lincoln Plaza theater.

1994 Mr 23, C17:1

Above the Rim

Directed by Jeff Pollack; written by Barry Michael Cooper and Mr. Pollack; director of photography, Tom Priestley Jr.; edited by Michael Ripps and James Mitchell; music by Marcus Miller; production designer, Ina Mayhew; produced by Mr. Pollack and Benny Medina; released by New Line. Running time: 96 minutes. This film is rated R.

Kyle-Lee Watson	Duane Martin
Birdie	Tupac Shakur
Bugaloo	Marlon Wayans
Shep	Leon
Mailika	Tonya Pinkins
Flip	Bernie Mac

By JANET MASLIN

When you'd like to make a film featuring fast, furious basketball sequences, Tom Priestley Jr. is clearly the man to see. Mr. Priestley shot "Blue Chips," and he is also the cinematographer on "Above the Rim," which is set in Harlem and revolves around a fiercely competitive playground game. Presiding over this action is a grinning gangster named Birdie (Tupac Shakur), who stands to make money on the game. Birdie hopes he can improve his odds by forcing Kyle-Lee Watson (Duane Martin) to play for his team.

Kyle is a familiar character, the young man torn between good intentions and bad influences. If Birdie is the latter, the film's positive role model is Shep (Leon), who was once a local basketball star in his own right and now works as a security guard in Kyle's school. Matters are complicated by the fact that Shep attracts the interest of Mailika (Tonya Pinkins), a pretty, vivacious woman who happens to be Kyle's mother. Kyle and Mailika argue heatedly about which one of them has the right to ground the other.

"Above the Rim" has its formulaic elements, but it has been vigorously directed by Jeff Pollack, who appreciates the lively and unpretentious aspects of the story. The casting is especially adroit, with Leon (the handsome star of "Cool Runnings") well used as a foil for Birdie. Leon is as much the cool customer as Mr. Shakur is the angry hothead, so the casting works strictly as a matter of contrast. The story, by Mr. Pollack and Benny Medina (Mr. Pollack wrote the screenplay with Barry Michael Cooper), gives this relationship an effective extra twist.

Also in "Above the Rim" is Marlon Wayans, who does a funny job as the film's motor-mouthed cutup, and Bernie Mac, who makes a brief but compelling appearance as a derelict with a glorious past. The film's sense of history stretches back to the early 1970's, an era being celebrated at a Harlem movie theater that has a blaxploitation film series under way. As Shep and Mailika talk about how much they liked "Shaft," Mr. Pollack's own film harks back to a more innocent, less jaded breed of film about black characters.

For that reason, the abundant tough-guy posturing in "Above the Rim" (with heavy emphasis on racial and mother-insulting expletives)

seems especially gratuitous. The story here is gentle, and the performances are straightforward and good. Mr. Martin is quietly effective, and Leon and Mr. Shakur have great potential in the matinee idol department. It should have been possible to make this film without songs titled "Big Pimpin'," "Stick 'Em Up," "Crack 'Em" and "Pour Out a Little Liquor" to jive up the atmosphere.

●

"Above the Rim" is rated R (Under 17 requires accompanying parent or adult guardian). It includes violence and considerable profanity.

1994 Mr 23, C17:1

Cronos

Written and directed by Guillermo del Toro, in Spanish with English subtitles; director of photography, Guillermo Navarro; edited by Raul Davalos; music by Ian Deardon; production designer, Brigitte Broch; produced by Bertha Navarro and Arthur Gorson; released by October Films. At the Roy and Niuta Titus Theater 1 in the Museum of Modern Art, 11 West 53d Street, Manhattan, as part of the New Directors/New Films series of the Film Society of Lincoln Center and the museum's department of film and video. Running time: 92 minutes. This film is not rated.

Jesús Gris	Federico Luppi
Angel de la Guardia	Ron Perlman
Dieter de la Guardia	Claudio Brook
Aurora Gris	Tamara Shanath

By JANET MASLIN

For proof that the vampire film is resoundingly undead, consider "Cronos," a very stylish and sophisticated Mexican variation on some age-old themes. With the very names of his principal characters (Jesús Gris and Angel de la Guardia), Guillermo del Toro, the writer and director, signals the mordant playfulness of his film. Not every vampire has a granddaughter named Aurora, either.

In terms of its essential subject matter, "Cronos" has not discovered much that's new under (or out of) the sun. But this film's reflective, even stately style elevates it from the ranks of ordinary stake-through-the-heart vampire dramaturgy, turning it into something much more exotic. Suffused with clever ambiguities and staged with unexpected grace, "Cronos" finds its originality in unlikely ways. This must be the only vampire film in which an impeccably dressed, white-haired gentleman has ever felt compelled to lie down and lick a bathroom floor.

The gentleman in question is Jesús Gris (Federico Luppi), an antiques dealer who comes across a mysterious artifact one memorable morning. Buried inside the base of a statue is the title object, an innocent-looking golden egg that happens to possess the obligatory magic powers. Mr. del Toro does not handle the Cronos device conventionally, any more so than he falls back on familiar methods to present this film's other staples. The Cronos itself is seen from the inside at times, as a mixture of gleaming gold and throbbing, pulsating living matter. It is also full of beetles when it first appears. Here and elsewhere, Mr. del Toro's elegant yet ghoulish sensibility brings that of David Cronenberg ("The Fly," "Naked Lunch") powerfully to mind.

Once Jesús finds himself in the grip (quite literally) of the Cronos device, his life is not the expected downhill slide. Like the audience itself, Jesús is initially both fearful and puzzled,

gradually learning to live with his new condition. Patient little Aurora, who works with him in the antiques shop, is made part of this process and at one point even protects the Cronos device by hiding it inside her teddy bear. It seems that the device is desperately wanted by Angel de la Guardia (Ron Perlman), an ugly American whose second fondest dream is having plastic surgery. De la Guardia's first wish is to save the life of his uncle, an industrialist named Dieter, by securing the Cronos and bending it to Dieter's will.

With great macabre gusto, Mr. del Toro moves from one unexpected setting to another: the antiques shop, the apartment where the dying Dieter keeps his excised tumors in bottles, even the cremation parlor that becomes a setting for black comedy. (The film's special makeup effects, which are much less gory than might be expected, were done by an outfit named Necropia.) He has a considerable asset in Mr. Luppi, who remains soigné and reasonably calm no matter what happens to him, in a role that would also have been perfect for Vincent Price. Mr. Luppi's responses are so courtly and measured that the audience can share in his sense of wonder once the Cronos device proves to be much more interesting than any garden-variety vampire-making gadget. Mr. Perlman brings a tongue-in-cheek scariness to the exaggerated role of the thug.

As a film that displays high style while reveling in its own many mysteries, "Cronos" is one of the standouts at this year's New Directors/New Films series. It is to be be shown tonight at 6 P.M. and tomorrow at midnight. It opens on Wednesday at the Angelika Film Center and Angelika 57.

1994 Mr 24, C16:6

Clerks

Written and directed by Kevin Smith; director of photography, David Klein; edited by Scott Mosier and Mr. Smith; music by Scott Angley; produced by Mr. Smith and Mr. Mosier; released by Miramax Films. At the Roy and Niuta Titus Theater 1 in the Museum of Modern Art, 11 West 53d Street, Manhattan, as part of the New Directors/New Films series of the Film Society of Lincoln Center and the museum's department of film and video. Running time: 91 minutes. This film is not rated.

Dante	Brian O'Halloran
Randal	Jeff Anderson
Veronica	Marilyn Ghigliotti
Caitlin	Lisa Spoonhauer
Jay	Jason Mewes
Silent Bob	Kevin Smith

By JANET MASLIN

Have you ever wondered whether the contractors working on the Death Star didn't become innocent victims during the climactic battle of the "Star Wars" adventures? No? Well, it may take a certain kind of workaday atmosphere to bring such thoughts to mind. Dante Hicks (Brian O'Halloran) and his friend Randal (Jeff Anderson) are seen experiencing that atmosphere to the fullest in Kevin Smith's "Clerks," a buoyant, bleakly funny comedy chronicling a day's worth of activity at two adjoining stores. Though nominally situated in New Jersey, this convenience store and video rental place are in spirit somewhere very near the end of the world.

●

In this dismal setting, the customer who takes all the eggs out of their

cartons until he assembles a perfectly matched dozen is enough to pique the clerks' imaginations. "I'll bet you a million dollars he's a guidance counselor," says one, thinking the man may be suffering the ill effects of having "a meaningless job." Dante and Randal understand perfectly. So does the 23-year-old Mr. Smith, who has worked off and on at Quick Stop Groceries in Leonardo, N. J., since he was 19 and shot his extremely low-budget black-and-white film there. The upshot, an exuberant display of film-student ingenuity, is a classic example of how to spin straw into gold.

To appreciate Mr. Smith's cleverness, you need only realize how little promise his basic elements provide. The stores look realistically drab, and this film's fuzzy, grainy production values place it at the garage-band level in terms of pure technique. Although the two main actors are fresh and engaging, nobody on camera looks or sounds like much of a pro.

And as for drama, how much activity can really be coaxed out of a day spent renting videos and selling gum? More than might be expected. Without too much strain, Mr. Smith contrives a romantic crisis for Dante, an on-site hockey game that exhausts the convenience store's supply of Gatorade, a parade of colorful customers and a bizarrely funny disaster in which one visitor unwittingly has sex with a corpse. None of this need be taken seriously, and all of it is unexpectedly varied and wry.

In his closing credits, Mr. Smith pays homage to the usual suspects: Hal Hartley, Spike Lee, Jim Jarmusch and Richard Linklater. That's the Mount Rushmore of contemporary cool, yet Mr. Smith has his own not-too-derivative style (despite occasional titles flashing words like "Harbinger," "Syntax," "Perspicacity" and "Malaise"). He also has an uncommonly sure sense of deadpan comic timing. Studied nonchalance can go flat very easily, but Mr. Smith keeps his film's improbable elements just loony enough to sustain energy. Both Mr. O'Halloran and Mr. Anderson enthusiastically rise to the tasks of looking desperately bored and bantering with equal heat about philosophical constructs or trivial pursuits.

Also in the film are Marilyn Ghigliotti, as the current girlfriend who horrifies Dante with her catalogue of sexual exploits, and Lisa Spoonhauer as the ex-girlfriend Dante decides he wants back. ("I think the idea or the conception of our dating is a lot more idyllic than what actually happens when we date," she eventually tells him.) Mr. Smith himself is seen briefly in the role of Silent Bob, one of the several hangers-on who are unaccountably drawn to this red-hot center of inertia.

●

"Clerks" is true to the slacker motif of mixing smart twentyish characters (Dante is 22) with precocious burnouts, throwing them together in an atmosphere of funny yet frustrating paralysis. Randal, who will debate about absolutely anything and who enjoys tormenting his customers, has succumbed to this spirit more fully than Dante, who still exhibits faint signs of ambition. Dante's erratic efforts to keep the Quick Stop running smoothly (including a sign that reads "If you plan to shoplift, let us know") mean he may actually move on to bigger things some day. Mr. Smith is certain to do the same.

In the store where Randal works, one customer complains about the way videos are packaged: "They say so much, but they never tell you if it's any good." "Clerks" should not be subject to that confusion. It's small and rough-edged, with all the earmarks of a first effort. But it's one of the good ones.

•

"Clerks" will be shown at 9 tonight and Monday night as part of the New Directors/New Films series, on the same bill with "Ice Cream," a short by Louis C. K. "Ice Cream" is sharp-edged too, and even cooler than its title in presenting a series of blackout sketches. Two people meet in, yes, a convenience store. They marry. They are next seen lying woodenly on a bed. Immediately afterward, they stand beside the bed looking down at a baby. "We'd better not do that anymore," the husband says.

1994 Mr 25, C10:1

Sirga

Directed by Patrick Grandperret; written (in French, with English subtitles) by Olivia Brunoyghe, based on the novel by René Guillot; director of photography, Jean-Michel Humeau; edited by Sean Barton, Yann Dedet and Terry Stokes; music by Salif Keita; produced by Yannick Bernard and Mr. Grandperret; production company, RGP Productions, Odessa Films. At the Roy and Niuta Titus Theater 1 in the Museum of Modern Art, 11 West 53d Street, Manhattan, as part of the New Directors/New Films series of the Film Society of Lincoln Center and the museum's department of film and video. Running time: 86 minutes. This film is not rated.

Oulé.............................Mathurin Sinze
Léna...............Sophie-Véronique Toue Tagbe

By CARYN JAMES

Among the many astonishing scenes in "Sirga" is one in which a small lion cub frolics with a baby just about its size. It is a sweet, endearing episode, perfectly in tune with the characters played by these unlikely actors. The baby is Oulé, a boy from an African village who is magically in touch with the animal world. The cub is his mystical twin sister, Sirga, a lion princess who protects the village from angry elephants who used to rule the territory. While the baby Oulé and Sirga act out every animal-loving child's fantasy, adults can pass the time wondering, "How did they film that?"

The animal sequences are the heart of "Sirga," which had a long run as a children's favorite in France and which will be shown tonight at 6 and tomorrow at 1 P.M. at the Museum of Modern Art as part of the New Directors/New Films series. The film will also be shown at the Walter Reade Theater at Lincoln Center in its Movies for Kids program on April 2, 3, 9 and 10. At the Walter Reade screenings, English translations will be available over headsets. There isn't much dialogue in the film, and even smaller children should be able to follow the story that way if they are able to sit still for the headphones.

The tale, set in no specific time, begins when Oulé and his best friend, a girl named Léna, are captured and taken from their village by warring tribesmen. In flashback, the story follows Oulé from birth through boyhood. As a baby, he is protected by a snake. As a child, he entices a swarm of bees to cover a large wound on his back; when the bees fly away, his

wound has healed. As the children grow, Léna becomes jealous of Oulé's relationship with Sirga, but the story is always secondary to the incredible photography of elephant stampedes, lion hunts and tornadoes.

Directed by Patrick Grandperret, "Sirga" was filmed in several African locations, including Mali, Zimbabwe and the Ivory Coast (the home of Mathurin Sinze and Sophie-Véronique Toue Tagbe, the wonderfully natural children who play Oulé and Léna). Nonetheless, "Sirga" is definitely a story with a European narrative and sensibility imposed on an African setting. The tale may borrow from African myths, but the movie's series of dramatic conflicts and resolutions is far different from the leisurely, flowing narrative style of true African films.

That, however, is a grown-up's quibble. Family audiences will find "Sirga" to be a rare and engaging close-up view of a world where animals and humans think and act like brother and sister, complete with love and sibling rivalry.

1994 Mr 25, C10:5

D2: The Mighty Ducks

Directed by Sam Weisman; written by Steven Brill; director of photography, Mark Irwin; edited by John F. Link and Eric Sears; music by J. A. C. Redford; production designer, Gary Frutkoff; produced by Jordan Kerner and Jon Avnet; released by Buena Vista Pictures. Running time: 107 minutes. This film is rated PG.

Gordon Bombay....................Emilio Estevez
Tibbles..........................Michael Tucker
Jan...............................Jan Rubes
Michele Mackay...................Kathryn Erbe

By CARYN JAMES

Any movie can inspire merchandising tie-ins like T-shirts and dolls. The 1992 Disney hit "The Mighty Ducks" is the only film in history to have inspired the creation of an actual hockey team, the Disney-owned Anaheim Mighty Ducks of the National Hockey League. It makes the head spin just to think about professional hockey players wearing their bright green jerseys with the cartoonish team logo inspired by a children's movie: a scowling duck in a goalie's mask with hockey sticks crossed behind him like a kiddie skull-and-crossbones. Yeah, they're tough.

What makes the head spin even more is the message of the movie's sequel. The point of "D2: The Mighty Ducks" is that commercialism in sports is bad. Emilio Estevez returns as Gordon Bombay, who in the original was a high-powered lawyer arrested for drunken driving and forced to do community service by coaching a ragtag children's team. Of course, he recaptured his boyhood love of the game. In "D2," when the Ducks travel from Minnesota to Los Angeles to play in the Junior Goodwill Games, Bombay loses his sportsmanlike bearings. The evidence of his distraction is that he becomes a peewee-league Pat Riley, with slicked-back hair, designer suits and many commercial endorsements. Good luck to parents trying to explain this to children while standing in line to buy their Mighty Ducks hockey shirts.

"D2" follows the "Sister Act 2" law of sequels. It is twice as sugary and half as entertaining as the original. In the first "Mighty Ducks," Bombay

started off as a man who said, "I hate hockey and I don't like kids," which left plenty of room for a transformation. At the start of "D2," he is already soft-hearted.

•

He is lured back to coaching when a manufacturer of hockey equipment offers to sponsor the team at the Goodwill Games. The Ducks go to Los Angeles, where they are joined by a handful of demographically and ethnically diverse new players. The combined team includes a Hispanic player from Florida, a Korean-American former figure skater, a Stetson-wearing boy from Texas, a couple of black players and two girls. The group is proudly and loudly referred to as "Team U.S.A." by everyone, in a rah-rah tone that suggests they are all auditioning to become network sports announcers.

It's doubtful whether children will care about the corrupting influence of Bombay's big beachfront house. But if they make it through the long wind-up, "D2" comes through with the kind of cute, kids-on-ice action that made the first film a hit. One player's secret weapon is a wild "knuckle-puck"; another player skates fast but has trouble stopping; the Texan lassos someone from the opposite team during a game. When the players are rambunctious, they are the kind of realistic characters children can identify with. "D2" gets into trouble when the team is forced to be goody-goody. The players realize long before Bombay does that the true meaning of sports has nothing to do with appearing on a cereal box.

The film also conveniently forgets that coaches with slicked-back hair and designer suits have been known to tout team spirit and to win. But maybe it's best not to try to make sense of "D2." Young viewers will be drawn back to join in the team's rallying cry: "Quack! Quack! Quack!"

•

"D2: The Mighty Ducks" is rated PG (parental guidance suggested). It includes some rough behavior on the ice.

1994 Mr 25, C17:1

Under One Roof

Directed by Paulo Thiago; written by Alcione Araujo in Portuguese, with English subtitles; director of photography, António Penido; edited by Marco Antônio Cury; music by Tulio Mourão; production designer, Clovis Bueno; produced by Glaucia Camargos; released by Castle Hill Productions. At the Quad Cinema, 13th Street west of Fifth Avenue, Greenwich Village. Running time: 95 minutes. This film is not rated.

Gertrudes....................Norma Bengell
Madalena...............Maria Zilda Bethlem
Lucia.........................Lucelia Santos
Plumber/Alfredo................Marcos Frota

By STEPHEN HOLDEN

Early in "Under One Roof," Paulo Thiago's disjointed comic satire of life in contemporary Brazil, a little girl walking along a street has a loaf of bread snatched out of her hands by a thief. It is the first of many images of a society in which everyone has gone a little batty and crime is so rampant that a knock on the door is as likely to signal an armed robbery as a neighborly visit.

The film, which opens today at the Quad Cinema, focuses on the tumultu-

Castle Hill Productions
Maria Zilda Bethlem

ous domestic life of three eccentric women who share an apartment in an unnamed port city. Gertrudes (Norma Bengell), a strait-laced widow and piano teacher of 60, fancies herself a surrogate mother for her two troublesome boarders. Sensual, defiantly free-spirited Madalena (Maria Zilda Bethlem), who works as a nurse in a mental hospital, enjoys embarrassing the prudish Gertrudes by parading bare-breasted in front of the window. At night, she prowls the local cafes, picking up men and having quick, wild sex in odd places.

Lucia (Lucelia Santos), by contrast, appears to be both schizophrenic and emotionally retarded. One minute, she is an overgrown infant, quaking and crying, pursued to the brink of suicide by unseen demons. The next, she is nursing steamy erotic fantasies about the building's plumber (Marcos Frota), who, she persists in imagining, is really a circus performer named Alfredo.

Gertrudes, who thinks she can save Lucia from her self-destructive urges, watches over her with a ferocious protectiveness. But she, too, has her mental lapses. When she is alone, Gertrudes entertains bizarre fantasies of her husband's return from the dead.

•

In its portrait of the three women struggling for a familial stability and failing at every turn, "Under One Roof" offers a pungent metaphor for a chaotic society that is pretending to have a sense of national unity. Each of the three women can be seen as a different aspect of the Brazilian psyche run amok. Gertrudes, with her delusions that the past can somehow be resurrected, represents a traditional culture that is all but dead. She deludes herself into believing that Lucia's sick, self-destructive behavior is just an attitude problem that can be adjusted with proper care and feeding. Although Lucia has occasional moments of rationality, she is just one step away from either suicide or incarceration.

The nihilistic Madalena lives defiantly for the moment and takes pride in flouting all social rules. But as her liaison with a crazy, gun-toting man who says he is an astronaut shows, such recklessness has its risks.

For all its intriguing symbolism, "Under One Roof" never achieves a fluent narrative drive, and its mo-

ments of comic levity are too scattered for it to be very funny. The movie is marred by uneven subtitles and an obtrusive, cheesy musical soundtrack.

The best moments belong to Miss Bethlem, whose portrait of a wanton sensualist conveys both the intensity of the chase and the frantic boredom that spurs it.

1994 Mr 25, C18:1

Zero Patience

Written and directed by John Greyson; director of photography, Miroslaw Baszak; edited by Miume Jan; composer, Glenn Schellenberg; production designer, Sandra Kybartas; produced by Louise Garfield and Anna Stratton; released by Cinevista. This film is not rated.

Sir Richard Francis Burton....John Robinson
Zero.............................Normand Fauteux
Mary...............................Dianne Heatherington
George........................Ricardo Keens-Douglas

Pool Days

Written, directed and produced by Brian Sloan; 'executive producer, Robert Miller; cinematographer, Jonathan Schell. This film is not rated.

WITH: Kimberly Flynn, Nick Poletti and Josh Weinstein.

At the Roy and Niuta Titus Theater 1 in the Museum of Modern Art, 11 West 53d Street, Manhattan, as part of the New Directors/ New Films Series of the Film Society of Lincoln Center and the Museum's department of film and video. Running time: 100 minutes.

By STEPHEN HOLDEN

"Zero Patience," John Greyson's audacious film musical about AIDS, bubbles with so many ideas that it has the feel of several movies compressed into an unwieldy if stimulating Brechtian revue. Underneath its giddy surface, it systematically discredits myths surrounding AIDS, most notably the notion that gay male promiscuity can be blamed for the epidemic.

The film, which has screenings at the Museum of Modern Art at 9 tonight and at 6 P.M. tomorrow as part of the New Directors/New Films series, has almost as many mood swings as it has themes. One minute it is telling the beyond-the-grave love story of the Victorian adventurer Sir Richard Francis Burton (John Robinson) and the ghost of Patient Zero (Normand Fauteux), the gay French-Canadian airline steward portrayed in Randy Shilts's "And the Band Played On" as a critical early carrier of the AIDS virus.

The next it is a ribald musical comedy that includes one song about how to find sex in a bathhouse and another number that cheerily deconstructs taboos about anal sex. In its angrier moments, the film takes up the disruptive politics of the AIDS organization Act Up.

•

"Zero Patience," which parodies the story of Scheherazade, begins with Patient Zero, stuck in the primordial void, pleading for someone to save his life by telling his story. His wish is granted, and he appears to Burton, who has achieved eternal life after an encounter with the Fountain of Youth. Alive and well and working as a taxidermist in a Canadian museum, Burton is preparing an exhibition called the Hall of Contagion. One of its proposed displays is a sensationalistic look at AIDS that focuses on Patient Zero's promiscuity.

John Robinson, left, and Normand Fauteux in "Zero Patience."

The movie follows the transformation of Burton from a disinterested exploiter of the story of Patient Zero into a rebel who sabotages the very exhibition he originally planned.

"Zero Patience," despite its grim subject, has a loopy buoyancy. The songs, composed by Glenn Schellenberg, with lyrics by Mr. Schellenberg and Mr. Greyson, suggest a bouncy stylistic hybrid of Gilbert and Sullivan, Ringo Starr, the Kinks and the Pet Shop Boys. In the number that finds the movie's sharpest mixture of politics and humor, the late Michael Callen, in drag, appears through a microscope as the AIDS virus, Miss H.I.V. "Tell a story of a virus,/ Of greed, ambition and fraud," he sings in a cutting falsetto. "Tell a tale of friends we miss/ A tale that's cruel and sad."

"Zero Patience" opens at Film Forum 1 on Wednesday and will play through April 12.

Brian Sloan's "Pool Days," which New Directors is showing with "Zero Patience," is an acutely observed study of a 17-year-old boy who awakens to his possible homosexuality while working as a pool attendant at a Washington health club. Justin Mitchell (Josh Weinstein) is torn between a female aerobics instructor (Kimberly Flynn) and a male club member (Nick Poletti), who makes a pass at him and later plays a practical joke that has erotic consequences. Fluently directed and superbly acted, the 27-minute film examines youthful sexual confusion with an attitude that is unruffled, even slightly amused, but never condescending to its teenage protagonist.

1994 Mr 26, 14:1

My Great Big Daddy

Directed by Kjell-Ake Andersson; written by Magnus Nilsson and Mr. Andersson (in Swedish, with English subtitles); director of photography, Per Kallberg; edited by Susanne Linnman; production design, Birgitta Brensen and Stig Boquist; produced by Bert Sundberg and Anders Granstrom. At the Roy and Niuta Titus Theaters in the Museum of Modern Art, 11 West 53d Street, Manhattan, as part of the New Directors/New Films series of the Film Society of Lincoln Center and the museum's department of film and video. Running time: 102 minutes. This film is not rated.

OswaldNick Borjlind
Tjaffo....................................Rolf Lassgard
Mother..................................Ann Petren
Cutie......................................Yvonne Schaloske

By CARYN JAMES

"My Great Big Daddy" is a small, sweet coming-of-age story heavily influenced by Ingmar Bergman in its lyrical view of the Swedish countryside and its sense of the harsh inner lives of children. Oswald (Nick Borjlind) is an 11-year-old who looks like a somber version of Macaulay Culkin. In 1959, he and his parents spend the summer with relatives in the country. His father, Tjaffo (Rolf Lassgard), is tall and heavyset but his greatness is all in Oswald's mind.

•

Tjaffo is a hapless drinker and womanizer, the kind who glides through life on charm. Among his most endearing actions, he organizes a local church choir and teaches them Argentine hymns. Oswald's mother (Ann Petren) is patient, understanding and totally without illusions about her husband. The most intriguing aspect of the film is Oswald's understandable hero worship of his father, an identification so thorough that the boy sometimes treats his mother with cruel neglect.

•

The story unfolds in a leisurely, episodic manner that suits the characters' tendency to ignore every potential crisis. At one point Tjaffo, fresh from another assignation, ends up standing in the middle of the road in his underwear, arguing with his wife. At that moment, his choir marches toward the church; when they see Tjaffo, one man hands him a coat and the group silently turns and walks back the way it came.

In a film where such scenes pass for high drama, the characters need more depth than they exhibit here. Kjell-Ake Andersson's direction is smooth and the countryside is beautifully photographed. But the people remain faint echoes of Bergman characters. "My Great Big Daddy" will be shown at the Museum of Modern Art tomorrow at 9 P.M. and Monday at 6 P.M. as part of the New Directors/New Films series.

1994 Mr 26, 14:2

These Hands

Written, produced and directed by Flora M'mbugu-Schelling, in Kimakonde with English subtitles; director of photography, Suleiman Kissoky; edited by Evodia Ndonde. Running time: 45 minutes. This film is not rated.

The Track of the Ants

Produced, directed and photographed by Rafael Marziano-Tinoco, in Spanish with English subtitles; edited by Dorota Wardeszkiewiez; music by Jesús Eduardo Álvarez. Running time: 54 minutes. This film is not rated.

At the Roy and Niuta Titus Theater 1 in the Museum of Modern Art, 11 West 53d Street, Manhattan, as part of the New Directors/ New Films series of the Film Society of Lincoln Center and the museum's department of film and video.

By STEPHEN HOLDEN

One of the work songs that the female stone crushers at a quarry in Tanzania chant while sitting in a circle and pounding rocks into fragments asks the question, "What kind of jungle is this?" It is a jungle that will eventually swallow everything into quietness, the song continues. The jungle is "where the mother went, where the father went, where the children went."

Most of the women who work in the sun from dawn till dusk are self-employed single mothers who bring their children with them. Many have fled the poverty and political turmoil of neighboring Mozambique. They labor for a subsistence wage, pounding rocks into pieces that will be used to make concrete. The work is dangerous. One slip of the hammer could cause serious injury.

"These Hands," which will be shown at the Museum of Modern Art today at 3:30 P.M. and tomorrow at 1 P.M. as part of the New Directors/ New Films series is a movie of few words. Except for the occasional song, the sound track is dominated by the rhythmic tapping of the women's hammers mingled with the roar of the industrial machines digging out the quarry.

But in looking at lives that in most ways seem hopeless, "These Hands," which was directed by Flora M'mbugu-Schelling, finds a communal warmth and flashes of joy. The women delight in their children and take a ritualistic pleasure in their work. In one scene several women are shown taking turns doing impromptu dances on a pile of rocks.

Rafael Marziano-Tinoco's film, "The Track of the Ants," which shares the bill with "These Hands," is a gloomy, impressionistic study of Caracas in which the Venezuelan capital is portrayed as a quintessential urban jungle. The movie opens with a scene of an actual jungle being cleared for human settlement, then switches to scenes of rush-hour gridlock intended to show that one jungle has been exchanged for another.

•

"The Track of the Ants" suggests a low-budget antidote to sweeping documentaries like "Koyaanisqatsi" and "Baraka" that invest the human panorama, even in its most miserable aspects, with a certain grandeur. Although the city looks pretty in the movie's overhead shots, most of the film is devoted to enumerating the urban problems of crime, corruption, poverty, pollution, prostitution and overcrowding. It is a depressing film.

1994 Mr 26, 14:5

The Coriolis Effect

Written and directed by Louis Venosta; photography by Paul Holohan; edited by Luis Colina; music by Hal Lindes; production design, Michael Hartog and Bjarne Slettland; produced by Kathryn Arnold. Running time: 25 minutes. This film is not rated.

Ray.......................................Dana Ashbrook
Suzy.....................................Corinne Bohrer
Stanley.................................James Wilder
Ruby.....................................Jennifer Rubin

Some Folks Call It a Sling Blade

Directed by George Hickenlooper; written by Billy Bob Thornton; photography by Kent Wakeford; edited by Henni Boumeester and Mr. Hickenlooper; music by Bill Boll; produced by Adam Lindemann, Mr. Hickenlooper and Kevin Hudnell. Running time: 25 minutes. This film is not rated.

Karl	Mr. Thornton
Charles	J. T. Walsh
Teresa Tatum	Molly Ringwald

Two or Three Things My Stepfather Taught Me

Written, produced, directed and edited by Michael Wheeler; photography by Anthony Jacques. Running time: 35 minutes. This film is not rated.

Steven	Cale Clarke
Larry	Harold Cannon-Lopez
Lorraine	Joanna Bloem
Lance	Steven Cook

At the Roy and Niuta Titus Theaters in the Museum of Modern Art, 11 West 53d Street, Manhattan, as part of the New Directors/New Films series of the Film Society of Lincoln Center and the museum's department of film and video.

By CARYN JAMES

A woman who walks into a tornado, a murderer who explains himself, and the nerdiest stepfather in the suburbs are the heroes of the three films joined under the rubric "Tall Tales." The works have nothing much in common beyond black-and-white photography, a length more suited to sitcoms than arty films like these (a half-hour, give or take five minutes) and a slightly macabre view of human relationships. In quality, their dissimilarities are even more glaring.

The best is "The Coriolis Effect," a fresh, self-assured film about sexual jealousy, dangerous living and the afterlife, with a nod to "The Wizard of Oz." The tale begins with the sounds of a jazzy saxophone and of a couple making love, as it happens on their kitchen table. In the midst of this, with a tornado heading their way, Suzy (Corinne Bohrer) tells her boyfriend, Ray (Dana Ashbrook, from "Twin Peaks"), that she has slept with his best friend, Stanley (James Wilder)..

•

Almost immediately Ray and Stanley are called to their unlikely jobs as tornado watchers. On the road, chasing the twister, Stanley says he feels bad about his fling with Suzy. "I was so busy thinking about you I didn't even have any fun," he tells Ray. The film takes a deft, fantastic turn when the men wander upon Ruby (Jennifer Rubin), a young woman who may have stepped out of Stanley's dreams, and who insists she wants to walk into the tornado and beyond it to another world.

Mordantly funny and sharp, "The Coriolis Effect" was written and directed by Louis Venosta, a screenwriter whose credits include the Mel Gibson-Goldie Hawn movie "Bird on a Wire." Despite some fussy camera movements, this is the only film of the three to create the sense of discovery that the New Directors/New Films series is all about.

•

In "Some Folks Call It a Sling Blade," Molly Ringwald goes to an institution to interview Karl, a still-maladjusted murderer about to be released after 25 years. Fearful of fluorescent lighting, he sits under the glare of a floor lamp to describe what made him a killer at the age of 13. The film was directed by George Hickenlooper, one of the makers of the fine documentary "Hearts of Darkness," and written by Billy Bob Thornton, who plays Karl. (Mr. Thornton also acted in, and was a co-writer of, the stylish 1992 crime film "One False Move.") He evokes pity for the troubled, neglected Karl. But "Some Folks Call It a Sling Blade" is more an acting exercise than a compelling film.

"Two or Three Things My Stepfather Taught Me," written and directed by Michael Wheeler, has a few good moments as a young boy tries to adjust to his ridiculous stepfather, a man who cuts his toenails in the kitchen, the better to sweep up the clippings. But it is strained, in the manner of film-school exercises.

"Tall Tales" will be shown tonight at 6:30 and tomorrow afternoon at 3:30 at the Museum of Modern Art. The program is more admirable than it is engaging.

1994 Mr 26, 14:5

Everything I Like

Directed by Martin Sulik; written by Ondrej Sulaj and Mr. Sulik; director of photography, Martin Strba; edited by Dusan Milko; music by Vladimir Godár; production designer, Frantisek Liptik; produced by Rudolf Biermann; production companies, Charlie's and Slovak Television. At the Roy and Niuta Titus Theater 1 in the Museum of Modern Art, 11 West 53d Street, Manhattan, as part of the New Directors/New Films series of the Film Society of Lincoln Center and the museum's department of film and video. Running time: 92 minutes. This film is not rated.

Ann	Gina Bellman
Tomas	Juraj Nvota
Magda	Zdena Studenkova
Vaclav	Jiri Menzel
Andrej	Jakub Ursiny
Father	Anton Sulik

By JANET MASLIN

Martin Sulik's "Everything I Like" begins and ends at the same spot, a serene waterfront setting where Tomas (Juraj Nvota) pauses to collect his thoughts. Using these scenes as visual bookends, Mr. Sulik's rueful, quixotic film spends the rest of its time identifying the major landmarks in Tomas's life. This appealing Slovakian film is more wistful than dramatic, but Mr. Sulik's direction recalls the poetic delicacy of Czechoslovak cinema at its best. "Don't play what I sing, I haven't got a good ear," Tomas tells his son, summing up the film's intuitive spirit. "Play what's in my head."

Tomas's head is filled with a lifelike array of unmade choices and unresolved family problems. The very ordinariness of the issues he contemplates gives them a certain inviting familiarity, which Mr. Sulik explores with quiet precision. "Everything I Like" offers a drily witty amalgam of minor crises, tied together by the director's eccentric overview and by Tomas's bemused outlook on his own troubles. When he decides to stop eating during the period spanned by this story, Tomas is tackling the situation about as actively as he knows how.

Tomas can't decide what to do about Ann (Gina Bellman), his alluring English girlfriend, who gets along with him beautifully but is gently pressuring him to accompany her when she leaves Prague. (Ann is also tutoring him in English, which allows Mr. Sulik an early scene in which Tomas plays rapist just to try out his command of English vernacular.) Meanwhile, Tomas has an ex-wife, Magda (Zdena Studenkova), who refers to Ann spitefully as "the American" and has never quite disappeared from his life. Magda has an unnerving habit of breaking into Tomas's apartment whenever Tomas leaves town.

•

Tomas' son, Andrej (Jakub Ursiny), is approaching puberty in ways that Tomas finds utterly confounding. The boy's flirtation with Ann, his potential stepmother, is rendered with particularly wry sensitivity. In one scene, after closing a door to escape his father's prying eyes, Andrej is seen with Ann, dancing a madly exuberant can-can, a giddy celebration of his sexual awakening. Tomas, having of course opened the door to see what he's missing, finds this so unexpected that he can only look on in wonder.

In addition, Tomas is privy to the sexual secrets of his father, who shows up in town one day and is found in bed with a young woman who doesn't speak his language. The father (Anton Sulik) cannot communicate with this one-night stand at all, but he claims that she was selling him a vacuum cleaner. "Everything I Like" is capricious enough to make sure that there actually is a vacuum cleaner in the scene. It's also serious enough to carry a sting when Tomas's father chides him for making such a mess of his life.

Mr. Sulik presents this story in discrete, separately titled segments, which allows him some necessary detachment. Told more straightforwardly, it might seem light and prosaic; this way, the film maker's overview shapes the material and lends it substance and originality. Mr. Sulik also includes a couple of scenes featuring Jiri Menzel, the director whose 1967 "Closely Watched Trains" exemplifies the flowering of Czechoslovak cinema, and who presides over this film (in the role of a renowned intellectual) as if bestowing a benediction. In the category of wild card references, "Everything I Like" also finds ways of incorporating the Beatles, Buster Keaton and Andy Warhol's mother.

"Everything I Like" will be shown tonight at 6 and Thursday at 9 P.M. as part of the New Directors/New Films series.

1994 Mr 29, C13:1

The Days

Written, produced and directed by Wang Xiaoshuai, in Mandarin with English subtitles; director of photography, Liu Jie and Wu Di; edited by Qingqing; music by Liang Heping; production company, Shu Kei's Creative Workshop Ltd. Running time: 80 minutes. This film is not rated.

WITH: Yu Hong and Liu Xiaodong.

Bui Doi
Life Like Dust

Directed by Ahrin Mishran and Nick Rothenberg. Running time: 29 minutes. This film is not rated.

WITH: Ricky Phan.

At the Roy and Niuta Titus Theater 1 in the Museum of Modern Art, 11 West 53d Street, Manhattan, as part of the New Directors/New Films series of the Film Society of Lincoln Center and the museum's department of film and video.

By CARYN JAMES

Who knew there were slackers in China? "The Days" examines the personal boredom and professional frustration of two painters in their 20's, an unmarried couple who have been together since art school. Now teachers, they still live in a tiny apartment in Beijing more suited to students than adults, and are stymied about the future. Xiaodong is an intense-looking man, with large glasses and a roomful of paints and canvases. But as the narrator says, "He dreamed of nothing but being rich," and the fantasy paralyzed him. "He couldn't even paint." Xiaochun is so ready to leave the relationship and the country that she writes to relatives in New York and hopes to join them.

The film is most intriguing when it becomes a window on aspects of Chinese culture rarely depicted on screen. Some early-morning sex between Xiaodong and Xiaochun is discreet by American standards, but the scene is long and emphatic enough to be unusual in a Chinese film. And at times "The Days" effectively suggests the tension between an awful past that the characters want to forget and a present that seems cut off from all meaning. Xiaochun's parents had been persecuted by her entire school when she was 16. There is no need for the film to belabor the point that when she finally goes to New York, she writes to Xiaodong without reference to their life together. In the words of the narrator, she acts "as if the past had evaporated."

But "The Days," a first feature written and directed by the 29-year-old Wang Xiaoshuai, is far better as sociology than as a film. Only 80 minutes long, it nonetheless seems excruciatingly slow. Though it glancingly evokes the loose, textured feel of early Jim Jarmusch films, it is humorless and not well-shot. That this is a black-and-white film about painters says more about the film's low budget than it does about the characters' or the film maker's esthetic styles.

•

"The Days" will be shown tonight at 9 and tomorrow at 6 P.M. at the Museum of Modern Art as part of the New Directors/New Films series. It will share the bill with "Life Like Dust," a quasi-documentary that presents a more complex and dramatic version of a misguided life. At the center of the film is Ricky Phan, a refugee from the Vietnam War whose family came to California when he was an adolescent. He is now serving 11 years in prison for armed robbery, and in "Life Like Dust" he narrates scenes from his own past as a gang member. The gang was his family, and the film includes scenes of its members at home, eating, singing, creating the false sense that this was a way of life with a future.

Much of the film was shot by the directors, Ahrin Mishan and Nick Rothenberg, in the three years before Mr. Phan's arrest. Mixing after-the-fact scenes with documentary episodes, the film raises some disturbing questions about the film makers' responsibility and the mix of truth and fiction. But like "The Days," "Life Like Dust" offers a fresh view of a part of society that mainstream movies ignore.

1994 Mr 29, C17:3

Jimmy Hollywood

Written and directed by Barry Levinson; director of photography, Peter Sova; edited by Jay Rabinowitz; music by Robbie Robertson; production designer, Linda De Scenna; produced by Mark Johnson and Mr. Levinson; released by Paramount. Running time: 110 minutes. This film is rated R.

Jimmy Alto.........................Joe Pesci
WilliamChristian Slater.
Lorraine..........................Victoria Abril

By JANET MASLIN

"Jimmy Hollywood" brings Barry Levinson bounding back from the otherworldly catastrophe of "Toys" to the bittersweet tale of a would-be actor who can't find any usual way of breaking into movies. Since "Jimmy Hollywood" actually looks and feels as if it were made on Planet Earth, it qualifies as an improvement right from the start.

The title character is Jimmy Alto (Joe Pesci), who at one point has a daydream in which he becomes so famous that friends speak admiringly of him in television interviews. "He's a genius in a town that doesn't embrace geniuses," Jimmy imagines one friend telling the cameras. Although "Jimmy Hollywood" is a semisatire, it seems to intend that statement somewhat more seriously than is helpful. Misunderstood genius is best not mentioned here, not even in a whisper.

As written and directed by Mr. Levinson, "Jimmy Hollywood" tries to celebrate the kind of quirky, real-world bravado that worked so well for "Tin Men" and "Diner." But this ambitious, wildly uneven film takes a confused view of its hero. On the one hand Jimmy is a lovable fool, someone who lists acting jobs he didn't get when asked about his professional credits. ("I gave a hell of a reading for that part," he says of a co-starring role on television, "but I think they felt I was a little too strong for Andy Griffith.") On the other, after fate throws him a chance to fight for the lost glory of Hollywood, he becomes a holy avenger. The film is seldom sure whether to laugh at Jimmy, pity him as a ragtag embodiment of Hollywood's hopelessness or join in his crusade.

•

"Jimmy Hollywood" has practically nothing to do with movie-star glamour, and everything to do with the seamy, disillusioning reality of life among the also-rans on Hollywood Boulevard. Dark and unpredictable, this isn't the antic comedy it looks like in ads; it's more like "Celluloid Heroes," the Kinks' haunting lament for Tinseltown daydreams, filtered through the pitiless vision of Nathanael West. For all Mr. Levinson's efforts to emphasize the buoyant side of his story, what works best about "Jimmy Hollywood" is the sense of utter desperation that colors Jimmy's exploits. Mr. Pesci's edgy, abrasive performance is a welcome antidote to the film's efforts to seem breezy.

As Jimmy, Mr. Pesci is first seen counting the stars on the sidewalk there, scolding himself for not knowing every name with his eyes closed. He takes celebrityhood seriously, an outlook that later confounds him when he becomes a local hero. That happens when Jimmy and his friend William (Christian Slater), a dazed and gentle burnout, decide to clean up the streets by capturing criminals and handing them over to the police. To heighten the drama, they make a videotape of Jimmy posing as Jeri-

Brian Hamill/Paramount Pictures
Joe Pesci in Barry Levinson's new film, "Jimmy Hollywood."

cho, the purported leader of an underground vigilante ring.

But Jimmy is so hooked on being famous that he barely notices the moral implications of this scheme. His obliviousness is meant to be funny, since all he cares about is having landed an unexpectedly high-profile new role. It doesn't help "Jimmy Hollywood" that the idea of Symbionese Liberation Army-type vigilantes taking over the airwaves feels fake and dated, or that Jimmy himself (a big fan of early Brando) seems slightly old hat. Mr. Levinson is on safer ground when he gets away from the vigilante idea. "Jimmy Hollywood" isn't lucid or tough enough to flirt with "Death Wish," anyway.

This film's woebegone Hollywood ambiance is nicely personified by its three main characters: Jimmy, William and Lorraine (Victoria Abril), the long-suffering girlfriend with endless patience for Jimmy's big dreams. Early in the film, it turns out that he has emptied Lorraine's bank account to rent a bus-bench advertisement for "Jimmy Alto, Actor Extraordinaire" (featuring a photo of Mr. Pesci that's so hammy it's almost worth the price of admission). "It's an investment in us," Jimmy insists. Lorraine, played charmingly by Ms. Abril (the Spanish star best known for her work with Pedro Almodóvar) in her first American leading role, knows better. But she's sweet enough to pretend she believes him.

Jimmy, Lorraine and William are all convincingly steeped in the sun-baked California craziness that later pushes Jimmy over the edge. One of the film's more forceful scenes shows Jimmy blowing a gasket over the theft of his car radio: he stands in the middle of the street, taunting and bellowing at a complete stranger, while Mr. Levinson's camera circles wildly around him, emphasizing the depths of his frustration. This unexpected fury reaches straight to the dark heart of "Jimmy Hollywood." But the film isn't often gutsy enough to let it show.

Among the punches pulled by "Jimmy Hollywood" is the incompleteness of a subplot involving Mr. Slater's William, who drifts through the story as a good listener and an afterthought. Abandoning his usual broad mannerisms, Mr. Slater can't do more than serve the snappish, feisty Mr. Pesci as an agreeable foil.

Also in the film briefly is the director Rob Weiss ("Amongst Friends"), as one of the many Hollywood film makers who won't give Jimmy a job. Mr. Levinson himself turns up in a coda

that shows what might happen if Jimmy Alto became as famous as, say, Joey Buttafuoco. It's funny, but it's essentially borrowed from "The Player."

"Jimmy Hollywood" is helped enormously by the lulling rhythms of Robbie Robertson's whispery, insinuating score. Peter Sova's cinematography makes gritty, unpredictable use of the film's many Hollywood settings, which range from the streets to the old Egyptian Theater to the offices of the Screen Actors Guild. None of these places offer much solace to Jimmy Alto. He's a stranger wherever he goes.

•

"Jimmy Hollywood" is rated R (Under 17 requires accompanying parent or adult guardian). It includes mild violence and considerable profanity.

1994 Mr 30, C15:3

Major League II

Directed by David S. Ward; written by R. J. Stewart; director of photography, Victor Hammer; edited by Paul Seydor; music by Michel Colombier; production designer, Stephen Hendrickson; produced by James G. Robinson and Mr. Ward; released by Warner Brothers. Running time: 105 minutes. This film is rated PG.

Rick (Wild Thing) Vaughn........Charlie Sheen
Jake TaylorTom Berenger
Dorn................................Corbin Bernsen
Pedro Haysbert......................Pedro Cerrano

By CARYN JAMES

In the chaotically funny "Major League," Charlie Sheen played a one-time car thief with a killer fastball. Nicknamed Wild Thing, he was not even the strangest member of the ragtag Cleveland Indians team that made it to the playoffs at the end of the hit 1989 movie. The oddest player was Pedro Cerrano (Dennis Haysbert), who built a voodoo shrine in his locker.

In "Major League II," Wild Thing has lost his fastball, and he's not the only one. There has rarely been such a steep and strange decline between a movie and its sequel as the one between the fast, silly original and the dismal, boring "Major League II."

The same characters and most of the actors are back, including Pedro, who has switched from voodoo to Buddhism. Wild Thing has been ruined by success, arriving for spring training in a new Rolls-Royce instead of his Harley-Davidson. There is plenty of potential here and it would seem to be in the right hands; David S. Ward, who wrote and directed the first film, also directed the sequel. But while the first film ran riot with baseball clichés, this one plods along and almost takes them seriously.

•

Tom Berenger goes from being a weak-kneed catcher to a coach. Corbin Bernsen, once a glamour-boy player, is the team owner until he runs out of money. Then he sells the team back to the vicious former owner, Margaret Whitton, as if the film makers just needed to get her back in the movie. The script seems as desperate as those changes suggest.

At times the film is actively annoying. Randy Quaid gets a lot of screen time as the kind of fan you would dread sitting near. Screaming and leaping, he berates the team like a fifth-rate heckler.

The brightest moments come from James Gammon, as the manager who happens to be in the hospital for a bypass operation during a crucial game. The doctor has ordered him to watch only British television programs; surely they will not excite him. But he listens to the game on radio with a hidden earphone, which leads to the curious sight of him whooping and jumping around in his bed while watching two ladies drink tea on "The House of Eliott."

Bob Uecker also has a few good scenes as Harry Doyle, the radio announcer who does the Indians' play-by-play. Doyle's disgust with this spectacle is close to what the movie audience might feel. When one player steps up to the plate, the announcer says: "He's 0 for ... I don't know! Who cares?" It's hard to argue.

•

"Major League II"' is rated PG (Parental guidance suggested). It includes some rude language.

1994 Mr 30, C16:3

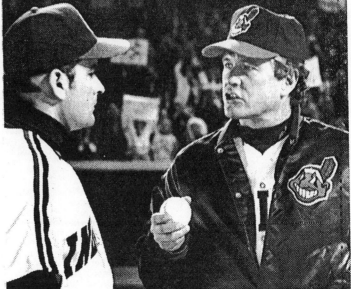
Van Redin/Warner Brothers
Tom Berenger, right, and Charlie Sheen in "Major League II."

Hans Christian Andersen's 'Thumbelina'

Directed by Don Bluth and Gary Goldman; written by Mr. Bluth; editor, Thomas V. Moss; music by Barry Manilow, William Ross, Jack Feldman and Bruce Sussman; production designer, Rowland Wilson; produced by Mr. Bluth, Mr. Goldman and John Pomeroy; released by Warner Brothers. Running time: 85 minutes. This film is rated G.

Thumbelina	Jodi Benson
Mrs. Fieldmouse	Carol Channing
Delores Toad	Charo
Prince Cornelius	Gary Imhoff
Mr. Beetle	Gilbert Gottfried
Mr. Mole	John Hurt
Jacquimo	Gino Conforti
Mother	Barbara Cook
Queen Tabitha	June Foray
King Colbert	Kenneth Mars

By STEPHEN HOLDEN

If there is an underlying message in Don Bluth's animated musical, "Hans Christian Andersen's 'Thumbelina,' " it is that nice little girls with big dreams should stay as far away from show business as possible. The parade of characters who try to manipulate and possess Thumbelina (Jodi Benson), a tiny 16-year-old girl who springs magically from the center of a flower, are a rogue's gallery of unwholesome show-business types. When not ogling and pawing the thumb-size girl, they promise her a grubby, compromised notoriety on the lower rungs of the show-business ladder.

In Mr. Bluth's freewheeling cinematic adaptation of the popular 19th-century story, Thumbelina is plunged into a nightclub netherworld the night after she meets and falls in love with the fairy prince of her dreams. The scenes of their courtship, in which her dream lover, Cornelius (Gary Imhoff), flies them around on a bumblebee and the dancing couple glide and dip like an Olympic figure-skating team, are among the movie's most captivating.

The pop composer Barry Manilow and his lyric collaborators Bruce Sussman and Jack Feldman have provided them with a soaring, sugarcoated ballad, "Let Me Be Your Wings," which lends their cavortings a gentle inspirational lift.

But before Thumbelina can live happily ever after with her prince, she must endure a series of hardships. Abducted from her bed and thrown into the clutches of Mrs. Delores Toad (Charo), she is forced to join the Singers de España, a tacky family singing group made up of Mrs. Toad and her three sons. The group provides an excuse for the composer and his collaborators to write a jolly Latin-flavored production number in the style of Mr. Manilow's 1970's hit "Copacabana."

When Mrs. Toad insists that Thumbelina marry one of her sons, she escapes, only to find herself the protégée of a lecherous beetle (Gilbert Gottfried), who has the flamboyant airs of a vaudeville impresario and a voice like Jimmy Durante's. Stardom is promised to Thumbelina, but only if she denies her true nature and impersonates a beetle in a nightclub chorus line. Once again she escapes, with the help of a friendly swallow named Jacquimo (Gino Conforti) who affects the French accent and cheery demeanor of Maurice Chevalier.

Winter comes, and Thumbelina finds temporary refuge in an discarded shoe. She is saved from freezing to death by the wily Miss Fieldmouse (Carol Channing), who takes her into her underground lair. The busybody Fieldmouse arranges Thumbelina's marriage to her neighbor, Mr. Mole (John Hurt), a grand and portly English gentleman. But Thumbelina flees at the last minute, with her would-be suitors in hot pursuit.

One movie to which "Thumbelina" is bound to be compared is "The Little Mermaid," the sleeker, smoother Disney version of a similar parable about growing up. Although thoroughly engaging, "Thumbelina" lacks "The Little Mermaid's" streamlined ease and perfection of detail, and its casting is a little shaky. With her soaring girlish voice, Ms. Benson makes an ideal Thumbelina. And Barbara Cook, who plays her mother, is also winning. But Mr. Imhoff's Prince has a wavering voice and a blandly boyish appearance that make him something less than dreamy.

Mr. Manilow's tunes are as sweetly hummable as Alan Menken's songs for "The Little Mermaid" and "Beauty and the Beast." But the lyrics by Mr. Feldman and Mr. Sussman lack the chiseled-in-stone wit of Howard Ashman's brilliant lyrics for those films.

On the most obvious level, "Hans Christian Andersen's 'Thumbelina' " is a straightforward fable about being true to your heart. But it also upholds the traditional notion that fame and fortune aren't worth a hill of beans compared to the love of a good old-fashioned prince.

1994 Mr 30, C19:1

Little Dreams

Written and directed by Khaled al-Hagar, in Egyptian with English subtitles; director of photography, Samir Bahzan; edited by Adel Mounir; music by Rageh Daoud; production designer, Hamed Hemdan; produced by Gabriel Khoury; production companies, Misr International Films; ZDF. At the Roy and Niuta Titus Theater 1 in the Museum of Modern Art, 11 West 53d Street, Manhattan, as part of the New Directors/New Films series of the Film Society of Lincoln Center and the museum's department of film and video. Running time: 90 minutes. This film is not rated.

Hoda	Mervat Amin
Mahmoud	Salah al-Saadany
Samah	Ragaa Hussein
Ghareeb	Tamer Ashraf

By JANET MASLIN

"Little Dreams," an earnest but inept Egyptian film rounding out the year's geographical range of this year's New Directors/New Films series, observes the 1967 war between Egypt and Israel through the eyes of a young Egyptian boy. Ghareeb (Tamer Ashraf), who is only 13 at the time of the film's climactic events, has already seen his short life greatly influenced by war. His father died in the Suez war of 1956. The boy's destiny is shaped by memories of a man he barely knew.

During "Little Dreams," which will be shown tonight at 9 and tomorrow at 6 P.M., Ghareeb is taken under the wing of Mahmoud (Salah al-Saadany), a comrade of his father's. "Your father was a hero and you will complete his task," Mahmoud tells the boy, who lives in Suez with his mother. Mahmoud gladly steps into the role of father figure and leads Ghareeb toward a political awakening, during which the boy learns to share his mentor's admiration for Gamal Abdel Nasser, Egypt's President. Mahmoud's devotion to his country's leader runs so deep that he is moved to tears by Nasser's wartime resignation. "Why, Gamal?" Mahmoud asks, hugging Nasser's framed portrait.

"Little Dreams," a first feature written and directed by Khaled al-Hagar, has only the slenderest story. Some of it revolves around Ghareeb's effort to persuade his mother's suitor, who owns a printing press, to print political tracts for Mahmoud. The rest concerns Ghareeb's devotion to his mother, who, like Mahmoud, is played in a high, histrionic style much more forced than young Mr. Ashraf's unmannered acting. Most of the film's real drama comes from the advent of Egypt's war with Israel, which is rendered through newsreel glimpses of war planes, scenes of rubble and the grief-stricken faces of bombing victims. "Little Dreams" is more memorable for the anger in these images than for any of the more tepid moments that come before.

1994 Mr 30, C19:1

The House of the Spirits

Written and directed by Bille August, based on the novel by Isabel Allende; director of photography, Jorgen Persson; edited by Janus Billeskov Jansen; music by Hans Zimmer; production designer, Anna Asp; produced by Bernd Eichinger; released by Miramax. Running time: 132 minutes. This film is rated R.

Clara	Meryl Streep
Esteban Trueba	Jeremy Irons
Ferula	Glenn Close
Blanca	Winona Ryder
Pedro	Antonio Banderas
Nivea	Vanessa Redgrave
Severo del Valle	Armin Mueller-Stahl
Esteban García	Vincent Gallo

By JANET MASLIN

AS a film that revolves around the cruelty of a patriarchal South American senator, "The House of the Spirits" rightly indulges in some ruthlessness of its own. Even for those who counted on a deeper and more faithful rendering of Isabel Allende's sweeping novel, this handsome, none too reverent film — the intimate, star-crossed story of a powerful family, played out on an epic scale — has the appeal of the unexpected.

Purists, beware: this is not a by-the-numbers screen version. Nor is it as politically charged as Ms. Allende's story. Nor does it even retain the flavor of her setting, which here seems oddly European at times. But it does take daring chances with a book that could not have been adapted otherwise, using extraordinary actors to rise above its occasional lapses. The lack of fidelity is often offset by intelligence of a subtler kind.

Among this film's virtues is the fact that its star quotient is truly staggering, despite the strange internationality of some of its casting. And its whimsical component is counterbalanced by a Danish director, Bille August ("Pelle the Conqueror," "The Best Intentions"), who is not known for lightheartedness. Mr. August has clearly been galvanized by the passion and colorfulness of this story, even as he supplies a welcome restraint. He

Miramax

Glenn Close

makes "The House of the Spirits" a cool, ravishing film filled with odd gaps and understated miracles. And the style he devises turns out to be as interestingly fanciful as his subject matter. This odd Danish-Latin hybrid amounts to magical realism on ice. "The House of the Spirits" is as daunting a book as any film maker could tackle. Adapting it must have been about as easy as predicting the future or levitating small objects (which are the sorts of supernatural events that punctuate the story). Dense and changeable, the novel evolves from a family chronicle colored by hallucinatory details (a young beauty with green hair, a man who shrinks, a dog who becomes a rug) into a ringing political indictment of a right-wing junta. Its sensibility is distinctly feminine, despite the fact that some of it is narrated by Esteban Trueba (Jeremy Irons). Esteban, a cold and ambitious man, is no match for any of the women in his life.

The women are the mesmerizing spirits in this story, not least because they happen to be played on screen by Glenn Close, Winona Ryder, Vanessa Redgrave and Meryl Streep. Many of the film's satisfactions come from simply watching these players interact. Ms. Streep, whose appearance here crystallizes both the film's strengths and its stretches of credulity, is asked to play a virginal young woman when she first appears as Clara, the woman who eventually marries Esteban. Obviously, this is a tall order for Ms. Streep, but she handles it with remarkable grace. And she goes on to age throughout the film with magnificent delicacy. By late in the story, Ms. Streep has developed a serene, knowing manner that is an uncanny evocation of Ms. Redgrave, who happens to play her mother.

Ms. Streep's Clara, the story's clairvoyant character, is the daughter of Severo del Valle (Armin Mueller-Stahl), a liberal candidate for political office. This big, ambitious drama watches Clara's fortunes shift until she is inextricably tied to the conservative Esteban, who has political ambitions of his own. The narrative, spanning several generations and a wide economic spectrum, presents these developments in ways that are often ripely symbolic. For instance, Esteban's exploitation of the peasants farming his estate is represented by the dreamlike rape of a silent young woman, who later bears Esteban an extremely ungrateful child.

Mr. August's style is restrained, and he has dispensed with most of the story's surreal elements. But he does not make the mistake of handling the rest of it in a purely realistic fashion. So Mr. Irons, in the especially unwieldy role of Esteban, begins to sound more and more like William F. Buckley and Richard Nixon as he

grows more curmudgeonly, just as Clara is often surrounded by celestial motifs. (Anna Asp's dazzling production design is at its wittiest in presenting Clara's starry bedroom.) Even the bloody political upheaval that shapes the film's ending has a vibrant, faintly exaggerated quality. Jorgen Persson's glorious cinematography, using a palette of warm, natural hues, gives the film a look of bracing clarity.

In streamlining Ms. Allende's story, Mr. August (who wrote the screenplay) uses such a free hand that he compresses or even loses important characters. For instance, Ms. Ryder's Blanca, the rebellious daughter of Clara and Esteban, is actually an uneasy composite of their daughter and granddaughter. And Blanca's two brothers have disappeared entirely, as have the dog rug and the green hair. Perhaps this should make more difference, but the film is filled with actors who, like Ms. Ryder, are captivating regardless of what the screenplay makes them do. Ms. Ryder makes yet another radiant impression as the Trueba who pays the heaviest price for Esteban's actions. Antonio Banderas works his matinee-idol magic as the rebellious young man Blanca loves, and Vincent Gallo does a sinister turn as her dangerous half-brother.

An especially powerful presence here is Ms. Close, who plays Esteban's repressed, unmarried sister, Ferula, and even turns up midway through the story as an apparition. All hurt pride and bubbling rage, Ms. Close's Ferula is for a while fueled by bitter jealousy of Clara. But Ms. Close and Ms. Streep have some lovely scenes together as new sisters-in-law who become great allies. Ferula can't stay spiteful once she realizes that Clara can read her mind.

"In the big house on the corner," Ms. Allende writes late in her novel, "Senator Trueba opened a bottle of French Champagne to celebrate the overthrow of the regime that he had fought against so ferociously, never suspecting that at that very moment his son Jaime's testicles were being burned with an imported cigarette." Mr. August's "House of the Spirits" should not be overly faulted if it fails to achieve quite that level of breathtaking ferocity. There are plenty of moments when it comes close. Glossy as it is, this film still knows how to be tough.

●

"The House of the Spirits" is rated R (Under 17 requires accompanying parent or adult guardian). It includes sexual situations and brief nudity, and graphic and disturbing violence.

1994 Ap 1, C1:1

Fresh

Written and directed by Boaz Yakin; director of photography, Adam Holender; edited by Dorian Harris; music by Stewart Copeland; production designer. Dan Leigh; produced by Lawrence Bender and Randy Ostrow; released by Miramax. At the Roy and Niuta Titus Theater 1 in the Museum of Modern Art, 11 West 53d Street, as part of the New Directors/New Films series of the Film Society of Lincoln Center and the museum's department of film and video. Running time: 115 minutes. This film is not rated.

Fresh	Sean Nelson
Esteban	Giancarlo Esposito
Sam	Samuel L. Jackson
Nicole	N'Bushe Wright
Chuckie	Luis Lantigua

By JANET MASLIN

In addition to being the most commercially viable film to come out of this year's New Directors/New Films series, Boaz Yakin's "Fresh" is likely to be the most controversial. "Fresh" is the story of the title character, an impassive black 12-year-old who is first seen stopping off to visit an elderly couple on his way to school. The woman busily offers him milk and cookies. Fresh delivers her supply of drugs.

Fresh (Sean Nelson) has two important men in his life. One is Esteban (Giancarlo Esposito), the seductive drug dealer who employs him as a courier without realizing that Fresh is actually quite an independent-minded little entrepreneur. The other is Sam (Samuel L. Jackson), Fresh's father, an indigent chess whiz who does what he can to discipline his son. He can't do much. When Sam scolds the boy for casually using the word "nigger," Fresh makes it clear he's not about to take orders from any no-income, chess-playing old man.

"Fresh" starts off in such a slow, deliberate style that it initially looks like nothing special, at least in dramatic terms. Is this yet another story of a sensitive young man forced to choose between good and bad role models? No, it is not: it's much more complicated, thanks to the film's portrait of Fresh as a deeply troubling character. This isn't the usual preteen innocent, nor even the standard bad seed. This is a seemingly decent kid who can sit there eating a candy bar while other people die.

As "Fresh" examines the stock ideas that usually shape such stories, it ponders the question of how fully accountable Fresh is for his behavior. The film presents an ultimately devastating panorama of Fresh's problems, to the point where his actions can only be understood in a larger context. The warring drug dealers in his community are immensely powerful, which makes it clear why Fresh has learned to get along with them. His home life, with the 11 cousins who share his aunt's apartment, offers nothing. And the violence Fresh observes is terrible. Mr. Yakin doesn't include many violent episodes in this film, but the ones he stages are made so meaningful that their impact is brutalizingly intense.

Since Mr. Yakin is white, there are bound to be those who question his drug-, violence- and prostitution-filled vision of Fresh's world. But "Fresh" cannot be mistaken for an exploitation film; it earns the right to approach this subject through the obvious thoughtfulness of Mr. Yakin's direction. Deliberately lurid elements are avoided, especially noisy ones; there's a moody, effective score by Stewart Copeland instead of loud music, and the crowded apartment where Fresh lives is as quiet as a library. The film's most brazenly decadent characters, like Mr. Esposito's sinuous Esteban, are still played with intelligence and care.

Even the screenplay's jargon comes in for close examination. Fresh is so numb to racial epithets that he often uses "nigger" when addressing his white friend. This friend is Chuckie (Luis Lantigua), whose big-talking, reckless behavior within the drug culture underscores the value of Fresh's calculating restraint. One of the film's most anguished episodes involves Chuckie's dog, who should have been a pet but is being forced to fight instead. Fresh likes the dog, and he has reason to

Sean Nelson

Miramax Films

sympathize with its situation. Because of that, Fresh's last scene with this animal provides the film's most bitterly shocking moment.

Mr. Nelson is often so blank-faced he keeps Fresh's inner thoughts opaque. Backhandedly, that becomes an advantage. Only at the end of the film, as Fresh engineers a staggering set of human chess moves and goes on to acknowledge that his father's lessons have not been lost after all, is this boy's character fully revealed.

Mr. Yakin's pacing seems overly slow at first, but his measured style pays off in a major way. His screenplay has been written with similar care. He has also been inspired enough to hire Adam Holender, the cinematographer whose work on "Midnight Cowboy" apparently stuck in Mr. Yakin's memory. Mr. Holender does a stunning job: he makes "Fresh" extraordinarily handsome, with a sharply sunlit look that brings out the hard edges in its urban landscapes. The subject and visual style could not be more forcefully matched.

"Fresh" features delicate and sympathetic work from both Mr. Esposito and Mr. Jackson, whose fine characterizations say a lot about the originality of this film's vision. N'Bushe Wright makes a sadly affecting appearance as Nicole, Fresh's drug-addicted older sister. Though she seems barely to notice him, she becomes the essential pawn in Fresh's game.

"Fresh" will be shown tonight at 6 and Sunday at 9 P.M. at the Museum of Modern Art as part of the New Directors/New Films series.

1994 Ap 1, C6:2

Down the Drain

Directed and edited by Shinobu Yaguchi; written by Mr. Yaguchi, Takuji Suzuki and Yasunobu Nakagawa, in Japanese with English subtitles; photography by Binbun Furusawa and Kazuhiro Suzuki; music by Unohana; designer, art direction Akihiko Inamura; produced by Mr. Furusawa and Mana Katsurada; production companies, the Pia Corporation and Pony Canyon Inc. At the Roy and Niuta Titus Theater 1 in the Museum of Modern Art, 11 West 53d Street, as part of the New Directors/New Films series of the Film Society of Lincoln Center and the museum's department of film and video. Running time: 92 minutes. This film is not rated.

Junko	Saori Serikawa
Mother	Miwako Kazi
Yoko	Akane Asano

By JANET MASLIN

The fashionably affectless Japanese film "Down the Drain" follows the mishaps that befall a math-loving schoolgirl once her life turns unexpectedly bizarre. The schoolgirl, Junko (Saori Serikawa), is buffeted from one strange event to the next, never registering much more than worry or mild surprise. The director, Shinobu Yaguchi, concentrates on absurd coincidences, eccentric minor figures and long, studied shots in which characters look woebegone and do nothing. One of the few genuine insights provided by Mr. Yaguchi is that these days Jim Jarmusch must be the most eagerly imitated film maker in the world.

But it takes perfect deadpan timing, like Mr. Jarmusch's, to get this right. And "Down the Drain" lacks most of the necessary aplomb. Mr. Yaguchi's film begins promisingly with its first set of accidents, but its pacing eventually grows wearisome and slack. The events are crazy without being crazy enough. They seem to have their own kind of sameness after a while.

Junko is stopped by transit police after trying to use a train pass belonging to her boyfriend, who has taken some racy Polaroids of her. As the Polaroids fall into the wrong hands, Junko flees to her grandmother's house, where she is caught by her parents, since her grandmother has just died. Subsequent troubles include an automobile accident and Junko's mishandling of the urn that contains her grandmother's ashes. Only when the urn breaks and its contents are immediately whisked away by a street-sweeper does the film approach anything resembling humor.

An hour and many more escapades later, the film feels less liberating than it did at the outset. And Mr. Yaguchi has revealed that his downward-spiraling story had nowhere much to go. Only infrequently does "Down the Drain" reveal itself to have a truly rebellious streak, as when Junko's friends start scribbling "Junko Must Die" as their all-purpose motto. More angry touches might have disrupted the studiously vacant mood, but they also might have helped.

●

On the same bill is "Family Remains," a much more successful stab at deadpan wit featuring a mother, a daughter, several suitors and a corpse. Inventively written and directed by Tamara Jenkins, whose visual cleverness is particularly impressive, "Family Remains" reduces the battle of the sexes to basic elements like food (within the limits of propriety, mother and daughter will do almost anything for a man who brings groceries) and feminine wiles.

The mother (Donna Mitchell) lectures her long-suffering daughter (Annette Arnold) endlessly on such things, and also voices her opinions about Mr. Right. "They don't make men like Frank Sinatra anymore," the mother warns. "You'll see."

"Down the Drain" and "Family Remains" will be shown tonight at 9 and tomorrow at 1 P.M. at the Museum of Modern Art as part of the New Directors/New Films series.

1994 Ap 1, C6:5

Clifford

Directed by Paul Flaherty; written by Jay Dee Rock and Bobby Von Hayes; director of photography, John A. Alonzo; edited by Pembroke Herring and Timothy Board; music by Richard Gibbs; production designer, Russell Christian; produced by Larry Brezner and Pieter Jan Brugge; released by Orion. Running time: 90 minutes. This film is rated PG.

Clifford	Martin Short
Uncle Martin	Charles Grodin
Sarah Davis	Mary Steenburger
Gerald Ellis	Dabney Coleman

By CARYN JAMES

Bankruptcy has been kind to "Clifford," a gimmicky film in which Martin Short plays an excessively polite, extremely demented 10-year-old. Originally meant to be released two years ago and delayed because of Orion Pictures' bankruptcy, Clifford's obsession with dinosaurs now seems like a shrewd, post-"Jurassic Park" move.

A less lethal version of the bad seed, Clifford is seriously disappointed when his Uncle Martin (Charles Grodin) postpones a promised visit to Dinosaurworld, a theme park whose most thrilling ride, Larry the Scary Rex, Martin happened to design. Clifford, as usual, confides his plans for revenge to Steffen, the toy dinosaur he carries around. The dinosaur angle may not have been what the film makers had in mind, but at this point they should take what they can get. "Clifford" is more a stunt than a movie.

It's not the stupidest trick anybody ever devised. Mr. Short, a brilliantly funny comedian when he has the right material, plays Clifford as one of those preternaturally mature children who talk and dress like grown-ups. In his short pants, navy blazer and school tie, Clifford is meant to look like a little adult from the start. The fact that he steals and lies and forces a plane to make an emergency landing, all in the opening scenes, marks him as some kind of bad-boy savant. And it's easier to dislike a fake child than a real one.

●

But even Mr. Short's most devoted fans are likely to get tired of seeing him shot only from the waist up to disguise his height. Not far into the film the most pressing questions become: Is he walking on his knees? Is he standing on a box? (In fact, his co-stars are usually standing on boxes and next to slightly oversize props.)

One thing that hasn't changed in the last two years is that Mr. Short is still searching for a movie script to match his talent. That material would have to be much stronger than the muddled "Clifford," which never quite knows whether it's for children or adults. Some of Clifford's stunts are filled with childish humor (handing his uncle a glass of hot sauce instead of a Bloody Mary). But Clifford is so nasty that he manages to get his uncle arrested, and the nastiness he deservedly gets in return puts the film beyond the grasp of small children. When Martin puts Clifford on a harrowing hyperspeed version of the Larry the Scary Rex ride, the special effects are impressive, but not worth waiting for.

Despite Mr. Short's stunt-acting, Mr. Grodin runs away with the film as a man who pretends to like children to impress his fiancée (Mary Steenburgen) only to be visited by the nephew from hell. Martin's floundering attempts to deal with his nephew and his fiancée make him more appealing than the one-note Clifford.

Another thing that hasn't changed in the last two years is that Mr. Grodin can almost save any movie he's in.

●

"Clifford" is rated PG (Parental guidance suggested). It includes a National Geographic-style glimpse of nudity, impolite language and much misbehavior by Clifford.

1994 Ap 1, C8:5

It's Happening Tomorrow

Directed by Daniele Luchetti; written by Mr. Luchetti, Franco Bernini, Angelo Pasquini, in Italian with English subtitles; director of photography, Franco di Giacomo; edited by Angelo Nicolini; music by Nicola Piovani; production designers, Giancarlo Basili and Leonardo Scarpa; produced by Nanni Moretti and Angelo Barbagallo; released by Sacis. At the Joseph Papp Public Theater, 425 Lafayette Street, at Astor Place, East Village. Running time: 92 minutes. This film is not rated.

Lupo	Paolo Hendel
Edo	Giovanni Guidelli
Gianloreto	Ciccio Ingrassia
Vera	Margherita Buy

By STEPHEN HOLDEN

'It's Happening Tomorrow," Daniele Luchetti's elegant and witty meditation on modern history, imagines 19th-century Italy as a land dotted with eccentric intellectuals and mad scientists who share an obsession with the future. In the most magical scene from the film, which sees the world as a kind of surreal international exposition of quaint notions, the founding genius of a utopian farm community dazzles his flock with a crude demonstration of electric light. Moments later, a group of coal workers, who feel threatened by the display, set fire to the place, which despite its name, New Harmony, perpetuates its own version of the class system.

These and other unusual events are seen through the eyes of two Tuscan cowherds, Lupo (Paolo Hendel) and Edo (Giovanni Guidelli), who are fleeing the law after a botched robbery attempt. In hot pursuit are three Austrian mercenaries and the son of the landowner they tried to rob. It is 1848, the year of several European revolutions. As Lupo and Edo make their way through the gorgeous Italian countryside, they are drawn into one strange scenario after another.

●

Early in their flight, they encounter a band of kidnappers who have taken two English aristocrats hostage and don't know what to do with them. Later, they are sheltered by an aristocratic family who treats them as guinea pigs in a Darwinian social experiment. Edo, the younger and handsomer of the two, is selected by the lustful young marquise to be instructed in literature, music and courtly manners, while Lupo is sent out to harvest eels.

Striking out on his own with the mercenaries still in pursuit, Lupo stumbles upon New Harmony, a utopian farm where many of the normal rules of civilization are suspended. The grounds are strewn with weird inventions, and free love is practiced. The place is really an amusing 19th-century parody of the late 20th century and its obsessions with technology and sex. Lupo has a short-lived romance with Vera (Margherita Buy), an inventor of perfumes.

Joseph Papp Public Theater

Giovanni Guidelli

Revolution breaks out, and the nobles flee the area after the Grand Duke of Tuscany is forced to give the people a constitution. Lupo and Edo, still pursued by the mercenaries, reunite on the road in time to join a revolution they know nothing about.

To fully appreciate "It's Happening Tomorrow," which opens today at the Joseph Papp Public Theater, it helps to have some knowledge of Italian history. Even then, the story is not always easy to follow. But the film has a beguiling picaresque imagination and a rich visual sweep.

●

The adventures of Lupo and Edo are loaded with political subtext about class and education. As the two peasants find themselves caught up in the lives of aristocrats and dreamers, they also find themselves fantasy figures in these people's schemes and notions. To some they are noble savages, and to others simply savage. Wherever they go, they encounter some sort of social hierarchy into which they have to be fitted.

The film takes a gently satirical view of its assorted nobles and intellectuals who, despite their high-flown ways, refinement and educations, appear fundamentally foolish and self-deluded.

For the all energy that the characters devote to future-gazing, the film implies, things have not changed for the better. The electric light may be illuminating the world, but the same human frailties and social inequities that have always governed human society still prevail.

1994 Ap 1, C12:1

A Romance Of Missed Connections

"A Tale of Winter" was shown as part of the 1992 New York Film Festival. Following are excerpts from Vincent Canby's review, which appeared in The New York Times on Oct. 2, 1992. *The film, in French with English subtitles, opens today at the Lincoln Plaza, 63d Street and Broadway.*

No matter how Eric Rohmer classifies his films, whether as "Moral Tales," "Comedies and Proverbs" or "Tales of the Four Seasons," which is the title of his current cycle, each film comes down to the same thing: a most singular woman. She is always young, usually very pretty, sometimes beautiful, with a capacity to enchant that is equaled only by her maddeningly stubborn, sometimes wayward pursuit of destiny as she sees it.

This has been true since the 1969 release of "My Night at Maud's," the French director's first hit in this country. It is still true in "A Tale of Winter," his second installment in "Tales of the Four Seasons," which he initiated with "A Tale of Springtime." Although the Rohmer films' methods and obsessions are now familiar, their particular details are always new.

"A Tale of Winter" is about Félicié (Charlotte Véry) who, in an idyllic opening credit montage, is seen on a holiday at the seashore in the middle of a passionate affair with a young man who turns out to be Charles (Frédéric Van Den Driessche). By the end of the credits, Félicié and Charles are at the railroad station saying goodbye. She gives him her address. He says he is between addresses and will write when he settles.

It is five years later when "A Tale of Winter" actually begins. Félicié, a hairdresser, has a sweet 4-year-old daughter, Élise (Ava Loraschi), and no Charles. In the excitement of parting at the station, she gave him the wrong address. Did he ever try to reach her? She is sure he did. In the meantime, she is delighted to have his child and has blithely gone on with her life.

At this juncture, Félicié has two suitors, Maxence (Michel Voletti), a handsome man who owns a string of beauty salons and whom she finds sexually attractive, and Loïc (Hervé Furic), a librarian who excites her mind but whose admiration bores her a bit. In the weeks before New Year, Félicié is pushed into deciding between Max and Loïc. First she feels that she has to marry Max, if only because he has left his wife for her. When she backs out of that commitment, after moving with him to Nevers, she begins to consider Loïc in a new light.

Through all these indecisions, she has always been open and above-board about her loyalty to the vanished Charles. She continues to expect that sometime, somewhere, they will meet again and resume what she serenely believes was the love of a lifetime for each.

At least part of the comic appeal of Mr. Rohmer's work is the complete confidence, clarity and decisiveness with which he dramatizes the utter confusion of his emotionally besieged heroines. Félicié is no egghead, by her own admission, although she delights Loïc by spontaneously coming out with pensées that echo Pascal, with insights about reincarnation that suggest Plato. She doesn't read, but she does use her brain.

Ms. Véry takes her place in the long line of actresses who have realized Mr. Rohmer's dreams over the last 30 years, many never to be seen here again. She is lovely, fresh and young, as all his actresses are. He grows older. His admirers grow older. His vision of youth does not age.

1994 Ap 1, C12:6

266

Midnight Edition

Directed by Howard Libov; written by Michael Stewart, Yuri Zelster and Mr. Libov, based on the autobiography "Escape of My Dead Men," by Charles Postell; director of photography, Alik Sakharov; edited by Yosef Grunfeld; music by Murray Attaway; production designer, Guy Tuttle; produced by Ehud Epstein, Johnathan Cordish and Mr. Libov; released by Shapiro Glickenhaus Entertainment. At the Quad Cinema, 13th Street west of Fifth Avenue, Greenwich Village. Running time: 97 minutes. This film is rated R.

Jack Travers........................Will Patton
Darryl Weston.......................Michael DeLuise
Becky...............................Sarabeth Tucek
Sarah..............................Clare Wren
Maggie.........................Nancy Moore Atchison

By STEPHEN HOLDEN

Will Patton, an actor who specializes in playing angelic-looking rebels with twisted psyches, has a role that seems almost custom-made for him in Howard Libov's "Midnight Edition." In this moody but confusing psychological thriller, Mr. Patton portrays Jack Travers, a hot-headed journalist for a small-town Georgia newspaper.

No sooner has Jack returned to his sleepy Georgia hometown from a two-year job in Miami than he happens onto a career-making story. Shortly after Darryl Weston (Michael DeLuise), a disturbed 19-year-old, slays a family of three for no apparent reason, Jack pounces on the case. After Darryl is apprehended, tried and sentenced to the electric chair, Jack approaches him on death row for a series of soul-baring interviews. In one of those details that lend the movie a fine naturalistic edge, Darryl agrees so long as Jack brings him his favorite dish, broiled shrimp with garlic butter, on each visit.

Jack's articles, which are picked up by a major wire service, win him a degree of fame. But in drawing out his subject, Jack becomes emotionally attached to him. The bond is strengthened after Jack allows Darryl's girlfriend, Becky (Sarabeth Tucek), to seduce him into becoming an unwitting pawn in Darryl's escape plan.

The reporter's sympathies with the killer earn him the enmity of both his neighbors and his colleagues. They also alarm his wife, Sarah (Clare Wren), who rightly fears both for her own safety and for that of the couple's 11-year-old daughter, Maggie (Nancy Moore Atchison).

"Midnight Edition," which opens today at the Quad Cinema, poses far more questions than it can begin to discuss. One ethical issue is Jack's supposed desire to help Darryl avoid execution to prolong the journalist's lucrative career-making story.

But Mr. Patton's furtive, volatile performance suggests that worldly recognition has little to do with Jack's loss of perspective. From the moment they meet, Jack and Darryl become locked in a psychological cat-and-mouse game that Jack foolishly believes to be a brotherly bond. In the role of a murderer who can be as charming as he is feral, Mr. DeLuise exudes a taut, twitching intensity that is often scary.

The film, Mr. Libov's debut feature, is ultimately much better at sustaining a dark, edgy atmosphere than at telling a story. The screenplay never satisfactorily explains the relationship between the reporter and his wife and daughter, who waited two years for his return and who accept him with only minor grumbling. And a subplot involving a dishonest small-

SGE Entertainment
Michael DeLuise

town policeman is introduced so abruptly that it throws off the story.

"Midnight Edition" has many ingenious visual touches. During the murder scene, the camera pointedly avoids showing the full carnage. A shot of a blood-spattered dinner plate that holds a single uneaten biscuit does the trick.

•

"Midnight Edition" is rated R (Under 17 requires accompanying parent or adult guardian). It includes strong language, violence and sexual situations.

1994 Ap 1, C18:5

Johnny 100 Pesos

Produced and directed by Gustavo Graef Marino; in Spanish, with English subtitles; written by Gerardo Caceres and Mr. Marino; director of photography, José Luis Arredondo; edited by Danielle Fillios; music by Andres Pollak; production designer, Juan Carlos Castillo; production company, Catalina Cinema. At the Roy and Niuta Titus Theater 1 in the Museum of Modern Art, 11 West 53d Street, as part of the New Directors/New Films series of the Film Society of Lincoln Center and the museum's department of film and video. Running time: 90 minutes. This film is not rated.

Johnny.........................Armando Araiza
Gloria.........................Patricia Rivera
Freddy.........................Willy Semler

By CARYN JAMES

"Johnny 100 Pesos" is a Chilean "Dog Day Afternoon" with less flamboyant characters. A nervous teen-ager named Johnny García walks into a video rental club in a high-rise building. The club is really a front for an illegal foreign-money exchange, and Johnny is no innocent himself. He pulls a gun out of his brightly colored school backpack and lets several older, more obviously threatening cohorts into the room. Before they can escape with the cash, the police are alerted, the robbers become accidental hostage-holders and the entire incident is broadcast live on television. With armed police on the streets and venomous reporters at the door, Johnny flirts with Gloria, the money-changer's seductive secretary and lover.

Based on an actual botched-and-broadcast robbery that took place in Santiago in 1990, the film is an effective satire of the news media and even makes some glancing political

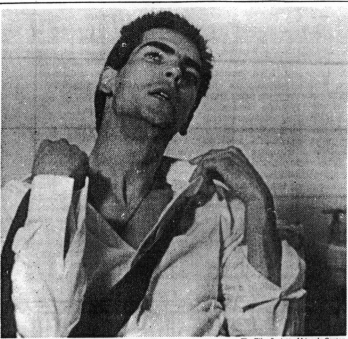
The Film Society of Lincoln Center
Armando Araiza in Gustavo Graef Marino's film "Johnny 100 Pesos."

comments. But "Johnny 100 Pesos" works best as a smart thriller with dark comic undertones.

The director and co-writer, Gustavo Graef Marino, has created a tale without heroes. The robbers range from bumbling to abusive. The innocent hostages are scarcely characterized. The guilty hostages, the money-changer and his lover, would be more comfortable siding with the robbers. And Johnny is so naïve he has left his school identification card in the backpack, which he tosses out the window.

The ID leads reporters to Johnny's school and the film's funniest scenes. The school choir sings to him to inspire his rehabilitation, rightly assuming that he is watching. Johnny's former girlfriend gets an individual interview. "Say a word to Johnny," the reporter urges. "I can't" she answers on the air. "My father has forbidden me to talk to him."

Women don't come off very well in this macho setting. Johnny's mother is easily duped by a reporter. Gloria's motives are shady. But Johnny is less a character than a type, too. He is the starry-eyed kid who chose the wrong heroes.

"Johnny 100 Pesos" is so much a genre film that its glimpses at politics seem forced. The Government becomes involved in the negotiations and is reluctant to let the police shoot. "We've only had a democratic government for two years and you want to sanction a murder," one official says. Whatever they decide, there is no way to avoid a nasty ending.

Also on the program is "The Black Rider," a 12-minute German work that recently won the Academy Award for best short film. The title is literal. A young black man rides a streetcar and is loudly insulted by the little old white lady. He is quiet and patient until he takes a perfectly harmless and just revenge. It is a stylish essay on bias that translates all too well. Together "The Black Rider" and "Johnny 100 Pesos" create a strong closing-night program for the New Directors/ New Films series. The films will be shown at the Museum of Modern Art tonight at 9 and tomorrow afternoon at 3:30.

1994 Ap 2, 17:1

When I Close My Eyes

Produced and directed by Franci Slak; in Slovene, with English subtitles; written by Mr. Slak and Silvan Furlan; director of photography, Sven Pepeonik; edited by Neva Fajon; music by Mitja Vrhovnik-Smrekar; production designer, Toma Marolt; production companies, TV Slovenia; Bindweed Soundvision. At the Roy and Niuta Titus Theater 1 in the Museum of Modern Art, 11 West 53d Street, as part of the New Directors/New Films series of the Film Society of Lincoln Center and the museum's department of film and video. Running time: 94 minutes. This film is not rated.

Ana............................Petra Govc
Inspector.....................Pavle Ravnohrib
Aunt..........................Mira Sardo
Ivan..........................Valter Dragan

By JANET MASLIN

The Slovenian film "When I Close My Eyes" doesn't aspire to much, but its reach still exceeds its grasp. Made awkwardly in the manner of a psychological thriller, it presents the lonely Ana (Petra Govc), who becomes fascinated by the man who has robbed the post office where she works.

After she witnesses the robbery, Ana pockets some money the robber left behind and proceeds to get a better haircut and flashier clothes. Razor-sharp police investigators notice this. "Nice chick!" says one. "But I've got a hunch she's mixed up in this."

The film uses this crisis in Ana's life to examine her character, bring forth an array of unlikely suitors and summon up her childhood memories of discovering her father's corpse hanging in the woods (hence the title). During the film, Ana learns more than the audience will believe about what supposedly happened to her father. These past events are loosely interwoven with the robbery plot. Meanwhile, Ana sends the robber mash notes saying things like: "It's not easy to be perfect. You came close to it."

As directed blandly by Franci Slak, "When I Close My Eyes" has only the seeds of an interesting psychological premise. Ana's fixation on the outlaw is presented without much nuance or surprise. Beyond Miss Govc, who works hard, the acting is barely adequate, and the same can be said for

the film's technical attributes. Whenever characters converse in a car, all extraneous noise vanishes. This seems to be more of an equipment failure than an expression of point of view.

"When I Close My Eyes" will be shown tonight at 6:30 and tomorrow at 1 P.M. as part of the New Directors/New Films series.

1994 Ap 2, 17:1

Child Murders

Written and directed by Ildiko Szabo, in Hungarian, with English subtitles; director of photography, Tamas Sas; edited by Panny Kornis; music by Janos Masik; produced by Istvan Kardos, Pal Erdoss, Gerd Haag, Istvan Darday and Marton Ledniczky; production companies, Hetfoi Muhely and Studio Alapitvany. At the Roy and Niuta Titus Theater 1 in the Museum of Modern Art, 11 West 53d Street, as part of the New Directors/New Films series of the Film Society of Lincoln Center and the museum's department of film and video. Running time: 78 minutes. This film is not rated.

Zsolt	Barnabas Toth
Bizsu	Ilona Faillai
Juli	Maria Balogh

By CARYN JAMES

The title of "Child Murders" has a chilling double meaning. A child is killed in this bleak and affecting film from Hungary, but the story also suggests how children's spirits can be deadened early on. The hero, a somber 12-year-old boy named Zsolt, lives a hopeless life caring for his ailing grandmother in their tiny apartment. When he takes violent action, is he acting out of some innate immorality? Or is he another victim of a society that abandoned him?

The director, Ildiko Szabo, has created a precise and moving route to these larger questions. The scenes of Zsolt painstakingly bathing his grandmother, singing to her and helping her put on her wig and makeup each morning are presented with an eerie fascination. "It's morning," reads a sign Zsolt leaves on the blackboard for her. "Everything is on the table." Each scene evokes pathos without sentimentality. And the stark black-and-white photography creates the right mood for the child's painfully circumscribed condition.

He is teased by the other children for his bottle-like glasses. A neighborhood girl with flowing curls, always clothed in immaculate frilly-white dresses, is particularly taunting. But Zsolt is capable of being as mean-spirited as the next person. He jeers at her and calls her Snow White. She becomes the target of his worst impulses.

It's no wonder that when Zsolt sees a pregnant young woman, a gypsy who has run away from a juvenile center, he follows and befriends her. She lives in an abandoned railway car and is very much a child herself, yet she manages to mother Zsolt. The drama of "Child Murders" begins when the young woman has a miscarriage. There are elements of suspense that should not be revealed here, but the audience is handed a provocative jolt.

Barnabas Toth, the young actor who plays Zsolt, has been directed to perfection. Much of the story is told from his perspective. Though his thoughts are never revealed, his emotions are plainly seen behind the impassive expression he usually maintains. Avoiding any simple answers or spiritual uplift, the film is honest and unrelentingly dark.

"Child Murders" will be shown today at 4 and tomorrow at 6:30 P.M. as part of the New Directors/ New Films series at the Museum of Modern Art. It will be preceded by "Avenue X," Leslie McCleave's equally accomplished and bleak 16-minute film about children in distress. Filmed at Coney Island, it seems at first to be an essay on abandoned buildings and equally empty lives. At the last minute, it becomes a violent drama. A longer film couldn't get away with that last-minute swerve, but "Avenue X" makes its final moments seem inevitable.

1994 Ap 2, 17:4

Sankofa

Written, directed and edited by Haile Gerima; director of photography, Agustin Cubano; music by David White; produced by Mr. Gerima and Shirikiana Aina; released by Mypheduh Films. At the Harlem Victora Five Theater, 235 West 125th Street, Manhattan. Running time: 125 minutes. This film is not rated.

Mona/Shola	Oyafunmike Ogunlano
Shango	Mutabaruka
Nunu	Alexandra Duah
Joe	Nick Medley
Father Raphael	Reginald Carter
Noble Ali	Ofemo Omilani
Sankofa, the Divine Drummer	Kofi Ghanaba
Juma	Hasinatou Camara

By CARYN JAMES

In "Sankofa," a contemporary African-American woman travels back in time and experiences slavery. Haile Gerima's poetic and precisely detailed film takes its audience into its heroine's life and mind as her moral sense is challenged and changed. No viewer can avoid the discomforting questions the film so eloquently raises.

The opening sequences, set and filmed in Ghana, are alternately seductive and off-putting. Among drums and chants, a voice invokes ancestral ghosts. "Spirit of the dead, rise up," the voice says, "and claim your story." The film's title is a West African term meaning to reclaim the past in order to go forward, and "Sankofa" stumbles only in its depiction of the present.

Mona is a young model first seen posing for a callous white photographer on a beach. She is dressed in a pseudo-Tina Turner getup complete with blonde wig. This is a heavy-handed way of showing that she has lost her connection to her past, that slavery still shapes her life as she is enslaved by contemporary images.

•

But the film soon moves on, convincingly, to a surreal experience. Mona wanders into a dungeon, a holding place from which slaves were shipped to the United States. She has walked into the past, where she is stripped, chained and beaten. Suddenly she is on a plantation, a house slave called Shola, with no memory of Mona or the 20th century.

The longest and finest part of "Sankofa" is its depiction of the daily life of the slaves and the way witnessing its brutality changes Shola. She falls in love with a rebellious field slave, who urges her to poison her white owners. Shola refuses. Though the master rapes her at will, she believes killing is wrong, no matter what injustice has been done to her.

But Shola soon sees a pregnant runaway slave beaten to death, her living child taken from her body. And

Bebeto Matthews/Mypheduh Films
Oyafunmike Ogunlano, left, and Alexandra Duah.

she idolizes Nunu, a strong and motherly slave who has joined the rebels.

Nunu's son, Joe, is the head slave, who has an easier life and seems to have turned against his own people. He is blue-eyed and in the thrall of the white priest, and his story should have been as compelling as Shola's. But his character is less convincing, partly because his tortured sense of identity is so often depicted by sudden mood swings and glances at paintings of white Madonnas in church.

Shola, however, (played with great strength by Oyafunmike Ogunlano) carries the audience into the heart of her experience. When she lifts a machete over a sleeping white overseer, the film has led its viewers to a place where either choice — to kill or not — might be justified. "Sankofa" asks its audience to enter a different moral universe, one that slavery created.

Mr. Gerima is an Ethiopian-born film maker who has lived in the United States for decades and teaches at Howard University. His film is ambitious in its depiction of slavery and accomplished in its visual command, from the bright red scarves of the rebellious slaves to a fire they set in the fields.

"Sankofa" opens today at the Harlem Victoria 5 Theater. Engrossing and provocative, it sends Shola back to the present as Mona, and sends viewers along with her. Armed with visceral new knowledge, she can make of it what she will.

1994 Ap 8, C8:5

Critic's Choice

2d African Film Festival

One of last year's landmark film series is now an annual event. The second New York African Film Festival, co-sponsored by the Film Society of Lincoln Center and African Film Festival Inc., begins tonight and will run for more than two weeks at the Walter Reade Theater at Lincoln Center. An African film festival is especially welcome because of the infrequency with which African films are shown here commercially. (The Ethiopian-financed "Sankofa," opening today at the Harlem Victoria Five Theater, is a notable exception.) It's also welcome because Africa's diverse cultures offer such a wealth of thematic possibilities and because so many of these little-known works happen to be so good.

The series includes 11 first features along with a couple of old favorites, like the 1990 "Tilai" from Idrissa Ouedraogo, the film maker from Burkina Faso whose works have the eloquence and simplicity of folk tales. The films, from 13 countries, deal with subjects as diverse as life in pre-colonial Africa (Gaston Kaboré's "Wend Kuuni," Burkina Faso, 1982) to the romance between an African student and his Russian lover (Abderrahmane Sissako's "October," a 37-minute work from Mauritania, 1992). The festival's opening feature, Isaac Mabhikwa's "More Time" (Zimbabwe, 1993), is also one of its most topical in that it addresses AIDS.

Among the more notable titles are "The Golden Ball," an especially appealing tale by Cheik Doukouré about a young boy who dreams of becoming a soccer star; "Rue Princess," a new film from Henri Duparc of the Ivory Coast, whose "Dancing in the Dust" was one of last year's high points, and the lively 1949 artifact "Jim Comes to Jo'Burg" (a k a "African Jim"), directed by Don-

ald Swanson when a South African film with an all-black cast was a rarity indeed. "Jim Comes to Jo'Burg" is also one of many films examined in "In Darkest Hollywood: Cinema and Apartheid," an extremely informative 1992 documentary by Peter Davis and Daniel Riesenfeld.

Among the more startling revelations here is that Jamie Uys, the white South African director of "The Gods Must Be Crazy" (1984), created a fake African "bushman" to be his film's star. N!Xau, the erstwhile actor, who was a cook and not a primitive tribesman, is seen in 1990 saying he deeply regrets having appeared in the film. A professor of literature articulates the objection to such demeaning images of Africans, and of their insidious consequences, when he says: "You can't even begin to think of them governing a complex industrial society like South Africa's when they still think there's something magical about an empty bottle of Coca-Cola."

The second New York African Film Festival is sure to undermine many other misconceptions and stereotypes with equal ease. The series runs through April 24. Tickets: $7; $4 for those under 12 and for the elderly at screenings before 6 P.M. Monday through Friday. Screening schedule and other information: (212) 875-5600.

JANET MASLIN

1994 Ap 8, C8:5

Red Rock West

Directed by John Dahl; written by John and Rick Dahl; director of photography, Mark Reshovsky; edited by Scott Chestnut; music by William Olvis; production designer, Rob Pearson; produced by Sigurjon Sighvatsson and Steve Golin; released by Roxie Releasing. At the Cinema Village, 22 East 12th

Street, Greenwich Village. Running time: 98 minutes. This film is not rated.

Michael.............................Nicolas Cage
Lyle.................................Dennis Hopper
Suzanne........................Lara Flynn Boyle
Wayne.................................J. T. Walsh
Truck Driver..................... Dwight Yoakam

By CARYN JAMES

A dusty, desolate Wyoming town is a logical setting for an updated film noir. The first of many gleeful twists in "Red Rock West" is that Nicolas Cage arrives, as the man least likely to survive a tangle of murder, greed and infidelity. Michael is not stupid; he just has the hapless luck of the terminally honest.

He drives 1,200 miles from Texas to a promised job at a Wyoming oil rig, only to admit on his application that he has a bad knee. Back on the road, he spends his last $5 on gas, though an unguarded cash drawer is spilling bills in front of him. This time his honesty saves him, for the gas-station owner enters at the moment Michael would have had his hand in the till. The director and co-writer, John Dahl, keeps up this perfect swift timing throughout the film, playfully loading on every suspense-genre trick he can imagine. "Red Rock West" is a terrifically enjoyable, smartly acted, over-the-top thriller.

Mr. Cage, once a champion over-the-top actor himself, has become more restrained, funnier and appealing in the last few years (in films like "Honeymoon in Vegas"). He gives the film an intelligent edge, playing Michael with the slightest Elvis drawl and the trace of a dim-witted expression.

When Michael arrives in the town of Red Rock, he allows himself to be mistaken for someone named Lyle, a Texan who has been offered a job at the dingy bar owned by Wayne Brown (J. T. Walsh). It turns out that Lyle is not the bartender Michael assumed, but a hit man hired for $10,000 to bump off Wayne's beautiful young wife, Suzanne (Lara Flynn Boyle). When Michael warns Suzanne, she instantly doubles the offer if he will take care of Wayne instead. Even Michael is smart enough to figure out that this has something to do with Suzanne's lover, a young, good-looking man who lives in a trailer.

The straight-faced wit of "Red Rock West" is most apparent in the polite, neatly written note that Michael then sends to the sheriff: "Wayne Brown may have hired a killer to murder his wife. She may have done the same. Please talk to them before someone gets hurt." The sheriff, it turns out, is not inclined to be sympathetic. Michael and Suzanne try to escape Red Rock alive, but somehow always find their way back.

The many coincidences that threaten their lives include stolen money, false identities and two car accidents, one involving Michael and Suzanne's lover, the other Michael and the real Lyle. (Well, it's a small town.) Lyle is played by Dennis Hopper with his trademark mix of menace and likable good will. He insists on buying Michael a drink because they are both former marines. Michael is dragged back into Wayne's bar, the last place he wants to be. Eventually, the entire cast slugs it out and shoots it out in a foggy cemetery.

"Red Rock West" opens today at the Cinema Village, though the film had such a hard time finding a distributor that it has already been released on video. It should never have

fallen through the cracks. This clever little film is a real find.

1994 Ap 8, C12:1

Threesome

Written and directed by Andrew Fleming; director of photography, Alexander Gruszynski; edited by William C. Carruth; music by Thomas Newman; production designer, Ivo Cristante; produced by Brad Krevoy and Steve Stabler; released by Tri-Star Pictures. Running time: 93 minutes. This film is rated R.

Alex...................................Lara Flynn Boyle
Stuart.................................Stephen Baldwin
Eddy..Josh Charles
Dick...................................Alexis Arquette

By JANET MASLIN

Groaning and eye-rolling aren't possible for inanimate objects, but if they were, the portrait of Jack Kerouac seen in "Threesome" wouldn't keep a straight face. Kerouac decorates a bedroom in the college dormitory apartment where Eddy (Josh Charles), Stuart (Stephen Baldwin) and Alex (Lara Flynn Boyle) flatter themselves into thinking they are a boldly bohemian trio. The film is so proud of its alleged daring that it even begins with a dictionary definition of the word "deviant." "Sitcom" would have been more like it.

It cannot have been easy to throw three young, nubile characters into close quarters and sustain an utterly sexless, charmless atmosphere. But Andrew Fleming ("the 'Generation X' film maker whose age belies his considerable experience behind the camera," according to production notes) has done exactly that. Mr. Fleming treats the non-events in this story as if they were of monumental importance, meanwhile managing to postpone the inevitable three-way sexual encounter until the final reel. If you are sufficiently interested, you may wonder why three people sharing very close quarters don't decide to fool around until they are out skinny-dipping, in a highly visible spot, where they can be interrupted by a troupe of kiddie hikers.

In the meantime, there are bathroom jokes, gay-baiting wisecracks, wildly pretentious narration ("Solitude brought out the worst in me; it gave me time to brood over the nature of things") and truly excruciating literary references. The principals see fit to compare themselves to characters in both "The Catcher in the Rye" and "Jules and Jim." Interesting footnote: It is while discussing the Salinger reference, not the one to Truffaut, that Alex smokes thoughtfully and sports a beret.

"Threesome" gets off to its contrived start once the boorish, sex-obsessed Stuart and the quieter, smarter Eddy realize that a campus computer has accidentally assigned them a female roommate. (With typical grace, the film makes this point by sending Eddy to the toilet while Alex is in the shower.) The three trade insults briefly, then realize that they are becoming fast friends. But matters are complicated: Alex resists Stuart and likes Eddy. Eddy is attracted to Stuart. Stuart isn't interested in Eddy, a point he makes by using the words "fag" and "homo" with great regularity.

The film suggests that Stuart may be protesting too much, but what does it matter? Every time the characters threaten to become appealing, Mr. Fleming has them do things like

spray each other with shaving cream. Top honors for obnoxious behavior are not easily won, and Mr. Baldwin seems to have the edge, what with all his constant leering and a terrible haircut to boot. But Ms. Boyle wins handily with a scene that has her writhing orgasmically atop a library table while Eddy reads Hawthorne, in order to demonstrate that big words turn her on. "I'll mold you into a heterosexual with my bare hands!" she tells Eddy in another scene.

"Threesome" has the bad luck to arrive while other, much better films about three-way relationships between feckless young characters are within recent memory ("Three of Hearts," which starred Mr. Baldwin's brother William) or currently in release. Among the charms of the buoyant "Reality Bites" is that film's ability to pinpoint the pop-cultural context for its characters' lives without sounding smug. "Threesome," on the other hand, has Stuart complaining about his date by saying: "I was out to dinner with her the other night, and I asked her if she liked Scorsese. She said, 'Well, I'm not really that hungry.'"

•

"Threesome" is rated R (Under 17 requires accompanying parent or adult guardian). It includes nudity, a lot of profanity, and a couple of discreet scenes featuring all three principals in bed. The men barely touch each other. The film is careful to keep some distance between them.

1994 Ap 8, C12:4

A Life Colored by AIDS

Derek Jarman's "Blue" was shown as part of the 1993 New York Film Festival. Here are excerpts from Stephen Holden's review, which appeared in The New York Times on Oct. 2, 1993. Mr. Jarman died on Feb. 19. The film opens today at Film Forum 2, 209 West Houston Street, South Village.

The sole visual content of Derek Jarman's film "Blue" is the color blue projected uninterruptedly and without variation for the movie's entire 76 minutes. Against this field of color so evocative of sky, ocean, blindness, heaven and eternity unfolds a soundtrack of music, poetry and scalding excerpts from a diary by the English film maker, who has been living with AIDS for several years.

"Blue" is by turns heartbreaking, enraged, boring, pretentious and riveting. The narration, delivered with a stately equanimity by John Quentin, Nigel Terry and Tilda Swinton, is interwoven with music and sound effects to suggest a stream of consciousness that is continually changing levels. There are moments when the film maker's spirit seems on the verge of taking leave of his body and drifting into the ether. At other times the writing is so incendiary that he seems ready to jump out of his sickbed and burn down the hospital. After a gentle beginning in which bells toll elegiacally and a voice contemplates the color blue and its associations, the screenplay narrows in on the film maker's physical problems, of which the most acute is failing eyesight. From here, it veers between lulling metaphysical speculation and brutal physical reality.

When the language turns vague and dreamy, "Blue" can seem like an indulgent exercise in languid poeticizing. But when the narrator expresses fear, rage and contempt, the film assumes a ferocious intensity in which the gap between the blankness on the screen and the emotions being expressed becomes the distance between one brilliant, cranky individual and nothingness.

In the most pointed passages, the film maker, who is being treated in a public hospice, rails against the very idea of charity and the way it salves the conscience, allowing people to avoid contact with what disturbs them. The recitation of the possible side effects of an experimental drug is horrifying; many sound far worse than the blindness the drug is intended to thwart. In other searing moments the film maker asserts his homosexuality with the vengeful pride of someone for whom it is a badge of integrity in a corrupt, mediocre, inhuman society whose imminent destruction is to be devoutly wished for.

1994 Ap 8, C13:1

Family as Revolution in Microcosm

"The Blue Kite" was shown as part of the 1993 New York Film Festival. Here are excerpts from Vincent Canby's review, which appeared in The New York Times on Oct. 2. The film — in Mandarin with English subtitles — opens today at the Lincoln Plaza Cinemas, Broadway and 63d Street.

In China it can't be easy being a film maker, someone who wants to explore on screen the contradictory events that have shaped not only the Communist revolution but also his own life. It's a delicate, complicated task. The film maker is dependent on Government departments created by

the same system whose legacies he's examining. The production and release of any film of this kind thus become something of a triumph.

Such a film is "The Blue Kite." A co-production by the Chinese Government and private Hong Kong movie interests, it's the work of Tian Zhuangzhuang, whose "Horse Thief" was seen at the Film Forum in 1988.

"The Blue Kite" is the story of the Chen family of Beijing, as the son, Tietou, recalls his infancy, childhood and adolescence. It follows the fortunes of the Chens, their relatives and their friends from 1953, when Tietou's

parents marry and Chairman Mao's revolution is still young and vigorous, into the dark, vengeful days of the Cultural Revolution in the late 1960's. This mix of politics and domestic drama isn't always easy to follow, but Mr. Tian demonstrates a rigorous, unsentimental control of the material that becomes very moving, at least in part because of the director's understatement.

The Chens initially appear to be members of an enlightened, comparatively prosperous lower middle class. Some of the Chens enthusiastically support the new Government's radical reforms. Others seem apolitical. Whatever their commitments, all suffer equally.

The movie comes to dramatic life only in its final sections, relating to the excesses of the Red Guards. These sequences are harrowing. "The Blue Kite" looks gorgeous. It's well acted by a large cast, but, to appreciate it fully, one needs more footnotes to history than most ordinary moviegoers are going to have in mind or pocket.

1994 Ap 8, C13:3

Serial Mom

Written and directed by John Waters; director of photography, Robert M. Stevens; edited by Janice Hampton and Erica Huggins; music by Basil Poledouris; production designer, Vincent Peranio; produced by John Fiedler and Mark Tarlov; released by Savoy Pictures. Running time 93 minutes. This film is rated R.

Beverly Sutphin.....................Kathleen Turner
Eugene Sutphin........................Sam Waterston
Misty Sutphin.................................Ricki Lake
Chip Sutphin..........................Matthew Lillard
Dottie Hinkle....................................Mink Stole
Suzanne Somers....................................Herself

By CARYN JAMES

If you're going to build a career on bad taste, sooner or later you'll have to tackle the most sacred icon of all, motherhood. John Waters is just the man to do it, for he sends up only what he deeply adores. In "Serial Mom" he takes to heart the idea that being the All-American mother is enough to drive a woman crazy. What could be more sympathetic?

Kathleen Turner leaps into the most delicious role she has had in years as Beverly Sutphin. She is a Baltimore housewife with perfectly bobbed hair, a sparkling clean kitchen, a dentist husband (Sam Waterston) and two teen-age children with names that seem lifted from "Ozzie and Harriet": Chip and Misty. But the strain of being a perfect mom is showing, for Beverly has developed a tendency to murder anyone who gets on her nerves.

How dare a teacher suggest that Chip (Matthew Lillard) may need therapy? Beverly responds with normal disbelief, then finds the teacher in the parking lot and runs him down with her car. When Misty (Ricki Lake) is stood up by a handsome date, she will regret crying to her mother, "I wish he were dead."

Mr. Waters, of course, no longer traffics in the truly vulgar, as he did in early films like "Pink Flamingos" (notorious for its canine scatology). With his recent lighthearted films of 50's and 60's adolescence, "Hairspray" and "Crybaby," he entered the mainstream, where his sense of the tacky fit right in. With "Serial Mom" he concocts a cute suburban satire, a warmly funny movie that even a mother could love.

The movie is milder than its premise makes it sound. Although the story is set in the present, Beverly seems stuck in one of Mr. Waters's favorite twilight zones: 50's sitcoms that shaped a generation of dysfunctional families. A detective who questions the Sutphins even points out how remarkably Beverly brings to mind June Cleaver, though he misses a crucial clue about the obscene note sent to their whiny neighbor, Dottie Hinkle (Mink Stole). The note is signed with a smiley face. As soon as the detectives and her loving family are out the door, Beverly displays girlish delight at muttering dirty words in an anonymous prank call to Dottie. Beverly is the kind of matron who would profess to be disgusted by a John Waters movie while secretly relishing every cathartic moment.

The film is shaped by Mr. Waters's flair for capturing the excruciating details of suburban life. An especially nice touch is the way Beverly cheerily sings Barry Manilow's "Daybreak" while cleaning her house or driving to another murder. Ms. Turner plays the good mother with such sunny conviction that her murderous side seems plausibly self-righteous. And Mr. Waterston, escaping from many earnest roles, shows a flair for understated comedy that works perfectly for the befuddled husband.

Like all Waters films, "Serial Mom" is uneven and often predictable. When the police close in on Beverly while she is riding to church with the whole family, she wonders, "Do you think I need to call a lawyer?" The astute Chip answers, "You need an agent." Suzanne Somers, in a cameo role, suddenly wants to make a mini-series of Beverly's life. The media frenzy about the latest megastar killer is too close to reality to work as satire.

Despite Mr. Waters's tame approach, there are still some disgusting moments in "Serial Mom," including a close-up of what looks like a human liver skewered on a fireplace poker. He hasn't, after all, lost his sense of values. Who would you rather be? he seems to ask. The famous serial mom or the neighbor who, when a favorite ceramic egg has been broken, wails: "It's Franklin Mint! I collect Franklin Mint!"

One victim rents a video of "Annie," settles into her easy chair and starts singing along with "Tomorrow." Legally that doesn't justify murder. But there are higher esthetic issues involved. They explain why, in the world of John Waters, this serial mom is a pop-culture heroine.

•

"Serial Mom" is rated R (Under 17 requires accompanying parent or adult guardian). It includes foul language, sexual suggestiveness and some bloody murders.

1994 Ap 13, C15:1

The Secret Adventures of Tom Thumb

Written and directed by Dave Borthwick; music by John Paul Jones and the Startled Insects; released by Zeitgeist Films. Running time 60 minutes. This film is not rated.

Food

Directed by Jan Svankmajer. Running time 17 minutes. This film is not rated.
At Film Forum 1, 209 West Houston Street, South Village.

By CARYN JAMES

Though "The Secret Adventures of Tom Thumb" and "Food" have titles that are soothingly general, it's hard to get more specialized than this program of two stop-action animated works opening today at Film Forum. Both use clay figures and live actors to achieve an eerie effect, as if the actors were mannequins come to life. But the technique, which takes still photographs and runs them together as in cartoon animation, is only as good as the stories it tells. This program is more likely to appeal to animation fans than to movie lovers.

The hourlong "Secret Adventures of Tom Thumb" is a bizarre revision of the classic tale, one definitely not for children. This Tom is a mutant product of genetic engineering. A tiny clay figure with wide blue eyes, he looks like a cross between E.T. and a fetus, and is quite an endearing and vulnerable character.

He is born into a world set deliberately outside time. The dank streets look seedily Victorian and his parents (Nick Upton and Deborah Collard) have the unhealthy appearance of people whose walls are always damp. Stolen by government agents, Tom lands in a laboratory, then in a toxic swamp where clay figures his own size wear medieval clothes and are determined to get revenge on the larger world. The animation is atmospheric and impressive, but the confusing fable takes on so many pieces of history — industrialization, feudalism, the apocalypse — that the technique itself becomes the focus.

Dave Borthwick, the director of "The Secret Adventures of Tom Thumb," is among the many film makers influenced by the great contemporary Czech animator Jan Svankmajer. At their best, Mr. Svankmajer's films are as emotionally haunting as Kafka's stories. His 17-minute "Food" is caustically witty but slight. At breakfast, a man becomes a human vending machine, dispensing food from a dumbwaiter inside his body. At lunch, two men at a restaurant eat everything in sight: silverware, the table, their own clothes. At dinner, people eat their own body parts.

Mr. Svankmajer conceived the film in the 1970's, when it seemed too risky a political allegory to be made. Finally made last year, it now seems too simple a statement about how people are devoured by mechanistic states and each other. His feature-length "Alice," a retelling of the Lewis Carroll story, sets a standard that is hard even for Mr. Svankmajer to match.

1994 Ap 13, C19:1

32 Short Films About Glenn Gould

Directed by François Girard; written by Mr. Girard and Don McKellar; director of photography, Alain Dostie; edited by Gaétan Huot; music by various composers; produced by Niv Fichman; released by Samuel Goldwyn Company. At the Lincoln Plaza Cinemas, Broadway and 63d Street. Running time: 94 minutes. This film is not rated.

WITH: Colm Feore as Glenn Gould

By JANET MASLIN

In the control room of a recording studio, the engineers discuss the merits of taking cream in their coffee, only half-noticing the enraptured figure behind the soundproof glass. There, Glenn Gould (Colm Feore) begins by casually testing his blood pressure, then listens to a playback of his recording of Bach. To the sounds of the English Suite No. 2, he begins swaying and floating in the throes of esthetic ecstasy, his white shirt billowing in gravity-defying slow motion. Far removed from the engineers' prosaic talk, he seems truly to have passed into another dimension.

The audience for "Thirty-Two Short Films About Glenn Gould," a brilliant and transfixing cinematic portrait by François Girard, can look forward to enjoying much the same sensation. For an hour and a half, without repeating himself or resorting to tactics that are even slightly familiar, Mr. Girard, whose film opens today at the Lincoln Plaza Cinemas, thoughtfully holds the viewer in thrall.

Though it glancingly incorporates a great deal of biographical information, this carefully measured film does not choose to describe Gould in ordinary terms. Suffused as it is with the artist's musical sensibility, it doesn't even have to show him playing the piano. Instead, Mr. Girard explores and replicates his subject's eccentric thought processes in a remarkably visceral way, drawing the audience palpably into Gould's state of mind. This film works hypnotically, with great subtlety and grace, in ways that are gratifyingly consistent with Gould's own thoughts about his music and his life.

Mr. Girard's film is indeed a compilation of 32 glimpses, each of them instantly intelligible, some of them strung together in supremely delicate ways. The format makes dependable sense: this is hardly the first time the variations motif has been brought to bear in describing Gould. More than an homage to his triumphant recordings of Bach's "Goldberg" Variations, this multifaceted structure seems the only possible means of approaching such a complex individual. If it sounds defiantly arty, that suits the subject and his "academic owlishness" (in the words of his biographer Otto Friedrich) perfectly. If it sounds obscure and daunting, it most certainly is not.

If anything, "Thirty-Two Short Films About Glenn Gould" should prove even more mesmerizing to those who know little about Gould's life than to those aware that he really did have tastes for ketchup, tranquilizers, arrowroot cookies and Petula Clark (not necessarily in that order). In its own quirky way, it assembles a surprisingly rigorous and illuminating portrait of the man. Defying any usual constraints of narrative or chronology, Mr. Girard can leap freely from Gould's boyhood to his mature work, from the hotel room to the concert stage, from the raptures of the music to silly questions asked by the press. The individual fragments are so meticulously realized that the whole becomes much greater than the sum of its parts.

Typically fascinating is "L.A. Concert," a fine example of how cannily Mr. Girard can present the facts of Gould's life. We first see the pianist backstage, poised over a sink, soaking his arms in steaming water five minutes before a concert is to begin. Pill bottles are conspicuously arrayed in front of him. Called to the stage, he next appears dressed and ready, maintaining a serene detachment as an aide tries to instruct him about the irritating show-business realities of the evening. Just before reaching the stage, he pauses to talk with a stagehand and winds up signing a program for the man. Only when the stagehand examines the

autograph does he learn that Mr. Gould has decided to make this 1964 concert performance his last.

It would be difficult to think of a more adroit, economical way to convey all this information in a such relatively brief time. "Thirty-Two Short Films About Glenn Gould," which was written by Mr. Girard with Don McKellar, is also able to fuse the informative with the poetic, particularly in the passages that deal hauntingly with Gould's final days. (He died at 50, in 1982.) One of the film's last images is of a Voyager satellite that went into space carrying aural souvenirs of Earth's culture, including Gould's recording of Bach's "Well-Tempered Clavier." The film's announcement that the two Voyager spacecraft left our solar system in 1987 and 1989, respectively, suits its lingering impression that Gould was never quite of this world.

Mr. Feore, a Canadian stage actor, does not overwhelmingly resemble Gould, but he becomes a commanding and believable presence all the same. With a voice that has been made to sound strangely disembodied, and with the ability to project brooding, playful intelligence, Mr. Feore enhances the film's sense of deep mystery. Equally lulling and seductive are Mr. Girard's fluid camera movements, which enable the film to prowl and survey with uncom-

mon ease. In the end, his methods induce a complete and satisfying immersion into his many-faceted subject.

•

Among the individual glimpses that must be mentioned here: "Practice," in which Gould resonates to his own thrilling impression of Beethoven's "Tempest" Sonata without ever touching a keyboard; "Truck Stop," in which he hears and seems to orchestrate the voices of people around him; "Personal Ad," in which he toys with the language of the lovelorn, then chuckles at the thought of ever representing himself in that way; "Diary of One Day," a stunning compilation of formulas, medical notations, heartbeats and detailed X-rays of a person playing the piano. Even before the film reaches this last juncture, you will know that the heart and blood of the pianist have been captured on screen.

Also worth noting: some significant omissions. Mr. Girard knew better than to mention Gould's intense admiration for Barbra Streisand, or to use those sections of the "Goldberg" Variations that have powerfully evoked Dr. Hannibal Lecter ever since they were used to shocking effect in "The Silence of the Lambs."

1994 Ap 14, C15:1

Naked in New York

Directed by Dan Algrant; written by Mr. Algrant and John Warren; director of photography, Joey Forsyte; edited by Bill Pankow; music by Angelo Badalamenti; production designer, Kalina Ivanov; produced by Frederick Zollo; released by Fine Line Features. Running time: 91 minutes. This film is rated R.

Jake Briggs	Eric Stoltz
Joanne White	Mary-Louise Parker
Chris	Ralph Macchio
Shirley Briggs	Jill Clayburgh
Carl Fisher	Tony Curtis
Elliot Price	Timothy Dalton
Dana Coles	Kathleen Turner
Helen	Lynne Thigpen
Mr. Reid	Roscoe Lee Browne
Tragedy Mask	Whoopi Goldberg

By JANET MASLIN

In directing his first feature, "Naked in New York," about how hard it is to be an aspiring young playwright, Dan Algrant manages to make film making look wonderfully easy. Mr. Algrant's agile, self-deprecating wit and his flair for ensemble comedy make "Naked in New York" as knowing and clever as it is charming. Although the film maker is a protégé of Martin Scorsese (Mr. Scorsese served as executive producer), his dry, offbeat style recalls someone else. "Naked in New York" is descended, in the most funny and refreshing way, from "Annie Hall."

The resemblance goes well beyond the fact that this film's hero, Jake Briggs (Eric Stoltz), is a bespectacled, red-haired fellow who tends to worry a lot. Or that his girlfriend, Joanne White (Mary-Louise Parker), is a sly, winsome neurotic who never fully says what's on her mind. "Naked in New York" also ponders the problems of trying to combine love and work, the lure of ambition and the terrors posed by any prospect of permanent commitment. And none of it is made to look easy. When Jake is a little boy, he is seen coaching his mother (Jill Clayburgh) with the phrase, "I am the master of my emotions," which turns out to be a hearty joke for them both.

At 25, Jake approaches all his worries with appealing nonchalance, as when he begins the film by saying: "One of the few things

that I know about life, other than that it ends, is that it's a good idea to be with someone during it. Preferably someone you love." Mr. Algrant, who wrote the film with John Warren, doesn't overburden such lightweight observations, but his film is more thoughtful than it initially sounds. Its characters remain ruefully perceptive about one another even when the pressures of love and work threaten to drive them far apart.

•

"Naked in New York" is loosely narrated by Jake, whose memories have a suitably antic quality; he can recall himself as a baby, on the lazy susan at a table in a Chinese restaurant, on the day his parents split up. Later, Jake recalls living in Cambridge, Mass., across the street from a nut factory ("driving the local squirrels mad from the constant roasting"), and falling in love with Joanne. At the same time, he makes his first stab at playwriting with a short piece about a homicidal lumberjack. A teacher (Roscoe Lee Browne) praises his craftsmanship, but adds: "On a personal level, I think you might want to go talk with someone in health services."

Jake is coaxed from Boston to New York by his friend Chris (Ralph Macchio), an aspiring actor, who thinks breaking into the theater depends on being where the action is. Meanwhile, Joanne is hired by Elliot Price (Timothy Dalton) to work at his art gallery. Overnight, she begins looking as if she loves her work a little too well.

One of the film's nervier sequences has Elliot flying Jake and Joanne to Martha's Vineyard on his private plane ("Why is Patsy Cline playing on the tape? Is that a joke?" asks a terrified Jake) and including them in a celebrity-packed literary party. "Before they were movies, I read them," Jake manages to say — flatteringly, he hopes — to a deadpan William Styron. Mr. Algrant is savvy enough to satirize the idea of celebrity cameos while making sure that his film features them everywhere. David Johansen provides the voice of a helpful orangutan, Eric Bogosian and Quentin Crisp turn up at the same party, and Whoopi Goldberg is part of a talking frieze on the front of a New York theater.

"Naked in New York" deftly divides its attention between Joanne's new life in the art world and Jake's New York theater experiences. (The details are often exactly right; Joanne's favorite photographer isn't Cartier-Bresson, it's Mary Ellen Mark.) In Manhattan, Mr. Algrant has found a particularly fertile setting for his film's brand of urbane humor. His Manhattan fixtures include Tony

Fine Line Features

Mary-Louise Parker and Eric Stoltz in Dan Algrant's film "Naked in New York."

Curtis, letter-perfect in the role of a lovably crass off-Broadway producer, and Kathleen Turner as a leonine soap opera star who yearns alarmingly for more stage experience. "She makes the boat float, don't you understand that?" asks Mr. Curtis, as he insists on miscasting her in Jake's precious play.

Mr. Algrant switches gears with impressive ease when he moves from satire to more serious concerns. The film includes a surprising, beautifully acted scene involving a sexual overture made in the midst of a New York party. This gentle encounter is troubling for both parties, and Mr. Algrant captures it with empathy and intelligence: qualities that keep even the zanier moments in "Naked in New York" from feeling like fluff.

"Naked in New York" is made even more entertaining by Angelo Badalamenti's inspired score, and by a production design that keeps the film as visually interesting as it is verbally bright. The casting is full of welcome surprises, particularly Mr. Macchio's grown-up performance in a quiet but important role. Mr. Algrant's showier directorial tricks — swiveling camerawork, occasional fantasy sequences — sometimes try too hard, but his talent is never in doubt.

Even before spring was in the air, this was shaping up as an exceptionally rosy season for ensemble-minded romantic comedy. Along with "Reality Bites" and the especially enchanting "Four Weddings and a Funeral," "Naked in New York" qualifies as one more warm, seductive delight.

•

"Naked in New York" is rated R (Under 17 requires accompanying parent or adult guardian). It includes sexual situations, profanity and nudity.

1994 Ap 15, C3:1

In Custody

Directed by Ismail Merchant; written in Urdu, with English subtitles, by Anita Desai and Shahrukh Husain, based on a novel by Ms. Desai; director of photography, Larry Pizer; edited by Roberto Silvi; music by Zakir Hussain and Ustad Sultan Khan; produced by Wahid Chowhan; released by Sony Pictures Classics. Running time: 123 minutes. This film is rated PG.

Nur	Shashi Kapoor
Deven	Om Puri
Imtiaz Begum	Shabana Azmi
Sarla	Neena Gupta
Murad	Tinnu Anand

By CARYN JAMES

Lying on his side in a narrow bed is a corpulent, aging Indian poet named Nur. He is a curiously imposing figure, even with his back to the camera, and provides what may be the greatest role in the long career of Shashi Kapoor. Almost 30 years ago, Mr. Kapoor was the slender, handsome youth in the early Merchant-Ivory film "Shakespeare Wallah," and more recently the outraged father in Stephen Frears's "Sammy and Rosie Get Laid." In Ismail Merchant's rich and enticing "In Custody," Mr. Kapoor turns Nur into a present-day Balzac: fierce and wise, yet with all the signs of having lived a little too well.

The visitor who has awakened him at midday is a meek college teacher named Deven (Om Puri), honored at the very thought of interviewing one of India's greatest poets. By the end of the day, Deven will see this idol surrounded by drunken admirers, scolded by his shrewish young wife, collapsed on the floor in his own vomit. Yet Nur retains his greatness and

Deven his justified hero worship. And Mr. Merchant, known as the producing half of the Merchant-Ivory partnership (with James Ivory directing instant classics like "Howards End" and "The Remains of the Day"), shows himself to be a passionate, accomplished director.

As a producer, Mr. Merchant is famous for getting luxurious-looking films on screen for a pittance of what they would cost in Hollywood. That is certainly true of "In Custody," whose settings are not elegant but are swarming with brightly colored details. In Deven's village of Mirpor, bazaars are crowded with food stands and Pepsi signs, and his son's school bus is a horse-drawn surrey that travels dusty roads. In Bhopal, where much of the film was shot, Deven walks through narrow alleys, sidestepping goats and mud puddles to arrive at the flower-filled courtyard and large, shabby house of Nur.

Mr. Merchant has done much more than create a vibrant backdrop, though. Nur and Deven are deeply wrought characters who are all the more moving because they are personally flawed. Their story is both a lyric appreciation of poetry and a comedy of errors about literary lives.

•

Deven is lured into interviewing Nur by a shifty old schoolfriend, Murad (Tinnu Anand), who edits an Urdu literary journal. Urdu is an endangered literary language in a country dominated by Hindi, and is the language spoken in the film. (The encroachment of the modern world on the language is apparent in the way English words like "TV," "VCR" and "tape recorder" leap out

Sony Pictures Classics

Shashi Kapoor

from the dialogue.) To Deven, Urdu poetry is a means of escape from a thwarted life, in which he expresses frustration by snapping at his wife. Though Deven looks intense, with deep-set eyes and a constant frown, in his soul he is a scared rabbit.

Nur, the poet of a dying language, is surrounded by hangers-on who pretend to value his work but really value his whisky. Deven is appalled at the roomful of admirers who wolf down food with their fingers, then belch loudly. He is astonished to see Nur's two jealous wives begin to scratch each other's eyes out, while Nur puts his head in his hands and weeps. The poet and his worshiper realize they can save each other, but the obstacles are comic and frustrating.

When Deven gets his college to put up money for a tape recorder, it is a hopelessly old-fashioned reel-to-reel contraption that Murad gets from a shop loaded with boom boxes and VCR's. Attempting to record Nur in a brothel where they have rented a room, Deven holds the microphone up portentously and hears Nur intone, "Send for some biryani from the bazaar."

Yet there is much real poetry in Nur and in the film, which turns out to be its greatest flaw. In any work about an artist, it is risky to play the music or show the paintings or, in this case, hear Nur's poetry read and sung. The poetry attributed to the fictional Nur was actually written by Faiz Ahmed Faiz, who died in 1984 and is considered among the preeminent Urdu poets of the century. But it is difficult to appreciate his greatness in translation and nearly impossible in subtitles.

Anita Desai, in the English novel on which "In Custody" is based, chose a less ambitious strategy and offered only brief lines of poetry. On the screen, fragments ("Your memory like a desert spring") would have been enough to hint at Nur's lyric style. There are also two lengthy scenes in which minor characters sing Urdu poems. Such episodes make the two-hour film seem a half-hour too long. It is as if, after years of producing (and directing a documentary, "The Courtesans of Bombay"), Mr. Merchant needed to cram all his affection for Indian culture into this one work. At times that approach makes the film serve the stately function of artistic ambassador.

But "In Custody" never loses sight of the confused humanity of its heroes, so strongly played by Mr. Kapoor and Mr. Puri. Deven finally becomes the custodian of Nur's last poems. If the film shows that large lives have their petty aspects, it also offers the hope that small ones like Deven's can be touched by greatness.

•

"In Custody" is rated PG (Parental guidance suggested). It includes some mild sexual innuendoes.

1994 Ap 15, C6:3

Two Small Bodies

Written and directed by Beth B; co-written by Neal Bell, based on his play; director of photography, Phil Parmet; edited by Melody London and Andrea Feige; art director, Agnette Schlosser; music by Swans; produced by Daniel Zuta and Beth B. At the Quad Cinema, 34 West 13th Street, Greenwich Village. Running time: 85 minutes. This film is not rated.

Lieutenant Brann	Fred Ward
Eileen Maloney	Suzy Amis

By CARYN JAMES

"Two Small Bodies" is a sharply focused, intense drama about a woman whose young son and daughter are missing, and the detective who thinks she may have murdered them. There aren't many actors able to carry a two-character film, and Suzy Amis and Fred Ward are among the few who can. Eileen Maloney and Lieutenant Brann engage in a stylized dance that is antagonistic, sexual and unsettling as it reveals the dark impulses beneath their obvious social roles.

Most of the film takes place in Eileen's drab suburban home, which Brann goes to at all hours, day after day. Eileen is a hostess in a strip club, which makes her a scarlet woman and, both she and Brann agree, more likely to be accused of murder. Brann is another sort of stereotype, the macho detective modeled on B-movie heros. He wears a trench coat and a slouch hat and seems to have no other cases to bother about.

Based on a 1977 play by Neal Bell, the film has been smartly directed by Beth B in a manner that emphasizes its theatrical roots instead of trying to disguise them. Brann's questions are often monosyllabic and the dialogue at times intentionally repetitious. But the characters effectively use that dialogue to recreate possible scenarios for the murder, allowing the audience to visualize what might have happened.

As the film moves further away from realism, it reaches deeper into the characters' emotions and complex motives. When Brann arrives at breakfast time and changes his clothes in front of Eileen, is it a sexual provocation, a strategy to unnerve her or a perversion? "Your children are missing; they may be dead," he says calmly, crunching into a piece of toast. When she refuses to respond with any emotion, is it a sign of guilt or grief or both? Looking determinedly frumpy at home and tarty when

Castle Hill Productions

Fred Ward

she arrives home from work, she actively plays into Brann's worst image of her. She says sarcastically about her children, "I read them bedtime stories from the Kama Sutra." This is an obsessive dance of attraction and repulsion.

Though the director emphasizes the theatrical dialogue, she also moves the camera in a way that prevents the film from becoming static. She might close in on Eileen's face as Brann makes some outrageous accusation, or watch Eileen walk around in her slip in a way that allows viewers to witness her as the detective sees her.

•

"Two Small Bodies," which opens today at the Quad Cinema, is never as profound or socially revealing as it promises to be. It may be best not to bother with the fact that when Mr. Bell's play was first produced, it seemed a thinly veiled account of a timely murder case in which Alice Crimmins, a Queens cocktail waitress, was accused of killing her two children. The best part of the film is watching Ms. Amis and Mr. Ward, who are endlessly fascinating as they find the emotional and psychological disruptions beneath the calm surface of their characters.

1994 Ap 15, C10:1

I Only Want You to Love Me

Written and directed by Rainer Werner Fassbinder; based on the book "Life Sentence," by Klaus Antes and Christine Erhardt; in German, with English subtitles; director of photography, Michael Ballhaus; edited by Liesgret Schmitt-Klink; music by Peer Raben; produced by Peter Maethesheimer. At the Joseph Papp Public Theater, 425 Lafayette Street, East Village. Running time: 104 minutes. This film is not rated.

Peter	Vitus Zeplichal
Erika	Elke Aberle
Mother	Ernie Mangold
Father	Alexander Allerson
Grandmother	Johanna Hofer

By STEPHEN HOLDEN

Peter (Vitus Zeplichal), a fanatically hard-working •construction worker who bows and scrapes his way through Rainer Werner Fassbinder's sadly compelling "I Only Want You to Love Me," is one of the more poignant social casualties to be examined in the films of the great German director.

A caricature of a dutiful son and model employee, he regards the world with frightened rabbity eyes that plead for a love he is incapable of demanding out loud. Instead of verbalizing his needs, Peter tries to buy with gifts the love he craves so desperately but doesn't believe he deserves. In one scene after another, he is shown standing on a doorstep, a silent supplicant holding a wrapped bouquet of flowers.

The film's Manhattan engagement, which begins today at the Joseph Papp Public Theater, is the American premiere of a movie that was made in the mid-1970's but not released in the United States until now because of legal problems. Based on a true story from a German anthology called "Life Sentence," it offers a merciless view of bourgeois German society in the feverish grip of capitalism. The cost of West Germany's postwar economic miracle, it suggests, was emotionally and spiritually devastating.

The world it portrays is an environment in which the value of everything can be measured in monetary credit. Especially in the scenes of Peter's shopping sprees, the clerks have the look and body language of well-dressed mannequins guarding precious goods that have the glow of sacred icons. The credit agreements that Peter signs assume an almost religious significance. So much of the movie is devoted to detailing the financial plight of a couple living beyond their means that it might as easily have been called "Tragedy on the Installment Plan" or "Time Payment Madness."

At the same time, the story is a typically blunt and bitter Fassbinder parable of a misfit ground down by the relentless social machinery. Without delving deeply into the psychological whys and wherefores, it presents Peter as an eager, uncomplaining slave to the needs of his cold, imperious parents. The movie's opening scenes show him single-handedly building a house for them and then receiving only scant gratitude. A flashback of the young Peter being spanked suggests that the parents always confused administering discipline with giving love.

Peter shyly courts a neighbor, Erika (Elke Aberle), and then marries her in a ceremony at which the parents wear expressions of grim disapproval. After deciding to seek his fortune in Munich, which he is warned is the most expensive city in Germany, Peter takes a job on a construction site and rents a small two-room apartment. Once he has settled in with his wife, he is as desperate to please her as he was his parents. Not only does he furnish the apartment lavishly, but he also shows Erika with expensive gifts that he can't afford, going ever more deeply into debt.

The situation spins out of control when Erika becomes pregnant, and Peter is forced to buy maternity items on credit. The turning point of the drama comes when Erika insists Peter ask his parents for money, and he cannot bring himself to do it because it would be a sign of his failure. With no escape from his problems, Peter cracks up and commits an act of senseless violence against a man who resembles his father.

"I Only Want You to Love Me" looks at Peter from three distinct perspectives. The bulk of the film sees the world through his eyes. It is a cold, scary place in which everybody — employers, store clerks, patrons in a bar — exudes an ominous authoritarian aura, and he is the only person in the world who is unsure of his place. Periodically, the story is interrupted by documentary-style snatches of an interview with Peter by a prison psychiatrist, in which the prisoner seems merely bewildered. Now and then, the director intrudes with printed commentary expressing outrage at Peter's plight.

"I Only Want You to Love Me" is a grim Germanic variation on a classic theme that can never bear too much repeating: Can't buy me love.

1994 Ap 15, C10:4

Backbeat

Written and directed by Iain Softley; co-writers, Michael Thomas and Stephen Ward; director of photograhy, Ian Wilson; edited by Martin Walsh; production designer, Joseph Bennett; produced by Finola Dwyer and Stephen Woolley; released by Gramercy Pictures. Running time 100 minutes. This film is rated R.

Astrid Kirchherr	Sheryl Lee
Stuart Sutcliffe	Stephen Dorff
John Lennon	Ian Hart
Paul McCartney	Gary Bakewell
George Harrison	Chris O'Neill
Pete Best	Scot Williams

By JANET MASLIN

In the realm of Beatles lore, Stu Sutcliffe is the man who got away. He was the Liverpool art student who exerted a strong stylistic influence over his best friend, John Lennon, and turned his back on Lennon's band just as that band reached the threshold of fame. Sutcliffe preferred to pursue a career as an Abstract Expressionist painter and to live in Hamburg with his German girlfriend, Astrid Kirchherr. Ms. Kirchherr, then celebrated for her bohemian style, is now the guiding force behind "Backbeat," an evocative new Sutcliffe-centric account of the Beatles' early history.

"Backbeat," directed by Iain Softley, is lively, galvanizing and unexpectedly well made, a far cry from the Madame Tussaud approach often used to enshrine contemporary celebrities. But it also has the whiff of the authorized version, which brings it more than a touch of smugness. After all, it's possible to view Sutcliffe's drifting away from the Beatles as an act of extremely shortsighted folly. But "Backbeat" celebrates his lofty rejection of rock music in favor of more serious art. It also sees a grand act of abdication in Sutcliffe's decision to be with the woman he loved.

This sort of myth making can be strenuous. "With or without the Beatles, he satisfies every requirement of a doomed pop hero," write Alan Clayson and Pauline Sutcliffe (Stu's sister) in their biography, "The Lost Beatle." "Gilding the aura of fated youth are dark glasses shielding restless eyes; prominent cheekbones in an ashen complexion; the slouch; the kismet supercool; the brooding intensity, and to round it off, the 'beautiful sadness' of an early death." True, Sutcliffe was admired for having a look reminiscent of James Dean's, and Ms. Kirchherr is credited with having talked the Beatles into the mop-top hairdo. But beyond that the Sutcliffe mystique has never succeeded in striking much of a chord.

•

"Backbeat" tries to correct that with hip revisionism, the kind that will work best for viewers born after the Beatles' heyday. It presents these young musicians as pre-punk nihilists, concentrating on the raunchy Hamburg interludes that helped solidify their hard-rocking style. Although it underscores the Sutcliffe factor, all its energy comes from John Lennon, who is presented as bristling and self-destructive in ways that would light a fire under any rock band. John is also conveniently romantic, saying of Astrid: "I might have fallen in love with her, but she fell in love with me best friend and that was the end of that."

John is played furiously well by Ian Hart (who actually looks a lot more like Julian Lennon, John's son). And Mr. Hart improves forcefully upon his strong earlier performance as John in "The Hours and Times." Each of these films (the other was about John and Brian Epstein, the Beatles' manager) gave John the kind of homoerotic longings best hinted at when the principal is no longer able to sue. The character is confused, but Mr. Hart's raging, bitterly funny John is a still welcome contrast to Stephen Dorff's Stu, who is all self-important attitude and dark glasses.

On the other hand, Mr. Dorff has the hard job of keeping a straight face while being told: "We're gonna be big, you know. You'll miss it, Stu. You're gonna kick yourself." Luckily, only when "Backbeat" resorts to such fateful-sounding dialogue does it really ring false. For the most part, Mr. Softley (who wrote the film with Michael Thomas and Stephen Ward) has done a fond, imaginative job of summoning the try-anything atmosphere in which the Beatles' style was born. You need not recognize the Reeperbahn, the Cavern Club or any of the other sites painstakingly re-created here to find in "Backbeat" a colorful chapter in pop music history.

With Paul McCartney and George Harrison reduced to Rosencrantz and Guildenstern status (and played none too flatteringly by actors who barely resemble them), and with Pete Best (another "fifth Beatle") pointedly left out of the action, the film concentrates on ambiance and on its central romantic triangle. In setting the scene, Mr. Softley's dark shadings and supple camerawork can be extremely effective, as when he tracks the first visit by beautiful Astrid (Sheryl Lee, the Laura Palmer of "Twin Peaks") into the club where she discovers the band.

Somehow, Ms. Lee's performance is appealing and unmannered enough to survive the film's overbearing claims about Astrid's style and sophistication. (Among its points: that she adores Rimbaud and Cocteau, and has never loved a man who didn't love Édith Piaf.) Also, Mr. Dorff seems more comfortable in gentle scenes with Ms. Lee than in those that find him and Mr. Hart looking down from various rooftops, discussing their plans to change the world.

"Backbeat," which for all its pretensions can often be impressively canny and affectionate about its subject, is helped enormously by newly recorded versions of Beatle records. As produced expertly by Don Was, these songs have a raw, jubilant sound that brings the film fully to life. This music actually sounds a lot better than the Beatles did in those early days, but that's appropriate: "Backbeat" isn't about rough edges. As an old story told through knowing new eyes, it's slicker than it looks.

•

"Backbeat" is rated R (Under 17 requires accompanying parent or adult guardian). It includes profanity and considerable nudity, as well as sexual situations.

1994 Ap 15, C15:1

Cops and Robbersons

Directed by Michael Ritchie; written by Bernie Somers; director of photography, Gerry Fisher; edited by Stephen A. Rotter and William S. Scharf; music by William Ross; production designer, Stephen J. Lineweaver; produced by Ned Tanen, Nancy Graham Tanen and Ronald L. Schwary; released by Tri-Star Pictures. Running time: 95 minutes. This film is rated PG.

Norman Robberson	Chevy Chase
Jake Stone	Jack Palance
Helen Robberson	Dianne Wiest
Osborn	Robert Davi
Tony Moore	David Barry Gray

By JANET MASLIN

In "Cops and Robbersons," Chevy Chase has an unfortunate chance to prove that there's something even more unfunny than his disastrous

Sidney Baldwin/Tri-Star Pictures
Chevy Chase

talk show. In this, a Chase vehicle with four flat tires, he plays a sad-sack suburbanite who secretly yearns to live dangerously, having watched too many police dramas on television.

He gets his chance when a surveillance team in his squeaky-clean neighborhood takes over the house next door. Jack Palance, as the policeman in charge of the operation, has the film's only fun when gazing appreciatively at the pitiful Norman Robberson (Mr. Chase). "He's an idiot," Mr. Palance says happily.

The film treats him like an idiot, that's for sure. As directed surprisingly lifelessly by Michael Ritchie, the joke-free "Cops and Robbersons" condescends miserably to its one-note characters. Dianne Wiest is especially ill-used as Norman's wife, who boasts fatuously about her abilities as a housewife and is so orderly she has posted a household schedule for bathroom time: "Now we have two that work! We're a normal family again!" she exclaims, once Jake (Mr. Palance) finds time to fix the Robberson's broken toilet.

Fix the toilet? Help out around the house? "Cops and Robbersons" goes from bad to worse once Jake changes from glowering sourpuss (Mr. Palance's strong suit) into — oh, no! — nice guy. It turns out that Norman and Jake are going to become friends and become better people. Once the Robberson children begin calling Jake "Uncle Jake," you may as well crawl under your seat and close your eyes. Jake is in a Santa Claus suit before the film is over.

As for Bernie Somers's screenplay, it includes the following exchange about a hand-rolled old cigarette: "I learned this from an old Rastafarian friend in college." "Where was he from?" "Oh, Rastafaria." "I never been there." Feeble as that is, it can't match the squirm quotient of the film's embarrassingly bland, supposedly satirical décor. Single worst moment: Mr. Chase's lamely imitating Robert De Niro's "You talkin' to me?" riff from "Taxi Driver."

The best Mr. Chase manages to do here is remind viewers how much funnier he has been playing the same type of character in National Lampoon comedies. The best the film makers can do is concoct a sequence in which two strangers inadvertently share a bathroom and wind up naked in the same shower. Nobody's as stupid as that.

"Cops and Robbersons" is rated PG (Parental guidance suggested). It includes profanity and fleeting nudity.

1994 Ap 15, C23:1

White Fang 2
Myth of the White Wolf

Directed by Ken Olin; written by David Fallon; director of photography, Hiro Narita; edited by Elba Sanchez-Short; music by John Debney; production designer, Cary White; produced by Preston Fischer; released by Buena Vista. Running time: 105 minutes. This film is rated PG.

Henry Casey	Scott Bairstow
Lily Joseph	Charmaine Craig
Moses	Al Harrington
Peter	Anthony Michael Ruivivar

BY STEPHEN HOLDEN

In the time-honored tradition of heroic Hollywood canines, the title character of "White Fang 2: Myth of the White Wolf" is an infallible judge of character. Half dog, half wolf, White Fang can be as plaintively devoted a helpmate as Lassie. But when scenting evil, he becomes as relentlessly ferocious as Charles Bronson settling a score. In the most spectacular of the movie's several rescue scenes, White Fang leaps from a cliff onto a speeding horse-drawn wagon to save an Indian princess from being spirited away by a slave-driving gold miner.

The story is set in Alaska in 1906, and White Fang shares a log cabin with Henry Casey (Scott Bairstow), an ingenuous young prospector with carefully styled hair and the gee-whiz manner of the younger Robbie Benson. After Henry is rescued from drowning by Lily (Charmaine Craig), a beautiful Indian woman from the peaceful Haida tribe, he is persuaded to fulfill a prophecy that was given to the tribal chief, Moses (Al Harrington), in a dream. During a ceremony in which he dons a wolf mask, Henry is dubbed White Wolf. His mission, undertaken with the assistance of Lily, Moses' son Peter (Anthony Michael Ruivivar) and his trusty wolf-dog, is to locate a mysteriously vanished caribou herd that once served as the tribe's food supply.

•

Although the film is the sequel to the 1991 movie "White Fang," it seems only distantly related to the more rugged predecessor. "White Fang 2" has a few taut moments, but it spends far too much time being dewy-eyed and cute. Both master and dog become smitten with prospective mates. Henry moons over the proud Lily, who gives him bow-and-arrow lessons in words that might have come from "Zen and the Art of Archery." White Fang, when not saving lives, is affectionately cuffing and rubbing noses with a snow-white timber wolf.

Doug Curran/Walt Disney Pictures
Scott Bairstow

"White Fang 2," which was directed by Ken Olin, tells a story that makes little basic sense and in a language that is often ridiculously portentous and clichéd. The dialogue sounds all the more fatuous for being mouthed by actors who look as though they had just stepped out of a Ralph Lauren ad. Not only are the action sequences tepid, they have been edited with the seams glaringly in evidence.

The film's underlying message is also deeply silly. A helpless tribe faces starvation until a callow white teen-ager from San Francisco appears from the wilderness to save it. Aw, c'mon.

•

"White Fang 2: Myth of the White Wolf" is rated PG (Parental guidance suggested). It includes some mild violence.

1994 Ap 15, C23:1

Surviving the Game

Directed by Ernest Dickerson; written by Eric Bernt; director of photography, Bojan Bazelli; edited by Sam Pollard; production designer, Christiaan Wagener; produced by David Permut; released by New Line Cinema. Running time: 94 minutes. This film is rated R.

Jack Mason	Ice-T
Burns	Rutger Hauer
Cole	Charles S. Dutton
Hawkins	Gary Busey
Wolf Sr.	F. Murray Abraham
Griffin	John C. McGinley
Hank	Jeff Corey
Wolf Jr.	William McNamara

By JANET MASLIN

"Surviving the Game" is a maladroit, racially inflammatory action film in which a homeless man named Jack Mason (Ice-T) is recruited to become the prey of wealthy hunters. With the exception of Cole, played by Charles S. Dutton (the star of television's "Roc"), the hunters are white and grotesquely evil. To give the film an unwanted campy edge, they also happen to sound like Iron John on steroids. "Allow yourself to feel the purity of your primal essence!" a scary Gary Busey declares.

Although this latest variation on the story "The Most Dangerous Game" (the recent Jean-Claude Van Damme film "Hard Target" was another), is clearly intended for hard-core action audiences, it miscalculates. Viewers eager for the cinematic equivalent of red meat will not care to watch a talky, tame adventure story featuring F. Murray Abraham baying in the wilderness.

Mr. Abraham plays a character named Wolf Sr., who is introduced as "one of the most feared men on Wall Street" and has come hunting with his pretty-boy son Wolf Jr. (William McNamara, a serviceable Tom Cruise look-alike). One of the film's jollier moments finds sensitive Junior making himself the lone Wolf to protest the killing game. "You're too much like your mother!" Senior hisses in reply.

"Surviving the Game," the second film directed by the cinematographer Ernest Dickerson (best known for his fine work with Spike Lee), is a far cry from the grittier "Juice," which could count among its strong points a secure sense of place. This film is quite literally lost in the wilderness, with an intermittent, picturesque prettiness that doesn't suit the action at all. More damagingly, Mr. Dickerson does nothing to keep his cast from chewing up the mountain scenery.

The Dutch actor Rutger Hauer, who makes the film's most magnetic heavy, probably deserves credit for having perfected the accent of an authentic American redneck. Ice-T, whose specialty is the scowl-accompanied angry wisecrack, isn't helped by having to spend time feigning wordless reactions in the woods alone. Jeff Corey, who makes a brief appearance as Mason's homeless friend, is used to further the bogus idea that this film's antagonisms are not racial in origin.

John C. McGinley, as a hunter who recently lost a daughter, nicely counteracts that thought by telling Mason that the young woman was probably murdered by "someone like you." This is not one of those films that make the world a better place.

•

"Surviving the Game" is rated R (Under 17 requires accompanying parent or adult guardian). It includes less violence than might be expected, but more than enough to disturb young viewers. One especially graphic scene depicts a character with his legs blown off.

1994 Ap 16, 11:3

The Bergmans Are United in a Family Project

"Sunday's Children" was shown as part of the 1993 New Directors/New Films series. Following are excerpts from Vincent Canby's review, which appeared in The New York Times on April 3, 1993. The film opens today at the Film Forum, 209 West Houston Street, South Village.

"Sunday's Children," a new Swedish film, is a gorgeous, richly poignant memoir written by Ingmar Bergman but directed by his son Daniel as his first feature.

The film is smaller in scale than both "Fanny and Alexander" (1982), Mr. Bergman's fantastical epic about his maternal grandparents' family, and "The Best Intentions" (1992), which examines the troubled relationship of his parents just before his own birth in 1918. Bille August directed that film from Mr. Bergman's screenplay.

Although the master keeps saying he has retired from film making, you would hardly know it from the extraordinary films that continue to appear. "Sunday's Children" is so of a piece with "Fanny and Alexander" and "The Best Intentions" that comparisons are beside the point. It is a continuation of those films, not necessarily of their narratives, but of their concerns.

"Sunday's Children" is a novella alongside the two novelistic earlier films. It's really little more than a single anecdote, but an anecdote so full of mirrors, so magically placed,

that the film manages to reflect the future while also revealing new interpretations of the past. Not since "Wild Strawberries" has Mr. Bergman dealt with time in a way that is simultaneously quite so limpid and so mysterious.

•

The new film is set in the late 1920's in a serene Swedish countryside where the Bergman surrogate figure, Pu (Henrik Linnros), who appears to be about 9 or 10, is spending the summer with his family: Henrik, his father; Karin, his mother; his older brother, younger sister, aunts, uncles, cousins and family retainers. It's a big, gregarious household. People drop in unannounced. The servants sit at the family table to share the meals they prepare.

When first seen, the independent little boy is taking a shortcut through a birch forest to a village railroad station. The rest of the family travels by carriage. They are meeting his father, returning home after tending to his duties as pastor to the royal family.

Pu seems to idolize his father, who loves him in return. Yet as the summer progresses, there is increasing tension between them. Henrik (Thommy Berggren) isn't a naturally demonstrative man. He is in all ways correct, though a little chilly. All this vacation intimacy makes him feel cornered. Through the walls of the house at night, Pu hears muffled arguments between his parents.

It is midsummer and hot. Flies and mosquitoes come in such swarms that windows must be closed against breezes as well as insects. A pretty serving girl tells Pu about the Feast of the Transfiguration, Aug. 6, when it's possible to know the future. On this day Pu accompanies his father on one of his journeys to a distant parish.

The day is full of bewildering emotions. His father flies into a fury when Pu sits on the prow of the ferry, dangling his legs in the water. The boy comes upon an old woman laid out in her coffin. In the course of the day, the future is seen in brief, bold flashes. It is suddenly 1968, and the aging Pu is visiting his ancient, widowed father, who has lost his faith and become afraid of death. Henrik asks Pu's forgiveness.

•

Is the film jumping forward, or is the story of Pu's childhood summer the flashback from 1968? It makes no difference in the long, rigorous view of things that Mr. Bergman takes. These shifts in time force an abrupt reconsideration of everything that's gone before. They're also a spectacular coup de cinéma of a kind only Mr. Bergman could bring off.

On their way home, Pu and Henrik are caught in a great summer thunderstorm. The boy thinks the Day of Judgment is at hand. Father and son are drenched but liberated by the elements. They're almost giddy. Yet 1968 continues to impinge on Pu in ways to suggest that the son has been forever bent by his father's fraud. The exact nature of that fraud remains unclear, but its effect has been to make the adult Pu as merciless as any god his father ever believed in.

The relations of Henrik and Pu are so profoundly dark that "Sunday's Children" inevitably prompts speculation about the relations between Ingmar Bergman and Daniel. From the evidence of this film, the son would seem to be a gifted film maker, although having an Ingmar Bergman screenplay must be an enormous advantage. The screenplay dictates the manner of the film to such a degree that, for anyone who wasn't on the set during the production, it's impossible to be sure who did what or how.

1994 Ap 20, C20:1

Bad Girls

Directed by Jonathan Kaplan; screenplay by Ken Friedman and Yolande Finch, story by Albert S. Ruddy and Charles Finch; director of photography, Ralf Bode; edited by Jane Kurson; music by Jerry Goldsmith; production designer, Guy Barnes; released by 20th Century Fox. Running time: 97 minutes. This film is rated R.

Cody Zamora	Madeleine Stowe
Anita Crown	Mary Stuart Masterson
Eileen Spenser	Andie MacDowell
Lilly Laronette	Drew Barrymore
Kid Jarrett	James Russo
William Tucker	James LeGros
Josh McCoy	Dermot Mulroney
Frank Jarrett	Robert Loggia

By JANET MASLIN

"Bad Girls," a decorative western about female outlaws, has all the legitimacy of Cowpoke Barbie with a lot less entertainment value. Conceived most enthusiastically as a fashion statement, it busily works endless corsets, bloomers, chaps, gun belts and cute hats into an otherwise entirely uninvolving plot.

The only good news is the casting: Madeleine Stowe, Andie MacDowell, Mary Stuart Masterson and Drew Barrymore are the glamorous wranglers who play prostitutes — or "harlots," in the screenplay's quaint argot — on the run. When the film begins, they are all working in the same brothel. And they flee together when one is accused of murder. Once they're home on the range, they hatch a plan to run away to Oregon and manage a sawmill. Here's a line you won't soon forget: "We sold our bodies; why can't we sell some wood?"

Speaking of selling wood, Jonathan Kaplan directs "Bad Girls" in a surprisingly stilted manner, without the slightest feel for the western genre in either its traditional or neo-feminist forms. The film feels stiff and looks awkward, despite Mr. Kaplan's usually serious, accomplished way of telling a story.

Actually, "Bad Girls" seems to have less to do with Mr. Kaplan's best recent films, like "The Accused" and "Unlawful Entry" and "Love Field," than with his much earlier "Student Teachers" and "Night Call Nurses." Only when this film strains to incorporate feminist posturing into old western formulas does Mr. Kaplan's earnest touch really show.

•

Along those lines, it is explained that the film's heroines have become prostitutes only because of extenuating circumstances: one lost her husband, another's father went broke, etc. ("At least I never let another man kiss me," the widow-turned-harlot says.) These foxily liberated women also swig whisky, shoot guns and wield knives with gender-bending abandon.

Ms. Stowe, who gives the film's most interesting performance, has always had a deep-voiced toughness that plays intriguingly against her delicate beauty, and she turns that grit to good advantage here. As the leader of the group, and the one who's quickest on the trigger, she comes close to giving the story some sense of purpose. On the other hand, she's the one who shows great bravado in

20th Century Fox

Mary Stuart Masterson

one scene only to be caught by a whip-wielding villain, then rescued and nursed back to health by a male helpmate. Presenting Ms. Stowe's character as both gunslinger and damsel in distress is the film's idea of having it all.

The other actresses play less coherent roles, since most of their scenes seem constructed as isolated gambits. Ms. MacDowell and Ms. Barrymore do a good deal of flirting and flouncing, in scenes that suggest there must have been more curling irons out on the prairie than anyone ever knew. Ms. Masterson, a smart, steely actress who ought to be right at home in these western surroundings, is given surprisingly little to do. The screenplay also incorporates assorted boyfriend and outlaw types, including Dermot Mulroney, James Russo, the appealingly bashful James LeGros and a grizzled Robert Loggia. The men are photographed in glamorous close-up almost as often as the women are.

It wasn't possible to make this crew look bad, but the rusty sepia tones of Ralf Bode's cinematography are no beauty aid. Even less helpful is the soundtrack, featuring Jerry Goldsmith's thunderously trite western score. Happily, there isn't a theme song or a detachable rock video. This film's fetchingly costumed heroines are window dressing enough.

•

"Bad Girls" is rated R (Under 17 requires accompanying parent or adult guardian). It includes mild profanity, brief nudity, suggestions of rape, frequent references to prostitution and violence.

1994 Ap 22, C8:5

The Inkwell

Directed by Matty Rich; written by Paris Qualles; cinematographer, John L. Demps Jr.; edited by Quinnie Martin Jr.; music by Terence Blanchard; production designer, Lester Cohen; produced by Irving Azoff and Guy Riedel; released by Buena Vista Pictures. Running time: 112 minutes. This film is rated R.

Drew Tate	Larenz Tate
Kenny Tate	Joe Morton
Brenda Tate	Suzzanne Douglas
Spencer Phillips	Glynn Turman
Francis Phillips	Vanessa Bell Calloway
Heather Lee	Adrienne-Joi Johnson
Harold Lee	Morris Chestnut
Lauren Kelly	Jada Pinkett

By STEPHEN HOLDEN

If you crossed the 1970's sitcom "Good Times" with "Dirty Dancing" and threw in a vintage beach-party movie, you might end up with a film like "The Inkwell," a serious comedy that frantically dashes about in an elusive search for coherence. A rowdy farce one minute, a political tract the next, the movie eventually turns into an improbable coming-of-age drama that strains for a poignancy it never begins to evoke.

The movie is the second feature by the young director Matty Rich, who made such a promising debut with his grim semi-autobiographical film "Straight Out of Brooklyn." It looks like a classic case of a talented young director bamboozled by the exigencies of Hollywood commercialism along with his own inexperience.

Set in the summer of 1976, the movie follows the adventures of Drew Tate (Larenz Tate), a shy 16-year-old youth from upstate New York, when he and his family spend two weeks with well-to-do relatives on Martha's Vineyard. Drew's parents, Kenny (Joe Morton) and Brenda (Suzzanne Douglas), worry that their son is emotionally disturbed. His favorite companion is a doll with which he engages in animated one-sided conversations. They also fear that a fire he accidentally set in the family garage foreshadows a future as an arsonist.

On Martha's Vineyard, Drew is thrown into an affluent, party-loving black society that congregates on a beach known as the Inkwell. The visit is also the occasion of some bitter family strife. Drew's Aunt Francis (Vanessa Bell Calloway) and her husband, Spencer (Glynn Turman), are conservatives whose walls are plastered with pictures of Republican dignitaries. In the movie's sharpest scenes, Kenny, a former Black Panther, and Spencer argue furiously about racial issues. The movie clearly despises Spencer, who wears expensive preppie clothes, smokes with a cigarette holder, and dismisses Malcolm X and his followers as "Harlem hoodlums."

"The Inkwell" devotes too much of its energy to Drew's bumbling pursuit of the insufferably snooty Lauren (Jada Pinkett), a teen-ager whose personality seems to change with each scene. He also befriends Heather (Adrienne-Joi Johnson), an attractive young woman whose husband, Harold (Morris Chestnut), is a faithless louse. The movie's simmering little dramas all come to a head on the Fourth of July, when the Bicentennial fireworks end up symbolizing a lot more than America's 200th birthday.

As if trying to force his movie's disparate generic ingredients to jell through sheer emotionalism, Mr. Rich has directed the cast to overact with an intensity that often borders on the hysterical. Had he demonstrated a knack for comic timing, the stridency might have paid off in laughs. But Mr. Rich seems to have had trouble setting up the basic mechanics of many scenes. He is not helped by a screenplay that has the stiff, fractured tone of a substandard television comedy or by Mr. Tate's nervous, too-smiley performance.

Even when its being aggressively zany, "The Inkwell" generates very little fun because it is so busy shouting its frustrations.

•

The movie is rated R (Under 17 requires accompanying parent or adult guardian). It includes strong language and sexual situations.

1994 Ap 22, C8:5

Brainscan

Directed by John Flynn; screenplay by Andrew Kevin Walker, story by Brian Owens; director of photography, François Protat; edited by Jay Cassidy; music by George S. Clinton; production designer, Paola Ridolfi; produced by Michel Roy; released by Triumph Releasing. Running time: 96 minutes. This film is rated R.

Michael	Edward Furlong
Detective Hayden	Frank Langella
The Trickster	T. Ryder Smith
Kimberly	Amy Hargreaves
Kyle	Jamie Marsh
Martin	Victor Ertmanis

By JANET MASLIN

"Brainscan" makes a case for the long, hearty camping trip as it tells what happens to 16-year-old Michael (Edward Furlong), a boy who clearly spends too much time indoors. The décor of Michael's room involves a toy noose hanging from the ceiling, horror and heavy-metal artifacts, abundant audio, video and computer equipment and a special chair in which Michael can sit when he feels like having his senses blasted by any of the above.

The film is about what happens when Michael tries out "the ultimate experience in interactive terror," and tests the limits of technohorror as a spectator sport. Goaded by an equally horror-crazed friend (Jamie Marsh), he decides to try the video game of the title. And he expects nothing life-altering when the Brainscan CD-ROM arrives in the mail. But the game lures Michael into committing what may or may not be real acts of murderous violence. It also makes him the plaything of the Trickster (T. Ryder Smith), a smirking, foppish villain whose manner suggests an aging rock star on a very bad day.

The Trickster springs out of Michael's television set to ask what are meant to be burning questions ("Real, unreal, what's the difference, so long as you don't get caught?"). But "Brainscan" is less interested in probing the moral implications of Michael's descent into high-tech hell than in exploiting them in its own high-tech way. John Flynn's film is more disturbing as a compendium of angry, isolating teen-age tastes than as the cautionary tale of a boy who plays with fire.

•

Here is what the audience sees during Michael's first Brainscan adventure: the camera finding its way into a stranger's house and pausing in the kitchen, where Michael's hand selects a butcher knife. A trip into the bedroom, where the stranger is sleeping. A slaughter scene, culminating in the mutilation of the stranger. And later, when Michael is no longer playing the game, his dismay at discovering unexplained body parts in his refrigerator. Frank Langella has the insinuating role of a police detective who just knows that Michael has been up to no good.

With its trance-inducing special effects to simulate Brainscan, and with some messy but energetic morphing when Michael finally does battle with the Trickster, "Brainscan" does approach the mind-glazing effects of an overlong video game. Mr. Furlong, who became a founding father of this film's video-fun house mentality when he co-starred in "Terminator 2," is wrenchingly real as the kind of lonely boy who uses his video camera to spy on the girl next door.

And Mr. Smith brings nasty gusto to the Trickster, a colorful villain despite the fact that his is a distinctly limited appeal. The Trickster is the sort of apparition who breaks his own fingers to test someone else's ideas of illusion and reality. A little of that goes a long way. Still, when last seen, the Trickster is ready to make more mischief. He may just be in a position to kick off "Brainscan 2."

•

"Brainscan" is rated R (Under 17 requires accompanying parent or adult guardian). It includes partial nudity, profanity and graphic, gory violence.

1994 Ap 22, C12:6

Chasers

Directed by Dennis Hopper; written by Joe Batteer, John Rice and Dan Gilroy; director of photography, Ueli Steiger; edited by Christian A. Wagner; music by Dwight Yoakam and Pete Anderson; production designer, Robert Pearson; produced by James G. Robinson; released by Warner Brothers. Running time: 112 minutes. This film is rated R.

Rock Reilly	Tom Berenger
Eddie Devane	William McNamara
Toni Johnson	Erika Eleniak
Howard Finster	Crispin Glover
Stig	Dean Stockwell
Sgt. Vince Banger	Gary Busey
Master Chief Bogg	Seymour Cassell
Duane	Federic Forrest
Katie	Marilu Henner
Doggie	Dennis Hopper

By JANET MASLIN

As a director, Dennis Hopper can be counted on to fill the sidelines of a film with amusing wild-card diversions, even if he has more trouble holding together a central plot. In the amiable, loose-knit "Chaser," which opened yesterday at local theaters, all the fun is in the digressions. The film's ragtag South Carolina setting yields plenty of local color, which is just right for a director who enjoys staging a fight scene on a miniature golf course. By the time this happens, late in "Chaser," audiences will long since have lost track of the film's barely believable story line.

"Chaser" is a mega-macho road movie about two Navy men assigned to escort a maximum-security prisoner. One of the escorts is brash, conniving Eddie Devane (William McNamara), who is rounded up for special duty on the eve of his discharge from the service. The other is gruff Rock Reilly (Tom Berenger), who can say "Ha-ha-ha" about as sourly as anyone ever has on screen.

These two soon discover that the dangerous criminal they are escorting is actually quite the model prisoner. She is Toni Johnson (Erika Eleniak), who looks just like a centerfold and has miraculously developed a perfect all-over tan while in jail. The film's real purpose is simply to get these three characters into close quarters. Although some energy is spent on establishing Toni's cleverness about staging escape attempts, the film's idea of feminine wiles is having her sabotage a van by stuffing Tampax into its gas tank. The men aren't a whole lot smarter.

But Mr. Berenger, grousing steadily, and Mr. McNamara, in a boyish Ricky Nelson mode, are likably matched. Ms. Eleniak, who also made a playful and picturesque Elly May Clampett in "The Beverly Hillbillies," succeeds here in rising above the cheesecake level. The women in this film tend to be hookerish (Marilu Henner also appears as a very available waitress), while the men trade endless colorful insults. Mr. Hopper thoughtfully gives himself this story's King Pervert role, as an underwear salesman who barks like a dog and picks up Ms. Eleniak in his Cadillac convertible. No one familiar with Mr. Hopper's oeuvre will be surprised to see an inflatable party doll come out of the Cadillac's trunk.

Also in "Chaser" are Frederic Forrest as a truck driver who seems to have a carrot tattooed near his ear, Dean Stockwell as a golf-playing Porsche salesman, Crispin Glover as Eddie's partner in crime, Gary Busey as a sneering marine who can't contain his mockery of the Navy, and Seymour Cassel as the kind of officer whose idea of naval activity is building a ship in a bottle. These characters aren't really connected, but Mr. Hopper's imprint is strong enough to turn them all into kindred spirits.

•

"Chaser" is rated R (Under 17 requires accompanying parent or adult guardian). It includes considerable profanity, one sexual episode and nudity.

1994 Ap 23, 15:1

Linda R. Chen/Warner Brothers

William McNamara, left, and Tom Berenger in "Chasers."

You So Crazy

Directed by Thomas Schlamme; director of photography, Arthur Albert; edited by Stephen Semel and John Neal; production designer, Richard Hoover; produced by Martin Lawrence; released by the Samuel Goldwyn Company. Running time: 89 minutes. This film has no rating.

With: Martin Lawrence

By CARYN JAMES

"Martin Lawrence: You So Crazy" is a film for people who think Beavis and Butt-head are genteel wimps. The stand-up comedy in this concert film is raunchy, sexually graphic, intermittently funny and, because of a ratings skirmish, already semi-notorious. When the film was given an NC-17 rating, it was dropped by its distributor, Miramax. It is now being released without a rating by the Samuel Goldwyn Company.

But Mr. Lawrence has higher ambitions than to throw street language and sexual gestures at mainstream audiences. In "You So Crazy," he creates a blunt comedy of hip-hop manners, and politeness has nothing to do with it. He paces around the stage, slipping easily and impressively in and out of many voices, accents, walks and faces. He imitates Hispanic people commiserating with blacks about the treatment of Rodney King ("The way they beat Rodney Dangerfield was bad"). He plays both parts in a conversation between a man and a woman trapped, through every fault of their own, in a bad relationship. And in his half-minute version of "Driving Miss Daisy," he kicks old Daisy out of the car. That's the demure part.

He also uses language so strong that few sentences can be quoted whole. For much of the film Mr. Lawrence acts like Beavis and Butt-head's older neighbor, a guy who actually has sex instead of just thinking about it all the time, but who hasn't outgrown his need to snicker.

His characteristic routine might be called the big sniff. He suggests how a

Miramax

Martin Lawrence performing in his one-man concert film "Martin Lawrence: You So Crazy."

man might defend himself against prison rape; it involves a profound lack of bathroom hygiene. A bit about women's bodily scents has him with his finger to his nose, sniffing. He will offend many people, but it's a safe bet those people are not part of Martin Lawrence's built-in audience.

•

That largely teen-age audience knows him as the star of the tame Fox sitcom "Martin," and the host of HBO's raucous "Def Comedy Jam." And he may be best known to mainstream audiences as the host who outraged viewers on "Saturday Night Live" with a tamer variation of the feminine lack-of-hygiene routine in "You So Crazy." Mr. Lawrence certainly misjudged the standards of network television that night, but in "You So Crazy" he is trying to outrun the mainstream, not appease it.

Though his stories come from black experience, the real dividing line is age, not race. "You So Crazy"

was filmed at the Brooklyn Academy of Music in front of a crowd (not seen in close-up) that looks about college age, the right group to appreciate his humor. Anyone older than Mr. Lawrence, who is 28, is likely to find him tiresome. His stories, after all, are about going to clubs, hanging out with friends or casually masturbating while watching old sitcoms. Even an appeciative audience is likely to find that these stories go on too long.

It may be that Mr. Lawrence is a better comic actor than comedy writer. Another good omen for his future is that despite its rawness, there is nothing mean-spirited about his act. That quality sets him apart from a has-been like Andrew Dice Clay and from the misogyny of much gangster rap. Though women are seen as sexual objects (except for Mr. Lawrence's hard-working mother), men are seen as people who let their genitals do the thinking, when they think at all. "You So Crazy" depicts equal-gender idiocy.

1994 Ap 27, C18:1

When a Man Loves a Woman

Directed by Luis Mandoki; written by Ronald Bass and Al Franken; director of photography, Lajos Koltai; edited by Garth Craven; music by Zbigniew Preisner; production designer, Stuart Wurtzel; produced by Jordan Kerner; released by Touchstone Pictures. At

Cinema 1, Third Avenue at 60th Street, Manhattan. Running time: 126 minutes. This film is rated R.

Michael Green	Andy Garcia
Alice Green	Meg Ryan
Emily	Ellen Burstyn
Amy	Lauren Tom
Jess Green	Tina Majorino
Casey Green	Mae Whitman

By JANET MASLIN

IN "When a Man Loves a Woman," Alice Green (Meg Ryan) makes a terrible confession. She tells of having been out doing errands, driving drunk and arriving home to realize she had mislaid her baby daughter along the way. So intoxicated that she couldn't even remember where she'd been, Alice had to depend on luck to locate her child, but that kind of luck doesn't last forever. "When a Man Loves a Woman" means to provide a sobering look at what happens to Alice when her luck runs out.

As such, this film is well situated to explore the 12-stepping of American culture, a topic that so dominates best-seller lists and daytime talk shows that it ought to be a natural on screen. Clearly, there's a great wave of interest in addictive behavior, co-dependency, substance abuse, enabling and all the related buzzwords that can be used to describe this story. But discussing these matters is very different from dramatizing them, as this film makes all too clear. The Hollywood esthetic, with its intrinsic prettiness, overwhelms the painful, unglamorous realities that this cautionary tale is supposed to be about.

The film's ambitious screenplay, by Ronald Bass and Al Franken, says one set of things about Alice Green, her husband, Michael (Andy Garcia), and their troubled family; its tidy visual appearance says another. Even the casting of two such handsome, controlled-looking actors works against the idea that they have a problem. So the film starts out by overcompensating wildly, with Alice getting so drunk in an early scene that she pelts the family car with eggs and then playfully rolls around in this mess. The next day, at work as a high school guidance counselor, Alice is mildly cranky but not otherwise impaired.

If the realities of addictive behavior are not usually so picturesque, neither are they this easy to describe. But in relying on broad strokes to establish that Alice is approaching a crisis, the film elects to leave reality far behind. In quick succession, Alice

parties so hard she tumbles out of a rowboat, drinks from a vodka bottle in a garbage can, forgets to mind the children when her husband has to leave town and gets so drunk that she falls through the plate glass of a shower door. Somehow, in spite of all this, Ms. Ryan maintains that impossible zippiness and continues to look just fine.

•

Glossy treatment of serious problems is nothing new in movies, but it's a particular shame this time: this film clearly intends something more. The screenplay, while choppy and overly cute in places, tries to explain honestly what Alice's drinking has done to shape her marriage to Michael. "I know we have pressures, and we need to have fun," he says early in the story, "but wringing you out at the end of an evening is less fun than it used to be."

Michael is the one who picks up the pieces, enjoys feeling competent and appreciates Alice's sexual abandon when she gets high. He's also the one left bewildered once Alice gets help, becomes sober and doesn't feel like such a party girl anymore. "When a Man Loves a Woman" has much more to say about how alcoholism affects the drinker's partner than it does about being an alcoholic. That particular subject is so rarely addressed on film that it's compelling even when sugarcoated.

"Clean and Sober," still the best recent film about drug or alcohol abuse, managed to avoid obvious excesses by starting out on the day the addict decided to change his life and noting the hard-won little steps of his progress. The much less subtle "When a Man Loves a Woman" wants the whole roller-coaster ride, but it can't sustain believable ups and downs. Mr. Garcia, an enormously likable actor who seldom finds roles that really suit him, does much better with the nice-guy side of Michael than with the shrill outbursts, which come out of nowhere. The film shows him coping patiently with his wife's excesses, then suddenly has him let the household go to pieces in a single overheated scene.

•

If there's anything that public discourse about alcoholism has underscored, it's that recovery is not a matter of flipping a switch. But Ms. Ryan's Alice gets better in record time, remains fetching in the process and is soon inspiring warm comments from fellow Alcoholics Anonymous members like the remark to

Michael that "your wife's a very comforting person." It would have been helpful to find a little less comfort and a little more grit, but this film does cling to its perkiness. As directed by Luis Mandoki, whose sturdy "Gaby — A True Story" was followed by the fiascos "White Palace" and "Born Yesterday," it touches all the obligatory bases. But it's neither real enough to capture an ordinary day in Alice's life nor tough enough to be a film in which anyone could lose a baby on a shopping trip.

"When a Man Loves a Woman," which opens today at Cinema 1, also features Ellen Burstyn in a too-brief appearance as Ms. Ryan's mother and Lauren Tom, of "The Joy Luck Club," as a nanny who is essential to the Green family but less necessary to the movie. Among its other tacked-on touches are a prologue in which the principals meet cute while Alice happens to be having a beer for lunch. Then there's the title song, an old hit that has no overriding relevance here, except for its marketing value.

The soundtrack also includes a cover version of Van Morrison's "Crazy Love," which would have provided no less arbitrary a title. Also heard in the background are two suddenly gorgeous recent songs by Rickie Lee Jones, who can sound with equal ease like a lost soul or an indestructible survivor. Ms. Jones is the perfect muse for this story.

"When a Man Loves a Woman" is rated R (Under 17 requires accompanying parent or adult guardian). It includes nudity and profanity.

1994 Ap 29, C1:1

P.C.U.

Directed by Hart Bochner; written by Adam Leff and Zak Penn; director of photography, Reynaldo Villalobos; edited by Nicholas C. Smith; music by Steve Vai; production designer, Steven Jordan; produced by Paul Schiff; released by 20th Century Fox. Running time: 81 minutes. This film is rated PG-13.

Droz	Jeremy Piven
Tom Lawrence	Chris Young
Rand McPherson	David Spade
President Garcia-Thompson	Jessica Walter
Katy	Megan Ward
Gutter	Jon Favreau
Mullaney	Alex Désert

Peter Sorel/Touchstone Pictures

Couple in trouble: Meg Ryan as an alcoholic and Andy Garcia as her husband.

By JANET MASLIN

Politically correct thinking is the target of choice for satirists these days, and for good reason. "Please note," writes James Finn Garner, after retelling the story of the Three Little Pigs in a slender new book called "Politically Correct Bedtime Stories": "The wolf in this story was a metaphorical construct. No actual wolves were harmed in the writing of the story."

As for the wolf in Little Red Riding Hood: "He burst into the house and ate Grandma, an entirely valid course of action for a carnivore such as himself. Then, unhampered by rigid, traditionalist notions of what was masculine or feminine, he put on Grandma's nightclothes and crawled into bed."

No wonder some of us were secretly looking forward to "P.C.U.," a film well situated to skewer its subject once and for all. But "P.C.U." turns out to be a surprisingly lame and unfocused campus comedy, one that pays remarkably little attention to its own comic possibilities. Lazily staged in neo-"Animal House" fashion, it rarely concentrates on the cultural clashes that ought to give it some spark. And when it does, it manages to be ham-handed enough to generate sympathy for the politically correct caricatures it wants to malign.

"P.C.U." centers on a co-ed band of slackers, led by the fast-talking Droz (Jeremy Piven, who recalls the fast-talking young Richard Dreyfuss), who do their utmost to disrupt various self-righteous protest groups on campus. What this amounts to, in practice, is throwing meatballs at vegetarians and suggesting that militant feminists are secretly looking for a good time. Aside from not being especially funny, this line of thinking isn't even allowed to take center stage, since the film also dwells on stoned hippie types who play Frisbee wearing tie-dyed long johns. Somebody here seemed to think anything about hippie nostalgia was bound to be amusing, even an inexplicable guest appearance by George Clinton and Parliament-Funkadelic, who provide a most peculiar blast from the past.

Also on hand is David Spade, the "Saturday Night Live" cast member whose specialty is extreme smugness, in the role of an anti-Semitic Reaganite preppy type who wants to

Rob McEwan/Twentieth Century Fox
Jeremy Piven

regain control of campus culture. Jessica Walter plays the college president, who is so obnoxiously condescended to by Mr. Spade that you may just sympathize with her plan to replace the school mascot with an endangered species, the whooping crane. The film, directed somewhat awkwardly by Hart Bochner, even hauls out an actual whooping crane, but then has no idea what to do with it. The idea is funnier than the bird itself, and when you've seen one whooping crane, you've seen them all.

"P.C.U." was written by Adam Leff and Zak Penn, who dreamed up the initial, pre-rewrite version of "The Last Action Hero" and whose movie-minded sensibility provides some of this screenplay's workable jokes. One of its groggier characters is permanently glued to his television set, trying to prove that either Michael Caine or Gene Hackman is in every film ever made. It might have helped if either of them had been in this one.

•

"P.C.U." is rated PG-13 (Parents strongly cautioned). It includes profanity.

1994 Ap 29, C6:3

High Lonesome
The Story of Bluegrass Music

Written and directed by Rachel Liebling; cinematographer, Buddy Squires; editor, Toby Shimin; producer, Andrew Serwer; released by Tara releasing. At Angelika 57, 57th Street between Broadway and Seventh Avenue. Running time: 95 minutes. This film has no rating.

WITH: Bill Monroe, Ralph Stanley, Mac Wiseman, Jimmy Martin, Earl Scruggs.

By JANET MASLIN

"High Lonesome: The Story of Bluegrass Music" is one of those enthralling documentaries that draw their heretofore-unexplored subject matter with supreme ease. You need not have the slightest interest in bluegrass music to find this film a fascinating bit of Americana, a patchwork of historical, moral and cultural influences that conspired in creating an unusually pure American folk tradition.

Rachel Liebling, who makes this an exceptionally enterprising musical portrait, communicates vast, toe-tapping enthusiasm for her material. She also displays prodigious research, as well as a deep understanding of the forces that conspired to create bluegrass.

The central focus of her film, which opens today at the Angelika 57, is the famous Bill Monroe ("the story of bluegrass is the story of his musical legacy"), and if ever there lived a more gentlemanly American musician it would be hard to name him. When Mr. Monroe says modestly that he thinks of his audience as "people who get up in the morning and make a lot of biscuits," he offers some idea of why this music has sustained its simple beauty.

Interspersing a wonderful array of musical excerpts with flickery archival images of country life — baptisms, bareback horses, a little boy dancing a jig for his attentive family — Ms. Liebling deftly traces bluegrass and its history. It pretty much began with Mr. Monroe, who remembers that his mother still found time to play the fiddle while caring for eight children, and who is seen here pensively visiting his dilapidated

Charles A. Meyer/Northside Films
Bill Monroe

childhood home in Kentucky. "Some called it folk music with overdrive," says the narrator, while the film's images recall the Appalachia of Walker Evans and James Agee. But if the images that Ms. Liebling has found are less studied and mournful, maybe bluegrass itself is a factor. Even when dealing with sad subjects, this is music to make the spirit soar.

"High Lonesome" documents many different influences that shaped bluegrass, including that of black laborers who arrived in Appalachia when the railroad came, and who introduced the banjo, which had once been an African instrument; it also traces the music back to its Scottish-Irish origins. Later on, Ms. Liebling mentions the influence of mass culture in explaining the pressures that bluegrass has had to withstand, not least of them the onset of Elvis Presley, who brought a new glitter to what had once been hillbilly music. Two bluegrass-loving elderly farmers in overalls stand in their field, leaning on shovels, to discuss Elvis and other matters. "His doin's was foolish to me," one says.

Unlike tales in which folk traditions are destroyed by so-called progress, this is not a sad story. Ms. Liebling presents bluegrass as alive and well, thanks in large part to its improbable popularity with hippie audiences in the late 1960's and early 70's. Her film's many musical interludes, featuring performers like Ralph Stanley, Earl Scruggs, Mac Wiseman and of course Mr. Monroe and his Bluegrass Boys, capture the haunting beauty of the music, as well as some of its wildcard moments. Seen at one outdoor concert is an Asian bluegrass band in bell-bottoms, which only goes to prove that the tradition is thriving.

Now 82 and a fine interview subject, the courtly Mr. Monroe accounts for no small degree of this music's durability. As the film explains, he has been at this for so long that at least 65 different fiddle players have worked for him. And as the other musicians explain, Mr. Monroe's mixture of shyness, soulfulness and "a solemn performance style that defied the hayseed stereotype" have been an inspiration to them all. And they have been constant. "You see, if I'd a changed," Mr. Monroe says succinctly, "the people wouldn't have liked that a-tall."

1994 Ap 29, C8:5

The Favor

Directed by Donald Petrie; written by Sara Parriott and Josann McGibbon; director of photography, Tim Suhrstedt; edited by Harry Keramidas; music by Steve Tyrell; production designer, David Chapman; produced by Lauren Shuler-Donner; released by Orion Pictures. Running time: 97 minutes. This film is rated R.

Kathy	Harley Jane Kozak
Emily	Elizabeth McGovern
Peter	Bill Pullman
Elliott	Brad Pitt
Joe Dubin	Larry Miller
Tom Andrews	Ken Wahl

By JANET MASLIN

Sex comedy usually has a masculine outlook, but "The Favor" has a sneakily feminine sense of humor. Consider its opening sequence, in which Kathy Whiting (Harley Jane Kozak) sashays brazenly in a tight red outfit, then wordlessly seduces a hunky young football player. Cut to reality: Kathy is jolted awake to face her two small daughters and her husband of 10 years, a mathematician named Peter (Bill Pullman). Peter is sweet, and he has the amusing habit of playing blues harmonica while working on equations, but that doesn't keep Kathy from dreaming.

When a man in a movie fantasizes about Bo Derek, the movie tends to be a lot more guilt-free than "The Favor." Sure, Kathy is obsessed by memories of Tom (Ken Wahl), her football-playing high school boyfriend. But she feels pretty bad about imagining she could run off with him if her husband had a fatal accident in church. (On the Sunday when she cooks up that thought, the subject of the sermon is "God Knows All Our Dreams.") So perky and clean-cut that she even sees herself as Donna Reed in one fantasy sequence, she's much too timid to act out her rogue thoughts. So adultery by proxy becomes her only option.

Kathy dispatches her best friend, Emily (Elizabeth McGovern), who is single, to find Tom and "complete the mission." "The Favor" spends a lot of time exploring the friendship between Kathy and Emily, which is sorely tested after Emily really does meet Tom for a one-night stand. Kathy has enough trouble accepting this without facing the fact that it happened on the butcher block in Tom's kitchen. In her worst daydreams, she imagines her friend and her old beau together, with Tom barely remembering Kathy, and Emily saying rotten things like "Well, her hips have really spread since she had the children."

"The Favor," another casualty of Orion Pictures' fiscal troubles, has been on the shelf so long that Kathy's long-awaited high-school reunion is set to take place in 1990. It's so dusty that Brad Pitt, as the cute, beret-wearing artist who's also having an affair with Emily, looks very boyish and gets minor billing. But this film hasn't aged badly, and its daring heroines make it a welcome novelty. Women don't often get the chance to display such genuine friendliness or independence on screen.

"The Favor" was directed by Donald Petrie ("Grumpy Old Men"), who displayed a similar flair for down-to-earth female camaraderie with "Mystic Pizza." Its screenplay is by Sara Parriott and Josann McGibbon, and it's a big improvement over their other efforts, like the bland "Three Men and a Little Lady" and the smugly sexist "Worth Winning." Until its final scenes degenerate into dizzy bedroom farce, "The Favor" remains funny and credible in ways that prove feminist comedy is not an oxymoron.

This time, apparently working from semi-autobiographical experience, these friends have some fun with the disparity between married life and independence. And they capture the dynamics of the story's central friendship with appealing ease. "Why don't they just call it a ring?" Kathy asks, eyeing the pregnancy test that Emily has taken, which is supposed to display a shape called a

For a Friend
In "The Favor," Elizabeth McGovern and Brad Pitt play a couple whose troubles begin after a class reunion, when her best friend (played by Harley Jane Kozak) asks her to get close to another man.

Lore, ...bastian/Orion Pictures

doughnut if the result is positive. "I guess it's a potentially sensitive subject for some of us," Emily answers drily.

•

Among this film's more unusual minor touches is a subplot in which Kathy's husband, played with funny nonchalance by Mr. Pullman, is goaded into sexual jealousy by an obnoxious colleague (Larry Miller). It's unusual to find two middle-aged male characters feeling frankly threatened by someone as young and confident as Mr. Pitt.

It's equally unusual to find a housewife and mother eyeing Mr. Pitt's character and musing, "If you're going to have a hot fling, you might as well have one with somebody who looks like that." "The Favor" would sound a lot more lecherous if its sex roles were reversed, but they aren't. Ms. Kozak and Ms. McGovern, refreshing and funny, deliver this sort of blithe dialogue without anything resembling a leer.

•

"The Favor" is rated R (Under 17 requires accompanying parent or adult guardian). It includes sexual situations and profanity.

1994 Ap 29, C8:5

With Honors

Directed by Alek Keshishian; written by William Mastrosimone; director of photography, Sven Nykvist; edited by Michael R. Miller ; music by Patrick Leonard; production designer, Barbara Ling; produced by Paula Weinstein and Amy Robinson; released by Warner Brothers. Running time: 103 minutes. This film is rated PG-13.

Simon	Joe Pesci
Monty	Brendan Fraser
Courtney	Moira Kelly
Everett	Patrick Dempsey
Jeff	Josh Hamilton
Pitkannan	Gore Vidal

By CARYN JAMES

The concept of "With Honors" shouts cliché: a group of Harvard students befriends a homeless man and learns there is more to life than grades. Any knowing moviegoer will cringe at the thought of those insufferable rich kids adopting a man — bound to be smart, spunky and down on his luck — as if he were a pet. Surprisingly, the film is far more engaging than it sounds. The well-meaning plot about homelessness

turns out to be the insufferable part, but the appealing actors who play the four roommates give the film a casual charm.

The director, Alek Keshishian, went to Harvard and has a powerful feeling for the comfortable, insular, anxious lives of its students. This may be the first movie set at Harvard that actually likes the place ("Love Story" thought it was snobbish and "The Paper Chase" resented it), and that attitude almost saves "With Honors" from its mawkish, manipulative story.

The hero is a serious student of government named Monty, played by Brendan Fraser. With his preppy good looks and shy, sincere manner, Mr. Fraser earns his reputation as Hollywood's latest hunk. Monty is secretly in love with his housemate, Courtney (Moira Kelly), who pretends to be one of the guys and, on her way out for the night, casually borrows condoms from a third roommate, Everett (Patrick Dempsey).

Everett is the kind of guy who has cultivated an ironic, florid manner ("Lord Montague," he says in greeting Monty) that somehow works for him. The fourth roommate, Jeff (Josh Hamilton), is functional. He exists to be angry whenever the homeless man turns up.

It's apparent that everyone involved in the film is more comfortable dealing with Harvard than with homelessness because the most visceral, traumatic moment takes place when Monty's computer screen flashes "Hard drive failure." His thesis has vanished, and as he carries his only printout to a copy shop, it falls through a sidewalk grate. Simon, the man who lives in the basement of the library, recovers it and sells Monty a page at a time in exchange for food, shelter, a bath. (Try not to think of Harvey Keitel selling Holly Hunter piano keys.)

As Simon, Joe Pesci can't do much with a role written as a caricature. The dirt on his face is a smudge of movie makeup. Any line of his dialogue might cause groaning. "I'm a bum, but I'm a Harvard bum," he says. He refers to Monty as "Harvard," the way Ali MacGraw called Ryan O'Neal "Preppie." What was he doing in the library? "Well, I was reading 'Germinal' by Zola until I was so rudely interrupted." Homeless people can obviously be well educated and erudite. But no one — homeless or housed, educated or not — talks that way outside of movies.

The film also tries too hard to make Simon zany, especially when he takes a bubble bath while wearing a Viking helmet and singing "The Battle Hymn of the Republic." From the start, viewers are primed to see him as the wise, lovable father figure he predictably becomes. If Simon had been more believable, the transformation of the students might have meant something.

Yet Mr. Fraser makes Monty's affection for Simon believable, even if Simon is not. In a small role, Gore Vidal is absolutely on target as Monty's priggish mentor. And Mr. Keshishian, whose previous film was the Madonna documentary "Truth or Dare," proves that he knows how to make a commercial feature. "With Honors" is a half-baked movie, but half-baked is better than not baked at all

•

"With Honors is rated PG-13 (Parents strongly cautioned). It includes brief glimpses of partial nudity.

1994 Ap 29, C12:1

Critic's Choice

Skewing Italy's Scandals

Margarethe von Trotta's gripping political thriller "The Long Silence" takes the recent corruption scandals in Italy and skews history just enough to suggest a sinister criminal design behind it all. The film, which has the first of two screenings tonight at 9 at the Loews Village Theater VII as part of the fifth Human Rights Watch International Festival, is set in Rome in the immediate future.

Marco Canova (Jacques Perrin), a judge investigating an arms-running and bribery scandal, and his wife, Carla (Carla Gravina), a successful gynecologist, live in terror for their lives at the hands of the syndicate he is investigating. Carla's nightmares come true when her husband's plane is blown up and she has to decide how to dispose of her husband's papers.

This straightforward, suspenseful film follows Carla's attempts to carry on Marco's work by rallying the frightened widows of other murdered judges. The film, which has a strong feminist subtext, is a cry for justice and freedom of expression. In a festival that seeks to expose human-rights abuses around the world, "The Long Silence" also wakes us up to the preciousness and fragility of liberties we may take for granted.

The same message is expressed with equal force in Raoul Peck's "Man by the Shore," which has the first of two festival screenings tonight at 6:30. The movie looks back 30 years to the political oppression in Haiti during the dictatorship of François (Papa Doc) Duvalier. Events are remembered through the frightened eyes of 8-year-old Sarah (Jennifer Zubar), who, with her two sisters, was entrusted to the care of her fearless grandmother (Toto Bissainthe) when her par-

ents fled the country. The action is set in a seaside town, which is ruled with a brutal authoritarianism by Janvier (Jean-Michel Martial), a sadistic Army officer who teaches the little girl a lesson he will live to regret.

"The Long Silence" and "The Man by the Shore" are two of the strongest among the more than 50 films (42 of them New York premieres) to be shown at the Loews Village Theater VII through May 12.

Among the festival's high points will be the first American retrospective of Miss von Trotta's films. In addition to "The Long Silence," four other movies — "The Lost Honor of Katharina Blum" (1975), "The Second Awakening of Christa Klages" (1977), "Marianne and Juliane" (1981) and "Rosa Luxemburg" (1986) — will be shown.

Another high point will be on May 6, with the world premiere of Michael Apted's "China: Moving the Mountain," a 70-minute documentary tracing the events leading to the 1989 uprising in Tiananmen Square. The documentary follows the personal histories of two student leaders of the protest, Li Lu and Chai Ling, who escaped to the West, and includes their first filmed interviews since leaving China.

The Saravejo Group of Authors, an organization of journalists, writers, film makers and artists who have remained in Sarajevo through the war, has also contributed a program of films and seminars to run next weekend. One presentation, on May 7, will be "Godot-Sarajevo," a film directed by Pjer Zalica, which chronicles Susan Sontag's staging of "Waiting for Godot" last summer with a troupe of Sarajevan actors in the war-torn city.

All festival screenings are at the Loews Village Theater VII (Third Avenue and 11th Street, Greenwich Village). Admission is $6.50. Advance tickets may be bought through Teleticket by calling (212) 59-LOEWS or at the box office. Schedule information: (212) 978-8991.

STEPHEN HOLDEN

1994 Ap 29, C12:5

The Secret Rapture

Directed by Howard Davies; screenplay by David Hare; director of photography, Ian Wilson; edited by George Akers; music by Richard Hartley; production manager, Anita Overland; produced by Simon Relph; released by Castle Hill Productions. At Cinema Third Avenue, at 60th Street, Manhattan. Running time: 96 minutes. This film is rated R.

Isobel Coleridge	Juliet Stevenson
Katherine Coleridge	Joanne Whalley-Kilmer
Marion French	Penelope Wilton
Patrick Steadman	Neil Pearson
Tom French	Alan Howard

By STEPHEN HOLDEN

The English playwright David Hare has always excelled at creating characters whose psychological struggles mirror deeper social and political stresses. In his 1988 play "The Secret Rapture," which dramatized the bitter personality clash of two sisters after their father's death, he created a disquieting parable of ideological combat in Margaret Thatcher's Britain.

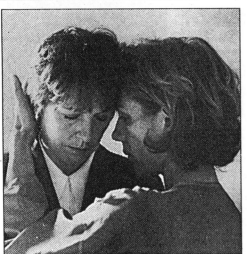

Post-Mortem
Penelope Wilton, left, and Juliet Stevenson star as very different sisters who are brought together by the death of their father in "The Secret Rapture."

Castle Hill Productions

"The Secret Rapture" came to Broadway five years ago in an intriguing if stiff production directed by the playwright. The film version, adapted for the screen by Mr. Hare and directed by Howard Davies, who oversaw the original London production, is by no means easygoing. But its emotional texture is considerably richer than the Broadway production. And its wrenching performances and dark, clammy atmosphere cast an unsettling chill.

When their father, a provincial bookseller, dies in the stone country house in which they grew up, his two daughters, Isobel (Juliet Stevenson) and Marion (Penelope Wilton), who have steered clear of each other for years, are forced to come together to make some hard decisions. The most delicate immediate problem is what to do about Katherine (Joanne Whalley-Kilmer), their young, alcoholic stepmother, who has been left with nothing but the house.

•

The sisters embody opposing philosophies. Isobel, the younger, who was her father's favorite, is a volatile, passionate bohemian with a fierce sense of loyalty to the father she adored. With her lover, Patrick (Neil Pearson), a gifted illustrator, she runs a small graphic design business that is marginally profitable. Although she fears that her stepmother's instability could destroy her fragile sense of well-being, out of loyalty to her father's memory she feels obligated to take Katherine into her home.

Marion is the sort of forbiddingly stern woman who used to be called a battle-ax. A successful businesswoman married to a born-again Christian, she is a virtual caricature of Margaret Thatcher as a staunch proponent of a survival-of-the-fittest capitalist ethic. Marion proposes that she and her husband expand Isobel's graphic design business by bringing in investors and making Katherine a partner whose job will be to drum up new business. Although Isobel has grave misgivings about the proposal, she agrees to it once Marion has convinced Patrick that it would be for the best.

Soon enough, Isobel's premonitions of disaster come true. The running of a high-powered business destroys the stability of her relationship with Patrick and turns her once-enjoyable work into an exhausting grind. And as her relationship with Patrick deteriorates, her devoted lover begins to display a streak of obsessive dependence. At the same time, the step mother also begins to come apart. In the film's harshest scene, Katherine, who uses raw sexual provocation as a business tool, goes crazy during a lunch at which she is humiliated by some would-be clients.

•

Much of the power of the film, which opens today at Cinema Third Avenue, lies in the lurching unpredictability of its story. Instead of a plot whose elements are neatly manipulated to make a moral point, Mr. Hare allows the behavior of Patrick and Katherine, the drama's two loose cannons, to explode conventional expectations. Neither Isobel's do-good liberalism nor Marion's stern, economic self-interest has really taken into account the fact that people crack up and run amok.

The movie's pained acknowledgment of this possibility supports a bleak historical view in which the course of events is as likely to be determined by the whims of a Lee Harvey Oswald as by an ideological or philosophical dialogue. We are all ultimately left hostage to crazy, destructive forces that could erupt anytime, anywhere.

In observing the characters up close, the film exudes an emotional intensity that was missing from the more politically pointed Broadway production. As dislikable as Marion may be, Ms. Wilton's portrayal allows us enough glimpses through her mask of hard self-sufficiency to suggest the fearful, unloved child beneath. Isobel, with her outpourings of concern and conscience, is far more sympathetic. But Ms. Stevenson also doesn't shy away from showing the character's streaks of stubbornness and hysteria.

The film's flashiest performance belongs to Ms. Whalley-Kilmer as the impulsive, sexually magnetic Katherine. At moments she oddly suggests a young, tipsy Joan Collins whose bravado cannot conceal her lack of an inner core.

•

The film's biggest flaw is its attempt to compress too much story into too little space, in scenes that shift abruptly from character to character. In Ian Wilson's dank cinematography, much of the action unfolds in bleak, dimly lighted spaces. Two scenes in the vicinity of the house use fire to ominously eerie effect. Early in the film, Isobel rises in the middle of the night, like a woman possessed, to burn her father's possessions outside on the lawn. Many months later, when she and Katherine are living a primitive existence in the same house, which is stripped of furnishings and utilities, the two women turn the barren living room into a bizarre shrine illuminated with hundreds of lighted candles.

"The Secret Rapture" offers a warning to people who believe in tidy, buttoned-down solutions. For the untidy, unbuttoned majority, it says, unruly passion will ultimately have its way.

•

"The Secret Rapture" is rated R (Under 17 requires accompanying parent or adult guardian). It includes nudity, strong language and sexual situations.

1994 Ap 29, C15:1

Castle Hill Productions
Joanne Whalley-Kilmer

John Robbins	Ray Liotta
Father	Lance Henriksen
Marek	Stuart Wilson
Casey	Kevin Dillon
Stephano	Kevin J. O'Connor

By CARYN JAMES

You think it's easy to make a no-brain action movie? "No Escape" demonstrates how hard it really is. Ray Liotta plays a prisoner in the year 2022, shipped to a privately owned maximum-security prison in Australia. The high-tech prison actually looks like a bunch of cheap metal canisters on pilings, and he doesn't stay there long. He is dropped on a jungle island, where he's caught between two no-tech groups of prisoners: the ruthless Outsiders, and the peaceful Insiders. He tries to ... escape

On paper, this might have seemed like a foolproof mix of elements borrowed from other, proven action movies. Take a bit of "Mad Max," add a dash of "Demolition Man," mix with a soupçon of "Escape From New York." The plan backfires. "No Escape" is long and lethargic. The action looks fake, and the special effects are cheesy.

Mr. Liotta is always interesting to watch, and he is the only character worth saving. The Insiders include a robed father figure called Father (Lance Henriksen) and a baby-faced kidnapper (Kevin Dillon), both of whom are so annoying they belong on a lonely island. The Outsiders are led by Marek (Stuart Wilson), who has a very bad dreadlock hair weave. He seems to be a cross between Richard Dawson as the game-show host in the Arnold Schwarzenegger movie "The Running Man" and Tina Turner in "Mad Max: Beyond Thunderdome." He sounds like a flat-toned guy from the Midwest.

The director, Martin Campbell, has made a couple of underrated thrillers, including "Criminal Law" and "Defenseless." The producer, Gale Anne Hurd, was a producer of "The Terminator." Somehow they concocted "No Escape," the movie that proves too much borrowing is a dangerous thing.

•

"No Escape" is rated R (Under 17 requires accompanying parent or adult guardian). It includes much violence. Characters are knifed, beheaded, impaled and otherwise done in.

1994 Ap 29, C15:1

No Escape

Directed by Martin Campbell; based on the novel "The Penal Colony," by Richard Herley; director of photography, Phil Meheux; the novel "The Penal Colony," by Richard Herley; director of photography, Phil Meheux; edited by Terry Rawlings; music by Graeme Revell; production designer, Allan Cameron; produced by Gale Anne Hurd; released by Savoy Pictures. Running time: 118 minutes. This film is rated R.

Just Before They Invented the Blockbuster

By JANET MASLIN

THE ONLY TIME I EVER CAUSED a traffic accident, it was while trying to read a three-tiered movie marquee. The place was Cambridge, Mass., the theater the Orson Welles, and the films were head-turning enough to wreak havoc on the roadways, at the very least. The time was the early 1970's, a period that has come to look like an astonishingly fertile era within the realm of film. It was a turbulent time that witnessed worlds colliding, a major changing of the guard, an

enthusiastic embrace of the cinematic past and troubling harbingers of the future.

There are higher points in the history of cinema: the zenith of silent film in the 1920's; the great days of Ford, Hawks, Hitchcock, Sturges, Welles, Lubitsch and Cukor in the early 1940's; and the French New Wave in the late 1950's and early 1960's, which coincided with the most stunning phases in the careers of Federico Fellini and Ingmar Bergman. But the early 1970's were immensely valuable, since they represented such a colorful crossroads. This was a volatile period, a time of bizarre excesses and vital, unequivocal triumphs. In its spirit of passionate upheaval, it wound up forging essential connections between old and new.

If the link between film's early visionaries and their 1970's descendants was strong, it was also refreshingly un-self-conscious. The American film makers who came to prominence during that era — Martin Scorsese, Francis Ford Coppola, Robert Altman, Steven Spielberg, George Lucas, Paul Mazursky, Brian De Palma and Woody Allen, to name only the most conspicuous — could freely absorb the lessons of the past without compromising the originality of their new ideas.

For both film makers and audiences, the interplay between past and present was galvanizing and ever-present. The interplay signaled a wild burst of creativity among new American film makers. And the great works of the past — the ones now hard to find in video stores or only occasionally included in film series — remained regularly on view.

The cinematic vigor of that time was truly global. While successful art houses featured a dazzling range of retrospectives, the era's new foreign releases signaled a worldwide resurgence of creative energy. Among the foreign films released here in 1972: Rohmer's "Chloe in the Afternoon," Buñuel's "Discreet Charm of the Bourgeoisie," Truffaut's "Two English Girls," Bergman's "Cries and Whispers" and Ozu's "Tokyo Story." In 1973: Bertolucci's "Last Tango in Paris," Truffaut's "Day for Night." In 1974: Bertolucci's "Conformist," Louis Malle's "Lacombe, Lucien," Fellini's "Amarcord," Renoir's "Petit Théâtre de Jean Renoir."

A spectacular roster, to be sure. But it was matched in vitality and inventiveness by much of what appeared on the home front. Consider the energy level of Francis Ford Coppola, whose amazing credits between 1972 and 1974 included writing and directing the first two "Godfather" films along with "The Conversation"; Mr. Coppola also wrote the screenplay for the overblown "Great Gatsby" and co-produced George Lucas's "American Graffiti."

These were times when inventive new film makers were encouraged to work fast, switch gears and do much more than replicate past triumphs. Robert Altman, the most protean and influential American film maker of the period, made six mesmerizing and varied films between 1971 and 1975: "McCabe and Mrs. Miller," "Images," "California Split," "Thieves Like Us," "The Long Goodbye" and "Nashville." Martin Scorsese went from "Mean Streets," still the most ardently imitated film among young directorial wannabe's, to "Alice Doesn't Live Here Any More," in an entirely different vein.

At that time, risk taking was deemed more artistically valuable than commercially foolhardy, which is one good way of distinguishing between the creative climate of the early 1970's and that of today. Peter Bogdanovich, who made his reputation with the small, perfect film "The Last Picture Show" in 1971, and whose latest film ("The Thing Called Love," starring River Phoenix) went straight to video after it performed disappointingly in regional markets, recently speculated about whether he could ever have begun his career in a cutthroat bottom-line-oriented atmosphere like today's. The answer, he thought, was probably no.

By comparison, the early 70's were a fine time for personal, idiosyncratic films not aimed at the lowest common denominator, the kinds of films that would be deemed much too chancy by the major studios today. But in those times, intelligence and precision were apparent even in broadly commercial Hollywood films: William Friedkin's "French Connection" and "Exorcist," Mike Nichols's "Carnal Knowledge," Alan Pakula's "Klute" and "Parallax View," Elaine May's "Heartbreak Kid," Sydney Pollack's "Three Days of the Condor" and "The Way We Were," Sidney Lumet's "Dog Day Afternoon."

A period that could yield Roman Polanski's "Chinatown" and Hal Ashby's "Shampoo" as part of the cinematic mainstream (and as testament to the talents of Robert Towne, who wrote both these moody, enduring 70's classics) could justifiably be appreciated for flouting middle-of-the-road tastes. Meanwhile, closer to the fringes, there was many a haunting discovery to be made.

Nicolas Roeg's "Don't Look Now," Terrence Malick's "Badlands" and Robert Benton's "Bad Company" were among the period's most exquisite and rigorous films, but there was also a strain of rollicking experimentation in the air. John Cassavetes's "Husbands" and "Woman Under the Influence" crystallized his boisterous, psychologically probing approach to film making, just as Paul Mazursky's "Blume in Love" wickedly mirrored the period's preoccupation with conspicuous personal change.

Even the bad films of the early 1970's now seem memorable, with the kinds of strong personalities that today's assembly-line failures sadly lack. Say what you like about "Billy Jack," "Harold and Maude," "Heavy Traffic," "The Night Porter" or "The Great Gatsby," those were definitely films worth talking about. And they still resonate: in the current "Above the Rim," two characters are seen attending a festival of black films from the 1970's and wistfully remembering how much they once enjoyed "Shaft." Blaxploitation produced its share of clinkers, but it was a lively indicator of the 70's creative freedom.

Why were films that aimed to please distinct, specialized audiences so much more possible then? Maybe because the megamass-audience phenomenon was barely a gleam in the average studio executive's eye. If there was a single day when the era ended, it was June 21, 1975, just after two landmark films had appeared on the respective covers of Time and Newsweek. Newsweek's cover film was "Nashville," thought by some to be the film of the decade, but it was not the one that changed Hollywood forever. "Jaws" was.

I HAPPENED TO BE IN NEW YORK that day, working on an article about Steven Spielberg, the boy-wonder director of yet another bright 70's discovery, "The Sugarland Express." There was by then a certain drumbeat about his new shark picture, and Mr. Spielberg had just received a phone call from Universal, telling him that opening-day business looked phenomenal. He didn't quite believe it. He wasn't yet used to this sort of thing. He had to see it for himself.

A car took him to Times Square, where another traffic accident would easily have been possible, since the front of the theater where "Jaws" was playing was mobbed. People had turned up hours ahead of time to see the next show of "Jaws," and the line stretched all the way to the corner. And around the block. And around another corner. Mr. Spielberg was thrilled, but he was also, understandably, a little shocked. He got over it. The movie industry never did.

When "Jaws" made it possible for every would-be viewer in America to be targeted for a unilateral marketing blitz, it created irrevocable change. Films would now be held to a different and increasingly exacting standard, one that accepted across-the-board popularity as the ultimate sign of merit. A stellar new generation of film makers would do their best to translate personal concerns into broad, crowd-pleasing terms, and would often do so with great success. But the golden age was over. The time of the blockbuster had begun. □

1994 My 1, II:30:1

La Scorta

Directed by Ricky Tognazzi; written by Graziano Diana and Simona Izzo (in Italian with English subtitles); director of photography, Alessandro Gelsini; edited by Carla Simoncelli; music by Ennio Morricone; production designer, Mariangela Capuano; produced by Claudio Bonivento; released by First Look Pictures. Film Forum 1, 209 West Houston Street, South Village. Running time: 92 minutes. This film is not rated.

Angelo Mandolesi	Claudio Amendola
Andrea Corsale	Enrico Lo Verso
Raffaele Frasca	Tony Sperandeo
Fabio Muzzi	Ricky Memphis
Judge De Francesco	Carlo Cecchi

By CARYN JAMES

Though the recent corruption scandals in Italy have thrown powerful men out of office, "La Scorta" ("The Bodyguards") considers the impact of anti-Mafia action on lowlier and nobler figures. The film, a smart political thriller, focuses on the bodyguards protecting an honest, imperiled judge trying to clean up a Sicilian town. The story is based loosely on the life of an actual judge, Francesco Taurisano. But the director, Ricky Tognazzi, is looking at broader issues: the pervasiveness of government corruption and the way the bodyguards try to maintain a shadow of their normal lives.

As the film starts, a judge and his bodyguard are murdered in the Sicilian town Trapani. A replacement, Judge De Francesco, is sent from Rome to take over the investigation into the town's Mafia ties, and is assigned four bodyguards, all of them young locals. The captain among them is Andrea, a calm family man with three small children. Angelo is hotheadedly eager for the assignment because the murdered guard was his friend. Another guard is secretly engaged to a local woman but can't reveal this because it might be cause

for a transfer, and the fourth is trying to be reassigned to guarding doors or pouring coffee at some relatively safe government building. He would seem to be the smart one, but this film values heroism.

•

"La Scorta," which opens today at Film Forum, has an understated style and a deliberate pace that emphasize how commonplace its explosive subject is in Italy. Throughout the film, Mr. Tognazzi interweaves details of the investigation with richly textured scenes of daily lives, effectively photographed on narrow streets and in cramped apartment buildings. It is too dangerous for Judge De Francesco to socialize with anyone except his guards, so on one evening he is seen trying to cook a simple dinner of pasta and broccoli for himself, and on others he is invited to big family dinners at Andrea's house along with the other men.

Meanwhile, the judge learns that the local water supply is being controlled by the Mafia and a corrupt Senator. Important documents vanish from De Francesco's office. His own superior seems suspect; it becomes difficult not to suspect everyone. As the film goes on, the action picks up and the danger is inescapable. Even Andrea's children and the judge's young daughter, who has come for a birthday visit, are threatened.

Though the film takes a cynical view of how difficult it is to overcome corruption, it has a simplistic view of honest and evil characters. The good guys and the bad guys are as easy to spot as if they were wearing signs, and the viewer is never wrong about a first impression. That avoids confusion, but adds a note of naïveté. Still, "La Scorta" is absorbing and unlike

any other film on screen at the moment, offering a fresh perspective on another country's scandals.

1994 My 4, C16:3

Babyfever

Directed by Henry Jaglom; written by Mr. Jaglom and Victoria Foyt; director of photography, Hanania Baer; edited by Mr. Jaglom; sound by Sunny Meyer; produced by Judith Wolinsky; released by Rainbow Film Company. Running time: 110 minutes. This film is not rated.

Gena	Victoria Foyt
James	Matt Salinger
Anthony	Eric Roberts
Rosie	Frances Fisher

By JANET MASLIN

Henry Jaglom approaches film making as if it were a form of party giving, assembling his guests in suitably grand surroundings and then encouraging them to make small talk. And no talk is too small. Mr. Jaglom's reluctance to pull the plug on his performers' loose, improvised musings can produce the occasional memorable thought, but it can also leave his actors hanging badly. It is not impossible, under these free-form circumstances, for a person whose remarks are too fatuous to be upstaged by a bowl of fruit.

Still, Mr. Jaglom's subjects seem to love the chance to reveal themselves, if only because the director's attention would seem to be so flattering. Once again assembling a large group of extroverted women (with a special penchant for the types who wear hats indoors during the daytime), Mr. Jaglom displays a therapist's patience for hearing them ventilate. The plot of "Babyfever" is so negligible that Mr. Jaglom often lets his cast members simply face the camera and say what's on their minds.

•

In "Babyfever," which opens today, the main topic is motherhood. That makes this film a shade more serious than "Eating," in which the women's thoughts turned to various food-related obsessions and yielded rueful, lightly comic observations that fit the subject. Incidentally, if Mr. Jaglom's cast members are mostly women, that may be because he thinks it would be harder to find men who are so willing to sound self-absorbed and frivolous on camera. Would a man compare life's changes to the problems of finding a new lipstick shade? Not in public, anyway.

The women in this film are meant to appear honest and disarming, and some of them are. (Frances Fisher, one of the few familiar actresses in a mostly amateurish-sounding cast, brings a rare degree of poise and precision to these rambling proceedings.) But a lot of them chatter on about wanting babies because babies are fun to dress, because all their friends are doing it, because it seems like the ultimate exercise in self-actualization.

When it's about the prospect of bringing up real children, this kind of narcissism isn't nearly as amusing as it was when applied (in "Eating") to the difference between having sex and eating a baked potato. Nor does it help that the ostensible focus of "Babyfever" is Gena, who thinks she may be pregnant by a handsome, accommodating yuppie (Matt Salinger). Gena doesn't much like him, nor does she want to become pregnant by an ex-boyfriend (Eric Roberts) who has just reappeared in her life. And on top

of that, she has to go to a friend's baby shower. That's the plot.

•

Gena is played by Victoria Foyt, who is now married to Mr. Jaglom and wrote the film with him. Wide-eyed and desperately earnest, she spends a lot of time bemoaning Gena's problems in a tone that mirrors the film's whiny, self-indulgent outlook. ("I'm waiting for my life to happen so I can *have* my life, and I'm not having it while I'm *in* it!") This is also a film in which the baby-shower guests spend screen time singing several different verses of "Twinkle, Twinkle, Little Star."

Mr. Jaglom's camerawork remains powerfully reminiscent of Robert Altman's, zooming in attentively to catch even the tiniest behavioral nuances in such a scene. The secret to making this method succeed continues to elude Mr. Jaglom, whose work proves that endless patience isn't enough to make one a keen observer of human nature. It's also necessary to know when to cut.

1994 My 4, C16:6

Kika

Written and directed by Pedro Almodóvar, in Spanish with English subtitles; director of photography, Alfredo Mayo; edited by José Salcedo; produced by Mr. Almodóvar; released by October Films. Running time: 115 minutes. This film has no rating.

Kika	Verónica Forqué
Nicholas	Peter Coyote
Andrea Scarface	Victoria Abril
Ramon	Alex Casanovas
Juana	Rossy de Palma
Amparo	Anabel Alonso

By JANET MASLIN

Pedro Almodóvar continues to give new meaning to the phrase screwball comedy with his antic, gleefully fashion-conscious bedroom farces, each of which has its own lovingly developed kinky streak. Mr. Almodóvar's new "Kika" finds the film maker working in a relatively innocent vein, which means only voyeurism, self-flagellation, a slapstick rape sequence, and an orange section used as a sexual device. Orange section? Don't ask. Viewers familiar with the full Almodóvar oeuvre probably won't have to.

"Kika" is actually one of this film maker's more buoyant recent efforts, a sly, rambunctious satire that moves along merrily until it collapses — as many Almodóvar films finally do —

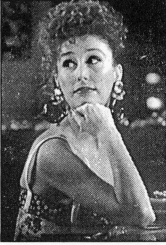

October Films

Verónica Forqué in "Kika."

under the weight of its own clutter. Like "High Heels," its dourer 1991 predecessor, this film insists on incorporating a darker murder plot that weighs down its giddier aspects. As such, the murder story is superfluous. Mr. Almodóvar invests even his films' zanier elements with serious meaning, and those lighter ingredients are a lot more fun.

Audiences for "Kika" may be too busy studying wild costumes, paperweight collections or lava lamps to notice the more earnest components of this film's frenetic plot anyway. At its center is the title character, a dizzy, good-hearted bombshell who works as a makeup artist and whose ingenuous sexiness affects everyone she meets. Even Ramon, a corpse whom Kika (Verónica Forqué) has been hired to paint, responds to her effervescent chatter. ("I haven't been very selective, Ramon," she confides while discussing her sexual past.) It turns out that Ramon has only been in a cataleptic trance. Still, Kika's friendliness is enough to wake the dead.

●

Kika quickly sets up housekeeping with Ramon (Alex Casanovas), who specializes in taking fashion photographs of lingerie-clad models and who takes Polaroids even when in bed with Kika. Voyeurism also guides many of the film's other characters, from the mysterious neighbor who spies on Kika and Ramon's apartment to Andrea Scarface (Victoria Abril), an evil television star. Andrea is the hostess of "Today's Worst," a program specializing in real-life crime scenes. Mr. Almodóvar has said he thought of calling this film "Today's Worst" but couldn't bear to give reviewers and headline writers such a clear opening for potshots about his work.

In any case, "Today's Worst" is one of the better touches in "Kika," thanks to Jean-Paul Gaultier's dazzlingly outlandish costumes for Miss Abril; in a gore-trimmed gown made to look as if it had exploded to expose her breasts, she perfectly captures this film's sardonic view of exploitative television. Even more spectacular is a suit that turns her into a one-woman video crew, the better to film anything tragic or violent that comes her way. Andrea and Kika eventually cross paths when Kika is raped, in the kind of bawdy comedy-of-errors sequence that separates Mr. Almodóvar's admirers from those of fainter heart. Let's just say that if anyone can stage a laugh-inducing rape scene, it's he.

Also ricocheting through "Kika" is Peter Coyote as Nicholas Pierce, an American author who is Ramon's widowed stepfather, Kika's sometime lover and a guest on yet another television show, "Let's Read More." He tries to persuade the host, a sweet-faced old granny, that American writers have a tradition of killing their wives. "I don't think I'll read it," she says pleasantly, after hearing about Nicholas's latest book.

Then there is Juana, a servant played by the unforgettably strange-looking Rossy de Palma, whose dream is to become a prison matron and who lets her comically bestial brother have sex with her just to keep him from hurting the neighbors. Comically bestial? Even this, by the standards of earlier Almodóvar films, is relatively tame. And Mr. Almodóvar, who this time comes close to the sustained exuberance of

his 1987 "Women on the Verge of a Nervous Breakdown," has a way of making such excesses work.

●

It helps that "Kika" is alive with loud colors, knickknack-filled sets and tarty costumes, some of which have also been supplied by Gianni Versace. ("Don't be surprised if they ask 'How much?'" Kika says to a friend upon seeing that friend's hookerish idea of street clothes.) This kind of visual energy gives Mr. Almodóvar's films their distinctive fashion sense, but in "Kika" it hasn't been allowed to get out of hand. It certainly makes this film livelier than "High Heels," in which the most significant esthetic contrast was the difference between Armani and Chanel.

The two principal stars, Ms. Forqué and Ms. Abril, are spirited and appealing, never in danger of being overpowered by their surroundings. Men in Mr. Almodóvar's films have a harder time remaining interesting. But Mr. Coyote, the try-anything actor whose current specialty (also in Roman Polanski's "Bitter Moon") is playing bad expatriate American writers, makes himself right at home.

1994 My 6, C8:1

Being Human

Written and directed by Bill Forsyth; director of photography, Michael Coulter; edited by Michael Ellis; music by Michael Gibbs; production designer, Norman Garwood; produced by Robert F. Colesberry and David Puttnam; released by Warner Brothers. Running time: 118 minutes. This film is rated PG-13.

Hector	Robin Williams
Deirdre	Kelly Hunter
Girl Child	Maudie Johnson
Boy Child	Max Johnson
Lucinnius	John Turturro
Thalia	Grace Mahlaba
Beatrice	Anna Galiena
Narrator	Theresa Russell

By JANET MASLIN

In "Being Human," his idiosyncratic history of mankind ranging from the cave to the car phone, Bill Forsyth ("Gregory's Girl," "Housekeeping") magically finds an 11th-hour way to bring his material into focus. Magic may be nothing new for a film maker who once casually revealed (in "Local Hero") that one of his characters was a mermaid. But it stands out sharply here, if only because it is otherwise in short supply.

Set against lovely verdant scenery but structured as a series of rambling vignettes, the stories in "Being Human" don't entirely mesh. Though they all concern a man named Hector (Robin Williams), sound similar themes and are strung together by the same voice-over narrator (Theresa Russell), they don't have the fundamental coherence to justify this narrative format. Mr. Forsyth works best in simpler and more mysterious ways than are possible here. Much of the time, a smaller film seems to be trying to escape the overpowering ambitions of this large one.

Mr. Forsyth, whose usual style is so winningly capricious and gentle, is this time weighed down by the cumbersome business of finding a different version of Hector in several different time periods, beginning in the Bronze Age. It isn't all that easy to write Bronze Age dialogue, either. "I get food," Mr. Williams succinctly tells his family during this sequence. "Stay here. No noise. Don't move. Don't cry."

David Appleby/Warner Brothers

Robin Williams and Anna Galiena

The bona fide simplicity of those lines is not helped by the more precious innocence of the narration, which begins with a disagreement about what sort of story this ought to be. "This is the story of a story," concludes the narrator, which does not bode well for the story's later stages. At times the story even talks, which strains its ingenuousness to the breaking point. "Well, said the story to itself, I suppose I must have been a love story," recites Ms. Russell, when the narrative turns to love.

The film's five tales feature, in varying degrees, similar issues: family ties (often badly ruptured), enslavement to work, the yearning for home, the need for freedom, the sense of one's obligations to others. If that sounds like Mr. Forsyth's definition of humanity, it eventually emerges as exactly that.

And it makes the most sense when the film maker gives it some tension, setting the milder ideas that have cropped up during the film's whimsical early episodes against the cold, dehumanizing realities of modern life. Only when "Being Human" isolates the caveman longings in Mr. Williams's last character, a harried, divorced New York landlord, does this film spring movingly to life.

"Being Human" presents its first flashback in the splendid isolation of the Scottish coastline, lovingly photographed by Michael Coulter, who has shot four of Mr. Forsyth's other films. Here Mr. Williams plays a caveman whose family is abducted by foreign marauders, their unintelligible dialogue being one of the film's many affectations. This loss then leads into the story of a second Hector, a slave in ancient Rome, who has long since lost his own family but has fallen in love with a slave from Africa (Grace Mahlaba). Their yearning for connection and a family becomes part of the film's overriding pattern, as does Hector's amiable rapport with Lucinnius (John Turturro), the buffoonish businessman who owns him.

The Roman scenes between Mr. Williams and Mr. Turturro are staged with both sweetness and humor, as these two debate the merits of double suicide once Lucinnius gets into fatal trouble. ("You're my closest, my dearest slave," he tells Hector. "What will they say about me if you refuse to die with me?") As such, they reverberate nicely with later images of enslavement, particularly when the modern Hector finds himself enslaved by his own business affairs.

But "Being Human" isn't often this sharply etched, nor does it often give Mr. Williams the opportunity to play scenes with a humorous edge. In a career that divides sharply between funny roles and those that are otherwise, this falls clearly into the otherwise category. Mr. Williams often grows wide-eyed when he takes on holy innocent roles, but here he maintains real dignity and sweetness

throughout. Still, all of these Hectors are passive souls, and the film doesn't often give him enough to do.

The film's medieval segment, in which Hector forsakes his past to fall in love with a beautiful woman who cannot speak his language, and its 16th-century idyll, with heavily costumed Portuguese travelers shipwrecked on a beach in North Africa, are even more meandering than what has come before. Fortunately, they are offset by final grace notes, which are tender and beatific in ways that give great poignancy to the whole film.

Aiming high and falling short of his own mark, Mr. Forsyth remains a film maker of vivid, unpredictable imagination. Meandering as they are, this film's historical sequences also have an unexpected lightness. They transcend the literalness of sets, costumes and period research to suggest that Mr. Forsyth's mind simply wandered back to earlier times. Certainly there's a kernel of wisdom in what he found there.

●

"Being Human" is rated PG-13 (Parents strongly cautioned). It includes mild profanity.

1994 My 6, C10:3

Clean Slate

Directed by Mick Jackson; written by Robert King; director of photography, Andrew Dunn; edited by Priscilla Nedd-Friendly; music by Alan Silvestri; production designer Norman Reynolds; produced by Richard D. Zanuck and Lili Fini Zanuck; released by Metro-Goldwyn-Mayer. This film is rated PG-13.

Pogue	Dana Carvey
Sarah	Valeria Golina
Dolby	James Earl Jones
Rosenheim	Kevin Pollak
Cornell	Michael Gambon
Dr. Doover	Michael Murphy

By CARYN JAMES

On the surface, "Clean Slate" is a "Groundhog Day" clone, played in reverse. Instead of Bill Murray waking up every morning doomed to repeat the day before, in "Clean Slate" Dana Carvey wakes up with no memory of the previous day at all. But the new film is not a slavish copy; it is an amiable movie with its own ambitions, and too many missteps to duplicate the comic sweetness of last year's hit.

Mr. Carvey's character leaves a tape recorder by his bed at night. Each morning he turns it on and listens to his own voice remind him that he is a detective named Maurice Pogue. Or as he tells himself, "You're a small-time gumshoe" in Venice, Calif. The film has a 1930's or 40's story, and sometimes style, trapped in a 90's comedy. A woman named Sarah Novak (Valeria Golino), dressed in a 40's suit and hat, comes dashing into Pogue's run-down office, saying: "They're following me. They're trying to kill me." Soon Pogue learns that Sarah is supposedly dead, and that they are both being hunted by a thug looking for a coin worth $7 million.

Mr. Carvey has some genuinely funny moments, most of them when Pogue stumbles into some awkward situation in which it would come in handy to have a memory. He tries to talk his way out of trouble at a surprise birthday party in his honor and while giving important testimony in court. He plays Pogue as a regular

guy, and not as a series of broad comic inventions, but it wasn't an inspired idea to create a movie around a character who has no character. Pogue is too much of a cipher to make the romantic plot work. The suspense seems like a flimsy excuse for the comedy, and the deliberate old-movie echoes are abandoned not long into the story. Children may not be annoyed by this mishmash, but adults probably will.

Minor characters are played by an overqualified and underused cast that includes James Earl Jones as a district attorney in a neck brace and wheelchair, Michael Gambon as a rich thug in a white suit, Michael Murphy and Kevin Pollak. The film also gets much comic mileage from Pogue's dog, a terrier with a depth perception problem. The dog wears an eye patch that obviously isn't much help, because he keeps aiming for and missing the doorway, the food bowl, his owner's hand.

The director, Mick Jackson, handles the film in a low-keyed manner far more reminiscent of his mild "L.A. Story," (written by and starring Steve Martin) than his busy, Kevin Costner-Whitney Houston blockbuster, "The Bodyguard." Like "L.A. Story," "Clean Slate" is perfectly pleasant to sit through, but always feels as if it's about to become funnier than it is. Something is cockeyed about a movie in which the dog is the most consistently comic character.

•

"Clean Slate" is rated PG-13 (Parents strongly cautioned). It includes a bit of mild language.

1994 My 6, C10:3

Dream Lover

Written and directed by Nicholas Kazan; director of photography, Jean-Yves Escoffier; edited by Jill Savitt and Susan Crutcher; music by Christopher Young; production designer, Richard Hoover; produced by Sigurjon Sighvatsson, Wallis Nicita and Lauren Lloyd; released by Gramercy Pictures. Running time: 103 minutes. This film is rated R.

Ray Reardon	James Spader
Lena Reardon	Mädchen Amick
Elaine	Bess Armstrong
Buddy	William Shockley
Norman	Larry Miller
Larry	Fredric Lehne

By JANET MASLIN

When Ray Reardon (James Spader) meets Lena Mathers (Mädchen Amick) she behaves hatefully, which is really the sort of thing he ought to notice. But Ray is understandably distracted by Lena's good looks. A debonair yuppie architect, he has a fine eye for the beautiful edifice, and he is also impressed by some of Lena's other talents. When they go out for dinner at a sushi place, it's a tossup over which one speaks better Japanese.

Dazzled by Lena, Ray begins to see her as the perfect mate, which is how he finds himself at the center of the ingeniously contrived waking nightmare that is "Dream Lover." As written and directed suspensefully by Nicholas Kazan, this film delves deep into the mysteries that lurk behind romance, and it pulls no punches about its characters' capacity for malice.

Mr. Kazan, whose screenwriting credits include "Frances," "Patty Hearst" and the acid-dripping "Reversal of Fortune," knows how to keep this story surprising. Even at the last minute, when a plot like this might be expected to run out of steam, he has in reserve one last nifty, malevolent twist.

Continuing to make a career out of finding the humanity in thoroughly unlovable characters, Mr. Spader makes the perfect fall guy for this story. Suave, overconfident and recently divorced, he becomes touchingly smitten by Lena's blinding charms, which Mr. Kazan presents in slightly heightened, unreal fashion. The whole film has the intensity of a dream, and Mr. Kazan selects his fantasy elements with great care. The sequence in which Ray and Lena consummate their romance uses pearls, bare skin and satin sheets to capture the full eroticism of the ties that bind them together.

Much of the interest in "Dream Lover" centers on what happens when those ties begin to unravel. "I never thought it would be possible for me to have such a normal life," Lena admits early in her marriage to Ray; even their happiest days are full of alarm bells like that one. Mr. Kazan has wicked fun undermining Lena's calm, confident veneer, and giving Ray more and more reason to suppose that his wife may be something of a liar.

In one memorable sequence, Ray steals away to Texas to try to find out where Lena came from and meets a man in a gas station who definitely seems to know her. "She did things to me I can't even pronounce," laughs Buddy (William Shockley), a scene-stealing character who corroborates all of Ray's worst suspicions.

"Dream Lover" can be watched as a cautionary tale about its characters' illusions, but it's much more enjoyable simply as a smart, diabolical thriller. For all of Mr. Kazan's occasional freshman flourishes, like brief sequences that show Ray being taunted about his love life by a clown, his film maintains a gratifying simplicity. With an eerie, brittle glamour and pale cinematography that accentuates Ms. Amick's lush good looks, "Dream Lover" easily holds the attention even without the added frisson of its characters' cruelty. Occasionally, Mr. Kazan tries to provide some psychological underpinnings to Lena's behavior, but a character like this is most scarily effective when she's left unexplained.

Mr. Spader and the slinky Ms. Amick, well teamed for this deadly pas de deux, are flanked by Larry Miller as Ray's wisecracking buddy and Bess Armstrong and Fredric Lehne as happily married friends who remain a little leery of Lena. Had Mr. Kazan really wanted to make his story's ending a complete surprise, he might have thrown in a few less transparent supporting characters, but never mind. "Dream Lover" is as cleverly malevolent as it means to be, and an unnerving reminder that beauty's only skin deep. For anyone who didn't know.

•

"Dream Lover" is rated R (Under 17 requires accompanying parent or adult guardian). It includes nudity, profanity and sexual situations.

1994 My 6, C11:1

That's Entertainment! III

Written, directed, edited and produced by Bud Friedgen and Michael J. Sheridan; additional music arranged by Marc Shaiman; music supervision by Marilee Bradford; released by Metro-Goldwyn-Mayer. At the Ziegfeld, Avenue of the Americas and 54th Street. Running time: 113 minutes. This film is rated G.

WITH: June Allyson, Cyd Charisse, Lena Horne, Howard Keel, Gene Kelly, Ann Miller, Debbie Reynolds, Mickey Rooney and Esther Williams.

By CARYN JAMES

On the left side of the split screen, Cyd Charisse looks slinky and sophisticated, lip-synching to the song "Two-Faced Woman" in a scene cut from "The Bandwagon." That 1953 film was a high point and a last gasp for the long reign of MGM musicals, and in those studio days very little went to waste. To prove it, the right side of the screen in "That's Entertainment! III" shows what happened to the song, recorded by a ghost singer named India Adams, later that year. In the now forgotten film "Torch Song," Joan Crawford, wooden and broad-shouldered in a short black wig and a baby-blue spangled dress, tries to slither down a staircase while lip-synching. She is wearing what the narration in "That's Entertainment!" kindly calls "tropical makeup," though it might more accurately be called blackface. As she vamps in her role as a Broadway star, she resembles nothing so much as a bad Crawford impersonator in drag.

This is entertainment, all right, but of a different sort from the unsurpassed musical numbers that filled the first "That's Entertainment" 20 years ago and made a good case for the genius of the MGM musical. A sequel, "That's Entertainment! Part 2," followed two years later. By now the archivists have made their way far back into the vaults. With the best material used up, "That's Entertainment! III" cleverly focuses on outtakes, unfinished numbers and behind-the-scenes glimpses of the old musicals. This results in a lively and funny compilation of curiosities suggesting what might have been. The clips have been wonderfully restored and are shown in wide-screen, dazzling color at the Ziegfeld, where "That's Entertainment! III" opens today.

•

Most of the time, it is easy and fascinating to see why these numbers didn't make it to the screen in their day. Debbie Reynolds, also one of the film's nine hosts, is seen in a feathered fuchsia costume, surrounded by men in tuxedos singing "A Lady Loves" from "I Love Melvin." That is followed by the version that was scrapped, with Ms. Reynolds as a country girl in a short gingham costume. This time she is surrounded by a chorus line of cowboys wearing bright purple T-shirts and dancing while they eat pie.

An elaborate number called "March of the Doagies," cut from the 1946 film "The Harvey Girls," has Judy Garland leading a torchlight procession of Western townsfolk. Maybe it would have worked better in context; here it looks as if the town has set off to search for Boris Karloff in "Frankenstein." There is also a glimpse of Garland in the production number "I'm an Indian," filmed before she dropped out of "Annie Get Your Gun" and was replaced by Bet-

Metro-Goldwyn-Mayer

Betty Jaynes, Mickey Rooney and Judy Garland, in the MGM movie "Babes in Arms."

ty Hutton. One of the best scenes shows Hutton and Howard Keel exuberantly topping each other in "Anything You Can Do," from "Annie Get Your Gun."

Another highlight is a split-screen view of Fred Astaire in different costumes (casual shirt sleeves and dapper suit) doing the same solo song and dance, "I Wanna Be a Dancin' Man," from "The Belle of New York." There are also brief bits of Astaire with Ginger Rogers and Cyd Charisse. He was heavenly with everyone, but seeing him dance side by side with himself is an eloquent reminder that Fred Astaire's best partner was always Fred Astaire.

When Lena Horne takes her turn as host, she proves to be the only one with a real point to make. She is seen singing "Ain't It the Truth" in a bubble bath, a scene cut from "Cabin in the Sky" because it was, she says, too provocative to show a black woman bathing. (Thank goodness they didn't replace her with Joan Crawford in tropical makeup.)

The scenes of Ms. Horne and of Astaire suggest that simpler was often better. The fussier, more elaborate productions have become quaintly dated. Even the intentionally comic ones seem funnier than they were meant to be, especially a snippet from the 1948 film "The Kissing Bandit," in which Ann Miller and Ms. Charisse (both among the film's hosts as well) dance a jealous flamenco cat fight with a hapless Ricardo Montalban in the middle.

The one real problem with "That's Entertainment! III" is that so many of the clips are extremely short. Because these excerpts are so much weaker than the glorious musical numbers, excerpted at greater length in the first "That's Entertainment!," it makes some sense to cut them drastically. But over the course of a two-hour film, the effect is jarring, like stop-and-go driving in heavy traffic.

Of course, as a line in the final credits point out, these films "are available in their entirety on videocassette and laser disk from MGM/UA Home Video," a commercial reminder that turns "That's Entertainment! III" into a giant trailer. But then the previews are sometimes the best part of going to the movies.

1994 My 6, C17:1

3 Ninjas Kick Back

Directed by Charles T. Kanganis; written by Mark Saltzman, based on a screenplay by Simon Sheen; director of photography, Christopher Faloona; edited by David Rennie; music by Richard Marvin; production designers, Hiroyuki Takatsu and Gregory Martin; produced by James Kang, Martha Chang and Arthur Leeds; released by Tri-Star. Running time: 95 minutes. This film is rated PG.

Grandpa	Victor Wong
Colt	Max Elliott Slade
Rocky	Sean Fox
Tum Tum	Evan Bonifant
Koga	Sab Shimono

By STEPHEN HOLDEN

The film "3 Ninjas Kick Back," the sequel to the hit 1992 children's movie "3 Ninjas," is as frantically disjointed as its forerunner was unnervingly slick. In the follow-up, the same three plucky brothers — Rocky, Colt and Tum Tum — trained by their grandfather (Victor Wong) in the martial arts, travel all the way to Japan to outwit a slew of cartoonishly bumbling bad guys.

The incoherent story concerns a cave of gold that can be unlocked only with a dagger belonging to the boys' grandfather. Koga (Sab Shimono), their teacher's embittered old enemy, dispatches his nephew's heavy-metal band to steal the weapon. But neither the young musicians, who look and act like rejects from "Wayne's World," nor a gymnasium full of sumo wrestlers can deter the resourceful boy ninjas from keeping the dagger out of his hands.

The movie has none of the athletic grace of "3 Ninjas," which suggested a Disney-style fusion of "Home Alone" and a Bruce Lee film aimed at children under 12. Instead of exalting physical grace and virtuosity, this film's slapdash action sequences resort repeatedly to the old trick of accelerating the action to the speed of

Tri-Star Pictures

Tokyo Story

Caroline Junko King plays a young ninja who teams up with Rocky, Colt and Tum Tum in "Three Ninjas Kick Back."

a silent-film chase. But "3 Ninjas Kick Back," which was directed by Charles T. Kanganis, is so poorly put together that the device only adds confusion to an already hopeless muddle.

Despite its questionable approval of the idea of raising warrior children, the original film at least had something positive to say about the virtues of self-discipline and concentration; "3 Ninjas Kick Back" is a hectic free-for-all with no point at all.

This movie is rated PG (parental guidance suggested). It has lots of bloodless, frankly phony fight sequences.

1994 My 7, 18:5

Murder Magic

Written and directed by Windell Williams; co-producers, Mr. Williams and Mavis K. Fowler; director of photography, John Rosnell; edited by Spence Daniels; music by Reginald Woods; executive producer, Alvin Rothkopf; released by Metropolis Pictures. Opens at the Harlem Victoria V Movie Theater, 235 West 125th Street. Running time: 90 minutes. This film is not rated.

Buddy Dixon	Ron Cephas Jones
Leo Dixon	D. Ruben Green
Gabrielle	Collette Wilson
Betty	Jeni Anderson
Gleason	Glenn Dandridge

By STEPHEN HOLDEN

Buddy Dixon (Ron Cephas Jones), the sleazy villain and occasional narrator of "Murder Magic," is a character who doesn't beat around the bush. In the film's opening scene, Buddy, who has just been released from prison after serving three years, turns to the camera and announces cheerfully that he is on his way to New York to kill his brother. Moments later, he hitches a ride with a silly European woman who asks him if he is Jack Kerouac. He convinces her that he is the Rev. Dr. Martin Luther King Jr.

The sole item Buddy carries with him on the road is a magician's bag of tricks. His favorite stunt, used to seduce women, is conjuring a long-stemmed red rose out of thin air.

Leo (D. Ruben Green), Buddy's intended victim, is a rising Brooklyn prosecutor with a straight-arrow image who is running for the City Council and dreams of becoming the state's first black governor. As it develops, he is far less virtuous than he first appears. His charmed life begins to unravel from the moment Buddy shows up on his doorstep. Leo has neglected to tell his wife, Gabrielle (Collette Wilson), about the existence of his brother. On the day Buddy arrives, Leo is threatened by a mysterious West Indian who has something to do with a case he is prosecuting.

"Murder Magic," which opened on Friday at the Harlem Victoria V, never forsakes the jaunty comic tone of its opening moments, even as its plot thickens with corruption, murder and shocking family revelations.

Once Buddy has moved in with Leo and Gabrielle, "Murder Magic" turns into an odd combination of a bedroom farce and a comic thriller with an idea borrowed from "Strangers on a Train." The womanizing Buddy pursues Gabrielle and Betty (Jeni Anderson), the faithless wife of Leo's next-door neighbor, Gleason (Glenn Dandridge).

With its zany premise, "Murder Magic" isn't nearly as funny as it ought to be. The outrageous situations

cry out for funnier dialogue than Mr. Williams's often flat screenplay provides.

Beneath the movie's insouciant veneer is the hint of a parable. Four of the five main characters have only recently migrated from the South. The group portrait that emerges suggests people so desperate to bury the past and invent glamorous new lives for themselves that they will stop at nothing, not even murder, to realize their ambitions.

1994 My 10, C19:1

The Crow

Directed by Alex Proyas; based on the comic-book series by James O'Barr; director of photography, Dariusz Wolski; edited by Dob Hoenig and Scott Smith; music by Graeme Revell; production designer, Alex MacDowell; produced by Edward R. Pressman and Jeff Most; released by Miramax Films. Running time: 1 hour 45 minutes. This film is rated R.

Eric	Brandon Lee
Albrecht	Ernie Hudson
Top Dollar	Michael Wincott
T-Bird	David Patrick Kelly
Sarah	Rochelle Davis

By CARYN JAMES

The first time Brandon Lee appears on screen in "The Crow," he is climbing out of his grave. (The scene is the first in which his face can be recognized; an earlier scene shows his character's body lying on the street in the shadowy distance.) Lee's ghoulish entrance is the eeriest possible sight, of course, because he was killed by a misloaded prop gun while making this movie just over a year ago. Now he howls as he stands in the mud and rain in the middle of the night playing Eric Draven, a small-time rock musician who has risen from the dead to get justice a year after he and his fiancée were murdered.

The advance publicity lavished on "The Crow" comes almost entirely from its newsy, tragic sidelight. Based on a comic-book character created by James O'Barr in the early 1980's, this is definitely a genre film. It is a dark, lurid revenge fantasy and not the breakthrough, star-making movie some people have claimed. But it is a genre film of a high order, stylish and smooth. Its dark look of midnight terror and its skewed cityscape link it to the "Batman" movies, but "The Crow" makes even the bleak "Batman II" seem like a kiddie's playground.

The crow that accompanies Draven on his brief return to earth is his link between the worlds of the living and the dead. In flashback scenes, fragmented and full of jumpy camera movements, we see that Draven's fiancée was raped and murdered in their apartment and that he was sent flying out the window by a seamy band of drug dealers who resented the couple's attempts to clean up the neighborhood.

On his return from the dead, Draven puts white makeup on his face and paints black lines to exaggerate his eyes and mouth. This lithe and gaunt figure is clearly a comic-book avenger with supernatural powers. When he is shot, his wounds heal magically. Ernie Hudson, as a policeman who saw Draven's corpse, looks quizzical when he notices him walking the streets, but quickly accepts the fact that a man has returned from the dead; it's just the kind of thing that happens in fantasy land.

Robert Zuckerman/Miramax

Brandon Lee in "The Crow."

Like most action-genre movies, "The Crow" spends much of its time showing the brutality with which Draven goes after his murderers. There are several major shootouts, a couple of explosions and one death in which Draven's victim ends up with a dozen or so hypodermic needles sticking out of his body. As the gang leader, called Top Dollar, Michael Wincott has a genuinely evil rasp in his voice. Top Dollar seems to be sleeping with his half-sister, a sorceress, but none of the characters are individualized much.

"The Crow" is more mainstream than it might have been, because script changes were made to soften the story after Lee's death. Sarah, a young girl befriended by Draven and his fiancée, now offers a voice-over at the film's beginning and end about preserving the memory of those you have loved. Draven saves Sarah from her drug-addled mother. Rochelle Davis makes Sarah a sympathetic, streetwise girl, but her enhanced role merely adds a trendy death-culture gloss. It doesn't change the film's violent nature or eye-for-an-eye message.

Brandon Lee had only three days of filming left when he was killed, and the performance is essentially his. There are some scenes in shadow that use a double, and some computer-enhanced scenes that seamlessly lift his image from one setting and place it in another. None of this becomes distracting.

Lee had great presence, but who knows if this movie would have led to more mainstream parts for him? The truth is that the role of Draven didn't require a huge amount of acting.

The film does offer promise for the future of its director, Alex Proyas, a 33-year-old Australian who is a veteran of music videos and commercials. Mr. Proyas's flair suggests he might make the leap to mainstream success. Sleek and accidentally haunting though it is, "The Crow" belongs in its niche.

"The Crow" is rated R. It includes much violence and strong language, and depictions of drug use.

1994 My 11, C15:4

Crooklyn

Directed by Spike Lee; written by Joie Susannah Lee,
Cinqué Lee and Spike Lee; director of photography,
Arthur Jafa; edited by Barry Alexander Brown; music
by Terence Blanchard; production designer, Wynn
Thomas; produced by Spike Lee; released by Univer-
sal Pictures. 115 minutes. This film is rated PG-13.

Carolyn	Alfre Woodard
Woody	Delroy Lindo
Tony Eyes	David Patrick Kelly
Troy	Zelda Harris
Clinton	Carlton Williams
Aunt Maxine	Joie Susannah Lee
Snuffy	Spike Lee

By JANET MASLIN

Foremost among the stereotypes undone
by Spike Lee's "Crooklyn" is the usual idea
of a Spike Lee film. None of the edgy, con-
frontational drama or stark handsomeness
of Mr. Lee's other work distinguishes this
noisy, crowded family story. Nor will "Crook-
lyn" spark debate on racial or sexual issues,
as some of Mr. Lee's films have. Instead,
"Crooklyn" is so mild that it's the first Spike
Lee film with the potential to be turned into a
television show. More important, it's the first
one to display real warmth of heart.

From some film makers, tender feelings
are de rigueur; from others, they're cloying
or easy. From Mr. Lee, they're nothing if not
a surprise. Messy as the semiautobiographi-
cal "Crooklyn" often is, it succeeds in becom-
ing a touching and generous family portrait,
a film that exposes welcome new aspects of
this director's talent. The phrase "kinder,
gentler Spike Lee" may not sit well with
those who admire the film maker's harder
edges, but it does come to mind.

Mr. Lee's fond evocation of a lost time and
place, the Brooklyn of the early 1970's, be-
comes a means of conjuring up intense feel-
ings of loss among his film's school-age char-
acters. After meandering boisterously
through much of its first half, "Crooklyn"
finally toughens up with the advent of a
family tragedy, and shows how its principals
are strengthened despite their loss.

In addition to being the first of Mr. Lee's
films that will appeal to children, "Crooklyn"
is his first to tell a story through the eyes of a
little girl. And a wise little girl, too: Troy
(Zelda Harris, a winning young actress)
watches everything that goes on in her neigh-

David Lee

Zelda Harris

borhood with a knowing and baleful eye.
Whether squabbling with her four brothers or
sizing up an awfully large, loud person in the
grocery store (played by the transvestite
RuPaul), Troy quietly appraises those
around her and learns from their behavior.
The heart of this coming-of-age story be-
comes Troy's need to fight for her independ-
ence while she solidifies vital family ties.

The two-parent, middle-class Carmichael
family of "Crooklyn" is conspicuously abnor-
mal, at least among black families in Ameri-
can films. Despite its title, this story unfolds
in a safe neighborhood where the father,
Woody (Delroy Lindo), drinks Pepsi, the chil-
dren play hopscotch and everyone eats
healthy meals, though not without a lot of
back talk about vegetables. Early in the film,
Mr. Lee often dwells on such details to ex-
cess, sacrificing the story's shapeliness for
the sake of broad, nostalgic touches. Plenty
of the anecdotes here, like one in which Troy
steals her brother's coin collection to buy ice
cream, feel more like family reminiscences
than interesting dramatic events.

In the past, Mr. Lee's films have often been
family affairs, since his sister, Joie Susannah
Lee, has acted in most of them (including this
one, as a Carmichael aunt). And his father,
Bill Lee, has provided musical scores. This
time, having written the screenplay with Joie
and his brother Cinqué Lee, the director has
worked less rigorously than usual, often
pausing for episodes that serve no strong
narrative purpose. (He also appears as a
neighborhood glue-sniffer.)

Audiences will at first be struck by the
cacophony of "Crooklyn," as the five Carmi-
chael siblings chatter furiously while they
are overpowered by a nonstop, all-hit 70's
soul soundtrack. But even the music works
better in the film's later stages, with familiar
love songs used movingly to reflect Troy's
thoughts about a death in the family.

It helps that the Carmichael parents are
played by such sturdy, likable actors. Alfre
Woodard appears as Carolyn, the family's
formidable mother, and along with Mr. Lindo
she helps give the material much-needed
ballast. This film's portrait of a marriage is
hazily constructed, but each parent emerges
as a forceful, compelling character. There's
a particular honesty in the depiction of Caro-
lyn as both loving mother and furiously stern
taskmaster: at one point, she drags her chil-
dren out of bed in the middle of the night
because they forgot to clean up the kitchen.
That behavior may not make sense, but it
feels real.

Much of "Crooklyn" is simply a cheerful
celebration of 70's black culture (with one
notable addition: the Carmichaels' wide-
eyed Partridge Family sing-along is a natu-
ral show-stopper). Clothes, songs and televi-
sion clips give the film an appealing gaiety,
as well as an innocence that suits its young
characters. Less successful are some of Mr.
Lee's visual affectations, including the bi-
zarre trick of compressing images by using
the wrong aspect ratio, for scenes in which
Troy goes to live with prim Southern rela-
tives. This device is less likely to evoke
Troy's mental state than to prompt hasty
trips to projection booths in movie theaters
across the land.

Noticeably absent from the credits of
"Crooklyn" is Ernest Dickerson, the cinema-
tographer whose vital contribution to earlier
Lee films is underscored by the bland look of
this one (shot by Arthur Jafa, whose own
credits include the hauntingly lovely
"Daughters of the Dust"). Mr. Dickerson,
who recently directed the mean-spirited ex-
ploitation film "Surviving the Game," obvi-
ously owes Mr. Lee a debt in kind.

●

"Crooklyn" is rated PG-13 (Parents
strongly cautioned). It includes moderate
profanity.

1994 My 13, C5:1

Trading Mom

Directed by Tia Brelis; based on the story "The Mommy Market" by Nancy Brelis, director of photography, Buzz Feitshans 4th; edited by Isaac Sehayek; music by David Kitay; production designer, Cynthia Charette; produced by Raffaella de Laurentiis; released by Trimark Pictures. Running time: 82 minutes. This film is rated PG.

Mommy and others	Sissy Spacek
Elizabeth	Anna Chlumsky
Jeremy	Aaron Michael Metchik
Harry	Asher Metchik
Mrs. Cavour	Maureen Stapleton

By CARYN JAMES

There's a lot to be said for a fantasy in which children can trade in their mothers for better models. In "Trading Mom," Sissy Spacek plays the harried single mother of three perfectly typical children. Twelve-year-old Elizabeth (Anna Chlumsky of the "My Girl" movies) and her two younger brothers would like a parent who is more like a fairy godmother and less of a working mom who makes them clean their rooms. They get their wish when a magical neighbor, played by Maureen Stapleton, tells them how to erase their own mother from memory and pick a new one at the Mommy Market, a kind of mall where new mothers are on display.

There are singing moms, dancing moms, cooking moms, and a few who look suspiciously like Sissy Spacek taking on multiple roles in outlandish makeup and costumes. This is where "Trading Mom" loses its appeal. The children choose three different mothers in turn, taking them home with disastrous results. But none seems remotely like the kind of mother kids would choose. Instead, they smack of adult attempts to give Ms. Spacek something exotic to do.

•

The first mother is Mama, a wealthy Frenchwoman with a maid, a cook and the world's longest cigarette holder. As the youngest child, Harry, puts it, "She looks like Cruella De Vil." Soon she is traded in for an outdoorsy type who thinks camping out in the rain is no problem. She is played by Ms. Spacek with a Katharine Hepburn accent and a silly-looking baseball cap. Finally there is Natasha, a clown with a Russian circus. No one listens to Harry, who said all along they should have chosen the mother with the chocolate-chip cookies stuck on her headband.

"Trading Mom" is the first feature directed by Tia Brelis, based on a 1966 story, "The Mommy Market," written by her mother, Nancy Brelis. Although the film tries hard, it lacks the spark that would have made it come to life as an enticing fantasy. The most alluring moments for children will probably be those in which the school principal is accidentally splattered with mud, hit in the face with a giant pancake and hung upside down from a tree. Their own imaginary mothers are likely to be far more entertaining than Mama or Natasha could ever be.

•

"Trading Mom" is rated PG (Parental guidance suggested). It includes a few mean slapstick tricks and a scene in which Mama is splattered with horse dung, direct from the horse.

1994 My 13, C10:5

The Conviction

Directed by Marco Bellocchio; screenplay by Massimo Fagioli and Mr. Bellocchio, in Italian, with English subtitles; director of photography, Giuseppe Lanci; edited by Mirco Garrone; music by Carlo Crivelli; production designer, Giantito Burchiellaro; producer, Pietro Valsecchi; released by International Film Circuit. At the Joseph Papp Public Theater, 425 Lafayette Street, East Village. Running time: 92 minutes. This film is not rated.

Lorenzo Colajanni	Vittorio Mezzogiorno
Sandra Celestini	Claire Nebout
Giovanni Malatesta	Andrzej Seweryn
Monica	Grazyna Szapolowska

By CARYN JAMES

There was a time when Marco Bellocchio was mentioned in the same breath as Bernardo Bertolucci. But that was a couple of decades ago when they were among the wild young things of the Italian film industry. Today Mr. Bellocchio is best known in the United States for his X-rated 1985 film, "Devil in the Flesh," and his latest work is not likely to raise his profile. "The Conviction," a 1990 film opening today at the Joseph Papp Public Theater, takes topical, explosive issues — rape, sexual harassment, power plays between the sexes — and reduces them into a forgettable puff of hot air.

The film begins in a promising, if calculated, way. An ordinary-looking young woman named Sandra (Claire Nebout) finds herself locked in a museum overnight. A handsome architect named Lorenzo (Vittorio Mezzogiorno, who died in January) has intentionally stayed behind as well. When he begins to rape her, at first she fights back. Then she freezes.

From that point on, the film takes one ludicrous turn after another. Shamed by her own coldness, Sandra invites Lorenzo to have sex she will enjoy. She does this by taking off her clothes and posing in an odalisque position in front of the museum's paintings, while they both expostulate about art and life.

Then Sandra drags Lorenzo into court. On the witness stand, she actually says, "He has a force of character that drives a woman to sexuality even if she doesn't want it." He wishes. So, it seems, do Mr. Bellocchio and his co-author, the psychoanalyst Massimo Fagioli. They regard Sandra as an authentic woman rather than a male fantasy out of Freud by way of D. H. Lawrence.

•

Soon the film shifts its attention to the prosecuting attorney, a man whose lover complains about his lack of passion. The prosecutor is played by Andrzej Seweryn with an unchanging look — a furrowed brow and staring eyes — that makes him look catatonic. Eventually he goes to the rapist for advice, wondering, "How do you lose your head for a woman?" Don't even ask about the scene in which the prosecutor stumbles across a peasant who looks and acts as if she were inhabited by the ghost of Anna Magnani.

Mr. Bellocchio obviously intends the sly references and stylized nature of this film, but he couldn't possibly have intended it to be this much of a howler. Relations between the sexes are complicated, but rarely as lunatic as they are made to seem here.

1994 My 13, C10:5

Widows' Peak

Directed by John Irvin; screenplay by Hugh Leonard; director of photography, Ashley Rowe; edited by Peter Tanner; music by Carl Davis; production designer, Leo Austin; produced by Jo Manuel; released by Fine Line Features. At the Paris, 58th Street west of Fifth Avenue. Running time: 101 minutes. This film is rated PG.

Mrs. Doyle Counihan	Joan Plowright
Miss O'Hare	Mia Farrow
Edwina Broome	Natasha Richardson
Godfrey	Adrian Dunbar
Mr. Clancy	Jim Broadbent

By CARYN JAMES

In the 1920's, in the Irish town of Kilshannon, is an enclave known as Widows' Peak. It is a world of women, defined by law. Joan Plowright, as the dowager always called by her full, unwieldy name, Mrs. Doyle Counihan, is the unofficial ruler of this well-off community, which the terms of her mother's will decreed off limits to all but widows.

One exception to the law is Mrs. Doyle Counihan's bachelor son, Godfrey (Adrian Dunbar), clingingly devoted to his "Mammy." Another is the penniless, mysterious Miss O'Hare. She is craftily played by Mia Farrow as a woman approaching middle age with her prettiness still intact but possibly a few stray marbles rattling around in her skull. When a widow named Edwina Broome arrives, she is the flamboyantly beautiful and shockingly modern Natasha Richardson, who drives her own car, smokes cigarettes, wears bright red lipstick and flirts shamelessly with Godfrey like any common hussy. You can see the conflicts coming, but they are quite delicious to watch.

"Widows' Peak" is a bright, light-hearted comedy with the hint of a murder mystery tossed in. Like last year's female-ensemble hit "Enchanted April," it has an idyllic country setting, much escapist charm, and a taste for flouncy, wide-brimmed hats. But what sets it apart from "Enchanted April" is even more interesting. This woman's world is not based on a sentimental longing for romantic husbands or sisterly solidarity. The community of Widows' Peak plays by female rules that are an unabashed throwback: Mrs. Doyle Counihan, Miss O'Hare and Mrs. Broome stage a power struggle based on gossip, innuendo and scheming, sometimes in the guise of gentility, sometimes in an outright cat fight. To be sure, this stereotype is deeply buried in the film and even justified by its historical setting. But it exists, and this brazenly incorrect attitude gives the film a gleeful, slightly naughty edge.

The script, by Hugh Leonard (best known for his play "Da"), creates sketchy characters that the actresses exploit to wry comic effect. Miss Plowright does an Irish turn on the comically smug older woman she played in "Enchanted April." Here she is a matriarch so sure of herself that she controls every detail of life in Widows' Peak, including the seating arrangements at the movie theater.

•

Mrs. Doyle Counihan is surrounded by biddies dressed in black, which instantly sets Miss O'Hare apart. She wears practical, slightly shabby pastel frocks and is being courted by Mr. Clancy (Jim Broadbent), the local dentist. Though the women rule Widows' Peak, the male characters have their share of mordant lines. Clancy is seen pulling Godfrey's tooth, anesthetizing himself with whisky and of-

Jonathan Hassion/Fineline Features
Mia Farrow

fering the peculiar aphorism that women are "born for widowhood" and blossom in that state.

Miss O'Hare and Mrs. Booth instantly dislike each other. Someone is up to no good, but the film is careful not to let on who is hiding what. Ms. Farrow pitches this performance just right, and it is a great relief to see her freed from her latest Woody Allen roles. Her long association with him provided her with fabulous parts early on, but in the last several films she and her characters had become annoying and dithery. There is none of that in Miss O'Hare, who may be a jealous spinster or something more sinister. No one in Widows' Peak credits her claim that Edwina Broome is trying to kill her.

•

But the film lets on that Edwina has some scheme of her own. Why else would she deliberately hire as her maid the town's biggest gossip, a woman who actually eavesdrops on other people in the confessional? Edwina is spreading some kind of disinformation. Ms. Richardson, as an English-born woman raised in America, has the wiliest role and plays it with a carefree sense of mischief that dominates the film. When she takes the hapless Godfrey on a picnic she is actually dressed as a scarlet woman: red hat, red dress, everything but a scarlet letter to identify her as trouble. Miss O'Hare almost slugs Edwina at a dance; later Edwina almost runs Miss O'Hare down with a boat. Maybe these were accidents.

The director, John Irvin, is better known for macho action movies like "Hamburger Hill" than for anything like this winsome chamber comedy. He manages the details beautifully, including a scene in which Miss O'Hare pours her tea into a saucer with unexpected comic results.

The secrets in "Widows' Peak," which opens today at the Paris, are not all that hard to guess. But the suspense plot with its surprise twist near the end — and the surprise twist after that one — is really an excuse for these frivolous characters to exist. The three stars run riot with them, all the way back to a day when gossiping was an acknowledged female art.

•

"Widows' Peak" is rated PG (Parental guidance suggested). It includes some mild language and meek sexual innuendos.

1994 My 13, C16:1

Critic's Choice

AIDS Patients on Life and Death

- Clinica Estetico

Juan Botas's and Lucas Platt's "One Foot on a Banana Peel, the Other Foot in the Grave," with Ramon Hodel, left, and Daniel Chapman, is part of the 1994 New York Lesbian and Gay Film Festival.

Among the growing number of films that focus on people living with AIDS, no documentary has done so with the stunning intimacy of Juan Botas and Lucas Platt's "One Foot on a Banana Peel, the Other Foot in the Grave." It is a high point of the 1994 New York Lesbian and Gay Film Festival, which runs through May 22 at the Quad Cinema in Greenwich Village.

"One Foot," which is subtitled "Secrets From the Dolley Madison Room," records the conversations of a group of men with AIDS in their doctor's office (nicknamed the Dolley Madison Room), where they gather to receive regular intravenous medication. Unlike other AIDS documentaries, "One Foot," which was produced by Jonathan Demme and Peter Saraf, is not relentlessly upbeat in the face of tragedy. As the emaciated patients reminisce, joke and talk about life, love, sex and death, their collective reflections become a microcosm of changeable human emotion, devastatingly heightened by their situation. Sadness and grief coincide with an antic humor and an irrepressible passion for life.

Botas, who died of AIDS in August 1992, was a well-known graphic designer who began making the film three months before his death. After he died, the filming continued for nine more months; the final 85-minute documentary was assembled from more than 100 hours of film.

"One Foot," which has the first of two screenings at 5 P.M. tomorrow, is among nearly 200 feature films, shorts, documentaries and experimental works in this year's festival.

•

The festival opened last night with Rose Troche's erotic comedy,

"Go Fish," which created a stir at the last Sundance Festival. Rough-hewn and sexually frank, this light-hearted view of the lives of five women in their 20's has a cheerfully raunchy sensibility that has led to its being described as a lesbian answer to Spike Lee's first feature, "She's Gotta Have It." It is to open commercially in New York and other major cities on June 10.

Two documentaries of unusual interest will be screened this weekend: Isaac Julien's "Darker Side of Black" on Sunday at 8 P.M. and Arthur Dong's "Coming Out Under Fire" tomorrow at 8:10 P.M.

"Darker Shade of Black" examines virulent anti-gay bias in Jamaican dancehall music and the genre's close connections with American hip-hop. The film includes interviews with Shabba Ranks and Buju Banton, Jamaican musicians whose song lyrics include incendiary anti-gay language and who cite biblical passages to justify it. Other interviews explore the similarities between the oppression of homosexuals and the history of slavery. More than an exposé of an ominous trend in pop music, the film is a clear-

headed examination of the political and social roots of dancehall, which has succeeded reggae as the sound of young Jamaica.

"Coming Out Under Fire," a documentary history of homosexuality in the United States Army during World War II, features interviews in which nine lesbian and gay veterans recall their war experiences. The movie traces the evolution of the military's anti-homosexual stance as the war progressed, with firsthand reports that gay people who were let alone early in the war were later persecuted and thrown out of the military. The film suggests that anti-gay sentiment is as entrenched in the military today as it was when witch hunts landed suspected homosexuals in "queer stockades" or forced them out of the service, stigmatized as undesirables.

Starting today, festival screenings begin at 1 P.M., with the final feature each night at 10. Tickets, at $7 and can be purchased from Ticketmaster (212 307-7171) or at the Quad Theater box office, 34 West 13th Street, Greenwich Village, from 1 to 10 P.M. daily. Information: (212) 343-2707.

STEPHEN HOLDEN

1994 My 13, C28:4

A Seaside Outing,
With Undertones

"Bhaji on the Beach" was shown as part of the recent New Directors/New Films series. Following are excerpts from Janet Maslin's review, which appeared in The New York Times on March 19. The film opens today at the Film Forum, 209 West Houston Street, South Village.

"This is your day!" exclaims the organizer of the bus outing seen in Gurinder Chadha's "Bhaji on the Beach," a thoughtful, warmly inviting film about Asian women adapting to life in England. "Have a female fun time!" That feeble nod to feminist solidarity avoids the fact that these

women actually seem to have little in common. They range from boy-crazy teen-agers to old ladies in saris, with a stylish visitor from Bombay who waves a cigarette holder and wears a fuchsia suit. Their problems and prejudices are as different as their clothes.

On an organized trip from Birmingham to Blackpool for a day and night of sampling tacky seaside ambiance and avoiding the men in their lives, these women provide this film's enterprising director with a colorful cross section of attitudes. Ms. Chadha, who has said that she thinks of this as a very English film and that the director she most admires is Ken Loach, weaves her characters' personal crises into a broader social portrait of their adopted homeland. She does this with impressive deftness and humor, even when addressing the ever-present matter of racism. "They Curried My Budgie!" reads a shrill tabloid headline on the morning when the film begins.

Ms. Chadha very successfully confines "Bhaji on the Beach" to the events of a single day. ("Bhaji" refers to a snack food that is itself an English-Indian hybrid.) It is the day when Hashida (Sarita Khajuria), the first person in her family to plan to go to medical school, discovers she is pregnant by Oliver (Mo Sesay), her boyfriend, who is black. It is also the day when Ranjit (Jimmi Harkishin), whose wife, Ginder (Kim Vithana), has run away from him, is goaded into trying to get her back. Ms. Chadha lets these and other developments emerge during the course of a busy morning, while she also depicts vibrant life in various other Asian households around Birmingham.

A man who runs a newsstand washes racist graffiti off his door. When one young woman, who shares a crowded kitchen with members of her husband's family, is asked to name an American movie, she very pointedly mentions "Married to the Mob." The teen-agers Ladhu (Nisha Nayar) and Madhu (Renu Kochar) tote a boom box, which is one of many reasons they have their mother worried. Simi (Shaheen Khan), one of the story's cooler heads, has daydreams in the giddy, overblown style of Indian commercial movies, and fantasizes about ways in which traditional Indian culture is being demolished by everyday English realities. "This country has cost us our children," one of the story's older characters eventually says.

"Bhaji on the Beach" generates enough small culture clashes to remain bustling and energetic most of the way through. The touristy Blackpool setting is used well and provides its own set of distractions, from the foppish "actor, historian and ancient Blackpudlian" who tries to woo Simi (she has a hilarious Indian musical fantasy in which she tries to imagine him as a traditional suitor) to a restaurant where the women are gratuitously insulted. "The Khyber Pass is just around the corner," the proprietor sneers.

By the later stages of the story (the screenplay was written by Meera Syal), Ms. Chadha is forced into a certain amount of manipulation. She lets several of the film's male characters also turn up at the beach, most notably Oliver, who is played tenderly by Mr. Sesay and faces his own set of problems dealing with the bigotry of

Hashida's elders. Yet even when the film develops a case of third-act-itis, leaving Ms. Chadha too busy tying up loose ends, it sustains its intelligence and charm.

1994 My 18, C20:2

Maverick

Directed by Richard Donner; written by William Goldman, based on the television character created by Roy Huggins; director of photography, Vilmos Zsigmond; edited by Stuart Baird; music by Randy Newman; production designed by Tom Sanders; produced by Bruce Davey and Mr. Donner; released by Warner Brothers. Running time: 120 minutes. This film is rated PG.

Maverick	Mel Gibson
Annabelle	Jodie Foster
Zane Cooper	James Garner
Joseph	Graham Greene
The Commodore	James Coburn
Angel	Alfred Molina

By CARYN JAMES

"YOU always been gutless?" an ornery poker player snarls across the table at Bret Maverick. Mel Gibson looks thoughtful — for all the world like Jack Benny pondering "Your money or your life?" — then cheerfully answers, "Yeah, I guess so." As the suave but disaster-prone Maverick has cause to say later, "Being spineless has kept me alive a long time." It also helps that he's quicker on the draw than most gunslingers, smarter than the average gambler and wears a lucky poker shirt.

Fast, funny, full of straight-ahead action and tongue-in-cheek jokes, "Maverick" is "Lethal Weapon" meets "Butch Cassidy and the Sundance Kid." That combination won't win any prizes for originality, but it works like a movie mogul's dream and sets the summer-film season off to an unbeatable start.

Heading for a high-stakes poker game on a riverboat, Maverick is a few days away, $3,000 short and trailed by villains hired to keep him out of the game. On the way he hooks up with Jodie Foster as Annabelle Bransford, a semi-efficient con woman, and James Garner, television's original Maverick, as Zane Cooper, a marshal who can teach Maverick a thing or two about spineless survival. As they bumble their way through the Old West, they turn it into the New West of moviedom with their smart contemporary tone.

Richard Donner, who directed Mr. Gibson in all three "Lethal Weapon" pictures, takes a similar approach here. Just as "Lethal Weapon" is an action movie that chuckles at action movies without straining anyone's brain, "Maverick" exploits and undermines every western cliché from gunfights to war-whooping Indians to runaway stagecoaches and heroes hanging off cliffs.

William Goldman isn't shy about borrowing from his own classic "Butch Cassidy" screenplay. No meeting between strangers is quite what it seems in this story, which relies on con after con after con. You don't have to know anything about poker to guess that even away from the table, everyone in "Maverick" is bluffing all the time.

The stars are wildly comfortable in roles that seem shaped for them. Mr. Gibson, one of our best comic actors, plays Maverick with a gleam in his eye, knowing enough not to take the character too seriously. Though he wears fancy vests and his hat cocked back on his head, Maverick is not always the debonair hero. When the film starts, he is sitting on a horse with a noose around his neck, urging the horse not to move. In a flashback he remembers how he got into this fix, starting with the day he rode into town on a burro looking to scrape together the extra $3,000. Men with names like Pork Chop owe him money, but he's not good at collecting debts. That leads to lines like, "The widow Pork Chop conned me!" He is fond of quoting things "my old pappy used to say," though those self-preserving sayings don't help much when he is dragged behind the runaway stagecoach or surrounded by hissing snakes.

When Annabelle, a poker player herself, throws herself into Maverick's arms and announces how stunningly attractive he is, maybe she means it and maybe it's a ruse. From Annabelle's fake Southern accent to her gestures at the poker table, Ms. Foster keeps us guessing about when the character is putting on an act. She and Maverick are more cohorts than lovers, though there is one notable, frantic tryst between poker games.

Mr. Garner, of course, is the father of all Mavericks and the master of the wry, slow take. He also brings to his character a lot of Jim Rockford's dryness. And while his presence adds a warm and generous touch to the movie, as the story develops it becomes clear that his role is not just ceremonial. More than a stable counterpoint to the reckless Maverick, his Coop becomes central to the plot in a couple of unpredictable ways.

At almost every turn, "Maverick" adds sly comic episodes. Among the most elaborate and entertaining is a sequence in which Graham Greene plays Joseph, a smooth-operating Indian who masquerades as a me-want-wampum type of guy. When Joseph and his tribe, in full war paint, surround Maverick, Annabelle and Coop, it's a good thing Maverick can speak Joseph's Indian dialect.

Andrew Cooper/Warner Brothers
Mel Gibson

Danny Glover also appears in a small cameo with his "Lethal Weapon" partner. And the riverboat gamblers, led by James Coburn, are a portrait gallery of familiar western faces, from Doug McClure of "The Virginian" to country singers like Clint Black and Waylon Jennings.

The film has an affectionate surprise ending, with the hero in a bubble bath. It's the perfect slippery conclusion for a smart, newfangled "Maverick."

●

"Maverick" is rated PG (Parental guidance suggested). It includes some action scenes and some strong language.

1994 My 20, C1:3

Even Cowgirls Get the Blues

Written and directed by Gus Van Sant, based on the novel by Tom Robbins; directors of photography, John Campbell and Eric Alan Edwards; edited by Mr. Van Sant and Curtiss Clayton; music by K. D. Lang and Ben Mink; production designer, Missy Stewart; produced by Laurie Parker; released by Fine Line Features. Running time: 90 minutes. This film is rated R.

Sissy Hankshaw	Uma Thurman
The Countess	John Hurt
Bonanza Jellybean	Rain Phoenix
The Chink	Noriyuki (Pat) Morita
Julian Gitche	Keanu Reeves
Delores Del Ruby	Lorraine Bracco
Miss Adrian	Angie Dickinson
Marie Barth	Sean Young
Howard Barth	Crispin Glover
Rupert	Ed Begley Jr.
Carla	Carol Kane
Madame Zoe	Roseanne Arnold
Dr. Dreyfus	Buck Henry

By CARYN JAMES

The 70's haven't aged well, especially if you take them seriously. "Tell me about being a cowgirl," the large-thumbed Sissy Hankshaw says to her future lover, Bonanza Jellybean. "When you say the word you make it sound like it's painted in radiance on the side of a pearl." One of the many problems with Gus Van Sant's tortured, worked-over "Even Cowgirls Get the Blues" is that Sissy Hankshaw talks like a novel, and a dated one at that.

To read Tom Robbins's 1976 bestseller today is to step into a different cultural moment, a time when Sissy, a natural-born hitchhiker with enormous phallic thumbs, could plausibly have been the heroine of a free-spirited counterculture. But the 70's were fading even then, and it's impossible all these years later to film "Cowgirls" without assuming some perspective on the past. Mr. Van Sant, who was more successful with "Drugstore Cowboy" and more ambitious with "My Own Private Idaho,"

seems to have swallowed "Cowgirls" whole.

Much of the liveliness of Mr. Robbins's novel comes from the way it scatters all over the place. It takes off in verbal flights and digressions to tell the story of Sissy, a poor girl from Virginia, who becomes a high-fashion model, makes her way west to the all-female Rubber Rose Ranch, falls in love with Bonanza Jellybean and has an enlightening affair with a wise man called the Chink, who pontificates about time and space. Mr. Van Sant's movie is all over the place, too, but that strategy makes the film scattershot instead of vibrant.

●

Still, no one can say he didn't try to get a grip on it, and "Cowgirls" can stand as one of the more intriguing failures of its day. It is well known by now that the film was scheduled to appear last fall. After it was shown at the Venice Film Festival (where I first saw it) and the Toronto Film Festival, where it was coolly received, Mr. Van Sant decided to re-edit the movie and delay the opening.

The bad old version of "Cowgirls" seemed to be about six things at once: Sissy, the 70's, pop culture, lesbians, the West and the mystical mumbo-jumbo about time and space. The new version eliminates the mysticism, and is about five things.

The central problem is Sissy. Uma Thurman looks the part. But she has a strained backwoods Virginia accent and is carried along by a script that tries to cram in so much of Sissy's life that she careers from one city to another without becoming more than a character sketch. It would have taken some serious rewriting and re-shooting to give Sissy the substance to carry the film.

Rain Phoenix has the best-written part and is wonderfully natural as Bonanza Jellybean. Determined to turn herself into a cowgirl, Bonanza has the conviction of her obsession.

●

As the Countess, Sissy's sometime benefactor and the owner of the Rubber Rose, John Hurt has red-painted nails, pale-white makeup and a sashaying manner. When he arrives at the ranch and faces a cowgirl takeover, he trills at them, "You pathetic little cutesy-poos." Mr. Hurt camps it up, but at least he has some energy and a welcome attitude that suggests: the 70's are gone, God love 'em.

Lorraine Bracco has one of the worst-written parts as Delores Del Ruby, the ranch forewoman who finds that peyote gives her visions from the Mother Goddess. And many brief appearances stand as a tribute to Mr. Van Sant's once and future talent. Keanu Reeves is a nerdy urban Indian whom Sissy loves. Buck Henry is the local doctor who advises

Abigayle Tarsches/Fine Line Features
Uma Thurman, left, and Lorraine Bracco in a scene from "Even Cowgirls Get the Blues."

her on her thumbs, and Roseanne Arnold the fortuneteller who predicts Sissy's future. Most of Noriyuki (Pat) Morita's role as the Chink has been cut, but bits of his philosophy remain. "Ha ha. Ho ho. Hee hee" is one, which hints that no amount of editing could have saved this film.

"Even Cowgirls Get the Blues" is rated R (Under 17 requires accompanying parent or adult guardian). It includes sex scenes and much strong language.

1994 My 20, C10:1

Desperate Remedies

Direction and screenplay by Stewart Main and Peter Wells; produced by James Wallace. Released by Miramax. Running time: 94 minutes. This film has no rating. At the Quad Cinema, 13th Street west of Fifth Avenue, Greenwich Village.

WITH: Jennifer Ward-Lealand, Kevin Smith, Lisa Chappell and Cliff Curtis.

By STEPHEN HOLDEN

"Desperate Remedies," Stewart Main's and Peter Wells's gorgeous but silly mock epic, is a film that wants to have its cake and eat it too. The New Zealand film, which opened yesterday at the Quad Cinema, aspires to be the 90's answer to a 40's Hollywood costume drama, but with a big wink in its eye and layers of sexual ambiguity added.

Unfolding as a series of tableaux in which the actors mouth deliberately wooden dialogue while the camera adores their faces, the movie isn't acted so much as it is posed in a style that suggests a hybrid of Ken Russell and a Calvin Klein Obsession perfume ad. Peter Scholes's overwrought score, larded with excerpts from Donizetti's "Forza del Destino" coats the proceedings with a thick quasi-operatic gloss.

"Desperate Remedies," which is set in a mythical colonial town called Hope, follows the adventures of Dorothea Brook (Jennifer Ward-Lealand), a beautiful and wealthy draper who lives in luxury with her doting companion, Anne Cooper (Lisa Chappell), and her younger sister, Rose (Kiri Mills). Dorothea is besieged with problems, the worst of which is Rose's opium addiction, stoked by a scoundrel lover named Fraser (Cliff Curtis).

Dorothea determines that the only way to save Rose is to buy off Fraser and pay someone else to marry her sister. An ideal candidate appears in the form of Lawrence Hayes (Kevin Smith), a handsome stranger with a mysterious past, whom Dorothea spots coming off a ship.

In the omnisexual world of "Desperate Remedies," everybody gives everybody else the eye. Even Fraser and Lawrence pause in the middle of a fight to consider an erotic connection. Dorothea faces the most difficult romantic decisions. Will she choose a respectable marriage of convenience to William Poyser (Michael Hurst), a nasty local politician who wants her money? The dashing but disreputable Lawrence? Or the devoted Anne, who smothers her with kisses at every opportunity?

Had "Desperate Remedies" had any narrative sweep it might have been an amusing genre-busting coup. But the story unfolds so choppily that it amounts to little more than an art

director's pastiche of glamorous images, a series of beautifully photographed storyboards.

Yet as an allusive post-modern spoof of movie history, "Desperate Remedies" has its charms. Ms. Ward-Lealand looks and acts like a cross between Greta Garbo in "Queen Christina" and Catherine Deneuve. Mr. Curtis's Fraser suggests the 50's John Derek wearing too much makeup and a nipple ring. Old-time movie fans will delight in spotting dozens of other homages to an era when the notion that the girl might end up going off with the girl instead of with the boy was unimaginable.

1994 My 23, C14:4

Little Buddha

Directed by Bernardo Bertolucci; screenplay by Mark Peploe and Rudy Wurlitzer, based on a story by Mr. Bertolucci; cinematographer, Vittorio Storaro; edited by Pietro Scalia; music by Ryuichi Sakamoto; production and costume designer, James Acheson; produced by Jeremy Thomas; released by Miramax Films. Running time: 123 minutes. This film is rated PG.

Prince Siddhartha Keanu Reeves
Dean Conrad Chris Isaak
Lisa Conrad Bridget Fonda
Jesse Conrad Alex Wiesendanger
Lama Norbu Ying Ruocheng

By JANET MASLIN

Living in pre-Industrial Light and Magic times, the Buddha attained spiritual enlightenment the old-fashioned way: sitting beneath a bodhi tree until he arrived at perfect knowledge. But in Bernardo Bertolucci's "Little Buddha," a rapturous $35 million epic about rejecting worldly excess to embrace simpler values, there is a better way.

Or at least a bigger one. And so, as Prince Siddhartha (Keanu Reeves), who will evolve into the Buddha (or Enlightened One) through this experience, is seen beneath the tree during this film's most staggering sequence, all the wonders of the special-effects world are unleashed to convey his visions. If this dazzling mixture of Buddhist thought and cinematic fireworks had been possible a couple of decades ago, it would have prompted the "Oh, wow" heard round the world. Even today, in less giddy times, it makes for a gorgeous, grandly presumptuous spectacle that really deserves to be seen.

"Little Buddha," a crazily mesmerizing pop artifact that ranks alongside Herman Hesse's novel "Siddhartha" in terms of extreme earnestness and quasi-religious entertainment value, finds Mr. Bertolucci working in an uncharacteristic vein. For all its obvious seriousness, "Little Buddha" has a naïve, miracle-gazing intensity that turns it into Mr. Bertolucci's first Spielberg movie, complete with awestruck faces and intimations of higher knowledge. This is also the film maker's first close encounter with visual tricks like morphing, which makes for religious experience of another kind.

"Little Buddha" also has a greater visual sophistication that echoes some of Mr. Bertolucci's own widescreen exoticism, as captured most recently by "The Last Emperor" and "The Sheltering Sky." Photographed stunningly by Vittorio Storaro, accompanied by Ryuichi Sakamoto's powerfully insinuating score, this film rises above its own obviousness

to work in genuinely mysterious ways. At his best, Mr. Bertolucci can present an image of cars on a highway and still suggest something of the unknown.

Once again following his own compass to extraordinarily beautiful places (in Bhutan, in Katmandu and even in Seattle), Mr. Bertolucci tells a two-tiered story. This film's means of approaching the tale of Prince Siddhartha, the young Buddha, is by means of the Conrad family of Seattle and a group of Tibetan monks. Led by Lama Norbu (played with courtly distinction by Ying Ruocheng), the monks seek out the Conrads for a reason. They reveal to Lisa Conrad (Bridget Fonda) and her husband, Dean (Chris Isaak), that they think the couple's 9-year-old son, Jesse (Alex Wiesendanger), is the reincarnation of a Tibetan lama. Lisa and Dean are sufficiently open-minded to take this news in stride.

Whenever "Little Buddha" explains a basic Buddhist tenet like reincarnation, it takes pains to find some kind of visual correlative. When Jesse is told that meditation can make bad thoughts seem like passing clouds, for instance, he is in an airplane and there are passing clouds outside the window. This didacticism would be more tedious if it were not presented so avidly, and if the other half of "Little Buddha" were not so splashy. If movies experienced reincarnation, then the pageantry-filled early scenes of Prince Siddhartha's story probably had an earlier life as "The Ten Commandments."

Bronzed, painted and bejeweled, with a head covered with luxuriant ringlets, Mr. Reeves is truly a thing of beauty. That's not the same as being a plausible stand-in for one whose teachings have so profoundly influenced life on this planet, but for the purposes of this film, it works. Despite the fact that Mr. Reeves' voice sounds oddly reprocessed, and that he retains traces of surfer-boy body language at the most unexpected moments, he more than commands interest during those sections of the film that depict Siddhartha's evolution. When a huge cobra magically appears to shield Siddhartha from rain, for instance, Mr. Reeves need only sit in meditation and look serene. That he can do.

The screenplay, by Mark Peploe and Rudy Wurlitzer from a story by Mr. Bertolucci, is free to take liberties, since so little is actually known about Siddhartha's early life. They fare more successfully in these religious sections than in the ordinary business of understanding the Conrads, despite the airy, affirmative quality both Ms. Fonda and Mr. Isaak bring to the film. And the screenplay also pales when it reveals that two other children are candidates for being the reincarnated lama. Although the word candidate is used, the idea of competition is meaningless to "Little Buddha," since the film strives for such a beatific mood. That attitude is admirable, but it also serves to put a damper on the film's dramatic possibilities.

Despite the screenplay's stray anachronisms (Siddhartha uses words like "ego" and "architect"), the writers succeed in giving a storybook tone to much of this material. In fact, an actual storybook is used to ease transitions between the Siddhartha tale, in a stroke of simplicity that communicates the film's overall sweetness. In this, "Little Buddha" displays a deliberate innocence that

suits its subject, even if it contrasts so markedly with much of Mr. Bertolucci's moodier, more unsettling work. "Lama, what's impermanence?" Jesse asks in one scene. For one example, his teacher could point to "Little Buddha" and its untroubled inner peace.

"Little Buddha" is rated PG (Parental guidance suggested). It includes mild profanity.

1994 My 25, C13:1

Beverly Hills Cop III

Directed by John Landis; written by Steven E. de Souza, based on characters created by Danilo Bach and Daniel Petrie Jr.; director of photography, Mac Ahlberg; music by Nile Rodgers; production designer, Michael Seymour; produced by Mace Neufeld and Robert Rehme; released by Paramount Pictures. Running time: 103 minutes. This film is rated R.

Axel Foley Eddie Murphy
Billy Rosewood Judge Reinhold
Jon Flint Hector Elizondo
Janice Theresa Randle
Serge Bronson Pinchot
Ellis DeWald Timothy Carhart
Orrin Sanderson John Saxon
Uncle Dave Thornton Alan Young

By CARYN JAMES

As surely as if it were a McDonald's or a Burger King, "Beverly Hills Cop III" is part of a money-making franchise, though this one has been abandoned for so long it has cobwebs on top of cobwebs. It has been seven years since "Beverly Hills Cop II," and a decade since the blockbuster original. But recently Eddie Murphy's career has seen some box-office duds like "Boomerang," so it's no surprise that "Beverly Hills Cop III" has surfaced, a sequel designed to be as foolproof as possible. The strategy is to bring back familiar characters while throwing lots of cash and special effects at the screen.

This time Axel Foley, the Detroit detective who always outsmarts the villains *and* the laid-back Beverly Hills police, winds up in an elaborate California theme park called Wonder World, a front for a crime ring that also has the F.B.I on its trail. The film includes so many explosions, car chases, gunfights and other unnatural disasters — all played with frenetic energy — that it takes a while to realize something is off kilter besides the Tilt-a-Whirl. Axel has lost his sense of humor.

Every comic moment is cut short and even Mr. Murphy's smile seems forced. No longer the hero who hid behind a "Saturday Night Live" array of accents and a knowing grin, this Axel might as well be Axl Rose.

The opening sequence, set in Detroit, promises the high-voltage mix of humor and action that made the original "Cop" movies so popular. Axel and his men close in on a ring of car thieves. Inside the garage, the radio plays the Supremes' "Come See About Me," and the thuggish mechanics do a wicked lip-sync, complete with choreography and a strategic Diana Ross elbow to one of the back-up singers.

Then, the episode takes off in an extended, violent scene that includes a couple of murders, many machine guns and a car chase in which the hood of Axel's car is blown off. As he accidentally runs over a body

dumped from a moving truck, Axel gives a facial expression that says, "Whoops." It's irreverent and effective.

John Landis, who directed Mr. Murphy in "Trading Places" and "Coming to America," pulls out all the stops. But the action is never again as fast, furious or suspenseful as in the opening scenes.

And the few moments of genuine satire that follow make viewers realize what's missing. When Axel arrives at the gate of the Beverly Hills Police Department, he is greeted with an automated voice that offers to continue the message in English, Spanish, French or Farsi, and to direct him to the riot-rumor hot line.

The high point of the film belongs to Bronson Pinchot as Serge, the character with the tortured foreign accent who was a crowd pleaser in the original "Beverly Hills Cop." No longer working at the art gallery, Serge now owns a Survival Boutique, dealing in fashionable self-defense weapons, or as he puts it, "wee-pons." His sing-song sales pitch for items to foil car thieves: "Do you want to die for your Camry? I don't sink so."

Judge Reinhold returns as Axel's Beverly Hills police pal, Billy Rosewood, and Hector Elizondo is a new

family-man character, replacing Sergeant Taggart in the earlier films. These men don't have much to do until the final shootout.

Playing it safe, "Beverly Hills Cop III" even uses the trendy ploy of dropping in celebrity cameos, including many directors. Among them is George Lucas as a patron Axel annoys by cutting in line at Wonder World, Barbet Schroeder as a man parking a Porsche, and John Singleton as a fireman. The founder of Wonder World, lovable Uncle Dave, is played by Alan Young, better known as the owner of Mr. Ed.

Mr. Murphy seemed to be having much more fun in the maligned "Boomerang." At least he tried something different there, playing a caddish romantic hero. "Beverly Hills Cop III" is a generic action movie, an Eddie Murphy film with only a trace of Eddie Murphy.

•

"Beverly Hills Cop III" is rated R. (Under 17 requires accompanying parent or adult guardian.) It includes much violence and some strong language.

1994 My 25, C14:3

The Flintstones

Directed by Brian Levant; written by Tom S. Parker, Jim Jennewein and Steven E. de Souza, based on the animated series by Hanna-Barbera Productions Inc.; director of photography, Dean Cundey; edited by Kent Beyda; music by David Newman; production designer, William Sandell; produced by Bruce Cohen; released by Universal Pic.

tures. Running time: 92 minutes. This film is rated PG.

Fred Flintstone	John Goodman
Wilma Flintstone	Elizabeth Perkins
Barney Rubble	Rick Moranis
Betty Rubble	Rosie O'Donnell
Cliff Vandercave	Kyle MacLachlan
Miss Stone	Halle Berry
Pearl Slaghoople	Elizabeth Taylor

By CARYN JAMES

THERE are many learned theories about why "The Flintstones" are pop-culture icons. One involves the theme song: "Flintstones! Meet the Flintstones! They're the modern Stone Age fa-mi-ly." Just try to get that out of your head.

Another is that the Flintstones have been kept alive by vitamins. "You took the vitamin; now see the movie" might not have been a bad marketing slogan. A couple of generations of children have popped chewable versions of Fred, Barney and Wilma into their tiny mouths daily.

But the theory best reflected in the goofy new live-action "Flintstones" concerns Fred himself. Among his many commercial ventures outside the television show, he once became the official logo of a luckily named New England bank. "Yabba-dabba-doo!" he yelled in his gravelly voice in ads. "Love that Old Stone Bank!" People who wonder why anyone would give their money to an institution with a Flintstone mascot are missing the point. Fred may have been a cartoon, but he was a trustworthy, likable cartoon, a regular guy reassuring enough to have remained that bank's spokesman for years.

The minute John Goodman stomps through the door of his suburban cave and yells "Wilm-a-a-a!" in the "Flintstones" movie, the familiar, likable old Fred is back. Mr. Goodman plays him for all the lovable loudness, false bravado and sentimental heart he's worth. Wearing his bright orange pelt (what is that animal, anyway?) and a dazed look that suggests Fred is not a lot smarter than the rocks in the quarry where he works, Mr. Goodman turns in a comic performance as oversized as the movie's giant props. He goes a long way toward carrying "The Flintstones" over a script that is essentially a bunch of rock jokes and puns stretched to feature-film length.

In fact, while the movie may act like a madeleine for television-obsessed baby-boomers, it works even better as a colorful playland that will

appeal to small children. Bedrock is populated by dinosaurs, woolly mammoths and other vivid, Muppet-like creatures (designed by Jim Henson's Creature Shop) that turn the Stone Age into a magical world shared by humans, animals and missing links.

All the characters remain faithful to the 60's series, right down to their voices, costumes and roles in life. As Fred's neighbor, best friend and co-worker at the quarry, Rick Moranis has that Barney Rubble smirk and second-banana attitude. Elizabeth Perkins as Wilma and Rosie O'Donnell as Betty are stay-at-home wives and mothers, and the actresses even have the characters' unmistakable giggles down cold.

Elizabeth Taylor offers a refreshing contemporary touch as Wilma's social-climbing mother, Pearl Slaghoople. Miss Taylor looks as if she has just stepped out of one of her own perfume ads. In the middle of so much déjà vu, she works effectively against the grain, although she plays the classic complaining sitcom mother-in-law. "You could have married Eliot Firestone," she snaps at Wilma, "the man who invented the wheel."

The wit doesn't get much above that, and neither does the barely functional plot. When Fred is made a company executive, he and Wilma get swelled heads. Fred is too dense to see that the evil Cliff Vandercave (Kyle MacLachlan) and his sexy assistant, Miss Stone (Halle Berry), are scheming to embezzle money and let Fred take the rap.

•

Even in the television series, the cleverest parts were always the modern Stone Age props and comic asides. In the film, Dino is especially lifelike, although this version of the Flintstones' big, slurping purple housepet is computer-generated. Other engaging special-effects creatures include the pigasaurus garbage disposal (a trash-eating animal hidden under the sink), and a woolly mammoth whose trunk is the Flintstones' shower. A bird who takes dictation in Fred's office offers wise advice in a

world-weary, aristocratic voice provided by Harvey Korman. And when the Flintstones go to dinner and dancing at Cavern on the Green, that outdoor restaurant bears a curious resemblance to Stonehenge.

The greatest lost opportunity in "The Flintstones" is that its writers (more than 30) are so faithful to the 60's television series that they failed to add enough updated pop-culture references. The few included are among the film's best jokes.

When Fred is charged with embezzlement, Wilma finds out by watching a live report on CNN, the Cave News Network. Later, Jay Leno appears as host of the television series "Bedrock's Most Wanted," and Betty even recognizes the actor portraying Fred: "He plays Dr. Gravelman on 'The Young and the Thumbless,' " she says.

The director, Brian Levant, started as a sitcom writer and director and also directed the hit family film "Beethoven." Adults waiting for the second coming of "The Honeymooners" won't find it here, and the rock jokes do become tiresome. (Though I wouldn't have had the film lose its chiseled-in-stone newspaper offering "All the News That's Fit to Chip.")

Bedrock is also rife with product names adapted to pre-history, like the Chevrok filling station, that threaten to overwhelm the movie. But one of the film's rockily adapted names belongs to the man whose production company is behind the film and hints why the Stone Age creatures are so vivid, Bedrock is so cozily livable and "The Flintstones" are so child-friendly. The onscreen credit reads, "Steven Spielrock Presents." And who's going to argue with *him* about dinosaurs?

•

"The Flintstones" is rated PG (Parental guidance suggested). There is a bit of rough action.

1994 My 27, C1:1

Ron Batzdorff/Universal Pictures
Prehistoric suburbia: Elizabeth Perkins as Wilma and John Goodman as Fred in Bedrock.

FILM VIEW/Janet Maslin

Discoveries Made Along The Croisette

Lisa Leona/Columbia Pictures
Lauren Vélez and Jon Seda in "I Like It Like That."

CANNES, France

THE REWARDS OF THE CANNES INTERNA-tional Film Festival go well beyond the pleasure of hearing the word Hudsucker pronounced with a French accent, though certainly that was one of them. Cannes offers an incomparably broad overview of world cinema, with all its contrasts and extremes. The arts of self-promotion are as well displayed here as the artistry on screen, and it takes a cool head to keep them separate. Nearly two weeks' worth of cinematic overload and celebrity drumbeating do not encourage cool thinking, but then that's the whole point. The first step to frenzy is well-orchestrated confusion.

Cannes thrives on that. You arrive here to daily press handouts that do not necessarily intend to shed light. From one Monday's listings, some sample film synopses: "A deluded bank robber believes he is King Arthur." "The humdrum life of a couple is disrupted by the arrival of an anonymous love poem." "A nocturnal homosexual preys on elderly women, kidnapping them and killing them." "A retired judge wins the affection of a young model who accidentally hit his dog with her car."

■

I can't speak for the first two, since they appeared on a day when the program guide listed 166 screenings. But the third and fourth are, respectively, "I Can't Sleep," a widely admired French film by Claire Denis, the director of "Chocolat," and Krzysztof Kieslowski's "Rouge," a supremely subtle and enveloping work that could not possibly be summed up in a single sentence. Definitely not a sentence about a dog being hit by a car. But the fact that nothing at Cannes is what it sounds like only enhances the festival's suspenseful atmosphere.

So does the potential for making discoveries. This was a strong year for films outside the main competition, and a number of them will find international audiences now that this event is over. Among those that attracted attention: Hal Hartley's droll, spare "Amateur," which may not expand Mr. Hartley's following but should certainly please his admirers; "Muriel's Wedding," an Australian film by a director named Paul J. Hogan, not to be confused with Crocodile Dundee, although he turned up, too; "Eat Drink Man Woman," a tasty, commercial comedy from the Taiwanese director of "The Wedding Banquet," and "Bandit Queen," a super-violent Indian film about an avenging female outlaw.

The Leningrad Cowboys, Aki Kaurismaki's hopeless musical group known for their shellacked hairdos, could be seen roaming the Croisette during the wee hours. But they didn't do much for "Tatyana, Take Care of Your Scarf," an hourlong Kaurismaki film that continues the Cowboys' globe-trotting adventures. A more successful publicity gambit was the so-called Bronx Block Party to promote "I Like It Like That." This bright urban comedy is directed by Darnell Martin, who brings a knowing feminine sensibility to bear on her material and who made the most of Cannes's prominence as a showcase for new film makers. As a smart, appealing, young African-American film maker with impressive talent, Ms. Martin came to the right place at the right time.

Films in the main competition usually arouse the strongest emotions in Cannes, since the festival's international audiences are not shy about expressing audible opinions. But the crowds were polite this year, perhaps because half the main competition films were so eminently forgettable. Shrugs greeted "The Browning Version," starring Albert Finney and signaling every shading of Terence Rattigan's play within its first 10 minutes. Along with "The Whores," a black-and-white Italian film that is exactly what it sounds like, it prompted the greatest doubts about the festival's selectivity.

Many of the other main competition films played like rough drafts, since they will call for serious editing if they are to receive wide release. "Les Patriotes," a solemn two-and-a-half-hour spy film by Eric Rochant that could have been an hour shorter, was typical in that regard. On the other hand, Quentin Tarantino's "Pulp Fiction" had virtually the same running time and didn't seem long. Mr. Tarantino, with an energy level that is somewhere beyond the volcanic, has no trouble holding an audience's attention.

Mr. Tarantino's success story is the sort that lends excitement to this entire event. Two years ago he was a new kid on the block with his first film, "Reservoir Dogs," which was shown in one of Cannes's ancillary festivals. This year he won the main competition with a much bigger film, jump-started the careers of some of his actors (notably John Travolta, whose performance was dubbed "la surprise du festival" by Le Figaro), and came across as such a fresh, avid cinéaste that he will doubtless inspire many others.

The subject of screen violence always comes up when Mr. Tarantino's name is mentioned. And an event like this festival also raises the issue of violence in broader terms. For documentary film makers, addressing the bloodshed in Bosnia is now a matter of compelling interest; there are several such documentaries here, although the essence of the tragedy is not easily captured. A poster for one film, entitled "MGM Sarajevo — Man, God, the Monster," also turned up in the window of an extravagant Cannes gourmet shop, which may offer some idea of how jarring festival-induced contrasts can be.

A different but equally fundamental idea of violence has colored recent Chinese films dealing with the Cultural Revolution. In Zhang Yimou's "To Live," hardship and brutality are depicted only indirectly, in the ways they affect the film's central family, and yet the horrors are overwhelming. It's truly disorienting to move from a film of such gravity, which split the grand jury prize, to something like Lodge Kerrigan's "Clean, Shaven," which tries to convey the inner turmoil of its deeply disturbed protagonist by shocking the audience in bloody, graphic terms. (A sign warning that "Clean, Shaven" might be violent enough to upset viewers guaranteed that screenings here drew huge crowds.)

■

The self-mutilation scenes in Mr. Kerrigan's film look ugly and exploitative, but then that's the way some critics dismissed "Reservoir Dogs" two years ago. If Mr. Kerrigan turns out to have new stature as dramatic and unexpected as Mr. Tarantino's, then the festival circuit (his work has already been shown at New Directors and Sundance) will have served its purpose.

Meanwhile, Mr. Tarantino has himself come a long way in dealing with violence. This time he has toned down the gore to a much more bearable level and offset it with wild, unexpected humor.

At a lunch with Mr. Tarantino (who turned up in one of the south of France's toniest restaurants wearing a Fred Flintstone T-shirt), both Mr. Travolta and Bruce Willis gave some thought to the violence in "Pulp Fiction." Mr. Travolta brought up "Goodfellas," which combines horror and humor in similar ways, and rightly observed that the unusual circular structure of Mr. Tarantino's film makes it ultimatley seem anything but exploitative. Mr. Willis, having starred in films in which the body count climbs into the hundreds, said that he saw this film as something very different from that brand of escapism. It is.

Mr. Willis and Mr. Travolta are old hands at dealing with celebrity. And,

notwithstanding the fact that Mr. Willis rightfully blew his cork when a woman spoke contemptuously of his work at his festival press conference, they bring an obvious professionalism to the job. At the other end of the spectrum, 14-year-old Sean Nelson, who plays a drug dealer in "Fresh," came to France from the Bronx just after his picture had been plastered all over Cannes and was politely thrilled by the whole experience. Politeness, professionalism: nice qualities. But they aren't always what the Cannes press corps is after. And they can't compare to the inimitable je ne sais quoi of Mickey Rourke.

Mr. Rourke was only here for a couple of days, during which he announced his intention to be a Hollywood team player, then had a public fit. But on one of his good days, he appeared jauntily for an early-morning (1 P.M.) interview accompanied by a friend of his, a novelist named Michael Davis. Claiming that Mr. Davis deserved screenwriting credit on his latest movie, "S.F.W.," Mr. Rourke loyally defaced a poster to add his buddy's name. He punctuated his remarks with a "You agree with that, Mike?" every now and then. Sure enough, Mike agreed.

THE GREAT MYSTERY about Mr. Rourke, inescapable in Cannes, is that the French love him so. So he explained that he loved them too and had many French friends, including the renowned photographer Robert Doisneau, who recently died.

Mr. Rourke was too busy to go to the funeral, he said. So Mike went instead. Mr. Rourke wasn't sure how to spell his friend Doisneau's name. So Mike did that too.

"You see?" Mr. Rourke exclaimed, grinning at Mike. "That's why you always need a writer."

Or that's why you always need a writer in Cannes. □

1994 My 29, II:9:5

Corrections

Because of an editing error, the Film View column on page 9 of the Arts and Leisure section today, about the festival in Cannes, misstates the title of a movie discussed by the actor Mickey Rourke. It is "F.T.W.," not "S.F.W."

1994 My 29, 2:5

The Boys of St. Vincent

Directed by John N. Smith; written by Des Walsh, Mr. Smith and Sam Grana; director of photography, Pierre Letarte; produced by Mr. Grana and Claudio Luca; released by Alliance Communications. At Film Forum 1, 209 West Houston Street, South Village. Running time: in two parts, each of which is 93 minutes. This film is not rated.

WITH: Henry Czerny, Brian Dodd and Johnny Morina.

By JANET MASLIN

Whenever 10-year-old Kevin Reevey (Johnny Morina) is sent for an evening visit to the office of Brother Peter Lavin (Henry Czerny), the other boys at St. Vincent's orphanage in Newfoundland exchange furtive, embarrassed glances. They know too well what those visits are about, and they know they have no recourse. Within the cloistered, terrifying world of St. Vincent's, it will do no good to complain.

It won't help because the All Saints Brothers, who run the orphanage, exercise absolute authority over their charges. Their authority is as physically overwhelming as the size difference between Brother Lavin and shy little Kevin. It is as morally daunting as Brother Lavin's stories about hell, which he avidly tells the children. "You will be forced out on the street and you will have nowhere to go but the gutter," the orphans are angrily told, once rumors of physical and sexual abuse leak out and the events at St. Vincent's threaten to get out of hand.

Having long been forced into complete obedience, these boys have experienced their own kind of purgatory. Yet they are old enough to have an inchoate grasp of their victimization. Clutched in a suffocating embrace by Brother Lavin during the single saddest scene in "The Boys of St. Vincent," Kevin cries out: "My mother's dead and always will be! You're not my mother." The director, John N. Smith, knows such a moment needs no melodramatic fanfare. It is wrenching enough when presented in straightforward fashion.

•

"The Boys ᴏᶠ St. Vincent," a cool, thoughtful two-part Canadian drama about obviously incendiary subject matter, opens today at the Film Forum, which will give it well-deserved attention. This film previously ran into extreme censorship problems with Canadian television. Its broadcasting was delayed by injunctions relating to the trials of former Christian Brothers whose activities at the Mount Cashel orphanage in Newfoundland inspired some of this fictionalized story. The fact that tabloid television routinely presents material much more lascivious than Mr. Smith's serious, responsible dramatization makes the furor that much harder to understand.

•

The two halves of "The Boys of St. Vincent," each of which runs about an hour and a half, are separated by 15 years. The first portion is devoted to discreet accounts of the outrages that have occurred at the orphanage, and the events that bring the crimes to light. Telling his story with a matter-of-factness that gives it the solid credibility of a documentary, Mr. Smith observes St. Vincent's daily routine and lets it imply a great deal about both the boys' and the Catholic brothers' behavior. The boys scrub hard in the shower, where some of the brothers watch them with a shade too much interest. When one of the boys jokingly wears a bra and plays at being a woman in another scene, the film's tone remains calm while its discomfort level escalates off the charts.

•

The goings-on at St. Vincent are first suspected by a kindly janitor, who alerts the police. Far from solving the problem, the police investigation only illustrates how life at St. Vincent's got out of hand. The orphanage is about to receive a Government grant, and political scandal is to be avoided at all costs. The police chief is even squeamish enough to find the very charges against the brothers pornographic. "I need a nice clean report for the files," he tells an investigator. "And you're going to write it up."

As the first segment ends, Brother Lavin's excesses have cost him his job, but little more. The toll these events will take on Kevin, his feistier friend Steven (Brian Dodd) and the other boys remains to be seen. In fact, it is revealingly documented by the second installment, which works as both courtroom drama and a longitudinal study examining the effects of sexual abuse. Even bleaker and more fascinating than the film's early exposition, these later sequences cast light on the power of such abuse to harm both victims and perpetrators.

Even in these later scenes, "The Boys of St. Vincent" sustains its impressive, near-scientific calm. Not even its trial scenes reach the pitch of ordinary television histrionics, which comes as a great relief. Mr. Smith, who wrote the screenplay with Des Walsh and Sam Grana, keeps his horror in focus while also insisting on a wide, even charitable overview. As played with anguished intensity by Mr. Czerny, Lavin himself feels injured in ways that a more lurid film might never understand.

"The Boys of St. Vincent" offers a sensitive, illuminating look at a tough subject. It deserves to be seen, and its arrival is long overdue.

1994 Je 1, C11:1

A Landscape of Strife From the Cows' Vantage

"Cows" was shown as part of last year's New Directors/New Films series. Following are excerpts from Stephen Holden's review, which appeared in The New York Times on March 30, 1993. The film opens today at the Papp Public, 425 Lafayette Street, East Village.

Every so often in "Cows" ("Vacas"), Julio Medem's epic portrayal of two feuding families in the Basque region of northern Spain, the camera draws away from the tumultuous passions of its characters to focus on the eyes of the cattle that are essential to these people's livelihoods. After contemplating their expressionless faces, the camera returns to the drama, but detachedly, as though the director has decided to observe the world and its butchery through uncomprehending bovine eyes.

Wielded by a lesser film maker, this conceit, which alludes to the eye-slashing opening sequence in "Un Chien Andalou," the seminal 1929 Surreal collaboration between Luis Buñuel and Salvador Dali, might seem pretentious. But "Cows" is a film so overflowing with what can only be called life-force energy that these digressions lend it an extra depth and poignancy. At these turning points, the viewer is momentarily prodded to see the film's larger-than-life characters as tragic, mortal creatures in a landscape that will outlast them and their joys and torments no matter how intensely they live.

"Cows," tells four related short stories that cover 60 years. It begins in 1875 in a trench during the Second Carlist War. Manuel Irigibel, a panic-stricken soldier, escapes a massacre by playing dead. He covers his face with the blood of his dead neighbor Camilo and rolls out of the cart that is carrying away the bodies of the slain soldiers. Only a lone cow witnesses his tumble to survival.

The film then jumps ahead 30 years. Manuel, who has never fully recovered from his war experience, is now a gentle, eccentric painter (obsessed with drawing cows) who shares a farmhouse with his son Ignacio and his family at one end of a beautiful, remote valley. At the other end, separated by a lush forest teeming with mystery and enchantment, live Camilo's children, Juan and Paulina. In one of the film's most viscerally exciting scenes, the rival clans

New York Shakespeare Festival
Manuel Blasco and Emma Suarez in Julio Medem's "Cows."

meet at a log-chopping contest between Ignacio and Juan; it has the ferocity of a duel.

The intensity of that contest is matched by the secret passion shared by Ignacio and Paulina, which is later consummated violently in the forest. Their union produces an illegitimate son, Peru, who lives for a time with Manuel's family and becomes deeply attached to his half-sister, Cristina.

In the final story, set in 1936, Peru, who has been living in America with his parents, returns to the valley, to cover the Spanish Civil War as a photojournalist. This final section includes some remarkable thick-of-battle sequences set in the forest and shot with a hand-held camera.

More successfully than any film in recent memory, "Cows" brings to the screen the epic sweep and magical realist sensibility found in the work of writers like Gabriel García Márquez. Much more than a witty Surrealist joke, the recurrent cow imagery builds into a resonant symbol of the natural world and of the profound ties that the characters have to the land and to their past.

The movie offers many other powerful allegorical symbols. One is a scarecrow-like figure of the scythe-bearing reaper, built by Manuel, that turns in the wind and is a potentially deadly booby trap. Another, situated in the heart of the forest, is a bottomless pit in which dead animals are buried and out of which eerie cries emanate.

In a stroke of conceptual audacity, the director has cast Carmelo Gómez, an actor with hawklike features and slightly hooded eyes, as the young Manuel, his son Ignacio and the adult Peru. Mr. Gómez succeeds wonderfully in creating very different personalities while at the same time suggesting a mystical continuity that transcends genetics and has to do with the soul and its relation to the land.

Ultimately, of course, the bovines that wander through the film lack any way of retrieving the past and forming an idea of history that the human characters create with their paintings, photographs and memories. In Mr. Medem's eyes, the related wars that form the bookends of the story are only manifestations of the mysterious, nearly ungovernable drives of people reared in a landscape that is as savage as it is ravishingly beautiful.

If "Cows" is so intense that its emotions border on the excessive, this stunning debut is clearly the work of a born film maker with a talent for translating memory into images so sharp and sensuous you can almost touch and smell them.

1994 Je 1, C16:5

Grief

Written and directed by Richard Glatzer; director of photography, David Dechant; edited by Robin Katz and William W. Williams; music by Tom Judson; production design, Don Diers; produced by Ruth Charny and Yoram Mandel; released by Strand Releasing. Running time: 87 minutes. This film is not rated.

Bill	Alexis Arquette
Jo	Jackie Beat
Harvey	Kent Fuher
Mark	Craig Chester
Leslie	Illeana Douglas
Paula	Lucy Gutteridge
Jeremy	Carlton Wilborn

By CARYN JAMES

The voice-over that begins "Grief" is unmistakably male; light, but male. Jo, the person to whom it belongs, turns out to resemble Divine if he had tried to dress like a managerial woman, in discreet suits and silk scarfs. Jo (Jackie Beat, also known as Kent Fuher) is the producer of a television show called "Love Court," and the character's cross-dressed casting is just the start of the sexual shape-shifting that goes on in the office where Jo is the resident tyrant and earth mother.

Mark, one of the show's writers, is coming up on the one-year anniversary of his lover's death from AIDS. Jeremy, another writer, is also gay and Mark's college friend. Both Mark and Jeremy are sexually interested in Bill. And just because Bill might get back with his girlfriend doesn't mean he would pass up a fling with Jeremy or Mark.

The film's writer and director, Richard Glatzer, based "Grief" on his own experience as a producer for "Divorce Court," and the film is dedicated to his own lover, who died. With so much emotion behind it, and so much potential in the "Love Court" scenes, it sounds as if "Grief" is onto something rich. In fact, the film is sluggish, and the actors spend much of the time sitting around discussing their emotional lives in stilted dialogue.

The cast has a good deal of experience. Alexis Arquette, who plays Bill, was first-rate in "Last Exit to Brooklyn." So was Craig Chester, who plays Mark, in "Swoon." Little of that experience shows here. In this company Illeana Douglas, as Jo's assistant (an office oddity, a heterosexual), and Carlton Wilborn, as Jeremy, stand out as beacons of professionalism. And if a film can't wring more laughter from "Love Court" plots summarized in shorthand, like "circus lesbians," there's not much hope.

It's easy to think these characters just need to get out of the office more, but Mr. Glatzer's point seems to be that this little band of co-workers is a family. Wasn't that the idea behind "The Mary Tyler Moore Show"? Though "Grief" sounds daringly honest, it has the sentiments of a sitcom without the laughs.

1994 Je 3, C6:5

Renaissance Man

Directed by Penny Marshall; written by Jim Burnstein; director of photography, Adam Greenberg; edited by George Bowers and Battle Davis; music by Hans Zimmer; production designer, Geoffrey Kirkland; produced by Sara Colleton, Elliot Abbott and Robert Greenhut; released by Touchstone Pictures. Running time: 124 minutes. This film is rated PG-13.

Bill Rago	Danny DeVito
Sergeant Cass	Gregory Hines
Captain Murdoch	James Remar
Jack Markin	Ed Begley Jr.
Jamaal Montgomery	Kadeem Hardison
Donnie Benitez	Lillo Brancato Jr.
Tommy Lee Haywood	Mark Wahlberg

By JANET MASLIN

If you're looking for a learning experience, "Renaissance Man" is ready to teach you what the words simile, metaphor, oxymoron and formula mean. The last, in this case, refers to the story of a down-on-his-luck individual who gets a shot at

Ron Batzdorff/Buena Vista Pictures
Danny DeVito

redemption by teaching nice, somehow-disadvantaged innocents who can benefit from his wisdom. Maybe he's a coach ("The Air Up There," "Cool Runnings," "The Mighty Ducks") or maybe he's a failed ad copywriter (this film). Probably he's a white male, unless he's Whoopi Goldberg teaching nuns about rock-and-roll.

Inherently condescending, and finally awash in warm-bath sentimentality, this setup never goes out of style. It has certainly worked for Disney, whose "Dead Poets Society" is a landmark within this realm, and for Penny Marshall, whose "Awakenings" and "League of Their Own" flirted with the same motif. This time, Ms. Marshall directs the story of Bill Rago (Danny DeVito), whose advertising career is in ruins when he takes a temporary job educating Army recruits. The recruits are supposed to need remedial teaching, but they're funny, sensitive and eager to learn. When they stand up and read Bill their first creative writing exercises, their stories put the average screenwriter to shame.

"Renaissance Man," from a semi-autobiographical screenplay by Jim Burnstein, spends a lot of time watching Bill explain "Hamlet" to his charges. It enjoys its share of wisecracks, and beyond that means to be a cry for literacy and learning. But as a one-book movie, it's part of the problem rather than part of the solution. "Hamlet" is desperately overused, whether in bad jokes ("That's about a little bitty pig, right?") or impromptu musical exercises (the class recites "this above all, to thine own self be true" while practicing percussion). The strain is most evident in a scene that shows the class performing a supposedly spontaneous hip-hop "Hamlet" riff, while Mr. DeVito beams in frozen admiration.

The film's first half-hour is directed in such a wry, breezy style that its subsequent pedantic streak comes as a big letdown. As always, Ms. Marshall's rueful humor can be natural and disarming, provided it isn't working overtime to make the world a better place. Early scenes of Mr. DeVito in cranky combat with an unemployment-office worker, or reacting with horror to 4:30 A.M. reveille at the Army post, have an easy give-and-take. That relaxed tone is badly missed once the story takes its earnest turn.

So is the film's initially quick pacing: "Renaissance Man" runs longer than two hours, and would have been

funnier with some of its padding removed. Yet even at its present length, the film has some confusing lapses, like the sight of a kitchen that Bill is told he will share with a next-door neighbor at the Army post. ("I've died and gone to Gomer Pyle's house," he complains.) No neighbor appears, and the house isn't seen again. Later on, a brief, implausible scene giving Bill a girlfriend seems shoehorned in just to advance a plot point. But the girlfriend may have played a larger role, since she makes a token appearance at the feel-good finale.

"Renaissance Man" does succeed in assembling a highly likable band of recruits. Their antics give the film some fizz, even when its Shakespearean pretensions threaten to flatten all else. The actors are appealing enough to override the fact that each of them has a one-sentence, fairly heartbreaking problem that will be addressed by the story's end. Outstanding among these performers are Kadeem Hardison as the group cut-up and Lillo Brancato Jr., still doing the De Niro imitation he perfected as the son in "A Bronx Tale." Mark (Marky Mark) Wahlberg, playing a tough Southern soldier who finds ample reasons to take his shirt off, oozes gritty confidence and makes a strong, swaggering impression on the big screen.

Also in "Renaissance Man," and used to much less successful effect, are James Remar as an improbably nice officer and Gregory Hines as an improbably harsh one. Mr. Hines must do the thankless job of looking stunned when one of Bill's students recites the "We few, we happy few, we band of brothers" speech from "Henry V," once the class finally begins learning a second play.

As a drill sergeant, Mr. Hines's character has sneered at the idea that Shakespearean education can make for a better fighting force, but this scene is supposed to change all that. At such moments, the score by Hans Zimmer can be counted on to deliver the obligatory crescendo, the musical equivalent of a self-congratulatory pat on the back.

•

"Renaissance Man" is rated PG-13 (Parents strongly cautioned). It includes mild profanity.

1994 Je 3, C6:5

Bruce Brown's 'The Endless Summer II'

Directed by Bruce Brown; written by Mr. Brown and Dana Brown; director of photography, Mike Hoover; edited by Mr. Brown and Mr. Brown; music by Gary Hoey and Phil Marshall; produced by Ron Moler and Roger Riddell; released by New Line Cinema. Running time: 100 minutes. This film is rated PG.

WITH: Robert (Wingnut) Weaver and Patrick O'Connell.

BY STEPHEN HOLDEN

Surfing has come a long way since those lazy, hazy, crazy days of the early 1960's when the sport was a cult phenomenon in Southern California and Hawaii. As "Bruce Brown's 'The Endless Summer II'" makes abundantly clear, it has grown into a worldwide network of enthusiasts with its own professional tour circuit and star galaxy.

But while "The Endless Summer II" notes many of the changes in the sport, from the shortening of surf-

New Line Cinema
Robert (Wingnut) Weaver, left, and Patrick O'Connell.

boards to the overcrowding of popular beaches, its main goal is to recapture the innocent mystique of Mr. Brown's 1964 film, "The Endless Summer." It was 30 years ago that this modest, 16-millimeter feature film became an international hit and did much to popularize the sport around the world. In that movie, which had the perky ingenuousness of an early Beach Boys anthem, Mr. Brown trekked around the globe with two young surfers on a quest for the so-called perfect wave.

In "The Endless Summer II," Mr. Brown retraces many of those steps with two fresh-faced surfing fanatics, Robert (Wingnut) Weaver and Patrick O'Connell, who look and act like throwbacks to three decades ago. The journey takes them to Alaska, South Africa, Costa Rica, France, Indonesia, Australia, the Fiji Islands and Hawaii. As he did in the original film, Mr. Brown narrates their adventures in the gee-whiz style of southern California teen-agers in the early 1960's.

•

Technically, "The Endless Summer II," which was shot in 35-millimeter film, is a lot more sophisticated than its forerunner. The biggest waves are more mountainous, and the techniques of riding them more varied and virtuosic. In scene after scene, the camera almost dives into the curl of a wave as it tracks a surfer skimming across its gleaming inner wall to emerge in a burst of spray. Although the surfing sequences that dominate the film are spectacular, they are not especially exciting. The waves may be enormous, but the people who ride them seem as attuned to the water as porpoises. If their exploits involve some risk, the movie conveys little of the danger and drama.

Had "The Endless Summer II" stuck to its subject, it would be a pleasant diversion. But it is weighed down with frivolous travel vignettes that are as dull as they are cute and contrived. In one snickering scene in the south of France, the two young surfers are embarrassed to find themselves on a topless beach. In another, the companions, neither of whom reads French, order dinner by pointing randomly at items on a menu and appear shocked when the waiter returns with a plate of snails.

A South African sequence patronizes a black man who is referred to as the world's only Zulu surfer, and fun is made of the fact that he knows how to ride a wave but cannot swim. A native ceremony in the Fiji Islands is also treated as a sort of exotic joke. The surfers' hijinks reach a peak of inanity in Australia when their adventurous tour guide, who is a local surfing star, subjects them to a series of daredevil escapades that seem a lot tamer than Mr. Brown would have us believe.

Through it all, Mr. Weaver and Mr. O'Connell remain ciphers, completely devoid of personality. The only things distinguishing them is that one is blond, the other brown-haired, and that one surfs with a longer board than the other.

•

"Bruce Brown's 'The Endless Summer II' " is rated PG (Parental guidance suggested). It has a scene at a beach with topless sunbathing.

1994 Je 3, C12:1

The Princess and the Goblin

Directed by Jozsef Gemes; produced and written by Robin Lyons, based on the novel by George MacDonald; animation director, Les Orton; edited by Magda Hap; music by Istvan Lerch; released by Hemdale Communications. Running time 82 minutes. This film is rated G.

With the voices of:

King	Joss Ackland
Great-Great-Grandmother	Claire Bloom
Princess Irene	Sally Ann Marsh
Prince Froglip	Rik Mayall
Curdie	Peter Murray
Queen	Peggy Mount

By STEPHEN HOLDEN

Jozsef Gemes's animated film "The Princess and the Goblin" is not to be confused with the kind of fairy tale in which a royal kiss turns a hideous creature into a shining prince. An adaptation of a popular 1872 tale by the Scottish author George MacDonald, it tells the less romantic story of a sheltered princess who overcomes her childhood fears and saves her father's kingdom from a race of evil goblins.

The film is a whimsical allegory of self-reliance in which the wispy-voiced princess, Irene (Sally Ann Marsh), guided by the ghost of her great-great-grandmother (Claire Bloom), grows into a take-charge woman who survives all sorts of punishing physical ordeals. If the subtext of the tale suggests that the goblins are really one's own unconscious childhood fears, visually the movie doesn't begin to plumb Freudian waters.

The enemies of the kingdom are a belligerent tribe of creatures who resemble a hybrid of cavemen and cartoon monsters. These creatures, who have dark circles under their eyes and crooked gapped teeth, don't exude malevolence so much as a slovenly decadence. Their leader, Froglip (Rik Mayall), who hopes to marry Irene, is a sadistic mama's boy who is mercilessly goaded by his mother, the angry queen.

The goblins, whose plan for conquest involves flooding the mines around the castle, are easily intimidated. They can't stand to hear people sing and are immobilized by pain when their feet are stepped on.

If "The Princess and the Goblin" is mildly diverting children's fare, its characters are not sharply focused visually or verbally. And Irene, with her English accent and little-girl voice, is not someone with whom children today will readily identify. Everywhere she goes, Irene travels with her tiny gray kitten, Turnip, a generically wimpy feline with no personality. In a cinema that teems with terrifying monsters, the goblins appear to be ineffectual and unmenacing even when they are on the warpath.

Even the film's one song, "A Spark Inside Us," is mediocre by cartoon

song standards. A stolid pop march, it is as aggressively uplifting as it is humorless.

1994 Je 3, C15:1

Fear of a Black Hat

Written and directed by Rusty Cundieff; director of photography, John Demps Jr.; edited by Karen Horn; music supervisor, Larry Robinson; production designer, Stuart Blatt; produced by Darin Scott; released by the Samuel Goldwyn Company. Running time: 86 minutes. This film is rated R.

Tasty-Taste	Larry B. Scott
Tone-Def	Mark Christopher Lawrence
Ice Cold	Rusty Cundieff
Nina Blackburn	Kasi Lemmons

By JANET MASLIN

Flattering the daylights out of Rob Reiner and his "Spinal Tap" crew, Rusty Cundieff turns "Fear of a Black Hat" into an unapologetic "Spinal Tap" imitation. And there's no point in faulting Mr. Cundieff for such derivativeness, because "Fear of a Black Hat" is too savvy and cheerful to warrant complaints. Anyway, the more the merrier: what "Spinal Tap" did for heavy metal certainly deserves to be done for rap, which is the target this time. If Mr. Cundieff doesn't match the satirical genius of Mr. Reiner's film, he does understand the rules of the game.

For instance, the band being studied in mock-documentary format must be publicly overconfident and privately pretty badly confused. Accompanying the group should be at least one unctuous flunky. "I really enjoy your work, fellas," one white manager says to some of this film's tough-guy black rappers. "Rich emotional tapestry."

White managers are deemed essential by the members of Niggaz With Hats, since the managers tend to get caught in crossfire and suffer other music-related mishaps. They drop like flies, just as Spinal Tap's drummers did.

Niggaz With Hats consists of Tasty-Taste (Larry B. Scott), Tone Def (Mark Christopher Lawrence) and Ice Cold (Mr. Cundieff). This group, like Spinal Tap, loves to explain the deeper meaning of its music when shutting up would be a better idea. Mr. Cundieff, who wrote and directed this film and is its funniest performer, earnestly explains why the group's name and extremely silly outfits are a subtle comment on slavery, for instance. Likewise, he can explain why the group's "Kill Whitey" album was unfairly tarred as racist, and point out that N.W.H.'s most sexist-sounding lyrics are actually political commentary.

Not surprisingly, this group is having career problems. For instance, the three rappers turn up for a concert and find themselves billed as "And Special Guest" on a marquee. Beyond stringing together episodes like this, "Fear of a Black Hat" doesn't have any more plot than "Spinal Tap" did, but it does trace the familiar show-biz misadventures. So Ice Cold complains bitterly about imitators (the film's other Ices include Tray, Coffee, Water, Berg and Box). And the group switches from a white-run record company to one whose owner so shamelessly flatters N.W.H. that he brings up Marcus Garvey, Bob Marley and Malcolm X in the process.

None of this helps, especially not Ice's efforts to start an acting career. In one of this film's faster, wittier sketches, Ice appears in a violent exploitation film and pauses to lecture an inner-city child about the evils of drug-dealing. The child is young enough to be in a baby carriage, but in a movie like this, he already has a beeper. Incidentally, the rappers' own stage costumes feature beepers as well as crazy hats, which owe a lot to Dr. Seuss. Tasty-Taste, the gun-crazy member of N.W.H. and the one most prone to ostentation, turns up at one concert with a full-size gold trophy hanging around his neck from a gold chain.

This film's musical parodies have titles and lyrics that are mostly unprintable, often borrowing directly from specific rap hits. You don't need to know the original to get the gist or to realize that these sendups are mildly amusing rather than really devastating. After "Spinal Tap," it became impossible to watch any heavy metal band with a straight face. While "Fear of a Black Hat" does blow the lid off certain stereotypes — one of its toughest-looking rappers is exposed as a prep-school graduate who was once nicknamed Chip — it's not as subversive. Nor is it as "def chill fresh," as one of the film's more hopeless, rap-loving characters likes to say.

•

"Fear of a Black Hat" is rated R (Under 17 requires accompanying parent or adult guardian). It has considerable raw profanity.

1994 Je 3, C15:1

The Slingshot

Written and directed by Ake Sandgren, based on the novel by Roland Schutt; in Swedish, with English subtitles. Director of photography, Goran Nilsson; edited by Grete Moldrup; music by Bjorn Isfalt; art director, Lasse Westfelt; produced by Waldemar Bergendahl; released by Sony Pictures Classics. At Lincoln Plaza Cinema, Broadway and 62d Street. Running time: 102 minutes. This film is rated R.

Roland Schutt	Jesper Salen
Fritiof Schutt	Stellan Skarsgard
Bertil Schutt	Niclas Olund
Zipa Schutt	Basia Frydman

By CARYN JAMES

"The Slingshot" takes a light-handed approach to the idea that surviving childhood may be the toughest part of life. Though every coming-of-age story has a personal quirk, this one is built on a most particular identity crisis. "Can you be a Jew and a socialist?" wonders 10-year-old Roland, who is doubly persecuted in the Sweden of the 1920's. Once he has solved that problem, he goes on to ask, "How do I know I was meant to be Swedish?"

Roland's father is a socialist with heroic illusions and a serious limp; his mother is a Russian-born Jew, an idealist who sells condoms illegally; his older brother is an aspiring boxer who practices on Roland's nose instead of a punching bag. Roland's other problems include ordinary sexual curiosity, a sadistic anti-Semitic teacher and being teased by bullying older boys. It's a wonder he survived at all.

Ake Sandgren's winsome film, which opens today at the Lincoln Plaza Cinemas, is based on an autobiographical novel by Roland Schutt. The film's immense visual clarity — bright light illuminating the picturesque landscape and the dark wood of

Jesper Salen

Sony Pictures Classics

cluttered interiors — reflects the hero's attitude. Roland senses that life is too complicated, but he never whines and the film is never sentimental. As Roland walks along a snowy street with his father, they pass trolley tracks, horse-drawn carts and the occasional car, all suggesting that the century itself is at a crossroads. Poor Roland is buffeted by it.

Early in the story, some mean older boys dare him to put his tongue on a lamppost, and his mother has to release him with the help of a blowtorch. "Time for some fried Jewnose," one boy sneers, and from then on Roland is rarely without a bloody nose from one source or another.

His mother sells a socialist paper, "Red Voices," and after she begins selling condoms, Roland becomes an inventor. The film's liveliest moments come from his enterprising ideas. He stretches a condom over his foot, immerses it in a bucket of water, and announces to himself: "The Underwater Sock, by Roland Schutt." When he tries to sell condom-slingshots at school, it's another excuse for the teacher to beat him. One of his father's fiercest lessons is that Roland must learn to take all of life's beatings, physical and verbal, with his eyes open.

Scene for scene, "The Slingshot" achieves just the right tones: it is tough and political when Roland defies his teacher; comic when he sells his condom inventions; gently sad when this child of two socialists shows his kitten a bike he bartered for, saying: "That's mine. Do you get it? That's mine." By giving Roland's large and small crises equal importance, Mr. Sandgren purposefully captures the quality of daily life. But that is also the problem with "The Slingshot." Whenever it seems about to explore one issue in some depth, the film moves on to another and never accumulates the weight or feeling it promises.

Jesper Salen is ideal as Roland. The wide-eyed boy is defiant to the end, even after he is duped by the older boys and made to take the blame for petty crimes he was too innocent to know he was committing. But for all his idiosyncrasies, this Jewish-socialist-Swedish hero is finally too much like many other film characters. "The Slingshot" is a bit like "Europa, Europa" and a bit like "My Life as a Dog." Its freeze-frame ending suggests Mr. Sandgren has

seen "The 400 Blows" one time too many. Though "The Slingshot" doesn't have the spark of originality that set those other films apart, it has inherited much of their alluring style.

●

"The Slingshot" is rated R (Under 17 requires accompanying parent or adult guardian). It includes sexual innuendo, a couple of slightly bloody accidents and a glimpse of a drowned corpse.

1994 Je 3, C19:1

The Cowboy Way

Directed by Gregg Champion; screenplay by Bill Wittliff, based on a story he wrote with Rob Thompson; director of photography, Dean Semler; edited by Michael Tronick; music by David Newman; production designer, John Jay Moore; produced by Brian Grazer; released by Universal Pictures. Running time: 102 minutes. This film is rated PG-13.

Pepper Lewis	Woody Harrelson
Sonny Gilstrap	Kiefer Sutherland
Nacho	Joaquin Martinez
Officer Sam Shaw	Ernie Hudson
Stark	Dylan McDermott
Teresa	Cara Buono
Margarette	Marg Helgenberger

By CARYN JAMES

All you need to know about "The Cowboy Way" is obvious when Woody Harrelson spits tobacco juice on the shoes of a rodeo rider who's getting on his nerves. As a champion rider called Pepper, Mr. Harrelson lives in the land of the crass-is-cute macho hero. And though the appeal of raucous tobacco-spitters is purely a matter of taste, it's hard to imagine who the audience might be for a film whose action is so predictable and humor so dispirited.

Pepper is the hot-tempered part of the film's buddy team. Kiefer Sutherland plays his former partner, Sonny, the responsible one. Though Pepper left Sonny in the lurch by not showing up at the national championships, the two are forced together when their friend Nacho disappears. (Why Sonny isn't named after a food, too, is one of the film's impenetrable mysteries.) Nacho (Joaquin Martinez) has vanished in New York, where he has traveled to find his grown daughter, who has been illegally brought in from Cuba for a price.

The minute Sonny and Pepper hit the city, they behave like rubes. "That looks like a motel, right there," Pepper says, pointing at the Waldorf-Astoria. They dine there with their hats on, as if they're never seen a fancy restaurant on television. And though they can't even navigate a menu, strangely enough they drive their old red pickup through Manhattan without ever taking a wrong turn or getting flummoxed by one-way streets.

As they search for the sweatshop where Nacho's daughter is being held

Barry Wetcher/Universal Pictures

Marg Helgenberger and Woody Harrelson

prisoner, they are helped by Ernie Hudson as a mounted policeman named Sam. He's apparently a renegade, too. When Sonny is in trouble and Pepper has to find him, Sam yells "Hop on," and they gallop across Fifth Avenue.

A film in which Sonny and Pepper outwit the bad guys and midtown traffic by charging down Lexington Avenue on horseback ought to be a lot more fun than it is. Even the big climax, in which the heroes chase an elevated train across the Manhattan Bridge, seems lifeless. (A hint to non-New Yorkers: if you're ever chasing a subway from the Upper East Side to Brooklyn, do not follow the cowboys' directions. That major detour they took past the Statue of Liberty would really have cost them some time.)

Though Mr. Harrelson and Mr. Sutherland have made better movies, "The Cowboy Way" may be the ultimate test of their appeal. Together they make this mess watchable, a much harder trick than roping or riding.

●

"The Cowboy Way" is rated PG-13 (Parents strongly cautioned). It includes violence, gunshot wounds and a scene in which a calf mistakes a man for its nursing mother.

1994 Je 3, C21:1

FILM VIEW/Caryn James

Gleaning the Painted Clues Dropped by a Master Director

A MAN FLIES THROUGH THE AIR, guided by a white-robed angel who holds his hand. The painting's strong lines, bright colors — pink clouds against a turquoise-green sky — and sense of mystery instantly bring to mind Chagall. But the artist is the great director Akira Kurosawa, the flying man is him, and the scene depicts an episode planned for "Akira Kurosawa's Dreams," the 1990 film that is a collection of eight stunningly surreal vignettes following a fictional Kurosawa from boyhood to manhood.

"Dreams" is one of several masterpieces Mr. Kurosawa has turned out late in his career. And beginning with "Kagemusha" in 1980, he has prepared for each of his five latest films by painting elaborate watercolors. As cagey as he is brilliant, Mr. Kurosawa remains enigmatic about how his films take shape, but he continues to drop rich clues in the form of these paintings.

■

The "Flying" series is among more than 100 works on view in "Image: Drawings by Akira Kurosawa," at the Ise Foundation Gallery in Manhattan, through July 9. There are sumptuous costume designs of kimonos and soldiers' armor from the epic "Kagemusha." Vivid, glaring portraits from "Ran," his masterly reimagining of "King Lear" set in 16th-century Japan, reveal much about the wickedness of his warring characters. A few paintings are half-finished, others displayed with stray pencil marks still visible. Some are extremely practical, working out the directions from which arrows will fly during the civil war scenes in both those epics.

And while only the "Flying" paintings suggest Chagall, van Gogh's influence is heavy in the drawings from "Dreams," which includes one segment in which van Gogh himself appears, played by Martin Scorsese. Graceful lines and a sense of motion are evident everywhere, even in a painting depicting dozens of horses that have fallen in one great, tangled mass. More than mere plans for his films, these paintings offer a tantalizing view of the director as he molds some of his greatest work for the screen.

Often the paintings reveal possibilities that were rejected for the films. The "Flying"

scenes are doubly mysterious because Mr. Kurosawa never filmed this segment of "Dreams." In the first painting from the sequence, the man walks a tightrope over a brightly colored city. In the most exquisite, he flies with the angel into a midnight-blue sky filled with blue, yellow and green stars. One scene depicts the sky filled with mathematical equations. And in others the angel looks down as the man falls gently to earth, later landing in a field of flowers that might have been borrowed from the Impressionists. The paintings suggest otherworldy reassurance, a glimpse at mysteries that ordinary human knowledge cannot touch, and some serious indecision about what color to make the sky.

As Mr. Kurosawa has said, "Man is a genius when he is dreaming." It is not surprising that someone so drawn to the power of inexplicable images would show little patience for the nosy American need to ask questions. In written questions submitted to him through a translator, he was asked recently what the story of "Flying" would have been. The reply came back, "Mr. Kurosawa said he did not have an answer for that question." He said that the "Flying" story, and two others not represented in the exhibit, were cut because the cost of the film and its length were growing too much.

And when the 84-year-old director was asked about future projects, the answer was a model of polite restraint: "Mr. Kurosawa has already started new drawings and will begin shooting his new film within the month. Because he is in the initial stages of shooting, he regrets that he can give no details."

■

No matter. The watercolors are hint enough at the precision and the playfulness behind his films. As Mr. Kurosawa explains in an introduction to the exhibition catalogue, the paintings were never meant to stand alone as art. When he was having trouble raising money to make "Kagemusha," his story of a peasant who poses as a powerful warlord, he made hundreds of drawings, as if the script were taking visual shape on paper. Partly, he writes, the paintings were "a consoling necessity," a way to realize his vision even if it would never get on film. The illustrations also gave him something concrete to show producers, to demonstrate why the film — with its large-scale battle scenes, hundreds of horsemen in color-coded regalia and detailed 16th-century costumes — would be expensive.

Though as a young man Mr. Kurosawa planned to be a painter, he gave up the idea when he turned to film. Even now he writes about these paintings: "To create skillful pictures was not my intention. Rather, these are tiny fragments of my films."

Mr. Kurosawa seems to try out color here the way other directors try out camera angles and movements in more primitively drawn sketches. His great early films, like "Rashomon" and "The Seven Samurai," were made in black and white, and it wasn't until 1970 that he made his first full-length color film, "Dodesukaden." Since then, color has helped him define character on screen, and the unrealistic colors of these paintings often capture the characters' souls as well as their clothes.

Portraits of Hidetora, the Lear figure in "Ran," often show him with a bright face and fire-engine-red eyes. The characters's demonic past as a murderous warlord is clear enough from the film, but never so obvious as it is here. These distilled, intensified portraits rarely depict Hidetora with the sympathy that softens his character on screen.

At times the paintings also hint that the artist was amusing himself. In one especially

Ise Foundation

A painting for "Dreams"—Van Gogh appears, played by Martin Scorsese.

captivating portrait, Hidetora stares straight out at the viewer. Heavy green and black lines crease his forehead and his eyes are deeply rimmed with bright red. It is a sinister image until you notice that it also works upside down, producing another face in which the forehead lines become a mouth, the ritual topknot turns into a beard and the red circles beneath the eyes become eyebrows. This new face, which belongs to no character in the film, is benign, though wackily out of proportion.

The painting was clearly torn out of a sketchbook, and the paper has the ragged spiral edge to prove it. It serves as a warning not to read too much into every line and squiggle, yet remains one of the most powerful works in the exhibit, provided you don't stand on your head.

ANOTHER PORTRAIT FROM "Ran," of Lady Kaede (Hidetora's power-hungry daughter-in-law, a Lady Macbeth figure imported to this version of "Lear") is among the most serenely beautiful and evocative. She wears a red and gold kimono and stands against a golden background. But the white makeup and gold-painted whites of her eyes present a masklike face, and the way she gazes — not directly at the viewer but sideways so as not to meet our eyes — suggests the hidden motives and intrigue that define her character.

In some cases, the drawings suggest choices not made for the film. In the watercolor of Lady Kaede's death by beheading, she is in full view, captured at the moment when the sword, swung by one of her husband's loyal soldiers, hits her neck. A great gush of red paint shows the

direction of the blood as it splashes against the wall behind them. On film, the scene is more discreet, as Lady Kaede's husband steps in front of her body just in time to block the camera's view of the beheading. The swing of the sword and the final splash of blood, however, occur just as they are depicted in the painting.

In a room at the back of the gallery, a videotape shows more Kurosawa paintings. The camera pans across each work while the corresponding soundtrack from the film is heard. Though it is easy to see these paintings come to life, the distance bewtween the paintings and what finally appears on screen usually tells a more fascinating story.

A portrait of an old man in "Dreams" unmistakably evokes van Gogh's portraits. Yet the old man does not appear in the van Gogh section of the film, called "Crows," but in an unrelated segment, "The Village of the Watermills." Obviously van Gogh was much on Mr. Kurosawa's mind at the time. "Crows" is a dream come true, in which the fictional Kurosawa steps into van Gogh's time, watches him paint, then walks through life-size versions of his paintings.

Playing van Gogh, Mr. Scorsese obsessively paints a wheat field and explains to the Kurosawa character, "A scene that resembles a painting does not make a painting." "Crows" illustrates the transformation from the realistic, picturesque filmed vision before us to the oversize van Goghs that the fictional Kurosawa can enter. He walks on a road among fields of heavy green and yellow paint. To walk through Mr. Kurosawa's exhibit is to realize that a scene resembling a film does not make a film, either. The paintings on the wall are stages in some mysterious transformation. ☐

1994 Je 5, II:13:1

Go Fish

Directed by Rose Troche; written and produced by Ms. Troche and Guinevere Turner; director of photography, Ann T. Rossetti; edited by Ms. Troche; music by Brendan Dolan, Jennifer Sharpe and Scott Aldrich; released by Samuel Goldwyn. Running time: 87 minutes. This film is not rated.

Ely.............................. V. S. Brodie
Max.............................. Guinevere Turner
Kia.............................. T. Wendy McMillan
Daria.............................. Anastasia Sharp
Evy.............................. Migdalia Melendez

By JANET MASLIN

Who could blame the women of "Go Fish" for complaining about those "touchy-feely, soft-focus, sisters-of-the-woodlands" movies that account for so many lesbian images on screen? Rose Troche, the director, wrote the film with Guinevere Turner, and obviously intended it to be a funnier and more realistic alternative.

Working in black and white on a near-nonexistent budget, they still display a solid comic sensibility that shines through. "Go Fish" has its arty, annoying excesses, but it also looks at love between women with a wit that's long overdue.

This film's girl-meets-girl plot is as rudimentary as anything a heterosex-

ual comedy might get away with. What makes it different is the rueful attention to detail. When Max, a pert tomboy played with feisty energy by Ms. Turner, enters into a reluctant courtship with the bashful Ely (V. S. Brodie), she feigns horror while telling her friends about Ely's "severe case of hippie-itis." Ely turns out to have "a hundred different kinds of tea, all decaf" in her apartment.

•

Not to mention a cat, and a lot of sensitive feelings. When Ely hears that Max thinks she's living in a time warp, she gets rid of the long, droopy hair that makes her look like a shy, nervous woman, and adopts a brush cut that makes her look like a shy, nervous man. Ms. Brodie, who makes Ely bashful and reticent enough to be extremely pleased by this new haircut, is the film's sweetest and most unexpected invention. She exists far outside the usual stereotypes for lesbian characters on screen.

Within this film's scheme, it's a given that either Max or Ely will describe every last detail of their mostly chaste relationship to friends. This film treats lesbian matchmaking almost as a form of political activism, and even stages a Kafkaesque episode in which Daria (Anastasia Sharp), the film's comically girl-chasing character, is denounced by angry peers who suspect her of having had sex with a man. Happily promiscuous, and another of the film's nicely innovative figures, she endures this grilling without being perturbed. The film builds a running joke around Daria's habit of cheerfully doing exactly what she wants.

Also sturdy is T. Wendy McMillan as Kia, a college professor who assumes a motherly, matchmaking role in throwing Max and Ely together. (She also starts the film by offering her students a list of "lesbians and wannabes" in politics and show business.) But some of the story's minor characters are less three-dimensional, reflecting more politically correct diversity and pride than individual personality.

•

This film would have been better if its supporting figures had as much authenticity as those involved in the central love affair. The background women are uniformly happy and well-adjusted, except when intolerant friends and relatives impinge on their freedom. That's more admirable

Samuel Goldwyn Company
Guinevere Turner, left, and V. S. Brodie in "Go Fish."

than interesting, and it becomes monotonous after a while.

So do Ms. Troche's flights of visual fancy, like repeatedly replaying shots of hair falling when Ely gets her new coiffure, or interspersing abstract fantasy images from time to time. The storytelling is otherwise so down-to-earth that it makes these excesses grating. Ms. Troche does better with the occasional arrangement of talking heads, as Max and Ely's friends comment as a Greek chorus upon the nascent love affair.

Even this could have been staged with less overbearing stylishness. Ditto Max's occasional voice-overs, which sound more poetic than conversational. The film's muddy sound quality further turns Max's jumble of private thoughts into a needless affectation. But these are excesses that smack of inexperience. They don't obscure Ms. Troche and Ms. Turner's real comic verve, or their real promise.

1994 Je 10, C6:4

Speed

Directed by Jan De Bont; written by Graham Yost; director of photography, Andrzej Bartkowiak; edited by John Wright; music by Mark Mancina; production designer, Jackson De Govia; produced by Mark Gordon; released by 20th Century Fox. Running time: 120 minutes. This film is rated R.

Jack Traven.............................. Keanu Reeves
Howard Payne.............................. Dennis Hopper
Annie.............................. Sandra Bullock
Captain McMahon.............................. Joe Morton
Harry Temple.............................. Jeff Daniels

By JANET MASLIN

At the time of year when Hollywood traditionally bludgeons its audience back into the Stone Age (sobering statistic: the witless "Flintstones" grossed as much in its first weekend as "Four Weddings and a Funeral" has grossed in the United States in three months), you can still pick your poison. The summertime no-brainer needn't be entirely without brains. It can be as savvy as "Speed," the runaway-bus movie that delivers wall-to-wall action, a feat that's never as easy as it seems. This film's dialogue isn't much more literate than a bus schedule, but its plotting is smart and breathless enough to make up for that.

"Speed" presents a falling elevator, a hijacked subway train, the above-mentioned bus and Jack Traven (Keanu Reeves), the Los Angeles Police Department trouble-shooter whose business is solving such problems. This role, for Mr. Reeves, is less an acting challenge than a rite of passage. It's a means of proving that he's ready to play the tough guy in suitably grim, purposeful style.

Better known for comic nonchalance than for killer machismo, the newly bulked-up Mr. Reeves still furrows his brow manfully and winds up doing a terrific job. Blank as he sometimes seems, he has still become an actor of real charisma, even when he's treated as a found object ("Little Buddha") or given a career-torpedoing role ("Even Cowgirls Get the Blues").

As directed with no-frills efficiency by Jan De Bont, the cinematographer on films including "Die Hard," "Basic Instinct" and "Black Rain," "Speed" takes its cue from its title. This film's sole objective is to keep moving, preferably at a pace that keeps the viewer from asking questions. Action is everything, as when

20th Century Fox
Sandra Bullock and Keanu Reeves in a scene from "Speed."

Traven makes his first entrance in a police car that seems to leap through the air. Once the car stops, the camera circles excitedly around Traven and his partner, Harry Temple (Jeff Daniels), who have screeched up to a high-rise to settle that elevator situation. Fast, kinetic shots like these are the cinematic equivalent of junk food, which is not to say that their empty calories are unsatisfying.

Dennis Hopper, playing the first mad bomber of the summer, is Howard Payne, who stabs an innocent security guard ("Nothing personal!") in the film's opening moments. Howard has cut the elevator's cables and wired the car to explode on cue, hoping to extort money in exchange for the passengers' safety. He may not have counted on Jack and Harry's ingenuity, but he has definitely seen other movies of this sort, in which the police-baiting terrorist always seems to have the same motives and the same career history. Beyond the bus gimmick, which is quite a good one, not much about "Speed" really pretends to be new.

•

Once Jack and Harry have emerged victorious from the elevator episode ("Was it good for you?" Jack asks, in what amounts to the film's wittiest line), Payne turns out to have the bus trick up his sleeve. He has loaded a Santa Monica bus with a bomb and wired the device to be activated once the bus's speed rises above 50 miles per hour. After that, if the speedometer falls below 50, the bomb will go off. In view of Southern California's traffic problems, the film's very setting becomes devilish.

So do we care that when Jack first finds the bus he is able to keep up with it on foot? That this means the bomb isn't active yet? Or that Jack doesn't simply end the crisis by using his gun to shoot out the tires? Definitely not. It's a lot more fun to wonder how Jack will get onto and off a speeding vehicle, whether the bus can catapult over a missing section of freeway, whether it can execute a sharp turn at high speed or whether it will mow down Los Angeles pedestrians. Among this film's truly terrifying stunts is the one that finds Mr. Reeves flat on his back beneath the bus, riding on a dolly that may or may not be crushed beneath the wheels. In the film's scariest moments, he appears to come so close to the pavement that his combat gear almost gives off sparks.

•

Also in "Speed" is Sandra Bullock as a passenger named Annie who is enlisted to drive the bus during all this excitement. Ms. Bullock, who registers all the perkier forms of panic, is to bus drivers what Mr. Reeves is to S.W.A.T. policemen, but verisimilitude is beside the point. It doesn't even matter than when these two begin the obligatory flirting, Mr.

Reeves still seems perfunctory and a bit remote. Cleverer action films ("Die Hard II" and "The Fugitive," for instance) deliver more sardonic intelligence, but this one still gets the job done.

Mr. Hopper finds nice new ways to convey crazy menace with each new role. Certainly he's the most colorful figure in a film that wastes no time on character development or personality. Graham Yost's screenplay pays more attention to ingenious trickery than to giving each bus passenger more than, say, one distinguishing characteristic. But that suits a story whose overriding lesson, in the words of the L.A.P.D., is as simple as this: "Don't get dead."

●

"Speed" is rated R (Under 17 requires accompanying parent or adult guardian). It includes profanity, violence and (under the circumstances) relatively little gore.

1994 Je 10, C12:1

Minotaur

Written and directed by Dan McCormack; director of photography, Dan Gillham; edited by Martin Hunter; music by William T. Stromberg; production designers, Michael Krantz and Martha Rutan Fay; produced by Kris Krengel; released by Headliner Entertainment Group. At Quad Cinema, 13th Street west of Fifth Avenue, Greenwich Village. Running time: 55 minutes. This film is not rated.

The Minotaur..........................Michael Faella
Mink..Ricky Aiello
Cindy..Holley Chant

By STEPHEN HOLDEN

The title character of Dan McCormack's satirical film "Minotaur" is a monstrous pop star who looks like a cross between Meat Loaf and John Belushi, sounds like a mediocre Frank Sinatra imitator and is as popular as Elvis.

In the opening scene, the star, whom everyone calls the Boss, is shown in his Las Vegas hotel suite inhaling stimulants, popping handfuls of pills, and shooting drugs until the veins bulge in his forehead and his eyes roll back. Clad only in shorts and a studded leather harness, he climbs into a giant glass of pink champagne in which a beauty contestant lolls about, laughing hysterically. Moments later, he strangles her.

As fantasies of pop-star excess go, the scene is one of the more grotesque and also one of the angriest to be found in a recent film. Mike Faella, who plays the Minotaur, is a genuinely repulsive presence, especially when photographed sitting half-comatose on the toilet, with vomit on his chin.

●

Once it has presented the Minotaur in all his depravity, the film, which opens today at the Quad Cinema, doesn't know where to go. After the homicide, another bout of drug-taking leaves the character a near-vegetable. In an effort to jog him back to reality, a team of doctors straps him into a Rube Goldberg-style device that mechanically feeds him burgers, cigarettes and beer while showing him videos of his own stage performances. A much lighter touch might have made these scenes amusing.

Eventually "Minotaur" turns mushy. On the verge of death, the star hallucinates childhood encounters with his parents in which the three of them converse by telephone over the breakfast table. From a mean-spirited spoof of pop-star excess, the movie falls back on clichéd notions of the performer as a lonely, fearful child with a bullying father. By this time, a movie that started out as an all-out attack on the sanctification of Elvis has lost its nerve. It dissipates into convoluted reflections on fame, stardom and identity that are as pretentious as they are impenetrable.

●

Sharing the bill with "Minotaur" is George Hickenlooper's 25-minute film "Some Folks Call It a Sling Blade," which had its world premiere in March at the 1994 Sundance Festival. Shot in a mock-documentary style, it tells the story of a newspaper reporter (Molly Ringwald) who visits a mental hospital in Northern California to interview a patient (Billy Bob Thornton), who committed a double murder 25 years earlier.

1994 Je 10, C12:5

City Slickers II
The Legend of Curly's Gold

Directed by Paul Weiland; written by Billy Crystal, Lowell Ganz and Babaloo Mandel; director of photography, Adrian Biddle; edited by William Anderson; music by Marc Shaiman; production designer, Stephen J. Lineweaver; produced by Mr. Crystal; released by Castle Rock. Running time: 116 minutes. This film is rated PG-13.

Mitch Robbins.............................Billy Crystal
Phil Berquist..............................Daniel Stern
Glen Robbins..................................Jon Lovitz
Duke/Curly Washburn................Jack Palance

By JANET MASLIN

"City Slickers II: The Legend of Curly's Gold" centers on a treasure hunt, and there's no mistaking the kind of loot it's after. This sequel has no real purpose beyond the obvious one of following up a hit, although the original film was just as casual at times. Both of them rely on Billy Crystal's breezy, dependably funny screen presence to hold the interest, even when not much around him is up to par. Both also count on the irascible Jack Palance, even though Mr. Palance's Curly was dead and buried when the first film was over.

One mark of this sequel's listlessness is that it takes so long to orchestrate Mr. Palance's return, this time in the role of Duke, Curly's twin brother. Twin brother? That's almost as desperate as suggesting the first film's ending was all a dream. But the real problem with the screenplay (by Mr. Crystal with Lowell Ganz and Babaloo Mandel) is that it unfolds so slowly. It takes almost an hour to get Mitch Robbins (Mr. Crystal) away from the New York radio station where he works, and away from some gruesome marital hanky-panky with his wife (Patricia Wettig), who isn't any more fun than she was the first time.

These domestic scenes may be intended as loving, but once again Mitch is awfully glad to escape to the Wild West. There is almost too big-hearted to disparage Mitch's wife, who keeps promising him a red-hot birthday celebration and calls him at the office to describe her plans in graphic detail. However, it does reduce her to nothing but a set of nagging rings on Mitch's cellular phone, which is eventually crushed by a horse.

The first "City Slickers" was about its characters' midlife crises, which have not exactly abated. Daniel Stern, as Mitch's hapless friend Phil, still makes the most of his crybaby role. Jon Lovitz, in the new role of Mitch's pesty brother, manages to be comparably annoying. But beyond their whining, which was central to the first film's sense of fun, these three tenderfeet also follow a treasure map left behind by Curly and embark on an adventure. Compared with the first film's cattle drive and its homage to "Red River," this idea is, according to Mitch, "more fun — and you don't have to watch where you step."

But beyond giving Mr. Crystal chances to do what he calls "the Walter Huston dance" (the gleeful jig from "The Treasure of the Sierra Madre"), this story isn't as compelling as the earlier one. The idea of male urban yuppies experiencing their self-doubts in a cowboy setting was at the heart of "City Slickers," and it isn't well used this time. It falls to Mr. Crystal to register the absurdity of the setting in his own distinctive way, as when he looks at one dangerous, unfriendly westerner and says: "Gays in the military. Your thoughts?" A little of this would go a long way, but there's not enough of it to go around.

Mr. Palance does a nice job of reiterating his earlier, Oscar-winning turn, laughing wickedly at Mr. Crystal and never quite explaining what the one big secret of life might be. His last scene suggests a third "City Slickers" in the offing, but by then even this genial second installment has run out of gas. Also notable are Bob Balaban, as a radio talk-show host who will be reduced to being a movie critic if he isn't careful, and Jayne Meadows. She delivers one of the film's few moments of real hilarity when she provides the voice of Mitch's mother wishing him happy birthday.

"City Slickers II" also has animated opening credits, which are cute but slightly creaky in ways that echo the film's overall tone. The credits also recall the first film's cattle-birthing episode, while making viewers glad this isn't a line-by-line copy. At least nobody in "City Slickers II" feels precisely the same need to have a cow.

●

"City Slickers II: The Legend of Curly's Gold" is rated PG-13 (Parents strongly cautioned). It includes slight sexual suggestiveness and mild profanity.

1994 Je 10, C19:1

Jack Be Nimble

Written and directed by Garth Maxwell; director of photography, Donald Duncan; edited by John Gilbert; music by Chris Neal; production designer, Grant Major; produced by Jonathan Dowling and Kelly Rogers. At the Joseph Papp Public Theater, 425 Lafayette Street, East Village. Running time: 95 minutes. This film is not rated.

Jack..Alexis Arquette
Dora................................Sarah Smuts-Kennedy
Teddy..Bruno Lawrence

By STEPHEN HOLDEN

The Gothic horror film "Jack Be Nimble" has a hallucinatory power and psychological refinement that you won't find in any number of movie adaptations of Stephen King novels, including "Carrie." Written and directed by Garth Maxwell, a young New Zealander, it tells the story of Jack and Dora (Alexis Arquette and Sarah Smuts-Kennedy), a young brother and sister whose mother's nervous breakdown leads to their separation and adoption by different couples.

●

Growing up apart, the siblings cling to their childhood memories of one another, each longing for a time when they will be reunited. As the film cuts back and forth between scenes of their childhood and adolescence, it evokes their misery and isolation with a feverish intensity that recalls scenes from Hitchcock and De Palma.

Dora, a misfit who is taunted at school by her classmates, begins hearing voices after suffering a serious head injury in a schoolyard fight. It is years before she comes to realize that the strange angry cries in her head are related to her brother's traumatic abuse. For while Dora has lived in relative comfort, Jack's childhood has been a continual nightmare. Adopted by a sadistic hog farmer and his wife, who live in a squalid shack with four silent, grim-faced daughters, Jack is treated as a prisoner and a pariah.

●

No sooner has he been taken home by his new family than the four sisters grab him and force him to watch their father slaughter a pig. In the film's most agonizing moment, he is savagely whipped by the father with a length of rusted barbed wire. These and other scenes of physical and psychological torture capture primal feelings of fear and helplessness not often found in a horror film.

Eventually Jack wreaks a revenge whose totality satisfyingly matches the cruelty that was visited on him. His instrument of deliverance is a primitive device he has invented that uses flashing lights to send spectators into a deep hypnotic trance.

From this point on, "Jack Be Nimble," which opens today at the Joseph Papp Public Theater, loses some of its ferocity as it takes more metaphysical paths. Jack and Dora finally do reunite and seek out their original parents. Although the bond between brother and sister is deep, it is troubled by Jack's unquenchable rage against the world. He is insanely possessive of his sister, who has begun an uncertain love affair with a loner named Teddy (Bruno Lawrence), who has telepathic abilities similar to hers.

●

What makes "Jack Be Nimble" a superior genre film is that it never loses its focus on childhood trauma and obsession and their tragic repercussions. In the film's opening scenes, where the children watch their mother go crazy, we see the events mostly through their frightened, uncomprehending eyes. Curtains blowing in the wind and a children's song on the phonograph assume an ominously scary resonance that haunts them for years. It is only much later that the pieces of what actually occurred are put together, for both the viewer and the characters. In the scenes of Jack's humiliation, the images of mud, pigs and the family's glowering, hateful faces conjure the most frightening fairy-tale figures of childhood fantasy.

In the end, the movie shakily aspires toward a transcendent resolution. The voices in Dora's head and her ability to transmit and receive mental calls from others, it suggests,

are not just freakish abilities but latent gifts possessed by many. "Jack Be Nimble" becomes a cautionary fable of parental irresponsibility and its dire consequences.

1994 Je 10, C21:4

White

Written and directed by Krzysztof Kieslowski, in Polish and French, with English subtitles; director of photography, Edward Klosinski; edited by Urszula Lesiak; music by Zbigniew Preisner; produced by Marin Karmitz; released by Miramax. At Lincoln Plaza Cinema, Broadway at 63d Street. Running time: 92 minutes. This film is rated R.

Karol Karol	Zbigniew Zamachowski
Dominique	Julie Delpy
Mikolaj	Janusz Gajos
Jurek	Jerzy Stuhr

By CARYN JAMES

Anyone who has seen the austere, pretentious "Blue," the first film in Krzysztof Kieslowski's "Three Colors" trilogy, will scarcely believe that the witty, deadpan "White" was made by the same man. How could the creator of "Blue," the story of a woman who grieves by moping around Paris in a chichi haircut, possibly have followed it with such a rich, light-handed marvel? Here Mr. Kieslowski takes Karol, an apparently hapless hero, and ships him from Paris home to Poland hidden in a suitcase, only to have the suitcase missing from the baggage claim on the other side. How can Karol's helpful accomplice explain to the airline that the lost luggage held 165 pounds worth of clothes?

Mr. Kieslowski is always uncompromising, leaving it to his viewers to follow him or not, sometimes in wildly wrong directions. Though "Blue" was widely praised by some critics when it opened last year, its minimalist manner and laughably serious tone played like a parody of a film by a Major European Director. "White," which opens today at the Lincoln Plaza Cinema, is laughable on purpose. When Mr. Kieslowski is at his best, as he is here and in earlier films like "The Double Life of Véronique," he simply *is* a major director without making a fuss about it.

"White" begins in Paris, where Karol (Zbigniew Zamachowski), a hairdresser from Poland, is being divorced by his French wife, Dominique (Julie Delpy). She tells the judge that their marriage was never consummated, which Karol admits to be true. They had a terrific sex life before they were married, but he has been unaccountably impotent since their wedding day. Here is the essence of Karol's life: he is always making the right moves at the wrong time and vice versa. Even after the divorce, when Karol sneaks into his hairdressing shop and Dominique takes one last fling at sex with him, he can only look forlorn and say meekly in French, "Pardon," when he fails again.

Mr. Kieslowski has said that Karol (Charlie in Polish) is a tribute to Chaplin, which is obvious enough. Mr. Zamachowski's small stature and a gaze that looks baffled but often turns out to be smart adds to the picture. But Karol also echoes Beckett's heroes, bringing ingenuity and composed acceptance to the absurd conditions of his life.

Tossed out by Dominique, without money or a passport, Karol takes his suitcase and sits in it while playing a Polish song on a comb in the Metro. There he meets a fellow Pole who offers to help him home.

The suitcase and Karol make it back, though not how or where he expected. One of the finest moments in "White" takes place when Karol realizes his escape has worked. By then he is in a snowy field in Poland. His face is bloody, his nose is runny. He looks out at a nearby dump covered by scavenger birds and calls out, "Home at last!"

He has, in fact, landed quite near his old home and the old hairdressing shop his brother has kept going under a gaudy new sign.

"You bought a neon sign," he says.

"This is Europe now," his brother answers, sounding the note of cultural floundering and readjustment that runs subtly through the film. As Karol discovers, this new Euro-Poland is a place where anything can be bought, including, eventually, a corpse. Within a year he changes from a hairdresser to a shady entrepreneur with slicked-back hair and a cashmere coat. Still pining for Dominique, he ruthlessly concocts a plot to lure her to Poland, and his successful dream becomes a nightmare with bitter and tender results.

"White" is in no way a sequel to "Blue." The films are connected only by a glimpse of some of the characters' crossed paths. Dominique is seen sitting in the courtroom in the earlier film, and Juliette Binoche, the heroine of "Blue," sticks her head in the courtroom door in "White" only to be shooed out.

The trilogy is just as loosely pegged to the symbolic colors of the French flag, with blue meaning freedom, white equality and red fraternity. The terms are so broad they might encompass anything. Though "White" toys with the idea of political equality, its generous themes of love and friendship make it seem that this should be the film about fraternity. Officially that theme will be covered in "Red," the lavishly praised finale, which unexpectedly failed to win any prizes at the Cannes International Film Festival last month. ("Red" is scheduled to open in the United States in December.)

"White" even looks more subtle than its predecessor, which was overwhelmed by blue shadows. Here the misty beauty of Paris and the snowy Polish countryside are effective but not blinding. Throughout, "White" is filled with exquisite scenes that don't press too hard — when Karol saves a suicidal friend by offering him a second chance to live — and those moments are all the richer for their understatement. "White" manages to make "Blue" look better in retrospect, too. Though Mr. Kieslowski is sometimes wrong-headed, "White" makes it clear that his ambitious trilogy is worth following.

●

"White" is rated R (Under 17 requires accompanying parent or adult guardian). It includes sexual suggestiveness and some violent scenes.

1994 Je 10, C23:1

The Lion King

Directed by Roger Allers and Rob Minkoff; written by Irene Mecchi, Jonathan Roberts and Linda Woolverton; songs by Tim Rice and Elton John; score by Hans Zimmer; production designer, Chris Sanders; story by Burny Mattinson, Barry Johnson, Thom Enriquez and others; animators, Tom Bancroft, Broose Johnson, T. Daniel Hofstedt, Danny Wawrzaszek and others; produced by Don Hahn; released by Walt Disney Pictures. Running time: 87 minutes. This film is rated G.

Voices by:

Young Simba	Jonathan Taylor Thomas
Adult Simba	Matthew Broderick
Mufasa	James Earl Jones
Scar	Jeremy Irons
Adult Nala	Moira Kelly
Young Nala	Niketa Calamed
Pumbaa	Ernie Sabella
Timon	Nathan Lane
Rafiki	Robert Guillaume
Zazu	Rowan Atkinson
Sarabi	Madge Sinclair
Hyenas	Whoopi Goldberg, Cheech Marin and Jim Cummings

By JANET MASLIN

The circle of life, as described in and borne out by "The Lion King," is a cycle of evolution. Birth, growth, maturity, decline: nothing is immune to change, not even Disney animation.

Taking its place in the great arc of neo-Disney classics that began with "The Little Mermaid," "The Lion King" is as visually enchanting as its pedigree suggests. But it also departs from the spontaneity of its predecessors and reveals more calculation. More so than the exuberant movie miracles that came before it, this latest animated juggernaut has the feeling of a clever, predictable product. To its great advantage, it has been contrived with a spirited, animal-loving prettiness no child will resist.

Let's put this in perspective: nobody beats Disney when it comes to manufacturing such products with brilliance, precision and loving care. And films that lure the lunch-box set never lack for blatantly commercial elements. Still, the wizardry of "Beauty and the Beast" managed to seem blissfully formula-free, while "The Lion King" has more noticeably derivative moments. Strangely enough, the fact that this film has an original story makes it less daring than Disney films based on well-known fairy tales.

●

"The Lion King," which opens today for a limited run at Radio City Music Hall before expanding into wide release on June 24, is about Simba, a cub who endures certain rites of passage before becoming ruler of his kingdom. Describing the classic hero's journey in baby-Joseph Campbell fashion, the screenplay (by Irene Mecchi, Jonathan Roberts and Linda Woolverton) adds a touch of Shakespeare for good measure.

In addition to his noble father, Mufasa (with the voice of James Earl Jones), Simba is also influenced by his delectably wicked uncle, Scar (Jeremy Irons). Scar arranges Mufasa's disturbing on-screen death in a manner that both banishes Simba to the wilderness and raises questions about whether this film really warranted a G rating. (In addition to the trampling of Mufasa by a herd of computer-generated wildebeests, there is also a violent fight at the end of the story.)

This tale, with its emphasis on myth making and machismo, has no heroine, unlike its immediate predecessors. Nor does it rely as effectively on music, although songs by Elton John and Tim Rice are interjected into the action at regular intervals. ("Can You Feel the Love Tonight," an obligatory romantic ballad that accompanies the grown-up Simba's romp with a lioness friend named Nala, has been shoehorned into the film for particularly gratuitous reasons.)

Instead, its seriousness is leavened with various sure-fire forms of comic relief, humor of the sort that is a true Disney specialty. "The Lion King" counts on the wittiest group of voices Disney has yet assembled — also including Nathan Lane, Whoopi Goldberg, Matthew Broderick and Rowan Atkinson, the mixed-up minister from "Four Weddings and a Funeral" — to advance its story.

●

And once again, Disney's animators (under the direction of Roger Allers and Rob Minkoff) display their anthropomorphic genius. All of the film's secondary characters are clever and colorful, with Mr. Lane's wise-cracking meerkat, Timon, and Mr. Atkinson's worried hornbill, Zazu, as special standouts. Together with a vibrant palette and grandly scenic African landscapes, these elements give the best of "The Lion King" a bright, energetic appeal.

For the grown-ups, there is Mr. Irons, who has been as devilishly well-captured by Disney's graphic artists (Scar's supervising animator: Andreas Deja) as Robin Williams was in "Aladdin." Bored, wicked and royally sarcastic, Mr. Irons's Scar slithers through the story in grandiose high style, with a green-eyed malevolence that is one of film's chief delights. "Oh, and just between us, you might want to work on that little roar of yours, hmm?" he purrs to Simba, while purporting to be a mentor to his young nephew. Scar, who also gives a reprise of Mr. Irons's best-known line from "Reversal of Fortune," may not be much of a father figure, but he's certainly great fun.

That's not the case with the solemn Mufasa, who is given the job of articulating the film's very 1990's heroic ethos. The message boils down to something like "Find Your Inner King," and Mufasa is sometimes positioned against a starry sky to emphasize his noble stature.

"Look inside yourself, Simba," he says mystically at one juncture. "You are more than what you have become. You must take your place in the circle of life." At least this is soothingly vague, unlike Mufasa's early announcement that his son will be king of "everything the light touches" within his field of vision. When it comes to its characters' regal heritage, the film manages to sound simultaneously caring, sensitive and power-mad.

Later on, straying from his life of privilege, the golden boy Simba is waylaid by three hoodlum hyenas (Ms. Goldberg, Cheech Marin and Jim Cummings) in a burned-out region that is this story's version of an inner city. At times like this, the subtext definitely gets dicey; "The Lion King" is in all ways on safer ground with the lush, sweeping landscapes that provide most of its backdrop. Among its most visually stunning sequences are the opening musical episode, dazzlingly introducing all the denizens of the animal kingdom, and a comic number in which young Simba is taught, among other things, how to survive on a diet of brilliantly colorful bugs.

●

The film's musical numbers are a peculiar hybrid of Mr. John's bouncy, irrepressible pop sensibility and Mr.

The Walt Disney Company

In "The Lion King," from Disney, Simba is a curious cub who has to overcome numerous obstacles, including those posed by his evil uncle, Scar.

Columbia Pictures

Jack Nicholson

Rice's fastidious, remarkably joyless lyrics. These songs are very different from the earlier films' Alan Mencken-Howard Ashman numbers, but they are used in strenuously similar ways. The Oscar-ready love ballad and the big, gala production number, once so fresh, have become Disney staples by now.

Sometimes the derivativeness is just plain irritating, as with the cute, lilting "I Just Can't Wait to Be King," which sounds as if Michael Jackson were singing "Under the Sea." Pop music doesn't get any safer than that; nor does it get any more familiar. The soundtrack of "The Lion King" also includes a version sung by Mr. John, free of those encumbrances and delivered as a nice, clean jolt of rock-and-roll. A song, like anything else, works best when it has a style all its own.

1994 Je 15, C11:1

Wolf

Directed by Mike Nichols; written by Jim Harrison and Wesley Strick; director of photography, Giuseppe Rotunno; edited by Sam O'Steen; music by Ennio Morricone; production designer, Bo Welch; produced by Douglas Wick; released by Columbia Pictures. Running time: 121 minutes. This film is rated R.

Will Randall..............................Jack Nicholson
Laura AldenMichelle Pfeiffer
Stewart Swinton James Spader
Charlotte Randall......................Kate Nelligan
Detective Bridger..................Richard Jenkins
Raymond Alden...........Christopher Plummer
Mary..Eileen Atkins

By JANET MASLIN

All of us experience the occasional touch of beastliness, but Will Randall's case is something special. For Will, a suave, well-respected New York book editor, it would be helpful to have an animal urge or two. Polished and civilized as he is, Will has no self-protective instincts when it comes to the laws of the jungle, professional variety. And he needs some. There are times, as the first hour of "Wolf" makes enjoyably clear, when going for the jugular is exactly the right etiquette in corporate life.

So it's almost a boon for Will when his car hits an animal in Vermont one night. Getting out to investigate, Will is bitten by a wolf, and the short-terms results are remarkably salutary. He returns to his office with strange new powers nicely suited to the business world. His senses are more acute, his energy revitalized. He now has the advantage of being able to see, hear and sniff out whatever sneakiness is going on behind his back.

So long as it stays confined to the level of metaphor, as it does in the first hour of "Wolf," this idea really is irresistible. And Mike Nichols's own killer instincts as an urbane social satirist are ideally suited to this milieu. Just as he did in the opening, not-yet-sentimental sections of "Regarding Henry," Mr. Nichols knowingly captures the smooth viciousness behind his characters' great shows of sophistication.

Only later, when the wolf motif is allowed to become literal, does "Wolf" sink its paws into deep quicksand. This would have been a far better film if Jack Nicholson, who perfectly embodies the courtly New York executive as an endangered species, had never been made to sprout fangs and grow hair on his hands.

Mr. Nicholson, who actually totes a briefcase for this role and gives one of his subtlest performances in recent years, is well suited to the conversational savagery that marks "Wolf" at its best. The story pits him against two well-drawn adversaries: Raymond Alden (Christopher Plummer), an elegant tycoon who has just taken over Will's publishing house, and Stewart Swinton (James Spader), the smiling young schemer who has just talked his way into Will's job.

In the film's most extravagantly entertaining sequence, Will is invited to a soiree at Alden's estate for the express purpose of being dismissed — or, to put it more politely, reassigned to a meaningless job in Eastern Europe. True to this film's air of treacherous good taste, the ax falls during a peaceable stroll around the grounds. "You're a nice person," Alden says when it's over. "Thank God I replaced you."

Stunned by this turn of events, Will winds up near Alden's stable and is befriended by the sullen, jaded Laura (Michelle Pfeiffer), Alden's rebellious daughter. "What're you, the last civilized man?" she asks him skeptically, although that is how the film would describe him. When Laura becomes interested in Will, it makes a certain sense: not only is he an obvious father figure, but he's also just right for a tough younger woman who says she's always been attracted to the wrong men. If Laura likes danger, then a guy who goes out marauding under the full moon is a fine choice.

"Wolf" tries to circumvent the usual werewolf exposition by treating Will's condition matter-of-factly. That he doesn't hide his problem from Laura signals a certain appealing sang-froid. So it's too bad when "Wolf" becomes carried away with special effects (by Rick Baker, the master of movie werewolf tricks) and lethal escapades, none of which is brought off with much panache. Unlike Francis Ford Coppola, who revealed a surprising enthusiasm for horrific vampire tricks in "Bram Stoker's 'Dracula,'" Mr. Nichols shows no great gusto for the supernatural. Nor can he deliver the magic it would have taken to provide "Wolf" with a half-decent ending.

Some of the trouble lies in the writing: "Wolf" is credited to both the rugged novelist Jim Harrison ("Sundog," "Warlock") and the genre screenwriter Wesley Strick ("Final Analysis," "True Believer," "Arachnophobia," "Cape Fear"). Small wonder that the material is wildly inconsistent at times, with a macho streak ("It feels good to be the wolf, doesn't it?") that hardly matches its better-developed soigné side. Late in the story, the writing even takes a soggily romantic turn that doesn't suit the actors at all. Lines like "I've never loved anyone this way" and "Maybe there's happy endings even for people who don't believe in them" don't belong here.

In addition to Mr. Nicholson, who cocks his ears and narrows his eyes with gleeful, wolfly flair, there are admirable performances from Mr. Spader, still turning the business of being despicable into a fine art, and Kate Nelligan, as Will's deceptively brisk and efficient wife. Smaller roles (like that of Eileen Atkins, as Will's devoted secretary) have been filled with Mr. Nichols's customary attention to detail.

Ms. Pfeiffer's role is underwritten, but her performance is expert enough to make even diffidence compelling. Mr. Plummer, as he should, radiates a self-satisfaction so great it actually seems carnivorous. "I'd never have fired you in the first place if I'd known you were *this* ruthless," he tells Will admiringly midway through the story. "Thank you," Will modestly replies.

Giuseppe Rotunno's richly hued cinematography, Ann Roth's costumes (with a lot of corduroy for the newly bookish Mr. Nicholson), Sam O'Steen's crisp editing and Bo Welch's lavish production design combine to create a high gloss. But their work is overshadowed by special-effects overkill in the film's later outbursts. It is shown off best in the early scenes' sleek, decorous atmosphere, where there are predators enough.

•

"Wolf" is rated R (Under 17 requires accompanying parent or adult guardian). It includes sexual situations, mild profanity and discreet, nasty violence.

1994 Je 17, C4:1

My Life's in Turnaround

Written and directed by Eric Schaeffer and Donal Lardner Ward; director of photography, Peter Hawkins; edited by Susan Graef; music by Reed Hays; produced by Daniel Einfeld; released by Arrow Releasing. Running time: 84 minutes. This film has no rating.

Splick Featherstone..................Eric Schaeffer
Jason Little......................Donal Lardner Ward
Sarah Hershfeld..........................Lisa Gerstein
Rachael...................... Dana Wheeler Nicholson
Amanda ...Debra Clein
Beverly Spannenbaum..................Sheila Jaffe
WITH: Casey Siemaszko, Martha Plimpton, Phoebe Cates and John Sayles

By JANET MASLIN

"My Life's in Turnaround," a scrappy low-budget comedy with lots of insouciant charm, is the semi-autobiographical story of its two film makers, Eric Schaeffer and Donal Lardner Ward. Calling themselves Splick Featherstone and Jason Little, they play friends who simply fell into this line of work after other pursuits proved to be less than promising. They also present themselves as lacking ambition and talent. That's definitely a little white lie.

Grainy enough to look at times as if it's been shot through a tea bag, "My Life's in Turnaround" has to get by on wit alone. The two hapless stars present themselves as an over-stressed cabbie (Mr. Schaeffer) and an alcohol-avoiding bartender (Mr. Ward). (Does Jason go to A.A. meetings "because that's where all the big deals are getting made?" a girlfriend asks him. "No, 'cause I'm a drunk," he answers.) So they are eager for a change of pace, once a friend (Lisa Gerstein) with a talent agency steers them toward the movie world. "Get us meetings," Jason tells her. "Yeah, we're film makers now," Splick says.

•

The only trouble is the lack of a game plan. That's a slight problem for "My Life's in Turnaround," too. Beyond re-creating some of the more amusing accidents that led them to make this film, Mr. Schaeffer and Mr. Ward haven't much to fall back on beyond assorted self-deprecating gags and some contrivances about their troubles in finding girlfriends. To their credit, only in ,the latter scenes does this film seem ordinary or strained.

There are several cameo appearances in "My Life's in Turnaround," some of them from people these two really encountered on their climb up the slippery slope. Casey Siemaszko, playing actor turned producer, asks the two wannabes to adapt a screenplay so fat that it makes a nice footstool. Whether it would make a nice movie is unclear, since it's in Polish and they can't read it. "Oh, don't worry about the text," Mr. Siemaszko says confidently.

Also on hand are Martha Plimpton and Phoebe Cates, both of whom did actually run into Mr. Schaeffer while he drove his cab. Neither actress has much luck recapturing the spontaneity of that first encounter, but their scenes do have a genial home-movie feel (even Ms. Plimpton's, an attempt to re-create an intense scatological discussion she had with the auteurs).

John Sayles has a funnier scene as a producer who's briefly interested in these aspiring talents until he realizes they don't want to make a "When Harry Met Sally" knockoff, a Vietnam picture or either of the other ideas he mentions. "Those are all the stories!" he insists indignantly.

The two stars' easy on-camera rapport contributes greatly to making such episodes work. Mr. Ward is presented as the glamorous type, surrounded by a bevy of teen-age models who lean on him so adoringly that one falls over when he leaves his seat. Mr. Schaeffer comes across as more comically high-strung. Alone together, they abandon all pretense of cool, often bursting into little songs ("We're making movies now!" "We have girlfriends now!") to celebrate their good fortune.

Eric Schaeffer, left, and Donal Lardner Ward.

"My Life's in Turnaround" is so small in scale that even though it tacks on outtakes during the closing credits, the running time is only 84 minutes. Doesn't matter: what's important is that the film makers mention Matty Rich ("Straight Out of Brooklyn") and Nick Gomez ("Laws of Gravity") among those who made worthy, attention-getting films on the strength of perseverance and sheer drive. And that they can now add their own names to that list.

1994 Je 17, C5:5

Getting Even With Dad

Directed by Howard Deutch; written by Tom S. Parker and Jim Jennewein; director of photography, Tim Suhrstedt; edited by Richard Halsey; music by Miles Goodman; production designer, Virginia L. Randolph; produced by Katie Jacobs and Pierce Gardner; released by MGM/UA. Running time: 108 minutes. This film is rated PG.

Timmy	Macaulay Culkin
Ray	Ted Danson
Theresa	Glenne Headly
Bobby	Saul Rubinek
Carl	Gailard Sartain

By CARYN JAMES

"You dating yet?" Ted Danson asks, in another handsome but none-too-bright role.

"I'm 11," says Macaulay Culkin, in another of his grown-ups-are-idiots parts.

As father and son, these two still have the crowd-pleasing charm many cynics have been waiting for them to lose. But the stars are not the problem in "Getting Even With Dad." The film makers have taken what should have been a foolproof idea for these two — a neglected boy who blackmails his ex-con father into spending time with him — and thrown it away with a hackneyed script and unbelievably sluggish direction. The film should have been a roller coaster ride; instead, watching it is like trudging through a swamp.

Ray (Mr. Danson), recently released from Folsom prison and newly employed as a cake decorator, is planning one last heist so he can buy his own bakery. The day before the robbery, his son, Timmy (Mr. Culkin), is dropped on his doorstep. Timmy has been living with his aunt since his mother died, and the aunt has left him with his father for a week to go off on a sudden honeymoon.

What happens from then on is as fake and nonsensical as Mr. Danson's conspicuously glued-on ponytail. Timmy hides the stolen loot and won't reveal its hiding place until his father takes him to the aquarium, a ball game and other attractions on a long wish list that might have been devised by the San Francisco Chamber of Commerce. Timmy's secret motive is to save his inept dad from being caught and sent to prison again.

The most annoying part of the movie is that Ray is saddled with two thoroughly unappealing, unamusing accomplices. Bobby (Saul Rubinek) is a mean-spirited sleaze in a leather jacket. Carl (Gailard Sartain) is the target of a series of fat jokes. Carl says, while watching Ray decorate a cake with great artistry, "You remind me of that Michael dude over in Italy, who did the ceiling," which is a good example of the film's pathetic wit. Bobby and Carl get an immense amount of screen time as they accompany Ray and Timmy all over San Francisco in scenes that have less punch than a travel agent's brochure.

Glenne Headly plays a policewoman who becomes Ray's love interest, and she makes the most strained character of all work. The scene in which Timmy picks her up for his father has the crisp, engaging style missing from much of the movie. So does the moment when Ray tries to explain why he hasn't had time to play with Timmy. "I was planning a robbery, son," he says with baffled sincerity.

Both Mr. Danson and Mr. Culkin make the film's predictable ending far more effective than it might have been. They are warm without being sappy. It's too bad that the audience, parents and children, are likely to have grown restless long before then.

•

"Getting Even With Dad" is rated PG (Parental guidance suggested). It has a few strong words and a couple of punches.

1994 Je 17, C12:5

FILM VIEW/Caryn James

The Werewolf Within Dances With Abandon

IN "THE COMPANY OF WOLVES," Neil Jordan's deliciously dark fairy tale, Granny offers her adolescent granddaughter some timeless advice. The 1984 film, based on Angela Carter's shrewd story, turns "Little Red Riding Hood" into a blatant tale of erotic awakening. To navigate the wolf-filled woods of adulthood, Granny tells the girl, "Never stray from the path; never eat a windfall apple; never trust a man whose eyebrows meet." Or, she might have added, whose eyebrows arch as demonically as Jack Nicholson's.

Granny (Angela Lansbury) would have instantly spotted the hero of "Wolf" as part of a new breed of movie werewolves. Though Mike Nichols's film is being advertised with the provocative line "The animal is out," one of Granny's sentiments would have served much better. "The worst kind of wolves," she warns, "are hairy on the inside."

"Wolf" is a film that half works, and its success is all in the first half. Mr. Nicholson, as a book editor named Will Randall, is bitten by a wolf on a snowy road and develops strange symptoms of rejuvenation. Eventually the film loses its grip and becomes a routine horror movie, a genre in which the director seems profoundly uninterested. Until then the emerging wolfishness of Randall's character gives the film its entertaining, satiric edge and unexpectedly revealing pop-culture soul.

"I feel as if the wolf passed something along to me, a scrap of its spirit in my blood," Randall says as he begins to feel unusually good. He consults an expert on animal possession (as he explains, that's possession by an animal, not the kind of ownership that leads to the veterinarian's office) who calmly informs him he is changing into a wolf, and that not everyone who is bitten has the talent for such transformation. "There must be something wild within, an analogue of the wolf," the expert explains.

Something wild within? This Nichols-Nicholson wolf is definitely out of touch with typical werewolf movies. From the classic 1941 film "The Wolf Man," starring Lon Chaney Jr., to John Landis's eerie, special-effects-laden "American Werewolf in London" in 1981, werewolf films have been about growing a snout, sprouting hair on your feet and being possessed by a murderous beast.

But the Nicholson wolf is perfectly in tune with today's pop psychology. He is the male version of the heroines in "Women Who Run With the Wolves." Clarissa Pinkola Estes's appealing book, subtitled "Myths and Stories of the Wild Woman Archetype," has been on the best-seller list for 93 weeks.

In the stories Ms. Estes collects, the wolf-woman represents the essential self, powerful and benign but also informed by the natural predator in humans. Randall's "analogue of the wolf" resembles Ms. Estes's "Wild Woman soul," and his introspective werewolf is the man of the moment — a moment when we are all supposed to be looking for our inner wolf cubs.

In one respect this spiritual focus is responsible for a major lost opportunity in "Wolf." Werewolf stories have been adapted for hundreds of years, to cover everything from mental illness to demonic possession. But the lore has almost always involved submerged sexuality and an animal released from within a man, whether he likes it or not. The appeal of the werewolf myth — and its frightening power — has much to do with loss of control and reason.

Such a myth would seem perfect for the age of AIDS, when sex is supposed to be a matter of calm reason and of risks diminished by the thoughtful use of condoms. What more apppropriate fantasy than a scenario in which animal desires are unleashed against one's will? ("No, he didn't use a condom. He turned into a werewolf so fast!")

And for a time "Wolf" seems ready to explore that part of the myth. Dr. Vijay Alezias (Om Puri), the aged Indian expert whom Randall consults, assumes the Maria Ouspenskaya role; she was the wise old Gypsy woman in "The Wolf Man" who could see in a flash that Lon Chaney Jr. was headed for a furry future. Alezias tells Randall: "It feels good to be a wolf, doesn't it? Power without guilt, love without doubt." Alluring and sensible though that idea is — the perfect fantasy of irresponsibility for an age burdened with caution — it seems left over from some other, better version of the script. Bestial freedom is a minor part of the Nicholson character, though he does discreetly tryst with Michelle Pfiffer at the Mayflower Hotel before running out to Central Park to bay at the moon.

His shrewd, intelligent, wolfish senses are awakened more dramatically. Mr. Nicholson is mordantly funny as he gargles in the morning, making subtle wolf sounds. His receding hairline improves and he can read without his glasses. He can smell an early-morning

'Wolf' is perfectly in tune with 90's pop psychology — the male version of 'Women Who Run With the Wolves.'

nip of tequila on a co-worker's breath from the other side of the corridor and hear soft conversations taking place on another floor. In this neat twist on the typical horror movie,

François Duhamel/Columbia Pictures

Jack Nicholson and Michelle Pfeiffer, above, in "Wolf," and Lon Chaney Jr. and Evelyn Ankers in the 1941 film "The Wolf Man"—The appeal of the werewolf myth has to do with loss of control.

Photofest

he is less a werewolf than Superman in need of a shave. And he uses his improved senses well. He sniffs his wife's dress, identifies the scent of her lover and soon bites the other man's hand before bounding up the stairs on all fours to catch his wife in the man's apartment.

Randall has the analogue of the wolf, all right, but as Alezias says, only an evil man will become an evil wolf. From the Middle Ages on, werewolves — and lycanthropes, people who imagined they became wolves — were often thought to be demonically possessed. "Wolf" toys briefly with that idea too, though it seems to come out of nowhere. "I, too, will become a demon wolf," Alezias says when he asks Randall to do him a favor and bite him. But since Randall's inner-wolf analogue is basically good, he's not feeling devilish enough to comply. What kind of wimpy, nouveau wolf is he?

His ancestors, those more conventional movie werewolves, traded off on the myth of the unleashed beast (different from the vampire myth of eternal life), and on special effects that reached their height in "An American Werewolf in London" and Michael Jackson's video "Thriller," also directed by John Landis. Sometimes werewolf conventions were played for laughs. Michael Landon's career was jump-started when he played the lead in "I Was a Teen-Age Werewolf" (1957), and Michael J. Fox had a hit in the updated "Teen Wolf" (1985). "The Howling" (1981) is a werewolf satire that manages to be funny and creepy.

They all owe their spirits to "The Wolf Man," with Chaney as Larry Talbot, the ultimate good guy doomed because he was bitten by Bela Lugosi, as a Gypsy werewolf. Since a werewolf cannot be trusted to act like a gentleman (it's no mistake that wolf is a slangy term for womanizer), Talbot must resist the woman he loves. If a man's animal side comes out, the woman dies, at least in terms of social respectability in 1941. The typical werewolf myth on screen reinforces the idea of social and sexual restraint, for loss of control carries lethal consequences.

Newer variations suggest the value of embracing the inner wolf (not to mention dancing with them), and "The Company of Wolves" offers the most fascinating twist on the myth. In the Carter story, even more emphatically than in the film, the Red Riding Hood character, Rosaleen, gives herself freely to a wolf man. The act suggests the acceptance of her own emerging sexuality. Still, wolves are destructive and terrifying in this tale; so is human nature, with its capacity for evil and violence. It is an ambiguous freedom that allows Rosaleen to give herself to a wolf and become one.

But at least she isn't reduced to wolf bait, the way Michelle Pfeiffer is in "Wolf." One of the film's most annoying throwbacks to "The Wolf Man" is that her character is a convenient cliché, the woman in danger. As "Wolf" goes on, it seems to lose its early interest in character and wit, giving in to scenes of fangy teeth, yellow eyes and the contagious spread of werewolfness.

If "Wolf" had combined its two parts — the clever satire and the horror flick — with more assurance, Mr. Nicholson might have been a wolf for the ages. As it is, he makes an amusing wolf for the moment, hairy inside and out. □

1994 Je 19, II:13:1

Freedom on My Mind

Directed and produced by Connie Field and Marilyn Mulford; written and edited by Michael Chandler; a Tara Release. At Film Forum 1, 209 West Houston Street, South Village. Running time: 105 minutes. This film has no rating.

By CARYN JAMES

The idealism of the 1960's can seem like a cultural artifact now, as distant from the 90's as those quaint black-and-white television reports are from today's high-tech, second-to-second coverage. "Freedom on My Mind," the story of the volatile battle to register black voters in Mississippi during the summer of 1964, makes provocative use of that old film to situate viewers in a blatantly racist time and place. "I am a Mississippi segregationist and proud of it," says Ross Barnett, the Governor of the state. A well-dressed white man sitting in a little café says, "The colored people are very happy in Mississippi." Among the clips are scenes of the idealistic civil rights volunteers, black and white, who gave the lie to statements like that.

Interwoven with the archival material are recent interviews with many who were active in the civil rights movement: L. C. Dorsey, a sharecropper's daughter from Mississippi; Bob Moses, a black graduate student from Harvard; Marshall Ganz, one of many white, middle-class college students bused in to register black voters and to attract the kind of news-media attention that Southern blacks would have been unlikely to draw on their own. As they look back 30 years to what was called Freedom Summer, their testimony adds a complex layer to the film. An absorbing work of historical preservation and strong ideas, "Freedom on My Mind" won the grand jury prize for documentary at this year's Sundance Film Festival. It opens today at Film Forum 1.

Among those the film follows through Freedom Summer, Endesha Ida Mae Holland offers the most dramatic personal story. Known today as a playwright, she recalls being raped at the age of 11 by a white man. She soon dropped out of school and became a prostitute. When the white volunteers arrived in Mississippi in 1964, she responded by looking for customers, but stayed on as a volunteer. "The movement said to me I was somebody," she says buoyantly.

The film doesn't bypass harsh facts about the movement. Black people lost their jobs and risked their lives for daring to register to vote. There were cultural tensions between the Northern white students and the Southern black families with whom they lodged. Many of the black volunteers had never sat at a table with white people before. The students were aware (though perhaps not aware enough) that they were in the touchy paternalistic position of self-appointed saviors.

Mr. Moses was at the center of the political strategy. He led the Mississippi Freedom Democratic Party (a group that wanted to unseat the official, all-white Dixiecrat delegates) to the 1964 Democratic Convention in Atlantic City. For true culture shock, "Freedom on My Mind" offers scenes of a boardwalk packed with middle-American delegates, and the sound of that convention's theme song, "Hello, Dolly" (recast as "Hello, Lyndon"). While Fannie Lou Hamer spoke on live television in favor of seating the civil rights delegates, President Johnson called a news conference that strategically bumped her off the air. Mr. Moses calls the rejection of the Freedom Democratic Party "a betrayal" by the Democrats and sees it as a turning point in the civil rights movement. "It led directly to armed struggle," he says, "one of the great tragedies of this country."

Mr. Moses alone expresses such a sense of betrayal. Only when the final credits roll does the audience discover that he eventually left the United States to spend several years working in Africa before returning to create a public education program in Boston. He and the other Freedom Summer volunteers interviewed here remain idealistic, in ways that are inexplicable but convincing. Mr. Ganz, who went on to work with Cesar Chavez, says simply that the movement "gave us hope."

Ms. Dorsey, the sharecropper's daughter, who went on to earn a Ph.D. in public health, is eloquent on the subject of the deep cultural shift the civil rights movement set in motion. Black children in her generation were taught to stay in their place in regard to white people, she recalls; the next generation was not.

Connie Field and Marilyn Mulford, who together produced and directed "Freedom on My Mind," have created the best kind of historical record, one that resonates today.

1994 Je 22, C13:1

Alma's Rainbow

Directed and written by Ayoka Chenzira; director of photography, Ronald K. Gray; edited by Lillian Benson; music by Jean-Paul Bourelly; produced by Ms. Chenzira, Howard Brickner and Charles Lane; a Paradise Plum presentation. At Harlem Victoria 5, 235-237 West 125th Street. Running time: 85 minutes. This film has no rating.

Rainbow	Victoria Gabriella Platt
Alma	Kim Weston-Moran
Ruby	Mizan Nunes
Blue	Lee Dobson

By STEPHEN HOLDEN

Alma Gold (Kim Weston-Moran), the title character of Ayoka Chenzira's good-humored coming-of-age film, "Alma's Rainbow," is the strait-laced owner of a beauty parlor who lives with her adolescent daughter, Rainbow (Victoria Gabriella Platt). The daughter, who attends a strict parochial school and studies dance, is just becoming aware of boys. Although Alma has no dearth of suitors, she has fooled herself into believing she has outgrown the need for male companionship. And she sternly advises her daughter to follow her example and keep men at a distance.

Their austere life is disrupted when Alma's sister, Ruby (Mizan Nunes) appears out of the blue for an extended visit. Ruby is everything her sister is not. A flamboyantly sexy nightclub performer with a trunk full of glittering costumes, she has been making her living in Paris as a Josephine Baker imitator. Although Ruby's time has passed, she is too proud to admit it, and she still puts on the airs of an international star who is between engagements. Using her wiles, she inveigles the neighborhood's pompous undertaker into shuttling her to auditions in his hearse. He even allows her use his funeral home for a solo performance.

To Alma's dismay, Ruby takes Rainbow under her wing and stimulates the girl's nascent show-business ambitions. It isn't long before Rainbow starts trying on her aunt's clothes and imitating her sassy walk.

●

"Alma's Rainbow," which opened today at the Harlem Victoria 5, is a hip urban sitcom with sepia-toned flashbacks. Although the screenplay largely transcends television formulas, the characters verge on being stock comic types. In its affection for them and in its robust evocation of an black urban milieu, "Alma's Rainbow" recalls Spike Lee's first film, "She's Gotta Have It."

The heart of the movie is the struggle between the self-righteously prudish Alma and the flamingly free-spirited Ruby for Rainbow's respect. The movie makes no bones about being on Ruby's side. Her live-for-the-moment manner sets an example for both mother and daughter, allowing Alma to take a lover and smoothing Rainbow's transition from a street-dancing tomboy into a more sexually self-assured young woman.

"Alma's Rainbow," made for only $300,000, is a promising directorial debut.

1994 Je 23, C15:1

Wyatt Earp

Directed by Lawrence Kasdan; written by Dan Gordon and Mr. Kasdan; director of photography, Owen Roizman; edited by Carol Littleton; music by James Newton Howard; production designer, Ida Random; produced by Jim Wilson, Kevin Costner and Mr. Kasdan; released by Warner Brothers. Running time: 190 minutes. This film is rated PG-13.

Wyatt Earp	Kevin Costner
Doc Holliday	Dennis Quaid
Nicholas Earp	Gene Hackman
Virgil Earp	Michael Madsen
James Earp	David Andrews
Morgan Earp	Linden Ashby
Allie	Catherine O'Hara
Ed Masterson	Bill Pullman
Urilla	Annabeth Gish
Big Nose Kate	Isabella Rossellini
Bessie Earp	JoBeth Williams
Mattie	Mare Winningham
Josie	Joanna Going

By CARYN JAMES

WHENEVER Wyatt Earp experiences a dark night of the soul — which happens more than once in Lawrence Kasdan's and Kevin Costner's 3-hour-and-10-minute epic — you can bet it will be a dark and stormy night outside, too. At a turning point in the story that takes Wyatt from the Iowa cornfields of his boyhood to old age, he lies in a jail cell.

He is a sweaty, dirty, drunken young man who doesn't blink when a giant bug crawls across his chest. And to make sure no one misses the point, there is rain and thunder and lightning, not to mention some fancy movie lighting that allows Mr. Costner's All-American face to be seen clearly among the shadows. Visually and thematically, this version of Wyatt Earp's life may be the darkest ever put on screen.

The film's symbolic darkness is part of its vast, strong ambition. Mr. Costner's Wyatt Earp is a man tortured by the pull between two types of justice: the lawful kind that first made him a deputy sheriff and the frontier kind that turned him into a cold-blooded murderer seeking vengeance for his younger brother's death. His great and mordant friend Doc Holliday (spectacularly played by Dennis Quaid) describes him as "a marshal and an outlaw, the best of both worlds."

That is a great concept, but the film's literal-minded approach to the hero's dark soul is one of its terrible problems. "Wyatt Earp" labors to turn this mythic figure into a complex man; instead it makes him a cardboard cutout and his story a creepingly slow one.

In a typical scene, Wyatt disarms an out-of-control man and suddenly finds himself a deputy in Dodge City, Kan. A tin star is pinned on him; Mr. Costner touches it dramatically; James Newton Howard's overripe music swells. Time and again, watching "Wyatt Earp" is like being hit in the head with the butt of a rifle for no good reason at all.

Along the way, though, the film has episodes that almost live up to its ambition. They come from a parade of minor characters far more lifelike than Wyatt himself. The story, which is as much about family loyalty as it is about heroism and the Old West, gives Gene Hackman another chance to show he can do anything. As Nicholas Earp, the patriarch, he brings his grandiose lines down to earth. "Nothing counts so much as blood," he says with biblical certainty while sitting at

Ben Glass/Warner Brothers

Kevin Costner, left, and Gene Hackman in "Wyatt Earp."

the head of the dinner table. "The rest is just strangers."

Wyatt and his brothers will live by that code as Western lawmen. But before then Wyatt has to make it through his youth, first as a buffalo hunter and then as a married man. Much time is spent depicting his courtship and idyllic marriage to his first wife, Urilla (Annabeth Gish). But she exists here mostly so she can die of typhoid, in Wyatt's arms, providing him with his everlasting tortured soul.

After Urilla's death, Wyatt hits bottom, becoming a thief and landing in that jail. His father bails him out and talks some sense into him. Then he becomes a recovering alcoholic. Though the film never uses the anachronistic term, it is there in anachronistic spirit; Wyatt is forever walking into saloons and pointedly getting a cup of coffee.

Soon several Earp brothers have joined Wyatt in Dodge: the level-headed marshal, Virgil (Michael Madsen); the addled-by-drink bartender, James (David Andrews); the hot-headed deputy, Morgan (Linden Ashby).

As Doc Holliday, Mr. Quaid is the finest of Wyatt's cohorts, and not only because he has lost 40 pounds to achieve the gaunt look of a man dying of tuberculosis. He frowns and looks out at the world from under the brim of his black hat with a cool, sardonic gaze. When he meets the film's hero, he says in a slow voice dripping with the scent of magnolias, "Have you evuh been to Georgia, Wyatt Earp?" The former dentist, by then known as a notorious killer, describes himself deliciously as "a sporting man."

•

Yet a film that tries so hard to offer intelligent entertainment too often forgets to entertain. The famous showdown in Tombstone, Ariz., with the Earp brothers and Doc Holliday facing the cattle-rustling Clanton gang, is staged with greater historical accuracy than usual. It is not set at the O.K. Corral, but on an open street. Wyatt, Virgil, Morgan and Doc walk in a row through the dusty town, and take part in a brief, bloody gunfight at close range. One of the most famous scenes in all of Western legend is anti-climactic.

As in the Earp brothers' lives, women are functional in this film. Mare Winningham is Wyatt's pathetic, prostitute common-law second wife, Mattie. Joanna Going is his appealing, stylish third wife, Josie. Jo-Beth Williams gives whores a good name as James's feisty, sharptongued wife, Bessie. But poor Catherine O'Hara, as Virgil's wife, Allie, is stuck with the unnecessary, audience-nudging line: "You're a cold man, Wyatt Earp."

The screenplay was written by Dan Gordon and rewritten by Mr. Kasdan. But there is little of Mr. Kasdan's deft style in the script or the direction, which is so unlike that of his other films: "The Big Chill," "Body Heat" and, most conspicuously, his smart, light-handed western, "Silverado."

This earnest film does have Kevin Costner's fingerprints all over it. (He is one of its producers.) "You're not a deliberate man, Ed," Wyatt says in a monotone to his reasonable deputy, Ed Masterson (Bill Pullman). "I don't sense that about you. You're too affable." Only a fool would underestimate Mr. Costner's popularity in a period epic, but there isn't much to redeem this film at such softheaded moments, when it threatens to become "Dances With Wyatt" or "Wyatt Earp: Prince of Marshals."

"Wyatt Earp" is rated PG-13 (Parents strongly cautioned). It includes violence, strong language and a glimpse of a photograph of a half-naked Josie.

1994 Je 24, C1:5

Thieves Quartet

Directed and written by Joe Chappelle; cinematographer, Greg Littlewood; film editors, Randy Bricker and Scott Taradash; music by John Zorn; produced by Colleen Griffen; presented by Headliner Entertainment Group. At Quad Cinema, 13th Street, west of Fifth Avenue, Greenwich Village. Running time: 90 minutes. This film has no rating.

Jimmy Fuqua	Phillip Van Lear
Art Bledsoe	Joe Guastaferro
Jessica Sutter	Michele Cole
Mike Quinn	James (Ike) Eichling
Morgan Luce	Richard Henzel
Ray Higgs	Jamie Denton

By STEPHEN HOLDEN

"Thieves Quartet," a kidnapping drama set in and around present-day Chicago, sets out with a vengeance to demystify the romance of the caper movie. Among the four main characters who conspire to kidnap the daughter of a wealthy businessman, three are shabby losers without a trace of decency or loyalty, and the fourth is a well-meaning fool.

Art Bledsoe (Joe Guastaferro), who masterminds the scheme, is a bartender in his late 40's who, when not plotting crimes, likes to blabber on pretentiously about the genius of Miles Davis. With a peace symbol stuck on his shirt and his salt-and-pepper hair tied into a ponytail, he embodies the last dregs of 1960's idealism steamed into a putrid puddle of suppressed rage.

Two of Art's cohorts, Mike Quinn, played by James (Ike) Eichling, and Jessica Sutter (Michele Cole), are a bullying trigger-happy former policeman and an aimless tramp. Only Jim-

my Fuqua (Phillip Van Lear), an earnest ex-convict who has been struggling to earn a living at a car wash, has a glimmering of moral intelligence. His chief failing could be that he has seen and believed too many caper movies in which the conspirators adhere to a code of honor.

•

"Thieves Quartet," which opens today at the Quad Cinema, is the first feature film by Joe Chappelle, a 33-year-old writer and director who studied film at Northwestern University. Although a standard genre movie with film-noir overtones, it nevertheless has a conviction that is missing in many of its slicker Hollywood forerunners. One of its strengths is an edgy score by John Zorn that echoes Miles Davis while reinforcing the film's very dim view of the human condition.

The movie is better at establishing ambiance and evoking character than it is at telling a story. The environs of Chicago and Lake Michigan in the dead of winter make an effectively desolate visual corollary to the film's moral outlook. The taut, well-coordinated performances convey more sharply than do many similar movies the way the world of the affluent might appear through the eyes of embittered, footloose people with low expectations.

The film's storytelling isn't always smooth. The details of the kidnapping and ransom are fuzzy. And the untimely interference of a policeman (Jamie Denton) with his own crazy agenda comes too abruptly and fails to convince. The movie's awkward, drawn-out denouement on the shores of Lake Michigan clashes with the tone of the rest of the film. A movie that has been grimly anti-romantic reaches for an operatic flourish and misses.

1994 Je 24, C10:5

Critic's Choice

Precursor of 'Passion,' And Other Italian Treats

The timing couldn't better for a revival of Ettore Scola's "Passione d'Amore," the 1981 movie that inspired "Passion," the new musical by Stephen Sondheim and James Lapine. The film, which opens the Joseph Papp Public Theater's 1994 Italian Summer Festival tonight at 8:05, is remarkably similar in its look and its pacing to the Broadway musical adaptation except for one crucial difference. The character of Fosca, the ugly, ailing woman who conceives an obsessive passion for Giorgio, a handsome 19th-century cavalry officer, was softened for the Broadway musical.

The difference between Valeria D'Obici's movie portrayal of Fosca and Donna Murphy's Broadway performance is the difference between commedia dell'arte and Chekhov, between Margaret Hamilton in "The Wizard of Oz" and Olivia de Havilland in "The Heiress." The scenes in which Miss D'Obici's bony, hollow-eyed Fosca throws herself at Bernard Giraudeau's dashing

Giorgio lend the film an undertone of gallows humor. The character is a leering, voracious symbol of death. Ms. Murphy's lush voice and air of mournful abjection, deepened by Mr. Sondheim's yearning music, makes Fosca seem more romantically tragic than scary. The two performances are equally powerful in their very different ways.

After tonight, "Passion d'Amore" will return for a one-week engagement from July 27 through Aug. 2. It is one of three Scola films in this year's festival. The director's newest film, "Mario, Maria e Mario" (1993), about the collapse of Communism in Eastern Europe and its impact on Italian Communists, will have four screenings, tomorrow and Sunday. Its star, Giulio Scarpati, is also the leading actor in the second film to be shown tonight, at 10:15: Alessandro di Robilant's "Il Giudice Ragazzino" ("Law of Courage"), the true story of a young Sicilian magistrate who takes on the Mafia.

New York Shakespeare Festival

Elisa Cegani in Blasetti's 1941 film "La Corono di Ferro."

The third Scola film in the festival, "La Più Bella Serata Della Mia Vita" ("The Most Wonderful Evening of My Life"), is a serious comedy about an amoral Italian businessman and bon vivant (Alberto Sordi) who is subjected to a mock-trial by four retired judges while stranded at a Swiss mountain chateau. The trial takes place at a banquet so sumptuous that it makes the cuisine in "Babette's Feast" seem almost paltry. The 1972 film, which has its surreal moments, is a rich allegorical critique of the Italian character.

The cinematic styles in this year's festival range from Neo-Realism to the most grandiose pageantry. "Bellissima," Luchino Visconti's 1951 Neo-Realist masterpiece about a working-class woman who will stop at nothing to get her awkward, untalented 6-year-old daughter a screen test, has a blazing performance by Anna Magnani. Beneath its comic surface, the film, which plays July 22 to 24, is an excoriating exploration of class struggle, bourgeois materialism and Hollywood dreams.

Perhaps the oddest movie in the series, Alessandro Blasetti's "Corono di Ferro" ("The Iron Crown"), comes from the opposite end of the stylistic spectrum. This swashbuckling costume epic, set in the Middle Ages, suggests a fusion of "Ben Hur" and Wagner's "Ring" cycle. Made in 1941 during Mussolini's ascendancy, and acted in a kitschy operatic style, the film is a revealing reflection of the political climate of its era. It will be screened Tuesday through Thursday.

The festival includes 18 films, several of which are recent and unfamiliar to American audiences. Among the more famous older, rarely shown films are Roberto Rossellini's "Germany Year Zero" (1948), Bernardo Bertolucci's "Spider's Strategem" (1969) and Visconti's "Ludwig". (1973).

The theater is at 425 Lafayette Street, in the East Village. Opening-night tickets are $10. For the rest of the festival, tickets to individual screenings are $6; $7.50 for double bills. Information and screening times: (212) 598-7171.

STEPHEN HOLDEN

1994 Je 24, C27:1

I LOVE TROUBLE

Directed by Charles Shyer; written by Nancy Meyers and Mr. Shyer; director of photography, John Lindley; edited by Paul Hirsch; music by David Newman; production designer, Dean Tavoularis; produced by Ms. Meyers and Bruce A. Block; released by Touchstone Pictures. Running time: 120 minutes. This film is rated PG.

With: Olympia Dukakis, Robert Loggia, Marsha Mason, Nick Nolte and Julia Roberts.

By CARYN JAMES

As a veteran Chicago reporter named Peter Brackett, Nick Nolte glares down at his computer keyboard. Floating over the letters, covering the keys one by one until the whole alphabet vanishes, is row after row of Julia Roberts's face. She is Sabrina Peterson, his chief crosstown rival, and during her first few days on the job she has written enough front-page stories to get her picture on the side of the Chicago Globe's delivery trucks. Of course, Brackett has a head start in the fame department. He already has his picture on the Chicago Chronicle's trucks, and his face on a Gap ad on a bus shelter. Don't go to "I Love Trouble" looking for realism.

And don't even bother comparing it to the classic spar-until-they-fall-in-love movies of the 30's and 40's, even if this film begs an audience to make that self-defeating connection. "I Love Trouble" is breezy summer escapism, and taken on those light-spirited terms it is loaded with charm. Ms. Roberts has her best role since "Pretty Woman," a part that plays up her unmistakable Audrey Hepburn allure. And Mr. Nolte shows a surprising flair for this kind of blithe comedy. They may not be the first couple that pops into mind to play gritty, love-resisting reporters, but they make the film an appealing, easy-to-take confection.

In this comic-romantic-thriller, the thriller part is the weak link. Brackett and Peterson meet while covering what looks like an ordinary train wreck, and soon uncover industrial sabotage. To say that the muddled plot involves a chemical company and a secret formula for enhancing milk production is as much as anyone needs to know going in, and probably as much as anyone will remember coming out. The story is an excuse for Brackett and Peterson to race around the country, from Chicago to Wisconsin to Las Vegas, stumbling in and out of danger. They are so busy being shot at on rooftops and turning up for interviews only to find that their sources have turned to corpses, that they scarcely have time to notice their simmering attraction to each other. There's no doubt where the film is headed, but it goes there gracefully and with a few surprises tucked away.

"I Love Trouble" glides along because the actors carry off their roles with such panache, as if they just invented the Brackett and Peterson types. Brackett, who had got so lazy he was recycling old columns, resents being assigned to cover the train wreck until Peterson spurs his competitive spirit. He's tough, but not crass or overbearing.

Peterson is green, but not too naïve to outwit him. When they decide to pool their information and investigate together (sure, happens all the time) they are constantly duping each other. These cat-and-mouse games allow Ms. Roberts to display her great range of smiles and to show why her stardom is no fluke. She has the quality of being the girl-next-door wildly enhanced, so that she seems at once extraordinary and accessible, appealing and unthreatening to both men and women. The character of Sabrina (the name, after all, of an Audrey Hepburn movie) is smart yet vulnerable, casually chic, and tailor-made for Ms. Roberts.

"I Love Trouble" was created by the husband-and-wife team of Charles Shyer and Nancy Meyers, whose last film was the Steve Martin remake of "Father of the Bride" (the film being shown on a plane in "I Love Trouble"). Their work is not full of sly, ironic references to old movies. They create smooth, warmhearted films that make up in style what they lack in freshness.

Here, Mr. Nolte and Ms. Roberts even make their weak banter seem amusing. When Brackett, a notorious womanizer, insists that Peterson is not his type, she says, "I didn't know you had a type."

He does, he tells her: "The opposite of you."

"Tall, dark and stupid?" she snaps back.

In that scene they come awfully close to revealing the essence of much romantic comedy: generating enough heat to make the lines seem a lot more clever than they are.

Ron Batzdorff/Buena Vista Pictures

Nick Nolte and Julia Roberts are reporters for rival newspapers who exchange misinformation and quips in "I Love Trouble."

"I Love Trouble" is rated PG (Parental Guidance Suggested). It includes some violent gunplay.

1994 Je 29, C15:1

LITTLE BIG LEAGUE

Directed by Andrew Scheinman; screenplay by Gregory K. Pincus and Adam Scheinman, story by Mr. Pincus; director of photography, Donald E. Thorin; film editor, Michael Jablow; music by Stanley Clarke; production designer, Jeffrey Howard; produced by Mike Lobell; released by Castle Rock Entertainment. Running time: 119 minutes. This film is rated PG.

WITH: Luke Edwards, Timothy Busfield, John Ashton, Ashley Crow and Kevin Dunn

BY STEPHEN HOLDEN

Who was the first black player in major league baseball? What batter was standing on deck when Bobby Thomson hit his historic 1951 home run that clinched the National League pennant for the New York Giants? "Little Big League," the ultimate Hollywood movie for baseball trivia buffs, has the answers to these and other questions. So does the movie's main character, Billy Heywood (Luke Edwards), a 12-year-old Wunderkind and walking encyclopedia of baseball lore.

A serious-minded youth who suggests a pint-size, preadolescent Griffin Dunne, Billy inherits the Minnesota Twins when his grandfather (Jason Robards) dies suddenly. To the astonishment of the professional baseball world, he immediately appoints himself the manager of the team. And in typical Hollywood movie fashion, he miraculously leads the Twins out of a prolonged slump to become American League pennant contenders.

"Little Big League," which opens locally today, is a more good-natured film than most Hollywood movies about children who suddenly find themselves wielding grown-up clout. Billy wins over the initially hostile members of the Twins by appealing to the child in them. He reminds them how lucky they are to be in the major leagues and to have their faces on baseball cards. "Don't worry about winning and losing," he tells them. "Just go out and play. Have fun."

In other scenes, "Little Big League" looks and sounds like a training film for future business executives. Like any tough manager, Billy is forced to make difficult decisions. The most painful is the letting go of his earliest childhood idol, a legendary slugger who is well past his prime. There are other, homier lessons to be learned. As his fortunes rise, Billy unwittingly begins patronizing his grade-school buddies. Eventually he becomes so obsessed with his job that he forgets his own advice about how the game should be fun.

The movie, which is the directorial debut of Andrew Schienman, has its icky formulaic side. Billy is the only child of a picture-perfect single mother, Jenny (Ashley Crow), who always says the right thing and never has to raise her voice. The movie asks us to believe that until Jenny is approached by Lou Collins (Timothy Busfield), the Twins' kindly first baseman, she hasn't had a date in many years. The knotty psychological complications of Billy being Lou's boss are barely skirted.

The movie's best scenes are those shot on the playing field in Minneapolis's immaculate Metrodome, which

looks like a contemporary baseball Garden of Eden. Because the Twins are played by professional athletes who can act (not by the actual team members), the scenes on the ballfield have a credibility that is unusual in a baseball film. Adding to the realism are the appearances of a number of major league players as the Twins' opponents. The glow and cleancut innocence of these scenes evokes the magic of the game as seen through the eyes of a youthful fan.

"Little Big League" is rated PG (Parental Guidance Suggested). It includes one scene of a boy watching a soft-core movie.

1994 Je 29, C21:1

THE SHADOW

Directed by Russell Mulcahy; written by David Koepp, based on Advance Magazine Publishers' character; director of photography, Stephen H. Burum; edited by Peter Honess; music by Jerry Goldsmith; production designer, Joseph Nemec 3d; produced by Martin Bregman, Willi Baer and Michael S. Bregman; released by Universal Pictures. Running time: 104 minutes. This film is rated PG-13.
WITH: Alec Baldwin, Peter Boyle, Tim Curry, John Lone, Ian McKellen, Penelope Ann Miller and Jonathan Winters.

By CARYN JAMES

The ability to "cloud men's minds," as the Shadow puts it — to place them in hypnotic trances so that people and even buildings seem to disappear — is a handy trick to know if you're fighting Mongol warriors in Manhattan. So is a talent the Shadow is struggling to master, that of hurling a knife through the air telekinetically. This particular knife has a golden handle shaped like the head of a batlike creature, whose fierce eyes snap open and whose extra-sharp fangs bite its victim. Early in the film, that knife goes flying into Lamont Cranston, who is not yet a suave, crime-fighting playboy. In those pre-Shadow days he is a long-haired crime lord called Ying Ko, the Butcher of Lhasa, the meanest American in Tibet.

"The Shadow" is, of course, based on the exceptionally popular radio character, who appeared in 1930 and didn't vanish from the airwaves until 1954. "Who knows what evil lurks in the hearts of men? The Shadow knows," is one of the most famous phrases in American pop culture, familiar even to people who have no idea who the Shadow was or what he did.

In this sleek, entertaining new movie, the Shadow is Alec Baldwin, a wily actor who brings along just the right mix of do-goodism and evil potential. Style is almost everything here, and it's a tough call whether the star is handsomer than the sets. Sumptuously designed to within an inch of its life, the film is crammed with Art Deco nightclubs, high-rise buildings and 1930's yellow cabs. And though it includes some whizzing up-to-the-minute visual effects, the appeal of "The Shadow" is the retro fantasy of an old-fashioned crime fighter whose followers wear rings that emit secret signals.

The story begins with a brief episode set in Tibet that tells how Cran-

Ralph Nelson/Universal Pictures
Alec Baldwin

ston got to know so much about lurking evil. The sequence smoothly sets up the radio program's famous phrases, too. Cranston is captured and dragged to a building that has always been invisible to him. "The clouded mind sees nothing," his captor says. A wise teacher hurls the golden knife at him and says, "You know what evil lurks in the hearts of men because you have seen it in your own heart." Seven years later, the good-hearted Cranston is back home in Deco New York, in the guise of the Shadow, busy saving a man in cement overshoes who is about to be dumped off a bridge.

When Cranston turns into the Shadow, he does more than dress in a large black hat and cape, with a red scarf wrapped over his mouth. His nose actually gets longer, his blue eyes darken, all his facial features seem heavier, as if he is burdened with saving the world. In this get-up Mr. Baldwin looks a lot like the cover art on the "Shadow" pulp-fiction novels, but he looks even more like his younger brother Stephen.

The Shadow's nemesis is Shiwan Khan (John Lone), the last descendant of Genghis Khan, who travels to New York by having himself shipped to the American Museum of Natural History in a crate. He appears in elaborate, emerald-green armor and headdress, though the friendly cabbie who picks him up seems not to notice. Khan is bent on recruiting Cranston to join the forces of evil and has his own little army to help. "My Mongol warriors aren't very smart," Khan admits dryly, "but they are loyal."

One of the failings of "The Shadow" is that the film seems wary of pushing its wit too far. Jonathan Winters has an all-too-small role as Cranston's uncle, the police commissioner. When he says to a waiter, "More chives," he inexplicably makes the line hilarious, suggesting how much his nonsensical humor might have added.

A bigger failing is that neither the Shadow himself nor the plot are very compelling. Cranston's love interest, Margo Lane (Penelope Ann Miller), has little to do, even though she can read minds. Ian McKellen plays her father, a scientist unwittingly helping to make an atomic bomb. Tim Curry is funny, though conspicuously out of place, as his power-hungry assistant.

The plot, about saving the United States from nuclear disaster, is ludicrous even by fantasy standards. If an atomic bomb had hit New York in

the 1930's, wouldn't we have heard about it on the radio? The movie's period touches work better, like the billboard advertising Llama cigarettes, with the slogan, "I'd climb a mountain for a Llama." The director, Russell Mulcahy, who made the action-fantasy film "Highlander" and its sequel, keeps "The Shadow" speeding along. But the production designer, Joseph Nemec 3d, the costume designer, Bob Ringwood, and the cinematographer, Stephen H. Burum, are at least as important.

Good-looking though he is, the Shadow is no fuller a character than the heros of "Batman" or "The Crow." Such dark-hearted, cartoonish crime fighters are awfully familiar on screen right now, and this movie is too meek to set itself apart. Without the daring to exploit Cranston's latent attraction to evil, "The Shadow" isn't anything like a great picture. But it offers a diverting, nostalgic retreat to the innocent days when crime fighting was a pleasant, rich man's hobby.

"The Shadow" is rated PG-13 (Parents strongly cautioned). It includes some bloody murders and other violence.

1994 Jl 1, C1:1

BLOWN AWAY

Directed by Stephen Hopkins; screenplay by Joe Batteer and John Rice, story by Mr. Rice, Mr. Batteer and M. Jay Roach; director of photography, Peter Levy; edited by Timothy Wellburn; production designer, John Graysmark; music by Alan Silvestri; produced by John Watson, Richard Lewis and Pen Densham; released by Metro-Goldwyn-Mayer. Running time: 120 minutes. This film is rated R.
WITH: Suzy Amis, Jeff Bridges, Lloyd Bridges, Tommy Lee Jones, Stephi Lineburg and Forest Whitaker.

By CARYN JAMES

When Tommy Lee Jones turns on his coffeemaker, he could be making a cup of coffee or he could be making a bomb. At least that's what viewers ought to think for more than the fraction of a second that the seriously mistimed "Blown Away" allows. It's no surprise that Mr. Jones is brewing a bomb, and such lack of suspense is a pretty big problem in a thriller about a mad bomber.

"Blown Away" tries to be much more than that, of course. The film might have been the thinking person's "Speed," adding character and dialogue, even ideas, to action. Jeff Bridges plays a member of the Boston bomb squad, trying to outwit Mr. Jones as a brilliant bomber who has targeted him and the entire squad. Unfortunately, the characters are half-formed and the dialogue is stilted. Those factors would have done in "Blown Away" even if its awkward pacing hadn't.

One of the most intriguing actors around, Mr. Bridges is always worth watching, but as Jimmy Dove he is forced into countless hackneyed situations. Whenever he defuses a bomb, he has a black-and-white flashback to another bombing in Ireland. He is about to resign from the squad, but on his wedding day his former partner is killed on duty.

Joel Warren/Metro Goldwyn Mayer
Jeff Bridges

Jimmy identifies the bomber as Ryan Gaerity (Mr. Jones), with whom he has a secret shared past, and becomes determined to find him.

Gaerity begins the film by breaking out of an Irish prison, but by the time he arrives in Boston the most interesting part of his story is over. The script underuses Mr. Jones, and the supposed cat-and-mouse chase between the men degenerates into a series of awkward speeches. Gaerity's smartest move is to acquire a cassette by the group U2, which gives the movie a lively and distracting score.

As Jimmy's wife, Kate, Suzy Amis is given the film's worst lines. After Jimmy confesses that he has another identity, she says, "I don't even know who you are," an especially bad choice of words, since he has just told her his real name. Forest Whitaker is Jimmy's new partner. And as Jimmy's great friend and father-figure, Lloyd Bridges figures in the only bomb scene with any real suspense or emotion behind it. Otherwise, the squad defuses some bombs, and many others go off. The explosions provide big, magnificent special effects, but there is no buildup that makes sense. The pattern of the film is: talk, a big kaboom and fireball, more talk. Often that dialogue involves Irish accents that come and go like the wind.

When Jimmy jumps on a moving Jeep booby-trapped with a bomb, yelling at the driver, "Don't step on the brake," it's too bad that the audience will inevitably think of "Speed." Although "Speed" has nothing on its mind, every bit of its no-brain action works. "Blown Away" has more ambition, but nothing works. No film with this cast could be a total waste, but "Blown Away" is surely one of the summer's major disappointments.

"Blown Away" is rated R (Under 17 requires accompanying parent or adult guardian). It includes several deaths by bombing.

1994 Jl 1, C3:1

BABY'S DAY OUT

Directed by Patrick Read Johnson; written by John Hughes; director of photography, Thomas E. Ackerman; film editor, David Rawlins; music by Bruce Broughton; production designer, Doug Kraner; produced by Mr. Hughes and Richard Vane; released by 20th Century Fox. Running time: 90 minutes. This film is rated PG.
WITH: Lara Flynn Boyle, Brian Haley, Joe Mantegna, Joe Pantoliano, Cynthia Nixon, Adam Robert Worton and Jacob Joseph Worton.

By STEPHEN HOLDEN

Baby Bink, the rosy-cheeked 9-month-old infant who crawls and gurgles his way through "Baby's Day Out," is as indestructible a movie hero as Superman and a lot more adventurous. During a day spent on the streets of Chicago on his hands and knees, Bink fearlessly wends his way through traffic, staying so close to the ground that the cars and trucks whiz right over him. A construction site becomes his playground. Elevators are carnival rides, and loose boards on ledges 500 feet aloft become slides and seesaws.

But there are many critical maneuvers that "Baby's Day Out" doesn't show. How is Bink able to crawl from the street into the back seat of a taxi? Or onto a bus? At such moments, the camera simply turns away and leaves these impossible transitions to the imagination. And how is it that through all his grubby adventures, Bink remains indefatigably cheerful, alert and spotlessly clean?

The most refreshing thing about "Baby's Day Out" may be its absolute absurdity. This soap bubble of a movie with a slapstick heart would like to be a contemporary version of a two-reel silent comedy. Co-produced and written by John Hughes, the mastermind behind "Home Alone," it also wants to be the infant version of that blockbuster.

This time around, the comic villains are three bumbling kidnappers (Joe Mantegna, Joe Pantoliano and Brian Haley) who pose as a French baby photographer and his assistants. After wresting Bink from his parents' mansion during a bogus photo session, they demand a $5 million ransom. But Bink doesn't remain in their hands for long.

Marsha Blackburn/20th Century Fox
Joe Mantegna and Baby Bink

While one kidnapper dozes off, he crawls out the window and embarks on a series of adventures that parallel scenes from his favorite storybook.

At this point, the movie becomes a slapstick chase in which the kidnappers desperately try to retrieve Bink and are cruelly thwarted at every turn. By the end of the movie, they have taken enough punishment — from dunkings in cement and garbage to blows on the head — to kill each of them many times over. In the funniest scene, the kidnappers follow Bink to the zoo, where they try to extract him from the cage of a possessive gorilla.

Although Patrick Read Johnson, who directed, shows some promise as a director of slapstick comedy, "Baby's Day Out" is so intent on keeping the action lively that many of its stunts feel rushed and incomplete. Among the three kidnappers, Mr. Mantegna comes the closest to being a classically goofy villain. But in an early scene, in which he impersonates a pretentious French photographer, it is clear that this gifted actor is no Peter Sellers when it comes to comedy.

There is a big hole at the center of the movie that no amount of cuteness and physical comedy can overcome. As adorable as Bink may be, a protagonist who can neither walk nor talk is, finally, less a character than a comic conceit. And Bink, who is played by identical twins (Adam Robert Worton and Jacob Joseph Worton), wears out his welcome long before the end of the film.

"Baby's Day Out" is rated PG (Parental guidance suggested). The kidnapping may frighten some young children.

1994 Jl 1, C3:1

A PLACE IN THE WORLD

Directed and produced by Adolfo Aristarain; screenplay (in Spanish, with English subtitles) by Mr. Aristarain with Alberto Lecchi; original story by Mr. Aristarain and Kathy Saavedra; director of photography, Ricardo De Angelis; edited by Eduardo Lopez; music by Emilio Kauderer; released by First Look Pictures. At Lincoln Plaza Cinema, Broadway at 63d Street. Running time: 120 minutes. This film has no rating.
WITH: Hugo Arana, Gaston Batyi, Leonor Benedetto, Lorena Del Rio, Federico Luppi, Rodolfo Ranni, Cecilia Roth and José Sacristán.

By STEPHEN HOLDEN

The most charismatic character in "A Place in the World," an elegiac remembrance of the hard-scrabble existence in a remote Argentine valley, is a cynical Spanish geologist named Hans Meyer Plaza who calls himself a "hired gun." Hans, played with a fiery gravity by José Sacristán, has been employed by an unnamed multinational corporation to determine the feasibility of a hydro-

First Look Pictures

Lorena Del Rio and Gaston Batyi

electric project in the desolate Bermejo Valley, 90 miles from Buenos Aires.

Hans, who has also been checking the area for oil, professes indifference to the fact that his work might precipitate the eradication of a pastoral society that has existed for centuries. In his Darwinian view, human beings are "primates who cannot be changed."

The audience for his speech includes Mario and Ana (Federico Luppi and Cecilia Roth), political idealists who have organized the valley's shepherds into a cooperative, and their colleague Nelda (Leonor Benedetto), a politically committed nun who refuses to wear clerical garb. Exiled to Spain during Argentina's military dictatorship, Mario and Ana have returned to their homeland to work for a more just society.

One of the triumphs of the film, which opens today at Lincoln Plaza Cinema, is its portrayal of Mario, Ana and Nelda as complex, quirky adults with genuinely noble instincts. They are good people, but not too good to be true.

"A Place in the World" is narrated by Mario and Ana's son, Ernesto (Gaston Batyi), a medical student who has returned to the valley to visit his father's grave. The movie is a sustained flashback of the world seen through the eyes of the 12-year-old Ernesto.

Written and directed by the Argentine film maker Adolfo Aristarain, the film has the feel of an epic western like "Shane," but with a modern political sensibility. In the characters of Mario and Hans, it gives Ernesto two heroes to admire. One is a passionate, fearless advocate for social justice who has made enormous sacrifices to follow his beliefs. The other, who takes Ernesto under his wing, is a hard-bitten man of the world with a streak of poetry in his soul.

While the film convincingly shows how two or three dedicated people can make a difference in the world, it also suggests that in the long run their cause is lost. Mario and Ana do daily battle with Andrada (Rodolfo Ranni), a wealthy landowner who wants to destroy the cooperative and force the shepherds to sell him their wool at a price he determines. In several vicious acts of intimidation, he demonstrates the extent of his ruthlessness.

Against this tumultuous political and social canvas, the emotions of the characters assume a larger-than-life dimension. Hans and Ana feel an intense attraction that is so obvious that it embarrasses those around them. Ernesto has his first crush on Luciana (Lorena Del Rio), the adolescent daughter of Andrada's ominous foreman, Zamora (Hugo Arana).

In the film's most magical scene, Hans teaches an impromptu geology class in the rudimentary schoolhouse Mario has built. Hans's survival-of-the-fittest ethic extends to the inanimate world. In a poetic speech, he evokes the movements of the earth over millions of years, declaring that ice is a mountain's worst enemy. He even says he can hear the groans of a mountain when it is threatened. Examining some rocks under an ultraviolent lamp, he calls the light a beacon into their souls. Such moments lift "A Place in the World" out of the realm of social realism and lend a Shakespearean dimension.

1994 Jl 1, C3:1

THE KINGDOM OF ZYDECO

Directed by Robert Mugge. At Cinema Village, 22 East 12th Street. Running time: 71 minutes. This film has no rating.

By JON PARELES

The hooting accordions and clattering percussion of zydeco music still rule the dance floors of the Louisiana bayous. But who rules zydeco? That question sent the documentary film maker Robert Mugge to Lake Charles, Lawtell, Eunice and other zydeco strongholds for his latest music documentary, "The Kingdom of Zydeco," which is the midnight show tonight and tomorrow at Cinema Village. There are also morning shows today, tomorrow and Monday at 11:45.

It's a question of royal succession. Clifton Chenier was the undisputed king of zydeco until his death in 1987. At that point, Rockin' Dopsie, who had called himself the crown prince, began wearing a crown. Before Dopsie died in 1993, he told the Louisiana Hall of Fame that Boozoo Chavis, who made the first commercial zydeco recording in 1954, should inherit the title. But there are other contenders, chief among them the current dancehall favorite, Beau Jocque, and a larger issue: How far and how fast should zydeco evolve?

The center of the film is a show that's billed as a battle of the bands between the 63-year-old Mr. Chavis and the 39-year-old Beau Jocque. Mr. Chavis's zydeco is utterly distinctive, with its own kind of two-step rhythm and modal melodies that hark back to both African and Celtic (Cajun) roots. Mr. Jocque, who acknowledges Mr. Chavis as a source, takes in more modern elements: funk-bass lines, John Lee Hooker's boogie vamps, even a touch of rap. But some observers, like Irene Hebert of House Rocker Records, worry that the music has become "a lot of screaming and hollering," and that no one records slow songs anymore.

While both contenders start out saying that the battle is just a promotional gimmick, the competitive spirit emerges. "I know more music than he's ever going to learn," Mr. Chavis says. "I done forgot more."

Mr. Jocque says, "I wish him well, but he don't have a chance!"

And they play hard, as Mr. Jocque stretches out his regional hit, "Give Him Cornbread," with solos all around the band, and Mr. Chavis churns out his unstoppable groove. Mr. Mugge catches the details of band members' efforts and dancers' leg-swinging footwork.

The film also reveals the resentment around Mr. Chavis's coronation from other musicians and zydeco entrepreneurs. "Let the public decide," says Sherman Richard, the owner of Richard's Club in Lawtell and a Beau Jocque partisan. There's also commentary and informal, accordion-and-rubboard performances by Nathan Williams (of Nathan and the Zydeco Cha-Chas) and by John Delafose (who leads the Eunice Playboys).

Music documentaries often present local styles as idyllic and unspoiled; Mr. Mugge lets viewers see the tension in the local scene. In the meantime, those accordions keep everybody dancing.

1994 Jl 2, 13:3

FORREST GUMP

Directed by Robert Zemeckis; written by Eric Roth, based on the novel by Winston Groom; director of photography, Don Burgess; edited by Arthur Schmidt; music by Alan Silvestri; production designer, Rick Carter; produced by Wendy Finerman, Steve Tisch and Steve Starkey; released by Paramount Viacomcoel. Running time: 140 minutes. This film is rated PG-13.
WITH: Sally Field, Tom Hanks, Gary Sinise, Mykelti Williamson and Robin Wright.

By JANET MASLIN

When a television news report overheard in "Forrest Gump" mentions American astronauts, the audience can be forgiven for wondering whether the title character will soon be seen walking on the moon. The charmed life of Forrest Gump has led him practically everywhere else, from the White House (where Presidents Kennedy, Johnson and Nixon appear to be greeting him amiably) to an Alabama boarding house (where he gives pelvis-shaking lessons to a guest, the as-yet-unknown Elvis Presley).

And "Forrest Gump" is such an accomplished feat of cyber-cinema that it makes these tricks, not to mention subtler ones, look amazingly seamless. As he did in "Who Framed Roger Rabbit?" and the "Back to the Future" films, Robert Zemeckis is bound to leave viewers marveling at the sheer wizardry behind such effects. Even the opening credit sequence, featuring a feather that drifts along a perfectly choreographed trajectory until it reaches its precise destination — a fine visual embodiment of Forrest's own path through life — is cause for astonishment.

But as with Mr. Zemeckis's "Death Becomes Her," the audience won't simply ask how; it will also wonder why. This film maker, the one who made Meryl Streep appear to speak with her head on backward, remains much more successful at staging brilliant technical sleight-of-hand than at providing the dramatic basis for his visual inventions. Structured as Forrest's autobiography, and centering on his lifelong love for an elusive beauty named Jenny, "Forrest Gump" has the elements of an emotionally gripping story. Yet it feels less like a romance than like a coffee-table book celebrating the magic of special effects.

Luckily, "Forrest Gump" has Tom Hanks, the only major American movie star who could have played Forrest without condescension and without succumbing to the film's Pollyanna-ish tone. "Let me say this: bein a idiot is no box of chocolates," says the slow-witted narrator of Winston Groom's tart, playful novel, on which Eric Roth's screenplay is based. The film's Forrest expresses this thought in much more saccharine fashion, announcing that his mother used to say life was like a box of chocolates because "you never know what you're gonna get."

On screen, "Forrest Gump" doesn't get much tougher than that. It's a loose string of vignettes, presented at an unemphatic, page-flipping pace by Mr. Zemeckis, and establishing Forrest as an accidental emblem of his times. Forrest's love of Jenny (Robin Wright) is the film's only unifying thread, but it's a thread stretched almost to the breaking point. You are sure to watch this story chiefly for its digressions, especially those expressed with Forrest's comically oblivious powers of description: "Now the really good thing about

Phil Caruso/Paramount Pictures

Gary Sinise, left, has words for Tom Hanks, who stars in "Forrest Gump" as an innocent caught up in great events of the 20th century.

meetin' the President of the United States is the food."

Forrest says this when, having been named an All-American, he visits the Kennedy White House and winds up drinking too much Dr. Pepper. Typical of the film's magic is a brief glimpse of Forrest writhing uncomfortably and telling the President that he has to go to the bathroom, with a naïveté that makes Mr. Kennedy chuckle.

The President's voice sounds authentic, his mouth movements match his movie dialogue, and he and Mr. Hanks appear to be on precisely the same film stock, in the same frame. Special kudos for this go to Ken Ralston, the film's special-effects supervisor, and to Industrial Light and Magic, pushing the technical envelope further than ever. Superb gamesmanship like this is its own reward, even if it accounts for only a fraction of the film's screen time and sometimes is allowed to wear thin (a patently phony shot seating Forrest next to John Lennon on the Dick Cavett show, with Mr. Lennon's small talk consisting of "Imagine" lyrics).

Disabled as a young boy but goaded by his loving Mama (Sally Field) to make the best of his abilities, Forrest eventually becomes a football star, a war hero, a successful businessman and an international Ping-Pong champion. Is Mr. Hanks hitting real Ping-Pong balls at high speed? Or have the balls and whacking sounds been artificially added? By the time this sequence comes around, viewers will have lost all ability to distinguish real images from clever counterfeits. The single most dazzling special effect turns Gary Sinise, as Forrest's Vietnam friend and subsequent business partner, into a double amputee.

Meanwhile, American popular culture explodes around Forrest, allowing Mr. Zemeckis to contrive a string of Zeitgeist-laden picture postcards.

Jenny goes from country girl to hippie to political activist to druggie and onward. When she goes to San Francisco during the flower-power days, viewers will know exactly which pop song to expect in the background.

In fact, "Forrest Gump" is so loaded with hit songs and eye-catching costumes that these superficial elements often supplant the narrative. When Forrest, demostrating the kind of benign whimsy that brings to mind Kurt Vonnegut's early fiction, decides that he feels like running across America for a couple of years, "Running on Empty," "It Keeps You Runnin'," "Go Your Own Way" and "On the Road Again" are all used for musical accompaniment. While en route, he also invents one very popular bumper slogan and the "Have a Nice Day" T-shirt logo.

If Forrest is a holy fool, Mr. Hanks makes his holiness very apparent. Only in this touching, imaginatively childlike performance does the film display any emotional weight. Sitting on a bench at a bus stop during most of the film, eagerly recounting his life story for a succession of strangers, Mr. Hanks's Forrest has an unerring sincerity and charm. If it's difficult to reconcile this sweet, guileless performance with the film's technical obsessiveness (a special satellite was used to track the sun's position and determine optimum lighting for the film's outdoor scenes), well, maybe it should be.

Deserving of special mention among the actors are Mykelti Williamson, as the Army buddy who turns out to be a perfect match for Forrest, and Mr. Sinise, whose dark, bitter performance offers an element of surprise. Ms. Wright's role is structured mostly as a set of costume changes, but she is as strong and resilient as the material requires. Ms. Field, unfazed by the job of playing Mr. Hanks's mother, charges through

the story in flowery, emphatically genteel Southern costumes. Like everything else about "Forrest Gump," she looks a little too good to be true.

"Forrest Gump" is rated PG-13 (Parents strongly cautioned). It includes brief nudity, sexual references and mild profanity.

1994 Jl 6, C9:3

HIGH SCHOOL II

Directed, produced and edited by Frederick Wiseman; photography by Richard Leiterman. At Film Forum 1, 209 West Houston Street, South Village. Running time: 220 minutes. This film has no rating.

HIGH SCHOOL

Directed, produced and edited by Frederick Wiseman; photography by Richard Leiterman. Running time: 75 minutes. This film, made in 1968, has no rating.

By CARYN JAMES

Back in 1968, when Frederick Wiseman was a cinéma vérité pioneer, he made average-length films like "High School," which captured the all-American educational system in action at a Pennsylvania school. "You don't talk, you just listen!" yells a burly, crew-cut teacher as he bullies a student into putting on a gym uniform.

Some things have changed since then. Mr. Wiseman is now a master of the epic documentary. And his new, 3-hour-40-minute film, "High School II," brings his leisurely but incisive style to Central Park East Secondary School, an alternative public school in East Harlem. It urges its students, a multiracial mix that includes politi-

cal organizers and teen-age parents, to talk, listen and think for themselves. Both "High School" and "High School II" open today at Film Forum 1.

Mr. Wiseman's approach has remained the same over the last 25 years. There is no narration, no identification of characters. His camera simply settles in and eavesdrops. Central Park East is the perfect setting for a film that forces viewers to draw their own conclusions. The school's program includes constant, casual talks between students and teachers, who are always called by their first names: Bridget, Debbie, Richard. Each episode of "High School II" creates a tiny drama of its own, until the film assumes the breadth of a mini-series and the fascination of a trenchant novel of manners.

When Mr. Wiseman visited the school, in May 1992, some students were organizing a march on City Hall to protest the verdict in the first Rodney King trial. Their mix of outrage, idealism and school solidarity offers a sharp portrait of smart adolescents.

Perhaps the most poignant episode is a conference among several teachers, a 15-year-old student who has just had a baby, the baby's teen-age father and the student's mother. The conversation is led by Debbie, a kind, gray-haired faculty member with dangling earrings, who wants to welcome the student back, talk through the difficulties she'll have and make sure she feels safe. Apparently teachers have heard gossip that some other students might start a fight.

Debbie's wise and eloquent voice comes through clearly in "High School II." What the film doesn't say is that she is Deborah Meier, so highly regarded as an innovative educator that she has received a MacArthur Fellowship. Obviously, Mr. Wiseman was not bent on capturing a typical school.

Instead, his film becomes a study in social mobility. It is clear from the family conferences that these college-bound students will be far better educated than their parents. And it is enlightening to hear the students, most of them poor, discuss "A Raisin in the Sun" and lambaste the American dream as an idea that has degenerated into something that is all about money.

Of course, not every episode is scintillating. Sometimes the film brings back the bad old feeling of being stuck in a high school class watching the clock. More often, "High School II" is absorbing and optimistic.

The student-friendly Central Park East may be the school many of us wish we had gone to, but the setting of the original "High School," with its scenes of rigid authoritarianism, may be closer to the average even now. In its lighter moments, this film is wry and quaint, as girls are lectured about proper skirt lengths and boys receive a primitive sex-education talk. One young teacher holds up a Simon and Garfunkel album, announces, "The poet is Simon," then goes on to analyze the lyrics to "The Dangling Conversation." At least she's trying, and doing a better job than the teacher who reads "Casey at the Bat" to her class.

The film brings to mind a different Paul Simon lyric. When he looks back on all the stuff he learned in high school, he sings, "It's a wonder I can think at all."

1994 Jl 6, C14:1

CRITIC'S NOTEBOOK

Sadness and Madness In French Film Series

By CARYN JAMES

MURDEROUS obsession, a medieval romance, a lovesick soldier and a woman in love with a chimp: the French don't own the idea that love is strange, but they've always known what to do with it. Now it is the basis for a wickedly delightful series celebrating crazy love. "L'Amour Fou: French Films of Passion, Romance and Obsession," begins today and runs for the next five weeks at the Walter Reade Theater at Lincoln Center. The idea is irresistible, probably because it is so obviously true. You could make a good case that amour is always fou; if it's rational it's not love, but more like a business deal.

One of tonight's opening features, the alluring, little-known 1937 film "Gueule D'Amour," features Jean Gabin as a Foreign Legionnaire in the south of France. Known as Lover Boy (Gueule d'Amour), he has the society matrons complaining; in the last six months they have lost nine maids, all distracted by his charms. Even now, on screen, it's easy to see why women would have followed the dashing Gabin into the desert.

But in a neat twist, Lover Boy is soon lovelorn. He becomes obsessed with a glamorous woman (Mireille Balin, who had starred with Gabin the year before in the better-known "Pépé le Moko.") She takes his money, pretends to gamble with it, and keeps it. Then she closes the door in his face. After that, of course, he's hooked. Though he knows she's worthless, he follows her to Paris, where he finds work as a typesetter while she is kept by a rich lover. As she toys with his emotions, he seems to age overnight, until she literally drives him crazy and provokes him to murder.

Like other love stories of the period, "Gueule d'Amour" has a melodramatic surface, yet it hits a nerve in anyone who has ever spent too much time thinking about the wrong person. And this film is an extravagant feast of all the crazed elements that other movies in the series handle in a more selective way: sexual passion, dreamy romance, obsession and violence, with issues of class and money lurking in the background.

Almost all these films explore the dark consequences of passion, but it would be pushing too hard to find anything like a consistent theme here. L'amour fou is not a rigorous idea but a convenient catchall that allows the series fantastic variety. Without any attention to chronology, the program swerves giddily through movies that range from Luis Buñuel's then-scandalous "L'Age d'Or" (1930), in which a frustrated woman sucks the toe of a statue, to Buñuel's last film, the 1977 satire of endlessly unfulfilled passion, "That Obscure Object of Desire."

Out of the Shadows

Though the series is rich with such classics, its greatest appeal is that it brings back so many lesser-known films (a number of them not available on video.) Some are by great directors like Marcel Carné and François Truffaut. Others are by directors who were famous in their day, and whose reputations have been buried too long, like Jean Grémillon, the director of "Gueule d'Amour" and Jean Duvivier, whose "Pot Bouille" ("House of Lovers") is the slighter half of tonight's double feature.

"Pot Bouille" is a period piece in two senses: Gérard Philipe is a 19th-century social-climbing playboy, and the 1957 comedy of manners has a smooth, polite manner that later films about sexual adventurers would explode. Fluffy movies like this are the French equivalent of second-rank films from the Golden Age of the Hollywood studios; they can be wildly entertaining, and deserve to be rediscovered.

If you pick your way along this series, you can see social attitudes and the depiction of sex on screen change before your eyes. Films move from the discreet (Max Ophüls's sumptuous 1953 "Earrings of Madame de...") to the nakedly smarmy (Brigitte Bardot in Roger Vadim's 1956 "And God Created Woman") before settling into the matter-of-fact explicitness we know today.

Louis Malle's 1958 film "The Lovers," with the camera focusing on the orgasmic face of Jeanne Moreau, was a triumph because it was both blunt and veiled. As a bored, upper-middle-class wife, Ms. Moreau's character is swept away by her physical attraction to a young stranger, yet she cloaks her earthy desire in dreamy romance. "It was impossible to hesitate," she says. "One does not resist happiness." Blending sex and romance, as "The Lovers" does, is one surefire way to create eroticism.

Passion and infidelity may not be limited to the rich, but these films are always aware of how class distinctions shape the erotic and the emotional. In "The Baker's Wife," Marcel Pagnol's 1938 classic of provincial life, the sad-sack baker's pretty young wife runs off with a handsome shepherd. There is much humor in this village, but no secrets.

"So, baker, you're a cuckold?" one neighbor asks.

"A word for rich people," the baker answers. "If it happened to me I wouldn't be a cuckold; I'd be unhappy."

Hoping Against Hope

Some of the best-known French romances deal with a love that is fated to fail, yet whose hopeless spirit lives on. The most famous is Carné's "Enfants du Paradis," ("Children of Paradise") with Jean-Louis Barrault's mime always pining for the prostitute played by Arletty. But this series includes several other Carné films,

like the peculiar romance "Les Visiteurs du Soir" ("The Devil's Envoys"), set in the 15th century. Arletty and Alain Cuny are emissaries of the devil disguised as troubadours. When they arrive at a castle intending to disillusion a knight's daughter and her fiancé, the evil envoys fall in love with the humans instead. The film is elaborate, stately and old-fashioned, its story inspired by legend and its look taken from the illuminated manuscript "Les Très Riches Heures du Duc du Berry."

The film's undercurrent is at least as intriguing as its romantic story. Made in 1942, during the Occupation, it is widely considered an allegory in which the Devil is Germany and the lovers, France. Though the Devil turns the knight's daughter and her once-devilish lover into a joined statue, their hearts go on beating within.

Such lush tales might inspire sighs or sugar-shock, but they are only part of the story. If the French are experts on the generous romance of the heart, they are just as knowing about fierce, even lethal, jealousy. For every "Enfants du Paradis" there is an "Enfants Terribles" (1949), Jean-Pierre Melville's faithful version of Jean Cocteau's weird novel about a brother and sister who live together in claustrophobic devotion to each other, a relationship based on an obvious but unstated attraction. Inevitably, other lovers intrude, with violent consequences. "I may be a monster," the sister says, pulling a gun, "but I'm not a coward."

Violence to Rapture

Often romance and violence are themes in the career of a single director, like Truffaut. His early film "La Peau Douce" ("The Soft Skin"), a tale of adultery and murder, is one of his harshest, most cynical and least known. It is balanced in this series by his rapturous and beautiful "Story of Adele H." in which Isabelle Adjani, as Victor Hugo's daughter, follows her caddish lover across two continents with an obsessive passion that is both crazy and heroic.

This series includes many other rare delicacies and old favorites. Highlights include René Clair's "Beauty and the Devil," a retelling of the Faust legend in which Michel Simon is Faust and Gérard Philipe appears as Mephistopheles (another devil's envoy), his hair rakishly combed to suggest horns.

Georges Franju's "Eyes Without a Face" really has no business in this series at all. But why complain about such a bizarrely effective horror story? The film's foggy poetic atmosphere raises it above the plot: a mad doctor and his assistant (Alida Valli) kill young women so he can use their skin to surgically replace his daughter's face, ravaged in an accident.

Among the seldom-shown films are "L'Amour Fou," Jacques Rivette's four-and-a-quarter-hour tale about a director and actress whose marriage is falling apart. Like so many Rivette works, it is about love, art and reality. The series also includes a restored version of "Siren of the Tropics," with Josephine Baker. She can't sing in this silent film, but she can dance.

Unexpected Lover

And in the 1986 satire "Max Mon Amour," Charlotte Rampling plays Margaret, the wife of a British diplo-

Film Society of Lincoln Center

Charlotte Rampling and friend in a scene from "Max Mon Amour," part of the film series "L'Amour Fou" at the Walter Reade Theater.

mat in Paris. Bored wives really do spell trouble in these movies. The husband suspects Margaret is having an affair, but he is not prepared to learn that her lover is a chimpanzee named Max, and that they are helplessly devoted to each other.

There are no tasteless scenes of Max and Margaret in the act, though they indulge in a few romantic smooches. When Max sucks Margaret's fingers, the series seems to have come full circle from the statue-sucking woman in "L'Age d'Or." "Max Mon Amour," directed by Nagisha Oshima, has obviously been influenced by Buñuel's irreverence about social conventions and the silly fuss made about love.

"Max" is funniest when the husband falls back on the stock phrases of so many unbelieving spouses. He suggests that Max move into the house and share their lives, but his open-mindedness only lasts so long. Eventually, he can't help asking about the chimp, "Is he better than I am?" Finally the jealous husband threatens, "Some day I'll take a gun and go shoot him."

Passion, obsession, violence. We're a long way from "Gueule d'Amour," but really not so far at all. "L'Amour Fou" is based on an unshakable, universal premise. Though few of us have fallen in love with chimps, at times we've all been monkeys in love.

1994 JI 8, C1:3

COMING OUT UNDER FIRE

Directed and produced by Arthur Dong; written by Allan Bérubé and Mr. Dong; director of photography, Stephen Lighthill; edited by Veronica Selver; music by Mark Adler; released by Zeitgeist Films. At Quad Cinema, 34 West 13th Street, Greenwich Village. Running time: 71 minutes. This film is not rated.

By STEPHEN HOLDEN

At the core of "Coming Out Under Fire," Arthur Dong's quietly devastating documentary film about homosexuality in the military during World War II, are interviews with 10 gay men and women who served in the armed forces.

Some, like Phillis Abry, a radio technician in the Women's Army Corps, were able to carry on homosexual relationships without being detected and received honorable discharges. Others, like Marvin Liebman, who was in the special services of the United States Army Air Corps, were identified as gay, having "psychopathic" personalities, and were discharged as undesirable.

In the witch-hunt atmosphere that pervaded the military toward the end of the war, people suspected of being gay were relentlessly interrogated and manipulated into identifying other homosexuals. Many were sent to psychiatric hospitals or imprisoned for months in "queer stockades." Discharged as undesirable, they often found themselves pariahs, unwelcome in their hometowns and unable to find work.

Mr. Liebman was interrogated when military censors read a letter

he had written to a friend whom he addressed as "darling" in the campy language of Dorothy Parker. Another veteran, identified as Clark, was an Army clerk and typist who helped create a mimeographed newsletter, The Myrtle Beach Bitch. The campy publication, which was circulated privately among gay servicemen, eventually got him into trouble. He was court-martialed and served nine months in prison. He has spent years challenging his undesirable discharge status.

These and many other personal testimonies are skillfully woven into an absorbing portrait of 1940's military life that brings in Army training films, newsreels and period documents.

"Coming Out Under Fire," which opens today at the Quad Cinema, traces the hardening of the military's anti-homosexual attitudes as the war progressed. At the start of the war, the military hoped to exclude homosexuals from service simply by asking new recruits about their sexual orientation and excluding those who said they "liked" members of their own sex. As it became clear that thousands of gay men and lesbians had chosen to serve, a climate of relative tolerance abruptly gave way to an atmosphere of paranoia and denunciation that increased even after the war ended. The witch-hunting reached its peak in the early 50's in the McCarthy era when the State Department dismissed hundreds of gay and lesbian employees as alleged security risks.

The film, which is based on Allan Bérubé's history of gay men and women in World War II, also has scenes suggesting that despite the official condemnation of homosexuality, gay and straight servicemen and women could co-exist harmoniously. The armed services liberated lesbians from the traditional attitudes and trappings of femininity.

Servicemen staged drag entertainments for one another in which many of the performers were gay. As Tom Reddy, who served in the Marines, recalls: "I went in at 17 and came out at 21, and I knew I was a man. It took nerve to put on a dress and run out there in front of 500 or 1,000 of your peers that were all pretending to be so macho."

For all the feelings of pride and self-esteem that are expressed in the stories, "Coming Out Under Fire"

has a bitter undertone. Even those who went undetected and received honorable discharges recall that when the witch hunts began they had to modify their behavior and start looking over their shoulders.

The film sets these events against a backdrop of the Congressional hearings last year on homosexuals in the military. As these scenes make abundantly clear, the Pentagon's view of homosexuality as incompatible with military service remains implacable.

1994 JI 8, C8:5

CHICKEN HAWK
Men Who Love Boys

RED LIGHT, GREEN LIGHT

Directed by Bill Brose; written by Michael Halbern; director of photography, Phil Lohmann; edited by Mark Snegoff. Running time: 20 minutes.
Both films released by Stranger Than Fiction Films. At Cinema Village, 22 East 12th Street, East Village. These films are not rated.

By STEPHEN HOLDEN

Adi Sideman's crude documentary "Chicken Hawk: Men Who Love Boys," has an inflammatory title that belies its even-handed portrait of the North American Man/Boy Love Association, the notorious pedophile organization better known as Nambla.

The film, which opens today at Cinema Village, is built around interviews with several men whose professed objects of desire are youths under the legal age of consent. One after another, they defend themselves against the view of Nambla as an organization of sadistic child molesters and pornographers, arguing that Nambla is a civil rights organization opposed to the age-of-consent laws. The more outspoken among them talk of child liberation in a "sexophobic" society.

Nambla's opponents, like Tom McDonough, who founded a conservative action group called Straight Kids U.S.A., are also heard from. Mr. McDonough is shown yelling "Baby-raper!" in a demonstration outside the apartment of a Nambla member. Participants in the 1993 gay and lesbian march on Washington express chagrin at having a Nambla contingent march in their ranks. And a Nambla member, Renato Corazzo, is shown monitoring obscene hate messages on the organization's hot line.

Nambla, founded in 1978, claims a membership of around 1,500. Besides the hot line, it publishes a monthly newsletter illustrated with photos of pubescent boys.

Among those interviewed is Peter Melzer, a teacher at the Bronx High School of Science who was suspended from his job when it became known that he was a Nambla member. Mr. Melzer says he has never broken the law.

The film's most outspoken and vivid personality, Leyland Stevenson, was imprisoned several years ago for distributing child pornography. He describes his sexual relations with boys in the quasi-religious language of a persecuted fanatic. He even allows the camera to show him cruising in a suburban mini-mall. From his attitude of messianic hauteur, it is clear why Mr. Stevenson was chased out of his West Virginia town. And his creepy grandiosity casts a clammy chill over the film.

"Red Light, Green Light," the short film that accompanies "Chicken Hawk," teaches children to identify adult strangers who may be molesters. It presents a series of scenarios it calls "red light" situations in which a stranger's advances should send up warning alarms.

1994 JI 8, C8:5

Spoofing The Artists And Art Of New York

"The Genius" was shown as part of last year's New Directors/New Films Series. Following is Stephen Holden's review, which appeared in The New York Times on April 2, 1993. The film opens today at Anthology Film Archives, Second Avenue at Second Street.

Few subjects are riper for satire than the New York art world, with its hyperinflated egos and exalted prices for gimmicky trash. And in their goofy 16-millimeter feature, "The Genius," the directing team of Joe Gibbons and Emily Breer has created a ramshackle art-world farce whose charm lies in its not taking itself too seriously.

"The Genius" is part science-fiction spoof, part SoHo-style home movie. Set in the near future, it imagines a time when Manhattan's downtown galleries have been taken over by the ultra-conservative American Family League. They now bear the names of Wall Street brokerage houses and promote what is called "the new formalism." The film's most nefarious character is a greedy dealer (Tony Conrad) who hooks his artists on a creativity-enhancing drug. Turned into compulsive painting machines, they grind out canvases of corporate logos.

Into this milieu stumbles Desmond Denton (Mr. Gibbons), a scientist who has discovered a technique for extracting the personality attributes of one individual and transferring them to the brain of another. When

Phyllis Abry
Zeitgeist Films

Renato Corazza
Stranger Than Fiction Film

Desmond falls in love with Kitty Church (Karen Finley), an artist who was dropped by her gallery for being too controversial, he conceives the

A greedy dealer hooks painters on a creativity-enhancing drug.

notion of transplanting the personality of her boyfriend, Les (Tony Oursler), into his own brain.

Although Desmond achieves the romantic results he had hoped for, he remains unsatisfied. Ultimately, he decides that instead of trying to appeal to Kitty, he will simply assume her personality. Unbeknownst to him, she is the terrorist who has made national headlines bombing Manhattan galleries, and soon he is stalking around SoHo, planting explosives.

Mr. Gibbons, who produced and wrote "The Genius," in addition to being a co-director and one of its stars, has achieved cult popularity with a series of Super-8 comic fantasies with an autobiographical bent, in which he addresses the camera directly. "The Genius" is a technically more sophisticated extension of those experiments. Desmond is not only the central character, but also a combination of host, narrator, lab specimen and loopy alter ego for Mr. Gibbons.

As diverting as it is, "The Genius" is too long. Its dullest moments are sequences in which Desmond tries on euphoric, depressed and psychopathic personalities. And in spoofing the censorship battles of the Bush Administration, the film also feels slightly behind the times. Among the home-movie-style comic performances, Ms. Finley nearly walks away with the film. As Kitty, Ms. Finley is volatile, funny and scary in many of the same ways she is in her outspoken solo performance-art pieces.

1994 Jl 8, C12:6

TRUE LIES

Written and directed by James Cameron, based on a screenplay by Claude Zidi, Simon Michael and Didier Kaminka; director of photography, Russell Carpenter; edited by Mark Goldblatt, Conrad Buff and Richard A. Harris; music by Brad Fiedel; produced by James Cameron and Stephanie Austin; released by 20th Century Fox. Running time: 135 minutes. This film is rated R.

WITH: Tom Arnold (Gib), Tia Carrere (art expert), Jamie Lee Curtis (Helen Tasker), Charlton Heston (agency head), Art Malik (Aziz), Bill Paxton (Simon), Arnold Schwarzenegger (Harry Tasker)

By JANET MASLIN

THE director James ("Terminator") Cameron has accomplished many a neat trick on screen, but nothing to match this: turning Arnold Schwarzenegger and Jamie

Zade Rosenthal/20th Century Fox

Fancy footwork. Arnold Schwarzenegger and Jamie Lee Curtis.

Lee Curtis, most delightfully, into the Nick and Nora Charles of the heavy-demolition set. By the end of "True Lies," the long-awaited escapist high of the summer movie season, these two stars are gamely tangoing on the dance floor and looking proud of their fancy footwork. As well they should.

Which is not to say that "True Lies" stints on special effects for the sake of its main characters, even if (by the standards of action films, anyway) those characters are unusually appealing. Mr. Cameron's latest, giddiest rollercoaster ride also offers many occasions for gripping the armrests and reminding oneself that this is only a movie. A furiously inventive, thrill-packed movie in which a fight sequence looks real even if it takes place high above Miami, in midair.

If Mr. Cameron's immense technical cleverness has been used to make impossible events appear ordinary, that is also the key to the story. Mr. Cameron's screenplay (from an earlier screenplay by Claude Zidi, Simon Michael and Didier Kaminka) presents Mr. Schwarzenegger as Walter Mitty with a machine gun. And as James Bond: the star makes his entrance in classic Bond fashion, materializing out of a frozen Swiss lake wearing black tie under his wet suit, and debonairly weaving his way through a party full of rich international villains. When Harry Tasker (Mr. Schwarzenegger) talks to one security guard, subtitles inform the audience that his Arabic is perfect.

Harry is a spy most of the time, except on those rare occasions when he comes home to Helen, who thinks her husband is awfully dull. What does he do? Sell computers. Where does he go? To computer conventions. Harry's sidekick Gib, his partner at a top-secret government agency for foiling terrorists, helps to maintain Harry's cover while also kidding him mercilessly throughout the story.

Surprisingly, Tom Arnold is just the right kidder for this role, even if he delivers the film's most desparately unfortunate wisecrack ("Women: can't live with 'em, can't kill 'em).

Early in the film, Harry and Gib uncover an Arab terrorist group called Crimson Jihad, and Harry practices his own brand of one-man warfare against Aziz (Art Malik), its leader. The terrorists are crude, outrageously unflattering ethnic stereotypes; the action and dialogue are sometimes needlessly vulgar; the body count is high: like it or not, those are the rules of this particular game. On the other hand, "True Lies" is less reckless and gun-crazy than many films of its genre. Its real firepower comes from sensational visual gimmickry, like Harry's frantic ride to the roof of a high-rise modern hotel. On a horse.

Constructing this story to cram in as much variety as possible, Mr. Cameron is happy to switch gears a third of the way through. Now the focus shifts to Helen, a legal secretary and homebody whose mousiness provides Ms. Curtis with a comic opportunity that she handles beautifully. Imagine Harry's surprise when he discovers that Helen has a secret admirer named Simon (Bill Paxton), who tries to seduce lonely wives by pretending to be a spy. ("If not for me — do it for your country!" Simon suggests.) Harry hardly knows which to do first, scare the daylights out of this wannabe or get even with his wife.

Irked as he is, Harry is also intrigued by the thought that Helen might crave excitement, and that she is considerably less mousy than he supposed. One of the film's most attention-getting sequences finds Helen, by now thinking of herself as a spy, going undercover as a femme fatale. The visual transformation of Ms. Curtis from schoolmarm to bombshell is especially well done.

Instructed during this episode by a mysterious, half-hidden man to behave seductively, Helen strips to her underwear and dances as alluringly

as she can (falling down only once in the process). The scene has the potential to seem unpleasantly exploitative, but Ms. Curtis is much too deft a comedian to let that happen. And her own enjoyment of the moment comes through so clearly that the audience can enjoy it too. A bonus: the mystery man watching her turns out to be an astounded, newly lovestruck Harry.

Mr. Schwarzenegger is not in the habit of playing either jealous or romantic husbands, but "True Lies" brings out a gentler, funnier side of him, too. It may take a certain chutzpah to allude to the ending of "North by Northwest" in an Arnold Schwarzenegger movie, but both the star and the director are fearless in that regard. Mr. Schwarzenegger has never had an easier rapport with his costars, or shifted so effortlessly from pistol-packing to personal matters. The film's ultimate combat sequence, with Mr. Schwarzenegger flying an airplane that may just kill one of his next of kin, manages to combine shoot-'em-up excitement with something resembling family values.

If that sounds warmhearted, rest assured that Mr. Cameron is no cream puff: his idea of an interesting woman is one who looks good in a low-cut dress while socking another woman on the jaw. Among the death-defying diversions that he uses to keep this story moving are a breathless car chase through the Florida Keys (with a section of bridge blown out); a deadly brawl in a public toilet, complete with flying fixtures used as weapons, and two attack dogs who leap at Mr. Schwarzenegger only to have him smack their heads together. "Have you ever killed anyone?" Helen finally asks her husband, once she begins to understand where his talents really lie. "Yeah, but they were all bad," he says. That is this film's idea of both a good joke and a fair answer.

Also in "True Lies," and embodying the kind of hilarious mock sophistication possible only in slam-bang action movies, is Tia Carrere, babe extraordinaire of "Wayne's World." Here, she plays a Sanskrit-reading art expert who can speak casually about ancient Persia ("Very good! Sixth century B.C., to be exact"). Charlton Heston, as the head of the intelligence agency, wears an eye patch and gives orders in time-honored spy-movie style.

The look of "True Lies" is straightforward, frankly exciting, never aggressively stylish. In a movie season dominated by showy special effects, that simplicity is especially welcome. It's obvious that Mr. Cameron is in absolute command of the technology his film utilizes. When a film maker's idea of mind-boggling mayhem is this sensational, it's quite enough.

"True Lies" is rated R (Under 17 requires accompanying parent or adult guardian). It includes considerable profanity, much mayhem, sexual suggestiveness and occasional graphic bloodshed.

1994 Jl 15, C1:1

SPANKING THE MONKEY

Written and directed by David O. Russell; director of photography, Michael Mayers; edited by Pamela Martin; production designer, Susan Block; produced by Dean Silvers; released by Fine Line Features. Running time: 98 minutes. This film is not rated.

WITH: Jeremy Davies (Raymond Aibelli), Carla Gallo (Toni Peck), Benjamin Hendrickson (Tom Aibelli), Matthew Puckett (Nicky) and Alberta Watson (Susan Aibelli).

By CARYN JAMES

The title "Spanking the Monkey" works like a generational litmus test. People, in their 20's and younger recognize it, although it may baffle anyone older. In this very funny dark comedy, the phrase conveys a healthy, cross-generational attitude toward masturbation.

Ray Aibelli, the film's frustrated college-age hero, belongs to a generation that seems to take a rational, clearsighted approach to sex. But he finds himself at the center of a twisted coming-of-age story. His misguided experience involves a brief fling at incest -with his attractive mother, among other bitter family dysfunctions. Yet "Spanking the Monkey" remains good-humored, sane and amusing. It's as if David O. Russell, the film's 35-year-old writer and director, had dared himself to do the impossible in his first feature and gotten away with it. It is no fluke that the film won the Audience Award at this year's Sundance Film Festival. With its witty, nonexploitative treatment of a lurid subject, "Spanking the Monkey" is an unexpected crowd pleaser. It is also the sort of astonishingly fresh and self-assured work that can make a reputation.

Ray (Jeremy Davies) has been forced to give up a summer internship in Washington to stay home in suburban Connecticut nursing his mother, whose broken leg is in a cast. His father (Benjamin Hendrickson), a penny-pinching salesman of self-help videos, is on the road. When his dad says goodbye at the airport, he leaves Ray with a maze of looney rules about not using the car and maybe walking Frank, the dog. He also hands Ray a toothbrush, which he must use to clean the dog's delicate gums. Frank is not considerate in return. Whenever Ray tries to masturbate, the dog howls at the bathroom door.

Fine Line Features

Alberta Watson

From his father's meaningless rules to Ray's relationship with his mother, here is the way the film works: Mr. Russell begins with convincing, detailed realism, then gradually pushes the characters over the edge into lunatic behavior.

Ray's mother, Susan (Alberta Watson), is around 40, bored, lonely and depressed. As she lies on the bed, her long hair gives her a languorous look, and her sleepy manner is sensuous but not overtly sexual. She is certainly not a monster, although she is careless in the way she demands attention from her son.

When Ray has to help her stand in the shower, the scene is not titillating, but it's not exactly innocent or proper, either. Mr. Russell has a smooth way of breaking the tension with irreverent humor, like having Ray notice that his mother has a birthmark shaped like a shopping cart on her buttock.

Meanwhile, Ray rattles around the house, resentful at losing his internship. He tries to see old friends, but he has no real friends left in town. A sweet high school junior, a psychiatrist's daughter named Toni (Carla Gallo), is interested in him, but she seems decades too young.

All the actors are perfectly in tune with the film's deadpan, understated manner, and Mr. Davies gives an especially deft performance. When Susan asks Ray to massage her toes, she says sadly, "I can never get your father to do these things for me anymore." Mr. Davies's expression is both repressed and disturbed. Throughout the film he suggests that Ray is bothered by his mother's sexuality, yet he never overdramatizes what is, after all, an intimate response.

The incest scene itself is brief and discreet, and it happens in part because Ray and Susan have had too many vodka tonics while watching television on Susan's bed. They start tossing bits of cheese at the television screen, laughing hysterically, then rolling around. There is a quick cut to the next morning.

Mr. Russell makes it clear that incest isn't funny. But the aftermath, as Ray tries to find a road back to mental health, is even more comic than his descent into forbidden sex. Toni comes to Ray's room, which makes Susan furiously jealous. The psychiatrist's daughter responds, "I don't see how you can have so much inappropriate control over his life."

"Is this how you like them?" Susan asks Ray. "Little baby psychobabble?"

"Spanking the Monkey" leaves behind a nagging question: did this film have to be about incest? It's true that few other experiences would have gone so directly to the heart of a story about escaping from one's parents, yet at times the mother-son sex seems curiously beside the point, no more than an attention-getting pretext. The question is legitimate, but perhaps what matters most is that it never surfaces while the audience is watching this smart, accomplished film. "Spanking the Monkey" is ultimately a triumph of freedom for Ray and for Mr. Russell, who has set himself up as a director able to tackle anything.

1994 Jl 15, C5:1

MI VIDA LOCA
MY CRAZY LIFE

Written and directed by Allison Anders; director of photography, Rodrigo Garcia; edited by Kathryn Himoff and Tracy Granger; music by John Taylor; production designer, Jane Stewart; produced by Daniel Hassid and Carl-Jan Colpaert; released by Sony Pictures Classics. Running time: 92 minutes. This film is rated R.

WITH: Magali Alvarado (La Blue Eyes), Angel Aviles (Sad Girl), Jessie Borrego (El Duran), Seidy Lopez (Mousie), Marlo Marron (Giggles), Julian Reyes (Big Sleepy) and Jacob Vargas (Ernesto).

By CARYN JAMES

In "Mi Vida Loca My Crazy Life," Allison Anders tries what few directors would have had the interest or intelligence to think of. She looks beyond the surface of the lives of Hispanic girl gangs and attempts to create a deeper portrait of young women in the Echo Park section of Los Angeles. They use gang names, like Sad Girl, Mousie and Whisper. And though violence is part of their lives, they are likely to be teen-age mothers struggling to get by.

Sad Girl wears deep black lipstick wherever she goes. Mousie has the biggest hair in the neighborhood. They have been best friends since childhood, but the friendship is strained because they have both had babies by the same man, Ernesto. He tries to be a good father, but seems to care more for his elaborately painted truck.

After Mousie challenges Sad Girl to meet her to fight it out, Mousie tells Ernesto matter-of-factly: "You lied. Now I have to kill my friend." A bleached-blond gang member called Whisper brings Sad Girl a scapular medal and a gun, equal means of protection in their world. (All the major roles are played by professional actors, but Whisper plays herself.)

The form of "Mi Vida Loca" is as daring as its subject, but it also creates a serious problem. The film tells several stories: the everyday drama of Sad Girl and Mousie scraping by on welfare; the scary tale of Whisper trying to join Ernesto's drug-dealing business; the dreamy romance of Sad Girl's sister, a college student called La Blue Eyes, who lives through an exchange of poetic letters with a man in prison, someone she has never met.

But while the characters are colorful and vibrant, the film is strangely flat. It has the feel of a work that

Sony Pictures

Jesse Borrego

wants to be part documentary and part drama, and has trouble mixing the two elements. Though the film is largely about telling stories, there are too many voice-overs. And at times the dialogue strains to make its point.

Giggles, a slightly older gang member just released from prison, tells the others, "We girls need new skills, cause by the time our men are 21 they're either disabled or in prison or dead." True enough, but the line is heavy-handed the first time and even more so when it is repeated at the end of the film. Every one of Ms. Anders's choices here is reasonable, but that doesn't mean they succeed.

Ms. Anders, who lives near Echo Park, is neither condescending nor arrogantly intimate in her approach to these characters. Maybe that position, neither inside nor outside, contributes to the film's problems. "Mi Vida Loca" does not have the immediacy or the grace of Ms. Anders's first film, "Gas Food Lodging," the beautifully told story of a single mother with two daughters. Smart though it is, too much of "Mi Vida Loca" elicits a response from the head, rather than a heartfelt reaction to the the energy of the lives on screen.

"Mi Vida Loca My Crazy Life" is rated R (Under 17 requires accompanying parent or adult guardian). It includes some tough language and several shootings.

1994 Jl 15, C5:1

Sony Pictures Classics

Girlz N the Hood In "My Crazy Life" (originally "Mi Vida Loca"), two Latina gang members (Nelida Lopez, left, and Angel Aviles) love and lose the same man, but find a way to remain friends.

ANGELS IN THE OUTFIELD

Directed by William Dear; screenplay by Dorothy Kingsley, George Wells and Holly Goldberg Sloan, based on the motion picture "Angels in the Outfield" from the Turner Entertainment Company Library; director of photography, Matthew F. Leonetti; edited by Bruce Green; music by Randy Edelman; production designer, Dennis Washington; produced by Irby Smith, Joe Roth and Roger Birnbaum; released by Walt Disney Pictures. Running time: 105 minutes. This film is rated PG.

WITH: Tony Danza (Mel Clark), Milton Davis Jr. (J. P.) Danny Glover (George Knox), Brenda Fricker (Maggie Nelson), Ben Johnson (Hank Murphy), Joseph Gordon-Levitt (Roger) and Christopher Lloyd (Al the Angel).

By STEPHEN HOLDEN

"Angels in the Outfield," this summer's second baseball movie intended for a family audience, is a big dripping scoop of marshmallow sentiment topped with whipped-cream spirituality. Updated from the 1951 film starring Paul Douglas as George Knox, a hard-hearted baseball coach, the new version has a glowering Danny Glover in the role of Knox, who is now the bitter, scowling manager of the California Angels.

The Angels, who are in last place, are so bad that their playing is buffoonish. But with some unexpected heavenly intervention, they begin performing wondrous feats. What transforms the team from pathetic clowns into heroic ones is a little boy's fervent prayer. When Roger (Joseph Gordon-Levitt), an 11-year-old foster child, hears his father, a drifter, sarcastically remark that the chances of the family's reuniting are as good as those of the Angels winning the pennant, the boy takes it as a promise. That night, Roger prays to a star for the Angels to win the pennant, and it twinkles back at him. The very next day, winged, white-robed seraphim, visible only to Roger, appear in the stadium to help the players make impossible catches, hit crucial home runs and throw some of the fastest balls ever pitched.

The movie lays on the sugarcoated cuteness with a trowel. Roger's adorable sidekick, J. P. (Milton Davis Jr.), who shares his room in a foster home, quips, "It could happen," every other time he opens his mouth. The boys' foster mother, Maggie (Brenda Fricker), is a storybook vision of comfy maternal warmth. Al the Angel (Christopher Lloyd), who oversees a corps of heavenly dogooders, is an affable fellow with a big goofy grin who materializes (to Roger's eyes only) out of a paper soft-drink cup.

This Disney movie, directed by William Dear, aspires to the tone of one of the studio's animated fantasies. And when a gold-winged angel swoops down from the sky to lift an outfielder to an impossible height to catch a fly ball, it begins to look a bit like "Aladdin." Unfortunately, "Angels in the Outfield" lacks a story even a fraction as compelling or magical.

The movie is essentially a series of gags held together by sugar filling. The main drama is the predictable thawing of Knox's heart as his team begins winning with the help of forces that he senses are divine. Against his better judgment, Knox comes to rely on Roger to signal him every time an angel appears. When one does, Roger points out the player it is standing behind, who will be tapped for glory. In scenes portraying the angelic resurrection of a chronically injured pitcher (Tony Danza) who doesn't know he is terminally ill, the screenplay tries to force out an extra drop of synthetic pathos.

"Angels in the Outfield" is wildly different in style from "Little Big League," the other summer baseball movie, which opened late last month and has fared tepidly at the box office. Where "Little Big League" takes baseball and its mystique seriously and has realistic scenes of play, "Angels in the Outfield" doesn't focus on the details of the game. Made for a younger audience, it is a candied fable about faith and daddies wrapped up in ribbons and bows and served on a banana-split platter.

"Angels in the Outfield" is rated PG (Parental guidance suggested). It has strong language that stops short of profanity.

1994 Jl 15, C10:1

CIAO, PROFESSORE!

Directed by Lina Wertmuller, written by Ms. Wertmuller, Leo Benvenuti, Piero De Bernardi Alessandro Bencivenni and Domenico Saverni, based on the book "Io Speriamo Che Me Lo Cavo" (Me, Let's Hope I Make It") by Marcello D'Orta (in Italian with English subtitles), director of photography, Gianni Tafani, edited by Pierluigi Leonardi; produced by Ciro Ippolito, and Mario and Vittorio Cecchi Gori; released by Miramax Films. Running time 91 minutes. This film is rated R.

WITH Paolo Bonacelli (Ludovico), Pier Francesco Borruto (Peppiniello), Esterina Carloni (Esterina), Isa Danieli (The Principal), Ciro Esposito (Raffaele), Gigio Morra (Custodian), Sergio Solli (Cardboard Dealer), Marco Troncone (Giustino) and Paolo Villaggio (Marco Sperelli).

By CARYN JAMES

The story of a teacher who changes the lives of streetwise students in a Neapolitan village seems utterly predictable. It also sounds totally wrong for Lina Wertmuller, who made her name with savvy, tough-minded films like "Seven Beauties." Yet in the delightful, sweet-tempered comedy "Ciao, Professore!" the teacher is transformed in ways that link him to earlier, imperfect Wertmuller characters. By the end of this idealistic teacher's brief stay in the village of Corzano, his most rebellious student tells him: "You stole a van; you smacked a nun against a wall. A few weeks more, and you'd learn how to live." The boy means it as a compliment, and in this case he's right.

The teacher, Marco Sperelli (Paolo Villaggio), was assigned to his rough-and-tumble third-grade class by a minor computer error. He was meant to teach in the more refined northern town of Corsano but instead was assigned to Corzano in the crime-ridden south. In that crowded village, education means nothing next to scraping together a living. Even the children help in the family businesses: hawking stolen cigarettes on the street, or working in restaurants, barber shops and fruit stands.

It doesn't take long for Sperelli to see where the problem is. The school janitor is so corrupt he sells the children essentials like chalk and toilet paper. The principal, accustomed to the criminal life of Corzano, knows better than to try to change it. Sperelli, of course, was dropped into this movie to do exactly that.

He begins by dragging the kids to school, in an energetic scene that has him gathering the children kicking and screaming from the streets. The little boys who have been pulled away from the cafe and barber shop are still wearing their white uniform jackets, and the daughter of the fruit-stand owner has a large rope of garlic around her neck.

Much of the humor comes from the way the children act like little adults, despite their missing front teeth and innocent faces. That approach can be as much of a trap as making kids too sugary. But the children are so natural that they prevent the film from becoming mawkish or coy. They are all amateur actors, but they are also movie-ready Italians, complete with hand gestures and rough language. From the fat boy who identifies with his portly teacher to the pretty little girl who develops a schoolgirl crush, the characters are types. The film is lively enough to make those types seem adorable all over again.

Raffaele, the toughest boy in the class, has the weakest story, though. His desperate mother persuades Sperelli not to give up on Corzano, a scene that plummets "Ciao, Professore!" down to its lowest, most predictable point. But it recovers quickly. By the time the mother becomes ill and Sperelli is called on to help, he learns an important lesson: when in Corzano, do as the Corzanans do. That is, bend the law and speak the local language of insults. When an ambulance refuses to come, he steals the van. When a nun at the hospital refuses to treat the mother fast enough, he screams what any other villager would: "You ugly raghead." He gets results.

Although Mr. Villaggio is effective as Sperelli, he has a too-pat sad-sack look much of the time. And the song that ends the film, Louis Armstrong's version of "Wonderful World," is so blatant a steal from "Good Morning, Vietnam" that the idea backfires. "Ciao, Professore!" (formerly called "Me, Let's Hope I Make It") doesn't need to nudge the audience into responding to its children.

Ms. Wertmuller has been off the radar in recent years. Films like "Saturday, Sunday, Monday," with Sophia Loren, have not been released commercially in the United States. "Ciao, Professore!" is one of her slighter films, but it brings her back with the most accessible, comic and commercial movie she has made in a long time. And she hasn't completely lost her tough-mindedness. The film that "Ciao, Professore!" brings to mind is François Truffaut's "Small Change," from 1976. The films share an awareness that while children are cute, it's their resilience that often plays best on screen.

"Ciao, Professore!" is rated R (Under 17 requires accompanying parent or adult guardian). It includes strong language.

1994 Jl 15, C10:5

L.627

Directed by Bertrand Tavernier; written by Michel Alexandre and Mr. Tavernier (in French, with English subtitles); director of photography, Alain Choquart; edited by Ariane Boeglin; music by Philippe Sarde; produced by Frédéric Bourbouon and Alain Sarde; released by Kino International. At the Quad Cinema, 13th Street west of Fifth Avenue, Greenwich Village. Running time: 145 minutes. This film is not rated.

WITH: Didier Bezace (Lulu), Jean-Paul Comart (Dodo), Cécile García-Fogel (Kathy), Lara Guirao (Cécile), Charlotte Kady (Marie), Jean-Roger Milo (Manuel), Nils Tavernier (Vincent) and Philippe Torreton (Antoine).

By STEPHEN HOLDEN

Don't blame the French director and writer Bertrand Tavernier for the fact that his police drama "L.627," seems so mild-mannered compared with its American counterparts. His melancholy portrait of the life of a Parisian narcotics officer suggests that the meaner streets of America's cities are 10 times scarier and more hazardous than the slums of Paris.

In "L.627," which opens today at the Quad Cinema, there are no gory shoot-outs, no car chases, no screaming of obscenities. The film studies the day-to-day life of Lucien Marguet (Didier Bezace), an undercover narcotics agent in his mid-30's, with a thoroughness and detachment that lend it a semi-documentary flavor.

For every action scene — and the arrest sequences are tense and well directed — there are two scenes of police officers bickering at headquarters. When Lucien is not surreptitiously filming drug transactions from a surveillance van, he supplements his income by filming weddings.

Although Lucien, or Lulu, as he is called, is no hero, he is one of the few police officers in the film who regard their occupation as more than just a daily grind with arrest quotas to fill. The difference between his attitude and that of most his colleagues is suggested by the film's opening scene, in which he is called back to headquarters from a stakeout moments before an arrest because a drunken superior needs the police van for his personal transportation. When Lucien explodes with rage, he is punished with a transfer to another precinct. His new office is a ramshackle trailer equipped with manual typewriters.

Most of "L.627," whose title refers to a French antidrug statute, follows Lucien's adventures with a newly formed special drug squad. In this job, Lucien, who has been a detective for 13 years, finds himself once again thwarted by bureaucrats ignorant of the ways of the street. The head of the drug unit, Dodo (Jean-Paul Comart), is a cynical practical joker concerned more with statistics than with arresting drug kingpins.

Police brutality is matter-of-fact. A low-level drug dealer who is dragged into the trailer is slapped around and humiliated. What does it say about French law enforcement that most of those pursued are African or Arab?

A subplot involves Lucien's bitter-sweet relationship with an informant, Cécile (Lara Guirao), a prostitute and drug addict who is H.I.V.-positive. It is only when she mysteriously disappears that Lucien, who has turned down her offers of sex, realizes he is half in love with her and frantically tries to find her.

Lucien is quite happily married. And the scenes of him and his wife, Kathy (Cécile García-Fogel), are among the film's weakest, because her character doesn't come into focus. Although the film implies that Lucien has spent so much time spying on others that he has become a voyeur of his own marriage, it doesn't develop the theme in any meaningful way.

"L.627" is suffused with the same spirit of existential angst that lent "Round Midnight," his moody elegy to 1950's American jazz musicians in Paris, an atmosphere of cigarette smoke and dankness. Divested of its customary glamour, the City of Light

Kino International
Didier Bezace and Lara Guirao

becomes a drab urban background for people wearily contemplating their tarnished ideals and fraying dreams.

1994 Jl 15, C14:1

THE CONJUGAL BED

Written and directed by Mircea Daneliuc (in Romanian with English subtitles); director of photography, Vivi Dragan Vasile; edited by Melania Oproiu; music by Richard Strauss; produced by Alpha Films International; released by Leisure Time Features. At the Quad Cinema, 13th Street west of Fifth Avenue, Greenwich Village. Running time: 102 minutes. This film has no rating.

WITH: Coca Bloos (Carolina), Lia Bugnar (Stela), Geo Costiniu (Eugen), Gheorghe Dinica (Vasile), Valentin Teodosiu (Misu) and Valentin Uritescu (The Actor).

By STEPHEN HOLDEN

Communism may have been overthrown in Eastern Europe, but its disappearance seems to have left whole populations conditioned to see themselves as oppressed and helpless. The disappointment of discovering that freedom doesn't immediately cancel the old paranoid mind-set is a theme that literally screams and shouts through "The Conjugal Bed," Mircea Daneliuc's harshly surreal comedy of life in post-Communist Romania.

Much of the shouting is done by the film's unsympathetic main character, Vasile (Gheorghe Dinica), who runs a decrepit movie theater that shows American films. Learning that his wife, Carolina (Coca Bloos), is pregnant with a third child they can't afford, he bullies her into trying to abort by jumping off a dresser. When that doesn't work, he fantasizes about finding a way to sell the child abroad.

Bit by bit, whatever stability is left in Vasile's life crumbles, along with his sanity. One day he finds a stack of paper money in his desk and is convinced that he is being set up by the police for some unspecified political crime. At the same time, his beautiful assistant and mistress, Stela (Lia Bugnar), abruptly quits her job to become a "tourist guide" who sells her body to foreigners who can pay with dollars.

Business is so bad in the movie house that Vasile is forced to rent the hall for political meetings, to former Communists who have reorganized and now call themselves the Original Democracy Party. The populace is so demoralized that nostalgia for the Ceaucescu dictatorship is on the rise. In an eerie street rally, the helicopter in which the dictator escaped Bucharest during the revolution is declared a monument. Vasile also discovers that his most precious possession is a glossy coffee-table collection of Communist dreams called "The Future of Romania." During the Ceaucescu

era, it was considered worthless propaganda.

In the film's most disturbing scenes, Vasile arrives home after a brief incarceration in a mental hospital to find that his wife has rented the premises to a film crew for a pornographic movie being shot in his very bed. The star is none other than Stela, who by this point in the film has become a symbol of Romania's moral chaos.

"The Conjugal Bed," which opens today at the Quad Cinema, has no room for subtlety or sentiment. As a strident political fable, it uses the well-worn metaphors of prostitution and insanity to suggest a society near collapse. The story, which is not always easy to follow, unfolds in abrupt fits and starts. And the English subtitles are confusing.

Yet "The Conjugal Bed" has a furious, flailing conviction. It rubs your nose in drabness and poverty. The architecture is dingy; the streets are rutted and muddy. The aimless crowds who gather everywhere are shabbily dressed and irritable. The movie may be a chamber of commerce's nightmare, but it conveys a scorching frustration.

1994 Jl 15, C18:1

FRANÇOIS TRUFFAUT
Stolen Portraits

Directed by Serge Toubiana and Michel Pascal (in French, with English subtitles); director of photography, Maurice Fellous; edited by Dominique Martin; produced by Monique Annaud; released by Myriad Pictures. At Film Forum 2, 209 West Houston Street, South Village. Running time: 93 minutes. This film is not rated.

WITH: Fanny Ardant, Nathalie Baye, Gérard Depardieu, Marcel Ophüls, Marie-France Pisier, Eric Rohmer, Bertrand Tavernier, and Ewa and Laura Truffaut.

By STEPHEN HOLDEN

Early in "François Truffaut: Stolen Portraits," a probing collection of remembrances of the great French film director, Gérard Depardieu reads a breathlessly excited letter that Truffaut wrote when he was only 17. "Three films a day, three books a week and some good music will keep me happy until my death," he declared, going on to announce, "I don't look at the sky because afterward the earth looks awful."

The mixture of blunt matter-of-factness and passionate enthusiasm suggested by those words eventually found artistic expression in the 21 full-length movies and four short films that Truffaut completed before his death 10 years ago at the age of 52. How closely did the themes of his movies parallel his life? "Stolen Portraits" proposes that his films were even more autobiographical than commonly thought. One of his friends, the writer Claude de Givray, maintains that Truffaut trusted only stories that were true.

The film, directed by Serge Toubiana and Michel Pascal, weaves interviews with more than two dozen talking heads — including the director's former wife, Madeleine Morgenstern, and their daughters, Ewa and Laura — with short film clips into a tantalizing if incomplete psychological portrait. The clips are used merely as footnotes, and most are too brief to have any dramatic integrity.

Many of the facts of Truffaut's boyhood are supplied by Robert La-

chenay, a childhood friend, who helps sort truth from invention in "The 400 Blows," the fictionalized memoir of Truffaut's unruly adolescence.

The director, who was born out of wedlock, rebelled against his mother and stepfather's severity by dabbling in petty thievery. The fictionalized portraits of his mother and stepfather in "The 400 Blows" are said to have hit them hard. Truffaut's estranged relationship with his mother left him convinced that he had not been loved enough as a child.

One of the more intriguing revelations in "Stolen Portraits" is the story of how after his mother died, Truffaut hired a private investigator to find his real father, who turned out to be a Jewish dentist. Having discovered his father, Truffaut visited the man's house, but never confronted him.

Several of Truffaut's fellow directors ponder his esthetics and recall his transition from a critic at Les Cahiers du Cinéma into a film maker. It is suggested that one reason he became a film maker was that unlike many of his fellow writers who could join family businesses, Truffaut had no occupation to fall back on.

The most unflattering story, told by the director Bertrand Tavernier, portrays the young Truffaut as an unscrupulous careerist. After writing a scathing critique of several other film makers in Cahiers du Cinéma, Truffaut is said to have written a letter of apology to the screenwriter Pierre Bost suggesting that the attack was only a flashy career move that didn't express his true feelings.

"Stolen Portraits," which opens today at Film Forum 2, also explores

the relationship between Truffaut and Jean-Pierre Léaud, who played his alter ego, Antoine Doinel, in numerous films. But since Mr. Léaud was not interviewed for "Stolen Portraits," this crucial collaboration is merely skimmed. It is said that Truffaut felt responsible for "hijacking Léaud's destiny" and at the same time that "his double became too unnerving."

Although fascinated with psychology, especially the work of Bruno Bettelheim, Truffaut avoided psychotherapy, believing that his art was sustained by his neuroses.

Clips from several films are used to illustrate the assertion that Truffaut's tumultuous inner life was ruled by emotions that were barely under control. Although there are allusions to Truffaut's obsession with women and to his love affairs, neither his wife nor the actress Fanny Ardant, with whom he also had a daughter, Joséphine, begins to describe the dynamics of her relationship with him. For all its depictions of Truffaut as love-starved, work-obsessed and possibly a little ruthless, the portrait that emerges is both reverential and fiercely protective.

In one of the film's sweetest moments, Truffaut and Alfred Hitchcock are shown being interviewed jointly on French television. Impish and delightful, Truffaut comes up with perfect words of praise for the master of suspense: "He makes scenes of murder look like scenes of love."

It wasn't only in his films that Truffaut had the gift of being charming and truthful at the same time.

1994 Jl 15, C27:1

FILM VIEW/Caryn James

The Woman in 'True Lies,' a Mouse That Roared

IN THE EARLY SCENES OF "TRUE Lies," Helen Tasker doesn't *look* like a woman who is wearing Victoria's Secret underwear. Her hair is mousy, her clothes are frumpy, and her job as a legal secretary seems to offer all the excitement she can handle. It's as if she doesn't know she is married to Arnold Schwarzenegger.

That, of course, is the plot and the joke of "True Lies," which opened on Friday: Helen (Jamie Lee Curtis) doesn't realize that her snooze of a husband, Harry (Mr. Schwarzenegger), is a globe-saving spy. But that's just the start of the story. Like Sandra Bullock, who drives the bus in "Speed," in the course of "True Lies" Ms. Curtis changes from a mouse to an action hero. Her change is witty and liberating, and a turning point in a film that might be a comic-action version of "Scenes From a Marriage."

Just when you're amazed that she has made herself so convincingly drab as Helen, she is transformed. Harry, trying to add ex-

Photographs by Zade Rosenthal/20th Century Fox

Jamie Lee Curtis as Helen in "True Lies"—Mouse.

vertently, and in their exaggerated ways these films hint at how women's lives have changed.

The heroines of "Aliens" and "Terminator 2," however, developed their biceps between movies, in the time lapse between the original films and the sequels. By showing Helen's transformation in "True Lies," Mr. Cameron charts the comic course of a female stereotype falling to pieces.

THE MOST ENGAGING PART OF the film is the long middle section, which toys with marital types. If Helen is the bored, uncomplaining wife, Harry is the obtuse, work-obsessed husband who takes her for granted. When it seems that Helen has given in to the fake charms of a sleazy used-car salesman, Harry is so distraught he almost walks in front of a bus. He is the image of the tough guy undone by the little woman.

As this comedy of manners unfolds, it is played for all-out action as well as satiric humor. Spying on Helen, Harry calls out helicopters, radar and national-security experts. He doesn't know what else to do, because, like all men in this movie, Harry is befuddled about women. His only advice comes from his partner, Gib (Tom Arnold, so overexposed in gossip columns and talk shows, and so strong and funny here). The survivor of several divorces, Gib cheerfully welcomes Harry to the club when he hears that Helen may be fooling around.

Mr. Cameron carefully walks a narrow line throughout the film. Harry, hiding behind a two-way mirror and a voice-disguising device, interrogates Helen until he finds out that she loves him. The misuse of Government machinery is nothing next to the misuse of his role as a husband.

But, in an evenhanded way, Helen later gets to grill him back, after he has been given a truth serum. "Have you ever killed anyone?" she asks.

citement to his wife's dull life, dupes her into thinking that she is on a Government mission posing as a call girl. Ordered to "wear something sexy," Helen arrives in the frilliest, least sexy frock ever imagined. Even Helen suddenly knows that this costume will give her away, so she desperately tears off the long, puffy sleeves, high neck and flouncy skirt. She is left wearing a tiny, body-hugging black dress. This is an old movie scene: the one in which the secretary takes off her glasses, lets down

her hair and turns into a vamp. But it still works.

When she starts dancing, in little black undergarments that are hardly what she would have been wearing beneath that matronly dress, you can give the movie some leeway. Despite appearances, from that point on Helen is more than the hero's sexual sidekick. She is at least as crucial to the plot — saving America from terrorists with a nuclear bomb — as Harry.

Much of the appeal of "True Lies" comes from the smooth grafting of battle-of-the-sexes comedy onto a high-tech action picture. The movie's advertising art includes a clever, apt image: a hand grenade with an engagement ring as its pin. James Cameron, the film's writer and director, blows up plenty of bridges, trucks and jets here. Along the way he explodes sexual stereotypes too.

Mr. Cameron is the master of movies that put women at the center of the action. He is responsible for the macho Sigourney Weaver in "Aliens" and the pumped-up, rifle-toting Linda Hamilton in "Terminator 2: Judgment Day." Expanding women's roles in action movies like these, and to a lesser degree in Jan De Bont's "Speed," has little to do with charting social change (as if these movies cared). It is simply a smart commercial move. Traditionally, action films have been directed at male viewers; adding a character with whom women can identify broadens the audience appeal. But pop culture always reflects mainstream attitudes, if only inad-

Helen after her transformation—Amateur heroine.

"Yes, but they were all bad," he says, giving a perfect reading of a perfect Schwarzenegger line. Though Ms. Curtis comes close, no one has stolen a Schwarzenegger movie yet.

Every sexist gesture or remark comes from a villain (a terrorist slaps his female accomplice) or an idiot (the used-car salesman thinks woman are sex objects, and it turns out that he is a flop at seduction). Even Helen's sexiness is carefully modulated. Dancing in her underwear, Ms. Curtis takes a pratfall.

Like Annie, the bus driver in "Speed," Helen is an amateur in the action business who doesn't know nearly as much as her male partner. Yet these women seem naturally gifted with obscure skills, like outwitting terrorists.

Helen may bumble her way into shooting a dozen terrorists, but she eliminates them. She slugs the female villain (Tia Carrere), accidentally cutting the other woman's face with her engagement ring. By the end of the film she has changed the female role from adoring spectator to heroic partner.

Giving Ms. Curtis's character so strong a role was a generous, and it turns out, shrewd move on Mr. Schwarzenegger's part. "True Lies" succeeds in doing what his previous movie, the much-maligned "Last Action Hero," tried to: it makes him a softer, more human character and stretches his acting range ever so slightly. He's no Cary Grant, but along with Ms. Curtis he makes "True Lies" the first successful romantic comedy in which trucks, as well as heartstrings, are blown to bits. □

1994 Jl 17, II:13:1

THE CLIENT

Directed by Joel Schumacher; written by Akiva Goldsman and Robert Getchell, based on the novel by John Grisham; director of photography, Tony Pierce-Roberts; edited by Robert Brown; music by Howard Shore; production designer, Bruno Rubeo; produced by Arnon Milchan and Steven Reuther; released by Warner Brothers. Running time: 124 minutes. This film is rated PG-13.

WITH: Susan Sarandon (Reggie Love), Tommy Lee Jones (Roy Foltrigg), Brad Renfro (Mark Sway), Mary-Louise Parker (Dianne Sway), Anthony LaPaglia (Barry Muldano), J. T. Walsh (McThune), Anthony Edwards (Clint Von Hooser), Bradley Whitford (Thomas Fink), Will Patton (Sergeant Hardy) and Ossie Davis (Harry Roosevelt).

By JANET MASLIN

If the opening episode of "The Client" has not yet entered the pantheon of classic American storytelling, at least it's well known on every beach, bus and airplane in the land. Here it is: an 11-year-old boy sneaks off to smoke a cigarette, then witnesses the suicide of a mob lawyer, right after the lawyer has told him where an important body is buried. John Grisham, reigning master of the instant grabber, has yet to concoct a savvier beginning than this.

Knowing that Mr. Grisham has never written a book that Hollywood didn't like, his readers may recognize this as the blueprint for a movie scene. But until they see "The Client" on screen, they might not suppose that the boy wears an earring, looks sullen and furtively watches his mother's pocketbook in hopes of stealing cigarettes behind her back. Or that this thriller has room for countless other small, knowing touches that bring it to life.

Filling in the blanks for Mr. Grisham's fast-moving, essentially colorless stories is the main challenge for any film maker who adapts the writ-

er's work. And Joel Schumacher directs "The Client" with a keen eye for such detail. The Grisham screen score card, so far: "The Firm" remains the most thoughtful, interestingly acted version of a Grisham book; "The Pelican Brief" remains the most unabashedly slick, and "The Client," with a fast, no-nonsense pace and three winning performances, is the movie that most clearly echoes the simple, vigorous Grisham style.

"The Client," nicely compressed in a screenplay by Akiva Goldman and Robert Getchell, tells what happens when young Mark Sway (Brad Renfro, a fine and compelling new actor) finds himself enmeshed in a web of legal trouble. After Mark and his younger brother witness the lawyer's death, Mark becomes a target, because the lawyer told him where a murdered United States Senator was buried. Mobsters in New Orleans want to make sure Mark keeps quiet. (Mr. Schumacher's ridiculous idea of swaggering Southern mobsters is one of the film's rare shaky aspects.) Meanwhile, Roy Foltrigg (Tommy Lee Jones), a grandstanding, Scripture-quoting United States Attorney with political ambitions, would very much like to use Mark for his own purposes.

Enter Reggie Love (Susan Sarandon), a crusading lawyer who takes on Mark's case. Reggie, a brisk, gray-haired, motherly presence in the book ("she wasn't old and she wasn't young"), becomes a much foxier character in the movie without losing any of her cleverness or grit. In fact, the film makes all three of its principals more appealing than they were on paper. Ms. Sarandon's Reggie is both tough and alluring, with a soulfulness that makes sense of her growing fondness for Mark; Mr. Renfro's scrappy boy has a precocious manliness that makes him a sturdy hero.

The film minimizes the maudlin possibilities of Reggie and Mark's mother-son affection.

As for Mr. Jones, he's just irresistible. In a smaller but still commanding role that loosely recalls his performance in "The Fugitive," his coiled-cobra gaze and that smart, steely delivery remain in perfect form. Happily barking orders at his subordinates (a well-cast group including Anthony Heald and Bradley Whitford, with J. T. Walsh as an amusing aspirant), preening for the television cameras, oozing Louisiana charm down to the tiniest "y'all," Mr. Jones rivets attention. His combative scenes with Ms. Sarandon are particularly charged, since there is the flirty suggestion that Roy might actually be interested in Reggie if he was not already so much in love with Roy.

The film pares down the novel's legal battles, retaining only a few choice episodes of this kind. One of its most enjoyable scenes finds Roy and his henchmen trying to sweet-talk Mark, only to find out the hard way that Reggie has wired her client with a recording device. Later on, with Ossie Davis playing a memorably imperious judge, there is real suspense in a sequence during which Mark might finally be forced to tell what he knows. As is typical with Mr. Grisham's stories, real suspense is in increasingly short supply as "The Client" goes on. The film's events have an especially trumped-up feeling as it struggles for an effective ending.

If Mr. Schumacher's main job here is deflecting attention from such weaknesses, he does it well. Only occasionally (as in the overwrought opening scene, with music blaring and the suicidal mob lawyer at fever pitch) does the film strike a preposterous note. For the most part, "The Client" is more believable than it has any right to be, with actors who are vivid enough to make its case. Also among them are Mary-Louise Parker, authentically angry and desperate as Mark's hard-luck mother, Will Patton as a sinister cop and Anthony Edwards as Reggie's office assistant.

Contributing to the film's plausibility are expressive costume and production design by Ingrid Ferrin and Bruno Rubeo. Handsome cinematography by Tony Pierce-Roberts, who has done superb work on the most memorable Merchant-Ivory films, is another asset. The straightforwardness of Mr. Schumacher's direction is also welcome. Only once does he stop to linger for the standard Grisham scenic touch, a shot of tourists and hustlers on the streets of New Orleans.

"The Client" is rated PG-13 (Parents strongly cautioned). It includes profanity and mild violence.

1994 Jl 20, C11:1

LATCHO DROM

Written and directed by Tony Gatlif, in Romany with English subtitles; director of photography, Eric Guichard; edited by Nicole D. V. Berckmans; Alain Weber, musical adviser; Denis Mercier, design and artistic adviser; produced by Michele Ray-Gavras; released by Shadow Distribution Inc. Film Forum 1, 209 West Houston Street, South Village. Running time: 103 minutes. This film is not rated.

By STEPHEN HOLDEN

A little boy traveling with a Gypsy caravan through the desert in north-

western India raises his voice in a piercing lament for the fate of his people, who are destined to wander the earth. Moving through a landscape as breathtaking as a Rousseau painting, he cries: "I will burn my horoscope that exiled me so far from those I love. I want to return to my family and run barefoot."

A group of Gypsy women gather on the street of an unidentified Spanish town and sing about the hatred they feel from the outside world. "Some evenings, like many other evenings, I find myself envying the respect you give your dog," go the lyrics for this traditional flamenco ballad.

An old Romanian man in a rain-swept field accompanies himself on a battered one-string violin as he sings in a high breaking voice of the destruction wrought by the regime of Nicolae Ceausescu.

These scenes are among the more arresting moments in Tony Gatlif's film "Latcho Drom" ("Safe Journey"), an intensely lyrical portrait of Gypsy culture. The movie, which opens today at the Film Forum, is a musical travelogue that uses traditional songs instead of spoken words to evoke the unhappy history of the Rom people.

From its opening desert scenes, the movie follows the westward migratory path the Roms took from India a thousand years ago. By the beginning of the 16th century, they had settled throughout Europe. Today they are most densely concentrated in Eastern Europe, especially in Romania.

As the film's settings shift from Egypt to Turkey to Romania, Hungary, France and Spain, the Gypsy music changes in texture, instrumentation and style. The Indian sitar and tabla give way to the acoustic guitar, violin and accordion. But no matter what the location or the instrumentation, the music never loses its essential spirit. While the voices, harmonies and playing express a passionate forlornness, the music's relentless propulsion makes much of it almost irresistibly danceable.

"Latcho Drom" has the stylized look and feel of a movie musical. The songs follow one another like production numbers in a traveling pageant where the landscape and architecture are photographed to suggest giant stage sets. Lingering over full moons, misty fields and centuries-old buildings, the camera paints them as elements of a mystical, ever-changing backdrop.

In the most elaborate numbers, Gypsy musicians, as though simultaneously heeding a mysterious call, grab their instruments, pop out of their houses and converge joyously to form spontaneous folk orchestras. Among the most effective shots are those in which the camera slowly pulls away from a scene so that the songs transcend their immediate settings to become cosmic laments lifted to heaven.

For all it visual and musical sumptuousness, "Latcho Drom" proceeds in a way that often feels bumpy and haphazard. And the information it gives is frustratingly inadequate. Subtitles translate key song lyrics, but most of the settings are not identified. Individual musicians are not identified until a final credit sequence that is more confusing than enlightening.

"Latcho Drom" is a messy cinematic tone poem to Gypsy culture. With more judicious editing and documentation, it could have been a symphony.

1994 Jl 20, C18:1

THE WEDDING GIFT

Directed by Richard Loncraine; written by Jack Rosenthal; director of photography, Remi Adefarasin; edited by Ken Pearce; music by Colin Towns; production designer, Tony Burrough; produced by David Lascelles; released by Miramax Films. Running time: 87 minutes. This film is rated PG-13.

With: Julie Walters (Diana Longden), Jim Broadbent (Deric Longden), Sian Thomas (Aileen Armitage), Thora Hird (Deric's Mother), Andrew Lancel (Nick Longden) and Anastasia Mulrooney (Sally Longden)

By CARYN JAMES

A devoted middle-aged husband, whose wife is dying of a mysterious disease, is attracted to another woman. The wife senses this, though she hasn't guessed that the other woman is a blind novelist. "Blind?" the dying but upbeat wife chirps. "She'd have to be if she took a shine to you!" That's her idea of a joke, and it's probably the most memorable among dozens of embarrassing attempts at wit in "The Wedding Gift," a film that manages to make its tragic characters seem annoying. Made by the BBC, the film was originally shown on television in England under the title "Wide-Eyed and Legless," which gives a fair idea of how it strains to be cheeky.

"Wide-Eyed and Legless" is the name of a song that Deric and Diana Longden (Jim Broadbent and Julie Walters) sing as they drive to the hospital. For three years Diana's muscles have been growing weaker; her hands are cramping into fists; the doctors' best diagnosis is hysteria.

The Longdens and their story, set in 1984, are based on fact. As a printed, on-screen explanation reveals at the film's end, after Diana's death her illness was diagnosed as chronic fatigue and immune dysfunction syndrome.

But "The Wedding Gift" is less about her medical condition than about the couple's pluck in facing it. Diana calls everyone "Luv" and paints her fingernails red, even though she wears painful metal contraptions on her hands to keep the fingers straight. Ms. Walters' performance has a one-note perkiness, except for the few scenes in which she suddenly cries alone or calls the suicide prevention hotline.

She and Deric are obviously using humor to keep their upper lips stiff, but their dialogue is genuinely grating anyway. Deric tells his sweet but dotty old mother, "Wish I had a mother like you." Mr. Broadbent is familiar as the bartender in "The Crying Game" and as Miranda Richardson's stuffy husband in "Enchanted April." He is a first-rate actor defeated by lines like, "No matter how sick she is, she's more alive than anyone I know."

When Deric falls for the blind woman, Aleen Armitage (Sian Thomas), the film doesn't wonder whether he has grown comfortable in the caretaker's role. Aleen is obviously the perfect rematch for Deric because she makes feeble jokes, too. Diana befriends Aleen and sets her up as a replacement, but that is a subplot, which the film's new title emphasizes too much.

At its best, "The Wedding Gift" might have been a small-scale "Shadowlands" or "Lorenzo's Oil." As it is, the film comes closer to a Monty Python routine.

"The Wedding Gift" is rated PG-13. It includes some strong language and a glimpse of Diana in the bathtub.

1994 Jl 20, C18:1

LASSIE

Directed by Daniel Petrie; written by Matthew Jacobs, Gary Ross and Elizabeth Anderson; director of photography, Kenneth MacMillan; edited by Steve Mrkovich; music by Basil Poledouris; production designer, Paul Peters; produced by Lone Michaels; released by Paramount. Running time: 95 minutes. This film is rated PG

WITH: Thomas Guiry (Mat Turner), Helen Slater (Laura Turner), Jon Tenney (Steve Turner), Brittany Boyd (Jennifer Turner) Frederic Forrest (Sam Garland), Richard Farnsworth (Len Collins), Michelle Williams (April), Charlie Hofheimer (Jim Garland) and Clayton Barclay Jones (Josh Garland).

By JANET MASLIN

THE chipper new "Lassie," a work of exceptional (if somewhat misplaced) optimism, begins with an aerial shot of green, unspoiled terrain. Seen from afar is the film's four-legged heroine, scampering across a hilltop as she ecstatically herds sheep. If Lassie could sing, is there any doubt we'd be hearing "The Sound of Music" at a moment like this? What a pity that Lassie's not a singer. She's only a dog.

Only a real live dog. During a summer movie season replete with optical, digital, computer-generated miracles, many of them aimed at children who would not think it strange to find full-sized dinosaurs chasing them home from school. Current movie audiences are fully accustomed to seeing impossible phenomena made so mundane that the truly unimaginable feats become old-fashioned ones. Talk about unimaginable: Can there really be a "Lassie" revival today?

Returning to the screen in a stubbornly sweet, picturesque children's film, the new Lassie faces even bigger obstacles than the original screen collie overcame (in the 1943 "Lassie Come Home") when she ran from Scotland to Yorkshire to be with the family she loved. Are there still viewers naïve enough to be charmed by dog tricks? Will audiences believe in a simple country family that lives for the love of its pet? Is there anything left that Lassie, once a wartime icon embodying bravery, loyalty and family values, can really stand for? "'Lassie Come Home' is the story of a dog," explained the introduction to that film, "but it's also the story of a people."

Like a lot of children's films, the new "Lassie" is inadvertently revealing about the people for whom it was ostensibly made. The mood is nostalgic but knowing; after all, no dog story with a soundtrack featuring the Beatles, Bob Dylan and the Allman Brothers can be considered precisely quaint. This film (from the producers of "Coneheads") even presumes a degree of viewer cynicism about Lassie lore. Early in the story, a little girl named Jennifer Turner (Brittany Boyd) watches "Lassie" on television while her older, hipper brother Matt (Thomas Guiry) sneers. Matt doesn't believe in Santa Claus, and he doesn't think a 50's canine rerun can beat MTV.

The Turner family starts out in Baltimore, and then is conveniently forced to relocate to Franklin Falls, Va. All 148 of this town's residents seem to wear overalls. And at least one of them is an expert dog groomer, since Lassie remains freshly fluffed throughout the story.

Lassie? *The* Lassie? It turns out that while Steve Turner (Jon Tenney) and his second wife, Laura (Helen Slater), are driving to farm country, they stop at the scene of a traffic accident in which the owner of a beautiful, very clean collie has just been killed. Lassie — who else? — peers insistently at the Turners and winds up hopping into their back seat. Lassie was never anyone's fool.

The first half of the film is pure bucolic yuppie fantasy, as the

A collie adopts a city family and turns them into country folk.

Turners evolve from urban professionals to plaid-wearing, pie-baking country folk. Past "Lassie" stories have been about acute financial hardship for farm families, but this back-

Bob Greene/Paramount Pictures

Old-fashioned feats by a four-legged heroine: Thomas Guiry and Lassie explore a Virginia hilltop in a story of a family's retreat to a quiet country life.

to-nature escapade looks like more of a lark. Steve had some job trouble, but he doesn't appear strapped. Laura just waxes euphoric about the wide open spaces and breathes fresh air.

The Turners do have problems, but those problems are emotional rather than economic ones. Laura is the children's stepmother, and Matt is having trouble accepting her. Everyone (except Laura) misses Mom. The farm belongs to a Gramps character (Richard Farnsworth), the father of Steve's deceased wife, Ann; Ann once wrote in her girlhood diary about how she longed to own a collie. Somehow, this explains how the Turners have managed to affect a simple, modest life while apparently owning half of Virginia.

If the adults' story is deliberately farfetched, adults are only this film's secondary target. (Parents can expect to be pleasantly surprised during the story's first hour, increasingly bored thereafter.) For children, there may be innocent appeal in the way Lassie yanks the headphones off Matt's Walkman and forces him to enjoy the great outdoors. Surely it took nerve to make a film that extolls the virtues of the 4-H Club or focuses adoringly on a lamb. Actually, Matt is made to seem relieved when forced to give up his urban habits and embrace a new life that's so squeaky-clean.

"Lassie," directed in prettily innocuous fashion by Daniel Petrie, is too intent on a vague feel-good spirit to provide real conflict. The film's villains, a rich sheep-ranching family headed by San Garland (Frederic Forrest), are more obnoxious than evil. Chewing tobacco, toting guns and disparaging animals (sheep are "just wool and good eatin'") are their principal sins. For today's viewers, maybe that's supposed to be wickedness enough.

Lassie, a liveaction, non-animatronic, eighth-generation descendant of the original star, is exactly what might be expected: a dog who appears to be responding to the orders of an off-screen trainer. With a more limited range of stunts and expressions than past canine actors have had, this Lassie depends on the camera, the adoring actors and the swelling soundtrack to turn her into a love object. Of course, she gets some help from our memories.

"Lassie" is rated PG (Parental guidance suggested). It includes mild profanity but is otherwise very suitable for young children.

1994 Jl 22, C1:1

NORTH

Directed by Rob Reiner; written by Alan Zweibel and Andrew Scheinman; director of photography, Adam Greenberg; edited by Robert Leighton; music by Marc Shaiman; production designer, J. Michael Riva; produced by Rob Reiner and Alan Zweibel; released by Columbia Pictures. Running time 87 minutes. This film is rated PG.

WITH: Elijah Wood (North), Jason Alexander (North's Dad), Julia Louis-Dreyfus (North's Mom), Bruce Willis (Narrator), Jon Lovitz (Lawyer), Alan Arkin (Judge), and Mathew McCurley (Winchell), Dan Aykroyd (Pa Tex), Reba McEntire (Ma Tex), Kathy Bates (Alaskan Mom), Graham Greene (Alaskan Dad), Kelly McGillis (Amish Mom) and Alexander Godunov (Amish Dad).

By JANET MASLIN

Rob Reiner has made both big, high-profile Hollywood movies ("A

Bruce McBroom/Castle Rock Entertainment
Elijah Wood

Few Good Men," "When Harry Met Sally ... ") and more offbeat films with funny, knowing, youthful sensibilities all their own ("Stand by Me," "The Sure Thing," "This Is Spinal Tap"). The latter ones are much more interesting, even when, like "North," they're quite literally all over the map.

"North," a playful modern fable about a boy in search of new parents, doesn't always work, but much of it is clever in amusingly unpredictable ways. Mr. Reiner's daring is a great comic asset, and it's very much in evidence here. So evident, in fact, that "North" has the scattershot energy of a Mel Brooks farce: before the audience can be sure whether one gambit really works, this film is on to the next one. It's hard to resist a comedy that's so full of surprises and so eager to please.

Based on a slender novel by the comedy writer Alan Zweibel (of "Saturday Night Live" and "It's Garry Shandling's Show"), and written by Mr. Zweibel and Andrew Scheinman, "North" unfolds in a fast, jaunty style. A string of quick glimpses describe North's happy-looking life in the fourth grade ("North's Tevye moved me," says a classmate of North's triumphant performance in "Fiddler on the Roof") while also revealing trouble in paradise.

North (Elijah Wood) looks like a big success, but his parents (Julia Louis-Dreyfus and Jason Alexander) don't understand him. Nor do they even notice him. North's father is much too interested in his career as an inspector of pants, which is the kind of notion Mr. Reiner knows just what to do with. All he needs to show is a quick glimpse of the pants factory, where North's father (one of many imaginative pants testers) tries out pink and blue evening pants by feigning ballroom dancing.

Another nice sight gag presents North on his way to the secret place where he goes when he wants to be alone. Through the woods, past a treehouse, North wanders the countryside until he winds up inside a furniture store at a shopping mall, where he can brood undisturbed in a nice big armchair. It's there that he meets Bruce Willis, an Easter Bunny full of advice and badly in need of a shave. Mr. Willis, lending the film a touch of hip insouciance, turns up in many guises throughout the film and makes a nicely laid-back guardian angel.

North decides to seek freedom from his family and roam the world

in search of new parents. Naturally, he can't do this without a lawyer (Jon Lovitz, who shows up in school with his client and advises him not to answer a question about the inventor of the cotton gin). And he can't do it without generating public interest: telephone operators are seen fielding calls from prospective parents who want to know everything about North. "Don't even get him started on the Warren Commission," one operator advises.

Much of the film strings together North's geographical exploits, which take him to places including Texas (Dan Aykroyd, Reba McIntyre, shades of "Dallas" and "Bonanza"), Alaska (Kathy Bates and Graham Greene in an igloo with a garage-door opener) and Pennsylvania's Amish country (Kelly McGillis and Alexander Godunov, who give a reprise of their "Witness" roles and scare North with an offer to make him part of their solemn brood). Some of these moments are a lot less funny than others. The film's comic range goes all the way from tasteless jokes in Hawaii, where North's prospective parents want to use his bare rump on billboards, to a quick, side-splitting scene in Paris, where North sits with a beret-wearing couple watching Jerry Lewis on every television station.

Mr. Wood is currently the most natural, confident child actor of his generation, but he's not always an ideal straight man. Too many of the tall tales in "North" require him to sit still and just flinch in disbelief. However, he's very likable throughout, and Mr. Reiner has surrounded him with a good deal of comic relief. The film gets some extra energy from Alan Arkin, turning himself into Sid Caesar to play a wild-eyed judge, and Mr. Lovitz, sleazy as ever and better used than he was in "City Slickers II." Mr. Alexander and Ms. Louis-Dreyfus also have some funny moments, even if they spend much of the story installed in the Smithsonian, enjoying "the longest simultaneous coma in medical history."

"North" also has a subplot in which the hero's power-mad classmate, a venal pre-yuppie named Winchell (Mathew McCurley), schemes against him. Children may enjoy this character, but there's a lot for children to enjoy in "North" anyway. Aside from being the least original part of an otherwise inventive story, this conventional twist bogs down the film in other ways. There are enough large, venal yuppies on screen these days. We don't need small ones.

"North" is rated PG (Parental guidance suggested). It includes mild profanity.

1994 Jl 22, C3:1

JUST LIKE A WOMAN

Directed by Christopher Monger; written and produced by Nick Evans, based on the book "Geraldine" by Monica Jay; director of photography, Alan Hume; edited by Nicolas Gaster; music by Michael Storey; production designer, John Box; released by the Samuel Goldwyn Company. At Quad Cinema, 13th Street west of Fifth Avenue, Greenwich Village. Running time: 102 minutes. This film is not rated.

WITH: Adrian Pasdar (Gerald/Geraldine), Julie Walters (Monica), Paul Freeman (Miles Millichamp), Gordon Kennedy (C. J.) and Susan Wooldridge (Louisa).

By CARYN JAMES

Even if this weren't the season for exploding buses and animals who act

human, "Just Like a Woman" would qualify as one of the quirkiest films on screen. It is a sweet little comedy about the sunny side of transvestism.

Gerald (Adrian Pasdar) is a handsome young American working as a banker in London. When he hears that his wife and two small children have returned from a trip unexpectedly, he races home in a panic, but he's too late. His wife has already found women's lingerie, makeup and jewelry scattered around their bedroom and is tossing them out the window. The hopeless Gerald can't bear to explain that the feminine clothes belong to him.

During the divorce he rents a room from Monica (Julie Walters), a plain-looking older woman just out of a bad marriage herself. She is attracted to her tenant, and curious about the tall woman who lets herself into Gerald's room late at night — not the most stylish young woman in London, but pretty enough to make Monica jealous.

After Gerald becomes Monica's friend and lover, he tells her that he is that woman, Geraldine. He has always been a heterosexual who likes to wear women's clothes. Monica has a good laugh and decides the idea is just fine. They continue to be lovers, and Monica comes to call Geraldine a bird of paradise. That's not a bad description, because Geraldine is slightly overdressed for most occasions. "But I only have evening wear," he frets, as he and Monica set out on a daytime shopping trip with Geraldine in a shiny dress, carrying a little beaded bag.

"Just Like a Woman" maintains its cheerful, good-natured demeanor because the story is not played as a raucous farce or satiric drag show. It is presented as a straightforward tale of love and friendship. Much of its easygoing tone comes from Nick Evans's script and Christopher Monger's direction. But even more comes from the smooth, comfortable performances. Mr. Pasdar makes Gerald immensely likable and Geraldine vulnerable, without ever becoming smarmy or sentimental. Ms. Walters plays Monica as an open-minded, level-headed woman whose loneliness and boredom are relieved by this titillating romance.

Geraldine and Monica socialize at a transvestite club, a perfectly proper place where burly men happen to wear dresses, and where Geraldine and Monica pal around with a married couple. The wife says she thinks of transvestism as her husband's hobby, "like golf."

This approach requires glossing over a lot of darker issues, of course. But it's just as well that the film blithely assumes transvestism is one more hobby, as refreshing for some people as a walk in the woods is for others. The movie weakens when it begins to get serious. Gerald, dressed as Geraldine, is pulled over for speeding and falsely arrested for soliciting. He loses his job, and in a conclusion that drags on too long, Geraldine and Monica team up to save one of Gerald's business deals. The film could stand to be shorter, with the plot about Gerald's Japan-bashing boss pared down.

"Just Like a Woman" is based on a memoir by the real Monica Jay, a London housewife. It ends with the questionable statistic that 1 man in 20 likes to dress in women's clothes.

Though the film is as fluffy as Geraldine's wig, it convinces an audience that in Gerald's case anyway, there's a decent guy beneath all that mascara and lipstick.

1994 Jl 22, C12;1

THE MASK

Directed by Charles Russell; written by Mike Webb, based on the story by Michael Fallon and Mark Verheiden; director of photography, John R. Leonetti; edited by Arthur Coburn; music by Randy Edelman; production designer, Craig Stearns; produced by Bob Engelman; released by New Line Cinema. Running time: 102 minutes. This film s rated PG-13.

WITH: Jim Carrey (Stanley Ipkiss), Cameron Diaz (Tina), Peter Greene (Dorian Tyrel), Richard Jeni (Charlie Schumacher), Peter Riegert (Lieutenant Kellaway), Amy Yasbeck (Peggy Brandt) and Milo (Max).

By JANET MASLIN

FOR a movie industry enamored of cartoon heroes, Jim Carrey ought to be a dream come true. With his sparkling, silly grin and his true talent for physical clowning, Mr. Carrey comes as close to being an animated creature as a live actor ever could. Add to that a goofy, ingenuous screen persona with obvious appeal for children and you have the not-so-surprising popularity of "Ace Ventura: Pet Detective," the lowball hit of the winter season.

Now, primed for broader success in vehicles better tailored to his talents, Mr. Carrey returns in "The Mask," an astonishingly lazy and perfunctory effort that does little to realize his comic potential. Listless as it is, "The Mask" succeeds in illustrating two of the more troubling cinematic trends of the moment.

First of all, this is another film in which a seemingly mild-mannered, powerless man (Jack Nicholson in "Wolf," Arnold Schwarzenegger in "True Lies," even Tom Hanks in "Forrest Gump") releases his secret reserves of viciousness or ambition. (Exempt Mr. Hanks from that thought if you really believe it's possible to drift like a feather into wealth and fame.) The idea turns particularly sour in "The Mask," a revenge fantasy in which meek Stanley Ipkiss (Mr. Carrey) develops the power to play nasty tricks on anyone who's done him wrong.

Second, "The Mask" underscores the shrinking importance of conventional storytelling in special effects-minded movies, which are happy to overshadow quaint ideas about plot and character with flashy, up-to-the-minute gimmickry. Far more energy has gone into stretching Mr. Carrey's face, twirl-ing his legs and conceiving animation-style gags for him to exploit than into creating a single interesting character or memorable line. Even more egregiously than most of this summer's blockbusters, "The Mask" tells a story that wouldn't be worth telling without tricks.

But if you build a film this way, as Hollywood continues to discover, they — audiences — will come. Viewers even turned out for a film as feeble as "The Flintstones," which transformed live actors into cartoonish characters, not because the notion was clever but simply because it could be executed at all. So it's been a murderous summer at the multiplex, with high-tech hits hugely dominant and quieter films crowded out faster than you can say "Wyatt Earp." "The Mask" exudes the confidence of a film sure to fall into the more fortunate category, if only because Mr. Carrey's antics have novelty value. They needn't be clever to be an automatic draw.

Actually, Mr. Carrey works very hard here, as do the ingenious special-effects pioneers at Industrial Light and Magic, who exaggerate the star's manic gestures until they take on frenetic intensity. But these pyrotechnics, costly and elaborate as they are, take up only a small proportion of screen time. The rest of "The Mask" plods though a drab, time-killing story featuring the sad-sack Ipkiss, a stock hoodlum named Dorian Tyrel (Peter Greene) and a policeman named Kellaway (Peter Riegert, the only actor besides Mr. Carrey to show any signs of life here). Scaring away the Carrey-loving kiddie audience is Tina Carlyle (Cameron Diaz), a gorgeous, dopey bimbo who's enough to make Anna Nicole Smith look like a feminist college professor.

The early part of the film follows Ipkiss, a milquetoast bank clerk, through a series of petty humiliations; showing up at a fancy nightclub in a beat-up car is supposed to be a particularly wounding experience. He also meets and ogles Tina, who is actually in cahoots with a gang of hoods, none of which matters in the slightest. The only event worth noticing is Ipkiss's accidental discovery of the title object (which, like a lot of things in "The Mask," looks like nothing special). He puts it on, becomes a demonic nut and goes wild.

Soon, with a green face and a sneer as wicked as the Joker's, Ipkiss can indulge in malicious mischief of the no-fault kind. As in the Chuck Jones and Tex Avery cartoons that provide obvious visual inspiration, Ipkiss can tease, torment, clobber and humilate others without consequence. (He wakes up innocent and maskless on the mornings after.) He himself can even fall out a window and go splat, rising up to yell: "Look, Ma! I'm mad kill! Ha ha ha!" This is a far cry from the sweeter, more personable humor of Mr. Carrey's "Ace Ventura" days.

Temporarily diverting are a couple of musical interludes, in one of which the Mask (as Ipkiss's alter ego is called) is surrounded by police officers and coaxes them into dancing the rhumba. Another, in a nightclub, finds the Mask's tongue, eyeballs and heart all popping out at the arousing sight of Tina, which certainly strains the limits of animation-inspired metaphor. Mr. Carrey is funniest doing quick, movie-based impressions, like a Dirty Harry turn that lets him flash colossal guns. The film's single best stunt has Milo (Max), Ipkiss's small dog, slipping into the mask and turning into as wild a lunatic as his master.

As directed by Charles Russell, whose work on "Nightmare on Elm Street III" and a "Blob" remake has done little to prepare him for this ambitious venture, "The Mask" goes absolutely dead when not following its hero's insane outbursts. And since Mr. Carrey remains an actor who can even shut a drawer with comic panache, that kind of dreariness is all

New Line Cinema

Up-to-the-minute gimmickry: Jim Carrey, transformed by animation-inspired wizardry, displays heart-throbbing passion.

the more wasteful. Bright-eyed, crazily intense, irrepressibly silly, Mr. Carrey can be funny without fireworks. He deserves material clever enough to let him do just that.

"The Mask" is rated PG-13 (Parents strongly cautioned). It includes cartoon violence and strong sexual innuendo.

1994 Jl 29, C1:3

BARCELONA

Written, produced and directed by Whit Stillman; director of photography, John Thomas; edited by Christopher Tellefsen; music by Mark Suozzo; production designer, José María Botines; released by Fine Line Features. Running time: 101 minutes. This film is rated PG-13.

WITH: Chris Eigeman (Fred Boynton), Taylor Nichols (Ted Boynton), Tushka Bergen (Montserrat), Mira Sorvino (Marta), Pep Munne (Ramón), Thomas Gibson (Dickie Taylor) and Jack Gilpin (Consul).

By JANET MASLIN

Anyone familiar with Whit Stillman's captivating 1990 "Metropolitan" knows that his precise, urbane intelligence is a true tonic on screen. Both of his films, the second of which is the equally appealing new "Barcelona," have an offbeat, amusing specificity that is distinctive and rare.

Each film is firmly rooted in subject matter of no great universal familiarity. ("Metropolitan," set in the uneasy world of New York debutantes and their escorts, was by far the simpler to describe.) And each radiates the film maker's fervent, occasionally crazy confidence in the legitimacy of his interests. Mr. Stillman can be dead serious about, say, NATO without sacrificing a gently sardonic tone. And he's capable of linking theories of salesmanship with thoughts of love. He makes odd, tender, uncategorizable films that must utterly confound the market researchers whose opinions shape Hollywood. Good.

"Barcelona," a slender, deadpan romantic comedy with an eye toward world affairs, centers on the bickering relationship between two cousins. It begins when Fred (Chris Eigeman) appears on the Spanish doorstep of his cousin Ted (Taylor Nichols), who greets him with the old saw about house guests stinking after three days. Fred moves in anyway. Ted is a prim, fussy sort with a lot of pent-up resentments and furtive habits, all of which Fred is happy to ignore. Fred, a

naval officer, has come to Barcelona as an advance man for the Sixth Fleet, and he has more to worry about than Ted's bad mood.

Set during "the last decade of the Cold War," "Barcelona" manages to find comic material in the anti-American attitudes then prevalent in Spain. Since both Fred and Ted quickly become involved with smart, self-assured, sexually liberated Spanish women, they find themselves on the defensive both personally and politically. Fred, the more belligerent of the cousins, loudly defends his opinions no matter what the cost. "I think it's well known that anti-Americanism has its roots in sexual impotence, at least in Europe," he says pointedly on one occasion.

Naturally, Ted is often embarrassed by Fred's behavior. It doesn't help their case with Montserrat (Tushka Bergen), the beauty who takes up with Ted even though she also lives with Ramón (Pep Munne), when Fred decides to pick a fight with Ramón and his passionately anti-American friends. At an outing in the country, ants are used in an analogy for American imperialism; Ramón maintains that Americans are like a red-ant minority oppressing a black-ant majority. Fred's answer to this is to squash the ants outright. "I did not confirm their worst assumption," Fred insists afterward, when Ted tries to scold him. "I *am* their worst assumption."

He might well be, in a film more strident and less deft than this one. But Mr. Eigeman is the film's funniest performer, and his rapport with Mr. Nichols is much too droll to have a bullying edge. These two, who also played petty minor characters in "Metropolitan," have the kind of flat, absurdist comic timing that perfectly suits Mr. Stillman's buttoned-down sensibility. Neither the actors nor the film makers ever nudge the audience for laughs. "Barcelona," like "Metropolitan," indulges in long, hair-splitting discussions without resorting to broad gags or worrying about wearing out its welcome.

"Barcelona" has the slightly chaotic feel of an autobiographical film. Mr. Stillman, who has lived in Barcelona and has a wife who was brought up there, makes little attempt to narrow his interests into a streamlined plot. So this anecdotal, sometimes sketchy story pauses to convey the seductive beauty of the title city, the ambiance of late 1970's disco culture, the cultural chasm between Spanish and American characters, and various theories on beauty, salesmanship, sexual freedom and the sinking of the Maine.

A spectrum so broad saps the film's narrative interest, but it also yields crazily inspired moments, like one in which Ted — who has been concealing a Bible inside his copy of The Economist — begins reading the Scriptures while dancing rakishly to "Pennsylvania 6-5000." He thinks he's home alone, but Fred comes back by accident. "What is this," Fred asks indignantly, "some strange, Glenn Miller-based religious ceremony?" If you enjoy that thought, you should also appreciate many of Mr. Stillman's other notions.

"Barcelona" has a much brighter, more polished look than "Metropolitan" (though both were shot by the same cinematographer, John Thomas) and a sometimes keener sense of the absurd. All the principal actors speak in unreasonably calm tones that nicely suit the film's larger incongruities. Also in the cast is Mira Sorvino, as a woman who first meets Fred when she is dressed à la Marie Antoinette and thinks Fred's naval officer's uniform must mean he, too, is headed for a costume party. Later on, listening to one of Fred's more untenable thoughts, she handles him in the most tactful way possible by answering, "I think maybe my English is not so good."

"Barcelona" is rated PG-13 (Parents strongly cautioned). It includes sexual references and slight violence.

1994 Jl 29, C3:1

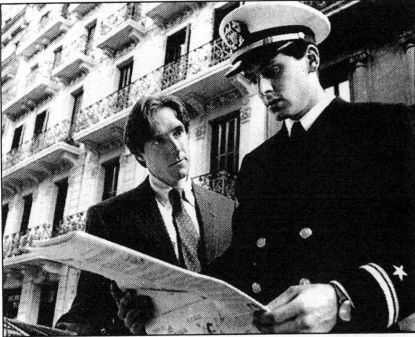

Martha Sentis/Fine Line Features

Two bickering cousins abroad: Taylor Nichols, left, and Chris Eigeman.

FOREIGN STUDENT

Directed by Eva Sereny; written by Menno Meyjes, based on the novel "The Foreign Student," by Philippe Labro; director of photography, Franco Di Giacomo; edited by Peter Hollywood; music by Jean-Claude Petit; production designer, Howard Cummings; produced by Tarak Ben Ammar and Mark Lombardo; released by Gramercy Pictures. Running time: 96 minutes. This film is rated R.

WITH: Marco Hofschneider (Phillippe), Charles S. Dutton (Howlin' Wolf), Hinton Battle (Sonny Boy Williamson), Robin Givens (April), Jack Coleman (Rex Jennings), Edward Herrmann (Zach Gilmore), Rick Johnson (Cal) and Charlotte Ross (Sue Ann).

By CARYN JAMES

In 1956, Phillippe is a French exchange student at a Virginia college where tradition is sacred. He picks up a certain amount about the local culture, but that doesn't mean he's ready to live by it. When he finds himself outside a blues club in the black section of town, chased and harassed by the locals, he can only run around the parking lot yelling out the truth: "I'm not a redneck! I am not a Southern gentlemen! I am French!"

In fact, that difference saves him. The black musicians (Charles S. Dutton and Hinton Battle, in roles that are too brief) remember how well they were treated in Paris and take Phillippe inside to hear them play. It is the liveliest scene in "Foreign Student," a small, sincere film that burdens poor Phillippe one semester in the Shenandoah Valley with the weight of American culture and history in the 1950's.

Phillippe found his way to the club because of his romance with April, a grammar-school teacher and part-time housekeeper for his English professor. Their interracial love affair is the centerpiece of the story, and although the film acknowledges that the couple is acting dangerously in that time and place, the affair is presented sentimentally, as one of those deep but fleeting passions that was never meant to be anything more. "Foreign Student" is a coming-of-age story that happens to be about racism in America, a choice that creates an unbalanced sensation.

This is the first feature directed, in a smooth style, by Eva Sereny. She has found the perfect Phillippe in Marco Hofschneider, who was so strong and effective in "Europa, Europa" as the Jewish boy who survives by pretending to be a Nazi. For "Foreign Student," he has cultivated a self-consciously shy, wide-eyed look that works for Phillippe, who knows how to turn on the charm.

But as April, Robin Givens is nothing like the sweet backwoods teacher who dreams of seeing the world yet realizes that her romance with Phillippe is doomed. With her flowing hair, heavy eye makeup and model's cheekbones, the glamorous April looks like Robin Givens acting in a movie. Ms. Givens can give a performance (as she did in "A Rage in Harlem"), but she never approaches this character.

But then the script often gives its characters such clumsy material. The narrator's voice is that of Phillippe as a middle-aged man, making pretentious remarks about the past. And as if it's not enough that the young Phillippe falls into a dangerous love affair, he also hears Faulkner give a reading, sees a genuine Southern belle go mad and plays in the season's big football game. It's a lot to cram into one semester, and too much for one little movie.

"Foreign Student" is rated R (Under 17 requires accompanying parent or adult guardian). It includes rough language and a sex scene with a bit of nudity.

1994 Jl 29, C10:5

IT COULD HAPPEN TO YOU

Directed by Andrew Bergman; written by Jane Anderson; director of photography, Caleb Deschanel; edited by Barry Malkin; music by Carter Burwell; production designer, Bill Groom; produced by Mike Lobell; released by Tri-Star Pictures. Running time: 101 minutes. This film is rated PG.

WITH: Nicolas Cage (Charlie Lang), Bridget Fonda (Yvonne Biasi), Rosie Perez (Muriel Lang), Red Buttons (Walter Zakuto), Seymour Cassel (Jack Gross), J. E. Freeman (Sal Bontempo), Isaac Hayes (Angel), Wendell Pierce (Bo Williams) and Stanley Tucci (Eddie Biasi).

By CARYN JAMES

There is a miracle at the center of "It Could Happen to You," the blandly named romantic comedy that had the punchier working title "Cop Gives Waitress $2 Million Tip." The original title plays itself out early in the film when the cop, Nicolas Cage, runs out of cash to tip the coffee-shop waitress, Bridget Fonda. He offers to share a lottery ticket instead, and the next day wins $4 million. But that quirk of fate is nothing beside another odds-defying event: two good-hearted people find each other in New York City. Now that's a miracle, at least in the scheme of this movie, a sometimes awkward mix of savviness and schmaltz.

The other miracle is that the two stars of "It Could Happen to You" keep it sailing over a script that is often as predictable and flat as the movie's new title. In one of the brighter touches, Charlie (Mr. Cage) is introduced carrying a blind man across the street and delivering a baby on a bus, presumably all in a day's work. He is so impossibly selfless that the story begins with a fairy-tale prologue, in which a man named Angel says: "Once upon a time in New York there was a cop named Charlie. He was a very decent guy."

No one needs a fairy godfather more than Yvonne (Ms. Fonda), who is introduced in bankruptcy court explaining to a judge why she married her loser of a husband, who has since left her with an overextended credit card and too little cash to pay for a divorce. He took her to "real restaurants, with linen and wine and good lighting," she says.

When Charlie wins the lottery, his money-obsessed wife, Muriel (Rosie Perez), sees it as their ticket out of Queens. The decent Charlie, of course, insists on sharing it with Yvonne. "A promise is a promise," he says, as if such honesty were always self-evident. Though Muriel is the standard, screeching Rosie Perez character, with a lot of energy and tacky taste, she provides some of the funniest moments. Muriel knew they'd be lucky in the lottery because she saw a sign in a dream: her dead father's face appeared in place of cherries on a slot machine.

Charlie and Yvonne are obviously made for each other. The easy part is getting them together. The toughest trick in the film is to to keep them human and likable in the midst of all this fairy dust. Mr. Cage and Ms. Fonda manage to do that with winning simplicity. Mr. Cage's sincere,

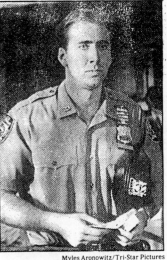
Myles Aronowitz/Tri-Star Pictures
Nicolas Cage

hangdog expression lights into an immense warm smile whenever Yvonne is around. Ms. Fonda makes Yvonne sweet, smart and modest. Her idea of splurging after she becomes a millionaire is to buy a large jar of macadamia nuts, and to savor every one.

It can't have been easy for the actors to liven up so many syrupy scenes, though. The film is loaded with episodes that seem too flabby to have come from Andrew Bergman, the writer and director of extremely funny, edgy comedies like "Honeymoon in Vegas" and "The Freshman." The script is by Jane Anderson, who wrote the television satire "The Positively True Adventures of the Alleged Texas Cheerleader-Murdering Mom." Either one of them might have been expected to come up with sharper comedy and fresher romance.

Here, Yvonne and Charlie give away subway tokens at rush hour. They take neighborhood kids to play at Yankee Stadium while in the background Frank Sinatra sings: "Fairy tales can come true,/It can happen to you,/When you're young at heart." How's that for being literal-minded?

Leaning so hard on the film's fairy-tale quality doesn't help. Genuine fairy tales, whether from the Brothers Grimm or Frank Capra, seem effortless. Calling attention to the improbable fantasy of Charlié and Yvonne's grand adventure might sound like a wry touch. It comes off as a desperate move that makes the story more, not less, manipulative. Thank goodness for Muriel's abrasiveness. Eventually she becomes the film's cartoon villain, the wicked wife buying out Fifth Avenue and demanding all the lottery winnings for herself. Yet even her tantrums become part of the film's genial but static quality.

The detailed touches work best. Tabloid headlines make Charlie and Yvonne fleeting celebrities, lottery winners in love. When Yvonne's estranged husband shows up asking for money, she escapes to the Plaza Hotel. She enters the room, walks up to a huge bouquet of flowers and touches them to make sure they're real, in a brief gesture that is honest and affecting.

Though "It Could Happen to You" lacks Mr. Bergman's usual flash of originality, it is not nearly as soupy as last year's romantic hit "Sleepless in Seattle," and it isn't saddled with the tortured plot of "I Love Trouble." It ends with yet another last-minute miracle, one that proves New York is full of good-hearted people after all.

Like so much in this sweetly amusing movie, it's an idea that carries more hope than conviction.

"It Could Happen to You" is rated PG (Parental guidance suggested). It includes some violence when Charlie is shot in the line of duty.

1994 Jl 29, C10:5

BLACK BEAUTY

Written and directed by Caroline Thompson, based on the novel by Anna Sewell; director of photography, Alex Thomson; edited by Claire Simpson; music by Danny Elfman; production designer, John Box; produced by Robert Shapiro and Peter Macgregor-Scott; released by Warner Brothers. Running time: 87 minutes. This film is rated G.

WITH: Sean Bean (Farmer Grey), David Thewlis (Jerry Barker), Jim Carter (John Manley), Peter Davison (Squire Gordon), Andrew Knott (Young Joe Green), Peter Cook (Earl of Wexmire) and Eleanor Bron (Countess of Wexmire).

By JANET MASLIN

Picture the sort of horse that might sit at a writing table prettily composing its memoirs, and you have some idea of what the narrator's voice in "Black Beauty" is like. The screenwriter Caroline Thompson ("Edward Scissorhands," "The Secret Garden"), making her directorial debut, takes a cue from Anna Sewell's well-loved 1877 novel (which is subtitled "The Autobiography of a Horse") and goes well beyond that book's horse-centric point of view.

So Ms. Thompson affords her four-legged hero extreme sensitivity, especially by horse standards. Black Beauty is heard cataloguing his feelings in exquisite detail. With a thoroughness to rival David Copperfield's, he even begins his story at the moment of birth. Later on, he falls in love, dreams about his mother, rhapsodizes about oats and complains bitterly about wearing a harness with a bit.

"If you've never had one in your mouth you can't imagine what a shock it is!" Black Beauty declares vehemently on that last point. More often than not, there's an implied exclamation point at the end of what he says.

This level of equine empathy takes getting used to, but it's worth the trouble. Ms. Thompson's film may be precious, but it's also rapturously pretty and filled with surprising passion. As Black Beauty's outlook becomes increasingly credible, Ms. Thompson underscores the injustices and disappointments that shape his destiny. ("Sold? Every horse knows that terrifying word!" he says at one juncture.) While it may be difficult to imagine an element of social realism in a film set amongst topiary hedges, "Black Beauty" manages some stirring contrasts in describing the life of its hero.

Structured as a flashback, with Black Beauty resting in a grassy spot and recalling his many adventures, the film begins with an idyllic colthood on privileged, pastoral terrain. Black Beauty's story ("a story of trust and betrayal and learning to trust again," he says, rather melodramatically) then proceeds downhill. There are sad partings, cruel owners, knee injuries and other forms of peril, all of them set forth in serial fashion. The film is so episodic that its two top-billed stars, Sean Bean (as Black Beauty's original

owner) and David Thewlis (as a London cabbie) are separated by an hour of screen time.

Mr. Thewlis is the biggest surprise here, moving from his corrosive, taunting character in "Naked" to one that couldn't be more different. Clean-shaven, looking startlingly boyish in short hair and a bowler hat, he plays one of the film's most kindhearted characters with supreme ease. The performance is brief, but confirms the impression that Mr. Thewlis is an arresting, eerily authentic actor in any sort of role. Also notable in the large cast, playing wicked aristocrats with quiet glee, are Peter Cook and Eleanor Bron.

Ms. Thompson offsets the inherent sadness of "Black Beauty" with gorgeous flora and fauna, so that her film often has the enveloping look of a nature documentary. In terms of accessibility for young viewers, that leaves it halfway between the breezy "Homeward Bound: The Incredible Journey" (which Ms. Thompson also wrote) and the solemn, arid "Secret Garden." Certainly "Black Beauty" is the most distinguished children's film of the season, one that should appeal to horse-loving, Anglophilic adults, too. Its appeal is enhanced by unusually expressive animal acting and by Danny Elfman's lovely, brooding score.

1994 Jl 29, C29:1

CLEAR AND PRESENT DANGER

Directed by Phillip Noyce; written by Donald Stewart, Steven Zaillian and John Milius, based on the novel by Tom Clancy; director of photography, Donald M. McAlpine; edited by Neil Travis; music by James Horner; production designer, Terence Marsh; produced by Mace Neufeld and Robert Rehme; released by Paramount Pictures. Running time: 142 minutes. This film is rated PG-13.
WITH: Harrison Ford (Jack Ryan), Willem Dafoe (Mr. Clark), Anne Archer (Cathy Ryan), James Earl Jones (Admiral Greer), Joaquim de Almeida (Félix Cortez), Henry Czerny (Robert Ritter), Harris Yulin (James Cutter), Donald Moffat (President Bennett), Miguel Sandoval (Ernesto Escobedo) and Benjamin Bratt (Ramirez).

By JANET MASLIN

Taming the eyeball-glazing prose of Tom Clancy's "Clear and Present Danger" with the same brisk efficiency they brought to "Patriot Games," the makers of this latest espionage thriller have made their first-rate work look easy. And clearly, it was anything but. No amount of exercise under the hot sun will beat the workout involved in following this story, with its dozens of locations, interchangeable-sounding character names (Cutter, Ritter, Clark, Ryan, many more) and high-tech military jargon. A film with a "cellulose encased laser-guided bomb" for a conversation piece is not to be watched casually.

Yet, "Clear and Present Danger" (photographed crisply by Donald M. McAlpine and scored by James Horner) looks so lean and moves so vigorously that it actually seems streamlined most of the time. As directed by Philip Noyce, who also did "Patriot Games," this becomes another fast, gripping spy story with some good tricks up its sleeve, and with a much more economical style than that of Mr. Clancy's best-selling novel. Three distinctive screenwriters — Steven Zaillian ("Schindler's

List"), John Milius ("Apocalypse Now") and Donald Stewart (co-writer on "Patriot Games" and "The Hunt for Red October") — deliver dialogue that is both colorful and swift.

Harrison Ford, making only his second screen appearance as Mr. Clancy's heroic C.I.A. agent, Jack Ryan, has already become Old Faithful in this role. Mr. Ford may be the most reticent of American movie stars, but he brings considerable subtlety to the job of humanizing Jack Ryan. In a film that opens with the sight of a waving American flag, subtlety may not be foremost on anyone's mind. But Mr. Ford's wary intelligence does wonders for a potentially one-dimensional character. Jack's heroism on screen has much broader appeal than it does on the page.

Jack is now deputy director of the C.I.A., once his much-admired superior, Adm. James Greer (James Earl Jones, giving a touching, unmannered performance), becomes gravely ill. And one of this film's minor pleasures is the sight of Jack flashing his prestigious C.I.A. business cards at some of the Latin American drug lords who set the story in motion.

"Clear and Present Danger" begins with the discovery of a yacht whose passengers have been murdered, a crime that turns out to be the drug lords' handiwork. Complicating this event are the facts that the principal victim made off with huge sums of money belonging to a drug cartel, and that he was a close friend of the President of the United States. The President, played by Donald Moffat with a Reaganesque mixture of caginess and imperfect hearing, tacitly authorizes a bit of payback.

Unbeknown even to most top C.I.A. personnel, a covert Latin American anti-drug operation is instigated by Cutter, the National Security Adviser (Harris Yulin), with the help of Ritter (Henry Czerny), a rogue C.I.A. man. Mr. Czerny, a Canadian actor who will eventually be familiar to American television audiences when he is seen starring so effectively in "The Boys of St. Vincent," makes a perfect spook. Fidgety, intense, loaded with menace, he becomes the worthiest and most sinister of Ryan's many adversaries in this story.

One of the film's cleverest sequences pits these two in a computer espionage battle, as Ryan and Ritter both try frantically to access Ritter's top-secret files while they also make small talk on the telephone. ("You play tennis?") Only in the brave new world of Mr. Clancy's techno-thrillers does this sort of thing define the meaning of suspense.

Another standout episode, and one of the few here to involve graphic bloodshed, finds Ryan and a group of colleagues suddenly ambushed on a narrow street in Bogotá. Equally effective (if a bit less personal) is the scene that follows a smart bomb through the clouds until it hits a drug czar's villa. The villa is one of dozens of varied, sharply evoked international settings here, from the mountains of Colombia all the way to the Oval Office.

The film pays great attention to the lavish, family-oriented home life of Ernesto Escobedo (Miguel Sandoval), who along with his henchman Félix Cortez (Joaquim de Almeida) represents the forces of evil, debonair foreign division. Any similarity to the real drug cartel leader Pablo Escobar, whose death occurred while

"Clear and Present Danger" was being filmed, is as fortuitous as it is grim.

Also figuring prominently in "Clear and Present Danger" is a tawny, physically imposing Willem Dafoe as Clark, the mysterious C.I.A. field operative who figures prominently elsewhere in the Clancy canon. The ambiguity of Clark's character suits Mr. Dafoe intriguingly, since it goes so far beyond the ordinary villainy to which he has often been confined. Scenes between Mr. Dafoe and Mr. Ford have a special edginess, since one of them has been so deeply misled about what the other is up to.

There also happen to be a few women in "Clear and Present Danger," but their roles (Hope Lange as a Senator, Ann Magnuson as a hapless pawn in the drug cartel's game) are small. The role that's not small enough is that of Cathy Ryan, the wise, smiling, insufferable wife played again by Anne Archer. Only Cathy seems out of sync with the tough, muscular manner of this story. Cathy doesn't quite ask Jack whether he's remembered his galoshes when he goes off on a dangerous C.I.A. mission, but she comes close.

"Clear and Present Danger" is rated PG-13 (Under 17 requires accompanying parent or adult guardian). It includes violence, most of it discreet, and occasional profanity.

1994 Ag 3, C11:1

EAT DRINK MAN WOMAN

Directed by Ang Lee; written (in Chinese, with English subtitles) by Mr. Lee, Hui-Ling Wang and James Schamus; director of photography, Jong Lin; edited by Tim Squyres; music by Mader; produced by Li-Kong Hsu; released by the Samuel Goldwyn Company. Running time: 123 minutes. This film has no rating.
WITH: Sylvia Chang (Jin-Rong), Winston Chao (Li Kai), Chao-Jung Chen (Guo-Lun), Ah-Leh Gua (Mrs. Liang), Chin-Cheng Lu (Ming-Dao), Sihung Lung (Mr. Chu), Yu-Wen Wang (Jia-Ning), Yu-Chien Tang (Shan-Shan), Chien-lien Wu (Jia-Chien) and Kuei-Mei-Yang (Jia-Jen).

By JANET MASLIN

"Eat Drink Man Woman," the delectable new film from Ang Lee, the director of "The Wedding Banquet," is about a father who has lost his joie de vivre. No happier than Mr. Chu (Sihung Lung) are the three beautiful daughters whose romantic lives are star-crossed and who can't seem to escape their father's spell. Mr. Chu, a widower, is considered a great man in some circles, but at home it's another matter. Sunday dinner for father and daughters is a terrible ordeal. Family tensions run so high the participants can barely even eat.

It's possible that Mr. Lee, a warmly engaging storyteller under any circumstances, could have made the father a celebrated singer or dog-trainer with equal ease. As it happens, he presents Mr. Chu as the greatest chef in Taipei, which not only makes the Sunday dinner sequence a spectacular affair but also turns "Eat Drink Man Woman" into an almost edible treat.

Wonderfully seductive, and nicely knowing about all of its characters' appetites, "Eat Drink Man Woman" makes for an uncomplicatedly pleasant experience. Its thoughts about its characters don't go much deeper than the bottom of a soup bowl, but

those thoughts are still expressed with affection, wit and an abundance of fascinating cooking tips. As in the comparably crowd-pleasing "Like Water for Chocolate," this film's use of food is both voluptuous and serious, amplifying the story even as it offers an irresistible diversion. The film succeeds in presenting Mr. Chu's intricate cooking (rendered for the camera by three amazingly artful chefs) as an expression of larger traditionalism and as an endangered art.

Less audacious in subject matter than "The Wedding Banquet" (in which a gay man marries a woman to deceive his parents), "Eat Drink Man Woman" is more ambitious in other ways. It unfolds on a broader canvas, with each character's separate story given room to play out, and each used somehow to illustrate the film's title. "Food and sex," one character says succinctly, amplifying that four-ideogram phrase. "Basic human desires. Can't avoid them."

But each of this film's main characters *is* trying to avoid them, somehow. Mr. Chu, widowed 16 years earlier, spends much of his time as a lonely homebody, cooking obsessively and even doing his daughters' laundry while they're at work. Finally finding someone on whom he can dote, Mr. Chu begins supplying exquisite multi-course lunches to little Shan-Shan (Yu-Chien Tang), a schoolgirl whose mother is a family friend. Her classmates are dazzled, all the more so because they are too young to realize that Mr. Chu's cooking is often flawed. Symbolically enough, he has lost the use of his taste buds, which seems all too fitting to the daughters, who view him as joyless and remote.

Equally joyless, in her own way, is Jia-Chien (Chien-Lien Wu), the most beautiful and successful of the young women. With a prominent job as an airline executive, an ex-lover she has sex with as a convenience, and intentions to move into a new high-rise apartment building called Little Paris in the East, the gorgeous Jia-Chien radiates a brittle professionalism. Even less satisfied with her life is the eldest daughter, Jia-Jen (Kuei-Mei-Yang), a prim schoolteacher who has never recovered from an unhappy love affair. The youngest daughter, Jia-Ning (Yu-Wen Wang), delivers the most obvious reproach to her father and all he stands for. She is a counter clerk at a Wendy's.

Mr. Lee introduces a couple of other characters sure to shake up this family. Li Kai (Winston Chao), the handsome new executive at Jia-Chien's office, is certain to be trouble; Mrs. Liang (Ah-Leh Gua), a harpy newly returned to the neighborhood, has set her sights on Mr. Chu. And her best friend's boyfriend begins courting Jia-Ning with the kind of wry comic style that marks this film at its best. "I want to end this addiction to love," says this young man, who reads Dostoyevsky and rides a motorcycle, "but I'm too weak."

Many of these actors also appeared in "The Wedding Banquet" (and in Mr. Lee's first film, "Pushing Hands"). Well used as they all are (particularly Mr. Lung, whose performance has a true poignancy), they are understandably upstaged by such artifacts as a watermelon carved to resemble a decorative Chinese vase and a cooked green-dragon-shaped delicacy draped across a dinner plate. At its best, though, the film warmly integrates food and humor, as in a lovely sequence that finds Mr.

Chu summoned on an emergency basis by a crowd of frowning, toque-wearing chefs. The occasion is an important banquet, and the shark fin soup is simply shot. "The guy who bought the fins didn't know anything," someone explains. Mr. Chu solemnly studies this situation, then he saves the day.

Intermingling a sexual episode with a glimpse of Mr. Chu blowing air into a duck, Mr. Lee often makes his characters seem oblivious in certain basic ways. By the end of the film — a slightly false but happy ending, as in "The Wedding Banquet" — he has delivered enough last-minute surprises to belie that impression.

1994 Ag 3, C16:3

THE OLYMPIC SUMMER

Written (in German, with English subtitles), produced and directed by Gordian Maugg, based on the novel "Der Geselle" ("The Journeyman") by Günther Rücker; director of photography, Andreas Giesecke; edited by Monika Schindler and Behzad Beheshtipour; music by Heidi Aydt and Frank Will; released by New Yorker Films. Film Forum 1, 209 West Houston Street, South Village. Running time: 84 minutes. This film has no rating.

WITH: Jost Gerstein (Apprentice) and Verena Plangger (Widow); narrated by Otto Sander

By STEPHEN HOLDEN

Gordian Maugg's "Olympic Summer" is not the first movie to interweave decades-old news and documentary film clips with fictional scenes that duplicate as closely as possible the look and style of an earlier era. Still, one is hard pressed to recall a film in which the past and the present are blended so seamlessly that contemporary actors portraying 1930's characters give the illusion of people being caught on film nearly six decades ago.

The movie, which opens today at Film Forum 1, is at once a wildly romantic fable of love and lost innocence in Nazi Germany and a showy exercise in cinematic style and technology. Much of its charm owes to an ingenious technological experiment Mr. Maugg, a 27-year-old German director and screenwriter, filmed the actors using the same sort of hand-cranked camera that was used to film the movie's documentary scenes of Berlin street life and of the 1936 Olympic Games.

The director is so enamored of this technological gimmickry that he lays on the fancy visual effects. His favorite device, which he is especially fond of applying to the movie's love scenes, is to slow down the action so that one can follow the film making process frame by frame. The rich, inky cinematography of these images gives them a semi-mythical resonance.

Enhancing the film's period flavor is a voice-over narration by Otto Sander, whose oratorical formality also smacks of a much earlier time. Period recordings of 1930's German pop songs and still photographs help smooth the still readily discernible boundaries between the archival and the contemporary sections. Although the film has lavish sound effects, it has no spoken dialogue.

"The Olympic Summer," which is based on a novel by Günther Rücker, is a standard old-fashioned fable of innocence and corruption in the big city. A strapping 16-year-old youth (Jost Gerstein), apprenticed to a country butcher, bicycles from his village to Berlin to attend the 1936 Olympics. While in the city he attracts the attention of a 35-year-old widow (Verena Plangger) who invites him to her boathouse. She seduces him, and they enjoy a rapturous summer idyll. Come the fall, he moves to the city and drifts into the demimonde, still supported by the widow.

His real troubles begin when a Nazi officer makes a pass at him and is shot dead by two fellow officers. The apprentice is imprisoned and war breaks out. He spends several unhappy years in prison, and the story comes to an abrupt, melodramatic conclusion at the end of the war.

"The Olympic Summer" is less a narrative film than a romantic tone poem that uses recurrent poetic images, many taken from nature, to evoke and sustain an autumnal mood. In Mr. Gerstein and Miss Plangger, the director has found two wonderfully expressive faces. And the scenes of their developing relationship, in which the apprentice discovers his sexual powers and the widow delights in his discovery, are at once sensual and poignant.

The film is less successful at telling a coherent story. After lingering over the couple's summer idyll, the movie jumps forward in increasingly jerky scenes that show the apprentice's decline and fall. Although the film includes some striking images of bombed-out Berlin, it never fully conveys the sweep of events. What began as a palpitating love story turns into an impressive but ultimately unmoving exercise in cinematic technique.

1994 Ag 3, C16:3

AIRHEADS

Directed by Michael Lehmann; written by Rich Wilkes; director of photography, John Schwartzman; edited by Stephen Semel; music by Carter Burwell; production designer, David Nichols; produced by Robert Simonds and Mark Burg; released by 20th Century Fox. Running time: 81 minutes. This film is rated PG-13.

WITH: Steve Buscemi (Rex), Brendan Fraser (Chazz), Adam Sandler (Pip), Chris Farley (Wilson), Amy Locane (Kayla), Joe Mantegna (Ian), Michael McKean (Milo), Nina Siemaszko (Suzzi), Michael Richards (Doug Beech) and Reginald E. Cathey (Marcus).

By JANET MASLIN

Maybe the rock-and-roll world has been so thoroughly satirized that it's parody-proof by now. More likely, "Airheads" just isn't funny enough to get the job done. "Airheads" tells what happens — not much — when three rock-star wannabes brandish toy guns and take over a radio station, demanding that their demo tape be played on the air. The idea has anarchic possibilities, but the film itself is awfully tame.

With a cast of appealing actors (several of whom have "Saturday Night Live" credentials) and just enough gags to make a terrific two-minute trailer, "Airheads" may look like a lot more fun than it is. Indeed, it starts promisingly then begins to meander and never stops. Having introduced the characters and set up the basic situation, the director (Michael Lehmann) and screenwriter (Rich Wilkes) seem almost to have bailed out in midmovie. Mr. Lehmann, remembered for the caustic edge of "Heathers," is also remembered for the hopeless chaos of "Hudson Hawk."

Part of the problem this time is unavoidable: once Chazz (Brendan Fraser), Rex (Steve Buscemi) and Pip (Adam Sandler) take over the radio station, they have no real demands to make and the movie has nowhere to go. "I don't want anything!" Pip wails (with Mr. Sandler doing what another character calls his "I seem so stupid I must be cute" routine). "I just don't wanna go outside!"

Despite the title, these three aren't quite dopey enough to make a virtue of their dimness. One of the film's only real witticisms comes from the fact that their band's name is the Lone Rangers and three guys working together aren't precisely lone. "I have no idea what you're saying," says Pip, when someone tries to explain this to him. Another worthwhile gag has Chazz asking a record-company executive which side he took in the David Lee Roth-Van Halen breakup. The man gives the wrong answer and thus proves he's an undercover cop.

Mr. Sandler and his "Saturday Night Live" colleague Chris Farley (as a nervous young cop) have some amusing moments, but they're wasted in underwritten roles. Barely there is another television actor, Michael Richards of "Seinfeld," who just crawls through air ducts at the radio station and gets hurt. Mr. Fraser, as the long-haired lead singer, certainly looks right, but the screenplay saddles him with a tiresome strain of idealism. When characters in this film debate the virtues of "the classics," they're talking about rock-and-roll before John Lennon died. When "Moby-Dick" is mentioned, one of them is surprised to learn that the movie has been made into a book.

Mr. Buscemi, looking utterly demonic as the wild-eyed runt of the band, appears more than ready for the story to go wild. Most of the time,

Film Forum

Widow's Peak In "The Olympic Summer," Jost Gerstein plays a boy en route to the 1936 Berlin Olympics who has an affair with a wealthy widow (Verena Plangger).

Merie W. Wallace/20th Century Fox

Accidental Terrorists In "Airheads," Brendan Fraser, left, and Steve Buscemi are struggling rock musicians who just want to get their record played but end up taking over a radio station.

all he gets to do is shake his head in exaggerated disgust. So does Joe Mantegna, giving the film's only fully formed performance as a jaded disk jockey, an aging hipster with limited patience for young would-be rebels.

Also among the radio station's Establishment personnel are Michael McKean as a sleazy manager, Nina Siemaszko as an over-the-top bimbo, and Reginald E. Cathey as a disk jockey who's a lot cooler than the Lone Rangers will ever be. Kicking and screaming at Chazz is Amy Locane as his beautiful, scary girl-friend. There should have been enough material here for six sitcoms. Instead, there's not even enough for one movie.

"Airheads" is rated PG-13 (Parents strongly cautioned). It includes profanity.

1994 Ag 5, C10:1

THE LITTLE RASCALS

Directed by Penelope Spheeris; written by Paul Guay, Stephen Mazur and Ms. Spheeris, based on a story by them, Robert Wolterstorff and Mike Scott; director of photography, Richard Bowen; edited by Ross Albert; music by William Ross; production designer, Larry Fulton; produced by Michael King and Bill Oakes; released by Universal Pictures. Running time: 80 minutes. This film is rated PG.

WITH: Travis Tedford (Spanky), Bug Hall (Alfalfa), Brittany Ashton Holmes (Darla), Kevin Jamal Woods (Stymie), Zachary Mabry (Porky) and Ross Elliot Bagley (Buckwheat).

By JANET MASLIN

"Is that a cowlick, or are you just glad to see me?" Reba McEntire asks Alfalfa (Bug Hall) in "The Little Rascals." Well, a cowlick is all it used to be. But this quaint material has been dragged into the present, picking up an overproduced visual style and the occasional phrase like "bite me" or "boy toy." Along the way, a little innocence is lost, and none of what's gained is worth having.

Visual ideas don't get much simpler than those of "The Little Rascals," which once depended on raffish

Spanky's World Some new faces, including Petey, the dog, portray some very familiar young characters from the "Our Gang" comedies in "The Little Rascals."

George Lange/Universal Pictures

children to behave in funny, precocious ways while the camera rolled. Now, on the big screen, the precocity becomes exaggerated and the children are aggressively cuter. Most of the wide-eyed kiddie actors seen here have worked in commercials, which gives "The Little Rascals" a slick, adorable style devoid of spontaneity. If you can, stick around for the much funnier out-takes that accompany the closing credits, with the kids behaving normally and Penelope Spheeris, the director, heard saying things like "Don't look at the camera, sweetie."

Ms. Spheeris, who once wittily chronicled the decline of Western civilization (in her two rock documentaries by that name) and is now in danger of becoming part of the process, had better luck with "The Beverly Hillbillies." There she could sometimes wink at her material, but "The Little Rascals" does too much winking of its own.

Reviving the Rascals' old "He Man Womun Haters Club," it lets Spanky (Travis Tedford), Stymie (Kevin Jamal Woods), Porky (Zachary Mabry), Buckwheat (Ross Elliot Bagley) and the other boys register horror once Alfalfa starts courting Darla (lushly gorgeous little Brittany Ashton Holmes, the current Baby Guess model). If the film exaggerates its characters' gender roles, making the girls little coquettes in pink ruffles, it also tries to overcompensate with some Band-Aid feminism in the closing moments, and with a sequence that puts Spanky in drag.

Laughs would have helped, but there aren't many. (Sample dialogue: "My father bought the oil refinery." "That explains why you're so refined.") Celebrity cameos don't improve matters, with Donald Trump actually among the funnier walk-ons in a group including Daryl Hannah, Whoopi Goldberg and Mel Brooks. Not even Mr. Brooks is funny here.

The main trouble is that "The Little Rascals" is caught in a time warp, lost between the ingenuous ragamuffins of the early talkies and the more willfully streetwise children of today. So even working the title into the screenplay becomes a strain. "Rascals" isn't a word heard often these days, perhaps because it, too, has a kind of innocence. A man in the film

succeeds in calling the children "You little rascals!" but only after they've knocked him down with a Go Kart.

"The Little Rascals" is rated PG (Parental guidance suggested). It includes mild profanity.

1994 Ag 5, C21:1

THE ADVENTURES OF PRISCILLA, QUEEN OF THE DESERT

Directed by Stephan Elliott; written by Mr. Elliott; director of photography, Brian J. Breheny; edited by Sue Blainey; music by Guy Gross; production designer, Owen Paterson; produced by Rebel Penfold-Russell; released by Gramercy Pictures. Running time: 102 minutes. This film is rated R.

WITH: Sarah Chadwick (Marion), Bill Hunter (Bob), Guy Pearce (Adam/Felicia), Terence Stamp (Bernadette) and Hugo Weaving (Tick/Mitzi)

By JANET MASLIN

Terence Stamp's wistful blue eyes, so memorable for their look of martyred innocence in the 1962 screen version of "Billy Budd," will now be remembered in a distinctly different way. Heavily mascaraed, peering out from beneath bright eyeshadow and behind a long, luxuriant Veronica Lake hairdo, Mr. Stamp cuts a spectacular figure as a sardonic transsexual named Bernadette, part of a three-queen drag act on a bus tour through the wilds of Australia. Even on his own, marvelously ladylike and loaded with sly, acerbic wisecracks, he's worth the price of admission.

And together, the trio of Bernadette, Mitzi (Hugo Weaving) and Felicia (Guy Pearce) is enough to shake the kookaburras right out of the trees. Or to rattle the small-town mentality of the provinces, which is what Stephan Elliott's flamboyantly colorful new film is really about. Taking its name from the tour bus on which this trio travels, "The Adventures of Priscilla, Queen of the Desert" presents a defiant culture clash in generous, warmly entertaining ways. For all its glitter, this is the sort of film in which everyone becomes happier and nicer by the final reel.

Mr. Elliott, as both writer and director, readily communicates his characters' outrageous appeal. The sight of three men dressed in spangles and ostrich feathers while on a camping trip, for instance, is a measure of the film maker's well-developed sense of spectacle. Indeed, "The Adventures of Priscilla" wastes very little time even developing a pretext for the road show, simply throwing together its three principals on a bus supplied with makeup, spangles, ruffles and a sewing machine. Lizzy Gardiner and Tim Chappel, the costume designers credited with the sensational get-ups featured throughout the story, are among this film's true stars.

Bernadette, who becomes understandably upset when anyone calls her Ralph, is grieving over a lost lover, a younger man accidentally asphyxiated by peroxide fumes. Mr. Elliott does stage a drag funeral early in the movie, but he otherwise treats his characters' troubles gently; this film is too buoyant to turn serious very often. Yet lighthearted as he is, Mr. Elliott conveys a deep affection for his performers and their daring. This film laughs along with its principals, never more heartily than when they laugh at themselves.

As the cattiest member of the group, Felicia (a k a Adam) gets the best gags and the most frequent opportunities for vamping. Most of Felicia's asides don't bear repeating here, and her jokes about Abba, the Swedish bubblegum group of the 1970's, may set a new standard for bad taste. Felicia (who would no doubt find that flattering) also pushes the limits of provocation when she walks, in full drag, into a rural mining town and provokes a predictably unpleasant scene.

But the few mean-spirited moments in "The Adventures of Priscilla, Queen of the Desert" are effectively defused by Mr. Elliott, whose soothing, feel-good vision is finally one of a tolerant world. The little boy who joins the cast late in the story is presented as one of the best-adjusted children on the planet.

"The Adventures of Priscilla" alternates between pit stops in unlikely places (Bernadette does an expert job of startling a crowd of drunks in one small town) and eye-catching musical numbers, which are the film's real raison d'être. The mere sight of Mr. Stamp, who is one creaky song-and-dance artist, and who manages to convey both glee and world weariness while going through his stage motions, captures this film at its most delicately droll. "Oh, I did this years ago!" this drag veteran complains about one musical routine.

Mr. Weaving, the unsettling star of Joceyln Moorhouse's "Proof," gives an equally effective performance here. He throws himself into the film's musical interludes with impossible gusto and also brings real tenderness to scenes that depict his off-stage past. One of the film's funniest moments comes when he sports a quintessentially straight outfit and establishes his masculinity by spitting for emphasis. Also immensely likable is Bill Hunter, as a heterosexual mechanic whose mail-order bride turns out to outdo Felicia when it comes to wild behavior, and who finds himself strangely attracted to Bernadette. In its own outrageous, convention-flouting way, "The Adventures of Priscilla" is sweetly old-fashioned enough to believe in happily ever after.

"The Adventures of Priscilla, Queen of the Desert" is rated R (Under 17 requires accompanying parent or adult guardian). It includes strong suggestiveness and is very graphic.

1994 Ag 10, C9:1

Down and Not at All Far From Out

"Zombie and the Ghost Train" was shown as part of the 29th New York Film Festival. Following are excerpts from Janet Maslin's review, which appeared in The New York Times on Oct. 4, 1991. The film opens today at the Joseph Papp Public Theater, 425 Lafayette Street, East Village.

Zombie (Silu Seppala), the central figure in Mika Kaurismaki's "Zom-

bie and the Ghost Train," really looks the part. With his pasty skin, dark--ringed eyes and matted black hair, he seems to have joined the ranks of the living dead, and so Mr. Kauris-maki does what he can to explain how Zombie got that way.

This Finnish film, most of which is structured as a flashback, divides it-self between observing Zombie with a cool, bemused eye and seriously con-templating the alcoholism that has contributed to his decline.

First seen living on the streets in an unspecified city (which turns out to be Istanbul), Zombie is then found six months earlier being welcomed home to Helsinki by a group of friends. He has just found his way out of the army, in a move that both the army and Zombie considered agreeable and perhaps inevitable, after Zombie expressed his unhappiness with army life by pouring turpentine into the soup while on mess duty.

What Zombie has to come home to are a girlfriend, Marjo (Marjo Lein-onen), who now has developed new interests; staid parents who don't look much older than their ravaged son, and a group of musician friends who specialize in American coun-try-and-western cachet, somewhat like that which figured in "Leningrad Cowboys Go America," a film by Mr. Kaurismaki's brother Aki. This time, the very mention of the word "Missis-sippi" in a song lyric is meant to convey something vaguely hip and humorous that doesn't travel well be-yond Finnish soil.

What do travel nicely are Zombie's perfectly deadpan manner and his

distinctively blunt approach to solv-ing problems; when irked by Marjo's new boyfriend, for example, Zombie simply marches up to him on the street and kicks him hard in the an-kle. The tough nonchalance of this is not entirely compatible with the more maudlin voice-overs that Mr. Kauris-maki allows his hero. ("I was like a sick tree whose heart was devoured by loneliness.")

"Zombie and the Ghost Train," which takes the latter part of its title from a strange rock band that's seen but never heard, divides itself be-tween quick, droll glimpses of Zom-bie's glum existence and more dis-turbing scenes that find him passed out in an alcoholic stupor. After the comedy begins to subside — Zombie can't keep a morgue job because he's afraid of corpses, or a construction job because he's afraid of heights — the film is left with a self-pitying and deeply self-destructive hero whom it still attempts to treat in fairly light-hearted fashion.

Mr. Seppala's taciturn perform-ance as Zombie makes the character disarming no matter how little he does. But eventually the hopelessness of Zombie and his situation begins to be overpowering. By the film's end, when Zombie's devoted friend Harri (Matti Pellonpaa) has followed him to Istanbul, the film has lost much of its momentum. Harri's devotion is as hard to fathom as Zombie's misery.

1994 Ag 10, C12:4

À LA MODE

Directed by Rémy Duchemin; written by Richard Morgiève and Mr. Duchemin, based on Mr. Morgiève's novel "Fausto" (in French, with English subtitles); director of photography, Yves Lafaye; edited by May-line Marthieux; music by Denis Barbier; production designer, Fouillet et Wieber; produced by Joël Faulon and Daniel Daujon; released by Miramax Films. Run-ning time: 77 minutes. This film is rated R. WITH: Ken Higelin (Fausto), Jean Yanne (Mietek), François Hautesserre (Raymond) and Florence Darel (Tonie).

By JANET MASLIN

Like fashion itself, the French film "À la Mode" depends heavily on whimsy and charm. And if proof is needed that those can be elusive virtues, it's here on screen. "À la Mode" supposes that its hero, a 17-year-old orphan with a flair for concocting odd outfits, is a delight to everyone he meets. As Fausto, Ken Higelin is earnest and lively, but he's never the adolescent dreamboat that the film describes.

Fausto's buddy, Raymond (François Hautesserre), a plump, ungainly sidekick whose specialty is flatulence on cue, has a similar charisma problem. The film follows these two after they meet in an orphanage, talk earnestly about girls for a while, and then begin work as apprentices in a Jewish section of the nearby town. Raging hormones turn this into a coming-of-age story, at least for Fausto, who becomes smitten with a pretty young woman (Florence Darel) who wears mechanic's overalls. She becomes his fashion muse, and she also fixes cars.

Fausto goes to work for Mietek Breslauer (Jean Yanne), the veteran tailor who is the film's most aggressive entertainer and whose gambits will be most successful with any audience. "Their stomachs must an-nounce proudly, 'I am dressed by Mr. Bres-lauer!' " he says, sharing with Fausto one of his tailoring secrets in making clothes for

men. Mr. Yanne brings flamboyant gusto to the film's only amusing role.

While the women of the town flutter over the irrepressible Fausto, he begins forging a tailoring style of his own. Concluding that it's

A grass jacket and a four-sleeve shirt for a certain je ne sais quoi.

good for business to make very conspicuous creations, he designs a jacket made of live grass, a shirt with two extra sleeves and other madcap extravagances. The film's cos-tume ideas — among them a wedding dress that looks like white wrought-iron lawn furni-ture, and high-fashion outfits incorporating yarmulkes and a Jewish prayer shawl — are merely nutty, as opposed to witty. They sug-gest more of a circus atmosphere than the world of Paris couture, for which the gifted Fausto is supposedly destined.

"À la Mode" is the first film directed by Rémy Duchemin, a veteran assistant direc-tor on films that include Marguerite Duras's "Nathalie Granger," Jean Eustache's "Mother and the Whore" and Joseph Losey's "Monsieur Klein." Based on a novel by Rich-ard Morgiève (who wrote the screenplay with Mr. Duchemin), it has a staid, ordinary look that seldom suits the eccentricities of this material. Little about "À la Mode" is stylish at all.

"À la Mode" is rated R (Under 17 requires accompanying parent or adult guardian). It includes brief nudity.

1994 Ag 12, C3:1

CORRINA, CORRINA

Directed and written by Jessie Nelson; director of photography, Bruce Surtees; edited by Lee Percy; music by Bonnie Greenberg; production designer, Jeannine Claudia Oppewall; produced by Ms. Nelson, Paula Mazur and Steve Tisch; executive producers, Ruth Vitale and Bernie Goldmann; released by New Line Cinema. Running time: 115 minutes. This film is rated PG. WITH: Don Ameche (Grandpa Harry), Whoopi Gold-berg (Corrina Washington), Ray Liotta (Manny Sing-er), Tina Majorino (Molly), Larry Miller (Sid), Jenifer Lewis (Jevina), Joan Cusack (Jonesy) and Curtis Williams (Percy).

By JANET MASLIN

Jessie Nelson, who wrote and directed the semi-autobiographical "Corrina, Corrina," based the title character on a 70-year-old housekeeper who helped to bring her up after her mother died. Somewhere along the way, the housekeeper became 40 years younger and the role became earmarked for Whoopi Goldberg, who inherited all the ma-terial's built-in confusion. Ms. Goldberg gives a lovely, measured performance as a woman rising to a tricky challenge. But she doesn't quite succeed in making sense of this loose-knit story.

Stylish, well-educated and skilled in the art of amateur psychoanalysis, Corrina is glar-ingly overqualified for her domestic job. But she needs the work, so she signs on with the grieving Singer family and finds herself drawn both to troubled little Molly (Tina Majorino) and to Manny (Ray Liotta), Mol-ly's lonely father. Soon Manny begins to notice this housekeeper's exceptional talents. Over dinner with the Singers, listening to a recording of Erik Satie's "Trois Gymnopé-

S. Hanover/New Line Cinema

Whoopi Goldberg

dies," she asks: "Can you imagine being so poised and having such boldness in a composition when you're only 22?" (Manny, by the way, writes jingles for Jell-O and Mr. Potato Head, among other clients.) When Manny listens to Corrina, his jaw nearly hits the floor.

In a film that proceeds as leisurely therapy-drama, Corrina's scenes with Molly provide the most tender moments. Intuitively, the housekeeper draws the little girl out of her shell and helps her to express her sorrow ("You'll always miss your Mommy, and that's O.K.") Ms. Majorino, a very poised and sturdy little actress, easily holds her own during these delicate episodes.

Less clear is the connection between Corrina and Manny, especially since the film avoids forcing them into a conventional romance. Ms. Goldberg brings a wise, worldly manner to her role, and she conveys both fondness and exasperation in her dealings with Manny. Mr. Liotta, seeming more absent and shell-shocked than the material requires, suggests that Manny has no idea what his feelings for Corrina are. The affection between them is evident, but not even by the end of her story has Ms. Nelson decided what sort of affection it is. That may be true to life, but for an otherwise mainstream movie, it's trouble.

"Corrina, Corrina" also wavers in its depiction of the racial tensions underlying the story. Set in 1959, the film ignores any whiff of prejudice until the last reel, when a few slurs and incidents are used to provoke sudden crises between Corrina and the Singers. In artificially saving these issues until late in story and then manipulating them so blatantly, Ms. Nelson only heightens the film's indecisive feeling.

Fortunately, "Corrina, Corrina" is bolstered by its two main actresses and some well-drawn secondary characters in Corrina's family (with Jenifer Lewis playing her skeptical sister, and Curtis Williams as a lively little nephew). It's also helped by hugely evocative period décor. "Corrina, Corrina" is loaded with nostalgic props, costumes, television shows, ice cream vendors, you name it. Hula-Hoops, Zorro outfits, chicken with cherries and pineapple: the charac-

ters regard these things as so ordinary that they don't even get a second look. These artifacts don't become overbearing, and they convey the repressed, fastidious cultural atmosphere in which the story takes place.

The film's score heightens the impression of Corrina's sophistication. Bill Evans, Billie Holiday, Louis Armstrong and Dinah Washington are among the musicians heard in the background, setting a cool, graceful mood for the action. Also in "Corrina, Corrina" are Joan Cusack, playing yet another nanny from hell; Wendy Crewson as Manny's predatory would-be girlfriend, and Don Ameche as Manny's father. Mr. Ameche, looking terribly fragile, isn't on camera much, but his gentle presence suggests the Singers are a deep-rooted family. He died just after completing this role.

"Corrina, Corrina" is rated PG (Parental guidance suggested). It includes mild profanity.

1994 Ag 12, C3:2

THE LAST KLEZMER

Directed by Yale Strom; director of photography, Oren Rudavsky; edited by David Notowitz; music by Leopold Kozlowski and Yale Strom; produced by Bernard Berkin; released by Malestrom Films. At the Walter Reade Theater, Lincoln Center. Running time: 84 minutes. This film is not rated.

WITH: Leopold Kozlowski

By STEPHEN HOLDEN

The propulsive Jewish folk music known as klezmer that was played by itinerant bands throughout Eastern Europe before World War II has earned many sobriquets, among them "Jewish jazz." The pumping rhythms, modal harmonies and cantorial cry of this European roots music have filtered into countless Broadway musicals. And in recent years, klezmer has gained increasing recognition in America as an essential folk tradition that distills and keeps alive the rich Yiddish culture that the Nazi death camps attempted to eradicate.

Probably no one living has done more to perpetuate klezmer traditions than Leopold Kozlowski, the subject of Yale Strom's absorbing documentary film "The Last Klezmer," which opens today at the Walter Reade Theater. A Holocaust survivor who is now in his early 70's, Mr. Kozlowski, whose original name was Leopold Kleinman, is the nephew of a noted klezmer clarinetist, Naftule Brandwein, who immigrated to the United States in the 1920's.

Before the Holocaust, there were as many as 5,000 klezmer musicians performing in Eastern Europe. Mr. Kozlowski is one of the few who survived and who has remained in Poland. An indefatigable promoter of the music, he lives in Krakow and teaches klezmer to students who are not Jewish but who regard the music as an indigenous regional style.

Klezmer is nothing less than the "soul of the people," Mr. Kozlowski declares. To perform the music correctly, he insists, requires "real Jewish humor and feeling." And in scenes in which he plays the piano and sings, he demonstrates the mixture of robust drive and intense emotionality that animates the music at its most expressive. In an enlightening musical illustration, "Hello, Dolly" is played in a klezmer style that makes

it sound exactly like a traditional Eastern European folk tune.

"The Last Klezmer" follows Mr. Kozlowski on a pilgrimage to Peremyshlyany, his hometown, south of Lvov in Ukraine. Beginning as an ebullient celebration of klezmer music, the movie gradually changes in tone, as he and a film crew visit sites of his childhood that stir up painful memories.

The heart of the movie is an oral history of Mr. Kozlowski's Holocaust experience, during which he lost both parents and his younger brother, Dulko, a gifted violinist. Visiting his father's grave in the forest outside the village, he falls to his knees and kisses the earth, weeping. At the home of his childhood piano teacher, he listens as her daughter recalls her mother's praise for his abilities. He is also joyfully reunited with a former partisan and fellow survivor whom he hasn't seen in 50 years.

Mr. Kozlowksi, who spent time in forced labor camps, reels off one horror story after another. In the saddest vignette he recalls how his brother was slain by anti-Semitic Ukrainian nationalists just one week before the arrival of the Russians.

"The Last Klezmer" is a no-frills documentary. There are no flashbacks, fancy editing or scholarly commentary. The camera crew traipses along with Mr. Kozlowski from one location to another, recording his immediate reactions to things. His memories aren't shaped into sculptured vignettes that might give them more dramatic weight. Historical gaps are filled in by a narrator.

With his mutton-chop sideburns and fondness for garlic (he demonstrates his cooking as well as his musical skills), Mr. Kozlowski emerges as an endearingly open-hearted man with a zest for life. It is clear how profoundly he is nurtured by the music he performs with such gusto.

1994 Ag 12, C6:1

IN THE ARMY NOW

Directed by Daniel Petrie Jr.; written by Mr. Petrie, Ken Kaufman, Stu Krieger, Fax Bahr and Adam Small, based on a story by Steve Zacharias, Jeff Buhai and Robbie Fox; director of photography, William Wages; edited by O. Nicholas Brown; music by Robert Folk;

A Soldier's Story In "In the Army Now," Pauly Shore plays a young man who joins the Army Reserves just for the paycheck, but soon finds himself being shipped off to war.

Kelvin Jones/Hollywood Pictures

production designer, Craig Stearns; produced by Michael Rotenberg; released by Hollywood Pictures. Running time: 91 minutes This film is rated PG.
WITH: Pauly Shore (Bones Conway), Andy Dick (Jack Kaufman), David Alan Grier (Fred Ostroff), Lynn Whitfield (Sergeant Ladd) and Lori Petty (Christine Jones).

By JANET MASLIN

Pauly Shore in a movie featuring explosives? It's a tempting thought, given Mr. Shore's track record as a smug, irritating neo-hippie character on screen. But in his third starring role (after "Encino Man" and "The Son-in-Law") Mr. Shore plays it relatively straight. As Bones Conway, a failed video salesman, Mr. Shore is seen enlisting in the Army Reserve, getting his head shaved and ending up on the battlefield. Believe it or not, he's supposed to be a leader of men.

Putting Mr. Shore under the authority of a pretty female drill sergeant (Lynn Whitfield) is, along with that bad haircut, one of this film's only ways of getting laughs. It's not exactly sure-fire. (Bones: "Let's not fight — c'mere!") Neither is the vulture-in-the-desert sight gag that recalls "Ishtar," a much funnier film than this.

Playing a reasonably smart, competent character this time, Mr. Shore winds up losing much of his novelty value. Complacent as he seems, he does have a distinctive approach to playing dim-witted. And dimness is very big this year. But Bones and his buddy, Jack Kaufman (Andy Dick), don't have enough to be spectacularly stupid about here, even if they do mix up slogans for the Navy, the Marines and the Energizer Bunny. Not even

Bones's explanation of why he signed up for a water-purification unit (because it sounded like being a pool man) is loopy enough. Too often, Mr. Shore just winds up affecting foxy diffidence, very like Bill Murray's manner in "Stripes." "Stripes" was funnier, too.

"In the Army Now," directed by Daniel Petrie Jr. ("Toy Soldiers"), uses up all of its quirky energy during an opening half-hour that sets up the premise; once Bones and his unit reach the desert, there's not much left for them to do. The diversity of this four-member group is established by David Alan Grier, giving a scene-stealing performance as a scaredy-cat dentist, and Lori Petty, a supposedly tough female soldier who winds up finding Bones adorable and wearing her T-shirt as a halter top.

Arab soldiers seen in the film are presented as witless caricatures, with one even managing to get stepped on by his camel. Those looking for political subtext in a Pauly Shore film may also be interested in this comedy's gently mocking, mostly admiring outlook on military life.

"In the Army Now" is rated PG (Parental guidance suggested). It includes profanity and sexual suggestiveness.

1994 Ag 12, C6:4

ANDRE

Directed by George Miller; written by Dana Baratta, based on the book "A Seal Called Andre" by Harry Goodridge and Lew Dietz; director of photography, Thomas Burstyn; edited by Harry Hitner and Patrick Kennedy; music by Bruce Rowland; production designer, William Elliott; produced by Annette Handley and Adam Shapiro; released by Paramount Pictures. Running time: 94 minutes. This film is rated PG.
WITH: Keith Carradine (Harry Whitney), Chelsea Field (Thalice Whitney), Joshua Jackson (Mark), Tina Majorino (Toni Whit-

ney), Shane Meier (Steve Whitney), Keith Szarabajka (Billy) and Tory the Sea Lion (Andre).

By JANET MASLIN

"The winter weather grew bleaker and so did Andre's spirits," says the narrator of "Andre" as the star (Tory the Sea Lion) acts the dickens out of this moment. Posed thoughtfully beside his bathtub, Andre twitches his whiskers, blinks his big brown eyes and offers the camera his sad, noble profile. Compared with Andre, who can also make raspberry sounds and do the Peppermint Twist, none of the human actors in this too-too-cute family film has a flipper to stand on.

Hoping for a whiff of "Free Willy," "Andre" tells of a lonely sea creature who becomes a part-time pet for animal-loving children. Little Toni Whitney (Tina Majorino), the kind of girl who waits patiently with a bucket of fish until the runaway Andre waddles back home, is the heroine of this story. Toni is part of a perky, plaid-clad Maine family that winds up making Andre a guest in their Rockport home, which is already crammed with pets like Prince Charming (a frog), Miss Cluck (a chicken) and Walter Pigeon. If you can't guess what Walter is, do yourself a favor and stay home.

Presiding over this brood is Keith Carradine as a grinning, back-slapping dad. Mr. Carradine's Harry Whitney is nominally the town's harbor master, but he behaves more like the social director on an interminable sea cruise. Mr. Carradine often seems to be saying "Well, I'll be!" and he delivers every boisterous line without nuance, as if he were playing to the cheap seats in a theater rather than a movie camera at close range. To be fair, it's not possible to be subtle with a line like "What're you tryin' to tell me, Andre?" At least not when you're talking to a seal.

Seals? We've seen them swim and bark and catch a herring or two. But

how can a seal carry a movie, even when that seal wears a tropical shirt and a beret? The answer is that there isn't much of a film around Andre, despite the fact that he is modeled on a real seal of exceptional talent. The celebrity seal at the center of this story used to make yearly marathon journeys from the aquarium, where he spent the winter, to Rockport, where he was once named Townperson of the Year by the Chamber of Commerce. However fondly it mentions Rockport, this film was shot in British Columbia.

Since the seal-related part of the story is minimal, "Andre" is loaded with filler. The Whitneys' fractious family quarrels take up screen time, and Mom (Chelsea Field) is often seen puttering briskly around the house. Holidays make for time-consuming photo opportunities. Naturally, there's Halloween.

And Toni's pet-loving nature is well established by Ms. Majorino, who's much more studiously adorable here than she is in "Corrina, Corrina." Sign of the times: "Andre," "Corrina, Corrina" and "Angels in the Outfield" are all family-oriented films that incorporate anti-smoking warnings aimed at young viewers.

"Andre" was directed in relentlessly sugary style by George Miller ("The Man From Snowy River," "Frozen Assets"), who should not be confused with George Miller ("Mad Max," "Lorenzo's Oil," "The Witches of Eastwick"), even though he easily could be. It is unlikely that the latter Mr. Miller would ever look on the sunny side of a seal.

"Andre" is rated PG (Parental guidance suggested). It includes very mild profanity.

1994 Ag 17, C9:3

Jack Rowand/paramount Pictures

Tina Majorino as a Maine girl with Tory the Sea Lion in the title role of "Andre."

DREAM GIRLS

Directed by Kim Longinotto and Jano Williams, in Japanese with English subtitles; director of photography, Kim Longinotto; edited by John Mister; produced by Jano Williams; released by Women Make Movies. At Film Forum, 209 West Houston Street, South Village. Running time: 50 minutes. This film is not rated.

Interviews by Jano Williams.

WORK ON THE GRASS

Written and directed by Tetsuo Shinohara, in Japanese with English subtitles; director of photography, Shogo Ueno; edited by Yoko Nishioka; music by Hiroyuki Murakami; produced by Tetsuo Shinohara, Akemi Sugawara and Shogo Ueno. At Film Forum, 209 West Houston Street, South Village. Running time; 42 minutes. This films is not rated.

WITH: Naoki Goto (gardener) and Hikari Ota (writer)

By STEPHEN HOLDEN

If you fused military basic training with charm school and added precision drilling in Broadway-style song and dance, you might come up with an approximation of the Takarazuka Music School, a Japanese cultural institution with a status roughly comparable to that of Miss America in the United States. The all-female school, which is the subject of Kim Longinotto and Jano Williams's film, "Dream Girls," was founded in 1914 and is near Osaka. Each year it produces a glitzy revue that suggests a demure, ritualized mixture of a Las Vegas floor show, a Ziegfeld-style Broadway extravaganza and a cross-dressed beauty pageant.

"Dream Girls," which opens today at Film Forum, is a 50-minute documentary that pointedly illustrates the ways the Takarazuka school and revue reflect Japanese puritanism and sexual politics. Depending on their vocal registers and physiques, the students are assigned to male or female roles in the school's much-admired productions. In these shows, the girls who impersonate men become the stars. Preening and gliding in formal evening wear with their stage sweethearts, they are seen as the suave romantic heroes of fantasies that suggest Astaire-Rogers movies reimagined as modern soap opera.

The revue's most ardent fans are hordes of adolescent girls who deluge the show's cross-dressed stars with love letters and tokens of affection. Their passion, while hysterical, is not strongly erotic. Older women who attend the shows regularly explain the appeal of the suave, transvestized performers, who don't seem especially masculine despite their tuxedos and slicked hair. They are fantasy alternatives to the reality of the average Japanese husband, who, the women say, is coarse, work-obsessed and unromantic.

Although the film's attitude toward the school is respectful, the movie maintains a deadpan satiric undertone. The girls' training (only 40 are accepted each year out of thousands of applicants) involves the wearing of drab uniforms and laborious cleaning chores that are supposed to teach endurance. Women who have been through the school attest that the discipline helps them be better wives. And in Japan, where feminism has had only a glancing impact on middle-class life, better means being more comfortable in a subservient role to men.

A similar questioning of the Japanese mania for discipline and order runs through Tetsuo Shinohara's "Work on the Grass," which shares the bill with "Dream Girls." In this metaphorically loaded vignette, two field workers equipped with high-powered rotary mowers spend a hot summer day cutting a vast expanse of tall grass.

One of them, Hiroshi Wakana (Naoki Goto) is an experienced worker, and the other, Shin Mayumi (Hikari Ota), a novice who hopes to be a writer. The two men clash when the novice begins botching the job. Eventually, through an exchange of lunch-time stories, the two achieve a rapprochement that has ambiguous sexual overtones.

What keeps the 42-minute movie from drifting into pretentiousness is its acute visual focus. In concentrating on the details of the work, the mechanics of the power tools, and the texture of the grass, the movie conveys a pungent sense of the physical world and the exhausting difficulty of hard labor.

Without straining very hard, the vignette abounds with resonances about the Japanese work ethic and the pressures on young people to conform in a society so rigid that 1950's America seems bohemian by comparison.

1994 Ag 17, C12:3

CAFÉ AU LAIT

Written and directed by Mathieu Kassovitz; in French with English subtitles; director of photography, Pierre Aim; edited by Colette Farrugia and Jean-Pierre Segal; music by Marie Daulne and Jean-Louis Daulne; production designer, Marc Piton; produced by Christophe Rossignon; released by New Yorker Films. Running time: 94 minutes. This film is not rated.

WITH: Julie Mauduech (Lola), Hubert Kounde (Jamal), Mathieu Kassovitz (Félix) and Brigitte Bemol (Julie).

By JANET MASLIN

A NEWS report heard at the end of "Café au Lait" makes a dire prediction: racial mixing will yield "a bastardized, impoverished race in which black and white will have no place." But Mathieu Kassovitz, the director, writer and star of the French-Belgian "Café au Lait," has a better idea. Mr. Kassovitz's film, the warmly comic story of an interracial ménage à trois, is filled with teasing epithets and stereotypes turned inside out. In homage to the American director who most often addresses racial issues, Mr. Kassovitz comes up with the unimaginable: Spike Lee Lite.

In this fond variation on Mr. Lee's "She's Gotta Have It," Mr. Kassovitz himself plays the Spike Lee role. As the clowning, bicycle-riding loser who competes for the heroine's attentions, he has an irascible screen presence something like Mr. Lee's. But one difference between this film and "She's Gotta Have It" is that Félix (Mr. Kassovitz) is Jewish, and it is black-Jewish relations at which the film steadily pokes fun. Remarks that would sound stinging in a more solemn film are

New Yorker Films
Julie Mauduech

delivered with disarming breeziness, even good cheer.

The source of all the trouble is Lola (Julie Mauduech), a beautiful, light-brown-skinned woman who is pregnant by either her white lover, Félix, or her black one, Jamal (Hubert Kounde). Like Nola, the heroine of "She's Gotta Have It," Lola is remarkably untroubled by a very complicated love life, radiating the kind of sexy, womanly serenity that's less often found in the real world than on the movie screen.

The film begins as Lola announces her pregnancy to both men simultaneously, and it follows their long-running fight for her affections. Stopping short of Mr. Lee's daring, Mr. Kassovitz keeps the teeth out of his story by avoiding frank, complicated sexual relationships on screen and sticking to a sitcom tone. Racial tensions are presented in a similarly painless style.

But the jokes come easily. ("Forget it," a black man tells scrappy little Félix at a gym, having heard that Félix's girlfriend has a black lover. "You've got no chance.") And those jokes are often rude. ("She's been through worse things," Félix's grandfather says about his grandmother, who's about to learn of the pregnancy. "She spent a year in Buchenwald.")

What raises this comedy above the level of mere insults are the close ties that develop between its three principals, and the film maker's way of making racism his broadest comic target. It makes perfect sense, in this film's topsy-turvy scheme, that Félix irritates Jamal by playing rap music and that Jamal is terrible at playing basketball.

Mr. Kassovitz even makes jokes about the absence of prejudice, in a scene where Jamal asks Julie, his blond girlfriend, to describe him; she names all his obvious characteristics but simply won't say that he's black. For all its attention to race, "Café au Lait" itself seems genuinely color-blind. It's a light, free-spirited romantic fantasy in which any form of real prejudice would be badly out of place.

With the same sort of mild, sunny bohemianism that made a hit out of "Three Men and a Cradle," Mr. Kassovitz looks at the antics of his story's ménage. In addition to amorous disputes, he also supplies enough cultural contrasts to turn this into a slender comedy of manners. Jamal comes from a distinguished family, a detail that spoils at least one of his pitches to Lola. ("Our grandparents were slaves," he says. "Your grandparents were diplomats," she answers.) Meanwhile, in Félix's middle-class Jewish neighborhood, saying, "Where's the pogrom?" is like asking, "What's your hurry?"

The rift between Jamal and Félix remains pronounced even when they join forces and compare notes about Lola. "She told me it was a class trip," says one of the suitors, recalling the time Lola took off for Rome and Athens. "I'm the class," the other says proudly. And the squabbling continues all the way to the maternity ward, where the film's title may or may not describe the baby's skin color: which man is the father, anyhow? When one candidate thinks a baby should be named David or Jacob and the other votes for Mohammed, what's the solution?

If Mr. Kassovitz's answers appear to have a Band-Aid quality at times, that, too, is the essence of his film's appeal. Maybe no mother-to-be would be as cavalier as Lola, but "Café au Lait" has a decency more profound than the sort required to settle simple questions of paternity. This new film maker, making a derivative yet immensely promising debut, imagines a world where laughter is a formidable weapon, beating out bigotry every time. That notion may be naïve, but Mr. Kassovitz makes it hard to resist.

1994 Ag 19, C1:1

KILLING ZOE

Written and directed by Roger Avary; director of photography, Tom Richmond; edited by Kathryn Himoff, production designer, David Wasco; produced by Samuel Hadida; released by October Films. Running time: 96 minutes. This film is rated R.

WITH: Eric Stoltz (Zed), Julie Delpy (Zoe), Jean-Hugues Anglade (Eric) and Gary Kemp (Oliver).

By JANET MASLIN

For the time being, Roger Avary will remain better known as Quentin Tarantino's fellow writer (on "True Romance" and "Pulp Fiction") and fellow clerk (at Video Archives, that neo-Schwab's Drugstore in Manhattan Beach, Calif.) than as the writer and director of "Killing Zoe." Mr. Avary's debut feature, fiercely ambitious but way out of control, is an orgiastically violent exercise in hand-me-down nihilism, much more firmly

October Films

Eric Stoltz

rooted in cinematic posturing than in real pain.

What has put Mr. Tarantino on the map, and does not yet work for Mr. Avary, is an ability to offset savage violence with outrageous wit, creating a vivid directorial perspective and lending that violence a moral dimension. "Killing Zoe" has the bloodshed and the pretensions down pat, but in other respects it is noticeably slack. Mr. Avary may have urged his actors, most of whom play deadly, drug-crazed bank robbers, to read "Beowulf" for its Viking excesses (according to the production notes), but he neglects the simpler and more basic demands of this story.

"Killing Zoe" tells what happens after Zed (Eric Stoltz) arrives in Paris and lazily consents to pay a call girl named Zoe (Julie Delpy) for the evening. "Sometimes you just need the honesty and security of a whore," he later explains, in a screenplay by Mr. Avary loaded with strenuous world-weariness in that vein. The film comes closest to a lasting image of Zed's precarious state of mind during this episode as Mr. Avary intercuts

Ah, the romance of Paris: prostitution, heroin, guns.

erotic images of Zoe, a Pre-Raphaelite vision, with shots of "Nosferatu" on the hotel television screen. Zed is on an interesting precipice here, but then Mr. Avary lets him fall over the edge.

Into the hotel room bursts Eric (Jean-Hugues Anglade), a wild-eyed childhood friend of Zed's. Eric is not about to let Zed slide effortlessly into the nothingness that his name suggests. He has enlisted Zed, who is a safecracker, to execute a Bastille Day bank robbery with a gang of Eric's equally druggy and volatile cronies. First Eric, who unceremoniously drags Zoe out of the shower and throws her into the hallway, wants to offer Zed a proper induction into the Parisian underworld.

So the night before the crime is spent in lurid, stoned, somewhat studious debauchery. "Before we do a job, we live life!" Eric

declares. "It's better that way, O.K.?" Living life, in this case, involves smoke, booze, heroin, Dixieland music, a series of dizzyingly distorted images, and a woman in a black bra who announces, "I need to be treated like a dog." Eric, Zed and the other gang members do their bleary-eyed celebrating in a lovingly evoked cellar nightclub, to the tune of "When the Saints Go Marching In."

The next morning, these saints march into a bank and start shooting, and "Killing Zoe" goes off the tracks. Having created some slight tension between Zed's reserve and Eric's scary flamboyance, Mr. Avary lets the film slide enthusiastically into Eric's madness, with no resistance from Zed to slow it down. In nasty episodes meant to make "A Clockwork Orange" look like a day at nursery school, the robbers don party masks, revel in the terror they've created and kill their hostages with hair-trigger petulance. In a flourish that's staged to attract particular notice, one of the robbers casually drops his cigarette butt in a pool of blood.

"Killing Zoe" isn't exceptionally violent by current standards. But it wears its excesses as a sign of daring, and it revels in a near-sexual enjoyment of the events inside the bank, turning one slow-motion shooting into an ecstatic moment that would have given Sam Peckinpah pause. These events take place within a dramatic and moral vacuum, and they reach a pinnacle of hysteria that hasn't been earned by the story's earlier developments. To make his audience feel something beyond revulsion, Mr. Avary needed to put something serious at stake here. And that he doesn't do.

The film's O. Henry touch is Zoe's presence as one of the bank hostages, but not even that is allowed to matter. Ms. Delpy's baleful, angelic face is sometimes seen glaring at the robbers, but she is pointedly overlooked until the film's final moments. Mr. Avary's use of Zoe gives the film some kind of closure, but it also suggests that "Killing Zoe" is a short story told at feature length, in the shadow of the French New Wave. So do the essentially one-note, unsurprising changes that occur in Zed and Eric as the film hurtles along.

The actors are left to indulge every possible brand of moody flamboyance, the better to suggest that these empty events have a core. More bleakly stylish than really affecting, the performances here are limited by the shallow underpinnings of the story. Mr. Stoltz's cool indifference is too often merely hip and chilly. (At one point he seems to allude to "Easy Rider.") And Ms. Delpy has a decorative, essentially passive role.

Gary Kemp of "The Krays" emerges as the most tortured and compelling of the secondary hoods. Mr. Anglade, a furiously anarchic presence, breathes disturbing life into the spectacle of Eric's disintegration. A ravaged, potentially symbolic decline, it's a spectacle that should have offered something better than cheap thrills.

"Killing Zoe" is rated R (Under 17 requires accompanying parent or adult guardian). It includes nudity, profanity and extreme violence.

1994 Ag 19, C3:1

COLOR OF NIGHT

Directed by Richard Rush; written by Matthew Chapman and Billy Ray; director of photography, Dietrich Lohmann; edited by Jack B. Hofstra; music by Dominic Frontiere; production designer, James Schoppe; produced by David Matalon and Buzz Feitshans; released by Hollywood Pictures. Running time: 120 minutes. This film is rated R.

WITH: Bruce Willis (Dr. Bill Capa), Scot Bakula (Dr. Bob Moore), Rubén Blades (Martinez), Jane March (Rose), Lesley Ann Warren (Sondra), Brad Dourif (Clark) and Shirley Knight (Edith).

By JANET MASLIN

In "Color of Night," his first film since the cult success of "The Stunt Man" (1980), the director Richard Rush has cast Bruce Willis as a thoughtful, sensitive New York psychologist. This is not so much a casting decision as a throwing down of the gauntlet, an announcement that this film's defiant follies will not be run of the mill.

Indeed, the enthusiastically nutty "Color of Night" has the single-mind-

Jane O'Neal/Cinergi Pictures

Bruce Willis

edness of a bad dream, and about as much reliance on everyday logic. Set up as a conventional cat-and-mouse thriller, it plays more like a gleefully demented campfire tale. Mr. Rush, whose eclectic résumé also includes "Getting Straight" (1970) and "Freebie and the Bean" (1974), hasn't come close to making a good movie out of "Color of Night." But he does succeed, at times backhandedly, in creating something memorably bizarre.

This film's looniness extends right to the bewildering appearance of one of its characters, who is supposed to be in mufti but whose disguise won't fool anyone, anywhere. Is this character's identity supposed to be a mystery? Or are we simply meant to enjoy the joke? Mr. Rush indulged in plenty of gamesmanship in "The Stunt Man," and in that respect he hasn't changed. The difference is that this time his material is more ordinary, and it less reasonably accommodates jokey little extravagances like this.

"Color of Night" begins when Dr. Bill Capa (a very solemn, sometimes bespectacled Mr. Willis) accidentally provokes the suicide of one of his patients, and moves to Los Angeles to forget. The screenplay (by Matthew Chapman and Billy Ray) throws in the dimly Hitchcockian idea that Dr. Capa has become unable to see the color red.

Mr. Rush has a more blunt way of emphasizing the trauma: in a bold, De Palma-like shot from below sidewalk level, the camera looks up through a sheet of glass at the victim's body lying in a pool of blood. Later on, locked up symbolically and otherwise, Dr. Capa lives in a house with a doorway resembling a keyhole. Stylistic timidity is not a problem here.

But storytelling is, once Dr. Capa arrives in California and helps to oversee the therapy group run by Dr. Bob Moore (Scott Bakula), his old friend. Each of the five patients is a fruitcake, and one of them has threatened Dr. Moore's life.

"It'll probably just blow over," says Dr. Moore, shortly before he is killed by someone wearing a fingerless chain-mail glove with a built-in dagger at the knuckles. Soon Dr. Capa, who is said to be a veritable "tuning fork" when it comes to being sensitive to his patients' personalities, is hot on the trail of the killer.

By the time that killer's identity is unveiled, "Color of Night" has turned sufficiently home-improvement goth-

ic to equip the villainous party with a nail-shooting gun. And the story's psychological pretensions have truly gone berserk. But the middle of the film keeps busy with the colorful problems of the patients (including Lesley Ann Warren as a beaming nymphomaniac, and a hilariously fussy Brad Dourif as a lawyer). It also dwells on the affair between Dr. Capa and Rose (Jane March), who first meets him by ramming into his car.

Cheerfully referring to herself as "the old fender-bender," Rose shows up in a variety of get-ups, like the ruffly apron she wears around his kitchen, sans other clothing. In a more level-headed film, Rose would strike any psychologist as A-plus patient material, but here she manages to pass as reasonably normal. Graphic, acrobatic sex scenes between Mr. Willis and Ms. March (who reveals much the same talent she displayed in "The Lover") have much more to do with this film's potential grosses than with its plot.

A subdued Mr. Willis appears to be taking "Color of Night" very seriously, which is not the best tack. Far more successful is Rubén Blades, giving the film's most flamboyantly funny performance as a police detective who simply blurts out whatever is on his mind. Examining the ornate bed of the late Dr. Moore, Mr. Blades exclaims: "Everybody's having fun but me!"

Also in "Color of Night," appearing briefly and delivering dialogue that's just as wild, is Shirley Knight. "My husband died last year," she says. "If it makes you feel better, he suffered a lot. Well, anyway, it made me feel better."

"Color of Night" is rated R (Under 17 requires accompanying parent or adult guardian). It includes gory violence, nudity, profanity and graphic sexual sequences.

1994 Ag 19, C6:1

BODO

Directed by Huang Mingchuan; written by Mr. Mingchuan and Angel Chen (in Taiwanese, with English subtitles); edited by Mr. Mingchuan and J. J. Chen; music by Tomomoto and Shi Chenlan; produced by Tzou Bukam. At the Joseph Papp Public Theater, 425 Lafayette Street, East Village. Running time: 82 minutes. This film is not rated.

WITH: Bodo (Bodo), Shi Nanhua (Kanghua), Tsai Yi (Yisan), Huang Gichi (Aki), Huang Hongbin (Yisan's father) and Lin Wenyi (Commander)

By STEPHEN HOLDEN

Huang Mingchuan's hallucinatory film "Bodo" revels in multiple meanings and blurred identities Its ambiguities begin with the title, a Taiwanese-dialect nickname for Taiwan. Bodo is also the name of the film's fictional setting, an island off Taiwan, as well as the name of one of the film's main characters and of the actor who plays him.

These name games are only the beginning of the teasing ambiguities presented by "Bodo," an audacious but confusing film, which opens the series "Thunder From the East: New Visions From China, Taiwan and Hong Kong" at the Joseph Papp Public Theater today. The series, which runs through Sept. 8, presents seven films by young independent film makers. There are four from China,

two from Taiwan and one from Hong Kong.

Also opening today is Ho P'ing's film "Eighteen," another modernist fable, with a narrative structure even more fragmented than that of "Bodo."

Rather like Taiwan itself, the island of Bodo is a military stronghold where the soldiers remain prepared for an invasion from the sea that never comes. To pass the time, the commander (Lin Wenyi) has invented a William Tell-style game in which the soldiers, using live ammunition, try to shoot beer cans off the heads of their superior officers.

The movie is narrated by Aki (Huang Gichi), a private whose dreams are literally haunted by a captain who has been shot during one of the games and who has left behind a notebook full of cryptic drawings. At night, Aki imagines that the captain is talking to him, and the drawings come to nightmarish life in his head. Aki has an obsessive crush on the captain's former girlfriend, Kanghua (Shi Nanhua), and is also involved in a gun-running operation that remodels inferior firearms and sells them to local gangsters.

The film also follows the flight of Yisan (Tsai Yi), the soldier who shot the captain and who deserts after the accident. Searching for Yisan is his eccentric father (Huang Hongbin), who finds a surrogate son in Bodo (Bodo), a drifter who is also involved in the gun-running business.

The story takes turns that are increasingly supernatural and melodramatic. Among the evocative settings visited by the film are a deserted Government housing project for aboriginals that was abandoned after a flood. The film culminates in a surreal dream sequence at a military watch tower in which soldiers' uniforms, drying in the sun, spontaneously burst into flame.

"Bodo" is a handsome but very enigmatic film that is hard to follow as it abruptly shifts from one character to another. To anyone unfamiliar with Taiwanese history and sociology, its portentous symbolism will seem frustratingly elusive.

1994 Ag 19, C6:4

A MAN IN UNIFORM

Written and directed by David Wellington; director of photography, David Franco; edited by Susan Shipton; music by Ron Sures and the Tragically Hip; production designer, John Dondertman; produced by Paul Brown; released by the I.R.S. Releasing Corporation. At Village East Cinemas, Second Avenue at 12th Street, East Village. Running time: 97 minutes. This film is not rated.

WITH: Tom McCamus (Henry Adler), Brigitte Bako (Charlie Warner), Kevin Tighe (Frank) and Henry Czerny (Joseph Riggs).

By JANET MASLIN

In the Canadian film "A Man in Uniform," opening today at Village East Cinemas, the trouble with Henry (Tom McCamus) is that he likes his work. Not his dreary bank clerk's job, but his stab at moonlighting: playing a bit part as a policeman on a lurid television show. A bashful aspiring actor, Henry begins to change dramatically once he is given a uniform, a nightstick and a new name (Flanagan). Falling in love with his tough-guy dialogue, he even finds ways to use lines like "Shut up, punk: I'll ask the questions" in his workaday world.

I.R.S. Releasing

Tom McCamus and Brigitte Bako

At first, all Henry does is to impress a casting director with the extra gusto he brings to his hot-tempered audition scene. Then Henry buys a police radio and begins showing up at crime scenes, wearing his actor's uniform and making the most of each improvisatory opportunity. "You watch too much TV, kid," a real cop finally tells him, after watching Henry overdo it with one real-life perpetrator. It hardly helps that Henry has also begun using words like "scum," "punk" and "dirt bag" at the bank.

Nor does it help that audiences will know exactly where David Wellington's flat, earnest film is headed long before "A Man in Uniform" actually gets there. Not surprisingly, Henry is bound for ever-deepening trouble, which the film documents in patient detail.

Mr. Wellington builds his story dutifully. But there's not enough madness to his method, especially in view of Henry's supposed mental deterioration. As played in nervous, mousy style by Mr. McCamus, who seems more serious than frightening, Henry remains a mild character even when the screenplay insists he is becoming dangerous.

"A Man in Uniform" has a couple of isolated, effectively eerie moments, one of them right at the start: Henry witnesses the shooting of a real policeman, and the event has a surreal, otherworldly quality that the rest of this drab film lacks. There's also a very strange bank robbery, featuring a seductive thief dressed tauntingly as Marilyn Monroe in "The Seven Year Itch." And Henry is pushed over the edge by his yearning for Charlie (Brigitte Bako), a pretty actress with a tawdry role on the same television show. "Whenever they need a slut to slap around, I seem to get the nod," Charlie tells him

If "A Man in Uniform" intends to satirize the television show's sensationalism or to link Henry's decline to a larger idea of social decadence, it doesn't make much of these opportunities. Nor does its quiet, somber style hold much dramatic interest. Blink and you may miss Henry Czerny, the sinister star of "The Boys of St. Vincent" and a scheming heavy in "Clear and Present Danger," in a brief role as a citizen Henry tries to interrogate. Henry doesn't easily fool anyone.

1994 Ag 19, C10:1

Critic's Choice

Feed a Hunger for Horror On Uncle Vincent's Treats

To some people, Vincent Price is just another B-movie actor, but to the folks at Film Forum 2 he is the official patron saint of their Annual Festival of Fantasy, Horror and Science Fiction.

A large, affectionate cult of moviegoers grew up watching Mr. Price, who died last year at the age of 82. No one was better at playing madmen oozing charm. Tim Burton, the director of "Batman" and "Edward Scissorhands," is the most visible among those who idolize Mr. Price, but the feeling is easy to understand. The audience sensed that no matter how horrific a character he played, Mr. Price was in on the joke, like a favorite uncle who told deliciously scary bedtime stories.

"Saint Vincent," a weeklong tribute to Mr. Price, begins today at Film Forum, at 209 West Houston Street in the South Village. Today and tomorrow offers a real treat: the 1959 movie "The Tingler," with Mr. Price as a scientist studying the effects of fear on the human body. When a woman literally dies of fright, Mr. Price's autopsy reveals the physical manifestation of the chill that runs up and down your spine: the Tingler, an object that looks like a giant caterpillar covered by a lobster shell. When the Tingler appears in close-up, it's hard to miss the string pulling it along.

Best of all, Film Forum will show "The Tingler" in a format called Percepto, which means the seats vibrate when Mr. Price's character yells: "Ladies and gentlemen, scream for your life! The Tingler is loose in the theater!" More comic than horrific, "The Tingler" is still a scream.

Sunday's feature is "House of Wax," with Mr. Price as a mad sculptor, shown in Film Forum's first-rate 3-D format. The Fantasy, Horror and Science Fiction series goes on through Sept. 15, featuring favorite movies from previous years' festivals. (Schedule and other information: 212 727-8110.) But this is the week that brings back the creepy fun of horror movies, and shows why Vincent Price must be looking down from above, laughing his kindly, maniacal laugh.　　　*CARYN JAMES*

1994 Ag 19, C18:1

Correction

A picture caption in Weekend on Friday with a Critic's Choice article about a tribute to Vincent Price at the Film Forum misidentified a woman shown with Mr. Price in a scene from "The Tingler," because of incorrect information provided by the theater. She was Pamela Lincoln, not Judith Evelyn.

1994 Ag 23, A2:6

BLANKMAN

Directed by Mike Binder; written by Damon Wayans and J. F. Lawton; director of photography, Tom Sigel; edited by Adam Weiss; music by Miles Goodman; production designer, James Spencer; produced by Eric L. Gold and C. O. Erickson; released by Columbia Pictures. Running time: 91 minutes. This film is rated PG-13.

WITH: Damon Wayans (Darryl Walker), David Alan Grier (Kevin Walker), Jason Alexander (Mr. Stone), Robin Givens (Kimberly Jonz) and Jon Polito (Michael (the Suit) Minelli)

By STEPHEN HOLDEN

Darryl Walker (Damon Wayans), the alter ego of "Blankman," a bumbling would-be superhero who grew up worshiping Batman, is a ditsy young inventor whose junk gadgets give Rube Goldberg's contraptions a run for their money in sheer silliness. Darryl's zany mechanical concepts

Nicola Goode/Columbia Pictures

Damon Wayans plays a befuddled do-gooder in "Blankman." He also helped write the screenplay.

extend to his appearance. His damaged eyeglasses are held up by a dinner fork that he wears tucked behind one ear.

One of Darryl's more amusing inventions is a buzzing, airborne device that looks something like a trash-encrusted model plane, whose purpose is to catch flies. After taking off, it loops noisily around and crashes into everything in sight in pursuit of its prey. Darryl's mechanical sidekick is an equally clumsy robot, who bumps into walls and tips over as it heeds electronic summonses. This thing, which has a battered old tub for a body, is crowned with bright-blue tassels and a cap.

When Darryl changes into his hilarious imitation of the caped crusader's masked disguise, he metamorphoses from the eccentric to the ridiculous. His cape looks like a tacky, patterned bedspread, his red mask a swatch of old bath towel. Around his waist he wears an absurdly unwieldy belt, which is equipped with everything from a crude two-way radio to a homemade stink bomb.

Once Blankman establishes his identity as the most inefficient, unreliable superhero ever to sweep down from the sky, he sets up shop in an abandoned subway station, which he fills with his inventions stitched together from discarded appliances. For transportation, he rattles around the subway tracks in the Blankwheel, a precarious vehicle that looks like a cross between a battered dune buggy and a flattened motorcycle.

"Blankman," which opened yesterday, gets most of its comic mileage from its wonderful gadgets and from Mr. Wayans's sweetly myopic performance. With the mannerisms of a prissy absent-minded professor, Blankman is at heart a befuddled do-gooder with an uncontrollable urge to help people.

Darryl's human sidekick and comic stooge is his brother, Kevin (David Alan Grier), who works as a cameraman for the television station WWHY. The two brothers live with their grandmother in a city that suggests a disheveled futurist hybrid of Chicago and Detroit. In the movie's negligible story, Blankman does battle with a cartoonish mobster (Jon Polito) and falls in love with a television anchor (Robin Givens).

Directed by Mike Binder, "Blankman" plays it light and silly but not so broadly that the movie collapses into chaos. The screenplay, by Mr. Wayans and J. F. Lawton, manages to get in a few choice digs at tabloid television. One of WWHY's top-rated programs is "Hard Edition." Each evening, its producer, a ranting, bald sadist in a motorized wheelchair, throws darts at a board marked with sleazy buzzwords, then combines the first three words he hits into a story.

"Blankman" is rated PG-13 (Parents strongly cautioned). It includes some profanity.

1994 Ag 20, 13:3

THE ADVOCATE

Written and directed by Leslie Megahey; director of photography, John Hooper; edited by Isabelle Dedieu; produced by David Thompson; released by Miramax Films. Running time: 101 minutes. This film is rated R.

WITH: Amina Annabi (Samira), Lysette Anthony (Filette), Jim Carter (Mathieu), Colin Firth (Richard Courtois), Michael Gough (magistrate), Ian Holm (Albertus), Donald Pleasence (Pincheon) and Nicol Williamson (The Seigneur)

By JANET MASLIN

Set in 15th-century France and featuring a dignified English cast, "The Advocate" begins with what looks like a pretty fair Monty Python moment. A man is fitted with a noose, about to be executed for having had "carnal knowledge of the she-ass here present." By his side, and also about to be hanged, is a sexually complicit donkey, since this story is set at a time when animals and inanimate objects could be tried under civil law.

When a last-minute pardon arrives, it's not for the man but for his impassive-looking consort. "She is released without stain to her character," intones a solemn magistrate (Michael Gough), who then presides over the man's execution. Decked out in face grime and a fancy array of medieval millinery, the local peasants watch eagerly as justice is done.

Unfortunately, "The Advocate" proves not to be particularly playful about such events. As an earnest, leeringly ribald foray into arcane legal history, with an emphasis on four-legged defendants, its main selling points turn out to be crassness and curiosity value. Anachronisms are also worth notice: "The Advocate" could well prompt speculation about whether early lawyers actually paced the courtroom like 20th-century television stars, or whether there were silicone breast implants during the late Middle Ages.

Miramax, this film's distributor, has tried its best to invite comparison with "The Crying Game," suggesting that "The Advocate" has a big secret in store. But in fact, for all its legal exotica, this film is so ordinary in visual style and basic story line that it holds few surprises. As for the mysterious identity of one defense client, let's just say that "The Advocate" was released in England as "The Hour of the Pig" and that its barnyard-cum-courtroom ambiance loses

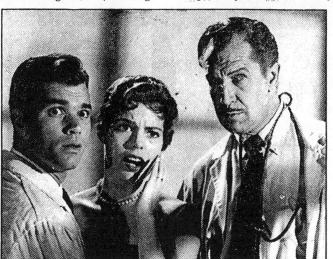

Film Forum

Vincent Price, right, in the 1959 movie "The Tingler," with Darryl Hickman and Judith Evelyn, part of a series at the Film Forum.

Colin Firth (left), a Paris lawyer who becomes a public defender in the country, with Jim Carter and Ian Holm in "The Advocate."

Miramax

novelty very quickly. An audience's enjoyment of "The Crying Game" truly depended on keeping that film's secret, but there's no comparable revelation here.

Directed·with wavering degrees of levity by Leslie Megahey, whose previous credits are in radio and television, "The Advocate" follows the adventures of its title character, a Parisian lawyer named Richard Courtois (Colin Firth), who travels to a small country town to become a public defender. Along with his idealism, he brings a remarkable assortment of hats, which come close to upstaging the finer points of the law.

The town is controlled by a sardonic, acid-tongued feudal lord (Nicol Williamson) who has bought his title thanks to great success in business and who retains such privileges as the right to preside over civil trials. The film's interest in such historical data, and in the tensions between the church's and the state's separate legal systems, is matched by equal interest in co-ed medieval bathhouses, rollicking wenches and dungeons where the prisoners are left naked.

Aided by his clerk, Mathieu (Jim Carter, providing welcome comic relief), Courtois tries to bring a crusading, grandstanding manner to local trials. His courtroom strategy leans toward lines like "the truth, as always, gentlemen, is simple," which actually suits the film's story better than it should. Despite such novel touches as rats are asked to testify (never seen on camera, they are described as "witnesses of no fixed abode"), not much about this

mystery's denouement would be out of place in contemporary Beverly Hills.

"The Advocate," which opens today, gets a high gloss from the presence of actors like Ian Holm, as a priest who contributes greatly to Courtois's worldly education, and Donald Pleasence, as the weary prosecutor who warns: "Don't grow old and tired in a place like this." Mr. Firth, a pleasantly urbane leading man, glides amiably through an assortment of colorful locals, including the feudal lord's giddy daughter (Lysette Anthony), and an accused witch (Harriet Walter), whose fate is fairly mild, under the circumstances. There's nothing of "The Devils" in this film's blithe version of medieval persecution.

Also on hand is a smoldering Gypsy lass (the Tunisian-born French singer Amina Annabi) whose presence lets the film explore the era's reigning prejudices. Every so often, "The Advocate" finds room for remarkable footnotes about the small-mindedness of its time. Rats can be summoned as courtroom witnesses, but a Jewish doctor cannot. The story, which begins in 1452, is said to take place only 30 years after cohabiting with a Jew ceased to be a capital crime.

"The Advocate" is rated R (Under 17 requires accompanying parent or adult guardian). It includes profanity, considerable nudity and sexual situations.

1994 Ag 24, C11:1

a courier without realizing that Fresh is actually quite an independent-minded little entrepreneur. The other is Sam (Samuel L. Jackson), Fresh's father, an indigent chess whiz who does what he can to discipline his son. He can't do much.

"Fresh" starts off in such a slow, deliberate style that it initially looks like nothing special, at least in dramatic terms. Is this yet another story of a sensitive young man forced to choose between good and bad role models? No, it is not: it's much more complicated, thanks to the film's portrait of Fresh as a deeply troubling character. This isn't the usual preteen innocent, nor even the standard bad seed. This is a seemingly decent kid who can sit there eating a candy bar while other people die.

As "Fresh" examines the stock ideas that usually shape such stories, it ponders the question of how fully accountable Fresh is for his behavior. The film presents an ultimately devastating panorama of Fresh's problems, to the point where his actions can only be understood in a larger context. The warring drug dealers in his community are immensely powerful, which makes it clear why Fresh has learned to get along with them. His home life, with the 11 cousins who share his aunt's apartment, offers nothing. And the violence Fresh observes is terrible. Mr. Yakin doesn't include many violent episodes in this film, but the ones he stages are made so meaningful that their impact is brutalizingly intense.

Since Mr. Yakin is white, there are bound to be those who question his drug-, violence- and prostitution-filled vision of Fresh's world. But "Fresh" cannot be mistaken for an exploitation film; it earns the right to approach this subject through the obvious thoughtfulness of Mr. Yakin's direction. Deliberately lurid elements are avoided, especially noisy ones; there's a moody, effective score by Stewart Copeland instead of loud music, and the crowded apartment where Fresh lives is as quiet as a library. The film's most brazenly decadent characters, like Mr. Esposito's sinuous Esteban, are still played with intelligence and care.

Mr. Nelson is often so blank-faced he keeps Fresh's inner thoughts opaque. Backhandedly, that becomes an advantage. Only at the end of the film, as Fresh engineers a staggering

set of human chess moves and goes on to acknowledge that his father's lessons have not been lost after all, is this boy's character fully revealed.

Mr. Yakin's pacing seems overly slow at first, but his measured style pays off in a major way. His screenplay has been written with similar care. He has also been inspired enough to hire Adam Holender, the cinematographer whose work on "Midnight Cowboy" apparently stuck in Mr. Yakin's memory. Mr. Holender does a stunning job: he makes "Fresh" extraordinarily handsome, with a sharply sunlit look that brings out the hard edges in its urban landscapes. The subject and visual style could not be more forcefully matched.

"Fresh" features delicate and sympathetic work from both Mr. Esposito and Mr. Jackson, whose fine characterizations say a lot about the originality of this film's vision. N'Bushe Wright makes a sadly affecting appearance as Nicole, Fresh's drug-addicted older sister. Although she seems barely to notice him, she becomes the essential pawn in Fresh's game.

1994 Ag 24, C13:1

NATURAL BORN KILLERS

Directed by Oliver Stone; written by David Veloz, Richard Rutowski and Mr. Stone, based on a story by Quentin Tarantino; director of photography, Robert Richardson; edited by Hank Corwin and Brian Berdan; production designer, Victor Kempster; produced by Jane Hamsher, Don Murphy and Clayton Townsend; released by Warner Brothers. Running time: 120 minutes. This film is rated R.
WITH: Woody Harrelson (Mickey), Juliette Lewis (Mallory), Robert Downey Jr. (Wayne Gale), Tommy Lee Jones (Dwight McClusky), Tom Sizemore (Jack Scagnetti), Rodney Dangerfield (Mallory's father), Edie McClurg (Mallory's mother) and Russell Means (Old Indian).

By JANET MASLIN

MEET Mickey (Woody Harrelson) and Mallory (Juliette Lewis), two renegades living out the oldest story in the teen-age wasteland. They're young, they're in love and they kill people, in thrill-crazy, rock-video style. "If I don't kill you," Mickey says to one soon-to-be victim, "what is there to talk about?" For Mickey, it's more than just a rhetorical question.

With more sophistry than poetry, Oliver Stone apotheosizes these trash archetypes in "Natural Born Killers," his supposed satire about an America despoiled by violence and exploitation. Satire? In his skill as a manipulator of thoughts and images, in his short-circuiting ordinary narrative, and in his intuitive visual brilliance, Mr. Stone could well turn out to be the most influential American film maker of his generation. But as a satirist, he's an elephant ballerina.

Scratch the frenzied, hyperkinetic surface of "Natural Born Killers" and you find remarkably banal notions about Mickey, Mallory and the demon media. ("Media's like weather, only it's man-made weather," says Mickey, delivering one of the rare memorable lines in the screenplay.) To wit: Born bad. Blame society. The sins of the fathers. Lost innocence. True love.

A Child at the Center Of a Deadly Business

"Fresh" was shown as part of this year's New Directors/New Films series. Following are excerpts from Janet Maslin's review, which appeared in The New York Times on April 1. The film opens today.

In addition to being the most commercially viable film to come out of

this year's New Directors/New Films series, Boaz Yakin's "Fresh" is likely to be the most controversial. "Fresh" is the story of the title character, an impassive black 12-year-old.

Fresh (Sean Nelson) has two important men in his life. One is Esteban (Giancarlo Esposito), the seductive drug dealer who employs him as

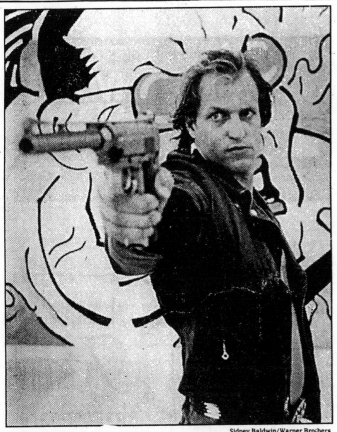

Sidney Baldwin/Warner Brothers
On the rampage in a tasteless world: Woody Harrelson as Mickey.

Wild horses, deadly rattlers, fireworks, freight trains. Elements like these would appear more honestly threadbare if Mr. Stone were not a match for Mickey and Mallory in the area of overkill.

But he has exploded the slender premise of "Natural Born Killers" (from a story by Quentin Tarantino, whose distinctive voice is not heard here) into a firestorm of quick cuts, hot colors, gyroscopic camera movements and emblematic visions. Such techniques, intensified so furiously (thanks to superb editing by Hank Corwin and Brian Berdan) that they become pharmacologically seductive, have a way of obscuring this film's more mundane troubles. Not least of them is the fact that "Natural Born Killers" is dense and unmodulated enough to be exhausting. Despite isolated moments of bleak, disturbing beauty, it is finally less an epiphany than an ordeal. Not for the first time, Mr. Stone assembles an arsenal of visual ideas and then fires away point-blank in his audience's direction. If viewers flinch during this tireless two-hour barrage, are they simply no match for the film maker's tough, unrelenting style? Or has he by now perfected his own form of exploitative fallacy? While "Natural Born Killers" affects occasional disgust at the lurid world of Mickey and Mallory, it more often seems enamored of their exhilarating freedom. If there is a juncture at which these caricatures start looking like nihilist heroes, then the film passes that point many times.

Meanwhile, how can anything Mr. Stone says about his characters be dismissed as tasteless or unfunny, since they themselves are meant to be embodiments of a tasteless world? "I Love Mallory," a grotesque sitcom version of Mallory's childhood, with

Rodney Dangerfield in stained underwear as her lecherous father, is fairly typical of the film's light touch. Arriving on the scene as the Prince Charming who will rescue Mallory by helping to murder her parents, Mickey shows up carrying a dripping 50-pound bag of raw meat.

Equally representative is an opening sequence at a roadside restaurant, where Mallory taunts the locals by writhing seductively to the jukebox, then savagely attacks a man who tries to flirt with her. At first, while this goes on, Mickey simply sits at the counter, reading a newspaper whose headline says he and Mallory have just killed six teen-agers at a slumber party.

Then he joins in, as Mr. Stone bumps up the music, switches film stock, lets the camera sway vertiginously, shows a bullet circling playfully toward the scared face of someone about to die, and so on. Grand flourish: when the spree is over, Mickey and Mallory dance together to "La Vie en Rose," with fireworks exploding romantically behind them. Mini-witticism: Mickey may have killed almost everyone in sight, but when he spoke to the waitress, he ordered nonfat milk.

Unfolding in only semi-linear fashion, "Natural Born Killers" devotes its first hour to Mickey and Mallory's rampage, interspersing lurid bloodshed with moments of eerie tenderness. (After the opening slaughter, these two find themselves in the moonlight, with a holy glow enveloping Mallory as she squats in the dirt and speaks about angels.) The couple's blood wedding, with an exchange of rattlesnake rings and Mallory's white veil drifting off into the abyss of a deep canyon, offers one of the film's most genuinely haunting visions, if only because it eludes easy understanding.

That's hardly the case with "American Maniacs," the tabloid television show starring Wayne Gale (Robert Downey Jr.), who appreciates Mickey and Mallory for their entertainment value. At one of its funnier moments, the film dwells on the show's re-enactment of their exploits, with a title that says "A Dramatization" as two actors, playing Mickey and Mallory, shoot a bicyclist identified as an American bronze medalist. Finally persuading Mickey to sit for an interview after 50 killings in three weeks, Wayne asks the inevitable question: "Any regrets?"

As played by Mr. Downey with a thick Australian accent and perfect lip-smacking unctuousness, Wayne is one of the film's more deft inventions. But he, like everything else about "Natural Born Killers," is allowed to go overboard. After their operatic arrest in a ghastly, green-lit drugstore (another of Mr. Stone's genuinely disturbing images), Mickey and Mallory go to prison and are manipulated by a leering detective (Tom Sizemore) and a publicity-happy warden (Tommy Lee Jones). Even before it culminates in an actual riot, this section of the film becomes hysterical, to the point where it even features the rare out-of-control performance from Mr. Jones.

Mr. Harrelson and Ms. Lewis deal as captivatingly as they can with the film's wavering attitudes toward their characters. Both hit the requisite raw nerves, and both also make sense of the material's occasional romantic reveries. Used in a labored effort to give this story a spiritual dimension is Russell Means, as the only character in the film whose life means anything to Mickey and Mallo-

ry. Balthazar Getty is seen briefly as a young man who gets killed at a gas station, which probably qualifies as some kind of black joke.

Mr. Harrelson looks wild-eyed and deadly during parts of "Natural Born Killers," but he is at his scariest when serenely telling Wayne that he feels possessed of a certain purity. "I don't think I'm any scarier than you are," he says. "That's *your* shadow on the wall. You can't get rid of your shadow, can you, Wayne?" The point is made even more chillingly over the closing credits, as Leonard Cohen, a true poet of doom, sings succinctly: "Get ready for the future, it is murder."

Just before those credits roll, Mr. Stone shoots himself in the foot with a quick montage of tabloid television's latest, greatest hits: the Bobbitt and Menendez trials, Tonya Harding, O. J. Simpson. For better or worse, those are spectacles that cast a long shadow. And for all its surface passions, "Natural Born Killers" never digs deep enough to touch the madness of such events, or even to send them up in any surprising way. Mr. Stone's vision is impassioned, alarming, visually inventive, characteristically overpowering. But it's no match for the awful truth.

"Natural Born Killers" is rated R (Under 17 requires accompanying parent or adult guardian). It includes strong language, sexual situations and extreme, frequent violence, of the sort that could well have warranted a tougher rating.

1994 Ag 26, C1:1

CAMP NOWHERE

Directed by Jonathan Prince; written by Andrew Kurtzman and Eliot Wald; director of photography, Sandi Sissel; edited by John Poll; music by David Lawrence; production designer, Rusty Smith; produced by Michael Peyser; released by Buena Vista Pictures. Running time: 96 minutes. This film is rated PG.
WITH: Christopher Lloyd (Dennis Van Welker), Jonathan Jackson (Morris Himmel), Tom Wilson (Lieut. Eliot Hendricks), Wendy Makkena (Dr. Celeste Dunbar) and M. Emmet Walsh (T. R. Polk)

By JANET MASLIN

What's more alone than "Home Alone"? It's "Camp Nowhere," in which a band of pre-teen-agers have the bright idea of escaping their pushy parents for the summer. While the parents contemplate various educational camps for their children ("Camp Microchippewa" is an option for the computer-conscious), the campers scrounge up enough money to rent some empty cabins and hire Dennis Van Welker (Christopher Lloyd) to pretend to be an adult. For Dennis, a good-natured, down-and-out casualty of the 60's, this is not an easy assignment.

If "Camp Nowhere" stuck to the predictable high jinks — buying toys, having pie fights, jumping off the roof onto mattresses — it would be about as welcome as poison ivy. Fortunately, there's a funny screenplay (by Andrew Kurtzman and Eliot Wald, two "Saturday Night Live" writers), good-humored direction by Jonathan Prince, and a nice young cast. Most of the actors have television experience, and they bring a sturdy, no-frills professionalism to their roles.

Best of all, this film provides a good opportunity for Mr. Lloyd, an actor who has figured appealingly in many child-oriented hits (the "Back to the Future" and "Addams

Suzanne Tanner/Hollywood Pictures

Members of the young cast frolic in a scene from "Camp Nowhere."

Family" films; "Who Framed Roger Rabbit"). This time, Mr. Lloyd gets to play a cheerful, eager burnout whose hippie past is never far behind him. Reading the label on a medicine bottle prescribed for Morris (Mud) Himmel (Jonathan Jackson), the campers' ringleader, he advises four pills every hour. But the label says one pill every four hours. "Ooh!" sighs Dennis. "Not the first time that mistake's gotten me in trouble."

Dennis will try anything to fool a bill collector (M. Emmet Walsh), the local law officer (Tom Wilson, the bully of the "Back to the Future" series) or the campers' parents. This is handy, since some of those parents think they've sent their children to military camp; some think it's diet, acting ("Shakespeare Hamlet") or computer camp ("Binary Pines"), respectively.

The film's pièce de résistance comes when the parents insist on visiting, and their children stage a complicated four-tiered visiting day. This sequence is long and amusing enough to make up for the film's slower stages. Best moment: when a sign that reads "To Saigon" for mock military maneuvers is changed to read "Miss Saigon" when the Broadway-minded parents arrive.

Smaller children may miss jokes like this, but they should enjoy the overall good humor on display. And for adults in the audience, Mr. Lloyd is a definite bonus. Trying to woo a pretty local doctor (Wendy Makkena), for instance, he invites her to dinner, pretending to be Mud's loving father. Then Mud falls asleep, and the boy becomes an inconvenient presence. Lovingly, Dennis lifts Mud, opens the cabin door and deposits him in what is supposedly a bedroom — and is actually the back porch.

Later on, confronted about this in broad daylight by the doctor, Dennis looks suitably aghast. He surveys the porch, thinks fast, and delivers the only feasible comeback: "Good lord, there must've been a tornado!"

"Camp Nowhere" is rated PG (Parental guidance suggested). It includes mildly off-color language and some smooching in its last reel.

1994 Ag 26, C3:2

Young People Adrift In Beautiful Hong Kong

"Autumn Moon" was shown as part of the 1992 New York Film Festival. Following are excerpts from Stephen Holden's review, which appeared in The New York Times on Sept. 26, 1992. The film — in English, Cantonese and Japanese with English subtitles — opens today at the Papp Public Theater, 425 Lafayette Street, East Village.

Hong Kong, with its modern skyscrapers soaring over a misty harbor framed by a spectacular mountain backdrop, is one of the most photogenic cities in the world. And it has never looked more imposingly spiffy than in Clara Law's gorgeous "Autumn Moon."

But in Miss Law's elegiac comedy, the city also symbolizes a modern world in which technology and popular culture have all but erased cultural traditions that are centuries old. In aerial shots of the city's skyscrapers, parks and beltways, Hong Kong could be any modern metropolis. The young people adrift in this environment tote expensive cameras and film equipment, eat at McDonald's and drop the names of pop stars. As they wander around, conversing in a careful, slightly broken English, they exude an uneasy melancholia that, given their ages, seems premature.

Tokio (Masatoshi Nagase), the film's world-weary young protagonist, has come to Hong Kong from Japan, looking for good restaurants, he says. When he first meets Wai (Li Pui Wai), a 15-year-old girl who lives with her aged grandmother, he is. fishing in a harbor that seems unlikely to yield much of anything. In an early conversation, he regales her with the prices of everything from his camera to his underwear. When Wai worries that in Canada, where her parents have recently moved, no one will have heard of Madonna, he assures her: "Don't worry. Madonna is everywhere." The character is also an intrepid Lothario. While in Hong Kong, he begins an affair with Miki (Maki Kiuchi), the sister of a woman he seduced and coldly dropped. Divorced and a bit older than Tokio, Miki is flawlessly beautiful, yet she keeps referring to her wrinkles and evinces a pathetic gratitude for his attentions. Tokio also encourages Wai to ask a young classmate whom she fancies out on a date. When they meet, all he can talk about are his plans to go to America and make a fortune as a computer-wise nuclear physicist.

"Autumn Moon" is more concerned with ways of looking at the world than with telling a dramatic story. Although visually magnificent, it is not especially deep or emotionally involving. Like the city itself, the characters are in transition, caught in a cultural void between East and West. Visually, the film alternates between lingering shots of the city and its environs, all photographed with an exquisite eye for composition, and the more constricted, bluish pictures of the same scenes as viewed through the lens of Tokio's movie camera.

When the characters, who seem to be perpetually at loose ends in a city that is almost empty of people, have nothing better to do, they interview one another. Beneath his suave exterior, Tokio reveals himself as a nihilist. His greatest fear, he tearfully admits, is that life is worthless.

The traditions that the modern world is sweeping away are represented by Wai's 80-year-old grandmother. The ailing old woman cooks traditional meals that seem exotic to Tokio when Wai takes him home for dinner. She also practices daily devotions in front of a Buddhist shrine in her apartment. The fading old ways are ultimately symbolized by a midautumn ceremony involving bamboo-and-paper lanterns that are set on fire and floated out on the water.

That ceremony is re-enacted by the young people in "Autumn Moon," but using plastic and light bulbs. As their electric lanterns drift away from the shore to an explosion of fireworks, one senses that a way of life is being inexorably washed out to sea with nothing to replace it.

1994 Ag 26, C8:1

WAGONS EAST!

Directed by Peter Markle; written by Matthew Carlson; director of photography, Frank Tidy; edited by Scott Conrad; music by Michael Small; production designer, Vince J. Cresciman; produced by Gary Goodman, Barry Rosen, Robert Newmyer and Jeffrey Silver; released by Tri-Star Pictures. Running time: 100 minutes. This film is rated PG-13.

WITH: John Candy (James Harlow), Melinda Culea (Constance Taylor), Ellen Greene (Belle), Ed Lauter (John Slade), Richard Lewis (Phil Taylor) and John C. McGinley (Julian)

By STEPHEN HOLDEN

What if the citizens of Prosperity, a frontier town in the Old West, got fed up with their pioneer existence and decided to head back East? And what if they chose for the leader of their wagon train a drunken tub of a man who can barely tell left from right? That is the less-than-scintillating premise of "Wagons East!," a dimwitted comedy that like the addled wagonmaster John Harlow (John Candy), who tries to lead them home, takes all the wrong turns.

"Wagons East!" has the distinction of being Candy's final film, and it is dedicated to his memory. That, unfortunately, is its only distinction. Directed by Peter Markle, from a screenplay by Matthew Carlson, this series of loosely strung-together gags is so desperate for humor that it falls back on jokes about flatulence and penis size. Candy, who was a gifted comic actor, has little to do but lumber around and act endearingly dumb.

Most of the passengers on the wagon train are contemporary urban types who find themselves way out of their element. Richard Lewis is a neurotic surgeon who has developed a phobia about wielding a scalpel, and who during the trek insists on conducting group-therapy sessions. And when he finally does pick up a scalpel, watch out!

Another traveler is a homosexual bookseller who has given up trying to peddle Jane Austen to the rough-and-ready frontiersmen at whom he is always making eyes. As played by John C. McGinley, he is a walking dictionary of stereotypically effeminate gay mannerisms. Ellen Greene plays Belle, a whore with a heart of gold, with the same Betty Boop voice she brought to "Little Shop of Horrors."

On their eastward trek, the travelers accidentally stray into Sioux Indian territory and are menaced first by a professional gunslinger and then by the United States Cavalry. Both the gunslinger, whom Ed Lauter plays as a Clint Eastwood caricature, and the cavalry are mobilized by a greedy railroad baron who sees the party's retreat as signaling a trend-setting economic threat.

Typical of the movie's humor is the moment when a bellicose young Indian protests to his father that he despises his name, which subtitles reveal means Little Feather. On the spot he is rechristened with a name that means Big Snake That Makes Women Faint. "Wagons East!" is the kind of movie that stops in its tracks every time it tries to tell a joke, and it is invariably one that is not worth repeating.

"Wagons East!" is rated PG-13 (Parents strongly cautioned). It has off-color humor and mild violence.

1994 Ag 26, C16:1

MILK MONEY

Directed by Richard Benjamin; written by John Mattson; director of photography, David Watkin; edited by Jacqueline Cambas; music by Michael Convertino; production designer, Paul Sylbert; produced by Kathleen Kennedy and Frank Marshall; released by Paramount Pictures. Running time: 110 minutes. This film is rated PG-13.

WITH: Melanie Griffith (V), Michael Patrick Carter (Frank), Ed Harris (Dad), Anne Heche (Betty), Malcolm McDowell (Waltzer) Philip Bosco (Jerry the Pope) and Casey Siemaszko (Cash)

By JANET MASLIN

For 10 sniggery minutes, "Milk Money" actually has something to do with pre-adolescent sexuality. It tells what happens when three sex-obsessed junior high school boys pool their money to raise $100, which they plan to pay some woman — any woman — for taking off her clothes.

In search of a candidate, they bicycle from their suburb to a nearby city, their faces flushed with the thrill of adventure. Richard Benjamin, laboring under the idea that this is an enchanting premise, directs such episodes as if he were Norman Rockwell in a trenchcoat.

Let's not sprain anything, although the screenwriter (John Mattson) may have, explaining how the boys happen to meet V (Melanie Griffith). She's a prostitute who happens to need $100 in the worst way. So V is easily persuaded to display brief, partial nudity, which is not shown on camera. What the audience does see is wide-eyed little Frank (Michael Patrick Carter) chomping corn chips as V, whose back is to the audience, prepares to drop the top of her dress. Frank finally doesn't look, and he doesn't have to. As it turns out, the movie's naughtiness was only a plot device to throw Frank and V together. It is gone right after this

Jon Farmer/Paramount Pictures
Melanie Griffith in "Milk Money."

"Milk Money" may be the first brainless American comedy that deserves to be remade by the French, if only because Gallic sophistication about sex would be so much more welcome than Hollywood coyness. After all, there comes a point in this story where Frank tells V, "And don't take your clothes off for money!"

What makes Frank turn puritan? The fact that he decides V would make a good wife for his widowed dad (Ed Harris). Accordingly, he tells his father that V is a math tutor, which leads Dad into unwitting double-entendres like: "Frank was telling me what you do. Do you enjoy it?" Or: "I would teach him" — Frank — "myself, but I'm way out of practice."

V, who shortened her name from Eve "because it sounded too biblical," is a movie prostitute. This is not the same thing as a woman who actually takes money for sexual favors. V is seen with only a single client, and the closest she comes to having sex with him is sitting in the back of his car, feeding him chocolate-dipped strawberries and calling him "Big Boy." Instead, she's a dreamer, the sort who secretly yearns for a simpler life and enjoys being told she resembles Grace Kelly. The movie actually manages to lob Kelly-related compliments at V on a regular basis.

As V begins cleaning up her act, she begins dressing up in the flowered frocks that belonged to Frank's mother, charming Dad and leaving her past behind. What past? This film is so darned open-minded that Frank is able to deliver this homily: "Dad, you always say it's not what you do, it's who you are."

The film may try to renounce its own tawdriness, but not Ms. Griffith; she brings a certain irrepressible gusto to her role. Among the few genuinely amusing scenes here are those that show her flouncing through the small town where Frank and Dad live, scandalizing the locals and even finding one ex-client strolling with his wife on Main Street.

Like any good movie prostitute, she wears precisely the right costume for such occasions. It's skimpy but not truly cheap, and it's hot enough to excite the fashion sense of local preteen girls. "Milk Money" seems to think a stray hooker would fascinate and charm them, even when she's

used by a proud Frank as an exhibit in biology class.

Mr. Harris manages to be improbably charming, despite the fact that his character, an amateur ecologist, is presented as one of the dimmest creatures ever to crawl out of the tide pool. This film's ending, which allows V to indulge her own heretofore-unknown ecological interests, deserves comparison with the last moments of "Indecent Proposal," a much more entertaining neo-prostitution tale. Philanthropy in such stories is a favorite way of encouraging viewers to forget what they're really about.

"Milk Money" is rated PG-13 ("Parents strongly cautioned"). It includes brief, partial nudity and sexual suggestiveness.

1994 Ag 31, C11:1

ONLY THE BRAVE

Written (In Spanish, with English subtitles) and directed by Sonia Hermán Dolz; director of photography, Ellen Kuras; edited by Andrez de Jong; music by Leo Anemaet; produced by Kees Ryninks; released by Scorpio Film Productions. Film Forum, 209 West Houston Street, South Village. Running time: 89 minutes. This film is not rated.

WITH: Justo Algaba, José González, Franklin Gutiérrez, Justo Martín, Enriqueta Martínez, Antonio Novillo, José Manuel Pacheco and Juan Ruiz

By STEPHEN HOLDEN

"Only the Brave," Sonia Hermán Dolz's handsome documentary film about bullfighting, scrupulously avoids taking sides in the controversy over the spectacle that is more than Spain's national sport. Opponents of bullfighting, none of whom are addressed in the film, regard the it as a form of animal torture. To its legions of supporters, including the breeders of the animals that are slain in the ring, it is a time-honored ritual that conflates religious and esthetic ideals with a lofty code of machismo.

The movie, which opened today at the Film Forum, lets its images speak for themselves. It shows how the bulls used in combat are bred to be hot-tempered and aggressive. Long before they enter the ring, they

are confined in pens where they are teased and prodded in order to make them more short-tempered. Once in the ring, they are goaded to charge by toreros waving capes and later by horsemen who implant barbed ornamental sticks in their withers.

The film's most brutal sequence is a quick video montage of furious carnage. This nightmare sequence is dropped into the film shortly before Enrique Ponce, the 20-year-old torero who is the film's representative bullfighter, does battle with a particularly feisty animal.

"Only the Brave" doesn't try to tell the history of bullfighting or to explain the rules of the sport. An impressionistic view, stunningly photographed by Ellen Kuras, it divides its time between following Mr. Ponce around (the film was shot two summers ago) and showing how the bulls are bred and trained. There is much talk about the mystique of bullfighting and how only a "real man" can face down the threat of imminent death posed by an angry bull. Scenes of bull branding intercut with scenes of baptism underscore its religious aura. The night before a match, Mr. Ponce is shown in church lighting candles to the Virgin Mary. He also solemnly endures a hysterical telephone call from his mother pleading with him to give up the profession.

To aficionados of bullfighting, both the torero and his animal adversary are imbued with a heroic spirit. There is high-flown talk about the mystical relationship between the bull and the torero when facing each other eye to eye. These solemn, chest-pounding disquisitions about death-defying courage have a familar ring. Ernest Hemingway used similar language to describe bullfighting in "Death in the Afternoon."

Mr. Ponce is every inch the stoic young hero. Handsome and poised, he exhibits the grace and magnetism of a great ballet dancer as he and assorted bulls do a pas de deux. The movie culminates with the match that made Mr. Ponce a bullfighting legend. At the end of a fierce duel with a particularly spirited animal, Mr. Ponce honors the bull by pardoning him and sparing his life. The crowd becomes delirious and carries Mr. Ponce out of the stadium on its shoulders.

1994 Ag 31, C14:3

A Sociological Look at Modern Life in Beijing

"The Days" was shown as part of this year's New Directors/New Films series. Following are excerpts from Caryn James's review, which appeared in The New York Times on March 29. The film opens today at the Papp Public Theater, 425 Lafayette Street, East Village.

Who knew there were slackers in China? "The Days" examines the personal boredom and professional frustration of two painters in their 20's, an unmarried couple who have been together since art school. Now teachers, they still live in a tiny apartment in Beijing more suited to students than to adults, and are stymied about the future. Xiaodong is an

intense-looking man, with large glasses and a roomful of paints and canvases. But as the narrator says, "He dreamed of nothing but being rich," and the fantasy paralyzed him. "He couldn't even paint." Xiaochun is so ready to leave the relationship and the country that she writes to relatives in New York and hopes to join them.

The film is most intriguing when it becomes a window on aspects of Chinese culture rarely depicted on screen. Some early-morning sex between Xiaodong and Xiaochun is discreet by American standards, but the scene is long and emphatic enough to be unusual in a Chinese film. And at times "The Days" effectively sug-

gests the tension between an awful past that the characters want to forget and a present that seems cut off from all meaning. Xiaochun's parents had been persecuted by her entire school when she was 16. There is no need for the film to belabor the point that when she finally goes to New York, she writes to Xiaodong without reference to their life together. In the words of the narrator, she acts "as if the past had evaporated." But "The Days," a first feature written and directed by the 29-year-old Wang Xiaoshuai, is far better as sociology than as a film. Only 80 minutes long, it nonetheless seems excruciatingly slow. Though it glancingly evokes the loose, textured feel of early Jim Jarmusch films, it is humorless and not well shot. That this is a black-and-white film about painters says more about the film's low budget than it does about the characters' or the film maker's esthetic styles

1994 Ag 31, C14:3

A SIMPLE TWIST OF FATE

Directed by Gillies MacKinnon; written by Steve Martin; suggested by the novel "Silas Marner," by George Eliot; director of photography, Andrew Dunn; edited by Humphrey Dixon; music by Cliff Eidelman; production designer, Andy Harris; produced by Ric Kidney; released by Touchstone Pictures. Running time: 106 minutes. This film is rated PG-13.
WITH: Steve Martin (Michael McCann), Alana Austin (Mathilda McCann, age 10), Alyssa Austin (Mathilda, age 5), Alaina and Callie Mobley (Mathilda, age 3), Gabriel Byrne (John Newland), Victoria and Elizabeth Evans (Mathilda age 1), Laura Linney (Nancy Newland), Catherine O'Hara (Mrs. Simon) and Stephen Baldwin (Tanny Newland).

By JANET MASLIN

It's safe to surmise that nobody but Steve Martin thinks Mr. Martin needed to appear in a lighthearted, contemporary screen version of "Silas Marner," casting himself in the role of George Eliot's lonely miser. But Mr. Martin was doubtless searching for another "Roxanne" and a role with a poignancy to match Cyrano's. So he has adapted this tale in contemporary terms, to the point where a horse in the 1861 version is now a Mercedes-Benz.

"A Simple Twist of Fate" borrows the not-so-simple twists of a novel that has been the bane of many a high school English class, and that even its author was known to denigrate. "Indeed, I should not have believed that anyone would have been interested in it but myself (since Wordsworth is dead)," she once wrote to her publisher. But what interests Mr. Martin is the redemptive love experienced by Silas Marner, a k a Michael McCann, once he stops caring about money and lets an orphaned little girl into his life.

"Silas Marner," in brief: A disgraced weaver, romantically spurned and wrongly accused of a crime, leaves the town he lives in and moves to tiny village. Living nearby is a wealthy squire whose supposedly upright son is secretly married to an opium addict. Another, no-good son has tried to blackmail his brother about this. This son also happens to rob Silas, who is known to hoard money in his cottage.

Silas is heartbroken. Time passes. Then, miraculously, Silas spies something golden in his cottage, which turns out to be the flaxen hair of a little lost girl. She is the daughter of the Squire's son and the opium addict, and she provides Silas with a chance at happiness. Not knowing her parentage, he raises the girl lovingly until, years later, her natural father tries to claim her as his own.

Melodramatic as it is, this story also has a strain of realism, which was naturally the first thing lost in translation. The social currents of 19th-century England are not easily adapted to the Virginia countryside, which is where the film takes place. And many a strange adjustment becomes necessary. One of the film's daffier choices is making the baby's natural father a local politician named John Newland, and assigning the role to Gabriel Byrne, an Irish actor struggling mightily to wrap his vowels around a thick Virginia accent. Mr. Martin, as Michael, has no accent at all.

What's craziest about "A Simple Twist of Fate" is its tone: warm and comic, with frequent dashes of fate-twisting pathos. Even allowing for the fact that this has become principally a Steve Martin vehicle, it's hard to reconcile the story's heart-wrenching moments with the scene where Michael and Mathilda, his adopted daughter, dance and pantomime to the tune of "Running Bear." This is strictly a Steve Martin "King Tut" moment, and there weren't many of those in Silas Marner's life.

The best to be said for "A Simple Twist of Fate" is that it's gentle and lively enough to hold the interest during even its rockiest moments, and that it could have been so much worse. The smartest choice made here is that of the director, Gillies MacKinnon, the Scottish film maker known for the enormous charm of "The Playboys."

That film's story was also about a strong-willed single person struggling to raise a child. And it had a pleasing, colorful sense of small-town life that is echoed here. If there was anyone who could make even partial sense of this material, it was Mr. MacKinnon, and he does his considerable best.

Mr. Martin tries hard, too, but he tries too many different modes. His comic moments, with little Mathilda playing straight man, interfere with the story's dramatic weight, while the drama bogs down the humor. In a tacked-on courtroom ending that George Eliot never imagined, he even manages to offset the tension of the moment with a practical joke. At least one preview audience seemed to be watching this film avidly but bewilderedly, never quite knowing when it was time for Mr. Martin to start clowning and do what he does best.

Also in the film is Catherine O'Hara, adding comic relief and playing a modest small-town memorabilia dealer who happens to sell Michael some very valuable gold coins. (The shadow of "Silas Marner" makes for endless farfetched touches like that one.) Stephen Baldwin disappears very quickly as Mr. Byrne's bad-boy brother, and Laura Linney makes a glamorous impression as Mr. Byrne's picture-perfect wife. Six little girls play Mathilda at ages 1 through 10, among them two talented sisters, Alana and Alyssa Austin. To his credit, and to make some sense of why this film was made at all, Mr. Martin shows off a lovely, playful rapport with these young girls.

"A Simple Twist of Fate" is rated PG-13 (Parents strongly cautioned). It includes occasional rude language and several tragic moments that might upset young children.

1994 S 2, C3:1

SALMONBERRIES

Directed and written (in English and German, with English subtitles) by Percy Adlon; director of photography, Tom Sigel; edited by Conrad Gonzalez; music by Bob Telson; production designer, Amadeus Capra; produced by Eleonore Adlon; released by Roxie Releasing. At Quad Cinema, 13th Street west of Fifth Avenue, Greenwich Village. Running time: 94 minutes. This film is not rated.
WITH: K. D. Lang (Kotzebue), Rosel Zech (Roswitha), Chuck Connors (Bingo-Chuck), Jane Lind (Noayak), Oscar Kawagley (Butch) and Wolfgang Steinberg (Albert).

By JANET MASLIN

Not even K. D. Lang's most ardent fans will find much to like about "Salmonberries," the film in which she makes an uneasy acting debut. Nor is there much to recommend the stilted direction of Percy Adlon, who also wrote the screenplay and conceived his film with Ms. Lang in mind. The likable eccentricities of Mr. Adlon's earlier works (including "Sugarbaby," "Bagdad Cafe" and "Rosalie Goes Shopping") are no preparation for the amateurishness of this one.

"Salmonberries," which opens today at the Quad Cinema, happens to have been voted best film at the 1991 Montreal Film Festival. But that says more about film festivals than it does about this halting, awkward effort. Set in a dismal little Alaskan outpost, it tells the story of Kotzebue (Ms. Lang), who looks like a feral boy and works on the Alaskan pipeline. Kotzebue doesn't say much but has clearly become fixated on Roswitha (Rosel Zech), the town's German librarian.

Early in the film, to prove she is in fact not a boy, Kotzebue shocks Roswitha by suddenly appearing naked

among the library shelves. The moment ought to have some erotic tension, but it's staged so clumsily that it raises all the wrong questions. After all, this is Alaska, and most of the actors have to deliver their lines from behind furry parka hoods. How is it possible for Kotzebue to drop all her clothes so quickly and be back in boots and snow gear only a moment later?

In any case, Kotzebue begins wooing Roswitha in very Alaskan ways. At one point, she appears on Roswitha's doorstep holding a large fish, which she intends as a friendship offering. Eventually these two become close, and they travel to Berlin together to resolve some of the problems in Roswitha's past. "Salmonberries," which takes its name from the endless jars of preserved berries that line the walls of Roswitha's bedroom (don't ask!), occasionally conveys some idea of their mutual tenderness. But it stops short of a full-fledged lesbian romance.

It happens that Ms. Zech is a real actress, best known for Fassbinder's "Lola" and "Veronika Voss." And her warmth and naturalness only emphasize Ms. Lang's discomfort in front of the camera. Mr. Adlon hardly helps by leaving these two alone in the snow for long intervals, heavily bundled and not having any idea what to do with their hands. Frequently having no notion of what to do himself, he relies excessively on the same two music cues: Beethoven's "Spring" Sonata, which is linked to memories of Roswitha's late husband, and "Barefoot," a lush, throaty love song by Ms. Lang. The song is much, much better than the movie.

Also in "Salmonberries" are a cast of nonchalant Alaskans and Chuck Connors, who plays a grizzled bingo game caller known as Bingo-Chuck. All of them are left to plow through long, empty moments and are upstaged by showy directorial touches (sharp camera angles, arty editing) at the film student level.

At one point, when Roswitha and Kotzebue walk down a Berlin street, Mr. Adlon even positions a tightrope walker on a nearby steel beam. Why a tightrope walker? All the mimes must have been busy.

1994 S 2, C12:5

RED BEADS

Directed by He Yi; written by Liu Xiaojing and You Ni (in Mandarin, with English subtitles); directors of photography, Nie Tiejun and Yu Xiaoyang; edited by Liu Xiaojing; music by Guo Xiaohong; released by Fortissimo Films. At Papp Public Theater, 425 Lafayette Street, East Village. Running time: 90 minutes. This film is not rated.
WITH: Liu Jiang (Jingsheng), Shi Ke (Jiyun) and Tian Guobin (Doctor Sha).

By CARYN JAMES

"Red Beads" opens in a nondescript Chinese restaurant with Formica tables and a loud lunchtime crowd, a scene that feels so familiar and ordinary it could be set on Mott Street instead of somewhere in Beijing. But this small, arty film quickly moves from the banal to the eerie. A young man sitting alone in the restaurant looks out a window. The next thing we know, he is at work as an orderly in the psychiatric section of a hospital. He sneakily reads the chart of a beautiful young woman and becomes intrigued by her. Eventually they become lovers, or so he imagines. Maybe she imagines it, too.

As the man moves from the bright daylight of the restaurant to the claustrophobic, hauntingly photographed hospital, this shrewd film follows a similar pattern. Soon it becomes impossible to distinguish reality from the dreams and daydreams that seem so lifelike.

This low-budget film is the first feature directed by He Yi, who has worked as an assistant to Zhang Yimou and Chen Kaige. Shot in black and white in 12 days, it is nowhere near as lush and accomplished as the work of those better-known Chinese directors. But it comes from a film maker with a powerful visual sense and the ability to make a pompous idea tantalizing on screen. "Red Beads" opens today at the Joseph Papp Public Theater as part of the series Thunder From the East.

The orderly, Jingsheng, serves meals to the woman, Jiyun, who spends most of her time combing her hair and putting on makeup. We don't understand what is troubling her, but she tells her doctor about a recurring dream: red beads are scattered all over the hospital corridor.

The red beads are never seen, because the director is uninterested in surreal dreaminess. Instead, Jiyun leaves her room, walks through a snowy yard, and turns up at Jingsheng's. An artist, he has been making pencil sketches of her face. The episode has the feel of reality, but the impossible circumstances signal that it is imaginary. When Jingsheng tells the doctor that he is dreaming of red beads, too, perhaps there has been a strange transferral of personality. Or maybe he has just been reading Jiyun's chart too much. Though the hospital and Jiyun's doctor seem sinister, the film is less about Chinese society than about the universal power of the imagination.

"Red Beads" moves slowly and can be heavy-handed. The conversations create the sense that some of the dialogue, as well as many nuances, have been lost in the subtitles' sparse English translation. But the film is saved by its eloquent photography. The repeated image of Jingsheng mopping the floor, alone in the corridor with a strange expressionistic light shining through a glass door behind him, is more eloquent than any amount of talk about red beads. The story ends back in the daylit restaurant, a startling return to the real world that suggests how completely the film has carried its viewers away.

1994 S 2, C12:5

Critic's Choice

A Boy, Drugs And Chess

As a film about a 12-year-old drug dealer in the inner city, "Fresh" may sound exploitative and even familiar. Instead, it's a devastating original, directed by Boaz Yakim with uncommon toughness and precision. Mr. Yakim's stylistic restraint is so unexpected that this film's isolated moments of violence stand out in sharp relief, as the quiet, deliberate boy named Fresh (Sean Nelson) tries to make sense of his world. The chess games that figure in the story signal the startling cunning that Fresh eventually displays.

"Fresh" features fine-tuned performances by Samuel L. Jackson and Giancarlo Esposito, as father and drug dealer, who influence Fresh more profoundly than either can realize. Not until its final moments does this film really show its hand, revealing just what has been going on behind Fresh's blank, guileless expression.

Also outstanding: Stewart Copeland's moody score and extraordinarily fine cinematography by Adam Holender, who shot "Midnight Cowboy" and has exceptional flair with urban landscapes. Mr. Holender makes this a bright, hard-edged film that's as bleak as it is coolly beautiful.
JANET MASLIN

1994 S 2, C16:4

FILM VIEW/Stephen Holden

Why Two Soundtracks Are Music to Boomers' Ears

FORGET THE HIT ALBUMS BY the Rolling Stones, Stone Temple Pilots and Counting Crows. In the pop-album sweepstakes of late summer, the runaway best sellers have been the soundtracks for the movies "The Lion King" and "Forrest Gump." The hearts of both these misty-eyed fables are in the music-driven youth culture of the 1960's, when all things seemed possible.

"The Lion King," which includes songs by the baby-boomer idol Elton John, offers gentle advice on how to prevent a divisive 1960's-style generation gap. "Forrest Gump," awash in 60's and 70's oldies, is one long sigh for lost innocence.

The cartoon portrait of the African wild in 'The Lion King" is rainbow colored and eco-friendly, and so is its music. The only threats to this harmonious environment where everyone is content with his place in the food chain are the evil, upstart hyenas. The story is a therapy-hazed variation of the parable of the prodigal son. But in this version, the disobedient child whose father died while saving his life learns to accept his royal lineage by transcending his guilt. A contemporary human parallel might be the hippie rebel growing up into an enlightened yuppie millionaire.

Hans Zimmer's musical score for "The Lion King" is an upbeat, inspirational pastiche of Hollywood symphonics and African chant. At moments, this music becomes oppressively bombastic. But it upholds the movie's fuzzy-sweet vision of harmony among all peoples and species.

■

It also helps camouflage the weaknesses of the nondescript original songs by Mr. John and Tim Rice. While the teaming of a pop superstar (Mr. John) with an old hand from Broadway (Mr. Rice) augured a promising fusion of two musical worlds, their collaboration falls far below the high standards set by Alan Menken and Howard Ashman in "Aladdin," "Beauty and the Beast" and "The Little Mermaid." The fact that "The Lion King" has become the Disney studio's biggest hit, despite its mediocre songs, is not a happy

sign for the artistic future of the animated musical.

It was just two decades ago that the success of "American Graffiti" jolted Hollywood into recognizing the commercial potential of weaving rock-and-roll classics into the fabric of a story. Since then, countless coming-of-age films have used oldies to confer instant period authenticity.

"Forrest Gump" goes much further than any previous film in its reliance on oldies to push emotional buttons. Where "American Graffiti" and that other oldies-laced blockbuster, "The Big Chill," focused on a crucial transitional moment in the life of a group of baby boomers, "Forrest Gump" telescopes the history of a whole generation by compiling the traumatic flashpoints into an anthology of singing postcards.

Surveying four decades of American life, the movie sees the procession of events from the perspective of a 60's rock fan. Every loaded media image is captioned with a vintage pop hit. The Vietnam scenes are underscored with Creedence Clearwater Revival, Jimi Hendrix and the Doors. Hippies stream westward to the strains of "California Dreamin' " and "San Francisco (Flowers in Your Hair)." Later, when the title character becomes a runner crisscrossing America, the soundtrack blares out "Running on Empty," "On the Road Again," "Against the Wind" and "Go Your Own Way."

But all too often, the music takes the place of action, filling a dramatic vacuum with instant nostalgia. At such moments, "Forrest Gump" begins to feel like nothing so much as

The scores for 'Forrest Gump' and 'The Lion King' shamelessly push a generation's emotional buttons.

a musty "March of Time" newsreel revamped for the postwar era and outfitted with a hip rock soundtrack.

"Forrest Gump" 's vision of American life is as sweetly sentimental as "The Lion King" 's view of the African wild. "Forrest Gump" 's unabashedly nostalgic use of classic rock has a lot to do with the movie's success at playing both ends against the middle in an effort to offend no one.

Forrest, who succeeds in his every endeavor despite having an I.Q. of 75, is an irresistibly likable figure whose mystique parallels that of the music that accompanies his ascent. Much like rock-and-roll itself, Forrest reconciles seemingly opposite views of the individual power in America. He is both a helpless innocent at the mercy of history and a mover and shaker who shapes events.

The myth of rock-and-roll is that it originated as a classless all-American music sprung from the soul of the common people in reaction to a genteel tradition imported from Europe. Paradoxically, rock-and-roll became profitable beyond its pioneers' wildest expectations and a potent commercial tool.

With its cyber-cinematic jokes about Forrest's influence on pop culture, the movie honors the mythic place of rock-and-roll in baby-boomer consciousness. In an early sequence, Forrest teaches Elvis Presley how to shimmy. Later, he unwittingly inspires John Lennon to write "Imagine."

These creative coups by an idiot savant reinforce the notion popular in the late 1960's that Lennon, Bob Dylan and other rock deities were fully sprung geniuses whose every utterance was gospel simply because it came out of their mouths. One of the most oft-repeated maxims of 60's pop culture held that "everybody is a star." "Forrest Gump" presents an appealingly nostalgic 90's variation on that fantasy. □

1994 S 4, II:22:1

PAUL BOWLES
The Complete Outsider

Directed and produced by Catherine Warnow and Regina Weinreich; cinematographer, Burleigh Wartes; edited by Jessica Bendiner and Amanda Zinoman; music by Paul Bowles. Running time: 60 minutes. This film has no rating. At the Cinema Village, 22 East 12th Street, Greenwich Village.
WITH: Allen Ginsberg, Ned Rorem and Mr. Bowles.

DEATH IN VENICE, CALIF.

Directed and written by P. David Ebersole. Running time: 30 minutes. This film has no rating. Also at the Cinema Village.
WITH: Nick Rafter, Shirley Knight and Rob Keith

By STEPHEN HOLDEN

When Paul Bowles was an aspiring young writer and composer visiting Paris in the late 1920's, he looked up Gertrude Stein and showed her some of his poems. One of the verses she read began, "The heated beetle pants." Stein sternly pointed out that beetles don't pant and advised him that his real talent was for prose.

Stein also insisted on calling Mr. Bowles Freddy because she felt that Paul was too romantic a name for someone who she sensed didn't have an ounce of romanticism.

These are two of many revealing anecdotes related in Catherine Warnow and Regina Weinreich's absorbing documentary film, "Paul Bowles: the Complete Outsider," which opens today at Cinema Village. Mr. Bowles, of course, took Stein's advice, all but gave up poetry, and went on to write 20 books, including "The Sheltering Sky," that made him a literary cult figure much admired by the Beats. It is only recently that the author and composer, who has lived in Tangier since the early 1950's, has begun to win wider recognition as an American literary master and composer of significance. Or in the language of Allen Ginsberg, who appears several times in the movie, he is "a caviar writer."

Although the film is just under an hour, it covers a great deal of territory with maximum efficiency. In the composite portrait that emerges from the recollections of friends and associates, Mr. Bowles comes across as contradictory, enigmatic and temperamentally cool. Shy and misanthropic, he nevertheless connected with everybody who was anybody ir the arts in the 40's, 50's and 60's. Anyone of note in the arts who was passing through Tangier visited him. As a composer, he wrote music for plays by Tennessee Williams and Lillian Hellman, worked with Orson Welles and scored a ballet for Salvador Dali.

The movie does an especially good job of evoking the texture of Mr. Bowles's complicated marriage to his fellow author Jane Auer Bowles,

who died in 1973. Although both were homosexual, they were bohemian soul mates who cared deeply for each other. It is suggested that to some extent he vampirized her work. It is also suggested that her lesbian Moroccan lover was a demonic influence on an already unstable and alcoholic personality.

At the center of the film stands Mr. Bowles, who was interviewed in Tangier. Slender, white-haired and exuding a patrician reserve, the octogenarian writer talks about his work in tantalizing riddles. "What's in the novel is not important," he observes. "It's how it's told, it's the language." He strongly disputes the popular notion that violence is a dominant theme in his writing. Only 5 of his 50 stories are violent, he says. It just happens that those stories are the most frequently anthologized.

Through smoking kif (Moroccan marijuana), Mr. Bowles says, he cultivated a form of automatic writing whose aim was to "let the subconscious take over." And well-chosen excerpts from his work that he reads accomplish that goal elegantly. The prose is spare and resonant but ultimately dispassionate. His music, for which the composer Ned Rorem makes a convincing case, conveys the same sensibility, at once Spartan and visionary.

As the movie amply demonstrates, Stein's early impressions of Mr. Bowles were accurate. He was definitely more of a Freddy than a Paul.

P. David Ebersole's short film, "Death in Venice, Calif.," which is also on the bill, is an ambitious but forced attempt to transplant the Thomas Mann novella to contemporary Southern California. In this version, the narrator, Mason Carver (Nick Rafter), is a refined scholar of romantic love, suffering from nervous distress, who visits his sister Mrs. Dickens (Shirley Knight) at her beach house in Venice. No sooner has he arrived than her hunky, raffish 18-year-old stepson Sebastian (Rob Keith), who has a very active sex life in public lavatories, throws himself at Mason.

Although handsomely photographed and well-acted, this darkly moody film tries to compact far too much story into its half-hour running time. Making the soup even thicker is a lot of heavy symbolism about the martyrdom of St. Sebastian. "Death in Venice, Calif." is watchable but wildly pretentious.

1994 S 7, C13:4

RAPA NUI

Directed by Kevin Reynolds; written by Tim Rose Price; director of photography, Stephen F. Windon; edited by Peter Boyle; music by Stewart Copeland; production designer, George Liddle; costumes, John Bloomfield; produced by Jim Wilson; released by Warner Brothers. Running time: 108 minutes. This film is rated R.

WITH: Jason Scott Lee (Noro), Esai Morales (Make) and Sandrine Holt (Ramana).

By JANET MASLIN

Venturing all the way to remote, exotic Easter Island, the makers of "Rapa Nui" try to capture the natural beauty of a place that can no longer be called unspoiled. There aren't any gas stations in evidence, but the landscape is now knee-deep in cheesy props and faux primitivism, with the sound of ridiculous dialogue lingering in the air. In its insistence on imposing the dopiest movie dramaturgy on such a pristine setting, "Rapa Nui" does its best to shrink the world.

"Rapa Nui," which takes its title from the island's original name, is no two-bit folly. Extravagantly staged, it has been directed by Kevin Reynolds in the snooze-inducing style of his "Robin Hood," though it has none of that film's star power. The biggest luminary attached to "Rapa Nui" is Kevin Costner, one of its two producers.

"We just have this little space in time that we occupy the planet and, for as bad as we are, we're trying to open our eyes," Mr. Costner has said, sounding no less lucid than the "Rapa Nui" screenplay. "And this film does that in the biggest and smallest of ways."

Another thing it does, in a regrettably big way, is to edge out Lawrence Kasdan's over-long but genuinely serious "Wyatt Earp," which starred Mr. Costner, as the movie debacle of the summer. "Wyatt Earp" had problems, but it looks awfully good compared to this.

"Rapa Nui" is itself so far from serious-ness that even its legitimate historical details have a far-fetched ring. The story centers on an authentic island custom involving an annual contest to retrieve the first eggs of the migratory sooty tern.

(Pause for a moment and imagine the story conference where this was first proposed. Now imagine that conference without mention of Mr. Costner.)

Young men of the island would swim to a nearby rock, clamber up to find birds' nests, and try to return home with intact eggs strapped to their foreheads. The victor would be given great power, and a title that in the film becomes "Birdman." Taking its cue from Easter Island's moaii, its famous elon-gated stone statues, the film also incorporates Long Ears, tribesmen with stretched ears like those on the statues, and Short Ears, an oppressed class. Short Ears are seen performing back-breaking labor while Long Ears give orders and gloat.

Allegorical possibilities abound, as do opportunities to graft banal story ideas onto the tribesmen's lives. So the film has a Long Ear Romeo in the person of Noro (Jason Scott Lee), and a Short Ear Juliet in Ramana (Sandrine Holt). Noro also has a seething, Short Ear rival named Make (Esai Morales), who was once his friend.

This leads to lines like, "We were friends once, so I'll let you live!," and, "I don't need your Long Ear handouts anymore!" With such dialogue (from a screenplay by Tim Rose Price and Mr. Reynolds), and with feathers, tattoos and topknots adorning the half-naked actors, the film has definite campy possibilities. But it's just too dull to be fun.

Occasional humor arises from the acting, since the only important casting requirement seems to have been an ability to look good in a loincloth. Actors are sweatily athletic. Actresses are topless, in a studiously innocent, National Geographic sort of way. Another source of faint merriment is the ominous rumbling that accompanies any moving of the large moaii, which look to be made out of papier-mâché. In a story that also laments the ecological rape of the island, the crowning moment is the sight of Noro hugging a tree.

More than an hour into "Rapa Nui," the film improves greatly when the actors are forced to stop talking and start hunting eggs. The dives are dramatic and perilous, the vistas genuinely lovely, and the egg-smashing pratfalls at a relative minimum. Still, there comes a moment when one of the human contestants waxes thoughtful with a sooty tern, asking the bird: "Where do you come from? Where do you go?"

Paradise lost.

"Rapa Nui" is rated R (Under 17 requires accompanying parent or adult guardian). It includes slight violence and a lot of partial nudity.

1994 S 9, C3:1

Ben Glass/Warner Brothers
Jason Scott Lee

A GOOD MAN IN AFRICA

Directed by Bruce Beresford; screenplay by William Boyd; director of photography, Andrzej Bartkowiak; edited by Jim Clark; music by John du Prez; production designer, Herbert Pinter; producers, John Fiedler and Mark Tarlov; co-producers, Mr. Boyd and Mr. Beresford; released by Gramercy Pictures. Running time: 93 minutes. This film is rated R.

WITH: Colin Friels (Leafy), Sean Connery (Murray), John Lithgow (Fanshawe), Diana Rigg (Chloe Fanshawe), Sarah-Jane Fenton (Priscilla Fanshawe), Louis Gossett Jr. (Adekunle), Maynard Eziashi (Friday), and Joanne Whalley-Kilmer (Celia)

By JANET MASLIN

A good book is the basis for "A Good Man in Africa," but its mordant humor has curdled badly on the screen. Although William Boyd, the author of these gimlet-eyed observations of colonial antics in Africa, adapted his own novel and also served as one of the film's producers, "A Good Man in Africa" now has none of the cunning that it had on the page.

The film has been directed in woefully unfunny fashion by Bruce Beresford ("Driving Miss Daisy," "Black Robe," "Tender Mercies"), whose talents ordinarily take a more quietly dramatic turn. Here, lumbering through the machinations of a fren-zied farce, he displays a comic touch that is unfailingly mirthless, and a penchant for offending his audience in needless, obvious ways. Oliver Stone looks like Ernst Lubitsch compared to this.

The real problem on screen is one of the book's best aspects: the caustic voice of its narrator, a hapless middle-level British diplomat named Morgan Leafy. As written, Leafy is furtive and hilariously withering enough to echo Kingsley Amis's "Lucky Jim," but his astuteness has been lost in translation. All that remain are the insults. And without a larger comic context, they become downright insulting. It doesn't help that this story has a zany, convoluted plot, and that the plot seems pointless without Leafy's overview holding it together.

As played by Colin Friels, Leafy becomes a smirky, unctuous figure who regards Africa as a benighted place. So while the story's British diplomats are played as stuffed shirts, and the diplomats' female relatives as sex-starved vixens, the African characters turn into buffoons. Leafy's humorous habit of insulting his black employees and black mistress is only one of the film's many obnoxious elements. It also seems to be making fun of African religion. One subplot, about the rites surrounding a female servant who has been

struck by lightning, is quite literally funny as a corpse.

Sean Connery, as the good man of the title, makes a dashing doctor in a Panama hat, but he has a terrible role. Among its highlights: examining Leafy for venereal disease, in a sequence that had some humor on the page but becomes understandably unpleasant when Mr. Beresford lingers over it on screen. Leafy's tireless womanizing, the occasion for much wide-eyed mugging from Mr. Friels, yields disease-related jokes that are all too harmonious with the rest of the film.

The only enjoyment here comes from watching isolated performances, particularly John Lithgow's supremely stuffy turn as Fanshawe, the boob who is Leafy's boss, and whose wife (Diana Rigg) and daughter (Sarah-Jane Fenton) wind up dallying with Leafy in various ways. Ms. Rigg also ought to be a welcome presence, but her role is downright humiliating, since it sends her swooning over the unappetizing Leafy. Louis Gossett Jr. has some tart, funny moments as a corrupt politician well versed in manipulating British diplomats, though Joanne Whalley-Kilmer overworks the role of his eager wife. Maynard Eziashi, a fine African actor who was the star of Mr. Beresford's "Mr. Johnson," is overlooked in the role of Leaty's servant.

Perhaps the film's most fabulously unfunny scene is one in which Mr. Friels and Ms. Rigg, in the midst of a dangerous escapade, stagger into an African bar in their tattered evening clothes. Amid an all-black clientele, these two white characters happen to find Mr. Eziashi spending a quiet moment. Without question or complaint, he abandons what he is doing and is ready to chauffeur them somewhere, while the film offers no insight into his thoughts. Anyone looking to find fault with "A Good Man in Africa" need look no further than this.

"A Good Man in Africa" is rated R (Under 17 requires accompanying parent or adult guardian). It includes nudity, sexual situations and mild profanity.

1994 S 9, C6:1

DECEMBER BRIDE

Directed by Thaddeus O'Sullivan; screenplay by David Rudkin, from the novel by Sam Hanna Bell; photography by Bruno de Keyzer; music by Jurgen Knieper; produced by Jonathan Cavendish. At the Quad Cinema, 13th Street west of Fifth Avenue, Greenwich Village. Running time: 85 minutes. This film has no rating.

WITH: Saskia Reeves (Sarah), Donal McCann (Hamilton), Ciaran Hinds (Frank), Patrick Malahide (Sorleyson), Brenda Bruce (Martha) and Geoffrey Golden (Father)

By CARYN JAMES

A woman in 19th-century dress stands on a hill, her back to the camera, looking toward the gorgeously photographed sea. She brings to mind many other enigmatic heroines in movies and novels, from "The French Lieutenant's Woman" to "The Piano." Like them, Sarah, the title character of "December Bride," embodies the flip side of Victorian repression. She is a sexual rebel, a servant in turn-of-the-century Ireland who moves into the house of two brothers, becomes pregnant, and defies anyone in their narrow community of Ulster Presbyterians to make her reveal which of the men is the child's father.

What sets this 1990 Irish film apart from others of the enigmatic-heroine school is that Sarah (Saskia Reeves) seems more willful than sensuous, her rebellion one of class at least as much as passion. She insists that her son have her name, and his existence elevates her status in the household.

Thaddeus O'Sullivan, a cinematographer directing his first feature, has smoothly overcome a thorny problem here. "December Bride" is a passionate film about people who seem uncomfortable with sex, an eloquent film about inarticulate characters.

The older brother, Hamilton (Donal McCann, best known for his role in John Huston's final film, "The Dead"), is well into middle age, and full of emotional warmth and responsibility. He is willing to marry Sarah, but she refuses.

His younger brother, Frank (Ciaran Hinds), is the handsome one. He is also the selfish one, who yells at Sarah's mother, "Remember that you are a servant in this house!" That line is among his longer speeches, and it sends the old woman packing, while Sarah remains behind with the brothers. Faced with a neat split between Frank's sexual attractiveness and Hamilton's affection, Sarah chooses both.

The secret of which brother she loves, and when, is kept from the movie audience almost as thoroughly as it is from the community. Keeping things mysterious makes sense; though her affections seem to sway from one brother to the other, the three are profoundly linked. Eventually the brothers battle each other, yet the ménage à trois stands united against a scandalized neighborhood.

Bruno de Keyzer's rich photography makes the seaside landscape look varied and stunning, from a wild storm at sea to a peaceful church garden and whitewashed thatched cottages with dim interiors. But the emotional tone of "December Bride," which opens today at the Quad Cinema, is as harsh and complicated as the lives of its characters.

The main actors are exceptional at suggesting, through looks and gestures, the complications beneath their arrangement. Ms. Reeves's stern face and manner suit Sarah's willfulness; even at her youngest and prettiest there is nothing soft about her. Mr. McCann makes Hamilton just alluring enough to entice Sarah, though his natural personality seems as dull as their old wooden table. Mr. Hinds even creates sympathy for Frank, a man whose idea of courtship is to grab Sarah without a word.

A chorus of minor characters, all acted with great impact, define the narrow world that has provoked Sarah. Early in the film, Frank and Hamilton's father (Geoffrey Golden) makes a dramatic gesture that ends his own life and influences Sarah's. Brenda Bruce, as Sarah's mother, reveals her character's sincerity even when she is maddening, trying to hector everyone back to religion. And as the minister who tries to urge Sarah and the brothers to make things right, Patrick Malahide is a

sad vision: thin-lipped, self-righteousness yet astute. "When the community are offended these are a people with hard hearts," he tells Hamilton. Hard though she seems on the surface, Sarah's heart turns out to be soft after all. At the end, the film jumps ahead 18 years. Sarah makes a grand concession to society, but she keeps more than one secret.

1994 S 9, C6:5

WHAT HAPPENED WAS . . .

Directed and written by Tom Noonan; director of photography, Joe DeSalvo; edited by Richard Arrley; music by Ludovico Sorret; production designer, Dan Ouellette; produced by Robin O'Hara and Scott Macaulay; released by the Samuel Goldwyn Company. Running time: 92 minutes. This film has no rating.

WITH: Karen Sillas (Jackie) and Tom Noonan (Michael).

By JANET MASLIN

In his small, edgy two-character film, "What Happened Was . . .," Tom Noonan aims for something universal. Charting an uneasy evening spent by two slightly acquainted people on a first date, Mr. Noonan reaches into the depths of their loneliness, letting them reveal themselves gradually over the course of an awkward dinner.

As the writer, director and leading man of this rueful drama, Mr. Noonan makes it clear that "What Happened Was . . ." is a labor of love. He shaped the film with its other star, Karen Sillas, as a workshop production with the Paradise Theater Company in the East Village, and let the characters develop in this semi-improvisatory fashion. Working in this gradual, cumulative way, he and Ms. Sillas clearly brought a great deal of care and urgency to their roles. When Mr. Noonan took his film to the Sundance Film Festival last winter, it won both the Grand Jury Prize and the Waldo Salt screenwriting award.

In light of all that, it would be gratifying to find "What Happened Was . . ." more stirring and perceptive than it proves to be. Just as Jackie (Ms. Sillas) and Michael (Mr. Noonan) want to like each other, audiences are apt to want to like this film. But Mr. Noonan, in dramatizing a story that carries a hint of romantic disappointment, generates disappointment of another kind. For all its eagerness and candor, "What Happened Was . . . " never quite rings true.

Set entirely in Jackie's apartment, where even the discordant posters on the wall indicate her uncertainty about herself, the film starts with some instantly revealing details: A banged-up cake, a bottle of wine, a few worried changes of clothes, a single message from a girlfriend on the answering machine: Jackie is a familiar figure, a single woman trying to enjoy her independence while worrying about her future. Luckily, she is rescued from stereotype by the touching and imaginative Ms. Sillas, a voluptuously physical actress who has had roles in Hal Hartley's "Trust" and "Simple Men." Ms. Sillas turns Jackie's yearning into something palpably real.

Enter Michael, a tall, gaunt, faintly ghoulish man whom Jackie has met at the law office where she works as an executive assistant. ("Is that what they call the secretaries?" Michael asks.) He is an aging paralegal.

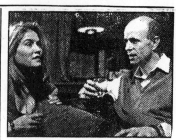

The Samuel Goldwyn Company

Karen Sillas and Tom Noonan.

("They call you Mr. Strange," Jackie tells him.) They have supposedly met and flirted a bit at the office, but for the film's dramatic purposes they start out as near-strangers. Only gradually do they reveal basic biographical facts about their lives.

Over the course of dinner and its aftermath, they get to know each other while the layers of artifice fall away. Michael's early shyness turns out to be laced with bitterness, much of it directed at the law partners in the office, about whom he is secretly writing a book. There's an education gap between Jackie, who likes Deep Purple and has a Queens accent, and Michael, who went to Harvard and found it "totally racist and sexist and corrupt." Jackie is impressed by that, and Michael is equally impressed, in a very different way, with the children's story Jackie has written. Late in the evening, she reads him a long, amazingly violent tale featuring a car crash and topless go-go dancers, a fable that seems intended as a pièce de résistance for the film.

Although the progress of the evening appears to follow a loose outline, the dialogue is otherwise unstructured, sounding all too lifelike at times. The actors stammer, repeat themselves and speak with the awkwardness of real people. ("You know when there's something you gotta do, you just gotta do — you know what I mean?") At the same time, they fall into the solipsism of an actors' exercise, never quite escaping their individual characters, never quite connecting in ways that might color a real exchange between two strangers. Mr. Noonan supplies certain larger revelations for the film's denouement, but it's the smaller insights that are missing.

The high point of the film comes late, from Ms. Sillas, whose character is by far the sturdier and more wrenching of the two. In an intense, heated monologue, she finally articulates the powerful desperation that is at this film's heart. "You finally grow up, you figure out who you are, and just when you've got something interesting to say, they're not interested anymore!" she exclaims. The film doesn't get any more sadly trenchant than this, and it doesn't reach this peak at other moments.

Mr. Noonan, best known for villainous roles (as in "Robocop 2," in which he had his brain removed), is a more elusive presence here. "I'm not like a lot of people," he says, as Michael. "My face doesn't have much to do with what I'm feeling." Michael, who thinks he hears a secret message in one Beatles record, may actually be the more real and troubling of this film's two lonely characters, but his is the more difficult role. In performance, as in the rest of this film, Mr. Noonan only haltingly captures what he seeks.

1994 S 9, C16:4

YOUNG BLACK CINEMA II

A series of nine shorts by various directors. At the Papp Public Theater, 425 Lafayette Street, East Village. Total running time: 120 minutes. These films have no rating.

By STEPHEN HOLDEN

"Notes in a Minor Key," the most confident of the nine short films being shown in a new anthology, "Young Black Cinema II," tells a story of sibling rivalry between young musicians in a style that is as crisply assured as the Louis Jordan-style jazz that infuses the movie with a swinging buoyancy.

When a teen-ager accidentally discovers his grandfather's saxophone, it opens up a painful chapter of family history that had been kept secret. It turns out that in the 1940's, the grandfather, Kansas (Keith David), and his brother, Teddy (Harry Lennix), played together in an up-and-coming Harlem jazz band. Most of the film is an extended flashback in which Kansas recalls the devastating consequences of his own professional and sexual envy of his more talented brother.

The best moments in the film, which was directed by Adisa from a screenplay by Avery O. Williams, evoke the night life of Harlem in the late 1940's with a smoldering ferocity. It is a world of hot music, wild women and drugs, all combining to fuel the characters' desperate, inchoate ambitions. Sooner or later, the lid has to blow, and when it does, the consequences are dire.

"Notes in a Minor Key," which has strong original music by Bobby Thomas and Kevin Dorsey, is tightly constructed and well-acted. Its story is framed in a way to make it a cautionary tale offered from one generation to another.

Among the other films in the anthology, which opens today at the Joseph Papp Public Theater, Austin Phillips's "Familiar Differences" is equally impressive, although not as polished. This story of an unemployed man trying to establish a relationship with his illegitimate 6-year-old daughter is a revealing case study that explores the paternal rights of unwed fathers.

The main character, Sonny Davis (Jaime Perry), is caught in a frustrating bind. Because the mother of his daughter refuses to acknowledge his paternity, the courts refuse to grant him the right to visit the child. When he breaks the law by visiting, he is briefly thrown in jail. In desperation, he takes his case to court; the judge orders blood tests, which confirm his paternity. But to see his child, he must agree to pay child support, and he is unemployed. Sonny's position, which the film implies is shared by thousands of unwed inner-city fathers, is extremely precarious. With decent jobs hard to come by, drug-dealing looms as an easy, if ultimately disastrous solution to his problems.

Mr. Phillips's film is admirably even-handed in depicting the love-hate relationship of Sonny and his daughter's mother, who, infuriated by the court's decision, takes drastic action. Although the storytelling and acting seem too methodical at times, "Familiar Differences" finds a smooth and convincing mixture of drama and sociology.

Racism and racial paranoia are the subjects of Robert Patton-Spruill's "Gaming Table" and Lewis Payton's "Slowest Car in Town." In "The Gaming Table," which updates Amiri Baraka's play "The Dutchman" to New York City's after-hours club scene, a vicious white woman tries to seduce a genteel black man by baiting him with epithets that are degrading and sexually charged. The central character of "Slowest Car In Town" is a black corporate executive descending in an elevator who fantasizes that the other passengers see him as a series of scary low-life stereotypes.

Anaye Milligan's "Downtown With the Cat" is a succinct little melodrama about a terrified young man whom mobsters recruit to be a hit man. Other films in the anthology include Dwight Smith's animated, updated spoof of "Samson and Delilah"; Kimson Albert's crude graffiti-style animated evocation of teen-age violence in schools, "How Can I Be Down?," and "The Hardest Part," an easygoing vignette about teen-age romance, directed by Michael Dennis. The most stylish of the shorter films is "Hung Up," directed by Pat Hartley, the only woman among the nine film makers. Her movie is an amusing vignette in which a technologically jinxed phone call reveals the insecurities of a shaky domestic partnership.

If "Young Black Cinema II" is an uneven collection, even the crudest films in the anthology reveal some film-making talent. Which film makers go on to have significant careers will depend to a large degree on which ones receive the most financial support. Judging from this program, Adisa, Mr. Phillips and Ms. Hartley have a head start.

1994 S 9, C17:1

TRIAL BY JURY

Directed by Heywood Gould; written by Jordan Katz and Mr. Gould; director of photography, Frederick Elmes; film editor, Joel Goodman; music by Terence Blanchard; production designer, David Chapman; produced by James G. Robinson, Chris Meledandri and Mark Gordon; released by Warner Brothers. Running time: 108 minutes. This film is rated R.

WITH: Joanne Whalley-Kilmer (Valerie), Armand Assante (Pirone), Gabriel Byrne (Graham), William Hurt (Vesey)

By CARYN JAMES

There are two schools of thought about serving on a jury. One side holds that it's a civic responsibility; the more cynical view is that no one should be judged by 12 people who aren't smart enough to get out of jury duty. In the supposed thriller "Trial by Jury," Joanne Whalley-Kilmer plays Valerie, a woman who starts out in the first camp, much to the derision of all her friends. A single mother and owner of a vintage clothing store, she could get out of jury duty in a flash. But she's so responsible she's even willing to judge a mob boss named Rusty Pirone (Armand Assante). Does anyone have to be told she lives to regret it?

Pirone is conspicuously guilty, but even after he has one witness killed — a stoolpigeon called Limpy Demarco — the prosecutors blackmail another former associate into testifying. What's a mobster to do? He threatens the idealistic Valerie, of course. If she wants her son to live, she will vote to acquit Pirone.

This premise sets up the audience for a taut psychological game. What we get instead is a chance to hear some first-rate actors practice their tough-guy accents. Gabriel Byrne plays Graham, the prosecutor determined to get Pirone because they share a similar background. As the mobster tells him in court: "I forgot. There's another Brooklyn boy here who made good." That's the way people in this movie talk.

William Hurt, cast against type, plays Vesey, a sleazy rumpled former policeman who now works for Pirone. It is his job to keep Valerie in line. The movie telegraphs most of the plot, including the fact that he is her designated savior. A hit woman who finds Vesey irresistible observes his reaction to Valerie. "Admit it, Vesey, that chick turns you on," she says. Ms. Whalley-Kilmer smartly underplays the role of "that chick."

But all these actors together can't outwit a flabby script and a sluggish pace. Directed by Heywood Gould, whose last film was "One Good Cop," "Trial by Jury" is predictable when it should be suspenseful, slick when it should be gritty. Valerie may not have been smart enough to get off jury duty, but is there any doubt she'll find a way to outwit the mob? As she does, "Trial by Jury" becomes less and less plausible. As Pirone says, "I'm the guy that falls into a sewer and comes out with his pants pressed."

"Trial by Jury" is rated R (Under 17 requires accompanying parent or adult guardian). It includes several murders and suggested, off-camera rape.

1994 S 10, 14:5

THE NEXT KARATE KID

Directed by Christopher Cain; written by Mark Lee; director of photography, Laszlo Kovacs; edited by Ronald Roose; music by Bill Conti; production designer, Walter P. Martishius; produced by Jerry Weintraub; released by Columbia Pictures. Running time: 104 minutes. This film is rated PG.

WITH: Noriyuki (Pat) Morita (Miyagi), Hilary Swank (Julie Pierce), Michael Ironside (Dugan), Constance Towers (Louisa), Michael Cavalieri (Ned)

By STEPHEN HOLDEN

"Fighting not good: someone always get hurt," Noriyuki (Pat) Morita declares in his role as a Japanese karate master who turns 17-year-old Julie Pierce (Hilary Swank) into a teen-age lethal weapon in "The Next Karate Kid."

That saying is one of many pseudo-Zen Buddhist platitudes that the character, Miyagi, drops every two or three minutes in what may be the silliest episode yet in the popular "Karate Kid" series.

When Miyagi gets his hands on Julie, she is a sullen high school student who is still hurting from the recent death of her parents in a car accident. Her only consolation is a wounded bird named Angel that she secretly (and improbably) tends in a cage on the roof of her high school. Julie's high school is one of the oddest such institutions to be shown in a Hollywood film. With the school's apparent approval, a monstrous teacher named Colonel Dugan (Michael Ironside) brutally trains a group of boys called the Alpha Elite to keep order in the hallways. If a student is spotted so much as dropping a candy wrapper on the floor, an Alpha Elite officer can force him to pick it up and eat it. The colonel's star pupil, Ned (Michael Cavalieri) is a sadistic bully with an obsessive desire to rape Julie, although the PG-rated movie leaves his specific intentions verbally unstated.

"The Next Karate Kid," which opened yesterday, doesn't even try to achieve surface credibility. Under the patient ministrations of Miyagi, Julie metamorphoses from an angry tomboy into a loving, disciplined beauty in a matter of weeks. In one of the goofiest scenes, he uses karate moves to teach her how to waltz just in time for the prom.

The turning point in her education is a visit to a Zen monastery tended by roly-poly monks who bake her a birthday cake and do line dancing to her rock-and-roll records. Not long after her visit, the monks take a break from the monastic life and go to a bowling alley where they wow a bunch of Boston suburbanites by knocking down pins with their eyes closed.

Hilary Swank, an actress who suggests a much younger Sandra Bernhard, makes an appealing debut as Julie. But in its attitude toward violence, the movie is duplicitous. Forgetting Miyagi's advice about fighting not being good, the movie doesn't let Julie win her ultimate self-esteem until she has succeeded, in her words, in "kicking some butt."

"The Next Karate Kid" is rated PG. (Parental guidance suggested.) It has moderately brutal fight scenes and strong suggestions of sexual menace.

1994 S 10, 14:5

QUIZ SHOW

Produced and directed by Robert Redford; written by Paul Attanasio, based on the book by Richard N. Goodwin; director of photography, Michael Ballhaus; film editor, Stu Linder; music by Mark Isham; production designer, Jon Hutman; released by Hollywood Pictures. Running time: 120 minutes. This film is rated PG-13.

WITH: Hank Azaria (Albert Freedman), Ralph Fiennes (Charles Van Doren), Rob Morrow (Dick Goodwin), David Paymer (Dan Enright), Paul Scofield (Mark Van Doren) and John Turturro (Herbert Stemple).

By JANET MASLIN

The brilliantly unsettling prologue to "Quiz Show" is a seduction scene in an automobile showroom, with a shiny new Chrysler working its wiles upon a wary young man. The car promises late 1950's-style perfection, but its allure is undercut by an air of sleek unreality and a hint of danger. The salesman looks uneasy. The car's radio mentions Sputnik. The film's soundtrack, delectably sinister, accompanies the opening credits with "Mack the Knife."

"Hey," says the customer, aptly anticipating what will follow. "I thought it used to be the man drove the car. Now the car drives the man."

Confronted by that Chrysler as a symbol of false values and misplaced optimism, the audience faces the most salient aspect of the American dream: that we had to wake up. "Quiz Show," a supremely elegant and thoughtful parable about that awakening, transcends its narrow time frame and resonates with a piercing disillusionment that dates back to the events described here, and has not gone away.

As directed with quietly dazzling acuity by Robert Redford, "Quiz

Show" offers a portrait of slipping standards, delicate lies and a sensation-loving public that may genuinely prefer such falsehoods to the truth. "We're going to go right on watching," one fan blithely told Life magazine, even after it had been revealed that rigged quiz shows taxed contestants' acting ability instead of their much-vaunted brainpower.

Greatly surpassing the polite excellence of his past work, Mr. Redford has made a rich, handsome, articulate film about a subject truly worth talking about. He captures the full scope of a fascinating, overlooked story, also adding something of his own. Like Clint Eastwood, Mr. Redford now takes a lifetime's worth of experience as an American icon and uses it as a mirror, reflecting the culture that chose to lionize him. If America's daunting ideas about manhood are what Mr. Eastwood knows best, Mr. Redford understands the adoration and envy accorded its golden boys, its easy winners, including the exemplary one who is his film's fallen hero.

The nominal focus of "Quiz Show" is the patrician, erudite Charles Van Doren (Ralph Fiennes), whose string of canned victories on "Twenty-One" once riveted the nation. He is seen in pointed contrast to the other main characters: Herbert Stempel (John Turturro), the wild-eyed, nontelegenic contestant whom he unseats; Dick Goodwin (Rob Morrow), who investigates the quiz show scandal for Congress, and Mark Van Doren (Paul Scofield), the literary lion whose reputation casts a long shadow over his son.

Charlie is also contrasted with the television talent that winds up shaping his fate, including Jack Barry (Christopher MacDonald), the professionally suave host of "Twenty-One." Glimpsing the authentically refined Charlie for the first time at NBC's offices, Barry asks amazedly, "Why would a guy like that want to be on a quiz show?"

That's the $64,000 question. The film's answer is clearest during a bravura garden party set in Connecticut, where Mark Van Doren's birthday is being celebrated by family and friends. The latter group includes Thomas Merton and Edmund Wilson (presented with perfect casualness by Mr. Redford), and the conversation runs to erudite quips and quotations from Shakespeare. But the young women at the table are more interested in asking Charlie about Dave Garroway, the "Today" show celebrity. And everyone's ears prick up at the mention of Charlie's substantial winnings.

Charlie, enjoying a family supremacy that has not been his before, then presents his father with a television set, something the senior Van Dorens have never owned. Mr. Redford and Paul Attanasio, who wrote the perceptive screenplay, suggest just how easily a television-based culture will sweep this world away.

If Charlie is the film's supposed center, he also poses a dramatic problem. Even without knowing the facts that shape this story, viewers will sense that some figures, who either are dead or cooperated with the film makers, lend themselves to more dramatic license than the reclusive Mr. Van Doren, who has refused to talk about these events and remains out of reach. The film has a fine idea of how the Van Dorens' genteel father-son rivalry might have contributed to Charlie's cheating, but it's barely plausible about the other particulars of his life. (Not men-

tioned: that he married a woman he had hired to answer fan mail.)

So the role is thin, but Charlie still successfully embodies something Mr. Redford himself has conveyed as an actor: that when golden boys elicit special treatment, they are left with a special sense of failure. "I have flown too high on borrowed wings," Charlie says ultimately, making his extraordinary confession to a Congressional committee. "Everything came too easy. That is why I am here today."

Nothing comes easily for Herbert Stempel, played with such glee and fury by the scene-stealing Mr. Turturro that he becomes the film's most magnetic figure. An improbable television star as the story begins, he wears a look of frenzied disbelief as the quiz show's masterminds throw him overboard. ("I guess the sponsor wants a guy on 'Twenty-One' who looks like he could get a *table* at '21,'" someone acknowledges early in the story.)

In a restaurant scene that is another of this film's high points, Stempel loses his fragile composure when told by Dan Enright (David Paymer), the show's producer, that he is expected to lose in a particularly em-

One golden boy tells the story of another who fell from grace.

barrassing way. As Stempel grasps the full extent to which the Van Dorens of this world will always outdo him, the camera (beautifully handled by Michael Ballhaus, in a film of deep, burnished colors) gives the moment an added cruelty by simply gliding away.

Mr. Redford, always a fine director of actors, elicits knowing, meticulous performances. One hallmark of this film's high caliber is that its smaller performances are impeccable. There are memorable cameos from Barry Levinson as Dave Garroway and Martin Scorsese as the quiz show's cool, ruthless sponsor. Allan Rich, as NBC's president, has the gruff assurance of a real executive, and all of the principals' family members look and sound right.

Among the principals, Mr. Fiennes sometimes appears to be working in a vacuum as the bland, idealized Charlie, who can be as dreamily pretty as an old-fashioned crooner. But he is brought into focus by his razor-sharp scenes with Mr. Scofield, and by the memory of "Schindler's List," which underscores his astonishing range. Mr. Scofield is a marvel, managing in one brief performance to convey so much about an American as particular as Mark Van Doren, and so much that is universal between accomplished fathers and their sons.

Mr. Morrow faces a difficult job, since the film ascribes too much crusading nobility to Mr. Goodwin, and since Mr. Redford's own acting career has helped make the heroics of the lone investigator look so familiar. But the performance is vigorous, and when the film sets Goodwin between Stempel and Van Doren, it touches currents of anti-Semitism, self-deception and golden-boy quicksand that once again lift it out of the ordinary.

Also deserving special mention are Johann Carlo as the long-suffering

Mrs. Stempel and Hank Azaria, as the NBC executive who makes a comic foil to Mr. Paymer's grim Enright. Together, these two lure Van Doren into his Faustian deal. But "Quiz Show" is too good to make them easy villains. "I've learned a lot about good and evil," Charlie finally tells Congress. "They're not always what they appear to be." Seldom has a movie about dissolving morality made that more clear.

"Quiz Show" is rated PG-13 (Parents strongly cautioned). It includes no violence, no sexual situations and occasional mild profanity. It is quite suitable for older children.

1994 S 14, C11:1

IN THE LAND OF THE DEAF

Written and directed by Nicolas Philibert; director of photography, Frédéric Labourasse; film editor, Guy Lecorne; produced by Serge Lalou; released by International Film Circuit. In French sign-language and French with English subtitles. Running time: 99 minutes. This film is not rated.
WITH: Florent (boy on poster), Jean-Claude Poulain (sign language teacher)

By CARYN JAMES

Florent, a little boy who seems about 6 years old, romps on the lawn with his mother. He playfully grabs the film maker's microphone and mugs at the camera. While his mother tries to teach the deaf child to speak, the stubborn Florent says, "I look so I can hear."

Nicolas Philibert, the director of the French documentary "Land of the Deaf," has said, "My idea was to make a film that would plunge the viewer into the world of the deaf, a film whose mother tongue would be sign language." Mr. Philibert is not arrogant; he does not try to recreate the experience of being deaf. Instead, he follows vivid characters like Florent and through them carries viewers into a different but completely understandable culture, a world with its own rich language. Film is the perfect medium for capturing this beautifully lyrical, visual language of gestures.

"Land of the Deaf," which opens today at Film Forum 1, includes English subtitles for spoken French and for the sign language that carries

much of the dialogue. But the subtitles never distract from the eloquence of people speaking with their hands. Moviegoers who associate sign language with Patty Duke as Helen Keller laboriously spelling out the letters W-A-T-E-R in "The Miracle Worker" will be stunned by the grace of sign language, which uses a sophisticated pattern of symbols, not letters.

Mr. Philibert gives much attention to Florent and his classmates as they are being taught to speak. It is a slow process that tries the limited patience of the children. Yet it is a vast improvement over the old days.

Jean-Claude Poulain, a middle-aged deaf man who teaches sign language to adults, recalls that as a child his hands were tied behind him so he would learn to speak. Now education is bilingual, he says, with children taught both French and sign language. As Mr. Poulain teaches his class or discusses deaf culture for the camera, his expressive face and the broad, smooth movements of his hands convey a sense of how people who sign have individual accents and patterns of speech. He is obviously eloquent, a voluble storyteller with his hands. He also explains that sign language varies from one country to another, signing the words for man and woman in French, English and a few other languages. Despite their differences, he explains, within days a French visitor to China can be "chattering away" in a new language.

The film depicts the deaf as a community of people with a huge network of support for one another, yet Mr. Philibert doesn't overlook the obstacles deaf people face in a hearing world. The film follows a young deaf couple from their wedding day through the first year or so of marriage. Their wedding is joyful, as they sign their vows. Later, when they try to rent an apartment with the help of a deaf friend who speaks for them, it becomes nearly impossible for the agent to communicate that heat and water are not included in the rent. Through such precise details, "Land of the Deaf" becomes a warm, engrossing, eye-opening experience.

1994 S 14, C16:1

Florent, the deaf child featured in "In the Land of the Deaf."

THE SATIN SLIPPER

Written and directed by Manoel de Oliveira from a play by Paul Claudel; director of photography, Elso Roque; music by João Paes; produced by Paulo Branco; released by MGM. French and Portuguese with English subtitles. Running time: 428 minutes in two parts. This film is not rated.
WITH: Luis Miguel Cintra (Don Rodrigue) and Patricia Barzyk (Dona Prouheze).

By STEPHEN HOLDEN

To watch Manoel de Oliveira's seven-hour epic romance, "The Satin Slipper," is to be transported from a secular age back to a time and place (16th-century Spain) where the conflict between earthly desire and religious faith could ignite a lifetime of unconsummated passion.

The two major characters, Don Rodrigue (Luis Miguel Cintra) and Doña Prouheze (Patricia Barzyk), represent opposing arguments in an impassioned religious debate. Is the pursuit of earthly happiness wrong, the film asks, because it distracts one from preparing for the afterlife? Ultimately, it suggests that the refusal to give in to erotic desire is a kind of self-imposed purgatory that will speed the soul into heaven. Our time on earth, it implies, is but a dutiful and agonizing prelude to something infinitely sublime.

"The Satin Slipper," which opens today at the Joseph Papp Public Theater, is the Portuguese director's adaptation of a seldom-performed play that the French dramatist Paul Claudel wrote between 1919 and 1924. Its film adaptation is considered by some to be a masterwork of the film maker, who was born in 1908 and whose works are infrequently seen in the United States. A two-hour version was shown nine years ago at the New York Film Festival.

The full seven-hour film, while rewarding, is not easy viewing. It is a filmed play whose highly stylized production is influenced by Noh theater. The dialogue is in verse, which has been carefully translated into subtitles that convey fairly effectively the intensity of the poetry.

To those who have the patience and concentration, "The Satin Slipper" with its slow, stately rhythms and intense language, has the accumulating power of a somber, extended pageant. All the action takes place on handsome, painted sets that resemble the illustrations in an illuminated manuscript. When characters converse, they face the camera, usually talking over each other's shoulders. The acting, like the language, is formal and elevated, with minimal emoting. There are no tears, or passionate kisses. The closest thing to a love scene is a discreet merging of silhouettes behind a curtain. Often when speaking, the characters stare out into space, as though anticipating the judgments of history and of God.

"The Satin Slipper" is all about history, God and the sense of divine mission that helped spur the age of exploration. Rodrigue is a Spanish knight and conquistador whose explorations carry him to the Americas, the Philippines and Japan. The film follows him from a vigorous young manhood to an eccentric late middle age, when he has lost a leg. His status also changes from that of one king's golden boy to another's whipping boy.

Doña Prouheze, the love of Don Rodrigue's life, is a French Catholic of exceptional beauty who is married to a governor. Although she returns his love, their relationship remains unconsummated by her intention. Over time, she becomes more than just a romantic icon. She is an earthly manifestation of divinity.

In the service of God, Prouheze forsakes a comfortable life in Spain to oversee a Spanish citadel in Morocco. When her husband dies, she marries a ruthless adventurer by whom she has a daughter. She presents the child to Rodrigue as his spiritual child. Rodrigue's idealization of Prouheze ultimately transforms him from an adventurer into a utopian idealist who holds out a vision of a united Europe to a scornful king.

Perhaps the greatest accomplishment of "The Satin Slipper" is its success in depicting the religious fervor that drove the Spanish explorers to sail into the unknown and establish their fragile colonies. Although the desire for earthly riches certainly had a lot to do with it, these expeditions were also holy crusades. Fueled by a burning belief in Roman Catholicism as the one true faith, their aim was to save souls who would otherwise be damned. That fervor was bound up with nationalist fanaticism and the notions of divine right. Religious urgency, the film suggests, justified all manner of carnage and brutality.

The film is not without a sense of humor. In the funniest scenes, sailors smugly ridicule such newfangled notions as that the world is round and that the earth revolves around the sun. At heart, however, "The Satin Slipper" is a profoundly religious movie that exalts self-sacrifice redemption and eternal life.

"The Satin Slipper" can be seen in two parts or as a marathon. Part 1 is at 8 P.M. today through Friday and Tuesday. Part 2 is at 8 P.M. next Wednesday through Sept. 23 and on Sept. 27. Both parts will be shown together starting at 2 P.M. Saturday and Sunday and Sept. 24 and 25.

1994 S 14, C16:1

TIMECOP

Directed by Peter Hyams; written by Mike Richardson and Mark Verheiden; director of photography, Mr. Hyams; film editor, Steven Kemper; music by Mark Isham; production designer, Philip Harrison; produced by Moshe Diamant, Sam Raimi and Robert Tapert; released by Universal. Running time 95 minutes. This film is rated R.

WITH: Jean-Claude Van Damme (Walker), Ron Silver (McComb), Mia Sara (Melissa) and Gloria Reuben (Fielding).

By JANET MASLIN

IN the year 2004, according to the sci-fi thriller "Timecop," it will be possible for a law-enforcement officer like Walker (Jean-Claude Van Damme) to go back into the past and correct injustices. And changes made in the past will alter the future. In other words, someone whose life is shaped by disappointments can have a different, happier fate once those letdowns have been revisited and set right.

By those rules, there might even be a time warp or parallel dimension in which Mr. Van Damme is a major movie star. If he'd had better luck with any of his hard-working, flat-footed martial-arts films (among them "Bloodsport," "Kickboxer" and "Universal Soldier"), he could be well over the top by now. As it is, he has languished as an also-ran, with a barrier between him and those surer-fire action stars whose names begins with S: Schwarzenegger, Seagal and Stallone. This time, through sheer force of willpower, he may just kick that barrier down.

Years of tireless persistence have begun to work in Mr. Van Damme's favor. It's hard not to enjoy his energy, even if his acting gifts still leave a lot to be desired. The fact is that he looks good, behaves affably and kicks with gusto, which is quite enough to satisfy the demands of "Timecop," a knotty but formulaic tale of the future. When the style is Junior Terminator, success lies in the details, and this time Mr. Van Damme gets his own part of the process right.

Clearly, Mr. Van Damme has been engaged in a bit of image-doctoring. Last time out, in John Woo's super-violent "Hard Target," he was seen biting the head off a rattlesnake; this time he can be found returning a stolen handbag to a grateful little old lady. He does this strolling through a mall with his devoted wife (Mia Sara), while the film works overtime to show off his domestic side. And when a thief grabs the old lady's purse, all it takes to stop him is a glimpse of the Van Damme shoe, strategically placed in mid-air. Even crooks now appreciate the star's famous fighting feet.

The film starts in 1994, and things are bad: Ron Silver is in the Senate. But they'll be worse a decade later, when Mr. Silver is running for President and financing his campaign with ill-gotten gains. Time travel has proved lucrative for those who can pinpoint the right moments to commit highway robbery or stock fraud. Mr. Silver, as the wicked Senator McComb, has minions to commit these crimes, and he also has a humorously high opinion of himself as "an ambitious, Harvard-educated visionary." Does that make him a fit Presidential candidate? "Maybe he'll calm down after the election," someone says wishfully about McComb.

Mr. Silver makes an entertaining villain in a film that finally supports Mr. Van Damme with diverting co-stars. Also well used is Gloria Reuben, a fellow time-police officer who plays the inevitable new partner with effervescent charm. Even in his scenes with her, Mr. Van Damme displays a nicely self-deprecating nature, as when Ms. Reuben braces herself for a scary time trip and asks Mr. Van Damme what he thinks about at such moments. "Not swallowing my tongue," he replies.

Short but sweet is the only hope when it comes to Van Damme dialogue. And the screenplay, based by Mark Verheiden on the comic series he created with Mike Richardson, even mentions the Belgian-born star's efforts to grapple with a new language. "Smart kid, he read my mind," Mr. Van Damme jokes, after stopping that purse-snatcher early in the story. "With your English," says his wife, "he doesn't have much choice."

True, the film also indulges in those noxious wisecracks that are the bane of no-brainer action film making; stars in this genre should be permanently prohibited from clobbering anyone while saying "Have a nice day." Another problem with the script is its giddy overcomplication, with characters eventually talking to their own earlier incarnations and saying things like "Never interrupt me when I'm talking to myself."

By the time 2004-vintage Mr. Van Damme has begun helping avert tragedy for his 1994-vintage self, and a jowly 2004-vintage Mr. Silver has warned his own younger counterpart to quit eating cookies, you may feel like time-traveling just to get out of the theater. Stick around to learn that when two versions of the same person accidentally occupy the same space, they melt.

"Timecop," directed in reasonably snappy fashion by Peter Hyams, indulges in fashionable morphing tricks without otherwise spending much time or money on futuristic touches. It concentrates on more tangible assets, like intermittent humor and Mr. Van Damme's ability to leap onto a kitchen counter and land in a full split.

Indeed, the star looks so agile that he doesn't need the choppy editing that breaks up his action scenes, making his stunts look more artificial than they probably are. Well, nobody's perfect. But Mr. Van Damme, so vigorous and eager to please, seems to get better all the time.

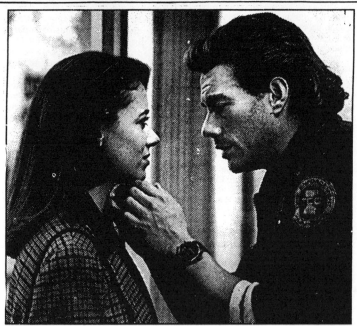

Joseph Lederer/Largo Entertainment

Mia Sara and Jean-Claude Van Damme star in "Timecop."

"Timecop" is rated R (Under 17 requires accompanying parent or adult guardian). It includes violence, | *profanity, nudity and one brief sexual situation.*

1994 S 16, C1:3

THE NEW AGE

Written and directed by Michael Tolkin; director of photography, John Campbell; film editor, Suzanne Fenn; music by Mark Mothersbaugh; production designer, Robin Standefer; produced by Nick Wechsler and Keith Addis; released by Alcor Films. Running time: 115 minutes. This film is rated R.

WITH: Judy Davis (Katherine Witner), Peter Weller (Peter Witner), Adam West (Jeff Witner), Rachel Rosenthal (Sarah Friedberg), Patrick Bauchau (Jean Levy) and Samuel L. Jackson (Dale).

By JANET MASLIN

One day, out of the blue, Peter Witner (Peter Weller) decides to live dangerously. Tired of his job at an ad agency, he announces that it's time for a change. "I welcome what my next step in my journey is going to be, and so I quit," he announces serenely at a business meeting.

Meanwhile, Peter's wife, Katherine (Judy Davis), is experiencing her own business difficulties, in response to which she goes shopping. Meeting at home that evening, after an arduous day that Katherine has spent wasting money and Peter has spent in bed with his mistress, they make love stimulated by the fantasy that they are somewhere else. "It's not real," Katherine acknowledges afterward, vaguely troubled. "I don't think you're really here."

Sensing that they have indeed reached some kind of precipice, the Witners respond by giving a party, during which one friend delivers some sanguine advice. "Peter," he says, "when you sail beyond the horizon you fall off the edge of the world. Forget what they taught you in school. The earth is flat."

"The New Age," a frequently caustic, ambitious film about going over that edge, is the work of Michael Tolkin, whose corrosive talents have real bite. As the novelist and screenwriter behind "The Player," Mr. Tolkin painted an unforgettably cold-blooded portrait of nouveau Hollywood. And his second novel, "Among the Dead," plumbed the darkest, angriest thoughts of a plane crash survivor. "The Rapture," his haunting film about a woman bent on religious redemption, gazed with frightening intensity upon the failings of a morally debased world.

In writing dialogue for "The New Age," Mr. Tolkin shows off that same sharpness, with a pitiless ear for his story's glib Californian characters. Phrases like "following my bliss" and "money's not money; money's just an expression of something else" summon the laissez-faire satirical style of Paul Mazursky, whose best films of the 1970's simply let such characters skewer themselves with small talk.

Indeed, Mr. Tolkin tells a story that recalls the trendy truth-seekers of Mazursky films like "Bob and Carol and Ted and Alice" and "Blume in Love." As Peter and Katherine fall into a fiscal sinkhole, they gravitate to various New Age teachers and healers while also moving into retailing, opening a boutique. The place, called Hipocracy, is so au courant that a couple of spiritual advisers appear to give advice on where the dressing rooms ought to be. Not directly in line with the front door; too much bad energy from the street.

The trajectory of the Witners' downhill slide is interrupted by set pieces that provide a tourist's guide to the New Age universe. Death rites, a fireside feminist ceremony, a communing in the desert, a spiritually awakened sex club: all of these are meant to deliver the solace Peter and Katherine once found elsewhere in their empty world.

Amusingly representative of that emptiness is Adam West as Peter's father, a suave character who's even more skillful at picking up young women than his son is. When Peter reveals to his father that he's in dire financial trouble, the older man is happy to write him a bad check. Another of the film's more down-to-earth characters is the huckster played by Samuel L. Jackson, a ball of fire as he teaches Peter how to swindle strangers by making telephone sales.

Mr. Tolkin has a lot to work with here, but his best work has been done on paper. Despite the presence of two smart, daring stars ready to plunge headlong into a scathing story, the film is unexpectedly soft around the edges. Some of that can be ascribed to the director's intense love-hate relationship with his main characters, with a subtle and forgiving overview he seems

Filling empty lives with assorted rites of passage.

better equipped to write about than to film. Mr. Tolkin's novelistic skills aren't yet matched by a cinematic vocabulary of comparable precision.

So the direction here is often as awkward as the dialogue is deft, with scenes that simply trail off and moments when the camera seems at a loss. Pacing is also a problem, as when suicide rites for one of the Witners' mortally ill friends are simply sandwiched between comic sequences at the store. Ambiguities that are built into the material, particularly when it comes to assessing how Peter and Katherine feel about each other, become frustratingly hazy. Occasional intrusive camera tricks, like flying flowers in one sequence, come off as strange rather than bold.

What sustains "The New Age" through these falterings are its edgy stars, its lively unpredictability, and the essential serious-

K. C. Bailey/Warner Brothers

Judy Davis and Peter Weller

ness of Mr. Tolkin's thoughts. Even when working in an atypically upbeat mode, in a film that never dares follow its dark prophecy to the bitter end, he sustains a disturbing frankness. There is, for instance, Katherine's rich friend who boasts fatuously about a trip to Bali ("$5,000 just to get there ... the most spiritual place I've ever been") but then becomes more honest. She is avoiding Katherine, she says, because she's simply made uncomfortable by other people's troubles.

Making people uncomfortable, in the starkest, most provocative ways, remains Mr. Tolkin's clear mission despite this film's distracting shortcomings. He still has a tough, trenchant vision that often hits home.

"The New Age" is rated R (Under 17 requires accompanying parent or adult guardian). It includes profanity, nudity and sexual situations.

1994 S 16, C5:3

BLUE SKY

Directed by Tony Richardson; written by Rama Laurie Stagner, Arlene Sarner and Jerry Leichtling; director of photography, Steve Yaconelli; film editor, Robert K. Lambert; music by Jack Nitzsche; production designer, Timian Alsaker; produced by Robert H. Solo; released by Orion Pictures. Running time: 101 minutes. This film is rated PG-13.

WITH: Tommy Lee Jones (Hank Marshall), Anna Klemp (Becky Marshall), Jessica Lange (Carly Marshall), Amy Locane (Alex Marshall), Powers Boothe (Vince Johnson), Chris O'Donnell (Glenn Johnson) and Carrie Snodgress (Vera Johnson).

By CARYN JAMES

"Tom Jones" will always be the first film that comes to mind at the mention of Tony Richardson's name. The director's career was uneven after that 1963 high point. But "Blue Sky," the film he completed shortly before he died of AIDS three years ago, turns out to be a wonderful posthumous triumph. Put on the shelf after Orion Pictures' bankruptcy, "Blue Sky" is among Richardson's finest work, a film as strong and as flawed as its heroine.

Set in 1962, it is a powerful portrait of a family imploding. Jessica Lange is the manic-depressive Carly Marshall, an Army officer's wife who can hardly tell her own life from Brigitte Bardot's. Tommy Lee Jones is her husband, Hank, an engineer who studies the lethal effects of nuclear testing.

Although the film's subplot concerns Hank's uneasiness about nuclear tests, the focus of the story is on Carly. It is a lavish role for Ms. Lange, and she brings to it fierce

emotions and tact. At the start, Carly is seen bathing topless on a beach in Hawaii, then doing a flamenco for a group of visiting soldiers. She models her behavior as well as her

A drama of control versus chaos caps Tony Richardson's career.

clothes (a series of tight strapless dresses) on that of movie stars like Marilyn Monroe. It doesn't take much for her to scandalize the Army community, and soon the family, including Carly and Hank's two adolescent daughters, have been transferred to Alabama. With her fantasies about the Hollywood career she might have had and her uncontrollable actions, Carly echoes Ms. Lange's dazzling role in "Frances."

When Carly sees the shabby, claustrophobic house that awaits them, she falls apart. She screams, smashes furniture, then tears away in the family's Chevrolet station wagon. While Hank goes after her, the younger daughter, Becky (Anna Klemp), says, "It's starting again." The older daughter, Alex (Amy Locane), is at a more irreverent age. "He's blind and she's crazy," she says of her parents. And when Alex tells her father that her mother needs help, he calls her Miss Freud and insists he can handle things. "Blue Sky" is a magnificent period

Cliff Lipson/Orion Pictures

Tommy Lee Jones and Jessica Lange in "Blue Sky."

piece, from the details of the Marshalls' lives to Hank's attitude that family problems should stay in the family.

Mr. Jones's performance matches Ms. Lange's in strength and subtlety. Hank is a tough, controlled military man whose competence masks the strain of caring for his wife. At a dance on the Army base, Hank refuses to dance with Carly, so she takes to the floor with his manipulative commanding officer, Vince Johnson (Powers Boothe). They all but seduce each other on the dance floor. Hank's response is to drag Carly away and desperately toss her into a swimming pool. He is a patient, frustrated man coming to the end of his rope.

When the Marshalls' lives are finally unraveling, Hank quietly tells Carly: "I don't know how much longer I can go on. I'm tired." The understated depths Mr. Jones reaches offer a reminder of his range after a series of over-the-top character roles in films like "The Client" and "Natural Born Killers."

The problems in "Blue Sky" turn up in a script that is sometimes obvious and melodramatic. When the commanding officer's wife (Carrie Snodgress) introduces herself to Carly, one of the first things she says is, "The officers' wives, we're doing a show," a line that can only make the audience think, "Uh-oh." And the Johnsons conveniently have a son (Chris O'Donnell) who falls for Alex. That romance seems invented so that the teen-agers can glimpse his father and her mother in the middle of a tryst. Yet the acting overcomes the screenplay's flaws.

For a long while the plot about a secret test project called "Blue Sky" doesn't seem to mesh with the family story, but at the end this subplot comes to the front. Hank is put in a mental hospital and drugged to keep him quiet. Carly has to find a way to save him, which she does with typical dramatic flair.

Three years on the shelf haven't hurt "Blue Sky," a film that arrives in time to burnish Tony Richardson's reputation. At his best, he evoked unsurpassed emotions from actors and put them indelibly on screen.

"Blue Sky" is rated PG-13 (Parents strongly cautioned). It includes a glimpse of nudity, strong language and some violence.

1994 S 16, C8:1

MAKING UP!

Directed and edited by Katja von Garnier; written by Ms. von Garnier, Benjamin Taylor and Hannes Jaenicke; director of photography, Torsten Breuer; music by Peter Wenke and Tillmann Höhn; production design, Irene Edenhofer and Nikolai Ritter; produced by Ewa Karlström; released by Seventh Art Releasing. Running time: 90 minutes. This film is not rated.

WITH: Katya Riemann (Frenzy), Nina Kronjäger (Maischa), Gedeon Burkhard (René), Daniela Lunkewitz (Susa) and Max Tidof (Mark)

By JANET MASLIN

As a humorous, lighthearted German film about two wisecracking modern heroines, Katja von Garnier's "Making Up!" has obvious novelty value that was much admired in its native land. A sleeper hit in Germany, this wry, energetic first feature also travels well, bristling with a funny insouciance that makes sense anywhere.

The awkwardly titled "Making Up!" (originally titled "Abgeschminkt!") is actually a short, sweet vignette about courtship rituals, with an emphasis on the heroines' Cosmo-girl wiliness about men. Mingling love and work, it begins with a creative crisis for Frenzy (Katja Riemann), a cartoonist who is short on material for her popular character, a foxy little feminine insect.

"You try coming up with funny things from your everyday life," she complains. So for inspiration, she borrows the exploits of Maischa (Nina Kronjäger), her best friend, who is a flirty nurse. Maischa is the foxier and more predatory of the two, but Frenzy turns out to be the one who finds romantic adventure.

The plot is slender, consisting of little more than Maischa's efforts to land a handsome stranger while foisting one of his friends upon a reluctant Frenzy. But onto this sketchy structure, Ms. von Garnier loads plenty of rueful observations about the dating game. Even though Maischa's boy-crazy outlook, plus some emphasis on cold cream and eyelash curlers, threatens to make the film feel retrograde, the director's attitudes remain enjoyably fresh. Her outlook is also sharply feminine, as when it comes to depicting miserable sex or the maneuvers that go with waiting for the phone to ring.

In a film that runs just under an hour, Ms. von Garnier shows a sure command of her subject matter and a bright comic style. Her film has commercial polish, and it also has two likable performances from its stars. Ms. Kronjäger is a particularly promising comic actress, with a game, savvy manner that makes her no man's plaything. Her character's tireless self-involvement is also amusing, as when she studies her handsome dinner companion and muses (in voice-over): "Those eyelashes! Two tons of mascara and I can't get mine to look like that."

As the story progresses, it yields a little surprise as Frenzy, not Maischa, winds up lovelorn. And Maischa tries to reassure her. "Think of all the work you got done," Maischa says. "Feeling bad must be good for you."

"You're saying men who aren't around make you creative?" Frenzy asks. Not even Maischa is saying that, but "Making Up!" does have some legitimate wisdom to pass along.

On the same bill is "The Coriolis Effect," a 25-minute short about two male friends, which was previously reviewed as part of this year's New Directors/New Films series. At that time, Caryn James, writing in The New York Times, called it "a fresh, self-assured film about sexual jealousy, dangerous living and the afterlife, with a nod to 'The Wizard of Oz.'"

1994 S 16, C8:5

Critic's Choice

To Discover Jean Renoir or Savor Him Again

Sometimes the most familiar directors are the most surprising; "100 Years of Cinema and ... Jean Renoir" is a glorious retrospective of Renoir's work that begins today and runs for five weeks at Film Forum. All his masterpieces are there: "The Rules of the Game," "The Golden Coach" and "Grand Illusion," which opens the series. "Grand Illusion" is the ultimate and most humane among prisoner-of-war movies, with Jean Gabin as the French prisoner in a World War I camp run by Erich von Stroheim. These films carry the thrill of discovery for anyone catching them for the first time; from then on, they can never be seen too often.

But perhaps even more tantalizing are the lesser-known, equally rich films in this series, which celebrates the 100th year of Renoir's birth. Among the best early films is "La Chienne" ("The Bitch"), a 1931 work that Fritz Lang remade in Hollywood as "Scarlet Street." Michel Simon, best known as the hero of Renoir's "Boudu Saved From Drowning," is a sometime painter (later the Edward G. Robinson role) who makes a tragic fool of himself over a tawdry, unscrupulous young woman. With its mesmerizing love triangle and the graceful storytelling that was Renoir's signature, "La Chienne" is even better than the remake.

Highlights from Renoir's later career include "French Cancan," the 1954 Technicolor spectacle in which Gabin plays the impresario who brings the cancan to the Moulin Rouge. The series ends with Renoir's final work, "The Little Theater of Jean Renoir," an an-thology of delicious episodes introduced by the director himself. In one story, Jeanne Moreau sings; in another, a woman is obsessed with polishing her floor. This is one series where it's hard to go wrong.

It's also hard to go wrong if you wander over to the third screen at Film Forum. A restored print of Bernardo Bertolucci's extravagant and haunting 1970 film, "The Conformist," was held over during its July run and returns today for a month. Mr. Bertolucci's best films, like "The Conformist" and "1900," always set personal emotions against the political backdrop that shaped them. In "The Conformist," Jean-Louis Trintignant is a young doctor terrified by a homosexual experience in his youth. He becomes so determined to blend into mainstream society that he becomes a Fascist spy. There is no escape from the period's decadence, of course. Even his supposedly bland wife (Stefania Sandrelli) goes dancing with a beautiful woman (Dominique Sanda), whom the doctor himself lusts after. This print, restored under the supervision of its cinematographer, Vittorio Storaro, shows why Mr. Bertolucci is a master of extravagantly visual and resonant storytelling.

(Film Forum is at 209 West Houston Street in the South Village. Tickets are $7.50. Information and screening times: 212-727-8110.)
CARYN JAMES

1994 S 16, C10:1

PRINCESS CARABOO

Directed by Michael Austin; written by Mr. Austin and John Wells; director of photography, Freddie Francis; film editor, George Akers; music by Richard Hartley; production designer, Michael Howells; produced by Andrew Karsch and Simon Bosanquet; released by Tristar Pictures. Running time: 94 minutes. This film is rated PG.
WITH: Phoebe Cates (Princess Caraboo), Wendy Hughes (Mrs. Worrall), Kevin Kline (Frixos), John Lithgow (Professor Wilkinson), Stephen Rea (Gutch) and Jim Broadbent (Mr. Worrall).

By CARYN JAMES

In 1817, a time when English law allows for vagrants and beggars to be hanged, a mysterious and penniless young woman appears on the streets of Bristol. Caraboo (Phoebe Cates) wears a turban and speaks a language no one can identify, but manages to convey that her father is a king and will not be amused if she is tossed into prison. Befriended by a grand family, the kind with fine manners and "Masterpiece Theater" set decoration, she is clothed and given a place at their table, where their pompous Greek butler, Frixos (Kevin Kline), leans over while serving her. In a clipped and funny accent, he whispers, "I know you are an impostor and I spit in your soup." She doesn't blink, which means nothing except that she doesn't blink.

"Princess Caraboo" is a gentle, charming family comedy, a romp whose strength is in its enchanting cast. While the entire town tries to decide whether Caraboo is a kidnapped princess or England's cleverest impostor, the film surrounds her with a group of hilarious, warm-blooded minor characters.

The story's narrator and hero is a reporter named Gutch, played by Stephen Rea. He is determined to discover the truth about Caraboo, and like most men is infatuated with her. He hopes she *is* a fraud, making fools of the gentry that wouldn't give her a shilling or the time of day unless they believed she had royal blood.

And high society does look foolish here. Mrs. Worrall (Wendy Hughes), the good-hearted woman who opens her home to Caraboo, tries ineffectually to protect her. But a princess, possibly from Java, is too exotic and precious a form of social currency to keep secret. Mr. Worrall (Jim Broadbent) thinks the cachet of having her in the house will save his failing bank; he even climbs on the roof to rescue Caraboo when she sits there banging a gong and chanting in some possibly Javanese ritual.

John Lithgow appears as an Oxford professor who examines Caraboo, giving her language tests and making learned pronouncements. He arrives certain that she is a fake, but leaves thoroughly smitten with her and the extravagant tatoos on her thighs. The smug professor ends up a sobbing lovelorn puddle of a man.

Before long there are soirees at which Caraboo dances with a degenerate, foppish prince. All the while Gutch is on the case, and his biggest clue is a disturbing one. When she was discovered, Caraboo was carrying a book from a home for reformed prostitutes. Mr. Rea anchors this film with a quiet but compelling performance as the sad and suspicious reporter who too easily separates his head from his heart.

As Caraboo, Ms. Cates becomes more appealing as the film goes along. At first she has an unvarying frown that simply makes the princess look as if she has a constant headache. But she rises to the level of the first-rate comic actors around her, and is especially good in her scenes with Mr. Kline (her real-life husband) and Mr. Lithgow. As the fussy Frixos, Mr. Kline wears a Greek hat and fancy waistcoats and sells inside information to Gutch. He throws in the knowledge that Mrs. Worrall is too kind and Mr. Worrall is an idiot.

At the end, the secret of Caraboo's identity is even revealed, tying things up in a perfect fairy-tale manner. This story is based on fact — the real-life Caraboo existed and was taken up by English society — though the film adds a fictional romance to the happy ending. The colorful production design and flouncy costumes enhance the film's storybook playfulness. The English director Michael Austin creates a sense of fun. "Princess Caraboo" is not a particularly sharp satire, but it is a great lark.

"Princess Caraboo" is rated PG (Parental guidance suggested). The princess kicks and bites in self-defense, which is the most intense behavior in this family film.

1994 S 16, C12:1

CRIME BROKER

Directed by Ian Barry; written by Tony Morphett; director of photography, Dan Burstall; film editor, Nicholas Beaumans; music by Roger Mason; production designer, Roger Ford; produced by Chris Brown, John Sexton and Hiroyuki Ikeda; released by A-Pix Entertainment. At the Village East Cinemas, Second Avenue at 12th Street, East Village. Running time: 93 minutes. This film is rated R.
WITH: Jacqueline Bisset (Holly McPhee) and Masaya Kato (Dr. Jin Okazaki)

By STEPHEN HOLDEN

"Crime Broker" has the dubious distinction of having some of the most uncomfortable love scenes to be found in a recent film. This Australian thriller, directed by Ian Barry, teams Jacqueline Bisset, an icon of mature sensuality, with Masaya Kato, a handsome young Japanese actor and model.

They make a striking pair, but the moment they touch, their mutual discomfort, magnified in close-up, douses any hope of sparks. There is an awkward sense of both actors gritting their teeth as they paw each other, and when kissing they can barely bring their lips to connect. It doesn't help that Mr. Kato mutters his endearments in the same robotic monotone with which he delivers all his lines, many of which are unintelligible. Ms. Bisset, for her part, never sheds her aura of chilly aristocratic reserve.

In "Crime Broker," which opens today at the Village East, Ms. Bisset plays Holly McPhee, a contemporary superwoman who leads a preposterous double life. A successful magistrate who is married with two children, she can hardly wait to go into a public restroom, put on a frizzy wig and change into a cheap red dress. As her silly-looking alter ego, she sells computer-perfect plans for bank robberies to the underworld for 10 percent of the haul.

The screenplay suggests that Holly's picture-perfect existence is so boring that this is her only way of getting kicks. Well, why doesn't she take up gardening?

Mr. Kato is Jin Okazaki, a crime-solving wizard from Tokyo who is brought in to investigate the series of crimes Holly has masterminded. No sooner have they met than the two team up to commit more daring robberies.

"Crime Broker" has the feel of a story concept that was filled out at the last moment with little idea of where to go or how to proceed. Holly's double life is given no rhyme or reason, and her criminal escapades are sketched so crudely they are impossible to make sense of. When the movie can't figure out what to do next, it has Ms. Bisset put on a different absurd disguise and trail her lover through the warehouse district of Sydney. Interminably.

"Crime Broker" is rated R (Under 17 requires accompanying parent or adult guardian). It has brief nudity and adult situations.

1994 S 16, C14:4

Rejuvenated Lady, Looking Even Fairer After 30 Years

By JANET MASLIN

Time ravaged the original negative of "My Fair Lady," but it has been kind to this lavish movie musical all the same. Never a great film but always a glorious confection, it is even more glorious as it reopens today, at the Ziegfeld Theater, 30 years after it was made.

Audiences were once jaded when it came to wide-screen Super Panavision musicals, which were losing their novelty value by 1963. But today, an extravaganza on this scale looks like a treasure. Especially when the treasure features Cecil Beaton's astounding costumes, George Cukor's stately direction, the best-loved, most hummable of all Broadway scores and a sublime cast headed by Rex Harrison and Audrey Hepburn. Not to mention the considerable contributions of George Bernard Shaw.

Sublime was not a word originally used to describe Miss Hepburn's performance here. Too much controversy surrounded the choice of such a divinely decorative actress in the singing role that Julie Andrews had played triumphantly on stage. There was also carping about the adaptation itself, since the Broadway "My Fair Lady" was fresh in viewers' memories. Today, the surprise is how serene and dazzling Miss Hepburn appears in a role that seemed so strenuous at the time.

A vision in Beaton's deliriously fanciful outfits, she also shines as an inspired comic actress: the Ascot sequence, during which Eliza Doolittle's imperfectly ladylike manners yield some great gaffes, remains a hilarious high point of the film. Of course, this scene can be watched for its millinery alone, but few eyes will stray from Miss Hepburn even when the hats are at their craziest. Her magnetic presence fits perfectly with the debonair wit displayed by Rex Harrison in his most celebrated role.

Filled out by a marvelous supporting cast (this film would be worth watching for Stanley Holloway's rendition of "Get Me to the Church on Time" alone), "My Fair Lady" seems to exist in its own world. It's hard to believe that news of the Kennedy assassination interrupted shooting of one of the Covent Garden scenes. It may also be hard to realize how badly damaged this film could become in only three decades, but today's bright, colorful print is the result of major restoration efforts. Once again, Robert A. Harris and James C. Katz, the team behind the "Lawrence of Arabia" restoration, have performed an invaluable labor of love.

But you won't see what they've done, at least not very often. You won't see the holes and cracks in the film that have been filled in digitally, using the same kinds of high-tech methods that more commonly ac-company special effects tricks (à la "Forrest Gump"). Nor will you hear flaws on the soundtrack that have been carefully removed, so that the film now meets contemporary standards.

Another thing you won't hear, unfortunately, is Miss Hepburn's heartbreakingly sweet rendition of "Wouldn't It Be Loverly," which has been restored separately and is not part of the finished print. Too bad: Mr. Harrison was way ahead of his time in insisting on performing in his natural voice. Miss Hepburn's singing was dubbed prettily by Marni Nixon, but it's a greater pleasure to hear the star really struggling to communicate her own personality in song.

Except for some minor color variations, which only serve as a reminder of how hard Mr. Harris and Mr. Katz worked restoring this film to near-mint condition, "My Fair Lady" may not look all that unusual to viewers brought up on home video. Those viewers may even start off thinking it looks a lot like the bright, cropped-off television version. If so, just point out the spaciousness and grand scale of the Ziegfeld. Mention the lost, hypnotic power of wide-screen movie magic. Tell them to sit back and enjoy the show.

1994 S 21, C13:4

THE LOST WORDS

Directed by Scott Saunders; written by Dan Koeppel, Michael Kaniecki and Mr. Saunders; directors of photography, Marc Kroll and Mr. Saunders; edited by Mr. Saunders; music by Mr. Kaniecki and Chris Burke; produced by Mr. Saunders, Katrina Charmatz and Vanessa Baran; released by Film Crash. Cinema Village, 22 East 12th Street, Greenwich Village. Running time: 85 minutes. This film has no rating.

WITH: Zelda Gergel (Marcie), Michael Kaniecki (Charles), Salley May (Bettina), Deborah McDowell (Louise), Bob McGrath (Sid), Brian O'Neill (Jeff), Rini Stahl (Judie) and Fred Tietz (Fred)

By STEPHEN HOLDEN

The central character in Scott Saunders's faux home movie, "The Lost Words," is a nerdy New York film editor and sometime singer and songwriter named Charles (Michael Kaniecki), who decides to videotape his own life. He intends to use the film, he says, to study his troubled relationship with his live-in girlfriend, Marcie (Zelda Gergel). In exchange for free meals, he enlists a friend (never shown) to trail around behind him with a camcorder.

After Marcie refuses to let him tape their intimate conversations, Charles's poker-playing pals and the women they live with become his main subjects. Long after Marcie has left him, Charles continues filming his meetings with his buddies, whose domestic arrangements turn out to be as precarious as his. Larded into the film are what seem to be random interviews with strangers who theorize about the battle of the sexes. These colorful Woody Allen-style snippets contribute to the movie's illusion of documentary authenticity.

"The Lost Words," which opens today at the Cinema Village, is a small film-making coup on several levels. Made for only $20,000, it looks like a far more expensive film. If you didn't know it ahead of time, it could easily be mistaken for an actual home movie, albeit a flashily edited one. The understated performances by a cast of professional actors playing everyday people gives the same feeling of real-life spontaneity that the actors in Whit Stillman's "Metropolitan" brought to their portrayals of upper-crust Manhattan socialites. The more prosaic milieu of "The Lost Words" is semi-bohemian downtown New York.

With titles announcing its scenes and several post-punk songs punctuating the action, "The Lost Words" has plenty of verbal and visual snap. Beneath its surface pep, it is a morose social comedy that takes a deeply pessimistic view of relationships. The movie clearly blames the male characters for most of the domestic tumult. Without exception, Charles and his pals behave like churlish, whiny little boys masking their anxiety behind a transparent bravado.

One ends up admiring Marcie's patience for tolerating a boyfriend who, while loving, is physically unattractive, self-pitying and pathologically jealous. Her breaking point comes when she arrives home exhausted and later than expected from a European vacation and finds herself accused for no reason of having had an affair.

Charles's two best friends, Sid (Bob McGrath) and Jeff (Brian O'Neill) are equally obnoxious. Sid is a crass businessman whose irritating sales-pitch manner extends to his personal communications. "I am not a pig," he insists. "I support the feminist agenda." The next second, he denounces feminism as "mind control." His girlfriend, Judie (Rini Stahl), who paints and talks vaguely about needing her "space," isn't much better at communication.

Good-looking, macho Jeff cheats on his long-suffering girlfriend, Lou-

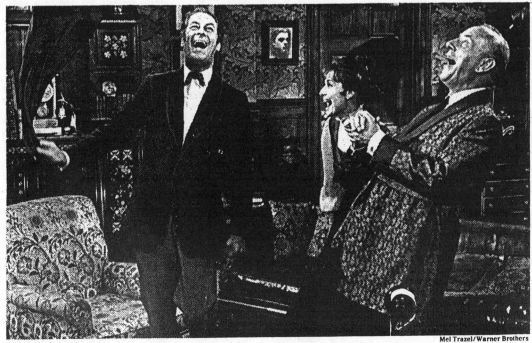

Mel Trazel/Warner Brothers
Rex Harrison, Audrey Hepburn and Wilfrid Hyde-White sing "The Rain in Spain" in "My Fair Lady."

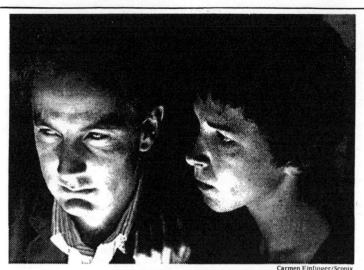

Carmen Einfinger/Scopix

Bob McGrath and Zelda Gergel in the film "The Lost Words."

ise (Deborah McDowell), under the false assumption that she doesn't know. Infuriatingly smug, Jeff is forever mouthing clichés about men being hunters and women nurturers. The extent of the men's immaturity is revealed when they engage in a tittering game of truth or dare that focuses on pre-adolescent sexual experiences.

Are relations between the sexes in supposedly sophisticated New York really this sour? Probably not. But in its opening moments, the movie declares that love in the 90's can best be summed up by five words: discord, suspicion, anger, disappointment and sex. The rest of the film presents the depressing evidence to back up its case.

1994 S 21, C18:1

PULP FICTION

Written and directed by Quentin Tarantino; director of photography, Andrzej Sekula; edited by Sally Menke; music by Karyn Rachtman; production designer, David Wasco; produced by Lawrence Bender; released by Miramax Films. At Alice Tully Hall at 7:30 P.M. and Avery Fisher Hall at 8:30 P.M., as part of the 32d New York Film Festival. Running time: 149 minutes. This film is rated R.

WITH: John Travolta (Vincent Vega), Bruce Willis (Butch), Samuel L. Jackson (Jules), Harvey Keitel (Wolf), Uma Thurman (Mia), Christopher Walken (Koons), Maria de Medeiros (Fabienne), Amanda Plummer (Honey Bunny), Rosanna Arquette (Jody), Ving Rhames (Marsellus Wallace), Tim Roth (Pumpkin), Eric Stoltz (Lance) and Quentin Tarantino (Jimmie).

By JANET MASLIN

EVER since Quentin Tarantino's "Pulp Fiction" created a sensation at this year's Cannes Film Festival, where it won top honors (the Palme d'Or), it has been swathed in the wildest hyperbole. In fact, it has sparked an excitement bound to look suspect from afar. It must be hard to believe that Mr. Tarantino, a mostly self-taught, mostly untested talent who spent his formative creative years working in a video store, has come up with a work of such depth, wit and blazing originality that it places him in the front ranks of American film makers.

But tonight, as "Pulp Fiction" opens this year's New York Film Festival at Lincoln Center, the proof is on the screen.

What proof it is: a triumphant, cleverly disorienting journey through a demimonde that springs entirely from Mr. Tarantino's ripe imagination, a landscape of danger, shock, hilarity and vibrant local color. Nothing is predictable or familiar within this irresistibly bizarre world. You don't merely enter a theater to see "Pulp Fiction": you go down a rabbit hole.

This journey, which progresses surprisingly through time as well as through Los Angeles and environs, happens to be tremendous fun. But it's ultimately much more than a joy ride. Coming full circle at the end of a tight, deliberate two and three-quarter hours. "Pulp Fiction" leaves its viewers

with a stunning vision of destiny, choice and spiritual possibility. The film needn't turn explicitly religious to reverberate when one character escapes death on a motorcycle labeled "Grace."

Remarkably, all this takes place in a milieu of obscenity-spouting petty hoodlums, the small-timers and big babies Mr. Tarantino brings to life with such exhilarating gusto. "Reservoir Dogs," the only other film he has written and directed (he also wrote "True Romance" and has a story credit on "Natural Born Killers"), offered only a glimmer of the high style with which he now conjures lowlifes. It also prefigures some of the chronology tricks that shape the much more ambitious "Pulp Fiction."

"Reservoir Dogs" attained well-deserved notoriety for its violence, especially in an expert but excruciating sequence involving the playful torture of a policeman. In the less gory "Pulp Fiction," where the disturbing scenes (from stories by the director and Roger Avary) are tempered by wild, impossible humor, it's especially clear that there is method to Mr. Tarantino's mad-dog moments. He uses extreme behavior to manipulate his audience in meaningful ways.

Surprisingly tender about characters who commit cold-blooded murder, "Pulp Fiction" uses the shock value of such contrasts to keep its audience constantly off-balance. Suspending his viewers' moral judgments makes it that much easier for Mr. Tarantino to sustain his film's startling tone. When he offsets violent events with unexpected laughter, the contrast of moods becomes liberating, calling attention to the real choices the characters make. Far from amoral or cavalier, these tactics force the viewer to abandon all preconceptions while under the film's spell.

Consider Christopher Walken's only scene in the film, in which he plays a military officer and delivers a lengthy monologue explaining how he happened to come by a gold watch, which he is now presenting to a little boy named Butch. The speech builds teasingly to an outrageous punch line, after which Mr. Tarantino knows just when to quit, moving on to the story of the adult Butch (Bruce Willis). Anyone surprised to be laughing at the gross-out gold-watch anecdote will be even more surprised to admire the noble side of the sadomasochistic episode in which Butch is soon embroiled.

Butch's story is the second of three vignettes presented here, though the order in which the tales are told on screen proves not to be the order in which they actually occur. In addition, the film is framed by opening and closing coffee-shop scenes that turn out to dovetail. Far from confusing his audience, Mr. Tarantino eventually makes the film's time scheme crystal clear, linking episodes with dialogue that may sound casual but sticks indelibly in memory. When a man named Pumpkin (Tim Roth) off-handedly addresses a waitress as "Garçon!" it's not easily forgotten.

Trapped together in absurd predicaments, splitting conversational hairs about trivia that suddenly comes into sharp focus, Mr. Tarantino's characters speak a distinctive

language. The bare bones of the stories may be intentionally ordinary, as the title indicates, but Godot is in the details. So the first episode, "Vincent Vega and Marsellus Wallace's Wife," finds Vincent (John Travolta) and his partner, Jules (Samuel L. Jackson), debating emptily and pricelessly while preparing to embark on a professional mission. Their profession is killing. Jules, easily the more thoughtful of the two (it's no contest), likes to recite Ezekiel's prophecy against the Philistines to scare those who are about to die.

Like all of Mr. Tarantino's characters, these two are more appealing than they have any right to be. They're all also worried, in Vincent's case with good reason. Vincent has been recruited to take out Mia Wallace (a spirited Uma Thurman) while her husband (Ving Rhames), the impassive kingpin he and Jules work for, is out of town. Marsellus is rumored to have had a man thrown out of a fourth-story window for massaging Mia's feet.

The date makes for a deliriously strange evening, featuring a drug-related mishap (involving a fine group of miscreants, among them Eric Stoltz and Rosanna Arquette) and a dance contest at a fantasy restaurant called Jack Rabbit Slim's. This set, spectacularly photographed by Andrzej Sekula with a 1950's motif dreamed up by Mr. Tarantino, is so showy and hallucinatory that it leaves poor Vincent in a daze. When he finally tells Mia what he has heard about that foot massage, Mr. Tarantino proves he can write clever, sardonic women on a par with his colorful men. "When you little scamps get together, you're worse than a sewing circle," says the mischievous, glittery-eyed Mia.

Mr. Travolta's pivotal role, which he acts (and even dances) with immense, long-overlooked charm, is one measure of why Mr. Tarantino's screenplays are an actor's dream. Mr. Travolta, Mr. Jackson and Mr. Willis may all sound like known quantities, but none of them have ever had quite the opportunities this material offers. Mr. Jackson, never better, shows off a vibrant intelligence and an avenging stare that bores holes through the screen. He also engages in terrific comic teamwork with Mr. Travolta. Mr. Willis, whose episode sags only slightly when it dwells on Fabienne (Maria de Madeiros), his baby-doll girlfriend, displays a tough, agile energy when placed in the most mind-boggling situation.

The third story, "The Bonnie Situation," finds Harvey Keitel playing a suave sanitation expert named Wolf, whose specialty is unwanted gore. "Now: you got a corpse in a car minus a head in a garage," Wolf says. "Take me to it." Lest this sound too hard-boiled, consider details, like the fact that Wolf is first

glimpsed in black tie, at what looks like a polite party that happens to be under way at 8 A.M. And that Mr. Tarantino turns up wearing a bathrobe and offering everyone coffee. Small pleasantries don't count for much here, but at least they're mentioned, as when Wolf brusquely gives Vincent orders about cleaning up after the corpse. "A please would be nice," Vincent complains.

"Pulp Fiction" is the work of a film maker whose avid embrace of pop culture manifests itself in fresh, amazing ways. From surf-guitar music on the soundtrack to allusions to film noir, television, teen-age B movies and Jean-Luc Godard (note Ms. Thurman's wig), "Pulp Fiction" smacks of the second-hand. Yet these references are exuberantly playful, never pretentious. Despite its fascination with the familiar, this film itself is absolutely new.

Mr. Tarantino's audacity also extends to profane street-smart conversation often peppered with racial epithets, slurs turned toothless by the fact that the film itself is so completely and amicably integrated. When it comes to language, "Pulp Fiction" uses strong words with utter confidence, to the point where nothing is said in a nondescript way. High praise, in this film's argot, has a way of sounding watered down if it's even printable. But "Bravo!" will have to do.

"Pulp Fiction" is to be shown tonight at 7:30 and 8:30 as part of the New York Film Festival. (It opens commercially on Oct. 7 in New York and Los Angeles.) On the same Film Festival bill is the brief, archly amusing "Michelle's Third Novel," a film by Karryn De Cinque, in which the title character successfully overcomes her writer's block. Sticking a knife in a toaster, she learns, is as good a way to get jump-started as any.

"Pulp Fiction" is rated R (Under 17 requires accompanying parent or adult guardian). It includes frequent obscenities, sexual frankness, occasional violence and moderate gore.

1994 S 23, C1:1

THE SHAWSHANK REDEMPTION

Written and directed by Frank Darabont, based on the novella "Rita Hayworth and the Shawshank Redemption," by Stephen King; director of photography, Roger Deakins; edited by Richard Francis-Bruce; music by Tom Newman; production designer, Terence Marsh; produced by Niki Marvin; released by Columbia Pictures. Running time: 142 minutes. This film is rated R.

WITH: Morgan Freeman (Red), Tim Robbins (Andy), Gil Bellows (Tommy), Clancy Brown (Captain Hadley), Bob Gunton (Warden Norton), Mark Rolston (Bogs Diamond), William Sadler (Heywood) and James Whitmore (Brooks Hatlen).

By JANET MASLIN

There are standard ways to stage a prison film and standard ways to tell a story by Stephen King. But "The Shawshank Redemption," based on a King novella and set in the correctional institution of the ti-

tle, succeeds in avoiding the familiar.

Without a single riot scene or horrific effect, it tells a slow, gentle story of camaraderie and growth, with an ending that abruptly finds poetic justice in what has come before. The writer and director, Frank Darabont, tells this tale with a surprising degree of loving care.

There are times when "The Shawshank Redemption" comes dangerously close to sounding one of those "triumph of the human spirit" notes. But most of it is eloquently restrained. Despite an excess of voice-over narration and inspirational music, Mr. Darabont's film has a genuine dignity that holds the interest. It is helped greatly by fine, circumspect performances from Morgan Freeman as a rueful lifer named Red and Tim Robbins as Andy, the new kid on the cellblock. The film spans nearly 20 years of friendship between these two.

When Andy is convicted of his wife's murder, the judge pronounces him "a particularly remorseless and icy man." He sustains that chill when he first arrives at Shawshank, remaining aloof from other inmates even when those inmates threaten him with physical harm. "I wish I could tell you that Andy fought the good fight," says Red, who knows Andy has been gang-raped by fellow prisoners, in one of the film's only halfway-brutal episodes. "I wish I could tell you that, but prison is no fairy-tale world."

Needless to say, the heroes of such stories usually do succeed in defending themselves, at least when Hollywood is telling the fairy tale. But "The Shawshank Redemption" has its own brand of iconoclasm, with Mr. Darabont's direction as quiet, purposeful and secretive as Andy is himself.

Eventually Andy begins to fit in, especially after he wows the guards with skills left over from his pre-prison banking career. From the first time he advises one guard to make a one-time-only tax-free gift to his wife, Andy gets a new lease on life as "a convicted murderer who provides sound financial planning." Andy does special fiscal favors for the warden. ("You know, the funny thing is, on the outside I was an honest man, straight as an arrow,' he says about this. "I had to come to prison to be a crook.") He also makes the occasional dramatic gesture, like commandeering the prison's loudspeaker and playing a Mozart aria for all his fellow inmates. The film has a tendency to wax romantic at such moments, but more often it sustains an intelligent reserve.

Mr. Freeman is so quietly impressive here that there's reason to wish Red's role had more range. As written, he spends his time observing Andy fondly and describing prison life. But Mr. Freeman's commanding presence makes him a much stronger figure than that. Mr. Freeman is especially moving when he suggests how dependent Red has become on the prison walls that give shape to his life. Even so, Red has kept his ruefulness. "Only guilty man in Shawshank," he jokes about himself.

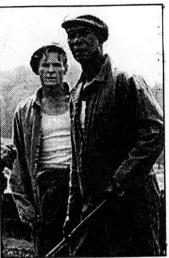

Michael Weinstein/Castle Rock Entertainment

William Sadler, left, and Morgan Freeman in a scene from "The Shawshank Redemption."

Mr. Robbins has the trickier role of someone whose still waters run deep, but whose experience doesn't add up until an exposition-packed denouement. (The film's swift, enjoyably farfetched closing scenes are a sharp reminder of who is the author of this story, after all.) Andy's is the more subdued role, but Mr. Robbins plays it intensely, and he ages effectively from newcomer to father figure during the story. One of Andy's projects is improving the prison library, which once contained nothing but the equivalent of books by Stephen King.

To raise funds for this undertaking, Andy is steady and patient, writing weekly letters to state officials until he gets what he wants. Mr. Darabont, a screenwriter making an impressive directorial debut, works in much the same quietly persistent way. "The Shawshank Redemption" takes shape slowly and carefully, displaying an overall subtlety that's surprising in a movie of this genre. In the end, like Andy and Red, it gets to where it wanted to go.

"The Shawshank Redemption" is rated R (Under 17 requires accompanying parent or adult guardian). It includes profanity and occasional violence, including a scene that discreetly suggests homosexual rape.

1994 S 23, C3:1

SLEEP WITH ME

Directed by Rory Kelly; written by Duane Dell'Amico, Roger Hedden, Neal Jimenez, Joe Keenan, Mr. Kelly and Michael Steinberg; director of photography, Andrzej Sekula; edited by David Moritz; music by David Lawrence; production designer, Randy Eriksen; produced by Mr. Steinberg, Mr. Hedden and Eric Stoltz; released by United Artists. Running time: 86 minutes. This film is rated R.

WITH: Eric Stoltz (Joseph), Meg Tilly (Sarah), Craig Sheffer (Frank), Adrienne Shelly (Pamela), Lewis Arquette (Minister), Todd Field (Duane), Susan Traylor (Deborah), Tegan West (Rory) and Quentin Tarantino (Sid).

By CARYN JAMES

One of these days Eric Stoltz will have a first-rate career, and he'll deserve it. Right now, he's the only good reason to see "Sleep With Me," an innocuous romantic comedy about three friends in a love triangle and the other friends who have nothing better to do than talk about it.

Mr. Stoltz plays a landscape designer named Joseph, who is about to marry Sarah (Meg Tilly). Joseph's best friend, Frank (Craig Sheffer), loves Sarah, too. At barbecues, poker games and dinner parties, "What should Frank do?" becomes a hot topic of conversation.

The film might have been invented at one of those parties. It was written by six friends, including Neal Jimenez and Michael Steinberg, who together directed one of Mr. Stoltz's best films, "The Waterdance." They formed a kind of screenwriting tag

A triangle in which friendship leads to romance, which leads to talk.

team, each creating one social gathering in the evolution of Joseph and Frank and Sarah's messy situation. (Coyly, the credits don't reveal who wrote what scenes.)

The gimmick is not as bad as it sounds; the characters are, at least, consistent. The problem is that they are consistently flat except when they are actively annoying.

At a pre-wedding party, Joseph gets drunk and Sarah kisses Frank, setting the scene for the inevitable seduction. Sarah is meant to be strong and independent; Frank is meant to be sensitive. But she's a pill, he's a wimp and the wonder is that Joseph doesn't kiss them both goodbye.

Mr. Stoltz suggests a complexity — love for Sarah, fear of being trapped, a blasé attitude masking strong emotions — beyond anything written into Joseph's character. He even gets away with one of the film's worst lines, during an argument with his wife: "Honey, I'm about to cloud up and rain all over you." Frank's dialogue is more typical and banal: "I'm trying to tell your wife I'm in love with her, Joseph."

Rory Kelly, a first-time director, plays a bit with different styles for different sections, but his choices are often stale. There are dizzying camera swoops during a fight and many videos that the characters take of each other.

"Sleep With Me" has some small saving moments. Quentin Tarantino took time out from being the hottest director around to do a very funny cameo. As a party guest who has thought about movies way too much, he delivers a monologue about the homosexual subtext of "Top Gun."

It's a rapid-fire one-way conversation that echoes the goofy, slangy dialogue of his own films. And Adrienne Shelly, as a date Frank takes to yet another party, is baffled to find herself riding home between Frank and Sarah. Her exaggerated comic touch breathes some freshness into the film during her few scenes, but she doesn't stick around long. Her character isn't nearly self-conscious, self-important or self-absorbed enough to fit into this closed circle.

"Sleep With Me" is rated R (Under 17 requires accompanying parent or adult guardian). It includes strong language and some discreet sex scenes.

1994 S 23, C10:1

...AND GOD SPOKE

Directed by Arthur Borman; written by Gregory S. Malins and Michael Curtis, based on a story by Arthur Borman and Mark Borman; director of photography, Lee Daniel; edited by Wendey Stanzler; production designer, Joe B. Tintfass; produced by Mark Borman and Richard Raddon; released by Live Entertainment. At Sony Theaters 19th Street East, at Broadway. Running time: 83 minutes. This film is rated R.
WITH: R. C. Bates (God), Anna B. Choi (Claudia), Andy Dick (Abel), Lou Ferrigno (Cain), Fred Kaz (Noah), Eve Plumb (Mrs. Noah), Stephen Rappaport (Marvin Handelman), Michael Riley (Clive Walton), Soupy Sales (Moses) and Daniel Tisman (Chip Greenfield).

By CARYN JAMES

If you were making a biblical epic, whom would you get to play God? Clive and Marvin, the director and producer in the mock documentary "... and God Spoke," go for Marlon Brando and Bobby De Niro, as they call him. But the high point of their careers is a film called "Nude Ninjas," their budget is not epic, and they settle for an unknown. "You wouldn't recognize God," Marvin says. It's perfect casting.

They're luckier with Moses; there they get a name. It's Soupy Sales, good-naturedly playing himself here. When he comes down the mountain with the Ten Commandments, he brings product placement to new extremes, but he's a recognizable star.

It's also easy to recognize the main inspiration for this film, one of many attempts to clone Rob Reiner's hilarious "This Is Spinal Tap." But it's hard to sustain satire as well as Mr. Reiner did. "... and God Spoke," which opens today at Sony Theaters 19th Street East, has several funny episodes as it follows the film makers, who inadvertently turn the Bible into a potboiler, but there are also many lulls and sections that are not nearly as sharp as they need to be.

The director of "... and God Spoke," Arthur Borman, obviously knows his targets. Michael Riley is especially funny as Clive, the perfect image of a hack director with artistic pretensions. He has the goatee and wire-rim glasses to prove that he's serious. And the film's best scenes approach the demented irreverence this material calls for. Clive and Marvin cast Lou Ferrigno

Jennifer Roper/Live Entertainment
Michael Riley, left, and Stephen Rappaport.

as Cain and a slightly built unknown (played by Andy Dick) as Abel. Unfortunately, Abel doesn't know he's the victim, not the murderer. "Take thy best shot," he says, swinging at the man who played the Incredible Hulk. Eve Plumb, Jan from "The Brady Bunch," is cast as Mrs. Noah.

But after films like "The Player," making a behind-the-scenes Hollywood movie, even one about the losers, is harder than ever. "... and God Spoke" is much milder than its best moments make it sound.

"... and God Spoke" is rated R (Under 17 requires accompanying parent or adult guardian). It includes strong language and a scene with topless women in "Nude Ninjas."

1994 S 23, C10:5

Correction

A picture caption in Weekend on Friday with a film review of "... and God Spoke" reversed the names of the actors shown. Stephen Rappaport was on the left, with Michael Riley.

1994 S 27, A2:6

ME AND THE MOB

Directed by Frank Rainone; written by Rocco Simonelle, James Lorinz and Mr. Rainone; director of photography, Adam Kimmel; edited by Michelle Gorchow; music by Doug Katsaros; music produced by Phil Ramone; production designer, Susan Bolles; produced by Mr. Rainone; released by Arrow Releasing. Running time: 86 minutes. This film has no rating.
WITH: James Lorinz (Jimmy Corona), Sandra Bullock (Lori), Tony Darrow (Tony Bando), Anthony Michael Hall (Jimmy's friend), Stephen Lee (Bobby Blitzer), Ted Sorel (George Stellaris), Vinny Pastore (Aldo Badamo), Frank (Butch the Hat) Aquilino (Joey Tantillo) and Steve Buscemi.

By JANET MASLIN

In "Me and the Mob," a struggling magazine writer named Jimmy Corona (James Lorinz) decides to hang

Arrow Releasing
James Lorinz, left, Vinny Pastore and Frank Aquilino in a scene from "Me and the Mob."

around with gangsters in search of "real life crime stories." Instead of real life, he winds up finding a whole slew of mob movie stereotypes, with actors doing De Niro imitations of varying credibility and dialogue that is colorful in all the expected ways. ("Joey was as slippery as cooked squid, but the calamari had the edge in the looks department.")

As produced and directed by Frank Rainone, who wrote the screenplay along with Rocco Simonelle and Mr. Lorinz, this semiautobiographical film is more facetious than funny. Though cartoonish titles and a vaguely jazzy score (produced by Phil Ramone) suggest somebody thinks the film has "Pink Panther" possibilities, it labors awfully hard to achieve its lighter moments.

The mobsters in the movie do nothing that would surprise anyone who has seen "The Godfather," nor do they really satirize the genre. The best mimicry comes from Tony Darrow, who had a role in "Goodfellas" and here plays Jimmy's gangster uncle. "Your mother, God bless her — every time my name comes up she spits on the ground," he says, with feeling.

Also in the film are an uncredited Steve Buscemi, briefly playing an enthusiastic conspiracy nut, and Sandra Bullock as Jimmy's girlfriend. In her one scene here, she appears in black underwear and has comically simulated sex with Jimmy while giving him passionate advice about his writing career. The success of "Speed" means Ms. Bullock won't have to do such things any more.

1994 S 23, C10:5

In the niftiest stunt, a car with a woman locked in its trunk is dumped out of an airplane. The hero jumps out of the same plane, catches up to the car, unlocks the trunk, pulls out the woman, and opens his parachute just in time for them to land safely at the bottom of a canyon.

That hero is a wisecracking, womanizing daredevil named Ditch Brodie (Charlie Sheen). The woman he saves, Chris Morrow (Nastassja Kinski), is a former agent for the K.G.B. (jokingly referred to in the film as the "K.G Used-to-Be") who is fighting off the Russian mafia in order to return $600 million of stolen gold bricks to her economically troubled homeland. Just how and why those bricks wound up in the Arizona desert on a hijacked airliner, the movie hardly bothers to explain.

The Russian criminals, as imagined by the movie, are a fearsome mob of glowering bilingual villains who speak English with perfect American accents. With apparently unlimited firepower at their disposal, they turn a large number of vehicles into hunks of metallic Swiss cheese.

There is a thin line between an action-adventure movie that has a human touch and one that doesn't, and "Terminal Velocity" falls on the inhuman side. For all its concentration on action, the recent blockbuster "Speed," which "Terminal Velocity" sometimes recalls, included two or three characters who behaved like everyday people. Their hair-raising journey on a speeding bus was an adventure that anyone who has ridden on a freeway could identify with.

"Terminal Velocity," which was directed by Deran Sarafian, reaches for a similar level of nonstop visceral excitement but misses on two counts. For one, skydiving is not a common experience, like driving. The film doesn't devote enough time to the sport to make it seem anything more than an exotic hobby. For another, filmed bodies tumbling through space seem almost to be motionless. With few exceptions, the scenes on the ground are more exciting than those in the air.

The chemistry between Mr. Sheen and Ms. Kinski is also flat. Although Mr. Sheen's cocky, sarcastic performance suggests that he has a chance of becoming another Robert Mitchum, his character is too loutish to be sympathetic. And Ms. Kinski gives a thin, jittery performance that is lacking in both sensuality and feeling. After all its rollercoaster thrills, the movie provides no romantic payoff.

"Terminal Velocity" is rated PG-13 (Parents strongly cautioned). It includes a lot of violence and some strong language.

1994 S 23, C20:5

TERMINAL VELOCITY

Directed by Deran Sarafian; written by David Twohy; director of photography, Oliver Wood; edited by Frank J. Urioste and Peck Prior; music by Joel McNeely; production designer, David L. Snyder; produced by Scott Kroopf and Tom Engelman; released by Hollywood Pictures. Running time: 102 minutes. This film is rated PG-13.
WITH: Charlie Sheen (Ditch Brodie), Nastassja Kinski (Chris Morrow) and Gary Bullock (Lex).

By STEPHEN HOLDEN

"Terminal Velocity," a thriller set in the world of skydiving, has many picturesque scenes of bodies tumbling in free fall high above the Arizona desert. The prettiest shot shows two aerialists silhouetted against the final moments of a glorious sunset.

ED WOOD

Directed by Tim Burton; written by Scott Alexander and Larry Karaszewski, based on a biography by Rudolph Grey; director of photography, Stefan Czapsky ; edited by Chris Lebenzon; music by Howard Shore; production designer, Tom Duffield; produced by Denise DeNovi and Mr. Burton; released

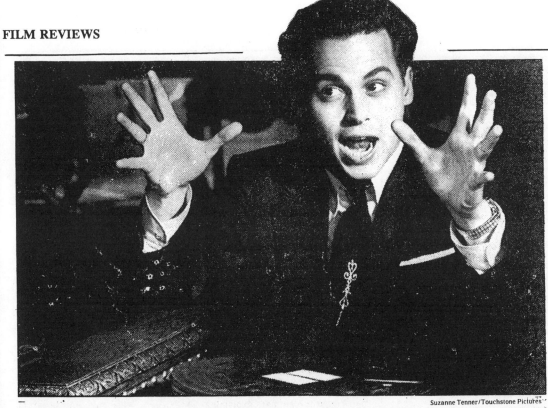

Capturing all the can-do optimism: Johnny Depp in the role of the director Ed Wood in Tim Burton's film.

Suzanne Tenner/Touchstone Pictures

by Touchstone Pictures. At Alice Tully Hall tomorrow at 9 P.M. and midnight, as part of the 32d New York Film Festival. Running time: 120 minutes. This film is rated R.
WITH: Johnny Depp (Ed Wood), Sarah Jessica Parker (Dolores Fuller), Martin Landau (Bela Lugosi), Patricia Arquette (Kathy O'Hara), Bill Murray (Bunny Breckinridge), Mike Starr (George Weiss), Vincent d'Onofrio (Orson Welles) and George (The Animal) Steele (Tor Johnson).

By JANET MASLIN

"Ed Wood," Tim Burton's very good film about a very bad film maker, has a cheerful defiance that would surely have appealed to Orson Welles, who was Ed Wood's hero. Late in the film, Welles appears (played deftly by Vincent d'Onofrio, who really looks like him) to advise Wood that independence is everything and that an artist's visions are worth fighting for. Mr. Burton, currently Hollywood's most irrepressible maverick, has taken that credo to heart.

So here is the Z-movie ethos of Edward D. Wood Jr., as filtered through the dark wit and visual brilliance of Mr. Burton. Two questions immediately present themselves: Who and why? To answer the first, Ed Wood was a director working on the outermost fringes of Hollywood in the 1950's. He made the kind of science-fiction film that used Cadillac hubcaps for flying saucers.

He's best remembered for the transcendent tackiness of "Plan 9 From Outer Space" and for "Glen or Glenda," which achieved midnight movie notoriety for its story about a man who loved wearing angora sweaters. Ed Wood played that role himself, and he played it from the heart.

Even allowing for the special ineptitude of the Wood oeuvre, or for Wood's habit of turning up in full drag to do his directing, it would take more to explain Mr. Burton's fascination with this subject. Wood was also a dauntless guerrilla film mak-

er, assembling his own band of outsiders as a stock company and using anything or anyone he could commandeer for the film-making process.

His daring deserves to be legendary: he made films on a shoestring, raised funds by hook or by crook, and really did steal a fake octopus for use in a scene with Bela Lugosi, who had to wrestle with the thing in a shallow pool of water (as depicted in "Ed Wood"). He also lovingly resurrected the aging Lugosi, rescuing him from oblivion just as Mr. Burton rescues Ed Wood today.

Ed Wood eventually descended into terminal sleaze, drinking himself to death, writing books with titles like "Death of a Transvestite Hooker" and making hard-core porn like "Necromania," which depicts oral sex in a coffin. So the biggest surprise about "Ed Wood" is that it manages to be a sweet, sunny mainstream comedy, with its kinkiness reduced to the level of a joke. There is, for instance, the moment when Ed Wood's girlfriend, Dolores Fuller (Sarah Jessica Parker), asks: "Where's my pink sweater? I can never seem to find my clothes any more." Angora-loving Ed Wood (Johnny Depp) says nothing but looks guiltily at the camera.

Mr. Depp isn't best known as a comic actor, but he gives a witty and captivating performance, bringing wonderful buoyancy to this crazy role. He captures all the can-do optimism that kept Ed Wood going, thanks to an extremely funny ability to look at the silver lining of any cloud. " 'The soldiers' costumes are very realistic,' " he exclaims early in the film, reading aloud the nicest line in a review of one of Wood's plays. "That's positive!"

"Ed Wood" has devilish fun revisiting the scenes of Wood's many cinematic crimes, depicting with glee and accuracy the horrible conditions under which his films were made. George Weiss (Mike Starr), who dis-

-tributed Wood's films in extremely out-of-the-way places, gives the director a motto of sorts when he says: "Shoot whatever baloney you want. Just make sure it's seven reels long."

And Ed Wood himself, happily exclaiming, "That was perfect!" after any bad shot, is seen directing his cast in typical laissez-faire fashion. "You're upset — no, no, you're not that upset," he tells an actor who accidentally walks into a door.

"Ed Wood" is in love with bad-movie high jinks, and with nutty, improvisatory film making as an antidote to the antiseptic slickness of today. But its real heart is in the Wood-Lugosi friendship. The aging vampire star, played with hilarious crankiness by an outstandingly fine Martin Landau, becomes a poignant figure even at his most bizarre. (Early in the film, Lugosi is seen at home in full cape and regalia, watching "Dracula" on television and holding a chihuahua in each hand.) Through all the humor about Lugosi's histrionics, and through pathos about his drug addiction, Mr. Burton's respect and admiration are unmistakable.

When it comes to respect, "Ed Wood" pays homage with loving reenactments of authentic Wood movie scenes and with actors who look uncannily like members of Wood's freakish troupe. (A closing credit notes that Tor Johnson, the bald, hulking wrestler played here by George "The Animal" Steele, achieved "greatest fame as a best-selling Halloween mask.") Though the real Wood scenes looked starkly awful, "Ed Wood" is an unobtrusively gorgeous black-and-white film (expertly shot by Stefan Czapsky, Mr. Burton's usual fine cinematographer) with a wide range of striking visual effects.

If "Ed Wood" has a major failing, it's the lack of momentum. Wood's

career had nowhere to go, and to some extent the film (written by Scott Alexander and Larry Karaszewski, based on Rudolph Grey's enterprising biography of Wood) has the same problem. Still, Mr. Burton has no trouble holding his audience's attention with incomparable Wood antics like the group baptism of his "Plan 9 From Outer Space" cast. That film's financing came from the Baptist Church of Beverly Hills and church officials insisted on both baptism and the removal of "Grave Diggers" from the original title.

One cast member is John (Bunny) Breckinridge, played by a delightfully demure Bill Murray in a suit, lipstick and pearls. Mr. Murray's slyest moment comes during the filming of "Plan 9," when he wonders whether he ought to wear antennas on screen.

"No!" exclaims Ed Wood. "You're the ruler of the galaxy! Show a little taste."

"Ed Wood" is to be shown tomorrow at 9 P.M. and midnight as part of the New York Film Festival. It opens commercially in New York and Los Angeles on Wednesday.

"Ed Wood" is rated R (Under 17 requires accompanying parent or adult guardian). It includes mild profanity and wild cross-dressing.

1994 S 23, C34:1

EXOTICA

Written and directed by Atom Egoyan; director of photography, Paul Sarossy; edited by Susan Shipton; music by Michael Danna; production designers, Linda Del Rosario and Richard Paris; produced by Atom Egoyan and Camelia Frieberg; released by Miramax Films. At Alice Tully Hall at 2:45 and tomorrow at 9:30 P.M. as part of the 32d New York Film Festival. Running time: 103 minutes. This film has no rating.
WITH: Elias Koteas (Eric), Mia Kirshner (Christina), Don McKellar (Thomas), Bruce Greenwood (Francis), Victor Garber (Harold), Calvin Green (customs officer), Arsinée Khanjian (Zoé), Sarah Polley (Tracey).

By CARYN JAMES

A very young woman dressed in a schoolgirl's uniform steps onto the stage of a strip club called Exotica. Eric, a disk jockey with a voice as creepy as it is suggestive, introduces her as Christina, "a sassy bit of jailbait," and says she will dance at your table for $5. Eric's crass words seem at odds with this extravagant place. The men wear suits and ties, the lush jungle décor evokes a Rousseau painting after innocence has been lost, and everything is nearly respectable. Somehow, Eric and Christina will have to cross paths with Thomas, a meek, bespectacled man whom Canadian customs officials have been watching through a one-way mirror as he enters the country.

Early in Atom Egoyan's brazen "Exotica," the director deftly drops in the ideas that come to haunt the film: eroticism, secrecy and the skewed way we look at things. Nothing is what it seems, least of all the film we're watching. Despite its lurid-sounding subject, "Exotica" turns out to be less erotic than eerie. It raises moral questions of guilt and

responsibility, plays with post-modern ideas about perception and, by the end, even involves blackmail and murder.

Like many of the mordant characters in Mr. Egoyan's earlier films, Christina (Mia Kirshner) is at the center of several complicated relationships. She and Eric (Elias Koteas) have been lovers. Eric has signed a contract to impregnate Zoé (Arsinée Khanjian), the club owner, who is so obsessed with taking over her dead mother's role as hostess that she obsessively wears the wigs and clothes her mother left behind. And a handsome, sad-looking man named Francis (Bruce Greenwood) turns Christina's table dances into a strange private ritual, night after night repeating the same question, "How could anyone hurt you?"

This sounds like the stuff of torrid melodrama, but Mr. Egoyan leaves any hint of banality in the dust. The 34-year-old Canadian writer and director is an original who has already created a dazzling body of work, at once cerebral, powerfully dramatic and accessible. His obsessive characters often view life through television screens and camera lenses. And his smooth but penetrating style in "Exotica," cutting to the heart of every scene, then filling in the background later, will be familiar to audiences who know his work from previous festivals. "Family Viewing" was shown at the 1988 New Directors festival, and "Speaking Parts," "The Adjuster" and "Calendar" at recent New York Film Festivals.

"Exotica," his most fluid film yet, will be shown at the New York Film Festival today at 2:45 and tomorrow night at 9:30. It is scheduled to be released by Miramax Films early next year, finally offering Mr. Egoyan the wider recognition in the United States that he deserves.

Mr. Egoyan never lets his viewers give in to easy expectations. Francis is seen in his car giving money to a young woman, but it turns out that she is not a child prostitute, as any audience would assume. When the situation is gradually explained, it becomes just as disturbing in a different way. The gawky, apparently inept Thomas (Don McKellar) owns an exotic pet shop and has smuggled rare, valuable birds' eggs into Canada. Francis enters the pathetic shop, full of empty cages, and begins looking at Thomas's financial records. Francis, it seems, is either a black-market business partner or a tax auditor.

At the heart of the story is the mysterious, deep connection between Francis and Christina, perfectly played by Mr. Greenwood and Ms. Kirshner with an unsettling mix of sexuality and innocence. The heartbreaking tangle beneath their relationship is not revealed until the final scenes.

Until then, the characters' pasts are uncovered bit by eloquent bit. There are flashbacks of Eric and Christina walking in an idyllic field, searching for a lost girl. There are references to the death of Francis's young daughter. Through all this, Mr. Egoyan is never confusing, never elliptical for the sake of being elliptical. He creates a dreamy at-

mosphere, one that reflects the partial, fragmented, slippery way we know and think about other people.

The production design of "Exotica" enhances every scene's mood, and ranges from the pseudorich look of the club to Francis's comfortable, middle-class house and Thomas's dingy shop. The music, from seductive Indian-influenced melodies to Leonard Cohen, works just as well.

"Exotica" may not be as perfectly formed as some of Mr. Egoyan's earlier work. Because Thomas's subplot is not as intriguing as the scenes in the club, the stories take too long to merge. But the flaws are minor. Mr. Egoyan continues to build an important, uncompromising career.

"Exotica" is preceded by "All the Kind People," a darkly comic five-minute British short, directed by Erlend Eriksson, in which a tired man shares a train compartment with strangers whose helpfulness takes on a Hitchcockian cast.

1994 S 24, 11:1

STRAWBERRY-AND CHOCOLATE

Directed by Tomás Gutiérrez Alea and Juan Carlos Tabío (in Spanish, with English subtitles); written by Senel Paz; director of photography, Mario García Joya; edited by Miriam Talavera and Osvaldo Donatién; music by José María Vitier; production designer, Fernando O'Reilly; produced by Miguel Mendoza; released by Miramax Films. At Alice Tully Hall tonight at 6 and tomorrow at 1:30 P.M. as part of the 32d New York Film Festival. Running time: 110 minutes. This film has no rating.
WITH: Jorge Perugorría (Diego), Vladimir Cruz (David), Jorge Angelino (Germán), Francisco Gattorno (Miguel), Mirta Ibarra (Nancy), Marilyn Solaya (Vivian)

By CARYN JAMES

The unlikely friendship between two men in Havana who couldn't be more different — one a middle-aged, gay counterrevolutionary and the other a young, heterosexual Communist — is the story of "Strawberry and Chocolate." But the film's most amazing aspect is that it is a breezy charmer about a relationship shaped by severe political struggle.

The gay, well-educated Diego (Jorge Perugorría) buys ice cream at an outdoor cafe and contrives to sit at a table with David (Vladimir Cruz), a student whose education, from books and life, hasn't gone very far. David's fiancée has married another man, leaving him a virgin. When Diego later mentions John Donne, David asks, "Is he a friend of yours?" Diego is charmed.

Diego invites the student to his apartment, strategically spills coffee on his guest's shirt and insists that he take it off. David is naïve, but he's not that naïve.

"Strawberry and Chocolate" was made by one of Cuba's major directors, Tomás Gutiérrez Alea. (When Mr. Gutiérrez Alea became ill during the filming, Juan Carlos Tabío took over some of the scenes.) In tone, it has much in common with Mr. Gutiérrez Alea's sweetly lyrical "Letters From the Park," based on a Gabriel García Marquez story about a man who writes love letters for other people.

Diego's unfulfilled yearning for David shares that film's sense of luxurious romantic doom set against a candy-colored backdrop. Yet this film's concerns are still those of the man who made the groundbreaking 1968 film "Memories of Underdevelopment," about an intellectual adrift in postrevolutionary Cuba. In "Strawberry and Chocolate," politics shapes the characters' relationship, but ideological battles are so much a part of their lives that they almost take them for granted.

Mr. Perugorría is especially good as Diego. One more swish of his hips and the performance would have been too campy. Instead, Diego is overt about his sexuality — there's no mistaking the desire with which he gazes at David across the ice cream — but he stops short of becoming a caricature. He is amusingly self-centered. "Do you know Oscar Wilde, Gide, Lorca?" he asks David. "All of them have something in common with me."

David may not know all those names, but he is certain that Diego is coming on to him. "There was chocolate and he ordered strawberry," David tells his roommate, explaining how he was so sure, from the meeting at the ice-cream parlor, that Diego was a homosexual. David's ignorant certainties are the source of much humor. Though he is a committed member of the Communist League, David's history is shaky. "Truman Capote dropped the A-bomb," he blurts out. "I mean Harry Truman."

Diego is aghast. "Truman Capote, never!" he says. "He was a homosexual!"

Though the friendship sets the film's warm, sentimental tone, the relationship develops on the strength of politics and personal betrayal. David decides to befriend Diego to gain evidence that he is a counterrevolutionary, evidence that is not hard to come by. David pilfers a copy of Time magazine from his friend's apartment. Diego offers him Scotch from the United States, ironically asking David to toast their mismatched relationship with "the enemy's whisky." And Diego's apartment is cluttered with garishly painted religious sculptures made by a friend. Diego is angrily fighting the officials who are trying to thwart his friend's exhibit, though every defiant letter he writes puts him in political jeopardy.

"Strawberry and Chocolate" was a hit in Cuba, where it was reportedly the first film with a gay hero and where its critique of Government intolerance was obviously a more volatile subject than it is here.

As the odd friendship develops, the film comes to feel a little too much like "Kiss of the Spider Woman," with a lighter tone because the characters are not in prison. And the friendship becomes cloying at the end. But Mr. Gutiérrez Alea has created a delightful, humane film about people who love in spite of politics.

"Strawberry and Chocolate" will be shown at the New York Film Festival tonight at 6 and tomorrow afternoon at 1:30 and is scheduled to be released in theaters early next year. Playing with it is "Catalina,"

Tommy O'Haver's witty short about a gay man who falls for a straight man.

1994 S 24, 16:3

MARTHA

Written and directed (in German, with English subtitles) by Rainer Werner Fassbinder, based on a novel by Cornell Woolrich; director of photography, Michael Ballhaus; edited by Liesgret Schmitt-Klink; production designer, Kurt Raab; produced by Peter Märthesheimer. At Alice Tully Hall today at noon as part of the 32d New York Film Festival. Running time: 116 minutes. This film is not rated.
WITH: Margit Carstensen (Martha Hyer-Salomon), Karlheinz Böhm (Helmut Salomon), Ingrid Caven (Ilse), Ortruc Beginnen (Erna), Gisela Fackeldey (Martha's mother), Adrian Hoven (Martha's father), Barbara Valentin (Marianne).

By STEPHEN HOLDEN

Social comedy doesn't get any nastier than "Martha," Rainer Werner Fassbinder's pitch-black satire of bourgeois marriage and patriarchal dominance in modern Germany. The 1973 film, which will be shown today at noon at Alice Tully Hall as part of the New York Film Festival, follows a pathetically obedient wife on her path to destruction at the hands of a sadistic husband.

With a title character who is named after Martha Hyer, a star of 1950's Hollywood melodramas, and whose address is Douglas Sirk Boulevard, the film is also a grimly farcical homage to the sort of pulpy, overwrought soap opera that used to be cranked out by Universal-International.

In the movie's opening scene, Martha (Margit Carstensen) witnesses the death from a heart attack of her cold, much-adored father while they are touring Rome. Returning to Germany, she finds her mother celebrating the death by chasing down Valium with swigs from a whisky bottle. Liberated at last, her mother soon ends up in a mental institution.

Martha turns down a marriage proposal from her boss at a research library and instead weds Helmut Salomon (Karlheinz Böhm), a civil engineer who mauls her violently when they first meet, at a formal dinner party. One of the film's most audacious set pieces, this party is staged like a grotesque state funeral, at which the guests are nearly smothered under banks of flowers.

In a film that piles one episode of mental and physical sadism on another, the cruelest scene takes place during the couple's seaside honeymoon. Announcing that he likes a woman who is tan, Helmut persuades Martha to lie in the sun without sun block. Hours later at their hotel, where Martha is immobilized with a severe burn, Helmut brutally throws himself on her naked body.

Helmut's mental humiliations are as outrageous as his physical abuse. Without consulting her, he arranges for her job resignation. He denounces her beloved Donizetti records as trash and forces her to listen to the more severe Renaissance music of Orlando di Lasso. In a grimly funny sequence, she dutifully recites from memory whole chunks of a civil-engineering text he has required her to study.

Helmut's possessiveness escalates to the point where he has their telephone disconnected and insists that Martha never leave their house. Although she disobeys, it is not rebelliousness but terror that drives her.

Sumptuously photographed in a style that parodies old-time Technicolor glamour, "Martha" is relentless, down to its final searing images of the captive wife and her too-possessive husband. The film, which has never been released in the United States, is essential viewing for admirers of the director, who died in 1982. You don't have to agree with its premise — that middle-class marriage equals sadomasochism — to respond to the bravura comic glee with which the director lays it out.

1994 S 24, 16:3

THROUGH THE OLIVE TREES

Produced, written, directed and edited by Abbas Kiarostami (in Farsi, with English subtitles); directors of photography, Hossein Djafarian and Farhad Saba; released by Miramax Films. At Alice Tully Hall tomorrow evening at 6:45 as part of the 32d New York Film Festival. Running time: 108 minutes. This film has no rating.
WITH: Hossein Rezai (the man), Mohamad Ali Keshavarz (the director), Tahereh Ladania (the woman), Ahmad Ahmadpour (a brother), Babak Ahmadpour (a brother), Mahbanou Darabin (the grandmother), Farhad Kheradmand and Zarifeh Shiva.

By STEPHEN HOLDEN

In Abbas Kiarostami's film "Through the Olive Trees," Hossein Rezai, a nonprofessional actor with soulful eyes and a streak of stubbornness that is as big as his ego, plays a love-smitten bricklayer whose would-be fiancée (Tahereh Ladania) refuses to acknowledge his existence. Complicating matters is the fact that the two have been cast as newlyweds in a movie about earthquake survivors in northern Iran.

The film, which will be shown at Alice Tully Hall tomorrow evening at 6:45 P.M. as part of the New York Film Festival, is the story of one persistent man's pursuit of a woman who believes he is beneath her. It is also a richly textured quasi-documentary portrait of a rural Muslim society in which the people display a remarkable resilience in the face of catastrophe.

In "Through the Olive Trees," the Iranian director has some serious cinematic fun in the manner of Truffaut's "Day for Night." Because Mr. Rezai essentially plays himself, truth and fiction become thoroughly blurred. The film revels virtuosically in such Pirandellian paradoxes. Conceived as a fictional cinéma-vérité documentary about the making of another movie, the same director's "And Life Goes On," which was shown two years ago at the New York Film Festival, "Through the Olive Trees" is a cinematic Chinese box inside of the earlier film.

"And Life Goes On" is also a largely improvised quasi-documentary, shot in the same area only days after a major earthquake. Most of the players used in both films are nonprofessional local residents, many of whose lives were devastated by the quake.

Mr. Rezai was featured in one of that film's more memorable vignettes, playing a young man who describes going ahead with his wedding despite the destruction of his home and the loss of 65 relatives. He tells of living in a field with his wife in an improvised shelter. The filming of that scene is re-enacted in "Through the Olive Trees."

Adding an extra conceptual twist is the fact that Mr. Kiarostami does not portray himself in the new movie. Mohamad Ali Keshavarz, who portrays the director, is a shaggy-haired bear of a man who suggests an Iranian version of John Huston. The way all this theory plays out is much less complicated than it might seem.

Mr. Rezai emerges as an intriguing, if not entirely likable, character. Now that he's an actor, he announces, he will never do masonry again. But as he pursues the object of his affection, who refuses to speak to him or even to make eye contact, his ardent appeals become badgering. In the film's spectacular final scene, the camera follows him in a long shot as he trails behind his beloved on a course that takes them up and down a mountain slope and across a field until the two of them almost disappear.

Like the earlier movie, "Through the Olive Trees" combines a panoramic visual beauty with an acute sense of human tininess in the face of eruptive natural forces.

1994 S 24, 16:3

CARO DIARIO

Written and directed by Nanni Moretti (in Italian, with English subtitles); director of photography, Giuseppe Lanci; edited by Mirco Garrone; music by Nicola Piovani; production designer, Marta Maffucci; produced by Nanni Moretti, Nella Banfi and Angelo Barbagallo; released by Fine Line Features. At Alice Tully Hall tonight at 9 and tomorrow at 6 P.M. as part of the 32d New York Film Festival. Running time: 96 minutes. This film has no rating.
WITH: Nanni Moretti (as himself), Renato Carpentieri (Gerardo), Antonio Neiwiller (Mayor of Stromboli), Moni Ovadia (Lucio) and Mario Schiano (Prince of Dermatologists)

By JANET MASLIN

There are social critics as lively and opinionated as Nanni Moretti on many a park bench, but they don't share Mr. Moretti's rare gift for captivating an audience. This funny, contentious Italian film maker, who was voted best director at this year's Cannes International Film Festival, wanders through "Caro Diario" ("Dear Diary") airing his thoughts in delightfully offbeat ways. As both a skillful director and a lovable oddball, he commands interest. It's easy to follow him anywhere.

He has many different destinations in "Caro Diario," one of the high points of this year's New York Film Festival. Divided into three sections, this film starts out with a portrait of Mr. Moretti's Rome. Cruising serenely in "On My Vespa," he visits a nice selection of settings that bear out his worldview. Cinemas are especially important, like the one playing a film in which

dour yuppies bemoan their disillusionment.
"We used to shout awful, violent slogans," complains an actor in this film-within-the-film. "Look how old and ugly we've gotten."
"You shouted awful, violent slogans," retorts Mr. Moretti, who has been catcalling from the audience. "You've gotten ugly. I shouted the right slogans, and I'm a splendid 40-year-old!" It's never harder than this to know where he stands.

Another highlight of the film's Roman section is Mr. Moretti's trip to see "Henry: Portrait of a Serial Killer." Afterward, horrified, "I wander around the city for hours trying to remember who it was that said good things about this film," he says. Then he finds and torments the critic who was responsible. Crazy about dancing, Mr. Moretti also ruminates about Jennifer Beals and "Flashdance" until he happens to find her strolling on the sidewalk. "You just have to be calm," Ms. Beals murmurs to her husband as she is accosted by Mr. Moretti. "He's a little bit off."

But he isn't the least bit off. For all his apparent casualness, Mr. Moretti is a perfectionist who shapes his material with subtle care. With a seductive rhythm, the film alternates between wry encounters and lovely restful interludes, the latter presented so soothingly that they create a contemplative mood. (An elegiac, wordless visit to the place where the director Pier Paolo Pasolini was killed is one example.) Beautiful Italian scenery is also among this film's many pleasures.

The middle section, "Islands," is an ironic travelogue in which Mr. Moretti goes exploring with his friend Gerardo (Renato Carpentieri), a scholar looking for a peaceful place to work. Having spent many years shunning popular entertainment and studying "Ulysses," Gerardo becomes so enthralled by American soap operas during this voyage that when he meets American tourists climbing the volcanic mountains of Stromboli, he is full of urgent questions about "The Bold and the Beautiful."

Also seen during this segment: a visit to an island where all parents are obsessed with their children and the children respond by behaving like tyrants. Every public phone on the island is manned by a grown-up forced to make animal noises in order to placate some tot on the other end. "Mom and Dad are here," one little boy tells a harried caller. "But first I'm going to tell you a story."

"Doctors," the film's final section, has more gravity, since it chronicles a real medical crisis experienced by Mr. Moretti. He begins by filming himself receiving chemotherapy, then goes back to explain the odd symptoms and even odder medical advice that preceded his diagnosis. Even here, Mr. Moretti sustains a gently inviting tone and a keen appreciation of the absurd. A masseuse tells him authoritatively to avoid red foods. A doctor advises cotton socks. This doctor, telling Mr. Moretti that "my family are your fans," also gives him a special price and his phone number at a beach house.

Only there does Mr. Moretti make reference to his popularity in Italy, where this and seven previous films have won him an avid cult following. It would be no surprise if his work were equally well liked here.

"Caro Diario" will be shown tonight at 9 and tomorrow at 6 P.M. as part of the New York Film Festival. On the same bill is Luc Moullet's "Attempt at an Opening," an equally single-minded film in which men match wits with a coke bottle. The bottle wins.

1994 S 26, C11:3

CHUNGKING EXPRESS

Written (in Cantonese, with English subtitles) and directed by Wong Kar-wai; directors of photography, Christopher Doyle and Lau Wai-keung; edited by William Chang, Hai Kit-wai and Kwong Chi-leung; music by Frankie Chan and Roel A. Garcia; production designer, William Chang; produced by Chan Yi-kan. At Alice Tully Hall this evening at 6 as part of the 32d New York Film Festival. Running time: 97 minutes. This film is not rated.
WITH: Brigitte Lin Ching-hsia (Drug dealer), Tony Leung Chiu-wai (Cop 663), Valerie Chow (Air hostess), Takeshi Kaneshiro (He Quiwu, Cop 223), Faye Wang (Faye).

By JANET MASLIN

Lurching, vertiginous camera work is one hallmark of Wong Kar-wai's "Chungking Express," a film from Hong Kong with a tirelessly capricious sense of style. While its slender, two-tiered plot links love affairs that happen largely by accident, the film's real interest seems to lie in raffish affectation. Mr. Wong has legitimate visual flair, but his characters spend an awful lot of time playing impish tricks. A film in which a man talks to his dishtowel has an overdeveloped sense of fun.

Mr. Wong, whose "Days of Being Wild" was shown at the New Directors/New Films series in 1991, displays aggressive energy, but his material is slight. In the first vignette, a mysterious blond-wigged moll oversees a comically intense drug-smuggling operation while a policeman

A hyperkinetic tale of love affairs that happen by chance.

mopes about the loss of his longtime girlfriend. These two strangers will eventually fall in love, we are told.

Meanwhile, the film displays the first sign of its fixation on canned goods as the policeman looks for pineapple with a certain expiration date, thinking that eating it will bring him luck in love. "I wonder if there's anything in the world that won't expire," he muses.

This sentimental soul would seem to be no match for the drug dealer, who's so tough that she simply carts off a little girl when the girl's father behaves recalcitrantly. (After an ice-cream sundae, the little girl is returned.) When the cop and the blonde do meet, the encounter is

Brigitte Lin as a drug dealer in "Chunking Express."

The Film Society of Lincoln Center

The cartoonist Robert Crumb in "Crumb," directed by Terry Zwigoff.

archly effective, but it still seems less consequential than the edgy, hyperkinetic mannerisms used to tell the story.

The film's second section concerns a different policeman, whose romance with a stewardess has become star-crossed, perhaps because when they met for a tryst he played with a toy airplane. A pretty cook at a fast-food restaurant becomes obsessed with supplanting the stewardess in the cop's imagination. She sneaks into his apartment, touching and rearranging things until she seems to know everything about him, even down to how he feels about his dishtowel. Wherever she goes, she likes to bop along to "California Dreamin'."

Beyond the Mamas and the Papas, "Chungking Express" is filled with global-village references to fast food, video, convenience stores, Bruce Willis and Demi Moore. While Mr. Wong's visual energy harks back to early New Wave experimentation, it also has a substantial rock-video component, which suggests that the detritus of mass culture has a way of coming home to roost.

Like "Days of Being Wild," "Chungking Express" is clumsily subtitled, which also detracts from its effectiveness. On the same bill is "Eating Out," a deadpan, funny Norwegian short set in the most dismal greasy-spoon restaurant under the midnight sun.

"Chungking Express" and "Eating Out" will be shown this evening at 6 as part of the New York Film Festival.

1994 S 26, C14:1

CRUMB

Directed by Terry Zwigoff; director of photography, Maryse Alberti; edited by Victor Livingston; music by David Boeddinghaus; produced by Lynn O'Donnell and Mr. Zwigoff. At Alice Tully Hall at 9 P.M. as part of the 32d New York Film Festival. Running time: 119 minutes. This film has no rating.

WITH: Robert Crumb, Beatrice Crumb, Charles Crumb, Max Crumb, Dana Morgan, Robert Hughes and Aline Kominsky.

By STEPHEN HOLDEN

When the cartoonist Robert Crumb was a little boy, he reveals in Terry Zwigoff's riveting documentary portrait, he was sexually attracted to Bugs Bunny, even carrying around a picture of this buck-toothed rabbit. Eventually it became crumpled and was all but destroyed after he had his mother iron it for him. At 12, he developed a new fixation. He became erotically obsessed with the television character Sheena, Queen of the Jungle.

Although Mr. Crumb went on to create such famous modern cartoon characters as Fritz the Cat and Mr. Natural, and helped to found the underground-comic movement, Bugs Bunny and Sheena continued to reverberate through his art. Bugs Bunny's cheery irreverence was sharpened into a satirical sensibility that has been compared to Daumier and George Grosz. Sheena's descendants are the devouring Amazonian women portrayed in work that is often savagely misogynistic and pornographically explicit.

The cartoonist's memories of his childhood sexual fantasies are only the tip of the confessional iceberg in "Crumb," which the New York Film Festival is showing this evening at 9

at Alice Tully Hall. Much more than a polite documentary profile of an artist's life and times, the film offers an astonishingly unguarded portrait of Mr. Crumb, who is 51, and his seriously dysfunctional family. Just when you think the film couldn't probe any more intimately, it offhandedly reveals information about people's medications, bathroom habits and genitalia.

Long stretches of the film are devoted to the cartoonist's talented, mentally disturbed elder brother, Charles, who committed suicide recently. Calmed by medication, Charles, who never moved out of his mother's house, recalls the homicidal impulses he felt toward Robert when they were growing up. The film offers ample documentation to show that Charles was as talented an artist as Robert. But as his mental illness worsened, he gave up drawing.

A third brother, Max, is also interviewed. A self-punishing ascetic and sometime artist who lives in San Francisco, he is shown preparing to meditate while lying bare-backed on a bed of nails. Neither of the artist's two sisters cooperated in the making of the film.

Mr. Crumb makes no bones about his anger at his late father and at American society in general. He readily admits that his urge to succeed was fueled by a desire for revenge. His father, a Marine Corps officer turned businessman, is remembered as a cold and tyrannical straight-arrow who remained aloof from his eccentric sons and stopped speaking to Robert after a colleague showed him some of his work. In high school, the cartoonist was a nerd who could not get a date. As his autobiographical drawings of his high school days illustrate, he was permanently wounded by his adolescent peers' rejection.

Although Mr. Crumb and his characters are widely identified with the hippie movement, and he concedes that many of his ideas grew out of experiments with LSD, he never

lived the hippie life style. He was far too much of a misanthropic loner.

The artist's grievances extend well beyond high-school pariahhood. Early in the film, he expresses enormous bitterness at the paltry sums he made for two of his most famous works: a poster bearing the slogan "Keep on Truckin'" and the cover art for Big Brother and the Holding Company and Janis Joplin's best-selling album "Cheap Thrills." He is shown abruptly turning down an offer from Hollywood, which he resents for mutilating his character Fritz the Cat.

If "Crumb" were merely a behind-the-scenes portrait of the artist and his troubled family, it would exert a gothic sort of fascination. But the film does much more. It succeeds at showing how one man's psychic wounds contributed to an art that transmutes personal pain into garish visual satire. While the film's amazingly candid interviews with the artist, his friends, family members and his current and former wives shed light on the sources of his work, the final leap from neurosis into artistic brilliance remains mysterious.

The art critic Robert Hughes calls Mr. Crumb "the Bruegel of the 20th century." That may be overstating it. But the film's many examples of Mr. Crumb's work present a vision of American life as a phantasmagoric gallery of grotesques that is as gripping as it is harshly funny.

1994 S 27, C16:

COLD WATER

Written (in French, with English subtitles) and directed by Olivier Assayas; director of photography, Denis Lenoir; edited by Luc Barnier; production designer, Gilbert Gagneux; produced by George Benayoun and Paul Rozenberg. At Walter Reade Theater at 9 tonight and tomorrow at 6 P.M. as part of the 32d New York Film Festival. Running time: 92 minutes. This film has no rating.

WITH: Jackie Berroyer (Christine's father), Jean-Christophe Bouvet (Teacher), Jean-Pierre Darroussin (Inspector), Dominique

Faysse (Christine's mother), Cyprien Fouquet (Gilles), Virginie Ledoyen (Christine), Smail Mekki (Mourad), Laszlo Szabo (Gilles' father).

By JANET MASLIN

During a rare meeting with his father, who openly acknowledges he has little time for his son, Gilles (Cyprien Fouquet) stands by uncomfortably while his parent speaks rapturously of Caravaggio. "Few images of suffering move me more than this," says the father, pointing to a reproduction in an art book, and ignoring the subtler but more immediate unhappiness manifested by his son.

Not long afterward, Christine (Virginie Ledoyen), the bored, restless beauty with whom Gilles is shyly in love, wanders through an anarchic teen-age party. Goaded by private demons and by the churning sounds of a Janis Joplin record (the year is 1972), Christine picks up a pair of scissors as she walks and begins hacking angrily at her hair.

As the central figures in Olivier Assayas's "Cold Water," these two adolescent characters display a turbulence that is well reflected by the film's visual style. Unusual, disjointed framing and edgy camera work help crystallize the feeling that the young lovers' lives are going dangerously askew.

Mr. Assayas's screenplay is loose and uneventful, but his direction has more energy. During the best parts of this small, intense character study, his camera prowls apprehensively through fiery teen-age gatherings and colorless adult settings, trying to describe the desperation his young principals feel. Though the narrative is too elliptical for much background detail, it's established that Christine is genuinely troubled and has been hospitalized by her parents. Gilles's problems are more ordinary, but he is torn between adhering to conventional behavior or following his heart.

"Cold Water," which carries these two to the brink of crisis before ending on a deliberately uncertain note, is a moody evocation of their distress. Though the essence of his story is familiar, Mr. Assayas gives it a disturbing energy, as when a party mysteriously builds momentum until the revelers begin burning chairs. Though the film is set near Paris, it is made more interestingly cryptic by the absence of a clear backdrop to the story. The store where Christine is caught shoplifting records (after which she calmly invents a lie about having been sexually harassed by security guards) provides as much context as the film ever has.

By international coincidence, the soundtrack for "Cold Water" includes music by Leonard Cohen, whose songs are also heard in two other New York Film Festival selections, Atom Egoyan's "Exotica" and Nanni Moretti's "Caro Diario." Mr. Cohen, also very audible in "Natural Born Killers," is clearly the musician of choice for film makers seeking a mood of dark, knowing anomie.

"Cold Water" will be shown tonight at 9 and tomorrow night at 6, on a bill that also includes "Jump," a 15-minute film by Melissa Painter. Shot in cold, hard daylight by Lodge Kerrigan, it depicts a nubile 12-year-old named Heather on a visit to the beach. Also present are Heather's friend, the friend's mother and a flirtatious man who seems to know the mother well. The action mostly consists of nuances in a coming-of-age vein. When Heather finally tells her mother "nothing happened," she's close to the truth.

1994 S 28, C13:1

WHISPERING PAGES

Written (in Russian, with English subtitles) and directed by Aleksandr Sokurov; director of photography, Aleksandr Burov; edited by Leda Semyonova; music by Gustav Mahler, sung by Lina Mkrtchyan; production designer, Vera Zelinskaya; produced by Vladimir Foteyev. At Alice Tully Hall at 6 tonight as part of the 32d New York Film Festival. Running time: 77 minutes. This film has no rating.
WITH: Sergei Barkovsky (Official), Aleksandr Cherednik (Hero), Elizaveta Korolyova (Girl).

THE CLOUD DOOR

Directed by Mani Kaul; director of photography, Anil Mehta; edited by Lalitha Krishna; music by Usted Zio Foriduddin Dagar; produced by Regina Ziegler. At Alice Tully Hall at 6 tonight as part of the 32d New York Film Festival. Running time: 29 minutes. This film has no rating.
WITH: Anu Arya Aggarwal (Kurangi), Murad Ali (Ratnasen) and Vasudeva Bhatt, Bahauddin Dagar, Irfan, Yusef Khurram, Shambhavi and Shashi.

By CARYN JAMES

Plenty of works at this year's New York Film Festival are assured a commercial afterlife. You can spot them faster than you can say Quentin Tarantino or even Woody Allen. At the opposite end of the spectrum are the two films in the program called "Avant-Garde Visions," works that revel in their nonnarrative styles and quirky, nontheatrical lengths. Made by masterly film makers — Alexander Sokurov from Russia and Mani Kaul from India — they are like elegant visual riffs on literary themes.

"Whispering Pages" is Mr. Sokurov's haunting black-and-white meditation on themes from 19th-century Russian literature, most conspicuously "Crime and Punishment." There is a murderer, the Raskolnikov character, who lives in a hovel and wanders the banks of a river. There is a woman, the holy prostitute figure. She becomes the focus of he murderer's philosophical questions about life, guilt and God, phrased in the film's sparse dialogue. Mostly there is extraordinary photography, a palette of dusty gray tones that echo the faded look of 19th-century photographs.

As in his features (like "The Second Circle," and "Save and Protect," a version of "Madame Bovary), Mr. Sokurov's camera moves languorously, as if it were caressing each building, statue and person in its path. Some characters meet in a noisy, cavernlike dining room; others leap off a bridge into the river. For 77 minutes, "Whispering Pages" creates a meeting place where Dostoyevsky, the viewer's awareness of his themes, and Mr. Sokurov's interpretation can mingle.

In "The Cloud Door," Mr. Kaul plays with literary themes in much the same way, but faces a serious problem of cultural translation. Because his sources are erotic themes from Hindu and Muslim literature, his film is bound to be less accessible to Western viewers than Mr. Sokurov's film. Deprived of its cultural context, the 29-minute "Cloud Door" becomes a succession of brightly colored images that almost tell a story: a beautiful woman, perhaps a courtesan; a green, long-tailed parrot who repeats the erotic phrases he's picked up in her room; potential lovers; a fish that laughs.

"Red," by the Spanish film maker Teresa de Pelegri, is set in Spain in 1940. This 11-minute film tells a poignant tale about a boy who learns about death from a wounded soldier and his pet dog.

Presenting these film makers to an audience — even if it never reaches blockbuster size — is among the festival's valuable roles. "Avant-Garde Visions" will be shown tonight at 6.

1994 S 28, C14:3

JASON'S LYRIC

Directed by Doug McHenry; written by Bobby Smith Jr.; director of photography, Francis Kenny; edited by Andrew Mondshein; music by Afrika and Matt Noble; production designer, Simon Dobbin; produced by Mr. McHenry and George Jackson; released by Gramercy Pictures. Running time: 119 minutes. This film is rated R.
WITH: Suzzanne Douglas (Gloria), Eddie Griffin (Rat), Allen Payne (Jason Alexander), Jada Pinkett (Lyric), Lahmard Tate (Ron), Treach (Alonzo), Forest Whitaker (Maddog), Bokeem Woodbine (Joshua)

By CARYN JAMES

The title "Jason's Lyric" says a lot about what's wrong with this picture. Jason is the name of the hero and Lyric the name of the woman he loves. The phrase "Jason's Lyric" makes it sound as if he owns her instead. That's just the first of several thoughtless problems in a muddled film that takes a standard urban action movie and adds a veneer of overwrought romance.

This is the first film directed by Doug McHenry, who has been more successful as a producer ("New Jack City"). It is the good brother-bad brother story, set in the run-down black section of Houston called the Wards. Jason (Allen Payne) is the responsible young man who has a job in a television repair shop and lives at home with his hard-working mom. Joshua (Bokeem Woodbine) is the brother just released from jail and obviously bound for some violent end.

When Lyric (Jada Pinkett) walks into the shop to buy a television, Jason has met his perfect match. She has dreams of escape, and inspires Jason to do supposedly romantic things like borrow a city bus to take her on a date. The film's familiar urban scenes work best. Joshua deals drugs for short-term cash and joins a gang plotting a bank robbery. Mr. Woodbine makes Joshua vehement and careless, and his scenes have a texture that suggests why Joshua's life is so limited and why his brother's attempts to help are frustrated.

But there is real trouble when Mr. McHenry and the screenwriter, Bobby Smith Jr., get poetic. The height of this excess comes when Jason and Lyric take a romantic ride in a rowboat — she wears a floppy hat and the photography looks gauzy — then make love in the woods. The scene is like Lyric's character: an idealized vision of a dreamy woman who couldn't exist outside the screenwriter's fantasies about ladylike aspirations.

In a series of flashbacks during the first 20 minutes or so, Forest Whitaker plays the boys' father, Maddog. Throughout the film, Jason has nightmares about a tragedy in his childhood. Either Jason or Joshua killed Maddog while he was drunkenly attacking their mother. Which brother pulled the trigger isn't revealed until the end, but the editing is so choppy that for a long while it seems the movie is unintentionally confusing rather than deliberately holding back information.

"Jason's Lyric" is most interesting as a footnote to the latest mindboggling move by the Motion Picture Association of America's rating board, often criticized for being much more horrified by sex than violence. That's certainly the case here. The film was rated R instead of NC-17 only after some sex scenes were cut and suggestive advertising art replaced. Yet "Jason's Lyric" remains one of the most violent films of the year. Joshua is tortured by some furious gang members and when he comes to his inevitable bad end, Lyric's family house is the scene of a bloodbath, the walls splat-

The Film Society of Lincoln Center
Virginie Ledoyen, who plays Christine in "Cold Water."

tered and the yard strewn with bodies.

"Jason's Lyric" is rated R (Under 17 requires accompanying parent or adult guardian.) It includes much violence, some of it unusually brutal; and some sex scenes that are explicit, but no more daring than in many other R-rated films.

1994 S 28, C14:3

LONDON

Written, directed and photographed by Patrick Keiller; edited by Larry Sider; produced by Keith Griffiths; released by Zeitgeist Films. Film Forum, 209 West Houston Street, South Village. Running time: 84 minutes. This film has no rating.
WITH: Narration by Paul Scofield

CAN'T GO WRONG WITHOUT YOU

Directed by the Brothers Quay; music by His Name Is Alive; released by Zeitgeist Films. Film Forum, 209 West Houston Street, South Village. Running time: 3 minutes. This film has no rating.

By STEPHEN HOLDEN

The city of London is not a hospitable-looking place in Patrick Keiller's exceedingly arch cinematic meditation on England's largest city. Filmed during Prime Minister John Major's 1992 re-election campaign, "London" examines a metropolis whose stately old architecture is increasingly dwarfed by hideous postmodern skyscrapers and mocked by garish billboards.

A gray pall of air pollution hangs over the Thames. Members of the English royal family, shown discharging their ceremonial duties, look like wind-up dolls surrounded by toy soldiers. And terrorist bombings by the I.R.A. inflict staggering property losses in the heart of the city. Because the film has no live soundtrack apart from the narration and some faraway sound effects, it has the feel of an examination conducted through thick one-way glass.

Although "London," which opened today at the Film Forum, has the appearance of a documentary, this eccentric movie is really a sly combination of fact and fantasy. Paul Scofield, who narrates, plays a man who has returned to London after a seven-year absence and tours the city with his former lover, an unseen, unheard character named Robinson. His narration is largely an account of Robinson's observations on the decline of the city, as the two of them visit historical sites associated with famous authors and painters.

The tours they undertake are part of a vague research project whose purpose is never stated. The first of three trips takes them from Strawberry Hill to Twickenham (where Horace Walpole wrote "The Castle of Otranto") to Vauxhall (the area associated with Sherlock Holmes). The second expedition begins at a house once occupied by a woman who rejected Guillaume Apollinaire's offer of marriage and ends at a school where Edgar Allan Poe was

once a pupil. The final jaunt, in the city's outer suburbs, follows the River Brent.

Along the way there is a lot of prattle about the French poets Baudelaire, Verlaine and Rimbaud's impressions of London. The narration is heavily seasoned with lofty quotations on the character of the city and on urban life in general. One of the most resonant comes from the 19th-century Russian socialist Aleksandr Herzen, who observed: "There is no town in the world which is more adapted for training one away from people and training one into solitude than London."

Although the film makes a token attempt to celebrate the vitality of neighborhoods where immigration has created a multi-ethnic swirl, it is at heart an extended cranky complaint against modernism and the decline of civility. The unrelieved hauteur of Mr. Scofield's character eventually becomes tedious, and "London" takes on the tone of a dry, circuitously worded editorial.

"Can't Go Wrong Without You," the three-minute music video by the Brothers Quay that opens the program, is a typically eerie visual nightmare by the experimental film makers. In this black and white film for the underground rock band His Name Is Alive, a stuffed rabbit battles devilish forces for the possession of an elusive Easter egg.

1994 S 28, C14:3

AMATEUR

Written and directed by Hal Hartley; director of photography, Michael Spiller; edited by Steven Hamilton; music by Jeff Taylor and Ned Rifle; production designer, Steve Rosenzweig; produced by Ted Hope and Mr. Hartley; released by Sony Pictures Classics. At Alice Tully Hall tonight at 9 and tomorrow at midnight as part of the 32d New York Film Festival. Running time: 105 minutes. This film is rated R.
WITH: Isabelle Huppert (Isabelle), Martin Donovan (Thomas), Elina Lowensohn (Sofia), Damian Young (Edward), Chuck Montgomery (Jan), David Simonds (Durt), Pamela Stewart (Policewoman), Erica Gimpel (Angry Woman), Jan Leslie Harding (Waitress) and Terry Alexander (Frank the cook).

By CARYN JAMES

Many romantic triangles are bizarre, but in "Amateur" Hal Hartley has concocted the most irresistibly strange one to hit the screen in a long time. A pretty former nun is trying to earn a living by writing for pornographic magazines. She falls for a sensitive man who has amnesia and traces of a sordid past. He is still married to a prostitute, who is trying to kill him and leave her old life behind. Add to this an arms dealer who sends his thugs after the prostitute, and life couldn't be more complicated or more deliciously droll. The nun, the amnesiac and the prostitute fit neatly into Mr. Hartley's distinctive world, a place that is always serious and comically absurd. "Amateur" is his most ambitious view of that world yet.

Isabelle Huppert plays Isabelle, who sits in a coffee shop all day nursing a cup of coffee and talking out loud as she labors over her pornographic stories. She is just 10 months out of the convent and still a

Sony Pictures Classics
Isabelle Huppert in "Amateur."

virgin, so it's no wonder she rarely earns enough food money.

Thomas (Martin Donovan) is first seen lying unconscious on a street in TriBeCa, where Sofia (Elina Lowensohn), a woman in a whorish outfit, runs away from him. He wanders into the coffee shop with a pocketful of Dutch coins and no memory of his past. But he is so obviously a good, respectable man that Isabelle offers him a place to stay. Soon she is explaining, without a hint of lunatic fervor, that God has chosen her for some mission that she can accomplish only outside the convent. She also explains that she is a nymphomaniac as well as a virgin.

"How can you be a nymphomaniac and never have sex?" Thomas asks.

"I'm choosy," Isabelle answers, in a tone so matter-of-fact you have to believe her.

Though Thomas has amnesia, Sofia certainly remembers him. He lured her into a world of drugs and prostitution when she was 12 and later married her, but the honeymoon is over. She is the one who pushed him out a window, causing his memory loss.

All the marks of Mr. Hartley's sharp yet leisurely style are here: the skewed dialogue that never leaves the believable world behind, and the actors whose deadpan readings make that skewed dialogue seem true. Mr. Hartley's earlier films — "The Unbelievable Truth," "Trust" and "Simple Men" — involved hermetic family situations, with larger issues as comic backdrops. With "Amateur" he leaps into a sleazy adult world that allows him to take on weightier issues more directly. This is a wry look at the social roles people play and the "real" characters hidden beneath them. Thomas literally wakes up a new man after his fall from the window, but others are shedding outdated roles, too. The nun discovers romantic desire, the prostitute becomes a wholesome heroine, and even the pornographer who hires Isabelle sees himself as a once-and-future muckraking reporter.

The tone of this film is intentionally darker than Mr. Hartley's earlier work, but his playful attitude guarantees that he never becomes pre-

tentious. The key is finding actors perfectly in sync with his understated attitude. Ms. Huppert's expressive face and sincere tone make Isabelle both innocent and smart. "When I make mistakes," she says flatly of her 15 years in the convent, "they tend to be big ones."

Mr. Donovan perfected the Hartley style in "Trust" and "Simple Men." As Thomas overhears troubling details about himself, he creates a sense of low-key amazement, as if Thomas were thinking, "That doesn't sound like me, but anything is possible." Ms. Lowensohn, who was also in "Simple Men," makes Sofia's transformation totally convincing. Between her slight Romanian accent and Ms. Huppert's even slighter French accent, "Amateur" exists in a world that is familiar and foreign at once.

A blackmail plot is the device Mr. Hartley uses to send his characters racing through evocative settings, photographed by Michael Spiller with a slight bluish cast that makes the ordinary look mysterious. Sofia escapes thugs in Grand Central station. Later, the three of them wind up in Thomas's apartment, where Isabelle puts on Elina's tight black work clothes and a subtle trade of identities begins. Eventually they flee the thugs by running to Isabelle's old convent and a medieval atmosphere (the scenes were filmed at the Cloisters) far from the grimy downtown streets where Isabelle lives.

Much humor in "Amateur" comes from its mockery of suspense movies, and much from minor characters. Edward (Damian Young) is trying to save Sofia, and his wild-eyed, manic look brings to mind Renfield in "Dracula." A wonderfully overwrought police officer named Patsy Melville (Pamela Stewart) is always about to burst into sympathetic tears over her missing-person reports.

"Amateur" will be shown at the New York Film Festival tonight at 9 and tomorrow at midnight and is scheduled to be released commercially in April. While refining his style, Mr. Hartley obviously has plenty of surprises left.

"Suspicious," which will be shown before "Amateur," is a wittily acted 15-minute film by David Koepp. Janeane Garofolo plays a nervous woman who drives into a gas station late at night and finds an attendant whose intense stares make her uneasy. It helps that he's played by Michael Rooker, better known as the title character in "Henry: Portrait of a Serial Killer." The film shares some of Hal Hartley's wryness.

1994 S 29, C16:3

BULLETS OVER BROADWAY

Directed by Woody Allen; written by Mr. Allen and Douglas McGrath; director of photography, Carlo Di Palma; edited by Susan E. Morse; production designer, Santo Loquasto; costumes, Jeffrey Kurland; produced by Robert Greenhut; released by Miramax Films. At Alice Tully Hall tomorrow at 6 P.M. and Sunday at 1:30 P.M. as part of the 32d New York Film Festival. Running time: 99 minutes. This film is rated PG.
WITH: Dianne Wiest (Helen Sinclair), John Cusack (David Shayne), Jennifer Tilly (Olive Neal), Rob Reiner (Sheldon Flender), Chazz

Palminteri (Cheech), Tracey Ullman (Eden Brent), Mary-Louise Parker (Ellen), Joe Viterelli (Nick Valenti), Jack Warden (Julian Marx), Annie-Joe Edwards (Venus), Jim Broadbent (Warner Purcell) and Harvey Fierstein (Sid Loomis).

By JANET MASLIN

"THE point is, no great artist has ever been appreciated in his lifetime," opines one of the minor characters in Woody Allen's "Bullets Over Broadway," a playwright (Rob Reiner) who says his work is "written specifically to go unproduced." Mr. Allen wrote that line about fame, but he has reason to know otherwise.

Having been appreciated ad nauseam, in every possible public light, he now considers the artist's sometimes-conflicting obligations to his work and to his conscience. In the process, he successfully re-invents himself as comic philosopher, finding wicked humor in questions of artistic life or death. One way or another, Mr. Allen has been well served by recent experience. "Bullets Over Broadway" is a bright, energetic, sometimes side-splitting comedy with vital matters on its mind, precisely the kind of sharp-edged farce he has always done best.

"Bullets Over Broadway," the first of Mr. Allen's films to be included in the New York Film Festival, will be shown tomorrow at 6 P.M. and Sunday at 1:30 P.M.

Set during Prohibition and centered on a pleasant young playwright (John Cusack) with a delusional view of his own talents, it enjoys the antics of cheerfully ridiculous stock characters while also throwing in a stunning wild card. He is a gangster named Cheech (an expertly gruff Chazz Palminteri). He happens to be more of a theatrical genius than the nice young man will ever be.

It will take David Shayne (Mr. Cusack) a long time to figure that out. Declaring himself an artist in the film's opening line, he is too proud to let compromises be made in his work. Of course, this stubbornness provides a fine comic opportunity, since the only backing that can be drummed up by David's agent (Jack Warden) comes from a gangster named Nick (Joe Viterelli). Nick has a talentless girlfriend named Olive (Jennifer Tilly). Olive has trouble remembering a line more complicated than "Charmed, charmed, charmed, charmed!" but she wants a starring role in David's play.

Also waiting in the wings is Helen Sinclair (a wonderfully funny Dianne Wiest), a scene-stealing grande dame who is a teensy bit over the hill. She is (by her own description) "some vain Broadway legend."

But it's also true, in the words of her manager (Harvey Fierstein), that in recent years she's "been better known as an adulteress and a drunk, and I say that with all due respect." Helen happily drops the names of "Max" Anderson and "Gene" O'Neill at every opportunity, but she's ready to take a chance on a newcomer. She's also ready to make him rewrite his play so that it becomes more flattering to her.

During the jubilant introductory scenes to "Bullets Over Broadway," Mr. Allen has a field day with this situation. The story moves fast and features two terrific ensemble episodes, the first at Nick and Olive's madly swanky Art Deco apartment, where the color scheme is black-and-white and Olive is a vision in salmon marabou. (Kudos to Santo Loquasto's production design and Jeffrey Kurland's costumes, as usual.) Also on hand is Venus (Annie-Joe Edwards), the maid who sees no reason to mince words around Olive. When Olive later declares herself not in the mood for Nick's advances, Venus retorts: "You better *get* in the mood, honey, 'cause he's paying the rent."

Then there's the first rehearsal session, bringing together members of David's cast. (As a further commitment to his art, he has decided to direct.) The inflatable Warner Purcell (Jim Broadbent), a matinee idol with a weight problem, arrives asking, "Would it be frightfully tiresome if I just had hot water and lemon?" He is soon sneaking cake and drumsticks every chance he gets. Eden Brent (Tracey Ullmann), an aging ingénue, arrives giddily, trilling at her lap dog.

Nobody beats Helen Sinclair when it comes to making an entrance, though. "Please forgive me!" she booms, sweeping in late for the meeting. "My pedicurist had a stroke. She fell forward onto the orange stick and plunged it into my toe, and it required bandaging." Gazing around the empty theater, Helen feels the urge to offer grandiose greetings ("Mrs. Alving! Uncle Vanya. There's Cordelia! Here's Ophelia") to the cheap seats.

The place isn't entirely deserted. Cheech is loitering in the audience, having been assigned the job of guarding Olive. Initially disgusted by the baloney coming from the stage, he begins offering informal critiques after a while. His thoughts are blunt. "You don't write like people talk," he tells David. (Mr. Allen has a fine time writing bad Broadway dialogue, by the way.)

The trouble is, Cheech is right. And the rest of "Bullets Over Broadway" ponders the disparity between David, who has studied playwriting as hard as he can, and Cheech, who instinctively knows what it's really about. The important difference between them, beyond that of talent, is ethical. David allows himself to be swayed by everyone around him. Cheech is single-minded, and he thinks a good play is, quite literally, to die for.

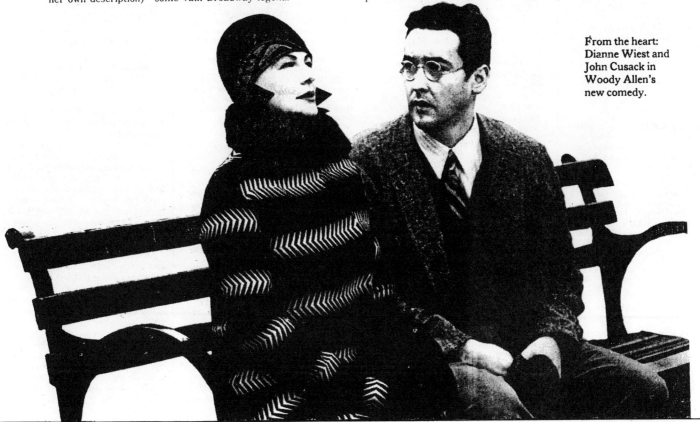

From the heart: Dianne Wiest and John Cusack in Woody Allen's new comedy.

Mr. Allen has drawn on autobiographical specifics in other films, but this may be the one in which he speaks most seriously from the heart. Although the film seems to make pronouncements in boldface by the final scene, delivering a pat solution to one of the fundamental problems in any artist's life, there is a haunting ambiguity hanging over these closing moments. Only a nice, weak-willed writer like David would find an easy answer to the questions raised by this story. Surely that's part of the point.

Mr. Allen establishes the tougher underpinnings of "Bullets Over Broadway," which opens commercially on Oct. 14, with the disarming ease that informs his most satisfying work. As one of his more ebullient recent films, it can be watched as a deft, glossy ensemble piece with the occasional razor edge. Carlo Di Palma's camera work, blessedly steady after a couple of hand-held Allen experiments, captures a rich, affectionate vision of Broadway in its heyday. And again Mr. Allen finds new ways to love New York. When Mr. Cusack and a gorgeously costumed Ms. Wiest sit on a bench flanked by a sea of flowers, the image is so rhapsodic it's hard to believe this is Central Park.

Loving care has also gone into the nightclub musical numbers seen briefly here (with chorus girls in pagoda or skyscraper-and-martini costumes) and into witty musical accompaniment that's perfect for the time period. ("Up a Lazy River" is just right for a mob hit.) Production values here are so fine they bring to mind David's compliment to Helen, whom he tells that her taste is exquisite.

"My taste is *superb*," Helen corrects him. "My *eyes* are exquisite." Whatever.

"Bullets Over Broadway" is rated PG (Parental guidance suggested). It includes mild profanity, discreet sexual situations, and a remark by Ms. Wiest that is the very last word in anatomical simile.

1994 S 30, C1:1

THE RIVER WILD

Directed by Curtis Hanson; written by Denis O'Neill; director of photography, Robert Elswit; edited by Joe Hutshing and David Brenner; music by Jerry Goldsmith; production designer, Bill Kenney; produced by David Foster and Lawrence Turman; released by Universal Pictures. Running time: 108 minutes. This film is rated PG-13.
WITH: Meryl Streep (Gail), Kevin Bacon (Wade), David Strathairn (Tom), Joseph Mazzello (Roarke), John C. Reilly (Terry), Benjamin Bratt (Ranger Johnny), Victor H. Galloway (Gail's father), Elizabeth Hoffman (Gail's mother) and Stephanie Sawyer (Willa).

By JANET MASLIN

The fact that Meryl Streep has a body may not be front-page news, but it's more surprising than you'd think. First seen exercising strenuously in "The River Wild," she emphasizes that her past performances, however stunning, have rarely had much of a physical compo-

nent. So here she is, looking fit and ready to make up for lost time. Only the insurance company covering "The River Wild" can have found Ms. Streep's white-water stunt work more exciting than an audience will.

Proving herself more than equal to the semi-verbal demands of the action genre, Ms. Streep seems smart and energetic whether clobbering a villain with an oar or giving her dialogue an acerbic edge. "You know what hypothermia is?" she asks one of her captors, once this adventure story has taken its predictably Gothic turn. "Probably not." This must be the first time Ms. Streep has ever delivered such tough-guy phrases as "finish him off."

Once again, Curtis Hanson, who also directed "The Hand That Rocks the Cradle," has the makings of a lean, mean thriller with roots in real middle-class malaise. And once again Mr. Hanson's outlook will be of particular interest to women in the audience. He does another deft job of conveying a heroine's secret anxieties, at least during the first half of his story.

Gail (Ms. Streep), who lives in Boston, has an unsatisfying marriage to Tom (David Strathairn), a workaholic architect. When Gail goes out West for a rafting trip with her son, Roarke (Joseph Mazzello), she seems secretly relieved to be striking out on her own. Visiting her mother, Gail voices regret about the state of her marriage, but she brightens considerably at the sight of Wade (Kevin Bacon), a sexy, laconic rafter who flirts with her. Then Tom shows up, looking gloomy and carrying his briefcase. Surprise! When Wade asks who Tom is, Gail coyly identifies her husband as "Roarke's father."

As Wade and his friend Terry (John C. Reilly) proceed downstream alongside this nuclear family, Wade and Gail keep the flirtation afloat. And Ms. Streep has occasion to remind audiences that she is, after all, the best American actress of her generation. The role is narrow, but it has its nuances; Ms. Streep's different ways of handling Tom and Wade mean the shaky marriage itself would have made for an interesting drama.

Then, on a dark and stormy night, Gail ruins her credentials as an outdoorswoman by bathing in a river during an electrical storm. And with this bit of stage lightning, Mr. Hanson abruptly changes directions in midstream. He did the same thing with "The Hand That Rocks The Cradle," which also began in a realistic mode but boiled over into melodrama halfway through.

This time, thanks to hints that are obvious even to Gail and Tom's yellow labrador, the audience learns that Wade and Terry are wicked criminals. And what Wade really wanted from Gail was her rafting expertise. Once a skilled white-water guide, Gail is now enlisted to help the baddies escape downstream.

Now "The River Wild" becomes much broader, turning into an Outward Bound expedition that's painfully short on small talk. Denis O'Neill's screenplay runs out of conversational ideas, confining itself to

visual tricks like starting a fire with the magnifying glass on a Swiss Army knife. The one novel ingredient becomes Gail's career as a teacher of deaf students, since she can use sign language to converse furtively with members of her family.

To streamline the suspense of its later rafting sequences, the film supplies a quick fix for Tom and Gail's marriage. It suggests that all they really needed was a good, life-threatening rafting trip to rekindle the romance; luckily, this rafting trip really is good. Ms. Streep appears to be doing very physically dangerous work here, and she more than proves her mettle. She captures both Gail's terror and her exhilaration at rediscovering a spirit of adventure.

Mr. Bacon is also ruggedly appealing, at least until the movie turns him from a three-dimensional character into a two-dimensional creep. Mr. Strathairn doesn't fit easily into the milquetoast role, being too lanky and attractive in his own right to make a convincing bore. But he's here to blossom, and he does it on cue.

Also on hand, as virtually the only other person on the river, is Benjamin Bratt as the strapping young ranger who had Gail as a rafting teacher when he was a little boy. Many women will enjoy the escapism of this story, but they'll find that a sobering thought.

"The River Wild" is rated PG-13 (Parents strongly cautioned). It includes moderate profanity and mild violence.

1994 S 30, C8:1

INEVITABLE GRACE

Written and directed by Alex Canawati; director of photography, Christian Sebaldt; edited by Grace Valenti; music by Christopher Whiffen; production designer, Marc Rizzo; produced by Christian Capobianco; released by Silverstar Pictures. At Quad Cinema, 13th Street west of Fifth Avenue, Greenwich Village. Running time: 104 minutes. This film has no rating.
WITH: Maxwell Caulfield (Adam Cestare), Jennifer Nicholson (Veronica), Tippi Hedren (Dr. Marcia Stevens), Stephanie Knights (Lisa Kelner), Andrea King (Dorothy) and Samantha Eggar (Britt).

By STEPHEN HOLDEN

Alex Canawati's campy melodrama, "Inevitable Grace," is a movie so caught up in flaunting its flagrant references to earlier films — "Psycho," "Vertigo," "Sunset Boulevard," "Marnie" and "Suddenly Last Summer," to name only a few — that it never bothers to make basic storytelling sense.

In the movie, which opens today at the Quad Cinema, Maxwell Caulfield plays Adam Cestare, a wealthy young eccentric who becomes obsessed with Lisa Kelner (Stephanie Knights), a psychiatrist tending his hysterical wife, Veronica (Jennifer Nicholson). Adam lives in a creepy mansion filled with portraits of old movie stars, which is presided over by a gargoylish housekeeper (Andrea King) who has many shocking secrets.

Lisa works at a mental hospital whose frosty superintendent, Dr. Marcia Stevens (Tippi Hedren), is always photographed in doorways, peering suspiciously at the world. When she was younger, Dr. Stevens recalls, she was pursued by a man obsessed with blondes. She ended the relationship by changing the color of her hair. "Inevitable Grace" is a movie about changing hair color as much as it is about anything. As it turns out, Adam compels the women in his life to be made over in a very specific way. By the end of the film, the dark-haired Lisa is as blond as the muscle boys Adam hires to appear in his homemade porno films dressed in drag and adorned with platinum-blond wigs.

Had it been directed as farce instead of erotic melodrama, "Inevitable Grace" might have been amusing, in an early John Waters-style way. But the film maintains a tone of deadly seriousness. Mr. Caulfield, whose promising movie career stalled with "Grease 2," gives a mannered performance that suggests he has been studying the vocal inflections of Burt Lancaster. What sinks the film is the blank central performance of Ms. Knights, who delivers all her lines in a peevish Valley Girl whine.

1994 S 30, C8:5

SECOND BEST

Directed by Chris Menges; written by David Cook, based on his novel, "Second Best"; director of photography, Ashley Rowe; edited by George Akers; music by Simon Boswell; production designer, Michael Howells; produced by Sarah Radclyffe; released by Warner Brothers. Running time: 105 minutes. This film is rated PG-13.

WITH: John Hurt (Uncle Turpin), William Hurt (Graham Holt), Chris Cleary Miles (James), Jane Horrocks (Debbie), Nathan Yapp (Jimmy) and Keith Allen (John).

By JANET MASLIN

"Second Best" is all too fair a title for Chris Menges's new film, in which William Hurt plays a lonely postmaster who hopes to adopt a son. Casting Mr. Hurt in this role doesn't do much for the film or the leading man.

The story, set in a tiny Welsh village, calls for an actor whose Welsh qualities extend beyond a faltering accent. And Mr. Hurt, hidden beneath long reddish curls and thick black glasses, needn't have tried so hard to convince an audience that he isn't a handsome American movie star. There are worse things, after all.

Adapted by David Cook from his own novel, "Second Best" offers sincere therapeutic insights into its two main characters. James (Chris Cleary Miles), a sullen, uncommunicative boy who has been placed in an orphanage while his father is in jail, must come to terms with his feelings of abandonment and with his reluctance to trust those who care about him. James's troubles are interwoven with those of Graham Holt (Mr. Hurt), whose interest in this boy crystallizes his own memories of an unhappy childhood.

Narrow and introspective as this may sound on paper, it's even more mysteriously colorless on the screen. Delving into these two characters' past troubles, the film never seems much more impassioned than the stiff, somnambulant Graham. Its one attempt at flamboyance, in the person of a chatty social worker named Debbie (Jane Horrocks), is strikingly at odds with the rest of the material. But Debbie is on hand to tell Graham, "I need to know what happened to send you scuttlin' inside yourself."

What happened is explained by flashbacks depicting Graham's father at different stages of life, flashbacks that are often triggered by watching James try to resolve his own set of parent-child feelings. It's easy to imagine that the intricate texture of such overlapping relationships was better captured by a novel than it is here.

Mr. Menges grew up very near the Welsh village where "Second Best" was filmed, and he pays faithful attention to his film's sense of place. But its dolorousness becomes all too real. The film's sad, sensitive mood is rarely broken by Mr. Hurt, though he becomes better and better as his character is pushed toward self-assertion. Mr. Miles, a straightforward young actor making his film debut, is a believable presence.

"Second Best" is finally more moving for the anguished father-son drama it might have been than for the muted, unfocused one it has become. There is much untapped pathos in the tale of a middle-aged bachelor, moved by his father's failing health and his isolation, trying to give a troubled boy "a proper 'ome."

"Second Best" is rated PG-13 (Parents strongly cautioned). It includes mild profanity.

1994 S 30, C10:1

I DON'T WANT TO TALK ABOUT IT

Directed by María Luisa Bemberg; written (in Spanish, with English subtitles) by Ms. Bemberg and Jorge Goldenberg, based on a short story by Julio Llinás; director of photography, Felix Monti; edited by Juan Carlos Macias; music by Nicola Piovani; produced by Oscar Kramer; released by Sony Pictures Classics. At 68th Street Playhouse, Third Avenue and 68th Street, Manhattan. Running time: 102 minutes. This film is rated PG-13. WITH: Marcello Mastroianni (Ludovico D'Andrea), Luisina Brando (Leonor), Alejandra Podesta (Charlotte), Betiana Blum (Madama) and Roberto Carnaghi (Padre Aurelio).

By JANET MASLIN

On her daughter's second birthday, Leonor (Luisina Brando) comes to terms with a fact central to the girl's life. Her daughter is a dwarf, which causes Leonor to make a covert nighttime visit to her neighbor's garden. There, she destroys ornamental statues with elfin shapes. Back home, she burns copies of "Gulliver's Travels," "Thumbelina" and "Snow White and the Seven Dwarfs."

But by then, even though she doesn't realize it, Leonor has begun to live out a dark fairy tale of her own.

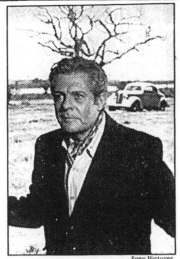

Sony Pictures

Marcello Mastroianni

"I Don't Want to Talk About It," which opens today at the 68th Street Playhouse, is a stately, haunting fable told by the Argentine director María Luisa Bemberg (whose films include the Oscar-nominated "Camilla"). It describes what happens when the daughter, Carlotita (Alejandra Podesta), grows up. Dedicating her film "to all the people who have the courage to be different in order to be themselves," Ms. Bemberg tells this strange story as an extended metaphor and turns it into an unlikely romance.

As such, it becomes a victory of imagination over reality, a tale made moving by its principals' absolute refusal to face facts (hence the title). Ms. Bemberg, who also clearly has the courage to be different, directed her first film, "Momentos" (1981), at the age of 54. She directs this one with quiet authority and clear faith in the importance of what it has to say.

The film's central figure is actually Ludovico D'Andrea, a courtly, mysterious gentleman who meets Leonor's daughter when she is 15 and falls under her spell. Having given the girl a classical education and changed her name to Charlotte, Leonor has aspirations for her child's future, but Ludovico's arrival exceeds her wildest dreams.

This man, variously thought to be a spy, a political radical or a melancholy millionaire, finds himself fascinated by little Charlotte. The girl is no beauty, but she seems an immensely sympathetic person. Her gaze suggests keen intelligence. When she speaks, she seems to speak from the heart.

Having cast a dashing star like Marcello Mastroianni in the role of Ludovico, Ms. Bemberg does not strain her audience's credulity. Ludovico and Charlotte are not often seen together, and what actually goes on between them is beside the point. What matters is that Ludovico begins to believe he is falling in love, and that the idea causes him great distress. Upon first acknowledging his feelings, he feels fatalistic enough to provoke a duel with another man. "Ah, doctor," he says afterward, "why didn't you shoot me through the heart?"

But Ludovico gradually begins to question his own assumptions. He wonders whether he isn't right to love Charlotte after all, and to suspect that no one else's opinion matters. When he finally meets with Leonor and announces his love for her daughter, there is the predictable misunderstanding: Leonor, herself a generation younger than this aging roué, naturally thinks she herself has captured his heart. Everyone in "I Don't Want to Talk About It" must think twice about the essence of romantic love once Ludovico begins violating taboos of the film's provincial setting.

There is enough magical realism to Ms. Bemberg's storytelling to extend "I Don't Want to Talk About It" beyond the realm of a love story. There are repercussions to Leonor's deliberate blindness, to Charlotte's innocence and to Ludovico's transporting passion that give the film a wider meaning. Crucial to the success of the whole enterprise is Mr. Mastroianni, whose courtliness and dignity banish all possibility of skepticism. Also most effective is Ms. Podesta, whose inner beauty is so vital to the story. She seems entirely to be the odd individual whom she plays.

Like Charlotte, "I Don't Want to Talk About It" is more impressive for its sheer force of personality than for physical beauty. The film's style, plain and forthright, is as pure as the unconventional love it describes.

"I Don't Want to Talk About It" is rated PG-13 (Parents strongly cautioned). It includes discreet sexual situations set in a brothel.

1994 S 30, C12:1

THE SCOUT

Directed by Michael Ritchie; written by Andrew Bergman, Albert Brooks and Monica Johnson; director of photography, Laszlo Kovacs; edited by Don Zimmerman and Pembroke Herring; music by Bill Conti; production designer, Stephen Hendrickson; produced by Albert S. Ruddy and André E. Morgan; released by 20th Century Fox. Running time: 101 minutes. This film is rated PG-13. WITH: Albert Brooks (Al Percolo), Brendan Fraser (Steve Nebraska), Dianne Wiest (Dr. Aaron) and Anne Twomey (Jennifer).

By CARYN JAMES

For the first half-hour or so, "The Scout" appears to be a funny Albert Brooks movie. He plays a New York Yankees scout named Al Percolo who has made some bad choices. If his goofy orange straw hat is any indication, his judgment has hit bottom. He goes to great and funny lengths to sign a young pitcher from a religious household. Al wears a cross around his neck and with the satiric intensity Mr. Brooks does better than anyone, he insists that Mickey Mantle's sister was a nun, Sister Micki Elizabeth. He signs the pitcher, who becomes nauseous on the mound during his first game. Before he knows it, Al is scouting in Mexico.

There he finds a natural baseball genius named Steve Nebraska

Ralph Nelson/20th Century Fox

Brendan Fraser and Albert Brooks in "The Scout."

(Brendan Fraser), who is a brilliant pitcher and a switch-hitter to boot. He is also not quite in sync with society, and that's where "The Scout" starts to go wrong. For a time it seems that Steve is some kind of feral child, or a relative of the unfrozen caveman Mr. Fraser played in "Encino Man," someone who just never learned the rules of etiquette. But by the time he and Al get to New York, Steve is being taken to a psychiatrist, played by Dianne Wiest in a role so inane you tend to agree with Al when he wants proof that she is actually licensed and went to Harvard.

At this point, "The Scout" takes a weird turn into the Twilight Zone. Steve, it seems, has many problems buried in his childhood. The film takes them seriously enough to destroy any shred of wit, yet not seriously enough to make sense. Nothing can save the movie from then on, not even Mr. Brooks, not even Mr. Fraser doing an off-key version of "I Left My Heart in San Francisco" from the audience while Tony Bennett himself is onstage.

"The Scout" was directed by Michael Ritchie and written by Mr. Brooks and Monica Johnson from a script written by Andrew Bergman years ago. It's probably not all that valuable to wonder how so many talented people went so wrong. The film actually ends with a big game and a freeze-frame of Steve on the field at Yankee Stadium. It might be more intriguing to ponder one of the many questions left hanging at the end: Why does Steve have such an intense love of doing the laundry?

"The Scout" is rated PG-13 (Parents strongly cautioned). It includes a few strong words.

1994 S 30, C23:1

TO LIVE

Directed by Zhang Yimou; written (in Mandarin, with English subtitles) by Yu Hua and Lu Wei, based on the novel by Mr. Yu; director of photography, Lu Yue; edited by Du Yuan; music by Zhao Jiping; produced by Chiu Fusheng; released by the Samuel Goldwyn Company. At Alice Tully Hall at 6 tonight

and at 8:45 P.M. tomorrow as part of the 32d New York Film Festival. Running time: 129 minutes. This film has no rating.
WITH: Ge You (Fugui), Gong Li (Jiazhen), Niu Ben (Town Chief), Guo Tao (Chungsheng), Jiang Wu (Er Xi), Ni Da Hong (Long Er), Dong Fei (Youqing), Liu Tian Ch. (Fengxia as adult), Zhang Lu (Fengxia as adolescent) and Xiao Cong (Fengxia as child).

By CARYN JAMES

In the gambling house where Fugui (Ge You) spends his nights, letting his family fortune slip from his grasp, he is treated like a young prince. The setting is China in the prerevolutionary 1940's, and after hours of gambling, Fugui is carried home at dawn through the streets of his small town on the back of a man who deposits him at his extravagant house. Fugui's wife, Jiazhen (Gong Li), begs him to stop gambling, for the sake of their small daughter and the child she is carrying.

Of course, he doesn't, and soon loses the family home to a bounder called Long Er. One of many great comic ironies in "To Live," Zhang Yimou's family melodrama that sweeps through 30 years of Chinese history, is that this misfortune turns out to be a major piece of luck. When the revolution comes, the house is burned by the Communists and the landowning Long Er is executed. There, but for the grace of his gambling, goes Fugui.

"Your family's timber was first-rate," a good Communist tells him, describing how fast the house went up in flames. By then Fugui has developed a sense of survival that is by turns funny and heartbreaking and that expresses the very soul of this tragicomic film. "That wasn't my family's timber," he says. "That was counterrevolutionary timber."

"To Live" is purposefully more sentimental than anything Mr. Zhang has done before. After Fugui has lost the house, he takes over a traveling shadow puppet show. While he and his friend Chungsheng are on the road with their theater, they are captured by the losing Nationalist army. When Fugui returns to his much-changed town, he finds that Jiazhen earns a living by delivering water door to door. An illness has left their daughter, Fengxia, deaf. And their son, Youqing, is a spirited boy who becomes the victim of his father's desperate need to disguise his past as a wealthy man.

This film is also less sumptuously photographed than Mr. Zhang's other works; in the lives of these characters, touches of red on a gray uniform have to pass for glamour. Depicting the characters responding to Mao's changes, "To Live" brings to mind Chen Kaige's "Farewell, My Concubine," though set among poor townspeople rather than against the rich backdrop of the Beijing Opera. In its emphasis on individuals, "To Live" has less in common with Mr. Zhang's earlier, less dramatic films, "Red Sorghum" and "Ju Dou," than with his recent ones, the glorious soap opera "Raise the Red Lantern" and the comic tale of a rebellious woman, "The Story of Qiu Ju." (All of them starring Gong Li.)

But the masterly Mr. Zhang knows he's creating melodrama and exaggerates to profound effect. The fam-

The Samuel Goldwyn Company
Xiao Cong and Gong Li

ily tragedies in "To Live" demonstrate how China's politics scarred individuals who were treated as pawns in Mao's progress, and its sentimentality shows that ideology is no comfort in the face of personal anguish. In two magnificent performances, Gong Li carries the story's emotions and Ge You the weight of history. Gong Li is, as always, a powerful heroine. But Mr. Ge is a revelation, evoking sympathy and pity as a man whose weakness causes him to bend like a reed in the changing winds of Chinese politics and whose strength allows him to endure the consequences.

During the Great Leap Forward in the 1950's (the historical changes are explained clearly in succinct titles through the film), the entire town donates all metal objects to support steel production. Even the family's pans are taken away, and everyone eats at the communal kitchen. That is where the mischievous Youqing pours a huge amount of chili sauce on a big bowl of noodles, then calmly dumps it on the head of a boy who has been taunting his sister. For that, Fugui publicly spanks his son, agreeing that the little boy's gesture was a counterrevolutionary act meant to undermine the communal kitchen.

Irreverent though Mr. Zhang's take on Chinese history is, "To Live" is primarily a story of living with sadness. Fugui's old friend Chungsheng becomes a district leader and accidentally causes a death. "You owe us a life," Jiazhen screams at him, and the line becomes a refrain that resonates through the film.

In the 60's, during the Cultural Revolution, Fugui and Jiazhen hear that their prospective son-in-law, a committed Maoist, is tearing their house apart. They race home only to find him helpfully repairing the roof and painting huge murals of Mao on the walls. Throughout, Mr. Zhang creates an inescapable sense of the tension and fear that informs the characters' daily lives.

The Communist revolution is increasingly blamed for the family's tragedies. When someone dies because the reactionary doctors have been taken away from the hospital, leaving only inept students behind, there is no mistaking the political toughness of this melodrama's message.

This film has created serious problems for Mr. Zhang. The Chinese Government was unhappy that "To Live" was entered in competition at this year's Cannes Film Festival, where Gong Li and Ge You were present and won best acting awards. In the last few weeks, the Government has stopped production on Mr. Zhang's new movie, partly

financed with French money, and barred him from working on foreign co-productions.

"To Live" will be shown at the New York Film Festival tonight at 6 and tomorrow night at 8:45, and is scheduled to open commercially in November. It would be an extravagant and emotional film, even if it weren't a politically brave one too.

1994 S 30, C30:1

THE SILENCES OF THE PALACE

Directed by Moufida Tlatli; written (in Arabic, with English subtitles) by Ms. Tlatli and Nouri Bouzid; director of photography, Youssef Ben Youssef; edited by Ms. Tlatli; music by Anouar Brahem; produced by Ahmed Baha Eddine Attia and Richard Magnien. At Alice Tully Hall tonight at 9:15 P.M. and tomorrow at 11:30 A.M. as part of the 32d New York Film Festival. Running time: 127 minutes. This film has no rating.
WITH: Amel Hedhili (Khedjia), Hend Sabri (Young Alia), Najia Ouerghi (Khalti Hadda), Ghalia Lacroiix (Adult Alia) and Kamel Fazaa (Sidi Ali).

By CARYN JAMES

In many ways "The Silences of the Palace" is an exotic foreign film. Set mostly in Tunisia in the 1950's, during the reign of its last monarchs, it tells of life for a kitchen servant and her daughter. Yet in other ways this is a universal coming-of-age story with a feminist twist, a tale that translates effortlessly.

The heroine, Alia, grows up in the palace at a time when the female servants are expected to be sexually available to the men they serve. Years later, as a woman, she is still searching for independence from her lover. This blend of the exotic and the common makes "The Silences of the Palace" a strong first film directed by Moufida Tlatli, who has spent many years as a movie editor.

The film begins with Alia at 25, singing at a wedding, then fleeing in disgust with her life. At home, the reason becomes clear. Her lover is insisting she have an abortion, not her first. He also tells her that Sidi Ali, the prince for whom her mother worked, has died. Alia returns to the palace she left 10 years before, to pay her respects. As she puts it, she is revisiting "the past I thought I'd buried with my mother."

What follows is a long flashback to Alia's girlhood and adolescence. Alia's mother, Khedjia, is the favorite of Sidi Ali, with whom she has a tender relationship despite a position that is close to sexual slavery. (The same is not true of her feelings for Sidi Ali's brother, who forces himself on her to her obvious revulsion.) Sidi Ali is also fond of Alia, who may be his daughter, although Khedjia refuses to say who Alia's father is.

In eloquent scenes that recreate the details of their lives, Alia is seen playing the lute with her girlhood friend Sarra. She is seen in the kitchen when her mother and the women gossip, and at a party she sneaks a look at her mother dancing for elegantly dressed men and women.

The colorful tiled palace walls, the gardens, the simple room where Alia and her mother live are presented in rich visual detail. Yet as Alia begins to awaken to the social and sexual truths of her world, Ms. Tlatli does not often enough capture the sense of mystery her heroine must have been experiencing. When Alia looks through a window and glimpses her mother, wearing a slip, in bed with Sidi Ali, she races from the window and runs around in circles on the lawn in a motion of confusion and sexual energy she barely knows she has. More of those moments would have made "The Silences of the Palace" truly exceptional. As it is, this is a fascinating and accomplished film.

"The Silences of the Palace" will be shown at the New York Film Festival tonight at 9:15 and tomorrow morning at 11:30.

1994 S 30, C30:3

THEREMIN: AN ELECTRONIC ODYSSEY

Produced and directed by Steven M. Martin; directors of photography, Robert Stone, Cris Lombardi and Ed Lachman; edited by David Greenwald; music by Hal Willner. At Alice Tully Hall at 4 P.M. tomorrow as part of the 32d New York Film Festival. Running time: 84 minutes. This film has no rating.
WITH: Leon Theremin, Todd Rundgren, Brian Wilson, Robert Moog, Clara Rockmore and Nicolas Slonimsky

By JANET MASLIN

Surely the theremin is the weirdest of all musical instruments. It looks like a podium with a horizontal loop and a vertical antenna. It is played by musicians who don't touch it, creating sounds simply by moving hands in the air. The noise it emits, described by newspapers of the 1920's as "ether music" and "music like none other ever played," can suggest a violin or a soprano or a Martian making a landing. It is surpassingly strange.

The theremin's sound may not be instantly identifiable, but it has been prominent in certain thrillers and science fiction films, used to signal the presence of the unknown. You can also hear it on the Beach Boys' "Good Vibrations," in those octave-skipping wheeps and whorls that shoot through instrumental breaks in the song.

If the theremin itself is bizarre, the story of its creator is much more so. It is told in Steve M. Martin's "Theremin: An Electronic Odyssey," a fascinating, offbeat documentary that stands as a fine job of detective work as well. Painstakingly, Mr. Martin pieces together the separate parts of Leon Theremin's life, which spanned nearly a century in milieus as different as the avant-garde music world of New York in the 1920's and the inner circles of the K.G.B. He died last November at 97.

The Russian-born Theremin invented his instrument accidentally in 1918 while trying to build a radio. He found that an electromagnetic field produced noises that could then be controlled, and by 1922 he was in

The Film Society of Lincoln Center

Clara Rockmore playing a theremin in 1945 in a scene from the film "Theremin: An Electronic Odyssey" at the New York Film Festival.

the Kremlin, demonstrating his instrument for Lenin. In 1928 he was the toast of New York, playing at Carnegie Hall. He had a pretty young protégé, Clara Rockmore, whose 18th birthday he celebrated by building a cake that lighted up and rotated when anyone approached it.

Clara Rockmore, still a theremin virtuoso, is on hand to play movingly for Mr. Martin's camera and to help tell this story. She and other acquaintances of the inventor describe his disappearance in 1938, when he was kidnapped by Soviet agents from his West 54th Street studio. His wife, a ballerina named Lavinia Williams, never saw him again, nor did any of his old friends for a very long while. After a reporter found him in the Soviet Union, it became known that Theremin had been enlisted to pioneer the art of electronic bugging.

Although the film begins with the sound of a quavery, heavily accented voice describing his memories of light glimpsed from within his mother's womb, Theremin's eventual appearance on camera is almost a surprise. By the time the film has described such Theremin ideas as making cars move through the air without bridges, the inventor himself has taken on an eerie, otherworldly aura.

Robert Moog, who went from building theremins to inventing the synthesizer, has been heard attesting to Theremin's brilliance. And Brian Wilson, the unpredictable genius behind the Beach Boys, has spoken meanderingly about what the instrument meant to him. So when the inventor begins reminiscing with Mr. Martin, the film has already invested him with considerable magic. That magic also colors a staged New York reunion between the inventor and Ms. Rothmore, a meeting

that would seem contrived if it were not so honestly touching.

"Isn't it nice we could see each other in our old age?"
"What old age?" Theremin asks.
"Theremin," a fond, engrossing portrait of an astonishing man, will be shown at 4 P.M. tomorrow as part of the New York Film Festival. On the same bill is "Carnival," a five-minute short featuring clouds, parasols, animated shapes, strange headgear and a chicken, all moving about the screen to musical accompaniment. Arty but whimsical, the short works better in the context of Mr. Martin's film than it would alone. The Film Festival's short films have been particularly well paired with its features this year.

1994 O 1, 11:4

A CONFUCIAN CONFUSION

Written and directed by Edward Yang (in Mandarin, with English subtitles); directors of photography, Arthur Wong, Zhang Zhan, Li Longyu and Hong Wuxiu; edited by Chen Bowen; music by Antonio Lee; production designers, Tsai Chin and Edward Yang; produced by Yu Weiyen. At Alice Tully Hall today at 2:45 and tomorrow at 6:30 P.M. as part of the 32d New York Film Festival. Running time: 127 minutes. This film has no rating.
WITH: Chen Xiangqi (Qiqi), Ni Shujun (Molly), Wang Weiming (Ming), Wang Zongzheng (Akeem), Wang Yeming (Birdy), Danny Deng (Larry), Yan Hongya (Molly's brother-in-law), Richie Li (Feng), Chen Limei (Molly's sister) and Chen Yiwen (Liren)

By STEPHEN HOLDEN

The title of "A Confucian Confusion," a frantically up-to-the-minute comedy of manners about life in present-day Taipei, refers to a novel written by one of the characters in

the movie. In the book, Confucius is reincarnated as a popular media personality. To his chagrin, the ancient Chinese sage discovers he is admired not for who he is but for being such a brilliant impostor.

In this satirical film, which was written and directed by the Taiwanese film maker Edward Yang, confusion between appearance and reality runs to the heart of Taipei's ostensibly puritanical society. The movie, which is being shown at Alice Tully Hall this afternoon at 2:45 and tomorrow night at 6:30 as part of the New York Film Festival, follows the amorous and career peregrinations of a bunch of urbane young Taipeians, most of whom are well-to-do and bored.

As they drive around Taiwan's opulent, spankingly clean capital, they debate such things as selling out their artistic careers and marrying for money rather than love. The only way for an artist to succeed, the film reiterates, is by peddling icky sweetness and light. The most successful younger writer in the city's tightly knit media and art world is not only a sellout, but also a plagiarist, and a Lothario of the casting couch.

The movie is cheerfully critical of its 20-something characters, who are volatile, self-absorbed yuppies. At the center of the social circle under examination is Molly (Ni Shujun), a rich young woman who runs a failing public-relations business financed by her wealthy fiancée, Akeem (Wang Zongzheng). Whenever Molly can't figure a way out of her business problems, she throws a tantrum and abruptly dismisses someone. Her childish future husband isn't any better. In a fit of jealousy over Molly's rumored infidelity, he goes on a weepy, self-pitying bender.

Somewhat more likable are Molly's loyal assistant Qiqi (Chen Xiangqi) and Qiqi's fiancée, Ming (Wang Weiming), who comes from a working-class background. The satellite characters include Birdy (Wang Yeming), a once-serious author who has become famous writing trashy television plays, and Larry (Danny Deng), Akeem's trouble-making sycophantic assistant.

Molly's sister (Chen Limei) is the host of Taipei's most popular talk show and the estranged wife of the author of "A Confucian Confusion" (Yan Hongya), who gave up a successful career writing romances to live in a garret and turn out gloomy existential tracts.

In both its look and its sound, "A Confucian Confusion" is a bright and jangling movie full of hysteria. All the action takes place over a two-day period in which alliances shift, couples break up and the author of "A Confucian Confusion" has a silly revelation that makes him decide to rejoin the commercial world.

There are many moments when the movie's debates about art versus commerce and the keeping up of appearances to avoid gossip suggest that Taiwan, with its newly found wealth, has a lot in common with America in the era of "The Man in the Gray Flannel Suit."

The underlying message is a very familiar one: Affluence, as desirable as it may be, brings its own woes, not the least of which is a spiritual vacuum.

1994 O 1, 12:1

SEE HOW THEY FALL

Directed by Jacques Audiard; written (in French, with English subtitles) by Alain Le Henry and Mr. Audiard, based on the novel "Triangle" by Teri White; director of photography, Gérard Sterin; edited by Juliette Welfling and Monique Dartonne; music by Alexandre Desplat; production designer, Jacques Rouxel; produced by Didier Haudepin. At Alice Tully Hall at 9:30 P.M. tomorrow and at 6 P.M. Monday as part of the 32d New York Film Festival. Running time: 100 minutes. This film has no rating.

WITH: Jean-Louis Trintignant (Marx), Jean Yanne (Simon), Mathieu Kassovitz (Johnny), Bulle Ogier (Louise), Christine Pascal (Sandrine), Yvon Back (Mickey), Yves Verhoeven (Prostitute), Marc Citti (Informer) and Roger Mollien (Marion)

By CARYN JAMES

In "See How They Fall," Jean-Louis Trintignant plays a scruffy, small-time crook accurately described by another character as "an old guy with a game leg." Seeing the onetime romantic star as a character actor gives the film some curiosity value. There isn't much else to recommend this uninspired French work, part buddy movie and part film noir.

At the start, a salesman named Simon (Jean Yanne) is surprised to find himself getting old. As his wife says in voice-over, "What did he have, 15 or 20 years left?" Any other middle-aged men might have quit his job or had an affair, but Simon has a more drastic response. When his friend Mickey is shot and left brain dead, he tracks down the people who did it.

The film then moves to Marx (Mr. Trintignant), who owes some money to thugs and who is hitchhiking with a young accomplice, Johnny (Mathieu Kassovitz, the director and star of "Café au Lait."). The story switches back and forth between these plots until Simon finds Marx and Johnny to take revenge.

This is the first film directed by Jacques Audiard, an experienced screenwriter ("Baxter"). But the script, which he wrote with Alain Le Henry, is as confusing and tiresome as the direction. What is meant to be a touching, comic relationship between Marx and Johnny is simply flat. And though Mr. Yanne gives Simon a sense of desperation, his motives are murky.

"See How They Fall" will be shown at the New York Film Festival tomorrow night at 9:30 and Monday night at 6. It will be preceded by something even more curious. "A Pair of Boots" is a 25-minute episode of "The Lloyd Bridges Show" from 1962, directed by John Cassavetes. Mr. Bridges plays a journalist writing about the Civil War centennial. Dramatizing the journalist's story, he portrays a rebel leader whose men meet up with some Yankees. One of the rebels really, really wants a pair of boots. One of the Yankees is Beau Bridges, who gets shot. This

contrived, high-blown episode is a throwback to the last gasp of anthology shows. There is nothing to suggest Mr. Cassavettes's eye. There is everything to suggest he had to earn a living.

1994 O 1, 12:4

TO THE STARRY ISLAND

Produced and directed by Park Kwang Su (in Korean, with English subtitles); director of photography, Yoo Young Gil; edited by Kim Hyun; music by Song Hong Sup. At Alice Tully Hall at 9 tonight and 6 P.M. tomorrow as part of the 32d New York Film Festival. Running time: 102 minutes. This film has no rating.
WITH: Ahn Sung Ki (Mr. Kim/Kim Chul), Moon Sung Keun (Moon Duk Bae/Moon Chae Ku), Shm Hae Jin (Oknim) and Ahn So Young (Poltoknyeo).

By STEPHEN HOLDEN

In the beautiful and mysterious opening scene of Park Kwang Su's film "To the Starry Island," a boat bearing a coffin makes its way across a rain-swept bay to the remote island of Kwisong, off the coast of South Korea. As members of the funeral party watch aghast, inhabitants of the island meet the visitors and angrily refuse to let the body be buried there.

One of the travelers, Kim Chul (Ahn Sung Ki), falls into the water and nearly drowns while trying to mediate with the islanders. A poet who was born on Kwisong and educated in Seoul, he has not seen his native soil in many years.

The movie that unfolds is Kim Chul's passionate remembrance of growing up on the island at the time of the Korean War. As Kim, whose father was the village teacher and the island's only educated inhabitant, sorts through his memories, the reasons for the resentment against the dead man, Moon Duk Bae (Moon Sung Keun), are gradually revealed.

"To the Starry Island," which the New York Film Festival is showing this evening at 9 and tomorrow at 6 P.M. at Alice Tully Hall, is at once a portrait of an insular, tribal society and a meditation on the bitter division between South and North Korea. If the country is ever reunited, the film intimates, the wounds of the past will not be easily healed.

The film presents a wonderfully rich portrait of life on Kwisong during the 1950's, and suggests that the island's way of life, at once primitive and puritanical, has changed little over four decades.

The heart of the film is a series of vignettes artfully woven into a tapestry of village life that is anything but idyllic. Some of the tales are comic, like the story of Kim Chul's friend Oknim (Shim Hae Jin), a mentally retarded woman who throws the aged fisherman she has been forced to marry out of the house on their wedding night. Others, like the story of Opsunne (Lee Young Yi), an abused wife who becomes a shaman when she is possessed by the scolding spirit of her husband's

father, take a mystical turn. In the film's eerie and poetic final scene, Opsunne, now an aged, powerful shaman, summons a benediction from the spirit of the dead man.

Moon Duk Bae, the man who is to be buried, emerges as the film's most unsympathetic character. A faithless husband and perennial malcontent, he blames his wife, Nopdotaek (Choi Hyung In) for giving birth to a hunchbacked daughter. When the girl dies, Nopdotaek goes crazy, and he leaves the island with her, returning not long afterward with a new wife. Although he claims that Nopdotaek committed suicide after escaping from a mental hospital on the mainland, the villagers suspect foul play, and he is punished and sent into exile. He wreaks revenge for his expulsion in an act of devastating political trickery that tears apart the fragile, frightened community.

Park Kwang Su, who directed and collaborated on the screenplay, conveys an unusually powerful sense of the physical world. If the island's lushness and its changing weather are almost palpable, so is the air of suffocating boredom felt by the islanders.

In one of the film's many resonant images, a man courting an adolescent girl pumps the swing on which they are standing higher and higher until they can catch a glimpse of the harbor. The strange sight of naval vessels abruptly ends their play, sending a shock of terror. Are they Communist or Republican ships? The fact that the villagers barely know and would rather not know the difference between the two sides of the conflict hastens a tragedy that will reverberate for decades to come.

1994 O 3, C12:3

RED

Directed by Krzysztof Kieslowski; written (in French, with English subtitles) by Krzysztof Piesiewicz and Mr. Kieslowski; director of photography, Piotr Sobocinski; edited by Jacques Witta; music by Zbigniew Preisner; production designer, Claude Lenoir; produced by Marin Karmitz. At Alice Tully Hall at 9 tonight and at 6 P.M. tomorrow as part of the 32d New York Film Festival. Running time: 95 minutes. This film is rated R.
WITH: Irène Jacob (Valentine), Jean-Louis Trintignant (the judge), Frédérique Feder (Karin) and Jean-Pierre Lorit (Auguste).

By JANET MASLIN

In the dense, archly mysterious films of Krzysztof Kieslowski, bold but ineffable patterns shape the characters' lives. Coincidences, missed opportunities, overbearing visual clues and strange, haunting parallels: all of these contribute to a gradually emerging sense of destiny. Stories develop like photographs in a darkroom. They are sharply defined only in retrospect, when the process is complete.

So it is with "Three Colors," the schematic, madly audacious trilogy that is Mr. Kieslowski's latest work, after "The Double Life of Véronique." (Claiming to be through with film making, the 53-year-old Mr.

Miramax

Irène Jacob in "Red."

Kieslowski also insists that it will be his last.)

The arrival of "Red," this series' last installment, is an event in its own right. (It will be shown tonight at 9 and tomorrow at 6 P.M. as part of the New York Film Festival.) In fact, "Red" succeeds so stirringly that it also bestows some much-needed magic upon its predecessors, "Blue" and "White." The first film's chic emptiness and the second's relative drabness are suddenly made much rosier by the seductive glow of "Red."

Not for nothing is red the warmest of these three colors, which Mr. Kieslowski has taken from the French flag. Nor is it unhelpful that "Fraternité," the theme that follows "Liberté" and "Égalité" in his series, is potentially the most engaging of his subjects. "Red" gets an additional leg up from the presence of two exceptionally fine actors, Irène Jacob and Jean-Louis Trintignant, who are perfectly suited to playing polar opposites here. They act their roles in an intricate story of friendship and deliverance while also serving as tuning forks for the director's larger intuitions.

"I feel something important is happening around me," one of them says, describing the gripping, legitimately portentous mood Mr. Kieslowski captures best. As the earlier films (particularly "Blue") made clear, such thoughts can have a hollow ring when not borne out by a larger meaning. The greatest virtue of "Red" is its profound sense of purpose. At last, making the whole trilogy transcend the sum of its parts, Mr. Kieslowski abandons the merely cryptic in favor of real consequence.

In addition to being the best-acted of these three films, "Red" is the one that weaves the most enveloping web. Working more assuredly and less arbitrarily than he did at the series' start, Mr. Kieslowski plays deftly with the crossed wires that

either connect or separate his principals in mysterious ways.

Early in the film, a literal image of telephone cable is enough to question what it means for these characters to communicate. When Valentine (Ms. Jacob) makes a phone call to her lover, Michael, a phone is seen ringing in the apartment of Auguste (Jean-Pierre Lorit), who lives across the street from Valentine. Why? Valentine and Auguste do not precisely know each other. But maybe they do, or should, or will. Mr. Kieslowski is particularly expert this time in constructing puzzling, overlapping patterns that bind lonely people together. A higher order can be glimpsed, quite movingly, beyond such bonds.

Satisfying even on the level of gamesmanship, with the film maker reaching new heights of mischievous color-coding, "Red" is bolstered by a more deeply contemplative side. Valentine, the young model whose very name evokes the title color, accidentally makes contact with a bitter ex-judge (Mr. Trintignant), who lives in a Geneva suburb called Carouge. Many of the film's encounters are unwitting, with characters moving like ships passing in the night, but Valentine meets the judge through a direct collision.

After her car hits the judge's dog, she carries it to his house, finding herself face to face with a cruel recluse who rejects his own pet and spends time spying electronically on his neighbors. One of these is Karin, whose romance with Valentine's neighbor Auguste will turn out to be a strange echo of events in the judge's life. Karin has a telephone job dispensing "personal weather forecasts" for travelers, which is wittily appropriate. Even when their paths intersect, these characters remain separate enough to require their own individual weather.

The idea of fraternity emerges through Valentine's highly charged encounters with the judge. Though not a love story in any conventional sense, "Red" is very much about the redemptive power of love. Ms. Jacob, the enchanting star of "The Double Life of Véronique," once again displays a lovely, eager naturalness that encompasses all the complexities of this director's work. Mr. Trintignant, moving from brusqueness to tenderness, transforms himself memorably, and in the process communicates real fraternity, an acceptance and generosity that go beyond the bounds of ordinary romance.

"Red," which is itself filled with echoes and foreshadowing (greatly heightened by Zbigniew Preisner's insinuating music), culminates in a ferry crossing with an eerie similarity to the one in last week's news. As a red advertising billboard of Valentine becomes a prophecy, she is brought together with the principals from "Blue" and "White." This juxtaposition of destinies, which is not made to tie up narrative loose ends, is satisfying without being pat. Speaking hauntingly of new beginnings, it raises the wish that Mr. Kieslowski, now working at the height of his enigmatic powers, would take his own advice.

On the same program is "Bête de Scène," a droll 18-minute French film by Bernard Nissille, with an amusing theatrical setting. Following the antics of a stellar company (including Bulle Ogier, Michel Piccoli and the director Patrice Chéreau) staging "A Winter's Tale," it has as its hero a young actor, Emmanuel Salinger, in a bear costume. Backstage beastliness neither begins nor ends with him.

1994 O 4, C15:1

RISK

Directed by Deirdre Fishel; written by Ms. Fishel; director of photography, Peter Pearce; edited by Ms. Fishel and Gordon McLennan; music by John Paul Jones; production designer, Flavio Galuppo; produced by Mr. McLennan; released by Seventh Art Releasing. At the Quad Cinema, 13th Street west of Fifth Avenue, Greenwich Village. Running time: 85 minutes. This film is not rated.

WITH: Karen Sillas (Maya), David Ilku (Joe), Molly Price (Nikki), Jack Gwaltney (Karl) and Christie MacFadyen (Alice)

By JANET MASLIN

The risk in "Risk," a film by Deirdre Fishel, is ostensibly the chance taken by Maya (Karen Sillas) when she lets an eager young man pick her up on a bus. Maya is a struggling artist living a lonely New York life, and Joe (David Ilku) is so eager he's hard to resist. Following Maya home after he first meets her, he surveys her apartment and abruptly decides to take a bath, which turns into a seduction. "If you don't let me spend the night," says Joe, "I'm going to have to kill myself."

Despite the intense attraction between these two, which the film captures forcefully, there are warning signs of trouble. Joe has a mercurial temper and a checkered past, but Maya is too charmed by him to worry. Her own life, involving rejections by art galleries and disheartening work as a nude figure model for art students, has been stagnant. Joe dispels those blues and even takes her out of New York City, insisting they can start all over in a rustic new place.

With a spare, striking look and two strong leading performances, "Risk," which played at Sundance and opens today at the Quad Cinema, works best simply watching these two lonely people get to know each other. This is the second current film in which Ms. Sillas can be seen going through that process, as in "What Happened Was," she is touchingly real. Ms. Sillas's performances have an unfettered honesty that works well in such small, intimate dramas, and this is the steamier role. Mr. Ilku, a performance artist, brings a natural winsomeness to the trickier and less credible role of Joe.

"Risk" takes its own big chances when it tries to graft too much psychodrama onto a simple situation. Although Ms. Fishel has based this film on a true story, its later, more histrionic developments don't ring true. Her characters never seem as reckless or dangerous as the screenplay makes them, partly because

Seventh Art Releasing

Karen Sillas and David Ilku, stars of the film "Risk."

"Risk" is far better acted and photographed than it is written. Both leads are compelling, but they are rarely given anything surprising to say.

Although "Risk" is intimate enough to feel like a two-character drama, it also spends time with Nikki, Joe's pregnant sister (Molly Price), and Karl (Jack Gwaltney), her husband, who winds up making the wrong moves with both Maya and Joe. This part of the film is the closest "Risk" comes to explaining what has made Joe a desperate character. The explanation is pat, and hardly as interesting as Joe is. It doesn't come close enough.

1994 O 5, C18:1

FROSH
Nine Months In a Freshman Dorm

Directed by Dan Geller and Dayna Goldfine; director of photography, Mr. Geller and Ms. Goldfine; edited by Ms. Goldfine, Mr. Geller and Deborah Hoffmann; music by Don Hunter; produced by Mr. Geller and Ms. Goldfine; released by Horizon Unlimited. Cinema Village, 22 East 12th Street, East Village. Running time: 99 minutes. This film is not rated.

WITH: Monique, Brandi, Shayne, Sam, Cheng, Nicholas, Gerardo, Debbie and Scott.

By CARYN JAMES

Day after day in a coed dorm at Stanford University, a group of freshmen sit around on beds and on the floor, discussing sex, religion and books. Nick blithely announces that he is bisexual, which causes Debbie to giggle and admit she has always been taught sex is wrong. Sam, a gangly boy from New Jersey, says he wishes he had a girlfriend, just once. Cheng, a first-generation Chinese-American from the Midwest fears he is not as smart as his classmates. And a black woman named Monique decides that Aristotle would not be taught if he were black or a woman, "especially because he's always wrong." In between crises they go to the bookstore and cafeteria, and for the first time try on attitudes away from their parents.

To make the documentary "Frosh: Nine Months in a Freshman Dorm," Dan Geller and Dayna Goldfine followed 10 Stanford students at Trucco Hall through their first year. The film is best when it captures the sense of culture shock that all freshmen undergo. One boy stands in the doorway, his mouth hanging open in astonishment, as Monique talks about her parents. He is more amazed by the fact that her mother and father never married than he is by the information that Monique's mother is a crack addict she hasn't seen for several years.

Monique's background is sadder and more dramatic than the other students'. Despite the film makers' determinedly multi-cultural cast, "Frosh" focuses on freshmen from a relatively narrow, conservative range. Several of the men in the dorm are uncomfortable when a campus newspaper runs a photograph of two men kissing. The school year is a long process of students confronting one another's racism, sexism and homophobia.

But a little bit of life in a dorm goes a very long way. As the film's retro title suggests, "Frosh" shares a heavy dose of its subjects' freshman earnestness, and offers few surprises. The dormmates have none of the slickness, irony or style of the roommates on MTV's reality-based series "The Real World" (the obvious comparison), and this sedate film has none of MTV's flashy camera work. That tame approach may make the students seem typical of many in Middle America, but it quickly turns dull. "Frosh" opens today at Cinema Village.

1994 O 5, C18:1

THE RED LOTUS SOCIETY

Directed by Stan Lai; written (in Mandarin, with English subtitles) by Mr. Lai; director of photography, Christopher Doyle; edited by Chen Bowen; music by Fumio Itabashi; production designer, Samuel Wang; produced by Wang Ying-hsiang. At Alice Tully Hall today at 9 P.M. and Saturday at 6 P.M. as part of the 32d New York Film Festival. Running time: 125 minutes. This film is not rated.

WITH: Ying Zhaode (Ahda), Chen Wenming (Dan), Li Tongcun (Mao), Lee Lichun (Ahda'a father), Lo Manfei (Miss Sung) and Li Bojun (Old Master)

By STEPHEN HOLDEN

Every society has its own mythological expressions of the human urge to fly. In America, comic-book heroes like Superman and Batman fulfill that fantasy. A trademark of Hong Kong action films is the aerial martial arts combat by kung-fu virtuosos whose spectacular leaps have a supernatural levity.

In "The Red Lotus Society," the Taiwanese film maker Stan Lai's elegant and lighthearted reflection on Chinese myths of the mind and body, the dream has been realized by a group of seven men and women who, according to legend, came to Taiwan from the Chinese mainland in 1949. Trained in the art of "vaulting," the ability to leap great distances, they were sent back to the mainland on a secret mission. After a series of reversals worthy of the trickiest film noir plot, the three survivors of the mission disappeared into Taiwanese society. One became a shipping clerk, another the operator of a dumpling stand and the third a blind masseur.

Some of group's exploits are recounted in flashbacks in the movie, which the New York Film Festival is showing at Alice Tully Hall today at 9 P.M and on Saturday at 6 P.M. The film, set mostly in present-day Taipei, follows the adventures of Ahda, a pony-tailed student from Taipei who is determined to master the secrets of vaulting. The most basic part of his training consists of jumping up steps with bags of iron powder steeped in Chinese herbs tied to his ankles.

The movie is a kind of philosophical and psychic detective story in which Ahda becomes the protégé of three teachers who appear in succession to instruct him in the physical and mental disciplines necessary for flight. His teachers include a janitor, a masseur and a successful businesswoman specializing in risky loans.

Of the three, the movie devotes the most time to the businesswoman, Miss Sung (Lo Manfei), a beautiful, self-assured tycoon operating out of a makeshift office whose walls are lined with fax machines. Miss Sung makes many of her decisions based on the visions of Kuei (Na Weixun), a psychic who happens to have been Ahda's best friend in school. Other fantastic characters include Mr. Mao, a storyteller who claims to have been a cook for the secret society, Ahda's sometime sweetheart Dan and Ahda's father, a bone doctor who has a business selling fake jade.

Ahda's instruction is rooted in paradox. He must never ask questions about vaulting, he is told, because the skill doesn't exist. And those who learn how to fly must never exhibit their skill.

As "The Red Lotus Society" skips lightly from one episode to another, t has a visual and narrative buoyancy that echoes a piece of advice that Ahda is given by one of his instructors. The ability to vault can only be achieved, he is told, by understand-

ing and surrendering to "the floating quality of the world."

Without being didactic about it, the movie creates that floating atmosphere. Luminously photographed in a way that presents a tantalizing mystery behind every closed door, it has the feel of a dreamlike puzzle whose pieces, when fitted together, will allow the spirit, if not the body, to soar.

1994 O 5, C18:1

THE TROUBLES WE'VE SEEN

Written and directed by Marcel Ophuls; dialogue in French, German and Serbo-Croatian, with English subtitles; director of photography, Pierre Boffety; edited by Sophie Brunet; sound by Michel Faure; produced by Bertrand Tavernier and Frédéric Bourboulon. At Alice Tully Hall tonight at 6 as part of the 32d New York Film Festival. Running time: Part 1, 90 minutes; Part 2, 135 minutes. This film is not rated.

WITH: Philippe Noiret, John F. Burns, Patrick Poivre d'Arvor, Martha Gellhorn, Mr Ophuls and others.

By JANET MASLIN

Taking its perfect title from the old spiritual song, Marcel Ophuls's engrossing new documentary "The Troubles We've Seen" calls attention to the missing phrase: "Nobody knows." No one besides journalists operating within the cauldron of a war zone really understands the occupational hazards of such work. But Mr. Ophuls, the contemplative documentary film maker whose specialty is plumbing the depths of unfathomable experience, has made it his business to try.

Working on his usual vast canvas, Mr. Ophuls constructs another brave, enveloping inquiry into a compelling subject, reveling in the investigative process as he presents it imaginatively on screen. The topics here range from journalistic ethics to survival tactics to grace under pressure. And a leisurely four-hour running time lets Mr. Ophuls explore them in rambling, frequently surprising ways.

Basing himself in Sarajevo, Mr. Ophuls captures the full spectrum of journalistic behavior. It ranges from the stellar French anchor who makes a showy 24-hour visit in a flak jacket to the American newspaper reporter, in the city's embattled marketplace, peering into an old woman's grocery bag to assess the quality of life. Mr. Ophuls's frank partisanship only helps to enliven such vignettes. He openly admires the newspaperman (John F. Burns of The New York Times) and pointedly asks the television star (Patrick Poivre D'Arvor), "How does your 24 hours here change anything?"

"The Troubles We've Seen" has great and whimsical range, incorporating everything from old film clips to a Bosnian surgeon singing the title song. Mr. Ophuls, never shy about injecting himself into the debate, even works in an homage to "Annie Hall" (which itself paid homage to his "Sorrow and the Pity"). The playfulness of such touches cannot be confused with a lack of seriousness, not even when Mr. Ophuls is seen taking a break in Vienna with a

naked woman draped across the bed in his hotel room. Outrageously or otherwise, he appreciates the intense pressures that color life in a war zone.

The reporters' own gallows humor and cathartic bonhomie are emphasized early in the film, with a sharp contrast between the joking that preserves their sanity and the dedication they bring to their work. Indeed, the reporters' camaraderie is so lively that Mr. Ophuls chastises one star, the BBC's John Simpson, for trying to disguise it. ("You're getting awfully serious about this. You were funnier about it when the camera wasn't on.")

"It seems so indecent to say we are having the most tremendous amount of fun in the midst of all this misery," Mr. Burns says, capturing his compatriots' outlook. "It's not fun, but it's an experience that I would not want to miss."

It hardly takes long for the gravity of the correspondents' situation to come through. "Not exactly what you sign up for, is it?" says one of them, describing the injuries of a female colleague whose jaw was blown off. The reporters are seen as torn between terrible danger and the perils of egotism, which may lead them to upstage their own stories.

"I think war correspondents are highly privileged and shouldn't be glorified," insists Martha Gellhorn, whose own adventures as a World War II correspondent were certainly glorified in their day. Ms. Gellhorn also notes that it was easy for her to gain access by pretending she was only interested in the woman's angle of war coverage ("I've just come to interview the nurses").

One of many French journalists seen here describes a disparity between French and English reportage: the British "always go for reason" while the French are always concerned with the human aspect of the story. By that standard, Mr. Ophuls works in a distinctly French manner, using a wealth of interviews and anecdotes to define the issues at hand.

He sharply examines the personalities involved in glossy television news shows, which have the same problems in France that they do here. "Courage, perhaps, is not their greatest virtue," says the actor Philippe Noiret, who turns out to be a trenchant social critic in discussing the stars of television news. "Not when they're face to face with our leaders."

Mr. Ophuls also considers the different roles played by men and women in broadcast news reporting, the wage discrepancies between workers and stars, even the networks' refusal to protect the safety of reporters while never being short on funds for game shows. On a deeper level, he raises many important questions about content and reportorial technique. "Fewer people do fewer things and more people comment on those things," Mr. Noiret points out. "In the past, it was the opposite."

Mr. Ophuls also makes extremely deft use of film clips from works by his father, Max Ophuls. A reporter's cruel question to a mother whose son has been blinded prompts him to excerpt a scene from "Lola Mon-

tes," in which Lola is made the focus of an earlier form of sensationalism. The senior Ophuls's film "From Mayerling to Sarajevo" is also put to ironic use, since its depiction of the assassination that triggered World War I was filmed at the very start of World War II. "History never ends," says the younger Mr. Ophuls. In thoughtful, mesmerizing political documentaries like this one, he has long since proved that point.

"The Troubles We've Seen" eventually considers the essence of a journalist's moral responsibility in wartime, bringing up examples as disparate as Walter Cronkite's outspokenness about Vietnam and evidence that one of Robert Capa's most powerful Spanish Civil War

photographs was faked. However stirred and outraged they are by what they witness, all the journalists seen here must deal with the conundrum that, as one puts it, "the more horrible the situation, the more successful we become."

And all must recognize that they are only incidental parts of the conflicts they describe. What does it mean when one news-addicted photographer, taking a break from battle scenes, makes himself photograph flowers and butterflies? "I condemn myself to peace," he ruefully says.

"The Troubles We've Seen" will be shown tonight at 6 o'clock as part of the New York Film Festival.

1994 O 6, C17:1

HOOP DREAMS

Directed by Steve James; director of photography, Peter Gilbert; edited by Frederick Marx, Steve James and Bill Haugse; music by Ben Sidran; produced by Mr. Marx, Mr. James and Mr. Gilbert; released by Fine Line Features. At Avery Fisher Hall on Sunday at 8 P.M. as part of the 32d New York Film Festival. Running time: 171 minutes. This film is rated PG-13.

WITH: Steve James, William Gates, Arthur Agee, Emma Gates, Sheila Agee and Gene Pingatore.

By CARYN JAMES

AT a high point in his young career, Arthur Agee, a 14-year-old basketball player at St. Joseph High School in Chicago, stands on the court with his idol, Isiah Thomas. The N.B.A. star is visiting his old school, and as Arthur goes one-on-one with his hero, the boy flashes a smile as big and joyous as any you've ever seen.

Four years later, Arthur's classmate William Gates, who also dreams obsessively about playing in the National Basketball Association, has progressed to the Nike All-America basketball camp, where college coaches look over high school players. Spike Lee visits and tells the students a cold-blooded truth: they are being used and the one way to protect themselves is to know it. "The only reason you are here is because you can make their schools win and they can make a lot of money," Mr. Lee says of the coaches. "This whole thing is about money." It is the kind of valuable advice boys like Arthur and William, from poor black neighborhoods, hear all too rarely.

"Hoop Dreams" is a brilliantly revealing documentary that follows Arthur and William through high school to their first year of college. Along the way it raises many potent questions, none more difficult than this: How can you encourage the kinds of dreams that transform Arthur's face while keeping harsh reality in sight?

The film makers, Steve James, Frederick Marx and Peter Gilbert, spent four and a half years with the boys and their families, acquiring 250 hours of film. Their fascinating, suspenseful film turns the endless revision of the American dream into high drama. The story begins when Arthur and William are actively recruited by St. Joseph, a mainly white, Roman Catholic school with a major basketball program. Just as the boys' paths seem settled — William is heading for a dazzling college career and pro prospects, while Arthur is spiraling downward — they face abrupt changes. "Hoop Dreams" is the profound social tale of these two emblematic boys, who are sucked into a system ready to toss them aside, disillusioned and uneducated, the minute they stumble on the basketball court.

"Hoop Dreams" will close the New York Film Festival on Sunday night at 8, the first documentary ever to do so. (It will open in New York next Friday

and around the country on Oct. 21.) It is a daring choice for the prestigious closing-night slot because the movie, though finely made, is not about bravura film making. Instead, "Hoop Dreams" affirms the role of film as a medium for exploring social issues. And like any important

documentary, this one raises crucial questions beyond what is on screen. How does the camera change the subjects' behavior? How well can the film makers, who are white, see beyond the stereotypes of poor black kids and their broken families?

Though it tries, "Hoop Dreams" doesn't find the complex people behind the stereotypes often enough; as viewers, we remain sympathetic voyeurs rather than intimates. The film's great achievement is to reveal the relentless way in which coaches and recruiters refuse to see Arthur and William as anything other than social clichés.

Arthur lives in the Cabrini-Green housing project with his parents and siblings. In the course of the film, Arthur's parents break up and get together again, and his father overcomes a crack addiction after serving time in prison. William lives with his single mother and older brother in a slightly better neighborhood. Both families are too dream-besotted themselves to offer good advice.

William's older brother, Curtis, failed in his own college basketball career and has invested his dreams in his brother. Arthur's father also missed out on a college career, and says of his son with a confidence that is eerily short-sighted, "I don't even think about him not making it."

St. Joseph seems the way to a pro career. Both boys are given partial scholarships, though they read at a fourth-grade level. Gene Pingatore, the head coach, who never lets the boys forget that he launched Isiah Thomas, is the distillation of all the white coaches and recruiters in the film. He talks a good game about caring for the boys' future, but over and over the film captures his hideously callous behavior. The strongest proof is what happens to Arthur.

Arthur doesn't shine in sports or academics. "I've just never been around a lot of white people, but I can adjust," he says. When he starts behaving badly in class, Coach Pingatore tells the camera Arthur is reverting to the influence of "his environment." Arthur is tossed out of St. Joseph in the middle of his sophomore year because his family owes $1,500 in back tuition.

Two years later, when Arthur needs his freshman transcript to graduate from the local public school, St. Joseph's holds the records hostage until the Agees arrange to make monthly payments on the back tuition. In a brutal documentary moment, St. Joseph's finance director condescends to Mr. and Mrs. Agee, who act amazingly grateful for the chance to pay the old debt. The subjects could not have guessed what a painful impression they would all make.

William has financial problems, too. But he has raised his reading level and done well on the varsity team. St. Joseph's finds a private sponsor to take care of his share of the tuition.

Primed for success, William becomes the more articulate and vibrant of the two, with Arthur seeming guarded and shy. Then William injures his knee, and the camera closes in on his impassive face as the doctor says he might have to sit out a year. It's hard to guess how much of his stoicism is an act for the audience.

Arthur's mother becomes the warmest and fullest character, because she is the only one we see looking past the camera and talking to the person behind it. After celebrating Arthur's 18th birthday, she learns he has been cut off welfare, even though he is still a full-time student. "Do you all wonder sometime how am I living?" she asks, clearly talking to a person and not posterity. In all those hours of film, there were certainly other, unused moments when the barrier of the camera was broken down, but Sheila Agee must have done that a lot. She encourages her son, wears a Detroit Pistons sweatshirt and triumphantly passes a course to become a nurse's assistant. Yet she is plainly furious at St. Joseph's for what she considers the broken promises that let her son down and temporarily shattered his self-confidence.

In shaping "Hoop Dreams" into a dramatic 2-hour-and-51-minute narrative, the film makers do an expert job of demonstrating the pressures and excitement surrounding the boys. Both have crowds cheering as they take last-minute shots in do-or-die games that might lead to the state championship.

By his junior year, William is getting dozens of letters from big-time basketball schools like Georgetown. One letter offers the lure, "We play on national television." Yet his grades have fallen so much he might be ineligible to play in college; he has fathered a child. He later recalls that when he went to Coach Pingatore for help dealing with his family, he was told, "Write them off."

Arthur, who has grown taller and wears a stylish fade haircut, has regained some confidence. But he has had a few weak seasons and hears from places like Mineral Area Junior College in Missouri. When he visits there, he finds they have no dorms. They do have an isolated house for the basketball team; six of the school's seven black students live there.

What is most disturbing about "Hoop Dreams" is that no one seems willing or equipped to help William and Arthur navigate between their dreams and reality. When William says wearily toward the end of the film, "Basketball is my ticket out of the ghetto," it sounds as if he is parroting a phrase that has been drilled into him, as if an alien has taken over his mind.

The story behind "Hoop Dreams" is not over, either. The TNT cable channel is planning to remake the story as a fictional movie for television. A book based on transcripts from the interviews will be released in the spring. Meanwhile, William and Arthur are now college seniors, William at Marquette University and Arthur at Arkansas State.

The National Collegiate Athletic Association has ruled, despite the film makers' appeals, that neither the boys nor their families may receive any money from the sale of the film because they would lose their amateur status and their scholarships. And just last week, St. Joseph High School filed a civil suit for defamation against the film makers and the distributor, Fine Line Features.

Depite all the drama on and off screen, a particularly quiet moment best captures the life lesson of "Hoop Dreams" and is the scene most likely to have audiences cheering. William, about to graduate from St. Joseph, tells Coach Pingatore of his college plans. "I'm going into communications," he says, "so when you come asking for donations, I'll know the right way to turn you down."

"Hoop Dreams" is rated PG-13 (Parents strongly cautioned). It includes some graphic scenes of knee surgery.

1994 O 7, C1:1

Corrosive Gay Portrait In Numbered Segments

*"Totally F***ed Up" was shown as part of last year's New York Film Festival. Following are excerpts from Janet Maslin's review, which appeared in The New York Times on Oct. 9, 1993. The film opens today at the Quad Cinema, 13th Street, west of Fifth Avenue, Greenwich Village.*

"Everything that homos are supposed to like — disco music, drag shows, Joan Crawford — I hate," says one character in "Totally F***ed Up," Gregg Araki's fractured, corrosive portrait of a group of gay comrades. Mr. Araki, who has described his film as a "ragtag story of the fag-and-dyke teen underground," brings an angry intelligence to bear upon disaffected characters, so that his work plays vigorously as part movie, part manifesto.

"Formally, the picture's use of an exploded, free-associative narrative and direct-to-camera address is as radical as the 60's French New Wave (or its rip-off, 90's MTV)," Mr. Araki has also written, none too bashfully, about his film. In its closing credits, where friends and sponsors are usually thanked, he also includes a colorful "no thanks" to "you all know who you are." And the asterisks in the title amount to more of the same.

Clearly, Mr. Araki means to underscore the subversive aspects of his work. That attitude was especially effective in "The Living End," his bold, bleakly funny road movie about two young nihilists who were H.I.V.-positive. This time, paying more strenuous homage to Jean-Luc Godard, Mr. Araki avoids a story line as linear as that. Instead, he presents 15 numbered segments, interspersed with titles like "Life Styles of the Bored and Disenfranchised" and "To Live and Fry in L.A.," as a means of describing six intimate, highly opinionated gay friends. Questions of identity are all-important to these four teen-age boys and two girls, who get together to discuss everything from masturbation to whether love exists. "Can this world really be as sad as it seems?" one of the film maker's titles asks.

Because the film begins and ends with the thought of teen-age suicide, it offers a potentially despairing answer to that question. But Mr. Araki also captures the vitality of his characters and the urgency of their yearnings, even if he does so in scattershot style. Making one of them an aspiring film maker gives Mr. Araki occasion to overuse the home video interview format, but the actors' speeches to the camera are sometimes memorably raw. This feisty, disjointed film finds something compelling in its characters even when they're so druggy they can barely stand.

Standing up is pretty well beside the point anyway, because Mr. Araki's characters spend much of their time on the floor, either sitting and talking or communing on mattresses. The film's settings are as studiously cool as its characters, one of whom is seen speaking between two television sets, each with the sound turned down, and flanked by a foot-high copy of Michelangelo's "David."

In this atmosphere, the friends' various romantic troubles make as much sense as anything else does, even if one character's loneliness and uncertainty eventually lead to a fatal cocktail of house-cleaning chemicals. Another of the film's idiosyncratic milestones, an artificial-insemination party for one of its lesbian characters, is equally plausible under these circumstances.

The film is at times overly scrambled and affectless in presenting its narrative (even if Mr. Araki helpfully includes a title reading "Start Narrative Here"). But its sting comes from attitude-defining asides, like the above-mentioned remark about discos, Joan Crawford and the purported gay establishment. Even when Mr. Araki's directorial affectations overshadow his film's lucidity, his daring, outrage and inventiveness are always clear.

1994 O 7, C8:5

ONLY YOU

Directed by Norman Jewison; written by Diane Drake; director of photography, Sven Nykvist; edited by Stephen Rivkin; music by Rachel Portman; production designer, Luciana Arrighi; produced by Norman Jewison, Cary Woods, Robert N. Fried and Charles Mulvehill; released by Tri-Star Pictures. Running time: 108 minutes. This film is rated PG.

WITH: Marisa Tomei (Faith), Robert Downey Jr. (Peter), Bonnie Hunt (Kate), Joaquim de Almeida (Giovanni), Fisher Stevens (Larry) and Billy Zane (the False Damon Bradley).

By JANET MASLIN

In the frankly touristy "Only You," a Pittsburgh schoolteacher named Faith flees her dull fiancé and races off to Italy, traveling cute in a black raincoat over a bouffant wedding dress.

Supposedly the purpose of this trip is Faith's finding her true soul mate, a man whose name — Damon Bradley — she has been given by a Ouija board. Actually it's all about scenery, as the story moves from Venice to Rome to Positano, stopping for suitably fabulous vistas and fountains and flowers. There are worse things than commissioning Sven Nykvist to photograph Italy at its most picturesque.

One of those worse things was assigning the role of Faith to Marisa Tomei, who may be the least convincing actress ever to pretend to teach school. Too adorable by half, Ms. Tomei does nothing here to recall that her comic talents (in "My Cousin Vinny") have brought her an Academy Award. This performance does suggest that if the current mania for feature-length films based on old television shows ever extends to "That Girl," the Marlo Thomas role will be easy to cast.

Ms. Tomei does have the advantage of statuesque good looks, which are greatly enhanced by Milena Canonero's slinky, glamorous costumes and do something to compensate for her brittle, bright-eyed delivery. "Only You" is only about appearances anyway. It's the kind of film in which strangers applaud when young lovers kiss and tourists say things like "He promised to take me on a tour of the fountains."

Trying for either "Roman Holiday" or something in the tradition of his own "Moonstruck" (and throwing in glimpses of a great big moon whenever possible), Mr. Jewison takes a voluptuously cornball approach to this story. And the story itself, by Diane Drake, is actually rather sweet. In search of her phantom lover, Faith ignores the fact that she has met Mr. Right. He is Mr. Peter Wright (Robert Downey Jr.), to be precise. But when he figures out that only Damon Bradley can make Faith happy, he calls himself Damon Bradley instead.

Meanwhile, Faith's sister-in-law, Kate (Bonnie Hunt), decides to make a much-needed getaway from Faith's brother, Larry (Fisher Stevens), a Pittsburgh roofer. Once in Rome, she is courted by Giovanni (Joaquim de Almeida), a skilled hand-kisser who knows what unhappily married American tourists like. (They like rooftop restaurants with nice views of Rome and exclamations like: "La bella Italia! She's waiting!")

Meanwhile, mistaken identity and the Damon Bradley question keep Faith in a series of swoons and snits, while love-struck Peter Wright waits for her to come to her senses. A yacht figures prominently in these developments. So does Billy Zane, who has some funny moments as a handsome Mr. Wrong.

Mr. Downey, who recently weathered "Natural Born Killers," continues to prove how versatile and enter-

Emilio Lari/Tri-Star Pictures
Marisa Tomei and Robert Downey Jr. in "Only You."

taining he can be in any surroundings. Even in this stock role, he shows off a lively comic style. "Only You" also includes a first-rate supporting performance from Ms. Hunt, who makes a fine sardonic sidekick for Ms. Tomei. Mr. de Almeida, last seen as part of the drug underworld in "Clear and Present Danger," goes from sinister to suave without missing a beat. Mr. Stevens also has a few amusing moments, during which he pronounces "Italy" as a two-syllable word.

Mr. Jewison does his utmost to keep "Only You" big and glossy, but sometimes reality intrudes. The film conspicuously plugs every hotel and restaurant it features, doubtless meaning to help viewers who'd like to make travel plans. Not shown: the exciting moment when Faith, Kate, Peter and Larry return home from their mad escapades and open those credit card bills.

"Only You" is rated PG (Parental guidance suggested). It includes mild profanity, mild sexual situations and brief, partial nudity.

1994 O 7, C12:1

LADYBIRD, LADYBIRD

Directed by Ken Loach; written by Rona Munro; director of photography, Barry Ackroyd; edited by Jonathan Morris; music by George Fenton; production designer, Martin Johnson; produced by Sally Hibbin; released by Samuel Goldwyn Productions. At Alice Tully Hall, tonight at 6 and tomorrow at 3 P.M. as part of the 32d New York Film Festival. Running time: 102 minutes. This film is not rated.
WITH: Crissy Rock (Maggie), Vladimir Vega (Jorge), Sandie Lavelle (Mairead), Mauricio Venegas (Adrian) and Ray Winstone (Simon).

By JANET MASLIN

Ken Loach's "Ladybird, Ladybird" asks viewers to imagine what it is like for Maggie (Crissy Rock) to open a newspaper one day and see a photograph of a boy in need of adoptive parents. "I've never had much love," says the caption. "Can you give me some now?" The photograph is of Maggie's own son.

Maggie, the central figure in this raw, wrenching film based on a true story, is first seen as a mother of four who has no children. English social service agencies have seen fit to take all of them away. And those agencies are not presented as simply villainous. Maggie's history is troubling enough to yield different opinions on whether she is a fit parent for her children.

Mr. Loach knows better than to present Maggie's story as a mere case of bureaucratic injustice, even though it escalates into exactly that before it is over. His interest goes beyond the black-and-white outline of such a horrific situation, and into the harrowing gray reality. "Ladybird, Ladybird" is a tough, utterly absorbing film even at moments when it seems to skirt some of the fine points of Maggie's difficulties. It's not necessary to see her as a pure victim to appreciate the hellishness of her ordeal.

The film begins as Maggie, who looks like a heavier, blowsier Susannah York, meets Jorge (Vladimir Vega), a gentle Paraguayan immigrant. After he approaches her in a karaoke bar, she tells him about her past. Raised by an abusive father, she had four children by four different men, at least one of whom also had a violent temper; he is seen savagely beating Maggie with a beer can during one of the film's flashbacks. The four children are a racially mixed group. Racial prejudice can be seen as contributing to Maggie's uneasy relations with various social workers, most of whom are white.

But Maggie's biggest problem with these authorities is Maggie herself. One night she makes an inexcusable mistake, leaving her children home alone while she goes out on a singing engagement. She locks them in the apartment, supposedly for their own protection. A fire breaks out. One boy is badly burned, and the whole group is summarily removed from Maggie's care and classified "At Risk" by government agencies.

Maggie's subsequent behavior makes matters worse. One night, she shows up late to visit the burned boy in his foster home, expressing surprise that he is already in bed at 8:30. Volatile and quarrelsome, she instantly picks a fight with the foster mother, and then barges in to visit her son. Insisting on changing his bandage, she is so clumsy that she hurts him. Whatever has made Maggie this distraught, the fact is that she has become her own worst enemy. She screams at any authority figure who comes to visit her, badly compounding the communications failure on all sides.

"Ladybird, Ladybird" watches Maggie fall into a love affair with the patient, generous Jorge, who does his best to get her back on her feet. It then watches, first with hope and then with horror, as Maggie and Jorge prepare for a new start with a child of their own. The social service workers who once expressed concern over whether Maggie was "coping" (a favorite word here) have lost patience, and they become more invasive. And Maggie goes to war with an increasingly brutal bureaucracy,

in a series of struggles that take some unimaginably ghastly turns.

One of these events takes place in a hospital room and is so wrenching that it makes a nurse cry. "Ladybird, Ladybird" is extremely upsetting at such moments, fully sharing Maggie's hopelessness and grief. Although a closing title says Maggie's life took a positive turn after the events seen here, the film does little to give credence to that possibility. By the end of the story, her fate has come to seem irremediably bleak, and Mr. Loach has stirred a fierce sense of outrage. The facts presented here are devastatingly cruel. The final impression is that somehow it needn't have been so.

Does it matter that Mr. Loach has altered the names and characteristics of his film's two principals? Or that a "based on a true story" credit makes it possible to eliminate unpleasant facts? No: even if Jorge tends toward saintliness and the question of Maggie's real competence as a mother remains unexamined, the film has honesty and immediacy on its own dramatic terms. Mr. Loach incorporates enough ambiguity to keep his story painfully lifelike, and he finds scorching social realism beyond the bare facts of this tale.

"Ladybird, Ladybird," which takes its title from the nursery rhyme about children in peril, is acted with passionate intensity by Ms. Rock. She rails terrifyingly at those around her in some of the film's most disturbing scenes. An imposing actress of mercurial range, she also displays a warm intimacy in scenes with Mr. Vega, whose sympathetic presence softens Jorge's Prince Charming role.

"Ladybird, Ladybird" will be shown tonight at 6 and tomorrow at 3 P.M. as part of the New York Film Festival. It is accompanied by "Cross Examination," a short film by Lori Hiris about the Clarence A. Thomas-Anita F. Hill hearings. The camera remains fixed on the eyes of a black woman who occasionally sheds tears while portions of testimony from the hearings are heard. A statement about feminism and race accompanies the closing titles.

A flatly polemical film like this does a disservice to the complexity of "Ladybird, Ladybird," which is itself far beyond easy answers.

1994 O 7, C18:3

WILD REEDS

Directed by André Téchiné; written (in French, with English subtitles) by Mr. Téchiné, Gilles Taurand and Olivier Massart; director of photography, Jeanne Lapoirie and Germain Desmoulins; edited by Martine Giordano; sound by Jean-Paul Mugel; produced by Georges Benayoun and Alain Sarde. At Alice Tully Hall tonight at 9 and tomorrow at noon as part of the 32d New York Film Festival. Running time: 110 minutes. This film is not rated.
WITH: Élodie Bouchez (Maïté), Gaël Morel (François), Stéphane Rideau (Serge), Frédéric Gorny (Henri), Michèle Moretti (Mme. Alvarez) and Jacques Nolot (Mr. Morelli).

By CARYN JAMES

"Wild Reeds" is André Téchiné's delicate, lovingly photographed,

strongly acted coming-of-age story in which a smart, sensitive boy named François falls in love with his classmate, a peasant boy named Serge. Set in the French countryside in 1962, at the end of the Algerian war, the film is more successful at making François an evocative character than it is in its lukewarm attempt to make politics an integral part of the story.

In a discreet scene at school one night, François and Serge sleep together. It is clear that for Serge, this is an adolescent experiment, done for lack of any females around. But François falls painfully in love, and has no idea what to do about it.

In the film's most vivid scene, François decides to go to the owner of the local shoe store, a man he has heard is a homosexual, too. With touching naïveté, he decides to ask the man for advice. "It's not about my shoes," he tells the bewildered stranger. "It's about my destiny."

Yet too much of "Wild Reeds" seems stilted. François's best friend and confidante is a girl named Maïté, who is unbelievably wise beyond her years and well ahead of her time. "I slept with a boy," François tells her, and she calmly replies, "I don't care what you do with others."

Henri, an Algerian schoolmate of François and Serge, is meant to carry the weight of the political theme, his sense of Algerian oppression being the counterpart to François's unacceptable status as a homosexual. Yet politics seems a veneer laid over the film. Mr. Téchiné gives short shrift to a more intriguing aspect of that theme. Maïté's mother refuses to help a young man avoid the war, then falls apart because she feels responsible for his fate.

"Wild Reeds" will be shown as part of the New York Film Festival tonight at 9 and tomorrow at noon. Like Mr. Téchiné's "Scene of the Crime," which was shown at the festival in 1986, it is too tepid to generate much excitement.

It will be preceded by Lara Shapiro's six-minute "Crawl," a brightly colored tale in which a young woman goes to a swimming pool, makes eye contact with a handsome man, and becomes disillusioned. Ms. Shapiro creates an ominous sense of foreboding and playfully demonstrates a theme her film shares with Mr. Téchiné's: that the ideal object of your affection is not always the person in your direct line of vision.

1994 O 7, C18

SATANTANGO

Directed by Bela Tarr; written (in Hungarian, with English subtitles) by Mr. Tarr and László Krasznahorkai, based on the novel "Satantango," by Mr. Krasznahorkai; director of photography, Gabor Medvigy; edited by Agnes Hranitzky; music by Gyorgy Kovacs; produced by Mr. Tarr. At the Walter Reade Theater, Sunday at 11 A.M., as part of the 32d New York Film Festival. Running time: 420 minutes (plus intermissions). This film is not rated.
WITH: Mihaly Vig (Irimias), Dr. Putyi Horvath (Petrina), Erika Bok (Estike), Peter Berling (The Doctor) and Miklos B. Szekely (Futaki)

By JANET MASLIN

Brave souls in tomorrow's sold-out audience for "Satantango" will have ample opportunity to ponder the meaning of a seven-hour running time. Is this a declaration of greatness, or simply a means of crushing viewers into submission? Do the thoughts stirred by such an uncompromisingly long film fully occupy all the ruminative space they have been given? Is time somehow altered when, thanks to the hypnotic effects of Bela Tarr's deliberately lulling direction, time is made to stand almost still?

"Satantango," Mr. Tarr's bleak, imposing cinematic experiment, sometimes lives up to great expectations, but its unevenness allows many questions to creep in. Moving at a pace that would suit a glacier, Mr. Tarr contemplates a group of grim-faced, wretched characters whose agricultural collective has fallen into decay, and who engage in desperate forms of chicanery as a way of denying their failure.

In this remote, unnamed outpost and in a nearby town, characters cheat, betray and spy on each other. They also prepare to be relocated as their communal life comes to an end. "Don't take me as a liberator," one of them says, encapsulating the prevailing spirit of despondency. "Regard me as a sad researcher who investigates why everything is as terrible as it is."

Based on a novel by Laszlo Krasznahorkai, the Hungarian film "Satantango" has been accidentally mischaracterized in New York Film Festival advertising as the definitive statement on the death of Communism. It anticipates that cataclysm, but the novel was published in 1985. In fact, this can be seen as the definitive statement on the death of just about anything, since it works on the level of paralyzing misery and vague forboding. In a barren, crumbling, muddy setting, Mr. Tarr presents a microcosmic view of social and spiritual collapse.

The events in "Satantango" are few, some of them repeated at different times and from different points of view. By slowing and manipulating these occurrences until they seem to expand, Mr. Tarr creates a trancelike mood, achieving what one Hungarian critic has called "meditation through ugliness." As this critic, Andras Balint Kovacs, explains it: "'Satantango' does not last so long because the director wants to tell us or show us so much. Tarr wants to say very little and show very little. But he wants us to see and understand what he says and shows it to us exactly as it is. He wants us to see devastation at the bottom of everything."

Devastation is hard to miss. The skies pour down what a narrator calls "the long autumn rains which turn track into bog." Characters remark dismally and repeatedly that it is raining. Flies buzz. Spiders weave. Water drips. Animals root desultorily in the barnyard. The camera sometimes watches, immobilized, for endless-seeming stretches. At other times, Mr. Tarr employs long, long tracking shots down roads across the featureless landscape.

When actors walk away from the camera in "Satantango," the director waits patiently almost until they reach the horizon.

The effect of such methods is to communicate a haunting emptiness, even when that emptiness threatens to drive an audience mad. During its single looniest episode, "Satantango" gathers its few despondent characters in a drab bar where they lurch and stagger and dance drunkenly as the same loop of accordion music plays over and over and over. Most of the film is more somber and brooding than that.

"Satantango" breaks down into separate episodes, like a long, tense, disturbingly effective sequence involving a young girl and her pet cat. At first the girl simply sits, waits and stares at a doorway while the wind blows. She strokes the cat. She strokes harder. She begins to toy with the cat, understanding her power over the animal as the film evokes larger feelings of helplessness and betrayal. It seems to take an hour for this episode to end in tragedy and release, but here the eerie meticulousness of Mr. Tarr's method pays off.

An appreciation of the slow, stark, meditative films of Andrei Tarkovsky is a necessary prerequisite for admiring Mr. Tarr, who reflects a strong Tarkovsky influence. A good night's sleep before tomorrow's screening, which begins at 11 A.M., is another must.

The striking black and white look of "Satantango" avoids any form of conventional beauty, and really does achieve a transporting nihilism that casts a heavy spell. And the Film Festival performs a valuable service in providing this showcase for a daring, difficult film maker whose work might otherwise be unavailable. Stubborn solemnity on a scale like this commands attention, for better or worse.

1994 O 8, 11:2

THE SPECIALIST

Directed by Luis Llosa; written by Alexandra Seros; director of photography, Jeffrey L. Kimball, A.S.C.; edited by Jack Hofstra, A.C.E.; music by John Barry; produced by Jerry Weintraub; released by Warner Brothers. Running time: 103 minutes. This film is rated R.
WITH: Sylvester Stallone (Ray Quick), Sharon Stone (May Munro), James Woods (Ned Trent), Rod Steiger (Joe León) and Eric Roberts (Tomás Leon)

By CARYN JAMES

It takes a while before Sylvester Stallone and Sharon Stone meet face to face in "The Specialist." He plays an explosives expert whom she wants to wipe out a few members of a crime family. Her idea of a job offer is to compliment him in a suggestive voice on his reputation for carefully targeted fireworks, but he is reluctant. Things might have moved faster if they had noticed they had cute little rhyming names. He's Ray, she's May, and they're obviously meant to be a perfect match.

In a completely unintended way, they are. Mr. Stallone's Ray is stony-faced and monosyllabic, with a wide-eyed stare that is meant to hint at sad depths but instead makes him seem to be struggling to stay awake. Ms. Stone does what she does best in movies. She struts and poses, sometimes half naked, as if she were just hanging around the house waiting for a Playboy photographer to ring the doorbell. Her acting range never moves beyond that, though May is supposedly a tortured soul who saw her parents killed before her eyes when she was a child and is obsessed with getting the men who did it. Mr. Stallone and Ms. Stone trying to act together is a meeting as disastrous as the Hindenberg crashing into the Titanic. Though "The Specialist" is full of giant explosions, the biggest bomb is the movie itself.

The story begins in 1984 with a brief scene that explains why Ray has decided that his C.I.A. partner, Ned, is a murderous villain. Ned is played by James Woods, so why is Ray surprised?

Then it jumps ahead to Miami today. Ray is lonely, but determined to turn down the sultry-voiced May's job. Like the Little Red Hen, she decides, very well, she'll do it herself. She sidles up to Tomas (Eric Roberts), part of the Cuban-American León family and one of her parents' murderers. Ray has to save her, and by a miraculous movie coincidence it turns out that Ned is working for the Leóns.

It also turns out that the León patriarch, Joe, is Rod Steiger, who pants, growls and speaks with a Cuban accent better suited to a bad stand-up comic than a killer. "He's an essplosive esspert," he says of Ray. When Joe finds out just how essplosive Ray is, he rails at Ned, "I blame jou!"

There are plot twists and double-crosses not worth following. There are scenes that come out of nowhere. When Ray takes on a gang of hoods on a bus, kicking one through the window, it seems a desperate attempt to give Mr. Stallone's fans some action.

And toward the end there is a nude shower scene, revealing that Ray and May must spend a fortune on personal trainers. The camera makes sure to get a good shot of Ray's bare buttocks. The soggy sex scene doesn't heat things up, but at least it's a diversion from the plot.

Everything in Mr. Stallone's career suggests he needs a strong director, like Renny Harlin, who surrounded him with superbly paced action and evoked a witty performance in "Cliffhanger." Luis Llosa doesn't come close here. There is little suspense, even when a whole section of a hotel is about to fall into the ocean. "The Specialist," which opened yesterday, is less a movie than a celebrity photo session with special effects.

"The Specialist" is rated R (Under 17 requires accompanying parent or adult guardian). It includes sexual scenes, strong language and much violence.

1994 O 8, 11:4

POSTCARDS FROM AMERICA

Directed by Steve McLean; written by Mr. McLean, adapted from the writings of David Wojnarowicz; director of photography, Ellen Kuras; edited by Elizabeth Gazzara; sound by Tim O'Shea; production designer, Therese Deprez; produced by Craig Paull and Christine Vauchon. At Alice Tully Hall at 9 and Midnight tonight as part of the 32d New York Film Festival. Running time: 93 minutes. This film is not rated.
WITH: Jim Lyons (Adult David), Michael Tighe (Teen David), Olmo Tighe (Young David), Michael Imperioli (Teen Hustler), Michael Ringer (David's father) and Maggie Low (David's mother)

By STEPHEN HOLDEN

If any American artist in the past decade can be said to have lobbed verbal hand grenades into the culture, it is David Wojnarowicz, the New York-based artist and poet who died of AIDS two years ago. In his writings, paintings, photographs and installations, Wojnarowicz transmuted his rage as an H.I.V.-positive gay man into explosively visceral polemics that railed against society's hatred of homosexuality, his fatal illness and governmental indifference.

Wojnarowicz's autobiographical books, "Close to the Knives" and "Memories That Smell Like Gasoline," which inspired Steve McLean's film, "Postcards From America," evoke a life of desperate alienation. A runaway child from an abusive father, Wojnarowicz was a New York street hustler in his early teens. As an adult, he pursued anonymous sex in situations often fraught with physical peril.

Mr. McLean's film adaptation of the books, which the New York Film Festival is showing this evening at 9 and midnight at Alice Tully Hall, makes a heavy-handed Freudian equation between the vicious beatings Wojnarowicz endured at the hands of his father and his cruising for rough trade at truck stops and on the road. Except for the snippets of "I remember"-style narration that accompany dramatized scenes from his youth, the film barely alludes to the inflammatory works that made

The Film Society of Lincoln Center
Michael Imperioli as the Hustler in "Postcards From America."

Wojnarowicz a star of the East Village art world during the 1980's.

With different actors portraying the adult David (Jim Lyons), the teen-age David (Michael Tighe) and the prepubescent David (Olmo Tighe), the film presents Wojnarowicz as a passive, inarticulate victim drifting sulkily through a landscape peopled with macho, gun-crazed nuts.

A loosely constructed collage of dramatized scenes that ramble back and forth in time, the film opens with the adult David traveling in the desert, then jumps back to childhood memories of his drunken brute of a father (Michael Ringer) terrorizing the family. Contributing to the desolation of these flashbacks is the succession of tinny Connie Francis hits blared on the soundtrack.

Although the cinematography has a dreamlike glow, these childhood scenes are so choppily written and stiffly acted that they fail utterly to convey horror or to evoke much sympathy. It's not entirely the fault of the three actors playing Wojnarowicz that the character seems so blank. Beyond the fragmentary voice-over remembrances, Wojnarowicz has almost no dialogue.

The film breaks out of its lethargy only at odd moments. In the best scene, the teen-age David and his pal (Michael Imperioli) pick up a man in a park and intimidate him with meat cleavers they have just stolen from Macy's. Playing a volatile hot-wired street hustler boasting about his own craziness, Mr. Imperioli, who has very little screen time, still manages to walk away with the movie.

1994 O 8, 14:1

BOSNA!

Directed by Bernard-Henri Lévy and Alain Ferrari; written (in French, with English subtitles) by Mr. Lévy and Gilles Herzog; director of photography, Pierre Boffety; edited by Frédéric Lossignol and Yann Kassile; music by Denis Barbier; production designer, Dominique Charitat; produced by Bosnia-Herzegovina Radio Television and France 2 Cinéma with Canal +, and the Centre National de la Cinématographie; released by Zeitgeist Films. Film Forum, 209 West Houston Street, South Village. Running time: 117 minutes. This film is not rated.

By STEPHEN HOLDEN

"Bosna!," Bernard-Henri Lévy and Alain Ferrari's documentary polemic about the war in Bosnia, is a blunt, impassioned call for the countries of Western Europe and the United States to step in and halt the bloodshed. The movie, which opens today at Film Forum, is narrated by Mr. Lévy, the noted French philosopher, who also wrote the script. With its grisly images of children mutilated in the siege of Sarajevo and of emaciated Bosnian prisoners near starvation in Serbian death camps, the film, which was shot between September 1993 and March 1994, wants to prick the conscience of the world.

The Serbian forces carrying out their policy of "ethnic cleansing" are denounced as butchers and thugs

seeking to establish a racist dictatorship. The defenders of Sarajevo are seen as heroic freedom fighters struggling against terrible odds to preserve a democratic ideal.

Those odds have been increased, Mr. Lévy states, by the official stance taken by the Western European powers. Instead of being treated as a victim of fascist aggression, he declares, Bosnia is being viewed as an international charity case. He bitterly compares the relief effort to the administering of blood transfusions to a terminal patient. And he urges the lifting of the international arms embargo that has left an all-but-defenseless Bosnia reliant upon supplies smuggled through hills infested with the Serbian militia.

Western Europe's failure to intervene, Mr. Lévy asserts, is part of a historical pattern of denial and appeasement of fascism that allowed the Spanish dictatorship and the rise of Hitler.

In the case of Bosnia, he speculates, a distaste for Islam is another reason that Western Europe has chosen to keep its distance. But he argues that Bosnian Muslims are non-fundamentalists who practice a tolerant, liberal Islam. Western Europeans, he suggests, have also traditionally seen the Balkans as the Continent's "black hole," an area in need of policing. Could it be, he wonders, that a cynical Europe subconsciously hopes that the Serbians will take over a role that the Communists abandoned? In a moment of gallows humor, he calls the European attitude toward the Balkans "desperately seeking despot."

"Bosna!" bolsters its polemics with disheartening images of the devastation of Sarajevo, a city strewn with rubble and fortified with sandbags. In the opening scenes, the camera follows Bosnian soldiers into the deep, muddy trenches that have prevented Serbian army tanks from entering the city. The camera lingers over the devastation to schools, churches and the public works of a city that Mr. Lévy says, used to be a cosmopolitan "little Vienna."

The most shocking testimony comes from the mouth of a Serbian soldier who graphically describes raping seven Bosnian women and slitting the throat of another "like a pig." In portraying Serbian atrocities, the movie knows just where to stop.

"Bosna!" doesn't pretend to be anything other than what it is, an inflammatory, highly partisan cry for help. Let it not be said, Mr. Lévy pleads in the film's final words, that "Europe died at Sarajevo."

1994 O 12, C13:1

THE BROWNING VERSION

Directed by Mike Figgis; written by Ronald Harwood, based on the play by Terence Rattigan; director of photography, Jean François Robin; edited by Herve Schneid; music by Mark Isham; production designer, John Beard; produced by Ridley Scott and Mimi Polk; released by Paramount Pictures. Loew's Paris Fine Arts Theater, 4 West 58th Street, Manhattan. Running time: 97 minutes. This film is rated R.

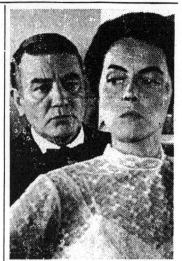

Clive Coote, Paramount Pictures
Albert Finney and Greta Scacchi in "The Browning Version."

WITH: Albert Finney (Andrew Crocker-Harris), Greta Scacchi (Laura Crocker-Harris), Matthew Modine (Frank Hunter), Ben Silverstone (Taplow), Michael Gambon (Dr. Frobisher) and Julian Sands (Tom Gilbert).

By CARYN JAMES

Even viewers who have never seen the classic 1951 film "The Browning Version," with Michael Redgrave as an emotionally chilly professor at a boys' school, will recognize the ghost of the past in the new film directed by Mike Figgis. Today's "Browning Version," with Albert Finney as the classics professor, has been updated but not substantially changed. It carries the unmistakable whiff of a musty tale dragged into the 90's, where it seems conspicuously out of place.

The story, from Terence Rattigan's 1939 play, was always a slight, rickety concept, redeemed by Redgrave's touching performance. You might think of Andrew Crocker-Harris (Mr. Finney) as the anti-Mr. Chips, a man who with each year becomes more dictatorial and humorless. He has no idea how to talk to adolescent boys.

It is the end of the term, and Crocker-Harris (Mr. Finney) has been forced out of his job. His wife, Laura, (Greta Scacchi), is a younger woman having an affair with his colleague Frank (Matthew Modine). Finally, a student named Taplow gives Crocker-Harris a present that brings him to tears: a copy of Robert Browning's translation of "Agamemnon," inscribed by Taplow with genuine affection.

The strength of "The Browning Version" has always been the way it staves off sentimentality until the very end, and Mr. Figgis succeeds in that. This is the harsh tale of an unloved man nicknamed by his class "the Hitler of the lower fifth" and "the Crock." Mr. Finney, who has given some over-the-top performances in his time, is wonderfully restrained here, terse and not afraid to be unlikable.

Ms. Scacchi appears as a faded beauty, worn down by a bad marriage and 15 years in academe. She dominates one of the most convincing scenes, when she horrifyingly

humiliates her husband in public, charging that Taplow's gift is merely a bribe for a good grade. More often, the Crocker-Harrises' confrontations are pale, along the lines of Laura's charge: "Do you know what you are Andrew? A wimp." Minor updatings, like using the word wimp, don't go far toward making the Crocker-Harrises seem like a contemporary couple. We know little about their past or about why Laura has no interests of her own.

Playing Frank as an irreverent American, Mr. Modine livens up the stuffy school and the film, but there is so little to his character that he isn't used to much effect.

"The Browning Version" works only if we believe Laura when she says of her husband, "He wasn't always the Crock." That sense of his hidden emotional depths is missing from the film and from Mr. Finney's performance. Every change — from Crocker-Harris's decision that he will stand up for himself, to his wife's final tears of contrition — rings hollow because the characters seem contrived to walk through their paces. The screenplay (by Ronald Harwood, the author of the play "The Dresser") is so faithful to the Rattigan play that it all but abandons the actors.

This stately, prettily photographed "Browning Version," which opens today at Loew's Paris Fine Arts Theater, does not have the sharpness of Mr. Figgis's "Internal Affairs" or the atmospheric style of his "Stormy Monday." The camera relies on a clumsy, blunt way of capturing the most obvious reactions.

Julian Sands, as Crocker-Harris's replacement, and Michael Gambon, as the headmaster, are fine in minor roles. And Ben Silverstone is exceptionally good as Taplow; he makes the boy seem sincere and spontaneous, capturing the spirit of "The Browning Version" better than all the adults around him.

"The Browning Version" is rated R (Under 17 requires accompanying parent or adult guardian). It includes strong language.

1994 O 12, C17:2

WES CRAVEN'S NEW NIGHTMARE

Written and directed by Wes Craven; director of photography, Mark Irwin; edited by Patrick Lussier; music by J. Peter Robinson; production designer, Cynthia Charette; produced by Marianne Maddalena; Robert Shaye and Mr. Craven, executive producers; released by New Line Productions. Running time: 112 minutes. This film is rated R.
WITH: Robert Englund (Himself), Heather Langenkamp (Herself), Miko Hughes (Dylan), David Newsom (Chase Porter), John Saxon (Himself), Wes Craven (Himself), Robert Shaye (Himself) and Tracy Middendorf (Julie).

By JANET MASLIN

Ten years after "A Nightmare on Elm Street" first scared the daylights out of audiences, Wes Craven returns to his now classic horror premise and takes it to a new dimension. With equal debts to Pirandello

and P.T. Barnum, Mr. Craven brings his prize creation, Freddy Krueger, out of the realm of Halloween masks and into the so-called real world.

Realism is fundamental to the "Nightmare" series. Mr. Craven does not deal chiefly in phantasmagoric demons; he deals in terrifying extensions of everyday experience, the stuff of which true nightmares are made. The Northridge earthquake in California coincidentally occurred during the shooting of "Wes Craven's New Nightmare," and has been cleverly incorporated into this film's strange story. But if that earthquake hadn't happened (far exceeding one prophetic tremor that the film maker had already staged at a cemetery), it could easily have been something Mr. Craven invented.

"You know, it's life on the fault line," Heather's baby sitter says breezily, when Heather (Heather Langenkamp) thinks she feels an aftershock or two. In this edgy, postquake atmosphere, Heather feels a premonition that warns her not to leave her young son for the day, which is just the sort of small, believable, nervous-making thought Mr. Craven exploits best. In his films, life on the fault line is a constant state of mind.

Although nothing is precisely amiss at the start of this intricate new "Nightmare," the film is loaded with warning signals, like the fake Freddy Krueger hand that flexes its claws unexpectedly and seems to have a mind of its own. The film begins with (and returns to) an image of Heather in the midst of horror-film special effects, including fire and brimstone along with that runaway hand. Who but Mr. Craven would send his heroine to hell and back in pajamas?

Ms. Langenkamp, the terrified ingénue of the first "Elm Street" (she also appeared in the third one), seems to be playing herself this time. She is addressed by her real name and is seen working as an actress, making a horror film while her husband, Chase (David Newsom), works on special effects. Heather and Chase have a young son, Dylan (Miko Hughes), whose arrival has made Heather worry about some of the films on her résumé. Horror is especially disturbing when juxtaposed with Heather's super-wholesome domestic life.

Heather has made her break with Freddy Krueger, but he still leaves subliminal scratch marks on her consciousness. Post-earthquake cracks in the wall have a peculiar pattern. Dylan shapes a familiar evil face in his oatmeal. Then there are those bad dreams, with awful intimations of Freddy bleeding seamlessly into Heather's normal thoughts. Mr. Craven, working at a high pitch of anxiety, is not about to make things easier on his audience by indicating where these dreams actually leave off.

Bit by bit, Heather finds her loved ones in peril and her life subverted. And as Mr. Craven, her former co-stars and executives from New Line Cinema work their way into this story, Heather is lured back to Elm Street. She even visits New Line's president, Robert Shaye, in an office

conveniently devoid of "Mask" toys but lined with "Elm Street" memorabilia. "The fans, God bless 'em, they're clamoring for more," Mr. Shaye insists. "I guess evil never dies, right?"

Craftily following that thought past its natural limits, Mr. Craven appears on camera to deliver a definitive pronouncement, telling Heather that only by battling Freddy in another Craven film can she put an age-old demon to rest. Within the wisdom and hucksterism of that thought there lies an ingenious storytelling idea, and Mr. Craven spins it into a dizzying web. What's best about "Wes Craven's New Nightmare" is its wicked unpredictability. If Mr. Craven's thinking about good and evil works its way to a peculiar netherworld, his film gets there too.

Meanwhile, "Wes Craven's New Nightmare" takes time to contemplate what Mr. Craven's old nightmares have wrought. There is the celebrity of Freddy Krueger, who turns up here on a talk show. ("Love ya, babe! We'll do lunch!'") There is the eerie co-option of Robert (Freddy Krueger) Englund, who supposedly plays himself here but drifts weirdly into Freddy mode during the story. There is the influence of horror on small children, a matter that comes up repeatedly, whether Heather is reading her son "Hansel and Gretel" or being lectured by a doctor about her son's welfare. "I'm sorry," says the doctor, "but I'm convinced those films can tempt an unstable child over the edge."

"Wes Craven's New Nightmare" is Mr. Craven's own best defense against such charges, an ingenious, cathartic exercise in illusion and fear. Its embrace of horror as a creative outlet for the imagination is best expressed by a minor character who turns up in a morgue scene. (But of course.) "Sometimes," he says, "it's what we *don't* see that gets us through the night."

Special effects here are sinister and intense, like the tongue that springs out of a telephone, until they boil over somewhere in purgatory. The film's flat-out climactic battle is elaborately staged. But after a lot of subtler menace, it plays as overkill.

Ms. Langenkamp, who looks enough like Nancy Kerrigan to have played her in a television movie, is a capable heroine. Mr. Englund should delight his fans by seeming even stranger without Freddyisms than he does with them. Little Miko Hughes, who also develops a Krueger tic or two, is eerily convincing. It's alarming that a 7-year-old should even see this "Nightmare," let alone appear in it.

"Wes Craven's New Nightmare" is rated R (Under 17 requires accompanying parent or adult guardian). It includes graphic gore and violence, as well as scenes that are frightening in more discreet ways.

1994 O 14, C8:5

LOVE AFTER LOVE

Directed by Diane Kurys; written (in French with English subtitles) by Ms. Kurys and Antoine Lacomblez; director of photography, Fabio Conversi; edited by Hervé Schneid; music by Yves Simon; produced by Robert Benmussa; released by Rainbow. At the Quad Cinema, 13th Street between Fifth Avenue and Avenue of the Americas, Greenwich Village. Running time: 104 minutes. This film is not rated.
WITH: Isabelle Huppert (Lola), Bernard Giraudeau (David), Hippolyte Giradot (Tom) and Lio (Marianne)

By CARYN JAMES

Diane Kurys's best films carry a resonance beyond the lives of their distinctive characters: "Peppermint Soda" is the sweetly comic tale of adolescent girls coming of age, and "Entre Nous" the incisive story of female friendship set against World War II and its aftermath. Her lesser films are smaller but still engrossing pictures of tangled relationships, like "A Man in Love" and her new work, "Love After Love," the fine, quirky story of a novelist named Lola (Isabelle Huppert). Lola doesn't make that grand artistic leap into the universal, even though her love life sounds like a case study out of "Smart Women, Foolish Choices."

Lola has tried to be reasonable about love, but at 35 the complications are piling up like dirty laundry. She lives with an architect named David, with whom she has a long-term relationship. Along the way, David also became openly involved with Marianne, with whom he has two sons and a continuing connection. Lola accepts this as part of the modern world of grown-ups. Yet she has recently begun a secret affair with Tom, a married songwriter who has two small daughters. "The two men I love have children," she writes in her journal, moaning about the inconvenience of this rather than questioning her own judgment.

The film is best at defining the characters and depicting how gingerly they dance around the deep problems they are creating. David is a weakling but at times shows an appealing directness, especially if he's cornered. Tom, on the other hand, is a selfish cad who asks Lola to meet him in the supermarket while he does the family shopping because he's too busy to see her any other time. When Lola goes to Pompeii with him, only to have his wife and children turn up unexpectedly, she finally writes in her journal: "Why do I accept this? I'm pathetic," then dumps a bottle of ink over the words. As both the director and actress make plain, Lola is not pathetic. In Ms. Huppert's direct portrayal, she is unflappable and strong-willed; her life is just out of control.

That bottle of ink is the kind of radically wrong detail that undermines the film, though. "Love After Love" never makes Lola's career as a writer believable. All the people in this film have lives too conveniently picturesque to seem real. Who has a bottle of ink in a hotel room? When Lola pulls out some old journals, she scatters them around her study in what looks like a pretty, pastel window display in a stationery store.

Rainbow Releasing

Hippolyte Girardot and Isabelle Huppert in "Love After Love."

The sign that she is blocked in writing her new novel is that she has crumpled up 200 sheets of paper and thrown them on the floor. "Love After Love" is even neatly constructed to span a year in Lola's life, from one birthday party to another. All this arranged artistry pulls against the emotional messiness that is supposedly the point.

"Love After Love" opens today at the Quad Cinema. Whatever its shortcomings, there's a lot to be said for a film that treats its audience like adults.

1994 O 14, C10:6

LITTLE GIANTS

Directed by Duwayne Dunham; written by James Ferguson, Robert Shallcross, Tommy Swerdlow, Michael Goldberg and Michael Wilson; director of photography, Janusz Kaminski; edited by Donn Cambern; music by John Debney; production designer, Bill Kenney; produced by Arne L. Schmidt; released by Warner Brothers. Running time: 106 minutes. This film is rated PG.

WITH: Ed O'Neill (Kevin O'Shea), Rick Moranis (Danny O'Shea), Shawna Waldron (Becky O'Shea) and John Madden (Himself).

By STEPHEN HOLDEN

Anyone who was ever rejected or picked last for a team can relate to the concept behind "Little Giants," a slickly contrived family movie about an inept junior football team that succeeds in spite of spectacular liabilities. "Football is 80 percent mental and 40 percent physical," a strapping pro-football player tells the children on the Little Giants team in a pre-game pep talk. The team's ascent is about as unlikely as 80 and 40 adding up to 100.

The film follows the struggle between the Little Giants and the Cowboys to determine which will represent Urbania, Ohio, a fictional town in the peewee football league. The Little Giants, who are largely made up of Cowboys' rejects, are the brainchild of Becky O'Shea (Shawna Waldron), an 11-year-old tomboy who was rejected by the Cowboys

simply for being a girl. Fueling the contest is the lifelong sibling rivalry of the team's two coaches. Becky's father, Danny (Rick Moranis), who has lived in the shadow of his football-star elder brother, Kevin (Ed O'Neill), leads the Little Giants, while Kevin coaches the Cowboys.

In typical Hollywood fashion, "Little Giants" raises issues about competition, machismo and sexism in American sports, then blithely skirts them in confrontations that let everyone have his cake and eat it too. Midway through the movie, Becky, experiencing the first flush of puberty, gets a crush on a teammate. Overnight, the founder of the Little Giants metamorphoses from one of its star players into a cheerleader. True to Hollywood formulas, however, the movie allows Becky one last moment of gridiron glory before she trades in her helmet and shoulder pads for lipstick and a prom dress.

"Little Giants," which was directed by Duwayne Dunham, devotes much of its energy to such comic antics as balls getting stuck into face masks, and wispy little kids practicing looking intimidating. The farcical playing scenes involve one bizarre maneuver after another. The most ridiculous play, one that decides the contest, is a sort of gridiron relay race called, for no apparent reason, "the annexation of Puerto Rico."

"Little Giants" is rated PG (Parental guidance suggested). It includes strong language that stops short of outright profanity.

1994 O 14, C12:6

IMAGINARY CRIMES

Directed by Anthony Drazan; written by Kristine Johnson and Davia Nelson, based on the novel by Sheila Ballantyne; director of photography, John J. Campbell; edited by Elizabeth Kling; music by Stephen Endelman; production designer, Joseph T. Garrity; produced by James G. Robinson; released by Morgan Creek Productions. Running time: 105 minutes. This film is rated PG.

WITH: Harvey Keitel (Ray Weiler), Fairuza Balk (Sonya), Kelly Lynch (Valery), Vincent D'Onofrio (Mr. Webster) and Elisabeth Moss (Greta).

By CARYN JAMES

On a chilly night at the start of "Imaginary Crimes," a little girl and her father walk through the snowy streets to a store. The father buys Wild Turkey and tries to talk the liquor store owner into investing in his latest scheme, a chemical to restore the nap on old serge suits. The little girl gets ice cream, and as they walk home a young woman's voice recalls this scene as one of the enduring memories of her childhood, "me with a father who has the audacity to buy ice cream on the coldest night of the year." As audacious actions go, it's not much, but soon it becomes clear that the exaggerated claim is intended.

The voice belongs to 17-year-old Sonya, a talented but untrained writer describing her unsettled family life in her journal. Her slightly over-

Lorey Sebastian/Warner Brothers

Harvey Keitel, Fairuza Balk, right, and Elisabeth Moss.

wrought style is just one of the perfectly pitched elements in this exquisite little film. There is nothing precious or overdone about "Imaginary Crimes" itself, the story of how Sonya and her younger sister try to build a normal life with their con-man father.

With Harvey Keitel as Ray Weiler and Fairuza Balk as Sonya, the film relies on two heartbreaking performances. Sonya is clear sighted, sometimes belligerent and certainly put upon but through it all somehow knows she is much loved. The film's low-key tone is not that of a family drama but of an eloquent remembrance.

Most of the action takes place in 1962, Sonya's senior year in high school. Mr. Keitel looks like a slightly shabby salesman from the period, his hair cut short on the sides and in back, his white shirts always slightly rumpled. Ms. Balk, who played the younger daughter in "Gas Food Lodging," has been transformed from a beauty to a frumpy adolescent here. Her short hair makes her face look pudgy, and she has the slumping posture of an awkward adolescent who is ill at ease every minute of the day.

She has good reasons for embarrassment. As Ray tries to enroll her in the private girls' school that her mother attended, he shamelessly flatters the headmistress and invokes the memory of his dead wife. Then, when asked to leave a tuition deposit, he gropes in his pockets and says he has forgotten his checkbook. "I'll have my assistant take care of it this afternoon," he lies. Sonya and her sister, Greta, have already become adept at dodging landlords and skeptical about Ray's plans to strike it rich in mining.

What sets "Imaginary Crimes" apart from similar family stories is that Ray never becomes that cliché, the shallow charming con man. His flaws are hugely visible, yet his character isn't coddled or condemned. He is merely understood as a man doing everything he knows how to do. Mr. Keitel anchors the film with a performance that is full of nuance, from the calm tone of his voice to the way his hands naturally assume a pleading gesture when he finds himself in serious trouble and begs a judge for compassion.

It is completely understandable that Sonya would lose patience with such a father, and Ms. Balk's subtle performance measures up to Mr. Keitel's. Even in the rare moments when Sonya explodes, Ms. Balk does so with the mixture of anger, pain and love that defines her relationship with her father. Based on a

novel by Sheila Ballantyne, "Imaginary Crimes" is brought to the screen with a terrific ear and eye. When Sonya writes in her journal about her mother (Kelly Lynch), the scenes depict Valerie Weiler as beautiful, sad and elegant, sitting in a basement apartment playing solitaire and smoking cigarettes in a pretty dress. She is the romanticized figure Sonya would have remembered, until illness transforms her.

Elisabeth Moss, as Greta, and Vincent D'Onofrio, as the teacher who encourages Sonya's writing, give quietly compelling performances.

There are a few glitches in "Imaginary Crimes," a delicate story that shouldn't be oversold. It is hard to fathom just how the Weilers live at times, especially when Ray briefly leaves his daughters on their own. The film moves slowly and could have used tighter editing. But this is a terrific jump ahead for the director, Anthony Drazan, whose first film was "Zebrahead," an overhyped movie about an interracial high-school romance.

"Imaginary Crimes" is infinitely more mature in its subject and style. At the film's piercing conclusion, an older Sonya says, "I used to wonder if a con man were capable of genuine love, and if that love could cancel out all his crimes, real and imaginary." Hers is not a trite psychobabble story of forgiveness but a restrained and touching portrayal of a love profound enough to cancel those crimes.

"Imaginary Crimes" is rated PG (Parental guidance suggested). It includes a bit of strong language.

1994 O 14, C16:1

EXIT TO EDEN

Directed by Garry Marshall; written by Deborah Amelon and Bob Brunner, based on the novel by Anne Rice; director of photography, Theo Van De Sande; edited by David Finfer; music by Patrick Doyle; production designer, Peter Jamison; produced by Alexandra Rose and Mr. Marshall; released by Savoy Pictures. Running time: 113 minutes. This film is rated R.

WITH: Dana Delany (Lisa), Paul Mercurio (Elliot), Rosie O'Donnell (Sheila) and Dan Aykroyd (Fred).

By JANET MASLIN

For times when a 900 number isn't enough, there's always "Exit to Eden," a sadomasochistic porno-comedy with a lingerie fetish as big as all outdoors. Here's a film that insists on scrambling eroticism with humor, even if most people think sex is better when nobody's laughing.

Having made prostitution look good in "Pretty Woman," Garry Marshall takes on the greater challenge of a 1985 novel by Anne Rice, who wrote under pseudonyms (in this case, Anne Rampling) when dealing with subjects like naked slave auctions, bondage and bisexuality.

However tempted Mr. Marshall was by that material, he sure isn't comfortable with it. Neither is anybody else in "Exit to Eden." Just watch the extras fidgeting their way through the movie's awkward party scenes, which suggest the world's

Steve Schapiro/Savoy Pictures
Dana Delany

first X-rated bar mitzvah, complete with ice sculpture. Those extras are dying.

No wonder: "Exit to Eden" is an incredible mess, a movie that changes gears so often and so nonsensically it seems to have been edited in a blender. The most obvious problem is that in a screenplay by Deborah Amelon and Bob Brunner, there are two different films at war. One of them turns Ms. Rice's graphic story into a watered-down sexual sitcom, a kind of "Dirty Love Boat" in which hinting about kinky sex becomes one more vacation sport, right up there with Ping-Pong and roller skating. You will be reminded of sincere nudist-camp documentary scenes in which everyone pleasantly plays volleyball.

Ms. Rice's sex slaves are now heterosexual "Citizens" and often the subject of silly jokes. ("Citizen Julie, report to the sticky buns booth.") All this fun is presided over by Mistress Lisa (Dana Delany), who dresses as Bondage Barbie but looks as if she couldn't beat an egg white. Indeed, the film's only real cry for whips and chains comes when Lisa begins revealing that she is actually a sweet, romantic, old-fashioned girl who fell into this line of work almost by accident. All the Civil Service jobs must have been taken.

Shoehorned into this story is something about an international diamond-smuggling ring and two Los Angeles police detectives, Sheila (Rosie O'Donnell) and Fred (Dan Aykroyd). In a plot that's not Ms. Rice's fault and can generously be called demented, Sheila and Fred chase the smugglers and have no choice but to make an undercover visit to Eden, an S-and-M island sex club off the coast of Mexico. They speak for couch potatoes everywhere as they register both horror and voyeuristic curiosity over what they see.

Ms. O'Donnell's performance deserves a Purple Heart. Bravely storming her way through a queasy, unfunny story, she delivers enough wisecracks and voice-over witticisms to paper over the movie's worst embarrassments. Though the Fred-Sheila subplot is so transparently tacked on to the rest of the film that it requires loony editing transi-

tions, it's still a big help. And Ms. O'Donnell, a walking sight gag in black leather regalia, is good sport enough to make the best of Sheila's down-to-earth attitude.

"How can I fulfill your fantasy?" asks the barely clad young man assigned to please Sheila. "Go pain my house," she replies.

Paul Mercurio, the Australian actor who danced his way through "Strictly Ballroom," lands the role of Elliot, the photojournalist who inexplicably signs on for a stint at Eden and becomes Lisa's favorite new recruit. Mr. Mercurio is athletic and personable, but the best explanation for his casting is what the film, which avoids graphic language along with graphic anything else, might call his tush.

After all, how many actors lined up for the chance to stand with arms and legs restrained, wearing only a blindfold and a dog collar, while ministered to by Ms. Delany and her silver hairbrush? Mr. Mercurio's only real acting challenge is knowing how alarmed to look when he's given that first little smack.

Acting isn't exactly the point here, anyhow. Ms. Delany, an utterly humorless performer stuck in the midst of an alleged comedy, looks good in cast-metal costumes and could at least make her own exercise video. Mr. Aykroyd is almost as helpful as Ms. O'Donnell, even if he has to mug his way through a ha-ha hernia exam. Hector Elizondo plays the wealthy character who sends Elliot to Eden, for reasons nobody could possibly explain. Iman, the model (as opposed to actress-model), looks foxiest and scariest in lace-up vinyl. Only she sounds snappish enough to suit the S-and-M atmosphere.

"Exit to Eden" includes a couple of sex scenes, one involving butter, cinnamon and a pitiful "Last Tango in Paris" reference. It also includes brief nude scenes of Ms. Delany and Mr. Mercurio, but most of it is remarkably sexless, under the circumstances.

Mr. Marshall confines himself to heavy smirking and to costumes that would suit the skin-magazine version of a high-class orgy. Speaking of classy, "Exit to Eden" also works in an incoherent reference to the forthcoming film version of "Interview With the Vampire." Ms. Rice's fans will want to cross their fingers, get out the garlic and hope it's less gruesome than this.

"Exit to Eden" is rated R (Under 17 requires accompanying parent or adult guardian). That rating accurately reflects the extent to which nudity and profanity are included here, but otherwise misses the point. This film's overall conception makes it unsuitable for viewers under 17.

1994 O 14, C20:4

I LIKE IT LIKE THAT

Written and directed by Darnell Martin; director of photography, Alexander Gruszynski; production designer, Scott Chambliss; produced by Ann Carli and Lane Janger; released by Columbia Pictures. Running time: 94 minutes. This film is rated R.

WITH: Lauren Vélez (Lisette Linares), Jon Seda (Chino Linares), Jesse Borrego (Alexis), Lisa Vidal (Magdalena Soto), Griffin Dunne (Price), Rita Moreno (Rosaria) and Tomas Melly (Li'l Chino).

By JANET MASLIN

When Lisette Linares (Lauren Vélez), one very smart spitfire from the Bronx, wants to land a job at a record company, she doesn't exactly sit down and fill out an application. She bluffs, coaxes and just plain charms her way to success, sweeping away any obstacles with the same kind of assurance shown by Darnell Martin, the talented new director telling Lisette's story.

"I Like It Like That," Ms. Martin's terrifically buoyant debut feature, is as scrappy and alluring as its heroine. With an obvious debt to Spike Lee but a sure knowledge of her very different terrain, Ms. Martin shows what life is like for a feisty young woman with no money, three children and a husband who cheats on her and has just landed himself in the Bronx House of Detention. Not to mention a transvestite brother who sweetly helps her with day care.

"You live *here?*" asks the yuppie boss who drives her home to her Bronx tenement at 167th Street and Findlay Avenue, halfway through the story. "No, I'm just vacationing," snaps Lisette. Here's a high-wattage heroine who's afraid of nobody and has an answer for anything.

Lisette's problems may not sound like the stuff of warm, vibrant comedy, but Ms. Martin makes her irresistible. And "I Like It Like That" has more than flash and local color: it also has the genuinely touching story of a young couple trying to work out their private problems under terrible pressure. They also play out their story for the benefit of every busybody in their neighborhood. There doesn't seem to be a soul on a front stoop in this film without an opinion about whether Lisette is too flat-chested or Chino, her husband (Jon Seda), is a real man.

Sometimes Ms. Martin has to manipulate her characters blatantly to move her film along. And she has to fall back on the occasional stereotype. (Rita Moreno, as Chino's excitable Hispanic mother, who boasts about her "pure Castilian blood," denigrates Lisette's black lineage and has no idea how to handle her three grandchildren, is one of the film's typically broad comic figures.) But she brings such familiarity and affection to this material that it works exuberantly, with a keen appreciation of back talk and backbone from all its characters. As a forthright visual stylist who coaxes the very best out of her actors, Ms. Martin has no difficulty bringing her story to life.

Lisette ought to be in despair as "I Like It Like That" begins, with rambunctious children, a supermacho husband and no breathing room of her own. (Ms. Martin's feminine perspective makes her especially funny about Lisette's bad sexual experiences with self-involved men.) Matters worsen once the feckless Chino, a bicycle messenger, does some impetuous looting during a blackout and lands himself in jail. On top of

this, there is the goading of Magdalena (Lisa Vidal), the neighborhood bombshell, who has eyes for Chino. "I got the face and I got the body and I got your man," Magdalena proclaims.

Lisette is broke and Magdalena's father owns the grocery store. Lisette is forced to hock her wedding ring, to a pawnbroker who already has a large pile of wedding bands in his drawer. Finally she heads to Times Square in search of work, borrowing some very tangible figure ideas from Alexis (Jesse Borrego), her cross-dressing brother. By happy accident, she talks her way into a job with Price (Griffin Dunne), a record executive who specializes in Hispanic acts and says it's just coincidental that he himself was not born Hispanic. Price's treatment of Lisette might qualify as sexual harassment if Lisette had time to worry about such things, but she's much too preoccupied to notice.

Keeping her film in constant motion, with Lisette, Chino and Magdalena as a quarrelsome romantic triangle, Ms. Darnell also creates a vivid social backdrop for her story. From the outdoor mural in memory of Chino's brother, a policeman killed by drug dealers, to the ways neighborhood machismo affects Li'l Chino (Tomas Melly), the Linares's tough little 8-year-old, "I Like It Like That" is finally as poignantly real as it is funny. Ms. Martin doesn't have to dwell on the father-son friction between the two Chinos to convey what the cycle of violence is like for these characters. Or to end her film on a warmly satisfying note, with hope that that cycle can be broken.

"I Like It Like That" is full of fine supporting performances, with Ms. Moreno, Mr. Borrego, Ms. Vidal and solemn little Mr. Melly fully bringing their characters to life. But it is Ms. Vélez who is in almost every scene, holding the movie together and carrying off a flamboyant role with bright, scrappy style. She and Mr. Seda are touchingly matched, both of them outwardly bold and secretly delicate, trying hard to live up to their own ideas of what adulthood is supposed to be like. The romance in "I Like It Like That" may look like a parade of turbulent, seriocomic crises, but it also looks like true love.

"I Like It Like That" is rated R (Under 17 requires accompanying parent or adult guardian). It includes brief, graphic sexual activity, scattered profanity and slight violence.

1994 O 14, C23:1

FILM VIEW/Janet Maslin

When Fate Is Calling The Tune

FATE PLAYED A STARRING ROLE AT THIS year's New York Film Festival, figuring prominently in a surprisingly large number of films on the schedule. Destiny may have a firm hand in shaping any story, but it doesn't always call attention to itself as insistently as it did in these selections, both fiction films and documentaries.

Beginning with "Pulp Fiction," the thermodynamic miracle that is both the hottest and coolest film of the year, fate made its presence felt. The unusual chronology of Quentin Tarantino's film accentuates the way his characters' decisions can change their destinies, even as their futures are seen falling into place. Circular in structure, the movie closes with the image of a man who is fated to die — earlier in the film, we have already seen his death occur — because he has not understood how to save his own life. (Following another character along a newly adopted path of righteousness would have made all the difference in the world.)

A vision like this elevates "Pulp Fiction" well above its own ebullient sense of fun, even establishing it as the anti-"Gump." Mr. Tarantino's film violently refutes the idea that drifting passively is a good way to fulfill one's destiny and get through life. It says, instead, that we make choices that can count.

The real-life workings of fate can be observed at close range during "Hoop Dreams," the intense, revealing documentary that follows the fortunes of Arthur Agee and William Gates, two aspiring basketball players from the streets of Chicago. Ambitiously staking out nearly five formative years in these young men's lives, "Hoop Dreams" introduces them as scholarship students recruited by St. Joseph, a private high school that promises them escape from ghetto life. It doesn't take long, however, before Arthur's fortunes separate him from William. He is forced to leave St. Joseph and go to a public school closer to home.

If this were an ordinary drama, that roll of the dice could settle everything about how these two young men's stories played out. But one of the most gripping things about "Hoop Dreams" is how well it captures life's real unpredictability. Further reversals affect both Arthur and William, leaving them on graduation day in circumstances that they never could have anticipated during freshman year. If plans proceed, ridiculously, to remake this candid documentary as a dramatic feature (and such plans are under way, with Spike Lee producing for TNT), that fascinating element of fatefulness will be the first thing lost.

Another of the festival's documentaries, Terry Zwigoff's "Crumb," offers an even more haunting glimpse into the capriciousness of fate in the workings of a single family. This is a portrait not only of the successful cartoon artist R. Crumb but also of his two brothers, Max and Charles. Destiny and heredity made each of them a talented graphic artist. Each of them is also an eccentric, detached and angry man.

R. Crumb, who is best known for "Fritz the Cat," the "Keep On Truckin' " logo and an album cover for Big Brother and the Holding Company, need not be anyone's favorite caricaturist for this film to feel wrenchingly effective. Indeed, the savage extremes of Mr. Crumb's drawings make his success with a mass audience that much more startling a victory of form over content.

"Crumb" contemplates the mysterious destiny that brought so much misery to Max and Charles Crumb while bringing Robert friends, lovers, children and a popular outlet for his grotesque fantasies. Artworks by Max and Charles are equally skillful and no less bizarre. Meanwhile, Max is an uneasy loner who has quite literally built himself a bed of nails, which he sits on for the benefit of the camera.

Charles, who was filmed while under the influence of tranquilizers and antidepressants, shares Robert's hostility and misogyny so much that he lives with his mother and has apparently never had a sexual relationship with another person. He seems a rueful, sensitive, intelligent man with all too keen an appreciation of his terrible fortune. Charles committed suicide a year after these interviews were conducted.

"Crumb" doesn't oversimplify its material by providing an explanation for the disparities in the brothers' fortunes. It simply underscores the power of destiny while acknowledging how unfathomable that power can be.

Working in a very different style, Krzysztof Kieslowski evokes similar thoughts by the end of "Red," the stunningly successful film that concludes his Three Colors trilogy. Telling stories about characters seemingly unrelated, Mr. Kieslowski brilliantly evokes echoes and overlapping patterns that suggest a universe of mysterious connections.

In this, the warmest, best-acted and most fully realized of his three color-coded films, Mr. Kieslowski brings together a young model named Valentine (Irène Jacob) and an embittered ex-judge (Jean-Louis Trintignant). The haunting parallels and near-misses that affect these two and that virtually bind them to other characters in this film (even to characters in "Blue" and "White") can be endlessly analyzed. After all, gamesmanship is one of the satisfactions of Mr. Kieslowski's schematic work. But "Red" is most moving in what it leaves unknowable: the real workings of an inescapable, enigmatic power. Even at its most cryptic, the influence of fate is best not ignored. ☐

1994 O 16, II:13:5

VANYA ON 42D STREET

Directed for the screen by Louis Malle; directed for the stage by André Gregory; written by David Mamet, based on the play "Uncle Vanya" by Anton Chekhov; director of photography, Declan Quinn; edited by Nancy Baker; music by Joshua Redman; production designer, Eugene Lee; produced by Fred Berner; released by Sony Pictures Classics. Running time: 119 minutes. This film is rated PG.

WITH: Wallace Shawn (Vanya), Julianne Moore (Yelena), Brooke Smith (Sonya), Larry Pine (Dr. Astrov), George Gaynes (Serybryakov), Lynn Cohen (Maman), Phoebe Brand (Marina), Jerry Mayer (Waffles) Madhur Jaffrey (Mrs. Chao) and André Gregory (himself)

By JANET MASLIN

The actors and spectators for "Vanya on 42d Street" make their entrances casually, drifting into one another at the New Amsterdam Theater and making idle conversation. That chitchat has evolved into Chekhov almost before a movie audience is ready to notice. By the time the viewer fully apprehends the grand, cavernous scale of this crumbling theater or the naturalness of the actors, the performance is under way. This is bare-bones Chekhov, though it is hardly Chekov without cachet.

Under the direction of André Gregory, this version of "Uncle Vanya" (filmed simply yet enthrallingly by Louis Malle) has a significant pedigree. Evolving over a period of years as a workshop production, and available only to small, select audiences, it developed the inevitable mystique, which is only heightened by Mr. Malle's participation. With Wallace Shawn in the title role and memories of "My Dinner With André" as a quirky, dazzling collaboration by these principals, "Vanya on 42d Street" has a lot to live up to.

So the lack of fanfare in the film's opening moments amounts to a declaration. This "Vanya" is not so colorfully eccentric as "My Dinner With André," but it is no less single-minded. It seeks to isolate the very essentials of the play, with an adaptation by David Mamet to expedite the task. Delving the despair of Chekhov's characters in what is actually quite a rarefied creative atmosphere, it incorporates its share of contradictions, in a way that recalls the most desolate Woody Allen films about privileged, luxuriantly introspective characters. On screen, at intimately close range, a similarly refined angst emerges from "Uncle Vanya."

But the elegant understatement of this production turns it into a livelier experiment, a fluent, gripping version of one of Chekhov's more elusive plays. There is no objective correlative of cherry orchard caliber here, no naturally riveting image that survives when the furniture and scenery are stripped away. Instead, there are only wayward emotions and deep regrets, the raw essentials of a psychodrama that has been coaxed forth here with illusory ease.

The actors wear street clothes. The props aren't more than tables, chairs and takeout coffee cups. The intent-looking audience consists only of Mr. Gregory and a few friends. And the absence of obvious artifice is used by Mr. Malle to focus attention entirely on a group of forthright, unmannered actors, with the camera appearing to gaze into their very souls. Exquisitely lighted and well served by the ravaged beauty of this unexpectedly photogenic old theater, "Vanya on 42d Street" has a visual elegance that seems to isolate and purify its characters and their troubles.

"Uncle Vanya" is set at a rambling Russian country house, and Mr. Mamet has retained the atmos-

pheric touches, right down to the samovars. But his neat, concise adaptation gives the dialogue a contemporary ring without noticeably departing from the text. (Mamet: "The people won't remember, but God will." Chekhov: "They don't need to remember. God remembers.") The convoluted problems of the household emerge that much more easily thanks to Mr. Mamet's unmannered adaptation.

The most peculiar aspect of this production comes with the casting, which reveals an oddly wavering approach to the play. Julianne Moore makes a sleek Yelena, the beautiful wife of a pompous, aging professor (George Gaynes), and a woman who stirs the yearnings of both Vanya, her brother-in-law (Mr. Shawn) and Astrov (Larry Pine), a country doctor with a worldly air. The history of this production goes back to 1989, so that it was Ms. Moore's appearance in "Uncle Vanya" that led Robert Altman to cast her memorably in "Short Cuts."

But Ms. Moore's sly, delicately shaded performance, which is also made extraordinarily photogenic by careful lighting of her red hair, is in a very different key from Mr. Shawn's more comedic Vanya. That character's bitterness and frustration emerge very clearly, but the farcical side of Mr. Shawn is incongruous at times. When he tells Yelena passionately that she has mermaid's blood, he seems almost to be joking.

Mr. Gaynes, another actor known for humorous screen roles, is another surprising presence here, though both he and Mr. Shawn perform with obvious conviction. In a more straightforward vein, Mr. Pine plays Astrov with the rakishness of a younger Jason Robards. And Brooke Smith, memorable as that tough kidnapping victim in "The Silence of the Lambs," makes a luminous and heartbreaking Sonya, the lonely young woman who adores Astrov but senses that her destiny is drearier than her aspirations.

Also in "Vanya on 42d Street" are Phoebe Brand, the venerable teacher and Group Theater actress, as the household's reassuring Nanny; Lynn Cohen as Maman; Jerry Mayer as Waffles, and Madhur Jaffrey as one of the celebrityish guests chatting with Mr. Gregory during occasional breaks in the performance. Declan Quinn's muted, precise cinematography adds one more grace note to an already graceful production.

"Vanya on 42d Street" is rated PG (Parental guidance suggested). It has mild profanity and a brief scene involving a gun.

1994 O 19, C13:1

L'ENFER

Directed by Claude Chabrol; adapted by Mr. Chabrol from an original script by Henri-Georges Clouzot (in French with English subtitles); director of photography, Bernard Zitzerman; edited by Monique Fardoulis; music by Matthieu Chabrol; production manager, Yvon Crenn; produced by Marin Karmitz; released by MK2 Productions USA. Running time: 100 minutes. This film is rated R.

WITH: François Cluzet (Paul), Emmanuelle Béart (Nelly), Nathalie Cardone (Marylin), André Wilms (Dr. Arnoux) and Marc Lavoine (Martineau)

By CARYN JAMES

At the center of Claude Chabrol's new psychological thriller is a man who brings the phrase "insanely jealous" to life. Paul (François Cluzet) owns a hotel by a serene lake. He marries the beautiful Nelly (Emmanuelle Béart), they have a son, and soon Paul begins hearing voices in his head that tell him Nelly is unfaithful. "L'Enfer" ("Hell") works best in its early stages, when it is clear that Paul is losing his mind but unclear just what Nelly might be up to. She does, after all, have a blasé sex appeal and a hotelful of men to choose from. Paul catches her in the dark, watching slides with a muscular guest. And she has lied about how much she paid for a cute new handbag, so what else has she lied about? Attached to Paul's point of view, we never catch Nelly in a compromising situation, but that doesn't mean she's innocent.

The film's pedigree encourages these suspicions. Mr. Chabrol, the New Wave veteran and the director of the recent "Madame Bovary," also has a taste for stylish thrillers. And he has adapted the script from one written by Henri-Georges Clouzot, who directed "Diabolique," the classic story in which a man's wife and mistress team up to murder him. Clouzot, in fact, started to film "L'Enfer" in 1964, but abandoned it when the lead actor and then he himself became ill.

But for all the murder and suspense swirling, before long "L'Enfer" settles into a psychological study of Paul's mental hell of jealousy. There the story begins to lose power. Paul is clearly tormented. At one point all the hotel guests watch home movies, and we see what Paul sees: his wife on the shore of the lake in a torrid embrace with her lover, a humiliation projected before all the guests. In a minute he snaps back to reality and realizes the guests are watching film of his small son on the beach. Mr. Chabrol handles those scenes perfectly, but there are too few of them. More often we see Paul making crazy accusations without our entering his imagination and the hellish circle of his mind.

Mr. Cluzet makes the helpless Paul sympathetic, and doesn't overplay the role. Ms. Béart, best known as "Manon of the Springs," gives Nelly just the right touch of innocence and sexuality. Yet Mr. Chabrol's updated script is full of problems. Why does it take so long for anyone to suggest that the obviously troubled Paul get to a doctor?

"L'Enfer" opens today at Cinema Third Avenue. At its best it includes the kind of chilling touches Mr. Chabrol has mastered: the razor that Paul uses early on and that figures in one last tortured night; the dissonance between the pretty, calm countryside and the chaos of Paul's mind; the lurking chance that there will be some lethal reversal at the end.

1994 O 19, C17:1

Stores Where the Customer Is Always Good for a Laugh

"Clerks" was shown as part of this year's New Directors/New Films series at Lincoln Center. Following are excerpts from Janet Maslin's review, which appeared in The New York Times on March 25. The film is opening today at the Angelika Film Center, Mercer and Houston Streets, Greenwich Village.

Have you ever wondered whether the contractors working on the Death Star didn't become innocent victims during the climactic battle of the "Star Wars" adventures? No? Well, it may take a certain kind of workaday atmosphere to bring such thoughts to mind. Dante Hicks (Brian O'Halloran) and his friend Randal (Jeff Anderson) are seen experiencing that atmosphere to the fullest in Kevin Smith's "Clerks," a buoyant, bleakly funny comedy chronicling a day's worth of activity at two adjoining stores. Though nominally situated in New Jersey, this convenience store and video rental place are in spirit somewhere very near the end of the world.

In this dismal setting, the customer who takes all the eggs out of their cartons until he assembles a perfectly matched dozen is enough to pique the clerks' imaginations. "I'll bet you a million dollars he's a guidance counselor," says one, thinking the man may be suffering the ill effects of having "a meaningless job." Dante and Randal understand perfectly. So does the 23-year-old Mr. Smith, who has worked off and on at Quick Stop Groceries in Leonardo, N.J., since he was 19 and shot his extremely low-budget black-and-white film there. The upshot, an exuberant display of film-student ingenuity, is a classic example of how to spin straw into gold.

To appreciate Mr. Smith's cleverness, you need only realize how little promise his basic elements provide. The stores look realistically drab, and this film's fuzzy, grainy production values place it at the garage-band level in terms of pure technique. Although the two main actors are fresh and engaging, nobody on camera looks or sounds like much of a pro.

And as for drama, how much activity can really be coaxed out of a day spent renting videos and selling gum? More than might be expected. Without too much strain, Mr. Smith contrives a romantic crisis for Dante, an on-site hockey game that exhausts the convenience store's supply of Gatorade, a parade of colorful customers and a bizarrely funny disaster in which one visitor unwittingly has sex with a corpse. None of this need be taken seriously, and all of it is unexpectedly varied and wry.

In his closing credits, Mr. Smith pays homage to the usual suspects: Hal Hartley, Spike Lee, Jim Jarmusch and Richard Linklater. That's the Mount Rushmore of contemporary cool, yet Mr. Smith has his own not-too-derivative style (despite occasional titles flashing words like "Harbinger," "Syntax," "Perspicacity" and "Malaise"). He also has an uncommonly sure sense of deadpan comic timing.

"Clerks" is true to the slacker motif of mixing smart twentyish characters with precocious burnouts, throwing them together in an atmosphere of funny yet frustrating paralysis. Randal, who will debate about absolutely anything and who enjoys tormenting his customers, has succumbed to this spirit more fully than Dante, who still exhibits faint signs of ambition. Dante's erratic efforts to keep the Quick Stop running smoothly (including a sign that reads, "If you plan to shoplift, let us know") mean he may actually move on to bigger things some day. Mr. Smith is certain to do the same.

1994 O 19, C17:1

MINBO — OR THE GENTLE ART OF JAPANESE EXTORTION

Written and directed by Juzo Itami (in Japanese, with English subtitles); director of photography, Yonezo Maeda; edited by Akira Suzuki; music by Toshiyuki Honda; production designer, Shuji Nakamura; produced by Yasushi Tamaoki; released by Northern Arts Entertainment. Running time: 123 minutes. This film is not rated.

WITH: Nobuko Miyamoto (Mahiru Inoue), Akira Takarada (General Manager Kobayashi), Yasuo Daichi (Yuki Suzuki), Takehiro Murata (Taro Wakasugi) and Hideji Otaki (Chairman of the Hotel Europa)

By JANET MASLIN

Juzo Itami's "Minbo — or the Gentle Art of Japanese Extortion" is a film already notorious for its aftermath. Within days of its 1992 Japanese premiere, this satire about the mobsters known as Yakuza prompted a vicious assault on the film maker, who was slashed and seriously wounded. What seemed to have galled the Yakuza most was the film's suggestion that they make empty threats.

Certainly "Minbo," which opens at the Cinema Village today, takes the brave step of presenting these tough guys as buffoons. The Yakuza seen here travel in large, safe groups and make demands with grunts and grimaces. Blackmail is their specialty, and the film demonstrates some of their favorite, most colorful methods. Mr. Itami apparently intended this as a cautionary tale and wound up succeeding all too well in that regard.

Otherwise, "Minbo" is a relatively broad, farcical film by a director ("The Funeral," "Tampopo," "A Taxing Woman") whose other work has been subtler and more surprising. Perhaps inhibited by the black-and-white nature of his subject matter, and by an eagerness to show countrymen how to deal with mob intimidation, Mr. Itami is less droll and incisive than usual. Even so, he remains a deft satirist with a frequently amusing story to tell.

"Minbo" paints its gangsters as colorful monsters and invents a fearless woman — another dauntless Itami heroine — to slay these dragons.

Set in the microcosm of the garish, Western-style Hotel Europa, "Minbo" depicts mousy staff members who live in fear of the swaggering Yakuza. Much to the staff's horror, the Yakuza are very fond of the Europa and use it as a place to congregate. This is terrible for business, since it isn't helping the hotel's chances of attracting summit conferences and corporate meetings. So staff members are asked to step forward and fight off the mobsters.

Nobody volunteers. That's understandable. Even a tiny, stooped doorman who knows the names of 2,000 customers is considered too valuable to be wasted on Yakuza-baiting duty. In desperation, an accountant named Suzuki (Yasuo Daichi) and a bellboy named Wakasugi (Takehiro Murata) are assigned this dangerous task.

They cower badly for a while, in scenes that mix an antic pop spirit with the film's grittier subject matter. Mr. Itami approached "Minbo" with investigative zeal and documented real-life Yakuza tricks, like forcing victims into compromising situations and then extorting hush money. On a less delicate level, there are even stunts like planting a bug in the lasagna and then threatening to report the hotel for health code violations.

The Yakuza are seen hurting one another, most notably by severing fingers (a real Yakuza tactic). But by American standards their brand of crime is restrained, even quaint. "Minbo" is without savage beatings or gunfire or other staples of our own gangster stories. Everyone here, on either side of the legal system, displays an almost touching faith in the law's importance in settling disputes.

So it's fitting that the film's heroine is a lawyer named Mahiru Inoue, played by Nobuko Miyamoto, Mr. Itami's wife and his savvy, familiar star. Hired by the hotel to solve its thug problem, Mahiro plays such a keen game of hardball that even the mobsters are impressed. No scam or threat or dirty trick seems to rattle her. It is revealed later in the film that Mahiro's father was a casualty of Yakuza activity, and that she learned her lessons the hard way.

Mahiro insists that the Yakuza can be dealt with through reason. And her example helps strengthen the hotel's cowardly employees, though the film continues to embroil them in Yakuza-related escapades. All of this moves "Minbo" toward an uplifting and not entirely unexpected resolution. But along the way, Mr. Itami's playful direction gives way to a menacing turn of events, one that anticipates his own victimization. Neither the film nor the facts leaves any doubt about Mr. Itami's fundamental daring.

1994 O 19, C17:3

LOVE AFFAIR

Directed by Glenn Gordon Caron; written by Robert Towne and Warren Beatty, based on the 1939 film "Love Affair"; director of photography, Conrad L. Hall; edited by Robert C. Jones; music by Ennio Morricone; production designer, Ferdinando Scarfiotti; costume designer, Milena Canonero; produced by Mr. Beatty; released by Warner Brothers. Running time: 107 minutes. This film is rated PG-13.
WITH: Warren Beatty (Mike Gambril), Annette Bening (Terry McKay) and Katharine Hepburn (Ginny).

By JANET MASLIN

Warren Beatty isn't quite Cary Grant in "Love Affair," though he plays the same ladies' man Grant made so fabulously debonair in Leo McCarey's 1957 "An Affair to Remember." (Charles Boyer also played this role, in 1939.) Surprisingly, he isn't quite Warren Beatty either.

Never has Mr. Beatty seemed less foxy or confident than he does playing out this star-crossed romance opposite his real-life spouse, Annette Bening, who has the once glamorous Deborah Kerr role (played earlier by Irene Dunne). A rule of thumb for male stars looking to set off flirtatious sparks: not with your wife, you don't. Not on screen.

Mr. Beatty and Ms. Bening generated plenty of electricity in "Bugsy," but that film took a much less labored approach toward love. This time there's not much else to talk about. And Mr. Beatty and Robert Towne have come up with a remarkably tongue-tied script. That's amazing, since the earlier screenplays are loaded with arch rejoinders, and all anyone had to do was use them. "An Affair to Remember" was celebrated in "Sleepless in Seattle" for its weepy finale, but it's most fondly remembered for state-of-the-art sophisticated banter.

In a role that brings Mr. Beatty to the brink of self-parody, he plays Mike Gambril, a one-time sports star with "a reputation for playing the field." "Love Affair" even trots out familiar paparazzi shots of Mr. Beatty with various girlfriends (their images have been doctored) on television shows like "Hard Copy," just to show he's a famous Romeo. Certainly his well-documented attractiveness should have eliminated any need for the ridiculously coy cinematography that overprotects him here. Both stars are filmed in such a rosy, gauzy glow that a star actually seems to gleam off Mr. Beatty's teeth in one scene. Both look better in the few scenes shot outdoors, in natural light.

Conrad L. Hall, the usually first-rate cinematographer, is among several behind-the-scenes talents whose presence here ought to attest to Mr. Beatty's skill at producing. He has rounded up the composer Ennio Morricone, the costume designer Milena Canonero and the production designer Ferdinando Scarfiotti (who won an Oscar for "The Last Emperor"), but none of them rise to this occasion. "Love Affair" sounds schmaltzy and looks contrived, with uneasy direction by Glenn Gordon Caron that raises further questions about who, if anyone, was minding the store.

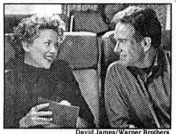
David James/Warner Brothers
Annette Bening and Warren Beatty in "Love Affair."

Then there's the love affair itself. Not for Mike and Terry McKay (Ms. Bening) the sleek, black-tie shipboard romance seen in 1957; these two meet more awkwardly on an airplane, which crash-lands in the South Pacific, forcing them onto a comical-looking Russian cruise ship. Fans of this story know that the ship makes a stop so the leading man can visit a wonderful, elderly relative who knows all about love. This time, she's played by Katharine Hepburn, who does not go gently into sweet little old lady roles.

Ms. Hepburn, who hasn't made a feature film since "On Golden Pond" and is ill served by this one, looks acutely uncomfortable playing an aunt of Mike's who happens to live in a Tahitian paradise. Visited by Mike and Terry, she gives these lovebirds her benediction with an impossible speech about ducks and swans. She must also sit playing the piano while Ms. Bening hums thoughtfully and Mr. Beatty gazes admiringly at his sweetheart. This was bad enough when Ms. Kerr had to do it. It's exactly the sort of thing that could have been expected to dry up in a 1994 version.

But no: "Love Affair" is faithful to its model in the most farfetched ways. So Mike and Terry fall in love at sea but then decide to have a cooling-off period back home, since they happen to be engaged to other people (Kate Capshaw and Pierce Brosnan, who seem perfectly fine alternatives). The waiting period is now three months, not six. But the appointed meeting place is still the Empire State Building, because Ms. Kerr once called it the closest thing to heaven. "It's not the biggest building in the world anymore," Terry says lamely, "but you can't miss it."

That sound you hear is the World Trade Center breathing a sigh of relief.

"Love Affair" then sends its principals back to their separate lives, where Mike has his lawyer, Kip (Garry Shandling), as his sidekick. The scene-stealing Mr. Shandling is more fun than anything else in the film, and he actually makes Mr. Beatty relax into his familiar, appealing self. Meanwhile, the usually peevish Terry beams with generosity while teaching schoolchildren in a disadvantaged neighborhood. You do not want to be around when Ms. Bening sings "The Farmer in the Dell" with this crowd, or when the kids show up at her hospital room in Santa outfits, serenading her with Christmas cheer.

Hospital room? Well, this "Love Affair" carbon copies the traffic accident seen in 1957 and even gives Mr. Beatty straight Cary Grant dia-logue for the story's tear-jerking final scene. Mr. Beatty does best here when he's finally given something lively to say, and Grant-style diffidence turns out to suit him very well. Cary Grant's shoes aren't fillable, but Mr. Beatty could have come closer if "Love Affair" had given him half a chance.

"Love Affair" is rated PG-13 (Parents strongly cautioned). It includes very mild profanity and very slight sexual suggestivness.

1994 O 21, C3:1

Correction

A film review in Weekend yesterday about "Love Affair" referred incorrectly in some copies to one of Katharine Hepburn's film credits. "On Golden Pond" was the last major film in which she starred, not the last feature film she made.

1994 O 22, 2:6

RADIOLAND MURDERS

Directed by Mel Smith; written by Willard Huyck, Gloria Katz, Jeff Reno and Ron Osborn, based on a story by George Lucas; director of photography, David Tatersall; edited by Paul Trejo; music by Joel McNeely; production designer, Gavin Bocquet; produced by Rick McCallum and Fred Roos; released by Universal. Running time: 112 minutes. This film is rated PG.
WITH: Brian Benben (Roger), Mary Stuart Masterson (Penny), Ned Beatty (General Whalen), George Burns (Milt Lackey), Anita Morris (Claudette), Scott Michael Campbell (Billy) and Christopher Lloyd (Zoltan).

By CARYN JAMES

Some movies are so big and so bad that they're funny, like "The Specialist." Others are bad in a grim and boring way, like "Radioland Murders." Even George Lucas makes mistakes, and "Radioland Murders" is one of his whoppers.

Mr. Lucas, the "Star Wars" genius, created the story and served as executive producer and technical czar on the film, which is set in 1939 on the night a radio station is going national. Penny (Mary Stuart Masterson) is the efficient secretary who keeps everything running. She has decided to divorce her husband, Roger (Brian Benben), one of the show's writers. He claims he was framed when Penny caught him in the sexy singer's dressing room. And as the station's employees are murdered one by one, it seems that Roger is being framed for that, too. In one night he has to solve the murders, save his marriage and finish writing a show that's already on the air.

The film tries to pay homage to its period by reproducing a radio show and echoing the snappy dialogue, savvy romance and frenetic pace of 30's comedies, adding suspense along the way. But that germ of an idea is the only part that works.

Much of the blame belongs to an excruciatingly unclever script, with no feel for the period. It is credited to Willard Huyck and Gloria Katz (who

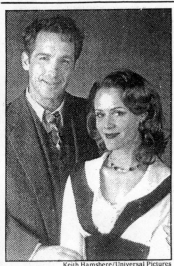

Keith Hamshere/Universal Pictures

Brian Benben and Mary Stuart Masterson.

at their best wrote "Indiana Jones and the Temple of Doom" from Mr. Lucas's story, but also created the fiasco "Howard the Duck") and Jeff Reno and Ron Osborn.

The dialogue is flat. Penny sarcastically calls the star's attempted seduction of Roger "assault with a friendly weapon." The radio-show parodies are lame, as in a soap opera called "Home Is Where the Heart Aches." A hundred characters are sent scurrying around: chorus girls, an orchestra, a roomful of writers. Yet the pace is busy without being chaotically frenzied and funny, a real disappointment since the director, Mel Smith, made the frenetically funny film "The Tall Guy."

And the mystery palls quickly. The murders are mundane. Someone is electrocuted, someone falls down an elevator shaft, and even death by laughing gas fails to make the sure-fire technique of contagious laughter work. The music is presented in such quick snips that the soundtrack creates a dinning headache, as if someone were compulsively switching stations. The biggest waste is to bring Rosemary Clooney on stage, then let her performance of "That Old Feeling" trail off to become a faint background sound as Roger in a penguin suit finds Penny on the building's roof.

Mr. Benben (of the HBO series "Dream On") tries hard and gives a strenuously grinning performance; in disguise he does make a good Carmen Miranda. Otherwise, only Anita Morris, as the vampy singer, and Scott Michael Campbell, as the page who becomes Roger's sidekick, have the right shade of goofy exaggeration the material calls for.

What's left? Computers. The production notes for "Radioland Murders" are inordinately proud of the way the film relied on up-to-the-minute technology, generating walls instead of building them and sometimes combining two characters in one scene though their parts were filmed separately. Amazingly, none of those seams show on screen. But who knows how much that technique accounts for the film's bloodless quality? This whole by-the-numbers movie might have been made by computer, after the humans signed off. As the ever-efficient Penny says to her chief engineer, "This is a nightmare, Max."

"Radioland Murders" is rated PG (Parental guidance suggested). In addition to the innocuously filmed deaths, it includes some strong language and a glimpse of a bare-breasted chorus girl.

1994 O 21, C5:1

were shaved off here and there from the version originally shown in the United States.

No matter how many times you've seen it, "Diabolique" still has one of the all-time great endings. There is a cigar-chomping detective, dark corridors, a mysteriously typed note and a surprise in the bathtub. It is one of the most influential suspense scenes ever filmed. "Fatal Attraction" wouldn't be the same without it.

CARYN JAMES

1994 O 21, C8:5

Critic's Choice/Film

Subversive Intentions Behind the Humor

One of the best ways of insinuating subversive messages into a repressive culture has always been to present them in a humorous guise. Take, for example, two pitch-black comedies by the Spanish director Luis García Berlanga that are included in the series Spanish Eyes III: Classics of the Spanish Cinema, 1960-1975, which opens today at the Joseph Papp Public Theater. On the surface, both films, which were made during the waning years of the Franco dictatorship, don't seem particularly political. But peel away the humor, and you will find acerbic critiques of Spanish culture under Franco in which the bitterness is masked by farcical loquacity and absurdism.

Mr. Berlanga's 1961 film, "Plácido," which begins a six-night engagement this evening, is a chattery comedy about an impoverished man who spends the day before Christmas trying to avoid foreclosure on his motorbike. The character's frantic dealings with bankers and lawyers are set against the film's satirical canvas of a provincial town putting on a showy Christmas campaign called "Seat a Poor Man at Your Table." With its harshly funny portrait of the penny-pinching gentry, of greedy nuns and aggressive salespeople pushing pressure cookers as miraculous kitchen tools, the film offers a scabrously mocking portrait of officialdom putting on a display that is as grotesque as it is hypocritical.

"El Verdugo" ("The Executioner"), which plays Nov. 4 to 6, was made two years later and is no less cynical. José Luis, the main character, is an assistant to an undertaker who falls in love with the daughter of the local executioner. To be able to marry her, he agrees to become the executioner's apprentice and eventual successor. When his father-in-law retires, José Luis, who has fooled himself into believing that he will never have to kill anyone, travels to Majorca to preside over a possible execution. In the film's most harrowingly funny scene, he is dragged kicking and screaming across the floor to perform his homicidal duty.

Critic's Choice/Film

The Murder Is Easy; It's Disposal That's Hard

For diabolical wit, nothing surpasses Henri-Georges Clouzot's 1954 thriller, "Diabolique," which plunges viewers into a morally murky world, then takes off through a brilliant tale of suspense. At a boys' school in a Paris suburb, it's hard to know whom the mean-spirited principal mistreats more: his sweet, pigtailed wife, a brunette fresh from the convent (Vera Clouzot, the director's real-life wife) or his hard-as-nails blond mistress (Simone Signoret), dangling a cigarette from her mouth. Both women teach at the school, and form an unlikely friendship when they conspire to murder their lover.

That's just the start of the story, whose twists shouldn't be revealed. Nothing will ever replace the jolt of seeing "Diabolique" for the first time. It's enough to say that the murder is easy; getting rid of the body is hard. Keep your eye on the big wicker trunk the women take on a trip and don't be surprised at anything that does or doesn't turn up at the bottom of the school's filthy swimming pool. As the women wait to see if they got away with murder, Clouzot focuses on the effects of a bad conscience as much as on the trail of clues, and that pervasive sense of guilt raises the film beyond the level of a simple murder mystery.

A restored version of "Diabolique" opens today and runs through Nov. 3 at Film Forum 2, 209 West Houston Street, South Village. Information: (212) 727-8110. This fresh print restores the clarity of the black-and-white photography, adds new subtitles and returns nine minutes that

Joseph Papp Public Theater

Casto Sendra, left, and Mario de Bustos in Luis García Berlanga's "Plácido," which opens a Spanish film series at the Public.

Another significant film in the series, "Llanto por un Bandido" ("Lament for a Bandit"), is a 1963 spaghetti western by the highly esteemed Spanish director Carlo Saura. The lushly photographed film, which was censored at the time, is set in the early 19th century. It treats the story of an Andalusian bandit, who becomes a symbol of liberty, and an escaped political prisoner as an allegory of contemporary Spanish politics. (The film is to be shown on Nov. 4 to 6 and Nov. 8 to 10.)

More famous is Mr. Saura's 1973 film, "La Prima Angelica" ("Cousin Angelica"), which won him a best director award at the Cannes International Film Festival. The film, which is to be shown Oct. 25 to 27, was banned by the Spanish Government but went on to become the director's first international box-office hit. The movie tells the story of a middle-aged man who returns to the small town he grew up in during the Spanish Civil War and becomes obsessed with the teenage daughter of his childhood sweetheart. Along the way, the film pokes vicious fun at the fascist military structure.

Because it deals with gender identity, Jaime de Armiñan's 1971 film, "Mi Querida Señorita" ("My Dear Lady"), which plays Oct. 28 to 30 and Nov. 1 to 3, is in some ways the most contemporary of all the films in the series. Adela, the central character, is a spinster who lives a retiring life with her devoted maid, Isabel. When the widower of a friend proposes marriage to Adela, who has never been attracted to men, she consults a doctor, discovers that she is actually a man, and leaves town. Dressing in male attire and calling himself Juan, but lacking an official identity, Adela establishes a sewing business in Madrid. Things become complicated when Isabel appears, and a romance develops between the two. The lighthearted, gender-bending comedy ends with a terrific punch line.

The series was organized by the Spanish Ministry of Culture, the Institute of Cervantes in New York and the S.G.A.E., the Sociedad General de Autores de España.

The Papp Public Theater is at 425 Lafayette Street in the East Village. Tickets for each film are $7.50. Information and screening times: (212) 598-7171 or 598-7150
STEPHEN HOLDEN

1994 O 21, C8:5

THE PUPPET MASTERS

Directed by Stuart Orme; written by Ted Elliott and Terry Rossio and David S. Goyer, based on the novel by Robert A. Heinlein; director of photography, Clive Tickner; edited by William Goldenberg; music by Colin Towns; production designer, Daniel A. Lomino; produced by Ralph Winter; released by Buena Vista Pictures. Running time: 109 minutes. This film is rated R.
WITH: Donald Sutherland (Andrew Nivens), Eric Thal (Sam Nivens), Julie Warner (Mary Sefton) and Keith David (Holland).

By STEPHEN HOLDEN

Science-fiction horror, like other kinds of movie violence, has escalated in sophistication so sharply that yesterday's sure-fire tricks for grabbing audiences by the throat are liable to be today's ho-hum special effects. Those who cowered in terror through "Alien," in which extraterrestrial monsters exploded out of people's bodies, aren't likely to be overly impressed by the invaders in "The Puppet Masters," a science-fiction thriller adapted from Robert A. Heinlein's novel.

To be sure, these slimy, lizardlike parasites that leech themselves onto people's backs and control their minds and nervous systems are creepy. But in generating nightmarish anxiety, they can't hold a candle to the gut-busting surprise-attackers in "Alien."

"The Puppet Masters," which opened locally yesterday, nevertheless succeeds in building up a fair amount of suspense, at least in the first half. In high-concept terms, the movie could be described as "Alien" meets "Invasion of the Body Snatchers," since once attached to their hosts, the aliens turn their victims into grim-faced automatons who look like normal humans with their shirts on.

Things begin innocently enough with a mysterious celestial event outside a small Iowa town. But when Andrew Nivens (Donald Sutherland), the saturnine head of the Office of Scientific Central Intelligence visits the site with his son, Sam (Eric Thal), and Mary Sefton (Julie Warner), a space scientist, there's something ominous in the air. At the local television station, which first reported a U.F.O. landing and then claimed it was a hoax, their suspicions are confirmed. The station has been taken over by the aliens who are hellbent on keeping the team from leaving town. When they finally escape in the movie's best action sequence, they bring with them to Washington a dead alien specimen.

Like so many science-fiction films with limited budgets, "The Puppet Masters" is much better at setting up a terrifying scenario than in developing it. It quickly turns out that

Marsha Blackburn/Hollywood Pictures
Donald Sutherland as Andrew Nivens in "The Puppet Masters."

the aliens are multiplying so fast that they threaten to take over the world in a matter of days. The only chance for salvation is through a daredevil operation that involves a nighttime parachute jump into downtown Des Moines. At this point, Stuart Orme, who directed the film, loses control of the narrative, and "The Puppet Masters" becomes a choppy, unsuspenseful succession of chases, melodramatic showdowns and routine special effects.

Mr. Sutherland invests his role with a glowering ferocity that lends the film a psychological weight whenever he is on the screen. The rest of the cast, rather like the Iowans once their bodies have been taken over, merely go through the motions demanded by the genre.

"The Puppet Masters' is rated R (Under 17 requires accompanying parent or adult guardian). It has many scenes of violence.

1994 O 22, 18:1

THE LAST SEDUCTION

Directed by John Dahl; written by Steve Barancik; director of photography, Jeffrey Jur; edited by Eric L. Beason; music by Joseph Vitarelli; production designer, Linda Pearl; produced by Jonathan Snestack; released by October Films. Sony Village Theater VII, Third Avenue at 11th Street. Running time: 110 minutes. This film is rated R.
WITH: Linda Fiorentino (Bridget Gregory), Peter Berg (Mike Swale), J. T. Walsh (Frank Griffith), Bill Nunn (Harlan) and Bill Pullman (Clay Gregory).

By JANET MASLIN

A hired assassin, an innocent fall guy and a husband and wife intent on killing each other made a sterling film noir spectacle out of "Red Rock West," John Dahl's recently released sleeper. Now Mr. Dahl, whose work will never again fall into the sleeper category, is back with "The Last Seduction," which makes his earlier miscreants look like a collection of cream puffs. "Red Rock West" was memorably smart and steely. But it's a walk in the park picking buttercups compared with this.

Nothing else about "The Last Seduction" is as polite or colorless as its title. Certainly not Bridget Gregory (Linda Fiorentino), the hot, slinky monster who is this film's central character. There were 1940's noir heroines with Bridget's brand of undiluted self-interest, but she also throws in a few tricks from the "Basic Instinct" school of interpersonal relations. Only in the insect or animal worlds are there comparable models for feminine behavior. And the female praying mantis is nicer to her mates than Bridget is to the men in this movie.

It takes about five minutes for Mr. Dahl to establish Bridget's breathtaking ruthlessness, as she robs her husband Clay (Bill Pullman) of the proceeds from a drug deal. Maybe she does this because Clay treated her a little badly, and maybe she's just ready for new scenery. Anyway, Bridget takes the money and leaves New York City, winding up in Beston, a friendly little town near Buffalo. No one in Beston has ever seen

October Films
Linda Fiorentino as a ruthless heroine in "The Last Seduction."

anything like Bridget, and neither have you.

Both Mr. Dahl, who directs this film with stunning economy, and Ms. Fiorentino, whose performance is flawlessly hard-boiled, exult in the sheer wickedness of Bridget's character. What make this easy to do are Bridget's stony seductiveness and her spellbinding talent for getting exactly what she wants. For instance, she soon appropriates Mike Swale (Peter Berg), a naïve Beston resident who's wowed by Bridget's drop-dead sophistication. Their meeting alone, with Bridget unceremoniously unzipping Mike's pants in a crowded barroom, is guaranteed to make every man in the audience squirm. And wonder what's next.

Bridget, now using the name Wendy, lures Mike into one-half of an intense affair. (She herself remains maddeningly aloof.) Meanwhile, she puts down a few tentative roots in Beston, despite the fact that the neighbors' neighborliness is enough to make her cringe. She rents a house in suburbia (Mr. Dahl has great fun with that little contrast) and finds a job at the insurance company where Mike works. But she wants to keep their relationship a secret, so she slaps Mike when he tries talking to her at the office. "A woman loses 50 percent of her authority when people find out who she's sleeping with," Bridget declares.

Bridget will not be mistaken for a crusading feminist. Her outlook is much too selfishly pathological to have a political edge, and her glamour is too scarily seductive. Besides, Bridget is a more darkly fascinating anomaly, with old-style killer instincts along with a liberated aggressiveness that suits the present day. The audience can only sit back and watch in astonishment as Bridget embroils Mike in an intricate, deadly scheme that harks back to

James M. Cain, while also doing her best to keep Clay off her trail.

"Red Rock West" had a mostly nocturnal look and eventually bogged down under the weight of its genre affectations. "The Last Seduction," which opens today at Sony Village Theater VII, looks sunnier and sounds less derivative. That's because its malice is so nonchalant and springs from the depths of Bridget's character, not from the machinations of an overloaded plot. Steve Barancik's clever screenplay builds up carefully and delivers a perfect payoff, one that suits the story while also acknowledging Bridget's very special toughness.

"Why do I have to turn off the lights?" Mike asks, when Bridget tries to give him orders about how to commit a murder. But of course: that's the heart of any noir-based love story.

"Pop psychology," she answers. "Let yourself know you've finished an unpleasant chore."

"The Last Seduction," a devilishly entertaining crime story with a heroine who must be seen to be believed, is as satisfying an ensemble piece as "Red Rock West." J. T. Walsh, who was also in "Red Rock," shows up as Bridget's lawyer and asks her the question on every mind: "Anyone check you for a heartbeat lately?" Mr. Pullman is especially good as a man who really did deserve to be married to Bridget, and clearly gave as good as he got while the union lasted, with all the dark humor that job demanded.

Mr. Berg is gently appealing and makes the perfect chump, which is no small compliment in such a story. And Bill Nunn has some fine scenes as the private investigator who thinks he can get the best of Bridget. Maybe male praying mantises feel that way, too.

Mr. Dahl's early admirers will find the promise of "Red Rock West" (and one other film, "Kill Me Again") furthered by a gripping story and a tight, suspenseful directorial style, not to mention a heroine who's literally to die for. Mr. Dahl was good to begin with, and now he's badder and better.

"The Last Seduction" is rated R (Under 17 requires accompanying parent or adult guardian). It includes profanity, explicit sexual situations and partial nudity.

1994 O 26, C13:1

FAUST

Written and directed by Jan Svankmajer; based on texts by Goethe, Marlowe and Grabbe; animation, Bedrich Glaser; director of photography, Svatopluk Maly; editor, Marie Zemanova; music, Charles Gounod and Johann Sebastian Bach; produced by Jaromir Kallista; released by Zeitgeist Films. Film Forum, 209 West Houston Street, South Village. Through Nov. 8. Running time: 97 minutes. This film is not rated.
WITH: Petr Cepek.

By CARYN JAMES

Marionettes, dolls and pieces of clay have never seemed as sinister and surreal as they do in the films of the brilliant Czech animator Jan Svankmajer. His shorts, many evoking Poe or Kafka, bring the menace of the subconscious to life, and his extraordinary feature "Alice" depicts an eerie wonderland darker than any Lewis Carroll dared. His new feature, "Faust," combines his usual mix of animated elements with a great deal of live action to tell an updated version of the old devilish story; the result will probably be more intriguing to Svankmajer cultists than to newcomers.

Mr. Svankmajer's Faust (Petr Cepek) is a dour-looking man who lives in today's Prague and is first seen walking out of a subway. He is handed a map with a large red mark on it, and eventually follows the directions to a ramshackle building that conceals an abandoned dressing room. There he puts on Faust's costume, begins reading from a script of Goethe's play and finds himself in the middle of a peculiar experience that is part real, part theatrical.

In stop-motion photography, a piece of clay becomes a baby whose body remains the same while his head ages before Faust's eyes, becoming a boy, an adult with Faust's face, and, finally, a skeleton. Mephistopheles is a life-size marionette, and a jester is a human wearing a large mask over his head. The characters speak in excerpts from the Faust plays of Goethe and Marlowe, among other sources, and there are snippets from Gounod's opera.

Mr. Svankmajer's premise is that each age makes its own pact with the devil, and in interviews he has explained the political implications of his film. His Faust has passively accepted capitalism as easily as he used to swallow totalitarianism. "Faust is manipulated like a puppet," Mr. Svankmajer has said.

While a Faust who surrenders his soul easily is a radical revision of the legend, the idea presents a serious dramatic problem. A passive Faust, especially one who looks like an ordinary man, is not very compelling. It takes far too long for Faust to make his bargain with Mephistopheles. And by relying so much on live action, Mr. Svankmajer loses much of the bizarre, imagistic power of his earlier work.

"Faust" opens today at Film Forum 1. There are glimpses of Mr. Svankmajer's greatness here, but viewers who have never seen his work before may wonder why so many people rightly regard him as a film maker of the first rank.

1994 O 26, C15:1

THE SEX OF THE STARS

Directed by Paule Baillargeon; written by Monique Proulx, in French with English subtitles; director of photography, Eric Cayla; edited by Hélène Girard; music by Yves Laferrière; produced by Pierre Gendron and Jean-Roch Marcotte; released by First Run Features. At the Quad Cinema, 13th Street west of Fifth Avenue, Greenwich Village. Running time: 104 minutes. This film is not rated.
WITH: Denis Mercier (Marie-Pierre), Marianne-Coquelicot Mercier (Camille), Sylvie Drapeau (Michèle) and Tobie Pelletier (Lucky).

By STEPHEN HOLDEN

In "The Sex of the Stars," a French Canadian film awash in sudsy histrionics, Denis Mercier portrays an astronomer who returns to Montreal after a sex-change operation to visit his 12-year-old daughter, Camille (Marianne-Coquelicot Mercier, who is not related to Mr. Mercier). When Henri-Pierre, who left Canada seven years earlier to live in New York, reappears as Marie-Pierre, his former wife, Michèle (Sylvie Drapeau), goes ballistic and his former employer tells him flatly that he looks ridiculous.

In fact, he does. Mr. Mercier's Marie-Pierre looks and acts like a manly man doing an unsophisticated drag act that could fool no one. Batting his eyes and anxiously clutching his breast while wearing an insipid little smile, the actor is far less believable as a dowdy matronly type than Dustin Hoffman was in "Tootsie." "Tootsie," of course, was a comedy. "The Sex of the Stars," which opens today at the Quad Cinema, doesn't crack a smile.

Camille, who is torn between loyalty to a mother against whom she is rebelling and to an idolized father she insists on calling "Dad" in public places, is a lonely, introverted child. When not peering through a telescope at the stars and making portentous pronouncements about the universe, she is hanging out with her only friend, Lucky (Tobie Pelletier), a 13-year-old street hustler who regularly sells his body to a middle-aged homosexual. In the film's silliest scene, Lucky insists on taking Camille to a drag bar whose denizens are coiled around one another like a bunch of leering, heavily painted reptiles. It is the kind of place that exists only in nightmares.

The tedious tug of war for Camille's affections unfolds like an overheated soap opera, rife with tearful recriminations and endless soul-searching. At one point, Camille, turning improbably aggressive, wipes off her father's makeup, fixes his hair into a more casual do and orders him to put on men's clothes. On the street, he takes one look at his disheveled image in a storefront window and stumbles back to his apartment.

"The Sex of the Stars" is being marketed as a transgender version of "Kramer vs. Kramer." Although it earnestly seeks to address issues of sexual identity and child-rearing, it is far too shocked by its own subject matter to go beyond first base.

1994 O 28, C6:5

STARGATE

Directed by Roland Emmerich; written by Dean Devlin and Mr. Emmerich; director of photography, Karl Walter Lindenlaub; edited by Michael J. Duthie and Derek Brechin; music by David Arnold; production designer, Holger Gross; produced by Joel B. Michaels, Oliver Eberle and Mr. Devlin; released by Metro-Goldwyn-Mayer. Running time: 125 minutes. This film is rated PG-13.
WITH: James Spader (Dr. Daniel Jackson), Kurt Russell (Col. Jack O'Neil), Jaye Davidson (Ra) and Viveca Lindfors (Catherine).

By CARYN JAMES

There are almost as many plots in "Stargate" as there are characters, but the idea behind the movie is simple: space adventure in ancient Egypt. It works better than you'd think. For kids, there are relentless special effects, from a spaceship that looks like a flying pyramid to spears that turn into rocket launchers. For adults, there is a smartly designed parallel universe that echoes the Egypt of old Bible movies, and the appearance of Jaye Davidson (the androgynous star of "The Crying Game") as the sun god, Ra. Try to imagine him voguing around a party at the Temple of Dendur and you'll have the right image. Juggling all this makes "Stargate" move more slowly than any action movie should, but it has plenty of enticing moments.

The story begins in Giza, Egypt, in 1928, when archeologists discover a large stone wheel with mysterious symbols carved on it. Leaping to the present, we see James Spader as an Egyptologist, Dr. Daniel Jackson, being laughed off the podium when he suggests that the Egyptians didn't build the pyramids. He doesn't know who did build them, but the answer is lurking in outer space.

He is recruited to work on a project deciphering the symbols on the stone, and he discovers that this object is a stargate, a portal to another world. When he translates the seventh symbol on the wheel, its center turns into a curtain of shimmering, watery light and the film takes off into a sequence that includes its best special effects. Along with a military contingent led by Kurt Russell as Col. Jack O'Neil, Jackson walks through the stargate and is sent whizzing through a dark tunnel, emerging among the stars and landing on a planet that looks Egyptian.

That planet has three moons shining in daylight, a vast desert dotted with pyramids, and a slave population dressed like Bedouins, the obvious builders of their pyramids and ours. There is also a breed of mysterious animals resembling camels with shaggy hair extensions, and a language it takes Jackson a while to figure out. When Jackson gives a native a candy bar, the reaction sounds a lot like "bunny wah." (Occasionally the language is translated by subtitles.)

There are laughable holes in the plot. Before going through the stargate, Jackson is asked if he's certain he'll know how to get back. He says yes and no one asks him how, which raises a red flag for anyone who has ever seen a stranded-on-a-distant-planet movie. But Mr. Spader holds this film together. After a series of smarmy roles (like the junior wolf in "Wolf"), he seems to relish playing a sincere guy. With his wire-rimmed glasses and blond hair hanging in his eyes, Jackson looks like a befuddled graduate student lost in his work. Mr. Russell has a smaller part, as the military leader with the brush cut. It turns out he has a risky secret mission.

"Stargate" is well along in this story before Ra appears, making a

suitably divine entrance. Mr. Davidson's hair is in a long braid, and his costumes include a golden breastplate and flowing robes. His voice is electronically enhanced to give it a godlike rumble and on occasion the whites of his eyes are enhanced, too. There isn't much acting involved. Mr. Davidson may not have wide-ranging career possibilities, but he makes the perfect Ra mannequin.

And the film takes off again when Ra appears, for he is truly vile and high-tech. His courtiers wear Egyptian headdresses in the shapes of birds and jackals, which automatically retract in a flash to reveal their faces. They have a Star Trek-style transporter and nuclear weapons. The plot becomes even sillier, but the director, Roland Emmerich (whose work includes the action film "Universal Soldier"), keeps things moving toward the end.

The uneven "Stargate" may not appeal to adults who don't already have a taste for this kind of science fantasy. It borrows too much from other films, some as good as the Indiana Jones trilogy and others as flat as "Dune." And the story is bound to be too confusing for very small children. But "Stargate" is a clever adventure that should find its audience.

"Stargate" is rated PG-13 (Parents strongly cautioned). It includes some strong language, and a shoot-out at the end.

1994 O 28, C6:5

SILENT FALL

Directed by Bruce Beresford; written by Akiva Goldsman; director of photography, Peter James; edited by Ian Crafford; music by Stewart Copeland; production designer, John Stoddart; produced by James G. Robinson; released by Warner Brothers. Running time: 104 minutes. This film is rated R.

WITH: Richard Dreyfuss (Jake Rainer), Ben Faulkner (Tim Warden), Liv Tyler (Sylvie Warden), Linda Hamilton (Karen Rainer), John Lithgow (Dr. Harlinger) and J. T. Walsh (Sheriff Mitch Rivers).

By CARYN JAMES

In "Silent Fall," Richard Dreyfuss plays a psychiatrist who solves a double murder witnessed by the victims' 9-year-old autistic son. As the final credits roll, the singers Wynonna and Michael English wail the movie's theme song: "Healin', I'm healin.' " It's the last ludicrous touch in a film that starts out offering the depth and suspense of a mediocre made-for-television movie and ends up as something much worse.

As Jake Rainer, Mr. Dreyfuss is overwrought even before he is called by the sheriff to the house of a wealthy couple. In an example of the film's wincingly bad dialogue, the sheriff says, "Meet the Wardens," pointing to two extremely bloody sheets not entirely covering the corpses. Their son, Tim (Ben Faulkner), is downstairs holding a knife and making stabbing motions. Tim's beautiful 18-year-old sister, Sylvie, is cowering in a closet.

Mr. Dreyfuss's performance mercifully calms down as he tries to

Jane O'Neal/Warner Brothers
Ben Faulkner, left, and Richard Dreyfuss in "Silent Fall."

discover what Tim knows, but first the doctor has to be persuaded to take the case. Jake used to run a group home for autistic children, and changed his specialty after a boy in his care drowned. Though Jake was found innocent of manslaughter in the boy's death, "Silent Fall" inadvertently makes you wonder. At one point, he leaves little Tim alone in a shed full of sharp tools; at another, he turns his back and the boy climbs on the roof.

That's the good half of the film. The second part takes a lurid turn that includes enough fodder for several tabloid television shows and a few Stephen King novels. Using autism as a plot device may seem callous, but it pales next to the sordid twists that turn up at the end. Among the least of them is the uncanny way Tim mimics voices. His dying father's voice growls out of the boy's mouth in a manner that recalls "The Exorcist."

The actors do the best they can, and Mr. Dreyfuss is not the only one wasted. John Lithgow plays a doctor who wants to drug Tim to make him talk. Linda Hamilton plays Jake's wife. All her lines are variations of, "You're quitting again, Jake." Liv Tyler, in her first film, is straightforward and convincing as Sylvie, no small accomplishment.

The one whose career will need the most healing is the director, Bruce Beresford. Whatever suspense the film sustains is largely due to his steady narrative focus, but his recent "Good Man in Africa" came and went in a blip, making "Silent Fall" his second fiasco in two months. His films have been overly revered ("Driving Miss Daisy") and justly praised ("Tender Mercies"). "Silent Fall" belongs with "King David" in another Beresford category: What in the world was he thinking?

"Silent Fall" is rated R (Under 17 requires accompanying parent or adult guardian). It includes the gruesome murder site and strong language.

1994 O 28, C10:1

THE ROAD TO WELLVILLE

Written and directed by Alan Parker; based on the novel by T. Coraghessan Boyle; director of photography, Peter Biziou; edited by Gerry Hambling; music by Rachel Portman; production designer, Brian Morris; produced by Mr. Parker, Armyan Bernstein and Robert F. Colesberry; released by Columbia. Running time: 117 minutes. This film is rated R.

WITH: Anthony Hopkins (Dr. John Harvey Kellogg), Bridget Fonda (Eleanor Lightbody), Matthew Broderick (Will Lightbody), John Cusack (Charles Ossining), Dana Carvey (George Kellogg), Camryn Manheim (Virginia), Michael Lerner (Goodloe), Lara Flynn Boyle (Ida), John Neville (Endymion Hart-Jones), Carole Shelley (Mrs. Hookstratten), Colm Meaney (Dr. Lionel Badger) and Traci Lind (Nurse Irene Graves).

By JANET MASLIN

In the process of lampooning turn-of-the-century health food faddists, "The Road to Wellville" displays lunacy of its own. Here is a lavish, overproduced satire that finds its hilarity in bowel jokes, bowel-touting slogans and bowel-related dinner-time conversation. ("Sore rectum?" "Yes, somewhat.") Don't count on being amused if you don't think the best place for a high colonic is the movie screen. Don't be surprised when one scene unfolds in a sanitarium's Fecal Analysis Room, where an exam is under way.

"The Road to Wellville" may be loaded with intestine-invading contraptions, but heads were what needed to be examined. Based on a wildly unfilmable novel by T. Coraghessan Boyle, it has only the faintest satirical potential, which has been squashed by too many sets, costumes, extras and woebegone stars. The film was grandly shot at Mohonk Mountain House in New Paltz, N.Y., which is undoubtedly a nicer place to visit without the signs that read "Clean Bowels Make for Clean Thoughts," and so on.

Matthew Broderick has the thankless job of playing Will Lightbody, this story's guinea pig of a hero. As the director and screenwriter Alan Parker has written about Will, he is "douched, scrubbed, fried, poked, prodded and purged, his intestines 'snipped out like a wart' as he fights a resentful stomach and pursues his errant wife." Mr. Broderick endures all this looking as fearful as he should have been when first reading the screenplay.

The wife and the stomach are in league together during the Lightbodys' first scene, as they take the train to Battle Creek, Mich., for a stay at Dr. John Harvey Kellogg's spa. Eleanor (Bridget Fonda) stands worriedly outside a bathroom on board their train and interrogates Will after he emerges, thus offering the audience a fair idea of what is to come. Will is genteel and sickly, which makes him a prime candidate for the ministrations of Dr. Kellogg, whose punishing, messianic digestive philosophy would make a better subject for a documentary than a farce. As comic material, it doesn't even approach the cornflake, which also figures in this story.

Once at the sanitarium, Will and Eleanor are separated according to house rules and thus freed to experience separate forms of spiritual regeneration. His involves a frail, greenishly pale patient (Lara Flynn Boyle) and the pretty nurse who purges him (Traci Lind); hers comes from a quack doctor whose specialty is erotic massage. Meanwhile, extras romp through the film in grotesquely unbecoming ways and Anthony Hopkins makes a buffoonish Dr. Kellogg in buck teeth, spectacles and knickers. He looks like Teddy Roosevelt, sounds like

John Huston and adds nothing helpful to his résumé.

"The Road to Wellville," which brings to mind Mr. Parker's "Angel Heart" a lot faster than it summons "Mississippi Burning" or "The Commitments," presents all its actors in histrionic overdrive. The usually subtle John Cusack is all hand-waving excess as one of the cereal shysters who provide the backdrop for the story. Dana Carvey, with blackened teeth and stringy hair as Dr. Kellogg's rebellious foster son, delivers an element of gratuitous grunge. Distinguished actors like John Neville, Carole Shelley and Colm Meaney are underused in smallish, bizarre roles.

Ms. Fonda can be an enchanting actress in contemporary roles, but historical satire and chatty dialogue don't suit her reticent style. Camryn Manheim and Michael Lerner, as the robust sidekicks of Ms. Fonda and Mr. Cusack, respectively, do what little is possible to provide comic relief.

Mr. Parker plows steadfastly through "The Road to Wellville" with a conviction that this material is insightful, though he eclipses any bearing it has on the body-worshiping puritanism of today. As the film contrasts its characters' natural instincts with Dr. Kellogg's invasive, repressive approach to health, it misses any possibility of a larger point. "The Road to Wellville" may have one felicitous effect on its viewers' well-being, though. See it if you're dieting and you won't eat for days.

"The Road to Wellville" is rated R (Under 17 requires accompanying parent or adult guardian). It includes nudity, sexual situations and incessant scatological references.

1994 O 28, C13:1

DROP SQUAD

Directed by David Johnson; written by Mr. Johnson with Butch Robinson and David Taylor, based on "The Deprogrammer," a story by Mr. Taylor; director of photography, Ken Kelsch; edited by Kevin Lee; music by Michael Bearden; production manager, Buddy Enright; produced by Mr. Robinson and Shelby Stone; executive producer, Spike Lee; released by Gramercy Pictures. Running time: 86 minutes. This film is rated R.

WITH: Eriq LaSalle (Bruford Jamison Jr.), Vondie Curtis-Hall (Rocky), Ving Rhames (Garvey), Vanessa Williams (Mali) and Nicole Powell (Lenora Jamison).

By JANET MASLIN

In "Drop Squad," Bruford Jamison Jr. (Eriq LaSalle), a token black employee at an advertising agency, is supposed to help pitch dubious products to what his white boss calls "the colored community." Bruford's accounts include Mumblin' Jack Malt Liquor, a beverage "available everywhere black people are served."

There's also the Gospel-Pak, which is fast-food fried chicken with such Biblical overtones as scripture-like quotations on the Gospel-Pak napkins. To pitch this product, there's a television commercial featuring two choir singers, a cashier in

Ruth Leitman/Gramercy Pictures

Eriq LaSalle

a racially demeaning costume and Spike Lee, the film's executive producer.

Not surprisingly, Bruford's cooperation with such marketing schemes has alarmed his family. "You know, we used to *march* to get away from stuff like that," his aunt says. "Some things you don't sell," adds his uncle.

Bruford's family is also dismayed by his reluctance to help his needier relatives. But Bruford's cousins have names like Flip and Stink, and Bruford, who used to be known as Boo-Boo, doesn't see much place for them in his slick new life. He flinches visibly at a family reunion, where Mumblin' Jack is the beverage of choice.

"Drop Squad" offers a vigorous hands-on cure for Bruford and other upwardly mobile types who choose to lose touch with their roots. It presents a vigilante-style group of black deprogrammers who kidnap sellouts, subjecting them to a barrage of slides, posters, slogans and family photographs in hopes of restoring their sense of community. "Sometimes," as one squad member best puts it, "when you get over the wall, you gotta throw a rope back — not help them build it higher."

As directed by David Johnson (based on a short story by David C.

Taylor), "Drop Squad" has satirical possibilities that struggle with its tendency to lecture. Mr. Johnson, who made a 1988 short film out of this idea and may have covered all its bases in that more limited format, doesn't often sharply dramatize his film's concerns. The Drop Squad deprogramming sequences are particularly chaotic, with hand-held camerawork capturing silly tactics that smack more of fraternity hazing than of consciousness-raising. When some of the Drop Squad members worry about being ineffectual, they're right.

"Drop Squad" does succeed in conveying the earnestness of its central questions and in bringing some of its characters to life. Mr. LaSalle plays Bruford as a three-dimensional figure, even if the trivialness of some of what he's subjected to makes that difficult at times. As Rocky, a walking monument to Black Panther nostalgia, Vondie Curtis-Hall accentuates the film's questions about what means are necessary to achieve the Drop Squad's aims. (The phrase "by any means necessary" is used, but only in connection with selling products to black customers.)

Big, brooding Ving Rhames, who plays the gangster kingpin of "Pulp Fiction," is especially imposing here as one of the more philosophical, less passive members of the organization. Vanessa Williams, who's not the singer and "Spider Woman" star and is thus destined to be known as "the other Vanessa Williams," is a solid, vigorous actress playing another member of this co-ed group.

"Drop Squad" would have hit harder with more well-honed satirical segments (like the one featuring Mr. Lee) and with a more insistent tone. It's seldom very funny or bold. And it doesn't make sense either of the elaborateness of the Drop Squad's schemes or of their peculiar tepidness. Since this film's message is so forceful, its methods should have been just as strong.

"Drop Squad" is rated R (Under 17 requires accompanying parent or adult guardian). It includes profanity.

1994 O 28, C19:1

MARY SHELLEY'S FRANKENSTEIN

Directed by Kenneth Branagh; written by Steph Lady and Frank Darabont, based on the novel by Mary Shelley; director of photography, Roger Pratt; edited by Andrew Marcus; music by Patrick Doyle; production designer, Tim Harvey; produced by Francis Ford Coppola, James V. Hart and John Veitch; released by TriStar Pictures. Running time: 128 minutes. This film is rated R.

WITH: Robert De Niro (Creature), Kenneth Branagh (Victor), Tom Hulce (Henry), Helena Bonham Carter (Elizabeth), Aidan Quinn (Walton), Ian Holm (Victor's Father) and John Cleese (Professor Waldman).

By JANET MASLIN

DESPITE the chivalry of its title, "Mary Shelley's Frankenstein" will not strike anyone as chiefly Mary Shelley's invention. Its principal architect is Kenneth Branagh, who does not hide his light under bushels, not even bushels of classic literary stature. In a dazzling display of hubris, Mr. Branagh takes on the godlike, idealistic young scientist's role while also directing this "Frankenstein" as an overheated romantic fable. For a film of such lavishness and chaotic sprawl,

creating-a-monster quips are obvious but inevitable.

"Frankenstein" is a cogent reminder that Mr. Branagh's reputation as a film maker rests primarily on seductive popularizations of Shakespeare ("Henry V" and especially the star-studded, visually glamorous "Much Ado About Nothing"). An extravagant entertainer, Mr. Branagh has a flair for capturing the mass appeal of familiar texts, so "Frankenstein" sounds reasonably well suited to his talents. But this material is easily caricatured and dauntingly overexposed. The monstrousness of "Frankenstein" extends to nearly 30 other films, not to mention a permanent place in the pantheon of Halloween masks and pop-cultural archetypes.

Unlike Francis Ford Coppola, who is a producer of this film and whose homage to "Dracula" was a more stylish, rapturous undertaking, Mr. Branagh is in over his head. He displays neither the technical finesse to handle a big, visually ambitious film nor the insight to develop a stirring new version of this story. Instead, this is a bland, no-fault "Frankenstein" for the 90's, short on villainy but loaded with the tragically misunderstood. Even the Creature (Robert De Niro), an esthetically challenged loner with a father who rejected him, would make a dandy guest on any daytime television talk show.

Since the linchpin of "Frankenstein" is a fascination with the moral ramifications of science, this story should be even more relevant today than it was in 1818. Remarkably sophisticated despite its author's tender age (she wrote it at 19), the book envisioned Dr. Frankenstein as "the modern Prometheus" as he harnessed technology to create life.

Today's astounding medical advances even fulfill some of Mary Shelley's implicit prophecies, but Mr. Branagh never addresses that, preferring to keep his film exaggeratedly quaint.

Despite an immense laboratory that could be run only by a large team of special-effects experts, this Dr. Frankenstein's methods are primitive: a brain on ice, some amniotic fluid, a reanimated dead toad and off we go

Mr. Branagh has said that he intended to make "less a horror film than a larger-than-life Gothic fairy tale." So his "Frankenstein" achieves a quieter version of Ken Russell's pop grandiosity, with little Victor Frankenstein growing up in a house that pointedly resembles a stage set. Victor's story is told in flashback, beginning in the movie-studio version of an Arctic wasteland, where the adult, ruined Victor (Mr. Branagh) tells his life story to a ship's captain (Aidan Quinn). To hear Mr. Branagh declare "I am ... Vic-tor Frank-en-stein!" is to sense the troubled waters ahead.

The story moves deliriously past a boyish Victor, who is dressed like a boyish Mozart (the year is 1773), to the youth who becomes heartbroken when his mother dies in childbirth. Mr. Branagh, who is much too mature for his role as a young student, stages the mother's demise with a gory realism that underscores the importance of birth in Frankenstein lore. It's turning out to be a great season for "I Love Lucy" reruns among viewers who don't enjoy gruesome special effects on screen.

Vowing to vanquish death, Victor also falls in love with Elizabeth, his adopted sister (Helena Bonham Carter), whose beauty is underscored by the camera's habit of spinning ecstatically around her whenever it sees her. Ms. Carter, usually a model of intelligent composure, is all atwit-

ter here, as is everything else about "Frankenstein." The film's style isn't consistent in its exaggerations, but much of it has a frantic, breathless energy that seems to come from nowhere.

Amid the harpsichord interludes and glycerine tears that mark Victor and Elizabeth's romance, the film also makes medical progress. A long-haired, humorless, unrecognizable John Cleese plays the professor with whom Victor boldly discusses the alchemist Paracelsus, and whose brain Victor winds up borrowing for research purposes. The rest of the "appropriate raw materials" — that is to say, the body — come from the thief played by Mr. De Niro, who winds up with his head shaved and rows of stitches circling his face and cranium. The effect is that of post-blood-bath Travis Bickle crossed with a baseball, but Mr. De Niro still manages to convey remarkable pathos and dignity.

The screenplay, by Steph Lady and Frank Darabont (he is the writer and director of "The Shawshank Redemption"), envisions a talkative and even scoldy Creature. "Did you ever consider the consequences of your actions?" he reproachfully asks his creator. Though the film's sympathies for the Creature disappear by the time he rips somebody's heart out, he is largely seen as a victim of forces beyond his control.

David Appleby/Tristar Pictures

Helena Bonham Carter

That conception is compassionate, but it won't surprise or scare anyone.

Mr. De Niro's appearance is transfixingly bizarre, aided by astonishing makeup effects and the actor's own physical transformation into a grieving, lumbering outsider. Also impressive, in a similarly ostentatious way, is the laboratory sequence leading up to the Creature's birth, during which Mr. Branagh doffs his shirt to get into the nativity spirit. Freed of the demands of a precious, unconvincing love story, the film here tastes some of the terrifying exhilaration with which "Frankenstein" is usually associated. Ms. Carter's best and most ghastly scene is in a similar, horrific vein.

Also in "Mary Shelley's Frankenstein" are Ian Holm as the senior Frankenstein and Tom Hulce, breaking the film's potboiling mood with occasional comic relief as Victor's friend and fellow student. Mr. Branagh, who rarely disappears into a role without signaling the fact that he is doing so, fades before Mr. De Niro but overshadows most of the other actors with whom he shares the screen.

"Mary Shelley's Frankenstein" is rated R (Under 17 requires accompanying parent or adult guardian). It includes graphic gore, a brief sexual episode and many medicine-minded scenes that may disturb squeamish viewers.

1994 N 4, C1:2

THE WAR

Directed by Jon Avnet; written by Kathy McWorter; director of photography, Geoffrey Simpson; edited by Debra Neil; music by Thomas Newman; production designer, Kristi Zea; produced by Mr. Avnet and Jordan Kerner; released by Universal Pictures. Running time: 127 minutes. This film is rated PG-13.
WITH: Elijah Wood (Stu), Kevin Costner (Stephen), Mare Winningham (Lois), Lexi Randall (Lidia), Latoya Chisholm (Elvadine) and Charlette Julius (Amber).

By JANET MASLIN

Set in a small Mississippi town and centered on a children's battle over a tree house, "The War" is an allegory about love, death, pacifism, family values and the spiritual and physical wounds of Vietnam. To no small degree it is also about movie stars, who have the power to transform platitudes into warm, affecting insights when they make their presence sufficiently persuasive on screen.

"The War" has the benefit of two such presences: Kevin Costner, who is at his most disarming in the role of Stephen Simmons, a Vietnam veteran having trouble returning to his wife and children (the year is 1970), and Elijah Wood, who plays his son. Mr. Costner's folksy sincerity is enough to lure the Spanish moss right off the live oaks, and he works hard in the potato fields the way only a major movie star can. He's effortlessly appealing, and Mr. Wood holds up his end of the story with equal assurance.

Well established as a first-rate child actor (in films including "The Good Son" and "The Adventures of Huck Finn"), Mr. Wood has also developed that stellar shine. He eases effortlessly into the role of a tough, sturdy Southern boy who struggles to hold his family together, and whose sentimental scenes late in the story will send many hardened moviegoers groping for their hankies. If "The War" had confined itself solely to the love between this father and son, it would have had a small but satisfying story to tell.

As it is, "The War" contends with too many minor plot threads and a too-wrenching switch of gears late in the story. As written atmospherically but sometimes preachily by Kathy McWorter, it incorporates a wider array of lessons than it can comfortably handle. Jon Avnet, whose first feature was "Fried Green Tomatoes" (after a successful producing and directing career on television), had better luck last time in juggling characters and keeping a busy story on track.

Mr. Avnet grew up in Great Neck, L.I., but he clearly has a strong feel for the rural South. "The War" does a fine job of conjuring tiny Juliette, Miss., where Stephen and his wife, Lois (Mare Winningham), struggle to support their 11-year-old twins, Stu (Mr. Wood) and Lidia (Lexi Randall). Life is hard, thanks to poverty and the town bullies. But the Simmonses have love.

The film's big contrivance is a fight with those bullies over an elaborate tree house, which Stu and Lidia build with some friends' help, and which looks almost as big as the Simmons home. (Kristi Zea's production design brings visual interest to both these settings.) The fight turns into overkill once the Simmons children experience a tragedy and Stu digs out his father's leftover Vietnam artifacts in order to escalate the battle. If the story weren't set in the backwoods, this behavior would be called acting out. It gives a stagy, moralizing tone to an otherwise gently realistic story.

"The War" works best in small, uninstructive moments, like some sweet scenes between Lidia and her two best friends (Latoya Chisholm and Charlette Julius), who defy the doldrums of country life by dancing like the Supremes. Children's roles here have been cast with an eye toward naturalness, which works with the film's hominy-and-homilies rustic style.

"The War" views the world through the eyes of children even when depicting adults, as when Mr. Costner explains that he gave cotton candy to two little bullies " 'cause it looked like they hadn't been given nothin' in a long time." Mr. Costner is star enough to turn the noblesse oblige of that gesture into nobility.

"The War" is rated PG-13 (Parents strongly cautioned). It includes mild profanity, fleeting violence and sad events that might disturb very young children.

1994 N 4, C10:5

A PASSION TO KILL

Directed by Rick King; written by William Delligan; director of photography, Paul Ryan; edited by David H. Lloyd; music by Robert Sprayberry; production designer, Ivo Cristante; produced by Bruce Cohn Curtis; released by Rysher Entertainment. At Village East Cinemas, Second Avenue at 12th Street. Running time: 93 minutes. This film is rated R.
WITH: Scott Bakula (David), Chelsea Field (Diana), Sheila Kelley (Beth), France Nuyen (Lou Mazaud) and John Getz (Jerry).

By JANET MASLIN

B movies used to look cheaper than their higher-class counterparts, but today they can have the antiseptically affluent look of a television show. Not to mention the cast: "A Passion to Kill" stars Scott Bakula ("Quantum Leap") as a California psychiatrist who falls for his best friend's wife (Chelsea Field, the mom in "Andre," the summer's petseal movie) despite the warnings of his ex-girlfriend (Sheila Kelley of "L.A. Law"). "A Passion to Kill" also has the abundance of close-ups and medium shots that suggest television or video-is its natural home.

It does have a B-movie screenplay (by William Delligan) with some inadvertent merriment. The fun is enhanced because we know Diana (Ms. Field) to be a knife-wielding psycho and David (Mr. Bakula), despite his psychiatric training, hasn't a clue. David seems to be better at racquet sports and drinking orange juice out of the carton than he is at fathoming the mysteries of the human mind.

"Ever been in therapy?" David asks Diana one day.

"Oh God, no, not me," Diana replies. "I'm much too ordinary." Right after this, Diana has a screaming fit and slugs her tennis coach. Then she goes to take a nap, pronouncing her tantrum "nothing a little Valium won't cure."

Even though the look of "A Passion to Kill" is so non-noir that the flowery curtains at Diana's house match the wallpaper, it does embroil Diana and David in an illicit affair that leads to murder. David deserves an extra-special grapefruit and a free set of Raymond Chandler for agreeing to say Diana was in bed with him on the night of the killing so the police will know she was sleeping with her best friend's husband. "The more involved they think we are," he reasons, "the more they'll believe our alibi."

The film's only reasonable performance comes from Ms. Kelley, as the old girlfriend who conveniently turns out to be a district attorney once the story turns to murder. Ms. Field models skin-tight costumes in a film whose only departure from TV-movie format is more graphic sex. She also makes a perfect Beverly Hills exit: "If you'll excuse me, I do have to talk to our chef."

Mr. Bakula looks hunky but sheepish, saying his lines perfunctorily but posing for the camera in a practiced, photogenic way. Also in the cast is France Nuyen, as a colleague of David's who tries to anaylze his awfully simple problems. The director, Rick King, takes his one stylistic chance by resorting to a hand-held camera during a drunk scene. Otherwise, it's by the numbers.

"A Passion to Kill" is rated R (Under 17 requires accompanying parent or adult guardian). It includes profanity, brief violence, sexual situations and nudity.

1994 N 4, C10:5

Critic's Choice

Still Scary, Now in Mint Condition

Sometimes a cigar isn't just a cigar: for instance, when Stanley Kubrick's camera gazes up at the face of Gen. Jack D. Ripper (Sterling Hayden), the militaristic madman obsessed with "precious bodily fluids" and casually responsible for having triggered Armageddon in "Dr. Strangelove." The cigar-chomping general offers a hilarious if unsubtle image of masculine paranoia, which took on epic proportions in Mr. Kubrick's scathing doomsday comedy.

In a post-cold war climate, "Dr. Strangelove" remains a supremely scary classic. Thirty years have done little to date its rogues' gallery of guided missiles and

Peter Sellers in the 1964 black comedy "Dr. Strangelove."

misguided commanders, all of them conspiring to destroy the world in the most businesslike possible fashion. Kubrick's chilliness remains every bit as disturbing as the threat of nuclear war, but it also inspires awe. So does the fact that with a fastidiousness some of his own characters might have appreciated, Mr. Kubrick has rephotographed every frame of this film with a Nikon camera to create a mint-condition print for its 30th anniversary.

Beginning a two-week run today at the Film Forum, 209 West Houston Street in the South Village, (212) 727-8110, this restored "Strangelove" returns to the squarish 1.66:1 ratio Kubrick originally intended, with more detail now visible at the top and bottom of the screen. The print is also so breathtakingly sharp that every last light in the Pentagon's War Room shines clearly, with the film maker's brilliant compositional sense more obvious in every scene. The pristine quality is enhanced by the utter absence of the special effects audiences now take for granted. Mr. Kubrick needed only a cockpit, a few dials and some cloud shots to signal some of the most heart-stopping military maneuvers ever found on screen.

But if "Dr. Strangelove" is the most warmly remembered of cold war artifacts, thank its pitch-black humor. Each savage caricature here is remembered for a few landmark lines (George C. Scott's Gen. Buck Turgidson, on projected nuclear casualties in the tens of millions: "I don't say we wouldn't get our hair mussed.") But the performances are even better when seen in full, and Peter Sellers's three-role tour de force is more devastating than ever. Be sure to notice the least familiar of his three characters, R.A.F. Group Capt. Lionel Mandrake, who sounds like the voice of reason beside Sellers's eerily recognizable Strangelove and his milquetoast President.

Not seen: the War Room custard-pie fight with which Kubrick originally intended this film to end. Mr. Kubrick finally realized that mushroom clouds and sardonic music were enough to send "Dr. Strangelove" to its place in history. And the film maker, unlike his characters, had the sense to stop short of disaster.

JANET MASLIN

1994 N 4, C14:1

Critic's Choice

Calm During a Storm: Celebrating Bresson

These days, Robert Bresson may be the least-shown of master film makers. His signature style is the clear-sighted film that serenely explores emotional and social upheavals, like "Diary of a Country Priest," the 1950 tale of a quiet priest's religious crises. "The Devil, Probably" is a late, little-known Bresson film that takes the same calm approach to a world crumbling from the inside out. The film was shown at the 1977 New York Film Festival, then virtually disappeared from the United States until today, when it begins a weeklong run at the Walter Reade Theater at Lincoln Center.

The film, set in contemporary Paris, begins with a newspaper account of a young man's suicide, then flashes back to the final six months of his life. Charles is 20 and in despair over a meaningless life. With his head hanging down, and his long hair parted in the center and hanging over his face like curtains, he seems a fragile, Christ-like creature. He has lost interest in the causes that consume his closest friends. One leads an environmental group; another hands out anti-clerical pamphlets in church. And when Charles finally sees a psychiatrist, the advice he gets is the most dangerous of all. Who controls such a world? "The

devil, probably," says a man on a bus engaged in a typical Bressonian philosophical argument.

As in Mr. Bresson's best work, his main character embodies the social currents swirling around him rather than artificially symbolizing them. As Vincent Canby wrote in The New York Times when the film was shown in 1977, " 'The Devil, Probably' has the air of something out of the 1960's in that it recalls a time when dropping out was so fashionable it was virtually epidemic among the young of the bourgeoisie." That remains true today. The film was a period piece, in the best sense, when it was new, capturing the spirit of an age distant enough to seem like history but near enough to be still shedding its influence on the present.

Mr. Bresson, now 87, has made only 13 features in his long career and only one more after "The Devil, Probably" ("L'Argent," from 1983). Here is a chance to fill in an important piece of his rigorous, rewarding career. (Tickets are $7.50; $5 for members of the Film Society of Lincoln Center; $4 for children and the elderly for weekday matinees. Screening times and information: (212) 875-5601.)

CARYN JAMES

1994 N 4, C14:5

FLOUNDERING

Written, produced and directed by Peter McCarthy; director of photography, Denis Maloney; edited by Dody Dorn and Mr. McCarthy; music by Pray for Rain; production designer, Cecilia Montiel; released by Strand Releasing. At Quad Cinema, 13th Street west of Fifth Avenue, Greenwich Village. Running time: 97 minutes. This film is not rated.
WITH: James Le Gros (John), Chief Fence (Nelson Lyon), Steve Buscemi (Ned), John Cusack (JC), Ethan Hawke (Jimmy), and Sy Richardson (Commander K).

By STEPHEN HOLDEN

"Am I losing my mind? Am I sick?" worries John Boyz (James Le Gros), the unemployed, 30-something narrator of Peter McCarthy's brave but misguided contemporary satire, "Floundering." The Los Angeles riots have barely subsided, and John, who lives in Venice Beach, is haunted by what he calls a "pervasive feeling of doom." His edgy mood is made worse by his morbid habit of obsessively replaying his own home-made videotapes of the riots. Prominently featured in those videos is Merryl Fence (Nelson Lyon), a Los Angeles police chief who suggests a monstrous caricature of the real-life Daryl F. Gates.

John seems almost eager for disaster to strike, and on one especially terrible day it finally does. In the space of a few hours, he discovers that the Internal Revenue Service has put a lien on his savings account, his unemployment compensation has run out, and his brother has fled a drug rehabilitation clinic. Seeking solace from his girlfriend, Jessica (Lisa Zane), he finds her in bed with another man.

John begins losing his grip on reality, and as he does, the movie slips back and forth between reality and fantasy in a way that thoroughly mixes them up. Voices in John's television set address him. His dead parents appear at his bedside and advise prayer. John's descent accelerates when he joins some crack-smoking revolutionaries in front of his apartment building, takes a toke on a pipe, and winds up passed out on the sidewalk for hours while pedestrians gleefully strip him of his valuables. But somehow he is able to muster one last burst of spirit.

The movie, which has several frank sex scenes and profanity, eventually turns into an exhilarated daydream in which the poor and downtrodden of Los Angeles have miraculously organized into a revolutionary army, and John finds love with a woman he has kidnapped. The late-blooming love story seems tacked on and completely out of character.

"Floundering," which opens today at the Quad, is the directorial debut of Mr. McCarthy, a producer associated with such cult favorites as "Repo Man," "Sid and Nancy" and "Tapeheads." The movie, which includes vivid cameo performances by John Cusack, Ethan Hawke and Steve Buscemi, as well as appearances by rock performers like David M. Navarro, Exene Cervenka and Zander Schloss in acting roles, wants to be something like the slacker generation's answer to "Easy Rider."

In the movie's vague but impassioned us-and-them view of Los An-

geles, the "us" are symbolized by a Hispanic woman who supports her family collecting soda cans in John's neighborhood. Representing "them" are the fulminating police chief whom John fantasizes assassinating and a smug businessman friend who refuses to lend him money.

Almost everybody in "Floundering" has a pet theory about what's wrong with Los Angeles and a drastic remedy for curing the city's ills. Mr. McCarthy's screenplay includes so many speeches on the subject that the film often takes on the emotionally frustrated tone of a radio talk show. Because the speechifying lacks the cutting comic edge that distinguishes good satire, "Floundering" too often blubbers when it should be viciously funny.

1994 N 4, C15:3

DOUBLE DRAGON

Directed by James Yukich; written by Michael Davis and Peter Gould; director of photography, Gary Kibbe; edited by Florent Retz; music by Jay Ferguson; production designer, Mayne Berke; produced by Sunil R. Shah, Ash R. Shah and Alan Schecter; released by Gramercy Pictures. Running time: 99 minutes. This film is rated PG-13.
WITH: Robert Patrick (Koga Shuko), Mark Dacascos (Jimmy Lee), Scott Wolf (Billy Lee) and Kristina Malandro Wagner (Linda Lash).

By STEPHEN HOLDEN

It is the year 2007, and what was once Los Angeles is now a gruesome post-earthquake trash heap rechristened New Angeles. Seven years earlier, the Big One struck, reducing the city to rubble. The Capitol Records tower sags like a twisted accordion. Hollywood Boulevard has become the highly flammable Hollywood River, and curbside oxygen booths provide the only relief from the suffocating smog.

Although order has been partially restored, by night the city is ruled by outlaw gangs of punkish monsters pumped up on steroids. Each day's horrors are reported on television by the smiling news anchors Vanna White and George Hamilton. Madonna has just left Tom Arnold and moved to Paris, they report: "She wants to be alone."

Although these scene-setting futuristic details have some humorous promise, "Double Dragon," the movie they embellish, is an incoherent children's adventure based on a popular video game. The movie follows the adventures of two orphaned teenage brothers, Jimmy (Mark Dacascos) and Billy (Scott Wolf), who drive around the city in a flame-shooting station wagon fueled by garbage.

When the brothers' guardian entrusts them with half of an ancient Chinese medallion that has magical powers, they find themselves menaced by Koga Shuko (Robert Patrick), the ruthless tycoon who possesses the other half. Koga Shuko's part controls the body, and he knows how to use it. The brothers have no idea how to unleash the power of their half, which controls the soul. Koga Shuko, needless to say, wants both for himself.

"Double Dragon" is a movie of frantic action and clever special effects. The niftiest is the way Koga Shuko dissolves himself into a shadow that scoots along the floor and enters other people's bodies at will.

The director James Yukich, who comes from the world of music video, has given the film a jumpy nonstop energy that overrides the script's incongruities and the amateurish performances by the two leading actors. Every once in a while, the film pointedly reminds the viewer of its source by momentarily turning into a video game.

If "Double Dragon" doesn't look or feel as if it were set in Los Angeles, despite its use of scale-model Hollywood landmarks, that's because it wasn't filmed there. It was made in Cleveland.

"Double Dragon" is rated PG-13 (Parents strongly cautioned). It includes some violence.

1994 N 4, C19:1

OLEANNA

Written and directed by David Mamet, based on his play; director of photography, Andrzej Sekula; edited by Barbara Tulliver; music by Rebecca Pidgeon; production designers, David Wasco and Sandy Reynolds Wasco; produced by Patricia Wolff and Sarah Green; released by the Samuel Goldwyn Company. Running time: 90 minutes. This film is not rated.
WITH: William H. Macy (John) and Debra Eisenstadt (Carol).

By CARYN JAMES

For David Mamet, conversation is a blood sport and words are lethal weapons. In "Oleanna," his incendiary play about sexual harassment, a college student and her professor pace around his office hurling words at each other, actions that inspired knock-down-drag-out verbal fights in theater lobbies when the play was first produced. But that was in 1992, when the Clarence Thomas-Anita Hill hearings were still fresh in our minds. Since then, sexual harassment has sometimes dominated the news, as in the Tailhook and West Point scandals, or in Paula Jones's accusations against President Clinton. And the issue has even become fodder for popular entertainment, as in Michael Crichton's best-selling novel "Disclosure," coming up as a Christmas movie.

Now this faithful, flat-footed screen version, directed by Mr. Mamet, offers a reminder that "Oleanna" was always more effective as a debate topic than a work of drama. Its two characters, Carol and John, are puppets manipulated by their creator, which makes "Oleanna" less volatile today than when it was the only sexual-harassment game in town.

As in the play, Carol and John have three extended meetings, their roles reversing a bit more with each encounter. She begins as a confused young thing, failing his course and wailing, "I don't understand." He is the voice of sympathetic, if impatient, authority. They discuss pedagogy. She says she feels stupid; he tells her he once felt so insecure he

Samuel Goldwyn Company
Debra Eisenstadt and William H. Macy in a scene from "Oleanna."

judged his normalcy against a story that rich people have sex less frequently than poor people, but take off more of their clothes.

Carol's next visit takes place after she has filed a complaint with the tenure committee, including charges that John told her a pornographic story. By the third visit, John is drinking and looks disheveled. Carol has assumed an air of power and has accused John of trying to rape her, a charge we know to be untrue.

Recreating his stage role, William H. Macy is by far the best part of the film. He gives John the precise enunciation of a pedant, yet as the camera moves in on his face he reveals the confusion behind the eyes. In his subtle, powerful performance, Mr. Macy, the perfect Mamet actor, makes it clear that John's youthful insecurities are still lurking beneath the teacher's superior posture. John is no hero, but at worst he is a bad teacher and an egotist, guilty of poor judgment. Yet by the end the heavy hand of Mr. Mamet has pushed the character into behavior that supports Carol's view of him as a villain.

As in the play, Carol is the film's deep, inescapable flaw. As her charges against John escalate, "Oleanna" allows for only two possibilities: she is viciously manipulative or seriously self-deluded. Mr. Mamet has loaded the drama so that she cannot be right, a dramatic strategy that shifts the focus away from the slippery he said-she said of sexual harassment and toward Carol's underwritten state of mind. As Carol, Debra Eisenstadt wisely doesn't tip the scales toward lunacy or power lust, but the role itself is hopelessly vague.

Mr. Mamet can be a first-rate film maker, and in works like "House of Games" and "Homicide" he trusts language as much as he relies on small, subtle camera movements. Here both the language and Mr. Mamet's film making let him down.

Instead of setting the action entirely in John's office, the film occasionally follows them as they walk down a corridor, or briefly puts John alone after a party in the new house he hopes to buy. This compromise neither enlivens the action nor reproduces the intentional claustrophobia of the one-set play.

There is the typical Mamet barrage of stylized language, full of interruptions, repeated phrases and the kind of formal diction that works only in Mr. Mamet's closed world. "What do you want of me?" Carol asks. But often the language is too feeble and abstract to carry its load of passion. "You think I want revenge?" Carol says toward the end.

"I don't want revenge. I want understanding."

And the film is so shadowy-looking that at times half the characters' faces are obscured. (It's no use arguing that this reflects ambiguity; there's a problem if we're straining to see a character's eyes.)

What is intriguing about "Oleanna" today is how quickly its moment passed.

1994 N 4, C22:4

ANCHORESS

Directed by Chris Newby; written by Judith Stanley-Smith and Christine Watkins; director of photography, Michel Baudour; edited by Brand Thumim; production designer, Niek Kortekaas; produced by Paul Breuls and Ben Gibson; released by International Film Circuit in association with Upstate Films. Film Forum, 209 Houston Street, South Village. Running time: 108 minutes. This film is not rated.
WITH: Natalie Morse (Christine Carpenter), Eugene Bervoets (Reeve), Toyah Willcox (Pauline Carpenter), Peter Postlethwaite (William Carpenter) and Christopher Eccleston (Priest).

By CARYN JAMES

Withdrawing from the medieval world to devote herself to the Virgin Mary, a young woman named Christine happily chooses to be forever walled into a tiny room adjoining the church. As the last stone is put in place, "Anchoress" creates a chilling sense of entrapment while making the young woman's sense of relief and escape clear. Now she won't have to marry the reeve, the belligerent overseer of the manor where Christine, her sister and their parents sleep in a single bed in their thatched cottage. At times "Anchoress," an eccentric, beautifully photographed black-and-white film, offers an eerie immersion in a distant world.

In his first feature, the English director Chris Newby deftly carries our century's attitudes about spiritual freedom and feminism into an artfully constructed past in which

such attitudes came from the Devil. The story is based on scant historical references to the real Anchoress of Shere. Two letters written on a church wall in the English countryside tell of Christine Carpenter, who escaped from the world only to long for it again. The film's Christine (Natalie Morse) is like an emotional time traveler, a bridge between our attitudes and those of the 14th century.

Like a modern re-creation of a medieval pageant, "Anchoress" is stylized, the bluish black-and-white images creating poetic tableaux. At the start, Christine stands alone in an overgrown wheat field and glimpses in the distance a new statue of the Virgin being carried to church. Later, in veneration, she and her sister steal apples and arrange them in sunlike rays on the floor at the statue's feet.

Convincing the priest of her devotion, Christine becomes an anchoress, much to the horror of her mother (Toyah Willcox), whose lingering paganism causes her to pour liquor on the ground to feed Mother Earth. Christine's father (Peter Postlethwaite, who played Daniel Day-Lewis's father in "In the Name of the Father") is convinced that his wife has become intimate with a goat, the final sign of her witchery.

In such times, a girl could do worse than retreat to the life of an anchoress. Isolated in her cell, Christine is considered a wise woman. Food and flowers are left outside her window, and local men and women come to her for advice. Yet when she embroiders an altar cloth that shows the Virgin's robes red instead of blue, the hypocritical, power-mad priest insists that she stop this rebellion. Eventually, Christine's eyes are opened to all she has lost, and she plans an escape that will damn her soul.

"Anchoress," which opens today at Film Forum, is a film of great stillness and at times near silence. There is no background music to cue the emotions, and the dialogue is spare. Yet at times it becomes a bit

Film Forum
Natalie Morse embraces entrapment, then plans her escape.

precious and too Bergmanesque for its own good. "Anchoress" evokes the style of Ingmar Bergman's medieval tales, "The Virgin Spring" and "The Seventh Seal," without their emotional power. Still, this eloquent film brims with its own daring and artistic conviction.

1994 N 9, C12:1

INTERVIEW WITH THE VAMPIRE

Directed by Neil Jordan; written by Anne Rice, based on her novel; director of photography, Philippe Rousselot; edited by Mick Audsley and Joke Van Wijk; music by Elliot Goldenthal; production designer, Dante Ferretti; produced by Stephen Woolley and David Geffen; released by Geffen Pictures. Running time: 120 minutes. This film is rated R.

WITH: Tom Cruise (Lestat), Brad Pitt (Louis), Christian Slater (Malloy), Kirsten Dunst (Claudia), Stephen Rea (Santiago) and Antonio Banderas (Armand).

By JANET MASLIN

EROTICISM bubbles beneath the surface of every vampire story, but Anne Rice is a writer to make the pot boil. Ms. Rice's hothouse blend of pretension, swooning seduction and avidly sensual horror has brought strikingly contemporary nuances to the vampire genre, infusing it with the literary equivalent of new blood. Her dense, suffocating novels have done as much to plumb old mysteries of the occult as to create new ones atop the best-seller list — but that's another story.

Ms. Rice once insisted publicly that her heady brew could not possibly be captured on film, at least not in a film directed by Neil Jordan and starring a noted nonvampire like Tom Cruise. Now rightfully eating her hat over such pronouncements, she ought to be the most appreciative viewer that Mr. Jordan's "Interview With the Vampire" has. His sumptuous film is as strange and mesmerizing as it is imaginatively ghastly. It's a sophisticated, spookily intense rendering of Ms. Rice's story.

This film is so faithful that during an unusually gruesome season for mainstream movies "Interview With the Vampire" will strike the hottest sparks of controversy. No less an arbiter of popular tastes than Oprah Winfrey has conspicuously walked out of a screening, even if it could be argued that this film is hardly more sickening than the routine content of daytime talk shows.

But as Ms. Rice's readers know, "Interview With the Vampire" is strong stuff: bloodletting, wanton cruelty, innocent victims, even the sight of Mr. Cruise sinking his teeth heartily into a rat. In terms of flouting middle-of-the-road values, the film also takes the frankly homoerotic overtones of Ms. Rice's novel and makes them more so. There may be times when even the most admiring viewer longs for something comparatively tame — say, the transvestite hairdresser of Mr. Jordan's "Crying Game" — for a change of pace.

Talk about risky business: here is the most clean-cut of American movie stars, decked out in ruffles and long blond wig, gliding insinuatingly through a tale in which he spiritually seduces another foppish, pretty young man. And here is the surprise: Mr. Cruise is flabbergastingly right for this role. The vampire Lestat, the most commanding and teasingly malicious of Ms. Rice's creations, brings out in Mr. Cruise a fiery, mature sexual magnetism he has not previously displayed on screen.

Except for a few angry outbursts here, there are no signs of the actor's usual boyishness. Instead, adopting a worldly manner and an exquisite otherworldly look, he transforms himself into a darkly captivating roué who's seen it all. "In Paris, a vampire must be clever for many reasons," he sighs, during the part of the film that is set in Louisiana. "Here all one needs is a pair of fangs."

Lestat's main prey in "Interview With the Vampire" is a handsome lost soul named Louis (a lofty, impassive Brad Pitt), who Lestat thinks will make the perfect protégé. As Louis narrates this story two centuries later, during the interview of the title (with Christian Slater asking the questions), he explains how Lestat first found him late in the 18th century, while Louis's life was at a particularly low ebb. Lestat was attracted both by Louis's good looks and by his large plantation (this kind of motivational point is much clearer in Ms. Rice's novel). So Lestat puts him out of his misery with a killer's kiss.

This shocker of a neck-biting embrace is the film's first. And Mr. Jordan gives it a vibrant sexual energy that sends the two men hurtling toward the heavens. The film then brings Louis into the ranks of the undead and locks these two into a family unit with Claudia (the precocious Kirsten Dunst), who looks like a little girl but develops the most scheming mind in this story. Entertainingly staged by Mr. Jordan, this two-men-and-a-baby section manages to be both playful and bonechilling. "Interview With the Vampire" promises a constantly surprising vampire story and it keeps that promise.

The film begins perfunctorily with a tracking shot into the San Francisco hotel room where Louis is interviewed. It neither has nor needs much introduction. Understandably, Mr. Jordan adopts a take-it-or-leave-it attitude toward an absurdly snobbish, self-important tale that doesn't make great sense and seldom works as metaphor (although, of course, its mingling of blood, sexuality and danger evokes thoughts of AIDS). The film never condemns its characters' murderousness nor thinks a thought deeper than "we must be powerful, beautiful and without regret."

Instead, its power is visceral. The single most haunting image is that of a prostitute who emerges from Lestat's embrace with a look of rapture on her face, only to register a slow-dawning terror as she sees that her gown is drenched in blood. Mr. Jordan, whose facility with startling erotic effects was well established by "The Crying Game," displays much the same ability to unnerve viewers while working in a style that expands upon "The Company of Wolves," his earlier film in a supernatural vein.

By the later part of "Interview With the Vampire," after the ménage has exploded disastrously and the story has moved to Paris, this material's many affectations temporarily run amok. As the smoldering head of an all-vampire theatrical company, Antonio Banderas makes one more pretty, posturing figure than the story needs. And Stephen Rea is underused as a puckish actor with the troupe, even if the film's special-effects wizards find time to hand him a grisly fate. Later, the film recoups its energy with a witty present-day ending that should send viewers out of the theater humming the perfect theme song.

Humming the costumes (by Sandy Powell) and production design (by Dante Ferretti) is almost as possible, since this film's impact is heightened by extraordinary technical contributions. Philippe Rousselot's cinematography creates an exceptionally inviting, varied look for this nocturnal story, and special visual effects are smoothly integrated into the action. The makeup that adds pale eyes, ghostly pallor and tiny blue veins to the principals' faces manages to create a frisson of danger without marring the actors' attractiveness. These guys may be undead, but they're drop-dead, too.

"Interview With the Vampire" is rated R (Under 17 requires accompanying parent or adult guardian). It includes violence, scenes in which blood is sapped from murder victims, horrific special effects and nonsexual scenes with unmistakable sexual overtones.

1994 N 11, C1:3

AN UNFORGETTABLE SUMMER

Written and directed by Lucian Pintilie, in Romanian, French and English with English subtitles; based on the short story "La Salade" by Petru Dumitriu; director of photography, Calin Ghibu; edited by Victorita Nae; music by Anton Suteu; production designer, Titi Popescu; produced by Mr. Pintilie; released by MK2 Productions USA. Running time: 82 minutes. This film is not rated.

Demon In "Interview With the Vampire," Tom Cruise plays Lestat, a 200-year-old French vampire who moves to New Orleans and makes a new vampire, who eventually talks to a reporter.

François Duhamel/Warner Brothers

François Duhamel/Warner Brothers

Brad Pitt

WITH: Kristin Scott-Thomas (Marie-Thérèse Von Debretsy Dumitriu), Claudiu Bleont (Capt. Petre Dumitriu), Olga Tudorache (Madame Vorvoreanu) and George Constantin (General Tchilibia).

By CARYN JAMES

To appreciate "An Unforgettable Summer," it helps to dismiss the mawkish, romance-novel title. Set in Romania in 1925, the film begins with scenes of cosmopolitan decadence, jazz-age glamour and fierce political undercurrents. On their way to a glittering, fancy-dress ball, Romanian army officers stop by a brothel, where they beat the women yelling antimilitary slogans at them. Next, Kristin Scott-Thomas (the sophisticate from "Four Weddings and a Funeral") arrives at the ball. She plays the beautiful, elegant Marie-Thérèse Von Debretsy Dumitriu, a woman with bobbed hair, diaphanous dresses and an unaccountably graceful smile. As Marie-Thérèse dances, an elderly relative at the party describes her background.

Her wealthy father turned over his land to the Communists when the revolution approached, but was killed anyway, and Marie-Thérèse was saved from poverty by her marriage to Petre Dumitriu (Claudiu Bleont), a short, fussy officer with a monocle. Raised in London, she speaks, as her relative points out, "perfect Romanian with a ghastly Oxford accent." Her life is soon to change again, but her elegance never leaves her or this evocative film by Lucian Pintilie. Like its heroine, the film's serene and beautiful appearance masks a powerful conscience.

Mr. Pintilie's last film, "The Oak," was an absorbing, complicated black comedy about Romania at the end of the Ceausescu regime. "An Unforgettable Summer" is simpler, often lyrical and far more accessible. Yet together these strong-minded, stylish films form bookends about the beginning and end of Communism in Romania.

When Marie-Thérèse rejects the advances of her husband's superior officer, Petre is transferred and put in command at an isolated border town in southern Romania, where most of the film is set. The Dumi-

trius arrive in this parched landscape with their three small children, a nanny and a harpsichord, on which Marie-Thérèse plays Mozart. "Don't regret marrying me," Petre says more than once. "We won't be here long." Marie-Thérèse's unwavering reply is, "I like it here."

Yet she ignores the signs of trouble that carry Mr. Pintilie's brutal message about death in the endless Balkan struggles for borders and power. Mud is thrown at the door of the family cottage. A rock is thrown through the window, shattering a mirror. Much worse, border bandits kill and mutilate Romanian soldiers.

No one can identify the bandits, but the officers assume they were Macedonians, perhaps of Bulgarian background. So Petre is ordered to round up a group of Bulgarian peasants, probably innocent of the attack, and execute them as a warning. The Bulgarians tend the Dumitrius' garden while Petre stalls, struggling to choose between what he knows to be right and the high cost of defiance. Marie-Thérèse serves them tea, insists on paying them for their work and offers naïve assurances that they will soon be released.

"An Unforgettable Summer" would have been more trenchant if

Petre's character had been more fully developed. But Marie-Thérèse is, deliberately, the apolitical soul of the film, shifting the focus from politics to the humanity that transcends border disputes and ethnic loyalties. Ms. Scott-Thomas makes the film work because she shows Marie-Thérèse to be something other than a shallow woman playing Lady Bountiful. She is sincere, rather helpless and, finally, shaken with disillusionment. Neither pure heroine nor villain, by the end she is unable to escape the murderous impact of politics.

The film begins and ends with a narrative by Marie-Thérèse's now-grown son, looking back at that unforgettable summer. The device offers an ironic update on her character, but otherwise doesn't add anything to the film. Yet the narrative is so brief it doesn't do much harm either. Mr. Pintilie lived in exile for 20 years, concentrating on theater before returning to Romania to make "The Oak." His return has added a significant name to the list of world film makers.

1994 N 11, C12:1

New York, Shown at Its Best Through a Hero at His Worst

"Manhattan by Numbers" was shown as part of the 1993 New Directors/New Films series. Following are excerpts from Vincent Canby's review, which appeared in The New York Times on April 2, 1993. The film opens today at the Quad Cinema, 13th Street west of Fifth Avenue, Greenwich Village.

Amir Naderi's "Manhattan by Numbers" is a quite beautiful if uninvolving exercise in urban alienation, prettily shot against a variety of photogenic New York locations.

In the course of a single day, George Murphy (John Wojda), a youngish out-of-work newspaper reporter, desperately crisscrosses Manhattan in a futile hunt for $1,200

to pay the back rent on his apartment. George is about to be evicted, and his life is collapsing. His wife has left him, taking their child. He's out of touch with former colleagues.

In his need to find the money, he searches for Tom, a long-lost friend who becomes as elusive as the grail. Many mutual friends have seen Tom recently, but either they have forgotten where, or Tom has departed when George arrives at the place. The search for Tom doesn't narrow; it widens. It turns into a search for Tom's apartment superintendent, for his other friends, for his wife.

It's quickly obvious that Mr. Naderi, who wrote, directed and edited the film, regards the search as an

end in itself, although the unfortunate George continues to push on. That much is clear almost from the start of the film. "Manhattan by Numbers" is less concerned with conventional narrative than with evoking a state of mind and a sense of place.

Yet Mr. Naderi's manner of evoking a sense of place overwhelms George's state of mind. The film's images are so pristine, and so perfectly chosen to create a cross section of the city, that poor George, who looks handsome and untouched by care, becomes a tiny cipher at the center of the screen. He's a mobile model surrounded by scenery. The film's poetic concerns seem to have little to do with the elegance of its techniques.

"Manhattan by Numbers" is the first English-language feature by the Iranian-born film maker, whose "Water, Wind, Sand" was presented at the New Directors/New Films series in 1990.

1994 N 11, C12:5

PONTIAC MOON

Directed by Peter Medak; written by Finn Taylor and Jeffrey Brown; director of photography, Thomas Kloss; edited by Anne V. Coates; music by Randy Edelman; production designer, Jeffrey Beecroft; produced by Robert Schaffel and Youssef Vahabzadeh; released by Paramount Pictures. Running time: 108 minutes. At Sony Theaters New York Twin, Second Avenue at 66th Street, Manhattan. This film is rated PG-13.

WITH: Ted Danson (Washington Bellamy), Mary Steenburgen (Katherine Bellamy), Ryan Todd (Andy Bellamy) and Cathy Moriarty (Lorraine).

By JANET MASLIN

At least "Pontiac Moon" is what it sounds like: a movie about a Pontiac and about the moon. If there is anything else pleasant to be said, it's that the car is a cream-colored 1949 Pontiac Chief convertible in excellent condition. Both it and the moon look nice.

Now then: the film contrives a connection between the car and the Apollo XI moon shot. The idea is that because the car's odometer has almost reached the 238,857 miles the astronauts will traverse on their trip to the moon, driving the car the remaining distance will become a meaningful symbolic gesture. With typical understatement, this plan is referred to as "one perfect act" and culminates in "that day the universe was reborn."

The scheme is explained by Ted Danson, who plays a pontificating, shaggy-haired science teacher named Washington Bellamy. In this role, Mr. Danson waves his cane excitably, rhapsodizes about science, addresses a bartender as "noble barkeep" and speaks as if every line ended with an exclamation point ("Life! It's passing you by!"). That may be all you need to know.

Washington decides to take his son (Ryan Todd) on the requisite four-day road trip ("This is our chance, Andy! Our chance to be part of something!"). He leaves behind his timid, agoraphobic wife (Mary Steenburgen), who once turned down a date with John F. Kennedy, now

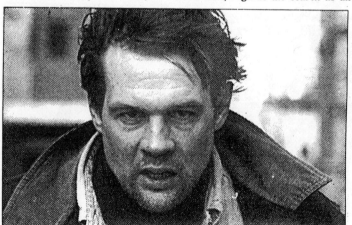

Seeker In "Manhattan by Numbers," John Wojda plays an unemployed newspaper reporter in New York who needs $1,200 for back rent and ends up searching the city for an old friend.

MK2 Productions
Kristin Scott-Thomas

dresses like Jackie and takes off in a cute little car on a cute little voyage-of-discovery of her own.

Some things to be sure of: the wife will experience a personality and fashion make-over. All vehicles will pass through Monument Valley. A terrible secret will be revealed, in this case one that involves an earlier car crash. "Funny thing was, it was a fruit truck," one character says about this. "So when we were crushed against the retaining wall, we were covered in blackberries." The screenplay, equally heavy on broad comedy and sensitive musings, is by Finn Taylor and Jeffrey Brown.

During the course of this story, Washington Bellamy manages to quote Robert Frost on the road not taken when he reaches a traffic intersection. He also stands up in a honky-tonk and sings "Cheek to Cheek." He meets a waitress with a heart of gold (Cathy Moriarty). There is also quite a bit of wistful gazing at the moonlit sky, and a comparison between the whims of human nature and the dependability of a steering wheel.

"Pontiac Moon," which opens today at Sony Theaters New York Twin, was directed by Peter Medak ("The Krays," "Romeo Is Bleeding"), who certainly fares better with tougher material than he does in this ultrawhimsical vein. The music booms, the actors all overplay and the journey feels long enough for a real trip to the moon.

"Pontiac Moon" is rated PG-13 (Parents strongly cautioned). It includes mild profanity.

1994 N 11, C18:3

DINGO

Directed by Rolf de Heer; written by Marc Rosenberg; director of photography, Denis Lenoir; edited by Suresh Ayyar; music by Michel Legrand and Miles Davis; production designer, Judith Russell; produced by Mr. de Heer, Giorgio Draskovic, Marie-Pascale Osterrieth and Mr. Rosenberg; released by Greycat Films. At Cinema Village, 22 East 12th Street, East Village. Running time: 108 minutes. This film is not rated.

WITH: Colin Friels (John Anderson), Miles Davis (Billy Cross), Helen Buday (Jane Anderson), Joe Petruzzi (Peter) and Bernadette Lafont (Angie Cross).

By STEPHEN HOLDEN

One day in the remote Australian village of Poona Flat, strange music drops out of the sky, and a little boy named John Anderson has an epiphany. It is 1969. A cargo plane carrying members of a jazz ensemble has been diverted to the outback for an unscheduled layover. As the villagers stare, dumbfounded, seven musicians file onto the runway and give an impromptu jazz concert. John is riveted by the sounds coming from the trumpet of the group's lead player, Billy Cross (Miles Davis). "You seemed tuned into it," Billy tells the star-struck boy afterward. "If you ever come to Paris, look me up."

So begins Rolf de Heers's film "Dingo," a wildly romantic story about a jazz musician in pursuit of his muse. The 1991 film, which opens

a two-week engagement today at Cinema Village, jumps forward two decades. John (Colin Friels), now married and the father of two girls, ekes out a living trapping the Australian wild dogs known as dingos. A largely self-taught trumpeter who has learned the instrument by studying Billy Cross records, he plays on weekends with a local "bush band," whose skiffle-style rock-and-roll has nothing to do with jazz. Alone in the desert, he aims his instrument at the sky and produces lonely warbling doglike cries that echo the sounds of his idol's records, and earn him the nickname Dingo.

John, who corresponds with Billy's agent, has secretly saved $3,000 for a trip to Paris to reunite with his boyhood idol. In the last third of the movie, when he makes the trip, the film changes from a gritty portrait of a talented musician's frustrated life in the Australian boondocks into a starry-eyed fantasy of the jazz life in Paris. Within hours of his arrival, not only does John find himself treated like Billy's long-lost soul mate, he also wows the audience at an improbable jam session in a smart Parisian club.

"Dingo," which switches abruptly back and forth between Australia and Paris, is a film with a seriously split personality. Just when the scenes of Billy playing in the local band, trapping dingos and squabbling with his wife, Jane (Helen Buday), have begun to cohere into a pungent portrait of Australian rural life, the movie fantasizes the Parisian jazz life as a millionaire's dream world. Despite strong, volatile performances by Mr. Friels and Ms. Buday, neither half of the story ultimately gets its due. And a subplot in which Jane is tempted to run off with her husband's wealthy childhood pal Peter (Joe Petruzzi) seems extraneous.

In his dramatic-film debut, Davis, who died in September 1991, suggests an eccentric variation of his famously reclusive, enigmatic self. Sartorially eccentric and glowering through sunglasses with gold-studded frames, he delivers his lines in a gravelly whisper, with no facial expression at all.

Although the film's discontinuities are somewhat redeemed by its score, composed by Michel Legrand and Davis, and featuring the trumpets of Davis and Chuck Findley, the music doesn't begin to make the film's two halves fit together.

1994 N 11, C19:3

THE SANTA CLAUSE

Directed by John Pasquin; written by Leo Benvenuti and Steve Rudnick; director of photography, Walt Lloyd; edited by Larry Bock; music by Michael Convertino; production designer, Carol Spier; produced by Brian Reilly, Jeffrey Silver and Robert Newmyer; released by Walt Disney Pictures. Running time: 95 minutes. This film is rated PG.

WITH: Tim Allen (Scott Calvin), Judge Reinhold (Neal), Wendy Crewson (Laura), Eric Lloyd (Charlie), David Krumholtz (Bernard) and Mary Gross (Ms. Daniels).

By JANET MASLIN

It may be early for Christmas, but it's not too early for a clever, enter-

taining children's film with a realistic edge and a minimum of seasonal mush. "The Santa Clause" easily transports Tim Allen from success on television (he is the star of "Home Improvement") to bright prospects on the big screen.

Behind Mr. Allen's rubbery-faced amiability there lurks a welcome cynicism, one that serves him well in this fresh, cheerful story. Mr. Allen plays Scott Calvin, a divorced father who finds himself unexpectedly roped into a career of delivering presents and talking to reindeer, to the surprise and delight of his young son. If Christmas is the film's nominal subject, its subtext is mending the wounds of divorce. It deals with that issue in graceful, reassuring ways.

The film begins at Christmastime, as Scott has to wrangle with his ex-wife, Laura (Wendy Crewson), and her boyfriend, Neal (Judge Reinhold), over a visit with little Charlie (Eric Lloyd). A seasonal dinner gives Mr. Allen the chance to use a fire extinguisher on a turkey, thus echoing his television routines. And a lonely Christmas meal in a restaurant, where the clientele consists of divorced dads and foreign businessmen, creates a mood of humorously evoked seasonal gloom.

Then, back home, Scott hears a noise on the roof and accidentally startles Santa, who tumbles to the ground and dies. (This scene will not frighten young children, nor will "The Santa Clause" rock their certainty that Santa exists.)

Anyway, the real Santa vanishes, leaving behind sled, reindeer, presents and an empty suit. And Scott steps temporarily into the breach, not realizing that if he puts on Santa's suit he will be abandoning "any previous identity, real or implied." Santa has put him under contract to take the job on a permanent basis, and the contract has fine print.

The rest of the film has fun with Scott's transformation into Santa, entertainingly evoked through weight gains, increasingly Christmasy costumes and smart children, like the little girl who sees him and whispers, "I want some ballet slippers." The special effects and prosthetic aids that plump up Mr. Allen are outstandingly good, and the film finds amusing ways to joke about his

diet. Early in the film, irritable about being pressed into Santa duty, he refuses Santa's traditional Christmas Eve milk and cookies "because Santa is watching his saturated fats."

Like practically every Christmas movie, "The Santa Clause" moves from skepticism to faith, but it faces some typically modern obstacles to suspending disbelief. Since Neal, Charlie's mother's boyfriend, is a psychiatrist, and since Charlie begins talking about knowing Santa, there is much trendy talk of denial and delusion regarding Scott's behavior. Even in school, Charlie can't get anyone to take him seriously. When he talks about friends from the North Pole, his teacher (Mary Gross) just smiles sweetly and corrects him: "They're little people. Don't say elves."

The film's North Pole set is a colorful treat. ("You know, I must say, you look pretty good for your age," Scott tells one elf, who looks like a little girl but is supposedly centuries old. "Thanks, but I'm seeing someone in wrapping," she answers.) And it also uses some flashy, effective morphing tricks to send Mr. Allen down chimneys and turn radiators into fireplaces for Santa's visits.

But this film's nicest touch is its sugar-free resolution of Charlie's problems with his parents, who, despite the fact that one of them has become Santa Claus, are not forced into a dishonest resolution. The story's ending avoids heavy-handedness while giving Charlie the gift he wants most in the world.

"The Santa Clause" is brightly directed by John Pasquin, whose solid television credits include "Home Improvement" and "Roseanne," and who knows how to hold an audience's interest. The screenplay is by Leo Benvenuti and Steve Rudnick, whose background in stand-up comedy keeps lively gags coming at a steady pace.

If "The Santa Clause" incorporates enough of a red-and-green color scheme without developing a cloying look, it helps that the cinematographer, Walt Lloyd, has more solemn credits, including "Short Cuts" and "Sex, Lies and Videotape." This film looks festive enough, but it also has an admirable restraint. Here is a

Attila Dory/Buena Vista Pictures

Saint In "The Santa Clause," Tim Allen plays an everyday dad who is transformed into Santa (by trying on his suit) and discovers just what a big job that is. Paige Tamada, right, is Judy, one of his elves.

savvy Christmas fable about the kind of Santa who's not always in the mood for ho-ho-hoing, and who knows he's not the only delivery game in town. The movie also makes reference to Federal Express.

"The Santa Clause" is rated PG *(Parental guidance suggested). It includes very mild profanity and no violence beyond Santa's discreetly staged fatal mishap. It's just fine for children of all ages.*

1994 N 11, C24:1

Seeking the Man Within the Monster

By CARYN JAMES

ONE VAMPIRE TO ANOTHER, Antonio Banderas looks into Brad Pitt's icy-blue eyes and sizes him up: "A vampire with a human soul."

That's not necessarily a compliment in the land of the undead, but it's accurate and goes a long way toward explaining why Neil Jordan's new movie, "Interview With the Vampire," is one of the most horrific, emotional and best films of the year. Though Tom Cruise gets star billing, this is the haunting tale of Louis (Mr. Pitt), a reluctant vampire who struggles across two centuries to retain some shred of human emotion. Changing from man to vampire, he learns to sip blood and live in the dark. ("Coffins, unfortunately, are a necessity," he tells the interviewer recording his life story.) But through it all he continues to feel love, guilt, grief; he is a vampire we can identify with.

Meanwhile, in an ice cave in "Mary Shelley's Frankenstein," Robert De Niro as the Creature looks across a fire at Kenneth Branagh as Victor Frankenstein. "What of my soul?" the monster asks his creator. "Do I have one?" Too bad for this film, he doesn't. Mary Shelley gave him one, but Mr. Branagh, who also directs, is as careless with the Creature's human soul as Frankenstein himself.

Coincidentally released back-to-back, these films illustrate what sets a great horror film apart from just another monster movie. Enduring horror films like "Interview" work because we can find the humanity in the monster, often a creature invented to defy that most terrifying of human experiences, death. Monster movies like "Mary Shelley's Frankenstein" rely on soulless beings who thump out of the dark woods, offering a mundane chill.

In "Interview" Mr. Jordan has followed Anne Rice's novel and made perfect visual choices to give his vampires an almost human look. They are pale without being Kabuki white. They have a few exaggerated blue veins showing on their foreheads and cheekbones; their irises are a bit enlarged, giving them a staring gaze. If you passed Louis on the street, you would think he looked peculiar and eerily beautiful, not a bit monstrous.

But while "Interview" is stylish, its resonance comes from the vampires' frightening emotions. The vampire Lestat (Mr. Cruise) in 1791 offers Louis the choice of dying or becoming a vampire. He drinks Lestat's blood and is transformed. Mourning his dead wife and child, Louis wanted to end his human pain but unwittingly lets himself in for more.

He is tortured at the thought of killing humans and for a long while prefers to live off the blood of rats and chickens. His human guilt is engaged in an endless battle with the vampire tendencies that lead him to admit, "I knew peace only when I killed."

The conscience-stricken Louis is wildly different from the monstrous Lestat, who revels in being a vampire and in exercising what he calls the godlike power to kill indiscriminately. Mr. Cruise's smart performance is, intentionally, campier and funnier than anything else in the film. At times Lestat seems to have wandered in from the Addams Family, telling Louis, "The Paris Opera is in town, and we can try some French cuisine." There is a strategic trade-off here. Lestat adds lightness to a film that would be unbearably intense without it, at the cost of some stylistic unity.

But Lestat's more important choices go to the heart of the film's emotional tug-of-war between Lestat and Louis. It is Lestat who turns a little girl named Claudia (Kirsten Dunst) into a child-vampire in order to keep Louis near him; he knows Louis will not abandon the orphan girl whose blood he found irresistible. And the homoerotic aspect of Lestat's attraction to Louis is clear when Lestat first drinks Louis's blood, and they rise into the air entwined like two bees mating.

As Lestat and Louis argue about the nature of being a vampire, the film indirectly explores what it means to be human as well. Vampire lore itself cuts into our thoughts two ways. It offers the promise of eternal life but also suggests there is a fate worse than death: the state of being undead.

THE GREATEST TRAGEDY is that of Claudia, the child fated never to grow to adulthood, her body stunted while her mind and emotions mature. She replaces the child and perhaps the wife Louis lost, and he pours into her centuries' worth of love. They live in 19th-century Paris without Lestat, among a band of vampires led by the 400-year-old Armand (Mr. Banderas), who tries to lure Louis from Claudia. When Louis kills a woman to create a vampire-mother for Claudia, he says, "What has died is the last breath of me that was human." But he cannot save Claudia from a vampire's worst fate. When Armand suggests they start a fresh vampire life together, Louis says, "What if all I have is my suffering, my regret?" He is still clinging to the mourning and guilt of his humanity.

The superficially frightening elements of "Interview" are powerful enough to create nightmares. The creepiness ranges from rat's blood drunk from a crystal goblet to the lingering sense that the next gorgeous, pale man you see might be lethally attracted to the veins in your neck. But the deeper power of the film depends on Mr. Pitt's rich and deeply affecting performance. Low-key and serene, he makes Louis convincing as a bereaved father, lover, even son. "He was my maker," Louis says respectfully about the vile

Lestat. "He gave me this life, whatever it is."

Like Louis, the monster in "Mary Shelley's Frankenstein" was also created to vanquish death, in this case by creating new life from spare parts. And like the vampires, the Creature played by Mr. De Niro looks more human than monstrous. With his head shaved and stitches covering his face, he is bound to bring to mind Travis Bickle after a bad accident. And at times the Creature's humanity approaches and echoes that of Louis.

"Why do you weep?" the monster is asked after Frankenstein's death.

"He was my father," the monster says.

On paper, "Mary Shelley's Frankenstein" should have been just as trenchant as "Interview With the Vampire." As it turns out, there is too much Frankenstein and too little of the monster to reflect the terror of Mary Shelley's novel. Boris Karloff's silent, square-headed monster, from the classic 1931 "Frankenstein," has become an indelible and beloved image. So it may come as a shock to find that the De Niro monster doesn't have enough good lines to suit Mary Shelley's purpose.

The fearful essence of her "Frankenstein" is that the monster and his creator are doubles, in a tale of human ambition run wild. Both Frankenstein and his monster start with good intentions and turn vengeful and murderous. At first Frankenstein wants to restore life and the monster wants to share the emotions he secretly observes among a family in an isolated cottage. Lurking outside the cottage window, he learns to read in no time. When the family rejects the monster, he kills everyone Frankenstein loves; Frankenstein in turn wants revenge and tracks his monster toward the frozen Arctic.

In all of this, the film is faithful to the plot of the novel but doesn't come

On paper, 'Frankenstein' should have been just as trenchant as 'Interview With the Vampire.'

near its spirit. Shelley's Frankenstein said of the learned Creature: "He is eloquent and persuasive; and once his words had even power over my heart: but trust him not. His soul is as hellish as his form." The De Niro monster may sob against a tree when the family rejects him, but his emotions are fleeting, and eloquence eludes him. Instead he faces the camera and bellows: "I will have revenge. FRANKENSTEIN!" This is not much of an improvement on grade-B monsters.

He is a descendant of the Karloff monster, who has gained a crude power of speech; he was meant to be

much more. Even now, Karloff's Creature remains more affecting, a baffled giant who accidentally kills a little girl and can only howl in distress. (The 1931 film strays far from Mary Shelley, too, nowhere more quaintly than in the credits that say it is "from the novel by Mrs. Percy B. Shelley." But, then, that movie didn't call itself "Mrs. Percy B. Shelley's Frankenstein.")

The scene that works best in "Mary Shelley's Frankenstein" is an atypical one: the tête-à-tête between Frankenstein and the Creature in the ice cave. "You gave me these emotions, but you didn't tell me how to use them," the monster says, suggesting how haunting Mr. Dè Niro could have been in this role with a smarter script. "Now two people are dead because of us. Why?" Those are the questions the film needed to explore.

The film fails the ultimate test of a horror film. It is impossible to imagine stepping into "Mary Shelley's Frankenstein" and grappling with its characters. But if Tom Cruise showed up and promised eternal life, at the price of drinking a little blood, wouldn't you at least think it over? ☐

1994 N 13, II:1:1

HEAVENLY CREATURES

Written (with Frances Walsh) and directed by Peter Jackson; director of photography, Alun Bollinger; edited by Jamie Selkirk; music by Peter Dasent; production designer, Grant Major; produced by Jim Booth; released by Miramax Films. Running time: 98 minutes. This film is rated R.
WITH: Melanie Lynskey (Pauline Parker), Kate Winslet (Juliet Hulme), Sarah Peirse (Honora Parker), Diana Kent (Hilda Hulme), Clive Merrison (Henry Hulme) and Simon O'Connor (Herbert Rieper).

By JANET MASLIN

"Next time I write in this diary, Mother will be dead," wrote Pauline Parker, a 15-year-old living in Christchurch, New Zealand, in 1954. "How odd — yet how pleasing." Making good on that promise, Pauline and her school friend Juliet Hulme went on an outing with Honora Parker, Pauline's mother, and bludgeoned her to death with a brick stuffed in a stocking. Just before this fateful stroll in the woods, the threesome had stopped to enjoy tea.

Like Leopold and Loeb, their American counterparts, Pauline and Juliet scandalized their countrymen in ways that have not yet been forgotten. They were smugly superior; they were caught in the grip of illicit passion; they were capable of murdering an innocent relative for no good reason. On top of this, they broke more serious taboos. They were genteel schoolgirls who fell in love with each other and, goaded by that love, committed a terminally unladylike crime.

What sent them over the edge? Although Pauline's diary became a matter of public record when the girls went to trial, it left many unanswered questions. No less arrogantly delusional than Leopold and Loeb, Pauline and Juliet had come to inhabit a dream world populated by

imaginary royalty and teen-age fave raves (they shared a huge crush on the singer Mario Lanza), who sometimes acted as stand-ins for the adults in their lives. With ebullient imagination, they invented a secret, mischievous universe open only to "heavenly creatures" like themselves. Pauline used that phrase to describe Juliet and herself.

"Heavenly Creatures" is Peter Jackson's effort to explore that universe, mimicking the killers' schoolgirl daydreams in a whirl of giddy, all-consuming fantasy. Like Oliver Stone's "Natural Born Killers," it enters an insular, volatile world of high-hormone adolescence and captures its characters' scary detachment from reality. In keeping with its heroines' thoughts of secret gardens and giant butterflies, Mr. Jackson's film is virtually bloodless, looking fussily benign. But its exaggerated sweetness is every bit as chilling as more familiar masculine reveries about violence and irrational revenge.

Mr. Jackson, whose previous credits ("Bad Taste," "Dead Alive") are in the science-fiction and horror realm, gives "Heavenly Creatures" a visual extravagance to match its characters' excitement. Structured as a chronological account of the girls' growing friendship, it interjects flights of increasingly wild imagination into their story. Fascinatingly eccentric at first, the film loses some of its tension as it becomes evident that Mr. Jackson will not see beyond the killers' claustrophobic point of view.

This story went well beyond the film, which ends with a postscript after the crime. For instance, both girls disappeared after serving brief sentences, released under the condition that they never meet again. And Juliet recently made international headlines when she was revealed to be Anne Perry, a successful writer of mystery novels.

Aside from questions about the story's aftermath, "Heavenly Creatures" leaves gaps about the objective facts of the crime, since it deliberately confines itself to a subjective viewpoint. That's surprising, since Mr. Jackson has brought an investigator's zeal to reconstructing this story, basing his screenplay on interviews with people who knew the girls and including Pauline's own observations. The film's actors apparently bear close resemblances to the real figures in this famous case, but the film's realism doesn't go much beyond that.

Stylish and eerily compelling before it overplays its campy excesses, "Heavenly Creatures" does have a feverish intensity to recommend it. Mr. Jackson elicits a particularly unsettling performance from Melanie Lynskey, the sullen-looking newcomer who comes to life in the presence of haughtier, more supercilious Juliet (Kate Winslet, another disturbingly effective actress). The film viscerally understands why quiet, awkward Pauline falls so madly in love with the more daring Juliet, whose upper-class parents have left her free to indulge in an active fantasy life. The Hulmes's garden, where the girls hatch their schemes, is the real place where the girls played and attests to Mr. Jackson's meticulous attention to detail.

On a loonier level, Mr. Jackson also disguises extras as life-size clay figures to flesh out the girls' private mythology (there is even a clay Orson Welles) and executes tricks like sending his camera racing through the interior of a sand castle. Weirdly ingenious until they become exhausting, such methods overpower the film's humbler figures even more than they have to. The girls' parents (with Diana Kent and Sarah Peirse affecting and well contrasted as Juliet's and Pauline's respective mothers), but the film would have delved deeper if it rescued them from two-dimensional caricature.

"Heavenly Creatures" reaches one pinnacle of subjective madness when Juliet's garden morphs magically into the "Fourth World" in which the girls think they belong, and another when Pauline is finally sent to a psychiatrist. "But she's always been a normal, happy child," her mother insists, in a scene that is played as giddy caricature. "Heavenly Creatures" knows what it means to deem that kind of comment reason enough for murder.

"Heavenly Creatures" is rated R (Under 17 requires accompanying parent or adult guardian). It includes brief, disturbing violence and sexual situations.

1994 N 16, C17:1

Melanie Lynskey, left, as Pauline and Kate Winslet as Juliet in "Heavenly Creatures."

Pierre Vinet/Miramax Films

STAR TREK GENERATIONS

Directed by David Carson; written by Ronald D. Moore and Brannon Braga, based on a story by Rick Berman, Mr. Moore and Mr. Braga, and the television series "Star Trek," created by Gene Roddenberry; director of photography, John A. Alonzo; edited by Peter E. Berger; music by Dennis McCarthy; production designer, Herman Zimmerman; produced by Mr. Berman; released by Paramount Pictures. Running time: 110 minutes. This film is rated PG.
WITH: William Shatner (Kirk), Patrick Stewart (Picard), Malcolm McDowell (Soran), Whoopi Goldberg (Guinan), Jonathan Frakes (Riker), Brent Spiner (Data), LeVar Burton (Geordi), Michael Dorn (Worf), Gates McFadden (Beverly), Marina Sirtis (Troi), James Doohan (Scotty) and Walter Koenig (Chekov)

By JANET MASLIN

Thirteen "Star Trek" books are sold every minute, and that's just on the planet Earth. The Trekkie phenomenon is so indefatigable that there's even a volume ("Trek: The Lost Years," by Edward Gross) about a time period when the televi-

Elliott Marks/Paramount Pictures

Aboard the new Starship Enterprise: Walter Koenig, left; William Shatner, center, and James Doohan in "Star Trek Generations."

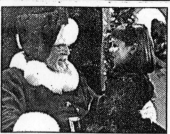

Michael P. Weinstein/20th Century Fox

Richard Attenborough and Mara Wilson in a scene from "Miracle on 34th Street."

sion show was off the air. In the face of such enthusiasm, a "Star Trek" film needn't do more than exist to generate sighs of contentment among die-hard fans. But a couple of them ("II" and "IV") have had legitimate crossover potential, bridging the entertainment gap between the Starship Enterprise and the real world.

"Star Trek Generations" is the series' most ambitious film, if only because it mixes the casts of two "Star Trek" television series with the help of "some sort of a temporal flux." For readers who find it baffling that there even *are* two television series (actually there are three, with a fourth on the way), the question is obvious. How much interest does this new installment hold for general audiences, for "Trek"-resistant moviegoers who turn elsewhere for their religious experiences and wouldn't know a main deflector shield from a satellite dish? What can "Generations" really say to the jargon-impaired?

Answer: just enough. "Generations" is predictably flabby and impenetrable in places, but it has enough pomp, spectacle and high-tech small talk to keep the franchise afloat. And in an age when much fancier futuristic effects can be found elsewhere, even its tackiness is a comfort. It's been more than 25 years since the maiden voyage of the Enterprise, yet the camera still rocks excitably while the actors cower during simulated explosions. And the crew still stands at attention in the control room, gazing worriedly out that big, bogus spaceship window while they wonder what new perils are in store.

In "Generations," the phenomenon causing trouble is an intergalactic ribbon, a celestial band that shoots off bolts of electricity and supposedly threatens peace in the universe, even though the worst it really suggests is serious trouble with a toaster coil. This menace is ultimately important enough to require the joint services of Capt. James T. Kirk (William Shatner, revered stalwart of the series) and Capt. Jean-Luc Picard (Patrick

Stewart, his glowering, debonair successor).

If the film intends any contest between these two, or the different "Star Trek" casts they represent, it's no contest. Mr. Shatner can't match Mr. Stewart's thespian manner and Shakespearean intonations. But he's the one with the twinkle in his eye and the pampered, cosseted look of a star beloved by a gazillion fans. Mr. Stewart is admirably commanding, but he and the "Next Generation" cast don't have quite as much personality as the original show's old standbys. Mr. Shatner's appearance only bookends the movie, but he arrives and exits this story as a convivial old friend.

The film's techno-babble is confusing enough to require at least a second visit for absolute clarity; of course, that must be the point. In brief, Captain Kirk returns from retirement to find the Enterprise in the hands of young whippersnappers, and is barely on board before a crisis strikes. Then there are explosions, and Kirk vanishes. After this, the film catches up with the "Next Generation" crowd 78 years later. They are in the midst of playing naval games on their holodeck, which looks like a frigate but quickly rearranges itself into the Enterprise once an alarm sounds. Nostalgia for old-fashioned sailing ships and homey family scenes is rampant among the space travelers.

Also in "Generations," and making a dandy, taunting villain, is Malcolm McDowell as Soran, a mad scientist who looks like Sting and plans to blow up a star to reach the intergalactic ribbon and attain eternal joy. Or something. The meaning of the ribbon is explained by Whoopi Goldberg, who appears as Guinan, her "Next Generation" character. It's time for Ms. Goldberg to duck roles that require her to be patient, kindly and wise.

"Generations" lumbers along companionably until, after an hour and a half, it reaches a crucial juncture. Soon after the Enterprise crashes in a forest (delivering the film's most impressive special-effects sequence), Picard finds himself beside Kirk, creating a kind of

Trekkie Mount Rushmore. The meeting is pleasant, but the screenplay (by Ronald D. Moore and Brannon Braga) doesn't deliver any fireworks here. And Mr. Shatner, amusingly convivial in more casual scenes, doesn't bring much agility to his final tussle with the gleeful, diabolical Mr. McDowell.

As directed by David Carson "Generations" moves slowly but equitably among the two series' regulars, giving each a bit of fan-pleasing shtick. So Data (Brent Spiner), the blank-faced robotic character who's meant to compensate for the absent Mr. Spock, gets a computer chip that gives him emotions, which yield predictable comic results. As with most of "Generations," this will speak most clearly to the already converted but still seem reasonably diverting to the neophyte. Even if you came in late for "Star Trek," you can come in here.

"Star Trek Generations" is rated PG (Parental guidance suggested). It includes mild violence and nothing sexual, except a few Klingon women with cleavage.

1994 N 18, C3:1

MIRACLE ON 34TH STREET

Directed by Les Mayfield; written by George Seaton and John Hughes, based on the story by Valentine Davies and the 1947 motion picture screenplay by Mr. Seaton; director of photography, Julio Macat; edited by Raja Gosnell; music by Bruce Broughton; production designer, Doug Kraner; produced by Mr. Hughes; released by 20th Century Fox. Running time: 114 minutes. This film is rated PG.
WITH: Richard Attenborough (Kriss Kringle), Elizabeth Perkins (Dorey Walker), Dylan McDermott (Bryan Bedford), J. T. Walsh (Ed Collins), Robert Prosky (Judge Harper) and Mara Wilson (Susan Walker)

By CARYN JAMES

You could build a good case for remaking "Miracle on 34th Street." Though the 1947 original remains as charming as ever, the story seems perfect for the 90's. There is the divorced mother (Maureen O'Hara in the original), the daughter who doesn't believe in Santa (the very young Natalie Wood) and a Macy's Santa (Edmund Gwenn) who insists he is the real Kriss Kringle and proves it in court. He restores the child's faith in magic and even sends shoppers down the street to Gimbel's, ideas that seem ripe for a time when Christmas has become dizzyingly commercial and many children are in nontraditional families.

Well, the perfect Santa movie for children of divorce has arrived, but it turned up last week as "The Santa Clause," starring Tim Allen. The new "Miracle on 34th Street," produced by John Hughes (the mastermind behind shrewd hits like "Home Alone") and written by him with George Seaton, is a dull project that makes only cosmetic changes in the original. It loses the warmth and nostalgia of the old movie, but is too timid to give the story the sharp, contemporary spin it needs.

One major change in the remake is apparent in the big Thanksgiving

Day Parade that begins both films. Macy's refused to give the film makers permission to use its name this time, so the Manhattan department store is now called Cole's. Though the store looks suspiciously like the Macy's on 34th Street, Mr. Hughes would have done better to call his film "A Miracle at the Mall" and take it from there.

At the parade, Dorey Walker (Elizabeth Perkins) finds that her Santa has had too much whisky and on the spot hires a man who looks the way Santa should. Of course, Susan Walker can't believe in a Santa her mother hired and Dorey doesn't want her daughter to grow up with illusions, anyway. Dorey's boyfriend, Bryan (Dylan McDermott), a lawyer, is inclined to believe in Kriss.

"Miracle on 34th Street" is almost saved by the appeal of two stars. As Kriss Kringle, with half-glasses and a snowy beard, Richard Attenborough is miraculously convincing. Kriss lives in a retirement home and believes so firmly in his identity that he ends up in Bellevue. Mr. Attenborough plays him knowingly, as a kind man who just might be magical enough to grant Susan's Christmas wish: a Dad, a baby brother and a house.

Susan is played by Mara Wilson, who was Robin Williams's youngest daughter in "Mrs. Doubtfire." She is an absolute sweetie, a wise child on the surface but still a wide-eyed little girl eager to believe in Santa. Yet "Miracle on 34th Street" often leaves these two charmers behind to concentrate on Dorey and Bryan's courtship, a plot children and adults are likely to snooze through.

The highlight of the new "Miracle," which was directed by Les Mayfield, is still Kriss's appearance in court, though as Bryan defends him the audience has to suffer through lines like: "What is worse? A lie that draws a smile or a truth that draws a tear?" And one highlight of the old film, a scene in which the post office delivers bags of mail to Kriss in court, is missing now. Instead, Mr. Hughes has added a religious slant. The instinct that led him to this material may have been sound, but the effect is like a deflated balloon from the Cole's Thanksgiving Day Parade.

"Miracle on 34th Street" is rated PG (Parental guidance suggested). There are scenes of drunkenness among false Santas and a scene in which Kriss swats one of them with his cane.

1994 N 18, C12:1

Zhang Yimou's 'To Live'

"To Live" was shown as part of this year's New York Film Festival. Following are excerpts from Caryn James's review, which appeared in The New York Times on Sept. 30. The film — in Mandarin with English subtitles — opens today in Manhattan.

Samuel Goldwyn Company

Xiao Cong, left, and Gong Li.

In the gambling house where Fugui (Ge You) spends his nights, letting his family fortune slip from his grasp, he is treated like a young prince. The setting is China in the pre-revolutionary 1940's, and after hours of gambling, Fugui is carried home at dawn through the streets of his small town on the back of a man who deposits him at his extravagant house. Fugui's wife, Jiazhen (Gong Li), begs him to stop gambling, for the sake of their small daughter and the child she is carrying.

Of course he doesn't, and soon loses the family home to a bounder called Long Er. One of many great comic ironies in "To Live," Zhang Yimou's family melodrama that sweeps through 30 years of Chinese history, is that this misfortune turns out to be a major piece of luck. When the revolution comes, the house is burned by the Communists and the land-owning Long Er is executed. There but for the grace of his gambling goes Fugui.

"Your family's timber was first-rate," a good Communist tells him, describing how fast the house went up in flames. By then Fugui has developed a sense of survival that is by turns funny and heartbreaking and that expresses the very soul of this tragicomic film. "That wasn't my family's timber," he says. "That was counterrevolutionary timber."

"To Live" is purposefully more sentimental than anything Mr. Zhang has done before. After Fugui has lost the house, he takes over a traveling shadow-puppet show. While he and his friend Chungsheng are on the road with their theater, they are captured by the losing Nationalist army. When Fugui returns to his much-changed town, he finds that Jiazhen earns a living by delivering water door to door. An illness has left their daughter, Fengxia, deaf. And their son, Youqing, is a spirited boy who becomes the victim of his father's desperate need to disguise his past as a wealthy man.

This film is also less sumptuously photographed than Mr. Zhang's other works; in the lives of these characters, touches of red on a gray uniform have to pass for glamour.

But the masterly Mr. Zhang knows he's creating melodrama and exaggerates to profound effect. The family tragedies in "To Live" demonstrate how China's politics scarred individuals who were treated as pawns in Mao's progress, and its sentimentality shows that ideology is no comfort in the face of personal anguish. In two magnificent performances, Gong Li carries the story's emotions and Ge You the weight of history. Gong Li is, as always, a powerful heroine. But Mr. Ge is a revelation, evoking sympathy and pity as a man whose weakness

causes him to bend like a reed in the changing winds of Chinese politics and whose strength allows him to endure the consequences.

During the Great Leap Forward in the 1950's (the historical changes are explained clearly in succinct titles through the film), the entire town donates all metal objects to support steel production. Even the family's pans are taken away, and everyone eats at the communal kitchen. That is where the mischievous Youqing pours a huge amount of chili sauce on a big bowl of noodles, then calmly dumps it on the head of a boy who has been taunting his sister. For that, Fugui publicly spanks his son, agreeing that the little boy's gesture was a counter-revolutionary act meant to undermine the communal kitchen.

Irreverent though Mr. Zhang's take on Chinese history is, "To Live" is primarily a story of living with sadness. Fugui's old friend Chungsheng becomes a district leader and accidentally causes a death. "You owe us a life," Jiazhen screams at him, and the line becomes a refrain that resonates through the film.

The Communist revolution is increasingly blamed for the family's tragedies. When someone dies because the reactionary doctors have been taken away from the hospital, leaving only inept students behind, there is no mistaking the political toughness of this melodrama's message.

1994 N 18, C12:4

THE PROFESSIONAL

Written and directed by Luc Besson; director of photography, Thierry Arbogast; edited by Sylvie Landra; music by Eric Serra; production designer, Dan Weil; Gaumont/Les Films du Dauphin production, released by Columbia Pictures. Running time: 112 minutes. This film is rated R.
WITH: Jean Reno (Leon), Gary Oldman (Gary Stansfield), Natalie Portman (Mathilda) and Danny Aiello (Tony).

By JANET MASLIN

As the first American big-studio film about a man who dearly loves his houseplant, "The Professional" is bound to raise eyebrows. And raise them on both sides of the Atlantic, since this is the work of the film world's most attention-getting man without a country, Luc Besson.

In "La Femme Nikita," Mr. Besson stylishly melded American luridness with Gallic sophistication, though the violence level was enough to dismay French audiences and prompt a coarse American remake ("Point of No Return"). Emboldened by the success of that hybrid, Mr. Besson has now made a film in New York, featuring characters who speak like Americans, think like Frenchmen and behave appallingly in any language. "The Professional" lacks the sexy élan of "La Femme Nikita" and suffers from infinitely worse culture shock.

The man with the plant is Leon (Jean Reno), a gentle, childlike soul. He lives a quiet life, drinking milk and dusting his plant's leaves. ("It's my best friend," he says about the plant, thus helping more obtuse members of the audience. "Always happy. No questions. It's like me, you see.") He is also seen watching a Gene Kelly movie, which fills him with an innocent delight. How strange it is that he happens to be a paid killer!

By chance, a young girl named Mathilda (Natalie Portman) becomes Leon's soul mate. This wistful, pretty creature is his neighbor in a New York apartment house, one of the many Manhattan locations that Mr. Besson films peculiarly, with a loving attention to other films about New York rather than New York life.

Leon sometimes sees the girl in the hallway, where she sits smoking pensively, wearing the bobbed hair, black choker and striped jersey that make her look like a mini-Parisian streetwalker and certainly like a pederast's delight. "Is life always this hard?" she asks Leon one day. "Or just when you're a kid?"

"Always, I guess," Leon thoughtfully replies.

Mathilda's life becomes hard when her entire sleazy family is rubbed out by Gary Stansfield (Gary Oldman), a fantastically corrupt drug-enforcement agent who says things like "Death is whimsical today." In this preposterous role, Mr. Oldman expresses most of the film's sadism as well as many of its misguidedly poetic sentiments. During the buildup to an ugly shootout, he even claims that the calm before the storm reminds him of Beethoven, a thought that may help viewers get through the nastiness that follows. (Mr. Oldman will actually be playing Beethoven in another, less gun-toting movie, "Immortal Beloved," soon.)

Among the condescending American stereotypes with which Mr. Besson has filled "The Professional" (Danny Aiello plays a mobster who does business out of an Italian restaurant), there are elevating cinematic references. Leon checks into a hotel using the Hitchcockian name MacGuffin. And he is seen playfully imitating John Wayne ("O.K., Peelgreem!").

These touches all underscore the idea that Leon has a true sweetness, and that he and Mathilda can redeem each other with the purity of their platonic love. Although she begs Leon to teach her how to be a hit person, claiming to be interested in "the theory" of such work, "The Professional" is much too sentimental to sound shockingly amoral in the

least. Even in a finale of extravagant violence, it manages to be maudlin.

Mr. Reno, who also appeared in "La Femme Nikita" and Mr. Besson's "Subway," plays Leon with a soulful air that overstresses his superiority to a brutish world. Ms. Portman, a ravishing little gamine, poses far better than she acts.

"The Professional" is full of howling mistakes that emphasize its alienness, like the call to Mathilda's incredibly sordid household from the starchy headmistress of the private school Mathilda supposedly attends. Mathilda eventually digs a hole for Leon's houseplant on the school's grounds, giving it symbolic life without realizing it will die in the first frost.

"The Professional" is rated R (Under 17 requires accompanying parent or adult guardian). It includes a great deal of graphic violence.

1994 N 18, C18:5

THE SWAN PRINCESS

Directed by Richard Rich; written by Brian Nissen; edited by James Koford and Armetta Jackson-Hamlett; music by Lex & Azevedo, with additional songs by David Zippel and Mr. de Azevedo; production designers, Mike Hodgson and James Coleman; produced by Mr. Rich and Jared F. Brown; released by Nest Entertainment. Running time: 90 minutes. This film is rated G.
WITH THE VOICES OF: Jack Palance (Rothbart), Howard McGillin (Prince Derek), Michelle Nicastro and Liz Callaway (Princess Odette), John Cleese (Jean-Bob), Steven Wright (Speed), Steve Vinovich (Puffin), Mark Harelik (Lord Rogers), James Arrington and Davis Gaines (Clamberlain), Joel McKinnon Miller (Bromley), Dakin Matthews (King William) and Sandy Duncan (Queen Uberta)

By CARYN JAMES

An arrogant French frog named Jean-Bob (whose voice belongs to John Cleese) is convinced that one kiss from the beautiful Princess Odette will turn him into a handsome prince. Stranger acts of magic have happened, and "The Swan Princess" is one of them. Loosely based on the legend that inspired "Swan Lake," and blatantly borrowing the formula of Disney's "Beauty and the Beast," this animated musical turns out to be funny and enchanting on its own. Directed by Richard Rich, who started an animation company after 14 years at Disney, "The Swan Princess" makes first-rate copying seem like a good idea.

The film begins shamelessly, with a Disney-looking castle in the background and the words "Once upon a time there was a king named William." This is a movie that luxuriates in its classic fairy-tale style, with a few updated twists.

King William (Dakin Matthews) and the neighboring Queen Uberta (Sandy Duncan) plan for his daughter, Odette, and her son, Derek, to marry and unite their kingdoms. In one brisk, bouncy song, "This Is My Idea," Derek and Odette move from childhood through their scrappy adolescence, when they can't stand each other, to young adulthood, when they fall in love. Tchaikovsky, of course,

is nowhere to be heard. The songs, by the composer Lex de Azevedo and the lyricist David Zippel, are Menken-and-Ashman imitations, and the weakest part of the film. The melody of "Far Longer Than Forever," the theme from "The Swan Princess," even echoes the first five notes of "Beauty and the Beast." But the songs, ranging from ballads to Broadway-inspired show tunes, serve the story well.

Like all fairy princesses, Odette is beautiful. Like many cartoon Prince Charmings, Derek is underwritten and wears a silly Prince Valiant hairdo. But their marriage is thwarted for an up-to-date reason. When Derek compliments Odette on her beauty, she asks, "Is beauty all that matters to you?"

"What else is there?" the dunderheaded Derek replies, and everyone else in the room realizes how wrong he is. The wise counselor Lord Rogers mutters, "He should write a book: 'How to Offend Women in Five Sentences or Less.'" The film doesn't press hard on this idea. It quickly sends Odette and King William on their way, the engagement broken. As they ride through the woods, the evil sorcerer Rothbart (Jack Palance, with his raspy, villainous voice) puts a spell on Odette. She becomes a swan by day. When the moonlight hits her wings, she turns into a woman again. Only Derek's promise of eternal love can break the spell.

Created from hand-drawn cels rather than computer animation, "The Swan Princess" flows along like a dream. The backdrops are beautifully realized, from the colorful palace to the midnigh blue of the swan lake in Rothbart's kingdom. And the vivid characters include several endearing comic creatures who help rescue Odette. They are led by the lovelorn Jean-Bob (with Mr. Cleese at his comic best), along with a tortoise named Speed (with the comedian Steven Wright's drawling voice) and a puffin (Steve Vinovich).

The lavish and funny musical production numbers include a parody beauty pageant called "Princesses on Parade," which shows Derek that beauty isn't everything. And Mr. Palance's Rothbart has a star turn dancing and singing "No More Mr. Nice Guy," complete with a pushup.

The list of ways in which "The Swan Princess" shadows "Beauty and the Beast" would be a long one. The French-accented Jean-Bob is the counterpart of the Maurice Chevalier-inspired Lumière. "Princesses on Parade" echoes the Busby Berkeley choreography of "Be Our Guest." The end credits even offer a pop duet of the movie's love theme, this one sung by Regina Belle and Jeffrey Osborne. "The Swan Princess" might as well be the unofficial sequel to "Beauty and the Beast." It's not quite as good or fresh but it's delicious all the same, bound to amuse children and entertain their trapped parents, too.

1994 N 18, C20:5

TERROR 2000

Directed by Christoph Schlingensief; written in German with English subtitles by Mr. Schlingensief, Oskar Roehler and Uli Hanisch; director of photography, Reinhard Köcher; edited by Bettina Böhler; music by Kambiz Giahi and Jacques Arr; production designer, Uli Hanisch; produced by DEM FILM Christoph Schlingensief, Mülheim, in cooperation with WDR and NDR; released by Leisure Time Features. At Quad Cinema, 13th Street west of Fifth Avenue, Greenwich Village. Running time: 79 minutes. This film is not rated.
WITH: Peter Kern (Peter Körn), Margit Carstensen (Margret), Alfred Edel (Bössler) and Udo Kier (Jablo).

By STEPHEN HOLDEN

If a Keystone Kops film were written by William S. Burroughs, peopled with characters from George Grosz by way of Russ Meyer and directed in a style that suggests Jean-Luc Godard on speed, you would have a movie with the style and mood of "Terror 2000."

This slam-bang comedy lampooning neo-Nazism and xenophobia in contemporary Germany wallows in ridiculously fake gore and grotesque sexual couplings. The director Christoph Schlingensief's idea of how to film a shooting is to show a gun aimed at someone's face and a moment later to have that face doused with a bucket of entrails.

The central characters in this punk expressionistic fable, which opens today at the Quad Cinema, are a husband-and-wife detective team, Peter and Margret Körn (Peter Kern and Margit Carstensen). Charged to investigate the kidnapping of a social worker who was escorting a family of Polish immigrants to a refugee camp, they have one brutal adventure after another. Events culminate with a surprisingly tepid riot by inmates in the refugee camp.

The absurdist characters include a television psychic whose visions turn the search for the missing Poles into a frenzied media circus, and a Hitler caricature and his ragtag band of followers.

Spoofing Nazis is a tricky business, since treating hatemongers as absurdist buffoons makes them seem harmless. The social climate that "Terror 2000" addresses is anything but benign. That's one reason why "Terror 2000," despite its frantic style, has no satirical bite. It is a shapeless, hysterical mess.

1994 N 18, C20:5

MRS. PARKER AND THE VICIOUS CIRCLE

Written (with Randy Sue Coburn) and directed by Alan Rudolph; director of photography, Jan Kiesser; edited by Suzy Elmiger; music by Mark Isham; production designer, Francois Seguin; produced by Robert Altman; released by Fine Line Features. Running time: 125 minutes. This film is rated R.
WITH: Jennifer Jason Leigh (Dorothy Parker), Campbell Scott (Robert Benchley), Matthew Broderick (Charles MacArthur), Andrew McCarthy (Eddie Parker), Peter Gallagher (Alan Campbell), Jennifer Beals (Gertrude Benchley), Gwyneth Paltrow (Paula Hunt), Sam Robards (Harold Ross), Martha Plimpton (Jane Grant), Wallace Shawn (Horatio Byrd), Lili Taylor (Edna Ferber), Keith Carradine (Will Rogers) and Tom McGowan (Alexander Woollcott).

By JANET MASLIN

Famed for their stinging wit and conversational savagery, the wags of the Algonquin Round Table would undoubtedly have had claws out for a drama like "Mrs. Parker and the Vicious Circle," Alan Rudolph's name-dropping celebration of their heyday. Surely Dorothy Parker herself, a caustic critic who lacerated even "The House at Pooh Corner," could have had a field day with this film's pretensions, omissions and overweening literary lights.

But that would miss the fascination of a film with a charismatic, unforgettable heroine, stunningly well-played by Jennifer Jason Leigh. "Mrs. Parker and the Vicious Circle" has its obvious flaws, but it also has a heartfelt grasp of what set Dorothy Parker apart from her fellow revelers and makes her so emblematic a figure even today. The film lives up to Mr. Rudolph's observation (cited in production notes) that "the 20's seemed to me the source of many contemporary notions, only with better language."

Since that language is both a bane and a windfall for "Mrs. Parker," it takes getting used to. (So does the acid purr with which Ms. Leigh delivers her lines, imitating a woman whose best bons mots were often muttered under her breath. This actress makes the most of her sodden vocal intonations, whether charming a full panoply of Algonquin walk-ons or gazing at the camera to recite breathtakingly bitter examples of Mrs. Parker's verse.)

One of Mr. Rudolph's chief affectations here (in a screenplay written with Randy Sue Coburn) is the use of wall-to-wall quips, many of them famous and all delivered with studied, improbable nonchalance. The cleverness is so incessant that Robert Benchley, played beautifully by Campbell Scott as the true, unavailable love of Dorothy Parker's life, cannot so much as order eggs without asking for them "loosely scrambled — like my brains."

Jarring at first, this mannerism becomes useful as it incorporates so much droll dialogue and lively biographical information into the film. Sure, the tone can be too arch and there are assorted howlers (about Harold Ross's new magazine: "Well, if it's about New York, why not call it The New Yorker"?) And there are major gaps, like the absence of any significant mention of Dorothy Parker's left-wing political passions. But this film crams a remarkable amount of fact and nuance into the telling of its wrenchingly sad story.

If Dorothy Parker, whose celebrated brightness dissolved into such a boozy haze, is remembered as a victim, she is also recalled as a smart, tough woman who was the architect of her own destiny. That is why she remains of such enduring interest: as a brilliantly rueful writer whose intellect brought her more acclaim and attention than she could handle, and who wrote scathingly about love and self-loathing, about frivolity forcing talent into decline.

This film is trenchant enough to capture both the Mrs. Parker who gazed contemptuously at Mrs. Benchley (Jennifer Beals), dismissing her as a homebody, and the one who longed for romantic and domestic satisfactions she denied herself. Drinking, wisecracking and lavishing love on her dogs became the only ways out. And there came a point at which the waning Algonquin party was emphatically over.

"Mrs. Parker" first finds her in Hollywood, a fading legend thinking back to her glory days. ("I suppose it was — colorful," she says, beginning a flashback that moves the film awkwardly from black and white to color.) Then, younger and more sparkling, she is seen at the end of her marriage to Edwin Parker (Andrew McCarthy), newly returned from World War I with an addiction to morphine and little apparent appreciation of his wife's repartee. "You don't want to become the town drunk, Eddie," she cautions him. "Not in Manhattan."

Mrs. Parker, whose friends called her that or Dottie, is also seen being forced to leave Vanity Fair for writing scorching reviews, after which her friend Mr. Benchley quits in solidarity. The platonic affection between these two is stirringly captured in a way that makes full sense of what Alexander Woollcott said when someone pointed to Mrs. Parker and asked, "Would that be Mrs. Benchley?"

"Yes, that would be Mrs. Benchley, were it not for the fact that there already is a Mrs. Benchley," Woollcott explained.

"Mrs. Parker" fares best with intimate exchanges between these two and well-played figures like Charles MacArthur (Matthew Broderick), whose love affair with Dottie left her brokenhearted, or Alan Campbell (Peter Gallagher), the husband she disparaged but married twice. Much showier and chancier are big scenes packed with caricatured literary figures, who do emblematic things like play croquet or invent the famous Round Table.

The cast is huge, uneven, and not always easily recognizable; in the film's more crowded scenes, it takes a keen ear for name-dropping to determine who's who. The screenplay's nonvintage lines can also be clumsy: "Oh, here's Kaufman — George!" "I'm hungry, aren't you?" "No, I'm Mr. Sherwood."

As she confirms here and also showed with her amazing mimickry in "The Hudsucker Proxy," Ms. Leigh has lately evolved from a promising young performer to an accomplished actress capable of dazzling surprises. One of this film's best scenes is its very last, in which her aging, distracted Dorothy Parker is asked to deliver her own epitaph. With sudden relish she rises to that occasion, answering: "What a morbid thing to ask a person! You've just stolen my heart."

Milling on the outskirts of "Mrs. Parker and the Vicious Circle" are actors who often physically resemble their characters and seldom deliver more than a line or two. Lili Taylor's Edna Ferber appears only briefly, but startles the Algonquin

sophisticates with her bluntness; Sam Robards is around for a mention of "the little old lady in Dubuque," but does not otherwise suggest Harold Ross; Wallace Shawn (as the hotel maitre d') and Keith Carradine (doing Will Rogers) help to think up the Round Table.

Mr. Rudolph lets much of this run on too long, but he doesn't seriously meander. He sustains a sharp idea of where Dorothy Parker fit into this group portrait, and why her brittle fun with the Algonquin's Vicious Circle came to such a lonely end.

"Mrs. Parker and the Vicious Circle" is rated R (Under 17 requires accompanying parent or adult guardian). It includes mild profanity, brief nudity and sexual situations.

1994 N 23, C9:3

JUNIOR

Produced and directed by Ivan Reitman; written by Kevin Wade and Chris Conrad; director of photography, Adam Greenberg; edited by Sheldon Kahn and Wendy Greene Bricmont; music by James Newton Howard; production designer, Stephen Lineweaver; released by Universal Pictures. Running time: 110 minutes. This film is rated PG-13.

WITH: Arnold Schwarzenegger (Dr. Alexander Hesse), Danny DeVito (Dr. Larry Arbogast), Emma Thompson (Dr. Diana Reddin), Frank Langella (Noah Banes) and Pamela Reed (Angela).

By JANET MASLIN

Virtual comedy is often the province of Ivan Reitman ("Twins," "Kindergarten Cop," "Ghostbusters"), whose films can look a lot funnier than they actually are. Big stars, attention-getting stories and bright, shiny backdrops create a comic imprint that has more to do with brand-name manufacturing than with a humorous directorial touch. Last year's "Dave" was much more ingenious than that, at least

before it took the second-hour sentimental turn that is another of Mr. Reitman's trademarks. But where "Dave" had the nimble Kevin Kline in a dual role, "Junior" has Arnold Schwarzenegger in a pink maternity dress. "Junior," about a man who becomes pregnant, proceeds efficiently but never quite lives up to its own potential as a sight gag.

Part of the problem is apparent in the premise. It's amusing to think of Mr. Schwarzenegger looking pretty in pink, but "Junior" has him truly pregnant, right down to the cramps and the medical tests. The supposition is that no one, not even those who are reproductively disadvantaged by the possession of male anatomy, should be unable to bear children. Aside from carrying political correctness to an uncomfortable extreme, this idea also means watching Mr. Schwarzenegger take a needle in his stomach and, eventually, give birth. (Happily, the delivery is by Caesarean section.)

"If men can carry babies to term, it's going to really confuse our perception of what makes us different as men and women," Mr. Reitman has commented. Viewers may agree without necessarily wanting to explore that notion to the fullest.

But "Junior" jokes about it as heartily as possible, with phrases like "Lamb Chop's got a bun in the oven" and Danny DeVito to provide comic relief. It also places Mr. Schwarzenegger in the timid role of a straight man and takes a long time setting up the pregnancy scheme. Why would a man become pregnant? Because he is a scientist developing a new drug for pregnant women and the Food and Drug Administration has decided to abandon his crucial research. Wanting to continue his work, Dr. Alex Hesse (Mr. Schwarzenegger) agrees to serve as a secret guinea pig. A purloined frozen egg and that big needle are supposed to allay further questions about how the medical miracle works.

The real point of the movie is for Dr. Hesse to become hormonally weepy, be told he looks radiant, declare "I just can't keep anything down," ask "Does my body disgust you?" and so on. Drawing on pickles-and-ice-cream ideas of pregnancy, "Junior" simply arranges a role reversal and waits for the laughs to come.

Mechanically contrived supporting roles feature a salty Mr. DeVito as a scientific sidekick, Pamela Reed as his companionably pregnant ex-wife (who experiences pangs of solidarity with Dr. Hesse) and Frank Langella as a stock villain seeking to disrupt the research. The singer Judy Collins has a small, odd role when Dr. Hesse is shipped off to a spa full of pregnant women. Oases like this are more easily found in screenwriters' imaginations than in the world at large.

"Junior" does feature a delightful performance from Emma Thompson, playing a madcap scientist much as the young Katharine Hepburn might have played her, and falling for Mr. Schwarzenegger's more earnest character in a perfectly charming way. Mr. Schwarzenegger is smooth and affable, even though he is not helped by a muted, nice-guy role trumpeting his sensitivity. All the actors perform with a comfortable professionalism that assuredly makes the trains run on time.

"Junior," written by Kevin Wade ("Working Girl") and Chris Conrad, remains jaunty and confident even at its most predictable. Audiences, unlike men who bear children, will find the experience painless and know exactly what to expect.

"Junior" is rated PG-13 (Parents strongly cautioned). It includes brief sexual references and medical details.

1994 N 23, C9:3

Bruce McBroom/Universal Pictures

Emma Thompson, Arnold Schwarzenegger and Danny DeVito in Ivan Reitman's "Junior."

THE BEANS OF EGYPT, MAINE

Directed by Jennifer Warren; written by Bill Phillips, based on the novel by Carolyn Chute; director of photography, Stevan Larner; edited by Paul Dixon; music by Peter Manning Robinson; production designer, Rondi Tucker; produced by Rosilyn Heller; released by Live Entertainment. Running time: 99 minutes. This film is rated R.

WITH: Martha Plimpton (Earlene Pomerleau), Kelly Lynch (Roberta Bean), Rutger Hauer (Reuben Bean), Patrick McGaw (Beal Bean) and Richard Sanders (Lee Pomerleau)

By STEPHEN HOLDEN

Beal Bean (Patrick McGaw), the stammering backwoods hunk who stomps through the film adaptation of Carolyn Chute's best-selling 1985 novel, "The Beans of Egypt, Maine," brings to mind a Cole Porter lyric from the late 1920's. In "Find Me a Primitive Man," the hankered-after object is described as "someone with vigor and vim/I don't mean the kind that belongs to a club/But the kind that has a club that belongs to him."

As played by Mr. McGaw, Beal is a Chippendale's vision of stubbly machismo and not the bearded bear of a man described in the novel. The fantasy of mating with such a man is lived out by Earlene Pomerleau (Martha Plimpton), the film's plucky narrator. If her life with Beal brings the excitement of Tarzan-and-Jane sex and a rugged outdoor life, its griefs far outweigh its pleasures. Dependent on erratic, low wages earned in the timber industry, the couple live in desperate poverty that Beal is too proud to alleviate with the help of food stamps. When Beal goes hunting, it is as likely to be for dinner as it is for sport.

"The Beans of Egypt, Maine," which is opening today at the 57th Street Playhouse and the Village East Cinemas, is the story of Earlene's absorption into the roughneck clan of Beans, who live in a kerosene-lighted trailer only a few yards from her childhood home. Growing up in a strict Christian household, Earlene peers through the picture window at the comings and goings of these exotic peasants, whose raw sensuality and drunkenness her God-fearing father condemns in grim, tight-lipped denunciations.

The most dramatic event she witnesses is the arrest of Reuben Bean (Rutger Hauer), the Paul Bunyan-

The backwoods life, under a romantic glow.

like family patriarch, after he beats up the local sheriff, who has caught him shooting deer out of season. The scene in which Reuben impulsively bashes the sheriff in the face with a rifle butt is the most visceral moment in a film that softens the novel's harsher edges and romanticizes its characters.

The romanticizing takes place despite the fact that the screenplay, by Bill Phillips, lifts whole chunks of dialogue from the pages of the book. Like the novel, the film, which was

directed by Jennifer Warren, is more concerned with offering impressions of backwoods life than with presenting coherent family histories. As in the book, there are abundant suggestions of incest between Beal and Reuben's woman, Roberta (Kelly Lynch). In the film's more pungent moments, it plunges one into a rugged work environment of whining chain saws and logging trucks rumbling down rutted roads.

Drawn inexorably into the Bean world, the teen-age Earlene has a child by Beal, but for six years she refuses to acknowledge its paternity. She falls into a deep depression that the Bean family literally drags her out of and eventually marries Beal and has a second child. Briefly she becomes a modern-day version of a contented pioneer wife, at once hardy and submissive. The movie's most poignant scenes show Beal's decline into delirium and raging violence after he refuses to be treated for a splinter in his eye, which becomes infected.

For all its respect for the text, the movie never fully enters the backwoods world it studies. The hard-bitten twang of Ms. Chute's prose is softened by actors who bring too much urban angst to their performances. Ms. Plimpton, who has a rich history of playing rebellious and complicated women, delivers Earlene's salty observations in the slightly dreamy voice of someone narrating a memory play. Mr. McGaw seems more concerned with suggesting Beal's underlying sensitivity than with embodying his brute force. Ms. Lynch's Roberta has a faraway look, and she seems awfully well tended for someone living in a log cabin with a brood of children.

In "The Beans of Egypt, Maine," the words and images may come from Ms. Chute's book, but the hazy, nostalgic mood is more in keeping with "The Waltons."

"The Beans of Egpyt, Maine" is rated R (Under 17 requires accompanying parent or adult guardian). It includes strong language and sexual situations.

1994 N 23, C13:1

NOSTRADAMUS

Directed by Roger Christian; written by Knut Boeser and Piers Ashworth, based on the story by Mr. Boeser, Mr. Ashworth and Mr Christian; director of photography, Denis Crossan; edited by Alan Strachan; music by Barrington Pheloung; production designer, Peter J. Hampton; produced by Edward Simons and Harold Reichebner; released by Orion Classics. Quad Cinema, 13th Street west of Fifth Avenue, Greenwich Village. Running time: 118 minutes. This film is rated R.
WITH: Tcheky Karyo (Nostradamus), F. Murray Abraham (Scalinger), Rutger Hauer (Monk), Amanda Plummer (Catherine de Medici) and Julia Ormond (Marie).

By CARYN JAMES

"I am Michel de Nostradame," the French actor Tcheky Karyo says in English, his impassive face and monotone suggesting he might be an android. But no. "I am a scientist," he says. "Nostradamus" is an over-stuffed historical soap opera about the 16th-century doctor, astrologer, prophet and all-around great guy. Its silly, anachronistic dialogue must have been hard to take seriously, which may account for the entire cast's poker faces.

Fighting the plague, Nostradamus gently puts little tablets made from rose petals under his patients' tongues. Though he has alarming visions (World War I is much on his mind, shown in sepia-toned scenes of German soldiers and tanks), his prophecies are less important at first than his persecution by the Inquisition. And, of course, there are his hot romances. You knew Nostradamus made prophecies — interpreted as foretelling everything from the French Revolution to Armageddon — but did you know he was irresistible to women?

Among his many conquests is his first wife, Marie (Julia Ormond). An assistant to Nostradamus's mentor (F. Murray Abraham), she is annoyed at being shut out of the men's research. "If you can't treat me as an equal, then find another woman," she shouts. Maybe Mrs. Nostradamus was just prophesying what women would be saying in 300 years.

Eventually Nostradamus peers into a basin of water and sees Hitler, John and Jacqueline Kennedy riding in the Dallas motorcade, and a nuclear explosion.

The film becomes giddiest when Catherine de Medici (Amanda Plummer) invites Nostradamus to the French royal court. He meets her children and sees a bloody future in which gallons of bright red paint flow down the walls. "I will prepare myself for some terrible times ahead," the queen says stiffly.

The film was directed by Roger Christian, the art director of "Alien," and it looks opulent as it sweeps through the Romanian countryside (doubling for France.)

"Nostradamus," which opens today at the Quad, ends with the legend: "There is still time to understand his words." Making sense of this movie would have been more than enough.

"Nostradamus" is rated R. It includes a graphic autopsy and partial nudity during a sex scene.

1994 N 23, C14:1

LOVE AND A .45

Written and directed by C. M. Talkington; director of photography, Tom Richmond; production designer, Deborah Pastor; edited by Bob Duscay; music by Tom Verlaine; produced by Darin Scott; released by Trimark Pictures. Running time: 101 minutes. This film is rated R.
WITH: Gil Bellows (Watty Watts), Renee Zellweger (Starlene), Rory Cochrane (Billy Mack), Jeffrey Combs (Dino Bob) and Jace Alexander (Creepy Cody).

By JANET MASLIN

As one more gory road movie about gun-toting, media-mad white trash on the rampage, C. M. Talkington's "Love and a .45" has elements of parody. There's enough of "Natural Born Killers" here to suggest that Mr. Talkington has read the mind of Quentin Tarantino, or at least taken satirical notice of Mr. Tarantino's early screenplay for that Oliver Stone film. On the other hand, maybe murderous teen-age lovebirds yearning to be television stars are simply a staple of our culture these days. And maybe some ideas are just plain parody-proof.

In any case, "Love and a .45" is too mean-spirited to be funny, and it winds up nastily derivative rather than clever. Mr. Talkington shows some visual talent and has assembled a head-bangingly effective soundtrack, but he's short on dramatic inspiration. Sentimental young sweethearts who take Polaroids of their hostages and are spurred into marriage by the thrill of murder are definitely old news.

Mr. Talkington exaggerates a few shades in telling the story of Watty Watts (Gil Bellows), who narrates the film with amusingly hollow solemnity, and his girlfriend, Starlene (Renee Zellweger), the daughter of hippie burnouts (Peter Fonda and Ann Wedgeworth). For instance, when Starlene says she thinks she and Watty belong in a movie like "Bonnie and Clyde," Watty nervously tells her that the young lovers wind up dead in those movies. And Watty says he can feel their destiny stretched out before them "like an ever-expanding pool of blood."

Minor characters also say things like "Well, I'm gonna go to the store and get me some K-Y and some cigarettes." However, Mr. Talkington stages his torture scenes too fondly to get much mileage out of his film's lighter moments. Extreme violence tends to wipe out the film's other potential.

The actors in "Love and a .45" (with Rory Cochrane as a druggy creep who gets tortured by a tattooing implement) are only as good as the material permits. At least Mr. Bellows (who plays a young convict in "The Shawshank Redemption") manages to deliver many of his lines with the wink they desperately need.

"Love and a .45" is rated R. It includes ugly, graphic violence and sexual situations.

1994 N 23, C14:4

RESISTANCE

Directed by Paul Elliot and Hugh Keays-Byrne; written by the Macau Collective; director of photography, Sally Bongers; edited by Stewart Young; music by Davood A. Tabrizi; production designer, MacGregor Knox; produced by Christina Ferguson, Pauline Rosenberg and Jenny Day; released by the Macau Light Corporation. Angelika 57, 225 West 57th Street. Running time: 112 minutes. This film is not rated.
WITH: Lorna Lesley (Jean), Helen Jones (Natalie), Stephen Leeder (Colonel Webber), Robyn Nevin (Wiley), Harold Hopkins (Peach) and Maya Sheridan (Sister).

By STEPHEN HOLDEN

Few areas of the world have inspired more mystically shimmering cinematography than the Australian outback, the setting for "Resistance," a contemporary political thriller directed by Paul Elliot and Hugh Keays-Byrne. That aura of magical translucence has been heightened by the film's director of photography, Sally Bongers, to evoke a vision of Australian rural life that is hallucinatory in its intensity and precision.

Ms. Bongers was largely responsible for the surreal ambiance that gave Jane Campion's films "Sweetie" and "The Piano" their otherworldly quality. And in "Resistance," which opens today at Angelika 57, she has outdone herself in creating beautiful but disturbing cinematic pictures that give the expression "the land down under" a more than geographic resonance.

Visually the film presents an epic vision of modern agricultural society as a contradictory world of high technology and raw instinct. Again and again, the camera draws back from the story to survey the landscape in breathtaking shots of primitive people and their sophisticated machines harvesting a half-tamed wilderness.

The cinematography is so stunning that it partly camouflages the seams and clichés of a story that is intended as a sweeping political fable. The setting is Ithaca Plains, a remote shantytown in the Australian breadbasket, populated mainly by migratory farmers, indigenous people and truck-stop service workers. Over the five days after a military coup, army troops arrive to enforce martial law and encounter a growing resistance movement.

Among the characters followed in the movie's loose mosaic structure are Natalie (Helen Jones), an Australian tribal woman; Jean (Lorna Lesley), a truck stop waitress with two children, and Wiley (Robyn Nevin), a feisty labor organizer who becomes one of the crackdown's first casualties. These and others who struggle against the oppression remain frustratingly undeveloped. And as the film dashes from person to person, it is not always clear how they are connected.

The invading troops are led by a steely-eyed colonel (Stephen Leeder) who, in the film's most heavy-handed sequence, is shown singing German lieder. The intimations of Nazism are jarringly out of place in a movie in which nothing else is remotely Germanic. The movie also devotes far too much time to the mad exploits of his sadistic henchman, Peach (Harold Hopkins).

Although peopled with characters who are either too sketchy or clichéd to care very much about, "Resistance" still accumulates an eerie power as it shows a rural society reacting moment by moment to the pressure of a military boot against its throat. With its superb crowd scenes, refined acting and menacing sense of physical invasion, the movie leaves you with the feeling that this is exactly how it could happen in the hinterlands of a modern industrialized state.

1994 N 23, C18:1

Correction

A film review yesterday about "Resistance" misstated a film credit for its director of photography, Sally Bongers. She did not work on "The Piano"; the cinematographer for that film was Stuart Dryburgh.

1994 N 24, A2:5

STEFANO QUANTESTORIE

Directed by Maurizio Nichetti; screenplay by Mr. Nichetti and Laura Fischetto (in Italian with English subtitles); story by Mr. Nichetti; director of photography, Mario Battistoni; edited by Rita Rossi; music by Rocco Tnica (Sergio Conforti) and Felez (Paolo Panigada); produced by Ernesto Di Sarro; released by Italtoons. Film Forum, 209 West Houston Street, South Village. Running time: 90 minutes. This film is not rated.
WITH: Maurizio Nichetti (Stefano), James Spencer Thiérrée (young Stefano), Amanda Sandrelli (the toy maker) and Elena Sofia Ricci (the stewardess).

By CARYN JAMES

Maurizio Nichetti, the director and star of the mildly funny and excruciatingly whimsical "Stefano Quantestorie," should not be confused with Nanni Moretti, the director and star of the current "Caro Diario," a far more sophisticated and droll film. Both have been compared, wrongheadedly, to Woody Allen, but a taste for one does not translate to the other.

Mr. Nichetti, whose "Stefano Quantestorie" opens today at Film Forum, once studied as a mime. He has a tendency to cast himself in the role of a mournful clown, and to load his films with multiple, overlapping stories that sound cleverer than they are.

In "Stefano Quantestorie" ("Stefano Many Stories"), Mr. Nichetti plays six roles. The central character is a policeman named Stefano. Visiting his parents, he encounters a woman working in a toy shop who, he believes, may be a robber the police are looking for. That is the plot from which the film leaps into five alternative stories that show how Stefano's life might have turned out differently. He might have been an airline pilot cheating on his wife with a stewardess. He might have been a math professor or even one of the robbers he is now pursuing.

Each life is played out in flashback, interwoven with the story of Stefano the policeman. Mr. Nichetti's hair changes with each role, but his hapless character is essentially the same. Characters from one story reappear in others in ways that are meant to be funny but turn out to be predictable. Stefano the professor turns out to be the husband of the airline stewardess with whom Stefano the pilot is fooling around.

The best surprise in the film is James Spencer Thiérrée, portraying Stefano as a young man who dreams of becoming a saxophone player. It would be easy to recognize Mr. Thiérrée as a gifted, graceful physical comedian even if he didn't bear a distinct resemblance to his grandfather Charlie Chaplin. In his silent role, he is a bumbler whose very clothes seem to be booby-trapped, and he offers a relief from the antic, ultimately tiresome stream of characters played by Mr. Nichetti.

"Stefano Quantestorie" is being shown with a deft and witty five-minute black-and-white film called "Hung Up," directed by Pat Hartley. In this quintessential New York story, a young woman calling her boyfriend from a pay phone tries hard to maintain her sanity, and just as important, her sense of style, under crazy-making circumstances.

1994 N 23, C18:1

THE PAGEMASTER

Directed by Maurice Hunt (animation) and Joe Johnston (live action); written by David Casci, David Kirschner and Ernie Contreras; director of photography, Alexander Gruszynski; edited by Kaja Fehr; music by James Horner; production designer, Gay Lawrence and Valerio Ventura; produced by Mr. Kirschner and Paul Gertz; released by 20th Century Fox. Running time: 75 minutes. This film is rated G.
WITH: Macaulay Culkin (Richard Tyler), Ed Begley Jr. (Alan Tyler), Mel Harris (Claire Tyler) and Christopher Lloyd (Mr. Dewey) and WITH THE VOICES OF: Mr. Culkin (Richard Tyler), Mr. Lloyd (the Pagemaster), Patrick Stewart (Adventure), Whoopi Goldberg (Fantasy), Frank Welker (Horror), Leonard Nimoy (Dr. Jekyll and Mr. Hyde) and George Hearn (Captain Ahab).

By CARYN JAMES

Unless Macaulay Culkin gets lost in some age-defying time warp, "The Pagemaster" has to be one of the last films in which this 14-year-old can play a cute little boy. He still does it very well as a scaredy-cat named Richard, who is fearful of everything, including his own treehouse. His father (Ed Begley Jr.) is worried by the way Richard can recite the statistical odds of being injured while playing baseball.

But Mr. Culkin's charm can't take this children's movie far. "The Pagemaster" is a pallid film framed at the start and finish by live action and mostly composed of cheap-looking animation. The movie proclaims that reading is an adventure, and though books literally come alive (one even has Whoopi Goldberg's streetwise voice and personality) the adventure never takes off.

When Richard wanders into a library during a thunderstorm, he discovers a ceiling mural that portrays the librarian (Christopher Lloyd) as a wizard called the Pagemaster. In a clever scene, the mural drips paint from the ceiling to create huge crayon-colored waves that chase Richard through the stacks, turning him and the entire movie into a cartoon.

Richard finds himself in the world of books, where he meets three friendly guides called Adventure, Fantasy and Horror: books with little legs and faces along their spines. The liveliest is Adventure, who benefits from the robust voice of Patrick Stewart (Star Trek's Jean-Luc Picard). Adventure has a peg leg and a kerchief around his head and calls people "mate." Fantasy (Ms. Goldberg) is a mauve-colored book who wears glass slippers and waves a magic wand, but her lines sound like castoffs from other Goldberg mov-ies. When someone points to a bird in the distance and says: "Look! Mother Goose!" she shouts, "Hey, girl!" (That's the entire Mother Goose sequence.) Horror (Frank Welker) has a blue, grinchlike face, but a heart as kind as that of Boris Karloff's monster. The book characters are clichés, but they're cute clichés.

The animation has the flat, stiff look of made-for-television cartoons, in which nothing in the background ever moves. And the film has an even bigger problem. As Richard and his friends make their way toward the exit sign that leads back to the real world, they run across scenes from classic stories. These episodes are lame snippets that children will find baffling and dull. Ahab goes after Moby-Dick in a scene painted red, an inexpensive but not especially effective way to add excitement. Did anyone think such scenes would send 8-year-olds scrambling to read Melville? Or even ask for an explanation? When the books and Richard wander into Dr. Jekyll's house (his voice is Leonard Nimoy's) the transformation into Mr. Hyde is not at all chilling. "The Pagemaster" is the kind of well-meaning film some parents think their children ought to like, but it ignores a child's sense of fun.

When Richard returns to the real world (and the film to live action), he proves he has overcome his fears by jumping his bicycle over a barrel in a dangerous stunt. Instead of leaving the theater talking about books, parents are likely to leave warning little bikers, "Don't ever try that!"

1994 N 23, C18:1

Kieslowski's Trilogy Finale: 'Red'

"Red" was shown as part of this year's New York Film Festival. Following are excerpts from Janet Maslin's review, which appeared in The New York Times on Oct. 4. The film opens today at Lincoln Plaza Cinemas, Broadway at 63d Street.

In the dense, archly mysterious films of Krzysztof Kieslowski, bold but ineffable patterns shape the characters' lives. Coincidences, missed opportunities, overbearing visual clues and strange, haunting parallels: all of these contribute to a gradually emerging sense of destiny. Stories develop like photographs in a darkroom. They are sharply defined only in retrospect, when the process is complete.

The arrival of his "Red," is an event in its own right. In fact, "Red" succeeds so stirringly that it also bestows some much-needed magic upon its predecessors, "Blue" and "White." The first film's chic emptiness and the second's relative drabness are suddenly made much rosier by the seductive glow of "Red."

Not for nothing is red the warmest of these three colors, which Mr. Kieslowski has taken from the French flag. Nor is it unhelpful that Fraternité, the theme that follows Liberté and Égalité in his series, is potentially the most engaging of his subjects. "Red" gets an additional leg up from the presence of two exceptionally fine actors, Irène Jacob and Jean-Louis Trintignant, who are perfectly suited to playing polar opposites here. They act their roles in an intricate story of friendship and deliverance while also serving as tuning forks for the director's larger intuitions.

In addition to being the best-acted of these three films, "Red" weaves the most enveloping web. Working more assuredly and less arbitrarily than he did at the series's start, Mr. Kieslowski plays deftly with the crossed wires that either connect or separate his principals in mysterious ways.

Early in the film, a literal image of telephone cable is enough to question what it means for these characters to communicate. When Valentine (Ms. Jacob) makes a phone call to her lover, Michael, a phone is seen ringing in the apartment of Auguste (Jean-Pierre Lorit), who lives across the street from Valentine. Why? Valentine and Auguste do not precisely know each other. But maybe they do, or should, or will. Mr. Kieslowski is particularly expert this time in constructing puzzling, overlapping patterns that bind lonely people together. A higher order can be glimpsed, quite movingly, beyond such bonds.

The idea of fraternity emerges through Valentine's highly charged encounters with a judge (Mr. Trintignant). Though not a love story in any conventional sense, "Red" is very much about the redemptive power of love.

"Red," which is itself filled with echoes and foreshadowing (greatly heightened by Zbigniew Preisner's insinuating music), culminates in a ferry crossing. As a red advertising billboard of Valentine becomes a prophecy, she is brought together with the principals from "Blue" and "White." This juxtaposition of destinies, which is not made to tie up narrative loose ends, is satisfying without being pat.

1994 N 23, C18:1

A LOW DOWN DIRTY SHAME

Written and directed by Keenen Ivory Wayans; director of photography, Matthew F. Leonetti; edited by John F. Link; music by Marcus Miller; production designer, Robb Wilson King; produced by Joe Roth and Roger Birnbaum; released by Caravan Pictures. Running time: 108 minutes. This film is rated R.
WITH: Keenen Ivory Wayans (Shame), Charles S. Dutton (Rothmiller), Jada Pinkett (Peaches), Salli Richardson (Angela) and Andrew Divoff (Mendoza).

By STEPHEN HOLDEN

In the funniest moment of "A Low Down Dirty Shame," a lighthearted detective yarn written and directed by and starring Keenen Ivory Wayans, the star deflects the charge of three dripping-fanged Dobermans by slipping into a James Brown imitation. From a supercool private eye, Mr. Wayans abruptly trans-

forms himself into a caricature of the godfather of soul, barking instructions to his backup singers on how to perform "Say It Loud, I'm Black and Proud." Caught up in the spirit, the canines halt their pursuit and begin rotating their heads in time with the beat.

For all its jokes, "A Low Down Dirty Shame" is not an out-and-out spoof of the blaxploitation genre like Mr. Wayans's 1989 comedy hit, "I'm Gonna Git You Sucka." The film, which opens today, is a good-natured action film that doesn't take itself at all seriously. Every few minutes the story stops in its tracks to deliver the same sort of broad situation comedy humor found on the star's hit television series, "In Living Color." The movie isn't afraid to offend. One running gag involves an interracial gay couple who are presented as mincing, lisping buffoons.

The story isn't much to speak of. Mr. Wayans plays Andre Shame, a former cop turned private eye whose business is going nowhere. Just when things are about to collapse, Shame is hired by an officer of the Drug Enforcement Agency to find $20 million dollars in missing drug money. Shame's adversary, Mendoza (Andrew Divoff), is a notorious drug czar rumored to be dead but actually alive and well and living with Shame's former sweetheart, Angela (Salli Richardson). In a movie in which almost everyone is a crude stereotype, Mendoza conforms to the typical Hollywood image of a Latin American drug czar as a fiendish, cackling sadist with bad skin.

Even in a genre that loves nothing more than the sound of shattering glass, "A Low Down Dirty Shame" has more than its share of flashy window-breaking. The glass smashing reaches a frenzied peak late in the movie in a sequence that reduces every transparent surface in a shiny new mall to glittering splinters.

Mr. Wayans is an agreeable screen presence, but he makes a surprisingly bland action hero. In scene after scene, he goes through the motions with the calm self-possession of someone who knows he is invulnerable and can't be bothered to pretend otherwise. The actor's aloofness isn't leavened by the tongue-in-cheek awareness that Wesley Snipes has brought to the action-adventure genre.

Shame is supposed to be a lady-killer but proves as dispassionate a lover as he is a fighter. As the object of two competing women, he seems bored by a contest that builds into a furious argument about who is a better fighter, Mike Tyson or Muhammad Ali. The combatants are the sultry Angela, whose preferred mode of escaping danger is to seduce her attacker, and Shame's adoring secretary and assistant, Peaches (Jada Pinkett).

As emotionally impulsive as she is tough, Peaches is a crazed soap opera fanatic who is hopelessly addicted to a show called "As the Heart Turns." When she spies the handsome young actor who plays a heel on the show, without thinking she charges through the fans and bops him one. Ms. Pinkett, whose performance is as sassy and sizzling as

a Salt-n-Pepa recording, walks away with the movie.

"A Low Down Dirty Shame" is rated R (Under 17 requires accompanying parent or adult guardian). It has violence, strong language and sexual situations.

1994 N 23, C18:5

CHANTONS SOUS L'OCCUPATION

Written (in French, with English subtitles) and directed by André Halimi; director of photography, Jean Rouch; edited by Henri Colpi and Michel Valio; produced by Argos Films, Les Films Armorial and the Institut National de l'Audiovisuel; released by Argos Films. At the Walter Reade Theater, 165 West 65th Street, Manhattan. Running time: 95 minutes. This film is not rated.

By JANET MASLIN

That the gaiety of Paris remained uncompromised throughout much of World War II remains a topic of some delicacy and relatively limited discussion. Certainly it was still controversial in 1976, when "Chantons Sous L'Occupation" ("Singing Through the Occupation"), André Halimi's thoughtful, unflinching documentary on this subject, was shown in Paris to hostile public and critical response.

Opening today for a six-day run at the Walter Reade Theater, Mr. Halimi's trenchant film uses images of sunny, uplifting show business personages to create a chilling mood. The inspirational power of popular entertainment is shown to be profoundly disturbing when subverted, as it was in Occupied France, to raise morale artificially and quell the impulse to resist.

Those who are interviewed for the film debate the value of keeping a nation's spirits up under such circumstances. "If you don't try to have fun at a time like that, when will you?" one man asks. And a woman who enjoyed the company of Nazi officers prides herself on never having let them do more than kiss her hand. "You can't reproach me for being 18 then, and carefree," she insists. Another man counters more substantively, capturing the filmmaker's perspective: "Nobody should have entertained the thought of mixing with these gangsters; worse than gangsters, criminals. They imposed their presence on us. We kept on dancing as if nothing had happened."

The film's many musical interludes and film clips attest to the way cheerful French performers ignored any link between art and accountability. There are breezy glimpses of famous figures like Maurice Chevalier, Sacha Guitry, Fernandel and Édith Piaf ("That girl was an artist, sure enough, but she stuck her head in the sand," someone says). Mr. Halimi also interjects sobering glimpses of the wartime realities that French audiences were eagerly escaping, but he does not overwork his opportunities for ironic contrast. The blithe, festive tone of these forms of entertainment speaks for itself.

Interviews conducted during the 1970's with prominent French figures variously criticize and explain this behavior. One man describes performers who kept working during wartime as either "embittered failures who grabbed the chance in life" or "people used to playacting who still wished to appear in the papers and on the screen." The existence of the Vichy Government played a role, too, some say; the collaboration of a leader like Marshal Petain encouraged his countrymen to follow suit.

The film also offers many examples of simple opportunism, and even snobbery, that contributed to collaboration. One madam remembers that "the Germans were generous, paid well and acted like gentlemen." She suggests that had American soldiers been in Paris instead, they wouldn't have been so well-mannered.

Mr. Halimi incorporates various French and German newsreel scenes to affirm the illusion that French life during wartime was one long holiday. There are amusement parks, foot races, showgirls, cafe scenes; there are fashion shows, one featuring an outfit called "The Last Metro." One man sardonically describes the fashion appeal, for those who chose truly to be blind, of German officers: "a sense of theater with a taste for boots, leather and metal."

The very fact that Parisian glamour remained visible and sacrosanct under the Nazis is this film's most sobering thought. As an image for manipulation, the city's legendary allure became a weapon of the war. And its citizens took on a new set of responsibility to their own consciences, as well as to the world. "Singing Through the Occupation" is a provocative, principled examination of what those responsibilities really were.

1994 N 25, C12:1

Critic's Choice

A Jamaican Journeyer in Search of His African Roots

Howard A. Trott, the subject of Fritz Baumann's film "The Journey of the Lion," is a Jamaican Rastafarian who lives an impoverished existence with his two children in a shack on the outskirts of Kingston. Disgusted with modern civilization, Brother Howie, as he is known, dreams of repatriation in Africa. Out of the blue one day, he receives a letter from the sister he hasn't seen in 30 years inviting him to visit her in London. Leaving Jamaica for the first time in his life, he embarks on a journey that takes him to England and eventually to Egypt and Ghana.

The eloquently simple film, which is to be screened twice this weekend at Cinema Village (tomorrow at 3:50 P.M. and Sunday at 9 P.M.), is among 13 movies having their American premieres as part of the Contemporary Films of the African Diaspora Festival. The festival, which opens at noon today with "Life is Rosy," a musical comedy from Zaire, is presenting 32 recent feature films from around the world.

Much of the screenplay for "The Journey of the Lion" consists of letters from the road written by Brother Howie to his children, Irey and Makeba. On his first plane trip, he is surprised by the "tinned things" that are served and by the fact that when flying you don't feel as if you are moving. In London, he is entranced by everything from frost on a windshield to the efficiency of the subway system.

It is there that he befriends a photographer, who takes him to northern Africa where he discovers that the desert can be cold and that the people are mostly Mus-

lim. From Egypt, he sets off by himself for Ghana. Here is where he finally begins to feel at home, recognizing the roots of his Jamaican culture in the music and storytelling. In the film's touching final scene, he stands on the remains of a coastal fortress and reflects on his ancestors who were carried off as slaves.

Three other feature films are to have their American premieres this weekend at the festival. The South African movie "Friends" is the story of three women, two black and one white, who struggle to maintain their friendship in the face of apartheid. "Xime," from Guinea Bissau, is set in 1963 and follows the independence movement against Portuguese rule as it affects a village that has a tradition of nonviolence.

"Cachao" is the Hollywood actor Andy Garcia's tribute to Israel (Cachao) López, the master Afro-Cuban bassist and mambo pioneer. Mr. Garcia produced and directed the concert film, which includes appearances by Gloria Estefan and Paquito D'Rivera.

Cinema Village is at 22 East 12th Street, East Village. Tickets: $7. Box office: (212) 924-3363.

STEPHEN HOLDEN

1994 N 25, C12:1

TOM AND VIV

Directed by Brian Gilbert; written by Michael Hastings and Adrian Hodges, based on Mr. Hastings's play; director of photography, Martin Fuhrer; edited by Tony Lawson; music by Debbie Wiseman; production designer, Jamie Leonard; produced by Peter Samuelson, Marc Samuelson and Harvey Kass; released by Miramax. At Cinema 2, Third Avenue at 60th Street, Manhattan. Running time: 125 minutes. This film is rated R.

WITH: Willem Dafoe (Tom), Miranda Richardson (Viv), Tim Dutton (Maurice), Rosemary Harris (Rose Haigh-Wood) and Nickolas Grace (Bertrand Russell).

By CARYN JAMES

T. S. Eliot was a genius and a prig — not an endearing combination in life, and not an easy one to portray on screen. Willem Dafoe, whose usual screen presence is hot and passionate, is one of the last actors who come to mind to play him. But as "Tom and Viv" tells the ghastly story of Eliot's marriage to Vivien Haigh-Wood, Mr. Dafoe's stunningly sharp, sympathetic portrait raises the film above a script that is full of serious holes and stilted dialogue.

Mr. Dafoe's Eliot has the forced accent of an American who desperately wants to be British, a voice as unnatural as a hothouse English rose. His face is thin to the point of gauntness. His narrow nose is a little too beaked to be truly refined, yet it carries the perfect expression of his pinched, hawklike nature. Here is a man terrified of emotional chaos, who marries a woman guaranteed to give him nothing but.

"Tom and Viv," which began as a play by Michael Hastings (who wrote the screenplay with Adrian Hodges), is one of those reclamation projects in behalf of a woman almost lost to history. Its scope is limited to the years of Tom Eliot's marriage to Vivien (Miranda Richardson), from their meeting at Oxford in 1915 until her death in 1947, a span that includes his writing of "The Wasteland." As Vivien's brother, Maurice (Tim Dutton), says in voice-over at the start of the film, "Vivien suffered from what we used to call women's troubles," probably a hormonal imbalance that led to wild emotional swings, behavior that was often impolite rather than lunatic, and severe menstrual bleeding that disgusted her fastidious husband. In 1938, with her husband's consent, she was carted off to a mental hospital, where she died nine years later. Eliot had not seen her or spoken to her in a dozen years.

However sympathetic to Vivien the film is, it cannot overcome the simple fact that Eliot, an enduring poet and a horrid individual, was far more interesting than his wife. "Tom and Viv" is fascinating and troubling, yet it is notable not for Vivien, but for her husband and his immersion in the dark side of the English upper middle class, whose repression matched his own perfectly and disastrously. Wanting to leave his American past behind, Eliot carried a stifling puritanism right back where it came from.

With no trace of its stage-bound beginning, the film colorfully cap-

Miramax Films

The story of a marriage: Willem Dafoe and Miranda Richardson.

tures the allure of the life to which Eliot aspired. He travels from the stateliness of Oxford to the opulent country house of the Haigh-Wood family, all dark wood walls and formal gardens. Vivien's family and its social standing evoke more passion from Eliot than his wife ever did. At the Haigh-Woods' everyone dresses for dinner, and Vivien, whose medicine is failing to help, refers to their friend Bertrand Russell in a loud voice: "Bertie wants to go to bed with me. Did you know that, Tom?" Her mother, beautifully played by Rosemary Harris with helpless concern, quickly ushers Vivien from the dining room.

Tragic though Vivien's story is, Ms. Richardson has been handed a role that approaches cliché, that of a woman misunderstood by medical science and disparaged by her culture. Her doctor diagnoses a mental disorder that leads to "disregard for propriety," and she is committed as much for being unruly as for any medical malady. There is little sense of what was distinctive about the supposedly high-spirited and literate Vivien Eliot.

At first she is treated like a child and behaves like one. She whispers at a dinner party, in Virginia Woolf's presence, that Woolf called her "a bag of ferrets" around poor Tom's neck. (Woolf did.) Eventually there are lunatic moments. Vivien melts chocolate and pours it through the mail slot of her now-famous husband's offices at Faber & Gwyer publishers. The chocolate scene was invented, though in reality Eliot's secretaries often pretended he wasn't in when his wife called. The film is not scrupulous about facts, but its sometimes exaggerated scenario is always based on reality.

The omissions are a greater problem. Although Vivien is seen typing Tom's manuscripts and looking over his shoulder as he works, there is no sense of how powerfully the relationship, and Eliot's persistent guilt about his emotional failures, shaped his poetry.

And there is no hint of Eliot's own bizarre behavior, including a period during which his Bloomsbury

friends noticed that he wore greenish face powder, the better to enhance his martyred appearance. On screen, his self-pity is merely hinted at by the reproduction of "The Martyrdom of St. Sebastian" that hangs over his desk.

Yet despite the limitations of the role, Mr. Dafoe captures Eliot's chilling inability to deal with anyone's emotions, especially his own. Vivien listens to him lecture a roomful of admirers, telling them that "poetry is not an expression of emotion, but an escape from emotion." Mr. Dafoe's rigid face and haunted eyes suggest what Eliot's poetry cost him in human terms. As Maurice says at the end of the film, when he visits the fading Vivien at the hospital: "Vivien was, of course, the strong one. She made cowards of us all." The triumph of Mr. Dafoe's portrayal is that he depicts Eliot's brutality and cowardice without making him inhuman.

Brian Gilbert, whose previous films include the forgettable "Vice Versa" and the ludicrous "Not Without My Daughter," has directed "Tom and Viv" with surprising tact and intelligence. "Tom and Viv" opens today at Cinema 2 for one week to qualify for Academy Awards and is to begin its regular run in January. Mr. Dafoe's role doesn't offer the flamboyant rant that usually captures Oscar votes, but in its brilliant restraint it is one of the finest performances of the year.

"Tom and Viv" is rated R (Under 17 requires accompanying parent or adult guardian). It includes a bit of strong language.

1994 D 2, C3:1

COBB

Written and directed by Ron Shelton; director of photography, Russell Boyd; edited by Paul Seydor and Kimberly Ray; music by Elliot Goldenthal; production designers, Armin Ganz and Scott T. Ritenour; produced by David Lester; released by Warner Brothers. Running time: 130 minutes. This film is rated R.

WITH: Tommy Lee Jones (Ty Cobb), Robert Wuhl (Al Stump) and Lolita Davidovich (Ramona)

By JANET MASLIN

The gamesmanship explored by Ron Shelton's "Cobb" doesn't have much to do with baseball. Guts, cunning, endurance, agility: useful as these are on the playing field, they're also part of the myth-making process that exalts a sports hero. In his story about Ty Cobb, the notoriously sour baseball legend, Mr. Shelton wrestles with raw material — a drunken, violent, abusive, bigoted figure — that is indeed raw. So how badly, "Cobb" wonders, does America need its heroes? Badly enough to play by new rules when the star athlete is a miserable man?

The answers can't be found in Cobb's glory days, which are dealt with so summarily in this blustery, fire-snorting film that they may disappoint sports fans eager to see Cobb in action. Instead, those answers come at the 11th hour, with Cobb (Tommy Lee Jones) a bitter old reprobate and Al Stump (Robert Wuhl) a sportswriter hired to sugarcoat his story. Actually, the one-man title of "Cobb," Mr. Shelton's adroitly written but unevenly directed film, is misleading, since this collaboration to shape Ty Cobb's legend makes for a two-character, buddy-movie duel.

"Cobb" unfolds rambunctiously from this sportswriter's perspective, which has grown bittersweet since Mr. Stump helped lionize Cobb with the star's 1961 autobiography, "My Life in Baseball: The True Record." With hindsight, Cobb's 10-month collaboration with Mr. Stump no longer sounds like innocent hagiography. And it's unlikely that a journalist would try so hard to shield a rattlesnake like Ty Cobb from warts-and-all public scrutiny. Yet it's hard to avoid hero-worship in describing an athlete of Cobb's stature.

As a film maker ("Bull Durham," "White Men Can't Jump") who has his own love-hate romance with the sports world, Mr. Shelton is naturally drawn to his writer's uneasy relationship to Cobb. And at its best, this film explores the edgy compromises that link these two, while at worst it dramatizes the relationship broadly and histrionically. "That night I made a decision," Stump announces at one such overheated juncture. "I decided to tell the truth."

The truth wasn't pretty. Relishing his role as the most hated man in baseball, Ty Cobb was the sort to save uncanceled stamps from his fan mail and burn the rest of it to save on firewood. Rich and miserly, he could go without heat and hot water to spite the electric company. Flagrantly racist, he once kicked a chambermaid who objected to a racial slur. A disaster as a family man, he was divorced twice on grounds of cruelty and horsewhipped Ty Jr. when the boy flunked out of Princeton.

Do revelations like these, contained in Mr. Stump's still-admiring revisionist biography, "Cobb," tarnish a man whose lifetime batting average remains unsurpassed? "Cobb" thinks otherwise; like "Bullets Over Broadway," it suggests that genius makes its own rules. But when depicting the darker side of such genius, it helps to rely on Mr.

Sidney Baldwin/Warner Brothers

Tommy Lee Jones

Jones, an actor whose own genius can make him someone audiences love to hate. Imagine Sean Penn, who actually resembles Ty Cobb, as this cursing, brawling, vicious character and you might have a much more honest portrait of such a misanthrope — and a movie nobody would see.

Seeing Mr. Jones is a more frankly captivating experience. He's an actor whom audiences would follow anywhere, one whose other work released this year (in "The Client," "Blown Away" and "Blue Sky") shows off a snappish, gritty presence that lends any film a little extra fury. (Only "Natural Born Killers" falls short of that.) This time, directed at high tragicomic pitch by Mr. Shelton, he must vacillate between scenes searching for Cobb's human side and those that show the monstrous aspect at full, cartoonish throttle. But he easily inhabits this big, colorful role. He gives this film the entertaining demon it needs.

Mr. Wuhl, playing Al Stump as straight man and sounding board, is clearly overmatched, especially

when the film veers toward clumsy comedy. Athlete and biographer first meet, for instance, in a scene that has Cobb smashing glass, swilling pills and booze, ranting insults and randomly firing his Luger. Even allowing for the intentional excesses of such an episode, delicacy is a casualty here.

Following Cobb and Mr. Stump on the road together as they visit Reno, Cooperstown, N.Y., and then Cobb's native state of Georgia, the film contrives ways for Cobb to act out his troubles and relive troubled moments in flashback. Mr. Jones is especially strong in a Reno scene dramatizing the septuagenarian Cobb's impotence and loathing for women. The scene works with startling force, even if Mr. Jones never seems remotely elderly and Lolita Davidovich, as a nightclub cigarette girl, is even more shrill than her role requires.

Mr. Shelton also makes effective use of repetition by opening the film with a cheery newsreel account of Cobb's life and then replaying it later, at the Baseball Hall of Fame, with Cobb imagining uglier scenes that depict his real experience. A repeated flashback showing the shooting of Cobb's father suggests the roots of Cobb's monumental skepticism about the human race.

But "Cobb" is finally nowhere near as tough as the man was himself. A sportswriters' brand of romanticism creeps into later scenes, suggesting a softie of a Cobb who is secretly more frail, wounded and generous than he cares to let on. "How do I look?" he eventually asks Mr. Stump, who has arrived at the grudging sentimentality that is the core of Mr. Shelton's view of his subject.

The softball answer: "Like the greatest ballplayer of all time."

"Cobb" is rated R (Under 17 requires accompanying parent or adult guardian.) It includes profanity, brief violence and frontal nudity.

1994 D 2, C8:5

ble as a no-show in the Oscar race, giving one more black mark to the arcane nominating procedures of the Academy of Motion Picture Arts and Sciences. China, which now bans some of its most distinguished film makers from traveling abroad and even working, required Mr. Zhang to produce a written apology for "To Live" and isn't likely to submit his scathing film as a possible nominee.

The academy still relies on nominations made by a film's country of origin. Aside from allowing politics to influence the process, this system works against international co-productions, which are more and more present. So Krzysztof Kieslowski's haunting "Red," a nominally Swiss film with a Polish director and French producer, is considered unacceptable as a candidate from any of those countries.

"To Live" and "Red" will not be the only impressive films unreasonably overlooked by the Oscars. There's a casualty of the academy's television rule, which disqualifies films if they were seen on television before their American theatrical release. Best-actress nominees will be elusive this year, and Linda Fiorentino's scarifying performance as a ruthless con woman looks like a real contender. But "The Last Seduction" was first shown on HBO, so it hasn't got a chance.

JANET MASLIN

1994 D 2, C10:1

BOYS LIFE

Released by Strand Releasing. At Quad Cinema, 13th Street west of Fifth Avenue, Greenwich Village. Running time: 90 minutes. These films are not rated.

POOL DAYS, written, directed and produced by Brian Sloan; director of photography, Jonathan Schell; edited by Mr. Sloan; music by Hundred Pound Head; production designer, Carol Giardono.

WITH: Josh Weinstein (Justin), Nick Poletti (Russell) and Kimberly Flynn (Vicky).

A FRIEND OF DOROTHY, written, directed and produced by Raoul O'Connell; director of photography, W. Mott Hupfel 3d; edited by Chris Houghton; music by Tom Judson.

WITH: Raoul O'Connell (Winston), Anne Zupa (Anne), Kevin McClatchy (Tom) and Greg Lauren (Matt).

THE DISCO YEARS, written and directed by Robert Lee King; director of photography, Greg Gardiner; edited by Paul McCudden; music by Wendall J. Yuponce; production designer, Les Brown; produced by Mr. King, John Peter James and Richard Hoffman.

WITH: Matt Nolan (Tom), Russell Scott Lews (Matt), Gwen Welles (Melissa) and Dennis Christopher (Mr. Reese).

By STEPHEN HOLDEN

The protagonists of each of the three short films that open today at the Quad Cinema under the title "Boys Life" are young, white, middle-class men facing the realities of being 17 or 18 and gay. Although it may be less traumatic for young gay men to come out to their friends and families today than it was 25 years ago, these three films suggest that acknowledgement of one's own homosexuality in a predominantly straight society is still no picnic even in a supposedly liberated era.

In Raoul O'Connell's "Friend of Dorothy" and Robert Lee King's

"Disco Years," the main characters are students who have to tiptoe with excruciating care through environments that could turn viciously hostile with one indiscreet gesture. The protagonist of Brian Sloan's "Pool Days" is a virginal 17-year-old lifeguard who is just becoming aware of his homosexuality but has yet to act on his desires.

The endearing but technically crude "Friend of Dorothy" was written, directed and produced by Mr. O'Connell, who stars as Winston, a shy and lonely New York University student desperate to make some kind of erotic contact. Winston, whose dorm room is covered with Barbra Streisand posters, hankers after his handsome roommate, Tom (Kevin McClatchy), and tries to pick up men in a library, in a lavatory and in Washington Square Park. Winston's attempts to make sexual contact are portrayed as a rueful waiflike comedy that verges on farce when one young man he picks up turns out to be a recruiter for the Unification Church. Winston's biggest cheerleader and adviser is his best friend, Anne (Anne Zupa), who observes his quest with an amused affection. But a scene in which he is contemptuously gay-baited by Tom's best friend, Matt (Greg Lauren), pointedly shows the social risks Winston faces.

At its best, "A Friend of Dorothy" has an easygoing documentary quality that captures the texture of college life with a knowing good humor. A scene at a collegiate pot-smoking party has an especially satiric bite. Despite its choppy editing, "A Friend of Dorothy" conveys a keen sense of what it feels like to be 18 and innocent and have a heart bursting with inchoate longings.

Tom (Matt Nolan), the protagonist of "The Disco Years," is a bit more knowing and self-assured than the rabbity Winston. In this politically edged memory play, Tom recalls his coming out in the late 1970's with a tennis partner, Matt (Russell Scott Lewis), who seduces, then rejects him. Matt goes on to lead a student hate campaign against a gay teacher. And Tom, whose mother refuses to accept her son's homosexuality, is forced to make extremely difficult choices, which the movie glosses over far too quickly for comfort.

"The Disco Years," although bluntly schematic, is well acted and chillingly captures the cruelty of teen-age homophobia.

"Pool Days," which was reviewed in March as part of the New Directors/New Films series, is easily the most polished of the three. In this comedy of health-club manners, Justin (Josh Weinstein), an inexperienced 17-year-old lifeguard at an indoor pool, faces erotic choices in a job that also entails his playing sexual watchdog in the men's steam room. Mr. Weinstein's portrayal of a blushing innocent reluctantly confronting his confusion is utterly convincing. Nick Poletti and Kimberly Flynn, as sophisticates who offer to initiate Justin into gay and straight sex, give their roles a sly comic edge that makes each of them almost likable.

1994 D 2, C16:5

Critic's Choice

Mixing Humanity and History to Illustrate the Flux of Family Life in China

With exquisite simplicity, the astonishing Chinese film maker Zhang Yimou tells stories that pierce the heart. "To Live," his latest (after "Raise the Red Lantern," "Ju Dou" and "The Story of Qiu Ju"), is one more stirring example of this director's ability to mix humanity with history, letting a politically charged drama unfold on the most intimate, affecting scale. Mr. Zhang's daringly iconoclastic work remains banned in China, but it deserves to be admired in every corner of the globe.

"To Live," an eloquent and devastating chronicle of family life in

modern China, spans three decades in the marriage of a couple (played wonderfully by Ge You and Gong Li) buffeted by political upheaval. Those changes manifest themselves in indirect ways, but family tragedies and reversals of fortune are inextricably linked to larger changes in Chinese life. That theme is familiar among today's Chinese film makers, but Mr. Zhang makes it particularly personal and moving. He also sets forth this sad story with a superb eye for revealing detail.

"To Live," one of this year's very best foreign films, will also be nota-

TRAPPED IN PARADISE

Written and directed by George Gallo; director of photography, Jack N. Green; edited by Terry Rawlings; music by Robert Folk; production designer, Bob Ziembicki; produced by Jon Davison and Mr. Gallo; released by 20th Century Fox. Running time: 111 minutes. This film is rated PG-13.
WITH: Nicolas Cage (Bill Firpo), Jon Lovitz (Dave Firpo), Dana Carvey (Alvin Firpo), Florence Stanley (Ma Firpo), Mädchen Amick (Sarah Collins) and Donald Moffat (Clifford Anderson).

By JANET MASLIN

Since "Trapped in Paradise" assembles three actors as amusing as Nicolas Cage, Dana Carvey and Jon Lovitz, it's a minor holiday miracle that this homey comedy barely elicits even a chuckle. Setting his cumbersome story among small-town folks at Christmastime, the writer and director George Gallo ("29th Street") succeeds all too well in capturing his characters' ordinariness without allowing them any particular spark.

Quaint little Paradise, Pa., isn't plastered with neon signs, but if it were, they would tout this as Capra country. This wholesome burg is meant to be a humorously incongruous place to find the Firpo brothers: one restaurateur (Mr. Cage) and two crooks (Mr. Carvey and Mr. Lovitz) on the lam.

As the fall guy who is crazily roped into his brothers' troubles, Mr. Cage behaves with the loony chagrin he brought to a gleefully improbable comedy like Andrew Bergman's "Honeymoon in Vegas." But this situation isn't sufficiently Bergmanesque, and Mr. Gallo develops it at a lumbering pace. The crooks lure their brother to Paradise, where the three wind up robbing a bank, only to feel guilty afterward because the locals are so darned nice. Stuck in this quagmire of kindliness, the film can't even cook up the claustrophobic energy of "Groundhog Day."

As "Trapped in Paradise" pokes along (often in snowy nighttime scenes, which give it a cheerless look), the actors resort to good-humored if predictable comic gambits. Mr. Carvey, playing a high-voiced, childlike kleptomaniac, will remind audiences that he is a funny performer who has yet to find a film role worth his time. Mr. Lovitz oils his way pleasantly through an underwritten role. Mr. Cage, a master of the slow burn, uses his durable comic reactions even when the film gives him little reason to be indignant, astonished, exasperated or otherwise aflame.

Mädchen Amick is on hand as a clean-cut, perfectly uninteresting love interest for one of the brothers. You will easily guess which one, since Mr. Gallo's screenplay is without surprises. The film's sole enjoyably over-the-top performance comes from Florence Stanley, who plays the boys' caustic mother. She screams out her role even when locked in the trunk of a car.

"Trapped in Paradise" is rated PG (Parents strongly cautioned). It includes mild profanity.

1994 D 2, C16:5

BERENICE ABBOTT
A View of the 20th Century

Produced, edited and directed by Martha Wheelock and Kay Weaver; director of photography, Ms. Wheelock; released by Ishtar Films. Cinema Village, 22 East 12th Street, Greenwich Village. Running time: 57 minutes. This film is not rated.
WITH: Berenice Abbott (herself) and commentary by Hilton Kramer, Dr. Daniel Walkowitz, Dr. Michael Sundell, Dr. Philip Morrison, Julia Van Haaften and Maria Morris Hamburg.

BEYOND IMAGINING
Margaret Anderson and The Little Review

Written, produced, edited and directed by Wendy L. Weinberg; director of photography, Ms. Weinberg; music by Michael Aharon; released by Women Make Movies. Cinema Village, 22 East 12th Street, Greenwich Village. Running time: 30 minutes. This film is not rated.
WITH: Marcia Saunders (Voice of Margaret Anderson).

By STEPHEN HOLDEN

"The world doesn't like independent women," muses the 92-year-old photographer Berenice Abbott in Martha Wheelock and Kay Weaver's handsomely filmed documentary of her life. "Why, I don't know, but I don't care."

Abbott, a self-described loner who died in 1991, shortly after the film was completed, was a giant of American photography. The film, which uses over 200 of her black-and-white photographs, presents her as a proud proto-feminist who near the end of her life declares matter-of-factly, "There is nothing smarter than an old woman."

"Berenice Abbott: A View of the 20th Century," which opens today at Cinema Village, surveys Abbott's six-decade career, during which she underwent an astounding creative metamorphosis. She was born in Springfield, Ohio, and moved to Paris in the early 1920's, becoming Man Ray's photographic assistant. After striking out on her own, she compiled a photographic Who's Who of the Parisian literary and art worlds. Among the famous photographic portraits shown in the film are those of Jean Cocteau, André Gide, James Joyce and Janet Flanner.

Upon moving to New York City in 1929, Abbott reinvented herself as a documentary portrayer of the American landscape and especially New York during the Depression. Her beautifully composed studies of the city around the time that Rockefeller Center was under construction found as much visual poetry in a newsstand or a grocery store window as in a view of a boat passing in front of the skyline.

Her blend of classicism and documentary realism, the film reveals, owed much to the French photographer Eugène Atget, whose work she championed aggressively. Expressing her esthetic views with a terse vehemence, she asserts that photography that isn't documentary "isn't photography."

In the 1950's, Abbott entered the third major phase of her career with her ground-breaking scientific photography. Among the pictures shown in the film are her lucid and elegant studies of electricity, magnetism, water waves and multiple light beams.

In the spirit of Abbott's work, the film celebrating that work is a model of clear, balanced portraiture. The commentary by scholars, curators and critics is interwoven with her own common-sense observations with a concision that wastes few words. Abbott reiterates several times that the value of a photographic image ultimately depends on choosing the right subject. And the resonance of the work shown in the film demonstrates that her choices were almost always right.

The one area the film leaves unexplored is Abbott's personal life. No significant personal relationships are mentioned or even alluded to. The impression left by the film is of a proud, thorny woman who early in life became so immersed in her work that she came to look down on the interpersonal realm as a trivial distraction from higher pursuits. By contrast, "Beyond Imagining: Margaret Anderson and The Little Review," a shorter film sharing the bill with "Berenice Abbott," celebrates its subject's personal relationships. In Wendy Weinberg's portrait of the woman who founded the influential avant-garde magazine The Little Review and who was prosecuted for serializing James Joyce's "Ulysses," Anderson emerges as a fearlessly flamboyant and charismatic editor given to grandly hyperbolic enthusiasm.

The film devotes considerable time to exalting her longtime lesbian relationships with Jane Heath, with whom she ran The Little Review and whom she called "the world's greatest talker," and with Georgette Leblanc, the soprano and actress with whom she later lived in France until the outbreak of World War II.

Although "Beyond Imagining," like "Berenice Abbott," presents its subject as a feminist role model, it suggests that Anderson and Abbott, whose paths crossed, were temperamental opposites. Work for Abbott was a solitary, pioneerlike mission. For Anderson, it was a passionate adventure to be shared with an equally free-spirited companion.

1994 D 7, C15:4

CURFEW

Written (in Arabic, with English subtitles) and directed by Rashid Masharawi; director of photography, Klaus Juliusburger; edited by Hadara Oren; music by Said Mouraad/Sabreen; art director, Sharif Waked; produced by Hany Abu-Assad, Samir Hamed, Henri P. N. Kuipers and Peter van Vogelpoel; released by New Yorker Films. Film Forum, 209 West Houston Street, South Village. Running time: 75 minutes. WITH: Salim Daw (Abu Raji), Naila Zayaad (Um Raji), Younis Younis (Radar), Mahmoud Qadah (Akram), Assem Zoabi (Raji), Areen Omari (Houda) and Salwa Naqara Haddad (Salma).

By JANET MASLIN

"Curfew" visits a Palestinian household in Gaza, an extended family uneasily confined to quarters by an open-ended military curfew. The time is 1993, just before peace negotiations began, and the atmosphere is both torpid and tense. Rashid Masharawi, a film maker who was himself raised in a refugee camp, understands the slowly debilitating effects of such confinement. He describes them in a compassionate but obvious film that spans one long, claustrophobic day.

So "Curfew," which opens today at the Film Forum, depicts the ways this family accommodates itself to imprisonment. The film is a virtual catalogue of curfew-related troubles, from the difficulty of shaving when water is shut off to the use of onions to stave off painful effects of tear gas. A baby cries inconsolably. Vegetables spoil. The patriarch, Abu Raji (Salim Daw), suffers a backache but is trapped at home, unable to alleviate his pain.

Mr. Masharawi presents these inconveniences as effectively symbolic, as when women living under the shadow of military rule discuss the difficulties of drying laundry without enough sunlight. Abu Raji himself spends much of the day in pajamas, sadly resigned to a life in limbo. "Curfew" does not deal explicitly with Palestinian-Israeli politics (beyond glimpses of Israeli soldiers occasionally raiding nearby households). But its characters are presented as helpless, uncomplicated innocents. Its mood is one of lingering despair and its political thrust more than clear.

While Mr. Masharawi displays a keen understanding of his characters' paralysis and the spiritual toll exacted by their oppression, he often expresses these thoughts in blunt, stilted ways. Hovering uncertainly between documentary and drama, "Curfew" lacks the grit that its subject warrants. The characters behave with patience and stoicism during most of the film, but when their frustration suddenly escalates, the change feels stagy. Meanwhile, the film's predictable way of pointing out each hardship renders it less surprising than a cinéma vérité portrait could have been.

"Curfew" does have a smooth, proficient visual style and an affecting cast, with a particularly touching performance from Mr. Gaw. His air of weary resignation conveys terrible frustration and runs agonizingly deep. That body language speaks much more subtly than Mr. Masharawi's earnest but overbearing screenplay.

1994 D 7, C17:1

DISCLOSURE

Directed by Barry Levinson; written by Paul Attanasio, based on the novel by Michael Crichton; director of photography, Anthony Pierce-Roberts; edited by Stu Linder; music by Ennio Morricone; production designer, Neil Spisak; produced by Mr. Levinson and Mr. Crichton; released by Warner Brothers. Running time: 128 minutes. This film is rated R.
WITH: Michael Douglas (Tom Sanders), Demi Moore (Meredith Johnson), Donald Sutherland (Bob Garvin), Caroline Goodall (Susan Hendler), Roma Maffia (Catherine Alvarez), Nicholas Sadler (Don Cherry) and Dennis Miller (Mark Lewyn).

By JANET MASLIN

AT the end of her first day at the Seattle offices of Digicom, Meredith Johnson (Demi Moore) can be found charging out of her office with her clothes unbuttoned, yelling, "You get back here and finish what you started!" to the man who got away. Beyond making the after-hours cleaning woman wonder just how Meredith landed her powerful position, this sequence is meant to provoke debate. It's also supposed to make "Disclosure," the glossy, techno-torrid film version of Michael Crichton's alarmist novel, look more daring than it really is.

In the brave new corporate culture of "Disclosure," is Meredith's behavior truly threatening? Are there legions of saucy female executives ready to act this way? Should nice guys like Tom Sanders (Michael Douglas) be worried about falling prey to such vixens? And why on earth is Mr. Douglas, an actor known to audiences as Mr. Kinky Philanderer for his steamier roles in "Basic Instinct" and "Fatal Attraction," playing the man who is sexually harassed by Meredith but just says no?

Actually, Mr. Douglas is here in something more like his "Falling Down" capacity: as an ordinary Joe pushed to the limit by a big, bad, unreasonable world. In this case, unreasonableness is a high-powered babe who chatters meaningfully about "the new compression algorithms" while also saying, "You know, I like all the boys under me to be happy" and "You just lie back and let *me* be the boss."

Meredith's subversion of old-fashioned womanly wiles is too stiffly contrived to be upsetting. But what's legitimately disturbing about "Disclosure" is its utter confusion of technology and eroticism. The computer-age products in this film easily eclipse the human players, and the sex appeal of ingenious engineering is everywhere. Ms. Moore's bold mega-cleavage, presented almost as weaponry during the story's brief, all-important seduction scene, fits in perfectly with this film's other technological marvels.

Meredith and Tom are supposed to be former lovers, though the film is too perfunctory about mere personal matters to make their past history plausible. A salient fact about their seduction scene is that Meredith has plied Tom with wine; not just any wine, but wine they once liked during a fact-finding mission to the vineyards of Napa Valley. Here is yuppie eros with a vengeance. And here's why "Disclosure" is more bloodless and farfetched than its stars' hotter movie hits.

"Disclosure" also finds Barry Levinson, a director once known for warmly intimate films about believable people ("Diner," "Tin Men"), severing all apparent ties to the real world. Mr. Levinson's direction is proficient enough to keep the film moving, but it's too soft-edged and fussy to achieve the crisp, efficient manner best used to suggest cleverness and hide a thriller's glaring flaws. Mr. Levinson is never fully at ease with a story that for all its scientific ingenuity, barely has two dimensions.

The real star of "Disclosure" is the business-world fantasy that is Digicom, an environment the film tries to make more inviting than any of its human characters. With production design (by Neil Spisak) almost as fancy as that of his overblown "Toys," Mr. Levinson confines the film to offices so casually, staggeringly sophisticated that the viewer may crave a job as a forest ranger before this story is over.

The correct language for this workplace is so chock-full of layman-daunting jargon (a Crichton hallmark) that the actors' biggest challenge is to sound sentient while speaking. But it's never easy to suppose any of them has more than 10 percent of an idea of what he or she is talking about. As the film's confusing yet simple-minded denouement reveals, no characters here are as smart as their talk about milliseconds and prototypes makes them sound.

Whether smugly delivering a corporate presentation or discussing a database while on her exercise machine, Ms. Moore is overweening enough to annoy audiences as a boss they'd love to hate. Certainly she has that effect on Tom even before she pounces on him, since Meredith has supplanted Tom at the company. "You used to have fun with a girl," another businessman mutters darkly aboard the ferry Tom takes to work. "Nowadays she probably wants your job."

"Disclosure" takes only one work week to hand Meredith her comeuppance, set up a scheme about a corporate merger and let Tom reassert himself in the natural order of things. But the week is not otherwise a busy one. This film really has only two big sequences: the harassment interlude, which isn't the show stopper it promises to be, and a scene that sends Tom into a virtual-reality corridor to look through top-secret company records. Children would enjoy the second episode, which is rife with special effects, if they weren't in danger of being permanently damaged by the first.

Understanding a virtual-reality corridor isn't a prerequisite for following the film, but patience is. Much of the rest is talky and uneventful, with legal maneuverings and corporate strategies substituting for more energetic drama. The film's biggest fun comes from watching Tom trying to convince his wife, Susan (Caroline Goodall), that his misadventure with Meredith was no big deal. "I'm so old-fashioned I greet my subordinates with handshakes," Susan says.

Roma Maffia's performance as Tom's straight-talking lawyer is another highlight. Donald Sutherland has some sly moments as the company's suave boss, particularly in a scene that makes him part of Tom's nightmare. Dennis Miller and Nicholas Sadler play two amiable lower-echelon computer nerds, with Mr. Sadler's resemblance to Kurt Cobain accentuated to suit the Seattle setting. But "Disclosure" hardly needed to be any trendier than it already is.

"Disclosure" was adapted by Paul Attanasio with considerably less subtlety than he brought to writing "Quiz Show," but that bluntness is traceable to Mr. Crichton. The storytelling of "Disclosure" is too forced and polemical to be on a par with better Crichton tales like "Jurassic Park." This time, it's the author who's the dinosaur.

"Disclosure" is rated R (Under 17 requires accompanying parent or adult guardian). It includes strong language, sexual references and one sexual episode.

1994 D 9, C1:1

FEDERAL HILL

Written, produced and directed by Michael Corrente; director of photography, Richard Crudo; edited by Kate Sanford; music by Bob Held and David Bravo; production designer, Robert Schleinig; released by Trimark. Running time: 97 minutes. This film is rated R.
WITH: Nicholas Turturro (Ralph), Anthony De Sando (Nicky), Libby Langdon (Wendy), Michael Raynor (Frank), Jason Andrews (Bobby) and Robert Turano (Joey)..

By CARYN JAMES

On Federal Hill, a section of Providence, R.I., that is like a Little Italy inside a Little Italy, a lot of conversations start like this: "Not for nothing, but . . ." It's an opener that acts like a tiny hit upside the head. Nicky, the good-looking young hero, says it when he's frustrated by his hot-headed best friend, Ralph. "Not for nothing, Ralphie, but . . ." why did you bash in the windshield of a college boy's Jeep with a tire iron while speeding on the highway? The wife of one of Nicky's mob-connected friends uses it, too. When she runs into a Brown University student who is treating Nicky as if he were a sex toy, the friend's wife butts in. "Wendy," she says, "not for nothing, but I know how much you mean to him."

The story of five punk Italian-American friends, "Federal Hill" is "Mean Streets" in Providence. Sometimes it seems that every director who comes along has to make a version of Martin Scorsese's 1973 classic. It's a way of saying, "Not for nothing, but I know how to make a movie."

Michael Corrente wrote and directed "Federal Hill" and shot it in black and white, on a minuscule budget, on his native turf in Providence. He really *does* know how to make a movie. "Federal Hill" is lively and likable, a first film with the kind of swift action, clever dialogue and clear-cut characters that suggest an expert director's touch.

The movie features a strong performance by Anthony De Sando as the sensitive Nicky and a terrific, movie-stealing one by Nicholas Turturro (from "N.Y.P.D. Blue") as the irreponsible Ralph. Nicky would be the Harvey Keitel character in "Mean Streets," too smart to be so smugly settled in his neighborhood. Ralph would be the Robert De Niro character, explosively angry at everyone, and not nearly as smart as he thinks.

A creative house robber, Ralph will stop to make himself a sandwich and feed the cat if he feels like it. Nicky, a sometime mechanic, is content to ride around with his friends in big cars from his father's lot ("Can I borrow the Caddy?") until Wendy (Libby Langdon) looks him up to buy some cocaine for a party. Before long he is cooking her spaghetti with oil, and Ralph is giving him jealous warnings. "That broad comes from somewhere in the middle of the West, and you're Johnny wanna-buy-a-kilo from Federal Hill," Ralph says. This once, he's right.

Mr. Corrente weaves this thread of a plot through vibrant settings. He relies on some unmistakably real locations, including Haven Brothers, an all-night hot-dog stand in a trailer parked across from the Providence City Hall. The steps of City Hall are the setting of Nicky and Wendy's drug deal. And when the camera follows Ralph on his robberies, each shot is designed to create the sleekest possible effect.

Like its lawless characters, the movie flounders when it strays from home. The scenes supposedly set at Brown are conspicuously wrong. Wendy walks into an archeology class and her teacher abruptly offers her a summer internship at a dig in Italy. It's not just Nicky's perspective, but the film's as well, that treats the Ivy League as if it were run by the Wizard of Oz instead of people who read grant applications before they toss around money. With her pearl earrings and anchorwoman hairdo, Wendy doesn't look or act like any real-life student. But Mr. De Sando makes Nicky's desperate, deluded affection for her touching. Wendy offers him his first glimpse of the world outside Federal Hill, where no one cares whether Nicky is a good mechanic or makes a mean plate of spaghetti.

It is Mr. Turturro's Ralph who gives the film its high-energy feeling, though. He is by turns maddening, comic and frighteningly out of control. At times, Ralph is someone to laugh at, and at times he is someone to grab by the shoulders and shake. In this tricky role, Mr. Turturro is always convincing.

Ralph creates an ingenious scam that involves valet parking, but it's not so funny when the local mob boss catches on. This has to end badly. Some guys are never getting out of Federal Hill alive; Michael Corrente is not one of them.

"Federal Hill" is rated R (Under 17 requires accompanying parent or adult guardian). It includes many expletives, in English and Italian, sexual suggestivenesss and some violence.

1994 D 9, C6:1

THE BUDDHA OF SUBURBIA

Directed by Roger Michell; written by Hanif Kureishi and Mr. Michell, based on the novel by Mr. Kureishi; director of photography, John McGlashan; edited by Kate Evans; music by David Bowie; production designer, Roger Cann; produced by Kevin Loader;

released by BBC Enterprises Limited. At the Papp Public Theater, 425 Lafayette Street, East Village. Running time: four episodes of 55 minutes each; shown in two two-hour parts. This film is not rated.
WITH: Narveen Andrews (Karim Amir), Roshan Seth (Haroon Amir), Susan Fleetwood (Eva Kay) and Steven Mackintosh (Charlie).

By CARYN JAMES

Whatever happened to Hanif Kureishi? His reputation took a quick route downward after the late 1980's, when his screenplays for "My Beautiful Laundrette" and "Sammy and Rosie Get Laid," both directed by Stephen Frears, established him as one of the freshest, smartest voices to come out of England in a while. In 1990 Mr. Kureishi published a curiously mild satirical novel, "The Buddha of Suburbia," and the next year he wrote and directed a film, "London Kills Me," which turned out to be the kind of critical and commercial disaster that can kill a career.

And here, belatedly, is the four-hour 1992 BBC mini-series adapted from "The Buddha of Suburbia." Written by Mr. Kureishi and directed by Roger Michell, who wrote the screenplay with him, it is more than enough to restore your faith in Mr. Kureishi and his humane yet acerbic vision.

Set in the late 1970's, "The Buddha of Suburbia" focuses on a young man named Karim (Narveen Andrews). Karim, the son of an Indian father and an English mother, has never seen India, though that doesn't exclude him from being called a half-caste. As he goes through an expansive and witty coming of age, it becomes clear that Karim shares some first-rate qualities with his creator (who is half-English, half-Pakistani). Karim is defiant in the face of every attempt to make him ordinary.

Yet as the son of suburbanites, the ordinary is all around him. Karim's father, Haroon (Roshan Seth), gives lessons in meditation and Eastern spirituality in the homes of the upper-middle class. The film satirizes the way Easternism became posh in the 70's, at least partly because of Indian-inspired fashions. "Your father looks like a magician," a young Englishwoman tells Karim at one session. "He looks more like George Harrison to me," is Karim's astute reply. The period details — especially the peacock look for men, with long hair and flamboyant shirts — is realistic and laughable, without being exaggerated into caricature.

The dark, attractive Karim is always being pursued by women, who are often blithely unaware of their own biases. "I want to know more about your culture; where are you from?" he is asked. "Bromley," he says, naming his London suburb.

His suburban life is shattered when Haroon leaves the family to live with a free-spirited woman named Eva (Susan Fleetwood), taking Karim along. For a while, Eva's pale son, Charlie (Steven Mackintosh), is the object of Karim's longing. Throughout the story, Karim is attracted to men and to women, and assumes he ought to just sleep with everyone.

In the most serious subplot, Karim's honorary uncle goes on a hun-

Film at the Public
Roshan Seth, left, and Narveen Andrews.

ger strike to force his daughter into an arranged marriage. On the lighter side, Charlie becomes a gaunt rock star called Charlie Hero. (Mr. Kureishi actually went to school with a boy named Bill who grew up to become Billy Idol.)

Mr. Andrews's performance makes Karim a distinct individual and the appealing center of the film. Yet as cultural attitudes swirl around him, "The Buddha of Suburbia" shrewdly explores the themes of Mr. Kursiehi's best films: old England clashing with new England in the form of the children of its large immigrant population.

Eventually, Karim becomes an actor, sending the film into a gleeful, funny mockery of the experimental theater groups of the 70's. In this supposedly enlightened environment, Karim's starring role is Mowgli in "The Jungle Book." And he learns that his theater group is largely about sex. The film includes frequent full nudity and a plot that allows all kinds of sexual combinations, but there is nothing salacious about it. The unself-conscious nudity reflects 70's attitudes. Karim is a bit shocked but more enchanted at his sexual possibilities, which is the intended effect on the audience, too.

The "Buddha of Suburbia" opens today and runs through Dec. 17 at the Joseph Papp Public Theater, closing the series "Against the Odds: BBC Drama 1975-94." The film will be shown in two parts, with separate admissions, each running nearly two hours.

If this film doesn't have the edgy, nervous energy of the Frears-Kureishi films, that is because its pace suits the mini-series form. Watching it on screen in two big gulps is not the ideal way to experience it. The first episodes, packaged as Part 1, are more leisurely. The final half is funnier, as Karim and Charlie's careers take them to New York. But the film's resonance depends on the attention to detail accumulated from the start.

However it is seen, "The Buddha of Suburbia" affirms how rare it is to find a vision as perceptive and blunt as Mr. Kureishi's. It is a relief to find him in top, entertaining form.

1994 D 9, C8:1

Correction

A film review of "The Buddha of Suburbia" in Weekend yesterday misstated its scheduled closing date at the Joseph Papp Public Theater in the East Village. The film runs through Dec. 27, not Dec. 17.

1994 D 10, 2:6

QUEEN MARGOT

Written in French (English subtitles) by Danièle Thompson and Patrice Chéreau, based on the novel by Alexandre Dumas; directed by Mr. Chéreau; director of photography, Philippe Rousselot; edited by François Gédigier and Hélène Viard; music by Goran Bregovic; production designers, Richard Peduzzi and Olivier Radot; produced by Claude Berri; released by Miramax. At Cinema 2, Third Avenue at 60th Street, Manhattan. Running time: 143 minutes. This film is rated R.
WITH: Isabelle Adjani (Margot), Daniel Auteuil (Henri de Navarre), Jean-Hugues Anglade (Charles IX), Vincent Perez (La Môle), Pascal Greggory (Duc d'Anjou), Julien Rassam (Duc d'Alençon) and Virna Lisi (Catherine de Médicis)

By JANET MASLIN

The year: 1572. The place: The Louvre. The aristocracy: Scheming and randy. Patrice Chéreau's highly excitable "Queen Margot" presents a slew of double-dealing French noblemen in a struggle for power, fueled by ambition, forbidden passions and religious strife. At its center is a rare beauty who loves purely, suffers exquisitely and poses for many ravishing close-ups before this tale is over. It's a big, splashy role for the regal Isabelle Adjani, the French Garbo.

Based on an especially convoluted novel by Dumas Père that has been "unavailable to American readers for nearly a century" (according to a new paperback edition), this is a story involving dozens of potentially confusing historical figures. It incorporates the St. Bartholomew's Day Massacre, features several present or future kings, and culminates in both a poisoning and a beheading. Be grateful there won't be a quiz when the film is over.

Mr. Chéreau, a noted director of theater and opera, attacks this story of rival Catholic and Huguenot royalty with raging revisionist passion. Assuming his audience is thoroughly conversant with the events described here, he interprets those events with painterly style (the delicately beautiful cinematography is by Philippe Rousselot) coupled with incongruous, heavy turbulence to describe his characters' emotions.

So here in the 16th century are hand-held camera work, rock star hairdos (the sons of Catherine de Médicis could pass for an aging heavy-metal band) and remarks like "Love me like never before!" and "I need a man tonight." In this overheated atmosphere, the St. Bartholomew's Day Massacre, involving the slaughter of thousands of Protestants by Catherine's minions, is actually one of the calmer episodes depicted on screen.

"Queen Margot" has been given data-packed opening titles and a

Miramax Films
Jean-Hugues Anglade and Isabelle Adjani in "Queen Margot."

fairly economical version of this massacre, which went on at greater, gorier length when the film was shown at Cannes last spring. Though it runs close to two-and-a-half hours, "Queen Margot" is now considerably clearer and more sedate than it used to be. Still, the story's early scenes introduce an impossible number of significant characters, and confusion clouds much of the story. The film's hysterical edge also remains jarringly intact.

"Queen Margot" begins with an arranged marriage between the Catholic Marguerite de Valois, also known as Margot, and the Protestant Henri de Navarre (Daniel Auteuil), who will one day rule France as Henri IV. She has a lover, he has a mistress and the marriage has no meaning except as a method of quelling warfare between religious factions. The match has been engineered by the conniving Catherine, whose antipathy to Henri and his family is expressed in typically casual, anachronistic fashion. When the bride and groom remark about their mothers on the wedding day, Margot says, "Yours hated me." Henri's answer: "Yours killed mine."

As played by Virna Lisi, whose shockingly witchy appearance and evil mannerisms won her the best-actress prize at Cannes this year, Catherine is indeed someone to be reckoned with. She manipulates the strange, unstable Charles IX (Jean-Hugues Anglade), the King of France, while clearly favoring another of her sons, the Duc d'Anjou (Pascal Greggory). The Duc d'Alençon (Julien Rassam), a third son, is also in his mother's good graces, and the happy family portrait is compounded by strong hints of incest, which also envelop Margot. One of the film's typically impassioned exchanges finds Margot very nearly being raped by her brothers.

The good news about "Queen Margot" is that Mr. Chéreau creates an atmosphere in which his actors' flamboyance can be entertaining. Ms. Adjani is decked out gloriously to play the very young Margot, a raven-haired vision described by Dumas as a French national treasure. She preens with all due magnificence, even when, during one of the film's most deliciously ludicrous moments, she roams the streets of Paris wearing a ball gown and a tiny eye mask, trying to pass incognito while searching for a lover. The man she finds, the Comte Joseph-Hyacinthe Boniface de Lerac de la Môle (Vincent Perez), is presented as so noble a figure that religious music sanctifies each Margot-La Môle love scene.

Mr. Anglade, familiar for his mad gleam in films by Luc Besson and Jean-Jacques Beineix (as well as the recent "Killing Zoe"), is particularly impressive for his intense, unpredictable energy here. Mr. Auteuil, the fascinatingly subtle actor seen in "Jean de Florette" and "Un Coeur en Hiver," helps to anchor the film by making Henri an increasingly interesting figure as the story progresses. As the wicked Anjou, Mr. Greggory smirks insinuatingly in every scene, often to amusing effect. In a film this feverish, nothing less will do.

"Queen Margot" is rated R (Under 17 requires accompanying parent or adult guardian). It includes full frontal nudity, sexual situations, much violence and several horrible deaths.

1994 D 9, C10:1

DROP ZONE

Directed by John Badham; written by Peter Barsocchini and John Bishop, based on a story by Tony Griffin, Guy Manos and Mr. Barsocchini; director of photography, Roy H. Wagner; edited by Frank Morriss; music by Hans Zimmer; production designer, Joe Alves; produced by D. J. Caruso, Wallis Nicita and Lauren Lloyd; released by Paramount Pictures. Running time: 102 minutes. This film is rated R.

WITH: Wesley Snipes (Pete Nessip), Gary Busey (Ty Moncrief), Yancy Butler (Jessie Crossman), Michael Jeter (Earl Leedy), Corin Nemec (Selkirk) and Kyle Secor (Swoop).

By STEPHEN HOLDEN

The most spectacular sequence in John Badham's deftly paced action-adventure film "Drop Zone" applies the esthetics of water ballet to a sky diving exhibition over Washington. In a night sky bursting with fireworks, a team of sky divers wearing illuminated uniforms arranges itself in glowing geometric patterns while plummeting earthward.

Simultaneously, the movie's villains, a posse of sky diving criminals, is parachuting into the headquarters of the Drug Enforcement Agency. Their mission is to obtain computer information, including identification snapshots of a worldwide network of undercover drug agents, to sell to the leaders of an international drug cartel. The only man who can stop them is Pete Nessip (Wesley Snipes), a United States marshal who has overcome his fear of heights to pursue the gang in one aerial chase after another.

"Drop Zone" is the second splashy action-adventure this fall to be set in the world of professional sky diving. In "Terminal Velocity," Charlie Sheen played a sky diving daredevil who rescues Russia's stolen gold reserves from a ruthless gang of former K.G.B. members. If "Drop Zone" has a plot that is only slightly less preposterous, it is more fun. And with the glaring exception of Mr. Snipes's performance, it is also better acted.

From "Saturday Night Fever" to "American Flyer," Mr. Badham has shown a special knack for capturing the flavor of a tightly knit subculture

in scenes that make a closed little world look dynamic and glamorous. With their own in-jokes, exclusive hangouts and roughhouse sense of humor, the sky diving elite, as portrayed in "Drop Zone," have the mystique of flying cowboys. The values of this society are embodied by Pete's sky diving teacher, Jessie (Yancy Butler), an attractive, flippant tomboy with a streak of vulnerability under her bravado. In Ms. Butler's wonderful live-wire performance, Jessie slowly melts from a defiant foe into a true-blue pal as she initiates Pete into the rituals of her profession.

"Drop Zone" is better than most action-adventure films in presenting secondary characters with dimension. As Ty Moncrief, a corrupt former drug agent who leads the posse, Gary Busey flashes a lethally goofy grin that suggests an antic cowpoke gone rotten. Michael Jeter is equally sharp as Leedy, a whining computer nerd whom Ty bullies into cracking access codes. Corin Nemec as a sky diving novice with daredevil aspirations, and Kyle Secor as a veteran daredevil with a zany streak, contribute to the movie's view of the sport as an elite cult activity.

Incongruously thrust into this setting, Mr. Snipes drifts through the movie seemingly unsure of whether to play it straight or tongue-in-cheek, and winds up wobbling between the two. In action sequences where the rest of the cast exerts itself intensely, Mr. Snipes remains poker-faced and unruffled. The only times he displays some personality are the moments when he is physically forced into a stressful situation. The most memorable is a sky diving simulation class in which the actor, blown into the air by a vertical wind tunnel, frantically flails around to make sure he doesn't land on his head.

"Drop Zone" is rated R (Under 17 requires accompanying parent or adult guardian). It includes some strong language and scenes of extreme violence.

1994 D 9, C12:1

A Mother Who Is Her Own Worst Enemy

"Ladybird, Ladybird" was shown as part of this year's New York Film Festival. Following are excerpts from Janet Maslin's review, which appeared in The New York Times on Oct. 7. The film opens today at Film Forum, 209 West Houston Street, South Village.

Ken Loach's "Ladybird, Ladybird" asks viewers to imagine what it is like for Maggie (Crissy Rock) to open a newspaper one day and see a photograph of a boy in need of adoptive parents. "I've never had much love," says the caption. "Can you give me some now?" The photograph is of Maggie's own son.

The Samuel Goldwyn Company

Crissy Rock plays a troubled mother in "Ladybird, Ladybird."

Maggie, the central figure in this raw, wrenching film based on a true story, is first seen as a mother of four who has no children. English social service agencies have seen fit to take all of them away. And those agencies are not presented as simply villainous. Maggie's history is troubling enough to yield different opinions on whether she is a fit parent for her children.

Mr. Loach knows better than to present Maggie's story as a mere case of bureaucratic injustice, even though it escalates into exactly that before it is over. His interest goes beyond the black-and-white outline of such a horrific situation, and into the harrowing gray reality. "Ladybird, Ladybird" is a tough, utterly absorbing film even at moments when it seems to skirt some of the fine points of Maggie's difficulties. It's not necessary to see her as a pure victim to appreciate the hellishness of her ordeal.

The film begins as Maggie, who looks like a heavier, blowsier Susannah York, meets Jorge (Vladimir Vega), a gentle Paraguayan immigrant. After he approaches her in a karaoke bar, she tells him about her past. Raised by an abusive father, she had four children by four different men, at least one of whom also had a violent temper; he is seen savagely beating Maggie with a beer can during one of the film's flashbacks. The four children are a racially mixed group. Racial prejudice can be seen as contributing to Maggie's uneasy relations with various social workers, most of whom are white.

But Maggie's biggest problem with these authorities is Maggie herself. One night she makes an inexcusable mistake, leaving her chil-

dren home alone while she goes out on a singing engagement. She locks them in the apartment, supposedly for their own protection. A fire breaks out. One boy is badly burned, and the whole group is summarily removed from Maggie's care and classified "At Risk" by government agencies.

Maggie's subsequent behavior makes matters worse. One night, she shows up late to visit the burned boy in his foster home, expressing surprise that he is already in bed at 8:30. Volatile and quarrelsome, she instantly picks a fight with the foster mother, and then barges in to visit her son. Insisting on changing his bandage, she is so clumsy that she hurts him. Whatever has made Maggie this distraught, the fact is that she has become her own worst enemy.

"Ladybird, Ladybird" watches Maggie fall into a love affair with Jorge, who does his best to get her back on her feet. It then watches, first with hope and then with horror, as Maggie and Jorge prepare for a new start with a child of their own. The social service workers who once expressed concern over whether Maggie was "coping" (a favorite word here) have lost patience, and they become more invasive. And Maggie goes to war with an increasingly brutal bureaucracy, in a series of struggles that take some unimaginably ghastly turns.

One of these events takes place in a hospital room and is so wrenching that it makes a nurse cry. "Ladybird, Ladybird" is extremely upsetting at such moments, fully sharing Maggie's hopelessness and grief. Although a closing title says Maggie's life took a positive turn after the events seen here, the film does little to give credence to that possibility. By the end of the story, her fate has come to seem irremediably bleak, and Mr. Loach has stirred a fierce sense of outrage.

Does it matter that Mr. Loach has altered the names and characteristics of his film's two principals? Or that a "based on a true story" credit makes it possible to eliminate unpleasant facts? No: even if Jorge tends toward saintliness and the question of Maggie's real competence as a mother remains unexamined, the film has honesty and immediacy on its own dramatic terms.

1994 D 9, C23:1

FILM VIEW/Janet Maslin

In the Battle Of the Big Guys, One's a Turkey

THANKSGIVING'S WORST STOMach trouble was experienced by "Junior," Ivan Reitman's comedy about a pregnant Arnold Schwarzenegger. "Junior" emerged as an

instant disappointment, taking in only $13 million over the holiday weekend, with business likely to go downhill from there. Meanwhile, "The Santa Clause," the other new film about a man with a paunch, drew bigger crowds for its third weekend ($27 million) than it had on its first ($19 million) and emerged as the surprise hit of the season.

When these two comedies went belly to belly, why was the shoo-in overshadowed by the sleeper? After all, "Junior" started out with a clear advantage, since the Reitman-Schwarzenegger combination ("Twins," "Kindergarten Cop") is a proven commercial winner. And "Junior" had a cute premise just right for high-concept poster art, which is sometimes half the game. All "The Santa Clause" had was one more television star (albeit with a hit show) trying to break into movies. And a Christmasy premise during a season crammed with Christmasy family films.

So by the logic of Hollywood marketing, the outcome is a big upset. But for the real live movie audiences that Hollywood claims to understand, that outcome makes perfect sense. On the simplest level, "The Santa Clause" is doing business because it's funny, original, good-hearted and not too sentimental; people like it, and they're telling other people to go. "Junior," from the date of its conception, had an insurmountable problem that audiences were quick to recognize. There is a certain resistance to watching a world-famous tough guy take a needle in his abdomen and become pregnant. In a word: yuck.

"Junior" isn't often that clinical, even if it has just enough grasp of medical reality to make an audience queasy. And pregnancy, as described here, is indeed a delicate condition. It might be possible to make a crazily funny film about a gravid guy, but "Junior" is rooted in conventionally sensible attitudes and heavy sensitivity. So Mr. Schwarzenegger gets a rosy complexion, is made weepy by his hormones and complains about having sore nipples. That last thought alone should have been enough to set off alarm bells all over the Universal lot.

What really backfires about "Junior" is that it unmans its hero, and not just by putting him in a maternity dress. This film's central sight gag is funny, yet its soggy notions of gender-bending behavior are too pious to be amusing. Not even pregnant women in films behave with the stereotypical sweetness shown by Mr. Schwarzenegger..

Pamela Reed, who plays another parent-to-be in "Junior," is at least allowed a few tough edges and a sex life, which Mr. Schwarzenegger's character notably lacks until the last reel. Ms. Reed plays a woman who experienced fertility problems with her ex-husband (Danny DeVito), an obstetrician, and later becomes pregnant by someone connected with Aerosmith, returning to her husband to ask him to deliver the baby. Only in a movie as painfully enlightened and mechanically contrived as "Junior" could that set of circumstances eventually make for one big happy family.

On the other hand, Mr. Allen's "Santa Clause" character has problems his audience can actually understand — one big reason this film has struck a chord. A divorced father trying to build a solid relationship with his son, Mr. Allen's Scott Calvin is inadvertently roped into becoming Santa Clause, which leads to a sudden, embarrassing weight gain.

So this comedy has its own walking sight gag, which becomes especially funny at the toy company where Scott works, a place where weight watching is a competitive sport. Scott appalls his co-workers as he bulks up shockingly and begins to wear more and more Santa-like clothes.

If the star's prosthetic gut is once again the focus of attention, this time it has a different meaning: it's something that empowers him. Becoming Santa gives Scott added stature in his son's eyes. And when Scott's ex-wife (Wendy Crewson) and her boyfriend, a psychiatrist (Judge Reinhold), grow worried that the boy's Santa Clause stories are only daydreams, the film has a nice opportunity to validate Scott's outlook and affirm faith over reason.

Unlike "Mrs. Doubtfire," the hit to which it must inevitably be compared, "The Santa Clause" doesn't turn divorce into a war of nerves. Nor does it use a father's elaborate masquerade to prove his superiority to his former spouse. Becoming Santa doesn't make Scott a better man at anyone else's expense. It just offers an interesting new career opportunity and a chance to behave generously in ways his son is sure to admire. Not to mention a reason to show him morph-

Walt Disney Pictures (Allen); Theo Westenberger/Universal Pictures (Schwarzenegger)

Arnold Schwarzenegger, above, in "Junior," is the bigger star, but has been beaten by a television comic, Tim Allen, in "The Santa Clause," a runaway hit.

ing his way down very small chimneys, giving "The Santa Clause" some nifty special effects that enhance its audience appeal.

The humor in "The Santa Clause" springs from the gut, so to speak: from real conflicts that viewers recognize, and from a delightful fantasy role that lets an ordinary man quite literally rise above his troubles. Mr. Schwarzenegger's character is supposed to be improved by his childbearing adventure, too, but that's a much bigger stretch than this Santa story. Stretch marks and all.

1994 D 11, II:19:1

NELL

Directed by Michael Apted; written by William Nicholson and Mark Handley, based on Mr. Handley's play "idioglossia"; director of photography, Dante Spinotti; edited by Jim Clark; music by Mark Isham; production designer, Jon Hutman; produced by Renée Missel and Jodie Foster; released by 20th Century Fox. Running time: 112 minutes. This film is rated PG-13.
WITH: Jodie Foster (Nell), Liam Neeson (Jerome Lovell) and Natasha Richardson (Paula Olsen)

By JANET MASLIN

How fitting that Jodie Foster, in "Nell," should play a free-spirited woman who dances to her own secret music. Ms. Foster has carved out just that role for herself in Hollywood, choosing unusual material and largely avoiding the mainstream. Her independence has been impressive enough to suggest that "Nell," the first film from Ms. Foster's production company, Egg, would be subtler and riskier than ordinary fare.

And "Nell" is the work of Michael Apted, a thoughtful director ("Coal Miner's Daughter," "Gorillas in the Mist") who understands strong heroines and exotic places. With its isolated North Carolina setting and its title character, a mysterious

A study in innocence and the mixed messages of good intentions.

young woman raised without any experience of contemporary civilization, "Nell" promises something well out of the ordinary.

What's remarkable is how seldom it delivers. For all its technical brilliance, not even Ms. Foster's intense, accomplished performance in the title role holds much surprise. The wild-child story of "Nell" unfolds in unexpectedly predictable ways, clinging fiercely to the banal thought that Nell's innocence makes her purer than anyone else in the story. In light of the stock nature of the two other main characters, a kindly doctor (Liam Neeson) and a levelheaded psychologist (Natasha Richardson), it's hard to argue that point.

Discovered when her mother dies, Nell is a strange, fearful young woman who speaks her own unintelligible language. When first seen, she

Andrew Cooper/20th Century Fox
Jodie Foster in "Nell," the first film from her company, Egg.

makes a startling impression, behaving in a rivetingly feral manner. Scrunching her body like a chimp's, she keens and shrieks in wrenching, absolute, utter terror. These are gestures that send signals: to the Academy of Motion Picture Arts and Sciences, where a star's ability to effect such a transformation is traditionally appreciated, and to Drs. Jerome Lovell (Mr. Neeson) and Paula Olsen (Ms. Richardson). These two join forces to help Nell. In the process, wouldn't you know it, they fall in love.

As this may suggest, "Nell" has its overlay of conventional drama, one that too easily eclipses the fascination of Nell's own story. Before long, Dr. Olsen has set up shop on a cute little houseboat near Nell's cabin, and Dr. Lovell has begun to make house calls. Nell ought to occupy center stage in this story, but too much of the time she is relegated to the capacity of pet primitive. There

is the terrible feeling that the doctors will be learning valuable lessons from their experience with Nell.

Though all three stars are fine actors, only Ms. Foster's Nell commands real interest. And much of that interest derives from her sheer strangeness, whether she is swaying like a tree or speaking passionately in her indecipherable tongue. But gradually, after quite a bit of ecstatic moonlight skinny-dipping to affirm Nell's natural beauty, her thoughts begin to become understandable. What she needs, it turns out, is for the doctors to become a happy couple and love her as their surrogate child.

The ways that "Nell" unravels its heroine's secrets suggest more entertainment value than science. It is one of the doctors' important missions, for instance, to overcome Nell's terror of men by arranging for her to take a nude swim with Dr. Lovell. "You think I'm planning to abuse the doctor-patient relationship?" he asks indignantly. Well, yes, as a matter of fact. "Nell" would have been more interesting and believable if it owned up to Nell's adult sexuality and also acknowledged that attraction.

Mr. Neeson labors mightily to breathe life into a weakly written role. (The film is adapted by William Nicholson and Mark Handley from "Idioglossia," a play by Mr. Handley. Mr. Handley and his wife spent six years living, like Nell, in a secluded log cabin without electricity or running water.) He succeeds in radiating charm more easily than he does seriousness, but he does summon enough "Yes, ma'ams" to suit the setting. Rounding out this festival of accents is Ms. Richardson, who has such a familiar career-woman role that her special radiance seldom shines through. Mr. Neeson and Ms. Richardson generate palpable warmth, but their story should have been more secondary.

Nell herself, rendered too stagy to seem authentically wild, reveals more about Ms. Foster's great skill than about the human condition. With the stark, luminous beauty of a woman in a Walker Evans photograph, Ms. Foster moves through "Nell" with an intensity that needed to be more uncompromising. By the end of this story, Nell has accommodated herself not only to the small-town folk of North Carolina, but to Hollywood, too.

"Nell" is rated PG-13 (Parents strongly cautioned). It includes brief sexual suggestiveness and considerable nudity.

1994 D 14, C15:1

IMMORTAL BELOVED

Written and directed by Bernard Rose; director of photography, Peter Suschitzky; edited by Dan Rae; music by Georg Solti; production designer, Jiri Hlupy; produced by Bruce Davey; released by Columbia Pictures. At Sony Theaters Lincoln Square, Broadway at 67th Street. Running time: 203 minutes. This film is rated R.
WITH: Gary Oldman (Ludwig van Beethoven), Jeroen Krabbé (Anton Felix Schindler), Isabella Rossellini (Anna Marie Erdödy), Johanna Ter Steege (Johanna Reiss), Marco Hofschneider (Karl van Beethoven) and Valeria Golino (Giulietta Guicciardi).

By JANET MASLIN

"It is the power of music to carry one into the mental state of the composer," asserts Ludwig van Beethoven, dazzlingly impersonated by Gary Oldman in Bernard Rose's brash biographical film "Immortal Beloved." "The listener has no choice. It is like hypnotism." Thanks to its hugely effective use of Beethoven's most thrilling, tumultuous music, this film exerts much the same hypnotic power.

If the accomplishments that inspire awe here are Beethoven's rather than Mr. Rose's, that's not surprising. Nor is it accidental: this film maker is so well attuned to his subject that he deliberately subjugates his imagery to the film's soundtrack. But Mr. Rose contributes a passionate enthusiasm for the music and an eagerness to fathom the forces that brought about its creation. At its best, his film almost brings those forces to life.

"Immortal Beloved" may prompt skepticism for its highly selective use of biographical data, but it does not seem intended as straightforward drama. Think of this as an extremely ambitious classical music video, with visual ideas that merely echo the moods of the music. The music tells its own story, and the music is glorious. With the London Orchestra conducted by Georg Solti, the score features Murray Perahia, Yo-Yo Ma, Bryn Terfel and Emanuel Ax as its principal soloists and selects particularly beautiful passages from well-known Beethoven compositions.

Mr. Rose has concocted a mystery framework centering on the title figure, to whom Beethoven addressed the far us letter that has long perplexed his biographers. Theories abound as to who that "Immortal Beloved" may have been, but Mr. Rose pays those theories little heed. His own solution happens to be more dramatically satisfying than it is feasible. We would be well advised to doubt the accuracy of biographical entertainments anyhow.

"Immortal Beloved" begins with the sight of Beethoven on his deathbed, with the opening sounds of the Fifth Symphony to provide a suitable jolt. It's a warning that this film will seldom be staid, though it's much less shrill than "Amadeus" and much less feverishly intense than any of Ken Russell's musical biographies. Mr. Rose, an English director whose previous credits include several promising, offbeat films that never quite worked ("Paperhouse," "Candyman," "Chicago Joe and the Showgirl"), isn't a relentless stylist like Mr. Russell. Some of his images are quite ordinary, and only occasionally does he indulge in wild flights of fancy.

In its search for the woman to whom Beethoven wrote his letter, "Immortal Beloved" narrows the field to three possibilities, each of some historical significance. Countess Giulietta Guicciardi (Valeria Golino) was the very young woman to whom Beethoven dedicated the "Moonlight" Sonata; Countess Anna Maria Erdödy (a graceful Isabella Rossellini) met the composer very

publicly by escorting him from the stage after his behavior during the first performance of the "Emperor" Concerto revealed his deafness, which he had long tried to hide.

And Johanna Reiss (played by Johanna Ter Steege, an arrestingly blunt Dutch actress), was his sister-in-law, against whom he eventually brought suit to gain custody of his nephew, Karl (Marco Hofschneider). Also figuring in the film is Anton Felix Schindler (Jeroen Krabbé), Beethoven's friend and factotum, who visits these three women as he solves the mystery.

Beyond those few facts, "Immortal Beloved" is mostly feeling: grand, turbulent emotions meant to shed light on the music's meaning. Among this film's most expressive sequences is a stunner that accompanies the "Ode to Joy," with the aged Beethoven remembering the terrors of his boyhood and registering the all-embracing nature of great art. As the music thunders, a boy is seen running through the woods in his nightshirt, then immersing himself in a moonlit pond, finally disappearing into a cosmos of twinkling stars. The image is wordless and it is the film's most eloquent. Indeed, when one of the women next says that in this composition Beethoven "had revealed his most hidden secrets to us," she's saying too much.

The volatile Mr. Oldman, an actor of especially varied range, is as inspired here as he is noxious in another current film, "The Professional." Mr. Oldman is never far-fetched, and he captures Beethoven as a believably brilliant figure struggling with his deafness and other demons. His performance combines bitterness and eccentricity with the deep romanticism that can be heard in the music. He also manages to echo familiar notions of what this composer was like while also providing a larger vision of lonely, single-minded genius.

Like "The Accompanist" and "Tous les Matins du Monde," "Immortal Beloved" is something other than a strictly cinematic experience; succumbing to its musical voluptuousness makes it that much more overwhelming. Those French films had much greater elegance, but let's not forget that Mr. Rose was Beethoven. Don't be surprised to tap your toes while Mr. Perahia plays a galloping excerpt from the "Emperor" Concerto behind the closing credits.

"Immortal Beloved" can be heard in the enveloping new Sony Dynamic Digital Sound. That technology makes the music especially forceful and full.

"Immortal Beloved" is rated R (Under 17 requires accompanying parent or adult guardian). It includes brief nudity, sexual situations and mild violence.

1994 D 16, C4:4

SPEECHLESS

Directed by Ron Underwood; written by Robert King; director of photography, Don Peterman; edited by Richard Francis-Bruce; music by Marc Shaiman; production designer, Dennis Washington; produced by Renny Harlin and Geena Davis; released by Metro-Goldwyn-Mayer. Running time: 98 minutes. This film is rated PG-13.

WITH: Michael Keaton (Kevin), Geena Davis (Julia), Christopher Reeve (Freed) and Bonnie Bedelia (Annette).

By JANET MASLIN

"Speechless" suggests that if James Carville and Mary Matalin didn't exist, someone would have had to invent them. And invent them as adorable, wisecrack-lobbing lovebirds, as if the American political process weren't already screwball enough.

This comedy makes some funny observations about campaign follies, as when a candidate finds himself trapped at a podium with nothing but song lyrics on his Teleprompter ("Someone's in the kitchen with Dinah ... ") and is forced to recite them as meaningfully as he can. But it's less adroit with the love affair between its main characters, a television sitcom writer enlisted to help the Republican camp (Michael Keaton) and a feisty, idealistic Democrat (Geena Davis). Ron Underwood, the director of "City Slickers," once again compromises appealing actors and an entertaining premise with a needless overlay of mush.

"Speechless" focuses on a Senate race in New Mexico, where the candidates are regularly upstaged on television by a furry animal that has fallen down a well. ("It was Day 2 in the struggle of one small bear cub to stay alive," begins a hard-hitting broadcast.) Within this hotly combative atmosphere, Kevin (Mr. Keaton) and Julia (Ms. Davis) are not supposed to mingle. But they meet cute, fighting over medicine to cure their insomnia, and then they keep on meeting in strenuously playful ways. Both these actors are too good for scenes that have them fumbling amorously and causing mechanical mishaps, like knocking a car's gearshift or scrambling dials in a television station's control room.

Mr. Keaton's natural cynicism serves him well in scenes about the campaign itself. For instance, he feigns showing up without knowing which side he's working for. ("Which candidate, sir?" asks a hotel desk clerk. "You know, what's his name," fumbles Mr. Keaton serenely. "Help me out here.") He's also enjoyably flippant in scenes that have him flirting with Ms. Davis before they both realize the full extent of their professional rivalry.

When the news does come out, as both speech writers are asked to address the same group of schoolchildren, Robert King's screenplay turns the sparring into a string of jokey, juvenile insults. Ms. Davis, who is less at home here, blusters especially hard on such occasions. And "Speechless" never questions the thought that its characters' eagerness to swap slurs means they are in love.

The stars try gamely, but they strike more sparks in scenes satirizing the separate campaigns than they do together. The story's sidelines are especially enlivened by Christopher Reeve, who plays Julia's other suitor, an egotistical television newsman in a shrapnel-torn vest, a reminder of the combat duty that won him the nickname "Baghdad Bob." "Well, at a certain point you don't worry about the Scuds anymore," he remarks with a great show of casualness. "You just do the job."

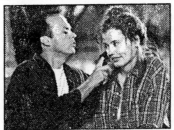

David James/Metro-Goldwyn-Mayer
Michael Keaton and Geena Davis

Also lively is Bonnie Bedelia, playing a take-charge co-worker with close ties to Kevin and an old habit of bossing him around. Ms. Bedelia articulates the film's amusing sharkiness when discussing the issue of a proposed barrier separating campaign territory from Mexico. Her Republican candidate is in favor of this but suggests calling it "The Friendship Ditch," to give it the proper upbeat spin. "Our guy's for it," Ms. Bedelia warns. "Don't bring it up in the barrio."

Ms. Bedelia is a victim of the film's unflattering costumes, which are tarty enough to go several notches beyond the point of satire. Another idiosyncrasy is the settings, which say less about the quirks of campaigning than about the film's eagerness to disguise its uneventfulness and breathe life into its central romance. When Mr. Keaton makes the expected declaration that "politics and love never mix — never!," he's busy arguing with Ms. Davis in the middle of a cattle pen.

"Speechless" is rated PG-13 (Parents strongly cautioned). It includes mild profanity and brief sexual situations.

1994 D 16, C10:5

DUMB AND DUMBER

Directed by Peter Farrelly; written by Mr. Farrelly, Bennett Yellin and Bobby Farrelly; director of photography, Mark Irwin; edited by Christopher Greenbury; music by Todd Rundgren; production designer, Sidney J. Bartholomew Jr.; produced by Charles B. Wessler, Brad Krevoy and Steve Stabler; released by New Line Cinema. Running time: 106 minutes. This film is rated PG-13.

WITH: Jim Carrey (Lloyd), Jeff Daniels (Harry), Lauren Holley (Mary) and Teri Garr (Helen Swanson)

By STEPHEN HOLDEN

If critical traditions count for anything, Jim Carrey can look forward one day to being discovered by the French film establishment and canonized as the new Jerry Lewis. There are moments all through his newest movie, "Dumb and Dumber," when the rubber-faced actor with a chipped front tooth, his hair in bangs and his cough-drop eyes ablaze with maniacal mischief, is almost a dead ringer for Mr. Lewis on one of his hyperactive jags.

Mr. Carrey's version of Mr. Lewis, it should be noted, adds hefty dashes of sex and scatology in a 6-year-old's style. The funniest scene in the movie involves a powerful laxative, a broken toilet and some graphically colorful sound effects.

Mr. Lewis is only the strongest comic influence on "Dumb and Dumber," a movie that fully lives up to its name, right down to an opening credit sequence rife with intentional misspellings and grammatical errors. Paired with Jeff Daniels, whose hangdog goofiness makes a perfect foil for his spasmodically edgy comic style, Mr. Carrey plays Beavis to Mr. Daniels's Butt-head as they go on a wild cross-country road trip from Providence, R.I., to Aspen, Colo.

Mr. Carrey is Lloyd, the world's clumsiest limousine driver, and Mr. Daniels is Harry, Lloyd's dog-grooming roommate who travels around in a "Mutts Cutts" truck, a van transformed into a giant sheep dog, complete with tongue and wagging tail. Their careers on the skids, they hit the road in the truck for Colorado, carrying a briefcase that Mary (Lauren Holley), one of Lloyd's passengers, accidentally left in an airport. Unbeknownst to Lloyd, it contains ransom money for a kidnapping, and the two find themselves pursued by thugs.

"Dumb and Dumber," which was directed by Peter Farrelly, who wrote the screenplay with his brother Bobby and Bennett Yellin, is a movie that knows much better than to try to make sense. It is essentially a strung-together series of gags, most of them thought up by Lloyd, an inveterate practical joker. His pranks include sneaking red-hot chili peppers into the burgers of unsuspecting diners, plying pesky state troopers with urine-filled beer bottles and selling decapitated birds to children who are blind.

When Lloyd and Harry get going, they are also quite a musical team. Sandwiched between them in the front seat of the Mutts Cutts truck, one unfortunate passenger has his eardrums shattered with their boisterous call-and-response version of "Mockingbird."

Once Lloyd and Harry arrive in Aspen, they embark on a spending spree that finds them living the high life in eye-catching orange and powder-blue formal wear. When Lloyd pops a Champagne cork at a stuffy banquet of preservationists, you can be sure that it will do some lethal damage. Harry's idyllic outing on the ski slopes with Mary is marred by an unfortunate accident. His tongue becomes frozen on a metal bar of the ski lift, and the only solution is for Mary to grab his head and pull hard.

Just how dumb is Mr. Carrey's character in "Dumb and Dumber"? During a conversation in a diner, Lloyd solemnly informs his sidekick that the Monkees were the biggest influence on the Beatles. Glancing at a framed front-page news story announcing the 1969 moon landing, Lloyd's mouth drops open in astonishment and he gushes: "Hey, no way! That's great!"

"Dumb and Dumber" is rated PG-13 (Parents strongly cautioned). The language is profanity-free, but much of the humor is scatological.

1994 D 16, C10:5

CAMILLA

Directed by Deepa Mehta; written by Paul Quarrington; director of photography, Guy Dufaux; edited by Barry Farrell; music by Daniel Lanois; costumes, Milena Canonero and Elisabetta Beraldo; production designer, Sandra Kybartas; produced by Christina Jennings and Simon Relph; released by Miramax Films. At 68th Street Playhouse, 68th Street and Third Avenue, Manhattan. Running time: 90 minutes. This film is rated PG-13.

WITH: Jessica Tandy (Camilla Cara), Bridget Fonda (Freda Lopez), Elias Koteas (Vince Lopez), Maury Chaykin (Harold Cara), Hume Cronyn (Ewald) and Graham Greene (Hunt Weller)

By JANET MASLIN

Jessica Tandy's graceful presence in one of her final roles gives "Camilla" a valedictory grandeur. Though this is by far the lesser of two new films dedicated to Tandy's memory (the other is "Nobody's Fool," opening next week), it's the one that gives this great, unforgettable actress the more substantial showcase. "Camilla" spends an awful lot of time admiring Tandy in the title role, but that admiration is deserved. She moves enchantingly through an otherwise treacly film that wouldn't work without her.

Tandy, who died in September at the age of 85, approached this film with daring and surprising ease. While "Camilla" reveres its heroine, hers is hardly a standard great-lady role. Not every octogenarian actress would be game for skinny-dipping, fishing, violin playing and a wonderfully tender bedroom scene with her real-life husband. When Tandy and Hume Cronyn finish the film with a courtly scene on a beach at sunset, they provide a gallant, heartbreaking flourish.

As played by Tandy, Camilla is a free spirit whose wit and vitality are undimmed by age. She was once a concert violinist, and she is full of grand, untrustworthy stories of her musical heyday. Those memories are coaxed forth by the arrival of Freda (Bridget Fonda) on the Georgia island where Camilla now lives a sheltered life. Freda is an aspiring musician, which gives her and Camilla rather too much reason to talk about their art.

The two women become friends through ungainly plot contrivances that soon separate Freda from her insensitive husband (Elias Koteas) and send her and Camilla on a trip to Canada. Ms. Fonda, whose character is supposed to be discovering herself, performs a couple of wispy musical numbers and generally gets the worse half of this arrangement.

The trip revolves around Camilla, who flaunts her joie de vivre every chance she gets. This character's flamboyance could easily have been unbearable, but Tandy fills her with tact and good humor. She is as comfortable pretending to have known impossible celebrities, from Gandhi

to the Duke of Nottingham, as she is gently reciting a John Masefield poem to Mr. Cronyn. Tandy even does a credible job of pretending to play Brahms's Violin Concerto, which Camilla regards as an essential challenge and the film treats as a metaphor for her overall determination.

Dressed strikingly by Milena Canonero and Elisabetta Beraldo, Tandy moves graciously through a range of escapades, ending up in glamorous white satin for a performance of the Brahms in Canada. Mr. Cronyn, as a violin maker who is Camilla's long-lost love, gallantly affirms the film's emphasis on both music and romance. Ms. Fonda glows prettily and is a soothing presence whenever the film doesn't require her to assert artistic pretensions. There is a picture of Frida Kahlo in Freda's music studio, where she writes songs with lyrics like "If I could give you anything, I'd give you back yourself."

Also in "Camilla," which opens today at the 68th Street Playhouse, is Graham Greene, the kind of colorful eccentric who has been perking up road movies ever since Jack Nicholson joined Ms. Fonda's father, Peter, and Dennis Hopper in "Easy Rider." Mr. Greene doesn't do much more than create a detour and provide brief comic relief, but it's welcome. Maury Chaykin, as Camilla's son, a crass film-business type, is less charming. As directed by Deepa Mehta and written by Paul Quarrington, this mild, uneven Canadian film gets by on charm alone, and it is lucky to share some of Tandy's enduring luster.

"Camilla" is rated PG-13 (Parents strongly cautioned). It includes profanity, brief nudity and very discreet sexual situations.

1994 D 16, C16:1

TEMPTATION OF A MONK

Directed by Clara Law; written (in Mandarin, with English subtitles) by Eddie Fong Ling-ching and Lilian Lee, based on Ms. Lee's novella; director of photography, Andrew Lesnie; edited by Jill Bilcock; music by Tats Lau; production designers, Timmy Yip. Yang Zhanjia and William Lygratte; produced by Teddy Robin Kwan; released by Northern Arts Entertainment Ltd. At Cinema Village, 22 East 12th Street, Greenwich Village. Running time: 118 minutes. This film is not rated.

WITH: Joan Chen (Princess Scarlet; Violet), Wu Hsin-kuo (General Shi), Zhang Fengyi (Huo Da), Michael Lee (Old Abbot) and Lisa Lu (Shi's Mother).

By STEPHEN HOLDEN

One of many phantasmagoric scenes in "Temptation of a Monk," Clara Law's visually striking reverie of China during the Tang Dynasty, follows a group of Buddhist monks as they forsake their austere monastic life for a night of sensual abandon in a nearby town. Inside a flickering candlelit pleasure dome, they are plied with wine and meat by aggressive prostitutes who wear bizarre, towering headdresses. Within minutes, the monks have broken most of the 10 prohibitions that were solemnly taught them by a 10-year-old holy man.

Tedpoly Films Limited
Joan Chen

Midway in the orgy, General Shi (Wu Hsin-kuo), a warrior who has disguised himself as a monk, is led by his sometime lover Princess Scarlet (Joan Chen) into an inner sanctum with a bathing pool. As they begin to make love, they are joined by drunken monks and prostitutes laughing and thrashing around wildly. The revels are cut short when the child monk reveals that there is a 10,000-tael reward for Shi's arrest and removal to the imperial capital.

In scenes like these, Ms. Law's seventh-century costume drama, which opens today at Cinema Village, suggests an Asian answer to a film like "Fellini Satyricon." Like the 1969 Fellini film, "Temptation of a Monk" wants to re-imagine a distant time using imagery that looks and feels as far away from the present as the film maker's imagination can allow.

General Shi, the film's picaresque main character, is a brilliant soldier who is duped by a fellow general, Huo Da (Zhang Fengyi), into acquiescing in a plot to assassinate the empire's crown prince. A bloody massacre ensues, and Shi is forced to flee the diabolical new ruler, but not before Shi's mother (Lisa Lu), who is held hostage, commits ritual suicide in her son's presence.

Shi begins an odyssey in which he and his henchmen hide from Huo by becoming monks in a remote Buddhist temple. When Huo's soldiers catch up with him, Shi flees to another crumbling temple, where he is tutored in Buddhist principles by a wily old abbot. The slow-moving story gathers steam near the end when a mysterious young widow who bears a remarkable resemblance to Scarlet appears and asks that the abbot preside over the cremation of her husband. From this point, the movie turns into an exotic slam-bang adventure film with an ending straight out of a Hollywood western.

"Temptation of a Monk" works on two levels. It is an elaborate historical epic filled with ritual, pageantry and battle scenes that are as elegantly staged as they are blood-lettingly fierce. But it also observes events with a Zen Buddhist detachment and concentrated focus. The screenplay and cinematography are as concerned with Shi's spiritual awakening as they are with his adventures. Scenes of flower petals being strewn and of a woman's head being ritually shaved are given equal weight with battle sequences that use slow-motion imagery and the deft alternation of sound effects and silence.

For all its beauty, the film has its lethargic moments, and the tangled political intrigue that drives the story is not easy to follow. Although Wu Hsin-kuo brings a concentrated intensity to Shi, the character remains a poker-faced enigma. If the lesson he learns about the paths of glory leading nowhere is scarcely fresh, at least it is handsomely illustrated.

1994 D 16, C18:1

An Algonquinite's Screen Anthology

By JANET MASLIN

"A great many people have come up to me and asked me how I manage to get so much work done and still keep looking so dissipated," Robert Benchley wrote in "How to Get Things Done," a short essay that typifies his self-deprecating, breezy insouciance. "My answer is 'Don't you wish you knew?' and a pretty good answer it is, too, when you consider that 9 times out of 10 I didn't hear the original question."

That tone, which was second nature to Benchley on the page, also made him famous on screen. As the star and writer of nearly 50 short films (as well as a minor player in many full-length features), he perfected a tongue-in-cheek comic persona that still has its influence today. Benchley's idea of the seemingly instructive little lecture, which is in fact hilariously unhelpful, has become a staple of late-night television comedy. And Benchley himself, as

played so appealingly by Campbell Scott, is a haunting figure in "Mrs. Parker and the Vicious Circle," a film that excites strong interest in the Film Forum 2's current three-part series of Benchley shorts.

These short films, which span nearly two decades, show how Benchley's small comic diversions grew more polished over time. Billed as miniatures and often deliciously droll, Benchley's film routines could also have their strained side. The early shorts, in particular, can have an edge of condescension as the patent-leather-haired Benchley smiles insincerely at the camera, expounding earnestly on trivial subjects or bumbling in gentlemanly fashion. Over time he became much more comfortable with his audience and skewered subjects of more lasting interest than "The Sex Life of the Polyp" — although that loony 1928 riff on reproduction remains a Benchley classic.

Seen delivering a lecture in pleased, pompous fashion, Mr.

Benchley here indulges in the genteel anthropomorphism that was one of his trademarks. While describing the poor benighted polyp and using illustrations of a tentacled, bloblike organism to make his point, he presents the polyp's courtship rites in the politest imaginable form. ("The gentleman is able to bring the lady around to, um, his point of view.") The arch, fragile essence of this humor is the idea that a male polyp might "make a conquest" of even a crumb of corn bread, which he might easily mistake for the female of his species. Mr. Benchley can be seen describing all this with immense, enjoyably misplaced enthusiasm.

The delivery is stilted here, as it was when Benchley's fellow Algonquinites Alexander Woollcott and Donald Ogden Stewart tried to follow suit. In "Mr. W's Little Game" (1934), Mr. Woollcott comes across as particularly insulting and sour. Mr. Stewart fares better presenting his own maps of Manhattan in "Traffic Regulations" (1929). ("If you will use these maps, I can assure you that you will get to the theater practically the same night you start.")

Of these three, it was Benchley who was best able to move beyond merry trivia to the more pointed, topical satire of his "How To" films of the late 1930's. By then, he appears more genial and relaxed, even going so far as to act in his more ambitious undertakings.

Among the especially enjoyable shorts in this series, installments of which will be shown today and the next two Mondays, is the ever-timely "How to Figure Income Tax" (1938), in which a befuddled Benchley tries to unravel the fine print of a tax form. "Oh well, that's self-explanatory!" he proclaims about a particularly knotty passage. "That's the diameter of the earth!" he remarks about a large number. "Belongs on another chart, I guess."

The Benchley charm is also much in evidence with "The Romance of Digestion" (1937), which manages to make a description of the how food is processed by the body sound like the story of a happy little family, among other things. (In Benchley's characteristically vivid account, teeth become "the ivory gates to the body" and "nature's tiny sentinels.") Then there's "Important Business" (1944) an elaborate sketch in which Joe Doakes, Benchley's businessman alter ego, is summoned to Washington on what he thinks is a vital mission. Mr. Benchley maneuvers his way through this story with the finesse of a seasoned comic performer.

No Benchley collection would be complete without classics like "How to Sleep" (1935) and "The Treasurer's Report" (1928); some of the latter comedy of errors is nimbly re-enacted by Mr. Scott in "Mrs. Parker." Check the Film Forum 2's schedule for exact information about which shorts appear on each of the three separate Monday programs.

1994 D 19, C16:4

LITTLE WOMEN

Directed by Gillian Armstrong; written by Robin Swicord, based on the novel by Louisa May Alcott; director of photography, Geoffrey Simpson; edited by Nicholas Beauman; music by Thomas Newman; production designer, Jan Roelfs; produced by Denise Di-Novi; released by Columbia Pictures. Running time: 115 minutes. This film is rated PG.
WITH: Winona Ryder (Jo March), Gabriel Byrne (Friedrich Bhaer), Trini Alvarado (Meg March), Samantha Mathis (older Amy March), Kirsten Dunst (younger Amy March), Claire Danes (Beth March), Christian Bale (Laurie), Eric Stoltz (John Brooke), John Neville (Mr. Laurence), Mary Wickes (Aunt March) and Susan Sarandon (Mrs. March)

By JANET MASLIN

"Some books are so familiar reading them is like being home again," Jo March observes in the new film version of Louisa May Alcott's classic novel. She's talking about Shakespeare, but we all know "Little Women" is a book like that, one of the most seductively nostalgic novels any child ever discovers. As the gold standard for American girlhood, it lingers in our collective consciousness as a wistful, inspiring memory. Ladies, get out your hand-hemmed handkerchiefs for the loveliest "Little Women" ever on screen.

Gillian Armstrong's enchantingly pretty film is so potent that it prompts a rush of recognition from the opening frame. There in Concord, Mass., are the March girls and their noble Marmee, gathered around the hearth for a heart-rendingly quaint Christmas Eve. Stirring up a flurry of familial warmth, Ms. Armstrong instantly demonstrates that she has caught the essence of this book's sweetness and cast her film uncannily well, finding sparkling young actresses who are exactly right for their famous roles. The effect is magical. And for all its unimaginable innocence, the story has a touching naturalness this time.

Remember that these are fresh-faced teen-agers who wassail and embroider. They put on little plays for at-home entertainment; they live

out the pieties of "Pilgrim's Progress"; they talk passionately about music and literature. ("Your spelling's atrocious," Jo snaps at Amy, her princessy younger sister. "Your Latin's absurd.") The Marches' rare neighborliness and generosity are enough to heartstrings by summoning a world more benign than our own. Even when this film becomes family viewing on home video, watched with a passivity so different from the no-tech, active atmosphere of the March household, its idealism will come through.

The direction by Ms. Armstrong, who long ago summoned memories of "Little Women" with "My Brilliant Career" (1978), is sentimental without being saccharine. And the film maker is too savvy to tell this story in a cultural and historical vacuum. So this "Little Women" has ways of winking at its audience, most notably when the tomboyish, intellectually ambitious Jo March reveals that she has cut off and sold her mane of hair. "Jo, how could you?" wails Amy. "Your one beauty!" Well, this Jo is Winona Ryder and the joke is that she has beauty to spare, along with enough vigor to dim memories of Katharine Hepburn in the now badly dated 1933 George Cukor version. Ms. Armstrong reinvents "Little Women" for present-day audiences without ever forgetting it's a story with a past.

Once the March sisters have made their introductory embraces — and these are girls who embrace, never just hug — the four familiar personalities emerge. Ms. Ryder, whose banner year also includes a fine comic performance in "Reality Bites," plays Jo with spark and confidence. Her spirited presence gives the film an appealing linchpin, and she plays the self-proclaimed "man of the family" with just the right staunchness.

The perfect contrast to take-charge Jo comes from Kirsten Dunst's scene-stealing Amy, whose vanity and twinkling mischief make so much more sense coming from an

11-year-old vixen than they did from grown-up Joan Bennett in 1933. Ms. Dunst, also scarily effective as the baby bloodsucker of "Interview With the Vampire," is a little vamp with a big future.

Amy undergoes a jarring personality change when, after a four-year forward leap in the story, she grows up into the more ladylike Samantha Mathis. Meanwhile, Trini Alvarado captures the ladylike composure of Meg, the oldest and most marriageable of the sisters. Miss Alcott joked that the second half of her book ought to be called "Wedding Marches" for its way of realizing these young women's ambitions with a quick succession of nuptials and babies.

As written by Robin Swicord, this "Little Women" works overtime to balance such recidivist plotting with the occasional feminist mouthful, mostly spoken by Susan Sarandon's exceedingly prim mother figure. This version emphasizes the "marm" in "Marmee" with an excess of instructional dialogue that echoes the thinking of Alcott's progressive Concord parents. So the film makes reference to transcendentalism and raises Marmee's political consciousness a few notches. ("I so wish I could give my girls a just world. I know you'll make it a better place.") While the sentiments are admirable, the stridency can be irritating, especially since the film's moral tenor is never far from its surface.

There are also men in "Little Women." As they were on the page, they're a bit secondary. Ms. Armstrong deals with that difficulty by casting attractive actors to breathe life into shapeless roles. So the handsome Christian Bale makes a dreamboat out of Laurie, the boy next door to the March family. (If viewers have trouble understanding why Jo wouldn't marry him, Miss Alcott's readers had the same problem.) Gabriel Byrne does his best with the thankless, tedious part of Professor Bhaer, the shy older man who courts Jo and is one of the book's nonautobiographical figures.

Joseph Lederer/Columbia Pictures

Claire Danes as Beth, left, Trini Alvarado as Meg, Winona Ryder as Jo and Kirsten Dunst as Amy, taking breakfast to eat with a poor family.

Eric Stoltz makes a puckish John Brooke, Laurie's tutor, even if he's the one actor here who seems to have wandered in from a later century. The March girls also have a father, but he is away as a Civil War chaplain when the story begins. Not even the joyful tears that mark his return make it credible that there really is an important man around this house.

Speaking of tears, Claire Danes is given the job of coaxing forth great torrents in the role of Beth, the doomed angel of the March family. While no reader of Miss Alcott's ever saw Beth through the valley of the shadow of death dry-eyed, the film's Beth is its one relatively ineffectual character. Ms. Danes, the disarming star of television's "My So-Called Life," does a fine job. But Beth is a quiet character, and the film has become too diffuse by the time it bids her farewell. Once the sisters leave home and hearth, Ms. Armstrong has more trouble keeping the story's strands together than she did when the girls were part of a single pretty picture.

"Little Women" also has a larger visual attractiveness, with picturesque views of Orchard House (the real Alcott home) and pristine, snowy Canadian scenery to suggest the rest of Concord. Indoor scenes have the warm glow of candlelight, and the production design is appealing without excess, in keeping with the Marches' limited means. The film's buoyant good looks stop just this side of trouble. One more violet painted on a teacup would have been too much.

"Little Women" is rated PG. It includes violence, profanity, graphic sexual situations and . . . Not! It's the most innocent movie in town.

1994 D 21, C13:1

TIGRERO
A Film That Was Never Made

Written, directed, produced and edited by Mika Kaurismaki; director of photography, Jacques Cheuiche; music by Chuck Jonkey, Nana Vasconcelos and the Karaja Indians; production designer, William O'Dwyer Fogtman; released by Arrow Releasing. Film Forum, 209 West Houston Street, South Village. Running time: 75 minutes. This film is not rated.

WITH: Samuel Fuller, Jim Jarmusch and the Karaja Indians.

By CARYN JAMES

You can just imagine the preview: Tyrone Power is the faithless husband, trapped in a South American prison! Ava Gardner is the loyal wife, who will do anything to help him escape! John Wayne is the spear-wielding "tigrero," the jaguar hunter she hires to set them all free! This romantic adventure was in the works in 1955, until it turned out that the stars would have to be insured for $18 million in case they were chomped on by piranhas while shooting in the Amazon. The movie was scrapped before it was begun. What remained was some film of the Karaja Indians the director Samuel

Arrow Releasing
The director Samuel Fuller in the home of the Karaja Indians in "Tigrero: A Film That Was Never Made," by Mika Kaurismaki.

Fuller had taken while scouting locations in Brazil the year before.

Mr. Fuller, the director of gritty movies like "Pickup on South Street," is now 82 and an idol to many young film makers. In "Tigrero: A Film That Was Never Made," he and the director Jim Jarmusch travel to the Brazilian village Mr. Fuller filmed 40 years ago. The new movie is part documentary about the Karaja as they face modernization. But it is mostly a road show in which the two directors, both cult heroes, do their version of a song-and-dance routine. Mixing Mr. Fuller's flair for authenticity with Mr. Jarmusch's droll observations, "Tigrero" is an amusing treat for movie buffs. It opens today at Film Forum 1, and at 75 minutes is exactly the right length.

Mr. Fuller, for whom the adjective "crusty" must have been invented, scowls and growls when he talks. He chomps endlessly on a cigar; white curls creep out from under his baseball cap. On a mission to find the same Karajas he had met before, he stands on the beach, shakes his fist and says, "We gotta take a *crack* at it!" Mr. Jarmusch is as deadpan as his own films, including "Stranger Than Paradise," "Mystery Train" and "Night on Earth." His prematurely white hair sticks out from under his baseball cap, too. He smokes cigarettes instead of cigars. But these two make a good team.

When they find the Karajas' village, Mr. Fuller looks around and says: "I've been away 40 years. There was *nothing* here."

Mr. Jarmusch says, "There's nothing here now, Sam," and he seems to be right.

Today electrical wires cross over the thatched roofs of the Karajas' huts. They have survived an airstrip built nearby and a hotel that has since burned down, but they have preserved the rituals Mr. Fuller filmed when he visited them, including a coming-of-age ceremony in which boys have their legs and

thighs scraped with a comb made from piranhas' teeth. Mr. Fuller becomes a hero in the village, too, showing the Indians his scenes of their younger selves and of long-dead relatives.

For all its sincerity about the Karajas, the film's heart is in its warm admiration for Mr. Fuller. Describing his lost "Tigrero," he says when he put a "w" in the margin of the script it meant, "I'd like to get a weird flavor of the film." The resourceful director used a bit of the Brazilian film in his 1963 thriller, "Shock Corridor," when a mental patient dreams he is an Indian whose legs are being combed with the teeth of a piranha.

"Tigrero: A Film That Was Never Made" was written and directed by Mika Kaurismaki, the Finnish film maker whose work includes "Zombie and the Ghost Train." (He is not his brother Aki, the director of mordant films like "Leningrad Cowboys Go America.") In one scene Mr. Fuller stops talking to Mr. Jarmusch, then looks toward the camera and says, "You can cut any time." It's the only acknowledgment that another director is around, and Mr. Kaurismaki deserves credit for knowing when to stay in the background. Who, after all, would even try to direct Sam Fuller?

1994 D 21, C18:3

MIXED NUTS

Directed by Nora Ephron; written by Nora Ephron and Delia Ephron, based on the French film "Le Père Noël Est une Ordure"; director of photography, Sven Nykvist; edited by Robert Reitano; music by George Fenton; production designer, Bill Groom; produced by Paul Junger Witt, Tony Thomas and Joseph Hartwick; released by Tri-Star Pictures. Running time: 97 minutes. This film is rated PG-13.

WITH: Steve Martin (Philip), Madeline Kahn (Mrs. Munchnik), Robert Klein (Mr. Lobel), Anthony LaPaglia (Felix), Juliette Lewis (Gracie), Rob Reiner (Dr. Kinsky), Adam Sandler (Louie), Rita Wilson (Catherine) and Liev Schreiber (Chris).

By JANET MASLIN

The dead man wears tennis shoes and stands on his head, covered with branches and disguised as a Christmas tree. "Mixed Nuts," Nora Ephron's frenetic comedy about a suicide hot line in Venice, Calif., is about as funny as that corpse, and about as natural. Adapted from the French film "Le Père Noël Est une Ordure," it has a farcical tone that loses everything in translation, with only hand-waving, door-slamming and zany costumes left behind. A title song incorporating the names of nut varieties is only one of the film's desperate ploys.

Ms. Ephron is generally so much funnier than this that "Mixed Nuts" leaves a mystifying impression. Not even its screenplay, which she adapted with her sister Delia Ephron, shows much comic style. The film's modus operandi is unleashing a horde of not-so-cute eccentrics in a confined setting and encouraging them all to talk, fuss and gesticulate at the same time. This leads to a scene with five people crammed noisily into the same bathroom, four of them oblivious and the fifth using the toilet.

The revelers here include Steve Martin as a lonely-guy suicide prevention worker along with Rita Wilson, a nervous wallflower type who has to go sit in the bathtub, fully clothed, whenever life becomes overwhelming. Madeline Kahn plays their boss as a variation on her character in "The Sisters Rosensweig," which would be fine if the film were less hysterical and didn't require her to become wackily unstrung.

Juliette Lewis, as a pregnant shop owner with a husband dressed as Santa Claus, is as funny as this comedy gets, which is a meaningful measure. If you can't guess whether she will go into labor at the height of the story's New Year's Eve frenzy, you haven't been paying attention.

Staged as pure fluff without an ounce of ballast, "Mixed Nuts" succeeds only in getting its cast into Halloween-caliber crazy costumes by the time it's over. There is also a soundtrack full of pop Christmas songs, which don't do for this film what Jimmy Durante did for Ms. Ephron's "Sleepless in Seattle."

The cast (including Rob Reiner, Robert Klein, Anthony LaPaglia and Liev Shreiber as a very large transvestite) inspires good will whenever possible. But in the case of Adam Sandler, it's out of the question. Mr. Sandler dresses as a gondolier, plays the ukulele and sings stupid little nonsense songs in an irritating falsetto. If you didn't know this was part of his established shtick on "Saturday Night Live," you might think "Mixed Nuts" was simply crazy.

"Mixed Nuts" is rated PG-13 (Parents strongly cautioned). It includes profanity, sexual references and jokey violence.

1994 D 21, C18:4

RICHIE RICH

Directed by Donald Petrie; written by Tom S. Parker and Jim Jennewein, based on the story by Neil Tolkin and the characters appearing in Harvey Comics; director of photography, Don Burgess; edited by Malcolm Campbell; music by Alan Silvestri; production designer, James Spencer; produced by Joel Silver and John Davis; released by Warner Brothers. Running time: 95 minutes. This film is rated PG.

WITH: Macaulay Culkin (Master Richie Rich), John Larroquette (Lawrence Van Dough), Edward Herrmann (Richard Rich), Christine Ebersole (Regina Rich), Jonathan Hyde (Cadbury), Michael McShane (Professor Keenbean) and Reggie Jackson as himself.

By STEPHEN HOLDEN

Macaulay Culkin has reached that awkward age — 14 — when he is too old to play a moppet whose adorability redeems a mania for mischief and too young to jump on a motorcycle with Drew Barrymore. Perched on the brink of puberty in "Richie Rich," a movie based on the popular comic strip, the young actor seems wary and introverted, as though compelled to hoard his energy until the full rush of adolescence strikes.

As Master Richie, the sole heir to a $70 billion fortune, the young star wears three-piece suits and has his reddish hair slicked back. Though he recalls Ron Howard in his youthful "Happy Days" incarnation, there is a sultriness in Mr. Culkin's hooded eyes and puckered lips that suggests he could never become a symbol of innocent, golden-age nostalgia.

"Richie Rich" is a thoroughly contemporary version of the myth of the poor little rich boy. Which is to say that the title character is wildly overindulged and that his troubles are few. Although the opening scenes make a halfhearted effort to show how unhappy Richie is without everyday playmates, the movie quickly rectifies the problem by giving him a bunch of street kids to play with. It is symptomatic of the film's sense of values that he wins their affection by wowing them with his toys. In the 90's, money does buy love.

The movie's more exuberant scenes flaunt Richie's fantastic privileges. A precocious slugger, he is personally coached in baseball by none other than Reggie Jackson. The Riches' endless backyard (much of the movie was filmed on the 8,000-acre Biltmore estate in Asheville, N.C.) includes ample space for Richie's own roller coaster. Tucked in a corner of the family mansion is his own private McDonald's.

The boy's parents, Richard (Edward Herrmann) and Regina (Christine Ebersole), are endearing madcaps out of a screwball comedy. The most benign mogul ever to amass a multi-billion-dollar fortune, the father boasts that he has never dismissed anyone from his company. Father and son keep in touch through a computerized "locater," by which the son can communicate with his peripatetic dad anywhere at anytime.

When his parents are not around, Richie is instructed in gentlemanly conduct by his kindhearted English valet, Cadbury (Jonathan Hyde), and tutored by an eccentric live-in

Don Smetzer/Warner Brothers
Macaulay Culkin in "Richie Rich."

teacher and sometime inventor, Professor Keenbean (Michael McShane).

If "Richie Rich" has the ingredients for a sweet-natured fantasy of ultimate childhood bounty, the movie, directed by Donald Petrie, lacks any sense of wonder. Its visual perspective is decidedly grown-up and demystified. That perspective is reinforced by the star's suave, poker-faced performance. Mr. Culkin is incapable of projecting the childlike wistfulness that might have given his character a residue of poignancy. This emotional void is glaring in a story in which his parents' private jet is blown up by a greedy company executive (John Larroquette), and they are briefly presumed dead.

Here and are there are signs that beneath the movie's cut-and-dried surface, a zany slapstick comedy is struggling to get out. Among Professor Keenbean's inventions are an electronic bee operated by remote control, a spray that makes clothes bulletproof, a super-adhesive glue and a "molecular organizer" that turns people into inanimate objects. When several of these devices are deployed against the bad guys in the movie's final action sequence, "Richie Rich" begins to show some signs of life.

But the playfulness is much too tentative and comes far too late. Most of the time, "Richie Rich" is too busy oohing and ahhing over the junk that money can buy to relax and have a good time.

"Richie Rich" is rated PG (Parental guidance suggested). A scene of an airplane explosion involving Richie's parents might upset very young children.

1994 D 21, C19:1

A MAN OF NO IMPORTANCE

Directed by Suri Krishnamma; written by Barry Devlin; director of photography, Ashley Rowe; edited by David Freeman; music by Julian Nott; production designer, Jamie Leonard; produced by Jonathan Cavendish; released by Sony Pictures Classics. Running time: 98 minutes. This film is rated R.

WITH: Albert Finney (Alfie Byrne), Brenda Fricker (Lily Byrne), Michael Gambon (Carney), Tara Fitzgerald (Adele Rice), and Rufus Sewell (Robbie Fay).

By CARYN JAMES

No writer was ever more urbane and sophisticated than Oscar Wilde, so it comes as a shock that Albert Finney has discovered Wilde's warm and fuzzy side. In "A Man of No Importance," Mr. Finney plays Alfie Byrne, a bus conductor in Dublin in the early 1960's. He wears Wilde's trademark green carnation while riding an emerald-green double-decker bus. He reads Wilde's plays and poetry aloud to his rapt passengers every morning, and he directs local productions of Wilde's plays at the parish hall. Mr. Carney, the rough-hewn butcher (Michael Gambon), usually plays the lead.

Alfie is almost as enamored of Wilde as he is of Robbie (Rufus Sewell), the handsome young driver of his bus, though he will admit this passion only to his own bedroom mirror. A repressed homosexual masquerading as one more Dublin bachelor, Alfie doesn't see why his little drama group shouldn't put on Wilde's "Salome," complete with the dance of the seven veils. He is one of the last true innocents.

Adopting the tone of its cheerful, unsophisticated characters, "A Man of No Importance" is a small film with far more charm than its premise might suggest. It is acted with great warmth and wit by an ideal cast, including Brenda Fricker as Alfie's spinster sister, Lily, and Tara Fitzgerald as Adele, a young woman who inadvertently provokes a crisis in Alfie's life.

The audience is always a step ahead of the plot, though just a step. Alfie's love for Robbie is clear, but before the film becomes coy about it there is a scene in which Alfie puts on eye makeup while reciting Wilde to his mirror, then kisses a framed portrait of Robbie.

Robbie himself prefers to be oblivious to Alfie's affection, even though Alfie calls him Bosie, the pet name Wilde used for his lover, Lord Alfred Douglas. "I'm going to find out who this Bosie is," Robbie says warily, but he never asks.

The film overcomes a shaky plot with its vivid, detailed picture of Alfie's neighbors, a group portrait of ignorance as bliss. Mr. Carney and Lily have the kind of friendship that suggests a comfortable, longstanding marriage. Lily is free to stop by the butcher stop, downstairs from the apartment she and her brother share, wearing her bathrobe. Mr. Carney pours her a drink. Both ignore the severed pig's head that sits comically on the counter next to them.

When Adele, a newcomer to Dublin, first walks on the bus, Alfie sees her as the star of "Salome." He regards her as a virginal princess in real life, too, ignoring the lust that Wilde poured into his heroine. Robbie senses something more experienced in Adele, but Alfie ignores his warning.

At certain points throughout the film, though, Alfie is clobbered by reality. When he goes to Adele's rooming house and hears moans coming from behind her door, only a naïf like Alfie could think she was ill. And when he opens the door, only an actor as profoundly talented as Mr. Finney could register all the emotions behind his horrified face. He is disillusioned, scared and obviously witnessing something he has never seen before.

"A Man of No Importance" is smartly directed by Suri Krishnamma, whose previous work has been for television. The film merely glances off Oscar Wilde, just as its title glances off his comedy "A Woman of No Importance," and its final reconciliation has a television-movie neatness. Pushed to the limit, Alfie decides to leave the house dressed in a large hat and cape like his hero. It is typical of this blithe, entertaining movie that he looks a lot more like Quentin Crisp.

"A Man of No Importance" is rated R (Under 17 requires accompanying parent or adult guardian). It includes a nude scene and some violence when a man is beaten on the street.

1994 D 22, C11:1

READY TO WEAR

Produced and directed by Robert Altman; written by Mr. Altman and Barbara Shulgasser; directors of photography, Pierre Mignot and Jean Lépine; edited by Geraldine Peroni; music by Michel Legrand; production designer, Stephen Altman; released by Miramax Films. Running time: 132 minutes. This film is rated R.

WITH: Lauren Bacall (Slim Chrysler), Kim Basinger (Kitty Potter), Linda Hunt (Regina Krumm), Sally Kellerman (Sissy Wanamaker), Sophia Loren (Isabella de la Fontaine), Marcello Mastroianni (Sergei), Stephen Rea (Milo O'Brannagan), Tim Robbins (Joe Flynn), Julia Roberts (Anne Eisenhower), Danny Aiello (Major Hamilton), Anouk Aimée (Simone Lowenthal), Jean-Pierre Cassel (Olivier de la Fontaine), Teri Garr (Louise Hamilton), Richard E. Grant (Cort Romney), Tracey Ullman (Nina Scant) and Forest Whitaker (Cy Bianco)

By JANET MASLIN

ROBERT ALTMAN'S "Ready to Wear" makes its ultimate fashion statement with a scene showing models as they parade on the runway of a Paris showroom, wearing nothing but the emperor's new clothes. Beyond showing off the prurience that has passed for artistic candor in Mr. Altman's recent work (most notably

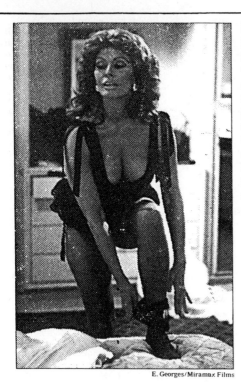

Paris, 1994
In "Ready-to-Wear," Sophia Loren plays a very recent widow who arranges a tryst with a man from her past (Marcello Mastroianni) amid the madness of the French fashion shows. The film's many other stars include Kim Basinger, Julia Roberts and Stephen Rea.

E. Georges/Miramax Films

"Short Cuts"), this sequence has another unintended effect. It's a reminder that if "Ready to Wear" has stripped anything bare, it's the director's methods that are embarrassingly exposed. Mr. Altman is his own naked emperor this time.

Although an all-star swipe at the fashion trade may have sounded tailor-made for Mr. Altman, his laissez-faire satirical style proves ineffectual for shooting fish in this barrel. Fashion is too self-conscious to be skewered so casually. It's more willfully absurd than the worlds of film ("The Player"), country music ("Nashville") or campaign politics ("Tanner '88"), and it calls for a sharp scalpel. Yet this time Mr. Altman, such a stunningly intuitive portraitist when he truly plumbs the mysteries that guide his characters, works without inventiveness and with glaring nonchalance.

Beyond being so slack, the bleached, hazy "Ready to Wear" commits a cardinal fashion sin: it doesn't even look good. Nothing that has been staged for "Ready to Wear," which opens on Christmas Day, has the sparkle or outrageousness of the real fashion shows that the film glimpses. What's more, when Mr. Altman had his actors mingle with designers and spectators at the Paris prêt-à-porter shows, the result was production still photographs that now seem wittier and more alive than the finished scenes. Speaking of "Prêt-à-Porter," the panicky last-minute decision to Anglicize that title eliminates one of the film's rare touches of class. "Ready to Wear" just coasts, too confident that the

ricocheting of well-known actors in an amusing setting will yield some sort — any sort — of cinematic combustion. That worked brilliantly in "Nashville," and maybe it works for molecular particles. But it doesn't work for performers who have been assembled more as a coterie than a cast, and who are left shockingly adrift.

Though it credits Mr. Altman and Barbara Shulgasser as writers, this film seems practically scriptless, to the point where much of it plays like a first rehearsal. Actors are left standing helplessly when they haven't yet found ways to improvise. Or as Linda Hunt says, in the role of a high-powered magazine editor, cornered by Kim Basinger's television interviewer: "Hey! Uh, uh ... hey."

As in "Nashville," Mr. Altman uses a dizzy female journalist to interview other characters and tie

up loose ends. Functioning a bit the way Geraldine Chaplin did in that Altman masterpiece is Ms. Basinger, as the breathless reporter who waylays Ms. Hunt and many others with fatuous questions. But if Mr. Altman took the trouble to weave Ms. Chaplin's character into that earlier film and to give her some sharp edges, Ms. Basinger is simply made ridiculous and kept very visible. This time the actors' celebrity counts for more than their ability to keep the narrative on track.

That's because there is no narrative. There are only several dozen characters who cross paths or echo one another's amusing actions. (Stepping in dog excrement is meant to be one of those fun gaffes, and it happens a lot.) Not many of the performers in such roles have the chance to do much acting, but

"Ready to Wear" does deliver the occasional scathing caricature. Stephen Rea, looking like Bob Dylan in the role of a mean-spirited, big-name photographer whose specialty is humiliating people who are hapless enough to be caught by his camera, becomes the film's most meaningful character for all too obvious reasons.

Among those who wander through "Ready to Wear" with some semblance of purpose are Tim Robbins and Julia Roberts. They play two strangers, both journalists, who lose their luggage, are forced to share a hotel room and soon find ways to keep busy without clothes. Their brief scenes are nicely played (particularly one in which Mr. Robbins, forced to file some copy for his newspaper, listens to a television reporter's news story and simply dictates it verbatim). Those scenes might even have been the basis for another movie, but they don't have much place in this one. Neither does Sophia Loren, though she turns up grandly and often. The very sight of her is enough to suggest this film has some kind of fashion sense.

Ms. Loren swans through "Ready to Wear" as the grief-free widow of a fashion dignitary (Jean-Pierre Cassel) whose mistress (Anouk Aimée) actually mourns him. The widow is stalked by a mysterious Russian (a sly Marcello Mastroianni), whose necktie mysteriously matches the dead man's. That's about the tightest plotting in a melee that also includes rival magazine editors (Sally Kellerman, Tracey Ullman, Ms. Hunt), one color-blind fashion doyenne (Lauren Bacall), a cross-dressing buyer (Danny Aiello) and his hard-shopping wife (Teri Garr).

Then there are fake designers (Forest Whitaker, Richard E. Grant), who are mild fun, and real designers (including Gianfranco Ferré, Issey Miyake and Sonia Rykiel), who seem uniformly bewildered about what sort of film they're in. "Well, it's all about looking good ..." begins Thierry Mugler, delivering one of the film's typically tepid pronouncements. But Mr. Altman can't make those thoughts sound empty without better thoughts of his own.

"Ready to Wear" is rated R (Under 17 requires accompanying parent or adult guardian). It includes profanity, sexual situations and full frontal nudity during an extended fashion-show scene.

1994 D 23, C1:1

DEATH AND THE MAIDEN

Directed by Roman Polanski; written by Rafael Yglesias and Ariel Dorfman, based on the play by Mr. Dorfman; director of photography, Tonino Delli Colli; edited by Herve de Luze; music by Wojciech Kilar; production designer, Pierre Guffroy; produced by Thom Mount and Josh Kramer; released by Fine Line Features. Running time: 103 minutes. This film is rated R.

WITH: Sigourney Weaver (Paulina Escobar), Ben Kingsley (Dr. Roberto Miranda) and Stuart Wilson (Gerardo Escobar).

By CARYN JAMES

Roman Polanski knows that a sleek, stylish thriller is often the best route to weightier matters. Without its glossy commercial surface, "Rosemary's Baby" would never have made Devil worship so viscerally chilling. His new film, "Death and the Maiden," is a similar triumph for Mr. Polanski. His brilliance with the camera turns Ariel Dorfman's well-meaning but pretentious play about human rights into a harrowing experience.

The film, which opens today, is a three-character story set in an unspecified South American country (standing in for Mr. Dorfman's native Chile) after the fall of a dictator. Sigourney Weaver plays Paulina Escobar, a woman who was kidnapped and tortured during the dictatorship. Stuart Wilson plays her husband, Gerardo, a lawyer who has just been named to head a human-rights commission, a panel that will investigate murder but not cases of unlikely survival like Paulina's. Ben Kingsley is Roberto Miranda, a doctor who gives Gerardo a lift home when his car breaks down, and whom Paulina insists is her torturer. Though she was blindfolded throughout her captivity, she knows his voice, she knows his favorite turns of phrase and she is determined to make him confess.

The look and atmosphere of the film are crucial, and stunningly effective. The setting is Paulina and Gerardo's idyllic beach house. But a violent rainstorm makes the lights and phone work erratically, and there is an eerie, persistent lighthouse beam in the distance. Mr. Polanski has created the backdrop for a horror movie, which turns out to be precisely right for the horrors the film will explore.

As the doctor creepily fawns over Gerardo's role on the human-rights commission, Paulina hears his voice from the other room, sneaks off and sends his car off a cliff. When she returns, she ties him in a chair. In a scene that resonates with the idea of sex as a weapon of torture, she pulls off her underpants, uses them to gag him, then tapes his mouth and tears the tape with her teeth while straddling his lap. She speaks to him with all the vulgarity he once used on her. At that point, she wants to rape him,

François Duhamel/Fine Line Features
Ben Kingsley and Sigourney Weaver.

as he did her. Eventually she demands a confession. .

Ms. Weaver is sternly terrific here. Wisely, the film doesn't flash back to scenes of the torture, focusing instead on the power of memory and language to recreate pain. Ms. Weaver calmly and angrily describes how she was given electrical shocks and raped repeatedly by a man who played Schubert's "Death and the Maiden" Quartet in the background. Now, holding a gun on the doctor, she puts "Death and the Maiden" on a tape player and says, "Let's listen to it for old times' sake." She says this with a steely determination that is much more powerful than dripping irony would have been.

Mr. Wilson, a stage actor who played Julius Beaufort in "The Age of Innocence," is extraordinary at capturing Gerardo's confusion, as he wonders if his wife is right or deranged. He carries his own burden, for Paulina was tortured for refusing to reveal his name. "I would have given them your name to save my skin," he admits sadly.

Mr. Kingsley has a role that may seem like a tour de force but is really no more than a trick. The story is supposedly set up as a mystery: Has Paulina identified her torturer or is she mistaken? But the answer is weighted toward her, so Miranda's character has nowhere to go. Mr. Kingsley's face is a blank slate, which is not the same thing as an enigma.

The screenplay, with some crucial new scenes, was written by Mr. Dorfman and Rafael Yglesias. Like the play, it too often raises questions in a heavy, self-important way, without being thoughtful about the answers. Does Paulina have the right to torture her torturer? Should she rise above that?

But Mr. Polanski treads lightly on the clumsier lines, and sustains tension by creating an elegant, unobtrusive dance with the camera. The taut "Death and the Maiden" suggests the discipline of "Frantic" rather than the go-for-broke excess of "Bitter Moon."

Mr. Kingsley gets a big, chilling scene near the end, and the film comes full circle to a concert of the Schubert quartet, where Paulina and Gerardo spot Miranda. The scene restores the elegant facade of their lives, which this film has so violently shattered.

"Death and the Maiden" is rated R (Under 17 requires accompanying parent or adult guardian). It includes strong language, violence and graphic descriptions of torture.

1994 D 23, C3:4

RUDYARD KIPLING'S 'THE JUNGLE BOOK'

Directed by Stephen Sommers; written by Mr. Sommers, Ronald Yanover and Mark D. Geldman, based on "The Jungle Book," by Rudyard Kipling; director of photography, Juan Ruiz-Anchia; edited by Bob Ducsay; music by Basil Poledouris; production designer, Allan Cameron; produced by Edward S. Feldman and Raju Patel; released by Walt Disney Pictures. Running time: 108 minutes. This film is rated PG.

WITH: Jason Scott Lee (Mowgli), Cary Elwes (Boone) and Lena Headey (Kitty).

By STEPHEN HOLDEN

Brashly panoramic in the candy-colored style of a children's story book, the newest film incarnation of Rudyard Kipling's "Jungle Book" is a movie that is absolutely clear in what it wants to say. Human beings may think they're better than animals, but they are probably worse, since animals kill only for food. Those who do not seek to live in harmony with nature risk being devoured by nature. Greed is bad, especially when it involves exploiting the jungle.

Variations on these themes are intoned regularly by Mowgli (Jason Scott Lee), Kipling's Victorian version of a wild child brought up by animals in the Indian jungle. Even when hunted like an animal by cartoonishly evil British Army officers, Mowgli's attitude is more indignant than enraged. His only aggressive acts are those of self-defense.

As portrayed by Mr. Lee, who became a star in the title role of "Dragon: The Bruce Lee Story," Mowgli is exotic enough to convince young children that he grew up with wolves and tigers but handsome enough to be a teen-age heartthrob. After hours spent running through the jungle, he emerges glistening and clean-cut, like a model in an after-shave ad.

"Rudyard Kipling's 'The Jungle Book,'" which opens on Christmas Day, is the third Hollywood movie based on the much-loved Kipling stories. There was the 1942 film, starring Sabu, and the 1967 Disney animated classic, in which Mowgli's animal companions assumed cartoon personalities. In this new live-action interpretation, also by Disney, the animals don't talk. Based only loosely on Kipling and directed by Stephen Sommers, who wrote the screenplay with Ronald Yanover and Mark D. Geldman, it is a chaste teen-age love story with an ecological sensibility and some terrific scenery.

In this version, Mowgli decides to rejoin civilization to be close to Kitty, his childhood playmate from the time he was lost in the jungle and presumed dead. Even as a child, Mowgli had a preternatural empathy with wild animals. When Mowgli and Kitty recognize each other years later, their childhood attachment flares into an instant mutual crush. But Kitty still feels obliged to follow convention and becomes engaged to Boone (Cary Elwes), an arrogant, brutal army captain. The full extent of Boone's monstrosity is revealed when he forces Mowgli to lead a search party to find a lost city of treasure in the heart of the jungle.

The scenes in which Boone and his twittish companions torture Mowgli are spun directly from countless high school rites-of-passage movies in which a student from the poor side of town is ritually humiliated by the snooty rich in-group, and a girl, who is drawn to the newcomer, is torn between conforming with the clique and following her heart.

Because "The Jungle Book" is a live-action movie, the personalities of Kipling's animal characters remain undeveloped, and the book's rich layer of allegorical fantasy, in which figures from the animal kingdom evoke the range of human personality, is missing.

If this version of "The Jungle Book" makes for a fable that is thinner than it might have been, the film is splendidly picturesque and moves along briskly. The scenes of Mowgli running with wolves and facing down a tiger in eye-to-eye challenge and of an eerie jungle city run by chattering monkeys who hilariously mock the vanity of kings are impressive in their pictorial sweep and dynamism.

The film's idea of Victorian India may have a lot more of Beverly Hills in it than it should, but the story is told in clear, confident strokes. The wildlife is wondrous. And the film's ultimate vision of the jungle as a peaceable kingdom, governed by its own eternal, majestic and inviolable law, still exerts a mystical tug.

"Rudyard Kipling's 'The Jungle Book'" is rated PG (Parental guidance suggested). Very young children might be frightened by scenes of wild animals on the rampage and by the story of a child who is lost in the jungle.

1994 D 23, C5:1

NOBODY'S FOOL

Written and directed by Robert Benton; based on the novel by Richard Russo; director of photography, John Bailey; edited by John Bloom; music by Howard Shore; production designer, David Gropman; produced by Scott Rudin and Arlene Donovan; released by Paramount Pictures. Running time: 112 minutes. This film is rated R.

WITH: Paul Newman (Sully), Jessica Tandy (Miss Beryl), Bruce Willis (Carl Roebuck), Melanie Griffith (Toby Roebuck), Dylan Walsh (Peter), Pruitt Taylor Vince (Rub Squeers), Gene Saks (Wirf), Josef Sommer (Clive Peoples Jr.), Catherine Dent (Charlotte), Alexander Goodwin (Will) and Elizabeth Wilson (Vera).

By CARYN JAMES

You hear Paul Newman before you see him in "Nobody's Fool," yelling affectionately to Jessica Tandy as his landlady, Miss Beryl. With the raspiness his voice has taken on recently and the irreverence that has always been part of his charm, he shouts: "Still alive in there, old lady? Didn't die in your sleep, did you?" Then he sits in her living room chair to put on his work boots, which isn't easy. He has a bad knee that is getting worse and an occasional off-the-books job working construction for Carl Roebuck (Bruce Willis), who owes him money. He lives alone in the apartment above Miss Beryl's, and at 60 he is running out of time for his life to turn out all right. It says everything about Mr. Newman's performance, the single best of this year and among the finest he has ever given, that you never stop to wonder how a guy so good-looking as Paul Newman ended up this way.

As Donald Sullivan, called Sully by everyone except Miss Beryl, Mr. Newman does look good, even with a limp and muddy work clothes. But

he plays Sully from the inside out. Though the character's humor carries traces of earlier Newman heroes, the effect is as natural as if Sully had watched Butch Cassidy or Cool Hand Luke and decided on a strategy: take life as it comes and face it down with a wisecrack.

Mr. Newman's approach — without cheap sentiment or self-pity — is matched by the film itself, exquisitely directed by Robert Benton and adapted by him from Richard Russo's novel. On screen as in the book, "Nobody's Fool" has the rich texture of a 19th-century novel, as if Thackeray's "Vanity Fair" were transported to the blue-collar town of North Bath in upstate New York.

Instead of glamour, Bath has the Iron Horse, the local bar where Sully and his perpetually losing lawyer (Gene Saks) bet on the outcome of the People's Court on television. There are tenement houses behind chain-link fences and a banner across Main Street that promotes the town as the future home of the Ultimate Escape Theme Park. Bath is the kind of place people usually try to escape, but "Nobody's Fool" is the nearly plotless story of those who stay. In a series of lifelike small encounters, some comic and some deeply emotional, Sully discovers how many people count on him.

They include his friend and co-worker Rub Squeers (Pruitt Taylor Vince), who has far more loyalty than intelligence. There is Miss Beryl, who doesn't have much use for her son, Clive (Josef Sommer), the local banker. "He isn't my son; they switched bassinets at the hospital," she says tartly at Thanksgiving dinner with her business associates. In one of her last performances, Ms. Tandy is perfection, spry without being cute.

Sully flirts with Carl's wife, Toby (Melanie Griffith), who knows her husband is messing around with his secretary but can't seem to kick him out for good. She is a woman whose beauty is almost ready to fade, and her relationship with Sully has the ease and electricity of an attraction bound to go nowhere.

Throughout the film, Sully's past unfolds gracefully, as the pieces fall into his line of vision. An important part of the past literally drives into view while Sully is hitchhiking, and his son, Peter (Dylan Walsh), stops on the road. Peter has just been fired from his job as a college English teacher in West Virginia, and has driven with his wife and two small sons to spend Thanksgiving with Sully's ex-wife, the fastidious Vera (Elizabeth Wilson).

Peter is the one character let down by the screenplay. Every word he says seems to express anger at the way Sully abandoned the family when Peter was a baby. His dialogue goes beyond what an injured son might say, and lands in the area of clumsy exposition, even in a comic scene in which Peter helps his father knock out a Doberman and steal a snowblower.

The theme of redeeming yourself in someone's love works better and with greater subtlety in Sully's scenes with his grandson, Will (Alexander Goodwin). "Want to drive?" Sully asks the boy, putting him on his

lap as they drive his old red pickup truck and revealing the easy charm that has made Sully a survivor.

A lesser problem is the feeling that something is slightly off in Sully's relationship with Toby. In fact, the film has cut out the character who balanced her in the novel, a married woman named Ruth with whom Sully has had a long on-and-off affair. Ruth's absence plagues the film like a phantom limb, making Sully more isolated; stranding him without a sex life and perhaps making him more acceptable to mainstream movie audiences.

But these are slight flaws in a film in which almost everything works. John Bailey photographs Bath with brisk, natural clarity. Mr. Willis uses smarminess to good effect, and Mr. Vince and Mr. Saks create two different but equally touching small-town failures.

"Nobody's Fool" opens on Christmas Day. In its elegiac final scene, Ms. Tandy walks toward her kitchen to make tea, still lively and clearheaded. Sully is asleep in her chair, physically back where he started but emotionally several leaps ahead. If "Nobody's Fool" is often heartbreaking in its sense of loss, it is also hopeful in the strength of its emotions and the sheer beauty of its performances.

"Nobody's Fool" is rated R (Under 17 requires accompanying parent or adult guardian). It includes some nudity.

1994 D 23, C5:1

I.Q.

Directed by Fred Schepisi; produced by Carol Baum and Mr. Schepisi; written by Andy Breckman and Michael Leeson; director of photography, Ian Baker; edited by Jill Bilcock; music by Jerry Goldsmith; production designer, Stuart Wurtzel; released by Paramount Pictures. Running time: 96 minutes. This film is rated PG.

WITH: Tim Robbins (Ed Walters), Meg Ryan (Catherine Boyd), Walter Matthau (Albert Einstein), Gene Saks (Boris Podolsky) and Lou Jacobi (Kurt Godel).

By JANET MASLIN

The nice thing about "I.Q." is that its intelligence doesn't stop at the title. In a romantic comedy that mingles brilliant physicists with auto mechanics, everybody manages to seem smart. Most of all Fred Schepisi, the director, who has figured out how to get the absolute best out of his leading actors. Mr. Schepisi is so clever that his audience will have no trouble believing Walter Matthau as Albert Einstein, and that's just for starters.

"I.Q.," which opens on Christmas Day, features wonderful comic performances from both Meg Ryan, who is newly calm and composed here, and Tim Robbins, who is all dimples and slow, easy delivery. Oozing total sexual confidence, Mr. Robbins plays a mechanic who really likes comets, and Ms. Ryan plays a scientist who doesn't much like auto mechanics. And happens to be Einstein's niece. Another thing Mr. Schepisi makes easy to believe is

Princeton, 1955
In "I.Q.," Walter Matthau plays Albert Einstein and Meg Ryan is his extremely intelligent niece, who may be marrying the wrong man. Tim Robbins co-stars as a mechanic who never went to college but may be Mr. Right.

Demmie Todd/Paramount Pictures

that when these two meet, they fall instantly in love.

The point, alarmingly, is that brains aren't everything. "I.Q." is poised to announce that the heart matters more than the head, and that romance is such an equalizer it puts the theory of relativity on an equal footing with fixing cars. But "I.Q." is so smart that it doesn't really do much with this dumbing-down angle. It prefers to keep its characters warm, bright and interesting as long as it can.

The humor can be supremely sly, and all the more gratifying since it avoids the danger of treating Einstein as a walking sight gag. Einstein to Ed, Mr. Robbins's mechanic, as Einstein hatches a scheme to throw Ed and Catherine (Ms. Ryan) together: "Are you thinking what I am thinking?" Ed, thoughtfully: "Well, what would be the odds of that happening?"

Set in an idyllic-looking Princeton, N.J., during the Eisenhower years, "I.Q." is also a visual pleasure. Ms. Ryan has been smashingly costumed as the kind of cool, elegant blonde who would have driven Alfred Hitchcock wild. And Mr. Matthau's Einstein, who bumbles around town adorably in the company of his elderly, professorial cronies (including Gene Saks and Lou Jacobi), is no less attractive in his own shaggy way. As for Mr. Robbins, he does a mean Marlon Brando impersonation and a convincing job of sweeping not only Catherine but also the scientists off their feet.

As written by Andy Breckman and Michael Leeson, "I.Q." is able to generate loads of good will before it runs into story problems. There's a central contrivance about making Ed look like a brilliant physicist so that Catherine will accept him, and this gimmick eventually overwhelms the romance, leaving the second half of the story rather flat. By the time the film actually brings President Eisenhower to Princeton,

"I.Q." has become a little silly in terms of plot. But the main characters are so strong that the film's gentle pleasures persist even when its focus drifts. Ed, gazing at the stars: "Do you know why a comet's tail always points away from the sun?" Catherine: "Yes!" He: "Me too."

The film's biggest surprise is Ms. Ryan, who is seldom this serene. She's a much more captivating comic actress without busy mannerisms, and when she beams in this film, the sun really shines. One of the film's scientist characters says it best, speaking in the idiom that the screenplay renders most deftly: "Wonderful to the power of three."

"I.Q." is rated PG (Parental guidance suggested). It includes mild profanity and a number of flirty double-entendres.

1994 D 23, C8:5

COLONEL CHABERT

Directed by Yves Angelo; written (in French, with English subtitles) by Jean Cosmos and Mr. Angelo, based on the novel by Honoré de Balzac; director of photography, Bernard Lutic; edited by Thierry Derocles; production designer, Patrick Bordier; produced by Jean-Louis Livi; released by October Films. At Sony Theaters Lincoln Square, Broadway at 68th Street. Running time: 110 minutes. This film is not rated.

WITH: Gérard Depardieu (Chabert), Fanny Ardant (Countess Ferraud), Fabrice Luchini (Derville) and André Dussollier (Count Ferraud).

By JANET MASLIN

● The year is 1817 and the events described have been strongly influenced by Napoleon. But "Colonel Chabert," the new film version of a Balzac novel, which opens today at Sony Theaters Lincoln Square, has an odd and timely resonance. Much

of its enduring interest comes from the familiar unpleasantness of bitter legal wrangling that is at the center of this story. Such strife yields an intimate, disturbing perspective on the social fabric that binds the tale's characters and defines their lives.

When an earlier French version of "Colonel Chabert" opened here in 1947, Bosley Crowther of The New York Times said it involved "mostly a lot of talking with lawyers about signing things and precious little action of a revealing or absorbing sort." That's still true. But this time, in a quietly intense film directed by Yves Angelo (the cinematographer whose decorous credits include "The Accompanist" and "Un Coeur en Hiver"), those legal maneuvers become subtly ferocious and revealing.

The film reunites Gérard Depardieu and Fanny Ardant, two formidable actors who brought such heat to Truffaut's "Woman Next Door," as a couple experiencing extraordinary marital difficulties. These two are expert, as might be expected, but the startling performance comes from Fabrice Luchini (who had a supporting role in "Claire's Knee") as their lawyer. The very fact that the warring spouses share a legal representative is one of the film's interesting peculiarities, as is the response of Countess Ferraud (Ms. Ardant) when she realizes how cleverly she is being manipulated to her husband's advantage. As she tells Derville (Mr. Luchini), her attorney, with sardonic admiration, "I'll never have any lawyer but you."

The opposing party is not precisely her husband. Playing an acutely civilized character who recalls his appearance in "The Return of Martin Guerre," Mr. Depardieu has the title role, that of an officer presumed killed in 1807 at the Battle of Eylau. Mr. Angelo begins his film with horrific glimpses of that battle's aftermath, and of society's orderly ways of dealing with such carnage. Then he finds the man who claims to be Colonel Chabert 10 years later.

He returns home greatly changed, a disaffected outsider. And he finds that his wife, thinking herself a widow, has married the ambitious Count Ferraud (André Dussollier, so expert with handsome, self-interested characters), who would now like to be rid of her. The Count aspires to a peerage, but his rich wife is a social liability, since her wealth was amassed during the reign of Napoleon. Napoleon is now desperately out of fashion.

One of the film's more arresting scenes is that in which Chabert first persuades Derville, who already represents the Count and Countess, to take his case. This glittery-eyed, intent lawyer is so fascinated by the situation's complex possibilities that he even agrees to handle Chabert at a financial risk. "Even if I lose my money, I won't regret it," he says, about a case that will force an investigation of Chabert's veracity. "I'll have seen the most skilled actor of our time."

Indeed. Recovering from "Germinal," his last literary-historical behemoth, Mr. Depardieu is solemnly good here and sometimes even shocking, as when he smiles cryptically in a mirror after having put

Ms. Ardant's Countess through a grueling emotional scene. She provides a rueful and impassioned presence, and these two stars have some wrenching, beautifully modulated scenes together as they finally discuss the ramifications of their problem. The Countess is terrified, knowing she could be abandoned by a second husband who has every reason to get rid of her. Chabert is second only to his lawyer in enjoying the manipulative opportunities in such a situation.

"Colonel Chabert" peaks at this juncture, since its final stages are interior and literary in ways that elude the camera. But Mr. Angelo makes a thoughtful directorial debut and affirms his visual expertise (this film's cinematography is by Bernard Lutic). He succeeds in elevating Chabert's mystery beyond questions of fact and into the subtle, debilitating compromises of eternal warfare, whether it is conducted in the bedroom, in the courtroom or on the battlefield.

1994 D 23, C8:5

LEGENDS OF THE FALL

Directed by Edward Zwick; written by Susan Shilliday and Bill Wittliff, based on the novella by Jim Harrison; director of photography, John Toll; edited by Steven Rosenblum; music by James Horner; production designer, Lilly Kilvert; produced by Mr. Zwick, Mr. Wittliff and Marshall Herskovitz; released by Tri-Star Pictures. Running time: 133 minutes. This film is rated R.

WITH: Brad Pitt (Tristan), Anthony Hopkins (Ludlow), Aidan Quinn (Alfred), Julia Ormond (Susannah), and Henry Thomas (Samuel)

By JANET MASLIN

There's some mighty pretty country on display in "Legends of the Fall," Ed Zwick's big, fancy film based on Jim Harrison's lean, muscular novella. Not to mention the mighty pretty people roaming through it. Foremost among them is Brad Pitt, departing from the solemnity of his "Interview With the Vampire" performance and wearing a rakish grin as big as all outdoors. Mr. Pitt's diffident mix of acting and attitude works to such heartthrob perfection it's a shame the film's superficiality gets in his way.

But it does, maddeningly so. In gussying up this tale of a prosperous prairie family at the time of World War I, Mr. Zwick goes for the Kodak moment at every opportunity, drowning out dialogue with swelling music and sweeping scenery. Instead of simply letting its characters speak, this film would rather resort to handsome, sincere gazes from the photogenic principals. Mr. Zwick, whose visual grandiosity also showed in "Glory," hasn't cast a single actor who wouldn't be perfectly at home in a modeling spread, man, woman or child.

Beyond good looks, he has enlisted some serious, blue-eyed talent to play this story's fashion-plate ranchers: Anthony Hopkins as William Ludlow, a retired Army colonel, with Mr. Pitt, Aidan Quinn and Henry Thomas as his sons. In Mr. Harrison's story, two of those young men

fall in love with the same woman. The movie, with characteristic extravagance, makes matters more confusing by involving her with all three.

The woman is Susannah (the graceful Julia Ormond, first spotted by one of the brothers "at a Harvard tea for Amy Lowell." Her arrival at the ranch is filmed with typical fanfare, as if it were an advertisement for outdoor life. Father and sons Samuel (Mr. Thomas) and Alfred (Mr. Quinn) arrive, looking shy and dashing; warm glances are exchanged all sides. Then Tristan (Mr. Pitt) thunders up on horseback, exuding the brash cowboy arrogance and giving Susannah, who is his brother Samuel's fiancée, one of the film's most meaningful looks. If we've seen "East of Eden," we know what it means.

But "Legends of the Fall," which opens on Christmas Day, has lots of other business to take care of. The story is heavily plotted, which turns Mr. Zwick's reliance on soggy wordless effects into a huge liability. And in such a relentlessly picturesque film, it's hard to accommodate Mr. Harrison's most macho flourishes, like the idea that after one of the brothers is killed in World War I, Tristan, the hunter and free spirit of the story, will cut his brother's heart out so it can be brought home for burial. No Kodak moment there — though not for lack of trying.

"Legends of the Fall" does bring together gripping material and good actors, however unlikely their circumstances (this may be the only time Mr. Hopkins will ever be seen in a bandanna). But it winds up all the more disappointing for its great promise. Before it turns exhaustingly hollow, this film shows the potential for bringing Mr. Harrison's tough, brooding tale to life. And the actors may have captured the spirit of the story, but that's impossible to know. These are performances that lost too much in the editing room, smothered by music and overshadowed by a picture-postcard vision of the American West.

"Legends of the Fall" is rated R (Under 17 requires accompanying parent or adult guardian). It includes gory violence, nudity and sexual situations.

1994 D 23, C10:5

STREET FIGHTER

Written and directed by Steven E. de Souza, based on the Capcom Video Game "Street Fighter II"; director of photography, William A. Fraker; edited by Anthony Redman, Robert F. Shugrue, Ed Abroms and Donn Aron; music by Graeme Revell; production designer, William Creber; produced by Edward R. Pressman and Kenzo Tsujimoto; released by Universal Pictures. Running time: 101 minutes. This film is rated PG-13.

WITH: Jean-Claude Van Damme (Colonel Guile), Raul Julia (Bison), Ming-Na Wen (Chun-Li), Damian Chapa (Ken), Kylie Minogue (Cammy), Simon Callow (A.N. Official), Roshan Seth (Dhalsim), Wes Studi (Sagat) and Byron Mann (Ryu).

By STEPHEN HOLDEN

If Jean-Claude Van Damme's newest action-adventure film, "Street Fighter," is remembered for

anything, it will probably be for Raul Julia's flaming portrayal of Gen. M. Bison, an international villain of Hitlerian proportions. An insane warlord in the make-believe South Asian country of Shadaloo, General Bison is hellbent on world conquest. One of his tools is a lethal laboratory-engineered soldier, programmed to kill, who looks like a Frankenstein monster and speaks in an electronic drone.

General Bison has tricks up his sleeve that are not deployed until the movie's chaotic final action sequence. The most spectacular is a pair of electromagnetic shoes that enable him to levitate and fly around like Superman, while proclaiming himself a god. This role was Mr. Julia's final screen performance (the movie is dedicated to him). And the actor gives it his all, widening his eyes into an electric glare of cartoonish ferocity, swishing his cape and cackling fiendishly.

Mr. Julia's nostril-flaring campiness befits a film that is the latest action-adventure movie to be spun off from a video game. Like other movies that originated as toy software, "Street Fighter," which opened yesterday, does not feel obliged to do much more than create a live-action simulation of a video game's rhythms. The movie is fast and jerky, with no narrative continuity and lots of candy-colored pyrotechnics and characters who talk in cartoon-balloon fragments, usually in a monotone.

Mr. Van Damme plays Colonel Guile, an Allied Nations commander who leads a party of soldiers into Shadaloo City to rescue a group of imprisoned relief workers whom General Bison hopes to ransom for $20 billion. Subsidiary characters include a television reporter with surprising martial arts skills (Ming-Na Wen) and two young adventurers (Damian Chapa and Byron Mann) who keep getting in and out of scrapes.

If Steven E. de Souza, who wrote and directed "Street Fighter," has captured the look and mood of a video game, the film is an otherwise dreary, overstuffed hodgepodge of poorly edited martial arts sequences and often unintelligible dialogue. As Mr. Van Damme fumbles through his part, you are likely to find yourself staring at the big lump on the right side of his forehead and wondering how it got there.

"Street Fighter" is rated PG-13 (Parents strongly cautioned). It is loaded with violence, but mostly of the cartoonishly bloodless variety.

1994 D 24, 11:1

THE MADNESS OF KING GEORGE

Directed by Nicholas Hytner; written by Alan Bennett, based on his play, "The Madness of George III"; director of photography, Andrew Dunn; edited by Tariq Anwar; music adapted from George Frideric Handel by George Fenton; production designer, Ken Adam; produced by Stephen Evans and David Parfitt; released by the Samuel Goldwyn Company. Running time: 105 minutes. This film is not rated.

WITH: Nigel Hawthorne (George III), Helen Mirren (Queen Charlotte), Ian Holm (Willis), Amanda Donohoe (Lady Pembroke), Rupert Graves (Greville), Julian Wadham (Pitt) and Rupert Everett (Prince of Wales)

By JANET MASLIN

All the world's a stage for King George III, the royally irrepressible ruler who holds sway throughout "The Madness of King George." While there's much to admire in Nicholas Hytner's splendid screen adaptation of Alan Bennett's neo-Shakespearean play ("The Madness of George III"), this exuberant tragicomedy is first and foremost a superb showcase. The monarch is a corker, and he commands almost all the attention.

Grandly played by Nigel Hawthorne, who repeats his stage role with a stunningly mercurial display of wit, pathos and fiery emotion, this wily King is a figure to be reckoned with even when his powers decline. It was under the stormy reign of George III (1760-1810) that England's monarchy lost a substantial degree of its authority to Parliament, while England itself lost the United States (or "the place we mustn't mention," as it's called in the film). As for George himself, he began losing his reason periodically in 1788, when the film takes place, and was deemed quite mad during the last 10 years of his monarchy.

Mr. Bennett's drama finds him at a critical juncture, still in control but well aware of the "catalogue of regal nonconformities" he presents to courtiers and loved ones. For all his comic fireworks, Mr. Hawthorne poignantly captures the King's understanding that his power may be slipping, that he may not be able to halt that process, and that a long list of adversaries eagerly awaits his decline.

The star, the film maker and the playwright find something universal in the ways this embattled man fends off the inevitable, using every behavioral weapon in his arsenal to keep his enemies at bay. In the process, they also enjoy the essential hollowness of keeping up appearances in royal fashion. "Smile at the people," King George exhorts his family, with a puckishness that certainly resonates today. "Wave to them. Let them see that we're happy. That's why we're here."

The early part of the film offers broadly entertaining displays of how this cagey, mocking King uses royal prerogatives to frazzle those around him. There is the music recital he attends, sweeping in to hear "Greensleeves" played on bells and then declaring: "Fascinating stuff, what-what? Let's have it again!" There is the fact that he refuses to let pregnant women be seated during this cultural ordeal, announcing: "If everybody who's having a baby wants to sit down, next thing it'll be everybody with gout."

There are his ways of addressing the Queen sweetly as "Mrs. King," though he is also capable of accusing her of sleeping with their son. There is his sudden decision to rouse his servants for a run at sunrise, announcing: "Six hours' sleep is enough for a man, seven for a woman and eight for a fool!" There is the

413

Samuel Goldwyn Company

London, 1788
In "The Madness of King George," Nigel Hawthorne plays George III, who has attacks of mental illness and finds his sons strangely unsupportive. Helen Mirren and Ian Holm co-star.

visit to a barnyard where the King, who regards himself as a farmer, has a nice, companionable chat with a tiny pig.

Events like these convince those closest to King George that it may be time to question his authority. And Mr. Hytner, the prodigiously talented stage director (of "Carousel" and "Miss Saigon"), who directed "King George" for London's Royal National Theater and now makes a vigorous film debut, has no trouble explicating this chicanery in colorful, entertaining fashion. "The Madness of King George" mixes the ebullience of "Tom Jones" with a pop-theatrical royal back-stabbing that is reminiscent of films like "The Lion in Winter." That makes it a deft, mischievous, beautifully acted historical drama with exceptionally broad appeal.

Mr. Bennett explicates a convoluted governmental crisis in ways that are both lucid and sly. Challenged on all sides by Prime Minister William Pitt (Julian Wadham); a Member of Parliament, Charles James Fox (Jim Carter), and his own son, the scheming Prince of Wales (a flamboyantly memorable Rupert Everett), this King even winds up reading Shakespeare aloud with his Lord Chancellor one day. " 'King Lear' — is that wise?" asks the Lord Chancellor, who has been enlisted to play Cordelia. "I had no idea what it was about, sir," the King's physician replies.

Mr. Bennett certainly knows what "King Lear" is about, but he is content with only an echo or two; for all its intimations of loss, "The Madness of King George" is largely lighthearted. Much of this film devotes itself to subsidiary matters like the abysmal medical practices to which the King is subjected once his condition becomes cause for concern. Typical of the film's contemporary asides is the declaration by one of the King's aides, a man named Fortnum, that he's tired of bedpan duty and thinks going off to Piccadilly to start a provision company might be a good career move. This film loves making hay out of hindsight.

"The Madness of King George" begins blithely and takes on substance as the King appreciates his own frailty, especially after he is forced to become a patient of Dr. Willis (Ian Holm). This doctor effectively scares the King back to his senses, understanding the problem at a time when ordinary doctors

regarded even a physical examination as an impertinence. (The King's malady was eventually thought to be porphyria, a metabolic imbalance whose symptoms include mental disturbance.) Dr. Willis remarks that there are unhinged individuals who imagine themselves to be king. "He *is* the King," he says of his royal patient. "Where shall *his* fancy take refuge?"

As Mr. Hytner and Mr. Bennett follow that fancy so engagingly, "The Madness of King George" also thrives on the talents of a fine supporting cast. Helen Mirren makes a patient and formidable Queen, tolerating even the King's overt lunges at Lady Pembroke (Amanda Donohoe), her lady-in-waiting. "Did we ever forget ourselves?" King George asks Lady Pembroke, during a spell when the madness has subsided and he can assess his life with uncharacteristic calm. "Because if we did, I should like to remember."

As that suggests, this film eventually sounds grace notes that signal acceptance and understanding, even of facts that were heretofore unbearable. "We must get used to it," King George eventually sighs about the nation formed from his American colonies. "I have known stranger things. I once saw a sheep with five legs."

"The Madness of King George" is not rated. It includes swearing, sexual references and bathroom details closely linked to the King's medical condition.

1994 D 28, C11:3

Linda R. Chen/Miramax Films

JANET MASLIN

Bruce Willis, above, as an aging
boxer in "Pulp Fiction";
and Hugh Grant, below
and John Hannah in "Four
Weddings and a Funeral."

Four Weddings, a Funeral, a Party
(That Fizzled) and a Nasty Encounter

Pulp Samurai About to escape the hellish pawnshop in "Pulp Fiction," Bruce Willis chose to go back and do the right thing. He tried out weapons — a hammer? a baseball bat? a chain saw? — and selected a samurai sword as the perfect implement for his mission. That gesture affirmed both the wild humor and the unexpected decency of Quentin Tarantino's exultantly imaginative crime drama, the very best film of the year.

Film Verse The graveside scene in "Four Weddings and a Funeral," when one character eulogized a dead friend, did wonders for W. H. Auden, bringing one of his untitled poems great new popularity and even a name ("Funeral Blues"). Not a bad byproduct for this sparkling, literate English comedy.

Perfectly Bad Keanu Reeves, Uma Thurman and Sean Young met up in a brief, spectacularly awful party sequence in Gus Van Sant's "Even Cowgirls Get the Blues," the year's most disastrous film. Duds this deadly deserve remembering, too.

Seeing the Light In a spectacular scene, Keanu Reeves, sitting beneath a tree in the widely overlooked "Little Buddha," achieved spiritual enlightenment, aided by dazzling special effects. When even Bernardo Bertolucci goes in for fancy morphing tricks, you know they're here to stay.

Docu-Dreams The most effective shot in "Hoop Dreams," the documentary about basketball and Chicago teen-agers, was the parting one leveled by one of the players, William Gates, against his exploitative coach: "I'm going into communications so when you come asking for donations, I'll know the right way to turn you down." Documentary film makers depend on luck, and they don't get any luckier than this.

Gramercy Pictures

Cake and Tea, And a Taste Of Blood

Family Relations Robert Redford's "Quiz Show" probably didn't mean to send out a subliminal suggestion to eat chocolate cake and drink milk, but some people walked out of the movie with an inexplicable craving for comfort food. In one of the best scenes in one of the year's best films, Ralph Fiennes, as the corrupt quiz-show contestant Charles Van Doren, sits at the family table eating his mother's homemade cake and having a misguided conversaton with his patrician father (Paul Scofield). Like most movie moments that follow you home, this one captures something essential about the film. The sympathetic father talks about the difficulty of finishing books; the audience knows that Charles is longing for the simple honor he has lost. With an eloquence that goes beyond easy symbolism, the scene embodied the sense of lost innocence "Quiz Show" explored so deftly.

Hidden Emotions Paul Newman, as the tough-spirited Sully in "Nobody's Fool," sinks into a chair in the parlor of his landlady (Jessica Tandy) and refuses a cup of tea. "Not now, not ever," he says, in a performance as great as any Mr. Newman has given. The elegiac moment — in one of Ms. Tandy's last roles — captures the film's deep, unsentimental emotions.

Lestat and Louis In "Interview With the Vampire," a turn of Tom Cruise's head conveyed his passing resemblance to Paul Newman while Brad Pitt was looking his most Redfordlike. It's "Butch and Sundance: The Vampire Years," evidence of a new generation of movie stars.

At Jackrabbit Slim's For pure fun nothing beats John Travolta and Uma Thurman twisting to Chuck Berry's "You Never Can Tell" in "Pulp Fiction," a movie you can dance to.

François Duhamel/Warner Brothers
Tom Cruise, left, and Brad Pitt in "Interview With the Vampire."

Cross-Dressers In the Outback And a Family With Problems

Parker's Pen Socialites should think twice before asking their famous guests to behave like performing seals. When prodded to give a reading at a lawn party, a scowling Dorothy Parker (Jennifer Jason Leigh) reels off her nasty meditation on suicide. "Guns aren't lawful/ Nooses give/ Gas smells awful/ You might as well live," she intones in a punch-drunk voice that stops the party cold. Ms. Leigh's performance was exceptionally brave for being so relentlessly bitter. Although her portrayal may have been highly mannered, it was a convincing portrait of a lonely alcoholic malcontent with a viper's tongue.

Best Performance in a Dress Terence Stamp's portrayal of Bernadette, an aging drag queen, in "The Adventures of Priscilla, Queen of the Desert" had a witty mixed message about sexual identity and role playing. The oldest of a trio of transvestite entertainers traveling through the Australian outback, Bernadette personified genteel drag-queen hauteur. Yet Bernadette also shucked off her matronly airs long enough to rescue the trio from imminent peril. Echoes of Mr. Stamp as a dashing movie hero in the late 60's filtered through the women's clothing to suggest volumes about yin and yang.

Crumb-ology "Crumb," Terry Zwigoff's documentary portrait of the underground cartoonist Robert Crumb, offered an astoundingly intimate picture of an artist's deeply dysfunctional family. Its most harrowing scene was an interview with Robert and his brother Charles, who committed suicide shortly after the film was completed. A recluse, Charles was revealed to be as tal-

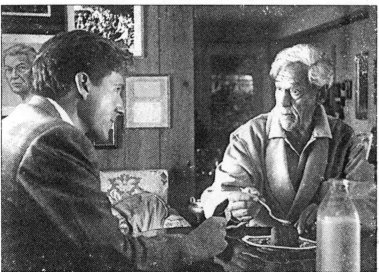
Hollywood Pictures
Ralph Fiennes, left, and Paul Scofield in "Quiz Show."

Joyce Rudolph/Fine Line Features

Jennifer Jason Leigh in "Mrs. Parker and the Vicious Circle."

ented as his brother but too psychotic to work. The movie, which will be released commercially next year, was shown at the New York Film Festival. Come Oscar time, it should be one of the films nominated for best documentary. "Crumb" offers a disturbing vision of family psychology straight from an R. D. Laing text.

1994 D 25, II:17:1

Critic's Notebook

Innovation And Incest, Glitches And Tinsel

By CARYN JAMES

Special to The New York Times

PARK CITY, Utah, Jan. 30 — In the year of dysfunction at the Sundance Film Festival — when abused, violent and delusional characters ruled the films in competition — the Audience Award for most popular dramatic film was given to "Spanking the Monkey." It is a surprisingly witty and engaging story about an ordinary teen-ager whose relationship with his mother turns incestuous. The first feature written and directed by David O. Russell was one of the few festival movies to avoid the talk-show clichés of its lurid subject, and the film's deftness marks Mr. Russell as one of the most original directors to come out of Sundance in years.

Fine Line Features bought the movie just minutes before the awards were announced on Saturday evening, at a misbegotten ceremony loaded with technical snafus and thank-yous to corporate sponsors.

The Audience Award in the documentary category went to "Hoop Dreams," a nearly three-hour film about two Chicago teen-agers hoping to become professional basketball players. The film makers — Steve James, Fred Marx and Peter Gilbert — followed the youths and their families for five years, from junior high through the beginning of college. As the tale expands to include money worries, family pride and a crack-addicted father, it becomes a portrait of inner-city American culture. "Hoop Dreams" is to open at Film Forum in Manhattan on March 2.

Associated Press

The Grand Jury Prize at the Sundance Film Festival was awarded to "What Happened Was ...," Tom Noonan's literate, two-character study of a couple on an awkward first date. Robin O'Hara and Scott Macaulay, the producers, accepted the award on Saturday night.

The Audience Award, voted by festival moviegoers, is not the most prestigious prize, but it is the most important as a forecast of mainstream success. (It is the award Steven Soderbergh's first film won; they might as well rename it the "Sex, Lies and Videotape" prize and get it over with.)

Officially, the Grand Jury Prize, voted on by five judges in each category, is the top award. This year's jury chose one of the most mature works: "What Happened Was ...," Tom Noonan's literate, two-character study of a couple on a first date in her apartment. Based on a 1992 play that Mr. Noonan wrote and appeared in, it is still essentially a brightly written, filmed dialogue that owes a great deal to "My Dinner with André."

In choosing a work about two middle-aged characters who have emotional wounds, the jurors showed their distance from the youth-oriented films that dominated the competition. This year's dramatic jurors were the writers and directors Allison Anders, Maggie Greenwald and Neal Jimenez, the actor Matthew Modine and the actress Tantoo Cardinal. Mr. Noonan missed the ceremony because he was in New York appearing in "Wifey," the Off Off Broadway play he wrote.

The Grand Jury Prize for a documentary went to "Freedom on My Mind," by Connie Field and Marilyn Mulford. It is a history of the civil rights movement in Mississippi in 1963 and '64, and was one of the less talked-about films at the festival.

Anyone who worries that Hollywood glitz will overtake Sundance would have had those fears dispelled at the awards ceremony. The event is always homey and casual, but this year it was also anti-climactic and amateurish, a strange thing to say about a ceremony featuring an appearance by Robert Redford.

Mr. Redford slipped onto the stage at the start, thanked the staff and film makers, then disappeared. Other welcoming speeches and thank-yous included one tacky touch: remarks by a representative from Mercedes-Benz, which sponsors the competition. It was as if someone from Taco Bell were given time on the "MacNeil/Lehrer Newshour."

The host was Ben Stiller, the actor and comedian whose first film as a director, "Reality Bites," had its premiere on Friday night. At the awards presentation, Mr. Stiller appeared on-stage after the lengthy thank-yous and began by thanking "my mother, my father and the Mercedes-Benz guy." It was the only lighthearted touch of the evening.

He moved straight to the awards, only to find that the clips from the winning films were full of glitches. More than once, they turned into frozen stills. The award for cinematography in the documentary category went to Morten Sandtroen for "Colorado Cowboy: The Bruce Ford Story," about a rodeo champion. Holding his award, Mr. Sandtroen said the clip shown was actually from archival material in the film and not among work he photographed. "I should really find out who shot that, and I'll pass this on," he said.

1994 Ja 31, C13:6

A Dark Comedy Wins at Cannes

By JANET MASLIN

Special to The New York Times

CANNES, France, May 23 — "Pulp Fiction," Quentin Tarantino's electrifying and original dark comedy about an assortment of underworld characters, received the Palme d'Or tonight as the best film at this year's Cannes International Film Festival. This film, an American entry, stars Bruce Willis, John Travolta, Harvey Keitel and Uma Thurman.

A grand jury prize, honoring runners-up in the best-film category, was split between the festival's two most politically charged favorites: Zhang Yimou's "To Live," the story of. a long-married couple whose lives reflect changing phases of recent Chinese history, and "Burnt by the Sun," Nikita Mikhalkov's tragic yet lyrical tale of a Stalinist hero in the Soviet Union.

Ge You, who plays the husband in Mr. Zhang's film, was voted best actor. He had been considered a leading candidate for the acting prize, but the best-actress winner, Virna Lisi, was a surprise. Miss Lisi, who is made up to look pale and sinister for her performance as Catherine di Medici in Patrice Chereau's "La Reine Margot," arrived at the Palais du Festival looking blond and radiant by contrast. She cried profusely upon accepting her award, and was greeted with especially warm applause.

Rare Prize for a Script

Nanni Moretti, the Italian film maker whose "Caro Diario" takes the form of a cinematic diary, was voted best director. A screenwriting prize that had not been given in a decade was awarded to Michel Blanc, who is also the star of his own "Grosse Fatigue." Mr. Blanc's film, which often shows him conversing with his own double, also won an award for special effects.

An additional jury prize, ranking below the others, was also given to Mr. Chereau for "La Reine Margot." A separate international critics' prize was awarded earlier to Atom Egoyan, the Canadian film maker of Armenian extraction, for "Exotica."

No Prize for a Favorite

Among those presenting awards were Mr. Willis, John Travolta, Carmen Maura, Geraldine Chaplin and Kathleen Turner, the star of "Serial Mom," which was the festival's out-of-competition closing-night film.

Among the most unexpected developments was the complete overlooking of "Rouge," the well-received third film in Krzysztof Kieslowski's "Trois Couleurs" trilogy. Even more remarkable was that the rest of the awards, by and large, made terrific good sense. In Cannes, that is always the biggest surprise of all.

1994 My 24, C15:6

Critics Honor 'Pulp Fiction' And 'Quiz Show'

By JANET MASLIN

"Quiz Show," Robert Redford's thoughtful, elegant examination of the television game-show scandals of the 1950's and how they signaled a loss of innocence in American life, was voted the best film of 1994 by the New York Film Critics Circle.

Voting yesterday at the offices of the Newspaper Guild of New York, the group gave its awards for direction and screenwriting to "Pulp Fiction," Quentin Tarantino's audacious crime drama with its interwoven stories. Roger Avary wrote that film with Mr. Tarantino, its director.

The group also chose to give a lifetime achievement citation, its first, to Jean-Luc Godard. "What better way to celebrate the Circle's 60th year than by honoring Godard's example of a film critic who actually supported and changed the art of movies?" asked Armand White of The City Sun. Mr. White is the group's current chairman.

Paul Newman was voted best actor for his portrayal of a wry blue-collar character who winds up reassessing his life in "Nobody's Fool." Linda Fiorentino was named best actress for her performance as a staggeringly cold-blooded schemer in "The Last Seduction." The group's choice for best supporting actress was Dianne Wiest, who plays a theatrical grande dame in "Bullets Over Broadway."

Martin Landau was voted best supporting actor for playing a grumpy, curmudgeonly Bela Lugosi in Tim Burton's "Ed Wood." Stefan Cszapsky's black-and-white cinematography for that film was also cited.

The group's choice for best foreign film was Krzystof Kieslowski's "Red." The winner for best documentary was "Hoop Dreams," which follows the lives of two inner-city high school athletes. The group also voted an award for best first film to Darnell Martin's "I Like It Like That," the tale of a scrappy young woman from the Bronx.

The awards are to presented on Jan. 22 in a ceremony at the Pegasus Room of the Rainbow Room.

1994 D 16, C4:6

The Good, Bad and In-Between in 1994 Films

By JANET MASLIN

Flukes set the standard for 1994 on screen. While big films ("Wyatt Earp") and even big seasons (Christmas) fizzled, the triumphs came out of extreme left field. Foreign films were in serious decline, but American independent cinema experienced a burst of creative fervor. And, of course, Gump happened. More about that in a moment.

While 1994 was short on major fireworks, it brought so many solid successes that this year's 10-best list includes a dozen entries. Arithmetic should never matter more than merit.

So here are the 10-best films of 1994, in order:

PULP FICTION. Moral tales for a jaded, topsy-turvy world, told with dark, outrageous humor and absolute command of style. Quentin Tarantino, one natural-born killer of a film maker, has been facetiously labeled the directorial flavor of the decade. But if he sustains the brilliance of

Colm Feore in "32 Short Films About Glenn Gould."

Samuel Goldwyn Company

Gong Li in Zhang Yimou's "To Live."

Samuel Goldwyn Company

Amanda Plummer and Tim Roth in Quentin Tarantino's "Pulp Fiction."

Linda R. Chen/Miramax Films

this instant classic, he'll earn that title for real.

HOOP DREAMS. The year's most heart-stopping drama came from a work of nonfiction. A documentary masterpiece, endlessly revealing, about two inner-city high school basketball players and the forces that exploit their raw talent. The film makers had everything: time, patience, insight and the cooperation of people who sensed the emblematic importance of their own story. Tough, gripping and profoundly illuminating in ways that make it a landmark.

QUIZ SHOW. Graceful and subtle, Robert Redford's exegesis of the 1950's television scandals had a rare, ruminative intelligence and delivered some of the year's best acting. John Turturro and Paul Scofield expertly defined opposite extremes in a film that took eroding American scruples as the subject of its $64,000 questions.

THIRTY-TWO SHORT FILMS ABOUT GLENN GOULD. Dazzlingly, form followed function in this biographical meditation modeled on Bach's "Goldberg" Variations. With its starkly imaginative approach to character study, it summoned an eerie intensity perfectly suited to the elusive Canadian pianist and his idiosyncratic genius.

TO LIVE. China's most daring film maker, Zhang Yimou, viewed his country's recent history through the eyes of its humble, fearful citizenry and told the tale of one such couple with devastating understatement. Once again, this great storyteller displayed extraordinary gifts for distilling major political and cultural events into intimate human drama.

THE LAST SEDUCTION. John Dahl single-handedly reinvigorated film noir with two made-for-television sleepers. This film, more streamlined and deliciously brazen than his "Red Rock West," showed off a hardboiled director and a scorchingly effective star. Films were full of street-smart attitude in 1994, but Linda Fiorentino's ice-blooded schemer was tough cookie of the year.

FOUR WEDDINGS AND A FUNERAL. Sparkling wit made a delightful comeback in this swift, literate English ensemble film propelled by Oxbridge talent on and off the screen. While Mike Newell and Richard Curtis, the director and screenwriter, found an unexpected but wonderfully buoyant structure for their comic confection, previously little-known Hugh Grant emerged as the year's brightest of new stars.

RED. Krzysztof Kieslowski's "Three Colors" trilogy ended on a high note, with a beautifully intuitive film that displays this director's cryptic style at its most penetrating. A grand feat of gamesmanship, linking events, emotions and parallel characters in a web of haunting complicity.

CARO DIARIO. With a fresh, funny approach to social criticism, the Italian film maker Nanni Moretti took stock of his country's health and, ultimately, his own. The diary format made this a winningly nimble and varied film, soothingly contemplative in some spots and cheerfully

overbearing in others. A reminder of how radical and satisfying such one-man-army tactics can be.

NOBODY'S FOOL. Robert Benton's pitch-perfect literary adaptation of Richard Russo's wry novel performed a remarkable balancing act, describing everything about the life of a small, upstate New York town without skipping a sardonic beat. Paul Newman, as the wisecracking fulcrum of this unexpectedly stirring story, will be the old pro to beat at Oscar time. A rare big-studio movie with the wisdom to think small.

BULLETS OVER BROADWAY. Beneath the smooth comic professionalism of Woody Allen's best recent film lurked truly audacious thoughts about art, love and genius. This sly, expert period piece combined big laughs with real bite.

LADYBIRD, LADYBIRD. Wrenching social realism from Ken Loach, who told his story with full respect for its staggering ambiguities. As a mother battling social service agencies for custody of her children, Crissy Rock gave a searingly good performance, one that did justice to the complex agonies Mr. Loach addressed.

Runners-Up and Losers

This was an unusually strong year for runners-up, so here are the best: "The Madness of King George," a royally entertaining screen version of Alan Bennett's play, with Nigel Hawthorne holding court. "I Like It Like That," Darnell Martin's jubilant Bronx comedy with a savvy, feminist point of view. "Clerks," Kevin Smith's no-budget miracle from a convenience store in New Jersey. "Spanking the Monkey," a down-to-earth "Graduate" for these dysfunctional times. "Little Women," Gillian Armstrong's smart, unmannered retelling of that heirloom tale. "I'll Do Anything," James Brooks's soulful Hollywood satire, unfairly blasted for a big budget and the last-minute removal of its musical score.

Also: "Ed Wood," Tim Burton's hilarious and touching valentine to Z-movie bravado. "The Boys of St. Vincent," an unflinching Canadian drama about pederast priests, directed with cool, documentarylike intensity. "Savage Nights," the ragged, desperate AIDS-era romance directed by the late Cyril Collard. "Eat Drink Man Woman," Ang Lee's lighthearted culinary and comedic treat. "Vanya on 42d Street," presenting Chekhov with rare intimacy in an unusual film-theatrical hybrid. "Little Buddha," a grand, gorgeous folly of a theology lesson from Bernardo Bertolucci. And "Interview With the Vampire," the best conceivable film version of an Anne Rice story. Rats and all.

Now for the flip side: 10 worst films of 1994, each with the kind of disastrousness that is emblematic in some notable way. "Even Cowgirls Get the Blues": all thumbs, with Gus Van Sant turning a pitifully dated Tom Robbins novel into a full-scale creative calamity. "Exit to Eden": really bad sex, with Garry Marshall taking all the fun out of black leather. "The Flintstones": a cynical marketing ploy masquerading as a movie. "The Specialist": ugly, third-rate film making with only the big

Phil Caruso/Paramount Pictures
Tom Hanks and Robin Wright in their love scene in "Forrest Gump."

names of two bored-looking stars to give it drawing power.

"The Road to Wellville": an extended bathroom joke, but its literary origins (in T. Coraghessan Boyle's novel) meant a big budget and an absurd veneer of respectability. "Milk Money": fulfilling every boy's fantasy of having Dad marry an ex-hooker built like Melanie Griffith. "Love Affair": the year's most shameless vanity production, with its most embarrassing soft-focus cinematography. "Ready-to-Wear": its biggest non-event, a lifeless party filmed by Robert Altman on automatic pilot. "Mary Shelley's Frankenstein": epic overreaching, with Kenneth Branagh straying far afield to make a big, ungainly monster hash.

And "Forrest Gump": because its hollow man was exactly that, self-congratulatory in his blissful ignorance, warmly embraced as the em-

bodiment of absolutely nothing. We shouldn't settle for movie heroes who don't do more than show up. And we all look that much more dumbed-down when, as it did in 1994, Gump happens on a global scale.

1994 D 27, C13:1

Correction

A Critic's Notebook article yesterday about the best films of 1994 misstated the medium for which "The Last Seduction" was produced. It was made for theatrical release, but the broadcast rights were acquired by Home Box Office, which showed it on cable television starting in July. Its United States theatrical premiere was in October.

1994 D 28, A2:6

'Pulp Fiction' Gets Top Prize From National Film Critics

By JANET MASLIN

"Pulp Fiction," the exuberant, innovatively structured crime drama directed by Quentin Tarantino, was named the best film of 1994 by the National Society of Film Critics yesterday. Voting at the Algonquin Hotel, the 42-member group also cited Mr. Tarantino as best director and gave its best-screenplay prize to him

and Roger Avary as the film's co-writers.

Jennifer Jason Leigh was voted best actress for her performance as the caustic, brittle heroine of "Mrs. Parker and the Vicious Circle." Diane Weist was named best supporting actress for playing a grandly theatrical diva in "Bullets Over Broadway." "Red," the last film in Kryzsztof Kieslowski's "Three Col-

ors'' trilogy, was voted best foreign film.

Paul Newman was chosen as best actor for his performance in ''Nobody's Fool'' as an amiable failure in an upstate New York town, and Martin Landau was voted best supporting actor for playing an endearingly cranky Bela Lugosi in ''Ed Wood.'' One interesting peculiarity of the voting was that Samuel L. Jackson, who plays a Bible-quoting hit man in ''Pulp Fiction,'' was first runner-up in both the best actor and best supporting actor categories.

The group's cinematography award went to Stefan Czapsky, for his richly varied black and white work in ''Ed Wood.'' The best-documentary prize went to ''Hoop Dreams,'' the keenly watchful study of two high school basketball players and their families, which was also a runner-up (after ''Red'') in the best-film category. Special citations for experimental work were awarded to ''Satantango,'' a seven-hour Hungarian film by Bela Tarr, and ''The Pharaoh's Belt,'' an animated film by Lewis Klahr.

1995 Ja 4, C14:2

In Hollywood, a Party Is a Party And an Awards Show Is Even Better

By BERNARD WEINRAUB

Special to The New York Times

HOLLYWOOD, Jan. 22 — The annual awards season in Hollywood is defined by two ceremonies that are polar opposites.

The prime event, the Academy Awards, scheduled for March 27, is a serious and, let's face it, sometimes deadly affair given by the movie industry to congratulate itself.

The Talk of Hollywood

And then, for better or worse, there's the Golden Globes ceremony.

''Darling, it's the best party of the year,'' proclaimed Joan Collins, who's been to a party or two, as she walked along a red carpet crammed with movie and television stars at the Beverly Hilton just moments before the 52d annual Golden Globe Awards on Saturday night.

Nearby, Edward Zwick, a creator of ''Thirtysomething'' and a nominee as best director for the drama ''Legends of the Fall,'' spoke quietly as Jamie Lee Curtis and then Jason Priestley strode past him to the screams of fans.

''Hollywood is sort of like high school with money,'' he said. ''This isn't the senior prom; it's more like the junior prom. It's still nice to be asked.''

More than 1,300 people attended.

As the biggest, glitziest and probably most curious party in town, the Golden Globes ceremony, presented by the Hollywood Foreign Press Association, is actually surreal.

For one thing, no one quite knows much about the association, but the town turns out anyway on the premise that a party is a party and an award show is even better.

No event, including the Oscars, pulls in so many stars and studio chiefs who cram into a ballroom to table-hop, schmooze, pass the wine

and watch the goings-on, which are broadcast live on TBS. (In pretelevision days, the party was a little wilder and attendees often got, well, more than a little tipsy.)

Beyond this, the Globes sometimes predict the Academy Awards, although the track record is mixed. The Globes are also given to numerous television shows, but it's movies that dominate the action.

So many stars showed up this time that even the stars themselves were awe-struck. ''I just met Arnold Schwarzenegger,'' said Hugh Grant, who won an award for his starring role in ''Four Weddings and a Funeral.''

''Nearly fainted,'' he added, smiling.

On Saturday night, the major winner on the movie side was ''Forrest Gump,'' the hugely successful comedy-drama about 40 years in the life of an innocent mentally disabled man. It won awards for best drama, best performance by an actor in a drama (Tom Hanks) and best director (Robert Zemeckis).

Winning the best actress award for a drama was Jessica Lange, for her role as a bewildered and restless military wife in Tony Richardson's drama ''Blue Sky,'' a film whose release was delayed four years because its producer, Orion, was in financial turmoil. In the supporting category for film, Dianne Wiest won for her performance as the Broadway diva in ''Bullets Over Broadway'' and Martin Laudau won for his portrayal of Bela Lugosi in Tim Burton's ''Ed Wood.''

Mr. Landau said candidly that actors' careers follow peaks and valleys, and that his professional life had been in ''a very deep valley'' until the film came along. Mr. Hanks, on the other hand, who won an Oscar last year for ''Philadelphia'' and is a prime candidate for another one for ''Forrest Gump,''

told reporters that it was inevitable his career would hit a valley, too.

''I know for a fact, folks, one of these days you'll say, 'What happened, Tom?' '' he said.

A highlight of the evening was the appearance by the extraordinarily glamorous Sophia Loren, who is 60, accepting an honorary award named after Cecil B. De Mille. Though she recently appeared in Robert Altman's film ''Ready to Wear,'' good roles are generally elusive for her, so the actress is in quasi-retirement. ''I could be in many films,'' she told journalists, ''but I think the stories should be appropriate to my personality and my age.''

What gives the Golden Globes ceremony its dreamy, never-never-land quality, which seems utterly appropriate for the town, is the fact that the ballyhooed prizes are actually given by an odd group of 80 or so foreign journalists, most of them freelance and some of whom don't write too much.

Rumors that some of them are also jewelers and waiters on the side are denied by Globe officials, although the organization's past has been marked by some unseemly episodes. There was the unfortunate Pia Zadora incident in the early 1980's, when the association voted the actress newcomer of the year. It was later revealed that a few days before the voting, Ms. Zadora's producer (and later husband) had flown the members to Las Vegas for fun and games.

Studio executives say privately that Hollywood Foreign Press Association members never met a meal they didn't like and are plied with piles of food after screenings in order to gain their favor. They generally carry cameras to news conferences, and when a movie star appears to speak to them, everyone clicks away. Moreover, they insist that movie stars like Arnold or Clint or Kevin pose with each of them, and the stars usually agree to do so.

Yet Hollywood has accepted these foibles for years. And if there's perhaps a tainted quality to the awards, the common attitude is, who cares? It's a lavish party. It's Hollywood.

And Aida Takla-O'Reilly, president of the organization, insisted that whatever the problems of the past, the Hollywood Foreign Press Association has found redemption and is as honest as anything else in town.

Ms. Takla-O'Reilly, who covers Hollywood for an Egyptian weekly, Nisf lel Dunia, insisted that membership requirements had been tightened and that only ''valid journalists'' from abroad are now admitted.

''The criticisms of the past are over,'' she said in an interview. ''We are a very credible group, as you see. And we get bigger every year. Bigger and better. Next year NBC is televising our show.''

The rumor that Hollywood Foreign Press members freelance on the side as waiters or businessmen

was not entirely brushed aside by Ms. Takla-O'Reilly. ''We're professional in what we do,'' she said. ''How they spend their time is up to them.''

Actually, the most dramatic moments of the show involved television, not films. The HBO drama ''The Burning,'' about the life of Chico Mendes, won awards for best picture made for television, best supporting role (Edward James Olmos) and best actor (Raul Julia). Tributes to Mr. Julia, who died in October, were given by his widow, Merel Poloway; Mr. Olmos, and John Frankenheimer, who directed ''The Burning.''

The major surprise was that the Fox show ''The X-Files'' defeated such series as ''E.R.,'' ''N.Y.P.D. Blue,'' ''Picket Fences'' and ''Chicago Hope'' as best dramatic television series.

But it was movie stars and movies that dominated. And it was Mr. Grant who made a gentle mockery of all the humble thank-you speeches at such events.

After winning his award as best actor in a motion picture comedy, Mr. Grant said: ''It's tragic how much I'm enjoying getting this It's heaven. Right up my alley. I can't tell the Foreign Press Association how much I admire them.''

He added that the script for ''Four Weddings'' came to him from his agent in London. ''He's extremely small and extremely vicious,'' said Mr. Grant, who brought down the house.

1995 Ja 23, C11:1

'Gump' Is Winner Of Directors' Award

BEVERLY HILLS, Calif., March 12 (AP) — The Directors Guild of America gave its top award today to Robert Zemeckis for his film ''Forrest Gump,'' making the movie a virtual sure thing for a top Academy Award on March 27.

Almost every film that wins a top guild award goes on to win the Oscar for best picture. The last three guild winners — ''The Silence of the Lambs,'' ''Unforgiven'' and ''Schindler's List'' — swept the top Academy Awards.

''Hoop Dreams'' was recognized by the Directors Guild as the year's best documentary. The story of two high school basketball players was thought to have a chance at a best-picture Oscar nomination, but was omitted from that category as well as from the documentary selections. The omission prompted the academy to review its documentary nomination procedures.

The prizes were announced at a ceremony at the Marriott Marquis hotel in New York City. Some were presented there and others at a separate West Coast ceremony at the Beverly Hilton Hotel in Beverly Hills.

1995 Mr 13, C13:2

'Forrest Gump' Triumphs With 6 Academy Awards

By WILLIAM GRIMES

"Forrest Gump," the runaway hit about a simple soul caught up in the most turbulent events of postwar America, triumphed last night at the 67th Academy Awards, sweeping all three major awards for which it was nominated, including best picture. Robert Zemeckis won the Oscar for best director, and Tom Hanks was named best actor for his performance in the title role.

The sweep represented a vote for traditional Hollywood values as the feel-good film triumphed over the rawer, more experimental "Pulp Fiction," which won only one award. The other nominees for best picture, "Four Weddings and a Funeral," "Quiz Show" and "The Shawshank Redemtion," were shut out.

"Gump" also won Oscars for film editing, visual effects and best adapted screenplay, by Eric Roth, based on Winston Groom's novel.

Mr. Hanks, who won last year's Oscar for best actor for "Philadelphia," became the first person to receive back-to-back Oscars in the category since Spencer Tracy, who won in 1937 and 1938 for "Captains Courageous" and "Boys Town."

Accepting the award, Mr. Hanks, close to tears, said, "The power and the pleasure of this moment are as constant as the speed of light; it will never be diminished." The 13 nominations for "Forrest Gump" fell just one short of the record, set by "All About Eve" in 1950, and equaled the number of nominations for "Gone With the Wind."

The Oscar for best actress went to Jessica Lange for her performance as the manic-depressive wife of an Army officer in "Blue Sky," a film that struggled to make it to theaters after the studio distributing it, Orion Pictures, went bankrupt. Ms. Lange won an Oscar as best supporting actress for "Tootsie" in 1982 and had previously been nominated four times as best actress.

Ms. Lange, in accepting the award, paid tribute to Tony Richardson, who died soon after directing the film. "He kept nudging me over the edge," she said, "and with a character like this, it's exactly what I needed."

Dianne Wiest was named best supporting actress for her performance as an aging Broadway ham with delusions of grandeur in "Bullets Over Broadway." It was Ms. Wiest's second Oscar and third nomination in the category. She won for "Hannah and Her Sisters" in 1986 and was nominated for "Parenthood" in 1989.

Martin Landau was named best supporting actor for his performance as an aged Bela Lugosi in "Ed Wood," the director Tim Burton's homage to the director of 50's megabombs like "Plan 9 From Outer Space" and "Bride of the Monster."

The Oscar for best foreign-language film went to "Burnt by the Sun," a Russian film directed by Nikita Mikhalkov. Mr. Mikhalkov brought his young daughter onstage, calling her the only actress with whom he had never experienced any problems. He then lifted her up, slung her over his shoulder and marched toward the wings.

Quentin Tarantino and Roger Avary, who wrote "Pulp Fiction," won the Oscar for best original screenplay.

In a year remarkable for its lack of Oscar-caliber films, David Letterman, making his first appearance as host of the event, held at the Los Angeles Shrine Auditorium, was the subject of as much pre-Oscar talk as the nominees themselves. In essence, Mr. Letterman transferred his television show, "Late Show With David Letterman," to the Oscar stage, right down to the top-10 list and stupid pet tricks. Judging by the audience reaction, a lot was lost in the translation. A running gag about introducing "Uma" (Thurman) to "Oprah" (Winfrey) died on the vine, and some others seemed to cut a little too close to the Hollywood bone.

Referring to Dreamworks SKG, the company recently formed by Steven Spielberg, Jeffrey Katzenberg and David Geffen, Mr. Letterman said: "I think that this partnership is going to be really, really good for Hollywood. Now, instead of hoping that they're not successful individually, you can hope that they're not successful as a group." A taut silence ensued, punctuated by nervous laughter.

Hans Zimmer's score for "The Lion King" received the Oscar for musical score. The Oscar for original song went to "Can You Feel the Love Tonight," one of three nominated songs from "The Lion King," all of them composed by Elton John with lyrics by Tim Rice.

The evening's official theme was comedy in the movies, and the musical numbers were interspersed with clips of pratfalls taken by Charlie Chaplin, W. C. Fields, Laurel and Hardy and other movie comedy teams. Arthur Hiller, the president of the Academy of Motion Picture Arts and Sciences, which awards the Oscars, also introduced a political note in his opening remarks, pleading against proposed cuts in the budget of the National Endowment for the Arts. His call was echoed by Mr. Landau and Quincy Jones, who was given the Jean Hersholt Humanitarian Award.

Clint Eastwood received the Irving G. Thalberg Memorial Award in honor of his work as a film producer. Malpaso, the film company he founded 25 years ago, has produced 30 films, including "Unforgiven," "White Hunter, Black Heart," "Tightrope," "Bird," "Magnum Force" and "High Plains Drifter." The award was presented by Arnold Schwarzenegger, who called Mr. Eastwood "a Hollywood institution." In accepting the award, Mr. Eastwood turned to Mr. Schwarzenegger and said, "Thank you, my son." He added, "If I were in Dirty Harry's sights and he said, 'Do you feel lucky?,' I'd say 'You're damn right I do.'"

A special Oscar for lifetime achievement was presented by Jack Nicholson to the influential Italian director Michelangelo Antonioni, whose films include "L'Avventura" "La Notte," "Blow-Up," and "The Passenger." Mr. Antonioni accepted the award with a simple "grazie" after his wife, Enrica, delivered a short speech thanking the academy.

The Oscar for costume design went to "The Adventures of Priscilla, Queen of the Desert." In an evening notable for its lack of outrageous attire, Lizzy Gardiner, who accepted the award with her co-winner, Tim Chappel, made a vivid impression in a dress made of American Express gold cards.

"Ed Wood" won the Oscar for makeup, and "Speed" won for sound effects editing and sound. John Toll received the Oscar for cinematography for "Legends of the Fall." The Oscar for art direction went to "The Madness of King George."

Two films tied for the Oscar for live-action short: "Franz Kafka's It's a Wonderful Life" and "Trevor." The Oscar for animated short film went to "Bob's Birthday."

"A Time for Justice" won the Oscar for documentary short subject. The Oscar for documentary features went to "Maya Lin: A Strong, Clear Vision," about the architect who created the Vietnam Veterans Memorial in Washington. The academy became the target of fierce criticism when it failed to nominate the widely acclaimed "Hoop Dreams" in the documentary feature category.

The show ran a grueling three and a half hours, but Mr. Letterman offered hope. "I know it's been a long night," he said, "but continental breakfast is included."

1995 Mr 28, C13:2

The 1995 Oscar Winners

The 67th Academy Awards were presented on Monday night at the Los Angeles Shrine Auditorium. These were the winners.

By The Associated Press

Picture: "Forrest Gump"
Actor: Tom Hanks, "Forrest Gump"
Actress: Jessica Lange, "Blue Sky"
Supporting Actor: Martin Landau, "Ed Wood"
Supporting Actress: Dianne Wiest, "Bullets Over Broadway"
Director: Robert Zemeckis, "Forrest Gump"
Original Screenplay: Quentin Tarantino and Roger Avary, "Pulp Fiction"
Adapted Screenplay: Eric Roth, "Forrest Gump"
Foreign Film: "Burnt by the Sun," Russia
Art Direction: "The Madness of King George"
Cinematography: "Legends of the Fall"
Costume Design: "The Adventures of Priscilla, Queen of the Desert"
Documentary Feature: "Maya Lin: A Strong Clear Vision"
Documentary Short Subject: "A Time for Justice"
Film Editing: "Forrest Gump"
Makeup: "Ed Wood"

Original Score: Hans Zimmer, "The Lion King"
Original Song: "Can You Feel the Love Tonight," "The Lion King"
Animated Short Film: "Bob's Birthday"
Live Action Short Film: (tie) "Franz Kafka's It's a Wonderful Life" and "Trevor"
Sound: "Speed"
Sound Effects Editing: "Speed"
Visual Effects: "Forrest Gump"
Honorary Award: Michelangelo Antonioni for lifetime achievement
Irving G. Thalberg Memorial Award: Clint Eastwood for a consistently high quality of motion picture production
Jean Hersholt Humanitarian Award: Quincy Jones
Technical Award of Merit: The Eastman Kodak Company for the development of the Eastman EXR Color Intermediate Film 5244
Technical Award of Merit: Petro and Paul Viahos for the conception and development of the Ultimatte Electronic Blue Screen Compositing Process

1995 Mr 29, C12:5

Index

This index covers all the reviews included in this volume. It is divided into three sections: Titles, Personal Names, and Corporate Names.

Citations in this index are by year, month, day, section of newspaper (if applicable), page, and column; for example, 1989 Ja 11,II:12:1. Since the reviews appear in chronological order, the date is the key locator. The citations also serve to locate the reviews in bound volumes and microfilm editions of The Times.

In the citations, months are abbreviated as follows:

Ja - January	My - May	S - September
F - February	Je - June	O - October
Mr - March	Jl - July	N - November
Ap - April	Ag - August	D - December

TITLE INDEX

All films reviewed are listed alphabetically. Articles that begin titles are inverted. Titles that begin with a number are alphabetized as though the number was spelled out. Whenever possible, foreign films are entered under both the English and foreign-language titles. Films reviewed more than once and films with identical titles are given separate listings.

PERSONAL NAMES INDEX

All persons included in the reviews are listed alphabetically, last name first. Their function in the film is listed in parentheses: Screenwriter, Director, Producer, Cinematographer, Composer, Original Author, Narrator. Other functions (such as Editor, Production Designer, etc.) are listed as Miscellaneous. Where no such qualifier appears, the person was a performer (actor, actress, singer, dancer, musician). A person with multiple functions will have multiple entries.

Names beginning with Mc are alphabetized as if spelled Mac.

Names beginning with St. are alphabetized as if spelled Saint.

Entries under each name are by title of film, in chronological order.

CORPORATE NAME INDEX

All corporate bodies and performance groups mentioned in reviews as involved in the production or distribution of the film or in some other function connected with it are listed here alphabetically. Names that begin with a personal name are inverted (e.g., Goldwyn, Samuel, Company). The function of the organization is given in parentheses as Prod. (for Producer), Dist. (for Distributor), or Misc. (for Miscellaneous). A company that has more than one function is listed twice.

Entries under each name are by title of film, in chronological order.

Searching for Bobby Fischer 1993,Ag 11,C13:3
Josh and S.A.M. 1993,N 24,C12:1
Allen, Karen
Sandlot, The 1993,Ap 7,C17:1
King of the Hill 1993,Ag 20,C1:1
Ghost in the Machine 1993,D 30,C11:5
Allen, Keith
Second Best 1994,S 30,C10:1
Allen, Marit (Miscellaneous)
Secret Garden, The 1993,Ag 13,C3:1
Allen, Nancy
Robocop 3 1993,N 5,C29:3
Allen, Rosalind
Children of the Corn II: The Final Sacrifice 1993,Ja
30,16:4
Allen, Tim
Santa Clause, The 1994,N 11,C24:1
Santa Clause, The 1994,D 11,II:19:1
Allen, Woody
Manhattan Murder Mystery 1993,Ag 18,C13:5
Allen, Woody (Director)
Manhattan Murder Mystery 1993,Ag 18,C13:5
Bullets over Broadway 1994,S 30,C1:1
Allen, Woody (Screenwriter)
Manhattan Murder Mystery 1993,Ag 18,C13:5
Bullets over Broadway 1994,S 30,C1:1
Allende, Isabel (Original Author)
House of the Spirits, The 1994,Ap 1,C1:1
Allers, Roger (Director)
Lion King, The 1994,Je 15,C11:1
Allerson, Alexander
I Only Want You to Love Me 1994,Ap 15,C10:4
Alley, Kirstie
Look Who's Talking Now 1993,N 5,C12:6
Allyson, June
That's Entertainment! III 1994,My 6,C17:1
Almereyda, Michael (Director)
Another Girl, Another Planet 1993,Ap 1,C22:1
Another Girl, Another Planet 1993,Ap 4,II:17:5
Almereyda, Michael (Producer)
Another Girl, Another Planet 1993,Ap 1,C22:1
Almereyda, Michael (Screenwriter)
Another Girl, Another Planet 1993,Ap 1,C22:1
Almodóvar, Pedro (Director)
Kika 1994,My 6,C8:1
Almodóvar, Pedro (Producer)
Kika 1994,My 6,C8:1
Almodóvar, Pedro (Screenwriter)
Kika 1994,My 6,C8:1
Alonso, Anabel
Kika 1994,My 6,C8:1
Alonzo, John A. (Cinematographer)
Meteor Man, The 1993,Ag 7,9:3
Clifford 1994,Ap 1,C8:5
Star Trek Generations 1994,N 18,C3:1
al-Saadany, Salah
Little Dreams 1994,Mr 30,C19:1
Alsaker, Timian (Miscellaneous)
Blue Sky 1994,S 16,C8:1
Altman, Bruce
Rookie of the Year 1993,Jl 7,C14:6
Altman, John (Composer)
Bad Behavior 1993,S 3,C6:1
Bhaji on the Beach 1994,Mr 19,13:1
Altman, Robert (Director)
Short Cuts 1993,O 1,C1:1
Short Cuts 1993,N 14,II:13:5
McCabe and Mrs. Miller 1994,Ja 21,C16:5
Short Cuts 1994,Ja 21,C16:5
Ready to Wear 1994,D 23,C1:1
Altman, Robert (Producer)
Mrs. Parker and the Vicious Circle 1994,N 23,C9:3
Ready to Wear 1994,D 23,C1:1
Altman, Robert (Screenwriter)
Short Cuts 1993,O 1,C1:1
Short Cuts 1993,N 14,II:13:5
Ready to Wear 1994,D 23,C1:1
Altman, Stephen (Miscellaneous)
What's Love Got to Do with It 1993,Je 9,C15:1
Short Cuts 1993,O 1,C1:1
Ready to Wear 1994,D 23,C1:1
Alvarado, Magali
Mi Vida Loca My Crazy Life 1994,Jl 15,C5:1
Alvarado, Trini
American Friends 1993,Ap 9,C8:5
Little Women 1994,D 21,C13:1
Alvarez, Jesús Eduardo (Composer)
Track of the Ants, The 1994,Mr 26,14:5

Alves, Joe (Miscellaneous)
Geronimo: An American Legend 1993,D 10,C21:1
Drop Zone 1994,D 9,C12:1
al-Zoubajdi, Kais (Miscellaneous)
Night, The 1993,O 4,C15:3
Amano, Sayoko
Tokyo Decadence 1993,Jl 30,C12:6
Ambat, Madhu (Cinematographer)
Praying with Anger 1993,S 15,C26:1
Ambrose, Trevor (Miscellaneous)
Stepping Razor-Red X 1993,Ag 20,C21:1
Ameche, Don
Homeward Bound: The Incredible Journey 1993,F
3,C15:1
Corrina, Corrina 1994,Ag 12,C3:2
Amelio, Gianni (Director)
Ladro di Bambini, Il 1993,Mr 3,C13:4
Amelio, Gianni (Screenwriter)
Ladro di Bambini, Il 1993,Mr 3,C13:4
Amelon, Deborah (Screenwriter)
Exit to Eden 1994,O 14,C20:4
Amendola, Claudio
Scorta, La (Bodyguards, The) 1994,My 4,C16:3
Amick, Mädchen
Dream Lover 1994,My 6,C11:1
Trapped in Paradise 1994,D 2,C16:5
Amiel, Jon (Director)
Sommersby 1993,F 5,C8:1
Sommersby 1993,F 14,II:13:1
Amies, Caroline (Miscellaneous)
In the Name of the Father 1993,D 29,C11:3
Amigoréna, Santiago (Screenwriter)
Samba Traoré 1993,S 10,C3:1
Normal People Are Nothing Special 1994,Mr
18,C1:1
Amin, Mervat
Little Dreams 1994,Mr 30,C19:1
Amiralay, Omar (Producer)
Night, The 1993,O 4,C15:3
Amiranaschvili, Amiran
Night Dance 1993,Mr 31,C20:1
Amis, Suzy
Rich in Love 1993,Mr 5,C8:1
Watch It 1993,Mr 26,C12:1
Watch It 1993,Ap 18,II:11:1
Ballad of Little Jo, The 1993,Ag 20,C10:1
Ballad of Little Jo, The 1993,O 10,II:13:5
Two Small Bodies 1994,Ap 15,C10:1
Blown Away 1994,Jl 1,C3:1
Ammar, Tarak Ben (Producer)
Foreign Student 1994,Jl 29,C10:5
Ammon, Ruth (Miscellaneous)
Who's the Man? 1993,Ap 23,C19:1
Amos, John
Mac 1993,F 19,C17:1
Amrine, Joe
Execution Protocol, The 1993,Ap 28,C13:1
Amundson, Peter (Miscellaneous)
Dragon: The Bruce Lee Story 1993,My 7,C19:1
Amurri, Franco (Director)
Monkey Trouble 1994,Mr 18,C8:4
Amurri, Franco (Screenwriter)
Monkey Trouble 1994,Mr 18,C8:4
Anand, Mukul S. (Director)
God Is My Witness 1993,Ag 20,C8:5
Anand, Tinnu
In Custody 1994,Ap 15,C6:3
Anders, Allison (Director)
Gas Food Lodging 1993,Ja 10,II:11:1
Mi Vida Loca 1994,Ja 31,C17:1
Mi Vida Loca My Crazy Life 1994,Jl 15,C5:1
Anders, Allison (Screenwriter)
Mi Vida Loca My Crazy Life 1994,Jl 15,C5:1
Andersen, Hans Christian (Original Author)
Red Shoes, The 1993,D 31,C26:5
Red Shoes, The 1994,Ja 9,II:6:1
Anderson, Cletus (Miscellaneous)
Dark Half, The 1993,Ap 23,C10:1
Anderson, Elizabeth (Screenwriter)
Lassie 1994,Jl 22,C1:1
Anderson, Jamie (Cinematographer)
What's Love Got to Do with It 1993,Je 9,C15:1
Anderson, Jane (Screenwriter)
It Could Happen to You 1994,Jl 29,C10:5
Anderson, Jeff
Clerks 1994,Mr 25,C10:1
Clerks 1994,O 19,C17:1

Anderson, Jeni
Murder Magic 1994,My 10,C19:1
Anderson, Kevin
Night We Never Met, The 1993,Ap 30,C10:6
Rising Sun 1993,Jl 30,C1:4
Anderson, Pete (Composer)
Chasers 1994,Ap 23,15:1
Anderson, William (Miscellaneous)
Fearless 1993,O 15,C12:5
City Slickers II: The Legend of Curly's Gold 1994,Je
10,C19:1
Andersson, Kjell-Ake (Director)
My Great Big Daddy 1994,Mr 26,14:2
Andersson, Kjell-Ake (Screenwriter)
My Great Big Daddy 1994,Mr 26,14:2
Andre, Rosa Castro
Dark at Noon 1993,Ag 20,C12:5
Andrews, David
Wyatt Earp 1994,Je 24,C1:5
Andrews, Jason
Federal Hill 1994,D 9,C6:1
Andrews, Naveen
Wild West 1993,N 5,C6:6
Buddha of Suburbia, The 1994,D 9,C8:1
Andrey, Margarita
Radio Stories 1993,N 12,C20:5
Anemaet, Leo (Composer)
Only the Brave 1994,Ag 31,C14:3
Angelino, Jorge
Strawberry and Chocolate 1994,S 24,16:3
Angelo, Lou (Miscellaneous)
Between the Teeth 1994,F 2,C15:1
Angelo, Yves (Cinematographer)
Coeur en Hiver, Un (Heart in Winter, A) 1993,Je
4,C3:1
Accompanist, The 1993,D 23,C7:1
Germinal 1994,Mr 11,C1:1
Angelo, Yves (Director)
Colonel Chabert 1994,D 23,C8:5
Angelo, Yves (Screenwriter)
Colonel Chabert 1994,D 23,C8:5
Angelopoulos, Theo (Director)
Beekeeper, The 1993,My 7,C21:4
Angelopoulos, Theo (Screenwriter)
Beekeeper, The 1993,My 7,C21:4
Angelou, Maya
Poetic Justice 1993,Jl 23,C1:1
Angelou, Maya (Miscellaneous)
Poetic Justice 1993,Jl 23,C1:1
Angier, Carole (Screenwriter)
Wide Sargasso Sea 1993,Ap 16,C6:5
Anglade, Jean-Hugues
Killing Zoe 1994,Ag 19,C3:1
Queen Margot 1994,D 9,C10:1
Angley, Scott (Composer)
Clerks 1994,Mr 25,C10:1
Angone, Conrad E. (Miscellaneous)
China Moon 1994,Mr 4,C6:5
Anisimova, Tatyana
Get Thee Out 1993,Ja 26,C14:3
Anisimova, Yelena
Get Thee Out 1993,Ja 26,C14:3
Aniston, Jennifer
Leprechaun 1993,Ja 9,17:1
Ann-Margret
Grumpy Old Men 1993,D 24,C16:1
Annabi, Amina
Advocate, The 1994,Ag 24,C11:1
Annaud, Monique (Producer)
François Truffaut: Stolen Portraits 1994,Jl 15,C27:1
Anspaugh, David (Director)
Rudy 1993,O 13,C21:1
Antes, Klaus (Original Author)
I Only Want You to Love Me 1994,Ap 15,C10:4
Anthony, Lysette
Look Who's Talking Now 1993,N 5,C12:6
Advocate, The 1994,Ag 24,C11:1
Antin, Steven
Inside Monkey Zetterland 1993,O 15,C12:5
Antin, Steven (Screenwriter)
Inside Monkey Zetterland 1993,O 15,C12:5
Anunciation, Derek
Mad Dog and Glory 1993,Mr 5,C3:1
Anwar, Gabrielle
Scent of a Woman 1993,Ja 22,C1:1
For Love or Money 1993,O 1,C8:5
Three Musketeers, The 1993,N 12,C10:5
Body Snatchers 1994,F 4,C6:5

B

Broderick, Matthew
Night We Never Met, The 1993,Ap 30,C10:6
Lion King, The 1994,Je 15,C11:1
Road to Wellville, The 1994,O 28,C13:1
Mrs. Parker and the Vicious Circle 1994,N 23,C9:3
Brodie, V. S.
Go Fish 1994,Je 10,C6:4
Brody, Adrien
King of the Hill 1993,Ag 20,C1:1
Brokaw, Cary (Producer)
Short Cuts 1993,O 1,C1:1
Bromfield, Valri
Needful Things 1993,Ag 27,C17:1
Bron, Eleanor
Black Beauty 1994,Jl 29,C29:1
Bronson, Charles
Death Wish V: The Face of Death 1994,Ja 17,C18:1
Brook, Claudio
Cronos 1994,Mr 24,C16:6
Brooks, Albert
I'll Do Anything 1994,F 4,C3:1
Scout, The 1994,S 30,C23:1
Brooks, Albert (Screenwriter)
Scout, The 1994,S 30,C23:1
Brooks, Christopher (Miscellaneous)
Space Is the Place 1993,S 3,C9:1
Brooks, James L. (Director)
I'll Do Anything 1994,F 4,C3:1
Brooks, James L. (Producer)
I'll Do Anything 1994,F 4,C3:1
Brooks, James L. (Screenwriter)
I'll Do Anything 1994,F 4,C3:1
Brooks, Joel
Indecent Proposal 1993,Ap 7,C13:1
Brooks, Mel
Robin Hood: Men in Tights 1993,Jl 28,C13:1
Robin Hood: Men in Tights 1993,Ag 1,II:11:4
Little Rascals, The 1994,Ag 5,C21:1
Brooks, Mel (Director)
Robin Hood: Men in Tights 1993,Jl 28,C13:1
Robin Hood: Men in Tights 1993,Ag 1,II:11:4
Brooks, Mel (Producer)
Robin Hood: Men in Tights 1993,Jl 28,C13:1
Brooks, Mel (Screenwriter)
Robin Hood: Men in Tights 1993,Jl 28,C13:1
Robin Hood: Men in Tights 1993,Ag 1,II:11:4
Brooks, Stanley M. (Producer)
Opposite Sex, The 1993,Mr 27,15:2
Broomfield, Nick (Director)
Aileen Wuornos: The Selling of a Serial Killer
1993,O 9,16:3
Aileen Wuornos: The Selling of a Serial Killer
1994,F 4,C15:1
Broomfield, Nick (Producer)
Aileen Wuornos: The Selling of a Serial Killer
1993,O 9,16:3
Brose, Bill (Director)
Red Light, Green Light 1994,Jl 8,C8:5
Brosnan, Pierce
Mrs. Doubtfire 1993,N 24,C11:1
Love Affair 1994,O 21,C3:1
Brothers, Dr. Joyce
National Lampoon's Loaded Weapon 1 1993,F
5,C6:6
Brothers Quay. *See* Quay, Stephen; Quay, Timothy
Broughton, Bruce (Composer)
Homeward Bound: The Incredible Journey 1993,F
3,C15:1
So I Married an Axe Murderer 1993,Jl 30,C3:1
Tombstone 1993,D 24,C6:1
Baby's Day Out 1994,Jl 1,C3:1
Miracle on 34th Street 1994,N 18,C12:1
Brower, Leo (Composer)
Like Water for Chocolate 1993,F 17,C13:3
Brown, Barry Alexander (Miscellaneous)
Crooklyn 1994,My 13,C5:1
Brown, Bruce (Director)
Bruce Brown's "The Endless Summer II" 1994,Je
3,C12:1
Brown, Bruce (Miscellaneous)
Bruce Brown's "The Endless Summer II" 1994,Je
3,C12:1
Brown, Bruce (Screenwriter)
Bruce Brown's "The Endless Summer II" 1994,Je
3,C12:1
Brown, Chris (Producer)
Crime Broker 1994,S 16,C14:4

Brown, Clancy
Shawshank Redemption, The 1994,S 23,C3:1
Brown, Dana (Miscellaneous)
Bruce Brown's "The Endless Summer II" 1994,Je
3,C12:1
Brown, Dana (Screenwriter)
Bruce Brown's "The Endless Summer II" 1994,Je
3,C12:1
Brown, David (Producer)
Cemetery Club, The 1993,F 3,C14:4
Brown, Dennis R.
Sure Fire 1994,Ja 12,C13:1
Brown, Derek (Miscellaneous)
Bhaji on the Beach 1994,Mr 19,13:1
Brown, Gregory (Producer)
Sugar Hill 1994,F 25,C10:6
Brown, Jared F. (Producer)
Swan Princess, The 1994,N 18,C20:5
Brown, Jeffrey (Screenwriter)
Pontiac Moon 1994,N 11,C18:3
Brown, Julie
Opposite Sex, The 1993,Mr 27,15:2
Raining Stones 1993,O 2,11:3
Raining Stones 1994,Mr 11,C13:1
Brown, Keith (Miscellaneous)
Split 1993,S 3,C6:5
Brown, Les (Miscellaneous)
Disco Years, The (Boys Life) 1994,D 2,C16:5
Brown, O. Nicholas (Miscellaneous)
Free Willy 1993,Jl 16,C12:6
Heart and Souls 1993,Ag 13,C14:5
Lightning Jack 1994,Mr 11,C8:5
In the Army Now 1994,Ag 12,C6:4
Brown, Paul (Producer)
Man in Uniform, A 1994,Ag 19,C10:1
Brown, Phillip R.
Sure Fire 1994,Ja 12,C13:1
Brown, Ralph
Wayne's World 2 1993,D 10,C20:6
Brown, Robert (Miscellaneous)
Client, The 1994,Jl 20,C11:1
Browne, Roscoe Lee
Naked in New York 1994,Ap 15,C3:1
Brownjohn, John (Screenwriter)
Bitter Moon 1994,Mr 18,C8:1
Brozek, Jiri (Miscellaneous)
Last Butterfly, The 1993,Ag 20,C23:1
Bruce, Brenda
Splitting Heirs 1993,My 1,17:1
December Bride 1994,S 9,C6:5
Bruckner, Pascal (Original Author)
Bitter Moon 1994,Mr 18,C8:1
Brugge, Pieter Jan (Producer)
Pelican Brief, The 1993,D 17,C1:5
Clifford 1994,Ap 1,C8:5
Brunet, Sophie (Miscellaneous)
Troubles We've Seen, The 1994,O 6,C17:1
Bruni-Tedeschi, Valeria
Normal People Are Nothing Special 1994,Mr
18,C1:1
Brunner, Bob (Screenwriter)
Exit to Eden 1994,O 14,C20:4
Brunoyghe, Olivia (Screenwriter)
Sirga 1994,Mr 25,C10:5
Bruns, Phil
Opposite Sex, The 1993,Mr 27,15:2
Bryce, Ian (Producer)
Beverly Hillbillies, The 1993,O 15,C20:3
Bryniarski, Andrew
Program, The 1993,S 24,C16:6
Buba, Pasquale (Miscellaneous)
Dark Half, The 1993,Ap 23,C10:1
Striking Distance 1993,S 17,C17:1
Buchanan, John
Sidekicks 1993,My 1,17:4
Buchholz, Horst
Faraway, So Close 1993,D 22,C15:1
Buck, Detlev (Director)
No More Mr. Nice Guy 1993,O 23,16:1
Buck, Detlev (Screenwriter)
No More Mr. Nice Guy 1993,O 23,16:1
Buckley, Betty
Rain Without Thunder 1993,F 5,C8:5
Buckley, William F., Jr.
Life and Times of Allen Ginsberg, The 1994,F
18,C10:1
Buday, Helen
Dingo 1994,N 11,C19:3

Bueno, Clovis (Miscellaneous)
Under One Roof 1994,Mr 25,C18:1
Buff, Conrad (Miscellaneous)
Getaway, The 1994,F 11,C12:5
True Lies 1994,Jl 15,C1:1
Buffard, Claude-Henri (Miscellaneous)
Mazeppa 1993,D 3,C10:4
Buffard, Claude-Henri (Screenwriter)
Mazeppa 1993,D 3,C10:4
Bufford, Takashi (Miscellaneous)
House Party 3 1994,Ja 13,C17:1
Bufford, Takashi (Screenwriter)
House Party 3 1994,Ja 13,C17:1
Bugnar, Lia
Conjugal Bed, The 1994,Jl 15,C18:1
Buhai, Jeff (Miscellaneous)
In the Army Now 1994,Ag 12,C6:4
Bukam, Tzou (Producer)
Bodo 1994,Ag 19,C6:4
Bukin, Valentin
Get Thee Out 1993,Ja 26,C14:3
Bukowski, Bobby (Cinematographer)
Ethan Frome 1993,Mr 12,C8:5
Household Saints 1993,S 15,C15:2
Golden Gate 1994,Ja 28,C10:6
Bullock, Gary
Terminal Velocity 1994,S 23,C20:5
Bullock, Sandra
Vanishing, The 1993,F 5,C3:4
Vanishing, The 1993,F 14,II:13:1
Demolition Man 1993,O 8,C23:1
Demolition Man 1993,O 24,II:11:1
Wrestling Ernest Hemingway 1993,D 17,C12:6
Speed 1994,Je 10,C12:1
Me and the Mob 1994,S 23,C10:5
Bumstead, Henry (Miscellaneous)
Perfect World, A 1993,N 24,C11:1
Bunge, Norbert (Cinematographer)
Manufacturing Consent: Noam Chomsky and the
Media 1993,Mr 17,C17:1
Buono, Cara
Cowboy Way, The 1994,Je 3,C21:1
Burch, J. Christopher (Producer)
Watch It 1993,Mr 26,C12:1
Burchiellaro, Giantito (Miscellaneous)
Conviction, The 1994,My 13,C10:5
Burg, Mark (Producer)
Airheads 1994,Ag 5,C10:1
Burgess, Don (Cinematographer)
Josh and S.A.M. 1993,N 24,C12:1
Forrest Gump 1994,Jl 6,C9:3
Richie Rich 1994,D 21,C19:1
Burke, Chris (Composer)
Lost Words, The 1994,S 21,C18:1
Burke, Michelle
Coneheads 1993,Jl 23,C3:2
Dazed and Confused 1993,S 24,C12:5
Burke, Robert John
Robocop 3 1993,N 5,C29:3
Burkhard, Gedeon
Making Up! (Abgeschminkt!) 1994,S 16,C8:5
Burnett, Alan (Screenwriter)
Batman: Mask of the Phantasm 1993,D 28,C21:1
Burnett, Frances Hodgson (Original Author)
Secret Garden, The 1993,Ag 13,C3:1
Burnford, Sheila (Original Author)
Homeward Bound: The Incredible Journey 1993,F
3,C15:1
Burns, George
Radioland Murders 1994,O 21,C5:1
Burns, Jere
Greedy 1994,Mr 4,C15:1
Burns, John F.
Troubles We've Seen, The 1994,O 6,C17:1
Burns, Keith Brian (Miscellaneous)
Poetic Justice 1993,Jl 23,C1:1
Burns, Tim (Screenwriter)
Freaked 1993,O 2,14:3
Burnstein, Jim (Screenwriter)
Renaissance Man 1994,Je 3,C6:5
Burov, Aleksandr (Cinematographer)
Whispering Pages 1994,S 28,C14:3
Burr, Raymond
Godzilla, King of the Monsters 1993,Mr 14,II:13:5
Burrough, Tony (Miscellaneous)
Wedding Gift, The 1994,Jl 20,C18:1
Burruano, Luigi Maria
Aclà 1993,D 3,C12:6

440

C

Capra, Amadeus (Miscellaneous)
Salmonberries 1994,S 2,C12:5
Capra, Bernt (Miscellaneous)
Hear No Evil 1993,Mr 29,C16:1
What's Eating Gilbert Grape 1993,D 17,C3:4
Capra, Francis
Bronx Tale, A 1993,S 29,C13:4
Capshaw, Kate
Love Affair 1994,O 21,C3:1
Capuano, Mariangela (Miscellaneous)
Scorta, La (Bodyguards, The) 1994,My 4,C16:3
Cara, Irene
Happily Ever After 1993,My 29,13:1
Carax, Léos (Director)
Amants du Pont Neuf, Les 1994,F 18,C1:1
Carcassonne, Philippe (Producer)
Coeur en Hiver, Un (Heart in Winter, A) 1993,Je
4,C3:1
Cardinal, Tantoo
Silent Tongue 1994,F 25,C3:2
Where the Rivers Flow North 1994,Mr 4,C15:1
Cardinale, Claudia
Son of the Pink Panther 1993,Ag 28,9:5
Cardone, Nathalie
Enfer, L' (Hell) 1994,O 19,C17:1
Carhart, Timothy
Beverly Hills Cop III 1994,My 25,C14:3
Carlei, Carlo (Director)
Flight of the Innocent 1993,O 22,C8:5
Flight of the Innocent 1993,O 31,II:15:5
Carlei, Carlo (Miscellaneous)
Flight of the Innocent 1993,O 22,C8:5
Carlei, Carlo (Screenwriter)
Flight of the Innocent 1993,O 22,C8:5
Carli, Ann (Producer)
I Like It Like That 1994,O 14,C23:1
Carlisi, Christina
Hear No Evil 1993,Mr 29,C16:1
Carlo, Johann
Quiz Show 1994,S 14,C11:1
Carloni, Esterina
Ciao, Professore! 1994,Jl 15,C10:5
Carlson, Matthew (Screenwriter)
Wagons East! 1994,Ag 26,C16:1
Carlson, Roy (Screenwriter)
China Moon 1994,Mr 4,C6:5
Carlyle, Robert
Riffraff 1993,F 12,C10:5
Carmet, Jean
Germinal 1994,Mr 11,C1:1
Carmody, Don (Producer)
Sidekicks 1993,My 1,17:4
Carnaghi, Roberto
I Don't Want to Talk About It 1994,S 30,C12:1
Carné, Marcel (Director)
Visiteurs du Soir, Les (Devil's Envoys, The) 1994,Jl
8,C1:3
Carney, Art
Last Action Hero 1993,Je 18,C1:3
Caron, Glenn Gordon (Director)
Wilder Napalm 1993,Ag 20,C14:1
Love Affair 1994,O 21,C3:1
Carpenter, Russell (Cinematographer)
Hard Target 1993,Ag 20,C8:5
True Lies 1994,Jl 15,C1:1
Carpenter, Willie
Hard Target 1993,Ag 20,C8:5
Carpentieri, Renato
Caro Diario (Dear Diary) 1994,S 26,C11:3
Carr, Colby (Screenwriter)
Blank Check 1994,F 11,C12:5
Carradine, Keith
Andre 1994,Ag 17,C9:3
Mrs. Parker and the Vicious Circle 1994,N 23,C9:3
Carrasco, Ada
Like Water for Chocolate 1993,F 17,C13:3
Carre de Malberg, Stanislas
Coeur en Hiver, Un (Heart in Winter, A) 1993,Je
4,C3:1
Carrere, Tia
Rising Sun 1993,Jl 30,C1:4
Wayne's World 2 1993,D 10,C20:6
True Lies 1994,Jl 15,C1:1
True Lies 1994,Jl 17,II:13:1
Carrey, Jim
Ace Ventura, Pet Detective 1994,F 4,C8:6
Ace Ventura, Pet Detective 1994,Mr 6,II:17:1
Mask, The 1994,Jl 29,C1:3

Dumb and Dumber 1994,D 16,C10:5
Carrey, Jim (Screenwriter)
Ace Ventura, Pet Detective 1994,F 4,C8:6
Carrière, Jean-Claude (Original Author)
Sommersby 1993,F 5,C8:1
Carrière, Mathieu
Malina 1993,S 27,C15:1
Carrillo, Mary
Pisito, El (Little Apartment, The) 1993,N 26,C14:1
Carruth, William C. (Miscellaneous)
Threesome 1994,Ap 8,C12:4
Carson, David (Director)
Star Trek Generations 1994,N 18,C3:1
Carstensen, Margit
Martha 1994,S 24,16:3
Terror 2000 1994,N 18,C20:5
Carter, Jim
Black Beauty 1994,Jl 29,C29:1
Advocate, The 1994,Ag 24,C11:1
Madness of King George, The 1994,D 28,C11:3
Carter, John (Miscellaneous)
Cemetery Club, The 1993,F 3,C14:4
Sister Act 2: Back in the Habit 1993,D 10,C10:4
Carter, Michael Patrick
Milk Money 1994,Ag 31,C11:1
Carter, Reginald
Sankofa 1994,Ap 8,C8:5
Carter, Rick (Miscellaneous)
Jurassic Park 1993,Je 11,C1:1
Forrest Gump 1994,Jl 6,C9:3
Carter, Roger (Cinematographer)
Life and Times of Allen Ginsberg, The 1994,F
18,C10:1
Carter, Thomas (Director)
Swing Kids 1993,Mr 5,C8:5
Cartlidge, Katrin
Naked 1993,O 15,C3:3
Naked 1993,D 16,C20:3
Caruso, D. J. (Producer)
Drop Zone 1994,D 9,C12:1
Caruso, David
Mad Dog and Glory 1993,Mr 5,C3:1
Caruso, Fred (Producer)
Super Mario Brothers 1993,My 29,11:1
Carver, Raymond (Original Author)
Short Cuts 1993,O 1,C1:1
Short Cuts 1993,N 14,II:13:5
Short Cuts 1994,Ja 21,C16:5
Carvey, Dana
Wayne's World 2 1993,D 10,C20:6
Clean Slate 1994,My 6,C10:3
Road to Wellville, The 1994,O 28,C13:1
Trapped in Paradise 1994,D 2,C16:5
Carville, James
War Room, The 1993,O 13,C15:4
War Room, The 1993,N 3,C23:1
War Room, The 1993,D 3,C31:1
Casanovas, Alex
Kika 1994,My 6,C8:1
Casci, David (Screenwriter)
Pagemaster, The 1994,N 23,C18:1
Caselli, Chiara
Especially on Sunday 1993,Ag 13,C14:5
Fiorile 1993,O 13,C21:1
Fiorile 1994,F 2,C20:1
Casey, Bernie
Cemetery Club, The 1993,F 3,C14:4
Casey, Padraig
Summer House, The 1993,D 21,C19:1
Caso, Maria (Miscellaneous)
Cop and a Half 1993,Ap 2,C17:1
Caso, Mark
Teen-Age Mutant Ninja Turtles III 1993,Mr 20,15:1
Cassavetti, Patrick (Producer)
American Friends 1993,Ap 9,C8:5
Cassel, Jean-Pierre
Between Heaven and Earth 1993,O 1,C5:1
Ready to Wear 1994,D 23,C1:1
Cassel, Seymour
Indecent Proposal 1993,Ap 7,C13:1
Boiling Point 1993,Ap 17,16:1
Chain of Desire 1993,Je 25,C19:3
Chasers 1994,Ap 23,15:1
It Could Happen to You 1994,Jl 29,C10:5
Cassidy, Jay (Miscellaneous)
Bodies, Rest and Motion 1993,Ap 9,C11:1
Brainscan 1994,Ap 22,C12:6

Cassidy, William J. (Miscellaneous)
8 Seconds 1994,F 25,C14:1
Cassidy, Zane
Short Cuts 1993,O 1,C1:1
Cassini, John
Man's Best Friend 1993,N 20,17:1
Castelloe, Molly
Clean, Shaven 1994,Mr 22,C19:1
Castellow, Danny
Sex Is . . . 1993,S 9,C17:5
Castile, Christopher
Beethoven's 2d 1993,D 17,C10:5
Castilla, Sergio M. (Director)
Girl in the Watermelon, The 1994,Mr 18,C29:1
Castilla, Sergio M. (Miscellaneous)
Girl in the Watermelon, The 1994,Mr 18,C29:1
Castilla, Sergio M. (Screenwriter)
Girl in the Watermelon, The 1994,Mr 18,C29:1
Castillo, Enrique
Bound by Honor 1993,Ap 30,C8:1
Castillo, Juan Carlos (Miscellaneous)
Johnny 100 Pesos 1994,Ap 2,17:1
Castle, John
Robocop 3 1993,N 5,C29:3
Castle, Nick (Director)
Dennis the Menace 1993,Je 25,C12:6
Castle, Robert
Philadelphia 1993,D 22,C15:3
Castro, Eduardo (Miscellaneous)
Sugar Hill 1994,F 25,C10:6
Castro, Emmanuelle (Miscellaneous)
Normal People Are Nothing Special 1994,Mr
18,C1:1
Caswell, Robert (Screenwriter)
Far-Off Place, A 1993,Mr 12,C15:1
Cates, Darlene
What's Eating Gilbert Grape 1993,D 17,C3:4
Cates, Phoebe
Bodies, Rest and Motion 1993,Ap 9,C11:1
Bodies, Rest and Motion 1993,Ap 18,II:11:1
My Life's in Turnaround 1994,Je 17,C5:5
Princess Caraboo 1994,S 16,C12:1
Cathey, Reginald E.
Airheads 1994,Ag 5,C10:1
Catillon, Brigitte
Coeur en Hiver, Un (Heart in Winter, A) 1993,Je
4,C3:1
Caton-Jones, Michael (Director)
This Boy's Life 1993,Ap 9,C10:1
Caulfield, Maxwell
Inevitable Grace 1994,S 30,C8:5
Cavalieri, Michael
Next Karate Kid, The 1994,S 10,14:5
Cavazos, Lumi
Like Water for Chocolate 1993,F 17,C13:3
Caven, Ingrid
Martha 1994,S 24,16:3
Cavendish, Jonathan (Producer)
Into the West 1993,S 17,C17:1
December Bride 1994,S 9,C6:5
Man of No Importance, A 1994,D 22,C11:1
Cayabyab, Dr. Pedro
Execution Protocol, The 1993,Ap 28,C13:1
Cayla, Eric (Cinematographer)
Sex of the Stars, The 1994,O 28,C6:5
Cazes, Lila (Producer)
Bank Robber 1993,D 10,C10:1
Cecchi, Carlo
Scorta, La (Bodyguards, The) 1994,My 4,C16:3
Cecchi Gori, Mario (Producer)
Ciao, Professore! 1994,Jl 15,C10:5
Cecchi Gori, Vittorio (Producer)
Ciao, Professore! 1994,Jl 15,C10:5
Cenci, Athina
Fiorile 1993,O 13,C21:1
Cepek, Petr
Faust 1994,O 26,C15:1
Ceperac, Branka (Miscellaneous)
Virgina 1993,Mr 27,15:1
Ceraolo, Franco (Miscellaneous)
Flight of the Innocent 1993,O 22,C8:5
Cervenka, Exene
Floundering 1994,N 4,C15:3
Césaire, Ina (Screenwriter)
Blue Eyes of Yonta, The 1993,Mr 20,16:5
Chabrol, Claude
François Truffaut: Portraits Volés (François Truffaut:
Stolen Portraits) 1993,Je 13,II:15:1

Cohn, Marya
Vermont Is for Lovers 1993,Mr 26,C6:5
Colao, Manuel
Flight of the Innocent 1993,O 22,C8:5
Flight of the Innocent 1993,O 31,II:15:5
Cole, Brandon (Screenwriter)
Mac 1993,F 19,C17:1
Cole, Kermit (Director)
Living Proof: H.I.V. and the Pursuit of Happiness 1994,Ja 28,C8:5
Cole, Kermit (Producer)
Living Proof: H.I.V. and the Pursuit of Happiness 1994,Ja 28,C8:5
Cole, Michele
Thieves Quartet 1994,Je 24,C10:5
Colefax, Kim (Miscellaneous)
Real McCoy, The 1993,S 10,C10:6
Coleman, Charlotte
Four Weddings and a Funeral 1994,Mr 9,C15:5
Coleman, Dabney
Amos and Andrew 1993,Mr 5,C14:1
Beverly Hillbillies, The 1993,O 15,C20:3
Clifford 1994,Ap 1,C8:5
Coleman, Jack
Foreign Student 1994,Jl 29,C10:5
Coleman, James (Miscellaneous)
Swan Princess, The 1994,N 18,C20:5
Coleman, Jimmy
Riffraff 1993,F 12,C10:5
Coleman, Marilyn
Menace II Society 1993,My 26,C13:4
Meteor Man, The 1993,Ag 7,9:3
Colesberry, Robert F. (Producer)
Being Human 1994,My 6,C10:3
Road to Wellville, The 1994,O 28,C13:1
Coley, Byron
Half Japanese: The Band That Would Be King 1993,O 7,C20:5
Colick, Lewis (Miscellaneous)
Judgment Night 1993,O 15,C8:5
Colick, Lewis (Screenwriter)
Judgment Night 1993,O 15,C8:5
Colin, Grégoire
Olivier, Olivier 1993,F 24,C17:5
Colin, Margaret
Amos and Andrew 1993,Mr 5,C14:1
Colina, Luis (Miscellaneous)
Coriolis Effect, The 1994,Mr 26,14:5
Collard, Cyril
Savage Nights 1993,Mr 20,11:4
Savage Nights 1993,Ap 4,II:17:5
Savage Nights 1994,F 25,C16:1
Savage Nights 1994,F 27,II:17:5
Collard, Cyril (Director)
Savage Nights 1993,Mr 20,11:4
Savage Nights 1993,Ap 4,II:17:5
Savage Nights 1994,F 25,C16:1
Savage Nights 1994,F 27,II:17:5
Collard, Cyril (Screenwriter)
Savage Nights 1993,Mr 20,11:4
Savage Nights 1993,Ap 4,II:17:5
Collard, Deborah
Secret Adventures of Tom Thumb, The 1994,Ap 13,C19:1
Colleton, Sara (Producer)
Renaissance Man 1994,Je 3,C6:5
Collin, Maxime
Léolo 1993,Ap 2,C17:1
Collins, Judy
Junior 1994,N 23,C9:3
Collister, Peter Lyons (Cinematographer)
Poetic Justice 1993,Jl 23,C1:1
Colombier, Michel (Composer)
Program, The 1993,S 24,C16:6
Major League II 1994,Mr 30,C16:3
Colpaert, Carl-Jan (Producer)
Mi Vida Loca My Crazy Life 1994,Jl 15,C5:1
Colpi, Henri (Miscellaneous)
Chantons sous l'Occupation (Singing Through the Occupation) 1994,N 25,C12:1
Coltrane, Robbie
Adventures of Huck Finn, The 1993,Ap 2,C15:1
Columbus, Chris (Director)
Mrs. Doubtfire 1993,N 24,C11:1
Colyar, Michael
Hot Shots! Part Deux 1993,My 21,C6:5
Comart, Jean-Paul
L.627 1994,Jl 15,C14:1

Combs, Holly Marie
Chain of Desire 1993,Je 25,C19:3
Combs, Jeffrey
Love and a .45 1994,N 23,C14:4
Coney, John (Director)
Space Is the Place 1993,S 3,C9:1
Conforti, Gino
Hans Christian Andersen's "Thumbelina" 1994,Mr 30,C19:1
Conforti, Sergio (Composer)
Stefano Quantestorie (Stefano Many Stories) 1994,N 23,C18:1
Congdon, Dana (Miscellaneous)
Bad Girls 1994,Ja 28,C8:5
Conlon, Gerry (Original Author)
In the Name of the Father 1993,D 29,C11:3
Conn, Nicole (Director)
Claire of the Moon 1993,Ap 16,C11:1
Conn, Nicole (Producer)
Claire of the Moon 1993,Ap 16,C11:1
Conn, Nicole (Screenwriter)
Claire of the Moon 1993,Ap 16,C11:1
Connelly, Chris
Last Action Hero 1993,Je 27,II:15:4
Connery, Sean
Rising Sun 1993,Jl 30,C1:4
Good Man in Africa, A 1994,S 9,C6:1
Connolly, Billy
Indecent Proposal 1993,Ap 7,C13:1
Connors, Chuck
Salmonberries 1994,S 2,C12:5
Connors, Richard (Cinematographer)
Just Another Girl on the IRT 1993,Mr 19,C12:5
Conrad, Chris (Screenwriter)
Junior 1994,N 23,C9:3
Conrad, Scott (Miscellaneous)
Temp, The 1993,F 13,17:1
Wagons East! 1994,Ag 26,C16:1
Conrad, Steve (Screenwriter)
Wrestling Ernest Hemingway 1993,D 17,C12:6
Conrad, Tony
Genius, The 1993,Ap 2,C34:1
Genius, The 1994,Jl 8,C12:6
Conroy, Jack (Cinematographer)
Silent Tongue 1994,F 25,C3:2
Conroy, Kevin
Chain of Desire 1993,Je 25,C19:3
Batman: Mask of the Phantasm 1993,D 28,C21:1
Conroy, Rory
Into the West 1993,S 17,C17:1
Constantin, George
Unforgettable Summer, An 1994,N 11,C12:1
Constantine, Michael
My Life 1993,N 12,C17:1
Conte, D. Constantine (Producer)
Born Yesterday 1993,Mr 26,C17:2
Conti, Bill (Composer)
Captive in the Land, A 1993,Ja 15,C6:5
Adventures of Huck Finn, The 1993,Ap 2,C15:1
Bound by Honor 1993,Ap 30,C8:1
Rookie of the Year 1993,Jl 7,C14:6
By the Sword 1993,O 22,C15:1
8 Seconds 1994,F 25,C14:1
Next Karate Kid, The 1994,S 10,14:5
Scout, The 1994,S 30,C23:1
Contreras, Ernie (Screenwriter)
Pagemaster, The 1994,N 23,C18:1
Contreras, Federico (Composer)
Pisito, El (Little Apartment, The) 1993,N 26,C14:1
Conversi, Fabio (Cinematographer)
Love After Love 1994,O 14,C10:6
Convertino, Michael (Composer)
Aspen Extreme 1993,Ja 23,16:5
Bodies, Rest and Motion 1993,Ap 9,C11:1
Wrestling Ernest Hemingway 1993,D 17,C12:6
Guarding Tess 1994,Mr 11,C12:1
Milk Money 1994,Ag 31,C11:1
Santa Clause, The 1994,N 11,C24:1
Cooder, Ry (Composer)
Geronimo: An American Legend 1993,D 10,C21:1
Cook, Barbara
Hans Christian Andersen's "Thumbelina" 1994,Mr 30,C19:1
Cook, Bart Robinson
George Balanchine's "The Nutcracker" 1993,N 24,C11:1
George Balanchine's "The Nutcracker" 1993,D 1,C17:3

Cook, David (Original Author)
Second Best 1994,S 30,C10:1
Cook, David (Screenwriter)
Second Best 1994,S 30,C10:1
Cook, Peter
Black Beauty 1994,Jl 29,C29:1
Cook, Steven
Two or Three Things My Stepfather Taught Me 1994,Mr 26,14:5
Coolidge, Martha (Director)
Lost in Yonkers 1993,My 14,C10:5
Angie 1994,Mr 4,C6:5
Cooper, Barry Michael (Screenwriter)
Sugar Hill 1994,F 25,C10:6
Above the Rim 1994,Mr 23,C17:1
Cooper, Chris
This Boy's Life 1993,Ap 9,C10:1
Coote, Greg (Producer)
Lightning Jack 1994,Mr 11,C8:5
Copeland, Stewart (Composer)
Riffraff 1993,F 12,C10:5
Wide Sargasso Sea 1993,Ap 16,C6:5
Airborne 1993,S 18,14:3
Raining Stones 1993,O 2,11:3
Bank Robber 1993,D 10,C10:1
Fresh 1994,Ap 1,C6:2
Fresh 1994,S 2,C16:4
Rapa Nui 1994,S 9,C3:1
Silent Fall 1994,O 28,C10:1
Copping, David (Miscellaneous)
Fortress 1993,S 4,11:1
Coppola, Francis Ford (Director)
Bram Stoker's "Dracula" 1993,Ap 2,C1:4
Coppola, Francis Ford (Producer)
Mary Shelley's Frankenstein 1994,N 4,C1:2
Coppola, Sofia
Inside Monkey Zetterland 1993,O 15,C12:5
Corbett, Toby (Miscellaneous)
Meteor Man, The 1993,Ag 7,9:3
Corbitt, Wayne
Sex Is . . . 1993,S 9,C17:5
Cordero, José
Pisito, El (Little Apartment, The) 1993,N 26,C14:1
Cordish, Johnathan (Producer)
Midnight Edition 1994,Ap 1,C18:5
Corey, Jeff
Surviving the Game 1994,Ap 16,11:3
Cornfeld, Stuart (Producer)
Wilder Napalm 1993,Ag 20,C14:1
Cornwell, Stephen (Director)
Philadelphia Experiment 2 1993,N 13,18:3
Corrao, Angelo (Miscellaneous)
Dr. Bethune 1993,S 17,C13:1
Corrente, Michael (Director)
Federal Hill 1994,D 9,C6:1
Corrente, Michael (Producer)
Federal Hill 1994,D 9,C6:1
Corrente, Michael (Screenwriter)
Federal Hill 1994,D 9,C6:1
Corriveau, André (Miscellaneous)
Being at Home with Claude 1993,Ag 6,C8:5
Cort, Robert W. (Producer)
Air Up There, The 1994,Ja 7,C16:6
Corwin, Hank (Miscellaneous)
Natural Born Killers 1994,Ag 26,C1:1
Cosby, Bill
Meteor Man, The 1993,Ag 7,9:3
Cosloy, Gerard
Half Japanese: The Band That Would Be King 1993,O 7,C20:5
Cosmatos, George P. (Director)
Tombstone 1993,D 24,C6:1
Cosmos, Jean (Screenwriter)
Colonel Chabert 1994,D 23,C8:5
Costa, João (Cinematographer)
Jit 1993,Mr 20,16:1
Costanzo, Robert
Man's Best Friend 1993,N 20,17:1
Costigan, George
Hawk, The 1993,D 10,C21:1
Costiniu, Geo
Conjugal Bed, The 1994,Jl 15,C18:1
Costner, Kevin
Perfect World, A 1993,N 24,C11:1
Perfect World, A 1993,D 31,C26:5
Wyatt Earp 1994,Je 24,C1:5
War, The 1994,N 4,C10:5

445

Ellsworth, Barry (Cinematographer)
Secuestro: A Story of a Kidnapping 1994,Ja 19,C20:1
Elmassian, Jeff (Composer)
Inside Monkey Zetterland 1993,O 15,C12:5
Elmes, Frederick (Cinematographer)
Saint of Fort Washington, The 1993,N 17,C19:3
Trial by Jury 1994,S 10,14:5
Elmiger, Suzy (Miscellaneous)
Mrs. Parker and the Vicious Circle 1994,N 23,C9:3
Elswit, Robert (Cinematographer)
Dangerous Woman, A 1993,D 3,C19:1
River Wild, The 1994,S 30,C8:1
Elwes, Cary
Crush, The 1993,Ap 3,17:1
Robin Hood: Men in Tights 1993,Jl 28,C13:1
Robin Hood: Men in Tights 1993,Ag 1,II:11:4
Rudyard Kipling's "The Jungle Book" 1994,D 23,C5:1
Elwes, Cassian (Producer)
Chase, The 1994,Mr 4,C14:1
Emmerich, Roland (Director)
Stargate 1994,O 28,C6:5
Emmerich, Roland (Screenwriter)
Stargate 1994,O 28,C6:5
Endelman, Stephen (Composer)
Imaginary Crimes 1994,O 14,C16:1
Endre, Lena
Sunday's Children 1993,Ap 3,13:1
Engelbrecht, Constanze
Fiorile 1993,O 13,C21:1
Fiorile 1994,F 2,C20:1
Engelhard, Jack (Original Author)
Indecent Proposal 1993,Ap 7,C13:1
Engelman, Bob (Producer)
Man's Best Friend 1993,N 20,17:1
Mask, The 1994,Jl 29,C1:3
Engelman, Tom (Miscellaneous)
Temp, The 1993,F 13,17:1
Engelman, Tom (Producer)
Temp, The 1993,F 13,17:1
Terminal Velocity 1994,S 23,C20:5
Engle, Jerret (Miscellaneous)
Something Within Me 1993,My 28,C15:1
Engle, Jerret (Producer)
Something Within Me 1993,My 28,C15:1
Englund, Robert
Wes Craven's New Nightmare 1994,O 14,C8:5
Engstrom, Charles (Composer)
Ruby in Paradise 1993,O 6,C15:1
Enright, Buddy (Miscellaneous)
Drop Squad 1994,O 28,C19:1
Enriquez, Thom (Miscellaneous)
Lion King, The 1994,Je 15,C11:1
Ensign, Michael
Born Yesterday 1993,Mr 26,C17:2
Ephron, Delia (Screenwriter)
Mixed Nuts 1994,D 21,C18:4
Ephron, Nora (Director)
Sleepless in Seattle 1993,Je 25,C10:5
Mixed Nuts 1994,D 21,C18:4
Ephron, Nora (Screenwriter)
Sleepless in Seattle 1993,Je 25,C10:5
Mixed Nuts 1994,D 21,C18:4
Epps, Omar
Program, The 1993,S 24,C16:6
Epstein, Ehud (Producer)
Midnight Edition 1994,Ap 1,C18:5
Epstein, Pierre
Indecent Proposal 1993,Ap 7,C13:1
Epstein, Robert (Director)
Where Are We?: Our Trip Through America 1993,Jl 30,C14:1
Epstein, Robert (Producer)
Where Are We?: Our Trip Through America 1993,Jl 30,C14:1
Erbe, Kathryn
Rich in Love 1993,Mr 5,C8:1
D2: The Mighty Ducks 1994,Mr 25,C17:1
Erdoss, Pal (Producer)
Child Murders 1994,Ap 2,17:4
Erhardt, Christine (Original Author)
I Only Want You to Love Me 1994,Ap 15,C10:4
Erickson, C. O. (Producer)
Blankman 1994,Ag 20,13:3
Eriksen, Randy (Miscellaneous)
Sleep with Me 1994,S 23,C10:1

Ermey, R. Lee
Hexed 1993,Ja 23,16:1
Ernsberger, Duke
Ernest Rides Again 1993,N 12,C10:5
Ernst, Robert
Sure Fire 1994,Ja 12,C13:1
Ertmanis, Victor
Paris, France 1994,F 4,C6:5
Brainscan 1994,Ap 22,C12:6
Escoffier, Jean-Yves (Cinematographer)
Dream Lover 1994,My 6,C11:1
Esparza, Moctesuma (Producer)
Gettysburg 1993,O 8,C16:1
Esposito, Ciro
Ciao, Professore! 1994,Jl 15,C10:5
Esposito, Giancarlo
Amos and Andrew 1993,Mr 5,C14:1
Fresh 1994,Ap 1,C6:2
Fresh 1994,Ag 24,C13:1
Fresh 1994,S 2,C16:4
Esquivel, Laura (Miscellaneous)
Like Water for Chocolate 1993,F 17,C13:3
Esquivel, Laura (Original Author)
Like Water for Chocolate 1993,F 17,C13:3
Esteban, Luis (Screenwriter)
Only the Strong 1993,Ag 27,C8:4
Estern, Evan (Cinematographer)
Shvitz, The (New York in Short) 1993,O 22,C13:1
Estevez, Emilio
National Lampoon's Loaded Weapon 1 1993,F 5,C6:6
Another Stakeout 1993,Jl 23,C8:5
Judgment Night 1993,O 15,C8:5
D2: The Mighty Ducks 1994,Mr 25,C17:1
Eszterhas, Joe (Miscellaneous)
Nowhere to Run 1993,Ja 16,16:5
Eszterhas, Joe (Screenwriter)
Nowhere to Run 1993,Ja 16,16:5
Sliver 1993,My 22,11:5
Ettinger, Barbara (Director)
Martha and Ethel 1994,Ja 28,C5:1
Ettinger, Wendy (Producer)
War Room, The 1993,O 13,C15:4
Evanoff, Lorraine
Dark at Noon 1993,Ag 20,C12:5
Evans, Annette
Resonance (Boys' Shorts) 1993,Jl 21,C17:1
Evans, Arthur
CB4 1993,Mr 12,C13:1
Evans, David Mickey (Director)
Sandlot, The 1993,Ap 7,C17:1
Evans, David Mickey (Screenwriter)
Sandlot, The 1993,Ap 7,C17:1
Evans, Elizabeth
Simple Twist of Fate, A 1994,S 2,C3:1
Evans, Kate (Miscellaneous)
Buddha of Suburbia, The 1994,D 9,C8:1
Evans, Nick (Producer)
Just Like a Woman 1994,Jl 22,C12:1
Evans, Nick (Screenwriter)
Just Like a Woman 1994,Jl 22,C12:1
Evans, Robert (Producer)
Sliver 1993,My 22,11:5
Evans, Stephen (Producer)
Much Ado About Nothing 1993,My 7,C16:1
Madness of King George, The 1994,D 28,C11:3
Evans, Victoria
Simple Twist of Fate, A 1994,S 2,C3:1
Everett, Rupert
Inside Monkey Zetterland 1993,O 15,C12:5
Madness of King George, The 1994,D 28,C11:3
Evora, Cesaria (Composer)
Normal People Are Nothing Special 1994,Mr 18,C1:1
Eziashi, Maynard
Bopha! 1993,S 24,C18:1
Good Man in Africa, A 1994,S 9,C6:1

F

Fab 5 Freddy
Who's the Man? 1993,Ap 23,C19:1
Fabre, Jean-Marc (Cinematographer)
Ivan and Abraham 1994,Mr 23,C17:1

Fackeldey, Gisela
Martha 1994,S 24,16:3
Faella, Michael
Minotaur 1994,Je 10,C12:5
Fagioli, Massimo (Screenwriter)
Conviction, The 1994,My 13,C10:5
Faillai, Ilona
Child Murders 1994,Ap 2,17:4
Fair, David
Half Japanese: The Band That Would Be King 1993,O 7,C20:5
Fair, Jad
Half Japanese: The Band That Would Be King 1993,O 7,C20:5
Fairbrass, Craig
Cliffhanger 1993,My 28,C1:4
Fairchild, Morgan
Freaked 1993,O 2,14:3
Fajon, Neva (Miscellaneous)
When I Close My Eyes 1994,Ap 2,17:1
Falck, Susanne (Screenwriter)
Colin Nutley's House of Angels 1993,Ag 6,C10:6
Falk, Peter
Faraway So Close 1993,My 21,C1:1
Faraway, So Close 1993,D 22,C15:1
Fallon, David (Screenwriter)
White Fang 2: Myth of the White Wolf 1994,Ap 15,C23:1
Fallon, Michael (Miscellaneous)
Mask, The 1994,Jl 29,C1:3
Falls, Kevin (Miscellaneous)
Temp, The 1993,F 13,17:1
Falls, Kevin (Screenwriter)
Temp, The 1993,F 13,17:1
Faloona, Christopher (Cinematographer)
3 Ninjas Kick Back 1994,My 7,18:5
Falwell, Jerry
Last Party, The 1993,Ag 27,C14:1
Fanto, George (Miscellaneous)
It's All True: Based on an Unfinished Film by Orson Welles 1993,O 15,C8:5
Farago, Katinka (Producer)
Good Evening, Mr. Wallenberg 1993,Ap 23,C12:6
Fardoulis, Monique (Miscellaneous)
Betty 1993,Ag 20,C12:1
Enfer, L' (Hell) 1994,O 19,C17:1
Farentino, Debrah
Son of the Pink Panther 1993,Ag 28,9:5
Farina, Dennis
Another Stakeout 1993,Jl 23,C8:5
Striking Distance 1993,S 17,C17:1
Farley, Chris
Coneheads 1993,Jl 23,C3:2
Airheads 1994,Ag 5,C10:1
Farnham, Euclid
Vermont Is for Lovers 1993,Mr 26,C6:5
Farnsworth, Richard
Lassie 1994,Jl 22,C1:1
Farr, Eric
Rock Hudson's Home Movies 1993,Ap 2,C20:6
Farrell, Barry (Miscellaneous)
Camilla 1994,D 16,C16:1
Farrell, Tom Riis
Sleepless in Seattle 1993,Je 25,C10:5
Farrelly, Bobby (Screenwriter)
Dumb and Dumber 1994,D 16,C10:5
Farrelly, Peter (Director)
Dumb and Dumber 1994,D 16,C10:5
Farrelly, Peter (Screenwriter)
Dumb and Dumber 1994,D 16,C10:5
Farrow, Mia
Widows' Peak 1994,My 13,C16:1
Farrugia, Colette (Miscellaneous)
Café au Lait 1994,Ag 19,C1:1
Fassbinder, Rainer Werner (Director)
I Only Want You to Love Me 1994,Ap 15,C10:4
Martha 1994,S 24,16:3
Fassbinder, Rainer Werner (Screenwriter)
I Only Want You to Love Me 1994,Ap 15,C10:4
Martha 1994,S 24,16:3
Faulk, Mary Chang
Manhattan by Numbers 1993,Ap 2,C34:4
Faulkner, Ben
Silent Fall 1994,O 28,C10:1
Faulon, Joël (Producer)
A la Mode 1994,Ag 12,C3:1
Faure, Michel (Miscellaneous)
Troubles We've Seen, The 1994,O 6,C17:1

Fricke, Ron (Cinematographer)
Baraka 1993,S 24,C14:6
Fricke, Ron (Director)
Baraka 1993,S 24,C14:6
Fricke, Ron (Miscellaneous)
Baraka 1993,S 24,C14:6
Fricke, Ron (Screenwriter)
Baraka 1993,S 24,C14:6
Fricker, Brenda
Utz 1993,F 10,C15:5
So I Married an Axe Murderer 1993,Jl 30,C3:1
Angels in the Outfield 1994,Jl 15,C10:1
Man of No Importance, A 1994,D 22,C11:1
Frieberg, Camelia (Producer)
Exotica 1994,S 24,11:1
Fried, Robert N. (Producer)
So I Married an Axe Murderer 1993,Jl 30,C3:1
Rudy 1993,O 13,C21:1
Only You 1994,O 7,C12:1
Friedberg, Mark (Miscellaneous)
Ballad of Little Jo, The 1993,Ag 20,C10:1
Friedgen, Bud (Director)
That's Entertainment! III 1994,My 6,C17:1
Friedgen, Bud (Miscellaneous)
That's Entertainment! III 1994,My 6,C17:1
Friedgen, Bud (Producer)
That's Entertainment! III 1994,My 6,C17:1
Friedgen, Bud (Screenwriter)
That's Entertainment! III 1994,My 6,C17:1
Friedkin, William (Director)
Blue Chips 1994,F 18,C17:3
Friedman, Jeffrey (Director)
Where Are We?: Our Trip Through America 1993,Jl
30,C14:1
Friedman, Jeffrey (Producer)
Where Are We?: Our Trip Through America 1993,Jl
30,C14:1
Friedman, Ken (Screenwriter)
Bad Girls 1994,Ap 22,C8:5
Friedman, Louis G. (Producer)
Hexed 1993,Ja 23,16:1
Friedman, Peter
Blink 1994,Ja 26,C15:1
Friedson, Adam (Producer)
Children of Fate 1993,My 27,C13:1
Friels, Colin
Good Man in Africa, A 1994,S 9,C6:1
Dingo 1994,N 11,C19:3
Froelich, Bill (Producer)
Children of the Corn II: The Final Sacrifice 1993,Ja
30,16:4
Fromont, Raymond (Cinematographer)
Moving In 1993,O 16,18:1
Frontiere, Dominic (Composer)
Color of Night 1994,Ag 19,C6:1
Frost, Sadie
Splitting Heirs 1993,My 1,17:1
Frota, Marcos
Under One Roof 1994,Mr 25,C18:1
Frutkoff, Gary (Miscellaneous)
King of the Hill 1993,Ag 20,C1:1
By the Sword 1993,O 22,C15:1
D2: The Mighty Ducks 1994,Mr 25,C17:1
Frydman, Basia
Slingshot, The 1994,Je 3,C19:1
Frydman, Marc (Producer)
Boiling Point 1993,Ap 17,16:1
Frye, E. Max (Director)
Amos and Andrew 1993,Mr 5,C14:1
Frye, E. Max (Screenwriter)
Amos and Andrew 1993,Mr 5,C14:1
Fuchs, Fred (Producer)
Secret Garden, The 1993,Ag 13,C3:1
Fuher, Kent
Grief 1994,Je 3,C6:5
Fuhrer, Martin (Cinematographer)
Tom and Viv 1994,D 2,C3:1
Fujimoto, Tak (Cinematographer)
Philadelphia 1993,D 22,C15:3
Fukazawa, Atsushi
Okoge 1993,Mr 29,C13:1
Fuller, Samuel
Tigrero: A Film That Was Never Made 1994,D
21,C18:3
Fullerton, Carl (Miscellaneous)
Philadelphia 1993,D 22,C15:3
Fulton, Larry (Miscellaneous)
Little Rascals, The 1994,Ag 5,C21:1

Furic, Hervé
Tale of Winter, A 1994,Ap 1,C12:6
Furlan, Silvan (Screenwriter)
When I Close My Eyes 1994,Ap 2,17:1
Furlong, Edward
American Heart 1993,My 14,C10:1
Home of Our Own, A 1993,N 5,C29:3
Brainscan 1994,Ap 22,C12:6
Furusawa, Binbun (Cinematographer)
Down the Drain 1994,Ap 1,C6:5
Furusawa, Binbun (Producer)
Down the Drain 1994,Ap 1,C6:5

G

Gabin, Jean
Gueule d'Amour 1994,Jl 8,C1:3
Grand Illusion 1994,S 16,C10:1
Gabor, Zsa Zsa
Happily Ever After 1993,My 29,13:1
Beverly Hillbillies, The 1993,O 15,C20:3
Gagneux, Gilbert (Miscellaneous)
Cold Water 1994,S 28,C13:1
Gaines, Davis
Swan Princess, The 1994,N 18,C20:5
Gainsbourg, Charlotte
Cement Garden, The 1994,F 11,C24:1
Gajos, Janusz
White 1994,Je 10,C23:1
Galabru, Michel
Belle Epoque 1994,F 25,C10:1
Galeen, Henrik (Screenwriter)
Nosferatu: A Symphony of Horror 1993,Ap 2,C1:4
Galiena, Anna
Jamón Jamón (Ham Ham) 1993,S 24,C18:4
Being Human 1994,My 6,C10:3
Galipeau, Annie
Map of the Human Heart 1993,Ap 23,C21:3
Map of the Human Heart 1993,My 2,II:24:1
Gallagher, Bronagh
You, Me and Marley 1993,Mr 20,16:1
Gallagher, David
Look Who's Talking Now 1993,N 5,C12:6
Gallagher, Peter
Watch It 1993,Mr 26,C12:1
Watch It 1993,Ap 18,II:11:1
Short Cuts 1993,O 1,C1:1
Malice 1993,O 1,C5:1
Hudsucker Proxy, The 1994,Mr 11,C8:5
Mother's Boys 1994,Mr 19,18:6
Mrs. Parker and the Vicious Circle 1994,N 23,C9:3
Gallardo, Carlos
El Mariachi 1993,F 26,C6:5
Gallardo, Carlos (Producer)
El Mariachi 1993,F 26,C6:5
Gallardo, Carlos (Screenwriter)
El Mariachi 1993,F 26,C6:5
Gallo, Carla
Spanking the Monkey 1994,Jl 15,C5:1
Gallo, George (Director)
Trapped in Paradise 1994,D 2,C16:5
Gallo, George (Producer)
Trapped in Paradise 1994,D 2,C16:5
Gallo, George (Screenwriter)
Trapped in Paradise 1994,D 2,C16:5
Gallo, Vincent
House of the Spirits, The 1994,Ap 1,C1:1
Galloway, Victor H.
River Wild, The 1994,S 30,C8:1
Galuppo, Flavio (Miscellaneous)
Risk 1994,O 5,C18:1
Gamble, Mason
Dennis the Menace 1993,Je 25,C12:6
Gambon, Michael
Clean Slate 1994,My 6,C10:3
Browning Version, The 1994,O 12,C17:2
Man of No Importance, A 1994,D 22,C11:1
Gammon, James
Cabin Boy 1994,Ja 7,C12:6
Major League II 1994,Mr 30,C16:3
Gandolfini, James
Angie 1994,Mr 4,C6:5
Gant, Richard
Jason Goes to Hell: The Final Friday 1993,Ag
14,12:4

Ganz, Armin (Miscellaneous)
Philadelphia Experiment 2 1993,N 13,18:3
Cobb 1994,D 2,C8:5
Ganz, Bruno
Last Days of Chez Nous, The 1993,F 26,C6:5
Nosferatu the Vampyre 1993,Ap 2,C1:4
Faraway So Close 1993,My 21,C1:1
Especially on Sunday 1993,Ag 13,C14:5
Faraway, So Close 1993,D 22,C15:1
Ganz, Lowell (Screenwriter)
Greedy 1994,Mr 4,C15:1
City Slickers II: The Legend of Curly's Gold 1994,Je
10,C19:1
Ganz, Marshall
Freedom on My Mind 1994,Je 22,C13:1
Garber, Victor
Life with Mikey 1993,Je 4,C8:5
Sleepless in Seattle 1993,Je 25,C10:5
Exotica 1994,S 24,11:1
Garcia, Andy
When a Man Loves a Woman 1994,Ap 29,C1:1
Garcia, Rodrigo (Cinematographer)
Mi Vida Loca My Crazy Life 1994,Jl 15,C5:1
Garcia, Roel A. (Composer)
Chungking Express 1994,S 26,C14:1
García Berlanga, Luis (Director)
Welcome Mr. Marshall 1993,N 19,C18:6
Plácido 1994,O 21,C8:5
Verdugo, El (Executioner, The) 1994,O 21,C8:5
García Berlanga, Luis (Screenwriter)
Welcome Mr. Marshall 1993,N 19,C18:6
García-Fogel, Cécile
L.627 1994,Jl 15,C14:1
García Joya, Mario (Cinematographer)
Strawberry and Chocolate 1994,S 24,16:3
García Leoz, Jesús (Composer)
Welcome Mr. Marshall 1993,N 19,C18:6
García Sanchez, José Luis (Miscellaneous)
Belle Epoque 1994,F 25,C10:1
Garde, James
Bank Robber 1993,D 10,C10:1
Gardiner, Greg (Cinematographer)
Suture 1994,Mr 18,C15:1
Disco Years, The (Boys Life) 1994,D 2,C16:5
Gardiner, Lizzy (Miscellaneous)
Adventures of Priscilla, Queen of the Desert, The
1994,Ag 10,C9:1
Gardner, Pierce (Producer)
Fatal Instinct 1993,O 29,C8:1
Getting Even with Dad 1994,Je 17,C12:5
Gardos, Eva (Miscellaneous)
Hear No Evil 1993,Mr 29,C16:1
Garfield, Louise (Producer)
Zero Patience 1994,Mr 26,14:1
Garfunkel, Art
Boxing Helena 1993,S 3,C1:3
Garland, Judy
That's Entertainment! III 1994,My 6,C17:1
Garner, Helen (Screenwriter)
Last Days of Chez Nous, The 1993,F 26,C6:5
Garner, James
Fire in the Sky 1993,Mr 13,16:5
Maverick 1994,My 20,C1:3
Garofalo, Janeane
Reality Bites 1994,F 18,C3:2
Garr, Teri
Dumb and Dumber 1994,D 16,C10:5
Ready to Wear 1994,D 23,C1:1
Garreau, Jean-François
Betty 1993,Ag 20,C12:1
Garrel, Maurice
Coeur en Hiver, Un (Heart in Winter, A) 1993,Je
4,C3:1
Garrick, Barbara
Sleepless in Seattle 1993,Je 25,C10:5
Dottie Gets Spanked (Avant-Garde Visions) 1993,O
5,C18:3
Garris, Mick (Miscellaneous)
Hocus Pocus 1993,Jl 16,C16:1
Garris, Mick (Screenwriter)
Hocus Pocus 1993,Jl 16,C16:1
Garrity, Joseph T. (Miscellaneous)
Son-in-Law 1993,Jl 2,C14:6
Twenty Bucks 1993,O 22,C8:5
Imaginary Crimes 1994,O 14,C16:1
Garrone, Mirco (Miscellaneous)
Conviction, The 1994,My 13,C10:5
Caro Diario (Dear Diary) 1994,S 26,C11:3

Gorney, Mark (Miscellaneous)
 Space Is the Place 1993,S 3,C9:1
Gorny, Frédéric
 Wild Reeds 1994,O 7,C18:3
Gorson, Arthur (Producer)
 Cronos 1994,Mr 24,C16:6
Gosnell, Raja (Miscellaneous)
 Rookie of the Year 1993,Jl 7,C14:6
 Mrs. Doubtfire 1993,N 24,C11:1
 Miracle on 34th Street 1994,N 18,C12:1
Gosney, Paige
 Once Upon a Forest 1993,Je 18,C10:1
Gosse, Bob
 Another Girl, Another Planet 1993,Ap 1,C22:1
Gosse, Bob (Producer)
 Another Girl, Another Planet 1993,Ap 1,C22:1
Gossett, Louis, Jr.
 Good Man in Africa, A 1994,S 9,C6:1
Goto, Kenji (Miscellaneous)
 Okoge 1993,Mr 29,C13:1
Goto, Naoki
 Work on the Grass 1994,Ag 17,C12:3
Gottfried, Gilbert
 Hans Christian Andersen's "Thumbelina" 1994,Mr
 30,C19:1
Gottlieb, Mallory (Miscellaneous)
 Rain Without Thunder 1993,F 5,C8:5
Gough, Michael
 Age of Innocence, The 1993,S 17,C1:3
 Wittgenstein 1993,S 17,C15:1
 Advocate, The 1994,Ag 24,C11:1
Gould, Heywood (Director)
 Trial by Jury 1994,S 10,14:5
Gould, Heywood (Screenwriter)
 Trial by Jury 1994,S 10,14:5
Gould, Peter (Screenwriter)
 Double Dragon 1994,N 4,C19:1
Gounod, Charles (Composer)
 Faust 1994,O 26,C15:1
Goupil, Sophie (Producer)
 Moving In 1993,O 16,18:1
Gouriet, Gerald (Composer)
 Hold Me, Thrill Me, Kiss Me 1993,Jl 30,C12:1
Goursaud, Anne (Miscellaneous)
 Wide Sargasso Sea 1993,Ap 16,C6:5
Goutine, Andrei
 Luna Park 1994,Ja 21,C6:5
Govc, Petra
 When I Close My Eyes 1994,Ap 2,17:1
Goyer, David S. (Screenwriter)
 Puppetmasters, The 1994,O 22,18:1
Graas, John Christian
 Philadelphia Experiment 2 1993,N 13,18:3
Grabbe, Christian Dietrich (Original Author)
 Faust 1994,O 26,C15:1
Grabol, Sofie
 Silent Touch, The 1993,N 5,C3:1
Grabowsky, Paul (Composer)
 Last Days of Chez Nous, The 1993,F 26,C6:5
Grace, Nickolas
 Tom and Viv 1994,D 2,C3:1
Graef, Susan (Miscellaneous)
 My Life's in Turnaround 1994,Je 17,C5:5
Graf, Allen
 Nowhere to Run 1993,Ja 16,16:5
Graf, Ralph (Composer)
 Passages 1993,Mr 23,C14:3
Graf, Roland (Director)
 Tango Player, The 1993,N 3,C23:1
Graf, Roland (Screenwriter)
 Tango Player, The 1993,N 3,C23:1
Graff, Todd (Screenwriter)
 Vanishing, The 1993,F 5,C3:4
 Angie 1994,Mr 4,C6:5
Graham, Aimee
 Amos and Andrew 1993,Mr 5,C14:1
Graham, Angelo (Miscellaneous)
 Mrs. Doubtfire 1993,N 24,C11:1
Graham, Gerrit
 Philadelphia Experiment 2 1993,N 13,18:3
Grahn, Judy
 Last Call at Maud's 1993,Mr 19,C6:5
Grana, Sam (Producer)
 Boys of St. Vincent, The 1994,Je 1,C11:1
Grana, Sam (Screenwriter)
 Boys of St. Vincent, The 1994,Je 1,C11:1
Grandperret, Patrick (Director)
 Sirga 1994,Mr 25,C10:5

Grandperret, Patrick (Producer)
 Sirga 1994,Mr 25,C10:5
Granger, Tracy (Miscellaneous)
 Mi Vida Loca My Crazy Life 1994,Jl 15,C5:1
Granstrom, Anders (Producer)
 My Great Big Daddy 1994,Mr 26,14:2
Grant, Hugh
 Remains of the Day, The 1993,N 5,C1:1
 Sirens 1994,Mr 4,C16:1
 Four Weddings and a Funeral 1994,Mr 9,C15:5
 Bitter Moon 1994,Mr 18,C8:1
Grant, Jim (Miscellaneous)
 Bad Behavior 1993,S 3,C6:1
Grant, Richard E.
 Age of Innocence, The 1993,S 17,C1:3
 Ready to Wear 1994,D 23,C1:1
Graser, Michael (Miscellaneous)
 Wonderful, Horrible Life of Leni Riefenstahl, The
 1993,O 14,C15:1
Graver, Gary (Cinematographer)
 It's All True: Based on an Unfinished Film by Orson
 Welles 1993,O 15,C8:5
Graves, Rupert
 Madness of King George, The 1994,D 28,C11:3
Gravier, Luigi
 Volere, Volare 1993,F 3,C14:1
Gravier, Mario
 Volere, Volare 1993,F 3,C14:1
Gravina, Carla
 Long Silence, The 1994,Ap 29,C12:5
Gray, David Barry
 Cops and Robbersons 1994,Ap 15,C23:1
Gray, Erin
 Jason Goes to Hell: The Final Friday 1993,Ag
 14,12:4
Gray, Maggie (Miscellaneous)
 Four Weddings and a Funeral 1994,Mr 9,C15:5
Gray, Ronald K. (Cinematographer)
 Alma's Rainbow 1994,Je 23,C15:1
Gray, Spalding
 Pickle, The 1993,My 1,11:1
 King of the Hill 1993,Ag 20,C1:1
 Twenty Bucks 1993,O 22,C8:5
 Paper, The 1994,Mr 18,C19:1
Gray, Thomas K. (Producer)
 Teen-Age Mutant Ninja Turtles III 1993,Mr 20,15:1
Graysmark, John (Miscellaneous)
 So I Married an Axe Murderer 1993,Jl 30,C3:1
 Blown Away 1994,Jl 1,C3:1
Grazer, Brian (Producer)
 For Love or Money 1993,O 1,C8:5
 My Girl 2 1994,F 11,C22:1
 Greedy 1994,Mr 4,C15:1
 Paper, The 1994,Mr 18,C19:1
 Cowboy Way, The 1994,Je 3,C21:1
Grede, Kjell (Director)
 Good Evening, Mr. Wallenberg 1993,Ap 23,C12:6
Grede, Kjell (Screenwriter)
 Good Evening, Mr. Wallenberg 1993,Ap 23,C12:6
Green, Alfred E. (Director)
 Baby Face 1994,F 4,C1:1
Green, Bob (Screenwriter)
 Baraka 1993,S 24,C14:6
Green, Bruce (Miscellaneous)
 Vanishing, The 1993,F 5,C3:4
 Cool Runnings 1993,O 1,C8:5
 Angels in the Outfield 1994,Jl 15,C10:1
Green, Calvin
 Exotica 1994,S 24,11:1
Green, D. Ruben
 Murder Magic 1994,My 10,C19:1
Green, Jack N. (Cinematographer)
 Rookie of the Year 1993,Jl 7,C14:6
 Perfect World, A 1993,N 24,C11:1
 Trapped in Paradise 1994,D 2,C16:5
Green, Mike (Miscellaneous)
 Just Another Girl on the IRT 1993,Mr 19,C12:5
Green, Sarah (Producer)
 Oleanna 1994,N 4,C22:4
Green, Seth
 Airborne 1993,S 18,14:3
Greenberg, Adam (Cinematographer)
 Dave 1993,My 7,C12:1
 Renaissance Man 1994,Je 3,C6:5
 North 1994,Jl 22,C3:1
 Junior 1994,N 23,C9:3
Greenberg, Bonnie (Composer)
 Corrina, Corrina 1994,Ag 12,C3:2

Greenberg, Henry
 Birthplace 1993,O 14,C20:5
Greenberg, Richard (Miscellaneous)
 Last Action Hero 1993,Je 18,C1:3
Greenberg, Robbie (Cinematographer)
 Free Willy 1993,Jl 16,C12:6
Greenberg, Robert
 Guncrazy 1993,Ja 27,C17:2
Greenberg, Stan
 War Room, The 1993,O 13,C15:4
Greenberger, David
 Half Japanese: The Band That Would Be King
 1993,O 7,C20:5
Greenburg, Zack O'Malley
 Lorenzo's Oil 1993,Ja 3,II:9:1
Greenbury, Christopher (Miscellaneous)
 National Lampoon's Loaded Weapon 1 1993,F
 5,C6:6
 Dumb and Dumber 1994,D 16,C10:5
Greene, Ellen
 Wagons East! 1994,Ag 26,C16:1
Greene, Graham
 Rain Without Thunder 1993,F 5,C8:5
 Benefit of the Doubt 1993,Jl 16,C17:1
 Maverick 1994,My 20,C1:3
 North 1994,Jl 22,C3:1
 Camilla 1994,D 16,C16:1
Greene, James
 Philadelphia Experiment 2 1993,N 13,18:3
Greene, Peter
 Judgment Night 1993,O 15,C8:5
 Clean, Shaven 1994,Mr 22,C19:1
 Mask, The 1994,Jl 29,C1:3
Greenfield, Debra (Producer)
 Mr. Jones 1993,O 8,C10:5
Greenhut, Robert (Producer)
 Manhattan Murder Mystery 1993,Ag 18,C13:5
 Renaissance Man 1994,Je 3,C6:5
 Bullets over Broadway 1994,S 30,C1:1
Greenland, Seth (Screenwriter)
 Who's the Man? 1993,Ap 23,C19:1
Greenman, Adam (Miscellaneous)
 Three of Hearts 1993,Ap 30,C16:4
Greenman, Adam (Screenwriter)
 Three of Hearts 1993,Ap 30,C16:4
Greenwald, David (Miscellaneous)
 Theremin: An Electronic Odyssey 1994,O 1,11:4
Greenwald, Maggie (Director)
 Ballad of Little Jo, The 1993,Ag 20,C10:1
 Ballad of Little Jo, The 1993,O 10,II:13:5
Greenwald, Maggie (Screenwriter)
 Ballad of Little Jo, The 1993,Ag 20,C10:1
 Ballad of Little Jo, The 1993,O 10,II:13:5
Greenwald, Robert (Director)
 Hear No Evil 1993,Mr 29,C16:1
Greenwood, Bruce
 Exotica 1994,S 24,11:1
Gregg, Kenneth (Cinematographer)
 War Against the Indians, The 1993,Ap 16,C15:1
Greggory, Pascal
 Queen Margot 1994,D 9,C10:1
Grégoire, Richard (Composer)
 Being at Home with Claude 1993,Ag 6,C8:5
Gregory, André
 Vanya on 42d Street 1994,O 19,C13:1
Gregory, André (Miscellaneous)
 Vanya on 42d Street 1994,O 19,C13:1
Gregory, Ben
 Once Upon a Forest 1993,Je 18,C10:1
Gregory, Jon (Miscellaneous)
 Naked 1993,O 15,C3:3
 Four Weddings and a Funeral 1994,Mr 9,C15:5
Greisman, Alan (Producer)
 Mr. Jones 1993,O 8,C10:5
Greist, Kim
 Homeward Bound: The Incredible Journey 1993,F
 3,C15:1
Grémillon, Jean (Director)
 Gueule d'Amour 1994,Jl 8,C1:3
Grey, Joel
 Music of Chance, The 1993,Mr 19,C25:1
 Music of Chance, The 1993,Je 4,C13:1
 Music of Chance, The 1993,Je 20,II:19:5
Grey, Rudolph (Original Author)
 Ed Wood 1994,S 23,C34:1
Greyson, John (Director)
 Zero Patience 1994,Mr 26,14:1

458

H

Halfter, Ernesto (Composer)
Radio Stories 1993,N 12,C20:5
Halimi, André (Director)
Chantons sous l'Occupation (Singing Through the
Occupation) 1994,N 25,C12:1
Halimi, André (Screenwriter)
Chantons sous l'Occupation (Singing Through the
Occupation) 1994,N 25,C12:1
Hall, Albert
Rookie of the Year 1993,Jl 7,C14:6
Hall, Anthony Michael
Six Degrees of Separation 1993,D 8,C17:1
Me and the Mob 1994,S 23,C10:5
Hall, Bug
Little Rascals, The 1994,Ag 5,C21:1
Hall, Carol E.
Love Your Mama 1993,Mr 5,C14:5
Hall, Conrad L.
Visions of Light: The Art of Cinematography
1993,Ap 2,C10:5
Hall, Conrad L. (Cinematographer)
Searching for Bobby Fischer 1993,Ag 11,C13:3
Love Affair 1994,O 21,C3:1
Hall, Roger (Miscellaneous)
Air Up There, The 1994,Ja 7,C16:6
Hallahan, Charles
Body of Evidence 1993,Ja 15,C3:1
Hallgrimsson, Haraldur
Ingalo 1993,Ap 1,C24:1
Hallowell, Todd (Miscellaneous)
Paper, The 1994,Mr 18,C19:1
Hallstrom, Lasse (Director)
What's Eating Gilbert Grape 1993,D 17,C3:4
Halsey, Colleen (Miscellaneous)
So I Married an Axe Murderer 1993,Jl 30,C3:1
Halsey, Richard (Miscellaneous)
So I Married an Axe Murderer 1993,Jl 30,C3:1
Getting Even with Dad 1994,Je 17,C12:5
Halston, Julie
Dottie Gets Spanked (Avant-Garde Visions) 1993,O
5,C18:3
Hambling, Gerry (Miscellaneous)
In the Name of the Father 1993,D 29,C11:3
Road to Wellville, The 1994,O 28,C13:1
Hamburg, Maria Morris
Berenice Abbott: A View of the 20th Century
1994,D 7,C15:4
Hamed, Samir (Producer)
Curfew 1994,D 7,C17:1
Hamill, Mark
Batman: Mask of the Phantasm 1993,D 28,C21:1
Hamilton, Josh
Alive 1993,Ja 15,C6:5
With Honors 1994,Ap 29,C12:1
Hamilton, Linda
Silent Fall 1994,O 28,C10:1
Hamilton, Steven (Miscellaneous)
Amateur 1994,S 29,C16:3
Hammer, Barbara (Director)
Nitrate Kisses 1993,Ap 9,C10:6
Hammer, Barbara (Miscellaneous)
Nitrate Kisses 1993,Ap 9,C10:6
Hammer, Barbara (Producer)
Nitrate Kisses 1993,Ap 9,C10:6
Hammer, Victor (Cinematographer)
House of Cards 1993,Je 25,C18:5
Surf Ninjas 1993,Ag 21,9:1
Program, The 1993,S 24,C16:6
8 Seconds 1994,F 25,C14:1
Major League II 1994,Mr 30,C16:3
Hammett, Dashiell (Original Author)
Maltese Falcon, The 1993,Je 25,C1:1
Hampton, Janice (Miscellaneous)
Ghost in the Machine 1993,D 30,C11:5
Serial Mom 1994,Ap 13,C15:1
Hampton, Peter J. (Miscellaneous)
Nostradamus 1994,N 23,C14:1
Hamsher, Jane (Producer)
Natural Born Killers 1994,Ag 26,C1:1
Han Shanxu
Looking for Fun 1994,Mr 19,18:4
Hanan, Michael (Miscellaneous)
My Boyfriend's Back 1993,Ag 6,C16:6
Hanania, Caroline (Miscellaneous)
Wild West 1993,N 5,C6:6
Hancock, John Lee (Screenwriter)
Perfect World, A 1993,N 24,C11:1

Handel, George Frideric (Composer)
Madness of King George, The 1994,D 28,C11:3
Handley, Annette (Producer)
Andre 1994,Ag 17,C9:3
Handley, Mark (Original Author)
Nell 1994,D 14,C15:1
Handley, Mark (Screenwriter)
Nell 1994,D 14,C15:1
Handman, David (Miscellaneous)
Jason Goes to Hell: The Final Friday 1993,Ag
14,12:4
Hanisch, Uli (Miscellaneous)
Terror 2000 1994,N 18,C20:5
Hanisch, Uli (Screenwriter)
Terror 2000 1994,N 18,C20:5
Hanks, Tom
Sleepless in Seattle 1993,Je 25,C10:5
Sleepless in Seattle 1993,Jl 18,II:10:1
Philadelphia 1993,D 22,C15:3
Forrest Gump 1994,Jl 6,C9:3
Hanley, Daniel (Miscellaneous)
Cop and a Half 1993,Ap 2,C17:1
Paper, The 1994,Mr 18,C19:1
Hannah, Daryl
Grumpy Old Men 1993,D 24,C16:1
Little Rascals, The 1994,Ag 5,C21:1
Hannah, Daryl (Director)
Last Supper, The 1994,Ja 28,C5:1
Hannah, John
Four Weddings and a Funeral 1994,Mr 9,C15:5
Hänsel, Marion (Director)
Between Heaven and Earth 1993,O 1,C5:1
Hänsel, Marion (Producer)
Between Heaven and Earth 1993,O 1,C5:1
Hänsel, Marion (Screenwriter)
Between Heaven and Earth 1993,O 1,C5:1
Hansen, Erik (Screenwriter)
Heart and Souls 1993,Ag 13,C14:5
Hansen, Gregory (Screenwriter)
Heart and Souls 1993,Ag 13,C14:5
Hanson, Curtis (Director)
River Wild, The 1994,S 30,C8:1
Hap, Magda (Miscellaneous)
Princess and the Goblin, The 1994,Je 3,C15:1
Hara, Toru (Producer)
My Neighbor Totoro 1993,My 14,C14:1
Hardaway, Anfernee (Penny)
Blue Chips 1994,F 18,C17:3
Harden, Marcia Gay
Crush 1993,S 10,C8:5
Harding, Jan Leslie
Amateur 1994,S 29,C16:3
Hardison, Kadeem
Renaissance Man 1994,Je 3,C6:5
Hardwicke, Catherine (Miscellaneous)
Posse 1993,My 14,C15:1
Freaked 1993,O 2,14:3
Tombstone 1993,D 24,C6:1
Car 54, Where Are You? 1994,Ja 31,C16:5
Hardwicke, Edward
Shadowlands 1993,D 29,C11:1
Hare, David (Original Author)
Secret Rapture, The 1994,Ap 29,C15:1
Hare, David (Screenwriter)
Secret Rapture, The 1994,Ap 29,C15:1
Harelik, Mark
Swan Princess, The 1994,N 18,C20:5
Harfouch, Corinna
Tango Player, The 1993,N 3,C23:1
Hargreaves, Amy
Brainscan 1994,Ap 22,C12:6
Harkishin, Jimmi
Bhaji on the Beach 1994,Mr 19,13:1
Bhaji on the Beach 1994,My 18,C20:2
Harlin, Renny (Director)
Cliffhanger 1993,My 28,C1:4
Harlin, Renny (Producer)
Cliffhanger 1993,My 28,C1:4
Speechless 1994,D 16,C10:5
Harlow, Jean
Red-Headed Woman 1993,My 30,II:20:1
Harman, Sylvia
Super Mario Brothers 1993,My 29,11:1
Harmon, Robert (Director)
Nowhere to Run 1993,Ja 16,16:5
Harper, Robert (Producer)
Rookie of the Year 1993,Jl 7,C14:6

Harper, Sam (Screenwriter)
Rookie of the Year 1993,Jl 7,C14:6
Harrell, Andre (Composer)
Who's the Man? 1993,Ap 23,C19:1
Harrelson, Woody
Indecent Proposal 1993,Ap 7,C13:1
Indecent Proposal 1993,Ap 11,II:11:5
Cowboy Way, The 1994,Je 3,C21:1
Natural Born Killers 1994,Ag 26,C1:1
Harrington, Al
White Fang 2: Myth of the White Wolf 1994,Ap
15,C23:1
Harrington, J. Mark
Only the Strong 1993,Ag 27,C8:4
Harris, Andy (Miscellaneous)
Simple Twist of Fate, A 1994,S 2,C3:1
Harris, Dorian (Miscellaneous)
Watch It 1993,Mr 26,C12:1
Fresh 1994,Ap 1,C6:2
Harris, Ed
Firm, The 1993,Je 30,C15:3
Needful Things 1993,Ag 27,C17:1
China Moon 1994,Mr 4,C6:5
Milk Money 1994,Ag 31,C11:1
Harris, Harriet
Dottie Gets Spanked (Avant-Garde Visions) 1993,O
5,C18:3
Harris, James B. (Director)
Boiling Point 1993,Ap 17,16:1
Harris, James B. (Screenwriter)
Boiling Point 1993,Ap 17,16:1
Harris, Julie
Dark Half, The 1993,Ap 23,C10:1
Harris, Leslie (Director)
Just Another Girl on the IRT 1993,Mr 19,C12:5
Harris, Leslie (Producer)
Just Another Girl on the IRT 1993,Mr 19,C12:5
Harris, Leslie (Screenwriter)
Just Another Girl on the IRT 1993,Mr 19,C12:5
Harris, Luke Charles (Screenwriter)
Question of Color, A 1993,Je 25,C15:1
Harris, Mel
Suture 1994,Mr 18,C15:1
Pagemaster, The 1994,N 23,C18:1
Harris, Michael
Suture 1994,Mr 18,C15:1
Harris, Richard
Wrestling Ernest Hemingway 1993,D 17,C12:6
Silent Tongue 1994,F 25,C3:2
Harris, Richard A. (Miscellaneous)
Last Action Hero 1993,Je 18,C1:3
True Lies 1994,Jl 15,C1:1
Harris, Robert A. (Miscellaneous)
My Fair Lady 1994,S 21,C13:4
Harris, Rosemary
Tom and Viv 1994,D 2,C3:1
Harris, Timothy (Producer)
Falling Down 1993,F 26,C3:1
Harris, Zelda
Crooklyn 1994,My 13,C5:1
Harrison, Amy (Director)
Guerrillas in Our Midst 1993,Ap 14,C14:5
Harrison, Amy (Producer)
Guerrillas in Our Midst 1993,Ap 14,C14:5
Harrison, Jim (Original Author)
Legends of the Fall 1994,D 23,C10:5
Harrison, Jim (Screenwriter)
Wolf 1994,Je 17,C4:1
Harrison, Michael Allen (Composer)
Claire of the Moon 1993,Ap 16,C11:1
Harrison, Philip (Miscellaneous)
Point of No Return 1993,Mr 19,C10:5
Malice 1993,O 1,C5:1
Timecop 1994,S 16,C1:3
Harrison, Rex
My Fair Lady 1994,S 21,C13:4
Harrold, Jamie
Chain of Desire 1993,Je 25,C19:3
Harrow, Lisa
Last Days of Chez Nous, The 1993,F 26,C6:5
Hart, Ian
Backbeat 1994,Ap 15,C15:1
Hart, James V. (Producer)
Mary Shelley's Frankenstein 1994,N 4,C1:2
Hart, Kitty Carlisle
Six Degrees of Separation 1993,D 8,C17:1
Hart, Moss (Original Author)
Man Who Came to Dinner, The 1993,Ja 8,C1:1

Hernandez, Felicia
Ruby in Paradise 1993,O 6,C15:1
Herman Dolz, Sonia (Director)
Only the Brave 1994,Ag 31,C14:3
Herman Dolz, Sonia (Screenwriter)
Only the Brave 1994,Ag 31,C14:3
Herring, Pembroke (Miscellaneous)
Groundhog Day 1993,F 12,C3:4
Sister Act 2: Back in the Habit 1993,D 10,C10:4
Clifford 1994,Ap 1,C8:5
Scout, The 1994,S 30,C23:1
Herrington, Rowdy (Director)
Striking Distance 1993,S 17,C17:1
Herrington, Rowdy (Screenwriter)
Striking Distance 1993,S 17,C17:1
Herrmann, Edward
Born Yesterday 1993,Mr 26,C17:2
My Boyfriend's Back 1993,Ag 6,C16:6
Foreign Student 1994,Jl 29,C10:5
Richie Rich 1994,D 21,C19:1
Hershey, Barbara
Falling Down 1993,F 26,C3:1
Swing Kids 1993,Mr 5,C8:5
Splitting Heirs 1993,My 1,17:1
Dangerous Woman, A 1993,D 3,C19:1
Hershman, Joel (Director)
Hold Me, Thrill Me, Kiss Me 1993,Jl 30,C12:1
Hershman, Joel (Screenwriter)
Hold Me, Thrill Me, Kiss Me 1993,Jl 30,C12:1
Herskovic, Patricia (Producer)
Mother's Boys 1994,Mr 19,18:6
Herskovitz, Marshall (Director)
Jack the Bear 1993,Ap 2,C12:6
Herskovitz, Marshall (Producer)
Legends of the Fall 1994,D 23,C10:5
Herzner, Norbert (Miscellaneous)
Knight Moves 1993,Ja 23,16:3
Herzog, Gilles (Screenwriter)
Bosna! 1994,O 12,C13:1
Herzog, Werner (Director)
Nosferatu the Vampyre 1993,Ap 2,C1:4
Hessman, Robin (Director)
Portrait of a Boy with Dog 1994,Mr 19,18:5
Heston, Charlton
Wayne's World 2 1993,D 10,C20:6
Tombstone 1993,D 24,C6:1
True Lies 1994,Jl 15,C1:1
Heston, Fraser C. (Director)
Needful Things 1993,Ag 27,C17:1
Heyman, Norma (Producer)
Summer House, The 1993,D 21,C19:1
Hibbin, Sally (Producer)
Riffraff 1993,F 12,C10:5
Raining Stones 1993,O 2,11:3
Ladybird, Ladybird 1994,O 7,C18:3
Hickenlooper, George (Director)
Some Folks Call It a Sling Blade 1994,Mr 26,14:5
Hickenlooper, George (Miscellaneous)
Some Folks Call It a Sling Blade 1994,Mr 26,14:5
Hickenlooper, George (Producer)
Some Folks Call It a Sling Blade 1994,Mr 26,14:5
Hickey, Tom
Raining Stones 1993,O 2,11:3
Raining Stones 1994,Mr 11,C13:1
Hickie, Gordon (Cinematographer)
Leon the Pig Farmer 1993,S 10,C8:1
Hickman, Darryl
Tingler, The 1994,Ag 19,C18:1
Hickner, Stephen (Producer)
We're Back! A Dinosaur's Story 1993,N 24,C20:6
Hickox, Anthony (Director)
Warlock 1993,S 25,19:5
Hicks, Simon (Miscellaneous)
Leon the Pig Farmer 1993,S 10,C8:1
Hicks, Taral
Bronx Tale, A 1993,S 29,C13:4
Hides, Bernard (Miscellaneous)
Lightning Jack 1994,Mr 11,C8:5
Higelin, Ken
A la Mode 1994,Ag 12,C3:1
Higgins, Anthony
For Love or Money 1993,O 1,C8:5
Higgins, Clare
Bad Behavior 1993,S 3,C6:1
Higgins, Douglas (Miscellaneous)
Needful Things 1993,Ag 27,C17:1
Hiken, Nat (Miscellaneous)
Car 54, Where Are You? 1994,Ja 31,C16:5

Hill, Dana
Tom and Jerry: The Movie 1993,Jl 30,C10:6
Hill, Dennis M. (Miscellaneous)
Three of Hearts 1993,Ap 30,C16:4
Son-in-Law 1993,Jl 2,C14:6
Hill, Lauryn
King of the Hill 1993,Ag 20,C1:1
Hill, Matt
Teen-Age Mutant Ninja Turtles III 1993,Mr 20,15:1
Hill, Michael (Miscellaneous)
Paper, The 1994,Mr 18,C19:1
Hill, Walter (Director)
Geronimo: An American Legend 1993,D 10,C21:1
Hill, Walter (Producer)
Geronimo: An American Legend 1993,D 10,C21:1
Hill, Walter (Screenwriter)
Getaway, The 1994,F 11,C12:5
Hiller, Arthur (Director)
Married to It 1993,Mr 26,C8:6
Himoff, Kathryn (Miscellaneous)
Hold Me, Thrill Me, Kiss Me 1993,Jl 30,C12:1
Mi Vida Loca My Crazy Life 1994,Jl 15,C5:1
Killing Zoe 1994,Ag 19,C3:1
Hinds, Ciaran
December Bride 1994,S 9,C6:5
Hinds-Johnson, Marcia (Miscellaneous)
Josh and S.A.M. 1993,N 24,C12:1
Hines, Gene Patrick (Producer)
Cliffhanger 1993,My 28,C1:4
Hines, Gregory
Renaissance Man 1994,Je 3,C6:5
Hinkle, Jaymes (Miscellaneous)
National Lampoon's Loaded Weapon 1 1993,F 5,C6:6
Man's Best Friend 1993,N 20,17:1
Hinman, Joel D. (Producer)
Between the Teeth 1994,F 2,C15:1
Hirao, Tadanobu (Producer)
Tokyo Decadence 1993,Jl 30,C12:6
Hird, Thora
Wedding Gift, The 1994,Jl 20,C18:1
Hirovnen, Tahvo (Cinematographer)
Ingalo 1993,Ap 1,C24:1
Hirsch, Paul (Miscellaneous)
Falling Down 1993,F 26,C3:1
Wrestling Ernest Hemingway 1993,D 17,C12:6
I Love Trouble 1994,Je 29,C15:1
Hisaishi, Jo (Composer)
My Neighbor Totoro 1993,My 14,C14:1
Hisey, Hal (Producer)
112th and Central: Through the Eyes of the Children 1993,Ag 18,C18:1
Hitner, Harry (Miscellaneous)
Look Who's Talking Now 1993,N 5,C12:6
Andre 1994,Ag 17,C9:3
Hjartarson, Jon
Ingalo 1993,Ap 1,C24:1
Hloch, Zbynek (Miscellaneous)
Last Butterfly, The 1993,Ag 20,C23:1
Hlupy, Jiri (Miscellaneous)
Immortal Beloved 1994,D 16,C4:4
Ho, A. Kitman (Producer)
Heaven and Earth 1993,D 24,C1:4
On Deadly Ground 1994,F 19,11:1
Hobbs, Christopher (Miscellaneous)
Long Day Closes, The 1993,My 28,C12:3
Hodder, Kane
Jason Goes to Hell: The Final Friday 1993,Ag 14,12:4
Hodges, Adrian (Screenwriter)
Tom and Viv 1994,D 2,C3:1
Hodgson, Mike (Miscellaneous)
Swan Princess, The 1994,N 18,C20:5
Hodor, Darek (Miscellaneous)
Good Evening, Mr. Wallenberg 1993,Ap 23,C12:6
Hoenig, Dob (Miscellaneous)
Crow, The 1994,My 11,C15:4
Hoey, Gary (Composer)
Bruce Brown's "The Endless Summer II" 1994,Je 3,C12:1
Hofer, Johanna
I Only Want You to Love Me 1994,Ap 15,C10:4
Hoffman, Dustin
Midnight Cowboy 1994,F 20,II:11:5
Hoffman, Elizabeth
River Wild, The 1994,S 30,C8:1
Hoffman, Philip
My Boyfriend's Back 1993,Ag 6,C16:6

Hoffman, Richard (Producer)
Disco Years, The (Boys Life) 1994,D 2,C16:5
Hoffmann, Deborah (Miscellaneous)
Frosh: Nine Months in a Freshman Dorm 1994,O 5,C18:1
Hoffmann, E. T. A. (Original Author)
George Balanchine's "The Nutcracker" 1993,N 24,C11:1
Hoffmann, Gaby
Man Without a Face, The 1993,Ag 25,C13:1
Hoffmeyer, Stig
Sofie 1993,My 21,C8:1
Hofheimer, Charlie
Lassie 1994,Jl 22,C1:1
Hofman, Ota (Screenwriter)
Last Butterfly, The 1993,Ag 20,C23:1
Hofschneider, Marco
Foreign Student 1994,Jl 29,C10:5
Immortal Beloved 1994,D 16,C4:4
Hofstedt, T. Daniel (Miscellaneous)
Lion King, The 1994,Je 15,C11:1
Hofstra, Jack (Miscellaneous)
Color of Night 1994,Ag 19,C6:1
Specialist, The 1994,O 8,11:4
Hogan, Paul
Lightning Jack 1994,Mr 11,C8:5
Hogan, Paul (Producer)
Lightning Jack 1994,Mr 11,C8:5
Hogan, Paul (Screenwriter)
Lightning Jack 1994,Mr 11,C8:5
Hoger, Hannelore
Heimat II: Chronicle of a Generation 1993,Je 17,C11:3
Höhn, Tillmann (Composer)
Making Up! (Abgeschminkt!) 1994,S 16,C8:5
Hoi, Vuong Hoa
Scent of Green Papaya, The 1993,O 11,C15:2
Holbrook, Hal
Firm, The 1993,Je 30,C15:3
Holden, David (Miscellaneous)
By the Sword 1993,O 22,C15:1
Holden, Marjean
Philadelphia Experiment 2 1993,N 13,18:3
Holender, Adam (Cinematographer)
Fresh 1994,Ap 1,C6:2
Fresh 1994,Ag 24,C13:1
Fresh 1994,S 2,C16:4
Holland, Agnieszka (Director)
Olivier, Olivier 1993,F 21,II:17:5
Olivier, Olivier 1993,F 24,C17:5
Secret Garden, The 1993,Ag 13,C3:1
Holland, Agnieszka (Miscellaneous)
Blue 1993,O 12,C15:1
Holland, Agnieszka (Screenwriter)
Olivier, Olivier 1993,F 24,C17:5
Holland, Endesha Ida Mae
Freedom on My Mind 1994,Je 22,C13:1
Holland, Isabelle (Original Author)
Man Without a Face, The 1993,Ag 25,C13:1
Holland, Tom (Director)
Temp, The 1993,F 13,17:1
Hollander, Barbara
Life with Mikey 1993,Je 4,C8:5
Holley, Don (Miscellaneous)
National Lampoon's Loaded Weapon 1 1993,F 5,C6:6
Holley, Don (Screenwriter)
National Lampoon's Loaded Weapon 1 1993,F 5,C6:6
Holley, Lauren
Dragon: The Bruce Lee Story 1993,My 7,C19:1
Dumb and Dumber 1994,D 16,C10:5
Holliday, Polly
Mrs. Doubtfire 1993,N 24,C11:1
Holliman, Elaine (Director)
Chicks in White Satin (Oscar Shorts 1993) 1994,Mr 5,19:1
Holloway, Kamal
Twenty Bucks 1993,O 22,C8:5
Holloway, Stanley
My Fair Lady 1994,S 21,C13:4
Hollywood, Peter (Miscellaneous)
Foreign Student 1994,Jl 29,C10:5
Holm, Ian
Advocate, The 1994,Ag 24,C11:1
Mary Shelley's Frankenstein 1994,N 4,C1:2
Madness of King George, The 1994,D 28,C11:3

I

K

Kahn, Michael (Miscellaneous)
 Alive 1993,Ja 15,C6:5
 Jurassic Park 1993,Je 11,C1:1
 Schindler's List 1993,D 15,C19:3
Kahn, Sheldon (Miscellaneous)
 Dave 1993,My 7,C12:1
 Beethoven's 2d 1993,D 17,C10:5
 Junior 1994,N 23,C9:3
Kai Kit Wai (Miscellaneous)
 Hard-Boiled 1993,Je 18,C12:6
Kako, Takashi (Composer)
 Between Heaven and Earth 1993,O 1,C5:1
Kalandjonak, Mykola (Composer)
 Famine-33 1993,D 15,C23:1
Kalinowski, Waldemar (Miscellaneous)
 Mr. Jones 1993,O 8,C10:5
 Wrestling Ernest Hemingway 1993,D 17,C12:6
Kallberg, Per (Cinematographer)
 My Great Big Daddy 1994,Mr 26,14:2
Kallista, Jaromir (Producer)
 Faust 1994,O 26,C15:1
Kamen, Michael (Composer)
 Splitting Heirs 1993,My 1,17:1
 Last Action Hero 1993,Je 18,C1:3
 Wilder Napalm 1993,Ag 20,C14:1
 Three Musketeers, The 1993,N 12,C10:5
Kaminka, Didier (Miscellaneous)
 True Lies 1994,Jl 15,C1:1
Kaminski, Dana
 Super Mario Brothers 1993,My 29,11:1
Kaminski, Janusz (Cinematographer)
 Adventures of Huck Finn, The 1993,Ap 2,C15:1
 Schindler's List 1993,D 15,C19:3
 Little Giants 1994,O 14,C12:6
Kammer, Salome
 Heimat II: Chronicle of a Generation 1993,Je
 17,C11:3
Kane, Big Daddy
 Posse 1993,My 14,C15:1
Kane, Bob (Miscellaneous)
 Batman: Mask of the Phantasm 1993,D 28,C21:1
Kane, Carol
 Addams Family Values 1993,N 19,C3:4
 Even Cowgirls Get the Blues 1994,My 20,C10:1
Kane, Irene
 Killer's Kiss 1994,Ja 14,C6:3
Kane, Mary (Producer)
 Dangerous Game 1993,N 19,C14:5
Kaneshiro, Takeshi
 Chungking Express 1994,S 26,C14:1
Kang, James (Producer)
 3 Ninjas Kick Back 1994,My 7,18:5
Kanganis, Charles T. (Director)
 3 Ninjas Kick Back 1994,My 7,18:5
Kaniecki, Michael
 Lost Words, The 1994,S 21,C18:1
Kaniecki, Michael (Composer)
 Lost Words, The 1994,S 21,C18:1
Kaniecki, Michael (Screenwriter)
 Lost Words, The 1994,S 21,C18:1
Kanin, Garson (Original Author)
 Born Yesterday 1993,Mr 26,C17:2
Kano, Tenmei
 Tokyo Decadence 1993,Jl 30,C12:6
Kantor, Mickey
 War Room, The 1993,O 13,C15:4
Kantorow, Jean-Jacques
 Coeur en Hiver, Un (Heart in Winter, A) 1993,Je
 4,C3:1
Kao Tung-hsiu
 Puppetmaster, The 1993,O 6,C19:1
Kapisky, Tracey
 American Heart 1993,My 14,C10:1
Kaplan, Jonathan (Director)
 Bad Girls 1994,Ap 22,C8:5
Kaplan, Martin (Screenwriter)
 Striking Distance 1993,S 17,C17:1
Kapoor, Shashi
 In Custody 1994,Ap 15,C6:3
Karadzic, Radovan
 Serbian Epics 1993,My 7,C21:1
Karaindrou, Helen (Composer)
 Beekeeper, The 1993,My 7,C21:4
Karanovic, Srdjan (Director)
 Virgina 1993,Mr 27,15:1
Karanovic, Srdjan (Screenwriter)
 Virgina 1993,Mr 27,15:1

Karaszewski, Larry (Screenwriter)
 Ed Wood 1994,S 23,C34:1
Kardos, Istvan (Producer)
 Child Murders 1994,Ap 2,17:4
Karinska (Miscellaneous)
 George Balanchine's "The Nutcracker" 1993,N
 24,C11:1
Karlen, John
 Surf Ninjas 1993,Ag 21,9:1
Karlsson, Bjorn
 Ingalo 1993,Ap 1,C24:1
Karlström, Ewa (Producer)
 Making Up! (Abgeschminkt!) 1994,S 16,C8:5
Karmitz, Marin (Producer)
 Betty 1993,Ag 20,C12:1
 Blue 1993,O 12,C15:1
 Mazeppa 1993,D 3,C10:4
 White 1994,Je 10,C23:1
 Red 1994,O 4,C15:1
 Enfer, L' (Hell) 1994,O 19,C17:1
Karpik, Avi (Cinematographer)
 Seventh Coin, The 1993,S 10,C5:1
Karr, Gary (Miscellaneous)
 Sugar Hill 1994,F 25,C10:6
Karr, Sarah Rose
 Beethoven's 2d 1993,D 17,C10:5
Karsch, Andrew (Producer)
 Princess Caraboo 1994,S 16,C12:1
Karyo, Tcheky
 Nostradamus 1994,N 23,C14:1
Kasdan, Lawrence (Director)
 Wyatt Earp 1994,Je 24,C1:5
Kasdan, Lawrence (Producer)
 Wyatt Earp 1994,Je 24,C1:5
Kasdan, Lawrence (Screenwriter)
 Wyatt Earp 1994,Je 24,C1:5
Kases, Karl (Cinematographer)
 Rain Without Thunder 1993,F 5,C8:5
Kash, Linda
 Ernest Rides Again 1993,N 12,C10:5
Kasper, Norayr (Cinematographer)
 Calendar 1993,O 16,18:1
Kass, Harvey (Producer)
 Tom and Viv 1994,D 2,C3:1
Kassile, Yann (Miscellaneous)
 Bosna! 1994,O 12,C13:1
Kassovitz, Mathieu
 Café au Lait 1994,Ag 19,C1:1
 See How They Fall 1994,O 1,12:4
Kassovitz, Mathieu (Director)
 Café au Lait 1994,Ag 19,C1:1
Kassovitz, Mathieu (Screenwriter)
 Café au Lait 1994,Ag 19,C1:1
Katashima, Kazuki (Miscellaneous)
 Tokyo Decadence 1993,Jl 30,C12:6
Kato, Masaya
 Crime Broker 1994,S 16,C14:4
Katsaros, Doug (Composer)
 Me and the Mob 1994,S 23,C10:5
Katsulas, Andreas
 Fugitive, The 1993,Ag 6,C1:1
Katsurada, Mana (Producer)
 Down the Drain 1994,Ap 1,C6:5
Katz, A. L. (Screenwriter)
 Children of the Corn II: The Final Sacrifice 1993,Ja
 30,16:4
Katz, Gloria (Screenwriter)
 Radioland Murders 1994,O 21,C5:1
Katz, James C. (Miscellaneous)
 My Fair Lady 1994,S 21,C13:4
Katz, Jordan (Screenwriter)
 Trial by Jury 1994,S 10,14:5
Katz, Omri
 Matinee 1993,Ja 29,C6:4
 Hocus Pocus 1993,Jl 16,C16:1
Katz, Robert (Producer)
 Gettysburg 1993,O 8,C16:1
Katz, Robin (Miscellaneous)
 Grief 1994,Je 3,C6:5
Katz, Stephen (Cinematographer)
 Watch It 1993,Mr 26,C12:1
Kauderer, Emilio (Composer)
 Place in the World, A 1994,Jl 1,C3:1
Kaufman, George (Director)
 Senator Was Indiscreet, The 1993,Ja 8,C1:1
Kaufman, George (Original Author)
 Man Who Came to Dinner, The 1993,Ja 8,C1:1

Kaufman, Ken (Screenwriter)
 In the Army Now 1994,Ag 12,C6:4
Kaufman, Peter (Producer)
 Rising Sun 1993,Jl 30,C1:4
Kaufman, Philip (Director)
 Rising Sun 1993,Jl 30,C1:4
Kaufman, Philip (Screenwriter)
 Rising Sun 1993,Jl 30,C1:4
Kaul, Mani (Director)
 Cloud Door, The 1994,S 28,C14:3
Kaurismaki, Aki (Director)
 Vie de Bohème, La 1993,Je 20,II:19:5
 Vie de Bohème, La 1993,Jl 29,C15:4
 Vie de Bohème, La 1993,S 3,C3:1
Kaurismaki, Mika (Director)
 Zombie and the Ghost Train 1994,Ag 10,C12:4
 Tigrero: A Film That Was Never Made 1994,D
 21,C18:3
Kaurismaki, Mika (Miscellaneous)
 Tigrero: A Film That Was Never Made 1994,D
 21,C18:3
Kaurismaki, Mika (Producer)
 Tigrero: A Film That Was Never Made 1994,D
 21,C18:3
Kaurismaki, Mika (Screenwriter)
 Tigrero: A Film That Was Never Made 1994,D
 21,C18:3
Kavner, Julie
 I'll Do Anything 1994,F 4,C3:1
Kawagley, Oscar
 Salmonberries 1994,S 2,C12:5
Kawajiri, Yoshiaki (Director)
 Running Man (Neo-Tokyo) 1993,Jl 23,C12:6
Kawajiri, Yoshiaki (Screenwriter)
 Running Man (Neo-Tokyo) 1993,Jl 23,C12:6
Kaz, Fred
 . . . And God Spoke 1994,S 23,C10:5
Kazan, Lainie
 Cemetery Club, The 1993,F 3,C14:4
Kazan, Nicholas (Director)
 Dream Lover 1994,My 6,C11:1
Kazan, Nicholas (Screenwriter)
 Dream Lover 1994,My 6,C11:1
Kazanjian, Howard (Producer)
 Demolition Man 1993,O 8,C23:1
Kazi, Miwako
 Down the Drain 1994,Ap 1,C6:5
Keach, Stacy, Jr.
 Batman: Mask of the Phantasm 1993,D 28,C21:1
Keating, Kevin (Cinematographer)
 On the Bridge 1993,O 8,C10:5
Keaton, Diane
 Manhattan Murder Mystery 1993,Ag 18,C13:5
 Look Who's Talking Now 1993,N 5,C12:6
 Mrs. Soffel 1993,N 28,II:13:1
Keaton, Michael
 Much Ado About Nothing 1993,My 7,C16:1
 My Life 1993,N 12,C17:1
 Paper, The 1994,Mr 18,C19:1
 Speechless 1994,D 16,C10:5
Keays-Byrne, Hugh (Director)
 Resistance 1994,N 23,C18:1
Keegan, Kari
 Jason Goes to Hell: The Final Friday 1993,Ag
 14,12:4
Keel, Howard
 That's Entertainment! III 1994,My 6,C17:1
Keenan, Joe (Screenwriter)
 Sleep with Me 1994,S 23,C10:1
Keens-Douglas, Ricardo
 Zero Patience 1994,Mr 26,14:1
Keiko
 Free Willy 1993,Jl 16,C12:6
Keiller, Patrick (Cinematographer)
 London 1994,S 28,C14:3
Keiller, Patrick (Director)
 London 1994,S 28,C14:3
Keiller, Patrick (Screenwriter)
 London 1994,S 28,C14:3
Keiser, Marina (Miscellaneous)
 Benefit of the Doubt 1993,Jl 16,C17:1
Keita, Mamady
 Djembefola 1993,S 15,C26:2
Keita, Salif (Composer)
 Sirga 1994,Mr 25,C10:5
Keitel, Harvey
 Point of No Return 1993,Mr 19,C10:5
 Piano, The 1993,My 18,C13:3

L

473

Lynch, Kelly
Three of Hearts 1993,Ap 30,C16:4
Imaginary Crimes 1994,O 14,C16:1
Beans of Egypt, Maine, The 1994,N 23,C13:1
Lynch, Randall (Composer)
Rain Without Thunder 1993,F 5,C8:5
Lynd, Laurie (Director)
R.S.V.P. (Boys' Shorts) 1993,Jl 21,C17:1
Lynd, Laurie (Screenwriter)
R.S.V.P. (Boys' Shorts) 1993,Jl 21,C17:1
Lyne, Adrian (Director)
Indecent Proposal 1993,Ap 7,C13:1
Indecent Proposal 1993,Ap 11,II:11:5
Lynn, Jonathan
Greedy 1994,Mr 4,C15:1
Lynn, Jonathan (Director)
Greedy 1994,Mr 4,C15:1
Lynn, Meredith Scott
Girl in the Watermelon, The 1994,Mr 18,C29:1
Lynskey, Melanie
Heavenly Creatures 1994,N 16,C17:1
Lyon, Nelson
Floundering 1994,N 4,C15:3
Lyon, Phyllis
Last Call at Maud's 1993,Mr 19,C6:5
Lyon, Robert
George Balanchine's "The Nutcracker" 1993,D 1,C17:3
Lyons, James (Miscellaneous)
Dottie Gets Spanked (Avant-Garde Visions) 1993,O 5,C18:3
Lyons, Jim
Postcards from America 1994,O 8,14:1
Lyons, Robin (Producer)
Princess and the Goblin, The 1994,Je 3,C15:1
Lyons, Robin (Screenwriter)
Princess and the Goblin, The 1994,Je 3,C15:1

M

Ma Huiwu (Miscellaneous)
Women from the Lake of Scented Souls 1994,F 16,C20:1
Ma, Tzi
Golden Gate 1994,Ja 28,C10:6
Ma, Yo-Yo
Immortal Beloved 1994,D 16,C4:4
Maal, Baaba (Composer)
Guelwaar 1993,Jl 28,C18:1
Maas, Dick (Producer)
Northerners, The 1993,N 6,13:1
Maberly, Kate
Secret Garden, The 1993,Ag 13,C3:1
Mabry, Zachary
Little Rascals, The 1994,Ag 5,C21:1
Mac, Bernie
House Party 3 1994,Ja 13,C17:1
Above the Rim 1994,Mr 23,C17:1
Mac, Lara (Miscellaneous)
Sex Is . . . 1993,S 9,C17:5
McAfee, Anndi
Tom and Jerry: The Movie 1993,Jl 30,C10:6
McAlpine, Andrew (Miscellaneous)
American Friends 1993,Ap 9,C8:5
Piano, The 1993,O 16,13:1
McAlpine, Donald M. (Cinematographer)
Man Without a Face, The 1993,Ag 25,C13:1
Mrs. Doubtfire 1993,N 24,C11:1
Clear and Present Danger 1994,Ag 3,C11:1
MacArthur, Charles (Director)
Crime Without Passion 1993,Ja 8,C1:1
Scoundrel, The 1993,Ja 8,C1:1
MacArthur, Charles (Producer)
Crime Without Passion 1993,Ja 8,C1:1
Scoundrel, The 1993,Ja 8,C1:1
MacArthur, Charles (Screenwriter)
Senator Was Indiscreet, The 1993,Ja 8,C1:1
Crime Without Passion 1993,Ja 8,C1:1
Scoundrel, The 1993,Ja 8,C1:1
Macat, Julio (Cinematographer)
So I Married an Axe Murderer 1993,Jl 30,C3:1
Ace Ventura, Pet Detective 1994,F 4,C8:6
Miracle on 34th Street 1994,N 18,C12:1
Macaulay, Scott (Producer)
What Happened Was . . . 1994,S 9,C16:4

McBride, Elizabeth (Miscellaneous)
Made in America 1993,My 28,C5:1
McCabe, Ruth
Snapper, The 1993,O 8,C21:1
Snapper, The 1993,N 24,C14:1
McCabe, Stephen (Miscellaneous)
Bodies, Rest and Motion 1993,Ap 9,C11:1
McCall, Dan (Original Author)
Jack the Bear 1993,Ap 2,C12:6
McCall, Mitzi
Opposite Sex, The 1993,Mr 27,15:2
McCallum, Rick (Producer)
Radioland Murders 1994,O 21,C5:1
McCamus, Tom
Man in Uniform, A 1994,Ag 19,C10:1
McCann, Donal
December Bride 1994,S 9,C6:5
McCann, Sean
Air Up There, The 1994,Ja 7,C16:6
McCarthy, Andrew
Weekend at Bernie's II 1993,Jl 10,15:4
Mrs. Parker and the Vicious Circle 1994,N 23,C9:3
McCarthy, Dennis (Composer)
Star Trek Generations 1994,N 18,C3:1
McCarthy, John (Composer)
Paris, France 1994,F 4,C6:5
McCarthy, Kevin
Matinee 1993,Ja 29,C6:4
McCarthy, Peter (Director)
Floundering 1994,N 4,C15:3
McCarthy, Peter (Miscellaneous)
Floundering 1994,N 4,C15:3
McCarthy, Peter (Producer)
Floundering 1994,N 4,C15:3
McCarthy, Peter (Screenwriter)
Car 54, Where Are You? 1994,Ja 31,C16:5
Floundering 1994,N 4,C15:3
McCarthy, Todd (Director)
Visions of Light: The Art of Cinematography 1993,Ap 2,C10:5
McCarthy, Todd (Screenwriter)
Visions of Light: The Art of Cinematography 1993,Ap 2,C10:5
Macchio, Ralph
Naked in New York 1994,Ap 15,C3:1
McClatchy, Kevin
Friend of Dorothy, A (Boys Life) 1994,D 2,C16:5
McClure, Doug
Maverick 1994,My 20,C1:3
McClurg, Edie
Airborne 1993,S 18,14:3
Natural Born Killers 1994,Ag 26,C1:1
McConnell, John
King of the Hill 1993,Ag 20,C1:1
McCord, Kent
Return of the Living Dead 3 1993,O 29,C8:4
McCormack, Dan (Director)
Minotaur 1994,Je 10,C12:5
McCormack, Dan (Screenwriter)
Minotaur 1994,Je 10,C12:5
McCormack, Leigh
Long Day Closes, The 1993,My 28,C12:3
McCormick, Carolyn
Rain Without Thunder 1993,F 5,C8:5
McCormick, Patrick (Producer)
Angie 1994,Mr 4,C6:5
McCourt, Emer
Riffraff 1993,F 12,C10:5
McCowen, Alec
Age of Innocence, The 1993,S 17,C1:3
McCracken, Mark
Matinee 1993,Ja 29,C6:4
McCudden, Paul (Miscellaneous)
Disco Years, The (Boys Life) 1994,D 2,C16:5
McCulloch, Kyle
Careful 1993,Ag 27,C8:5
McCurley, Mathew
North 1994,Jl 22,C3:1
McDermott, Alice (Original Author)
That Night 1993,Ag 6,C8:1
McDermott, Debra (Miscellaneous)
Hexed 1993,Ja 23,16:1
McDermott, Dylan
In the Line of Fire 1993,Jl 9,C1:3
Cowboy Way, The 1994,Je 3,C21:1
Miracle on 34th Street 1994,N 18,C12:1
McDermott, Shane
Airborne 1993,S 18,14:3

McDevitt, Faith
Claire of the Moon 1993,Ap 16,C11:1
McDonald, Christopher
Benefit of the Doubt 1993,Jl 16,C17:1
Fatal Instinct 1993,O 29,C8:1
Monkey Trouble 1994,Mr 18,C8:4
Quiz Show 1994,S 14,C11:1
MacDonald, George (Original Author)
Princess and the Goblin, The 1994,Je 3,C15:1
MacDonald, Jennifer
Clean, Shaven 1994,Mr 22,C19:1
McDonald, John (Screenwriter)
By the Sword 1993,O 22,C15:1
MacDonald, Richard (Miscellaneous)
Firm, The 1993,Je 30,C15:3
McDonnell, Mary
Sneakers 1993,Ja 10,II:11:1
Passion Fish 1993,Ja 24,II:11:1
Blue Chips 1994,F 18,C17:3
McDormand, Frances
Short Cuts 1993,O 1,C1:1
MacDowell, Alex (Miscellaneous)
Crow, The 1994,My 11,C15:4
MacDowell, Andie
Groundhog Day 1993,F 12,C3:4
Groundhog Day 1993,Mr 14,II:22:1
Short Cuts 1993,O 1,C1:1
Deception 1993,D 3,C10:1
Short Cuts 1994,Ja 21,C16:5
Four Weddings and a Funeral 1994,Mr 9,C15:5
Bad Girls 1994,Ap 22,C8:5
McDowell, Deborah
Lost Words, The 1994,S 21,C18:1
McDowell, Malcolm
Happily Ever After 1993,My 29,13:1
Chain of Desire 1993,Je 25,C19:3
Bopha! 1993,S 24,C18:1
Milk Money 1994,Ag 31,C11:1
Star Trek Generations 1994,N 18,C3:1
McElhinney, Ian
You, Me and Marley 1993,Mr 20,16:1
McElwee, Ross (Director)
Time Indefinite 1993,My 12,C13:1
McElwee, Ross (Miscellaneous)
Time Indefinite 1993,My 12,C13:1
McElwee, Ross (Narrator)
Time Indefinite 1993,My 12,C13:1
McElwee, Ross (Producer)
Time Indefinite 1993,My 12,C13:1
McEntire, Reba
North 1994,Jl 22,C3:1
Little Rascals, The 1994,Ag 5,C21:1
McEveety, Stephen (Miscellaneous)
Airborne 1993,S 18,14:3
McEveety, Stephen (Producer)
Airborne 1993,S 18,14:3
McEwan, Ian (Original Author)
Cement Garden, The 1994,F 11,C24:1
McEwan, Ian (Screenwriter)
Good Son, The 1993,S 24,C12:5
McFadden, Gates
Star Trek Generations 1994,N 18,C3:1
MacFadyen, Christie
Risk 1994,O 5,C18:1
McGarry, Aris (Producer)
Kalifornia 1993,S 3,C11:1
McGaw, Patrick
Amongst Friends 1993,Jl 23,C10:6
Beans of Egypt, Maine, The 1994,N 23,C13:1
McGehee, Kelly (Miscellaneous)
Suture 1994,Mr 18,C15:1
McGehee, Scott (Director)
Suture 1994,Mr 18,C15:1
McGehee, Scott (Producer)
Suture 1994,Mr 18,C15:1
McGehee, Scott (Screenwriter)
Suture 1994,Mr 18,C15:1
McGibbon, Josann (Screenwriter)
Favor, The 1994,Ap 29,C8:5
McGillin, Howard
Swan Princess, The 1994,N 18,C20:5
McGillis, Kelly
North 1994,Jl 22,C3:1
McGinley, John C.
Watch It 1993,Mr 26,C12:1
Hear No Evil 1993,Mr 29,C16:1
Car 54, Where Are You? 1994,Ja 31,C16:5
On Deadly Ground 1994,F 19,11:1

Surviving the Game 1994,Ap 16,11:3
Wagons East! 1994,Ag 26,C16:1
McGinley, John C. (Producer)
Watch It 1993,Mr 26,C12:1
McGlashan, John (Cinematographer)
Buddha of Suburbia, The 1994,D 9,C8:1
McGovern, Elizabeth
King of the Hill 1993,Ag 20,C1:1
Me and Veronica 1993,S 24,C25:1
Favor, The 1994,Ap 29,C8:5
McGowan, Tom
Mrs. Parker and the Vicious Circle 1994,N 23,C9:3
McGrath, Bob
Lost Words, The 1994,S 21,C18:1
McGrath, Derek
Freaked 1993,O 2,14:3
McGrath, Douglas (Screenwriter)
Born Yesterday 1993,Mr 26,C17:2
Bullets over Broadway 1994,S 30,C1:1
Macgregor-Scott, Peter (Producer)
Black Beauty 1994,Jl 29,C29:1
McHenry, Doug (Director)
Jason's Lyric 1994,S 28,C14:3
McHenry, Doug (Producer)
Jason's Lyric 1994,S 28,C14:3
Machkov, Vladimir
Ivan and Abraham 1994,Mr 23,C17:1
Macias, Juan Carlos (Miscellaneous)
I Don't Want to Talk About It 1994,S 30,C12:1
Maciejko-Kowalczyk, Katarzyna (Miscellaneous)
Birthplace 1993,O 14,C20:5
McKay, Craig (Miscellaneous)
Mad Dog and Glory 1993,Mr 5,C3:1
Philadelphia 1993,D 22,C15:3
Mackay, James (Producer)
Blue 1993,O 2,16:2
McKean, Michael
Coneheads 1993,Jl 23,C3:2
Airheads 1994,Ag 5,C10:1
McKellan, Ian
Last Action Hero 1993,Je 18,C1:3
McKellar, Danica
Sidekicks 1993,My 1,17:4
McKellar, Don
Exotica 1994,S 24,11:1
McKellar, Don (Screenwriter)
32 Short Films About Glenn Gould 1994,Ap 14,C15:1
McKellen, Ian
Ballad of Little Jo, The 1993,Ag 20,C10:1
Six Degrees of Separation 1993,D 8,C17:1
Shadow, The 1994,Jl 1,C1:1
McKenzie, Jacqueline
Romper Stomper 1993,Je 9,C17:1
MacKinnon, Gillies (Director)
Simple Twist of Fate, A 1994,S 2,C3:1
McKinnon, Ray
Needful Things 1993,Ag 27,C17:1
Mackintosh, Steven
Buddha of Suburbia, The 1994,D 9,C8:1
MacLachlan, Kyle
Rich in Love 1993,Mr 5,C8:1
Trial, The 1993,N 24,C16:1
Flintstones, The 1994,My 27,C1:1
MacLaine, Shirley
Used People 1993,Ja 3,II:9:1
Wrestling Ernest Hemingway 1993,D 17,C12:6
Guarding Tess 1994,Mr 11,C12:1
MacLaren, Deborah
Naked 1993,O 15,C3:3
Maclean, Alison (Director)
Crush 1993,S 10,C8:5
Maclean, Alison (Screenwriter)
Crush 1993,S 10,C8:5
McLean, Steve (Director)
Postcards from America 1994,O 8,14:1
McLean, Steve (Screenwriter)
Postcards from America 1994,O 8,14:1
McLennan, Gordon (Miscellaneous)
Risk 1994,O 5,C18:1
McLennan, Gordon (Producer)
Risk 1994,O 5,C18:1
McMartin, Susan (Miscellaneous)
Son-in-Law 1993,Jl 2,C14:6
McMillan, Kenneth (Cinematographer)
Lassie 1994,Jl 22,C1:1
McMillan, T. Wendy
Go Fish 1994,Je 10,C6:4

McNamara, Pat
Trusting Beatrice 1993,F 12,C10:5
McNamara, William
Surviving the Game 1994,Ap 16,11:3
Chasers 1994,Ap 23,15:1
McNaughton, John (Director)
Mad Dog and Glory 1993,Mr 5,C3:1
Mad Dog and Glory 1993,Mr 14,II:22:1
McNeely, Joel (Composer)
Iron Will 1994,Ja 14,C6:3
Terminal Velocity 1994,S 23,C20:5
Radioland Murders 1994,O 21,C5:1
McNeil, Leslie (Miscellaneous)
Benny and Joon 1993,Ap 16,C13:1
MacNicol, Peter
Addams Family Values 1993,N 19,C3:4
MacPherson, Elle
Sirens 1994,Mr 4,C16:1
McRae, Frank
Last Action Hero 1993,Je 18,C1:3
MacRury, Malcolm (Screenwriter)
Man Without a Face, The 1993,Ag 25,C13:1
McShane, Michael
Richie Rich 1994,D 21,C19:1
McTiernan, John (Director)
Last Action Hero 1993,Je 18,C1:3
McTiernan, John (Producer)
Last Action Hero 1993,Je 18,C1:3
McWorter, Kathy (Screenwriter)
War, The 1994,N 4,C10:5
Macy, William H.
Benny and Joon 1993,Ap 16,C13:1
Searching for Bobby Fischer 1993,Ag 11,C13:3
Twenty Bucks 1993,O 22,C8:5
Oleanna 1994,N 4,C22:4
Madame X
Sex Is . . . 1993,S 9,C17:5
Maddalena, Marianne (Producer)
Wes Craven's New Nightmare 1994,O 14,C8:5
Madden, John
Little Giants 1994,O 14,C12:6
Madden, John (Director)
Ethan Frome 1993,Mr 12,C8:5
Golden Gate 1994,Ja 28,C10:6
Maddin, Guy (Director)
Careful 1993,Ag 27,C8:5
Maddock, Brent (Screenwriter)
Heart and Souls 1993,Ag 13,C14:5
Mader (Composer)
Wedding Banquet, The 1993,Ag 4,C18:1
Eat Drink Man Woman 1994,Ag 3,C16:3
Madigan, Amy
Dark Half, The 1993,Ap 23,C10:1
Madonna
Body of Evidence 1993,Ja 15,C3:1
Body of Evidence 1993,Ja 17,II:11:1
Body of Evidence 1993,Ja 22,C1:1
Dangerous Game 1993,N 19,C14:5
Madsen, Michael
Free Willy 1993,Jl 16,C12:6
Getaway, The 1994,F 11,C12:5
Wyatt Earp 1994,Je 24,C1:5
Maeda, Yonezo (Cinematographer)
Minbo—or the Gentle Art of Japanese Extortion 1994,O 19,C17:3
Maerten, Rudi (Miscellaneous)
Moving In 1993,O 16,18:1
Maerthesheimer, Peter (Producer)
I Only Want You to Love Me 1994,Ap 15,C10:4
Martha 1994,S 24,16:3
Maffia, Roma
Disclosure 1994,D 9,C1:1
Maffucci, Marta (Miscellaneous)
Caro Diario (Dear Diary) 1994,S 26,C11:3
Maganini, Elena (Miscellaneous)
Mad Dog and Glory 1993,Mr 5,C3:1
Magidson, Mark (Miscellaneous)
Baraka 1993,S 24,C14:6
Magidson, Mark (Producer)
Baraka 1993,S 24,C14:6
Magidson, Mark (Screenwriter)
Baraka 1993,S 24,C14:6
Magnani, Anna
Bellissima 1994,Je 24,C27:1
Magnien, Richard (Producer)
Silences of the Palace, The 1994,S 30,C30:3
Magnuson, Ann
Cabin Boy 1994,Ja 7,C12:6

Clear and Present Danger 1994,Ag 3,C11:1
Maguire, Jeff (Screenwriter)
In the Line of Fire 1993,Jl 9,C1:3
Mahlaba, Grace
Being Human 1994,My 6,C10:3
Mahler, Gustav (Composer)
Whispering Pages 1994,S 28,C14:3
Mahoney, John
Striking Distance 1993,S 17,C17:1
Reality Bites 1994,F 18,C3:2
Mai, Vu
Joy Luck Club, The 1993,S 8,C15:3
Maidment, Rex (Cinematographer)
Summer House, The 1993,D 21,C19:1
Mailer, Norman
Life and Times of Allen Ginsberg, The 1994,F 18,C10:1
Maillé, Claudette
Like Water for Chocolate 1993,F 17,C13:3
Main, Stewart (Director)
Desperate Remedies 1994,My 23,C14:4
Main, Stewart (Screenwriter)
Desperate Remedies 1994,My 23,C14:4
Maina, Charles Gitonga
Air Up There, The 1994,Ja 7,C16:6
Major, Grant (Miscellaneous)
Jack Be Nimble 1994,Je 10,C21:4
Heavenly Creatures 1994,N 16,C17:1
Majorino, Tina
When a Man Loves a Woman 1994,Ap 29,C1:1
Corrina, Corrina 1994,Ag 12,C3:2
Andre 1994,Ag 17,C9:3
Mak, Michael (Director)
Sex and Zen 1993,O 29,C10:6
Makkena, Wendy
Sister Act 2: Back in the Habit 1993,D 10,C10:4
Camp Nowhere 1994,Ag 26,C3:2
Mako
Sidekicks 1993,My 1,17:4
Rising Sun 1993,Jl 30,C1:4
Makuvachuma, Dominic
Jit 1993,Mr 20,16:1
Malahide, Patrick
December Bride 1994,S 9,C6:5
Malas, Mohammed (Director)
Night, The 1993,O 4,C15:3
Malas, Mohammed (Screenwriter)
Night, The 1993,O 4,C15:3
Malas, Omar
Night, The 1993,O 4,C15:3
Malchus, Karyn
Hocus Pocus 1993,Jl 16,C16:1
Freaked 1993,O 2,14:3
Malcomson, Paula
Another Girl, Another Planet 1993,Ap 1,C22:1
Maleret, Dominique (Miscellaneous)
Barjo 1993,Jl 7,C14:3
Malherbe, Annet
Northerners, The 1993,N 6,13:1
Malik, Art
True Lies 1994,Jl 15,C1:1
Malina, Judith
Household Saints 1993,S 15,C15:2
Malinger, Ross
Sleepless in Seattle 1993,Je 25,C10:5
Malins, Gregory S. (Screenwriter)
. . . And God Spoke 1994,S 23,C10:5
Malkiewicz, Lisa
Mr. Jones 1993,O 8,C10:5
Malkin, Barry (Miscellaneous)
It Could Happen to You 1994,Jl 29,C10:5
Malkovich, John
Alive 1993,Ja 15,C6:5
In the Line of Fire 1993,Jl 9,C1:3
In the Line of Fire 1993,Jl 11,II:10:4
In the Line of Fire 1993,Ag 29,II:11:5
Malle, Louis (Director)
Damage 1993,Ja 22,C1:1
Lovers, The 1994,Jl 8,C1:3
Vanya on 42d Street 1994,O 19,C13:1
Mallet, Corinne
Genius, The 1993,Ap 2,C34:1
Mallian, Jeffrey B. (Producer)
Leprechaun 1993,Ja 9,17:1
Maloney, Denis (Cinematographer)
Floundering 1994,N 4,C15:3
Maltby, Barbara (Producer)
King of the Hill 1993,Ag 20,C1:1

Ladybird, Ladybird 1994,O 7,C18:3
Morris, Mary McGarry (Original Author)
Dangerous Woman, A 1993,D 3,C19:1
Morris, Redmond (Producer)
Splitting Heirs 1993,My 1,17:1
Morrison, Jenny
Intersection 1994,Ja 21,C8:6
Morrison, Dr. Philip
Berenice Abbott: A View of the 20th Century
1994,D 7,C15:4
Morriss, Frank (Miscellaneous)
Point of No Return 1993,Mr 19,C10:5
Drop Zone 1994,D 9,C12:1
Morrow, Rob
Quiz Show 1994,S 14,C11:1
Morse, David
Good Son, The 1993,S 24,C12:5
Getaway, The 1994,F 11,C12:5
Morse, Natalie
Anchoress 1994,N 9,C12:1
Morse, Susan E. (Miscellaneous)
Manhattan Murder Mystery 1993,Ag 18,C13:5
Bullets over Broadway 1994,S 30,C1:1
Mortensen, Viggo
Boiling Point 1993,Ap 17,16:1
Carlito's Way 1993,N 10,C19:4
Deception 1993,D 3,C10:1
Mortimer, John (Miscellaneous)
Innocents, The 1993,Je 25,C1:1
Morton, Amy
Rookie of the Year 1993,Jl 7,C14:6
Morton, Joe
Inkwell, The 1994,Ap 22,C8:5
Speed 1994,Je 10,C12:1
Morton, Rocky (Director)
Super Mario Brothers 1993,My 29,11:1
Moses, Bob
Freedom on My Mind 1994,Je 22,C13:1
Mosher, Howard Frank (Original Author)
Where the Rivers Flow North 1994,Mr 4,C15:1
Mosier, Scott (Miscellaneous)
Clerks 1994,Mr 25,C10:1
Mosier, Scott (Producer)
Clerks 1994,Mr 25,C10:1
Moskowicz, Sergio (Producer)
Girl in the Watermelon, The 1994,Mr 18,C29:1
Moss, Elizabeth
Once Upon a Forest 1993,Je 18,C10:1
Imaginary Crimes 1994,O 14,C16:1
Moss, George
Riffraff 1993,F 12,C10:5
Moss, Thomas V. (Miscellaneous)
Hans Christian Andersen's "Thumbelina" 1994,Mr
30,C19:1
Most, Jeff (Producer)
Crow, The 1994,My 11,C15:4
Mothersbaugh, Mark (Composer)
New Age, The 1994,S 16,C5:3
Mothes, Stefan (Miscellaneous)
Wonderful, Horrible Life of Leni Riefenstahl, The
1993,O 14,C15:1
Motta, Camila (Director)
Secuestro: A Story of a Kidnapping 1994,Ja
19,C20:1
Motta, Camila (Producer)
Secuestro: A Story of a Kidnapping 1994,Ja
19,C20:1
Mounir, Adel (Miscellaneous)
Little Dreams 1994,Mr 30,C19:1
Mount, Peggy
Princess and the Goblin, The 1994,Je 3,C15:1
Mount, Thom (Producer)
Death and the Maiden 1994,D 23,C3:4
Mouraad/Sabreen, Said (Composer)
Curfew 1994,D 7,C17:1
Mourão, Tulio (Composer)
Under One Roof 1994,Mr 25,C18:1
Mourouzi, Nadia
Beekeeper, The 1993,My 7,C21:4
Moussard, Laurent (Screenwriter)
Betrayal 1994,Mr 19,18:1
Moy, Judy (Producer)
Combination Platter 1993,Mr 27,11:2
Mtukudzi, Oliver
Jit 1993,Mr 20,16:1
Mtwa, Percy (Original Author)
Bopha! 1993,S 24,C18:1

Mueller-Stahl, Armin
Utz 1993,F 10,C15:5
House of the Spirits, The 1994,Ap 1,C1:1
Mugel, Jean-Paul (Miscellaneous)
Wild Reeds 1994,O 7,C18:3
Mugge, Robert (Director)
Kingdom of Zydeco, The 1994,Jl 2,13:3
Mulcahy, Russell (Director)
Real McCoy, The 1993,S 10,C10:6
Shadow, The 1994,Jl 1,C1:1
Mulford, Marilyn (Director)
Freedom on My Mind 1994,Je 22,C13:1
Mulford, Marilyn (Producer)
Freedom on My Mind 1994,Je 22,C13:1
Mulkey, Chris
Ghost in the Machine 1993,D 30,C11:5
Mullally, Ken (Miscellaneous)
War Against the Indians, The 1993,Ap 16,C15:1
Mullen, Dan
Vermont Is for Lovers 1993,Mr 26,C6:5
Mullen, Jeramiah
Vermont Is for Lovers 1993,Mr 26,C6:5
Müller, Ray (Director)
Wonderful, Horrible Life of Leni Riefenstahl, The
1993,O 14,C15:1
Wonderful, Horrible Life of Leni Riefenstahl, The
1994,Mr 16,C20:1
Muller, Robby (Cinematographer)
Mad Dog and Glory 1993,Mr 5,C3:1
Mullins, Peter (Miscellaneous)
Son of the Pink Panther 1993,Ag 28,9:5
Mulroney, Dermot
Point of No Return 1993,Mr 19,C10:5
Silent Tongue 1994,F 25,C3:2
Bad Girls 1994,Ap 22,C8:5
Mulrooney, Anastasia
Wedding Gift, The 1994,Jl 20,C18:1
Mulvehill, Charles (Producer)
Malice 1993,O 1,C5:1
Only You 1994,O 7,C12:1
Munn, Michael (Miscellaneous)
Masala 1993,Mr 26,C10:1
Munne, Pep
Barcelona 1994,Jl 29,C3:1
Munro, Rona (Screenwriter)
Ladybird, Ladybird 1994,O 7,C18:3
Murakami, Hiroyuki (Composer)
Work on the Grass 1994,Ag 17,C12:3
Murakami, Kouen
Original Sin 1993,Mr 26,C6:1
Murakami, Ryu (Director)
Tokyo Decadence 1993,Jl 30,C12:6
Murakami, Ryu (Screenwriter)
Tokyo Decadence 1993,Jl 30,C12:6
Murata, Takehiro
Okoge 1993,Mr 29,C13:1
Minbo—or the Gentle Art of Japanese Extortion
1994,O 19,C17:3
Murawski, Bob (Miscellaneous)
Army of Darkness 1993,F 19,C10:5
Hard Target 1993,Ag 20,C8:5
Murch, Walter (Miscellaneous)
House of Cards 1993,Je 25,C18:5
Romeo Is Bleeding 1994,F 4,C15:1
Murger, Henri (Original Author)
Vie de Bohème, La 1993,Jl 29,C15:4
Vie de Bohème, La 1993,S 3,C3:1
Murillo, Christine
Vie de Bohème, La 1993,Jl 29,C15:4
Murnau, F. W. (Director)
Nosferatu: A Symphony of Horror 1993,Ap 2,C1:4
Murota, Hideo
Original Sin 1993,Mr 26,C6:1
Murphy, Bill (Miscellaneous)
Romper Stomper 1993,Je 9,C17:1
Murphy, Charlie
CB4 1993,Mr 12,C13:1
Murphy, Don (Producer)
Natural Born Killers 1994,Ag 26,C1:1
Murphy, Eddie
Beverly Hills Cop III 1994,My 25,C14:3
Murphy, Fred (Cinematographer)
Jack the Bear 1993,Ap 2,C12:6
Pickle, The 1993,My 1,11:1
Murphy, Karen (Producer)
Twenty Bucks 1993,O 22,C8:5
Murphy, Michael
Clean Slate 1994,My 6,C10:3

Murphy, Reilly
Dangerous Game 1993,N 19,C14:5
Murray, Bill
Groundhog Day 1993,F 12,C3:4
Mad Dog and Glory 1993,Mr 5,C3:1
Mad Dog and Glory 1993,Mr 14,II:22:1
Groundhog Day 1993,Mr 14,II:22:1
Mad Dog and Glory 1993,Ap 11,II:11:5
Ed Wood 1994,S 23,C34:1
Murray, Graeme (Miscellaneous)
Knight Moves 1993,Ja 23,16:3
Murray, Peter
Princess and the Goblin, The 1994,Je 3,C15:1
Mussen, Samuel
Between Heaven and Earth 1993,O 1,C5:1
Mutabaruka
Sankofa 1994,Ap 8,C8:5
Muthu, Mike
Praying with Anger 1993,S 15,C26:1
Muti, Ornella
Especially on Sunday 1993,Ag 13,C14:5
Muto, John (Miscellaneous)
Heart and Souls 1993,Ag 13,C14:5
Wilder Napalm 1993,Ag 20,C14:1
Mutrux, Floyd (Screenwriter)
Bound by Honor 1993,Ap 30,C8:1
Myers, Mike
So I Married an Axe Murderer 1993,Jl 30,C3:1
Wayne's World 2 1993,D 10,C20:6
Myers, Mike (Screenwriter)
Wayne's World 2 1993,D 10,C20:6
Myers, Stanley (Composer)
Summer House, The 1993,D 21,C19:1
Myers, Stephen (Miscellaneous)
Fatal Instinct 1993,O 29,C8:1
Myerscough-Jones, David (Miscellaneous)
Hawk, The 1993,D 10,C21:1
Myhre, John (Miscellaneous)
Airborne 1993,S 18,14:3
Myles, Lynda (Producer)
Snapper, The 1993,O 8,C21:1
Mynster, Karen-Lise
Sofie 1993,My 21,C8:1
Sofie 1993,Je 20,II:19:5

N

Na Weixun
Red Lotus Society, The 1994,O 5,C18:1
Naderi, Amir (Director)
Manhattan by Numbers 1993,Ap 2,C34:4
Manhattan by Numbers 1994,N 11,C12:5
Naderi, Amir (Miscellaneous)
Manhattan by Numbers 1993,Ap 2,C34:4
Manhattan by Numbers 1994,N 11,C12:5
Naderi, Amir (Screenwriter)
Manhattan by Numbers 1993,Ap 2,C34:4
Manhattan by Numbers 1994,N 11,C12:5
Nae, Victorita (Miscellaneous)
Unforgettable Summer, An 1994,N 11,C12:1
Nagarjuna
God Is My Witness 1993,Ag 20,C8:5
Nagase, Masatoshi
Original Sin 1993,Mr 26,C6:1
Autumn Moon 1994,Ag 26,C8:1
Nagata, Yosuke (Producer)
Tokyo Decadence 1993,Jl 30,C12:6
Nagatsuka, Kyozo
Okoge 1993,Mr 29,C13:1
Nailer, John (Miscellaneous)
War Against the Indians, The 1993,Ap 16,C15:1
Najimy, Kathy
Hocus Pocus 1993,Jl 16,C16:1
Sister Act 2: Back in the Habit 1993,D 10,C10:4
Nakagawa, Yasunobu (Screenwriter)
Down the Drain 1994,Ap 1,C6:5
Nakahara, Takeo
Okoge 1993,Mr 29,C13:1
Nakajima, Takehiro (Director)
Okoge 1993,Mr 29,C13:1
Nakajima, Takehiro (Producer)
Okoge 1993,Mr 29,C13:1
Nakajima, Takehiro (Screenwriter)
Okoge 1993,Mr 29,C13:1

Nakamura, Shuji (Miscellaneous)
Minbo—or the Gentle Art of Japanese Extortion 1994,O 19,C17:3
Nardi, Tonino (Cinematographer)
Ladro di Bambini, Il 1993,Mr 3,C13:4
Narita, Hiro (Cinematographer)
Hocus Pocus 1993,Jl 16,C16:1
Gunmen 1994,F 4,C8:6
White Fang 2: Myth of the White Wolf 1994,Ap 15,C23:1
Naschak, Andrea
Hold Me, Thrill Me, Kiss Me 1993,Jl 30,C12:1
Nasso, Julius R. (Producer)
On Deadly Ground 1994,F 19,11:1
Nathansen, Henri (Original Author)
Sofie 1993,My 21,C8:1
Naumann, Kurt
Architects, The 1993,O 27,C14:3
Navarro, Bertha (Producer)
Cronos 1994,Mr 24,C16:6
Navarro, David M.
Floundering 1994,N 4,C15:3
Navarro, Guillermo (Cinematographer)
Cronos 1994,Mr 24,C16:6
Nayar, Nisha
Bhaji on the Beach 1994,Mr 19,13:1
Bhaji on the Beach 1994,My 18,C20:2
Nazaraschwili, Awto (Composer)
Night Dance 1993,Mr 31,C20:1
Ndemera, Winnie
Jit 1993,Mr 20,16:1
Ndiaye, Thierno
Guelwaar 1993,Jl 28,C18:1
Ndonde, Evodia (Miscellaneous)
These Hands 1994,Mr 26,14:5
Neal, Chris (Composer)
Jack Be Nimble 1994,Je 10,C21:4
Neal, John (Miscellaneous)
You So Crazy 1994,Ap 27,C18:1
Neale, Brent
Careful 1993,Ag 27,C8:5
Nebout, Claire
Conviction, The 1994,My 13,C10:5
Nedd-Friendly, Priscilla (Miscellaneous)
That Night 1993,Ag 6,C8:1
Undercover Blues 1993,S 11,13:1
Clean Slate 1994,My 6,C10:3
Neeson, Liam
Ethan Frome 1993,Mr 12,C8:5
Deception 1993,D 3,C10:1
Schindler's List 1993,D 15,C19:3
Nell 1994,D 14,C15:1
Negre, Alain (Miscellaneous)
Scent of Green Papaya, The 1993,O 11,C15:2
Neighbors, Troy (Screenwriter)
Fortress 1993,S 4,11:1
Neil, Debra (Miscellaneous)
War, The 1994,N 4,C10:5
Neill, Sam
Piano, The 1993,My 18,C13:3
Jurassic Park 1993,Je 11,C1:1
Piano, The 1993,O 16,13:1
Piano, The 1993,N 12,C12:6
Piano, The 1993,N 28,II:13:1
Sirens 1994,Mr 4,C16:1
Neiwiller, Antonio
Caro Diario (Dear Diary) 1994,S 26,C11:3
Nelligan, Kate
Fatal Instinct 1993,O 29,C8:1
Wolf 1994,Je 17,C4:1
Nelson, Davia (Screenwriter)
Imaginary Crimes 1994,O 14,C16:1
Nelson, Jessie (Director)
Corrina, Corrina 1994,Ag 12,C3:2
Nelson, Jessie (Producer)
Corrina, Corrina 1994,Ag 12,C3:2
Nelson, Jessie (Screenwriter)
Corrina, Corrina 1994,Ag 12,C3:2
Nelson, Lee (Producer)
Seventh Coin, The 1993,S 10,C5:1
Nelson, Mari
Bad Girls 1994,Ja 28,C8:5
Nelson, Novella
Weekend at Bernie's II 1993,Jl 10,15:4
Nelson, Richard (Screenwriter)
Ethan Frome 1993,Mr 12,C8:5
Nelson, Sean
Fresh 1994,Ap 1,C6:2

Fresh 1994,Ag 24,C13:1
Fresh 1994,S 2,C16:4
Nemec, Corin
Drop Zone 1994,D 9,C12:1
Nemec, Joseph, III (Miscellaneous)
Judgment Night 1993,O 15,C8:5
Getaway, The 1994,F 11,C12:5
Shadow, The 1994,Jl 1,C1:1
Nene, Sibongile
Jit 1993,Mr 20,16:1
Neri, Francesca
Flight of the Innocent 1993,O 22,C8:5
Neufeld, Mace (Producer)
Beverly Hills Cop III 1994,My 25,C14:3
Clear and Present Danger 1994,Ag 3,C11:1
Neumann, Wolfgang (Composer)
Wonderful, Horrible Life of Leni Riefenstahl, The 1993,O 14,C15:1
Neumeier, Marco
Passages 1993,Mr 23,C14:3
Neuwirth, Bebe
Malice 1993,O 1,C5:1
Neville, Aaron
Posse 1993,My 14,C15:1
Neville, John
Road to Wellville, The 1994,O 28,C13:1
Little Women 1994,D 21,C13:1
Neville, Sarah
Careful 1993,Ag 27,C8:5
Nevin, Robyn
Resistance 1994,N 23,C18:1
Newborn, Ira (Composer)
Opposite Sex, The 1993,Mr 27,15:2
Ace Ventura, Pet Detective 1994,F 4,C8:6
Naked Gun 33 1/3: The Final Insult 1994,Mr 18,C14:6
Newby, Christopher (Director)
Relax (Boys' Shorts) 1993,Jl 21,C17:1
Anchoress 1994,N 9,C12:1
Newby, Christopher (Screenwriter)
Relax (Boys' Shorts) 1993,Jl 21,C17:1
Newell, Mike (Director)
Into the West 1993,S 17,C17:1
Four Weddings and a Funeral 1994,Mr 9,C15:5
Newman, David (Composer)
Sandlot, The 1993,Ap 7,C17:1
Coneheads 1993,Jl 23,C3:2
That Night 1993,Ag 6,C8:1
Undercover Blues 1993,S 11,13:1
Air Up There, The 1994,Ja 7,C16:6
My Father, the Hero 1994,F 4,C10:6
Flintstones, The 1994,My 27,C1:1
Cowboy Way, The 1994,Je 3,C21:1
I Love Trouble 1994,Je 29,C15:1
Newman, Jim (Miscellaneous)
Space Is the Place 1993,S 3,C9:1
Newman, Jim (Producer)
Space Is the Place 1993,S 3,C9:1
Newman, Laraine
Coneheads 1993,Jl 23,C3:2
Newman, Paul
Hudsucker Proxy, The 1994,Mr 11,C8:5
Nobody's Fool 1994,D 23,C5:1
Newman, Peter (Producer)
Household Saints 1993,S 15,C15:2
Newman, Randy (Composer)
Paper, The 1994,Mr 18,C19:1
Maverick 1994,My 20,C1:3
Newman, Thomas (Composer)
Flesh and Bone 1993,N 5,C10:1
Threesome 1994,Ap 8,C12:4
Shawshank Redemption, The 1994,S 23,C3:1
War, The 1994,N 4,C10:5
Little Women 1994,D 21,C13:1
Newman, William
Leprechaun 1993,Ja 9,17:1
Newmyer, Robert (Producer)
Opposite Sex, The 1993,Mr 27,15:2
Indian Summer 1993,Ap 23,C10:5
Wagons East! 1994,Ag 26,C16:1
Santa Clause, The 1994,N 11,C24:1
Newsom, David
Wes Craven's New Nightmare 1994,O 14,C8:5
Newton, Jeremiah
Split 1993,S 3,C6:5
Ng, Irene
Joy Luck Club, The 1993,S 8,C15:3

Ng, Lawrence
Sex and Zen 1993,O 29,C10:6
Nga, Thi Thanh. See Tiana
Ngor, Haing S.
My Life 1993,N 12,C17:1
Heaven and Earth 1993,D 24,C1:4
Ngor, Peter (Cinematographer)
Sex and Zen 1993,O 29,C10:6
Ni Da Hong
To Live 1994,S 30,C30:1
Ni Shujun
Confucian Confusion, A 1994,O 1,12:1
Niami, Ramin (Producer)
Manhattan by Numbers 1993,Ap 2,C34:4
Niang, Isseu
Guelwaar 1993,Jl 28,C18:1
Nibbelink, Phil (Director)
We're Back! A Dinosaur's Story 1993,N 24,C20:6
Nicastro, Michelle
Swan Princess, The 1994,N 18,C20:5
Nichetti, Maurizio
Volere, Volare 1993,F 3,C14:1
Stefano Quantestorie (Stefano Many Stories) 1994,N 23,C18:1
Nichetti, Maurizio (Director)
Volere, Volare 1993,F 3,C14:1
Stefano Quantestorie (Stefano Many Stories) 1994,N 23,C18:1
Nichetti, Maurizio (Miscellaneous)
Stefano Quantestorie (Stefano Many Stories) 1994,N 23,C18:1
Nichetti, Maurizio (Screenwriter)
Volere, Volare 1993,F 3,C14:1
Stefano Quantestorie (Stefano Many Stories) 1994,N 23,C18:1
Nicholas, Thomas Ian
Rookie of the Year 1993,Jl 7,C14:6
Nichols, David (Miscellaneous)
Groundhog Day 1993,F 12,C3:4
Airheads 1994,Ag 5,C10:1
Nichols, Kyra
George Balanchine's "The Nutcracker" 1993,N 24,C11:1
George Balanchine's "The Nutcracker" 1993,D 1,C17:3
Nichols, Mike (Director)
Wolf 1994,Je 17,C4:1
Wolf 1994,Je 19,II:13:1
Nichols, Mike (Producer)
Remains of the Day, The 1993,N 5,C1:1
Nichols, Taylor
Barcelona 1994,Jl 29,C3:1
Nicholson, Dana Wheeler
My Life's in Turnaround 1994,Je 17,C5:5
Nicholson, Jack
Few Good Men, A 1993,Ja 3,II:9:1
Wolf 1994,Je 17,C4:1
Wolf 1994,Je 19,II:13:1
Nicholson, Jennifer
Inevitable Grace 1994,S 30,C8:5
Nicholson, William (Original Author)
Shadowlands 1993,D 29,C11:1
Nicholson, William (Screenwriter)
Shadowlands 1993,D 29,C11:1
Nell 1994,D 14,C15:1
Nicita, Wallis (Producer)
Dream Lover 1994,My 6,C11:1
Drop Zone 1994,D 9,C12:1
Nickson-Soul, Julia
Sidekicks 1993,My 1,17:4
Nicolaides, Steve (Producer)
Poetic Justice 1993,Jl 23,C1:1
Nicolini, Angelo (Miscellaneous)
It's Happening Tomorrow 1994,Ap 1,C12:1
Niculescu, Christian (Miscellaneous)
Betrayal 1994,Mr 19,18:1
Nie Tiejun (Cinematographer)
Red Beads 1994,S 2,C12:5
Niehaus, Lennie (Composer)
Perfect World, A 1993,N 24,C11:1
Nielsen, Leslie
Surf Ninjas 1993,Ag 21,9:1
Naked Gun 33 1/3: The Final Insult 1994,Mr 18,C14:6
Nikaido, Miho
Tokyo Decadence 1993,Jl 30,C12:6
Nilsson, Goran (Cinematographer)
Slingshot, The 1994,Je 3,C19:1

O

P

Perlich, Max
Born Yesterday 1993,Mr 26,C17:2
Perlman, Itzhak
Schindler's List 1993,D 15,C19:3
Perlman, Rhea
We're Back! A Dinosaur's Story 1993,N 24,C20:6
Perlman, Ron
Adventures of Huck Finn, The 1993,Ap 2,C15:1
Cronos 1994,Mr 24,C16:6
Permenter, David
Leprechaun 1993,Ja 9,17:1
Permut, David (Producer)
Temp, The 1993,F 13,17:1
Surviving the Game 1994,Ap 16,11:3
Pernel, Florence
Blue 1993,O 12,C15:1
Peroni, Geraldine (Miscellaneous)
Short Cuts 1993,O 1,C1:1
Ready to Wear 1994,D 23,C1:1
Perpignani, Roberto (Miscellaneous)
Fiorile 1993,O 13,C21:1
Perreau, Brigitte (Miscellaneous)
Normal People Are Nothing Special 1994,Mr
18,C1:1
Perrier, Mireille
Shades of Doubt (Ombre du Doute, L') 1993,O
2,16:1
Betrayal 1994,Mr 19,18:1
Perrin, Jacques
Flight of the Innocent 1993,O 22,C8:5
Long Silence, The 1994,Ap 29,C12:5
Perrin, Jacques (Producer)
Guelwaar 1993,Jl 28,C18:1
Perrine, Valerie
Boiling Point 1993,Ap 17,16:1
Perry, David
Sex Is . . . 1993,S 9,C17:5
Perry, Frank
On the Bridge 1993,O 8,C10:5
Perry, Frank (Director)
On the Bridge 1993,O 8,C10:5
Perry, Frank (Producer)
On the Bridge 1993,O 8,C10:5
Perry, Jaime
Familiar Differences (Young Black Cinema II)
1994,S 9,C17:1
Perry, Luke
8 Seconds 1994,F 25,C14:1
Perry, Steve (Producer)
True Romance 1993,S 10,C5:1
Persson, Jorgen (Cinematographer)
Sofie 1993,My 21,C8:1
House of the Spirits, The 1994,Ap 1,C1:1
Perugorría, Jorge
Strawberry and Chocolate 1994,S 24,16:3
Pesci, Joe
Bronx Tale, A 1993,S 29,C13:4
Jimmy Hollywood 1994,Mr 30,C15:3
With Honors 1994,Ap 29,C12:1
Peterman, Donald (Cinematographer)
Addams Family Values 1993,N 19,C3:4
Speechless 1994,D 16,C10:5
Peters, Charlie (Screenwriter)
My Father, the Hero 1994,F 4,C10:6
Peters, Ilse (Miscellaneous)
Architects, The 1993,O 27,C14:3
Peters, Paul (Miscellaneous)
Lassie 1994,Jl 22,C1:1
Petersen, Detlef (Composer)
No More Mr. Nice Guy 1993,O 23,16:1
Petersen, Wolfgang (Director)
In the Line of Fire 1993,Jl 9,C1:3
In the Line of Fire 1993,Jl 11,II:10:4
In the Line of Fire 1993,Ag 29,II:11:5
Petievich, Gerald (Original Author)
Boiling Point 1993,Ap 17,16:1
Petit, Jean-Claude (Composer)
Foreign Student 1994,Jl 29,C10:5
Petit, Patricia (Screenwriter)
Scent of Green Papaya, The 1993,O 11,C15:2
Petitgand, Laurent (Composer)
Faraway, So Close 1993,D 22,C15:1
Petraglia, Sandro (Screenwriter)
Ladro di Bambini, Il 1993,Mr 3,C13:4
Fiorile 1993,O 13,C21:1
Petren, Ann
My Great Big Daddy 1994,Mr 26,14:2

Petrie, Daniel (Director)
Lassie 1994,Jl 22,C1:1
Petrie, Daniel, Jr. (Director)
In the Army Now 1994,Ag 12,C6:4
Petrie, Daniel, Jr. (Miscellaneous)
Beverly Hills Cop III 1994,My 25,C14:3
Petrie, Daniel, Jr. (Screenwriter)
In the Army Now 1994,Ag 12,C6:4
Petrie, Donald (Director)
Grumpy Old Men 1993,D 24,C16:1
Favor, The 1994,Ap 29,C8:5
Richie Rich 1994,D 21,C19:1
Pétron, Christian (Cinematographer)
Atlantis 1993,D 29,C19:5
Petrova, Marya (Miscellaneous)
Get Thee Out 1993,Ja 26,C14:3
Petruzzi, Joe
Dingo 1994,N 11,C19:3
Petryck, Jacek (Cinematographer)
Serbian Epics 1993,My 7,C21:1
Petty, Lori
Free Willy 1993,Jl 16,C12:6
In the Army Now 1994,Ag 12,C6:4
Peyser, Michael (Producer)
Night We Never Met, The 1993,Ap 30,C10:6
Camp Nowhere 1994,Ag 26,C3:2
Pfarrer, Chuck
Hard Target 1993,Ag 20,C8:5
Pfarrer, Chuck (Producer)
Hard Target 1993,Ag 20,C8:5
Pfarrer, Chuck (Screenwriter)
Hard Target 1993,Ag 20,C8:5
Pfeffer, Rachel (Producer)
Malice 1993,O 1,C5:1
Pfeiffer, Carolyn (Producer)
Silent Tongue 1994,F 25,C3:2
Pfeiffer, Michelle
Age of Innocence, The 1993,S 17,C1:3
Age of Innocence, The 1993,N 14,II:13:5
Wolf 1994,Je 17,C4:1
Wolf 1994,Je 19,II:13:1
Phan, Ricky
Bui Doi: Life Like Dust 1994,Mr 29,C17:3
Pheloung, Barrington (Composer)
Nostradamus 1994,N 23,C14:1
Philibert, Nicolas (Director)
In the Land of the Deaf 1994,S 14,C16:1
Philibert, Nicolas (Screenwriter)
In the Land of the Deaf 1994,S 14,C16:1
Philipe, Gérard
Pot Bouille (House of Lovers) 1994,Jl 8,C1:3
Beauty and the Devil 1994,Jl 8,C1:3
Philips, Michael (Miscellaneous)
Bopha! 1993,S 24,C18:1
Phillips, Austin (Director)
Familiar Differences (Young Black Cinema II)
1994,S 9,C17:1
Phillips, Bill (Screenwriter)
Beans of Egypt, Maine, The 1994,N 23,C13:1
Phillips, Brad
Sex Is . . . 1993,S 9,C17:5
Phillips, Lloyd (Producer)
Deception 1993,D 3,C10:1
Phillips, Lou Diamond
Shadow of the Wolf 1993,Mr 5,C19:1
Phoenix, Gemma
Raining Stones 1993,O 2,11:3
Raining Stones 1994,Mr 11,C13:1
Phoenix, Rain
Even Cowgirls Get the Blues 1994,My 20,C10:1
Phoenix, River
Silent Tongue 1994,F 25,C3:2
Piatigorsky, Sacha
Chasing Butterflies (Chasse aux Papillons, La)
1993,O 22,C10:6
Picardo, Robert
Matinee 1993,Ja 29,C6:4
Piccoli, Michel
Divertimento 1993,S 17,C16:6
Pichette, Jean-François
Being at Home with Claude 1993,Ag 6,C8:5
Picker, David V. (Producer)
Saint of Fort Washington, The 1993,N 17,C19:3
Pickett, Cindy
Son-in-Law 1993,Jl 2,C14:6
Pidgeon, Rebecca (Composer)
Oleanna 1994,N 4,C22:4

Pien, Tien
Wedding Banquet, The 1993,Ag 4,C18:1
Pierce, David Hyde
Sleepless in Seattle 1993,Je 25,C10:5
Pierce, Wendell
It Could Happen to You 1994,Jl 29,C10:5
Pierce-Roberts, Tony (Cinematographer)
Dark Half, The 1993,Ap 23,C10:1
Splitting Heirs 1993,My 1,17:1
Remains of the Day, The 1993,N 5,C1:1
Client, The 1994,Jl 20,C11:1
Disclosure 1994,D 9,C1:1
Piersanti, Franco (Composer)
Ladro di Bambini, Il 1993,Mr 3,C13:4
Piesiewicz, Krzysztof (Screenwriter)
Blue 1993,O 12,C15:1
Red 1994,O 4,C15:1
Pigott-Smith, Tim
Remains of the Day, The 1993,N 5,C1:1
Pike, Nicholas (Composer)
Blank Check 1994,F 11,C12:5
Pillars, Jeffrey
Ernest Rides Again 1993,N 12,C10:5
Pillsbury, Suzanne (Miscellaneous)
Rain Without Thunder 1993,F 5,C8:5
Pinchot, Bronson
True Romance 1993,S 10,C5:1
Beverly Hills Cop III 1994,My 25,C14:3
Pincus, Gregory K. (Miscellaneous)
Little Big League 1994,Je 29,C21:1
Pincus, Gregory K. (Screenwriter)
Little Big League 1994,Je 29,C21:1
Pine, Larry
Vanya on 42d Street 1994,O 19,C13:1
Pingatore, Gene
Hoop Dreams 1994,O 7,C1:1
Pinkett, Jada
Menace II Society 1993,My 26,C13:4
Inkwell, The 1994,Ap 22,C8:5
Jason's Lyric 1994,S 28,C14:3
Low Down Dirty Shame, A 1994,N 23,C18:5
Pinkins, Tonya
Above the Rim 1994,Mr 23,C17:1
Pinter, Harold (Screenwriter)
Trial, The 1993,N 24,C16:1
Pinter, Herbert (Miscellaneous)
Sniper 1993,Ja 29,C8:6
Good Man in Africa, A 1994,S 9,C6:1
Pintilie, Lucian (Director)
Oak, The 1993,Ja 22,C8:6
Unforgettable Summer, An 1994,N 11,C12:1
Pintilie, Lucian (Producer)
Unforgettable Summer, An 1994,N 11,C12:1
Pintilie, Lucian (Screenwriter)
Unforgettable Summer, An 1994,N 11,C12:1
Piovani, Nicola (Composer)
Jamón Jamón (Ham Ham) 1993,S 24,C18:4
Fiorile 1993,O 13,C21:1
It's Happening Tomorrow 1994,Ap 1,C12:1
Caro Diario (Dear Diary) 1994,S 26,C11:3
I Don't Want to Talk About It 1994,S 30,C12:1
Pirie, Arian
Night in Versailles, A 1993,Ap 1,C22:1
Piscopo, Joe
Sidekicks 1993,My 1,17:4
Pisier, Marie-France
François Truffaut: Stolen Portraits 1994,Jl 15,C27:1
Piton, Marc (Miscellaneous)
Café au Lait 1994,Ag 19,C1:1
Pitt, Brad
Kalifornia 1993,S 3,C11:1
True Romance 1993,S 10,C5:1
Favor, The 1994,Ap 29,C8:5
Interview with the Vampire 1994,N 11,C1:3
Interview with the Vampire 1994,N 13,II:1:1
Legends of the Fall 1994,D 23,C10:5
Piven, Jeremy
Judgment Night 1993,O 15,C8:5
Car 54, Where Are You? 1994,Ja 31,C16:5
P.C.U. 1994,Ap 29,C6:3
Pizer, Larry (Cinematographer)
In Custody 1994,Ap 15,C6:3
Pizo, Angelo (Screenwriter)
Rudy 1993,O 13,C21:1
Plangger, Verena
Olympic Summer, The 1994,Ag 3,C16:3

Robinson, André
Love Your Mama 1993,Mr 5,C14:5
Robinson, Butch (Producer)
Drop Squad 1994,O 28,C19:1
Robinson, Butch (Screenwriter)
Drop Squad 1994,O 28,C19:1
Robinson, Claudia
Wide Sargasso Sea 1993,Ap 16,C6:5
Robinson, Edward G.
Two Seconds 1994,F 4,C1:1
Robinson, J. Peter (Composer)
Wes Craven's New Nightmare 1994,O 14,C8:5
Robinson, James G. (Producer)
Crush, The 1993,Ap 3,17:1
Ace Ventura, Pet Detective 1994,F 4,C8:6
Major League II 1994,Mr 30,C16:3
Chasers 1994,Ap 23,15:1
Trial by Jury 1994,S 10,14:5
Imaginary Crimes 1994,O 14,C16:1
Silent Fall 1994,O 28,C10:1
Robinson, John
Zero Patience 1994,Mr 26,14:1
Robinson, Larry (Miscellaneous)
Fear of a Black Hat 1994,Je 3,C15:1
Robinson, Peter Manning (Composer)
Beans of Egypt, Maine, The 1994,N 23,C13:1
Robinson, Sally (Screenwriter)
Far-Off Place, A 1993,Mr 12,C15:1
Rochant, Eric (Director)
Patriotes, Les 1994,My 29,II:9:5
Rock, Chris
CB4 1993,Mr 12,C13:1
Rock, Chris (Screenwriter)
CB4 1993,Mr 12,C13:1
Rock, Crissy
Ladybird, Ladybird 1994,O 7,C18:3
Ladybird, Ladybird 1994,D 9,C23:1
Rock, Jay Dee (Screenwriter)
Clifford 1994,Ap 1,C8:5
Rock, Kevin (Screenwriter)
Philadelphia Experiment 2 1993,N 13,18:3
Rockmore, Clara
Theremin: An Electronic Odyssey 1994,O 1,11:4
Roddenberry, Gene (Miscellaneous)
Star Trek Generations 1994,N 18,C3:1
Rodgers, Nile (Composer)
Blue Chips 1994,F 18,C17:3
Beverly Hills Cop III 1994,My 25,C14:3
Rodionov, Aleksei (Cinematographer)
Orlando 1993,Mr 19,C1:5
Rodriguez, Paul
Made in America 1993,My 28,C5:1
Rodriguez, Robert (Cinematographer)
El Mariachi 1993,F 26,C6:5
Rodriguez, Robert (Director)
El Mariachi 1993,F 26,C6:5
El Mariachi 1993,F 28,II:13:5
Rodriguez, Robert (Miscellaneous)
El Mariachi 1993,F 26,C6:5
El Mariachi 1993,F 28,II:13:5
Rodriguez, Robert (Producer)
El Mariachi 1993,F 26,C6:5
Rodriguez, Robert (Screenwriter)
El Mariachi 1993,F 26,C6:5
El Mariachi 1993,F 28,II:13:5
Roebuck, Daniel
Fugitive, The 1993,Ag 6,C1:1
Roehler, Oskar (Screenwriter)
Terror 2000 1994,N 18,C20:5
Roelfs, Jan (Miscellaneous)
Little Women 1994,D 21,C13:1
Rogers, Ginger
That's Entertainment! III 1994,My 6,C17:1
Rogers, Ingrid
Carlito's Way 1993,N 10,C19:4
Rogers, Kelly (Producer)
Jack Be Nimble 1994,Je 10,C21:4
Rogers, Mimi
Monkey Trouble 1994,Mr 18,C8:4
Rohmer, Eric
François Truffaut: Portraits Volés (François Truffaut: Stolen Portraits) 1993,Je 13,II:15:1
François Truffaut: Stolen Portraits 1994,Jl 15,C27:1
Rohmer, Eric (Director)
Tale of Winter, A 1994,F 18,C1:1
Tale of Winter, A 1994,Ap 1,C12:6
Rois, Sophie
No More Mr. Nice Guy 1993,O 23,16:1

Roizman, Owen (Cinematographer)
Wyatt Earp 1994,Je 24,C1:5
Rojo, José Antonio (Miscellaneous)
Pisito, El (Little Apartment, The) 1993,N 26,C14:1
Rolf, Tom (Miscellaneous)
Mr. Jones 1993,O 8,C10:5
Pelican Brief, The 1993,D 17,C1:5
Rolffes, Kirsten
Sofie 1993,My 21,C8:1
Rolle, Esther
House of Cards 1993,Je 25,C18:5
Rollins, Henry
Chase, The 1994,Mr 4,C14:1
Rolston, Mark
Body of Evidence 1993,Ja 15,C3:1
Shawshank Redemption, The 1994,S 23,C3:1
Roma, Thomas
Another Girl, Another Planet 1993,Ap 1,C22:1
Romagnoli, Giovanna (Producer)
Especially on Sunday 1993,Ag 13,C14:5
Roman, Phil (Director)
Tom and Jerry: The Movie 1993,Jl 30,C10:6
Roman, Phil (Producer)
Tom and Jerry: The Movie 1993,Jl 30,C10:6
Romea, Alberto
Radio Stories 1993,N 12,C20:5
Welcome Mr. Marshall 1993,N 19,C18:6
Romero, George A. (Director)
Dark Half, The 1993,Ap 23,C10:1
Romero, George A. (Screenwriter)
Dark Half, The 1993,Ap 23,C10:1
Romero, Ned
Children of the Corn II: The Final Sacrifice 1993,Ja 30,16:4
Ronowicz, Stefan (Miscellaneous)
Serbian Epics 1993,My 7,C21:1
Rooker, Michael
Cliffhanger 1993,My 28,C1:4
Rooney, Mickey
That's Entertainment! III 1994,My 6,C17:1
Roos, Fred (Producer)
Secret Garden, The 1993,Ag 13,C3:1
Radioland Murders 1994,O 21,C5:1
Roose, Ronald (Miscellaneous)
Next Karate Kid, The 1994,S 10,14:5
Ropelewski, Tom (Director)
Look Who's Talking Now 1993,N 5,C12:6
Ropelewski, Tom (Screenwriter)
Look Who's Talking Now 1993,N 5,C12:6
Roper, Don
Execution Protocol, The 1993,Ap 28,C13:1
Roque, Elso (Cinematographer)
Satin Slipper, The 1994,S 14,C16:1
Roques, Jean-Louis (Composer)
Germinal 1994,Mr 11,C1:1
Roques, Jean-Pierre (Miscellaneous)
Scent of Green Papaya, The 1993,O 11,C15:2
Rorem, Ned
Paul Bowles: The Complete Outsider 1994,S 7,C13:4
Rosch, Philip
Relax (Boys' Shorts) 1993,Jl 21,C17:1
Rose, Alexandra (Producer)
Exit to Eden 1994,O 14,C20:4
Rose, Bernard (Director)
Immortal Beloved 1994,D 16,C4:4
Rose, Bernard (Screenwriter)
Immortal Beloved 1994,D 16,C4:4
Roseanne
Even Cowgirls Get the Blues 1994,My 20,C10:1
Rosella, Gualtiero (Screenwriter)
Flight of the Innocent 1993,O 22,C8:5
Rosen, Barry (Producer)
Wagons East! 1994,Ag 26,C16:1
Rosen, Charles (Miscellaneous)
Free Willy 1993,Jl 16,C12:6
My Girl 2 1994,F 11,C22:1
Rosen, Robert L. (Producer)
Sniper 1993,Ja 29,C8:6
Rosenberg, Marc (Producer)
Dingo 1994,N 11,C19:3
Rosenberg, Marc (Screenwriter)
Dingo 1994,N 11,C19:3
Rosenberg, Mark (Producer)
Fearless 1993,O 15,C12:5
Flesh and Bone 1993,N 5,C10:1
Rosenberg, Pauline (Producer)
Resistance 1994,N 23,C18:1

Rosenberg, Philip (Miscellaneous)
Guilty as Sin 1993,Je 4,C8:5
Pelican Brief, The 1993,D 17,C1:5
Rosenbloom, David (Miscellaneous)
Rudy 1993,O 13,C21:1
Blue Chips 1994,F 18,C17:3
Rosenblum, Steven (Miscellaneous)
Jack the Bear 1993,Ap 2,C12:6
Legends of the Fall 1994,D 23,C10:5
Rosenfeld, Keva (Director)
Twenty Bucks 1993,O 22,C8:5
Rosenfelt, Scott (Director)
Family Prayers 1993,Mr 19,C6:5
Rosenstock, Harvey (Miscellaneous)
Dangerous Woman, A 1993,D 3,C19:1
Tombstone 1993,D 24,C6:1
Rosenthal, Cheryl (Cinematographer)
Last Call at Maud's 1993,Mr 19,C6:5
Rosenthal, Henry S. (Producer)
Sure Fire 1994,Ja 12,C13:1
Rosenthal, Jack (Screenwriter)
Wedding Gift, The 1994,Jl 20,C18:1
Rosenthal, Jane (Producer)
Bronx Tale, A 1993,S 29,C13:4
Rosenthal, Mark (Screenwriter)
For Love or Money 1993,O 1,C8:5
Beverly Hillbillies, The 1993,O 15,C20:3
Rosenthal, Rachel
New Age, The 1994,S 16,C5:3
Rosenzweig, Steve (Miscellaneous)
Wedding Banquet, The 1993,Ag 4,C18:1
Amateur 1994,S 29,C16:3
Rose Price, Tim (Screenwriter)
Rapa Nui 1994,S 9,C3:1
Rosnell, John (Cinematographer)
Murder Magic 1994,My 10,C19:1
Ross, Annie
Short Cuts 1993,O 1,C1:1
Ross, Charlotte
Foreign Student 1994,Jl 29,C10:5
Ross, Gary (Screenwriter)
Dave 1993,My 7,C12:1
Lassie 1994,Jl 22,C1:1
Ross, Herbert (Director)
Undercover Blues 1993,S 11,13:1
Ross, Sharyn L. (Miscellaneous)
Benefit of the Doubt 1993,Jl 16,C17:1
Ross, William (Composer)
Look Who's Talking Now 1993,N 5,C12:6
Hans Christian Andersen's "Thumbelina" 1994,Mr 30,C19:1
Cops and Robbersons 1994,Ap 15,C23:1
Little Rascals, The 1994,Ag 5,C21:1
Rossberg, Susanna (Miscellaneous)
Between Heaven and Earth 1993,O 1,C5:1
Rossellini, Isabella
Fearless 1993,O 15,C12:5
Wyatt Earp 1994,Je 24,C1:5
Immortal Beloved 1994,D 16,C4:4
Rossetti, Ann T. (Cinematographer)
Go Fish 1994,Je 10,C6:4
Rossi, Rita (Miscellaneous)
Volere, Volare 1993,F 3,C14:1
Stefano Quantestorie (Stefano Many Stories) 1994,N 23,C18:1
Rossignon, Christophe (Producer)
Scent of Green Papaya, The 1993,O 11,C15:2
Café au Lait 1994,Ag 19,C1:1
Rossio, Terry (Screenwriter)
Puppetmasters, The 1994,O 22,18:1
Rotenberg, Michael (Producer)
Son-in-Law 1993,Jl 2,C14:6
In the Army Now 1994,Ag 12,C6:4
Roth, Ann (Miscellaneous)
Wolf 1994,Je 17,C4:1
Roth, Cecilia
Place in the World, A 1994,Jl 1,C3:1
Roth, Christopher (Miscellaneous)
Leprechaun 1993,Ja 9,17:1
Return of the Living Dead 3 1993,O 29,C8:4
Roth, Donna (Producer)
Benny and Joon 1993,Ap 16,C13:1
Roth, Eric (Miscellaneous)
Mr. Jones 1993,O 8,C10:5
Roth, Eric (Screenwriter)
Mr. Jones 1993,O 8,C10:5
Forrest Gump 1994,Jl 6,C9:3

Roth, Joe (Producer)
Three Musketeers, The 1993,N 12,C10:5
Angels in the Outfield 1994,Jl 15,C10:1
Low Down Dirty Shame, A 1994,N 23,C18:5
Roth, Steve (Producer)
Last Action Hero 1993,Je 18,C1:3
Roth, Tim
Bodies, Rest and Motion 1993,Ap 9,C11:1
Bodies, Rest and Motion 1993,Ap 18,II:11:1
Pulp Fiction 1994,S 23,C1:1
Rothenberg, Nick (Director)
Bui Doi: Life Like Dust 1994,Mr 29,C17:3
Rothkopf, Alvin (Producer)
Murder Magic 1994,My 10,C19:1
Rotman, David (Producer)
Cliffhanger 1993,My 28,C1:4
Rotter, Stephen A. (Miscellaneous)
Rising Sun 1993,Jl 30,C1:4
Cops and Robbersons 1994,Ap 15,C23:1
Rotunno, Giuseppe (Cinematographer)
Wolf 1994,Je 17,C4:1
Rouän, Brigitte
Olivier, Olivier 1993,F 24,C17:5
Rouch, Jean (Cinematographer)
Chantons sous l'Occupation (Singing Through the Occupation) 1994,N 25,C12:1
Roussea, Jenny
Beekeeper, The 1993,My 7,C21:4
Roussel, Myriem
Dark at Noon 1993,Ag 20,C12:5
Rousselot, Philippe (Cinematographer)
Sommersby 1993,F 5,C8:1
Flesh and Bone 1993,N 5,C10:1
Interview with the Vampire 1994,N 11,C1:3
Queen Margot 1994,D 9,C10:1
Rouxel, Jacques (Miscellaneous)
See How They Fall 1994,O 1,12:4
Roversi, Patrizio
Volere, Volare 1993,F 3,C14:1
Rowe, Ashley (Cinematographer)
Widows' Peak 1994,My 13,C16:1
Second Best 1994,S 30,C10:1
Man of No Importance, A 1994,D 22,C11:1
Rowe, Hahn (Composer)
Clean, Shaven 1994,Mr 22,C19:1
Rowell, Kathleen (Screenwriter)
Hear No Evil 1993,Mr 29,C16:1
Rowland, Bruce (Composer)
Lightning Jack 1994,Mr 11,C8:5
Andre 1994,Ag 17,C9:3
Roy, Michel (Producer)
Brainscan 1994,Ap 22,C12:6
Rozenberg, Paul (Producer)
Cold Water 1994,S 28,C13:1
Ruben, Joseph (Director)
Good Son, The 1993,S 24,C12:5
Good Son, The 1993,O 31,II:15:5
Ruben, Joseph (Producer)
Good Son, The 1993,S 24,C12:5
Rubeo, Bruno (Miscellaneous)
Sommersby 1993,F 5,C8:1
Bound by Honor 1993,Ap 30,C8:1
Client, The 1994,Jl 20,C11:1
Rubes, Jan
D2: The Mighty Ducks 1994,Mr 25,C17:1
Rubin, Bruce Joel (Director)
My Life 1993,N 12,C17:1
Rubin, Bruce Joel (Producer)
My Life 1993,N 12,C17:1
Rubin, Bruce Joel (Screenwriter)
My Life 1993,N 12,C17:1
Rubin, Danny (Miscellaneous)
Groundhog Day 1993,F 12,C3:4
Hear No Evil 1993,Mr 29,C16:1
Rubin, Danny (Screenwriter)
Groundhog Day 1993,F 12,C3:4
Rubin, Jennifer
Crush, The 1993,Ap 3,17:1
Coriolis Effect, The 1994,Mr 26,14:5
Rubin, Lance (Composer)
Hexed 1993,Ja 23,16:1
Rubinek, Saul
True Romance 1993,S 10,C5:1
Getting Even with Dad 1994,Je 17,C12:5
Rubinstein, Arthur B. (Composer)
Another Stakeout 1993,Jl 23,C8:5
Rücker, Günther (Original Author)
Olympic Summer, The 1994,Ag 3,C16:3

Rudavsky, Oren (Cinematographer)
Last Klezmer, The 1994,Ag 12,C6:1
Ruddy, Albert S. (Miscellaneous)
Bad Girls 1994,Ap 22,C8:5
Ruddy, Albert S. (Producer)
Scout, The 1994,S 30,C23:1
Rudin, Scott (Producer)
Life with Mikey 1993,Je 4,C8:5
Firm, The 1993,Je 30,C15:3
Searching for Bobby Fischer 1993,Ag 11,C13:3
Addams Family Values 1993,N 19,C3:4
Sister Act 2: Back in the Habit 1993,D 10,C10:4
Nobody's Fool 1994,D 23,C5:1
Rudkin, David (Screenwriter)
December Bride 1994,S 9,C6:5
Rudnick, Paul (Screenwriter)
Addams Family Values 1993,N 19,C3:4
Rudnick, Steve (Screenwriter)
Santa Clause, The 1994,N 11,C24:1
Rudolph, Alan (Director)
Equinox 1993,S 8,C20:3
Mrs. Parker and the Vicious Circle 1994,N 23,C9:3
Rudolph, Alan (Screenwriter)
Equinox 1993,S 8,C20:3
Mrs. Parker and the Vicious Circle 1994,N 23,C9:3
Ruehl, Mercedes
Lost in Yonkers 1993,My 14,C10:5
Last Action Hero 1993,Je 18,C1:3
Ruivivar, Anthony Michael
White Fang 2: Myth of the White Wolf 1994,Ap 15,C23:1
Ruiz, Juan
Only the Brave 1994,Ag 31,C14:3
Ruiz, Raul (Director)
Dark at Noon 1993,Ag 20,C12:5
Ruiz, Raul (Screenwriter)
Dark at Noon 1993,Ag 20,C12:5
Ruiz-Anchia, Juan (Cinematographer)
Far-Off Place, A 1993,Mr 12,C15:1
Mr. Jones 1993,O 8,C10:5
Rudyard Kipling's "The Jungle Book" 1994,D 23,C5:1
Rulli, Stefano (Screenwriter)
Ladro di Bambini, Il 1993,Mr 3,C13:4
Rundgren, Todd
Theremin: An Electronic Odyssey 1994,O 1,11:4
Rundgren, Todd (Composer)
Dumb and Dumber 1994,D 16,C10:5
Runté, Terry (Screenwriter)
Super Mario Brothers 1993,My 29,11:1
RuPaul
Crooklyn 1994,My 13,C5:1
Ruscio, Michael (Miscellaneous)
Equinox 1993,S 8,C20:3
Twenty Bucks 1993,O 22,C8:5
Rush, Maggie
Another Girl, Another Planet 1993,Ap 1,C22:1
Rush, Richard (Director)
Color of Night 1994,Ag 19,C6:1
Russell, Charles (Director)
Mask, The 1994,Jl 29,C1:3
Russell, David O. (Director)
Spanking the Monkey 1994,Ja 31,C17:1
Spanking the Monkey 1994,Jl 15,C5:1
Russell, David O. (Screenwriter)
Spanking the Monkey 1994,Jl 15,C5:1
Russell, Judith (Miscellaneous)
Dingo 1994,N 11,C19:3
Russell, Kurt
Tombstone 1993,D 24,C6:1
Stargate 1994,O 28,C6:5
Russell, Leigh
Romper Stomper 1993,Je 9,C17:1
Russell, Nipsey
Posse 1993,My 14,C15:1
Car 54, Where Are You? 1994,Ja 31,C16:5
Russell, Theresa
Being Human 1994,My 6,C10:3
Russin, Robin U. (Screenwriter)
On Deadly Ground 1994,F 19,11:1
Russo, Gianni
Super Mario Brothers 1993,My 29,11:1
Russo, James
Dangerous Game 1993,N 19,C14:5
Bad Girls 1994,Ap 22,C8:5
Russo, Rene
In the Line of Fire 1993,Jl 9,C1:3
In the Line of Fire 1993,Jl 11,II:10:4

Russo, Richard (Original Author)
Nobody's Fool 1994,D 23,C5:1
Rutowski, Richard (Screenwriter)
Natural Born Killers 1994,Ag 26,C1:1
Ryan, Meg
Sleepless in Seattle 1993,Je 25,C10:5
Sleepless in Seattle 1993,Jl 18,II:10:1
Flesh and Bone 1993,N 5,C10:1
When a Man Loves a Woman 1994,Ap 29,C1:1
I.Q. 1994,D 23,C8:5
Ryan, Mitch
Opposite Sex, The 1993,Mr 27,15:2
Ryan, Paul (Cinematographer)
Where the Rivers Flow North 1994,Mr 4,C15:1
Passion to Kill, A 1994,N 4,C10:5
Ryan, Remy
Robocop 3 1993,N 5,C29:3
Rydell, Christopher
By the Sword 1993,O 22,C15:1
Flesh and Bone 1993,N 5,C10:1
Rydell, Mark (Director)
Intersection 1994,Ja 21,C8:6
Rydell, Mark (Producer)
Intersection 1994,Ja 21,C8:6
Ryder, Winona
Bram Stoker's "Dracula" 1993,Ap 2,C1:4
Age of Innocence, The 1993,S 17,C1:3
Age of Innocence, The 1993,N 14,II:13:5
Reality Bites 1994,Ja 31,C17:1
Reality Bites 1994,F 18,C3:2
House of the Spirits, The 1994,Ap 1,C1:1
Little Women 1994,D 21,C13:1
Rykiel, Sonia
Ready to Wear 1994,D 23,C1:1
Ryninks, Kees (Producer)
Only the Brave 1994,Ag 31,C14:3

S

Saavedra, Kathy (Miscellaneous)
Place in the World, A 1994,Jl 1,C3:1
Saba, Farhad (Cinematographer)
Through the Olive Trees 1994,S 24,16:3
Sabath, Barry (Producer)
Ghost in the Machine 1993,D 30,C11:5
Sabella, Ernie
Lion King, The 1994,Je 15,C11:1
Sabri, Hend
Silences of the Palace, The 1994,S 30,C30:3
Sachs, William (Producer)
Leprechaun 1993,Ja 9,17:1
Sackler, Howard (Screenwriter)
Fear and Desire 1994,Ja 14,C6:3
Sacristan, José
Place in the World, A 1994,Jl 1,C3:1
Sadler, Nicholas
Disclosure 1994,D 9,C1:1
Sadler, William
Freaked 1993,O 2,14:3
Shawshank Redemption, The 1994,S 23,C3:1
Sáenz de Heredia, José Luis (Director)
Radio Stories 1993,N 12,C20:5
Sáenz de Heredia, José Luis (Screenwriter)
Radio Stories 1993,N 12,C20:5
Safonova, Elena
Accompanist, The 1993,D 23,C7:1
Sagalle, Jonathan
Schindler's List 1993,D 15,C19:3
Sagoskin, Alexandre (Miscellaneous)
Ivan and Abraham 1994,Mr 23,C17:1
Sainderichin, Sylvaine (Producer)
Map of the Human Heart 1993,Ap 23,C21:3
Saint, Assoto
No Regret 1993,Je 25,C15:1
St. John, Nicholas (Screenwriter)
Dangerous Game 1993,N 19,C14:5
Body Snatchers 1994,F 4,C6:5
Sainz de Rozas, Maria Elena (Miscellaneous)
Cows (Vacas) 1993,Mr 30,C19:1
Sakamoto, Ryuichi (Composer)
Tokyo Decadence 1993,Jl 30,C12:6
Little Buddha 1994,My 25,C13:1
Sakash, Evelyn (Miscellaneous)
Made in America 1993,My 28,C5:1

Sakasitz, Amy
Home of Our Own, A 1993,N 5,C29:3
Sakharov, Alik (Cinematographer)
Midnight Edition 1994,Ap 1,C18:5
Saks, Gene
Nobody's Fool 1994,D 23,C5:1
I.Q. 1994,D 23,C8:5
Salcedo, José (Miscellaneous)
Kika 1994,My 6,C8:1
Salen, Jesper
Slingshot, The 1994,Je 3,C19:1
Sales, Soupy
. . . And God Spoke 1994,S 23,C10:5
Salinger, Matt
Babyfever 1994,My 4,C16:6
Sallid, Otis (Miscellaneous)
Swing Kids 1993,Mr 5,C8:5
Salomon, Mikael (Director)
Far-Off Place, A 1993,Mr 12,C15:1
Salt, Waldo (Screenwriter)
Midnight Cowboy 1994,F 20,II:11:5
Saltzman, Mark (Screenwriter)
3 Ninjas Kick Back 1994,My 7,18:5
Salvi, Osavaldo
Volere, Volare 1993,F 3,C14:1
Salzmann, Laurence (Cinematographer)
Shvitz, The (New York in Short) 1993,O 22,C13:1
Samples, Chris
King of the Hill 1993,Ag 20,C1:1
Samuels, Stuart (Director)
Visions of Light: The Art of Cinematography
1993,Ap 2,C10:5
Samuels, Stuart (Producer)
Visions of Light: The Art of Cinematography
1993,Ap 2,C10:5
Samuelson, Marc (Producer)
Tom and Viv 1994,D 2,C3:1
Samuelson, Peter (Producer)
Tom and Viv 1994,D 2,C3:1
San, Lu Man
Scent of Green Papaya, The 1993,O 11,C15:2
Scent of Green Papaya, The 1994,Ja 28,C15:1
Sanchez-Short, Elba (Miscellaneous)
White Fang 2: Myth of the White Wolf 1994,Ap
15,C23:1
Sand, Elisabeth
Herman 1993,My 13,C20:3
Sanda, Dominique
Conformist, The 1994,S 16,C10:1
Sandell, William (Miscellaneous)
Hocus Pocus 1993,Jl 16,C16:1
Flintstones, The 1994,My 27,C1:1
Sander, Otto
Faraway So Close 1993,My 21,C1:1
Faraway, So Close 1993,D 22,C15:1
Sander, Otto (Narrator)
Olympic Summer, The 1994,Ag 3,C16:3
Sanderford, John
Leprechaun 1993,Ja 9,17:1
Sanders, Chris (Miscellaneous)
Lion King, The 1994,Je 15,C11:1
Sanders, Julio C. (Composer)
Tango Player, The 1993,N 3,C23:1
Sanders, Richard
Beans of Egypt, Maine, The 1994,N 23,C13:1
Sanders, Ronald (Miscellaneous)
M. Butterfly 1993,O 1,C3:4
Sanders, Tom (Miscellaneous)
Maverick 1994,My 20,C1:3
Sandgren, Ake (Director)
Slingshot, The 1994,Je 3,C19:1
Sandgren, Ake (Screenwriter)
Slingshot, The 1994,Je 3,C19:1
Sandler, Adam
Coneheads 1993,Jl 23,C3:2
Airheads 1994,Ag 5,C10:1
Mixed Nuts 1994,D 21,C18:4
Sandler, Kathe (Director)
Question of Color, A 1993,Je 25,C15:1
Sandler, Kathe (Producer)
Question of Color, A 1993,Je 25,C15:1
Sandler, Kathe (Screenwriter)
Question of Color, A 1993,Je 25,C15:1
Sandoval, Jimmy (Miscellaneous)
Wide Sargasso Sea 1993,Ap 16,C6:5
Sandoval, Miguel
Clear and Present Danger 1994,Ag 3,C11:1

Sandrelli, Amanda
Stefano Quantestorie (Stefano Many Stories) 1994,N
23,C18:1
Sandrelli, Stefania
Jamón Jamón (Ham Ham) 1993,S 24,C18:4
Conformist, The 1994,S 16,C10:1
Sands, Julian
Boxing Helena 1993,S 3,C1:3
Warlock 1993,S 25,19:5
Browning Version, The 1994,O 12,C17:2
Sandstorm, R. O. C. (Miscellaneous)
Army of Darkness 1993,F 19,C10:5
Sane, Joseph
Guelwaar 1993,Jl 28,C18:1
Sanford, Kate (Miscellaneous)
Federal Hill 1994,D 9,C6:1
Sangaré, Bakary
Samba Traoré 1993,S 10,C3:1
Mazeppa 1993,D 3,C10:4
Santo, Joselito (Amen) (Miscellaneous)
Only the Strong 1993,Ag 27,C8:4
Santos, Lucelia
Under One Roof 1994,Mr 25,C18:1
Sanz, Jorge
Belle Epoque 1994,F 25,C10:1
Sanz De Alba, Cecile
Valley of Abraham (Vale Abraão) 1993,O 5,C13:5
Valley of Abraham 1993,D 23,C9:1
Saperstein, Henry J. (Miscellaneous)
Godzilla, King of the Monsters 1993,Mr 14,II:13:5
Sara, Mia
By the Sword 1993,O 22,C15:1
Timecop 1994,S 16,C1:3
Saraf, Peter (Producer)
One Foot on a Banana Peel, the Other Foot in the
Grave 1994,My 13,C28:4
Sarafian, Deran (Director)
Gunmen 1994,F 4,C8:6
Terminal Velocity 1994,S 23,C20:5
Sarandon, Chris
Tim Burton's The Nightmare Before Christmas
1993,O 9,13:1
Sarandon, Susan
Lorenzo's Oil 1993,Ja 3,II:9:1
Lorenzo's Oil 1993,Ja 22,C1:1
Lorenzo's Oil 1993,Ap 25,II:17:5
Client, The 1994,Jl 20,C11:1
Little Women 1994,D 21,C13:1
Sarchielli, Massimo
Volere, Volare 1993,F 3,C14:1
Sarde, Alain (Producer)
L.627 1994,Jl 15,C14:1
Wild Reeds 1994,O 7,C18:3
Sarde, Philippe (Composer)
L.627 1994,Jl 15,C14:1
Sarde, Philippe (Miscellaneous)
Coeur en Hiver, Un (Heart in Winter, A) 1993,Je
4,C3:1
Sardo, Lucia
Aclà 1993,D 3,C12:6
Sardo, Mira
When I Close My Eyes 1994,Ap 2,17:1
Sarelle, Leilani
Harvest, The 1993,N 5,C30:4
Sarner, Arlene (Screenwriter)
Blue Sky 1994,S 16,C8:1
Saroj, Santosh (Screenwriter)
God Is My Witness 1993,Ag 20,C8:5
Sarossy, Paul (Cinematographer)
Masala 1993,Mr 26,C10:1
Exotica 1994,S 24,11:1
Sartain, Gailard
Real McCoy, The 1993,S 10,C10:6
Getting Even with Dad 1994,Je 17,C12:5
Sas, Tamas (Cinematographer)
Child Murders 1994,Ap 2,17:4
Sasakihara, Yasushi (Cinematographer)
Original Sin 1993,Mr 26,C6:1
Satia, Divya
Ruby in Paradise 1993,O 6,C15:1
Sato, Yoshiharu (Miscellaneous)
My Neighbor Totoro 1993,My 14,C14:1
Saunders, Marcia
Beyond Imagining: Margaret Anderson and The
Little Review 1994,D 7,C15:4
Saunders, Scott (Cinematographer)
Lost Words, The 1994,S 21,C18:1

Saunders, Scott (Director)
Lost Words, The 1994,S 21,C18:1
Saunders, Scott (Miscellaneous)
Lost Words, The 1994,S 21,C18:1
Saunders, Scott (Producer)
Lost Words, The 1994,S 21,C18:1
Saunders, Scott (Screenwriter)
Lost Words, The 1994,S 21,C18:1
Saura, Carlos (Director)
Llanto por un Bandido (Lament for a Bandit) 1994,O
21,C8:5
Prima Angelica, La (Cousin Angelica) 1994,O
21,C8:5
Sautet, Claude (Director)
Coeur en Hiver, Un (Heart in Winter, A) 1993,Je
4,C3:1
Saverni, Domenico (Screenwriter)
Ciao, Professore! 1994,Jl 15,C10:5
Savitt, Jill (Miscellaneous)
Blank Check 1994,F 11,C12:5
China Moon 1994,Mr 4,C6:5
Dream Lover 1994,My 6,C11:1
Savoca, Nancy (Director)
Household Saints 1993,S 15,C15:2
Savoca, Nancy (Screenwriter)
Household Saints 1993,S 15,C15:2
Sawyer, Stephanie
River Wild, The 1994,S 30,C8:1
Saxon, Edward (Producer)
Philadelphia 1993,D 22,C15:3
Saxon, John
Beverly Hills Cop III 1994,My 25,C14:3
Wes Craven's New Nightmare 1994,O 14,C8:5
Sayles, John
Matinee 1993,Ja 29,C6:4
My Life's in Turnaround 1994,Je 17,C5:5
Sayles, John (Director)
Passion Fish 1993,Ja 24,II:11:1
Sayles, John (Screenwriter)
Passion Fish 1993,Ja 24,II:11:1
Scacchi, Greta
Browning Version, The 1994,O 12,C17:2
Scalia, Pietro (Miscellaneous)
Little Buddha 1994,My 25,C13:1
Scalici, Valentina
Ladro di Bambini, Il 1993,Mr 3,C13:4
Scardapane, Dario (Screenwriter)
Posse 1993,My 14,C15:1
Scardino, Don (Director)
Me and Veronica 1993,S 24,C25:1
Scardino, Hal
Searching for Bobby Fischer 1993,Ag 11,C13:3
Scarfiotti, Ferdinando (Miscellaneous)
Love Affair 1994,O 21,C3:1
Scarpa, Leonardo (Miscellaneous)
It's Happening Tomorrow 1994,Ap 1,C12:1
Scarpa, Renato
Volere, Volare 1993,F 3,C14:1
Schaeffer, Eric
My Life's in Turnaround 1994,Je 17,C5:5
Schaeffer, Eric (Director)
My Life's in Turnaround 1994,Je 17,C5:5
Schaeffer, Eric (Screenwriter)
My Life's in Turnaround 1994,Je 17,C5:5
Schaffel, Robert (Producer)
Pontiac Moon 1994,N 11,C18:3
Schakmundes, Eva
Mazeppa 1993,D 3,C10:4
Schallert, William
Matinee 1993,Ja 29,C6:4
Schaloske, Yvonne
My Great Big Daddy 1994,Mr 26,14:2
Schamus, James (Producer)
Wedding Banquet, The 1993,Ag 4,C18:1
Schamus, James (Screenwriter)
Wedding Banquet, The 1993,Ag 4,C18:1
Eat Drink Man Woman 1994,Ag 3,C16:3
Schanzara, Tana
Dead Flowers 1993,Ap 30,C8:5
Scharf, Daniel (Producer)
Romper Stomper 1993,Je 9,C17:1
Scharf, William S. (Miscellaneous)
Rising Sun 1993,Jl 30,C1:4
Cops and Robbersons 1994,Ap 15,C23:1
Schecter, Alan (Producer)
Double Dragon 1994,N 4,C19:1
Scheider, Roy
Romeo Is Bleeding 1994,F 4,C15:1

Simpson, Claire (Miscellaneous)
Black Beauty 1994,Jl 29,C29:1
Simpson, Geoffrey (Cinematographer)
Last Days of Chez Nous, The 1993,F 26,C6:5
Mr. Wonderful 1993,O 15,C16:5
War, The 1994,N 4,C10:5
Little Women 1994,D 21,C13:1
Simpson, John
Troubles We've Seen, The 1994,O 6,C17:1
Simpson, O. J.
Naked Gun 33 1/3: The Final Insult 1994,Mr 18,C14:6
Sin Won Sop
Why Has Bodhi-Dharma Left for the East? 1993,S 25,13:1
Sinclair, Madge
Lion King, The 1994,Je 15,C11:1
Sinclair, Stephen (Miscellaneous)
Dead Alive 1993,F 12,C16:6
Sinclair, Stephen (Screenwriter)
Dead Alive 1993,F 12,C16:6
Singer, Joey Hope
Falling Down 1993,F 26,C3:1
Singer, Lori
Equinox 1993,S 8,C20:3
Short Cuts 1993,O 1,C1:1
Singer, Randi Mayem (Screenwriter)
Mrs. Doubtfire 1993,N 24,C11:1
Singleton, John
Beverly Hills Cop III 1994,My 25,C14:3
Singleton, John (Director)
Poetic Justice 1993,Jl 23,C1:1
Singleton, John (Producer)
Poetic Justice 1993,Jl 23,C1:1
Singleton, John (Screenwriter)
Poetic Justice 1993,Jl 23,C1:1
Sinise, Gary
Jack the Bear 1993,Ap 2,C12:6
Forrest Gump 1994,Jl 6,C9:3
Sintzel, Rene (Producer)
Wendemi 1993,O 9,16:5
Sintzel, Rene (Screenwriter)
Wendemi 1993,O 9,16:5
Sinyor, Gary (Director)
Leon the Pig Farmer 1993,S 10,C8:1
Sinyor, Gary (Producer)
Leon the Pig Farmer 1993,S 10,C8:1
Sinyor, Gary (Screenwriter)
Leon the Pig Farmer 1993,S 10,C8:1
Sinze, Mathurin
Sirga 1994,Mr 25,C10:5
Siqin Gaowa
Women from the Lake of Scented Souls 1994,F 16,C20:1
Sirtis, Marina
Star Trek Generations 1994,N 18,C3:1
Sissel, Sandi (Cinematographer)
Camp Nowhere 1994,Ag 26,C3:2
Siu, Stephen (Producer)
Sex and Zen 1993,O 29,C10:6
Sizemore, Tom
Watch It 1993,Mr 26,C12:1
Heart and Souls 1993,Ag 13,C14:5
Striking Distance 1993,S 17,C17:1
Natural Born Killers 1994,Ag 26,C1:1
Skarsgard, Stellan
Good Evening, Mr. Wallenberg 1993,Ap 23,C12:6
Slingshot, The 1994,Je 3,C19:1
Skerritt, Tom
Knight Moves 1993,Ja 23,16:3
Skinner, Claire
Naked 1993,O 15,C3:3
Naked 1993,D 16,C20:3
Skinner, William (Miscellaneous)
On Deadly Ground 1994,F 19,11:1
Skye, Ione
Guncrazy 1993,Ja 27,C17:2
Slade, Max Elliott
3 Ninjas Kick Back 1994,My 7,18:5
Slak, Franci (Director)
When I Close My Eyes 1994,Ap 2,17:1
Slak, Franci (Producer)
When I Close My Eyes 1994,Ap 2,17:1
Slak, Franci (Screenwriter)
When I Close My Eyes 1994,Ap 2,17:1
Slater, Christian
Untamed Heart 1993,F 12,C14:6
True Romance 1993,S 10,C5:1

True Romance 1993,S 19,II:15:1
Jimmy Hollywood 1994,Mr 30,C15:3
Interview with the Vampire 1994,N 11,C1:3
Slater, Helen
Lassie 1994,Jl 22,C1:1
Sleibi, Maher
Night, The 1993,O 4,C15:3
Slesin, Aviva (Director)
Ten-Year Lunch, The 1993,Ja 8,C1:1
Slettland, Bjarne (Miscellaneous)
Coriolis Effect, The 1994,Mr 26,14:5
Sloan, Brian (Director)
Pool Days 1994,Mr 26,14:1
Pool Days (Boys Life) 1994,D 2,C16:5
Sloan, Brian (Miscellaneous)
Pool Days (Boys Life) 1994,D 2,C16:5
Sloan, Brian (Producer)
Pool Days 1994,Mr 26,14:1
Pool Days (Boys Life) 1994,D 2,C16:5
Sloan, Brian (Screenwriter)
Pool Days 1994,Mr 26,14:1
Pool Days (Boys Life) 1994,D 2,C16:5
Sloan, Holly Goldberg (Miscellaneous)
Made in America 1993,My 28,C5:1
Sloan, Holly Goldberg (Screenwriter)
Made in America 1993,My 28,C5:1
Angels in the Outfield 1994,Jl 15,C10:1
Slodki, Naomi (Miscellaneous)
Leprechaun 1993,Ja 9,17:1
Slonimsky, Nicolas
Theremin: An Electronic Odyssey 1994,O 1,11:4
Sluizer, George (Director)
Vanishing, The 1993,F 5,C3:4
Utz 1993,F 10,C15:5
Vanishing, The 1993,F 14,II:13:1
Small, Adam (Screenwriter)
Son-in-Law 1993,Jl 2,C14:6
In the Army Now 1994,Ag 12,C6:4
Small, Michael (Composer)
Wagons East! 1994,Ag 26,C16:1
Smink, Feark
For a Lost Soldier 1993,My 7,C14:1
Smit, Maarten
For a Lost Soldier 1993,My 7,C14:1
Smith, Alexis
Age of Innocence, The 1993,S 17,C1:3
Smith, Anna Deavere
Dave 1993,My 7,C12:1
Philadelphia 1993,D 22,C15:3
Smith, Anna Nicole
Naked Gun 33 1/3: The Final Insult 1994,Mr 18,C14:6
Smith, Bobby, Jr. (Screenwriter)
Jason's Lyric 1994,S 28,C14:3
Smith, Britta
In the Name of the Father 1993,D 29,C11:3
Smith, Brooke
Vanya on 42d Street 1994,O 19,C13:1
Smith, Daniel
Heimat II: Chronicle of a Generation 1993,Je 17,C11:3
Smith, Dwight (Director)
Samson and Delilah (Young Black Cinema II) 1994,S 9,C17:1
Smith, Ebbe Roe
Falling Down 1993,F 26,C3:1
Smith, Ebbe Roe (Screenwriter)
Falling Down 1993,F 26,C3:1
Falling Down 1993,Mr 7,II:13:5
Car 54, Where Are You? 1994,Ja 31,C16:5
Smith, Howard (Miscellaneous)
Saint of Fort Washington, The 1993,N 17,C19:3
Smith, Irby (Producer)
Angels in the Outfield 1994,Jl 15,C10:1
Smith, John N. (Director)
Boys of St. Vincent, The 1994,Je 1,C11:1
Smith, John N. (Screenwriter)
Boys of St. Vincent, The 1994,Je 1,C11:1
Smith, Joshua (Screenwriter)
Space Is the Place 1993,S 3,C9:1
Smith, Kevin
Clerks 1994,Mr 25,C10:1
Desperate Remedies 1994,My 23,C14:4
Smith, Kevin (Director)
Clerks 1994,Ja 28,C5:1
Clerks 1994,Mr 25,C10:1
Clerks 1994,O 19,C17:1

Smith, Kevin (Miscellaneous)
Clerks 1994,Mr 25,C10:1
Smith, Kevin (Producer)
Clerks 1994,Mr 25,C10:1
Smith, Kevin (Screenwriter)
Clerks 1994,Ja 28,C5:1
Clerks 1994,Mr 25,C10:1
Smith, Kurtwood
Crush, The 1993,Ap 3,17:1
Boxing Helena 1993,S 3,C1:3
Fortress 1993,S 4,11:1
Smith, Lane
Son-in-Law 1993,Jl 2,C14:6
Smith, Lois
Falling Down 1993,F 26,C3:1
Smith, Maggie
Secret Garden, The 1993,Ag 13,C3:1
Sister Act 2: Back in the Habit 1993,D 10,C10:4
Smith, Mel (Director)
Radioland Murders 1994,O 21,C5:1
Smith, Nicholas C. (Miscellaneous)
P.C.U. 1994,Ap 29,C6:3
Smith, Roger Guenveur
Poetic Justice 1993,Jl 23,C1:1
Smith, Roy Forge (Miscellaneous)
Teen-Age Mutant Ninja Turtles III 1993,Mr 20,15:1
Robin Hood: Men in Tights 1993,Jl 28,C13:1
Smith, Rusty (Miscellaneous)
Camp Nowhere 1994,Ag 26,C3:2
Smith, Scott (Miscellaneous)
Sniper 1993,Ja 29,C8:6
Crow, The 1994,My 11,C15:4
Smith, T. Ryder
Brainscan 1994,Ap 22,C12:6
Smith, Will
Made in America 1993,My 28,C5:1
Six Degrees of Separation 1993,D 8,C17:1
Smith-Cameron, J.
That Night 1993,Ag 6,C8:1
Smoot, Reed (Cinematographer)
Homeward Bound: The Incredible Journey 1993,F 3,C15:1
Smuts-Kennedy, Sarah
Jack Be Nimble 1994,Je 10,C21:4
Snegoff, Mark (Miscellaneous)
Red Light, Green Light 1994,Jl 8,C8:5
Snestack, Jonathan (Producer)
Last Seduction, The 1994,O 26,C13:1
Snipes, Wesley
Boiling Point 1993,Ap 17,16:1
Rising Sun 1993,Jl 30,C1:4
Demolition Man 1993,O 8,C23:1
Demolition Man 1993,O 24,II:11:1
Sugar Hill 1994,F 25,C10:6
Drop Zone 1994,D 9,C12:1
Snodgress, Carrie
Ballad of Little Jo, The 1993,Ag 20,C10:1
8 Seconds 1994,F 25,C14:1
Blue Sky 1994,S 16,C8:1
Snyder, Blake (Screenwriter)
Blank Check 1994,F 11,C12:5
Snyder, David L. (Miscellaneous)
Super Mario Brothers 1993,My 29,11:1
Demolition Man 1993,O 8,C23:1
Terminal Velocity 1994,S 23,C20:5
Sobocinski, Piotr (Cinematographer)
Red 1994,O 4,C15:1
Sodann, Peter
Tango Player, The 1993,N 3,C23:1
Soderbergh, Steven (Director)
King of the Hill 1993,My 21,C1:1
King of the Hill 1993,Ag 20,C1:1
Soderbergh, Steven (Miscellaneous)
King of the Hill 1993,Ag 20,C1:1
Soderbergh, Steven (Screenwriter)
King of the Hill 1993,Ag 20,C1:1
Softley, Iain (Director)
Backbeat 1994,Ap 15,C15:1
Softley, Iain (Screenwriter)
Backbeat 1994,Ap 15,C15:1
Sokurov, Aleksandr (Director)
Whispering Pages 1994,S 28,C14:3
Sokurov, Aleksandr (Screenwriter)
Whispering Pages 1994,S 28,C14:3
Solaya, Marilyn
Strawberry and Chocolate 1994,S 24,16:3
Solinger, Michael (Miscellaneous)
Claire of the Moon 1993,Ap 16,C11:1

T

501

U

V

Vaananen, Kari
 Vie de Bohème, La 1993,Jl 29,C15:4
Vacano, Jost (Cinematographer)
 Untamed Heart 1993,F 12,C14:6
Vaccaro, Brenda
 Midnight Cowboy 1994,F 20,II:11:5
Vachon, Christine (Producer)
 Dottie Gets Spanked (Avant-Garde Visions) 1993,O 5,C18:3
Vadepied, Mathieu (Cinematographer)
 Samba Traoré 1993,S 10,C3:1
Vahabzadeh, Youssef (Producer)
 Pontiac Moon 1994,N 11,C18:3
Vai, Steve (Composer)
 P.C.U. 1994,Ap 29,C6:3
Valandrey, Charlotte
 Orlando 1993,Mr 19,C1:5
Valdes, David (Producer)
 Perfect World, A 1993,N 24,C11:1
Valenti, Grace (Miscellaneous)
 Inevitable Grace 1994,S 30,C8:5
Valentin, Barbara
 Martha 1994,S 24,16:3
Valentini, Mariella
 Volere, Volare 1993,F 3,C14:1
Valio, Michel (Miscellaneous)
 Chantons sous l'Occupation (Singing Through the Occupation) 1994,N 25,C12:1
Valk, Kate
 Dead Flowers 1993,Ap 30,C8:5
Valli, Alida
 Eyes Without a Face 1994,Jl 8,C1:3
Vallone, John (Miscellaneous)
 Cliffhanger 1993,My 28,C1:4
Valoy, Cuco (Composer)
 Normal People Are Nothing Special 1994,Mr 18,C1:1
Valsecchi, Pietro (Producer)
 Conviction, The 1994,My 13,C10:5
Vamos, Thomas (Cinematographer)
 Being at Home with Claude 1993,Ag 6,C8:5
Van Allen, John, Jr. (Composer)
 Love Your Mama 1993,Mr 5,C14:5
Vanaveski, Ene (Producer)
 Cement Garden, The 1994,F 11,C24:1
Vance, Courtney B.
 Adventures of Huck Finn, The 1993,Ap 2,C15:1
Van Damme, Jean-Claude
 Nowhere to Run 1993,Ja 16,16:5
 Last Action Hero 1993,Je 18,C1:3
 Hard Target 1993,Ag 20,C8:5
 Timecop 1994,S 16,C1:3
 Street Fighter 1994,D 24,11:1
Vandenburg, Gerard (Cinematographer)
 Utz 1993,F 10,C15:5
Van Den Driessche, Frédéric
 Tale of Winter, A 1994,Ap 1,C12:6
van der Post, Laurens (Original Author)
 Far-Off Place, A 1993,Mr 12,C15:1
Van De Sande, Theo (Cinematographer)
 Exit to Eden 1994,O 14,C20:4
Vandross, Luther
 Meteor Man, The 1993,Ag 7,9:3
Vane, Richard (Producer)
 Dennis the Menace 1993,Je 25,C12:6
 Baby's Day Out 1994,Jl 1,C3:1
Vangelis (Composer)
 Bitter Moon 1994,Mr 18,C8:1
Van Haaften, Julia
 Berenice Abbott: A View of the 20th Century 1994,D 7,C15:4
van Heijningen, Matthijs (Producer)
 For a Lost Soldier 1993,My 7,C14:1
Van Lear, Phillip
 Thieves Quartet 1994,Je 24,C10:5
Van Oostrum, Kees (Cinematographer)
 Gettysburg 1993,O 8,C16:1
Van Peebles, Mario
 Posse 1993,My 14,C15:1
 Gunmen 1994,F 4,C8:6
Van Peebles, Mario (Director)
 Posse 1993,My 14,C15:1

Van Peebles, Melvin
 Posse 1993,My 14,C15:1
Van Sant, Gus (Director)
 Even Cowgirls Get the Blues 1994,My 20,C10:1
Van Sant, Gus (Miscellaneous)
 Even Cowgirls Get the Blues 1994,My 20,C10:1
Van Sant, Gus (Screenwriter)
 Even Cowgirls Get the Blues 1994,My 20,C10:1
van Vogelpoel, Peter (Producer)
 Curfew 1994,D 7,C17:1
Van Voorst, Suzanne (Producer)
 Forbidden Quest 1994,Ja 5,C15:5
van Warmerdam, Alex
 Northerners, The 1993,N 6,13:1
van Warmerdam, Alex (Director)
 Northerners, The 1993,N 6,13:1
van Warmerdam, Alex (Screenwriter)
 Northerners, The 1993,N 6,13:1
van Warmerdam, Vincent (Composer)
 Northerners, The 1993,N 6,13:1
van Werveke, Thierry
 Dead Flowers 1993,Ap 30,C8:5
Van Wijk, Joke (Miscellaneous)
 Interview with the Vampire 1994,N 11,C1:3
Varda, Agnès (Director)
 Jacquot 1993,Je 20,II:19:5
 Jacquot 1993,Je 25,C21:1
Vargas, Antonio
 Strictly Ballroom 1993,F 12,C12:6
Vargas, Jacob
 Mi Vida Loca My Crazy Life 1994,Jl 15,C5:1
Varney, Jim
 Wilder Napalm 1993,Ag 20,C14:1
 Beverly Hillbillies, The 1993,O 15,C20:3
 Ernest Rides Again 1993,N 12,C10:5
Vartan, Michael
 Fiorile 1993,O 13,C21:1
 Fiorile 1994,F 2,C20:1
Vasconcelos, Nana (Composer)
 Tigrero: A Film That Was Never Made 1994,D 21,C18:3
Vasile, Vivi Dragan (Cinematographer)
 Conjugal Bed, The 1994,Jl 15,C18:1
Vasilescu, Razvan
 Oak, The 1993,Ja 22,C8:6
 Betrayal 1994,Mr 19,18:1
Vassdal, Kjell (Cinematographer)
 Herman 1993,My 13,C20:3
Vauchon, Christine (Producer)
 Postcards from America 1994,O 8,14:1
Vaughan, Peter
 Remains of the Day, The 1993,N 5,C1:1
Vawter, Ron
 Philadelphia 1993,D 22,C15:3
Váz, Dina
 Blue Eyes of Yonta, The 1993,Mr 20,16:5
Veber, Francis (Screenwriter)
 My Father, the Hero 1994,F 4,C10:6
Veevers, Graham (Cinematographer)
 You, Me and Marley 1993,Mr 20,16:1
Vega, Vladimir
 Ladybird, Ladybird 1994,O 7,C18:3
 Ladybird, Ladybird 1994,D 9,C23:1
Veitch, John (Producer)
 Mary Shelley's Frankenstein 1994,N 4,C1:2
Velez, Desiree Marie
 Super Mario Brothers 1993,My 29,11:1
Vélez, Lauren
 I Like It Like That 1994,My 29,II:9:5
 I Like It Like That 1994,O 14,C23:1
Veloz, David (Screenwriter)
 Natural Born Killers 1994,Ag 26,C1:1
Venegas, Mauricio
 Ladybird, Ladybird 1994,O 7,C18:3
Veneziano, Sandy (Miscellaneous)
 Fatal Instinct 1993,O 29,C8:1
Venosta, Louis (Director)
 Coriolis Effect, The 1994,Mr 26,14:5
Venosta, Louis (Screenwriter)
 Coriolis Effect, The 1994,Mr 26,14:5
Ventura, Valerio (Miscellaneous)
 Pagemaster, The 1994,N 23,C18:1
Venturino, Luciano
 Aclà 1993,D 3,C12:6
Verdú, Maribel
 Belle Epoque 1994,F 25,C10:1
Vereen, Ben
 Once Upon a Forest 1993,Je 18,C10:1

Verheiden, Mark (Miscellaneous)
 Mask, The 1994,Jl 29,C1:3
 Timecop 1994,S 16,C1:3
Verheiden, Mark (Screenwriter)
 Timecop 1994,S 16,C1:3
Verhoeven, Christian
 Passages 1993,Mr 23,C14:3
Verhoeven, Yves
 See How They Fall 1994,O 1,12:4
Verlaine, Tom (Composer)
 Love and a .45 1994,N 23,C14:4
Verley, Bernard
 Hélas pour Moi 1994,Mr 18,C15:1
Versace, Gianni (Miscellaneous)
 Kika 1994,My 6,C8:1
Verschueren, August (Miscellaneous)
 For a Lost Soldier 1993,My 7,C14:1
Véry, Charlotte
 Blue 1993,O 12,C15:1
 Tale of Winter, A 1994,Ap 1,C12:6
Viard, Hélène (Miscellaneous)
 Queen Margot 1994,D 9,C10:1
Vidal, Christina
 Life with Mikey 1993,Je 4,C8:5
Vidal, Gore
 With Honors 1994,Ap 29,C12:1
Vidal, Lisa
 I Like It Like That 1994,O 14,C23:1
Vidler, Susan
 Naked 1993,O 15,C3:3
Vig, Mihaly
 Satantango 1994,O 8,11:2
Vigne, Daniel (Original Author)
 Sommersby 1993,F 5,C8:1
Vigoda, Abe
 Batman: Mask of the Phantasm 1993,D 28,C21:1
 Sugar Hill 1994,F 25,C10:6
Villaggio, Paolo
 Ciao, Professore! 1994,Jl 15,C10:5
Villalobos, Reynaldo (Cinematographer)
 Bronx Tale, A 1993,S 29,C13:4
 P.C.U. 1994,Ap 29,C6:3
Villemaire, James
 Matinee 1993,Ja 29,C6:4
Vince, Pruitt Taylor
 Nobody's Fool 1994,D 23,C5:1
Vindevogel, Denise (Director)
 Mizike Mama 1993,S 15,C26:2
Viner, Michael (Producer)
 Morning Glory 1993,S 17,C12:6
Vinovich, Steve
 Swan Princess, The 1994,N 18,C20:5
Virkler, Dennis (Miscellaneous)
 Fugitive, The 1993,Ag 6,C1:1
Visconti, Luchino
 Bellissima 1994,Je 24,C27:1
Viscuso, Donna (Composer)
 Sex Is . . . 1993,S 9,C17:5
Vitale, Ruth (Producer)
 Corrina, Corrina 1994,Ag 12,C3:2
Vitar, Mike
 Sandlot, The 1993,Ap 7,C17:1
Vitarelli, Joseph (Composer)
 Last Seduction, The 1994,O 26,C13:1
Viterelli, Joe
 Bullets over Broadway 1994,S 30,C1:1
Vithana, Kim
 Bhaji on the Beach 1994,Mr 19,13:1
 Bhaji on the Beach 1994,My 18,C20:2
Vitier, José María (Composer)
 Strawberry and Chocolate 1994,S 24,16:3
Vlacos, Alex (Cinematographer)
 Ruby in Paradise 1993,O 6,C15:1
Vladic, Racoslav (Cinematographer)
 Tito and Me 1993,Mr 23,C13:4
Voight, Jon
 Midnight Cowboy 1994,F 20,II:11:5
Vojnov, Dimitrie
 Tito and Me 1993,Mr 23,C13:4
 Tito and Me 1993,Ag 18,C18:5
Voletti, Michel
 Tale of Winter, A 1994,Ap 1,C12:6
Volkers, Juana
 Passages 1993,Mr 23,C14:3
Volonté, Gian-Maria
 Red Circle, The 1993,S 22,C13:1
Volpi, Grazia (Producer)
 Fiorile 1993,O 13,C21:1

X

Y

G

H

I

K

L

M

N

O

P

Q

R

S

T

U

V

W

Y

Z